er tree			
		0 0	DEWCO 38-596
			30.0£ 30,
			50.
			2
			30:00 AL.
	R		10-5290
		0	
		ř,	JEFFER.
			30.17 OV
		-	86. 8 T 30
			5
			06.7
		OFT- 9A	Of a MAI
		W TYPH	86. E N
	_	200	(1213 U
		50, 4 0 M	16.63 XW
		50.61 YE	6.0330
	a a	10.8	2
	DNE	BTAQ	-

ART HISTORY

ART HISTORY Marilyn bestad

with the collaboration of Marion Spears Grayson and with chapters by Stephen Addiss, Bradford R. Collins, Chu-tsing Li, Marylin M. Rhie, and Christopher D. Roy

Riverside, California 92506

Harry M. Abrams, Inc., Publishers

Riverside Community College

Library

Library

4800 Magnolia Avenue

N 5300 .S923 1995

Stokstad, Marilyn, 1929-

) MY SISTER, KAREN L.S. LEIDER, AND MY NIECE, ANNA J. LEIDER

Art history

d editorial direction: Julia Moore

an Smith

Initial project management: Sheila Franklin Lieber

Developmental editing: Ellyn Childs Allison, David Chodoff, Sabra Maya Feldman, Mark Getlein,

James Leggio, Julia Moore, Diana Murphy, Jean Smith, Elaine Banks Stainton

Art direction: Samuel N. Antupit, Lydia Gershey

Design and production: Lydia Gershey, Yonah Schurink of Communigraph

Photo editing, rights and reproduction: Lauren Boucher, Jennifer Bright, Helen Lee, Catherine Ruello

Maps and timelines: York Production Services

Illustration: John McKenna

Copy editing: Richard G. Gallin, Joanne Greenspun

Project editing: Kate Norment, Denise Quirk

Indexing: Peter and Erica Rooney

Glossary: Rebecca Tucker

Project assistance: Monica Mehta

Library of Congress Cataloging-in-Publication Data

Stokstad, Marilyn, 1929-

Art history / Marilyn Stokstad, with the collaboration of Marion Spears Grayson; and with contributions by Stephen Addiss . . . [et al.].

p. cm.

Includes bibliographical references and index.

 $ISBN\ 0-8109-1960-5\ (Abrams\ hardcover).\ --ISBN\ 0-13-357542-X\ (Prentice\ Hall\ hardcover).$

ISBN 0-13-357500-4 (paperback, vol. 1). —ISBN 0-13-357527-6 (paperback, vol. 2).

1. Art—History. I. Grayson, Marion Spears. II. Addiss, Stephen, 1935– . III. Title

N5300.S923 1995

709—dc20

95-13402

CIP

Copyright © 1995 Harry N. Abrams, Inc.
Published in 1995 by Harry N. Abrams, Incorporated, New York
A Times Mirror Company

All rights reserved. No part of the contents of this book may be reproduced in any form for any purpose without the written permission of the publisher.

Printed and bound in Japan

Pages 2-3: Vincent van Gogh. Sunflowers. 1888. Oil on canvas. The National Gallery, London (detail of fig. 26)

On the chapter-opening pages: 34-35, Stonehenge (detail of fig. 1-21); 60-61, gold crown from Kalhu (detail of fig. 2-25); 90-91, Great Pyramids, Giza (detail of fig. 3-10); Landscape, Thera (detail of fig. 4-18); 150-151, Marshalls and Young Women, from the Parthenon (detail of fig. 5-48); 220-221, The Unswept Floor, mosaic (detail of fig. 6-70); 286-287, Anastasis, fresco, Istanbul (detail of fig. 7-52); 336-337, muqarnas dome, the Alhambra (detail of fig. 8-12); 364-365, Cave Temple of Shiva, Elephanta (detail of fig. 9-29); 394-395, Admonitions of the Imperial Instructress (detail of fig., 10-10); 420-421, Scene from The Tale of Genji (detail of fig. 11-13); 442-443, Maya vessel (detail of fig. 12-12); 464-465, The Herders' Village, wall painting, Algeria (detail of fig. 13-1); 478-479, Purse cover, from Sutton Hoo burial ship (detail of fig. 14-7); 506-507, Dream of Henry I, Worcester Chronicle (detail of fig. 15-28); 544-545, Shrine of the Three Kings (detail of fig. 16-56) 610-611, Laurana, Courtyard of the Ducal Palace, Urbino (detail of fig. 17-59); 678-679, Brueghel the Elder, Carrying of the Cross (detail of fig. 18-57); 748-749, Peeters, Still Life with Flowers, Goblet, Dried Fruit, and Pretzels (detail of fig. 19-44); 820-821, page from Hamza-nama, a Mughal manuscript from North India (detail of fig. 20-5); 834–835, Shitao, Landscape, from a Qing dynasty album (detail of fig. 21-12); 852–853, contemporary Japanese ceramic vessels (detail of fig. 22-16); 872-873, Machu Picchu, Peru (detail of fig. 23-7); 892-893, feather cloak, from Hawaii (detail of fig. 24-11); 908-909, Ashanti kente cloth, from Ghana (detail of fig. 25-11); 926-927, Turner, The Fighting "Téméraire" (detail of fig. 26-28); Renoir. Moulin de la Galette (detail of fig. 27-47); Robert Delaunay, Homage to Blériot (detail of fig. 28-46); Paik, Electronic Superhighway (detail of illustration page 1156)

Brief Contents

13	Credits	[] xəpul	18	Bibliography	19	Clossary
9011				World War II		
,		Furope since	pue sətet	S bətinU əht ni tıA	67	CHAPTER
0701				etst betinU edt		
0001		urope and		The Rise of Moder	87	CHAPTER
926				etst betinU edt		
J _ 0		า Europe and		Realism to Impress	77	CHAPTER
976	sətate bət	in∪ eht bns eqorua ni meio			97	CHAPTER
806				Art of Africa in the	72	CHAPTER
768				Art of Pacific Cult	74	CHAPTER
<i>7</i> ∠8		00	.s वर्ति १३	Art of the America	23	CHAPTER
758			1392	Japanese Art after	77	CHAPTER
<i>788</i>			087	Chinese Art after 1	17	CHAPTER
850			100	Art of India after 1	70	CHAPTER
8tZ		hAmerican Art	and Early	Baroque, Rococo,	61	CHAPTER
829		n-Century Europe	Sixteentl	Renaissance Art in	18	CHAPTER
019		cobe	u∃ ni ħA	Early Renaissance	4 1	CHAPTER
609		s9gA 9lbbiM ns9€	the Europ	to weive Review of		
<i>tt9</i>				Dothic Art	91	CHAPTER
909				Romanesque Art	12	CHAPTER
8 <i>\t</i>		Ә	donu∃ ni :	Early Medieval Ar	τl	CHAPTER
<i>†9†</i>			ся	iniA tnaionA to tnA	13	CHAPTER
777		1300	s before	Art of the America	15	CHAPTER
074			26£1 9	Japanese Art befor	11	CHAPTER
<i>768</i>			1280	Chinese Art before	01	CHAPTER
<i>₹98</i>			1100	Art of India before	6	CHAPTER
988				1slamic Art	8	CHAPTER
987				Early Christian, Je	7	CHAPTER
750		1		Etruscan Art and R	9	CHAPTER
091			929	Art of Ancient Gre		CHAPTER
971				hA nsəgəA	abla	CHAPTER
06			1q	Art of Ancient Egy	5	CHAPTER
09			_	Art of the Ancient		CHAPTER
<i>78</i>		ort in Europe	A siroteid	Prehistory and Pre	l	CHAPTER
67						Starter Kit
91					uo	itoducti
51					S	Use Note
7					stnemgbe	Acknowle
9						Preface

Preface

I have been privileged to teach art history for nearly four decades. Over that time I have become persuaded that our purpose in the introductory course should not be to groom scholars-to-be but rather to nurture an educated, enthusiastic public for the arts. I have also come to believe that we are not well-enough served by the major introductory text-books presently available, all of which originated two or more generations ago. What is needed is a new text for a new generation of teachers and students, a text that balances formalist traditions with the newer interests of contextual art history and also meets the needs of a diverse and fast-changing student population. In support of that philosophy I offer *Art History*.

I firmly believe students should *enjoy* their art history survey. Only then will they learn to appreciate art as the most tangible creation of the human imagination. To this end we have sought in many ways to make *Art History* a sensitive, accessible, engaging textbook.

We have made *Art History* contextual, in the best sense of the term. Throughout the text we treat the visual arts not in a vacuum but within the essential contexts of history, geography, politics, religion, and culture; and we carefully define the parameters—social, religious, political, and cultural—that either constrained or liberated individual artists.

Art History is both comprehensive and inclusive. Our goal has been to reach beyond the West to include a critical examination of the arts of other regions and cultures, presenting a global view of art through the centuries. We cover not only the world's most significant paintings and works of sculpture and architecture but also drawings, photographs, works in metal and ceramics, textiles, and jewelry. We have paid due respect to the canon of great monuments of the history of art, but we also have treated artists and artworks not previously acknowledged. We have drawn throughout on the best and most recent scholarship, including new discoveries (the prehistoric cave paintings in the Ardèche gorge in southern France, for example) and new interpretations of well-known works. And, bearing in mind the needs of undergraduate readers, we have sought wherever feasible to discuss works on view in many different museums and collections around the United States, including college and university museums.

No effort has been spared to make this book a joy to read and use—in fact, to make it a work of art in itself. Chapter introductions set the scene for the material to come, frequently making use of contemporary references to which readers can easily relate. While the text carries the central narrative of *Art History*, set-off boxes present interesting and instructive material that enriches the text. A number of thought-provoking boxes focus on such critical issues as "the myth of 'primitive' art" and the way the titles given to works of art may affect our perception of them. Other boxes provide insights into contextual influences, such as women as art patrons, the lives of major religious leaders, and significant literary movements. **Elements of Architecture** boxes explicate basic architectural forms and terminology.

Technique boxes explore how artworks have been made, from prehistoric cave paintings to Renaissance frescoes to how photography works. Maps and timelines visually place artworks in time and space, and time scales on each page let readers know where they are within the period each chapter covers. A Parallels feature in every chapter presents comparative information in tabular form that puts the major events and artworks discussed in that chapter in a global context. Finally, Art History includes an unprecedented illustration program of some 1,350 photographs—more than half in full color and some not published before—as well as hundreds of original line drawings (including architectural plans and cutaways) that have been created specifically for this book.

In addition, a complete ancillary package, including slide sets, CD-ROM, videodisc, videos, a student Study Guide, and an Instructor's Resource Manual with Test Bank, accompanies *Art History*.

Art History represents the joint effort of a distinguished team of scholars and educators. Single authorship of a work such as this is no longer a viable proposition: our world has become too complex, the research on and interpretation of art too sophisticated, for that to work. An individual view of art may be very persuasive—even elegant—but it remains personal; we no longer look for a single "truth," nor do we hold to a canon of artworks to the extent we once did. An effort such as this requires a team of scholar-teachers, all with independent views and the capability of treating the art they write about in its own terms and its own cultural context. The overarching viewpoint—the controlling imagination—is mine, but the book would not have been complete without the work of the following distinguished contributing authors:

Stephen Addiss, Tucker Boatwright Professor in the Humanities at the University of Richmond, Virginia

Bradford R. Collins, Associate Professor in the Art Department, University of South Carolina, Columbia

Chu-tsing Li, Professor Emeritus at the University of Kansas, Lawrence

Marylin M. Rhie, Jessie Wells Post Professor of Art and Professor of East Asian Studies at Smith College

Christopher D. Roy, Professor of Art History at the University of Iowa in Iowa City

Finally, the book would not have been possible without the substantial efforts of Marion Spears Grayson, an independent scholar with a Ph.D. from Columbia University who previously taught at Tufts University and Rice University. Her refinements and original contributions greatly enhanced the overall presentation. The book has also benefited greatly from the invaluable assistance and advice of scores of other scholars and teachers who have generously answered my questions, given their recommendations on organization and priorities, and provided specialized critiques.

Acknowledgments

Wilkins, University of Pittsburgh. York City; Randall White, New York University; and David Mark Weil, Washington University, St. Louis, Alison West, New Chapel Hill; Roger Ward, The Nelson-Atkins Museum of Art; Eleanor Tufts; Dorothy Verkerk, University of North Carolina, ception Abbey); Janis Tomlinson, Columbia University; the late Columbia; Thomas Sullivan, OSB, Benedictine College (Conmunity College; Anne R. Stanton, University of Missouri, chusetts; Tom Shaw, Kean College; Jan Sheridan, Erie Com-University of Chicago; Nancy Sevcenko, Cambridge, Massa-New Paltz; Diane G. Scillia, Kent State University; Linda Seidel, ty; Patricia Sands, Pratt Institute; Thomas Sarrantonio, SUNY H. Rubin, SUNY Stony Brook; John Russell, Columbia Universi-Kansas; Wendy W. Roworth, University of Rhode Island; James M. Roberts, Univer-sity of Iowa; Stanley T. Rolfe, University of sity; Howard Risatti, Virginia Commonwealth University; Ann Ramage, Ithaca College; Ida K. Rigby, San Diego State Univer-Michigan; Elizabeth Pilliod, Oregon State University; Nancy H. east Missouri State University; John G. Pedley, University of phis; Lawrence Nees, University of Delaware; Sara Orel, North-Ohio State University; William J. Murnane, University of Mem-Montet-White, University of Kansas; Anne E. Morganstern, gan; Vernon Minor, University of Colorado, Boulder; Anta University of Minnesota; Victor H. Miesel, University of Michi-

and Ann S. Zielinski, SUNY Plattsburgh. nesota; Elizabeth Valdez del Alamo, Montclair State College; University of Kansas; Michael Stoughton, University of Minof Akron; Lauren Soth, Carleton College; Linda Stone-Ferrier, Caryle K. Smith, University of Akron; Walter Smith, University Baruch College, CUNY; James Seaver, University of Kansas; Virginia Raguin, College of the Holy Cross; Pamela Sheingorn, Newcomb Memorial College; John Pultz, University of Kansas; man, The Cleveland Museum of Art; Michael Plante, H. Sophie University; Amy McNair, University of Kansas; Sara Jane Pear-Francisco State University; Bob Martin, Haskel Indian Nations of Art; Karen Mack, University of Kansas; Richard Mann, San University of Kansas; Charles Little, The Metropolitan Museum Robert Hoffmann, The Smithsonian Institution; Luke Jordan, Jane Hayward, The Cloisters, The Metropolitan Museum of Art; Kansas; Paula Gerson; Dorothy Glass, SUNY Buffalo; the late ern Reserve University; Stephen Goddard, University of D. Garrard, American University; Walter S. Gibson, Case West-House, Rochester; Ann Friedman, J. Paul Getty Museum; Mary Eldredge, University of Kansas; James Enyeart, Eastman ty of Kansas; Lois Drewer, Index of Christian Art; Charles Nancy Corwin, University of Kansas; Patricia Darish, Universi-Charles Cuttler; University of Iowa; Ralph T. Coe, Santa Fe; ern Methodist University; Susan Craig, University of Kansas; College, CUNY; Jaqueline Clipsham; Alessandra Comini, South-Robert G. Calkins, Cornell University; William W. Clark, Queens Elizabeth Gibson Broun, National Museum of America Art; and criticism—include: Janet Rebold Benton, Pace University; read chapters or sections of chapters, and offered suggestions interpretation—who have shared ideas and course syllabi, Others who have tried to keep me from errors of fact and

A Final Word

As each of us develops a genuine appreciation of the arts, we come to see them as the ultimate expression of human faith and integrity as well as creativity. I have tried here to capture that creativity, courage, and vision in such a way as to engage and enrich even those encountering art history for the very first time. If I have done that, I will feel richly rewarded.

Marilyn Stokstad, Spring 1995

my everlasting gratitude. Giele, Richard Watters, and Michael Willis, have truly earned My research assistants at the University of Kansas, Katherine tributed many helpful insights as the book neared completion. and layout. Alison Pendergast, marketing manager, conpane proken new ground with their clear and inviting design icas. Designer Lydia Gershey and associate Yonah Schurink chapters on the art of Pacific cultures and the art of the Amertory of craft, and to Jill Leslie Furst for her assistance on the to Nancy Corwin, who was an essential resource on the histers on Western art since the Renaissance. Special thanks also African art; and to Gerald Lombardi for his work on the chapextraordinary care in developing the chapters on Asian and work during the crucial early stages; to Mark Getlein for his Lieber, and Steve Rigolosi for their careful developmental Special thanks are due to Ellyn Childs Allison, Sheila Franklin final manuscript to make it clear and accessible to students. Chodoff at Prentice Hall and Jean Smith at Abrams refined the gestation. A team of developmental editors led by David Phil Miller were unfailingly supportive throughout its complex Bud Therien convinced me to undertake the project, and with their talents to the volume you now hold. Paul Gottlieb and photo editors, designers, and illustrators who contributed orchestrated, and guided the team of editors, researchers, Julia Moore, we never would have pulled it off. She inspired, be. Were it not for the editorial and organizational expertise of lenging undertaking than any of us originally thought it would Writing and producing this book has been a far more chal-

Peggy McDowell, University of New Orleans; Sheila McNally, Museum of Art; Virginia Marquardt, University of Virginia; Wayne State University; Michelle Marcus, The Metropolitan Alexander MacGillivray, Columbia University; Janice Mann, State University; Lisa F. Lynes, North Idaho College; Joseph Johnson County Community College; Franklin Ludden, Ohio College; Jeffrey Lang, University of Kansas; William A. Lozano, John F. Kenfield, Rutgers University; Ruth Kolarik, Colorado State University; Nina Kasanof, Sage Junior College of Albany; Paul E. Ivey, University of Arizona; Carol S. Ivory, Washington monwealth University; Mary Tavener Holmes, New York City; University of Southern California; Sharon Hill, Virginia Comversity of California, Irvine; Robert Grigg; Glenn Harcourt, Mark Fullerton, Ohio State University; Anna Gonosova, University of Utah; Joanna Frueh, University of Nevada, Reno; University; Craig Felton, Smith College; Mary F. Francey, Uni-Macon College; James D. Farmer, Virginia Commonwealth Eknoian, DeAnza State College; Mary S. Ellett, Randolph-Miami; Ross Edman, University of Illinois, Chicago; Gerald DePuma, University of Iowa; Brian Dursam, University of ter B. Denny, University of Massachusetts, Amherst; Richard Illinois University; Susan J. Delaney, Mira Costa College; Walginia Commonwealth University; Pamela Decoteau, Southern Lorelei H. Corcoran, University of Memphis; Ann G. Crowe, Virof Art; Frances Colpitt, University of Texas, San Antonio; ty of Texas, Austin; Robert Cohon, The Nelson-Atkins Museum Doesschate Chu, Seton Hall University; John Clarke, Universi-Buksbaum, Capital Community Technical College; Petra tenof Memphis; Daniel Breslauer, University of Kansas; Ronald Roberta Bernstein, SUNY Albany; Edward Bleiberg, University lege; Janet Catherine Berlo, University of Missouri, St. Louis; University; Joseph P. Becherer, Grand Rapids Community Col-Elizabeth Atherton, El Camino College; Ulku Bates, Columbia Polytechnic; Vicki Artimovich, Bellevue Community College; Barbara Abou-El-Haj, SUNY Binghamton; Jane Aiken, Virginia Every chapter has been read by one or more specialists:

Contents

Preface 6	Acknowledgments 7	Use N	otes 15 Introduction 16 Starter	Kit 29
CHAPTER 1	Prehistory and Prehisto Art in Europe 34	ric	THE MIDDLE KINGDOM 108 Architecture and Town Planning Tomb Art and Tomb Construction	108 109
THE PALEOLITH	IIC PERIOD 37		Scuplture Sciption Sci	111
	ginning of Architecture	38	Small Objects Found in Tombs	112
Small S		38		
Cave Ar		41	THE NEW KINGDOM 114 Great Temple Complexes	114
Portable	e Art	47	Akhenaten and the Art of the	114
THE NEOLITHIC	C PERIOD 47		Amarna Period	119
	nelter Art	48	The Sarcophagus of Tutankhamun	122
Archited		50	Tomb Decoration	122
Sculptur	re and Ceramics	55	Books of the Dead	124
THE BRONZE A	GE 58		Technique Boxes:	
Tankainus Baus			Egyptian Painting and Relief Sculpture	110
Technique Boxe	s: ric Wall Painting	42	Glassmaking and Egyptian Faience	112
	and Ceramics	57	Elements of Architecture:	
		37	Column and Colonnade	101
Elements of Arci		5 2	Mastaba to Pyramid	103
Doimen	and Passage Grave	53		
CHAPTER 2	Art of the Ancient Near East 60		CHAPTER 4 Aegean Art 126	
THE FEBTUS OF			THE AEGEAN WORLD 128	
THE FERTILE CR			THE CYCLADIC ISLANDS IN THE BRONZE AGE	129
SUMER 65			CRETE AND THE MINOAN CIVILIZATION 131	
AKKAD <i>73</i>			The Palace Complex at Knossos	133
			Sculpture	134
LAGASH 74			Metalwork	136
BABYLON AND	MARI 76		Ceramics Well Pointing	139
ASSYRIA 78			Wall Painting	139
NEO-BABYLON			MAINLAND GREECE AND THE MYCENAEAN CIVILIZATION 142	
ANATOLIA 8.	3		Architecture	143
ELAM 84			Sculpture	148
PERSIA 85			Metalwork	148
Technique Boxe	s:		Ceramics	149
Cone Mo		68	Technique Box:	
	Metalworking	88	Aegean Metalwork	137
Coining	Money	89		
CHAPTER 3	Art of Ancient Egypt 9	90	CHAPTER 5 Art of Ancient Greece	150
NEOLITHIC AN	D PREDYNASTIC EGYPT 93		THE EMERGENCE OF GREEK CIVILIZATION 153	}
EARLY DYNAST	IC EGYPT 94		Athens and the Concept of	
	is Beliefs	95	Democratic Rule	155
The Pale	ette of Narmer	96	Religious Beliefs and Sacred Places	155
Represe	ntation of the Human Figure	97	Historical Divisions of Greek Art	158
THE OLD KING	DOM 99		THE GEOMETRIC PERIOD 158	
	y Architecture	99	Ceramic Decoration	159
Sculptur		104	Metal Sculpture	160
Iomn D	ecoration	106	The First Greek Temples	160

OLC	Ceramic and Textile Arts	997	gnitnis9 llsW
348	Calligraphy	522	Portrait Sculpture
178	Architecture	522	Plebeian Relief Sculpture
	ART DURING THE EARLY CALIPHATES 340	253	The Arch of Titus
	ISLAM AND EARLY ISLAMIC SOCIETY 339	727	Architecture Architecture
			THE EARLY EMPIRE: THE JULIO-CLAUDIAN AND FLAVIAN DYNASTIES 252
	CHAPTER 8 Islamic Art 336		THE EARLY EMPIRE: THE ILLIO CLALIDIAN
		6 <i>t</i> 7	Wall Painting
018	Pendentives and Squinches	572	Augustan Sculpture
867	Basilica-Plan and Central-Plan Churches	543	Republican Sculpture
	Elements of Architecture:	177	Architecture in the Provinces
333	Byzantine Metalworking	238	City Life and Domestic Architecture
223	Technique Box:	532	Architecture in Roman Italy
			THE BECINNING OF THE EMPIRE 235
332	Painted Icons		ART OF THE REPUBLICAN PERIOD AND
333	Manuscripts		BOWAN CIVILIZATION 233
330	Ivories and Metalwork		VICE NOITVETIINIS NVVIOL
373	LATER BYZANTINE ART 323 Architecture and Its Decoration	187	Bronze Work
	I VIED BYZANITINE APT 323	677	SdmoT
60€	The Church and Its Decoration	572	Temples and Their Decoration
	EARLY BYZANTINE ART 308	573	The Etruscan City
302	Sculpture		ETRUSCAN CIVILIZATION 223
<i>267</i>	Architecture and Its Decoration		
	IMPERIAL CHRISTIAN ARCHITECTURE AND ART		Roman Art 220
CC7	codo ma ning		CHAPTER 6 Etruscan Art and
967 167	Painting and Sculpture Dura-Europos		
100	JEWISH ART AND EARLY CHRISTIAN ART 291		
		591	The Greek Architectural Orders
687	Early Christianity	t91	Greek Temple Plans
687	Early Judaism	VJL	Elements of Architecture:
687	JEWS AND CHRISTIANS IN THE ROMAN EMPIRE		
	Byzantine Art 286	791	Creek Painted Vases
gug			Technique Box:
pue	CHAPTER 7 Early Christian, Jewish,		
	CHAPTER 7 Early Christian, Jewish,	117	Sculpture
987	Roman Construction CHAPTER 7 Early Christian, Jewish,	117 017	The Corinthian Order in Architecture Sculpture
987 277	Roman Architectural Orders Roman Construction CHAPTER 7 Early Christian, Jewish,	117	Sculpture
987	Arch, Vault, and Dome Roman Architectural Orders Roman Construction CHAPTER 7 Early Christian, Jewish,	117 017 607	THE HELLENISTIC PERIOD 209 Theaters The Corinthian Order in Architecture Sculpture
987 277 977	Elements of Architecture: Arch, Vault, and Dome Roman Architectural Orders Roman Construction CHAPTER 7 Early Christian, Jewish,	807 807	The Art of the Goldsmith THE HELLENISTIC PERIOD 209 Theaters The Corinthian Order in Architecture Sculpture
987 277	Roman Mosaics Elements of Architecture: Arch, Vault, and Dome Roman Architectural Orders Roman Construction CHAPTER 7 Early Christian, Jewish,	807 807 507	Wall Painting and Mosaics The Art of the Goldsmith THE HELLENISTIC PERIOD 209 Theaters The Corinthian Order in Architecture Sculpture
987 277 977	Elements of Architecture: Arch, Vault, and Dome Roman Architectural Orders Roman Construction CHAPTER 7 Early Christian, Jewish,	117 607 807 203 107	Sculpture Wall Painting and Mosaics The Art of the Goldsmith THE HELLENISTIC PERIOD 209 Theaters The Corinthian Order in Architecture Sculpture
987 277 977	Roman Mosaics Elements of Architecture: Arch, Vault, and Dome Roman Architectural Orders Roman Construction CHAPTER 7 Early Christian, Jewish,	807 807 507	Architecture and Architectural Sculpture Sculpture Wall Painting and Mosaics The Art of the Goldsmith The Att of the Goldsmith The Att of the Goldsmith The Att of the Goldsmith Sculpture Sculpture
987 277 977	Technique Box: Roman Mosaics Elements of Architecture: Arch, Vault, and Dome Roman Architectural Orders Roman Construction CHAPTER 7 Early Christian, Jewish,	117 607 807 203 107	CLASSICAL ART OF THE FOURTH CENTURY 197 Architecture and Architectural Sculpture Sculpture Wall Painting and Mosaics The Art of the Coldsmith Sculpture
987 277 977	THE LATE EMPIRE: ROMAN TRADITIONALISM IN ART AFTER CONSTANTINE 284 Technique Box: Roman Mosaics Arch, Vault, and Dome Roman Architecture: Roman Architectures Roman Construction Roman Construction	117 017 607 807 507 107 861	Vase Painting CLASSICAL ART OF THE FOURTH CENTURY 197 Architecture and Architectural Sculpture Sculpture Wall Painting and Mosaics The Art of the Coldsmith The Art of the Coldsmith The Art of the Coldsmith The Art of the Coldsmith Sculpture
987 272 977 747	Portrait Sculpture THE LATE EMPIRE: ROMAN TRADITIONALISM IN ART AFTER CONSTANTINE 284 Technique Box: Roman Mosaics Arch, Vault, and Dome Roman Architectural Orders Roman Construction Roman Construction Roman Construction	117 017 607 807 507 107 861	Stela Sculpture Vase Painting CLASSICAL ART OF THE FOURTH CENTURY 197 Architecture and Architectural Sculpture Sculpture Wall Painting and Mosaics The Art of the Goldsmith The Art of the Goldsmith The Art of the Coldsmith The Art of the Coldsmith Sculpture
987 272 272 272 883 883	The Arch of Constantine Portrait Sculpture IN ART AFTER CONSTANTINE 284 Technique Box: Roman Mosaics Arch, Vault, and Dome Roman Architectural Orders Roman Construction Roman Construction Roman Construction Roman Construction Roman Construction	117 017 607 807 507 107 861 261 561	Sculpture and The Canon of Polykleitos Stela Sculpture Vase Painting CLASSICAL ART OF THE FOURTH CENTURY 197 Architecture and Architectural Sculpture Sculpture Wall Painting and Mosaics The Art of the Goldsmith The Art of the Goldsmith The Art of the Coldsmith The Art of the Coldsmith Sculpture
987 272 977 747	Portrait Sculpture THE LATE EMPIRE: ROMAN TRADITIONALISM IN ART AFTER CONSTANTINE 284 Technique Box: Roman Mosaics Arch, Vault, and Dome Roman Architectural Orders Roman Construction Roman Construction Roman Construction	117 017 607 807 507 107 861 261 561 561	The Acropolis Sculpture and The Canon of Polykleitos Stela Sculpture Vase Painting Architecture and Architectural Sculpture Sculpture Wall Painting and Mosaics The Art of the Coldsmith
987 272 272 272 883 883	Architecture The Arch of Constantine Portrait Sculpture IN ART AFTER CONSTANTINE 284 Technique Box: Roman Mosaics Arch, Vault, and Dome Roman Architectural Orders Roman Construction Roman Construction Roman Architectural Orders Roman Architectural Orders Roman Construction	117 017 607 807 507 107 861 261 561	The Athens Agors The Acropolis Sculpture and The Canon of Polykleitos Stels Sculpture Vase Painting Architecture and Architectural Sculpture Sculpture Wall Painting and Mosaics The Art of the Goldsmith The Art of the Coldsmith The Art of the Coldsmith Sculpture The Art of the Coldsmith The Art of the Coldsmith The Art of the Goldsmith
987 272 272 272 272 883 883 185	THE LATE EMPIRE: CONSTANTINE Architecture The Arch of Constantine The LATE EMPIRE: ROMAN TRADITIONALISM IN ART AFTER CONSTANTINE Roman Mosaics Roman Architecture: Roman Architecture: Arch, Vault, and Dome Roman Architecture: Roman Construction Roman Construction Roman Construction	117 017 607 807 507 107 861 261 561 561	The Acropolis Sculpture and The Canon of Polykleitos Stela Sculpture Vase Painting Architecture and Architectural Sculpture Sculpture Wall Painting and Mosaics The Art of the Coldsmith
987 277 977 727 887 887 187	Painting THE LATE EMPIRE: CONSTANTINE THE CREAT AND HIS LEGACY 280 Architecture The Arch of Constantine Portrait Sculpture IN ART AFTER CONSTANTINE 284 Roman Mosaics Roman Architecture: Arch, Vault, and Dome Roman Architecture: Roman Construction Roman Construction Roman Construction	117 017 607 807 507 107 861 261 561 561 581	The Athens Agors The Acropolis Sculpture and The Canon of Polykleitos Stels Sculpture Vase Painting Architecture and Architectural Sculpture Sculpture Wall Painting and Mosaics The Art of the Goldsmith The Art of the Coldsmith The Art of the Coldsmith Sculpture The Art of the Coldsmith The Art of the Coldsmith The Art of the Goldsmith
987 277 977 747 887 887 187 847 847	THE LATE EMPIRE: CONSTANTINE Architecture The Arch of Constantine The LATE EMPIRE: ROMAN TRADITIONALISM IN ART AFTER CONSTANTINE Roman Mosaics Roman Architecture: Roman Architecture: Arch, Vault, and Dome Roman Architecture: Roman Construction Roman Construction Roman Construction	117 017 607 807 507 107 861 261 561 561	Freestanding Sculpture Vase Painting THE HICH CLASSICAL PERIOD 184 The Athens Agora The Acropolis Sculpture and The Canon of Polykleitos Stela Sculpture Vase Painting Architecture and Architectural Sculpture Sculpture Wall Painting and Mosaics Wall Painting and Mosaics The Art of the Goldsmith The Act of the Goldsmith The Act of the Coldsmith The Act of the Coldsmith Sculpture Sculpture Sculpture
987 277 977 727 887 887 187	Sarcophagus Reliefs Painting THE LATE EMPIRE: CONSTANTINE Architecture Architecture The Arch of Constantine Portrait Sculpture IN ART AFTER CONSTANTINE 284 Roman Mosaics Roman Architecture: Roman Architecture: Arch, Vault, and Dome Arch, Vault, and Dome Roman Construction Roman Construction Roman Construction Roman Construction Roman Architecture: Roman Architec	117 017 607 807 507 107 861 261 561 581	Architectural Sculpture Freestanding Sculpture Vase Painting THE HICH CLASSICAL PERIOD 184 The Athens Agora Sculpture and The Canon of Polykleitos Stela Sculpture Stela Sculpture Architecture and Architectural Sculpture Sculpture Mall Painting and Mosaics Sculpture Sculpture Sculpture The Art of the Goldsmith The Art of the Goldsmith The Art of the Coldsmith The Art of the Coldsmith Sculpture Sculpture Sculpture Sculpture The Art of the Coldsmith The Art of the Goldsmith
987 277 727 727 887 887 187 827 927	Portrait Sculpture Sarcophagus Reliefs Painting THE LATE EMPIRE: CONSTANTINE THE LATE EMPIRE: ROMAN TRADITIONALISM IN ART AFTER CONSTANTINE Roman Mosaics Roman Architecture Roman Architecture: Roman Architecture: Roman Architecture: Roman Construction Roman Construction Roman Construction Roman Construction Roman Construction Roman Construction	117 017 607 807 507 107 861 261 561 581 581	Freestanding Sculpture Vase Painting THE HICH CLASSICAL PERIOD 184 The Athens Agora The Acropolis Sculpture and The Canon of Polykleitos Stela Sculpture Vase Painting Architecture and Architectural Sculpture Sculpture Wall Painting and Mosaics Wall Painting and Mosaics The Art of the Goldsmith The Act of the Goldsmith The Act of the Coldsmith The Act of the Coldsmith Sculpture Sculpture Sculpture
987 277 727 727 887 887 187 827 927	Architecture Portrait Sculpture Sarcophagus Reliefs Painting THE LATE EMPIRE: CONSTANTINE THE LATE EMPIRE: ROMAN TRADITIONALISM IN ART AFTER CONSTANTINE Portrait Sculpture THE LATE EMPIRE: ROMAN TRADITIONALISM IN ART AFTER CONSTANTINE Portrait Sculpture Technique Box: Roman Mosaics Elements of Architecture: Roman Mosaics Arch, Vault, and Dome Roman Architecture: Roman Construction Roman Construction Roman Construction	117 017 607 807 507 107 861 261 561 581 581 621 821 221	THE TRANSITIONAL OR EARLY CLASSICAL PERIOD Architectural Sculpture Preestanding Sculpture The Athens Agora The Athens Agora Sculpture and The Canon of Polykleitos Sculpture Stela Sculpture Stela Sculpture Architecture and Architectural Sculpture Sculpture Mall Painting and Mosaics Sculpture The Art of the Goldsmith The Art of the Coldsmith
987 277 977 747 887 887 827 847 947 947	THE LATE EMPIRE: FROM THE SEVERAN Architecture Sarcophagus Reliefs Painting THE LATE EMPIRE: CONSTANTINE THE CREAT AND HIS LEGACY 280 THE LATE EMPIRE: ROMAN TRADITIONALISM IN ART AFTER CONSTANTINE Portrait Sculpture The Arch of Constantine Architecture The Arch of Constantine Portrait Sculpture The Arch of Constantine Roman Mosaics Elements of Architecture: Roman Mosaics Roman Mosaics Architecture: Roman Mosaics Roman Mosaics Roman Mosaics Architecture: Roman Mosaics Architecture: Roman Mosaics Roman Mosaics Architecture: Roman Mosaics	117 017 607 807 507 107 861 261 581 581 621 821 221	Vase Painting THE TRANSITIONAL OR EARLY CLASSICAL PERIOD Architectural Sculpture Freestanding Sculpture The Athens Agora The Athens Agora The Acropolis Sculpture and The Canon of Polykleitos Stela Sculpture Architecture and Architectural Sculpture Sculpture Mall Painting and Mosaics Sculpture
987 277 977 747 887 887 887 847 947 947	Mosaics THE LATE EMPIRE: FROM THE SEVERAN Architecture Sarcophagus Reliefs Painting THE LATE EMPIRE: CONSTANTINE THE LATE EMPIRE: ROMAN TRADITIONALISM IN ART AFTER CONSTANTINE Portrait Sculpfure The Arch of Constantine The Arch of Constantine Portrait Sculpfure The LATE EMPIRE: ROMAN TRADITIONALISM IN ART AFTER CONSTANTINE Roman Mosaics Elements of Architecture: Roman Mosaics Arch, Vault, and Dome Roman Architecture: Roman Architecture: Roman Construction Roman Construction Roman Construction Roman Construction Roman Construction	117 017 607 807 507 107 861 261 561 581 581 621 821 221 691	Freestanding Sculpture Vase Painting THE TRANSITIONAL OR EARLY CLASSICAL PERIOD Architectural Sculpture Freestanding Sculpture The Athens Agora The Athens Agora Sculpture and The Canon of Polykleitos Sculpture and The Canon of Polykleitos Stela Sculpture Stela Sculpture Stela Sculpture Stela Sculpture Architecture and Architectural Sculpture Sculpture Mall Painting and Mosaics Sculpture The Art of the Goldsmith The Art of the Coldsmith The Art of the Coldsmith The Art of the Coldsmith
987 277 977 777 887 887 887 827 827 947 747	Portrait Sculpture Mosaics THE LATE EMPIRE: FROM THE SEVERAN Architecture Portrait Sculpture Sarcophagus Reliefs Painting THE LATE EMPIRE: CONSTANTINE THE LATE EMPIRE: ROMAN TRADITIONALISM IN ART AFTER CONSTANTINE Portrait Sculpture The Arch of Constantine The Arch of Constantine Portrait Sculpture The LATE EMPIRE: ROMAN TRADITIONALISM IN ART AFTER CONSTANTINE Soman Mosaics Boman Mosaics Architecture Roman Architecture: Roman Architecture: Roman Architecture: Roman Architecture: Roman Construction Roman Construction Roman Construction Roman Construction Roman Construction Roman Construction	117 017 607 807 507 107 861 261 561 581 581 621 821 221 691 991	Architectural Sculpture Preestanding Sculpture Vase Painting THE TRANSITIONAL OR EARLY CLASSICAL PERIOD Architectural Sculpture Freestanding Sculpture The Athens Agora The Athens Agora Sculpture and The Canon of Polykleitos Sculpture and The Canon of Polykleitos Sculpture Sculpture Architecture and Architectural Sculpture Sculpture Mall Painting and Mosaics Sculpture Sculpture Sculpture Architecture and Architectural Sculpture The Art of the Goldsmith The Art of the Coldsmith The Art of the Coldsmith
987 277 977 747 887 887 887 847 947 947	Mosaics THE LATE EMPIRE: FROM THE SEVERAN Architecture Sarcophagus Reliefs Painting THE LATE EMPIRE: CONSTANTINE THE LATE EMPIRE: ROMAN TRADITIONALISM IN ART AFTER CONSTANTINE Portrait Sculpfure The Arch of Constantine The Arch of Constantine Portrait Sculpfure The LATE EMPIRE: ROMAN TRADITIONALISM IN ART AFTER CONSTANTINE Roman Mosaics Elements of Architecture: Roman Mosaics Arch, Vault, and Dome Roman Architecture: Roman Architecture: Roman Construction Roman Construction Roman Construction Roman Construction Roman Construction	117 017 607 807 507 107 861 261 561 581 581 621 821 221 691	Temple Architecture Architectural Sculpture Freestanding Sculpture Architectural Sculpture Architectural Sculpture Architectural Sculpture Freestanding Sculpture Freestanding Sculpture The Athens Agora The Athens Agora Sculpture and The Canon of Polykleitos Sculpture and The Canon of Polykleitos Sculpture Sculpture Architecture and Architectural Sculpture Sculpture Architecture and Architectural Sculpture Sculpture Architecture and Architectural Sculpture The Art of the Goldsmith The Art of the Coldsmith The Art of the Coldsmith
987 277 977 777 887 887 887 827 827 947 747 747 897	Relief Sculpture Portrait Sculpture Mosaics THE LATE EMPIRE: FROM THE SEVERAN Architecture Portrait Sculpture Sarcophagus Reliefs Painting THE LATE EMPIRE: CONSTANTINE THE LATE EMPIRE: ROMAN TRADITIONALISM IN ART AFTER CONSTANTINE Portrait Sculpture The Arch of Constantine Architecture The Arch of Constantine Portrait Sculpture The Arch of Constantine Architecture Roman Mosaics Lechnique Box: Roman Mosaics Roman Mosaics Roman Architecture: Roman Architecture: Roman Architecture: Roman Construction	117 017 607 807 507 107 861 261 561 581 581 621 821 221 691 991	Architectural Sculpture Preestanding Sculpture Vase Painting THE TRANSITIONAL OR EARLY CLASSICAL PERIOD Architectural Sculpture Freestanding Sculpture The Athens Agora The Athens Agora Sculpture and The Canon of Polykleitos Sculpture and The Canon of Polykleitos Sculpture Sculpture Architecture and Architectural Sculpture Sculpture Mall Painting and Mosaics Sculpture Sculpture Sculpture Architecture and Architectural Sculpture The Art of the Goldsmith The Art of the Coldsmith The Art of the Coldsmith

Architecture Portable Arts Manuscript Illumination and Calligraphy	350 355 361	Calligraphy	407 408 409
	301	SUI AND TANG DYNASTIES 410	103
Technique Box: Carpet Making	359	Buddhist Art and Architecture	412 414
Elements of Architecture: Mosque Plans Arches and Mugarnas	345 347	Landscape Painting	415 416 418
CHAPTER 9 Art of India before 1100 Marylin M. Rhie with the assistance of Sonya Y. M.	364 Rhie	Technique Box:	400
THE INDIAN SUBCONTINENT 366		Elements of Architecture:	111
INDUS VALLEY CIVILIZATION 366		Pagodas	414
THE VEDIC PERIOD 370		CHAPTER 11 Japanese Art before 1392 4	120
THE MAURYA PERIOD 372		Stephen Addiss	
THE PERIOD OF THE SHUNGAS AND EARLY ANDHRAS 374 Stupas Buddhist Rock-Cut Halls	374 377	Yayoi and Kofun Periods	423 425
THE KUSHAN AND LATER ANDHRA PERIOD 378		ASUKA PERIOD 426	
The Gandhara School The Mathura School The Amaravati School	379 379 380	NARA PERIOD 429 HEIAN PERIOD 430 Esoteric Buddhism	431
THE GUPTA PERIOD 381 Buddhist Sculpture Painting	381 383	Pure Land Buddhism Poetry and Calligraphy	432 433 435
THE POST-GUPTA PERIOD 383 The Early Northern Temple Monumental Narrative Reliefs The Early Southern Temple	383 386 389		438 440
THE EARLY MEDIEVAL PERIOD 389 The Monumental Northern Temple The Monumental Southern Temple The Bhakti Movement in Art	389 391 391	CHAPTER 12 Art of the Americas before 1300 442	433
Elements of Architecture:		THE NEW WORLD 445	
CHAPTER 10 Chinese Art before 1280 Chu-tsing Li	³⁷⁵ 394	Teotihuacan	447 448 451
		CENTRAL AMERICA 456	
NEOLITHIC CULTURES 397 Painted Pottery Beyond the Yellow River Valley	398 399	The Moche Culture	457 459
BRONZE AGE CHINA 399 Shang Dynasty Zhou Dynasty	400 401		460 462
THE CHINESE EMPIRE: QIN DYNASTY 402		CHAPTER 13 Art of Ancient Africa 464	Į.
HAN DYNASTY 402 Daoism and Confucianism Confucianism and the State Architecture	404 404 406	Christopher D. Roy THE LURE OF ANCIENT AFRICA 466 SAHARAN ROCK ART 466	
		S. II. III II. II. II. II. II. II. II. I	

<i>t</i> 29	INTERIOR ARTS, PRINTS, AND BOOKS 672 European Printmaking and Book Printing	729 129	Independent Sculpture Book Arts
599 †99	Sculpture Painting	099	FRANCE 550 Architecture and Its Decoration
099	Architecture		THE GOTHIC STYLE 547
099	THE ITALIAN RENAISSANCE OUTSIDE FLORENCE		THE NV DUNG OF WHAT
759	gniitnis4		CHAPTER 16 Cothic Art 544
979	Sculpture		
179	THE ITALIAN RENAISSANCE IN FLORENCE 640 Architecture	215	Elements of Architecture: The Romanesque Church Portal
	CERMAN ART 639	<i>789</i>	Тесһпіque Box: Еmbroidery Techniques
	EKENCH VKT 638	CLC	
<i>L</i> E9	HISPANO-FLEMISH ART OF SPAIN AND PORTUGAL	243 689	Architecture Architectural Sculpture
<i>t</i> E9	Textiles and Tapestries		9£2 YJATI
<i>t</i> £ 9	Manuscript Illumination	885	Books
679 619	First-Generation Panel Painters Second-Generation Panel Painters	ZES	Metalwork
019	First-Generation Panel Painters	232	Architecture
/10	77 ,		CERMANY AND THE MEUSE VALLEY 535
219	Painting and Sculpture for the Chartreuse de Champmol	<i>789</i>	Тре Вауеих Тареяйу
519	Manuscript Illumination	285	Books
	CENTURY 614	089	Architecture
	FRENCH COURT ART AT THE TURN OF THE		BRITAIN AND NORMANDY 530
	THE EMERGENCE OF THE RENAISSANCE 613	275 274	Wall Painting Books
	ava adama	175	Independent Sculpture
	019 edona	915	Architectural Sculpture
	CHAPTER 17 Early Renaissance Art in	115	Architecture
			FRANCE AND NORTHERN SPAIN 510
	. 608 s9gA əlbbiM		ROMANESQUE CULTURE 509
	A Brief Review of the European		CHAPTER 15 Romanesque Art 506
629	The Cothic Castle		
855	The Cothic Church	E03	Books
225	Rib Vaulting	667	Sculpture
	Elements of Architecture:	864	THE OTTONIAN PERIOD 498 Architecture
669	gnou Eresco		
965	Cennini on Panel Painting	<i>t6t</i>	Books
699	swobniW ssslD-banist2	164	Architecture
	Technique Boxes:		THE CAROLINGIAN PERIOD 491
<i>565</i>	Painting		CHRISTIAN SPAIN 488
769			BRITAIN AND IRELAND 485 CHRISTIAN SPAIN 488
	Sculpture Painting		SCAUDINAVIA 487 SCAUDINAVIA 487
76 <u>9</u> 06 <u>9</u> 98 <u>9</u>	Sculpture ITALY 590 Architecture Sculpture Painting		THE MIDDLE AGES 481 CHRISTIAN SPAIN 488
76 <u>9</u> 06 <u>9</u>	Architecture Sculpture ITALY 590 Architecture Sculpture Painting		SCAUDINAVIA 487 SCAUDINAVIA 487
765 065 985 585	CERMANY AND THE HOLY ROMAN EMPIRE Architecture Sculpture Architecture Architecture Sculpture Sculpture Painting		THE MIDDLE AGES 481 CHRISTIAN SPAIN 488
765 065 985 585	Painted Altarpieces CERMANY AND THE HOLY ROMAN EMPIRE Architecture Sculpture Architecture Architecture Architecture Sculpture Sculpture Sculpture		Europe 478 The middle ages 481 Scandinavia 481 Britain and ireland 485 Christian spain 488
765 065 985 585 885 785	Book Arts Painted Altarpieces CERMANY AND THE HOLY ROMAN EMPIRE Architecture Sculpture Architecture Architecture Sculpture Architecture Sculpture Sculpture Sculpture		CHAPTER 14 Early Medieval Art in Europe 478 THE MIDDLE AGES 481 SCANDINAVIA 481 BRITAIN AND IRELAND 485 CHRISTIAN SPAIN 488
765 065 985 585	Architecture Book Arts Painted Altarpieces CERMANY AND THE HOLY ROMAN EMPIRE Architecture Sculpture Architecture Architecture Sculpture Architecture Architecture Architecture Architecture Sculpture Architecture	<i>t</i> 2 <i>t</i>	Great Zimbabwe CHAPTER 14 Early Medieval Art in THE MIDDLE AGES 481 SCANDINAVIA 481 BRITAIN AND IRELAND 485 CHRISTIAN SPAIN 488
765 065 985 585 785 785	SPAIN 582 Architecture Book Arts Painted Altarpieces Architecture Sculpture Sculpture Architecture Sculpture Architecture Sculpture Architecture Architecture Sculpture Architecture	<i>†</i> ∠ <i>†</i>	Djenné Great Zimbabwe CHAPTER 14 Early Medieval Art in THE MIDDLE AGES 487 SCANDINAVIA 487 BRITAIN AND IRELAND 485 CHRISTIAN SPAIN 488
765 065 985 585 785 785	Opus Anglicanum SPAIN 582 Architecture Book Arts Painted Altarpieces Architecture Sculpture Sculpture Architecture Sculpture Sculpture Sculpture Architecture Sculpture Architecture	<i>t\t</i>	URBAN CENTERS 474 Djenné Great Zimbabwe THE MIDDLE AGES 481 SCANDINAVIA 481 BRITAIN AND IRELAND 485 CHRISTIAN SPAIN 488
765 065 985 585 785 785 785 085	Book Arts SPAIN 582 Architecture Book Arts Painted Altarpieces Architecture Sculpture Sculpture Sculpture Sculpture Sculpture Sculpture Architecture Sculpture Sculpture Architecture Sculpture Sculpture Architecture	t2t 12t	Benin URBAN CENTERS 474 Djenné Great Zimbabwe THE MIDDLE AGES 481 SCANDINAVIA 481 SCANDINAVIA 481 CHRISTIAN SPAIN 488
765 065 985 585 785 785	Opus Anglicanum SPAIN 582 Architecture Book Arts Painted Altarpieces Architecture Sculpture Sculpture Architecture Sculpture Sculpture Sculpture Architecture Sculpture Architecture	<i>t\t</i>	URBAN CENTERS 474 Djenné Great Zimbabwe THE MIDDLE AGES 481 SCANDINAVIA 481 BRITAIN AND IRELAND 485 CHRISTIAN SPAIN 488

Technique Boxes: Painting on Panel Woodcuts and Engravings on Metal	619 673	SPANISH BAROQU Architecture Painting		776 777
Elements of Architecture: The Renaissance Palace Facade	645	FLEMISH BAROQUI Painting	E 780	780
	.1	DUTCH BAROQUE Painting an		786
CHAPTER 18 Renaissance Art in Sixtee Century Europe 678	enth-	ENGLISH BAROQU Architectur		800
EUROPE IN THE SIXTEENTH CENTURY 681 The Effects of the Reformation on Art The Changing Status of Artists	681 683	GERMAN AND AUS Architectur Sculpture in		803 804
Painting in Florence and Northern Italy Sculpture in Florence and Northern Italy Painting in Rome Sculpture in Rome Architecture in Rome and Its Environs Painting in Venice Architecture in Venice and the Veneto	683 687 691 697 699 704 709	in Germa Sculpture ir Painting in Craft Arts ir	e and Its Decoration any and Austria In Germany and France France In France and England CA BEFORE 1776 815	805 807 809 813
ITALIAN MANNERISM 712 Painting Sculpture	713 717	Painting Technique Box: Etching and	Drypoint	817 789
Architecture THE FRENCH COURT 719	717	Elements of Archite Baroque and	cture: d Rococo Church Facades	755
Painting Architecture and Its Decoration Craft Arts	720 721 722		Art of India after 1100	820
NETHERLANDISH ART 724		-	rith the assistance of Sonya Y. A	м. Khie
Painting GERMANY AND THE HOLY ROMAN EMPIRE 728 Painting and Printmaking Sculpture	724 729 739	LATE MEDIEVAL PE Buddhist A Jain Art Hindu Art		823 824 825
ENGLAND AND THE ENGLISH COURT 741 Court Painters Architecture	741 745	MUGHAL PERIOD Mughal Pai Mughal Arc Rajput Pain	nting chitecture	827 829 831
SPAIN AND THE SPANISH COURT 745 Architecture Sculpture Painting	745 746 746	MODERN PERIOD Technique Box: Indian Paint	833 ing on Paper	827
Technique Box: Painting on Canvas	704	CHAPTER 21	Chinese Art after 1280	834
		THE MONGOL INV		
CHAPTER 19 Baroque, Rococo, and E American Art 748	arly	YUAN DYNASTY	837	
THE BAROQUE PERIOD 751 ROMAN BAROQUE 753	752	Gardens ar Architectur	Professional Painting nd Decorative Arts re and City Planning	841 842 845
Architecture and Its Decoration Bernini's Sculpture Illusionistic Ceiling Painting Painting on Canvas	753 759 763 765	Literati Pai QING DYNASTY Orthodox F Individualis	848 Painting	846 848 848
FRENCH BAROQUE 769 Palace Architecture and Its Decoration	770	THE MODERN PER	IOD 851	
Sculpture Painting	773 773	Technique Box: Formats of C	Chinese Painting	840

ART IN ENGLAND 1002	
	RECENT ART IN OCEANIA 905
Sculpture Painting and Photography 996	New Zealand Sun Ze
ART IN THE UNITED STATES 996	Marquesas Islands 902 Hawaiian Islands 902
OUTGROWTHS 990	Easter Island 901
FRENCH NATURALISM AND REALISM AND THEIR	POLYNESIA 901
ЕАRLY РНОТОСВАРНУ 985	WICKONESIY 800
FRENCH ACADEMIC ART 982	New Ireland
Architecture 980	Papua New Guinea 898 Irian Jaya 899
Engineering 980	WELANESIA 897
TECHNOLOGICAL PROGRESS 980	AUSTRALIA 895
THE POSITIVIST AGE 979	THE PEOPLING OF THE PACIFIC 895
Bradford R. Collins	CHAPTER 24 Art of Pacific Cultures 892
876 sətst≥ bətinU	508 seriality siting to the Margarata
eht bas eqoruz ni	luka Masonry 880
CHAPTER 27 Realism to Impressionism	Elements of Architecture:
5.15	Тесhnique Вох: Ваѕkеtry 888
American Sculptors in Italy 970 Painting the American Scene 973	
Architecture	CONTEMPORARY NATIVE AMERICAN ART 891
THE UNITED STATES 966	The Southwest 888
†96 NI∀dS	Eastern Woodlands and the Great Plains 883 The Northwest Coast
CERMANY 962	NORTH AMERICA 883
Romantic Sculpture 962	The Affermath of the Spanish Conquest
£26 gnitinis9	The Aztec Empire 777 The Inka Empire 879
Meoclassical Architecture 950 Meoclassical Sculpture 951	MEXICO AND SOUTH AMERICA 875 The Aztec Empire 875
FRANCE 950	INDICENOUS AMERICAN ART 875
P41	
Architecture and Decoration 835	1300 872
BRITAIN 935	CHAPTER 23 Art of the Americas after
Antonio Canova 934 Bertel Thorvaldsen 935	Sasa niohs
<i>₽86</i> ₩1711	Elements of Architecture:
THE GRAND TOUR 931	Japanese Woodblock Prints 868
KEVOLUTION AND ENLIGHTENMENT 929	Technique Boxes: Lacquer 864
826 satist batinU and bus	THE MEIJI AND MODERN PERIODS 870
Romanticism in Europe	Ukiyo-e: Pictures of the Floating World 868
CHAPTER 26 Neoclassicism and	788 Maruyama-Shijo School
, , , , , , , , , , , , , , , , , , , ,	898 (oodəs sgark) 1988 (oodəs sgark)
CONTEMPORARY ART 924	Rimpa School 863
DEATH AND ANCESTORS 927	Теа Теа
LEADERSHIP 919	EDO PERIOD 862
THE SPIRIT WORLD 916	998 E2C
\$16 NOITAITINI	Architecture 859 Decorative Painting 860
CHIEDREN AND THE CONTINUITY OF LIFE 912	MOMOYAMA PERIOD 859
1 3 30 THE RESERVE TO SEE THE SPECIAL TO SEE THE SECOND SE	ij-nsovA
TRADITIONAL AND CONTEMPORARY AFRICA 911	358 Sainting Anl
Christopher D. Roy	MUROMACHI PERIOD 855
809 Fra Bra 908	ssibbA nədqət2
CHAPTER 25 Art of Africa in the	CHAPTER 22 Japanese Art after 1392 852

IMPRESSIONISM 1007		AMERICAN ART 1090	1090	
Édouard Manet 1007		European Influences		
Claude Monet		Realist Styles	1093	
Camille Pissarro	1010	Stieglitz and European Modernism	1096	
Pierre-Auguste Renoir	1011	American Scene Painting		
Edgar Degas	1012	and Photography	1099	
Mary Cassatt	1013	The Resurgence of Modernism		
Berthe Morisot	1014	in the 1930s	1104	
Later Impressionism	1015	Elements of Architecture:		
•		The Skyscraper	1065	
Technique Boxes:	985	The Skyscraper	1003	
Lithography Works	987	CHAPTER 29 Art in the United States	:	
How Photography Works	907	grupostala maranish suprimi pida di sa		
		and Europe since Worl	u	
The Disc of Mo	dornism	War II 1106		
CHAPTER 28 The Rise of Mo		Bradford R. Collins		
in Europe and t	he		100	
United States	1020	THE "MAINSTREAM" CROSSES THE ATLANTIC 1	109	
Bradford R. Collins		POSTWAR EUROPEAN ART 1109		
1022		ABSTRACT EXPRESSIONISM 1112		
WHAT IS MODERNISM? 1023		Action Painting	1116	
POST-IMPRESSIONIST ART 1026		Color Field Painting	1118	
Auguste Rodin	1026	Sculpture	1120	
Documenting Modern Life	1026	The Second Generation of		
Artistic Alternatives to Moder	n Life 1029	Abstract Expressionism	1121	
The Avant-Garde	1033	ALTERNATIVE DEVELOPMENTS FOLLOWING		
Expressionism	1036	ABSTRACT EXPRESSIONISM 1122		
EXPRESSIONUSTIC MOVEMENTS 1020		Return to the Figure	1122	
EXPRESSIONISTIC MOVEMENTS 1039	1039	Happenings	1124	
The Fauves	1041	Assemblage	1125	
Die Brücke Der Blaue Reiter	1041	Pop Art	1128	
Del Blaue Reiter	1043	Minimalism and Conceptualism	1131	
CUBISM 1048				
Picasso's Early Art	1048	FROM MODERNISM TO POSTMODERNISM 113		
Analytic Cubism	1051	Architecture	1135 1139	
Synthetic Cubism	1054	Photography "Red Reinting" and Super Realism	1141	
Responses to Cubism	1055	"Bad Painting" and Super Realism	1141	
ARCHITECTURE BEFORE WORLD WAR	1 1062	Post-Conceptual Art Earthworks	1144	
American Beaux-Arts	. 7002	Feminist Art	1146	
Architecture	1062		1110	
The American Skyscraper	1064	POSTMODERNISM 1149		
Frank Lloyd Wright	1066	Neo-Expressionism	1149	
Art Nouveau	1069	The Resurgence of European Art	1150	
Early Modernism	1072	Graffiti Art	1152	
•	DETIMEN !	Neo-Conceptualism	1153	
EUROPEAN ART AND ARCHITECTURE	REIWEEN	Later Feminism	1156	
THE WARS 1073	1074	Art and the Public	1157	
Postwar Classicism	1074	Art and Craft	1162	
Russian Utilitarian Art Forms	1075	Continuity versus Change	1164	
Dutch Rationalism	1077 1079	GLOSSARY G 1		
French Rationalism	1079 1081			
The Bauhaus Dada	1083	BIBLIOGRAPHY B 1		
Marcel Duchamp	1085	INDEX /1		
Surrealism	1087	CREDITS C1		
0 0111 0 01110111				

Use Notes

Boxes Special material that complements, enhances, explains, or extends the text is set off in three types of tinted boxes. Elements of Architecture boxes clarify specifically architectural features, such as "Space-Spanning Construction Devices" in the Starter Kit (page 32). Technique boxes (see "Lost-Wax Casting," page 31) amplify the methodology by which a type of artwork is created. Other boxes treat special-interest material related to the text.

Bibliography The Bibliography, at the end of this book beginning on page B1, contains books in English, organized by general works and by chapter, that are basic to the study of art history today, as well as works cited in the text.

Dates, Abbreviations, and Other Conventions This book uses the designations BCE and CE, abbreviations for "before the Common Era," instead of BC ("before Christ") and AD ("Anno Domini," "the year of our Lord"). The first century BCE is from the year I ce to 99 BCE to 1 BCE; the first century BCE is from the year I ce to 99 BCE to 100 BCE; the second century BCE is from 100 CE to 199 BCE to 200 BCE; the second century BCE is the period from 199 BCE to 100 BCE; the second century BCE is the period from 199 BCE to 100 BCE; the second century BCE is the period from 100 CE to 199 CE.

century ce	first century ce	first century BCE	second sce
\$001	66-l	1-66	500 L

Circa ("about" or "approximately") is used with dates, spelled out in the text and abbreviated to "c." in the captions, when an exact date is not yet verified.

An illustration is called a "figure," or "fig." Figure 6-70 is the seventieth numbered illustration in Chapter 6. Figures 1 through 29 are in the Introduction and the Starter Kit. There are two types of figures: photographs of artworks or of models, and line drawings. The latter are used when a work cannot be photographed or when a diagram or simple drawing is the clearest way to illustrate an object or a place.

When introducing artists, we use the words active and documented with dates—in addition to "b." (for "born") and "d." (for "died"). "Active" means that an artist worked during the years given. "Documented" means that documents link the person to the date.

Accents are used for words in Spanish, Italian, French, and German only.

With few exceptions, names of museums and other cultural bodies in Western European countries are given in the form used in that country.

Titles of Works of Art Most paintings and sculpture created in Europe and the United States in the last 500 years have been given formal titles, either by the artist or by critics and art historians. Such formal titles are printed in italics. In other traditions and cultures, a single title is not important or even recognized. In this book we use formal titles of artworks in cases where they are established and descriptive titles of artworks where titles are not established. If a work is best known by its non-English title, such as the original language precedes the translation.

The various features of this book reinforce each other, helping the reader to become comfortable with terminology and concepts specific to art history.

Introduction and Starter Kit The Introduction is an invitation to the pleasures of art history. The Starter Kit that follows the Introduction is a highly concise primer of basic concepts and tools. The outside margins of the Starter Kit pages are tinted to make them easy to find.

Captions There are two kinds of captions in this book: short and long. Short captions identify information specific to the work of art or architecture illustrated:

artist (when known)
title or descriptive name of work
date
original location (if moved to a museum or other site)
material or materials a work is made of
size (height before width) in feet and inches, with
centimeters and meters in parentheses
present location

The order of these elements varies, depending on the type of work illustrated. Dimensions are not given for architecture, for most wall painting, or for architectural sculpture. Some captions have one or more lines of small print below the identification section of the caption that gives museum or collection information. This is rarely required reading.

Long captions contain information of many kinds that complements the main text.

Definitions of Terms You will encounter the basic terms

of art history in three places:

IN THE TEXT, Where words appearing in **boldface** type are defined, or glossed, at the first use; some terms are explained more than once, especially those that experience shows are hard to remember.

IN BOXED FEATURES ON technique and other subjects and in Elements of Architecture boxes, where labeled drawings and diagrams visually reinforce the use of terms.

IN THE GLOSSARY AT THE GOOD WHICH CONtains all the words in **boldface** type in the text and boxes. The Glossary begins on page GI, and the outside margins are tinted to make the Glossary easy to find.

Maps, Timelines, Parallels, and Time Scales At the beginning of each chapter is a map with all the places mentioned in the chapter. Above the map, a timeline runs from the earliest through the latest years covered in that chapter. Small drawings of major artworks in the chapter are sited on the map at the places from which they come and are placed on the timelines at the times of their creation. In this way on the timelines at the times of their creation. In this way these major works are visually linked in time and place.

Parallels, a table near the beginning of every chapter, uses the main chapter sections to organize artistic and other events "at home and abroad." The Parallels offer a selection of simultaneous events for comparison without suggesting that there are direct connections between them.

Time scales appear in the upper corners of pages, providing a fast check on progress through the period.

Introduction

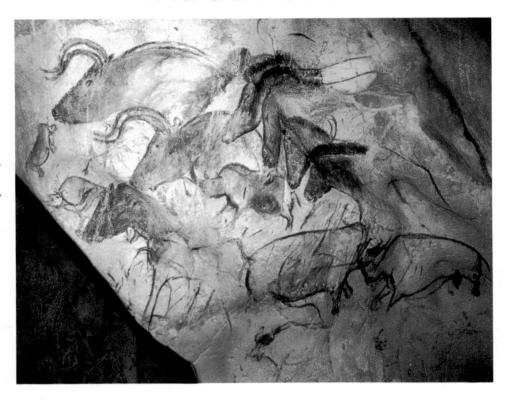

1. Wall painting with four horses, Vallon-Pont-d'Arc, Ardèche gorge, France.
c. 28,000 BCE. Paint on limestone

stood in front of that exquisite panel with the four horses' heads and . . . I was so overcome that I cried. It was like going into an attic and finding a da Vinci [painting]. Except that this great [artist] was unknown." With these words Jean Clottes, an eminent French authority on prehistoric cave art, described viewing one of the 300 breathtakingly beautiful paintings just discovered in a huge limestone cavern near the Ardèche River in southern France (Marlise Simons, "In a French Cave, Wildlife Scenes from a Long-Gone World," *The New York Times*, January 24, 1995, page C10).

These remarkable animal images, fixed in time and preserved undisturbed in their remote cavern, were created some 30,000 years ago (fig. 1). That such representations were made at all is evidence of a uniquely human trait. And what animals are painted here? When were they painted, and how have they been preserved? Why were the paintings made, and what do they tell us about the people who made them? All these questions—what is depicted, how, when, why—are subjects of art history. And, because *these* magnificent images come from a time before there were written records, they provide the best information available not just about early humans' art but also about their reality.

ART AND REALITY

What is art? And what is reality? Especially today, why should one draw or paint, carve or model, when an image

can be captured with a camera? In a nineteenth-century painting, *Interior with Portraits* (fig. 2), by the American artist Thomas LeClear, two children stand painfully still while a photographer prepares to take their picture. The paintings and sculpture that fill the studio have been shoved aside to make way for a new kind of art—the photograph. As the photographer adjusts the lens of his camera, we see his baggy pants but not his head. Is LeClear suggesting that the painter's head (brain and eye) is being replaced by the lens

(a kind of mechanical brain and eye) of the camera? Or even that the artist and the camera have become a single recording eye? Or is this painting a witty commentary on the nature of reality? Art history leads us to ask such questions.

LeClear's painting resembles a snapshot in its record of studio clutter, but LeClear made subtle changes in what he saw. Using the formal elements of painting—the arrangement of shapes and colors—he focused attention on the children rather than on the interesting and distracting objects that surround them. Light falls on the girl and boy and intensifies the brilliant coral and green of the cloth on the floor, Softer coral shades in the curtain and the upholstered chair

ısənbəg the Pauline Edwards made possible by Museum purchase ington, D.C. Institution, Wash-Smithsonian of American Art, National Museum .(mo 9.201 x 7.33). 257/8 X 401/2" on canvas, traits. c. 1865. Oil Interior with Por-2. Thomas LeClear.

this context, the ambiguities we noticed before—the con-Peck Dam, Montana. 1936 3. Margaret Bourke-White. Fort . P

on the cover of the first issue of Life in 1936 (fig. 4), made a

Bourke-White, whose photograph of Peck Dam (fig. 3), used

extraordinary photographer of that time was Margaret

people do today for their tavorite television program. An

Life magazine, with its photojournalism and photo essays, as

and 1940s people waited as eagerly for the weekly arrival of

two dimensions, and sometimes recorded in black and white.

three-dimensional world has been immobilized, reduced to

tells the truth. We forget that in a photograph a vibrant, moving,

graphs made to "lie," we generally accept that the camera

though we know that film can be manipulated and photo-

camera has become a universal tool for picture making. Even

between nature and art, on art and reality, and on the role of

nificance. Leclear seems to be commenting on the tension

fashioned, painted portrait on an easel-take on deeper sig-

between the new medium of photography and the old-

scape on the cloth in the background, the juxtaposition

trast between the reality of the studio and the unreal land-

the artist as a recording eye and controlling imagination.

But what about the reality of photographs? Today the

Photographs can be powerful works of art. In the 1930s

of American Art in Washington, D.C., once belonged to the to 1863. The painting, which is now in the National Museum

Thomas LeClear worked in Buffalo, New York, from 1847

these questions lead us to further doubts about the reality of portrait painted? Who owned the painting? The answers to

er into its significance. Who are the children? Why was their

we can also study the history of the painting to probe deepwith Portraits as a record of nineteenth-century America, but

paintings—than one first sees. We can simply enjoy Interior Certainly there is more to this painting—and to most

also a commentary on the artist as a creator of illusions. make us realize that the painting is more than a portrait; it is skin just slightly worn, painted cloth. These observations two-dimensional painted backdrop and the rug and animal mal skin, but the painting reveals that the landscape is just a will show the children in a vast landscape with a rug and ani-Leclear also reminds us that art is an illusion: the photograph frame the image, and the repeated colors balance each other.

this seemingly "realistic" work.

from what observation of the painting alone suggests. "real." Art historical research reveals a story entirely different from a photograph. In short, this image of "reality" cannot be instead, be a memorial portrait, perhaps painted by LeClear dren, then, could never have posed for this painting. It must, which is a type that was not used before 1860. The Sidway chillaw there. Another clue to the painting's date is the camera, seen in the painting may be one he borrowed from his son-intoo. LeClear moved to New York City in 1863, and the studio when James was a grown man-or possibly after his death, was not made until the 1860s, well after Parnell's death and a volunteer fire fighter. Evidence suggests that the painting younger brother James Sidway, died in 1865 while working as the painting, Parnell Sidway, died in 1849; the boy, her Sidway family of Buffalo. Family records show that the girl in

of vanished childhood, is a reflection on life and death. In the nature of art. The memorial portrait, with its re-creation This new knowledge leads us to further speculations on

November 23, 1936 First cover, Life magazine,

dramatic social-political statement about the role of government. In the depths of the economic depression of the 1930s, public works like the dam in the picture, which controlled floods and provided electric power, gave people hope for a better life. Bourke-White's photograph is a symbol of the power of technology and engineering over nature. It seems to equate the monumental grandeur of the dam with the architectural marvels of the past-Egyptian pyramids, the Roman Colosseum, medieval European castles. The arrangement of elements in the image reflects techniques that had been perfected by artists over the centuries: the repetition of simple forms, a steady recession into space, and a dramatic contrast of light and dark. Two red bands with bold white lettering turn the photograph into a handsome piece of graphic design, that is, a work in which art and design, typography, and printing are brought together to communicate a message.

Bourke-White's skillful capturing of the powerful dam reminds us that the camera is merely a mechanical tool for making records until an artist puts it to use. Anyone who has ever taken a snapshot of a friend only to find that the finished picture includes unnoticed rubbish and telephone wires will recognize the importance of the human brain's ability to filter and select. But an artist's vision can turn the everyday world into a superior reality—perhaps simply more focused or intense, certainly more imaginative.

We can easily understand a photograph of a dam, the imagery in a painting of a nineteenth-century artist's studio is not too strange to us, and even prehistoric animal paintings in a cave have a haunting familiarity. Other works, however, present a few more challenges. The fifteenth-century painting The Annunciation, by Jan van Eyck (fig. 5), is an excellent example of how some artists try to paint more than the eye can see and more than the mind can grasp. We can enjoy the painting for its visual characteristics—the drawing, colors, and arrangement of shapes—but we need the help of art history and information about the painting's cultural context if we want to understand it fully. Jan van Eyck (1390-1441) lived in the wealthy city of Bruges, in what is now Belgium, in the first half of the fifteenth century. The painting seems to be set in Jan van Eyck's own time in a church with stone walls and arches, tile floor, wooden roof, stained-glass windows, and wall paintings. The artist has so carefully recreated the colors and textures of every surface that he convinces us of the truth of his vision. Clearly something strange and wonderful is happening. We see a richly robed youth with splendid multicolored wings interrupting a kneeling young woman's reading. The two figures gesture gracefully upward toward a dove flying down streaks of gold. Golden letters float from their lips, forming the Latin words that mean "Hail, full of grace" and "Behold the handmaiden of the Lord." But only if we know something about the symbols, or iconography, of Christian art does the subject of the painting become clear. The scene is the Annunciation, the moment when the angel Gabriel tells the Virgin Mary that she will bear the Son of God, Jesus Christ (recounted in the New Testament of the Christian Bible, Luke 1:26-38). All the details have a meaning. The dove symbolizes the Holy Spirit. The white lilies are symbols of Mary. The one stainedglass window of God (flanked by wall paintings of Moses) is

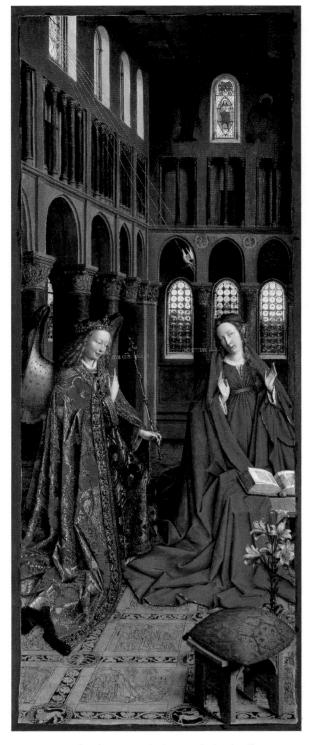

Jan van Eyck. *The Annunciation*. c. 1434–36. Oil on canvas, transferred from panel, painted surface 35³/₈ x 13⁷/₈" (90.2 x 34.1 cm). National Gallery of Art, Washington, D.C. Andrew W. Mellon Collection 1937.1.39

juxtaposed with the three windows enclosing Mary (representing the Trinity of Father, Son, and Holy Spirit), and this contrast suggests that a new era is about to begin. The signs of the zodiac in the floor tiles indicate the traditional date of the Annunciation, March 25. The placement of the figures in a much later architectural setting is quite unreal, however.

Stone, height 3" (7.4 cm). Naturhistorisches Museum, 6. Human figure, found at Galgenburg, Austria. c. 31,000 BCE.

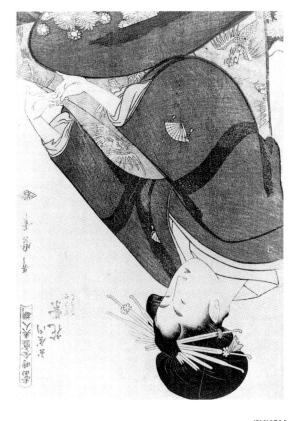

William Bridges Thayer Memorial Kansas, Lawrence (38.5 x 25.5 cm). Spencer Museum of Art, University of Mid-1790s. Color woodblock print, 151/8 x 10" Kitagawa Utamaro. Woman at the Height of Her Beauty.

senting a miracle but also is illustrating the idea that Mary is Art historians explain that Jan van Eyck not only is repre-

the new Christian Church.

National Gallery of Art in Washington, D.C., was once owned given by American financier Andrew W. Mellon to the ing and restoration, and its trail of ownership. The painting, tant too-its transfer from wood panel to canvas, its cleanlayers. The history of the painting (its provenance) is impordrawing, and the building of the images in transparent oil this case the preparation of the wood panel, the original gundy. They are also fascinated by painting techniques—in Jan's wife, Margaret, and his chief patron, the duke of Bur-Eyck, for example, they have investigated his brother Hubert, and those close to them. Seeking information about Jan van Art historians learn all they can about the lives of artists

are considered in our study of art's history. viewed it, and the places in which it has been displayed—all made it, the patron who paid for it, the audiences who have of other regions. The qualities of a work of art, the artist who ern art in the most detail, we also look extensively at the art from earliest times to the present. Although we treat West-In this book we study the history of art around the world

found expression in a variety of styles, The concept of beauty, however, has did more than simply help them survive. significance—objects we call art—that sought to create objects of beauty and For thousands of years people have

by Tsar Nicholas I of Russia.

mental effects combined with an effort to capture the lines. The elaboration of surface detail to create ornalously, but he depicts the woman's face with a few sweeping maro renders the patterned silks and carved pins meticua pattern, and pins hold her hair in elaborate shapes. Utastyle defy the laws of nature. Rich textiles turn her body into ed by convention and ritual. The woman's dress and hairblock of wood, is the creation of a complex society regulatprinted in color from a woodblock, or image carved out of a Beauty (fig. 7). This late-eighteenth-century Japanese work, seen in Kitagawa Utamaro's Woman at the Height of Her human forms. An equally abstract vision of woman can be ed all but the essentials, and emphasized the underlying abstract style (fig. 6). Its maker simplified shapes, eliminat-Austria, made more than 33,000 years ago, illustrates an or manners of representation. The figure from Galgenburg,

sages and be open to individual interpretation. see. Realistic art, as we have noted, can carry complex mesgreater or lesser accuracy, to be recording exactly what they ural subject, has a surface reality; the artists appear, with Realistic art, even if it represents an imagined or supernatation—exemplify a contrasting style known as realism. Leclear's Interior with Portraits and Jan van Eyck's Annunci-Two of the other works we have looked at so far-

essence of form is characteristic of abstract art.

ought to be. In ancient Greece and Rome artists made intense ism, artists aim to represent things not as they are but as they to the representation of beauty. In a third style, called ideal-Realism and abstraction represent opposite approaches

observations of the world around them and then subjected

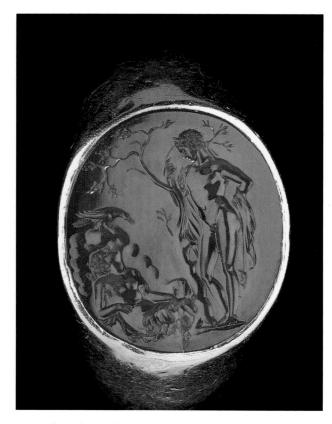

 Attributed to Aulos, son of Alexas. Gem with Apollo and Cassandra. 40–20 BCE. Gold with engraved carnelian, ring 1³/₈ x 1" (3.4 x 2.5 cm), gem ¹³/₁₆ x ³/₄" (1.9 x 2.1 cm). The Nelson-Atkins Museum of Art, Kansas City, Missouri Purchase: Acquired through the generosity of Mr. and Mrs. Robert S. Everitt (F93-22)

Apollo fell in love with Cassandra, and although she rejected him he gave her a potent gift—the ability to fore-tell the future, symbolized by the raven. To show his disappointment, the frustrated Apollo added a spiteful twist to his gift—no one would believe Cassandra's prophetic warnings. Today, doom-sayers are still called Cassandras, and ravens are associated with prophecy.

their observations to mathematical analysis to define what they considered to be perfect forms. Emphasizing human rationality, they eliminated accidents of nature and sought balance and harmony in their work. Their sculpture and painting established ideals that have inspired Western art ever since. The term *Classical*, which refers to the period in ancient Greek history when this type of idealism emerged, has come to be used broadly (and with a lowercase *c*) as a synonym for the peak of perfection in any period.

Classical idealism can pervade even the smallest works of art. About 2,000 years ago a Roman gem cutter known as Aulos added the opulence of imperial Rome to the ideals of Classical Greece when he engraved a deep-red, precious stone with the figures of the tragic princess Cassandra and the Greek god Apollo (fig. 8). Cassandra sleeps by rocky cliffs and a twisting laurel tree that suggest the dramatic natural setting of Delphi, Greece, a site sacred to Apollo. The god leans on the laurel tree, also sacred to him, with his cloak draped loosely and gracefully behind him. Apollo and Cassandra have the strong athletic bodies and regular facial features that charac-

terize Classical art, and their graceful poses and elegant drapery seem at the same time ideally perfect and perfectly natural. These beautiful figures and their story of frustrated love were not meant to be seen in a museum (a *museum* literally is the home of Apollo's Muses, the goddesses of learning and the arts). The carved gem was set in a gold finger ring and would have been constantly before its wearer's eyes. This sculpture reminds us that exceptional art can come in any size and material and can be intended for daily personal use as well as for special, occasional contemplation.

The flawless perfection of Classical idealism could be dramatically modified by artists more concerned with emotions than pure form. The calm of Cassandra and Apollo contrasts with the melodramatic representation of a story from the ancient Greek legend of the Trojan War. The priest Laocoön (fig. 9), who attempted to warn the Trojans against the Greeks, was strangled along with his two sons by serpents. Heroic and tragic, Laocoön represents a good man destroyed by forces beyond his control. His features twist in agony, and the muscles of his superhuman torso and arms extend and knot as he struggles. This sculpture, then at least sixteen centuries old, was rediscovered in Rome in the 1500s, and it inspired artists such as Michelangelo to develop a heroic style. Through the centuries people have returned again and again to the ideals of Classical art. In the United States official sculpture and architecture often copy Classical forms, and even the National Museum of American Art is housed in a Greek-style building.

How different from this ideal of physical beauty the perception and representation of spiritual beauty can be. A fifteenth-century bronze sculpture from India represents Punitavati, a beautiful and generous woman who was deeply devoted to the Hindu god Shiva (fig. 10). Abandoned by her greedy husband because she gave food to beggars, Punitavati offered her beauty to Shiva. Shiva accepted her offering, turning her into an emaciated, fanged hag. According to legend, Punitavati, with clanging cymbals, provides the music for Shiva as he dances the cosmic dance of destruction and creation that keeps the universe in motion. To the followers of Shiva, Punitavati became a saint called Karaikkalammaiyar. The bronze sculpture, although it depicts the saint's hideous appearance, is nevertheless beautiful both in its formal qualities and in its message of generosity and sacrifice.

Some works of art defy simple categories, and artists may go to extraordinary lengths to represent their visions. The art critic Robert Hughes called James Hampton's (1909– 1964) Throne of the Third Heaven of the Nations' Millennium General Assembly (fig. 11) "the finest piece of visionary art produced by an American." Yet this fabulous creation is composed of discarded furniture, flashbulbs, and all sorts of trash tacked together and wrapped in aluminum and gold foil and purple paper. The primacy of painting, especially oil painting, is gone. Hampton's inspiration, whether divine or not, knows no bounds. He worked as a janitor to support himself while, in a rented garage, he built his monument to Jesus. In rising tiers, thrones and altars are prepared for Jesus and Moses, the New Testament at the right, the Old Testament at the left. Everything is labeled and described, but Hampton invented his own language and writing system to express his vision. Although his language is still not fully

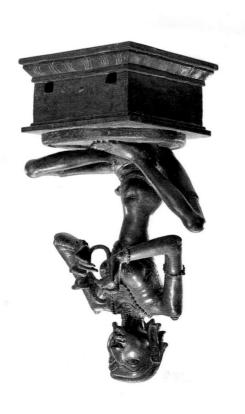

10. Punitavati (Karaikkalammatyar), Shiva saint, from Karaikkal, India. 15th century. Bronze, height 16¹/4" (41.3 cm). The Nelson-Atkins Museum of Art, Kansas City, Missouri Purchase: Nelson Trust (33-533)

11.) smes Hampton. Throne of the Third Heaven of the Nations' Millennium General Assembly. c. 1950–64. Gold and silver aluminum foil, colored Kraft paper, and plastic sheets over wood, paperboard, and glass, 10'6" x 27' x 14'6" (3.2 x 8.23 x 4.42 m). National Museum of American Art, Smithsonian Institution, Washington, D.C.

and speculate on the nature of things, on the nature of life. They constantly communicate with each other, and some of them even try to communicate with the past and future. We have seen that some artists try to record the world as they see it, and they attempt to educate or convince their viewers with straightforward stories or elaborate symbols.

Hagesandros, Polydoros, and Athanadoros of Rhodes. Laocoön and His Sons, perhaps the original of the 2nd or 1st century BCE or a Roman copy of the 1st century cE. Marble, height 8' (2.44 m). Musei Vaticani, Museo Pio Clementino, Cortile Ottagono, Rome

understood, its major source is the Bible, especially the Book of Revelation. On one of many placards he wrote his artist's credo: "Where there is no vision, the people perish" (Proveredo: "Where there is no vision, the people perish" (Proveredo: "Where there is no vision, the people perish" (Proveredo: "Where there is no vision, the people perish" (Proveredo: "Where there is no vision, the people perish" (Proveredo: "Where the people people perish" (Proveredo: "Where the people peop

These different ideas of art and beauty remind us that as viewers we enter into an agreement with artists, who, in turn, make special demands on us. We re-create works of art for ourselves as we bring to them our own experiences. Without our participation they are only hunks of stone or metal or pieces of paper or canvas covered with ink or colored paints. Artistic styles change with time and place. From ored paints. Artistic styles change with time and place. From tepresentational art at the other, artists have worked with representational art at the other, artists have worked with oredying degrees of realism, idealism, and abstraction. The challenge for the student of art history is to discover not only how but why these changes have occurred and ultimately what of significance can be learned from them, what meaning they carry.

ARTISTS We have focused so far on works of art. What of the artists who make the art? Biol-

ogists have pointed out that human beings are mammals with very large brains and that these large brains demand stimulation. Curious, active, inventive humans constantly look, taste, smell, and listen. They invent fine arts, fine food, fine perfume, and fine music. They play games, invent rituals,

Others create works of art inspired by an inner vision. Like the twentieth-century American Georgia O'Keeffe (fig. 12) they attempt to express in images what cannot be expressed in words. An organized religion such as Christianity or Buddhism may motivate them, but the artists may also divorce themselves from any social group and attempt to record personal visions or intense mystical experiences. These inner visions may spring from entirely secular insights, and the artist's motivation or intention may be quite different from the public perception of her or his art.

Originally, artists were considered artisans, or craftspeople. The master (and sometimes the mistress) of a workshop was the controlling intellect, the organizer, and the inspiration for others. Utamaro's color woodblock prints, for example, were the product of a team effort. In the workshop Utamaro drew and painted pictures for his assistants to transfer to individual blocks of wood. They carved the lines and color areas, covered the surface with ink or colors, then transferred the image to paper. Since ancient times artists have worked in teams to produce great buildings, paintings, and stained glass. The same spirit is evident today in the complex glassworks of American Dale Chihuly. His team of artist-craftspeople is skilled in the ancient art of glassmaking, but Chihuly remains the controlling mind and imagination. Once created, his pieces are transformed whenever they are assembled. Thus each work takes on a new life in accordance with the mind, eye, and hand of each ownerpatron. Made in the 1990s, Violet Persian Set with Red Lip Wraps (fig. 13) has twenty separate pieces whose relationship to each other is determined by the imagination of the assembler. Like a fragile sea creature of the endangered coral reefs, the glass is vulnerable to thoughtless depredation, yet it is timeless in its reminder of primeval life. The purple captures light, color, and movement for a weary second. Artists, artisans, and patrons unite in an ever-changing individual yet communal act of creation.

About 600 years ago, artists in western Europe, especially in Italy, began to think of themselves as divinely inspired creative geniuses rather than as team workers. Painters like Guercino (Giovanni Francesco Barbieri, 1591-1666) took the evangelist Luke as their model, guide, and protector-their patron saint. People believed that Saint Luke had painted a portrait of the Virgin Mary holding the Christ Child. In Guercino's painting Saint Luke Displaying a Painting of the Virgin (fig. 14), the saint still holds his palette and brushes while an angel holds the painting on the easel. A book, a quill pen, and an inkpot decorated with a statue of an ox (a symbol for Luke) rest on a table behind the saint, reminders that he wrote one of the Gospels of the New Testament. The message Guercino conveys is that Saint Luke is a divinely inspired and endowed artist and that all artists share in this inspiration through their association with their patron saint.

Even the most inspired artists had to learn their trade through study or years of **apprenticeship** to a master. In his painting *The Drawing Lesson* (fig. 15), Dutch artist Jan Steen (1626–1679) takes us into an artist's studio where an apprentice watches his master teaching a young woman. The woman has been drawing from a sculpture because women then were not permitted to work from live nude models.

12. Georgia O'Keeffe.

Portrait of a Day, First Day.
1924. Oil on canvas,
35 x 18" (89 x 45.8 cm).

Spencer Museum of Art,
University of Kansas,
Lawrence
Gift of the Georgia O'Keeffe
Foundation

The year before she painted Portrait of a Day, First Day, O'Keeffe wrote, "One day seven years ago [I] found myself saying to myself—I can't live where I want to—I can't go where I want to—I can't even say what I want to— School and things that painters have taught me even keep me from painting as I want to. I decided I was a very stupid fool not to at least paint as I wanted to and say what I wanted to when I painted as that seemed to be the only thing I could do that didn't concern anybody but myself—that was nobody's business but my own. . . I found that I could say things with color and shapes that I couldn't say in any other way—things that I had no words for. Some of the wise men say it is not painting, some of them say it is" (cited in Alfred Stieglitz Presents One Hundred Pictures: Oils, Watercolors, Pastels, Drawings by Georgia O'Keeffe, American, The Anderson Galleries, New York, exhibition brochure, January 29–February 10, 1923).

 Dale Chihuly. Violet Persian Set with Red Lip Wraps.
 1990. Glass, 26 x 30 x 25" (66 x 76.2 x 63.5 cm). Spencer Museum of Art, University of Kansas, Lawrence Peter T. Bohan Acquisition Fund

15. Jan Steen. The Drawing Lesson. 1665. Oil on wood, 193/8 x 161/4" (49.3 x 41 cm). The J. Paul Getty Museum, Malibu, California

16. Luis Jimenez. *Vaquero*. Modeled 1980, cast 1990. Cast fiberglass and epoxy, height 16'6" (5.03 m). National Museum of American Art, Smithsonian Institution, Washington, D.C.

This white-hatted, gun-slinging bronco buster whoops it up in front of the stately, classical colonnade of the Old Patent Building (now the National Museum of American Art, the National Portrait Callery, and the Archives of American Art). The Old Patent Office was designed in 1836 and finished in 1867. One of the finest Neoclassical buildings in the United States and the site of Abraham Lincoln's second inaugural ball, it was supposed to be destroyed for a parking lot when it was acquired by the Smithsonian in 1958.

14. Guercino. Saint Luke Displaying a Painting of the Virgin. 1652–53. Oil on canvas, 7'3" x 5'11" (2.21 x 1.81 m). The Nelson-Atkins Museum of Art, Kansas City, Missouri Purchase (F83-55)

Plaster reproductions hang on the wall and stand on the shelf, and a carved boy-angel has been suspended from the ceiling in front of a large tapestry. The painter holds his own palette, and we see his painting set on an easel in the background. Like Thomas Leclear's painting of the photographer's ground. Like Thomas Leclear's painting of the photographer's etudio, The Drawing Lesson is a valuable record of an artist's equipment and workplace, including such things as the equipment and workplace, including such things as the exercise the state of the provided in the seventeenth century.

The painting is more than a realistic **genre painting** (scene from daily life) or **still life** (an arrangement of objects). The Drawing Lesson is also an **allegory**, or symbolic representation of the arts. The objects in the studio symbolize shelf is more than a bookend; as we have already seen, it symbolizes Saint Luke, the painters' patron saint. The basbelf is more than a bookend; as we have already seen, it symbolizes Saint Luke, the painters' patron saint. The basbelf in the foreground holds not only the woman's fur muff but also a laurel wreath, a symbol of Apollo and the classification.

Artists draw on their predecessors in ways that make each work a very personal history of art. They build on the works of the past, either inspired by or

reacting against them, but always challenging them with their new creations. The influence of Jan Steen's genre painting, for example, can be seen in Thomas Leclear's Interior with Portraits, and Guercino's Saint Luke is based on an eartler icon—or miraculous image—he had seen in his local church. In his 1980–1990 Vaquero (Cowboy), Luis Jimenez revitalizes a sculptural form with roots in antiquity, the equestrian monument, or statue of a horse and rider (fig. 16).

HISTORY

AND ART

ARTISTS

Vaquero also reflects Jimenez's Mexican and Texan heritage and his place in a tradition of Hispanic American art that draws on many sources, including the art of the Maya, Aztec, and other great Native American civilizations, the African culture of the Caribbean Islands, and the transplanted art of Spain and Portugal.

Equestrian statues have traditionally been stately symbols of power and authority, with the rider's command over the animal emblematic of human control over lesser beings, nature, and the passions. Jimenez's bucking bronco turns this tradition, or at least the horse, on its head. Rather than a stately symbol of human control, he gives us a horse and cowboy united in a single exuberant and dynamic force. Located in front of the National Museum of American Art, the work can be seen as a witty satire on Washington, D.C.'s bronze monuments to soldiers. At the same time, it reminds us that real *vaqueros* included hard-working African Americans and Hispanic Americans who had little in common with the cowboys of popular fiction.

In his work, Jimenez has abandoned traditional bronze and marble for fiberglass. He first models a sculpture in a plastic paste called plasticine on a steel armature; then he makes a fiberglass mold, from which he casts the final sculpture, also in fiberglass. The materials and processes are the same as those used to make many automobile bodies, and as with automobiles, the process allows an artist to make several "originals." After a sculpture is assembled and polished, it is sprayed with the kind of acrylic urethane used to coat the outside of jet airplanes. Jimenez applies colors with an airbrush and coats the finished sculpture with three more layers of acrylic urethane to protect the color and emphasize its distinctive, sleek, gleaming surface. Vaquero is true public, popular art. It appeals to every kind of audience from the rancher to the connoisseur.

When artists appropriate and transform images from the past the way Jimenez appropriated the equestrian form, they enrich the **aesthetic** vocabulary of the arts in general. *Vaquero* resonates through the ages with associations to cultures distant in time and place that give it added meaning. This kind of aesthetic free-for-all encourages artistic diversity and discourages the imposition of a single correct or canonical (approved) approach or point of view. In the jargon of our time, no medium is *privileged*, and no group of artists is *marginalized*.

ART AND SOCIETY

The visual arts are among the most sophisticated forms of human communication, at once shaping and shaped by

the social context in which they find expression. Artists are often interpreters of their times. They can also be enlisted to serve social ends in forms that range from heavy-handed propaganda to the more subtle persuasiveness of Margaret Bourke-White's photographs for *Life* magazine. From the priests and priestesses in ancient Egypt to the representatives of various faiths today, religious leaders have understood the value of the visual arts in educating people about doctrine and in reinforcing their faith. Especially beginning in the eleventh century in western Europe, architecture and sculpture provided settings for elaborate rites and inspiring and instructive art. At the Cathedral of Santiago de Compostela in north-

17. Pórtico de la Gloria. Photograph by Joan Myers. 1988

Tradition required that pilgrims to the Cathedral of
Santiago de Compostela place their fingers in the tendrils
of the carved Tree of Jesse as they asked Saint James's
blessing on arrival in the church. Millions of fingers have
worn away the carving, leaving a rich patina of age.
The twefth-century sculpture still inspires twentiethcentury artists such as photographer Joan Myers.

western Spain, which shelters the tomb of Saint James, the marble of the central portal has been polished and the twelfth-century sculpture have been worn down by the touch of pilgrims' fingers (fig. 17).

Marxist art historians once saw art as an expression of great social forces rather than of individual genius, but most people now agree that neither history and economics nor philosophy and religion alone can account for the art of a Rembrandt or Michelangelo. The same applies to extraordinary "ordinary" people, too, who have created powerful art to satisfy their own inner need to communicate ideas. In Lucas, Kansas, in 1905, Samuel Perry Dinsmoor, a visionary populist, began building his Garden of Eden (fig. 18). By 1927 he had surrounded his home with twenty-nine concrete trees ranging from 8 to 40 feet high. He filled the branches with figures that told the biblical story of the Creation and the Expulsion from the Garden of Eden under the ever-present—and electrified—Eye of God. Adam and Eve succumb to the serpent; Cain strikes down Abel. Evil and death enter the world as creatures attack each other. In Dinsmoor's modern world, people defend themselves through their right to vote. Under the protection of the Goddess of Liberty draped in an American flag, a man and woman literally cut down big business with a saw labeled "ballot." Dinsmoor communicated his ideas forcefully and directly through haunting imagery. At dusk his electric

Spencer Museum of Art, University of Kansas, Lawrence Acrylic on canvas, 4'117/8" x 6'1/16" (1.52 x 1.83 m). 19. Roger Shimomura. *Diary* (Minidoka Series #3) 1978.

became entrepreneurs. In a painting by the seventeenth-

ing her work unsurpassed in the city of Paris, which she

the painting of a woman artist named Anastaise, consider-

illustrate, and decorate her books. She especially admired

was a patron, too, for she hired painters and scribes to copy,

senting her work to the queen of France (fig. 20). Christine

painting shows the French writer Christine de Pisan pre-

institutions they represented. An early-fifteenth-century

artists depended on the patronage of individuals and the

and vicariously participate in its creation. In earlier periods ence for the artist. Patrons provide economic support for art

refined evaluation, they become what we call connoisseurs. become scholars, when their expertise turns to questions of

love works of art. When collectors study diligently, they

51/2 x 63/4" (14 x 17 cm). The British Library, London

20. Christine Presenting Her Book to the Queen of France.

1410-15. Tempera and gold on vellum, image approx.

MS. Harley 4431, folio 3

The patrons of art constitute a very special kind of audi-

believed had the world's best painters of miniatures.

When a free market developed for art works, artists

and importance, and impressed others. Many collectors truly enhanced the owners' prestige, created an aura of power next, gaining luster or mysterious power with age. Art "curiosities" were passed along from one generation to the buried the dead with necklaces of fox teeth. Collections of

since prehistoric times when people They have collected special objects ple who are not artists "use" art, too. things appeal to human curiosity. Peo-Rare, valuable, beautiful, and strange

PATRONS QNA ARTISTS

makes a powerful political statement.

a personal style that expresses his own dual culture as it woodblock prints (see fig. 7) and American Pop Art to create bined two formal traditions, the Japanese art of color enclosed compound. In his painting Shimomura has comby an open door—a door that opens on a barbed-wiremother writing while he (the toddler) and his mother stand internment camp in Idaho. Shimomura painted his grandhis grandmother's record of the family's experience in an War II. Shimomura based his 1978 painting Diary (fig. 19) on try were forcibly confined in internment camps during World powerful statements. American citizens of Japanese ances-Artists like Roger Shimomura turn painting and prints into pilgrimage church or a half-acre concrete Garden of Eden.

Not all art with social impact is public on the scale of a nate the concrete and cement figures with an unearthly glow. light bulbs—his repeated "Ever-Seeing Eye of God"—illumi-

cement, over-lifesize Eden, Lucas, Kansas. 1905-32. Painted concrete and Destruction of the Trusts by the Ballot. Garden of

21. Gillis van Tilborch. Cabinet d'Amateur with a Painter. c. 1660-70. Oil on canvas, 381/4 x 51" (97.15 x 129.54 cm). Spencer Museum of Art, University of Kansas, Lawrence

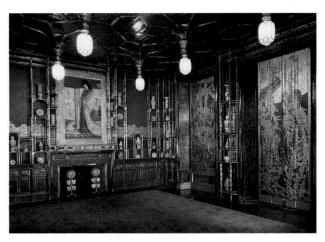

22. James McNeill Whistler. Harmony in Blue and Gold. The Peacock Room, northeast corner, from a house owned by Frederick Leyland, London. 1876-77. Oil paint and metal leaf on canvas, leather, and wood, 13'117/8" x 33'2" x 19'111/2" (4.26 x 10.11 x 6.83 m). Freer Gallery, Smithsonian Institution, Washington, D.C. (04.61)

century Flemish painter Gillis van Tilborch, an artist and an art dealer display their wares to patrons, who examine the treasures brought before them (fig. 21). Paintings cover the walls, and sculpture and precious objects stand on the table and floor. The painting provides a fascinating catalog of the fine arts of the seventeenth century and the taste of seventeenth-century connoisseurs.

Relations between artists and patrons are not always so congenial as Tilborch portrayed them. Patrons can change their minds about a commission or purchase or fail to pay their bills. Such conflicts can have simple beginnings and unexpected results. In the late nineteenth century the Liverpool shipping magnate Frederick Leyland asked James McNeill Whistler, an American painter living in London, what color to paint the shutters in the dining room where he planned to hang Whistler's painting The Princess from the Land of Porcelain. The room had been decorated with expensive embossed and gilded leather and finely crafted shelves to show off Leyland's Asian porcelain collection. Whistler was inspired by the Japanese theme of his own painting as well as the porcelain, and he was also caught up in the wave of enthusiasm for Japanese art sweeping Europe. He painted the window shutters with splendid turquoise, blue, and gold peacocks. Then, while Leyland was away, he painted the entire room (fig. 22), replacing the gilded leather on the walls with turquoise peacock feathers. Leyland was shocked and angry when he saw the results. Whistler, however, memorialized the confrontation with a painting of a pair of fighting peacocks on one wall of the room. One of the peacocks represents the outraged artist, and the other, standing on a pile of coins, represents the incensed patron. The Peacock Room, which Whistler called Harmony in Blue and Gold, is an extraordinary example of total design, and Leyland did not change it. The American collector Henry Freer, who sought to unite the aesthetics of East and West, later acquired the room and donated it on his death to

a museum in the Smithsonian Institution in Washington, D.C., where it can now be appreciated by all. Today museums are the primary collectors and preservers of art.

THE From time immemorial people have KEEPERS gathered together objects that they considered to be precious, objects that OF ART: considered to be produced to the product of MUSEUMS conveyed the idea of power and pres-

tige. The curators, or keepers of such collections, assisted patrons in obtaining the best pieces. The idea of what is best and what is worth collecting and preserving varies from one generation to another. Yesterday's popular magazine (see fig. 4) is today's example of fine photography and graphic design.

An art museum can be thought of in two ways: as a scholarly research institute where curators care for and study their collections and teach new scholar-curators, and as a public institution dedicated to exhibiting and explaining the collections. The first university art museum in the United States was established in 1832 at Yale University. Today museums with important research and educational functions are to be found in many universities and colleges, and museums with good collections are widespread. One does not have to live in a major population center to experience wonderful art. Of the twenty-six works illustrated in this chapter, eleven are located near the author in Kansas and Missouri, and four of these are in a single university museum. No one would assert that Kansas is the art capital of the world; the point is that encounters with the real objects are not out of most people's range. And no matter how faithful the quality of reproductions in a book or a slide or a monitor showing an image from a CD-ROM, there is no substitute for a "live interview" with an actual work of art or architecture.

The display of art is a major challenge for curators. Art must be put on public view in a way that ensures its safety

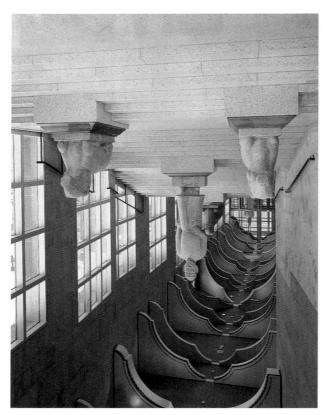

Ming dynasty tomb figures, Seattle Art Museum. 1986-91 24. Robert Venturi and Denise Scott-Brown. Stair Hall with

Purchase: Nelson Trust (34.10) Museum of Art, Kansas City, Missouri wooden screens, 17th century. The Nelson-Atkins paint, height 7'11" (2.41 m). Mural painting, 14th century; Sung or Liao dynasty, 11th-12th century. Wood with 23. The Water and Moon Kuan-yin Bodhisattva. Northern

that prides itself as a link between East and West. procession—and serve as an appropriate symbol for a city architecture—the museum coffee shop interrupts their stately serious contrast to the witty, theatrical, and "irreverent"

"I KNOM

but this level of "feeling" about art—"I to a painting or building or photograph, first we may simply react instinctively or intense, naive or sophisticated. At Our involvement with art may be casual

know what I like"—can never be fully satisfying. I CIKE" **TAHW**

quite independent of the painting's subject. The mind's eye rough texture provides a two-dimensional interest that is corded immediate visual sensations with flecks of color. The branches and leaves of trees, dark-clothed figures—he re-Rather than carefully drawing forms he knew to exist—the the reflected light that registers as color in human eyes. Capucines, Paris (fig. 25) tried to capture in paint on canvas sionist painters like Claude Monet in his Boulevard des ful depictions of nature people then expected to see. Impresand unfinished—merely "impressions"—rather than the carewere laughed at when first displayed. They seemed rough tury, now among the most avidly sought and widely collected, over time. Impressionist paintings of the late nineteenth cen-Opinions as to what constitutes a work of art change

> this challenge. Museum (fig. 24) illustrate two imaginative approaches to Museum of Art in Kansas City (fig. 23) and at the Seattle Art The installation of Chinese sculpture at the Nelson-Atkins and also enhances its qualities and clarifies its significance.

> of security. emphasizes its importance, and provides it with a measure ment that recalls the religious context of the art, subtly century. The curators successfully established an environre-created temple setting with screens from the seventeenth and together they form a magnificent ensemble, placed in a sculpture and painting are exceptional in their own right, majestically in front of a mural painting of the Buddha. The enlightened being, in the Nelson-Atkins Museum of Art sits A polychromed and gilded wooden bodhisattva, or

> orful festive arches, they provide a monumental and semiwelcoming guardians for the galleries above. Set under colures were cleaned, restored, and placed on the stairs like museum interior with the steep city street outside. The figished in 1991, had a monumental stairwell that united the designed by Robert Venturi and Denise Scott-Brown and finhad been almost ignored. The new Seattle Art Museum, in a park for years. Weather-beaten and moss-covered, they Their carved-stone Chinese tomb figures had stood outdoors The Seattle Art Museum had different problems to solve.

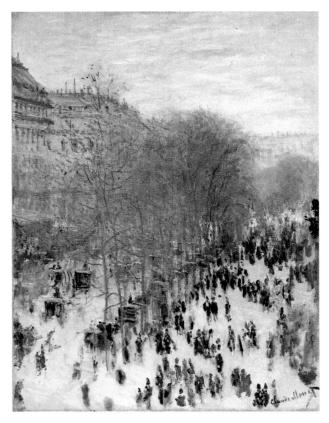

25. Claude Monet. Boulevard des Capucines, Paris. 1873–74.
Oil on canvas, 31¹/4 x 23¹/4" (79.4 x 59.1 cm). The Nelson-Atkins Museum of Art, Kansas City, Missouri
Purchase: the Kenneth A. and Helen F. Spencer Foundation Acquisition Fund (F72-35)

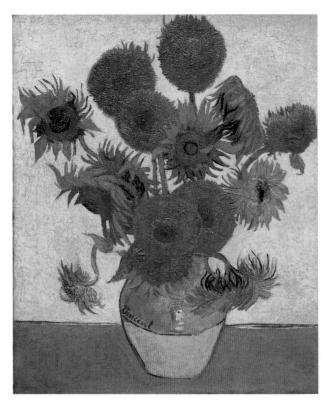

26. Vincent van Gogh. Sunflowers. 1888. Oil on canvas, $36^{1/4} \times 28^{3/4}$ " (92.1 x 73 cm). The National Gallery, London

interprets the array of colors as the solid forms of nature, suddenly perceiving the coral daubs in the lower right, for example, as a balloon man. When the critic Louis Leroy reviewed this painting the first time it was exhibited, he sneered: "Only, be so good as to tell me what those innumerable black tongue-lickings in the lower part of the picture represent?" (*Le Charivari*, April 25, 1874). Today we easily see a street in early spring filled with horse-drawn cabs and strolling men and women. In this magical moment the long-dead artist and the live viewers join to re-create nineteenth-century Paris.

Art history, in contrast to art criticism, combines the formal analysis of works of art—concentrating mainly on the visual elements in the work of art—with the study of the works' broad historical context. Art historians draw on biography to learn about artists' lives, social history to understand the economic and political forces shaping artists, their patrons, and their public, and the history of ideas to gain an understanding of the intellectual currents influencing artists' work. They also study the history of other arts—including music, drama, literature—to gain a richer sense of the context of the visual arts. Every sculpture or painting presents a challenge. Even a glowing painting like Vincent van Gogh's *Sunflowers* (fig. 26), of 1888, to which we may react with spontaneous enthusiasm, forces us to think about art, as well as feel and admire it.

Our first reaction is that Sunflowers is a joyous, colorful

painting of a simple subject. But this is far more than a bunch of flowers in a simple pot in a sunlit room. Art history makes us search for more. The surface of the painting is richly built up-van Gogh laid on the thick oil paint with careful calculation. The brilliant yellow ground that looks flat in a reproduction in fact resembles a tightly woven basket or textile, so deliberately and carefully placed are the small brushstrokes. The space is suggested simply—by two horizontal stripes, two bands of gold different in intensity and separated by just the slightest blue line, the color of maximum contrast. Here, in fact, there is no space, no setting; we imagine a table, a sun-filled room. But did van Gogh see a pot of flowers on a windowsill, against the blazing, shimmering heat and light of the true sun? Van Gogh had a troubled life, and that knowledge makes us reflect on the possible meaning of the painting to him—for the painting, despite its brightness, reflects something ominous, a foreboding of the artist's loneliness and despair to come.

As viewers we participate in the re-creation of a work of art, and its meaning changes from individual to individual, from era to era. Once we welcome the arts into our life, we have a ready source of sustenance and challenge that grows, changes, mellows, and enriches our daily experience. No matter how much we study or read about art and artists, eventually we return to the contemplation of the work itself, for art is the tangible evidence of the ever-questing human spirit.

Starter Kit

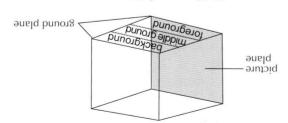

27. Diagram of picture space

represented in two dimensions in paintings and drawings. Artists have used many methods to depict objects as seeming to recede from the two-dimensional surface, called the picture plane is called the picture plane. The area "behind" the picture plane is called the picture space and conventionally contains three "Zones": foreseasount, middle and conventionally contains three "Sones": dicular to the picture plane, forming the "floor" of the space, is the ground plane.

Various techniques for conveying a sense of pictorial depth have been preferred by artists in different cultures and at different times (fig. 28).

CONTENT. Content is a less specific aspect of a work of art than is form. There is also less agreement as to what content is. Content includes subject matter, which quite simply is what is represented, even when that consists strictly of lines and formal elements—lines and color without recognizable subject matter, for example. Content includes the IDEAS contained in a work. When used inclusively, the term content can embrace the social, political, and economic contexts in which a work was created, the intention of the artist, the reception of the beholder (the ADDIENCE) to the work, and ultimately the meaning in the work of art.

The study of the "what" of subject matter is Iconography. The study of the "what" of sub-

STYLE. Understandably, specialized terminology is used to describe style in art history. Expressed very broadly, style is

the combination of form and content characteristics that

Representational and nonrepresentational style (also called nonobjectrive) refer to whether the subject matter is or is not recognizable.

make a work distinctive.

ject matter.

Linear describes the style in which an artist uses line as the primary means of definition. When shadows and shading or modeling and highlights dominate, the style may be called painterly. Architecture and sculpture may be linear or painterly.

Realistic, naturalistic, and idealized are often-found descriptions of style. Realist, Naturalist to depict objects as they are in actual, visible reality. Naturalism is a style of depiction in which the physical appearance of the rendered image in nature is the primary inspiration. A work in a naturalistic atyle resembles the original but not with the same exactitude

This is a very basic primer of concepts and working assumptions used in the study of art history—a quick reference guide for this entire book and for encounters with art in general.

What Art Is

A work of art may be described in basic, nonphilosophical terms as having two components: FORM and CONTENT. It is also distinguished by STYLE, MEDIUM, and PERIOD.

FORM. Referring to purely visual aspects of art and architecture, form includes LINE, COLOR, TEXTURE, SPATIAL QUALITIES, and COMPOSITION. These various attributes are often referred to as FORMAL ELEMENTS.

Line is an element—usually drawn or painted—that defines shape with a more-or-less continuous mark. The movement of the viewer's eyes over the surface of the work of art may follow a path determined by the artist and so create imaginary lines, or lines of force.

Color has several attributes. These include Hue, value, and interestry

HUE is what we think of when we hear the word color. Red, yellow, and blue are the PRIMARY COLORS Decause other colors (SECONDARY COLORS of Orange, green, and Purple) can be created by mixing (combining) them. Red, orange, and yellow are known as warm colors; and green, blue, and purple as cool colors.

value is the relative degree of lightness or darkness in the range from white to black and is created by the amount of light reflected from an object's surface. A dark green has a deeper value than a light green, for example, and light gray has a lighter value than dark

INTENSITY is the degree of brightness or dullness of color. For this reason, the word saturation is synonymous with intensity.

Texture is the tactile quality of a surface. It is perceived and described with words like *smooth*, *polished*, *satiny*, *rough*, *coarse*, or *oily*. Texture takes two forms: the texture of the actual surface of the work of art and the implied (imaginary) surface of the object the artist is representing.

Spatial qualities include mass, volume, and space.

wass and vorume are properties of three-dimensional

space may be three-dimensional and actual, as with sculpture and architecture, or may be represented in two dimensions. Unfilled space is referred to as PACE.

TIVE SPACE; solids are referred to as POSITIVE SPACE.

Composition is the organization, or arrangement, of form in

a work of art.

PICTORIAL DEPTH (SPATIAL RECESSION) is a specialized aspect of composition in which the three-dimensional world is

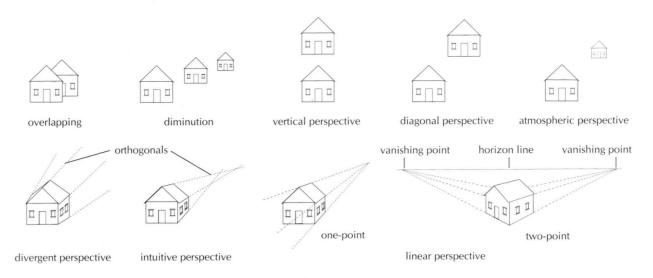

28. Pictorial devices for depicting recession in space

Among the simpler devices are OVERLAPPING, in which partially covered elements are meant to be seen as located behind those covering them, and DIMINUTION, in which smaller elements are meant to be perceived as being farther away than larger ones. In VERTICAL and DIAGONAL PERSPECTIVE, elements are stacked vertically or diagonally, with the higher elements meant to be perceived as deeper in space. Another way of suggesting depth is through ATMOSPHERIC PERSPECTIVE, which depicts objects in the far distance with less clarity than nearer objects, often in bluish gray hues, and treats the sky as paler near the horizon. For many centuries DIVERGENT PERSPECTIVE, in which forms widen slightly and lines diverge as they recede in space, was used by East Asian artists. Intuitive perspective, such as that in some late medieval European art, uses the opposite: forms become more narrow and lines converge the farther away they are from the viewer, approximating the optical experience of spatial recession. Linear Perspective, also called Scientific, Mathematical, One-Point, or Renaissance perspective, is an elaboration and standardization of intuitive perspective and was developed in fifteenth-century Italy. It uses mathematical formulas to construct illusionistic images in which all elements are shaped by imaginary lines called Orthogonals that converge in one or more vanishing Points on a horizon line. Linear perspective is the system that most people in Euro-American cultures think of as perspective. Because it is the visual code they are accustomed to reading, they accept as "truth" the distortions it imposes, including foreshortening, in which, for instance, the soles of the feet in the foreground are the largest element of a figure lying on the ground.

and literalness as a work in a realistic style. IDEALIZATION strives for perfection that is grounded in prevailing values of a culture. Classical Greek sculpture is an example of art that is both naturalistic and idealized. Abstraction is the stylistic opposite of the last three styles, because the artist makes forms that do not depict observable objects—often with the intention of extracting the essence of an object or idea. Much prehistoric art is abstract in this way. Expressionistic style appeals to the subjective responses of the beholder, often through exaggeration of form and expression.

MEDIUM. What is meant by medium (here we have used the plural *mediums*, to distinguish the word from the press *media*) is the material from which a given object is made. Even broader than medium is the distinction between two-dimensional, three-dimensional, mixed-medium, and ephemeral arts.

Two-dimensional arts include painting, drawing, the graphic arts, and photography.

Three-dimensional arts are sculpture, architecture, and many ornamental and practical arts.

Mixed medium includes categories such as collage and assemblage, in which the two-dimensional surface is built up from elements that are not painted, such as pieces of paper or metal or garments.

Ephemeral arts include such chiefly modern categories as performance art, earthworks, cinema, video art, and computer art, all of which have a central temporal aspect in that the artwork is viewable for a finite period of time and then disappears forever, is in a constant state of change, or must be replayed to be experienced.

Painting includes wall painting and fresco, illumination (decoration of books with paintings), panel painting (paintings on wood panels), miniature painting, handscroll and hanging scroll painting, and easel painting.

Drawings may be sketches (quick visual notes for larger drawings or paintings); studies (more carefully drawn analyses of details or entire compositions); drawings as complete artworks in themselves; and cartoons (full-scale drawings made in preparation for work in another medium, such as fresco).

Graphic arts are the printed arts—images that are reproducible and that traditionally include woodcut, engraving, etching, drypoint, and lithography.

Still photographs are a two-dimensional art.

Sculpture is a three-dimensional work of art that is carved, modeled, or assembled. Carved sculpture is reductive in the sense that the image is created by taking material away.

TECHNIQUE

Casting Inal sculpture. The sculptor carved the details in the wax. Rods and a pouring cup made of wax were attached to the model. A thin layer of fine, damp sand was pressed very firmly into the surface of the wax model, and then model, rods, and cup were encased in thick layers of clay. When the clay was completely dry, the mold was heated to melt out the wax. The mold was then turned upside down to receive the molten metal, which for the Benin was brass, heated to the point of liquification. The cast was placed in the ground. When the metal was completely cool, the outside clay cast and the metal was completely cool, the outside clay cast and the inside core were broken up and removed, leaving the

piece of sculpture, which could not be duplicated because

cast brass sculpture. Details were polished to finish the

The lost-wax casting process (also called cire perdue, the French term) has been used for

potates, are Henriff term) has been used for many centuries. It probably started in Egypt. By 200 BCE the technique was known in China and ancient Mesopotamia and was soon after used by the Benin peoples in Africa. It spread to ancient Greece sometime in the sixth century spread to ancient Greece sometime in the sixth century century, when a piece-mold process came to predominate. The usual metal is bronze, an alloy of copper and tin, or sometimes brase, an alloy of copper and tin, or sometimes brases, an alloy of copper and zinc.

The progression of drawings here shows the steps used by Benin sculptors. A heat-resistant "core" of clay—approximating the shape of the sculpture-to-be (and eventually becoming the hollow inside the sculpture)—was covered by a layer of wax about the thickness of the

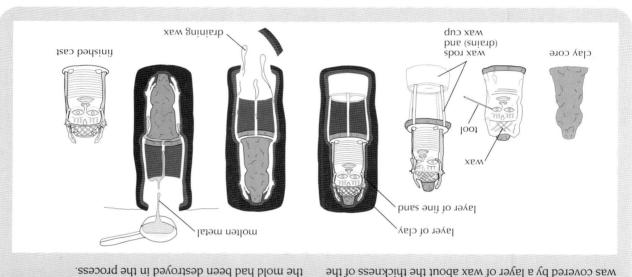

29. Diagrammatic drawings of buildings

tortion. Sections are imaginary vertical slices from top to bottom through a building that reveal elements "cut" by the slice. Cutaway drawings show both inside and outside elements from an oblique angle.

Other mediums. Besides painting, drawing, graphic arts, photography, sculpture, and architecture, works of art are made in the mediums of ceramic and glass, textile and stitchery, metalwork and enamel, and many other materials. Today anything—even "junk," the discards of society—can be turned into a work of art.

PERIOD. A word often found in art historical writing, period means the historical era from which a work of art comes. It is good practice not to use the words style and period interchangeably. Style is the sum of many influences and characteristics, including the period of its creation. An example of good usage is: "an American house from the example of good usage is: "an American house from the Colonial period built in the Georgian style."

Wood and stone sculpture, large and small, is carved sculpture because the material is not malleable. Modeled sculpture is considered additive, meaning that the object is built up from a material such as clay that is soft enough to be molded and shaped. Metal sculpture is usually cast (see molded and shaped. Metal sculpture is usually cast (see molded and shaped. Metal sculpture is usually cast (see similar means of joining.

Sculpture is either freestanding (sculpture in the round) or in relief, which means projecting from the surface of which it is a part. Relief may be high relief, with parts of the sculpture projecting far off the background, or low relief, in which the projections are only slightly raised. Sunken relief, found mainly in Egyptian sculpture, is imagery carved into the surface, with the highest part of the relief being the flat surface, with the highest part of the relief being the flat surface.

Architecture is three-dimensional and highly spatial, and it is closely bound up with developments in technology and materials. An example of the relationship among technology, materials, and function is how space is spanned (see "Elements of Architecture," page 32).

Buildings are represented by a number of two-dimensional schematic drawings, including plans, elevations, sections, and cutaways (fig. 29). PLANS are imaginary slices through a building at approximately waist height. Everything below the slice is drawn as if looking straight down from above. Elevations are exterior sides of a building as if seen from a moderate distance but without any perspective distant

ELEMENTS OF ARCHITECTURE

Space-Spanning Construction Devices

Gravity pulls on everything, presenting great challenges to the need to cover spaces. The purpose of the spanning element is to transfer weight to the ground. The simplest space-spanning device is post-

and-lintel construction, in which uprights are spanned by a horizontal element. However, if not flexible, a horizontal element over a wide span breaks under the pressure of its own weight and the weight it carries.

Corbeling, the building up of overlapping stones, is another simple method for transferring weight to the ground. Arches, round or pointed, span space. Vaults, which are essentially extended arches, move weight out from the center of the covered space and down through the corners. The cantilever is a variant of post-and-lintel construction. When concrete is reinforced with steel or iron rods, the inherent brittleness of cement and stone is then overcome because of metal's flexible qualities. The concrete can then span much more space and bear heavier loads. Suspension works to counter the effect of gravity by lifting the spanning element upward. Trusses of wood or metal are relatively lightweight spanners but cannot bear heavy loads. Large-scale modern construction is chiefly steel frame and relies on steel's properties of strength and flexibility to bear great loads. The balloon frame, an American innovation, is based in post-and-lintel principles and exploits the lightweight, flexible properties of wood.

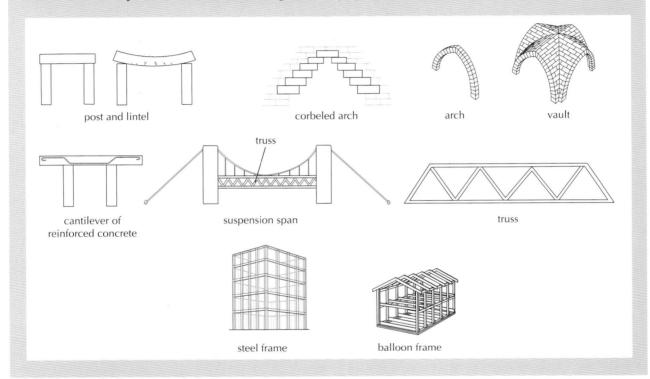

What Art History Is

Art history is a humanistic field of inquiry that studies visual culture. Increasingly, art history seeks to understand the role of visual culture in societies around the world and to learn more about the people and cultures who created the individual artworks through close yet multidimensional study of the art itself. Art history embraces many different approaches to visual culture. Contextual art History seeks to place and understand art as one expression of complex social, economic, political, and religious influences on the culture and the individuals within it. Formalism, or formal analysis, examines and analyzes the formal elements of works of art, in and of themselves. The most traditional approach is connoisseurship, the almost intimate appreciation and evaluation of works of art for their intrinsic attributes, including genuineness and quality. Connoisseurship necessarily involves AESTHETICS, a branch of philosophy concerned with the nature of beauty and taste. This book combines contextual art history and formal analysis, while acknowledging other approaches.

Museums

When you visit a museum, you need no special preparation, but planning can enhance your enjoyment. Several museum resources can help you as you study the works of art there. Publications such as exhibition catalogs and museum handbooks have entries on the artworks. Postcards are an inexpensive way to take an image home.

Museum behavior is simple common sense: don't do anything that endangers the art or interferes with other people's enjoyment of it. In the galleries take a quick look around to get a sense of what is there before going back to look more carefully at individual works that attract you. You can be systematic or selective. When you approach a work of art, look at it and think about it before you read the label. You may not see the same works of art that you have studied in this book, but you will see pieces that relate to both the ideas and the artworks presented in *Art History*. Reading about art—whether in books, in catalogs, or on museum labels—should supplement, not substitute for, looking at works of art.

Use Notes

Boxes Special material that complements, enhances, explains, or extends the text is set off in three types of tinted boxes. Elements of Architecture boxes clarify specifically architectural features, such as "Space-Spanning Construction Devices" in the Starter Kit (page 32). Technique boxes (see "Lost-Wax Casting," page 31) amplify the methodology by which a type of artwork is created. Other boxes treat special-interest material related to the text.

Bibliography The Bibliography, at the end of this book beginning on page B1, contains books in English, organized by general works and by chapter, that are basic to the study of art history today, as well as works cited in the text.

Dates, Abbreviations, and Other Conventions This book uses the designations BCE and CE, abbreviations for "before the Common Era," instead of BC ("before Christ") and AD ("Anno Domini," "the year of our Lord"). The first century BCE is from the year I CE to 99 ECE to I BCE; the first century BCE is from the year I CE to 99 ECE is limilarly, the second century BCE is from 100 CE to 199 BCE to 100 BCE; the second century BCE is the period from 199 BCE to 100 BCE; the second century BCE is from 100 CE to 199 CE.

second century ce	first Century CE	first Century BCE	second century BCE
\$00 L	66-L	1-66	s001

Circa ("about" or "approximately") is used with dates, spelled out in the text and abbreviated to "c." in the captions, when an exact date is not yet verified.

An illustration is called a "figure," or "fig." Figure 6-70 is the seventieth numbered illustration in Chapter 6. Figures 1 through 29 are in the Introduction and the Starter Kit. There are two types of figures: photographs of artworks or of models, and line drawings. The latter are used when a work cannot be photographed or when a diagram or simple drawing is the clearest way to illustrate an object or a place.

When introducing artists, we use the words *active* and *documented* with dates—in addition to "b." (for "born") and "d." (for "died"). "Active" means that an artist worked during the years given. "Documented" means that documents link the person to the date.

Accents are used for words in Spanish, Italian, French, and German only.

With few exceptions, names of museums and other cultural bodies in Western European countries are given in the form used in that country.

Titles of Works of Art Most paintings and sculpture created in Europe and the United States in the last 500 years have been given formal titles, either by the artist or by critics and art historians. Such formal titles are printed in italics. In other traditions and cultures, a single title is not important or even recognized. In this book we use formal titles of artworks in cases where they are established and descriptive titles of artworks where titles are not established. If a work is best known by its non-English title, such as Manet's Dejeuner sur l'Herbe (Luncheon on the Grass), the original language precedes the translation.

The various features of this book reinforce each other, helping the reader to become comfortable with terminology and concepts specific to art history.

Introduction and Starter Kit The Introduction is an invitation to the pleasures of art history. The Starter Kit that follows the Introduction is a highly concise primer of basic concepts and tools. The outside margins of the Starter Kit pages are tinted to make them easy to find.

 $\textbf{Captions} \ \ \text{There are two kinds of captions in this book: short and long. Short captions identify information specific to the work of art or architecture illustrated:$

artist (when known)

title or descriptive name of work

date
original location (if moved to a museum or other site)
material or materials a work is made of
size (height before width) in feet and inches, with
centimeters and meters in parentheses

present location

The order of these elements varies, depending on the type of work illustrated. Dimensions are not given for architecture, for most wall painting, or for architectural sculpture. Some captions have one or more lines of small print below the identification section of the caption that gives museum or collection information. This is rarely required reading.

Long captions contain information of many kinds that complements the main text.

Definitions of Terms You will encounter the basic terms of art history in three places:

IN THE TEXT, Where words appearing in **boldface** type are defined, or glossed, at the first use; some terms are explained more than once, especially those that experience shows are hard to remember.

IN BOXED FEATURES ON technique and other subjects and in Elements of Architecture boxes, where labeled drawings and diagrams visually reinforce the use of terms.

IN THE GLOSSARY at the end of the volume, which contains all the words in **boldface** type in the text and boxes. The Glossary begins on page GI, and the outside margins are tinted to make the Glossary easy to find.

Maps, Timelines, Parallels, and Time Scales At the beginning of each chapter is a map with all the places mentioned in the chapter. Above the map, a timeline runs from the earliest through the latest years covered in that chapter. Small drawings of major artworks in the chapter are sited on the map at the places from which they come and are placed on the timelines at the times of their creation. In this way on the timelines at the times of their creation. In this way these major works are visually linked in time and place.

Parallels, a table near the beginning of every chapter, uses the main chapter sections to organize artistic and other events "at home and abroad." The Parallels offer a selection of simultaneous events for comparison without suggesting that there are direct connections between them.

Time scales appear in the upper corners of pages, providing a fast check on progress through the period.

Woman from Willendorf c. 22,000–21,000

▲ UPPER PALEOLITHIC 40,000-8000

CHAPTER 1

Prehistory and Prehistoric Art in Europe

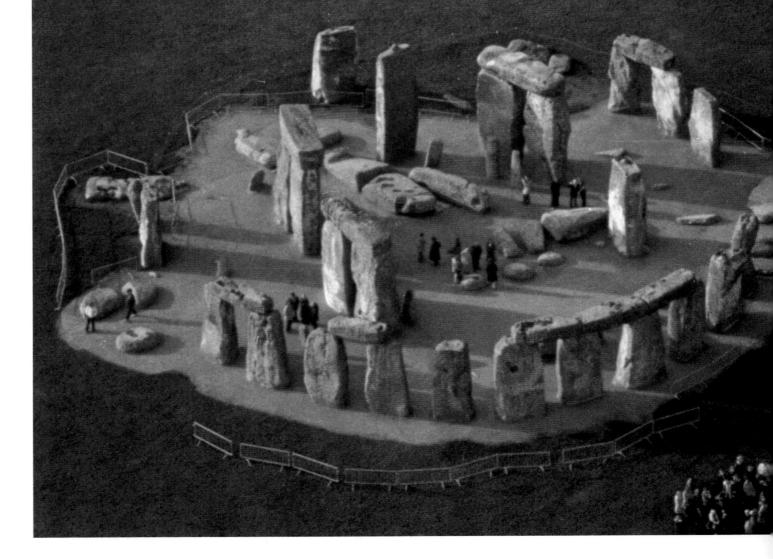

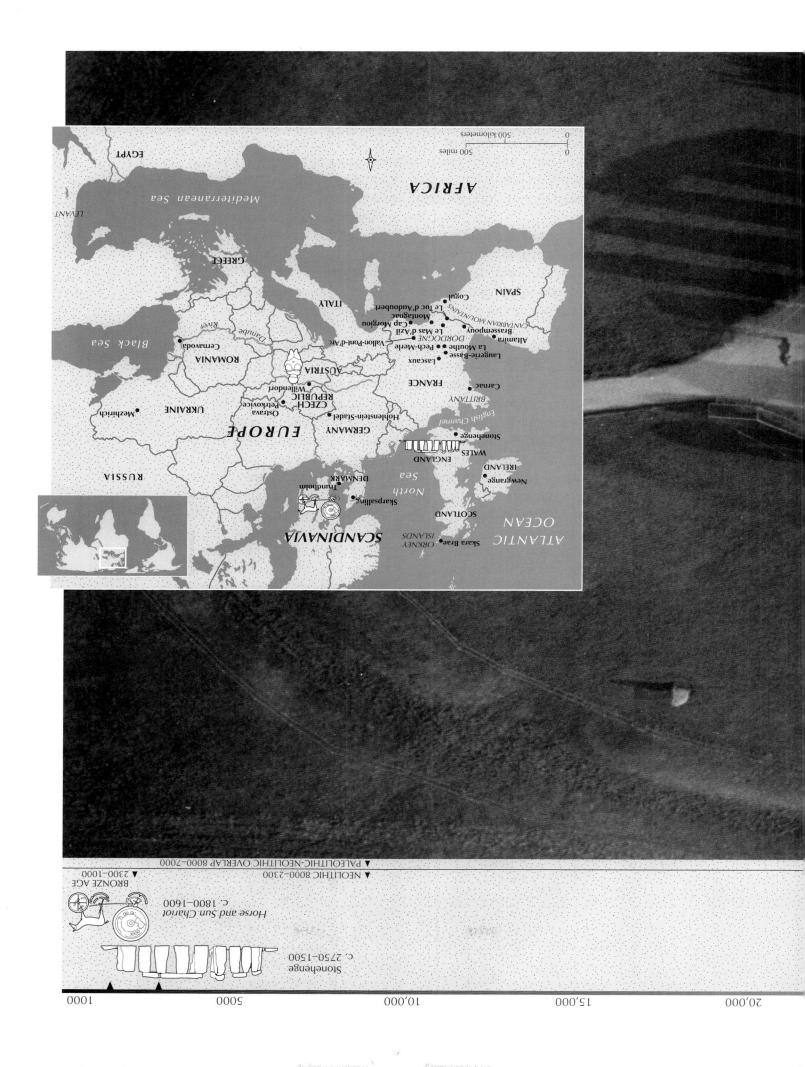

36,000 BCE 1000 BCE

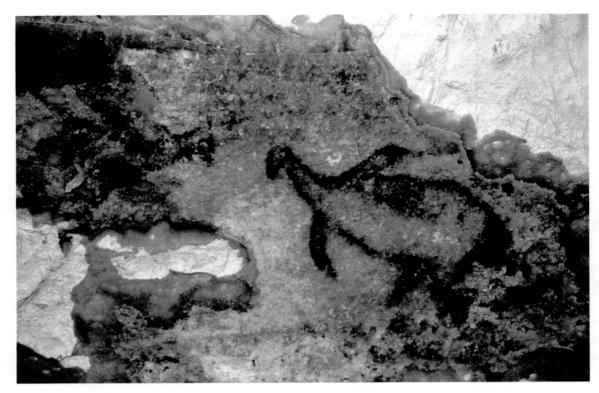

1-1. Auk, Cosquer cave, Cap Morgiou, France. c. 16,500 BCE. Charcoal and manganese dioxide on limestone

In July 1991, divers at Cap Morgiou, France, set out to explore what appeared to be a small cave with an entrance 121 feet below the surface of the Mediterranean. After swimming through a narrow, rising tunnel for nearly 600 feet, they suddenly bobbed up into a cavern above sea level. Looking around, they found to their amazement that the cavern walls were decorated with animal images and human handprints. The French explorers, led by diving instructor Henri Cosquer, had discovered a cave filled with prehistoric paintings in a region where no such paintings had been found before. Some of them, like the image of a playful auk, a seabird that became extinct in the Mediterranean about 150 years ago (fig. 1-1), simply delight the modern viewer. But more important, the paintings are the work of artists who recorded the interests and values of prehistoric peoples living on a-hillside near what was then the edge of the sea.

Prehistory includes all of human existence before the emergence of writing. Long, long before that defining moment, people were carving objects, painting images, and creating shelters and other structures. These works of prehistoric art and architecture are fascinating in part because they are so supremely beautiful and in part because of what they disclose about the people who made them.

Prehistoric art is therefore of interest not only to art historians, but also to archeologists and anthropologists, for whom the art is only one clue—along with fossils, pollens, and other finds—to an understanding of early human life and culture. Because the sculpture, paintings, and structures that survive are only the tiniest fraction of what was created over such a long span of time, conclusions and interpretations drawn from them have to be quite theoretical, making prehistoric art one of the most speculative areas of art history.

vary from place to place, the divisions are useful as we with them. Although the precise dates for these periods years ago, bringing the beginnings of Neolithic culture ed onto the continent between about 11,000 and 8,000 ual retreat of the ice, people from the Near East migratthe Mesolithic in other parts of the world. With the gradfew human traces from the period, which corresponds to Upper Paleolithic and Neolithic and therefore presents ered by glaciers in the transitional period between the about 9000-8000 BCE. Much of northern Europe was cov-37,000 years ago and lasted until the end of the Ice Age, Paleolithic period in Europe began between 42,000 and relative position in excavated strata, or layers. The Upper three phases, Lower, Middle, and Upper, reflecting their neo-, "new"). The Paleolithic period is itself divided into lithic (Greek meso-, "middle"), and the Neolithic (Greek

prehistoric art of other continents and cultures. In the Upper Paleolithic period, very long before the development of writing, our early ancestors created another form of communication: the visual arts. Many examples of sculpture, painting, architecture, and other arts have survived the long passage of time to move us, challenge us, and provide us with insights into the lives and beliefs of their makers. Nevertheless, it is nearly impossible to determine what "art" communicated to monosaible to determine what "art" communicated to whom in such early times, or what values its creators

the prehistoric art of Europe; later chapters consider the

examine developments in the arts. This chapter presents

THE Cates that the earliest upright cates that the earliest upright human species came into being 4.4 million years ago in b

Africa. How and when modern humans evolved is the subject of lively debate, but anthropologists now agree that the hominids called Homo sapiens ("wise humans") appeared about 200,000 years ago and that the species to which we belong, Homo sapiens, evolved about 120,000 to 100,000 years ago. Modern humans spread across Asia, into Europe, and finally to Australia and the Americas. The results of that this vast movement of people took place much earthast this vast movement of people took place much earbet this vast movement of people took place much earbet this vast movement of people took place much earbet this vast movement of people took place much earbet this vast movement of people took place much earbet this vast movement of people took place much earbet this vast movement humans have the ability to travel great disearly modern humans have the ability to travel great disearly modern humans have the ability to travel great disearly modern humans have the ability to travel great disearly modern humans have the ability to travel great disearly modern humans have the ability to travel great disearly modern humans have the ability to travel great disearly modern humans have the ability to travel great disearly modern humans have the ability to travel great disearly modern humans have the ability to travel great disearly modern humans have the ability to travel great disearly modern humans have the ability to travel great disearly modern humans have the ability to travel great disearly modern humans have the ability to travel great disearly modern humans have the ability to travel great disearly modern humans have the ability to travel great disearly modern humans have the ability to travel great disearly modern humans have the ability to travel great disearch humans have the ability that we have the ability to travel a

human "aesthetic spirit." Systematic study of ancient remains began only about 200 years ago. Struck by the wealth of stone tools, weapons, and figures found at ancient living sites, those first scholars named the whole period of early human development the "Stone Age." Today's researchers divide the Stone Age into three major periods: the Paleolithic (from the Creek paleo-, "old," and lithos, "stone"), the Meso- (from the Creek paleo-, "old," and lithos, "stone"), the Meso-

This book presents the tangible record of that uniquely

notes, they had "aesthetic spirit and questing intellect."

National Museum of Natural History in Washington, D.C.,

tances, but as the introduction to the galleries of the

8000–1000 BCE Plants domesticated, animal husbandry (Near East, Southeast Asia, the Americas); potter's wheel (Egypt); development of metallurgy (Sumer); development of writing (Sumer); development of writing (Sumer); development of writing (China, India); Great Pyramids at (China, India); Great Pyramids at Giza (Egypt); Stela of Hammurabi	End of Ice Age; plants domesticated; Skara Brae settled; megalithic tombs; unfired clay vessels; Stonehenge; megalithic figures	Bronze Age	C. 2300-1000 BCE
39000-10008	End of Ice Age. plants	Neolithic	c. 8000-2300 BCE
11,500–10,000 все Wooden buildings in South America (Chile); first pottery vessels (Japan); dogs domesticated; bow and arrow		Paleolithic-Neolithic overlap	C. 8000-7000 BCE
70,000–8000 в се Ісе А <u></u> gе	Lion-Human; Woman from Willendorf; mammoth-bone shelters; cave paintings	Jpper Paleolithic	C. 40,000-8000 BCE
World	Prehistoric Europe	<u>Period</u>	Years
			PARALLELS

attached to it.

1-2. Reconstruction drawing of mammoth-bone house from Ukraine. c. 16,000–10,000 BCE

The Beginning of Architecture

People have always found ingenious ways of providing themselves with shelter. It was always possible to occupy the mouth of a cave or to fashion a hut or tent next to a protective cliff. Traditionally, *architecture* has been a term applied to the enclosure of spaces with at least some aesthetic intent, and some would object to its use in connection with such improvisations. But building even the simplest of shelters requires a degree of imagination and planning deserving of the name "architecture."

In the Upper Paleolithic period, people in some regions were building shelters that were far from simple. Circular or oval huts of light branches and hides might measure as much as 15 to 20 feet in diameter. (Modern tents to accommodate six people vary from 10-by-11-foot ovals to 14-by-7-foot rooms.) Some peoples colored their floors with powdered ocher, a naturally occurring iron ore ranging in color from yellow to red to brown. Most activities were centered on the inside fire pit, or hearth; it was there that food was prepared and tools and utensils were fashioned. Larger dwellings might have had more than one hearth and other spaces set aside for different uses—working stone, making clothing, sleeping, and dumping refuse.

Well-preserved examples of Upper Paleolithic dwellings in Russia and Ukraine reveal the great ingenuity of peoples living in those less-hospitable northern regions. To meet the need for solid, weatherproof shelter in the treeless grasslands, these builders created settlements of up to ten houses using the bones of the woolly mammoth, a kind of elephant now extinct (fig. 1-2). One of the best-preserved mammoth-bone villages, discovered in Mezhirich, Ukraine, dates from 16,000-10,000 BCE. Most of its houses were from 13 to 26 feet in diameter, and the largest one measured 24 by 33 feet and was cleverly constructed of dozens of mammoth skulls, shoulder blades, pelvis bones, jawbones, and tusks. The long, curving tusks made excellent roof supports and effective arched door openings. The bone framework was probably covered with animal hides and turf. Inside the dwelling, archeologists found fifteen small hearths that still contained ashes and charred bones left by its final occupants.

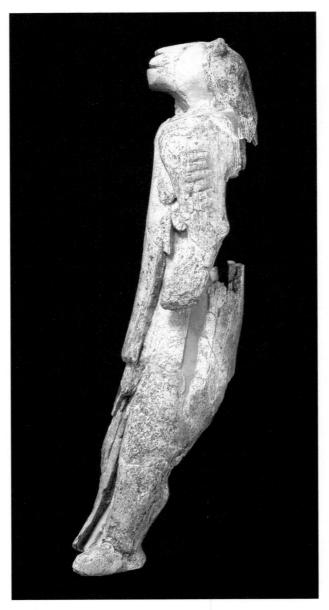

1-3. *Lion-Human*, from Hohlenstein-Stadel, Germany. c. 30,000–26,000 _{BCE}. Mammoth ivory, height 11⁵/s" (29.6 cm). Ulmer Museum, Ulm, Germany

Small Sculpture

The earliest known works of sculpture are small figures, or figurines, of people and animals and date from about 32,000 BCE. Thousands of such figures in bone, ivory, stone, and clay have been found across Europe and Asia.

A human figure carved from a piece of mammoth ivory nearly a foot tall—much larger than most early figurines—was found broken into numerous fragments at Hohlenstein-Stadel, Germany (fig. 1-3). At first it appeared that its head had been lost, but when one of the excavators placed the head from what was thought to be another figurine atop the reassembled body, it was found to be a perfect fit. Astonishingly, the head in question represented some species of cat. Was this lively, powerful figure intended to represent a person wearing

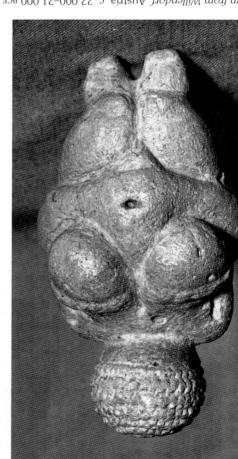

1-4. Woman from Willendorf, Austria. c. 22,000–21,000 BCE. Limestone, height 43/8" (11 cm). Naturhistorisches Museum, Vienna

much larger than it actually is. The sculptor has carved the stone in such a way as to convey the body's fleshiness, exaggerating its female attributes by giving it pendulous breasts, a big belly with deep navel, wide hips, and solid thighs. The gender-neutral parts of the body—the face, the arms, the legs—have been reduced to mere vestiges.

Another carved figure found in what is now the Czech Republic, the Woman from Ostrava Petrkovice, presents an entirely different perception of the female form (fig. 1-5). It is less than 2 inches tall and dates from about atockpiled with flintstone and rough chunks of hematite, the iron oxide ore powdered to make ocher pigment, discovered the figure next to the hearth. Someone at the house had apparently picked up one of the pieces of hematite and shaped it into the figure of a youthful, athlematite and shaped it into the figure of a youthful, athletic woman in an animated pose, with one hip slightly raised and a knee bent as if she were walking.

The hematite woman is so beautiful that one longs to be able to see her face. Perhaps it resembled the one preserved on a fragment from another female figure found in France. This is a tiny head in ivory known as the Woman from Brassempouy (fig. 1-6), which dates from about 22,000 BCE. The person who carved it was

aged to produce a work that still inspires wonder. skill, a gifted artist from as long as 30,000 years ago manture never seen in nature. With considerable technical that it took sophisticated thinking to create such a creathat can be said conclusively about the Lion-Human is their intellectual and spiritual life. One of the few things other. But it is much more difficult to form any notion of of their social organization and attitudes toward each types of dwellings. It is even possible to guess something dence—their physical appearance, their diet, tools, and historic people can be drawn from the available evi-Some conclusions about the material existence of preures portrayed in the art of this early period is frustrating. half beast? The inability to identify and interpret the figportrayal of some imagined creature, half human and a lion mask and taking part in some ritual? Or is this a

Animals and unclothed women are the subjects of most of the small sculpture from the Upper Paleolithic period. The most famous female figure from the period was discovered near Willendorf, Austria. The Woman from Willendorf (fig. 1-4) dates from about 22,000–21,000 bet and is a mere 43/8 inches tall. Carved from limestone and originally colored with red ocher, the figure is composed of rounded shapes that convey stability, dignity, and permanence—and incidentally make the work seem and permanence—and incidentally make the work seem

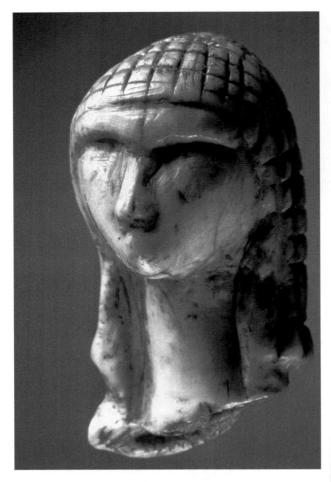

1-6. Woman from Brassempouy, Grotte du Pape, Brassempouy, Landes, France. c. 22,000 BCE. Ivory, height 1 1/4" (3 cm). Musée des Antiquités Nationales, St.-Germain-en-Laye

concerned solely with those contours necessary to identify the piece as a human head—an egg shape atop a graceful neck, a wide nose, and a strongly defined browline suggesting deep-set eyes. The cap of shoulder-length hair is decorated with a grid pattern perhaps representing curls or braiding. This is an example of **abstraction**: the reduction of shapes and appearances to basic forms that do not faithfully reproduce those of the thing represented.

Instead of copying a specific person's face detail by detail, the artist provided only those features common to all of us. This is what is known as a memory image, one that relies on the generic shapes and relationships that readily spring to mind at the mention of a specific object—in this case the human head. Although it is impossible to know what motivated the artist to carve them in just this way, the simplified planes of the tiny face from Brassempouy appeal to our twentieth-century taste for abstraction. Intentionally or not, with this figure some prehistoric artist managed to communicate something essentially human. Even isolated from any cultural context, its human presence shines across the millennia.

Because so many of the surviving human figures from the period are female, some scholars have speculated that prehistoric societies were matriarchal, or dominated by women. Others believe that these female

1-7. *Pregnant Woman and Deer* (?), from Laugerie-Basse, France. c. 14,000–10,000 BCE. Engraved reindeer antler, 2½ x 4" (6.7 x 10.5 cm). Musée des Nationales, St.-Germain-en-Laye

figures, many of them visibly pregnant, are a reflection of the religious notions of these early people. They suggest that early religion was chiefly concerned with perpetuating the familiar cycles of nature, thereby ensuring the continuing life of people, animals, and vegetation, and that these female figurines were created as fertility symbols. Quite likely, the *Woman from Willendorf*, the *Woman from Brassempouy*, and other Upper Paleolithic figures like them did have such a function (see "The Power of Naming," opposite). But they can also be interpreted as representations of actual women, as expressions of ideal beauty, as erotic images, as ancestor figures, or even as dolls meant to help young girls learn women's roles. Given the diversity of ages and physical types represented, it is possible that they were any or all of these.

Such self-contained, three-dimensional pieces are examples of sculpture in the round. Prehistoric carvers also produced relief sculpture in stone, bone, and ivory. In relief sculpture the surrounding material is carved away to a certain depth, forming a background that sets off the figure. A fine example of portable relief carving from the Upper Paleolithic is a 4-inch fragment of reindeer antler, dating from about 14,000-10,000 BCE, that reveals a new complexity in both subject matter and technique (fig. 1-7). On the side shown, a large deer or bison stands over a reclining woman who is unmistakably pregnant. The carver observed and rendered the slender woman's enlarged abdomen quite accurately. To emphasize the figures' contours, which are carved in very low relief, the artist used both U- and V-shaped gouges along with a technique called beveling—cutting at an angle—to create more-pronounced shadows. Also, by interrupting the lines of the woman's legs to make way for those of the deer, the artist created the illusion of space, with one figure realistically positioned behind the other. The woman wears bracelets on her raised left arm and also possibly a necklace, reflecting the delight human beings have taken in adorning themselves since very early times. As early as 35,000 years ago, they made ornamental beads from shells, teeth, bone, ivory, and stone, and at least 23,000 years ago they buried their dead with bits of finery like headbands and necklaces.

ural powers. What if these simply or were imputed to have supernatsculptures had religious significance there is no absolute proof that the fact, they probably were, although ity figures and mother goddesses. In to assume that these had to be fertilso often that even scholars began figures." The name was repeated came to be known as "Venus sculptures from the Upper Paleolithic

distorting prejudice is provided by An excellent example of such

them or of the times generally. prejudices of those responsible for to works may express the cultural about them. The names thus attached works' owners or by scholars writing were eventually supplied by the works of art had no "names." Names

ty. In no time, the majority of such

images of "classical" feminine beau-

that it was one of a long line of

sented an ideal of womanhood, and

with religious belief, that it repre-

sage that this figure was associated

newly discovered figure sent a mes-

and the use of her name for the

Roman goddess of love and beauty,

had been found. Venus was the Willendorf" after the place where it

was promptly dubbed the "Venus of

these to be discovered (see fig. 1-4)

of women they found. The first of

hundreds of small prehistoric statues

the names early scholars gave to the

call a friend by a complimentary when we select a name for a baby, we still exert the power of naming animals" (Genesis 2:19-20). Today, the birds of the air, and all the wild man gave names to all the cattle, all them, that would be its name. The "... whatever the man called each of 1:28) and allowed him to name them: dominion over the animals (Genesis the Old Testament, God gave Adam the power of words and names. In Early people recognized quite clearly ed-reveal a certain view of the we invent-or our ancestors invent-

OF NAMING symbols for ideas.

THE POWER Words are only

nickname, or use demeaning words world and can shape our thinking. But the very words

Before the twentieth century, many the ones used in a caption in a book. can also be affected by names, even Our ideas about a work of art to dehumanize those we dislike.

Cave Art

different ways. frees us to think about it in new and figure a "woman" instead of "Venus" cepted belief. Calling a prehistoric extremely difficult to challenge acter how wrongheaded, makes it at it. The tradition of a name, no matlendorf" influences the way we look was once labeled the "Venus of Willabels. Even knowing that the figure

easily compromised by distracting

interpret works of art creatively is

represent obese women?

Our ability to understand and

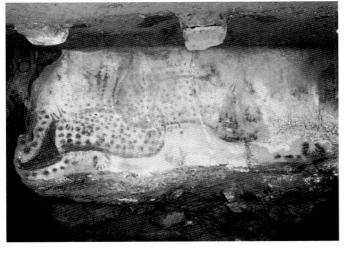

length approx. 11'2" (3.4 m) Dordogne, France. c. 16,000 BCE. Paint on limestone, 1-8. Spotted Horses and Human Hands, Pech-Merle cave,

folding needed for painting the cave's high ceilings walls. These may have been used to anchor the scafsmall holes have been found carved into a cave's rock dim flicker of light from burning animal fat. Occasional such caves (see fig. 1-15) indicate that they worked in the almost inaccessible today. Small stone lamps found in smallest chambers and recesses, many of which are worked not only in large caverns but also far back in the

5,000 years. Images of animals, handprints, and nearly been used and abandoned several times over a period of A cave site at Pech-Merle, in France, appears to have

the sealing of social alliances—just as we gather today people congregated in them to celebrate initiation rites or somehow reaffirmed and strengthened. It may be that they were gathering places where the social bond was but the evidence of artifacts and footprints suggests that subterranean galleries were not used as living quarters, erations, in some cases over thousands of years. These people returned to them time after time over many genquestion must have had a special meaning, because

of animal and bird paintings (see fig. 1). The caves in d'Arc in southern France—a tantalizing trove of hundreds was discovered in December 1994 near Vallon-Pontearliest known site of prehistoric cave paintings in Europe were painted between circa 28,000 and 10,000 BCE. The walls of caves in southern France and northern Spain sophisticated phase. Many of the images painted on the About 30,000 years ago, art in Europe entered a rich and

for baptisms, bar mitzvahs, weddings, funerals, or town

The most dramatic of these cave images are paintmeetings.

the first of the handprints found there date from long Morgiou (see fig. 1-1) were created about 16,500 BCE, but dots. The paintings of animals in the Cosquer cave at Cap dreds of geometric markings such as grids, circles, and ple, both male and female, many handprints, and hunthe wild goat, or ibex. Also included are occasional peo-(extinct ancestors of oxen), the woolly-haired rhino, and mammoth, the bear, the panther, the owl, deer, aurochs animals represented are the wild horse, the bison, the ings of grazing, running, or resting animals. Among the

before, as early as 25,000 BCE. In other caves, painters

600 geometric symbols have been found in thirty different parts of the underground complex. The earliest artists to work in the cave, some 18,000 years ago, specialized in painting horses (fig. 1-8). All of their horses have small, finely detailed heads, heavy bodies, massive extended necks, and legs tapering to almost nothing at the hooves. The horses were then overlaid with bright red circles. Some interpreters see these circles as ordinary spots on the animals' coats, but others see them as magic rock weapons hurled at the painted horses in a ritual meant to assure success in the hunt.

The handprints on the walls at Pech-Merle and other cave sites were almost certainly not idle graffiti or accidental smudges but were intended to communicate something. Some are positive images made by simply coating the hand with color pigment and pressing it against the wall. Others are negative images: the surrounding space rather than the hand shape itself is

painted. Negative images were made by placing the hand with fingers spread apart against the wall, then spitting or spraying paint around it with a reed blowpipe—an artist's tool found in such caves. Most of the handprints are small enough to be those of women or even children, yet footprints preserved in the mud floors at other caves show that they were visited by people of all sizes. A series of giant aurochs at Pech-Merle, painted in simple outlines without color, has been dated to a later period, about 15,000 BCE. Sometime afterward, other figures were created near the mouth of the cave by incising, or scratching lines into the walls' surface. Thanks to rapid advances in laboratory analysis techniques, it is only a matter of time until all prehistoric wall paintings can be dated more precisely.

The first cave paintings attributed to the Upper Paleolithic period were those discovered at Altamira, near Santander in the Cantabrian Mountains of northern

TECHNIQUE

WALL PAINTING

PREHISTORIC same size. The main pigments used in the original were ochers for the reds and manganese dioxide for the blacks. Since manga-

nese dioxide is poisonous if swallowed, Lorblanchet worked with charcoal. Jean Clottes, who has studied the composition of pigments used in cave painting in France and contributed a great deal toward their accurate dating, has determined that pigments used in a given region remained fairly consistent but that the "recipe" for the medium—the precise mix of saliva, water, and other liquids used to bind them—varied over time and from place to place.

Scientists are now very close to pinning down exactly when a given cave painting was executed, and imaginative archeologists like Lorblanchet are showing us how they were done. Although we may never know just what these paintings meant to the artists who produced them, the very process of creating them must have been rich with significance. Lorblanchet puts it quite eloquently: "Human breath, the most profound expression of a human being, literally breathes life onto a cave wall" (Archeology, November-December 1991, page 30).

In a dark cave in France, working by the light of a flickering lamp fueled with animal fat, an artist places charcoal in his mouth, chews it,

diluting it with saliva and water, then spews it out against the wall, using his hand as a stencil. The artist is Michel Lorblanchet, a cave archeologist. He is showing us how the original artists at Pech-Merle created their magnificent paintings. Other archeologists use sophisticated scientific techniques to analyze the color pigments they used to date their works, but Lorblanchet, inspired by his research on the cave painting of Australian aboriginals, seeks to re-create the actual experience of those early painters.

Having successfully reproduced a smaller painting of animals in 1979, Lorblanchet turned to the bestknown and most complex of the Pech-Merle paintings, the one of the spotted horses. He first made a light sketch in charcoal, then painted the horses' outlines using the spitting technique described above. By turning himself into a human spray can, he can produce clear lines on the rough stone surface much more easily than he could with a brush. To create the line of a horse's back, with its clean upper edge and blurry lower one, he simply blew pigment below his hand; to capture its angular rump, he placed his hand vertically against the wall, holding it slightly curved; to produce the sharpest lines, such as those of the upper hind leg and tail, he placed his hands side by side and blew between them. The forelegs and the hair on the horses' bellies he executed with finger painting, and to create a stencil for the dense, round spots he punched a hole in a piece of leather. In some places he chose to blow a thicker pigment through a reed, in others he applied it with a brush made by chewing the end of a twig.

Lorblanchet had painted his first panel in less than two hours; thirty-two hours were needed to reproduce the spotted horses. The fact that he could execute such a work in a relatively short time tends to confirm that a single artist-perhaps with the help of an assistant to mix pigments and tend the lamp—created the original. It has also been noted that all of the handprints are the

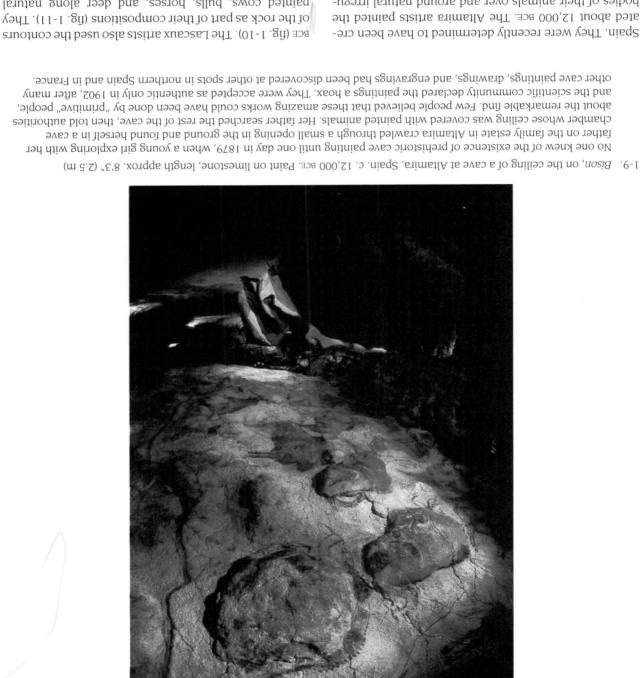

sn səysi the drawing of their silhouettes, or outlines, still astonanimals are full of life and energy, and the accuracy in Even when their poses are exaggerated or distorted, the the front, yet heads and bodies are rendered in profile. sized. Horns, eyes, and hooves are shown as seen from their most characteristic features have been emphaand even painted on top of one other. As in other caves, animals appear singly, in rows, face to face, tail to tail, ing and upper wall meets a rougher surface below. The ledges, where the smooth, white limestone of the ceilpainted cows, bulls, horses, and deer along natural

France. These have been dated to about 15,000-13,000 1940 at Lascaux, in the Dordogne region of southern The best-known cave paintings are those found in order to capture the distinctive appearance of the beasts. must have observed the bison herd with great care in the legs, tails, heads, and horns in black and brown. They shoulders, backs, and flanks, then added the details of brown ochers to paint the large areas of the animals' of the main cavern (fig. 1-9), they used rich red and tural effects. To produce the herd of bison on the ceiling larifies in the cave's walls and ceilings to create sculpbodies of their animals over and around natural irreguated about 12,000 BCE. The Altamira artists painted the Spain. They were recently determined to have been cre-

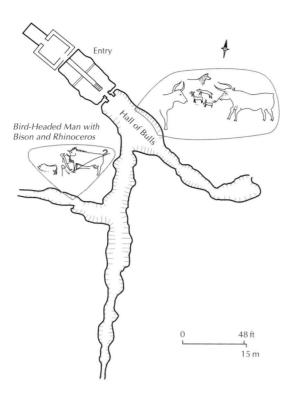

1-10. Plan of Lascaux caves, Dordogne, France

One scene at Lascaux is unusual not only because it includes a human figure but also because it is the only painting in the cave complex that seems to tell a story (fig. 1-12). It was discovered on a wall at the bottom of a 16-foot shaft containing spears and a stone lamp. A figure who could be a hunter, highly stylized but recognizably male and wearing a bird's-head mask, appears to be lying on the ground. A great bison looms above him. Below him lie a staff, or baton, and a spear thrower—a device that allowed hunters to throw farther and with greater force—the outer end of which has been carved in the shape of a bird. The long, diagonal line slanting across the bison's hindquarters is a spear. The bison has been disemboweled and will soon die. To the left of the cleft in the wall is a woolly rhinoceros—possibly the bison's slayer.

What is this scene really telling us? Why did the artist portray the man as only a sticklike figure when the bison was rendered with such accurate detail? It may be that the painting illustrates a myth or legend regarding the death of a hero. Perhaps it illustrates an actual event. Or it might depict the vision of a shaman. Shamans were—and still are—people thought to have special powers, an ability to foretell events and assist their people through contact with spirits. They typically make use of trance

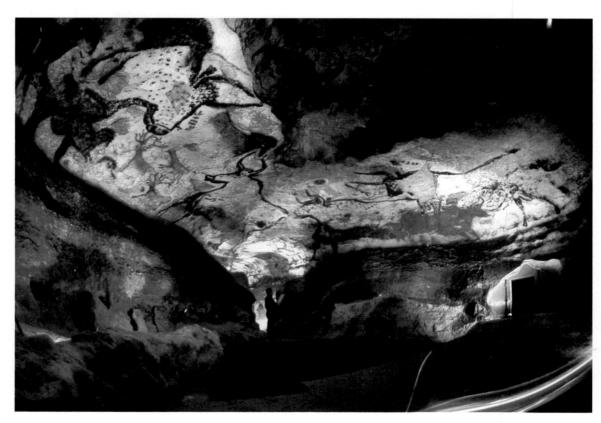

1-11. Hall of Bulls, Lascaux caves. c. 15,000-13,000 BCE. Paint on limestone

Discovered in 1940 and opened to the public after World War II, the prehistoric "museum" at Lascaux soon became one of the most popular tourist sites in France. Too popular, for the many visitors sowed the seeds of the paintings' destruction in the form of heat, humidity, exhaled carbon dioxide, and other insidious contaminants from the outside world. The cave was closed to the public in 1963, so that conservators might battle with an aggressive fungus that had attacked the paintings. Eventually they won, but instead of reopening the site, the authorities created a facsimile of it. Visitors at what is called Lascaux II may now view copies of the painted scenes without harming the precious originals.

states, in which they claim to receive communications from their spirit guides. The images they use to record their visions tend to be abstract, incorporating geometric figures and combinations of human and animal forms such as the bird-headed man in this scene from Lascaux or the lion-headed figure discussed above (see fig. 1-3). Some scholars have interpreted the horses with red dots on them at Pech-Merle as a shamanistic combination of on them at Pech-Merle as a shamanistic combination of an attention of them at Pech-Merle as a shamanistic combination of them at Pech-Merle as a shamanistic combination of an attention of the properties of the propert

Caves were sometimes adorned with relief sculpture as well as paintings. In some instances, an artist simply as well as paintings. In some instances, an artist simply heightened the resemblance of a natural projecting rock to a familiar animal form. Other reliefs were created by modeling, or shaping, the damp clay of the cave's floor. An excellent example of such work in clay from about 13,000 BCE is preserved at Le Tuc d'Audoubert, in the Dordogne region of France. Working with the clay underfoot, some early sculptor created two bison leaning against a ridge of rock (fig. 1-13). A third, smaller bison lies on the ridge of rock (fig. 1-13). A third, smaller bison lies on the

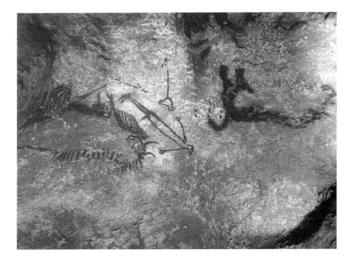

1-12. Bird-Headed Man with Bison and Phinoceros, Lascaux caves. Paint on limestone, length approx. 9' (2.75 m)

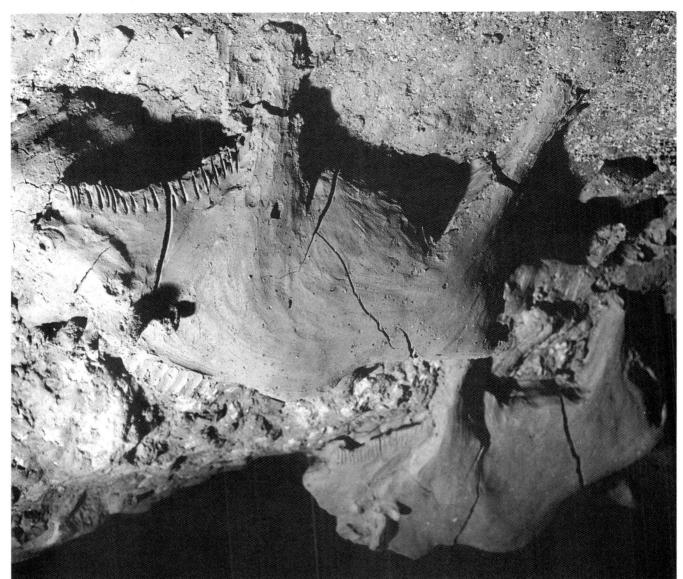

1-13. Bison, Le Tuc d'Audoubert, Ariège, France. c. 13,000 BCE. Unbaked clay, length 25" (63.5 cm) and 24" (60.9 cm)

16,000

cave floor. Although these beasts are modeled in very high relief, they display the same conventions as earlier painted ones, with emphasis on the broad masses of the meat-bearing flanks and shoulders. To make the animals even more lifelike, their creator engraved short parallel lines below their necks to represent their shaggy coats. Numerous small footprints found in the clay floor of this cave must have been left by young people, suggesting

that initiation rites may well have been performed here.

The prehistoric artists who worked in caves must have felt that their art would be of some specific benefit to their communities. Perhaps Upper Paleolithic cave art was the product of rituals intended to gain the favor of supernatural forces. If so, its significance may have had less to do with the finished painting than with the very act of creating it.

THE MEANING OF PRE-HISTORIC CAVE

What motivated people 30,000 or even 15,000 years ago to paint thousands of images of humans PAINTINGS and animals on the walls of caves? Dur-

ing the last hundred years, anthropologists and art historians have devised countless theories to explain prehistoric art, but these often tell us as much about the theorizers and their times as they do about the art itself. For all their useful insights, scholars still have not fully explained the meaning of these images.

The idea that human beings have an inherent desire to decorate themselves and their surroundingsthat an "aesthetic sense" is somehow innate to the human species-found ready acceptance in the nineteenth century. That was the century in which some artists promoted the idea of "art for art's sake," and many believed that people created works of art for the sheer love of beauty. Scientists agree that human beings have an aesthetic impulse and take pleasure in pursuing nonpractical activities, but the effort and organization required to accomplish the great paintings of Lascaux indicate that their creators were motivated by more than simple pleasure.

Early in the twentieth century, scholars rejected the idea of art for art's sake as a romantic notion. Led by Salomon Reinach, who believed that art fulfills a social function and that aesthetics are culturally relative, they proposed that prehistoric cave paintings might be products both of totemistic ceremonies, rites performed to strengthen the bonds within specific clans, and of increase ceremonies, or attempts to enhance the fertility of the animals on which people depended for food. In 1903 Reinach proposed that cave paintings were expressions of "sympa-

thetic magic." Encountered in many societies to this day, sympathetic magic relies on two principal assumptions: first, that things that look the same can have a physical influence on each other, and second, that things once in contact continue to act upon each other even at great distances. In the case of cave paintings, it may have been thought that producing a picture of a bison lying down would make sure that hunters found their prey asleep, or that ritual killing of the picture of a bison would ensure the hunters' triumph over the beast itself

In the early 1920s, Abbé Henri Breuil took these ideas somewhat further and concluded that cave paintings were early forms of religious expression. Convinced that caves were used as places of worship and the settings for initiation rites, he interpreted them as aids in rituals and in instruction.

In the second half of the twentieth century, scholars have tended to base their interpretations on rigorous scientific method and current social theory. Leading French scholars such as André Leroi-Gourhan and Annette Laming-Emperaire dismissed the "hunting magic" theory, noting that analysis of debris from human settlements revealed that the animals used most frequently for food were not the ones traditionally portrayed in cave art. Influenced by structuralist theories, these same scholars discovered that cave images were often systematically organized, with different animals predominating in different areas of the cave.

Although they disagreed on details, Leroi-Gourhan and Laming-Emperaire concluded that the cave images are definitely meaningful pictures. As Laming-Emperaire put it, the paintings "might be mythical representations . . . they might be the concrete expression of a very ancient

metaphysical system . . . they might be religious, depicting supernatural beings. They might be all these at one and the same time . . ." (Annette Laming-Emperaire, La signification de l'art rupestre paléolithique, 1962, pages 236-237). She felt certain that horses, bison, and women suggested "calm, peace, harmony," and were "concerned with love and life."

Ongoing research continues to discover new cave images and correct earlier errors of fact or interpretation. A restudy of the Altamira cave in the 1980s led Leslie G. Freeman to conclude that there artists had faithfully represented a herd of bison during the mating season, with females occupying the center space and males standing at the outside to defend the herd. Instead of being dead, asleep, or disabled—as earlier observers had supposed—the bison on the ground are simply "dust wallowing," common behavior during the breeding season. All in all, Freeman concluded that the great ceiling mural is simply a depiction of what hunters actually might have seen in late summer.

The recent discovery of paintings in the cave at Cap Morgiou reminds us how great a role chance plays in our endeavors. Meanwhile, rigorous scientific experimentation and the development of new dating techniques have enhanced our ability to place prehistoric artifacts in time with greater accuracy (see "How Early Art Is Dated," page 49). Anthropological studies have extended our knowledge of the cultures out of which cave art emerged. The study of cave painting is a rapidly changing field. It is altogether appropriate that curators at the National Museum of Natural History in Washington, D.C., chose to place over their ever-changing exhibit illustrating early human culture a prominent label reading "What's New."

are not only functional but also portable works of art. kinds. The most common tools and utensils of the period very early times is evident from Paleolithic artifacts of all ings. That these characteristics were richly developed in lems are among the characteristics unique to human be-An aesthetic sense and the ability to pose and solve prob-

birds perch atop its droppings. young ibex. The creature has just defecated, and two shaft. The functional hook at the end takes the form of a long and made of antler. Geometric patterns decorate its France (fig. 1-14) is a splendid example. It is about a foot A spear thrower from Le Mas d'Azil in southwestern

today—in an age no longer in need of spear throwers mals created a practical object that we readily appreciate observation of nature and skillful rendering of the anifowl picking over manure. In any case, the carver's sharp ever-recurring regeneration of nature while watching it may be that this hunter had had an intimation of the of finding the animal standing still. As for the two birds, this spear thrower may simply reflect the hunter's hope the hunter's triumph over the prey. The young ibex on identify the thrower's owner or were intended to assure ed some sort of personal or family emblem serving to mals. We do not know whether these animals representnotched ends of such spear throwers into images of animentum before setting it in flight. They often carved the arm in a great arc, giving the spear much greater moseated in the stick's socket, they could then swing their Balancing a spear atop the stick with the end of the shaft required was a stick with a notch or socket on one end. way to increase the range of their spears. All that was quate supply of food, early hunters devised an ingenious Driven by the ever-present need to assure an ade-

horns reflecting the curved outline of the lamp itself. animal's distinctive head is shown in profile, its sweeping lamp decorated its bowl with the image of an ibex. The found at La Mouthe, France (fig. 1-15). The creator of this Others were adorned with engraved images, like one designed to hold oil and wicks and to be easily portable. Some are carved in simple abstract shapes admirably that were both functional and aesthetically pleasing. Prehistoric lamps provide another example of objects as an elegant work of art.

under way that would alter human existence forever. grains and other edible plants. But a change was already ed upon their skill at hunting animals and gathering wild whose survival, up until about 10,000 years ago, depend-Objects like the ibex lamp were made by people

the span of just a few generations. abruptly changed human life over pons, and communication have medicine, transportation, wea-THE In modern times, advances in

to the Ice Age was so gradual that the people of the time slowly. The warming of the climate that brought an end Many thousands of years ago, change came much more

PERIOD

NEOLITHIC

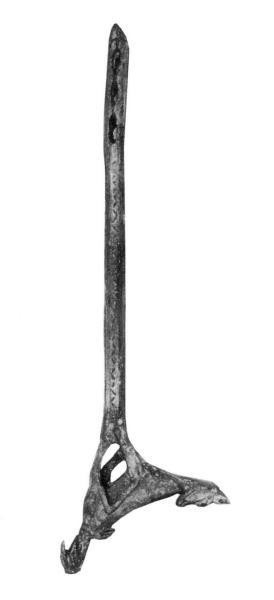

(30 cm). Musée de la Préhistoire, Le Mas d'Azil France. 16,000–9000 BCE. Carved antler, length 115/8" 1-14. Ibex-headed spear thrower, from Le Mas d'Azil, Ariège,

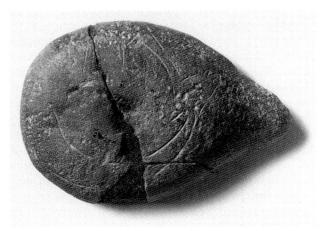

Nationales, St.-Germain-en-Laye 63/4 x 43/4" (17.2 x 12 cm). Musée des Antiquités Dordogne, France. 15,000-13,000 BCE. Engraved stone, 1-15. Lamp with ibex design, from La Mouthe cave,

could not have known it was occurring, yet it altered life as dramatically as any changes that have come since. The retreating glaciers exposed large temperate regions, and rising ocean levels changed the shorelines of continents, in some places making islands of major land masses. It was in this period, for example, about 6000 BCE, that the land bridge connecting England with the rest of Europe disappeared beneath the waters of what are now known as the North Sea and the English Channel. Europe became covered with grassy plains supporting new edible plants and forests that lured great herds of animals, such as deer, farther and farther northward. At the same time, the people in these more-hospitable regions were finding ways to enhance their chances of survival. The bow and arrow was invented and became the weapon of choice for hunters. Bows were easier to carry and much more accurate at longer range than spears and spear throwers. Dugout boats came into use, opening up new areas for fishing and hunting. With each such advance the overall standard of living improved.

The changing environment led to a new way of life. Although still essentially hunters and gatherers, people began domesticating animals and working the land to cultivate plants. As they gained greater control over their food supply, they no longer had to move around as before but could establish settled communities. None of these changes occurred overnight. Between 10,000 and 5,000 years ago, peoples in the Levant—the lands along the eastern shore of the Mediterranean—began domesticating wild grasses, developing them into more-productive grains such as wheat. In this same period, the people of Southeast Asia learned to grow millet and rice and those in the Americas began to cultivate the bottle gourd and eventually corn. Dogs probably first joined with human hunters more than 11,000 years ago, and cattle, goats, and other animals were later domesticated along with plants. Large numbers of people became farmers, living in villages and producing more than enough food to support themselves—thus freeing some people in the village to attend to other communal needs. Over time these early societies became increasingly complex. Although the majority may still have been involved in the production of food, others specialized in political and military affairs, still others in matters of religion. The new farming culture gradually spread across Europe, reaching Spain and France by 5000 BCE. Farmers in the Paris region were using plows by 4000 BCE.

These fundamental changes in the prehistoric way of life mark the beginning of the Neolithic period. These shifts occurred in some regions sooner than others. To determine the onset of the Neolithic in a specific region, archeologists look for the evidence of three conditions: an organized, ongoing system of agriculture; animal husbandry, or the maintenance of herds of domesticated animals; and permanent, year-round settlements. By the end of the period, villages had increased in size, trading had been developed between distant regions, and advanced building technology had led to the construction of some of the world's most awe-inspiring architectural monuments.

Rock-Shelter Art

The period of transition between Paleolithic and Neolithic culture saw the rise of a distinctive art combining schematic images-simplified, diagrammatic renderings—and geometric forms with depictions of people and animals engaged in everyday activities. Artists of the time preferred to paint and engrave such works on easily accessible, shallow rock shelters. In style, technique, and subject matter, these rock-shelter images are quite different from those found in Upper Paleolithic cave art. The style is abstract, and the technique is often simple line drawing, with no addition of color. Paintings from this period portray striking new themes: people are depicted in energetic poses, whether engaged in battle, hunting, or possibly dancing. They are found in many places near the Mediterranean coast but are especially numerous, beginning about 6000 BCE, in a region located in northeastern Spain.

At Cogul, near Lérida in Catalonia, the large surfaces of a rock shelter are decorated with elaborate narrative scenes involving dozens of relatively small figures men, women, children, animals, even insects (fig. 1-16). These date from between 4000 and 2000 BCE (see "How Early Art Is Dated," opposite). No specific landscape features are indicated, but occasional painted patterns of animal tracks give the sense of a rocky terrain, like that of the surrounding barren hillsides. In the detail shown here, a number of women are seen gracefully strolling or standing about, some in pairs holding hands. The women's small waists are emphasized by large, pendulous breasts. They wear skirts with scalloped hemlines revealing large calves and sturdy ankles, and all of them appear to have shoulder-length hair. The women stand near several long-horned cattle. These animals are larger than others appearing above, as though the artist wished to suggest a recession of the landscape into the distance, where other cattle, the Spanish ibex, red deer, and a pig can be seen grazing.

The manner in which this representation of distance has been created is a significant change in Upper Paleolithic painting. A pair of ibexes visible just above the cattle as well as a dog in the foreground are shown leaping forward with legs fully extended. This pose, called a flying gallop, has been used to indicate speed in a running animal from prehistory to the present.

In other paintings at the site, not shown here, some women seem to be looking after children while others carry baskets, gather food, and work the earth with digging sticks. It is easy to imagine that these paintings served solely as a record of daily life. They must have had some greater significance, however, for like other earlier cave paintings they were repainted many times over the centuries.

Because rock shelters were so accessible, people no doubt continued to visit these art sites long after their original purpose had been forgotten. At Cogul, in fact, there are inscriptions in Latin and an early form of Spanish left by Roman-era visitors—2,000-year-old graffiti intermingled with the much more ancient paintings.

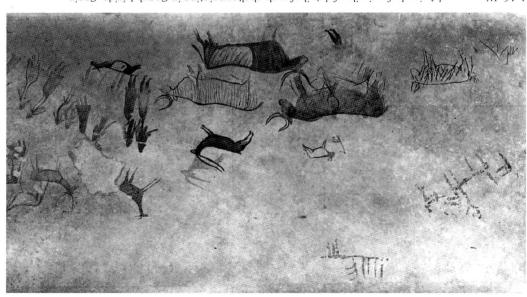

c. 4000-2000 BCE. Museo Arqueológico, Barcelona 1-16. Women and Animals, facsimile of detail of rock-shelter painting in Cogul, Lérida, Spain.

rather than the work itself. in the same context as the work of art quently test organic materials found

its surrounding soil. material such as tooth enamel and and microwave irradiation to date a techniques involve a magnetic field is heated. Electron spin resonance nescence produced when a sample it is found, determined by the lumiflint or pottery and the soil in which tal structure of a material such as measures the irradiation of the crys-1980s. Thermoluminescence dating been used in reports since the midable, two newer techniques have for which neither method is very reliyears old. For the long span of time with materials more than a million gon, an inert gas, is most reliable isotope into a stable isotope of arthe decay of a radioactive potassium um-argon dating, which measures 30,000 to 40,000 years old. Potassicurate for materials no more than Radiocarbon dating is most ac-

paintings. affempts to date particular cave paints, a finding that further improves different "recipes" when mixing their different generations of painters used other caves in France has shown that Clottes's analysis of pigments used in the handprints 27,000 years old. Jean cave are definitely 18,500 years old, that the animal images in the Cosquer bon-analysis series have determined precision. Twelve different radiocarto date cave paintings with increasing Recent experiments have helped

> Radiometric dating measures artifacts and preset markers. found, and its relationship to other layer (or stratum) in which it was find at a given "dig" by its area, the

art. For this reason, researchers frething rarely desirable in a work of to conduct this kind of test-somepart of the object must be destroyed have been centuries later. Also, some artist created the work, which could the tree was cut down, not when the shows only when the animal died or on a carved antler or wood sculpture art, however. Using carbon-14 dating ons grawbacks for dating works of organism died. This method has serimaterial can tell us how long ago the in an artifact made of an organic the amount of carbon-14 remaining bon. Under the right circumstances, organic matter lose their radiocarrates at which most types of dead over the years have determined the to lose its store of it. Experiments stops absorbing carbon-14 and starts ished. When the organism dies, it organism is constantly being replen-The carbon-14 content in a living measures potassium-argon ratios. radiocarbon, or carbon-14. Another It measures a carbon isotope called the pigments used in cave paintings. animal) materials—including some of still used for dating organic (plant or radiometric methods developed is absolute dating. One of the earliest most accurate of several methods of terials have disintegrated and is the the degree to which radioactive ma-

> at Altamira, Spain, in ings were discovered EARLY ART Paleolithic cave paint-When the first Upper

IS DATED MOH

extremely difficult. ture, painting, and architecture is specinte dates for prehistoric sculped. Arriving at even approximate years in which an artifact was creattermine a precise span of calendar date. Absolute dating aims to depresent, it can be assigned a relative even if "type B" is the only pottery apply that knowledge to another site; chronologically at one site, they can types A, B, and C follow each other mined, for example, that pottery sites. If archeologists have detereither a single excavation or several cal relationships among objects in tive dating relies on the chronologito determine an artifact's age. Relahave primarily used two approaches the twentieth century, archeologists ways of dating such finds. During veloped increasingly sophisticated discoveries, archeologists have deup on top of them. Since those first a layer of mineral deposits had built deed thousands of years old because ings discovered in France were inlater, it was shown that similar paint-Prehistoric Archeology. Seven years forgeries by the Lisbon Congress on 1879, they were promptly rejected as

ogs på myich they can record each pane developed painstaking methnot been disturbed. Archeologists the site at which it is discovered has Dating a work of art is easiest if

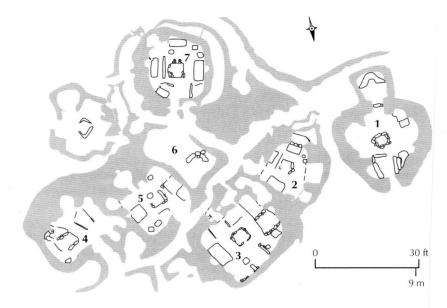

1-17. Plan, village of Skara Brae, Orkney Islands, Scotland. c. 3100-2600 BCE

Architecture

As people adopted a settled, agricultural way of life, they began to build large structures to serve as dwellings, storage spaces, and shelters for their animals. In Europe, timber had become abundant after the disappearance of the glaciers, and Neolithic people, like their Paleolithic predecessors, continued to construct buildings out of wood and other plant materials. People clustered their dwellings in villages and eventually larger towns, and outside their settlements, they built tombs and ritual centers so huge that they still have the power to fill us with awe.

Dwellings and Villages. A northern European village frequently consisted of only three or four long timber buildings, each of them housing forty-five to fifty people. These houses might be up to 150 feet long, and they included large granaries, or storage space for the harvest, a necessity in agricultural communities. The structures were rectangular, with a row of posts down the center supporting a ridgepole, a long horizontal beam against which the slanting roof poles were braced. Their walls were probably made of what is known as wattle and daub, branches woven in a basketlike pattern, then covered with mud or clay. They were most likely roofed with thatch, some plant material such as reeds or straw tied over a framework of poles. Similar structures can still be seen today in some regions, serving as animal shelters or even dwellings.

Around 4000 BCE, Neolithic settlers began to locate their communities at sites most easily defended, near rivers, on plateaus, or in swamps. For additional protection, they also frequently surrounded them with wooden walls, earth embankments, and ditches.

A Neolithic settlement has been excellently preserved at Skara Brae, in the Orkney Islands off the northern coast of Scotland (fig. 1-17). This one happens to

have been constructed of stone, an abundant building material in this austere, treeless landscape. A huge prehistoric storm buried this seaside village under a layer of sand. Another freak storm brought it to light again in 1850. The ruins thus exposed to view present a vivid picture of Neolithic life in the far north. Among the utensils found in these Orkney structures are stone cooking pots, a whalebone basin, a stone mortar for grinding, and pottery with incised decoration. Comparison of these artifacts with objects from sites farther south and laboratory analysis of the village's organic refuse date the settlement at Skara Brae to about 3100–2600 BCE, indicating that it lay buried for well over 4,000 years.

The village consists of a compact cluster of dwellings linked together by covered passageways. Each of the houses is in the shape of a square with rounded corners. The largest one measures 20 by 21 feet, the smallest 13 by 14 feet. Their walls were formed of layers of flat stones, with each layer, or **course**, projecting slightly inward over the one below. This type of construction is called **corbeling**. In some structures such inward-sloping walls come together at the top in what is known as a **corbel vault**, but at Skara Brae they stopped short of meeting, and the remaining open space was covered with hides or turf. There are smaller corbel-vaulted rooms within the main walls of some of the houses that may have been used for storage. One room, possibly a latrine, has a drain leading out under its wall.

The houses of Skara Brae were well equipped with space-saving built-in furniture. In the room shown (fig. 1-18), a large rectangular hearth with a stone seat at one end occupies the center of the space. Rectangular stone beds, some of them engraved with simple ornaments, stand against the walls on each side of the hearth. These boxlike beds would probably have been filled with heather "mattresses" and covered with warm furs. In the left corner is a sizable storage niche built into the thick outside wall. Smaller storage niches were provided over

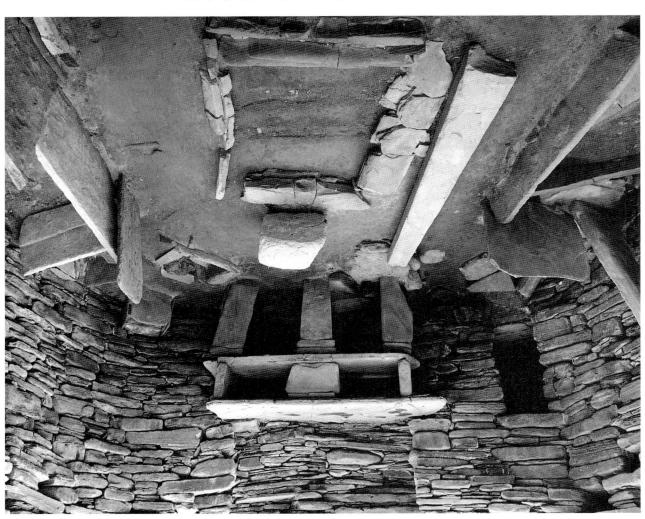

1-18. House interior, Skara Brae (house 7 in fig. 1-17)

strong leaders could have assembled and maintained the required labor force. Skilled engineers were needed to devise methods for shaping, transporting, and aligning the stones. Finally, powerful religious figures must have been involved, identifying the society's need for such atructures and dictating their design. The accomplishments of the builders of these monuments are all the more impressive considering the short life expectancy of the time. It was uncommon for anyone to survive past the time. It was uncommon for anyone to survive past the time. It was uncommon for anyone to survive past imposing structures were the work of teenagers.

Elaborate megalithic tombs first appeared in the Meolithic period. Some were built for single burials, others as mausoleums consisting of multiple burial chambers. The simplest type of megalithic tomb was the dolmen, built on the post-and-lintel principle. The tomb one or more tablelike rocks, or capstones. The structure was then mounded over with smaller rocks and dirt to form what is called a cairn. A more imposing structure was the passage grave, which was entered by one or more narrow, stone-lined passageways into a large room at the cairn's center (see "Elements of Architecture," page 53).

each of the beds. Stone tanks lined with clay to make them watertight are partly sunk into the floor. These were probably used as containers for live bait, for it is clear that the people at Skara Brae were skilled fisherfolk.

On the back wall is a two-shelf cabinet that is a splendid example of what is known as **post-and-lintel** construction. In this structural system, two or more vertical elements (posts) are used to support a bridging horizontal one (lintel). The principle has been used throughout history, not only for structures as simple as these shelves but also in huge stone monuments like Stonehenge (see fig. 1-23) and the temples of Egypt (Chapter 3) and Greece (Chapter 5).

Ceremonial and Tomb Architecture. In western and northern Europe, Meolithic people commonly erected ceremonial structures and tombs using huge stones. In some cases they had to transport these great stones over long distances. The monuments thus created are examples of what is known as megalithic architecture, the descriptive term derived from the Greek word roots for large (mega-) and stone (lithos). Architecture formed of such massive elements testifies to a more complex, of such massive elements testifies to a more complex, stratified society than any encountered before. Only stratified society than any encountered before. Only

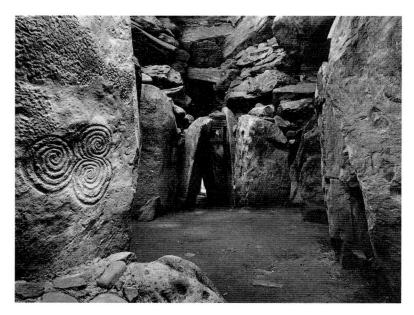

1-19. Tomb interior with corbeling and engraved stones, Newgrange, Ireland. c. $3000-2500\ \text{BCE}$

1-20. Menhir alignments at Ménec, Carnac, France. c. 4250-3750 BCE

One legend of Celtic Brittany explains the origin of the Carnac menhirs quite graphically. It relates that a defeated army retreating toward the sea found no ships waiting to carry it to safety. When the desperate warriors turned around and took up their battle stations in preparation for a fight to the death, they were miraculously transformed into stone. Another legend claims that the stones were invading Roman soldiers who were "petrified" in their tracks by a local saint named Cornely.

The passage grave was a burial chamber, also cov-

through a long, slab-lined passageway or passageways. ered over by an earth-and-pebble cairn, that was entered impression that they were built as open-air monuments. Today, most dolmens are exposed, giving the erroneous

The central space was sometimes segmented into sever-

al chambers and usually held multiple burials.

struction created a small, fully enclosed burial chamber. stones to form a cairn. This con-Passage Grave ed over with dirt and smaller Dolmen and more capstones, then moundstone slabs "roofed" with one or **VECHILECTURE** post-and-lintel frame of large, **ELEMENTS OF** The dolmen was made up of a

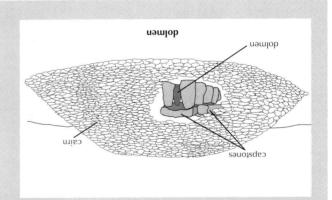

vation of the sun, moon, and stars. ble that they were points of reference for careful obsergroups of people celebrating public rites. It is also possimarked off an established procession route for large through the year. The menhirs at Carnac may well have sun and do all they could to assure its regular motion seasons, would have had every reason to worship the

passage grave

son holding one end of the cord is stationed in the cenor knotted to mark the desired radius of the circle. A perern times. All that is required is a length of cord either cut effective surveying method that persisted well into modtects likely relied on the human compass, a simple but would have posed no particular problem. Their archiup embankments. Laying out such circles with accuracy stones or posts, often surrounded by a ditch with built-England (figs. 1-21, 1-22, 1-23). A henge is a circle of strongly is Stonehenge, on Salisbury Plain in southern that has stirred the imagination of the public most Of all the megalithic monuments in Europe, the one

cord taut, steps off the circle's circumference. ter; a co-worker, holding the other end and keeping the

embankment to a pointed sarsen megalith—sarsen is a from the henge toward the northeast led well outside the liant white circle about 330 feet in diameter. An "avenue" characteristic of this part of England, thus creating a brilging through the turf, they exposed the chalk substratum rim to form an embankment more than 6 feet high. Digcircular ditch, placing the excavated material on the inside and 1500 BCE. In the earliest stage, its builders dug a deep, of at least four major building phases between about 2750 an extraordinary importance in its region. It is the product plicated megalithic sites. It must have had, or developed, to incorporate new elements, it is one of the most com-Neolithic period, but because it was repeatedly reworked Stonehenge is not the largest such circle from the

ring cycle of sowing, growing, harvesting, and tallow farming peoples, whose well-being depended on a recursome connection to the movement of the sun. Neolithic The east-west orientation of the alignments suggests on the eastern end to upward of 13 feet toward the west. ments, their stones graduated in height from about 3 feet known as alignments. There are thirteen rows of aligncircular patterns known as cromlechs or straight rows stones weighs several tons. They were placed in either stretch near Ménec (fig. 1-20). Each of these squared-off 3750 BCE. Over 3,000 of them still stand in a two-mile tical megaliths, were set up sometime between 4250 and Brittany, in France, thousands of menhirs, or single verentire region. In the Carnac district on the south coast of ritual centers that must have attracted the people of an Many megalithic structures were not tombs at all but practical and symbolic. monuments being built today, their function was both

the case with the elaborate mausoleums and funerary

that fostered communal pride and a group identity. As is

distinguished dead; they were truly public architecture

and richly decorated structures did more than honor the

at the rock surface with tools made of antlers. Such large out using strings or compasses, then carved by pecking

diamond shapes. These patterns must have been marked engraved with linear designs, mainly rings, spirals, and

stones at the entrance and along the passageway are

ber with a corbeled vault rising to a height of 19 feet. The

lined with standing stones, leads into a three-part cham-

around its perimeter. Its passageway, 62 feet long and

and was set off by a circle of decorated standing stones

diameter. The mound was built of sod and river pebbles

stood some 44 feet tall and measured about 280 feet in

grave (fig. 1-19) was discovered in a cairn that originally

At Newgrange, in Ireland, an elaborate passage

passageway

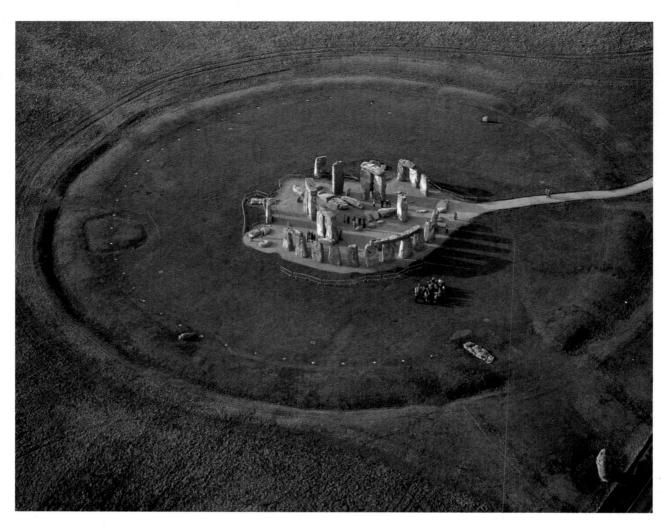

1-21. Stonehenge, Salisbury Plain, Wiltshire, England. c. 2750-1500 BCE

gray sandstone—brought from a quarry 23 miles away. Today, this so-called heel stone, tapered toward the top and weighing about 35 tons, stands about 16 feet high. The ditches and embankments bordering the approach avenue were constructed somewhat later, at the same time as the huge megalithic monument we see today.

By about 2100 BCE, Stonehenge included all of the internal elements reflected in the drawing shown here (fig. 1-22). Dominating the center was a horseshoeshaped arrangement of five sandstone trilithons, or pairs of upright stones topped by lintels. The one at the middle stood considerably taller than the rest, rising to a height of 24 feet, and its lintel was more than 15 feet long and 3 feet thick. This group was surrounded by the so-called sarsen circle, a ring of sandstone uprights weighing up to 50 tons each and standing 20 feet tall. This circle, 106 feet in diameter, was capped by a continuous lintel. The uprights were tapered slightly toward the top, and the gently curved lintel sections were secured by mortise and tenon joints, a conical projection from one piece fitting into a hole in the next. Just inside the sarsen circle was once a ring of bluestones—worked blocks of a bluish dolerite found only in the mountains of southern Wales, 150 miles away. Why the builders of Stonehenge felt it necessary to use specifically this type of stone is one of

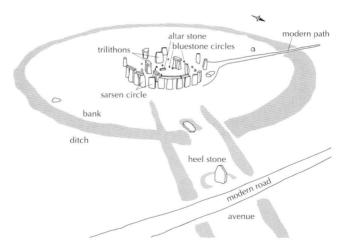

1-22. Diagram of Stonehenge, showing elements discussed here

the many mysteries of Stonehenge. Clearly the stones were highly prized, for centuries later, about $1500~{\rm BCE}$, they were reused to form a smaller horseshoe inside the trilithons that encloses the so-called altar stone.

Whoever stood at the exact center of Stonehenge on the morning of the summer solstice 4,000 years ago would have seen the sun rise directly over the heel stone (fig. 1-23). The observer could then warn people that the

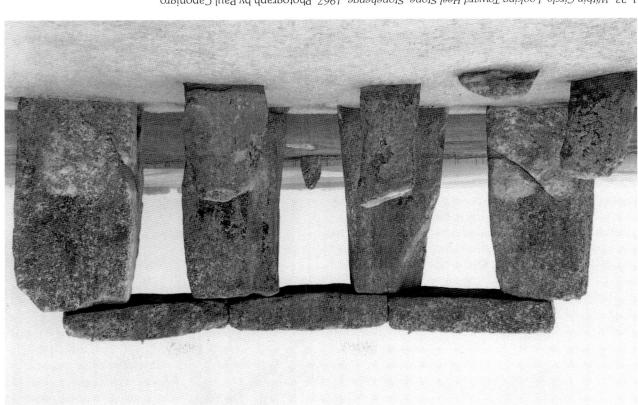

Caponigro, a great enthusiast of megalithic architecture, spent twenty years photographing prehistoric structures all over 1-23. Within Circle, Looking Toward Heel Stone, Stonehenge, 1967. Photograph by Paul Caponigro

over that distant marker. perimeter. It is from this spot that a dawn visitor to the site at the time of the summer solstice can see the sun rise directly above the large "altar stone" at the heart of the complex and aiming it toward the heel stone outside the monument's Europe. He admirably captures the harmonious grace and simplicity of Stonehenge by positioning his camera directly

Sculpture and Ceramics

shape of the letter U. A belt encircles her waist. Some to cover her breasts, so that each of her arms has the single bead at the center. The woman's hands are raised outline of a piece of jewelry, probably a necklace with a square jaw and wide, rectangular mouth is actually the resembling a headband. What first appears to be a and protruding eyes. Above the browline is something composed of a straight nose, a heavy, continuous brow, Montagnac, in southern France (fig. 1-24). The face is typical menhir statue is the one of a woman found in represent elements of ritual costume or body painting. A and backbones, but it is possible that they were meant to and backs of such figures have been interpreted as ribs indication of a mouth. Incised linear patterns on the sides and a horizontal one for the browline. Rarely is there any were usually suggested by a vertical ridge for the nose incised on all four sides of a single upright block. Faces the human figure reduced to near-geometric forms were high, and all were carved in a similar way. Elements of dating from between 3500 and 2000 BCE, stood 3 to 4 feet large, freestanding stone figures. Their menhir statues, of stone, Meolithic sculptors were capable of carving Having learned how to cut and transport massive blocks

try was once more gripped by winter. would grow shorter and the nights cooler until the counsun's strength would shortly begin to wane, that the days

advance, one that made possible, among other things, a technology developed for building them was a major structures were built may never be discovered, but the midsummer to thrill to its mystery. Why such megalithic nate the public. Crowds of people still gather there at function may have been, Stonehenge continues to fascisibly planting or harvest rituals. Whatever its original was an important site for major public ceremonies, posmic events. Anthropologists suspect that the structure prehistoric astronomers could track any number of coshave been a kind of observatory, with the help of which related to the movement of the sun, some think it may scholars even today. Because its orientation is clearly the Druids. It continues to challenge the ingenuity of was incorrectly associated with the religious practices of lin, the magician of the King Arthur legend. Later, the site was thought that the monument had been built by Merforward than about Stonehenge.) In the Middle Ages, it tions say more about the times in which they were put vanced to explain Stonehenge. (Most of these explana-Through the ages, many theories have been ad-

new kind of sculpture.

3000 36,000 BCE 1000 BCE

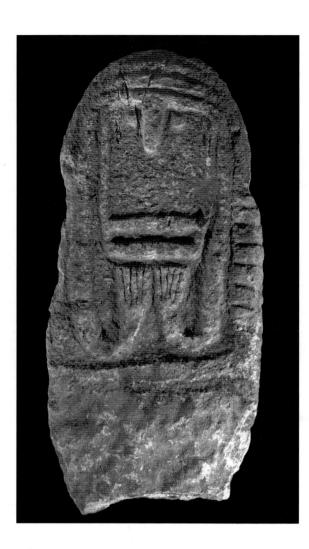

1-24. Menhir statue of a woman, from Montagnac, France. c. 2000 BCE. Limestone, height approx. 33" (85 cm). Musée d'Histoire Naturelle et de Préhistoire, Nîmes

figures of women have no arms or hands—only breasts and a necklace. Men often carry weapons.

In southern France, solitary menhir statues have been discovered on wooded hills and sometimes near tombs or villages. Set on hilly sites, they may have served as "guardians" and signposts for travelers making their way to sacred places. Those in the vicinity of tombs may have been "guardians of the dead." Some female figures found near dwellings are thought to have been household protectors.

Besides working in stone, Neolithic artists also commonly used clay. Their ceramics, whether figures of people and animals or vessels, display a high degree of technical skill and aesthetic imagination. This art required a different kind of conceptual leap. In the sculpture previously discussed, artists created their work out of an existing substance, such as stone, bone, or wood. To produce ceramic works, artists had to combine certain substances with clay—bone ash was a common addition— then subject the objects formed of that mixture to high heat for a period of time, thus creating an entirely new material. Among the ceramic figures discovered at a pottery-production center in the Danube River valley at Cernavoda, Romania, are a seated man and woman who form a most engaging pair (fig. 1-25).

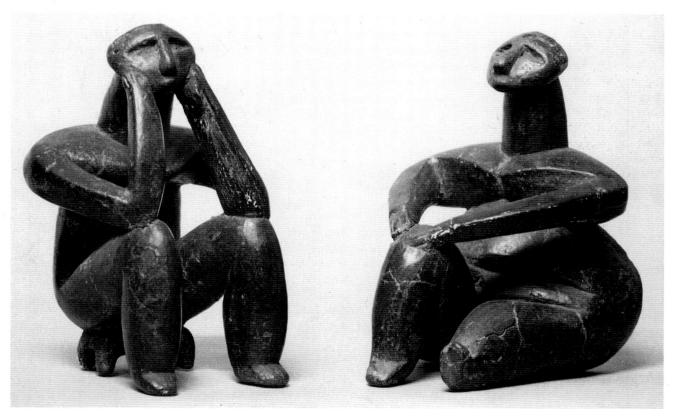

1-25. Figures of a man and a woman, from Cernavoda, Romania. c. 4000–3500 BCE. Ceramic, height 41/2" (11.5 cm). National Museum of Antiquities, Bucharest

36,000 BCE 1000 BCE **----**

TECHNIQUE

CERAMICS

The potter's wheel appeared in the ancient a uniformly shaped vessel in a very short time. POTTERY AND form on which it is relatively simple to produce

Near East about 3250 BCE and in China about 3000 BCE.

mon artifacts found in excavations of prehistoric settle-Fragments of low-fired ceramics are the most com-32,000 BCE. ered at prehistoric sites in Europe dating from as early as ovens for firing pottery, called kilns, have been discovhistoric pottery is art made at the hearth, but special maintained at a relatively uniform level. Low-fired prefore it is fired. For proper firing, the temperature must be After a pot is formed, it is allowed to dry completely be-

cialized forms and decorated with great finesse. 2300 BCE, vessels were produced in a wide variety of spewas left to dry. By the dawn of the Bronze Age, about ing—scratching lines into the surface of the clay before it of the first ways of decorating pottery was simple incisand reconstructing their living and trading patterns. One or potsherds, serve as a major key in dating lost cultures pottery disintegrates very, very slowly. Pottery fragments, constantly in demand to replace broken ones. Moreover, ments. Pottery is relatively fragile, and new vessels are

some confusion. The word ceramics came into interchangeably—and often are, which causes The terms pottery and ceramics may be used

baked-clay wares, ceramics is technically a more incluuse only in the nineteenth century. Because it covers all

sive term than pottery.

is technically known as earthenware. When subjected to not disintegrate in water. Fired at 700° centigrade, pottery centigrade. It then holds its shape permanently and will becomes a porous pottery when heated to at least 500° which is at the "high end" of ceramic technology. Raw clay Pottery is all baked-clay ware except porcelain,

is a stronger type of ceramics called stoneware. ments in the clay vitrify, or become glassy, and the result temperatures between 1200° and 1400°, certain stone ele-

had developed the potter's wheel, a round, spinning platgourd for example. By about 4000 BCE, Egyptian potters ty is to simply press the clay over an existing form, a dried tainer, and then smooth them by hand. A third possibiliraw clay, stack them on top of each other to form a conof raw clay. Another method is to coil long rolls of soft, possible, though difficult, to raise up the sides from a ball Pottery vessels can be formed in several ways. It is

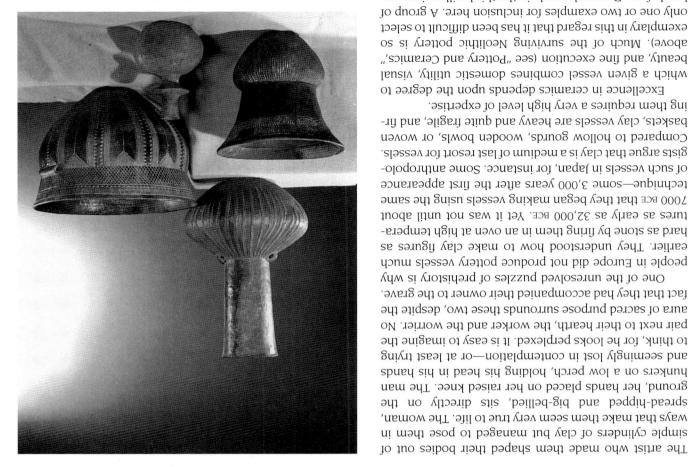

National Museum, Copenhagen heights range from 53/4" to 121/4" (14.5 to 31 cm). 1-26. Vessels, from Denmark. c. 3000-2000 BCE. Ceramic,

ing them requires a very high level of expertise. baskets, clay vessels are heavy and quite fragile, and fir-Compared to hollow gourds, wooden bowls, or woven gists argue that clay is a medium of last resort for vessels. of such vessels in Japan, for instance. Some anthropolotechnique—some 3,000 years after the first appearance 7000 BCE that they began making vessels using the same tures as early as 32,000 BCE. Yet it was not until about hard as stone by firing them in an oven at high temperaearlier. They understood how to make clay figures as people in Europe did not produce pottery vessels much One of the unresolved puzzles of prehistory is why

fact that they had accompanied their owner to the grave.

to think, for he looks perplexed. It is easy to imagine the

Neolithic artists working in clay (fig. 1-26). Taking their provides only a hint of the extraordinary achievements of bowls from Denmark, made in the third millennium BCE, only one or two examples for inclusion here. A group of exemplary in this regard that it has been difficult to select above). Much of the surviving Neolithic pottery is so beauty, and fine execution (see "Pottery and Ceramics," which a given vessel combines domestic utility, visual Excellence in ceramics depends upon the degree to

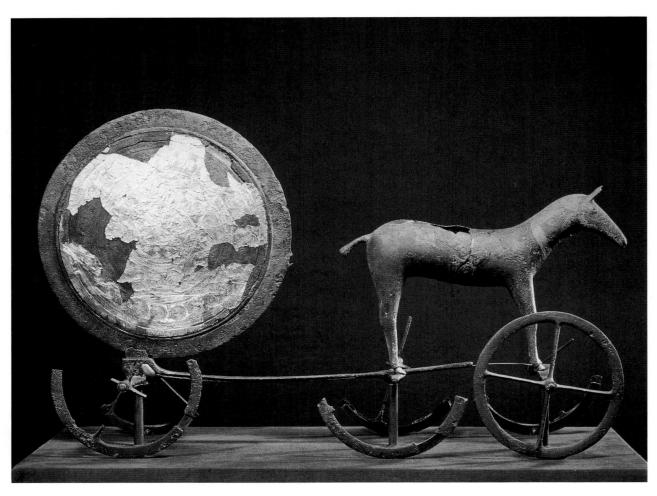

1-27. *Horse and Sun Chariot*, from Trundholm, Zealand, Denmark. c. 1800–1600 BCE. Bronze, length 23¹/4" (59.2 cm). National Museum, Copenhagen

forms from baskets and bags, the earliest pots were round and pouchlike and had built-in loops so that they could be suspended on cords. The earliest pieces in the illustration are the globular bottle with a collar around its neck (bottom center), a form perhaps inspired by eggs or gourd containers, and the flask with loops (top). Even when potters began making pots with flat bottoms that could stand without tipping, they often added hanging loops as part of the design. Some of the ornamentation of these pots, including hatched engraving and stitchlike patterns, seems to reproduce the texture of the baskets and bags that preceded ceramics as containers. It was also possible to decorate clay vessels by impressing stamps into their surface or scratching it with sticks, shells, or toothed implements. Many of these techniques appear to have been used to decorate the flat-bottomed vase with the wide, flaring top (bottom left), a popular type of container that came to be known as a funnel beaker.

The large engraved bowl (center right), found at Skarpsalling, is considered to be the finest piece of northern Neolithic pottery yet discovered. The potter lightly incised its sides with delicate linear patterns, then rubbed white chalk into them so that they would stand out against the dark body of the bowl—a technique similar to the one called **niello**, used to enhance linear designs incised in metal. Much of the finest art to survive from the Neolithic period is the work of potters; it is an art of the oven and the hearth.

THE BRONZE AGE

Neolithic culture persisted in northern Europe until about 2000 BCE. Metals made their appearance in the region about 2300. In southern Europe and the Aegean, copper, gold, and tin had

been mined, worked, and traded even earlier (Chapter 4). Exquisite objects made of bronze—an alloy, or mixture, of tin and copper—are frequently found in the settlements and graves of early northern farming communities, especially in Britain and Scandinavia, where major mining and smelting centers developed. The period that follows the introduction of metalworking is commonly called the Bronze Age.

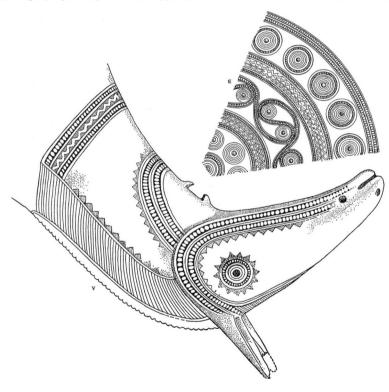

1-28. Schematic drawing of incised designs on unseen side of the Horse and Sun Charlot from Trundholm

I-28). Light striking its eyes turned them into tiny suns. Elaborate and very delicate designs were engraved on its collar and harness. The bronze sun disk, cast in two pieces, was engraved with concentric rings filled with zigzags, circles, spirals, and loops. A thin sheet of beaten gold was then applied to one of the bronze disks and pressed into the incised patterns. Finally, the disks were sealed together by means of an encircling metal band. The patterns on the horse tend to be geometric and rectilinear, but those of the sun disk are continuous and curvilinear, but those of the movement of the sun itself. Much of what we know about prehistoric peoples is based on the art they produced—from the smallest carviased on the art they produced—from the smallest carviased on the art they produced—from the smallest carviased on the art they produced—from the smallest carviased.

haden of what we know about prendent peoples is based on the art they produced—from the smallest carvings to menhir statues, from cave paintings to household wares. Progress continues to be made toward an understanding of when and how these works were created. We may never know why some of them were made. But the remote eras into which they afford us glimpses seem strangely familiar. The sheer artistry and immediacy of the images left by these very early ancestors connect us to them as surely as the earliest written records link us to to them as surely as the earliest written records link us to those who came later.

the sky. place in a ritual reenactment of the sun's passage across porse and sun cart could have been rolled from place to the region, with special ritual practices. The Trundholm be an indication that there was a widespread sun cult in through the sky by either an animal or a bird. These may gravings in northern Europe show the sun being drawn animals' strength dates from about 2000 BCE. Rock enwheeled chariots and wagons designed to exploit the Ukraine by about 4000 BCE, but the first evidence of holm, in Denmark. Horses had been domesticated in and 1600 BCE and was discovered at what is now Trundthe sun (fig. 1-27). The work dates from between 1800 with a large, upright disk commonly thought to represent Scandinavia depicts a wheeled horse pulling a cart laden A remarkable sculpture from the Bronze Age in

The valuable materials from which the sculpture was made and the great attention devoted to its details attest to its importance. The horse, cart, and sun disk were cast in bronze. After two faults in the casting had been repaired, the horse was given its surface finish, and its repaired, the horse were incised with ornamentation (fig.

Ain Ghazal figure c. 7000–6000

▲ EARLY NEOLITHIC 9000

▲ ELAM 7000-600

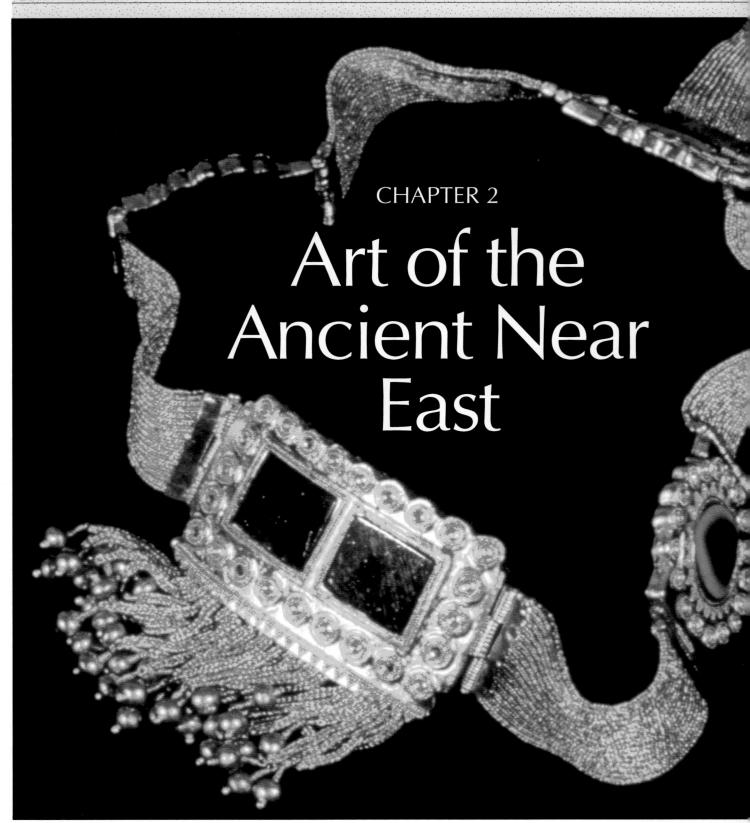

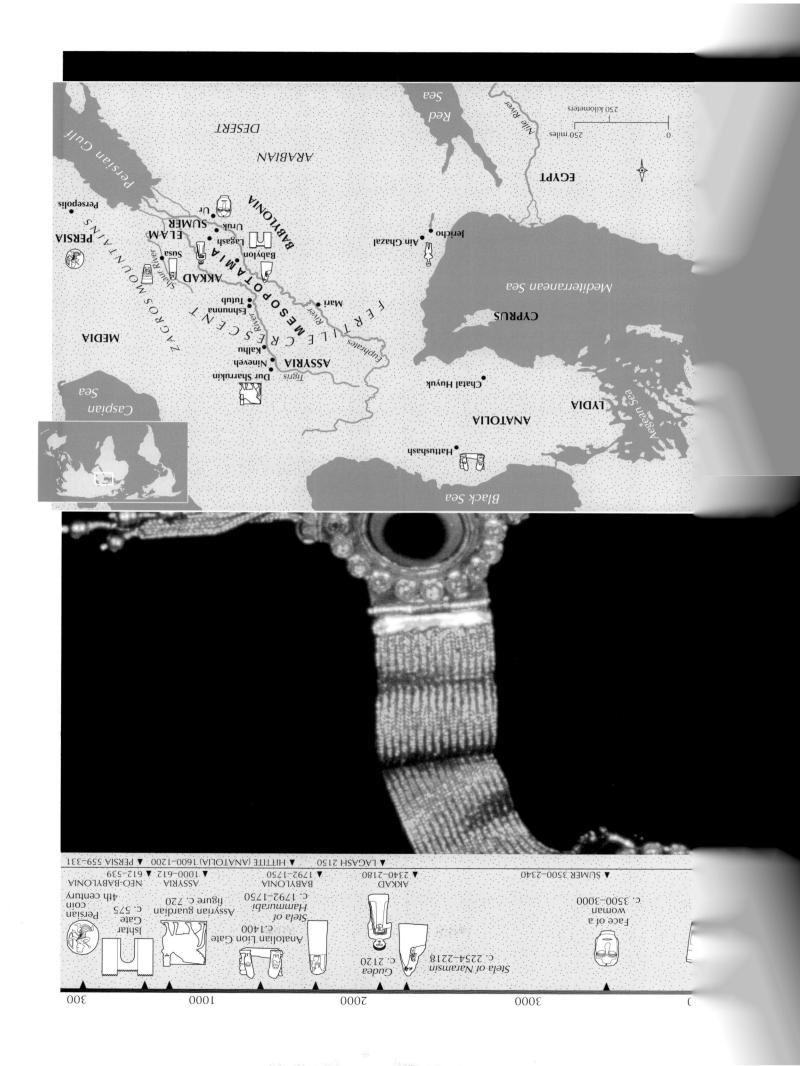

hen allied forces in the Persian Gulf region launched Operation Desert Storm in January 1991, their air attack on Iraq provoked an outcry from archeologists and art historians around the world. The bombs were not just falling on an army that had invaded Kuwait; they were falling on ancient Mesopotamia, the cradle of Western civilization, the most concentrated site of archeological remains on earth, places with fabled names like Nineveh, Ur, and Babylon. As one archeologist noted, "Almost all of Iraq is an archeological mound. . . . There are half a million archeological sites from all periods. About 40,000 or 50,000 of them are considered quite important. Between 100 and 200 of them were ancient capital cities" (William H. Honan, "Attacks on Iraq Worry and Divide Archeologists," The New York Times, February 9, 1991). Some of the most important of these ancient sites have not yet been located; others have been found but not excavated. Ironically, the great "archeological mound" is formed of accumulated layers of vanquished and vanished cultures, for people have been fighting over this area almost since the first settlements formed there.

CRESCENT

THE FERTILE Well before settled farming communities arose in Europe and Egypt, agriculture emerged in the

ancient Near East in an area long referred to as the Fertile Crescent. Geographically, the ancient Near East encompasses Anatolia (roughly modern Turkey), Mesopotamia (Iraq today), and Persia (Iran). The "crescent" rose along the Mediterranean coast through modern Jordan, Israel, Lebanon, and Syria, arched into central Turkey, and descended along the fertile plains of the Tigris and Euphrates rivers through Iraq and a slice of western Iran to the Persian Gulf. Neolithic culture began here about 9000 BCE, when the earliest settled farming communities arose, first in the hills above rivers and later in river valleys. Farming spread from this region to the east and northwest and reached Europe by about 5000 BCE. Mesopotamia's relatively harsh climate, prone to both drought and flood, may have contributed to this change, as early agriculturists cooperated to construct large-scale systems for controlling their water supply.

In the Near East, agricultural villages gradually evolved into cities, which anthropologists distinguish from villages as having a large population and a settled area clearly separated from its rural surroundings. Trade among distant communities increased. Between 4000 and 3000 BCE, a major cultural shift took place in Mesopotamia. Beginning in southern Mesopotamia, complex societies with hierarchies of priests and kings began to appear. Prosperous cities and their surrounding territory developed into city-states, each with its own government. Eventually these city-states were absorbed into larger kingdoms and empires. Urban life gave rise to increasing specialization. To satisfy the needs of city dwellers and to provide goods for export, city people began to develop skills besides those for farming. Factories for milling flour and making bricks, pottery, cloth, carpets, and metalware sprang up, and the construction of temples and palaces kept builders and artists busy.

The peoples of the ancient Near East were polytheistic; they worshiped numerous gods and goddesses, attributing to them power over human activities and the forces of nature. The importance of the various deities depended on the area of life they controlled. Each city had one special protective deity, and people believed the dominance of the city depended on its deity's being more powerful than the gods and goddesses of surrounding cities. The names of deities changed over time and as they spread from language to language. For example, Inanna, the Sumerian goddess of fertility, love, and war, was equivalent to the Babylonians' Ishtar, the Egyptians' Isis, the Greeks' Aphrodite, and the Romans' Venus.

A class of religious specialists emerged to control rituals and sacred sites. Large temple complexesclusters of religious, administrative, and service buildings-developed in each city as centers of worship and also as thriving businesses. The religious establishment owned substantial property, received a portion of the harvest, and engaged in various other commercial ventures. Religious and political power were closely interrelated, and both women and men had religious and political authority.

Mesopotamia's wealth and agricultural resources, as well as its few natural defenses, made its peoples vulnerable to repeated invasions from hostile neighbors and to internal conflicts between rivals. Over the centuries, the balance of power in Mesopotamia shifted between north and south and between local powers and outside invaders. The earliest group to rise was the Sumerians in the southern region. For a brief period they were eclipsed by the Akkadians, their neighbors to the north. When

construction. four stages of like; below are village looked view of what the anthropologist's ano swods The top drawing C. 7200-5000 BCE Ghazal, Jordan. houses at Ain drawings of 2-1. Reconstruction

CITIES **NEOLITHIC** in the Near East, is located in the **EARLY** Jericho, one of the earliest cities

have lived for nearly 12,000 years. a natural spring where humans West Bank territory at the site of

enormous size for its time. thick and 12 to 17 feet high. The site covered 6 acres, an in mud-brick houses protected by a stone wall 5 feet 7000 BCE, Jericho was home to about 2,000 people living well-insulated shelter. Sometime between 8000 and quite durable in the dry climate and provided sturdy, then hardened them in the sun. These "mud bricks" were ninth millennium BCE on, they molded bricks out of clay, neath their feet for construction materials. From the and stone were scarce, people turned to the earth be-Here, as throughout the ancient Near East, where wood

ported roof beams, which are believed to have been (fig. 2-1). On the interior, regularly spaced wood posts supdirt and pebbles, probably sealed with a layer of mud ing walls. Its houses had double stone walls with a core of laboriously shaped into terraces stabilized by stone retain-7200 to 5000 BCE, occupied 30 acres on a slope that was in 1981. Ain Ghazal ("Gazelle Spring"), dated from about tally during road construction just outside Amman, Jordan, An even larger Neolithic city was discovered acciden-

> entire Mear East and beyond. an empire that included not only Mesopotamia but the people from the mountains of modern-day Iran, forged sixth century BCE, the Achaemenid Persians, a nomadic to the east, and Persia, east of Elam. Beginning in the plain between the Tigris River and the Zagros Mountains well, such as the Hittite kingdom in Anatolia, Elam on the centers arose outside the margins of Mesopotamia as Neo-Babylonia. Throughout this time, important cultural ians in the north, then back again to Babylonia, called the south. Later, the center of power shifted to the Assyr-Babylonians were the next to ascend to dominance in kadians, the Sumerians regained power locally. The invaders from farther north in turn conquered the Ak-

> earlier, when people had come together in the first mighty Persian Empire had begun thousands of years through trade and conquest that culminated in the powers, specialization of roles, and cultural blending needs of religion. The evolution of political and religious greater impact on it, however, as did the dictates and the exchange of styles, techniques, and materials, had a Interior and exterior trade relations, which determined undoubtedly influenced by these broad political events. The art produced in the ancient Near East was

Neolithic cities.

PARALLELS

Dominant Culture	<u>Years</u>	Near East	World	
Early Neolithic	с. 9000 все	Jericho; Chatal Huyuk		
Elam Sumer Akkad	 с. 7000-600 все с. 3500-2340 все с. 2150-2030 все с. 2340-2180 все 	Earliest pictographs; wheeled carts; potter's wheel; White Temple ziggurat; bronze tools and weapons; <i>Gilgamesh</i> epic	4000–3000 BCE Potter's wheel (Egypt) 3000–2000 BCE World population about 100 million; hieroglyphic writing (Egypt); potter's wheel (China); first pottery in Americas (Ecuador); Stonehenge (England); Pyramids at Giza (Egypt)	
Lagash	с. 2150 все		2000 1000 207	
Babylonia	с. 1792–1750 все	Stela of Hammurabi	2000–1000 BCE Shang dynasty (China); Olmec civilization (Mesoamerica)	
Hittite (Anatolia)	с. 1600-1200 все	Iron tools and weapons	,	
Assyria	с. 1000-612 все		1000–336 все First Olympian Games (Greece); birth	
Neo-Babylonia	с. 612-539 все	Ishtar Gate	of Siddhartha Gautama, founder of Buddhism (Nepal); Parthenon (Greece);	
Persia	с. 559–331 все	Persepolis built; Alexander the Great conquers Persia	Alexander the Great becomes king of Macedonia	

covered by a mat of thickly woven branches and grasses sealed with mud. The lower walls, support posts, and floors were covered with plaster, a wet mixture of burned limestone ash and sand that dried quickly into a hard, water-resistant surface. These houses must have resembled the adobe pueblos that native peoples of the American Southwest began to build more than 7,000 years later.

Rather than expand the city beyond the safety and convenience of the original terraces, the people of Ain Ghazal met their growing need for space by reworking existing houses—dividing large rooms into smaller ones, adding storage pits, and enlarging hearths. As in other Neolithic settlements, the family dead were buried in graves below the floors around the hearths. Evidence from these graves suggests that infant mortality was high but that about a fifth of the population lived to be older than fifty.

Among the objects recovered from Ain Ghazal are plaster containers and painted plaster figures up to 3 feet tall (fig. 2-2). Sculptors molded the figures by applying wet plaster to frames of twigs and grasses bound together in the shape of the human form. Inset cowrie shells formed the eyes, and small dots of the black, tarlike substance bitumen—which Near Eastern artists used frequently—

formed the pupils. These statues may have been related to ancestor worship, possibly practiced at this and other nearby early Neolithic sites. Because the figures show individual characteristics, they seem to memorialize particular people. The feet of one figure, for example, have six toes, more likely a deliberate representation of a rare genetic trait than a slipup by the sculptor.

Although agriculture appears to have been the economic mainstay of these new year-round communities, other specialized activities, such as manufacturing and trade, were also important. Chatal Huyuk, a sizable city in Anatolia occupied from about 6500 to 5500 BCE, developed a thriving trade in obsidian, a rare, black volcanic glass that was used from Paleolithic into modern times for making sharp blades.

The inhabitants of Chatal Huyuk lived in densely clustered single-story buildings grouped around shared courtyards, which were used as garbage dumps. There were no streets, and people moved around by crossing from rooftop to rooftop. The shared walls gave the buildings stability, and rooftop defenders could effectively stop invaders, who had to emerge from one building to go into the next. Many of the interior spaces were elaborately decorated and are assumed to be shrines. Walls

2-3. Composite reconstruction drawing of a shrine room at Chatal Huyuk, Turkey. c. 6500–5500 BCE

the 1950s. Huyuk, which was reburied after it was excavated in vators' detailed records. This is especially true at Chatal subsequent investigators are forced to rely on the excaobject. Even scientific excavation destroys context, and them, an object from an unknown context is just an for artifacts to sell on the international art market. To terest in the context in which they find things, loot sites mation is lost when treasure hunters, who have no inpeople who inhabited them. Valuable scientific inforvated, such mounds yield concrete evidence about the generations of human habitation. When properly excaor huyuk—that represents the accumulated debris of naled by a large mound—known locally as a tell, tepe, In most cases an archeological site in a region is sig-Many ancient Near Eastern cities still lie undiscovered.

ture," page 67). the world's first written literature (see "Sumerian Literaorganized system of justice with written law codes and sary for commerce. They also show the emergence of an not only writing but also arithmetic, another tool necesby modern scholars document the gradual evolution of Thousands of Sumerian tablets painstakingly translated business records (see "Cuneiform Writing," page 66). ment) and was developed by wealthy temples to keep pressed into clay tablets with a stylus (writing instrumethod used a cuneiform ("wedge-shaped") script imsystem of writing between 3300 and 3000 BCE. This greatest contribution to later civilizations—inventing a in copper and bronze, and—perhaps the Sumerians' inventing the wagon wheel and the plow, casting objects The Sumerians have been credited with many "firsts":

The Sumerians' most notable contribution to architecture was the **ziggurat**, a stepped pyramidal structure with a temple or shrine on top. The first such structures were the result of repeated rebuilding at a sacred site, with rubble from one structure serving as the foundation for the next. Elevating religious sites on platforms originally may have been a way to protect shrines from flooding. Whatever their origin, these sacred structures

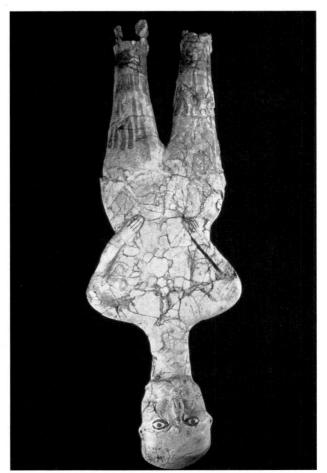

2-2. Figure, from Ain Chazal, Jordan. c. 7000–6000 BCE. Plaster with cowrie shell, bitumen, and paint, height approx. 35" (90 cm). National Museum, Amman, Jordan

had bold geometric designs, painted animal scenes, actual animal skulls and horns, and three-dimensional shapes resembling breasts and horned animals. On some walls, women were shown giving birth to bulls. In high-arched wall area above three large, projecting bulls' heads—braces herself as she gives birth to a ram (fig. 2-3). Although this dramatic image suggests worship of a fertility goddess, any such interpretation is risky because so little is known about the culture.

Like other early Near Eastern settlements, Chatal Huyuk seems to have been abandoned suddenly, for unknown reasons, and never reoccupied. The concentration of people and resources in such communities nevertheless represented a step toward the larger and more complex city-states that were to emerge in Mesopotamia and become usual in the ancient Near East.

SOMER First cities, then city-states, developed between about 3500 and 2800 BCE along the

rivers of southern Mesopotamia, and the cities in this region are known collectively as Sumer. The inhabitants of this region had migrated from the north, but their origins are otherwise obscure.

WRITING

CUNEIFORM The Sumerians developed the earliest known system

of writing in the late third millennium BCE, apparently for the purpose of keeping agricultural records. The earliest preserved tablets date to around 3300 BCE and represent an accounting system for food and other products traded at Uruk. The symbols on these thin clay slabs are pictographs, simple pictures that represent a thing or a concept. The head of a bull, for example, represents "bull." These pictographs were incised in the moist clay with a pointed tool. Between 2900 and 2400 BCE, the symbols evolved from simple pictures into phonograms—representations of the sounds of syllables in the Sumerian language-thus becoming a true writing system. During the same centuries, scribes adopted a stylus with one triangular, wedge end and one pointed end that could be pressed rapidly and repeatedly into a wet clay tablet to create the symbols, or characters, now increasingly abstract. Early modern scholars termed the ancient writing of Mesopotamia cuneiform, from the Latin words for "wedge-shaped," after the wedgeshaped marks made by the stylus.

The illustration here shows several examples of the shift from pictograph to cuneiform writing. The drawing of a bowl, which means "bread" and "food" and dates from about 3100 BCE, had been reduced by about 2400 BCE to a four-stroke sign, and by about 700 BCE to a highly abstract vertical arrangement of strokes. Combined with the pictograph and, later, cuneiform sign for head, the composite sign came to mean "to eat."

Cuneiform writing was a difficult skill, and few people in ancient Mesopotamia mastered it. Selected

children attended schools where they learned to read and write by copying their teachers' lessons. Clay exercise tablets have been excavated with a teacher's sample on one side and a student's efforts on the other. Only boys attended schools, but a small number of girls did learn to read and write, probably by being tutored at home. One of the fascinating things these ancient tablets reveal is that some 4,000 years ago there were textile businesses-concerned with both weaving and export-organized and operated by women entrepreneurs.

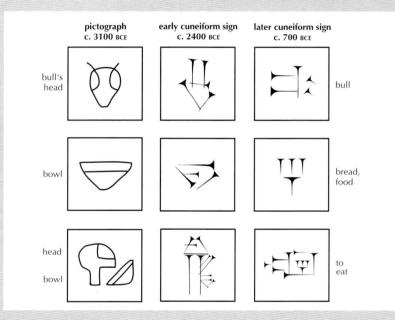

towering above the flat plain proclaimed the wealth, prestige, and stability of a city's rulers and glorified its protective gods. Ziggurats functioned symbolically, too, as lofty bridges between the earth and the heavens—a meeting place for humans and their gods. They were given names such as "House of the Mountain" and "Bond between Heaven and Earth," and temples were known as "waiting rooms" because the priests and priestesses waited there for the gods and goddesses to reveal themselves. Ziggurats were impressive not because of size alone but also because their exterior surfaces were decorated with paint and elaborate patterns of plain or colored bricks. The gods would have been pleased with all this handiwork, it was said, because they abhorred laziness in their people.

There were two large temple complexes at Uruk (modern Warka, Iraq), the first independent Sumerian city-state. One complex was dedicated to Inanna, the goddess of fertility, and the other probably to the sky god Anu, another major deity. The Anu Ziggurat was built up in stages over the centuries until it ultimately rose to a height of about 40 feet. Around 3100 BCE, a temple was erected on top that modern archeologists refer to as the White Temple because it was made of white-washed brick (fig. 2-4). This now-ruined structure was laid out as a simple rectangle oriented to the points of the compass. An off-center doorway on one of the long sides led into a large chamber containing a raised platform and altar; smaller spaces opened off this main chamber.

Many courtyards and interior walls in both the Inanna and the Anu compounds were decorated in a technique apparently invented at Uruk, the so-called cone mosaic (see "Cone Mosaic," page 68). Thousands of colored cones—shaped stone or baked clay—were pressed like thumbtacks into the wet plaster walls, their flat "heads" creating shimmering, multicolored designs. The technique was extremely labor intensive, but cone mosaics were exceptionally beautiful and durable.

About a thousand years after the completion of the White Temple, the people of Ur (modern Muqaiyir), a city along the Euphrates south of Uruk, built a ziggurat dedicated to the moon god Nanna, also called Sin, that illustrates the mature ziggurat form (fig. 2-5). Although

from Wolkstein and Kramer, pages perity. (Text and summary adapted proceed to enjoy peace and prosthe glory of Inanna's Uruk, and all of Eridu are forced to acknowledge to her people. Enki and the city her new divine powers, one by one, rejoicing and triumphantly presents enters Uruk's city gate amid much

gamesh ultimately learns to accept the gods ever granted eternal life. Gilworld, and the only people to whom good sent by the gods to destroy the wife, the only survivors of a great eternal life from Utnapishtim and his gamesh sets out to find the secret of When Enkidu dies, a despondent Gil-Uruk, and his companion Enkidu. mesh, a legendary Sumerian king of recounts the adventures of Gilga-Nineveh (modern Kuyunjik, Iraq). It surbanipal (ruled 669-c. 627 BCE) in the library of the Assyrian king Aswritten in Akkadian, was found in version survive. The fullest version, but only fragments of the Sumerian Gilgamesh. Its origins are Sumerian, ancient Mesopotamia is the Epic of The best-known literary work of

his mortality.

(.72-21)

challenged each other. They toasted each other; they Mother of the Earth,

sprine! In the name of my holy "In the name of my power! toasted Inanna: Enki, swaying with drink,

The high priesthood! To my daughter Inanna I shall

The noble, enduring crown! Godship!

Inanna replied: The throne of kingship!"

"I take them!"

fights them off. Inanna eventually boat, but each time Inanna's servant natural forces after the retreating Desperate, he sends a series of superold god realize what he has done. sailed away does the drink-crazed eighty of his powers into her boat and Only after Inanna has gathered all and each time she accepts his gifts. upon her more of his special powers, teen times, each time bestowing Enki toasts Inanna another thir-

> **FILEKATURE** thousands of cunei-SUMERIAN Among the tens of

performed with music. poetry, and some may have been merian beliefs. Most are written as and they tell us much about Suthe world's oldest written literature, proverbs, and fables. These make up texts, consisting of essays, debates, mourning, and so-called wisdom endary histories, hymns, songs of religious myths, heroic tales, leging about 30,000 lines of text—record number-fewer than 6,000, containvated thus far in Sumer, only a small form tablets exca-

Eridu, a city to the south of Uruk, to start from Uruk, decides to go to of these, Inanna, a young, untried upconcerns the goddess Inanna. In one One group of stories and hymns

together. Enki and Inanna drank beer visit Enki, the god of wisdom.

With the vessels of Urash, to overflowing, With their bronze vessels filled together. They drank more and more beer They drank more beer together.

C. 2100-2050 BCE (modern Muqaiyir, Iraq). 2-5. Nanna Ziggurat, Ur

Warka, Iraq). c. 3100 BCE Temple, Uruk (modern the Anu Ziggurat and White 2-4. Reconstruction drawing of

2-6. Face of a woman, from Uruk (modern Warka, Iraq). c. 3500–3000 BCE. Marble, height approx. 8" (20.3 cm). Iraq Museum, Baghdad

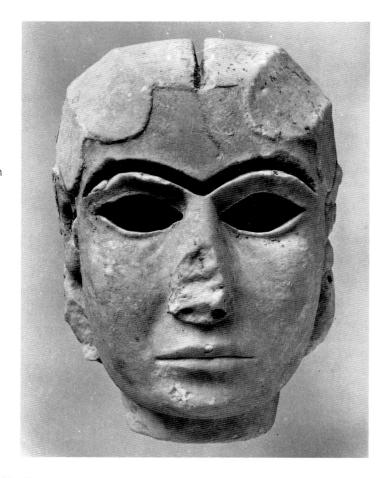

TECHNIQUE

CONE MOSAIC

To decorate wall surfaces and other architectural elements, Sumerians at Uruk devised the **cone mosaic**. The technique used small, cone-shaped cylinders of colored stone or baked clay that were pushed into a thick layer of wet plaster. The cones were closely spaced in rows to form bands of angular, decorative patterns such as zigzag, diamond, herringbone, and flame. Clay cones have been excavated in other sites throughout Mesopotamia, which suggests that other peoples adopted the Sumerian technique.

located on the site of an earlier temple, this imposing mud-brick structure was elevated by design, not as the result of successive rebuildings. Its base is a rectangle 190 by 130 feet with three sets of stairs converging at an imposing entrance gate atop the first platform. Each platform is angled outward from top to base, probably to prevent rainwater from forming puddles and eroding the mud-brick pavement. The first two levels of the ziggurat and their retaining walls have been reconstructed in recent times. Little remains of the upper level and the temple.

Sculpture of this period was associated with religion, and large statues were commonly placed in temples as objects of devotion. A striking marble face from Uruk may once have been part of such an image (fig. 2-6). Beardless, it may represent a goddess. With its compelling empty-eyed stare and sensitively rendered features, this lifesize face demonstrates the skill attained by Sumerian sculptors at roughly the time the White Temple was being built. The marble face would have been attached to a wooden head on a full-size wooden body. Now stripped of the plaited gold hair or flowing wig with which it was originally adorned, and lacking the inlay, that is, set-in decoration for the brows and eyes—probably shell for the whites and deep blue lapis lazuli for the pupils—and the paint on the lips and skin, the face is reduced to a stark, white mask.

A tall, carved, alabaster vase found near the ruins of a temple at Uruk almost certainly served some religious

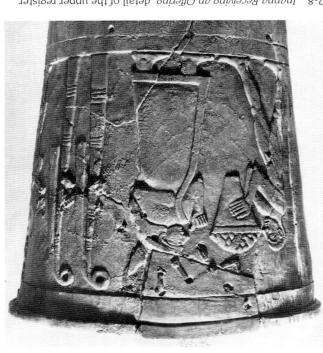

2-8. Inanna Receiving an Offering, detail of the upper register of the carved vase from Uruk (fig. 2-7)

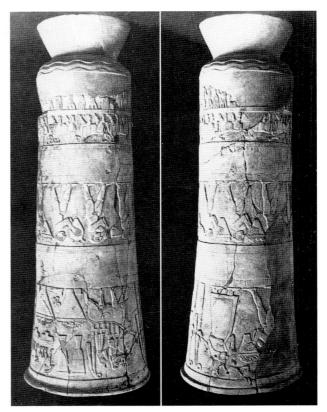

2-7. Carved vase (both sides), from Uruk (modern Warka, Iraq). c. 3500–3000 BCE. Alabaster, height 36" (91 cm).

riage between the divine female and a human male during the annual spring New Year's festival, which was meant to assure fertility for the city's crops, livestock, and people during the coming year.

The sculptors of the vase told their story with great economy and clarity through the use of symbolic detail. They organized the picture space into registers that show the symbolic ascent from plants and animals to the goddess and that mirror the physical ascent of a ziggurat from level to level. They also condensed and focused the narrative, much as modern comic-strip artists do. For the next 2,500 years this use of registers was the preferred next 2,500 years this use of registers was the preferred next 2,500 years this use of registers was the preferred next 2,500 years this use of registers was the preferred next 2,500 years this use of registers was the preferred next 2,500 years this use of registers was the preferred next 2,500 years this use of registers was the preferred next 2,500 years this use of registers was the preferred next 2,500 years this use of registers and preferred next 2,500 years this use of registers and preferred next 2,500 years the preferred next 2,500 years this next 2,500 years 2,500

ruins of a temple at Eshnunna (modern Tell Asmar, Iraq) reveal a somewhat humbler aspect of Mesopotamian religious art (fig. 2-9). These votive figures—statues made as an act of worship to the gods—depict individual uals. They represent an early example of an ancient Near Eastern religious practice—the setting up of simple, small statues of individual worshipers in a shrine before the larger, more elaborate image of a god. The early figurines from Ain Chazal may have served this function, and the face of a woman from Uruk may have been part of such a figure, although there is no proof of it. Apparanthe face of a woman from Uruk may have been part of such a figure, although there is no proof of it. Apparently anyone who could afford to might commission a self-portrait and dedicate it to a shrine. A simple inscription might identify the figure just as "One who offers lian might identify the figure just as "One who offers brayers." Longer inscriptions might recount in detail all prayers." Longer inscriptions might recount in detail all

purpose (fig. 2-7). It is decorated with bands, or **registers**, in **low relief**, a technique in which figures are carved to project only slightly from a flat background. Its lower registers show the natural world, including plants and anisters show the natural world, including plants and anisters show the natural world, including plants and anishale. In the lowest register, over a wavy line signifying water, barley and date palms grow; above them, on a solid **groundline**, rams and ewes alternate, facing right. In the middle register, facing in the opposite direction, a line of unclothed priests strides forward, carrying baskets heaped with food that may have been temple offerings or wedding gifts. Size was associated with importance in Mesopotamian art, and the sturdy priests are shown simultaneously in side or profile view (heads and legs) and in three-quarter view (torsos), which makes both shoulders visible and increases their breadth.

The repetition of figures found in the first two bands disappears in the top register, where the imagery is more complex. Inanna, in her role as fertility goddess, stands in front of her shrine, indicated by two reed door poles draped with curtains (fig. 2-8). She wears a long robe and the horned headdress of a deity. Her right hand is raised in a gesture of greeting or blessing, and she faces a naked priest, who presents a sort of cornucopia. Behind him are other offering bearers; the last one holds a tasseled belt for the figure ahead, who may be a ruler. Through the doorway to her shrine, her wealth is displayed: animals, containers of fruit, large vases like this one, and what appears to be a temple model with a man and woman inside. The scene is usually interpreted as the ritual marninside. The scene is usually interpreted as the ritual marninside. The scene is usually interpreted as the ritual marninside. The scene is usually interpreted as the ritual marninside. The scene is usually interpreted as the ritual marninside. The scene is usually interpreted as the ritual marninside.

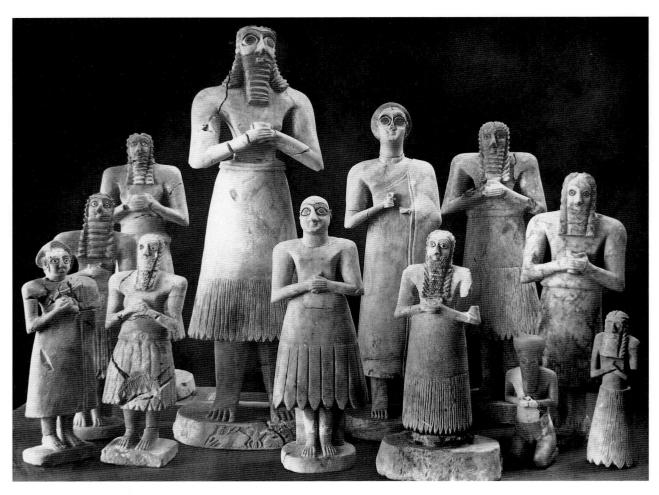

2-9. Votive statues, from the Square Temple, Eshnunna (modern Tell Asmar, Iraq). c. 2900–2600 BCE. Limestone, alabaster, and gypsum, height of largest figure approx. 30" (76.3 cm). The Oriental Institute of the University of Chicago; Iraq Museum, Baghdad

the things accomplished in the god's honor. Cuneiform texts reveal the importance of fixing on a god with an attentive gaze, hence the wide-open eyes. These standins are at perpetual attention, making eye contact and chanting their donors' praises through eternity.

The sculptors of the Eshnunna statues reduced the face, hair, body, and clothing to simple geometric shapes. The figures stand solemnly, hands clasped in respect. Like the face of a woman from Uruk, arched brows inlaid with dark shell, stone, or bitumen once emphasized their huge, staring eyes. The male figures, bare-chested and dressed in sheepskin skirts, are stocky and muscular, with heavy legs and large feet, big shoulders, and cylindrical bodies. The two female figures (the tall, regal woman near the center and the smaller woman at the far left) have somewhat slighter figures but are just as square-shouldered as the men.

The earliest pottery in the Near East dates to about 7000 BCE. Decorated vessels excavated in large numbers from grave sites provide some sense of the development of pottery styles in various regions. One popular type of Sumerian painted ceramic was Scarlet Ware, produced

from around 3000 to 2350 BCE (fig. 2-10). Designs on these vessels, predominantly in red with touches of black, were painted with colored mixtures of clay and water. Circles, herringbones, zigzags, diamonds, and other geometric patterns, as well as animal images, were common motifs. The vase pictured here is about a foot tall and includes human figures, which is unusual.

From about 3000 BCE on, Sumerian artisans worked in various metals, including the hard metal alloy bronze (hence the name "Bronze Age" for the period that followed the Neolithic). Many of their metal creations were decorated with—or were in the shape of—animals or composite animal-human-bird creatures. They did extraordinary work in precious metals, often combining them with other materials. A superb example of their skill is a lyre—a kind of harp—from the tomb of Queen Puabi of Ur (c. 2685 BCE), which combines wood, gold, lapis lazuli, and shell (fig. 2-11). From one end of the lyre, the three-dimensional head of a bearded bull glares. The head is intensely lifelike despite the fantastic, decoratively patterned blue beard and the simplified nose.

On the panel below the head, four horizontal regis-

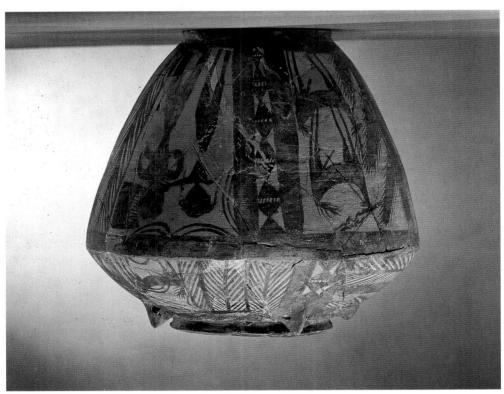

2-10. Scarlet Ware vase, from Tutub (modern Tell Khafajeh, Iraq). c. 3000–2350 BCE. Ceramic, height 11³/₄" (30 cm). Iraq Museum, Baghdad

The archeologist's best friend is the potsherd, or piece of broken pottery. Ceramic vessels are easily broken, yet the fragments are almost indestructible. Their earliest appearance at a site marks the time when people in the region began producing ceramics. Pottery styles, like automobile designs and fashions in clothing, change over time. Archeologists are able to determine the chronological order of such changes. By matching the potsherds excavated at a site with the types in this sequence, they can determine the relative date of the site (see "How Early Art Is Dated," page 49).

used in funeral rites, their imagery probably depicts the fantastic realm of the dead. The animals are the traditional guardians at the gateway through which the newly dead must pass. Cuneiform tablets preserve songs of mourning from Sumer, which may have been chanted by priests to lyre music at funerals.

common "animal combat" theme (fig. 2-13). A lone, nude The scene on one fine example is a variation on the elaborate scenes carved into them would not wear away. hard stone, such as marble, so that the tiny but often seals, usually less than 2 inches high, were made of a stamp seal in the form of a cylinder. Sumerian cylinder Around 3400 BCE, temple record keepers redesigned the tinctive design that could not be easily altered once dry. a damp clay surface, the seal left a mirror image of its distainer lids and storage-room doorways. Pressed against surface to sign documents and to mark clay seals on conple clay stamps with designs incised (cut) into one lishing property ownership. At first, Sumerians used simstamps and seals for identifying documents and estabpeared, Sumerian temple staff and merchants developed At roughly the same time written records first ap-

headed bulls. cept for a wide belt. He is clasping two rearing humanathletic man with long hair and a full beard, naked exdrinking bowl. In the top panel, facing forward, is an and mutton. A lion follows with a large wine jug and a knife in its belt carries a table piled high with pork ing food and drink for a feast. On the left a wolf with ter shows animal attendants, also walking erect, bringpercussion instrument, perhaps a rattle. The next registhe instrument's frame and a seated jackal plays a small instruments were played—while a standing bear braces plucks the strings of a bull lyre-showing how such depicts a pair of animal musicians. A seated donkey from which a ladle protrudes. The scene above this one out two tall cups, perhaps filled from the large container attended by a goat standing on its hind legs and holding are probably ritual objects in his upraised hands. He is the bottom register a man in scorpion dress holds what ters present scenes executed in inlaid shell (fig. 2-12). In

These scenes have puzzled scholars, but a new interpretation sheds light on their meaning. Because the lyre and others like it were found in graves and were

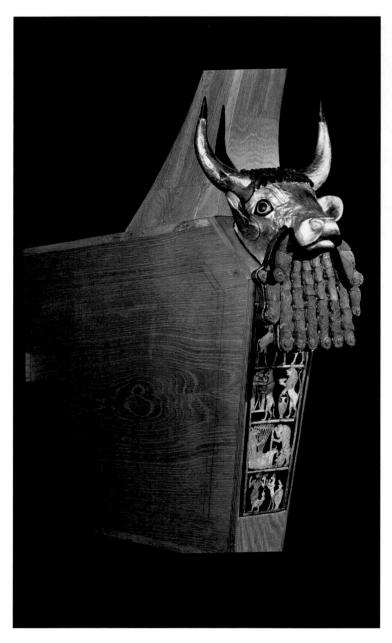

2-11. Bull lyre, from the tomb of Queen Puabi, Ur (modern Muqaiyir, Iraq). c. 2685 BCE. Wood with gold, lapis lazuli, and shell, reassembled in modern wood support. University Museum, University of Pennsylvania, Philadelphia

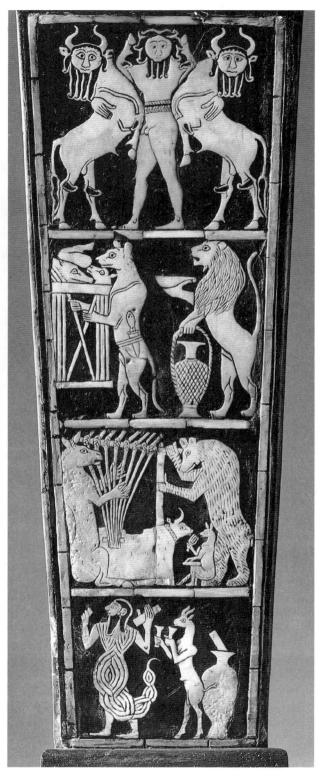

2-12. Mythological figures, detail of the sound box of the bull lyre from Ur (fig. 2-11). Wood with shell inlay, $12^{1/4} \times 4^{1/2}$ " (31.1 x 11 cm)

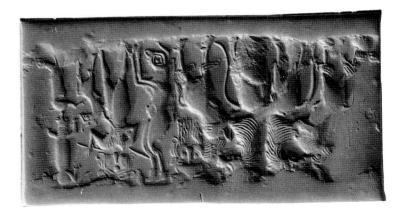

2-13. Cylinder seal from Sumer and its impression. c. 2500 BCE. Marble, height approx. 13/4" (4.5 cm). The Metro-politan Museum of Art, New York Gift of Walter Hauser, 1955 (55.65.4)

The distinctive design on the stone cylinder seal on the left "belonged" to its owner, like a coat of arms in the European Middle Ages or a modern cattle-rancher's brand. When rolled across soft clay applied to the closure to be sealed—a jar lid, the knot securing a bundle, or the door to a room—the cylinder left a raised image, or band of repeated raised images, of the design. Sealing discouraged unauthorized people from secretly gaining access to goods or information.

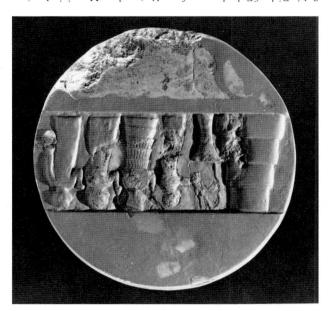

2-14. Disk of Enheduanna, from Ur (modern Muqaiyir, Iraq). c. 2300 BCE. Alabaster, diameter approx. 10" (25.4 cm). University Museum, University of Pennsylvania, Philadelphia

An inscription on the back of the disk reads: "Enheduanna, priestess of the moon god, [wife] of the moon god, child of Sargon the king of the universe, in Ishtar's temple of Ur she built [an altar] and named it ... Offering Table of Heaven" (adapted from William W. Offering Table of Heaven" (adapted from William W. 1994, page 48).

princesses serving as high priestesses, and she complemented her father's political consolidation of his empire by uniting religious authority within it. Her hymns in praise of Sargon and Inanna are among the earliest literary works whose author's name is known. She is memory works whose author's name is known. She is memorialized on several cylinder seals, as well as on an inscribed alabaster disk that bears her picture (fig. 2-14).

male tries to stop a long-maned lion from mauling a frightened stag, while another lion attacks the stag's mate. Flanking this main group are rearing bulls with human faces who appear to be sparring for dominance. As later Assyrian reliefs will show, it was an enduring tradition in Near Eastern art to depict leaders protecting their people from both human and animal enemies as well as exerting control over the natural world. Often the human enemies turned out to be warlike invaders, drawn by Sumer's natural resources and prosperity.

AKKAD During the period of Sumerian power, the fertile Mesopotamian plain attracted

a people known as the Akkadians, who settled the area near modern Baghdad to the north of Uruk and adopted Sumerian culture. Unlike the Sumerians, the Akkadians spoke a Semitic language (a language in the same family as Arabic and Hebrew). Under the powerful military and political figure Sargon I (ruled c. 2332–2279 BcE), they conquered the Sumerian cities and brought most of Mesopotamia under their control. For more than half a century, Sargon ruled this empire from his capital at Akkad, the actual site of which is yet to be discovered. As Mesopotamia under their control. For more than half a century, Sargon ruled this empire from his capital at Akkad, the actual site of which is yet to be discovered. As the actual site of the setting of the Assumed by the status of a god, setting a precedent followed by to the status of a god, setting a precedent followed by

Enheduanna, the daughter of Sargon I, was a major public figure who combined the roles of princess, priestess, politician, poet, and prophet and wielded exceptional power. During her lifetime, she was considered the embodiment of the goddess Uingal, the wife of the moon god Nanna, and after her death she herself may have been elevated to the status of goddess. She was apparently the only person to hold the office of high priestess ently the only person to hold the office of high priestess for both the ziggurat of Nanna, the moon god of Ur, and the ziggurat of Anu, the sky god of Uruk, Sumer's and the ziggurat of Anu, the sky god of Uruk, Sumer's two most prestigious gods. She began the tradition of

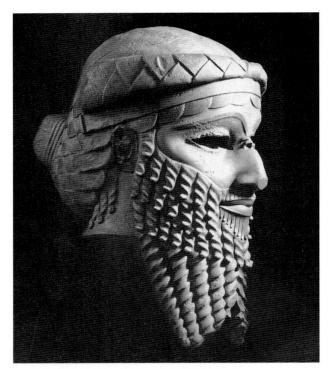

2-15. Head of a man, from Nineveh (modern Kuyunjik, Iraq). c. 2300–2200 BCE. Bronze, height 143/8" (36.5 cm). Iraq Museum, Baghdad

The figures carved in **high relief** in a band across the middle of this disk are participating in a ritual at the base of a ziggurat, seen at the far left. A nude priest pours ceremonial liquid from a pitcher onto an offering stand. The tall figure behind him, wearing a flounced robe and priestess's headdress, is presumed to be Enheduanna. She and the two figures to her right, probably priests with shaven heads, raise one hand in a gesture of reverent greeting. The disk shape of this work is unique and may have to do with its dedication to the moon god.

Enheduanna's well-documented career is an exception to the otherwise sparse information available about the Akkadians. Few artifacts can be traced to the courts of Akkad, making a lifesize bronze head dating from about 2300–2200 BCE especially precious (fig. 2-15). Its facial features and hairstyle probably reflect a generalized male ideal rather than the appearance of a specific individual. Also, it is possible that the head was symbolically mutilated to destroy its power, for the ears appear to have been deliberately removed, as have the inlays that would have filled the eye sockets.

The concept of imperial authority was literally carved in stone in another Akkadian work, the *Stela of Naramsin* (fig. 2-16). This 6½-foot-high **stela**, or upright stone slab, commemorates a military victory of Naramsin, Sargon's grandson and successor, and is an early example of a work of art created to celebrate the achievements of an individual ruler. In a sharp break with visual tradition, the sculptors replaced the horizontal registers with a unified scene. The images stand on their own, with no explanatory inscription. Watched over by three solar deities, symbolized by the rayed suns in the sky, Naramsin ascends a mountain wearing

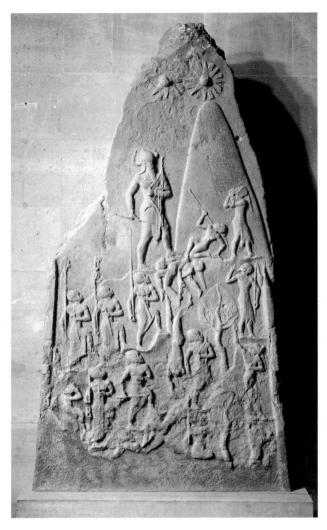

2-16. Stela of Naramsin. c. 2254–2218 BCE. Limestone, height 6'6" (1.98 m). Musée du Louvre, Paris

This stela probably came originally from Sippar, an Akkadian city on the Euphrates River, in what is now Iraq. It was not discovered at Sippar, however, but at the Elamite city of Susa (modern Shush, Iran), some 300 miles to the southeast. Raiders from Elam presumably took it there as booty in the twelfth century BCE.

the horned crown used to identify gods. His soldiers follow at rhythmic intervals, passing conquered enemy forces sprawled in death or begging for mercy. Both the king and his warriors hold their weapons upright. The godlike king is immediately recognizable. He stands at the dramatic center of the scene, closest to the mountaintop, silhouetted against the sky. As in most art from the Near East, his greater size in relationship to his soldiers is an indication of his greater importance. Although this stela depicts Akkadians in triumph, they managed to dominate the region for only about another half century.

LAGASH In about 2180 BCE, the Akkadian Empire fell under attack by the Guti, a mountain people from the northeast. The Guti controlled most of the Mesopotamian plain for a brief time, then the Sumerians regained control of their own region and

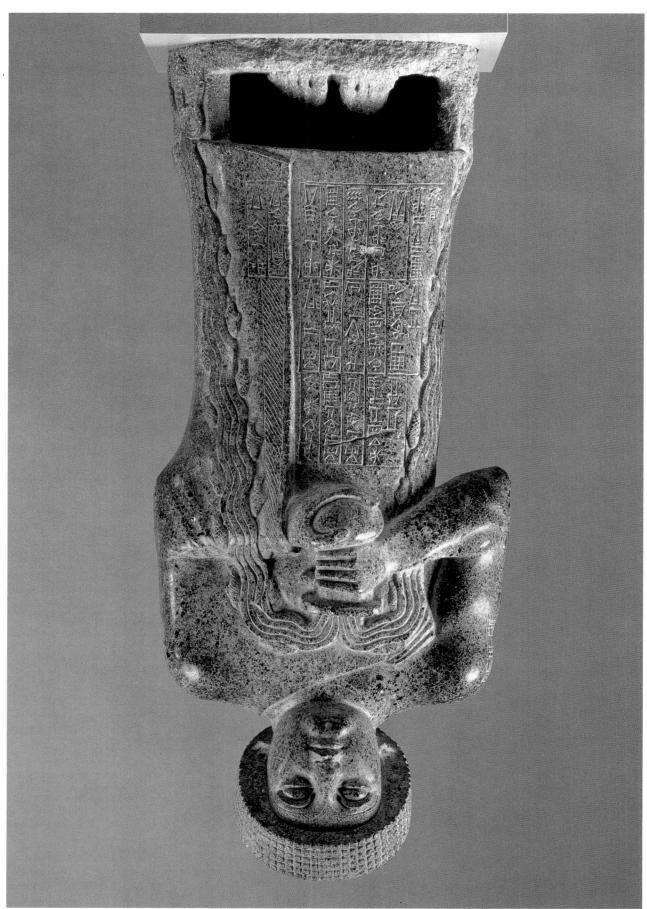

2-17. Votive statue of Gudea, from Lagash (modern Telloh, Iraq). c. 2120 BCE. Diorite, height 29" (73.7 cm). Musée du Louvre, Paris

Akkad. One large Sumerian city-state remained independent during the period of Guti control. This was Lagash, on the Tigris River in the southeast, under the ruler Gudea. Gudea built and restored many temples, in which he placed votive statues representing both himself as governor and the ideal of good rule that he embodied. The statues are made of diorite, a very hard stone that was difficult to work, prompting the sculptors to use compact, simplified forms for the portraits that are unusually durable. Twenty of them survive, all looking much alike, making Gudea's face a familiar one in ancient Near Eastern art.

Whether the ruler was shown sitting or standing, the smooth fall of his robe provided ample space for long cuneiform inscriptions. The text of the one shown here (fig. 2-17) relates that Gudea dedicated himself, the sculpture, and the temple in which the sculpture resided to the goddess Geshtinanna, the divine poet and interpreter of dreams. Imposing and impressive, this statue seems monumental, although it is only 2½ feet tall. Here Gudea holds a vessel from which life-giving water flows in two streams filled with leaping fish. (At least one statue has been found of a goddess holding a vessel engineered to spout real water, which would have poured down her robe.) The full face below the cuffed sheepskin hat appears youthful and serene, and the smoothly muscled body is clothed in a long garment similar to that worn by the female votive figures from Eshnunna. The oversized, wide-open eyes—better to return the gaze of the deity-and broad, bunched-up shoulders express intense concentration. The sculptor's top-heavy treatment of the human body, as in other Mesopotamian figures, emphasizes its power centers: the eyes, head, chest, and arms. Images of Gudea present him as a strong, peaceful, pious ruler worthy of divine favor.

BABYLON AND MARI

For the next 300 years, periods of political turmoil alternated with periods of stable government in

Mesopotamia. The Amorites, a Semitic-speaking people from the Arabian desert to the west, moved into the region and eventually reunited Sumer under Hammurabi (ruled 1792–1750 BCE). The capital city was Babylon, and the residents are called Babylonians. Among Hammurabi's achievements was a written legal code that listed the laws of his realm and the penalties for breaking them.

Hammurabi's code occupies most of the *Stela of Hammurabi*, a finely carved stone about 7 feet tall, but the relief sculpture at the top shows the king standing before the supreme judge, the sun god Shamash (fig. 2-18). The figures were executed in smooth, rounded forms with a minimum of linear surface detail. Shamash wears the four-tiered, horned headdress that marks him as a god and a robe that bares one shoulder and ends in a stiff, flounced skirt. Rays of the sun rise from behind his shoulders, and in his right hand he holds a measuring rod and a rope ring, symbols of justice and power. Hammurabi faces Shamash confidently, his hand raised in a gesture of greeting. Any suggestion of familiarity in the lack of

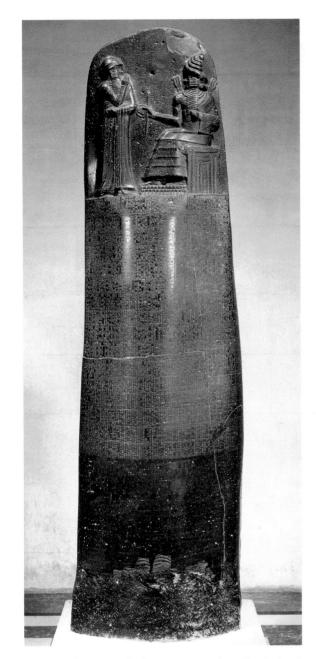

2-18. *Stela of Hammurabi*, from Susa (modern Shush, Iran). c. 1792–1750 BCE. Basalt, height of stela approx. 7' (2.13 m), height of relief 28" (71.1 cm). Musée du Louvre, Paris

In the introductory section of the stela's long cuneiform inscription, Hammurabi declared that with this code of law he intended "to cause justice to prevail in the land and to destroy the wicked and the evil, that the strong might not oppress the weak nor the weak the strong." Most of the 300 or so entries that follow deal with commercial and property matters. Only sixty-eight relate to domestic problems, and a mere twenty deal with physical assault. Punishments depended on the gender and social standing of the offender. Like the *Stela of Naramsin*, this stela was removed to Susa by Elamite invaders.

distance between the two is offset by the formality of his pose. The smaller, earthly law enforcer remains standing in the presence of the much larger divine judge, seated on his ziggurat throne. The Babylonian sculptor of this stela, like the Akkadian sculptor of the *Stela of Naramsin* (see fig. 2-16), indicated the relative importance of the

2-19. Investiture of Zimrilim, facsimile of a wall painting on mud plaster from the palace at Mari (modern Tell Hariri, Iraq), Court 106. c. 1750 BCE. Height 5'5" (1.7 m). Musée du Louvre, Paris

2-20. Blue Bird, detail of the wall painting from Mari (fig. 2-19)

panels are first a pair of towering palm trees with fanshaped, stylized foliage. The stylization is especially evident in the patterned forms of the palm fronds, which exaggerate the spiny leaf shapes and emphasize the round fruits. Then there are three tiers of mythical animals—bulls, winged lions, and crowned, human-headed winged creatures—all facing inward. Beyond these are date palms being climbed by two fruit pickers. An enormous blue bird, of a species still found in the Mari region, spreads its wings in the right-hand tree (fig. 2-20). At the

figures by size. The ziggurat-form throne represented their mountain meeting site.

examples of this fragile ancient Near Eastern art form. murals from the palace have survived and provide rare against Mari and destroyed Zimrilim's palace. A few once been allies, but in 1757 BCE Hammurabi marched notable art collection. Zimrilim and Hammurabi had shrines, hundreds of other rooms and courtyards, and a courtyard paved in alabaster, several temples and working industry. The palace boasted an enormous houses, sophisticated sanitation system, and bronzecial traffic on the river and was notable for its well-built miles northwest of Babylon. It prospered from commerstrategically located on the Euphrates River about 250 BCE), reflects this trend. Zimrilim's capital city of Mari was Hammurabi's contemporary Zimrilim (ruled 1779–1757 tecture. The great palace of another Amorite king, tant, palace architecture overshadowed temple archi-As kingship and empire became increasingly impor-

merge in the center to form a canopy. Flanking these two familiar from the Gudea statue (see fig. 2-17)—and streams of water that flow from the vases—a theme ing tall plants in red vases. They are surrounded by office. Below, a pair of goddesses face each other, hold-Other deities look on, affirming the king's assumption of extends to the king emblems of rule, the rod and the ring. and resting her foot on a lion-all emblems of powerframed upper register, the goddess, holding weapons symmetrical style familiar in earlier Sumerian art. In the the investiture ceremony, are organized in the formal, tility, and love (fig. 2-19). The central panels, devoted to authority from Ishtar, the Babylonian goddess of war, ferpalace's main courtyard, shows Zimrilim receiving his gious scenes in the administrative areas. One, in the terns in the royal family's quarters to military and reli-The subjects of the murals range from geometric pat-

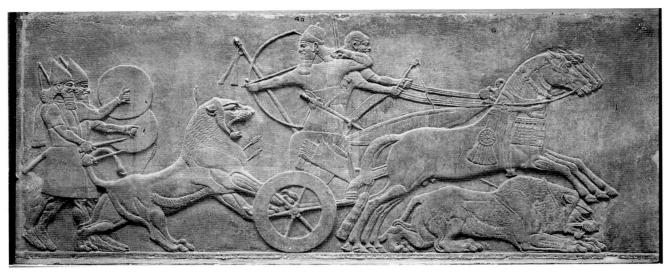

2-21. Assurnasirpal II Killing Lions, from the palace complex of Assurnasirpal II, Kalhu (modern Nimrud, Iraq). c. 850 BCE. Alabaster, height approx. 39" (99.1 cm). The British Museum, London

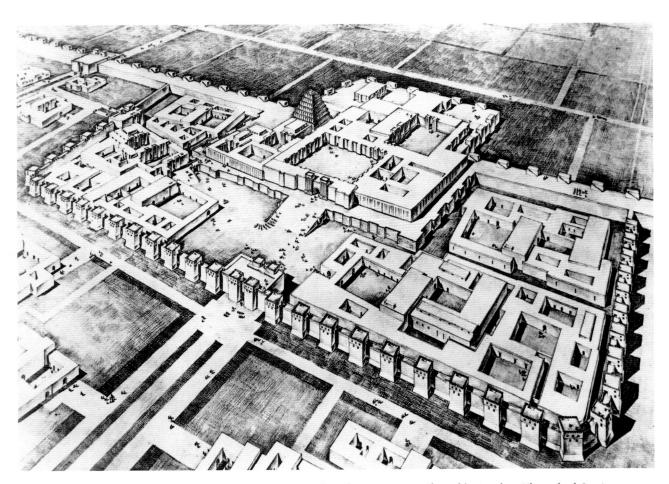

2-22. Reconstruction drawing of the citadel and palace complex of Sargon II, Dur Sharrukin (modern Khorsabad, Iraq). c. 721–706 BCE

edges of the picture two gigantic goddesses, hands raised, bestow their approval. Eye-catching checked and striped patterning throughout the mural makes its surface sparkle. The colors have darkened considerably, but they probably included blue, orange, red, brown, and white. The way in which paint was used here reveals what much Mesopotamian art looked like when it was new.

ASSYRIA After the centuries of power struggles among Sumer, Akkad, Lagash, and Mari in southern Mesopotamia, a people called the Assyrians began to rise to dominance in northern Mesopotamia. They had become very powerful by about 1400 BCE, and after about 1000 BCE they began to conquer neighboring regions. By the end of the ninth century BCE,

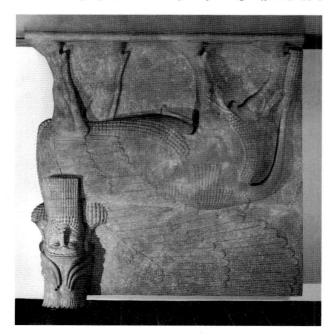

2-23. Guardian figure, from the entrance to the throne room, palace of Sargon II. c. 720 BCE. Limestone, height 16' (4.86 m). The Oriental Institute of the University of Chicago

Gates and doorways in Assyrian royal complexes were commonly protected by images of winged bulls with human heads. They were believed to guard against evil influences. As here, they were rendered with very realistic details—note the veins in the legs and the plumage of the wings—and their bodies were articulated in a lifelike way. At times, however, they were provided with a most unrealistic fifth leg, so that when viewed from the front they appeared to stand still, but when viewed from the side they seemed to be in motion.

right and temples on the left. The heart of the palace, protected by a reinforced wall with only two small, off-center doors, lay past the main courtyard. Within the inner compound was a second courtyard, lined with narrative relief panels showing tribute bearers, that functioned as an audience hall. Visitors would have entered the king's throne room from this courtyard through a stone gate sculpted in high relief with colossal guardian figures, such as the human-headed bull illustrated here fig. 2-23). These hybrid creatures also flank the gates of the citadel. Ranging from 13 to 16 feet tall and weighing about 40 tons, they would have been formidable stone guardians for a royal audience.

The ziggurat at Dur Sharrukin was set off in an open space between the temple complex and the palace. It towered over the city, declaring the might of Assyria's kings and symbolizing their claim to empire. It probably had seven levels, each about 18 feet high and painted a different color. The four levels still remaining were once white, black, blue, and red. Instead of separate flights of stairs between the levels, a single, squared-off spiral ramp rose continuously from the base, becoming smaller in circumference as it went up.

they controlled most of Mesopotamia, and by the early seventh century BCE they had externed their influence as internal weakness and external enemies, and by 600 BCE their empire had collapsed.

Various cities served at one time or another as the Assyrians' capital, and Assyrian architectural monuments include fine palaces set atop high platforms inside these fortified cities. The palaces were decorated with scenes of victorious battles, presentations of tribute to the king, combat between men and beasts, and religious the king, combat between men and beasts, and religious

During his reign (883–859 BCE), Assurnasirpal II moved the capital to Kalhu (modern Nimrud) on the east bank of the Tigris River and undertook an ambitious building program. His architects fortified the city with mud-brick walls 5 miles long, 120 feet thick, and 42 feet high, and his engineers constructed a canal that irrigated fields and provided water for the expanded population of the city. According to an inscription commemorating to celebrate the dedication of the new capital in 879 BCE. Most of the buildings in Kalhu were made from mud bricks, but alabaster—a more impressive and durable material—was used for architectural decorations such as material—was used for architectural decorations such as material—with scenes carved in low relief that depict the king participating in religious rituals, events from his war king participating in religious rituals, events from his war king participating in religious rituals, events from his war

nature. There is no question in this scene who will prevail. mals as their equal, but has assumed dominion over ever, the man is not part of nature, standing among animan confronting wild beasts. Unlike earlier works, howmany earlier works, Assurnasirpal II Killing Lions shows a sense of timelessness and toward visual narrative. As in image marks a shift in Mesopotamian art away from a by one into an enclosed area. The immediacy of this forth killing captured animals as they were released one tected by men with swords and shields, rode back and was probably a ceremonial hunt, in which the king, propierced by arrows, lies dead or dying on the ground. This four arrows protruding from its body. Another beast, draws his bow against an attacking lion that already has pal II stands in a chariot pulled by galloping horses and In a vivid lion-hunting scene (fig. 2-21), Assurnasir-

campaigns, and hunting expeditions.

was the main courtyard, with service buildings on the and religious officials were clustered. Beyond the ramp around which the residences of important government only by a wide ramp leading up from an open square, ical power. Guarded by two towers, it was accessible example of the use of art as propaganda to support politfortified platform about 52 feet high, is a monumental complex, centered at the back of the citadel on a raised, side of the city and straddled the city wall. The palace taining 200 rooms and 30 courtyards lay at the northwest appearance (fig. 2-22). A walled citadel, or fortress, contions have enabled archeologists to reconstruct the city's and night, but it was abandoned after his death. Excavascription says the grand project consumed the king day capital at Dur Sharrukin (modern Khorsabad). An in-Sargon II (ruled 721-705 BCE) built a new Assyrian

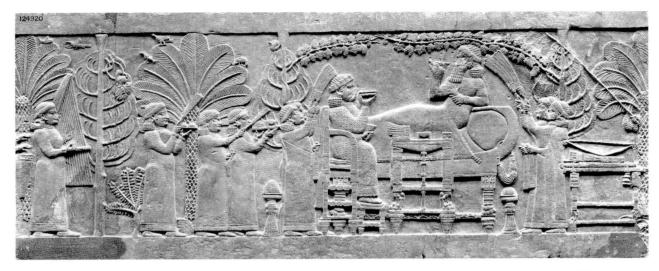

2-24. Assurbanipal and His Queen in the Garden, from the palace at Nineveh (modern Kuyunjik, Iraq). c. 647 BCE. Alabaster, height approx. 21" (53.3 cm). The British Museum, London

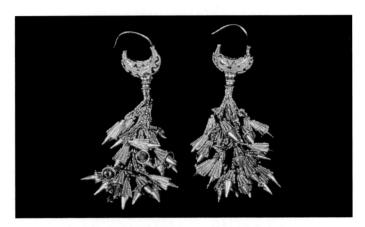

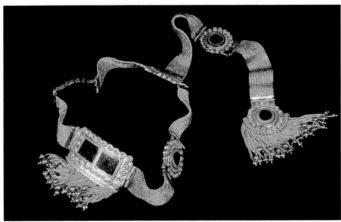

Assurbanipal (ruled 669-c. 627 BCE), king of the Assyrians three generations after Sargon II, had his capital at Nineveh (modern Kuyunjik). His palace was decorated with alabaster panels carved with pictorial narratives in low relief. Most show the king and his subjects in battle and hunting, but there are occasional scenes of palace life. One panel shows the king and queen in a pleasure garden (fig. 2-24). The king reclines on a couch, and the queen sits in a chair at his feet. Some servants arrive with trays of food, while others wave whisks to protect the royal couple from insects. A large, Egyptian-looking necklace hangs from the end of the couch at the right perhaps the king has taken it off while he relaxes, or perhaps it is displayed here as a symbolic reference to Assurbanipal's conquest of Egypt in 663 BCE. This apparently tranquil domestic scene is actually a victory celebration. The king's weapons (sword, bow, and guiver of arrows) are on the table behind him, and the upsidedown severed head of his vanquished enemy hangs from a tree at the far left. It was common during this period to display the heads and corpses of enemies as a form of psychological warfare, and Assurbanipal's generals would have sent him the head as a trophy.

Although much Assyrian art is relief carving, other arts were developing. One of the most spectacular archeological finds in the Near East was the discovery, beginning in 1988, of more than a thousand pieces of gold jewelry weighing more than 125 pounds in three Assyrian royal tombs at Kalhu dated from the ninth and eighth centuries BCE (fig. 2-25). The refinement and superb artistry of the crowns, necklaces, bracelets, armbands, ankle bracelets, and other ornaments recovered from these tombs—almost entirely Assyrian made—could never be discerned from depictions of jewelry in stone sculpture.

2-25. Earrings, crown, and rosettes, from the tomb of Queen Yabay, Kalhu (modern Nimrud, Iraq). Late 8th century BCE. Gold. Iraq Museum, Baghdad

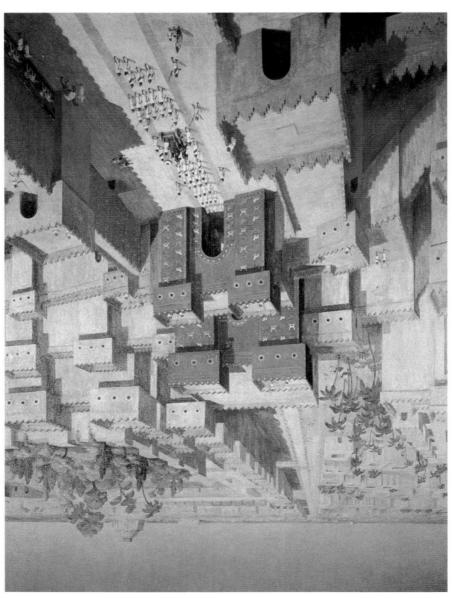

2-26. Reconstruction drawing of Babylon in the 6th century BCE. The Oriental Institute of the University of Chicago

In this view, the palace of Mebuchadnezzar II, with its famous Hanging Gardens, can be seen just behind and to the right of the Ishtar Gate, to the west of the Processional Way. The Marduk Ziggurat looms up in the far distance on the east bank of the Euphrates. This structure was at times believed to be the biblical Tower of Babel—Bab-il was an early form of the city's name.

The most famous Neo-Babylonian ruler was Nebuchadnezzar II (ruled 604–562 BCE). A great patron of architecture, he built temples dedicated to the Babylonian gods throughout his realm and transformed Babylon—the cultural, political, and economic hub of his empire—into one of the most splendid cities of its day. Babylon straddled the Euphrates River, its two sections joined by a broad avenue named "May the Enemy Not Have Victory," also called the Processional Way because it was the route taken by religious processional Way because the city's patron god, Marduk (fig. 2-26). This street, laid was the route taken by religious processions honoring was transplayed by a broad avenue named "May the Enemy Not was eity—it was the route taken by religious processions honoring the city's patron god, Marduk (fig. 2-26). This street, laid with large stone slabs set in a bed of bitumen, was up to 60 feet wide at some points. It ran east from the Euphrates bridge past the temple district, then turned

NEO-If the end of the seventh century BABYLONIA

If the end of the end of the seventh century BABYLONIA

If the end of the seventh century BABYLONIA

If the end of the

frigid regions of modern Russia and Ukraine invaded the northern and eastern parts of Assyria. Meanwhile, under a new royal dynasty, the Babylonians reasserted themselves. This Meo-Babylonian kingdom began attacking Assyrian cities in 615 BCE and formed a treaty with the Babylonians captured Mineveh. When the dust settled, Assyria was no more. The Medes controlled a swath of land below the Black and Caspian seas, and the Neoland below the Black and Caspian seas, and the Neoland below the Black are region that stretched from modern Turkey to northern Arabia and from Mesomodern Turkey the Babylonians controlled as region that a seasomodern Turkey to northern Babylonians controlled as region that a seasomodern Turkey the Babylonian Babyloni

ART OF THE ANCIENT NEAR EAST

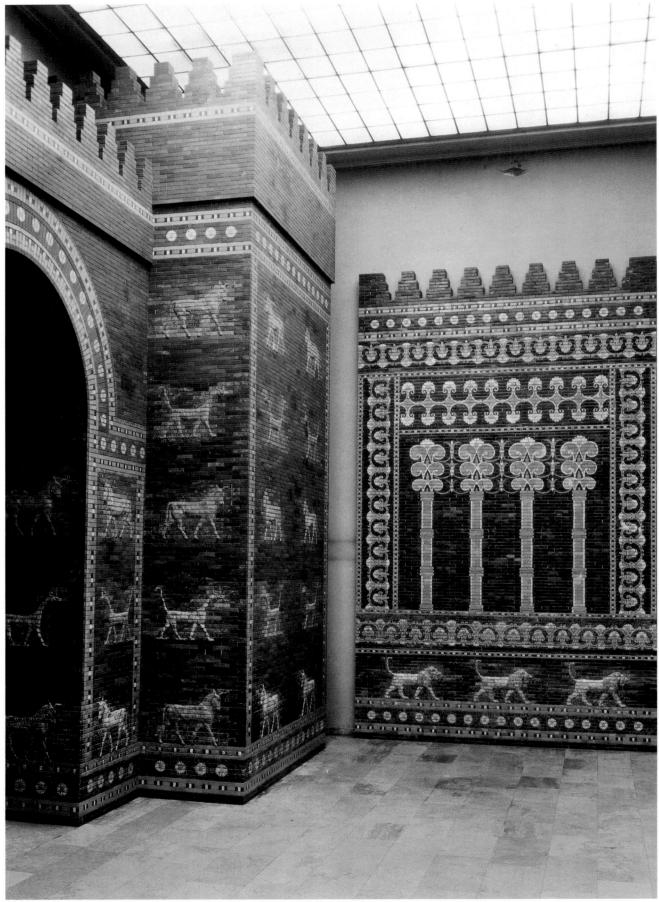

2-27. Ishtar Gate and throne room wall, from Babylon (Iraq). c. 575 BCE. Glazed brick. Staatliche Museen zu Berlin, Preussischer Kulturbesitz, Vorderasiatisches Museum

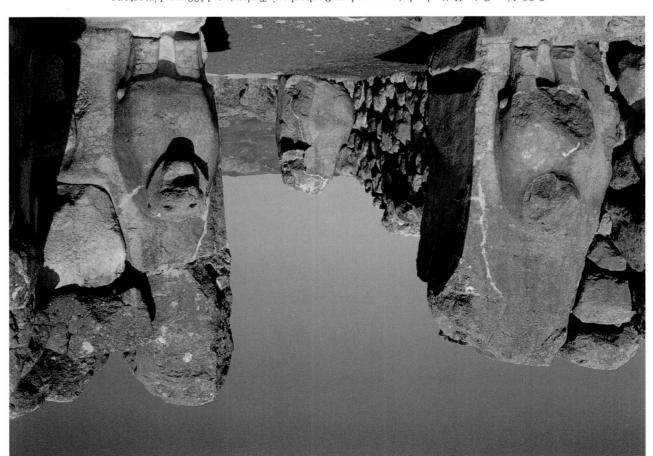

2-28. Lion Gate, Hattushash (near modern Boghazkeui, Turkey). c. 1400 BCE. Limestone

ANATOLIA Anatolia, before the rise of the Assyrians, had been home to several

gateways. imposing palace citadels with double walls and fortified noted for the artistry of their fine metalwork and of their chisels and hammers for sculptors and masons. They are iots, weapons, sickles and plowshares for farmers, and to work in iron, which they used for littings for war charinto Mesopotamia. They were apparently the first people the south (Chapter 3). The Hittites also made incursions Empire, which was expanding into the same region from Lebanon, bringing them into conflict with the Egyptian the Mediterranean Sea in the area of modern Syria and they created an empire that stretched along the coast of Turkey) about 1600 BCE. Through trade and conquest, their capital at Hattushash (near modern Boghazkeui, teaus of central Anatolia from the east and established whose founders had moved into the mountains and planation. The most powerful was the Hittite civilization, independent cultures that resisted Mesopotamian domi-

The foundations and base walls of the Hittite stronghold at Hattushash, which date to around 1400 BCE, were constructed with stone supplied from local quarries, but the upper walls, stairways, and walkways were finished in brick. The blocks of stone used to frame doorways were decorated in high relief with a variety of guardian figures, some 7-foot-tall, half-human-half-animal creatures, others naturalistically rendered animals like the lions shown here (fig. 2-28). These sculpted figures were

northward to end at the Ishtar Gate, one of the main entrances to the city. Along the way, the walls on both sides were faced with turquoise bricks that were glazed (painted and fired) and topped with notches, or crenelation. Among the brilliant turquoise bricks, specially molded, gold-colored bricks form images of lions striding along in honor of the goddess Ishtar.

lower stairs. silver, and gold, is the outline of its base and traces of the describe as painted white, black, crimson, blue, orange, remains of this ziggurat, which ancient documents World," page 102), and the Marduk Ziggurat. All that Hanging Gardens (see "The Seven Wonders of the none of which survive, were the city's walls, its fabled Mari (see fig. 2-19). Among Babylon's other marvels, ized palm trees reminiscent of those in the mural from In this fragment, lions walk in a zone beneath stylroom in Nebuchadnezzar's nearby palace (fig. 2-27). installed next to a panel from the outer wall of the throne one of the Berlin State Museums, the Ishtar Gate is with a number of other deities. Now reconstructed inside and the bulls with blue forelocks and tails associated is decorated with tiers of the dragons sacred to Marduk lonian power, was guarded by four crenellated towers. It The double-arched Ishtar Gate, a symbol of Baby-

Outside of Mesopotamia, other cultures—those of Anatolia, Elam, and Persia—were developing simultaneously and would have an impact on Mesopotamia before one of them, Persia, eventually overwhelmed it.

PROTECTION Some of the most bitter resentments spawned by war—

whether in Mesopotamia in the twelfth century BCE or in our own time-have involved the "liberation" or "protection" of art objects and other artifacts of great value and meaning to the people from whom they were taken. Museums around the world have been enhanced, if not outright stocked, with paintings, sculpture, and other works either snatched by invading armies or acquired as a result of conquest, prolonged occupation, or economic domination. Two historically priceless objects unearthed in the excavations of Elamite Susa, for example—the Akkadian Stela of Naramsin (see fig. 2-16) and the Babylonian Stela of Hammurabi (see fig. 2-18)—were not Elamite at all, but Mesopotamian.

Both had been brought there as military trophies by an Elamite king, who added an inscription to the *Stela of Naramsin* explaining that he had merely "protected" it.

The same rationale has been used in modern times to justify the removal of countless works of art from their cultural contexts. The Rosetta Stone, the key to the modern decipherment of Egyptian hieroglyphics, was discovered in Egypt by French troops in 1799, fell into British hands when they forced the French from Egypt, and ultimately ended up in the British Museum in London. In the early nineteenth century, a British nobleman, Lord Elgin, removed many renowned Classical Greek reliefs from the Parthenon on the Acropolis in Athens with the blessing of the Ottoman authorities who governed Greece at the time. Although

his actions may indeed have protected the reliefs from neglect and the ravages of the Greek war of independence, they have remained installed. like the Rosetta Stone, in the British Museum, despite continuing protests from Greece. The Ishtar Gate from Babylon (see fig. 2-27) is now in a museum in Germany. Many works in German collections were similarly "protected" at the end of World War II and are surfacing now. In the United States, Native Americans are increasingly vocal in their demands that artifacts and human remains collected by anthropologists and archeologists and lodged in the country's museums be returned to them. "To the victor," it is said, "belong the spoils." It continues to be a matter of passionate debate whether or not this notion is appropriate in the case of revered cultural artifacts.

part of the architecture itself, not added to it separately. The boulders-becoming-creatures on the so-called Lion Gate harmonize with the colossal scale of this construction. Despite extreme weathering, the lions have endured over the millennia and still convey a sense of vigor and permanence.

The strip of fertile plain known as Elam, between the Tigris River and the Zagros Mountains to the east (in present-day Iran), had become a flourishing farming region by 7000 BCE. About this time the city of Susa, later the capital of an Elamite kingdom, was established on the Shaur River. Elam had close cultural ties to Mesopotamia, but the two regions were often in conflict. In the twelfth century BCE, Elamite invaders looted art treasures from Mesopotamia and carried them back to Susa (see "Protection or Theft?," above).

In about 4000 BCE, Susa was a center of pottery production. Twentieth-century excavations there have uncovered nearly 8,000 finely formed and painted vessels (beakers, bowls, and jars), as well as coarse domestic wares. The fine wares have thin, fragile shells that suggest they were not meant for everyday use. Decorations painted in brown glaze on the pale yellow clay are sometimes purely geometric but are more often a graceful combination of geometric designs and stylized natural forms, mainly from the animal world, expertly balanced between repetition and variation of forms.

One handleless cup, or beaker, nearly a foot tall and weighing about 8 pounds, presents a pair of ibexes (only one of which is visible) that have been reduced to pure geometric form (fig. 2-29). On each side, the great sweep of the animals' horns encloses a small circular motif, or roundel, containing what might be a leaf pattern or a line of birds in flight. A narrow band above the ibexes shows

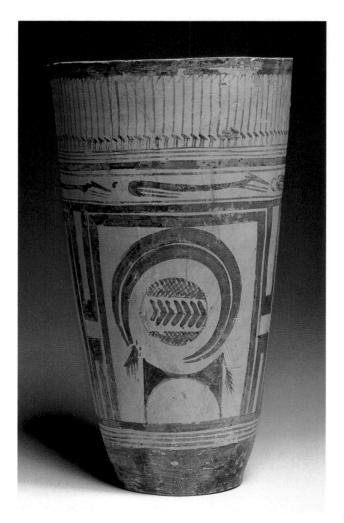

2-29. Beaker, from Susa (modern Shush, Iran). c. 4000 BCE. Ceramic, painted in brown glaze, height 111/4" (28.6 cm). Musée du Louvre, Paris

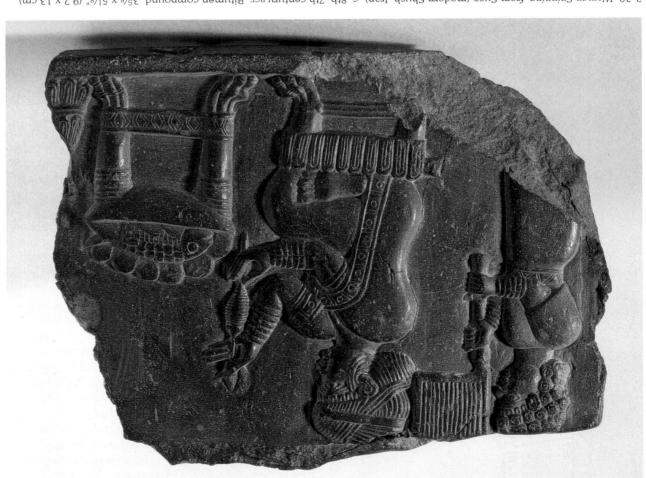

2-30. Woman Spinning, from Susa (modern Shush, Iran). c. 8th-7th century BCE. Bitumen compound, 35/8 x 51/8" (9.2 x 13 cm). Musée du Louvre, Paris

PERSIAIn the sixth century BCE, the Persians, a formerly nomadic, Indo-European-speaking

to both east and west. nearly two centuries, expanding the Achaemenid Empire this earth." Darius and his successors went on to rule for ius, great King, King of Kings, King of countries, King of ment official, took the throne, he proclaimed: "I am Dar-When Darius I (ruled 521-486 BCE), the son of a govern-Cambyses II (ruled 529-522 BCE) added Egypt and Cyprus. some of the Aegean islands far to the west. Cyrus's son stretched across northern Iran through Anatolia; and included Babylonia; the land of the Medes, which 530 BCE). By the time of his death the Persian Empire remarkable leader, Cyrus II (called the Great, ruled 559expansion began in 559 BCE with the ascension of a and are known as the Achaemenids. Their dramatic try to a semilegendary Iranian king named Achaemenes empire. The rulers of this new empire traced their ancesthe rest of the ancient Near East and established a vast Susa, they eventually overwhelmed Mesopotamia and the region of Parsa, or Persis (modern Fars), southeast of people related to the Medes, began to seize power. From

Darius, like many powerful rulers, created monuments to serve as visible symbols of his authority. He

short-haired, long-nosed dogs at rest. In the wide top band, stately wading birds stand motionless.

quet scene or it may depict a religious rite, possibly con-Interpretation of this scene is difficult; it may be a bangod or goddess to whom the offering is being made. shown wearing, which might indicate the presence of a a long, flounced garment such as deities are frequently corner of the fragment is what appears to be a portion of behind the woman, fanning her. At the lower right-hand haps fruit). A young servant, probably female, stands stand in front of her, together with six round objects (perthread onto a large spindle. A fish lies on an offering a lion-footed stool covered with sheepskin, spinning a patterned border. She sits barefoot and cross-legged on ments. Her hair is elegantly styled, and her garment has an important-looking woman adorned with many ornathe eighth to the seventh century BCE (fig. 2-30). It shows 36/8-inch-high fragment from a larger relief, dates from cal and decorative objects. An especially fine example, a defies laboratory analysis, they made a variety of practicarved when hard. From this compound, which still based compound that could be molded while soft and Susa's ingenious artisans produced a gray bitumen-

nected with ancestor worship.

made Susa his first capital and commissioned a 32-acre administrative compound to be built there. In about 518 BCE, he began construction of Parsa, a new capital in the Persian homeland in the Zagros highlands. Today this city, known as Persepolis, the name the Greeks gave it, is one of the best-preserved ancient sites in the Near East (fig. 2-31). Darius imported materials, workers, and artists from all over his empire for his building projects. He even ordered work to be executed in Egypt and transported to his capital. The result was a new style of art that combined many different cultural traditions, including Persian, Mede, Mesopotamian, Egyptian, and Greek. This artistic integration was simply a side effect of Darius's political strategy.

In Assyrian fashion, the imperial complex at Persepolis was set on a raised platform and laid out on a rectangular **grid**, or system of crossed lines. The platform was 40 feet high and measured 1,500 by 900 feet. It was accessible only from a single ramp made of wide, shallow steps to allow equestrians to ride up rather than dismount and climb on foot. Construction was spread out over nearly sixty years, and Darius lived to see the erection of only a treasury, the Apadana (audience hall), and a very small palace for himself. The Apadana, set above the rest of the complex on a second terrace (fig. 2-32),

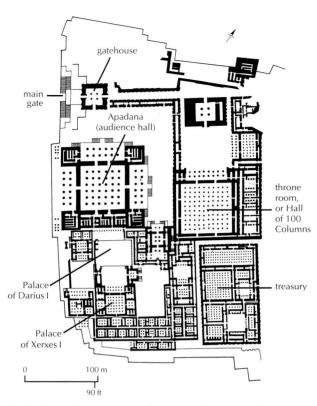

2-31. Plan of the ceremonial complex, Persepolis, Iran. $518\text{--c}.\ 460\ \textsc{bce}$

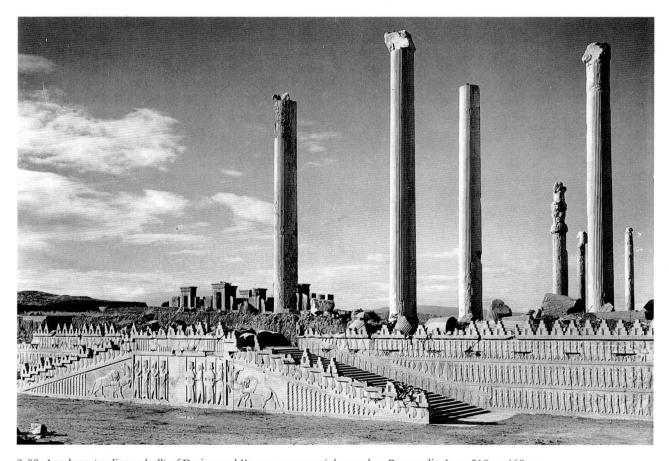

2-32. Apadana (audience hall) of Darius and Xerxes, ceremonial complex, Persepolis, Iran. 518–c. 460 BCE

The ancient historian Cleiarchus of Alexandria relates that Alexander the Great and his troops accidentally torched the royal compound at Persepolis during a wild banquet in celebration of their victory over the Persians. It is more probable that Alexander had it destroyed deliberately. The site was never rebuilt, and its ruins were never buried. Scholars have been measuring, mapping, and studying what remains of the complex for the past 200 years. Various pieces of architectural ornament have been stripped from Persepolis for display in museums around the world.

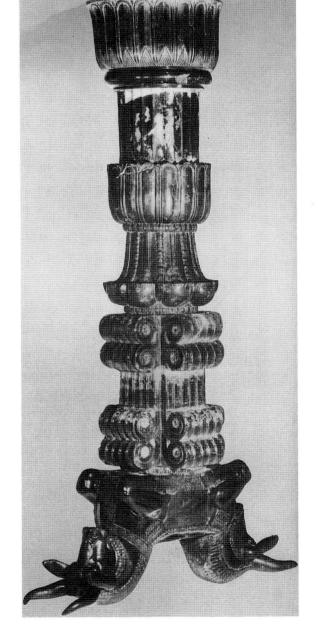

from the ceremonial complex, Persepolis, Iran. Iranbas-2-33. Partially reconstructed column with complete capital,

had open porches on three sides and a square hall large

464-425 BCE). work was done under Xerxes' heir, Artaxerxes I (ruled Columns, with its own guard gate. Most of the remaining began a vast new public reception space, the Hall of 100 complex for himself, enlarged the treasury building, and Xerxes I (ruled 485-465 BCE) added a sprawling palace enough to hold several thousand people. Darius's son

knife-edged pleats especially reflect Greek sources and the garments that reveal the body beneath and have fine, potamian, Egyptian, and Greek cultures. In those panels, panels from Persepolis also show influences from Mesoly painted in red, green, yellow, and blue. Large relief reveal that the Persepolis structures were originally richtures placed back to back (fig. 2-33). Traces of pigment scrolls, and the heads and forequarters of kneeling creapapyrus flowers, other plant forms, double vertical lavishly decorated with a combination of palm fronds, tion of the columns on which ceiling beams rested, were feeling of delicate refinement. The capitals, the top secing, which exaggerated their height and gave them a carved with evenly spaced vertical channels called flutrated with leaves. Their shafts, or vertical supports, were They stood atop bell-shaped bases (foundations) decoideas from Mede, Egyptian, and possibly Greek sources. a distinctly Persian flavor, the columns reflect design tecture," page 101). Although they were all executed with of columns found in Persepolis (see "Elements of Archievident in the varied appearance of the many hundreds The multicultural composition of imperial Persia is

Xerxes, listens from behind the throne (fig. 2-34). Such relief Darius holds an audience while his son and heir, nomic prosperity rather than with heroic exploits. In one lis were concerned with displays of allegiance and eco-Like some Assyrian palace reliefs, those at Persepomay indeed have been done by Greek sculptors.

Persepolis, Iran. 491-486 BCE. Limestone, height 8'4" (2.54 m). Iranbastan Museum, Teheran 2-34. Darius and Xerxes Receiving Tribute, detail of a relief from the stairway leading to the Apadana, ceremonial complex,

TECHNIQUE

The intricate lion's-head **terminals** of the gold **torque** seen in figure 2-35 were probably made using the **lost-wax casting** process, a

technique for fabricating fine metal objects developed at a very early date. A shape was carved out of wax exactly as the finished object was to look. This wax "sculpture" was then enclosed in a heat-resistant material such as clay or plaster. (If the piece was to be hollow, the wax was formed around a heat-resistant core.) Once the clay or plaster mold had dried, it was heated and the melted wax ran out through a vent. Molten metal was then poured into the mold. After the casting had cooled and the mold was removed, the metalsmith could decorate and finish the piece.

On this torque, tiny **inlays** made of lapis lazuli, turquoise, and mother-of-pearl are part of the design. First, the worker chiseled little wells in the surface of the face and lower part of the neck, then filled the holes with inlays of the same size and shape. Most of these inlays have been lost, but one piece can still be seen on the side

PERSIAN METAL-WORKING

of the head and two more at the top of the body. A different technique was used to create the intricate inlay work on the lion's neck.

Here, pieces of fine gold wire, known as **filigree**, were arranged in a pattern on the neck and subjected to just enough heat to fuse them to it. Diamond-shaped inlays were then inserted into the spaces outlined by the filigree.

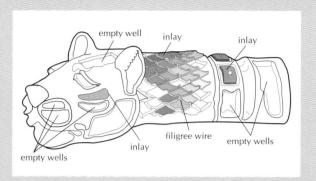

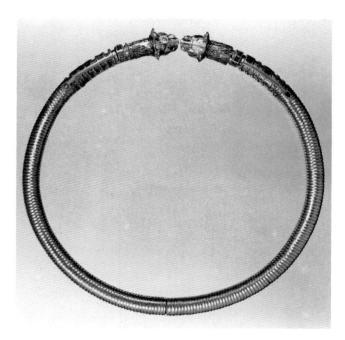

2-35. Torque with lion's-head terminals, from Susa (modern Shush, Iran). 4th century BCE. Gold with lapis lazuli, turquoise, and mother-of-pearl, diameter 8" (20.2 cm). Musée du Louvre, Paris

panels would have looked quite different when they were freshly painted in rich tones of deep blue, scarlet, green, purple, and turquoise, with metal objects such as Darius's crown and necklace covered in **gold leaf**, or sheets of hammered gold.

The Persians' decorative arts—including ornamented weapons, domestic wares, horse trappings, and jewelry—demonstrate high levels of technical and artistic sophistication. The imaginative use of animals in these arts can be seen in a late Achaemenid gold **torque**, or neckpiece, found in a Persian tomb at Susa and dated to the fourth century BCE (fig. 2-35). The tiny lion heads that form the ends, or **terminals**, of this piece are represented naturalistically, but the intricate inlays of lapis lazuli, turquoise, and mother-of-pearl transform them into pure ornament. In the Roman mosaic copy of a famous fourth-century BCE Greek painting (see fig. 5-70), Darius III of Persia (ruled 335–330 BCE) wears an identical torque.

The Persians learned to mint standard coinage from the Lydians of western Anatolia after Cyrus the Great defeated Lydia's fabulously wealthy King Croesus in 546 BCE (see "Coining Money," opposite). Croesus's wealth—the source of the lasting expression "rich as Croesus"—had made Lydia an attractive target for an aggressive empire builder like Cyrus. One type of Persian coin, the gold daric, named for Darius and first minted during his regime (fig. 2-36), is among the most valuable coins in the world today. Commonly called an "archer," it shows the well-armed emperor wearing his crown and carrying a lance in his right hand; he lunges forward as if he had just let fly an arrow from his bow.

At its height, the Persian Empire extended from Africa to India. Only mainland Greeks successfully resisted the armies of the Achaemenids, preventing them from advancing into Europe (Chapter 5). And it was a Greek who ultimately put an end to their empire. In 334 BCE, Alexander the Great of Macedonia crossed into Anatolia and swept through Mesopotamia, defeating Darius III and laying waste the magnificent Persepolis in 331 BCE. Although the Persian Empire was at an end, the art style unified there during the Achaemenid period clearly shows its links with Greece as well as Egypt, which may have been very heavily influenced by Mesopotamian culture.

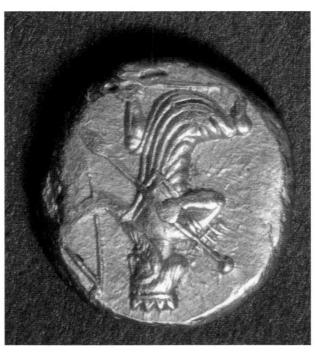

Museum, Oxford century BCE. Gold. Heberden Coin Room, Ashmolean 2-36. Daric, a coin first minted under Darius I of Persia. 4th

TECHNIQUE

ruler's portrait helps to date the objects around them. logical excavation of coins bearing that Long before the invention of coins, the peo- COINING MONEY monarch ruled, the discovery in an archeo-

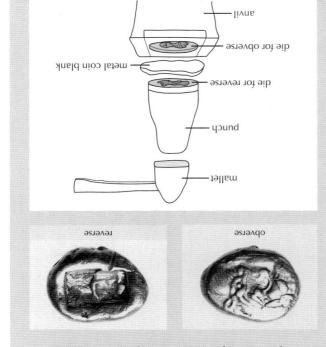

Room, Ashmolean Museum, Oxford Croesus, king of Lydia. 560-546 BCE. Heberden Coin Front and back of a gold coin first minted under

ple of the ancient world had used gold, silver,

other. The back side has only a squarish depression left heads and forelegs of a bull and lion, who face each king Croesus (ruled 560-546 BCE). It is stamped with the here, a coin first minted during the reign of the Lydian of the most beautiful of these earliest coins is illustrated about 525 BCE, coins bore an image on one side only. One a Sumerian invention—to designate their value. Until seventh century BCE, adapting the concept of the seal tice of producing metal coins in standard weights in the value. The Lydians of western Anatolia began the pracweighed every time it was used to establish its exact medium of exchange for trade. But each piece had to be bronze, and copper in either raw lumps or bricks as a

by the punch used to force the metal into the mold.

know at least approximately when a given ancient very much alive throughout the world. Because we often control of the coin of the realm. This custom is still on coins, proclaiming the ruler's sovereignty and his Beginning in the reign of Darius I, kings' portraits appear successors minted coins using the Lydian weight system. Cyrus the Great of Persia conquered Anatolia, he and his on top of the metal blank and struck with a mallet. After with the die of the reverse ("tail") design, was then placed design for the obverse ("head") of the coin. The punch, was placed over the anvil die, the one containing the weighed out to the exact amount of the denomination the design to be impressed in the coin. A metal blank and anvil, each of which held a die, or mold, incised with To make two-faced coins, the ancients used a punch

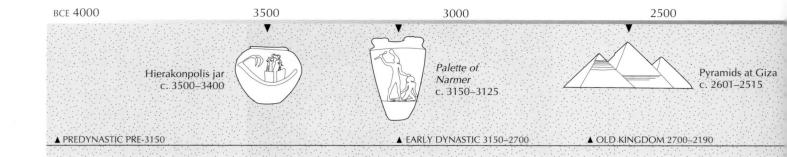

CHAPTER 3

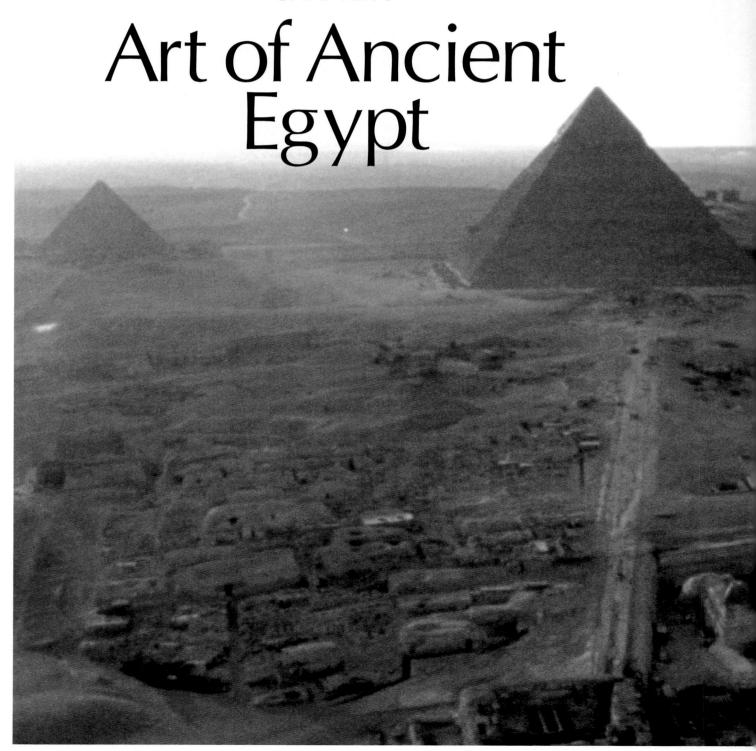

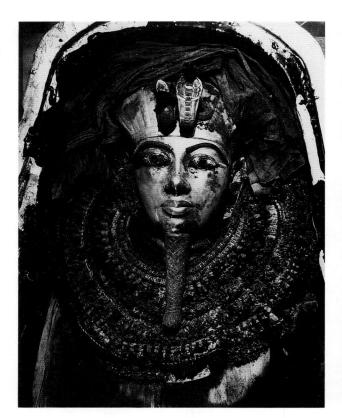

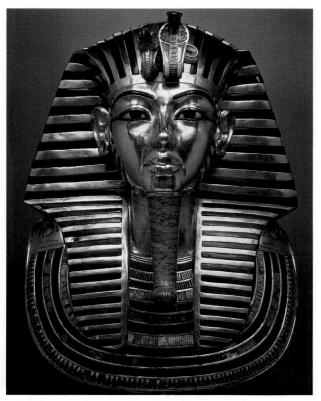

- 3-1. Funerary mask of Tutankhamun (ruled 1336/5–1327 BCE), from the tomb of Tutankhamun, Valley of the Kings, Deir el-Bahri, photographed the day it was discovered—October 28, 1925
 - A collar of dried flowers and beads covered the chest portion of the mask, and a linen scarf was draped around the head. The mask had been placed over the upper part of the young king's mummified body, which was enclosed in three coffins nested like a set of Russian dolls. These coffins were placed in a quartzite "box" that was itself encased within three gilt wooden shrines, each larger than the last. The innermost coffin, made of solid gold, is illustrated in figure 3-41. Tutankhamun's burial chamber was not the only royal tomb to survive unpillaged to the twentieth century, but it is by far the richest find.
- 3-2. Funerary mask of Tutankhamun. Gold inlaid with glass and semiprecious stones. Height 21¹/4" (54.5 cm). Egyptian Museum, Cairo

he first large-scale "archeological" expedition in history landed in Egypt with the armies of Napoleon in 1798. The French commander went there intending to take control of the region and to explore the possibility of digging a canal to connect the Mediterranean with the Red Sea. Clearly, he also sensed that Egypt sheltered great riches that might be won for France, for he took with him some 200 French scholars and charged them with mapping, excavating, and studying ancient sites. Napoleon's military adventure ended in failure, but the findings of his scholars, eventually published in thirty-six richly illustrated volumes, unleashed among his contemporaries a craze for all things Egyptian.

Popular fascination with this ancient African culture has not dimmed since Napoleon's time. As recently as May 1995, newspaper headlines around the world heralded a major discovery by archeologists working near Thebes, an ancient Egyptian capital some 300 miles south of Cairo. The huge, unusual burial complex they found in the Valley of the Kings has at least sixty-seven chambers, believed to hold the remains of many of Ramesses II's fifty-two sons. Because looters apparently have never penetrated the back chambers, the contents—including thousands of pieces of

pottery, statue fragments, beads, and jewelry—provide extraordinary documentation of a period in the thirteenth-century BCE when Ramesses II was expanding the Egyptian empire and building some of the monumental architecture for which Egypt is known.

Looters, ancient and modern, have been attracted to tombs by simple greed, archeologists and historians by scholarly interest. Ironically, one reason that this burial complex had not been discovered by either group was that its entrance was obscured by debris from a nearby excavation in the 1920s: the remarkable tomb of Tutankhamun (King Tut). When the "Treasures of Tutankhamun" exhibit was mounted in the late 1970s, some "Treasures of Tutankhamun" exhibit was mounted in the late 1970s, some "manilion visitors flocked to six of the world's major museums to marvel at a selection of artifacts placed in the tomb of an Egyptian ruler more than a selection of artifacts placed in the tomb of an Egyptian ruler more than

Much of what we know about life in ancient Egypt we owe to that culture's preoccupation with death. Many of Egypt's written records were lost in the accidental burning in Roman times of the great library at Alexandria—a fire that destroyed more than 700,000 ancient documents—and we must deduce what we can about Egypt from the decoration and outfitting of tombs like Tutankhamun's. The rulers of Egypt, even in earliest times, sought to immortalize themselves through the art and architecture they commissioned for their final resting places, and in a sense they succeeded richly. They are well remembered.

gation canals. It was apparently this common need that led many smaller riverside settlements to form alliances with their neighbors. Over time, these primitive federations expanded further by conquering and absorbing weaker communities. By about 3500 BCE there were several larger states, or chiefdoms, in the lower Nile Valley.

ical fitness. race on a specially built track in order to prove his physrenewing his "divine" powers. Preceding this, he ran a was symbolically buried and resurrected as a means of the sed festival, the king in the thirtieth year of his reign natural powers failed to work. In this later ritual, called may even have been killed when their supposed superticed in the Dynastic period suggests that early rulers a more promising leader installed. A royal ritual praca ruler failed to do this, he was removed from power and ural catastrophes such as droughts and insect plagues. If them not only from outside aggression but also from nat-Their subjects, in turn, expected such leaders to protect bolstered by the rulers' claims to have divine powers. type of leadership emerged in which political control was ily inherited Egypt's throne. During this period, a new tion of the dynasties, in which members of the same famunification of Egypt under a single ruler and the formawas a time of social and political transition preceding the The Predynastic period, roughly 4350 to 3150 BCE,

The surviving art of the Predynastic period consists chiefly of ceramic figurines, decorated pottery, and reliefs carved on stone plaques and pieces of ivory. A few examples of Predynastic wall painting—lively scenes filled with small figures of people and animals—were found in

The Greek traveler and historian Herodotus, writing in the fifth century BCE, remarked that "Egypt is the gift of the Nile." This great river—the longest in the world—has play like white beginning the like world—has be the Nile with the world—has be the play of the Nile world—has be th

NEOLITHIC AND PREDYNASTIC ECYPT

two major tributaries: the Blue Nile, which originates in the mountains of Ethiopia, and the White Nile, fed by a number of smaller rivers rising deep in equatorial Africa. The two tributary Niles merge at the city of Khartoum, in Sudan. From there, the Nile proper winds northward into the Mediterranean, where it forms a broad delta before emptying into the sea. Before it was dammed in the twentieth century at Aswan, the lower river, swollen with the runoff of heavy seasonal rains in the south, overflowed its banks for several months each year. Every flowed its banks for several months each year. Every allowed its banks for several months each usen. Every should be an expensive the floodwaters receded, they left behind a new layer of rich silt, which made the valley and delta uncommonly fertile, an attractive habitat for prehistoric hunters and gatherers.

By about 8000 BCE, the valley's inhabitants had become relatively sedentary, living off its abundance of fish, game, and wild plants. It was not until about 5500 BCE that they adopted the agricultural, village way of life associated with Meolithic culture (Chapter 1). At that time the climate of North Africa was growing increasingly dry. To secure an adequate supply of water for their crops and their own domestic use, the early agriculturalists along the Mile—much as had those in Mesopotamia—cooperated to control the river's flow, constructing dams and irried

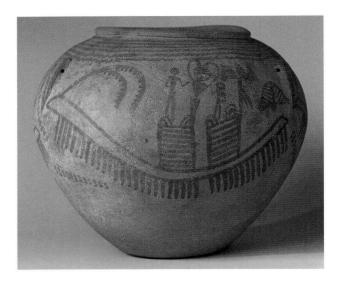

3-3. Jar, from Hierakonpolis. Predynastic, c. 3500–3400 BCE. Painted clay, 7 x 8½4" (17.5 x 20.9 cm). The Brooklyn Museum

Excavations of H. deMorgan 1907-8 (09.889.400)

what was either a temple or a tomb at Hierakonpolis, in Upper Egypt. This Predynastic town of mud-brick houses distributed over about 100 acres was once home to as many as 10,000 people.

Among the artifacts found at Hierakonpolis is a pottery jar, dating from about 3500–3400 BCE. It is made of buff-colored clay and decorated with a river scene in a dark reddish brown (fig. 3-3). Zigzag lines around the mouth of the jar symbolize the waters of the Nile, upon which floats a boomerang-shaped boat. According to one interpretation, the boat is laden with coffins, and the scene symbolizes the human journey on the "river of Life and Death." Palm fronds affixed to a pole on the prow bend in the wind, indicating the direction of the vessel's movement. The boat has two cabins on its deck, and a row of vertical strokes along the bottom of its hull represents oars. These lines and strokes are a kind of **abstract** visual shorthand. We recognize what they stand for even

though the forms they represent are reduced to the barest means. Two figures of nearly equal size, a man and woman, stand on the roof of the cabin on the left. The woman arches her long arms over her head in a gesture that may be an expression of mourning, while the man beside her and a smaller figure atop the other cabin reach out toward her. These three people possess a quality of expressiveness: the power of what they *feel* is evident.

EARLY DYNASTIC EGYPT

About 3150 BCE Egypt became a consolidated state. According to Egyptian legend, the country had previously evolved into two major kingdoms—the Two Lands—Upper

Egypt in the south and Lower Egypt in the north. Some powerful ruler from Upper Egypt, referred to in an ancient document as "Menes king-Menes god," finally conquered Lower Egypt and merged the Two Lands into a single kingdom. Modern Egyptologists, experts on the history and culture of ancient Egypt, suspect that the unification process was more gradual than the legend would have us believe.

In the third century BCE, an Egyptian priest and historian named Manetho compiled a chronological listing of Egypt's rulers since the most ancient times that was based on temple records and inscriptions on temple walls. He grouped them into dynasties, or families, and included the length of each king's reign. Although the list has been much modified since Manetho's time and scholars do not fully agree about many of its dates, this dynastic chronology is still the accepted guide to ancient Egypt's long history. Manetho listed thirty dynasties that ruled the country between about 3150 and 332 BCE, when it was conquered by the Greeks. Egyptologists have grouped these dynasties into larger periods reflecting broad historical developments. This chapter covers the Predynastic period through the New Kingdom (1069 BCE), and the dating system used throughout is based on the work of French Egyptologist Nicolas Grimal.

EGYPTIAN Symbolic of kingship, **SYMBOLS** the crowned figure is everywhere in Egyptian art. The false beard of a dead king is long, braided, and ends in a knob. A living king is portrayed with a shorter, squared-off beard (see fig. 3-15). The cobra, "she who rears up," was equated with the sun, the king, and some deities.

The god Horus, king of the earth and a force for good, is represented most characteristically as a falcon. Horus's eyes (*wedjat*) were regarded as symbolic of the sun and moon. The *wedjat* here is the solar eye. The ankh is symbolic of everlasting life. The scarab was associated with the creator god Atum and the rising sun.

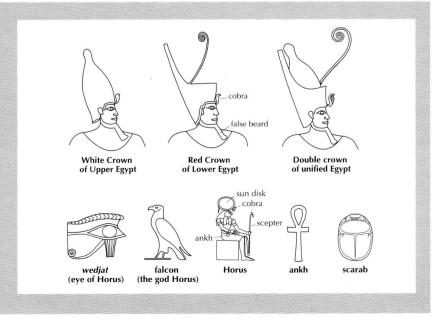

				PAKALLELS
:	Morld	Egypt	<u>Period</u>	Zears
	c. 3500–3000 BCE Earliest pictographs (Sumer); pictographs evolve into ideograms and phonograms (China, India); Skara Braesettled (Scotland)	Painted clay pottery	Predynastic	Before 3150 BCE
		Egypt united under "Menes"; Palette of Narmer; develop-ment of hieroglyphic writing; manufacture and export of papyrus scrolls	Early Dynastic (or Archaic) Dynasties 1–2	c. 3150-2700 BCE
		Djoser's stepped pyramid; Great Pyramids at Giza	Old Kingdom 2–6 sətiləsinya	c. 2700-2190 BCE
	c. 2000 все Gumer); widespread use of bronze tools (Thailand, China, northern Europe); earliest Minoan		First Intermediate DI-7 səitsenyO	с. 2190–2040 все
	palace at Knossos (Crete); first city- state in Anatolia	Hippopotamus Rock-cut tombs; faience	Middle Kingdom Dynasties 11–14	c. 2040−1674 BCE
	c. 1600–1500 все Pacific islands colonized; Shang dynasty (China); citadel at Mycenae (Greece)	Hyksos, from eastern Mediterranean, occupy Nile Delta	Second Intermediate Dynasties 15–17	c. 1674–1552 bce
	c. 1450–1200 BCE Minoan palaces destroyed (Crete); spread of phonetic alphabet devised by Canaanites (eastern Mediterranean); Israelites led out of Egypt by Moses (Canaan); Olmec civilization (Meso- america)	Great Temple of Amun, Kar- nak; <i>Nefertiti</i>	New Kingdom Dynasties 18–20	c. 1552–1069 BCE

Religious Beliefs

Osiris, for example, the god of the dead, regularly appears in human form, as does his wife, Isis. The sky god Horus, however, was most often depicted as having a human body but the head of a hawk. The sun god Ra appears at some times as a cobra, at other times as a scarab beetle some times as a cobra, at other times as a scarab beetle (see "Egyptian Symbols," opposite).

Certain gods took on different forms over the course of time, and a given god might be worshiped in different parts of the country under different names. In the New Kingdom at Thebes, the great creation god Amun and the sun god Ra came to be venerated as the single deity Amun-Ra. Everywhere else in Egypt in this period the two continued to be thought of as separate gods. At the heart of Egyptian religion are stories that explain how the world, the gods, and human beings came into being (see well as the supplies that explain how the supplies that explain the supplies the supplies that explain the supplies that explain the supplies

Egyptian religious beliefs reflect the sense of an ordered cosmos. The movements of the heavenly bodies,

Herodotus thought the Egyptians the most religious people he had ever encountered. It is certainly true that religious beliefs permeate Egyptian art of all periods, and some knowledge of them is needed to understand the art. At the time of the Early Dynastic period, Egypt's rulers were worshiped as gods after their deaths, thus, ordinary

Were worshiped as gods after their deaths, thus, ordinary Egyptians considered their kings to be their link to the invisible gods of the universe. To please the gods and ensure their continuing goodwill toward the state, Egypt's kings built them splendid temples and provided for priests to maintain them. The priests were responsible for seeing to it that statues of the gods, placed deep in the innermost rooms of their temples, were never without fresh food and clothing. The many gods and goddesses were depicted in various forms, some as human beings, others as animals, and still others as creatures half human, half animal and still others as creatures half human, half animal.

EGYPTIAN MYTHS OF CREATION

Herodotus's contention that the Egyptians were the most obsessively religious

people he knew is amply supported by the large number of gods encountered in ancient Egyptian documents. At one time even the Nile itself was revered as a god. Early Egyptian creation myths provide a convenient introduction to many of the earliest and most important deities in Egypt's confusing and sometimes contradictory pantheon. One myth, focusing on the origins of the gods themselves, relates that the sun god Ra-or Ra-Atum-formed himself out of the waters of chaos, or unformed matter, emerging from them seated atop a mound of sand hardened by his own rays. By spitting-or ejaculating-he then created the gods of wetness and dryness. Tefnut and Shu, who in turn begat the male Geb (earth) and the female Nut (sky). Geb and Nut produced two sons, Osiris and Seth-the gods of goodness and evil, respectively—and two daughters, Isis and Nephthys (Isis can be seen in figure 3-43).

Taking Isis as his wife, Osiris became king of Egypt. His envious brother Seth promptly killed Osiris and hacked his body to pieces, snatching the throne for himself. Isis and her sister, Nephthys, gathered up the scattered remains and, with the help of the god Anubis, patched Osiris back together. Despite her husband's mutilated condition, Isis somehow managed to conceive a son-Horus. Once Horus was on the scene (another power for good capable of guarding the interests of Egypt), he defeated Seth and became king of the earth, while Osiris retired to the underworld as overseer of the realm of the dead (see fig. 3-44).

As for the creation of human beings, it is said in one story that Ra once lost an eye. Unperturbed, he replaced it with a new one. When the old eye was found and brought back to him, it began to cry, angered that

it was no longer of any use. Human beings were born from its tears. In a variation on this myth, the people of Memphis insisted that it was their local god Ptah who created humankind, having formed us on his potter's wheel.

Some rulers of Akkad in the ancient Near East were held to be gods, and by the time of the Early Dynastic period, Egypt's kings were revered as gods in human form. A New Kingdom practice helps to explain the Egyptian belief of that period regarding the origin of rulers. Each year as part of the opet festival, the celebration of the flooding of the Nile, the statue of the god Amun from the temple at Karnak was carried in rich procession, along with statues of his wife and son, Mut and Khonsu, to their alternate temple at Luxor, to the south. Inscriptions in the processional colonnade record that while at Luxor the all-powerful god miraculously conceives a future ruler of Egypt.

the workings of the gods, and the humblest of human activities were all thought to be part of a grand design of balance and harmony. Death was to be feared only by those who lived in such a way as to disrupt that harmony; upright souls could be confident that their spirits would live on eternally.

The Palette of Narmer

The legendary king-god Menes may have been an actual king named Narmer (Dynasty 1, ruled c. 3150–3125 BCE), known from a famous stone plaque, the *Palette of Narmer* (fig. 3-4), found at Hierakonpolis. The palette is a slate slab carved in low relief on both sides with scenes and identifying inscriptions. The ruler's name appears on both sides in **pictographs**, or picture writing, in a small square at the top: a horizontal fish (*nar*) above a vertical chisel (*mer*). The cow heads on each side of his name symbolize the protective goddess Hathor.

Palettes, flat stones with a circular depression on one side, were common utensils of the time. They were used for mixing eye paint. Men and women both painted their eyelids to help prevent infections in the eyes and perhaps to reduce the glare of the sun, much as football players today blacken their cheekbones before a game. The *Palette of Narmer* has the same form as these common objects but is much larger. It and other large palettes decorated with animals, birds, and occasionally human figures probably had a ceremonial function.

King Narmer appears as the main character in the various scenes on the palette. They may commemorate a

specific battle, or they may simply make use of established images of conquest to proclaim Narmer the great unifier, protector, and leader of the Egyptian people. As in the Stela of Naramsin (see fig. 2-16), the ruler is shown larger than the other human figures on the palette to indicate his divine status. Interestingly, the kneeling man that Narmer holds by the hair and prepares to strike with his heavy mace would be very close to the king's height if he were standing (fig. 3-4, left). His size suggests that he may represent Narmer's counterpart, the conquered ruler of Lower Egypt. Narmer himself wears the White Crown of Upper Egypt, and from his waistband hangs a ceremonial bull's tail signifying strength. He is barefoot, suggesting that this is not an illustration of an actual military encounter but rather a symbolic representation of a hero's preordained victory. An attendant standing behind Narmer holds his sandals. Above Narmer's kneeling foe, the god Horus, in the form of a hawk with a human hand, holds a rope tied around the neck of a man's head next to a few stylized stalks of papyrus, a plant that grew in profusion along the lower Nile. This combination of symbols again makes it clear that Lower Egypt has been tamed. In the bottom register, below Narmer's feet, two of his enemies appear to be running away, or perhaps they are sprawled on the ground just as they fell when they were killed.

On the other side of the palette (fig. 3-4, right), Narmer is shown in the top register wearing the Red Crown of Lower Egypt, making it clear that he now rules both lands. Here his name—the fish and-chisel—appears not only in the rectangle at the top but also next to his

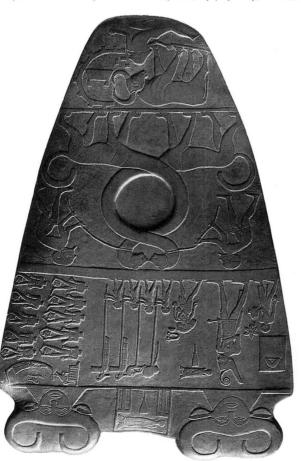

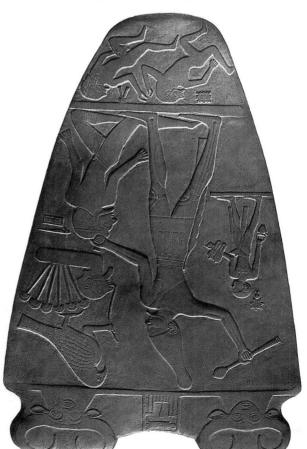

3-4. Palette of Narmer, from Hierakonpolis. Dynasty I, c. 3150-3125 BCE. Slate, height 25" (63.5 cm). Egyptian Museum, Cairo

Representation of the Human Figure

Forceful and easy to comprehend, the images on the Marmer palette present a king's exploits as he wished them to be remembered. For the next several thousand years, much of Egyptian art was created to meet the demand of royal patrons for similarly graphic, indestructible testimony to their glory.

high-arched insteps and a single big toe. This artistic on the groundline, showing both from the inside, with ed otherwise, they placed one foot in front of the other the body sideways. Unless the degree of action demandened the arm reaching across the body rather than turn were required in front of a figure, artists routinely lengthable to show hips, legs, and feet in profile. If both hands but at the waist they twisted the figure drastically to be body, they treated the shoulders as though from the front, these profile heads in frontal view. As for the rest of the when seen from the front, so artists rendered the eyes in identifying features. Eyes, however, are most expressive Heads are shown in profile, to best capture the subject's part of the body from the most characteristic angle. human figure. The Egyptians' aim was to represent each potamia, had arrived at a unique way of drawing the Narmer's time, Egyptian artists, like those in Mesothat would be impossible to assume in real life. By Many of the figures on the palette are shown in poses

head. With his sandal bearer again in attendance, he marches behind his minister of state and four men carrying standards that may symbolize different regions of the country. Before them, under the watchful eye of the hawk Horus, is a gory depiction of the enemy dead. The decapitated bodies of Lower Egyptian warriors have been placed in two neat rows, their heads between their feet. In the center register, the elongated necks of two

monstrous creatures with feline heads, each held on a leash by an attendant, curve gracefully around the rim of the cup of the palette. The intertwining of their necks is possibly another reference to the union of the Two Lands. In the bottom register, a bull menaces a fallen foe outside the walls of a fortress. The bull, an animal known for its great strength and virility, is probably meant to symbolize the king.

The images carved on the palette are strong and direct, and although scholars disagree about some of their specific meanings, their overall message is simple and clear: a king named Narmer rules over the unified land of Egypt with a strong hand. Narmer's palette is particularly important because of the way it uses pictoparticularly important because of the way it uses pictoment of writing in Egypt. Moreover, it provides very early examples of the quite unusual way Egyptian artists solved the problem of depicting the human form in two-solved the problem of depicting the human form in two-dimensional art such as relief sculpture or painting.

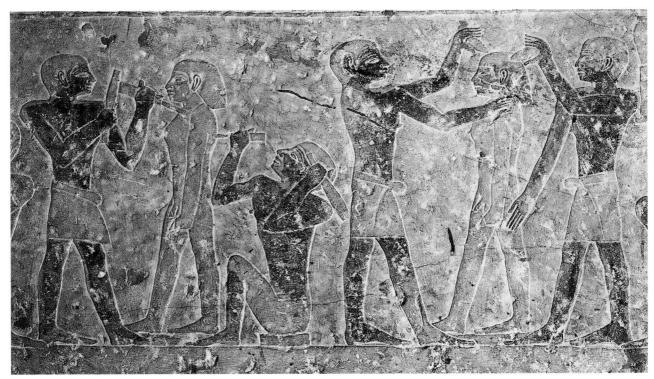

3-5. Sculptors at Work, relief from Saqqara. Dynasty 5, c. 2510-2460 BCE. Painted stone. Egyptian Museum, Cairo

tradition, or convention, was followed especially in the depiction of royalty and other dignitaries, and it was considered so successful that it persisted until the fourth century BCE. Persons of lesser social rank engaged in more active tasks tended to be represented more naturally (compare the figure of Narmer with those of his standard bearers in figure 3-4, right). Similarly, long-standing conventions governed the depiction of animals, insects, inanimate objects, landscape, and architecture. Flies, for example, are always shown from above, bees from the side.

In three-dimensional sculpture, figures could be constructed as they are in life. A painted relief from the funerary complex at Saqqara, created at least 600 years later than the *Palette of Narmer*, shows that artists working in two dimensions were perfectly capable of drawing "normal" figures as well (fig. 3-5). It shows a pair of sculptors putting the finishing touches on a statue. The "living" sculptors are portrayed in the conventional twisted pose, while the statue itself appears in full profile, as it would in reality.

Just as Egyptian artists adhered to artificial convention in the posing of figures, they also proportioned their figures in accordance with an ideal image of the human form, following an established canon of proportions. The ratios between a figure's height and all of its component parts were clearly prescribed. They were calculated as multiples of a specific unit of measure such as the width of the closed fist. It is likely that the ideal was in fact dictated to schools of artists by their royal patrons. Egypt's royalty in a given period may or may not have been of a different racial makeup than the general populace. In any case, they considered themselves a superior breed and

3-6. Diagram of a hypothetical grid for canon of proportions in use during the Old Kingdom

This canon set the height of the human body from heel to hairline at eighteen times the width of the fist. (There are eighteen squares between the heel of the king's left foot and the top of his headdress.) The hypothetical grid shown here is overlaid on a simple drawing of the statue of *Menkaure and His Wife, Queen Khamerernebty* (fig. 3-15). The proportions are for the figure on the left. Because the queen had to be smaller than the king, she was carved according to another, slightly smaller canon.

numerous underground chambers to accommodate centuries. Many such structures were enlarged with burial remained the standard for Egyptian royalty for was sealed off once interment was completed. Mastaba rounded by the appropriate grave goods. This chamber ceased reposed in a sarcophagus, or stone coffin, suractual burial chamber, where the remains of the detical shaft led from the top of the mastaba down to the to receive mourning relatives with their offerings. A vering the ka statue of the deceased, and a chapel designed mastaba contained a serdab, a small, sealed room housexterior facing, or veneer. In its simplest form, the 3 more and more incorporated cut stone, at least as an constructed of mud brick, but toward the end of Dynasty

Two of the most extensive of these early necropolises are the dead was held to be in the direction of the setting sun. of the desert on the west bank of the Nile, for the land of in a necropolis—literally, a city of the dead—at the edge plexes. These structures tended to be grouped together oration of more extensive aboveground funerary comdevote huge sums to the design, construction, and dec-The kings of Dynasties 3 and 4 were the first to

whole families.

those at Saggara and Giza, just outside modern Cairo.

tomb complex at Saqqara, King Djoser (Dynasty 3, ruled Djoser's Funerary Complex at Saqqara. For his

burial vault. From its top a 92-foot shaft descended to a granite-lined ture was originally faced with a veneer of limestone. its purpose of protecting a tomb. Djoser's imposing struc-Mesopotamia, it differs in both its planned concept and Although his final structure resembles the ziggurats of each other (see "Elements of Architecture," page 103). mastabalike elements of decreasing size placed on top of duced was a stepped pyramid (fig. 3-8) consisting of six to enlarge upon the concept. In the end, what he proser's tomb as a single-story mastaba, then later decided on affairs of state. It appears that he first planned Djoly educated and served as one of Djoser's chief advisers name. Born into a prominent family, Imhotep was hightomb. He is thus the first architect in history known by the serdab of the funerary temple to the north of the appears inscribed on the pedestal of Djoser's ka statue in er of the complex was a man called Imhotep. His name monumental architecture in Egypt (fig. 3-7). The designc. 2681-2662 BCE) commissioned the earliest known

of the ceremonies in a pavilion near the entrance to the had ensured his long reign. His spirit could await the start dead king could continue to observe the sed rituals that and other structures. They were provided so that the debris—representing chapels, palaces with courtyards, sham buildings—simple masonry shells filled with and the funerary chapel. To the east of the pyramid were peepholes bored through the wall between the serdab Djoser was able to observe these devotions through two worship of the dead king. In the form of his ka statue, miffed body in its tomb, was also used for continuing formed their final rituals before placing the king's mum-The adjacent funerary temple, where priests per-

Architecture," page 103). Mastabas were customarily above an underground burial chamber (see "Elements of topped, one-story building with slanted walls erected of tomb structure in Egypt was the mastaba, a flat-

In the Early Dynastic period, the most common type

ancient times.

the Egyptian state.

rate carvings.

KINCDOW

THE OLD

tity and value of these grave goods were so great that eternity (see "Preserving the Dead," page 121). The quansupplies and furnishings the ka might require throughout and placed them in burial chambers filled with all of the tures. They preserved the bodies of the dead with care Egyptians to develop elaborate funerary rites and struc-

The need to fulfill the requirements of the ka led the

the afterlife it would continue to ensure the well-being of able home for the ka of a departed king, so that even in

quate. It was especially important to provide a comfort-

and blood, a sculpted likeness of the deceased was ade-

needed a body to live in, but in the absence of one of flesh activities it had enjoyed in its former existence. The ka

on after the death of the body, forever engaged in the

was its life force, or spirit. This spirit, called the ka, lived

notion that an essential part of every human personality

Central to ancient Egyptian religious belief was the

could afford to have their tombs decorated with elabo-Numerous government officials and administrators also

Kings were not the only patrons of the arts, however.

to create lifesize, even colossal royal portraits in stone.

themselves. Court sculptors were regularly called upon plexity of the tomb structures they commissioned for

families of the period is reflected in the size and comdefend its borders. The increasing wealth of the ruling

try's rulers to mount occasional military excursions to

insects increasingly common and the need of the coun-

in Egypt's climate that made droughts and plagues of

either removed or covered up as the work progressed. made the process quite formulaic. The grid itself was

the waist x number of squares above the knee, and so on

a prescribed number of squares above the groundline,

was one square wide. Knowing that the knee should fall

basic unit of measure, the artist saw to it that each hand

mechanically. If the width of the fist was the canon's

(fig. 3-6). The figure could then be sketched quite occupy with a grid made up of a fixed number of squares

figure, the artist first covered the area the figure was to

ed did not. Having determined the size of a desired

ing concept and the means by which it was implement-

derived from it varied slightly over time, but the underly-

wished to have their own specific physical attributes held

up to the masses as those befitting majesty.

The specific measure employed and the proportions

political stability, despite changes

was a time of social cohesion and

The Old Kingdom (2700-2190 BCE)

Funerary Architecture

3-7. Plan of Djoser's funerary complex, Saqqara. c. 2681–2662 BCE (Dynasty 3)

Situated on a level terrace, this huge commemorative complex—some 1,800 feet long by 900 feet wide—was designed as a sort of miniature replica of the king's earthly realm. Its enclosing wall, fitted out with fourteen gates, only one of which was actually functional, represented the realm's boundaries. Inside rose the tomb structure proper, a funerary temple, and other buildings and courtyards for the king's use in the hereafter.

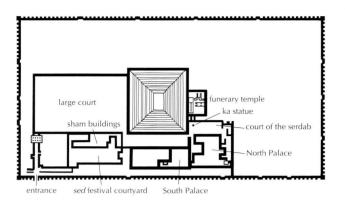

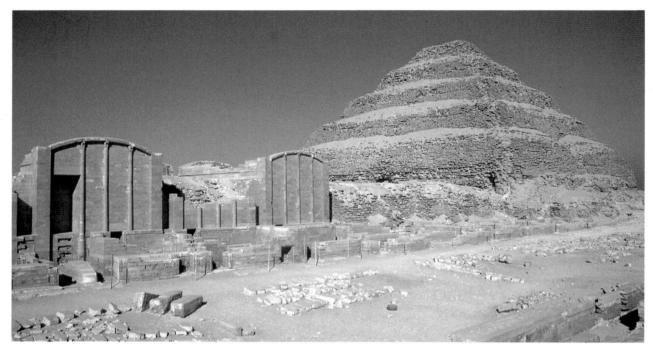

3-8. Stepped pyramid of Djoser, Saqqara. Limestone, height 204' (62 m)

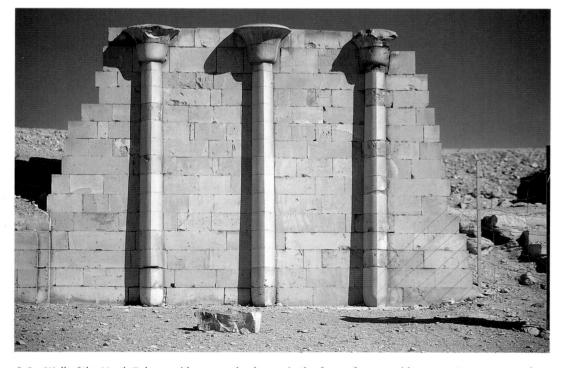

3-9. Wall of the North Palace, with engaged columns in the form of papyrus blossoms. Funerary complex of Djoser, Saqqara

is referred to as an engaged column or attached

use the same elements very differently. forms that are based on river plants. Persian columns and without bases, in their temple complexes, in horizontal member. Egyptians used columns, with A colonnade is a row of columns supporting a column (see fig. 3-9).

and Colonnade columns are freestanding Column a top, called a capital. Most sections: a base, a shaft, and ARCHITECTURE right pillar that has three **EFEMENTS OF** A column is a cylindrical, up-

used decoratively and attached to a wall, a column and are used to support weight, usually a roof. When

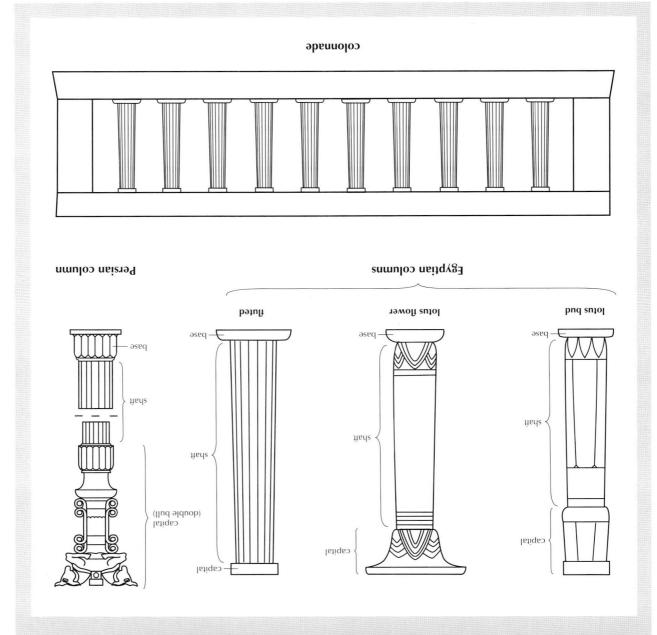

been patterned after the bundled papyrus stalks early soms serve as their capitals. These columns may have 3-9), resemble stalks of papyrus. Stylized papyrus blosthe exterior walls of the North Palace, for example (fig. of stylized plants. The engaged columns spaced along of these are plain except for fluting, others take the form in some places he made effective use of columns. Some Although most of the stone wall surfaces were left plain,

Egypt's Two Lands. Palace, to be symbolically crowned once again as king of proceeded first to the South Palace then to the North in the complex. After proving himself, the king's spirit sed festival took place in a long outdoor courtyard withcomplex in its southeast corner. The running trials of the

structural techniques and the purest of geometric forms. Imhotep's architecture employs the most elemental

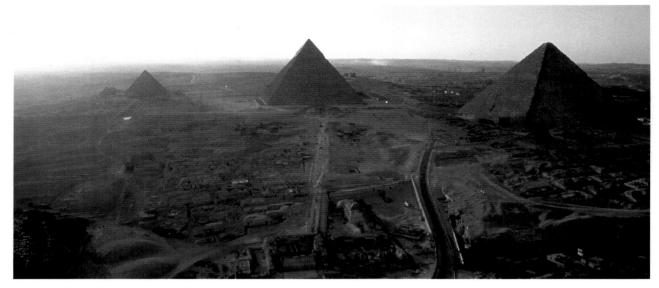

3-10. Great Pyramids, Giza. Dynasty 4, c. 2601-2515 BCE. Erected by (from left) Menkaure, Khafre, and Khufu. Granite and limestone, height of pyramid of Khufu 450' (137 m)

For many centuries it was not known that the pyramids were the tombs of early Egyptian rulers. One theory was that they were gigantic silos for storing grain during periods of drought and famine. This notion was fostered in part by the discovery that the pyramids' accessible interior spaces were empty. The designers of the pyramids tried to ensure that the king and the tomb "home" would never be disturbed. Khufu's builders placed his tomb chamber in the very heart of the mountain of masonry, at the end of a long, narrow, steeply rising passageway, sealed off after the king's burial by a 50ton stone block. Three false passageways, either deliberately meant to mislead or the result of changes in plan as construction progressed, obscured the location of the tomb. Despite such precautions, early looters managed to penetrate to the tomb chamber and make off with Khufu's funeral treasure.

Egyptian builders used to reinforce mud walls and symbolized Lower Egypt. By contrast, the architectural decorations of the South Palace featured plants symbolic of Upper Egypt, the flowering sedge and the lotus (see "Elements of Architecture," page 101).

The Pyramids at Giza. The architectural form most closely identified with Egypt is the true pyramid with a square base and four sloping triangular faces. The first such structures were erected in Dynasty 4 (see "Elements of Architecture," opposite). The angled sides of the pyramids may have been meant to represent the slanting rays of the sun, for inscriptions on the walls of pyramid tombs built in Dynasties 5 and 6 tell of deceased kings climbing up the rays to join the sun god Ra.

Egypt's most famous funerary structures are the three great pyramid tombs at Giza (fig. 3-10). These were built by the Dynasty 4 kings Khufu (ruled c. 2601–2578 BCE), Khafre (ruled c. 2570-2544 BCE), and Menkaure (ruled c. 2533-2515 BCE). The Greeks were so impressed

OF THE WORLD

THE SEVEN Lists for travelers of WONDERS marvelous sights not to miss are known from many ancient civilizations. Such

lists-more or less consistent-make their appearance in the writings of various Greek authors as early as 200-100 BCE, their attractions heralded as the Seven Wonders of the World. Not surprisingly, the majority of the sites included were examples of the Greeks' own engineering and architectural skill. The oldest of these "wonders," and the only one still reasonably intact today, is the trio of pyramids at Giza (see fig. 3-10), built

between 2601 and 2515 BCE. The next oldest, the so-called Hanging Gardens built for Nebuchadnezzar II in Babylon in the sixth century BCE (see fig. 2-26), had disappeared long before it made the list, although sections of what are believed to be its foundations have been excavated. The Greek entries, none of which survive, must be imagined from written descriptions, sculptural fragments, and archeological reconstructions. They include the temple of the goddess Artemis at Ephesos, from the sixth century BCE; the statue of the god Zeus at Olympia by Pheidias, about 430 BCE; the Mausoleum at

Halikarnassos, fourth century BCE (figure 5-61 shows a conjectural reconstruction of it); the Colossus of Rhodes, a bronze statue of the sun god Helios the height of a ten-story building, completed in 282 BCE (our own word colossal comes from this Greek term for an outsize human statue); and the lighthouse that guarded the port at Alexandria, in Egypt, built about 290 BCE and more than four times as tall as the Colossus. It is intriguing that people at this point in history chose to list the world's wonders. It is particularly telling that all of these wonders were the work of human hands.

smaller than the other two. ly smaller than Khufu's. Menkaure's is considerably that still has a remnant of its veneer at the top, is slightscraper. The pyramid of Khafre, the only one of the three summit, to roughly the height of a 48-story modern skystone that lifted its apex some 30 feet above the present was originally finished with a sheath of polished limeto a height of about 450 feet in its deteriorated state. It that of Khufu, which covers 13 acres at its base and rises beings. The oldest and largest of the Giza pyramids is of these rulers to commemorate themselves as divine and "Divine Is Menkaure," thus acknowledging the desire the Giza tombs as "Horizon of Khufu," "Great Is Khafre," of the World," opposite). The early Egyptians referred to world's architectural marvels (see "The Seven Wonders Greek term—that they numbered them among the by these huge, shining monuments—"pyramid" is a

Next to each of the pyramids was a funerary temple connected by causeway, or elevated road, to a valley died, his body was ferried across the Nile from the royal palace to his valley temple, where it was received with

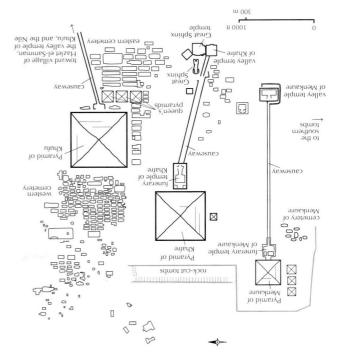

3-11. Plan of the funerary complex, Giza

pyramid

original burial chambers

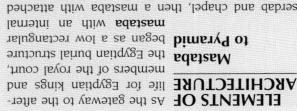

serdab and chapel, then a mastaba with attached chapel and serdab (not shown). Later, mastaba forms of decreasing size were stacked over an underground burial chamber to form the stepped pyramid. The culmination of the Egyptian burial site may be within the pyramid, in which the actual burial site may be within the pyramid—not below ground—with false chambers, false doors, and confusing passageways to foil potential tomb robbers.

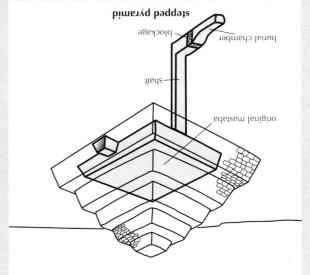

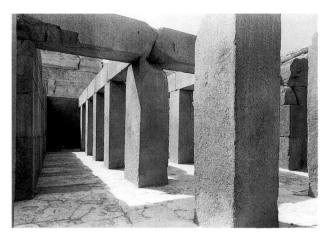

3-12. Valley temple of Khafre, Giza. Dynasty 4, c. 2570–2544 BCE. Granite posts and lintels, alabaster floor

elaborate ceremonies. It was then carried up the causeway to his funerary temple and placed in its chapel. There family members presented it with offerings of food and drink, and priests performed the rite known as the "opening of the mouth," in which the deceased's spirit consumed a meal. Then the body was entombed in a well-hidden vault inside the pyramid (see "Elements of Architecture," page 103). Khafre's funerary complex is the best preserved today. His valley temple was constructed of massive blocks of red granite. The corridor shown in figure 3-12 led to a chamber that once held a ka statue of the king (see fig. 3-13).

Constructing a pyramid was a formidable undertaking. A huge labor force had to be assembled, housed, and fed. Most of the cut stone blocks used in building the Giza complex—each weighing an average of two and a half tons—were quarried either on the site or nearby. Teams of workers transported them by sheer muscle power, at times employing small logs as rollers or pouring water on sand to create a slippery surface over which they could drag the blocks on sleds.

Scholars and engineers have advanced various theories about the method used in raising the pyramids. Some have been tested in computerized projections and a few in actual building attempts on a small but representative scale. The most efficient means of getting the stones into position might have been to build a temporary, gently sloping ramp around the body of the pyramid as it grew higher. The ramp might then be dismantled as the slabs of the stone veneer were laid from the top down. Clearly the architects who oversaw the building of such massive structures were capable of the most sophisticated mathematical calculations, for there was no room for trial and error. They had to make certain that the huge foundation layer was absolutely level and that the angle of each of the slanting sides remained constant so that the stones would meet precisely in the center at the top. They carefully oriented the pyramids to the points of the compass and may have incorporated other symbolic astronomical calculations as well. These immense monuments reflect not only the desire of a trio of kings to attain immortality but also the strength of the Egyptians' belief that a deceased ruler continued to affect the well-being of the state and his people from beyond the grave.

Sculpture

As was the custom, Khafre commissioned various stone portraits of himself to perpetuate his memory for all time. In his roughly lifesize ka statue, discovered inside his valley temple, he was portrayed as an enthroned king (fig. 3-13). The Great Sphinx, a colossal monument some 65 feet tall standing just behind the valley temple, combines his head with the long body of a crouching lion (fig. 3-14). Both images have the same compactness, symmetry of form, and simple, blocklike shape. Carved from a large rock formation left intact after stone had been quarried around it, Khafre's Great Sphinx was not the first such portrayal of a king, and there are many later ones. But in size it has no equal.

In his ka statue, Khafre sits erect on a simple but elegant throne. Horus perches on the back of the throne, protectively enfolding the king's head with his wings. Lions—symbols of regal authority—form the throne's sides, and the intertwined lotus and papyrus plants beneath the seat symbolize the king's power over Upper and Lower Egypt. Khafre wears the traditional royal costume: a short kilt, a linen headdress with uraeus, the cobra symbol of Ra, and a false beard symbolic of royalty. Viewed from the front (fig. 3-13, left), the vertical lines of the legs, torso, and upper arms convey a strong sense of dignity, calm, and above all permanence. The statue was carved in diorite, a stone chosen for its great durability, and the figure's compactness—the arms pressed tight to the body, and the body firmly anchored in the blockensured that the image would provide an alternative home for the king's ka for eternity.

When carving such a statue, Egyptian sculptors approached each face of the block as though they were simply carving a relief. In one the figure would be seen straight on from the front, in the others from the side or the back. Carving deeper and deeper, they finally ended up with a three-dimensional figure, and all that remained was to refine its forms and work up its surface details.

Dignity, calm, and permanence also characterize the double portrait of King Menkaure and Queen Khamerernebty, Khafre's son and daughter-in-law (fig. 3-15). But the sculptor's handling of the composition of this work, discovered in Menkaure's valley temple, makes it far less austere than Khafre's ka statue. The couple's separate figures, close in size, form a single unit, tied together by the stone out of which they emerge. They are further united by the queen's symbolic gesture of embrace. Her right hand emerges from behind to lie gently against his ribs, and her left hand rests on his upper arm. The king, depicted in accordance with the Egyptian ideal as an athletic, youthful figure nude to the waist, stands in a very Egyptian balanced pose with one foot in front of the other, his arms straight at his sides and his fists tightly

3-13. Khafre, from Giza. Dynasty 4, c. 2570-2544 BCE. Diorite, height 5'61/8" (1.68 m). Egyptian Museum, Cairo

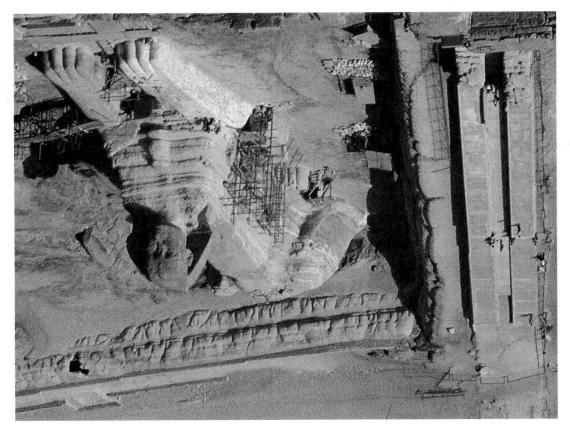

3-14. Great Sphinx, Giza. Dynasty 4, c. 2570-2544 BCE. Sandstone, height about 65' (19.8 m)

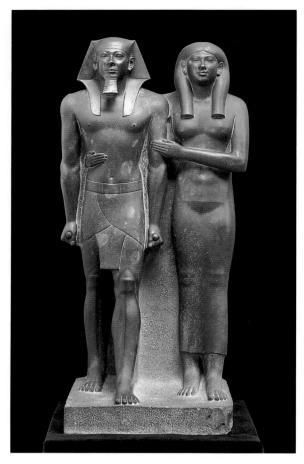

3-15. Menkaure and His Wife, Queen Khamerernebty, from Giza. Dynasty 4, c. 2515 BCE. Slate, height 541/2" (142.3 cm). Museum of Fine Arts, Boston Harvard University–MFA Expedition

An example of a type of royal portraiture that made its appearance in Dynasty 6 (2460–2200 BCE) is presented in figure 3-16. In this statue the figure of Pepy II (ruled c. 2383-2289? BCE), wearing the royal kilt and headdress but reduced to the size of a child, is seated on his mother's lap. The work thus pays homage to Queen Meryeankhnes, who wears a vulture-skin headdress linking her to the goddess Nekhbet and proclaiming her of royal blood. If Pepy II inherited the throne at the age of six, as Manetho claimed, then the queen may have acted as regent until he was old enough to rule alone. The sculptor placed the figure of the king at a right angle to that of his mother, thus providing two "frontal" views-the queen facing forward, the king to the side. In another break with convention, he freed the gueen's arms and legs from the stone block of the throne, giving her figure greater independence.

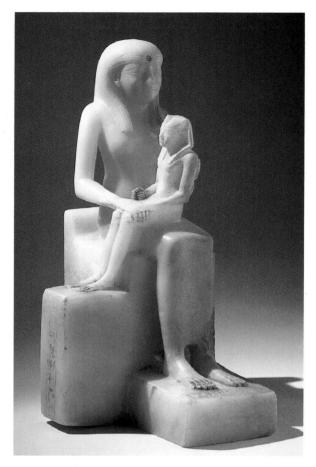

3-16. Pepy II and His Mother, Queen Merye-ankhnes.

Dynasty 6, c. 2383–2289? BCE. Calcite, height 151/4"
(39.2 cm). The Brooklyn Museum
Charles Edwin Wilbour Fund (39.119)

Old Kingdom sculptors were commissioned to produce portraits not only of kings and nobles but also of many figures of lesser prominence. As can be seen from the Seated Scribe (fig. 3-17), a painted limestone statue from Dynasty 5, these works tend to be livelier and less formal than royal portraits. The scribe's sedentary occupation has taken its toll on his physique, leaving him soft and flabby. His face, however, reveals an alert intelligence. He sits holding a papyrus scroll partially unrolled on his lap, his right hand clasping a now-lost reed pen. The modern viewer is likely to think this portrait realistic, but in fact it is a quite conventional Old Kingdom depiction of a man of lower class—however respected his position. Many other such statues of the period exhibit the same round head and face, large wide-open eyes, genial expression, and cap of hair cut close to the skull.

Tomb Decoration

In order to provide the ka with the most pleasant possible living quarters for eternity, wealthy families often had the interior walls and ceilings of their tombs decorated with paintings and reliefs. Much of this decoration was symbolic or religious, especially in royal tombs, but it could also include a wide variety of everyday scenes

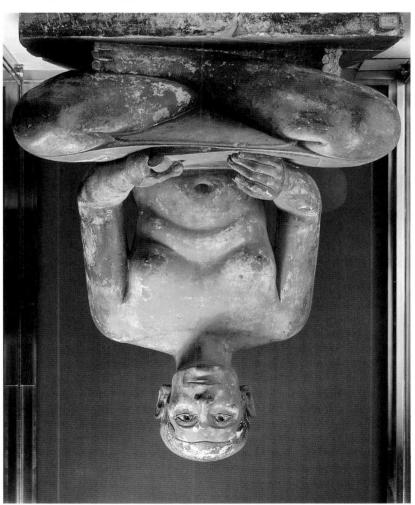

3-17. Seated Scribe. Dynasty 5, c. 2510-2460 BCE. Painted limestone, height 21" (53 cm). Musée du Louvre, Paris

earliest known libraries. were placed in related institutions called "houses of books," some of the studied, and repaired valuable sacred and scientific texts. Completed texts several "houses of life," where lay and priestly scribes copied, compiled, with a reputation as a great scholar could hope to be appointed to one of courtiers will greet" (cited in Strouhal, page 216). A high-ranking scribe soft, and you can wear white and walk like a man of standing whom [even] ment: "Become a scribe so that your limbs remain smooth and your hands cise tablet, probably copied from a book of instruction, offers encouragedemanding, but the rewards were great. An observation found in an exerwriting but also arithmetic, algebra, religion, and law. The studies were female scribe. Would-be scribes were required to learn not only reading and generally to have been closed to them, there is a Middle Kingdom word for Some girls learned to read and write, and although careers as scribes seem guarded profession, its skills generally passed down from father to son. Egyptian scribes began training in childhood. Theirs was a strenuously

relief employed a number of established conventions. They depicted the river as if seen from above, rendering it as a band of parallel wavy lines below the boats. The creatures in the river, however—fish, a crocodile, and hippopotamuses—are shown in profile for easy identification. The shallow boats carrying Ti and his men skim along the surface of the water unhampered by the papyrus stalks, shown as parallel vertical lines, that choke the marshy edges of the river. At the top of the panel, where Egyptian convention often placed background

recounting momentous events in the life of the deceased or showing them engaged in routine activities. Tombs therefore provide a wealth of information about ancient Egyptian culture.

A scene in the large mastaba of a Dynasty 5 government official named Ti—a commoner who had achieved great power at court and amassed sufficient wealth to build an elaborate home for his immortal spirit—shows him watching a hippopotamus hunt (fig. 3-18). The artists who created this painted limestone

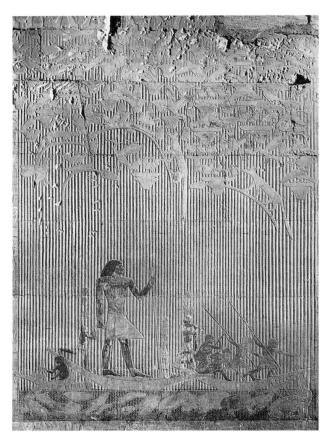

3-18. *Ti Watching a Hippopotamus Hunt*. Tomb of Ti, Saqqara. Dynasty 5, c. 2510–2460 BCE. Painted limestone relief, height approx. 45" (114.3 cm)

This relief forms part of the decoration of a mastaba tomb discovered by the French archeologist Auguste Mariette in 1865. Among Mariette's many other famous finds was the ka statue of Khafre (see fig. 3-13). A pioneer Egyptologist, Mariette was a man of great heart, intellect, and diverse talents. It was he who provided the composer Giuseppe Verdi with the scenario for the opera *Aida*, set in ancient Egypt. He pressed the Egyptians to establish the National Antiquities Service to protect, preserve, and study the country's art monuments. In gratitude, they later placed a statue of him in the new Egyptian Museum in Cairo. At his death, his remains were brought back to his beloved Egypt for burial.

scenes, several animals are seen stalking birds among the papyrus leaves and flowers. The erect figure of Ti, rendered in the traditional twisted pose, looms over this teeming Nile environment. The actual hunters, being of lesser rank and engaged in more-strenuous activities, are rendered more realistically.

In Egyptian art, as in that of the ancient Near East, scenes showing a ruler hunting wild animals served to illustrate the power to maintain order and balance. By dynastic times, hunting had become primarily a showy pastime for the nobility. The hippopotamus hunt, however, was more than simple sport. Hippos tended to wander off into fields, inflicting untold damage on crops. Killing them was an official duty of members of the court. Furthermore, it was believed that the companions of

Seth, the god of darkness, disguised themselves as hippopotamuses. Tomb depictions of such hunts therefore illustrated not only the valor of the deceased but also the triumph of good over evil.

THE MIDDLE KINGDOM

The collapse of the Old Kingdom, with its long succession of kings ruling the whole of

Egypt, was followed by roughly 150 years of political turmoil traditionally referred to as the First Intermediate period. In about 2040 BCE a prince Mentuhotep II, from Thebes, finally managed to reunite the country. He and his successors reasserted royal power, but beginning with the next dynasty, political authority became less centralized. Provincial governors claimed increasing powers for themselves, effectively limiting the king's responsibility to national concerns such as the defense of Egypt's frontiers. It was in the Middle Kingdom that Egypt's kings began maintaining standing armies to patrol the country's borders, especially its southern reaches in Lower Nubia, south of modern Aswan.

Another royal responsibility was the planning and construction of large-scale water management projects. Although farmers had long diverted the waters of the Nile to irrigate their crops, specific terms having to do with such projects—"canal" and "levee," for example—make their first appearance in Middle Kingdom documents and inscriptions. The first mention of ingenious methods of raising water from the level of the river to higher ground also dates from this period. Regional administrators and the farmers themselves were left to supervise irrigation locally. In this period Egypt's farmers enjoyed relatively liberal rights and freedoms, even though they were required to turn over most of what they produced to the nobles or priests who owned the land they worked. Those who failed to meet prescribed annual yields were subject to harsh punishments.

Architecture and Town Planning

The remains of Kahun, a town built by Senwosret II (Dynasty 12, ruled c. 1895–1878 BCE) near his pyramid tomb complex at el-Lahun, offer a unique view of the Middle Kingdom's social structure. Although the Egyptians used more-durable materials in the construction of tombs, they built their own dwellings with simple mud bricks. The bricks have either disintegrated over time or been carried away by farmers for their value as fertilizer, leaving only the foundations. From them, archeologists have developed a map of the site showing straight streets and avenues laid out in a mainly east-west orientation (fig. 3-19). The resulting rectangular blocks were divided into lots for homes and other buildings.

Kahun was built to provide housing for the king and the many officials, priests, and workers required in the service of his court. The town's design reflects three distinct economic and social levels. Appropriately, Senwosret's own semifortified residence occupied the highest ground and fronted on a large, open square. The district to the east of his palace, connected to the square by a

4000 BCE 0

town by a solid wall. Their families made do with small, five-room row houses built back to back along straight, narrow streets.

Tomb Art and Tomb Construction

might be kept at the edge for fishing. with water lilies and fish, were so large that a small boat source, some pools, lined with masonry and stocked and only the wealthy could afford their own backyard flanked by sycamore trees. Although water was precious with stylized lotus capitals. The garden has a central pool portico, or columned porch, having papyrus columns roofed structure opens into a walled garden through a reproduces a portion of a house (fig. 3-20). The flatof wood, plaster, and copper in about 2009-1997 BCE, interest to early grave robbers. One from Thebes, made because they were made of inexpensive materials of no estates of the deceased. Many of these models survive workers and animals reproduce everyday scenes on the of houses and farm buildings complete with figurines of Kingdom. Wall paintings, reliefs, and even small models Tomb art reveals much about domestic life in the Middle

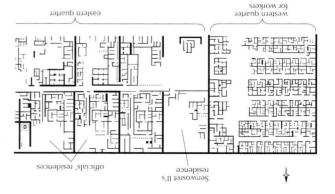

3-19. Plan of the northern section of Kahun, built during the reign of Senwosret II near modern el-Lahun. Dynasty 12, c. 1895–1878 BCE

wide avenue, was occupied by priests, court officials, and their families. Their houses were large and comfortable, with private living quarters and public rooms grouped around central courtyards. Some had as many as seventy rooms spread out over half an acre. The workers were try rooms spread out over half an acre. The workers were housed in the western district, set off from the rest of the

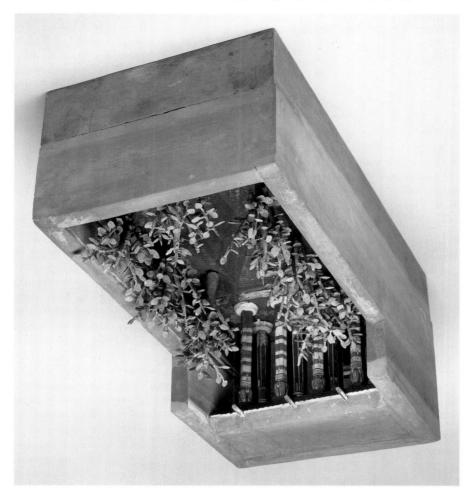

3-20. Model of a house and garden, from Thebes. Dynasty 11, c. 2009–1997 BCE. Painted and plastered wood and copper, length 33" (83.8 cm). The Metropolitan Museum of Art, New York

Purchase, Rogers Fund and Edward S. Harkness Gift, 1920 (20.3.13)

3-21. Rock-cut tombs, Beni Hasan. Dynasty 12, c. 1991-1785 BCE. At the left is the entrance to the tomb of the provincial governor and commander-in-chief Amenemhet.

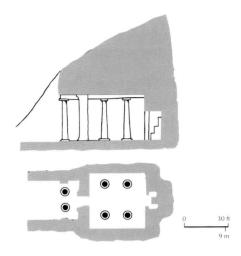

3-22. Plan and elevation of a typical rock-cut tomb at Beni Hasan

During Dynasties 11 and 12, members of the nobility and high-level officials frequently commissioned rockcut tombs—burial places hollowed out of the faces of cliffs—such as those in the necropolis at Beni Hasan on the east bank of the Nile. The various chambers of such tombs and their ornamental columns, lintels, false doors, and niches were all carved out of solid rock (fig. 3-21). Each one was therefore like a single, complex piece of sculpture, attesting to the great skill of their designers and carvers. A typical Beni Hasan tomb included an

TECHNIQUE

PAINTING AND RELIEF **SCULPTURE**

EGYPTIAN carvers were to work are in black. Egyptian artists worked in teams, each member of which had developed a particular skill. The sculptor who executed the carving on the right was following someone else's drawing. Had

there been time to finish the tomb, other hands would have smoothed the surface of this limestone relief, and still others would have made fresh drawings to guide the artists assigned to paint it.

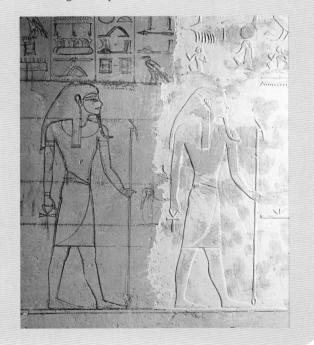

Painting relies for its effect on color and line. Relief sculpture usually depends on the play

of light and shadow alone, but in Egypt, relief sculpture was also painted. The walls and closely spaced columns of Egyptian tombs

and temples provided large surfaces for decoration, and in fact nearly every square inch of them was adorned with colorful figural scenes and hieroglyphic texts. Up until Dynasty 18 (New Kingdom), the only colors used were black, white, red, yellow, blue, and green. They were never mixed. Modeling might be indicated by overpainted lines in a contrasting color, but never by shading of the basic color pigment. In time, more colors were added to the palette, but the primacy of line was never challenged. In terms of composition, with comparatively few exceptions, figures, scenes, and texts were presented in bands, or registers. Usually the base line at the bottom of each register represented the ground. Determining the sequence in which a set of images is to be read can be problematic because it may run either horizontally or vertically.

The preliminary steps in the creation of paintings and relief carvings were virtually identical. Surfaces to be painted had to be smooth, so in some cases a coat of plaster was applied. The next step was to lay out the registers with painted lines and draw the appropriate grid (see fig. 3-6). In the remarkable photograph of a wall section in the unfinished Dynasty 19 tomb of Horemheb in the Valley of the Kings, the red base lines and horizontals of the grid are clearly visible. The general shapes of the hieroglyphs have also been sketched in red. The actual preparatory drawings from which the carver or

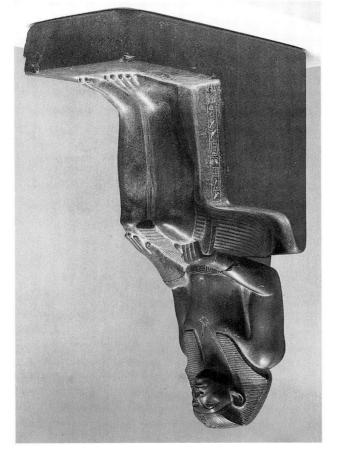

3-24. Senwosret III. Dynasty 12, c. 1878–1842 BCE. Black granite, height $21^{1/2}$ " (54.8 cm). The Brooklyn Museum

Charles Edwin Wilbour Fund (62.1)

There is little indication of how ancient Egyptians viewed the artists who created portraits of kings and nobles and recorded so many details of contemporary life, but they must have been admired and respected. Some certainly had a high opinion of themselves, as we learn from an inscription on the tombatone of a Middle Kingdom sculptor: "I am an artist who excels in my art, a man above the common herd in knowledge. I know the proper attitude for a statue for a man], I know how a woman holds herself, [and how] a spearman lifts his arm. ... There is no man famous for this knowledge other than I myself and my eldest son" (cited in Montet, page 159).

something of his personality and his inner thoughts. He appears to be a man wise in the ways of the world but lonely, saddened, and burdened by the weight of his responsibilities.

The statue shows the king in the conventional blocklike pose, seated, immobile, frontal, and erect. Despite its size—it is less than 2 feet tall—it conveys the sense of monumentality already noted in the much larger ka statue of the Old Kingdom ruler Khafre (see fig. 3–13). There are nevertheless significant differences between the two. Khafre gazes into eternity confident and serene, whereas Genwosret III appears preoccupied and emotionally drained. Deep creases line his sagging cheeks, his eyes as Senwosret III appears preoccupied and emotionally drained. Deep creases line his sagging cheeks, his eyes are sunken, his eyelids droop, and his jaw is sternly set.

3-23. Harvest Scene, tempera facsimile by Vina de Garis Davies of a wall painting in the tomb of Khnumhotep, Beni Hasan. Dynasty 12, c. 1928–1895 ce

entrance portico, a main hall, and a small burial chamber set back in its farthest recesses (fig. 3-22). The hall might be quite large, with slightly vaulted ceilings and rows of freestanding papyrus-style columns. Rock-cut tombs at other spots along the Mile exhibit variations on this simple plan, with different types of entrances and different interior layouts.

The walls of rock-cut tombs were commonly ornamented with painted scenes. Relief decorations were rare. Among the best-preserved paintings at Beni Hasan are those in the Dynasty 12 tomb of the local lord Khnumhotep, some of which present spirited depictions of life on his farms. In one scene, two men picking figs are forced to compete for the fruit with three friendly baboons seated in the trees (fig. 3-23). The baskets heaped high with neatly arranged figs indicate that the heaped high with neatly arranged figs indicate that the hornest is plentiful despite the animals' thievery. Like the hunters in the Old Kingdom painted relief of Ti on a hippopotamus hunt (see fig. 3-18), these active farmworkers are shown in almost full profile, not in the twist-workers are shown in almost full profile, not in the twist-

Sculpture

ed pose prescribed for royalty.

seems to reflect not only his achievements but also try's increasingly independent nobles. His portrait statue and did much toward regaining control over the coun-Nubia, overhauled the central administration at home, successful general who led four military expeditions into sensibility (fig. 3-24). Senwosret was a dynamic king and ruled c. 1878-1842 BCE) serves as an example of this new human existence. A statue of Senwosret III (Dynasty 12, ing a special awareness of the hardship and fragility of Kingdom sculptors continued in this direction, expressvigorous but placid young men. A number of Middle move away from the conventional portrayal of kings as preceding First Intermediate period had already begun to ing a trend in nonofficial portrait sculpture, artists of the exhibit the idealized rigidity of earlier examples. Emulat-Royal portraits from the Middle Kingdom do not always Intended or not, his image betrays a pessimistic view of life, a degree of distrust similar to that reflected in the advice given by Amenemhet I, this Senwosret's greatgreat-grandfather and the founder of his dynasty, to his son Senwosret I (cited in Breasted, page 231):

Fill not thy heart with a brother, Know not a friend, Nor make for thyself intimates, . . . When thou sleepest, guard for thyself thine own heart; For a man has no people [supporters], In the day of evil.

Small Objects Found in Tombs

Middle Kingdom art of all kinds and in all mediums, from official portrait statues such as that of Senwosret III to the least-imposing symbolic objects and delicate bits of jewelry, exhibits the desire of the period's artists for wellobserved, accurate detail. A hippopotamus figurine discovered in the Dynasty 12 tomb of a governor named Senbi, for example, has all the characteristics of the beast itself: the rotund body on stubby legs, the massive head with protruding eyes, the tiny ears and distinctive nostrils (fig. 3-25). The figurine is an example of Egyptian faience, with its distinctive lustrous glaze (see "Glassmaking and Egyptian Faience," below). The artist chose to make the hippo the watery blue of its river habitat, then painted lotus blossoms on its flanks, jaws, and head, giving the impression that the creature is standing in a tangle of aquatic plants. Such figures were often placed in tombs so that the deceased might engage in an eternal hippopotamus hunt, enjoying the sense of moral triumph that entailed (see the discussion of Ti Watching a Hippopotamus Hunt, fig. 3-18).

The simple beauty of this faience hippopotamus contrasts sharply with the intricate splendor of a pectoral, or chest ornament, found at el-Lahun (fig. 3-26). Executed in gold and inlaid with semiprecious stones, it was

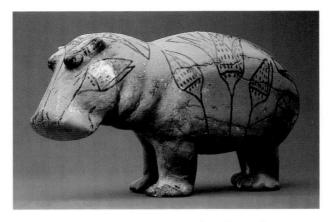

3-25. Hippopotamus, from the tomb of Senbi (Tomb B.3), Meir. Dynasty 12, c. 1962-1895 BCE. Faience, length 77/8" (20 cm). The Metropolitan Museum of Art, New York

Gift of Edward S. Harkness, 1917 (17.9.1)

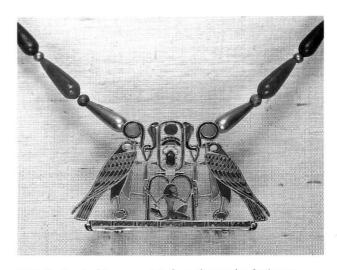

3-26. Pectoral of Senwosret II, from the tomb of Princess Sithathoryunet, el-Lahun. Dynasty 12, c. 1895–1878 BCE. Gold and semiprecious stones, length 31/4" (8.2 cm). The Metropolitan Museum of Art, New York Purchase, Rogers Fund and Henry Walters Gift, 1916 (16.1.3)

TECHNIQUE

AND EGYPTIAN

FAIENCE

Glass is produced by subjecting a mixture of sand, lime, and sodium carbonate or sodium sulphate to a very high temperature. It can be made to be transparent, translucent, or

opaque and, with the addition of certain substances, can be created in a vast range of colors. No one knows precisely when or where the technique of glassmaking was first developed. By the Predynastic period, the Egyptians were already experimenting with a substance called glass paste, or Egyptian faience. When fired, this mixture produced a smooth and shiny opaque finish. At first it was used to form small objects, mainly beads, charms, and color inlays. It was later employed as an ornamental colored glaze for pottery wares and clay figurines (see fig. 3-25).

The first evidence of all-glass vessels and other hol-

GLASSMAKING low objects dates from the early New Kingdom. At that time glassmaking was restricted to royal workshops, and only the aristocracy and priestly class could commission work

from them. The first objects to be made entirely of glass in Egypt were produced by the technique known as core glass. A lump of sandy clay molded into the desired shape of the finished vessel was wrapped in strips of cloth, then skewered on a fireproof rod. It was then briefly dipped into a pot of molten glass. Once the resulting coating of glass had cooled, the clay core was removed through the opening left by the skewer. To decorate the vessel thus created, glassmakers frequently heated thin rods of glass of different colors to the melting point and fused them to its surface in elegant wavy patterns, zigzags, and swirls (see fig. 3-39).

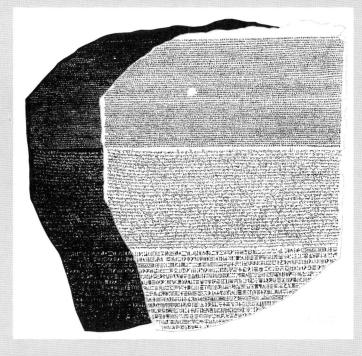

with the script reversed to appear black. glyphic, hieratic, and demotic. The stone itself is nearly black. It is shown here The Rosetta Stone with its three tiers of writing, from top to bottom: hiero-

phonogramic hieroglyphs were especially useful in rendering foreign names. Eight hieroglyphs with the sounds they represent. Used in combinations, such

cient Egypt that comes to light. inscription or document from antologists are able to read each new texts. Thanks to him, today's Egyphe had deciphered the two Egyptian "alphabet" of symbols, and by 1822 he was able to slowly build up an symbols for P, O, L, and T in demotic, thereby determined the phonetic both of the Egyptian scripts. Having the names Ptolemy and Cleopatra in Champollion (1790-1832) located brilliant Frenchman Jean-François sion in 1818. A short time later, the specific names in the Greek verlinked some of the hieroglyphs to sician interested in ancient Egypt, until Thomas Young, an English phytexts proved to be incomprehensible Creek translation, the two Egyptian demotic, and Greek. Even with the V had been carved in hieroglyphics, Memphis honoring the ruler Ptolemy a decree issued by the priests at stone stela dated from 196 BCE. On it, This irregular-shaped fragment of a leon's officers discovered it in 1799. near the spot where one of Napo-

appeared in the form of the Rosetta long-forgotten language. The key these various types of writing in a faced with the task of deciphering Modern scholars were therefore Egypt's inhabitants spoke Arabic. which time the great majority of trom the fourteenth century ce, by last documents written in it date arrival of the Greeks in 332 BCE. The of foreign rule, beginning with the ly died out as the result of centuries The Egyptian language gradualother texts in demotic. monuments in hieroglyphics, and all

written in hieratic, inscriptions on

purpose: religious documents were in use, each for its own specific

this time on, all three systems were ing (from demos, "the people"). From Greeks referred to it as demotic writand was easier to master, and the

priests and scribes. It was less formal ceased to be restricted exclusively to tury BCE, as written communication into use only in the eighth cen-The third type of writing came

on ceremonial objects continued to inscriptions in reliefs or paintings and Even after this script was perfected,

from the Greek word for "sacred." called hieratic, another term derived papyrus scrolls. This type of writing is

more quickly in lines of script on

simplified forms that could be written shorthand version of hieroglyphshowever, they evolved a kind of used this system of signs. In time, the earliest scribes must also have dence, and manuscripts of all sorts, For record-keeping, corresponsigns representing spoken sounds. ans. Others were phonograms, or similar to those used by the Sumericreatures or objects, or pictographs, symbols were simple pictures of gious significance. Some of these believed they were filled with relitheir name suggests, the Greeks "sacred," and glyphein, "to carve"). As hieroglyphs (from the Greek hieros, a large number of symbols called

est system employed

gave them. The earli-

the names the Greeks

are known today by

writing, all of which

obed three types of Ancient Egypt devel**WRITING**

DEMOTIC

HIERATIC,

CLYPHIC,

HIEBO-

DNA

be written in hieroglyphics.

1600 4000 BCE 0 discovered in the funerary complex of Senwosret II, in the tomb of the king's daughter Sithathoryunet. The pectoral's design incorporates the name of Senwosret II and a number of familiar symbols. Two Horus falcons perch on its base, and above their heads are a pair of coiled cobras, symbols of Ra, wearing the ankh, the symbol of life. Between the two cobras, a cartouche—an oval formed by a loop of rope—contains the hieroglyphs (symbols) of the king's name. The sun disk of Ra appears at the top, and a scarab beetle, another symbol of Ra suggestive of rebirth, at the bottom. Below the cartouche, a kneeling male figure helps the falcons support a double arch of notched palm ribs, a hieroglyphic symbol meaning "millions of years." Decoded, the pectoral's combination of images yields the message: "May the sun god give eternal life to Senwosret II."

THE NEW KINGDOM

During the Second Intermediate period—another turbulent interruption in the succession of dynasties ruling a unified country—an

eastern Mediterranean people called the Hyksos invaded Egypt's northernmost regions. It was only under the early rulers of Dynasty 18 (established in 1552 BCE) that the country regained its political and economic strength. The first kings of what is known as the New Kingdom managed to regain control of the entire Nile region from Nubia in the south to the Mediterranean in the north. Roughly a century later, one of the same dynasty's most dynamic kings, Tuthmose III (ruled 1479-1425 BCE), even succeeded in extending Egypt's influence along the eastern Mediterranean coast as far as the region of modern Syria. His accomplishment was the result of some fifteen or more military campaigns and his own skill at diplomacy. Tuthmose III was the first ruler to refer to himself as "pharaoh," a term that simply meant "great house." Egyptians used it in the same way that people in the United States commonly speak of "the White House" when they really mean the current president. The successors of Tuthmose III continued to use the term, and it ultimately found its way into the Hebrew Bible-and modern usage—as the name for the kings of Egypt.

By the beginning of the fourteenth century BCE, the most powerful Near Eastern kings acknowledged the rulers of Egypt as their equals. Marriages contracted between Egypt's ruling families and Near Eastern royalty helped to forge a generally cooperative network of kingdoms in the region. Among the benefits of such cooperation were stimulated trade and the promise of mutual aid at times of natural disaster and outside threats to established borders. Over time, however, Egyptian influence beyond the Nile diminished, and the power of Egypt's kings began to wane even within the country itself.

Great Temple Complexes

At the height of the New Kingdom, rulers undertook extensive building programs along the entire length of the Nile. Their palaces, forts, and administrative centers

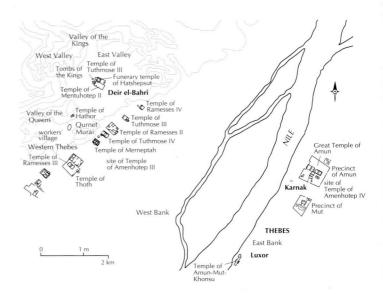

3-27. Map of the Thebes district

disappeared long ago, but remnants of temples and tombs of this great age have endured. Even in their ruined state, they grandly attest to the expanded powers and political triumphs of their builders. Early in this period the priests of the god Amun in Thebes, Egypt's capital city through most of the New Kingdom, had gained such dominance that worship of the Theban triad of deities—Amun, his wife Mut, and their son Khonsu—had spread throughout the country. Temples to these and other gods were a major focus of royal art patronage, as were tombs and temples erected to glorify the kings themselves.

Temples to the Gods at Karnak and Luxor. Two temple districts consecrated primarily to the worship of Amun, Mut, and Khonsu arose near Thebes, one at Karnak to the north and the other at Luxor to the south (fig. 3-27). Little of the earliest construction at Karnak survives, but the remains of New Kingdom additions to the Great Temple of Amun still dominate the landscape (fig. 3-28). Access to the heart of the temple, a sanctuary containing the statue of Amun, was through a principal courtyard, a hypostyle hall—a vast hall filled with columns—and a number of smaller halls and courts. Massive gateways, called pylons, set off each of these separate elements. The greater part of Pylons II through VI and the areas behind them were renovated or newly built and embellished with colorful wall reliefs between the reigns of Tuthmose I (Dynasty 18, ruled c. 1506–1493 BCE) and Ramesses II (Dynasty 19, ruled c. 1279-1212 BCE). A sacred lake to the south of the temple, where the king and priests might undergo ritual purification before entering the temple, was also added in this period. Behind the sanctuary of Amun, Tuthmose III erected a court and festival temple to his own glory. Amenhotep III (Dynasty 18, ruled 1390-1352 BCE) later placed a large stone statue of Khepri, the scarab beetle symbolic of the rising sun and everlasting life, next to the sacred lake.

Religious worship in ancient Egypt was not a matter of daily or weekly rituals performed in the presence of a congregation of laypeople. Only kings and priests were allowed to enter the sanctuary of Amun for the required devotions, including washing the god's statue every

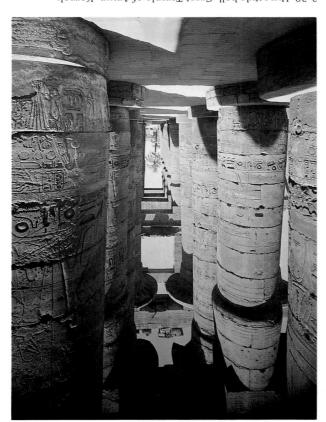

3-30. Hypostyle hall, Great Temple of Amun, Karnak

morning and clothing it in a new garment, as well as providing it with tempting meals twice a day. The god was thought to derive nourishment from the spirit of the food, which the priests then removed and ate themselves. Ordinary people were rarely permitted beyond the forecourts of the hypostyle halls, where they found themselves surrounded by inscriptions and images of kings and the god on columns and walls. During religious festivals, however, they lined the routes along which the statues of the gods were carried in ceremonial barks, or symbolic boats. At such times they might even submit petitions to the priests that they might even submit symbolic boats. At such times they might even submit petitions to the priests that they wished the gods to

into the darkness. bud capitals that must have seemed to march off forever capitals. The smaller columns on each side have lotus tall and 12 feet in diameter, with massive lotus flower columns supporting this higher part of the roof are 66 feet some 30 feet higher than the rest (figs. 3-29, 3-30). The stepped, flat stone roof, the center section of which rose feet long. Its 134 closely spaced columns supported a 071 bne əbiw 1991 046 saw lhah atl "The hall was 340 feet wide and 170 terms as "the place where the common people extol the monies. Ramesses II referred to it in more mundane Amun," it was perhaps used for royal coronation cereof the Spirit of Sety, Beloved of Ptah in the House of Ramesses II (ruled c. 1279–1212 BCE). Called the "Temple 19 rulers Sety I (ruled 1294-1279 BCE) and his son mous hypostyle hall erected in the reigns of the Dynasty Between Pylons II and III at Karnak stands the enor-

3-28. Plan of the Great Temple of Amun, Karnak.

The Karnak site had been an active religious center for more than 2,000 years before these structures were erected on it. Over the nearly 500 years of the New Kingdom, successive kings busily renovated and expanded the Amun temple. Later rulers added pylons, courtyards, hypostyle halls, statues, and temples or shrines to other deities to the east, west, and south of the main temple until the complex covered about 60 acres, an area as large as a dozen football fields. In this ongoing process, it was common to demolish older structures and use their materials in new construction.

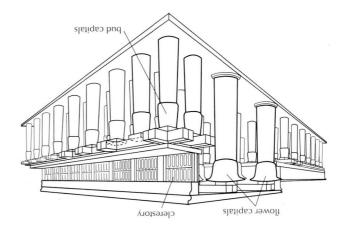

3-29. Reconstruction drawing of the hypostyle hall, Great Temple of Amun, Karnak. Dynasty 19, c. 1294–1212 BCE

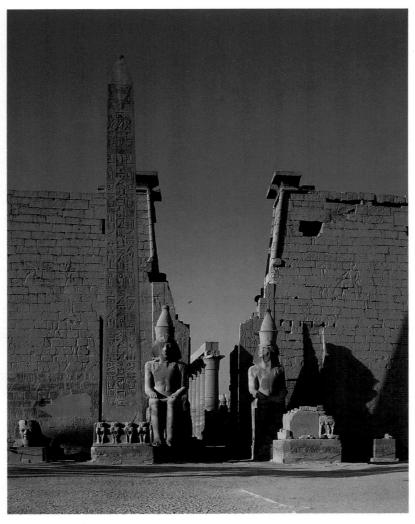

3-31. Pylon of Ramesses II with obelisk in the foreground, Temple of Amun, Mut, and Khonsu, Luxor. Dynasty 19, c. 1279–1212 BCE

In each of the side walls of the higher center section there was a long row of window openings, creating what is known as a **clerestory**. These openings were filled with stone grillwork, so they cannot have provided much light, but they did permit a cooling flow of air through the hall. Despite the dimness of the interior, artists were required to cover nearly every inch of the columns, walls, and cross-beams with reliefs.

The sacred district at Luxor was already the site of a splendid temple complex by the thirteenth century BCE. Ramesses II further enlarged the complex with the addition of a pylon and a **peristyle court**, or open courtyard ringed with columns and covered walkways (fig. 3-31). In front of his pylon stood two colossal statues of the king and a pair of **obelisks**—slender, slightly tapered square shafts of stone capped by a pyramidal shape called a **pyramidion**. The faces of the pylon are ornamented with reliefs detailing the king's military exploits. The walls of the courtyard present additional reliefs of Ramesses, shown together with various deities, his wife, seventeen of his sons, and other royal children, some hundred of whom he had by eight official wives and numerous concubines during his sixty-seven-year reign.

The Funerary Temple of Hatshepsut. The dynamic female ruler Hatshepsut (Dynasty 18, ruled c. 1478-1458 BCE) is a notable figure in a period otherwise dominated by male warrior-kings. Besides Hatshepsut, three other queens ruled Egypt—the little-known Sobekneferu and Twosret, and the notoriously famous Cleopatra, much later. The daughter of Tuthmose I, Hatshepsut married her half brother, who then reigned for fourteen years as Tuthmose II. When he died, she became regent for his underage son—born to one of his concubines—Tuthmose III. Hatshepsut had herself declared king by the priests of Amun, a maneuver that prevented Tuthmose III from assuming the throne for twenty years. In art she was represented in all the ways a male ruler would have been, even as a human-headed sphinx (fig. 3-32), and she was called "His Majesty." Sculpted portraits show her in the traditional royal trappings: kilt, linen headcloth, broad beaded collar, false beard, and bull's tail hanging from her waist.

Hatshepsut's closest adviser, a courtier named Senenmut, was instrumental in carrying out her ambitious building program. Her most innovative undertaking was her own funerary temple at Deir el-Bahri (fig. 3-33).

porticos on this level were shrines to Anubis and Hathor. water to the second level. At the ends of the columned visitor ascended a long, straight ramp flanked by pools of "Elements of Architecture," page 101). From there, the space before a long row of columns, or colonnade (see destroyed, to the first level of the complex, a huge open sphinxes once ran from a valley temple on the Nile, since center line (fig. 3-34). An elevated causeway lined with ments are symmetrically arranged along a dominant plex follows an axial plan—that is, all of its separate elesome miles away on the east bank of the Nile. The comoriented toward the Great Temple of Amun at Karnak, ple was magnificently positioned against high cliffs and a mile to the northwest (see fig. 3-27). Her funerary tema necropolis known as the Valley of the Kings, about half sut was to be buried, like other New Kingdom rulers, in The structure was not intended to be her tomb; Hatshep-

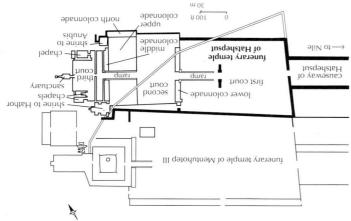

3-34. Plan of the funerary temple of Hatshepsut, Deir el-Bahri. Dynasty 18, c. 1478–1458 BCE

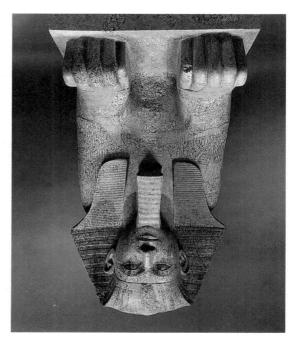

3-32. Halshepsut as Sphinx, from Deir el-Bahri. Dynasty 18, c. 1478–1458 BCE. Red granite, height 5'4" (164 cm). The Metropolitan Museum of Art, New York

Rogers Fund, 1931 (31.3.166)

Of the Egyptian queens who went down in history as "living gods" themselves and not merely "wives of gods," Hatshepsut may well have been the most commanding, Among the reliefs in her funerary temple at Deir el-Bahri (see fig. 3-33), she placed—just as a male king might have—a depiction of her divine birth. There she is portrayed as the daughter of her earthly mother, of ueen Ahmose, and the god Amun. She also honored her real father, Tuthmose I, by dedicating a chapel to him in her temple.

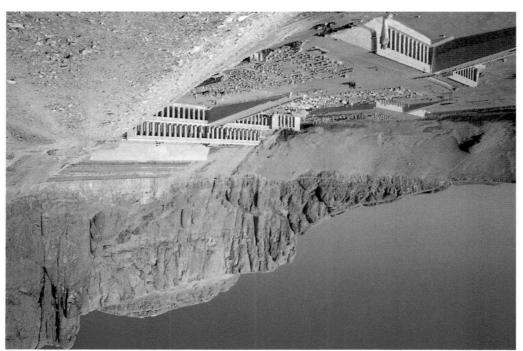

3-33. Funerary temple of Hatshepsut, Deir el-Bahri. At the far left, ramp and base of the funerary temple of Mentuhotep III. Dynasty 11, c. 2009–1997 BCE

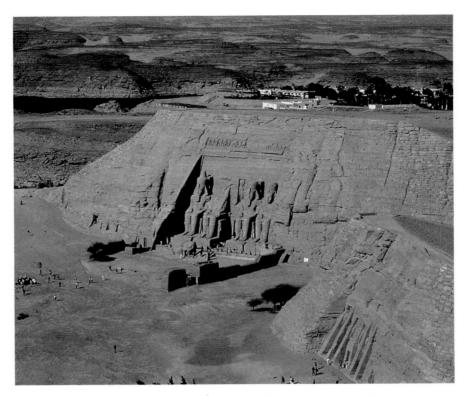

3-35. Temples of Ramesses II (left), and Nefertari (right), Abu Simbel, Nubia. Dynasty 19, c. 1279–1212 BCE

These two temples are no longer in their original location. That site was inundated as the result of the construction of the Aswan High Dam in the 1960s. An international campaign to salvage these monuments raised large sums of money, and astute engineers found a way to move the temples to a spot some 215 feet higher and 690 feet farther back from the river. The facade sculpture and the inner temple walls were cut into blocks and reassembled against artificial cliffs.

Relief scenes and inscriptions in the south portico relate that Hatshepsut sent a fleet of ships to Punt, an exotic, half-legendary kingdom probably located on the Red Sea or the Gulf of Aden, to bring back rare myrrh trees for the temple's terraces. The uppermost level consisted of another colonnade fronted by colossal royal statues, and behind this a large hypostyle hall with chapels to Hatshepsut, her father, and the gods Amun and Ra-Horakhty—the power of the sun at dawn and dusk. Centered in the hall's back wall was the entrance to the temple's innermost sanctuary. This small chamber was cut deep into the cliff in the manner of Middle Kingdom rock-cut tombs.

Hatshepsut's funerary temple, with its lively alternating of open spaces and grandiose architectural forms, projects an imposing image of authority. In its day, its remarkable union of nature and architecture, with many different levels and contrasting textures—water, stone columns, trees, and cliffs—made it far more impressive than the bleak expanse of stone ruins and sand that confronts the visitor today.

The Temple of Ramesses II at Abu Simbel. At the time of Ramesses II (ruled c. 1279–1212 BCE), whom some believe to be the "pharaoh" of the biblical story of Moses and the Exodus, Egypt was a mighty empire. Ramesses was a bold military commander and an effective political strategist. In about 1263 BCE he secured a peace agree-

ment with the Hittites, a rival power centered in Anatolia (Chapter 2) that had tried to expand its borders to the west and south at the Egyptians' expense. He reaffirmed that agreement a little over a decade later by marrying a Hittite princess.

In the course of his long and prosperous reign, Ramesses II initiated building projects on a scale rivaling the Old Kingdom pyramids at Giza. The most awe-inspiring of his many architectural monuments is found at Abu Simbel in Nubia, Egypt's southernmost region. There Ramesses ordered the construction of two temples, a large one to himself and a smaller one to his chief wife, Nefertari.

Like Hatshepsut's funerary temple at Deir el-Bahri, the monumental grandeur of the king's temple communicates to the viewer a sense of unlimited majesty. It was carved out of the face of a cliff in the manner of a rockcut tomb but far surpasses earlier temples created in this way. Its dominant feature is a row of four colossal seated statues of the king, each more than 65 feet tall (fig. 3-35). Large figures of Nefertari and other family members stand next to his feet, but they seem mere dolls by comparison, since they do not even reach the height of the king's giant stone knees. The interior of the temple stretches back some 160 feet and was oriented in such a way that on the most important day of the Egyptian calendar the first rays of the rising sun shot through its entire depth to illuminate a row of four statues—the king

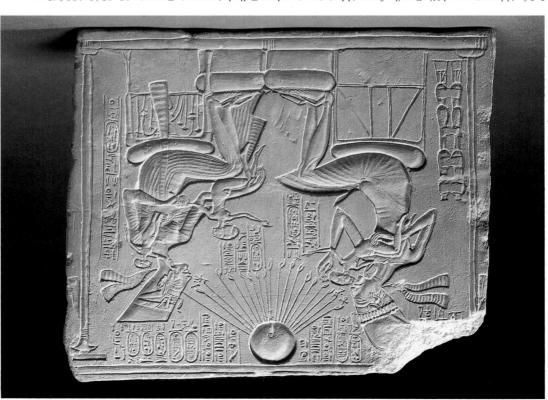

3-36. Akhenaten and His Family, from Akhetaten (modern Tell el-Amarna). Dynasty 18, 1348–1336/5 Bce. Painted limestone relief, 121/4 x 151/4" (31.1 x 38.7 cm). Staatliche Museen zu Berlin, Preussischer Kulturbesitz, Ägyptisches Museum

Egyptian relief sculptors often employed the technique seen here, called sunken relief. In ordinary reliefs, the background is carved away so that the figures project out from the finished surface. In this technique, the original flat surface of the stone is the background, and the outlines of the figures are deeply incised, permitting the development of three-dimensional forms within them. If an ordinary relief became badly worn, a sculptor might restore it by recarving it as a sunken relief.

ess. Temples to Aten were open courtyards, where altars could be bathed in the direct rays of the sun. In art Aten is depicted as a round sun sending down long thin rays ending in human hands, some of which hold the ankh, or symbol of life.

Akhenaten stressed the philosophical principle of maat, or divine truth, and one of his kingly titles was "Living in Maat." Such concern for truth found expression in new artistic conventions. In portraits of the king artists emphasized his unusual physical characteristics—long, thin arms and legs, a protruding stomach, swelling thighs, a thin neck supporting an elongated skull. Unlike his predecessors, and in keeping with his penchant for candor, harden urged his artists to portray the royal family in informal situations. Even private houses in the capital city were adorned with reliefs of the king and his family, an indication that he managed to substitute veneration of the indication that he managed to substitute veneration of the gods, such as that of Amun, Mut, and Khonsu.

A painted relief of Akhenaten, Queen Nefertiti, and three of their daughters exemplifies the new openness and a new figural style (fig. 3-36). In this **sunken relief**—the outlines of the figures have been carved into the surface of the stone, making it unnecessary to cut away the background—the king and queen sit on cushioned thrones background—the king and queen sit on cushioned thrones

and the gods Amun, Ptah, and Ra-Horakhty—placed against the back wall. The front of the smaller nearby temple to Nefertari is adorned with six statues 33 feet tall, two of the queen wearing the headdress of Hathor, and four of her husband.

Akhenaten and the Art of the Amarna Period

The most unusual ruler in the history of ancient Egypt was Amenhotep IV, who came to the throne in 1352 BCE (Dynasty 18). In his seventeen-year reign, he radically transformed the political, spiritual, and cultural life of the country. He founded a new religion honoring a single supreme god, the life-giving sun disk Aten, and accordingly changed his own name in 1348 BCE to Akhenaten ("One Who Is Effective on Behalf of Aten"). Abandoning dynasty and a city firmly in the grip of the priests of Amun, Akhenaten built a new capital much farther north, from the modern name for this site, Tell el-Amarna, historians refer to his reign as the Amarna period.

The king saw himself as Aten's son, and at his new capital he presided over the worship of Aten as a divine priest. His chief queen, Nefertiti, served as a divine priest-

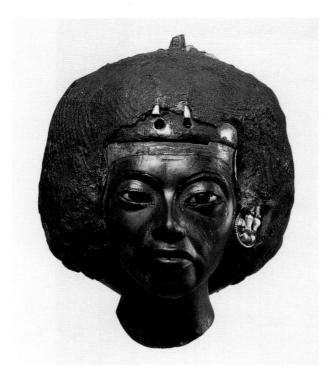

3-37. *Queen Tiy*, from Kom Medinet Ghurab (near el-Lahun). Dynasty 18, c. 1390–1352 BCE. Boxwood, ebony, glass, gold, lapis lazuli, cloth, clay, and wax, height 3³/₄" (9.4 cm). Staatliche Museen zu Berlin, Preussischer Kulturbesitz, Ägyptisches Museum

throne is adorned with the stylized symbol of a unified Egypt, which has led some historians to conclude that Nefertiti acted as co-ruler with her husband. The royal couple is receiving the blessings of Aten, whose rayhands penetrate the open pavilion and hold ankhs to their nostrils, giving them the "breath of life." Other rayhands caress the hieroglyphic inscriptions in the center. The king holds one child and lovingly pats her head. The youngest of the three perches on Nefertiti's arm and tries to attract her attention by stroking her cheek. The oldest sits on the queen's lap, tugging at her mother's hand and pointing to her father. The children are nude, and the younger two have shaved heads, a custom of the time. The oldest wears the sidelock of youth, a patch of hair left to grow and hang at one side of the head in a braid. The artist has conveyed the engaging behavior of the children and the loving concern of their parents in a way not even hinted at in earlier royal portraiture in Egypt.

Akhenaten's goals were actively supported not only by Nefertiti but also by his mother, Queen Tiy. She had been the chief wife of the king's father, Amenhotep III (Dynasty 18, ruled 1390–1352 BCE), and played a significant role in affairs of state during his reign. Queen Tiy's personality emerges from a miniature portrait head that reveals the exquisite bone structure of her powerful face, with its arched brows, uptilted eyes, and expressive mouth (fig. 3-37). This portrait contrasts sharply with a head of Nefertiti, in which her comparatively expressionless face—the heavy-lidded eyes and half smile—divulges almost nothing about her personal qualities (fig. 3-38). Part of the beauty of this portrait head is the result of the

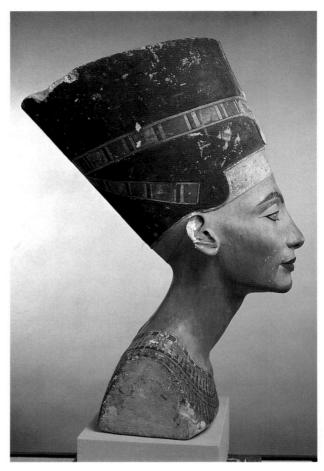

3-38. *Nefertiti*, from Akhetaten (modern Tell el-Amarna). Dynasty 18, c. 1348–1336/5 BCE. Limestone, height 20" (51 cm). Staatliche Museen zu Berlin, Preussischer Kulturbesitz, Ägyptisches Museum

This famous head was discovered along with various drawings and other items relating to commissions for the royal family in the studio of the sculptor Tuthmose at Akhetaten, the capital city during the Amarna period. Bust portraits, consisting solely of the head and shoulders, were rare in New Kingdom art. Scholars believe that Tuthmose may have made this one as a finished model to follow in sculpting or painting other images of his patron. From depictions of sculptors at work, we know that some statues were made in parts and then assembled, but there is no indication that this head was meant to be attached to a body.

artist's dramatic use of color. The hues of the blue head-dress and its colorful band are repeated in the rich red, blue, green, and gold of the jewelry. The queen's brows, eyelids, cheeks, and lips are heightened with color, as they no doubt were with cosmetics in real life. Whether or not Nefertiti's beauty is exaggerated, phrases used by her subjects when referring to her—"Fair of Face," "Mistress of Happiness," "Great of Love," "Endowed with Favors"—tend to support the artist's rendering.

The art of glassmaking flourished in the Amarna period. The craft could only be practiced by artists working for the king, and Akhenaten's new capital had its own glassmaking workshops. A fish-shaped bottle produced there was meant to hold scented oil (fig. 3-39). It is an example of what is known as **core glass**, named to indi-

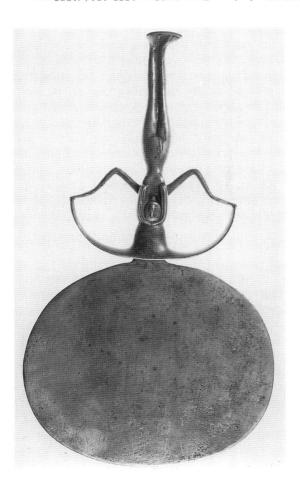

3-40. Hand mirror. Dynasty 18, c. 1552–1314/1295 Bce.. Bronze, height 93/4" (24.6 cm). The Brooklyn Museum Charles Edwin Wilbour Fund (37.365E)

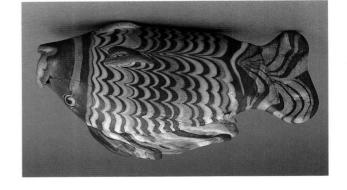

3-39. Fish-shaped vase, from Akhetaten (modern Tell el-Amarna). Dynasty 18, c. 1348–1336/5 $_{\rm BCE.}$ Core glass, length $5^{\rm l}/8^{\rm s}$ (13 cm). The British Museum, London

cate the early technique used in its manufacture (see "Glassmaking and Egyptian Faience," page 112). Its body was created first from glass tinted with cobalt, a dark blue metallic oxide. The surface was then decorated with swags resembling fish scales by heating small rods of white and orange glass to the point that they fused to the body and could be manipulated with a pointed tool. The fish that lent its shape to the bottle has been identified as a bolit, a species that carried its eggs in its mouth and spit out its offspring when they hatched. It was therefore a common symbol for birth and regeneration, especially the sort of self-generation that Akhenaten attributed to the sort of self-generation that Akhenaten attributed to the sun disk Aten.

Domestic objects routinely placed in tombs as grave goods often had similar symbolic significance. One such item is a hand mirror, less than 10 inches tall, discovered in a Dynasty 18 tomb (fig. 3-40). Its handle is formed by

mummy's legs. life, it was tucked in between the "last judgment" and win everlasting meant to help the deceased survive a fig. 3-44), a selection of magic spells furnished a Book of the Dead (see pings. If the family happened to have smaller objects among the wrapserted good luck charms and other shape. The linen winders often into produce the familiar mummy tional strips of cloth, layer after layer, shroud. They then wound it in addithen wrapped the whole body in a limbs separately with cloth strips, wonnd the trunk and each of the the body could now begin. They first The tedious ritual of wrapping stuffing them back into the body.

Egyptians developed these techniques to ensure that the ka, or life force, could live on in the body in the trait statue was provided as an altertrait statue.

gans in separate packets, either ments. They wrapped the major orsoaked in various herbs and ointby the family of the deceased and cavity with clean linen, provided a woman. They then packed the body red ocher for a man, yellow ocher for restore something of its color, using carefully dried it, they often dyed it to retrieved a body from the vat and to blacken, so once the workers had month or more. This caused the skin steep in this solution for a period of a naturally occurring salt. It was left to internal organs, in a vat of natron, a the body, together with its major sion in the left side. They then placed tied the body cavity through an incigenerally through the nose, and emppriest, workers removed the brains, balming. Under the supervision of a structure used exclusively for emwas taken to a mortuary, a special roughly as follows. The dead body

be placed in the tomb chamber or

putting them in special containers to

No actual ancient recipes for premillions of ibises. hundreds of thousands of cats and man remains, as well as mummies of stealing and destroying ancient huwas how to prevent people from second half of the nineteenth century uities Service after its founding in the cerns of the Egyptian National Antiqmedicinal value. One of the first contions, believing them to be of great and swallowed them in various soluprized pulverized mummy remains the eighteenth century, Europeans the Middle Ages and even up into tian mummies has a long history. In nation with Egyp-THE DEAD The world's fasci-PRESERVING

No actual ancient recipes for preserving the dead have been found, but the basic process seems clear enough from images found in tombs, the descriptions of later Greek writers such as Herodotus and Plutarch, scientific analysis of mummies, and modern experiments. By the time of the New Kingdom, the routine was the figure of a slender young woman, probably a dancer, balancing a giant lotus blossom on her head. Her arms reach out to support the flower's elongated sepals, forming with them a highly decorative shape. The mirror itself is a metal disk polished to a high gloss to create a reflecting surface. On one level, the young woman can be thought of as an attendant obediently holding the mirror for the person wishing to gaze in it. But she might also be interpreted as a fertility goddess supporting the sun disk. This elegant luxury item could have been placed in the tomb to symbolize the blessings of Aten and the hope that the deceased would live eternally in peace.

The Sarcophagus of Tutankhamun

Akhenaten's new religion and revolutionary ideas regarding the conduct appropriate for royalty outlived him by only a few years. His successors—it is not clear how they were related to him-had brief and troubled reigns, and the priesthood of Amun quickly regained its former power. The young king Tutankhaten (ruled 1336/35-1327 BCE) returned to traditional religious beliefs, changing his name to Tutankhamun. He also turned his back on Akhenaten's new city and moved his court to Memphis. He died quite young and was buried in the Valley of the Kings. Remarkably, although early looters did rob the tomb complex, his sealed inner tomb chamber was never plundered, and when it was opened in the 1920s its incredible riches were discovered just as they had been left. His body lay inside three nested coffins that identified him with Osiris, the god of the dead. The innermost coffin in the shape of a mummy is the richest of the three, for it is made of several hundred pounds of solid gold, with a "scrap value" of about \$1.5 million (fig. 3-41). Its surface is decorated with colored enamelwork and semiprecious gemstones, as well as very finely incised linear designs and hieroglyphic inscriptions. The king holds a crook and a flail—an implement used in threshing grain. Both symbols were closely associated with Osiris and were a traditional part of the royal regalia at the time. The king's features as reproduced on the coffin are those of a very young man. Even though they may not reflect Tutankhamun's actual appearance, the unusually full lips and thin-bridged nose hint at the continued influence of the Amarna-period style and its dedication to actual appearances.

Tomb Decoration

Living along the Nile was like living next to a major highway. Travel by boat was commonplace, an aspect of everyday life that is amply illustrated in tomb decorations. Paintings depict actual trips taken by the deceased, the ferrying upriver or down of their bodies in the course of funeral rites, and the symbolic journey into the afterlife, providing a great deal of information about Egyptian boats of this period. An especially beautiful, finely drawn example of such illustration dates from about 1348–1327 BCE (fig. 3-42). It comes from the tomb of the viceroy Amenhotep Huy at Qurnet Murai, across the Nile from

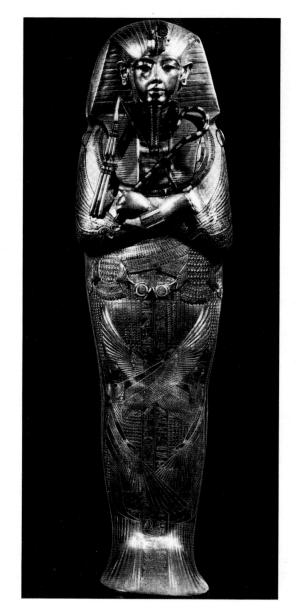

3-41. Inner coffin of Tutankhamun's sarcophagus, from the tomb of Tutankhamun, Valley of the Kings. Dynasty 18, 1336/5–1327 BCE. Gold inlaid with glass and semi-precious stones, height 6'7/8" (1.85 m). Egyptian Museum, Cairo

The English archeologist Howard Carter had worked in Egypt for more than twenty years before he undertook a last expedition, sponsored by the wealthy British amateur Egyptologist Lord Carnarvon, after World War I. In November 1922 Carter discovered the entrance to the tomb of King Tutankhamun, the only Dynasty 18 royal burial place as yet unidentified. By November his workers had cleared their way down to its antechamber, which was found to contain unbelievable treasures: jewelry, textiles, gold-covered furniture, a carved and inlaid throne, four gold chariots, and other precious objects. In February 1923, they pierced through the wall separating the anteroom from the actual burial chamber, and in early January of the following yearhaving taken great care to catalog all the intervening riches and prepare for their safe removal—they finally reached the king's astonishing sarcophagus. Figure 3-1 shows Tutankhamun's funerary mask as it was first seen in October 1925.

3-42. State Ship, detail of a tempera facsimile by Charles K. Wilkinson of a wall painting in the tomb of Governor Amenhotep Huy, Qurnet Murai. Dynasty 18, c. 1348–1327 BCE. The Metropolitan Museum of Art, New York

Rogers Fund, 1930 (30.4.19)

Thanks to the prevailing northerly winds, ships could easily sail southward up the Mile. When traveling downriver they were obliged to rely on oar power. Accordingly, the hieroglyph depicting a ship with a billowing sail came to mean "to travel south"—whether by water or on land—whereas the one showing a boat without a sail meant "to travel north." The supply, and the materials required for building large wooden vessels such as the one shown here had to be imported. Because the banks of the Mile were often choked with reeds, Egyptian boats tended to have shallow hulls without a keel. They were steered by means of a rudder in the stern. A large vessel required a captain, a pilot, and a large crew to tend the oars and sails.

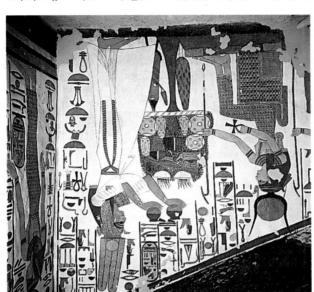

3-43. Queen Nefertari Making an Offering to Isis, wall painting in the tomb of Nefertari, Valley of the Queens, near Deir el-Bahri. Dynasty 19, c. 1279–1212 BCE

Thebes. Huy served as governor of Nubia, and here his official sailing ship is shown ready to set off in a southerly direction, perhaps to take him to Nubia. His horses are in their stalls, the rowers are in place, and the crew stands ready to trim the sails as soon as the navigator has tested the depth of the water and the captain has given the signal to depart.

The artists responsible for decorating the private tomb of Mefertari, the wife of Ramessees II, in the Valley of the Queens near Deir el-Bahri worked in a new style diverging very subtly but distinctively from earlier conventions. In one of the tomb's many beautiful, large-figured scenes, Mefertari offers jars of perfumed ointment to the goddess Isis (fig. 3-43). The queen wears the vulture-skin headdress of royalty, a royal collar, and a long, transparent white gown. Isis, seated on her throne behind a table heaped with offerings, holds a long scepter in her left hand, the ankh in her right. She too behind a table headdress, but hers is surmounted by the horns of Hathor framing a sun disk, clear indications of her divinity. The outline drawing and use of clear of ther divinity. The outline drawing and use of clear of her divinity. The outline drawing and use of clear

OF

RESTORING The tomb of Queen THE TOMB Nefertari, wife of Ramesses II, was discov-NEFERTARI ered in the Valley of the Queens, near

Deir el-Bahri, in 1904. Although it had been looted of everything that could be carried away, it still contained splendid large-figure wall paintings of the deceased queen in the company of the gods (see fig. 3-43).

Thanks to Egypt's dry climate and the care with which most tombs were sealed, many such paintings remained in excellent condition for thousands of years. Strangely, the ones in Nefertari's tomb had begun to deteriorate soon after they were completed. Conservators have theorized that the walls were left quite damp when priests sealed the tomb, so that salts from the plaster leached to the surface. Over time, this tended to loosen the layer of pigment, causing it to flake. The dampness also allowed various funguses to attack the paint. The process of disintegration accelerated dramatically when the tomb was opened to the public. Its many visitors raised the humidity level and introduced dirt and bacteria from outside. The resulting damage was so great by 1940 that the tomb was closed to the public.

In 1968 the Egyptian National Antiquities Service and the Getty

Conservation Institute in Santa Monica, California, undertook a multimillion-dollar conservation project to save the tomb's decorations. The painting restorers Paolo and Laura Mora were commissioned to supervise the work, which was carried out by a team of Italian and Egyptian conservators. Their first priority was to stop the paint from flaking and the plaster from crumbling any further. Over the course of a year, their crew applied over 10,000 "bandages" made of Japanese mulberry-pulp paper to the tomb's interior surfaces.

Once the paint and plaster had been stabilized, the restorers could begin their real work. Their goal was to salvage every flake of paint they could from these works created more than 3,000 years earlier. They carefully cleaned the paintings with cotton swabs dipped in distilled water. Using hypodermic needles and a special resin glue, they were able to reattach small spots of loose plaster or pigment. Larger detached areas were removed whole, cleaned, then glued back in place. In the past, it was common practice for conservators to re-create sections that had been wholly lost with conjectural painting of their own, but according to current thinking within the profession it is preferable to simply make such gaps less obvious by shading

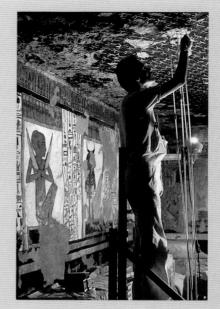

Getty Conservation Institute conservator S. Rickerby at work in Chamber K, Tomb of Nefertari. Valley of the Queens, near Deir el-Bahri Photo courtesy Getty Conservation Institute

them in tones matched to adjacent work. This was the procedure in Nefertari's tomb.

Thanks to the extremely painstaking labor of professional restorers like these, many such ancient treasures have been rescued for the instruction and delight of future generations.

colors reflect traditional practices, but quite new is the slight modeling of the body forms by small changes of hue to increase their appearance of solidity. The skin color of these women is much darker than that conventionally used for females in earlier periods, and lightly brushed-in shading makes their eyes and lips stand out more than before (see "Restoring the Tomb of Nefertari," above). The tomb's artists used particular care in placing the hieroglyphic inscriptions around these figures, creating an unusually harmonious overall design.

Books of the Dead

By the time of the New Kingdom, the Egyptians had come to believe that only a person free from sin could enjoy an afterlife. The dead were thought to undergo a "last judgment" consisting of two tests presided over by Osiris and supervised by Anubis, the overseer of funerals and cemeteries, represented as a man with a jackal's head. The deceased were first questioned by a delegation of deities about their behavior in life. Then their hearts, which the

Egyptians believed to be the seat of the soul, were weighed on a scale against an ostrich feather, the symbol of Maat, goddess of truth.

These beliefs gave rise to one specific funerary practice especially popular among the nonroyal classes. Family members would commission papyrus scrolls containing magical texts or spells to help the dead survive the tests, and they had the embalmers place the scrolls among the wrappings of their loved ones' mummified bodies. Early collectors of Egyptian artifacts referred to such scrolls, often beautifully illustrated, as Books of the Dead. They varied considerably in content. A scene from a Dynasty 19 example, created for a man named Hunefer, shows him at three successive stages in his induction into the afterlife (fig. 3-44). At the left, Anubis leads him by the hand to the spot where he will weigh his heart, contained in a tiny jar, against the "feather of Truth." Maat herself appears atop the balancing arm of the scales wearing the feather as a headdress. A monster—part crocodile, part lion, and part hippopotamus—watches eagerly for a sign from the ibis-headed

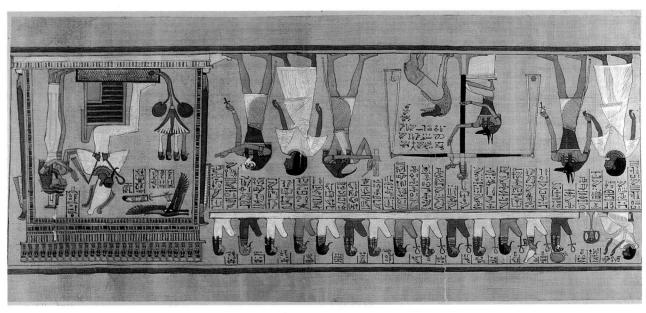

3-44. Judgment before Osiris, illustration from a Book of the Dead. Dynasty 19, c. 1285 BCE. Painted papyrus, height 155/8" (39.8 cm). The British Museum, London

Ositris, the god of the underworld, appears on the right, enthroned in a richly ornamented pavilion, or chapel, in the "Hall of the Two Truths." Here the souls of the deceased were thought to be subjected to a "last judgment" to determine whether they were worthy of eternal life. Osiris was traditionally depicted as a mummified man wrapped in a white linen shroud. His other trappings are those of an Egyptian king. He wears the double crown, incorporating those of both Opper and Lower Egypt, a false beard, and a wide beaded collar, and he brandishes the symbolic crook and flail in front of his chear. The figure in the center combining a man's body with the head of an ibis, a wading bird related to the of his chear. The figure in the renter combining a man's body with the head of an ibis, a wading bird related to the invertor of hieroglyphic writing.

the "Eater" and live on eternally in the company of the gods. But they also doubtless heeded the advice given in "The Harper's Song," a poem inscribed on a wall in the tomb of the Dynasty 14 king Inyotef VII at Dra Abu el-Naga (cited in Strouhal, page 266):

None comes from there

To tell of their state

To calm our hearts

Until we go where they have gone.

Hence rejoice in your heart

Make holiday, do not weary of it.

No one has come from there to tell us how the ancient Egyptians fared after death, but the art they produced has assured them of immortality. Their continuing creativity over many long centuries was acknowledged and admired by contemporary peoples—as it was by their eventual conquerors.

god Thoth, who prepares to record the result of the weighing. This creature is Ammit, the dreaded "Eater of the Dead."

But the "Eater" is left to go hungry. Hunefer passes the test, and on the right Horus presents him to Osiris. The god of the underworld sits on a throne floating on a lake of natron, the substance used to preserve the flesh of the deceased from decay (see "Preserving the Dead," page 121). The four sons of Horus, each of whom was entrusted with the care of one of the deceased's vital the lake. The goddesses Nephthys and Isis stand behind the lake. The goddesses Nephthys and Isis stand behind gesture similar to the one seen in the Old Kingdom sculpture of Menkaure and his queen (see fig. 3–15). In the top ture of Menkaure and his queen (see fig. 3–15). In the top register, Hunefer makes his appearance in the afterlife, kneeling before the nine gods of Heliopolis—the sacred city of the sun god Ra—and five personifications of life-city of the sun god Ra—and five personifications of life-

Life was short in ancient times. Few people could expect to live beyond their twenties. All hoped to escape

sustaining principles.

Cycladic figure c. 2500–2200

- ▲ MINOAN 3000-1400 ▲ CYCLADIC 3000-1600

egean Art

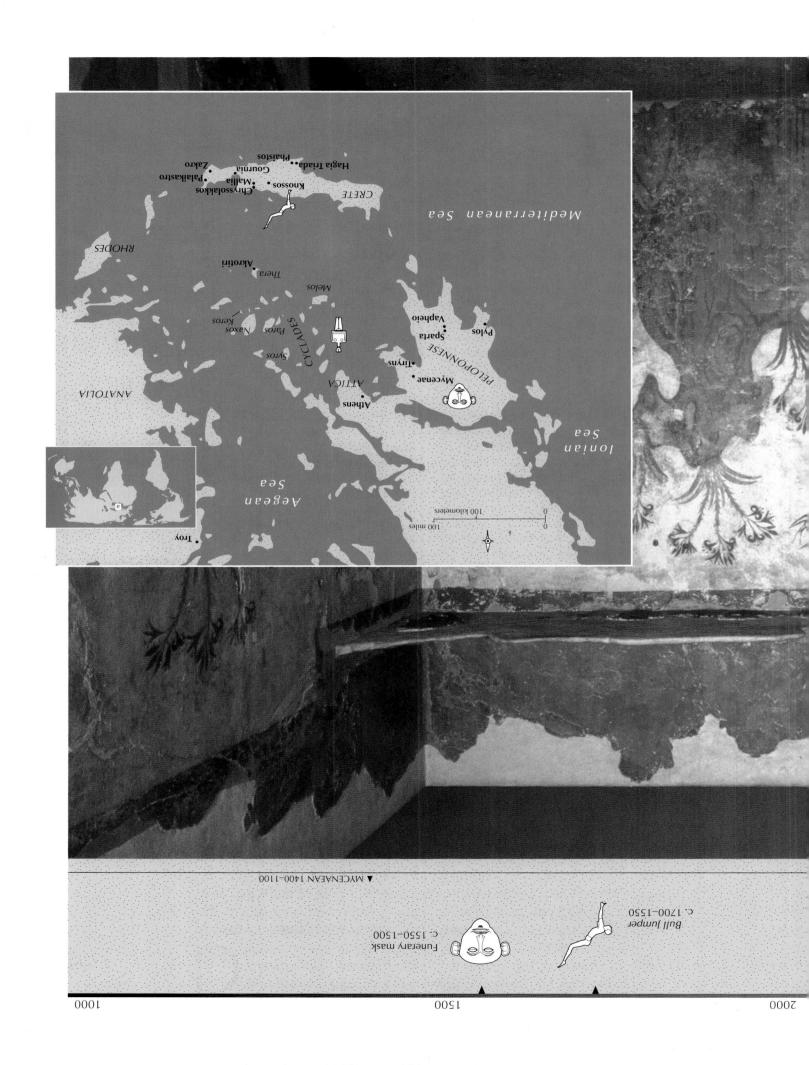

own through the ages, philosophers and visionaries from Plato to the Beatles have dreamed of utopian kingdoms under the sea where untold wealth could be found. The undersea realm the Beatles explored in Yellow Submarine was clearly fictional, but the "lost island of Atlantis" described by Plato in his Timaeus and Critias may have had some basis in fact. There is evidence that it may have been the island of Thera, in the Cyclades. Until it erupted in about 1623 BCE, the nearly 5,000-foot-tall volcano that dominated the island must have looked much like Japan's Mount Fuji, a majestic presence whose lower slopes were home to many people. When the volcano came to life, people had time to escape with what they could carry, but then the entire peak blew apart and the greater part of the island, like the fabled Atlantis, disappeared into the sea. All that remained was a crescent of jagged cliffs, fragments of what had been the mountain's base, some 13 miles in diameter. One of these fragments is the island in the Cyclades known also as Thira, where extensive excavations of the ancient site at Akrotiri have been carried out since 1967. And treasures have indeed been found. Under a layer of ash as much as 15 feet deep, well-preserved wall paintings and artifacts have been discovered that open a window on ancient Aegean culture during one of its richest periods.

AEGEAN WORLD

THE From about 5,000 to 3,000 years ago, the early European civilizations known as Aegean flourished on mainland Greece and on the islands offshore in the Aegean Sea, including the large

southern island of Crete and a cluster of smaller ones called the Cyclades. Scholars of these cultures have long studied their ruined palaces, fortresses, and tombs. In recent years the collaboration of archeologists and art historians, working with researchers in such fields as the history of trade and climate change, is providing a much clearer picture of Aegean society in which to place Aegean architecture, sculpture, metalwork, ceramics, and wall paintings.

Although the Aegean peoples were primarily farmers and herders, their lives were greatly influenced by their proximity to the sea. The sea provided their dry, rocky homelands with a defense against invaders, but because they were skillful seafarers, it also provided them a convenient link between the mainland and the islands, as well as the world beyond. Their contacts with Egypt and the civilizations of the Near East were especially important.

From about 3000 to 1000 BCE, one of the hallmarks of Aegean society was the use of bronze, an alloy that was superior to pure copper for making weapons and tools. Using metal ores from Europe, Arabia, and Anatolia, Aegean peoples created metalwares that became prized exports. The sudden technological shift to bronze, presumably as a result of contact with other cultures, occurred at the end of the Aegean Neolithic period and spurred a new consolidation of political and economic power in the Aegean Bronze Age.

Beginning in the third millennium BCE, palace com-

plexes, perhaps patterned after Near Eastern and Egyptian administrative centers, began to play a key role in the development of Aegean civilization. They appear to have functioned as religious, political, and economic hubs for Aegean society. A number of palace sites have been excavated, providing a wealth of art and information. However, a great many questions about that society remain unanswered, partly because only one of the three main Aegean writing systems has been deciphered.

What little is known about Aegean civilization from studying its art suggests that the region's religion was probably epiphanic-that is, during rituals gods and goddesses were believed to appear to their worshipers, often in the guise of human stand-ins. The chief deities seem to have been goddesses who controlled various aspects of the natural world and therefore had much in common with goddesses in other early cultures. These Aegean deities may also have been the ancestors of the later Greek goddesses Demeter, Artemis, and Athena. Female images are the most common form of religious art found in Aegean graves, hilltop sacred sites, and palace shrines and may represent goddesses, priestesses, or female worshipers.

Probably the thorniest problem in Aegean archeology is that of dating (see "The Date Debate," opposite). Archeologists have developed a chronological system for the Aegean Bronze Age, but dating specific sites and objects continues to be difficult and controversial. You may therefore encounter dates different from those given here and should expect dating to change in the future.

Our study of Aegean art focuses on three cultures: early Cycladic (on the islands of the Cyclades), Minoan (on Crete), and Mycenaean (in mainland Greece). It begins about 3000 BCE and ends about 1100 BCE.

Just beginning. ing partners, particularly Egypt, is Aegean civilizations and their tradhow to realign the chronologies for serious disarray, and the debate over

works from the island of Thera therecut-off dates of 2000 and 1100. Artbetween the more-or-less absolute objects may be relative to each other the dates given indicate only how old work in their familiar positions. Thus have been placed within this framefor Helladic art, then the artworks and Late Minoan stylistic periods and here been assigned for the Middle beginning and ending dates have be valid. For that reason, best-guess gories on which it is based must still interrelationships and stylistic catewas called into question, many of the when the date of the Thera eruption lost its chronological underpinnings region. Although this system also lished long ago for the Aegean chronology system of dating estabof us must fall back on the relative experts ponder the evidence, the rest results of the debate are in. While dates cannot be assigned until the illustrated in this chapter? Specific of Minoan and Mycenaean artworks How has this affected the dating

fore have simply been dated "before

material, though some dates can method for dating Aegean organic dating is increasingly useful as a nology. Radiocarbon, or carbon-14, toward arriving at an absolute chrochronology's periods, with a view able to assign dates to the relative scholars are now beginning to be goods in datable foreign contextsgean sites or undated Aegean trade foreign trade goods at undated Aereferencing of lucky finds—datable nium. By the careful cross-cultural Egypt going back to the third millenhave survived from the Near East and Fortunately, historical records

oughly devastated Minoan civiliza-Cycladic island of Thera had thorlute chronologies for the Aegean, work establishing relative and abso-After decades of painstaking two or three centuries.

only be determined within a span of

south, about 1450 BCE. tion on Crete, only 60 miles to the a huge volcanic explosion on the archeologists generally agreed that

Minoan and Mycenaean dating in in the 1620s. This finding leaves puts the date of the Thera eruption ash in ice cores from Greenlandand California and traces of volcanic ed growth in tree rings from Ireland New evidence—namely, stunt-

the Minoan) and refined it over the correspond more or less to those of ladic period, Greece's Bronze Age, mainland (the divisions of the Helthis system to the Cyclades and the noan. Later archeologists extended Minoan, Middle Minoan, and Late Mian culture into three periods: Early framework for Crete, dividing Minosos to devise a similar chronological different excavation levels at Knos-Arthur Evans used ceramic finds from Old, Middle, and New Kingdoms, Sir the division of Egyptian history into

A thriving late Neolithic and early

YCE IN THE **ISLANDS** CYCLADIC THE

years. Still, it remains inexact.

them absolute dates. Influenced by

tion to each other but cannot assign

indicates how old objects are in rela-

an Bronze Age. A relative chronology

a relative chronology for the Aege-

changes in pottery styles to construct

ten records, archeologists have used

methods are very close to pinning

but scholars using a combination of

soon to tell if the debate is truly over,

pened when in the Aegean. It is too

ing established ideas of what hap-

excavated. New evidence is challeng-

objects almost since they were first

THE DATE Considerable contro-

the dating of Aegean

versy has arisen over

down the key dates.

DEBATE

Because of the absence of writ-

them, as is the case with other Neolithic cultures. From their art is one of our main sources of information about and their origins remain obscure, cause they left no written records and hillside burial chambers. Be-**BKONZE** local stone to build fortified towns ufacturing, and trade. They used gaged in agriculture, herding, man-Cycladic Islands, where people en-Bronze Age culture existed on the

intended to be blackened by a cooking fire (fig. 4-1). A Syros, dated 2500-2200 BCE, indicates that it was never ers. The elaborate decoration on one side of a pan from to have been used as display objects as well as containeither painted or incised before firing. The vessels seem namented these "frying pans" with stylized designs, terra-cotta, an orange-brown, low-fired clay. They orters were vessels resembling large frying pans made of Among the more unusual products of Cycladic pot-

and animals, as well as domestic and ceremonial wares. crude but often engaging ceramic figurines of humans 3,000 years later, they continued to produce relatively poor-quality local clay to make a variety of objects. Some about 6000 BCE on, Cycladic artists had used a coarse,

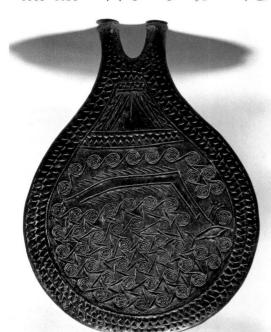

1630-1500 BCE."

National Archeological Museum, Athens Terra-cotta, diameter 11" (28 cm), depth 23/8" (6 cm). 4-1. "Frying pan," from Syros, Cyclades. c. 2500-2200 BCE.

PARALLELS

Years	<u>Culture</u>	Aegean	World
с. 3000-1600 все	Cycladic	"Frying pans"; marble figures; landscape painting; destruction of Thera	c. 3000–2000 BCE Potter's wheel (China); Great Pyramids at Giza (Egypt); ziggurats (Sumer); Stonehenge (England)
с. 3000–1400 все	Minoan	Bronze tools and weapons; written scripts; Knossos and other palace complexes; Woman or Goddess with Snakes; Bull Jumper; gold jewelry; potter's wheel; Kamares Ware	c. 2000–1100 BCE Gilgamesh epic (Sumer); widespread use of bronze tools (Thailand, China, northern Europe); Shang dynasty (China); Stela of Hammurabi (Babylo- nia); Lion Gate (Turkey); Olmec civi- lization (Mesoamerica)
с. 1400-1100 все	Mycenaean	Citadel at Mycenae; beehive tombs; "Treasury of Atreus"; shaft-grave treasures; Warrior Vase	

wide, geometric border encircles a scene showing a boat on a sea of waves depicted as linked spirals. With its curved hull and long banks of oars, the boat resembles those seen in Neolithic Egyptian art from Hierakonpolis (see fig. 3-3). The large fish to the left is probably a carved prow ornament. In the small area set off in the "handle," the artist incised a triangular symbol for the female pubic area, perhaps an indication that these objects were symbolic representations of the uterus and female genitalia. The pans may therefore have had some magical association with pregnancy and childbirth, as well as death, for they are most often found at gravesites.

The Cyclades, especially the islands of Naxos and Paros, had ample supplies of a fine and durable white marble that became the medium of choice for sculptors. Out of it they created a unique type of nude figure ranging in size from a few inches to about 5 feet tall. To shape the stone, these sculptors used scrapers and chisels made of obsidian from the island of Melos and polishing stones of emery, or corundum, from Naxos. The introduction of metal tools may have made it possible for them to carve on a larger scale, but since the stone fractured easily, they continued to limit themselves to simplified sculptural forms.

A few male figurines have been found, including depictions of musicians and acrobats, but they are greatly outnumbered by representations of women. The earliest female figures had simple, violinlike shapes. From these, a more familiar type evolved that has become the best-known type of Cycladic art (fig. 4-2). Compared with

4-2. Two figures of women, from the Cyclades. c. 2500–2200 BCE. Marble, heights 13" (33 cm) and 25" (63.4 cm). Museum of Cycladic Art, Athens Courtesy of the N. P. Goulandris Foundation

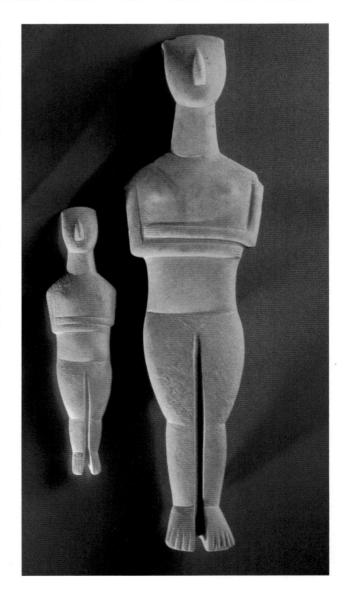

cerned with life in the present. Aegean culture, unlike that of Egypt, was primarily conan afterlife. From the evidence, however, it seems that contents of Aegean burial sites could point to a belief in sentations of the supernatural or as votive figures. The were set up for communal worship, whether as reprethis theory, the larger statues were not grave goods but bolically broken as part of the funeral ritual. According to and then buried with their owners, often after being symused by some of the population for worship in the home meaning are unclear, one interpretation is that they were ly in and around graves. Although their specific use and The smaller Cycladic figures have been found main-

Legend of the Minotaur," page 132). from the palace at Knossos (see "The that told of Minos, a king who ruled comes from a much later legend being on the island of Crete. Its name ture now called Minoan came into Around 3000 BCE, a distinctive cul-

NOITAX CIAIFI-**NAONIM AND THE**

CRETE

berhaps beyond. mainland Greece, Egypt, the Near East, Anatolia, and harbors to become a wealthy sea power, trading with took advantage of its strategic location and many safe bronze production, it was forced to look outward. Crete cattle and sheep. Because it lacked the ores necessary for producing its own grains, olives and other fruits, and and 36 miles wide. It was economically self-sufficient, Crete is the largest of the Aegean islands, 150 miles long

of Minoan culture. inventories, offering no information about many aspects proven to be only administrative records and temple form of Greek imported from the mainland-have viving documents in a later script, Linear B—a very early and Linear A, continue to defy translation, and the surtwo earliest forms of Cretan writing, called hieroglyphic served, very little is known about Minoan daily life. The number of written records from the period are preand remained powerful until about 1450 BCE. Although a Minoan civilization reached its peak about 1600 BCE

as scale and layout and the depiction of goddesses or ison. It has many similarities to Cretan palaces, such 2, especially fig. 2-19) provides an instructive compar-The Near Eastern palace of Zimrilim at Mari (see Chapter Egyptian institutions, but the evidence is contradictory. distinctively Minoan adaptations of Near Eastern or complexes, kingship, and priestess-run goddess cults are these centers. It has been speculated that the palace have overseen the all-important goddess worship in placed greater emphasis on the priestesses who seem to have played in palace society. Recent scholars have countryside. Little is known about the role kings might midable watchtowers and stone walls extending into the but it is now known that they were safeguarded by forcomplexes were long thought to have been unfortified, and religious centers. Scattered across the island, these which were simultaneously administrative, commercial, roughly 1900 to 1300 BCE were great palace complexes, The dominant architectural structures on Crete from

Museum, Athens Marble, height 81/2" (21.6 cm). National Archeological 4-3. Harp Player, from Keros, Cyclades. c. 2500–2200 BCE.

blue, which would have made them seem less austere. ed facial features, hair, and ornaments in black, red, and now starkly white, but they probably originally had paintis marked with a lightly incised triangle. These statues are hips, knees, and ankles are indicated, and the pubic area a minimum; the body's natural articulation lines at the corpselike, not stand. Anatomical detail has been kept to that the figures were intended to lie on their backs, back heads, folded arms, and down-pointed toes indicate marble slabs out of which they were carved. Their tiltedstatuettes shown here seem not far removed from the figure's essence. With their simple contours, the temale modern eyes like pared-down, elegant renderings of the Cycladic marbles from roughly 2500 BCE appear to many Egyptian statues from the same time (see fig. 3-13),

strings with the other. So expressive is the pose that we ing the instrument with one hand while plucking its knees and feet apart for stability, and arms raised, bracchair with a splayed base, head tilted back as if singing, ize an actual musician. The harpist sits on a high-backed careful attention to those elements that best characterure has been reduced to its geometric essentials, yet with and the solid forms, which balance each other. The figgave equal attention to the negative, or empty, spaces simplified as that of the female figurines. The sculptor ture in the round (fig. 4-3), yet its body shape is just as The Harp Player from Keros is fully developed sculp-

can almost hear the song.

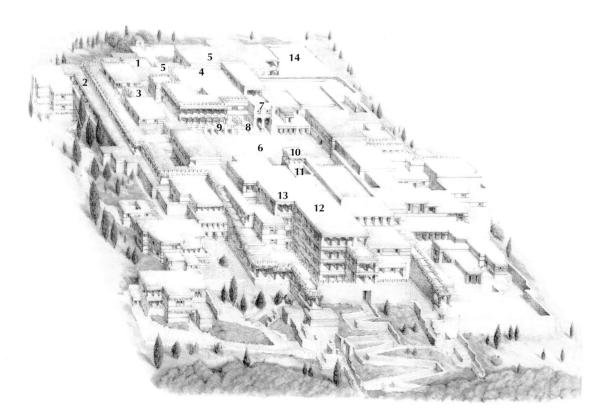

4-4. Bird's-eye reconstruction drawing of the palace complex, Knossos, Crete. c. 1700-1300 BCE Key: 1. west porch; 2. main corridor; 3. main stairs; 4. north-south corridor; 5. warehouse storage; 6. central courtyard; 7. so-called Throne Room (actually a ritual space); 8. west staircase and stepped porch; 9. main shrine; 10. grand staircase; 11. light well; 12. Hall of the Double Axes (main reception hall); 13. so-called Queen's Quarters; 14. outdoor performance area

priestesses in wall paintings. However, Minoan architecture is less massive and more open, and its palace art does not celebrate kings.

The walls of early Minoan palaces were made of rubble and mud bricks faced with cut and finished limestone. This was the first use of dressed stone as a building material in the Aegean. Columns and other interior elements were made of wood. In both the palaces and their surrounding towns, timber appears to have been used for framing and bracing walls so that its strength and flexibility would minimize damage from earthquakes. Nevertheless, a major earthquake in about 1750 BCE damaged

THE LEGEND According to Greek OF THE MINOTAUR

legend, the Minotaur was a monster. half man and half

bull. He was the son of Pasiphae, the wife of King Minos of Crete, and a bull belonging to the sea god Poseidon. The monster lived in the so-called Labyrinth, a maze constructed by the king's court artist and architect, Daedalus. To satisfy the Minotaur's appetite for human flesh and to keep him tranquil, King Minos ordered the city of Athens, which he ruled, to pay him a yearly tribute tax of fourteen young men and women. Theseus, the son of King Aegeus of Athens, vowed to free his people from this grisly burden by slaving the monster.

He set out for Crete with the

doomed young Athenians, promising his father that on his return voyage he would replace his ship's black sails with white ones as a signal of victory. In the manner of ancient heroes, Theseus won the heart of the Cretan princess Ariadne, who gave him a sword with which to kill the Minotaur and a spindle of thread to mark the path he took into the Labyrinth. Theseus defeated the Minotaur, followed his trail of thread back out of the maze, and sailed off to Athens with Ariadne and the relieved Athenians. Along the way, his ship put into port on the island of Naxos, where Theseus had a change of heart and left Ariadne behind as she lay sleeping. In his haste to return home, he "forgot" to raise the white sails.

When Aegeus saw the black-sailed ship approaching, he drowned himself in the sea that now bears his name. Theseus thus became king of Athens.

Such psychologically complex myths have long inspired European artists. In William Shakespeare's A Midsummer Night's Dream, the playwithin-the-play celebrates the marriage of Theseus to the Amazon queen Hippolyta. The plight of Theseus's abandoned lover Ariadnewho finds comfort in the arms of the Greek god Dionysos—is the subplot of an opera by Richard Strauss. In our own time, Pablo Picasso used the Minotaur as a symbol of the Spanish dictator Francisco Franco and the horrors of the Spanish Civil War.

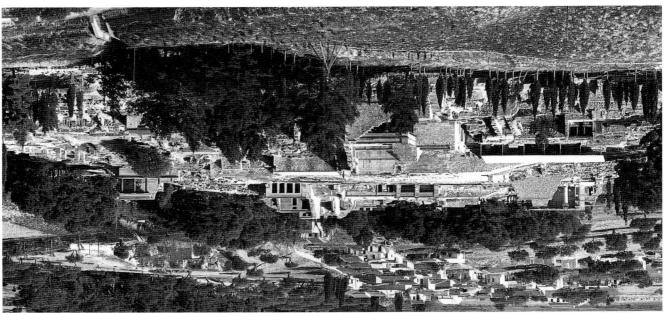

4-5. Palace complex, Knossos, Crete

The town at the foot of the palace had paved streets, comfortable houses, and an advanced water supply and drainage system. "Mansions" dotted the Cretan countryside outside such towns.

The Palace Complex at Knossos

In typical Cretan fashion, the religious, residential, complicated, the word labyrinth came to mean a maze. Because the layout of the complex was so dauntingly tion (see fig. 4-12 for a three-dimensional example). double-ax motifs were used in it as architectural decoraof the Double Axes (Greek labrys, "double ax"), because sos palace was called the Labyrinth, meaning the House six acres (figs. 4-4, 4-5). In later Greek legend the Knosabout 1700 BCE. In its heyday, the palace complex covered core of an elaborate new one built after an earthquake in these "old palaces," erected about 1900 BCE, formed the with a succession of Bronze Age palaces. The last of been occupied in the Neolithic period, then built over "Pioneers of Aegean Archeology," page 143). The site had ing and reconstructing the buildings he had found (see coast, in 1900 ce. Evans spent the rest of his life excavattraordinary palace complex at Knossos, on Crete's north Sir Arthur Evans discovered the buried ruins of the ex-Minoan civilization remained very much a mystery until

In typical Cretan tashion, the religious, residential, manufacturing, and warehouse spaces of the new palace were organized around a large, central courtyard. There were entrances at the four corners, but the main ceremonial approach seems to have been from the southwest. The route to the center of the complex from any of these entrances involved a number of turns. From the central courtyard, a few steps led down into the (misnamed) Throne Room to the west, and a grand staircase named) Throne Room to the west, and a grand staircase on the east side descended to the Hall of the Double

several palaces, including the best known of them at Knossos and Phaistos. The structures were then repaired, and enlarged. The resulting "new palaces"—multistoried, flat-roofed, and with many columns—shared a number of features. They were designed to maximize light, air, and adaptability, as well as to define access and circulation patterns. Daylight and fresh air entered through stagegon patterns. Daylight and fresh air entered through stagegered levels, open stairwells, and strategically placed air shafts and light wells.

found in a single storeroom enough ceramic jars to hold stuffs became apparent when excavators at Knossos The huge scale of their centralized management of foodpits in their floors were designed for the storage of grain. with enormous clay jars for oil and wine, and stone-lined mercial centers, for their storeroom walls were lined tion was officially controlled. Palaces were clearly comand around the complexes suggest that artistic producwas laid beneath the palace. Clusters of workshops in ing systems: at Knossos, a network of terra-cotta pipes colored murals, and extraordinarily sophisticated plumbquarters had many attractions: sunlit courtyards, richly stone, wood, or beaten earth. The palaces' residential Floors were either of plaster, plaster mixed with pebbles, plaster, and some of them were painted with murals. storerooms, and baths. Walls were generally coated with rooms and apartments, administrative and ritual areas, dors and staircases led to other courtyards, private cious rectangular courtyard from which a maze of corri-The focus of the complex was inward, toward a spa-

20,000 gallons of olive oil.

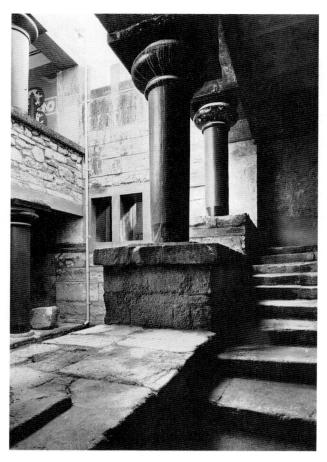

4-6. Court with staircase reconstructed by Sir Arthur Evans, leading to the southeast residential quarter, palace complex, Knossos, Crete

The hundreds of tapered, cushion-capitaled columns of the palace were made of wood, most painted a bright red, and only fragments of them survive. Sir Arthur Evans's restorers installed concrete replicas of columns, capitals, and lintels based on ceramic house models and paintings from the Minoan period. Today's archeologists might not attempt such wholesale reconstruction without absolutely authentic documentation, and they would make certain that reconstructed elements could never be mistaken for the originals.

Axes, an unusually grand example of a Minoan hall. This hall and others were supported by the uniquely Minoan type of wood columns that became standard in Aegean palace architecture. The tree trunks from which they were made were inverted so that they tapered toward the bottom. Thus, the top, supporting massive roof beams, was wider than the bottom (fig. 4-6). There is some evidence to suggest that Minoan builders were eventually unable to replace columns damaged by earthquakes or burned by invaders because they had already stripped the island of large trees, and this deforestation may have been one of the reasons why the palace-complex structure was finally abandoned.

Sculpture

Surviving Minoan sculpture consists mainly of small, finely executed works, largely on religious subjects, in

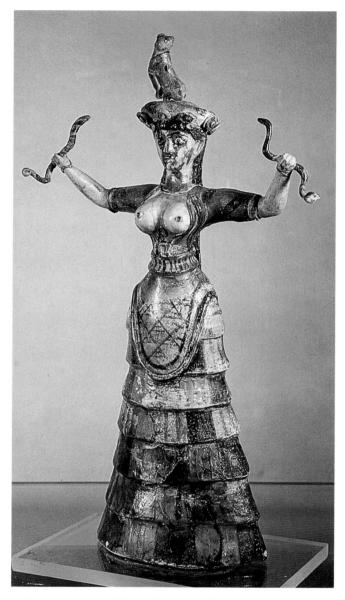

4-7. Woman or Goddess with Snakes, from the palace complex, Knossos, Crete. c. 1700–1550 BCE. Faience, height 11⁵/8" (29.5 cm). Archeological Museum, Iraklion, Crete

wood, ivory, precious metals, stone, and **faience**. The *Woman or Goddess with Snakes* from the palace at Knossos is intriguing both as a ritual object and as a work of art (fig. 4-7). Female figurines incorporating serpents were fashioned on Crete as far back as 6000 BCE and may have been associated—as they were elsewhere—with water, regenerative power, and protection of the home. Some early Minoan Bronze Age examples have tall, flaring headdresses with circles on the front and a writhing mass of intertwining snakes on the back.

The nearly foot-tall faience figurine from Knossos was found with other ceremonial objects in a pit in one of the palace's temple storerooms. Bare-breasted, arms extended, and brandishing a snake in each hand, the woman is a commanding presence. A wild cat is perched on her crown, which is ornamented with circles resembling those on the headdresses of earlier such statues. This shapely figure is dressed in a fitted, open bodice with

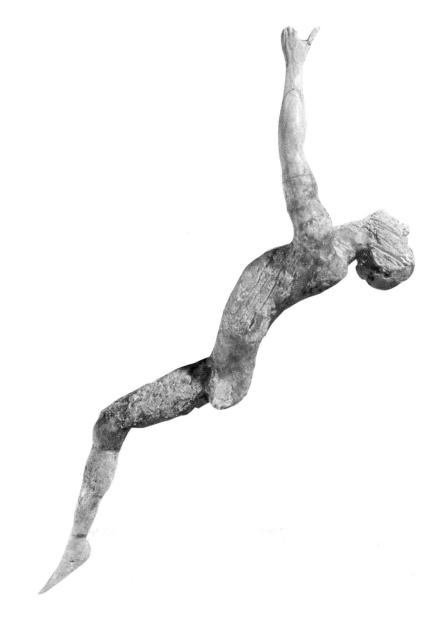

4-8. Bull Jumper (?), from the palace complex, Knossos, Crete. c. 1700-1550 BCE. Ivory with gilt bronze wire, length $11^5/8$ " (29.5 cm). Archeological Museum, Iraklion, Crete

toric cave paintings at Altamira and Lascaux (Chapter I), yet neither their images nor later myths offer any proof that the Minoans worshiped a bull god. According to later Greek legend, King Minos kept the bull-man called the Minotaur captive in his palace, but the creature was not an object of religious veneration (see "The Legend of the Minotaur," page 132). In addition to serving as livestock, bulls were apparently sacrificed by the Minoans on outdoor altars and figured in a rite called bull jumping. Paintings and sculpture show that both women and men, perhaps trained acrobats, took part in this dangerous contest, but its significance remains a mystery.

An ivory figurine of a nude leaping youth (fig. 4-8) was probably originally suspended above one of the Ceramic bulls found with it in the palace at Knossos. Despite its deteriorated state, this lithe figure captures the energy of athleticism as it vaults through space. Later the cenergy of athleticism as it vaults through space. Later of Greek culture glorified its athletes, and figures like this

an apron over a typically Minoan long, tiered skirt. A wide belt cinches the waist. The red, blue, and green geometric patterning on her clothing looks rather like snakeskin. In other pieces of this type, snakes sometimes wind around the woman's waist and arms.

Realistic elements and formal, stylized ones are so skillfully combined in this figure and others of its kind that they have both liveliness and power. In part because of this blending of elements, there is disagreement over whether these statues represent deities or their human attendants. These figures share certain stylistic and theman matic features with Mear Eastern sculpture, but both the style and the subject can be traced back to older Cretan examples as well.

A number of early cultures associated their gods and god-rulers with powerful animals, especially the lion and the bull. Depictions of bulls appear quite often in Minoan art, rendered with an intensity not seen since the prehis-

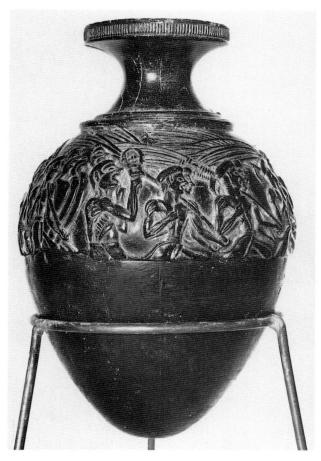

4-9. *Harvester Vase*, from Hagia Triada, Crete. c. 1650–1450 BCE. Steatite, diameter 4¹/₂" (11.3 cm). Archeological Museum, Iraklion, Crete

one may mark the beginning of the practice. The artistry of the ivory figurine is remarkable: its tiny fingernails, the raised veins on the backs of its hands, and its wavy hair are all painstakingly rendered—the latter with gilt, or gold-covered, wire.

Minoan sculptors also excelled in working in decorative stone. One of the treasures of Cretan art is the Harvester Vase, an egg-shaped rhyton—a vessel used for pouring liquids during sacred ceremonies—barely 41/2 inches in diameter (fig. 4-9). Made of steatite, or soapstone, it was probably originally covered with gold leaf, or sheets of hammered gold (see "Aegean Metalwork," opposite). A rowdy procession of twenty-seven men has been crowded onto its curving surface. The piece is exceptional for the freedom with which the figures occupy three-dimensional space, overlapping and jostling one another instead of marching in orderly single file across the surface in the manner of Near Eastern or Egyptian art. Also new is the exuberance of this scene, especially the emotions shown on the harvesters' faces. The merrymakers march and chant to the beat of a sistrum—a rattlelike percussion instrument—played by a man who sings at the top of his voice. The uneven arrangement of elements reinforces the boisterousness of the scene. The men have large, coarse features and sinewy bodies so thin that their ribs stick out. Perhaps they have suffered a lean time, which gives them all the more reason to celebrate a good harvest.

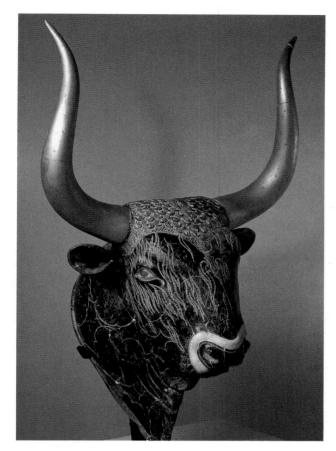

4-10. Bull's-head rhyton, from the palace complex, Knossos, Crete. c. 1550–1450 BCE. Steatite with shell, rock crystal, and red jasper, the gilt-wood horns restored, height 12" (30.5 cm). Archeological Museum, Iraklion, Crete

Rhytons were often given the form of a bull's head. The sculptor of one of this type found in a residence near the palace at Knossos used a block of greenish black steatite to create an image that approaches animal portraiture in its decorative detailing (fig. 4-10). Lightly engraved lines, filled with white powder to make them stand out, show the animal's coat: short, curly hair on top of the head, longer shaggy strands on the sides, and circular patterns to suggest its dappled coloring. White bands of shell outline the nostrils, and painted rock crystal and red jasper form the eyes. The horns, now restored, were made of wood covered with gold leaf. Bull'shead rhytons were used for pouring ritual fluids—water, wine, or perhaps even blood. They were not actual containers; liquid was poured into a hole in the neck and flowed out from the mouth.

Metalwork

By about 1700 BCE, Aegean metalworkers were producing decorative objects rivaling those of Near Eastern jewelers, whose techniques they seem to have borrowed. A necklace pendant in gold found at Chryssolakkos (fig. 4-11) employs several of these techniques (see "Aegean Metalwork," opposite). The artist arched a pair of bees or wasps around a honeycomb, providing their sleek bodies with a single pair of outspread wings—a visual "two in one." The pendant hangs from a spiderlike form, with

TECHNIQUE

a complex copper-based solder that fused **METALWORK** ancient smiths are now believed to have used overwhelmed the tiny, gold globules. The

MECEAN

metal with heat. Miello work was used for contrasting object being decorated, then fused to the surrounding sulfur—was rubbed into very fine engraved lines in the gellum—a black alloy of lead, silver, and copper with metal decoration up to the present time. Powdered niniello, which has continued as a common method of blades (fig. 4-28) employed a special technique called The artists who created the Mycenaean dagger strongly but nearly invisibly.

detail on both relief figures and backgrounds.

bull's-head rhyton, too, were gilded (fig. 4-10). of the Harvester Vase (fig. 4-9). The wooden horns of the Jumper (fig. 4-8) as well as for the now-bare stone surface individual bronze wire "hairs" of the Minoan ivory Bull to be gilded. This was done with amazing delicacy for the called gold leaf were meticulously affixed to the surface ing process by which paper-thin sheets of hammered gold made of some other material, was a technically demand-Gilding, the application of a gold finish to an object

> ably learned from Near Eastern metalsmiths, ite luxury goods. Their techniques, some prob-Aegean artists imported gold to create exquis-

the gold sheet. and then used this form as a mold over which to shape first have sculpted the entire relief design in wood or clay punches. For more elaborate decorations they would designs freehand or used standard wood forms or gold. Experienced goldsmiths may have done simple mered out relief forms from the back of a thin sheet of are examples of repoussé, in which the artist gently ham-Vapheio Cup (fig. 4-13) and the funerary mask (fig. 4-27) (embossing), granulation, niello, and gilding. The included lost-wax casting, inlay, filigree, repousse

heated metal alloys used as adhesives—melted and the granules were attached, since all modern solders for nearly a thousand years. The major mystery was how ulation, was only recently rediscovered after being lost dant (fig. 4-11). The secret of this technique, called granfused to the surfaces, as seen on the bees/wasps pening their goldwork with minute granules, or balls, of gold Cretan jewelers were especially skilled at decorat-

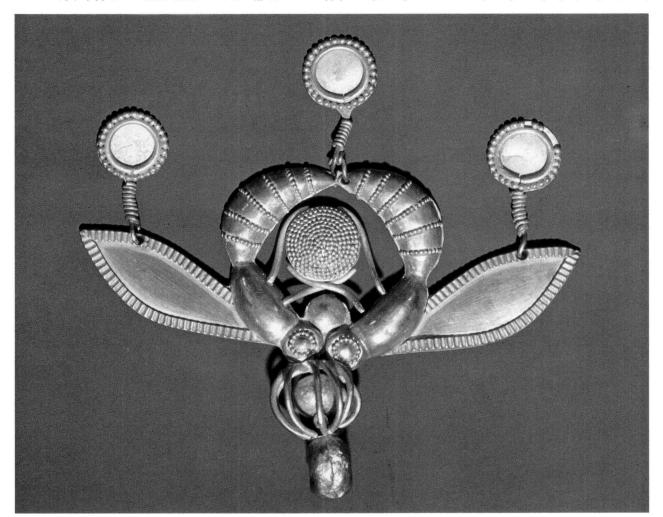

113/16" (4.6 cm). Archeological Museum, Iraklion, Crete 4-11. Pendant in the form of two bees or wasps, from Chryssolakkos, near Mallia, Crete. c. 1700-1550 bee. Gold, height approx.

Mallia's goldsmiths may have been influenced by Egyptian artists, who often depicted bees in this way. This pendant has been interpreted by some as two bees embracing a drop of honey, by others as two wasps fighting. 1500 3000 BCE 1000 BCE what appear to be long legs encircling a tiny, gold ball. Small disks dangle from the ends of the wings and the point where the insects' bodies meet. The simplified geometric patterns and shapes manage to convey close observation of the insects' actual appearance.

Another object notable for its symmetry is the double ax, a motif familiar from the palace at Knossos. The double ax was both a tool and a prominent Minoan cult object associated with blood sacrifice. Since it some-

4-12. Drawing of a bronze double ax with double blades, from Zakro, Crete. c. 1650–1500 BCE. Drawing by George Xylouris

Double-bladed axes were associated with ritual use. This ax may have adorned the wooden column of a palace or been set atop a wooden pole, as double axes are shown to be on some sarcophagi.

times appears painted above a bull's head on Minoan pottery, it would seem that bulls may have been sacrificed, and the Minotaur legend raises the possibility that human beings were as well. The double ax was associated with several deities, and its image appears in almost every Minoan art form, especially at religious sites. Both functional bronze axes and miniature gold replicas have been discovered. A large and richly decorated double ax made from a thick sheet of bronze was found in the central shrine treasury at Zakro, a palace complex on the eastern tip of Crete (fig. 4-12). The entire surface of its butterfly-shaped blades with perforated rims is incised with a design of lilylike flowers.

The skills of Minoan artists, particularly metalsmiths, made them highly sought after, especially in mainland Greece. Two magnificent gold cups found in a large tomb at Vapheio, on the mainland south of Sparta, were made about 1650-1450 BCE, either by Minoan artists or by local ones trained in Minoan style and techniques. One of them is shown here (fig. 4-13). Their relief designs were executed in repoussé—the technique of hammering from the inside. Their handles were attached with rivets. and they were then lined with sheet gold. In the scenes that circle the cups, men are depicted trying to capture bulls in various ways. On this one, a half-nude man has roped a bull's hind leg. The figures dominate the landscape, which literally bulges with a muscular vitality that belies the cups' small size—they are only 31/2 inches tall. The indication of olive trees could mean that the scene is a sacred grove and that these might be illustrations of exploits in some long-lost heroic tale rather than commonplace hunting scenes.

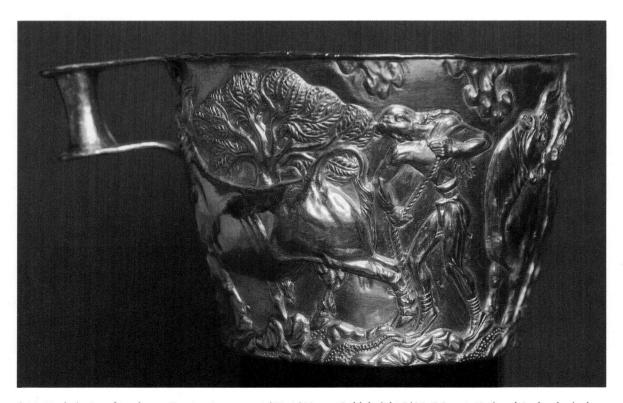

4-13. *Vapheio Cup*, found near Sparta, Greece. c. 1650–1450 BCE. Gold, height $3\frac{1}{2}$ " (8.9 cm). National Archeological Museum, Athens

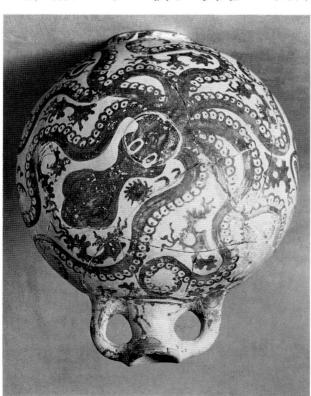

4-15. Octopus Flask, from Palaikastro, Crete. c. 1500–1450 BCE. Marine Style ceramic, height 11" (28 cm). Archeological Museum, Iraklion, Crete

a drop of pond water, sea creatures float across the sphere between an octopus's tangled tentacles. The decoration on the Kamares Ware jug reinforces the solidity of its surface, but here the pottery skin seems to dissolve. The painter captured the grace and energy of natural forms while presenting them as a stylized design in harmony with the vessel's shape.

Wall Painting

from Egyptian painting. ever, especially of landscapes, is quite different in feeling shaded areas of pure color. Minoan wall painting, howin the outlines of their figures and objects with un-Egyptian tomb painters, the Minoan palace artists filled were red, yellow, black, white, green, and blue. Like the even a combination of the two. Their standard colors have employed both techniques in different paintings, or technique was used by the artists at Knossos. They may flake off in time. There is some controversy over which painter does not need to hurry, but the pigments tend to painter is forced to work very quickly. In the dry one, the wet technique, pigments bind well to the wall, but the either on a still-wet plaster surface or on a dry one. In the and scenes of human activity. Murals can be painted palace rooms with geometric borders, views of nature, Minoan painters also worked on a larger scale, covering

Almost all of the wall paintings in the Knossos palace complex date from the "new palace" period, after about 1700 BCE. By reconstructing them, archeologists

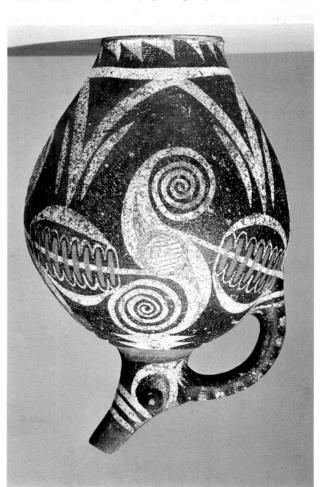

4–14. Kamares Ware jug, from Phaistos, Crete. c. 2000–1900 BCE. Ceramic, height $10^5/8"$ (27 cm). Archeological Museum, Iraklion, Crete

Ceramics

animals. mented by bold, curving forms derived from plants and white pigments, the jug's rounded contours are comple-(fig. 4-14). Decorated with black, brown, red, and creamy BCE has a globular body and a "beaked" pouring spout painted decoration. An example from about 2000-1900 cacy, its use of color, and its energetically stylized, exported as far away as Egypt and Syria—were its deliwas first discovered. The hallmarks of this select ware palace complex at Phaistos, in southern Crete, where it called Kamares Ware, after the cave overlooking the ized in palace workshops. One of these new types is was introduced and large-scale production was centralearly second millennium BCE, when the potter's wheel bly a result of the emergence of palace complexes in the The development of new types of clay wares was proba-

Another striking vessel from the eastern site of Palaikastro, a stoppered bottle known as the Octopus Flask, was made about 1500–1450 BCE (fig. 4-15). This is one of a group of pieces decorated in the so-called Marine Style, which probably celebrates Cretan sea power, then at its height. Like microscopic life teeming in

3000 BCE 1000 BC

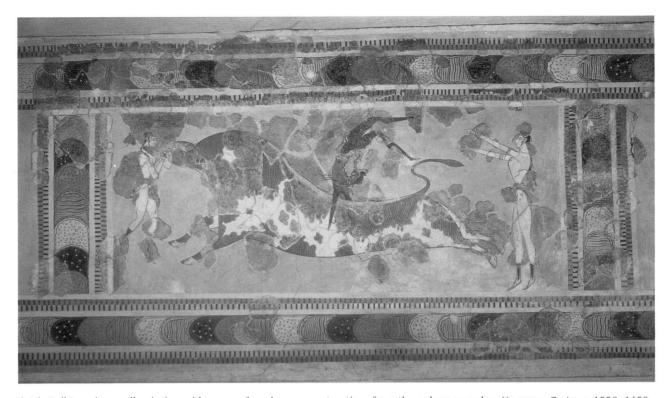

4-16. *Bull Jumping*, wall painting with areas of modern reconstruction, from the palace complex, Knossos, Crete. c. 1550–1450 BCE. Height approx. 24 1/2" (62.3 cm). Archeological Museum, Iraklion, Crete Careful sifting during excavation preserved many fragments of the paintings that once covered the palace walls. The pieces were painstakingly sorted and cleaned by restorers and reassembled into puzzle pictures that still had more pieces missing than found. The next step was to fill in the gaps with colors similar to the original ones, but lighter and grayer in tone. It is therefore obvious which are the restored portions, but the eye can still read and enjoy the image.

are learning more about the functions of some of the architectural spaces the paintings enhanced. For example, the small chamber in the west wing that Sir Arthur Evans called the Throne Room has now been identified as an epiphanic ritual space, in part on the basis of the imagery employed in its murals. Lilies, associated with

goddess-priestess celebrations, are among their prominent motifs. Taken together, the wall paintings at Knossos may have referred to some seasonal festival or series of festivals in honor of a goddess.

One of the best-preserved scenes is *Bull Jumping*, part of a group of paintings with bulls as subjects from a

THE WRECK Shipwrecks can pro-AT ULU vide vast amounts BURUN of information about the material culture

of societies whose contact with the rest of the world was by sea. The wreck of a trading vessel was discovered in the vicinity of Ulu Burun, off the south coast of modern Turkey between Rhodes and Cyprus. Thought to have sunk between 1400 and 1350 BCE, during the late Helladic period, the boat carried a cargo of metals, especially copper and tin ingots for making bronze, as well as a number of bronze weapons and tools. There was also a ton of terebinth on board, an aromatic resin used in making incense and per-

fume, as well as a variety of fruits, nuts, and spices. There were jewelry and beads, logs of African ebony for making fine furniture, ivory tusks for carving, ostrich eggs, and raw blocks of blue glass for use in faience and glassmaking workshops. Among the many gold objects was a scarab associated with Nefertiti, the wife of the Egyptian pharaoh Akhenaten (Chapter 3). The ship also carried more mundane items, including fishhooks, sinkers for fish lines and nets, sets of weights for use on scales, and ceramic wares made by potters from the Near East, mainland Greece, as well as Cyprus.

Its varied cargo suggests that this trading vessel cruised from port

to port, loading and unloading goods as it went. Which direction it was headed when it sank and where its home port might have been are still unknown, but the boat had clearly made a large circuit encompassing the coasts of Egypt, the Middle East, the Near East, Anatolia, and mainland Greece. It may even have navigated in and out of the Black Sea and as far west as Sardinia. It is tempting to see this trading vessel as evidence of Aegean entrepreneurship—there were merchant-traders in the Near East by this time—but some scholars believe that Aegean foreign trade, like that in Egypt, was conducted exclusively as exchange between courts by palace administrators.

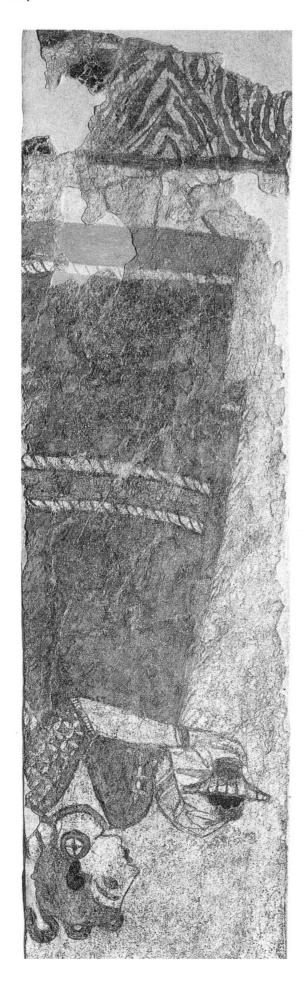

4-17. Priestess (?), detail of a wall painting from Akrotiri, Thera, Cyclades. Before 1630–1500 BCE. National Archeological Museum, Athens. (For an explanation of the date used here and for figure 4-18, see "The Date Debate," page 129.)

room in the palace's east wing (fig. 4-16). The work may represent an initiation or fertility ritual. Three scantily clad, youthful figures are around a dappled, charging bull. The pale-skinned person at the right—probably a woman—is either beginning or finishing her vault, the dark-skinned man is in the midst of his, and the paleskinned woman at the left grasps the bull by its horns. The bull's thundering power and sinuous grace are masterfully rendered. Variegated overlapping ovals set within striped bands frame the action.

function, then this painting would have adorned a ritual Knossos practice of matching mural subject to room crowned by a snake. If the artists on Thera followed the flowing hair, but this one appears to wear a fitted cap and large earrings. Such figures customarily have long, sleeves and ornamental bands, bracelets, a necklace, faces. The woman wears an elegant robe with patterned bear a striking resemblance to many modern Greek frontal eye suggests Egyptian conventions. Her features torso in three-quarter view and her head in profile. Her (fig. 4-17). The beautifully drawn figure stands with her familiar Cretan subject, making a ceremonial offering may show a young priestess of the snake goddess, a tan art, but others are new. One fragment, for example, inhabitants fled. Some of the subjects also occur in Creings provide clues about life on the island before the ers of volcanic ash in residences at Akrotiri. These paintin the 1620s BCE, vivid murals were preserved under layof Minoan culture. When the island literally blew apart tan influence at this time that it was virtually an outpost (today also called Santorini) was so heavily under Credes and mainland Greece. The Cycladic island Thera with other Minoan cultural influences to both the Cycla-The art of wall painting seems to have spread along

Another mural is an astonishing landscape unlike anything previously encountered in ancient art (fig. 4-18). A viewer standing in the center of the room is surrounded by orange-and-blue-striped rocky hillocks sprouting oversize deep red lilies. Swallows, represented by a few deft lines, swoop above and around the flowers. The artist's vision unifies the rhythmic flow of the undulating landscape, the stylized patterning imposed on the natural forms, and the decorative use of bright colors alternating with neutral tones, which were perchors and the result of represent areas of shadow. The impression is one of organic life and growth, a celebration of the sion is one of organic life and growth, a celebration of the

For reasons not entirely clear, Minoan civilization declined after about 1500 BCE, and between about 1450 and 1375 BCE the Cretan palace complexes succumbed to conquest by mainland Greeks. Knossos was burned, but

natural world symbolized by the lilies.

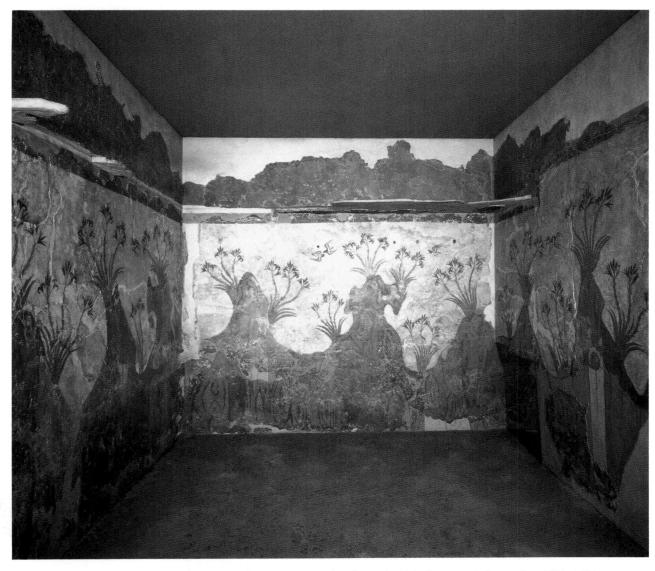

4-18. Landscape, wall painting with areas of modern reconstruction from Akrotiri, Thera, Cyclades. Before 1630-1500 BCE. National Archeological Museum, Athens

the invaders appear to have continued using the site for many years. By 1400 BCE the center of political and cultural power in the Aegean had shifted to mainland Greece, which at that time was home to wealthy warriorkings.

CIVILIZATION

MAINLAND Archeologists have used the GREECE term Helladic (from Hellas, the Greek word for Greece) to AND THE designate the Bronze Age in MYCENAEAN Greece. The Helladic period extends from about 3000 to 1000 BCE, overlapping with

the Minoan chronology of Crete. In the early part of this period, Greek-speaking peoples invaded the mainland. They brought advanced metalworking, ceramic, and architectural techniques and displaced the indigenous Neolithic culture. When Minoan culture declined after about 1500 BCE, a Late Helladic mainland culture known as Mycenaean, after the city of Mycenae, rose to dominance in the Aegean region.

Mycenaean culture was influenced by Minoan culture, but there was a marked difference in their social, political, and geographic circumstances. Life in Mycenaean strongholds such as Mycenae, Tiryns, and Pylos probably contrasted sharply with life in the open palace complexes on Crete 92 miles away. The communities centered around these strongholds were controlled by local princes or kings, and evidence from tombs dating to between 1600 and 1500 BCE suggests that at that time they were growing both increasingly wealthy and increasingly stratified.

palace at Knossos between 1900 and 1905. It was Evans who gave the name "Minoan"—after King Minos—to Cretan civilization from the Bronze Age. The chief focus in his study was on examples of early Minoan writing. He also made a first attempt to establish an absolute chronology for Minoan art, basing his conjectures on datable Egyptian artifacts found in the Cretan ruins and on Cretan finds in Egypt. Later scholars have revised and refined his datings.

Men were not the only energetic researchers in the field in those days. Sophia Schliemann contributed much to her husband's work, and an American woman, Harriet Boyd—assisted by Edith Hall—was responsible for the excavation of Cournia, which is one of the best-preserved Bronze Age towns in Crete. She published her findings in 1908.

sures, at the end of World War II. After his success at Hissarl

After his success at Hissarlik, Schliemann pursued his hunch that the grave sites of Homer's Greek royal family would be found inside the citadel at Mycenae. He did indeed uncovered near the Lion(ess) Gate, but accumulated scientific data later proved the graves to be too early to contain the bodies of Atreus, Agamemnon, and their relatives—if these legendary figures ever existed. Today's scholars, however, do accept the possibility that some Homeric legends are based on actual events.

In 1887 Schliemann tried unsuccessfully to buy a site on the island of Crete, where he hoped to find the palace of the legendary King Minos. That discovery fell to a British archeologist, Sir Arthur Evans (1851–01941), who led the excavation of the

The pioneering figure in the modern study of Aegean civi-

ARCHEOLOGY modern study of Aegean civilization was the German Heinrich Schliemann (1822–1890), who was inspired by Homer's epic tales, the limpoverished minister, from whom he inherited a love of literature and languages, Schliemann was forced by economic circumstances to follow by economic circumstances to follow cal course of study and enter the business world. He worked hard, grew rich, and retired in 1863 to pursue his lifelong dream of becoming sue his lifelong dream of becoming

he began conducting field work in

Greek in Paris, then in 1869-1870

1868, he studied archeology and

an archeologist. Between 1865 and

taken it, along with other art trea-Russia, where the Red Army had light again only in the mid-1990s in mysteriously disappeared. It came to never returned the treasure, which national museum in Turkey, but he Turks, he set up a fund to establish a 1873. After having been sued by the silver that he discovered in May pot containing objects in gold and Schliemann kept for himself a copper exchange for permission to dig, ment half of all valuable finds in agreed to give the Turkish govern-Homer's Troy. Although he had which is generally accepted as being modern Turkey, the sixth level of the multilayered site at Hissarlik, in phy in the Iliad, Schliemann located studying the descriptions of geogra-Homer's stories pure fiction, but by Scholars of that time considered

Greece and Turkey.

VECEAN

PIONEERS OF

View of Schliemann's excavation site of Troy from a 19th-century publication

Architecture

The Citadel at Mycenae. Later Greek writers recalled Mycenae, located near the east coast of the Peloponnese in southern Greece, as the home of the conquerors of the great city of Troy (fig. 4-19). Even today, the monumental mpressive reminder of the city's warlike past. The gate walles from about 1300–1200 BcE, perhaps a centuratel dates from about 1300–1200 BcE, perhaps a centuratel dates from about 1300–1200 BcE, perhaps a centuratel dates from about 1300–1200 BcE, perhaps a centurounding walls. Because of its size, proportions, and construction techniques, the gate conveys the same impression of military strength as does the Lion Gate of the ancient Hittite citadel near modern Boghazkeui, the ancient Hittite citadel near modern Boghazkeui,

Turkey (see fig. 2-28). Although formed of megaliths, this gate is very different in purpose and style from other megalithic structures of the time—Stonehenge, for example (Chapter I). The basic architecture of this gate is post-and-lintel construction with a relieving arch above. The corbel arch "relieved" the lintel of the weight of the wall that rose above it to a height of about 50 feet. As in Near Eastern citadels, the gate was provided with of lions or lionesses nearly 9½ feet tall in the arch openor liones or gold—then fastened into holes in the stone of lions or lionesses nearly 9½ feet tall in the stone of lions or lionesses nearly 9½ feet tall in the stone of lions or lionesses nearly 9½ feet tall in the stone of lions or lionesses nearly 9½ feet tall in the stone of lions or lionesses nearly 9½ feet tall in the stone.

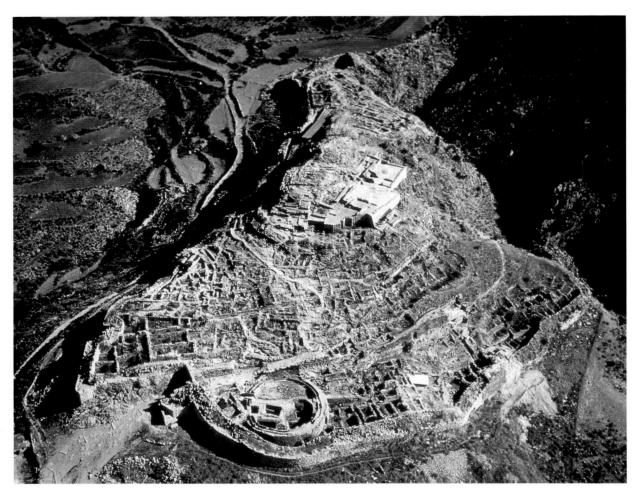

4-19. Mycenae, Greece. c. 1600–1200 BCE

The citadel's hilltop position and fortified ring wall are clearly visible. The Lioness Gate (fig. 4-20) is at the lower left, approached by a dirt path.

stone altars. From this gate, a long, stone passageway led into the citadel proper, at the center of which stood the king's palace.

Tombs assumed much greater prominence for Helladic period cultures of the mainland than for the Minoans, and ultimately they became the most architecturally sophisticated monuments of the entire Aegean period. By about 1600 BCE, the region's kings and princes had begun building large aboveground burial places commonly referred to as beehive tombs because of their rounded, conical shape. In their round plan, beehive tombs are somewhat similar to the prehistoric European megalithic tombs called passage graves, such as the one at Newgrange, Ireland (Chapter 1). In stone-lined pits off the center chambers of these structures, Helladic ruling families laid out their dead in opulent costumes and jewelry and surrounded them with ceremonial weapons, gold and silver wares, and other articles indicative of their high status, wealth, and power.

More than a hundred such tombs have been found on mainland Greece, nine of them in the vicinity of Mycenae. Possibly the most impressive is the so-called Treasury of Atreus (fig. 4-21), which dates from about 1300 to 1200 BCE. The structure is an example of **cyclopean construction**, so called because it was believed that only the

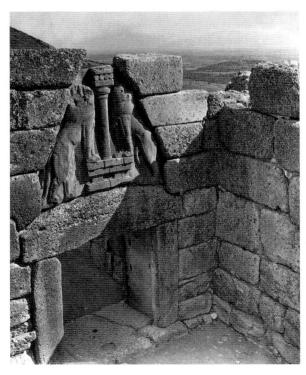

4-20. Lioness Gate, Mycenae. c. 1300–1200 BCE. Limestone relief, height of sculpture approx. 9'6" (2.9 m)

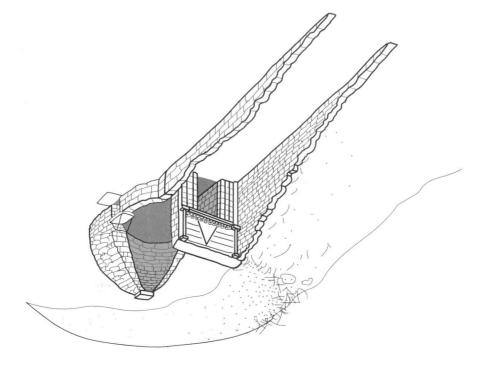

4-21. Cutaway drawing of the beehive tomb called the Treasury of Atreus, Mycenae, Greece. c. 1300–1200 BCE

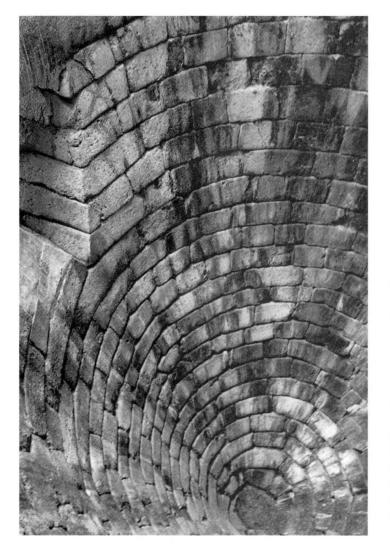

stone at the peak, a remarkable engineering feat. inward and carefully calculated to meet in a single capor layers, of ashlar-squared stones-smoothly leaning roofed with a corbeled vault built up in regular courses, lar room 471/2 feet in diameter and 43 feet high. It is 4-1, 4-12). The main tomb chamber (fig. 4-22) is a circuan motif seen in earlier Cycladic and Minoan art (see figs. inverted Vs—filled with running spirals, a Tavored Aegewere incised with geometric bands and chevrons was disguised behind a marble panel. The stone surfaces er engaged columns on each side, and the relieving arch of green marble. The section above the lintel had smallplaques and flanked by engaged, Minoan-type columns feet high and the door was 18 feet high, faced with bronze tomb's entrance facade. The original entrance was 34 feet long and 20 feet wide, open to the sky, led to the such massive stones. A walled passageway about 120 race of giants known as the Cyclopes could have moved

4-22. Corbeled vault, interior of the Treasury of Atreus. Stone, height of vault approx. 43' (13 m), diameter 47'6" (14.48 m)

This great beehive tomb, which remained half buried until it was excavated by Christos Stamatakis in 1878, is neither a storage space for treasures nor likely to be connected to Atreus, the father of King Menelaus and Agamemnon, who led the campaign against Troy in Homer's Iliad. For over a thousand years, this Mycenaean tomb remained the largest uninterrupted interior space built in Europe. The first European structure to exceed it in size was the Pantheon in Rome structure to exceed it in size was the Pantheon in Rome (Chapter 6), built in the first century BCE.

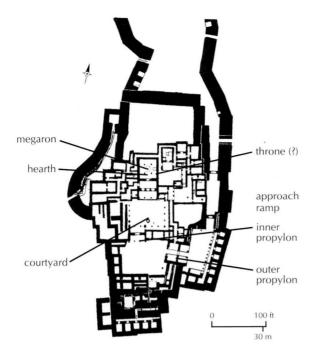

4-23. Plan of the citadel at Tiryns, Greece. c. 1300-1200 BCE

The Citadel at Tiryns. The builders of the citadel at Tirvns (fig. 4-23), about ten miles from Mycenae, made up for the site's lack of natural defenses by drawing heavily on their knowledge of military strategy. Homer referred to the resulting fortress as "Tiryns of the Great Walls." Its ring wall was about 20 feet thick, and the inner palace walls were similarly massive. The main entrance gate was approached along a narrow ramp that rose clockwise along the ring wall, forcing attacking soldiers to climb with their right sides exposed to the defenders on top of the wall and awkwardly try to cover themselves with shields held on their left arms. If they were lucky enough to reach the entrance, they still had to fight their way through a series of inner fortified gates. Corbel-vaulted casemates, or enclosures within the thickness of the ring walls, provided spaces for storing armaments and emergency shelter for soldiers or even for townspeople seeking safety within the citadel (fig. 4-24). In the unlikely event that the citadel gate was breached, the people inside could escape through openings from which they could combat attackers without opening the main gate.

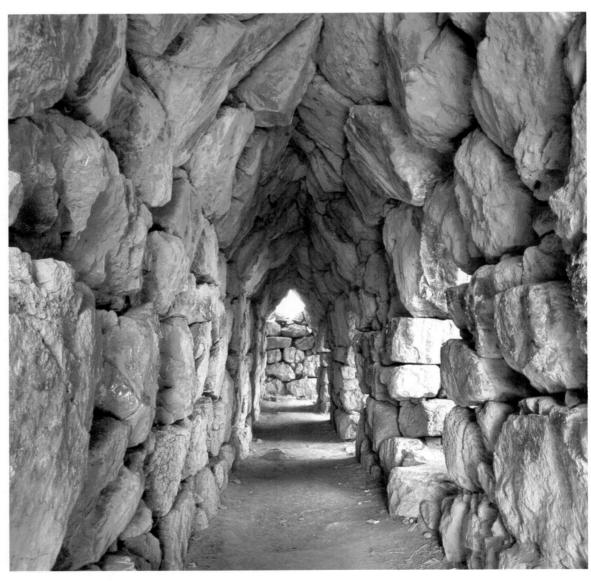

4-24. Corbel-vaulted casemate inside the ring wall of the citadel at Tiryns

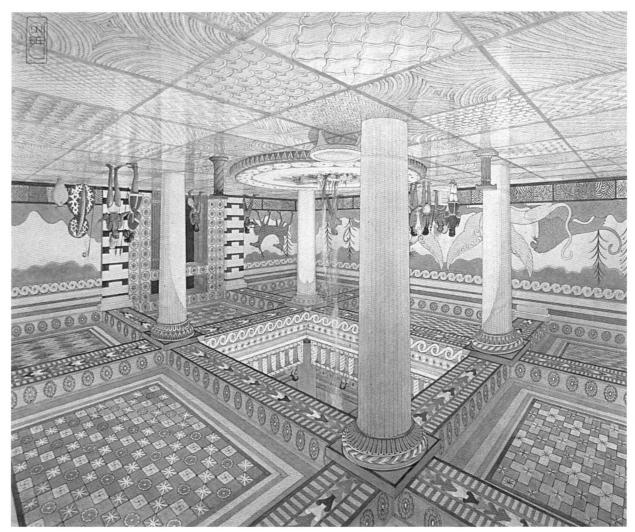

4-25. Reconstruction drawing of the megaron in the palace at Pylos, Greece. c. 1300–1200 BCE. Drawing in Antonopouleion Archeological Museum, Pylos

magnificent display of architectural and decorative prowess. The reconstructed view provided here (fig. 4-25) shows how the combined throne room and audience hall, with fluted Minoan-type columns supporting heavy ceiling beams, might have looked when new. Every inch was painted—the floors, ceilings, beams, and door frames with brightly colored abstract designs, and door frames with large mythical animals and highly stylized and landscape forms.

Linear B clay tablets found in the ruins of the palace include an inventory of the palace furnishings that indicates they were as elegant as the architecture. The listing on one tablet reads: "One ebony chair with golden back decorated with birds, and a footstool decorated with ivory pomegranates. One ebony chair with ivory back peifers, one footstool, ebony inlaid with ivory and pomegranates." It may be that the people of Pylos should have taken greater care to protect themselves. Within a centaken greater that the palace was destroyed by fires, apparently set during the violent upheavals that brought about the collapse of Mycenaean Greek dominance.

The palace area at Tiryns featured a large audience hall called a **megaron**, or "great room," accessible to the main courtyard through a porch and a vestibule—a much more direct approach than the winding path imposed on visitors in a Minoan palace. In the typical megaron plan, four large columns around a central hearth was ported the ceiling. The roof section above the hearth was either raised or open to admit light and air and permit either raised or open to admit light and air and permit amoke to escape. Architectural historians surmise that the megaron eventually came to be specifically associtied with royalty. The later Greeks therefore adapted its form when building temples, which they saw as earthly form when building temples, which they saw as earthly palaces for their gods.

The Palace at Pylos. Tityns required heavy defense works because of its location. The people of Pylos, in the extreme southwest of the Peloponnese, perhaps felt that their more remote location made military attack that their more remote location made military attack their more remote location made military attack their more remote location made military attack on a taised site without walls. Set behind a porch and on a raised site without walls. Set behind a porch and vestibule facing the courtyard, the Pylos megaron was a vestibule facing the courtyard, the Pylos megaron was a

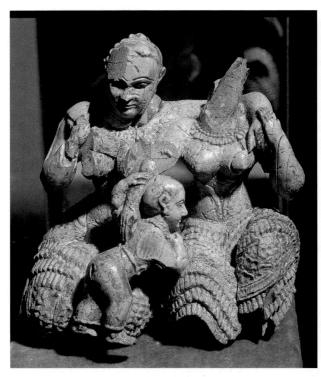

4-26. Two Women with a Child, found in the palace at Mycenae, Greece. c. 1400–1200 BCE. Ivory, height 2³/4" (7.5 cm). National Archeological Museum, Athens

Sculpture

Mainland artists were exposed to Minoan art through trading and even perhaps by working side by side with Minoan artists brought back by the Greek conquerors of the island. A carved ivory group of two women and a child (fig. 4-26), less than 3 inches high and found in the palace shrine at Mycenae, appears to be a product of Minoan-Mycenaean artistic exchange. Dating from about 1400-1200 BCE, the miniature exhibits carefully observed natural forms, an intricately interlocked composition, and finely detailed rendering. Because there are no clues to the identity or the significance of the group, we might easily interpret it as generational—with grandmother, mother, and child—but the figures could just as well represent two nymphs or devotees attending a child-god. In either case, the mood of affection and tenderness among the three is unmistakable, and, tiny as it is, the sculpture counters the militaristic vein of so much Mycenaean art.

Metalwork

The beehive tombs at Mycenae had been looted long before Heinrich Schliemann arrived to search for Homeric Greece, but the contents of the **shaft graves** he excavated in the 1870s reflect mainland culture at an even earlier date (see "Pioneers of Aegean Archeology," page 143). Shaft graves were vertical pits 20 to 25 feet deep, and those entombing rulers and their families were enclosed in a circle of standing stone slabs. Magnificent metal treasures in the form of swords, daggers, scepters,

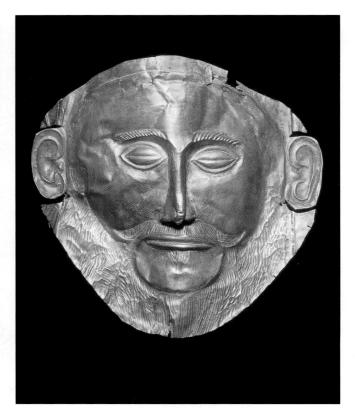

4-27. Funerary mask, from the royal tombs at Mycenae, Greece. c. 1550-1500 BCE. Gold, height approx. 12" (26 cm). National Archeological Museum, Athens When Heinrich Schliemann excavated the royal shaft graves just inside the Lion(ess) Gate at Mycenae in 1876, he believed that he had discovered the bodies of the legendary family of Atreus, including his son Agamemnon. Schliemann dubbed this gold mask from one of the graves the "Mask of Agamemnon"—a name it still carries in many books. Schliemann's discoveries at Mycenae and Troy have led scholars to conclude that the Homeric tales may have been rooted in historical fact, but Schliemann himself was unaware that the graves at Mycenae predate the possible siege of Troy by about three centuries, so that the funeral mask could not have been Agamemnon's even if he was an actual person.

jewelry, and drinking cups were often buried with members of the elite. As in the tombs of Egyptian royalty, some of the men were found wearing masks of gold or a silver-gold alloy called electrum, as if to preserve their heroic features forever. The realistic features embossed on the gold funerary mask often mistakenly called the "Mask of Agamemnon" (fig. 4-27), dated about 1550–1500 BCE, seem uncannily like those of a death mask cast from the actual face of the deceased—broad cheekbones, strong chin, thin, pointed nose, full beard and moustache, closed, bulging eyes, and narrow eyebrows.

Also found in one of the shaft graves at Mycenae were three bronze dagger blades decorated with inlaid scenes (fig. 4-28). The Mycenaean artist cut shapes out of different-colored metals—copper, silver, and gold—then set them into the bronze blades. Silver and gold inlays had to be first backed with copper. The fine details

4-28. Dagger blades, from shaft graves at Mycenae, Creece, c. 1550– 1500 BCE. Bronze inlaid with gold, silver, and copper, lengths 63/8" (16.3 cm), 87/16" (21.4 cm), and 93/8" (23.8 cm), National Archeological Museum,

Athens

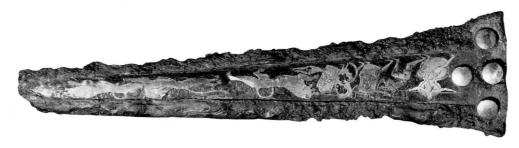

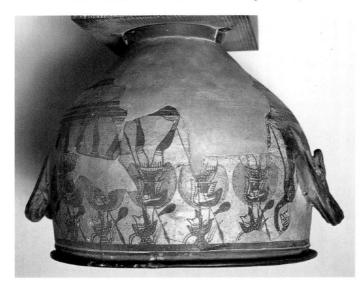

4-29. Warrior Vase, from Mycenae, Greece. c. 1300–1100 BCE. Ceramic, height 16" (41 cm). National Archeological Museum, Athens

By 1200 BCE, aggressive invaders were crossing into mainland Greece, and within a century they had taken control of the major cities and citadels. The period between about 1100 and 900 BCE was a kind of "dark age" in the Aegean, marked by political, economic, and artistic instability and upheaval. But a new culture was forming, one that looked back to the exploits of the Helladic warrior-princes as the glories of a heroic age and at the same time formed the basis of a new Creek civilization.

were added in **niello** (see "Aegean Metalwork," page 137). In the *Iliad*, Homer's epic poem about the Trojan War written before 700 BCE, Agamemnon's armor and Achilles's shield are described as having similar decorations. The decorations of the two larger blades—depictions. The decorations of the two larger blades—depictions men with shields battling three lions, and three lions racing across a rocky landscape—are typically Aegean in the animated and naturalistic treatment of the figures. Interestingly, the scene on the shortest blade, showing a leopard attacking ducks in a papyrus swamp, clearly leopard attacking ducks in a papyrus swamp, clearly reflects Egyptian influence.

Ceramics

machine.

In the final phase of the Helladic period, Mycenaean potters created highly refined ceramics in uniform sizes and shapes. Although their vessels were superior in terms of technique, the decorations applied to them were generally less innovative, more conventional than those of earlier wares. A narrative scene ornaments the Mycenaean Warrior Vase, dating from about 1300–1100 BCE left bids farewell to a group of helmeted men with beribboned lances and large shields marching off to the right. There is none of the vibrant energy of the Harvester Vase or the Vapheio Cup in this scene. The only indication of the woman's emotions is the symbolic gesture of an arm raised to her head, and the figures of the men are seemraised to her head, and the figures of the men are seemraised to her head, and the figures of the men are seemingly interchangeable parts in a rigidly disciplined war ingly interchangeable parts in a rigidly disciplined war

Dipylon vase c. 750

Corinthian pitcher c. 600

Kouros c. 600

▲ PROTO-GEOMETRIC 1000-900 ▲ GEOMETRIC 900-700

▲ ORIENTALIZING 700-600

▲ ARCHAIC 600-480

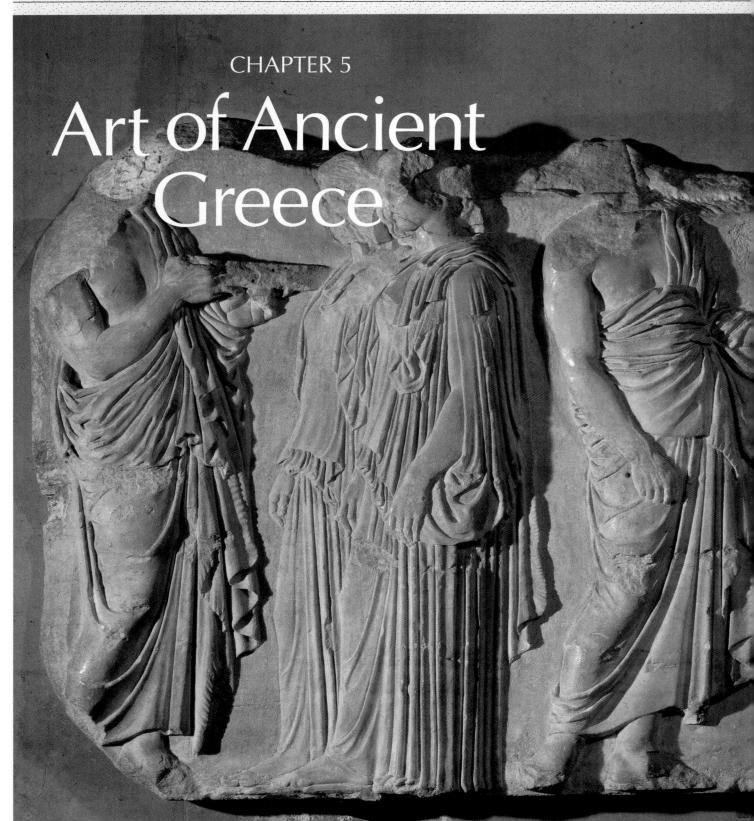

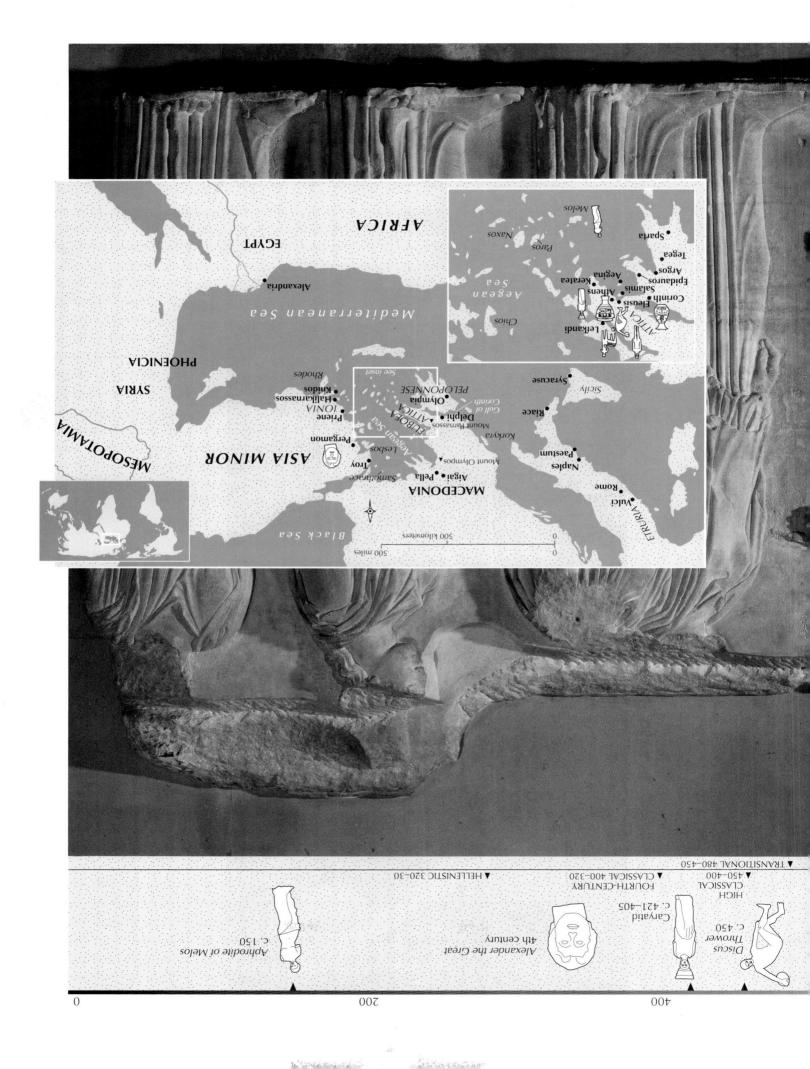

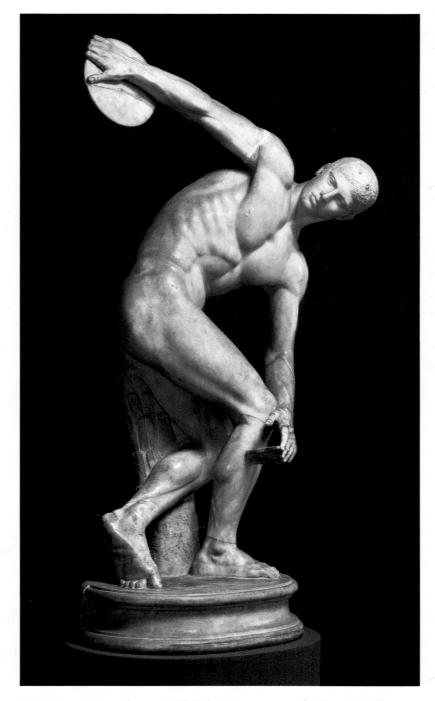

5-1. Myron. *Discus Thrower (Diskobolos*), Roman copy after the original bronze of c. 450 BCE. Marble, height 5'1" (1.54 m). Museo Nazionale Romano, Rome

sense of awe fills the stadium when the athletes recognized as the fastest runners in the world enter for the second day of competition. With the opening ceremonies behind them, each runner has only one goal: to win—to earn recognition as the best, to receive the award, the praise, and the financial rewards that accompany victory. The runners have come from near and far, as will the wrestlers and riders, the discus throwers and long jumpers, the boxers and javelin hurlers who will compete within sight of the Olympic flame. The year is 776 BCE.

1000 BCE 0 BCE

ration was carried from ancient Greece throughout the Western world. people, this image is an appropriate symbol for the way the light of inspisun at Olympia, Greece, and carried by relay to that year's site. For many Olympics begin with the lighting of a flame from a torch ignited by the not resumed until 1896.) In recognition of the original games, the modern Roman emperor Theodosius banned the games in 394 ce, and they were date the beginning of their history as a nation to those first games. (The BCE (fig. 5-1). The Olympian Games were so significant that many Greeks ture, such as the Discus Thrower created in bronze by Myron in about 450 expense. They were idealized for centuries in extraordinary Greek sculpgreatest of the athletes might well live the rest of their lives at public ners' deeds were celebrated by poets long after their victories, and the awards given at the Temple of Hera were crowns of wild olives. The wingod and his consort. The first day's ceremonies were sacrifices, and the of Hera and Zeus, near Olympia, Greece, to pay tribute to the supreme Olympian Games, the athletes gathered on sacred ground, the Sanctuary of an ideal. And indeed these are common elements. Yet at those first beings who seemed able to surpass even their own abilities in the glory political confrontation to physical competition, to individual human then as now, the best athletes came together. Attention shifted from At first, the scene seems comfortably familiar. Every four years,

Following the collapse of Mycenaean dominance about 1100 BCE, the Aegean region experienced a period of disorganization during which most prior cultural developments, including writing, were destroyed or forgotten. Although nothing is known of their origins or the dates of their arrivals, some of these immigrants may have been responsible for bringing Iron Age technology to these responsible for bringing Iron Age technology to these regions. This event failed, however, to halt the descent into a cultural dark age.

No archeological evidence exists to support it, but later Greek legendary history claimed that people called Dorians had invaded the mainland from the north and displaced the earlier settlers, called Aeolians and Ionians, forcing their migration to the Aegean islands and western Asia Minor. The Spartans of Peloponnesos claimed to have descended from the god-hero Herakles through the Dorians, who established themselves in west central Greece. The Athenians claimed descent from the Ionians who had supposedly occupied the Attic penintonians who had environs) in early times, and they maintained close political ties with the Ionian culture of western Asia Minor.

By about 900 BCE, the inhabitants of the Aegean region, living in self-sufficient, close-knit communities and all speaking some form of the same language, were again new migrants and earlier inhabitants, who came to be called Greeks. The early Greeks developed a distinctive form of city-state in the ninth and eighth centuries BCE form of city-state in the ninth and eighth centuries BCE form of city-state in the ninth and eighth centuries BCE form of city-state in the ninth and eighth centuries BCE form of city-state in the ninth and eighth centuries BCE form of city-state in the ninth and eighth centuries BCE form of city-state in the ninth and eighth centuries BCE form of city-state in the ninth and eighth centuries BCE form of city-state in the ninth and eighth centuries BCE form of city-state in the ninth and eighth centuries BCE form of city-state in the ninth and eighth centuries BCE form of city-state in the ninth and eighth centuries BCE form of city-state in the ninth and eighth centuries BCE form of city-state in the ninth and eighth centuries BCE form of city-state in the ninth and eighth centuries BCE form of city-state in the ninth and eighth centuries BCE form of city-state in the ninth and eighth centuries BCE form of city-state in the ninth and eighth centuries BCE form of city-state in the ninth and eighth centuries and eighth centuries

More than 2,000 years have passed since the artists and architects of ancient Greece worked, yet their achievements

CIVILIZATION THE EMERGENCE

continue to have a profound influence. The early Greeks' concepts of human beauty and of strength and dignity in architectural design no longer set the standards for Western art, but their genius and high aspirations are still awe-inspiring. Their legacy is especially remarkable given their relatively small numbers, the almost constant warfare that beset them, and the often harsh economic conditions of the time.

understanding its art. politics, religion, and culture of ancient Greece is vital to political developments. Nevertheless, knowledge of the definable stages in this stylistic progression rather than which ancient Greek art is traditionally divided reflect the clear stylistic and technical progression. The periods into painting to sculpture and architecture—that exhibits duce a body of work in every medium—from pottery and Greek artists explored a succession of new ideas to protively short span from around 900 BCE to about 100 BCE, artistic conventions for nearly 3,000 years. In the relanence and continuity induced artists to maintain many with that of Egyptian art, where the desire for permareason, the history of Greek art contrasts dramatically ments through changes in style and approach. For this them continually to improve upon their past accomplish-Greek artists sought a level of perfection that led

1000 pcr	O BCE

DADALIEIC

PARALLELS			
<u>Years</u>	Period	Greece	World
с. 900-700 все	Geometric	Dipylon vase; Homer's <i>Iliad</i> and <i>Odyssey</i> ; first Olympian Games; alphabet adopted	c. 900–700 BCE Upanishads (India); Olmec pyramids (Mesoamerica); Etruscans settle central Italy; legendary founding of Roeme (Italy); fall of Zhou dynasty (China); first goldwork in South America
с. 700-600 все	Orientalizing	Black-figure and white-ground vase painting	c. 700–600 BCE Demotic script (Egypt); Assyrian empire falls; growth of permanent villages in North America
с. 600-480 все	Archaic	Doric and Ionic orders; Temple of Hera (Argos); Temple of Artemis (Korkyra); red-figure vase painting; <i>Calf Bearer; François Vase</i> ; Temple of Hera I (Paestum, Italy); Sanctuary of Apollo, Siphnian Treasury (Delphi); Temple of Aphaia (Aegina); <i>Aesop's Fables</i> ; <i>Kroisos</i> ; Sappho	c. 600–400 BCE Hanging Gardens (Babylon); birth of Laozi, founder of Daoism, (China); Cyrus the Great (Persia) defeats Babylon; birth of Siddartha Gautama, founder of Buddhism (Nepal); Confucius (China); first fixed-value coins (Lydia); iron introduced in China; last Old Testament book written
с. 480-450 все	Transitional (Early Classical)	Kritios Boy; Charioteer; Riace Warriors; Myron's Discus Thrower; the Pan Paint- er's Artemis Slaying Actaeon; First Pelo- ponnesian War; Sophocles; Aeschylus	
с. 450-400 все	High Classical	The Canon of Polykleitos; Polykleitos's Spear Bearer; Little Girl with a Bird; Corinthian order; Perikles' rule; Kallikrates and Iktinos's Parthenon (Athens); Mnesikles' Propylaia and Erechtheion (Athens); Kallikrates' Temple of Athena Nike (Athens); Socrates; Herodotus; Euripides; Second Peloponnesian War	
с. 400-320 все	Fourth-Century (Late Classical)	Sanctuary of Athena Pronaia (Delphi); Mausoleum (Halikarnassos); Praxiteles' Aphrodite of Knidos and Hermes and the Infant Dionysos; Lysippos's The Scraper; rule of Alexander the Great; Abduction of Persephone; Plato; Aristotle	c. 400–30 BCE London founded (England); mound-building cultures (North America); lighthouse of Alexandria (Egypt); Rome subjugates Italy; Great Wall (China); Han dynasty (China); Rosetta Stone (Egypt); Great Stupa at Sanchi (India); Julius Caesar invades Gaul and Britain; sundial invented (China)
с. 320-30 все	Hellenistic	Theater at Epidauros; Cossutius's Temple of Olympian Zeus (Athens); Altar of Zeus (Pergamon); Colossos of Rhodes; Hagesandros, Polydoros, and Athanodoros's Laocoön; Nike of Samothrace; Aphrodite of Melos	

ernment, nor did slaves or men born outside Athens. adult male citizens. Women took no official part in government was democratic in principle, it was open only to the assembly of all citizens. Although this form of govfunctions and prepared legislation for consideration by boule. This council carried out routine administrative sentatives to a new 500-member council, called the precinct, into the basic political unit that sent 50 repre-He made the deme, a territorial unit equivalent to a reducing the dominance of the old aristocratic families. resentative base of Athenian government, effectively democracy," instituted reforms that broadened the reptrol of the city. Kleisthenes, often called the "father of Kleisthenes, with the support of the people, gained con-Following a period of factional sparring, a leader named the development of democratic institutions resumed. tratos's second son and successor was ousted in 510 BCE, the official texts of Homer's works recorded. After Peisisvals, building many temples and fountains, and having the city and enhanced it culturally by holding great festivisionary, Peisistratos generated considerable wealth for ruled as tyrant until 527 BCE. A shrewd planner and crat named Peisistratos seized control of Athens and

Religious Beliefs and Sacred Places

and Roman Deities and Heroes," page 156). erned several important aspects of human life (see "Greek and the moon; and Athena, a powerful goddess who gov-Aphrodite, goddess of love; Artemis, goddess of hunting god of the sun; Poseidon, god of the sea; Ares, god of war; pian deities were the ruling gods Zeus and Hera; Apollo, nesses and emotions. Among the most important Olymthem in human form and attributed to them human weakancient Near East and the Egyptians had, they visualized with supernatural powers, but, more than peoples of the The Greeks saw their gods as immortal and endowed Olympos in the northeast corner of the Greek mainland. sky gods, whose home was believed to be atop Mount Titans or Giants, and the sky gods. The victors were the end, involved a battle between the earth gods, called The creation of the world, according to ancient Greek leg-

extensive athletic facility with training rooms and arenas near Olympia, in the western Peloponnese, housed an dium for athletic events. The Sanctuary of Hera and Zeus ritual performances and literary competitions, and a stavisitors, an outdoor dance floor or permanent theater for various monuments and statues, housing for priests and temples, several treasuries for storing valuable offerings, home for the gods, called a temenos, with one or more added over time, a sanctuary might become a palatial as a tree, a rock, or a spring. As additional buildings were door altars or shrines and a sacred natural element such ground. The earliest sanctuaries had one or more outsanctuaries with walls and designated them as sacred their human worshipers. Local people then enclosed the themselves selected these sites to show favor toward more of the gods. The Greeks believed that the gods out Greece, called sanctuaries, were sacred to one or In addition to Mount Olympos, many sites through-

political identity for their residents, and they stimulated

The Greek mainland and the Aegean islands had litown domestic and foreign affairs. securing its own economic support, and managing its independent, deciding its own form of government, and nourished the emerging Greek civilization. Each was

example, founded the famed city of Syracuse on the eastorigin. Colonists from Corinth on mainland Greece, for taining close cultural and economic ties to their cities of ential commercial centers in their own right while mainoutlying colonies, some of which became wealthy, influgoods. To facilitate trade, the city-states established tiles, precious metals, wood for shipbuilding, and other ucts—olive oil, pottery, and metal wares—for grain, texfrom the Black Sea to Africa, exchanging Aegean prodcity-states developed sizable merchant fleets that ranged trade after the collapse of Mycenaean civilization. Many Near Eastern people who dominated Mediterranean which was probably adopted from the Phoenicians, a through such contacts, developed a new writing system, During the eighth century BCE, the Greeks, stimulated regions to meet the needs of their growing populations. Bronze Age predecessors, to depend on trade with other tle farmland, forcing the new communities, like their

to assume both commercial and cultural preeminence. located in Attica on the east coast of the mainland, began time the most powerful. By the sixth century BCE, Athens, located on major land and sea trade routes, was for a ence abroad. Among the emerging city-states, Corinth, home and sought economic rather than military influrule. At their best, they fostered urban development at and many cities prospered and expanded under their tyrants were not always tyrannical in the modern sense, often with popular support, in many city-states. These ers called "tyrants" imposed a dictatorial form of rule, extending into the sixth century BCE, self-appointed leadcratic councils. Then, beginning about 700 BCE and The Greek city-states were at first ruled by aristo-

of Democratic Rule Athens and the Concept

ern coast of Sicily.

Greek experiments in democracy. ments throughout the world today owe a debt to ancient els. Perhaps most significant, representative govern-States and Europe also owe much to ancient Greek mod-Greek ideal. Systems of higher education in the United that highly esteem athletic prowess reflect an ancient enduring influence in many parts of the world. Countries Their customs, institutions, and ideas have also had an The Greeks contributed more to posterity than their art.

zenship to males of many classes. In 560 BCE an aristoreforms and revise the city's constitution, extending cititent, appointed the poet-statesman Solon to institute Athens, facing an economic crisis and popular disconileged males were citizens. In 594 BCE the leaders of Athens in the sixth century BCE, although only a few privand responsibilities of government began to emerge in The idea that all citizens should share in the rights

AND AND

GREEK The ancient Greeks had many deities, and myths ROMAN about them varied over **DEITIES** time. Many deities had several forms, or mani-HEROES festations. Athena, for example, was revered as a

goddess of wisdom, a warrior goddess, a goddess of victory, and a goddess of purity and maidenhood, among others. The Romans later adopted the Greek deities but sometimes attributed to them slightly different characteristics. What follows is a simplified list of the major Greek deities and heroes, with their Roman names in parentheses when they exist. The list includes some of the most important characteristics of each deity or hero, which often identify them in art.

According to the most widespread legend, twelve major sky gods and goddesses established themselves in palatial splendor on Mount Olympos in northeastern Greece after defeating the earth deities, called Giants or Titans, for control of the earth and sky. The first five deities are the children of Earth and Sky.

ZEUS (Jupiter), supreme deity. Mature, bearded man; holds scepter or lightning bolt; eagle and oak tree are sacred to him.

HERA (Juno), goddess of marriage. Sister/wife of Zeus. Mature; cow and peacock are sacred to her.

HESTIA (Vesta), goddess of the hearth. Sister of Zeus. Her sacred flame burned in communal hearths.

POSEIDON (Neptune), god of the sea. Holds a three-pronged spear; horse is sacred to him.

HADES (Pluto), god of the underworld, the dead, and wealth. His helmet makes the wearer invisible.

The remaining seven sky gods, the offspring of the first five, are:

ARES (Mars), god of war. Son of Zeus and Hera. Wears armor; vulture and dog are sacred to him.

HEPHAISTOS (Vulcan), god of the forge, fire, and metal handicrafts. Son of Hera (in some myths, also of Zeus); husband of Aphrodite. Lame, sometimes ugly; wears blacksmith's apron, carries hammer.

APOLLO (Phoebus), god of the sun, light, truth, music, archery, and healing. Sometimes identified with Helios (the Sun), who rides a chariot across the daytime sky. Son of Zeus and Leto (a descendant of Earth); brother of Artemis. Carries bow and arrows or sometimes lyre; dolphin and laurel are sacred to him.

ARTEMIS (Diana), goddess of the hunt, wild animals, and the moon. Sometimes identified with Selene (the Moon), who rides a chariot or oxcart across the night sky. Daughter of Zeus and Leto; sister of Apollo. Carries bow and arrows, is accompanied by hunting dogs; deer and cypress are sacred to her.

ATHENA (Minerva), goddess of wisdom, war, victory, the city, and civilization. Daughter of Zeus, sprang fully grown from his head. Wears helmet and carries shield and spear; owl and olive trees are sacred to her.

APHRODITE (Venus), goddess of love. Daughter of Zeus and Dione; alternatively, daughter of Poseidon, born of his sperm mixed with sea foam; wife of Hephaistos. Myrtle, dove, sparrow, and swan are sacred to her.

HERMES (Mercury), messenger of the gods, god of fertility and luck, guide of the dead to the underworld, and god of thieves, commerce, and the marketplace. Son of Zeus and Maia, the daughter of Atlas, a Giant who supports the sky on his shoulders. Wears winged sandals and hat; carries caduceus, a wand with two snakes entwined around it.

Other important deities include:

DEMETER (Ceres), goddess of grain and agriculture.

PERSEPHONE (Proserpina), goddess of fertility and queen of the underworld. Wife of Hades; daughter of Demeter.

DIONYSOS (Bacchus), god of wine, the grape harvest, and inspiration. Shown surrounded by grape vines and grape clusters; carries a wine cup. His female followers are called maenads (Bacchantes).

EROS (Cupid), god of love. In some myths, the son of Aphrodite.

Shown as an infant or young boy, sometimes winged; carries bow and arrows.

EOS (Aurora), goddess of dawn.

GE, goddess of the earth; mother of the Titans.

ASKLEPIOS (Aesculapius), god of healing.

AMPHITRITE, goddess of the sea. Wife of Poseidon.

PAN, protector of shepherds, god of the wilderness and of music. Half man, half goat, he carries panpipes.

NIKE, goddess of victory. Often shown winged and flying.

Some specifically Roman gods not worshiped by the Greeks include:

FORTUNA, goddess of fate (fortune).

PRIAPUS, god of fertility.

SATURN, god of harvests.

JANUS, god of beginnings and endings. Has two faces, enabling him to look forward and backward.

POMONA, goddess of gardens and orchards.

TERMINUS, god of boundaries.

Important human heroes include:

HERAKLES (Hercules). A man of great and diverse strengths; granted immortality for his achievements, including the Twelve Labors.

PERSEUS. Killed Medusa, the snake-haired monster.

THESEUS. Killed the Minotaur, a bull-monster that killed and ate young men and maidens in a labyrinth in the palace of King Minos of Crete (see "The Legend of the Minotaur," page 132).

Heroes of the Trojan War include:

ODYSSEUS (Ulysses), Achilles, Patroclus, and Ajax among the Greeks; Paris, Hector, Priam, Sarpedon, and Aeneas (progenitor of the Romans) among the Trojans.

5-3. Reconstruction drawing of the Sanctuary of Apollo, Suing probable location of the Kassotis o stadium area

Delphi. c. 400 BCE

earth deities, by a wave of new settlers who believed in people of Greece, whose religion centered on female ical account of the conquest of the Early Bronze Age the site. This myth has been interpreted as a metaphorstood guard over his mother's shrine in the gorge below Python, the serpent son of the earth goddess Ge, who Here too, it was said, Apollo fought and killed the the omphalos (navel) of the earth by an umbilical cord.

From very early times, the sanctuary at Delphi was a supreme male sky god.

Pythian Games hall of fame (see fig. 5-37). ues dedicated to the victors of the competitions, a kind of The sanctuary grounds were filled with hundreds of statthe dance and poetry competitions in honor of Apollo. were not the athletic contests that took place, but rather ed participants from all over Greece. The principal events Games, a festival that, like the Olympian Games, attractcalled the Pythia. Delphi was also the site of the Pythian where the god Apollo spoke through a woman medium the messages. Even foreign rulers sought help at Delphi, places, relying on temple priests for help in interpreting Greeks and their leaders routinely sought advice at such delivered to human intermediaries, or mediums. The to communicate to humans by means of cryptic messages renowned as an oracle, a place where a god was believed

main temple, performance and athletic areas, and other lo as it looked about 400 BCE (fig. 5-3) shows that the A reconstruction drawing of the Sanctuary of Apol-

Here, according to Greek myth, the sky was attached to plateau in the shadow of Mount Parnassos (fig. 5-2). rugged landscape near the Gulf of Corinth on a high The Sanctuary of Apollo at Delphi is located in a

Games were held. 776 BCE, that the ancient prototypes of today's Olympic for track and field events. It was here, beginning in

Halys and were wiped out by the Persians. destroyed was his own, when his troops crossed the assault against the Persians. Ironically, the kingdom he Empire, and he ordered his generals to launch an to mean the Halys River, beyond which lay the Persian cross a river and destroy a great kingdom. He took this plans. The message he received was that he would sixth century BCE to consult Apollo about his military Asia Minor, for example, came to Delphi in the midthe Pythia's statements. King Croesus of Lydia in attributed many twists of fate to misinterpretations of often cryptic and ambiguous language. The Greeks response to a petitioner's question, she conveyed it in she had received the god's message, which might be a the crevice on a three-legged stool, or tripod. When to have induced hallucinations. She then sat over the sacred Kassotis Spring, both of which are thought spe chewed sacred laurel leaves and drank water from Pythia. To prepare herself to receive his messages, communicated through a woman medium called the municated with humans. At this oracle, Apollo believed to be an oracle, a place where the god comin an earthquake, was a natural site in the area built on the site of a sixth-century temple destroyed A feature of this sacred home of the Greek god Apollo, 5-2. Sanctuary of Apollo, Delphi. 4th century BCE

800 1000 BCE 0 BCE

buildings and monuments cleverly made full use of limited space while providing easy access. After visitors climbed the steep path up the lower slopes of Parnassos, they entered the sanctuary by a ceremonial gate in the southeast corner. From there they zigzagged up the Sacred Way, so named because it was the route of religious processions during festivals. Moving past the numerous treasuries and memorials built by Greece's various city-states (see fig. 5-16), they soon arrived at the long colonnade of the Temple of Apollo. This structure, built about 530 BCE on the ruins of an earlier temple, remained standing until it was destroyed by an earthquake in 373 BCE. Below the temple was a stoa, a columned pavilion open on all sides, built by the people of Athens. There visitors rested, talked, or watched ceremonial dancing on an outdoor pavement called a halos. At the back of the sanctuary on a higher level of the rocky plateau was a stadium area for athletic games.

Greek sanctuaries are quite different from the religious complexes of the ancient Egyptians (see, for example, the funerary complex of Hatshepsut, figs. 3-33, 3-34). Egyptian builders dramatized the power of gods or godrulers by placing their temples at the ends of long, straight, processional ways. The Greeks, in contrast, treated each building and monument within a temenos as an independent element in an arrangement of structures to be integrated with the natural features of the site. It is tempting to draw a parallel between this manner of organizing space and the way Greeks organized themselves politically: every structure, like every Greek citizen, was a unique entity meant to be encountered separately within its own environment while being closely allied with other entities in a larger scheme of common purpose.

Historical Divisions of Greek Art

The names by which the major periods of Greek art are known have remained standard despite changing interpretations that have led some to question their appropriateness. The primary source of information about Greek art before the seventh century BCE is pottery, and the Geometric period owes its name to the geometric, or rectilinear, forms with which artists of the time decorated ceramic vessels. The Orientalizing period is named for the apparent influence of Egyptian and Near Eastern art on Greek pottery of that time, spread through trading contacts and also through the travels and migrations of artists themselves. The name of the third period, Archaic, meaning "old" or "old-fashioned," stresses a presumed contrast between the art of that time and the art of the following Classical period, which was thought to be the most admirable and highly developed—a view that no longer prevails among contemporary art historians.

The Classical period has been subdivided into three phases: the Transitional or Early Classical, from about 480 to 450 BCE; the High Classical, from about 450 to the end of the fifth century BCE; and the Late Classical, from about 400 to about 320 BCE. "Transitional" is particularly appropriate for the Early Classical period in sculpture because it bridges the change from the relatively stiff

Archaic human figures to the more realistically active Classical figures, but it was also a time of change for architecture and painting. Art historians still use these subdivisions as convenient chronological markers, but they no longer see them as chapters in a story detailing the "rise and decline" of the Classical style. For this reason, the neutral term Fourth Century has largely replaced the term Late Classical, with its implication of decline.

The name of the final period of Greek art, Hellenistic, means "Greek-like." This period dates from the last decades of the fourth century, when Philip II of Macedon and his son Alexander conquered Greece and the Persian Empire. Hellenistic art was produced throughout this vast region as its non-Greek inhabitants gradually became imbued with Greek culture under Alexander and his successors. The history and art of ancient Greece end with the fall of Egypt, the last bastion of Hellenistic rule, to the Romans in 31–30 BCE.

THE GEOMETRIC PERIOD

The first appearance of a specifically Greek style of vase painting, as opposed to Minoan or Mycenaean, dates to about 1050

BCE. This style—known as Proto-geometric because it preceded and anticipated the Geometric style—was characterized by linear motifs, such as spirals, diamonds, and

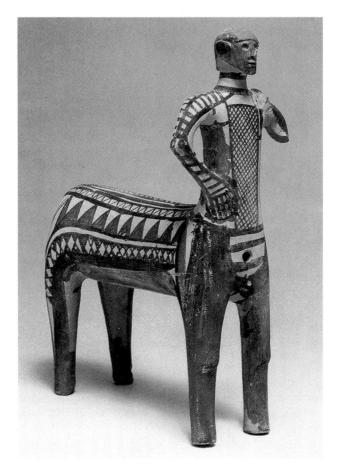

5-4. *Centaur,* from Lefkandi, Euboea. Late 10th century BCE. Terra-cotta, height 141/8" (36 cm). Archeological Museum, Eretria

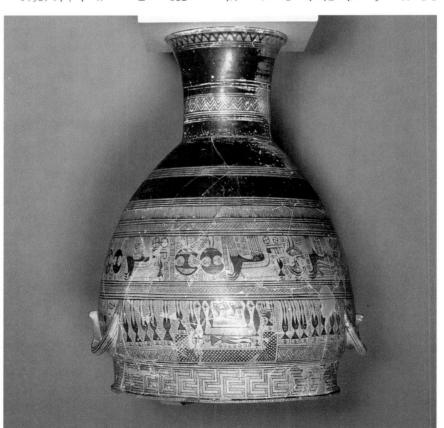

5-5. Vase, from the Dipylon Cemetery, Athens. c. 750 Bce. Terra-cotta, height 425/8" (108 cm). The Metropolitan Museum of Art, New York

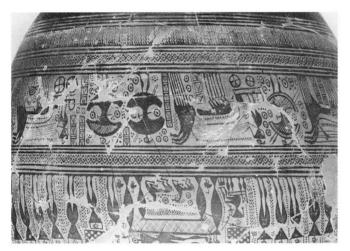

5-6. Detail of the Dipylon Cemetery vase (fig. 5-5)

Some vases discovered in the ancient cemetery of Athens just outside the Dipylon Gate, once the main western entrance into the city, exemplify the complex decoration typical of the Geometric style proper. Here human beings are depicted as part of a narrative, in a sharp departure from vase painting of earlier periods. The large funerary vase illustrated here, a grave marker meant to hold offerings, dated to about 750 BCE, provides a detailed record of the funerary rituals for an obviously important person (figs. 5-5, 5-6). The body of the deceased is placed on its side on a high platform at the centensor of the top register of the vase. Male and female ter of the top register of the vase. Male and female

Ceramic Decoration

types of art and endured until about 700 BCE.

crosshatching, rather than the stylized plants, birds, and sea creatures characteristic of Minoan vase painting. The Geometric style proper, an extremely complex form of decoration, became widespread after about 900 BCE in all

buried in the graves, their mourners, or both. Clearly, the object had special significance for the people ken into two pieces that were buried in adjacent graves. taur, discovered in a cemetery, had been deliberately brosymbolized the similar dual nature of humans. This cenmythology, had both a good and a bad side and may have portions of the figure. Centaurs, prominent in Greek standing out against the lighter color of the unslipped designs with a clay slip. The slip fired to dark brown, when these were dry, painted on the bold, abstract legs, arms, and a tail (now missing) to this body, and like a vase on a potter's wheel. The artist added solid than a foot tall) and because its hollow body was formed spheres. It is unusual, however, because of its size (more metric solids such as cubes, pyramids, cylinders, and and animal body parts in sculptural works to simple geoin painted decoration, and the reduction of human of the Protogeometric style: the use of geometric forms century BCE (fig. 5-4). This figure exemplifies two aspects creature called a centaur dates to the end of the tenth A striking ceramic figure of a half-horse, half-human

800 1000 BCE O BCE figures stand on each side of the body, their arms raised and both hands placed on top of their heads in a gesture interpreted as expressing anguish—it suggests that the mourners are literally tearing their hair with grief. In the bottom register, horse-drawn chariots and foot soldiers, who look like walking shields with tiny antlike heads and spindly legs, form a well-ordered procession.

The abstract forms used to represent human figures on this vase—triangles for torsos, more triangles for the heads in profile, round dots for eyes, long, thin rectangles for arms, tiny waists, and long legs with bulging thigh and calf muscles—were typical of the Geometric style. Figures are shown in either full-frontal or full-profile views that stress flat patterns and outline shapes. As in all abstract art, no attempt has been made to create the illusion of three-dimensional forms occupying real space. The artist has nevertheless managed to convey a deep sense of human loss by exploiting the rigidity, solemnity, and strong rhythmic accents of the carefully arranged elements.

Egyptian funerary art reflected the belief that the dead, in the afterworld, could continue to engage in activities they enjoyed while alive. Greek funerary art, in contrast, focused on the emotional reactions of the survivors, not the fate of the dead. The scene of human mourning and veneration on this vase contains no supernatural beings, nor any identifiable reference to an afterlife that might have provided solace for the bereaved. According to the Greeks, the deceased entered a place of mystery and obscurity that humans could not define precisely.

Metal Sculpture

Greek artists of the Geometric period produced many figurines of wood, ivory, clay, and especially cast bronze. These small statues of humans and animals are similar to those painted on the vases. A tiny bronze of this type, Man and Centaur, dates to about 750 BCE and is less than 41/2 inches tall (fig. 5-7). The sculptor reduced the body parts of the figures to simple geometric shapes, arranging them in a composition of solid forms and open, or negative, spaces that makes the piece pleasing from every view. Because the two figures confront each other in a seemingly peaceful way, they have been interpreted to be Achilles and Chiron, his teacher, but they could also be Herakles and the vengeful Nessos, who plotted his death, or an entirely different pair of mythical figures. Most such works have been found in sanctuaries, suggesting that they may have been votive offerings to the gods or perhaps trophies given to the winners of the various competitions regularly held at those sites.

The First Greek Temples

Few ancient Greek temples remain standing today. Their history has been pieced together largely from the debris of fallen columns, broken lintels, and fragments of sculptural decoration recovered from archeological excavations and somewhat from surviving ceramic models. The

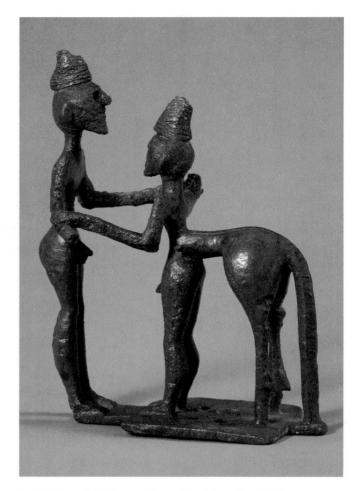

5-7. *Man and Centaur,* perhaps from Olympia. c. 750 BCE. Bronze, height 45/16" (11.1 cm). The Metropolitan Museum of Art, New York
Gift of J. Pierpont Morgan, 1917 (17.190.2072)

earliest remains of identifiably Greek temples date from the Geometric period. They consist of stone foundations that define buildings laid out in a simple rectangle or in a rectangular form with one or both ends rounded, and they were built presumably to shelter a statue of the god to whom the temple was dedicated. Nothing is left of their walls and roofs, which were constructed of mud brick and wood.

Small ceramic models, such as one from the eighth century BCE found in the Sanctuary of Hera near Argos, give some idea how Geometric period temples might have looked (fig. 5-8). The rectangular structure has a door at one end sheltered by a projecting **porch** supported on two sturdy columns. The steeply pitched roof forms a triangular area, or **gable**, in the **facade**, or front wall, that is pierced by an opening directly above the door. The abstract designs painted on the roof and side walls are similar to those used on other Geometric period ceramics; whether they reflect the way temples were actually decorated is not known.

Temple interiors followed an enduring basic plan adapted from the Mycenaean palace **megaron** (compare fig. 4-23 with plan (a) in "Elements of Architecture," page 164). The large audience hall of the megaron became the

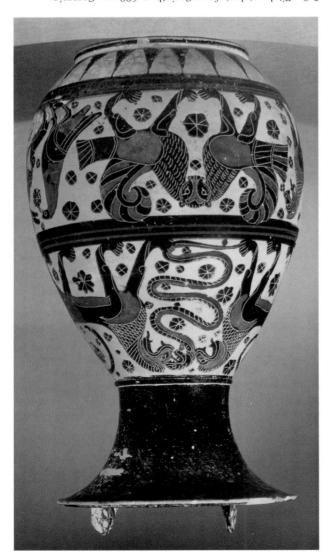

5-9. Pitcher (olpe), from Corinth. c. 600 BCE. Ceramic with black-figure decoration, height 111/2" (30 cm). The British Museum, London

very pale buff, the natural color of the Corinthian clay. Sometimes the background of a pot was painted as well, using a very fine, pure clay slip that turned almost white in the firing (see "Greek Painted Vases," page, 162). The artist incised fine details inside the silhouetted shapes with a sharp tool and added touches of white and reddish purple gloss, or clay slip mixed with metallic color pigments, to enhance the design.

The new Corinthian techniques were soon picked up by rival centers of pottery production. An **oinochoe**, or wine pitcher, from the island of Rhodes, for example, which dates to about 650–625 BCE, was decorated with the black-figure and white-slip techniques (fig. 5-10). Regainst a plain background scattered with atrong, simple geometric motifs, the artist arranged a two-register parade of ibexes, geese, songbirds, and a griffin, a mythical animal with a lion's body and an eagle's head and wings. The ibex was such a popular design element with the Rhodes painters that some art historians refer to their wase decoration as the "Wild Goat Style." The abstract

5-8. Model of a temple, found in the Sanctuary of Hera, Argos. Mid-8th century BCE. Terra-cotta, length 141/2" (36.8 cm). National Archeological Museum, Athens

main room of the temple, called the **cella** or **naos**. In the center of this room, where the hearth would have been in the megaron, stood a statue of the god to whom the temple was dedicated. The small reception room that preceded the audience hall in the megaron became the temple's vestibule, called the **pronaos**.

By the seventh century BCE, vase painters in major pottery centers in Greece had moved away from the dense decora-

THE ORIENTALIZING PERIOD

tion of the Geometric style to create more open compositions built around large motifs that included real and imaginary animals, abstract plant forms, and human figures. The source of these motifs can be traced to the arts of the Mear East, Asia Minor, and Egypt. Greek painters of the Mear East, Asia Minor, and Egypt. Greek painters of the Mear East, Asia Minor, and Eastern artists, however, Instead, they drew on work in a variety of mediums—including sculpture, metalwork, and textiles—to invent an entirely new approach to vase painting.

Among the first artists to make Orientalizing changes in pottery decoration were those of Corinth, a port city where luxury wares from eastern cultures were imported. A Corinthian **olpe**, or wide-mouthed pitcher, dating to about 600 BEE shows the Orientalizing style in the large mythical creatures silhouetted against a plain background dotted with stylized flower forms called thian technique for using background and foreground colors extending from black through browns and reds to colors extending from black through browns and reds to pure white. The type shown here, called **black-figure**, pure white the type shown here, called **black-figure**, pure white shapes silhouetted against a background of features dark shapes silhouetted against a background of

600 1000 BCE 0 BCE

TECHNIQUE

The three main types of Greek painted vase decoration are called **black-figure**, **red-figure**, and **white-ground**. The artists who produced

them had to be both skilled painters and highly trained and experienced ceramic technicians. They did not simply paint designs on a finished clay vessel. To create their works they had to master a complex procedure involving the use of specially prepared **slips** (mixtures of clay and water), the application of the slips to different areas in varying thicknesses, and the careful manipulation of the firing process in a kiln, or closed oven, to control the amount of oxygen reaching the vessel. If all went as planned (and sometimes it didn't), the designs painted in slip, which could barely be seen on the clay pot before firing, emerged afterward in the desired range of colors.

The firing process for both black-figure and redfigure painting involved three stages. In the first, a large amount of oxygen was allowed into the kiln, which "fixed" the whole vase in one overall color that depended on the composition of the clay used. In the second, or "reduction," stage, the oxygen in the **kiln** was reduced to a minimum, turning the whole vessel black, and the temperature raised to the point at which the slip partially vitrified (became glasslike). In the third phase, oxygen was allowed back into the kiln, turning the unslipped

GREEK areas red. The partially vitrified slipped areas, sealed against the oxygen, remained black.

In black-figure painting, artists painted designs—figures, objects, or abstract motifs—in silhouette on the clay vessel. Then, using a sharp tool called a **sty-lus**, they cut through the slip to the body of the vessel to incise linear details within the silhouettes. In red-figure painting, the approach was reversed, and the background around the designs was painted with the slip. The linear details inside the shapes were also painted with the same slip, instead of being incised. In both techniques, artists often enhanced their work with touches of white and red-dish purple **gloss**, metallic pigments mixed with slip.

White-ground vases became very popular in the High Classical period, especially for funerary use. The white ground, used since Archaic times, was created by painting the vessel with a highly refined, purified clay slip that turned white during the firing. The design elements were added to the white ground with either the black- or red-figure technique. After firing, the artists frequently enhanced their compositions by painting on details and areas of bright and pastel hues using **tempera**, a paint made from egg yolks, water, and pigments. Because the tempera paints were fragile, these colors flaked off easily, and few perfect examples have survived.

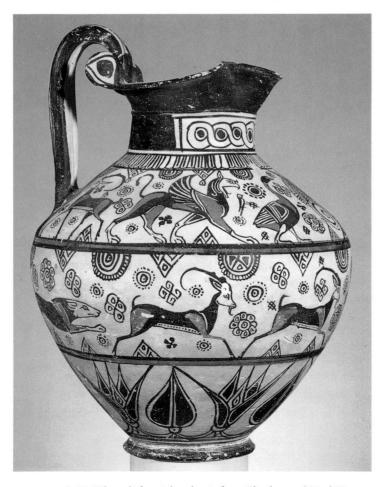

5-10. Wine pitcher (oinochoe), from Rhodes. c. 650–625 BCE. Ceramic with black-figure decoration on light ground, height 12¹/4" (31 cm). Museum of Fine Arts, Boston Gift of Mrs. S. T. Morse

bud or leaf patterns in the bottom register are similar to the lotus-bud motifs found in Egyptian art.

THE ARCHAIC PERIOD

The Archaic period, from about 600 to 480 BCE, was one of cultural energy and achievement during which the Greek city-states on the mainland, on the Aegean islands, and in

far-flung colonies grew and flourished. Athens, which had lagged behind the other city-states in population and economic development, began moving artistically, commercially, and politically to the forefront.

All Greek arts developed rapidly during the Archaic period. The poet Sappho on the island of Lesbos was writing poetry that would inspire the geographer Strabo, near the end of the millennium, to write: "Never within human memory has there been a woman to compare with her as a poet." On another island, the semilegendary slave Aesop was relating animal fables that became lasting elements in Western culture. Artists shared in the growing prosperity of the city-states by competing for lucrative commissions from city councils and wealthy individuals, who sponsored the creation of temples, shrines, government buildings, monumental sculpture, and fine ceramic wares. During this period, potters and vase painters first began to sign their works.

Temple Architecture

As Greek temples grew steadily in size and complexity over the centuries, stone and marble replaced the earlier mud-brick and wood construction. Temple builders evolved a number of standardized plans, ranging from simple one- and two-room structures with columned

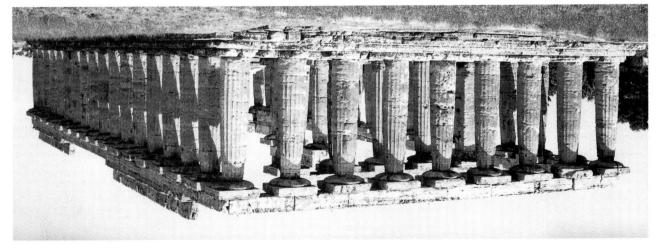

5-11. Temple of Hera I, Paestum, Italy. c. 550 BCE

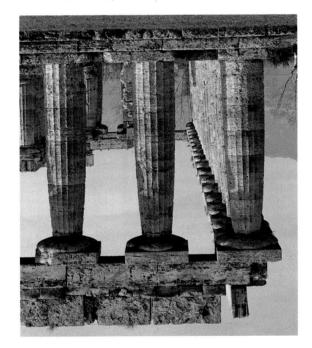

5-13. Corner view of the Temple of Hera I, Paestum

a dipteral temple. The columns stand on the top surface of the stylobate. The peristyle of Hera I originally supported a tall lintel area called the entablature. A peaked most element of the entablature. At each end, the horizontal cornice of the entablature and the raking calanted) cornice of the entablature and the raking calanted) cornice of the roof defined a triangular gable called the pediment.

The elevation design of Hera I was a local variation on the earliest major Greek order, the Doric. The standard form of the Doric order—incomplete on Hera I because of the damage it has suffered—includes fluted columns without bases resting directly on the stylobate; plain column capitals made up of two distinct parts, the round echinus and the square abacus; and a three-part architrave, topped by a decorated band, called the architrave, topped by a decorated band, called the architrave, and capped with a continuous carved architrave, and capped with a continuous carved strong bands called moldings. In the Doric frieze, flat stone bands called moldings. In the Doric frieze, flat

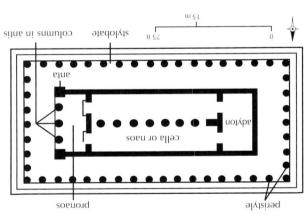

5-12. Plan of the Temple of Hera I, Paestum

porches to multiroomed structures with double porches surrounded by columns (see "Elements of Architecture," page 164). They also experimented with the design of temple elevations, and appearance of the temple foundation, the columns, and the linitels. Two standardized elevation designs, the Archaic order and the lonic order, emerged during the lonic order, became so popular later that it too is treated today as a standard Greek order (see "Elements of Architecture," page 165).

The site of Paestum, a Greek colony established in the seventh century BCE about fifty miles south of the modern city of Naples, Italy, contains some rare examples of early Greek temples. Although these temples reflect contemporary architectural developments on ticular colonial setting and are not typical of all Archaic Greek temples. The earliest standing temple there, built about 550 BCE, was dedicated to Hera, the queen of the about 550 BCE, was dedicated to Hera, to distinguish it from a second temple to Hera built adjacent to it about a century later.

Hera I is a large, rectangular, stone **post-and-lintel** structure with a stepped foundation supporting a **peri-style**, a row of columns that surrounds all four sides (fig. 5-12). This single peristyle defines Hera I as a **peripteral** temple; a double peristyle (two rows of columns) defines

ELEMENTS OF The simplest early temples ARCHITECTURE consist of a single room, the cella or naos, with side Greek Temple Plans walls incorporating pillars projecting forward to frame

two columns in antis (literally, "between the pillars") (a). In a prostyle temple (b) the columns form a portico,

or walkway, only across the building's front. An amphiprostyle temple (c) has a row of columns (colonnade) at both the front and back ends of the structure, not on the sides. If the colonnade runs around all four sides of the building, forming a peristyle, the temple is peripteral (d); if the surrounding colonnade is two columns deep, the temple is dipteral (e).

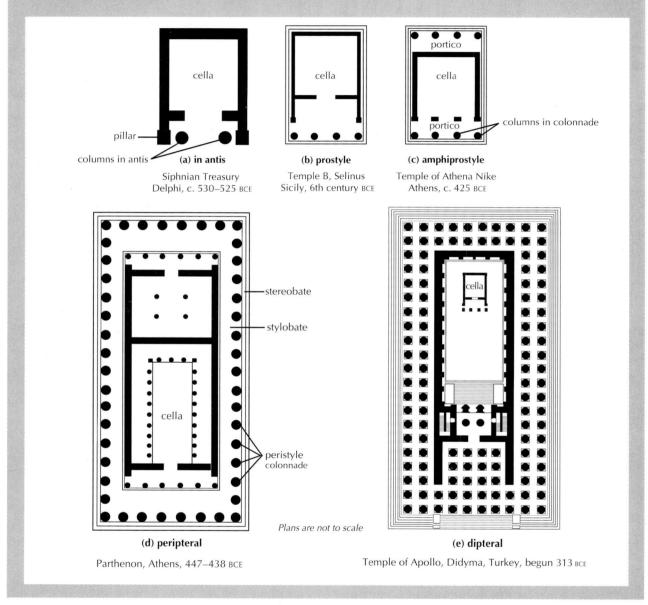

areas called metopes alternate with triglyphs, projecting blocks with three vertical grooves. The metopes were usually decorated with figures, either painted on or sculpted in relief and then painted.

Fragments of terra-cotta tiles painted in bright colors have been found in the rubble of Hera I, suggesting that they adorned parts of the temple, possibly the metopes. No sculptural fragments have survived. The Hera I builders created an especially robust column, only about four times as high as its maximum diameter, topped with a widely flaring capital (fig. 5-13). This design creates an impression of great stability and permanence. As the column shafts rise, they swell in the middle and contract

again toward the top, a common attribute of Greek columns known as entasis. This subtle adjustment gives a sense of energy and upward lift. In a local innovation not part of the standard Doric order, Hera I has an uneven number of columns—nine—across the short ends of the peristyle, placing a column instead of a space at the center of the ends. The entrance to the pronaos also has a central column, and a row of columns runs down the center of the wide cella to help support the ceiling. The statue of Hera may have been housed in the adyton, the small auxiliary space at the end of the cella proper. The unusual two-aisle arrangement suggests that the temple may have housed a second god statue, possibly of Zeus.

frieze, and the cornice, the topmost, projecting orders, the entablature includes the architrave, the echinus and the tabletlike abacus. As in the other The Doric capital itself has two parts, the rounded the necking, which provides a transition to the capital. deeply as in the other orders. At the top of the shaft is stylobate, without a base. The shaft is fluted but not as

the distinctive scrolled volute. Ionic capital, which has a thin, cushionlike abacus, is separated by flat surfaces, fillets. The hallmark of the on the columns are deeper and closer together and are Doric column's five-and-a-half-to-one ratio. The flutes diameter of the column at its base, as opposed to the than the Doric, its height being about nine times the The lonic order has more elegant proportions horizontal element.

center of each "side." corners and a boss, or projecting ornament, at the top rosettes, and they often have scrolled elements at the sheathed with stylized acanthus leaves, and sometimes temple exteriors as well. Its elaborate capitals are the Greeks for use in interiors but came to be used on The Corinthian order was originally developed by

> about 600 BCE. The Doric order Architectural orders were well developed by The Greek thian. The Doric and Ionic Doric, the Ionic, and the Corin-ARCHITECTURE architectural orders are the ELEMENTS OF The three classical Greek

elaborated it, as we shall see in Chapter 6. the Romans appropriated the Corinthian order and and was initially used by the Greeks in interiors. Later, variation of the Ionic, began to appear around 450 BCE and the islands off the coast. The Corinthian order, a region occupied by Greeks on the west coast of Anatolia the three orders. The Ionic order is named after Ionia, a Orders is the oldest and plainest of

levels below the stylobate form the stereobate. stand on the stylobate, the "floor" of the temple; the metal pegs. In Greek temple architecture, columns round sections, or drums, which are joined inside by capital; some also have a base. Columns are formed of and lintel. All types of columns have a shaft and a column and the entablature, which function as post The basic components of the Greek orders are the

The Doric order shaft rises directly from the

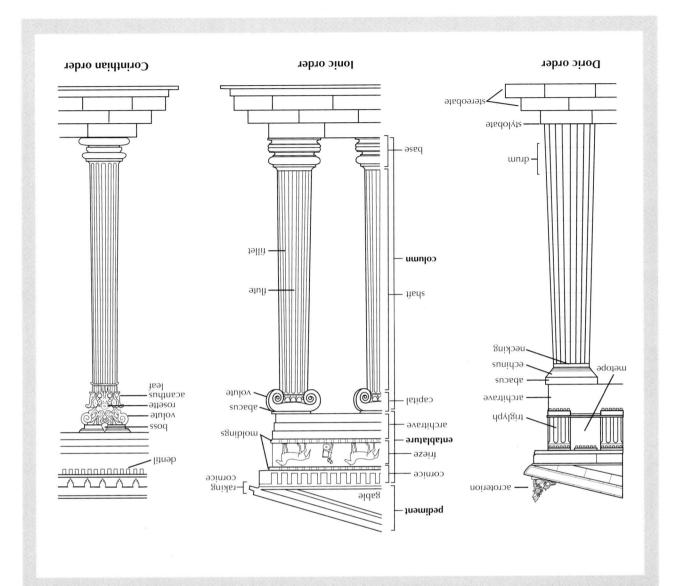

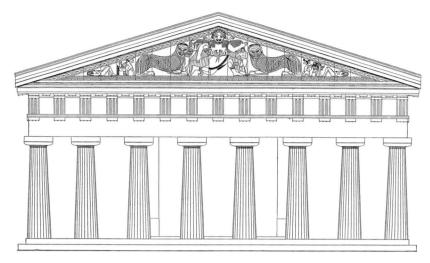

5-14. Reconstruction of the west pediment of the Temple of Artemis, Korkyra (Corfu), after G. Rodenwaldt. c. 600–580 BCE

Architectural Sculpture

As Greek temples grew larger and more complex, sculptural decoration took on increased importance. The Greeks may have looked to the civilizations south and east of them for ideas on combining sculpture with architecture, but the results were far from Egyptian or Near Eastern in appearance.

Perhaps the earliest surviving examples of Greek pedimental sculpture are fragments of the ruined Doric order Temple of Artemis on the island of Korkyra (Corfu) off the northwest coast of the mainland, which date to about 580 BCE (fig. 5-14). The figures in this sculpture were carved on separate slabs, then installed in the pediment space. They stand in such high relief from the background plane that they seem to burst out of their architectural frame, which was more than 9 feet tall at the peak. At the center is the rampaging snake-haired Medusa (fig. 5-15), one of three winged female monsters called Gorgons. Medusa had the power to turn humans to stone if they looked upon her face, and in this sculpture she fixes viewers with huge glaring eyes as if to work her dreadful magic on them. Flanking Medusa are the flying horse Pegasus on the left (only part of his rump and tail remain) and the giant Chrysaor on the right. These were Medusa's posthumous children, born from the blood that gushed from her neck after she was beheaded by the legendary hero Perseus. The crouching felines next to them literally bump their heads against the raking cornices of the roof. Dying human warriors lie on the ends of the pediment, their heads tucked into its corners and their knees rising with its sloping sides.

An especially noteworthy collaboration between builder and sculptor can still be imagined from the remains—housed today in the museum at Delphi—of the small but luxurious Siphnian Treasury, built in the Sanctuary of Apollo at Delphi between about 530 and 525 BCE. An old reconstruction of the facade of this building, now dismantled, shows a pronaos with two caryatids—

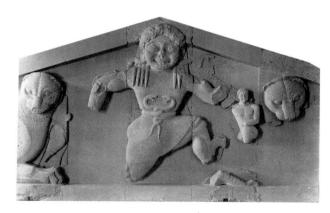

5-15. Medusa, fragment of sculpture from the west pediment of the Temple of Artemis, Korkyra. c. 580 BCE. Limestone, height of pediment at the center 9'2" (2.79 m). Archeological Museum, Korkyra

Ancient Greeks would have seen the image of Medusa at the center of this pediment as both menacing and protective. According to legend, countless people tried to kill this monster, only to die themselves merely because they looked at her face. The clever Greek hero Perseus succeeded because he beheaded her while looking only at her reflection in his polished shield. Thus the Medusa head became a popular decoration for Greek armor. See, for example, the shield of Ajax in figure 5-29.

columns carved in the form of draped women—set flush with the ends of the side walls, which were reinforced by square pillars, or **antae** (fig. 5-16). (This type of temple plan is called **in antis**, meaning "between the pillars"; see "Elements of Architecture," page 164.) The stately caryatids, with their finely pleated, flowing garments, are raised on **pedestals** and balance elaborately carved capitals on their heads. The capitals support a tall entablature conforming to the Ionic order, which features a plain, slightly extended architrave and a continuous

Cyclades. Aegean Sea just southwest of the from Siphnos, an island in the commissioned this treasury were to resemble gold. The people who white, with touches of yellow mainly dark blue, bright red, and bly once painted in strong colors, decorative moldings were probahillside. The figural sculpture and perched near one another on the Delphi were in their original state, eight small treasury buildings at elegant and richly ornamented the worlding a general idea of how graph is useful, however, in ments of the treasury. The photoexhibits separately the actual fragdismantled. The museum now out with reproductions—has been using real sculptural remains filled from the east and west facades, This old reconstruction—probably Archeological Museum, Delphi c. 530-525 BCE. Marble. Fragments: in the Sanctuary of Apollo, Delphi. Treasury, using fragments found 5-16. Reconstruction of the Siphnian

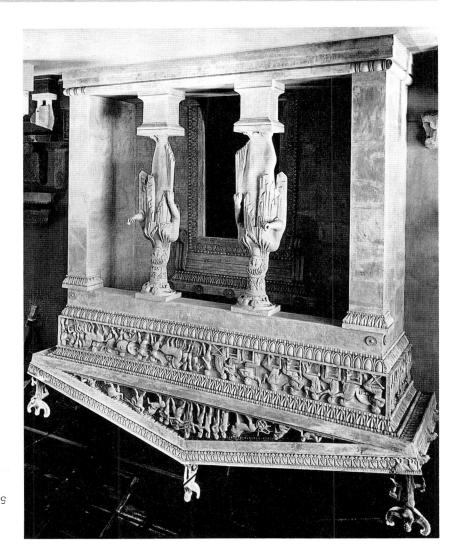

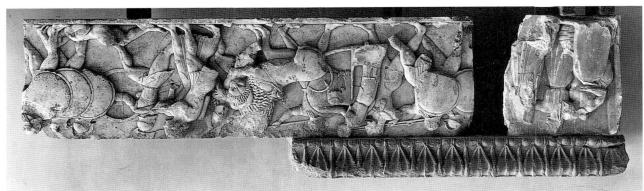

5-17. Battle between the Gods and the Giants, fragments of the north frieze of the Siphnian Treasury, from the Sanctuary of Apollo, Delphi, c. 530-525 BCE. Marble, height 26" (66 cm). Archeological Museum, Delphi

substitute for the standard columns in the lonic order. Both the continuous frieze and the pediments of the Siphnian Treasury were originally filled with relief sculpture. A surviving section of the frieze from the building's north side, which shows a scene from the legendary battle between the sky gods and the earth gods, is one of the earliest known examples of a trend in Greek relief sculpture toward a more natural representation of space (fig. 5-17). To give a sense of three dimensions, the sculptor

frieze, one uninterrupted by projecting elements. The relief that was often set off by bands of figures carved in moldings. The standard lonic order column is slender and fluted, with a base of plain moldings and a distinctive volute capital, consisting of a square echinus with two opposing "rolled" sides topped by a thin abacus that may be decorated with carving (see "Elements of Architecture," page 165). As in this case, caryatids sometimes tecture," page 165). As in this case, caryatids sometimes

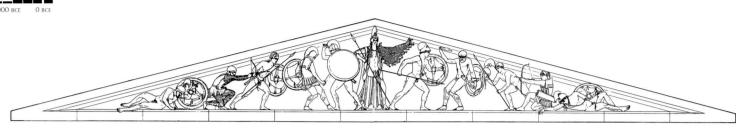

5-18. Reconstruction drawing of the east pediment of the Temple of Aphaia, Aegina. c. 480 BCE

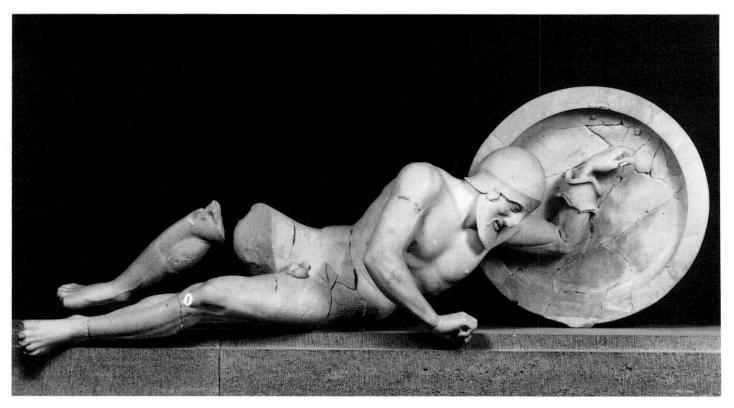

5-19. *Dying Warrior,* fragment of sculpture from the east pediment of the Temple of Aphaia, Aegina. c. 480 BCE. Marble, length 6' (1.83 m). Staatliche Antikensammlungen und Glyptothek, Munich

placed some figures behind others, overlapping as many as three of them and varying the depth of the relief from high on the foreground figures to lower and lowest on the figures behind. But countering any sense of deep recession, all the figures were made the same height with their feet on the same **groundline**.

The long pediments of Greek temples provided a perfect stage for storytelling, but the triangular pediment created a problem in composition. The sculptor of the east pediment of the Doric Temple of Aphaia at Aegina (fig. 5-18), dated to about 480 BCE, provided a creative solution that became a design standard, appearing with variations throughout the fifth century BCE. The subject of the Aphaia pediment, rendered in fully three-dimension-

al figures, is most likely a Trojan War battle scene. Fallen warriors fill the angles at both ends of the pediment base, while others crouch, lunge, and reel, rising in height toward an image of Athena as warrior goddess under the peak of the roof. The erect goddess, larger than the other figures and flanked by two defenders facing approaching opponents, dominates the center of the scene and stabilizes the entire composition.

Among the best-preserved fragments from this pedimental scene is the *Dying Warrior* from the far left corner, a tragic but noble figure struggling to rise while dying (fig. 5-19). This figure originally would have been painted and fitted with authentic bronze accessories, heightening the sense of reality it conveys. Fully exploit-

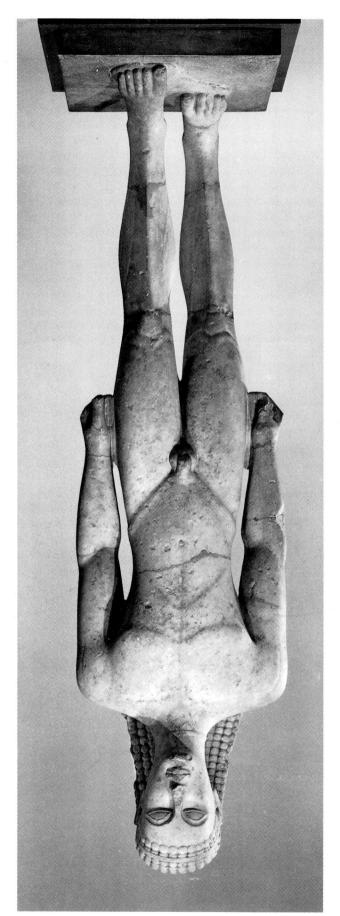

ing the difficult framework of the pediment corner, the sculptor portrayed the soldier's uptilted, twisted form turning in space, capturing his agony and vulnerability. The subtle modeling of the body conveys the softness of human flesh, which is contrasted with the hard, metallic geometry of the shield and helmet.

Freestanding Sculpture

In addition to decorating temple architecture, sculptors of the Archaic period created a new type of large, freestanding statue. A few surviving examples are made of wood or terra-cotta, but most are made of white marble, which is readily available in Greece, particularly on the islands of Paros and Naxos. Usually lifesize or larger, these male and female figures were depicted in reclining, were painted in bright, lifelike colors and sometimes were painted in bright, lifelike colors and sometimes bore inscriptions indicating that they had been commissioned by individual men or women for some commissioned by individual men or women for some commissioned by individual men or women for some commentative purpose. Many have been found marking graves, but the majority have been discovered in sanctuaries to the gods, where they were placed on pedestals lining the sacred way from the entrance to the main temple.

Traditionally, a female statue of this type is called a **kore** (plural korai), Greek for "young woman," and a male statue is called a **kouros** (plural kouroi), Greek for "young man." The Archaic korai were always clothed and are thought to have represented deities, priestesses, and nymphs, the young female immortals who served as attendants to the gods. The kouroi, nearly always nude, have been variously identified as gods, warriors, and victorious athletes. Because the Greeks associated young, athletic males with fertility and family continuity, the figures may have been symbolic ancestor figures. Pliny the Elder, a Roman naturalist and historian of the first century ce, believed that some of them portrayed famous athletes. He wrote:

It was not customary to make effigies [portraits] of men unless, through some illustrious cause, they were worthy of having their memory perpetuated; the first example was a victory in the sacred contest, especially at Olympia, where it was the custom to dedicate statues of all who had been victorious; and in the case of those who had been victorious; and in the case of those who ed [sculpted] a likeness from the actual features of the person, which they call "icons" (Naturalis of the person, which they call "icons").

A kouros figure dating to about 600 BCE (fig. 5-20) is reminiscent of standing males in Egyptian sculpture, such as the statue of Menkaure with his queen (see fig. 3-15). Like Egyptian figures, this young Greek is shown

5-20. Kouros. c. 600 Bce. Marble, height 6'4" (1.93 m). The Metropolitan Museum of Art, New York Fletcher Fund, 1932 (32.11.1)

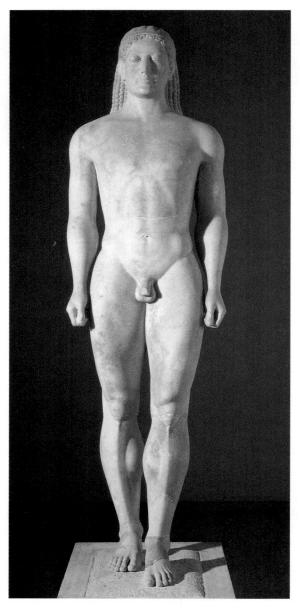

5-21. *Kroisos* (?), from a cemetery at Anavysos, near Athens. c. 525 BCE. Marble with remnants of paint, height 6'4" (1.93 m). National Archeological Museum, Athens

frontally, arms rigidly at his sides, fists clenched, and one leg slightly in front of the other. However, Greek artists of the Archaic period did not share the Egyptian obsession with permanence; they cut away all stone from around the body and introduced variations in appearance from figure to figure. Greek statues may be suggestive of the marble block from which they were carved, but they have a notable athletic quality quite unlike Egyptian statues. Here the artist delineated the figure's anatomy with ridges and grooves that form geometric patterns. The head is an ovoid shape with heavy features and schematized hair evenly knotted into tufts and tied back with a narrow ribbon. The eyes are relatively large and wide open, and the mouth forms a characteristic closed-lip smile known as the Archaic smile, apparently used to enliven the expressions of figures. In Egyptian sculpture, male figures were always at least partially clothed, wear-

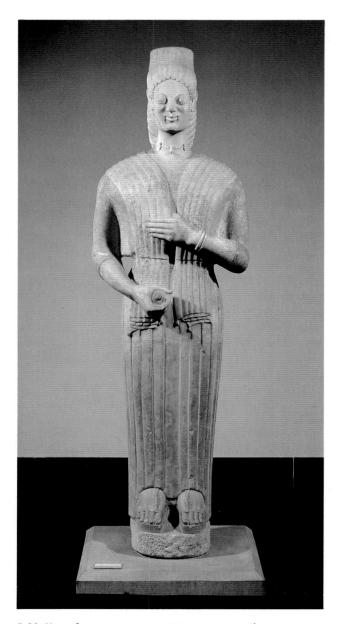

5-22. Kore, from a cemetery at Keratea, near Athens. 570–560 BCE. Marble with remnants of red paint, height 6'3" (1.9 m). Staatliche Museen zu Berlin, Preussischer Kulturbesitz, Antikensammlung

ing articles associated with their status, such as the headdresses, beaded pectorals, and kilts that identified kings. The total nudity of the Greek kouroi, in contrast, removes them from a specific time, place, or social class.

A kouros dated about seventy-five years later than figure 5-20 clearly shows in its swelling, rounded body forms the increasing interest of artists and their patrons in a more lifelike rendering of the human figure (fig. 5-21). The pose, wiglike hair, and Archaic smile echo the earlier style of kouros, but the torso and limbs were rendered with greater anatomical accuracy and may have been done from a specific human model. The statue, a grave monument to a fallen war hero, often called *Kroisos*, may portray a particular individual of that name. The inscription reads: "Stop and grieve at the tomb of the dead Kroisos, slain by wild Ares [god of war] in the front rank of battle."

Marble, height 48" (123 cm). Acropolis Museum, Athens 5-23. Peplos Kore, from the Acropolis, Athens. c. 530 BCE.

thin fabric of the chiton. legs reveals a rounded thigh showing clearly through the lent effect. A close look at what remains of the figure's orate hairstyle and abundance of jewelry add to the opua lighter fabric than the peplos, probably linen. The elaband gathering of the chiton indicate that it was made of onally and fastened on one shoulder. The fine pleating Greece. Over it, a cloak called a himation is draped diagcoast of Asia Minor but became popular throughout basic article of clothing that originated in Ionia on the wears a garment called a chiton, a relatively lightweight, forms that would peak in the fifth century BCE. The kore toward an increasingly lifelike depiction of anatomical (see fig. 5-21) and the Peplos Kore, it reflects a trend amount of paint that still adheres to it. Like the Kroisos

> apparently used some of the statues there to build barriing an attack by Persian forces, fled to the Acropolis and survived. In 480 BCE the desperate Athenians, anticipatplaced in the sanctuary over the centuries, but few have and commemorative statues like the Peplos Kore were (acro means "high" and polis means "city"). Many votive city and later served as a fortress and religious sanctuary Athens, a flat-topped hill that was the original site of the BCE, Was recovered from debris on the Acropolis of The Peplos Kore (fig. 5-23), which dates to about 530 ter) associated with the cultivation of crops. rebirth (spring and summer) and death (autumn and winseeds—symbolized fertility and the seasonal cycles of Persephone and the pomegranate-which has many months out of every year, from spring to autumn. Thus however, she was allowed to live aboveground for six world. Through her mother's intercession with Zeus, to become Hades' queen and live eternally in the under-Hades' garden, unaware that this act would destine her er, she became hungry and ate a pomegranate from While she was mourning her separation from her mothwas abducted by Hades, the god of the underworld. sephone, the daughter of the earth goddess Demeter, subject with artists was the myth in which young Perdess of the underworld and the harvest. A popular an attribute (identifying symbol) of Persephone, the godgold. The figure holds a pomegranate in her right hand, often used as a base for the application of thin sheets of pigment indicate that the robe was once red, a color further emphasizing its stately appearance. Traces of spaced, parallel folds like the fluting on a Greek column, or a nymph attendant. The thick robe falls in regularly goddess, although the statue may represent a priestess crown and thick-soled clogs—seem appropriate to a bodied figure, and 6-foot height-accentuated by a 570-560 BCE (fig. 5-22). The erect, immobile pose, fullcemetery at Keratea, for example, dates to about

> later than the earliest kouroi. An early kore found in a The first Archaic korai appear to date somewhat

> earrings and has traces of encaustic painting, a mixture ventionalized. The figure once wore a metal crown and hair are somewhat more individualized and less conflesh covering a real bone structure, and its smile and ure. Its bare arms and head convey a greater sense of soft pose of the earlier kore but a more rounded, feminine figeffect. The Peplos Kore has the same motionless, vertical wool, folded over the top and belted to give a bloused called a **peplos**—a draped rectangle of cloth, usually The Peplos Kore is named for its distinctive garment, Persian invasion. used as fill in the reconstruction of the Acropolis after the

> works suffered further destruction, and they finally were cades. When the Persians later sacked the city, these

> it is impressive for its sculpted costuming and the large this figure have been lost and its face has been damaged, the coast of Asia Minor. Although the arms and legs of have been made by a sculptor from Chios, an island off Another kore (fig. 5-24), dating to about 520 BCE, may

> of pigments and hot wax that left a shiny, hard surface

when it congealed.

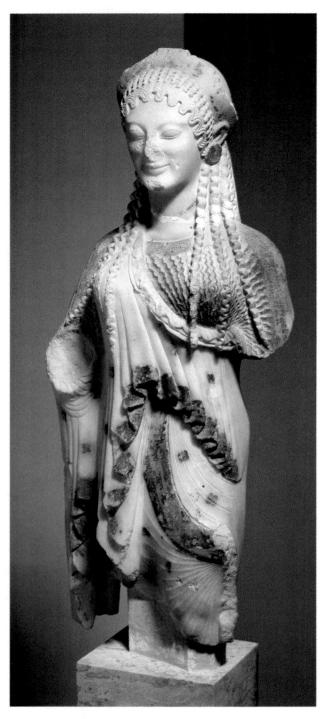

5-24. Kore, from Chios(?). c. 520 BCE. Marble, height 217/8" (56.6 cm). Acropolis Museum, Athens

Not all Archaic statues followed the conventional kouros or kore models for standing figures. A different type is a large statue fragment called the *Calf Bearer (Moschophoros)* (fig. 5-25). This statue, dated about 560 BCE, was also found in the rubble of the Acropolis, in the Sanctuary of Athena. It probably represents a priest or worshiper carrying an animal intended for sacrifice on the altar of a deity. The figure's smile, tufted hairdo, and wide-open eyes with large irises and semicircular eyebrows all reflect the Archaic style. Its short-cropped

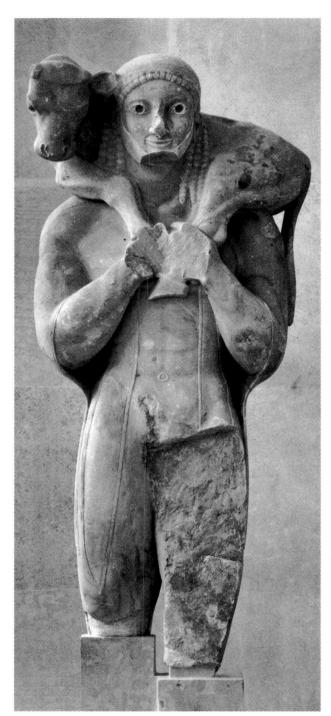

5-25. *Calf Bearer (Moschophoros)*, from the Acropolis, Athens. c. 560 BCE. Marble, height 5'5" (1.65 m). Acropolis Museum, Athens

beard is similar to that of other statues of the period depicting men in active poses, but the gauze-thin robe is unusual. The sculptor has rendered the calf with acute detail, capturing its almost dazed look and the twisted position in which its captor holds its forelegs.

Vase Painting

Greek vases, no matter how richly decorated, were created in only a few forms, which combined beauty with

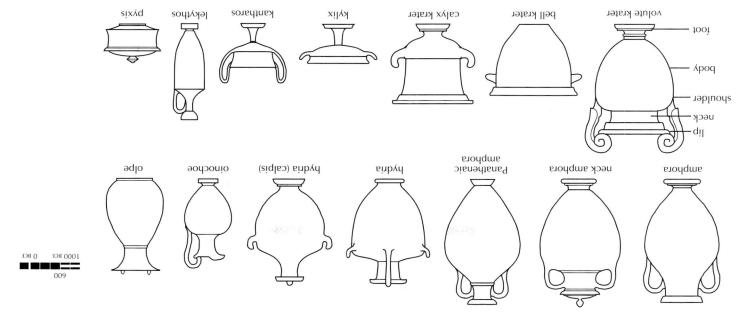

5-26. Standard Greek vase shapes

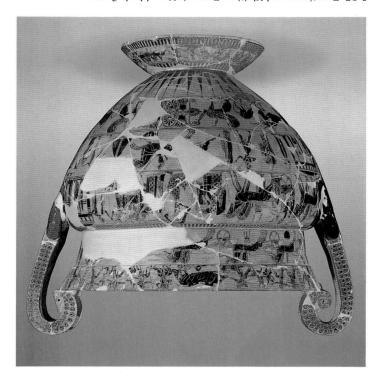

5-27. Ergotimos and Kleitias. François Vase, black-figure decoration on a volute krater. c. 570 BCE. Ceramic, height 26" (66 cm). Museo Archeològico Nazionale, Florence, Italy

This large mixing bowl was made and decorated by Athenian artists but discovered in modern times in an Etruscan tomb. The Etruscans, who were living in Etruria in central Italy at the time the early Roman civilization emerged, were great admirers and collectors of Greek pottery. Not only did they import vases, but they also brought in Greek artists. Because so much techniques and styles to local artists. Because so much Greek and Greek-style pottery was discovered in Creek and Greek-style pottery was discovered in the grant Greek and Greek-style pottery was discovered in the Greek and Greek-style pottery was discovered in Greek and Greek-style pottery was discovered in the Greek and Greek-style pottery was discovered in Greek and Greek-style pottery was discovered in Greek-style pottery was discovered in Greek and Greek

specific utilitarian functions (fig. 5-26). The artists who painted them had to accommodate their work to these fixed shapes. During the Archaic period, Athens became the dominant center for pottery manufacture and trade in Greece. Athenian painters adopted many Corinthian techniques, especially black-figure painting, which became the principal mode of decoration throughout who painted large, mythical beasts against floral back-grounds, Athenian painters retained a format that was characteristic of the Geometric period, with narrow bands of decoration and relatively small figures. Compared with of decoration and relatively small figures compared with of decoration and relatively small figures and the Dipylon Cemetery (see fig. 5-5), there are fewer bands and the Bon Cemetric patterning around the figures is reduced.

An important transitional work, the François Vase, illustrates these changes (fig. 5-27). This vase, which dates to about 570 BCE, is a **volute krater**. A **krater** is a dates to about 570 BCE, is a volute krater is one with scrolllarge vessel used for mixing the traditional Greek drink of wine and water, and a volute krater is one with scrollshaped, or volute, handles. The François Vase was discovered by an archeologist named François in an a people especially fond of Greek vases. It is one of the approach of the principle of the propose of the propose of the propose of the propose of the myth and legendary history, which he identified with inscriptions, providing an important pictorial record of the Greek pantheon. In all, the vase contains about 200 the Greek pantheon. In all, the vase contains about 200 the Greek pantheon. In all, the vase contains about 200

The main narrative scene, which occupies the third band down from the top and encircles the whole vase, is the marriage of Peleus and Thetis, the parents of Achilles. Thetis was a sea nymph and Peleus the king of Thessaly, and their wedding was attended by the Olympian gods. In the segment seen in figure 5-27, Peleus stands in front

human and animal figures.

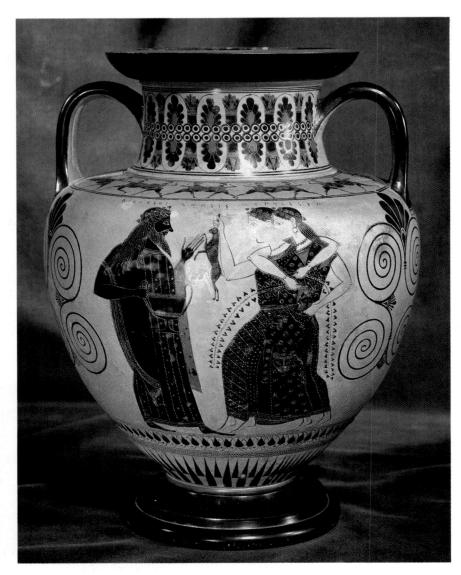

5-28. Amasis Painter. *Dionysos with Maenads*, black-figure decoration on an amphora. c. 540 BCE. Ceramic, height of amphora 13" (33.3 cm). Bibliothèque Nationale, Paris

of his palace, on the right, greeting the deities, who are arriving in a grand procession of chariots. The scenes on the neck of the vessel show, from the top down: the hunt for the dangerous Kalydonian Boar, led by the hero Meleager, and the funeral games in honor of Patroclus, Achilles' close friend who died in the Trojan War. On the body of the krater, below Peleus and Thetis, is a depiction of the ambush of the Trojan prince Troilus by Achilles. The Orientalizing style (see figs. 5-9, 5-10) is still evident on this Archaic period vase in the next band down, decorated with deer, griffins, and plant forms. On the foot of the vessel, very small warriors do battle with long-necked cranes, illustrating a story dating back to Homer's day that became a popular theme with vase painters. There are only three bands of pure geometric design—one of elongated triangles radiating up from the foot of the vessel and two narrow bands of looped decoration on the foot.

Over time, Athenian vase painters continued to decrease the number of bands and increase the size

of figures until a single scene, usually one per side, filled the whole body of a vessel. A mid-sixth-century BCE amphora—a large, all-purpose storage jar—illustrates this development (fig. 5-28). The decoration on this vessel, a depiction of the wine god Dionysos with maenads, his female worshipers, has been attributed to an anonymous artist called the Amasis Painter, because work of this distinctive style was first recognized on vessels signed by a prolific potter named Amasis. Most of the Amasis Painter's work is found on small vessels, but this handsome amphora is an exception.

In the scene shown here, two maenads, arms around each other's shoulders, skip forward to present their offerings—a long-eared rabbit and a small deer—to Dionysos. The maenad holding the deer wears the skin of a spotted panther (or leopard), its head still attached, draped over her shoulders and secured with a belt at her waist. The god, an imposing, richly dressed figure, clasps a large **kantharos** (wine cup). A band of grape leaves, an attribute of Dionysos, forms the groundline on which the

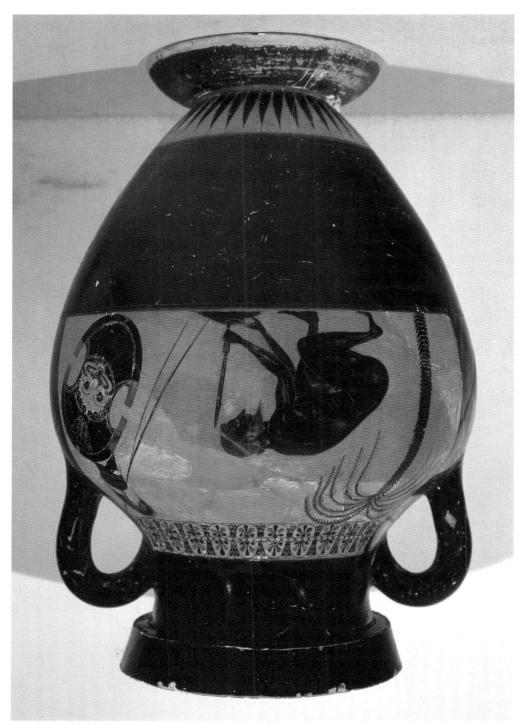

of amphora 27" (69 cm). Château-Musée, Boulogne-sur-Mer, France 5-29. Exekias. The Suicide of Ajax, black-figure decoration on an amphora. c. 540 BCE. Ceramic, height

rather than Ajax. Distraught by this humiliation—comthe Greeks bestowed his magic armor on Odysseus Achilles in bravery. After the death of Achilles, however, Ajax was a fearless Greek warrior, second only to an episode from the legends of the Trojan War (fig. 5-29). ity. A scene on an amphora, The Suicide of Ajax, recounts painted composition to vessel shape with great sensitiv-Exekias took his subjects from Greek legend, matching Exekias, signed his vessels as both potter and painter. Another Athenian artist of the mid-sixth century BCE,

their clothing. meticulously arranged hair, and the bold patterns on petal and spiral designs below each handle, the figures' and emphasized fine details, such as the large, delicate ventions for making figures appear to occupy real space, strong shapes and patterns, generally disregarding conone of reverence or fear. The Amasis Painter favored appears to be a joyful, celebratory occasion rather than grapevine. This encounter between humans and a god figures stand, and the maenads each carry a piece of

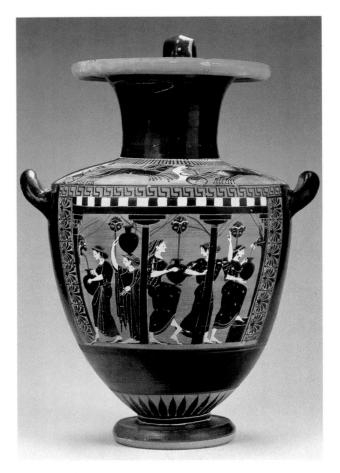

5-30. "A.D." Painter. Women at a Fountain House, black-figure decoration on a hydria. 520–510 BCE. Ceramic, height of hydria 207/8" (53 cm). Museum of Fine Arts, Boston William Francis Warden Fund

pounded by his family ties to Achilles, who was his cousin-Ajax killed himself. Other artists showed the great warrior either dying or already dead, but Exekias has captured the story's most poignant moment, showing Ajax preparing to die. He has set aside his helmet, shield, and spear and crouches beneath a tree, planting his sword upright in a mound of dirt so that he can fall upon it. The painting exemplifies the quiet beauty and perfect equilibrium for which Exekias's works are so admired today. Two upright elements—the tree on the left and the shield on the right-frame and balance the figure of Ajax, their in-curving lines echoing the swelling shape of the amphora and the rounding of the hero's powerful back as he bends forward. The whole composition focuses the viewer's attention on the head of Ajax and its dangerous proximity to the point of his sword.

Not all subjects used for vase painting involved gods and heroes. A handsome example of black-figure decoration, painted about 510 BCE on an Athenian **hydria**, or water jug, by an artist who signed the work with the initials "A.D.," gives an interesting insight into everyday Greek city life (fig. 5-30). The majority of women in ancient Greece were restricted to their homes and occupied with household tasks. Few houses had running

water, and the trip to the communal well, or fountain house, would have been an important daily event. The scene on the hydria shows five women gathered at such a place. In the shade of the columned porch, three of the women patiently fill hydrias like the one on which they are painted. A fourth balances her full jug on her head for the trip home, while a fifth woman, without a jug, appears to be waving in greeting to someone. The women's skin is painted white, a convention for female figures found also in Egyptian and Minoan art. Incising and touches of reddish purple paint were used to create fine details in the architecture and in the figures' clothing and hair.

The composition of this vase painting is a fine balance of vertical, horizontal, rectangular, and rounded elements. The columns, the decorative vertical borders, and even the streams of water flowing from the animalhead spigots echo the upright figures of the women. The wide black band forming the groundline, the architrave above the colonnade, and the left-to-right movement of the horse-drawn chariots across the shoulder area of the hydria emphasize the horizontal, friezelike arrangement of the women across the width of the vase. This geometric framework is softened by the rounded contours of the female bodies, the globular water vessels, the circular palmettes (fan-shaped petal designs) framing the main scene, and the arching bodies of the galloping horses on the shoulder.

In the last third of the sixth century BCE, while "A.D." and others were still creating handsome blackfigure wares, some pottery painters turned away from this meticulous process to a variation called red-figure decoration (see "Greek Painted Vases," page 162). This new method, as its name suggests, resulted in vessels with red figures against a black background, the opposite of black-figure painting. In the earlier method, artists painted figures on a vessel in a slip that turned black in the firing process, leaving the unpainted body of the vessel as the reddish background. Linear details on the figures were incised through the slip. In red-figure wares, the same dark slip was painted on as background around the outlined figures, which were left unpainted. Linear details were applied on the figures with a fine brush dipped in the slip. The result was a lustrous dark vessel with light-colored figures with dark-painted details. The greater freedom and flexibility of this more direct approach led artists to adopt it widely in a relatively short time.

One of the best-known artists specializing in the red-figure technique was the Athenian Euphronios, who was praised especially for his study of human anatomy. His rendering of the *Death of Sarpedon*, which dates to about 515 BCE, is painted on a **calyx krater**, so called because its handles curve up like a flower calyx (fig. 5-31). According to Homer's *Iliad*, Sarpedon, a Trojan warrior, was killed by the Greek warrior Patroclus, who had borrowed the magic armor of his comrade Achilles. Euphronios shows the winged figures of Hypnos (Sleep) and Thanatos (Death) carrying the dead Trojan warrior from the battlefield. Watching over the scene is Hermes, the messenger of the gods, identified by his winged hat and

that they appear to be coming toward or receding from forms and limbs—Sarpedon's left leg, for example—so real space around the figures by foreshortening body fine tip of a brush. Euphronios created the impression of their clothing, musculature, and facial features with the of the subjects, also portrayed amazingly fine details of painter, while conveying a sense of the mass and energy

and three of human figures, one in an active pose, one in sketches include one of a horse, some of human busts, human foot and hand, and several sketches. These paraphernalia: hammers, an ax and saw, molds of a workshop, filled with hanging tools and other foundry the figures are cleverly presented as the walls of the all the figures. The wedges of background space between of the foot to the vessel serves as the groundline for the vessel. The small circle that marks the attachment flaring space that extends upward from the foot of successfully organized this continuous scene within the bronze figures. The artist, known as the Foundry Painter, temporary foundry for casting lifesize and monumental about 490-480 BCE, to illustrate the workings of a conthe entire circular underside of this piece, which dates to composition to vessel shape (fig. 5-32). The artist used provides another example of the adaptation of scenic A red-figure kylix, or drinking cup, from Vulci, Italy,

yet been found. tunately, no examples of these early bronze figures have early as the first decades of the fifth century BCE. Unforcontrast to the static pose of the Archaic kouroi—as hollow-cast bronze statues in active poses—in marked clear evidence that the Greeks were creating large lifesize striding warrior figure. This painting provides shown putting the finishing touches on a larger-thancontinues past the handles, where more workers are The unattached head lies between his feet. The scene leaping figure that are braced against a molded support. er, on the right, assembles the already-cast parts of a haps the supervisor, leans on a staff, while a third worktend the furnace on the left. The man in the center, perlooks like a modern-day construction helmet squats to On the section shown here, a worker wearing what

faced a formidable threat peded by external powers, veloped relatively unimseveral centuries had de-Greek city-states, which for the fifth century bce, the **LHE** In the early decades of

dominant power on the Peloponnese, first blunted, then alliance of Greek city-states led by Athens and Sparta, the Plataea on land and in the straits of Salamis at sea—an Athens. In a series of encounters—at Thermopylea and large force and destroyed many Greek cities, including eral failed invasions, in 480 BCE the Persians came with a Ionia in Asia Minor into his empire in 546 BCE. After sevpire. Cyrus the Great had incorporated the Greek cities of to their independence from the expanding Persian Em-

PERIOD

CLASSICAL

OK EARLY

TRANSITIONAL

a standing pose, and one seated.

the viewer.

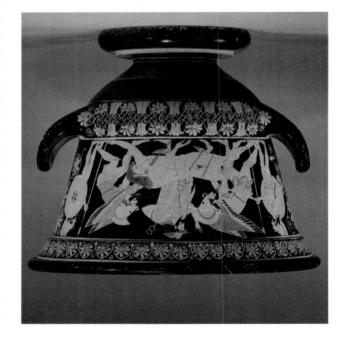

Ciff of Darius Ogden Mills, Ciff of J. Pierpont Morgan, and NGM YORK krater 18" (45.7 cm). The Metropolitan Museum of Art, on a calyx krater. c. 515 BCE. Ceramic, height of 5-31. Euphronios. Death of Sarpedon, red-figure decoration

Bequest of Joseph H. Durkee, by exchange, 1972 (1972.11.10)

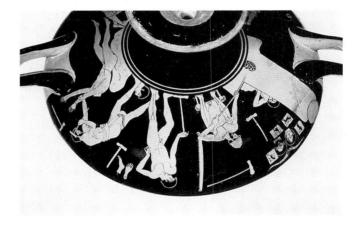

Berlin, Preussischer Kulturbesitz, Antikensammlung diameter of kylix 12" (31 cm). Staatliche Museen zu tion on a kylix from Vulci, Italy. 490-480 BCE. Ceramic, 5-32. Foundry Painter. A Bronze Foundry, red-figure decora-

to the netherworld. another important role, as the guide who leads the dead caduceus, a staff with coiled snakes. Hermes is there in

balance the horizontal elements of the composition. The bearers on each side and Hermes in the center counter-Hypnos and Thanatos. The upright figures of the lance curving lines of the handles mirror the arching backs of itate in the gentle grasp of its bearers, and the inwardhorizontal of the dead fighter's body, which seems to levof decoration above and below the scene echo the long that take the shape of the vessel into account. The bands feetly balanced composition of verticals and horizontals Euphronios, like the painter "A.D.," created a per-

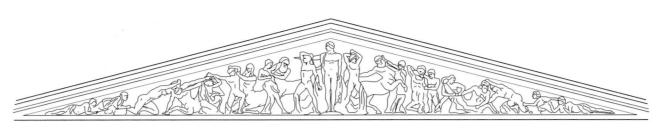

5-33. Reconstruction drawing of the west pediment of the Temple of Zeus, Olympia. c. 470-456 BCE

repulsed the invasion. By 479 BCE the stalwart armies and the small but formidable navies of the Greeks had triumphed over their enemies, and the victors turned to the task of rebuilding their devastated cities.

Some scholars have argued that the Greeks' success against the Persians imbued them with a self-confidence that accelerated the development of Greek art, inspiring artists to seek new and more effective ways to express their cities' accomplishments. In any case, the period that followed the Persian Wars, extending from about 480 to about 450 BCE, was a time of marked transition. Artists built on ideas that had emerged in earlier periods and at the same time initiated entirely new stylistic experiments. With the enthusiastic support of their patrons, they sought more **realistic** ways to portray the human figure in painting and sculpture and to place figures in more **naturalistic** settings (see "Realism and Naturalism," below).

Architectural Sculpture

Just a few years after the Persians had been routed, the citizens of Olympia began a new Doric temple to Zeus in the Sanctuary of Hera and Zeus. The temple was completed between 470 and 456 BCE. Today the massive temple base and columns, fallen capitals, and almost all the pediments remain, monumental even in ruins. Appropriately for its Olympian setting, the temple was decorated with works of sculpture celebrating legendary Greek victories, all of which are presented as due to the direct intervention of the gods Zeus, Apollo, and Athena.

The sculptural scene that once adorned the west pediment shows Apollo helping the Lapiths in their battle with the centaurs (fig. 5-33). This legendary battle erupted after the centaurs drank too much wine at the wedding feast of the Lapith king and tried to carry off some Lapith women. Apollo stands implacable at the center of the scene, quelling the disturbance supernaturally simply by raising his arm (fig. 5-34). Although some figures were restored later and may not exactly reflect their original appearance, the rising, falling, triangular composition attests to the skill of the artist. The contrast of angular forms with turning, twisting action poses dramatizes the physical struggle, which may have been symbolic of the triumph of reason over passion and civilization over barbarism.

The metope reliefs of the temple illustrated the mythological Twelve Labors imposed by King Eurystheus of Tiryns on Herakles. The hero, with the aid of the gods and his own phenomenal strength, accomplished these seemingly impossible tasks, thereby earning immortality. One of the labors was to steal gold apples from the garden of the Hesperides, the nymphs who guarded the trees that produced them. To do this, Herakles enlisted the aid of the giant Atlas, whose job was to hold up the heavens. Herakles offered to take on this job himself while Atlas fetched the apples for him. In the episode shown here (fig. 5-35), Herakles is at the center with the heavens on his shoulders. Atlas, on the right, holds out the gold apples to him. As we can see, and Atlas cannot, the human Herakles is backed, literally, by the goddess Athena, who effortlessly supports the sky with one hand.

REALISM AND Is it redundant to **NATURALISM** say that artists

say that artists "sought more re-

alistic ways to portray the human figure in painting and sculpture and to place figures in more **naturalistic** settings"? Are *realistic* and *naturalistic* interchangeable here, or is there a subtle difference in the way the two words are used?

Both realism and naturalism are defined as the attempt to depict observable things accurately and objectively, even imitatively. Thus, in the passage cited above, it may seem

that the two words mean exactly the same thing and that the author was simply avoiding repetition. But as with many terms used in art historical writing, these words have a subtle shading that may not be apparent in their dictionary definitions.

In the visual arts, realism is most often used to describe the representation of people and other living creatures in an accurate, "warts and all" fashion. Detailed portraits of people, as well as pictures of animals or imaginary figures, are often described as "realistic." Naturalism, on

the other hand, has a "softer" meaning, generally referring to the true-to-life depiction of the natural world, especially landscape and background elements. Although both terms involve realistic representation, they can carry a slightly different meaning depending on the context in which they are used—as demonstrated in the sentence above.

Many such words appear in the literature of art history. Those that are used in this book are explained in the text and are defined in the Glossary.

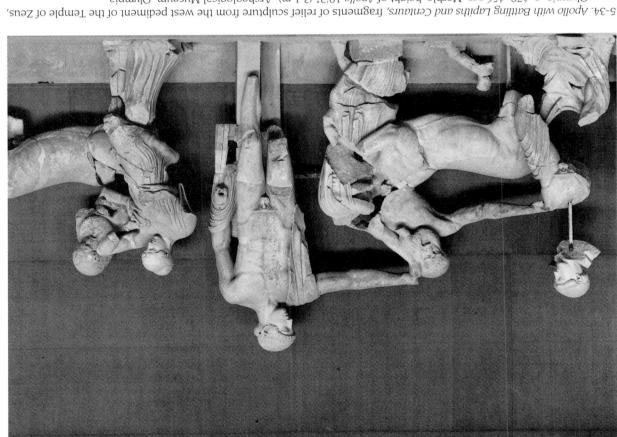

Olympia. c. 470-456 Bce. Marble, height of Apollo 10'2" (3.1 m). Archeological Museum, Olympia

Freestanding Sculpture

tation of the human figure embodied in the Archaic Greek sculptors moved far from the rigid, frontal presen-In the remarkably short time of only a few generations,

heavy drapery. flesh of her body pressing through the graceful fall of severe columnlike figure of the goddess suggests the reflect a strong sense of naturalism. Even the rather nude male figures. Sculpted in high relief, the figures heavily clothed Athena with profile views of the two The artist has balanced the erect, frontal view of the

5-35. Athena, Herakles, and Atlas, metope relief from the

.9681 ni The first modern Olympic Games were held in Athens de Coubertin to revive them on an international scale. interest in the games, inspiring the French baron Pierre Olympia in the late nineteenth century stimulated great covery and excavation of the site of the sanctuary at banned by the Christian emperor Theodosius. The disprogress. The games ended in 394 cE, when they were pended all political activities while the games were in came to be so highly regarded that the city-states susgold, silver, or bronze medals. The Olympian Games branches from the Sacred Grove of the gods instead of gious aspect, and the victors were rewarded with olive should be 600 feet long. The contests had a strong relirules for the games and decided that the stadium beginning in 776 BCE. Supposedly, Herakles drew up the Olympian Games, held every four years at Olympia The Greeks believed Herakles was the founder of the 5'3" (1.59 m). Archeological Museum, Olympia frieze of the Temple of Zeus, Olympia. Marble, height

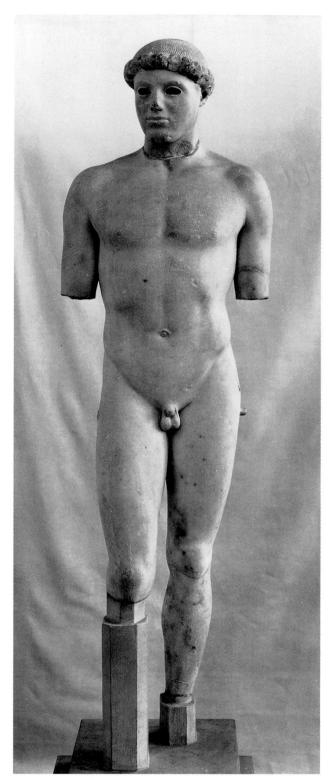

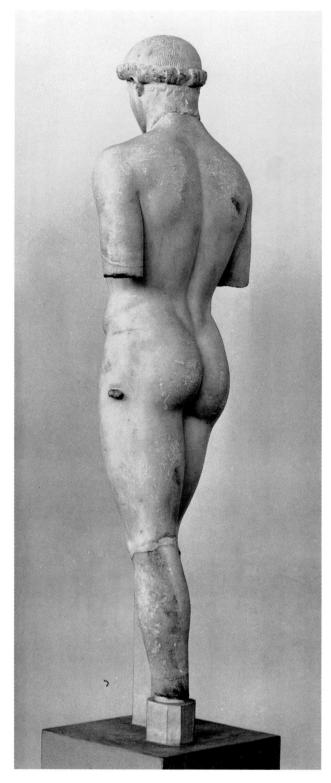

5-36. Kritios Boy. c. 480 BCE. Marble, height 46" (116 cm). Acropolis Museum, Athens

kouroi. One of the earliest and finest extant freestanding marble figures to exhibit more natural, lifelike qualities is the *Kritios Boy* of about 480 BCE (fig. 5-36). The damaged figure, excavated from the debris on the Athenian Acropolis, was thought by its finders to be by the Greek sculptor Kritios, whose work was known only from Roman copies. Unlike most Archaic kouroi, which represent

young men and are usually large, the *Kritios Boy* appears adolescent, and the complete figure would have been only a little over 3 feet tall. Despite his age, the *Kritios Boy* looks like an accomplished athlete. The solid, rounded body forms, large facial features, and thoughtful expression—which lacks even a trace of the Archaic smile—give the figure an air of extraordinary solemnity. The easy

Museum, Delphi c. 470 BCE. Bronze, height 5'11" (1.8 m). Archeological 5-37. Charioteer, from the Sanctuary of Apollo, Delphi.

the face, robe, and body visible to today's viewers. absorbed only its overall effect, not the fine details of bly jostled by crowds of fellow pilgrims, could have exhausted from the steep climb to the sanctuary, possichariot atop a tall monument. Viewers in ancient times, original outdoor location, standing in a horse-drawn tion. Its effect would have been very different in its ed from other works and spotlighted for close examinabase in the peaceful surroundings of a museum, isolatmakes. Today, this stunning figure is exhibited on a low The setting of a work of art affects the impression it

cast bronze more easily permits vigorous and even offoutstretched arms and legs far apart in stone, hollow-Although it is possible to create freestanding figures with became the medium of choice for Greek sculptors. flexible medium than solid marble or other stone and bronze was developed. This technique created a far more Archaic period a new technique for hollow-casting of librium under various conditions. At the end of the ics of sculptural materials—their ability to maintain equi-Solving this problem requires a familiarity with the statstanding sculpture is to assure that it won't fall over. of his shoulders.

uing movement rather than an arbitrary moment frozen poses that seemed to capture a natural feeling of continamong the ancient Greeks. Sculptors sought to find technique, the figure in action became a popular subject balance action poses. After the introduction of the new

that three-time winners in Greek competitions had their more lifelike Kritios Boy, recalling Pliny the Elder's claim but other characteristics place this work closer to the fluting of the robe are reminiscent of the Archaic style, flat-footed pose of the Charioteer and the long, columnar (Sicily) in the Pythian Games of 478 or 474 BCE. The erect, victory by a driver sponsored by King Polyzalos of Gela horses. According to its inscription, it commemorates a of Apollo, along with fragments of a bronze chariot and ologists found it in its original location in the Sanctuary was buried during a major earthquake in 373 BCE. Archewas saved from the metal scavengers only because it size bronze, the Charioteer (fig. 5-37), cast about 470 BCE, original Greek bronzes have survived. A spectacular lifeto recycle metal from old statues into new works, so few Unfortunately, foundries began almost immediately

Unlike the Archaic Kroisos, for example (see fig. features memorialized in statues.

ly or encounter a sudden breeze. swaying and rippling should the charioteer move slightand depth, and the whole garment seems capable of folds of the robe fall in a natural way, varying in width from molds made from the feet of a living person. The instep, are so realistic that they seem to have been cast ly observed toes, toenails, and swelled veins over the those of a particular individual. The feet, with their closeful male good looks, they are distinctive enough to be facial features suggest an idealized conception of youthand fine silver eyelashes. Although the smoothed-out sion is relieved by the use of glittering, colored-glass eyes away from the viewer. The rather intimidating expres-5-21), the charioteer's head turns to one side, slightly

southern coast of Italy. Known as the Riace Warriors, ger-than-lifesize bronze figures from the seabed off the In the early 1970s ce, divers recovered a pair of big-

THE DISCOVERY In 1972 a va-AND CONSER-VATION OF THE was scuba div-RIACE WARRIORS ing in the Ion-

cationer who ian Sea off the

south coast of Italy near the beach resort of Riace found what appeared to be a human elbow and upper arm protruding from the sand in about 25 feet of water. Taking a closer look, he discovered that the arm was made of metal, not flesh, and when he pushed away the sand he realized that it was part of a large statue. Investigating further, he soon uncovered a second statue nearby. He marked the location with a diver's buoy and reported his discovery to the director of the local museum, who also happened to be the Superintendent of Antiquities for the region. An experienced team of underwater salvagers then raised the statues, which turned out to be bronze warriors more than 6 feet tall. They were complete in every respect, except for their swords, their shields, and one helmet.

Where did the Warriors come from? In ancient times, there had been a Greek colony at the tip of Italy. The statues had probably been on a ship bound from or to that colony. But there was no evidence of a shipwreck in the vicinity of the find, leading to the conclusion that they must have accidentally slipped off the deck in rough seas or been deliberately jettisoned. After centuries underwater, the Warriors were entirely corroded and covered with lime accretions on their exterior surfaces, as the illustration shows. The clay cores used in the casting process were still inside the statues, adding to the deterioration by absorbing lime and sea salts.

To restore the Warriors, conservators first removed all the exterior

corrosion and lime encrustations using surgeon's scalpels, pneumatic drills with 3-millimeter heads, and high-technology equipment such as sonar (sound-wave) probes and micro-sanders. Then they painstakingly removed the clay core through existing holes in the heads and feet using hooks, scoops, jets of distilled water, and concentrated solutions of peroxide. Finally, they cleaned the figures thoroughly by soaking them in solvent solutions and sealed them with a fixative specially designed for use on metals (see fig. 5-38 left).

The Warriors were put on view in 1980. Since then, additional steps have been taken to assure their preservation for future generations. In 1993 conservators used a sonar probe mounted with two miniature video cameras to remove any remaining clay from inside the statues. With the cameras, they were able to find bits of clay, which they then blasted with sound waves from the probe. The statues were then flushed out with water.

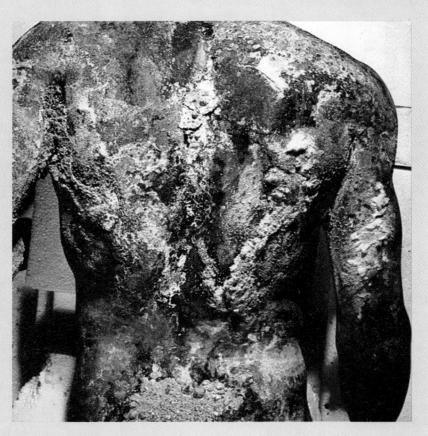

Back of the Young Warrior from Riace prior to conservation. Museo Archeològico Nazionale, Reggio Calabria, Italy

these original Greek statues date to about 460-450 BCE. Just what mishap sent them to the bottom is not known. They were not found with a wreck, so they may have fallen off a ship accidentally or perhaps been thrown from a ship in distress. The meticulous work of conservators has restored them to their original glory (see "The Discovery and Conservation of the Riace Warriors," above). A look at one of them, the so-called Young Warrior, reveals a striking balance between idealized anatomical forms and naturalistic details (fig. 5-38). The supple athletic musculature suggests a youthfulness belied by the maturity of the almost haggard facial features. Sharp cheekbones protrude through the figure's thin flesh, deep lines run from the nose to the corners of the mouth, and unmistakable bags sag beneath the eyes. Other minutely detailed touches—the navel, the swelling veins in the backs of the hands, and the strand-by-strand rendering of the hair—are also in marked contrast to the idealized, vouthful smoothness of the rest of the body. The sculptor heightened these lifelike effects by inserting eyeballs of bone and colored glass into the eye sockets, applying eyelashes and eyebrows of separately cast, fine strands

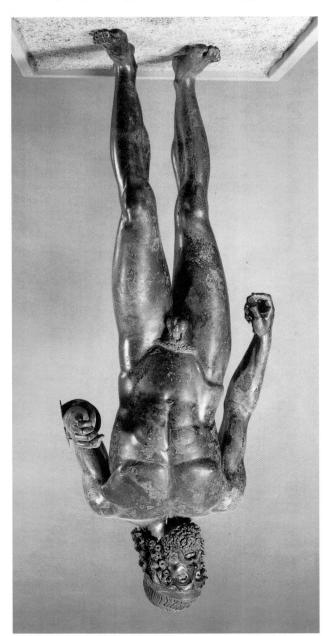

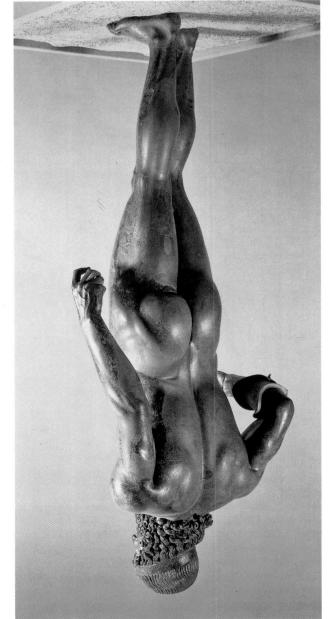

5-38. Young Warrior, found in the sea off Riace, Italy. c. 460–450 BCE. Bronze with bone and glass eyes, silver teeth, and copper lips and nipples, height 6'8" (2.03 m). Museo Archeològico Nazionale, Reggio Calabria, Italy

poraries, and it is interesting that he was as warmly admired for a sculpture that has not survived—a bronze cow—as for the *Discus Thrower*:

gnitnis9 essV

Vase painters continued to work with the red-figure technique throughout the fifth century BCE, refining their styles and experimenting with new compositions. Among the outstanding vase painters of the Transitional period was the prolific Pan Painter, who was inspired by the less-heroic myths of the gods to create an admirable body of red-figure works. The artist's name comes from a work involving the god Pan on one side of a bell-shaped krater that dates to about 470 BCE. The other side

of bronze, insetting the lips and nipples with pinkish copper, and plating the teeth that show between the parted

The Discus Thrower (Diskobolos), reproduced at the beginning of this chapter, was created in bronze by the sculptor Myron probably about 450 BCE (see fig. 5-1). It is known today only from Roman copies in marble, but in its original form it must have been as lifelike in its details as the Young Warrior from Riace. Like a sports photographer, Myron caught the athlete at a critical moment, the breathless instant before the concentrated energy of his breathless instant before the concentrated energy of his muscular torso is coiled tightly into a forward arch, and his powerful throwing arm is poised at the top of his backswing. Myron earned the adulation of his contemnation.

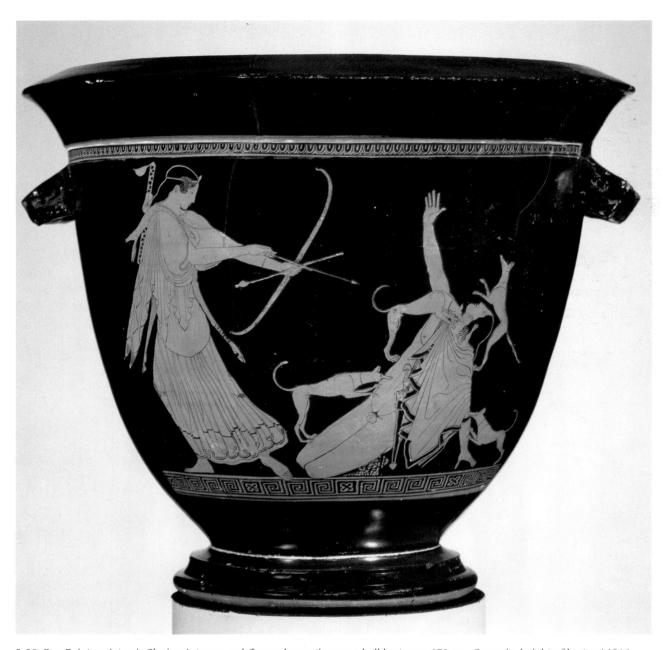

5-39. Pan Painter. *Artemis Slaying Actaeon*, red-figure decoration on a bell krater. c. 470 BCE. Ceramic, height of krater 14 5/8" (37 cm). Museum of Fine Arts, Boston James Fund and by Special Contribution

of this krater shows *Artemis Slaying Actaeon* (fig. 5-39). The most common version of this story is that Actaeon, while out hunting, happened upon Artemis, the goddess of the hunt, at her bath. The enraged goddess caused Actaeon's own dogs to mistake him for a stag, and they turned on him and killed him. The Pan Painter shows Artemis herself about to finish off the unlucky hunter with an arrow from her bow. The angry goddess and the fallen Actaeon each form roughly triangular shapes that conform to the flaring shape of the vessel. They are linked by the inverted triangular space between them. The scene is so dramatically rendered that one does not immediately notice the slender, graceful lines of the figures and the delicately detailed draperies that are the hallmarks of the Pan Painter's style.

THE HIGH CLASSICAL PERIOD

The High Classical period of Greek art, from about 450 to 400 BCE, corresponds roughly to an extended period of conflict between Sparta and Athens, which had emerged as

the leading city-states in the Greek world in the wake of the Persian Wars. Sparta dominated the Peloponnese and much of the rest of mainland Greece. Athens dominated the Aegean and became the wealthy and influential center of a maritime empire. In a series of conflicts known as the First Peloponnesian War (461–445 BCE), the Athenians were ultimately foiled in their attempts to expand into mainland Greece. After a brief interlude of peace, war erupted once again. This new struggle, which was known as the Second Peloponnesian War (431–404 BCE), came

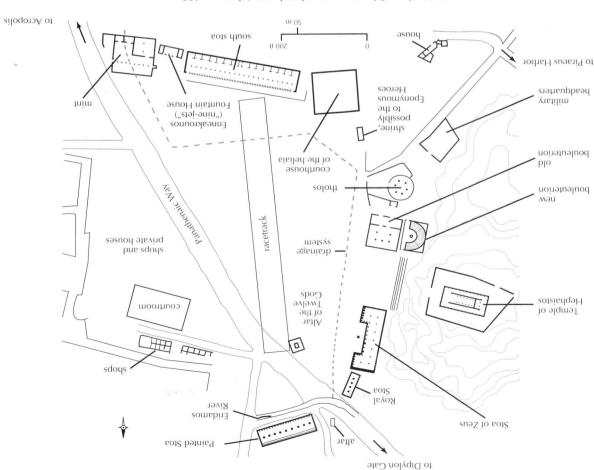

5-40. Plan of the Agora (marketplace), Athens, c. 400 BCE

primarily for religious rites and ceremonies, devoted mainly to the worship of the goddess Athena, the city's namesake and protector. The lower town, enclosed by a protective **ring wall**, became the residential and business center. In Athena, as in most cities of ancient Greece, commercial, civic, and social life revolved around the marketplace, or **agora**.

The Athens Agora

the great gods of Mount Olympos); and a shrine that may to the Twelve Gods (local deities not to be confused with sized temple to Hephaistos, the god of the forge; an altar racetrack. Among the religious structures were a goodreligious and administrative structures and even a small BCE, as figure 5-40 shows, the Agora contained several ing homes, administrative buildings, and shops. By 400 fountain house was built to provide water for surroundsystem was installed to prevent flooding, and a large important festival in honor of Athena. A stone drainage Panathenaic Way, a ceremonial road used during an around and within its perimeter on both sides of the various public and private structures were erected farmers and artisans displayed their wares. Over time, (fig. 5-40). It began as an unadorned open square where ed and studied, was situated at the foot of the Acropolis The Athens Agora, which has been extensively excavat-

to an end with the eventual defeat of Athens.

as the present age marvels at us now." It was a prophecy accomplishments, "future generations will marvel at us, Persians in 480 BCE. Perikles once said of his city and its much of the Acropolis, which had been laid waste by the tuaries of the gods who protected Athens and rebuilt perity, and power. He brought new splendor to the sanccity's artists to promote a public image of peace, prosthe adornment of the city and utilizing the talents of the of the arts, encouraging the use of Athenian wealth for scope of Athenian democracy. And he was a great patron instituted political reforms that greatly increased the nesian War and negotiated the peace that ended it. He his direction. He led Athens through the First Pelopon-Athens achieved its greatest wealth and influence under Olympian" because of his haughty, reserved personality, sometimes mocked him, calling him "Zeus" and "the in 429 BCE. Although the comedy writers of the time Athenian politics and culture from 462 BCE until his death namic, charismatic leader named Perikles dominated With the exception of a few brief interludes, a dy-

Classical Greece is today strongly identified with Athens, and the study of Classical art has long focused on the abundance of architectural monuments that have graced that city. Athens originated as a Neolithic site on the Acropolis. As the city grew, the Acropolis was used

he himself helped fulfill.

have honored the Eponymous Heroes, the legendary ancestors of the Athenians. The Agora was home to the Athens city mint, its military headquarters, and two buildings devoted to court business. One of these was a large hall where the dikasts, who acted as both judges and jury, tried major cases. The other was a lesser court where the heliaia, a group of citizens selected by the drawing of lots, decided civil and criminal cases. Thanks to a reform by Perikles, the heliaia were paid for their services like modern jurors.

Several large stoas offered protection from the sun and rain, providing a place for strolling and talking business, politics, or philosophy. The stoa, a distinctively Greek structure found nearly everywhere people gathered, could range in appearance from a simple roof held up by columns to a substantial, sometimes architecturally impressive, building with two stories and shops along one side. The Painted Stoa, built on the north side of the Athens Agora about 460 BCE, was so called because it was decorated with paintings by the most famous artists of the time, including Polygnotos of Thasos (active c. 475-450 BCE). Nothing survives of Polygnotos's work, but his contemporaries praised him for his ability to create the illusion of spatial recession in landscapes, his ability to render female figures clothed in transparent draperies, and his skill at rendering facial expressions conveying the full range of human emotions.

While city business could be, and often was, conducted in the stoas, agora districts also came to include buildings with specific administrative functions. In the Athens Agora, the 500-member boule, or council, met in a building called the bouleuterion. This structure, built before 450 BCE, was laid out on a simple rectangular megaron plan with a vestibule and large meeting room. Near the end of the fifth century BCE, a new bouleuterion was constructed to the west of the old one. This too had a rectangular plan. The interior, however, may have had permanent tiered seating arranged in an ascending semicircle around a ground-level podium, or raised platform, as in the outdoor theaters of the time. Nearby was a small, round building with six columns supporting a conical roof, a type of structure known as a tholos. Built about 465 BCE, this tholos was the meeting place of the 50-member executive committee of the boule. The committee members dined there at the city's expense, and, rotating the responsibility among themselves, a few of them always spent the night there to be available for any pressing business that might arise.

Some private houses could also be found in the Agora at this time. Compared with the often grand public buildings, houses in Classical Athens were rarely more than simple rectangular structures of **stucco**-faced mud brick with wooden posts and lintels supporting roofs of terra-cotta tiles. Rooms were small and few, consisting mainly of a kitchen, a dayroom in which women could sew, weave, and do other chores, a dining room with couches for reclining around a small table, a bedroom or two, and occasionally an indoor bathroom. Where space was not at a premium, houses sometimes opened onto small courtyards or porches.

The Acropolis

After Persian troops destroyed the Acropolis in 480 BCE, the Athenians initially vowed to keep it in ruins as a memorial. Perikles convinced them otherwise and set about rebuilding it to a new magnificence. One reason for this project was to honor the gods, especially Athena, who had helped the Greeks defeat the Persians. But Perikles also hoped to create a visual expression of Athenian values and civic pride that would glorify his city and bolster its status as the capital of the empire he was instrumental in building. He placed his close friend Pheidias, a renowned sculptor, in charge of the rebuilding and assembled under him the most talented artists and artisans in Athens and its surrounding countryside.

The cost and labor involved in this undertaking were staggering. Quantities of gold, ivory, and exotic woods had to be imported. Some 22,000 tons of marble had to be transported 10 miles from mountain quarries to city workshops. Perikles was severely criticized by his political opponents for this extravagance, but it never cost him popular support. In fact, many working-class Athenians—laborers, carpenters, masons, sculptors, and the merchants and carters who kept them supplied and fed—benefited from his expenditures.

Work on the Acropolis continued after Perikles' death and was completed by the end of the fifth century BCE (fig. 5-41). Visitors to the Acropolis in 400 BCE would have climbed a steep ramp on the west side of the hill to the sanctuary entrance, perhaps pausing to admire the small, marble temple dedicated to Athena Nike (Athena as the goddess of victory in war), poised on a projection of rock above the ramp. Turning left, they would have passed through the center of an impressive porticoed gatehouse called the Propylaia. (The Greeks called the gate to a religious precinct a propylon, meaning "front gate"; for especially large or elaborate gates they used the plural, propylaia.) Upon emerging from the gatehouse, they would have confronted a huge bronze figure of Athena Promachos (the Defender). This statue, designed and executed by Pheidias between about 465 and 455 BCE, showed the goddess in a helmet and bearing a spear. So tall was it that sailors entering Athens's port of Piraeus, about 10 miles away, could see the sun reflected off the helmet and spear tip. Behind this statue was a walled precinct that enclosed the Erechtheion, a temple dedicated to several deities. Visitors would have been able to see the upper part of this temple above the precinct wall.

To the left they would have seen several other small religious structures. Immediately to their right was a large stoa with projecting wings dedicated to Artemis Brauronia (the protector of wild animals). Beyond this stoa on the right stood the largest building on the Acropolis, looming above the precinct wall that enclosed it. This was the Parthenon, a temple dedicated to Athena Parthenos (the Virgin Athena). Walking along the main path, visitors would have come to the propylon to the Parthenon precinct. Passing through, they would have viewed the temple from its northwest corner. Ahead of

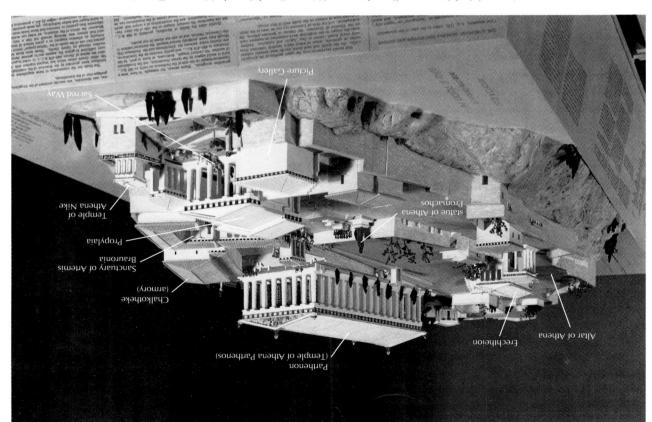

5-41. Model of the Acropolis, Athens, c. 400 BCE. Royal Ontario Museum, Toronto

The Parthenon. Sometime around 490 BCE the Athenanians began work on a new temple to Athena Parthenos that was still unfinished when the Persians sacked the Acropolis a decade later. Kimon of Athena then hired the architect Kallikrates to begin rebuilding on the old site. Work was halted briefly and resumed by Perikles, who then commissioned the architect Iktinos to redesign a larger temple utilizing the existing foundation and stone elements already in place. No expense was spared on this elegant new palace for Athena. The finest white marbins elegant new palace for Athena. The finest white marbins elegant new palace for Athena. The finest white marbins elegant new palace for Athena. The finest white marbins used throughout, even on the roof, in place of the more usual terra-cotta tiles.

The planning and execution of the Parthenon readilred extraordinary mathematical and mechanical skills and would have been impossible without a large contingent of distinguished architects and builders, as well as talented sculptors and painters. The result is thus as much a testament to the administrative skills as to the artistic vision of Pheidias, who supervised the entire project. The building was completed in 438 BCE, and its sculptural decoration, designed by Pheidias and executed by himself and other sculptors in his workshop, was complianced in 432 BCE (fig. 5-42).

The exterior form of the Parthenon is that of a typical Doric order peripteral temple on a three-step platform. The peristyle consists of forty-six columns, eight as viewed from each end and seventeen as viewed from the sides. The Parthenon's architects made many subtle adsides. The Parthenon's architects made many subtle adsides. The Parthenon's architects made many subtle adsides. The Parthenon's architects made many subtle adsides.

them, to the right of the Parthenon, was the Chalkotheke, or armory. The cella of the Parthenon faced east. To reach it, the visitors would have had to walk along the north side of the temple past an outdoor altar to Athena, where priests and worshipers made offerings to the goddess. With permission from the priests, they would have cilmbed the east steps of the Parthenon to look into the cilmbed the east steps of the Parthenon to look into the created by Pheidias and installed in the temple in 432 BeE. Although a few small structures were added in the Hellenistic and Roman periods, the Acropolis changed

lenge to the conservators who are dedicated to prepresents a new threat to the monuments and a new chaltunately, a dramatic rise in air pollution since the 1960s great pride the people of ancient Athens took in it. Unforthe Athenian sanctuary to the gods and appreciate the ern visitors can again experience some of the splendor of twentieth centuries. Thanks to these restorations, modprojects were undertaken there in the nineteenth and columns. The Acropolis then lay in ruins until restoration destroying the cella and the roof and toppling many Republic. A shell struck it and the gunpowder exploded, war between the Ottoman Empire and the Venetian used by Ottoman soldiers to store gunpowder during a tian church and later served as a mosque. In 1687 it was once the sacred home of Athena, also became a Chris-Christian church, then a Turkish harem. The Parthenon, use and disrepair. Later, the Erechtheion became first a little after 400 BCE. In the third century CE, it fell into dis-

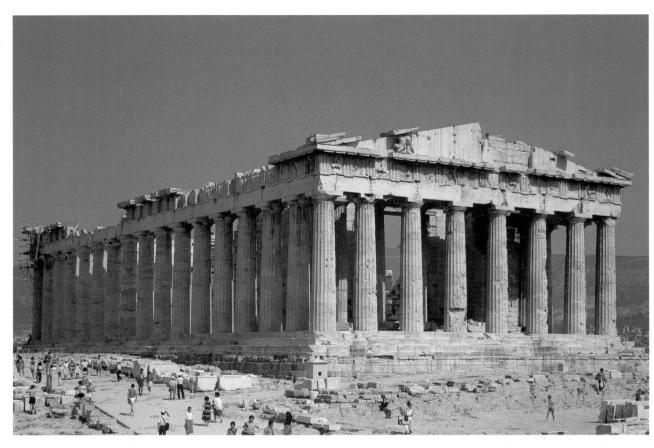

5-42. Kallikrates and Iktinos. Parthenon, Acropolis, Athens. 447-438 BCE. View from the northwest

act the effects of various optical illusions that would otherwise seem to distort its appearance when it was viewed from a distance. Long horizontal lines, for example, usually appear to sag in the center, but they do not here because the architects made both the base of the temple and the entablature curve upward slightly toward the center. In other refinements, the columns have a subtle swelling, or entasis, and tilt inward slightly from bottom to top, and the space between columns is less at the corners than elsewhere. These gentle curves and shifts in the arrangement of elements give the Parthenon a buoyant, organic appearance and prevent it from looking like a heavy, lifeless stone box. It is, in effect, a gigantic marble sculpture.

The extensive decoration of the Parthenon strongly reflects Pheidias's unifying vision despite being the product of many individuals. A coherent, stylistic whole, the sculptural decoration conveys a number of political and ideological themes: the triumph of the democratic Greek city-states over Persia's imperial forces, the preeminence of Athens thanks to the favor of Athena, and the triumph of an enlightened Greek civilization over despotism and barbarism.

Like the pediments of most temples, including the Temple of Aphaia at Aegina (see fig. 5-18), those of the Parthenon were filled with **sculpture in the round** set on the deep shelves of the cornice and secured to the wall with metal pins. Unfortunately, much of the Parthenon's pedimental sculpture has been damaged or lost over the

centuries. Using the locations of the pinholes, scholars nevertheless have been able to determine the placement of surviving statues and infer the poses of missing ones. The west pediment sculpture, facing the entrance to the Acropolis, illustrated the contest that Athena won over the sea god Poseidon for rule over the Athenians. The east pediment figures, above the entrance to the cella, illustrated the birth of Athena, fully grown and clad in armor, from the brow of her father, Zeus. The missing central element was probably Zeus seated on a throne with the just-born adult Athena standing at his side.

The statues from the east pediment are the best preserved of the two groups (fig. 5-43). Flanking the central figures were groups of three goddesses followed by single reclining male figures. In the left corner was the sun god Apollo in his chariot and in the right corner was the moon goddess Selene in hers. The reclining male nude on the left has been variously identified as Herakles, Ares, or Dionysos. His easy pose conforms to the slope of the pediment without a hint of awkwardness. The standing female figure just to the left of center is Iris, messenger of the gods, already spreading the news of Athena's birth. The three female figures on the right side (fig. 5-44), two sitting upright and one reclining, were once thought to be the Three Fates, whom the Greeks believed appeared at the birth of a child and determined its destiny. Most art historians now think that they are goddesses, perhaps Hestia (a sister of Zeus and the goddess of the hearth), Aphrodite, and her mother, Dione

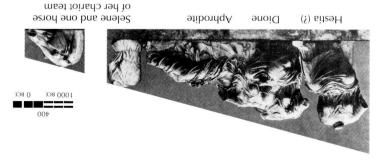

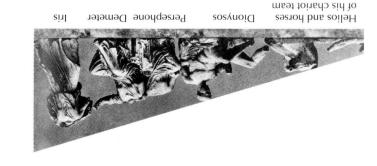

5-43. Photographic mock-up of the east pediment of the Parthenon (using photographs of the extant marble sculpture c. 438-432 BCE). The missing sculpture in the center equals in amount what is seen here.

At the beginning of the nineteenth century, Thomas Bruce, the British earl of Elgin and ambassador to Constantinople, acquired much of the surviving sculpture from the Parthenon, which was being used for military purposes. He shipped it back to London in 1801 to decorate a lavish mansion for himself and his wife. By the time he returned to England a few years later, his wife had left him and the ancient treasures were at the center of a financial dispute. Finally, he sold the sculpture for a very low price. Referred to as the Elgin Marbles, most of the sculpture is now in the British Museum, including all the elements seen here except the torso of Selene, which is in the Acropolis Museum, Athens. The Greek government has tried unsuccessfully in recent times to have the Elgin Marbles returned.

5-44. Three Seated Goddesses (possibly Hestia, Dione, and Aphrodite), from the east pediment of the Parthenon. Marble, over-lifesize. The British Museum, London

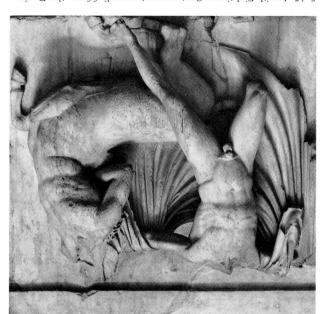

5-45. Lapith Fighting a Centaur, metope relief from the Doric frieze on the south side of the Parthenon. C. 440 BCE. Marble, height 56" (1.42 m). The British Museum, London

(one of Zeus's many consorts). These monumental interlocked figures seem to be awakening from a deep sleep, slowly rousing from languor to mental alertness. The sculptor, whether Pheidias or someone working in the Pheidian style, expertly rendered the female form beneath the fall of draperies. The clinging fabric both covers and reveals, creating circular patterns rippling with a life of their own over torsos, breasts, and knees and a life of their own over torsos, breasts, and knees and mitting the three figures into a single mass.

The Doric frieze on the exterior of the Parthenon

The Doric Interest on the extends of the Pathnenon was decorated with ninety-two metope reliefs, fourteen on each end and thirty-two along each side. These reliefs, which took only six years to complete, depicted legendary battles, symbolized by combat between two representative figures: a Lapith against a Crentaur; a Greek against a Trojan; or a Greek against an Amazon, a member of the mythical tribe of female warriors sometimes said to be the daughters of the war god Ares.

centaurs may have symbolized the triumph of reason noted earlier (see fig. 5-34), the legend of the Lapiths and implausible backdrop of his carefully draped cloak. As warrior's muscles and graceful movements against the an athletic ballet choreographed to show off the Lapith war between a man and a man-beast appears instead as of total equilibrium. What should be a grueling tug-of-Thrower (see fig. 5-1), the Lapith is caught at an instant easily accept its visual contradictions. Like the Discus cal art. So dramatic is the X-shaped composition that we historical episode—captures the essence of High Classichoice of a single, timeless image to stand for an entire forms to their most characteristic essentials, and its moment of pause within a fluid action, its reduction of panel shown here (fig. 5-45)—with its choice of a perfect tle between the Lapiths and the centaurs. The small from the south side, including several depicting the bat-Among the best-preserved metope reliefs are those

Enclosed within the Parthenon's Doric order perito the body of the temple consists of a cella, opening to the east, and an unconnected auxiliary space opening

over animal passion.

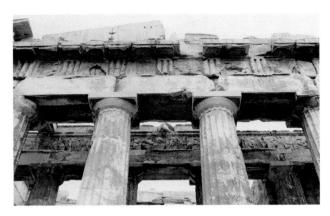

5-46. View of the outer Doric and inner Ionic friezes at the west end of the Parthenon

to the west. Short colonnades in front of each entrance support an entablature with an Ionic order frieze in relief that extends along both sides of the temples, for a total frieze length of 525 feet (fig. 5-46). The subject of this frieze is a procession almost certainly celebrating the festival of the Great Panathenaia, which took place in Athens every four years. In this ceremony, the women of the city carried a new wool peplos to the Acropolis sanctuary to clothe an ancient wooden cult statue of Athena housed there. Although the shrine housing the statue was partly ruined by the Persians in 480 BCE, the statue apparently remained there until it was moved to a new shrine to Athena in the Erechtheion about 405 BCE. The Panathenaic procession began just outside the city walls in the Kerameikos quarter, where the pottery-makers' workshops were located. People assembled there in a cemetery among the grave monuments of their ancestors. They then marched into the city through the Dipylon Gate, across the busy Agora along the Panathenaic Way, and up the ramp to the Acropolis. From the Propylaia, they moved onto the Sacred Way and completed their journey at Athena's altar.

The figures in Pheidias's portrayal of this major ceremony—skilled riders managing powerful steeds, for example (fig. 5-47), or graceful but physically sturdy

young walkers (fig. 5-48)—seem to be representative types, ideal inhabitants of a successful city-state. The underlying message of the frieze as a whole is that the Athenians are a healthy, vigorous people, enjoying individual rights but united in a democratic civic body looked upon with favor by the gods. The people were inseparable from and symbolic of the city itself. Despite its patriotic intent, the frieze probably drew wrath from Athenians who felt that it was disrespectful of the gods to decorate a religious building with scenes of contemporary human activity rather than mythological figures. Pheidias was supposedly accused of even depicting himself and Perikles among the figures in the procession, but no one in modern times has been able to identify what might be their portraits.

As with the metope relief of the Lapith Fighting a Centaur (see fig. 5-45) viewers of the processional frieze easily accept its disproportions, spatial incongruities, and such implausible compositional features as all the animal and human figures standing on the same groundline, and upright men and women being as tall as rearing horses. Carefully planned rhythmic variations—changes in the speed of the participants in the procession as it winds around the walls—contribute to the effectiveness of the frieze: horses plunge ahead at full gallop; women proceed with a slow, stately step, parade marshals pause to look back at the progress of those behind them; and human-looking deities rest on conveniently placed benches as they await the arrival of the marchers. In executing the frieze, the sculptors took into account the spectators' low viewpoint and the dim lighting inside the peristyle. They carved the top of the frieze band in higher relief than the lower part, thus tilting the figures out to catch the reflected light from the pavement and permit a clearer reading of the action. The subtleties in the sculpture may not have been as evident to Athenians in the fifth century BCE as they are now, because the frieze, seen at the top of a high wall and between columns, was originally completely painted. The background was dark blue and the figures were in contrasting red and ocher, accented with glittering gold and real metal details such as bronze bridles and bits on the horses.

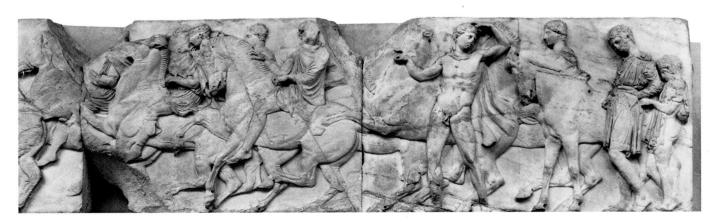

5-47. *Horsemen*, detail of the *Procession*, from the Ionic frieze on the north side of the Parthenon. c. 438–432 BCE. Marble, height 41³/₄" (106 cm). The British Museum, London

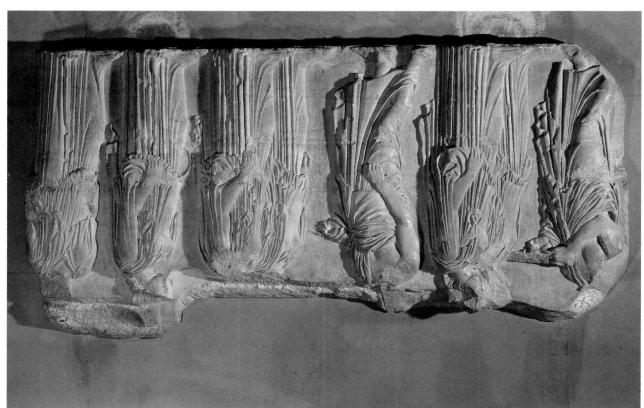

5-48. Marshals and Young Women, detail of the Procession, from the Ionic frieze on the east side of the Parthenon. c. 438–432.

BCE. Marble, height 43" (109 cm). Musée du Louvre, Paris

5-49. Mnesikles. Propylaia, Acropolis, Athens. 437–432 BCE. View from the southeast, facing the Picture Gallery

north porch. Another shrine housed a sacred spring dedicated to Erechtheus, a legendary king of Athens, during whose reign the goddess Demeter was said to have instructed the Athenians in the agricultural arts. The Erechtheion also contained a memorial to the legendary founder of Athens, Kekrops, half man and half serpent, who acted as the judge in the contest between Athena and Poseidon. And it housed a new shrine for the wooden cult statue of Athena that was the center of the Panathensic festival.

The Propylais and the Erechtheion. Upon completion of the Parthenon, Perikles commissioned an architect named Mnesikles to design the Propylais (fig. 5-49). Work began on it in 437 and stopped in 432 BCE, with the structure still incomplete. Visitors approaching the gateway from either the city or the sanctuary side with the structure still incomplete. Visitors approaching saw a Doric facade. Inside the central passageway, they walked along a ramp between rows of tall, slender, Ionic columns. These columns, which supported a raised roof, were placed far enough apart to allow wheeled vehicles to pass between them. The Propylais had no sculptural decoration, but its north wing was the earliest known of paintings for public view. The unfinished right wing of paintings for public view. The unfinished right wing became a passageway to the Temple of Athena Vike.

The Erechtheion, also designed by Mnesikles, was the second-largest structure erected on the Acropolis under Perikles' building program (fig. 5-50). Work began on it in the 430s and ended in 405 BeE, just before the fall levels reflect its multiple functions in housing many different shrines, as well as the sharply sloping terrain on which it was located. The mythical contest between the was said to have occurred within the Erechtheion precinct. During this contest, Poseidon struck a rock with his trident (three-pronged harpoon), bringing forth a spout of water. This sacred rock, believed to bear the spout of water. This sacred rock, believed to bear the spout of water. This sacred rock, believed to bear the spout of water. This sacred rock, believed to bear the spout of water. This sacred rock, believed to bear the spout of water. This sacred rock, believed to bear the spout of water. This sacred rock, believed to bear the spout of water. This sacred rock, believed to bear the spout of the trident, was enclosed in the Erechtheion's

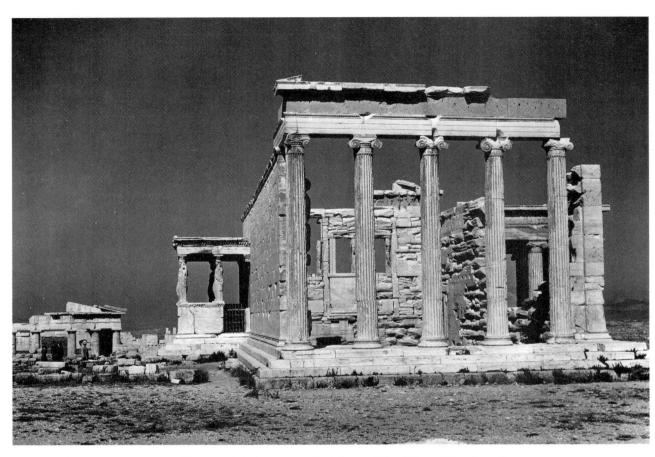

5-50. Mnesikles. Erechtheion, Acropolis, Athens. 430s-405 BCE. View from the east

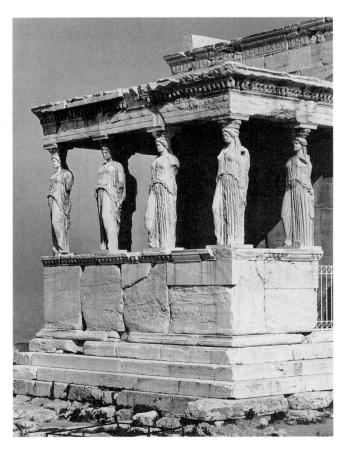

5-51. Porch of the Maidens (Caryatid Porch), Erechtheion, Acropolis, Athens. $421-405\ \mathrm{BCE}$

The Erechtheion was entered from porches on the north, east, and south sides. The most famous of these is the Porch of the Maidens (fig. 5-51), on the south side facing the Parthenon. Raised on a high base, its six stately caryatids with simple Doric capitals support an Ionic entablature made up of bands of carved molding. In a pose characteristic of Classical figures, each caryatid's weight is supported on one engaged leg, while the free leg, bent at the knee, rests on the ball of the foot. Viewed from straight on, the three caryatids on the left have their right legs engaged, and the three on the right have their left legs engaged, creating a sense of symmetry and rhythm. The vertical fall of the drapery on the engaged side resembles the fluting of a column shaft and provides a sense of stability, whereas the bent leg gives an impression of relaxed grace and effortless support. The hair of each caryatid falls in a loose but massive knot around its neck, a device that strengthens the weakest point in the sculpture while appearing entirely natural.

The Temple of Athena Nike. The Temple of Athena Nike (Athena as the goddess of victory in war), located south of the Propylaia (fig. 5-52), was designed and built about 425 BCE, probably by Kallikrates. It is an Ionic order temple built on an **amphiprostyle** plan, that is, with a porch at each end (see "Elements of Architecture," page 164). The porch facing out over the city is **blind**, with no entrance to the cella. Reduced to rubble during the Turkish occupation of Greece in the seventeenth century, the

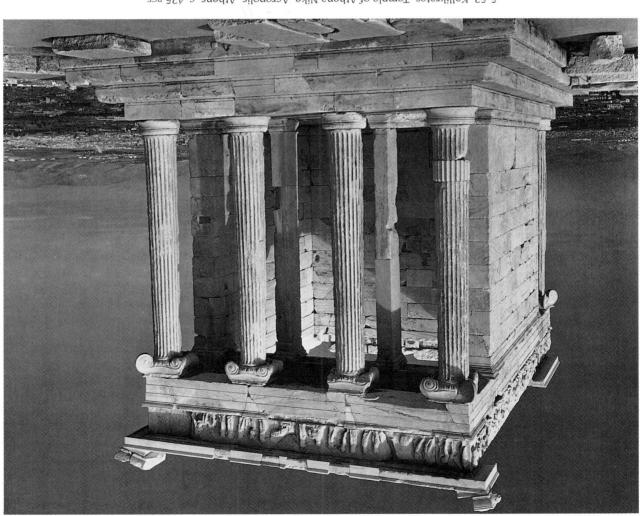

5-52. Kallikrates. Temple of Athena Nike, Acropolis, Athens. c. 425 BCE

appearances closely, the sculptors of the High Classical period selected those attributes they considered the most desirable, such as regular facial features, smooth skin, and particular body proportions, and combined them into a single ideal of physical perfection. This quest for the ideal can be seen also in the philosophy of Socrates (c. 470–399 BCE) and his disciple Plato (c. 429–347 BCE), both of whom argued that all objects in the physical world were reflections of ideal forms that could be discovered through reason.

The best-known art theorist of the Classical period was the sculptor Polykleitos of Argos. About 450 BCE he developed a set of rules for constructing the ideal human figure, which he set down in a treatise called The Canon (kanon is Greek for "measure," "rule," or "law"). To illustrate his theory, Polykleitos created a larger-than-lifesize bronze statue, the Spear Bearer (Doryphoros). Neither the writes, and later Roman artists made copies in stone of the Spear Bearer Bearer (Doryphoros). Useither the writes, and later Roman artists made copies in stone of copies, or replicas, scholars have tried to determine the set of measurements that defined the ideal of human set of measurements that defined the ideal of human proportions in Polykleitos's canon, which must have

like wet silk. this Nike appears delicate and light, clinging to her body robes of the Erechtheion caryatids, the textile covering ing the Parthenon goddesses or the weighty pleats of the pose. Unlike the decorative swirls of heavy tabric coveropen and one closed, effectively balance this unstable chiton to slip off one shoulder. Her large wings, one figure bends forward gracefully, causing her ample of Nike (Victory) Adjusting Her Sandal (fig. 5-53). The els from it have survived. One of the most admired is tion. The parapet no longer exists, but some of the pancalled Victories, as they prepared for a victory celebradepicting Athena presiding over her winged attendants, a parapet, or low wall, faced with narrative relief panels Between 410 and 407 BCE, the temple was surrounded by contrast to the massive Doric Propylaia adjacent to it. 27 by 19 feet, and refined Ionic decoration are in marked temple has since been rebuilt. Its diminutive size, about

Sculpture and The Canon of Polykleitos

Just as Greek architects defined and followed a set of standards for ideal temple design, Greek sculptors sought an ideal of human beauty. Studying human

400 1000 BCE 0 BCE

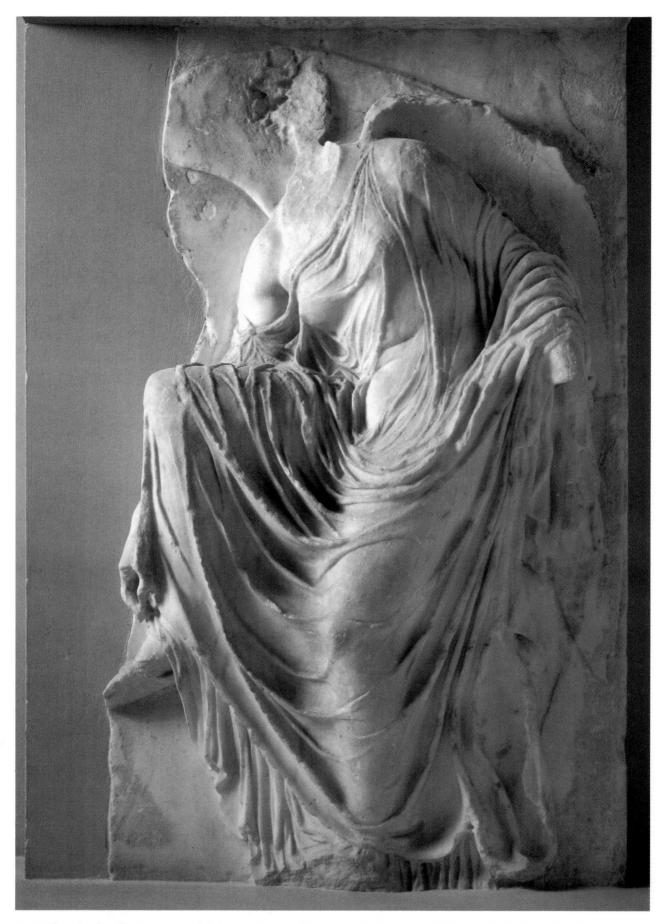

5-53. *Nike (Victory) Adjusting Her Sandal,* fragment of relief decoration from the parapet (now destroyed), Temple of Athena Nike, Acropolis, Athens. 410–407 BCE. Marble, height 42" (107 cm). Acropolis Museum, Athens

tangible form of sculpture. making it possible to replicate human perfection in the nition of the beautiful as it applied to the human figure,

perfect equilibrium, ready to step forward instantly. Spear Bearer appears to have paused for a moment in Young Warrior seems to stand still in alert relaxation. The and the fact that the heel of the Spear Bearer is raised. The the slightly different positions of the unengaged left legs in both, and their poses are nearly identical, except for tive. The treatment of the torso and groin is quite similar Young Warrior from Riace (see fig. 5-38) is also informathe engaged leg. A comparison of the Spear Bearer to the its ball, and the head is turned toward the same side as nounced to accommodate the raising of the left foot onto tilt of the hipline in the Spear Bearer is a little more prothe Kritios Boy (see fig. 5-36) of a generation earlier. The ing figure sculpture—differs to some degree from that of anced body pose—characteristic of High Classical standthe weight of the (missing) spear. This dynamically balrelaxed on the engaged side and the left bent to support reversed in the arrangement of the arms, with the right maintain. The pattern of tension and relaxation is raised high—an unnatural pose for anyone to try to knee, with the left foot poised on the ball with the heel the straight (engaged) right leg. The left leg is bent at the with the whole weight of the upper body supported over here (fig. 5-54) shows a male athlete, perfectly balanced The marble replica of the Spear Bearer illustrated

Stela Sculpture

gift of grain and instructed them in farming. In return for this kindness, Demeter gave his people the goddess of grain, as she searched for her lost daughter. pitality to Persephone's grieving mother, Demeter, the to the underworld. The king of Eleusis extended his hospicking flowers when Hades kidnapped her and took her to be located on the very spot where Persephone was Eleusis, near Athens (fig. 5-55). The sanctuary was said the ruins of the Sanctuary of Demeter and Persephone at one, and Triptolemos, dating about 440 BCE, was found in and freedom. A relief panel depicting Demeter, Persephbut it also frequently showed more compositional variety affected by the same general trends as figural sculpture, offerings, and tomb monuments. Stela sculpture was tremely popular among the Greeks for memorials, votive Individual panels, or stelae, decorated in relief were ex-

mind the earlier Kritios Boy (see fig. 5-36). The sculptor the Parthenon, whereas their young initiate brings to a resemblance to the Pheidian treatment of women on The robust, heavily draped bodies of the women bear Persephone places her hand over his head in blessing. sents him with what appears to be a bag of seeds while boy by Demeter, who holds up a sheaf of grain and pre-The subject of the relief seems to be the initiation of the spread the knowledge of agriculture among the Greeks. but more often as a pupil chosen by the goddesses to help tween them, is sometimes identified as Demeter's son on the right. Triptolemos, the husky youth standing be-The stela shows Demeter on the left and Persephone

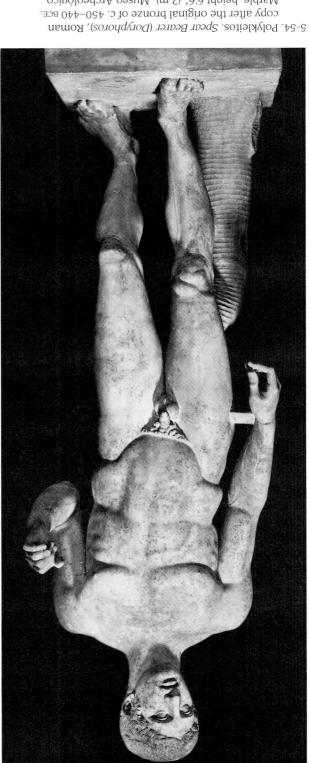

Nazionale, Naples, Italy Marble, height 6'6" (2 m). Museo Archeològico

onymous with the good. He sought a mathematical defichin to hairline. To Polykleitos, the beautiful was synothers suggest that it was the height of the head from index finger or the width of its hand across the knuckles; his basic unit may have been the length of the figure's length of various body parts. Some studies suggest that been based on the ratios between some basic unit to the

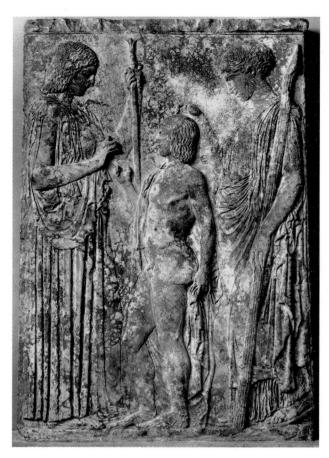

5-55. *Demeter, Persephone, and Triptolemos,* stela from Eleusis. c. 440 BCE. Marble, height 7'2³/8" (2.19 m). National Archeological Museum, Athens

An extremely influential and mysterious cult developed around Demeter and Persephone, comparable to that of Isis and Osiris in Egypt. Unlike most sanctuaries, the Sanctuary of Demeter and Persephone at Eleusis was under the private control of two aristocratic families and closed to all but initiated worshipers. Cult members were forbidden on pain of death to describe what happened inside the walls, and any outsider found trying to enter illegally would have been killed. None of the cult's activities—the Mysteries of Eleusis—was ever revealed, but they probably involved a ritual reenactment of Persephone's abduction and descent into the underworld and her return to earth.

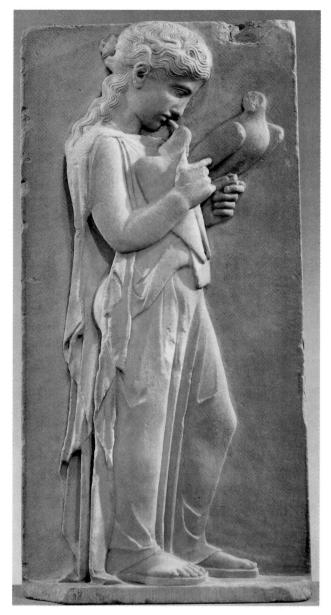

5-56. Little Girl with a Bird, grave stela from Paros. c. 450–440 BCE. Marble, height 31½" (80 cm). The Metropolitan Museum of Art, New York Fletcher Fund (1927,27,45)

has rendered the figures freely and naturally, rather than according to a strict canon, conveying not only the narrative elements of this symbolic event but also a sense of the warm maternal relationships among mother, daughter, and son-protégé.

The Greeks used stelae decorated with reliefs and inscriptions to mark graves, much as tombstones are used today. Although such markers were banned in Athenian cemeteries from about 510 to 430 BCE, no such restriction applied in other regions, where they remained popular. Children, as well as adults, were memorialized on these stones. Intimate, personalized scenes like that of the *Little Girl with a Bird* were typical of High Classical grave stela decoration (fig. 5-56). Dating about 450–440 BCE, this stela was found on the Aegean island of Paros

and is made of fine white Parian marble. Its top is missing, but it probably once had a decorative **finial**, or crowning ornament.

The realistic treatment of the child's body and her idealized facial features suggest that the sculptor was familiar with stylistic developments in Athens, but the simple, dignified treatment of drapery, the stylized hairdo, and the subtle yet simple way in which the "story" or meaning of the relief is conveyed bring it closer in approach and feeling to the metope reliefs on the Temple of Zeus at Olympia (see fig. 5-35). The little girl is dressed as a miniature adult in the same type of peplos that her mother would have worn, and her hair is carefully arranged in waves and curls with a knot at the back of her head. Her chubby arms and the way she kisses one

belled against it, killed Kritias, and restored democracy. Athens recovered its independence and its economy

After the Spartans defeated Athens in 404 BCE, they set up a pro-Spartan government led by the tyrant Kritias. This government was so oppressive that ment was so oppressive that within a year the Athenians re-

A white-ground lekythos decorated about 450–440 artist whose style of the Achilles Painter (an anonymous artist whose style is known from another vase depicting the hero Achilles) shows a young servant girl offering a small chest of valuables to a well-dressed woman of regal bearing, the dead person whom the vessel memorializes a quiet sadness pervades it. The two figures are separated by the white, central void of the vessel, and their glances just fail to meet. The woman does not actively glances just fail to meet. The woman does not actively reach to accept her jewels. Instead, she barely extends her reach to accept her jewels. Instead the barely extends her reach to accept her jewels.

White-ground vases were used in particular as devotional or commemorative pieces in the fifth century BCE. The tall, slender, one-handled lekythos, used to pour liquids during religious rituals, was the most common choice for these works. Funerary lekythoi have been with a scene of a departing figure bidding farewell, others with a picture of a grave stela draped with garlands. More common are scenes of the dead person in the prime of life, engaged in a seemingly everyday activity that on close scrutiny is imbued with signs of separation and loss.

vived for comparison. walls and panels, but no examples of those have surhave echoed the style of contemporary paintings on still be seen on many vases. White-figure painting must white. This fragile decoration deteriorated easily but can opaque, water-based medium mixed with glue or egg vessel with a full range of colors using tempera paint, an white background. They also began to enhance the fired figure technique to register basic design elements on a page 162). Artists used either a black-figure or a redplex than those earlier efforts (see "Greek Painted Vases," niques of the High Classical period were far more comcentury BCE (see fig. 5-9), but the white-ground techapplied on black-figure vases as early as the seventh ration grew in popularity. White backgrounds had been the Classical period, a new style of white-ground deco-Although red-figure vase painting continued throughout

Vase Painting

painted details.

of her pet doves are purely childlike, however, and like a child, she seems unconcerned for her clothing. The peptoos, a bit too long for her, pulls down at the center as though she were standing on its hem, and the claws of the doves have caught and pulled up the top. Traces of pigment indicate that the work was enhanced with some

Francis Bartlett Fund

5-57. Style of Achilles Painter. Woman and Maid, white-ground and black-figure decoration on a lekythos, with additional painting in tempera. c. 450–440 BCE. Ceramic, height 151/8" (38.4 cm). Museum of Fine Arts, Boston

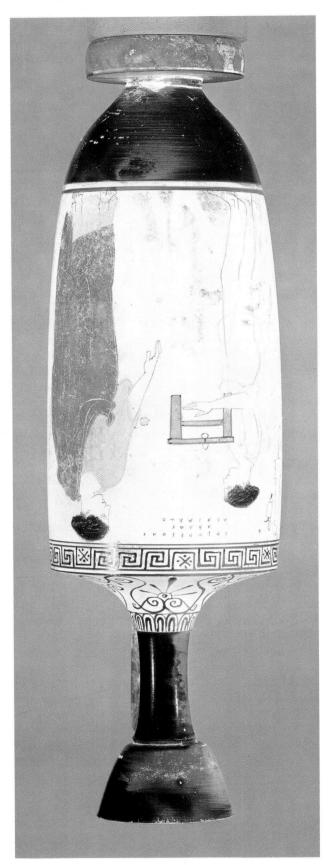

400 1000 BCE 0 BCE revived, but it never regained its dominant political and military status. Sparta failed to establish a lasting preeminence over the rest of Greece, and the city-states again began to struggle among themselves. Although Athens had lost its empire, it retained its reputation as a center of artistic and intellectual accomplishment. In 387 BCE the great philosopher-teacher Plato founded a school just outside Athens, as did Plato's student Aristotle later.

Among Aristotle's students was young Alexander of Macedon, whose father, Philip II, established Macedonian dominance over the Greek city-states in 338 BCE. When Philip was assassinated two years later, his throne and empire passed to Alexander, known to history as Alexander the Great. This able young leader, just entering his twenties, quelled the still-rebellious Greek citystates, then rallied them behind him for a war of revenge and conquest that carried him to Egypt, where the priests of Amun greeted him as a god, and as far east as India. where his weary troops finally balked at further campaigning. His dreams of endless conquest frustrated, Alexander began retracing his path homeward but died of a fever in Babylon in 323 BCE, at the age of thirty-three. Art historians mark the end of the Classical period in Greek art with his death and the subsequent breakup of his vast new empire.

The work of Greek artists during the fourth century BCE exhibits a high level of creativity and technical accomplishment. Changing political conditions never seriously dampened the Greek creative spirit. Indeed, the artists of the second half of the century in particular experimented widely with new subjects and styles. Although they observed the basic Classical approach to composition and form, they no longer adhered rigidly to its conventions. Their innovations were supported by a sophisticated and diverse new group of patrons, including the Macedonian courts of Philip and Alexander, wealthy aristocrats in Asia Minor, and foreign rulers anxious to import Greek wares and sometimes Greek artists.

Architecture and Architectural Sculpture

Despite the instability of the fourth century BCE, Greek cities undertook innovative architectural projects. Architects developed variations on the Classical ideal in urban planning, temple design, and the design of two increasingly popular structures, the tholos and the monumental tomb. In contrast to the previous century, much of this activity took place outside of Athens and even in areas outside of mainland Greece, notably in Asia Minor.

The Orthogonal City Plan. In older Greek cities such as Athens, which grew up on the site of an ancient **citadel**, buildings and streets developed irregularly according to the needs of their inhabitants and the requirements of the terrain. As early as the eighth century BCE, however, builders in some western Greek settlements began to implement a rigid, mathematical concept of urban development based on the **orthogonal** (rightangled) **plan**. New cities or razed sections in old cities

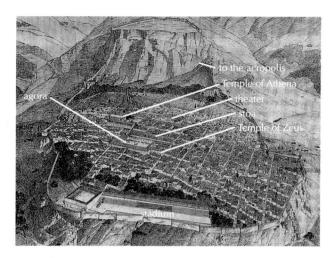

5-58. Plan and detail of the city of Priene, western Turkey. 4th century $_{\mbox{\footnotesize BCE}}$

were laid out on straight, evenly spaced parallel streets that intersected at right angles to create rectangular blocks. These blocks, or plats, were then subdivided into identical building plots. The orthogonal plan probably originated in Egypt, where it was used early in the second millennium BCE at such sites as el-Lahun, a city built by Senwosret II in Upper Egypt about 1895–1878 BCE (see fig. 3-19).

During the High Classical period, Greek architects promoted the orthogonal system as an ideal for city planning. Hippodamos of Miletos, a major urban planner of the fifth century BCE, had views on the city philosophically akin to those of Socrates and aesthetically akin to those of Polykleitos; all three believed that humans could arrive at a model of perfection through reason. According to Hippodamos, who seems to have been more concerned with abstract principles of order than with the human individual, the ideal city should be divided into three zones—sacred, public, and private—and limited to 10,000 citizens divided into three classes—artists, farmers, and soldiers. The basic Hippodamian plat was a square 600 feet on each side, divided into quarters. Each quarter was subdivided into six rectangular building plots measuring 100 by 150 feet on a side, a scheme widely used in Western cities and suburbs today.

Many Greek cities with orthogonal plans were laid out on relatively flat land that posed few obstacles to regularity. Miletos, in Asia Minor, for example, was redesigned by Hippodamos after its partial destruction by the Persians. Later the orthogonal plan was applied on less-hospitable terrain, such as that of Priene, which lies across the plain from Miletos on a rugged hillside. Priene, which originated about 1000 BCE, was rebuilt on a variation of the Hippodamian plan in the mid-fourth century BCE (fig. 5-58). The terrain of the city sloped steeply toward a rocky acropolis. As a result, the broad avenues crossing the slope were on a fairly level grade, but the narrower intersecting streets had to be stepped like stairs in places to make them passable and maintain the orthogonal pattern. Public buildings lay near the

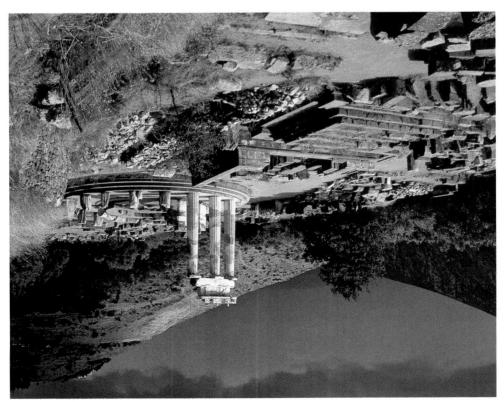

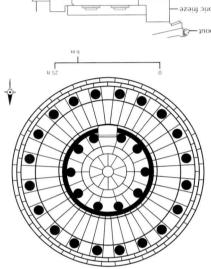

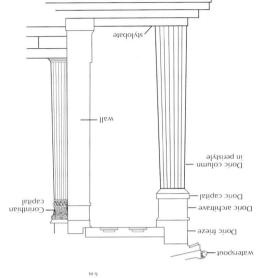

5-60. Plan and section of the tholos, Sanctuary of Athena Pronaia, Delphi

5-59. Tholos, Sanctuary of Athena Pronaia, Delphi. c. 400 BCE Often the term following the name "Athena" is an epithet, or title, identifying one of the goddess's many roles in ancient Greek belief. For example, as patron of craftspeople, she was referred to as Athena Ergane (Athena of the Worker). As guardian of the city-states, she was Athena Polias. The term "Pronaia" in this sanctuary name simply means "in front of the temples," referring to the sanctuary's location preceding several temples higher up along the mountain path.

intersection of the central axes, surrounded by private housing blocks measuring roughly 120 by 160 feet subdivided into building plots of about 30 by 80 feet. The agora, stadium, temple precincts, and other large structures occupied rectangular plots but interrupted the grid because of their size. The city's wall, unlike the city itself, followed the contours of the land, utilizing the defensive advantages offered by the site. The city's planners made no attempt to accommodate their grid to this irregular perimeter, leaving irregular plots wherever whole ones could not be imposed.

The Tholos. Buildings with a circular plan had a long history in Greece going back to Mycenaean beehive tombs (see fig. 4-21). In later times a variety of tholoi, or circular-plan buildings, were erected. Some were shrines or monuments and some, like the fifth-century BCE tholos in the Athens Agora (see fig. 5-40), were administrative buildings, but the function of many, such as a tholos built shortly after 400 BCE in the Sanctuary of Athena Pronaia at Delphi, is unknown (figs. 5-59, 5-60). Theodoros, the presumed architect, was from Phokaia in Asia doros, the presumed architect, was from Phokaia in Asia

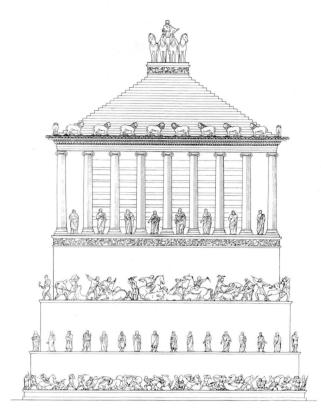

5-61. Reconstruction drawing of the Mausoleum (tomb of Mausolos), Halikarnassos (modern Bodrum, Turkey). c. 353 BCE

the three columns and a piece of the entablature that have been restored. Other remnants suggest that the interior featured a ring of columns with capitals carved to resemble the curling leaves of the acanthus plant. This type of capital came to be called "Corinthian" in Roman times (see "Elements of Architecture," page 165). It had been used on roof-supporting columns in temple interiors since the mid-fifth century BCE, but it was not used on building exteriors until the Hellenistic period.

The Monumental Tomb. Monumental tombs were designed as large, showy memorials to their wealthy owners. One such tomb was built for Mausolos, prince of Karia, at Halikarnassos in Asia Minor, where Herodotus, the "father of history," had been born more than a century earlier. This monument (fig. 5-61) was so spectacular that later writers glorified it as one of the Seven Wonders of the World. Mausolos, whose name has given us the term mausoleum (a large burial structure), was the Persian governor of the region. He admired Greek culture and brought to his court Greek writers, entertainers, and artists, as well as the greatest sculptors to decorate his tomb. The structure was completed after his death in 353 BCE under the direction of his wife, Artemisia, who was rumored to have drunk her dead husband's ashes mixed with wine.

Except for traces of the foundation, a few scattered stones, and many fragments of sculpture and moldings that are now in various museums, Mausolos's tomb vanished in the Middle Ages. Although early descriptions are

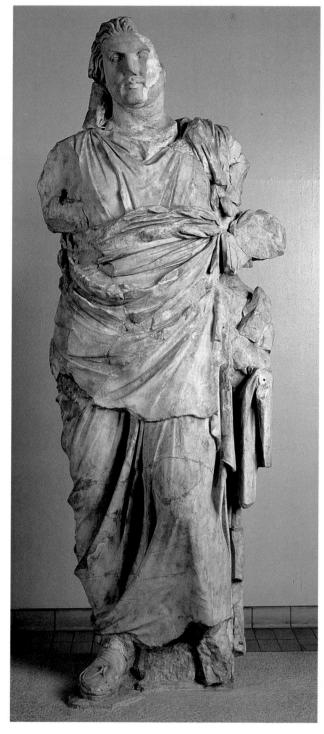

5-62. *Mausolos* (?), from the Mausoleum (tomb of Mausolos), Halikarnassos. Marble, height 9'10" (3 m). The British Museum, London

often ambiguous, the structure probably stood about 150 feet high and rose from a base measuring 126 by 105 feet. The elevation consisted of three main sections: a plain-surfaced podium, a colonnaded section in the Ionic order, and a stepped roof. The roof section measured about 24½ feet high and was topped with marble statues of a four-horse chariot and driver. The exterior decoration consisted of Ionic friezes and an estimated 250 freestanding statues, lifesize or larger, including more

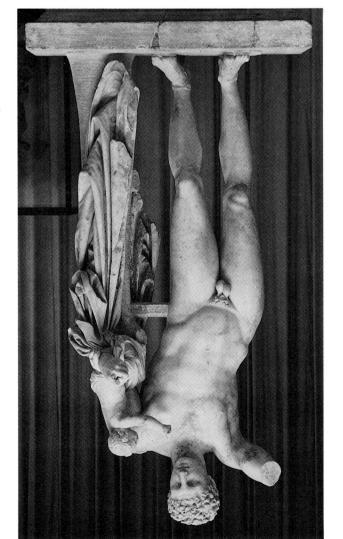

5-63. Followers of Praxiteles. Hermes and the Infant Dionysos, probably a Roman copy after an original of c. 300–250 BCE. Marble, with remnants of red paint on the lips and hair, height 7'1" (2.16 m). Archeological Museum, Olympia at Olympia in 1875, this statue is now widely accepted as a very good Roman copy. Support for this conclusion comes from certain elements typical of Roman sculpture: Hermes' sandals, which recent studies suggest are not accurate for a fourth-century BCE date; the supporting element of crumpled fabric covering a tree stump, and the use of a reinforcing strut, or brace, between and the use of a reinforcing strut, or brace, between

If it is a faithful copy, it reflects a number of differences between Praxiteles' style and that of the late fifth century. His Hermes has a smaller head and a more youthful body than Polykleitos's Spear Bearer, and its offearlier work (see fig. 5-54). This sculptor also created a sensuous play of light over the figure's surface. The gleam of the smoothly finished flesh contrasts with the textured quality of the crumpled draperies and the rough locks of hair, even on the baby's head. Surely owed to locks of hair, even on the baby's head. Surely owed to Praxiteles is the humanized treatment of the subject—

Hermes' hip and the tree stump.

than 50 lions around the roofline. The friezes were sculpted in relief with battle scenes of Lapiths against centaurs and Greeks against Amazons. As reconstructed in figure 5-61, statues of Mausolos's relatives and ancestors stood between the columns in the colonnade; statues of hunters killing lions, boars, and deer encircled the next level down; below them was a circle of unidentified standing figures; and around the base was a battle between Greeks and Persians. Originally, all the sculptural elements of the tomb were painted.

A preserved male statue from the tomb was long believed to be of Mausolos himself (fig. 5-62). The man's broad face, long, thick hair, short beard and moustache, and stocky body could represent the features of a particular individual, but it is more likely that the statue represents a new heroic ideal—a glorification of experience, maturity, and intellect over youthful physical beauty and athletic vigor. The heavy swathing of drapery drawn into a thick mass around the waist reveals the ery drawn into a thick mass around the waist reveals the bulk to make the figure impressive to a viewer at the bottom of the monument.

Sculpture

fully nude women in major works of art. moments. This period also saw the earliest depictions of taste for depictions of minor deities in lighthearted Olympian gods and legendary heroes and acquired a Patrons lost some of their interest in images of mighty introspection, dreaminess, or even fleeting anxiety. images of men and women with expressions of wistful lier figures gave way to more sensitively rendered works. The calm, noble detachment characteristic of eartall rather than the 61/2- or 7-head height of earlier figures—by Polykleitos's canon, some 8 or more "heads" ticular, developed a new canon of proportions for male those standards. The artists of mainland Greece, in partury artists, on the other hand, challenged and modified accepted by the next generation of artists. Fourth-cenized forms of the human figure had generally been mid-fifth century BCE for the ideal proportions and idealdards established by Pheidias and Polykleitos in the ment that is fundamental to Greek Classical art. Stanmaintained the equilibrium between simplicity and orna-Throughout the fifth century bce, sculptors carefully

The fourth century BCE was dominated by three sculptors—Praxiteles, Skopas, and Lysippos. Praxiteles was active in Athens from about 370 to 335 BCE or later. According to the Greek traveler Pausanias, writing in the second century CE, one of Praxiteles' most popular works was a statue of the messenger god Hermes teasing the baby Dionysos with a bunch of grapes, which he finds irresistible. Just such a sculpture in marble, Hermes and the Infant Dionysos, was discovered in the ruins of the ancient Temple of Hera in the Sanctuary of Hera and Seus at Olympia (fig. 5-63). It was accepted as an authentic work Dy Praxiteles until recent studies indicated that it is probably a very good Hellenistic or Roman copy after an original of about 300–250 BCE made by the followers of Praxiteles.

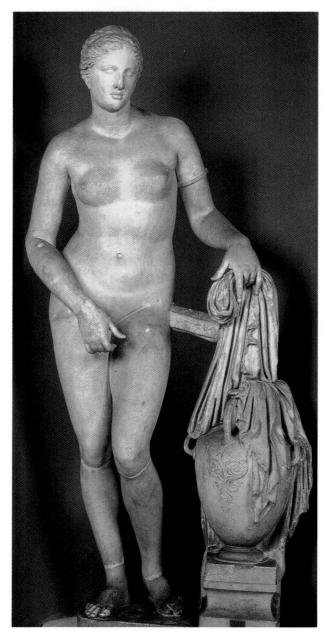

5-64. Praxiteles. *Aphrodite of Knidos,* composite of two similar Roman copies after the original marble of c. 350 BCE. Marble, height 6'8" (2.03 m). Musei Vaticani, Museo Pio Clementino, Gabinetto delle Maschere, Rome

In this composite of two Roman copies, the head is from one copy and the body from another. Seventeenth- and eighteenth-century restorers added the nose, the neck, the right forearm and hand, most of the left arm, and the feet and parts of the legs. This kind of restoration would rarely be undertaken today, but it was frequently done and considered quite acceptable in the past, when archeologists were trying to put together a body of work documenting the appearances of lost Greek statues. It was also done to create a piece suitable for sale to a private individual or for display in a museum.

two gods, one a loving adult and the other a playful child, caught in a moment of absorbed companionship. The interaction of the two across real space through gestures and glances creates an overall effect far different from that of the noble, austere deities of the fifth century BCE on the pediments and metopes of the Temple of Zeus (see figs. 5-34, 5-35), near where the work was found.

Around 350 BCE Praxiteles created a statue of Aphrodite that was purchased by the city of Knidos in Asia Minor. Although artists of the fifth century BCE had begun to hint boldly at the naked female body beneath tissuethin drapery, as in Nike Adjusting Her Sandal (see fig. 5-53), and a few earlier works by lesser-known artists showed female nudity, this Aphrodite was apparently the first statue by a well-known Greek sculptor to depict a fully nude woman, and it set a new standard (fig. 5-64). Although nudity among athletic young men was admired in Greek society, among women it had been considered a sign of low character, which may explain the reticence to depict it. The eventual wide acceptance of female nudes in large statuary may be related to the gradual merging of the Greeks' concept of their goddess Aphrodite with some of the characteristics of the Phoenician goddess Astarte (the Babylonian Ishtar), who was nearly always shown nude in Near Eastern art.

In the version of the statue seen here, actually a composite of two Roman copies, the goddess is preparing to take a bath, with a water jug and her discarded clothing at her side. Her right arm and hand extend in what appears at first glance to be a gesture of modesty, which in fact seems only to emphasize her nakedness. The bracelet on her left arm has a similar effect. Her well-toned body, with its square shoulders, thick waist, and slim hips, conveys a sense of athletic strength. She leans forward slightly with one knee in front of the other in a seductive pose that emphasizes the swelling forms of her thighs and abdomen.

Writers of the time relate that Praxiteles' original statue was of such enchanting beauty that it served as a public model of high moral value. According to an old legend, the sculpture was so realistic that Aphrodite herself made a journey to Knidos to see it and cried out in shock, "Where did Praxiteles see me naked?" The Knidians were so proud of their *Aphrodite* that they placed it in an open shrine where people could view it from every side. Hellenistic and Roman copies probably numbered in the hundreds, and nearly fifty survive in various collections today.

Skopas, another artist who was greatly admired in ancient times, had a brilliant career as both sculptor and architect that took him around the Greek world. Unfortunately, little survives, either originals or copies, that can be reliably attributed to him, even though early writers credited him with one whole side of the sculptural decoration of Mausolos's tomb. If the literary accounts are accurate, Skopas introduced a new style of sculpture admired in its time and influential in the following Hellenistic period. In relief compositions, he favored very active, dramatic poses over balanced, harmonious ones, and he was especially noted for the expression of emo-

known today only from Roman copies, he chose a typical Classical subject, a nude male athlete, but treated it in an unusual way (fig. 5-66). Instead of a figure actively engaged in a sport or atanding in the Classical shallow **S** curve, Lysippos depicted a young man methodically removing oil and dirt from his body with a scraping tool called a surigil. Judging from the athlete's expression, his thoughts are far from his mundane task. His deep-set eyes, dreamy stare, heavy forehead, and tousled hair eyes, dreamy stare, heavy forehead, and tousled hair

may reflect the influence of Skopas.

of its pose. of The Scraper's elongated body and the spatial extension inal rather than a copy, remarked on the subtle modeling authors, who may have been describing the bronze origaround the statue to absorb its full aspect. Roman the surrounding space, requiring the viewer to move view. In contrast, the arms of The Scraper break free into ly simple, compact contours and oriented to a frontal stretched arms. The Spear Bearer is contained within fairlegs are also in a wider stance to counterbalance the outfree one, with the free foot almost flat on the ground. The more evenly distributed between the engaged leg and the ferent canon of proportions, but the figure's weight is also Spear Bearer (see fig. 5-54). Not only does it reflect a difhead, makes a telling comparison with Polykleitos's The Scraper, tall and slender with a relatively small

Lysippos was widely known and admired for his monumental statues of Zeus, which may be why he was summoned to do a portrait of Alexander the Great. Lysippos portrayed Alexander as a full-length standing figure with an upraised arm holding a scepter, just as he is believed to have posed Zeus, though none of these statues still exists.

divine advice. decisions of great consequence and waiting to receive heavily lined, as though the figure were contemplating are unfocused and meditative, and the low forehead is a specific message about the subject. The deep-set eyes dered certain features in an idealized manner to convey was not meant to be entirely true to life. The artist renstrength earned him immortality. The Pergamon head great kinship with Herakles, whose acts of bravery and and pelt as a hooded cloak. Alexander would have felt his First Labor and is often portrayed wearing its head mythical hero Herakles, who killed the Nemean Lion as The treatment of the hair may be a visual reference to the man with a large Adam's apple and short, tousled hair. depicts a ruggedly handsome, heavy-featured young copies of Lysippos's original of Alexander (fig. 5-67). It standing figure is believed to be from one of several A head found at Pergamon that was once part of a

According to the Roman-era historian Plutarch, Lysippos depicted Alexander in a characteristic meditative pose, "with his face turned upward toward the sky, just as Alexander himself was accustomed to gaze, turning his neck gently to one side" (cited in Pollitt, page 20). Pergamon and others like it so well, the heads from Pergamon and others like it so well, the heads have been thought to be copies of the Alexander statue. On the other hand, the heads could also be viewed as

5-65. Skopas, or made in his workshop. Head from a pedimental figure, Temple of Athena Alea, Tegea. c. 340 BCE. Marble, height 113/4" (30 cm). National Archeological Museum, Athens

One of the most likely, though limited, sources of knowledge for his sculptural style is a group of fragments from the Temple of Athena Alea (Athena as goddess of good and bad fortune) at Tegea in southern Greece. Skopas supervised the construction of this temple, and if he did not actually create the statues, they must have been designed and executed according to his specifications, just as the sculptural decoration of the Parthenon was designed by Pheidias and executed by others under was designed by Pheidias and executed by others under

tion in the facial features and body gestures of his figures.

been designed and executed according to his specifications, just as the sculptural decoration of the Parthenon was designed by Pheidias and executed by others under his close direction. Among the fragments is a head from a figure originally in one of the pediments (fig. 5-65). Even in its damaged condition, the head conveys intensity with its deep-set eyes, heavy brow, slightly parted lips, and a gaze that seems to look far into the future.

The sculptor Lysippos is unique in that many details of his life are known. He claimed to be entirely self-taught and asserted that "nature" was his only model, but taught and asserted that "nature" was his only model, but

of his life are known. He claimed to be entirely self-taught and asserted that "nature" was his only model, but he must have received training in the technical aspects of his profession in the vicinity of his home in Sikyon, near Corinth. Although he expressed great admiration for Polykleitos, his own figures reflect a different set of proportions than those of the fifth-century BCE master, proportions than those of the fifth-century BCE master, with small heads and slender bodies like those of Praxiteles. For his famous work The Scraper (Apoxyomenos), iteles. For his famous work The Scraper (Apoxyomenos),

400 1000 BCE 0 BCE

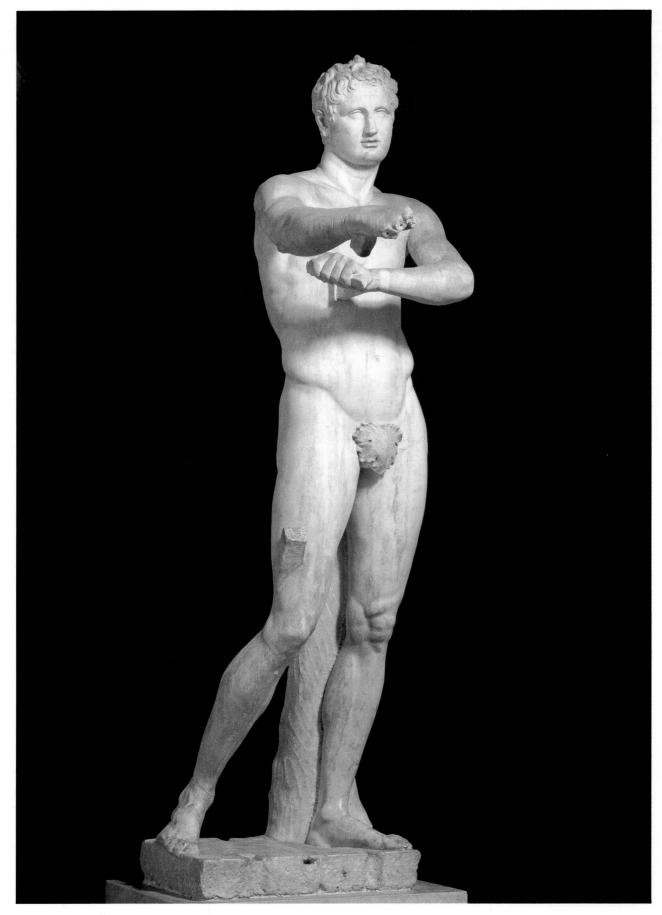

5-66. Lysippos. *The Scraper (Apoxyomenos*), Roman copy after the original bronze of c. 330 BCE. Marble, height 6'9" (2.06 m). Musei Vaticani, Museo Pio Clementino, Gabinetto dell'Apoxyomenos, Rome

5-69. Abduction of Persephone, detail of a wall painting in Tomb I (Small Tomb), Vergina, Macedonia. c. 366 BCE. Height approx. 391/2" (100.3 cm)

wall Painting and Mosaics

Greek painting has so far been discussed only in terms of pottery decoration because little remains of paintings in other mediums. Some excavations in the 1970s have enriched our knowledge of fourth-century BCE painting. At Vergina, the ancient Macedonian capital of Aigai, two previously undiscovered tombs were found in a large mound called the Great Tumulus, in a cemetery complex. Dated from **potsherds** to around the middle of the fourth mound called the Great Tumulus, in a cemetery complex. Dated from **potsherds** to around the middle of the fourth ings. The larger of the tombs (Tomb II), which contained a rich casket, armor, and golden wreaths, may be that of Alexander's father, Philip II.

A mural in the smaller of the tombs (Tomb I) depicts the kidnapping of Persephone by Hades (fig. 5-69). Even in its deteriorated state, the *Abduction of Persephone* is clearly the work of an outstanding artist. This mural, with its vigorous drawing style, complex foreshortening, and dynamic brushwork, proves claims by early observers such as Pliny the Elder that Greek painters were skilled in capturing the appearance of the real world. It also contradicts the view often held before its discovery that dractication to Hellenistic sculpture of the third to first centradicts the view often held expresentation in Greek art was confined to Hellenistic sculpture of the third to first century BCE. Hades has just snatched Persephone and is carrying her off in his chariot. The convincing twists of the figures, the foreshortened view of the huge wheels on the figures, and the swirl of draperies capture the story's the chariot, and the swirl of draperies capture the story's

5-67. Alexander the Great, head from a Hellenistic copy (c. 200 BCE) of a statue, possibly after a 4th-century BCE original by Lysippos. Marble fragment, height 161/8" (41 cm). Archeological Museum, Istanbul, Turkey

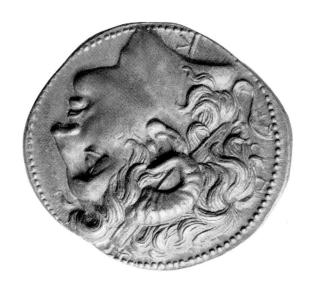

5-68. *Alexander the Great, 4*-drachma coin issued by Lysimachos of Thrace. 306–281 BCE. Silver, diameter 11/8" (30 mm). **The British Museum, London**

conventional, idealized "types" rather than identifiable portraits of Alexander. A reasonably reliable image of Alexander is found on a coin issued by Lysimachos, king of Thrace, in the late fourth and early third centuries BCE (fig. 5-68). It shows Alexander in profile wearing the curled ram's-horn headdress that identifies him as the Creek-Egyptian god Zeus-Amun. It is interesting to compare the low forehead, high-bridged nose, large lips, and thick neck to the Pergamon head.

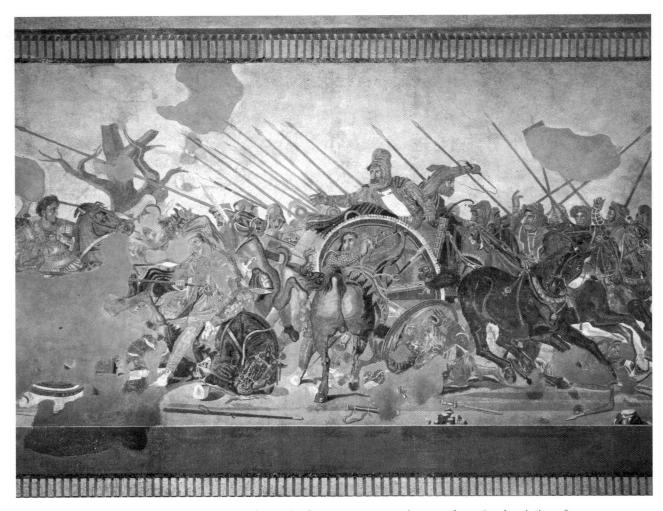

5-70. Alexander the Great Confronts Darius III at the Battle of Issos, Roman mosaic copy after a Greek painting of c. 310 BCE, perhaps by Philoxenos or Helen of Egypt. Museo Archeològico Nazionale, Naples, Italy

action, conveying the intensity of the struggle and the violent emotions it has provoked. Hades, with his determined expression, contrasts strikingly with the young Persephone, who evokes pity with her helpless gestures. The subject, certainly appropriate for a tomb painting, may be a metaphor for rebirth, the changing seasons, the cycle of life and death.

Later, Roman patrons greatly admired Greek murals and commissioned copies, as either wall paintings or mosaics, to decorate their homes. These copies provide another source of evidence about fourth-century BCE Greek painting. Together with evidence from red-figure vase painting, they indicate a growing taste for dramatic narrative subjects. A second-century BCE mosaic, *Alexander the Great Confronts Darius III at the Battle of Issos* (fig. 5-70), was based on an original wall painting of about 310 BCE. Pliny the Elder attributed the original to Philoxenos of Eretria; a recent theory claimed it was by a well-known woman painter, Helen of Egypt (see "Women Artists in Ancient Greece," opposite). Like the *Abduction*

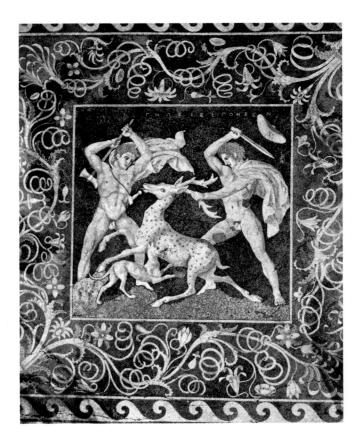

petitions, as they were, for the most participating in public artistic commen were simply excluded from the awards ceremony. Perhaps wofrom the other artists and left out of vase in the workshop. She is isolated

own careers and bring glory to the

tests so that they may further their

her young assistants to enter con-

status, perhaps she has encouraged

this workshop. Secure in her own

ever, is that the woman is the head of

Another interpretation, how-

workshop as a whole.

part, in athletics.

From pictorial evidence, we

know that women worked in pot-Issos (see fig. 5-70). exander the Great at the Battle of

diums in ancient Greece. Several of worked in many memen artists probably relatively few, wobers must have been Although their num-

ating a believable illusion of the real world was the sub-

Abduction of Persephone, but its condition makes them

areas in shadow. The same techniques were used in the

sions with highlights and shading undercut areas and

light on three-dimensional surfaces by touching protru-

of solid figures through modeling, mimicking the play of

of the original painting, the mosaicist created the illusion

safety in the Persian ranks. Presumably in close imitation apprehension as his charioteer whisks him back toward

who stretches out his arm in a gesture of defeat and

challenges the helmeted and armored Persian leader,

the left, his hair blowing free and his neck bare, Alexander

er's response to a dramatic situation. Astride a horse at

and radical foreshortening, all devised to elicit the viewof Persephone, this scene is one of violent action, gestures,

difficult to see in a photographic reproduction.

The great interest of fourth-century bee artists in cre-

ARTISTS IN

-IA to gnitining likw lanigino off

and may have been responsible for

have worked in the fourth century BCE

trained by her father, is known to

painter from Egypt who had been

Olympias, and Timarete. Helen, a

ed Aristarete, Eirene, Iaia, Kalypso,

ers. Pliny the Elder, for example, listthem are mentioned by ancient writ-

CREECE

ANCIENT

MOWEN

on a raised dais painting the largest tition. The woman, well-dressed, sits bolizing victory in an artistic compe-Nikes bearing victory wreaths, symers, who are being approached by position focuses on the male paintambiguous as to her status. The comsuch a workshop, but it is somewhat 450 BCE, shows a woman artist in illustrated here, dating from about tery-making workshops. The hydria

hydria from Athens. c. 450 BCE. Private collection A Vase Painter and Assistants Crowned by Athena and Victories, composite photograph of the red-figure decoration on a

"Pausanian" rather than "Glykeran." in later Greek painting and mosaics are described as perhaps unfair, that the opulent floral borders so popular legend, he succeeded. It is thus not surprising, although lifelike to the spectator as her real one. According to the ture of one of her complex works that would appear as Glykera to a contest, claiming that he could paint a picsias, the foremost painter of the day. Pausias challenged lands for religious processions and festivals—and Pauand greenery into stunning wreaths, swags, and garly praised for the artistry with which she wove blossoms legend involved a floral designer named Glykera-wideject of anecdotes repeated by later writers. One popular

scenes, such as the Stag Hunt (fig. 5-71), prominently 300 BCE, the floor features a series of framed hunting provides an example of a Pausanian design. Dated about A mosaic floor from a palace at Pella in Macedonia

400 1000 BCE 0 BCE signed by an artist named Gnosis. Blossoms, leaves, spiraling tendrils, and twisting, undulating stems frame this scene, echoing the linear patterns formed by the hunters, the dog, and the struggling stag. The over-lifesize human and animal figures are accurately drawn and modeled in light and shade. The dog's front legs are expertly foreshortened to create the illusion that the animal is turning at a sharp angle into the picture. The work is all the more impressive because it was not made with uniformly cut marble in different colors but with a carefully selected assortment of natural pebbles. The background was formed of dark stones, and the figures and floral designs were made of light-colored stones. The smallest pebbles were used to "paint" in the delicate shading and to create subtle details.

The Art of the Goldsmith

The work of Greek goldsmiths, which gained international popularity in the Classical period, followed the same stylistic trends and achieved the same high standards of technique and execution found in the other art mediums. Goldsmiths' work was especially admired by the Scythians, a once-nomadic people from northern Asia who themselves had an ancient tradition of outstanding goldwork. An elaborate example of Greek artistry, a large, gold pectoral dating from the fourth century BCE, was found in a Scythian chief's tomb in the Caucasus Mountains (fig. 5-72). A series of four gold torques of increasing diameter separates each of the sections. The upper and lower bands have figures, and the center one contains a stylized floral design that strongly resembles the floral border on the Pella floor (see fig. 5-71). In the pectoral's top band, the artist re-created a typical scene of Scythian daily life. At the center, two men are making a cloth shirt, while at the right another man milks a goat. Around them are cows and horses with their nursing calves and foals, all portrayed with great naturalistic detail. In contrast, the bottom band is devoted to a Near Eastern theme of animal combat, with griffinlike beasts attacking a group of horses. Is there a lesson here—that the domestication of animals is justified because it offers them protection from the dangers of the wild?

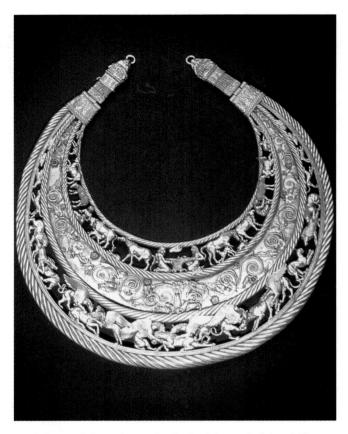

5-72. Pectoral, from the tomb of a Scythian at Ordzhonikidze, Russia. 4th century BCE. Gold, diameter 12" (30.6 cm). Historical Museum, Kiev

The jewelry designs popular with Greek women of the period were romantic ones. An embossed gold diadem dating from the late fourth century BCE, to be worn in the hair like a small crown (fig. 5-73), depicts a pair of mythological lovers, Ariadne—a Cretan princess abandoned by her lover, Theseus, on the island of Naxos—and the wine god Dionysos, who found and married her. The two recline back to back, listening to a concert played by women musicians seated between giant spiraling forms like those on both sides of the listening couple. The harpist at the near right in pose and instrument recalls

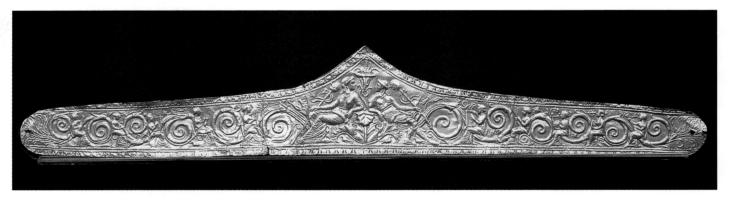

5-73. Diadem, reputed to have been found in a tomb near the Hellespont. Late 4th century BCE. Gold, 14½" (36.8 cm). The Metropolitan Musem of Art, New York Rogers Fund, 1906 (06.1217.1)

the Hellenistic period. its last ruler, the notorious Cleopatra, marks the end of almost two and one-half centuries. The death in 30 BCE of tered in Rome. Ptolemaic Egypt endured the longest, these kingdoms succumbed to the growing empire censia. Over the course of the second and first centuries BCE Seleucids controlled Asia Minor, Mesopotamia, and Permainland Greece; the Ptolemies ruled Egypt; and the

gamon in Asia Minor. parchment scrolls, was rivaled only by the library at Perlibrary, estimated to have contained 700,000 papyrus and great Hellenistic center of learning and the arts. Its of the World, according to ancient writers), emerged as a known for its lighthouse (another of the Seven Wonders maic capital, Alexandria in Egypt, a prosperous seaport Greek culture far beyond its original borders. The Ptole-Alexander's most lasting legacy was the spread of

rary taste for high drama. of the Hellenistic period largely reflected the contempoposes—became more pronounced. Even the architecture ments and to the emotions with dramatic subjects and the senses through lustrous or glittering surface treattrend introduced in the fourth century BCE—the appeal to emotion, and from drama to melodramatic pathos. A from gods to mortals, from aloof serenity to individual increasingly away from the heroic and to the everyday, artists sought the individual and the specific. They turned lier artists sought the ideal and the general, Hellenistic ably different from that of their predecessors. Where ear-Artists of the Hellenistic period had a vision notice-

Theaters

Later, builders improved them with stone. first, tiers of seats were simply cut into the side of the hill. were made into permanent open-air auditoriums. At served as a kind of natural theater. Eventually such sites ble, dramas were also presented facing a steep hill that incorporated into religious sanctuaries. Whenever feasidoor threshing floor (halos)—the same type of floor later hard-packed dirt or stone-surfaced pavement of an outvery early times, theater performances took place on the of religious belief through music, poetry, and dance. In tainment; it was a vehicle for the communal expression In ancient Greece, the theater was more than mere enter-

theaters have survived in their original form. and frequently modified over many centuries, no early of Dionysos. Because theaters were used continuously the performance of music and dance during the festival Athens Acropolis and in the sanctuary at Delphi, also for the fourth century BCE, including those on the side of the define tragedy for centuries. Many theaters were built in and Euripides-were creating the works that would the three great Greek tragedians—Aeschylus, Sophocles, formed at a festival dedicated to Dionysos. At this time, tragedies in verse based on popular myths and were per-During the fifth century BCE, the plays primarily were

good examples of the characteristics of early theaters which dates from the early third century BCE, presents The largely intact theater at Epidauros, however,

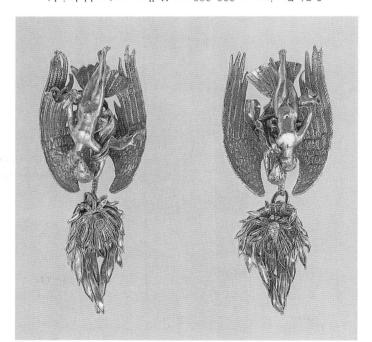

Harris Brisbane Dick Fund, 1937 (37.11.9-10) 23/8" (6 cm). The Metropolitan Musem of Art, New York 5-74. Earrings. c. 330-300 BCE. Hollow-cast gold, height

Scythian pectoral. spirals somewhat resemble the floral elements of the the Cycladic Harp Player (see fig. 4-3). The tumbling leafy

become a hallmark of Hellenistic art. depiction of swift movement through space, were to drama of its subject. Action subjects like this, with the the ear. Despite its small size, the earring conveys all the using the lost-wax process, no doubt to make it light on Slightly more than 2 inches high, it was hollow-cast charming decoration and a technical tour de force. (Keus) (fig. 5-74), dated about 330-300 BCE, is both a designed as the youth Canymede in the grasp of an eagle desses, but they adorned real ears as well. An earring were often placed on the ears of marble statues of godearrings in the form of tiny works of sculpture. These A specialty of Greek goldsmiths was the design of

at once his generals turned no accepted successor. Almost no administrative structure and BCE' ye left a vast empire with THE When Alexander died in 323

Democracy survived in form but not substance in govleague but never again achieved significant power. Greek city-states formed a new mutual-protection lost autonomy, and the empire began to break apart. The against one another, local leaders tried to regain their

Seleucus. The Antigonids controlled Macedonia and der's generals and their heirs: Antigonus, Ptolemy, and had emerged out of the chaos, ruled by three of Alexan-By the early third century BCE, three major powers

ernments dominated by local rulers.

PEKIOD

HELLENISTIC

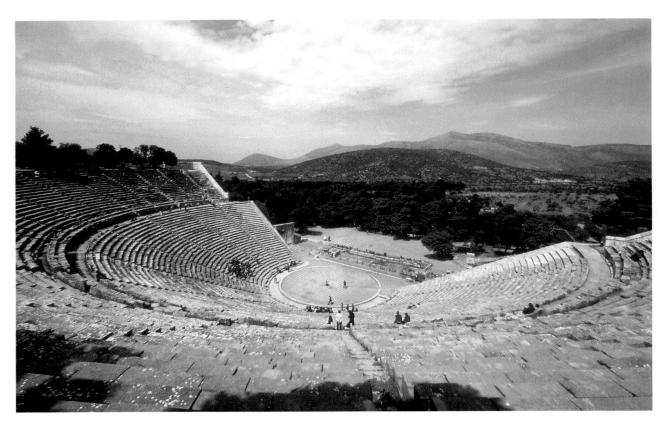

5-75. Theater, Epidauros. Early 3rd century BCE and later

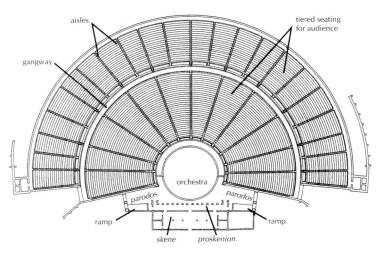

5-76. Plan of the theater at Epidauros

(figs. 5-75, 5-76). A semicircle of tiered seats built into the hillside overlooked the circular performance area, called the orchestra, at the center of which was an altar to Dionysos. Rising behind the orchestra was a two-tiered stage structure made up of the vertical *skene* (scene)—an architectural backdrop for performances and a screen for the backstage area—and the *proskenion* (**proscenium**), a raised platform in front of the *skene* that was increasingly used over time as an extension of the orchestra. Ramps connecting the *proskenion* with lateral passageways (*parodoi*; singular *parodos*) provided access to the stage for performers. Steps gave the audience access to the fifty-five rows of seats and divided the seating area into uni-

form wedge-shaped sections. The tiers of seats above the wide corridor, or gangway, were added at a much later date. This design provided uninterrupted sight lines and good acoustics and allowed for efficient crowd control of the 12,000 spectators. It has not been greatly improved upon since.

The Corinthian Order in Architecture

During the Hellenistic period there was increasing innovation in public architecture. A variant of the Ionic order featuring a tall, slender column with a Corinthian capital, for example, began to challenge the dominance of the Doric and Ionic orders on building exteriors. Invented in the late fifth century BCE, this highly decorative carved capital had previously been used only indoors, as in the tholos at Delphi (see fig. 5-60). Today, the Corinthian variant is routinely treated as a third Greek order (see "Elements of Architecture," page 165). In the Corinthian column the echinus becomes an unfluted extension of the column shaft set off by a collar molding called an astragal. From the astragal sprout curly acanthus leaves and coiled flower spikes reminiscent of the coiled volutes of the Ionic capital. The slightly flaring abacus has concave sides with a center relief element called a boss. The Corinthian entablature features a stepped-out architrave and bands of carved moldings, often including a line of vertical toothlike elements called dentils, just above the continuous frieze. The Corinthian design became a lasting symbol of elegance and refinement that is still used on banks, churches, and office buildings.

5-77. Temple of the Olympian Zeus, Athens. Building and rebuilding phases: foundation mid-6th century BCE; temple designed by Cossutius, begun 175 BCE, left unfinished 164 BCE, completed 132 CE using Cossutius's design

5-78. Gallic Chieflain Killing His Wife and Himself, Roman copy after the original bronze of c. 220 BCE. Marble, height 6'11" (2.1 m). Museo Nazionale Romano, Rome

simply, it is a Greek temple grown very large. portions and details followed traditional standards. Quite rooms enclosed within a screen of columns, and its prothree-stepped base, it had an enclosed room or series of temple followed long-established norms. It stood on a its height and luxurious decoration, the design of the new the Parthenon seems modest in comparison. But for all 57 feet above the stylobate. Viewed through its columns originals or Roman replicas of them. The peristyle soars great Corinthian columns may be the second-century BCE three centuries later under Roman rule. The temple's BCE. Work halted in 164 BCE and was not completed until that of an earlier temple dating to the mid-sixth century unusually large foundation, measuring 135 by 354 feet, is sutius in the second century BCE (fig. 5-77). The temple's ochus IV and was designed by the Roman architect Cos-Acropolis, was commissioned by the Seleucid ruler Antilocated in the lower city of Athens at the foot of the The Corinthian order Temple of the Olympian Zeus,

Sculpture

Hellenistic sculptors produced an enormous variety of work in a wide range of materials, techniques, and styles. The period was marked by two broad and conflicting from Classical models and toward experimentation with new forms and subjects; the other led back to Classical models, with artists selecting aspects of certain favored works by fourth-century sculptors and incorporating them into new styles.

viewer is known as expressionism, and it was to beattempt to elicit a specific emotional response in the that he is on the point of death. This kind of deliberate ing right arm and his unseeing downcast gaze indicate struggles to stay up, but the slight bowing of his supportsword into his own breast. The trumpeter, fatally injured, example, still supports his dead wife as he plunges the admiration and pity for his subjects. The chieftain, for "barbarians." The artist has sought to arouse the viewer's item of dress the Gauls wore in battle), identify them as and the trumpeter's twisted neck ring, or torque (the only dignity and heroism in defeat. Their wiry, unkempt hair a wounded soldier-trumpeter (fig. 5-79), extolling their chieftain and his wife (fig. 5-78) and the slow demise of pedestal. They depict the murder-suicide of the Gallic Roman copies in marble, were mounted on a large figures, originally in bronze but known today only from the Gauls, a people who invaded from the north. These the victory in 230 BCE of Attalos I (ruled 241-197 BCE) over a group of sculpture from a monument commemorating out the Hellenistic period. This new style is illustrated by sculptural style that had far-reaching influence throughleading center of arts patronage and the hub of a new ancient city in western Asia Minor. It quickly became a itself in the early third century BCE on the site of an breakaway state within the Seleucid realm, established The Pergamene Style. The kingdom of Pergamon, a

come a characteristic of Hellenistic art.

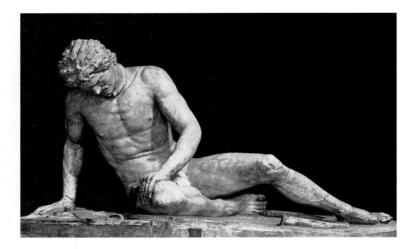

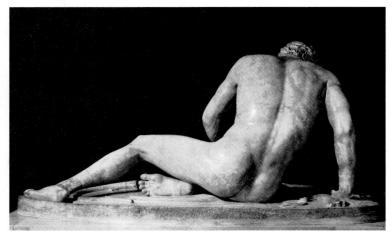

5-79. Epigonos(?). *Dying Gallic Trumpeter*, Roman copy after the original bronze of c. 220 BCE. Marble, lifesize. Museo Capitolino, Rome

The marble copies of these works are now separated, and no one knows exactly how the originals were positioned. Probably they formed part of an interlocked, multifigured pyramidal group that could have been viewed and appreciated from nearly every angle. Pliny the Elder described a work like the *Dying Gallic Trumpeter*, attributing it to an artist named Epigonos. Recent research indicates that Epigonos probably knew the early-fifth-century BCE sculpture of the Temple of Aphaia at Aegina, which included the *Dying Warrior* (see fig. 5-19), and could have had it in mind when he created his own works.

The style and approach of the works in the monument to the defeated Gauls became more pronounced and dramatic in later works, culminating in the decorative frieze on the base of the great altar at Pergamon (fig. 5-80). The wings and staircase to the entrance of the altar have been reconstructed inside a Berlin museum from fragments from the site. The original altar was a single-story structure with an Ionic colonnade raised on a high podium and entrances on each side. The main entrance, as shown here, was reached by a monumental staircase 68 feet wide and nearly 30 feet deep. The running frieze decoration, probably executed during the

reign of Eumenes II (197–159 BCE), depicts the battle between the Gods and the Giants, a mythical struggle that the Greeks are thought to have used as a metaphor for contemporary conflict—in this case, Pergamon's victory over the Gauls.

The panels are about 7½ feet high on the ends and taper to a few inches at the top of the steps. They show the Greek gods fighting not only human-looking Giants, but also grotesque hybrids emerging from the bowels of the earth. In a detail of the frieze (fig. 5-81), the goddess Athena at the left has grabbed the hair of a winged, serpent-tailed male monster and forced him to his knees. Inscriptions along the base of the sculpture identify him as Alkyoneos, a son of the earth goddess Ge, who rises from the ground on the right in maternal wrath as she reaches toward Athena. At the far right, a winged Nike rushes to Athena's assistance.

The figures in the Pergamon frieze not only fill up the sculptural space, they break out of their architectural boundaries and invade the space in front of it. They crawl out of the frieze onto the steps, where visitors had to pass them on their way up to the shrine. Many consider this theatrical and complex interaction of space and form to be a benchmark of the Hellenistic style, just as they con-

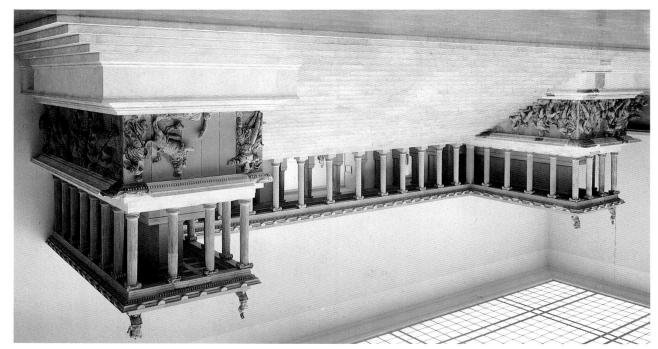

5-80. Reconstructed west front of the altar from Pergamon, Turkey. c. 166–156 BCE. Marble. Staatliche Museen zu Berlin, Preussischer Kulturbesitz, Pergamonmuseum

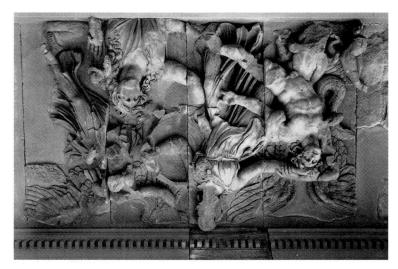

5-81. Alhena Altacking the Giants, detail of the frieze from the east front of the altar from Pergamon. Marble, frieze height 7'6" (2.3 m). Staatliche Museen zu Berlin, Preussischer Kulturbesitz, Pergamon-museum

and stability admired in the Classical style have given way to extreme expressions of pain, stress, wild anger, fear, and despair. In the High Classical style, figures stood they reached out into their immediate environment. In the Hellenistic style, they impose themselves, often forcefully, on the spectator. Whereas the High Classical artist asked only for an intellectual commitment, the Hellenistic artist demanded that the viewer respond both physically and emotionally.

sider the balanced restraint of the Parthenon sculpture to be the benchmark of the High Classical style. Where fifthcentury BEE artists sought horizontal and vertical equilibrium and control, the Pergamene artists sought to balance opposing forces in three-dimensional space along diagonal lines. The High Classical preference for smooth, sculpted surfaces reflecting a clear, even light has been replaced by a preference for dramatic contrasts of light and shade playing over complex forms sculpted of light and shade playing over complex forms sculpted an high relief with deep undercutting. The composure in high relief with deep undercutting. The composure

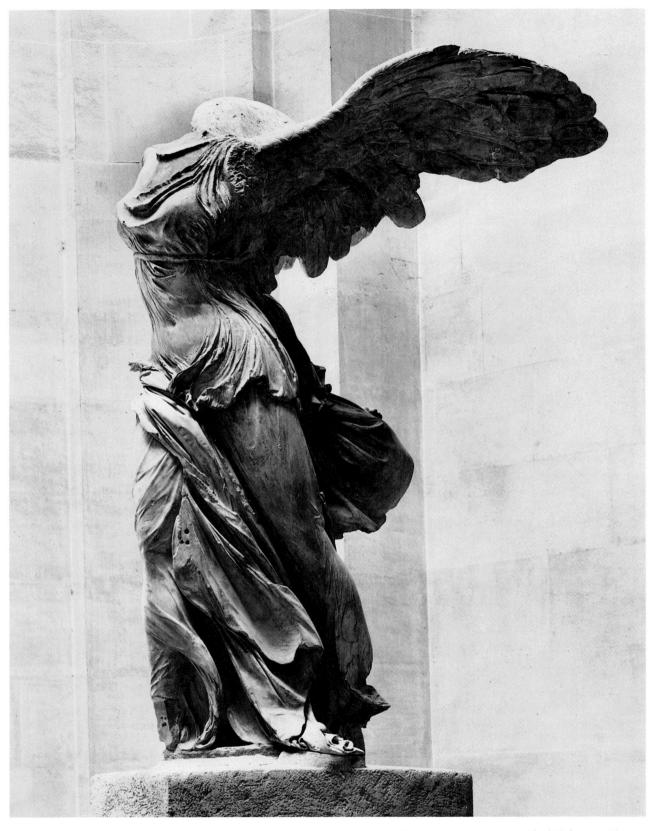

5-82. *Nike (Victory) of Samothrace,* from the Sanctuary of the Great Gods, Samothrace. c. 190 BCE (?). Marble, height 8' (2.44 m). Musée du Louvre, Paris

The wind-whipped costume and raised wings of this victory goddess indicate that she has just alighted on the prow of the stone ship that formed the original base of the statue. The work probably memorialized an important naval victory, perhaps the Rhodian triumph over the Seleucid king Antiochus III in 190 BCE. Lacking its head and arms, the Nike and a fragment of its ship base were discovered in the ruins of the Sanctuary of the Great Gods by a French explorer in 1863. Soon after, it entered the collection of the Louvre Museum in Paris. Poised high on the landing of the grand staircase, this famous Hellenistic sculpture continues to catch the eye and the imagination of thousands of museum visitors.

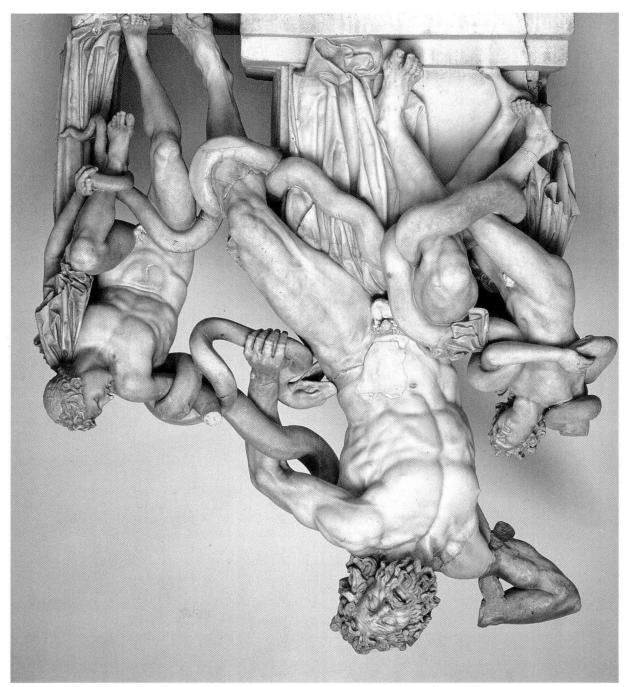

Clementino, Cortile Ottagono, Rome or 1st century bee or a Roman copy of the 1st century ce. Marble, height 8' (2.44 m). Musei Vaticani, Museo Pio 5-83. Hagesandros, Polydoros, and Athanadoros of Rhodes. Laocoon and His Sons, perhaps the original of the 2nd

mon, though it is not known which work is earlier. iniscent of the sculptures on the Altar of Zeus at Pergacontrasting textures of feathers, fabric, and skin are remof light and dark on the deeply sculpted forms, and the large, open movements of the figure, the strong contrasts powerful backward thrust of its enormous wings. The

Hagesandros, Polydoros, and Athanadoros, three sculp-Pergamene artists very likely inspired the work of

5-83). This work, in the collection of the Vatican since its

the creators of the famed Laocoon and His Sons (fig.

tors on the island of Rhodes named by Pliny the Elder as

momentum of the Nike's heavy body is balanced by the takingly appropriate for a war memorial. The forward image of a goddess alighting suddenly on a ship breathvictory in real life does often seem miraculous makes this en to determine the outcome of the drama. The fact that god-character in Greek plays who descends from heavvictory must have reminded the Samothracians of the nith spray from a fountain—this 8-foot-high goddess of high above the city of Samothrace and perhaps drenched theatrical still. In its original setting—in a hillside niche

The Nike (Victory) of Samothrace (fig. 5-82) is more

THE TROJAN WAR

The legend of the Trojan War and its aftermath held a central place in

the imagination of the ancient Greeks, inspiring the great epics of Homer-the Iliad and the Odyssey-and providing the poets and artists of the Classical period and beyond with a rich source of subject matter. According to the legend, the cause of the war was a woman's infidelity. While on a visit to the city of Sparta in southern Greece, young Paris, the son of King Priam of Troy, fell in love with Helen, a human daughter of Zeus who was the wife of the Spartan king Menelaus. With the help of Aphrodite, the goddess of love, she and Paris fled to Troy, a rich city in northwestern Asia Minor. The angry Greeks dispatched ships and a huge army to bring Helen back. Led by Agamemnon, king of Mycenae and the brother of Menelaus, the Greek forces laid siege to Troy. The two sides were deadlocked for ten years, until a ruse devised by the warrior Odysseus allowed the Greeks to win: the Greeks pretended to give up the siege and built a huge wooden horse to leave behind as a parting gift to the goddess Athena, or so they led the Trojans to believe.

In fact, Greek warriors were hidden inside the wooden horse. After the Trojans pulled the horse inside the gates of Troy, the Greeks slipped out and opened the gates to their comrades, who slaughtered the Trojans and burned the city.

The source of this legend is thought to have been a real attack on a coastal city of Asia Minor by mainland Greeks during the Late Bronze Age. The assault more likely resulted from a struggle for control over trade in and out of the Black Sea than from the abduction of a Helladic ruler's wife. Tales of the conflict, modified over the centuries, endured in a tradition of oral poetry into the eighth or seventh century BCE, when the epics that are attributed to Homer were written down.

Homer's Iliad recounts an incident that took place during the long siege of Troy. Achilles, offended by Agamemnon, refuses to fight, and in his absence the Greeks suffer reverses. His friend Patroclus borrows his magical armor and kills many Trojans (including the warrior Sarpedon, see fig. 5-31) before he is killed by the Trojan hero Hector (another son of Priam). Achilles, to avenge his friend's death, returns to the battle and slays Hector. Homer's Odyssey recounts the trials and triumphs of Odysseus, who was doomed to years of wandering after the war before he could return to his faithful wife, Penelope. Among the many other stories of the Trojan War that found their way into art and literature were the death of Agamemnon, slain by his wife Clytemnestra when he arrived home, and the suicide of Ajax (see fig. 5-29).

The Romans, too, found inspiration in the legendary struggle at Troy.

Seeking heroic origins for themselves, they claimed descent from Aeneas, a Trojan warrior. As recounted in the *Aeneid*, an epic by the Roman poet Vergil (70–19 BCE), Aeneas and his followers escaped from Troy and found their way to Italy.

As early as the seventeenth century CE, adventurers began searching for Troy. In the early nineteenth century, the Englishman Charles Mac-Laren and the American Frank Calvert both concluded that the remains of the legendary city might be found at the Hissarlik Mound in northwestern Turkey. When this relatively small mound—less than 700 feet across-was excavated, first by the German archeologist Heinrich Schliemann from 1872 to 1890 (see "Pioneers of Aegean Archeology," page 143) and later by an American team under Carl Blegen in the 1930s, it was found to contain the remains of at least nine successive cities, the earliest of which dated to at least 3000 BCE. The seventh of these shows evidence of a terrible fire, which led early researchers to identify it as the Troy of legend. A more recent hypothesis, however, is that the socalled Troy 7 was destroyed by a fire of natural causes and that Homer's city is more likely to have been the earlier Troy 6. This city flourished for at least 500 years, between about 1800 and 1300 BCE. At its height, its fortifications were substantially reinforced, suggesting that it was threatened by a powerful enemy.

excavation in Rome in 1506, has been assumed by many art historians to be the original version, although others argue that it is a brilliant copy commissioned by an admiring Roman patron. The date of the original work is also uncertain-either second or first century BCE. The complex sculptural composition illustrates an episode from the Trojan War (see "The Trojan War," above). The Trojans' priest Laocoön warned them not to take the wooden horse (filled with Greeks) inside their walls. The gods who supported the Greeks in the war retaliated by sending serpents into Troy to destroy Laocoon and his sons. The struggling figures, anguished faces, intricate diagonal movements, and skillful unification of diverse forces in a complex composition all suggest a strong relationship between Rhodian and Pergamene sculptors. Unlike the monument to the conquered Gauls, the Laocoön was composed to be seen from the front,

within a short distance. As a result, although sculpted in the round, the three figures appear as very high relief and are more like the relief sculpture on the Altar of Zeus.

Small-Scale Statues. Although "huge," "enormous," and "larger-than-life" are terms correctly applied to much Hellenistic sculpture, artists of the time also created fine works on a small scale. The grace, dignity, and energy of the 8-foot-tall *Nike of Samothrace* can also be found in a bronze only 8½ inches tall (fig. 5-84). This figure of a heavily veiled and masked dancing woman twists sensually under the gauzy, layered fabric in a complex spiral movement. The dancer clearly represents an artful professional performer who would have been equally in demand for religious celebrations and secular court entertainments. Private patrons must have delighted in such intimate works, which were made in large

gamon signals a social change between the Classical and Hellenistic periods. In contrast to the Classical world, which was characterized by relative cultural unity and social homogeneity, the Hellenistic world was varied and multicultural. In this environment, artists turned from idealism, the quest for perfect form, to realism, the attempt to portray the world as it is. Portraiture, for example, became popular during the Hellenistic period, as did the representation of people from every level of

numbers and featured a wide variety of subjects and treatments. This bronze would have been costly, but many such graceful figurines were produced in inexpensive terra-cotta from preshaped molds and would have been accessible to a very broad market.

The appeal to the emotions in the sculpture at Per-

long been called *Market Woman* (fig. 5-85), may represent a peasant woman on her way to the agora with three chickens and a basket of vegetables. Despite the bunched and untidy way the figure's dress hangs, it fabric. The hair too bears some semblance of a oncecareful arrangement. These characteristics, along with the woman's sagging lower jaw, unfocused stare, and lack of concern for her exposed breasts, have led some to speculate that she may represent an aging, dissolute to speculate that she may represent an aging, dissolute follower of the wine god Dionysos on her way to make follower of the wine god Dionysos on her way to make

society. Patrons were fascinated by depictions of unusual physical types as well as of ordinary individuals.

A marble statue a little over 4 feet tall, which has

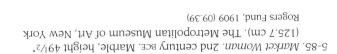

5-84. Veiled and Masked Dancer. Late 3rd or 2nd century Bren. Bronze, height 81/8" (20.7 cm). The Metropolitan Museum of Art, New York Bequest of Walter C. Baker, 1971 (1972.118.95)

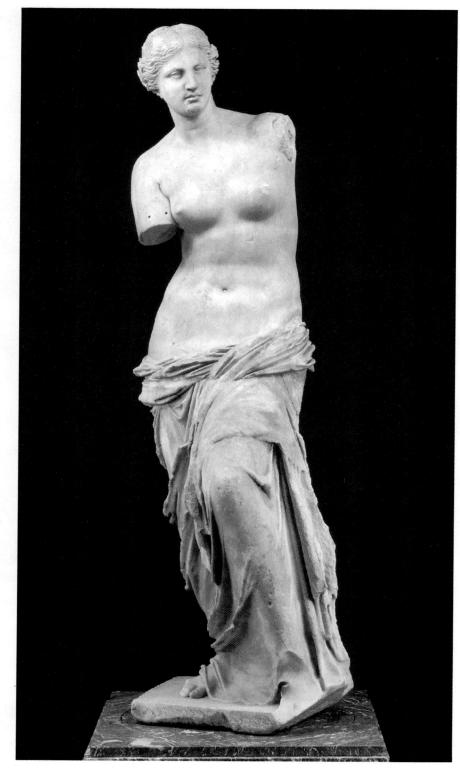

5-86. Aphrodite of Melos (also called Venus de Milo). c. 150 BCE. Marble, height 6'10" (2.1 m). Musée du Louvre, Paris

The original appearance of this famous statue's missing arms has been much debated. When it was dug up in a field in 1820, some broken pieces found with it (now lost) indicated that the figure was holding out an apple in its right hand. Many judged these fragments to be part of a later restoration, not part of the original statue. The image of Aphrodite admiring herself in the highly polished shield of the war god Ares was popular in the second century BCE, so this figure could have been holding a shield. If so, it would have been off to one side, tilted at an angle, and probably resting on the goddess's left thigh. This theoretical "restoration" seems to offer an explanation for the pronounced S-curve of the pose and the otherwise unnatural forward projection of the knee.

By the late first century BCE, the influence of Greek painting, sculpture, and architecture was paramount in the artistic communities of the emerging Roman civilization. Roman patrons and artists maintained their enthusiasm for Greek art into early Christian times. Indeed, so strong was the urge to emulate the great Greek artists

Also illustrative of this eclectic trend, but using other sources, is the larger-than-lifesize Hellenistic Ruler (fig. 5-87), which may reflect the heroic figure types favored for official and religious sculpture by Lysippos in the lost statues of Zeus and Alexander the Great. Certainly the elongated body proportions and small head recall Lysippos's Scraper (see fig. 5-66). Yet the impression of Helenistic realism overrides the lingering suggestions of Classical heroism and idealism. Hellenistic rulers often fancied themselves divine, and the overdeveloped musculature of this figure, the individualized features of the culature of this figure, the individualized features of the powly face, and the arrogant pose suggest the unbridled power of an earthly ruler elevated to the status of a demigod.

Hellenistic in concept and intent. a strong, insistent note of erotic tension that can only be of draperies, which seem about to slip off the figure, adds The sensuous juxtaposition of nude flesh with the texture with the Hellenistic sculpture of Rhodes and Pergamon. also has the rich, three-dimensional quality associated and later. The drapery around the lower part of the body knee are typical of Hellenistic art of the third century BCE but the twisting stance and the strong projection of the has the heavier proportions of High Classical sculpture, head with its dreamy gaze is very Praxitelean. The figure the Aphrodite of Praxiteles (see fig. 5-64), and indeed the tury. The sculpture was intended by its maker to recall Melos by French excavators in the early nineteenth cen-Aphrodite of Melos (fig. 5-86), found on the island of in the style of the fourth century BCE is exemplified by the les and Lysippos for their models. This renewed interest nostalgic for the past, looked back especially to Praxitetain popular sculptors, no doubt encouraged by patrons sical styles and combining them with new elements. Cerreexamining and borrowing elements from earlier Clas-Some turned to the past, creating an eclectic style by that characterized the artists of Pergamon and Rhodes. followed the trend toward realism and expressionism The Classical Alternative. Not all Hellenistic artists

celebrant, the subject of this work is the antithesis of the Nike of Samothrace. Yet, in formal terms, both sculpted figures are **expressionistic**. Both stretch out assertively into the space around them, both demand an emotional response from the viewer, and both display technical virtuosity in the rendering of forms and textures. They are closer to each other stylistically than either is to the Nike closer to each other stylistically than either is to the Nike 55-53, 5-64).

that, as we have seen throughout this chapter, much of our knowledge of Greek achievements comes primarily through Roman replicas of Greek artworks and descriptions of Greek art by Roman-era writers.

5-87. Hellenistic Ruler. c. 150–140 BCE. Bronze, height 7'9" (2.37 m). Museo Nazionale Romano, Rome

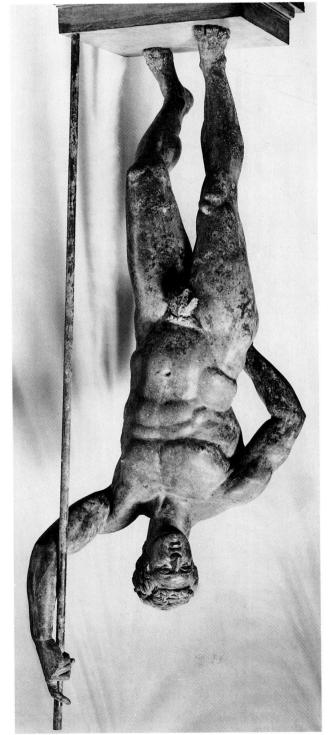

1000 BCE 0 BCE

▲ ETRUSCAN SUPREMACY 700-509

A REPUBLICAN PERIOD 509-27

OCE/

6-1. Cityscape, detail of a Second Style wall painting from a bedroom in the House of Publius Fannius Synistor, Boscoreale. Late 1st century CE. The Metropolitan Museum of Art, New York Rogers Fund, 1903 (03,14,13)

here must have been warning signs, that steamy August dawn in 79 CE, before the top of Mount Vesuvius exploded, spewing tiny fragments of volcanic rock, clouds of fine ash, and deadly gases over surrounding towns and farms and burying every trace of their existence. Those who fled took with them everything of value that could be carried. Those who stayed were quickly and completely entombed the gladiator straining against his chains, the woman trying to shelter her child. In Pompeii, a popular resort for Roman patricians, some 2,000 people died. Among the eruption's victims was Pliny the Elder (23-79 cE), author of Naturalis Historia (Natural History), an encyclopedia of natural science, geography, and art. He was commander of the Roman fleet in the Tyrrhenian Sea and died from toxic gases while trying in vain to help those on shore. His nephew, Pliny the Younger, was also in the area but lived to describe the horror: "The sea appeared to have shrunk, . . . the shore had widened, and many sea creatures were beached on the sand. In the other direction loomed a horrible black cloud ripped by sudden bursts of fire, writhing snakelike and revealing sudden flashes larger than lightning. . . . And now came the ashes . . . " (Letters to Tacitus 6.16, 20).

Rain falling with the ashes created a "cement" that formed an airproof seal. Absolutely everything—people, plants, foods, houses and their contents, public buildings—was encased. The eruption was so powerful and the volcanic material so voluminous that the course of nearby rivers changed, and sea beaches were built up so much that the original site of Pompeii ended up farther from the sea, obscuring its original location

or simply the root systems of garden plants and trees. would be revealed—perhaps a man clutching his treasure, a hapless pet, plaster into such cavities and digging carefully around it to see what fied mass of volcanic material. Excavators devised methods for injecting wood, left perfect molds of their original shapes and textures in the solidifound that even things that had disintegrated over time, such as flesh and for seventeen centuries. When the first excavators began to work, they

rituals and dreamlike, sacred landscapes. landscapes that resemble stage sets (fig. 6-1), while others depict exotic walls of private dwellings. Some open "windows" onto bizarre urban tion are especially remarkable. Most dramatic are the paintings on the ples. The fine examples of Republican buildings during a time of transi-Roman civilization more detailed than any available for other early peohas been revealed is a record of the material culture of first-century About three-fourths of Pompeii has now been excavated, and what

moment it was frozen in time—mirrors that of the land from which it rose. would later be overrun, to its becoming a Roman colony, to the disastrous Pompeii's history—from its founding about 600 BCE by invaders who

in Rome's expanding dominion. tury BCE, and by the third century BCE they had come withto the south. Their power was in decline by the fifth centhe Po River valley to the north and the Campania region power in the sixth century BCE when they expanded into coast of Italy, the Etruscans reached the height of their cities, including the major port of Populonia on the west Lebanon). Organized into a loose federation of a dozen coast of the Mediterranean Sea (in what is modern

tecture and urban planning throughout their vast empire. uscan culture, spreading Etruscan innovations in archiheavily from the Greeks, and they also absorbed Etrsculpture, and wall painting. The Romans, too, borrowed traditions to create distinctive styles of architecture, ed these influences, combining them with their own ishly copied what they admired. Instead, they assimilatfrom Greek and Near Eastern sources, they never slavartists patronized Greek artists and drew inspiration female deities in Etruscan religion. Although Etruscan in Greek society, perhaps because of the prominence of better educated and more conspicuous in Etruscan than ture except with respect to the role of women, who were The Etruscans were deeply influenced by Greek cul-

The Etruscan City

were added as needed, so that its overall plan was rarely lation grew, its boundaries expanded and building lots walls with protective gates and towers. As a city's popufrom it in all directions. Most cities were surrounded by town's business center, and residential areas spread out quadrangles. The intersection of these streets was the other east-west-that divided it into four sections, or main streets—one usually running north-south and the The Etruscan city was laid out on a grid plan around two

> the Alps, juts into the Mediter-CIVILIZATION sula, shielded to the north by ETRUSCAN The boot-shaped Italian penin-

in the twelfth century BCE.

encompassed the entire Mediterranean region. power, unified Italy, and established an empire that millennium BCE, the Romans had curtailed Etruscan ruled by kings of Etruscan lineage. By the end of the first of Rome, a town on the Tiber River, who were, for a time, Italic. Among these were the Latin-speaking inhabitants ples who spoke a closely related set of languages called tral Italy. Central Italy was also home to a variety of peo-Etruscans gained control of northern and much of censeventh and sixth centuries BCE a people known as the inated Italy's southern coastal regions. Between the lizations. Beginning about 750 BCE, Greek colonists domthe influence of Near Eastern, Egyptian, and Greek civiranean Sea, exposing its inhabitants in ancient times to

that they had originally come from Lydia, in Asia Minor, regions of Italy since the Bronze Age. Herodotus claimed lanovans, who had occupied the northern and western they were the descendants of a people called the Vilcans' origins a puzzle, but recent research suggests that linguistic distinctiveness for a long time made the Etrusently unrelated to any other European language. This resembles the Greek alphabet, their language was apparinscriptions on tombs show that although their alphabet the Etruscans' literature have been found, but numerous in Etruria (modern Tuscany). No surviving examples of Etruscan society emerged in the seventh century BCE

with the Greeks and with the Phoenicians, on the eastern resources in the close trading relations they maintained noted as both metalworkers and sailors, exploited these and abundance of metal ore. The Etruscans, who were Etruscan wealth was based on Etruria's fertile soil

PARALLELS			
<u>Years</u>	<u>Period</u>	Etruria/Rome	World
с. 800-700 все	Pre-Etruscan	Legendary founding of Rome; Greek colonies in southern Italy	c. 800–700 BCE Homer's <i>Iliad</i> and <i>Odyssey</i> (Greece); first Olympian Games (Greece); Greek alpha- bet adopted; Upanishads (India); fall of Zhou dynasty (China)
с. 700–509 все	Etruscan supremacy	Etruscan supremacy in central Italy; <i>Apollo</i> from Veii	c. 700–500 BCE Black-figure and red-figure vase painting (Greece); Byzantium founded; Sappho; Hanging Gardens (Babylon); birth of Laozi, founder of Daoism (China); Cyrus the Great (Persia) defeats Babylon; birth of Siddhartha Gautama, founder of Bud- dhism (Nepal); Aesop's Fables (Greece)
с. 509–27 все	Republican	Roman unification of Italy; Punic Wars (North Africa); invention of concrete; Sanc- tuary of Fortuna; Pont du Gard (Gaul); Cicero; Vergil	c. 500–1 BCE Greek orders; Confucius (China); Sophocles, Aeschylus, Euripides, Herodotus (Greece); last Old Testament book written; Polykleitos, Praxiteles, Lysippos (Greece); Parthenon (Greece); London founded (England); Alexander the Great (Greece) conquers Persia; Colossos of Rhodes; Han dynasty (China); unification of China; Nike of Samothrace (Greece); Great Wall (China); mound-building cultures (North America); Ramayana epic (India); Aphrodite of Melos (Greece)
с. 27 все-180 се	Early Empire	Emperor Augustus; Ara Pacis; Horace; Julio-Claudian dynasties; Pliny the Elder; Colosseum; eruption of Vesuvius; Emperor Trajan; Emperor Hadrian; Pantheon; Tetrarchs; Marcus Aurelius; empire at greatest extent	c. 1–400 CE Crucifixion of Jesus (Jerusalem); Yayoi and Kofun eras (Japan); Maya civilization (Mesoamerica); first Gupta dynasty (India)
c. 180-395 CE		Severan emperors; Baths of Caracalla; Emperor Diocle- tian; Emperor Constantine; Constantinople established; Christianity becomes official religion of empire; empire permanently divided	

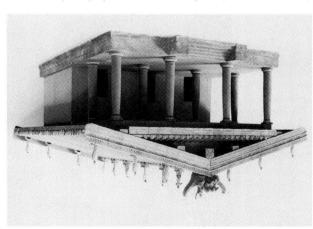

6-3. Reconstruction of an Etruscan temple, based on descriptions by Vitruvius. University of Rome, Istituto di Etruscologia e Antichità Italiche

6-4. Plan of an Etruscan temple, based on descriptions by Vitruvius

Temples and Their Decoration

the porch. The ground plan (fig. 6-4) was almost square lature supported the section of roof that projected over steps leading up to a front porch. Columns and an entaba platform called a podium and had a single flight of ments of Architecture," page 164). They were raised on generally similar to Greek prostyle temples (see "Eleaccount indicates that Etruscan temples (fig. 6-3) were the Etruscan and Roman architecture of his day. His time between 46 and 39 BCE compiled descriptions of writings of the Roman architect Vitruvius, who someance comes from ceramic votive models and from the ples is a few foundations. Knowledge of their appearbeliefs and practices. All that remains of Etruscan temevents. Beyond this, little is known about their religious using divination to predict, and possibly alter, future have adapted from ancient Mesopotamia the practice of and heroic figures into their pantheon. They also may From early on, the Etruscans incorporated Greek deities

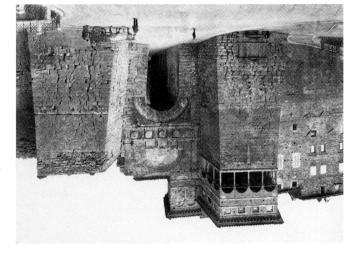

6-2. Porta Augusta, Perugia. 2nd century BCE

the originally symmetrical walled quadrangles. Because the Etruscans created house-shaped funerary urns and decorated the interiors of tombs to resemble houses, we know that their houses were rectangular mud-brick structures built either around a central courtyard or atructures built either around a central courtyard or drinking, cooking, and bathing fed by rainwater through a large opening in the roof.

The second-century BCE city gate of Perugia, called the Porta Augusta, is one of the few surviving examples of Etruscan architecture (fig. 6-2). A tunnel-like passageway between two huge towers, this gate is significant for two features that anticipate developments in Roman architecture. One is the monumental round arch, which is extended into a semicircular ceiling, called a **barrel vault**, over the passageway. The other is the decorative **post-and-lintel** design superimposed on the plain face of the gate.

is a second, smaller arch opening, now filled in, that is a Greek Doric frieze. Above this entablaturelike element is vaguely reminiscent of the triglyphs and metopes of tangular, columnlike uprights called pilasters. The effect row of circular panels, or roundels, alternating with recelement resembling an entablature. This is lined with a by a square frame surmounted by a horizontal decorative ta, which consists of a double row of voussoirs, is set off keystone, at the top center. The arch of the Porta Augusplace by the insertion of the final voussoir, called the inward from the tops of the Jambs and are locked into struction by a temporary wooden frame, curve up and stone blocks called voussoirs, supported during conthat border an opening. Precisely cut, wedge-shaped round arch rises from jambs, or vertical stone supports, overhanging courses of masonry meet at the top, the ture," page 226). Unlike the corbeled arch, formed when make widespread use of it (see "Elements of Architecapparently following Etruscan example, were the first to builders had been familiar with it-but the Romans, invention—ancient Near Eastern, Egyptian, and Greek The round arch was not an Etruscan or Roman

flanked by tall pilasters.

ELEMENTS OF The basic arch used in Western **ARCHITECTURE** architecture is the round arch, and the most elemental type of **Arch, Vault, and** vaulting is the extension of the Dome round arch, called a barrel vault. The round arch and bar-

rel vault were known and were put to limited use by Mesopotamians and Egyptians long before the Etruscans began their experiments with building elements. But it was the Romans who realized the potential strength and versatility of these architectural features and exploited them to the fullest degree

The round arch displaces most of the weight, or downward thrust (see arrows on diagrams), of the masonry above it to its curving sides and transmits that weight to the supporting uprights (door or window jambs, columns, or piers), and from there to the ground. Arches may require added support, called buttressing, from adjacent masonry elements. Brick or cut-stone arches are formed by fitting together wedge-shaped pieces, called voussoirs, until they meet and are locked together at the top center by the final piece, called the keystone. Until the mortar dries, an arch is held in place by wooden scaffolding, called centering. The inside surface of the arch is called the intrados, the outside curve of the arch the extrados. The points from which the curves of the arch rise, called springings, are often reinforced by masonry imposts. The wall areas adjacent to the curves of the arch are spandrels. In a succession of arches, called an arcade, the space encompassed by each arch and its supports is called a bay.

The **barrel vault** is constructed in the same manner as the round arch. The outside pressure exerted by the curving sides of the barrel vault usually requires buttressing within or outside the supporting walls. When two barrel-vaulted spaces intersect each other on the perpendicular, the result is a groin vault, or cross vault. The Romans used the groin vault to construct some of their grandest interior spaces, and they made the round arch the basis for their great freestanding triumphal arches.

A third type of vaulted ceiling brought to technical perfection by the Romans is the hemispheric **dome**. The rim of the dome is supported on a circular wall, as in the Pantheon (figs. 6-55, 6-56). This wall is called a drum when it is raised on top of a main structure. Often a circular opening, called an oculus, is left at the top.

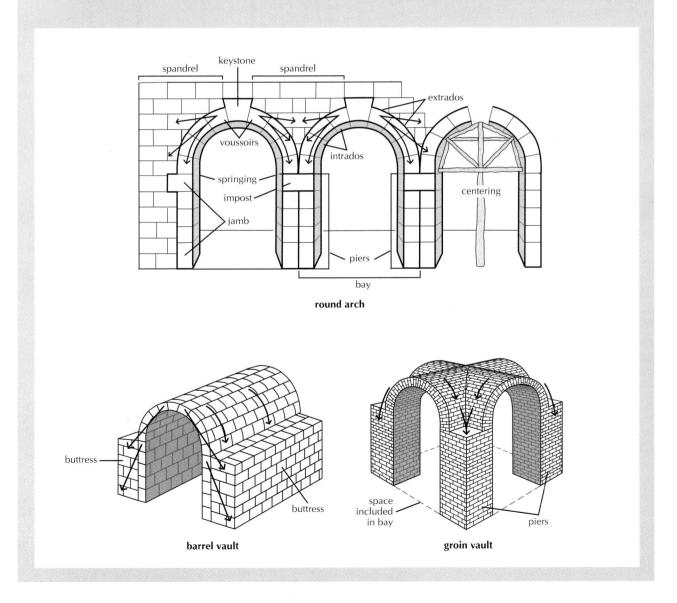

shafts (sometimes fluted), and capitals of the columns could resemble those of either the Greek Doric or the Greek Ionic orders, and the entablature had a frieze resembling that of the Doric order. Vitruvius used the Doric order, with an unfluted shaft and a simplified base, Doric order, with an unfluted shaft and a simplified base, capital, and entablature (see "Elements of Architecture," below). Although Etruscan temples were stark and geometrically simple in form, they were embellished with metrically simple in form, they were embellished with

and divided equally between porch and interior space. Often, as in figure 6-4, the interior space was divided into three rooms that probably housed cult statues. The building was entered directly from a courtyard or open city square.

The basic construction material of an Etruscan temple was mud brick. The columns and entablatures were made of wood or a quarried volcanic rock called tufa, which hardens upon exposure to the air. The bases,

The Etruscans and Romans adapted Greek architectural orders to their own tastes and uses. For example, the Etruscans modified the Greek Doric order by adding a base to the column. The Romans created the Composite order by incorporating the volute motif of the Greek lonic capital by incorporating the volute motif of the Greek lonic capital dy, unfluted Tuscan order, also a Roman development, derived from the Greek Doric order by way of Etruscan modived from the Greek Doric order by way of Etruscan modived from the Greek Doric order by way of Etruscan modived from the Greek Doric order by way of Etruscan modived from the Greek Doric order by way of Etruscan modived from the Greek Doric order by way of Etruscan modived from the Greek Doric order by way of Etruscan modived from the Greek Doric order by way of Etruscan modived from the Greek Doric order by way of Etruscan modived from the Greek Doric order by way of Etruscan modived from the Greek Doric order by way of Etruscan modived from the Greek Doric order by way of Etruscan modived from the Greek Doric order by way of Etruscan modived from the Greek Doric order by way of Etruscan modived from the Greek Doric order by way of Etruscan modived from the Greek Doric order by way of Etruscan modived from the Greek Doric order by way of Etruscan modification from the Greek Branch from the Greek Br

ELEMENTS OF

ARCHITECTURE

Classical orders. Each order is classical orders. Each order is dependent parts whose prodering of a system of interdependent parts whose producers.

Architectural

Architectural

Orders

Orders

ematical ratios. In Greek and Roman architecture, no element of an order could be changed without producing a corresponding change in the other elements.

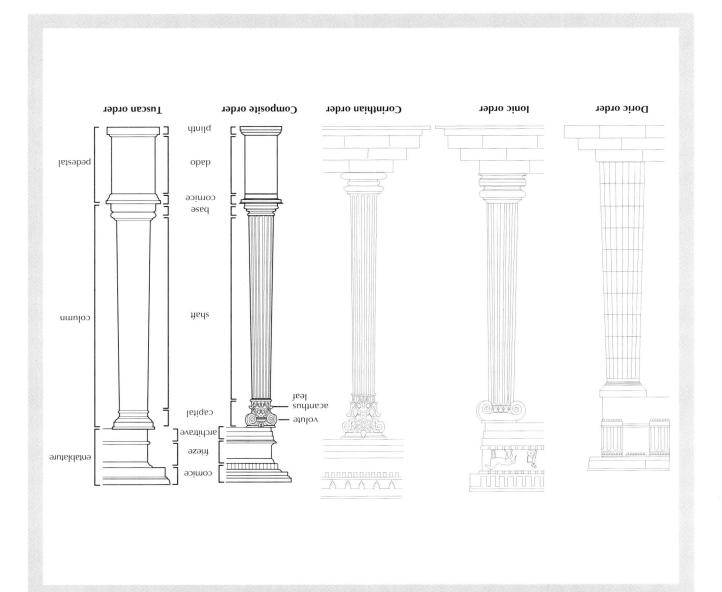

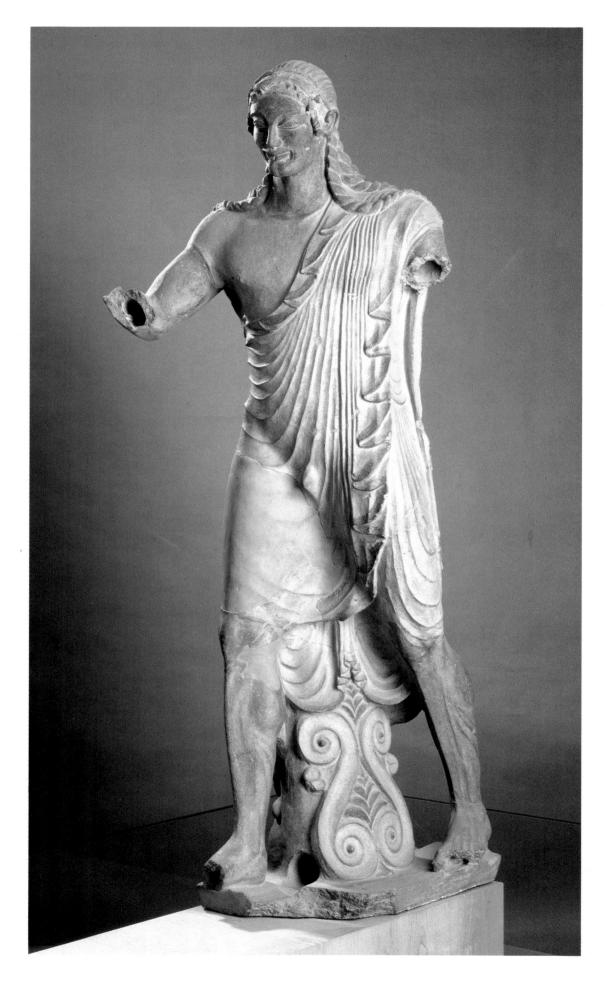

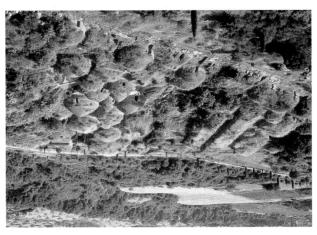

6-6. Etruscan cemetery of La Banditaccia, Cerveteri. 7th-4th century BCE

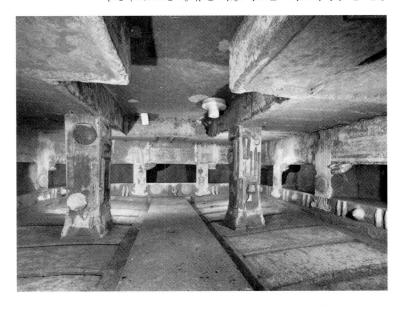

6-7. Burial chamber, Tomb of the Reliefs, Cerveteri. 3rd

sometimes with corbeled vaulting, and covered with dirt

funerary image. guardian of the gates of the underworld, an appropriate many heads—that probably represents Cerberus, the Tomb of the Reliefs is another kind of dog—a beast with tures from Etruscan mythology. On the back wall of the decorations also sometimes included frightening creato provide earthly comforts for their dead, but tomb As these details suggest, the Etruscans made every effort relief at the bottom of the center post is the family dog. like real objects hanging on hooks. Rendered in low axes, and other items were carved into the posts to look that can be easily modeled or molded. Pots, jugs, robes, ers simulated in stucco, a slow-drying type of plaster provided with a full range of furnishings, some real, oth-(fig. 6-7). Its walls were plastered and painted, and it was ple, has a flat ceiling supported by square, stone posts ble rooms in a house. The Tomb of the Reliefs, for exam-Some tombs were carved out of the rock to resem-

dazzling displays of terra-cotta sculpture. In an innovative feature, the temple roof served as a base for large statue groups.

Etruscan artists excelled at making monumental terra-cotta sculpture, a task of great technical and physical difficulty. A splendid example is a lifesize figure of Apollo. Dating from about 500 BCE and originally part of a four-figure scene depicting one of the labors of Hercules, the figure has survived from the temple at Veii ing for possession of a deer sacred to Diana while she and Mercury looked on (see "Roman Counterparts of Greek Gods," page 234). Apollo is shown in an active pose, looking as if he had just stepped over the decorative scrolled element that helps support the sculpture. This group of figures must have lent great sculpture. This group of figures must have lent great sculpture. This group of figures must have lent great

vitality to the otherwise static appearance of the temple

The well-developed body form and the Archaic smile of the Apollo from Veii clearly demonstrate that Etruscan sculptors were familiar with the Greek Archaic period kouroi. A comparison of the Apollo and the nearly contemporary Greek Kroisos (see fig. 5-21) reveals differences as well as obvious similarities. Unlike the Greek Greek Greek Professor (see fig. 5-21) reveals differences as well as obvious similarities. Unlike the Greek Greek Greek Professor Apollo is partially concealed by a robe with knife-edge pleats that cascades to his knees. The forward-moving pose of the Etruscan status also has a vigor that is only implied in the balanced, tense stance of the Greek figure. This quality of energy tense stance of the Greek figure. This quality of energy expressed in purposeful movement is characteristic of expressed in purposeful movement is characteristic of Etruscan sculpture and, especially, tomb painting.

Sq**m**0**T**

they graced.

Etruscan beliefs about the afterlife may have been somewhat similar to those of the Egyptians. Unlike the Egyptians, with their elaborate embalming techniques, the Etruscans favored cremation, but they nevertheless clearly thought of tombs as homes for the deceased. The Etruscan cemetery of La Banditaccia at Cerveteri (fig. 6-6) was laid out like a small town, with "streets" running between the grave mounds. The tomb chambers were between the grave mounds. The tomb chambers were partially or entirely excavated below the ground, and some were hewn out of bedrock. They were roofed over,

6-5. (opposite) Apollo, from Veii. c. 500 Bce. Painted terracotta, height 5'10" (1.8 m). Museo Nazionale di Villa Giulia, Rome

This lifesize figure is made of terra-cotta ("baked clay"), the same material used for pottery containers. Making and firing a large clay sculpture such as this one requires great technical skill. The artist must know how to construct the figures so that they do not collapse under their own weight while the clay is still wet and must know how to fire them, a process that requires precisely regulating the temperature in a large kiln for a long period of time. Etruscan terra-cotta artists must have been well known, for some of their names have come down to us, including that of a sculptor from Veii called Vulca, in whose workshop this Apollo may have been created.

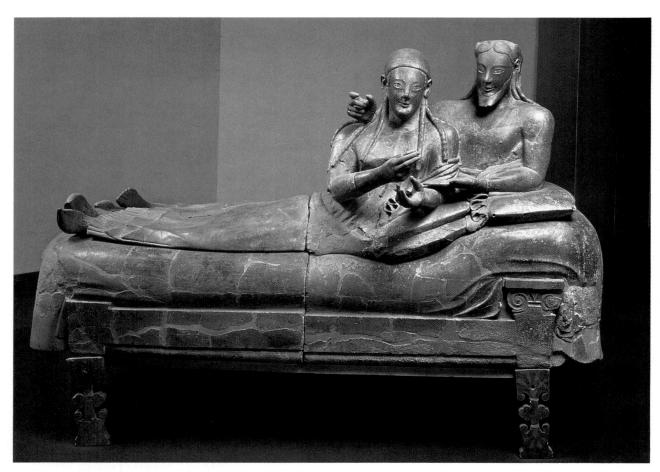

6-8. Sarcophagus, from Cerveteri. c. 520 BCE. Terra-cotta, length 6'7" (2.06 m). Museo Nazionale di Villa Giulia, Rome

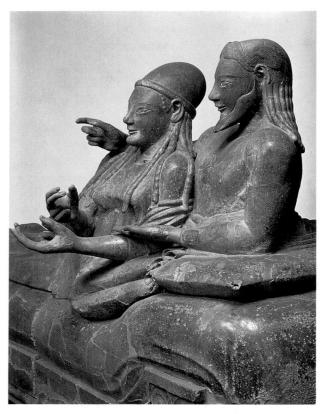

6-9. Detail of sarcophagus from Cerveteri

Sarcophagi, or coffins, also sometimes provided a domestic touch. In an example from Cerveteri of about 520 BCE, made entirely of terra-cotta (fig. 6-8), a husband and wife are shown reclining comfortably, as if they were on a couch. Rather than a cold, somber memorial to the dead, we see two lively, happy individuals rendered in sufficient detail to convey current hair and clothing styles (fig. 6-9). These genial hosts, with their smooth, conventionalized body forms and faces, their uptilted, almond-shaped eyes, and their benign smiles, make curious signs with their fingers, as if to communicate something important to the living viewer—perhaps an invitation to dine with them for eternity. Portrait coffins like this evolved from earlier terra-cotta cinerary jars with sculpted heads of the dead person whose ashes they held.

Brightly colored paintings of convivial scenes of feasting, dancing, musical performances, athletic contests, hunting, fishing, and other pleasures sometimes decorate tomb walls. Many of these murals are faded and flaking, but those on the tombs at Tarquinia are well preserved. In a detail of a painted frieze in the Tomb of the Lionesses, from about 480–470 BCE, a young man and woman engage in an energetic dance to the music of a double flute (fig. 6-10). These and other figures are grouped around the walls within a carefully arranged setting of stylized trees, birds, fish, animals, and architectural elements. Unlike in Greek tomb paintings,

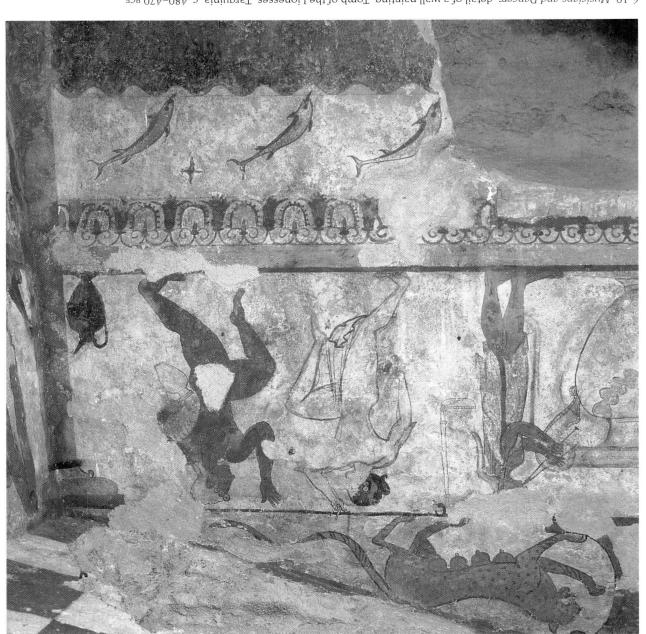

whether that designation is correct. Fresco is essentially painting with water-based pigments on a still-damp layer of 6-10. Musicians and Dancers, detail of a wall painting, Tomb of the Lionesses, Tarquinia. c. 480-470 BCE

from the artist accidentally painting on a wall before the plaster had dried. inconclusive. Some investigators think they are frescoes, while others claim that sections that appear to be fresco resulted plaster coating. Laboratory analyses to determine whether or not Etruscan wall paintings are true frescoes have been fresh plaster applied in sections over a finished wall surface. The pigment soaks in and becomes an integral part of the The Etruscan method of painting decorations on walls has often been called fresco, but there are continuing doubts as to

of the tightly curled ruff of fur around the animal's neck, details contrasts with the decorative, stylized rendering object of sympathy. The naturalistic rendering of these given birth—appears at the same time ferocious and an heavy, milk-filled teats—evidence that she has recently mouth, lean, tense body, thin flanks, protruding ribs, and wolf (fig. 6-11). This creature, with her open, snarling bronzes, which dates to about 500 BCE, portrays a sheof bronze objects over the centuries. One of these in the round that have survived the wholesale recycling pressive are the few examples of large-scale sculpture

rituals of a remote, long-dead civilization. us now, performing exuberantly, not enacting the formal walls. The dancers and musicians seem to be here with inhabit a bright, tangible world just beyond the tomb had a remarkable ability to suggest that their subjects women are active participants. The Etruscan painters

Bronze Work

widely acknowledged in ancient times. Especially im-The skill of Etruscan artists who worked in bronze was

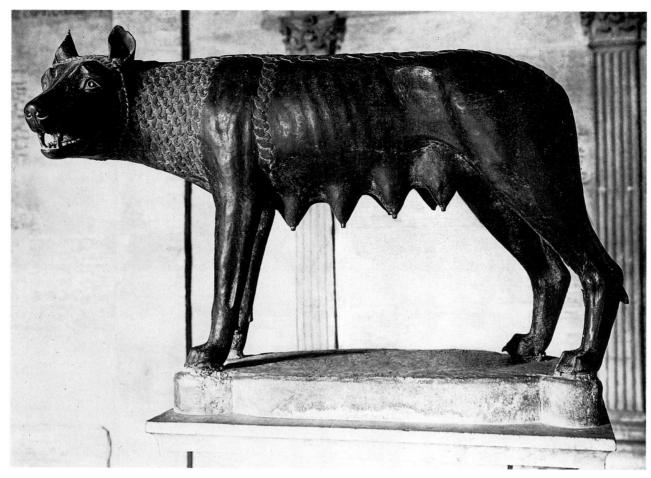

6-11. She-Wolf. c. 500-480 BCE. Bronze, height 331/2" (85 cm). Museo Capitolino, Rome

Although this sculpture was almost certainly the work of an Etruscan artist, it has long been associated with Rome. According to an ancient Roman legend, twin infants named Romulus and Remus, who had been abandoned on the banks of the Tiber River by a wicked uncle and left there to die, were suckled by a she-wolf that had come to the river to drink. The twins were raised by a shepherd, and when they grew up, they decided to build a city near the spot where they had been rescued by the wolf. They quarreled, however, about its exact location. Romulus killed Remus and then established a small settlement that would become the great city of Rome, an event that, according to tradition, occurred in 753 BCE. Romulus ruled the city for forty years as its first king. Long after the Roman Empire had fallen, the people living in Rome, who remembered the legend, installed the *She-Wolf* on the Capitoline Hill. During the Renaissance, castings of Romulus and Remus as suckling infants were added to this original statue, which remains on the Capitoline Hill to this day in a museum—a symbol of the city's 2,000-year history. Sometimes it is referred to as the *Capitoline Wolf* or the *Wolf of Rome*.

which was incised with a sharp cutting tool. The eyes, made of glass paste, were inserted after the figure was cast and incised.

After Etruria had fallen within Rome's orbit, Etruscan artists continued in high regard and gained the support of Roman patrons. A head that was once part of a bronze statue of a man may be an example of an important Roman commission (fig. 6-12). Often alleged to be a portrait of Lucius Junius Brutus, the founder and first consul of the Roman Republic (in 509 BCE), the head traditionally has been dated about 300 BCE, long after Brutus's death. Although it may represent an unknown Roman dignitary of the third century BCE, it could also be an imaginary portrait of an ancient hero (perhaps Brutus), a type of sculpture that gained great popularity in the first century BCE. The rendering of the strong, broad face with

its heavy brows, firmly set lips, and wide-open eyes (made of painted ivory) is scrupulously detailed. The sculptor seems also to have sought to convey the psychological complexity of the subject, showing him as a somewhat world-weary man who nevertheless projects strong character and great strength of purpose. We saw a similar approach to portraiture in the statue of the Egyptian ruler Senwosret III (see fig. 3-24) made some fifteen centuries earlier.

Etruscan bronze workers also created small items for either funerary or domestic use, such as a bronze mirror that dates from about 350 BCE (fig. 6-13). The subject of the decoration engraved on the back is a winged man, identified by the inscription as the Greek priest Calchas, who accompanied the legendary army of Greek heroes under Agamemnon to Troy (see "The Trojan War," page

Italian peninsula was well under way. dominance of Rome, whose march to total control of the this mirror was created, southern Etruria fell under the sionality convey a sense of realism. About the time that twist of drapery that emphasize the figure's three-dimenralistic suggestions of a rocky setting, and the pull and and with a jug at his feet. The complex pose, the natuthe artist has shown Calchas surrounded by grapevines live to drink his own wine. Perhaps alluding to this story, ironic death, laughing at a prophecy that he would not retired after the war to his vineyards, where he died an rifice his daughter Iphigenia. In another legend, Calchas on its way to Troy, told Agamemnon that he had to sacto determine why the Greek fleet had been left becalmed legend of the Trojan War in which Calchas, called upon rificed animal, possibly a reference to an incident in the bending over a table, intently studying the liver of a sacentrails could reveal the future. Here Calchas is shown cans, and Romans all believed the appearance of animal or how to secure their favor in the war. Greeks, Etrus-Calchas when they were uncertain about the gods' will 216). According to Homer, the Greeks often consulted

CIVILIZATION early second century ce, the **KOMAN** At its greatest extent in the

the Euphrates River to North Roman Empire reached from

emerged in Europe and elsewhere in their wake. century—leaving a lasting mark on the civilizations that turies—in the eastern Mediterranean until the fifteenth and cultural structure that endured for some five cenquered, they imposed on them a legal, administrative, called it. As the Romans absorbed the peoples they conranean Sea-mare nostrum, or "our sea," the Romans Africa to Scotland. The vast territory ringed the Mediter-

mortal princess from the central Italian city of Alba and Remus, the twin sons of Mars, the god of war, by a lar legend tells the story of Rome's founding by Romulus to Venus, was destined to rule the world. Another populife to the race that, in fulfillment of a promise by Jupiter burning Troy and made their way to Italy. There they gave of the gods, he and some compatriots escaped from the Thanks to his mother's intervention with Jupiter, the king Aeneas, was the mortal son of the goddess Venus. spring of a Trojan survivor of the Trojan War. This hero, (70–19 BCE) in his Aeneid, the Roman people were the offpopular legend, rendered in epic verse by the poet Vergil attributed to themselves heroic origins. According to one not surprisingly saw themselves in heroic terms and The people responsible for these accomplishments

nal). These first settlements were little more than tine, Caelian, Capitoline, Esquiline, Quirinal, and Vimithat would eventually become Rome (the Palatine, Avensouth of the Tiber River, as well as on the seven hills settled in permanent villages across the plains of Latium, Latin—and lived primarily by raising and tending sheep groups of people who spoke a common language mundane picture of Rome's origins. In Neolithic times, Archeologists and historians have developed a more

Longa (see caption, fig. 6-11).

(31.8 cm). Palazzo dei Conservatori, Rome 6-12. Head of a man. c. 300 BCE. Bronze, height 121/2"

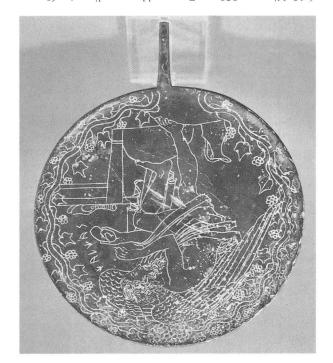

(15.3 cm). Musei Vaticani, Museo Gregoriano Etrusco, 6-13. Mirror. c. 350 BCE. Engraved bronze, diameter 6"

ing to whether the omens were good or bad. would also suggest a course of action to take accordmeaning of what they saw in the animal entrails, they diviners (fortune tellers) would not only determine the the back of this sumptuous bronze mirror. Etruscan ficial animals. That is the unusual subject engraved on in the entrails and organs, especially the liver, of sacripredict the future involved interpreting the signs found One of the methods the Etruscans used to attempt to

REIGNS OF SIGNIFICANT ROMAN EMPERORS

CE

27 все-14
14-37 CE
37-41
41-54
54-68
69-79
79-81
81-96
96-98
98-117
117-138
138-161
161-180
180-192
193-211
211-217
222-235
284-305
306-337

ROMAN COUNTERPARTS OF GREEK GODS

Greek God	Roman Name
Zeus, king of the gods	Jupiter
Hera, Zeus's wife and sister,	Juno
queen of the gods	
Athena, goddess of wisdom	Minerva
Ares, god of war	Mars
Apollo, god of the sun and reason	Apollo; also
	Phoebus
Aphrodite, goddess of love	Venus
Artemis, goddess of the moon	Diana
and hunting	
Hermes, messenger of the gods	Mercury
Hades, god of the underworld	Pluto
Dionysos, god of wine	Bacchus
Hephaistos, god of fire	Vulcan
Hestia, goddess of hearth and	Vesta
family	
Demeter, goddess of agriculture	Ceres
Poseidon, god of the sea	Neptune
Eros, god of love	Cupid or Amor
Herakles	Hercules

Although sometimes worshiped as a god, strictly speaking Hercules is a hero known for his physical strength.

More information about Greek gods and their attributes appears on page 156, "Greek and Roman Deities and Heroes."

clusters of small, round huts, but by the sixth century BCE Rome, located at an important crossing of the Tiber, had developed into a major transportation hub and trading center. By the Republican period nearly a million people lived there.

Early Rome was governed by a series of kings and an advisory body of leading citizens called the Senate. The population was divided into two classes, a wealthy and powerful upper class, the patricians, and a lower class, the plebeians. The last kings of Rome were members of an Etruscan family, the Tarquins. Legend has it that the last ruler in this line, Tarquinius Superbus, was a despot whose behavior led to his overthrow in 509 BCE, marking the beginning of what is known as the Republican period. The Senate, dominated by patrician families, gained in prestige and authority, and the early history of the Republic was marked by a struggle by plebeians against patricians for political and economic equality.

During the fifth century BCE, by a process of alliance and conquest, Rome began to incorporate neighboring territories in Italy. By 275 BCE Rome controlled the entire Italian peninsula. This expansion led to a confrontation with the powerful empire of Carthage, the Phoenician city on the north coast of Africa, which controlled Spain, Sicily, and the western North African coast. In a series of conflicts known as the Punic Wars (264–146 BCE), the Romans ultimately subdued the Carthaginians, destroyed Carthage, and gained control of the western Mediterranean. By the mid-second century BCE they had subdued Macedonia and Greece, and by 44 BCE had conquered most of Gaul (modern France) and the eastern Mediterranean.

During this period of overseas expansion, Rome changed from an essentially agricultural society to a commercial and political power. The warfare and expansion strained Rome's political system, weakening the authority of the Senate and leading ultimately to a series of civil wars among powerful generals whose authority derived from the support of their troops. In 46 BCE Julius Caesar emerged victorious over his rivals, had himself declared dictator, assumed autocratic powers, and ruled Rome until his assassination in 44 BCE. The renewed fighting that followed Caesar's death ended with the unquestioned supremacy of his grandnephew and heir, Octavian, over Rome and all its possessions.

Although Octavian maintained the forms of Republican government, he retained real authority for himself, and his ascension marks the end of the Republic. In 27 BCE he was granted the religious title *Augustus*, which came to mean "supreme ruler," and he is known to history by that name as the first emperor of Rome (see "Reigns of Significant Roman Emperors," above). Assisted by his astute and pragmatic second wife, Livia, Augustus proved to be an incomparable administrator. He brought opposing factions under his control and established efficient rule throughout the empire. In 12 CE he was given the title *Pontifex Maximus*, or High Priest, and thus also became the empire's highest religious official. After his death in 14 CE, the Senate ordered him to be venerated as a state god. This powerful man laid the foundation for an extended

generally considered little more than skilled laborers. been significant exceptions, professional artists were thy of our serious regard." Although there must have because of its gracefulness, the man who made it is worit does not necessarily follow that, if a work is delightful the Hera at Argos, ever wanted to be Polykleitos. . . . For Olympia, ever wanted to be Pheidias nor, upon seeing gifted young man, upon seeing the Zeus of Pheidias at Greek commentator of the first century ce, wrote: "No nied by universal admiration for artists. As Plutarch, a

despite occasional government efforts to suppress them. religion with its Olympian deities and deified emperors, called mystery religions flourished alongside the state with the soldier-emperors and their troops. All these sohero-god called Mithras also became popular, especially third century ce, an exclusively male cult of a Persian Judaism and Christianity spread from Palestine. In the Great Mother; and belief in the all-powerful God of duced from Egypt; from Anatolia came the cult of the they had conquered. The cult of Isis and Osiris was intromore personal, mystical religious beliefs of the peoples average person. As a result, many Romans adopted the perfunctory, and distant from the everyday life of the and the official religion became increasingly ritualized, to past rulers and oaths of allegiance to the living one, cast. Worship of ancient gods was mingled with homage Roman rule—the state religion took on a highly political culturally diverse populations that had come under deified—in part to attract and focus the allegiance of the state religion. When, after Augustus, the emperors were ed Greek religious beliefs and practices into a form of parts of Greek Gods," opposite.) The Romans assimilatthe Roman names of these figures; see "Roman Counter-Greek gods and heroes as their own. (This chapter uses Again like the Etruscans, the Romans adopted the

tects built religious buildings, styles. Although Roman archireflected in increasingly eclectic of other cultures began to be exposure to the art of Greece and ences. As the empire expanded, initially reflected Etruscan influture, sculpture, and painting great period of Roman architec-**VKL OF** During the Republic, the first

palaces, and tombs for the rich **EWPIRE OF THE BECINNINC AND THE PERIOD KEPUBLICAN**

building forms, discovered new structural principles, and ly and inexpensively as possible, they created new ulation of their empire. To meet those needs as efficientthe needs of ordinary people in the large and varied popand powerful, they were also concerned with satisfying

developed new materials.

Architecture in Roman Italy

concrete (see "Elements of Architecture," page 236). In also relied increasingly on a new building material, cast barrel vaulting. Beginning in the second century bce, they Roman architects relied heavily on the round arch and

> lasted about 200 years. ity known as the Pax Romana—the Roman Peace—which period of stability, internal peace, and economic prosper-

> enormous construction of civil architecture—reflect governmental and administrative structures, and its butions to Western civilization—its system of law, its trative skill. Some of Rome's most enduring contriplanning, massive logistical support, and great adminisnot only inspired leadership and tactics but also careful Conquering and maintaining a vast empire required

> tects developed rational planning, durable materials, and ciency, and human well-being, Roman builders and archi-To accomplish these tasks without sacrificing beauty, effiducts, middle-class housing, and even whole new towns. stadiums), theaters, public baths, roads, bridges, aqueistrative centers (basilicas), racetracks (circuses and complexity, mandating the construction of central adminundertook building programs of unprecedented scale and and attractive to its citizens, the Roman government the empire, as well as to make city life comfortable To facilitate the development and administration of these qualities.

> repairs and connecting links to make them function once still in use, and remnants of Roman aqueducts need only the streets of more than a few cities. Roman bridges are Roman engineers, and Roman-era foundations underlie European highways still follow the lines laid down by vast and sophisticated network of roads. Many modern the empire, and promote commerce, the Romans built a munications between Rome and the farthest reaches of To move their armies about efficiently, speed com-

> > highly sophisticated engineering methods.

again to carry fresh water over long distances.

empire became an increasing burden on the less fortumore luxurious life, however, the cost of the expanding homes. As these wealthy Romans developed an ever artists to paint landscapes on the interior walls of their Romans even brought nature indoors by commissioning functioning farms and as places of recreation. Wealthy attached to country villas, which served them both as larly to their estates, many Roman emperors were Washington and Thomas Jefferson, who returned regudens. Similar to United States presidents like George and the middle classes enjoyed their town-home garcity dwellers, the wealthy maintained country estates their love of nature. Even though they were essentially themselves as simple country folk who had never lost Despite their power, the Romans liked to portray

Greek and Hellenistic culture and borrowed heavily from Like the Etruscans, the Romans greatly admired tent internal conflict.

nate, which eventually led to the occurrence of intermit-

back to Rome. Greek city of Corinth of its art treasures and shipped them employed Greek artists. In 146 BCE they stripped the to decorate their architecture, imported Greek art, and quered Roman culture. The Romans used Greek orders conquered the Hellenistic world, Greek culture conit. Historians have even suggested that although Rome

Ironically, this love of Greek art was not accompa-

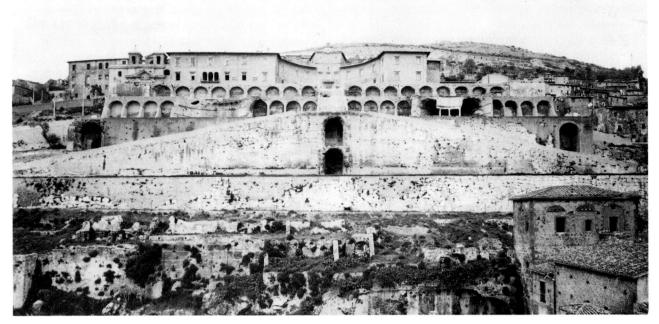

6-14. Sanctuary of Fortuna, Palestrina. Begun c. 100 BCE

ARCHITECTURE

Construction

ELEMENTS OF The Romans were pragmatic, and their pragmatism extended from recognizing and ex-Roman ploiting undeveloped potential in construction methods and physical materials to organiz-

ing large-scale building works. Their exploitation of the arch and the vault is typical of their adapt-and-improve approach. Their "invention" and use of concrete, beginning in the first century BCE, was a technological breakthrough of the greatest importance.

In the earliest concrete wall construction, workers filled a framework of rough stones with concrete: stone rubble soaked in a binder made from volcanic sand and clay. This stone-wall construction method, called opus incertum, was followed by opus reticulatum, in which the framework is a diagonal web of smallish, pyramidal concrete bricks set in a cross pattern. By the first century CE, Roman builders were setting concrete bricks in level courses, pointed ends inward, in a technique called opus testaceum.

The composite-material bricks were homely and were generally covered, or veneered, with better-looking materials, such as marble, stone, mosaic, and tile. Thus, an essential difference between Greek and Roman architecture is that Greek buildings reveal the building material itself, whereas Roman buildings show only the applied surface.

Concrete-based construction freed the Romans from the limits of right-angle forms and comparatively short spans. With this freedom, Roman builders pushed the established limits of architecture, creating some very large and highly original spaces, many based on the curve.

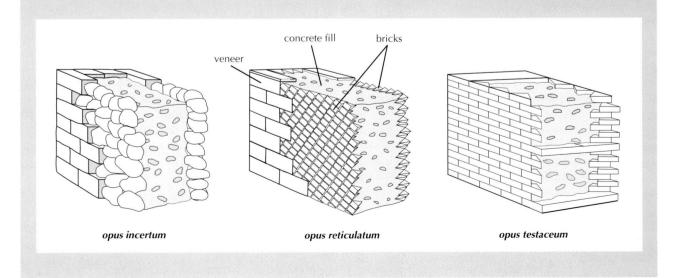

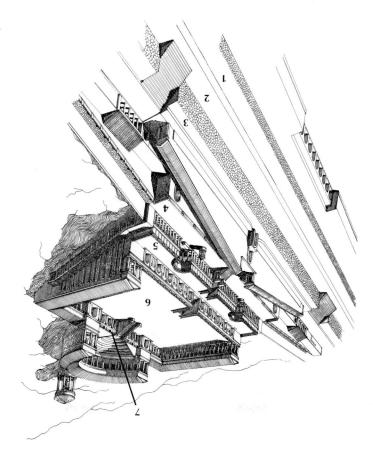

sal scale of the Altar of Zeus from Pergamon (see fig.

In a departure from Hellenistic style, the Romans staircases to successively higher levels. ascended long ramps to the second level, then steep forms or terraces that rise up a steep hillside. Worshipers partially open, and closed spaces on seven vaulted platand finely cut limestone, it consists of a series of open, 5-80). Built of concrete covered with a veneer of stucco

shepsut at Deir el-Bahri (see fig. 3-33). to mind the great Egyptian temples, such as that of Hatthe portico, to the tiny tholos temple, to the cave-brings large, open terrace up the semicircular staircase, through overall axial plan-the way it directs movement from the future events, had taken place from early times. The cut cave where important acts of divination, predicting small tholos temple to Fortuna, hiding the ancient rockfrom a large, open terrace. Behind this pavilion was a naded pavilion reached by a broad semicircular staircase the seventh level, a huge, theaterlike, semicircular colonarch openings on the fifth and sixth levels, and finally, on (half-circle niches) on the fourth level, rows of roundarchitectural rhythm: symmetrically placed exedrae structure's strict regularity and created a new kind of incorporated several rounded elements that relieved the

the Sanctuary of Fortuna, is a small, rectangular temple, An early example in Rome, nearly contemporary with manner, in the midst of congested commercial centers. Greeks were small urban temples built, in the Etruscan isolated, walled sanctuaries like those favored by the More typical of Roman religious architecture than

> Roman concrete consisted of powdered lime, sand two trained and experienced supervisors. built by a large, semiskilled work force directed by one or skilled workers, whereas concrete structures could be light, and easily transported. Stone structures required set in place—the components of concrete were cheap, ing to quarry, and difficult to transport, cut to size, and

> contrast to stone—which was expensive, time-consum-

good measure. cut stone; then they often added an overlay of plaster for ered exposed concrete surfaces with a veneer of brick or weakness was that it absorbed moisture, so builders covwalls, arches, and vaults for ever larger buildings. Its one advances it became indispensable for the construction of used mainly for poured foundations, but with technical ened them into a strong, solid mass. At first concrete was mixed with water, causing a chemical reaction that hardsuch as small rocks and broken pottery. These were abundance near Pompeii), and various types of rubble, (in particular a volcanic sand called pozzolana found in

architecture, such as the long colonnade and the colosdesign and size show the clear influence of Hellenistic was grander than any building in Rome in its time. Its dess of fate and chance, was begun about 100 BCE and (figs. 6-14, 6-15). The sanctuary, dedicated to the godplanning and concrete construction at its most creative tuna, an example of Roman Republican architectural Rome, discovered the remains of the Sanctuary of Forbombings of Palestrina, about 16 miles southeast of After World War II, teams clearing the rubble from

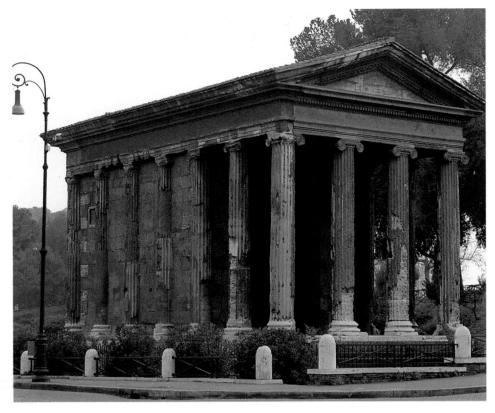

6-16. Temple perhaps dedicated to Portunus, Forum Boarium (cattle market), Rome. Late 2nd century $_{\mbox{\footnotesize BCE}}$

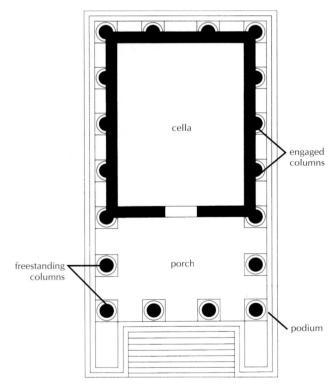

6-17. Plan of the temple perhaps dedicated to Portunus

perhaps dedicated to Portunus, the god of harbors and ports, that stands beside the Tiber River (figs. 6-16, 6-17). With a rectangular **cella** and a porch at one end reached by a single flight of steps, this temple, built in the late second century BCE, echoes the Greek prostyle plan. Almost like a piece of sculpture, it stands on a raised platform, or podium. The Ionic columns are freestanding on the porch and **engaged** around the cella. The entablature above the columns on the porch continues around the cella as a decorative frieze. The plan of this structure resembles that of a **peripteral** temple, but because the columns around the cella are engaged even though they appear to be freestanding, it is called **pseudoperipteral**. This design, with variations in the orders used with it, was to become standard for Roman temples.

City Life and Domestic Architecture

Pompeii was a thriving center of about 20,000 inhabitants on the day Mount Vesuvius erupted. An ancient village that had grown and spread over many centuries, it lacked the gridlike regularity of newer Roman cities, but its layout was typical for its time. Temples and government buildings surrounded a main square, or **forum**; paved streets were lined with shops and houses; and enclosing all was a protective wall with fortified gates (fig. 6-18). The forum was the center of civic life in Roman towns and cities, as the **agora** was in Greek cities. Business was conducted in its basilicas and pavilions, religious duties performed in its temples, and

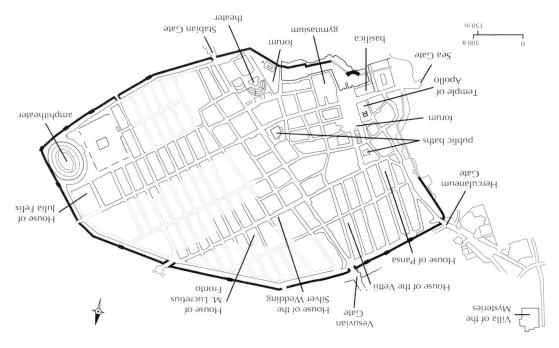

6-18. Plan of the city of Pompeii in 79 cE

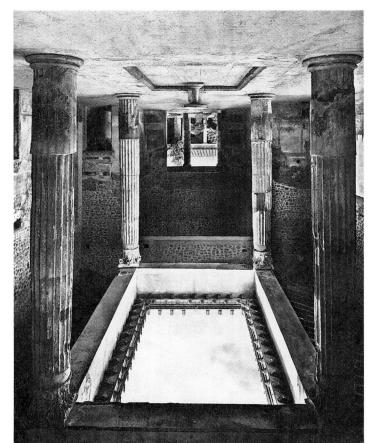

6-20. Atrium, House of the Silver Wedding, Pompeii. Early 1st century ce

Ancient Roman houses excavated at Pompeii and elsewhere are usually named after the families or individuals who once lived in them. In many cases, the owner is unknown. This house received its unusual name as a commemorative gesture. It was excavated in 1893, the year of the silver wedding anniversary of Italy's King Humbert and his wife, Margaret of Savoy, who had supported archeological fieldwork at Pompeii.

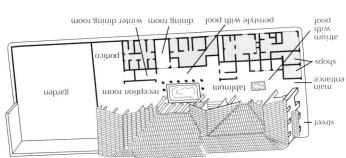

6-19. Reconstruction drawing and plan of the House of Pansa, Pompeii. 2nd century BCE

speeches presented in its open square. For recreation, people went nearby to the baths or the events in the amphitheater.

The people of Pompeii lived in houses behind or

above a row of shops, or in two- or three-story apartment buildings, or in gracious private residences with one or more gardens. Even upper-class homes often had streetlevel shops. If there was no shop, the wall facing the street was usually solid except for the door, an indication of the emphasis on interior rather than exterior design. In a sense, the inner orientation of domestic architecture reflects the central and sacred place of hearth and home in Roman religion.

A Roman house usually consisted of small rooms laid out on a straight, generally symmetrical plan, as illustrated in the reconstruction drawing of the House of Pansa in Pompeii (fig. 6-19). From the entrance, a corridor led to the atrium, a large space with a shallow pool for catching rainwater through an opening in the roof. The organization of the front part of the house—the centrally located atrium surrounded by small rooms—originated with the Etruscans. Figure 6-20 shows the atrium nated with the Etruscans. Figure 6-20 shows the atrium

GARDEN

THE URBAN The remains of urban gardens preserved in the vol-

canic fallout at Pompeii have been the focus of a decades-long study by archeologist Wilhelmina Jashemski. Her work has revealed much about the layout of ancient Roman gardens and the plants cultivated in them. Early archeologists, searching for more tangible remains, usually destroyed evidence about gardens, but in 1973 Jashemski and her colleagues had the opportunity to work on the previously undisturbed peristyle garden—a planted interior court enclosed by columns—of the House of G. Polybius in Pompeii. Workers first removed layers of debris and volcanic material to expose the level of the soil as it was before the eruption in 79 ce. They then collected samples of pollen, seeds, and other organic material and carefully injected plaster into underground root cavities to make casts for later study. These materials enabled botanists to identify the types of plants and trees cultivated in the garden, to estimate their size, and to determine where they had been planted. Some houses had both peristyle gardens and separate vegetable gardens.

The evidence from this and other excavations indicates that most urban gardens served a practical function. They were planted with fruit- and nut-bearing trees and occasionally with olive trees. Only the great luxury gardens were rigidly landscaped. Most gardens were randomly planted or, at best, arranged in irregular rows.

The garden in the house of Polybius was surrounded on three sides by a portico, which protected a large cistern on one side that supplied the house and garden with water. Young lemon trees in pots lined the fourth side of the garden, and nail holes in the wall above the pots indicated that the trees had been espaliered pruned and trained—a practice still in use today. Fig, cherry, and pear trees filled the garden space, and traces of a fruit-picking ladder, wide at the bottom and narrow at the top to fit among the branches, was found on the site. This evidence suggests

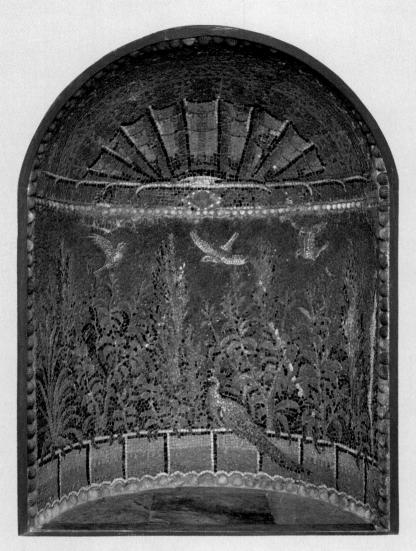

Wall niche, from a garden in Pompeii. Mid-1st century ce. Mosaic, 43³/₄ x 31¹/₂" (111 x 80 cm). Fitzwilliam Museum, University of Cambridge, England

that the garden was a densely planted orchard similar to the one painted on the dining-room walls of the villa of the empress Livia in Primaporta (see fig. 6-36).

An aqueduct built during the reign of the emperor Augustus gave Pompeii's residents access to a reliable and plentiful supply of water, replacing their dependence on wells and rainwater basins. This new source allowed them to add pools, fountains, and flowering plants that needed large amounts of water to their gardens. In contrast to the earlier, unordered plantings, formal gardens with low, clipped borders and plantings of ivy, ornamental boxwood, laurel, myrtle, acanthus, and rosemary—all mentioned by writers of the time-became fashionable. There is also evidence of topiary work, the clipping of shrubs and hedges into fanciful shapes. Sculpture and purely decorative fountains became popular. The peristyle garden of the House of the Vettii, for example, had more than a dozen fountain statues jetting water into marble basins (fig. 6-21). In the most elegant peristyles, mosaic decorations covered the floors, walls, and even the fountains. Some of the earliest wall mosaics, such as the one illustrated here, were created as backdrops for fountains.

Roman houses reflect architectural ideals seen also in monumental and public construction. The Romans, with their love of nature, softened the abstract regularity of their homes with beautifully planted gardens in the peristyle court (see "The Urban Garden," opposite). Larger residences also had a separate kitchen garden. In Pompeii, where the mild southern climate would have permitted gardens to flourish year-round, the peristyle court was often turned into an outdoor living room with wall murals, fountains, and sculpture on pedestals, as in the House of the Vettii (fig. 6-21), which dates from the

Architecture in the Provinces

mid-first century ce.

In many areas of Europe and the Mediterranean, impressive examples of Roman engineering still stand, powerful reminders of Rome's rapid spread and enduring impact. The Pont du Gard near Mîmes in southern France has a 900-foot span and rises 180 feet above the Gard River (fig. 6-22). Still in use in the twentieth century as a aqueduct, part of a system that brought water to Mîmes from the springs of Uzès 30 miles to the north. This feat from the springs of Uzès 30 miles to the north. This feat of hydraulic engineering, impressive even by modern of hydraulic engineering, impressive even by modern attention of Augustus's son-in-law Agrippa about 20 BCE. At the time it was built, the aqueduct could provide 100 gallons of water a day for every person in Nîmes.

in the well-preserved House of the Silver Wedding in Pompeii. Beyond the atrium, in a reception room called the tablinum, portrait busts of the family's ancestors might be displayed, and the head of the household conferred with clients. In later houses the tablinum often opened onto a central peristyle court, surrounded by a colonnaded walkway, or portico. The more private areas—such as the dining room, the family sitting room, bedrooms, the kitchen, and servants' quarters—usually were entered through the peristyle court.

6-21. Peristyle garden, House of the Vettii, Pompeii. Mid-1st century ce

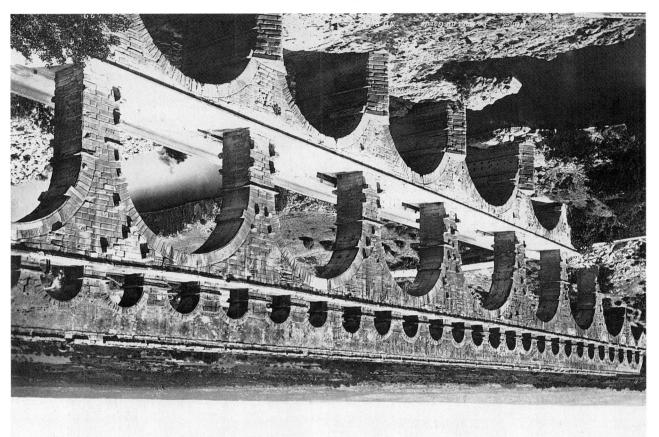

6-22. Pont du Gard, Nîmes, France. Late 1st century BCE

6-23. Maison Carrée, Nîmes, France. c. 20 BCE

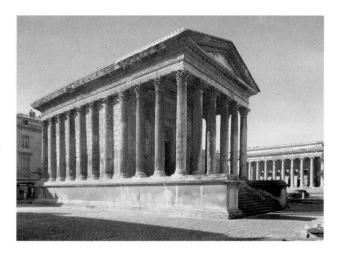

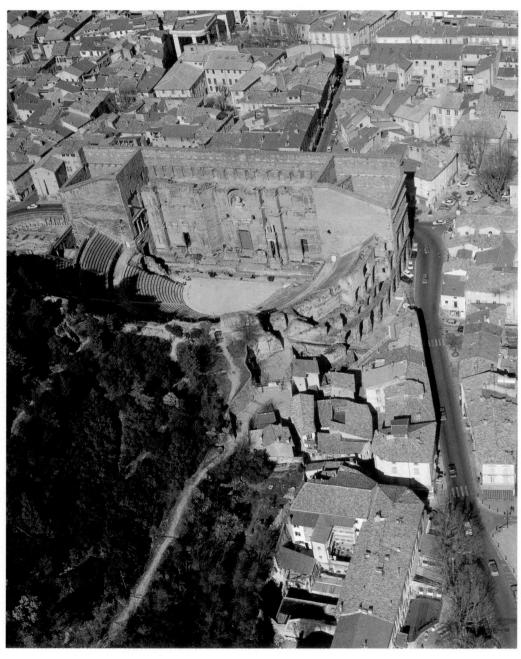

6-24. Roman theater, Orange, France. 1st century BCE Because of renovations, plays can still be staged at this theater, one of the rare Roman theaters still being used for its original purpose.

in the tablinum and carried in funerlong-dead ancestors to be displayed ate imaginary portraits of illustrious, Sculptors might also be asked to create bust portraits of the dead. tors might be commissioned to cresometimes cast in plaster, and sculp-35.6-7). The wax death masks were

mother's side and to the gods on her

her lineage to Rome's kings on her

tion for his aunt Julia. In it he traced

Caesar's famed speeches was an ora-

for his mother, Popilia. One of Julius

a new precedent by giving an oration

but in 102 BCE the consul Catulus set

men were honored by such orations,

much of the Republican period, only

portant part of a Roman funeral. For

most eminent member, was an im-

An oration in honor of the

deceased, delivered by the family's grave sites every February. They retions and left small offerings at their al processions. dead in elaborate funeral celebra-

opened into small side chambers for urns and busts of the dead and filled up. They were lined with niches scending to another level as space cemetery property to the other, denels extended from one edge of the

was present" (Naturalis Historia

his ancestors, all who ever existed, when anyone died, the entire roll of

family funeral processions, and thus,

the portraits which were carried in

home], so that they might serve as

were set out on separate chests [at

tice: "Wax impressions of the face

first century ce, describes this prac-

them. Pliny the Elder, writing in the

masks as a way of remembering

vered their ancestors and kept death

The Romans memorialized their called cubicula.

one end of the atrium. often in a room called the tablinum at documents, on view in their homes, masks of their ancestors and family with busts and casts from death kept the ash containers, together deceased. Instead, they frequently an earthly domestic setting for the ever, they made no effort to provide vases. Unlike the Etruscans, howashes in special cinerary urns or dead and placed the

PRACTICES erally cremated their

EUNERARY the early Romans gen-

Like the Etruscans,

ROMAN

pypogeum, or catacomb. The tuntunneled underground to create a level space in their cemetery, they members had used up the groundgroup cemeteries. When a group's organizations established private members of social clubs and other In Rome related individuals or

his own designs. said to have found inspiration in the Maison Carrée for

father's side.

ment is part of the performance setting, this theater Greek-style theaters, in which the surrounding environby a statue of the emperor in a central niche. Unlike guised with columns and pediments and presided over ry of the wall, 335 feet long and 1231/2 feet high, was dismany as 7,000 spectators. In its heyday, the plain masonof Augustus in the first century BCE, the theater held as enclosing wall faces the audience. Built during the reign part of the seating area. A raised stage with an elaborate area, has here been reduced to a semicircle and made Greek theaters is circular and is part of the performance in a semicircular cone shape. The orchestra, which in (fig. 6-24). As in Greek theaters, the seating is arranged France but north of Nîmes, on the east side of the Rhône hillside type can be found at Orange, also in southern tures on level terrain. A well-preserved example of the pillsides for the purpose of creating treestanding strucdition of building large outdoor theaters, using suitable The Romans carried on the Greek and Hellenistic tra-

tectural environment. isolated audience and actors alike in an entirely archi-

Republican Sculpture

of the Republican period clearly admired veristic por-"Roman Funerary Practices," above). In any case, patrons tice of making death masks of deceased relatives (see derived from Roman ancestor veneration and the pracfaithful portraits of individuals, called verism, may be surroundings. The convention of rendering accurate and believable images based on careful observations of their Sculptors of the Republican period sought to create architect Thomas Jefferson, who visited Nimes and was that appealed to the American president and amateur but conservative in design. It is perhaps these qualities marize Roman architecture: technologically advanced an order. Both the aqueduct and the temple seem to sumonly in its size and its use of the more opulent Corinthi-Augustus, the Maison Carrée differs from its prototype cated to Gaius and Lucius Caesar, the grandsons of Built in the forum at Nîmes about 20 BCE and later dedibut is larger and much more richly decorated (fig. 6-23). is similar to the temple dedicated to Portunus in Rome temple known as the Maison Carrée, or Square House, other well-preserved Roman structures. One of these, a the richest provinces of the empire and contains several The city of Vimes is located in what was once one of integration into its natural setting.

sense of balance, proportion, rhythmic harmony, and

vide easy access for repairs. It nevertheless conveys a

support scaffolding during construction were left to pro-

left undecorated, and the projecting blocks inserted to arcade. A purely utilitarian structure, the aqueduct was

trough. It has three arches for every one of the second narrowest and shortest of the three, supports the water

and set on one side of the roadbed. The third arcade, the

those of the base, but it is much narrower than the first

arches of the second arcade span the same distance as

and support a roadbed approximately 20 feet wide. The

huge stone piers (square or rectangular support posts) element. The arches of the thick base arcade spring from

exemplifies the simplest use of the arch as a structural

ly spaced arched openings) stacked one on the other and consists of three arcades (walls with a series of regular-

sized and precisely cut stones from a nearby quarry. It

The Pont du Gard was constructed of beautifully

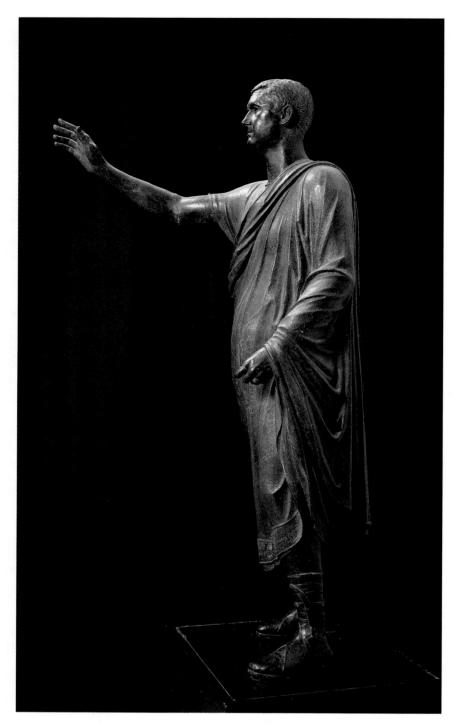

6-25. *Aulus Metellus*, found in the vicinity of Lake Trasimeno. Late 2nd or early 1st century BCE. Bronze, height 5'11" (1.8 m). Museo Archeològico Nazionale, Florence

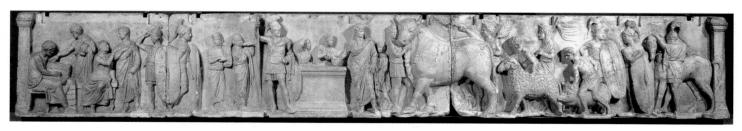

6-26. *Taking of the Roman Census*, frieze from a large base for statuary, possibly from the Temple of Neptune, Rome. c. 70 BCE. Marble, height 32" (81.3 cm). Musée du Louvre, Paris

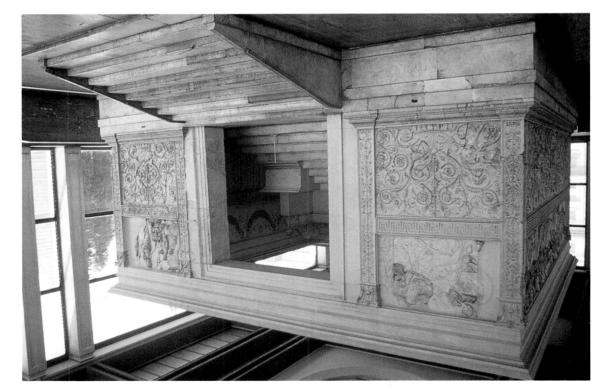

6-27. Ara Pacis. 13-9 BCE. Marble, approx. 34'5" (10.5 m) x 38' (11.6 m). Rome

The Ara Pacis—a war monument as famous in its day as the Vietnam Veterans' Memorial is in ours—has been reconstructed and is kept well preserved in a modern pavilion built at the time of the centennial of Italian unification in 1970. The pavilion is located beside the Tiber River near the tomb of Augustus, who commissioned the Ara Pacis as a memorial to his military conquests. The reign of Augustus marks the beginning of sioned the Ara Pacis as a memorial to his military conquests. The reign of Augustus marks the beginning of the Pax Romana, or Roman Peace, a period of stability in the empire that lasted nearly two centuries.

of the censor (official census taker) commemorated in this panel is not certain, making it impossible to date precisely. Some scholars have suggested that he is Marcus Antonius, an orator who was elected censor of Rome in 97 BEE. The sculptor's desire to convey in detail specific contemporary events, which required depicting the subjects with complete clarity, overrode concerns for an artistically balanced composition.

Augustan Sculpture

Drawing inspiration from Etruscan and Greek art as well as Republican traditions, Roman artists of the imperial period made their own distinctive contribution to the history of sculpture. They enriched and developed the art of portraiture, creating both official images and representations of private individuals, they recorded contemporary historical events on commemorative arches, columns, and mausoleums erected in public places, and they contributed unabashedly to Roman imperial propaganda.

The Ara Pacis, the Altar of Augustan Peace, was erected in Rome by Augustus between 13 and 9 BCE to commemorate his triumphal return to the city following the end of civil war and the establishment of firm Roman rule in Spain and France (fig. 6-27). In form, the rectangular structure is a Roman adaptation of earlier Greek and Hellenistic altars. Its decoration is a thoughtful union of portraiture and allegory, religion and politics, the

traits, and it is not surprising that they often turned to skilled Etruscan artists to execute them. The large bronze portrait statue of Aulus Metellus (fig. 6-25), the work of an Etruscan artist, dates to the late second or early first century BCE. The name of the subject, a Roman official, is inscribed on the hem of the toga in Etruscan letters. The statue, known from early times as "The Orator," depicts him addressing a gathering, his arm outstretched and slightly raised, a pose so expressive of authority and persuasiveness that it gained favor among later patrons. The orator wears sturdy laced leather boots and a folded and draped garment called a toga, both characteristic of a draped garment called a toga, both characteristic of a draped garment called a toga, both characteristic of a lace his were often placed atop columns as memorites like this were often placed atop columns as memorites in the individuals portrayed.

Historical events in ancient Rome were often preserved in the durable medium of relief sculpture. Perhaps the earliest historical reliefs discovered in Rome are two long marble panels dating from the early first century BCE, one of which depicts the Taking of the Roman Census (fig. 6-26). This panel and another now housed in a Runich museum may have been part of a base for a group of statues in one of Rome's temples, perhaps the Temple of Neptune. The left half of the panel shows the Official registration of citizens; the right half shows the lustrum, a ritual that involved the ascrificial killing of anilustrum, a ritual that involved the sacrificial killing of anilustrum, a ritual that involved the sacrificial killing of anilustrum, a ritual that involved the sacrificial killing of anilustrum, a ritual that involved the caption of anilus and a large pig being led in a procession to the altar at the center. The identity

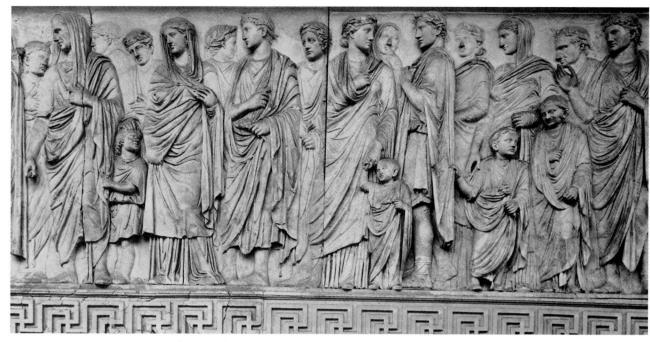

6-28. Imperial Procession, detail of a relief on the Ara Pacis. Height 5'2" (1.6 m)

The middle-aged man with the shrouded head at the far left is Marcus Agrippa, who would have been Augustus's successor had he not died in 12 ce, the year after the Ara Pacis was dedicated. The bored but well-behaved youngster pulling at Agrippa's robe—and being restrained gently by the hand of the man behind him—is probably Agrippa's son, Gaius Caesar. The heavily swathed woman next to Agrippa on the right is probably Augustus's wife, Livia, followed by the elder of her two sons, Tiberius, who would become the next emperor. Behind Tiberius is Antonia, the niece of Augustus, looking back at her husband, Drusus, Livia's younger son. She grasps the hand of Germanicus, one of her younger children. Behind their uncle Drusus are Gnaeus and Domitia, children of Antonia's older sister, who can be seen standing quietly beside them. The depiction of children in an official relief was new to the Augustan period and reflects Augustus's desire to promote private family life.

private and the public. The interior re-creates in marble the temporary altar—surrounded by garlands of flowers suspended in **swags**, or loops, from bucrania (ox skulls)—that would have been set up for the triumphal celebration. The ox skulls symbolize sacrificial offerings, and the garlands, which include flowering plants from every season, signify continuous peace.

Roman realism reached a new level of specificity in the sculpted panels along the exterior of the north and south sides of the Ara Pacis, which depict long double lines of mostly senators and imperial family members. These people appear to be waiting, after a just-completed procession, for other ceremonies to begin. At the head of the line on the south side of the altar is the badly damaged figure of Augustus. Surrounded by priests and other officials, he is probably performing a religious ritual. A detail shows many members of his family waiting at some distance behind him (fig. 6-28). Unlike the Greek sculptors who created the procession on the frieze of the Parthenon (see fig. 5-48), the Roman sculptors of the Ara Pacis depicted actual individuals. They also attempted to suggest spatial depth by carving the closest elements in high relief and those farther back in increasingly lower relief. In a device reminiscent of the Altar of Zeus at Pergamon (see fig. 5-81), they have drawn us, as spectators, visually into the event by making the feet of the nearest figures project from the architectural groundline into our space. Like the Parthenon sculptors, the Roman sculp-

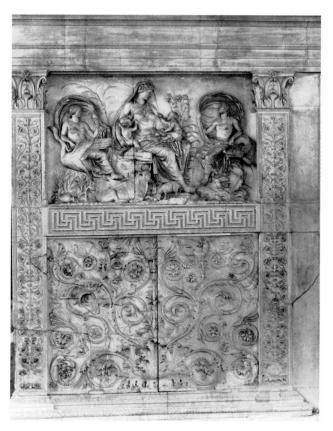

6-29. Allegory, relief on the Ara Pacis. Height 5'2" (1.6 m)

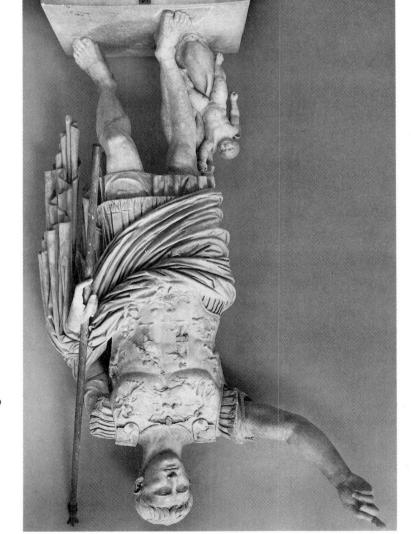

6-30. Augustus of
Primaporta.
Early 1st century
CE (perhaps a
copy of a bronze
statue of c. 20
BCE). Marble,
height 6'8" (2.03
m). Musei Vaticani, Braccio

Ииоуо, Rome

gorical theme—the Abundant Earth—is reinforced by the flowers and foliage in the background and the domesticated animals in the foreground.

raling vegetal forms are rendered are characteristic of tals. The delicacy and minute detail with which these spioverlay the pilasters, culminating in the acanthus capiforms. Similar forms, in a more rigid vertical pattern, lower panels are covered with stylized vine and flower and divides the wall into two horizontal segments. The with a Greek key pattern (meander) joins the pilasters pilasters support a simple entablature. A wide molding tectural elements carved in low relief. Corinthian order ing swaths of cloth. The scene is set into a frame of architurning the figures in space and wrapping them in revealconveyed a sense of three-dimensionality and volume by sources (see, for example, fig. 5-53). The artists have alized figures themselves are clearly drawn from Greek sents something new in monumental sculpture, the idenatural world—sky, water, rocks, and foliage—repre-Although the inclusion in this panel of features of the

Roman architectural decoration.

The Augustus of Primaporta (fig. 6-30), so named because it was discovered in the country villa belonging

water, and the wetlands vegetation, would have sugland wind, symbolized by the swan, the jug of fresh raries of Rome's dominion over the Mediterranean; the and waves, would have reminded Augustus's contempoland wind. The sea wind, symbolized by the sea dragon dragon. They are personifications of the sea wind and the a flying swan, the other reclining on a sea monster or women with billowing veils, one seated on the back of human form) of peace. She is accompanied by two young dess of grain, or simply a personification (symbol in may also be a maternal form of Venus, or Ceres, the godrepresented by the two chubby babies in her arms. She Mother Earth, symbolically nurturing the Roman people, figures. The woman in the center may be Tellus Mater, or empire (fig. 6-29). Scholars disagree on the identity of the prosperity that Augustus has presumably brought to the scene, an allegorical representation of the peace and best-preserved of these is a balanced and composed walls, we find panels of a quite different character. The naturalness, to the east and west ends of the enclosure Moving from this procession, with its immediacy and tors have provided no background setting for the figures.

gested the fertility of Roman lands. The underlying alle-

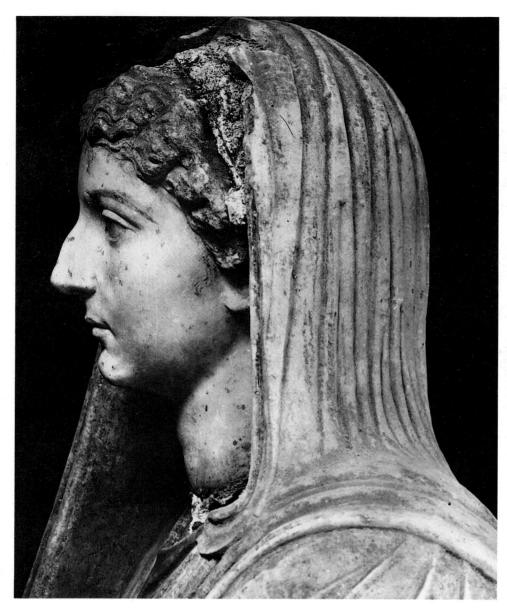

6-31. Livia. c. 20 BCE. Marble, height approx. 15" (38.5 cm). Antiquarium, Pompeii

to Augustus's wife, Livia, at Primaporta, demonstrates the creative assimilation of earlier sculptural traditions into a new context. It also illustrates the use of imperial portraiture for political propaganda, a practice among Romans that began with Augustus. The sculptor of this bigger-than-life marble statue eloquently adapted the orator's gesture of the Aulus Metellus (see fig. 6-25), combining it with the pose and body proportions prescribed by the Greek Polykleitos and exemplified in his Spear Bearer (see fig. 5-54). (Roman artists made many copies of this famous sculpture, and many Roman statues reflect its influence.) The god Cupid, son of the goddess Venus, rides a dolphin next to the emperor's right calf, probably a reference to the claim of the emperor's family, the Julians, to descent from the goddess Venus through her human son Aeneas. Although Augustus wears a cuirass (torso armor) and holds a commander's baton, his feet are bare, suggesting to some scholars that the work was made after his death and commemorates his **apotheosis**, or elevation to divine status. Augustus was in his late seventies when he died, but the features of this statue are those of a vigorous, young ruler. If it is a posthumous work, it might have been copied from a now-lost bronze statue. Since the decorations on the cuirass allude to Augustus's victory over the Parthians in 20 BCE, the original statue may have commemorated that event.

Taken as a whole, this imposing statue creates a recognizable image of Augustus, but one that is far removed from the kind of intensely individualized portrait that was popular during the Republican period. Its purpose was to encourage the Roman people to identify the beneficence of the state with the emperor's person. Whether it is seen as a general praising his troops or a peacetime leader speaking words of encouragement to his people, it projects an image of the emperor as a benign ruler, touched by the gods, governing by reason and persuasion, not autocratic power.

ing, shackled barbarians on the bottom right wait to be Tiberius's victory over the Germans in 12 ce, the coweroners who were paraded out during a celebration of captured from the defeated enemy is displayed. Like prisraising a trophy—a post or standard on which armor rulers is the earthly one, where Roman soldiers are

pagandistic, this cameo was probably commissioned by ly large and its subject matter and treatment highly prodepiction of historical events. Even though it is unusualof Hellenistic art, and a purely Roman approach to the characteristic of Classical Greek art, the dramatic action tea brilliantly combines idealized, heroic figures of a kind equally fine design and conception. The Gemma Auguscution was so skillful that it nearly overshadows the leaving the lower layer of blue as a background. The execarving the relief elements out of the white layer and The sculptor of this exquisite low relief created it by

Augustus's widow for commemorative use.

Wall Painting

tied to this trophy.

after the second century bee is greatly indebted to the The study of the development of Roman wall painting

details such as molded plaster columns. In the Second slabs of colored marble set off by real architectural illusion that the walls were actually covered with thin In the First Style (c. 200–80 BCE), artists created the nient way to examine wall painting in the Roman world. used to assign dates to architecture, they are a conve-Empire. Although the Pompeiian styles are no longer period, and the last two are associated with the Roman some overlap. The first two began during the Republican four types, or styles, that succeeded each other with cloth. At Pompeii these decorations can be grouped into metal, glass, or stone burnisher, then buffing with a added, applying the images, polishing with a special ment in a solution of lime and soap with a little wax and subject matter. Their technique involved mixing pigpainted decorations that varied greatly in appearance tures. On these invitingly flat, empty surfaces, artists smooth plaster surfaces without any architectural feation. The interior walls of Roman houses were plain, the communities surrounding Vesuvius during its erupand intact within the volcanic debris that descended over recovery of many examples preserved relatively fresh

Fourth styles are treated beginning on page 256. greater fantasy than in the Third Style. The Third and tectural details of the First and Second styles with even three styles, bringing together the more realistic archia complex combination of the features found in the other gnettes appear. The Fourth Style (beginning c. 45 cE) was architectural details, within which small, delicate viing it a solid color, decorated with slender, whimsical 45 ce) they emphasized the wall surface again by paintrather than molded plaster. In the Third Style (c. 15 BCE-Architectural details such as columns were painted "stage" or with a landscape or cityscape seen close up. visually with painted scenes of figures on a shallow Style (c. 80-15 BCE) they extended the space of a room

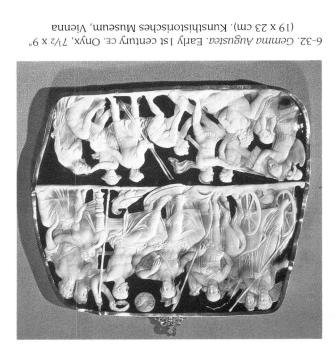

life not only a desirable state but a patriotic duty. and childless wives or widows. These laws made family women, and penalized bachelors, unmarried women, ily, provided increased legal protection to married rate. She supported laws that favored marriage and famsocial legislation aimed at increasing the Roman birth tus was childless, she was an influential promoter of expression (fig. 6-31). Although her marriage to Augusstriking woman with strong features and a serene about 20 BCE, when she was in her mid-thirties, reveals a she could marry Augustus. A portrait bust of her, dated band, Tiberius Claudius Nero, who divorced her so that second emperor of Rome) and Drusus, by her first huschild, Julia. Livia had two children, Tiberius (the future divorced her after the birth of what would be his only had married his first wife for political reasons and years. For both, this was a second marriage. Augustus woman who remained by his side for more than fifty Augustus's wife, Livia, was a strong and resourceful

Augustus. Below the transcendent realm of the godly to assume the imperial throne as the designated heir of Returning victorious from the German front, he is ready holding a lance and stepping out of a chariot at the left. Remus. Tiberius, the adopted son of Augustus, is shown god Mars through his human children Romulus and to the alleged descent of the Julian family from the war shield that serves as Augustus-Jupiter's footstool refers stellations in the zodiac, indicating the time of year. The between them may represent Capricorn, one of the conpersonification of Rome. The sea-goat in the roundel Sitting next to him may be Livia, portrayed as a goddess gods, and an eagle, sacred to Jupiter, stands at his feet. He has assumed the identity of Jupiter, the king of the victor's wreath, sits at the center right of the top panel. gustea (fig. 6-32). The emperor, being crowned with a stone carved in low relief) known as the Gemma Auapparently the subject of a large onyx cameo (a gem-The apotheosis of Augustus after his death in 14 ce is

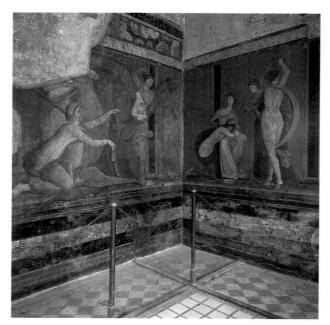

6-33. *Initiation Rites of the Cult of Bacchus* (?), detail of a Second Style wall painting in the Villa of the Mysteries, Pompeii. c. 50 BCE

One of the most famous painted rooms in Roman art is in the so-called Villa of the Mysteries at Pompeii (fig. 6-33). The room must have been a shrine or meeting place for a religious cult, probably that of Bacchus, the god of vegetation, fertility, wine, and the arts, who was one of the most important deities in Pompeii, along with Hercules and Venus. The Second Style murals depict what has been interpreted as the initiation rites of a new member of the cult, which was for a long time limited exclusively to women. The artists first painted an architectural setting consisting of a marble dado, a decoration on the lower part of a wall, and an elegant frieze supported by pilasters around the top of the wall. The action takes place along the top of the dado in a raised, shallow stage space with a backdrop painted a brilliant, deep red (now known as Pompeiian red) very popular with Roman painters. The stage runs around the entire room and the scenes on it depict a succession of events that culminate in the acceptance of the initiate into the cult.

The visual space of the paintings includes the viewer, who feels like a participant in the action. In the portion of the room seen in the illustration, a priestess (on the left) prepares to reveal draped cult objects, a

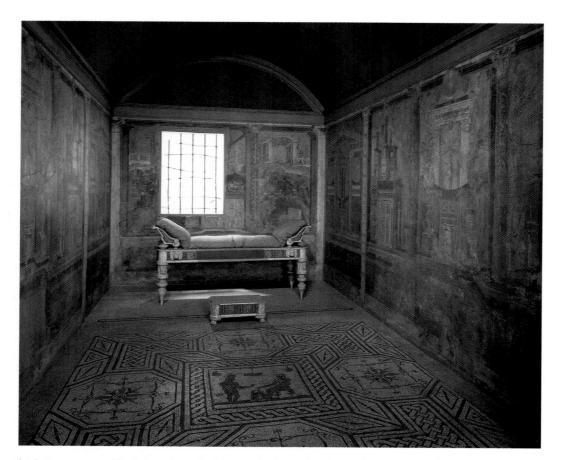

6-34. Reconstructed bedroom, from the House of Publius Fannius Synistor, Boscoreale, near Pompeii. Late 1st century CE, with some later furnishings. The Metropolitan Museum of Art, New York Rogers Fund, 1903 (03.14.13)

Although the elements in the room are from a variety of places and dates, they give a sense of how the original furnished room might have looked. The floor mosaic, found near Rome, dates to the second century CE. At its center is an image of a priest offering a basket with a snake to a cult image of Isis. The couch and footstool, which are inlaid with bone and glass, date from the first century CE. The wall paintings, original to the Boscoreale villa, may have been inspired by theater scene painting.

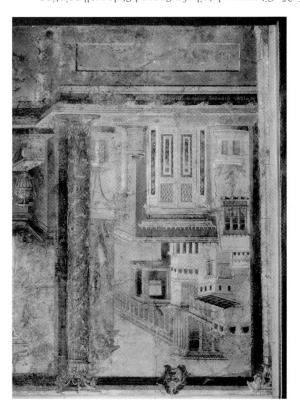

Mark Control (Co.)

6-35. Cityscape, detail of a Second Style wall painting from a bedroom in the House of Publius Fannius Synistor, Boscoreale. Late 1st century ce. The Metropolitan Museum of Art, New York Rogers Fund, 1903 (03.14.13)

theatrical design than with reality. Nevertheless, the artist has used intuitive perspective to create a general impression of real space. The architectural details follow diagonal lines that the eye interprets as parallel lines receding into the distance, and figures and objects that we are meant to understand as far away from the surface plane of the wall are shown smaller than those meant to plane of the wall are shown smaller than those meant to

appear near to it.

The Second Style decoration of the dining-room walls of the Villa of Livia at Primaporta exemplifies yet another approach to creating a sense of slightly expanded space (fig. 6-36). Instead of rendering a stage set or a ed space (fig. 6-36).

winged figure whips a female initiate lying across the lap of another woman, and a devotee dances with cymbals, perhaps to drown out the cries from the whipping. According to another interpretation, the dancing figure is the initiate herself, who has risen to dance with joy at the conclusion of her trials. The whole may be showing a purification ritual meant to bring enlightenment and blissful union with the god.

kind of drama known as a satyr play. On the side walls, visual reference to Bacchus, the traditional setting for a grotto with a fountain surmounted by a grape arbor, a wall, next to the window, for example, is a painting of a the room reinforce this theatrical association. On the rear ration for this type of home decoration. Other details in drops for a theatrical set, which may have been the inspiforms. This scene is made for viewing only, like backselves lost in an incomprehensible maze of floating through one of the painted doors we would find ourwhich the viewer might move. Were we able to walk There is no sense of space beyond these forms into columns and cornices, swinging garlands, and niches. Roman city (fig. 6-34). The wall surfaces dissolve into surrounds the room and provides a closed-off view of a Mysteries, but in this case a fantastic urban panorama type of shallow "stage" as the illusions in the Villa of the The Second Style paintings on the walls use the same with items roughly contemporary with the original villa. Metropolitan Museum of Art in New York and furnished urb of Pompeii, have been restored as a bedroom in the The walls of a room from a villa at Boscoreale, a sub-

The splendid portal in the painting at the far left end of the left wall of the room is flanked by potted plants and of the left wall of the room is flanked by potted plants and a statue of a goddess. Beyond this portal is a complex jumble of buildings with balconies, windows, arcades, and roofs at different levels that end in a magnificent colonnade (fig. 6-35). The vine-wrapped column that seems to sit on the ledge painted at the bottom of the wall and to support an entablature near the top of it enhances the illusion that we are looking into space. The enhances the illusion that we are looking into space. The reminder that the composition has more to do with

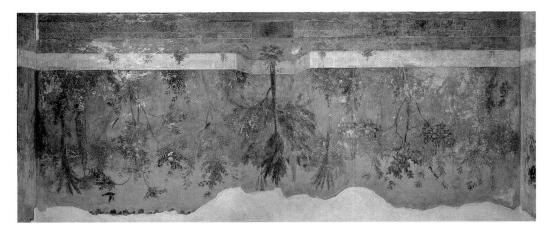

6-36. Garden Scene, detail of a Second Style wall painting from the Villa of Livia at Primaporta, near Rome. Late 1st century BCE. Museo Nazionale Romano, Rome

0 800 BCE 400 CE cityscape, the artist literally painted away the wall surfaces to create the illusion of being on a porch or pavilion looking out over a low, paneled wall toward an orchard of heavily laden fruit trees. These and the flowering shrubs are filled with a variety of wonderfully observed birds. When the Republican period drew to a close, the styles of painting, especially the Third Style, continued to dominate, but other art forms—most particularly architecture—would be put to new purposes.

THE EARLY EMPIRE: THE JULIOCLAUDIAN AND FLAVIAN DYNASTIES

Augustus's successor was his stepson Tiberius, and in acknowledgment of the lineage of both, the dynasty—the succession of related rulers—that begins with Tiberius is known as the Julio-Claudian (14–69 cE). Although this dynasty produced some capable administrators, it was also marked by suspicion, intrigue,

and terror in Rome. It ended with the reign of the despotic and capricious Nero. A brief period of civil war followed Nero's death in 68 ce, during which it became clear that the power to elevate emperors rested with the army and not with the Senate and other assemblies in Rome. Eventually, a powerful general, Vespasian, seized control of the government. The dynasty he founded, the Flavian, ruled from 69 to 96 ce. The emperors in this dynasty, Vespasian (ruled 69–79 ce), Titus (ruled 79–81 ce), and Domitian (ruled 81–96 ce), restored imperial finances and stabilized the empire's frontiers. Domitian's autocratic reign saw a return of intrigue and terror to the capital.

Architecture

The Colosseum, one of Rome's greatest monuments, was built during the reign of Vespasian (fig. 6-37). Construction on it began in 72 ce, and it was dedicated by Titus in 80 ce, after Vespasian's death. In this enormous entertainment center (it measures 615 by 510 feet and is 159 feet high) Roman audiences watched a variety of athletic events and spectacles, including animal hunts, fights to the death between gladiators or between gladiators and wild animals, performances of trained animals and acrobats, and even mock sea battles, for which the arena was flooded by a built-in mechanism. The Flavians erected it to bolster their popularity in Rome, and its name then was the Flavian Amphitheater. The name "Colosseum," by which it came to be known, derived from the Colossus, a bigger-than-life statue of Nero that had been left standing next to it. The opening performances in 80 ce lasted 100 days, during which time, it was claimed, 9,000 wild animals and 2,000 gladiators were killed.

The floor of the Colosseum was laid over a foundation of service rooms and tunnels that provided a backstage area for the athletes, performers, animals, and equipment. (This floor was covered in sand, or *arena* in Latin, hence the English term "arena.") Some 50,000 spectators could easily move through the seventy-six

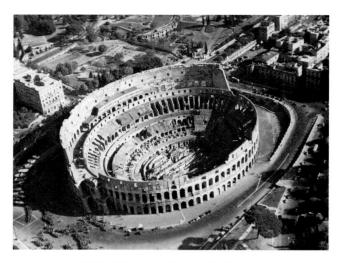

6-37. Colosseum, Rome. 72-80 ce

6-38. Colosseum. View of a radial passage with barrel and groin vaulting

entrance doors to the three sections of seats and the standing area at the top. Each had an uninterrupted view of the spectacle below. Like many stadiums today, the Colosseum was oval with a surrounding exterior wall and ascending tiers of seats laid over barrel-vaulted corridors that provided access to them (fig. 6-38). Entrance tunnels connected the ring corridors to the inside ramps and seats on each level. The intersection of the entrance tunnels and the ring corridors, both barrel-vaulted, created what is called a **groin vault** (see "Elements of Architecture," page 226). The walls on the top level of the

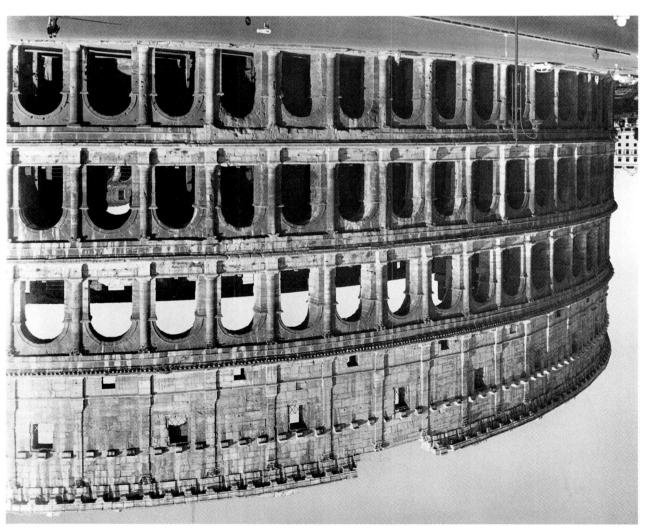

6-39. Colosseum

the Porta Augusta (see fig. 6-2), the addition of post-and-lintel decoration to arched structures was an Etruscan innovation. The systematic use of the orders in a logical succession from sturdy Tuscan to lighter Ionic to decorative Corinthian follows a tradition inherited from Hellenistic architecture (see "Elements of Architecture," page 227). This orderly, dignified, and visually satisfying way of articulating (organizing) the facades of large buildings is still popular. Unfortunately, much of the facade and the rest of the Colosseum were dismantled as a source of marble, metal fittings, and materials for later buildings.

The Arch of Titus

When Domitian assumed the throne in 81 cE, he immediately commissioned a **triumphal arch** to honor his brother and deified predecessor, Titus (fig. 6-40). During a triumph—a formal victory celebration granted to a general or emperor on his return to Rome after a significant eral or emperor on his return to Rome after a significant campaign—the victorious leader paraded with his

arena supported an awning system that could shade the seating areas. Former seamen who had experience in handling ropes, pulleys, and large expanses of canvas were employed to work the apparatus.

orative and serve no structural function. As we saw with projecting cornice. All of these elements are purely decthird level support another row of corbels beneath the Corinthian pilasters above the Corinthian columns of the in place and can be seen in the illustration. Engaged These were supported on corbels (brackets) that are still bronze shield-shaped ornaments called cartouches. square windows, which originally alternated with gildedon the fourth. The attic story is broken only by small, ond level, the Corinthian on the third, and flat pilasters Tuscan order on the ground level, the Ionic on the seclevel also uses a different architectural order: the plain marking the divisions between levels (fig. 6-39). Each gaged columns, which support entablaturelike bands (top) story. Each arch in the arcades is framed by enthree levels of arcade surmounted by a wall-like attic The curving, outer wall of the Colosseum consists of

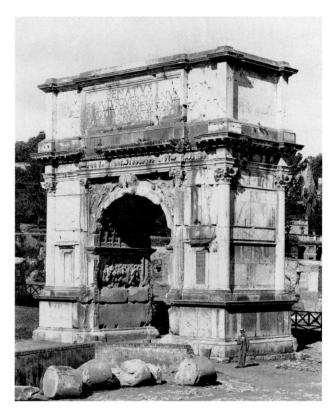

6-40. Arch of Titus, Rome. c. 81 ce. Concrete and white marble, height 50' (15 m)

The dedication inscribed across the tall attic story above the arch opening reads: "The Senate and the Roman People to the Deified Titus Flavius Vespasianus Augustus, son of the Deified Vespasian." The Romans typically recorded historic occasions and identified monuments with solemn prose and beautiful inscriptions in stone. The use by the sculptors of elegant Roman capital letters—perfectly sized and spaced to be read from a distance and cut with sharp terminals (serifs) to catch the light—established a standard that calligraphers and alphabet designers still follow.

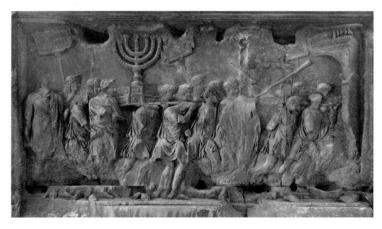

6-41. *Spoils from the Temple of Solomon, Jerusalem*, relief in the passageway of the Arch of Titus. Marble, height 6'8" (2.03 m)

troops, captives, and booty through the city. A triumphal arch was a freestanding stone arch erected to commemorate the occasion. The Arch of Titus memorializes his capture of Jerusalem in August 70 ce.

The arch, constructed of concrete and faced with marble, is essentially a freestanding gateway pierced by a passageway covered by a barrel vault. Originally the whole arch served as a giant base, 50 feet tall, for a statue of a four-horse chariot and driver, a typical triumphal symbol. Applied to the faces of the arch are columns in the **Composite order**—capitals are formed by superimposing Ionic **volutes** on a Corinthian capital—supporting an entablature. The inscription on the attic story declares that the Senate and the Roman people erected the monument to honor Titus.

Titus's capture of Jerusalem ended a fierce campaign to crush a revolt of the Jews in Palestine. His troops sacked and destroyed the Second Temple of Jerusalem and carted off its sacred treasures. These spoils were displayed in Rome during Titus's triumphal procession, impressing the Jewish eyewitness and historian Flavius Josephus (*The Jewish War*):

The most interesting of all were the spoils seized from the Temple of Jerusalem: a gold table weighing many talents, and a lampstand, also made of gold, which was made in a form different from that which we usually employ. For there was a central shaft fastened to the base; then spandrels [branches] extended from this in an arrangement which rather resembled the shape of a trident, and on the end of each of these spandrels a lamp was forged. There were seven of these, emphasizing the honor accorded the number seven among the Jews. The law of the Jews [Ark of the Covenant] was borne along after these as the last of the spoils. . . . Vespasian drove along behind [it] . . . and Titus followed him; Domitian rode beside them, dressed in a dazzling fashion and riding a horse which was worth seeing.

The reliefs on the inside walls of the arch, capturing the drama of the occasion, depict Titus's soldiers flaunting this booty as they carry it through the streets of Rome (fig. 6-41). Viewing them, the observer can feel that boisterous, disorderly crowd and might expect at any moment to hear the shouts and chanting of the participants.

The mood of the procession depicted in these reliefs contrasts with the relaxed but formal solemnity of the procession depicted on the Ara Pacis (see fig. 6-28). Like the sculptors of the Ara Pacis, the sculptors of the Arch of Titus showed the spatial relationships among figures by rendering close elements in higher relief than those more distant. A **menorah**, or seven-branched candle-holder, from the Temple of Jerusalem dominates the scene. Reflecting their concern for representing objects as well as people in a believable manner, the sculptors rendered this menorah as if seen from the low point of view of a spectator at the event, and they have positioned the arch on the right through which the procession is

Museo Gregoriano Profano, ex Lateranense, Rome century ce. Marble, height 41" (104 cm). Musei Vaticani, the Haterius family, Via Labicana, Rome. Late 1st 6-42. Mausoleum under Construction, relief from the tomb of

real skin and hair. sculpted surfaces gives the illusion of being reflected off lifelike. The play of natural light over the more subtly subject's curls. The overall effect, from a distance, is very this case the drill created the holes in the center of the straight sides that look like dark lines at a distance. In drill, a sculptor can rapidly cut deep grooves with ing it required skillful chiseling and drillwork. With a in a mass of ringlets in the latest court fashion. Executimpart an idealized, youthful glow. The hair is piled high neck—but the smoothly rendered flesh and soft, full lips nose and jaw, heavy brows, deep-set eyes, and a long includes well-observed, recognizable features—a strong manner of the Augustus of Primaporta (see fig. 6-30). It these (fig. 6-43). This bust is an idealized portrait in the

recorded on her face for future generations to admire. age—well earned and magnificent in their own way she appeared in her own mirror, with all the signs of her looks. The work she commissioned shows her exactly as latest style, was apparently not at all vain about her ject of this portrait, though she too wore her hair in the who sought to preserve their youthful looks, but the subers of the Flavian era liked to satirize vain older women style popular in the Republican period. The comic writolder woman (fig. 6-44), reflects a revival of the verist The second approach, exemplified by a bust of an

> him to a heavenly meeting with the gods. ed ceiling, which shows his apotheosis, an eagle carries chariot as a participant in the ceremonies. On the vaultthe other side of the arch interior shows Titus riding in his low relief for the figures in the background. The panel on tors have undercut the foreground figures and have used a technique also encountered on the Ara Pacis, the sculpabout to pass on a diagonal from the background. Using

Plebeian Relief Sculpture

tural elements and perspectives make the mausoleum raling garlands. Viewed as a whole, the jumbled strucrobust Corinthian columns are heavily carved with spiand vegetal reliefs that are symmetrical and upright. The garlands looped in swags, busts in shell-shaped niches, pedia of decorative motifs-egg-and-dart moldings, architecture, the image of the mausoleum is an encycloover the still-unfinished mausoleum. For the student of powered crane at the left being maneuvered into place area, and examining with fascination the giant, human-"tourist," ready to wander about studying this and that absorbed. The viewer should approach the image as a formation as possible—far more than can be readily zation and composition in order to convey as much inthe Roman Census (see fig. 6-26), sacrificed clear organisculptor of the relief, like the sculptor of the Taking of created for the tomb of an architect or a builder. The has led some scholars to believe that it was perhaps construction of the mausoleum itself, an occurrence that Haterius family (fig. 6-42). The relief memorializes the sculpture is a relief on the mausoleum of the plebeian associated with the deceased. A fine example of such mythological figures, sometimes of biographical scenes deceased, garlands, and narrative themes, sometimes of decorations of funerary reliefs were portraits of the were related to funerary situations. The most popular art. Most of the private commissions by the plebeians afford to do so also sought to memorialize themselves in Like Rome's rulers, less-lofty individuals who could

the artists who created reliefs of the type found on the Unlike the sculptors who worked on the Ara Pacis, look as if it is about to tumble to the ground.

in both public and private art throughout the empire. more prevalent, ultimately displacing the patrician style "story." This style, however, would become more and visually unrealistic way of presenting its subject matter or undercut forms, with stocky figures and a detailed but was characterized by crowded compositions and deeply The sculptural style that emerged from such commissions phisticated, though quite clear about what they wanted. sculptors. Their patrons were probably relatively unsowith the techniques and intentions of the Classical Greek tomb of the Haterius family were relatively unfamiliar

Portrait Sculpture

woman, whose identity is not known, exemplifies one of during the reign of the Flavians. A bust of a young Two approaches to portrait sculpture were popular

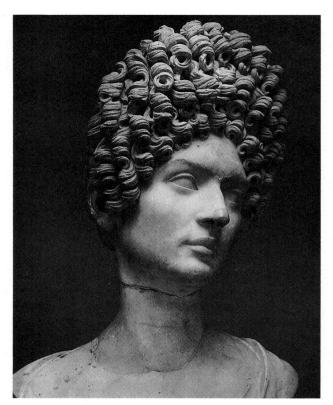

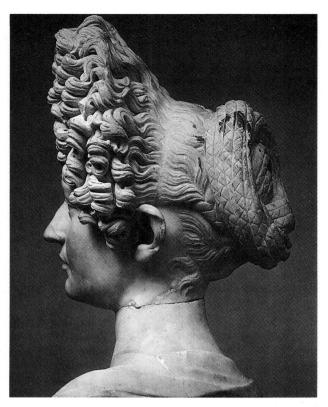

6-43. Young Flavian Woman. c. 90 ce. Marble, height 25" (65.5 cm). Museo Capitolino, Rome

The typical Flavian hairstyle seen on this woman and the older woman in figure 6-44 required a patient hairdresser handy with a curling iron and with a special knack for turning the back of the head into an intricate basketweave of braids. Male writers loved to scoff at the results. Martial described the style precisely as "a globe of hair." Statius spoke of "the glory of woman's lofty front, her storied hair." And Juvenal waxed comically poetic: "See her from the front; she is Andromache [an epic heroine]. From behind she looks half the size—a different woman you would think" (cited in Balsdon, page 256).

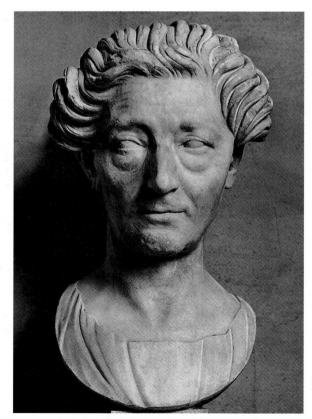

6-44. *Middle-Aged Flavian Woman*. Late 1st century ce. Marble, height 9½" (24.1 cm). Musei Vaticani, Museo Gregoriano Profano, ex Lateranense, Rome

Wall Painting

From the time of Augustus through about 45 ce, the third of the four styles identified at Pompeii predominated in Roman wall painting. In this Third Style, walls were treated mostly as solid, planar surfaces adorned with decorative details and "framed" paintings. The Third Style painting on a wall in the House of M. Lucretius Fronto in Pompeii dates to the mid-first century ce. As we see in a detail (fig. 6-45), the artist painted the wall in panels of black and red that emphasize its flatness. An echo of Second Style architecture can be seen in the borders between the panels and the suggestion of an upper level, but these elements show no logical layout and lack any significant illusion of depth. The rectangular pictures seem to be mounted on the black and red panels or placed in front of them, but they are actually painted on the wall. The scene with figures in the center is flanked by two small simulated window openings protected by grilles. The two pictures of country houses appear to be mounted on filigree.

The paintings that adorned Third and Fourth Style walls had every kind of subject, including historical and mythological scenes, landscapes and city views, portraits, and exquisitely rendered **still lifes**, or representations of inanimate objects. A still-life panel from a Fourth Style wall painting in the House of Julia Felix in Pompeii (fig. 6-46) depicts everyday domestic wares and the

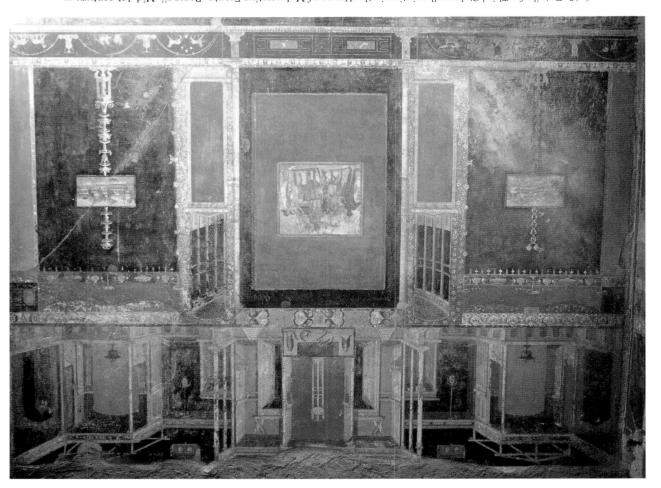

6-45. Detail of a Third Style wall painting in the House of M. Lucretius Fronto, Pompeii. Mid-1st century ce

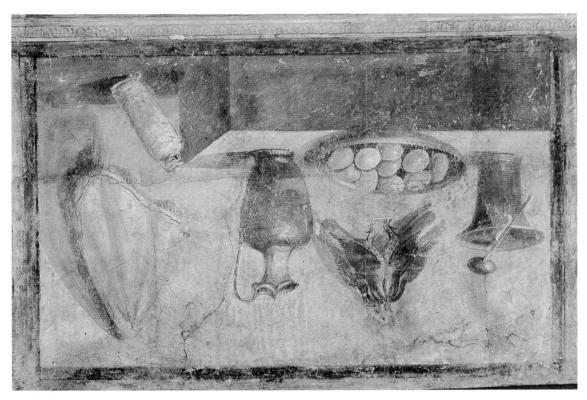

6-46. Still Life, detail of a wall painting from the House of Julia Felix, Pompeii. Late 1st century ce. Museo Archeològico Nazionale, Naples

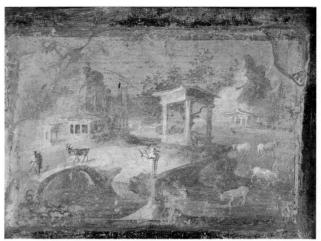

6-47. Sacred Landscape, detail of a wall painting, from Pompeii. 62–79 ce. Museo Archeològico Nazionale, Naples

makings of a meal—eggs and recently caught game birds. The items have been carefully grouped for clarity and balance in a near-symmetrical arrangement. The focus of the composition is the round plate filled with eggs and the household containers that flank it. The towel on a hook on the right of the painting and the subtle suggestion of triangularity in the bottle tilted against the end of the shelf echo the pyramidal shape of the brace of dead birds above the plate. A strong, clear light floods the picture from the left, casting shadows and enhancing the illusion of real objects in real space. Other paintings in this house show graphically the role of women at the time and how, so unlike their Greek contemporaries, they had an active life outside the home.

During the first century CE, landscape painting became especially accomplished in Pompeii. Its appeal was captured by Pliny the Elder, who described it in *Naturalis Historia* (35.116–117) as "that most delightful technique of painting walls with representations of villas, porticoes and landscape gardens, woods, groves, hills, pools, channels, rivers, coastlines—in fact, every sort of thing which one might want, and also various representations of people within them walking or sailing . . . and also fishing, fowling, or hunting or even harvesting the wine-grapes."

An example from Pompeii of a Third Style sacred landscape—a special type of landscape painting that usually includes shrines, statues, trees, water, rocks, figures, and animals—dates from the decade and a half between an earthquake in 62 ce and the final destruction of the city in 79 ce, the period in which Pliny wrote (fig. 6-47). In this scene, a brook runs through a meadow surrounded by rocky hills and trees. Altars and small temples are scattered about, and an open pavilion encloses a sacred tree. A shepherd crosses the bridge, followed by a goat. Watching over the scene is Terminus, the god of boundaries, in the form of a **herm** statue—a head and torso that merges at hip level into a plain plinth, or base. Two conventions

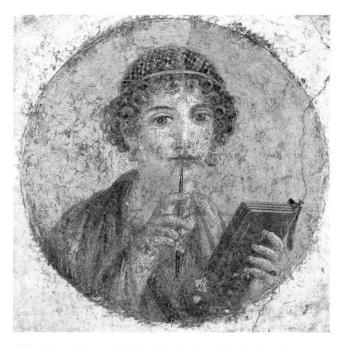

6-48. Young Woman Writing, detail of a wall painting, from Pompeii. Late 1st century ce. Diameter 14⁵/8" (37 cm). Museo Archeològico Nazionale, Naples

The fashionable young woman seems to be pondering what she will write about with her stylus on the

what she will write about with her stylus on the beribboned writing tablet that she holds in her other hand. Romans used pointed styluses to engrave letters on thin, wax-coated ivory or wood tablets in much the way we might use a small chalkboard; errors could be easily smoothed over. When a text or letter was considered ready, it was copied onto expensive papyrus or parchment. Tablets like these were also used by schoolchildren for their homework.

create the illusion of space: distant objects are rendered proportionally smaller than near objects, and the colors become slightly grayer near the horizon, an effect called **atmospheric perspective** that reproduces the tendency of distant objects to appear hazy.

Roman artists sought to capture a sense of peaceful, unspoiled nature in their landscapes, and the overall effect of this painting is one of wonder-invoking nature. It depicts the *locus amoenus*, the "lovely place" extolled by poets, where people lived effortlessly in union with the land. Such an idealized view of the world, rendered with free, fluid brushwork and delicate color, did not appear again in Western art until the latter part of the nineteenth century with the painting of the French Impressionists.

Portraits, perhaps imaginary ones, were popular for wall paintings. A late-first-century CE **tondo** (circular panel) from a house in Pompeii contains a portrait of a *Young Woman Writing* (fig. 6-48). The sitter has regular features and curly hair caught in a golden net. As in a modern studio portrait photograph, with its careful lighting and retouching, she is portrayed in an idealized fashion. In a convention popular among women patrons, she

nude model waiting for her to turn palette, and brushes and a young shown in her studio with paint pots, al painters. The tomb's occupant is that women did become professionrelief illustrated here is clear proof not highly regarded. But the tomb arts, no doubt because artists were erature about women in the visual pany. Almost nothing appears in litfound and run her own dance commanaged despite such restrictions to geous (and very wealthy) woman law to marry actresses. One couraadmired, and men were forbidden by how much their talents were utable members of society, no matter

and begin work.

considered among the most disrepactors—both male and female—were licly. During the imperial period, so long as they did not perform pubinstrumentalists, and even dancers,

to become accomplished singers, Women were also encouraged trious family. of Nero, wrote a history of her illusof the emperor Caligula and mother alike. The younger Agrippina, sister author Martial to men and women works were recommended by the cepted into male literary circles. Her Sulpicia, a writer of elegies, was acrespected for her poetry. Another, woman named Julia Balbilla was well even took up literature themselves. A not so much for any practical training shipbuilding, education was valued such male-dominated businesses as shopkeepers, and even overseers in dle-class women became physicians, same subjects. Although many midteacher, boys and girls studied the years old. In school, under a male ters to school until they were twelve families sent both sons and daughfor their daughters and less-affluent man. The upper classes hired tutors mired as much as a well-educated a well-educated woman was adreceived a formal education, and Greek counterparts. Many women more engaged in society than their Roman women were far freer and fact, careful study has shown that viewed with some reservation. In their male contemporaries must be son written attacks on women by ter than saintliness, and for that reathe contemporary world, sin sold betand society. In ancient Rome, as in ented, and active members of family social events, or well-educated, talpied with clothes, hairstyles, and wicked and willful, totally preoccuman women were either shockingly ing accounts of Roman writers, Ro-

AND THE ARTS

BOWYN MOWEN IL WE WE'RE

the conflict-

to judge from

some male writers. A few women joyed the praise and admiration of reputation for good conversation enlitical and cultural affairs and with a course. Women conversant with politerature, including his own, of classics and contemporary Roman young women to read both the Greek Ovid (43 BCE-C. 17 CE) advised all

it might provide as for the desirable

status it imparted.

Painter in Her Studio, tomb relief. 2nd century ce. Villa Albani, Rome

Aurelius (ruled 161-180 cE)— **EWPERORS**" (ruled 138-161 CE), and Marcus 117-138 CE), Antoninus Pius THE "COOD (ruled 98-117 cE), Hadrian (ruled **EWPIKE:** Nerva (ruled 96-98 cE), Trajan THE EARLY Five very competent rulers—

extent. He annexed Dacia (roughly modern Romania) in increased. Under Trajan the empire reached its greatest ly, and official and private patronage of the arts vastly and prosperity. Italy and the provinces flourished equal-Good Emperors," they oversaw a long period of stability of the Senate to be their successors. Known as the "Five them had natural sons, and they adopted able members succeeded the Flavians. Until Marcus Aurelius, none of

parably to men. pated in all aspects of daily life fully and apparently combusiness managers and domestic workers. They particishown as rich and poor, young and old, employed as Others were the subjects of the painters, and they are were the owners of houses where paintings were found. lives of women during this period. Some, like Julia Felix, ments. The paintings in Pompeii reveal much about the who wanted to be admired for her intellectual attainsional writer (see "Roman Women and the Arts," above) Perhaps, like many Roman women, she was a profesgaze suggest that she is composing a piece of writing. mien and clear-eyed but unfocused and contemplative is shown nibbling on the tip of a writing stylus. Her sweet

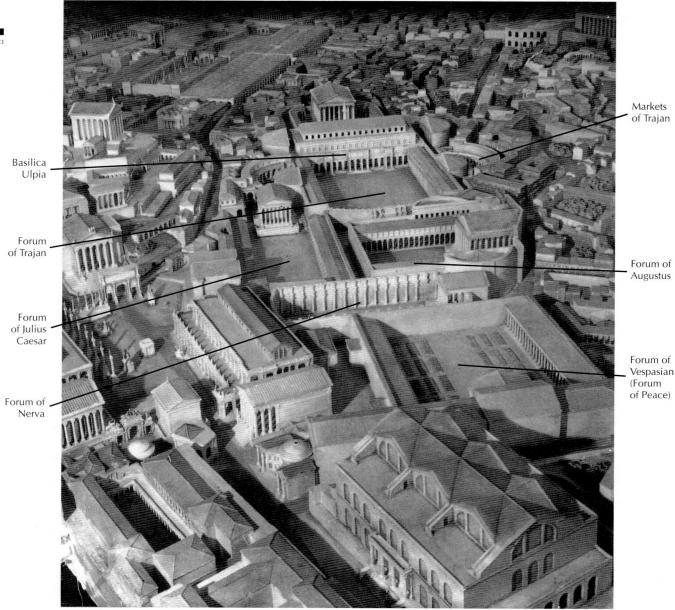

6-49. Model of the Imperial Forums, Rome. c. 46 BCE-117 CE

106 CE and expanded the empire's boundaries in the Middle East. His successor, Hadrian, consolidated the empire's borders and imposed far-reaching social, administrative, and military reforms. Hadrian was well educated and widely traveled, and his admiration for Greek culture spurred new building programs throughout the empire. By the reign of Marcus Aurelius, the empire was facing increasing strains and external threats.

Architecture in Rome and Environs

The Romans believed that their rule extended to the ends of the Western world, but Rome remained the heart and nerve center of the empire. During his long and peaceful reign, Augustus paved the city's old Republican Forum, restoring its temples and basilicas, and built the first

Imperial Forum. These projects marked the beginning of a continuing effort to transform the capital itself into a magnificent monument to imperial rule. Modern Rome has almost obliterated the ancient city, so we can only imagine its appearance from drawings, plans, and models. These models show major monuments such as the Colosseum, the Arch of Titus, the Circus Maximus (a track for chariot races), the Imperial Forums, the round, domed temple called the Pantheon, and the aqueducts among the densely packed temples, monuments, baths, warehouses, and homes that choked the city center.

The largest and most elaborate of the Imperial Forums (fig. 6-49) was that of Trajan, which he had constructed on a large piece of property next to the earlier forums of Augustus and Julius Caesar. For this major undertaking, Trajan chose a Greek architect, Apollo-

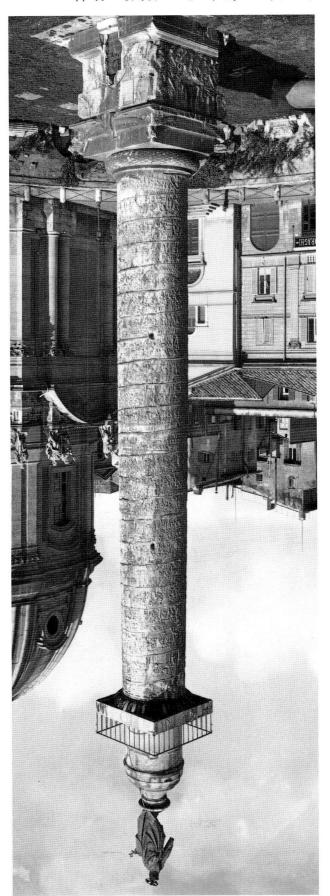

(m 77.62) "8'79 overall height with base 125' (38 m), column alone, 6-51. Column of Trajan, Rome. 106-13 ce. Marble,

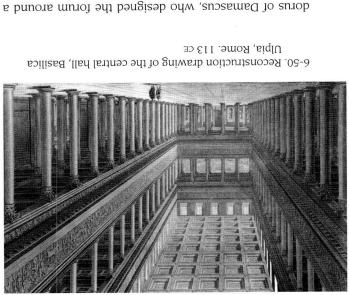

to Christians, who appropriated it for their churches. capacious and adaptable interior later made it attractive ica design was that it provided easy access in and out. Its drill halls, and schools. An important feature of the basillaw. Others served as imperial audience chambers, army adapted to many uses. The Basilica Ulpia was a court of general-purpose administrative structure, it could be with a rounded extension, called an apse, at each end. A belonged. A basilica was a large, rectangular building cated in 113 ce and named for the family to which Trajan the main building in the forum, the Basilica Ulpia, dedilar to the courtyard and closing it off at the north end was statue of Trajan on horseback at its center. Perpendicuchariot group into a large, colonnaded courtyard with a tus through a triple-arched gate surmounted by a bronze straight, central axis that leads from the Forum of Augus-

interior of the building. The apse spaces at each end of hypostyle hall (see fig. 3-29), that brought light to the creating a clerestory with windows, as in the Egyptian central space was taller than the surrounding gallery, were surmounted by open galleries (fig. 6-50). The The Basilica Ulpia had several doors on the long

the building provided imposing settings for judges when

the court was in session. central area bordered by two colonnaded aisles that sides. The interior space was partitioned into a large,

forum. It was built by the emperor Hadrian after his prethe fourth side of the court and closing off the end of the Divine Trajan stands opposite the Basilica Ulpia, defining a monument to him and his tomb. The Temple of the column was built between 106 and 113 ce and was both memorate his victory over the Dacians (fig. 6-51). The court in which Trajan erected a large column to comand Greek manuscripts. These buildings flanked an open built to house the emperors' large collections of Latin

Just behind the Basilica Ulpia were twin libraries

unfurled. Like a giant scroll, it contains a continuous upward in a band that would stretch about 656 feet if The relief decoration on the Column of Trajan spirals decessor's death and apotheosis in 117.

pictorial narrative of the entire history of the Dacian

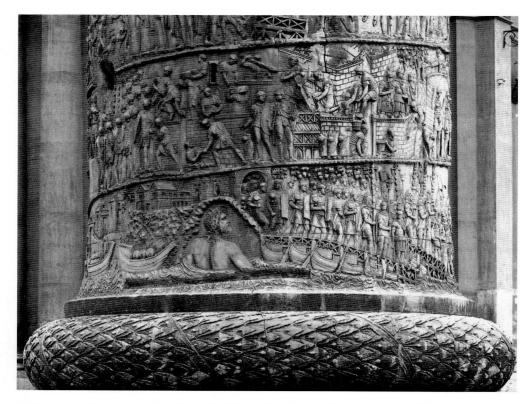

6-52. Romans Crossing the Danube and Building a Fort, detail of the lowest part of the Column of Trajan. Height of the spiral band approx. 36" (91 cm)

campaign. This remarkable sculptural feat involved creating more than 2,500 individual figures—including soldiers, animals, and hangers-on—linked by landscape, architecture, and the recurring figure of Trajan. The artist took care to make all of the scroll legible. The narrative band slowly expands from about 3 feet in height at the bottom, near the viewer, to 4 feet at the top, where it is far from the viewer, and the natural and architectural frames for the scenes have been kept small relative to the important figures in them.

The scene at the bottom of the column (fig. 6-52) shows the army crossing the Danube River on a pontoon (floating) bridge as the campaign gets under way. A giant river god, providing supernatural support, looks on. In the scene above, soldiers have begun constructing a battlefield headquarters in Dacia from which the men on the frontiers will receive orders, food, and weapons. Throughout the narrative, which is, after all, a spectacular piece of imperial propaganda, Trajan is portrayed as a strong, stable, and efficient commander of a well-run army, whereas his barbarian enemies are shown as pathetically disorganized and desperate. The hardships of war—death, destruction, and the suffering of innocent people—are ignored, and, of course, the Romans never lose a battle.

During the site preparation for the forum, much of the commercial district on the Quirinal Hill had to be razed and excavated. To make up for the loss, Trajan ordered the construction of a handsome public market in the shadow of the forum's wall (fig. 6-53). The complete ex-

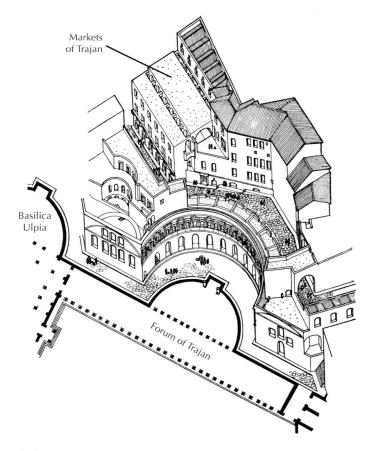

6-53. Axonometric drawing of the Markets of Trajan, Rome. 110- $12\ \text{CE}$

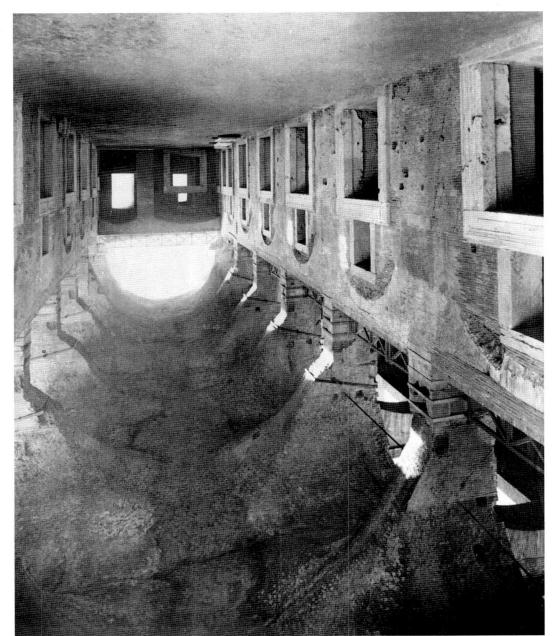

6-54. Main hall, Markets of Trajan

itself rather than the solid surfaces of the architecture intensely aware of the shape and tangibility of the space ple, the visitor feels isolated from the real world and 6-56). Standing at the center of this nearly spherical temin diameter and 143 feet from the floor at its summit (fig. ed on these is a huge, round, bowl-shaped dome, 143 feet with 20-foot-thick walls that rise nearly 75 feet. Support-Behind this porch is a giant rotunda (a circular building) ble the facade of a typical Roman temple (fig. 6-55). turies of dirt and street construction) and made to resemwas raised originally on a podium (now covered by cenany hint of what lies beyond the entrance porch, which separate from any surrounding structures. Nor is there suggestion of what it must have looked like when it stood later destroyed. The approach to the temple gives little

concrete, with only some detailing in stone and wood. after a disastrous fire in 64 ce, it was made of brick-faced compliance with a building code that was put into effect included a large groin-vaulted main hall (fig. 6-54). In than 150 individual shop spaces on several levels and the east wall of the Forum of Trajan. The market had more lar structure that follows the shape of the huge exedra in mall, is unknown. The remaining building is a semicircucompared favorably with any modern indoor shopping tent of this much-damaged structure, which would have

on the site of a temple erected by Agrippa in 27-25 BCE but patronage of Emperor Hadrian between 125 and 128 ce the Pantheon ("all the gods"). It was built under the viving in Rome is a temple to the Olympian gods called One of the most remarkable ancient buildings sur-

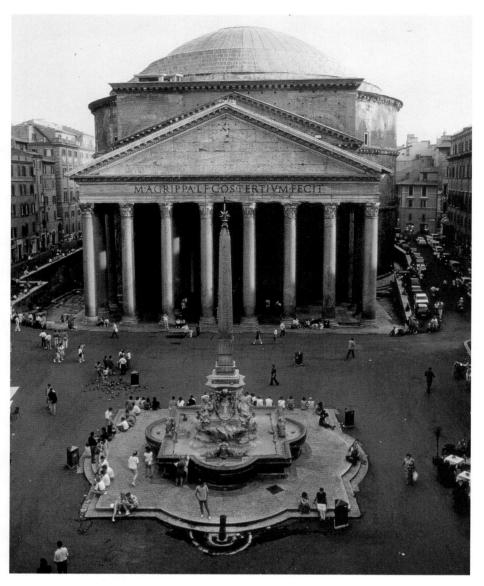

6-55. Pantheon, Rome. 125-28 CE

Although this magnificent monument was designed and constructed entirely during the reign of the emperor Hadrian, the long inscription on the architrave clearly states that it was built by "Marcus Agrippa, son of Lucius, who was consul three times." Agrippa, the son-in-law and valued adviser of Emperor Augustus, died in 12 $_{\rm BCE}$, but he was responsible for the building of a previous temple on this site in 27–25 $_{\rm BCE}$, which the Pantheon replaced. In essence Hadrian simply made a grand gesture to the memory of the illustrious Agrippa, rather than using the new building to memorialize himself.

enclosing it. The eye is drawn upward over the circle patterns made by the sunken panels, or **coffers**, in the dome's ceiling to the light entering the 29-foot-wide **oculus**, or central opening. Clouds can be seen through this opening on clear days; rain falls through it on wet ones, then drains off as planned by the original engineer; and occasionally a bird flies through it. But the empty, luminous space also imparts a sense of apotheosis, a feeling that one could rise buoyantly upward to escape the spherical hollow of the building and commune with the gods.

The simple shape of the Pantheon's dome belies its sophisticated design and engineering. Its surface of

marble veneer disguises the internal brick arches and concrete that support it. The walls, which form the structural **drum** that holds up the dome, are disguised by a wealth of architectural detail—columns, exedrae, pilasters, and entablatures—in two tiers. Seven niches, rectangular alternating with semicircular, originally held statues of the gods. This simple repetition of square against circle, which was established on a large scale by the juxtaposition of the rectilinear portico against the rotunda, is found throughout the building. The square, boxlike coffers inside the dome, which help lighten the weight of the masonry, may once have contained gilded bronze **rosettes** or stars suggesting the heavens.

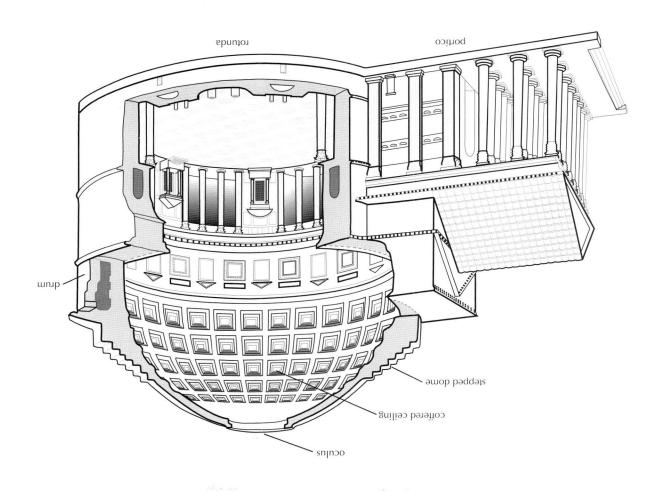

6-56. Reconstruction drawing of the Pantheon

It is not clear what the early Romans themselves thought of this architectural monument, so well known to travelers and students today, because it was rarely mentioned by any contemporary writers. An exception was Ammianus Marcellinus, who described it in 357 ce with restrained praise as being "rounded like the boundary of the horizon, and vaulted with a beautiful loftiness." Although the Pantheon has inspired hundreds—perhaps thousands—of faithful copies, inventive variants, and eclectic theory in the centuries, only recently has the true complexity and the innovative engineering of its construction been fully understood.

were not large, but they were extremely complex, providing ingenious examples of Roman planning and engineering. The villa's architects exploited to the fullest the flacing. The villa's architects exploited to the fullest the faced structures with veneers of marble and travertine and with exquisite mosaics resembling paintings (see and plants, turning the villa into a place of sensuous and plants, turning the villa into a place of sensuous and plants, turning the villa into a place of sensuous pool, called the Canopus after a site Hadrian had seen at that city on the Vile near Alexandria, was framed by a fanciful colonnade with alternating semicircular and straight entablatures (fig. 6-58). The spaces between the straight entablatures (fig. 6-58). The spaces between the

Hadrian was a great builder whose undertakings extended beyond public architecture to private dwellings. For his splendid villa at Tivoli outside Rome (fig. 6-57), he instructed his architects to re-create his favorite places throughout the empire: the Grove of Academe outside Athens in which Plato had founded his academy; the Painted Stoa in the Agora of Athens; and various buildings in and near the Ptolemaic capital of Alexandria, Egypt. Hadrian's Villa was not a single building but an architectural complex of many buildings, lakes, and garachitectural complex of many buildings, lakes, and garachitectural complex of many buildings, lakes, and garachitectural land as a square mile. Each section had its own inner logic, and each took advantage of natural land formations and attractive views. The individual buildings formations and attractive views. The individual buildings

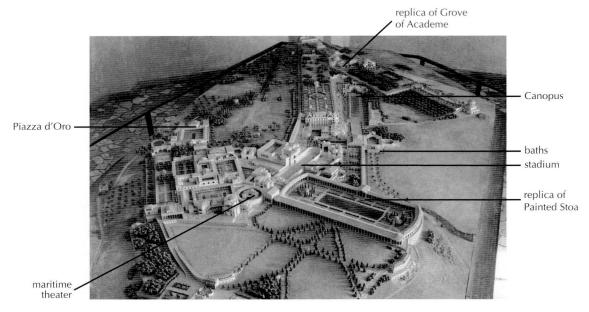

6-57. Model of Hadrian's Villa, Tivoli. c. 135 ce

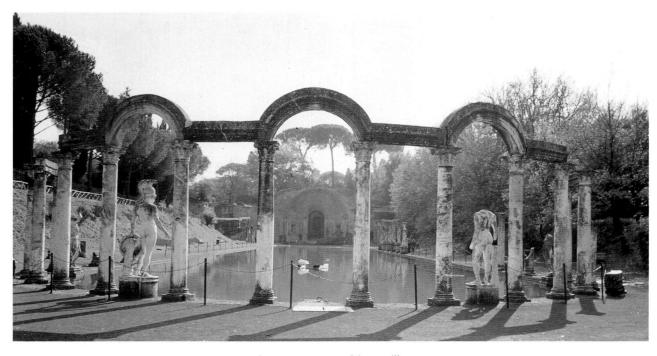

6-58. Canopus, Hadrian's Villa

columns were filled with copies of Greek statues. So great was Hadrian's love of Greek sculpture that he even had the **caryatids** of the Erechtheion (see fig. 5-51) replicated for his pleasure palace.

Architecture in the Provinces

During his reign, Trajan founded and built a new town at Timgad in the Algerian desert that was once home to 15,000 people (figs. 6-59, 6-60). This abandoned and ruined city has revealed almost as much about the culture of the empire as the cities buried by Vesuvius. The Roman architects who designed such new towns, cities,

and forts or who expanded and rebuilt existing ones were masters of urban planning. Adopting the grid plan of the Etruscan and later Greek cities, they divided towns into four quarters defined by intersecting north-south and east-west arteries, called, respectively, the *cardo* and the *decumanus* by modern archeologists. A town forum was usually located at this intersection. Terrain and climate had little effect on this simple, efficient plan, imposing in its symmetry, which remained much the same throughout the empire.

Timgad was a community where soldiers and their families, especially those who had served in the region, went when they retired. As such, it reflects the depen-

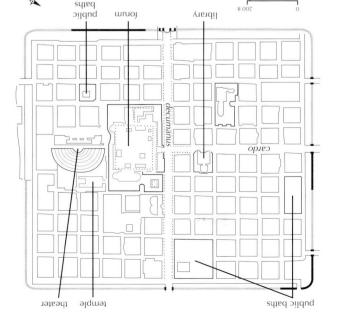

6-59. Plan of Timgad, Algeria. Begun c. 100 ce

dence of emperors on the support of their troops, for retiring soldiers received a pension in money or land. As land became scarce in Italy, the emperors established provincial communities like Timgad. As initially laid out, it was a square of about 30 acres with four equal districts set off by the main streets. The forum and a theater straddled the cardo just south of the intersection with the decumanus at the town center. Other amenities included a library and several public baths. Elaborate triumphal arches marked the main entrances to the town, and its streets, paved with precisely cut and fitted ashlar blocks, were once colonnaded (fig. 6-61).

Another of Trajan's projects was a grand market on the south side of Miletos in Asia Minor. Markets were an essential part of city life, and improving them, often with

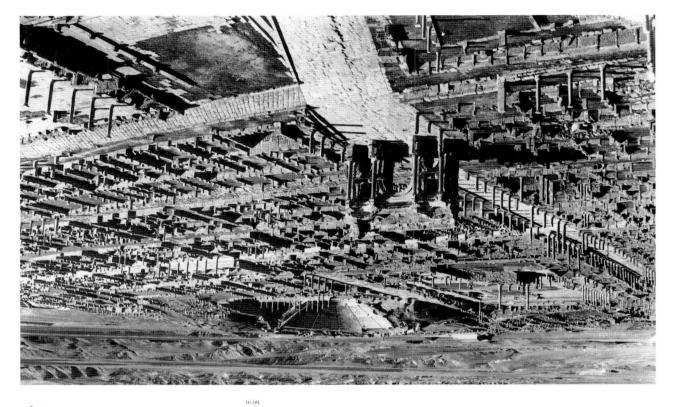

6-60. Ruins of Timgad

6-61. *Decumanus* (main east-west thoroughfare), Timgad

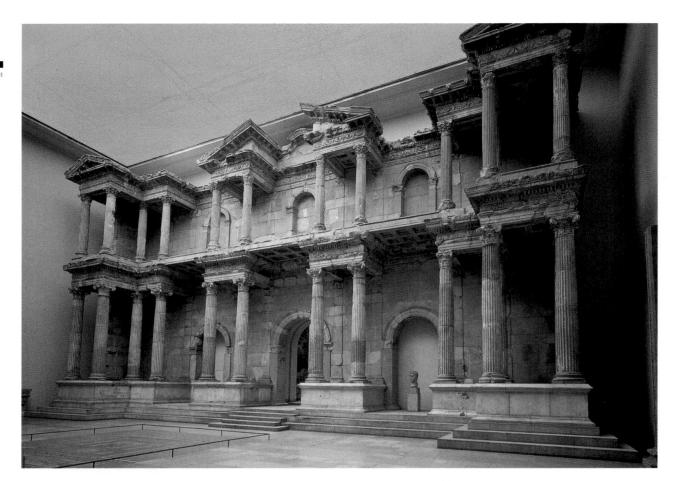

6-62. Market Gate, from Miletos (Turkey). c. 120 ce. Staatliche Museen zu Berlin, Preussischer Kulturbesitz, Antikensammlung

splendid architectural settings, was a way for wealthy families as well as emperors to curry popular favor. Only the core of Trajan's market buildings survives. The gate added in 120 ce, however, exemplifies the grandeur of some of these provincial projects (fig. 6-62). The twostory structure, now inside a museum in Berlin, is about 54 feet wide and resembles somewhat the backdrop of a Roman theater. It also brings to mind the fanciful illusionistic architecture seen in Pompeiian wall paintings. In its original setting, it functioned as a porchlike entrance to the market square. The facade, with its projecting ends, has three arched openings, and the whole is screened by a series of paired columns. The columns on the lower level are of the Composite order. These support short sections of entablature with carved friezes that in turn support the cornice of the second level. The shorter Corinthian columns and entablatures on the second level repeat the design of the lower level, except that the two center pairings support a broken pediment, which consists of the ends of a typical triangular pediment without a middle. The overall effect of structures like the gate at Miletos, with their design and structural innovations, was to evoke a sense of awe in the everyday passerby.

Hadrian's Wall, in northern Britain, was at the opposite end of the empire (fig. 6-63). Unlike the market gate, with its commercial, civilian setting, the wall and the forts

that protected it were strictly military structures. This stone barrier snakes from coast to coast across a narrow (80-mile-wide) part of Britain. Some 4 to 5 feet thick and 12 to 14 feet high, it created a symbolic as well as a physical boundary between Roman territory and that of the barbarian Picts and Scots to the north. Towers were located at every mile mark. Seventeen larger camps, located at regular intervals, housed auxiliary forces ready to respond to any trouble the sentries might spot. These camps—like towns modeled on them—were laid out in a grid, with main streets dividing them into blocks (fig. 6-64). In the center were the praetorium (the commander's house and administrative headquarters), granaries, and the hospital, and surrounding these were barracks. These facilities and the wall itself are impressive reminders of the Roman occupation of northern Europe.

Relief Sculpture

The port of Ostia near Rome had grown so busy by the early empire that it was expanded with a new artificial harbor a short distance from the sea and connected to it by a canal. This harbor came to be known as Trajan's Harbor after he expanded it further. A relief panel created about 200 CE and discovered near the harbor marvelously combines a depiction of bustling seaport life

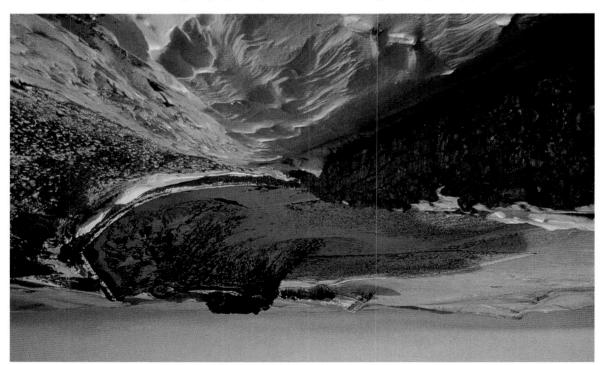

6-63. Hadrian's Wall, seen near Housesteads, England. 2nd century ce

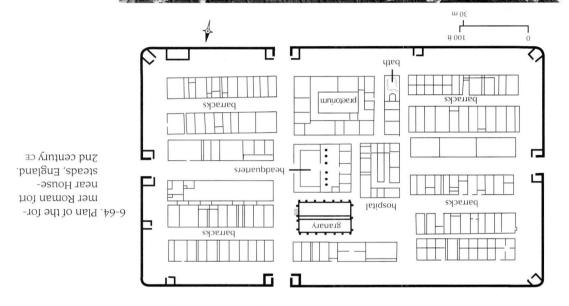

6-65. Allegorical
Harbor Scene,
relief found
near Trajan's
Harbor, Ostia.
c. 200 cE.
Marble.
Marble.
Museo Torlonia, Rome

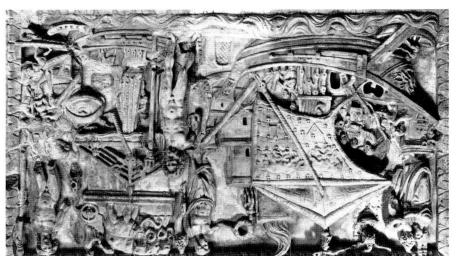

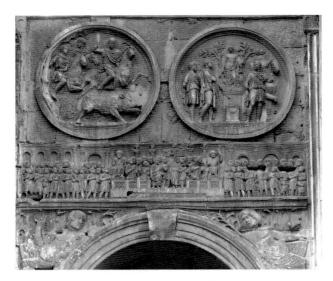

6-66. Hadrian Hunting Boar and Sacrificing to Apollo, roundels made for a monument to Hadrian and reused on the Arch of Constantine. 130–38 ce. Marble, roundel diameter 40" (102 cm)

with an allegorical representation of Rome's maritime power (fig. 6-65). Like earlier plebeian sculpture, this panel conveys a great deal of specific information. Minutely detailed figures of sailors, dockworkers, and harbor supervisors are shown hard at work, ship passengers settle themselves under sails, and large figures of the gods in Classical Greek poses overlook the activities. At the top right is Bacchus, leaning on his staff and pouring wine from a jug into the sea. At the center stands the sea god Neptune holding his trident. The well-outfitted ship that appears to be entering the harbor bears the symbol of Rome on its sail—a she-wolf nursing the twins Romulus and Remus. Flying above the ship is an eagle, and on each side of it are two figures—a personification of the Senate on the right and of the Roman people on the left extending wreaths of triumph. In the background is the harbor's lighthouse with its perpetual flame, and on the right, behind the ship with furled sails, can be seen the attic story of a triumphal arch, atop which is a statue of a rider and a chariot pulled by four elephants.

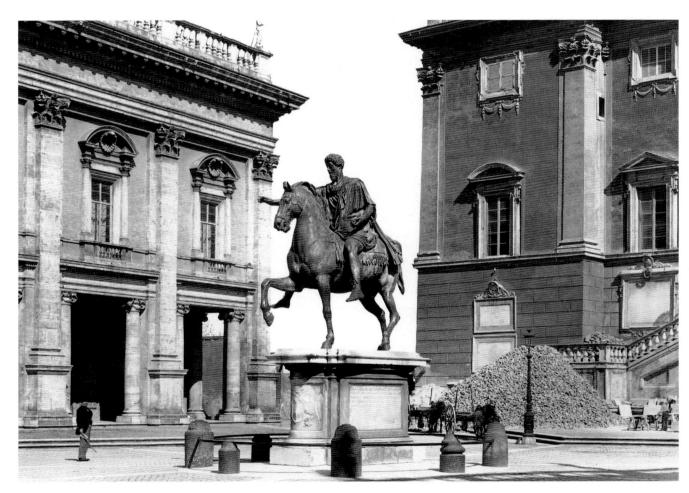

6-67. *Marcus Aurelius*. 161–80 ce. Bronze, originally gilded; height of statue 11'6" (3.5 m). Formerly in the Piazza del Campidoglio, Rome

This statue stood for centuries in the piazza fronting on the palace and church of Saint John Lateran in Rome. In January 1538 Pope Paul III had it moved to the Capitoline Hill, where it became the focus of a renovation and building program that created the Piazza del Campidoglio as it looks today. The statue is shown here in its original location, in the center of the piazza with the Palazzo Senatorio behind it and the Palazzo Nuovo (New Palace, today the Capitoline Museum) at the left. After being removed from its base for cleaning and restoration work some years ago, it was taken inside the Capitoline Museum to preserve it from the continued effects of Rome's polluted air.

each scene recarved with his own features or those of his umphal arch (see fig. 6-84) and had Hadrian's head in from the Hadrian monument placed on his own trifourth century ce, Emperor Constantine had the roundels figural depiction close to that of Classical Greece. In the for a time Roman artists achieved a level of idealized shows the influence of Hadrian's love of Greek art, and Much of the sculpture of the mid-second century ce and the bits of landscape are characteristically Roman. (Chapter 5), but the well-observed details of the features a distant debt to the works of Praxiteles and Lysippos and graceful yet energetic movement of the figures owe figures. The idealized heads, form-enhancing drapery, small, using them to frame the proportionally larger a natural landscape setting but kept them relatively the sculptor of these roundels has included elements of

Portrait Sculpture

father, Constantius Chlorus.

beneficent gesture. Augustus, he reaches out to the people in a persuasive, will of the gods. And like his illustrious predecessor like the Egyptian kings, he conquers effortlessly by the The emperor wears no armor and carries no weapons; ditional "philosopher" portraits of the Republican period. became popular among Roman men), resembles the trabegun by Hadrian to enhance his image and then with its thick, curly hair and full beard (a style that was trample a figure of a crouching barbarian (lost). His head, a commander. The raised foreleg of his horse is poised to emperor is dressed in the tunic and short, heavy cloak of other bronze equestrian statues from antiquity. The escaped the fate of being melted down, which befell all statue of Constantine, the first Christian emperor, and (fig. 6-67) came early but mistakenly to be revered as a once-gilded bronze equestrian statue of the emperor attainments. In a lucky error—or twist of fortune—a commander, but he was equally proud of his intellectual Marcus Aurelius, like Hadrian, was a successful military

found a balance acceptable to viewers of the time and, in trian portrait so that the rider stands out as the dominant It is difficult to balance the composition of an eques-

Marcus Aurelius was succeeded by his son Comand relatively small animals prized as war steeds. that it is from a Spanish breed of strong, compact, agile, high-arched neck, massive head, and short body suggest doing so, created a model for later artists. The horse's sculptor of this equestrian statue of Marcus Aurelius figure without making the horse look too small. The

facial features, and drapery. The portrait conveys the on the figure and bring out the textures of the hair, beard, and expert drillwork exploit the play of light and shadow character (fig. 6-68). The sculptor's sensitive modeling ble bust of Commodus dressed as Hercules reflects his the finest artists of the day for his commissions. A marand frivolous pursuits. He did, however, attract some of tunate reign (180–192 ce) he devoted himself to luxury competence, or intellectual distinction. During his unformodus, a man without political skill, administrative

(118 cm). Palazzo dei Conservatori, Rome 6-68. Commodus as Hercules. c. 190 ce. Marble, height 461/2"

golden apples from the garden of the Hesperides. club, the skin and head of the Nemean Lion, and the with references to the hero's legendary labors: his the emperor is shown in the guise of Hercules, adorned in his bath by a wrestling partner. In this portrait, including his mistress, arranged to have him strangled dressed and armed as a gladiator, his associates, diana. When he proposed to assume the consulship and changed the name of Rome to Colonia Commomonths of the Roman year to be renamed after him appeared in public as a gladiator. He ordered the and the incarnation of the god Jupiter, and he even at various times to be the reincarnation of Hercules not just decadent, he was probably insane. He claimed The emperor Commodus, son of Marcus Aurelius, was

door altar. As did the sculptor of the Column of Trajan, Hadrian makes a sacrificial offering to Apollo at an outciation to the gods for their support of his endeavors, bear and a lion. At the right, in a show of piety and appreroundels, not included here, show him confronting a courage and physical prowess in a boar hunt. Other (fig. 6-66). In the scene on the left, he demonstrates his designed to affirm his imperial stature and right to rule a monument that no longer exists—contain images eral large, circular reliefs or roundels—originally part of ture to promote himself and his accomplishments. Sev-Like his predecessors, Hadrian used monumental sculpenlightening contrast to the Allegorical Harbor Scene. An example of official imperial sculpture offers an

TECHNIQUE

Mosaics were used widely in Hellenistic ROMAN MOSAICS Urban Garden," page 240). So accomplished times and became enormously popular for decorating homes in the Roman period. Mosaic designs are created with pebbles or with small, regularly shaped pieces of hard stone, marble, or manufactured colored glass, called tesserae. Today the stones are usually glued onto a firm backing, but in ancient times they were pressed into a kind of soft cement called grout. When the stones were firmly set, the spaces between them were also filled with cement. After the surface dried, it was cleaned and polished. At first, mosaics were used mainly as durable, water-resistant coverings on floors and pavements. They were done in a narrow range of colors depending on the natural color of the stone—often earth tones or simply black or some other dark color on a light background. When they began to appear on walls at outdoor fountains, a wide range of colors was used (see "The

were some mosaicists that they could create works that looked like paintings. In fact, at the request of patrons, they often copied well-known paintings employing a technique in which very small tesserae, in all the needed colors, were laid down in irregular, curving lines that very effectively mimicked painted brushstrokes.

Mosaic production was made more efficient by the development of emblemata (the plural of emblema, "central design"). These small, mosaic compositions were created in the artist's workshop in square or rectangular trays of marble or terra-cotta. They could be made in advance, carried to a work site, and inserted into a floor or wall otherwise decorated with a simple background mosaic in a plain or geometric pattern. Emblemata were often salvaged from older floors and reused in new ones much later.

illusion of life and movement, but it also captures its subject's foolishness. The weakness of the man comes through the grand pretensions of his costume.

Mosaics

Pictorial mosaics covered the floors of fine houses, villas, and public buildings throughout the empire. Working with very small tesserae (pieces of glass or stone) and a wide range of colors, mosaicists achieved remarkable illusionistic effects (see "Roman Mosaics," above). A floor mosaic from Hadrian's Villa at Tivoli illustrates extraordinary artistry (fig. 6-69). It may be a copy of a work by the Greek artist Zeuxis, of the late fifth century BCE, who was said to have done a much-admired painting of a fight between centaurs and wild animals. In a

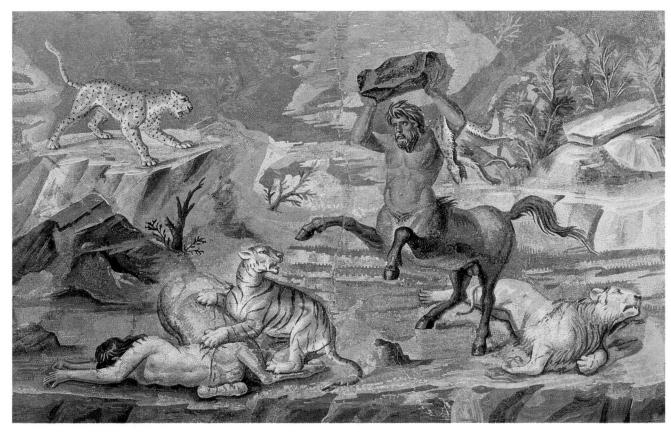

6-69. Battle of Centaurs and Wild Beasts, from Hadrian's Villa, Tivoli. c. 118-28 ce. Mosaic, 23 x 36" (58.4 x 91.4 cm). Staatliche Museen zu Berlin, Preussischer Kulturbesitz, Antikensammlung

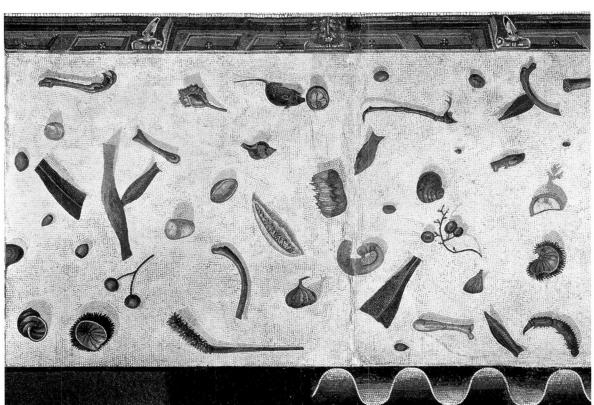

century ce. Musei Vaticani, Museo Gregoriano Profano, ex Lateranense, Rome 6-70. Heracleitus. The Unswept Floor, mosaic variant of a 2nd-century BCE painting by Sosos of Pergamon. 2nd

tary. Soon the army controlled rule became increasingly milithroughout the empire, imperial government. As strains spread in them, disrupting provincial frontiers, and many settled withbarian groups pressed on Rome's ical and economic decline. Barthe beginning of a period of polit-The reign of Commodus marked

TETRARCHS TO THE YTSANYQ SEVERAN **FROM THE EWPIRE: THE LATE**

successor in 217 ce.

the government, and the Imperial Guards set up and

leaders in their own ranks. from among poorly educated, power-hungry provincial deposed rulers almost at will, often selecting candidates

Geta and ruled alone until he in turn was murdered by his emperors in 211 ce, but in 212 ce, Caracalla murdered mius's sons, Caracalla and Geta, succeeded him as co-Temple of Vesta, into a large, luxurious residence. Septiof the House of the Vestal Virgins, who served the the old Republican Forum, including the transformation official portraits, and made some splendid additions to Julia Domna, restored public buildings, commissioned Septimius Severus (ruled 193–211 ce) and his Syrian wife, succeeded Commodus, the arts continued to flourish. Under the Severan emperors (193-235 cE) who

the last in the Severan line, began a half-century of The death of Severus Alexander (ruled 222-235 cE),

> erful animals, living and dead, in a variety of poses. range of figure types, including human torsos and powshading, foreshortening, and a great sensitivity to a mosaicist rendered the figures with three-dimensional and the dead lion at the feet of the male centaur. The in the attack—the white leopard on the rocks to the left another centaur. Two other felines apparently took part crush a tiger that has attacked and severely wounded male centaur raises a large boulder over his head to rocky landscape with only a few bits of green, an enraged

> a single light source—perhaps an open door—raking they cast on the floor, which seem to be the result of and re-created in meticulous detail, even to the shadows for the family pets. The objects are all intensely observed bones, shellfish, fruit, and nuts—seemingly tossed aside 6-70). It shows a mouse among table scraps—meat this design in a work called The Unswept Floor (fig. turies later, the Roman mosaicist Heracleitus adapted representation of a floor littered with refuse. Three cenpainting that included a trompe l'oeil ("fool the eye") BCE, in Pergamon, an artist named Sosos created a large and patrons of the Roman period. In the second century tration. These works fascinated and amused both artists inspired a long-lasting tradition of realistic still-life illusbeholder into thinking they were real seems to have 5) in creating images of flowers and fruit that fooled the The skill of Hellenistic painters like Pausias (Chapter

across from the right.

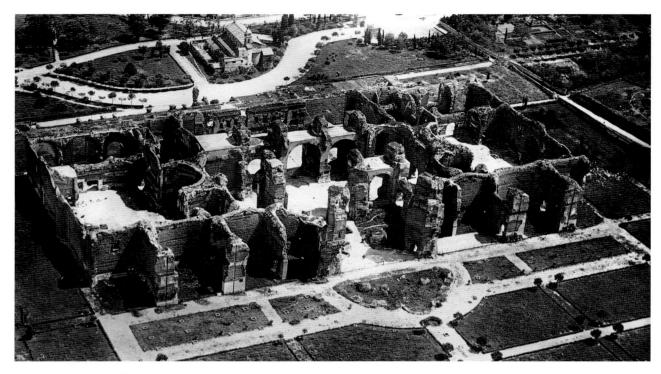

6-71. Baths of Caracalla, Rome. c. 211-17 CE

Although the well-to-do usually had private baths in their homes, women and men enjoyed the pleasures of socializing at the public baths. They did not do so together, however. In some cities, women and men had separate bathhouses, but it was also common for them to share one facility at different times of the day. Everyone—from nobles to working people—was allowed to use the public baths, no matter how grand. Men had access to the full range of facilities, including hot, tepid, and cold baths, moist- and dry-heat chambers (like saunas), pools for swimming, and outdoor areas for sunbathing or exercising in the nude. Women generally refrained from using very hot baths, dry-heat chambers, and the outdoor areas.

anarchy that ended with the rise to power of Emperor Diocletian (ruled 284–305 ce). This brilliant politician and general reversed the empire's declining fortunes, but he also initiated an increasingly autocratic form of rule, and toward the end of his reign he unleashed the persecution of Christians. He and his successors imposed ever more burdensome taxes on their subjects, and under them the social structure of the empire became increasingly rigid.

To distribute the task of defending and administering the empire and to assure an orderly succession, Diocletian devised a form of government called the Tetrarchy, or rule by four. Diocletian divided the empire in two; with the title of Augustus he would rule in the East, while another Augustus, Maximian, would rule in the West. Each Augustus designated a subordinate and heir, who held the title of Caesar. Each of the two regions was thus administered by one of these two co-rulers and his second-in-command. Although Diocletian intended that on the death or retirement of an Augustus, his Caesar would replace him and name a new Caesar, the plan failed when Diocletian tried to implement it.

Architecture

The year before his death in 211, Septimius Severus began a popular public-works project, the construction of magnificent new public baths on the southeast side of Rome (fig. 6-71). The baths were inaugurated in 216–217 ce by his son and successor, Caracalla. For the Romans,

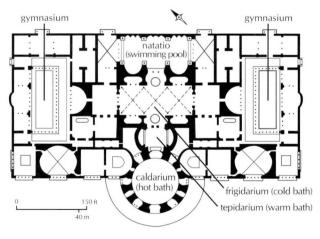

6-72. Plan of the Baths of Caracalla

baths were recreational and educational centers, not simply places to clean themselves, and the emperors built large bathing complexes to gain public favor. The marble, brick, and concrete Baths of Caracalla, as they are now called, were laid out on a strictly symmetrical plan. The bathing facilities were located together in the center of the main building to make efficient use of the belowground furnaces that heated them and to allow bathers to move comfortably from hot to cold pools and finish with a swim (fig. 6-72). Many other facilities—exercise rooms, shops, latrines, and dressing rooms—were housed on each side of the bathing block. The baths alone covered 5 acres. The entire complex, which included gardens, a

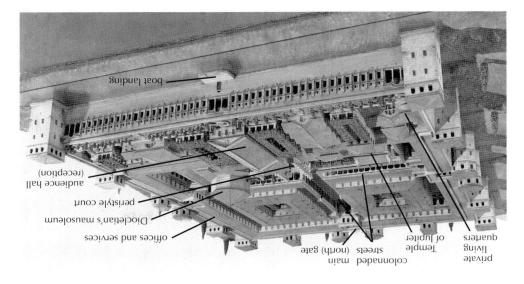

6-73. Model of Palace of Diocletian, Split, Serbian Croatia. c. 300 ce. Museo della Civiltà, Rome

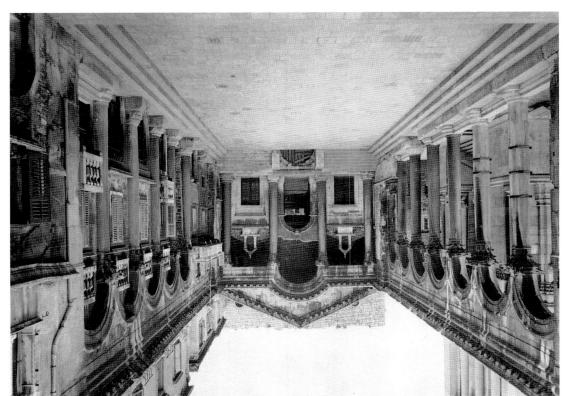

6-74. Peristyle court, Palace of Diocletian

lar enclosure 650 by 550 feet crossed by two colonnaded streets that divided it into quarters, each with a specific function. The emperor's residential complex, which included the reception hall on the main, north-south axis of the palace, faced the sea. Ships bearing supplies or providing transport for the emperor tied up at the narrow landing stage. The support staff lived and worked in buildings near the main gate. A colonnaded avenue extended from this entrance, leading to a peristyle court that ended in a grand facade with an enormous arched doorway through which the emperor made his ceredoorway through which the emperor made his ceremonial appearances (fig. 6-74). Like the Canopus at

stadium, libraries, a painting gallery, auditoriums, and huge water reservoirs, covered an area of 50 acres.

The great palaces such as Hadrian's Villa were often as extensive and semipublic as the Minoan palace at Knossos. Diocletian broke this tradition by building a huge and well-fortified imperial residence at Split, on the Compact, regular plan of a Roman army camp rather than compact, regular plan of a Roman army camp rather than the irregular, sprawling design of Hadrian's Villa. The palace was surrounded by a wall, a reflection of the unstable conditions of the time. It consisted of a rectanguatable conditions of the time. It consisted of a rectanguatable conditions of the time. It consisted of a rectanguatable conditions of the time.

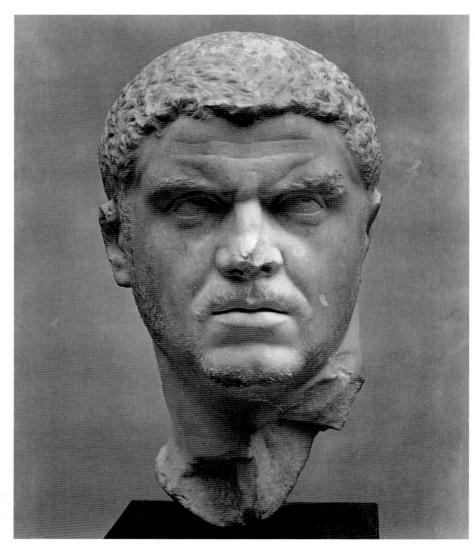

6-75. *Caracalla*. Early 3rd century ce. Marble, height 14½" (36.2 cm). The Metropolitan Museum of Art, New York

Samuel D. Lee Fund, 1940 (40.11.1A)

The emperor Caracalla (ruled $211-217 \, \text{CE}$) was consistently represented with a malignant, scowling expression, a convention meant to convey a particular message to the viewer: the emperor was not a god, not an effete intellectual, not a soft patrician, but a hard-as-nails, battle-toughened military man, a lethal opponent ready to defend himself and his empire.

Hadrian's Villa, the columns of the peristyle court supported arches rather than entablatures (see fig. 6-58). On one side of the court, the arcade opened onto Diocletian's mausoleum; on the other side, it opened onto the Temple of Jupiter.

Portrait Sculpture

Emperor Caracalla emerges from his portraits as a man of chilling and calculating ruthlessness. In the example shown here (fig. 6-75) the sculptor has enhanced the intensity of the emperor's expression by producing strong contrasts of light and dark with sensitive drill and chisel work. Even the marble eyes have been drilled and engraved to catch the light in a way that makes them glit-

ter. It is hard to believe that Caracalla could have favored a portrait that showed him in such unflattering terms, yet he clearly did. Unable to charm his subjects, he apparently preferred to terrify them. The contrast between this style and that of the portraits of Augustus is a telling reflection of the changing character of imperial rule. Augustus presented himself as the first among equals, ruling by persuasion; Caracalla presented himself as a no-nonsense ruler of iron-fisted determination.

The successors of the Severan emperors—the more than two dozen so-called soldier-emperors who attempted to rule the empire before the rise of Diocletian—continued to favor the style of Caracalla's portraits. A bust of Philip the Arab (ruled 244–249 ce), however, does not convey the same malevolence as

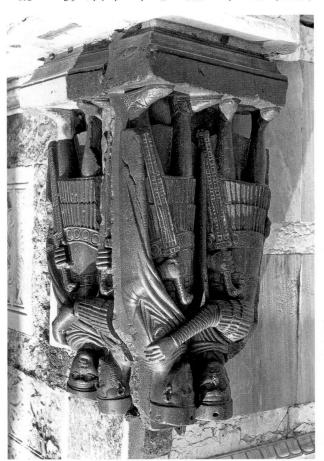

6-77. The Tetrarchs. c. 305 ce. Porphyry, height of figures 51" (129 cm). Installed in the Middle Ages at the corner of the facade of the Church of San Marco, Venice

During the turmoil of the third century, Roman artists

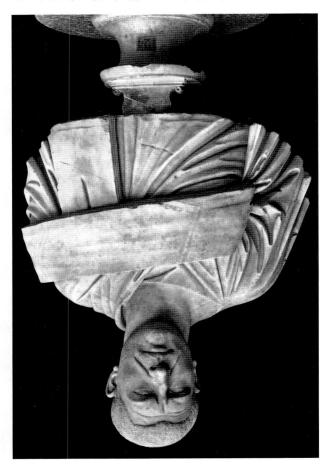

6-76. Philip the Arab. 244–49 ce. Marble, height 26" (71.1 cm). Musei Vaticani, Braccia Nuovo, Rome

tic conventions, may have contributed to the extremely and perhaps the sculptor's familiarity with Egyptian artishardness of the stone, which makes it difficult to carve, purple stone from Egypt reserved for imperial use. The it is unsurpassed. The sculpture is made of porphyry, a ganda and a summary of the state of affairs at the time, concerted strength and vigilance. As a piece of propaof imperial unity, proclaiming a kind of peace through swords at their sides, they embrace each other in a show nearly identical. Dressed in military garb and clasping shaven, probably the Caesars, their adopted sons—are beards, probably the senior Augusti, and two clean sentation of four-man rule. The four figures—two with and their Caesars, it reads instead like a symbolic reprea realistic portrait of Diocletian, his co-ruler Maximian, rulers from the early fourth century CE (fig. 6-77). Hardly The Tetrarchs, a depiction of Diocletian and his three coabstraction and symbolic representation can be seen in ors and the people they ruled. A further turn toward begun to convey the anxious state of mind of the empergeometric forms. By the mid-third century, portraits had subjects and expressing them in increasingly simplified, sizing instead the symbolic or general qualities of their lost interest in representing the natural world, empha-

Caracalla's portraits (fig. 6-76). Philip's expression is more tense and worried, suggesting a troubled man in troubled times. Philip had been the head of the Imperial Cuard but had plotted to murder and replace his predecessor, Emperor Gordian III (ruled 238–244 cE), whom he was pledged to defend. Philip's own short reign also ended in assassination.

muscles is a sense of guile, deceit, and fear. sidelong upward glance, quizzical lips, and tightened jaw itself. What comes through from Philip's twisted brow, nation of the spectator as much as on the carved stone the work depends on the effects of light and the imagithe light playing over the surface. The overall impact of sometimes give the impression of tension as they catch texture of hair. Around the mouth, these small scratches locks, in this portrait tiny flicks of the chisel suggest the which hair and beard were carved to show individual the portraits of Marcus Aurelius and Commodus, in light in the furrows of his face and in his drapery. Unlike and drill to deepen shadows and heighten the effects of structure of the emperor's head, then used both chisel a broad, flat band. The sculptor first modeled the broad hangs in a few stiff folds and drapes across the chest in typical of late imperial dress. Made of heavy material, it Philip is shown wearing a new style of toga that is

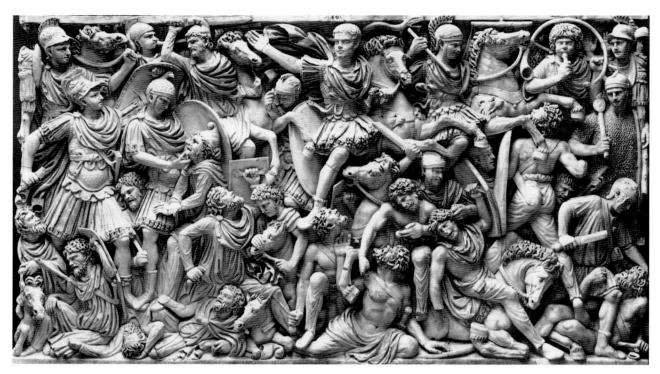

6-78. Battle between the Romans and the Barbarians, detail of the Ludovisi Battle Sarcophagus, found near Rome. c. 250 ce. Marble, height approx. 5' (1.52 m). Museo Nazionale Romano, Rome

abstract style of the work. The most striking features of *The Tetrarchs*—the simplification of natural forms to geometric shapes, the disregard for normal human proportions, and the emphasis on a message or idea—can nevertheless be seen in most Roman art by the end of the third century.

Sarcophagus Reliefs

Although portraits and narrative reliefs were the major forms of public sculpture during the second and third centuries ce, changing funerary practices—a shift from cremation to burial—led to a growing demand for funerary sculpture. A wealthy Roman might commission an elegant stone or marble sarcophagus to be placed in a mausoleum. Workshops throughout the empire produced thousands of these sarcophagi, which were carved with reliefs that ranged in complexity from simple geometric or floral ornaments to scenes involving large numbers of figures. The subjects of the more elaborate reliefs varied widely. Some included events from the life of the deceased and some showed dramatic scenes from Greek mythology and drama, such as the tragedies of Agamemnon's family, the events of the Trojan War, or the Labors of Hercules. Scenes of Bacchus and his followers were extremely popular, no doubt because this cult offered its worshipers an afterlife of perpetual ecstasy in union with the god.

A famous carved stone coffin known as the *Ludovisi Battle Sarcophagus* (after a seventeenth-century owner) dates to about 250 $_{\rm CE}$ (fig. 6-78). It shows a battle be-

tween Romans and barbarians in a style that has roots in the sculptural traditions of Hellenistic Pergamon. The Romans at the top of the panel are efficiently dispatching the barbarians—clearly identifiable by their heavy, twisted locks and scraggly beards—who lie fallen, dying, or beaten at the bottom of the panel. The artist has made no attempt to create a realistic spatial environment. The bare-headed young Roman commander, addressing his troops with an outstretched arm from the back of his valiant steed, is shown in the midst of the battle in a formal equestrian pose like that of the equestrian statue of Marcus Aurelius (see fig. 6-67).

Painting

A portrait of the family of Septimius Severus provides a remarkable insight into the history of the Severan dynasty in addition to revealing something about earlythird-century ce painting (fig. 6-79). The work is in the highly formal style of a region in northwestern Egypt called Faiyum, and it is probably a souvenir of an imperial visit to Egypt. The emperor, clearly identified by his distinctive divided beard and curled moustache, wears an enormous crown. Next to him is his wife, Julia Domna, portrayed with similarly recognizable features full face, large nose, and masses of waving hair. She looks out at the viewer in a defiant manner. Their two sons, Geta and Caracalla, stand in front of them, but Geta's features have been defaced. Perhaps because we know that he grew up to be a ruthless dictator, little Caracalla looks in this portrait like a disagreeable child. Soon

200 CE

after Septimius's death, Caracalla murdered Geta, perhaps with Julia Domna's help, and in a decree called damnatio memoriae declared that Geta's memory be abolished. Clearly the owners of this painting complied with the decree. The work emphasizes the trappings of imperial wealth and power—crowns, jewels, and direct, forceful expressions—rather than attempting a deep, psychological study. The rather hard drawing style, with its broadly brushed-in draperies, contrasts markedly with that of earlier portraits, such as the Young Woman with that of earlier portraits, such as the Young Woman Writing (see fig. 6-48).

Despite the trend toward abstraction, the earlier tradition of slightly idealized but realistic portraiture was slow to die out, probably because it showed patrons as they wanted to be remembered. In the Family of Vunnerius Keramus (fig. 6-80), the subjects are rendered as individuals, although the artist has emphasized their great almond-shaped eyes. The work seems to reflect the advice of Philostratus, who, writing in the late third century CE, commented: "The person who would properly master this art [of painting] must also be a keen observer of human nature and must be capable of discerning er of human nature and must be capable of discerning the signs of people's characters even though they are silent, he should be able to discern what is revealed in the expression of the eyes, what is found in the character of expression of the eyes, what is found in the character of

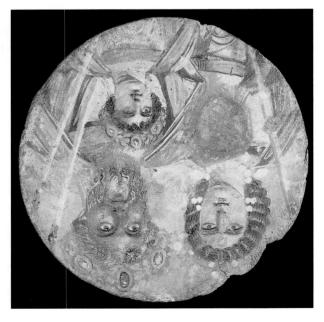

6-79. Septimius Severus, Julia Domna, and Their Children, Caracalla and Geta, from Faiyum, Egypt. c. 200 ce. Painted wood, diameter 14" (35.6 cm). Staatliche Museen zu Berlin, Preussischer Kulturbesitz, Antikensammlung

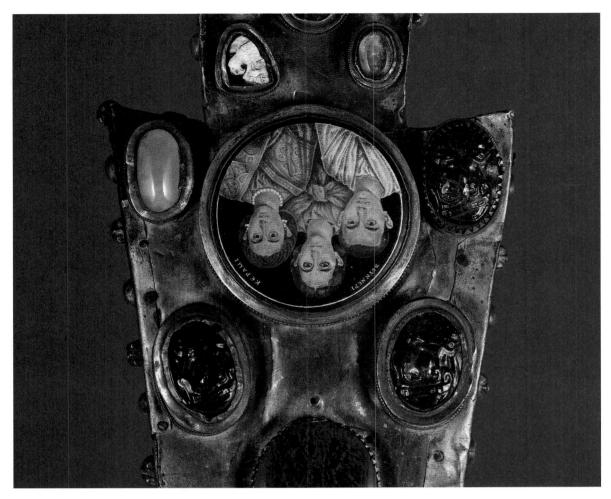

6-80. Family of Vunnerius Keramus. c. 250 cE. Gold leaf sealed between glass, diameter 2⅓8" (6 cm). Museo Civico dell'Età Cristiana, Brescia

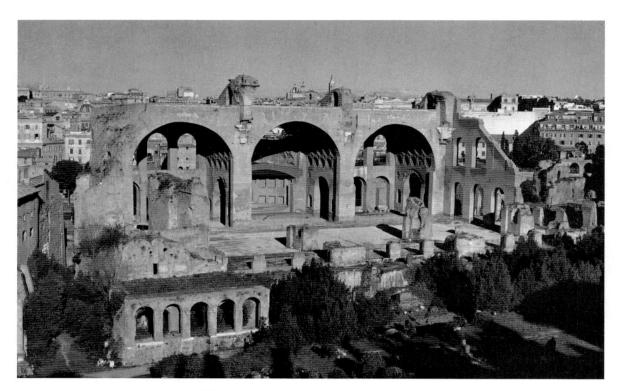

6-81. Basilica of Maxentius and Constantine, Rome. 306-13 ce

the brows, and, to state the point briefly, whatever indicates the condition of the mind."

The Family of Vunnerius Keramus was engraved and painted on sheets of **gold leaf**, then cut out and sealed between two layers of glass. This fragile, delicate medium, most often used for the bottoms of glass bowls or cups—many of which survive—seems appropriate for an age of material insecurity and emotional intensity. Curiously, this particular piece was inserted by a later Christian owner as the central jewel in a decorated seventh-century cross.

THE LATE EMPIRE: CONSTANTINE THE GREAT AND HIS LEGACY

In 305 ce Diocletian abdicated and forced his fellow Augustus, Maximian, to do likewise. The orderly succession he had hoped for failed to occur, and Augusti and Caesars began almost immediately to jockey with each other for position and

advantage. Two main contenders emerged in the western part of the empire: Maximian's son Maxentius (ruled 306–312 ce), and Constantine I, known as The Great (ruled 306–337 ce), son of the Augustus Constantius. Constantine emerged victorious in 312 after defeating Maxentius at the Battle of the Milvian Bridge, at the entrance to Rome. According to a legend popular for centuries, Constantine had a vision the night before the battle in which he saw a flaming cross in the sky and heard these words: "In this sign you shall conquer." The next morning he ordered that his army's shields and

standards be inscribed with the monogram 🔻 (formed of the Greek letters chi and rho, standing for Christos). The legend says that the victorious Constantine then showed his gratitude by ending persecution of Christians and recognizing Christianity as a lawful religion. (In fact chi and rho used together had long been an abbreviation of the Greek word chrestos, meaning "auspicious," and this was probably the reason Constantine used the monogram.) Whatever the impulse, in 313 ce, together with Licinius, who was Augustus in the East, Constantine issued the Edict of Milan, a model of religious toleration: "With sound and most upright reasoning. . . we resolved that authority be refused to no one to follow and choose the observance or form of worship that Christians use, and that authority be granted to each one to give his mind to that form of worship which he deems suitable to himself, to the intent that the Divinity . . . may in all things afford us his wonted care and generosity" (Eusebius, Ecclesiastical History 10.5.5). The Edict of Milan granted freedom to all religious groups, not just Christians. Constantine remained the Pontifex Maximus, or High Priest, of Rome's state religion and also reaffirmed his devotion during his reign to the military's favorite god, Mithras, and to the Invincible Sun, Sol Invictus, a manifestation of Helios Apollo, the sun god.

In 324 Constantine defeated Licinius, his last rival, and would rule as sole emperor until his death in 337. He made the port city of Byzantium his new capital, renaming it Constantinople. This new capital (modern Istanbul, in Turkey) was dedicated in 330, and thereafter Rome, which had already ceased to be the seat of government in the West, declined in importance.

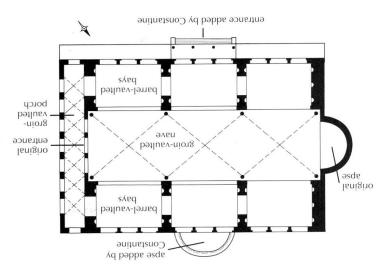

6-82. Plan and isometric reconstruction of the Basilica of Maxentius and Constantine

its gigantic statue of the emperor (see fig. 6-86). accommodate crowds, and another apse across the hall. The effect was to dilute the focus on the original apse, with west. After building had begun, Constantine's architects added another entrance on the southwest, probably to The original plan for the basilica called for a single entrance on the southeast side, facing a single apse on the north-

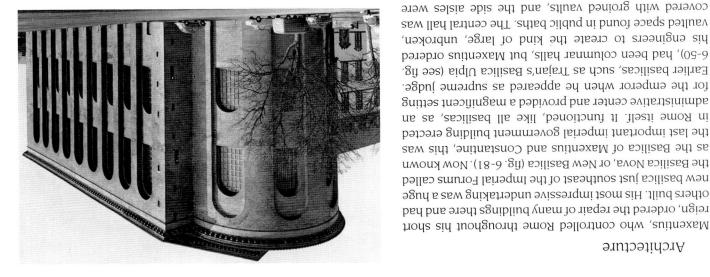

6-83. Basilica, Trier, Germany. Early 4th century CE

was adopted by Christians for use in churches. tional focus along a central axis from entrance to apse dows in the long walls and around the apse. The direcflat wooden-truss ceiling, and is lit by two rows of win-Maxentius and Constantine. It has no side aisles, has a ence for large, unbroken spaces seen in the Basilica of attention is focused. Inside, it carries further the preferand has a single apse opposite the entrance, on which all Basilica Ulpia, the building is entered through one end walls and around windows have disappeared. Unlike the neath the structure, and decorative exterior elements on ground level has risen and covered a high podium bewith a few exceptions (fig. 6-83). Over the centuries, the ing still looks much as it did in the early fourth century,

allowed generous window openings in the clerestory or projecting supports, for the central groin vault and covered with lower barrel vaults that acted as buttresses, covered with groined vaults, and the side aisles were vaulted space found in public baths. The central hall was his engineers to create the kind of large, unbroken, 6-50), had been columnar halls, but Maxentius ordered Earlier basilicas, such as Trajan's Basilica Ulpia (see 11g. for the emperor when he appeared as supreme judge. administrative center and provided a magnificent setting in Rome itself. It functioned, like all basilicas, as an the last important imperial government building erected as the Basilica of Maxentius and Constantine, this was

northern Germanic territories. The exterior of this buildbasilica, built about 310 cE, at Trier, the capital of the 7). Among his achievements was a new palace and a came empirewide by the later years of his reign (Chapter Constantine undertook a building campaign that be-

was an apse of the same width, which acted as a focal

central hall. At the opposite end of the long axis of the hall

(on the southeast) and sheltered a triple entrance to the

feet. A groin-vaulted porch extended across the short side

and the vaults of the central nave rose to a height of 114 Rome. The basilica originally measured 300 by 215 feet

crete barrel vaults still loom beside the streets of modern

areas over the side walls. Three of these brick-and-con-

point for the building (fig. 6-82).

Architecture

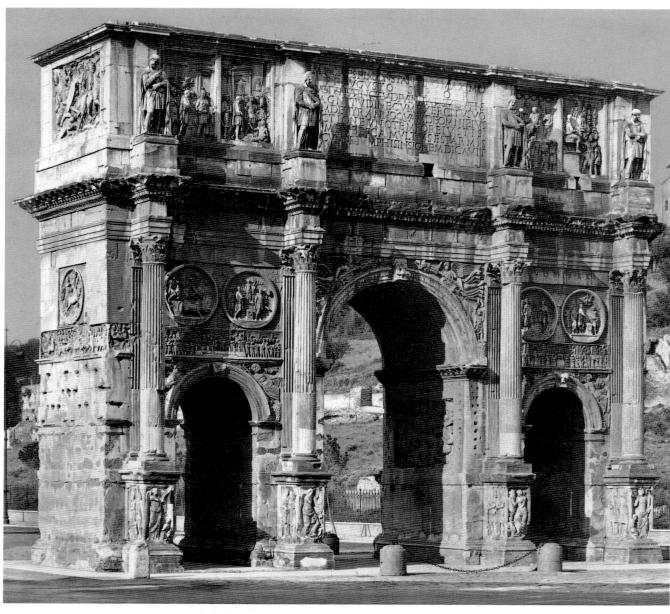

6-84. Arch of Constantine, Rome. 312-15 ce (dedicated July 25, 315)

This massive, triple-arched monument to Emperor Constantine's victory over Maxentius in 312 ce is a wonder of recycled sculpture. On the attic story, flanking the inscription over the central arch, are relief panels taken from a monument celebrating the victory of Marcus Aurelius over the Germans in 174 ce. On the attached piers framing these panels are large statues of prisoners made to celebrate Trajan's victory over the Dacians in the early second century ce. On the inner walls of the central arch (not seen here) are reliefs also commemorating Trajan's conquest of Dacia. Over each of the side arches are pairs of giant roundels taken from a monument to Hadrian (see fig. 6-66). The rest of the decoration is contemporary with the arch.

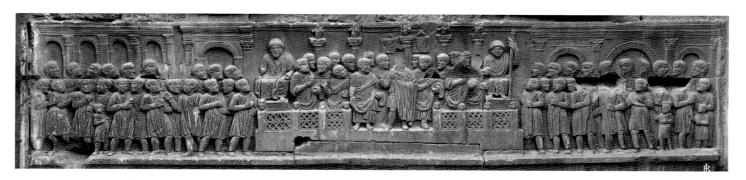

6-85. Constantine Speaking to the People, relief panel from the Arch of Constantine. Marble

800 BCE 400 CE

6-86. Constantine the Great, from the Basilica of Maxentius and Constantine, Rome. 325–26 ce. Marble, height of head 8'6" (2.6 m). Palazzo dei Conservatori, Rome

This fragment came from a statue of the seated emperor. The original sculpture combined marble, wood, and bricks. Only a few marble fragments survive—the head, a hand, a knee, an elbow, and a foot. The body might have been made of colored stone or of wood and bricks sheathed in bronze. This statue, although made of less-expensive materials, must have been as awe-inspiring as the gigantic ivory and gold-clad statues of Nerbens, made in the fifth century BeE by Pheidias, the favorite sculptor of Perikles. Constantine was a master as the use of portrait statues to spread imperial propasitorial. Heads like this, made according to official spectifications, were shipped throughout the provinces to be infractions, were shipped throughout the provinces to be attached to bodies that were locally sculpted.

the East, he commissioned a colossal, 30-foot portrail statue of himself and had it placed in the original apsed (fig. 6-86). This statue was, in effect, a permanent standin for the emperor in Rome, representing him whenever the conduct of business legally required his presence. The sculpture combines features of traditional Roman portraiture with the abstract qualities evident in The Tetrarchs (see fig. 6-77). The defining characteristics of Constantine's face—his heavy jaw, hooked nose, and jutting chim—have been incorporated into a rigid, symmetrical pattern in which other features, such as his eyes, rical pattern in which other features, such as his eyes, eyebrows, and hair, have been simplified into repeated eyebrows, and hair, have been simplified into repeated

The Arch of Constantine

of Septimius Severus is to the right. Julia and the Arch of Tiberius are to the left and the Arch images of Marcus Aurelius and Hadrian. The Basilica columns with the statues on top of them) and flanked by er's platform in front of a monument to the Tetrarchs (the is seated in the Republican Forum on a temporary speak-Maxentius (fig. 6-85). The emperor (his head is missing) making his first public speech after the triumph over tels, for example, depicts Constantine, in the center, ize his power and generosity. A panel in one of the linfor the arch recount the story of his victory and symbolthese earlier emperors to Constantine. New reliefs made virtues of strength, courage, and piety associated with lius. The reused items in effect transferred the old Roman the "good emperors" Trajan, Hadrian, and Marcus Aurements made for Constantine's illustrious predecessors, umphal insignia" were in part looted from earlier monuthis arch, decorated with triumphal insignia." The "triand his party by his army and noble arms, [we] dedicate great wisdom he has delivered the state from the tyrant Roman People. Since through divine inspiration and the Emperor Constantine from the Senate and the decoration and a traditional laudatory inscription: "To mounted by a large attic story with elaborate sculptural are flanked by columns on high pedestals and sur-Titus (see fig. 6-40). Its three barrel-vaulted passageways 6-84), a huge, triple arch that dwarfs the nearby Arch of memorial to Constantine's victory over Maxentius (fig. In Rome, next to the Colosseum, the Senate erected a

the art of the imperial past and the art of the European tian Church. Constantinian art is thus a bridge between ward form, this style was adopted by the emerging Chrisauthority, ritual, and symbolic meaning rather than outrealism of earlier imperial reliefs. With its emphasis on chical approach and stiff style is far removed from the sors on each side of him. This two-dimensional, hierarand connect him visually with the illustrious predecesenthroned Constantine clearly isolate the new Augustus uniform and undifferentiated participants below the ground plane. The arrangement and appearance of the by the miniature buildings of the forum into the forecent of figures in plebeian-style works—are compressed The stocky, mostly frontal, look-alike figures—reministinguishes them from the reused elements in the arch. change in style, approach, and subject matter that disrealistic detail, they nevertheless represent a significant Roman affection for depicting important events with Although these new reliefs reflect the long-standing

Portrait Sculpture

Middle Ages (roughly 476 to 1453 cE).

Constantine, seeking to impress the people of Rome with visible symbols of his authority, put his own stamp on projects Maxentius had started. To the Basilica Nova he added an imposing new entrance in the center of the long side and a giant apse facing it across the three sisles. After he had begun to construct his new capital in aisles. After he had begun to construct his new capital in

6-87. Helen, Mother of Constantine. c. 320 ce. Marble. Museo Capitolino, Rome

6-88. Julian the Apostate, coin issued 361-63 ce. Gold. The British Museum, London

geometric arcs. The result is a work that projects imperial power and dignity with no hint of human frailty or imperfection.

Constantine's mother, Helen, a devout Christian, played an important part in her son's career. Credited by legend with the discovery of Christ's cross, she was later made a saint and represented in Christian art. In one monumental portrait (fig. 6-87), she was depicted in the manner of a Classical Greek reclining goddess.

THE LATE EMPIRE: Constantine was bap-**TRADITIONALISM** his deathbed in 337 ce. IN ART AFTER After his death there

ROMAN tized formally into the Christian religion on CONSTANTINE was a period of civil war, the reuniting of

the empire under his son, Constantius II, then the brief reign (361-363 cE) of Julian, bringing with it religious tumult. Julian the Apostate, as Christian writers called him (apostate means "religious defector"), rejected Christianity and sought to reinstate the worship of Rome's ancestral gods. Himself a follower of Mithras, Julian officially forbade Christian scholars from teaching pre-Christian Greek and Roman literature and wrote treatises attacking the ideas of contemporary Christian writers. He did not ban Christianity but tried to undermine it by adapting some of its liturgical devices and charitable practices for the worship of the traditional gods. He had himself portrayed on coins as a bearded scholar-philosopher (fig. 6-88), an ancient portrait convention also favored by his illustrious predecessor Marcus Aurelius.

Julian died in battle and was succeeded by a series of Christian emperors. By the end of the fourth century, Christianity had become the official religion of the em-

pire, and non-Christians had become the targets of persecution. Many people resisted this shift and tried to revive classical culture. Among them were the Roman patricians Quintus Aurelius Symmachus, a strong opponent of Christianity, and Virius Nicomachus Flavianus, a champion of paganism. A famous ivory diptych—a pair of panels attached with hinges—attests to the close relationship between their families. One family's name is inscribed at the top of each joined panel of the diptych, which may commemorate a marriage between the families. On the panel inscribed "Symmachorum" (fig. 6-89), a stately, elegantly attired priestess makes a ritual offering, apparently to Bacchus, at a beautifully decorated altar. She is assisted by a small child, and the event takes place out of doors under the oak tree sacred to Jupiter. The Roman ivory carvers of the fourth century were extremely skillful, and their wares were widely admired and commissioned by pagans and Christians alike. For conservative patrons like the Nichomachus and Symmachus families, they were able to imitate Augustan style effortlessly. The exquisite rendering of the drapery and foliage is reminiscent of the reliefs on the Ara Pacis (see fig. 6-28).

Classical subject matter remained attractive to artists and patrons, and imperial repression could not immediately extinguish it. Even such great Christian thinkers as bishop and saint Gregory of Nazianzus spoke out in support of the right of the people to appreciate and enjoy their classical heritage, so long as they were not seduced by it to return to pagan practices. As a result, stories of the ancient gods and heroes entered the secular realm as lively, visually delightful, and even erotic decorative elements. As a large silver platter dating from the mid-fourth century CE shows, themes involving Bacchus, the god of grapevines and fertility, continued to

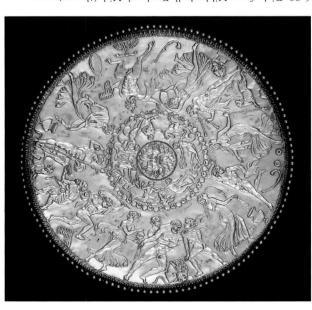

6-90. Dish, from Mildenhall, England. Mid-4th century ce. Silver, diameter approx. 24" (61 cm). The British Museum, London

between silver working and relief sculpture. stone and marble reliefs and suggesting a connection nique of undercutting used to add depth to figures in tours of the subtly modeled bodies, echoing the techskillful artist. Deeply engraved lines emphasize the conclarity, and liveliness of this platter reflect the work of a stupor into the supporting arms of two satyrs. The detail, Hercules has lost his lion-skin mantle and collapsed in a drink. Only a few figures away, the pitifully drunken hero ther, he listens to a male follower begging for another on his shoulder and one foot on the haunches of his panouter circle, Bacchus is the one stable element. Wine jug icking in the waves with fantastic sea creatures. In the of the sea god Oceanus is ringed by nude females frolaround a circular central design. In the center, the head dance to the piping of satyrs (half men, half goats) 6-90). The Bacchic revelers whirl, leap, and sway in a draped human body in complex, dynamic poses (fig. figural compositions displaying the nude or lightly provide artists with the opportunity to create elaborate

Found in a cache of both pagan and Christian treasures near Mildenhall, England, the platter may have been made elsewhere and imported into Britain. It suggests the wealth to be found in the outlying provinces of the Roman Empire. Such opulent items were often hidden away or buried to protect them from theft and looting, a sign of the breakdown of the long Roman peace. The plate's style and subject matter reflect a society in transition. Even as Roman authority gave way to local transition. Even as Roman authority gave way to local many people continued to appreciate classical learning and to treasure Greek and Roman art. In the East, classing and to treasure Greek and Roman art. In the East, classing the additions and styles endured to become an important element of Byzantine art.

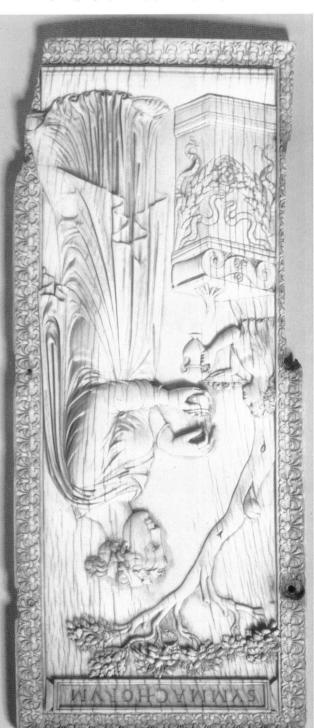

6-89. Priestess of Bacchus(?), right panel of a diptych. c. 390–401 ce. Ivory, 113/4 x 51/2" (29.9 x 14 cm). Victoria and Albert Museum, London

Hagia Sophia 532–37

▲ EARLY CHRISTIAN c: 100-6TH CENTURY:

▲ IMPERIAL CHRISTIAN 313-c. 6TH CENTURY

▲ EARLY BYZANTINE 527-867

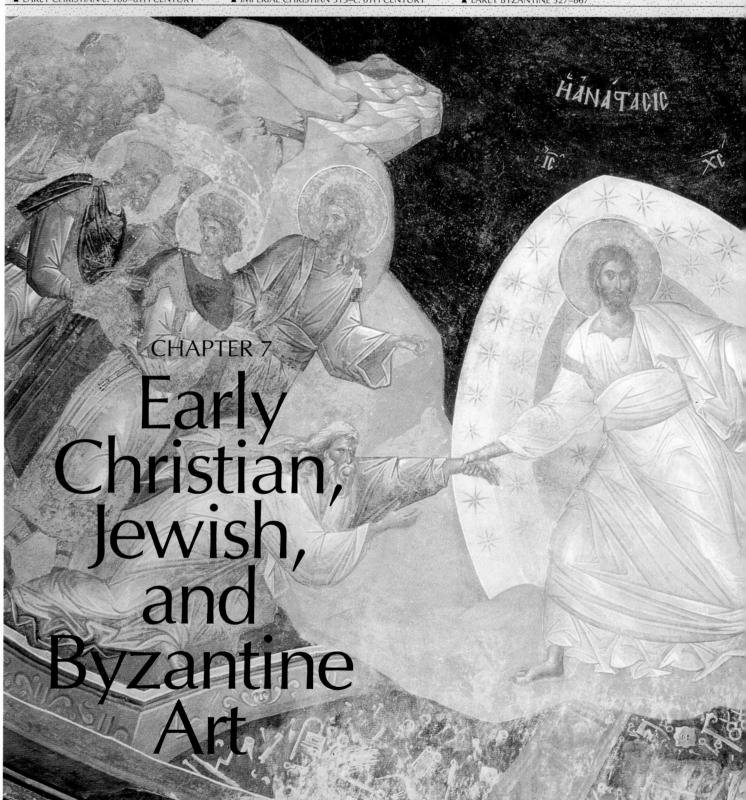

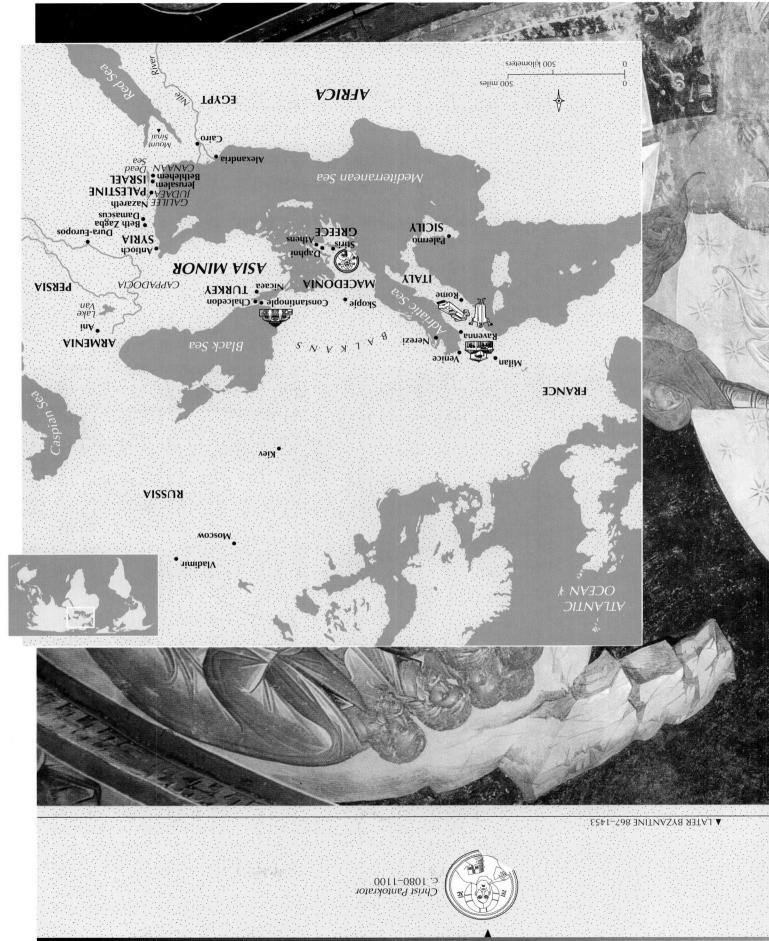

September 1987 September 1998

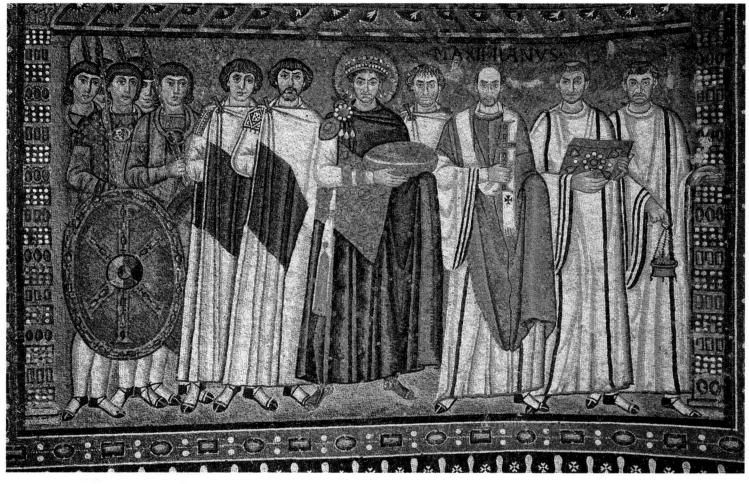

7-1. Emperor Justinian and His Attendants, mosaic on north wall of the apse, Church of San Vitale, Ravenna, Italy. c. 547. 8'8" x 12' (2.64 x 3.65 m)

n a large mosaic on the wall of a church on the northeast coast of Italy, the sixth-century Roman emperor known as Justinian the Great stands firmly between representatives of church and state (fig. 7-1). He dominates the scene just as he dominated his times, which are often referred to as the Golden Age of Justinian. As head of state, Justinian wears a huge jeweled crown and a purple cloak; as head of church, he carries a large golden bowl for the symbolic body of Jesus Christ. The Church officials at his left hold a jeweled cross and a gospel book symbolizing Christ and his church. Justinian's soldiers march under the chi rho monogram, which stands for Christ, on the shield they hold before them. On the opposite wall Empress Theodora, also dressed in royal purple, offers a golden chalice, a symbol steeped in Christian ritual and history (see fig. 7-32).

100 CE 1200 CE

Ironically, neither Justinian nor Theodora probably ever set foot in the Church of San Vitale in Ravenna, whose dedication these mosaics commemorate. Nevertheless, the mosaics are shimmering examples of a major art form of the time that dramatically illustrate the close relationship between secular and religious power in Justinian's world.

trated on the Arch of Titus (see fig. 6-41). golden menorah, the seven-armed candleholder illus-Rome in triumph included ritual articles and the great Josephus (Chapter 6). The sacred treasures carried off to 70 ce were so vividly described by the Jewish chronicler salem whose destruction and looting by the Romans in ond Temple. It was the rebuilt Second Temple of Jeru-BCE-4 cE), began the rebuilding and enlarging of the Secwas built. Herod the Great, king of the region (ruled 37 and about seventy years later, a second, smaller temple The Babylonians destroyed the First Temple in 586 BCE, Jerusalem in the tenth century BCE under King Solomon. ly conquered Canaan and built a permanent temple in ark with them on their desert wanderings until they finalcherubim, or attendant angels. The Israelites carried the Hebrew Scriptures (Exodus 25:10-21), topped by two wooden box whose construction was prescribed in the foundly sacred Ark of the Covenant, a gold-covered The Tablets of the Law were housed in the pro-

longer was an organized priesthood. After the destruction of the Second Temple, there no learning and an individual's direct relationship with God. Egypt. Early Jewish spiritual life emphasized religious over seder marking the Israelites' perilous journey out of cluded commemorative meals, among them the Passscrolls, books, and ritual objects. Important rituals inof Jewish history and belief inspired the creation of curtained shrines. Judaism's rich ceremonial affirmation bers, and Deuteronomy), were read publicly and kept in Hebrew Scriptures (Genesis, Exodus, Leviticus, Numcontaining the Pentateuch, the first five books of the Jerusalem. They were also the sites where Torah scrolls, for the dispersed community following the destruction of expanded, and they began to serve as places for prayer be any large room. Synagogues' role as places of study Judaism than in many religions, and a synagogue could agogues. Specialized architecture was less central in had buildings where they gathered, later known as syn-The Jews had the Temple in Jerusalem, but they also

Early Christianity

Christians believe in one God manifest in three Persons, the Trinity of Father (God), Son (Jesus Christ), and Holy Spirit. According to Christian belief, Jesus was the son of God by a human mother, the Virgin Mary (the Incarnation). His ministry on earth ended when he was execution). His ministry on earth ended when he was executed by being nailed to a cross (the Crucifixion). He rose from the dead (the Resurrection) and ascended into heaven (the Ascension). Christian belief, especially about

Three religions that arose in the Mear East dominate the spiritual life of the Western world: Judaism, Christianity, and Islam. All three religions are monotheistic; followers hold that only one god created and rules the

JEWS AND CHRISTIANS IN THE ROMAN EMPIRE

Middle Ages in Chapters 14, 15, and 16. cussed in Chapter 8, and Christian art of the European Church, are considered in this chapter. Islamic art is disincluding some of the later art of the Eastern Orthodox Gabriel. Jewish and Early Christian art and Byzantine art, in Arabic directly to Muhammad through the angel Muslim Koran, believed to be the Word of God revealed ment as well as the Christian New Testament; and the which includes the Hebrew Scriptures as its Old Testathe Hebrew Scriptures of the Jews; the Christian Bible, that have written records of their God's will and words: after Jesus' lifetime. All three are "religions of the book" through whom Islam was revealed some six centuries (Allah's) last and greatest prophet, the Messenger of God as divinely inspired, believe Muhammad to be God's lims, while accepting the Hebrew prophets and Jesus leadership of the apostles (his closest disciples). Musheaven after establishing the Christian Church under the execution, then rose from the dead and ascended to form, preached among men and women and suffered meaning "Messiah"). They believe that God took human Messiah (the title Christ is derived from the Greek term tional Christians believe that Jesus of Nazareth was that ing of a savior, the Messiah, "the anointed one." Tradithat they are God's chosen people. They await the comcovenant, or pact, with their ancestors, the Hebrews, and universe. Traditional Jews believe that God made a

Early Judaism

The Jewish people trace their origin to the patriarchs Abraham, Isaac, and Jacob. According to the Hebrew Scriptures, Jacob's twelve sons founded the twelve tribes of Israel, who migrated to Egypt, where they lived for several hundred years until harshly oppressed by one of the pharaohs. In the thirteenth century BCE the prophet promised land of Canaan between the Mediterranean promised land of Canaan between the Mediterranean Sea and the Jordan River in what was later called Palestine. The Hebrew Scriptures relate how, on their journey, tine. The Hebrew Scriptures relate how, on their journey, tine. The Hebrew Scriptures and gave Moses the Teation-tine with the Israelites and gave Moses the Ten Combip with the Israelites and gave Moses the Ten Com-

the divinity of Jesus, was formalized at the first all-Church Council, called by Constantine I at Nicaea (modern Iznik, Turkev) in 325.

The life and teachings of Jesus of Nazareth, who was born sometime between 8 and 4 BCE and was crucified at the age of thirty-three, were recorded between about 70 and 100 cE in the New Testament as books attributed to the Four Evangelists, Matthew, Mark, Luke, and John. These books are known as the Gospels (from an Old English translation of a Latin word derived from the Greek

euangelion, "good news"). In addition to the Gospels, the New Testament includes an account of the Acts of the Apostles (one book) and the Epistles, twenty-one letters of advice and encouragement to Christian communities in cities and towns in Greece, Asia Minor, and other parts of the Roman Empire. Thirteen of these letters are attributed to a Jewish convert, Saul, who took the Christian name of Paul. The twenty-seventh and final book is the Revelation (the Apocalypse), a series of enigmatic visions and prophecies concerning the eventual triumph of

ROME, CONSTANTINOPLE, tionship AND **CHRISTIANITY**

The relaof church and state in the Ro-

man-Byzantine world between the fourth and twelfth centuries was complex. This is a simplified account of the intertwined histories of the Roman and Byzantine Empires and the Eastern and Western Churches.

At its height in the second century CE, the Roman Empire extended from the Euphrates River to Scotland, an immense territory that was nearly impossible to defend and administer. Emperor Diocletian (ruled 284-305 cE) attempted a solution by dividing rule among four imperial tetrarchs (including himself) to oversee the Eastern and Western holdings of the empire in 286. Diocletian's experiment failed, leaving political chaos in its wake (Chapter 6). After Constantine I (ruled 306-337) defeated his rivals and became sole emperor in 324, he instituted numerous reforms. These included moving the empire's capital in 330 from Rome to Byzantium, located at the intersection of Europe and Asia. The site offered great advantages in military defense and trade, as well as escape from deteriorating conditions in Rome. The new capital, renamed Constantinople, was the sole seat of the Roman Empire until 395, when the empire split permanently in two, becoming the Western (Roman) Empire and the Eastern (Byzantine) Empire. What remained of the greatly weakened Roman Empire in the West collapsed in 476.

Constantinople inherited Rome's role as the center of power and culture. At its greatest extent, in the sixth century, the Eastern Empire included most of the area around the Mediterranean, including northern Africa, the Levant, Anatolia, and all of Greece, much of Italy, and a small part of Spain. The Byzantines always called themselves Romans and their empire the Eastern Roman Empire, despite the cultural division

that had existed between the two parts of the Roman Empire: the Latinspeaking West, where urban society was the product of comparatively recent imperial conquest, and the Greek-speaking East, heir to much older civilizations. The Byzantine Empire lasted until 1453, when Constantinople became an Islamic capital under the Ottoman Turks.

When the empire divided in the late fourth century, the Christian Church developed two branches, Eastern and Western; although in disagreement for centuries over doctrine and jurisdiction, the Church did not officially split until 1054. Since then, there has been the Western, or Catholic, Church and the Eastern, or Orthodox, Church. Through all this, Rome has continued as the seat of the Western Church, led by the pope. The patriarch of Constantinople has headed the Eastern Church, which, over time, has developed along regional lines, with several national patriarchs as semiautonomous leaders.

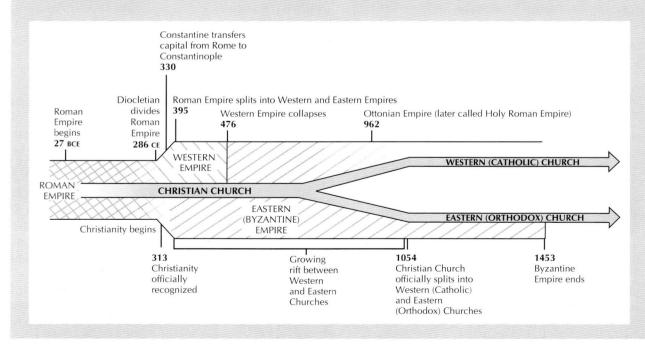

metropolitans (equivalent to archbishops) has governed Western, Catholic Church, and the patriarch with his schism, the pope has been the supreme authority in the er to be in error, and the Church split in two. Since this Western pope and Eastern patriarch declared one anoth-West, the Church remained united until 1054, when the Eastern Church. In spite of tensions between East and

against representational art was as idols, but this prohibition AKTimages that might be worshiped Jews were forbidden to make ple, and Christianity," opposite.) the Eastern, Orthodox Church. (See "Rome, Constantino-

the round in early Judaism. Jew-

applied primarily to sculpture in

ART**CHRISTIAN YND EYBLY JEMISH**

tian, depending on the context in which they occur. stretched—for example, can be pagan, Jewish, or Chrisdeliberate. Orant figures-worshipers with arms outings; such borrowings can be unconscious or quite images from other traditions, giving them new mean-In this process, known as syncretism, artists assimilate styles and imagery from Jewish and classical traditions. third century, and even then it continued to draw its ples of specifically Christian art exist before the early congregation as well as to glorify God. Almost no examtians began to use the visual arts to instruct the churches—as well as specialized equipment, and Chrisrites prompted the development of special buildings— Hebrew Scriptures and other Jewish sources. Christian symbols and narrative representations drawn from the have arisen out of Judaism, its art incorporated many symbolic and narrative. Since Christianity claimed to Roman elements to depict Jewish subject matter, both combined both Mear Eastern and classical Greek and ish art during the Roman Empire

Twenty-third Psalm: "The Lord is my shepherd; there is Jews and Christians saw him as the Good Shepherd of the mes the shepherd or Orpheus among the animals, but images is the Good Shepherd. In pagan art, he was Her-Perhaps the most important of these syncretic

nothing I lack" (Psalms 23:1).

Painting and Sculpture

three religions. subject, because the pictorial theme is common to all natively, it could represent either a pagan or a Christian wall called a lunette, may depict a Passover seder. Alter-Scene, painted in the crescent-shaped upper part of the platters and a large drinking cup (fig. 7-2). This Banquet white and arranged around a semicircular table with page 243), shows a group of men and women dressed in bers outside Rome (see "Roman Funerary Practices," comb of Priscilla, one of the underground burial cham-A late-second- or early-third-century mural in the Cata-

a Jewish catacomb in the Villa Torlonia in Rome, for symbolic objects specific to Judaism. A lunette mural in to be sure of, Jewish catacombs usually display certain Although the subject of the Banquet Scene is difficult

God at the end of the world, written about 95 ce.

probably occurred not long after Pontius Pilate was thought to have preached. Jesus' arrest and crucifixion emperor during the three-year period in which Jesus is Sea in the 1940s and 1950s. Tiberius (ruled 14-37 cE) was famous Dead Sea Scrolls found in caves near the Dead Jesus. This religious dissent was documented in the ish religious cults centered on prophetic figures such as the movements opposing Roman oppression were Jewleading to widespread political and social unrest. Among death in 4 BCE, Judaea came under direct Roman rule, now Lebanon, Syria, and Jordan. Following Herod's much of the rest of Palestine, as well as parts of what are Roman protectorate the Jewish kingdom of Judaea and tus (ruled 27 BCE-14 CE), when Herod the Great ruled as a Jesus was born during the reign of Emperor Augus-

ship with God, the forgiveness of sins, and the promise female, preaching love and charity, a personal relationgathered about him a group of disciples, male and where Joseph was a carpenter. At the age of thirty, Jesus in Nazareth in Galilee (in what is now northern Israel), gone to be registered in the Roman census. He grew up where his mother, Mary, and her husband, Joseph, had King David and that he was born in Bethlehem in Judaea, that Jesus was a descendant of the Jewish royal house of The Gospels' sometimes conflicting accounts relate

appointed administrator of Judaea in 26 ce.

Jesus limited his ministry primarily to Jews; Paul and of life after death.

and Roman philosophy into the texts. zianzus (c. 330-c. 389) incorporated elements of Greek art. Saint Augustine (354-430) and Saint Gregory of Nastories, changes reflected in later Christian ritual and editing, and the early Church tended to merge biblical centuries. The New Testament underwent significant ticated doctrine, both of which evolved over the next nizational structure coupled with increasingly sophisgrowth, they gradually instituted a more elaborate orga-Romans joined the Church during its first century of rapid from the lower classes. As well-educated, upper-class erless, and many early converts were women and people Empire. The faith had great appeal for the poor and pow-Christianity persisted and spread throughout the Roman teachings to non-Jews. Despite sporadic persecutions, other apostles, as well as later followers, took Jesus'

The patriarch of Constantinople became the head of the Western Church, holding the titles patriarch and pope. tant. The bishop of Rome eventually became head of the and Antioch (in southern Turkey) were the most imporbishops of Jerusalem, Rome, Constantinople, Alexandria, came to be called archbishops, among whom the archthe meaning "bishop's throne.") More powerful bishops Latin word cathedra, which meant "chair," but took on (A bishop's church is a cathedral, a word derived from the sees, or seats—were often in former provincial capitals. es, headed by priests. Bishops' headquarters-known as governors of dioceses made up of smaller units, parishments. Senior Church officials called bishops served as ical units, along the lines of Roman provincial govern-Christian communities were organized by geograph-

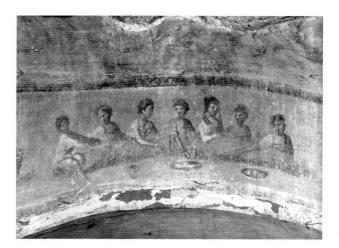

7-2. *Banquet Scene*, wall painting in the Catacomb of Priscilla, Rome. Late 2nd or early 3rd century

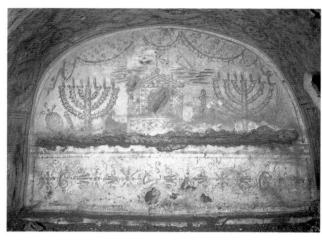

7-3. *Menorahs and Ark of the Covenant*, wall painting in a Jewish catacomb, Villa Torlonia, Rome. 3rd century. 3'11" x 5'9" (1.19 x 1.8 m)

example (fig. 7-3), shows the Ark of the Covenant flanked by two seven-branched menorahs that resemble the one carved on the Arch of Titus (see fig. 6-41). The original menorah had been constructed to light the portable sanctuary, or tabernacle, which had housed the ark during the early years of the Israelite kingdom (Exodus 25:31–40). After the First Temple had been built in Jerusalem, the menorah and ark were placed in it. The menorah form was probably derived from the ancient Near Eastern Tree of Life, symbolizing both the end of exile and the paradise to come. The painting also includes two symbols of the Jewish autumn harvest festival of Sukkoth, which also commemorates the Israelites' period of wandering in the desert: a palm branch on the left and an etrog (citron fruit) on the right.

Christians used catacombs as safe places in which to worship before their religion was granted official recognition. In the Christian Catacomb of the Jordani, dating from the third century, long rectangular niches in the walls, called loculi, each held two or three bodies (fig. 7-4). More affluent families created small rooms, or cubicula, off the main passages to house sarcophagi. The cubicula were hewn out of the soft tufa, a volcanic rock, then plastered and painted with imagery related to their owners' religious beliefs. The painters used the rapid brushwork, brilliant colors, and shaded forms typical of contemporary Roman painting. The finest Early Christian catacomb paintings imitated the murals in houses such as those preserved at Pompeii and Primaporta (see figs. 6-33, 6-36). Each scene was composed simply and clearly to convey its religious message.

Communal Christian worship focused on the central "mystery," or miracle, of the Incarnation and the promise of salvation. At its core was the ritual consumption of bread and wine, identified as the body and blood of Christ, which Jesus had instructed his followers to eat and drink in remembrance of him. Around these acts an elaborate religious ceremony, or liturgy, called the Eucharist (also known as Holy Communion or Mass) developed. The grapevine and grape cluster of the

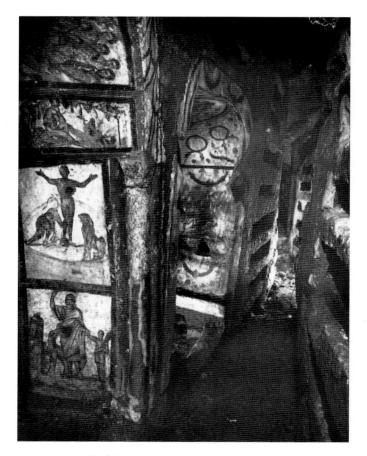

7-4. Catacomb of the Jordani, Rome. 3rd century

The narrow underground passage is lined with rectangular burial niches, once sealed with tile or stone slabs. On the left, arched doorways lead to small burial chambers that held sarcophagi and more wall niches. Typical subjects for Christian tomb paintings are Old Testament redemption stories, symbolizing God's power to save his people from death. At the center of the upper square panel on the left is Daniel in a den of lions that, miraculously, did not eat him (Daniel 6:16–23). The panel below shows Abraham, whom God tested by commanding him to sacrifice his son Isaac (Genesis 22:1–14).

₹ B¥LLELS	7d
------------------	----

£5 + 1- Z 98	La€er Byzantine	Hosios Loukas; separation of Eastern and Western Christian Churches; San Marco; Crusaders sack Constantinople; Dante's Divine Comedy; Boccaccio's Decameron; beginning of the Renaissance in Europe; Muslim Renaissance in Europe; Muslim	c. 900–1450 First Viking colony in Greenland; Lady Murasaki's Tale of Genji (Japan); the Crusades; Jenghiz Khan rules Mon-gols; Magna Carta (England); Hundred Years' War (England, France); Black Death in Europe; Chaucer's Canterbury Tales (England); Joan of Arc (France)
2 98 –2 7 5	early Byzantine	Hagia Sophia; San Vitale; Sant' Apollinare; Emperor Justin- ian reconquers Italy; Second Council of Micaea refutes Icono- clasm	c. 500–900 Birth of Muhammad, founder of Islam (Arabia); Buddhism in Japan; plague kills half the population of Europe; Koran; Muslim conquests; first blockprinted text (China); first permanent Japanese capital at Nara; Charlemagne is made emperor of the West; bronze casting in South America; Diabronze casting in Sou
313-c. 6th century	nstisindD lsirəqml	Old Saint Peter's; Santa Costan- za; Christianity is official religion of empire; empire permanently divided; Vulgate Bible; Mau- soleum of Galla Placidia; Italy falls to Ostrogoths	c. 300–500 First Gupta dynasty (India); Arabic script developed; library at Alexandria burns (Egypt); Attila the Hun; earliest surviving Hindu temples (India)
	Early Christian	Mew Testament completed; catacomb paintings; persecution of Christians; Constantinople established; Christians granted freedom to worship in empire	c. 100–300 Yayoi and Kofun eras (Japan); Maya civilization (Mesoamerica); Goths invade Asia Minor; Three Kingdoms period (China); Buddhism spreads in China
Years	Period	Roman/Byzantine Empires	World

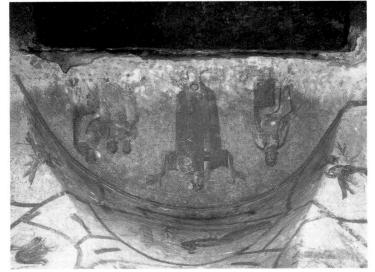

Roman god Bacchus were borrowed to symbolize the wine of the Eucharist and the blood of Christ (see "Christian Symbols," page 294). Feast scenes such as that in the Catacomb of Priscilla (see fig. 7-2) were appropriated to represent the Last Supper, in which Jesus inaugurated the Eucharist over a Passover meal with his disciples.

In a lunette painting in another cubiculum of the Catacomb of Priscilla, a veiled female orant—hands raised in prayer—dominates the room (fig. 7-5). The woman is flanked by images of a teacher-philosopher with pupils on the left and a woman holding a child on her lap on the right. Although its context indicates that this is a Christian site, its imagery derives from traditional classical

7-5. Teacher and Pupils, Orant, and Woman and Child, wall painting in a lunette, Crypt of the Veiled Lady, Catacomb of Priscilla, Rome. 3rd century

SYMBOLS

CHRISTIAN Symbols have always played an important part in Christian art.

Some were devised just for Christianity, but most were borrowed from pagan and Jewish traditions and adapted for Christian use.

Dove

The Old Testament dove is a symbol of purity, representing peace when it is shown bearing an olive branch. In Christian art a white dove is the symbolic embodiment of the Holy Spirit and is often shown descending from heaven, sometimes haloed and radiating celestial light.

Fish

The fish was one of the earliest symbols for Jesus Christ. Because of its association with baptism in water, it came to stand for all Christians. Fish are sometimes depicted with bread and wine to represent the Eucharist.

Lamb (Sheep)

The lamb, an ancient sacrificial animal, symbolizes Jesus' sacrifice on the cross as the Lamb of God, its pouring blood redeeming the sins of the world. The Lamb of God (Agnus Dei in Latin) may appear holding a cross-shaped scepter and/or a victory banner with a cross (signifying Christ's resurrection). The lamb sometimes stands on a cosmic rainbow or a mountaintop. A flock of sheep represents the apostles—or all Christians—cared for by their Good Shepherd, Jesus Christ. A single lamb can also be associated with Saint John the Baptist in certain contexts.

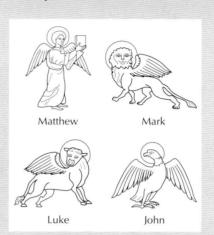

Four Evangelists

The evangelists who wrote the New Testament Gospels are traditionally associated with the following creatures: Saint Matthew, a man (or angel); Saint Mark, a lion; Saint Luke, an ox; and Saint John, an eagle. These emblems derive from visionary biblical texts and may be depicted either as the saints' attributes (identifying accessories) or their embodiments (stand-ins for the saints themselves).

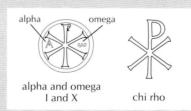

Monograms

Alpha (the first letter of the Greek alphabet) and omega (the last) signify God as the beginning and end of all things. This symbolic device was popular from Early Christian times through the Middle Ages. Alpha and omega often flank the abbreviation IX or XP. The initials I and X are the first letters of Jesus and Christ in Greek. The initials XP, known as the chi rho, were the first two letters of the word Christos. These emblems are sometimes enclosed by a circle.

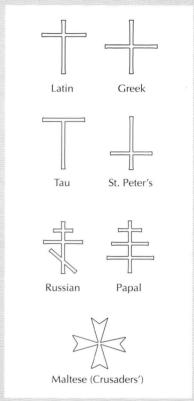

The primary Christian emblem, the cross, symbolizes the suffering and triumph of Jesus' crucifixion and resurrection as Christ. It also stands for Jesus Christ himself, as well as the Christian religion as a whole. Crosses have taken various forms at different times and places, the two most common in Christian art being the Latin and Greek.

themes: philosopher, mother and child, and praying supplicant. In a Christian interpretation, the philosopher can be seen as Jesus teaching and the woman as the Virgin Mary with the Christ Child, both important in later Christian art.

A fourth-century Roman catacomb contained bones, or relics, of Saints Peter and Marcellinus. Peter (died c. 64 CE) was the leader of the apostles who established the first Christian community, at Rome, and was venerated as the

precursor of the popes. Marcellinus was a third-century Roman soldier executed-martyred-for his Christian faith. Catacombs with the bones of martyrs and saints were sought-after burial places for other Christians as well. Here the domed ceiling of a cubiculum is partitioned by five medallions linked by the arms of a cross (fig. 7-6). At the center is a Good Shepherd whose pose has roots in Greek sculpture. In its new context, the image was a reminder of Jesus' promise, "I am the good

combs. On the left, Jonah is thrown from the boat, on the right, the monster spews him up; and at the center, Jonah reclines in the shade of a gourd vine, a symbol of paradise. Orants praying for the souls of the departed stand between the medallions.

Sculpture that is clearly Christian is even rarer than painting from before the time of Constantine I. What there is consists mainly of small statues and reliefs, many of them Good Shepherd images. A remarkable set of marble figurines, probably made in the third century in Asia Minor, also depicts the Jonah story (fig. 7-7); their function is unknown. Carved of a fine alabasterlike marble, they illustrate the biblical story with the same literalness and enthusiasm as the paintings on the catacomb ceiling.

Dura-Europos

The variety of religious buildings found in modern Syria at the abandoned Roman outpost of Dura-Europos, a Hellenistic fortress taken over by the Romans in 165 ce, illustrates the cosmopolitan character of frontier Roman society in the second and third centuries. Although Dura-Europos was destroyed in 256 ce by Persian forces, important parts of the stronghold have been excavated, including a Jewish house-synagogue, a Christian house-synagogue, a Christian house-adurch, shrines to the Persian gods Mithras and Zoro-aster, and temples to Roman ancestral gods. The Jewish had been built against the inside wall of the southwest had been built against the inside wall of the southwest rampart. When the desperate citizens attempted to

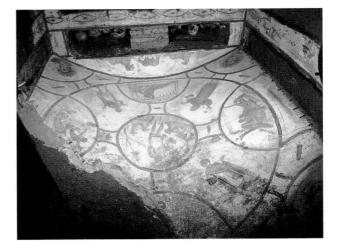

7-6. Good Shepherd, Orants, and Story of Jonah, painted ceiling of the Catacomb of Saints Peter and Marcellinus, Rome. 4th century

sheepherd. A good shepherd lays down his life for the sheep" (John 10:11). The semicircular compartments at the ends of the arms of the cross tell the Old Testament story of Jonah and the Whale (Jonah 1–2), in which God caused Jonah to be thrown overboard in a storm, swallowed by a whale, and released, repentant and unscathed, three days later. This story was reinterpreted by Christians as a parable of Christ's death and resurrection—and hence of the everlasting life awaiting true believers—and was a popular subject in Christian catabelievers—and was a popular subject in Christian catabelievers—and was a popular subject in Christian catabelievers—and was a popular subject in Christian catab

7-7. Jonah Swallowed and Jonah Cast Up, two statuettes of a set of three from the eastern Mediterranean, probably Asia Minor. 3rd century. Marble, heights 20 5/16" (51.6 cm) and 16" (40.6 cm). The Cleveland Museum of Art John L. Severance Fund, 65.237, 65.238

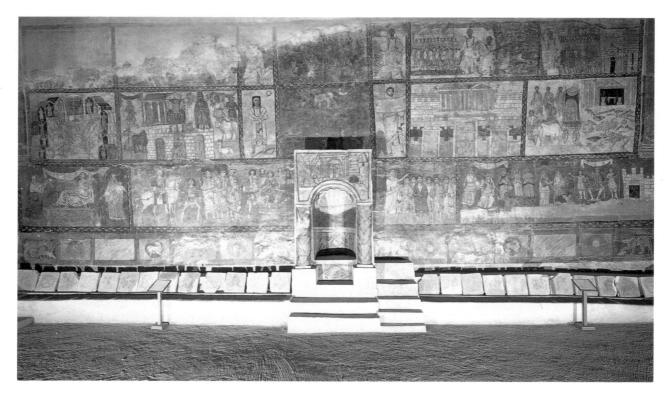

7-8. Wall with Torah niche, from a house-synagogue, Dura-Europos, Syria. 244–45. Tempera on plaster, section approx. 40' long. Reconstructed in the National Museum, Damascus, Syria

strengthen this fortification in futile preparation for the final attack, they buried these buildings. The entire site was abandoned and rediscovered only in 1920 by a French army officer.

In the house-synagogue, the congregational area was sealed off from the rest of the building. Its main room had only two special architectural features, a bench along its walls and a niche for the Torah scrolls (fig. 7-8). Women were seated in an alcove, separated from men.

Jewish representational art flourished in the third century, as seen in the murals that covered this synagogue's interior. Narrative and symbolic scenes depicting events from Jewish history unfold in three registers of framed panels. The work of more than one artist, they are done in a style in which statically posed, almost twodimensional figures float against a neutral background. In Finding of the Baby Moses (fig. 7-9), Moses' mother sets him afloat in a reed basket in the shallows of the Nile in an attempt to save him from the pharaoh's decree that all Jewish male infants be put to death (Exodus 1:8-2:10). He is found by the pharaoh's daughter, who acknowledges him as her own child. The painting shows these events unfolding in a continuous narrative set in a narrow foreground space. At the right, the princess spots the child hidden in the bulrushes; at the center, she wades nude into the water to save him; and at the left, she hands him to a nurse (actually his own mother). The frontal poses, strong outlines, and flat colors are distinctive pictorial devices; they are, in fact, features of later Byzantine art, perhaps derived from works such as this.

The Christian house-church, which was about 300 yards from the house-synagogue, had been a Roman-

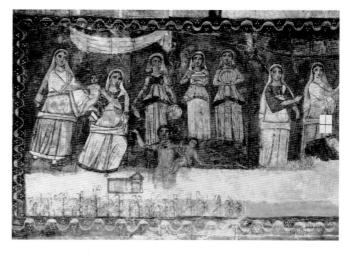

7-9. Finding of the Baby Moses, detail of a wall painting from a house-synagogue, Dura-Europos, Syria. Second half of 3rd century. Tempera on plaster. Yale University Art Gallery, New Haven, Connecticut Dura-Europus Collection

style dwelling built around a peristyle court. A red cross painted above the main entrance designated it as a gathering place for Christians. The congregation seems to have grown so much that by about 231 the space devoted to the church included a large meeting or dining hall, a room with a raised platform at one end for the leaders, and a small chamber that served perhaps for teaching initiates or as a place for storing liturgical equipment. Opening off this large hall was a **baptistry**, or place for

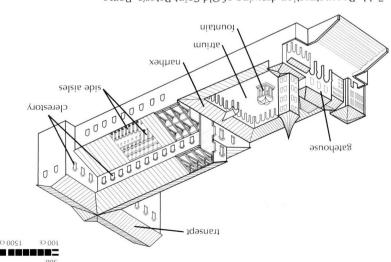

c. 320-27; atrium added in later 4th century 7-11. Reconstruction drawing of Old Saint Peter's, Rome.

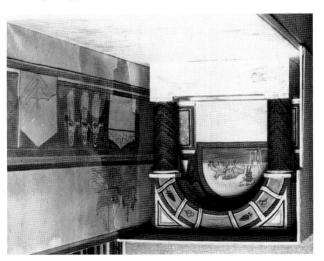

Dura-Europos Collection Haven, Connecticut Europos, Syria. c. 240. Yale University Art Gallery, New the baptistry of a Christian house-church, Dura-7-10. Small-scale model of walls and baptismal font, from

initiate reborn as a member of the community of the

and eternal life. Baptism washed away sin, leaving the

came to earth to carry his sheep (Christians) to salvation

an evil serpent. But the Good Shepherd (Jesus Christ)

tree of the knowledge of good and bad offered them by

woman disobeyed God and ate fruit from the forbidden

immortality by Original Sin, when the first man and

new Christians that humanity had been deprived of

and of Adam and Eve (fig. 7-10). These murals reminded

basin, above which were images of the Good Shepherd baptism, built into a niche and equipped with a water

Architecture and Its Decoration

commemorating a person or event in the patron's life. constructed as personal acts of devotion, sometimes ber of churches and shrines in Jerusalem; shrines were Palestine about 325, she convinced him to build a numburied. Also, after Constantine's mother, Helena, visited ed at the place where Christians believed Saint Peter to be The emperor ordered a monumental basilica constructthe highest-ranking Church official in the Roman Empire. these was a grand palace complex for the city's bishop, included many religious structures (Chapter 6). Among 324, Constantine I began a vast building program that As soon as he had consolidated imperial power, around

Christendom. power of the bishop of Rome over all other bishops in pope's church, it came to signify as well the superior glorifying the memory of the martyred apostle. As the tomb to protect it and make it accessible to the faithful, to construct a grand new basilica on the site of Peter's crucifixion. Perhaps as early as 320, Constantine decided that his martyrdom would be seen as lesser than Jesus' Rome, was crucified upside down at his own request so According to tradition, Saint Peter, the first bishop of they believed to be the burial place of the apostle Peter. Christians in Rome had placed a monument over what Basilica-Plan Churches. In the early second century

foundation they erected a building complex arranged on ed, destroying many tombs; then atop a large, concrete leveled the hillside cemetery on which it was to be locatological excavations at the site (fig. 7-11). Its builders study of other churches inspired by it, and modern archeings made before and while it was being dismantled, the teenth century) is based on written descriptions, drawit was completely replaced by a new building in the six-Our knowledge of Old Saint Peter's (so called because

> eration, combined with AND ART wished. This religious tolworship whatever god they Roman Empire freedom to CHBIZLIAN granted all people in the IMPERIAL In 313 the Edict of Milan

ARCHITECTURE

faithful.

ed with a dramatic increase in imperial architecture. mations in the philosophical and political arenas coincidimperial adviser from about 315 to 339. These transforbius (c. 260-c. 339), bishop of Caesarea, was a trusted example, tutored Constantine I's son Crispus; and Euseperiod. The Christian writer Lactantius (c. 240-320), for ular.") Christians also gained political influence in this same Latin word as vulgar, meaning "common" or "popversion of the Bible. (The term Vulgate derives from the ed about 400, this so-called Vulgate became the official into Latin, the language of the Western Church. Completnew translation from Hebrew, Greek, and Latin versions Jerome (c. 347-c. 420), the papal secretary, undertook a scholars edited and commented on the Bible, and Saint many ideas from Greek and Roman philosophy. Church cated philosophical and ethical system that incorporated Christianity to enter a new phase, developing a sophisti-Constantine's active support of Christianity, allowed

ARCHITECTURE

ELEMENTS OF The forms of early Christian buildings were based on two classical prototypes: rectangu-Basilica-Plan lar Roman basilicas (see figs. and Central-Plan 6-49, 6-50) and round-domed Churches structures-rotundas-such as the Pantheon (see figs. 6-55,

6-56). As in Old Saint Peter's in Rome (fig. 7-11), basilicaplan churches are characterized by a forecourt, the atrium, leading to a porch, the narthex, spanning one of the building's short ends. Doorways-known collectively as the church's portal—lead from the narthex into a long central area called a nave. The high-ceiling nave is separated from aisles on either side by rows of columns. The nave is lit by windows along its upper story-called a clerestory—that rises above the side aisles' roofs. At the opposite end of the nave from the narthex is a semicircular projection, the apse. The apse functions as the building's symbolic core where the altar, raised on a platform, is located. Sometimes there is also a transept, a horizontal wing that crosses the nave near the apse, making the building T-shaped; this is known as a Latin-cross plan.

Central-plan structures were first used by Christians as tombs, baptism centers (baptistries), and shrines to martyrs (martyria). (The Greek-cross plan, in which two similarly sized "arms" intersect at their centers, is a type of central plan.) Instead of the longitudinal axis of basilican churches, which draws worshipers forward toward the apse, central-plan churches such as Ravenna's San Vitale (see figs. 7-29, 7-30) have a more vertical axis. This makes the dome, which functions symbolically as the "vault of heaven," a natural focus. Like basilicas, centralplan churches generally have an atrium, a narthex, and an apse.

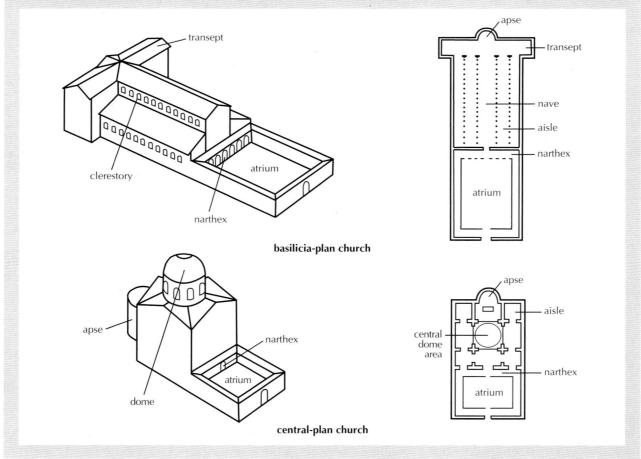

a central axis similar to the old Forum of Trajan (see fig. 6-49). Worshipers climbed a flight of steps to a large gatehouse and crossed a colonnaded atrium with a central fountain to reach the church's entrance.

Old Saint Peter's included architectural elements arranged in a way that has characterized Christian basilica-plan churches ever since (see "Elements of Architecture," above). A narthex, or porch, across the width of the building protected five doorways—a large, central portal into the nave and two portals on each side opening directly to double side aisles. The nave rose one story higher than these aisles to provide for an upper-level clerestory, the windows of which lit the interior. Nave and aisles had open, timberwork ceilings. The nave was lined with columns supporting an entablature, whereas the columns of the side aisles supported a series of round arches. At the end of the nave and aisles was a transept, which crossed them at right angles and projected at each end, a T form that anticipated the later Latin-cross church plan. This area served as common ground for rituals in which both congregation and clergy participated.

Below, Saint Peter's bones supposedly lie, marked by a permanent, pavilionlike structure supported on four columns called a ciborium. Catacombs lay beneath the church, and over time a large crypt, or underground vault, was created for the burial of popes. Sarcophagi and

proportions, simple geometric forms, and a dramatic contrast between exterior simplicity and interior luxury. A view of the nave of the Church of Saint Paul's Outside the Walls, begun in 385, gives some sense of what the interior of Old Saint Peter's might have been like (fig. 7-12). The long nave ends, like Old Saint Peter's, in a triumphal arch that springs from columns topped with short sections of entablature. Unlike Saint Peter's, arcades of tall Corinthian columns supporting arches define both nave and side aisles. After a fire in the early nineteenth century, the original beamed ceiling was renineteenth century, the original beamed ceiling was re-

placed with a coffered one with recessed panels.

is shown enthroned, flanked by attending angels and the exterior curves of adjoining arches or walls—she the triumphal arch's left spandrel—the surface between mains a humble mother in Eastern representations.) On appearance often seen in Western art. (The Virgin rehumble earthly mother of Jesus was first given the regal tokos, bearer of God. In the mosaics of this church, the Church Council of Ephesus (431) declared her to be Theochurch in Rome dedicated to the Virgin Mary after the the altar is located. Santa Maria Maggiore was the first ends in a triumphal arch leading to the sanctuary, where supporting an entablature line the two-story nave, which Mary the Great, fig. 7-13). As in Old Saint Peter's, columns designing the Church of Santa Maria Maggiore (Saint most a century later looked to them for inspiration when churches proved so valuable that Roman architects alability, and practicality in fourth-century basilica-plan The combination of architectural grandeur, adapt-

crowned as an empress.

Begun 385

tomb monuments eventually also lined the side aisles. Old Saint Peter's thus served a variety of functions. It was a congregational church, a pilgrimage shrine commemorating a place of martyrdom and containing the relics of a holy person, and a funeral hall-burial place. Old Saint Peter's could hold at least 14,000 worshipers, and it remained the largest of all Christian churches until the eleventh century.

Like many later churches, Old Saint Peter's depended for its aesthetic effect on sheer size, harmonious

7-13. Nave, Church of Santa Maria Maggiore, Rome. 432-40

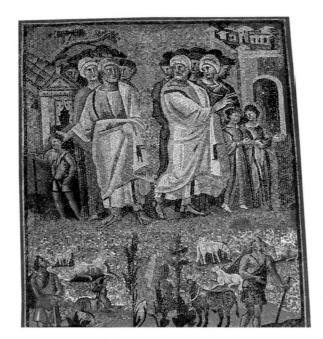

7-14. Parting of Lot and Abraham, mosaic in the nave arcade, Church of Santa Maria Maggiore. Panel approx. 4'11" x 6'8" (1.2 x 2 m)

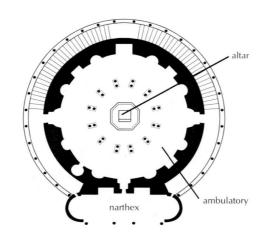

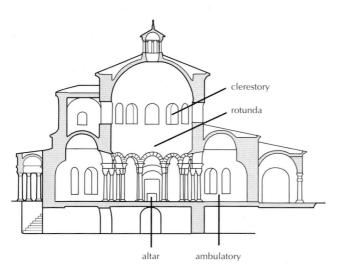

7-15. Plan and section of the Church of Santa Costanza, Rome. c. 338–50

The mosaics of the Church of Santa Maria Maggiore reflect a renewed interest in the earlier classicizing style of Roman art that arose during the reign of Pope Sixtus III (432-440). The mosaics along the nave walls, in framed panels high above the worshipers, illustrate Old Testament stories of the Jewish patriarchs and heroes— Abraham, Jacob, Moses, and Joshua-whom Christians believe foretold the coming of Christ and his activities on earth. Twenty-seven of the original forty-two nave mosaics remain. These panels were not primarily didactic—that is, they were not intended to instruct the congregation. Instead, like most of the decorations in great Christian churches from this time forward, they were meant to praise God through their splendor and make churches symbolic embodiments of the Heavenly Jerusalem that awaited believers.

Some of the most effective compositions are those in which a few large figures dominate the foreground space, as in the *Parting of Lot and Abraham* (fig. 7-14), a story told in the first book of the Hebrew Scriptures (Genesis 13:1–12). The people of Abraham and his nephew Lot, dwelling together, had grown too numerous, so the two agreed to separate and lead their followers in different directions. On the right, Lot and his daughters turn toward the land of Jordan, while Abraham and his wife stay in the land of Canaan. This parting is highly significant to both Jews and Christians since Abraham was the founder of the Israelite nation from which Jesus descended.

In the mosaic, the toga-clad men share a parting look as they gather their robes about them and turn decisively away from each other. The space between them in the center of the composition emphasizes their irreversible decision to part. Clusters of heads in the background represent Abraham's and Lot's followers, a contemporary artistic convention used effectively here. References to the earlier Roman illusionistic style can be seen in the solid three-dimensional rendering of foreground figures, the hint of perspective in the building, and the landscape setting, with its bit of foliage and touches of blue sky. The mosaic was created with thousands of marble and glass tesserae set closely together. The use of graduated colors creates shading from light to dark, producing three-dimensional effects that are offset by strong outlines. These outlines, coupled with the sheen of the gold tesserae, tend to flatten the forms.

Central-Plan Churches. A second type of ancient building—the **tholos**, or tomb with central plan and vertical axis—also served Christian builders for tombs, martyrs' churches, and baptistries (see "Elements of Architecture," page 298). One of the earliest surviving central-plan Christian buildings is the **mausoleum** of Constantina, the daughter of Constantine, which was built outside the walls of Rome just before 350 (fig. 7-15). The mausoleum was consecrated as a church in 1256 and is now dedicated to Santa Costanza (the Italian form of the Christian princess's name). The building consists of a tall rotunda with an encircling **barrel-vaulted** passageway called an **ambulatory** (fig. 7-16). A double ring of paired columns with Composite capitals and richly

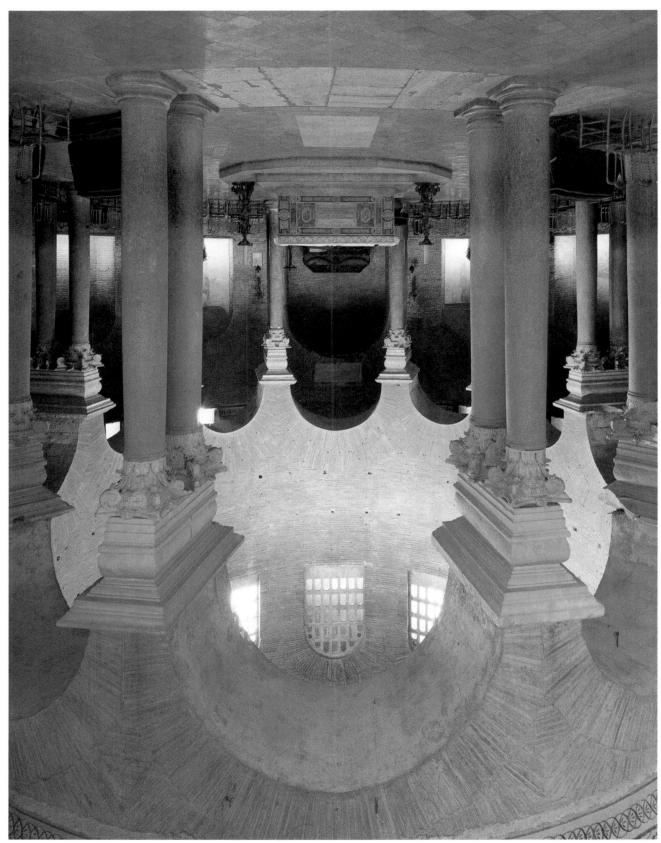

7-16. Church of Santa Costanza. View through ambulatory into central space

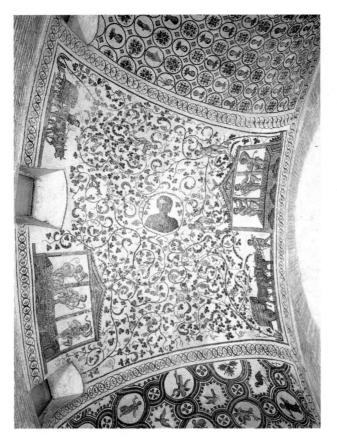

7-17. Harvesting of Grapes, mosaic in the the ambulatory vault. Church of Santa Costanza

molded entablature blocks supports the arcade and dome. The building's interior was entirely sheathed in mosaics and fine marble.

Mosaics in the ambulatory vault recall the catacombs' syncretic images. One section, for example, is covered with a tangle of grapevines filled with **putti**—naked male child-angels, or cherubs, derived from classical art—who vie with the birds to harvest the grapes (fig. 7-17). Along the bottom edges on each side, putti drive wagonloads of grapes toward pavilions covering large vats in which more putti trample the grapes into juice. The technique, subject, and style are Roman, but the meaning has been altered. The scene would have been familiar to the pagan followers of Bacchus, but in a Christian context the wine could suggest the wine of the Eucharist. For Constantina the scene probably evoked only one, Christian, interpretation; her pagan husband, however, may have recognized the double allusion.

As Rome lost its political importance, major buildings were erected in the new Italian capitals of Milan and Ravenna, to the north. In 395 Emperor Theodosius I split the Roman Empire into Eastern and Western divisions, each ruled by one of his sons. Arcadius (ruled 383–408), who had already ruled jointly with his father the Eastern part of the empire from Constantinople, assumed complete control of the Eastern Empire. The younger Honorius (ruled 395–423) established himself first at the new Western Roman Empire capital of Milan in northern Italy. When Germanic settlers laid siege to Milan in 402, Hon-

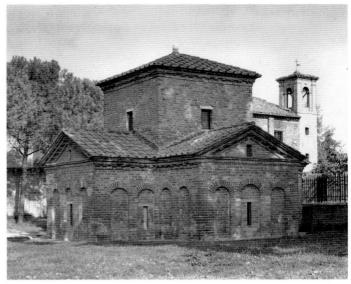

7-18. Mausoleum of Galla Placidia, Ravenna, Italy. c. 425-26

orius moved his capital to the east coast of Italy at Ravenna, where its naval base, Classis, had been important since the early days of the empire. In addition to military security, Ravenna offered direct access by sea to Constantinople. Ravenna flourished under Roman rule, and when Italy fell to the Ostrogoths in 476, the city became one of their headquarters. It still contains some dozen well-preserved fifth- and sixth-century monuments, a remarkable group.

One of the earliest surviving Christian structures in Ravenna is a funerary chapel attached to the church of the imperial palace (now Santa Croce, meaning "Holy Cross"). Built about 425-426, the chapel was constructed when Honorius's half sister, Galla Placidia, was acting as regent (ruled 425-c. 440) in the West for her son. The chapel came to be called the Mausoleum of Galla Placidia because she and her family were believed to be buried there (fig. 7-18). This small building is cruciform, or crossshaped; each of its arms is covered with a barrel vault, and the space at the intersection of the arms is covered with a pendentive dome, a dome formed of pendentives. The plain exterior is decorated with blind arcading—a series of ornamental arches applied to a solid wall—tall slit windows, and a simple cornice that surrounds and unifies the four arms. The vaults covering the arms of the cross have been hidden from view on the outside by sloping, tile-covered roofs.

The interior of the chapel contrasts remarkably with the exterior, a transition designed to simulate the passage from the real world into a supernatural one (fig. 7-19). The worshiper looking from the western entrance across to the eastern bay of the chapel sees a brilliant, abstract pattern of mosaic filling the barrel vault, suggesting a starry sky. Panels of veined marble sheath the walls below. Bands of luxuriant foliage and floral designs derived from funerary garlands cover the four central arches, and the walls above them are filled with the figures of standing apostles gesturing like orators. Birds

7-19. Mausoleum of Galla Placidia, eastern bays with sarcophagus niches and lunette mosaic of the Martyrdom of Saint Lawrence

7-20. Good Shepherd, mosaic in the lunette over the west entrance, Mausoleum of Galla Placidia

rocks are stepped back into a shallow space that rises from the foreground plane and ends in foliage fronds. The rocky band at the bottom of the lunette scene, resembling a cliff face riddled with clefts, separates the divine image from worshipers.

Just as the political role of Ravenna changed in the fourth and fifth centuries, so did the religious belief of its leaders. The early Christian Church faced many

flanking a small fountain between the apostles symbolize eternal life in heaven. In the lunette, a mosaic symbolically depicts the third-century martyrdom of Saint Lawrence, to whom the building was probably dedicated. The saint holds a cross and gestures under the window toward the metal gridiron, or grill, on which he was literally roasted. At the left stands a tall cabinet containing the Gospels, signifying the faith for which he died.

ular intervals to fill the spaces between animals, and the ly than before. Individual plants have been placed at regnatural landscape are there but are arranged more rigidgin Mary, angels, or saints.) The stylized elements of a reserved for holy personages—God, Jesus Christ, the Virtinguish rulers from ordinary people. (Later, halos were golden halo behind his head, a device artists used to disin a cross instead of a shepherd's crook. There is a large, gold and purple and holding a long, golden staff that ends mosaic he is a young adult wearing imperial robes of shepherd boy carrying an animal on his shoulders; in the changed. In the fourth-century painting he was a simple tional animal poses. The image of Jesus, however, has ing on solid forms, a suggestion of landscape, and tradishading and shadows to suggest a single light source actmany familiar classical elements, such as illusionistic in content and design. The Ravenna mosaic contains the same subject (see fig. 7-6) reveals significant changes parison of this version with a fourth-century depiction of entrance portal, is the Good Shepherd (fig. 7-20). A com-Opposite Saint Lawrence, in a lunette over the

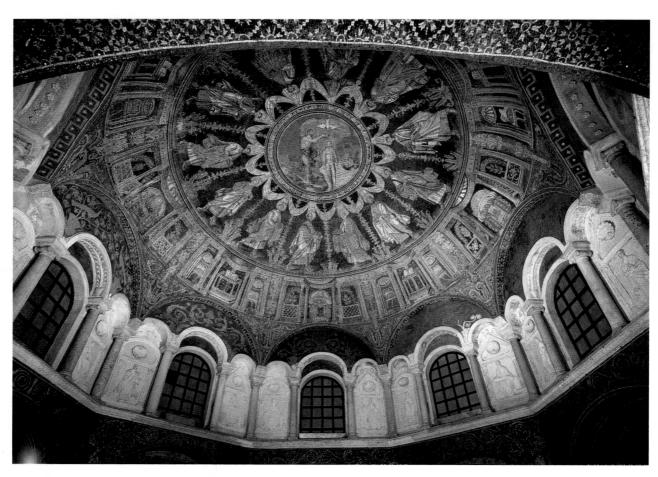

7-21. Clerestory and dome, Baptistry of the Orthodox, Ravenna, Italy. Early 5th century; dome remodeled c. 450-60

philosophical and doctrinal controversies, some of which resulted in serious splits, called schisms, within the Church. When this happened, its leaders gathered in church councils to decide on the orthodox, or official, position and denounce others as heretical. Two early forms of Christianity that were rejected were Arianism and Monophysitism.

Arianism was named after Arius (c. 250–336), a leader in the church of Alexandria. He and his followers believed that Jesus was coeternal with God but not fully divine, having been made by God. The first Church Council, called by Constantine at Nicaea in 325, declared the doctrine of the Trinity to be orthodox and denounced Arianism as heretical.

Monophysites took the opposite viewpoint from Arians. They believed that Jesus was an entirely divine being even while on earth. Attempting to address this belief, the Council of Chalcedon, near Constantinople, in 451 declared Jesus to be of two natures—human and divine—united in one. This declaration did not put an end to Monophysitism, which remained strong in Egypt, Syria, Palestine, and Armenia in Asia Minor.

In Ravenna two baptistries still stand as witness to these disputes: the Baptistry of the Orthodox and the Baptistry of the Arians. The Baptistry of the Orthodox was constructed next to the Cathedral of Ravenna in the early fourth century. Bishop Neon had it renovated and refurbished between 450 and 460, replacing the wooden

ceiling with a dome and adding splendid interior decoration in marble, stucco, and mosaic (fig. 7-21). On the clerestory level, an arcade springing from columns with large **impost** blocks repeats blind arcading below. Each main arch contains three arches framing a window. Flanking the windows are figures of Old Testament prophets in relief surmounted by pediments containing shell motifs. The pediment above the figure to the left of each window is round, whereas that on the right is pointed. The main arcading acts visually to turn the domed ceiling into a huge canopy tethered to the imposts of the columns.

In the dome itself, concentric rings of decoration draw the eye upward to a central image that reflects the structure's function: the baptism of Jesus by Saint John the Baptist, Jesus' older cousin, a desert hermit whom Christians regard as the last of the Old Testament prophets and the first of the New Testament saints, the forerunner of Jesus. The lowest ring consists of trompe l'oeil—a French term applied to highly illusionistic painting that "fools the eye." Among these deceptive "architectural elements" are eight circular niches, four of them containing altars holding gospel books. The four niches alternating with them hold empty thrones under ciboria. The empty thrones symbolize the throne that awaits Christ's Second Coming (Matthew 25:31-36), when he will return to earth and prepare his people for Judgment Day. In the next ring, toga-clad apostles stand holding

7-23. Sarcophagus of Junius Bassus. c. 359. Marble, 4' x 8' (1.2 x 2.4 m). Grottoes of Saint Peter, Vatican, Rome.

Sculpture

completely Christian. the classical roots of this work, which in its theme is setting, and the decorative framing patterns all indicate ies beneath their drapery, the architectural details of the ural poses of the figures, the solid modeling of the bodthe Christian promise of life after death. The varied natmummified Lazarus emerges from his tomb, symbolizing prove his divine power. In the top right door panel the Gospel story in which Jesus brings a man back to life to doors of the tomb show the Raising of Lazarus, the that the tomb is empty. The top panels of the carved (0-1:82 watthew)" wons as shift was white as snow." from a young man whose "appearance was like lightning moment when the Virgin Mary and Mary Magdalen learn event from the clouds. The bottom register shows the sented by the man in the upper right) acknowledge the sented by the ox in the upper left) and Matthew (repreguarding his tomb sleep, the evangelists Luke (repreboth symbolic and narrative terms. While the soldiers register shows the moment of Christ's resurrection in been an early example of this practice (fig. 7-22). The top panel found in Rome and dating to about 400 may have ple to be remembered with prayers during Mass. An ivory fifth century, inscribing a diptych with the names of peotians adapted the practice for religious use at least by the sides of a pair of carved ivory panels (see fig. 6-89). Chrisand, later, other events, inscribed in wax on the inner who sent to friends and colleagues notices of that event, ed with Roman politicians elected to the post of consul, diptychs—two carved panels hinged together—originatman forms for their own needs. Commemorative ivory In sculpture, as in architecture, Christians adapted Ro-

Monumental stone sculpture can be studied in sarcophagi, such as the elaborately carved *Sarcophagus of Junius Bassus* (fig. 7-23). Bassus was a Roman official who, as an inscription here tells us, died on August 25, who, as an inscription here tells us, died on August 25,

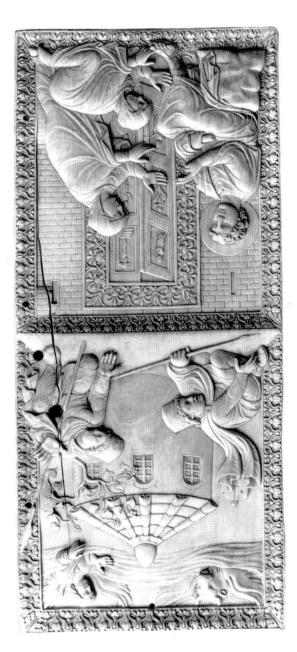

7-22. Resurrection and Angel with Holy Women at the Tomb, panel of a diptych, found in Rome. c. 400. Ivory, 141/2 x 53/8" (37 x 13.5 cm). Castello Sforzesco, Milan

their crowns of martyrdom, stylized golden plant forms dividing the deep blue ground between them. Although the figures cast dark shadows on the pale green grass, their cloudlike robes, shot through with golden rays, give their cloudlike robes, shot through with golden rays, give them an otherworldly presence. The landscape setting of the Baptism of Jesus in the central tondo—a circular image—exhibits classical roots, and the representation of the Jordan River in human form recalls pagan imagery. The background, however, is not the blue of the earthly sky but the gold of paradise. Already in the mid-fifth century, artists working for the Christian Church had begun to reinterpret and transform Roman naturalism into an abstract style better suited to the spiritual goals of their

patrons.

ICONOG-RAPHY OF THE LIFE OF IESUS

Iconography is the study of subject matter in art. It involves identifying both what a work of art repre-

sents—its literal meaning—and the deeper significance of what is represented—its symbolic meaning. Stories about the life of Jesus, grouped in "cycles," form the basis of Christian iconography. What follows is an outline of those cycles and the main events of each.

THE INCARNATION CYCLE AND THE CHILDHOOD OF JESUS

This cycle contains events surrounding the conception and birth of Jesus.

The Annunciation: The archangel Gabriel informs the Virgin Mary that God has chosen her to bear his son. A dove represents the Incarnation, her miraculous conception of Jesus through the Holy Spirit.

The Visitation: Mary visits her older cousin Elizabeth, pregnant with the future Saint John the Baptist. Elizabeth is the first to acknowledge the divinity of the child Mary is carrying. The two women rejoice.

The Nativity: Jesus is born to Mary in Bethlehem. The Holy Family—Jesus, Mary, and her husband, Joseph—is shown in a house, a stable, or, in Byzantine art, in a cave.

The Annunciation to the Shepherds and The Adoration of the Shepherds: An angel announces Jesus' birth to humble shepherds. They hasten to Bethlehem to honor him.

The Adoration of the Magi: The Magi—wise men from the East—follow a bright star to Bethlehem to honor Jesus as King of the Jews, presenting him with precious gifts: gold (symbolizing kingship), frankincense (divinity), and myrrh (death). In the European Middle Ages the Magi were identified as three kings.

The Presentation in the Temple: Mary and Joseph bring the infant Jesus to the Temple in Jerusalem, where he is presented to the high priest. It is prophesied that Jesus will redeem humankind but that Mary will suffer great sorrow.

The Massacre of the Innocents and The Flight into Egypt: An angel warns Joseph that King Herod—to eliminate the threat of a newborn rival king—plans to murder all the babies in Bethlehem. The Holy Family flees to Egypt.

Jesus among the Doctors: In Jerusalem for the celebration of Passover, Joseph and Mary find the twelve-year-old Jesus in serious discussion with Temple scholars. This is seen as a sign of his coming ministry.

THE PUBLIC MINISTRY CYCLE

In this cycle Jesus preaches his message.

The Baptism: At age thirty Jesus is baptized by John the Baptist in the Jordan River. He sees the Holy Spirit and hears a heavenly voice proclaiming him God's son. This marks the beginning of his ministry.

The Calling of Matthew: Passing by the customhouse, Jesus sees Matthew, a tax collector, to whom he says, "Follow me." Matthew complies, becoming one of his disciples (apostles).

Jesus and the Samaritan Woman at the Well: On his way from Judaea to Galilee, Jesus rests by a spring called Jacob's Well. Contrary to Jewish custom, he asks a local Samaritan woman drawing water for a drink. The apostles are surprised to find them conversing.

Jesus Walking on the Water: The apostles, in a storm-tossed boat, see Jesus walking toward them on the water. Peter tries to go out to meet

Jesus, but begins to sink, and Jesus saves him. When Jesus reaches the boat, the storm stops.

The Raising of Lazarus: Jesus brings his friend Lazarus back to life four days after he has died. Lazarus emerges from the tomb wrapped in his shroud.

The Delivery of the Keys to Peter: Jesus designates Peter as his successor, symbolically turning over to him the keys to the kingdom of heaven.

The Transfiguration: Jesus is transformed into a dazzling vision on Mount Tabor in Galilee as his closest disciples—Peter, James, and John the Evangelist—look on. A cloud overshadows them, and a heavenly voice proclaims Jesus to be God's son.

The Cleansing of the Temple: Jesus, in anger, drives money changers and animal traders from the Temple.

THE PASSION CYCLE

This cycle contains events surrounding Jesus' death and resurrection. (*Passio* is Latin for "suffering.")

The Entry into Jerusalem: Jesus, riding an ass, and his disciples enter Jerusalem in triumph. Crowds honor them, spreading clothes and palm fronds in their path.

The Last Supper: During the Passover seder, Jesus reveals his impending death to his disciples. Instructing them to drink wine (his blood) and eat bread (his body) in remembrance of him, he lays the foundation for the Christian Eucharist (Mass).

Jesus Washing the Disciples' Feet: After the Last Supper, Jesus humbly washes the apostles' feet to set an example of humility. Peter, embarrassed, protests.

The Agony in the Garden: In the Garden of Gethsemane on the Mount

359, at the age of forty-two. The front panel has two registers divided by columns into shallow stage spaces of equal width. On the top level, the columns are surmounted by an entablature incised with the inscription in Roman capital letters. On the bottom register, they support alternating triangular and arched roof gables resem-

bling little houses. Each stage, with the exception of one in the lower register containing the nude figures of Adam and Eve, is filled by toga-clad figures with short legs, long bodies, and large heads. Fragments of architecture, various types of seating, and occasional trees suggest the material setting for each scene.

the Virgin mourning alone with Jesus across her lap is known as a pietà (from the Latin pietas, "pity") or, in German, a Vesperbild.

The Entombment: Jesus' mother and friends place his body in a nearist done hastily because of the approaching Jewish Sabbath.

The Descent into Limbo (The Harrowing of Hell): No longer in mortal form, Jesus, now called Christ, descends into limbo, or hell, to free descrving souls, among them Adam, Eve, and Moses.

The Resurrection (The Anastasis): Three days after his death, Christ leaves his tomb while the soldiers guarding it sleep.

The Marys at the Tomb (The Holy Women at the Sepulchre): Christ's female followers—usually including the apostle James, also named Mary—discover his empty tomb. An angel announces Christ's resurrection. The soldiers guarding the tomb look on, terrified.

Moli Me Tangere ("Do Not Touch Me"), The Supper at Emmaus, and The Incredulity of Thomas: Christ makes a series of appearances to his followers in the forty days between his resurrection and his ascension. He first appears to Mary Magdalen as she weeps at his tomb. She reaches out to him, but he warns her not to the shares a meal with his apostles. In the shares a meal with his apostles. In the Incredulity of Thomas, Christ invites the doubting apostle to touch the wound in his side to convince him of his resurrection.

The Ascension: Christ ascends to heaven from the Mount of Olives, disappearing in a cloud. His disciples, often accompanied by the Virgin, watch.

accompanying incidents in fourteen images known as the Stations of the Cross: (1) Jesus is condemned to death; (2) Jesus picks up the cross; (3) Jesus picks up the cross; (4) Jesus meets his grieving mother; (4) Jesus of Cyrene is forced to help Jesus carry the cross; (6) Veronica wipes Jesus dain; (8) Jesus admonishes the again; (8) Jesus admonishes the women of Jerusalem; (9) Jesus falls a third time; (10) Jesus admonishes the Jesus is nailed to the cross; (12) Jesus falls a dies on the cross; (13) Jesus falks a dies on the cross; (13) Jesus faken down from the cross; (14) Jesus is taken down from the cross; (14) Jesus is

entombed.

flowing from Jesus' wounds will the promise of redemption: the blood buried. The association symbolizes place of the skull," where Adam was cution ground as Golgotha, "the his clothes; a skull identifies the exewith a spear, and others gamble for drink, another stabs him in the side vinegar instead of water for him to extends a sponge on a pole with Roman soldiers torment Jesus—one lowers mourn at the foot of the cross; gelist, Mary Magdalen, and other fol-Jesus; the Virgin Mary, John the Evannot), are crucified on either side of criminals (one penitent, the other the following narrative details: two depictions include some or all of alone or a cross and a lamb. Later abstract, showing either a cross sentations of the Crucifixion are The Crucifixion: The earliest repre-

The Descent from the Cross (The Deposition): Jesus' followers take his body down from the cross. Joseph of Arimathea and Vicodemus wrap it in linen with myrrh and sloe. Also present are the grief-stricken Virgin, John the Evangelist, and sometimes Mary Magdalen, other disciples, and angels.

.ni2 laniginO s'mabA yawa daaw

The Lamentation (Pietà or Vesperbild): Jesus' sorrowful followers of

of Olives, Jesus struggles between his human fear of pain and death and his divine strength to overcome them (agon is Greek for "contest"). An angelic messenger bolsters his courage. The apostles sleep nearby, oblivious.

The Betrayal (The Arrest): Judas Iscariot, one of the disciples, accepts a bribe to point Jesus out to his enemies. Judas brings an armed crowd to Gethsemane. He kisses Jesus, a prearranged signal. Peter makes a futile attempt to defend Jesus from the Roman soldiers who seize him.

The Denial of Peter: Jesus is brought to the palace of the Jewish high priest, Caiaphas, to be interrogated for claiming to be the Messiah. Peter follows, and there he three times denies knowing Jesus, as Jesus predicted he would.

Jesus before Pilate: Jesus is taken to Pontius Pilate, the Roman governor of Judaea, and charged with treason for calling himself king of the Jews. He is sent to Herod Antipas, ruler of Galilee, who scorns him. Pilate prodown by the mob, which demands down by the mob, which demands that he be crucified. Pilate washes his hands before the crowd to signify that Jesus' blood is on its hands, not his.

The Flagellation (The Scourging): Jesus is whipped by his Roman captors.

Jesus Crowned with Thorns (The Mocking of Jesus): Pilate's soldiers torment Jesus. They dress him in royal robes, crown him with thorns, and kneel before him, hailing him as king of the Jews.

The Bearing of the Cross (The Road to Calvary): Jesus bears the cross from Pilate's house to Golgotha, where he is executed. Medieval artists depicted this event and its

next frame to the right, the apostle Peter has just been arrested for preaching after the death of Jesus. Jesus himself appears in the center frame as a teacher-philosopher flanked by Saints Peter and Paul. In a reference to the pagan past, Christ in this scene rests his feet on the head of Aeolus, the god of the winds in classical mythology,

The scenes illustrate events in both the Old and New Testaments arranged in symbolic rather than narrative order. On the top left, Abraham, the first Hebrew patriarch, learns that he has passed the test of faith and need not sacrifice his son Isaac. Christians saw in this story a prophetic sign of Christ's sacrifice on the cross. In the

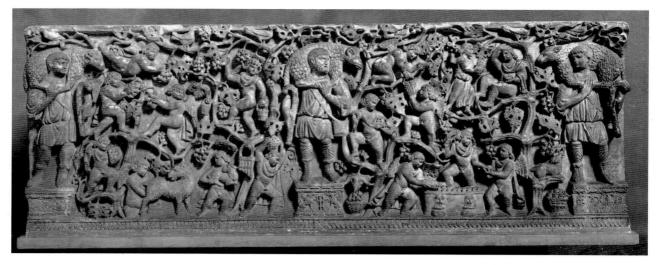

7-24. *Good Shepherd Sarcophagus*, from the Catacomb of Praetextatus, Rome. Late 4th century. Marble. Monumenti, Musei e Gallerie Pontificie, Vatican, Rome

shown with a veil billowing behind him. To Christians he personified the skies, so that Christ is meant to be seen as seated above, in heaven, where he is giving the Christian Law to his disciples, imitating the Hebrew Scriptures' account of God dispensing the Law to Moses. Next are two scenes from Christ's Passion (see "Iconography of the Life of Jesus," page 307), his arrest (second from right) and his appearance before Pontius Pilate (far right). The frame on the bottom left shows the Old Testament story of Job, whose trials provided a model for the sufferings of Christian martyrs. Next on the right is the Fall of Adam and Eve. Lured by the serpent, they have eaten the forbidden fruit, becoming conscious of their nakedness, and are trying to hide their genitals with leaves. At the bottom center, Jesus makes his triumphal entry into Jerusalem. The next frame to the right shows Daniel in the lions' den, and the frame on the bottom right shows Saint Paul being led to his martyrdom. These exemplars of Old and New Testament faith and acceptance of divine will merge here with the theme of salvation through Jesus Christ.

Another sarcophagus found in Rome, known as the Good Shepherd Sarcophagus, dates to the end of the fourth century (fig. 7-24). It combines an image of the Good Shepherd with a pattern of putti harvesting grapes like that found on the ceiling of the Church of Santa Costanza (see fig. 7-17). The sculptors clearly intended the shepherds to be seen as statues raised on bases, and the large sheep arching over their shoulders set off their heads like halos. The busy putti climb through the vines to pluck grapes, which they trample in the winepress between the statue bases on the right. On the left, one milks a ewe while his companion holds the lamb that would otherwise be nursing from its mother. The shallow relief was made to seem higher through deep undercutting around the figures and the use of drillwork. The imagery of the catacomb paintings here finds enduring three-dimensional form.

EARLY BYZANTINE ART

During the fifth and sixth centuries, while people living in the Italian peninsula experienced invasions and religious controversy, the Eastern Empire flour-

ished. Its capital, Constantinople, remained secure behind massive walls defended by the imperial army and navy. Its control of land and sea routes between Europe and Asia made many of its people wealthy. Their patronage, as well as that of the imperial family, made the city an artistic center, and Greek scholarship and philosophy continued to be taught in its schools. Influences from the regions under the empire's control—Syria, Palestine, Egypt, Persia, and Greece—gradually combined to create a distinctive Byzantine culture.

In the sixth century, Byzantine political power, wealth, and culture reached its height under Emperor Justinian I (ruled 527-565), ably seconded by Empress Theodora (c. 500-548). With the leadership of General Belisarius, imperial forces recovered northern Africa, Sicily, much of Italy, and part of Spain. Ravenna became the administrative capital of Byzantine Italy. The pope, although officially subject to Ravenna, remained head of the Western Church. However, the Byzantine policy of caesaropapism, whereby the emperor was head of both church and state, became a growing source of friction between the two halves of Christendom (see "Rome, Constantinople, and Christianity," page 290). As Slavs and Bulgars moved into the Balkan peninsula in southeastern Europe, they, too, came under the sway of the empire. Only on the frontier with the Persian Empire to the east did Byzantine armies falter, and there Justinian bought peace with tribute. To centralize his government and impose a uniform legal system, Justinian began a thorough compilation of Roman law known as the Justinian Code. Written in Latin, this code was later to serve as the foundation for the legal systems of Europe.

100 CE 1200 CE 200

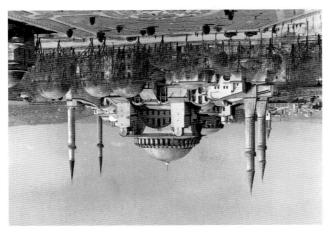

7-25. Anthemius of Tralles and Isidorus of Miletus. Church of Hagia Sophia, Istanbul, Turkey. 532–37. View from the southwest

The body of the original church is now surrounded by later additions, including the minarets built after 1453 under the Ottoman Turks.

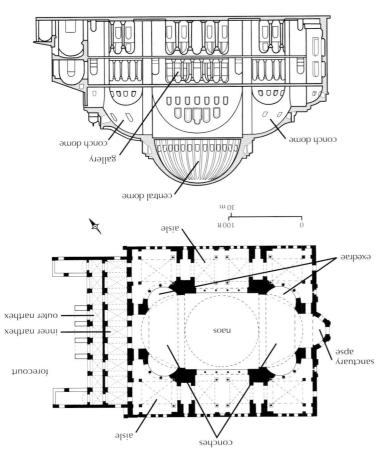

7-26. Plan and section of the Church of Hagia Sophia

ture," page 310). The origin of the dome on pendentives, which became the preferred method for supporting domes in Byzantine architecture, is obscure, but Hagia Sophia represents its earliest use in a major building. Here two semidomes flanking the main dome rise above exedrae with their own conch domes at the four corners

The Church and Its Decoration

that overshadowed any in the city since the reign of Continian and Theodora embarked on a building campaign crushed the rebels. As soon as order was restored, Juswords as a battle cry, imperial forces under Belisarius was the royal color) than flee for her life. Taking up her meaning that she would rather die an empress (purple resist the rioters, saying, "Purple makes a fine shroud" ically shrewd woman, is said to have spurred Justinian to was destroyed. The empress Theodora, a brilliant, politstreets. They set fire to the church, and soon half the city at a racetrack close to the imperial palace took to the tinian's religious and political foes, the excitable crowds church was destroyed during riots in 532. Spurred by Jusand successor in the East, Constantius II, after the old ry building erected during the reign of Constantine's son Wisdom, fig. 7-25). This church replaced a fourth-centunificent exception is the Church of Hagia Sophia (Holy tectural projects or of the old imperial city itself. A mag-Empire, Constantinople, but little remains of his archirenovation campaign on the capital of the Eastern Constantinople. Justinian focused his building and

Justinian chose two scholar-theoreticians, Anthemius of Tralles and Isidorus of Miletus, to rebuild Hagia Sophia as an embodiment of imperial power and Christian glory. Anthemius was a specialist in physics who had optics, and Isidorus a specialist in physics who had also studied vaulting. They developed a daring and magnificent design. The dome of the church provided a vast, golden, light-filled canopy high above a processional space for the many priests and members of the imperial court who assembled there to celebrate the Eucharist.

stantine two centuries earlier.

The new Hagia Sophia was not constructed by the miraculous intervention of angels, as was rumored, but by mortal builders in only five years (532–537). The architects, engineers, and masons who built it benefited from the accumulated experience of a long tradition of great architecture. Procopius of Caesarea, who chronicled Justinian's reign, claimed poetically that Hagia Sophia's gigantic dome seemed to hang suspended on a "golden chain from Heaven." Legend has it that Justinian himself, aware that architecture can be a potent symbol of earthly power, compared his accomplishment with that of the legendary builder of the Eirst Temple in Jerusalem, sayling, "Solomon, I have outdone you."

Hagia Sophia was based on a central plan with a dome inscribed in a square (fig. 7-26). To form a longitudinal nave, **conches**—semidomes—expand outward from the central dome to connect with the narthex on one end and the conch of the sanctuary apse on the other. This central core, called the **naos** in Byzantine architecture, is flanked by side aisles; **galleries**, or stories architecture, is overlooking the naos, are located above the

The main dome of Hagia Sophia is supported on pendentives, triangular curving wall sections built between the four huge arches that spring from piers at the corners of the dome's square base (see "Elements of Architec-

aisles.

ARCHITECTURE

Squinches

ELEMENTS OF Pendentives and squinches are two methods of supporting a round dome or its drum over **Pendentives and** a square or rectangular space. Pendentives are structural elements between arches that

form a circular opening into which the dome is set. Squinches are miniature quarter-dome brackets, or corbels, fitted into the walls' upper corners beneath the dome. Because squinches create an octagon, which is close in shape to a circle, they provide a solid base on which a dome may rest. Byzantine builders experimented with both pendentives (as at Hagia Sophia, fig. 7-27) and squinches. Elaborate squinch-supported domes became a hallmark of Islamic interiors (as at Córdoba's Great Mosque, see fig. 8-7).

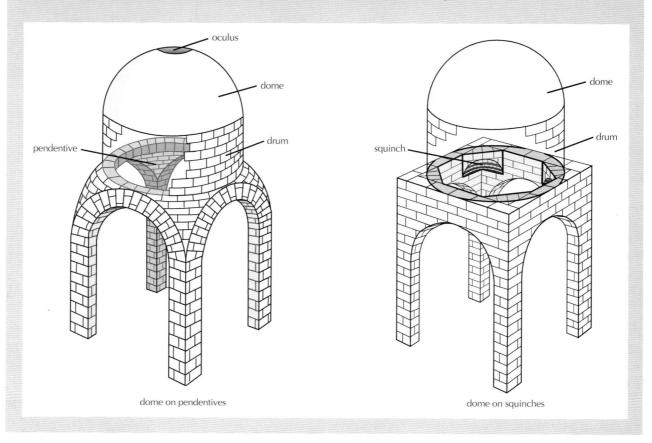

of the nave. Unlike the Pantheon's dome, which is solid with an oculus at the top (see fig. 6-56), Hagia Sophia's dome has a band of forty windows around its base. This daring concept challenged architectural logic by weakening the integrity of the masonry but created the allimportant circle of light that makes the dome appear to float (fig. 7-27). In fact, when the first dome fell in 558, it did so because a pier and pendentive shifted and the dome was too shallow, not because of the windows. Confident of their revised technical methods and undeterred, the architects designed a steeper dome that put the summit 20 feet higher above the floor. Exterior buttressing was added, and although repairs had to be made in 869, 989, and 1346, the church has since withstood the shock of earthquakes.

As in a basilica-plan church, worshipers entered Hagia Sophia through a forecourt and outer and inner narthexes on a central axis. Once through the portals, though, their gaze was drawn upward into the dome and then forward by the succession of domed spaces to the distant sanctuary. With this inspired design Anthemius and Isidorus had reconciled an inherent conflict in

church architecture between the desire for a symbolically soaring space and the need to focus attention on the altar and the liturgy. The domed design came to be favored by the Eastern Church.

The liturgy used in Hagia Sophia in the sixth century has been lost, but it presumably resembled the later rites of the Eastern Orthodox Church. Assuming that was the case, the celebration of the Mass took place behind a screen—at Hagia Sophia an embroidered curtain, in later churches an iconostasis, or wall hung with devotional paintings called icons ("images" in Greek). The emperor was the only layperson permitted to enter the sanctuary. Others stood in the aisles (men) or galleries (women). Processions of clergy moved in a circular path from the sanctuary into the nave and back five or six times during the ritual. The focus of the congregation was on the screen of images and up into the dome rather than ahead to the altar and apse. The upward focus reflects the interest of Byzantine philosophers in Neoplatonic theories that viewed meditation as a way to rise from the material world into a spiritual state. Worshipers standing on the church floor must have felt such a spiritual uplift as

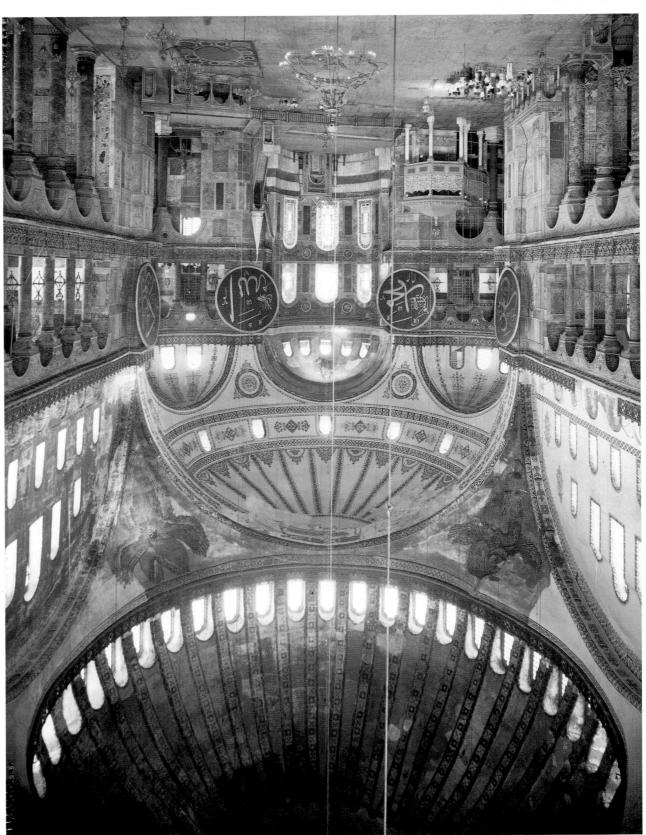

7-27. Church of Hagia Sophia

Hypatius of Ephesus, writing in the mid-sixth century, justified decorating churches in a luxurious manner as a means to inspire piety in the congregation. He wrote: "We, too, permit material adornment in the sanctuaries, not because God considers gold and silver, silken vestments and vessels encruated with gems to be precious and holy, but because we allow every order of the faithful to be guided in a suitable manner and to be led up to the Godhead, inasmuch as some men are guided even by such things towards the intelligible beauty, and from the abundant light of the sanctuaries to the intelligible and immaterial light" (cited in Mango, page 117).

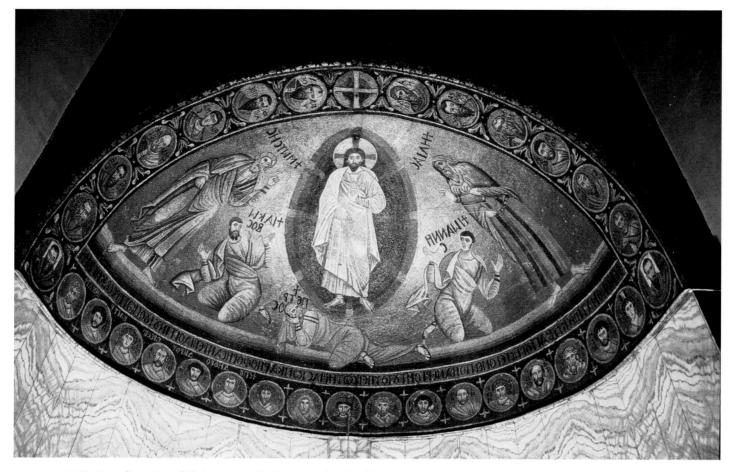

7-28. *Transfiguration of Christ*, mosaic in the apse, Church of the Virgin, Monastery of Saint Catherine, Mount Sinai, Egypt. c. 548–65

they gazed at the mosaics of saints, angels, and, in the golden central dome, heaven itself.

The churches of Constantinople were once filled with the products of imperial patronage: mosaics, rich furniture, and objects of gold, silver, and silk. Mosaics now in the Monastery of Saint Catherine on Mount Sinai in Egypt were one such donation. The apse mosaic of the monastery's church depicts the Transfiguration on Mount Tabor (see "Iconography of the Life of Jesus," page 306) in a simple, direct manner (fig. 7-28). Dated between 548 and 565, this imposing work shows the transfigured Christ in a triple blue **mandorla**, an almond-shaped halo that surrounds Christ's whole figure, against a golden sky that fills the apse conch. The visionary figure of Christ emits rays of light, and the standing Old Testament prophets Moses and Elijah descend to affirm his divinity. The astonished apostles on the ground are identified as

Saint Peter below, Saint John at the left, and Saint James at the right. A supernatural wind seems to catch the ends of their robes, whipping them into curiously jagged shapes. The apostles fall to the ground in fear and amazement, while Christ stands calmly in the relaxed pose of a Greek-Roman athlete or orator. Mount Tabor is suggested only by a narrow strip at the bottom, half green and half reflecting the golden light. This abstract rendering contrasts with the continuing classical influence seen in the figures' substantial bodies, revealed by their tightly wrapped drapery.

The formal character of the *Transfiguration of Christ* mosaic reflects an evolving approach to representation that began several centuries earlier. As was discussed in Chapter 6, the character of imperial rule began to change in the fourth century in ways that were reflected in works of art like *The Tetrarchs* (see fig. 6-77) and the relief pan-

100 CE 1200 CE

perspective in painting and relief sculptures, and standardized shorthand conventions to portray individuals and events.

Ravenna. Ravenna was conquered by the Byzantine Empire from the Ostrogoths in 540 and served as a base for the further conquest of Italy, completed by Justinian I in 553. Much of our knowledge of the art of this turbulent period—from the time of Honorius (emperor of the Western Roman Empire) through barbarian control to the triumphant victory of the Byzantine Empire—comes from the well-preserved monuments at Ravenna.

In 526 Ecclesius, Arian bishop of Ravenna from 521 to 532, commissioned two new churches, one for the city and one for its port, Classis. With funding from a wealthy local banker construction began on a central-plan church in Ravenna dedicated to the fourth-century Italian martyr cated to Saint Apollinaris, the first bishop of Ravenna. Weither was completed until after Justinian had conquered Ravenna and established it as the Byzantine quered Ravenna and established it as the Byzantine administrative capital of Italy. The Church of San Vitale was dedicated in 547, followed by the Church of San Vitale

Apollinare in Classe two years later.

The design of San Vitale is basically an octagon extended by exedralike semicircular bays and covered by a round dome (fig. 7-29). The strict symmetry of the design is broken by the extension of one bay into a rectangular sanctuary and apse that projects through one of the octagonal sides of the shell. Circular chapels with rectangular altar spaces flank this apse projection. A septectangular altar spaces flank this apsect of the octagonal stair tong-gone narthex in the form of a long, oval bays led to cylindrical stair towers that gave access to the second-floor gallery. This sophisticated design has distant roots in Roman buildings such as Santa Costanza tant roots in Roman buildings such as Santa Costanza

reinforced by the liberal use of gold tesserae in the surphysically and also create an airy, floating sensation, the second floor. They expand the circular central space the outer aisles on the ground floor and into galleries on ary. These two-story exedrae open through arches into eight large piers that frame the exedrae and the sanctulocking ceramic tubes and mortar. The whole rests on a light, strong structure ingeniously created out of interexterior by an octagonal shell and a tile-covered roof, is straight ahead of them. The round dome, hidden on the proached on axis with the sanctuary, which they saw openings, whereas those entering from the left apnave. People entering from the right saw only arched narthex with its double sets of doors leading into the the church, an effect that was enhanced by the offset effect of the complex, interpenetrating interior spaces of The floor plan of San Vitale only begins to convey the (see fig. 7-15).

> gallery apsidal chapels sanctuary dome area stairs to gallery

metric simplification of figures and objects, distortion of natural world. The new style was characterized by geophysicality of the real world in favor of a timeless superconcepts, artists rejected the space, light, color, and tangible images that would stand for intangible Christian than exact external appearance. Attempting to create sought to express essential religious meaning rather a new hieratic—formally abstract or priestly—style that the visual appearance of the material world gave way to In Christian art, especially, an early interest in capturing displaced the naturalism of Greek and Roman classicism. similar to that seen in Egyptian and Near Eastern works cial art of the period, a conventionalized style somewhat Sacred, Majestic, or Eternalness to address him. In the offipomp and ceremony; orators often used terms like or became an increasingly remote figure surrounded by els on the Arch of Constantine (see fig. 6-85). The emper-

доше экеэ

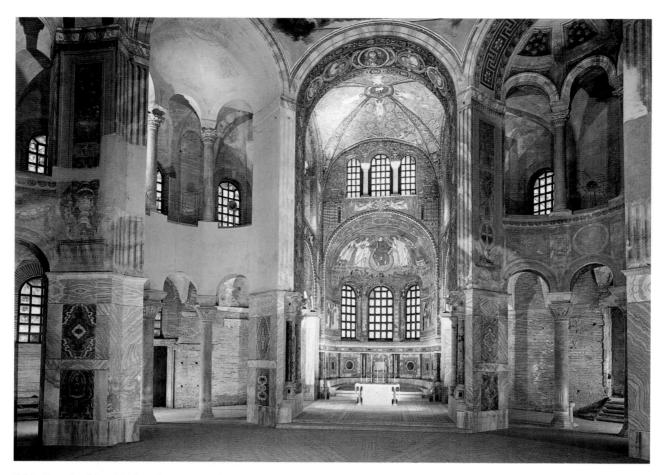

7-30. Church of San Vitale. View across the central space toward the sanctuary apse with mosaic showing Christ enthroned and flanked by Saint Vitalis and Bishop Ecclesius

In the conch of the sanctuary apse, an image of Christ enthroned is flanked by Saint Vitalis and Bishop Ecclesius, who presents a model of the church to Christ (fig. 7-30). The other sanctuary images relate to its use for the celebration of the Eucharist. Pairs of lambs flanking a cross decorate impost blocks above the intricately interlaced carving of the marble column capitals. The lunette on the south wall shows an altar table set with a chalice for wine and two patens, liturgical plates, to which the high priest Melchizedek on the right brings an offering of bread, and Abel, on the left, carries a sacrificial lamb (fig. 7-31). Their identities are known from the inscriptions above their heads.

The prophets Isaiah (right) and Moses (left) appear in the spandrels. Moses, while tending his sheep, heard the voice of an angel of God coming from a bush that was burning with a fire that did not destroy it. Moses is shown reaching down to remove his shoes, a symbolic gesture of respect in the presence of God or on holy ground. In the gallery zone of the sanctuary the Four Evangelists are depicted, two on each wall, and in the vault the Lamb of God supported by four angels appears in a field of vine scrolls.

Justinian and Theodora did not attend the dedication ceremonies for the Church of San Vitale conducted by Archbishop Maximianus in 547—they may never have set foot in Ravenna—but two large mosaic panels that face each other across its apse make their presence known. Justinian (see fig. 7-1), on the north wall, carries a large golden paten for the Host and stands next to Maximianus, who holds a golden, jewel-encrusted cross. The priestly celebrants at the right carry the Gospels, encased in a gold-and-jewel book cover, symbolizing the coming of the Word, and a censer containing burning incense to purify the altar prior to the Mass.

Theodora, on the south wall of the apse, carries a huge golden chalice studded with jewels (fig. 7-32). She presents this both as an offering for the Mass and as a gift of great value for Christ. With it she emulates the Magi (see "Iconography of the Life of Jesus," page 306), depicted at the bottom of her purple robe, who brought valuable gifts of gold, frankincense (fragrant wood), and myrrh (expensive, perfumed oil) to the infant Jesus. A courtyard fountain stands to the left of the panel and patterned draperies adorn the openings at left and right. The empress stands beneath a fluted shell canopy, a classical motif associated with the goddess Venus. Her head, with its huge pearled crown and golden halo, seems almost fixed in place, as if this were a holy image.

The mosaic decoration in the Church of San Vitale presents a unique mixture of imperial ritual, Old Testament narrative, and Christian liturgical symbolism that dissolves its architecture into shimmering light and color. The setting around Theodora—the conch, the

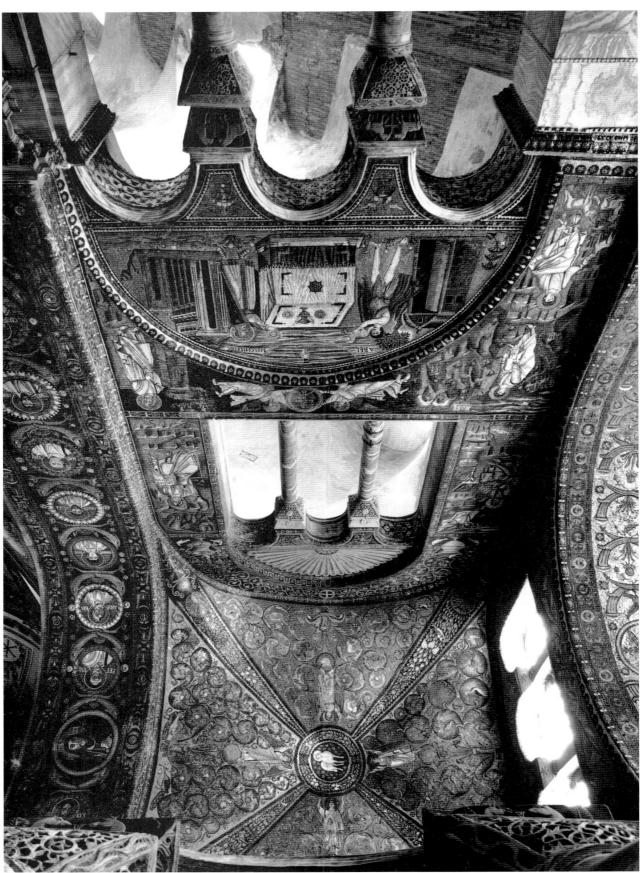

7-31. Church of San Vitale, south wall of the sanctuary, with Abel and Melchizedek in the lunette, Moses and Isaiah in the spandrels, portraits of the evangelists in the gallery zone, and the Lamb of God in the vault

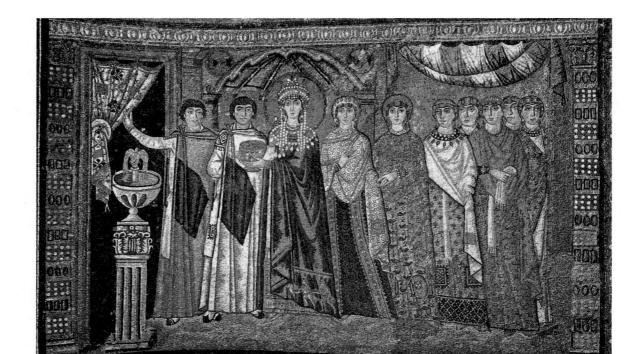

7-32. Empress Theodora and Her Attendants, mosaic on south wall of the apse, Church of San Vitale. c. 547. $8'8" \times 12' (2.64 \times 3.65 \text{ m})$

Just like royalty today, Theodora was the subject of much comment and conjecture in her time. Described in a "secret history" by a contemporary, the historian Procopius, as a small-boned woman with sparkling eyes and a will of iron, she was said to have been an actress, considered a risqué profession. Her father was an animal trainer for the circus, where the young heir to the imperial throne, Justinian, met her. Although Theodora's background was unacceptable in high circles, Justinian remained devoted to her. He named a new province, Theodorias, for her and treated her almost as if she were co-emperor. Theodora died in 548, not long after this mosaic portrait was completed.

fluted pedestal, the open door, and the swagged draperies—are classical illusionistic devices, yet the mosaicists deliberately avoid making them space-creating elements. Byzantine artists accepted the idea that objects exist in space, but they no longer conceived pictorial space the way Roman artists had, as a view of the natural world seen through a "window," the picture plane, and extending back from it toward a distant horizon. In Byzantine aesthetic theory, eye and image were joined by invisible rays of sight so that pictorial space extended forward from the picture plane to the eye of the beholder and included the real space between them. Parallel lines appear to diverge as they get farther away and objects seem to tip up in a representational system known as reverse perspective.

Bishop Maximianus consecrated the Church of Sant'Apollinare in Classe in 549 (fig. 7-33). The atrium has disappeared, but the simple geometry of the brick exterior clearly reflects the basilica's interior spaces. A narthex entrance spans the full width of the ground floor; a long, tall nave with a clerestory ends in a semicircular apse; and side aisles flank the nave.

On the interior, nothing interferes visually with the movement forward from the entrance to the raised sanctuary (fig. 7-34), which extends directly from a triumphalarch opening into the semicircular apse. The conch mosaic depicts an array of human and animal figures in

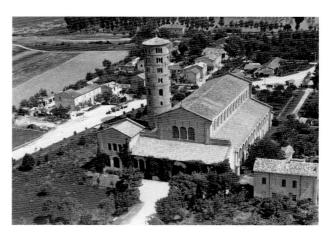

7-33. Church of Sant'Apollinare in Classe, the former port of Ravenna (Classis), Italy. 533–49

a stylized landscape and has many levels of meaning. A jeweled cross with the face of Christ at its center symbolizes the Transfiguration—Jesus' revelation of his divinity. The Hand of God reaches down from glowing clouds. The Old Testament figures Moses and Elijah emerge from clouds at each side, symbolically legitimizing the newer religion and attesting to the divine event. The apostles Peter, James, and John—represented here by the three sheep with raised heads—likewise witness

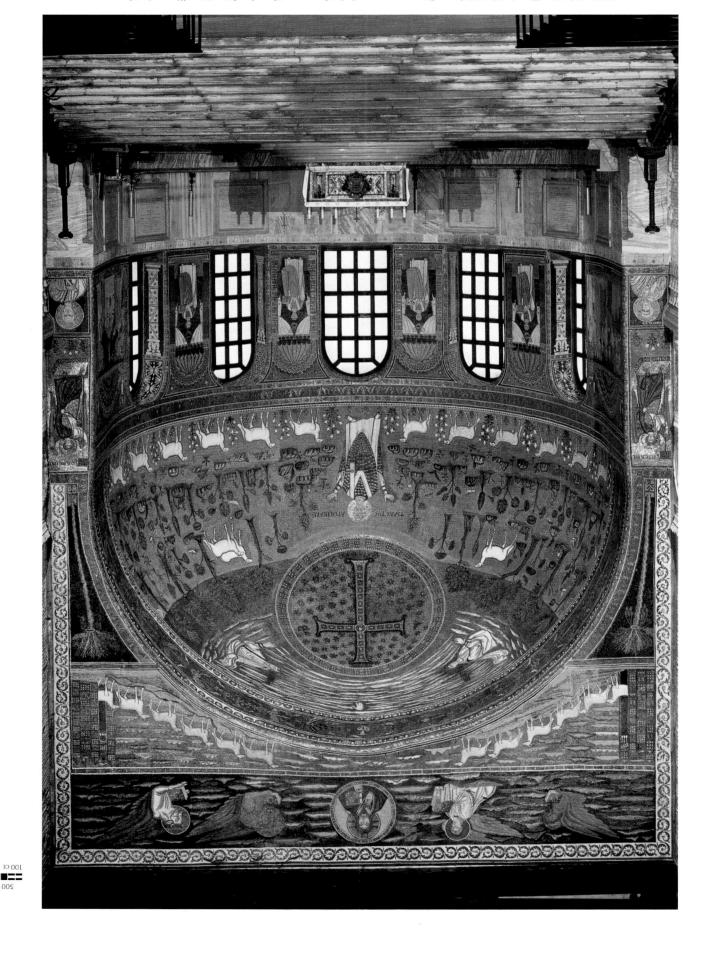

7-34. Saint Apollinaris, First Bishop of Ravenna, mosaic in the apse, Church of Sant' Apollinare in Classe

1200 CE

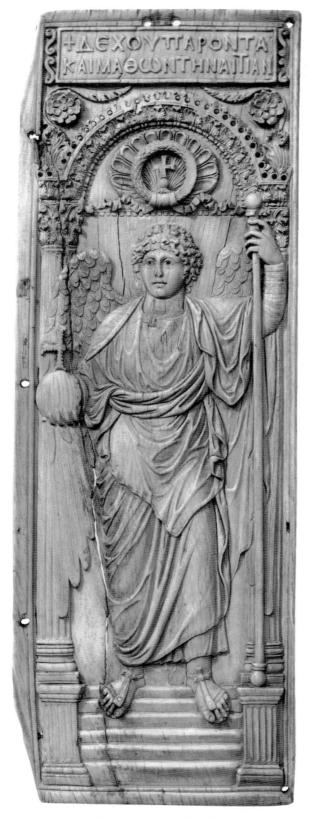

7-35. *Archangel Michael,* panel of a diptych, probably from the court workshop at Constantinople. Early 6th century. Ivory, 17 x 5¹/2" (43.3 x 14 cm). The British Museum, London

The other half of this devotional piece, now lost, would have completed the Greek inscription across the top, which begins: "Receive these gifts, and having learned the cause. . . . " Perhaps the other panel contained the portrait of the emperor or another high official who was presenting the panels as a gift to an important colleague, acquaintance, or family member.

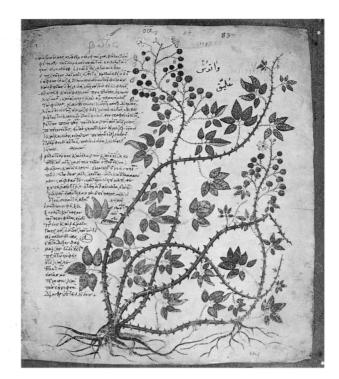

7-36. Page with *Wild Blackberry,* from *De Materia Medica,* by Pedanius Dioscorides (1st century), copy made and illustrated in Constantinople for Princess Anicia Juliana. c. 512. Tempera on vellum, 15 x 13" (38.1 x 33 cm). Österreichische Nationalbibliothek, Vienna

the event. At the center below the cross, Saint Apollinaris, in bishop's robes, is shown as an orant. The twelve lambs flanking him represent the apostles. Stalks of blooming lilies, along with tiny trees and other plants, birds, and oddly shaped rocks, fill the green mountain landscape. Unlike the landscape in the *Good Shepherd* lunette of the Mausoleum of Galla Placidia (see fig. 7-20), these highly stylized forms bear little resemblance to nature. The artists eliminated any suggestion of spatial recession by making the trees and lambs at the top of the golden sky larger than those at the bottom. The pictorial abstraction of the gigantic cross that dominates the conch similarly raises the imagery to a spiritual plane.

In the mosaics on the wall above the apse, which were added in the seventh and ninth centuries, Christ, now portrayed with a cross inscribed in his halo and flanked by symbols representing the evangelists, blesses and holds the Gospels. Lambs (the apostles) emerge from triumphal gateways and climb golden rocks toward their leader and teacher.

Ivories, Manuscripts, and Panel Paintings. Ivory reliefs were a popular product of the court workshops of Constantinople in the early sixth century. A treasured example of this form is a panel depicting an archangel, a high-ranking angel, probably Michael (fig. 7-35). The artist has rendered the figure in a classical style but has otherwise created an image meant entirely to convey certain abstract concepts. In his beauty, physical presence, and elegant setting, the archangel is comparable to the priestess of Bacchus in the Symmachus panel (see fig. 6-89). His

rence in the Mausoleum of Galla visible in the mosaic of Saint Lawholding the Gospels shown here and flat on shelves in cabinets like the one ally. These weighty tomes were stored example, were often bound individu-Old Testament (the Pentateuch), for Psalms, and the first five books of the separate books. The Gospels, the individual sections were made into Bible, in a single volume. As a result, large manuscript, such as an entire made it impractical to produce a very weight of parchment and vellum ivory, and enamels. The thickness and rated with precious metals, jewels, uscripts sometimes had covers decosheets of a codex flat. Very rich manfunctioned as a press to keep the wooden boards covered with leather Heavy covers in the form of

ing initials, others painting pictures, doing only borders, others decorat-Middle Ages, with some experts specialized during the European illumination became increasingly said to be illuminated. Manuscript decorated with gold and colors were reddish lead pigment. Manuscripts from minium, the Latin word for a books came to be called miniatures, or set off with frames. Illustrations in might also be placed within the text above or below the text, but they solution was to place illustrations tures and text varied. The simplest

kept records on a THE BOOK years ago, they have FORMS OF to write some 5,000 Since people began

and still others applying gold leaf.

Placidia.

Manuscripts, or handwritten books, were also comagainst the background of a scalloped-shell canopy. within the arch is a cross-topped orb, framed by a wreath, ly power in his right, a message reinforced by repetition: authority in his left hand and a sphere symbolizing worldshown here as a divine messenger, holding a staff of those found wanting in the eyes of God. The angel is after and its sobering counterpart, the torments of hell for

botanical encyclopedia known by its Latin title, De Mate-

missioned by the Byzantine court. Among these was a

image suggests both the joyful promise of life in the herethat would cause a human to teeter and fall forward. The but the rest of his body projects in front of them in a way a stair that clearly lies behind the columns and pedestals, however, is not realistic. His heels rest on the top step of spatial relation to the architectural frame around him,

> (61-1. Ravenna, Italy. c. 425-26 (see fig. lunette, Mausoleum of Galla Placidia, detail of a mosaic in the eastern Bookstand with Gospels codices,

but techniques for combining picuscripts often included illustrations, written by hand. From early on, manall books were manuscripts, that is,

Until the invention of printing, together. and sewing the two stacked sheets on one side, or by folding two sheets

times, cutting it, and then sewing it a large sheet of parchment three the eight-leaf quire, made by folding A basic unit of the early codex was predominant book form in the West. the codex replaced the scroll as the At the end of the first century ce,

scroll from one rod to the other. rod; the reader slowly unfurled the vertically. Each end was attached to a ten to be read either horizontally or and lighter, vellum. Scrolls were writknown as parchment or, when softer trimmed animal hide, a material thin sheets of cleaned, scraped, and together. Scrolls were also made from scrolls from sheets of papyrus glued on one side. Egyptian scribes made is made up of sheets bound together (plural codices), like the modern book, tinuous rolled strip, or scroll. A codex rotulus and codex. A rotulus is a concall books have taken two forms: paper. The extended works that we papyrus, animal skins, and finally wax tablets, pieces of broken pottery, variety of materials, including clay or

EARLY

trated work suitable for the imperial library (fig. 7-36). practical reference book in Greek into an exquisitely illus-

Book," above). The illustrators transformed what was a

sheets bound together on one side (see "Early Forms of the months in 472. It is in codex form, consisting of individual

whose father had been emperor in the West for a few

dated to about 512, was given to Princess Anicia Juliana,

earliest known surviving copy, from Constantinople and

scribes—professional document writers—copied it. The a highly regarded scientific treatise. Generations of

tematic treatment of such material and, in its time, was sician with the Roman army. His work was the first sys-

Dioscorides (c. 40-c. 90), who probably traveled as a phy-

first century ce by a Greek physician named Pedanius

inal uses of plants. The encyclopedia was compiled in the

ria Medica, listing the appearance, properties, and medic-

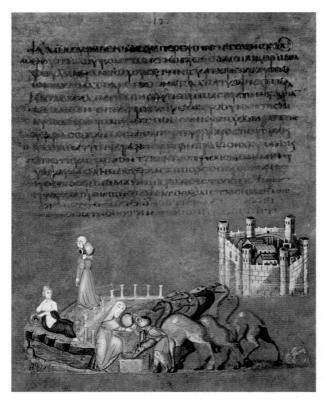

7-37. Page with *Rebecca at the Well*, from *Book of Genesis*, probably made in Syria or Palestine. Early 6th century. Tempera, gold, and silver paint on purple-dyed vellum, 13¹/₄ x 9⁷/₈" (33.7 x 25 cm). Österreichische Nationalbibliothek, Vienna

Although Dioscorides' work is secular and pagan, Christians found religious as well as medical significance in the plants it catalogs. For example, the wild blackberry bramble illustrated here came by tradition to represent the burning bush of Moses and the purity of the Virgin Mary.

Byzantine manuscripts often used very costly materials. Although plain sheets of vellum (a fine paperlike material made from calfskin) and natural pigments were used in this copy of De Materia Medica, purple-dyed vellum and inks of gold and silver were used in a Book of Genesis (fig. 7-37). The book was probably made in Syria or Palestine, and the purple vellum indicates that it may have been for an imperial patron (costly purple dye, made from the shells of murex mollusks, often was restricted to imperial use). The Genesis book, like the De Materia Medica, is in codex form and written in Greek. Illustrations appear below the text at the bottom of the pages. The illustration of the story of Rebecca at the Well (Genesis 24) shown here appears to be a single scene, but it actually mimics the continuous narrative of a scroll. Events that take place at different times in the story follow in succession. Rebecca, the heroine of the story, appears at the left walking away from the walled city of Nahor with a large jug on her shoulder to fetch water. She walks along a miniature colonnaded road toward a spring personified by a reclining pagan water nymph with a flowing jar. In the foreground, Rebecca, her jug now full, encounters a thirsty camel driver and offers him

water to drink. Unknown to her, he is Abraham's servant Eliezer in search of a bride for Abraham's son Isaac. Her generosity leads to marriage with Isaac. Although the realistic poses and rounded, full-bodied figures in this painting reflect an earlier Roman painting tradition, the unnatural purple of the background and the glittering silver ink of the text act to remove the scene from the mundane world.

An illustrated Gospels, signed by a monk named Rabbula and completed in February 586 at the Monastery of Saint John the Evangelist in Beth Zagba, Syria, provides a near-contemporary example of a quite different approach to religious manuscript decoration. Its illustrations may have been inspired by church paintings and mosaics. They are intended not only to depict biblical events but also to present the Christian story through a complex, multileveled symbolism. Besides full-page illustrations like those of the Crucifixion and the Ascension shown here, there are also lively smaller scenes, or vignettes, in the margins.

The Crucifixion in the Rabbula Gospels presents a detailed picture of Christ's death and resurrection (fig. 7-38). He appears twice, on the cross in the center of the upper register and with the two Marys—the Virgin and Mary Magdalen—at the right in the lower register. The Byzantine Christ is a living king who triumphs over death. He is shown as a mature, bearded figure, not the youthful shepherd depicted in the catacombs. Even on the cross he is dressed in a long, purple robe, called a colobium, that signifies his royal status. (In many Byzantine images he also wears a jeweled crown.) At his sides are the repentant and unrepentant criminals who were supposedly crucified with him. Beside the thief at the left stand the Virgin and Saint John the Evangelist; beside the thief at the right are the holy women. Soldiers beneath the cross throw dice for Jesus' clothes. A centurion stands on either side of the cross. One of them, Longinus, pierces Jesus' side with a lance; the other, Stephaton, gives him vinegar instead of water to drink from a sponge. The small disks in the heavens represent the sun and moon, who hide their faces in sorrow. In the lower register, directly under Jesus on the cross, stands the tomb, with its open door and stunned or sleeping guards. This scene represents the Resurrection. The angel reassures the holy women at the left, and Christ himself appears to them at the right. All these events (described in Matthew 28) take place in an otherworldly setting indicated by the glowing bands of color in the sky. The austere mountains behind the crosses give way to the lush foliage of the garden around the tomb. This very complete representation of the orthodox view of the Crucifixion may have been intended to counter the claim of the Monophysites that Christ was entirely divine.

The ascension of Christ into heaven (fig. 7-39) is described in the New Testament: "[A]s they [his apostles] were looking on, he was lifted up, and a cloud took him from their sight" (Acts of the Apostles 1:9). The cloud has been transformed into a mandorla supported by two angels. Two other angels follow, holding victory crowns in fringed cloths. The image directly under the mandorla

7-38. Page with The Crucifixion, from the Rabbula Gospels, from Beth Zagba, Syria. 586. 13½ x 10½" (33.7 x 26.7 cm). Biblioteca Medicea Lauren-riana, Florence

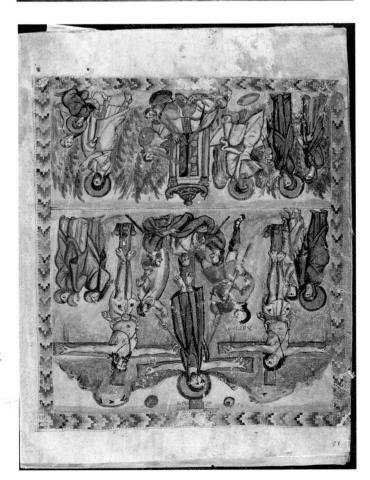

7-39. Page with The Ascension, from the Rabbula Gospels

ICONOCLASM Christianity, like Judaism and Is-

lam, has always been uneasy with the power of religious images. The early Church feared that the faithful would worship the works of art themselves instead of what they represented. This discomfort grew into a major controversy in the Eastern Church as images increasingly replaced holy relics as objects of devotion from the late sixth century on. Many icons were believed to have been created miraculously, and all were thought to have magical protective and healing powers. Prayer rituals came to include prostration before images surrounded by candles, practices that seemed to some dangerously close to idol worship.

In 726 Emperor Leo III launched a campaign of **iconoclasm** ("image breaking"), decreeing that all religious images were idols and should be destroyed. In the decades that followed, Iconoclasts undertook widespread destruction of devotional

pictures of Jesus Christ, the Virgin Mary, and the saints. Those who defended devotional images (Iconodules) were persecuted. The veneration of images was briefly restored under Empress Irene following the Second Council of Nicaea in 787, but the Iconoclasts regained power in 814. In 843 Empress Theodora, widow of Theophilus, the last of the iconoclastic emperors, reversed her husband's policy.

While the Iconoclasts held power, they enhanced imperial authority at the expense of the Church by undermining the untaxed wealth and prestige of monasteries, whose great collections of devotional art drew thousands of worshipers. They also increased tensions between the Eastern Church and the papacy, which defended the veneration of images and refused to acknowledge the emperor's authority to ban it. The Iconoclasts claimed that representations of Jesus Christ, because they portrayed him as human, promoted

heresy by separating his divine from his human nature or by misrepresenting the two natures as one. Iconodules countered that upon assuming human form as Jesus, God took on all human characteristics, including visibility. According to this view, images of Christ, testifying to that visibility, demonstrate faith in his dual nature and not, as the Iconoclasts claimed, denial of it: "How, indeed, can the Son of God be acknowledged to have been a man like us . . . if he cannot, like us, be depicted?" (Saint Theodore the Studite, cited in Snyder, page 128).

Those who defended images made a distinction between veneration—a respect for icons as representations of sacred personages—and worship of icons as embodiments of divinity, or idols. Moreover, they saw image making not only as an effective teaching tool but also as a humble parallel to the divine act of creation, when "God created man in his image" (Genesis 1:27).

combines fiery wheels and the four beasts of the Hebrew prophet Ezekiel's vision (Ezekiel 1). The four beasts also appear in the New Testament's Revelation and are associated with the Four Evangelists: Matthew, an angel; Mark, a lion; Luke, an ox; and John, an eagle. Christians interpreted this vision as a precursor of the vision of Judgment Day described in Revelation.

Below the vision, the Virgin Mary stands calmly in the pose of an orant, while angels at her side confront the astonished apostles. One angel gestures at the departing Christ and the other appears to be offering an explanation of the event to attentive listeners (Acts of the Apostles 1:10–11). The prominence accorded Mary here can be interpreted as a result of her relatively recent elevation to the status of Theotokos. She may also represent the Christian community on earth, that is, the Church. As we noted earlier, the Christian world at this time was filled with debate over the exact natures of Christ, the Trinity, and the Virgin Mary. Taken as a whole, the *Rabbula Gospels* would provide evidence of the owner's adherence to orthodoxy.

Eastern Christians prayed to Christ, Mary, and the saints while looking at images of them on icons. The first such image was believed to have been a portrait of Jesus that appeared miraculously on the scarf with which Saint Veronica wiped his face along the road to the execution ground. (Some people believe the so-called Shroud of Turin is this cloth.) Church doctrine toward the veneration of icons was ambivalent. Key figures of the Eastern Church, such as Saint Basil the Great of Cappadocia (c. 329–379) and Saint John of Damascus (c. 675–749), dis-

tinguished between idolatry—the worship of images—and the veneration of an idea or holy person depicted in a work of art. The Eastern Church thus prohibited the worship of icons but accepted them as aids to meditation and prayer. The images were thought to act as intermediaries between worshipers and the holy personages they depicted.

Most early icons were destroyed in the eighth century in a reaction to the veneration of images known as iconoclasm (see "Iconoclasm," above), making those that have survived especially precious. A few very beautiful examples were preserved in the Monastery of Saint Catherine on Mount Sinai, among them the Virgin and Child with Saints and Angels (fig. 7-40). As Theotokos, Mary was viewed as the powerful, ever-forgiving intercessor, or go-between, appealing to her Divine Son for mercy on behalf of repentant worshipers. She was also called the Seat of Wisdom, and many images of the Virgin and Child, like this one, show her holding Jesus on her lap in a way that suggests that she has become an imperial throne. The Christian warrior-saints Theodore (left) and George (right)—both legendary figures said to have slain dragons, representing the triumph of the Church over the "evil serpent" of paganism—stand at each side, while angels behind them look heavenward. The artist who painted the Christ Child, the Virgin, and the angels worked in a Roman-derived, illusionistic technique and created almost realistic figures. The male saints are much more stylized, and the artist barely hints at real bodies beneath the richly patterned textiles of their cloaks.

7-40. Virgin and Child with Saints and Angels, icon, Monastery of Saint Catherine, Mount Sinai, Egypt. Second half of 6th century. Encaustic on wood, 27 x 1878" (69 x 48 cm)

Architecture and Its Decoration

thodox Church was separate from the Eastern Orthodox "city of a thousand and one churches." The Armenian Or-Silk Road in the seventh century called its capital, Ani, the entrenched that foreign traders traveling the east-west tianity arrived very early in this region and became so of its history by the various empires surrounding it. Chrisday, are in ancient Armenia, a land fought over for much -or baniur ylleisirad and bandoned ally ruined toorative effects both inside and out. Some of the earliest multiplicity of geometric forms, verticality, and rich, decregions. These structures exhibit the builders' taste for a favored by Byzantine architects, also survived in outlying ceding centuries. Many central-plan domed churches, so city's Christian architecture looked like during the prebuilt, but enough remain to give us an idea of what the many of its churches were destroyed or extensively re-When Constantinople became a Muslim city in 1453,

Byzantine Christian art enjoyed three major productive phases. The first golden age began with the reign of Justinian I in the sixth century and centered on Concentury and centered on Concentury.

LATER BYZANTINE TAA

stantinople, ending in the eighth century, when the Iconoclasts rose to power in the Eastern Church. A second golden age began in 867 under the Macedonian dynasty and lasted until Christian Crusaders from the West occubied Constantinople in 1204 (Chapter 15). Byzantine culture flourished again in the fourteenth and early fifteenth centuries until Constantinople was conquered by Muslim of the Eastern Orthodox Church, it spread with Christianity through eastern Europe and became the source tianity through eastern Europe and became the source for national styles that still exist today. The Byzantine artistic tradition was, in the words of one scholar, "monartistic tradition was, in the words of one scholar, "monartistic tradition was, in the words of one scholar, "monartistic tradition was, in the words of one scholar, "monartistic tradition was, in the words of one scholar, "monartistic tradition was, in the words of one scholar, "monartistic tradition was, in the words of one scholar, "monartistic tradition was, in the words of one scholar, "monartistic tradition was, in the words of one scholar, "monartistic tradition was, in the words of one scholar, "monartistic tradition was, in the words of one scholar, "monartistic tradition was, in the words of one scholar, "monartistic tradition was," (Beckwith, page 344).

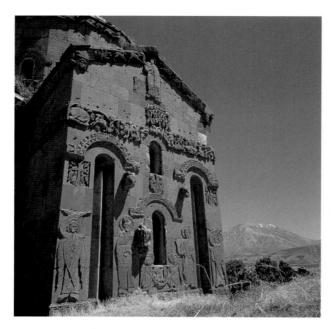

7-41. Church of the Holy Cross, Isle of Aght'amar, Lake Van, Armenia (modern Turkey). 915–21

Church, and the two architectural styles, while sharing certain features, sometimes diverged markedly.

One of the most exceptional Armenian central-plan domed churches is the Church of the Holy Cross, built between 915 and 921 on the Isle of Aght'amar in Lake Van in eastern Asia Minor (fig. 7-41). Originally part of a luxurious royal complex, the church was the product of the unusual and sophisticated taste of King Gagik of Vaspurakan (ruled 900/904-937). To build it, the king brought artisans "who came from every land" (cited in Thierry, page 173). A profusion of exterior stone sculpture is carved directly into the building blocks. Included are stylized figures in low, almost flat, relief; frieze bands in higher relief with deep undercutting; and fully threedimensional projecting animal heads. King Gagik is shown at the bottom, to the left of the center window. holding a nearly three-dimensional model of the church. Interestingly, Gagik is taller and more impressive in his wreathlike halo and patterned robes than Christ on the right. Various saints and archangels surround the bottom of the building, and two frieze bands, one above the arched openings and the other running under the eaves, show animals amid grapevines, a reminder of the heavenly paradise.

The two Churches of the Monastery of Hosios Loukas, built a few miles from the village of Stiris, Greece, in the tenth and eleventh centuries, provide excellent examples of the architecture of the second Byzantine golden age (figs. 7-42, 7-43). The Church of the Virgin Theotokos, on the right in the illustration, is joined to the Katholikon, on the left. Both churches are essentially compact, central-plan structures. Their exterior decoration is striking—light-colored stone and red brick arranged in decorative patterns. This style of decoration is known as cloisonné because the courses of brick outline the stone blocks and set them off like the fine-line

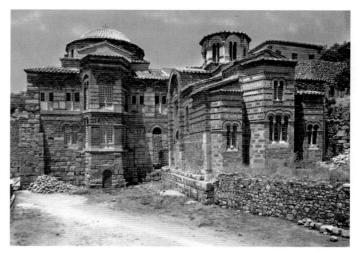

7-42. Churches of the Monastery of Hosios Loukas, near Stiris, Greece. Katholikon (left), early 11th century; Church of the Virgin Theotokos (right), 10th century

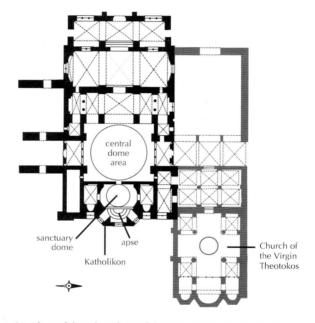

7-43. Plan of the Churches of the Monastery of Hosios Loukas

partitions (cloisons) in enamelwork. The dome of the Theotokos rises on pendentives over a square core; that of the Katholikon rises on **squinches** and an octagonal core. (Squinches, like pendentives, are devices for supporting a dome on a noncircular base; see "Elements of Architecture," page 310.) The domes are supported on high vaults covering interior bays. Separate narthexes and tall, slender sanctuary apses enrich the exteriors.

The high central space in the interior of the Katholikon carries the eye of the worshiper upward into the main dome, which soars above a ring of tall arched windows (fig. 7-44). Unlike Hagia Sophia, with its clear, sweeping geometric forms, the two churches of Hosios Loukas have a complex variety of forms, including domes, groin vaults, barrel vaults, pendentives, and

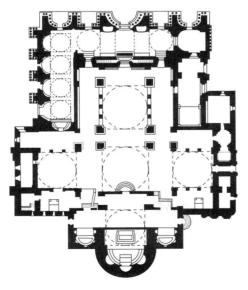

7-45. Plan of the Cathedral of San Marco, Venice. Begun 1063

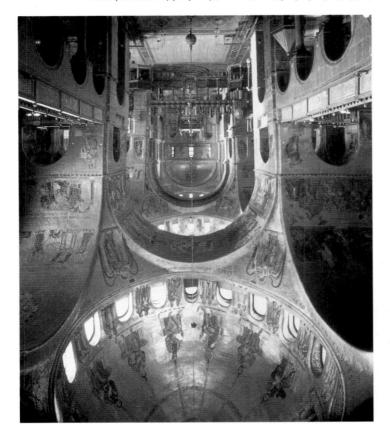

7-46. Cathedral of San Marco. View looking toward apse

The church is the third one built on the site. It is both the palace chapel and the martyrium where the bones of the patron of Venice, Saint Mark, are preserved. This great multidomed structure, consecrated as the Venice raibht to the present day.

supported by pendentives. Unlike Hagia Sophia, with its flow of space from the narthex through the nave to the apse (see fig. 7-27), San Marco's domed compartments—covered with golden mosaics—produce a complex space with five vertical axes (fig. 7-46).

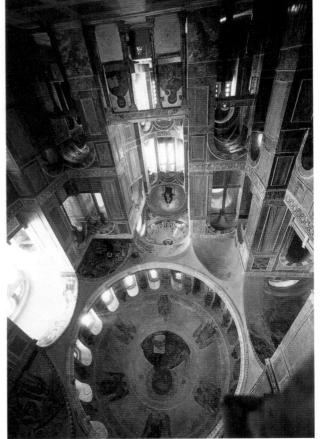

7-44. Central dome and apse, Katholikon, Monastery of Hosios Loukas. Early 11th century and later

squinches. (The squinches in the Katholikon are the small, fan-shaped niches above the corners of the lower walls.) Single, double, and triple windows create intricate and unusual patterns of light, illuminating a painting (originally a mosaic) of Christ Pantokrator, Ruler of the Universe, in the center of the main dome. The secondary, sanctuary dome of the Katholikon is decorated with a mosaic of the Lamb of God surrounded by the Twelve Apostles, and the apse conch has a mosaic of the Virgin and Child. Scenes from the Old and New Testavirgin and Child. Scenes from the old and New Testacolor and dramatic images.

At the end of the tenth century, Constantinople granted the northeastern Italian city of Venice, already a dominant sea power in the Adriatic, a special trade status that allowed its merchants to control much of the West commercial interchange between the East and the West Venetian architects looked to the Byzantine domed church for inspiration when the city's ruler, the doge, commissioned a much larger church to replace the palace chapel in 1063. This chapel had served since the ninth century as a **martyrium**, holding the relics of the ninth century as a **martyrium**, holding the relics of the drail of San Mark the Apostle, which were brought to Venice from Alexandria in the ninth century. The Cathedrial of San Marco has a Greek-cross plan, each square drail of San Marco has a Greek-cross plan, each square and of San Warco has a large state of which is covered by a dome (fig. 7-45). There are five great domes in all, separated by barrel vaults and five great domes in all, separated by barrel vaults and

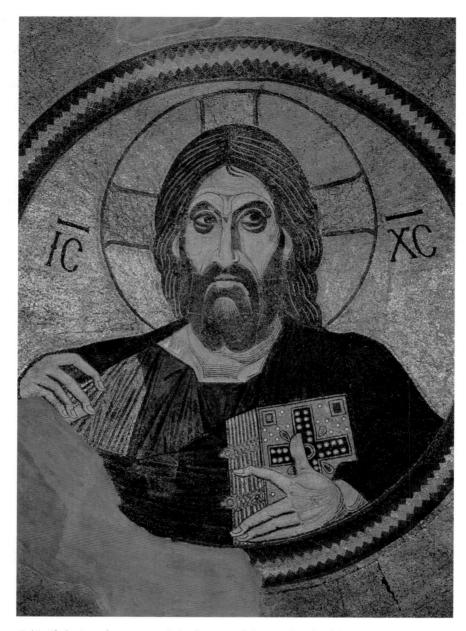

7-47. *Christ Pantokrator*, mosaic in the central dome, Church of the Dormition, Daphni, Greece. Central dome, c. 1080–1100

Eleventh-century mosaicists looked with renewed interest at models from the past, studying both classical art and the art of the Justinian era. They conceived their compositions in terms of an intellectual rather than a physical ideal. While representing the human figure and narrative subjects, some artists eliminated all unnecessary details, focusing on the essential elements of a scene to convey its mood and message. Other artists seemed absorbed in depicting anecdotal details, so that well-proportioned figures clothed in form-defining garments might also have draperies with patterns of geometric folds and jagged, flying ends bearing no relation to gravity. Instead of modeling forms with subtle tonal gradations, artists often relied on strong juxtapositions of light and dark areas.

The decoration of the Church of the Dormition at Daphni, Greece, provides an excellent eleventh-century

example of these developments. (The term dormition which comes from the Latin word for "sleep," which, in turn, derives from the Greek word for "sleep"-refers to the ascension to heaven of the Virgin Mary at the moment of her death.) The Christ Pantokrator, a bustlength mosaic portrayal, fills the central dome of the church (fig. 7-47). This awe-inspiring image, hovering in golden glory, is more than a picture of the Christian Savior; it is a powerful evocation of his promised judgment, with its reward for the faithful and punishment for sinners. On a wall in the north arm of the church is an image of Christ crucified (fig. 7-48). Jesus is shown with bowed head and sagging body, his eyes closed in death. Unlike the Crucifixion scene in the sixth-century Rabbula Gospels, which depicts many people, some anguished and others indifferent or hostile (see fig. 7-38), the artist of this image shows just two other figures, Mary and the

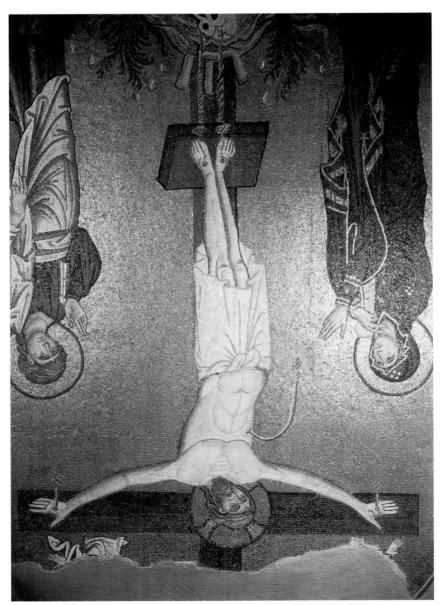

7-48. Crucifixion, mosaic in the north arm of the east wall, Church of the Dormition

in his First Letter to the Corinthians: "For just as in Adam all die, so too in Christ shall all be brought to life" (I Corinthians 15:22). The timelessness and simplicity of the image aid the Christian worshiper seeking to achieve a mystical union with the divine through prayer and meditation.

Other notable mosaics were created on the island of Sicily, a crossroads of Byzantine, Muslim, and European influence. Sicily was ruled by Muslims from 827 to the end of the eleventh century, when it fell to the Normans, descendants of the Viking settlers of northern France. The Norman Roger II (ruled 1105–1154) was crowned king in Palermo in 1130, and the pope, who assumed ecclesing Patermo in 1130, and the pope, who assumed ecclesing Patermo in 1130, and the first half of the twelfth endorsed Norman rule. In the first half of the twelfth endorsed Norman rule. In the first half of the twelfth endorsed kingdoms in Europe, Roger II extended enlightened kingdoms in Europe. Roger II extended

save humanity through his own sacrifice. As Paul wrote faithful, Jesus Christ was the new Adam sent by God to and the Crucifixion was said to have taken place. To the ancient Jerusalem where Adam was thought to be buried represent Golgotha, the "place of the skull," a hill outside mound of rocks and the skull at the bottom of the cross flowers, which suggest the promise of new life. The golden universe anchored to the material world by a few veys a sense of timelessness and otherworldly space, a essentials give the image great emotional power. It con-The simplification of contours and reduction of forms to blood springing from Jesus' side refers to the Eucharist. Christ, seems briefly to have overcome hers. The arc of John cannot hide his grief, but Mary, gesturing toward likely to elicit an emotional response from the viewer. care of his mother after his death. These two are the most young apostle John, to whom Jesus had entrusted the

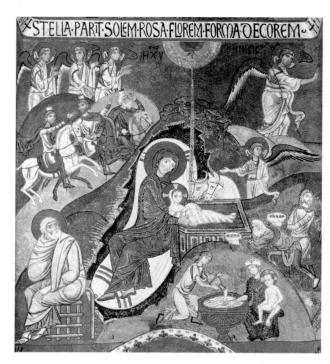

7-49. *Nativity*, wall mosaic in the Palatine Chapel, Palermo, Sicily. c. 1140–89

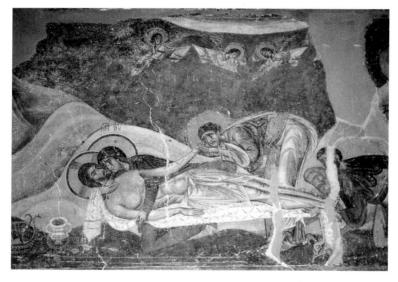

7-50. *Lamentation*, fresco in the Church of Saint Panteleimon, Nerezi, near Skopje, Republic of Macedonia. c. 1164

religious toleration to the kingdom's diverse population, which included Latins, Greeks, Arabs, and Jews. He involved all factions in his government, permitted everyone to participate equally in the kingdom's economy, and issued official documents in Latin, Greek, and Arabic.

Roger's court in his capital city of Palermo was a brilliant and exotic mixture of Norman, Muslim, and Byzantine cultures. The Palatine (palace) Chapel there reflects this diversity. The Western-style basilica-plan church has a Byzantine dome on squinches over the crossing.

An Islamic-style timber ceiling, inlaid marble floor and lower walls, and mosaic upper walls dramatically combine classical, Islamic, and Byzantine elements into an exotic whole.

Of special interest are the mosaic decorations completed between about 1140 and 1189 using the Byzantine style and technique but showing a Western preference for narrative over iconic images (fig. 7-49). In a wall mosaic, the Nativity story's events have been transformed into an exciting multipart drama, with each scene isolated by the rhythmic contours of hillocks and caves. At the center is the cave that, in the Eastern tradition, was the birthplace of Jesus. Mary lies on a mattress and supports the newborn Jesus on a solid, altarlike manger, where he is adored by the ox and the ass, symbols for Jews and Christians. At the lower right, the two midwives who had assisted at the birth are preparing a basin of water to bathe the baby. At the upper left, three angels seem to urge the Magi forward while pointing at the Star of Bethlehem, from which a single ray descends to the infant Jesus. The angel at the upper right has just announced the birth to three shepherds who appear in an extension of the mosaic on a neighboring wall, not shown here, at a right angle to this one. Two of the Magi appear a second time at the right presenting their gifts (the third is on the wall with the shepherds). Only Joseph at the lower left sits alone, lost in quiet contemplation of the miraculous events.

When money was no object, mosaic was the medium of choice for Byzantine wall decorations, but the less expensive and less durable medium of wall painting was also used effectively in many places. Paintings cover the walls of the small domed church dedicated to Saint Panteleimon on a mountainside near the Macedonian city of Skopje. Built in about 1164 under a distant relative of Emperor Alexios I, the church may have been decorated by painters from a major center working with local artists. Among the finest paintings is the Lamentation, a scene showing the body of the crucified Jesus mourned by his mother, John, Mary Magdalen, Peter, and perhaps Nicodemus, the wealthy man who offered his nearby mausoleum to house the body (fig. 7-50). The tension and quietude of this scene, which evoke the repressed feelings of the mourners for the untimely loss of a son, a friend, and a leader, contrast with the joyful bustle surrounding the Palermo Nativity. The horizontal composition emphasizes the prostrate form of the dead Jesus, and the repetition of rounded backs and rounded hills seems to make visible the waves of emotion sweeping over the living participants. The tender gestures of Mary pressing her cheek to her dead son's and John kissing his limp hand also convey the intensity of the moment. Because it evokes a powerful emotional rather than an intellectual response, the work is said to be **expressionistic**.

The third flowering of Byzantine art began after Western Crusaders, who had occupied Constantinople in 1204, were expelled from the city in 1261. The patronage of emperors, wealthy courtiers, and the Church stimulated renewed church building. In this new work, the physical requirements of the clergy and the liturgy took

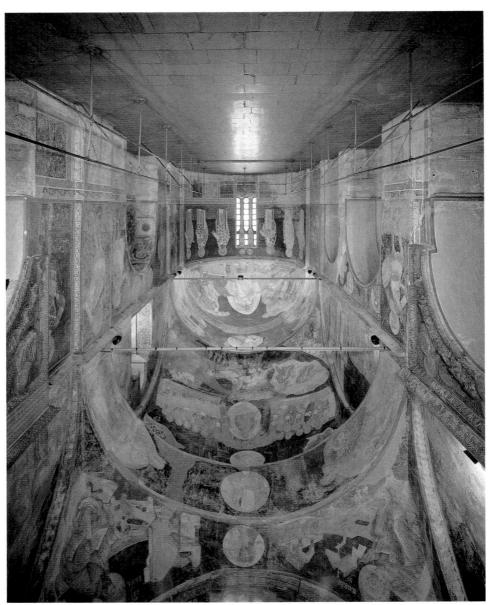

Turkey. c. 1315-21 7-51. Funerary chapel, Church of the Monastery of Christ in Chora (now Kariye Muzesi), Istanbul,

The funerary chapel is entirely painted (fig. 7-51). in Constantinople from the late Byzantine period.

ing (Chapter 16). rich colors, but it was not as durable as true fresco paintfrescolike technique allowed rapid work and produced egg and applied them directly over fresh wet plaster. This The painters mixed their pigments with a binder of oil or painting imitates marble panels in the surrounding dado. stood in the chambers beneath the church. Trompe l'oeil cophagi, surmounted by portraits of the deceased, once Church), saints, and martyrs line the walls below. Sar-Christian writers of the history and teachings of the the church fathers (a group of especially revered early themes appropriate to a funerary chapel. Large figures of and the Last Judgment, painted on the ceiling vault, are The resurrection of Christ, depicted in the apse conch,

skills and elegant and refined design. ings, nevertheless, often reflect excellent construction precedence over costly interior decorations. The build-

tain the most impressive interior decorations remaining funerary chapel on the south side. These structures conthe north side, two narthexes on the west side, and a after 1330. He added a two-story annex to its church on Metochites became a monk in this monastery sometime between 1315 and 1321. A humanist, poet, and scientist, of the Imperial Treasury at Constantinople, sponsored al projects that Theodore Metochites, the administrator Muzesi. The expansion of this church was one of sever-Chora, Constantinople, now a mosque known as Kariye these is the former Church of the Monastery of Christ in were added to many small, existing churches. Among New ambulatory aisles, narthexes, and side chapels

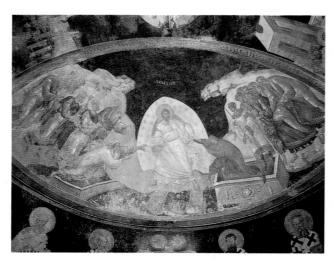

7-52. *Anastasis*, painting in the apse of the funerary chapel, Church of the Monastery of Christ in Chora

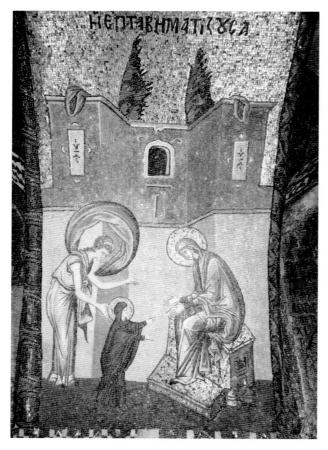

7-53. *The First Steps of Mary*, mosaic in the inner narthex, Church of the Monastery of Christ in Chora

A painting of the Resurrection known as the *Anastasis* fills the funerary chapel's apse vault (fig. 7-52). Artists in the West usually depicted the Resurrection as the Triumphant Christ (*Christus Triumphans*) emerging from his tomb in glory. The *Anastasis*, instead, depicts Christ descending into hell to rescue Adam and Eve and other devout people from Satan. Christ appears as an avenger

in white, moving with such force that even his starstudded mandorla has been set awry. He has trampled down the doors of hell; tied Satan into a helpless bundle; and shattered locks, chains, and bolts, which lie scattered over the ground. He drags the elderly Adam and Eve from their open sarcophagi with such force that their bodies seem airborne. Behind him are Old Testament prophets and kings, as well as his cousin John the Baptist.

In the inner narthex of the church, mosaics depicting scenes from the life of the Virgin Mary, a popular medieval cycle that included many subjects taken from popular tradition rather than from the Bible, fill the upper walls and vaults. Among them is a touching portrayal of Mary as an infant just learning to walk (fig. 7-53). The child, who appears as a tiny adult swathed in the dark draperies she will be shown wearing in later life, totters away from her nurse toward the encouraging arms of her mother, Anna (Saint Anne). The gestures and movement of the figures, although drawn with the exaggerated, elongated proportions and angular drapery of the late Byzantine style, create a mood of amused tenderness. The swinging draperies reinforce the curving arcs of the women's bodies, which along with the architectural elements form a protective, enfolding screen around the insecure toddler.

Constantinople had close commercial ties with Russia, and Christianity was introduced there in the late tenth century. Orthodox churches in Russia followed the traditional Byzantine plan of a dome over a Greek cross. Over the centuries the Russian preference for complexity and height led to a spectacular architectural style epitomized by the Cathedral of Saint Basil the Blessed in Moscow (fig. 7-54). Originally dedicated to the Intercession of the Virgin Mary, it was rededicated to Saint Basil the Blessed. The first Russian czar, Ivan IV, known as the Terrible (1530-1584), commissioned the church, and the architects Barna and Postnik designed it. Construction took place between 1554 and 1560. One of its most striking features is its combination of a Byzantine domed church with the steeply pitched Russian tent roof form called a shater, which kept dangerously large accumulations of snow from forming. The large, central shater seems to have spawned a brood of lesser domes of varying sizes. The multiplication of shapes and sizes and the layering of the surfaces with geometric relief elements all work to distract us from the underlying central plan—a central building surrounded by four arms ending in domed octagons and four domed cubical areas (fig. 7-55). Such an arrangement, a square with four corner units plus a center unit, is called a quincunx. Each of the exterior units has its own tall drum and a dome that seems to grow budlike from a tall, slender stalk. This spectacular church shows the evolution of Byzantine art into a distinctly national style found in later Russian Orthodox churches elsewhere, including the United States.

Ivories and Metalwork

During the second Byzantine golden age, from 867 to the Crusaders' occupation of Constantinople in 1204, artists

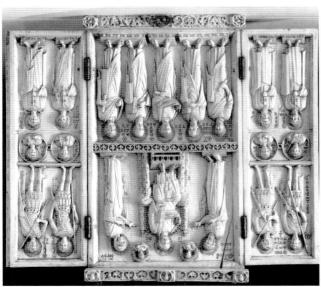

7-56. Harbaville Triptych. Late 10th century. Ivory, 11 x 91/2" closed (28 x 24.1 cm). Musée du Louvre, Paris

stance beneath a linear, decorative drapery. shoulders, thighs, and knees that suggest physical subessentially frontal and rigid, the figures have rounded saints and by Christ's throne. Although conceived as definition only by the small bases under the feet of the of worshipers. The figures exist in a neutral space given known as Deesis. The saints act as intercessors on behalf flanked by Mary and Saint John the Baptist, a group 7-56). This small ivory devotional piece represents Christ Harbaville Triptych, dating from the late tenth century (fig. simple beauty and religious meaning. Such a piece is the elements with iconic compositions, successfully joining refined. In style these works tended to combine classical such they had to be portable, sturdy, and exquisitely church functionaries as official gifts for one another. As items were commissioned by rulers and high secular and bers of the court as well as for the Church. Many of these duced small luxury items of a personal nature for memof impeccable ability and high aesthetic sensibility pro-

ivory panel (see fig. 7-35). The sheer artistry of this icon ness with which he was portrayed in a sixth-century pose and with the same idealized and timeless youthfularchangel appears here in essentially the same frontal removes the image from the physical world, although the 333). The colorful brilliance of the patterned setting enamel roundels (see "Byzantine Metalworking," page cate cloisonné and the framing borders are inset with oration. Halo, wings, and liturgical garments are in delirelief, are surrounded by intricate relief and enamel decshop (fig. 7-57). The angel's head and hands, executed in presumably made in the tenth century in a court workand-enamel icon of the archangel Michael. The icon was 1204, after their sack of Constantinople, was a silver-gilt-One of the prizes the Crusaders took back to Venice in expressed in precious materials such as silver and gold. the arts of the eleventh and twelfth centuries were also The refined taste and skillful work that characterize

7-54. Barna and Postnik. Cathedral of Saint Basil the Blessed, Moscow. 1554-60

Like most mid-sixteenth-century Russian churches, the entire exterior of Saint Basil's was originally painted white, and the domes were gilded. The bright colors we see today were added by later generations. The name of the church has also changed. It was originally dedicated to the Intercession of the Virgin Mary, a reflection of the veneration of the Waspin Mary, a reflection of the veneration of the waspin Mary in the Eastern Church.

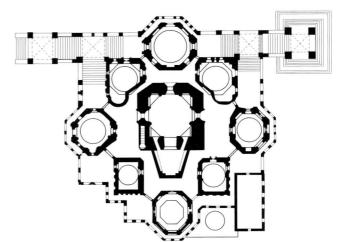

7-55. Plan of the Cathedral of Saint Basil the Blessed

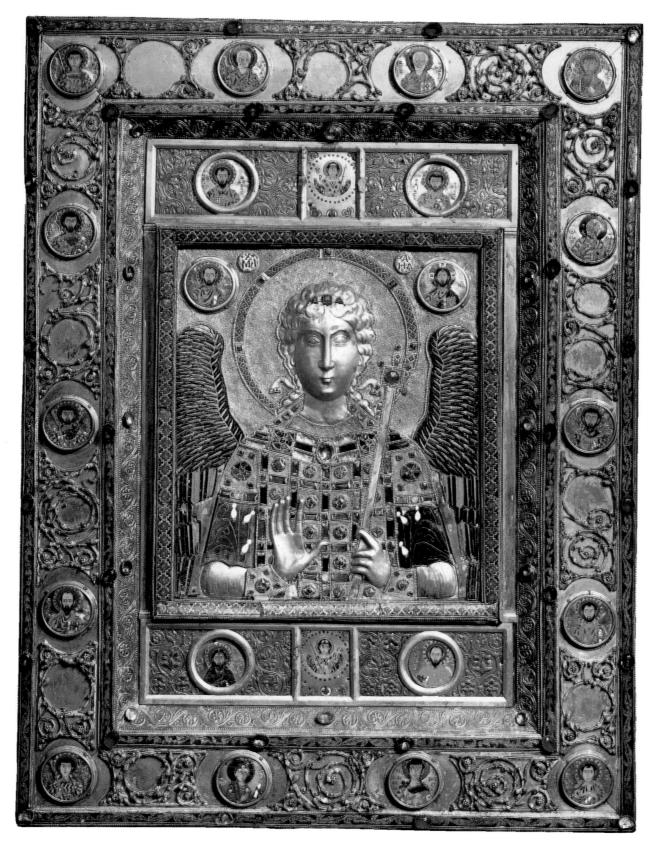

7-57. *Archangel Michael*, icon. 10th century. Silver gilt and enamel, 19 x 14" (48 x 36 cm). Treasury of the Cathedral of San Marco, Venice

TECHNIQUE

MOKKINC -JAT3M

create small, jewellike sections. powder melts and fuses onto the surface of the metal to dered colored glass. When the object is heated, the glass metal and then filling up the cells (cloisons) with powwires in a desired pattern to a panel made of similar by soldering a network of fine copper, gold, or silver use of cloisonné enamel, which is produced

ity work. They were particularly skilled in the

an international reputation for their high-qual-

Byzantine metalworkers and enamelers had

the artists pounded out the central image of metalwork. Using the repoussé technique, an especially elaborate example of Byzantine BYZANTINE The icon of Archangel Michael (fig. 7-57) is

text and incorporated into new works. lions are often found detached from their original conportrait medallions decorate the border. Such medaleffect of silk garments with jewels, and small cloisonné silver was then gilded. Colorful cloisonné creates the the archangel from the back of a thin plate of silver. The

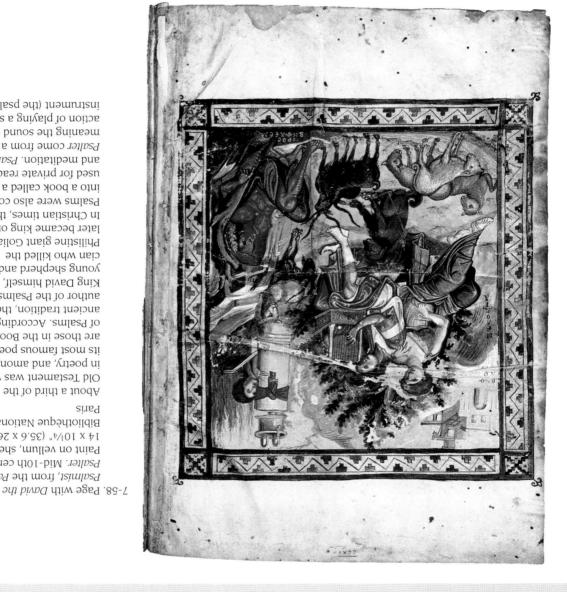

instrument (the psaltery). action of playing a stringed meaning the sound or Psalter come from a word and meditation. Psalm and used for private reading into a book called a Psalter, Psalms were also copied In Christian times, the later became king of Israel. Philistine giant Goliath and cian who killed the young shepherd and musi-King David himself, the author of the Psalms was ancient tradition, the of Psalms. According to are those in the Book its most famous poems in poetry, and among Old Testament was written About a third of the

Bibliothèque Nationale, 14 x 101/4" (35.6 x 26 cm). Paint on vellum, sheet size Psalter. Mid-10th century. Psalmist, from the Paris

trate the Paris Psalter, the first of which is devoted to on pages without text. Fourteen full-page paintings illus-(a version of the Psalms) includes scenes set off in frames earlier Rabbula Gospels (see figs. 7-38, 7-39), the Psalter mid-tenth century is one example (fig. 7-58). Like the tion for rich decorative forms. The Paris Psalter from the sion, aristocratic elegance, and a heightened appreciathese manuscripts combined intense religious expresartists who decorated church interiors, the illustrators of

philosophers of the time. pure spirit, an effect valued by the Neoplatonic Church color supplant form and material substance becomes seems to lift the image to a lofty plane where light and

Manuscripts

vived from the second golden age. As was true of the Several luxuriously illustrated manuscripts have sur-

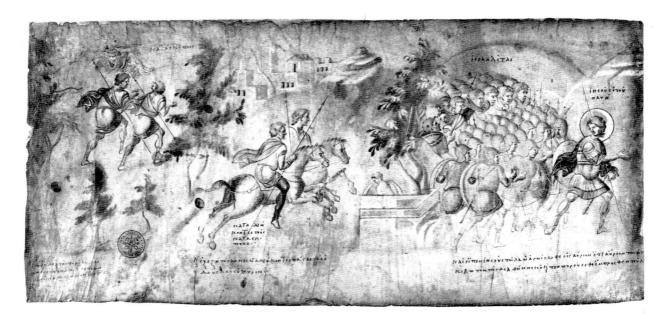

7-59. Page with *Joshua Leading the Israelites*, from the *Joshua Roll*, made in Constantinople. 10th century. Vellum rotulus with brown ink and colored washes, height of scroll 12³/₄" (32.4 cm). Biblioteca Apostolica Vaticana, Rome

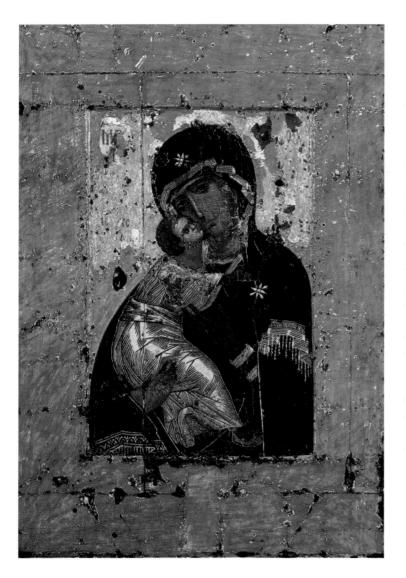

David, the Israelite king, traditionally the author of the Old Testament's Book of Psalms. The illuminators turned to earlier classical illustrations as source material. The idealized, massive, three-dimensional figures reside in a receding space with lush foliage and a meandering stream that seem directly transported from a Roman "sacred landscape" (see fig. 6-47). The architecture of the city and the ribbon-tied memorial column also derive from conventions in Greek and Roman funerary art, and in the ancient manner, the illustrator has personified abstract ideas and landscape features, an artistic technique known as allegory. Melody, a female figure, leans casually on David's shoulder, while another woman, perhaps the wood nymph Echo, peeks out from behind the column. The reclining youth in the lower foreground is a personification of Mount Bethlehem, as we learn from his inscription. The dog watching over the sheep and goats while his master strums the harp suggests the classical subject of Orpheus's charming the wild animals with music. The subtle modeling of forms, the integration of the figures into a three-dimensional space, and the use of atmospheric perspective all enhance the classical flavor of the painting.

The *Joshua Roll* (fig. 7-59), a tenth-century manuscript in scroll form also believed to have been created in a Constantinople **scriptorium** (writing room for scribes), reflects an approach different from that of the *Paris Psalter*. The illustrators worked on plain vellum, using ink and colored washes to convey the exploits of Moses' suc-

7-60. Virgin of Vladimir, icon, probably from Constantinople. Faces only, 12th century; the rest has been retouched. Tempera on panel, height approx. 31" (78 cm). Tretyakov Gallery, Moscow

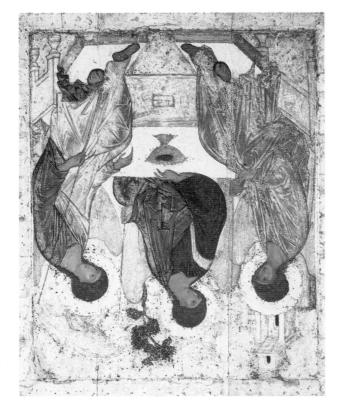

panel, 551/2 x 441/2" (141 x 113 cm). Tretyakov Gallery, Angels Visiting Abraham), icon. c. 1410-20. Tempera on 7-61. Andrey Rublyov. The Old Testament Trinity (Three

entertained three strangers who were in fact divine Hebrew patriarch Abraham and his wife, Sarah, who use an event in the Old Testament, the story of the solution, used here and in other late-medieval work, three Persons—was a great challenge to artists. One Representing the dogma of the Trinity—one God in

beings. was to show God as three identical individuals and to

sweet, poetic ambience distinguishes Rublyov's work. in the mosaics at Daphni (see figs. 7-47, 7-48). Yet a focus on a limited number of characters—such as those tions—simple contours, clongation of the body, and a spiritual in his work, Rublyov relied on typical convenstyle of expression within it. To capture the sense of the Rublyov managed, nevertheless, to create a personal approach imposed a basic uniformity, talented artists like the form of the haloed heads. Although this formulaic

ic world, with its own very rich aesthetic heritage. mad II, and the Eastern Empire became part of the Islamwas overrun by the forces of the Ottoman sultan Muhamsance. During the same period in the East, Constantinople sically inspired revivalist movement called the Renaislife just as western European artists were beginning a clas-In this artist's hands, the Byzantine style took on new

> serves as a reminder of the classical roots of Byzantine the Jordan River. Despite its stylization, this painting, too, wearing upper-body armor, he leads his soldiers toward at the far right. Crowned with a halo, unhelmeted but tures identify the figures. The main character, Joshua, is and landforms. Strategically placed labels within the picrecedes from the large foreground figures to distant cities the text are depicted in a continuous landscape that Christ. In the section shown here, the events described in land and whom Christians considered a precursor of Jericho (Joshua 6:1-20), who conquered the promised cessor, Joshua, the Old Testament hero of the Battle of

Painted Icons

culture.

Cathedral of the Dormition in the Kremlin. moved permanently to Moscow, where it graced the Suzdal and then to Vladimir in 1155. In 1480 it was between 1131 and 1136 and was moved to the city of the city where it resided. It arrived in Kiev sometime tinople) the panel was thought to protect the people of by Luke. Almost from its creation (probably in Constan-Some worshipers believed it to be the very painting done perhaps the most revered holy image in Russia (fig. 7-60). type known as the Virgin of Vladimir remains to this day following a vision he had of the Nativity. An icon of this thought to be a portrait painted by the evangelist Luke The source for this humanized portrayal was widely their cheeks together and gazing tenderly at each other. Compassion, show Mary and the Christ Child pressing same time.) Paintings of this type, known as the Virgin of trend was seen in the art of western Europe about the for a more immediate and personal religion. (A similar eleventh and twelfth centuries reflects a growing desire Virgin and Child in Byzantine art that emerged in the miraculous powers to icons. A new way of portraying the was frequently lost on the laity, many of whom attributed the veneration of the idea or person they represented worship of images, which was forbidden as idolatry, and The distinction drawn in Church doctrine between the

cle forms the underlying geometric figure, emphasized by ed human forms and features according to it. Here the cir-Byzantine artists invented an ideal geometry and depictwho based their formulas on close observation of nature, their work remarkable consistency. Unlike the Greeks, ate ideal figures, as did the ancient Greeks, thus giving relied on time-honored mathematical conventions to cre-This icon clearly illustrates how late Byzantine artists Sergius of the Trinity-Sergius Monastery, near Moscow. (fig. 7-61). It was commissioned in honor of the abbot 1410 and 1420 by the famed artist-monk Andrey Rublyov Angels Visiting Abraham), a large panel created between od in Byzantine art, is The Old Testament Trinity (Three Another remarkable icon, this one from the third periDome of the Rock c. 687–91

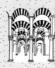

Great Mosque at Córdoba 785-86

UMAYYAD ▲ EARLY CALIPHS 633–61 ▲ DYNASTY 661–750 ▲ ABBASID DYNASTY 750–1258

▲ SPANISH UMAYYAD DYNASTY (756-1031)

▲ ANATOLIAN SELJUK DYNASTY (1037–1194)

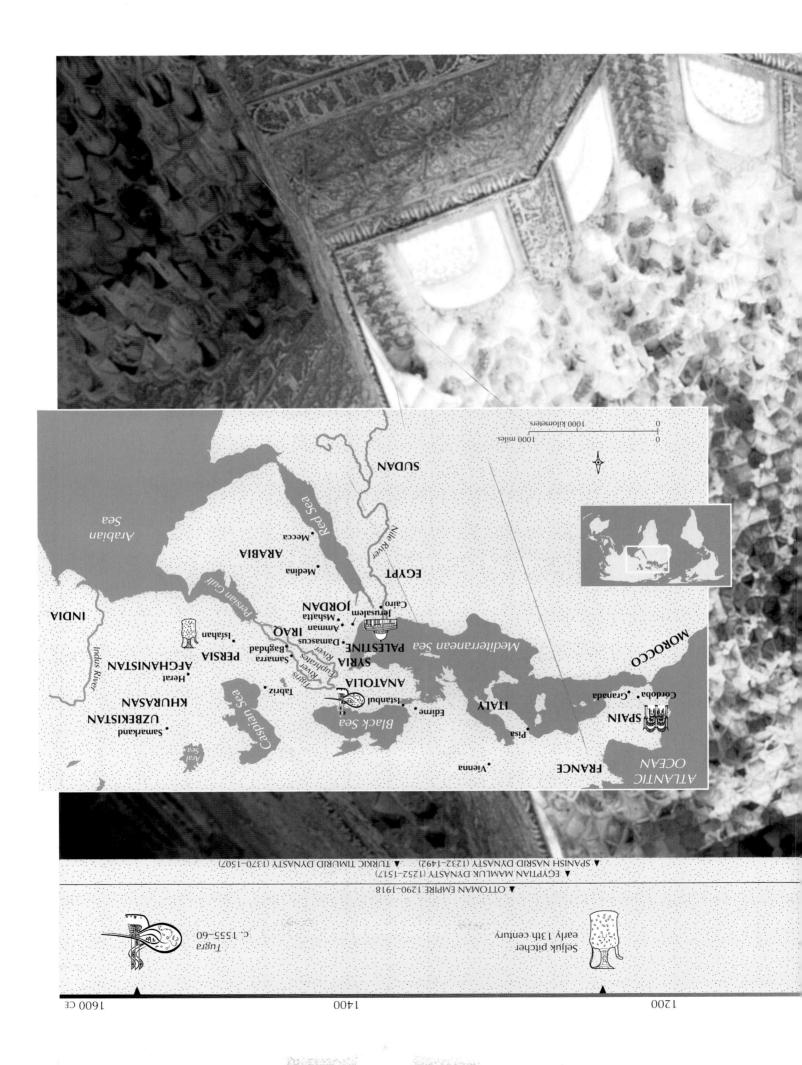

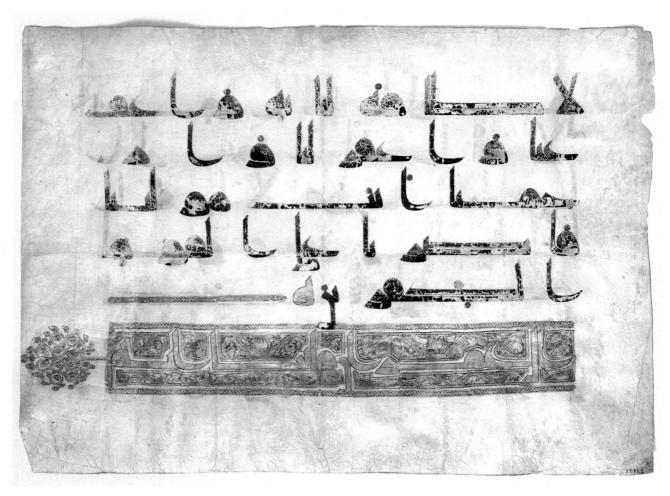

8-1. Page from Koran (surah 47:36) in kufic script, from Syria. 9th century. Ink, pigments, and gold on vellum, 93/8 x 131/8" (23.8 x 33.3 cm). The Metropolitan Museum of Art, New York Rogers Fund, 1937 (37.99.2)

uring the holy month of Ramadan in 610 ce, a merchant named al-Amin ("the Trusted One") sought solitude in a cave on Mount Hira, a few miles north of Mecca, in Arabia. On that night, "The Night of Power and Excellence," the angel Gabriel is believed to have appeared to him and commanded him to recite revelations from God. In that moment this merchant became Muhammad, the Messenger of God. The revelations dictated by Gabriel at Mecca formed the basis of a religion called Islam ("submission to God's will"), whose adherents are referred to as Muslims ("those who have submitted to God"). Today, nearly a billion Muslims turn five times a day toward Mecca to pray.

The Word of God was recorded in a book known as the Koran ("recitation"), which is a compilation of Muhammad's revelations. To transcribe these revelations, Arabic was adopted as the uniform script wherever Islam spread, and the very act of transcribing the Koran became sacred.

To accomplish this holy task, which is summarized in the ancient Arabic expression "Purity of writing is purity of the soul," scribes developed **calligraphy**, the art of writing, to an extraordinary degree (fig. 8-1). A prohibition against depicting representational images in religious art, as well as the naturally decorative nature of Arabic script, led to the handwritten documents. Perhaps the foremost characteristic of Islamic religious art, wherever it is found in the world and among every race, is religious art, wherever it is found in the world and among every race, is the presence of Koranic Arabic, used for reading and prayer, and for

Following the Prophet's death in 632, four of his closest associates assumed the title of caliph, or successor: Abu Bakr (ruled 633–634), Umar (ruled 644–656), and finally Ali (ruled 656–661). According to tradition, during the time of Uthman, the Koran assumed its final form.

The accession of Ali provoked a power struggle that led to his assassination. Muawiya (ruled 661–680), Ali's rival and a close relative of Uthman, then became caliph, founding the Umayyad dynasty (661–750). This struggle resulted in enduring divisions within Islam. Followers of Ali, known as Shiites, regard him as the Prophet's right-ful successor and the first three caliphs as illegitimate. Sunni Muslims, in contrast, recognize all of the first four caliphs as "rightly guided." Today about 10 percent of the world's Muslims are Shiites and about 85 percent cline world's Muslims are Shiites and about 85 percent Sunni.

dramatically. In just two decades, seemingly unstoppable dramatically. In just two decades, seemingly unstoppable Muslim armies conquered the Sassanian Persian Empire, Egypt, and the Byzantine provinces of Syria and Palestine. By the early eighth century, under the Umayyads, they had and penetrated France to within 100 miles of Paris before being turned back. The circumstances in Islamic lands of ther uniform nor consistent. In general, as "People of the Book"—non-Muslim followers of a monotheistic religion based on a revealed scripture—they enjoyed a protected status. However, they were also subject to a special tax and restrictions on dress and employment.

Islam has proven a remarkably adaptable faith. Part of that adaptability is due to its emphasis on the believer's direct, personal relationship with God through prayer and a corresponding lack of ceremonial paraphernalia. Every Muslim must observe the Five Pillars, or duties, of faith. The most important of these is the statement of faith: "There is no god but God and Muhammad is his messen-withere is no god but God and Muhammad is his messenthe poor, fasting during the month of Ramadan, and a pille grimage to Mecca—Muhammad's birthplace and the site grimage to Mecca—Muhammad's birthplace and the site of the Kaaba, Islam's holiest structure—once in a lifetime for those able to undertake it.

Islam spread rapidly after its founding, encompassing much of Africa, Europe, and Asia. The art of this vast region draws its disvast region draws its disvast region draws its disvast region frame.

SOCIETY SOCIETY SOCIETY

decoration.

influences shaped Islamic art in its formative centuries. noted for its art, these Persian and Roman-Byzantine to 641. Because the Arabian birthplace of Islam was not traditions of the ancient Near East, who ruled from 226 dynasty of Persia (modern Iran), the heirs of the artistic regions that had been under the control of the Sassanian representing animals and plants developed in the of the Byzantine and Roman empires. Stylized forms for traditions, such as those that had been under the control prominently in regions with strong pre-Islamic figural time to time and place to place), first developed most tation, to the extent it was permitted (which varied from side the Islamic world as arabesques. Figural represengeometric patterns and the scrolling vines known outmark of Islamic work. This vocabulary includes complex ulary of aniconic, or nonfigural, ornament that is a hallthe same period—Islamic artists developed a rich vocabparticularly in religious contexts—unlike Christian art of Because Islam discouraged the use of figurative images, diverse cultural traditions of the world's Muslims. tinctive character both from Islam itself and from the

Much of Islamic art can be seen as an interplay between pure abstraction and organic form. For Muslims, abstraction helps free the mind from the contemplation of material form, opening it to the enormity of the divine presence. Islamic artists excelled in surface decoration, using repeated and expanding patterns to suggest timelessness and infinite extension. Shimmering surfaces created by dense, highly controlled patterning are characteristic of much later Islamic art, including architecture, carpet making, calligraphy, and book illustration.

Muslims date the beginning of their history to the flight of the Prophet Muhammad from Mecca to Medina—an exodus called in Arabic the hijra—in 622 (see "The Life of the Prophet Muhammad," pages 340, 341). Over the next decade Muhammad succeeded in uniting the warring clans of Arabia under the banner of Islam.

688

THE LIFE OF THE PROPHET prophet of Islam,

Muhammad, the MUHAMMAD was born about 570 in Mecca, a

major pilgrimage center in west-central Arabia, to a prominent family that traced its ancestry to Ishmael, son of the biblical patriarch Abraham. Orphaned as a small child, Muhammad spent his early years among the Beduin, desert nomads. When he returned to Mecca, he became a trader's agent, accompanying caravans across the desert. At the age of twenty-five he married his employer, Khadija, a well-to-do, forty-year-old widow, and they had six children.

After Muhammad received the revelations from God in 610, the first to accept him as Prophet was his wife. Other early converts included members of his clan and a few friends, among them the first four successors, or caliphs, who led the faithful after Muhammad's death. As the number of converts grew, Muhammad encountered increasing opposition from Mecca's ruling clans, including some leaders of his own clan. They objected to both his religious teachings and the threat they posed to the trade that accompanied Mecca's status as a pilgrimage site. In 622 Muhammad and his companions fled Mecca and settled in the oasis town of Yathrib, which the Muslims renamed Medina, the Prophet's City. It is to this event, called the hijra ("emigration"), that Muslims date the beginning of their history. After years of fighting, Muhammad and his followers won control of Mecca in 630 with an army of 10,000, and its inhabitants converted to Islam. The Kaaba-a cube-shaped stone structure draped with black cloth that had once been the focus of idol worship-became the sacred center of Islam, toward which Muslims around the globe still turn to pray. Shortly thereafter, Islam spread throughout Arabia.

Muhammad married eleven times. (Muslim law allows men four coequal wives at once, although the Prophet was permitted more.) Some of these marriages were political and others were to provide for women in need-a social duty in a society in which clan feuds killed many men. Within the framework of Islam, women gained rights where there had been none before. Their degree of freedom depended greatly on the time and the place, but some became monarchs of countries such as Yemen and Indonesia, and many were significant sponsors of architecture programs.

Muhammad is reputed to have been a vigorous, good-looking man for whom the world was a fragrant paradise. One of his wives, Aisha, provided much of the information available about his personal life. "People used to ask [Aisha] how the Prophet lived at home. Like an ordinary man, she answered. He would sweep the house, stitch his own clothes, mend his own sandals, water the camels, milk the goats, help the servants at their work, and eat his meals with them; and he

would go fetch a thing we needed from the market" (cited in Glassé, page 281).

After making a farewell pilgrimage to Mecca, Muhammad died in Medina in 632. According to his wishes, he was buried in his house. in Aisha's room, where he breathed his last. His tomb is a major pilgrimage site. A generation after his death his revelations, which he continued to receive throughout his life, were assembled in 114 chapters, called surahs, organized from longest to shortest, each surah divided into verses. This is the sacred scripture of Islam, called the Koran ("recitation"). which is the core of the faith. Another body of work, the Hadith ("account"), compiled over the centuries, contains sayings of the Prophet, anecdotes about him, and additional revelations. The Koran and the Hadith are the foundation of Islamic law, guiding the lives of nearly a billion Muslims around the world.

Muslims consider Muhammad to be the last in a succession of prophets, or messengers of God, that includes Adam, Abraham, Ishmael, Moses, and Jesus. Like Judaism and Christianity but unlike the other religions prevalent in Arabia at the time, Islam is monotheistic, recognizing only a single, all-powerful deity. Muhammad's teaching emphasized the all-pervading immateriality of God and banned idol worship.

This painting shows Muhammad traveling by camel to a desert market fair to seek the support of his

Muslims are expected to participate in congregational worship at a mosque (masjid in Arabic) on Friday. When not at a mosque, the faithful simply kneel wherever they are to pray, facing the Kaaba in Mecca. The Prophet Muhammad himself lived simply and advised his companions not to waste their resources on elaborate architecture. Instead, he instructed and led them in prayer in a mud-brick structure, now known as the Mosque of the Prophet, adjacent to his home in Medina. This was a square enclosure with verandas supported by palm-tree trunks that framed a large courtyard. Muhammad spoke from a low platform on the south veranda. This simple arrangement—a walled courtyard with a separate space on one side housing a minbar (pulpit) for the imam (prayer leader)—became the model for the design of later mosques.

ART DURING THE EARLY **CALIPHATES**

The caliphs of the aggressively expansionist Umayyad dynasty ruled from their capital at Damascus (in modern Syria). They were essentially

desert chieftains who had scant interest in fostering the arts except for poetry, which had been held in high esteem among Arabs since pre-Islamic times, and architecture. The building of shrines and mosques throughout the empire in this period represented both the authority of the new rulers and the growing acceptance of Islam. The caliphs of the Abbasid dynasty, who replaced the Umayyads in 750 and ruled until 1258, governed in the grand manner of ancient Persian emperors from their capitals at Baghdad and Samarra (in modern Iraq). Their long and cosmopolitan reign saw achievements in med-

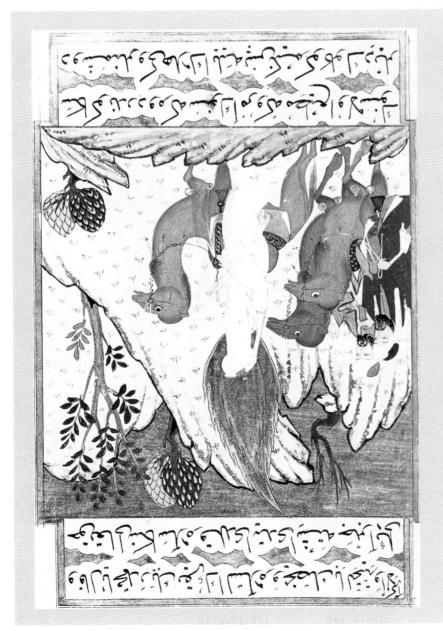

teenth century. Ottoman court at the end of the sixan illustration of its type at the ple suggests what was acceptable for work of art was to serve. This examwas interpreted and the purpose a the injunction against idol making in part on the strictness with which and from period to period depending Islamic art varied from place to place degree of representation permitted in and the making of idols, is not. The Islamic injunction against idolatry of Muhammad, in keeping with the of Abu Bakr and Ali are shown, that of the Shiite sect. Although the faces that ended in his death led to the rise the fourth caliph. The power struggle Muhammad's daughter Fatima, was nad's wife Aisha. Ali, husband of caliph, was the father of Muhamyoung warrior Ali. Abu Bakr, the first ates, the merchant Abu Bakr and the accompanied by two close associverts among the fairgoers. He is movement as well as to make conpowerful uncle for his religious

The Prophet Muhammad and His Companions Traveling to the Fair, from a later copy of the Slyar-i Nabi (Life of the Prophet) of al-Zarir (14th century), latanbul, Turkey. 1594. Pigments and gold on paper, 105/8 x 15" (27 x 38 cm). New York Public Library, New York Spencer Collection

Mount (Mount Moriah) and encloses a rock outcropping (fig. 8-3) that has long been sacred to the Jews, who identify it as the site on which Abraham prepared to sacrifice his son Isaac. Jews, Christians, and Muslims associate the site with the creation of Adam and the Temple of Solomon. Muslims also identify it as the site from which Muhammad, led by the angel Gabriel, ascended to heaven in the Night Journey, passing through the spheres of en in the Night Journey, passing through the spheres of heaven to the presence of God.

The Dome of the Rock was built by Syrian artisans trained in the Byzantine tradition, and its centralized plan—an octagon surrounding a circular core—derived from both Byzantine and local Christian architecture. Unlike its Byzantine models, however, with their plain exteriors, the Dome of the Rock, crowned with a golden dome that dominates the Jerusalem skyline, is opulently

icine, mathematics, the natural sciences, philosophy, literature, music, and art. They were generally tolerant of the ethnically diverse populations in the territories they subjugated and admired the cultural traditions of Byzantium, Persia, India, and China. (The early art of India is discussed in Chapter 9 and that of China in Chapter 10.)

Architecture

As Islam spread, architects adapted freely from Roman, Christian, and Persian models, which include the basilica, the martyrium, the peristyle house, and the palace audience hall. The Dome of the Rock in Jerusalem, built about 687–691, is the oldest surviving Islamic sanctuary and is today the holiest site in Islam after Mecca and Medina (fig. 8-2). It stands on the summit of the Temple Medina (fig. 8-2). It stands on the summit of the Temple

PARALLELS

Years	<u>Period</u>	Early Islam	World
633-661	Early caliphs	Conquest of Arabia, Sassanian Persia, Egypt, Syria, Palestine	c. 600–800 Beowulf (England); first Japanese capital at Nara; first block-print text (China); Charlemagne is made emperor of the West
661–750	Umayyad dynasty	Conquest of India, North Africa, southern France; capital at Damascus; Dome of the Rock; Mshatta palace	
750-1258	Abbasid dynasty	Umayyad dynasty in Spain; Great Mosque at Córdoba; capital at Baghdad, then Samarra (836); Great Mosque at Samarra; Samarkand ware; Seljuk dynasty in Anatolia; Masjid-i Jami at Isfa- han; Mamluk dynasty in Egypt	c. 800–1000 Bronze casting in South America; <i>Diamond Sutra</i> (China); first Viking colony in Greenland c. 1000–1200 Lady Murasaki's <i>Tale of Genji</i> (Japan); separation of Eastern and Western Christian Churches; William the Conqueror (England); the Crusades
1290-1918	Ottoman Empire	Alhambra at Granada; Ottomans take Constantinople; Selimiye Cami (Edirne)	c. 1200–1500 Jenghiz Khan rules Mongols; Magna Carta (England); Kublai Khan rules Mongols; Dante's Divine Comedy (Italy); beginning of Renaissance in Europe; Hundred Years' War (England/France); Black Death in Europe; Great Schism of Roman Church; Chaucer's Canterbury Tales (England); Joan of Arc (France); Gutenberg first prints Bible (Germany); Columbus's voyages (Spain); Spanish Inquisition

decorated both outside and inside. The central space is covered by a dome on a tall drum supported by an arcade. Concentric aisles enclose the rock. As at San Vitale in Ravenna (see fig. 7-30), interior surfaces were originally decorated with marble dadoes at ground level and glass mosaics above. Remains of the mosaics show Byzantine-style foliage combined in a new style with jewel-like Sassanian Persian insignia. This imagery consists of a double-winged motif often associated with Sassanian royalty. The more than 700 feet of Arabic inscriptions on the structure are a distinctly Islamic feature. Written in one script on the interior and another on the exterior, these inscriptions include the references to Jesus Christ in the Koran. Later Islamic architects built similar domed octagonal sanctuaries and saints' tombs from Morocco to China.

The Umayyad caliphs, disregarding the Prophet's advice about architectural austerity, built for themselves palatial hunting retreats on the edge of the desert. With profuse interior decoration depicting exotic human and animal subjects in stucco, mosaic, and paint, some had swimming pools, baths, and domed, private rooms. One of the later desert palaces was begun in the 740s at Mshatta (near present-day Amman, Jordan). Although never completed, this square, stone-walled complex is nevertheless impressively monumental (fig. 8-4). It measured about 470 feet on each side, and its outer walls and gates were guarded by towers and bastions reminiscent of a Roman fort. The space was divided roughly into thirds, with the center section containing a huge courtyard. The main spaces were a mosque and a domed, basilica-plan audience hall that was flanked by four

8-2. Dome of the Rock, Jerusalem, Israel. c. 687-91

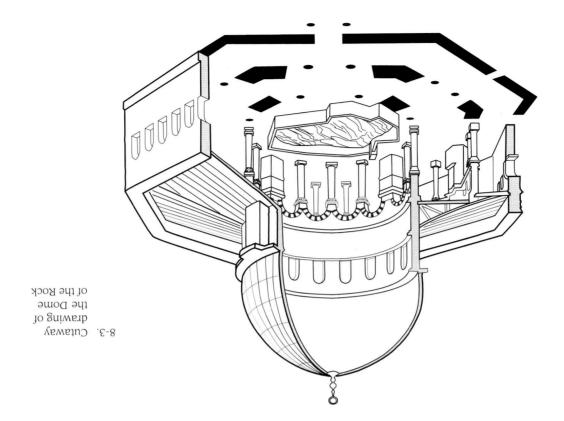

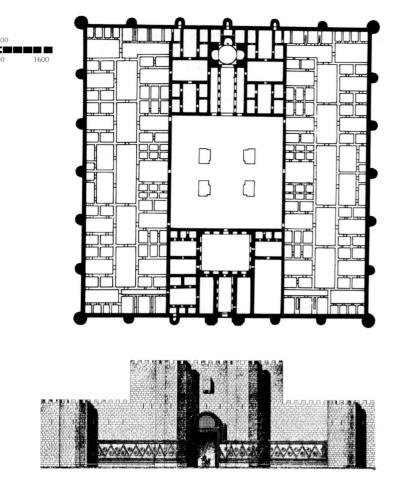

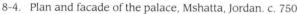

8-5. Frieze, detail of facade, palace, Mshatta. Stone. Staatliche Museen zu Berlin, Preussischer Kulturbesitz, Museum für Islamische Kunst

private apartments, or *bayts*. *Bayts* grouped around small courtyards, for the use of the caliph's relatives and guests, occupied the remainder of the building.

Unique among the surviving palaces, Mshatta was decorated with a **frieze** that extended in a band about 16 feet high across the base of its facade. This frieze was divided by a zigzag molding into triangular compartments, each punctuated by a large **rosette** carved in high relief (fig. 8-5). The compartments were filled with intricate carvings in low relief that included interlacing scrolls inhabited by birds and other animals (there were no animals on the mosque side of the building), urns, and candlesticks. Similar designs in both sculpture and mosaic adorned the interiors of Roman and Byzantine buildings but were never on exterior surfaces, and the designs were not so densely interwoven. Beneath one of the rosettes, two facing lions drink from an urn from which grows the Tree of Life, an ancient Persian motif.

With the development of mosque architecture during the early Umayyad period, the characteristic elements of this place of communal worship began to emerge (see "Elements of Architecture," opposite). There were facilities for ritual cleansing before entering the consecrated space, a *sahn*, or courtyard, and a large covered space to

accommodate Friday prayers. Worshipers prayed facing the **qibla** wall, which was oriented toward Mecca. A niche called a **mihrab** differentiated the qibla wall from the others. The imam delivered a sermon from the minbar, near the qibla wall. Some mosques included an enclosure called a *maqsura* near the mihrab for dignitaries. Muezzins, or criers, called the faithful to prayer from one or more towers, or **minarets** (literally "lighthouses"), on the exterior. Some early mosques were housed in modified pre-Islamic buildings.

When the Abbasids overthrew the Umayyads in 750, a survivor of the Umayyad dynasty, Abd ar-Rahman I (ruled 756–788), fled across North Africa into southern Spain (known as "al-Andalus" in Arabic), where, with the support of Syrian Muslim settlers, he established himself as the provincial ruler, or amir. The Umayyads continued to rule in Spain from their capital in Córdoba for the next three centuries (756–1031) and were noted patrons of the arts. Thus one of the finest surviving examples of Umayyad architecture, the Great Mosque of Córdoba, is in Spain.

This sprawling structure was begun on the site of a church in 785. Repeatedly enlarged until the fifteenth century, when it returned to Christian use, it combines

most developed in Persia, in buildings like Isfahan's behind and around the iwans. Four-iwan mosques were across a central sahn; related structures spread out

Central-plan mosques, such as the Selimiye Cami at Masjid-i Jami (see fig. 8-13).

wall and its mihrab opposite the entrance. Worship is directed, as in other mosques, toward a qibla large domed space uninterrupted by structural supports. architecture. Central-plan interiors are dominated by a Sophia (see fig. 7-27) and are typical of Ottoman Turkish Edirne (see fig. 8-17), were derived from Istanbul's Hagia

through an open courtyard, as the Great Mosque at Cor-**VECHILECTURE** pillared hypostyle halls such ELEMENTS OF The earliest mosques were

Mosque Plans doba (see fig. 8-6). Approached

leading, at the far end, to the mihrab niche of a qibla wall, the sahn, their interiors are divided by rows of columns

nally associated with madrasas (schools for advanced A second type, the four-iwan mosque, was origiwhich is oriented toward Mecca.

with wide-open, arched entrances-faced each other

study). The iwans—monumental barrel-vaulted halls

Selimiye Cami, Edirne nedeltl, imal i-bilsaM Great Mosque, Córdoba central-plan mosque four-iwan mosque hypostyle mosque 逦 olans are not to scale uyes uue: llaw aldip. newi aldip mihrab gibla

(Dodds, pages 12–13). a challenge to unravel the [mosque's] complexities" unruly staccato of colors confuse the viewer, presenting mirrors in which the constant echo of arches and the

Hakam's renovations was a new mihrab with three bays greatly wanted" (cited in Dodds, page 23). Among alcious for his subjects, something which both he and they place, with the goal of making this mosque more spato God, who "helped him in the building of this eternal ing for such ostentation with an inscription giving thanks The caliph attempted to answer their objections to payurious renovations that disturbed many of his subjects. focus of royal patronage, commissioning costly and lux-Al-Hakam II (ruled 961-976) made the Great Mosque a 961), the Umayyads boldly claimed the title of caliph. losophy. Beginning with Abd ar-Rahman III (ruled 912– Europe economically and in science, literature, and phia flourishing center for the arts. It surpassed Christian emerged as a major commercial and intellectual hub and In the final century of Umayyad rule, Córdoba

the hall into "a wild three-dimensional maze, a hall of historian, the overall effect of these features transforms soirs forming the curved arch. In the view of one art dents, is the alternation of pale stone and red brick vousarches, also adopted from Roman and Byzantine precetecture," page 347). Another distinctive feature of these Islamic architecture in the West (see "Elements of Archipre-Islamic rulers—came to be closely associated with from Roman times and favored by the Visigoths, Spain's distinctively shaped horseshoe arches—a form known or space and provides ample light and air within it. The ly imitated, effectively increases the height of the interithe columns. This double-tiered design, which was wideupper tier springs from rectangular posts that rise from arches, one over the other, surmount these columns; the been a wealthy Roman province (fig. 8-6). Two tiers of the ruins of classical buildings in the region, which had capitals in the hypostyle prayer hall were recycled from tinctive Spanish Islamic style. The marble columns and Umayyad, Abbasid, and pre-Islamic influences into a dis-

8-6. Prayer hall, Great Mosque, Córdoba, Spain. Begun 785–86

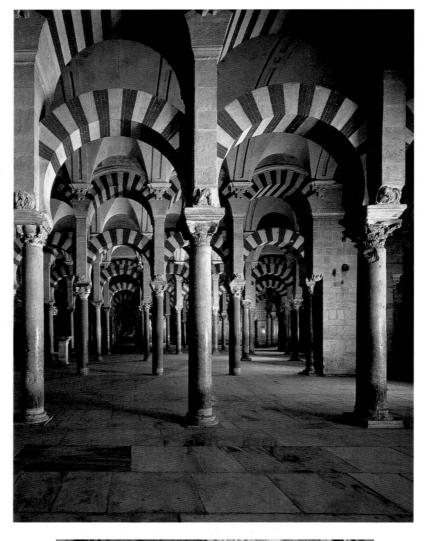

8-7. Dome in front of the mihrab, Great Mosque. 965

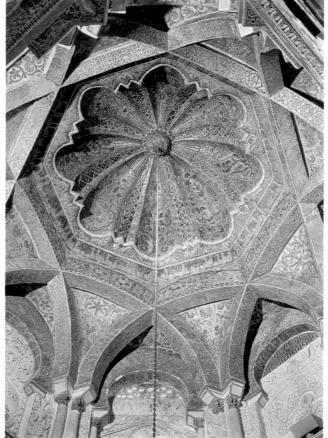

scale, to support domes. They are frequently used to line mihrabs and, on a larger increasingly ornamental, intricately faceted surfaces. niche-shaped vaulting units. Over time they became served a structural purpose as interlocking, load-bearing, used singly or in multiples (see fig. 8-12). Originally they "Elements of Architecture," page 310). Mugarnas may be Technically, a mugarnas is a corbeled squinch (see

ed, arch (see fig. 8-14). There Among these were two arch ARCHITECTURE of innovative structural devices. ELEMENTS OF Islamic builders used a number

ogival arch

Mugarnas fig. 8-6) and the ogival, or point-Arches and forms, the horseshoe arch (see

structural function beneath complex decoration. are many variations of each, some of which disguise their

mugarnas-filled niche

әшор seuлерит

East, rises more than 160 feet next to the mosque wall. perhaps inspired by the ziggurats of the ancient Near mosaic decoration. An unusual spiral-ramp minaret, round corner towers. The facade may originally have had and about 33 feet high, with curved buttressing and wall enclosing the complex was more than 8 feet thick qibla wall and 25 perpendicular aisles. The fortresslike It featured a hypostyle prayer hall 525 feet wide at the for a long time the largest mosque in the Islamic world. Great Mosque of Samarra (fig. 8-8). In ruins today, it was al-Mutawakkil (ruled 847-861) began construction of the miles north of Baghdad. In the mid-ninth century, Caliph lished a heavily fortified new capital at Samarra, about 60 836, however, Caliph al-Mutasim (ruled 833-842) estabcentury after they seized power from the Umayyads. In Abbasid dynasty ruled from Baghdad for more than a

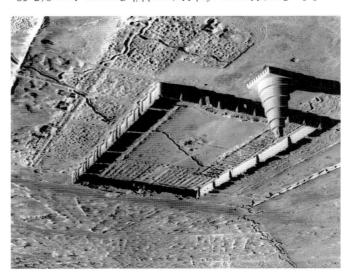

horseshoe arch

mid-tenth century. tall, cylindrical minaret evolved in Persia in roughly the as signposts on desert caravan routes. The classic from many miles away, they may also have functioned bly as commemorative victory monuments. Visible towers. They were first erected in western Asia, probareligious architecture, began as rectangular, stepped Minarets, the most readily identifiable feature of Islamic 8-8. Great Mosque of al-Mutawakkil, Samarra, Iraq. 847-52

Calligraphy

1000

The Arabic language and script have held a unique position in Islamic society and art from the beginning. As the language of the Koran and Muslim liturgy, Arabic has been a powerful unifying force within Islam. Reverence for the Koran as the word of God extended by association to the act of writing, and generations of extraordinary scribes made Arabic calligraphy one of the glories of Islam. Arabic script is written from right to left, and each of its letters takes one of three forms depending on its position in a word. With its rhythmic interplay between verticals and horizontals, this system lends itself to myriad variations.

Writing pervaded Islamic art. In addition to manuscripts, it featured prominently in architecture and on smaller-scale objects made of metal, glass, cloth, ceramic, and wood. The earliest scripts, called kufic (from the city of Kufa in modern Iraq), were angular and evolved from inscriptions on stone monuments. Kufic scripts were especially suitable for carved or woven inscriptions, as well as those on coins and other metalware; they are still used for Koran chapter headings. Most early Korans had only three to five lines per page and customarily had large letters because two readers shared one book (although they would have known the text by heart). A page from a ninth-century Syrian Koran exemplifies a style common from the eighth to the tenth century (see fig. 8-1). Red diacritical marks (pronunciation guides) accent the dark brown ink. Horizontals are elongated and fat-bodied letters are also emphasized. The chapter heading is set against an ornate gold band that contrasts with the simplicity of the letters.

Because calligraphy was a holy occupation, calligraphers enjoyed the highest status of all artists in Islamic society. Included in their numbers were a few princes and women. Their training was long and arduous, and their work usually anonymous. Not until the later Islamic centuries did it become common for calligraphers to sign their work, and even then only the most accomplished were allowed this privilege. Apprentice scribes had to learn secret formulas for inks and paints, become skilled in the proper ways to sit, breathe, and manipulate their tools, and develop their individual specialties. They also had to absorb the complex literary traditions and numerical symbolism that had developed around Arabic letters over the centuries.

The Koran was usually written on **vellum**, which, like parchment, was made from animal skin. Paper, a Chinese invention, was first imported into the Islamic realm in the mid-eighth century. Muslims subsequently learned how to make high-quality, rag-based paper and established their own paper mills. By about 1000, paper had largely replaced vellum and parchment, encouraging the proliferation of increasingly elaborate and decorative cursive scripts, which generally superseded kufic by the thirteenth century. Among the most influential calligraphers in this process was a woman named Shuhda. By the tenth century, more than twenty cursive scripts had come into use. They were standardized by Ibn Muqla

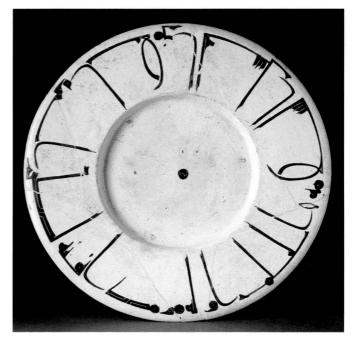

8-9. Bowl with kufic border, Samarkand, Uzbekistan. 9th–10th century. Earthenware with slip, pigment, and glaze, diameter 14¹/2" (37 cm). Musée du Louvre, Paris

The white ground of this piece imitated prized Chinese porcelains made of fine white kaolin clay. Both Samarkand and Khurasan were connected to the Silk Road (Chapter 10), the great caravan route to China, and were influenced by Chinese culture.

(d. 940), an Abbasid minister, who fixed the proportions of the letters in each and devised a method for teaching calligraphy that is still in use. The great calligrapher Yaqut al-Mustasim (d. 1299), the Turkish secretary of the last Abbasid caliph, codified six basic calligraphic styles, including thuluth (see fig. 8-20), naskhi (see the illustration in "The Life of the Prophet Muhammad," page 341), and *muhaqqaq* (see fig. 8-14). Al-Mustasim reputedly made more than 1,000 copies of the Koran.

Ceramic and Textile Arts

Kufic-style letters were used effectively as the only decoration on a type of white pottery made in the ninth and tenth centuries in and around Nishapur (a region also known as Khurasan, in modern northeastern Iran) and Samarkand (in modern Uzbekistan in Central Asia). Now known as Samarkand ware, it was the ancestor of a ware produced until fairly recently by Central Asian peasants. In the example here, a bowl of medium quality, clear lead glaze was applied over a black inscription on a white slip-painted ground (fig. 8-9). The letters have been elongated to fill the bowl's rim, stressing their vertical elements. The inscription translates: "Knowledge, the beginning of it is bitter to taste, but the end is sweeter than honey," an apt choice for tableware. Inscriptions on Samarkand ware provide a storehouse of such popular sayings.

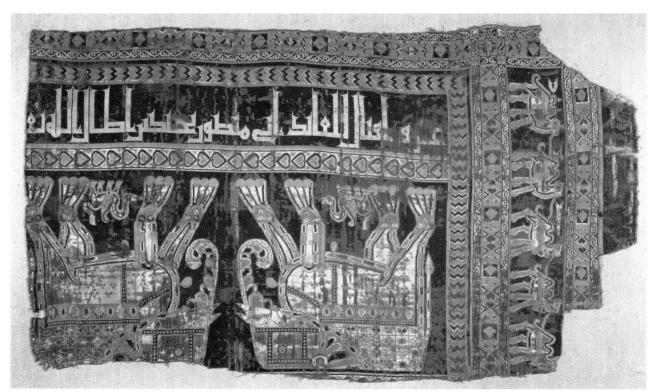

8-10. Textile with elephants and camels, from Khurasan, Persia (Iran). c. 960. Dyed silk, compound weave, largest fragment $37 \times 20^{1}/2$ " (94 x 52 cm). Musée du Louvre, Paris

Silk textiles were both sought-after luxury items and a medium of economic exchange. Government-controlled factories, known as *tiraz*, produced cloth for the court as well as for official gifts and payments. A number of fine Islamic fabrics robes, altar cloths, and covers for Christian saints' relics.

ART

ISLAMIC

LATER

woven silks of Sassanian Persia. The Persian weavers had, in turn, adapted Chinese silk technology to the Sassanian taste for paired heraldic beasts and other Mear Eastern imagery. This tradition, with modifications—the depiction of animals, for example, became less naturalistic—continued after the Islamic conquest of Persia.

The Abbasid caliphate began to disintegrate in the ninth century, and thereafter power in the Islamic world became fragmented among the more or less independent regional rulers. The eleventh

(mamluk means "slave"), held them off. In the West, (1252-1517), founded by descendants of slave soldiers as far as Egypt, where the young Mamluk dynasty swept out of Central Asia, encountering weak resistance by Jenghiz Khan (ruled 1206-1227) and his successors early thirteenth century, the Mongols—non-Muslims led of mosques, mausoleums, schools, and baths. In the were avid patrons of the arts and sponsored the building Seljuks of Anatolia, a number of queens and princesses the beginning of the fourteenth century. Among the ruled much of Anatolia (Turkey) from the late eleventh to that endured from 1037 to 1194. A branch of the dynasty Persia and most of Mesopotamia, establishing a dynasty verted to Islam in the tenth century. Seljuk rulers united had served as soldiers for the Abbasid caliphs and concentury saw the rise of the Seljuks, a Turkic people who

A different kufic inscription appears on a roughly contemporary fragment of silk from Khurasan (fig. 8–10): "Glory and happiness to the Commander Abu Mansur Bukhtakin, may God prolong his prosperity." Such formulaic inscriptions were extremely common in Islamic art, appearing as generic blessings on ordinary goods sold in the marketplace or, as here, personalized on "special orders." They can sometimes help determine where and when a work was made, but they can also be fire comparisons—in this case with other textiles, with the about the patron named in an object's inscription. Stylistic comparisons—in this case with other textiles, with the dother kufic inscriptions—can reveal more about it than other kufic inscriptions—can reveal more about it than other kufic inscriptions—can reveal more about it than the inscription alone.

mental coverings facing each other on a dark red ground, each with a mythical griffin between its hooves. A caravan of two-humped, Bactrian camels linked with rope moves up the left side, part of the elaborately patterned borders. The inscription at the bottom is upside-down, suggesting that the missing portion of the textile was the mirror image of the surviving fragment, with another pair of elephants joined back-to-back to this pair. The piece was created using an enormously complicated and expensive-to-operate drawloom weaving system that expensive-to-operate drawloom weaving system that technique and design derive from the sumptuous pattern. The

This fragment shows two elephants with rich orna-

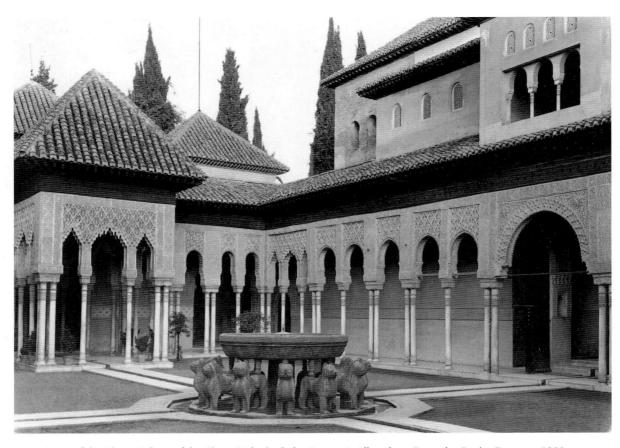

8-11. Court of the Lions, Palace of the Lions (Palacio de los Leones), Alhambra, Granada, Spain. Begun c. 1380 Granada, with its ample water supply, had long been known as a city of gardens. The twelve stone lions in the fountain in the center of this court were salvaged from the ruins of an earlier palatial complex on the Alhambra hill. The earlier structure was begun in the late eleventh century by a high Granadan official of Jewish heritage named Samuel ibn Naghralla and completed by his son Yusuf in the early twelfth century. Commentators of the time praised this complex, with its pools, fountains, and gardens. No doubt it was a source of inspiration for the builders of the later palaces.

Islamic control of Spain gradually succumbed to expanding Christian forces, ending altogether in 1492.

With the breakdown of Seljuk power in Anatolia in the early fourteenth century, another group of Muslim Turks seized power in the northwestern part of that region, having migrated there from their homeland in Central Asia. Known as the Ottomans, after an early leader named Osman, they pushed their territorial boundaries westward and, in spite of setbacks inflicted by the Mongols, ultimately created an empire that extended over Anatolia, western Persia, Iraq, Syria, Palestine, western Arabia (including Mecca and Medina), North Africa (including Egypt and the Sudan), and much of eastern Europe. In 1453 they captured Constantinople (renaming it Istanbul) and brought the Byzantine Empire to an end. The Ottoman Empire lasted until the end of World War I in 1918. Another dynasty, the Safavids, established a Shiite state in Persia beginning in the early years of the sixteenth century.

Although Islam remained a dominant and unifying force throughout these developments, the later history of Islamic society and art is a largely regional phenomenon. The following discussion focuses on architecture, port-

able arts, manuscript illumination, and calligraphy from Spain, North Africa, and western Asia.

Architecture

The best-preserved later Islamic monument left standing after the Christian reconquest of Spain in 1492 is the Alhambra. This fortified hilltop palace complex was the seat of the Nasrids (1232–1492), the last Spanish Muslim dynasty, whose territory had shrunk to the region around Granada in southeastern Spain. The Alhambra remained fairly intact in part because it represented the defeat of Islam to the victorious Christian monarchs, who restored, maintained, and occupied it as much for its commemorative value as for its beauty.

The Alhambra, which emerged from the distinctive local traditions established by the Córdoba Umayyads, exemplifies the growing regionalism in Islamic art. The complex was begun in 1238 on the site of a pre-Islamic fortress by the founder of the Nasrid dynasty. Successive rulers expanded it, and it took its present form in the fourteenth century. Literally a small town extending for about half a mile along the crest of a high hill overlook-

toward its lush courtyard gardens. They embodied the Muslim vision of paradise as a well-watered, walled garden (the English word paradise comes from the Persian term for an enclosed park, *Jaradis*). The so-called Palace of the Lions was a private retreat built by Muhammad V (ruled 1362–1391) in the late fourteenth century. At its heart is the Court of the Lions, a rectangular courtyard named for a marble fountain surrounded by stone lions (fig. 8-11). Although sanded today, the Court of the Lions was originally a garden, probably planted with aromatic

ing Granada, it included government buildings, royal barracks, gates, mosques, baths, and gardens.

Although it offered views to the landscape below, the

architectural focus of the Alhambra was largely inward

Four pavilions used for dining and performances of music, poetry, and dance open onto the Court of the Lions. One of these, the two-storied Hall of the Abencerrajes on the south side, may have been used year-round as a music room. Like the other pavilions (all of which had good acoustics), it is covered by a domed ceiling (fig. 8-12). The star-shaped dome rests on clustered squinches called muqarnas (see "Elements of Architecture,"

shrubs, flowers, and small citrus trees between the water channels that radiate from the fountain. Second-floor balconies overlook the courtyard. On the outside wall of a pavilion on the north side of the court (not visible in the illustration), a second-floor mirador—a projection with windows on three sides—looked out onto a large, lower garden and the plain below.

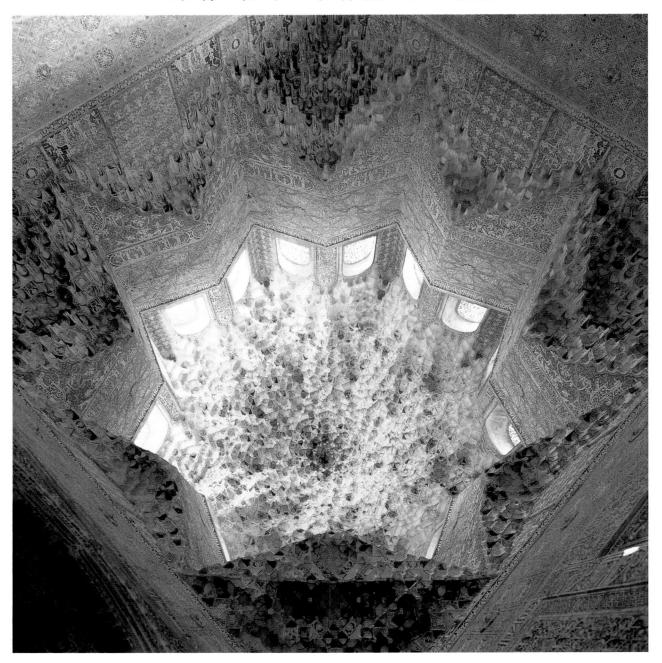

8-12. Mugarnas dome, Hall of the Abencerrajes, Palace of the Lions

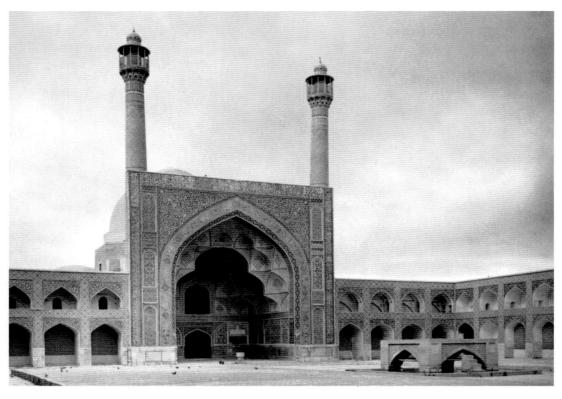

8-13. Courtyard, Masjid-i Jami (Great Mosque), Isfahan, Persia (Iran). 11th–18th century. View from the northeast

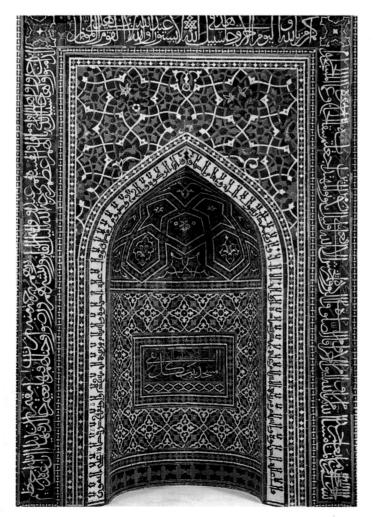

page 347). A honeycomb of *muqarnas* likewise covers the apex of the dome. The effect is of architectural lace, material form made immaterial.

The Alhambra was a sophisticated pleasure palace, an attempt to create paradise on earth. Imagining it as it once was—glittering with carved and painted stucco ornament, stained glass, glazed tiles, and lush carpets, its pavilions and gardens filled with courtiers dressed in glowing silks, jewelry, and cloth-of-gold—one can understand why it was legendary in its own time.

In the eastern Islamic world, the Seljuk rulers proved themselves enlightened patrons of the arts. One farreaching development during their reign was the introduction of the four-iwan mosque. In this plan, **iwans**, which are large, rectangular, barrel-vaulted halls with monumental arched openings, face each other across a courtyard. Reflecting the influence of Sufism, a literary and philosophical movement that arose in the late tenth and early eleventh centuries, iwans may represent symbolic gateways between outside and inside, open and closed, the material and the spiritual.

Iwans first appeared in **madrasas**, schools for advanced study that were the precursors of the modern uni-

8-14. Mosaic mihrab, from the Madrasa Imami, Isfahan, Persia (Iran). c. 1354 (restored). Glazed and painted ceramic on plaster, 11'3" x 7'6" (3.43 x 2.89 m). The Metropolitan Museum of Art, New York Harris Brisbane Dick Fund (39.20)

One of the three Koranic inscriptions on this mihrab dates it to approximately 1354. Note the combination of decorated kufic and cursive *muhaqqaq* scripts.

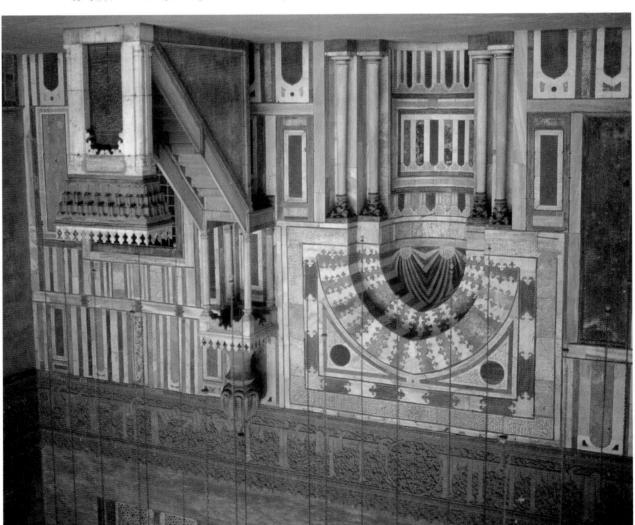

8-15. Qibla wall, main iwan (mosque), in a madrasa, Sultan Hasan complex, Cairo, Egypt. 1356-63

A fourteenth-century mosaic mihrab originally from a madrasa in Isfahan but now in the Metropolitan Museum of Art in New York is one of the finest examples of early architectural ceramic decoration in Islamic art (fig. 8-14). More than 11 feet tall, it was made with a painstaking process that involved cutting each piece of tile individually, including the pieces making up the letters on the curving surface of the niche. The color scheme—white against turquoise and cobalt blue with accents of dark yellow and green—was typical of this type of decoration, as was the harmonious but contrasting use of dense organic and geometric patterns.

A madrasa-mausoleum-mosque complex built in the mid-fourteenth century by the Mamluk sultan Hasan in Cairo, Egypt, shows Seljuk influence (fig. 8-15). The iwans in this structure functioned as classrooms, and students were housed in neighboring rooms. Hasan's domed tomb lies beyond the qibla wall of the largest of the four iwans, which served as the mosque for the entire complex. The walls and vaulting inside this main iwan are undecorated except for a wide stucco frieze band. Originally painted, this band combines calligraphy and

versity. Beginning in the eleventh century, hundreds of these institutions were founded and many are still in existence. Rulers and wealthy individuals endowed them as a form of pious charity. The four-iwan mosque may have evolved from the need to provide separate quarters for four schools of thought within madrasas.

The Masjid-i Jami (Great Mosque) in the center of the Seljuk capital of Isfahan (in modern Iran) was originally a hypostyle mosque. In the late eleventh century it was refurbished with two great brick domes, and in the twelfth century with four iwans and a monumental gate flanked by paired minarets (fig. 8-13). Construction continued sporadically on this mosque into the eighwhich became standard in Persia. The massive qibla which became standard in Persia. The massive qibla fourteenth-century mugarnas and seventeenth-century mugarnas and seventeenth-century of the iwans is unadorned; the facades, however, are sheathed in brilliant blue architectural tileevert. The massive dibla the interior of the iwans is unadorned; the facades, however, are sheathed in brilliant blue architectural tileevert. An Islamic trademark for which this monument work—an Islamic trademark for which this monument

is justly famous.

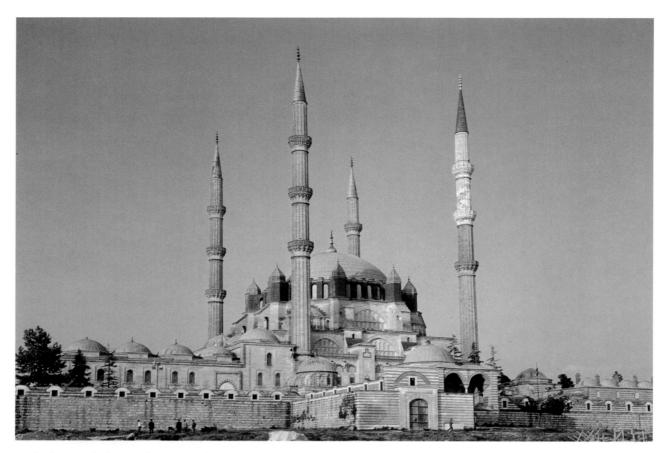

8-16. Sinan. Selimiye Cami (Mosque of Selim), Edirne, Turkey. 1570–74

The minarets that pierce the sky around the prayer hall of this mosque, their sleek, fluted walls and needle-nosed spires soaring to more than 295 feet, are only 12½ feet in diameter at the base, an impressive feat of engineering. Only royal mosques were permitted multiple minarets, and more than two was highly unusual.

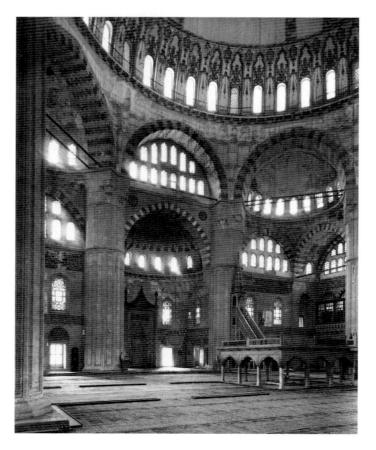

intricate carved scrollwork. The mihrab features marble panels, a double recess, and slender columns supporting **ogival arches**, a pointed form characteristic of Seljuk architecture (see "Elements of Architecture," page 347). Marble inlays create blue, red, and white stripes on the voussoirs, echoing the brick and stone bands of Umayyad architecture (see figs. 8-4, 8-6). Except for its elaborately carved door, the thronelike minbar at the right is made of carved stone instead of the usual wood.

After conquering Constantinople, the rulers of the Ottoman Empire converted the church of Hagia Sophia into a mosque, framing it with graceful Turkish-style minarets and adding calligraphic decorations to the interior (see figs. 7-25, 7-27). Inspired by this great Byzantine structure, Ottoman architects developed a domed, central-plan mosque. The finest example of this new form was the work of the architect Sinan (c. 1490-1588). Sinan began his career in the army and was chief engineer during the Ottoman siege of Vienna (1526-1529). He rose through the ranks to become chief architect for Suleyman (known as "the Lawgiver" and "the Magnificent"), the tenth Ottoman sultan (ruled 1520-1566). Suleyman, whose reign marked the height of Ottoman power, sponsored a building program on a scale not seen since the glory days of the Roman Empire. Sinan is credited with

8-17. Selimiye Cami

lines of four minarets, the mosque shifts from square to ducing covered market and baths. Framed by the vertical a hospital, and charity kitchens, as well as an income-promadrasa and other educational buildings, a burial ground, serene. In addition to the mosque, the complex housed a coherence on the interior, a space at once soaring and great geometric complexity on the exterior and complete than the dome of Hagia Sophia. It covers a building of this structure is more than 102 feet in diameter, larger century (fig. 8-16). The gigantic spherical dome that tops (ruled 1566-1574), in the third quarter of the sixteenth provincial capital of Edirne for Suleyman's son, Selim II he was at least eighty, was a mosque he designed at the Sinan's crowning accomplishment, completed when

The interior seems superficially very much like Hagia on a base at the city's edge, it dominates the skyline. octagon to circle as it moves upward and inward. Raised

softly glowing carpets with light. cream-colored stone, restrained tile decoration, and square. Windows at every level flood the interior's half-domes between the piers define the corners of a eight enormous piers topped with mugarnas. Smaller ization. The arches supporting the dome spring from covered by a muezzin platform emphasizes this centraldinal pull from entrance to sanctuary. A small fountain central-plan structure and lacks Hagia Sophia's longitua ring of light (fig. 8-17). The mosque, however, is a true Sophia's: an open expanse under a vast dome floating on

Islamic society was cosmopolitan, fostering the circula-

Portable Arts

much for the status they bestowed as for their usefulness. than buildings, and decorative objects were valued as textiles and books assumed greater cultural importance and pilgrimage. In this context, portable objects such as tion of goods and the movement of people through trade

creature's thighs include animals in medallions; the feathers, scales, and silk trappings. The trappings on the 1828. Made of cast bronze, it is decorated with incised played atop the cathedral in Pisa from about 1100 to how, through trade or pillage, to Italy, where it was disrange from Persia to Spain—but it found its way some-(fig. 8-18). Its place of origin is unknown—suggestions stylized griffin, may originally have been a fountain spout birds. One example of their work, an unusually large and and water pitchers in the shape of fanciful animals and applying them to new forms, such as incense burners of their Roman, Byzantine, and Sassanian predecessors, Metal. Islamic metalworkers inherited the techniques

thirteenth century (fig. 8-19). The work of an artist grand vizier, or chief minister, of Khurasan in the early was the possession of Majd al-Mulk al-Muzaffar, the blotting sand. One such container, an inlaid brass box, ers-emblems of their class-for their pens, ink, and leaders who often commissioned personalized contain-The Islamic world was administered by educated with kufic lettering and scale and circle patterns.

bands of cloth across its chest and back are decorated

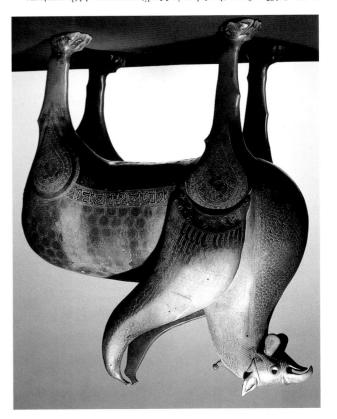

del Duomo, Pisa Bronze, height 421/8" (107 cm). Museo dell'Opera 8-18. Griffin, from the Islamic Mediterranean. 11th century.

Art, Smithsonian Institution, Washington, D.C. (36.7) 126/8", width 21/2" (5 x 31.4 x 6.4 cm). Freer Gallery of 1210-11. Brass with silver and copper; height 2", length 8-19. Shazi. Pen box, from Persia (Iran) or Afghanistan.

Islamic art. Al-Mulk enjoyed his box for only ten years; it one of the earliest examples of a signed work in dated it in animated kufic on the side of the lid, making from God. Shazi, the designer of the box, signed and animal forms in it), asked twenty-four blessings for him mated naskhi (an animated script is one with human or star of Islam." The largest inscription, written in anition in naskhi script on the lid calls him the "luminous orific phrases extolling its owner, al-Mulk. The inscrip-The inscriptions on this box include some twenty hon-

caravans—treasure houses, baths, bridges, viaducts, and kitchens and hospitals, caravansaries—way stations for madrasas and Koran schools, burial chapels, public more than 300 imperial commissions, including palaces,

he was killed in the Mongol sack of Merv in 1221.

124 large and small mosques.

8-20. Bottle, from Syria.
Mid-14th century.
Blown glass with
enamels and gilding, 19¹/₂ x 9³/₄"
(49.7 x 24.8 cm).
Freer Gallery
of Art, Smithsonian
Institution, Washington, D.C. (34.20)

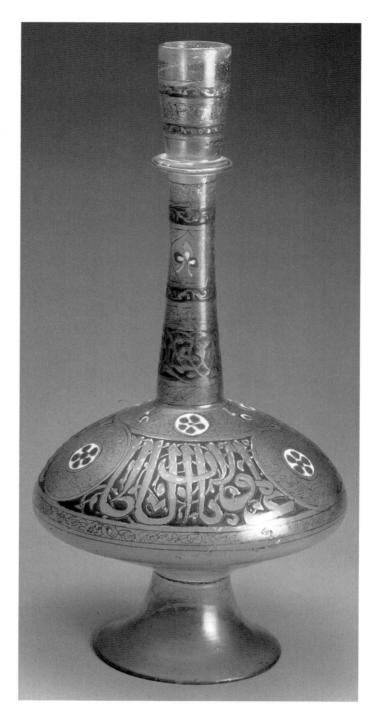

named Shazi, it was cast, engraved, embossed, and inlaid with consummate skill. Scrolls, interlacing designs, and human and animal figures enliven its calligraphic inscriptions. All these elements, animate as well as inanimate, seem to be engaged in lively conversation. That a work of such quality was made of brass rather than a costlier metal may seem odd. A severe silver shortage in the mid-twelfth century had prompted the development of inlaid brass pieces like this one that used the more precious metal sparingly. Humbler brassware would have been available in the marketplace to those of more modest means than the vizier.

Glass. Glass, according to the twelfth-century poet al-Hariri, is "congealed of air, condensed of sunbeam

motes, molded of the light of the open plain, or peeled from a white pearl" (cited in Jenkins, page 3). Made with the most ordinary of ingredients—sand and ash—glass is the most ethereal of materials. It first appeared roughly 4,000 years ago, and the tools and techniques for making it have changed little in the past 2,000 years. Like their counterparts working in metal, Islamic glassmakers generally adapted earlier practices to new forms. They were particularly innovative in the application of enameled decoration in gold and various colors. A tall, elegant enameled bottle from the mid-fourteenth century exemplifies their skill (fig. 8-20). One of several objects either given by Mamluk rulers to the Rasulid rulers of Yemen (southern Arabia) or ordered by the Rasulids from Mamluk workshops in Syria, it bears a large inscription nam-

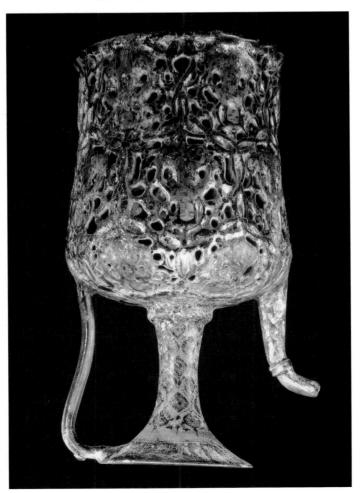

8-21. Pitcher, from Kashan, Persia (Iran). Early 13th century. Glazed and painted fritware, height 11¹³/16" (30 cm). The al-Sabah Collection, Kuwait

Fritware was used to make beads in ancient Egypt and may have been rediscovered there by Islamic potters searching for a substitute for Chinese porcelain. Composed of one part white clay, ten parts quarts, and one part quartz fused with soda, it produced a brittle, white ware when fired. The colors on this double-walled pitcher and others like it were produced by applying mineral glazes over black painted detailing. The deep blue comes from cobalt and the turquoise from copper. Lusterware, a thin, transparent glazes with a metallic sheen, was applied over the colored glazes. Lusterware was sheen, was applied over the colored glazes. Lusterware was to become a trademark of later Islamic ceramics.

Iusterware.

neck and an inscription encircles its rim. The pitchers are made of **tritware**—a mixture of white clay, quartz, and soda that fires into a brittle, white material—and are coated with a thin, transparent glaze that is known as

Textiles. The tradition of silk weaving that passed from Sassanian Persia to Islamic artisans in the early Islamic period (see fig. 8-10) was kept alive in Muslim Spain, where it was both economically and culturally important. Spanish designs, with their emphasis on architecturelike forms beginning in the thirteenth century, reflect a different aesthetic than those found in the earlier works. The pattern in the central section of a magnificent silk and gold banner (fig. 8-22) resembles the plan of a and gold banner (fig. 8-22) resembles the plan of a

ing and honoring a Rasulid sultan in thuluth—a popular Mamluk cursive script—and the Rasulid insignia, a five-petaled red rosette.

Ceramics. Seljuk potters produced tableware in a range of styles and techniques. Unusual among them was a double-walled form found on a group of early-thirteenth-century pitchers that may have derived from a similar form used by Roman glassmakers. The Seljuk pitchers, with their carved openwork shells and solid inner bodies, were difficult to execute. The form was probably intended more to be decorative than to serve a practical function like insulation. The shell of one of them (fig. 8-21) is a forest of twining vines in which perch them (fig. 8-21) is a forest of twining vines in which perch them (fig. 8-21) is a forest of twining vines in which perch them (fig. 8-21) is a forest of twining vines in which perch them (fig. 8-21) is a forest of twining vines in which perch them (fig. 8-21) is a forest of twining vines in which perch them (fig. 8-21) is a forest of twining vines in which perch them (fig. 8-21) is a forest of twining vines in which perch them (fig. 8-21) is a forest of twining vines in which perch them (fig. 8-21) is a forest of twining vines in which perch them (fig. 8-21) is a forest of twining vines in which perchanges in which perchanges in which was a forest of twining vines in which perchanges in which was a forest of twining vines in which perchanges in which was a forest of twining vines in a forest of twining vines in which was a forest of twining vines in which was a forest of twining vines in a forest of twining vines in which was a forest of twining vines in a forest of twining vines vines

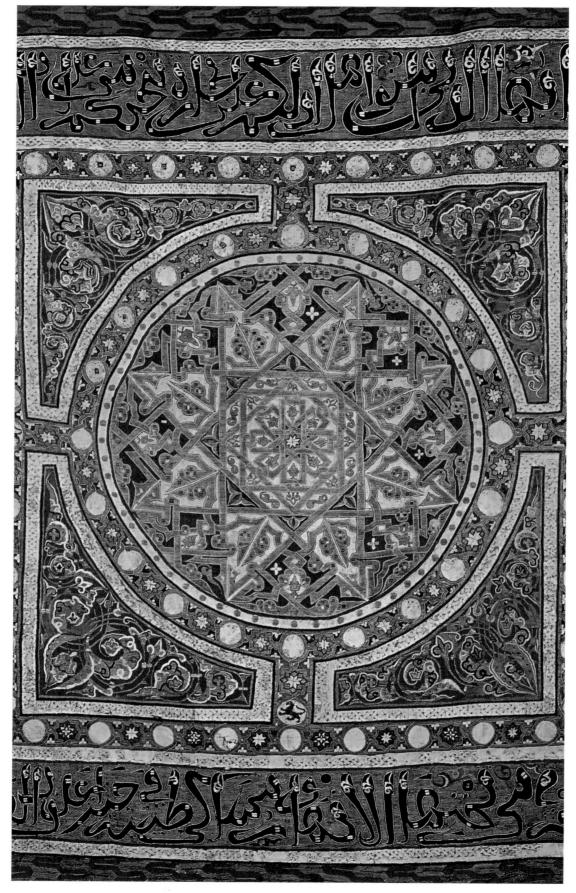

8-22. Banner of Las Navas de Tolosa, from southern Spain. First half of 13th century. Silk tapestry-weave with gilt parchment, 10'97/8" x 7'25/8" (3.3 x 2.2 m). Museo de Telas Medievales, Monasterio de Santa Maria la Real de Las Huelgas, Burgos, Spain. Patrimonio Nacional

TECHNIQUE

CARPET MAKING square inch, each one tied separately by hand.

are destroyed through use, very few rugs Because textiles, especially floor coverings,

details. Kilim weaving is done in the tapestry technique, geometric patterns and sometimes with embroidered ish kilims, which are typically woven in wool with bold, tal frames. The best-known flat-weaves today are Turkknotted. Both can be made on either vertical or horizonare two basic types of carpets: flat-weaves and pile, or from before the sixteenth century have survived. There

Knotted carpets are an ancient invention. The oldwhich allows free placement of each area of color (a).

tying colored strands of yarn, usually wool but occasionthe pile-the plush, thickly tufted surface-is made by may have originated in ancient Persia. In knotted rugs Achaemenid Persian art, suggesting that the technique the fourth or fifth century BCE, has designs evocative of est known example, excavated in Siberia and dating to

passes it on to the next generation. the art of carpet weaving at the loom and eventually ally, an older woman works with a young girl, who learns weave five carpets, tying up to 5,000 knots a day. Genering between September and May, these women may yarn against the warp threads before tying a knot. Workcalled a beater. The other woman pulls a dark red weft knots tightly against the row below it with a wood comb tern. The woman in the foreground pushes a row of Turkey, weaving a large carpet in a typical Turkish patshows two women, sisters in Ganakkale province in depending on local custom. The photograph in this box 8-24). Carpets were woven by either women or men, have traditionally been made in tents and homes (see fig.

most luxurious carpets (see fig. 8-23), most knotted rugs

第4次的2004年

Although royal workshops produced the

a. Kilim weaving pattern used in flat-weaving

to make pile, or knotted, carpets b. Turkish knots, used typically in Anatolia (Turkey)

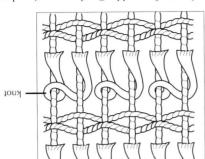

c. Persian knots, favored by Persian carpet makers

ble the pile. The finest carpets have a hundred knots per greater the number of knots, the denser and more duraknot, used for rendering curvilinear patterns (c). The straight-line designs (b), and the asymmetrical "Persian" symmetrical "Turkish" knot, which works well for colored knots. Two common tying techniques are the usually in undyed yarn and is eventually hidden by the rows (weft) that hold the carpet together. The weft is of the carpet. Rows of knots alternate with flat-woven later sheared, cut, and trimmed to form the plush surface (warp) of a yarn grid (b or c). These knotted loops are ally silk for deluxe carpets, onto the vertical elements

8-23. Garden carpet, from central Persia (Iran). Second half of 17th century. Dyed silk with metallic thread, 17'5" x 14'2" (5.31 x 4.32 m). The Burrell Collection, Glasgow Museums, Scotland

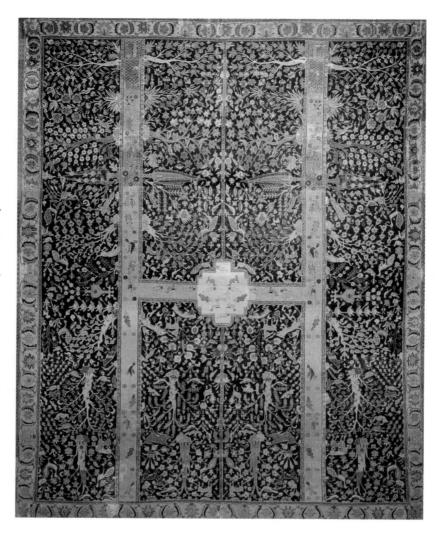

Spanish courtyard garden (see fig. 8-11), and the Koranic inscriptions that surround it include a reference to the Garden of Eden as a refuge from earthly suffering. The banner was captured in battle by Christian forces not long after it was made.

Since the late Middle Ages, the Islamic art form best known in the non-Islamic West has probably been the carpet. Knotted rugs (see "Carpet Making," page 359) from Persia and Turkey were so highly prized among Westerners that they were often displayed on tables rather than floors. Persian taste favored intricate, elegant designs that evoked the gardens of paradise. Written accounts indicate that such designs appeared on Persian carpets as early as the seventh century. In one fabled royal carpet, garden paths were rendered in real gold, leaves were modeled with emeralds, and highlights on flowers, fruits, and birds were created from pearls and other jewels.

A special kind of garden carpet, possibly derived from drawings by town planners and mapmakers, shows a bird's-eye view of an enclosed park. One such carpet from the second half of the seventeenth century depicts a walled hunting preserve irrigated by an H-shaped system of channels. In the middle is a basin filled with floating plants, fish, and birds (fig. 8-23). All kinds of animals and birds, some resting and others hunting, inhabit the

dense forests of leafy trees and blooming shrubs in the rectangular sections. The very finest carpets, like this, woven of silk or silk and wool in royal workshops, were as much status symbols *within* the Islamic world as they were *beyond* it.

Rugs and mats have long been used for Muslim prayer, which involves repeated kneeling and touching of the forehead to the floor. Prayer rugs came to be distinguished, particularly in Turkey, by mihrab-shaped frames or arches. The worshiper oriented the arch toward Mecca and stood within it. Portable, individual-size carpets could be unrolled as needed for the five daily prayers, either at a mosque or elsewhere. (This is still done today.) Like garden carpets, these were emblems of social prestige and were considered lucky, even magical. Many mosques were literally "carpeted" with wool pile rugs received as pious donations; wealthy patrons gave large, multiple-arched prayer rugs (note, for example, the rugs on the floor of the Selimiye Cami in figure 8-17).

An eighteenth-century carpet from western or central Turkey contains a representation of the Kaaba surrounded by its barricade and framed by a calligraphylike enclosure wall in the shape of a mihrab arch (fig. 8-24). Minarets in the enclosure wall flank the Kaaba barricade, and a minbar, banner flying, stands in front of it flanked by more minarets. Medallions dot the lower portion of

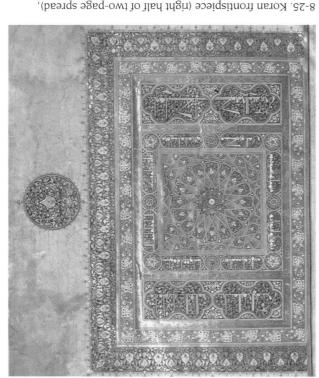

Cairo, Egypt. c. 1368. Ink, pigments, and gold on paper, 24 x 18" (61 x 45.7 cm). National Library, Cairo. Ms. 7
The Koran to which this page belonged was donated in 1369 by Sultan Shaban to the madrasa established by

The Koran to which this page belonged was donated in 1369 by Sultan Shaban to the madrasa established by his mother. Throughout the manuscript, as here, there is evidence of close collaboration between illuminator and scribe.

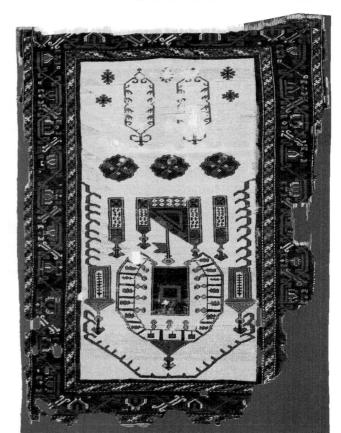

8-24. Prayer carpet with the Kaaba, from western or central Turkey. 18th century. Wool, $57^{1/2}$ x $43^{3/4}$ " (146 x 111 cm). Museum of Turkish and Islamic Arts, Istanbul

ates from a sixteen-pointed starburst, filling the central square (fig. 8-25). The surrounding **lozenges** and medallions are filled with interlacing foliage and stylized flowers that provide a backdrop for Koranic quotations. The page's resemblance to court carpets was not coincidental: designers worked in more than one medium, leaving the execution of their efforts to specialized artisans.

In addition to religious works, scribes also copied and recopied famous secular texts, especially scientific treatises, manuals of all kinds, fiction, and poetry. Painters supplied illustrations for these books and created individual small-scale paintings—miniatures—that were collected by the wealthy and placed in albums. Miniature painting was highly regarded because of its connection with books, whereas mural painting (associonnection with books, whereas mural painting (associon of the great royal centers of miniature painting not. One of the great royal centers of miniature painting of painting and calligraphy was founded there in the early fifteenth century under the cultured patronage of the Turkic Timurid dynasty (1370–1507).

The most famous artist of this school was Kamal al-Din Bihzad (c. 1440–1514). He headed the academy from about 1469 until the Safavids supplanted the Timurids and established their capital at Tabriz (in northwestern Persia) in 1506. Following this upheaval, Bihzad moved

the carpet. The elongated six-sided shapes at the bottom may be foot marks.

Manuscript Illumination and Calligraphy

The arts of book production flourished in the later Islamic centuries. Muslim societies enjoyed a high level of literacy among both women and men thanks to Islam's emphasis on the study of the Koran. Books on a wide range of secular as well as religious subjects were available, although even modest books copied on paper were fairly costly. Libraries, often associated with madrasas, were endowed by members of the educated elite. Books made for royal patrons had luxurious bindings and highly embellished pages, the result of workshop collaboration between noted calligraphers and illustrators. New scripts were developed for new literary forms.

The **illuminators**, or manuscript illustrators, of Mamluk Egypt executed superlative nonfigural designs for Korans. Geometric and botanical ornamentation reached unprecedented heights of sumptuousness and mathematical complexity in their work. As in contemporary architectural decoration, strict underlying geometric organisation was combined with luxurious allover patterning. In an impressive frontispiece page originally paired with its mirror image on the facing left page, energy radimith its mirror image on the facing left page, energy radimith its mirror image on the facing left page, energy radimith its mirror image on the facing left page, energy radimith its mirror image on the facing left page, energy radimith its mirror image on the facing left page, energy radimith its mirror image on the facing left page, energy radimith its mirror image on the facing left page, energy radimith its mirror image on the facing left page, energy radimith its mirror image on the facing left page, energy radimith its mirror image on the facing left page.

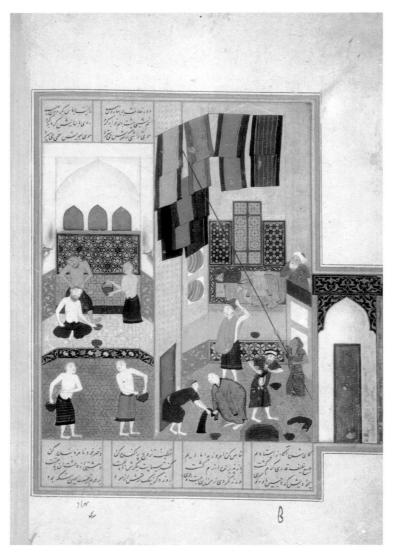

8-26. Kamal al-Din Bihzad. *The Caliph Harun al-Rashid Visits the Turkish Bath*, from a later copy of the *Khamsa* (Five Poems) of Nizami (12th century), Herat, Khurasan (Iran). c. 1494. Ink and pigments on paper, approx. 7 x 6" (17.8 x 15.3 cm). The British Library, London.

Oriental and India Office Collections (Ms. Or. 6810, fol. 27v)

Despite early warnings against it as a place for the dangerous indulgence of the pleasures of the flesh, the bathhouse (hammam), adapted from Roman and Hellenistic predecessors, became an important social center in much of the Islamic world. The remains of an eighth-century hammam are still standing in Jordan, and a twelfth-century hammam is still in use in Damascus. Hammams had a small entrance to keep in the heat, which was supplied by ducts running under the floors. The main room had pipes in the wall with steam vents. Unlike the Romans, who bathed and swam in pools of water, Muslims preferred to splash themselves from basins, and floors were slanted for drainage. A hammam was frequently located near a mosque, part of the commercial complex provided by the patron to generate income for the mosque's upkeep.

to Tabriz and briefly resumed his career there. The Herat academy, and Bihzad himself, executed commissions for both royal and nonroyal patrons. Under his leadership, top painters for the first time were permitted to sign their work. Unsigned miniatures by the more talented of his numerous students are often confused with his. Bihzad is remembered for having injected a vivid new naturalism and an interest in the psychological drama of everyday subjects into the super-refined, glittering dreamworld of the academy style. His influence on the next generations of painters was enormous.

Among Bihzad's authentic works are paintings done around 1494 to illustrate the *Khamsa* (Five Poems) by the twelfth-century mystic poet Nizami. These paintings

demonstrate Bihzad's ability to render human activity convincingly. He set his scenes within complex, stagelike architectural spaces that are stylized according to Timurid conventions, creating a visual balance between activity and architecture. In *The Caliph Harun al-Rashid Visits the Turkish Bath* (fig. 8-26), the bathhouse, its tiled entrance leading to a high-ceilinged dressing room with brick walls, provides the structuring element. Attendants wash long, decorative towels and hang them to dry on overhead clotheslines. A worker reaches for one of the towels with a long pole, and a client prepares to wrap himself discreetly in a towel before removing his outer garments. The blue door on the left leads to a room where the caliph is being groomed by his barber while

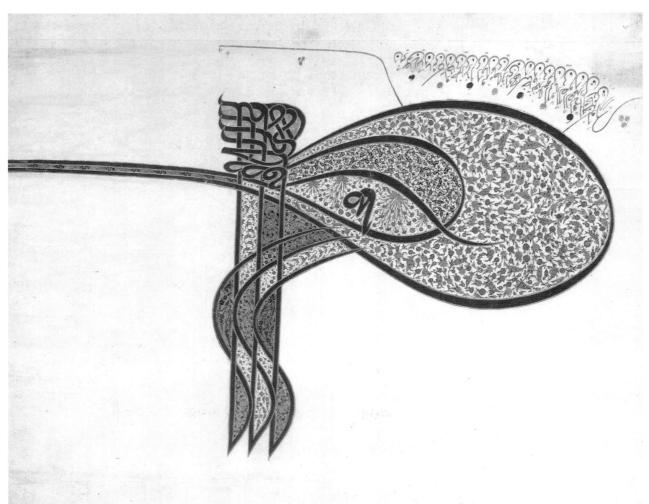

8-27. Illuminated *tug*ra of Sultan Suleyman, from Istanbul, Turkey. c. 1555–60. Ink, paint, and gold on paper, removed from a firman and trimmed to 20½ x 253/8" (52 x 64.5 cm). The Metropolitan Museum of Art, New York Rogers Fund, 1938 (38.149.1)

(fig. 8-27) is from a document endowing an institution in Jerusalem that had been established by Suleyman's wife, Sultana Hurrem.

Tugras on paper were always outlined in black or blue with three long, vertical strokes (tug means "horsetail") to the right of two horizontal teardrops, one inside the other. Early tugras were purely calligraphic, but decorative fill patterns became fashionable in the sixteenth century. This fill decoration had become more naturalistic by the 1550s and in later centuries spilled outside the emblems' boundary lines.

Figure 8-27 shows a rare, oversized *tugra* that required more than the usual skill to execute. The sweeping, fluid line had to be drawn with perfect control according to set proportions, and a mistake meant starting over. The color scheme of the delicate floral interlace enclosed in the body of the *tugra* was inspired by Chinese enclosed in the body of the *tugra* was inspired by Chinese only conditions.

Ottoman ceramics and textiles.

The Ottoman *tugna* is a sophisticated merging of abstraction with naturalism, boldness with delicacy, political power with informed patronage, and function—both utilitarian and symbolic—with adormment. As such, it is a fitting conclusion for this brief survey of Islamic art.

attendants bring buckets of water for his bath. The balanced placement of colors and architectural ornaments within each section ties the scene together in a unified whole.

A half century later at the Ottoman court of Sultan Suleyman in Constantinople, the imperial workshops also produced remarkable illuminated manuscripts. In addition, following a practice begun by the Seljuks and Mamluks, the Ottomans put calligraphy to another, political use, developing the design of imperial emblems—tugras—into a specialized art form. Ottoman tugras combined the ruler's name with the title khan ("lord"), his father's name, and the motto "Eternally Victorious" into an unvarying monogram. Tugras symbolized the authority of the sultan and of those select officials who were also granted an emblem. They appeared on seals, coins, and buildings, as well as on official documents called firmans, imperial edicts supplementing Muslim law, or sharia.

Suleyman issued hundreds of firmans. A high court official was entrusted with the important responsibility of affixing Suleyman's *tugra* at the top of official scrolls. For documents like imperial grants to charitable projects that required particularly fancy *tugras*, specialist calligraphers required particularly fancy *tugras*, specialist calligraphers and illuminators were employed. The *tugra* shown here

Mohenjo-Daro bust c. 2000

▲ INDUS VALLEY CIVILIZATION 2700-1500

▲ VEDIC PERIOD 1500-322

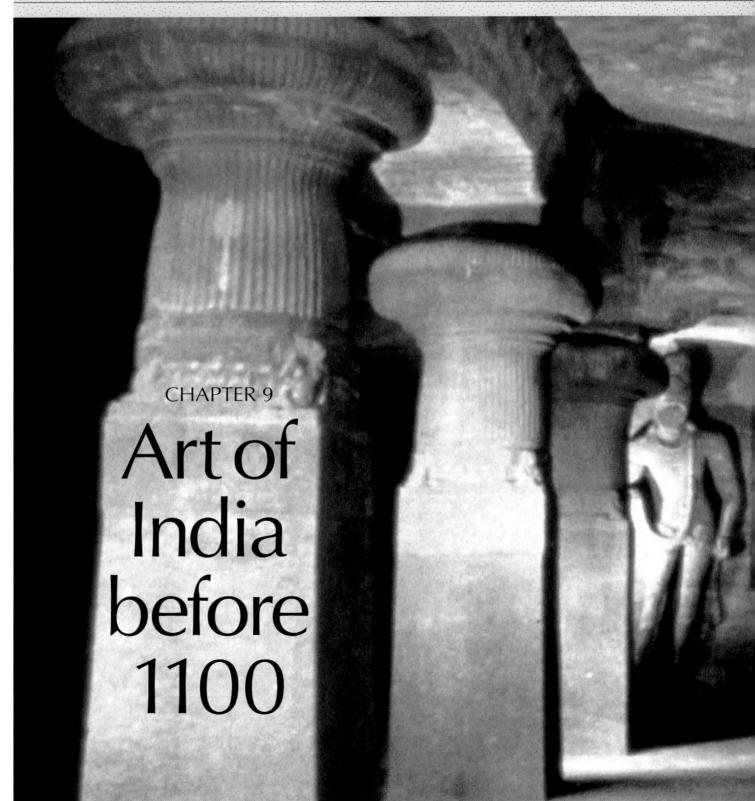

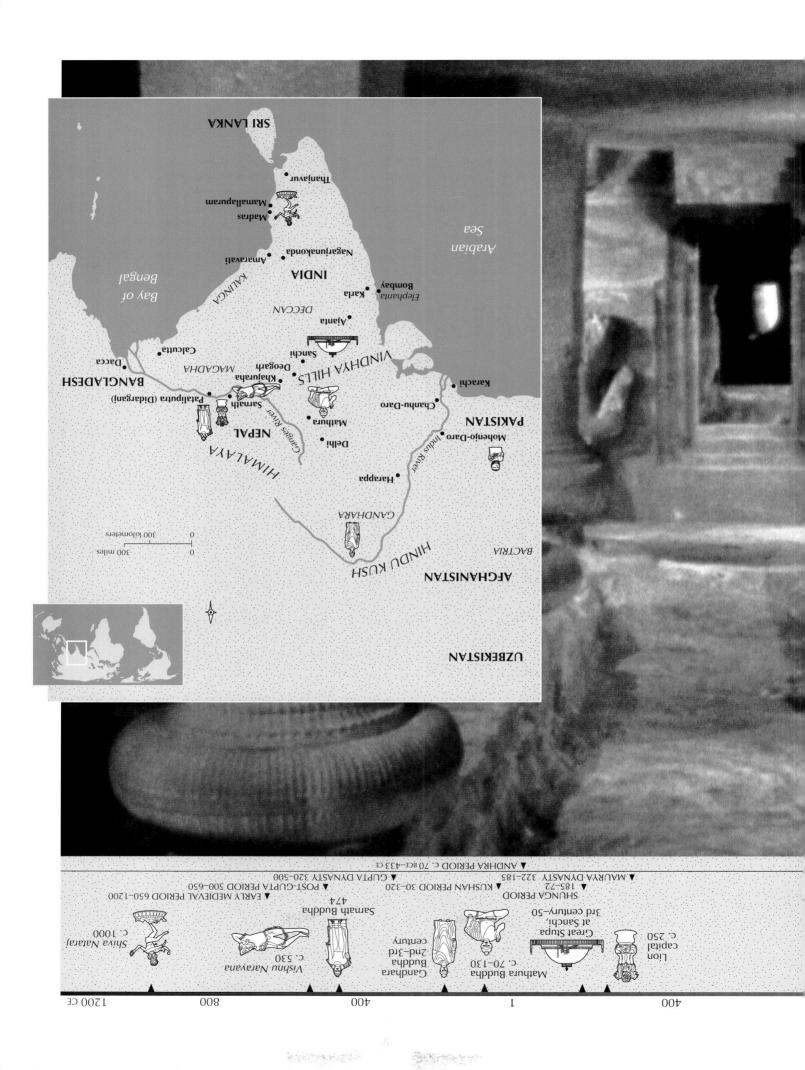

he ruler Ashoka was stunned by grief and remorse as he looked across the battlefield. In the tradition of his dynasty, he had gone to war, expanding his empire until he had conquered many of the peoples of the Indian subcontinent. Now, in 261 BCE, after the final battle in his conquest of the northern states, he was suddenly—unexpectedly shocked by the horror of the suffering he had caused. It is said that only one form on the battlefield moved, the stooped figure of a monk slowly making his way through the carnage. Watching this spectral figure, Ashoka abruptly turned the moment of triumph into one of renunciation. Decrying violence and warfare, he converted to Buddhism, which he established as the official religion of his realm. From that moment on, he set a noble example by living his belief in non-violence and kindness to all beings.

In his impassioned propagation of Buddhism, Ashoka stimulated an intensely rich period of art. He erected monuments to the Buddha throughout his empire—shrines, monasteries, sculpture, and the columns known as Ashokan pillars (see fig. 9-6). In his missionary ardor, he sent delegates throughout the Indian subcontinent and to countries as distant as Syria, Egypt, and Greece.

SUBCONTINENT

THE INDIAN The South Asian subcontinent, or Indian subcontinent, as it is commonly

called, includes the present-day countries of India, southeastern Afghanistan, Pakistan, Nepal, Bangladesh, and Sri Lanka. Throughout the history of the area, these lands have been culturally linked and are among the world's oldest, most productive, and most profoundly spiritual civilizations. Present-day India is approximately one-third the size of the United States. A low mountain range, the Vindhya Hills, acts as a kind of natural division that demarcates North India and South India, which are of approximately equal size. On the northern border rises the protective barrier of the Himalaya, the world's tallest mountains. To the northwest are other mountains through whose passes came invasions and immigrations that profoundly affected the civilization of the subcontinent. Over these passes, too, wound the major trade routes that linked the Indian subcontinent by land to the rest of Asia and Europe. Surrounded on the remaining sides by oceans, India has also been connected to the world since ancient times by maritime trade, and during much of the period under discussion here it formed part of a coastal trading network that extended from eastern Africa to China.

Differences in language, climate, and terrain within India have fostered distinct regional and cultural characteristics and artistic traditions. However, despite such regional diversity, several overarching traits tend to unite Indian art. Most immediately evident is a distinctive sense of beauty. Indian artists delight in full forms and a profusion of ornament, texture, and color. This extraordinary visual generosity is considered auspicious, and it reflects a belief in the abundance and favor of the gods. Another characteristic is the pervasive role of symbolism, which imbues Indian art with intellectual and emotional depths far beyond its immediate appeal to the eye. Third, and perhaps most important, is an emphasis on capturing the vibrant, pulsating quality of a world seen as infused with the dynamics of the divine. Gods and humans, ideas and abstractions come forth clothed in tactile, sensuous forms, radiant with inner spirit.

INDUS VALLEY CIVILIZATION

The earliest civilization of South Asia was nurtured in the lower reaches of the

Indus River (in present-day Pakistan and in northwestern India). Known as the Indus Valley or Harappan civilization (after Harappa, the first discovered site), it flourished from approximately 2700 to 1500 BCE, or during roughly the same time as the Old Kingdom period of Egypt, the Minoan civilization of the Aegean, and the dynasties of Ur and Babylon in Mesopotamia. Indeed, it is considered along with Egypt and Mesopotamia as one of the world's earliest urban, river-valley civilizations.

It was the chance discovery in the late nineteenth century of some small seals like those in figure 9-1 that provided the first clue that an ancient civilization had existed in this region. The seals appeared to be related to, but not the same as, seals known from ancient Mesopotamia (see fig. 2-13). Excavations begun in the 1920s

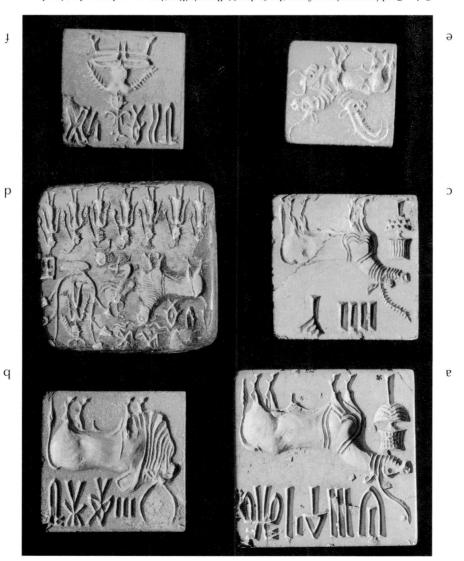

9-1. Seal impressions, from the Indus Valley civilization: a., c. horned animal; b. buffalo; d. sacrificial rite to a goddess (?); e. three-headed animal; f. yogi. c. 2500–1500 BCE. Seals: steatite, each approx. 11/4 x 11/4" (3.2 x 3.2 cm) More than 2,000 small seals and impressions have been found, offering an intriguing window on the Indus Valley civilization. Usually carved from circuits and impressions have been found, offering an intriguing window on the Indus Valley civilization. Usually carved from

More than 2,000 small seals and impressions have been found, offering an intriguing window on the Indus Valley civilization. Usually carved from steatite stone, the seals were coated with alkali and then fired to produce a lustrous, white surface. A perforated knob on the back of each may have been for suspending them. The most popular subjects are animals, the most common being a one-horned bovine standing before an altarlike object (a, common being a one-horned bovine standing before an altarlike object (a, silism, their taut, well-modeled surfaces implying their underlying skeletal ralism, their taut, well-modeled surfaces implying their underlying skeletal structures. The function of the seals, beyond sealing packets, remains enigmatic, and the pictographic script that appears so prominently in the enigmatic, and the pictographic script that appears so prominently in the enigmatic, and the pictographic script that appears so prominently in the

high. Among these buildings is the so-called Great Bath, a large, watertight pool that may have been used for ritual purposes. Stretching out below this elevated area was the city, arranged in a gridlike plan with wide avenues and narrower side streets. Its houses, often two stories high, were generally built around a central court-yard. Like other Indus Valley cities, Mohenjo-Daro was constructed of fired brick, in contrast to the less-durable constructed of fired brick in contrast to the less-durable city included a network of covered drainage systems that city included a network of covered drainage systems that

and continuing into the present have subsequently uncovered a number of major urban areas at points along the lower Indus River, including Harappa, Mohenjo-Daro, and Chanhu-Daro.

The ancient cities of the Indus Valley resemble each other in design and construction, suggesting a unified and coherent culture. At Mohenjo-Daro, the best preserved of the sites, archeologists discovered an elevated "citadel" area, presumably containing important goveritadel" area, presumably containing important government structures, surrounded by a wall about 50 feet

PARALIFIS

	PARALLELS			
2800 BCE 1200 CE	<u>Years</u>	<u>Dynasty/Period</u>	<u>Indian Subcontinent</u>	World
	с. 2700-1500 все	Indus Valley civilization	Mohenjo-Daro "citadel"; seals; Harappa torso	c. 2700–1500 BCE Great Pyramids at Giza (Egypt); Stonehenge (England); Minoan culture (Crete); citadel at Mycenae (Greece)
	с. 1500-322 все	Vedic period	Aryan invasions; Veda; Upanishads; birth of Sid- dhartha Gautama, founder of Buddhism; birth of Mahavira, founder of Jainism; <i>Mahabharata</i> ; <i>Ramayana</i>	c. 1500–1000 BCE Stela of Hammurabi (Babylonia); Israelites led out of Egypt by Moses (Canaan); Olmec civilization (Mesoamerica) c. 1000–500 BCE Legendary founding of Rome (Italy); first Olympian Games (Greece); black-figure and red-figure vase painting (Greece); Hanging Gardens (Babylon); Sappho (Greece); birth of Laozi, founder of Daoism (China); Cyrus the Great (Persia) defeats Babylon; Aesop's Fables (Greece)
	с. 322–185 все	Maurya dynasty	Conversion of Ashoka; Ashokan pillars	c. 500 BCE-100 CE Confucius (China); Sophocles, Aeschylus, Euripides, Herodotus (Greece); The Canon of Polykleitos (Greece); Parthenon (Greece); Alexander the Great (Greece) conquers Per-
	с. 185 все-30 се	Shunga/early Andhra period	Shunga dynasty (central India); Andhra dynasty (southern India); Great Stupa at Sanchi; rock-cut halls	sia; Colossos of Rhodes; Han dynasty (China Nike of Samothrace, Aphrodite of Melos (Greece); crucifixion of Jesus (Jerusalem); Emperor Augustus (Italy); Colosseum (Italy)
	c. 30–433 ce	Kushan/later Andhra period	Kushan dynasty (northern India and Central Asia); Andhra dynasty (southern India); rule of Kanishka; first images of the Buddha; Gandhara, Mathura, and Amaravati schools	c. 100–500 CE Pantheon (Italy); Yayoi and Kofun eras (Japan); Buddhism in China; Maya civilization (Mesoamerica); Emperor Constantine (Italy)
	с. 320-500 се	Gupta dynasty	Mathura and Sarnath Gupta schools	c. 500-800 ce
	c. 500-650 CE	Post-Gupta period	Pallava dynasty (southern India); rise of Hinduism; Dharmaraja Ratha (temple)	Hagia Sophia (Turkey); Buddhism in Japan; birth of Muhammad, founder of Islam (Ara- bia); plague kills half of European population; Tang dynasty (China); Koran (Arabia); Muslim conquests of Arabia, Persia, Syria, Iraq, Egypt, Carthage; Charlemagne is
	c. 650-1100 ce	Early Medieval period	Pallava dynasty (southern India); Chola dynasty (south- ern India); Pala dynasty (northeastern India); Chan- della dynasty (northern India); <i>Dancing Shiva</i> ; con- quest by Islam	made emperor of the West c. 800–1100 ce First Viking colony in Greenland; Lady Murasaki's <i>Tale of Genji</i> (Japan); separation of Eastern and Western Christian Churches; the Crusades

National Museum, New Delhi c. 2000 BCE. Red sandstone, height 33/4" (9.5 cm). 9-3. Torso, from Harappa, Indus Valley civilization.

utes of later Indian sculpture. the Harappa torso forecasts the essential aesthetic attribyogi able to control his breath. With these characteristics cular form. The abdomen is relaxed in the manner of a ture of the human body and the subtle nuances of musancient Greece, this sculpture emphasizes the soft tex-In contrast to the more athletic male ideal developed in of the human form to survive from any early civilization.

inches tall, it is one of the most extraordinary portrayals

of the contrasting naturalistic style (fig. 9-3). Less than 4

with its formal pose and simplified, geometric form the

long strands and may be an indication of rank. Certainly

narrow band encircling the head falls in back into two

filled with red paste and the eyes inlaid with shell. The

The depressions of the trefoil pattern were originally

something of the appearance of the Indus Valley peoples.

lips, and large, wide eyes. These traits may well record

emerge, including a narrow forehead, a broad nose, thick

an treatment of the head, distinctive physical traits

smooth, planar surfaces of the face reflect Mesopotamitamian art as well. Although the striated beard and the

with a trefoil, or three-lobed, motif found in Mesopo-

Mesopotamian style. The man's garment is patterned

The bust of a man in figure 9-2 is an example of the

statue conveys a human presence of great dignity.

A nude male torso found at Harappa is an example

National Museum of Pakistan, Karachi lization. c. 2000 BCE. Limestone, height 67/8" (17.5 cm). 9-2. Bust of a man, from Mohenjo-Daro, Indus Valley civi-

Although little is known about the Indus Valley civisize and had a population of about 20,000 to 50,000. Mohenjo-Daro was approximately 6 to 7 square miles in

highly advanced. At its peak, about 2500 to 2000 BCE,

nical and engineering skills of this civilization were

channeled away waste and rainwater. Clearly the tech-

Indian gods and goddesses. whose deities may have been ancient prototypes of later religious or ritual customs of Indus Valley peoples, ing worshiper. This scene may offer some insight into the ure standing in a tree—possibly a goddess—and a kneelelaborate headgear in a row or procession observe a figusually for spiritual purposes. In seal (d), persons with seeks mental and physical purification and self-control, posture associated in Indian culture with a yogi, one who ure 9-1, for example, depicts a man in the meditative continuities with later South Asian culture. Seal (f) in figfew artworks that have been discovered strongly suggest lization, a majority of motifs on the seals as well as the

artistic tradition in its sensuous naturalism. dering, while the other foreshadows the later Indian Mesopotamian art in its motifs and rather abstract rentechnique. Two main styles appear: one is related to reveal an astonishing maturity of artistic conception and stone and bronze statuettes have been found. They Numerous terra-cotta figurines and a few small

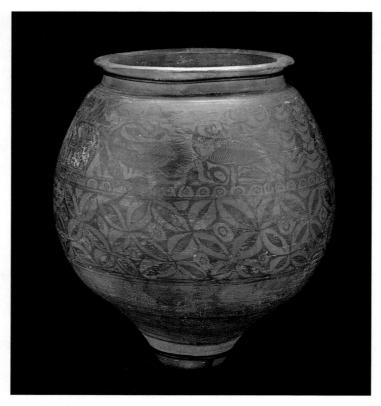

9-4. Large Painted Jar with Border Containing Birds, from Chanhu-Daro, Indus Valley civilization. c. 2400-2000 BCE. Reddish buff clay, height 97/8" (25 cm). Museum of Fine Arts, Boston Joint Expedition of the American School of Indic and Iranian Studies and the Museum of Fine Arts, Boston

No paintings from the Indus Valley civilization have yet been found, but there are remains of handsome painted ceramic vessels (fig. 9-4). Formed on a potter's wheel and fired at high temperatures, the vessels are quite large and generally have a rounded bottom. They are typically decorated with several zones of bold, linear designs painted in black slip. Flower, leaf, bird, and fish motifs predominate. The elegant vessel here, for example, is decorated with peacocks poised gracefully among leafy branches in the upper zone and rows of leaves formed by a series of intersecting circles in the lower zone. Such geometric patterning is typical of Indus Valley decoration.

The reasons for the demise of this flourishing civilization are not yet understood. All we know is that apparently around 1500 BCE—possibly because of climate changes, a series of natural disasters, or invasions—the cities of the Indus Valley civilization declined, and over the next thousand years predominantly rural societies evolved.

PERIOD

THE VEDIC The centuries between the demise of the Indus Valley civilization and the rise of the first unified empire in

the late fourth century BCE are generally referred to as the Vedic period. Named for the Vedas, a body of sacred writings that took shape over these centuries, the Vedic period witnessed profound changes in social structure and the formation of three of the four major enduring religions of India—Buddhism, Hinduism, and Jainism.

The period is marked by the dominance of Indo-European Aryans, a pastoral, seminomadic warrior people who entered India sometime around 1500 BCE from the northwest. Gradually they supplanted the indigenous populations that had created the Indus Valley urban centers. The Aryans brought with them a language called Sanskrit, a hierarchical social order, and religious practices that centered on the propitiation through fire sacrifice of exalted gods. The oldest layers of the Vedas, dating from the first centuries of Aryan presence, consist of hymns to such Aryan gods as the divine king Indrathe Vedic counterpart of the later Greek god Zeus. The importance of the fire sacrifice and the concept of religiously sanctioned social classes persisted through the Vedic period. At some point, the class structure became hereditary, with lasting consequences for Indian society.

During the latter part of this period, from about 800 BCE, the Upanishads were composed. These metaphysical texts examine the meanings of the earlier, more cryptic Vedic hymns. They focus on the relationship between the individual soul, or atman, and the universal soul, or Brahman, as well as on other concepts central to subsequent Indian philosophy. One is the assertion that the material world is illusory and that only Brahman is real

and Southeast Asia. mainly in southern India, Sri Lanka, Buddhism, in contrast, continued China, Korea, and Japan. Theravada also took root and flourished in in northern India and eventually Mahayana, became popular mainly

others achieve buddhahood before buddhahood but have vowed to help who are on the brink of achieving hisattvas are saintly, great beings whose essence is wisdom." Bodry of bodhisattvas, meaning "those Buddhism also developed the categolarly popular in East Asia. Mahayana Amitabha Buddha became particuknown as the Western Pure Land. and time), who dwells in a paradise Life (that is, incorporating all space Buddha of Infinite Light and Infinite Another is Amitabha Buddha, the the next buddha to appear on earth. Shakyamuni. One such is Maitreya, these buddhas became as popular as the past, present, and future. Some of also numerous other buddhas from not only Shakyamuni Buddha but Mahayana Buddhism recognizes

ly symbolic, and no spirit is believed bodhisattvas are recognized as puredhism portrayals of buddhas and may dwell in its image, but in Budmonk's robe. In Hinduism a deity of India, while buddhas wear a bodhisattvas wear the princely garb by their clothing and adornments: dhas are most clearly distinguished In art, bodhisattvas and budcrossing over themselves.

> and established the world's oldest disciples developed his teachings of eighty. After he died, his many teach until his death at the age tration. The Buddha continued to right mindfulness, and right concenaction, right livelihood, right effort, view, right resolve, right speech, right lowing the eightfold path of right

> A buddha is not a god but rather

monastic institutions.

tured spirits, or hell beings. various gods, humans, animals, torwe are born into the worlds of the holds us in its grip, no matter whether death, and rebirth that otherwise subject to samsara, the cycle of birth, the world and is therefore no longer one who sees the ultimate nature of

This form of Buddhism, known as sionate vow of saving all beings. which one could fulfill the compasvana, was the ultimate means by viewed as a higher state than nir-The attainment of buddhahood, came the primary motivating force. verse. Compassion for all beings befor every being throughout the uninirvana for oneself, but buddhahood expanded. The goal was no longer basis was clarified and its literature larged its scope. Its philosophical place in Buddhism that greatly enhowever, major developments took Around the turn of the millennium, the extinction of samsara for oneself. pose of attaining nirvana, which is stresses self-cultivation for the purknown as Theravada or Hinayana, The early form of Buddhism,

and eternal. Another holds that our existence is cyclical

to overcome this ignorance is by fol-

come and extinguished; (4) the way

rance; (3) this ignorance can be over-

suffering has a cause, which is igno-

dhism: (1) life is suffering; (2) this

which are the foundation of Bud-

exponuded the Four Moble Truths, the Deer Park at Sarnath. Here he

Shakyas," gave his first teaching in

Shakyamuni, meaning "sage of the

enlightenment while sitting under a

of meditation, he attained complete

twenty-nine years old. After six years

ascetic in the wilderness. He was

and his inheritance to live as an

Siddhartha left the palace, his family, to be the desperate human condition,

Deeply troubled by what he perceived

inevitable fate of all mortal beings.

of old age, sickness, and death—the

eventually exposed to the sufferings

Yet despite his efforts, the prince was

pleasure and shield him from pain.

father tried to surround his son with

rather than a holy man, Siddhartha's

lightened" being. Hoping for a ruler

ing" ruler—or a buddha—a "fully en-

a chakravartin—a "world-conquerforetold that he would become either

of the Shakya clan. At his birth it was

child of the ruler of the small kingdom

born Prince Siddhartha Gautama, the

of Nepal and central India. He was

483 BCE in the present-day regions

dha, who lived from about 563 to

the teachings of Shakyamuni Bud-

BUDDHISM The Buddhist reli-

gion developed from

pipal tree at Bodn Gaya.

Following his enlightenment,

The latter portion of the Vedic period also saw the individual atman with the eternal universal Brahman. is to attain liberation from samsara and to unite our of birth, life, death, and rebirth. The goal of religious life and that beings are caught in samsara, a relentless cycle

accessible and popular level. that bring the philosophical ideas of the Vedas to a more Indian literature, relate histories of gods and humans were taking shape. These texts, the cornerstones of and enduring religious epic in India and Southeast Asia, world literature, and the Ramayana, the most popular the eighteen-volume Mahabharata, the longest epic in ous and complex Sanskrit language. By around 400 BCE, flowering of India's epic literature, written in the melodi-

most influential teachers of these times were Shakyaary climate numerous religious communities arose. The In this stimulating religious, philosophical, and liter-

of social position. trast, Buddhism and Jainism were open to all, regardless society, with its powerful, exclusive priesthood. In confire sacrifice and the hereditary class structure of Vedic authority of the Vedas, and with it the legitimacy of the from the material world. However, they rejected the cyclical nature of existence and the need for liberation espoused some basic Upanishadic tenets, such as the religion. Both Shakyamuni Buddha and Mahavira "pathfinders" (tirthankaras), was the founder of the Jain last of twenty-four highly purified super-beings called "Buddhism"). Mahavira (599-527 BCE), regarded as the teachings form the basis of the Buddhist religion (see ened one," lived and taught in India around 500 BCE; his

muni Buddha and Mahavira. The Buddha, or "enlight-

to reside within.

ated between the third century BCE and the fifth century and provided the impetus for much of the major art cre-Buddhism became a vigorous force in South Asia

HINDUISM Hinduism is not one integral religion but

many related sects, each taking its particular deity as supreme. In Vaishnavism the supreme deity is Vishnu, in Shaivism it is Shiva, and in Shaktism it is the Goddess, Devi-a deity worshiped under many different names and in various forms. Each deity is revealed and depicted in multiple ways. Vishnu, for example, has ten major incarnations in which he manifests himself in the world. Shiva has numerous, complex "aspects" that reveal his nature, which is full of apparent contradictions and extremes. Devi has forms indicative of beauty, wealth, and auspiciousness, but also forms of wrath, pestilence, and power. Indeed, she can be more powerful than the male gods.

Though these three major Hindu sects differ from one another, they all draw upon the texts of the Vedas. which are believed to be sacred revelation. Of critical importance to all Hindu practice is ritual sacrifice, which harks back to ancient timespossibly as early as the Indus Valley

period—when offerings were placed into fire in the belief that it would carry prayers to the gods. Purity is essential if the sacrifice is to be effective. If any element of the sacrificial rite becomes polluted, Hindus believe that the deity will be displeased and the sacrifice rejected. As Brahmins, a social category dating back to Vedic times, priests are highly trained ritual specialists and are considered more pure than others. They perform ceremonies on behalf of other Hindus.

Hindu sacrifice is performed for a purpose, which is generally to obtain the favor of a deity in the hope that this will lead to moksha, or liberation from samsara, the endless cycle of birth, death, and rebirth. Hindu belief also holds that all action is performed for a purpose and that every action has its consequences. Desire for the fruits of our actions keeps us trapped in samsara. But there is hope. If we can consider our actions as sacrificial offerings to god, then we will no longer be attached to their fruits, for these now properly

belong also to the deity. With this in mind, we will act for the god's sake, not out of desire for ourselves. Pleased with our devotion, he or she will grant us moksha, an eternal state of sat, cit, and ananda-pure being, pure consciousness, and pure bliss. The most compelling and influential expression of these beliefs occurs in the Bhagavad Gita, a section of the Mahabharata, where Krishna, an incarnation of Vishnu, reveals them as truths to the warrior Arjuna on the battlefield.

Philosophically, Hindu deities are believed to arise from a state of being called Brahman or Formless One—a state of pure sat, cit, and ananda-into a Subtle Body stage. From the Subtle Body emanates our world of space-time and all that it contains. Into this world the deity then manifests itself in Gross Body form in order to help living beings. These three stages of a deity's emanation from One to the Many-Formless One, Subtle Body, and Gross Body—underlie much Hindu art and architecture.

ce. The Vedic tradition, meanwhile, continued to evolve, emerging later as Hinduism, a loose term that encompasses the many religious forms that resulted from the mingling of Vedic culture with indigenous, local beliefs (see "Hinduism").

MAURYA

THE After about 700 BCE, cities again began to appear on the subcontinent, especially in the north, where numerous **PERIOD** kingdoms arose. For most of its subse-

quent history, India remained a constantly shifting mosaic of regional dynastic kingdoms. From time to time, however, a particularly powerful dynasty formed an empire. The first of these was the Maurya dynasty (c. 322-185 BCE), which extended its rule over all but the southernmost portion of the subcontinent.

The art of the Maurya period reflects an age of heroes and the rise to prominence of Buddhism, which became the official state religion under the greatest king of the dynasty, Ashoka (ruled c. 273–232 BCE). The belief of the time fostered the ideal of upholding dharma, the divinely ordained moral law believed to keep the universe from falling into chaos. The authority of dharma seems fully embodied in a lifesize statue found at Didarganj, near the Maurya capital of Pataliputra (fig. 9-5). The statue probably represents a yakshi, a spirit associated in popular

belief with the productive forces of nature. With its large breasts and pelvis, the figure embodies the Indian association of female beauty with procreative abundance, bounty, and auspiciousness—qualities which in turn reflect the generosity of the gods and the workings of dharma in the world.

Sculpted from fine-grained sandstone, the statue conveys the yakshi's dharmic authority through the frontal rigor of her pose, the massive volumes of her form, and the strong, linear patterning of her ornaments and dress. Alleviating and counterbalancing this hierarchical formality are her soft, youthful face, the precise definition of prominent features such as the stomach muscles, and the polished sheen of her exposed flesh. This lustrous polish, the technique of which is a lost secret, is a special feature of Mauryan sculpture.

In addition to depictions of popular deities like the yakshis and their male counterparts, yakshas, the Maurya period is known for art associated with the imperial sponsorship of Buddhism. Emperor Ashoka, grandson of the dynasty's founder, is considered one of India's greatest rulers. After viewing the carnage on the bloody battlefield described at the beginning of this chapter, he vowed to become a chakravartin, or "world-conquering" ruler, not through the force of arms but through spreading the teachings of the Buddha. Among the monuments

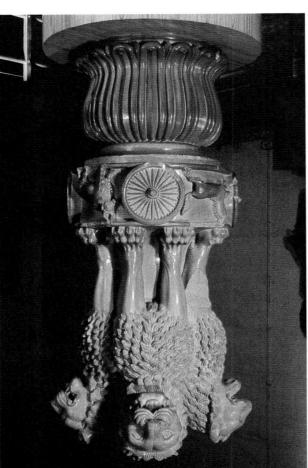

Sarnath sandstone, height 7' (2.13 m). Archaeological Museum, Pradesh, India. Maurya period, c. 250 BCE. Polished 9-6. Lion capital, from an Ashokan pillar at Sarnath, Uttar

events in the Buddha's life. monolithic pillars set up primarily at sites related to he erected to Buddhism throughout his empire were

realms, and through it the cosmic order was impressed resented the vital link between the human and celestial "axis of the world," joining earth with the cosmos. It repbelieve that the pillars symbolized the axis mundi, or were given the characteristic Maurya polish. Scholars capital bore animal sculpture. Both shaft and capital carved from a separate block of sandstone, an elaborate exhorting the Buddhist community to unity. At the top, carved inscriptions referring to Buddhist teachings or ground and rose to a height of around 50 feet. On it were stone foundation slab sunk more than 10 feet into the slightly tapered sandstone shaft, usually rested on a gion of Buddhism. The fully developed Ashokan pillar, a the symbolism of Indian creation myths and the new relipillars seem to have adapted this already-ancient form to India since earliest times. The creators of the Ashokan Pillars had been used as flag-bearing standards in

erected at Sarnath in northeast India, the site of the The capital in figure 9-6 originally crowned the pillar onto the terrestrial world.

again in Indian sculptures of the later Kushan period small bun sits on her forehead. This hairstyle appears gold. Her hair is bound in a large bun in back, and a her ankles probably represent anklets made of beaten rings, and rows of bangles. The nubbled tubes about encircles her neck. She wears a simple tiara, plug eartuous curves of her body. Another strand of pearls breasts, its shape echoing and emphasizing the volupnent. A double strand of pearls hangs between her mirrored this motion.) The yakshi's jewelry is promithe ground. (The missing left side of the shawl probably passes through the crook of her arm and then flows to zigzag of hems. Draped low over her back, the shawl feet in a broad, central loop of flowing folds ending in a drawn back up over the girdle, cascade down to her cate that it is gathered closely about her legs. The ends, place by a girdle. Subtly sculpted parallel creases indiskirtlike cloth. The cloth rests low on her hips, held in right hand, the yakshi wears only a long shawl and a works of Indian art. Holding a fly whisk in her raised tra, this sculpture has become one of the most famous Discovered near the ancient Maurya capital of Patalipustone, height 5'41/4" (1.63 m). Patna Museum, Patna Bihar, India. Maurya period, c. 250 BCE. Polished sand-9-5. Yakshi Holding a Fly Whisk, from Didarganj, Patna,

(c. second century ce).

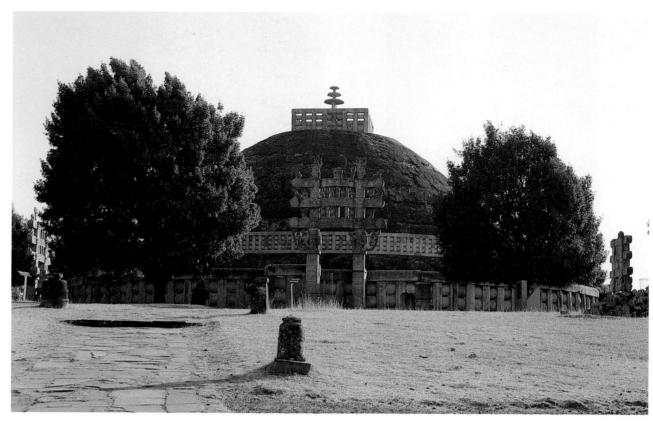

9-7. Great Stupa, Sanchi, Madhya Pradesh, India. Founded 3rd century BCE, enlarged c. 150-50 BCE

Buddha's first teaching. The lowest portion represents the down-turned petals of a lotus blossom. Because the lotus flower emerges from murky waters without any mud sticking to its petals, it symbolizes the presence of divine purity in the imperfect world. Above the lotus is an "abacus" embellished with low-relief carvings of wheels, called chakras, alternating with four different animals: lion, horse, bull, and elephant. The animals may symbolize the four great rivers of the world, which are spoken of in the same Indian creation myth that expresses the important axis mundi concept. Standing on this abacus are four back-to-back lions. Facing the four cardinal directions, the lions may be emblematic of the universal nature of Buddhism. Their roar might be compared to the speech of the Buddha that spreads far and wide. The lions may also refer to the Buddha himself, who is known as "the lion of the Shakya clan" (the clan into which the Buddha was born as crown prince). The lions originally supported a great copper wheel, now lost. A universal Buddhist symbol, the wheel refers to Buddhist teaching, for with his sermon at Sarnath the Buddha "set the wheel of the doctrine in motion."

Their formal, heraldic pose imbues the lions with something of the monumental quality evident in the statue of the yakshi earlier. We also find the same delight in the strong patterning of realistic elements: veins and tendons stand out on the legs; the claws are large and powerful; the mane is richly textured; and the jaws have a loose and fluttering edge.

THE PERIOD OF THE SHUNGAS AND EARLY ANDHRAS

With the demise of the Maurya Empire, India returned to local rule by regional dynasties. Between the second century BCE and the early first century CE, the most important of these dynasties were the Shungas in

central India and the early Andhras in South India. During this period, Buddhism continued as the main inspiration for art, and some of the most important and magnificent early Buddhist structures were created.

Stupas

Probably no early Buddhist structure is more famous than the Great Stupa at Sanchi in central India (fig. 9-7). Originally built by King Ashoka in the Maurya period, the Great Stupa was part of a large monastery complex crowning the top of a hill. During the mid-second century BCE the stupa was enlarged to its present size, and the surrounding stone railing was constructed. About 100 years later, elaborately carved stone gateways were added to the railing.

Stupas are fundamentally important in the Buddhist world (see "Elements of Architecture," opposite). The first Buddhist stupas were constructed to house the Buddha's relics—the remains after his cremation. At that time (c. 483 BCE) the relics were divided into eight portions and placed in eight reliquaries. Each reliquary was

tower. Unlike a Buddhist stupa's axis mundi, however, the garbhagriha's image, and out through the top of the cally up from the cosmic waters below the earth, through which contains a sacred image. An axis mundi runs verti-(halls) leads to an inner sanctuary, the garbhagriha, large capstones. On the interior, a series of mandapas South. Shikharas are crowned by amalakas, vimanas by ers called shikharas in the North and vimanas in the plinths and are dominated by their superstructures, towgreat stylistic diversity. Hindu temples are raised on India, respectively. Within these broad categories there is southern styles—corresponding to North India and South two general Hindu temple types are the northern and ber of styles and dedicated to a vast range of deities. The

share a site. counterparts. Buddhist, Hindu, and Jain temples may have much in common with their Buddhist and Hindu rock-cut monasteries and temples. Jain halls and temples Jain architecture consists mainly of structural and that of a Hindu temple is implied rather than actual.

> areas). All of these may be Stupas and complexes containing viharas and temples, often at monastic ARCHITECTURE Asia consists mainly of stupas **ELEMENTS OF** Buddhist architecture in South

Hindu architecture in South Asia consists mainly of rises a mast supporting tiers of disk-shaped "umbrellas." dome a railing defines a square, from the center of which path around the platform's edge. On top of the stupa's square plinth; stairs lead to an upper circumambulatory through the eastern torana. The stupa sits on a round or called toranas, aligned with the cardinal points; access is ground level. This railing is punctuated by gateways creates a sacred path for ritual circumambulation at shaped core. A major stupa is surrounded by a railing that burial mounds and contain relics beneath a solid, domecut—hewn out of a mountainside. Stupas derive from either structural—built up from the ground—or rock-

temples, either structural or rock-cut, executed in a num-

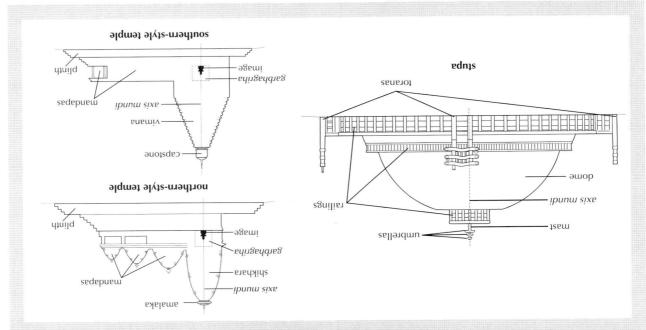

The stupa's plan is a carefully calculated mandala, or above it and anchoring everything in its proper place. cosmic waters below the earth with the celestial realm lessness. The mast itself is an axis mundi, connecting the the three realms of existence—desire, form, and formvarious ways. They may refer to the Buddhist concept of decreasing size. These disks have been interpreted in a mast bearing three stone disks, or "umbrellas," of gods atop the cosmic mountain. It encloses the top of stone railing, square in shape, defines the abode of the the outer, profane world. On top of the dome, another symbolic boundary between an inner, sacred area and religious architecture, the railing provides a physical and and approached by a pair of staircases. As is often true in upper circumambulatory walkway enclosed by a railing sky—sits on a raised base. Around its perimeter is an powdered seashells. The dome-echoing the arc of the covered with a shining white plaster made from lime and

symbolic meaning remains virtually the same. The Great rate. Its form may vary from region to region, but its A stupa may be small and plain or large and elabodhist tradition a monastery and its stupa are open to all. Anyone was free to venerate the stupa, for in the Budwise direction, following the sun's path across the sky. to circumambulate, or walk around, the stupa in a clockfrom rebirth. The method of veneration was, and still is, enlightenment and attainment of nirvana—liberation were venerated as his body and, by extension, his the early stupas held actual remains of the Buddha, they more stupas, probably including the one at Sanchi. Since original eight stupas and divided their relics among many the mid-third century BCE King Ashoka opened these then encased in its own burial mound, called a stupa. In

from rubble and dirt, faced with dressed stone, then Indian type. Its solid, hemispherical dome was built up Stupa at Sanchi is a representative of the early central

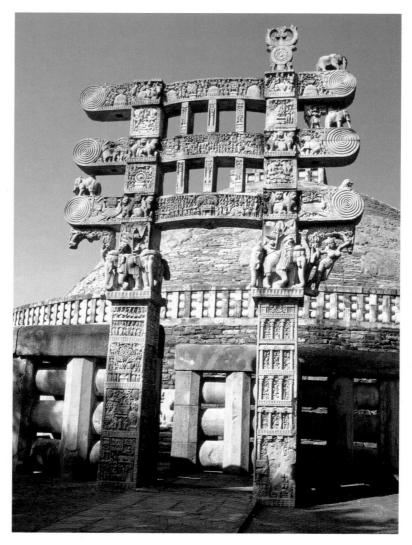

9-8. North torana of the Great Stupa at Sanchi. Early Andhra period, mid-1st century BCE. Stone, height 35' (10.66 m)

cosmic diagram, in the form of an ancient solar symbol called a svastika.

An 11-foot-tall stone railing rings the entire stupa, enclosing another, wider, circumambulatory path at ground level. Carved with octagonal uprights and lensshaped crossbars, it probably simulates the wooden railings of the time. This design became a pervasive motif in early Indian art, appearing time and again both in relief sculpture and as architectural ornament. Four stone gateways, or toranas, punctuate the railing (fig. 9-8). Set at the four cardinal directions, the toranas symbolize the Buddhist cosmos. According to an inscription, they were sculpted by ivory carvers from the nearby town of Vidisha. The only elements of the Great Stupa at Sanchi to be ornamented with sculpture, the toranas rise to a height of 35 feet. Their square posts are carved with symbols and scenes drawn mostly from the Buddha's life and his past lives. Vines, lotuses, geese, and mythical animals decorate the sides, while guardians sculpted on the lowest panel of each inner side protect the entrance. The "capitals" above consist of four back-to-back elephants

on the north and east gates, dwarfs on the south gate, and lions on the west gate. The capitals in turn support a three-tiered superstructure whose posts and crossbars are elaborately carved with still more symbols and scenes and studded with freestanding sculpture depicting such subjects as yakshis and yakshas, riders on real and mythical animals, and the Buddhist wheel. As in all known early Buddhist art, the Buddha himself is not shown in human form. Instead, he is represented by symbols such as his footprints, an empty "enlightenment" seat, or a stupa.

Forming a bracket between each capital and the lowest crossbar is a sculpture of a yakshi (fig. 9-9). These yakshis are some of the finest female figures in Indian art, and they make an instructive comparison with the yakshi of the Maurya period (see fig. 9-5). The earlier figure was distinguished by a formal, somewhat rigid pose, an emphasis on realistic details, and a clear distinction between clothed and nude parts of the body. In contrast, the Sanchi yakshi leans daringly into space with casual abandon, supported by one leg as the other charmingly crosses

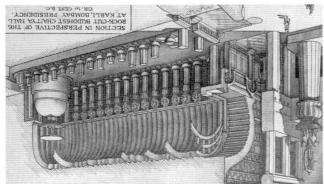

9-10. Section of the chaitya hall at Karla, Maharashtra, India. Early Andhra period, second half of 1st century BCE

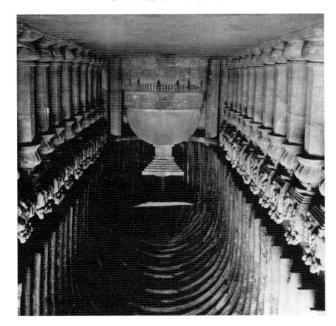

9-11. Chaitya hall at Karla

To enter one of these remarkable halls is to feel immediately removed to an otherworldly, sacred space. The energy of the living rock, the mysterious atmosphere created by the dark recess, the echo that magnifies the smallest sound—all combine to produce a state of intensely heightened awareness.

The monastic community made two types of rockcut halls. One was the **vihara**, used for the living quarters of the monks, and the other was the **chaitya**, meaning "sacred," which usually enshrined a stupa. A chaitya hall at Karla, dating from around the latter half of the first century BCE, is the largest and most fully developed example of these early Buddhist works (figs. 9-10, 9-11). At the entrance, a series of columns once supported a balcony, in front of which stood a pair of Ashocarved in relief with rows of small balcony railings and arched windows, simulating the facade of a great multi-sarved windows, simulating the facade of a great multi-storied palace. At the base of the side walls, enormous statues of elephants seem to be supporting the entire upper plants.

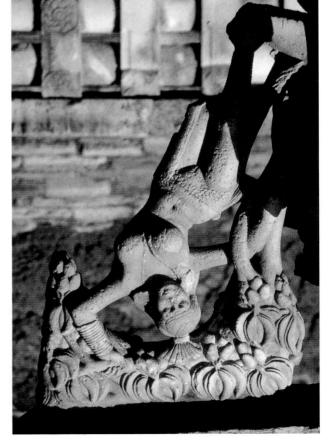

9-9. Yakshi bracket figure, on the east torana of the (152.4 cm)

behind. Her thin, diaphanous garment is noticeable only by its hems, and so she appears almost nude, which emphasizes the unity of her form. The band pulling gently at her abdomen accentuates the suppleness of her arching curves seem to bring this deity's procreative and bountiful essence to life. As anthropomorphic symbol of the waters, she is the source of life. Here she personifies the waters, she is the source of life. Here she personifies the sap of the tree, which flowers at her touch.

The profusion of designs, symbols, scenes, and figures carved on all sides of the gateways to the Creat Stupa not only relate the history and lore of Buddhism but also represent the teeming life of the world and the gods. Arrayed as protectors of the stupa, these forms, by their auspicious presence, indicate the wondrous nature of the site and augur the happiness of those who come to it.

Buddhist Rock-Cut Halls

From ancient times caves have been considered hallowed places in India, for they were frequently the abode of holy ones and ascetics. Around the second century use out of the stone plateaus in the western region of India known as the Deccan. The exteriors and interiors were carved from top to bottom like great pieces of sculpture, with all details completely finished in stone.

400 BCE

portion of the main facade is a large horseshoe-shaped opening called a "sun window" or "chaitya window," which provides the main source of light for the hall's interior. The window was originally fitted with a carved wood screen, some of which still remains, that softened and filtered the light within.

Three entrances in the main facade lead to the interior. The two side entrances are each approached through a shallow pool of water, which symbolically purifies visitors as it washes their dusty feet. Flanking the entrances are sculpted panels of *mithuna* couples. amorous male and female figures that evoke the harmony and fertility of life. The interior hall, 123 feet long, has a 46-foot-high ceiling carved in the form of a barrel vault ornamented with arching wooden ribs. A wide central aisle and two narrower side aisles lead to the stupa situated in the rounded apse at the far end.

The closely spaced columns that separate the side aisles from the main aisle are unlike any known in the West, and they are important examples in the long and complex evolution of the many Indian styles. The base resembles a large pot set on a stepped pyramid of planks. From this potlike form rises a massive octagonal shaft. Crowning the shaft, a bell-shaped lotus capital supports an inverted pyramid of planks, which serves in turn as a platform for sculpture. The statues facing the main aisle depict pairs of kneeling elephants, each bearing a mithuna couple; those facing the side aisles depict pairs of horses also bearing couples. These figures, the only sculpture within this austere hall, represent the nobility coming to pay homage at the temple. The pillars around the apse are plain, and the stupa is simply portrayed. A railing motif ornaments the base; the dome was once crowned with wooden "umbrella" disks, only one of which remains. The symbolism of this stupa is the same as that of the stupa at Sanchi, although it, like nearly everything in the cave, is carved from the living rock. Both exterior and interior were once brightly painted.

PERIOD

THE Around the first century ce the regions KUSHAN of present-day Afghanistan, Pakistan, and North India came under the con-AND trol of the Kushans, a nomadic people **LATER** from Central Asia. The impact of the **ANDHRA** Kushan dynasty on Indian culture was significant, but their history is clouded by lack of clear dates. The beginning

of the long reign of their most illustrious king, Kanishka, is variously dated from 78 to 143 ce. A patron of Buddhism, Kanishka caused many stupas and monasteries to be built, thus giving a renewed impetus to the religion.

Buddhism during this period was undergoing the profound developments that resulted in the form known as Mahayana, or Great Vehicle (see "Buddhism," page 371). This vital new movement, which was to sweep most of northern India and eastern Asia, probably inspired the first depictions of the Buddha himself in art. (Previously, as in the Great Stupa at Sanchi, the Buddha had been indicated solely by symbols.) It is not known where the first Buddha image appeared. However, the

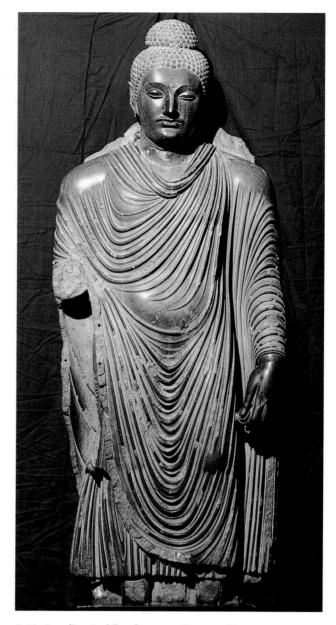

9-12. Standing Buddha, from Gandhara (Pakistan). Kushan period, c. 2nd-3rd century ce. Schist, height 7'6" (2.28 m). Lahore Museum, Lahore

two earliest schools of representation arose in the Gandhara region in the northwest (present-day Pakistan and Afghanistan) and in the famous religious center of Mathura in central India. Both of these areas were ruled by the Kushans. Slightly later, a third school, known as the Amaravati school after its most famous site, developed to the south in the region ruled by the Andhras.

While all three schools cultivated distinct styles, they shared a basic iconography in which the Buddha is readily recognized by certain characteristics. He wears a monk's robe called a sanghati, a long length of cloth draped over the left shoulder and around the body. The Buddha is said to have had thirty-two major distinguishing marks, called lakshana, some of which also passed into the iconography of his image (see "Buddhist Symbols," page 427). These include a golden-colored body,

9-13. Buddha and Altendants, from Katra Keshavdev,
Mathura, Madhya Pradesh, India.
Kushan period,
c. late 1st-early
Znd century BCE.
Red sandstone,
height 271/4"
Mathura

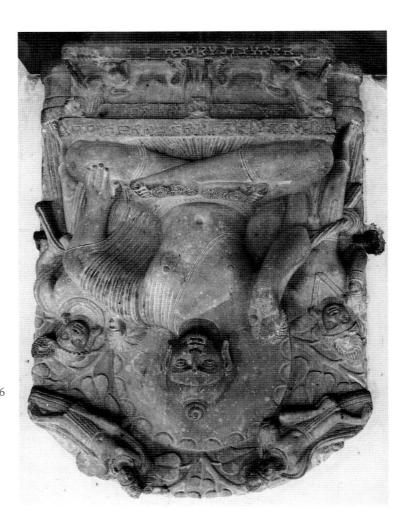

the early centuries of the first millennium ce. lated contact with Roman culture in the Near East during near the East-West trade routes appears to have stimureached the borders of India. Also, Gandhara's position century BCE, when the Greeks under Alexander the Great Afghanistan and southern Uzbekistan) since the fourth thrived in neighboring Bactria (present-day northern Western style in its art. Pockets of Hellenistic culture had tic world may have prepared the ground for this strongly Gandhara region's history of relations with the Hellenistrayals of the Buddha in Central and East Asia. The (see fig. 6-25), and it exerted a strong influence on porsembles the treatment of togas on certain Roman statues power within the image. This complex fold pattern reshape. The strong tension of the folds suggests life and arm; on the lower part they drape in a symmetric U

The Mathura School

The second major school of Buddhist art in the Kushan period, that at Mathura, was not allied with the Hellenistic-Roman tradition. Instead, its style evolved from representations of yakshas, the indigenous male nature deities. Images produced at Mathura during the early days of the school may well be the first representations of the Buddha to appear in art.

The stela in figure 9-13 is one of the finest of the

long arms that reached to his knees, the impression of a wheel (chakra) on the palms of his hands and the soles of his feet, and the **urna**—a tuft of white hair between his eyebrows. Because he had been a prince in his youth and had worn the customary heavy earrings, his earlobes are usually shown elongated. The top of his head is said to have had a protuberance called an **ushnisha**, which in images often resembles a bun or topknot and is symbolic of his enlightenment.

The Gandhara School

A typical image from the Gandhara school portrays the Buddha as a superhuman figure, more powerful and heroic than an ordinary human (fig. 9-12). This overlifesize Buddha dates to the fully developed stage of the from schiet, a fine-grained dark stone. The Buddha's body, revealed through the folds of the garment, is broad and massive, with heavy shoulders and limbs and a well-defined torso. His left knee bends gently, suggesting a slightly relaxed posture.

The treatment of the *sanghatt* is especially characteristic of the Gandhara manner. Tight, riblike folds alternate with delicate creases, setting up a clear, rhythmic pattern of heavy and shallow lines. On the upper part of the folds break asymmetrically along the left

MUDRAS Mudras (meaning "signs" in Sanskrit) are ancient symbolic hand gestures seen primarily in Buddhist art, where they function iconographically. Mudras are regarded as physical expressions of different states of being and are used during meditation to release these energies. Following are the most common mudras in Asian art.

Dharmachakra mudra

The gesture of teaching, setting the chakra (wheel) of the dharma (law, or doctrine) in motion. Hands are at chest level.

Dhyana mudra

A gesture of meditation and balance, symbolizing the path toward enlightenment. Hands are in the lap, the lower representing maya, the physical world of illusion, the upper representing nirvana, enlightenment and release from the world.

Vitarka mudra

This variant of *dharmachakra* mudra stands for intellectual debate. The right hand is at shoulder level, pointing downward, while the left is at hip level pointing upward.

Abhaya mudra

The gesture of reassurance, blessing, and protection, this mudra means "do not fear." The right hand is at shoulder level, palm outward.

Bhumisparsha mudra

This gesture calls the earth to witness Shakyamuni Buddha's enlightenment at Bodh Gaya. A seated figure's right hand reaches toward the ground, palm inward.

Varada mudra

The gesture of charity, symbolizing the fulfillment of all wishes. Alone, this mudra is made with the right hand; when combined with *abhaya* mudra in standing buddha figures, the left hand is shown in *varada* mudra.

early Mathura images. Carved in high relief from a block of red sandstone, it depicts a seated Buddha with two attendants. The Buddha sits in a vogic posture on a pedestal supported by lions. His right hand is raised in a symbolic gesture meaning "have no fear." Images of the Buddha rely on a repertoire of such symbolic gestures, called mudras, to communicate certain ideas, such as teaching, meditation, or the attaining of enlightenment (see "Mudras"). The Buddha's urna, his ushnisha, and the impressions of wheels on the palms and soles of his feet are all clearly visible in this figure. Behind his head is a large, circular halo; the scallop points of its border represent radiating light. Behind the halo are branches of the pipal tree, the tree under which the Buddha was seated when he achieved enlightenment. Two celestial beings hover above.

As in the Gandhara school, a powerful impression of the Buddha is emphasized. Yet the Mathura Buddha's riveting outward gaze and alert posture impart a more intense, concentrated energy to the image. The robe is pulled tightly over the body, allowing the fleshy form to be seen as almost nude. Where the pleats of the *sanghati* appear, such as over the left arm and fanning out between the legs, they are depicted abstractly through compact parallel formations of ridges with an **incised** line in the center of each ridge. This characteristic Mathura tendency to abstraction also appears in the face, whose features take on geometric shapes, as in the rounded forms of the widely opened eyes. Nevertheless, the heavy torso with its subtle and soft modeling is strongly naturalistic.

The Amaravati School

Events from the Buddha's life were popular subjects in the reliefs decorating Buddhist stupas and temples. One example from Nagarjunakonda, a site of the third major school of this period, the southern or Amaravati school. depicts a scene from the Buddha's life when he was a prince called Siddhartha, before his renunciation and subsequent quest for enlightenment (fig. 9-14). Carved in low relief, the panel reveals a scene of pleasure around a pool of water. Gathered around Siddhartha, the largest figure and the only male, are some of the palace women. One holds his foot, entreating him to come into the water; another sits with legs drawn up on the nearby rock; others lean over his shoulder or fix their hair; one comes into the scene with a box of jewels on her head. The panel is framed by decorated columns, crouching lions, and amorous mithuna couples. (One of these couples is visible at the right of the illustration.) The scene is skillfully orchestrated to revolve around the prince as the main focus of all eyes. Typical of the southern school, the figures are slighter than those of the Gandhara and Mathura schools. They are sinuous and mobile, even while at rest. The rhythmic nuances of the limbs and varied postures not only create interest in the activity of each individual but also engender a light and joyous effect.

During the first to third century ce, each of these three major schools of Buddhist art developed its own distinct

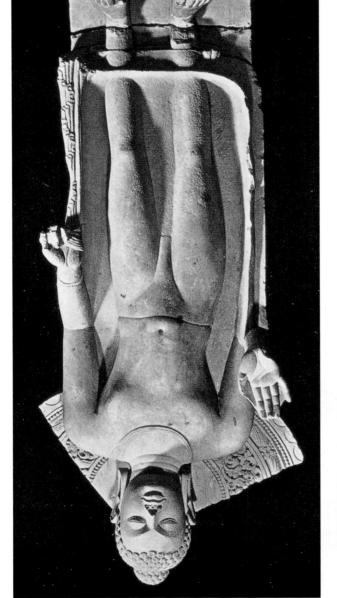

9-15. Standing Buddha, from Sarnath, Uttar Pradesh, India. Gupta period, 474 ce. Chunar sandstone, height 6'4" (1.93 m). Archaeological Museum, Sarnath

sponsored by Gupta monarchs, began the ascendancy that led to its eventual domination of Indian religious life. Art flourished, and the Gupta legacy includes some of India's most widely admired masterpieces of sculpture and painting.

Buddhist Sculpture

Two schools of Buddhist sculpture dominated in northern India: the Mathura, one of the major schools of the earlier Kushan period, and the school at Samath. Both reached their artistic peak during the second half of the fifth century.

The standing Buddha in figure 9-15 embodies the fully developed Sarnath Cupta style. Carved from fine-grained sandstone, the figure stands in a mildly relaxed

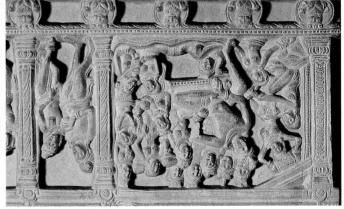

9-14. Siddhartha in the Palace, detail of a relief from Nagarjunakonda, Andhra Pradesh, India. Later Andhra period, c. 3rd century ce. Limestone. National Museum, New

thoughts, which were to change his life profoundly and seems already to bear the sobering demeanor of these though surrounded by women in the pleasure garden, age, disease and death?" In this relief, the prince, sit or lie at ease, still less laugh, when he knows of old on his return: "For what rational being would stand or the perfumed entreaties of the women who greet him Deeply shaken, he cannot bring himself to respond to confront Siddhartha with the nature of mortality. during an outing, a series of unexpected encounters time with the noble music of singing-women." Later, heavenly mansions come down to earth, he passed the with apartments suited to each season and resembling Then in the pavilions, white as the clouds of autumn, palace and did not allow him access to the ground. assigned him a dwelling in the upper storeys of the must see nothing untoward that might agitate his mind, monarch [Siddhartha's father], reflecting that the prince describes Prince Siddhartha's life in the palace: "The Buddha, the great Indian poet Ashvagosha (c. 100 ce) In his Buddhacharita, a long poem about the life of the

(Translated by E. H. Johnston)

idiom for expressing the complex imagery of Buddhism and depicting the image of the Buddha. The Candhara and Amaravati schools declined over the ensuing centuries, mainly due to the demise of the major dynasties ever, the schools of central India, including the school of Mathura, continued to develop, and from them came the next major development in Indian Buddhist art.

The Cuptas, the founders of a dynasty in the eastern region of central India known as Magadha,

THE CUPTA PERIOD

affect the world.

expanded their territories during the course of the fourth century to form an empire that encompassed northern and much of southern India. Though the peak of Gupta power lasted only about 130 years (c. 320–450 cE), the influence of Gupta culture was felt for centuries.

The Cupta period, extending from around 320 to 500 ce, is renowned for its high artistic and literary culture. Buddhism reached its greatest influence, and Hinduism,

400 CE 2800 BCE 1200 CE

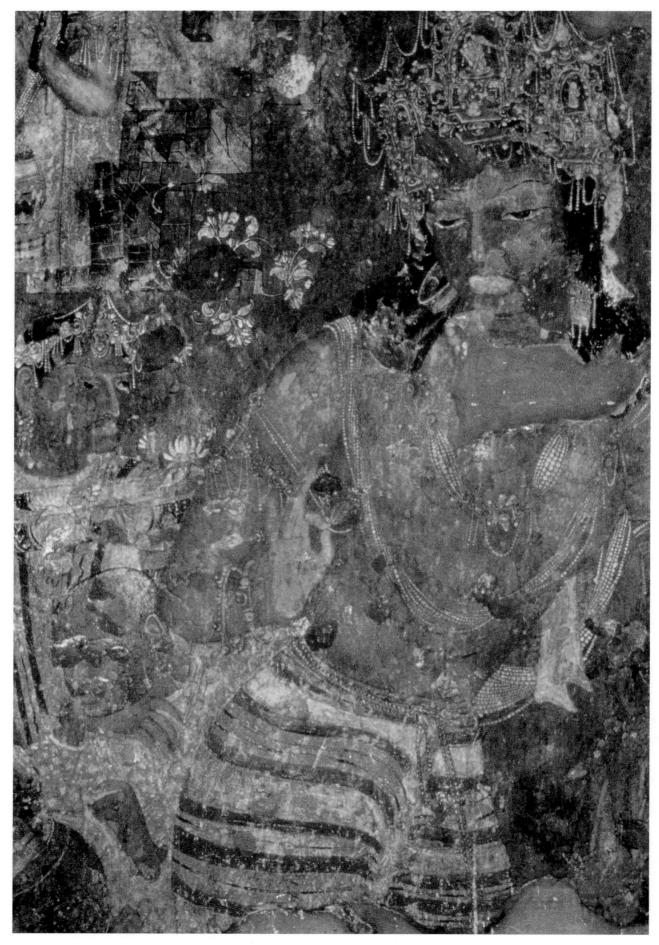

9-16. Bodhisattva, detail of a wall painting in Cave I, Ajanta, Maharashtra, India. Gupta period, c. 475 ce

383

evident also in the Sarnath statue, is the glory of Gupta same time so palpably human. This particular synthesis, pear so magnanimous and graciously divine yet at the known examples of Indian painting do bodhisattvas apbeauty of the languorous human form. In no other balanced, in typical Gupta fashion, by the magnetic background. Interest in sophisticated, realistic detail is tonality of the figure and the somber, flower-strewn these highlighted areas resonate against the subdued

artistic achievement.

DEBIOD ism, supported by the Gupta

POST-CUPTA during the fifth century, Hindu-

THE As Buddhism flourished in India

post-Cupta era of the sixth to mid-seventh century. quency during the Gupta period and its aftermath in the though known earlier, appeared with increasing freularity. Hindu temples and sculptures of the Hindu gods,

The Early Northern Temple

from around 530 ce (fig. 9-17). Much of the shikhara has ple of Vishnu at Deogarh in central India, which dates One of the earliest northern-style temples is the teming and Ritual in Hindu Temples and Images," page 385). the rationale behind their form and function (see "Meantemples, and it is one of the most important elements in pas, is carried out with elaborate exactitude in Hindu theme, familiar from Ashokan pillars and Buddhist stuconduit between the celestial realms and the earth. This into the earth below. In this way the temple becomes a image, finally passing through the base of the temple and down through the center of the garbhagriha and its through the exact center of the amalaka and shikhara, the entire temple, running from the point of the finial, the cosmic world. An imaginary axis mundi penetrates eye to a point where the earthly world is thought to join means "sundurst." From the amalaka a finial takes the a circular, cushionlike element called an amalaka, which terms, the shikhara is a paraboloid.) Crowning the top is in a mathematically determined ratio. (In mathematical an image of the temple's deity. As it rises, it curves inward less walls of the sanctum, or garbhagriha, which houses as a solid mass above the flat stone ceiling and window-"Elements of Architecture," page 375). The shikhara rises distinguished by a superstructure called a shikhara (see types, northern and southern. The northern type is chiefly throughout India, but it can be classified broadly into two The Hindu temple developed many different forms

cavern within the "cosmic mountain" of the temple.

deity's residence, the garbhagriha is likened to a sacred

dala on which the entire temple site is patterned. As the

responds to the center of a sacred diagram called a man-

temple has only one chamber, the garbhagriha, which cor-

eral metaphoric meanings of a Hindu temple. This early given the impression of a mountain, which is one of sev-

sive, solid structure built of large cut stones. It would have

shape with precision. Nevertheless, it was clearly a mas-

crumbled away, and so we cannot determine its original

chest muscles. Together with the details of the jewels, protruding parts such as the nose, brows, shoulders, and of three-dimensional form, with lighter tones used for defined shapes; the tonal gradations impart the illusion a major ingredient of Indian painting, creates clearly softly graded color tones. The outline drawing, always

The naturalism of the style balances outline and rounding figures.

is suggested by his large size in comparison with the surserenely outward toward the viewer. His spiritual power posture imparts his sympathetic attitude as he gazes striped cloth covers his lower body. The graceful bending of twisted pearl strands, armbands, and bracelets. A many tiny pearl festoons, large earrings, long necklaces delicate ornaments. He wears a complicated crown with sanghati. The bodhisattva here is lavishly adorned with worn by Shakyamuni as a prince) rather than the monk's buddhas in art by their princely garments (like those itual attainment already. They are distinguished from becoming buddhas and have reached a high level of spir-Bodhisattvas are beings who are in the process of

hisattvas, one of which is seen in figure 9-16. lives. Flanking the entrance to the shrine are two large bodthese paintings depict episodes from the Buddha's past mineral pigments on a prepared plaster surface. Some of were covered with murals painted in fresco technique with shrine chamber in the back. The walls of the central court hall with monks' chambers around the sides and a Buddha carved around 475 ce, including Cave I, a large vihara western India. Under a local dynasty, many caves were Buddhist rock-cut halls of Ajanta in the Deccan area of Some of the finest surviving works are murals from the The Gupta aesthetic also found expression in painting.

Painting

a buddha. the fully human—an expression fitting the true nature of ened seems completely synonymous with the nature of with, his physical purity. The nature of the fully enlightspiritual purity is evidenced by, and in some way fused erful, superhuman presence but as a being whose fection and equilibrium. He is not interpreted as a pow-The Sarnath Gupta style reveals the Buddha in per-

plain surfaces of the figure. foliage, it would have contrasted dramatically with the circular halo. Carved in concentric circles of pearls and man link. Behind the head are the remains of a large, spection, yet the gentle, open posture maintains a huelegance. The downcast eyes suggest otherworldly intro-Even the face, smooth and ovoid, shows this refined hems interrupt the purity of its subtly shaped surfaces. Only a few lines of the garment at the neck, waist, and with broad shoulders and a well-proportioned torso. emerges in high relief. The body is graceful and slight, trate attention on the perfected form of the body, which distinctive of the Sarnath school. Its effect is to concenand folds so prominent in the Kushan period images, is This plain sanghati, portrayed with none of the creases pose, the body clearly visible through a clinging robe.

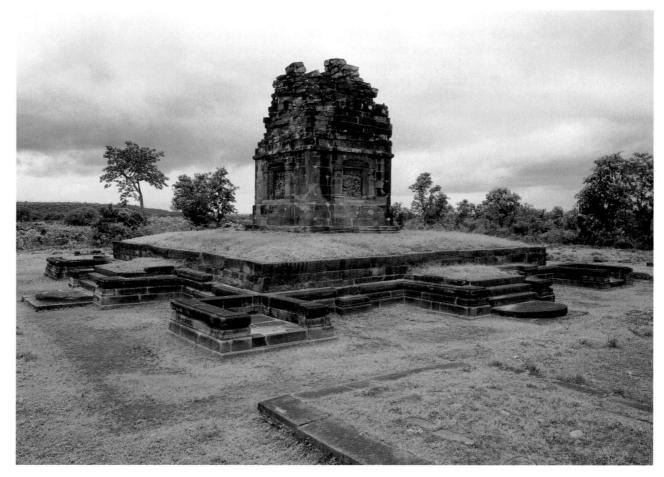

9-17. Vishnu Temple at Deogarh, Uttar Pradesh, India. c. 530 ce

The entrance to a Hindu temple is elaborate and meaningful. The doorway at Deogarh is well preserved and an excellent example (fig. 9-18). Because the entrance takes a worshiper from the mundane world into the sacred, stepping over a threshold is considered a purifying act. Two river goddesses, one on each upper corner of the lintel, symbolize the purifying waters flowing down over the entrance. These imaginary waters also provide symbolic nourishment for the vines and flowers decorating some of the vertical jambs. The innermost vines sprout from the navel of a dwarf, one of the popular motifs in Indian art. Mithuna couples and small replicas of the temple line other jambs. At the bottom, male and female guardians flank the doorway. Above the door, in the center, is a small image of the god Vishnu, to whom the temple is dedicated.

Large panels sculpted in relief with images of Vishnu appear as "windows" on the temple's exterior. These elaborately framed panels are not windows in the ordinary sense. They do not function literally to let light *into* the temple; they function symbolically to let the light of the deity *out* of the temple so it may be seen by those outside. The panels thus symbolize the third phase of Vishnu's threefold emanation from Brahman, the Formless One, into our physical world. (For a discussion of the emanation of Hindu deities, see "Hinduism," page 372.)

One panel depicts Vishnu lying on the Cosmic Waters at the beginning of creation (fig. 9-19). This vision

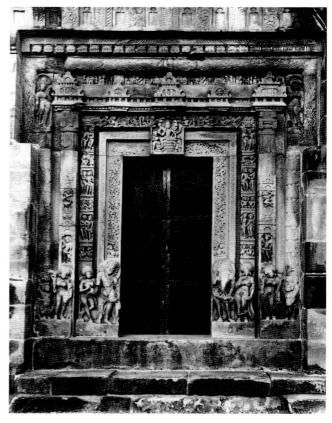

9-18. Doorway of the Vishnu Temple at Deogarh

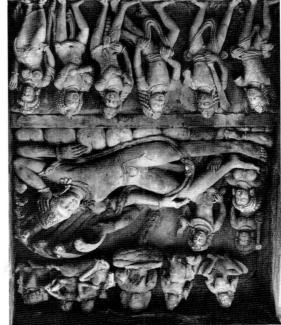

ing on the site, they lent it their

their stomping, breathing, and feed-

tion-were pastured there. Through

beasts since the Indus Valley civiliza-

seasons. After that, cows—sacred

The garbhagriha houses the temtemple compound.

ing dancing and ritual sacrifices.

also be much more elaborate, includ-

water and oil for the image, but it can

ferings such as food and flowers or

generally consists of prayers and of-

image in the garbhagriha. Worship

of the god who is embodied in the

more deities and be in the presence

devotee can make offerings to one or

tional worship. It is the place where a

individual devotion, not congrega-

taken from the people who worship it.

ern piece-will be respected and not

or a field, an ancient work or a mod-

worship"-whether it be in a temple

Even in India today, any image "under

is literally present is not taken lightly.

into the image. The belief that a deity

mystic syllables, that bring the deity

pleted, a priest recites mantras, or

its making. When the image is com-

low a set canon, and rituals surround

ensure perfection, its proportions tol-

ing that the god will inhabit it. To

image is made with the understand-

made of stone, bronze, or wood. The

Devi. Usually this image is a sculpture

one of the forms of Vishnu, Shiva, or

ple's main image-most commonly

A Hindu temple is a place for

sented by the enclosing wall of a compartments are usually reprements hold protector gods. These deities, while the outermost comparton the mandala design; together, earth, is imagined as superimposed human species. His body, fallen on Man, the primordial progenitor of the dala, the mandala of the Cosmic are based on the Vastupurusha manor space. Specifically, Hindu temples a schematic design of a sacred realm mystical plan known as a mandala, All Hindu temples are built on a ual to ensure its purity and sanctity. each phase was accompanied by ritpotency. When construction began,

surrounding squares belong to lesser testament to our deluded nature. The perceive the garbhagriha as dark is a Brahman is clear, pure light; that we "womb chamber." The nature of tum, the windowless garbhagriha, or corresponds to the temple's sancmanifest Formless One. This square sents Brahman, the primordial, unsquare. The central square represixty-four) surrounding a central a number of equal squares (usually form of a square subdivided into different ways, it always takes the dala can be drawn in any number of ing crop was harvested through two For a god to take up residence,

plowed and planted, and the resultground. The ground was then the temple might be raised on pure site were "invited" to leave so that its who were already inhabiting the that took several years. Various spirwas prepared, an elaborate process the earth fruitful. Next, the ground especially favored, for water makes bode well. A site near water was that was auspicious—promised to Silpa Shastra. First, a site was chosen detail in a group of texts called the tions had been recorded in exacting necessary procedures and explanaproperly. By the sixth century ce, the however, everything had to be done which a deity would dwell.

see the construction of an abode in

than the architect, who could over-

more highly revered in Indian society

start to finish. No artist or artisan was

sacred nature of the structure from

tect worked as a team to ensure the

tion itself. Patron, priest, and archi-

pnt also in the process of construc-

not only in a structure's many parts

and ritual functions are embedded

AND IMACES forms in Asian art.

AND RITUAL is one of the most

TEMPLES

IN HINDO

WEYNING

Age-old symbols

ingful architectural

complex and mean-

The Hindu temple

388

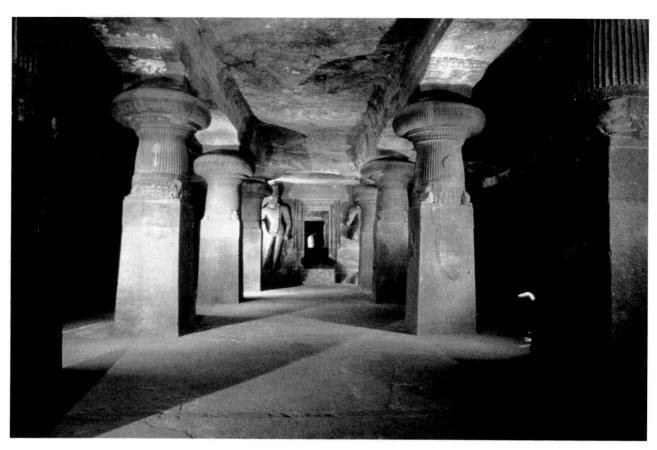

9-20. Cave-Temple of Shiva at Elephanta, Maharashtra, India. Mid-6th century ce. View along the east-west axis to the lingam shrine

represents the Subtle Body, or second, stage of the deity's emanation. Vishnu sleeps on the serpent of infinity, Ananta, whose body coils endlessly into space. Stirred by his female aspect (shakti, or female energy), personified here by the goddess Lakshmi, seen holding his foot, Vishnu dreams the universe into existence. From his navel springs a lotus (shown in this relief behind Vishnu), and the unfolding of space-time begins. The first being to be created is Brahma (not to be confused with Brahman), who appears here as the central, four-headed figure in the row of gods portrayed above the reclining Vishnu. Brahma turns himself into the universe of space and time by thinking, "May I become Many."

The sculptor has depicted Vishnu as a large, resplendent figure with four arms. His size and his many arms connote his omniscient powers. He is lightly garbed but richly ornamented. The ideal of the Gupta style persists in the smooth, perfected shape of the body and in the delight in details of jewelry, including Vishnu's characteristic cylindrical crown. The four rightmost figures in the frieze below personify Vishnu's powers. They stand ready to fight the appearance of evil, represented at the left of the frieze by two demons who threaten to kill Brahma and jeopardize all creation.

The birth of the universe and the appearance of evil are thus portrayed here in three clearly organized **registers**. Typical of Indian religious and artistic expression,

these momentous events are set before our eyes not in terms of abstract symbols but as a drama acted out by gods in superhuman form. The birth of the universe is imagined not as a "big bang" of infinitesimal particles from a supercondensed black hole but as a lotus unfolding from the navel of Vishnu.

Monumental Narrative Reliefs

Another major Hindu god, Shiva, was known in Vedic times as Rudra, "the howler." He was "the wild red hunter" who protected beasts and inhabited the forests. As Shiva, which means "benign," this god exhibits a wide range of aspects or forms, both gentle and wild: he is the Great Yogi who dwells for vast periods of time in meditation in the Himalaya; he is also the Husband par excellence who makes love to the goddess Parvati for eons at a time; he is the Slayer of Demons; and he is the Cosmic Dancer who dances the destruction and re-creation of the world. Shiva takes such seemingly contradictory natures purposefully, in order to make us question reality.

Many of these forms of Shiva appear in the monumental relief panels adorning the Cave-Temple of Shiva carved in the mid-sixth century on the island of Elephanta off the coast of Bombay in western India. The cave-temple is complex in layout and conception, perhaps to reflect the nature of Shiva. While most temples

temple and shrine. onymous with Shiva and is seen in nearly every Shiva Great Yogi who controls his seed. The lingam is synsymbolizes both his erotic nature and his aspect as the Shiva as the unmanifest Formless One, or Brahman. It bol of Shiva. The lingam represents the presence of In the center of the shrine is the lingam, the phallic symflanked by a pair of colossal standing guardian figures. center of the illustration. Each of its four entrances is

Body, the second stage of the threefold emanation. A is a relief on the south wall depicting Shiva in his Subtle The main focus of the north-south axis, in contrast,

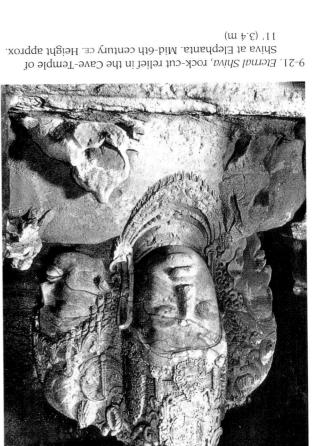

ular form as the slayer of Mahishasura, the buffalo

Madras, in southeastern India, depicts Durga in her pop-

powers of the gods. A large relief at Mamallapuram, near

desses are Lakshmi, goddess of wealth and beauty, and rance and pride. Among the most widely worshiped godto overcome the demons of our afflictions, such as ignodivine energy understood as feminine. Shakti is needed general, Devi represents the brilliant power of shakti, a covering many deities who embody the feminine. In The third great Hindu deity is Devi, a designation

that we still relate to the statue as an essentially human

has united three heads onto a single body so skillfully

readily accept their visions. Here, for example, the artist

these additions with such convincing naturalism that we

through multiple heads or arms. Their gift is to portray

convey the many aspects or essential nature of a deity

manifestation of Shiva in our world. Indian artists often

represent the third stage of emanation, the Gross Body

understand his nature. Taken as a whole, the reliefs

sented in the context of narratives that help devotees

of Shiva's powers and some of his different aspects, pre-

and three on the south wall. The panels portray the range

niches, one on either side of each of the three entrances

Measuring 11 feet in height, they are set in recessed examples of the Hindu monumental narrative tradition. garh (see fig. 9-19), the reliefs at Elephanta are early Like the relief panels at the temple to Vishnu in Deo-

wrathful, destroyer nature wears a flerce expression, and

a pearl-festooned crown. On his right shoulder, his tector nature is depicted as female, with curled hair and ted, piled-up hair of a yogi. On his left shoulder, his prointricately carved with designs and jewels, and the mat-Lordly and majestic, he easily supports his huge crown, heavy lower lip suggest the serious depths of the god. large eyes barely delineated, and the mouth with its introspection. The massiveness of the broad head, the releaser (top). The head in the front depicts Shiva deep in der), destroyer (right shoulder), obscurer (front), and fivefold nature as creator (back), protector (left shoulnever depicted, on top. The heads summarize Shiva's five heads are implied: the fourth in back and the fifth, resting upon the broad shoulders of the upper body, but nal Shiva, aspect (fig. 9-21). Three heads are shown huge bust of the deity represents his Sadashiva, or Eter-

snakes encircle his neck.

Durga is the essence of the splendid conquering Durga, the warrior goddess. west axis is a square lingam shrine, shown here at the otherwise sturdy forms. The main focus of the eastcately fluted, adding a surprising refinement to these "cushion" capital. Both column and capital are deliwhich has a pleasingly curved contour and a billowing nearly half the total height. Above is a circular column, nent of the cave. An unadorned, square base rises to space. The pillars are an important aesthetic compolapping mandalas that create a symmetric yet irregular

ther square nor longitudinal, but a combination of over-

within the framework of the cave shape, which is nei-

lars form orderly rows, but the rows are hard to discern

cave-temple, they are not structural (fig. 9-20). The pilbeams although, as with all architectural elements in a

living rock appear to support the low ceiling and its

balance—fit preparation for a meeting with Shiva, the

the usual expectations are absent and is thrown off-

complexity. A worshiper seems to be in a world where

the cave as a place of mysterious, almost confusing

ing cross- and back-lighting effects add to the sense of

entrances provide the only source of light, and the result-

one running north-south, the other east-west. The three

its size and grandeur, is designed along two main axes,

north, one east, and one west. The interior, impressive in

have one entrance, this temple offers three—one facing

most unpredictable of the Hindu gods.

Along the east-west axis, large pillars cut from the

9-22. Durga Mahishasura-mardini (Durga as Slayer of the Buffalo Demon), rock-cut relief, Mamallapuram, Tamil Nadu, India. Pallava period, c. mid-7th century ce. Granite, height approx. 9' (2.7 m)

demon (fig. 9-22). Triumphantly riding her lion, a symbol of her shakti, the eight-armed Durga battles the demon. His huge figure with its human body and buffalo head is shown lunging to the right, fleeing from her onslaught. His warriors are falling to the ground. Accompanied by energetic, dwarfish warriors, victorious Durga, though smaller in size, sits erect and alert, flashing her weapons. Thus the moods of victory and defeat are clearly distinguished between the left and right sides of the panel. The artist clarifies the drama by focusing our attention on the two principal actors. Surrounding figures play secondary roles that support the main action, adding visual interest and variety.

Stylistically, this and other panels at Mamallapuram represent the final flowering of the Indian monumental relief tradition. Here, as elsewhere, the reliefs portray

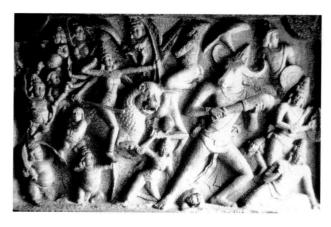

stories of the gods and goddesses, whose heroic deeds unfold before our eyes. Executed under the dynasty of the Pallavas, which flourished in southern India from the seventh to ninth century CE, this panel also illustrates the gentle, simplified figure style characteristic of Pallava sculpture. Figures tend to be slim and elegant with little ornament, and the rhythms of line and form have a graceful, unifying, and humanizing charm.

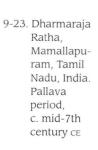

The Kandariya Mahadeva, a temple dedicated to Shiva at Khajuraho in central India, was probably built by a ruler of the Chandella dynasty in the late tenth or early

The Monumental Northern Temple

relatively long-lived, such as the Pallavas and Cholas in the south and the Palas in the northeast. Though Buddhism remained strong in a few areas—notably under the Palas—it generally declined. On the other hand, the Hindu gods Vishnu, Shiva, and the Goddess (mainly Durga) grew increasingly popular. Local kings rivaled each other in the building of temples to their favored deity, and many complicated and subtle variations of the Hindu temple emerged with astounding rapidity in different regions. By around 1000 cE the Hindu temple had reached unparalleled heights of grandeur and engineering.

During the Early Medieval period, which extends roughly from the mid-seventh to the eleventh century, many small kingdoms and dynasties flourished. Some were

THE EARLY Medieval Period

During the certaines that followed, boar moments and southern-style temples developed into complex, monumental forms, but their basic structure and symbolism remained the same as those we have seen in these simple, early examples at Deogarh and Mamallapuram.

During the centuries that followed, both northern-

which faces peer. The shrines not only serve to demarcate each story but also provide a measure of the loftiness of this palace for a god. Crowning the vimana is a dome-shaped octagonal capstone quite different from the amalaka of the northern style.

Southern and northern temples are most clearly distinguished by their respective superstructures. The Dharmaraja Ratha does not culminate in the paraboloid of the northern shikhara but in a pyramidal tower called a vimana. Each story of the vimana is articulated by a cornice and carries a row of miniature shrines. Both shrines and cornices are decorated with a window motif from and cornices are decorated with a window motif from

One of this group, the Dharmaraja Ratha, epitomizes the early southern-style temple (fig. 9-23). Though strikingly different in appearance from the northern style, it uses the same symbolism and it, too, is based on a mandala. The temple, square in plan, remains unfinished, and the garbhagriha usually found inside was never hollowed out. On the lower portion, only the columns and exterior niches have been carved. The use of a single deity in each niche forecasts the main trend in temple sculpture of in the centuries ahead. As the tradition of narrative reliefs began dying out, the stories they told became concentrated in statues of individual deities, which alone suffice to conjure up entire mythological episodes through chart to conjure up entire mythological episodes through chart acteristic poses and a few symbolic objects.

The coastal city of Mamallapuram was also a major temple site under the Pallavas. Along the shore are many large granite boulders and cliffs, and from these the Pallava stone cutters carved reliefs, halls, and temples. Among the most interesting Pallava creations is a group of temples known as the Five Rathas, which preserve a sequence of early architectural styles. As with other rock-cut temples, the Five Rathas were probably carved in the style of contemporary wood or brick structures that have long since disappeared.

The Early Southern Temple

9-24. Kandariya Mahadeva temple, Khajuraho, Madhya Pradesh, India. Chandella dynasty, Early Medieval period, C. 1000 ce

2800 BCE 1200 CE

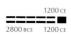

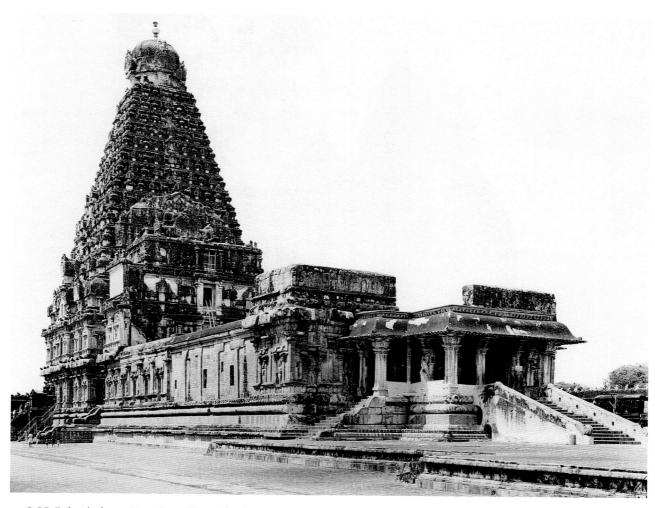

9-25. Rajarajeshvara Temple to Shiva, Thanjavur, Tamil Nadu, India. Chola dynasty, Early Medieval period, 1003–1010 ce

eleventh century (fig. 9-24). Khajuraho was the capital and main temple site for the Chandellas, who constructed more than eighty temples there, about twenty-five of which are well preserved. The Kandariya Mahadeva temple is in the northern style, with a shikhara rising over its *garbhagriha*. Larger, more extensively ornamented, and expanded through the addition of halls on the front and porches to the sides and back, the temple seems at first glance to have little in common with its precursor at Deogarh (see fig. 9-17). Actually, however, the basic elements and their symbolism remain unchanged.

As at Deogarh, the temple rests on a stone terrace that sets off a sacred space from the mundane world. A steep flight of stairs at the front (to the right in the illustration) leads to a series of three halls (distinguished on the outside by three pyramidal roofs) preceding the *garbhagriha*. Called **mandapas**, the halls symbolically represent the Subtle Body stage of the threefold emanation. They serve as spaces for ritual, such as dances performed for the deity, and for the presentation of offerings. The temple is built of stone blocks using only **post-and-lintel construction**. The vault and arch are not used, and thus the interior spaces are not large.

The exterior has a strong sculptural presence, and

the total effect is of a massive mountain (again, the "cosmic mountain") composed of ornately carved stone. Rising over the *garbhagriha*, the shikhara is the tallest element of the temple, reaching to a little over 100 feet. The top is crowned by an amalaka, which is rather small on this particular temple.

The shikhara is bolstered by the addition of many smaller shikhara motifs bundled around it. This decorative scheme adds a complex richness to the surface, but it also somewhat obscures the shape of the main shikhara. As a whole the shikhara is rather slender and its upward movement quite swift and impetuous. The roofs of the mandapas contribute to the impression of rapid ascent by growing progressively taller as they near the shikhara.

Despite its apparent complexity, the temple has a clear structure and forms a unified composition. The towers of the superstructure are separated from the lower portion by strong horizontal **moldings** and by the open spaces over the mandapas and porches. The moldings and rows of sculpture adorning the lower part of the temple create a horizontal emphasis that stabilizes the vertical thrust of the superstructure. Three rows of sculpture—some 600 figures—are integrated

nearly as prominent as the vimana's overall shape. proportion to the whole and thus appeared individually 9-23), the shrines on the vimana were much larger in ern style as embodied in the Dharmaraja Ratha (see fig. Mahadeva temple. Notice also that in the earlier southsmaller shikhara motifs on the shikhara of the Kandariya

ing the worldly from the cosmic sphere above. ence of the shrine a final time before the point separathoused thirteen stories below. It thus evokes the presexactly above, and the same size as, the garbhagriha the earlier southern-style temple. This huge capstone is dome-shaped capstone similar to the one that crowned more forceful and aggressive. At the top is an octagonal by its decorative motifs, its skyward ascent becomes Because the Rajarajeshvara vimana is not obscured

The Bhakti Movement in Art

bhakti movements found artistic expression mostly in this period primarily in the art of the north, while the out India, the influence of tantric sects appeared during devotional. Although both movements evolved throughtice and its art: the tantric, or esoteric, and the bhakti, or movements were taking place that affected Hindu prac-Throughout the Early Medieval period two major religious

the south.

works of sculpture. in the few remaining paintings and in the famous bronze India's greatest and most humanistic works, as revealed influenced by bhakti, southern artists produced some of devotion and giving up of oneself to god. Inspired and sonal, and loving relation with god, and the complete according to the Vedas, bhakti stresses an intimate, perfocusing on ritual and the performance of dharma them and whose minds are open to them. Rather than trapped. They also reveal truth to those who truly love gods who create maya, or illusion, in which we are all tween humans and deities. According to bhakti, it is the Gita. Bhakti revolves around the ideal relationship beideas expressed in ancient texts, especially the Bhagavad The bhakti devotional movement was based on

ing their hair in the "ascetic locks" of Shiva in his Great ing, and both emulate Shiva in their appearance by weardevotion to Shiva by holding a small flower as an offertreated by the king. Both figures openly allude to their equated with god, is both closely and yet respectfully saintly teacher, who in the devotee's or bhakta's view is skinned king. The position of the two suggests that the the aged teacher contrasts with the youthful, bronzeteacher (fig. 9-26). With his white beard and dark skin, simple mendicant humbly standing behind his religious not as a warrior or majestic king on his throne, but as a painting apparently depicts the ruler Rajaraja himself, later times, they were only recently rediscovered. One ha were originally adorned with frescoes. Overpainted in of the circumambulatory passages around its garbhagrihad already reached its peak by that time. The corridors a reflection of the fervent movement of Shiva bhakti that Rajaraja's building of the Rajarajeshvara was in part

Yogi aspect.

erful shape. This is quite different from the effect of the integrated into the surface and do not obscure the pow-

In addition to its horizontal emphasis, the lower porpresence within, and the transformation of one to many. express Shiva's divine bliss, the manifestation of his desses, some in erotic postures. They are thought to carved in high relief, the sculptures depict gods and godinto the exterior walls. Approximately 3 feet tall and

that unify the entire structure. bases also reinforce the sweeping vertical movements ward expansions to the ground plan, yet their curved tribute to the impression of complexity by adding outporches, two on each side and one in the back, conaccount for much of the rich texture of the exterior. The gaged columns and buttressing segments, and they elements. These impart an impression similar to enconcave movements created by protruding and receding tion of the temple is characterized by vertical convex/

The Monumental Southern Temple

the Rajarajeshvara dominates the area. River. Though some smaller shrines dot the compound, in a huge, walled compound near the banks of the Kaveri of Hindu architecture (fig. 9-25). The temple stands withtemple is the supreme achievement of the southern style (Tanjore). Known alternatively as the Brihadeshvara, this Rajarajeshvara Temple to Shiva in his capital, Thanjavur tude for his many victories in battle, Rajaraja built the Rajaraja I (ruled 985-1014 CE). As an expression of grati-Chola dynasty reached its peak during the reign of the far south well into the late thirteenth century. The ninth century, founded a dynasty that governed most of The Cholas, who superseded the Pallavas in the mid-

of parts and refined decor create a majestically powerful Clarity of structure combined with a formal balance

Rajarajeshvara have flat roofs, as opposed to the pyrasouthern style, the mandapa halls at the front of the especially with regard to its superstructure. Typical of the a longitudinal axis and greatly expanded dimensions, Mahadeva temple at Khajuraho, the Rajarajeshvara has est structure in India in its time. Like the Kandariya height of 216 feet, this temple was probably the tallstructure in the Rajarajeshvara. Rising to an astonishing

The base of the vimana, which houses the garbhamidal roofs of the northern style.

in marked contrast to the irregular, sloping, concaveance and formality to the lower portion of the temple, ular, and wide spacing of the niches imparts a calm balstatue, usually depicting a form of Shiva. The clear, regornamented with niches, each of which holds a single articulated by a large cornice. The exterior walls are griha, rises for two stories, with each story emphatically

convex rhythms of the northern style.

large in the overall scale of the vimana, they appear well the next story. Because these sculptural elements are not tifs, and robust dwarf figures who seem to be holding up story is decorated with miniature shrines, window mosided, hollow pyramid that rises for thirteen stories. Each

The vimana of the Rajarajeshvara is a towering, four-

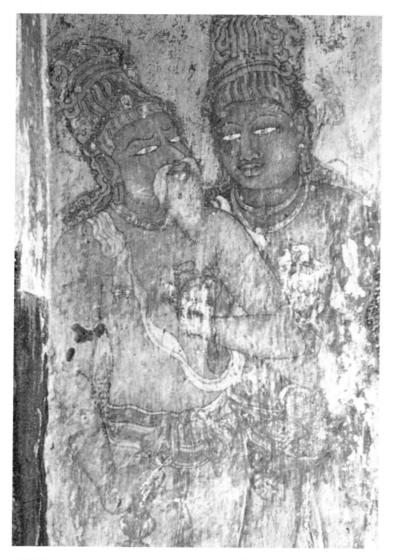

9-26. *Rajaraja I and His Teacher*, detail of a wall painting in the Rajarajeshvara Temple to Shiva. Chola dynasty, Early Medieval period, c. 1010 ce

The portrayal does not represent individuals so much as a contrast of types: the old and the youthful, the teacher and the devotee, the saint and the king—the highest religious and worldly models, respectively—united as followers of Shiva. Line is the essence of the painting. With strength and grace, the even, skillfully executed line defines the boldly simple forms and features. There is no excessive detail, very little shading, and no highlighting such as we saw in the Gupta paintings at Ajanta (see fig. 9-16). A cool, sedate calm infuses the monumental figures, but the power of line also invigorates them with a sense of strength and inner life.

Perhaps no sculpture is more representative of Chola bronzes than the famous statue of Shiva Nataraja, or Dancing Shiva (fig. 9-27). The dance of Shiva is a dance of cosmic proportions, signifying the cycle of death and rebirth of the universe; it is also a dance for each individual, signifying the liberation of the believer through

Shiva's compassion. In the iconography of the Nataraja, perfected over the centuries, this sculpture shows Shiva with four arms dancing on the prostrate body of Apasmaru, a dwarf figure who symbolizes "becoming" and whom Shiva controls. Shiva's extended left hand holds a ball of fire; a circle of fire, now lost, formerly ringed the god as well. The fire is emblematic of the destruction of samsara and the physical universe as well as the destruction of maya and our ego-centered concepts. Shiva's back right hand holds a drum; its beat represents the irrevocable rhythms of creation and destruction, birth and death. His front right arm gestures the "have no fear" mudra (see "Mudras," page 380). The front left arm, gracefully stretched across his body with the hand pointing to his raised foot, signifies the promise of liberation.

The artist has rendered the complex pose with great clarity. The central axis of the figure, which aligns with the nose, navel, and insole of the weight-bearing foot,

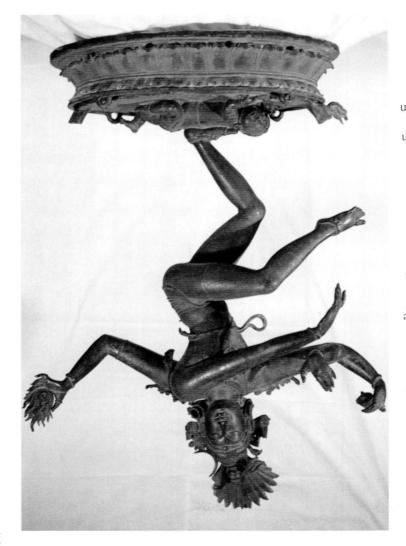

another dimension to India's artistic heritage.

uniquely Indian forms of Islamic art arise, adding yet action with the peoples of the subcontinent, so too did

eventually evolved from Islam's long and complex inter-

tic tradition of its own. Yet just as new religious forms Afghan Islamic factions. Islam brought with it a rich artis-

this time in the form of various Turkic, Persian, and

on, the passes at the northwest again brought invaders,

ture into the subcontinent, Islam. From the tenth century

ever, also witnessed the incursion of a new religious cul-

Late Medieval period into North India. This period, how-The bhakti movement spread during the ensuing

denied, is subsumed into the all-encompassing, human-

the depiction of the heroic feats of the gods, though not

one is saved. The earlier Hindu emphasis on ritual and

tionship with a lordly god through whose compassion

izing factor of grace.

by the sublime writings of a series of poetmovement was fueled in no small part cm). Government Museum, Madras period, c. 1000 ce. Bronze, height 45" (114.5 Nadu, India. Chola dynasty, Early Medieval limeT ,ubegnelevuriT morì ,ataraja, from Tiruvalangadu, Tanil

as a beggar. smeared his body with ashes and went about Brahma, the first created being, Shiva for having lopped off one of the five heads of symbols associated with the deity. In penance The ash the poem refers to is one of many tender, personal vision of the Shiva Nataraja. late sixth to mid-seventh century, wrote this these poet-saints, Appar, who lived from the saints who lived in the south of India. One of The fervent religious devotion of the bhakti

(Translated by Indira Vishvanathan would become a thing worth having. then even human birth on this wide earth raised up in dance, and the sweet golden foot the milk-white ash on coral skin, cool matted hair, on lips red as the kovvai fruit, the budding smile the arch of his brow, If you could see

Peterson)

maintains the center of balance and equilibrium while

unity of the body. is restrained and the detail does not detract from the broad shoulders tapering to a supple waist. The jewelry clothing reveals the beauty of his perfected form with its his waist, and delicately tooled ornaments. The scant side. Shiva wears a short loincloth, a ribbon tied above the remaining limbs extend asymmetrically far to each

belief in the importance of an intimate and personal relagodly and the human, this time expressing the bhakti ja presents a characteristically Indian synthesis of the Sarnath Cupta Buddha (see fig. 9-15), the Chola Natarahe generously displays himself for the devotee. Like the lordly and aloof, yet fully aware of his benevolent role as while openly extending his body to the sides. He appears ta (see fig. 9-21). Instead, he turns to face the viewer spective as he did in the Eternal Shiva relief at Elephan-The deity does not appear self-absorbed and intro-

Deity image from a *cong* before 3000 BCE

▲ NEOLITHIC c. 5000-2000 BCE

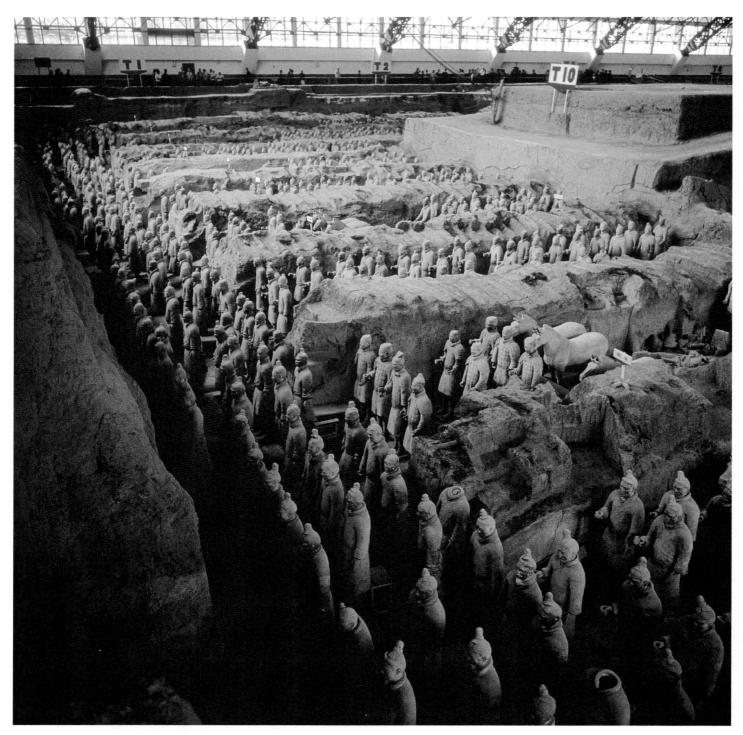

10-1. Soldiers, from the mausoleum of the first emperor of Qin, Lintong, Shaanxi. Qin dynasty, c. 210 BCE. Earthenware, lifesize

2000 BCE

dreamed that an astonishing treasure lay beneath the surface Shaanxi province had been part of the landscape. No one s long as anyone could remember, the huge mound in China's

first united the states of China into an empire. they had guarded the tomb of Emperor Shihuangdi, the ruthless ruler who 2,000 years, while the tumultuous history of China unfolded overhead, in vivid colors, they emerged from the earth a ghostly gray. For more than tary formation, facing east, ready for battle (fig. 10-1). Originally painted army of more than 7,000 lifesize clay soldiers and horses standing in milithe mound, they were stunned by what they found: a vast underground to light the first hint of the riches. When archeologists began to excavate until one day in 1974 when peasants digging a well accidentally brought

later than the Qin find. tell us about life—and death—during the Han dynasty, about 100 years so far uncovered are exceptional both in artistic quality and in what they figures. Although excavations there are barely under way, the artifacts an even richer vault, containing perhaps tens of thousands of terra-cotta In 1990 a road-building crew in central China accidentally uncovered

rewritten many times. so much has been unearthed that ancient Chinese history has been lie buried at thousands of sites across the country. Yet in that short period 1920s have scholars methodically dug into the layers of history that Archeology is a relatively young discipline in China. Only since the

Central Asia, India, Persia, and, eventually, Europe. nese history, as well as caravans and emissaries from the nomadic invaders that are a recurring theme in Chiwinter. Over its vast and vulnerable frontier have come

CULTURES

NEOLITHIC

of the Neolithic period, made its ture, the cornerstone technology scholars to believe that agricul-Early archeological evidence led

dated to about 2000 BCE. the earliest known palace have been uncovered and developed early society. Elsewhere, the foundations of 4000 BCE, the ruins point to the existence of a highly community center, a cemetery, and a kiln. Dated to about have been discovered surrounding the remains of a example, the toundations of more than 100 dwellings of towns and cities. At Jiangzhai, near modern Xi'an, for of Neolithic culture in China is the vigorous emergence lowed some 2,000 years later. One of the clearest signs 5000 BCE and that knowledge of Near Eastern grains folrice and millet arose independently in East Asia before findings, however, have shown that agriculture based on way to China from the ancient Near East. More recent

> ment, now traced back some its long, uninterrupted developworld, China is distinguished by Among the cultures of the

KINCDOW

THE MIDDLE

Within its borders lives one-fifth of the human race. an area slightly larger than the continental United States. occupies a large landmass in the center of Asia, covering dom, the country in the center of the world. Modern China name for the country the Chinese call the Middle King-8,000 years. From Qin, pronounced "chin," comes our

desert, hot in the summer and lashed by cold winds in the the north. The north country is a dry land of steppe and Sorrow" because of its disastrous floods, winds through trading network. The Yellow River, nicknamed "China's arose China's port cities, the focus of a vast maritime Along the southern coastline, rich with natural harbors, through lush green hills to the tertile plains of the delta. historical fates. In the south the Yangzi River flows regions with strikingly different climates, cultures, and ling Mountains divide Inner China into north and south, great rivers, the Yellow, the Yangzi, and the Xi. The Qintimes called Inner China—is the land watered by its three The historical and cultural heart of China-some-

1200---

PARALLELS

<u>Years</u>	<u>Period</u>	China	World
с. 5000-2000 все	Neolithic	Beginning of agriculture; Painted Pottery cultures	c. 5000–2000 BCE Beginning of agriculture in North Africa; potter's wheel (Egypt); Great Pyramids at Giza (Egypt); Indus Valley civilization (India)
с. 1700-221 все	Bronze Age	Legendary (?) Xia dynasty; Shang dynasty; development of writing; bronze casting; Zhou dynasty; birth of Confucius, Laozi, Mozi; iron tools and	c. 2000–1000 BCE Minoan and Mycenaean cultures (Aegean); Stela of Hammurabi (Babylonia); development of metallurgy (Near East); Olmec civilization (Mesoamerica) c. 1000 BCE–500 CE
с. 221-206 все	Qin dynasty	weapons Unification of China; centralized bureaucracy; standardized coinage; standardized written language; clay figures; Great Wall	First Olympian Games (Greece); black- figure and red-figure vase painting (Greece); birth of Siddhartha Gautama, founder of Buddhism (Nepal); Parthenon (Greece); Great Stupa at Sanchi (India); crucifixion of Jesus (Jerusalem); Colosseum (Italy); first Gupta dynasty (India); first Hindu temples (India)
с. 206 все-220 се	Han dynasty	Silk Road; Daoism; Confucian- ism made state philosophy; Buddhism introduced	(maid)
с. 220–579 се	Six Dynasties	Nomad invasions; growth of Buddhism; rock-cut caves; monumental buddhas	c. 500–1300 c Birth of Muhammad, founder of Islam (Ara-
с. 589–617 се	Sui dynasty	Reunification of China; Pure Land Buddhism grows; Daoism ascendant	bia); Muslim conquests; Hagia Sophia (Turkey); separation of Eastern and Western Christian Churches; the Crusades; Spanish Inquisition
с. 618–907 се	Tang dynasty	Repression of Buddhism; figure painting; Nanchan Temple	
с. 960–1279 се	Song dynasty	Neo-Confucianism; landscape painting; Guan Ware; invasion by Kublai Khan's Mongols	and a state of the second

Painted Pottery

In China as elsewhere distinctive forms of Neolithic pottery identify different cultures. One of the most interesting objects thus far recovered is a shallow red bowl with a turned-out rim (fig. 10-2). Found in the village of Banpo near present-day Xi'an, it was crafted sometime between 5000 and 3000 BCE. The bowl is an artifact of the Yangshao culture, one of the most important of the so-called Painted Pottery cultures of Neolithic China. Although the potter's wheel had not yet been developed, the bowl is perfectly round and its surfaces are highly

polished, bearing witness to a distinctly advanced technology. The decorations are especially intriguing. The marks on the rim may be among the earliest evidence of the beginnings of writing in China, which had been fully developed by the time the first definitive examples appeared in the later Bronze Age.

Inside the bowl, a pair of stylized fish suggest that fishing and hunting were important activities for the villagers. The image between the fish represents a human face with four more fish, one on each side. Although there is no certain interpretation of the image, it probably served some magical purpose. Perhaps it is a depic-

2000 BCE 1300 CE

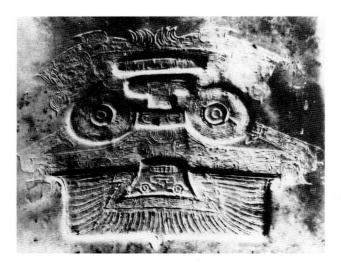

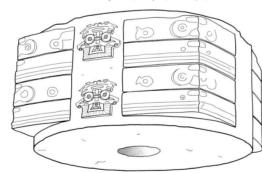

Schematic drawing of a cong

10-3. Image of a deity, detail from a cong recovered from Tomb 12, Fanshan, Yuyao, Zhejiang. Neolithic period, Liangshu culture, before 3000 BCE. Jade, 31/2 x 67/8" (8.8 x 17.5 cm). Zhejiang Provincial Museum, Hangshou

The cong is one of the most prevalent and mysterious of early Chinese jade shapes. Originating in the Neolithic era, it continued to play a prominent role in burials through the Shang and Zhou dynasties. Many scholars believe that the cong was connected with scholars believe that the cong was connected with They suggest that the circle symbolized heaven; the shamanism, the practice of contacting the saris connecting these two realms. The animals found carved on many cong may have portrayed the shaman's helpers or alter egos.

rative motif of Bronze Age ritual objects. Still later, Chinese historians began referring to the ancient motif as taotie, but its original meaning had already been lost. The jade carving here seems to be a forerunner of this most central and mysterious image. It suggests that eventually the various Meolithic cultures of China merged to form a single culture despite their separate origins thousands of miles apart.

China entered its Bronze Age in the second millennium BCE. As with agriculture, scholars

BRONZE ACE

at first theorized that the technology had been imported from the Near East. It is now clear, however, that bronze

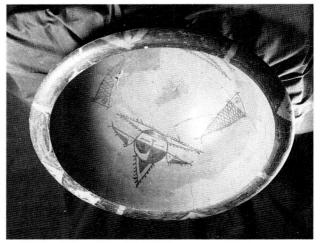

10-2. Bowl, from Banpo, near Xi'an, Shaanxi. Neolithic period, Yangshao culture, 5000–3000 BcE. Painted pottery, height 7" (17.8 cm). Banpo Museum

tion of an ancestral figure who could assure an abundant catch, for worship of ancestors and nature spirits was a fundamental element of later Chinese beliefs.

Beyond the Yellow River Valley

feet square and rises in three levels. recovered from this mound, which measures about 66 served as an altar. Hundreds of jade objects have been son buried in a large tomb at the top of a mound that great importance, for it was found near the head of a pertangular block. This cong must have been an object of an object resembling a cylindrical tube encased in a reccarved in low relief on the outside of a large Jade cong, from under a huge headdress. The image is one of eight Above the forehead, a second, smaller face grimaces slightly from the background pattern of wirelike lines. glasses, a flat nose, and a rectangular mouth protrude Large, round eyes linked by a bar like the frames of eyeanimal images more than 5,000 years old (fig. 10-3). eastern coastal region, have turned up half-human, halfexcavations in sites near the Hangzhou Bay, in the south-Neolithic cultures arose over a far broader area. Recent lization—though archeological finds have revealed that area traditionally regarded as the cradle of Chinese civi-Banpo lies near the great bend in the Yellow River, in the

The intricacy of the carving shows the technical sophistication of this jade-working culture, named the Liangzhu, which seems to have emerged around 4000 BCE. Jade, cherished by the Chinese throughout their hisatrists must have used sand as an abrasive to slowly grind the stone down, but we can only wonder at how they produced such fine work.

The meaning of the masklike image is open to interpretation. Its combination of human and animal features seems to show how the ancient Chinese imagined supernatural beings, either deities or dead ancestors. Strikingly similar masks later formed the primary deco-

TECHNIQUE

The early piece-mold technique for bronze casting is more complex than the lost-wax process developed in the ancient Mediterranean and Near East. Although we do not know the exact steps

Near East. Although we do not know the exact steps ancient Chinese artists followed, we can deduce the general procedure for casting a simple vessel.

First, a model of the bronze-to-be was made of clay and dried. To create the mold, damp clay was pressed onto the model; after the clay dried, it was cut away in pieces, which were keyed for later reassembly and then fired. The model itself was shaved down to serve as the core for the mold. The pieces of the mold were reassem-

PIECE-MOLD bled around the core and held in place by **CASTING** bronze spacers, which locked the core in posi-

tion and ensured an even casting space. The reassembled mold was then covered with another layer of clay, and a spue, or pouring duct, was cut into the clay to receive the molten metal. A riser duct may also have been cut to allow the hot gases to escape. Molten bronze was then poured into the mold. When the metal had cooled, the mold was broken apart with a hammer. Finally, the vessel could be burnished—a long process that involved scouring the surface with increasingly fine abrasives.

casting using the **piece-mold casting** technique arose independently in China, where it was brought to an unparalleled level of excellence.

Shang Dynasty

Traditional Chinese histories tell of three Bronze Age dynasties: the Xia, the Shang, and the Zhou. Modern scholars had tended to dismiss the Xia and Shang as legendary, but recent archeological discoveries have now fully established the historical existence of the Shang (c. 1700–1100 BCE) and point strongly to the historical existence of the Xia as well.

Shang kings ruled from a succession of capitals in the Yellow River Valley, where archeologists have found walled cities, palaces, and vast royal tombs. Their state was surrounded by numerous other states—some rivals, others clients—and their culture spread widely. Society seems to have been highly stratified, with a ruling group that had the bronze technology needed to make weapons. They maintained their authority in part by claiming power as shamans, intermediaries between the supernatural and human realms. The chief Shang deity, Shangdi, may have been a sort of Great Ancestor. Nature and fertility spirits were also honored, and regular sacrifices were believed necessary to keep the spirits of dead ancestors alive so that they might help the living.

Shang shamans communicated with the supernatural world through **oracle** bones. An animal bone or piece of tortoiseshell was inscribed with a question and heated until it cracked. Then a shaman interpreted the crack as an answer. Oracle bones, many of which have been recovered and deciphered, contain the earliest known form of Chinese writing, a script fully recognizable as the ancestor of the system still in use today (see "Chinese Characters," below).

CHINESE CHARACTERS

Each word in Chinese is represented by its own unique picture, called a character or **calligraph**. Some char-

acters originated as **pictographs**, images that mean what they depict. Writing reforms over the centuries have often disguised the resemblance, but if we place modern characters next to their oracle-bone ancestors, the picture comes back into focus:

water horse moon child tree mountain

Other characters are **ideographs**, pictures that represent abstract concepts or ideas:

sun + moon = bright

日 月 明

woman + child = good

女 子 好

Most characters were formed by combining a radical, which gives the field of meaning, with a phonetic, which

originally hinted at pronunciation. For example, words that have to do with water have the character for "water" abbreviated to three strokes as their radical. Thus "to bathe" to pronounced mu, consists of the water radical and the phonetic to which by itself means "tree" and is also pronounced mu. Here are other "water" characters. Notice that the connection to water is not always literal.

river sea weep pure, clear extinguish, destroy

河海淀 清 滅

These phonetic borrowings took place centuries ago. Many words have shifted in pronunciation, and for this and other reasons there is no way to tell how a character is pronounced or what it means just by looking at it. While at first this may seem like a disadvantage, in the case of Chinese it is actually a strength. Spoken Chinese has many dialects. Some are so far apart in sound as to be virtually different languages. But while speakers of different dialects cannot understand each other, they can still communicate through writing, for no matter how they say a word, they write it with the same character. Writing has thus played an important role in maintaining the unity of Chinese civilization through the centuries.

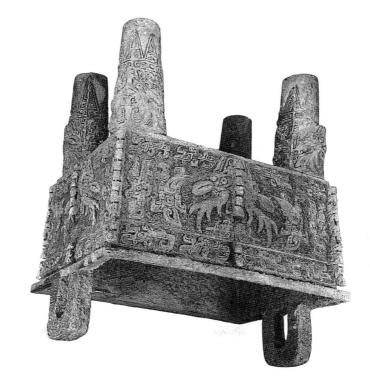

tude toward the supernatural world. ways to have a sense of mystery, evoking the Shang attistrange, sometimes fearsome, Shang creatures seem albut their deeper significance is unknown. Sometimes

Zhou Dynasty

customarily ranked in English by such titles as duke and BCE), a feudal society developed, with nobles related to the from western China. During the Zhou dynasty (1100-221 Around 1100 BCE, the Shang were conquered by the Zhou,

end of imperial rule in the early twentieth century. remained the personal cult of China's sovereigns until the Heaven, and the king ruled as the Son of Heaven. Heaven marquis.) The supreme deity became known as Tian, or king ruling over numerous small states. (Zhou nobility are

less warfare became routine. (402-221 BCE), intrigue, treachery, and increasingly ruthas powers. During the ensuing Warring States period ten or twelve states, later reduced to seven, emerged torians call the Spring and Autumn period (770-476 BCE), lowed up by their larger neighbors. During the time hismerely nominal allegiance. Smaller states were swalgrew increasingly independent, giving the Zhou kings later Eastern Zhou period was a troubled one. States ital to the east, their authority had been crippled, and the in the west. Although they quickly established a new capthe Zhou suffered defeat at the hands of a nomadic tribe were generally stable and peaceful. In 771 BCE, however, The first 300 years of this longest Chinese dynasty

a shift of focus from the supernatural to the human China's "one hundred schools" of philosophy, indicating fucius, Laozi, and Mozi. Traditional histories speak of China's great philosophers arose, such thinkers as Con-Against this background of constant social unrest,

> as containers for ritual offerings of food and wine. A were connected with shamanistic practices, serving Shang artifacts. Like oracle bones and jade objects, they Bronze vessels are the most admired and studied of for the dead in this culture. quantities of treasure to the earth, as well as reverence the power of a ruling class able to consign such great burials illustrates the great wealth of the civilization and ments, and bronze vessels. The enormous scale of Shang jade, ivory, and lacquer objects, gold and silver ornaial chamber. Above all, the tombs contain thousands of

> human skeletons lined the approaches to the central burtons of their horses and drivers; in another, dozens of tomb, for example, chariots were found with the skele-

> mals were sacrificed to accompany the deceased. In one

of great splendor and violence. Many humans and ani-

Ritual Bronzes. Shang tombs reveal a warrior culture

composite animals. are purely sculptural and take the form of fantastic seem to reproduce wooden containers, while still others shapes clearly derive from earlier pottery forms, others basic repertoire of about thirty shapes evolved. Some

ages seem to be related to the hunting life of the Shang, birds, dragons, and other fantastic creatures. Such imrest of the surface is filled with images resembling side, and images of deer are repeated on all four legs. The Instead, a large deer's head adorns the center of each forms. The taotie, usually so prominent, does not appear. rated with a complex array of images based on animal recovered. In typical Shang style its surface is deco-240 pounds, it is one of the largest Shang bronzes ever Yin, present-day Anyang (fig. 10-4). Weighing more than from the royal tombs near the last of the Shang capitals, with four legs, is one of hundreds of vessels recovered The illustrated bronze Jang ding, a square vessel

10-5. Set of sixty-five bells, from the tomb of Marquis Yi of Zeng, Suixian, Hubei. Zhou dynasty, 433 BCE. Bronze, with bronze and timber frame; frame height 9' (2.74 m), length 25' (7.62 m). Hubei Provincial Museum, Wuhan

world. Nevertheless, elaborate burials on an even larger scale reflected the continuation of traditional beliefs.

Ritual bronze objects continued to play an important role during the Zhou dynasty, and new forms developed. One of the most spectacular recent discoveries is a carillon of sixty-five bronze bells arranged in a formation 25 feet long (fig. 10-5), found in the tomb of Marquis Yi of the state of Zeng. Each bell is precisely calibrated to sound two tones—one when struck at the center, another when struck nearer the rim. The bells are arranged in scale patterns in a variety of registers, and several musicians would have moved around the carillon, striking the bells in the appointed order.

Music may well have played a part in rituals for communicating with the supernatural, for the taotie typically appears on the front and back of each bell. The image is now much more intricate and stylized, partly in response to the refinement available with the lost-wax process, which had replaced the older piece-mold technique. On the coffin of the marquis are painted guardian warriors with half-human, half-animal attributes. The marquis, who died in 433 BCE, must have been a great lover of music, for among the more than 15,000 objects recovered from his tomb were many musical instruments. Zeng was one of the smallest and shortest-lived states of the Eastern Zhou, but the contents of this tomb, in quantity and quality, attest to the high level of its culture.

THE CHINESE EMPIRE: QIN DYNASTY

Toward the middle of the third century BCE, the state of Qin launched military campaigns that led to its triumph over the other states by 221 BCE. For the first time in its history, China was united under a single ruler. This first emperor of Qin, Shi-

huangdi, a man of exceptional ability, power, and ruthlessness, was fearful of both assassination and rebellion. Throughout his life, he sought ways to attain immortality. Even before uniting China, he began his own mausoleum at Lintong, in Shaanxi province. This project continued throughout his life and after his death, until rebellion abruptly ended the dynasty in 206 BCE. Since that time, the mound over the mausoleum has always

been visible, but not until its accidental discovery in 1974 was the army of clay soldiers and horses even imagined (see fig. 10-1). Modeled from clay and then fired, the figures claim a prominent place in the great tradition of Chinese ceramic art. Individualized faces and meticulously rendered uniforms and armor demonstrate the sculptors' skill. Literary sources suggest that the tomb itself, which has not yet been opened, reproduces the world as it was known to the Qin, with stars overhead and rivers and mountains below. Thus did the tomb's architects try literally to ensure that the underworld—the world of souls and spirits—would be as good as the human world.

Qin rule was harsh and repressive. Laws were based on a totalitarian philosophy called legalism, and all other philosophies were banned, their scholars executed, and their books burned. Yet the Qin also established the mechanisms of centralized bureaucracy that molded China both politically and culturally into a single entity. Under the Qin, the country was divided into provinces and prefectures, the writing system and coinage were standardized, highways were built to link different parts of the country with the capital, and battlements on the northern frontier were connected to form the Great Wall. China's rulers to the present day have followed the administrative framework first laid down by the Qin.

HAN DYNASTY

The commander who overthrew the Qin became the next emperor and founded the Han dynasty (206 BCE-

220 cE). During this period the Chinese enjoyed a peaceful, prosperous, and stable life. Borders were extended and secured, and Chinese control over strategic stretches of Central Asia led to the opening of the Silk Road, a land route that linked China by trade all the way to Rome (see "The Silk Road," opposite).

The early Han dynasty marks the twilight of China's so-called mythocentric age, when people believed in a close relationship between the human and supernatural worlds, reflected in all the art we have looked at so far. From this time comes one of the most valuable works in Chinese art, a **T**-shaped silk banner that summarizes this early worldview (fig. 10-6). Found in the tomb of a noblewoman on the outskirts of present-day Changsha, the

2000 BCE 1300 CE 200 BCE Iraq, arriving finally at Antioch, in Syria, on the coast of the Mediterranean. From there, land and sea routes led on to Rome.

Sections of the Silk Road were used throughout history by traders, travelers, conquerors, emissaries, pill-grims, missionaries, explorers, and adventurers. But only twice was the entire length of it open, with relatively safe passage likely from end to end. The first time was during the days of the Han dynasty and the Roman Empire. The second was during the thirteenth and fourteenth centuries, when the route lay within the borders of the vast Mongol Empire.

present-day Uzbekistan, Iran, and they could continue on west through that stretched down into India, or could turn off into the Kushan Empire ent-day Afghanistan. There, travelers over the Pamir Mountains into presthe Taklamakan, before proceeding at Kashgar, on the western border of meeting up with the northern route India. Or they could continue on, tain pass into Kashmir, in northern route could turn off toward a moun-Khotan, travelers on the southern the vast Taklamakan Desert. At and southern routes diverged to skirt oasis of Dunhuang. Here northern Caravans headed first for the desert before reaching the Mediterranean.

THE SILK

At its height, in the second century cE, the Silk
Road was the longest
road in the world, a 5,000-mile netroworld, a 5,000-mile netron the world, a 5,000-mile netron the world.

road in the world, a 5,000-mile network of caravan routes from the Han capital of Luoyang on the Yellow River to Rome. The Western market for Chinese luxury goods such as silk and lacquer seemed limitless. For these goods, Westerners paid in gold and silver, for the West produced and silver, for the West produced nothing that China desired in trade.

The journey began at the Jade Gate (Yumen), at the westernmost end of the Great Wall, where Chinese merchants turned their goods over to Central Asian traders. Goods would change hands many more times

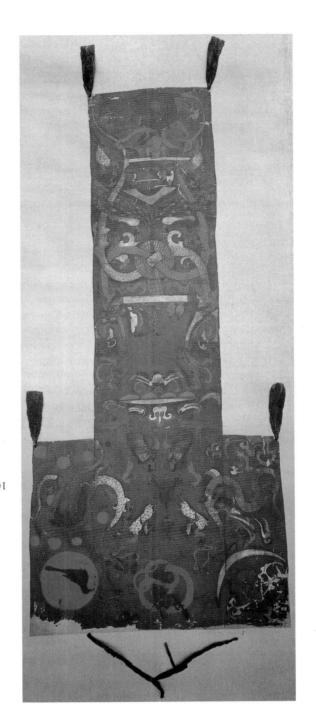

DAOISM Daoism is a kind of nature mysticism that brings together many ancient Chinese ideas regarding humankind and the universe. One of its first philosophers is said to have been a contemporary of Confucius (551-479 BCE) named Laozi, who is credited with writing a slim volume called the Daodejing, or The Way and Its Power. Later, a philosopher name Zhuangzi (369-286 BCE) took up many of the same ideas in a book that is known simply by his name, Zhuangzi. Together the two texts formed a body of ideas that crystallized into a school of thought during the Han period.

A *dao* is a way or path. The *Dao* is the Ultimate Way, the Way of the universe. The Way cannot be named or described, but it can be hinted at. It is like water. Nothing is more

flexible and yielding, yet water can wear down the hardest stone. Water flows downward, seeking the lowest ground. Similarly, a Daoist sage seeks a quiet life, humble and hidden, unconcerned with worldly success. The Way is great precisely because it is small. In fact, it is nothing, yet nothing turns out to be essential (cited in Cleary, page 14):

When the potter's wheel makes a pot the use of the pot is precisely where there is nothing.

To recover the Way, we must unlearn. We must return to a state of nature. To follow the Way, we must practice wu wei, or nondoing. "Strive for non-striving," advises the Daodejing.

All our attempts at asserting our egos, at making things happen, are

like swimming against a current and thus ultimately futile, even harmful. If we let the current carry us, however, we will travel far. Similarly, a life that follows the Way will be a life of pure effectiveness, accomplishing much with little effort.

It is often said that the Chinese are Confucians in public and Daoists in private, and the two approaches do seem to balance each other. Confucianism is a rational political philosophy that emphasizes morality, conformity, duty, and self-discipline. Daoism is an intuitive philosophy that emphasizes individualism, nonconformity, and a return to nature. If a Confucian education molded scholars outwardly into responsible, ethical officials, Daoism provided some breathing room for the artist and poet inside.

banner dates from the second century BCE and is painted with scenes representing the three levels of the universe: heaven, earth, and the underworld.

The heavenly realm is shown at the top, in the crossbar of the T. In the upper right corner is the sun, inhabited by a mythical crow; in the upper left, a mythical toad stands on a crescent moon. Between them is a primordial deity shown as a man with a long serpent's tail—a Han imagining of the Great Ancestor. Dragons and other celestial creatures swarm below.

A gate, indicated by two upside-down Ts and guarded by two seated figures, stands where the horizontal of heaven meets the banner's long, vertical stem. Two intertwined dragons loop through a circular jade piece known as a bi, itself usually a symbol of heaven, dividing this vertical segment into two areas. The portion above the bi represents the earthly realm. Here, the deceased woman and her three attendants stand on a platform while two kneeling figures offer gifts. The lower portion represents the underworld. Silk draperies and a stone chime hanging from the bi form a canopy for the platform below. Like the bronze bells we saw earlier, stone chimes were ceremonial instruments dating from Zhou times. On the platform, ritual bronze vessels contain food and wine for the deceased, just as they did in Shang tombs. The squat, muscular man holding up the platform stands in turn on a pair of fish whose bodies form another bi. The fish and the other strange creatures in this section are inhabitants of the underworld.

Daoism and Confucianism

The Han dynasty marked not only the end of the mythocentric age but also the beginning of a new age. During this dynasty, Daoism and Confucianism, two of the many philosophies formulated during the troubled times of the Eastern Zhou, became central in Chinese thought.

Their influence since then has been continuous and fundamental.

Daoism emphasizes the close relationship between humans and nature. It is concerned with bringing the individual life into harmony with the *Dao*, or Way, of the universe (see "Daoism," above). For some a secular, philosophical path, Daoism on a popular level developed into an organized religion, absorbing many traditional folk practices such as shamanism and the search for immortality.

Immortality was as intriguing to Han rulers as it had been to the first emperor of Qin. Daoist adepts experimented endlessly with diet, physical exercise, and other techniques in the belief that immortal life could be achieved on earth. A popular Daoist legend told of the Isles of the Immortals in the Eastern Sea, depicted on a bronze incense burner from the tomb of Prince Liu Sheng, who died in 113 BCE (fig. 10-7). Around the bowl, gold **inlay** outlines the stylized waves of the sea. Above them rises the mountainous island, busy with birds, animals, and people who had discovered the secret of immortality. Technically, this exquisite piece represents the ultimate development of the long tradition of bronze casting in China.

Confucianism and the State

In contrast to the metaphysical focus of Daoism, Confucianism is concerned with the human world, and its goal is the attainment of peace. To this end, it proposes an ethical system based on correct relationships among people. Beginning with self-discipline in the individual, Confucianism goes on to achieve correct relationships with the family, including ancestors, then, in ever-widening circles, with friends and others all the way up to the emperor (see "Confucius and Confucianism," opposite).

gold inlay, height 101/4" (26 cm).
Hebei Provincial Museum, Shijiazhuang sized II, or etiquette. Li includes scrupulous everyday manners as well as ritual, ceremony, protocol—well as ritual, ceremony, protocol—all of the formalities of social interac-

10-7. Incense burner, from the tomb of Prince Liu Sheng, Mancheng, Hebei. Han dynasty, 113 BCE. Bronze with Together with human-hearted-

youth wisely.

respect of his wife, of age to guide

subjects, of a husband to earn the

duty of a ruler is to earn the loyalty of

bilities flow the other way as well: the

popular with emperors. Yet responsi-

authority that made Confucianism

Deference to age is clearly built into this view, as is the deference to

younger friend, ruler and subject.

younger sibling, elder friend and

husband and wife, elder sibling and

Confucian society: parent and child,

Constant Relationships that define

li operate in the realm of the Five

society moved in harmony. Ren and

choreographed life so that an entire

tion. Such forms, Confucius felt,

concern is justice. reciprocity, and altruism. His primary inner integrity, self-control, loyalty, characteristics include moderation, petty or small-minded person. His tions. A junzi is the opposite of a thinking and right-acting in all situabecome a superior person, righteducation and self-cultivation had rected to mean one who through cating noble birth, the term was redi-Junzi, or gentleman. Originally indiized in the Confucian ideal of the The virtue of ren is most fully realstandards for all human interaction. morality and empathy as the basic man-heartedness. Ren emphasizes

ples and their followers into a book known in English as the Analects, which is the only record of his words. At the heart of Confucian thought is the concept of ren, or huBy Confucius's lifetime, warfare for supremacy among the various states of China had begun, and the traditional social fabric seemed to be breaking down. Looking back to the early Zhou dynasty as a sort of golden age, Confucius thought about how a just and harmonious society could again emerge. For many years he sought a ruler who would put his ideas into effect, but to no avail. Frustided, he spent his final years teaching. After his death in 479 BCE, his sayings were collected by his discination of the collected by his disci-

day Shandong province, into a declining aristocratic family. While still in his teens he set his heart on becoming a scholar, by his early twenties he had begun to teach.

Confucius was born in 551 BCE in the state of Lu, roughly present-

CIANISM AND CONFU-CONFUCIUS

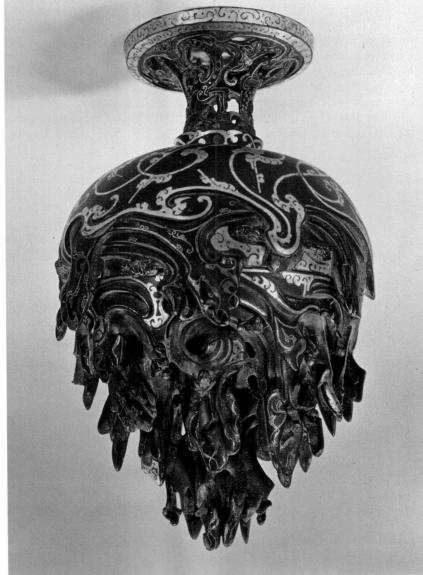

400 CE 5000 BCE 1300 CE

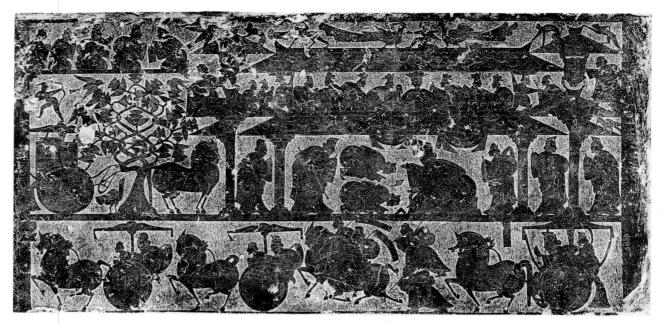

10-8. Détail from a rubbing of a relief in the Wu family shrine (Wuliangci), Jiaxiang, Shandong. Han dynasty, 151 ce. Stone, 27¹/₂ x 66¹/₂" (70 x 169 cm)

Emphasis on social order and respect for authority made Confucianism especially attractive to Han rulers, who were eager to distance themselves from the disastrous legalism of the Qin. The Han emperor Wu (ruled 141-87 BCE) made Confucianism the official imperial philosophy, and it remained the state ideology of China for more than 2,000 years, until the end of imperial rule in the twentieth century. Once institutionalized, Confucianism took on so many rituals that it too eventually assumed the form and force of a religion. Han philosophers contributed to this process by infusing Confucianism with traditional Chinese cosmology. They emphasized the Zhou idea, taken up by Confucius, that the emperor ruled by the mandate of heaven. Heaven itself was reconceived more abstractly as the moral force underlying the universe. Thus the moral system of Confucian society became a reflection of the universal order.

Confucian subjects turn up frequently in Han art. Among the most famous examples are the reliefs from the Wu family shrines built in 151 ce in Jiaxiang. Carved and engraved in low relief on stone slabs, the scenes were meant to teach such basic Confucian themes as respect for the emperor, filial piety, and wifely devotion. Daoist motifs also appear, as do figures from traditional myths and legends. Such mixed **iconography** is characteristic of Han art.

One relief shows a two-story building, with women in the upper floor and men in the lower (fig. 10-8). The central figures in both floors are receiving visitors, some of whom bear gifts. The scene seems to depict homage to the first emperor of the Han dynasty, indicated by his larger size. The birds and small figures on the roof may represent mythical creatures and immortals, while to the

left the legendary archer Yi shoots at one of the suncrows. (Myths tell how Yi shot all but one of the ten crows of the ten suns so that the earth would not dry out.) Across the lower register, a procession brings more dignitaries to the reception.

When compared to the Han dynasty banner (see fig. 10-6), this late Han relief clearly shows the change that has taken place in the Chinese worldview. The banner places equal emphasis on heaven, earth, and the underworld; human beings are dwarfed by a great swarming of supernatural creatures and divine beings. In the Wu shrine, the focus is clearly on the human realm. The composition conveys the importance of the emperor as the holder of the mandate of heaven and illustrates the fundamental Confucian themes of social order and decorum.

Architecture

Contemporary literary sources are eloquent on the wonders of the Han capital. Unfortunately, nothing of Han architecture remains except ceramic models. One model of a house found in a tomb, where it was provided for the dead to use in the afterlife, represents a typical Han dwelling (fig. 10-9). Its four stories are crowned with a watchtower and face a small walled courtyard. Pigs and oxen probably occupied the ground floor, while the family lived in the upper stories.

Aside from the multilevel construction, the most interesting feature of the house is the bracketing system supporting the rather broad eaves of its tiled roofs. **Bracketing** became a standard element of East Asian architecture, not only in private homes but more typically in palaces and temples. Another interesting aspect of

eccentric behavior. expressed their disdain for the world through willfully scape, drank, wrote poems, practiced calligraphy, and withdrew from public life. They wandered the land-Educated to serve the government, they increasingly to Daoism, which contained a strong escapist element. creators and custodians of China's high culture—turned

doctrine. Yet ultimately it was a new influence, Budnese culture, and Confucianism remained the official southern courts continued to patronize traditional Chiin its religious form. Though weak and disorganized, the sought answers in the magic and superstitions of Daoism available only to the educated elite. Far more people The rarefied intellectual escape route of Daoism was

China of the Six Dynasties. dhism, that brought the greatest comfort to the troubled

Painting

fucian view, which had emphasized art's moral and the spiritual value of painting contrasted with the Concould serve the same purpose. This new emphasis on dering in the mind's eye through a painted landscape ers and scholars of the Six Dynasties found that wancountryside was a source of spiritual refreshment. Paintduring this era. For Daoists, wandering through China's a major theme of Chinese art, first appeared as a subject that the period was an important one. Landscape, later abundant descriptions in literary sources make it clear Although few paintings survive from the Six Dynasties,

Reflections on the tradition of painting also inspired didactic uses.

stand the spirit in which China's painters worked. ticular offer valuable insight to anyone seeking to under-Xie He (c. 500-c. 535 cE). The first two principles in parnese painting are the six principles set out by the scholar liest and most succinct formulations of the ideals of Chithe first works on theory and aesthetics. One of the ear-

stories of wifely virtue from Chinese history. alternates illustrations and text to relate seven Confucian Attributed to the painter Gu Kaizhi (c. 344-406 cE), it Admonitions of the Imperial Instructress to Court Ladies. surviving from this period, a painted scroll known as lines of one of the most important of the very few works banner and again in the more controlled, rhythmical confident brushstrokes that outline the figures of the Han itself felt. We can sense this attitude already in the rapid, of a painter's brushwork that "spirit consonance" makes stroke is a vehicle of expression; it is through the vitality above all by the quality of its brushwork. Each brushprimary structural element. The Chinese judge a painting ognizes that brushstrokes are the "bones" of a picture, its them and infuses their work. The second principle recown spirit so that this universal energy flows through merely outward resemblance. Artists must cultivate their painting has qi, it will be alive with inner essence, not ation, the energy that flows through all things. When a "spirit" is the Daoist qi, the breath that animates all crenance" imbues a painting with "life's movement." This The first principle announces that "spirit conso-

known as Six Dynasties or Southern and Northern

Dynasties (220–579 ce).

inlaid with precious metals and stones. palaces as decorated with paint and lacquer but also their branches. Literary sources describe the walls of Han the trees flanking the gateway with crows perched in tels. Still other images evoke the world outdoors: notice of it illustrates structural features such as posts and lin-Much of the painting is purely decorative, though some the model is the elaborate painting on the exterior walls.

warring kingdoms. In 280 ce the **DYNASTIES** 220 CE, China splintered into three With the fall of the Han dynasty in

other in a period of almost constant turmoil broadly south, where six short-lived Dynasties succeeded each was commonplace. Tens of thousands of Chinese fled to a succession of largely foreign dynasties. Warfare carved out by invaders rose and fell before giving way developed separately. In the north, sixteen kingdoms For the next 250 years, northern and southern China out Chinese history, soon forced the court to flee south. peoples from Central Asia, a source of trouble throughempire was briefly reunited, but invasions by nomadic

fluence. In the south especially, many intellectuals—the In such chaos, the Confucian system lost much in-

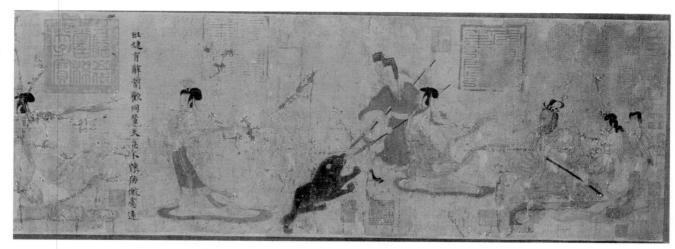

10-10. Attributed to Gu Kaizhi. Detail of *Admonitions of the Imperial Instructress to Court Ladies*. Six Dynasties period, c. 344–406 cE. Handscroll, ink and colors on silk, 9³/₄" x 11'6" (24.8 cm x 3.5 m). The British Museum, London

The first illustration depicts the courage of Lady Feng (fig. 10-10). An escaped circus bear rushes toward her husband, a Han emperor, who is filled with fear. Behind his throne, two female servants have turned to run away. Before him, two male attendants, themselves on the verge of panic, try to fend off the bear with spears. Only Lady Feng is calm as she rushes forward to place herself between the beast and the emperor.

The style of the painting is typical of the fourth century. The figures are drawn with a brush in a thin, evenwidth line, and a few outlined areas are filled with color. Facial features, especially those of the men, are quite well depicted. Movement and emotion are shown through conventions such as the bands flowing from Lady Feng's dress, indicating that she is rushing forward, and the upturned strings on both sides of the emperor's head, suggesting his fear. There is no hint of a setting; instead, the artist relies on careful placement of the figures to create a sense of depth.

The painting is on silk, a Chinese material with origins in the remote past. Silk was typically woven in bands about 12 inches wide and up to 20 or 30 feet long. Early Chinese painters thus developed the format used here, the handscroll—a long, narrow, horizontal composition, compact enough to be held in the hands when rolled up. **Handscrolls** are intimate works, meant to be viewed by only two or three people at a time. They were not displayed completely unrolled as we commonly see them today in museums. Rather, viewers would open a scroll and savor it slowly from right to left, displaying only a foot or two at a time.

Calligraphy

The emphasis on the expressive quality and structural importance of brushstrokes finds its purest embodiment in **calligraphy**. The same brushes are used for both painting and calligraphy, and a relationship between them was recognized as early as Han times. In his teachings Confucius had extolled the importance of the pursuit of knowl-

10-11. Wang Xizhi. Portion of a letter from the Feng Ju album. Six Dynasties period, mid-4th century ce. Ink on paper, $9\sqrt[3]{4} \times 18\sqrt[4]{2}$ " (24.7 x 46.8 cm). National Palace Museum, Taipei, Taiwan

The stamped calligraphs that appear on Chinese artworks are seals—personal emblems. The use of seals dates from the Zhou dynasty, and to this day seals traditionally employ the archaic characters, known appropriately as "seal script," of the Zhou or Oin. Cut in stone, a seal may state a formal, given name, or it may state any of the numerous personal names that China's painters and writers adopted throughout their lives. A treasured work of art often bears not only the seal of its maker but also those of collectors and admirers through the centuries. In the Chinese view. these do not disfigure the work but add another layer of interest. This sample of Wang Xizhi's calligraphy, for example, bears the seals of two Song dynasty emperors, a Song official, a famous collector of the sixteenth century, and two emperors of the Qing dynasty of the eighteenth and nineteenth centuries.

Buddhism originated in India during the fifth century BCE (Chapter 9), then gradually spread north into Central Asia. With the opening of the Silk Road during the Han dynasty, its influence reached China. To the Chinese of the Six Dynasties, beset by constant warfare and social devastation, Buddhism offered consolation in life and the promise of salvation after death. The faith spread throughout the country to all social levels, first in the north, where many of the invaders promoted it as the official religion, then slightly later in the south, where it found its first great slightly later in the south, where it found its first great slightly later in the south, where it found its first great slightly later in the south, where it found its first great slightly later in the south, where it found its first great slightly later in the south, and it found its first great patron in the emperor Liang Wudi (ruled 502–549 cE).

Buddhism

be learned along with other styles.

Feng Ju is an example of "walking" style, which is neither too formal nor too free but is done in a relaxed, easygoing manner. Brushstrokes vary in width and length, creating rhythmic vitality. Individual characters remain distinct, yet within each character the strokes are run together and simplified as the brush moves from one to the other without lifting off the page. The effect is fluid and graceful, yet still strong and dynamic. It was Wang and graceful, get still strong and dynamic. It was Wang Xizhi who first made this an officially accepted style, to

China's literati ("educated"), all of them Confucian scholars, have enjoyed being connoisseurs and practitioners of this abstract art. During the fourth century, calligraphy came to full maturity. The most important practitioner of the day was Wang Xizhi (c. 303–361 cE), whose works have served as models of excellence for all subsequent generations. The example here comes from a letter, now somewhat damaged and mounted as part of an album, known as Feng Ju (fig. 10-11).

edge and the arts. Among the visual arts, painting was felt to reflect moral concerns, while calligraphy was believed to reveal the style and character of the writer.

Calligraphy is regarded as one of the highest forms

of expression in China. For more than 2,000 years,

The front part of the cave has crumbled away, and the 45-foot statue is now exposed to the open air, clearly visible from a distance. The elongated ears, protuberance on the head (ushnisha), and monk's robe (sanghati) are traditional attributes of the Buddha. The masklike face, full torso, massive shoulders, and shallow, stylized drapery indicate strong Central Asian influence. The overall effect is remote and even slightly severe, a far cry from the more sensuous expression of the early traditions in India. The image of Buddha became increasingly formal and unearthly as it traveled east from its origins, reflecting a fundamental difference in the way the Chirellecting a fundamental difference in the way the Chirese and the Indians visualize their deities.

The caves at Yungang, in Shanxi province, contain many examples of the earliest phase of Buddhist sculpture in China, including the monumental seated Buddha in Cave 20 (fig. 10-12). The figure was carved in the latter part of the fifth century by imperial decree of a ruler of the Morthern Wei dynasty (386–535 cE), the longest-lived and most stable of the northern kingdoms. Most Wei rulers were avid patrons of Buddhism, and under their rule the religion made its greatest advances in the north.

from the Six Dynasties are the hundreds of northern rockcut caves that line the Silk Road between Xinjiang in Central Asia and the Yellow River Valley. Both the caves and the sculpture that fill them were carved from the solid rock of the cliffs. Small caves high above the ground were retreats for monks and pilgrims, while larger caves at the base of the cliffs were wayside shrines and temples.

less style cultivated in southern China. The most impressive works of Buddhist art surviving

Almost nothing remains in China of the Buddhist architecture of the Six Dynasties, but we can see what it must have looked like in the Japanese temple Horyu-ji have nuch in common with the figures in Cu Kaizhi's handscroll, and they indicate the delicate, almost weight-

many people became monks and nuns.

Almost nothing remains in China of the Buddh

10-12. Seated Buddha, Cave 20, Yungang, Datong, Shanxi. Wei dynasty, c. 460 ce. Stone, height 45'

10-13. Altar to Amitabha Buddha. Sui dynasty, 593 ce. Bronze, height 30½" (76.5 cm). Museum of Fine Arts, Boston Gift of Mrs. W. Scott Fitz (22.407) and Gift of Edward Holmes Jackson in memory of his mother, Mrs. W. Scott Fitz (47.1407-1412)

SUI AND TANG DYNASTIES

In 589 ce a general from the last of the northern dynasties replaced a child emperor and established a dynasty of his own, the Sui. Defeating all opposition, he molded

China into a centralized empire as it had been in Han times. The new emperor was a devout Buddhist, and his reunification of China coincided with a fusion of the several styles of Buddhist sculpture that had developed. This new style is seen in a bronze altar to Amitabha Buddha (fig. 10-13), one of the many buddhas espoused by Mahayana Buddhism. Amitabha dwelled in the Western Pure Land, a paradise into which his faithful followers were promised rebirth. With its comparatively simple message of salvation, the Pure Land sect eventually became the most popular form of Buddhism in China.

The altar depicts Amitabha in his paradise, seated on a lotus throne beneath a canopy of trees. Each leaf clus-

ter is set with jewels. Seven celestial nymphs sit on the topmost clusters, and ropes of pearls hang from the tree trunks. Behind Amitabha's head is a halo of flames. To his left, the **bodhisattva** Guanyin holds a pomegranate; to his right, another bodhisattva clasps his hands in prayer. Behind are four disciples who first preached the teachings of the Buddha. On the lower level, an incense burner is flanked by seated dogs and two smaller bodhisattvas. Focusing on Amitabha's benign expression and filled with objects symbolizing his power, the altar combines the sensuality of Indian styles, the schematic abstraction of Central Asian art, and the Chinese emphasis on linear grace and rhythm into a harmonious new style.

The short-lived Sui dynasty fell in 617 CE, but in reunifying the empire it paved the way for one of the greatest dynasties in Chinese history, the Tang (618–907 CE). Even today many Chinese living abroad still call themselves "Tang people." To them, Tang implies that part of

Cosmopolitan and tolerant, Tang China was confident in itself and curious about the world. Many foreigners came to the splendid new capital, Chang'an (present-day Xi'an), and they are often depicted in the art troupe of musicians reflects the Tang fascination with the troupe of musicians reflects the Tang fascination with the "exotic" Turkic cultures of Central Asia (fig. 10-14). The

ships carried on a lively trade with coastal cities. Chinese cultural influence in East Asia was so important that Japan and Korea sent thousands of students to study Chinese civilization.

Under a series of ambitious and forceful emperors, Chinese control again reached over Central Asia. As in the Silk Road. In the South China Sea, Arab and Persian ships carried on a lively trade with coastal cities. Chinships carried on a lively trade with coastal cities. Chinships carried on a lively trade with coastal cities.

the Chinese character that is strong and vigorous (especially in military power), noble and idealistic, but also realistic and pragmatic.

uralism, an important trend in both painting and sculpture. Compared to the rigid, staring ceramic soldiers of the first emperor of Qin, the Tang group is alive with gesture and expression. The majestic camel throws its head back; the musicians are vividly captured in mid-performance. Ceramic figurines such as this, produced by gorgeous variety of Tang tombs, offer a glimpse into the gorgeous variety of Tang time, The statue's three-color glazze technique was a specialty of Tang ceramicists. The glazce—usually chosen from a restricted palette of

three bearded musicians (one with his back to us) are Central Asian, while the two smooth-shaven ones are Han Chinese. Two-humped Bactrian camels, themselves exotic Central Asian "visitors," were beasts of burden in the caravans that crisscrossed the Silk Road. The motif of musicians on camelback seems to have been popular in the Tang dynasty, for it also appears in some paintings. Stylistically, the statue reveals a new interest in nat-

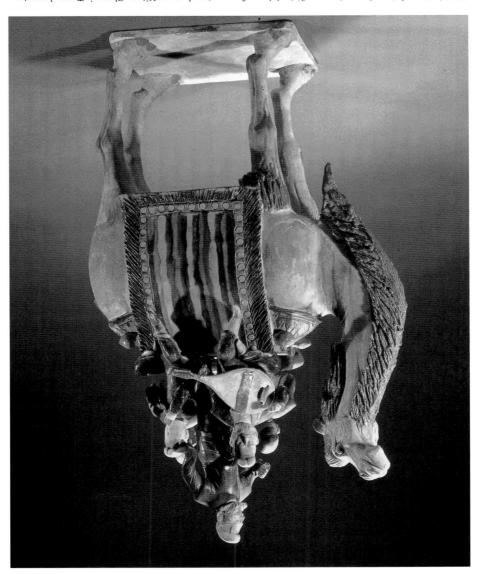

10-14. Camel Carrying a Group of Musicians, from a tomb near Xi'an, Shanxi. Tang dynasty, c. mid-8th century ce. Earthenware with three-color glaze, height 26¹/8" (66.5 cm). Museum of Chinese History, Beijing

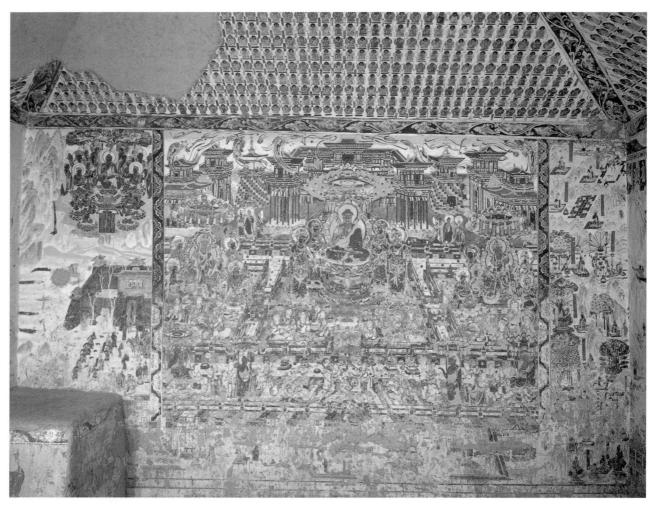

10-15. *The Western Paradise of Amitabha Buddha*, detail of a wall painting in Cave 217, Dunhuang, Gansu. Tang dynasty, c. 750 CE. 10'2" x 16' (3.1 x 4.86 m)

amber, yellow, green, and white—were splashed freely and allowed to run over the surface during firing to convey a feeling of spontaneity. The technique seems symbolic of Tang culture itself in its robust, colorful, and cosmopolitan expressiveness.

Buddhist Art and Architecture

Buddhism reached its greatest development in China during the Tang dynasty. From emperors and empresses to common peasants, virtually the entire country adopted the Buddhist faith. A Tang vision of the most popular sect, Pure Land, was expressed in a wall painting from a cave in Dunhuang (fig. 10-15). A major stop along the Silk Road, Dunhuang has some 500 caves carved out of its sandy cliffs, all filled with painted clay sculpture and decorated with wall paintings from floor to ceiling. The site was worked on continuously from the fifth to the fourteenth century, a period of almost a thousand years. Rarely in art's history do we have the opportunity to study such an extended period of stylistic and iconographic evolution in one place.

Amitabha Buddha is seated in the center, surrounded by four bodhisattvas who serve as his messengers to the world. Two other groups of bodhisattvas are clus-

tered at the right and left. In the foreground, musicians and dancers create a heavenly atmosphere. In the background, great halls and towers rise: the artist has imagined the Western Paradise in terms of the grandeur of Tang palaces. Indeed, the lavish entertainment could just as easily be taking place at the imperial court. This worldly vision of paradise contrasts tellingly with the simple portrayal in the earlier Sui altarpiece (see fig. 10-13), and it gives us our best visualization of the splendor of Tang civilization at a time when Chang'an was probably the greatest city in the world.

The early Tang emperors proclaimed a policy of religious tolerance, but during the ninth century a conservative reaction set in. Confucianism was reasserted and Buddhism was briefly persecuted as a "foreign" religion. Thousands of temples, shrines, and monasteries were destroyed and innumerable bronze statues melted down. Nevertheless, several Buddhist structures survive from the Tang dynasty, one of which, the Nanchan Temple, is the first important example of Chinese architecture.

Nanchan Temple. Of the few structures earlier than 1400 to have survived, the Nanchan Temple is the most significant, for it shows characteristics of both temples

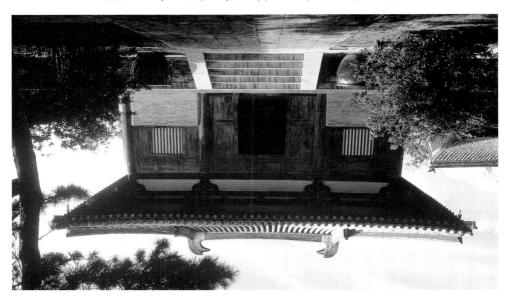

10-16. Nanchan Temple, Wutaishan, Shanxi. Tang dynasty, 782 ce

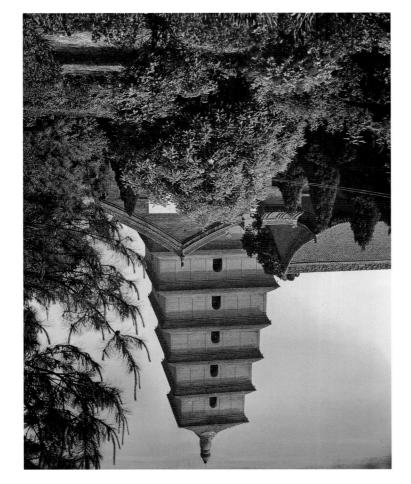

8th century ce Shanxi. Tang dynasty, first erected 645 ce; rebuilt mid-10-17. Great Wild Goose Pagoda at Ci'en Temple, Xi'an,

and grace. Tang architecture in its simplicity, symmetry, proportions, originally five), the pagoda still preserves the essence of fied and repaired in later times (its seven stories were under the projecting roofs of each story. Although modi-

> with three bays—gives an idea of the vast, multistoried ber of bays. Thus the Nanchan Temple-modest in scope create larger structures, an architect multiplied the numture as a sort of module, a basic unit of construction. To and their lintels. The bay functioned in Chinese architecwhich a cubic unit of space, a bay, is formed by four posts Also typical is the bay system of construction, in spondingly elaborate bracketing system. broad overhanging eaves are supported by a corre-

> increasingly pronounced in later centuries. The very a curved silhouette. Quite subtle here, this curve became seen in the Han tomb model (see fig. 10-9), has taken on small hall was constructed in 782 ce. The tiled roof, first Mount Wutai in the eastern part of Shanxi province, this and palaces of the Tang dynasty (fig. 10-16). Located on

> from Dunhuang. palaces of the Tang depicted in such paintings as the one

> The pagoda, a typical East Asian Buddhist structure, mith him. taught and translated the materials he had brought back year pilgrimage to India. At Ci'en Temple, Xuanzang famous monk Xuanzang on his return from a sixteen-10-17). The temple was constructed in 645 cE for the da at the Ci'en Temple in Xi'an, the Tang capital (fig. ument of Tang architecture is the Great Wild Goose Pago-Great Wild Goose Pagoda. Another important mon-

to resemble bays, and bracket systems are reproduced tecture of the time. The walls are decorated in low relief Goose Pagoda nevertheless imitates the wooden archiduce the pagoda. Built entirely in masonry, the Great Wild idea blended with a traditional Han watchtower to prounder the Kushan dynasty (c. 50-250 cE). In China this developed a multistoried form in the Gandharan region ments of Architecture," page 414). In India the stupa had burial mound that housed relics of the Buddha (see "Eleoriginated in the Indian Buddhist stupa, the elaborated

ARCHITECTURE

Pagodas

ELEMENTS OF Pagodas are the most characteristic of East Asian architectural forms. Originally associated with Buddhism, pagodas developed from Indian stu-

pas as Buddhism spread northeastward along the Silk Road. Stupas merged with the watchtowers of Han dynasty China in multistoried stone structures with projecting tiled roofs. This transformation culminated in wooden pagodas with upward-curving roofs supported by elaborate bracketing in China, Korea, and Japan. Buddhist pagodas retain the axis mundi masts of stupas. Like their South Asian prototypes, early East Asian pagodas were solid, with small devotional spaces hollowed out; later examples often provided access to the ground floor and sometimes to upper levels. The layout and construction of pagodas, as well as the number and curve of their roofs, vary depending on the time and place.

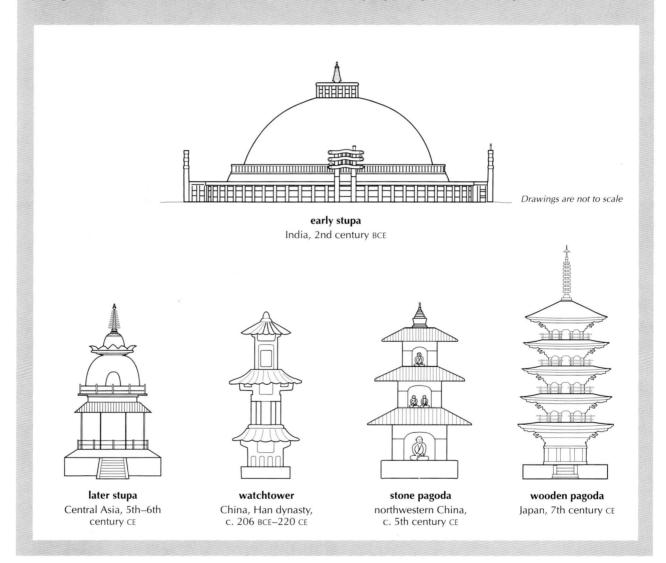

Figure Painting

Later artists looking back on their heritage recognized the Tang dynasty as China's great age of figure painting. Unfortunately, very few scroll paintings that can be definitely identified as Tang still exist. We can get some idea of the character of Tang figure painting from the wall paintings of Dunhuang (see fig. 10-15). Another way to savor the particular flavor of Tang painting is to look at copies made by later Song dynasty artists, which are far better preserved. An outstanding example of this practice is Ladies Preparing Newly Woven Silk, attributed to Huizong (ruled 1101-1125 cE), the last emperor of the Northern Song dynasty (fig. 10-18). A long handscroll in several sections, it depicts the activities of court women as they weave and iron silk. An inscription on the scroll informs us that the painting is a copy of a famous work by Zhang Xuan, an eighth-century painter known for his depictions of women at the Tang court. The original no longer exists, so we cannot know how faithful the copy is. Still, its refined lines and bright colors seem to share not only the grace and simplicity of Tang sculpture and architecture but also the quiet beauty characteristic of Tang painting.

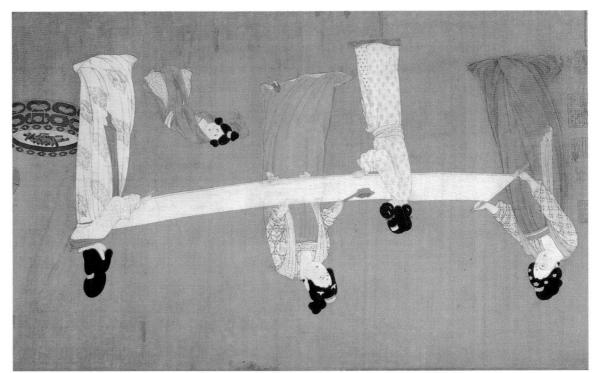

(36.8 x 145.5 cm). Museum of Fine Arts, Boston Zhang Xuan. Northern Song dynasty, early 12th century. Handscroll, ink and colors on silk, $14^{1/2} \times 57^{1/4}$ " 10-18. Attributed to Emperor Huizong. Detail of Ladies Preparing Newly Woven Silk, copy after a lost painting by

reinforcing a personal connection with the past. ancient master. This was at once an act of homage, a declaration of artistic allegiance, and a way of painters took up the practice of regularly executing a work "in the manner of" some particularly revered lessons of their great predecessors and to perpetuate the achievements of the past. In later centuries, Chinese painters regularly copied paintings of earlier masters. Painters made copies both to absorb the Confucius said of himself, "I merely transmit, I do not create, I love and revere the ancients." In this spirit,

art, especially painting and ceramics. for its depth. But the finest expressions of the Song are in

Neo-Confucianism

Neo-Confucianism. synthesis of China's three main paths of thought is called ing, all-embracing explanation of the universe. This new previously lacked, allowing it to propose a more satisfyprovided Confucianism with a metaphysical aspect it had rejected Buddhism itself as foreign. These innovations Daoism and especially Buddhism, even as they openly strengthening Confucian thought, philosophers drew on the Tang, of restoring Confucianism to dominance. In Song philosophers continued the process, begun during

the Creat Ultimate. This lifelong process resembles the self-cultivation so that our li may realize its oneness with beings is to rid our qi of impurities through education and completely present in every object. Our task as human first principle known as the Great Ultimate, which is verse, including humans, are but aspects of an eternal into the material world through qi. All the li of the uniof an underlying li we might call "Pine Tree Idea" brought idea) and qi (matter). All pine trees, for example, consist sists of two interacting forces known as li (principle or Neo-Confucianism teaches that the universe con-

> before China was again united, lowed the fall of the Tang dynasty A brief period of disintegration fol-

DYNASTY DNOS

established a new capital at Bienjing (present-day this time under the Song dynasty (960-1279 cE), which

was brilliant, especially in history, and its poetry is noted the "one hundred schools" of the Zhou. Song scholarship nese. Philosophy experienced its most creative era since tral Asia, Song culture was more self-consciously Chieagerly absorbing influences from Persia, India, and Cengrandeur. Where the Tang had reveled in exoticism, noted for its highly refined taste and intellectual was plentiful, and the arts flourished. Song culture is merce, and technology begun under the Tang. Patronage had increased because of advances in agriculture, com-Although China's territory had diminished, its wealth tion in retrospect called Northern Song (960-1126).

known as Southern Song (1127-1279), with the first por-

ital at Hangzhou. From this point on, the dynasty is Song forces withdrew south and established a new cap-

possession of much of the northern part of the country. Manchuria invaded China, sacked the capital, and took

ened military situation. In 1126 the Jurchen tribes of

was more introspective, a reflection of China's weak-

going confidence of the Tang, the mood during the Song

Kaifeng), near the Yellow River. In contrast to the out-

striving to attain buddhahood, and if we persist in our attempts, one day we will be enlightened—the term itself comes directly from Buddhism.

Landscape Painting

The Neo-Confucian ideas found visual expression in art, especially in landscape, which became the most highly esteemed subject for painting. Northern Song artists studied nature closely to master its many appearances—the way each species of tree grew, the distinctive character of each rock formation, the changes of the seasons, the myriad birds, blossoms, and insects. This passion for realistic detail was the artist's form of self-cultivation: mastering outward forms showed an understanding of the principles behind them.

Yet despite the convincing accumulation of detail, the paintings do not record a specific site. The artist's goal was to paint the eternal essence of mountain-ness, for example, not to reproduce the appearance of a particular mountain. Painting a landscape required an artist to orchestrate his cumulative understanding of *li* in all its aspects—mountains and rocks, streams and waterfalls, trees and grasses, clouds and mist. A landscape painting thus expressed the desire for the spiritual communion with nature that was the key to enlightenment. As the tradition progressed, landscape also became a vehicle for conveying human emotions, even for speaking indirectly of one's own deepest feelings.

In the earliest times, art reflected the mythocentric worldview of the ancient Chinese. During the period when the three religions dominated people's lives, there was a major shift in which religious images and human actions became the most important subjects. The choice of landscape as the chief means of expression, reflecting the general Chinese desire to avoid direct depiction of the human condition and to show things instead in a symbolic manner, was the second great shift in the focus of Chinese art. The major form of Chinese artistic expression thus moved from the mythical, through the religious and ethical, and finally to the philosophical and aesthetic.

One of the first great masters of Song landscape was the eleventh-century painter Fan Kuan (active c. 990–1030), whose surviving major work, *Travelers among Mountains and Streams*, is generally regarded as one of the greatest monuments in the history of Chinese art (fig. 10-19). The work is physically large—almost 7 feet high—but the sense of monumentality also radiates from the composition itself, which makes its impression even when much reduced.

The composition unfolds in three stages, comparable to the three acts of a drama. At the bottom a large, low-lying group of rocks, taking up about one-eighth of the picture surface, establishes the extreme foreground. The rest of the landscape pushes back from this point. In anticipating the shape and substance of the mountains to come, the rocks introduce the main theme of the work, much as the first act of a drama introduces the principal characters. In the middle ground, travelers and their

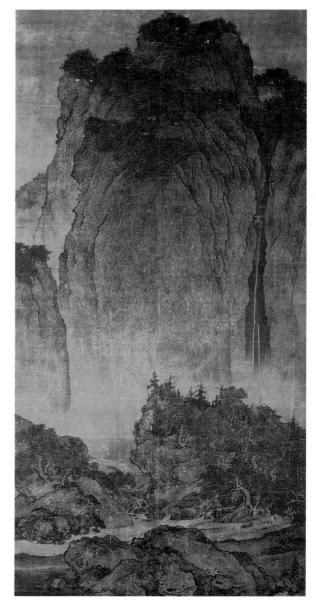

10-19. Fan Kuan. *Travelers among Mountains and Streams*. Northern Song dynasty, early 11th century. Hanging scroll, ink and colors on silk, height 6'9 1/4" (2.06 m). National Palace Museum, Taipei, Taiwan

mules are coming from the right. They are somewhat shocking, for we suddenly realize our human scale—how small we are, how vast nature is! This middle ground takes up twice as much picture surface as the foreground, and, like the second act of a play, shows variation and development. Instead of a solid mass, the rocks here are separated into two groups by a waterfall spanned by a bridge. In the hills to the right, the rooftops of a temple stand out above the trees.

Mist veils the transition to the background, with the result that the mountain looms suddenly. This background area, almost twice as large as the foreground and middle ground combined, is the climactic third act of the drama. As our eyes begin their ascent, the mountain solidifies. Its ponderous weight increases as it billows upward, finally bursting into the sprays of energetic brushstrokes that describe the scrubby growth on top. To

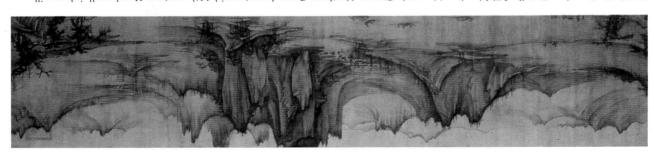

Purchase, Nelson Trust (33-1559) 19" x 6'10" (48.9 cm x 2.09 m). The Nelson-Atkins Museum of Art, Kansas City, Missouri 10-20. Xu Daoning. Detail of Fishing in a Mountain Stream. Northern Song dynasty, mid-11th century. Handscroll, ink on silk,

nature that is the goal of Chinese artistic expression. our journey, we again feel that sense of communion with reverse. Gazing out into the distance and reflecting on coming toward us, who will have our experience in vista. As we cross the bridge here, we meet travelers as a transition to the painting's finale, a broad, open ing both as an echo of the spectacular central group and gives way to a second, smaller group of mountains, servsome time with the fishers in their boats as the valley up the valley on the right. Or perhaps we may spend moment in the small pavilion the artist offers us halfway distance. We can imagine ourselves resting for a deep valley, where a stream lures our eyes far into the side of the bridge, we find ourselves looking up into a small footbridge the artist has placed for us. At the far spectacular view of the highest peaks from another onr path winds back along the bank, and we have a high mountains that show extraordinary shapes. Again the foreground with the beginning of a central group of Crossing over a small footbridge, we are brought back to small viewing area, then move them slowly leftward.) mimic the effect, use two pieces of paper to frame a observed only a small section of the scroll at a time. To mists and mountain peaks. (Remember that viewers broad, open view of a deep vista dissolving into distant the right foreground, we follow a path that leads to a Daoning (c. 970-c. 1052). Starting from a thatched hut in executed in the middle of the eleventh century by Xu

ory, for we do not see the scroll or hear the composition in both our sense of the overall structure relies on memdeveloped and varied, both are revealed over time, and tions. Both are generated from opening motifs that are tion of Western music, especially symphonic composivisual arts and are often compared instead to the tradi-Such handscrolls have no counterpart in the Western

in the first quarter of the twelfth century by Zhang is Spring Festival on the River, a long handscroll painted most spectacular products of this passion for observation animals, still others in palaces and buildings. One of the flowers. Other painters specialized in domestic and wild itely detailed, delicately colored paintings of birds and court painters who shared his passion for quiet, exquisseen in figure 10-18, gathered around himself a group of whose copy of Ladies Preparing Newly Woven Silk was extended beyond landscape. The emperor Huizong, The Northern Song fascination with exactitude

> Ultimate in a spiritual communion. human world behind to come face to face with the Great veys the feeling of climbing a high mountain, leaving the to enhance it by contrast. The whole painting, then, conthe powerful upward thrust of the mountain but simply the right, a slender waterfall plummets, not to balance

> middle ground to background is logically and convincrock surface. Spatial recession from foreground through texture" in Chinese) accurately mimic the texture of the acter. Layers of short, staccato strokes (called "raindrop tours of rocks and trees and express their rugged charin proper scale. Jagged brushstrokes describe the con-All the elements are depicted with precise detail and

> Although it contains realistic details, the landscape ingly handled, if not yet quite continuous.

> thought united, much as they are in Neo-Confucianism Daoist ideal. Thus we find the three strains of Chinese uncorrupted by human habitation, expresses a kind of hisattvas at his side. The landscape, a view of nature ters, and the Buddhist motif of the Buddha with bodsocial hierarchy, with the emperor flanked by his minisseems to reflect both the ancient Confucian notion of the central peak flanked by lesser peaks on each side, of the universe. The arrangement of the mountains, with nal, ordered composition, he expresses the intelligence presses the ideal forms behind appearances; in the ratiorepresents no specific place. In its forms, the artist ex-

> aloft in a balloon: distant, all-seeing, and mobile. imagine the ideal for Chinese artists as a film camera only what can be seen from a fixed viewpoint, we can turies of Western painters as a photograph, which shows mally given to see. If we can imagine the ideal for censuch limits and show a totality beyond what we are norgoal of Chinese painting is precisely to get away from that could be seen from a single, fixed vantage point. The oped a "scientific" system for recording exactly the view painters, searching for fidelity to appearances, develit is understood in the West. Fifteenth-century European sites is closely linked to the avoidance of perspective as out of ourselves and to let us wander freely through their The ability of Chinese landscape painters to take us

> in a Mountain Stream (fig. 10-20), a 7-foot-long painting handscrolls to survive from the Northern Song is Fishing ly as we move through the painting. One of the finest handscroll, where our vantage point changes constant-The sense of shifting perspective is clearest in the

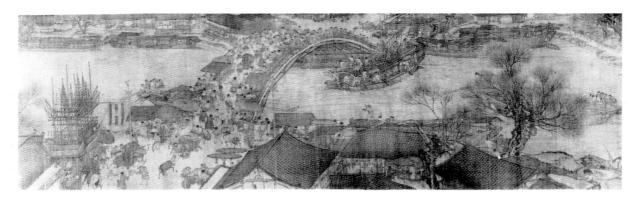

10-21. Zhang Zeduan. Detail of *Spring Festival on the River*. Northern Song dynasty, early 12th century. Handscroll, ink and colors on silk, 9³/₄" x 7¹/₄" (24.8 cm x 2.28 m). The Palace Museum, Beijing

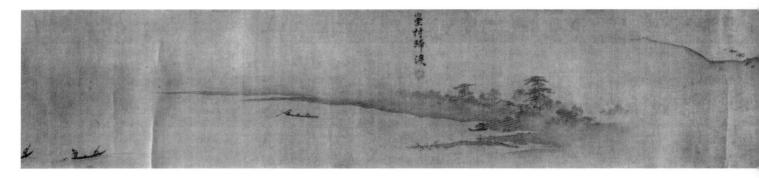

10-22. Xia Gui. Detail of *Twelve Views from a Thatched Hut*. Southern Song dynasty, early 13th century. Handscroll, ink on silk, height 11" (28 cm), length of extant portion 7'7 ¹/4" (2.31 m). The Nelson-Atkins Museum of Art, Kansas City, Missouri Purchase, Nelson Trust (32-159/2)

Zeduan, an artist connected to the court (fig. 10-21). Beyond its considerable visual delights, the painting is also an invaluable record of daily life in the Song capital.

The painting is set on the day of a festival, when local inhabitants and visitors from the countryside thronged the streets. One high point is the scene reproduced here, which takes place at the Rainbow Bridge. The large boat to the right is probably bringing goods from the southern part of China up the Grand Canal that ran through the city at that time. The sailors are preparing to pass beneath the bridge by lowering the sail and taking down the mast. Excited figures on ship and shore gesture wildly, shouting orders and advice, while a noisy crowd gathers at the bridge railing to watch. Stalls on the bridge are selling food and other merchandise; wine shops and eating places line the banks of the canal. Everyone is on the move. Some people are busy carrying goods, some are shopping, some are simply enjoying themselves. Each figure is splendidly animated and full of purpose; the buildings and boats are perfect in every detail—the artist's knowledge of this bustling world was indeed encyclopedic.

Little is known about the painter Zhang Zeduan other than that he was a member of the scholar-official class, the highly educated elite of imperial China. Interestingly, some of Zhang Zeduan's peers were already beginning to cultivate quite a different attitude toward painting as a form of artistic expression, one that placed overt skill at the lowest end of the scale of values. This emerging scholarly aesthetic later came to dominate Chi-

nese thinking about art, with the result that only in the twentieth century has *Spring Festival* again found an audience willing to hold it in the highest esteem.

Southern Song

Landscape painting took a very different course after the fall of the north and the removal of the court to its new capital in the south, Hangzhou. This new sensibility is reflected in the extant portion of *Twelve Views from a Thatched Hut* (fig. 10-22) by Xia Gui (c. 1180–1230), a member of the newly established Academy of Painters. In general, academy members continued to favor such subjects as birds and flowers in the highly refined, elegantly colored court style patronized by Huizong. Xia Gui, however, was interested in landscape and cultivated his own style. Only the last four of the twelve views that originally made up this long handscroll have survived, but they are enough to illustrate the unique quality of his approach.

In sharp contrast to the majestic, austere landscapes of the Northern Song painters, Xia Gui presents an intimate and lyrical view of nature. Subtly modulated, perfectly controlled ink washes evoke a landscape veiled in mist, while a few deft brushstrokes suffice to indicate the details showing through—the grasses growing by the bank, the fishers at their work, the trees laden with moisture, the two bent-backed figures carrying their heavy load along the path that skirts the hill. Simplified forms, stark contrasts of light and dark, asymmetrical composi-

In 1279 the Southern Song dynasty fell to the conosity and freely intuitive insights of Xia Gui's landscape.

which might lead to sudden enlightenment. The idea of cultivation could be achieved through contemplation, fucianism called "School of the Mind" insisted that self-During the late twelfth century a new school of Neo-Contangible to the intangible, had a parallel in philosophy. and intellectual to the emotional and intuitive, from the This development in Song painting from the rational

evokes a far deeper feeling for what lies beyond. limiting himself to a few essential details, the painter intangible is somehow more real than the tangible. By ing world that can be captured only in glimpses. The tion, and great expanses of blank space suggest a fleet-

later developments in the arts. resentment of "barbarian" rule, created the climate for political and cultural centers, coupled with a lasting rose to prominence during the Song. This separation of center of China remained in the south, in the cities that the northeast, in what is now Beijing. Yet the cultural the Yuan dynasty (1279-1368), setting up their capital in empire the world has ever seen. Mongol rulers founded was subsumed into the vast Mongol empire, the largest quering forces of the Mongol leader Kublai Khan. China

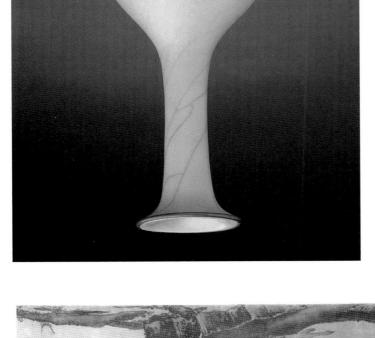

65/8" (16.8 cm). Percival David Foundation of Chinese

Porcelaneous stoneware with crackled glaze, height

10-23. Guan Ware vase. Southern Song dynasty, 13th century.

Art, London

ceramics is Guan Ware, made mainly for imperial use The most highly prized of the many types of Song ate more quietly beautiful pieces. turned away from the exuberance of Tang styles to creworld. Like their painter contemporaries, Song potters made their wares models of excellence throughout the achieved a technical and aesthetic perfection that has considerable accomplishments of the Tang, Song potters cerning in other arts such as ceramics. Building on the were created for a highly cultivated audience equally dis-The subtle and sophisticated paintings of the Song to follow this intuitive approach. circuit" the rational mind. Xia Gui's painting seems also

favor of meditation and techniques designed to "shortenlightenment as scripture, knowledge, and ritual in Zen. Chan Buddhists rejected such formal paths to dhism, better known in the West by its Japanese name, sudden enlightenment may have come from Chan Bud-

the same spirit that hovers behind the self-effacing virtua perfectly regular, perfectly planned form we can sense wares. In the play of irregular, spontaneous crackles over came to be used deliberately in some of the finest Song le technique was probably discovered accidentally, but it crackle pattern that spreads over the surface. The cracking. The aesthetic of the Song is most evident in the quality as eloquent as the blank spaces in Xia Gui's paintbreak from base to lip. The piece has an introspective Aided by a lustrous white glaze, the form flows without of this simple vase show a strong sense of harmony. (fig. 10-23). The everted lip, high neck, and rounded body

Jomon vessel c. 2000 BCE

JOMON c. 12,000-300 BCE

2600 BCE 1400 CE

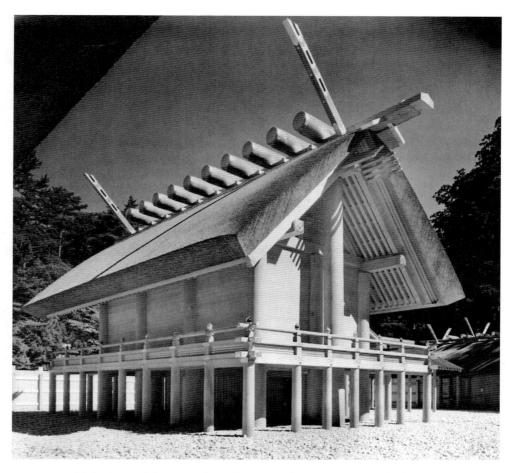

11-1. Inner shrine, Ise, Mie Prefecture. Early 1st century CE; rebuilt 1993

he shrine at Ise, on the coast southwest of Tokyo, is rebuilt every twenty years in exactly the same ancient Japanese style by expert carpenters who have been trained in this task since childhood. One of the most popular pilgrimage sites in Japan, visited by millions each year, this exquisitely proportioned shrine has been ritually rebuilt at intervals for nearly 2,000 years, most recently in 1993 (fig. 11-1). In this way, the temple—like Japanese culture itself—is both ancient and endlessly new.

The shrine, dedicated to the sun goddess, the legendary progenitor of Japan's imperial family, reflects several of the recurring features in Japanese art. Over a period of many centuries and in works of art in many mediums, these characteristic features appear, seem to vanish, then reappear in different guises in different epochs. The first of these characteristics is a respect for and delight in natural materials. Wooden architecture, for example, is often left unpainted—as is the bare cypress wood at Ise—and ceramics frequently display all or some of their clay bodies.

Another feature is a taste for asymmetry. Instead of the evenly balanced compositions frequently seen in Chinese and European art, the Japanese enjoy paintings and prints that seem off-balance but are actually adroitly composed. This affection for asymmetry is also evident in Japanese poetry, typically three or five lines long rather than the even number of lines in the verse of most other cultures.

2600 BCE 1400 CE

Japanese art is also marked by a sense of humor and playfulness that great power and depth. In many Japanese works of art strong contrasts create a sense of drama that heightens this spirit of fun.

Finally, the Japanese have been able over the centuries to tolerate, even welcome, paradoxes and illogic in their lives and art. They have produced at the same time works that are simple and profound as well as works that are ornate and decorative. They have strongly preserved their own cultural heritage while welcoming and creatively transforming foreign influences—first from China and Korea and more recently from the West. As the shrine at Ise so eloquently illustrates, they also have maintained a sense of history while always being up-to-date.

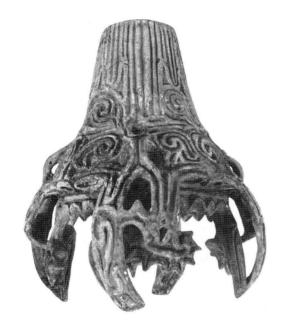

11-2. Vessel, from the Asahi Mound, Toyama Prefecture. Jomon period, c. 2000 BCE. Low-fired ceramic, height 143/4" (37.4 cm). Collection of Tokyo University

vessels were crafted with straight sides and flat bottoms, a shape that was useful for storage as well as cooking and eventually became the norm. Often the vessels were decorated with patterns made by pressing cord onto the damp clay (jomon means "cord markings"). Jomon usually crafted their vessels by building them up with coils of clay, then firing them in bonfires at relatively low temperatures. It is thought that Jomon pottery was made by women, as was the practice in most early societies, especially before the use of the potter's wheel.

During the middle Jomon period (2500–1500 BCE), pottery reached a high degree of creativity. By this time communities were somewhat larger, and each family may have wanted its ceramic vessels to have a unique design. The basic form remained the straight-sided cooking or storage jar, but the rim now took on spectacular, flamboyant shapes, as seen in one example from the Asahi Mound (fig. 11-2). Middle Jomon potters made full

PREHISTORIC

The earliest traces of human habitation in Japan are at least 30,000 years old. At that time the islands were still

linked to the East Asian landmass, forming a ring from Siberia to Korea around the present-day Sea of Japan, which was then a lake. With the end of the last Ice Age there, some 15,000 years ago, melting glaciers caused the sea level to rise, gradually submerging the lowland links and creating the islands as we know them today. Sometime after, Paleolithic peoples gave way to Neolithic hunter-gatherers, who crafted stone tools and gradually developed the ability to make and use ceramics. Recent scientific dating methods have shown some works of Japanese pottery to date earlier than 10,000 BCE, making them the oldest now known.

Jomon Period

endeavors as ceramics.

ty to develop their artistry for even such practical have enjoyed a peaceful life, giving them the opportunidwellings together. All in all, the Jomon people seem to period there were seldom more than ten or twelve people lived in small communities; in the early Jomon gathering society using stone tools and weapons. Its tivated, but still the Jomon remained primarily a huntingand gourds. Some 4,000 years later rice began to be culture emerged with the planting and harvesting of beans of their abundant food supply. Around 5000 BCE, agriculscale invasions by their island setting and also because culture in part because they were protected from largedevelop an unusually sophisticated hunting-gathering duced during this time. Jomon people were able to cord-marked patterns found on much of the pottery pro-The Jomon period (c. 12,000-300 BCE) is named for the

Jomon ceramics may have begun in imitation of reed baskets, as many early examples suggest. Other early Jomon pots have pointed bottoms. Judging from the burn marks along the sides, they must have been planted firmly into soft earth or sand, then used for cooking. Applying fire to the sides rather than the bottom allowed the vessels to heat more fully and evenly. Still other early

PARALLELS

Years	<u>Period</u>	J <u>apan</u>	World
с. 12,000-300 все	Jomon	Hunting and gathering; beginning of agriculture; decorated ceramic vessels; <i>dogu</i> figures	c. 12,000–300 BCE End of Ice Age in Europe; plants and animals domesticated (Near East, Southeast Asia, the Americas); development of metallurgy (Near East); development of writing (China, India); Great Pyramids at Giza (Egypt); Shang dynasty (China); Olmec civilization (Mesoamerica); birth of Siddhartha Gautama, founder of Buddhism (Nepal); Parthenon (Greece); Alexander the Great (Greece) conquers Persia
с. 300 все-300 се	Yayoi	Class structure; bronze tools and weapons; ironworking	C. 300 BCE-300 CE Roman unification of Italy; Han dynasty (China); Great Wall (China); crucifixion of Jesus (Jerusalem); Emperor Augustus (Italy); Buddhism in China; <i>Ramayana</i> epic (India); Maya civilization (Mesoamerica)
c. 300-552 ce	Kofun	Centralization of government; haniwa figures; Shintoism	c. 300–800 CE First Gupta dynasty (India); Christianity becomes official religion of Roman Empire; Attila the Hun (Mongolia); first Hindu temples (India); birth of Muhammad, founder of Islam (Arabia); Hagia Sophia (Turkey); Muslim conquests; Tang dynasty (China); Koran (Arabia); Beowulf (England); first block-print text (China); Charlemagne made emperor of the West
с. 552–646 се	Asuka	Buddhism; influx of writing and other culture from China and Korea; Horyu-ji	
с. 646–794 се	Nara	First permanent capital at Nara; Todai-ji; first histories and poetry collections; golden age of Buddhist painting; capital moved to Kyoto	
с. 794–1185 се	Heian	Lady Murasaki's <i>Tale of Genji</i> ; Esoteric Buddhism and Pure Land Buddhism arise; Byodo-in; development of Japanese writing system	c. 800–1400 CE Bronze casting in South America; <i>Diamond Sutra</i> (China); first Viking colony in Greenland; the Crusades; Jenghiz Khan rules Mongols; Renaissance begins in Europe; Black Death in Europe; Chaucer's <i>Canterbury Tales</i> (England)
с. 1185–1392 се	Kamakura	Rise of Minamoto and Taira clans; Pure Land Buddhism dominates; raigo; Zen Buddhism arises	

use of the tactile quality of clay, bending and twisting it as well as **incising** and applying designs. They favored asymmetrical shapes, although certain elements in the geometric patterns are repeated. Some designs may have had specific meanings, but the lavishly creative vessels also display a playful artistic spirit. Rather than working toward practical goals (such as better firing techniques or more useful shapes), the Jomon potters seem to have been simply enjoying to the full their imaginative vision.

The people of the middle and late Jomon period also used clay to fashion small human figures. These figures

were never fully realistic but rather were distorted into fascinating shapes. Called *dogu*, they tend to have large faces, small arms and hands, and compact bodies. Some of the later *dogu* seem to be wearing round goggles over their eyes. Others have heart-shaped faces. One of the finest, from Kurokoma, has a face remarkably like a cat's (fig. 11-3). The slit eyes and mouth have a haunting quality, as does the gesture of one hand touching the chest. The marks on the face, neck, and shoulders suggest tattooing and were probably incised with a bamboo stick. The raised area behind the face may indicate a Jomon hairstyle.

bells. Iron knives were developed later in this period, eventually replacing stone tools in everyday life.

Yayoi people lived in thatched houses with sunken floors and stored their food in raised granaries. The granary architecture, with its use of natural wood and thatched roofs, reveals the Japanese appreciation of natural materials, and the style of these raised granaries persisted in the architectural designs of shrines in later centuries (see fig. 11-1).

entered daily life. first used for ceremonial purposes in Japan and later proved kilns. Their new form of gray-green pottery was ing their knowledge of finishing techniques and im-Korean potters came to Japan in the fifth century, bringits of the dead and to serve them in their next life. Many large amounts of pottery, presumably to pacify the spirgoods were placed inside the tomb chambers, including structed following Korean examples. Various grave dess. When an emperor died, chamber tombs were convery rarely, empress) with deities such as the sun godin Japan, this system eventually equated the emperor (or, beginnings of an imperial system. Still in existence today social order, the veneration of leaders grew into the were built then. With the emergence of a more complex "old tombs," period, named for the large royal tombs that came more pronounced during the ensuing Kofun, or The trend toward centralization of government be-

The Japanese government has never allowed the major sacred tombs to be excavated, but much is known about the mortuary practices of Kofun era Japan. Some of the huge tombs of the fifth and sixth centuries were constructed in a shape resembling a large keyhole and surrounded by moats dug to preserve the sacred land from commoners. Tomb sites might extend over more than 400 acres, with artificial hills built over the tombs themselves. On the top of the hills built over the tombs called haniwa were placed.

The first haniwa were simple cylinders that may have held jars with ceremonial offerings. Gradually these cylinders came to be made in the shapes of ceremonial objects, houses, and boats. Still later, living creatures were added to the repertoire of haniwa subjects, including birds, deer, dogs, monkeys, cows, and horses. Fining birds, deer, dogs, monkeys, cows, and chorses. Finmales and females of all types, professions, and classes males and females of all types, professions, and classes (fig. 11-4).

Haniwa illustrate several enduring characteristics of Japanese aesthetic taste. Unlike Chinese tomb ceramics, which were often beautifully glazed, haniwa were left unglazed to reveal their clay bodies. Nor do haniwa show the interest in technical skill seen in Chinese ceramics. Instead, their makers explored the expressive potentials of simple and bold form. Haniwa shapes are mever perfectly symmetrical; the slightly off-center placement of the eye slits, the irregular cylindrical bodies, and the unequal arms give them great life and individuality. No one knows what purpose haniwa served. The popular theory that they were intended as tomb guardians is weakened by their origin as cylinders and by the irregular cylinders and by the particular congines.

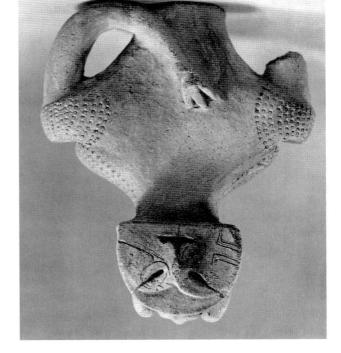

11-3. Dogu, from Kurokoma, Yamanashi Prefecture. Jomon period, c. 2000 Bce. Low-fired earthenware, height 10" (25.2 cm). Tokyo National Museum

The purpose of Jomon dogu remains unknown, but most scholars believe that they were effigies, figures representing the owner or someone else, and that they manifested a kind of sympathetic magic. Jomon people may have believed, for example, that they could transfer an illness or other unhappy experience to a dogu, then break it to destroy the misfortune. So many of these figures were deliberately broken and discarded that this theory has gained acceptance, but dogu may have had different functions at different times. Regardless of their purpose, the images still retain a powerful sense of magic thousands of years after they were created.

Yayoi and Kofun Periods

During the Yayoi (300 BCE–300 CE) and Kofun (300–552 CE) eras, several features of Japanese culture became firmly established. Most important of these was the transformation of Japan into an agricultural nation, with rice cultivation becoming widespread. This momentous change was stimulated by the arrival of immigrants from Korea, who brought with them more complex forms of society and government.

As it did elsewhere in the world, the shift from hunting and gathering to agriculture brought profound social changes, including larger permanent settlements, the division of labor into agricultural and nonagricultural tasks, more hierarchical forms of social organization, and a more centralized government. The emergence of a class structure can be dated to the Yayoi period, as can the development of metal technology. Bronze was used to create weapons as well as ceremonial objects such as to create weapons as well as ceremonial objects such as

_

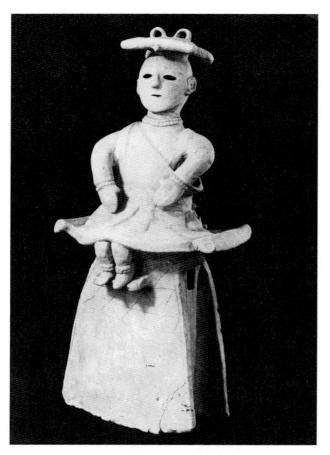

11-4. Haniwa, from Kyoto. Kofun period, 6th century ce. Earthenware, height 27" (68.5 cm). Tokyo National Museum

There have been many theories as to the function of haniwa. The figures seem to have served as some kind of link between the world of the dead, over which they were placed, and the world of the living, from which they could be viewed. This figure has been identified as a seated female shaman, wearing a robe, belt, and necklace and carrying a mirror at her waist. In early Japan, shamans acted as agents between the natural and the supernatural worlds, just as haniwa figures were links between the living and the dead

represent every aspect of Kofun period society. They may also reflect some of the beliefs of Shinto.

Shinto is often described as the indigenous religion of Japan, but whether it was originally a religion in the usual sense of the word is debatable. Perhaps Shinto is most accurately characterized as a loose confederation of beliefs in deities (kami). These kami were thought to inhabit many different aspects of nature, including particularly hoary and magnificent trees, rocks, waterfalls, and living creatures such as deer. Shinto also represents the ancient beliefs of the Japanese in purification through ritual use of water. Later, in response to the arrival of Buddhism in the sixth century CE, Shinto became somewhat more systematized, with shrines, a hierarchy of deities, and more strictly regulated ceremonies. Nevertheless, even today in many parts of Japan a torii, or wooden gateway, is the only sign that a place is sacred. Nature itself, not the gateway, is venerated.

One of the great Shinto monuments is the shrine at Ise (see fig. 11-1). Features typical of Shinto architecture include wooden piles raising the building off the ground, a thatched roof held in place by horizontal logs, the use of unpainted cypress wood, and the overall feeling of natural simplicity rather than overwhelming size or elaborate decoration. Only members of the imperial family and a few Shinto priests are allowed inside the fourfold enclosure housing the sacred shrine. The shrine in turn houses the three sacred symbols of Shinto—a sword, a mirror, and a jewel. This structure, which still preserves some features of Yayoi era granaries, is the one rebuilt every twenty years.

PERIOD

ASUKA Japan has experienced several periods of intense cultural transformation. Perhaps the greatest time of change was the be-

ginning of the Asuka period (552-646 ce). During a single century, philosophy, medicine, music, foods, clothing, agricultural methods, city planning, and arts and architecture were introduced into Japan from Korea and China. The three most significant introductions, however, were Buddhism, a centralized governmental structure, and a system of writing. Each was adopted and gradually modified to suit Japanese conditions, and each proved an enduring heritage.

Buddhism reached Japan in Mahayana form, with its many buddhas and bodhisattvas (see "Buddhism," page 371). After being accepted by the imperial family, it was soon adopted as a state religion. Buddhism represented not only different gods but an entirely new concept of religion itself. Where Shinto had found deities in beautiful and imposing natural areas, Buddhist worship was focused in temples. At first this change must have seemed strange, for the Chinese-influenced architecture and elaborate iconography introduced by Buddhism (see "Buddhist Symbols," opposite) contrasted sharply with the simple and natural aesthetics of earlier Japan. Yet Buddhism offered a rich cosmology with profound teachings of meditation and enlightenment. Moreover, the new religion was accompanied by many highly developed aspects of continental culture, including new methods of painting and sculpture.

The most significant surviving early Japanese temple is Horyu-ji, located on Japan's central plains not far from Nara. The temple was founded in 607 cE by Prince Shotoku (574-622 cE), who ruled Japan as a regent and became the most influential early proponent of Buddhism. Rebuilt after a fire in 670, Horyu-ji is the oldest wooden temple in the world. It is so famous that visitors are often surprised at its modest size. Yet its just proportions and human scale, together with the artistic treasures it contains, make Horyu-ji an enduringly beautiful monument to the early Buddhist faith of Japan.

The main compound of Horyu-ji consists of a rectangular courtyard surrounded by covered corridors, one of which contains a gateway. Within the compound are only two buildings, the kondo, or golden hall, and a fivestory pagoda. The simple layout of the compound is

ed earlobes, and theusand-spoked

Mandala

Mandalas are diagrams of cosmic realms, representing order and meaning within the spiritual universe. They may be simple or complex, three- or two-dimensional—as in an Indian stupa (see fig. 9-7) or a hanging scroll—and they assume a wide array of forms. The Womb World mandala, an early Japanese type used for meditation, depicts and symbolizes different aspects of "buddha nature." One is shown in figure 11-9

double, a representation of nirvana.

Chakra
An ancient sun symbol, the wheel (chakra) symbolizes both the various states of existence (the Wheel of Life)

(chakra) symbolizes both the various states of existence (the Wheel of Life) of the Law). A chakra's exact meaning of the Law). A chakra's exact meaning

Marks of a buddha

A buddha is distinguished by thirty-two physical attributes (*lakshanas*). Among them are a bulge on top of the head (*ushnisha*), a tuft of hair between the eyebrows (*usna*), elongat-

BUDDHIST A few of the most imsortant Buddhist symportant Buddhist symbottomic beautiful be

bols, which have myriad variations, are described here in their most generalized forms.

Lotus flower

Usually shown as a white water lily, the lotus (Sanskrit, padma) symbolizes spiritual purity, the wholeness of creation, and cosmic harmony. The flower's stem is an axis mundi.

Lotus throne

Buddhas are frequently shown seated on an open lotus, either single or

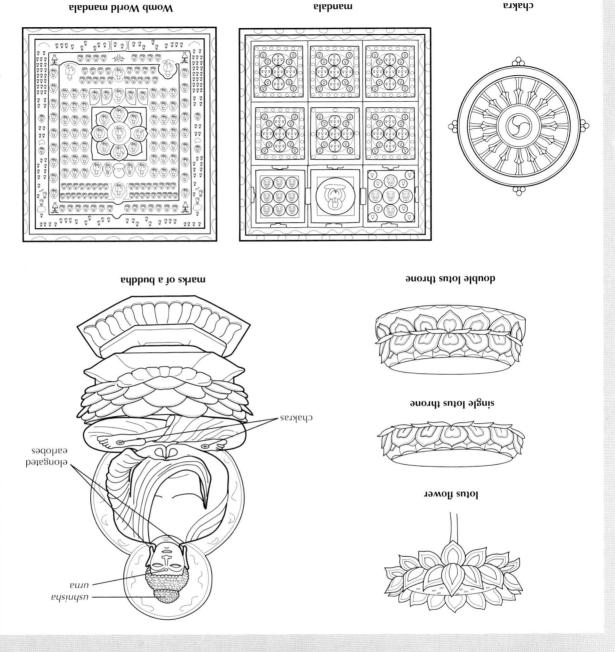

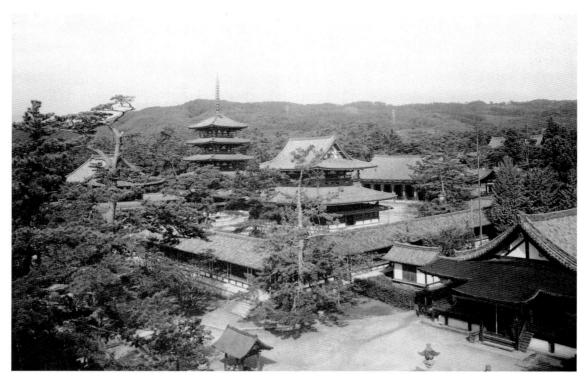

11-5. Main compound, Horyu-ji, Nara Prefecture. Asuka period, 7th century CE

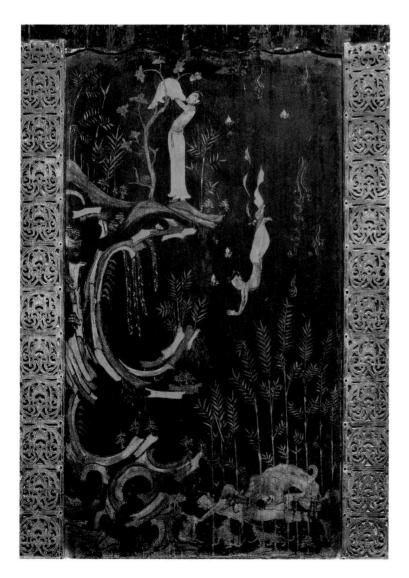

asymmetrical, yet the large *kondo* is perfectly balanced by the tall, slender pagoda (fig. 11-5). The *kondo* is filled with Buddhist images and is used for worship and ceremonies. The pagoda serves as a reliquary and is not entered. Other monastery buildings lie outside the main compound, including an outer gate, a lecture hall, a repository for sacred texts, a belfry, and dormitories for monks.

Among the many treasures still preserved in Horyuji is a miniature shrine decorated with paintings in lacquer. It is known as the Tamamushi Shrine after the
tamamushi beetle, whose iridescent wings were originally affixed to the shrine to make it glitter, much like
mother-of-pearl. There has been some debate whether
the shrine was made in Korea, in Japan, or perhaps by
Korean artisans in Japan. The question of whether it is,
in fact, a "Japanese" work of art misses the point that
Buddhism was so international at that time that matters
of nationality were irrelevant.

The Tamamushi Shrine is a replica of an even more ancient palace-form building, and its architectural details preserve a tradition predating Horyu-ji itself. Its paintings are among the few two-dimensional works of art to survive from the Asuka period. Most celebrated among them are two that illustrate jataka tales, stories about former lives of the Buddha. One depicts the future Buddha nobly sacrificing his life in order to feed his body to a starving tigress and her cubs (fig. 11-6). The tigers are at first too weak to eat him, so he must jump off a cliff to break open his flesh. The anonymous artist has

11-6. *Hungry Tigress Jataka*, panel of the Tamamushi Shrine, Horyu-ji. Asuka period, c. 650 ce. Lacquer on wood, height of shrine 7'7³/₄" (2.33 m). Horyu-ji Treasure House

seated figure height of Gilt bronze, C. 623 CE. Asuka period, .ii-uyıoH in the kondo, Shaka Triad, .inssua inoT .7-11

(mp 8.78) 341/5"

a form of compassionate idealism that is clearly exunified under an imperial system, Buddhism introduced Japanese culture. During an age when Japan was being quickly Buddhist art became an important feature of

PERIOD

NARA

pressed in its art.

Japan's first permanent imperial capital.

The Nara period (646-794) is named for

tocratic families that had traditionally dominated the that could no longer be threatened by the powerful arisrial system finally established an effective government of perhaps 200,000 people. During this period the impegrowth and consolidation. Nara swelled to a population Nara, the Japanese were able to enter a new era of longer practical. By establishing a permanent capital in Chinese-style government, however, this custom was no ly selected a new site. With the emergence of a complex, cation (and perhaps also of politics) his successor usualcapital was considered tainted, and for reasons of purifi-Previously, when an emperor died, his

today a large area of Nara is a park where numerous monasteries that dwarfed those built previously. Even construction in Nara of magnificent Buddhist temples and One positive result of strong central authority was the political world.

Another example of the international style of early spread Buddhism in Japan. Japan. These illustrations for the jataka tales helped

style largely shared during this time by China, Korea, and

trees, and bamboo represent an international Buddhist

figure and the somewhat abstract treatment of the cliff, starving animals. The elegantly slender renditions of the ward onto the rocks, and finally he is devoured by the

First, he hangs his shirt on a tree, then he dives downby the curves of the rocky cliff and tall sprigs of bamboo.

ful form of the Buddha appears three times, harmonized

created a full narrative within a single frame. The grace-

Shaka Triad and the Tamamushi Shrine reveal how of the figures shows his advanced technical skill. The earlier continental models, while the fine bronze casting drapery all suggest that Tori Busshi was well aware of outsized face and hands, and the linear treatment of the ern Wei dynasty (see fig. 10-12). The frontal pose, the reflects the strong influence of Chinese art of the Northinflux of craftspeople and artists. The Shaka Triad father had emigrated to Japan from China as part of an Busshi was a third-generation Japanese, whose grandname for Shakyamuni, the historical Buddha.) Tori Triad, by Tori Busshi (fig. 11-7). (Shaka is the Japanese Buddhist art at Horyu-ji is the sculpture called the Shaka

900 CE 2600 BCE 1400 CE temples preserve magnificent Nara period art and architecture. The grandest of these temples, Todai-ji, is so large that the area surrounding only one of its pagodas could accommodate the entire main compound of Horyu-ji. When it was built, and for a thousand years thereafter, Todai-ji was the largest wooden structure in the world. The park area of Nara also contains a number of other splendid temples, but not all the monuments of Nara are Buddhist. There are several Shinto shrines, and deer wander freely, reflecting Japan's Shinto heritage.

Buddhism and Shinto have coexisted quite comfortably in Japan over the ages. One seeks enlightenment, the other purification, and since these ideals did not clash, neither did the two forms of religion. Although there were occasional attempts to promote one over the other, more often they were seen as complementary, and to this day most Japanese see nothing inconsistent about having Shinto weddings and Buddhist funerals.

While Shinto became more formalized during the Nara period, Buddhism advanced to become the single most significant element in Japanese culture. One important method for transmitting Buddhism in Japan was through the copying of Buddhist sacred texts, the sutras. They were believed to be so beneficial and magical that occasionally a single word would be cut out from a sutra and worn as an amulet. Someone with hearing problems, for example, might use the word for "ear."

Copying the words of the Buddha was considered an effective act of worship by the nobility; it also enabled Japanese courtiers as well as clerics to become familiar with the Chinese system of writing—with both secular and religious results. During this period, the first histories of Japan were written, strongly modeled upon Chinese precedents, and the first collection of Japanese poetry, the *Manyoshu*, was compiled. The *Manyoshu* includes Buddhist verse, but the majority of the poems are secular, including many love songs in the five-line tanka form such as this example by the late-seventh-century courtier Hitomaro (all translations from Japanese are by Stephen Addiss unless otherwise noted):

Did those who lived in past ages lie sleepless as I do tonight longing for my beloved?

Unlike the poetry, most other art of the Nara period is sacred, with a robust splendor that testifies to the fervent belief and great energy of early Japanese Buddhists. Some of the finest Buddhist paintings of the late seventh century were preserved in Japan on the walls of the golden hall of Horyu-ji until a fire in 1949 defaced and partially destroyed them. Fortunately, they had been thoroughly documented before the fire in a series of color photographs. These murals represent what many scholars believe to be the golden age of Buddhist painting, an era that embraces the Tang dynasty in China (618–907 CE), the United Silla period in Korea (668–935 CE), and the Nara period in Japan.

11-8. Amida Buddha, fresco in the kondo, Horyu-ji. Nara period, c. 700 ce. Ink and colors (now severely damaged), 10'3" x 8'6" (3.13 x 2.6 m)

One of the finest of the Horyu-ji murals is thought to represent Amida (Amitabha in Chinese and Sanskrit), the Buddha of the Western Paradise (fig. 11-8). Delineated in the thin, even brushstrokes known as iron-wire lines, Amida's body is rounded, his face is fully fleshed and serene, and his hands form the "revealing the Buddhist law" mudra (see "Mudras," page 380). Instead of the somewhat abstract style of the Asuka period, there is now a greater emphasis on realistic detail and body weight in the figure. The parallel folds of drapery show the enduring influence of the Gandharan style current in India 500 years earlier (see fig. 9-12), but the face is fully East Asian in contour and spirit.

The Nara period was an age of great belief, and Buddhism permeated the upper levels of society. Indeed, one of the few empresses in Japanese history wanted to cede her throne to a Buddhist monk. Her advisers and other influential courtiers became extremely worried, and they finally decided to move the capital away from Nara, where they felt Buddhist influence had become overpowering. The move of the capital to Kyoto marked the end of the Nara period.

HEIAN PERIOD

The influences from China and Korea were fully absorbed and transformed by the Japanese during the Heian period

(794–1185). Generally peaceful conditions contributed to a new air of self-reliance on the part of the Japanese. Ties to China were severed in the mid-ninth century, and the imperial government was sustained by support from aristocratic families. An efficient method of writing the Japanese language was developed, and the rise of vernacular literature generated such masterpieces as the

11-9. Womb World mandala, To-Ji, Kyoto. Heian period, late 9th century ce. Hanging scroll, colors on silk, 6' x 5'11/2" (1.83 x 1.54 m)

Mandalas are used not only in teaching but also as vehicles for practice. A monk, initiated into secret teachings, may gradually work out from the center, meditating upon and assuming the gestures of each deity in turn so that he absorbs some of the deity's powers. The monk may also recite magical phrases called mantras as an aid to meditation. The goal is to achieve enlightenment through the powers of the different forms of the Buddha. Mandalas are created in sculptural and architectural forms as well as in paintings. Their integration of the two most basic shapes, the circle and the square, is an expression of the principles of the two most basic shapes, the circle and the square, is an expression of the principles of ancient geomancy (divining by means of lines and figures) as well as Buddhist cosmology.

important. Instead, the universal Buddha (called Dainichi, "Great Sun," in Japanese) was believed to preside over the universe. He was accompanied by buddhas, bodhisattvas, and guardian deities who formed flerce counterparts to the more benign gods.

Esoteric Buddhism is hierarchical, and its deities have complex relationships to each other. Learning all the different gods and their interrelationships was assisted greatly by works of art, especially mandalas, cosmic schematic order. The Womb World mandala from To-ji, for example, is entirely filled with depictions of gods. Dainichi is at the center, surrounded by buddhas of the four directions (fig. 11-9). Other deities, including some

world's first novel, Lady Murasaki's *Tale of Genji*. During these four centuries of splendor and refinement, two major forms of religion emerged: first Esoteric, or secret, major forms and later Pure Land Buddhism.

Esoteric Buddhism

With the removal of the capital to Kyoto, the older Nara temples lost their influence. Soon two new Esoteric sects of Buddhism, named Tendai and Shingon, grew to dominate Japanese religious life. Strongly influenced by polytheistic religions such as Hinduism, Esoteric Buddhism included a daunting number of deities, each with maginacluded a daunting number of deities, each with maginal powers. The historical Buddha was no longer very call powers. The historical Buddha was no longer very

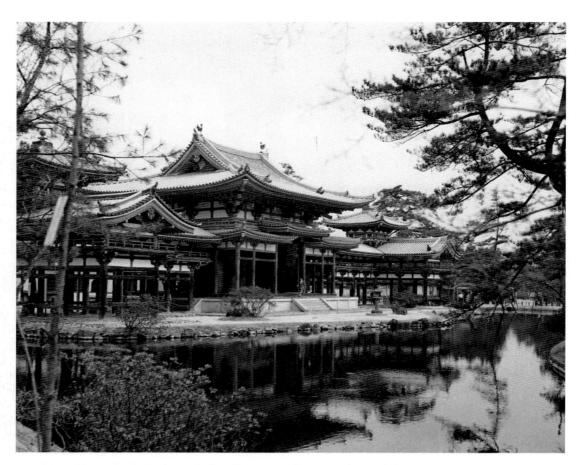

11-10. Byodo-in, Uji, Kyoto Prefecture. Heian period, c. 1053

with multiple heads and limbs, branch out in diagrammatical order, each with a specific symbol of power. To believers the mandala represents an ultimate reality beyond their visible world.

Perhaps the most striking attribute of many Esoteric Buddhist images is their sense of spiritual force and potency, especially in depictions of the wrathful deities, which are often surrounded by flames. Esoteric Buddhism, with its intricate theology and complex doctrines, was a religion for the leisured aristocracy, not for the masses. Its network of deities, hierarchy, and ritual found a parallel in the elaborate social divisions of the Heian court.

Pure Land Buddhism

During the latter half of the Heian period, a rising military class threatened the peace and tranquillity of court life. The beginning of the eleventh century was also the time for which the decline of Buddhism had been prophesied. In these uncertain years, many Japanese were ready for another form of Buddhism that would offer a more direct means of salvation than the elaborate rituals of the Esoteric sects.

Pure Land Buddhism, although it had existed in Japan earlier, now came to prominence. It taught that the Western Paradise (the Pure Land) of the Amida Buddha could be reached through nothing more than faith. In its

ultimate form, Pure Land Buddhism held that the mere chanting of a mantra—the phrase *Namu Amida Butsu* ("Hail to Amida Buddha")—would lead to rebirth in Amida's paradise. This doctrine soon swept throughout Japan. Spread by traveling monks who took the chant to all parts of the country, it appealed to people of all levels of education and sophistication. Pure Land Buddhism has remained the most popular form of Buddhism in Japan ever since.

One of the most beautiful temples of Pure Land Buddhism is the Byodo-in, located in the Uii Mountains not far from Kyoto (fig. 11-10). The temple itself was originally a secular palace created to suggest the palace of Amida in the Western Paradise. It was built for a member of the powerful Fujiwara family who served as the leading counselor to the emperor. After the counselor's death in the year 1052 the palace was converted into a temple. The Byodo-in is often called Phoenix Hall, not only for the pair of phoenix images on its roof but also because the shape of the building itself suggests the mythical bird. The lightness of its thin columns gives the Byodo-in a sense of airiness, as though the entire temple could easily rise up through the sky to the Western Paradise of Amida. The hall rests gently in front of an artificial pond created in the shape of the Sanskrit letter A, the sacred symbol for Amida.

The Byodo-in's central image of Amida, carved by the master sculptor Jocho (d. 1057), exemplifies the

308 009 BCE

the Heian period became the major medium for sculpalso reaffirmed the Japanese love of wood, which during ples constructed and dedicated to the Pure Land faith. It trayals of buddhas and bodhisattvas for the many tem-

at its most splendid. visitors to experience the late Heian period religious ideal state of preservation after more than 900 years allows awaits the fervent believer after death. Its remarkable Byodo-in was designed to suggest the paradise that some playing musical instruments. Everything about the are smaller wooden figures of bodhisattvas and angels, Surrounding the Amida on the walls of the Byodo-in

Poetry and Calligraphy

cal calligraphy quite unlike that of China. system allowed Japanese poets to create an asymmetriwith more complex Chinese characters, the new writing page 434). With its simple, flowing symbols interspersed native language (see "Writing, Language, and Culture," men and women wrote in the new kana script of their nobles continued to write many poems in Chinese, both turies, the influence from China waned. Although court equaled in Japan. Gradually over the course of four cenlar culture also arose at court that has never been While Buddhism pervaded the Heian era, a refined secu-

any man or woman at court who was not accomplished amorous interlude. Society was ruled by taste, and pity with equal elegance, he might not wish to repeat their welcome to visit her again. In turn, if she could not reply ligraphy were less than stylish, however, he would not be a single flower still wet with dew. If his words or his calloved at dawn would send her a poem wrapped around through the five-line tanka. A courtier leaving his beupon the sophisticated expression of human love was being burned. Much of court culture was centered by color, or a man for knowing which kind of incense for the way she arranged the twelve layers of her robes period aristocracy. A woman would be admired merely Refinement was greatly valued among the Heian

Gold leaf and lacquer on wood, height 9'8" (2.95 m) 11-11. Jocho. Amida Buddha, Byodo-in. Heian period, c. 1053.

nique allowed sculptors to create larger but lighter pornew joined-wood method of construction. This techlike earlier sculpture but from several blocks in Jocho's The figure was not carved from a single block of wood image seems to shimmer in its private mountain retreat. reflected in the water of the pond before it, the Amida the souls of all believers to his paradise (fig. 11-11). When serenity and compassion of the Buddha who welcomes

TECHNIQUE

in several forms of art.

SCULPTURE wood technique. Here the design for a statue Wood is a temperamental medium, as sculp- JOINED-WOOD A more effective method was the joined-

demand.

be produced with great efficiency to meet a growing became a sort of assembly line where large statues could crossed legs or lotus thrones. An artist's studio thus became specialists in certain parts, such as hands or be "farmed out" to teams of carvers, some of whom from any single block. Moreover, statue sections could sculptors could produce larger images than they could hollowed out and assembled. By using multiple blocks, carved from a separate block. These sections were then was divided into sections, each of which was

painted or lacquered, which interferes with the wood's the risk of splitting as it ages-especially if it has been A large statue carved from a single solid block thus runs the resulting shifts in tension can open up gaping cracks. gradually yields its moisture. As the core dries, however, dry thoroughly. The outside dries first, then the inside a living, sap-filled tree, it takes many years to

tors who work with it quickly learn. Cut from

natural "breathing."

al pieces, hollow them out, then fit them back together. vent cracking was to split a completed statue into sever-One strategy adopted by Japanese sculptors to pre-

WRITING, AND **CULTURE**

Chinese culture en-LANGUAGE, joyed great prestige in East Asia. Written Chinese served as an international

language of scholarship and cultivation, much as Latin did in medieval Europe. Educated Koreans, for example, wrote almost exclusively in Chinese until the fifteenth century. In Japan, Chinese continued to be used for certain kinds of writing, such as philosophical and legal texts, into the nineteenth century.

When it came to writing their own language, the Japanese initially borrowed Chinese characters, or kanji. Differences between the Chinese and Japanese languages made this system extremely unwieldy, so during the ninth century two syllabaries, or kana, were developed from simplified Chinese characters. (A syllabary is a system in which each symbol stands for a syllable.) Katakana, now generally used for foreign

words, consists of mostly angular symbols, while the more frequently used hiragana has graceful, cursive

Japanese written in kana was known as "women's hand," possibly because prestigious scholarly writing still emphasized Chinese, which women were rarely taught. Yet despite the respect for Chinese, Japan had an ancient and highly valued poetic tradition of its own, and women as well as men were praised as poets from earliest times. So while women rarely became scholars, they were often authors. During the Heian period kana were used to create a large body of literature, written either by women or sometimes for women by men.

A charming poem originated in Heian times to teach the new writing system. In two stanzas of four lines each, it uses almost all of the syllable sounds of spoken Japanese and thus almost every kana symbol. It was

memorized as we would recite our ABCs. The first stanza translates as:

Although flowers glow with color They are quickly fallen, And who in this world of ours Is free from change? (Translation by Earl Miner)

Below is the stanza written three ways. At the left, it appears in katakana glossed with the original phonetic value of each symbol. (Modern pronunciation has shifted slightly.) In the center, the stanza appears in flowing hiragana. To the right is the mixture of kanji and kana that eventually became standard. This alternating rhythm of simple kana symbols and more complex Chinese characters gives a special flavor to Japanese calligraphy. Like Chinese, Japanese is written in columns from top to bottom

and across the page from right to left.

(Following this logic, Chinese and

Japanese narrative paintings also

read from right to left.)

ツTsu-ワWa-チChi-イト ネne カka リri- ロro ナna-ヨyo ヌnu- ニni-ラra-タta-ルru ホ ho-ムmuレre ヲwoへ hekatakana hiragana kanji and kana

During the later Heian period, the finest tanka were gathered in anthologies. The poems in one famous early anthology, the Thirty-Six Immortal Poets, are still known to educated Japanese today. This anthology was produced in sets of albums called the Ishiyama-gire. These albums consist of tanka written elegantly on high-quality papers decorated with painting, block printing, scattered gold and silver, and sometimes paper collage. The page shown here reproduces two tanka by the courtier Ki no Tsurayuki (fig. 11-12). Both poems express sadness for the loss of a lover, the first lamenting:

> Until yesterday I could meet her, But today she is gone-Like clouds over the mountain She has been wafted away.

11-12. Album leaf from the Ishiyama-gire. Heian period, early 12th century. Ink with gold and silver on

decorated and collaged paper, 8 x 63/8" (20.3 x 16.1 cm). Freer Gallery of Art, Smithsonian Institution,

court into fiction in the first known novel, was written at The Tale of Genji, transposing the life-style of the Heian including diaries, mythical tales, and courtly romances. Women were noted for both their poetry and their prose,

contributed greatly to the art at the Heian court. in Japanese society was to decline in later periods, they vital force in Heian society. Although the place of women ten by women. It is sure, however, that women were a how much of the calligraphy of the time was actually writma-gire, was considered "women's hand," it is not known

Although writing in Japanese, such as in the Ishiya-

ing courtly Japanese taste.

ural imagery match the elegance of the poetry, epitomizpapers, the rich use of gold, and the suggestions of nat-The spiky, flowing calligraphy and the patterning of the

D.C., notgniidseW

11-13. Scene from *The Tale of Genji*. Heian period, 12th century. Handscroll, ink and colors on paper, 8⁵/₈ x 18⁷/₈" (21.9 x 47.9 cm). Tokugawa Art Museum, Nagoya

Twenty chapters from *The Tale of Genji* have come down to us in illustrated scrolls such as this one. Scholars assume, however, that the entire novel of fifty-four chapters must have been written out and illustrated—a truly monumental project. Each scroll seems to have been produced by a team of artists. One was the calligrapher, most likely a member of the nobility. Another was the master painter, who outlined in fine brushstrokes two or three illustrations per chapter and indicated the color scheme. Next, colorists went to work, applying layer after layer of color to build up patterns and textures. After they had finished, the master painter returned to reinforce outlines and apply the finishing touches, among them the details of the faces.

the beginning of the eleventh century by Lady Murasaki. It was written in Japanese at a time when men still wrote prose primarily in Chinese, and it remains one of Japan's—and the world's—great novels. Underlying the story of the love affairs of Prince Genji and his companions is the Japanese conception of fleeting pleasures and ultimate sadness in life, an echo of the Buddhist view of the vanity of earthly pleasures.

One of the earliest extant secular paintings from Japan is a series of scenes from The Tale of Genji, painted in the twelfth century by unknown artists in "women's hand" painting style. This style was characterized by delicate lines, strong if sometimes muted colors, and asymmetrical compositions usually viewed from above through invisible, "blown-away" roofs. The Genji paintings have a refined, subtle emotional impact. They generally show court figures in architectural settings with the frequent addition of natural elements, such as sections of gardens, that help to represent the mood of the scene. Thus a blossoming cherry tree appears in a scene of happiness, while unkempt weeds appear in a depiction of loneliness. Such correspondence between nature and human emotion is an enduring feature of Japanese poetry and art.

The figures in *The Tale of Genji* paintings do not show their emotions directly on their faces, which are simply rendered with the fewest possible lines. Instead, their feelings are conveyed by colors, poses, and the total composition of the scenes. One evocative scene portrays a seemingly happy Prince Genji holding a baby boy borne

by his wife, Nyosan (fig. 11-13). In fact, the baby was fathered by another court noble. Since Genji himself has not been faithful to Nyosan, who appears in profile below him, he cannot complain; meanwhile the true father of the child has died, unable to acknowledge his only son. The irony is even greater because Genji himself is the illegitimate son of an emperor. Thus what should be a joyful scene has undercurrents that lend it a sense of irony and sorrow.

One might expect a painting of such an emotional scene to focus on the people involved. Instead, they are rendered in rather small size, and the scene is dominated by a screen that effectively squeezes Genji and his wife into a corner. This composition deliberately represents how their positions in courtly society have forced them into this unfortunate situation. In typical Heian style Genji expresses his emotion by murmuring a poem:

How will he respond, The pine growing on the mountain peak, When he is asked who planted the seed?

The Tale of Genji scroll represents courtly life as interpreted through refined sensibilities and the "women's hand" style of painting. Heian painters also cultivated a contrasting "men's hand" style. Characterized by strong ink play and lively brushwork, it most often depicts subjects outside the court. One of the masterpieces of this style is *Frolicking Animals*, a set of scrolls satirizing the life of many different levels of society. Painted entirely in ink, the scrolls are attributed to Toba Sojo, the abbot of a

(30.5 cm). Kozan-ji, Kyoto

11-15. Detail of *Night Attack on the Sanjo Palace*. Kamakura period, late 13th century. Handscroll, ink and colors on paper,

Penollosa-Weld Collection

The battles between the Minamoto and Taira clans were fought primarily by mounted and armored warriors, who used both bows and arrows and the finest swords. In the year 1060, some 500 rebels opposed to the retired emperor Go-Shirakawa carried out a daring raid on the Sanjo Palace. In a surprise attack in the middle of the night, they abducted the emperor. The scene was one of great carnage, much of it caused by the burning of the wooden palace. Despite the drama of the scene, this was not the decisive moment in the war. The Minamoto rebels would eventually lose more important battles to their Taira enemies. In turn the Taira clan would eventually be destroyed in 1185 by the victorious Minamoto forces, heirs to those who carried out this raid.

KAMAKURA rame so engrossed in their own refinement that they neglected their responsibilities for governing the country. Clans of

their responsibilities for governing the country. Clans of warriors—samurai—from outside the capital grew increasingly strong. Drawn into the factional conflicts of the imperial court, these samurai leaders soon became the imperial court, these samurai leaders soon became

creasingly strong. Drawn into the factional conflicts of the imperial court, these samurai leaders soon became the real powers in Japan.

The two most powerful warrior clans were the Minamoto and the Taira, whose battles for domination became famous not only in medieval Japanese history

The two files bowcht warner claris were the manner and the Taira, whose battles for domination became famous not only in medieval Japanese history but also in literature and art. One of the great painted handscrolls depicting these battles is Night Altack on the Sanjo Palace (fig. 11-15). Painted perhaps a hundred years after the actual event, the scroll conveys a sense of eyewitness reporting even though the anonymous artist

Buddhist temple, and they represent the humor of Japanese art to the full.

In one scene, a frog is seated as a buddha upon an altar while a monkey dressed as a monk prays proudly to him; in other scenes frogs, donkeys, foxes, and rabbits are shown playing, swimming, and wrestling, with one frog boasting of his prowess when he flings a rabbit to the ground (fig. 11-14). Playful and irreverent though it may be, the quality of the painting is remarkable. Each line is brisk and lively, and there are no strokes of the brush other than those needed to depict each scene. Unlike the Cenji scroll, there is no text to Prolicking Animals, and we must make our own interpretations of the people and events being satirized. Nevertheless, the visual humor is so livebeing satirized. Mevertheless, the visual humor is so livebeing satirized. Wevertheless, the visual humor is so livebeing satirized.

ARMS AND ARMOR

Battles such as the one depicted in Night Attack on the

Sanjo Palace (see fig. 11-15) were fought largely by archers on horseback. Samurai archers charged the enemy at full gallop and loosed their arrows just before they wheeled away. The scroll clearly shows their distinctive bow, with its asymmetrically placed handgrip. The lower portion of the bow is shorter than the upper so it can clear the horse's neck. The samurai wear a long, curved sword at the waist.

By the tenth century, Japanese swordsmiths had perfected techniques for crafting their legendarily sharp swords. Sword makers face a fundamental difficulty: steel hard enough to hold a razor-sharp edge is brittle and breaks easily, but steel tough enough to withstand rough use is too soft to hold a keen edge. The Japanese ingeniously forged a blade from up to four strengths of steel, cradling a hard cutting edge in a softer, tougher support.

Samurai armor, illustrated here, was made of overlapping iron and lacquered leather scales, punched with holes and laced together with leather thongs and brightly colored silk braids. The principal piece wrapped around the chest, left side, and back. Padded shoulder straps hooked it back to front. A separate piece of armor was tied to the body to protect the right side. The upper legs

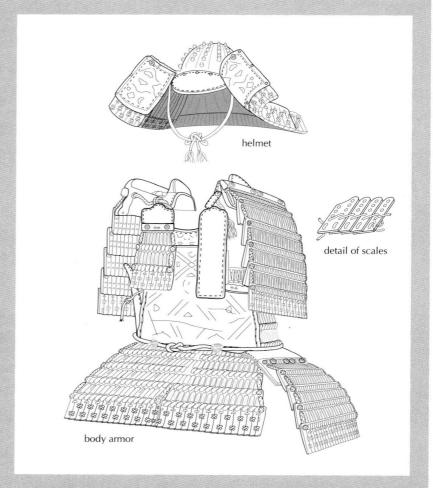

were protected by a skirt of four panels attached to the body armor, while two large rectangular panels tied on with cords guarded the arms. The helmet was made of iron plates rivet-

ed together. From it hung a neckguard flared sharply outward to protect the face from arrows shot at close range as the samurai wheeled away from an attack.

had to imagine the scene from verbal (and at best semi-factual) descriptions. The style of the painting includes some of the brisk and lively linework of *Frolicking Animals* and also traces of the more refined brushwork, use of color, and bird's-eye viewpoint of *The Tale of Genji* scroll. The main element, however, is the savage depiction of warfare (see "Arms and Armor," above). Unlike the Genji scroll, *Night Attack* is full of action: flames sweep the palace, horses charge, warriors behead their enemies, court ladies try to hide, and a sense of energy and violence is conveyed with great sweep and power. The era of poetic refinement was now over in Japan, and the new world of the samurai began to dominate the secular arts.

The Kamakura era (1185–1392) began when Minamoto Yoritomo (1147–1199) defeated his Taira rivals and assumed power as shogun (general-in-chief). In order to resist the softening effects of courtly life in Kyoto, he established his military capital in Kamakura. While

paying respects to the emperor, Yoritomo kept both military and political power for himself. He thus began a tradition of rule by shogun that lasted in various forms until 1868.

Pure Land Buddhist Art

During the early Kamakura period, Pure Land Buddhism remained the most influential form of religion. As noted earlier, it had been spread throughout the country by traveling monks who taught the chant *Namu Amida Butsu*. One of these monks, Kuya (903–972), encouraged people to chant by going through the countryside and singing such simple ditties as:

I've heard it said that Paradise is very far, But anyone who tries Can surely get there.

11-16. Kosho. Ku*ya Preaching.* Kamakura period, before 1207. Painted wood, height 46¹/4" (117.5 cm). Rokuhara Mitsu-ji, Kyoto

Kosho's solution to putting words into sculptural form was simple but brilliant (fig. 11-16). He carved six small buddhas emerging from Kuya's mouth, one for each of the six syllables *Na-mu-A-mi-da-Buts*(u) (the final u is not articulated). Believers would have understood that these six small buddhas embodied the Pure Land chant of traveling clothes, the small gong, the staff topped by deer horns, and especially the sweetly intense expression of Kuya give this sculpture a radiant sense of faith.

Pure Land Buddhism taught that even one sincere invocation of the sacred chant could lead the most wicked sinner to the Western Paradise. Paintings called raigo (literally "welcoming approach") were created depicting the Amida Buddha, accompanied by bodhisattwas, coming down to earth to welcome the soul of the dying believer. Golden cords were often attached to these paintings, which were taken to the homes of the dying. A person near death held onto these cords, hopings and a proposition of the paradise.

Even if chanting The name of Amida only once, A person cannot fail To reach the Lotus Land.

Kuya was depicted in sculpture by Kosho in the early thirteenth century. A son of the more famous sculptor Unkei, Kosho was a master in the new **naturalistic** style that evolved at this time. Just as the *Night Attack* revealed ors and forceful style, Kamakura era portraiture also saw a new emphasis on **realism**, including the use of crystal eyes in sculpture for the first time. Perhaps the warriors had a taste for realism, for many sculptors and painters of the Kamakura period became expert in depicting of the Kamakura period became expert in depicting taces, forms, and drapery with great attention to naturalistic detail. Kosho took on the more difficult task of representing in three dimensions not only the person of the famous monk Kuya but also his chant.

1400 CE 2600 BCE 1400 CE

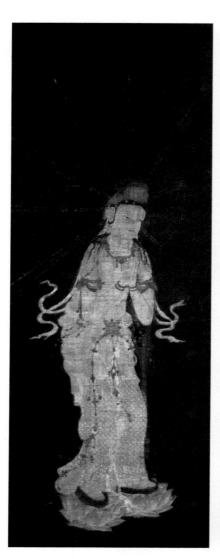

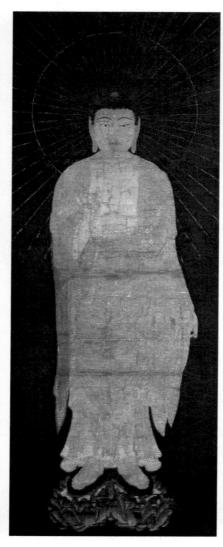

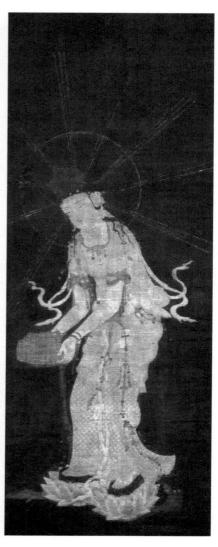

11-17. Descent of the Amida Trinity, raigo triptych. Kamakura period, late 13th century. Ink and colors with cut gold on silk; each scroll 54 x 19³/₄" (137.2 x 50.2 cm). The Art Institute of Chicago Kate S. Buckingham Collection, 1929.857

Raigo paintings are quite different in style from the complex mandalas and fierce guardian deities of Esoteric Buddhism. Like Jocho's sculpture of Amida at the Byodoin, they radiate warmth and compassion. One magnificent raigo, a set of three paintings, portrays Amida Buddha descending to earth with two bodhisattvas to welcome the soul of a dying believer (fig. 11-17). They have been portrayed not only with gold paint but also with slivers of gold leaf cut in elaborate patterning to suggest the radiance of their draperies. The sparkle of the gold over the figures is heightened by the darkening of the silk behind them, so that the deities seem to come forth from the surface of the painting. In the flickering light of oil lamps and torches, raigo paintings would have glistened and gleamed in magical splendor in a temple or a dying person's home.

In every form of Buddhism paintings and sculpture became vitally important elements in religious teaching and belief. In their own time they were not considered works of art but rather visible manifestations of belief.

The Introduction of Zen

Toward the latter part of the Kamakura period still another type of Buddhism appeared, the last major form to reach Japan. This was Zen. In some ways, Zen resembles the original teachings of the historical Buddha in stressing that individuals must reach their own enlightenment through meditation, without the help of deities or magical chants. It was very different from both Esoteric and Pure Land Buddhism, and the time was ripe in Japan for a new approach to age-old Buddhist truths.

Zen had already been highly developed in China for some time, but it had been slow to reach Japan because of the severing of relations between the two countries during the Heian period. During the Kamakura era, however, relations with China were reestablished. Zen was brought to Japan by both visiting Chinese and returning Japanese monks. It appealed to the self-disciplined spirit of the warriors, who were not satisfied with the older forms of Buddhism connected with the Japanese court.

with everyday people, however. Pure Land Buddhism remained the most popular form

of art. This sense of intense activity within daily life, rather than merely sitting back and enjoying it as a work needle. We are drawn into the activity of the painting his eyes, which then lead us out to his hand pulling the the position of the darker robe, focuses our attention on humorous compression of the monk's face, coupled with of Kao, it has the blunt style, strong sense of focus, and spirit. We can see this style in a remarkable ink portrait early Zen temple was a pioneer in the kind of rough and rather than in larger cities. An abbot named Kao at an Zen temples were usually built in the mountains

Buddhist prelates of other sects undoubtedly had subject, is a feature of the best Zen figure paintings. involving the viewer directly with the painter and the visual intensity of the finest Zen paintings. The almost of a monk sewing his robe (fig. 11-18). Bearing the seals simple ink painting that so directly expresses the Zen

dominate many aspects of Japanese culture. assistants to take care of such mundane tasks as repair-

Japan is famous for its imperial system, but for most toward the end of the fourteenth century Zen began to self-reliance appealed especially to samurai. As a result, ble for their lives as for their enlightenment. This spirit of own food, clean their temples, and are held as responsifrom wealthy believers. Zen monks grow and cook their no need to depend on contributions from the court or This principle extends to the entire monastery. There is how advanced, is expected to do all tasks for himself. ing a robe, but in Zen Buddhism each monk, no matter

Zen aesthetics had become established as the leading the seeds of the future were planted: warrior control and forms for 500 more years. As the Kamakura era ended, military was reaffirmed, and it was to last in various had reverted to the shogun. Control of government by the could not control events, however, and by 1392 power 1333 and assume full power. His loyalist movement who managed to overthrow the Kamakura shogunate in these ambitious sovereigns was Go-Daigo (1288-1339), decided to attempt to hold true power himself. One of sonally sacrosanct. Occasionally, however, an emperor they did not rule politically allowed them to remain pertained their social and cultural authority, the fact that division of power. While the emperors always mainargued that the imperial system survived because of this regents, powerful ministers, or shoguns. It could be of its history emperors were under the political control of

forces in Japanese life and art.

(83.5 x 35.4 cm). The Cleveland Museum of Art period, early 14th century. Ink on paper, 327/8 x133/4" 11-18. Attributed to Kao. Monk Sewing. Kamakura

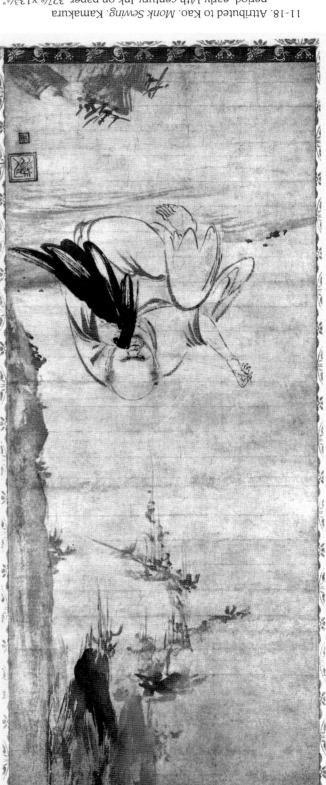

▲ FORMATIVE/PRECLASSIC PERIOD C. 1500 BCE-250 CE

▲ OLMEC c. 1200-400 BCE

▲ CHAVIN DE HUANTAR C. 800-200 BCE

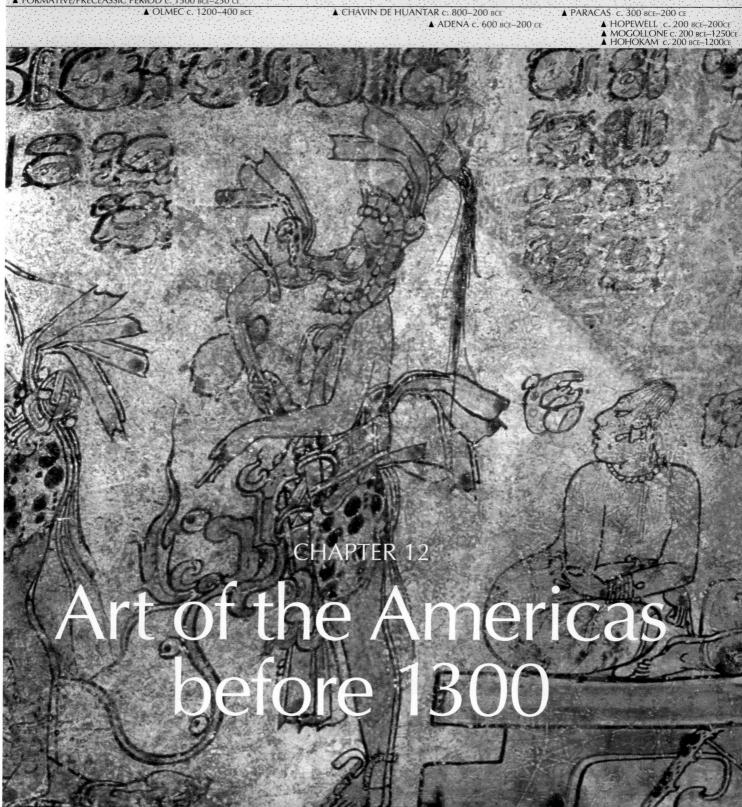

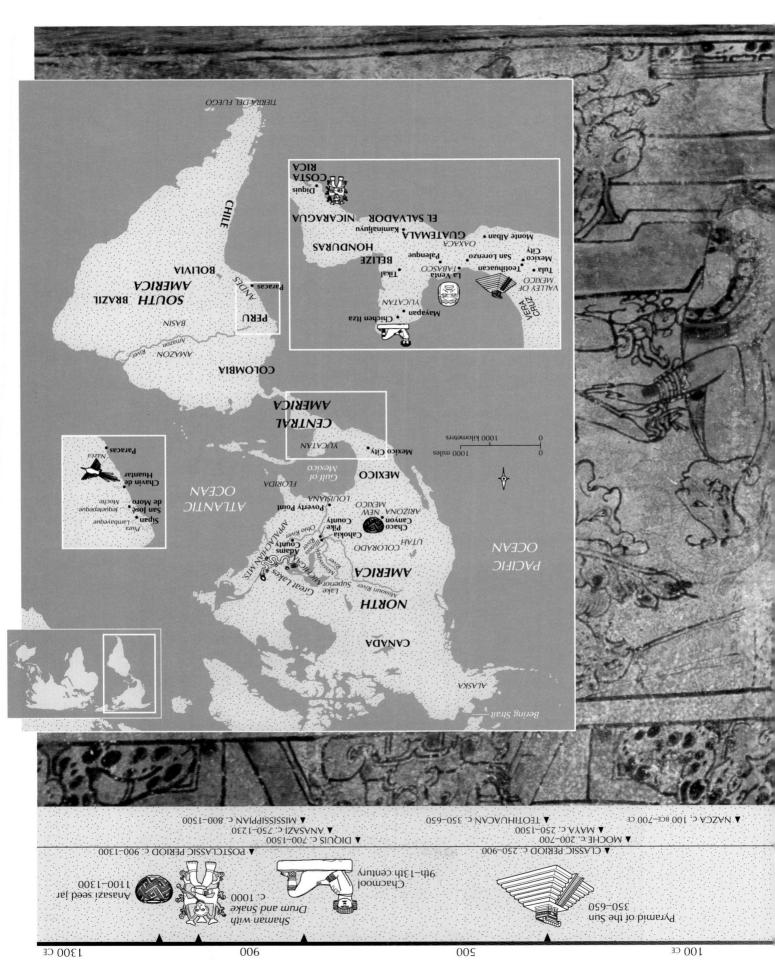

Wangard Co. Co.

12-1. Great Serpent Mound, Adams County, Ohio. Adena culture, c. 600 BCE-200 CE. Length approx. 1,254' (382.5 m)

hen the boldest of the white settlers in North America pushed beyond the Appalachian Mountains, they literally walked into a mystery. They found themselves facing, and in some cases climbing over, strange mounds of earth, large and small, that clearly had been created by human hands—a great many hands. The mounds took various forms. Some were shaped like birds and other animals. One, in present-day Ohio, a writhing earthen snake 1,254 feet long and 20 feet wide, meandered along the crest of a ridge overlooking a stream, with its head at the highest point of the ridge (fig. 12-1). The mounds were most concentrated near the Mississippi and Ohio rivers, but at least a few were found throughout the very wide area from the Great Lakes to the Gulf Coast.

The eighteenth-century settlers began to dig around in the mounds—sometimes to sate curiosity, sometimes to seek treasure, sometimes simply to plant their crops. What they found further puzzled them. Some mounds covered piles of refuse from permanent agricultural villages where none had been known to exist. Others were burial sites where human skeletons had been interred with carved artifacts unlike any seen before, sometimes made from materials not native to the area. Theories abounded about the creators of these mounds—including speculations that they had been survivors from the lost island of Atlantis or one of the lost tribes of Israel. Before he became president, Thomas Jefferson had excavated a burial mound in Virginia and had come close to the truth: that these monumental earthworks, in fact, were 3,000-year-old creations of the earliest peoples to settle the New World.

edge as fine as surgical steel. Native Americans were obsidian, a volcanic glass capable of holding a cutting as bone, ivory, stone, wood, and, where it was available, eral made tools and weapons from such other materials in the first millennium cE, but Native Americans in gento produce metal weapons and agricultural implements ver, and copper jewelry. The smiths of the Andes began an advanced metallurgy and produced exquisite gold, silmatics. Central and South American peoples developed accurate calendar, and a sophisticated system of mathe-Central America—developed writing, a complex and the region that extends from central Mexico to northern exploiting its potential. The peoples of Mesoamerica they lacked beasts of burden like horses and oxen for potter's wheel or the wheel in general, perhaps because ticated ceramic wares, although they did not develop the and splendor. New World civilizations produced sophis-Valley of Mexico rivaled those of the Old World in size

Southwest. river valleys of North America, and the North American South America, the southeastern woodlands and great Mesoamerica, Central America, the central Andes of ments of some of the cultures in five of those regions the Americas. This chapter explores the accomplishartistic traditions already flourished in many regions in more familiar today, but before 1300 ce extraordinary Pueblo of the North American Southwest are perhaps Later civilizations such as the Aztec, Inca, and

ing that produced some of the world's finest textiles (see

2000 BCE, they developed an enduring tradition of weavskilled in basketry, and in the Andes, beginning about

Mexico (the location of Mexico City) the area from north of the Valley of Ancient Mesoamerica encompasses

based on interlocking 260-day and 365-day cycles, a their common features are a complex calendrical system trade and displayed an overall cultural unity. Among arose in Mesoamerica varied, but they were linked by Reflecting this physical diversity, the civilizations that ranging from tropical rain forest to semiarid mountains. Central America. The region is one of great contrasts, to modern Belize, Honduras, and western Nicaragua in

often sacrificed.

play the game, and players were

warriors might have been made to

also associated with warfare. Captive

of the players. The ball game was held aloft and directed by the skill

bodies-the sun, moon, or stars-

ment of the ball represented celestial

sented in relief sculpture. The move-

and its attendant rituals were repre-

on stone votive sculpture; the game

ednibment, appear as figurines and

american art. Players, complete with

periodically trapped enough of the about 2.5 million years ago, glaciers During the last Ice Age, which began

MORLD **LHE NEM**

groves of scrub willow provided food and shelter for anisand miles wide, where grasses, sagebrush, sedge, and extent, this land bridge was a vast, rolling plain a thouland between Asia and North America. At its greatest world's water to lower the level of the oceans and expose

mals and birds.

Although most areas of present-day Alaska and

Eurasia until they were overrun by European conquerors were essentially cut off from the peoples of Africa and Bering Strait, the peoples of the Western Hemisphere ice had retreated and rising oceans had flooded the contact between Siberia and Alaska continued after the ern end of South America by 11,000 years ago. Although earliest uncontested evidence puts humans at the southspearheads traveled across most of North America. The whose tool kits included sophisticated fluted-stone tween 10,000 and 12,000 years ago, bands of hunters spread out into two vast, uninhabited continents. Begatherers emerged through this corridor and began to early as 20,000 to 30,000 years ago, Paleolithic hunter-Sometime before about 12,000 years ago, perhaps as narrow, ice-free corridor provided access to the south. Canada were covered by glaciers during the Ice Age, a

of the Old World, dogs. alpacas, guanacos, and vicuñas), and, as did the peoples turkeys, guinea pigs, llamas (and their cousins, the New World peoples also domesticated many animals: tobacco, cacao (chocolate), tomatoes, and avocados. domesticated in the New World included potatoes, vation of corn, beans, and squash. Other plants first developed an agricultural way of life, based on the cultiof the Paleolithic era elsewhere. In many regions they many of the same transformations that followed the end In this isolation New World peoples experienced

beginning in the late fifteenth century ce.

traditions. New World cities such as Teotihuacan in the architecture, and the development of elaborate artistic of ceremonial centers and towns with monumental places, the rise of hierarchical societies, the appearance was accompanied by population growth and, in some As elsewhere, the shift to agriculture in the Americas

The ritual ball game

The game had protound relicourt about 25 feet above the field. large stone rings set in the walls of the goals of the Chichen Itza court were the size of a modern football field. The ball court, at Chichen Itza, was about the goal varied. The largest surviving players on a team, and the nature of shape of the court, the number of or marker. The rules, the size and players directed the ball toward a goal

AMERICA

WESO-

"Andean Textiles," page 458).

was a common subject of Mesogious and political significance and

but not their hands—heavily padded Using their elbows, knees, or hipswith a large, solid, heavy rubber ball. played on a long, rectangular court times. The ball game was generally in antiquity, dating at least to Olmec quest, this game had its origins deep gion at the time of the Spanish conin some version throughout the reamerican society. Played CAME characteristics of Meso-BALL COSMIC was one of the defining

3HT

1100 BCE	
1500 BCF	1300 CE

PARALLELS

Period/Culture Peak Americas Paleolithic hunter-gatherers migrate to New World C. 1500 BCE-250 CE C. 1500 BCE-250 CE Formative/Preclassic period in Mesoamerica Olmec (Mesoamerica; C. 1200-400 BCE) C. 1200-400 BCE) Chavin de Huantar (Andes; Early Horizon period, c. 800-200 BCE) Adena (Ohio; c. 600 BCE-200 CE) Adena (Ohio; c. 300 BCE-200 CE) Hokokam (Arizona; C. 200 BCE-1200 CE) Hokokam (Arizona; C. 200 BCE-1200 CE) Paleolithic hunter-gatherers migrate to New World C. 1500 BCE-1200 BEF Development of metallurgy (Near East); Great Pyramids at Giza (Egypt); development of writing (China, India); earliest writing and calendars; early Maya Greece); black-figure and red-figure vase painting (Greece); birth of Siddhartha Gautama, founder of Buddhism (Nepal); Parthenon (Greece); Great Stupa at Sanchi (India); crucifixion of Jesus (Jerusalem); Pantheon (Italy) Hokokam (Arizona; Canals Canals Mound building carved law
migrate to New World Ice Age in Europe c. 1500 BCE-250 CE Formative/Preclassic period in Mesoamerica Olmec (Mesoamerica; C. 1200-400 BCE) Chavin de Huantar (Andes; Early Horizon period, c. 800-200 BCE) Adena (Ohio; c. 600 BCE-200 CE) Hokokam (Arizona; C. 200 BCE-1200 CE) Mingrate to New World Ice Age in Europe c. 1500 BCE-250 CE Development of metallurgy (Near East); Great Pyramids at Giza (Egypt); development of writing (China, India); Minoan, Mycenaean cultures (Greece); black-figure and red-figure vase painting (Greece); birth of Siddhartha Gautama, founder of Buddhism (Nepal); Parthenon (Greece); Great Stupa at Sanchi (India); crucifixion of Jesus (Jerusalem); Pantheon (Italy) Hokokam (Arizona; C. 200 BCE-1200 CE) Canals
Mesoamerica Olmec (Mesoamerica; C. 1200–400 BCE) Chavin de Huantar (Andes; Early Horizon period, c. 800–200 BCE) Adena (Ohio; c. 600 BCE–200 CE) Hokokam (Arizona; C. 200 BCE–1200 CE) Monand Lorenzo; La Venta; ritual ball games; colossal heads; earliest writing and calendars; early Maya Chavin de Huantar (Andes; Early Horizon period, c. 800–200 BCE) Mound building Chavin de Huantar (Andes; Early Horizon period, c. 800–200 BCE) Mound building Mound building Chavin de Huantar (Andes; Early Horizon period, c. 800–200 BCE) Mound building Mound building Mound building Mound building Canals Canals
Olmec (Mesoamerica; c. 1200–400 BCE) San Lorenzo; La Venta; ritual ball games; colossal heads; earliest writing and calendars; early Maya Chavin de Huantar (Andes; Early Horizon period, c. 800–200 BCE) Adena (Ohio; c. 600 BCE–200 CE) Paracas (Peru; c. 300 BCE–200 CE) Hokokam (Arizona; c. 200 BCE–1200 CE) San Lorenzo; La Venta; ritual ball games; colossal heads; early earliest writing and calendars; early Maya (Greece); black-figure and red-figure vase painting (Greece); birth of Siddhartha Gautama, founder of Buddhism (Nepal); Parthenon (Greece); Great Stupa at Sanchi (India); crucifixion of Jesus (Jerusalem); Pantheon (Italy) Canals
Chavin de Huantar (Andes; Early Horizon period, c. 800–200 BCE) Adena (Ohio; c. 600 BCE–200 CE) Mound building Meaving; embroidery Hokokam (Arizona; c. 200 BCE–1200 CE) Chavin de Huantar (Andes; Early Horizon in ceramics, metallurgy, textiles Mound building (Greece); birth of Siddhartha Gautama, founder of Buddhism (Nepal); Parthenon (Greece); Great Stupa at Sanchi (India); crucifixion of Jesus (Jerusalem); Pantheon (Italy) Canals
Adena (Ohio; c. 600 BCE–200 CE) Mound building (Greece); Great Stupa at Sanchi (India); crucifixion of Jesus (Jerusalem); Pantheon (Italy) Hokokam (Arizona; C. 200 BCE–1200 CE) Mound building (Greece); Great Stupa at Sanchi (India); crucifixion of Jesus (Jerusalem); Pantheon (Italy)
Paracas (Peru; c. 300 BCE–200 CE) Weaving; embroidery Jesus (Jerusalem); Pantheon (Italy) Hokokam (Arizona; Canals c. 200 BCE–1200 CE)
Hokokam (Arizona; Canals c. 200 BCE-1200 CE)
Henough (Illinois Obio) Mound building, comed ious
Hopewell (Illinois, Ohio; Mound building; carved jew- c. 200 BCE-200 CE) elry; stone pipes
Mogollon (New Mexico, Arizona; Pit houses c. 200 BCE-1250 CE)
C. 250–900 CE Classic period in Mesoamerica C. 250–900 CE Haniwa figures (Japan);
Nazca (Peru; c. 100 все–700 се) Weaving; polychrome pottery; colossal geoglyphs Weaving; polychrome pottery; colossal geoglyphs (Turkey); birth of Muham-
Moche (Peru; c. 200–700 CE) Sipan; Moche; Pyramid of the Sun Sipan; Moche; Pyramid of the bia); Muslim conquests of Arabia, Persia, Egypt, Syria,
Maya (Mesoamerica; c. 250–900 CE) Tikal; Palenque; hieroglyphic writing; calendar; codex- style painting Tikal; Palenque; hieroglyphic Africa; first block-print text (China)
Teotihuacan (Mesoamerica; Temple of the Feathered Serce. 350–650 CE) Temple of the Feathered Serpent; Pyramids of the Sun and the Moon
C. 900–1500 CE Postclassic period in Mesoamerica Maya center at Chichen Itza; C. 900–1500 CE First Viking colony in Greenland; Lady Murasaki's <i>Tale of</i>
Diquis (Costa Rica; c. 700–1500 ct) Lost-wax casting; goldwork (Europe); Jenghiz Khan rules
Anasazi (Four Corners, American southwest; c. 750–1230 CE) Multistory "apartments"; Mongols (Central Asia) Pueblo Bonita
Mississippian (Illinois; Earthenwork palaces; tem- c. 800–1500 cE) ples

12-2. Great Pyramid and ball court, La Venta, Mexico. Olmec culture, c. 900–600 BCE. Pyramid height approx. 100' (30 m)

Mexico, in the swampy coastal jungles of the modern Mexican states of Veracruz and Tabasco. In dense vegetation along slow, meandering rivers, the Olmec cleared farmland, drained fields, and raised earth mounds on which they constructed religious and political centers. These centers probably housed an elite group of rulerprises supported by a larger population of farmers who priests supported by a larger population of farmers who at Olmec sites of goods like obsidian, iron ore, and jade at Olmec sites of goods like obsidian, iron ore, and jade that are not found in the Gulf region but come from the olmec sites of goods like obsidian, iron ore, and jade that are not found in the Gulf region but come from the old of th

The earliest Olmec center, at San Lorenzo, flourished from about 1200 to 900 BCE and was abandoned by 400 BCE. The archeological findings here include a possible ball court, an architectural feature of other major nence after San Lorenzo declined, thriving from about nence after San Lorenzo declined, thriving from about tween rivers. Its most prominent feature, an earth mound tween rivers. Its most prominent feature, an earth mound about 100 feet (fig. 12-2). This scalloped mound may have been intended to resemble a volcanic mound may but its present form may simply be the result of erosion but its present form may simply be the result of erosion but its present form may simply be the result of erosion

ritual ball game (see "The Cosmic Ball Game," page 445), and aspects of the construction of monumental ceremonial centers. Mesoamerican society was sharply divided into elite and commoner classes.

The transition to farming began in Mesoamerica between 7000 and 6000 BCE, and by 3000 to 2000 BCE settled villages were widespread. Archeologists traditionally have divided the region's subsequent history into three broad periods: Formative or Preclassic (1500 BCE–250 CE), Classic (250–900 CE), and Postclassic (900–1500 CE). This chronology derives primarily from the archeology of the Maya—the people of Guatemala and the Yucatan peninthe Maya.—The Classic period brackets the time during which the Maya erected dated stone monuments. The term reflects the view of early Mayanists that it was a kind of plects the view of early Mayanists that it was a kind of reflects the view of early mayanists that it was a kind of more view of early may and the classical period in ancient Greece. Although this view is no longer current and the periods are only roughly applicable to other parts and the periods are only roughly applicable to other parts

тре Оітес

The first major Mesoamerican civilization, the Olmec, emerged during the Formative period along the Culf of

of Mesoamerica, the terminology has endured.

500 CE 1500 BCE 1300 CE after thousands of years of the region's heavy rains. The Great Pyramid stands at the south end of a large, open court, possibly used as a playing field, arranged on a north-south axis and defined by long, low mounds. An elaborate drainage system of stone troughs may have been used as part of a ritual honoring a water deity. Many of the physical features of La Venta—including the symmetrical arrangement of earth mounds, platforms, and central open spaces along an axis that was probably determined by astronomical observations—are characteristic of later monumental and ceremonial architecture throughout Mesoamerica. Found buried within the site were carved jade, serpentine stone, and granite artifacts.

Among Olmec carvings, the most pervasive images are jaguars and so-called were-jaguars, creatures that combine human and feline features. These images suggest that Olmec religion may have involved a belief in jaguar deities that could assume human form, as well as shaman figures who could assume animal (jaguar) form and mediate between humans and the spirit world. There is also sculpture showing a woman and a jaguar in close association, suggesting an origin myth involving the union of a human with a feline deity.

In addition to the smaller works in jade and serpentine, the Olmec produced an abundance of monumental basalt sculpture, including colossal heads, altars, and seated figures. The huge basalt blocks for the large works of sculpture were quarried at distant sites and transported to San Lorenzo, La Venta, and other centers. The colossal heads, ranging in height from 5 to 12 feet and weighing from 5 to more than 20 tons, are probably the best-known Olmec sculpture today (fig. 12-3). The heads represent adult males wearing close-fitting caps with chin straps and large, round earplugs. The fleshy faces have almond-shaped eyes, flat broad noses, thick protruding lips, a slight frown, and down-turned mouths. Each face is different, suggesting that they may represent specific individuals. Most scholars now consider them to be portraits of rulers. Nine heads were found at San Lorenzo; all had been mutilated and buried about 900 BCE, about the time the site went into decline. Seventyseven basalt monuments were found at La Venta, including four heads, which faced each other across the ceremonial core of the site.

The colossal heads and the subjects depicted on other monumental sculpture suggest that the Olmec elite, like their counterparts in later Mesoamerican civilizations, particularly the Maya, were preoccupied with the commemoration of rulers and historic events. This preoccupation was probably an important factor in the development of writing and calendrical systems, which first appeared around 600 to 500 BCE in areas with strong Olmec influence. By 200 ce forests and swamps were reclaiming Olmec sites, but Olmec civilization had spread widely throughout Mesoamerica and was to have an enduring influence on its successors. As the Olmec centers of the Gulf Coast faded, the great Classic period centers at Teotihuacan in the Valley of Mexico, at Monte Alban in the Valley of Oaxaca, and in the Maya region were beginning their ascendancy.

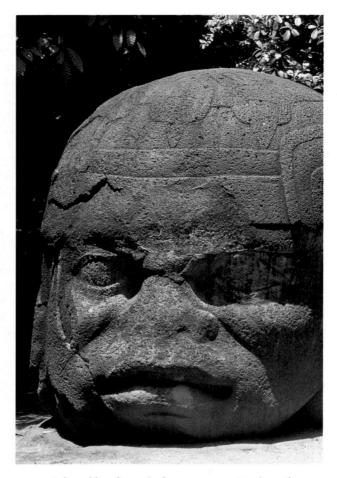

12-3. Colossal head (no. 4), from La Venta, Mexico. Olmec culture, c. 900–500 BCE. Basalt, height 7'5" (2.26 m). La Venta Park, Villahermosa, Tabasco, Mexico The naturalistic colossal heads found at La Venta and San Lorenzo are sculpture in the round that measure about 8 feet in diameter. They are carved from basalt boulders that were transported to the Gulf Coast from the Tuxtla Mountains, more than 60 miles inland.

Teotihuacan

Teotihuacan is located some 30 miles northeast of present-day Mexico City. Early in the first millennium CE it began a period of rapid growth, and by 200 it had emerged as a significant center of commerce and manufacturing, the first large city-state in the Americas. One reason for its wealth was its control of a source of highquality obsidian. Goods made at Teotihuacan, including obsidian tools and pottery, were distributed widely throughout Mesoamerica in exchange for luxury items such as the brilliant green feathers of the quetzal bird, used for priestly headdresses, and the spotted fur of the jaguar, used for ceremonial garments. The city's farmers terraced hillsides and drained swamps, and on fertile, reclaimed land they grew the common Mesoamerican staple foods, including corn, squash, and beans. From the fruit of the spiky-leafed maguey plant they fermented pulque, a mildly alcoholic brew still consumed today.

At its height, between 350 and 650 ce, Teotihuacan covered nearly 9 square miles and had a population of some 200,000, making it the largest city in the Americas

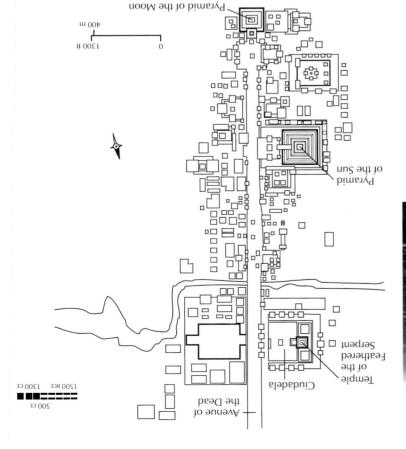

12-5. Plan of the ceremonial center of Teotihuacan

metrically placed platforms. of the Dead, facing a large plaza flanked by smaller, sym-Pyramid of the Sun, stands at the north end of the Avenue ed. The Pyramid of the Moon, not quite as large as the The exterior was faced with stone and stucco and paintlevel up the side of the pyramid to the temple platform. stood. A monumental stone stairway led from level to steps to a flat platform, where a two-room temple once feet on each side at its base. It rises in a series of sloping Sun is more than 210 feet high and measures about 720 huacan's architectural monuments, the Pyramid of the site and the source of its prestige. The largest of Teotithat may have been the original focus of worship at the

largement completely enclosed the previous structure, times, and typical of Mesoamerican practice, each en-Temple of the Feathered Serpent was enlarged several a frame and often filled with sculptural decoration. The vertical tablero, or entablature, which is surrounded by The sloping base, or talud, of each platform supports a that is a hallmark of the Teotihuacan architectural style. This structure exhibits the talua-tablero construction the Temple of the Feathered Serpent, or Quetzalcoall. assembly of more than 60,000 people. Its focal point was political centers, the Ciudadela could accommodate an temple platforms. One of the city's principal religious and fare, is the Ciudadela, a vast sunken plaza surrounded by Avenue of the Dead and the main east-west thorough-In the heart of the city, at the intersection of the

like the concentric layers of an onion.

east. It is built over a four-chambered cave with a spring Pyramid of the Sun flanks the Avenue of the Dead to the ment of structures around open courts or plazas. The america, is characterized by the symmetrical arrangeof the ceremonial center, in a pattern typical of Mesogrid to which the rest of the city strictly conforms. Much thoroughfare intersects it at right angles, establishing a axis and extending for more than 3 miles. Another major city, is a broad thoroughfare laid out on a north-south The so-called Avenue of the Dead, the heart of the

The Pyramid of the Moon is at the lower right, the Teotihuacan culture, 350-650 ce Ceremonial center of the city of Teotihuacan, Mexico. .F-21

dela and the Temple of the Feathered Serpent at Pyramid of the Sun at the middle left, and the Ciuda-

Pyramid of the Sun and the Pyramid of the Moon. place) of the Gods." Its principal monuments include the can, is an Aztec word meaning "The City (gathering gods created the sun and the moon. Its name, Teotihuarevered the site, believing it to be the place where the ish conquest in the early sixteenth century. The Aztec a legendary pilgrimage center until the time of the Spannever entirely abandoned, however, because it remained and imagery over the next several centuries. The site was northern Mesoamerica borrowed and transformed its art less, its influence continued as other centers throughout and the city went into a permanent decline. Nevertheter struck Teotihuacan: the ceremonial center burned,

Sometime in the middle of the eighth century disas-

12-6. Temple of the Feathered Serpent, the Ciudadela, Teotihuacan, Mexico. Teotihuacan culture, c. 350 ce (?)

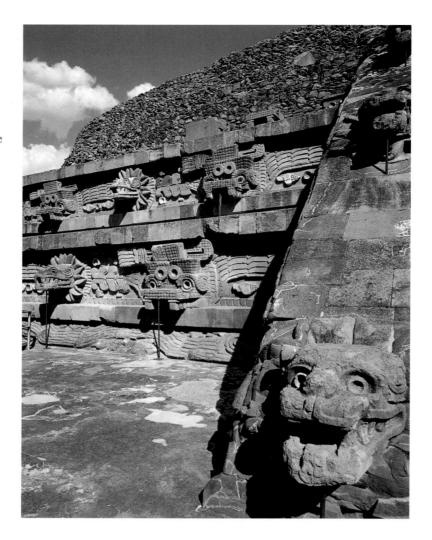

Archeological excavations of earlier-phase tableros and a stairway balustrade have revealed painted reliefs of the Feathered Serpent, the goggle-eyed Rain God (or Fire God, according to some), and aquatic shells and snails (fig. 12-6). Their flat, angular, abstract style is typical of Teotihuacan art and is a marked contrast to the three-dimensional, curvilinear style of Olmec art. The Rain God has a squarish, stylized head with protruding lips, huge round eyes originally inlaid with obsidian and surrounded by colored circles, and large, circular earspools. The fanged serpent heads, perhaps composites of snakes and other creatures, emerge from an aureole of stylized feathers. It is tempting to read cosmic imagery into the sculpture. The Rain God and the Feathered Serpent may represent alternating wet and dry seasons, may be symbols of regeneration and cyclical renewal, or may have some other meaning that has been lost.

The residential sections of Teotihuacan adhered to the grid established in the city's center. The large palaces of the elite, with as many as forty-five rooms and seven patios, stood nearest the ceremonial center. Artisans, foreign traders, and peasants lived farther away, in less luxurious compounds. The palaces and more humble homes alike were rectangular, one-story structures with high walls, thatched roofs, and suites of rooms arranged

symmetrically around open courts. Walls were plastered and, in the homes of the elite, covered with paintings.

Teotihuacan's artists worked in a true fresco technique, applying pigments directly on damp lime plaster. Their flat, abstract-style drawing is assured, and their use of color is subtle—one work may include five shades of red with touches of ocher, green, and blue. A detached fragment of a wall painting, now in The Cleveland Museum of Art, depicts a bloodletting ritual in which an elaborately dressed man enriches and revitalizes the earth with his own blood (fig. 12-7). The man's Feathered Serpent headdress, decorated with precious quetzal feathers, indicates his high rank. He stands between rectangular plots of earth planted with bloody maguey spines and scatters seeds or drops of blood from his right hand, as indicated by the panel with conventionalized symbols for blood, seeds, and flowers. The speech scroll emerging from his open mouth symbolizes his ritual chant. The visual weight accorded the headdress and speech scroll suggests that the man's priestly office and chanted words are essential elements of the ceremony. Above the figure is a two-headed, spotted serpent holding two birds in its angular coils. Such bloodletting rituals were not limited to Teotihuacan but were widespread in Mesoamerica.

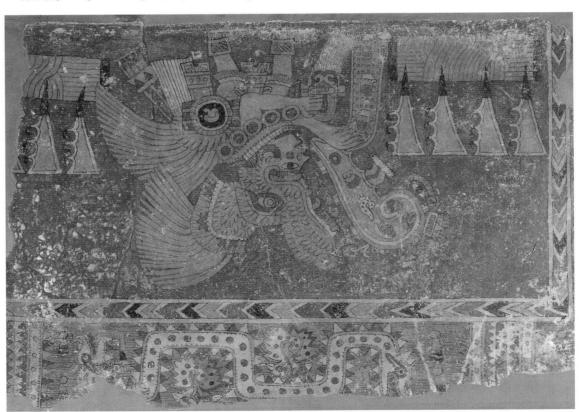

12-7. Maguey Bloodletting Ritual, fragment of a fresco from Teotihuacan, Mexico.Teotihuacan culture, 600–750 ce. Pigment on lime plaster, 321/4 x 451/4" (82 x 116.1 cm). The Cleveland Museum of Art Purchase from the J. H. Wade Fund (63.252)

The maguey plant supplied the people of Teotihuacan with food; fiber for making clothing, rope, and paper; and the sacramental drink pulque. As this painting indicates, priestly officials used it in rituals of self-sacrifice to draw their own blood.

An increasingly detailed picture of the Maya has been emerging from recent archeological research and advances in deciphering their writing. That picture shows a society divided into competing centers, each with a hereditary ruler and an elite class of nobles and priests supported by a far larger class of farmer-commoners. Rulers established their legitimacy, maintained through elaborate rituals, including ball games, bloodletting ceremonies, and human sacrifice. These rituals occurred in the pyramids, temples, and plazas that dominated Maya cities. Rulers commemorated such events and their military exploits on carved stelae. A complex and their military exploits on carved stelae. A complex partheon of deities, many with several manifestations, presided over the Maya universe.

Olmec influence was widespread in the Maya area during the middle Preclassic period (1000–300 BCE). The earliest distinctively Maya centers emerged during the late Preclassic period (300 BCE–250 CE), and Maya civilization reached its peak in the southern lowlands of the Yucatan peninsula during the Classic period (250–900 CE). Probably due to increased warfare and growing pressure on agricultural resources, the sites in the southern lowlands were shandoned at the end of the Classic period. The focus of Maya civilization then shifted to the northern Yucatan during the Postclassic period (900–1500 CE).

Тће Мауа

zero and place value before they were known in Europe. animals and developed the mathematical concepts of studied astronomy and the natural cycles of plants and precision unknown elsewhere in the Americas.) They endar, making it possible to date Maya artifacts with a ship between the Maya calendar and the European calwall paintings. (Scholars have determined the relationmemorative stelae, in books, on ceramic vessels, and on the accomplishments of their rulers in monumental com-Keeping," page 452). With these tools they documented Mesoamerican calendrical system (see "Maya Record Mesoamerica and the most sophisticated version of the developed the most advanced hieroglyphic writing in temples, palaces, and administrative structures. They densely populated cities they built imposing pyramids, ingly inhospitable tropical rain forest of the Yucatan. In ways to produce high agricultural yields in the seemare noted for a number of achievements. They developed the Maya's present-day descendants. The ancient Maya Spanish conquest and is still reflected in the culture of civilization created there endured to the time of the ern part of Honduras and El Salvador. The remarkable Guatemala, the Yucatan peninsula, Belize, and the east-The Maya homeland in southern Mesoamerica includes

MAYA RECORD KEEPING

Since the rediscovery of the Classic period Maya sites in the nineteenth century, schol-

ars have puzzled over the meaning of the hieroglyphic writing that abounds in Maya artwork. They soon realized that many of the glyphs were numeric notations in a complex calendrical system. By the early twentieth century the calendrical system had been interpreted and approximately correlated with the European calendar. The Maya calendar counts time from a starting date some 5,000 years ago, now securely established as August 13, 3114 BCE. This system, known as the long count, incorporates the short-count system, based on interlocking 260day and 365-day cycles, of other

Mesoamerican societies. The long count is unique to the Classic period Maya.

The meaning of the noncalendric inscriptions remained obscure until the late 1950s. Before that time many prominent Mayanists argued that the inscriptions dealt with astronomical and astrological observations, not historical events. This interpretation was in accord with the prevailing view that the Classic period Maya were a peaceful people ruled by a theocracy of learned priests. Since the late 1950s scholars have made enormous progress in deciphering Maya writing. The results of their work, combined with the results of archeological research, have overturned the earlier view of Maya society and Maya writing. The inscriptions on Maya architecture and the many stone stelae erected at Maya sites are, it turns out, almost entirely devoted to historic events in the lives of Maya rulers and the Maya elite. They record the dates of royal marriages, births of heirs, alliances between cities, and great military victories, tying them to astronomical events and propitious periods in the Maya calendar.

Maya writing, like the Maya calendar, is the most advanced in ancient Mesoamerica. About 800 glyphs have been identified, equivalent to the number in ancient Egyptian writing at some periods. The system combines logographs—symbols representing entire words—and symbols representing syllables in the Maya language.

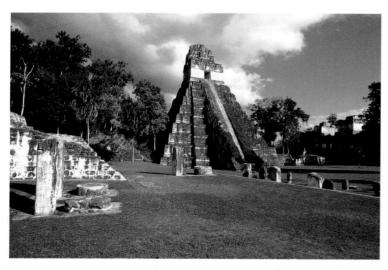

12-8. North Acropolis (right) and Temple I, called the Temple of the Giant Jaguar (tomb of Au Cacau), Tikal, Guatemala. Maya culture. North Acropolis, 5th century CE; Temple I, c. 700 CE

Tikal has been the focus of an extended program of research directed by archeologists from the University of Pennsylvania in cooperation with the Guatemalan government. This research is part of an explosive growth in Maya studies that has enormously enriched our understanding of Maya culture and history.

Classic Period Architecture at Tikal and Palenque.

The monumental buildings of Maya cities were masterful examples of the use of architecture for public display and propaganda. Seen from outside and afar, they would have impressed the common people with the power and authority of the elite and the gods they served.

Tikal, in what is now northern Guatemala, was the largest Classic period Maya city, with a population of as many as 70,000 at its height. Like other Maya cities—and

unlike Teotihuacan, with its rigid grid—Tikal conformed to the uneven terrain of the rain forest. Plazas, pyramid-temples, ball courts, and other structures stood on high ground connected by elevated roads, or causeways. One major causeway, 80 feet wide, led from the center of the city to outlying residential areas.

Figure 12-8 shows part of the ceremonial core of Tikal. The structure on the right, known as the North Acropolis, follows a north-south axis and dates to the early Classic period. It contained many royal tombs and covers earlier structures that date to the origin of the city, about 500 BCE. The tall pyramid in the center is known as Temple I or the Temple of the Giant Jaguar. It covers the tomb of Au Cacau (Lord Chocolate, 682–c. 727), who began an ambitious expansion of Tikal after a period in the sixth and early seventh century CE when there was little new construction at this or other major Maya sites. Under Au Cacau and his successors, Tikal's influence grew, with evidence of contacts that extended from highland Mexico to Costa Rica.

Temple I faces a companion pyramid, Temple II, across a large plaza. These two structures changed the orientation of the ceremonial center from north-south to east-west. The new plaza provided a monumental entrance to the North Acropolis, and the two new pyramids framed the ancestral core of the city, visually linking old and new.

From Au Cacau's tomb in the limestone bedrock, Temple I rises above the forest canopy to a height of more than 140 feet. It has nine layers, probably reflecting the belief, current among the Aztec and the Maya at the time of the Spanish conquest, that the underworld had nine levels. Priests climbed the steep stone staircase on the exterior to the temple on top, which consists of two long, parallel rooms covered with a steep roof supported by **corbeled vaults**. It is typical of Maya enclosed stone structures, which resemble the kind of pole-and-thatch

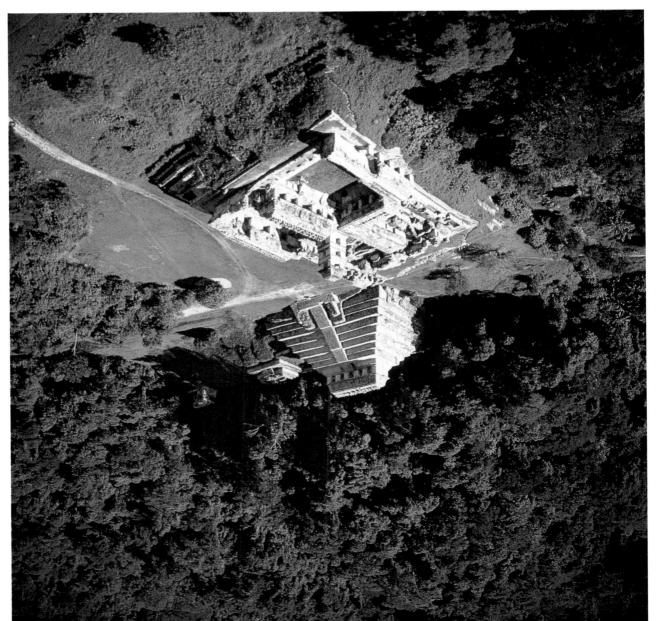

7th century ce 12-9. Palace (foreground) and Temple of the Inscriptions (tomb-pyramid of Lord Pacal), Palenque, Mexico. Maya culture,

southeast.

complex has five temples, two nearby adjacent temples,

major buildings are grouped on high ground. A northern

of the structures visible at Palenque today. As at Tikal,

He and the son who succeeded him commissioned most Pacal (Maya for "shield"), who ruled from 615 to 683 ce.

importance until the ascension of a powerful ruler, Lord

dynasty in 431 ce, but the city had only limited regional

glyphic inscriptions record the beginning of its royal

rose to prominence in the late Classic period. Hiero-Palenque, located in the Mexican state of Chiapas,

known as a roof comb, was originally covered with

there. The crest that rises over the roof of the temple,

facing the plaza and the commemorative stelae erected The only entrance to the temple was on the long side,

houses the Maya still build in parts of the Yucatan today.

brightly painted sculpture.

tral inner chamber. were carved on the back wall of the portico and the censculpture. The inscriptions that give the building its name roof comb. Its facade still retains much of its stucco a three-part, vaulted inner chamber surmounted by a tall the summit consisted of a portico with five entrances and Like Temple I at Tikal, it has nine levels. The shrine on to it is a pyramid that rises to a height of about 75 feet. residential complex. The Temple of the Inscriptions next terrace—may have been an administrative rather than a on two levels around three open courts, all on a raised The palace in the central group—a series of buildings

temples (fig. 12-9). A third group of temples lies to the

Palace, the Temple of the Inscriptions, and two other

and a ball court. A central group includes the so-called

ART OF THE AMERICAS BEFORE 1300

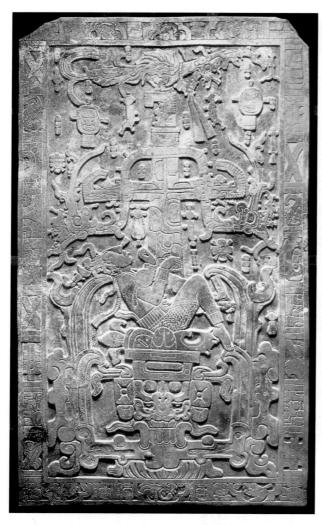

12-10. Sarcophagus lid, in the tomb of Lord Pacal, Temple of the Inscriptions, Palenque, Mexico. Maya culture. c. 683 ce. Limestone, approx. 12'6" x 7' (3.8 x 2.14 m)

In 1952 an archeologist studying the structure of the Temple of the Inscriptions discovered a corbel-vaulted stairway beneath the summit shrine. This stairway descended almost 80 feet to a small subterranean chamber that contained the undisturbed tomb of Lord Pacal himself, and in it were some remarkable examples of Classic sculpture.

Classic Period Sculpture. Lord Pacal lay in a monolithic sarcophagus with a lid carved in low relief that showed him balanced between the spirit world and the earth (fig. 12-10). With knees bent, feet twisted, and face, hands, and torso upraised, he lies on the head of a creature that represents the setting sun. Together they are falling into the jaws of the underworld. The image above him, which ends in the profile head of a god and a fantastic bird, represents the sacred tree of the Maya. Its roots are in the earth, its trunk is in the world, and its branches support the celestial bird in the heavens. The message is one of death and rebirth. Lord Pacal, like the setting sun, will rise again to join the gods after falling into the underworld. Lord Pacal's ancestors, carved on

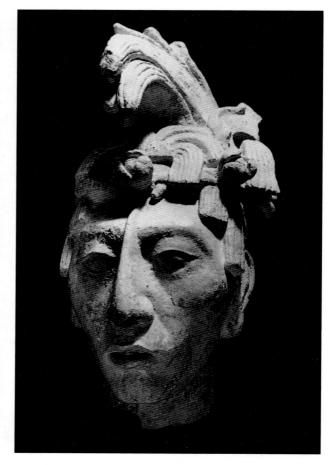

12-11. Portrait of Lord Pacal, from his tomb, Temple of the Inscriptions. Mid-7th century ce. Stucco, height 167/8" (43 cm). Museo Nacional de Antropología, Mexico City

This portrait of the youthful Lord Pacal may have been placed in his tomb as an offering. Possibly it formed part of the original exterior decoration of the Temple of the Inscriptions.

the side of his sarcophagus, witness his death and **apotheosis**. They wear elaborate headdresses and are shown only from the waist up, as though emerging from the earth. Among them are Lord Pacal's parents, Lady White Quetzal and Lord Yellow Jaguar-Parrot, supporting the contention of some scholars that both maternal and paternal lines transmitted royal power among the Maya.

Elite men and women, rather than gods, were the usual subjects of Maya sculpture, and most show rulers dressed as warriors performing religious rituals in elaborate costumes and headdresses. The Maya favored low-relief carving with sharp outlines on flat stone surfaces, but they also excelled at three-dimensional clay and stucco sculpture. A stucco portrait of Lord Pacal found with his sarcophagus shows him as a young man wearing a diadem of jade and flowers (fig. 12-11). His features—sloping forehead and elongated skull (babies had their heads bound to produce this shape), large curved nose (enhanced by an ornamental bridge, perhaps of latex), full lips, and open mouth—are characteristic of the Maya ideal of beauty. Traces of pigment indicate that this portrait, like much Maya sculpture, was colorfully painted.

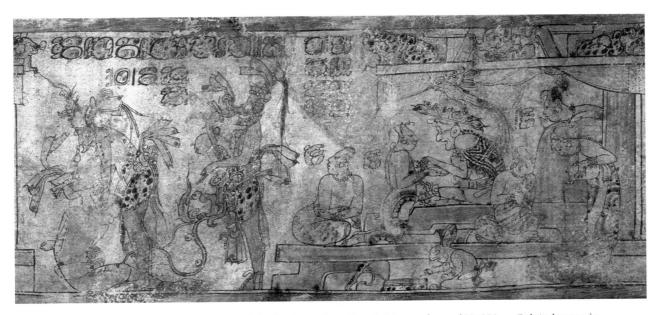

12-12. Cylindrical vessel (composite photograph in the form of a roll-out). Maya culture, 600–900 ce. Painted ceramic; diameter 6½" (16.6 cm); height 83/8" (21.5 cm). The Art Museum, Princeton University, New Jersey

The clay vessel was first covered by a creamy white slip and then painted in light brown washes and dark brown or black lines. The painter may have used turkey feathers to apply the pigments.

Classic Period Painting. Maya painting survives on ceramics and a few large murals. Most illustrated books have perished except for a few postconquest examples with astronomical and divinatory information. Scribes and vase painters were often members of the ruling elite and perhaps included members of the royal family not in the direct line of succession. Vases painted in the so-called codex style, referring to books of folded paper made from the maguey plant, often show a fluid line and elegance similar to that of the manuscripts.

A late Classic cylindrical vase in the codex style (fig. 12-12) may illustrate an episode from a legend recounted in the Book of Popol Vuh, a compendium of Maya myths written in Spanish in the sixteenth century by a Maya noble. The protagonists of this legend, the mythical Hero Twins, defeat the Lords of Xibalba, the Maya underworld, and overcome death. The vessel shows one of the Lords of Xibalba, an aged-looking being known to archeologists as God L, sitting inside a temple on a raised platform. Five female deities attend him. The god ties a wrist cuff on the attendant kneeling to his left. Another attendant, seated outside the temple, looks over her shoulder at a scene in which two men sacrifice a bound victim. A rabbit in the foreground writes in a manuscript, reminding us of the Maya obsession with historical records, as well as of the many books now lost. The two men may be the Hero Twins and the bound victim a bystander they sacrificed and then brought back to life in order to gain the confidence of the Xibalban lords. The inscriptions on the vessel have not been entirely translated. They include a calendar reference to the Death God and to Venus, the evening star, which the Maya associated with war and sacrifice.

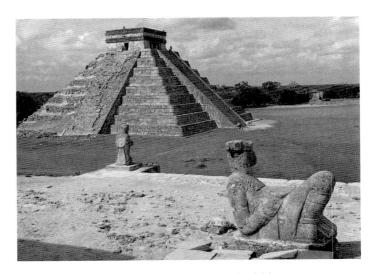

12-13. Castillo, with Chacmool in foreground, Chichen Itza, Yucatan, Mexico. Maya culture, 9th–13th century

Postclassic Art. A northern Maya group called the Itza rose to prominence when the focus of Maya civilization shifted northward in the Postclassic period. Their principal center, Chichen Itza, which means "at the mouth of the well of the Itza," grew from a village located near a sacred well. The city flourished from the ninth to the thirteenth century CE, eventually covering about 6 square miles. It shares many features with the site of Tula in central Mexico, but archeologists are uncertain what relationship the two centers had to each other.

One of Chichen Itza's most conspicuous structures is a massive pyramid in the center of a large plaza (fig. 12-13). Embellished with figures of the Feathered Serpent, this structure is known today as the Castillo (Spanish for "castle"). A stairway on each side leads to a

square, blocky temple on its summit. At the spring and fall equinoxes, the rising sun casts an undulating, serpentlike shadow on the stairway balustrades. Like earlier Maya pyramids, the Castillo has nine levels, but many other features of Chichen Itza are markedly different from earlier sites. The Castillo, for example, is lower and broader than the stepped pyramids of Tikal and Palenque, and Chichen Itza's buildings have wider rooms. Another prominent feature not found at earlier sites is the use of pillars and columns. Chichen Itza has broad, open galleries surrounding courtyards and inventive columns in the form of inverted, descending serpents. Brilliantly colored relief sculpture covered the buildings of Chichen Itza, and paintings of feathered serpents, jaguars, coyotes, eagles, and composite mythological creatures adorned its interior rooms. The surviving works show narrative scenes that emphasize the prowess of warriors and the skill of ritual ball players.

Sculpture at Chichen Itza, including the serpent columns and the half-reclining figures known as Chacmools (see fig. 12-13), has the sturdy forms, proportions. and angularity of architecture. It lacks the curving forms and subtlety of Classic Maya sculpture. The Chacmools probably represent fallen warriors and were used to receive sacrificial offerings. They once typified pre-Columbian sculpture for many Westerners.

After Chichen Itza's decline, Mayapan, on the north coast of the Yucatan, became the principal Maya center. But by the time the Spanish arrived, Mayapan, too, had declined. The Maya people and much of their culture would survive the conquest despite the imposition of Hispanic customs and beliefs. They continue to speak their own languages, to venerate traditional sacred places, and to follow traditional ways.

CENTRAL **AMERICA**

Unlike their neighbors in Mesoamerica, who lived in complex hierarchical societies, the people of Central

America generally lived in extended family groups led by chiefs. A notable example of these small chiefdoms was the Diquis culture, which developed in present-day Costa Rica from about 700 cE to about 1500.

The Diquis occupied fortified villages without monumental architecture or sculpture and seem to have engaged in constant warfare with one another. They nevertheless produced fine featherwork, ceramics, textiles, and gold objects. (The name Costa Rica, which means "rich coast" in Spanish, probably reflects the value the Spaniards placed on the gold.)

Metallurgy and the use of gold and copper-gold alloys were widespread in Central America. The technique of lost-wax casting probably first appeared in present-day Colombia between 500 and 300 BCE. From there it spread north to the Diquis. The small, exquisite pendant shown in figure 12-14 illustrates the sophisticated design and technical facility of Diquis goldwork. The pendant depicts a male figure wearing bracelets, anklets, and a belt with a snake-headed penis sheath. He plays a drum while holding the tail of a snake in his teeth and its head in his left hand. The wavy forms with ser-

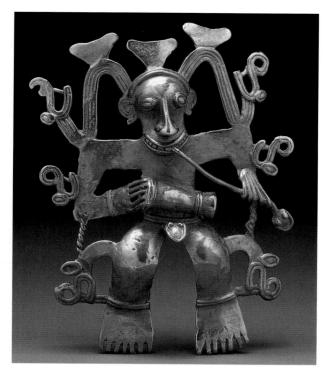

12-14. Shaman with Drum and Snake, from Costa Rica. Diquis culture, c. 1000 ce. Gold, $4^{1}/4 \times 3^{1}/4$ " (10.8 x 8.2 cm). Museos del Banco Central de Costa Rica, San José, Costa Rica

pent heads emerging from his scalp suggest an elaborate headdress, and the creatures emerging from his legs suggest some kind of reptile costume. The inverted triangles on the headdress probably represent birds' tails.

In Diquis mythology serpents and crocodiles inhabited a lower world, humans and birds a higher one. Their art depicts animals and insects as fierce and dangerous. Perhaps the man in the pendant is a shaman transforming himself into a composite serpent-bird or performing a ritual snake dance surrounded by serpents or crocodiles. The scrolls on the sides of his head may represent the shaman's power to hear and understand the speech of animals. Whatever its specific meaning, the pendant evokes a ritual of mediation between earthly and cosmic powers involving music, dance, and costume.

Whether gold figures of this kind were protective amulets or signs of high status, they were certainly more than personal adornment. Shamans and warriors wore gold to inspire fear, perhaps because gold was thought to capture the energy and power of the sun. This energy was also thought to allow shamans to leave their bodies and travel into cosmic realms.

SOUTH Like Mesoamerica, the central Andes AMERICA: of South America—primarily presentday Peru and Bolivia—saw the de-THE velopment of complex hierarchical **CENTRAL** societies with rich and varied artistic ANDES traditions. The area is one of dramatic contrasts. The narrow coastal

plain, bordered by the Pacific Ocean on the west and the abruptly soaring Andes on the east, is one of the driest deserts in the world. Life here depends on the rich marine

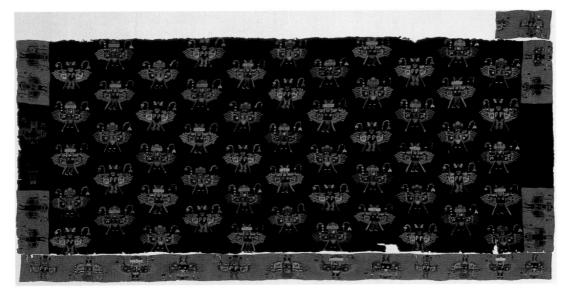

12-15. Mantle with bird impersonators, from the Paracas peninsula south coast, Peru. Paracas culture, c. 50–100 ce. Plain weave with stem-stitch embroidery, approx. 40" x 7'11" (101 cm x 2.41 m). Museum of Fine Arts, Boston The stylized figures display the remarkable Paracas sense of color and pattern. The all-directional pattern is also characteristic of Paracas art.

resources of the Pacific and the rivers that descend from the Andes, forming a series of valley oases from south to north. The Andes themselves are a region of lofty snow-capped peaks, high grasslands, steep slopes, and deep, fertile river valleys. The high grasslands are home to the Andean camelids—llamas, alpacas, vicuñas, and guanacos—that have served for thousands of years as beasts of burden and a source of wool and meat. The lush eastern slopes of the Andes descend to the tropical rain forest of the Amazon basin.

The earliest evidence of monumental architecture in Peru dates to the third millennium BCE, contemporary with the earliest pyramids in Egypt. On the coast, sites with ceremonial mounds and plazas were located near the sea. The inhabitants of these centers depended on marine and agricultural resources, farming the floodplains of nearby coastal rivers. Their chief crops were cotton, used to make fishing nets, and gourds, used for floats. Early centers in the highlands consisted of multiroomed stone-walled structures with sunken central fire pits that served to burn ritual offerings.

In the second millennium BCE, herding and agriculture became prevalent in the highlands. On the coast, people became increasingly dependent on agriculture. They began to build canal irrigation systems, greatly expanding their food supply. Settlements were moved inland, and large, **U**-shaped ceremonial complexes with circular sunken plazas were built. These complexes were oriented toward the mountains, the direction of the rising sun and the source of the water that nourished their crops. The shift to irrigation agriculture also corresponded to the spread of pottery and ceramic technology in Peru.

Between about 800 and 200 BCE an art style associated with the northern highland site of Chavin de Huantar spread through much of the Andes. In Andean chronology, this era is known as the Early Horizon, the first of three so-called Horizon periods marked by the widespread influence of a single style.

The Chavin site was located on a major trade route between the coast and the Amazon basin, and Chavin art features images of many tropical forest animals. The political and social forces behind the spread of the Chavin style are not known. Many archeologists suspect that they involved an influential religious cult. In any event, the period was one of artistic and technical innovation in ceramics, metallurgy, and textiles. These innovations found continued expression in the textiles of the Paracas culture on the south coast of Peru, the art of the subsequent Nazca culture there, and the ceramics and metalwork of the Moche culture on the north coast.

The Paracas and Nazca Cultures

The Paracas culture of the south coast flourished from about 300 BCE to 200 CE, overlapping with the Chavin period. It is best known for its stunning textiles, which were found in cemeteries wrapped in many layers around the dead. Some bodies were wrapped in as many as fifty pieces of cloth.

Weaving is of great antiquity in the central Andes and continues to be among the most prized arts in the region (see "Andean Textiles," page 458). Fine textiles were a source of prestige and wealth, and the production of textiles was an important factor in the domestication of both cotton and llamas. Andean peoples developed a simple, portable **backstrap loom** in which the **warp** (lengthwise thread) was looped and stretched between two poles. One pole was tied to a stationary object and the other to a strap circling the waist of the weaver. The weaver controlled the tension of the warp threads by leaning back and forth while threading a **bobbin**, or shuttle, through the warp to create the **weft** (crosswise thread).

The designs on Paracas textiles include repeated **embroidered** (needlework) figures of warriors, dancers, and composite creatures such as bird-people (fig. 12-15). Embroiderers used tiny overlapping stitches to create

ANDEAN TEXTILES

The creation of ancient Andean textiles, among the most tech-

nically complex cloths ever made, consumed a major portion of their societies' resources. Dyers, weavers, and embroiderers used nearly every textile technique known, some of them unique inventions of these cultures, and the production of a single textile might involve a dozen processes requiring highly skilled workers. A tunic would have taken approximately 500 hours of work. Some of the most elaborate textiles were woven, unwoven, and rewoven to achieve special effects that were prized for their labor-intensiveness and difficulty of manufacture as well as their beauty. The most finely woven pieces contain a staggering 500 threads per square inch. Because of their complexity, deciphering how these textiles were made can be a challenge, and scholars rely on contemporary Andean weavers-inheritors of this tradition-for guidance. Then, as now, textile production was

primarily in the hands of women.

Cotton was grown in Peru by 3000 BCE and was the most widely used plant fiber. The earliest Peruvian textiles were made without looms, and twining, knotting, wrapping, braiding, and looping continued to be used even after looms were invented in the early second millennium BCE. Tapestry-weaving (see below) was the main cloth-making technique for the next thousand or so years, followed by the introduction of embroidery on camelid fibers (llama, alpaca, or vicuña hair), the Andean equivalent of wool. (Embroidery on camelid fiber is seen in the Paracas mantle in figure 12-15.) From about 400 BCE on, animal fibers—superior in warmth and dye absorption—largely replaced cotton in the mountains, where cotton was hard to cultivate.

In tapestry, a technique especially suited to representational textiles, an undyed cotton warp was frequently combined with a vividly colored camelid-fiber weft that completely covered it. Each colored sec-

tion was woven as an independent unit (see illustration). Since the shuttle was not passed across the entire width of the fabric in one motion, as in other kinds of weaving, tapestry allowed greater pictorial freedom but was quite time-consuming.

Fabrics were colored with dyes made from plants and a few animals. The deep blue of the Paracas mantle, for instance, was probably derived from the indigo plant. Dyeing technology, too, was an advanced art form in the ancient Andes, with some textiles containing dozens of colors.

Textiles were of enormous importance in Andean life, serving significant functions in both private and public events. Specialized fabrics were developed for everything from ritual burial shrouds and shamans' costumes to rope bridges and knotted record-keeping devices. Clothing indicated ethnic group and social status and was customized for certain functions, the most rarefied being royal ceremonial garments made for specific occasions and worn only once.

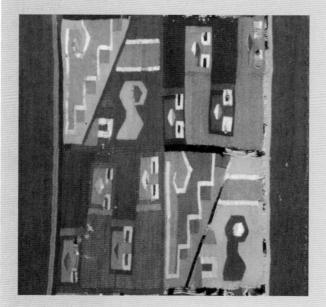

Detail of tapestry-weave mantle, from Peru. c. 700–1100 ce. Wool and cotton. The Cleveland Museum of Art

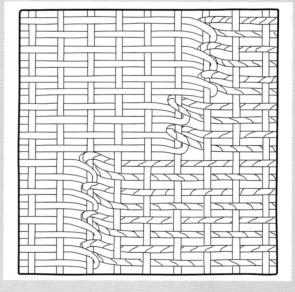

Diagram of toothed tapestry-weaving technique, one of many sophisticated methods used in Andean textiles

colorful, curvilinear patterns, sometimes using as many as twenty-two different colors within a single figure. The effect of the clashing and contrasting colors and tumbling figures is dazzling.

The Nazca culture, which dominated the south coast of Peru from about 100 BCE to 700 CE, overlapped the Paracas culture. Nazca artisans continued to weave fine fabrics, but they also produced multicolored pottery with

painted and modeled images reminiscent of those on Paracas textiles.

The Nazca are probably best known for their colossal earthworks, or **geoglyphs**, which dwarf even the most ambitious twentieth-century environmental sculpture. On great stretches of desert they literally drew in the earth. By removing a layer of dark gravel, they exposed the lighter underlying soil, then edged the resulting lines

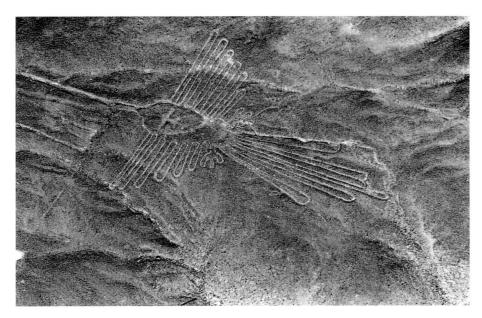

12-16. Earth drawing of a hummingbird, Nazca Plain, southwest Peru. Nazca culture, c. 200 BCE–200 CE. Length approx. 450' (138 m); wingspan approx. 200' (60.5 m)

with stones. In this way they created gigantic images—including a hummingbird, a killer whale, a monkey, a spider, a duck, and other birds—similar to those with which they decorated their pottery. They also made abstract patterns and groups of straight, parallel lines that extend for up to 12 miles. The beak of the hummingbird in figure 12-16 consists of two parallel lines, each 120 feet long. The purpose of these geoglyphs is not known.

The Moche Culture

The Moche culture dominated the north coast of Peru from the Piura Valley to the Huarmey Valley—a distance of some 370 miles—between about 200 and 700 ce. Moche lords ruled each valley in this region from a ceremonial-administrative center. The largest of these, in the Moche Valley (from which the culture takes its name), contained the so-called Pyramids of the Sun and the Moon. Both pyramids were built entirely of **adobe** bricks. The Pyramid of the Sun, the largest ancient structure in South America, was originally a cross-shaped structure 1,122 feet long by 522 feet wide that rose in a series of terraces to a height of 59 feet. This site had been thought to be the capital of the entire Moche realm, but evidence is accumulating that the Moche were not so centralized.

The Moche were exceptional potters and metalsmiths. They developed ceramic molds, which allowed them to mass-produce some forms. Vessels were made in the shape of naturalistically modeled human beings, animals, and architectural structures. They also created realistic portrait vessels and recorded mythological narratives and ritual scenes in intricate fine-line painting. Similar scenes were painted on the walls of temples and administrative buildings. Moche smiths, the most sophisticated in the central Andes, developed several innovative alloys.

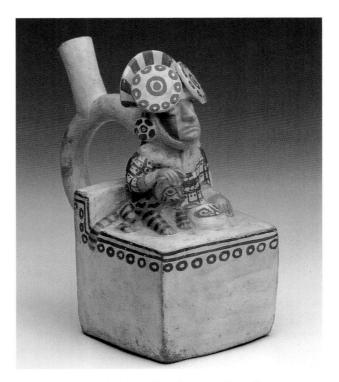

12-17. Moche Lord with a Feline, from Moche Valley, Peru.
Moche culture, c. 100 BCE-500 CE. Painted ceramic,
height 7¹/₂" (19 cm). The Art Institute of Chicago
Bingham Fund, 1955-2281

Behind the figure is the distinctive stirrup-shaped handle and spout. Vessels of this kind, used in Moche rituals, were also treasured as special luxury items and were buried in large quantities with individuals of high status.

The ceramic vessel in figure 12-17 shows a Moche lord sitting in a structure associated with high office. He wears an elaborate headdress and large earspools and strokes a cat or perhaps a jaguar cub. The so-called

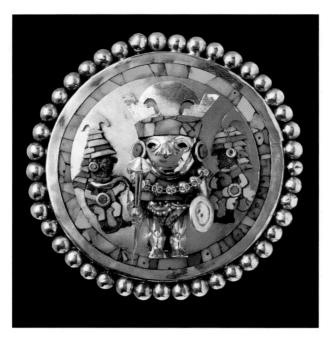

12-18. Earspool, from Sipan, Peru. Moche culture, c. 300 ce. Gold, turquoise, quartz, and shell, diameter approx. 5" (12.7 cm). Bruning Archeological Museum, Lambayeque, Peru

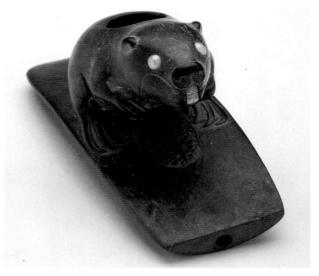

12-19. Beaver effigy platform pipe, from Bedford Mound, Pike County, Illinois. Hopewell culture, c. 100-200 ce. Pipestone, pearl, and bone, length 41/2" (11.4 cm). Gilcrease Museum, Tulsa, Oklahoma Pipes made by the Hopewell culture may have been used for smoking hallucinatory plants, perhaps during

rituals involving the animal carved on the pipe bowl.

stirrup, or **U**-shaped, spout appears on many high-quality Moche vessels. Paintings indicate that vessels of this type were used in Moche rituals.

A central theme in Moche iconography is the sacrifice ceremony, in which prisoners captured in battle are sacrificed and several elaborately dressed figures drink their blood. Archeologists have labeled the principal figure in the ceremony as the Warrior Priest and other important figures as the Bird Priest and the Priestess. The recent discovery of a number of spectacularly rich Moche tombs indicates that the sacrifice ceremony was an actual Moche ritual and that Moche lords assumed the roles of the principal figures. The occupant of a tomb at the site of Sipan in the Lambayeque Valley was buried with the regalia of the Warrior Priest. In a tomb at the site of San José de Moro in the Jequetepeque Valley, an occupant was buried with the regalia of the Priestess.

Among the riches accompanying the Warrior Priest at Sipan was a pair of exquisite gold-and-turquoise earspools, each of which depicts three Moche warriors (fig. 12-18). The central figure is made of beaten gold and turquoise. He and his companions are adorned with tiny gold-and-turquoise earspools. They wear spectacular gold-and-turquoise headdresses topped with delicate sheets of gold that resemble the crescent-shaped knives used in sacrifices. The crests, like feathered fans of gold, would have swayed in the breeze as the wearer moved. The central figure has a crescent-shaped nose ornament and carries a gold club and shield. A necklace of owl's-head beads strung with gold thread hangs around his shoulders. Many of his anatomical features have been rendered in painstaking detail.

AMERICA

NORTH Compared to the densely inhabited agricultural regions of Mesoamerica and South America, most of North

America remained sparsely populated until the arrival of European conquerors in the fifteenth century. People lived primarily by hunting, fishing, and gathering edible plants. In the Southeast, in the lands drained by the Mississippi and Missouri river system, a more settled way of life began to emerge, and by around 1000 BCE-in Louisiana as early as 2800 BCE, according to some anthropologists—nomadic hunting and gathering had given way to more settled communities. People cultivated squash, sunflowers, and other plants to supplement their diet of game, fish, and berries. People in the American Southwest began to adopt a sedentary, agricultural life toward the end of the first millennium BCE.

The Mound Builders

Sometime before 1000 BCE, people living in the Mississippi River Valley began building monumental earthworks and burying their leaders with valuable grave goods. The earliest of these earthworks, at Poverty Point in Louisiana, dates to about 1300 BCE. One of the most impressive is the Great Serpent Mound in present-day Adams County, Ohio (see fig. 12-1). Its date is unknown, but it is located near a burial mound of the Adena culture (600 BCE-200 CE). There have been many interpretations of the writhing snake form, especially the "head" at the highest point, which some see as opening its jaws to swallow a huge egg formed by a heap of stones.

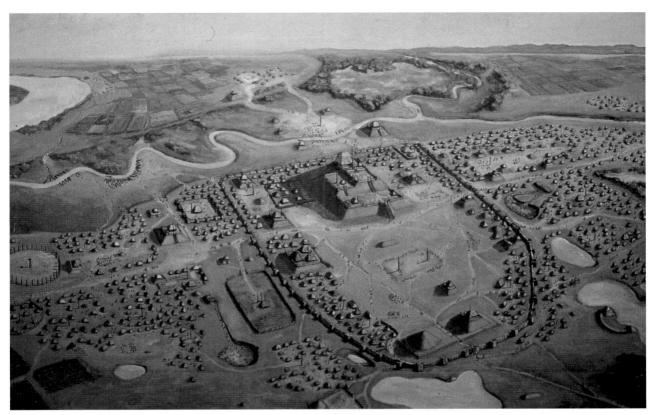

12-20. Reconstruction of central Cahokia, East St. Louis, Illinois. Mississippian culture, c. 1150 ce. Earth mounds and wooden structures; east-west length approx. 3 miles (4.5 km), north-south length approx. 2 1/4 miles (3.6 km); base of great mound, 1,037 x 790' (316 x 241 m), height approx. 100' (30 m). Painting by William R. Iseminger

The people of the Mississippi and Ohio valleys traded widely with other regions. For example, burials of the Adena culture and another mound-building culture, the Hopewell (centered in the Illinois and Ohio valleys, 200 BCE–200 CE), contained jewelry made with copper from Michigan's upper peninsula and silhouettes cut in sheets of mica from the Appalachian Mountains. The Hopewell people also made pipes of fine-grain pipestone carved with realistic representations of forest animals and birds, sometimes with inlaid eyes and teeth of freshwater pearls and bone. The Hopewell exchanged this pipestone and a flintlike stone used for tool-making for turtle shells and sharks' teeth from Florida. Hopewell pipes and pipestone have been found from Lake Superior to the Gulf of Mexico.

In a combination of realism and aesthetic simplification that is exceptionally sophisticated, a beaver crouching on a platform forms the bowl of a pipe found in Illinois (fig. 12-19). As in a modern pipe, the bowl—a hole in the beaver's back—could be filled with dried leaves (the Hopewell may not have grown tobacco), the leaves lighted, and smoke drawn through the hole in the stem. A second way that these pipes were used was to blow smoke inhaled from another vessel through the pipe to envelop the animal carved on it.

The people of the Mississippian culture ($800-1500\,\text{CE}$) continued the mound-building tradition of the earlier southeastern cultures. Cahokia, $16\,\text{miles}$ northeast of St. Louis near the juncture of the Illinois, Missouri, and Mis-

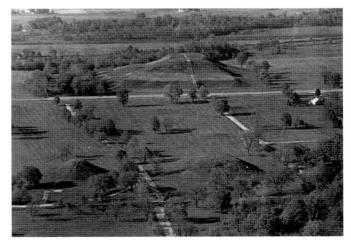

12-21. Cahokia

sissippi rivers (now East St. Louis, Illinois), was an urban center that at its height had a population of between 10,000 and 20,000 people, with another 10,000 in the surrounding countryside (figs. 12-20, 12-21). The site's most prominent feature is an enormous earth mound covering 15 acres. The location of the mound and the axis of the ceremonial center it dominated were established during the early part of the city's occupation (c. 900–1050 cE), but most construction occurred later, between about 1050 and 1250. A **stockade**, or fence, of upright wooden posts—a sign of increasing warfare—surrounded the

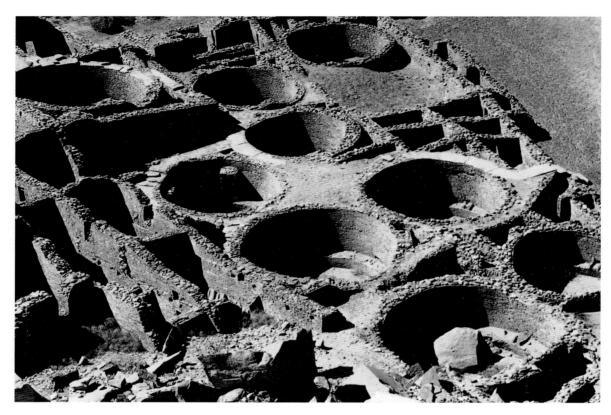

12-22. Pueblo Bonito, Chaco Canyon, New Mexico. Anasazi culture, c. 900-1250 ce

250-acre core. Within this barrier the principal mound rose in four stages to a height of about 100 feet. On its summit was a small, conical platform that supported a wood fence and a rectangular temple or house. Smaller rectangular and conical mounds in front of the principal mound surrounded a large, roughly rectangular plaza. In all, the walled enclosure contained more than 500 mounds, platforms, wooden enclosures, and houses. The various earthworks functioned as tombs and as bases for palaces and temples. A conical burial mound, for example, was located next to a platform that may have been used for sacrifices.

Postholes indicate that wooden **henges** were a feature of Cahokia. The largest, with a diameter of about 420 feet, had forty-eight posts and was oriented to the cardinal points. Sight lines between a forty-ninth post set east of the center of the enclosure and points on the perimeter enabled native astronomers to determine solstices and equinoxes.

The American Southwest

Three farming cultures emerged in the arid southwestern region of what is now the United States beginning around 200 BCE. The Mogollon culture, located in the mountains of west-central New Mexico and east-central Arizona, flourished from circa 200 BCE to about 1250 CE. The Hohokam culture, centered in central and southern Arizona, emerged around 200 BCE and endured until after

about 1200 ce. The Hohokam built large-scale irrigation systems with canals that were deep and narrow to reduce evaporation and lined with clay to reduce seepage. The Hohokam shared a number of customs with their Mesoamerican neighbors to the south, including the ritual ball game.

The third southwestern culture, the Anasazi (Navajo word meaning "the ancient ones"), emerged in the Four Corners region, where Colorado, Utah, Arizona, and New Mexico meet. The Anasazi, who adopted the irrigation technology of the Hohokam, turned to an agricultural, village way of life somewhat later than the other two groups. Around 750 ce they began building elaborate, multistoried, apartmentlike structures with many rooms for specialized purposes, including communal food storage. The Spaniards called these communities pueblos, or "towns." The descendants of the Anasazi, including the Hopi and Zuni, still occupy similar communities in the Four Corners area.

The largest known ancient Anasazi center is Pueblo Bonito in Chaco Canyon, which was built in stages between the tenth and mid-thirteenth centuries CE (fig. 12-22). In its final form this remarkable, **D**-shaped structure had hundreds of rooms and rose four stories high. Its outer perimeter wall was 1,300 feet long. The sandstone masonry walls on the ground floor were 4 feet thick, and trunks of ponderosa pines were used for roof beams. As new rooms were added over time, older rooms lost access to natural light. Amazingly, all aspects

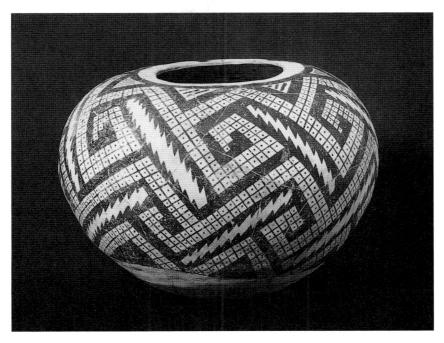

12-23. Seed jar. Anasazi culture, 1100–1300 ce. Earthenware and black and white pigment, diameter 14¹/2" (36.9 cm). The St. Louis Art Museum, St. Louis, Missouri

Purchase: Funds given by the Children's Art Festival 175:1981

of construction—including quarrying, timber cutting, and transport—were done without draft animals, wheeled vehicles, or metal tools.

Securing a steady food supply in the arid Southwest must have been a constant concern for the people of Chaco Canyon. At Pueblo Bonito the number of rooms far exceeds the evidence of human habitation, and many rooms were almost certainly devoted to food storage. Pueblo Bonito also has more than thirty kivas, which were centers of community ritual among pueblo dwellers. The presence of so many of them at Pueblo Bonito-including two that are more than 60 feet in diameter—attests to the importance of ritual at this site. The top of these circular, underground rooms became part of the floor of the communal plaza. Interlocking pine logs formed a shallow, domelike roof with a hole in the center through which only men would have entered. A pit in the floor directly under the entrance hole symbolized the place where the Anasazi ancestors had emerged from the earth in the mythic "first times." Here men performed important rituals and instructed youths in their adult ritual and social responsibilities.

Pueblo Bonito stood at the center of a network of wide, straight roads, in some places with curbs and paving. Almost invisible today, the roads were discovered and studied through aerial photography. The major roads run north and south in perfectly straight lines. The builders made no effort to avoid topographic obstacles;

when they encountered cliffs, they ran stairs up them. These characteristics suggest that the roads served as processional ways rather than practical thoroughfares.

Probably as a result of a climate change that made the Southwest increasingly arid, the population of Chaco Canyon declined during the twelfth century, and building at Pueblo Bonito ceased around 1230.

Women were the potters in Anasazi society. In the eleventh century they perfected a functional, aesthetically pleasing, coil-built earthenware, or low-fired ceramic. This ceramic tradition continues today among the Pueblo peoples of the Southwest. One type of vessel, a wide-mouthed seed jar with a globular body and holes near the rim (fig. 12-23), would have been suspended from roof poles, by thongs attached to the holes, out of reach of voracious rodents. The example shown here is decorated with black-and-white checkerboard and zigzag patterns. The patterns conform to the body of the jar, and in spite of their angularity, they enhance its curved shape. The intricate play of dark and light, positive and negative, suggests lightning flashing over a grid of irrigated fields.

Throughout the Americas for the next several hundred years, artistic traditions would continue to emerge, develop, and be transformed as the indigenous peoples of various regions interacted. The sudden incursions of Europeans, beginning in the late fifteenth century, would have dramatic and lasting impact on these civilizations and their art.

Saharan rock wall painting c. 2500–1500

▲ SAHARAN ROCK ART c. 8000-500

NOK ▲ c. 500 bce-200 ce

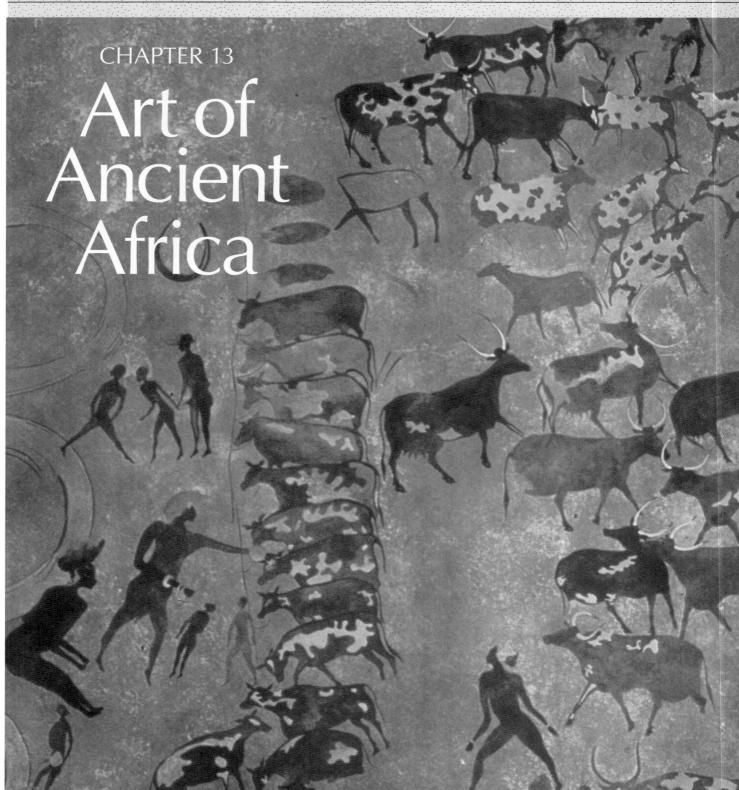

2500 BCE 1700 CE

descended [the Nile] with three hundred asses laden with incense, ebony, grain, panthers, ivory, and every good product." Thus the Egyptian envoy Harkhuf described his return from Nubia, the Black African land to the south of Egypt, in 2300 BCE. Some eight centuries after Harkhuf's journey, the Egyptian queen Hatshepsut, drawn by such treasures, ordered an expedition to the land of Punt, an African kingdom on the northern coast of present-day Somalia. So important was this kind of contact that portraits of the king and queen of Punt appear in Hatshepsut's funerary temple at Deir el-Bahri.

THE LURE OF ANCIENT AFRICA

The riches of Africa attracted merchants and envoys in ancient times, and through trade the continent was in contact

with the rest of the world. Egyptian relations, such as Hatshepsut's with African kingdoms to the south, continued through the Hellenistic era and beyond. To the west, dozens of settlements were founded along the Mediterranean coast of North Africa between 1000 and 300 BCE by Phoenicians and Greeks so that they could extend trade routes across the Sahara to the peoples of Lake Chad and the bend of the Niger River. When the Romans took control of North Africa, they continued this lucrative trans-Saharan trade. In the seventh and eighth centuries CE, the expanding empire of Islam swept across North Africa, and thereafter Islamic merchants were regular visitors to Bilad al-Sudan, the Land of the Blacks. Islamic scholars chronicled the great West African empires of Ghana, Mali, and Songhay, and West African gold financed the flowering of Islamic culture.

East Africa, meanwhile, had been drawn since at least the beginning of the Common Era into the maritime trade that ringed the Indian Ocean and extended east to Indonesia and the South China Sea. Arab, Indian, and Persian ships plied the coastline. A new language, Swahili, evolved from centuries of contact between Arabic-speaking merchants and Bantu-speaking Africans, and great port cities such as Mozambique, Kilwa, Mombasa, and Mogadishu arose.

In the fifteenth century, European ships ventured into the Atlantic Ocean and down the coast of Africa. After being cut off for centuries because of hostile relations with Islam, Europeans were only then rediscovering the continent at first hand. What they found often astonished them. "Dear King My Brother," wrote a fifteenth-century Portuguese king to his new trading partner, the king of Benin in West Africa. The Portuguese king's respect was well founded—Benin was vastly more powerful and more wealthy than the small European country that had just stumbled upon it.

European presence, benign and respectful at first, became over the centuries increasingly aggressive and territorial, culminating with the imposition of colonial rule over the entire continent during the late nineteenth century. European colonization was a watershed for Africa, dividing its long history of relatively independent development and forcing its entry into a world not of its own making.

As we saw in Chapter 3, Africa was home to one of the world's earliest great civilizations, that of ancient Egypt, and as we saw in Chapter 8, Egypt and the rest of North Africa contributed prominently to the development of Islamic art and culture. This chapter examines the artistic legacy of the rest of ancient Africa, beginning with the early peoples of the Sahara, then turning to other early civilizations.

SAHARAN ROCK ART

Like the Paleolithic inhabitants of Europe, early Africans painted and inscribed an abundance of images

on the walls of the caves and rock shelters in which they sought refuge. Rock art has been found all over Africa, in sites ranging from small, isolated shelters to great, cavernous formations. The mountains of the central Sahara—principally the Tassili-n-Ajjer range in the south of present-day Algeria and the Acacus Mountains in present-day Libya—have especially fascinating examples of rock art. The images there span a period of thousands of years, recording not only the artistic and cultural development of the peoples who lived in the region, but also the transformation of the Sahara from the fertile grassland it once was to the vast desert we know today.

The earliest images of Saharan rock art are thought to date from at least 8000 BCE, during the transition into a geological period known as the Makalian Wet Phase. At that time the Sahara was a great grassy plain, perhaps much like the game-park areas of modern East Africa. Vivid images of hippopotamus, elephant, giraffe, antelope, and other animals incised into rock surfaces testify to the abundant wildlife that roamed the region. Like the cave paintings in Altamira and Lascaux (Chapter 1), these images may have been intended as magic to ensure plentiful game or a successful hunt, or they may have been symbolic of other life-enhancing activities, such as healing or rainmaking.

By 4000 BCE the climate had become more arid, and hunting had given way to herding as the primary life-sustaining activity of the Sahara's inhabitants. Among the most beautiful and complex examples of Saharan rock art created in this period are scenes of sheep, goats, and cattle and of the daily lives of the people who tended them. One such scene, *The Herders' Village*, was found at Tassili-n-Ajjer and probably dates from late in the herding period, about 2500–1500 BCE (fig. 13-1). Men and women are gathered in front of their round, thatched houses, the men tending the cattle, the

PARALLELS

Years	Center	Africa	World	
с. 8000-500 все	Sahara	Rock art; herding; settled agri- culture; Great Pyramids at Giza; Sahara becoming desert; horse introduced; camel intro- duced; ironworking	C. 8000–500 BCE Bronze Age in Europe; plants and animals domesticated (Near East, Southeast Asia, the Americas); development of metallurgy (Near East); development of writing (Near East, China, India); Olmec civilization (Mesoamerica); birth of Laozi, founder of Daoism (China); birth of Siddhartha Gautama, founder of Buddhism (Nepal); Confucius (China)	
с. 500 все-200 се	Nok	First known sculpture; terracotta figures	c. 500 BCE-1000 CE Parthenon (Greece); crucifixion of Jesus (Jerusalem); Colosseum (Italy); Pantheon (Italy); first Gupta dynasty (India); earliest surviving Hindu temples (India); Hagia Sophia (Turkey); birth of Muhammad, founder of Islam (Arabia); Muslim conquests	
c. 200-present	Djenné	Great Friday Mosque		
c. 800 CE-present	lfe	Terra-cotta sculpture; bronze sculpture		
с. 1000 се-1500 се	Great Zimbabwe	Stone structures; carvings	c. 1000–1700 CE Separation of Eastern and Western Christian Churches; the Crusades; Spanish Inquisition; beginning of Renaissance in Europe; Aztec civilization (Mexico); end of Byzantine Empire; Columbus's voyages; the Reformation; first English colony in North America	
c. 1170 CE-present	Benin	Memorial sculpture; trade with Portuguese; Early, Middle, Late periods		

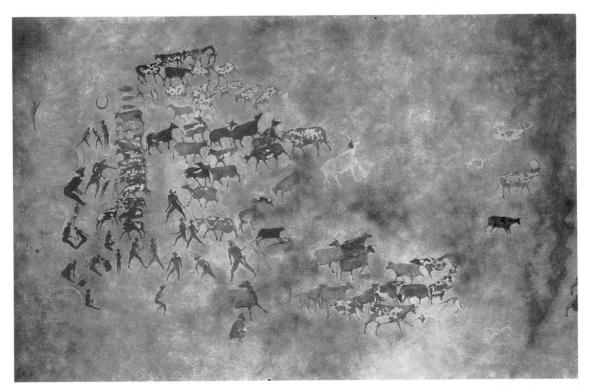

13-1. *Cattle Gathered next to a Group of Huts*, detail of *The Herders' Village*, rock-wall painting, Tassili-n-Ajjer, Algeria. c. 2500–1500 BCE. Watercolor facsimile painted by students of Henri Lhote. Musée de l'Homme, Paris, France

2500 BCE 1700 CE

THE MYTH OF "PRIMITIVE" tive has often ART

The word primibeen used by Western art his-

torians to lump together the art of Africa, the Pacific islands, and North, South, and Central America before the arrival of Columbus. The label implies, among other things, that all these areas are in some way similar cultures that produced similar art for similar reasons.

The term itself means "early," and its very use implies that these civilizations are frozen at an early stage of development, rather than that their cultures have developed along different paths than those of Europe. In the past, the criteria used for assigning the label primitive to a

people included so-called Stone Age technology, absence of written histories, and failure to build "great" cities. Yet the accomplishments of the peoples of Africa, to take just one example, strongly belie this categorization: Africans south of the Sahara have smelted and forged iron since at least 500 BCE, as the evidence of the Nok culture in northern Nigeria makes quite clear, and Africans in many areas have long smelted highquality steel for weapons and tools. Many African peoples have recorded their histories in Arabic since at least the tenth century. And the first European visitors to western Africa expressed their admiration for the political, economic, and social sophistication of such urban centers as

Benin, Luanda, and Mbanza Kongo.

Why, then, have labels like primitive persisted? Many historical attitudes were formed by Christian missionaries, who long described the people among whom they worked as "heathen," "barbaric," "ignorant," "tribal," "primitive," and other terms rooted in racism and colonialism. As these usages were perpetuated, they were extended to the creations of the cultures, and primitive art became the dominant label for the cultural products of these peoples. If the illogical notion that technological development equals quality of art were in fact valid, then the art of twentiethcentury Japan, for example, would be considered greater than the art of fifteenth-century Italy.

women preparing a meal and caring for children. A large herd of cattle, many of them tethered to a long rope, has been driven in from pasture. The cattle shown are quite varied. Some are mottled, others are white, red, or black. Some have short, thick horns, while others have graceful, lyre-shaped horns. The overlapping forms and the confident placement of near figures low and distant figures high in the picture create a sense of depth and distance.

By 2500-2000 BCE the Sahara had dried considerably and the great game had gone, but other animals were introduced that appear in the rock art. The horse was brought from Egypt by about 1500 BCE and is seen regularly in rock art over the ensuing millennia. The fifthcentury BCE Greek historian Herodotus described a chariot-driving people called the Garamante, whose kingdom corresponded roughly to present-day Libya, and rock-art images of horse-drawn chariots bear out his account. Around 600 BCE the camel was introduced into the region from the east, and images of camels have been painted on and incised into the rock from then to now.

The desiccation of the Sahara coincides with the rise of Egyptian civilization along the Nile Valley to the east. Similarities have been noted between Egyptian and Saharan motifs, among them images of rams with what appear to be disks between their horns. These similarities have been viewed as evidence of Egyptian influence on the less-developed regions of the Sahara. Yet in light of the great age of Saharan rock art, it seems just as plausible that influence flowed the other way, carried by people who had migrated into the Nile Valley in search of arable land and pasture when the grasslands of the Sahara dried up. This migration, by greatly expanding the population of the valley, may also have contributed to the tensions that resulted in the emergence of complex forms of social organization there.

SUB-SAHARAN CIVILIZATIONS

Saharan peoples presumably migrated southward as well, into the Sudan, the

broad belt of grassland that stretches across Africa south of the Sahara desert, bringing with them knowledge of settled agriculture and animal husbandry. The earliest evidence for settled agriculture in the Sudan dates from about 3000 BCE. Toward the middle of the first millennium BCE, at the same time that iron technology was being developed elsewhere in Africa, knowledge of ironworking spread across the Sudan, enabling its inhabitants to create more efficient weapons and farming tools. In the wake of these developments, larger and more complex societies emerged, especially in the fertile basins of Lake Chad in the central Sudan and the Niger and Senegal rivers to the west.

Nok Culture

Some of the earliest evidence of iron technology in sub-Saharan Africa comes from the so-called Nok culture. which arose in the western Sudan, in present-day Nigeria, as early as 500 BCE. The Nok people were farmers who grew grain and oil-bearing seeds, but they were also smelters with the technology for refining ore. Slag and the remains of furnaces have been discovered, along with clay nozzles from the bellows used to fan the fires. The Nok people created the earliest known sculpture of sub-Saharan Africa, producing accomplished terra-cotta figures of human and animal subjects between about $500\,\mathrm{BCE}$ and 200 ce.

Nok sculpture was discovered in modern times by tin miners digging in the alluvial deposits on the Jos plateau north of the confluence of the Niger and Benue rivers. Presumably, floods from centuries past had removed the

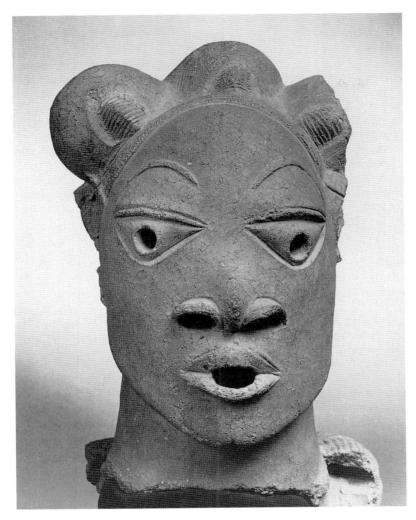

13-2. Head. Nok culture, c. 500 BCE-200 CE. Terra-cotta, height 14³/16" (36 cm). National Museum, Lagos, Nigeria

figures from their original contexts, dragged and rolled them along, then redeposited them. This rough treatment had scratched and broken many, often leaving only the heads from what must have been complete human figures. Following archeological convention, scholars gave the name of a nearby village, Nok, to the culture that created these works. Nok-style sculpture has since been found in numerous sites over a wide area.

The Nok head shown here (fig. 13-2), slightly larger than lifesize, originally formed part of a complete figure. The triangular or **D**-shaped eyes are characteristic of Nok style and appear also on sculpture of animals. Holes in the pupils, nostrils, and mouth allowed air to pass freely as the figure was fired. Each of the large buns of its elaborate hairstyle is pierced with a hole that may have held ornamental feathers. Other Nok figures boast large quantities of beads and other prestige ornaments. Nok sculpture may represent ordinary people dressed up for a special occasion, or it may portray people of high status, providing evidence of social stratification in this early farming culture. At the very least, the sculpture provides evidence of considerable technical accomplishment. The skill and artistry it reflects have led many

scholars to speculate that Nok culture was built on the achievements of an earlier culture still to be discovered.

Ife

Following the disappearance of the Nok culture, the region of present-day Nigeria remained a vigorous cultural and artistic center. The **naturalistic** sculpture created by the artists of the city of Ife, which arose in the southern, forested part of that region by about 800 CE, are among the most remarkable in art history (see "Who Made African Art?," page 470).

Ife was, and remains, the sacred city of the Yoruba people. Yoruba myth tells how at Ife the gods descended from heaven on iron chains to create the world. A tradition of naturalistic sculpture began there about 1050 ce and flourished for some four centuries. Although the line of Ife kings, or *onis*, continues unbroken from that time to the present, the knowledge of how these works were used has been lost. When archeologists showed the sculpture to members of the contemporary *oni's* court, however, they identified symbols of kingship on sculpture that had been worn within living memory, indicating that the figures represent rulers.

WHO MADE

Today many art AFRICAN ART? museums boast extensive col-

lections of African art. Yet on label after label, a standard piece of information is missing. Where are the artists' names? Who made this art?

Until quite recently, the role of the artist in many African societies was greatly misunderstood, and the answer would have been, "It doesn't matter-the question is irrelevant." Artists working in Africa used to be commonly portrayed as obedient craftsworkers. Bound to the style and iconography dictated to them by village elders, they carved by rote the same images again and again; their work was said to be anonymous and interchangeable.

Over the past several decades, however, these misconceptions have begun to crumble. One of the first non-Africans to understand that African art, as much as European art, was the work of identifiable artists was the Belgian art historian Frans Olbrechts. During the 1930s, while assembling a group of objects from present-day Zaire for an exhibition, Olbrechts noticed that as many as ten figures had been carved in a very distinctive style. A look at the labels revealed that two of the statues had been collected in the same town, Buli, in eastern Zaire. As a scholar of Western art history, Olbrechts was familiar with the practice of identifying individual styles and, when names were not available, assigning the artist an identity such as the Master of Frankfurt or the Master of the Saint Catherine Legend. Accordingly, he named the unknown African artist the Master of Buli

In the years since Olbrechts's exhibition, eleven more works have been identified as coming either directly from the hand of the Master of Buli or from his workshop. Interestingly, although the town of Buli is in an area populated predominantly by the Luba people, the style of the objects is closer to that of the Hemba people, who live just to the east. It may be that the Master of Buli was a Hemba artist working for Luba clients or for a large clientele spread across southeastern Zaire.

In the late 1970s, an object in the style of the Master of Buli was discovered in the Hemba area. Its owners identified the artist as Ngongo ya Chintu, of Kateba village, a short distance away. Kateba villagers in turn remembered Ngongo ya Chintu as an artist of great skill. His reputation had spread throughout southeastern Zaire, and he had attracted clients from a large area. Clearly, then, African artists did not work anonymously. So why have their names not been preserved?

One reason has to do with some African systems of patronage. As was the case in many lands, artists in many African countries created their works in response to specific commissions rather than to express a personal message. Art might be commissioned by an individual, a family, an organization, or an entire community, and negotiations between patrons and artists over the details of a commission were often protracted. Once the work had been created, however, the name of the artist was not necessarily made public. Instead, the work was generally associated with the names of its

owners or commissioners.

Another reason is that early collectors simply failed to ask. During the late nineteenth and early twentieth centuries, when many Western collections of African art were being formed, Westerners generally did not believe that Africans shared their sense of the uniqueness and importance of the individual. Thus the explorers, colonial officers, and missionaries who filled the storerooms of European museums rarely asked who had made or owned the objects they were acquiring. Nor did they always distinguish carefully what part of Africa a work came from. In European eyes Africa was a single country

As the story of Ngongo ya Chintu indicates, however, Africans are fully aware of the names of their artists. Inspired by Olbrechts's example, art historians and anthropologists have since identified numerous African artists and compiled catalogs of their work. In the case of the Yoruba people of present-day Nigeria, for example, we now know of such artists as Agbonbiofe of the Adeshina family of Efon-Alaye (d. 1945), Obembe Alaye of Efon-Alaye (1869-1939), Maku of Erin (d. 1928), and many others.

Certainly we will never know the names of the vast majority of African artists of the past, just as we do not know the names of the sculptors responsible for the sculpture portraits of late Rome or the monumental reliefs of the Hindu temples of South Asia. As elsewhere, the greatest artists in Africa were famous and sought after, while the others labored honorably at their art.

A lifesize brass head (fig. 13-3) shows the extraordinary artistry of ancient Ife. The modeling of the flesh is supremely sensitive, especially the subtle transitions around the nose and mouth. The lips are full and delicate. and the eyes are strikingly similar in shape to those of some modern Yoruba. The face is covered with thin, parallel scarification patterns (decorations made by scarring) in a style that was still occasionally seen on Nigerians until recently.

Holes along the scalp apparently permitted hair or perhaps a beaded veil to be attached. Large holes around the base of the neck may have allowed the head itself to be attached to a wooden mannequin for display during memorial services for a deceased oni. The mannequin

was probably dressed in the oni's robes and his crown was probably attached to the head by means of the holes along the hairline.

The artists of ancient Ife also worked in terra-cotta. Unlike their brass counterparts, terra-cotta heads are not fitted for attachments. They were probably placed in shrines devoted to the memory of each dead king. Two of the most famous Ife sculptures were not found by archeologists but had been preserved through the centuries in the oni's palace. One, a terra-cotta head, is said to represent Lajuwa, a court retainer who usurped the throne by intrigue and impersonation (fig. 13-4). The other, a lifesize copper mask, is said to represent Obalufon, the ruler who introduced bronze casting.

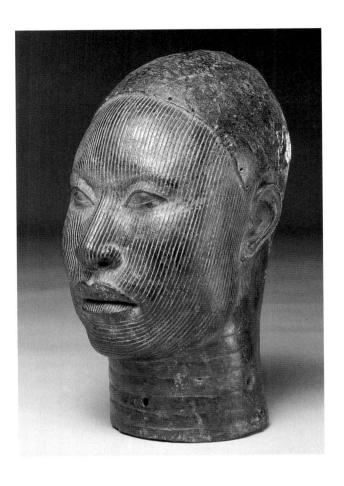

13-3. Head of a king, from Ife. c. 13th century ce. Brass, height 117/16" (29 cm). Museum of Ife Antiquities, Ife, Nigeria

The naturalism of Ife sculpture contradicted everything Europeans thought they knew about African art. The German scholar who "discovered" Ife sculpture in 1910 suggested that it had been created not by Africans but by survivors from the legendary lost island of Atlantis. Later scholars speculated that influence from ancient Greece or Renaissance Europe must have reached Ife. Scientific dating methods, however, finally put such misleading comparisons and prejudices to rest. When naturalism flowered in Ife, the ancient Mediterranean world was long gone and the European Renaissance still to come. In addition, the proportions of the few known full figures are characteristically African, with the head comprising as much as one quarter of the total height. These proportions probably reflect a belief in the head's importance as the abode of the spirit and the focus of individual identity.

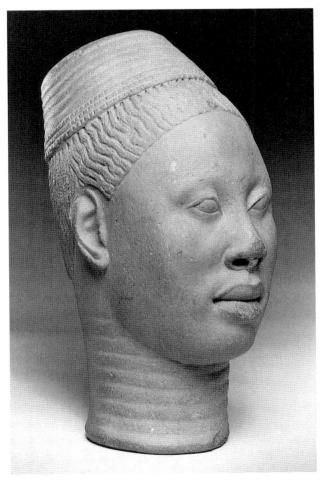

Scholars continue to debate whether the Ife heads are true portraits. Their striking anatomical individuality strongly suggests that they are. The heads, however, all seem to represent men of the same age and seem to embody a similar concept of physical perfection, suggesting that they are **idealized** images. In the recent past, Africans have not produced naturalistic portraits, fearing that they could house malevolent spirits that would harm the soul of the subject. If the Ife heads are portraits, then perhaps the institution of kingship and the need to revere royal ancestors were strong enough to overcome such concerns.

Benin

Ife was probably the artistic parent of the great city-state of Benin, which arose some 150 miles to the southeast. According to oral histories, the earliest kings of Benin belonged to the Ogiso, or Skyking, dynasty. After a long period of misrule, however, the people of Benin asked the *oni* of Ife for a new ruler. The *oni* sent Prince Oranmiyan, who founded a new dynasty in 1170 ce. Some two centuries later, the fourth king, or *oba*, of Benin decided to start a tradition of memorial sculpture like that of Ife, and he sent to Ife for a master metal caster named

13-4. Head said to represent the Usurper Lajuwa, from Ife. c. 1200–1300 ce. Terra-cotta, height 12 15/16" (32.8 cm). Museum of Ife Antiquities, Ife, Nigeria 1700 CE 2500 BCE 1700 CE

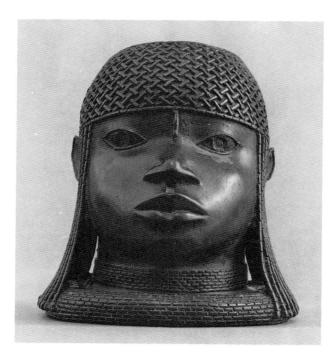

13-5. Memorial head, from Benin. c. 1400–1550 ce (Early Period). Brass, height 9³/₈" (23.4 cm). The Metropolitan Museum of Art, New York

The Michael C. Rockefeller Memorial Collection, Bequest of Nelson A. Rockefeller, 1979 (1979.206.86)

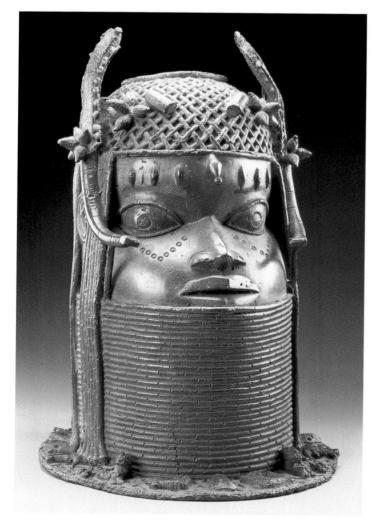

Iguegha. The tradition of casting memorial heads for the shrines of royal ancestors endures among the successors of Oranmiyan to this day.

Benin came into contact with Portugal in the late fifteenth century. The two kingdoms established cordial relations and carried on an active trade, at first in ivory and other forest products but eventually in slaves. Benin flourished until 1897, when, in reprisal for the massacre of a party of trade negotiators, British troops sacked and burned the royal palace, sending the *oba* into an exile from which he did not return until 1914. The palace was later rebuilt, and the present-day *oba* continues the dynasty started by Oranmiyan.

The British invaders discovered shrines to deceased *obas* filled with brass heads, bells, and figures. They also found wooden rattles and enormous ivory tusks carved with images of kings, court attendants, and sixteenth-century Portuguese soldiers. The British appropriated the treasure as war booty, making no effort to note which head came from which shrine. As a result, they destroyed evidence that would have helped establish the relative age of the heads and determine a chronology for the evolution of Benin style. Nevertheless, scholars have managed to piece together a chronology from other evidence.

Benin brass heads range from small, thinly cast, and naturalistic to large, thickly cast, and highly stylized. The heads that were being made at the time of the British invasion are of the latter variety, as are those still being cast today. Many scholars have concluded that the smallest, most naturalistic heads were created during a so-called Early Period (1400–1550 CE), when Benin artists were still heavily influenced by Ife (fig. 13-5). Heads grew increasingly stylized during the Middle Period (1550–1700 CE). Heads from the ensuing Late Period (1700–1897 CE) are very large and heavy, with angular, stylized features and an elaborate beaded crown (fig. 13-6). A similar crown is still worn by the present-day *oba*.

All of the heads include representations of coral-bead necklaces, which have formed part of the royal costume from earliest times to the present day. Small and few in number on Early Period heads, they increase in number until they conceal the chin during the Middle Period. During the Late Period, the necklaces form a tall, cylindrical mass that greatly increases the weight of the sculpture. Broad, horizontal flanges, or projecting edges, bearing small images cast in low relief ring the base of the Late Period statues, adding still more weight. The increase in size and weight of Benin memorial heads over time may reflect the growing power and wealth flowing to the *oba* from Benin's expanding trade with Europe.

The art of Benin is a royal art, for only the *oba* could commission works in brass. Artisans who served the court lived in a separate quarter of the city and were organized into guilds. Among the most remarkable visual records of court life are the hundreds of brass plaques, each about 2 feet square, that once decorated

13-6. Head of an *oba* (king), from Benin. c. 1700–1897 CE (Late Period). Brass, height 17¹/₄" (45 cm). Museum für Völkerkunde, Vienna/Musée Dapper, Paris

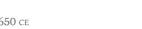

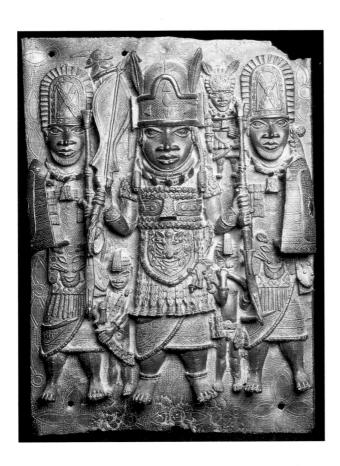

13-7. *General and Officers,* from Benin. c. 1550–1650 ce (Middle Period). Brass, height 21" (53.5 cm). National Museum, Lagos, Nigeria

The general wears an elaborate, appliqué apron depicting the head of a leopard, and the flanking officers wear leopard pelts. Leopards were symbols of royalty in Benin. Live leopards were kept at the royal palace, where they were looked after by a special keeper. Water pitchers in the form of leopards were cast in bronze and placed on altars dedicated to ancestors. An engraving from a European travel book of the sixteenth century depicts a procession of courtiers in Benin led by a pair of magnificent leopards.

the walls and columns of the royal palace. Produced during the Middle Period, the plaques are modeled in relief, sometimes in such high relief that the figures are almost freestanding. An exceptionally detailed plaque (fig. 13-7) shows a general in elaborate military dress holding a spear in one hand and a ceremonial sword in the other. Flanking the general, two officers, whose helmets indicate their rank, brandish spears and shields. Smaller figures appear between the three principal figures, one carrying a sword, another sounding a horn. Above the tip of the general's sword is a small figure of a Portuguese soldier.

Obas also commissioned important works in ivory. One example is a beautiful ornamental mask (fig. 13-8)

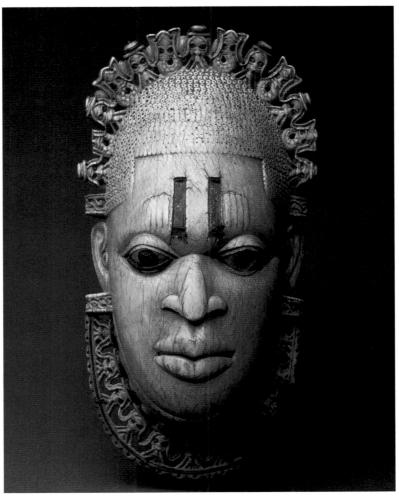

13-8. Mask representing an iyoba, from Benin. c. 1550 ce. Ivory, iron, and copper, height 93/8" (23.4 cm). The Metropolitan Museum of Art, New York The Michael C. Rockefeller Memorial Collection, Gift of Nelson A. Rockefeller, 1972 (1978.412.323)

that represents an iyoba, or queen mother. The woman who had borne the previous oba's first male child (and thus the mother of the current oba), the iyoba ranked as the senior female member of the court. This mask may represent Idia, the first and best-known iyoba. Idia was the mother of Esigie, who ruled as oba from 1504 to 1550 ce. She is particularly remembered for raising an army and using her magical powers to help her son defeat his enemies.

The mask was carved as a belt or hip ornament and was probably worn at the oba's waist. Its pupils were originally inlaid with iron, as were the scarification patterns on the forehead. The necklace represents heads of Portuguese soldiers with beards and flowing hair. Like Idia, the Portuguese helped Esigie expand his kingdom. In the crown, more Portuguese heads alternate with figures of mudfish, which in Benin iconography symbolized Olokun, the Lord of the Great Waters. Mudfish live on the riverbank, mediating between water and land, just as the oba, who is viewed as semidivine, mediates between the human world and the supernatural world of Olokun.

CENTERS

URBAN If e and Benin were but two of the many cities that arose in ancient Africa. The first European visitors to the West Afri-

can coast at the end of the fifteenth century were impressed not only by Benin, but also by the cities of Loango and Luanda near the mouth of the Zaire River. Exploring the East African coastline, European ships happened on cosmopolitan cities that had been busily carrying on long-distance trade across the Indian Ocean and as far away as China and Indonesia for hundreds of years.

Important centers also arose in the interior, especially across the central and western Sudan. There cities and the states that developed around them grew wealthy from the trans-Saharan trade that had linked West Africa to the Mediterranean from at least the first millennium BCE. Indeed, the routes across the desert were probably as old as the desert itself. Among the most significant goods exchanged in this trade were salt from the north and gold from West Africa. Such fabled cities as Mopti, Timbuktu, and Djenné were great centers of commerce, where merchants from all over West Africa met caravans arriving from the Mediterranean.

Djenné

In 1655, the Islamic writer al-Sadi wrote this description of Djenné:

This city is large, flourishing, and prosperous; it is rich, blessed, and favoured by the Almighty. . . . Jenne [Djenné] is one of the great markets of the Muslim world. There one meets the salt merchants from the mines of Teghaza and merchants carrying gold from the mines of Bitou. . . . Because of this blessed city, caravans flock to Timbuktu from all points of the horizon. . . . The area around Jenne is fertile and well populated; with numerous markets held there on all the

days of the week. It is certain that it contains 7,077 villages very near to one another.

> (Translated by Graham Connah in Connah, page 97)

By the time al-Sadi wrote his account, Djenné, in presentday Mali, already had a long history. Archeologists have determined that the city was established by the third century CE and that by the middle of the ninth century it had become a major urban center. By the ninth century also, Islam was becoming an economic and religious force in West Africa, having incorporated North Africa and the northern terminals of the trans-Saharan trade routes into the Islamic empire. Much of what we know about African history from this time on is based on the accounts of Islamic scholars, geographers, and travelers.

When Koi Konboro, the twenty-sixth king of Djenné, converted to Islam in the thirteenth century, he transformed his palace into the first of three successive mosques in the city. Like the two that followed, the first mosque was built of adobe brick, a sun-dried mixture of clay and straw. With its great surrounding wall and tall towers, it was said to have been more beautiful and more lavishly decorated than the Kaaba, the central shrine of Islam, at Mecca. The mosque eventually attracted the attention of austere Muslim rulers, who objected to its sumptuous furnishings. Among these was the earlynineteenth-century ruler Sekou Amadou, who had it razed and a far more humble structure erected on a new site. This second mosque was in turn replaced by the current grand mosque, constructed between 1906 and 1907 on the ancient site and in the style of the original. The reconstruction was supervised by the architect Ismaila Traoré, the head of the Djenné guild of masons.

The mosque's eastern, or "marketplace," facade boasts three tall towers (fig. 13-9). The finials, or crowning ornaments, at the top of each tower bear ostrich eggs, symbols of fertility and purity. The facade and sides of the mosque are distinguished by tall, narrow, engaged columns, which act as buttresses. These columns are characteristic of West African mosque architecture, and their cumulative rhythmic effect is one of great verticality and grandeur. The most unusual feature of West African mosques are the *torons*, wooden beams projecting from the walls. Torons provide permanent supports for the scaffolding erected each year so that the exterior of the mosque can be replastered.

Great Zimbabwe

Several thousand miles from Djenné, in southeastern Africa, an extensive trade network developed along the Zambezi, Limpopo, and Sabi rivers. Its purpose was to funnel gold, ivory, and exotic skins to the coastal trading towns that had been built by Arabs and Swahili-speaking Africans. There, the gold and ivory were exchanged for prestige goods, including porcelain, beads, and other manufactured items. Between 1000 and 1500 cE, this trade was largely controlled from a site that was called Great Zimbabwe.

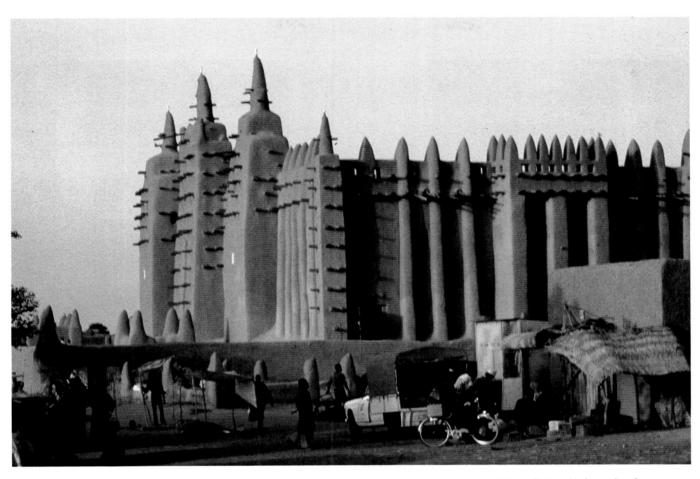

13-9. Great Friday Mosque, Djenné, Mali, showing the eastern and northern facades. Rebuilding of 1907, in the style of 13th-century original

The plan of the mosque is quite irregular. Instead of a rectangle, the building forms a parallelogram. Inside, nine long rows of heavy adobe columns some 33 feet tall run along the north-south axis, supporting a flat ceiling of palm logs. A pointed arch links each column to the next in its row, thereby forming nine east-west archways facing the mihrab, the niche that indicates the direction of Mecca. The mosque is augmented by an open courtyard for prayer on the west side, which is enclosed by a great double wall only slightly lower than the walls of the mosque itself.

The word *zimbabwe* derives from the Shona term for "venerated houses" or "houses of stone." Scholars agree that the stone buildings at Great Zimbabwe were constructed by ancestors of the present-day Shona people, who still live in the region. The earliest construction at the site took advantage of the enormous boulders abundant in the vicinity. Masons incorporated the boulders and used the uniform granite blocks that split naturally from them to build a series of tall enclosing walls high on a hill-top. Each enclosure defined a family's living or ritual space and housed dwellings made of adobe with conical, thatched roofs.

The largest building complex at Great Zimbabwe is located in a broad valley below the hilltop enclosures.

Known as Imba Huru, the Big House, the complex is ringed by a masonry wall more than 800 feet long, 32 feet tall, and 17 feet thick at the base. The buildings at Great Zimbabwe were built without mortar; for stability the walls are **battered**, or built so that they slope inward toward the top. Inside the great outer wall are numerous smaller stone enclosures and adobe foundations.

The complex seems to have evolved with very little planning. Additions and extensions were begun as labor and materials were available and need dictated. Over the centuries, the builders grew more skillful, and the later additions are distinguished by **dressed stones**, or smoothly finished stones, laid in fine, even, level courses. One of these later additions is a fascinating structure

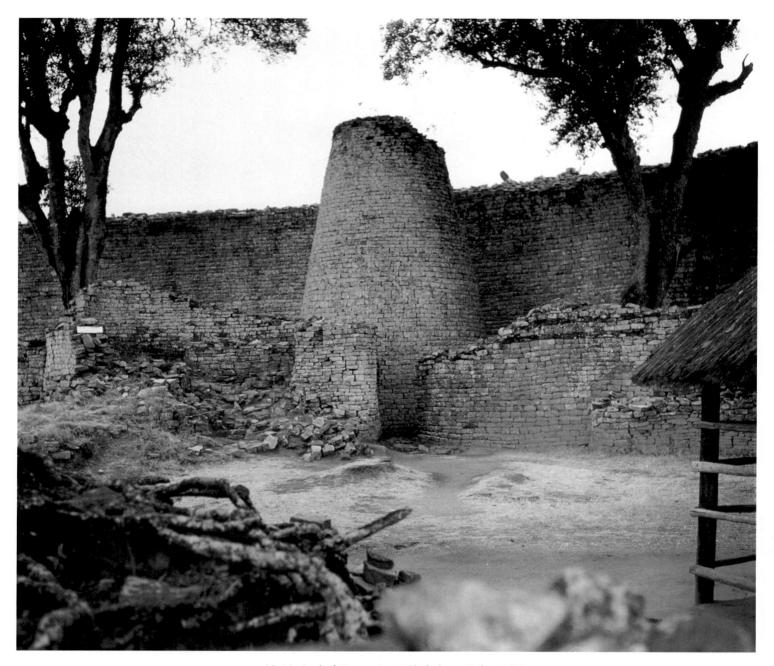

13-10. Conical Tower, Great Zimbabwe. Before 1450 $\scriptstyle{\text{CE}}$

known simply as the Conical Tower (fig. 13-10). Some 18 feet in diameter and 30 feet tall, the tower was originally capped with three courses of ornamental stonework. It may have represented the good harvest and prosperity believed to result from allegiance to the ruler of Great Zimbabwe, for it resembles a present-day Shona granary built large.

Among the many interesting finds at Great Zimbabwe are a series of carved soapstone birds (fig. 13-11). The carvings, which originally crowned tall **monoliths**, seem to depict birds of prey, perhaps eagles. They may, however, represent mythical creatures, for the species cannot be identified. Traditional Shona beliefs include an eagle called *shiri ye denga*, or "bird of heaven," who brings

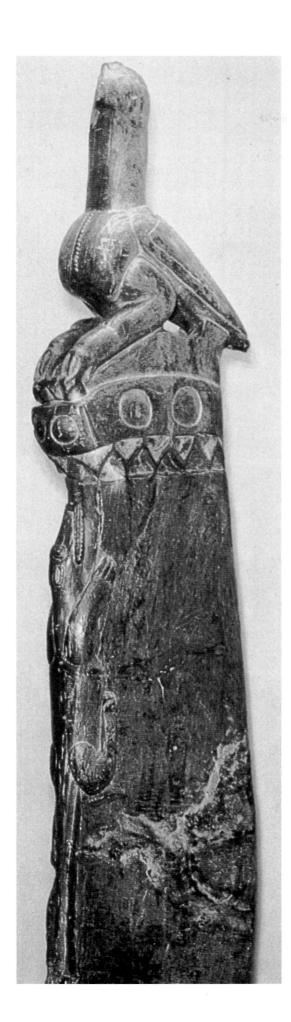

13-11. Bird, top part of a monolith, from Great Zimbabwe. c. 1200–1400 ce. Soapstone, height 141/2" (36.8 cm). Great Zimbabwe Site Museum, Zimbabwe

lightning, a metaphor for communication between the heavens and earth. These soapstone birds may have represented such messengers from the spirit world, or they may have served as symbols of royalty, expressing the king's power to mediate between his subjects and the supernatural world of spirits.

Although some of the enclosures at Great Zimbabwe were built on hilltops, there is no evidence that they were constructed as fortresses. There are neither openings for weapons to be thrust through nor battlements for warriors to stand on. Instead, the walls and structures seem intended to reflect the wealth and power of the city's rulers. The Big House was probably a royal residence, or palace complex, and other structures housed members of the ruler's family and court. The complex formed the nucleus of a city that radiated for almost a mile in all directions. It is estimated that at the height of its power in the fourteenth century, Great Zimbabwe and its surrounding city housed a population of more than 10,000 people. A large cache of goods containing items of such far-flung origin as Portuguese medallions, Persian pottery, and Chinese porcelain testify to the extent of its trade. Yet beginning in the mid-fifteenth century Great Zimbabwe was gradually abandoned. Its power and control of the lucrative southeast African trade network passed to the Mwene Mutapa and Kami empires only a short distance away.

During the twentieth century, the sculpture of traditional African societies—wood carvings of astonishing formal inventiveness and power—have found admirers the world over, becoming virtually synonymous with "African art." Admiration for these art forms was evident in earlier periods as well. In the mid-seventeenth century, for example, a German merchant named Christopher Weickman collected a Yoruba divination board, textiles from the Kongo, and swords with nubbly ray-skin sheaths from the Akan, all of which are now housed in a museum in Ulm, Germany. Wood decays rapidly, however, and little of African wood sculpture remains from before the nineteenth century. As a result, much of ancient Africa's artistic heritage has probably been as irretrievably lost as have, for example, the great monuments of wooden architecture of dynastic China. Yet the beauty of ancient African creations in such durable materials as terracotta, stone, and bronze bears eloquent witness to the skill of ancient African artists and the splendor of the civilizations in which they worked.

A CHRISTIAN SPAIN 500-

▲ BRITAIN/IRELAND 500-

▲ CAROLINGIAN PERIOD 750-900

CHAPTER 14

Early Medieval Art in Europe

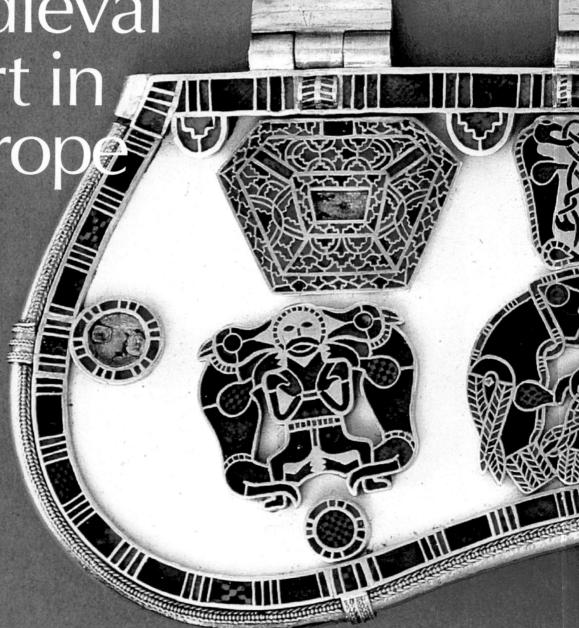

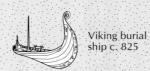

Bird and Serpent, from a Spanish manuscript 975

Adam and Eve, from the Hildesheim doors 1015

▲ OTTONIAN PERIOD 900-1000

▲ SCANDINAVIAN VIKING 800-1100.

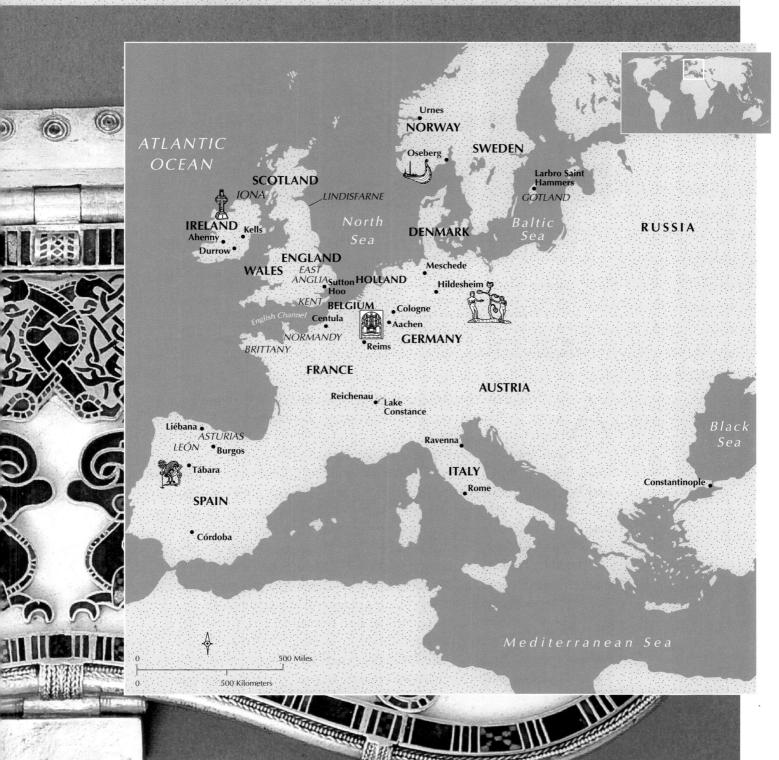

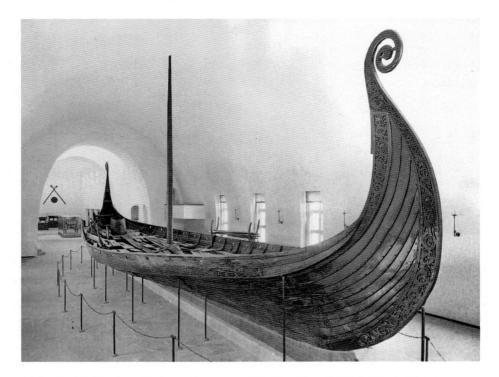

14-1. Burial ship, from Oseberg, Norway. c. 800. Wood, length 75'6" (23 m). Viking-skiphuset, Universitets Oldsaksamling, Oslo, Norway.
This vessel, propelled by both sail and oars, was designed not for ocean voyages but for travel in the relatively calm waters of fjords, narrow coastal inlets. The shelter at the center of this ship was used as the burial chamber for two women. A cart and four sleds, all made of wood with beautifully carved decorations, were stored on board. Fourteen horses, an ox, and three dogs had been sacrificed to accompany the women into the grave. It is also quite possible that one of the women was a willing sacrificial victim for the other, since Viking society believed that a courageous and honorable death was a guarantee of reward in the afterlife.

s a flotilla of 2,000 Viking ships approached Constantinople early in the tenth century, so the story goes, the intimidated Byzantines stretched an enormous chain across the strait to stop them. The remarkable mariners from Scandinavia had sailed eastward across the Baltic Sea and down rivers to the Black Sea. The chain they encountered was no more an obstacle to them than waterfalls and other impassable places on the rivers they had navigated, and they got around it the same way: they lifted their ships from the water, put them on rollers made of tree trunks, and rolled them around the barrier. The Byzantine emperor was so cowed by their ingenuity and aggressiveness that he paid the Vikings a huge tribute, established a trade treaty with them, and hired some of these "ax-bearing barbarians" as an elite guard for the imperial palace.

These Viking ships crossed land to find treasure, but another ship—a 75-foot-long vessel discovered in Oseberg, Norway, and dated about 800—served as the burial site for two women on a journey to eternity (fig. 14-1). The Vikings saw their ships as sleek sea serpents, and the prow and stern of the Oseberg ship rise and coil like a serpent's tail. These suggestive spirals may have been meant to terrify enemies and to protect against evil forces. Although the burial chamber was long ago looted of jewelry and precious objects, the ship itself and the remaining artifacts attest to the wealth and prominence of the ship's owner and have provided insight into the culture of Scandinavia in the Early Middle Ages.

THE **MIDDLE AGES**

The roughly 1,000 years of European history between the collapse of the Western Roman Empire in the fifth century and the Renaissance in the fif-

teenth are known as the Middle Ages, or the medieval period. These terms reflect the view of early historians that this was a dark "middle" age of ignorance, decline, and barbarism between two golden ages. Although this view no longer prevails—the Middle Ages are now known to have been a period of great richness, complexity, and innovation that gave birth to modern Europe—the terms have endured. Art historians commonly divide the Middle Ages into three periods: Early (ending in the tenth and eleventh centuries), Romanesque (from the tenth to the twelfth century), and Gothic (extending from the twelfth century into the fifteenth). The terms Romanesque and Gothic refer to distinctive artistic styles that were prevalent during the periods that bear their names. Chapters 7 ("Early Christian, Jewish, and Byzantine Art") and 8 ("Islamic Art") have already touched on some aspects of early medieval art. This chapter covers the art of the Early Middle Ages in western and northern Europe-Scandinavia, Britain, Ireland, Christian Spain, France, and Germany-from the sixth century to the eleventh century. Chapter 15 covers Romanesque art, and Chapter 16 discusses Gothic art.

As Roman authority crumbled at the outset of the Middle Ages, it was replaced by strong local leadersincluding the leaders of the various Germanic and other barbarian groups that had invaded or been drawn into the empire over the centuries—and by the Church, which was centered in Rome and retained the hierarchical administrative structure of the empire. The breakdown of central power, the fusion of Germanic and Roman culture, and the unifying influence of Christianity produced distinctive new political, social, and cultural forms. In a process that led ultimately to a type of social organization known as feudalism, relationships of patronage and dependence between the powerful—nobles and church officials—and the less powerful became increasingly important. A pattern of mutual support developed between secular leaders and the Church, with secular leaders defending the claims of the Church and the Church validating their rule. The Church emerged as a repository of learning, and church officials and the nobility became the principal patrons of the arts. The focus of their patronage was the Church itself, its buildings and liturgical paraphernalia, including altars, altar vessels, crosses, candlesticks, reliquaries (containers for holy relics), vestments, portrayals of Christian figures and stories, and copies of sacred texts.

As Christianity continued to spread north beyond the borders of the empire, northern artistic traditions similarly worked their way south. Out of a tangled web of themes and styles from north and south, east and west, pagan and Christian, urban and rural, brilliant new artistic styles were born.

SCANDINAVIA

Scandinavia, which encompasses the modern countries of Denmark, Norway, and Sweden, was never part of the Roman Empire. In the fifth century CE it was a land of small kingdoms and independent agricultural communities. Most of its inhabitants spoke variants of a language called Norse and shared a rich mythology with other Germanic peoples. Among other deities, they worshiped Odin, chief of the gods, who protected the courageous in battle and rewarded the fallen by allowing them entrance into Valhalla, the great hall where heroic souls were received.

Sometime in the late eighth century seafaring bands of Scandinavians known as Vikings (Viken originally meant "people from the coves" but eventually came to be synonymous with "raiders" or "pirates") began descending on the rest of Europe. Setting off in flotillas of as many as 350 ships, they explored, plundered, traded, and colonized over a vast area. Intermittently looting and destroying coastal and inland river communities, they were an unsettling presence in Europe for nearly 300 years. Frequently, their targets were isolated, but wealthy, Christian monasteries. Among the earliest recorded Viking attacks were two devastating raids: one in 793, on the religious community on Lindisfarne, an island off the northeast coast of Britain, and another, in 794, at Iona, off the west coast. Vikings explored the north Atlantic, settling in Iceland about 870 and Greenland by 1000. They established a short-lived outpost in North America after 1000. They also raided and settled in Ireland, England, Scotland, and France. In the early tenth century, the rulers of France bought off Scandinavian raiders (the Normans, or North men) with a large grant of land that became the duchy of Normandy. Some Viking groups also sailed down rivers to the Black Sea and Constantinople, while others established settlements around Novgorod, which ultimately became the northern state of Rusland, or Russia.

Christianity came to Scandinavia under two Norwegian rulers, Olaf Tryggvason (ruled 995-c. 999) and Olaf Haraldsson (ruled 1015–1030), both of whom converted while in England and brought Anglo-Saxon missionaries to Norway. Olaf Haraldsson, or Saint Olaf (he was made a saint soon after his death), made Christianity Norway's official religion. His son Magnus (ruled 1035-1037) and the Viking adventurer-king Harald Hardraade (d. 1066) consolidated royal authority in Norway. During the eleventh century both Christianity and strong monarchies began to take hold in the rest of Scandinavia as well, and by the beginning of the twelfth century kings supported by Christian bishops had broken the power of regional rulers. With these developments and the rise of powerful monarchies in England and France, Viking raids and the Viking era came to an end.

During the first millennium BCE, trade, warfare, and migration brought a variety of jewelry, coins, textiles, and other portable objects into northern Europe. Scandinavian artists, who had exhibited a fondness for abstract patterning from early prehistoric times, incorporated the solar disks, spirals, and stylized animals on these objects into their already rich artistic vocabulary (see fig. 1-27). Beginning about 300 ce, Roman influences were noticeable in Scandinavia. By the fifth century CE, the so-called

PARALLELS

Years	European Cultural Centers	<u>Europe</u>	World
с. 800-1100	Scandinavian Viking	Viking expeditions in northern Europe; colonies in Russia, Iceland, Greenland,	500–1000 Rise of Hinduism (India); Hagia
		North America; Christianization	Sophia (Turkey); birth of Muhammad, founder of Islam
c. 500-present	Britain/Ireland	Celtic culture; Anglo-Saxon culture; Beowulf; Hiberno-Saxon Style; Book of Kells	(Arabia); Muslim conquests of Arabia, Persia, Egypt, Syria, Palestine; Buddhism in Japan;
c. 500-present	Christian Spain	Visigoth presence; monumental architecture; Islam conquests; Mozarabic style; Commentary on the Apocalypse	a plague kills half of European population; Tang dynasty (China); Koran (Arabia); first block-print text (China); bronze
c. 750–900	Carolingian period	Rule of Charlemagne; strengthening of Roman Empire; Caroline minuscule script; <i>Utrecht Psalter</i>	casting in South America; <i>Diamond Sutra</i> (China)
c. 900-1000	Ottonian period	Otto I creates Holy Roman Empire; Liuthar Gospels	

animal style, with its impressive array of designs emphasizing fantastic animal forms, had become widespread. Certain underlying principles govern works in this complex style: they are generally symmetrically composed, and they depict animals in their entirety from a variety of perspectives—in profile, from above, and sometimes with their ribs and spinal columns exposed as if they had been X-rayed.

The Gummersmark brooch (fig. 14-2), a large silvergilt pin, probably one of a pair, was used to fasten a cloak around the wearer's shoulders. It is worked in an intricate animal style design. Dating from the sixth century CE and made in Denmark, this elegant ornament consists of a large, rectangular headplate and a medallionlike, openwork footplate connected by an arched central element which acts as a spring to help hold the pin on the garment. Its abstract, geometric motifs include spirals, narrow moldinglike bands, bird forms, human heads, and grotesque animal heads. Although it has no gemstones, its surface has been faceted with a technique called chip carving that makes it glitter in the light. The Romans developed chip carving as a cheap, fast way of decorating molded hardware for military uniforms. The northern artists who adopted the technique carefully crafted each item by hand, turning a process intended for fast production into an art form of great refinement.

The Vikings erected large memorial stones both at home and abroad. Those covered mostly with inscriptions are called **rune stones**; those with figural decoration are called **pictured stones**. Runes are letters of an early Germanic alphabet that was probably derived from ancient italic (Italian) alphabets. Traces of pigments on both rune and pictured stones suggest that they were originally painted in bright colors. Pictured stones from

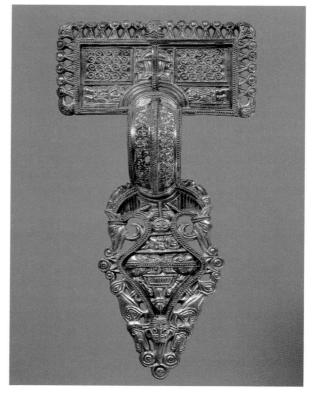

14-2. Gummersmark brooch, Denmark. 6th century. Silver gilt, height 5³/₄" (14.6 cm). Nationalmuseet, Copenhagen

The faceted surface of this pin seems to seethe with abstract human, animal, and grotesque forms such as the eye-and-beak motif that frames the headplate, the man compressed between dragons just below the bridge element, and the pair of crouching dogs with snapping tongues that forms the top of the footplate.

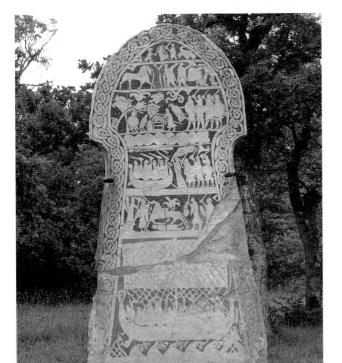

 Pictured stone, Larbro Saint Hammers, Gotland, Sweden. 8th century

Much of what we know about Viking beliefs comes from later writings, especially the Prose Edda, compiled in the early thirteenth century by a wealthy Icelandic farmer-poet, Snorri Sturluson (1178-1241), as a guide to Norse religion and a manual for writing poetry. Among the stories he recounts is that of Gudrun and her brothers, Gunnar and Hogni, which may be the subject of the scene in the register just above the large ship on this stone. According to this legend, Gudrun was engaged to King Atli, who was interested in her only for the treasures her brothers had hidden. The scene on the stone—which shows men with raised swords on each side of a horse trampling a fallen victim and a woman with a sword boldly confronting the horse—may illustrate Gudrun and her brothers in battle against Atli. The brothers were captured in this battle and horribly murdered. Gudrun then made peace with Atli and married him, but she later avenged her family's honor by serving him the hearts and blood of their children at a feast, following which she and a nephew killed Atli and burned his castle.

Gotland, an island off the east coast of Sweden, share a common design and a common theme—heroic death in battle—that was a popular subject for decoration on shields as well. An eighth-century stone from Larbro Saint Hammers on Gotland has a characteristic "mushroom" shape (fig. 14-3). The scenes are organized into horizontal registers and surrounded by a band of **ribbon** interlace, a complex pattern of woven and knotted lines that may derive from similar border ornamentation in ancient Greek and Roman mosaics. In northern art such popular patterns probably were not merely decorative but carried some symbolic significance. The bottom panel shows a large Viking ship with a broad sail, intricate rigging, and a full crew sailing over foamy waves. In

Viking iconography, ships symbolize the dead warrior's passage to Valhalla. Viking chiefs were sometimes cremated in a ship in the belief that this hastened their ascent to Valhalla.

The other registers show scenes of battle and scenes from Norse mythology, including rituals associated with the cult of Odin. The third register down, just above a horizontal band of interlace, depicts the ritual hanging of a willing victim in sacrifice to Odin, who among many other titles was known as "the god to the hanged." Directly in front of the hanged man is a burial mound, called the hall of Odin, and above it are symbols of Odin, the eagle and the triple knot.

In the Viking-era burial ship discovered in Oseberg (see fig. 14-1), two women, one young and one old, were laid out in the cabin on separate beds with comforters, blankets, and pillows. The cabin also contained empty chests that no doubt once held precious goods, as well as two looms, perhaps an indication of the craft of one or both women. The cabin walls had been covered with tapestries, fragments of which survived. Among the ship's artifacts are some of the few surviving examples of Scandinavian wood carving, a craft known to have been practiced with skill and imagination throughout the region. The bands of carved low relief running along the ship's bow and stern feature a type of design called **animal interlace**, in which the bodies of animals and birds are elongated into interwoven serpentine ribbons.

Images of strange beasts adorned all sorts of Viking belongings—jewelry, houses, tent poles, beds, wagons, sleds—and later even churches. Found in the cabin of the Oseberg ship were several wooden animal-head posts about 3 feet long with handles, the purpose of which is unknown (fig. 14-4). Although each is unique in style and design, all represent similar long-necked, grotesque, dogor catlike creatures with bulging eyes, short muzzles, snarling mouths, and large teeth. These ferocious creatures are encrusted with a writhing mass of delicately carved beasts that clutch at each other with small, clawlike hands (fig. 14-5). This type of animal interlace, known as "gripping beasts," is a hallmark of Viking ornament. The beasts are organized into roughly circular, interlocking groups surrounded by decorated bands. The faceted cutting emphasizes the flicker of light over the densely carved surfaces.

The penchant for carved relief decorations seen on the Oseberg ship endured in the decoration of Scandinavia's earliest churches. The facades of these structures often teem with intricate animal interlace. A church at Urnes, Norway, entirely rebuilt in the twelfth century, still has some remnants of the original eleventh-century carving (fig. 14-6). Although it did not originate with this church, the style of these carvings is known as "Urnes." The animal interlace in the Urnes style is composed of serpentine creatures snapping at each other, a transformation of the vicious little gripping beasts of the Oseberg headpost and the interlace pattern of the Oseberg ship's bow and stern. The satin-smooth carving of rounded surfaces, the contrast of thick and very thin elements, and the organization of the interlace into harmoniously balanced figure-8 patterns are characteristic of the Urnes

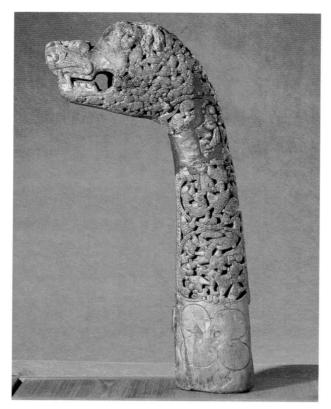

14-4. Post, from the Oseberg burial ship (fig. 14-1). c. 825. Wood, length approx. 36" (92.3 cm). Vikingskiphuset, Universitets Oldsaksamling, Oslo, Norway

style. The effect is one of aesthetic and technical control rather than wild disarray. Works such as the Urnes doorway panels suggest the persistence of Scandinavia's mythological tradition into the Early Christian period and demonstrate its enriching influence on the vocabulary of Christian art.

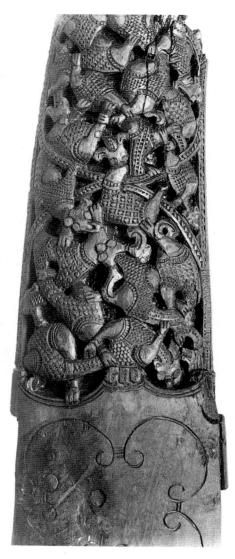

14-5. Detail of the Oseberg burial-ship post (fig. 14-4)

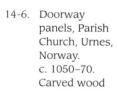

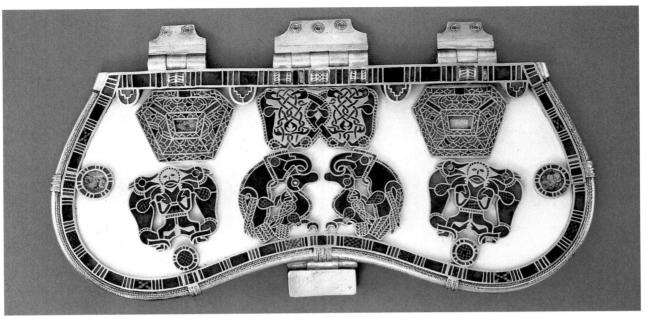

14-7. Purse cover, from the Sutton Hoo burial ship, Suffolk, England. c. 615–25. Cloisonné plaques of gold, glass, and enamel with garnets and emeralds, length 8" (20.3 cm). The British Museum, London. Illustrated upside down, as the wearer would see it

Only the decorations on this purse cover are original. The lid itself, of a rich tan-colored ivory or bone, deteriorated and disappeared centuries ago, and the white backing is a modern replacement. The purse was designed to hang at the waist, and the plaques were positioned on the cover for the wearer to enjoy.

BRITAIN AND IRELAND

When Roman armies first ventured into Britain in 55–54 BCE, it was a well-populated, thriving agricultural land of numerous small communities with close trading links to nearby regions of

the European continent. Like the inhabitants of Ireland and much of Roman Gaul (modern France), the Britons were Celtic. (Welsh, Breton—the language of Brittany, in France—and the variants of Gaelic spoken in Ireland and Scotland are all Celtic languages.) Following the Roman subjugation of the island in 43 ce, its fortunes rose and fell with those of the empire. Roman Britain experienced a final period of wealth and productivity from about 296 to about 370. Christianity flourished during this period and spread to Ireland, which was never under Roman control.

The Roman army abandoned Britain in 406 to help defend Gaul against various Germanic peoples pushing into the empire across the Rhine, leaving behind a power vacuum. The historical record for the subsequent period is sketchy, but it appears that civil disturbances erupted, the economy faltered, and large towns lost their commercial function and declined. Powerful Romanized British leaders took control of different areas, vying for dominance with the help of mercenary soldiers from the continent. These mercenaries—Angles, Saxons, and Jutes-soon began to operate independently, settling largely in the southeast part of Britain and gradually extending their control northwest across the island. Over the next 200 years the people under their control adopted Germanic speech and customs, and this fusion of Romanized British and Germanic cultures produced a new Anglo-Saxon culture. By the beginning of the seventh century, several large kingdoms had emerged in Britain, and the arts, which had suffered a serious decline, made a brilliant recovery. Celtic, Roman, and Germanic influences all contributed to vigorous new styles and techniques, especially in metalworking.

Anglo-Saxon literature is filled with references to splendid and costly jewelry and military equipment decorated with gold and silver. Leaders apparently gave such objects to their followers and friends, but few examples survive. The Anglo-Saxon epic *Beowulf*, composed perhaps as early as the seventh century, describes its hero's burial with a hoard of treasure in a mound grave near the sea. Such a grave, located near the English Channel coast in East Anglia at a site called Sutton Hoo (hoo means "hill"), was excavated in 1938–1939. As at Oseberg, the grave's occupant had been buried in a ship. His body had disintegrated and no inscriptions record his name, but associated coins date the burial to the early seventh century, suggesting that he was Raedwald, a Christian king of East Anglia at that time.

The treasures buried with him confirm that he was, in any case, a wealthy and powerful man. His burial ship was 86 feet long and shaped much like the Oseberg vessel. In it were weapons, armor, other equipment for the afterlife, and many luxury items, including a small but exquisitely worked lid for a purse decorated with cloisonné enamel, jewels, and meticulously cut pieces of glass (fig. 14-7). The designs on this lid derive from many sources. Those within the hexagons at the top right and left are purely geometric, but those in the element between them are a form of animal interlace. Below this are large, curved-beaked birds attacking ducks. Flanking

THE MEDIEVAL SCRIPTORIUM

Today books are made with the aid of com-

puter software that can lay out pages, set type, and insert and prepare illustrations. Modern presses can produce hundreds of thousands of identical copies in full color. In Europe in the Middle Ages, however, before the invention there of printing from movable type in the mid-1400s, books were made by hand, one at a time, with ink, pen, brush, and paint. Each one was an important, time-consuming, and expensive undertaking.

Medieval books were usually made by monks and nuns in a workshop called a **scriptorium** (plural scriptoria), which was usually within a monastery or a convent. As the demand for books increased, lay professionals joined the work, and great

rulers set up palace workshops supervised by well-known scholars. Books were written on animal skineither vellum, which was fine and soft, or parchment, which was heavier and shinier. (Paper did not come into common use in Europe until the early 1400s.) The Book of Kells (see fig. 14-9) required the skins of more than 150 calves, a great treasure considering the value of livestock at the time. The skins were cleaned, stripped of hair, and scraped to create a smooth surface that would absorb metallic inks and water-based paints, which themselves required time and experience to prepare. Many pigments-particularly blues and greens—had to be imported and were as costly as semiprecious stones. In early manuscripts, bright yellow was used to suggest gold, but later manu-

scripts were decorated with real **gold leaf** or gold paint.

Sometimes work on a book was divided between a scribe, who copied the text, and one or more artists, who did the illustrations, large initials, and other decorations. More often in the Early Middle Ages, scribe and artist were one. Although most books were produced anonymously, scribes and illustrators began to sign their work and provide a little background information on a page called the colophon (see fig. 14-13). One scribe even took the opportunity to warn the reader: "O reader, turn the leaves gently, and keep your fingers away from the letters, for, as the hailstorm ruins the harvest of the land, so does the injurious reader destroy the book and the writing" (cited in Dodwell, page 247).

these birds are images of a man standing between two animals, a design that may have been inspired by a Roman object—perhaps a coin, ivory **diptych**, or mosaic **emblema**—with the image of a ruler standing between eagles or columns. Similar themes are also found in the art of the ancient Near East (see fig. 2-12). The rich blend of motifs in this work heralds the complex Hiberno-Saxon style that flourished in England and Ireland during the seventh and eighth centuries (Hibernia was the Roman name for Ireland).

Although the Anglo-Saxons who settled in Britain were pagans, Christianity endured through the fifth and sixth centuries in southwestern England and in Wales, Scotland, and Ireland. Monasteries began to appear in these regions in the late fifth century. Some were located in inaccessible places, isolating the monks in them from the outside world. In many others, however, monks interacted with local Christian communities. The priests in the Christian communities spoke Celtic languages and had some familiarity with Latin. Cut off from Rome, they developed their own liturgical practices, church calendar, and distinctive artistic traditions. Before the Roman Church reestablished contact with Britain at the end of the sixth century, Irish Christians had founded influential missions in Scotland and northern England. In 597 Pope Gregory the Great (590–604), beginning a vigorous campaign of conversion in England, dispatched a mission from Rome to King Ethelbert of Kent, who had a Frankish Christian wife. The head of this mission, the monk Augustine (d. 604), became the archbishop of Canterbury in 601 and soon established several other bishoprics. The Roman Christian authorities and the Irish monasteries. although allied in the effort to Christianize England, came into conflict over their divergent practices. The Roman Church wanted to bring British Christianity under its authority and eventually triumphed in liturgical and

calendrical matters. Local traditions, however, continued to dominate both secular and religious art.

Rich and impressive copies of biblical scripture, especially the Gospels, were among the most prominent expressions of artistic creativity throughout Europe in the Early Middle Ages. Gospel books rested on the altar of every church and quickly became venerated objects as well as the source of liturgical readings. They were produced in local workshops called scriptoria (see "The Medieval Scriptorium," above). Scriptoria became major centers of learning and played a critical role in the diffusion of artistic styles and themes.

Irish monks produced many large, elaborately decorated Gospels, among them the Gospel Book of Durrow, dating to about 675. This manuscript is named for Durrow, in Ireland, where it was kept in the late medieval period, but no one knows exactly where it was made. A likely possibility is the monastery founded on the island of Iona off the northwest coast of Scotland by the Irish abbot Columba in the sixth century. The format and text of the book reflect a knowledge of Roman Christian prototypes, but its decoration is practically an encyclopedia of local design motifs, many of them adopted from metalwork. Each of the four books of the Gospel is preceded by a full-page symbolic "portrait" of the evangelist who wrote it. Mark, for example, is shown as a ferocious lion with sharp claws, jagged teeth, curling tail, and wild eye (fig. 14-8). The treatment is similar to that of the animals on the Sutton Hoo purse lid, and the lion seems as if it were based on a sculpted metal model rather than on a flesh-and-blood creature. Its eye, tail, and paws and the forms around its lower body are painted yellow to resemble gold, its head is decorated with a uniform beaded or perforated pattern, and the surface of its body is covered with geometric patterns identical to those found in cloisonné enamelwork. The two types of ribbon interlace on

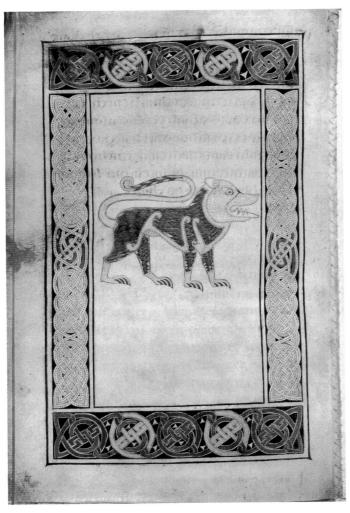

14-8. Page with *Lion*, Book of Mark, *Gospel Book of Durrow*, probably made at Iona, Scotland. c. 675. Ink and tempera on parchment, 95/8 x 511/16" (24.5 x 14.5 cm). The Board of Trinity College, Dublin, MS 57 (A.4.5), fol. 191v

the wide frame—a beaded pattern on the vertical bands and **cloisons** of bright green, red, and yellow on the horizontal bands—also suggest metallic decoration.

The Book of Kells, which an eleventh-century observer described as "the chief relic [religious objects] of the Western world," is one of the most beautiful, original, and inventive of the surviving Hiberno-Saxon gospel books. It was probably made at the monastery on Iona in the late eighth century and brought to the monastery at Kells, in Ireland, in the late ninth century.

In the twelfth century a priest named Gerald of Wales, describing a Hiberno-Saxon gospel book very much like the *Book of Kells*, wrote: "Fine craftsmanship is all about you, but you might not notice it. Look more keenly at it, and you will penetrate to the very shrine of art. You will make out intricacies, so delicate and subtle, so exact and compact, so full of knots and links, with colors so fresh and vivid, that you might say that all this was the work of

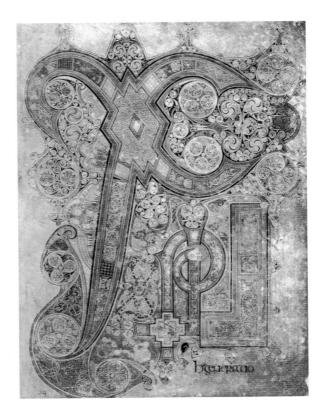

14-9. *Chi Rho Iota* page, Book of Matthew, *Book of Kells*, probably made at Iona, Scotland. Late 8th or early 9th century. Tempera on vellum, 13 x 9½" (33 x 25 cm). The Board of Trinity College, Dublin, MS 58 (A.1.6.), fol. 34v

The Greek letters *chi rho iota (XPI*, or *chri*) form the abbreviation for *Christi*, the first word in the Latin sentence *Christi autem generatio*, meaning: "Now this is how the birth of Jesus Christ came about" (Matthew 1:18). The word *autem* appears as another Latin abbreviation resembling an *h*, which is followed by *generatio* written out. The text continues on the next page. Medieval scribes had to learn a long list of standard abbreviations for Latin words, which were used like modern shorthand to save time and space in transcribing long documents or copying texts. Scribes in the courts of popes and secular rulers were even given the official title of "abbreviator."

an angel, and not of a man" (cited in Henderson, page 195). A close look at perhaps the most celebrated page in the Book of Kells—the one from the Book of Matthew (1:18-25) that begins the account of Jesus' birth—reveals what he means (fig. 14-9). The Greek letters chi, rho, and iota, the abbreviation for Christi, dominate the page. They are set within an irregularly shaped form that resembles a metal brooch. At first glance, the page seems completely abstract. The lines rippling out from the arms of the chi may suggest water, perhaps a reference to the mystery of Christ's conception and birth or to the four rivers that were thought to flow from heaven, bringing health to the Church. For those who "look keenly," however, there is more. Hidden in the dense thicket of spirals and interlaces are human and animal forms. The curve of the rho in the center of the page, for example, ends in the head of a youth with red hair, perhaps representing Christ, the heart of the world, from whom flow the "rivers" of

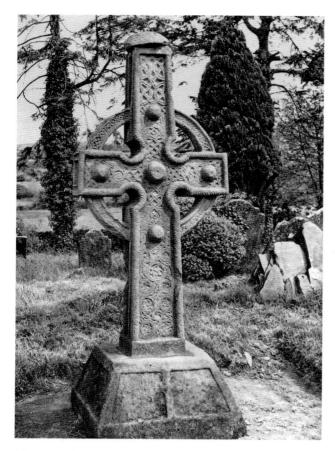

14-10. South Cross, Ahenny, County Tipperary, Ireland. 8th century

health. Three angels, perhaps representing heaven or air, hold the left edge of the *chi*. Below them, just to the right of the long stroke of the *chi*, is a group of tumbling cats and mice, a distant echo of the animal-combat motif in ancient Near Eastern art. This little scene undoubtedly had a religious meaning, perhaps representing the earth or the world of strife into which Jesus was born. Thus the "knots and links" of a page like this are not just ornamental, as in a brooch, but intellectual, forming a subtle and elusive tapestry of ideas.

Like manuscript illumination, the monumental stone crosses erected in Ireland in the eighth century also reflect the influence of metalwork designs and motifs. The origin of these crosses is obscure, but they began to appear throughout the British Isles at roughly the same time. In the Irish "high crosses," so called because of their size, a circle encloses the arms of the cross. The South Cross of Ahenny, County Tipperary, is an especially wellpreserved example of this type (fig. 14-10). It seems to have been deliberately modeled on metal ceremonial or reliquary crosses, that is, containers of holy relics in the form of a cross. It is outlined with **gadrooning** (notched, convex molding) and covered with spirals and interlace. The large bosses (buttonlike projections), which form a cross within the cross, resemble the jewels that were similarly placed on metal crosses. The pyramidal base, which is quite worn, contained relief images of Danjel in the Lion's Den and Noah's Ark, both of which symbolized God's power to save his people.

CHRISTIAN SPAIN

As Roman control of western Europe deteriorated in the fourth and fifth centuries, a Germanic

group known as the Visigoths, converts to Arian Christianity (Chapter 7), migrated across Gaul and into Spain. By the sixth century the Visigoths had established themselves as an aristocratic elite over the indigenous Spanish-Roman population, which probably outnumbered them by about 40 to 1. Although the Visigoths adopted Latin for writing and had switched to orthodox Christianity by the seventh century, they were never fully assimilated into Spanish society. Visigothic metalworkers, following the same late-Roman–Germanic tradition they shared with their counterparts in the north, created magnificent cloisonné jewelry similar in style and technique to the Sutton Hoo purse lid (see fig. 14-7).

The few sixth- and seventh-century churches surviving in Spain are probably the best-preserved examples of monumental architecture in western Europe from this period. Santa Maria de Quintanilla de las Viñas, located about 150 miles north of Toledo, was probably built in the late seventh century. This basilica-plan church (modeled on the Roman basilica; see "Elements of Architecture," page 298) originally had a nave and two aisles, which no longer exist. The aisles opened through narrow doorways into the choir, the area reserved for the clergy, which extended the full width of the church. The narrow doorways suggest that the choir acted more as a barrier than as a connection between the congregation and the priests celebrating the Eucharist in the square sanctuary apse. This marked partitioning of the nave from the choir and sanctuary, found in other Spanish churches of the same period, may reflect a change in liturgical practice in which the congregation was barred from approaching the altar to receive Communion.

A horseshoe arch frames the entrance to the apse at Santa Maria at Quintanilla de las Viñas (fig. 14-11), refuting a belief that Islamic architects introduced this type of arch in Spain in the eighth century (see the discussion of the Great Mosque of Córdoba in Chapter 8 and figure 8-6). The base of the arch juts inward slightly into the apse entrance, and the freestanding columns and large impost blocks likewise restrict it. The themes of the crisp bands of carving on the arch and impost blocks are found frequently in Early Christian art. On the impost blocks is Christ Triumphant between Angels. On the arch is a scrolling vine, the loops of which encircle birds and bunches of grapes, symbolic of the Eucharist (fig. 14-12). Like the carved decoration on the roughly contemporary South Cross at Ahenny, the style of these low-relief decorations is reminiscent of metalwork. A grooved border like the setting of a brooch contains the images on the arch, and the little lines that punctuate the border and scrollwork suggest fine threads of metal banding.

The Islamic conquest of Spain in 711 ended Visigothic rule. With some exceptions, Christians and Jews who did not convert to Islam but acknowledged the authority of the new rulers and paid the taxes required of non-Muslims were left free to follow their own religious practices. Christians in the Arab territories were called Mozarabs

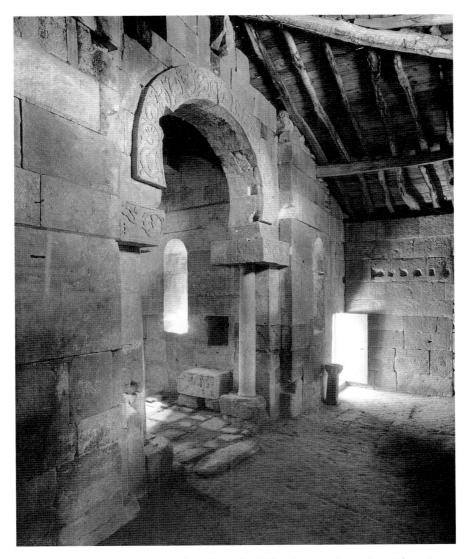

14-11. Church of Santa Maria, Quintanilla de las Viñas, Burgos, Spain. Late 7th century. View from the choir into the apse

(from the Arabic *mustarib*, meaning "would-be Arab"). The conquest resulted in a rich exchange of artistic influences between the Islamic and Christian communities. Christian artists adapted many features of Islamic style to their traditional themes, creating a unique, colorful new style known as Mozarabic. When Mozarabic artists migrated to the monasteries of northern Spain, which reverted to Christian rule not long after the initial Islamic invasion, they took this style with them, and it is known there as transported Mozarabic.

In northern Spain, the antagonisms among Muslims, orthodox Christians, and the followers of various heretical Christian cults provided fertile material for religious

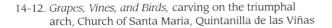

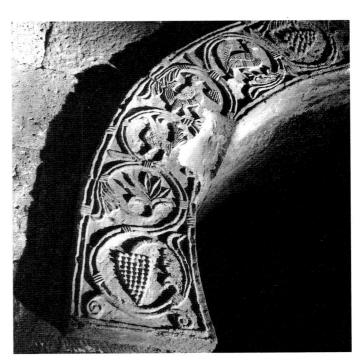

commentaries. One of the most influential of these was the Commentary on the Apocalypse compiled in the eighth century by Beatus, abbot of the Monastery of San Martín at Liébana, in the north Spanish kingdom of Asturias. The commentary is an analysis of the visions set down in the Book of Revelation (also called the Apocalypse), which is filled with vivid descriptions of the final, fiery triumph of Christ. Beatus's work is an impassioned justification of orthodox beliefs. It thus had enduring appeal for northern Christians in their long struggle against the Muslim rulers of the rest of Spain, and it was widely read, copied, and illustrated. Two copies from the late tenth century, illustrated in the Mozarabic style, were produced under the direction of the scribe-painter Emeterius, a monk in the workshop of the Monastery of San Salvador at Tábara in the kingdom of León.

The first of these commentaries was completed in 970 by Emeterius and a scribe-painter named Senior, who identified themselves in the manuscript. Artists were beginning to emerge from anonymity throughout Europe at this time. Book illustrators often signed their work, sometimes showed themselves occupied with pen and brush, and occasionally offered the reader spontaneous comments and opinions (see "The Medieval Scriptorium," page 486). On the colophon, the page of a manuscript or book that identifies its producers, is a picture of the five-story tower of the Tábara Monastery and the two-story scriptorium attached to it, the earliest known depiction of a medieval scriptorium (fig. 14-13). The tower, with horseshoe-arched windows, and the workshop have been rendered in a two-dimensional cross section that reveals many details of the interior and exterior simultaneously. In the scriptorium, Emeterius on the right and Senior on the left, identified by inscriptions over their heads, are at work at the same small table. A helper in the next room cuts sheets of parchment or vel**lum** for book pages. A monk standing inside (or perhaps outside) the ground floor of the tower pulls the ropes to the bell in the turret on the right. Three other men climb ladders between the floors, apparently on their way to the balconies on the top level. Brightly glazed tiles in geometric patterns, a common feature of Islamic architecture, cover what could be the tower's interior or exterior wall.

The other Beatus Commentary was produced five years later for a named patron, Abbot Dominicus. The colophon identifies Senior as the scribe for this project. Emeterius and a woman named Ende, who signed herself "painter and servant of God," shared the task of illustration. A full-page painting from this book shows an eaglelike bird with a luxurious topknot grasping a glittering snake in its beak (fig. 14-14). With abstract shapes and cloisons of bright color recalling Visigothic metalwork, the image illustrates a metaphorical description in Beatus of the triumph of Christ over Satan. A bird with a powerful beak and beautiful plumage (Christ) covers itself with mud to trick the snake (Satan). Just when the snake decides the bird is harmless, the creature swiftly attacks and kills it. "So Christ in his Incarnation clothed himself in the impurity of our [human] flesh that through

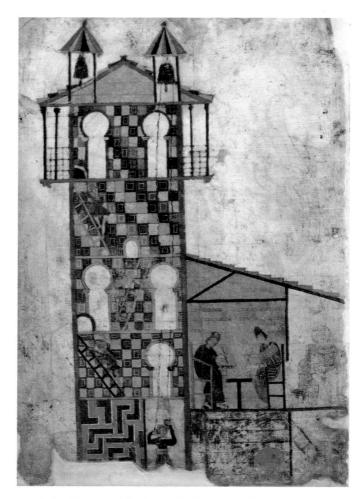

14-13. Emeterius and Senior. Colophon page, Commentary on the Apocalypse by Beatus and Commentary on Daniel by Jerome, made for the Monastery of San Salvador at Tábara, León, Spain. Completed July 27, 970. Tempera on parchment, 141/4 x 101/8" (36.2 x 25.8 cm). Archivo Histórico Nacional, Madrid, MS 1079B (formerly 1240) In medieval manuscripts the colophon was used to provide specific information about the production of a book. In addition to identifying himself and Senior on this colophon, Emeterius also praised his teacher, "Magius, priest and monk, the worthy master painter," who had begun the manuscript prior to his death in 968. Emeterius also took the opportunity to comment on the profession of bookmaking: "Thou lofty tower of Tábara made of stone! There, over thy first roof, Emeterius sat for three months bowed down and racked in every limb by the copying. He finished the book on July 27th in the year 1008 [970, by modern dating] at the eighth hour" (cited in Dodwell, page 247).

a pious trick he might fool the evil deceiver. . . . [W]ith the word of his mouth [he] slew the venomous killer, the devil" (from the Beatus Commentary, cited in Williams, page 95). Symbolic stories, or **allegories**, such as this were popular among artists, writers, and theologians in the Middle Ages. Because allegories translate abstract ideas into concrete events and images, their implications are accessible to almost anyone of any level of education.

14-14. Emeterius and Ende, with the scribe Senior. Page with *Battle of the Bird and the Serpent, Commentary on the Apocalypse* by Beatus and *Commentary on Daniel* by Jerome, made for Abbot Dominicus, probably at the Monastery of San Salvador at Tábara, León, Spain. Completed July 6, 975. Tempera on parchment, 15³/₄ x 10¹/₄" (40 x 26 cm). Cathedral Library, Gerona, Spain, MS 7[11], fol. 18v

THE CAROLINGIAN PERIOD

A new empire emerged in continental Europe during the second half of the eighth century that was forged by a dynasty known

as Carolingian, after its greatest member, Charlemagne, or Charles the Great (*Carolus* is Latin for "Charles"). The Carolingians were Franks, a Germanic people who had settled in northern Gaul by the end of the fifth century. Under Charlemagne (ruled 768–814) the Carolingian realm reached its greatest extent, encompassing western Germany, France, a bit of Spain, and the Low Countries (modern Belgium and Holland). Charlemagne imposed Christianity, sometimes brutally, throughout this territory and promoted church reform. In 800 Pope Leo III (795–816), in a ceremony in the Church of Saint Peter in Rome, granted Charlemagne the title of emperor, declar-

ing him to be the rightful successor to the first Christian Roman emperor, Constantine. This event reinforced Charlemagne's authority over his diverse realm and strengthened the bonds between the papacy and secular government in the West.

Charlemagne sought to restore the Roman Empire as a Christian state and to revive the arts. He placed great emphasis on education, gathering around him the finest scholars of the time, and his court became the leading intellectual center of western Europe. His architects, painters, and sculptors turned to Rome and Ravenna for inspiration, but what they created was not a simple copy of the Imperial Christian style.

Architecture

Charlemagne's biographer, Einhard, reported that the ruler, "beyond all sacred and venerable places . . . loved

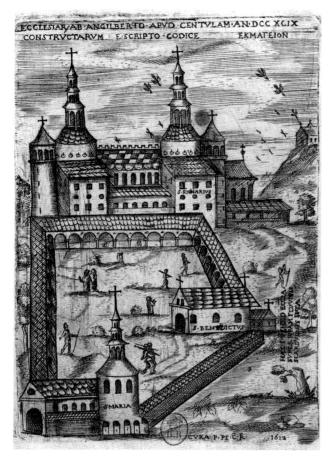

14-15. Abbey Church of Saint Riquier, Monastery of Centula, France, dedicated 799. Engraving dated 1612, after an 11th-century drawing. Bibliothèque Nationale, Paris

the church of the holy apostle Peter at Rome." Not surprisingly, Charlemagne's architects turned to Saint Peter's, a basilica-plan church with a long nave and side aisles ending in a projecting apse (see fig. 7-11), as a model for his own churches. These churches, however, included purely northern features and were not simply imitations of Roman Christian structures. Among these northern features was a multistory **narthex**, or vestibule, flanked by attached stair towers. Because church entrances traditionally faced west, this type of narthex is called a **westwork**.

The Abbey Church of Saint Riquier at the Monastery of Centula in northern France was an example of the Carolingian reworking of the Roman basilica-plan church. Built when Angilbert, a Frankish scholar at Charlemagne's court, was abbot at Centula, it was completed about 799. No longer standing, it is known today from archeological evidence and an engraved copy after a lost eleventh-century drawing of the abbey (fig. 14-15). A triangular enclosure linking the church and two independent chapels may have served as a cloister for the abbey's more than 300 monks. Cloisters are porticoed courtyards, sometimes with gardens, attached to a church or chapel, and other monastic buildings often cluster around them. The small, barnlike building at the right in the drawing was a chapel dedicated to Saint Benedict. The more elaborate structure at the lower left, a

polygonal **central-plan** building with twelve faces, was a shrine to the Virgin and the Twelve Apostles. The interior would have had an altar to the Virgin in the center, an **ambulatory** passageway around it, and altars to each of the apostles against the perimeter walls.

The Church of Saint Riquier followed a basic basilica plan, but it also included two features that gave equal weight to both ends of the nave: a multistory westwork with flanking stair towers to the left and, to the right, a similar structure over the **transept**, the part of the church that crosses the nave at the sanctuary end. A square choir space beyond the **crossing**, the intersection of the nave and transept, lengthened the sanctuary space. The towers, soaring from cylindrical bases through three arcaded levels to cross-topped spires, would have been the most striking feature of the building. They were apparently made of timber, which posed fewer problems for tall construction than masonry. This vertical emphasis was a northern contribution to Christian architecture.

Charlemagne, who enjoyed hunting and swimming, was drawn to the forests and natural hot springs of Aachen (Aix-la-Chapelle in French), in the northern part of his empire. He built a palace complex there and installed his court in it about 794, making it his capital. The complex included administrative offices and royal workshops for making books and luxury items. Directly across from the royal audience hall on the north-south axis of the complex stood the Palace Chapel (fig. 14-16). This structure functioned as Charlemagne's private chapel, the church of his imperial court, a martyrium for certain precious relics of saints, and, after the emperor's death, the imperial mausoleum. To satisfy all these needs, the emperor's architects created a large, centralplan building similar to that of the Church of San Vitale in Ravenna (see fig. 7-29), adding a square projecting entrance facade with a tall, cylindrical tower on each side. The chapel originally had a very large, walled forecourt where crowds could view the emperor as he stood in a window on the second story located within a huge niche in the wall of the projecting facade. The stairs in the twin towers led to a throne room on the second level that opened onto the chapel rotunda, allowing the emperor to observe Mass, the celebration of the Eucharist in which bread and wine consecrated by a priest are consumed by worshipers. Relics were housed above the throne room on the third level.

The chapel has a sixteen-sided outer wall. The central core of the building is an octagon that rises to a **clere-story** above the **gallery** level (fig. 14-17). An ambulatory aisle surrounds this central core and the gallery opens onto it through arched openings supported by two tiers of Corinthian columns. Compared to San Vitale, where the central space expands outward from the dome into semidomes and **conches**, the Aachen chapel is more visually divided. The columns and grilles on the gallery level lie flush with the opening overlooking the central area, screening it from the space beyond. The effect is to create a powerful vertical visual pull from the floor of the central area to the top of the vault. Unlike San Vitale, which is covered by a smooth, round dome, the vault

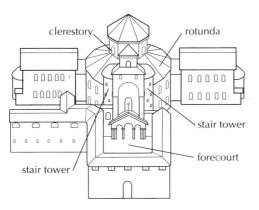

14-16. Reconstruction drawing of the Palace Chapel of Charlemagne, Aachen (Aix-la-Chapelle), Germany. 792–805

14-17. Palace Chapel of Charlemagne

Although this sturdily constructed chapel retains its original design and appearance, much of its decoration either has been restored or dates from later periods. The Gothic-style chapel seen through the center arches on the ground floor replaced the eighth-century sanctuary apse. The enormous "crown of light" suspended over the central space was presented to the church by Emperor Frederick Barbarossa in 1168. Extensive renovations took place both in the nineteenth century, when the chapel was reconsecrated as the Cathedral of Aachen, and in the twentieth century, after it was damaged in World War II.

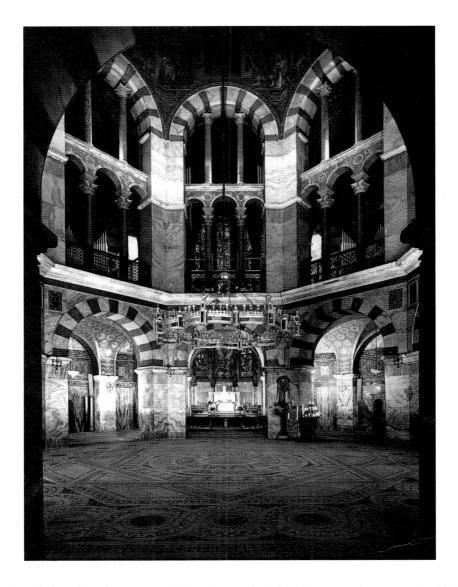

over the Palace Chapel rises from its octagonal base in eight curving masonry segments. The clear division of the structure into parts and the vertical emphasis are both hallmarks of the new style that developed under Charlemagne.

Monastic communities had grown numerous by the Early Middle Ages and had spread across Europe. In the early sixth century, Benedict of Nursia (c. 480–543) wrote

his *Rule for Monasteries*, a set of guidelines for monastic life. Benedictine monasticism quickly became dominant, displacing earlier forms, including the Irish monasticism that had developed in the British Isles. In the early ninth century, Abbot Haito of Reichenau developed a general plan for the construction of monasteries for his colleague Abbot Gozbert of the Benedictine Abbey of Saint Gall near Lake Constance (in modern Switzerland). The Saint Gall

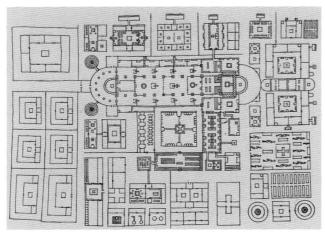

14-18. Plan of the Abbey of Saint Gall (redrawn). c. 817.
Original in red ink on parchment, 28 x 441/8"
(71.1 x 112.1 cm). Stiftsarchiv, Saint Gall, Switzerland, MS 1092

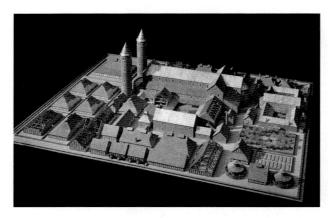

14-19. Model after the Saint Gall monastery plan (fig. 14-18), constructed by Walter Horn and Ernst Born, 1965

plan (fig. 14-18), originally drawn on five pieces of parchment sewn together, combines Benedictine guidelines with later ideas developed at Church councils. Figure 14-19 shows a model based on the original plan.

This extremely functional plan was widely adopted and can still be seen in many Benedictine monasteries. It reserved a central place for a basilica-plan church with apses at both ends and a transept crossing the nave at the eastern end. These apses would have housed separate chapels and displays of relics. Together with the adjacent cloister and refectory (dining hall), the church was the heart of the monastery's communal life. Monks entered it from the cloister or by stairs directly from their quarters. Members of the lay community that inevitably developed outside the walls of a large monastery used the main entryway. In the surrounding buildings, monks pursued their individual tasks. Scribes and painters, for example, spent much of their day in the scriptorium studying and copying books, and teachers staffed the monastery's schools and library. Benedictine monasteries generally had two schools, one inside the monastery proper for young monks and novices (those hoping to take vows and become brothers), and another outside for educating the sons of the local nobility.

Benedict insisted that monks extend hospitality to all visitors, and the large building in the upper left of the plan may be a hostel, or inn, for housing them. A porter would have looked after visitors, supplying them from the food produced by the monks. The plan also included a hospice for the poor and an infirmary. A monastery of this size had most of the features of a small town and would have indirectly or directly affected many hundreds of people. Essentially self-supporting, it would have had livestock, barns, agricultural equipment, a bakery and brewery, kitchen gardens (farm fields lay outside the walls), and even a cemetery. It would also have drawn on the support of extensive and widely scattered estates elsewhere.

Books

Books played a central role in the efforts of Carolingian rulers to promote learning, propagate Christianity, and standardize Church law and practice. As a result, much of the artistic energy of the period found an outlet in the empire's great northern scriptoria. One of the main tasks of these centers was to produce authoritative copies of key religious texts, free of the errors that tired, distracted, or confused scribes had introduced over the generations. The scrupulously edited versions of ancient texts that emerged are among the lasting achievements of the Carolingian period. The Anglo-Saxon scholar Alcuin of York, whom Charlemagne called to his court, spent the last eight years of his life producing a corrected copy of the Latin Vulgate Bible. His revision served as the standard text of the Bible for the rest of the Carolingian and subsequent medieval periods.

Carolingian scribes also developed a new, legible script to replace the confusing and hard-to-read scripts used since Roman times. Known as **Caroline minuscule**, it featured consistent separation of words and large capital letters for the opening of important sections. It is similar to many modern printed alphabets and is quite legible to modern readers.

One of the first surviving manuscripts in the new script, produced at Charlemagne's court between 781 and 783, was a collection of readings from the Gospels compiled by the Frankish scribe Godescalc and known as the *Godescalc Gospel Lectionary* or *Godescalc Evangelistary*. This richly illustrated and sumptuously made book (it has gold and silver letters and purple-dyed vellum pages) has a full-page portrait of the evangelist at the beginning of each Gospel section. The style of these illustrations suggests that Charlemagne's artists were familiar with the illusionistic painting style of imperial Rome as it had been preserved in Byzantine manuscripts.

In his portrait Mark is in the act of writing at a lectern tilted up to display his work (fig. 14-20). He appears to be attending closely to the small haloed lion in the upper left corner, the source of his inspiration and the iconographic symbol by which he is known. The artist has modeled the form of his arms, hips, and knees beneath his garment and rendered the bench and lectern to give a hint of three-dimensional space despite the otherwise flat background. Mark's round-shouldered posture and

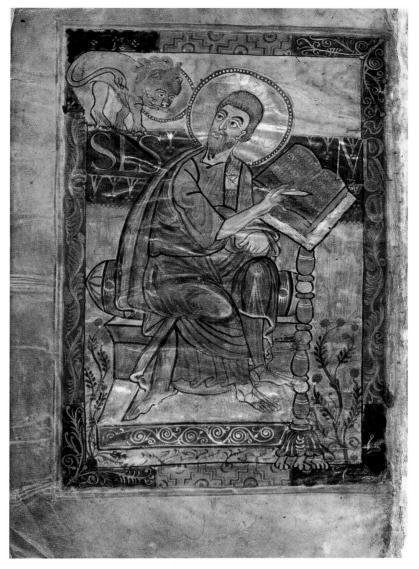

14-20. Page with *Mark the Evangelist*, Book of Mark, *Godescalc Evangelistary*. 781-83. Ink and colors on vellum. Bibliothèque Nationale, Paris

sandaled feet, solidly planted on a platform decorated with a classical spiraling-vine motif, contribute an additional naturalistic touch. Stylized plants set the scene out of doors, a convention seen also in an Early Christian mosaic (see fig. 7-14). Probably commissioned to commemorate the baptism of two of Charlemagne's sons in Rome, the *Godescalc Evangelistary* remained at the court for several decades, providing a model for a later series of famous, luxuriously decorated gospel books.

Louis the Pious, Charlemagne's son and only successor, appointed his childhood friend Ebbo as archbishop of Reims, and Ebbo established that northeastern French town as another brilliant center of bookmaking. A portrait of Matthew from a gospel book made for Ebbo, begun after 816 at the Abbey of Hautevillers near Reims, illustrates the unique style that emerged there (fig. 14-21). Although there are some similarities between this painting and the evangelist portraits in books produced at Charlemagne's court (fig. 14-20), the differences

are striking. The figure of Matthew vibrates with intensity, and the landscape in the background threatens to run off the page, contained only by the painted border. Even the acanthus-leaf trim in the frame seems blown by a violent wind. The rapid, calligraphic style focuses attention less on the physical appearance of the evangelist than on his inner, spiritual excitement as he hastens to transcribe the Word of God coming to him from the distant angel (Matthew's symbol) in the upper right corner. His head and neck jut awkwardly out of hunched shoulders, and his left hand clumsily grasps the book and inkhorn. His twisted brow and prominent eyebrows, represented by long, diagonal slashes, lend his gaze an intense, theatrical quality. As if to echo the saint's turbulent emotions, the desk, bench, and footstool tilt every which way and the top of the desk seems about to detach itself from the pedestal.

The most famous of all Carolingian manuscripts, the *Utrecht Psalter*, dating probably between 825 and 850,

14-21. Page with *Matthew* the Evangelist, Book of Matthew, Ebbo Gospels. c. 816–40. Ink and colors on vellum, 10½ x 8¾4" (26 x 22.2 cm). Bibliothèque Municipale, Epernay, France, MS 1, fol.18v

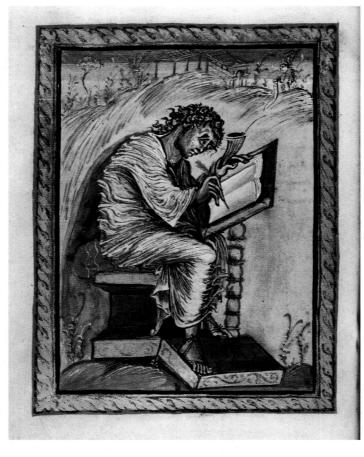

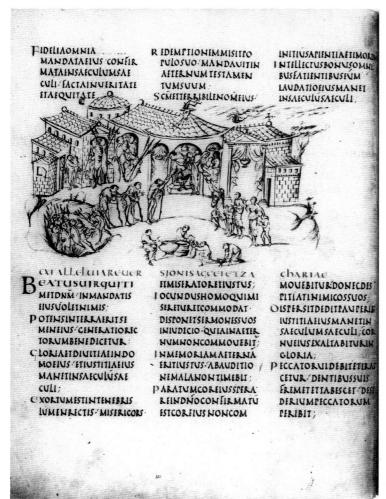

was also a product of the Reims workshop (fig. 14-22). This volume contains the Old Testament Book of Psalms illustrated with ink drawings that reflect the same linear vitality as the paintings in the Ebbo gospel book. The Psalms are difficult to represent because they do not tell a straightforward story. The *Utrecht Psalter* solves this problem by combining images derived from the core ideas of each Psalm into a single scene. The drawing in figure 14-22 illustrates Psalm 112.

- 1 Happy are those who fear the Lord, who greatly delight in God's commands.
- Their descendants shall be mighty in the land, a generation upright and blessed.
- ³ Wealth and riches shall be in their homes; their prosperity shall endure forever.
- ⁴ They shine through the darkness, a light for the upright; they are gracious, merciful, and just.
- ⁵ All goes well for those gracious in lending, who conduct their affairs with justice.
- 6 They shall never be shaken; the just shall be remembered forever.
- 7 They shall not fear an ill report; their hearts are steadfast, trusting the Lord.
- 8 Their hearts are tranquil, without fear, till at last they look down on their foes.
- 14-22. Page with the end of Psalm 111 and Psalm 112, with an illustration for Psalm 112 (CXI in the Vulgate Bible), Utrecht Psalter. c. 825–50. Ink on vellum or parchment, 13 x 97/8" (33 x 25 cm). Bibliotheek der Rijksuniversiteit, Utrecht, the Netherlands, MS script. ecol. 484, fol. 73v

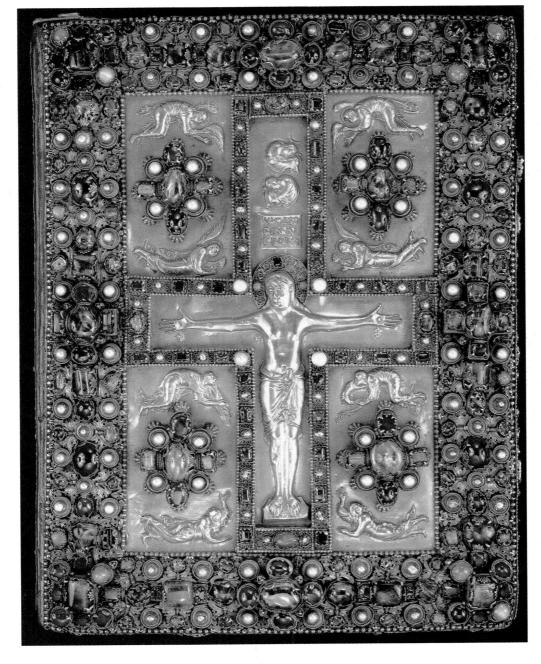

14-23. Crucifixion
with Angels
and Mourning
Figures,
outer cover,
Lindau Gospels.
c. 870–80.
Gold, pearls,
and gems,
13³/4 x 10³/8"
(36.9 x 26.7 cm).
The Pierpont
Morgan Library,
New York
(MS 1)

9 Lavishly they give to the poor; their prosperity shall endure forever; their horn shall be exalted in honor.
10 The wicked shall be angry to see this;

10 The wicked shall be angry to see this; they will gnash their teeth and waste away; the desires of the wicked come to nothing.

The hand of God is shown emerging from the clouds above the church on the right to bless "those who fear the Lord" (verse 1). The substantial stone buildings with tiled roofs represent their enduring prosperity (verse 3). The numerous hanging lamps in the buildings represent the "light for the upright" shining "through the darkness" (verse 4). A couple dispenses alms to the poor in the doorway of the central building, a deer's head with antlers ("their horn," verse 9, a symbol of vitality and honor) mounted on the roof above them. The people in the foreground, engaged in business, are "gracious in

lending" and "conduct their affairs with justice" (verse 5). Such high moral conduct naturally draws "foes," represented here by armed soldiers in the buildings on the left (verse 8). But the wicked, rounded up and tossed into a pit by the devil, "gnash their teeth and waste away" (verse 10). Illustrations like this convey the characteristically close association between text and image in Carolingian art.

The magnificent illustrated manuscripts of the medieval period represented an enormous investment in time, talent, and materials, so it is not surprising that they were often protected with equally magnificent covers. But because these covers were themselves made of valuable materials—ivory, enamelwork, precious metals, and jewels—they were frequently reused or broken up. The elaborate book cover of gold and jewels shown in figure 14-23 was probably made between 870 and 880 at one of the workshops of Charles the Bald (ruled 840–877),

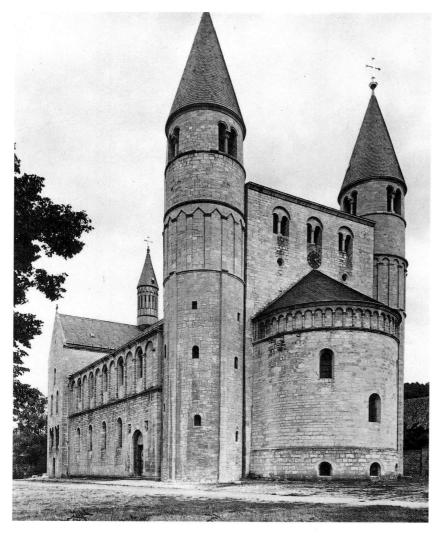

14-24. Church of Saint Cyriakus, Gernrode, Germany. Begun 961 and consecrated 973. The apse seen here replaced the original westwork entrance in the late 12th century.

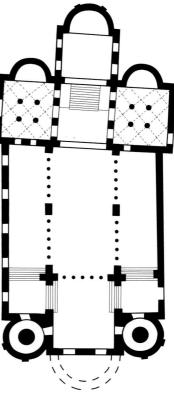

14-25. Plan of the Church of Saint Cyriakus (after Broadley)

who inherited the portion of Charlemagne's empire that corresponds roughly to modern France after the death of his father, Louis the Pious. It is not known what book it was made for, but sometime before the sixteenth century it became the cover of a Carolingian manuscript known as the *Lindau Gospels*, which was prepared at the Monastery of Saint Gall in the late ninth century.

The cross and the Crucifixion were common themes for medieval book covers. The Crucifixion scene on the front cover of the *Lindau Gospels* is made of gold with figures in **repoussé** relief surrounded by heavily jeweled frames. Angels hover above the arms of the cross. Over Jesus' head, hiding their faces, are figures representing the sun and moon. The graceful, expressive poses of the mourners who float below the arms of the cross reflect the style of the *Utrecht Psalter* illustrations. Jesus has been modeled in a rounded, naturalistic style suggesting classical influence, but his stiff posture and stylized drapery counter the emotional expressiveness of the other figures. He stands straight and wide-eyed with outstretched arms, announcing his triumph over death and welcoming believers into the faith.

THE OTTONIAN PERIOD

The Carolingian Empire broke up when it was divided among the heirs of Louis the Pious. In the tenth century, control of the east-

ern portion of the empire, which corresponded roughly to modern Germany and Austria, passed to a dynasty of Saxon rulers known as the Ottonians, after its three principal figures, Otto I (ruled 936–973), Otto II (ruled 973–983), and Otto III (ruled 983–1002). Otto I, who took control of Italy in 951, was crowned emperor by the pope in 962, and thereafter he and his successors dominated the papacy and appointments to other high Church offices. This union of Germany and Italy under a German ruler came to be known as the Holy Roman Empire.

Architecture

The Ottonian rulers, in keeping with their imperial status, sought to replicate the splendors of Christian Roman architecture within their realm. The German court in Rome gave northern architects access to Roman designs, which they reinterpreted in light of their own local mate-

14-26. Nave, Church of Saint Cyriakus

rials and time-tested techniques to create a new Ottonian style. Some of their finest churches were also strongly inspired by Carolingian structures like the Abbey Church of Saint Riquier (see fig. 14-15).

One of the best-preserved Ottonian buildings is the Church of Saint Cyriakus at Gernrode (fig. 14-24). A German noble named Gero founded the convent of Saint Cyriakus and commissioned the church in 961. Following the Ottonian policy of appointing relatives and close associates to important church offices, he made his widowed daughter-in-law the convent's first abbess. A basilica-plan structure, Saint Cyriakus originally had a westwork, which was replaced by a second apse in the twelfth century (fig. 14-25). The elevated floor of the choir and sanctuary apse at the east end covers a vaulted space known as a **crypt**. Two entrances on the south provided access between the church and the convent's cloister and dormitories. The towers and other vertical features that dominate the east and west ends of the church are reminiscent of similar features at Saint Riquier's, although not so dramatic as the towers that soared over that church. Windows, arcades, and blind arcades break the severity of the church's exterior.

The interior of Saint Cyriakus (fig. 14-26) has three levels: an arcade separating the nave from the side aisles, a gallery with groups of three arched openings, and a clerestory. A **triumphal arch** opening defines the end of the nave, and the flat ceiling is made of wood. Most of these features were also characteristic of Constantinian basilica-plan churches (see fig. 7-12). The alternation of columns and rectangular piers in Saint Cyriakus, however, creates a different rhythmic effect than the uniform

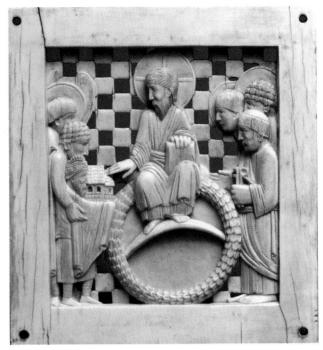

14-27. Otto I Presenting Magdeburg Cathedral to Christ, one of a series of nineteen ivory plaques, known as the Magdeburg Ivories. German or North Italian. c. 962-973. Ivory plaque, 5 x 41/2" (12.7 x 11.4 cm). The Metropolitan Museum of Art, New York Bequest of George Blumenthal, 1941 (41.100.157) During the reign of Otto I, Magdeburg was on the edge of a buffer zone between the Ottonian Empire and the pagan Slavs. In the 960s, Otto established a religious center there from which the Slavs could be converted. One of the important saints of Magdeburg was Maurice, a Roman Christian commander of African troops who is said to have suffered martyrdom in the third century for refusing to worship in pagan rites. In later times, he was often represented as a dark-skinned African (see fig. 16-58). The warrior saint appears here presenting both Otto and Magdeburg Cathedral to Christ.

arcading of such earlier churches, which pulled the viewer's gaze forward. Saint Cyriakus is likewise marked by vertical shifts in visual rhythm, with two pairs of arches between piers on the nave level surmounted by three pairs of arches on the gallery level, surmounted in turn by three windows in the clerestory. This seemingly simple architectural aesthetic, with its rhythmic alternation of heavy and light supports and its balancing of rectangular and round forms and horizontal and vertical movement, was to inspire architects for the next 300 years, finding full expression in the Romanesque period.

Sculpture

Carved ivory panels for book covers and diptychs were among the products of both Carolingian and Ottonian bookmaking workshops. An Ottonian plaque that shows Otto I presenting a model of the Magdeburg Cathedral to Christ may once have been part of the decoration of an altar or pulpit in the cathedral, which was dedicated in 968 (fig. 14-27). Otto is the diminutive figure holding the

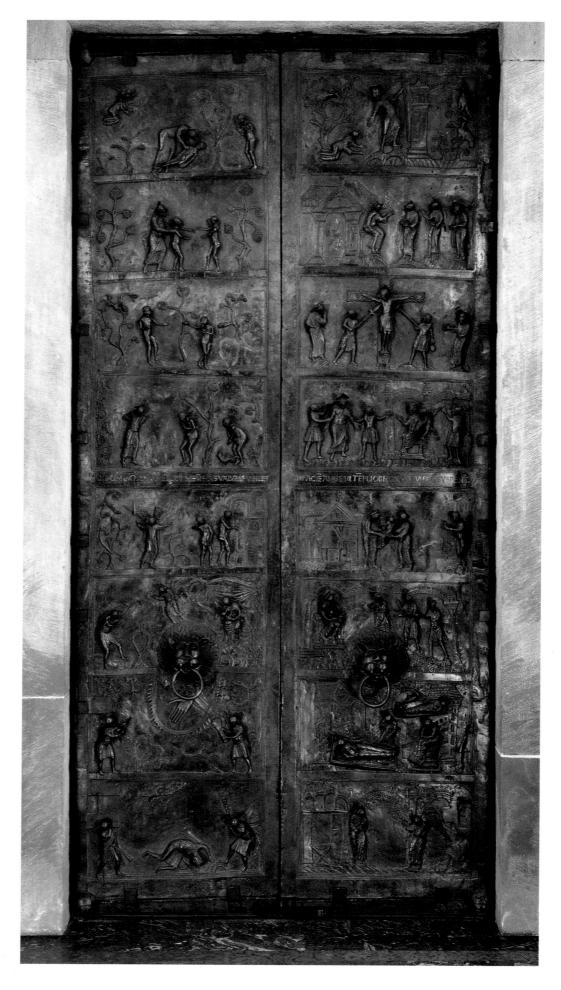

14.28. (opposite) Doors of Bishop Bernward, Cathedral (Abbey Church of Saint Michael), Hildesheim, Germany. 1015. Bronze, height 16'6" (5 m)

The design of these magnificent doors anticipated by nearly a century the great sculptural programs that would decorate the exteriors of European churches in the Romanesque period. Bishop Bernward, who was both a scholar and a talented artist, is thought to have been intimately involved in planning the iconography of the scenes.

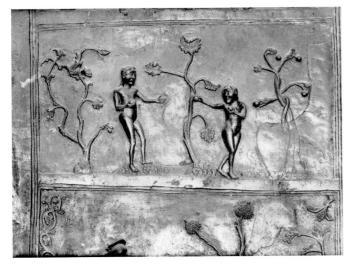

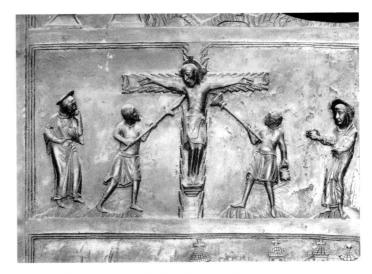

14-29. The Temptation (left) and The Crucifixion (right), detail of the Doors of Bishop Bernward

cathedral on the left. Christ is seated on a wreath, which may represent the heavens, and his feet rest on an arc that may represent the earth. Christ and Otto are surrounded by a crowd of witnesses. Saint Peter, patron of churches, faces Otto, and Saint Maurice, an important saint in Magdeburg, wraps his arm protectively around him. The action takes place on a very shallow stage. The heavy dignity and intense concentration of the figures are characteristic of the Ottonian court style.

In the eleventh century, Ottonian artists in northern Europe, drawing on Roman, Byzantine, and Carolingian models, created a new tradition of large sculpture in wood and bronze that would have a significant influence on later medieval art. An important patron of these sculptural works was Bishop Bernward of Hildesheim, who was himself an artist. His biographer, the monk Thangmar, described Bernward as a skillful goldsmith who closely supervised the artisans working for him. A pair of bronze doors made under his direction for his Abbey Church of Saint Michael represented the most ambitious and complex bronze-casting project since antiquity (fig. 14-28). The bishop had lived for a while in Rome as tutor for Otto III and may have been inspired by the carved wooden doors of the fifth-century Church of Santa Sabina located near Otto's palace there.

The inscription in the band running across the center of the doors states: "In the year of our lord 1015 Bishop Bernward installed the doors." They stand more than 16 feet tall and are decorated with Old Testament

scenes on the left and New Testament scenes on the right. According to the prevailing interpretation of the time, the Old Testament scenes in some way prefigured the New Testament scenes with which they were paired. The third panel down, for example, shows on the left the temptation of Adam and Eve in the Garden of Eden, believed to be the source of human sin, suffering, and death (fig. 14-29). This is paired on the right with the crucifixion of Jesus, whose sacrifice and suffering redeemed humankind, atoned for Adam and Eve's Original Sin, and brought the promise of eternal life.

The doors' rectangular panels recall the framed miniatures in Carolingian gospel books, and the style of the scenes within them is reminiscent of illustrations in works like the Utrecht Psalter. Small, extremely active figures populate nearly empty backgrounds. Architectural elements and features of the landscape are depicted in very low relief, forming little more than a shadowy stage for the actors in each scene. The figures stand out prominently, sculpted in varying degrees of relief, with their heads fully modeled in three dimensions. The result is lively and visually stimulating. The doors have endured intact although the church itself has suffered greatly over time. Completed in 1044, it was rebuilt in the eleventh, twelfth, and seventeenth centuries, destroyed during World War II, and finally rebuilt in 1958 according to the eleventh-century plan.

Another treasure of Ottonian sculpture is the *Gero Crucifix*, one of the few large works of carved wood to

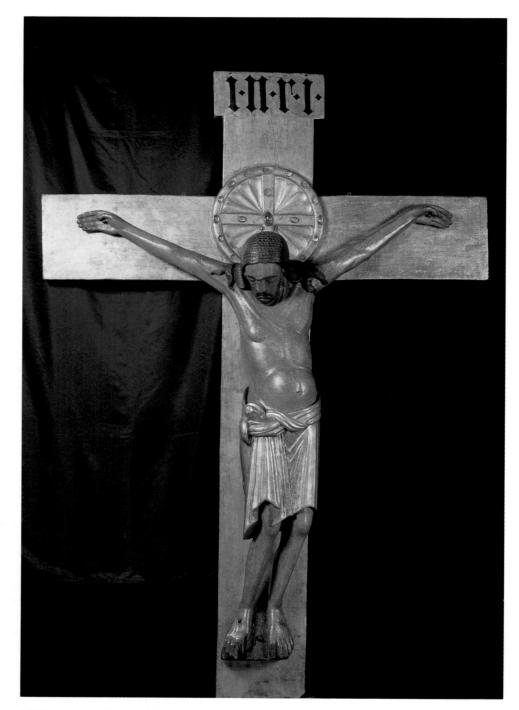

14-30. *Gero Crucifix*, Cologne Cathedral, Germany. c. 970. Painted and gilded wood, height of figure 6'2" (1.87 m)

This lifesize sculpture is both a crucifix to be suspended over an altar and a special kind of reliquary. A cavity in the back of the head was made to hold a piece of the host, or communion bread, already consecrated by the priest. Consequently, the figure not only represents the body of the dying Jesus but also contains within it the "body of Christ" obtained through the Eucharist.

survive from that period (fig. 14-30). It was commissioned by Gero, archbishop of Cologne (969–976), in northwest Germany, and was presented about 970 to his cathedral. (This is a different Gero from the patron of Saint Cyriakus at Gernrode.) The body of Jesus is more than 6 feet tall and made of painted and gilded oak. The focus here, following Byzantine models, is on Jesus' suffering. He is shown

as a tortured martyr, not, as on the cover of the *Lindau Gospels* (see fig. 14-23), a triumphant hero. The intent is to inspire pity and awe in the viewer. Jesus' broken body, near death, sags on the cross and his head falls forward, eyes closed. The fall of his golden drapery heightens the impact of his drawn face, emaciated arms and legs, sagging torso, and limp, bloodied hands. In this image of

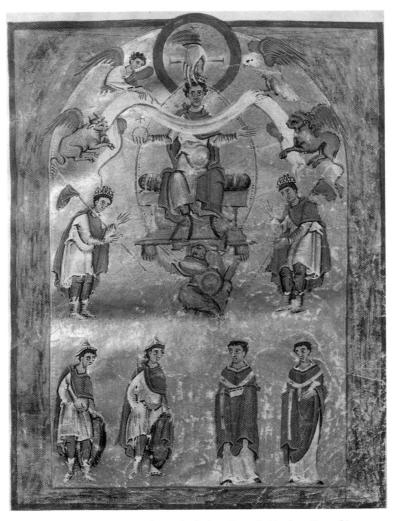

14-31. Page with *Otto III Enthroned, Liuthar Gospels* (*Aachen Gospels*). c. 1000. Ink and colors on vellum, 10⁷/8 x 8¹/2" (27.9 x 21.8 cm). Cathedral Treasury, Aachen

distilled anguish, the miracle and triumph of Resurrection seem distant indeed.

Books

Great variation in style and approach is characteristic of book illustration in the Ottonian period. The Liuthar (or Aachen) Gospels, made for Otto III around 1000, is the work of the so-called Liuthar School, named for the scribe or patron responsible for the book. The center of this school was probably a monastic scriptorium in the vicinity of Reichenau or Trier. The dedication page of the Liuthar Gospels (fig. 14-31) is a piece of imperial propaganda like the Ara Pacis (see fig. 6-27) and the Gemma Augustea (see fig. 6-32) made for Augustus, the first Roman emperor. It establishes the divine underpinnings of Otto's authority and depicts him as a near-divine being himself. He is shown enthroned in heaven, surrounded by a mandorla and symbols representing the evangelists. The hand of God descends from above to place a crown on his head. Otto's arms are extended in an allembracing gesture, and he holds the orb of the world surmounted by a cross in his right hand. His throne, in a symbol of his worldly dominion, rests on the crouching Tellus, the personification of earth. In what may be a reference to the dedication on the facing page—"With this book, Otto Augustus, may God invest thy heart"—the evangelists represented by their symbols hold a white banner across the emperor's breast, dividing body, below, from soul (heart and head) above.

On each side of Otto is an emperor bowing his crowned head toward him. These may represent his Ottonian predecessors or subordinate rulers acknowledging his sovereignty. The bannered lances they hold may allude to the Ottonians' most precious relic, the Holy Lance, believed to be the one used during the Crucifixion by the Roman soldier Longinus to pierce Jesus' side to see whether he was dead. In the lower register, two warriors face two bishops, symbolizing the union of secular and religious power under the emperor.

A second Gospels made for Otto III by the Liuthar School at about the same time as the *Liuthar Gospels*

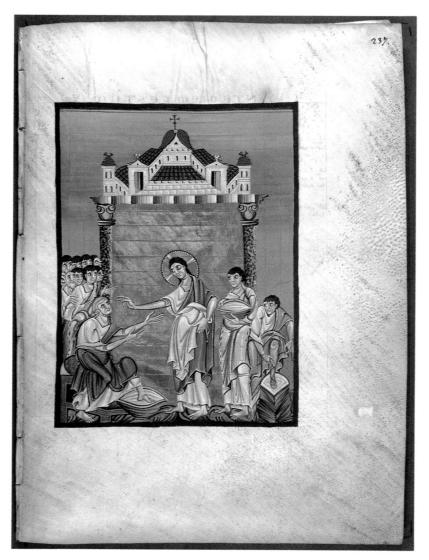

14-32. Page with *Christ Washing the Feet of His Disciples, Gospels of Otto III*. c. 1000. Staatsbibliothek, Munich

The washing of the disciples' feet, as told in John 13, was both a human gesture of hospitality, love, and humility and a symbolic transfer of spiritual power from Jesus to his "vicars," who would remain on earth after his departure to continue his work. At the time this manuscript was made, both the Byzantine emperor and the Roman pope practiced the ritual of foot-washing once a year following the model provided by Jesus: "If I, therefore, the master and teacher, have washed your feet, you ought to wash one another's feet" (13:14). The pope still carries out this ritual, washing the feet of twelve priests on every Maundy Thursday, the day before Good Friday.

contains a full-page illustration of an episode recounted in Chapter 13 of the Gospel according to John (fig. 14-32). Jesus, in one of his acts on the night before his crucifixion, gathered his disciples together to wash their feet. Peter, feeling unworthy, at first protests. The painting shows Jesus in the center, larger than the other figures, extending an elongated arm and hand in blessing toward the elderly apostle. Peter, his foot in a basin of water, reaches toward Jesus with similarly elongated arms. A disciple on the far right unbinds his sandals, and another, next to him, carries a basin of water. Eight other dis-

ciples look on from the left. The story is one of humility and mutual service, but the artist has transformed it into a symbolic representation of the all-powerful Christ of the Resurrection. The scene takes place outdoors in front of a gold curtain hung between green marble columns. Behind this barrier is a church, emphasizing an inherent message of the scene, the conferral of Jesus' blessing and authority on the apostles, his vicars on earth after his death.

The illustration on the presentation page of a Gospels made for Hitda (d. 1041), the abbess of the convent

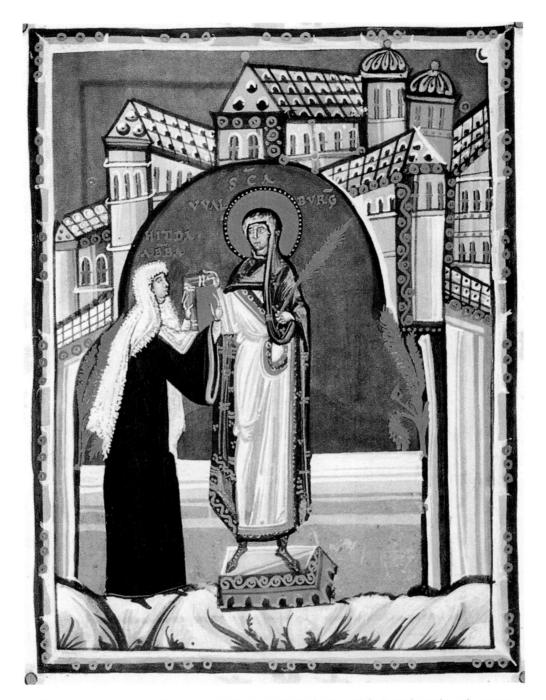

14–33. Presentation page with Abbess Hitda and Saint Walpurga, *Hitda Gospels*. Early 11th century. Ink and colors on vellum, $11^3/8 \times 5^5/8$ " (29 x 14.2 cm). Hessische Landes- und Hochschul-Bibliothek, Darmstadt, Germany

at Meschede, near Cologne, also in the early eleventh century, shows the abbess offering her book to Walpurga, her convent's patron saint (fig. 14-33). The simple contours of the stately figures give them a monumental quality. The artist has arranged the architectural lines of the convent in the background to frame the figures and draw attention to their transaction. The size of the convent underscores the abbess's position of authority. The foreground setting—a rocky, uneven strip of landscape—is meant to be understood as holy ground, separated from the rest of the world by the huge arch-shaped aura

that silhouettes Saint Walpurga. The calm atmosphere conveys a sense of spirituality and contained but deeply felt emotion.

These final manuscript paintings in a sense summarize the high intellectual and artistic qualities of Ottonian art as well as its great variety. Ottonian artists, drawing inspiration from the past—as reflected in the art of Christian Rome—created a monumental style for a Christian, German-Roman empire, the Holy Roman Empire. From such groundwork during the early medieval period emerged the arts of European Romanesque culture.

Speyer Cathedral c. 1030– early 1100s

Cathedral complex Pisa begun 1063

Bayeux Tapestry c. 1066–77

Sainte-Foy late 10th-11th century

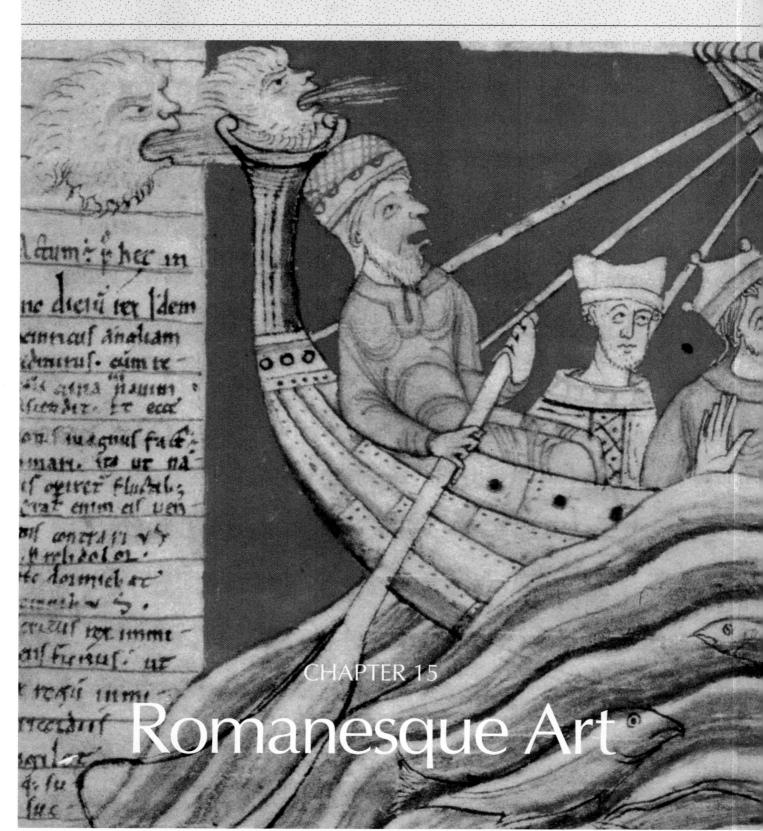

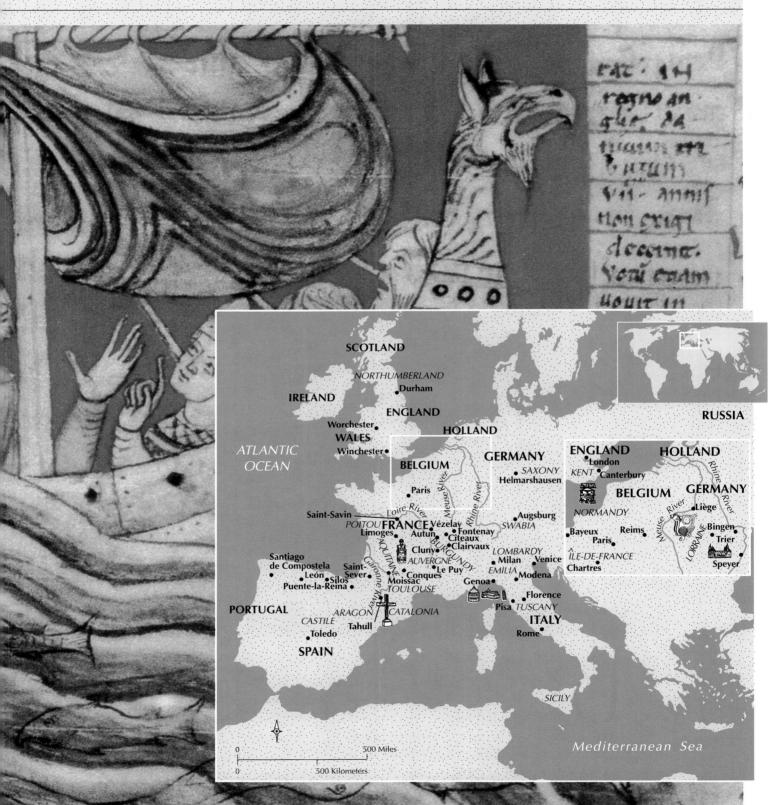

1050 CE 1200 CE

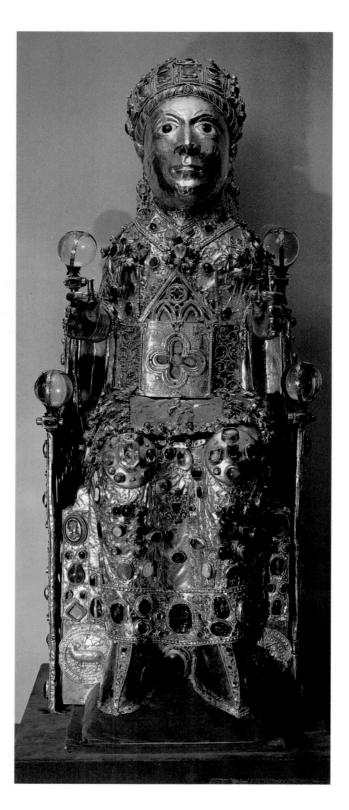

15-1. Reliquary statue of Saint Foy, made in the Auvergne region, France, for the Abbey Church of Sainte-Foy, Conques, Rouergue, France. Late 10th-11th century. Gold repoussé and gemstones over wood core (incorporating a Roman helmet and Roman cameos; later additions 12th-19th centuries), height 331/2" (85 cm). Cathedral Treasury, Conques, France According to legend, Saint Foy was a child martyr, burned to death in 303 for refusing to make sacrifices to pagan gods. The symbolic as well as visual focus of the reliquary, which contains the saint's cranium behind a Roman helmet, is its oversized crowned head. The statue originally stood on an altar in the sanctuary of the church, separated from worshipers in the ambulatory by a screen. The reliquary and other treasures were discovered inside a wall of the church during restoration in the 1860s. The monks had hidden them there for safekeeping, probably shortly before the abbey was burned by Protestants in 1568. This accident of survival helps us to imagine the original splendor of Romanesque churches.

uring the late Middle Ages, people in western Europe once again began to travel in large numbers as traders, soldiers, and Christians on pilgrimages. Pilgrims throughout history have journeyed to holy sites—the ancient Greeks to Delphi, early Christians to Jerusalem and to Rome, Muslims to Mecca—but in the eleventh century, pilgrimages to the holy places of Christendom dramatically increased, despite the great financial and physical hardships they entailed (see "The Pilgrim's Journey," page 513).

1050 CE 1200 CE

As difficult and dangerous as these journeys were, there were also rewards along the route even before the pilgrims reached their destination. They were often entertained by itinerant minstrels singing poems of epic heroes, perhaps to attract travelers to the sites where legendary figures were supposed to have been buried. One of the most celebrated songs to have come down through the centuries is *La Chanson de Roland* (*The Song of Roland*), composed about 1100 and telling of the heroic death of one of Charlemagne's knights, cast as a Christian martyr in the poem. This story was set near the very important tomb of the apostle Saint James (Santiago) in Santiago de Compostela in northwest Spain, and thus the song was a great favorite on the routes to it.

Crowds of pilgrims traveling to these major destinations would stop along the way to venerate significant relics—bone, cloth, wood, or other material said to have come from a holy person or object and encased in richly decorated containers called **reliquaries**—leaving donations and offerings with the churches and monasteries that housed the relics. These relics were widely believed to have miraculous powers, and the demand for them was so great that as early as the seventh century the bodies of saints were divided up and moved from place to place. As a result of the attraction of prestigious relics, monasteries sometimes competed for them. The Benedictine Abbey Church of Sainte-Foy at Conques in south-central France, for instance, drew pilgrims from far and wide to view the skull of the child saint in its famous jewel-encrusted golden reliquary (fig. 15-1). A monk from Conques had stolen her bones from another abbey in the ninth century, and by 883 Saint Foy was the patron of Conques.

To accommodate the faithful and instruct them in Church doctrine, many monasteries on the major pilgrimage routes built large new churches and filled them with sumptuous altars, crosses, and reliquaries. Sculpture and paintings on the walls illustrated important religious stories and doctrines and served to instruct as well as fascinate the faithful. These awe-inspiring works of art and architecture, like most of what has come down to us from the Romanesque period, had a Christian purpose. One monk wrote that by decorating the church "well and gracefully" the artist showed "the beholders something of the likeness of the paradise of God" (Theophilus, page 79).

ROMANESQUE CULTURE

Romanesque means "in the Roman manner," and the term applies specifically to a

medieval European style. The word was coined in the early nineteenth century to describe European church architecture of the eleventh and twelfth centuries, which displayed the solid masonry walls, rounded arches, and masonry vaults characteristic of Roman imperial buildings. Soon the term was applied to all the arts of the period from roughly the mid-eleventh to the late-twelfth century, even though the art reflects influences from many sources, including Byzantine, Islamic, and early medieval Europe, as well as Roman.

During the eleventh and twelfth centuries western Europe was divided into many small territories. The nations we know today did not exist. At the beginning of the eleventh century, powerful nobles ruled France. The southern part of the region had closer linguistic and cultural ties to northern Spain than to the north, and the king of France truly ruled only a small area around Paris. The duke of Normandy (a former Viking region on the northwest coast) and the duke of Burgundy paid the king only token obeisance. By the end of the twelfth century, however, the French monarchy centered in the Île-de-France around Paris was beginning to emerge as the core of a national state. After the Norman conquest of Anglo-Saxon Britain in 1066, England, too, began to emerge as a nation. In Germany and northern Italy, in contrast, the power of local rulers and towns ultimately prevailed against the attempts of the monarchs of the Holy Roman Empire to impose a central authority, and these regions remained politically fragmented until the nineteenth

century. Sicily and southern Italy, previously in the hands of Byzantine and Islamic rulers, fell under the control of the Norman adventurers. This political fragmentation led to the many distinctive regional styles that characterize Romanesque art.

Trade increased during the eleventh and twelfth centuries, promoting the growth of towns, cities, and an urban class of merchants and artisans. Europe remained, however, a predominately agricultural society, with land being the primary source of wealth and power. In many regions the feudal system that had developed in the Early Middle Ages governed social and political relations. In this system, a lord, a landowning aristocrat, granted some of his property to a vassal, offering the vassal protection and receiving in return the vassal's allegiance and promise of military service as an armed knight. Vassals, in turn, could become lords, granting part of their holdings to their own vassals.

The economic foundation for this political structure was the manor, an agricultural estate in which peasants worked in exchange for a place to live, food, military protection, and other services from the lord. Feudal estates, community-based and almost entirely self-sufficient, became hereditary over time. Economic and political power thus came to be distributed through a network of largely inherited but constantly shifting allegiances and obligations that defined relations among lords, vassals, and peasants. Women generally had a subordinate position in this hierarchical, military social system. When necessary, however, aristocratic women took responsibility for managing estates in their male relatives' frequent absences on military missions or pilgrimages. They could also achieve positions of authority and influence as the heads of religious communities. Among peasants and artisans, women and men often worked side by side.

In the Early Middle Ages the Church and state had forged an often fruitful alliance. Christian rulers helped assure the spread of Christianity throughout Europe and supported monastic communities and Church leaders, who were often their relatives, with grants of land. The Church, in return, provided rulers with crucial social and spiritual support, and it supplied them with educated officials. As a result secular and religious authority became tightly intertwined. In the eleventh century the papacy sought to make the Church independent of lay authority, sparking a conflict with secular rulers known as the Investiture Controversy over the right to "invest" Church officials with the symbols of office.

In the eleventh and twelfth centuries, Christian Europe, previously on the defense against the expanding forces of Islam, became the aggressor. In Spain the armies of the Christian north were increasingly successful against the Islamic south. In 1095 Pope Urban II, responding to a request for help from the Byzantine emperor, called for a Crusade to retake Jerusalem and the Holy Land. This First Crusade succeeded in establishing a short-lived Christian state in Palestine. Although subsequent Crusades were, for the most part, military failures, the crusading movement as a whole had

far-reaching cultural and economic consequences. The West's direct encounters with the more sophisticated material culture of the Islamic world and the Byzantine Empire created a demand for goods from the East. This in turn helped stimulate trade, and with it the rise of an increasingly urban society.

Western scholars rediscovered many classical Greek and Roman texts that had been preserved for centuries in Islamic Spain and the eastern Mediterranean. The combination of intellectual ferment and increased financial resources enabled the arts to flourish. The first universities were established at Bologna (eleventh century) and Paris, Oxford, and Cambridge (twelfth century). This renewed intellectual and artistic activity has been called the twelfth-century "renaissance," a cultural "rebirth." Monastic communities continued to be powerful and influential in Romanesque Europe, as they had been in the Early Middle Ages. Some monks and nuns were highly regarded for their religious devotion, for their learning, as well as for the valuable services they provided, including taking care of the sick and destitute, housing travelers, and educating the laity in monastic schools. Because monasteries were major landholders, they were part of Europe's power structure. The children of aristocratic families who joined religious orders also helped forge links between monastic communities and the ruling elite. As life in Benedictine communities grew increasingly comfortable, reform movements arose within the order itself. The first of these reform movements originated in the abbey of Cluny, founded in 910 in presentday east-central France.

AND NORTHERN

FRANCE For most of the Romanesque period, power in France was divided among the nobility, the Church, and the kings of the Capetian **SPAIN** dynasty, the successors to the Carolingians. Royal power was

negligible in the eleventh century. Northern France was dominated by the powerful feudal duchy of Normandy, and southern France had close linguistic and cultural ties to northern Spain. Beginning in the twelfth century, the Capetians began to consolidate their authority in the Îlede-France, the region around Paris. By the end of the century, they were able to assert their authority over their vassals in much of the rest of the country, laying the foundation for a powerful national monarchy.

The Iberian peninsula (present-day Spain and Portugal) remained divided between Muslim rulers in the south and Christian rulers in the north. The power of the Christian rulers was growing, however. Their long struggle with the Muslims had heightened their religious fervor, and they joined forces to extend their territory gradually to the south throughout the eleventh and twelfth centuries. The Christians in 1085 reconquered the Muslim capital and stronghold Toledo, a center of Islamic and Jewish culture in Castile. Toledo had been an oasis of concord between Christians, Muslims, and Jews until the early twelfth century; its scholars played an important role in the transmission of classical writings to the rest of Europe, contributing to the cultural renaissance of the twelfth century.

Architecture

The eleventh and twelfth centuries were a period of great building activity in Europe. Castles, churches, and monasteries arose everywhere. As one eleventh-century monk noted, "Each people of Christendom rivaled with the other, to see which should worship in the finest buildings. The world shook herself, clothed everywhere in a white garment of churches" (Radulphus Glaber, cited in Holt, *A Documentary History of Art*, I, page 18). That labor and funds should have been committed on such a scale to monumental stone architecture at the same time as the Crusades and in a period of frequent domestic warfare seems extraordinary today. The buildings that still stand, despite the ravages of weather, vandalism, neglect, and war, testify to the power of religious faith and local pride.

In one sense, Romanesque churches were the result of master builders solving the problems associated with each individual project: its site, its purpose, the building materials and work force available, the builders' own knowledge and experience, and the wishes of the patrons

providing the funding. The process was slow, often requiring several different masters and teams of masons over the years. The churches nevertheless exhibit an overall unity and coherence, in which each element is part of a geometrically organized, harmonious whole.

The basic form of the Carolingian and Romanesque church derives from earlier churches inspired by Early Christian basilicas. Romanesque builders made several key structural advances and changes in this form. Stone masonry vaulting replaced wooden roofs, increasing the protection from fire and improving the acoustics for chanting. The addition of ribs—curved and usually projecting stone members—as structual elements to both barrel vaults and groin vaults permitted builders more flexibility in laying out interior space (see "Elements of Architecture," page 552). Masonry buttresses reinforced walls at critical points. The introduction of an ambulatory (walkway) around the apse allowed worshipers to view relics displayed there, an efficient organization of architectural space for worship. The symbolic importance of towers, especially over the crossing (where the nave and transept intersect) and the west facade (the entrance to the church and, by extension, to paradise) was emphasized in Romanesque churches. This new form arose

1050 CE 1200 CE

PARALLELS

<u>Europe</u>	<u>1050–1125</u>	<u>1125–1200</u>
France/northern Spain	Strong aristocracy, divided political power; Capetian dynasty; illuminations of Beatus <i>Commentary</i> ; Church of Santiago de Compostela; Christians capture Toledo from Muslims; Cluny III; Cistercian order founded; <i>La Chanson de Roland</i> ; Church of Saint-Savin-sur-Gartempe; Church of Saint-Pierre, Moissac; elaborate sculpted portals, the San Clemente Master	Increasingly strong monarchy; University of Paris founded; Virgin Mary as Throne of Wisdom images
Britain and Normandy	Norman Conquest of England; William the Conqueror crowned; Durham Cathedral; <i>Bayeux Tapestry; Domesday Book</i> ; Oxford University founded	Winchester Psalter; Worcester Chronicle
Germany/Meuse Valley	Salian dynasty; Investiture Controversy; Speyer Cathedral; Saxon metalwork	Aquamaniles introduced from East; Hildegard of Bingen's <i>Liber Scivias</i>
Italy	Baptistry of San Giovanni; Pisa Cathedral; Normans control Sicily and southern Italy; Gregory VII elected pope; Rome sacked by Normans; first narrative portal sculpture; Church of San Clemente rebuilt	Church of San Marco, Venice
<u>World</u>	Separation of Eastern and Western Christian Churches; Seljuk Turks capture Baghdad; Christian Crusaders take Jerusalem; Song dynasty (China); Great Zimbabwe civilization (Africa); mound-building cultures (North America)	Omar Khayyam's <i>Rubaiyat</i> (Persia); Muslim conquests in India; Kamakura period (Japan); Jenghiz Khan rules Mongols; Benin civilization (Africa)

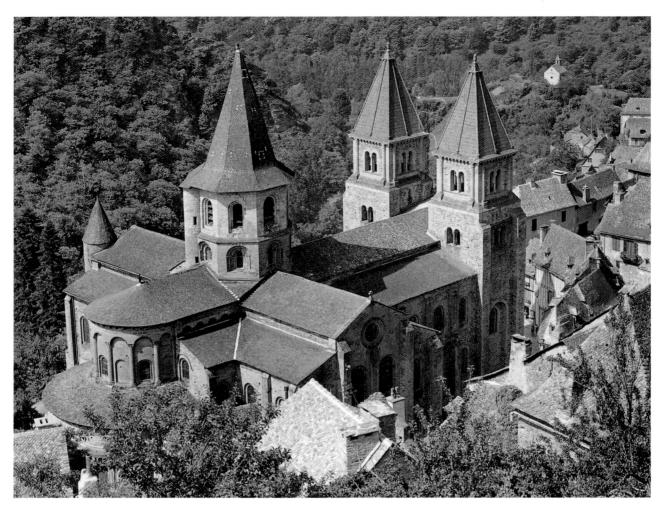

15-2. Abbey Church of Sainte-Foy, Conques, Rouergue, France. Mid-11th-12th century. Western towers rebuilt in the 19th century; crossing tower rib-vaulted in the 14th century, restored in the 19th century. View from the northeast

along the pilgrimage routes to Santiago de Compostela. One surviving example of such a pilgrimage church, the Benedictine Abbey Church of Sainte-Foy, perches on a remote hillside at Conques in south-central France (fig. 15-2). As already noted, the church was renowned for its golden reliquary with the remains of a child saint (see fig. 15-1).

Construction of a new, larger church at Conques to handle the influx of pilgrims began in the mid-eleventh century and continued into the next century. The western towers and the tall tower over the crossing were rebuilt during restorations in the nineteenth century. The original **cruciform** (cross-shaped) plan with a wide, projecting transept was typical of Romanesque pilgrimage churches (fig. 15-3). At the west a **portal**—large doorway—opens directly into the broad nave. The portals of the largest churches have three doors, the central leading into the nave and the flanking doors into the side aisles. The elongated **sanctuary** encompasses the **choir** and the **apse**, with its surrounding **ambulatory** and ring of chapels.

Inside, the feeling is strongly vertical (fig. 15-4). The nave walls are made of local sandstone that has weathered to a golden color and glows softly in the indirect light from windows in the outer walls of the upper-level

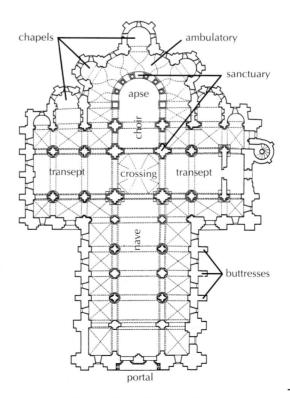

15-3. Plan of Abbey Church of Sainte-Foy

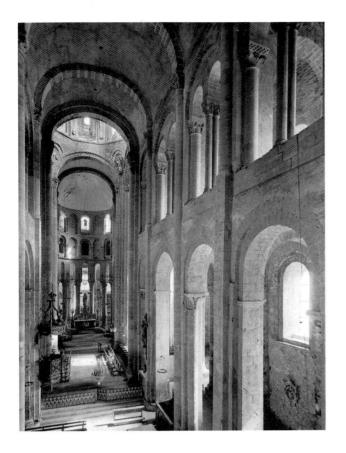

galleries, or passageways. The galleries along the side aisles overlook the nave. Ribbed barrel vaults cover the nave, groin vaulting spans the side aisles, and half-barrel vaulting called quadrant vaulting, the arc of which is one quarter of a circle, covers the galleries. The vaults over the galleries help strengthen the building by carrying the outward thrust of the nave vaults to the outer walls and buttresses.

The solid masonry piers that support the nave arcade have attached half columns on all four sides. This type of support, known as a **compound pier**, gives sculptural form to the interior and was a major contribution of Romanesque builders to architectural structure and aesthetics. Compound piers helped organize the architectural space by marking off the individual square, vaulted bays. Conques' square crossing is lit by an open, octagonal **lantern** tower resting on **squinches**. Light streaming in from the lantern and apse windows acted as a beacon, directing the worshipers' attention forward. During the Middle Ages the laity stood in the nave, separated from the priests and monks who celebrated the Mass in the choir.

Pilgrims arrived at Conques weary after many long days of difficult, perilous travel through dense woods and

THE PILGRIM'S JOURNEY

The eleventh and twelfth centuries in Western Europe saw an explosive growth

in the popularity of religious pilgrimages. The rough roads that led to the most popular destinations—the Constantinian churches of Rome and the Cathedral of Santiago de Compostela (Saint James at Compostela) in the northwest corner of Spain—were often crowded with travelers, who had to contend at times with bandits, and dishonest innkeepers and merchants. Pilgrims also set out for the Church of the Holy Sepulchre in Jerusalem. Journeys could last a year or more.

The stars of the Milky Way, it was said, marked the way to Santiago de Compostela. Still, a guidebook helped, and in the twelfth century the priest Aymery Picaud wrote one for pilgrims on their way to the great shrine through what is now France. In Picaud's time, four main pilgrimage routes crossed France, merging into a single road in Spain at Puentela-Reina and leading on from there through Burgos and León to Compostela. Conveniently spaced monasteries and churches offered food

and lodging. Roads and bridges were maintained by a guild of bridge builders and guarded by the Knights of Santiago.

Picaud described the best-traveled routes and most important shrines to visit. Chartres, for example, housed the tunic that the Virgin was said to have worn when she gave birth to Jesus. At Vézelay were the bones of Saint Mary Magdalen, and at Conques, those of Saint Foy, an early local martyr (see fig. 15-1). Churches associated with miraculous cures-Autun, for example, which claimed to house the bones of Saint Lazarus, raised by Jesus from the dead-were filled with the sick and injured praying to be healed. Like travel guides today, Picaud's book also provided shopping tips, advice on local customs, comments on food and the safety of drinking water, and pocket dictionaries of useful words in the languages the

"Das ist der Rom Weg," map of pilgrimage routes to Rome from Denmark. c. 1500. Woodcut, $15^{3}/4 \times 11^{1}/4$ " (40 x 28.5 cm). The British Library

pilgrim would encounter en route. His warnings about the people who prey on travelers seem all too relevant today.

mountains, probably thankful that they had been protected by the saint against bandits on the way. They no doubt paused in front of the west entrance to study its portal sculpture, a notable feature of Romanesque pilgrimage churches. Portal sculpture communicated the core doctrines of the Church to those who came to read its messages. At Conques, the Last Judgment in the **tympanum** (the **lunette** over the doorway) marked the passage from the secular world into the sacred world within the church. Inside, the walls resounded with the music of the plainchant, also called Gregorian chant after Pope Gregory I (590–604). The Benedictines spent eight-anda-half to ten hours a day in religious services. Today they still spend two-and-a-half to three hours.

A different Romanesque architecture could be found at the Benedictine Abbey Church of Cluny in Burgundy, founded in 910 as a reformed monastery. Cluny had a special independent status, its abbot answering directly to the pope in Rome rather than to the local bishop and feudal lord. This unique freedom, jealously safeguarded by a series of long-lived and astute abbots, enabled Cluny to become influential and prosperous in the eleventh and early twelfth centuries. Cluniac reform spread to other monasteries within Burgundy and beyond, to the rest of France, Italy, and Germany. Cluny attracted the patronage of successive rulers, as well as the favor of the pope in Rome. By the second half of the eleventh century there were some 300 monks in the abbey at Cluny alone. Cluny founded more than 200 priories (religious houses) in other locations-many along pilgrimage routes-and many more houses were loosely affiliated with it. At the height of its power 1,450 houses answered to the strong central administration of the abbot of Cluny.

Cluniac monks and nuns dedicated themselves to the scholarly and artistic interests of their order. Most important was the celebration of the eight Hours of the Divine Office, including prayers, scripture readings, psalms and hymns, and the Mass, the symbolic rite of the Last Supper, celebrated after the third hour (terce). They depended for support on the labor of laymen and laywomen who had not taken vows. Cluny's extensive land holdings, coupled with gifts of money and treasure, made it wealthy. Cluny and its affiliates were among the major patrons of art in Western Europe.

The great Hugh de Semur, abbot of Cluny for sixty years (1049-1109), began a new church at Cluny in 1088 with the help of financing from King Alfonso VI of León and Castile in northern Spain (ruled 1065-1109). Known to art historians as Cluny III (because it was the third building at the site), it was the largest and most spectacular church in all Europe when it was completed in 1130. Used as a stone quarry in the early 1800s after the French Revolution, the monastery is known today through the work of archeologists (fig. 15-5). Richly carved, painted, and furnished, it was described by a contemporary observer as fit for angels. Music and art were densely interwoven in Cluniac life, shaped by the Cluniac conception of the house of God. The proportions of Cluny III were based on harmonic relationships discussed in ancient Greek musical theory and mathematics. The

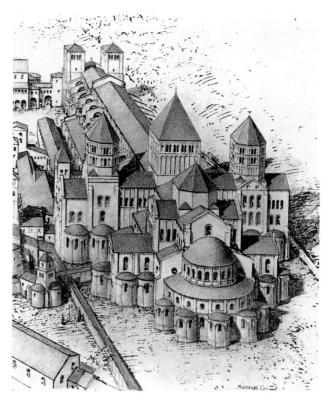

 Reconstruction drawing of the Abbey Church (Cluny III), Cluny, Burgundy, France. 1088–1130. View from the east (after Conant)

The magnificence of this church and the Cluniac power it represented made it a particular target of anti-Church violence. It was nearly destroyed after the French Revolution when the owner sold its stones as building material. Only the southeast transept and its tower survive.

towering barrel-vaulted ceiling—more than 100 feet high in a space more than 500 feet long from end to end—enhanced the sound of the monks' chants. Sculpture, too, picked up the musical theme: carvings on two surviving column capitals depict personifications of the eight modes of the plainchant. The hallmarks of Cluniac churches were functional design, skillful masonry technique, and the assimilation of elements from Roman and early medieval architecture and sculpture. Individual Cluniac monasteries, however, were free to follow regional traditions and styles; consequently Cluny III was widely influential, though not copied exactly.

Several new religious orders devoted to an austere spirituality arose in the late eleventh and early twelfth centuries. Among these were the Cistercians, another reform group within the Benedictine order. The Cistercians turned away from the elaborate liturgical practices and emphasis on the arts of Cluny to a simpler monastic life. The order was founded in the late eleventh century at Cîteaux (Cistercium in Latin, hence the order's name), also in Burgundy. Led by the commanding figure of Abbot Bernard of Clairvaux (abbacy, 1115–1154), the Cistercians thrived on strict mental and physical discipline. These virtues enabled them to settle and reclaim vast tracts of wilderness. In time, their enterprises stretched from present-day Russia to Ireland, and by the end of the

Middle Ages there were approximately 1,500 Cistercian abbeys, half of which were for women. Although their very success eventually undermined their austerity, they were able for a long time to sustain a way of life devoted to prayer and intellectual pursuits combined with shared manual labor. Like the Cluniacs, however, they depended on the assistance of laypersons.

Early Cistercian architecture reflects the ideals of the order. The Abbey Church of Nôtre-Dame at Fontenay, begun in 1139, is the oldest surviving Cistercian structure in Burgundy. The abbey has a simple geometric plan (fig. 15-6). The church has a long nave with rectangular chapels in the square-ended transept arms, and a shallow choir with a straight end wall. Lay brothers entered through the west doorway, monks from the attached cloister or upstairs dormitory. Situated far from the distractions of the secular world, the building made few concessions to the popular taste for architectural adornment, either outside or in. In other ways, however, Fontenay and other Cistercian monasteries fully reflect the architectural developments of their time in their masonry, vaulting, and proportions.

The Cistercians relied on harmonious proportions and fine stonework, not elaborate surface decoration, to speak the language of God in their architecture (fig. 15-7). A feature of Fontenay often found in Cistercian

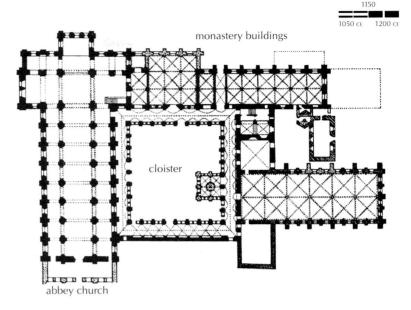

15-6. Plan of the Abbey of Nôtre-Dame, Fontenay, Burgundy, France. 1139–47

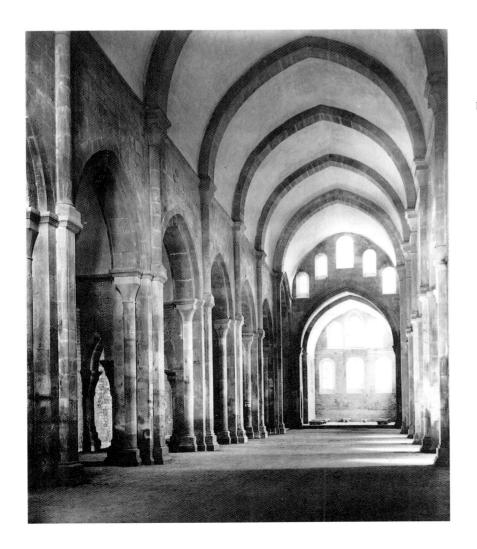

15-7. Nave, Abbey Church of Nôtre-Dame, Fontenay. 1139-47 Although the pointed arch is often referred to as the Gothic arch, its use in northwestern Europe began in the Romanesque period. Its origin may have been in Islamic building in southern Europe. Pointed arches are structurally more stable than round ones, directing more weight down into the floor, and they can span greater distances at greater heights without collapsing. Visually, pointed arches draw the eye inward and upward, an effect that can be translated into sacred symbolism—perhaps the intent of the builders of this church.

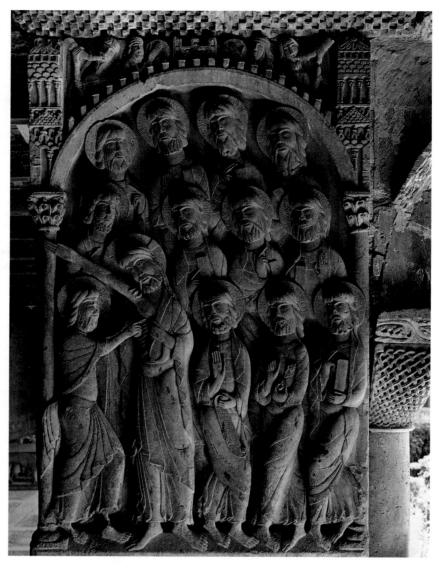

15-8. Doubting Thomas, pier in the cloister of the Abbey of Santo Domingo de Silos, Castile, Spain. Early 12th century

architecture is the use of pointed ribbed vaults over the nave and pointed arches in the nave arcade and side-aisle bays. Furnishings included little else than altars and candles. The large, triptychlike windows in the end walls provided the primary source of light and also had a symbolic function as a reminder of the Trinity.

This simple architecture spread from the Cistercian homeland in Burgundy to become an international style. From Scotland and Germany to Spain and Italy, Cistercian designs and building techniques varied only slightly. The masonry vaults and harmonious proportions were to be influential in the development of the Gothic style later in the Middle Ages.

Architectural Sculpture

Like Cluny and unlike the severe churches of the Cistercians, many Romanesque churches have a remarkable variety of painting and sculpture. Christ Enthroned in Majesty in heaven may be illustrated, as well as stories of Jesus among the people, or images of the lives and the miracles of the saints. The Virgin Mary gains importance in the paintings, and the prophets, kings, and queens of the Old Testament prefigure (symbolically foretell) events in the New Testament. Contemporary bishops, abbots, other noble patrons, and even ordinary folk are represented. A profusion of monsters, animals, plants, geometric ornament, allegorical figures such as Luxury and Greed, and depictions of real and imagined buildings surround the major works of sculpture. The Elect rejoice in heaven with the angels; the Damned suffer in hell, tormented by demons. Biblical and historical tales come alive, along with scenes of everyday life. It all looks as if it were taking place in a contemporary medieval setting.

Superb reliefs embellish the corner piers in the cloister of the Abbey of Santo Domingo de Silos in the kingdom of Castile. One of these illustrates the story, recounted in the Gospel of John (Chapter 20), in which Christ, appearing to his apostles after the Crucifixion, permits Thomas to touch his wounds to convince the

ELEMENTS OF The doorways of major Ro-ARCHITECTURE manesque churches are often grand sculpted portals. Wood The Romanesque or metal doors are surrounded Church Portal by elaborate stone sculpture arranged in zones to fit the

architectural elements. The most important imagery is in the semicircular tympanum directly over the door lintel.

Archivolts—curved moldings formed by the voussoirs of which the arch is constructed-frame the tympanum. Spandrels are the flat areas at the outside upper corners of the tympanum area. On both sides of the doors are jambs carved in the form of jamb columns, typically decorated with figures, called jamb figures. Pedestals sometimes form the bases of jamb columns. The receding jambs form a shallow porch leading into the church.

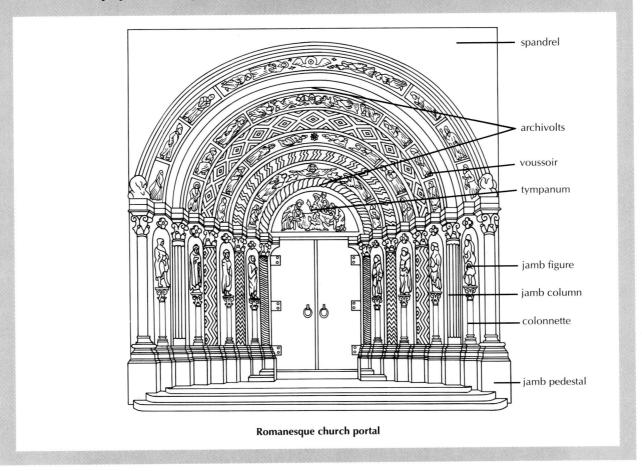

doubting apostle of his Resurrection (fig. 15-8). The organization of the composition is expert. Christ is shown larger than his disciples and placed off-center in the left foreground. His outstretched right arm forms a strong diagonal that bisects the space between his haloed head and that of Thomas in the lower left. Thomas's outstretched arm, reaching toward Christ's side, forms an opposing diagonal parallel to the slope between their heads, leading the eye back to Christ's face. The massed presence of the other apostles, bearing witness to the miracle, gives visual weight to the scene through the rhythmic repetition of form. The effect parallels the way the repetition of the nave bays in a Romanesque church culminates in the apse, its symbolic core.

Miniature buildings and musicians crown the arch that forms a canopy over the apostles' heads in the Silos pier relief. The sculptors used these lively images from medieval life to frame the biblical story, just as medieval preachers used elements of daily life in their sermons to provide a context for biblical messages. The art and literature of the period frequently combined "official" and "popular" themes in this way.

Carved portals are among the most significant innovations of Romanesque art. These complex works, which combine biblical narrative, legends, folklore, history, and Christian symbolism, represent the first attempt at largescale architectural sculpture since the end of the Roman Empire. By the early twelfth century, sculpture depicting Christ in Majesty (the Second Coming), the Last Judgment, and the final triumph of good over evil at the Apocalypse could be seen on the portals of churches in northern Spain, southern France, and Burgundy. The churches of Conques and Cluny had carved portals; so did the Churches of Saint-Pierre in Moissac in southern France, the Cathedral of Saint-Lazare at Autun, the Churches of Sainte-Madeleine at Vézelay in Burgundy, and Sainte-Foy at Conques. (We will look at Moissac and Autun as typical examples.)

The Cluniac priory of Saint-Pierre at Moissac was a major pilgrimage stop on the route to Santiago de

15-9. South portal and porch, Priory Church of Saint-Pierre, Moissac, Toulouse, France. c. 1115–30

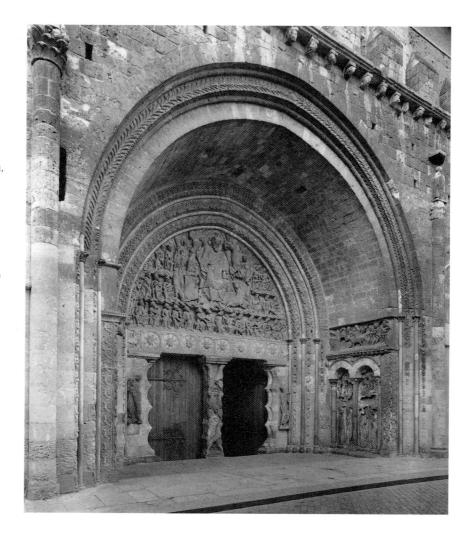

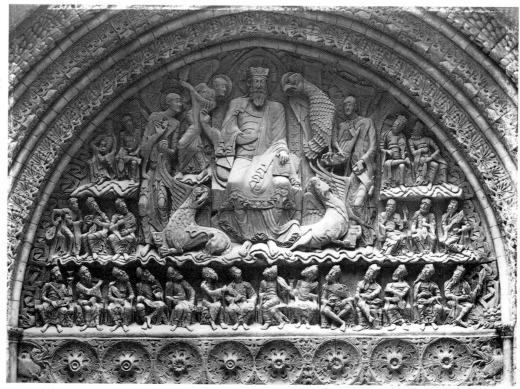

15-10. *Christ in Majesty*, tympanum of the south portal, Priory Church of Saint-Pierre. Width approx. 18' 6" (5.68 m)

1150 1050 CE 1200 C

Compostela. The original shrine at the site was reputed to have existed in the Carolingian period. After joining the congregation of Cluny in 1047, the monastery prospered from the donations of pilgrims and the local nobility, as well as from its control of shipping on the nearby Garonne River.

Moissac's monks launched an ambitious building campaign, and much of the sculpture from the cloister (c. 1100) and the church (1115–1130) has survived. The church was completed during the tenure of Abbot Roger (1115–1131), who commissioned the sculpture on the south portal and porch (fig. 15-9). This sculpture represented a genuine departure from earlier works in both the quantity and quality of the carving. The sculpture covers the **tympanum** (the **lunette** over the doorway), the **archivolts** (the curved rows of **voussoirs** outlining the tympanum), and the lintel, doorposts, and porch walls (see "Elements of Architecture," page 517). The stones still bear traces of the original paint.

The sculpture of Christ in Majesty dominates the huge tympanum (fig. 15-10). The scene combines images from the description of the Second Coming of Christ in Chapters 4 and 5 of the Apocalypse (the last book of the New Testament, called Revelation) with others derived from Old Testament prophecies, all filtered through the early twelfth century's view of Scripture. A crowned and fearsome Christ, as awe-inspiring as a Byzantine Pantokrator (see fig. 7-47), stares down at the viewer as he blesses and points to the book "sealed with seven seals" (Revelation 5:1). He is enclosed by a mandorla, and a cruciform halo rings his head. Four winged creatures symbolizing the evangelists—Matthew the Man (upper left), Mark the Lion (lower left), Luke the Ox (lower right), and John the Eagle (upper right)—frame Christ on either side, each holding a scroll or book representing his Gospel. Two elongated seraphim, Old Testament angels, stand one on either side of the central group, each holding a scroll. A band beneath Christ's feet and another passing behind his throne represent the waves of the "sea of glass like crystal" (Revelation 4:6). These define three registers in which sit twenty-four elders with "gold crowns on their heads" in varied poses, each holding either a harp or a gold bowl of incense (Revelation 4:4 and 5:8). According to the medieval view, the elders were the kings and prophets of the Old Testament and, by extension, the ancestors and precursors of Christ.

As in the Silos *Doubting Thomas* relief, secondary elements lighten the solemn intensity of the scene. Monstrous heads in the lower corners of the tympanum spew ribbon scrolls that run up its periphery. Similar creatures, akin to the beasts seen in the Scandinavian **animal style** of the Early Middle Ages (see fig. 14-5), appear at each end of the lintel, their tongues growing into ropes encircling a line of eight acanthus **rosettes**. A similar combination of animals, interlace, and rosettes can be found in Islamic art. Heraldic beasts and rosettes appeared together on Byzantine and Islamic textiles. Processions of naturalistically depicted rats and rabbits climb the piers on either side of the doors (fig. 15-11). Halos, crowns, and Christ's throne in the tympanum are adorned with stylized foliage.

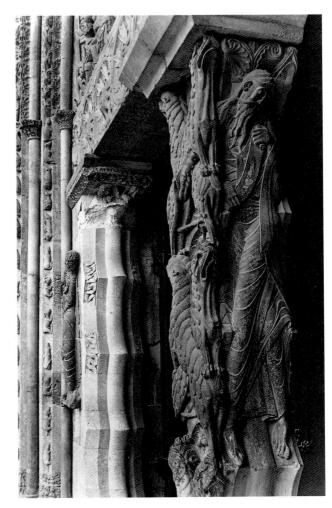

15-11. *Lions and Prophet Jeremiah (?)*, trumeau of the south portal, Priory Church of Saint-Pierre

In a letter to fellow cleric William of Saint Thierry, Bernard of Clairvaux, leader of the Cistercian order, objected to what he felt was excessive architectural decoration of Cluniac churches and cloisters. "So many and so marvellous are the varieties of diverse shapes on every hand," he wrote, "that we are more tempted to read in the marble than in our books, and to spend the whole day in wondering at these things rather than in meditating the law of God. For God's sake, if men are not ashamed of these follies, why at least do they not shrink from the expense?" (cited in Davis-Weyer, page 170).

The figures in the tympanum relief reflect a hierarchy of scale and location. Christ, the largest figure, sits at the top center, the spiritual heart of the scene, surrounded by smaller figures of the evangelists and angels. The elders, farthest from Christ, are roughly one-third his size. Despite this formality and the limitations forced on them by the tympanum's shape, the sculptors created a sense of action by turning and twisting the gesturing figures, shifting their poses off-center, and avoiding rigid symmetry or mirror images. Nonfigural motifs above and below Christ, too, skirt the central vertical axis, contributing to the dynamic play across the tympanum's surface. The sculptors carved the tympanum from twenty-eight stone blocks of different sizes. The elders were carved one or

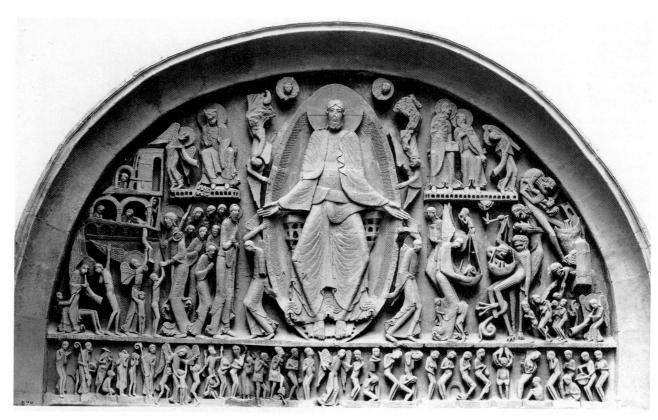

15-12. Gislebertus. Last Judgment, tympanum of the west portal, Cathedral of Saint-Lazare, Autun, Burgundy, France. c. 1120-35

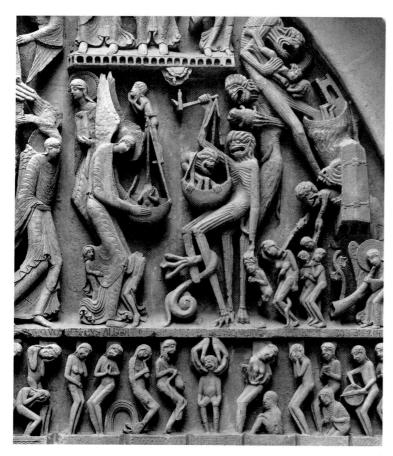

15-13. Gislebertus. Weighing of Souls, detail of Last Judgment

two per block, whereas the figures of the central group covered one or more blocks as needed. Paint would originally have disguised the join lines. The crowns and incense bowls—described as made of gold in Revelation—may have been gilded.

Two side jambs and a central pier-known as a trumeau—support the weight of the lintel and tympanum. Moissac's jambs and trumeau have scalloped profiles (see fig. 15-9). Saint Peter (holding his attribute, the key to the gates of heaven) is carved in high relief on the left jamb, the Old Testament prophet Isaiah on the right jamb. Saint Paul is carved on the left side of the trumeau. and another Old Testament prophet, usually identified as Jeremiah, is on the right. On the front face of the trumeau are pairs of lions crossing each other in X patterns. The tall, thin prophet in figure 15-11 twists toward the viewer with his legs crossed. The sculptors placed him skillfully within the constraints of the scalloped trumeau, his head, pelvis, knees and feet falling on the pointed cusps of the curved forms. On the front of the trumeau the lions' bodies also fit the cusps of the scalloped frame. Between each pair of lions are more rosettes. Such decorative scalloping was borrowed from Islamic art, and heraldic beasts and rosettes appeared on Byzantine and Islamic textiles. The sculpture at Moissac was done shortly after the First Crusade and Europe's resulting encounter with the Islamic art and architecture of the Holy Land. The lord of the Moissac region was a leader of the Crusade, and his followers presumably brought Eastern art objects and ideas home with them.

A very different pictorial style is seen in Burgundy. On

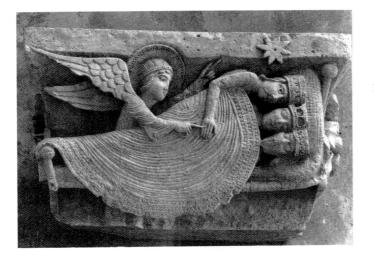

15-14. The Magi Asleep, capital from the nave, Cathedral of Saint-Lazare. c. 1120–32. Musée Lapidaire, Autun

the west portal of the Cathedral of Saint-Lazare at Autun (fig. 15-12), Christ has returned to judge the cowering, naked human souls at his feet. The Damned writhe in torment at his right, while the saved enjoy serene bliss at the left (the right hand of Christ). Christ dominates the composition as he did at Moissac. The surrounding figures are livelier than those at Moissac and are arranged in compartmentalized tiers. The overall effect is less consciously balanced than the pattern-filled composition at Moissac. The stylized figures, stretched out and bent at sharp angles, are powerfully expressive, successfully conveying the terrifying urgency of the moment as they swarm around the magisterially detached Christ figure. Delicate weblike engraving on the robes may have derived from metalwork or manuscript illumination.

Angels trumpet the call to the Day of Judgment at the far left of the middle register. Angels also help the departed souls to rise from their tombs and line up to await judgment. In the bottom register two men at the left carry walking staffs and satchels bearing the cross and a scallop-shell badge, attributes identifying them as pilgrims to Jerusalem and Santiago de Compostela. A pair of giant, pincerlike hands descends at the far right to scoop up a soul (fig. 15-13). Above and to the left of these hands, in a scene reminiscent of Egyptian Books of the Dead (see fig. 3-44), the archangel Michael oversees the weighing of souls on the scale of good and evil. In the early decades of the twelfth century, Church doctrine came increasingly to stress the role of the Virgin Mary and the saints as intercessors who could plead for mercy on behalf of repentant sinners. The tympanum at Autun shows angels also acting as intercessors. The archangel Michael shelters some souls in the folds of his robe and may be jiggling the scales a bit. Another angel boosts a saved soul into heaven, bypassing the gate at the top left. By far the most riveting players in the drama are the grotesquely decomposed, screaming demons grabbing at terrified souls and trying to tip the scales in the opposite direction.

A lengthy inscription in the band beneath Christ's feet identifies the Autun tympanum as the work of Gislebertus. This same sculptor may also have been responsi-

ble for a charming representation of the Magi asleep (fig. 15-14), one of the many capitals that illustrate stories in the nave arcade at Autun. The ingenious compression of instructive narrative scenes into the geometric confines of column capitals was an important Romanesque contribution to architectural decoration. The underlying form was usually that of the flaring **Corinthian** capital. Sculptors used **undercutting**, a technique known since ancient times, to sharpen contours and convey depth.

The Magi Asleep is one of a series of capitals depicting events surrounding the birth of Jesus. Medieval tradition identified the three Magi, or wise men-whom the Gospels say brought gold, frankincense, and myrrh to the newborn Jesus-as the kings Caspar, Melchior, and Balthasar. Caspar, the oldest, is shown bearded here; Melchior has a moustache; and Balthasar, the youngest, is clean shaven. He is often shown as a black African. The Magi, following heavenly signs, traveled from afar to acknowledge Jesus as King of the Jews. The position of the capital in the nave of the church suggests that it was meant to remind worshipers that they were embarking on a metaphorically parallel journey to find Christ. The slumbering Magi, wearing their identifying crowns, share a bed and blanket. An angel has arrived to hurry them on their way, awakening Balthasar and pointing to the Star of Bethlehem that will guide them. The sculptor's use of two vantage points simultaneously—the Magi and the head of their bed viewed from above, the angel and the foot of the bed seen from the side—communicates the key elements of the story with wonderful economy and clarity.

Independent Sculpture

Reliquaries, altar frontals, crucifixes, devotional images, and other sculpture once filled medieval churches. One form of devotional image that became increasingly popular during the later Romanesque period was that of the Virgin Mary holding the Christ Child on her lap, a type known as the Throne of Wisdom. This theme was used earlier by Byzantine and Ottonian artists (see fig. 7-40). A well-preserved example in painted wood dates from

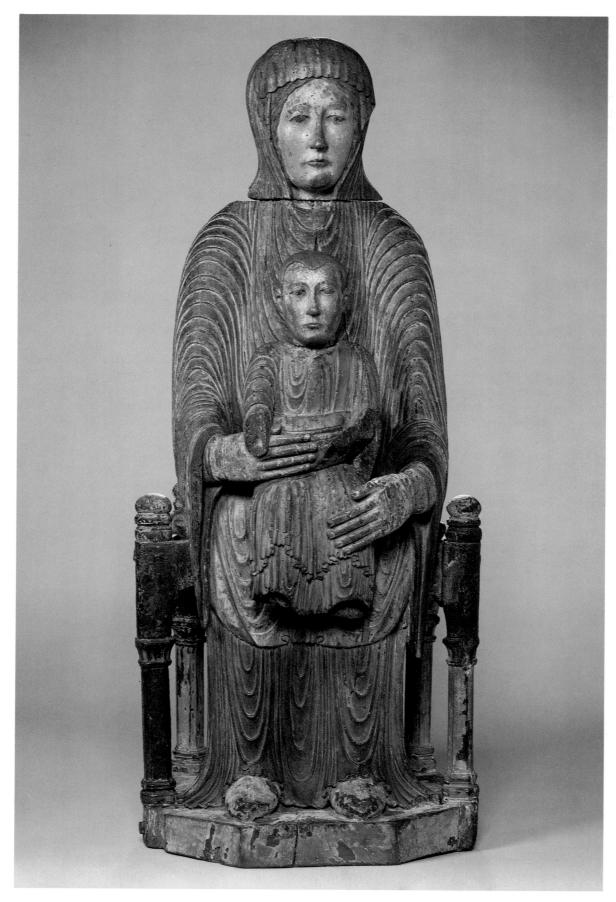

15-15. *Virgin and Child*, from the Auvergne region, France. c. 1150–1200. Oak with polychromy, height 31" (78.7 cm). The Metropolitan Museum of Art, New York Gift of J. Pierpont Morgan, 1916 (16.32.194)

the second half of the twelfth century (fig. 15-15). It was made in the Auvergne region of France, where such images were a local specialty. Mother and Child sit erect in a frontal pose, as rigid as they are regal, but appearing less remote than in earlier representations. Mary sits on a thronelike bench, protectively supporting the Christ Child. He holds a book in his left hand and raises his (now missing) right hand in a blessing. Traces of paint indicate that the figures' garments were painted dark blue and red, and their skin was a pale color. The sweet, slightly pouting expressions and softly modeled faces are typical of Auvergne figures.

Complex references to Church doctrine underlie the imagery of the Throne of Wisdom. The Christ Child is God incarnate (made flesh), from King David and King Solomon, renowned for their wisdom and justice. Mary becomes the throne; Jesus is enthroned on his mother's lap. The book he holds represents the Logos (Greek for "word"), that is, the Bible, the divine wisdom that he himself embodies. Mary is the Theotokos, bearer of God, who was revered increasingly from the twelfth century on as the nurturing, ever-merciful intercessor, second in heavenly power only to the Trinity.

Earlier in the Middle Ages, small, individual works of art were generally made of costly materials for royal or aristocratic patrons. In the twelfth century, however, when abbeys and local parish churches of more limited means began commissioning hundreds of statues, painted wood became an increasingly common medium. These lightweight devotional images were frequently carried in processions from place to place both inside and outside the churches. A statue of the Virgin and Child, like the one shown here, could also have played an important role in the liturgical drama performed at the Feast of the Epiphany, which in the Western Church celebrates the arrival of the Magi to pay homage to the baby Jesus. Participants representing the Magi would act out their journey by searching through the church until they came to the statue. (Some scholars see this as perhaps the earliest western European drama.)

The Crucifixion continued to be a primary devotional theme in the Romanesque period. The image of Jesus in the mid-twelfth-century Batlló Crucifix from Catalonia (fig. 15-16) derives from Byzantine sources and is quite different from the nearly nude, tortured Jesus of the Ottonianperiod Gero Crucifix (see fig. 14-30). Jesus' bowed head, downturned mouth, and heavy-lidded eyes convey a sense of deep sadness or contemplation; however, he still wears royal robes that emphasize his kingship (see Rabbula Gospels, pages 320, 321). He wears a long, medallion-patterned tunic with pseudo-kufic inscriptionsdesigns meant to resemble Arabic script—on the hem. The garment reflects how valuable silk brocades from Islamic Spain were in Europe at this time. They were widely used as cloths of honor to designate royal and sacred places, appearing, for example, behind rulers' thrones, or as altar coverings and backdrops. Many wooden crucifixes have survived from the Romanesque period. They were displayed over church altars and, like other devotional statues, were carried in processions

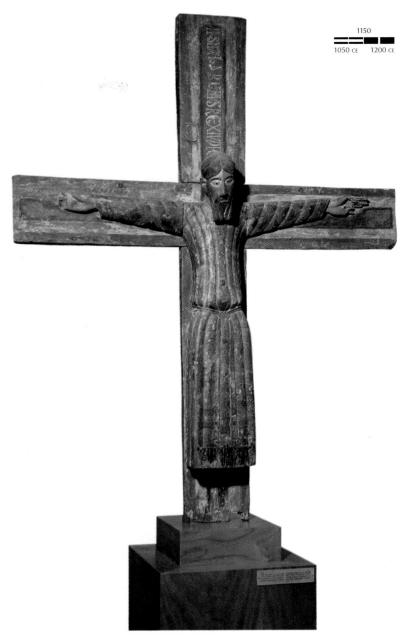

STANDARDE AND

15-16. *Batlló Crucifix*, from the Olot region, Catalonia, Spain. Mid-12th century. Wood with polychromy, height approx. 36" (91 cm). Museu Nacional d'Art de Catalunya, Barcelona

This crucifix was modeled on a famous medieval sculpture called the *Volto Santo* (Holy Face) that had supposedly been brought from Palestine to Italy in the eighth century. Legend had it that this image had been made by Nicodemus, a disciple of Jesus who is often portrayed as a witness to the Crucifixion. Many replicas of the *Volto Santo* still exist.

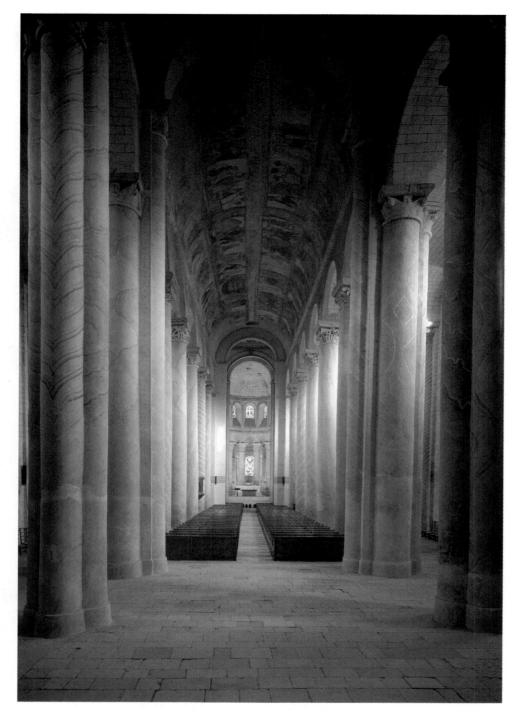

15-17. Nave, Abbey Church of Saint-Savin-sur-Gartempe, Poitou, France. c. 1100

The columns of Saint-Savin, painted to resemble veined marble, support an arcade and barrel vault without intermediate galleries or clerestory windows.

Wall Painting

Throughout Europe paintings on church walls glowed in flickering candlelight amid clouds of incense. During the Romanesque period, painted decoration largely replaced mosaics on the walls of churches. This change occurred at least partly for the same reason that wooden devotional sculpture came to predominate over that made of finer materials: growing demand, due to more churches, led to the use of less expensive materials and techniques.

Interestingly, however, wall painting did not experience the same innovation in imagery that sculptural decoration did. In some places it remained constrained by the conservative influences of Byzantine and Italo-Byzantine models. Wall painting is also less durable than architecture and sculpture and has not survived in the same abundance.

One of the most extensive programs of Romanesque wall painting is at the Benedictine Abbey Church of Saint-Savin-sur-Gartempe in the Poitou region of west-

15-18. Tower of Babel, painted detail of nave vaulting, Abbey Church of Saint-Savin-sur-Gartempe

ern France. The tunnel-like barrel vault running the length of the nave and choir provides a surface ideally suited to painted decoration (fig. 15-17). The narthex, crypt, and chapels were also painted. Old Testament scenes can be seen in the nave; New Testament scenes and scenes from the lives of two local saints, Savin and Cyprian, appear in the transept, ambulatory, and chapels. Although the paintings were all done about 1100, they show evidence of four distinct styles distributed in different parts of the church. The painters may have used manuscripts as their primary inspiration. They did not use the wet-plaster fresco technique favored in Italy for its long-lasting colors, but they did moisten the walls before painting, which allowed some absorption of pigments into the plaster, making them more permanent than paint applied to a dry surface.

The painters of the nave vault seem to have immediately followed the masons and used the same scaffolding. Perhaps this intimate involvement with the building process accounts for the vividness with which they portrayed the biblical story of the Tower of Babel (fig. 15-18). According to the account in Genesis (11:1-9), God punished the prideful people who tried to build a tower to heaven by scattering them and making their languages mutually unintelligible. The tower in the painting is a medieval-looking structure, reflecting the practice of depicting legendary events in contemporary settings. Workers haul heavy stone blocks to the tower, lifting them to masons on the top with a hoist. The giant Nimrod, on the far right, simply hands the blocks up. God confronts the people on the far left. He is shown in a twisting pose like that of the prophet on the trumeau at Moissac (see fig. 15-11). (There is some irony in the selection of this theme, given the considerable height of the Saint-Savin nave vaults. Perhaps it was intended as a kind of insurance, an affirmation that the builders of this heaven-climbing building did acknowledge their subordination to God and should not be punished.) The

scene's dramatic action, large figures, strong outlines, broad areas of color, and simplified modeling all help make it intelligible to a viewer looking up at it in dim light from far below.

Many Romanesque wall paintings survived in churches in the isolated mountain valleys of the Catalonian Pyrenees in northern Spain. The paintings have been detached from the walls and placed in museums for security. Among these are the paintings from the Church of San Clemente in Tahull. A magnificently expressive Christ in Majesty fills the curve of the apse and semidome (fig. 15-19). Its powerful presence recalls the tympanum sculpture at Moissac and Autun, which were made at about the same time (see figs. 15-10, 15-12), and indeed the tympanum sculptors may have been inspired by apse paintings. The San Clemente Christ reflects the Romanesque transformation of the Byzantine depiction of Christ Pantokrator, ruler and judge of the world. The strict frontal pose, the use of the symbols alpha and omega on each side of the head, and the open gospel, inscribed "ego sum lux mundi" ("I am the light of the world"; John 8:12), are all Byzantine features. But at Tahull the almost playful stylization of Christ's hair and beard, the rosy patches on his cheeks and forehead, and his broad midsection work to humanize the fearsome Pantokrator. Christ sits on a rainbow and is surrounded by a mandorla. Four gesturing angels, each paired with a symbol of one of the evangelists, float at his sides. At Christ's feet are the Virgin Mary (holding the Holy Grail) and six apostles, of whom Saints Bartholomew and John are visible here. Flanking them are columns painted with wavy lines that resemble those at Saint-Savin. The mosaiclike intensity of the colors was created by building up many thin coats of paint, a technique called glazing.

The San Clemente Master, as the otherwise anonymous Tahull painter is known, is considered to have been the finest Spanish painter of the Romanesque period. The work reflects the influence of a remarkable

1050 CE 1200 CE

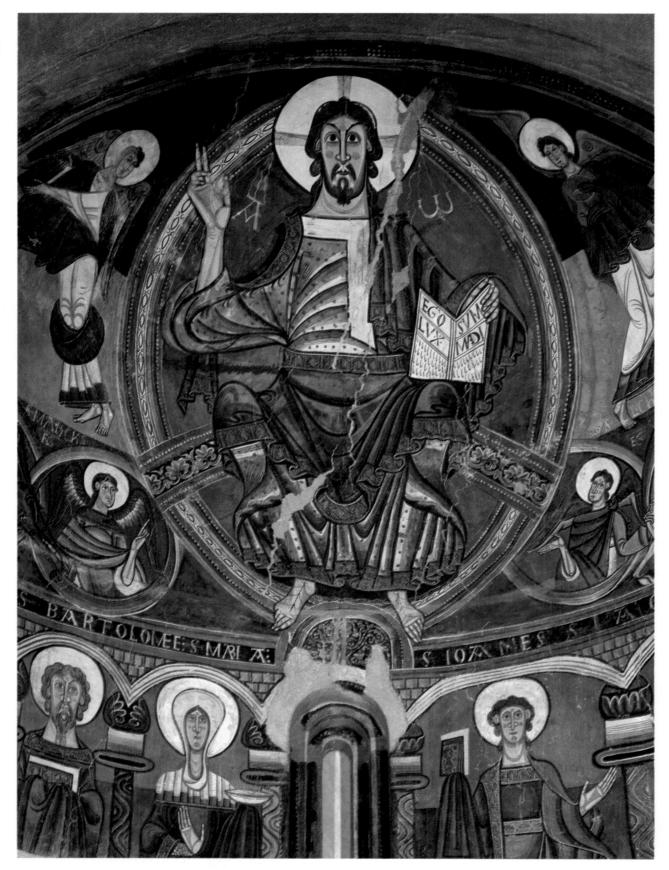

15-19. *Christ in Majesty*, detail of apse painting from the Church of San Clemente, Tahull, Lérida, Spain. c. 1123. Museu Nacional d'Art de Catalunya, Barcelona

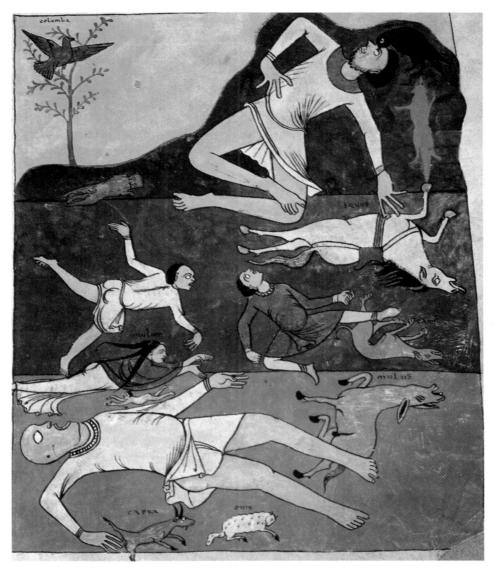

15-20. Stephanus Garsia. Page with *Flood, Commentary on the Apocalypse*, by Beatus of Liébana, made for the Abbey of Saint-Sever, Gascony, France. 1028–72. Ink and tempera on vellum, 14¹/₂ x 11" (36.5 x 28 cm). Bibliothèque Nationale, Paris

variety of artistic traditions, including Roman, Carolingian, Visigothic, Islamic, northern Italian (Lombardic), southern Italian (Italo-Byzantine), and southern French. The modeling and the treatment of faces and draperies follow Byzantine conventions. The refreshingly decorative feeling, however, comes from a southern French style that had been transmitted to the region over pilgrimage routes. The elongated oval faces, large staring eyes, and long noses, as well as the placement of figures against flat colored bands and the use of heavy outlining, reflect Mozarabic influence (Chapter 14).

Books

As today, illustrated books as portable art played a key role in the transmission of artistic styles and other cultural information from one region to another. Like other arts, the output of books increased dramatically in the eleventh and twelfth centuries, despite the labor and materials

required to make them. Monastic **scriptoria** continued to be the centers of production, copying originals in monastic libraries (see "The Medieval Scriptorium," page 486). These monastic scriptoria, however, were now also employing an increasing number of lay artisans. Some were itinerant, moving from place to place, and they worked in other mediums besides books. The largest producer of books, the Church, was also the largest consumer of books. Liturgical works were often large and lavish; other works were more modest, their embellishment confined to the initial letter of each section of text.

During the Romanesque period, scriptoria in northern Spain and France continued to copy and illustrate the *Commentary on the Apocalypse* written by Beatus of Liébana in the eighth century. These works evoke the dramatic terror of the Apocalypse in a stark, two-dimensional, intensely colored, and emotional style that was introduced by Mozarabic monks in the tenth century (see fig. 14-13). The page shown here (fig. 15-20) is from a

1050 CE 1200 C

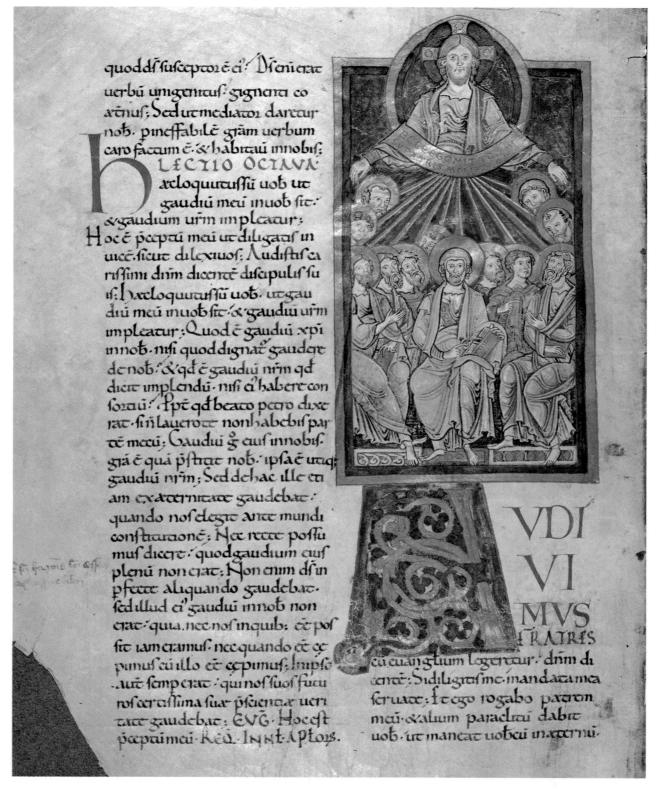

15-21. Page with *Pentecost, Cluny Lectionary*. Early 12th century. Ink and tempera on vellum, 9 x 5" (23 x 12.5 cm). Bibliothèque Nationale, Paris

copy of the *Commentary* illuminated by a monk named Stephanus Garsia in the middle of the eleventh century for the Abbey of Saint-Sever in Gascony (southern France). It illustrates the ravages of the final flood. Corpses are scattered helter-skelter, broken and awry. A black bird pecks at an eyeball of the man lying on the upper right, compounding the horror. Intense colors—

yellow, purple, red, and green—resonate with anguished force across the boldly banded field. The preoccupation with the Apocalypse may reflect the ongoing struggle between Christians and Muslims for control of Spain. In any case, Beatus manuscripts remained a regional phenomenon, although they were influential far beyond the Pyrenees.

1100 1050 CE 1200 C

An illuminated lectionary (fig. 15-21) made for the wealthy monastery of Cluny in the early 1100s seems calm and dignified compared to the Saint-Sever Apocalypse. Lectionaries contained biblical excerpts arranged according to the Church calendar for reading during Mass. This page contains the beginning of the eighth reading (lectio octava). The framed scene illustrates the beginning of the second chapter of the Acts of the Apostles, which recounts how "tongues as of fire" from the Holy Spirit descended on each of the apostles while they were assembled for Pentecost, and they began to speak "in tongues." Christ appears at the top of the picture, and glowing red rays—tongues of fire—stream from the gold banner draped over him to the heads of the Twelve Apostles below. Just under the picture is a beautifully interlaced A, the first letter of the word audivimus ("we have been hearing"). The subject—an unusual one for medieval art-may have been chosen as a symbolic reminder of Cluny's direct tie to the papacy. The picture may suggest that just as the apostles received miraculous powers from Christ, so Cluny derived its power directly from the pope, the heir to the apostle Peter. The image of Christ, like the Tahull Christ in Majesty (see fig. 15-19), is a reinterpretation of the Byzantine Pantokrator type. The faces of the figures have been delicately rendered with green and red highlighting. The drapery seems to fall over fleshy limbs. The illuminator deliberately de-emphasized the violence of the supernatural event described in the text, conveying instead the psychological bond between the figures.

Despite their ascetic teachings and austere architecture, the Cistercians produced many richly decorated books. A symbolic image known as the Tree of Jesse appears on a page from a copy of Saint Jerome's Commentary on Isaiah made in the scriptorium of the Cistercian mother house at Cîteaux about 1125 (fig. 15-22). Jesse was the father of King David, who according to the Gospels was an ancestor of Mary and, through her, of Jesus. The Cistercians were particularly devoted to the Virgin and are credited with popularizing the Tree of Jesse as a device for showing her position as the last link in the genealogy connecting Jesus Christ to the house of David. In the manuscript illustration, The Tree of Jesse depicts Jesse asleep, a small tree trunk growing from his body. A monumental Mary, standing on the forking branches of the tree, dwarfs the sleeping patriarch. The Christ Child sits on her right arm, which is swathed in her veil. Following late Byzantine and Romanesque convention, he is portrayed as a miniature adult with his right hand raised in blessing. His cheek presses against Mary's, a display of affection similar to that shown in Byzantine icons like the Virgin of Vladimir (see fig. 7-60). Mary holds a flowering sprig from the tree, a symbol for Christ, in her left hand. The church held by the angel on the left refers to Mary as the Christian Church, and the crown held by the angel on the right refers to her as Queen of Heaven. The dove perching on her halo represents the Holy Spirit. The treatment of drapery and the jeweled hems of Mary's robes reflect Byzantine influence and her elevated status. The subdued colors are in keeping with Cistercian restraint.

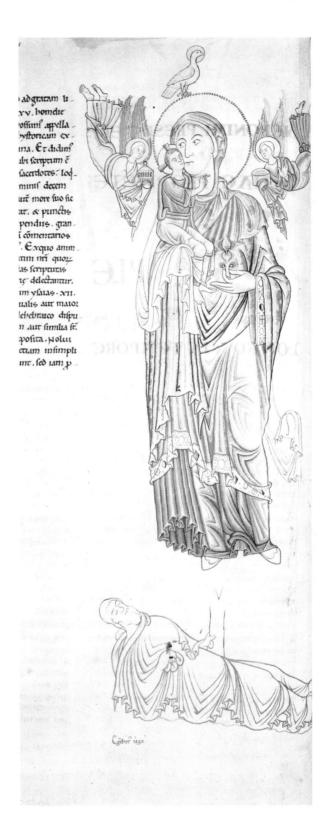

15-22. Page with The Tree of Jesse, Explanatio in Isaiam (Saint Jerome's Commentary on Isaiah), from the Abbey, Cîteaux, Burgundy, France. c. 1125. Ink and tempera on vellum, 15 x 43/4" (38 x 12 cm). Bibliothèque Municipale, Dijon, France

The Tree of Jesse, a pictorial representation of the genealogy of Jesus, was used to illustrate the Church's doctrine that Christ was both human and divine. The growing stress on devotion to Mary as the mother of God led to an emphasis on her place in this illustrious royal line.

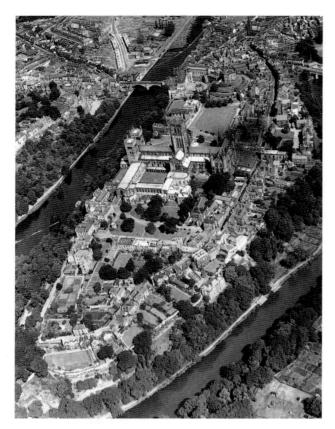

15-23. Castle-monastery-cathedral complex, Durham, Northumberland, England. c. 1075-1100s, plus later alterations and additions

Since 1837, the castle has housed the University of Durham (now joined with the University of Newcastle). The castle was added to and rebuilt over the centuries. The Norman portion extends to the left of the keep. Today the castle and cathedral share a park like green. South of the cathedral (lower in the photograph), the cloister with chapterhouse, dormitory (now a library), and kitchens are clearly visible. Houses of the old city cluster around the buildings as they would have in earlier days. Trees, however, would not have been allowed to grow near the approaches to this fortified outpost against the Scots.

AND NORMANDY

BRITAIN In the early tenth century a band of Norse raiders seized a peninsula in northwest France that came to be known as Normandy. In 911 their leader.

Rollo, gained recognition as duke of the region from the weak Carolingian king. Within little more than a century, Rollo's successors had transformed Normandy into one of Europe's most powerful feudal domains. The Norman dukes were astute and skillful administrators. They formed a close alliance with the Church, supporting it with grants of land and gaining in return the allegiance of abbots and bishops, many of whom also served as vassals of the duke. In 1066 Duke William II of Normandy (1035-1087) invaded England and, as William I ("the Conqueror"), became that country's new king. Norman nobles replaced the Anglo-Saxons' nobility, and England became politically and culturally allied to northern France.

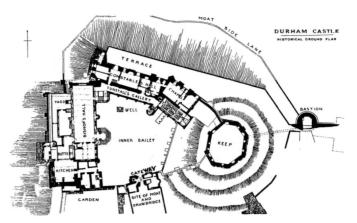

15-24. Plan of Durham Castle

In Norman times, the bishops of Durham lived in a three-story residence. An exterior staircase led from the courtyard (inner bailey) to a single undivided, multipurpose room on the middle floor occupied by the bishop and his principal servants (Constable's Hall and the Tunstall's Gallery in the plan). Other people occupied humbler wood structures within the castle complex or outside its walls in the village that served it. The structures at the left date from Gothic times.

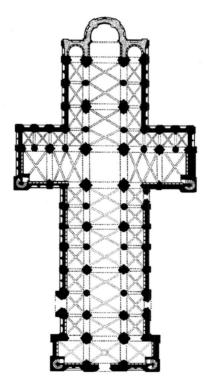

15-25. Plan of Durham Cathedral. 1093-1133

Architecture

Strategically located on England's northern frontier with Scotland, Durham grew after the Norman Conquest into a great fortified complex with a castle, a monastery, and a cathedral (fig. 15-23). (Durham's fame came from its having the relics of Saint Cuthbert, the revered seventhcentury bishop of Lindisfarne.) The Norman bishops of Durham also held secular titles, powers, and responsi-

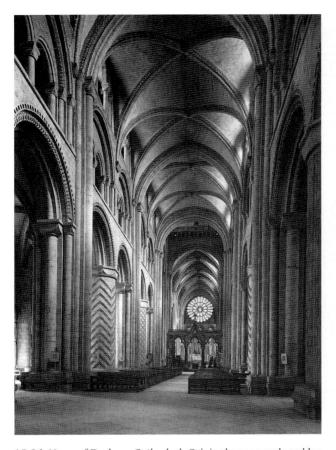

15-26. Nave of Durham Cathedral. Original apses replaced by a Gothic choir, 1242–c. 1280. View from the west

bilities. Within their domain they were functionally independent of the king.

Durham Castle is an excellent example of a Norman fortress (fig. 15-24). The only way in and out was over a drawbridge, which was controlled from a gatehouse. Beyond the gatehouse was the bailey, or courtyard. In times of danger, the castle's defenders took refuge in the keep (donjon in French), the massive tower to the east of the bailey. The keep stood atop a steep mound. Other buildings, including the great hall in which the bishops conducted their business, extended along the western rampart overlooking a sheer cliff. The Norman chapel, located between the great hall and the keep, was built about 1075 and may have been the first stone structure in the compound. Medieval fortresses were often surrounded by a defensive water-filled ditch known as a moat. At Durham, the Wear River acted as a natural moat, looping around the high, rocky outcrop on which the complex was built.

Durham Cathedral (figs. 15-23 and 15-25) and its adjoining monastery were built to the south of the castle. The cathedral, begun in 1093, is one of the most impressive of all medieval churches. Like most buildings that have been in continuous use, it has been altered several times. The visible parts of the towers, for example, are Gothic with eighteenth-century modifications. The cathedral's decor is as ambitious as its scale (fig. 15-26). Enormous compound piers alternating with robust columns support the nave arcade. The columns are carved with

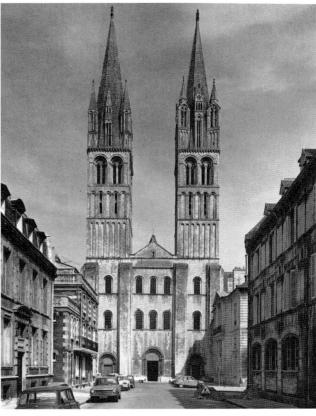

15-27. Church of Saint-Étienne, Caen, Normandy, France. Begun 1064; facade late 11th century; spires 13th century

chevrons, spiral fluting, and diamond patterns, and some have scalloped, cushion-shaped capitals. The arcades have round moldings and chevron ornaments. All this ornamentation was originally painted.

Above the cathedral's vigorous walls rise ribbed vaults. While most builders were still using timber roofs, the masons at Durham developed a new system of vaulting. The typical Romanesque ribbed groin vault (best seen in Milan, fig. 15-42) used round arches that produced separate domed-up spatial units. To create a more unified interior space, the Durham builders divided each bay with two pairs of crisscrossing ribs and so kept the crown of the vault at almost the same height as the keystone of the transverse arches. In the transept they also experimented with rectangular rather than square bays. Between 1093 and 1133, when the project was essentially complete, they developed a system of vaulting that was carried to the Norman homeland in France, was perfected in churches such as Saint-Étienne at Caen, then was adopted by French masons in the Gothic period (see "Elements of Architecture," page 552).

Saint-Étienne at Caen (fig. 15-27) was begun nearly a generation before Durham Cathedral, but work continued there through the century (the timber roof was not replaced by a stone vault until 1120). William the Conqueror had founded the monastery and had begun construction of its church by the time of his conquest of England. William's queen, Matilda, had already established an abbey for women in Caen. In spite of the

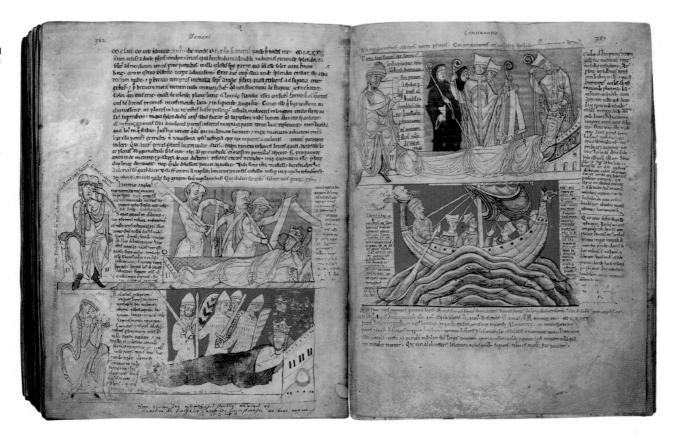

15-28. John of Worcester. Page with *Dream of Henry I, Worcester Chronicle*, Worcester, England, c.1140. Ink and tempera on vellum, each page $12^{3/4}$ x $9^{3/8}$ " (32.5 x 23.7 cm). Corpus Christi College, Oxford

One of the most significant achievements of Henry's father, William the Conqueror, was a comprehensive census of English property owners, the *Domesday Book*. Compiled into two huge volumes, this document was used to assess taxes and settle property disputes. After Henry, too, increased taxes and encountered protests, a series of visions and a life-threatening storm at sea made him promise a seven-year delay in implementing higher taxes.

devastation of Normandy in World War II, the two churches survived, their western towers still dominating the skyline. Soaring height seems to have been a Norman architectural goal, continuing the tradition of towers and verticality begun by Carolingian builders (see fig. 14-24). The west facade of Saint-Étienne was constructed at the end of the eleventh century, probably about 1096-1100. Wall buttresses divide the facade into three vertical sections, and small stringcourses, unbroken cornicelike moldings, at each window level suggest the three stories of the building's interior. Consequently, the design of the facade reflects the plan and elevation of the church itself, an idea that would be adopted by Gothic builders. Norman builders, with their brilliant technical innovations and sophisticated designs, in fact prepared the way for the architectural feats seen in Gothic cathedrals of the twelfth and thirteenth centuries.

Books

The great Anglo-Saxon tradition of book illumination, which declined for a time in the wake of the Norman Conquest, revived after about 1130. The *Worcester Chronicle* is the earliest known illustrated English history. This record of contemporary events by a monk named John was an

addition to a work called *The Chronicle of England*, written by Florence, another monk. The pages shown here concern King Henry I (ruled 1100–1135), the second of William the Conqueror's sons to sit on the English throne (fig. 15-28). The text relates a series of dreams the king had on consecutive nights in 1130 in which his subjects demanded tax relief. The illustrations depict the dreams with energetic directness. On the first night, angry farmers confront the sleeping king; on the second, armed knights; and on the third, monks, abbots, and bishops. In the fourth illustration, the king is in a storm at sea and saves himself by promising God to lower taxes for a period of seven years. The *Worcester Chronicle* assured its readers that this story came from a reliable source, the royal physician Grimbald, who appears in the margins next to most scenes.

More characteristic of Romanesque illumination are illustrated psalters. The so-called *Hellmouth* page from a psalter written in Latin and Norman French is one of the masterpieces of English Romanesque art (fig. 15-29). The psalter was produced at a renowned Anglo-Saxon monastic scriptorium in Winchester. The vigorous narrative style for which the scriptorium was famous had its roots in the style of the ninth-century workshop at Reims that produced the *Utrecht Psalter* (see fig. 14-22). The page depicts the gaping jaws of hell, a traditional Anglo-Saxon

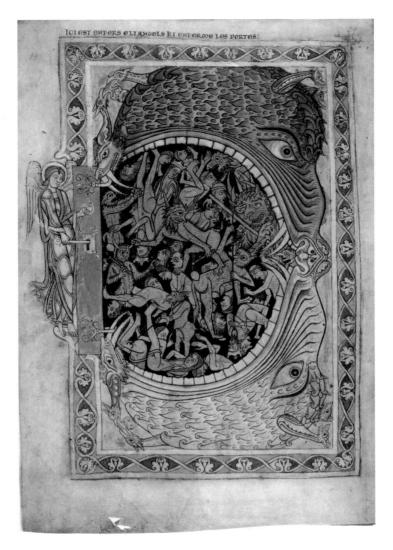

15-29. Page with *Hellmouth, Winchester Psalter*, Winchester, England. c. 1150. Ink and tempera on vellum, 12³/₄ x 9¹/₈" (32.5 x 23 cm). By permission of The British Library, London

There are fascinating parallels between Hellmouth images and the liturgical dramas—known in England as mystery plays—that were performed throughout Europe from the tenth through the sixteenth century. Depictions of the Hellmouth in Romanesque English art were based on the large and expensive stage props used for the hell scenes in mystery plays. Carpenters made the infernal beast's head out of wood, papier-mâché, fabric, and glitter and placed it over a trapdoor on stage. The wide jaws of the most ambitious Hellmouths, operated by winches and cables, opened and closed on the actors. Smoke, flames, foul smells, and loud noises came from within, to the delight of the audience. Hell scenes, with their often scatological humor, were by far the most popular parts of the plays. Performances are still given today.

subject, one that inspired poetry and drama as well as the vivid descriptions of the terrors and torments of hell with which the clergy enlivened their sermons.

The inscription at the top of the page reads: "Here is hell and the angels who are locking the doors." The ornamental frame that fills the page represents the door to hell. An angel on the left turns the key to the door in the keyhole of the big red doorplate. The frenzy of the Last Judgment, as depicted on the tympanum at Autun (see

fig. 15-12), has subsided. Inside the door the last of the damned are crammed into the mouth of hell, the wide-open jaw of a grotesque double-headed monster. Sharp-beaked birds and fire-breathing dragons sprout from the monster's mane. Hairy, horned demons torment the lost souls, who tumble around in a dark void. Among them are kings and queens with golden crowns and monks with shaved heads, a daring reminder to the clergy of the vulnerability of their own souls.

The Bayeux Tapestry

The best-known work of Norman art is undoubtedly the Bayeux Tapestry (fig. 15-30). This narrative wall hanging, 230 feet long and 20 inches high, documents events surrounding the Norman Conquest of England in 1066. Despite its name, the work is embroidery, not tapestry. It was embroidered in eight colors of wool on eight lengths of undyed linen that were then stitched together (see "Embroidery Techniques," below). It was made for William the Conqueror's half brother Odo, who was bishop of Bayeux in Normandy and earl of Kent in southern England. Odo commissioned it for his Bayeux Cathedral. and it may have been completed in 1077, in time for the cathedral's consecration. According to an inventory

The embroiderers of the Bayeux Tapestry prob-

ably followed drawings provided by a Norman,

perhaps even an eyewitness to some of the

events. The style of the embroidery, however, is Anglo-

Saxon, and the embroiderers were most likely women.

They worked in tightly twisted wool, dyed in eight colors

with dyes made from plants and minerals. Only two

stitches were used. The quick, overlapping, linear stem

made in 1476, it was "hung round the nave of the church on the Feast of relics" (Rud, page 9). Scholars disagree as to where it was made. Some argue for the famous embroidery workshops of Canterbury, in Kent, and others for Bayeux itself. A Norman probably directed the telling of the story and either an illuminator from a scriptorium or a specialist from an embroidery workshop provided drawings. Recent research suggests that the embroiderers were women.

The Bayeux Tapestry is a major political document, celebrating William's victory, validating his claim to the English throne, and promoting Odo's interests as a powerful leader himself. Today it is also a treasury of information about Norman and Anglo-Saxon society and technology, with depictions of everything from farming

TECHNIQUE

TECHNIQUES

EMBROIDERY consuming laid-and-couched work used to form blocks of color required three steps. The embroiderer first "laid" a series of long, parallel

covering stitches, anchored them with a second layer of regularly spaced crosswise stitches, and finally tacked everything down with tiny "couching" stitches. Some of the tapestry's laid-and-couched work was done in contrasting colors for particular effects. Skin and other lighttoned areas were represented by the bare linen ground.

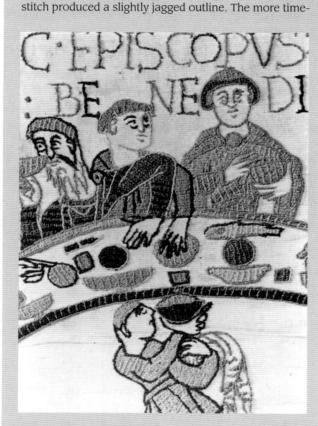

Laid-and-couched work and stem-stitch techniques are clearly visible in this detail of figure 15-30. Stem stitching outlines all the solid areas, is used to draw the facial features, and forms the letters of the inscription.

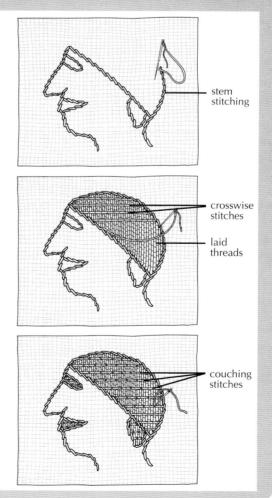

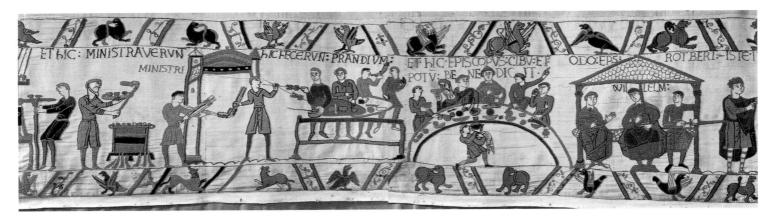

15-30. Bishop Odo Blessing the Feast, section 47-48 of the Bayeux Tapestry, Norman-Anglo-Saxon embroidery from Canterbury, Kent, England, or Bayeux, Normandy, France. c. 1066-82. Linen with wool, height 20" (50.8 cm). Centre Guillaume le Conquérant, Bayeux, France

The top and bottom registers of the Bayeux Tapestry contain a variety of subjects separated by diagonal bars. These include heraldic beasts, stylized plants, and figures spilling over from the action in the central register, as well as a knight killing a tethered bear, a pair of naked lovers, and a farmer plowing. Such peripheral imagery was an English specialty throughout the Middle Ages. The sheer number of images in the Bayeux Tapestry is staggering: there are some 50 surviving scenes containing 623 human figures, 202 horses, 55 dogs, 505 other creatures, 37 buildings, 41 ships and boats, 49 trees, and nearly 2,000 inch-high letters.

implements to table manners to warfare. The Bayeux Tapestry shows broadly gesturing actors on a narrow stage with the clarity and directness of English manuscript illustration. It is laid out in three registers. In the middle register, the central narrative, explained by Latin inscriptions, unfolds in a continuous scroll from left to right. Secondary subjects and decorative motifs adorn the top and bottom registers.

The section illustrated here shows Odo and William, on the eve of battle, feasting. Attendants provide roasted birds on skewers, placing them on a makeshift table of the knights' shields laid over trestles. The diners, summoned by the blowing of a horn, gather at a curved table laden with food and drink. Bishop Odo—seated at the center, head and shoulders above William to his right—blesses the meal while others eat. The kneeling servant in the middle proffers a basin and towel so that the diners may wash their hands. The man on Odo's left points impatiently to the next event, a council of war between William (now the central and tallest figure), Odo, and a third man labeled "Rotbert," probably Robert of Mortain, another of William's half brothers. These men held power after the conquest.

AND

 $\boldsymbol{GERMANY}$ In the early eleventh century a new dynasty, the Salians, replaced the Ottonians on the throne of the THE MEUSE Holy Roman Empire. The third VALLEY Salian emperor, Henry IV (ruled 1056-1106), became embroiled in

the dramatic conflict with the papacy known as the Investiture Controversy. This dispute involved the right of lay rulers to "invest" high-ranking clergy with the symbols of their spiritual offices. In 1075 Pope Gregory VII (papacy, 1073–1085) declared that only the pope and his bishops could appoint bishops, abbots, and other important clergy. The clergy now depended on the pope, not the emperor. Many German nobles sided with the pope; some nobles, with the emperor. The conflict unleashed by the Investiture Controversy divided Germany into many small competing states. The efforts of Holy Roman emperors of the late twelfth and early thirteenth centuries to reimpose imperial authority failed, and Germany remained divided until the late nineteenth century.

Religious and political problems sapped energy and wasted financial resources. Nevertheless, building and the other arts continued. Carolingian and Ottonian cultural traditions persisted in the German lands during the eleventh and twelfth centuries. Ties with the northern Italian region of Lombardy also remained strong and provided another source of artistic influence.

Architecture

The imperial cathedral at Speyer in the Rhine region of southwest Germany was a colossal structure that rivaled Cluny in size and magnificence. The Romanesque cathedral building was constructed on the foundations of an Ottonian imperial church between 1082 and 1106, during the reign of Henry IV. The emperor was fresh from recent successes against the papacy and a German rival, King Rudolf of Swabia, and the monumental rebuilding project was a testament to his power.

A seventeenth-century drawing shows the Romanesque cathedral, which more-recent construction has 1050 CE 1200 CE

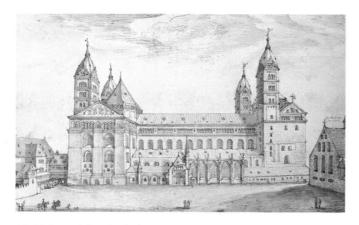

Imperial cathedral (Speyer II), Speyer, Germany.
 1030–early 1100s. Ink drawing by Wenzel Hollar,
 c. 1620. Graphische Sammlung Albertina, Vienna

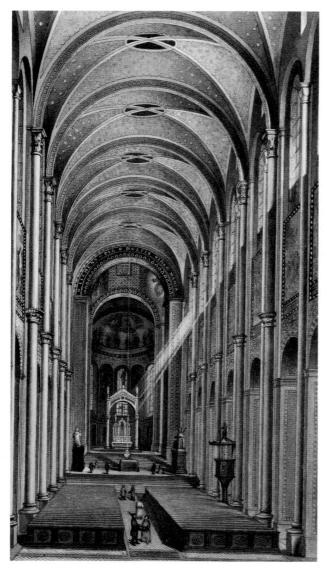

15-32. Nave, Speyer Cathedral. 1082–1100s; 19th-century alterations. Colored engraving by Carl Mayer, after a painting by J. M. Bayrer, 1855

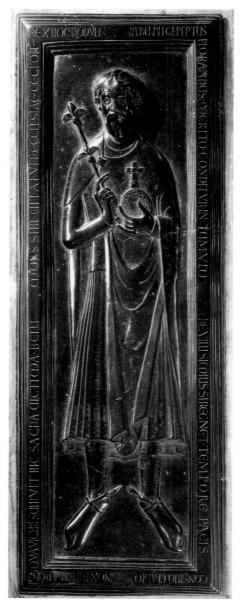

15-33. Tomb cover with effigy of Rudolf of Swabia; from Saxony, Germany. After 1080. Bronze with niello, approx. $6'5^1/2"$ x $2'2^1/2"$ (1.97 x .68 m). Cathedral, Merseburg, Germany

obscured (fig. 15-31). The east and west ends of the church, like its Ottonian predecessor, had nearly equal visual weight, emphasized by clusters of vertical elements. Tall stair towers rose at each side of the narthex and the apse, and octagonal lantern domes marked the crossing and the center narthex bay. Speyer's unusually wide nave, about 45 feet, is balanced by the great height of the groin-vaulted bays, which soar more than 100 feet overhead (fig. 15-32). Massive compound piers mark each nave bay and support the transverse ribs of the high vault. Lighter, simpler piers mark the aisle bays where two smaller bays cover the distance. This rhythmic alternation of heavy and light piers, first suggested for aesthetic reasons in Ottonian architecture, such as in Saint Cyriakus at Gernrode (see fig. 14-24), is regularized in Speyer and became an important design element in

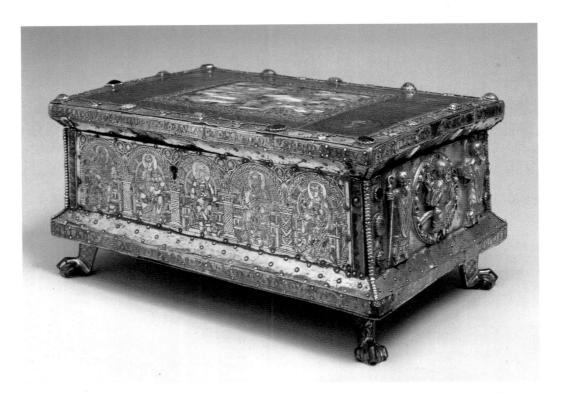

15-34. Roger of Helmarshausen. Portable altar of Saints Kilian and Liborius, from the Abbey, Helmarshausen, Saxony, Germany. c. 1100, with later additions. Silver with niello and gemstones, 6½ x 135/8 x 83/8" (16.5 x 34.5 x 21 cm). Erzhischöfliches Diözesanmuseum und Domschatzkammer, Paderborn, Germany

Roger, a monk, was also paid for a gold cross and another altar. Some scholars identify him with "Theophilus," the pseudonym used by a monk who wrote an artist's handbook, *On Diverse Arts*, about 1100. The book gives detailed instructions for painting, glassmaking, and goldsmithing. In contrast to Abbot Bernard of Clairvaux, "Theophilus" assured artists that "God delights in embellishments" and that artists worked "under the direction and authority of the Holy Spirit." He wrote, "most beloved son, you should not doubt but should believe in full faith that the Spirit of God has filled your heart when you have embellished His house with such great beauty and variety of workmanship. . . . Set a limit with pious consideration on what the work is to be, and for whom, as well as on the time, the amount, and the quality of work, and, lest the vice of greed or cupidity should steal in, on the amount of the recompense (Theophilus, page 43). The last admonishment is a worldly reminder about fair pricing.

Romanesque architecture. The ribbed groin vaults also relieve the stress on the side walls of the building so that windows can be larger. The result is both a physical and a psychological lightening of the building.

Metalwork

For centuries, three centers in western Germany supplied much of the best metalwork for aristocratic and ecclesiastical patrons throughout Europe: Saxony, the Meuse valley region (in modern Belgium), and the lower Rhine valley. The metalworkers in these areas drew on a variety of stylistic sources, including the work of contemporary Byzantine and Italian artists, as well as classical precedents as reinterpreted by their Carolingian forebears.

In the late eleventh century, Saxon metalworkers, already known for their large-scale bronze casting, began making bronze tomb effigies, or portraits of the deceased. Thus began a tradition of funerary art that spread throughout Europe and persisted for hundreds

of years. The oldest known bronze tomb effigy is that of King Rudolf of Swabia (fig. 15-33), who sided with the pope against Henry IV during the Investiture Controversy. The effigy, made soon after Rudolf's death in battle in 1080, is the work of an artist originally from the Rhine region. Nearly lifesize, it has fine linear detailing in niello, an incised design filled with a black alloy. The king's head has been modeled in higher relief than his body. The spurs on his oversized feet identify him as a heroic warrior. In his hands he holds the scepter and orb, emblems of kingship.

Most work of the time is anonymous, but according to the account books of the Abbey of Helmarshausen in Saxony, an artist named Roger was paid on August 15, 1100, for a portable altar dedicated to Saints Kilian and Liborius. Preserved in the treasury of the cathedral there, the foot-long, chestlike altar (one of two extant examples attributed to this artist) was made of silver with gemstones and niello (fig. 15-34). It rests on three-dimensionally modeled animal feet. On one end, in high relief,

15-35. Griffin aquamanile; from Mosan, near Liège, Belgium. c. 1130. Gilt bronze, silver, and niello, height 7¹/₄" (18.5 cm). Victoria and Albert Museum, London

are two standing saints flanking Christ in Majesty, enthroned on the arc of the heavens. On the front are five apostles, each posed somewhat differently, executed in two-dimensional engraving and niello. Saint Peter sits in the center, holding his key, with two other apostles on each side of him. Roger adapted Byzantine figural conventions to his personal style, imbuing his subjects with a sense of life despite their formal setting. He was clearly familiar with classical art, but his geometric treatment of natural forms, his use of decorative surface patterning, and the linear clarity of his composition are departures from the classical aesthetic.

Metalworkers in the Meuse Valley excelled in a very different style, perhaps the most distinctive of all Romanesque regional styles. They were well known for sumptuous small pieces, such as the gilt bronze aquamanile shown here, which was made about 1130 (fig. 15-35). Aquamaniles (from the Latin aqua, "water," and manus, "hand") were introduced into western Europe from the Islamic East, probably by returning Crusaders. In their homelands, Muslims used aquamaniles for rinsing their hands at meals. In the West, they found their way to church altars, where priests purified themselves by pouring water over their hands. This griffin aquamanile recalls its Islamic prototypes (see fig. 8-18). In its liturgical context, however, the hybrid beast known as a griffin symbolized the dual nature of Christ: divine (half eagle) and human (half lion). Black niello sets off the gleaming gold and silver, and the circular handle echoes the curved forms of the rest of the vessel.

15-36. Page of facsimile with *Hildegard's Vision, Liber Scivias*. c. 1150–1200. Original manuscript lost during World War II

The text that accompanies this picture of Hildegard of Bingen reads: "In the year 1141 of the incarnation of Jesus Christ the Son of God, when I was forty-two years and seven months of age, a fiery light, flashing intensely, came from the open vault of heaven and poured through my whole brain. . . . And suddenly I could understand what such books as the psalter, the gospel and the other catholic volumes of the Old and New Testament actually set forth" (Scivias, I, 1).

Books

The great Carolingian and Ottoman manuscript tradition continued in the Romanesque period. A painting on an opening page from the earliest illustrated copy of the *Liber Scivias* by Hildegard of Bingen (1098–1179) is as notable for the text it illustrates as for its artistic merit (fig. 15-36). Born into an aristocratic German family, Hildegard transcended the barriers that limited most medieval women, and she became one of the towering figures of her age. Like many women of her class, she entered a convent as a child. Developing into a scholar and a capable administrator, Hildegard began serving as leader of the convent in 1136. In about 1147 she founded a new convent near Bingen. Since childhood she had been subject to what she interpreted as divine visions, and in her forties, with the assistance of the

15-37. Page with initial *Q*, in a psalter from a nunnery in Augsburg(?), Swabia, Germany. Late 12th century. Tempera on vellum. Walters Art Gallery, Baltimore

monk Volmar, she began to record them. Her book, *Scivias* (from the Latin *scite vias lucis*, "know the ways of the light"), records her visions. In addition to *Scivias*, Hildegard wrote treatises on a variety of subjects, including medicine and natural science. Emerging as a major figure in the intellectual life of her time, she corresponded with emperors, popes, and the Cistercian Abbot Bernard of Clairvaux.

The opening page of this copy of *Scivias* shows Hildegard receiving a flash of divine insight, represented by the tongues of flame encircling her head. She records the vision on a tablet while Volmar, her scribe, waits in the wings. Stylistic affinities suggest to some art historians that this copy of *Scivias* was made at the scriptorium of the monastery of Saint Matthias in Trier, whose abbot was a friend of Hildegard. Others suggest it was made at Bingen under the direction of Hildegard herself.

In the Romanesque period, as earlier in the Middle Ages, women were involved in the production of books as authors, scribes, painters, and patrons (see fig. 14-14). A woman named Claricia may have worked on the decoration of a late-twelfth-century psalter probably from Augsburg, the Swabian capital. On a page from this psalter, a blithely swinging woman forms the tail of the initial Q (fig. 15-37). Her uncovered, flying braids and

fashionably long-sleeved dress suggest that she was a young, unmarried layperson. A nun or married woman would be dressed modestly, with her head covered. Written on each side of her head is the name Claricia, suggesting that this may be a self-portrait, one of the few from this period. Perhaps Claricia was a student at the abbey or a professional artist employed by the monastic scriptorium. In either case, such an expression of youthful exuberance and artistic pride is without contemporary parallel.

The eleventh and twelfth centuries were a ITALY period of significant change on the Italian peninsula. The north, deeply embroiled in the conflict between the papacy and the German emperors, experienced both economic growth and increasing political fragmentation. Toward the end of the eleventh century, towns such as Pisa and Genoa became self-governing municipal corporations known as communes, and by the middle of the twelfth century the major cities and towns of northern and central Italy were independent civic entities, feuding with one another incessantly in a pattern that continued for the next several hundred years. Port cities like Pisa, Genoa, and Venice maintained a thriving Mediterranean trade and also profited from their role in transporting Crusaders and pilgrims to the Holy Land. The great cathedrals of these urban centers played a leading role as patrons of the arts. Norman adventurers took control of Sicily and southern Italy in the late eleventh century, displacing Islamic and Byzantine rulers and introducing a distinctively northern cultural influence. And throughout Italy vestiges of imperial Rome were close at hand, helping shape the character of the Italian Romanesque.

Architecture

Pisa, on the west coast of Tuscany, was a great maritime power from the ninth through the thirteenth century. An expansionist republic, it competed with Muslim centers for control of trade in the western Mediterranean. In 1063 Pisa won a decisive victory over Muslim forces, and the jubilant city soon began constructing an imposing new cathedral dedicated to the Virgin Mary (fig. 15-38). The cathedral complex eventually included the cathedral itself; a campanile, or freestanding bell tower, a feature of Italian church architecture since the sixth century (now known for obvious reasons as the Leaning Tower); a baptistry; and the Campo Santo, a walled burial ground. The cathedral, designed by the master builder Busketos, was not fully completed until the late thirteenth century. Its plan is an adaptation on a grand scale of the cruciform basilica. It has a long nave with double side aisles crossed by a projecting transept. Three portals open on the nave and side aisles, and a clerestory rises above the side aisles and second-story galleries. A dome covers the crossing. Pilasters, blind arcades, and narrow galleries adorn the five-story, pale-marble facade. An Islamic bronze griffin sat atop the building from about 1100 until 1828 (see fig. 8-18).

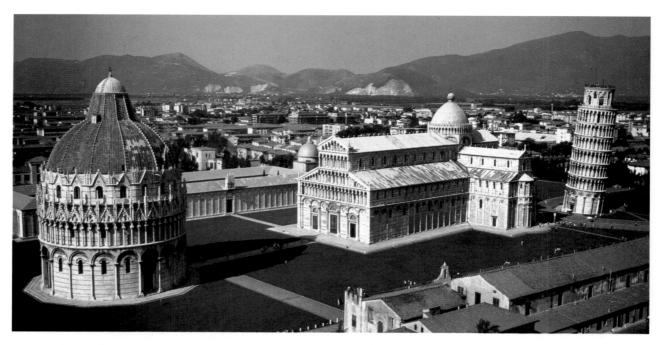

15-38. Cathedral complex, Pisa, Tuscany, Italy. Cathedral begun 1063; baptistry begun 1153; campanile begun 1174; Campo Santo dates from 13th century

When finished in 1350, the "Leaning Tower of Pisa" stood 179 feet high. It had begun to tilt while it was still under construction, and today it leans about 13 feet off the perpendicular. In the latest effort to keep it from toppling, engineers filled the base with tons of lead.

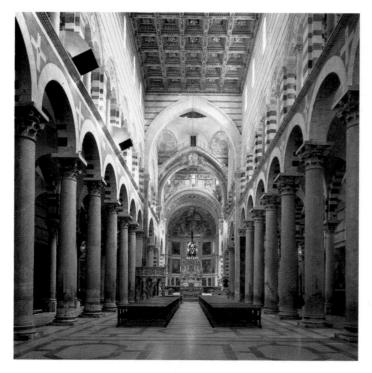

15-39. Nave, Pisa Cathedral. 1063-1100s

The nave arcade on the interior of the cathedral (fig. 15-39), with its evenly spaced Corinthian-style columns, progresses through the crossing to the sanctuary in a way reminiscent of imperial Roman basilica churches. The rhythmically progressing arches, a stringcourse, and the plain walls of the clerestory reinforce this horizontal orientation. In the gallery arcade, intermediate columns be-

tween piers support two-part openings. Contrasting bands of dark green marble decorate the arches and piers.

In medieval Europe, baptism involved immersion in water. Italy developed a tradition of erecting separate baptistry structures, usually round or octagonal buildings. The Pisa Baptistry, a round building with a coneshaped vault, was begun in 1153. The arcading and galleries on the lower levels of its exterior match those on the cathedral. The ornate upper levels are in a later, Gothic style. The present exterior dome is also later. The campanile was begun in 1174 by the master Bonanno Pisano. Built on inadequate foundations, it began to lean almost immediately. The cylindrical tower is encased in tier upon tier of marble arcades. This creative reuse of an ancient, classical theme is characteristic of Italian Romanesque art; artists and architects seem always to have been conscious of their Roman past, whether in the marble columns of Pisa or the monumental brickwork of Lombardy in northern Italy.

In Lombardy, the city of Milan had been the capital of the Western Roman Empire for a brief period in the fourth century, and the city's first bishop, Ambrose (d. 397), was one of the "fathers" of the Christian Church. In 1080, construction began on a new Church of Sant'Ambrogio (Saint Ambrose), replacing an often-renovated ninth-century church (figs. 15-40, 15-41). The builders reused much of the earlier structure, including the freestanding tenth-century "monks' tower" (shown at the right in figure 15-40). Lombard Romanesque architecture depended for its austere dignity on harmonious proportions and the restrained use of exterior **architectonic** elements—motifs derived from architectural forms. The exterior of

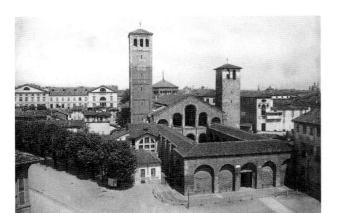

15-40. Church of Sant'Ambrogio, Milan, Lombardy, Italy. c. 1080–early 12th century. Restored after World War II

15-41. Plan of Church of Sant'Ambrogio

Sant'Ambrogio is decorated vertically with strip buttresses and horizontally with arched **corbel tables** (appearing as a scallop motif at a distance). The elements can be seen most clearly on the twelfth-century north tower (at the left in figure 15-40). The atrium, narthex, and semi-independent towers reflect the influence of Early Christian architecture still standing in Milan. Five huge arches, which correspond to the nave and side aisles below them, follow the roofline of the gabled, or pitch-roofed, second-story gallery and give it a dramatic appearance. Many churches in northern Italy adopted this type of gabled facade. Architectonic decoration of strip buttresses and arched corbel tables was carried to Germany, Normandy, and elsewhere by Lombard clerics and masons.

Following an earthquake in 1117, masons rebuilt the church using a technically advanced system of four-part rib vaulting (fig. 15-42). Compound piers support three domed-up ribbed groin vaults over the nave, and smaller intermediate piers support the ribbed groin vaulting over the side-aisle bays. In addition to the vaulting system, the builders took other steps to assure the stability of the church. Sant'Ambrogio has a nave that was wider than that of Cluny III (with which it was roughly contemporary), but, at 60 feet, only a little more than half as high. Vaulted galleries buttress the nave, and there are windows only in the outer walls.

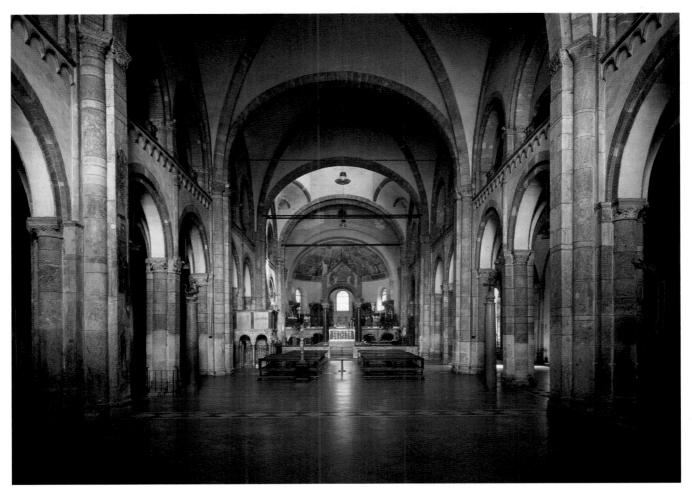

15-42. Nave, Church of Sant'Ambrogio. Vaulting after 1117

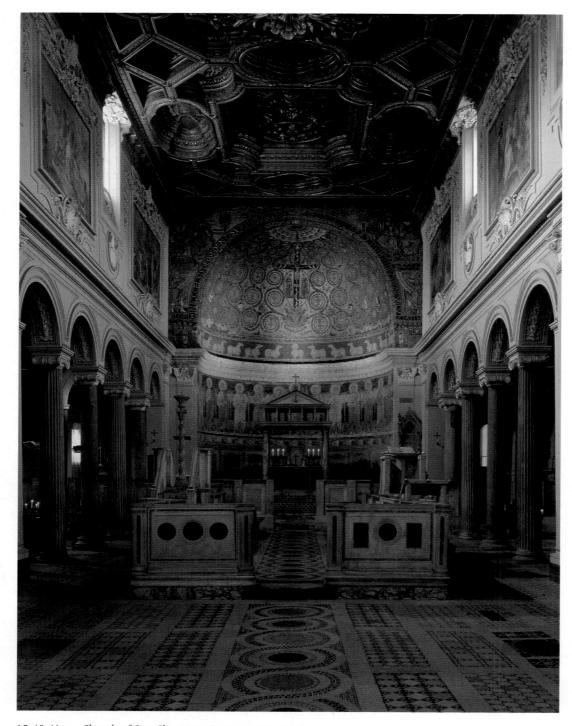

15-43. Nave, Church of San Clemente, Rome c. 1120–30

Ninth-century choir screens were reused from the earlier church. Upper wall and ceiling decoration are eighteenth century.

During the Investiture Controversy, Pope Gregory VII called on the Norman rulers of southern Italy for help when the forces of Emperor Henry IV threatened Rome in 1084. These erstwhile allies, however, looted and burned the city. Among the architectural victims was the eleventh-century Church of San Clemente. The Benedictines rebuilt the church between 1120 and 1130 as part of a program to restore Rome to its ancient splendor. The new church, built on top of the remains of both a fourth-century basilica and the eleventh-century

church, reflects a conscious effort to reclaim the artistic and spiritual legacy of the early Church (fig. 15-43). However, a number of features mark it as a Romanesque structure. A characteristic of early basilica churches, for example, was a strong horizontal movement down the nave to the sanctuary. In the new San Clemente, the rhythmic alternation of rectangular piers and Ionic columns interrupts this horizontal flow. The apse of the church followed the outline of the apse of the older structure beneath and was too small to accommodate all the

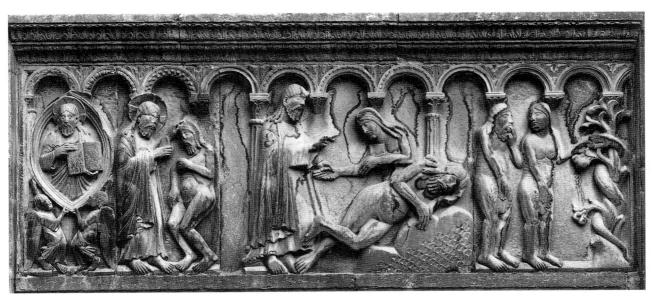

15-44. Wiligelmus. Creation and Fall, on the west facade, Modena Cathedral, Emilia, Italy. 1106-20. Height approx. 3' (92 cm)

participants in the liturgy of the time. As a result the choir, defined by the low barrier in the foreground of figure 15-43, was extended into the nave. In a configuration that came to be called the Benedictine plan, the nave and the side aisles each end in a semicircular apse. The different sizes of the apses, caused by the difference in the widths of the nave and the narrower side aisles, creates a stepped outline.

Mosaic was a rarely used medium in twelfth-century Europe because it required expensive materials and specialized artisans. The interior of San Clemente, however, is richly decorated with colored marble inlay and a gold mosaic apse semidome, another reflection of its builders' desire to recapture the past. The subject matter-a crucified Jesus, with his mother and Saint John placed against a vine scroll, and sheep representing the apostles and the Lamb of God—and style of the mosaics are likewise archaic. As in other Italian churches of the period, inlaid geometric patterns in marble embellish the floors of San Clemente. They are known as Cosmati work, from the family who perfected it. Ninth-century panels with relief sculptures, saved from the earlier church, formed the wall separating the choir from the nave. A baldachin (baldacchino), or canopy of honor symbolizing the Holy Sepulchre, covers the main altar in the apse.

Architectural Sculpture

The spirit of ancient Rome also seems to pervade the sculpture of Romanesque Italy. The 3-foot-high relief panels on the west facade of the Modena Cathedral, in north-central Italy, may have been the first narrative portal sculpture in Italy (c. 1106–1120). Wiligelmus, the sculptor, had studied the sculpture of ancient sarcophagi and may also have looked at Ottonian ivories. He took his subjects from the Old Testament Book of Genesis and included events from the Creation to the Flood. The panel

in figure 15-44 shows the Creation and the Fall of Adam and Eve. On the far left is a half-length Christ framed by a mandorla supported by two angels. The scene to the right shows God bringing Adam to life. Next, he brings forth Eve from Adam's side. On the right, Adam and Eve cover their genitals in shame as they greedily eat the fruit of the forbidden tree, around which the serpent twists.

Wiligelmus's deft carving and undercutting give these low-relief figures a strong three-dimensionality in the clear Italian light. Unlike Early Christian sarcophagi, which may have served as models, the spatial setting of the Modena reliefs is ambiguous. The figures seem to move in a shallow space under an arcade, which serves to unify rather than compartmentalize the individual scenes. In contrast, the arcading in the silver altar by Roger of Helmarshausen (see fig. 15-34) acts as a restrictive frame for the figures within it. Wiligelmus's figures, although not particularly graceful, effectively convey the emotional depth of the narrative. The panels were originally painted, which would have greatly increased their impact.

An inscription on one of the panels reads: "Among sculptors, your work shines forth, Wiligelmo [Wiligelmus]." This self-confidence turned out to be justified. Wiligelmus's influence can be traced throughout Italy and as far away as the cathedral of Lincoln in England. Wiligelmus, Roger, Gislebertus, and many anonymous women and men of the eleventh and twelfth centuries created a new art that—although based on the Bible and the lives of the saints—focused on human beings, their stories, and their beliefs. The artists worked on a monumental scale in painting, sculpture, and even embroidery, and their art moved from the cloister to the public walls of churches. While they emphasized the spiritual and intellectual concerns of the Christian Church, they also began to observe and record what they saw around them. In so doing they laid the groundwork for the art of the Gothic period.

Cathedral of Nôtre-Dame, Chartres c. 1134–1220

Salisbury Cathedral 1220–58

Palma Cathedral begun 1306

Giotto Virgin and Child Enthroned 1310

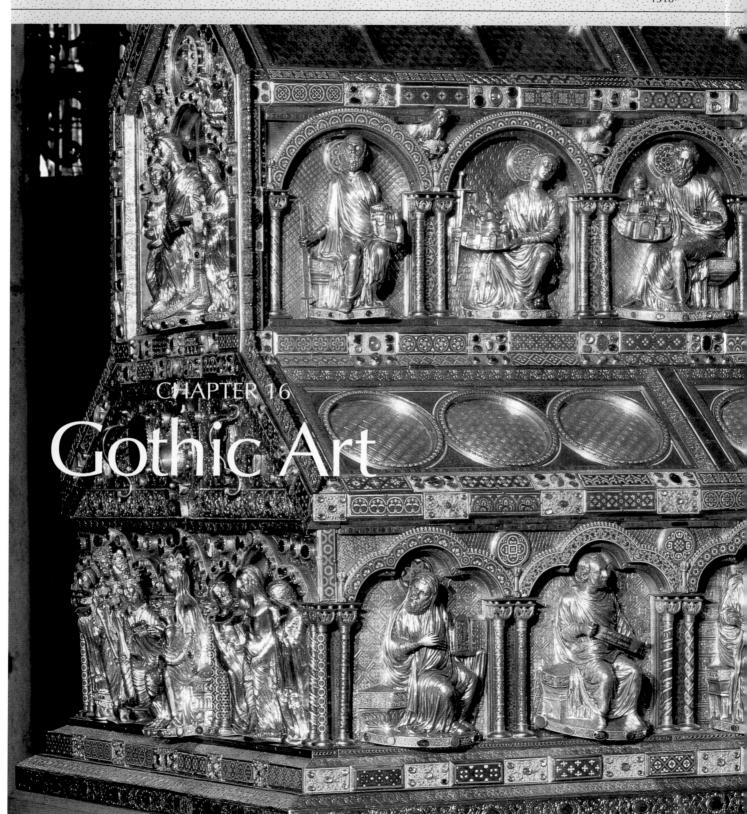

Virgin and Child, Paris c. 1339

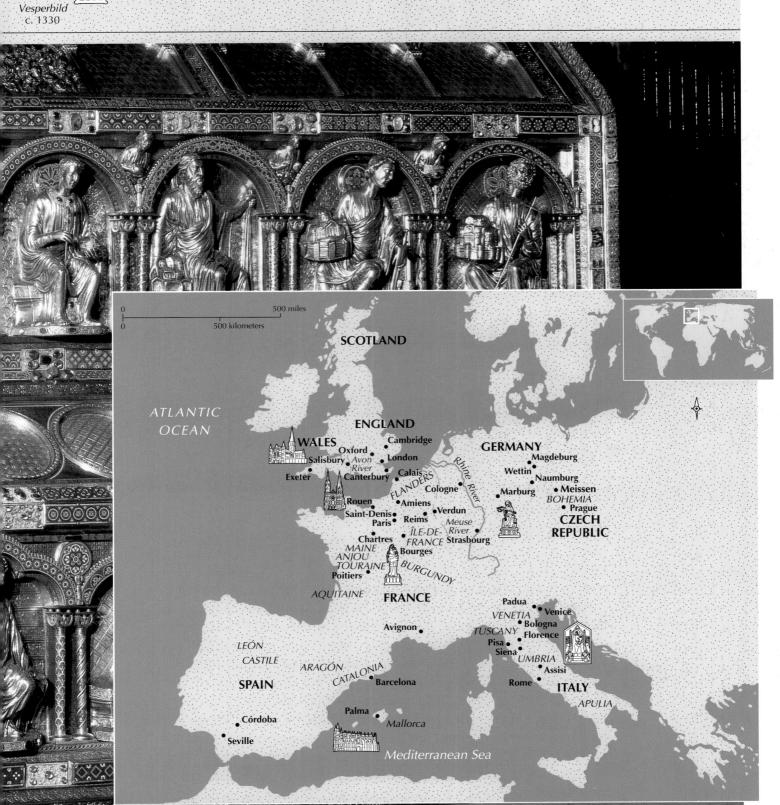

16-1. Triforium wall of the nave, Chartres Cathedral, Île-de-France, France. c. 1200-60

he twelfth-century Abbot Suger of Saint-Denis was, according to his biographer Willelmus, "small of body and family, constrained by twofold smallness, [but] he refused, in his smallness, to be a small man" (cited in Panofsky, page 33). He was educated at the monastery of Saint-Denis, near Paris, and rose from modest origins to become a powerful adviser to kings—even regent when the king was on crusade. And he built what many consider the first Gothic structure in Europe.

After Suger was elected abbot of Saint-Denis, he was determined to rebuild its church, where the relics of the patron saint were housed and the kings of the Franks had been buried since the seventh century. Suger saw Saint-Denis as the preeminent church in France, a church that embodied the history of the royal dynasty, and he waged a successful campaign to gain both royal and popular support for his rebuilding plans. The current building, he pointed out, had become inadequate. With a

touch of exaggeration, he claimed that the crowds of worshipers had become so great that women were being crushed and monks sometimes had to flee with their relics by jumping through windows.

In carrying out his duties, the abbot had traveled widely—to France, the Rhineland, and Italy, with four trips to Rome. As he began his plans for the church, he was quite familiar with the latest architecture and sculpture of Romanesque Europe. He also turned for inspiration to the authority of Church writings, including treatises erroneously attributed to a first-century follower of Saint Paul named Dionysius, who identified radiant light with divinity. Through the centuries Dionysius had become confused with Saint Denis, so Suger not unreasonably adapted his concept of divine luminosity into the redesign of the church dedicated to Saint Denis. Accordingly, when Suger began work on the choir after completing a magnificent Norman-inspired facade and narthex, he created "a circular string of chapels" so that the whole church "would shine with the wonderful and uninterrupted light of most luminous windows, pervading the interior beauty" (cited in Panofsky, page 101). Although Abbot Suger died before he was able to finish rebuilding Saint-Denis, his presence remained: this cleric of modest origins had himself portrayed in a sculpture at Christ's feet in the central portal, in a mosaic in the chapel, and in a stained-glass window in the apse. Suger is remembered not for these representations, however, but for his inspired departure from traditional architecture in order to achieve radiant light. It was this innovation that introduced the concept of large stained-glass windows, such as those that paint the inside walls of Chartres Cathedral with sublime washes of color (fig. 16-1).

THE In the middle of the twelfth century, when GOTHIC builders throughout Europe worked in the Romanesque style, a distinctive new STYLE church architecture known today as

Gothic emerged in the Île-de-France, the region around Paris that was the domain of French kings. The appearance of the new style there coincided with the emergence of the monarchy as a powerful centralizing force after centuries of weakness. The Gothic style prevailed in western European art from about 1150 to 1400, though it lingered for another century in some regions—the spire of the north tower of Chartres Cathedral, for example, was finished between 1507 and 1513, a period during which Michelangelo was creating Renaissance masterpieces in Florence. The term Gothic was introduced in the sixteenth century by the Italian artist and historian Giorgio Vasari. Vasari, who esteemed Michelangelo above all others, disparagingly attributed the style to the Goths, Germanic northerners who had destroyed the classical civilization of the Roman Empire that he and his contemporaries so admired. In its own day the Gothic style was simply called modern style or the French style. As it spread from the Îlede-France, it gradually displaced Romanesque forms but took on regional characteristics inspired by those forms. England developed a distinctive national style, which in

turn influenced architectural design in continental Europe. The Gothic style was slow to take hold in Germany but ultimately endured there well into the sixteenth century. Italy proved more resistant to French Gothic elements, and by 1400, Italian artists and builders there sought a return to classical traditions. In the late fourteenth century, the various regional styles of Europe coalesced into what is known as the International Gothic style.

Gothic architecture's elegant, soaring interiors, the light, colors, and sense of transparency produced by great expanses of stained glass, and its linear qualities became more pronounced over time. The style was adapted to all types of structures—including town halls, meeting houses, market buildings, residences, and Jewish synagogues, as well as churches and cathedralsand its influence extended beyond architecture and architectural sculpture to other mediums.

The people of western Europe experienced both great achievements and great turmoil during the Gothic period. In the twelfth and thirteenth centuries Europe was enjoying a period of vigor and growth. Town life stimulated intellectual life, and urban universities and cathedral schools supplanted rural monastic schools as centers of learning. The first European university, at Bologna, Italy, was founded in the eleventh century, and

1140 1500

PARALLELS

<u>Europe</u>	<u>1140–1275</u>	1275-1400
France	Saint-Denis; Gothic style emerges; Louis VII; Eleanor of Aquitaine; Nôtre-Dame de Paris designed; Chartres Cathedral; troubadour songs; University of Paris found- ed; Amiens Cathedral; Reims Cathedral; Thomas Aquinas; Villard d'Honnecourt's sketchbook; the Sainte- Chapelle; book arts flourish	Papacy in Avignon; Duke Philip the Bold of Burgundy; King Charles V; courtly love themes in literature and art
England	Henry II and Eleanor of Aquitaine found Plantagenet dynasty; Canterbury Cathedral; Cambridge and Oxford universities founded; King John signs Magna Carta; Salisbury Cathedral; Decorated style; Henry III and barons feud	Windmill Psalter; opus anglicanum; Hundred Years' War with France begins; first English translation of the Bible; Chaucer's Canterbury Tales
Spain	King Alfonso X; Christian reconquest of Muslim Spain continues	Palma Cathedral (Mallorca)
Germany	Nicholas of Verdun; hall churches develop; Holy Roman Emperor Frederick II	Gothic synagogue built in Prague (Bohemia); <i>Andachtsbilder</i>
Italy	Pisa Campanile; Saint Francis; Franciscan order founded; Padua University founded; Nicola Pisano; Giovanni Pisano; Cimabue's <i>Crucifix</i>	Giotto's frescoes; Duccio's <i>Maestà</i> ; Dante's <i>Divine Comedy</i> ; Boccaccio's <i>Decameron</i> ; Florence Cathedral; "Great Schism" in Western Christian Church; Renaissance style emerges
World	Second to Ninth Crusades; Benin civilization (Africa); Muslim conquest of India; Kamakura period (Japan); Aztec conquer Toltec (South America); Mississippian pottery (North America); Marco Polo in China; Jenghiz Khan invades China; Kublai Khan rules Mongols	Wu Chen's landscapes (China); Black Death ravages Europe; Ming dynasty (China); Tamerlane's conquests in Asia; Golden Pavilion (Japan)

important universities in Paris, Cambridge, and Oxford soon followed. The Gothic period also saw the flowering of distinctive art forms among the nobility—poetry and music in particular—centered on the concept of courtly love (see "Courtly Love," opposite).

Although Europe remained overwhelmingly rural during the Gothic period, towns gained increasing prominence. Nearly all the major cities in western Europe today were sizable urban centers by the late twelfth century. As towns grew, they became increasingly important centers of artistic patronage. The production and sale of goods in many towns was controlled by guilds. Artisans of all types, from bakers to painters, and merchants formed these associations to advance their professional interests. Medieval guilds also played an important social role, safeguarding members' political interests, organizing religious celebrations, and looking after members and their families in times of trouble.

A town's walls enclosed streets, wells, market squares, shops, churches, and schools. Homes ranged from humble wood-and-thatch structures to imposing

stone town houses. Although wooden dwellings crowded together made fire an ever-present danger and hygiene was rudimentary at best, towns fostered an energetic civic life and a strong communal identity, reinforced by public projects and ceremonies. An idealized portrait of the town of Siena in the mid-fourteenth century conveys some of the richness and energy of late-medieval civic life (fig. 16-2).

Urban cathedrals, the seats of the ruling bishops, superseded rural monasteries as centers of religious patronage throughout western Europe during the Gothic period. So many of these monumental testaments to the power of the Church were erected between 1150 and 1400 that this period is also known as the great age of cathedral building. Cathedral precincts functioned almost as towns within towns. The great churches dominated their surroundings and were central fixtures of urban life. Their grandeur inspired love and admiration; their great expense and the intrusive power of their bishops inspired resentment and fear. The twelfth century witnessed a growth of intense religiosity among the laity,

1140 1500

COURTLY The ideal of courtly love arose in southern LOVE France in the early twelfth century during the cultural renaissance that followed the First Crusade. It involved the passionate devotion of lover and loved one. The relationship was almost always illicit—the woman the wife of another, often a lord or patron-and its consummation was usually impossible. This movement transformed the social habits of western Europe's courts and has had an enduring influence on modern ideas of love. Images of gallant knights serving refined ladies, who bestowed tokens of affection on their chosen suitors or cruelly withheld their love on a whim, captured the popular imagination.

The literature of courtly love was initially spread by the musician-poets known as troubadours, some of them professionals, some of them amateur nobles, and at least twenty of them women. They sang of love's joys and heartbreaks in daringly personalized terms, extolling the ennobling effects of the lovers' selfless devotion. From this tradition came the famous romance of Tristam and Ysolt (Tristan and Isolde), so well known that it was the decorative motif on a hair comb from the fifteenth century, seen at the right.

Chrétien de Troyes, a French poet writing in the late twelfth century, tells of the love of the knight Lancelot for Guinevere, the wife of King Arthur. The literature of courtly love marked a major shift from the usually negative way in which women had previously been portrayed as sinful daughters of Eve. The following example, a stylized lovers' debate (the woman speaks first), is an example of courtly love poetry of southern France.

Friend, because of you I'm filled with grievous sorrow and despair, but I doubt you feel a trace of my affliction. Why did you become a lover, since you leave the suffering to me?

Why don't we split it evenly?

when it links two friends together, that whatever grief or joy they have each feels according to his way. The way I see it, and I don't

Lady, such is love's nature

Friend, I know well enough how skilled you are in amorous affairs, and I find you rather changed from the chivalrous knight you

exaggerate, all the worst pain's

I might as well be clear, for your mind seems quite distracted:

used to be.

do you still find me attractive?

Lady, may sparrow-hawk not ride my wrist, nor siren fly beside me on the chase, if ever since you gave me perfect joy I possessed another woman; I don't lie: out of envy evil men insult my name.

> (Attributed to the Countess of Dia and Raimbaut d'Orange, late twelfth century; cited in Bogin, pages 147–51)

The tradition of courtly love had a lasting influence on the development of Western literature. In Italy the Florentine poet Dante Alighieri (1265–1321) incorporated the form into his great work, *La Divina Commedia (The Divine Comedy, c.* 1310–1320), in which his idealized woman, Beatrice, guides him through paradise.

Comb, carved with *The Meeting of Tristam and Ysolt*, from eastern France or Switzerland. Early 15th century. Wood coated with gesso and paint, height 7³/₄ x 7⁵/₈" (19.7 x 19.5 cm). Museum of Fine Arts, Boston H. E. Bolles Fund

16-2. Ambrogio Lorenzetti. Detail of fresco *Allegory of Good Government in the City*, in the Sala della Pace, Palazzo Pubblico, Siena, Tuscany, Italy. 1338–39

particularly in Italy and France. The same devotional intensity gave rise in the early thirteenth century to two new religious orders, the Franciscans and the Dominicans, both of which went out into the world to preach and minister to those in need, rather than confining themselves in monasteries.

Crusading continued throughout the thirteenth century. In 1204, soldiers of the Fourth Crusade who had set out to conquer Egypt from the Muslims instead seized Constantinople—capital of the Byzantine Empire and the center of the Eastern Christian Church—and the city remained under Western control until 1261. The Crusades and the trade that followed from them brought western Europeans into contact with the Byzantine and Islamic worlds, and through them many literary works of classical antiquity, particularly those of Aristotle. These works posed a problem for medieval scholars because they

promoted rational inquiry rather than faith as the path to truth, and their conclusions did not always fit comfortably with Church doctrine. In the thirteenth century, Thomas Aquinas finally brought together faith and reason—the old belief and the new logic—in Scholastic philosophy, which has endured as a basis of Catholic thought to this day.

The all-embracing intellectual systems of the Scholastic thinkers had a profound influence on the arts. The sculptural programs in many cathedrals are as encyclopedic as the Speculum Maius (Greater Mirror) of Vincent de Beauvais, a thirteenth-century Parisian Dominican. He organized his eighty-volume encyclopedia to include categories of the Natural World, Doctrine, History, and Morality. Gothic master builders, like the Scholastics, saw divine order in geometric relationships and expressed these relationships in sculpture and architecture. Unlike their Romanesque predecessors, who used stylization and distortion to achieve emotional impact, thirteenth-century sculptors created more naturalistic forms that reflect the idealism and reasoned analysis of Scholastic thought. Gothic religious imagery became allencompassing, and like Romanesque imagery its purpose was to instruct and convince the viewer. Its effects. however, are more varied and subtle. In the Gothic cathedral it incorporates a wide range of subjects drawn from the natural world. Scholastic logic intermingles with the mysticism of light and color to create for the worshiper the direct, emotional, ecstatic experience of the church as the embodiment of God's house, filled with divine light.

In all these achievements lay potential disaster. By the middle of the fourteenth century much of Europe was in crisis. Prosperity had fostered population growth, which by about 1300 began to exceed food production, and thereafter famines became increasingly common. Peasant revolts began as worsening conditions frustrated rising expectations. In 1337 a prolonged conflict known as the Hundred Years' War (1337-1453) erupted between France and England, devastating much of France. In the middle of the fourteenth century a lethal plague swept northward from Sicily, wiping out as much as 40 percent of Europe's population (see "The Black Death," page 607). By depleting the labor force, however, the plague gave surviving peasants increased leverage over their landlords and increased the wages of artisans. The Church, too, experienced great strain during the fourteenth century. In 1309 the papal court moved from Rome to Avignon, in southeastern France, where it remained until 1377. From 1378 to 1417, in what is known as the Great Schism, the papacy split, with two contending popes, one in Avignon and one in Rome, claiming legitimacy.

FRANCE
The birth and initial flowering of the Gothic style took place in France against the backdrop of the growing power of the French monarchy. Louis VI (ruled 1108–1137) and Louis VII (ruled 1137–1180) consolidated royal authority over the Île-de-France and began to exert control over powerful nobles in other regions. Before acceding to the throne,

Louis VII had married Eleanor (1122-1204), heir to the region of Aquitaine (southwestern France), the largest and most prosperous feudal domain in western Europe. Eleanor of Aquitaine was one of the great figures of her age. She accompanied Louis on the Second Crusade (1147-1149), but they became estranged and the marriage was annulled by papal decree. Taking her wealthy province with her, Eleanor then married Henry Plantagenet-the duke of Normandy, count of Anjou, Maine, and Touraine, and soon-to-be King Henry II of England. Henry and Eleanor together controlled more French territory than the French king, although he was technically their feudal overlord. The resulting tangle of conflicting claims was responsible for centuries of friction between England and France that culminated in the Hundred Years' War.

Eleanor was estranged from Henry in 1170 and plotted with her sons and her former husband, Louis VII, to overthrow him. When these schemes failed, Henry kept her confined for more than a decade. After his death in 1189, the dowager queen Eleanor presided over her court in Poitiers, Aquitaine, while her sons Richard the Lion-Hearted and then John were kings of England and a daughter was queen of Castile in Spain. Poitiers gained renown for its patronage of high culture and the literature of courtly love (see "Courtly Love," page 549). A woman of great courage and stamina, she had ten children, including two daughters with Louis and five sons and three daughters with Henry. She remained a formidable figure in European politics into her eighties.

The successors to Louis VII continued the consolidation of royal authority and nation building, increasing their domains and privileges at the expense of aristocrats and the Church.

Architecture and Its Decoration

The political events of the twelfth and thirteenth centuries were accompanied by a burst of ecclesiastical construction. It has been estimated that during the Middle Ages several million tons of stone were quarried to build some 80 cathedrals, 500 large churches, and tens of thousands of parish churches, and that within 100 years some 2,700 churches were built in the Île-de-France region alone. This staggering undertaking drew on the wealth generated by the area's agricultural products particularly wheat and wine—and the commerce and industry of its town dwellers. Stone was but one of the expenses. In some instances, as at Chartres, the clergy already owned the quarry; in others, they bought it. Transporting the stone was sometimes a greater expense than the stone itself. Whenever possible, heavy construction material was transported by water on barges, and sometimes canals were built for this purpose. (Stone from France was often shipped by barge to England for this same reason.) When transport by land was necessary, the shortest possible route was taken, and new types of harnesses for coupling draft horses were developed. The ingenious machines created for lifting heavy materials were well documented in drawings of the time.

as was scaffolding—including some suspended from above rather than resting on the ground—and spiral staircases were sometimes built within the masonry. This explosion of cathedral building began at a historic abbey church on the outskirts of Paris.

Abbey Church of Saint-Denis. The Benedictine monastery of Saint-Denis, a few miles north of central Paris, had great symbolic significance for the French monarchy. It housed the tombs of French kings, regalia of the French Crown, and the relics of Saint Denis, the patron saint of France, who, according to tradition, had been the first bishop of Paris. In the 1130s, under the inspiration of Abbot Suger, construction began on the new abbey church, which is arguably Europe's first Gothic structure. Suger (c. 1081–1151) was a trusted adviser to both Louis VI and Louis VII, and he governed France as regent when Louis VII and Eleanor of Aquitaine were off crusading.

Suger described his administration of the abbey and the building of the Abbey Church of Saint-Denis in three books. His love of magnificent architecture and art brought him into conflict with the Cistercian leader, Abbot Bernard of Clairvaux (Chapter 15). As a widely traveled cleric, Suger knew all the latest developments in church building, and his design combines elements from many sources. Because the Île-de-France had great Carolingian buildings and little monumental Romanesque architecture, Suger brought in masons and sculptors from other regions. Saint-Denis became a center of artistic interchange. Unfortunately for art historians today, Suger did not record the names of the masters he employed, nor information about them and the techniques they used. The abbot took an active part in the building. He found the huge trees and stone needed by the workers on the abbey's own lands. To generate income for the rebuilding, he instituted economic reforms, receiving substantial annual payments from the town's inhabitants and establishing free villages on abbey estates to attract peasants. For additional funds, he turned to the royal coffers and even to fellow clerics.

The first part of the new structure to be completed was the west facade and narthex (1135-1140). Here Suger's masons combined Norman facade design like that at Caen (see fig. 15-27) and rib-vaulted structure like that at Durham (see fig. 15-26) with the richly sculptured portals of Burgundy. The east end represented an even more stunning change. The choir was completed in three years and three months (1140-1144), timing that Abbot Suger found auspicious. The plan of the choir (chevet in French) resembled that of a Romanesque pilgrimage church, with a semicircular sanctuary surrounded by an ambulatory from which radiated seven chapels of uniform size (fig. 16-3). All the architectural elements of the choir—rib groin vaults springing from round piers, pointed arches, wall buttresses to relieve stress on the walls, and window openings—had already appeared in Romanesque buildings. The dramatic achievement of Suger's master mason was to combine these features into a fully integrated architectural whole that empha-

16-3. Plan of the sanctuary, Abbey Church of Saint-Denis, Saint-Denis, Île-de-France, France. 1140–44

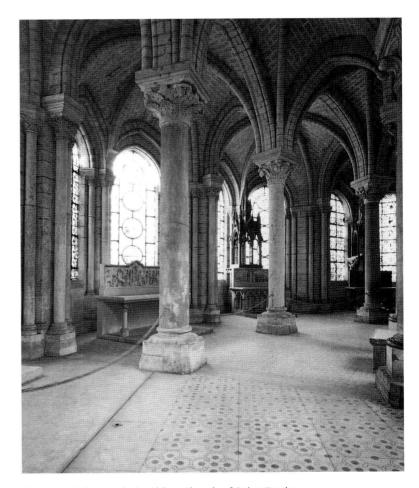

16-4. Ambulatory choir, Abbey Church of Saint-Denis

sized the open, flowing space. Sanctuary, ambulatory, and chapels opened into one another; walls of stained glass replaced masonry, permitting the light to permeate the interior with color (fig. 16-4). To accomplish this effect, the masons relied on the systematic use of advanced vaulting techniques, the culmination of half a century of experiment and innovation (fig. 16-5; see "Elements of Architecture," page 552).

ARCHITECTURE

ELEMENTS OF Rib vaulting was one of the chief technical contributions of Romanesque and Gothic **Rib Vaulting** builders. Rib vaults are a form of groin vault (see page 226) in

which the ridges (groins) formed by the intersecting vaults may rest on and be covered by curved moldings called ribs. These ribs were usually structural as well as decorative, and they strengthened the joins and helped channel the vaults' thrusts outward and downward. The ribs were constructed first and supported the scaffolding of the vault. Ribs developed over time into an intricate masonry "skeleton" filled with an increasingly lightweight "skin," the web of the vault, or webbing. Sophisticated variations on the basic rib vault created the soaring interiors for which Gothic churches are famous.

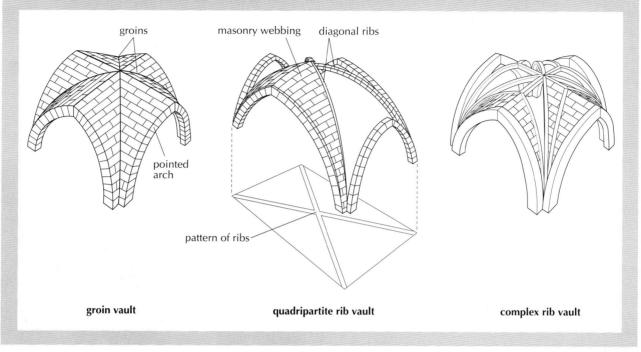

The apse of Saint-Denis represented the emergence of a new architectural aesthetic based on line and light. Citing early Christian writings, Suger saw light and color as a means of illuminating the soul and uniting it with God, a belief he shared with medieval mystics such as Hildegard of Bingen (Chapter 15). For him, the colored lights of gemstones and stained-glass windows and the glint of golden church furnishings at Saint-Denis transformed the material world into the splendor of paradise.

Louis VII and Eleanor of Aquitaine attended the consecration of the new choir on June 14, 1144. Shortly thereafter the impending Second Crusade became the primary recipient of royal resources, leaving Suger without funds to replace the old nave and transept at Saint-Denis. The abbot died in 1151, and his church remained unfinished for another century. (Saint-Denis suffered extensive damage during the French Revolution in the late eighteenth century. Its current condition is the result of nineteenthand twentieth-century restorations.)

The Abbey Church of Saint-Denis became the prototype for a new architecture of space and light based on a highly adaptable skeletal framework constructed from buttressed perimeter walls and an interior vaulting system of pointed-arch masonry ribs. It initiated a period of competitive experimentation in the Île-de-France and surrounding regions that resulted in ever larger churches enclosing increasingly taller interior spaces walled with ever greater expanses of colored glass (see "Nôtre-Dame of Paris," page 564). These great churches, with their

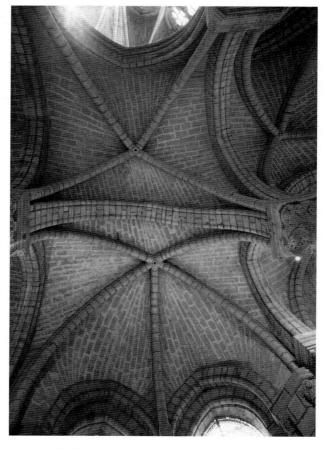

16-5. Ambulatory vaults, Abbey Church of Saint-Denis

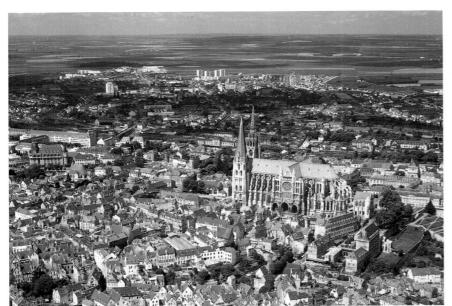

16-6. Cathedral of Nôtre-Dame, Chartres, Île-de-France, France. c. 1194–60; west facade begun c. 1134; north spire 1507–13. View from the southeast

Chartres was the site of a pre-Christian virgin-goddess cult and one of the oldest and most important Christian shrines in France. Its main treasure was a long piece of silk believed to have been worn by Mary—a gift from the Byzantine emperor to Charlemagne, donated to the cathedral by King Charles the Bold in 876—that was on display with other relics in a huge basement crypt. The healing powers attributed to this relic and its association with Mary made Chartres a major pilgrimage destination as the cult of the Virgin grew.

unabashed decorative richness, were part of Abbot Suger's legacy to France.

Chartres Cathedral. The great Cathedral of Nôtre-Dame (Our Lady, the Virgin Mary) dominates the town of Chartres, southwest of Paris (fig. 16-6). For many people, Chartres Cathedral is a near-perfect embodiment of spirit in stone and glass. Constructed in several stages beginning in the mid-twelfth century and extending into the mid-thirteenth, the cathedral reflects the transition from Early to High Gothic. A fire in 1134 that damaged the western facade of an earlier cathedral on the site prompted the building of a new facade, influenced by the Early Gothic style at Saint-Denis. After another fire in 1194 destroyed most of the rest of the original structure, a papal representative convinced reluctant local church officials to undertake a massive rebuilding project. A new cathedral was built between approximately 1194 and 1260.

To erect such an enormous building required vast resources-money, raw materials, and skilled labor. Contrary to common perceptions about "the great age of cathedral building," medieval people did not always support these ambitious undertakings with devout and selfless zeal, harnessing themselves to carts laden with building stones to help. Both nobles and ordinary people often opposed the building of cathedrals because of the burden of new taxes. Fundraising at Chartres got under way in a stagnant economy, with cathedral officials pledging all or part of their incomes for three to five years. The church's relics were sent on tour as far away as England to solicit contributions. As the new structure rose higher during the 1220s, the work grew more costly and funds dwindled. When the bishop and canons (cathedral clergy) tried to make up the deficit by raising feudal and commercial taxes, they were driven into exile for four years. The economic privileges claimed by the Church for the cathedral sparked intermittent riots by townspeople and the local nobility throughout the thirteenth century. Despite these tensions, the new cathedral emerged as a

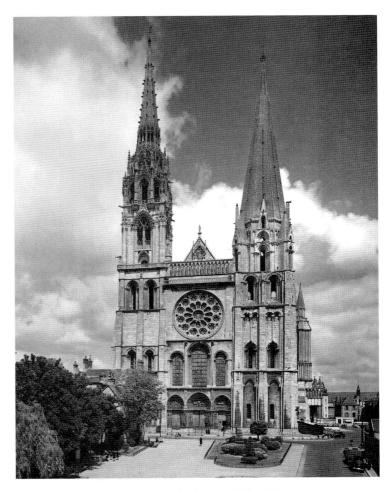

16-7. West facade, Chartres Cathedral. c. 1134–1220; south spire c. 1160; north spire 1507–13

work of remarkable balance and harmony, inspiring even to nonbelievers.

From a distance the most striking features of the west facade are its prominent round **rose window** and its two towers, with their mismatched spires (fig. 16-7). The spire on the north tower (left) was added in the

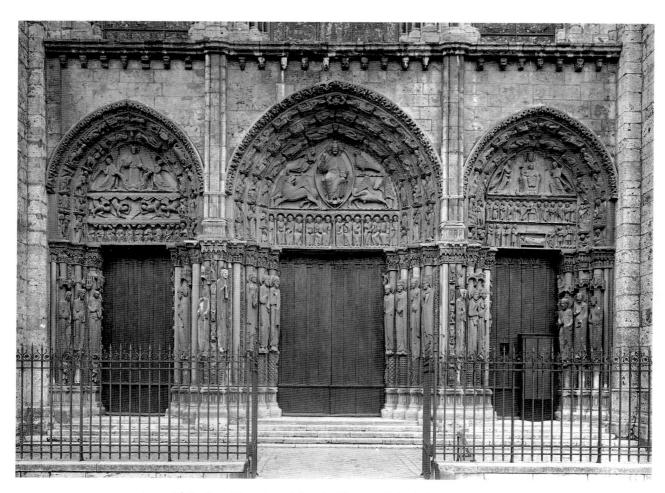

16-8. Royal Portal, west facade, Chartres Cathedral. c. 1145-55

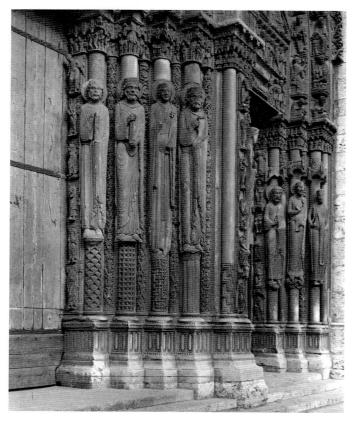

16-9. *Prophets and Ancestors of Christ*, right side, central portal, Royal Portal, Chartres Cathedral. c. 1145–55

early sixteenth century; the spire on the south tower dates from the twelfth century. On closer inspection the facade's three doorways—the so-called Royal Portal capture the attention with their sculpture (fig. 16-8). Christ Enthroned in Royal Majesty dominates the central tympanum. Flanking the doorways are monumental column statues, a form that originated at Saint-Denis. These column statues depict twenty-two Old Testament figures who were seen as precursors of Christ (fig. 16-9). In other biblical references the builders of Gothic cathedrals identified themselves symbolically with Solomon, the builder of the first Temple in Jerusalem, and the depiction of Old Testament kings and queens evokes the close ties between the Church and the French royal house. Because of this relationship, still potent after 600 years, most such figures at other churches were smashed during the French Revolution.

Earlier sculptors had achieved dramatic, dynamic effects by compressing, elongating, and bending figures to fit them into an architectural framework. At Chartres, in contrast, the sculptors sought to pose their high-relief figures naturally and comfortably in their architectural settings. The erect, frontal column statues, with their elongated proportions and vertical drapery, echo the cylindrical shafts from which they emerge. Their heads are finely rendered with idealized features.

Calm and order prevail in the imagery of the Royal Portal, in contrast to the somewhat more crowded

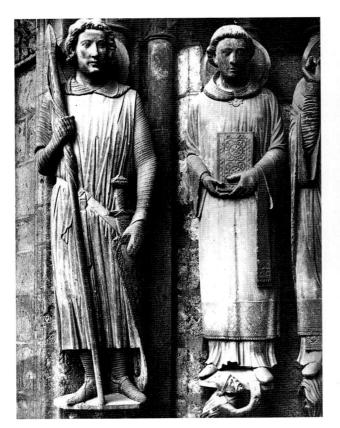

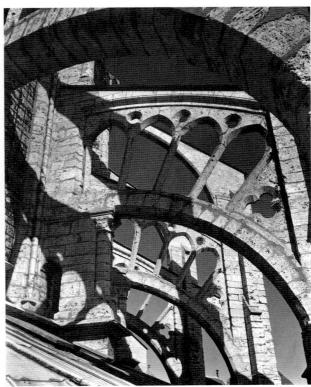

16-11. Flying buttresses, Chartres Cathedral. c. 1200-20

imagery at many Romanesque churches, such as those at Moissac (see fig. 15-9) and Autun (see fig. 15-12). Christ in the central tympanum of the Royal Portal appears imposing but more benign and less terrifying than in earlier representations. The Twelve Apostles in the lintel below him and the twenty-four elders in the archivolts above him have been arranged in a hierarchy of size and location, with little narrative interaction between them. Even in narrative scenes, calm prevails, as in the Ascension of Christ in the tympanum of the left doorway and the enthroned Virgin and Child in the tympanum of the right doorway.

Column statues became standard elements of Gothic church decoration, developing from shaftlike reliefs to fully three-dimensional figures that appear to interact with one another as well as with approaching worshipers. A comparison of the column statues of the Royal Portal with those of the later north and south transept portals illustrates this transition. Figure 16-10 shows two column statues from the south transept portal. Saint Stephen, on the right, was made between 1210 and 1220; Saint Theodore, on the left, between 1230 and 1235. More lifelike than their predecessors, they seem to stand on projecting bases with carved brackets. The bases reinforce the illusion that the figures are free of the architecture to which they are attached. In another change, the dense geometric patterning and stylized foliage around the earlier statues have given way to plain stone.

Saint Stephen, still somewhat cylindrical, is more naturally proportioned than the earlier figures on the west facade. The sculptor has also created a variety of textures to differentiate cloth, embroidery, flesh, and other features. The later Saint Theodore reflects its sculptor's attempt to depict a convincingly "alive" figure. The saint is dressed as a contemporary crusader and stands, purposeful but contemplative, with his feet firmly planted and his hips thrust to the side (a pose often called the Gothic S-curve). The meticulous detailing of his expressive face and the textures of his chain mail and surcoat help create a strong sense of physical presence.

Many nearby churches built by local masons about the same time as Chartres Cathedral reflect an earlier style and are relatively dark and squat. Unlike them, Chartres was the work of artisans from areas north and northeast of the town who were accomplished practitioners of the Gothic style. In the new cathedral they brought together the hallmark Gothic structural devices for the first time: the pointed arch, ribbed groin vaulting, the flying buttress, and the triforium, now designed as a mid-level passageway (see "Elements of Architecture," page 558). The flying buttress, a gracefully arched, skeletal exterior support, counters the outward thrust of the vaulting over the nave and aisles (fig. 16-11). The Gothic triforium (which was a flat wall in the basilica church or a gallery in Byzantine and Romanesque architecture) overlooks the nave through an arcaded screen

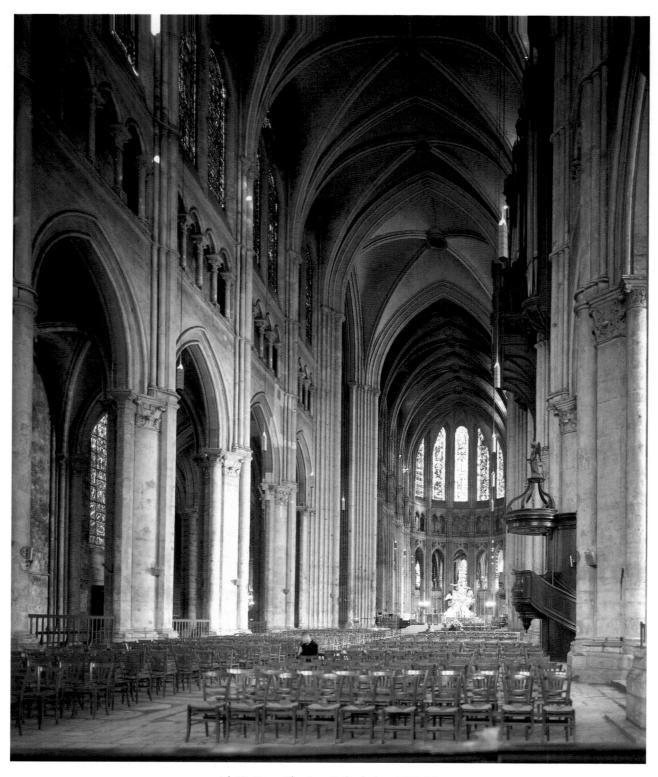

16-12. Nave, Chartres Cathedral. c. 1200-20

that contributes to the visual unity of the interior (fig. 16-12). Building on the concept pioneered at Saint-Denis of an elegant masonry shell enclosing a large open space, the masons at Chartres erected a structure with one of the widest naves in Europe and vaults that soar 118 feet above the floor. The enlarged sanctuary, another feature derived from Saint-Denis, occupies one-third of the building (fig. 16-13). Stained glass covers nearly half the clerestory surfaces. The large and luminous

clerestory is filled by pairs of tall, arched windows called lancets surmounted by circular windows, or oculi. Whereas at a Romanesque pilgrimage church like Sainte-Foy (see fig. 15-4) the worshiper's gaze is drawn forward toward the apse, at Chartres it is drawn upward—to the clerestory windows and the soaring vaults overhead—as well as forward. Relatively little interior architectural decoration interrupts the visual rhythm of shafts and arches. Four-part vaulting has superseded more complex

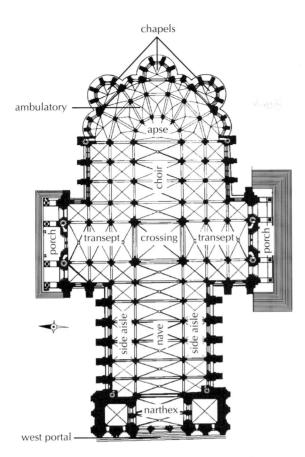

16-13. Plan of Chartres Cathedral. c. 1194-1220

systems such as that at Durham Cathedral (see fig. 15-26), and the alternating bays typical of Romanesque naves such as that at Speyer Cathedral (see fig. 15-32) have been eliminated.

At Chartres rational engineering went hand in hand with carefully calculated mystical numeric symbolism seen also in Cistercian architecture (Chapter 15). The Virgin, for example, was closely related to the number 7: she was associated with the Seven Liberal Arts, and 7 is composed of 3 (the Holy Trinity and the Divine) and 4 (the material world of four seasons, four directions, the winds, as well as the four rivers of paradise). The Virgin is represented in the **voussoirs** surrounding her image on the Royal Portal and among the seven gifts of the Holy Spirit that surround her in stained glass. The imagery at Chartres, which stresses themes involving Mary and the Old Testament precursors of Christianity, encompasses the entire panorama of Scholastic thought.

Chartres is unique among French Gothic buildings in that most of its stained-glass windows have survived. The light from these windows changes constantly as sunlight varies with the time of day, the seasons, and the movement of clouds. Stained glass is an expensive and difficult medium, but its effect on the senses and emotions makes the effort worthwhile (see "Stained-Glass Windows," page 559). Chartres was famous for its glassmaking workshops, which by 1260 had installed about 22,000 square feet of stained glass in 186 windows. Most of the glass dates between about 1210 and 1250, but a few earlier panels, from around 1150 to 1170, were pre-

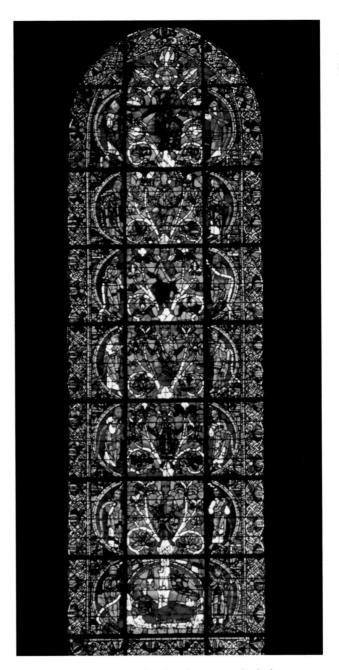

16-14. *Tree of Jesse*, west facade, Chartres Cathedral. c. 1150–70. Stained glass

served in the west facade. The iconography of the windows echoes that of the portal sculpture.

Among the twelfth-century works in the north aisle wall of the cathedral is the *Tree of Jesse* window (fig. 16-14). The monumental treatment of this Marian subject (relating to Mary), so different from its depiction in an early-twelfth-century Cistercian manuscript (see fig. 15-22), was apparently inspired by a similar window at Saint-Denis. The body of Jesse lies at the base of the tree, and in the branches above him appear, first, four kings of Judaea, Christ's royal ancestors, then the Virgin Mary, and finally Christ himself. Seven doves, the seven gifts of the Holy Spirit, encircle Christ, and fourteen prophets stand in the half-moons flanking the tree.

The glass in the *Tree of Jesse* is set within a rectilinear iron armature (visible as silhouetted black lines). In a

1200 _____

ELEMENTS OF Most large Gothic churches in ARCHITECTURE western Europe were built on the Latin-cross plan, with a The Gothic Church projecting transept marking the transition from nave to

sanctuary. The main entrance portal was generally on the west, the choir and apse on the east. A narthex led to the nave and side aisles. An ambulatory with radiating chapels circled the apse and facilitated the movement of worshipers through the church. Above the nave were a triforium passageway and windowed clerestory. Narthex, side aisles, ambulatory, and nave usually had rib vaults in the Gothic period. Church walls were decorated inside and out with arcades of round and pointed arches,

engaged columns and colonnettes, and horizontal moldings called stringcourses. The roof was supported by a wooden framework. A spire or crossing tower above the junction of the transept and nave was usually planned, though often never finished. The apsidal chapels ringing the apse were often visible on the exterior, as were the buttress piers and flying buttresses that countered the outward thrusts of the interior vaults. Portal facades were customarily marked by high, flanking towers or gabled porches ornamented with pinnacles and finials. Architectural sculpture covered each portal's tympanum, archivolts, and jambs. A magnificent stained-glass rose window typically formed the centerpiece of the portal facades. Stained glass filled the tall, pointed lancets.

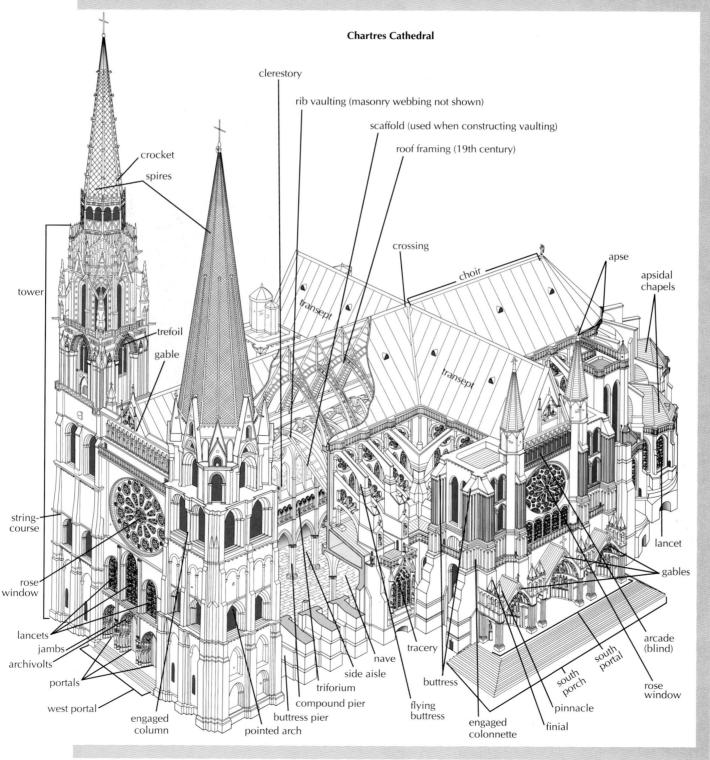

TECHNIQUE

WINDOWS

STAINED-GLASS technical experimentation to achieve new colors and greater purity and transparency. The colors of Romanesque glass-mainly reds and

has been known since the days of ancient Egypt. It involves the addition of metallic oxides—cobalt for blue, manganese for red and purple—to a basic formula of sand and ash or lime that is fused at high temperature. Such "stained" glass was used on a small scale in church windows during the Early Christian period and in Carolingian and Ottonian churches. Colored glass sometimes adorned Romanesque churches, but the art form reached a height of sophistication and popularity in the cathedrals and churches of the Gothic era.

The basic technique for making colored glass

Making a stained-glass image was a complex and costly process. A designer first drew a composition on a wood panel the same size as the opening of the window to be filled, noting the colors of each of the elements in it. Glass blowers produced sheets of colored glass, and then artisans cut individual pieces from these large sheets and laid them out on the wood template. Painters then added details with enamel emulsion, and the glass was reheated to fuse the enamel. Finally, the pieces were assembled and joined together with narrow lead strips, called cames. The assembled pieces were set into iron frames that had been preformed to fit the window opening.

The demand for stained-glass windows stimulated

blues with touches of dark green, brown, and orange yellow-were so deep that it was nearly opaque. The Cistercians adorned their churches with grisaille windows, painting foliage and crosses onto a gray glass. Early uncolored glass was full of impurities, but Gothic artisans developed a clearer material onto which they could draw elaborate narrative scenes. Many new colors were discovered accidentally, such as a sunny yellow produced by the addition of silver oxide. Flashing, in which a layer of one color was fused to a layer of another color, produced an almost infinite range of colors. Blue and yellow, for example, could be combined to make green. In the same way, clear glass could be fused to layers of colored glass in varying thicknesses to produce a range of hues from light to dark. The deep colors of early Gothic stained-glass windows give them a saturated and mysterious brilliance. The richness of some of these colors, particularly blue, has never been surpassed. Pale colors and large areas of grisaille glass became increasingly popular from the midthirteenth century on, making the windows of later Gothic churches bright and clear by comparison.

16-15. Charlemagne Window, ambulatory apse, Chartres Cathedral. c. 1210-36. Stained glass

This window depicts scenes from the Song of Roland, an epic based on events during the reign of Charlemagne; it acquired its final form sometime around 1100. The hero, Roland, was killed fighting Muslims in the Pyrenees Mountains, which lie between France and Spain. Roland is portrayed as an ideal feudal knight, devoted to his lord, his fellow knights, and his faith.

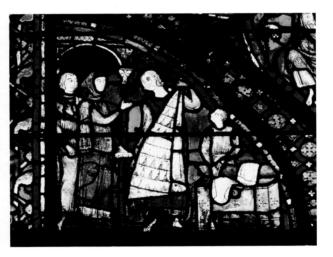

16-16. Furrier's Shop, detail of Charlemagne Window, Chartres Cathedral

This close-up shows how stained-glass artisans handled form and color. The figures have been reduced to simple shapes and their gestures kept broad to convey meaning from afar. The glass surfaces, however, are covered with fine lines that are invisible from the cathedral's floor. Forms stand out against a lustrous blue ground accented with red. Glowing clear glass serves as white, and violet-pink, green, and yellow complete the palette.

later work, the so-called Charlemagne Window, the glass is set within an interlocking framework of medallions so that colored glass and cames, the lead strips that join the pieces of glass, work together to make the window imagery easier to understand (fig. 16-15). The medallions contain narrative scenes, each surrounded by a field of stylized flowers, leaves, and geometric patterns. At the base of the Charlemagne Window is a scene of a customer buying a cloak in a furrier's shop (fig. 16-16). The furrier

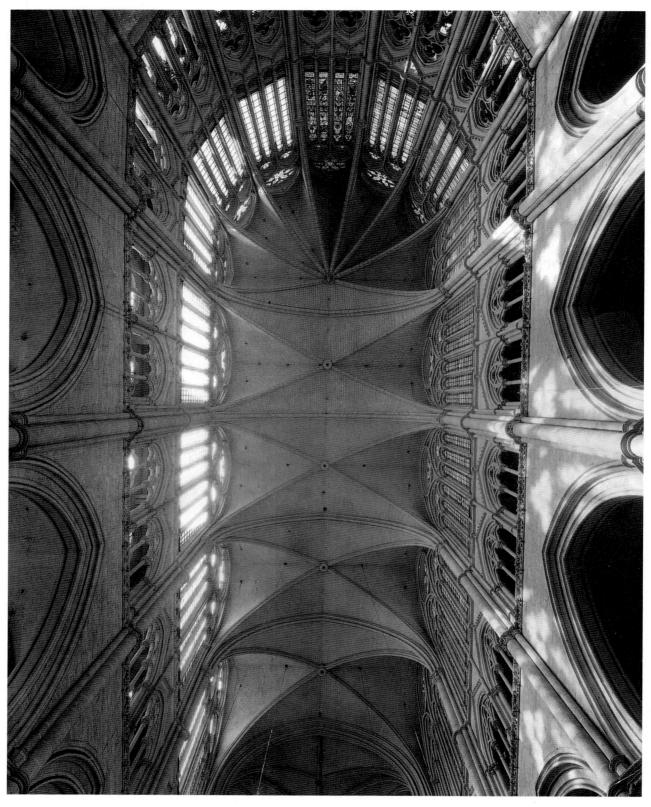

16-17. Vaults, sanctuary, Cathedral of Nôtre-Dame at Amiens, Île-de-France, France. 1270-88

displays a large cloak made of small pelts (perhaps rabbit or squirrel) taken from the chest at the right. The potential buyer has removed one glove and reaches out, perhaps to feel the fur, perhaps to bargain. This scene is one of several at Chartres showing various tradespeople at work. Others include bakers, wheelwrights, weavers, goldsmiths, and carpenters. Similar scenes appear in other Gothic churches. They were once thought to have reflected pious donations by local guilds, but recent scholarship suggests that this was not so. The merchants and artisans of Chartres had apparently not yet been permitted to form guilds in the early thirteenth century, and they contributed to the new cathedral only through the taxes assessed on them by Church officials. The vignettes of tradespeople might thus be a form of Church propaganda, images of an ideal world in which the Church was the center of society and the focus of everyone's work.

Amiens and Reims Cathedrals. As it continued to evolve, Gothic taste favored increasingly sculptural, ornate facades and intricate window tracery. Builders across northern France refined the geometry of church plans and elevations and found ways to engineer ever stronger masonry skeletons with ever larger expanses of stained glass.

The Cathedral of Nôtre-Dame at Amiens, an important trading and textile-manufacturing center north of Paris, burned in 1218, and as at Chartres, church officials devoted their resources to making its replacement as splendid as possible. Their funding came mainly from the cathedral's rural estates and from important trade fairs. Construction began in 1220 and continued for some seventy years. The result is the supreme architectural statement of elegant Gothic verticality. The nave, only 49 feet wide, soars upward 136½ feet. Not only is the nave exceptionally tall, its narrow proportions create an exaggerated sense of height (fig. 16-17).

A labyrinth, now destroyed, recorded the names of the master builders at Amiens on the inlaid floor of the nave (see "Master Builders," page 563). This practice honored the mythical Greek hero Daedalus, master builder of the first labyrinth at the palace of King Minos in Crete. The labyrinth identifies Robert de Luzarches (d. 1236) as the builder who established the overall design for the Amiens Cathedral. He was succeeded by Thomas de Cormont, who was followed by his son Renaud. The lower portions of the church were probably substantially complete by around 1240.

The plan of the cathedral of Amiens derived from that of Chartres, with some simple but critical adjustments (fig. 16-18). The narthex was eliminated, while the transept and sanctuary were expanded and brought forward toward the entrance. The result is a plan that is balanced east and west around the crossing. The elevation of the nave is similarly balanced and compact (fig. 16-19). Tracery and **colonnettes** (small columns) unite the triforium and the clerestory, which makes up nearly half the height of the nave. Evenly spaced piers with engaged half columns topped by foliage capitals support the arcades. An ornate floral stringcourse below the triforium level

16-18. Robert de Luzarches, Thomas de Cormont, and Renaud de Cormont. Plan of Amiens Cathedral. 1220–88

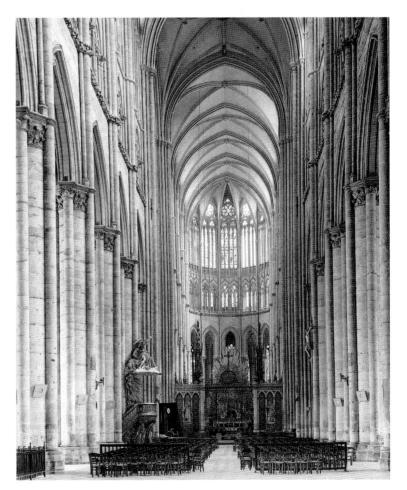

16-19. Nave, Amiens Cathedral. 1220-88

and a simpler one below the clerestory both run uninterrupted across the otherwise plain wall surfaces and colonnettes, providing a horizontal counterpoint. The vaulting and the light-filled choir date to the second phase of construction, directed by Thomas de Cormont.

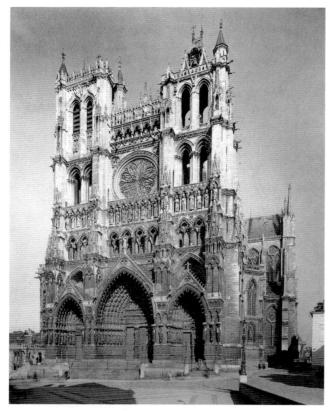

16-20. West facade, Amiens Cathedral. Begun c. 1220

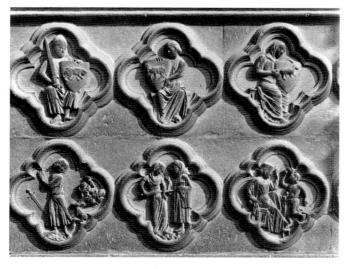

16-21. Virtues and Vices, central portal, west entrance, Amiens Cathedral. c. 1220–35

Quatrefoils appeared here as a framing device for the first time and soon became one of the most widespread decorative motifs in Gothic art. In the top row are the Virtues, personified as seated figures. Each holds a shield with an animal on it that symbolizes a particular virtue: the lion for Courage, the cow for Patience, and the lamb for Meekness. Below the Virtues are figures that represent the Vices that correspond to each of the Virtues: a knight dropping his sword and turning to run when a rabbit pops up (Cowardice); a woman on the verge of plunging a sword through a man (Discord); and a woman delivering a swift kick to her servant (Impatience or Injustice).

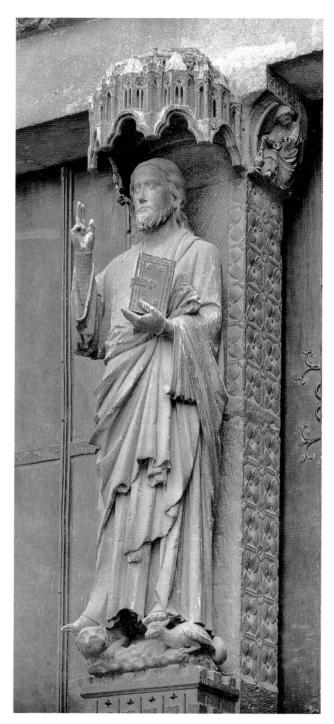

16-22. Beau Dieu, trumeau, central portal, west facade, Amiens Cathedral. c. 1220–35

The choir is illuminated by large windows subdivided by tracery into slender lancets crowned by **trefoils** (three-lobed designs) and circular windows.

The west front of Amiens reflects several stages of construction (fig. 16-20). The lower levels, designed by Robert de Luzarches, are the earliest, dating to between 1220 and about 1240, but building continued over the centuries. The towers date to the fourteenth and fifteenth centuries, and the tracery in the rose window is also late. Consequently, the facade has a somewhat disjointed appearance, and all its elements do not correspond to the

panum and archivolts of the central portal, the history of humanity ends in the Last Judgment. The left portal sculpture illustrates the life of Saint Firmin, an early bishop of Amiens and the town's patron saint; and those on the right portal are dedicated to Mary and her coronation as Queen of Heaven.

nation as Queen of Heaven.

A sculpture of Christ as the *Beau Dieu* (noble, or beautiful, God), the kindly teacher-priest bestowing his blessing on the faithful (fig. 16-22), forms the **trumeau** of the central portal. This exceptionally fine sculpture may have been the work of the master of the Amiens workshop himself. The broad contours of the heavy drapery wrapped around Christ's right hip and bunched over his left arm lead the eye up to the gospel-book he holds and past it to his face, which is that of a young king. He stands on a lion and a dragonlike creature called a basilisk, which symbolizes his kingship and his triumph over evil and death. With its clear, solid forms, elegantly cascading robes, and interplay of close observation with idealization, the *Beau Dieu* embodies the Amiens style and the

In the Church hierarchy, the bishop of Amiens was subordinate to the archbishop of Reims. Politically the archbishop also had great power, for the French kings

interior spaces behind them. Design begins to become detached from structural logic, an indication of the loosening of the traditional ties between architectural planning and the actual building process. This trend led to the elevation of architectural design—as opposed to structural engineering and construction—to a high status by the fifteenth century.

The sculptural program of the west portals of Amiens presents an almost overwhelming array of images in ascending registers. The sculpture was produced in a large workshop in only fifteen or so years (1220–c. 1235), making it stylistically more uniform than that of the cathedrals of Chartres or Reims. In the mid-thirteenth century Amiens-trained sculptors carried their style to other parts of Europe, especially Castile (Spain) and Italy.

Worshipers approaching the main entrance encountered figures of apostles and saints lined up along the door jambs and projecting buttresses, as were seen at Chartres, but something new captures the attention. On the base below the figures, at eye level, are **quatrefoils** (four-lobed medallions) containing relief sculpture illustrating Good and Evil in daily life (fig. 16-21), the virtues of manual labor, the lives of the saints, and biblical stories involving the figures above. High above, in the tym-

MASTER
BUILDERS
"At the beginning of the fifth year [of the rebuilding of England's

Canterbury Cathedral], suddenly by the collapse of beams beneath his feet, [master William of Sens] fell to the ground amid a shower of falling masonry and timber from . . . fifty feet or more. . . . On the master craftsman alone fell the wrath of God—or the machinations of the Devil" (Brother Gervase, Canterbury, twelfth century, cited in Andrews, page 20).

Master masons, "masters of the works," oversaw all aspects of church construction in the Middle Ages, from design and structural engineering to decoration. The job presented a formidable logistical challenge, especially at the great cathedral sites. The master mason at Chartres coordinated the work of roughly 400 people who were scattered, with their equipment and supplies, at many locations, from distant stone quarries to high scaffolding. This workforce set in place some 200 blocks a day. Master masons gained in prestige during the thirteenth century as they increasingly differentiated themselves from the laborers working under them. In the words of Nicolas de Biard, a thirteenth-century Dominican preacher,

"The master masons, holding measuring rod and gloves in their hands, say to others: 'Cut here,' and they do not work; nevertheless they receive the greater fees" (cited in Frisch, page 55). By the standards of their time they were well read; they traveled widely. They knew both aristocrats and high church officials, and they earned as much as knights. From the thirteenth century on, in what was then an exceptional honor, masters were buried, along with patrons and bishops, in the cathedrals they built. The tomb sculpture of a master mason named Hugues Libergier in the Reims Cathedral portrays him, attended by angels, as a well-dressed figure with his tools and a model of the cathedral. The names of more than 3,000 master masons are known today. In some cases their names were prominently inscribed in the labyrinths on cathedral floors.

Gothic spirit.

The illustration here shows a master—right-angle and compass in hand—conferring with his royal patron while workers carve a capital, hoist stones with a winch, cut a block, level a course of masonry using a plumb, and lay dressed stones in place. Masters and their crews moved constantly from site to site, and several masters contributed to a single

building. A master's training was rigorous but not standardized, so close study of subtle differences in construction techniques can reveal the hand of specific individuals. Fewer than 100 master builders are estimated to have been responsible for all the major architectural projects in the Îlede-France during the century-long building boom there, some of them working on parts of as many as forty churches. Funding shortages and technical delays, such as the need to let mortar harden for three to six months, made construction sporadic.

Page with King Henry III Supervising the Works, copy of an illustration from a 13th-century English manuscript; original in The British Library, London

OF PARIS

NÔTRE-DAME Think of Gothic architecture. Chances are, the

image that springs to mind is the Cathedral of Nôtre-Dame of Paris. Just as this structure rivals the Eiffel Tower as the symbol of Paris itself, Nôtre-Dame is the vision of what a Gothic cathedral should look like. In fact, the Nôtre-Dame we see today began as an early Gothic building that bridged the period between Abbot Suger's rebuilding of the Abbey Church of Saint-Denis and the thirteenth-century Chartres Cathedral. On this site—a small island in the Seine River called the Île-de-la-Cité, where the Parisii people who gave the city its name first settled -Pope Alexander III set the building cornerstone in 1163. Construction was far enough along for the altar to be consecrated twenty years later.

The nave dates to 1180-1200, the west facade to 1210-1215. By this time, massive walls and buttresses and six-part vaults, adopted from Norman Romanesque architecture, must have seemed very old-fashioned. Still, in its time, with its nave rising 226 feet high, pierced by lancets 50 feet tall, it was the tallest structure ever built in the West. (The 290-foot spire over the crossing is the work of the nineteenth-century architect Eugène-Emmanuel Violletle-Duc.) After 1225 new masters modernized the building by reworking the clerestory into the large double lancet and rose windows we see today. Nôtre-Dame had the first true flying buttresses, although those seen at the right of the photograph, rising dramatically to support the high vault of the choir, result from remodeling.

Following centuries of use as a Christian church, French Revolutionaries defamed monuments associated with deposed French nobility, transforming the cathedral temporarily into a secular Temple of Reason from 1793 to 1795. Soon thereafter Nôtre-Dame returned to Christian use and Napoleon crowned himself emperor at its altar in 1804. In our century the liberation of Paris from the Nazis in August 1944 was celebrated in Nôtre-Dame. Today, boats filled with tourists circle the Île-de-la Cité and drift under the Pont Neuf and other bridges, past the flower market, secluded squares, and treelined courtyards, to approach the beautiful cathedral. Nôtre-Dame so resonates with life and history that it has become more than a house of worship and work of art; it is part of the shared culture of humankind.

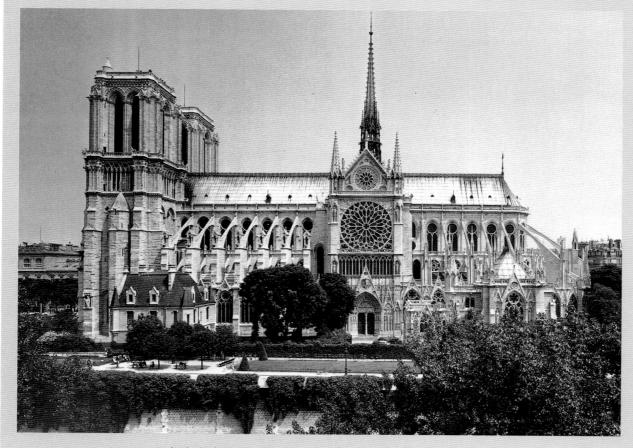

Cathedral of Nôtre-Dame, Paris. Begun 1163. View from the south

were crowned in his cathedral, though they were buried at Saint-Denis. Reims, like Saint-Denis, had been a cultural and educational center since Carolingian times. As at Chartres and Amiens, the community at Reims, led by the clerics responsible for the building, began to erect a new cathedral after a fire destroyed an earlier church. And as at Chartres, the expense of the project sparked

local opposition, with revolts in the 1230s twice driving the archbishop and canons into exile. Construction of the cathedrals of Chartres, Amiens, and Reims overlapped. and the artisans at each site borrowed from and influenced each other.

Many believe the Cathedral of Nôtre-Dame at Reims to be the most joyously beautiful of all Gothic cathedrals.

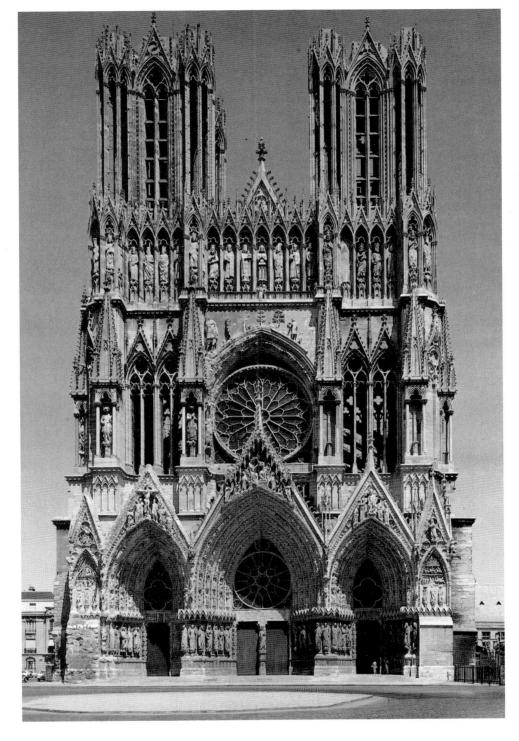

16-23. West facade, Cathedral of Nôtre-Dame at Reims, Île-de-France, France. 1255-60: towers mid-15th century The cathedral was restored in the sixteenth century and again in the nineteenth and twentieth centuries. During World War I it withstood bombardment by some 3,000 shells, eloquent testimony to the skills of its builders. It was recently cleaned.

surpassing even Chartres. Its cornerstone was laid in 1211 and work continued on it throughout the century. Its master builders, their names recorded in the cathedral labyrinth, were Jean d'Orbais, Jean le Loup, Gaucher de Reims, and Bernard de Soissons.

The magnificent west facade at Reims was built from 1255 through 1260 (fig. 16-23). Its massive gabled portals project forward, rising higher than those at Amiens. Their soaring peaks, the center one reaching to the center of the rose window, help to unify the facade. Large windows fill the portal tympana, displacing the sculpture usually found there. The deep porches are encrusted with sculpture that reflects changes in plan, iconography, and sculpture workshops. In a departure from tradition, Mar-

ian rather than Christ-centered imagery prevails in the central portal, a reflection of the growing popularity of Mary's cult. The enormous rose window, the focal point of the facade, fills the entire clerestory level. The towers were later additions, as was the row of carved figures that runs from the base of one tower to the other above the rose window. This "gallery of kings" is the only strictly horizontal element of the facade. Its subject matter is appropriate for a coronation church.

Different workshops and individuals worked at Reims over a period of several decades. Further complicating matters, a number of sculpture have been moved from their original locations, creating sometimes abrupt stylistic shifts. A group of four figures on the right jamb of

16-24. Annunciation
(left pair: Mary
c. 1245, angel
c. 1255) and
Visitation (right
pair: c. 1230),
right side,
central portal,
west facade,
Reims Cathedral

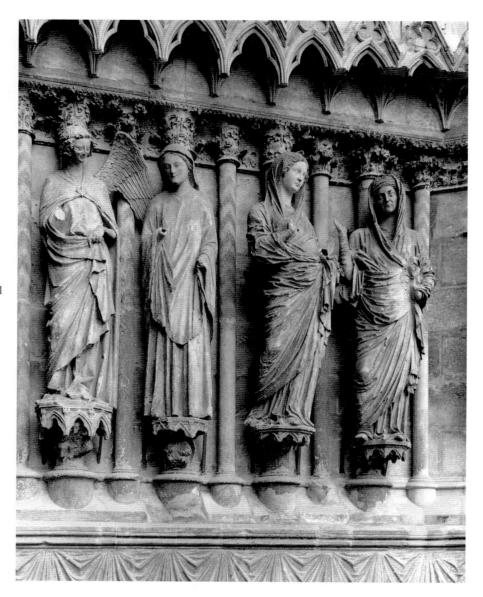

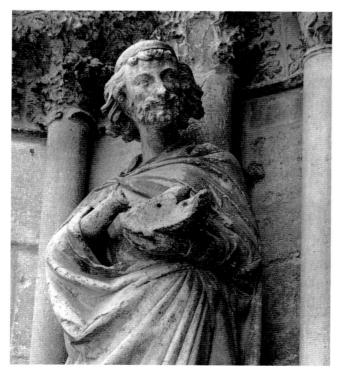

the central portal of the western front illustrates some of the Reims styles (fig. 16-24). The pair on the right is the work of the "Classical Shop," which was active beginning about 1230–1235, during the early years of construction at Reims. The subject of the pair is the Visitation, in which Mary (left), pregnant with Jesus, visits her older cousin, Elizabeth (right), who is pregnant with John the Baptist. The sculptors drew on classical sources, to which they had perhaps been exposed indirectly through earlier Mosan metalwork (see fig. 16-56) or directly in the form of local examples of ancient works (Reims had been an

16-25. Saint Joseph, left side, central portal, west facade, Reims Cathedral. c. 1255

On the column behind Joseph's head can be seen a "crescent moon" and four lines. These masons' marks, called setting marks, were used to position a piece of sculpture during installation. A crescent mark indicates the left side of the central doorway, and four lines indicate the fourth in a series. The work site for such an enormous project would have been filled with dressed and undressed stone blocks, sculptors carving slabs in various stages of completion, and work crews hauling and hoisting the finished pieces into place.

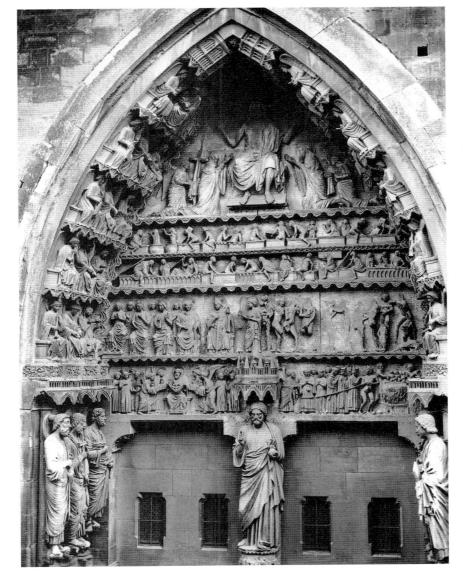

16-26. Last Judgment (tympanum), Christ (trumeau), Apostles (jambs), portal, north transept, Reims Cathedral. c. 1230

important Roman center). The heavy figures have the same solidity seen in Roman portrayals of noblewomen, and Mary's full face, gently waving hair, and heavy mantle recall imperial portrait statuary. The contrast between the features of the young Mary and the older Elizabeth is also reminiscent of the contrast between two Flavian portrait heads, one of a young woman and the other of a middle-aged woman (see figs. 6-43 and 6-44). The Reims sculptors used deftly modeled drapery not only to provide volumetric substance that stresses the theme of pregnancy but also to create a stance in which a weight shift with one bent knee allows the figures to seem to turn toward each other. The new freedom, movement, and sense of relationship implied in the sculpture inspired later Gothic artists toward ever greater realism.

The pair on the left of figure 16-24 illustrates the Annunciation, in which the archangel Gabriel (left) announces to Mary (right) that she will bear Jesus. The Mary in this pair, quiet and graceful, with a slight body, restrained gestures, and refined features, contrasts markedly with the bold tangibility of the Visitation Mary to the right. The drapery style and certain other details resemble those of Amiens, suggesting that those who made this

pair—and much of the sculpture of the west entrance as well—may also have worked at Amiens.

The figure of the angel Gabriel here is the distinctive work of a sculptor known today as the Saint Joseph Master or the Master of the Smiling Angels, whose work began to appear in the mid-thirteenth century. This artist created tall, gracefully swaying figures that suggest the fashionable refinement associated with the Parisian court in the 1250s (see fig. 16-36). The innovative facial features of Gabriel-and of Saint Joseph, on the opposite side of the doorway (fig. 16-25)—are typical of the Saint Joseph Master. A small, almost triangular head with a broad brow and pointed chin has short, wavy hair; long, puffy, almond-shaped eyes under arching brows; a well-shaped nose; and thin lips curving into a slight smile. Voluminous drapery arranged in elegant folds adds to the impression of aristocratic grace. These engaging figures were imitated from Paris to Prague, and their aristocratic refinement became a guiding force in later Gothic sculpture and painting.

The north transept portal sculpture show more variety. A figure of Christ stands on the trumeau with his apostles on the jambs beside him (fig. 16-26). In the

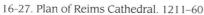

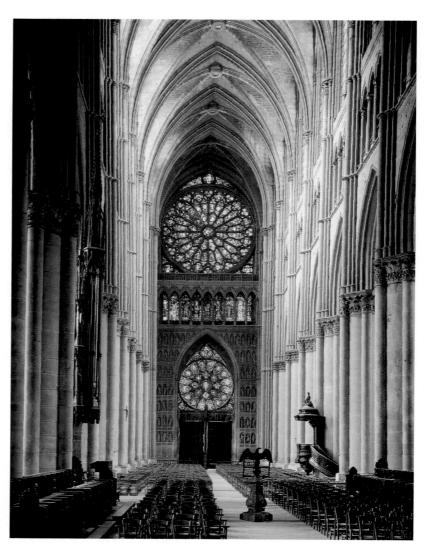

16-28. Nave, Reims Cathedral. 1211-60

tympanum, he appears again as judge in the Last Judgment. How different is this depiction of the Last Judgment from the Romanesque sculpture of Autun (see fig. 15-12). A hierarchy of scale still prevails, but Christ now seems less remote, less isolated from the figures around him. His bare, naturalistically rendered limbs emphasize his three-dimensional, physical presence. His mother and Saint John, as intercessors kneeling at his throne, indicate that he is an approachable, just judge. Humans, angels, and demons at Autun form an interlace of terror, but here at Reims they move in horizontal registers. Deep carving creates the impression of figures acting in limited but real space. Most of the figures at Autun are shown in profile view; those at Reims are shown from a variety of viewpoints, including some from the back, seated on the sarcophagi from which they arise to face judgment.

The architectural plan of Reims (fig. 16-27), like that of Amiens, was adapted from Chartres. The nave is longer in proportion to the choir, so the building lacks the perfect balance of Amiens. The three-part elevation and ribbed vault are familiar, too (fig. 16-28). The carvings on the capitals in the nave are notable for their variety, nat-

uralism, and quality. Unlike the idealized foliage of Amiens, the Reims carvings depict recognizable plants and figures. The remarkable sculpture and stained glass of the west wall complement the clerestory and choir. A great rose window in the clerestory, a row of lancets at the triforium level, and windows over the portals replace the stone of wall and tympana. Visually the wall "dissolves" in colored light. This great expanse of glass was made possible by bar tracery, a technique perfected at Reims, in which thin stone strips, called mullions, form a lacy matrix for the glass, replacing the older practice in which glass was inserted directly into window openings. Reims's wall of glass is anchored visually by a masonry screen around the doorway. Here ranks of carved Old Testament prophets and ancestors serve as moral guides for the newly crowned monarchs who faced them after coronation ceremonies.

The Sainte-Chapelle in Paris. In 1243 construction began on a new palace chapel to house Louis IX's prized collection of relics from Christ's Passion. The Sainte-Chapelle was finished in 1248, and soon thereafter Louis

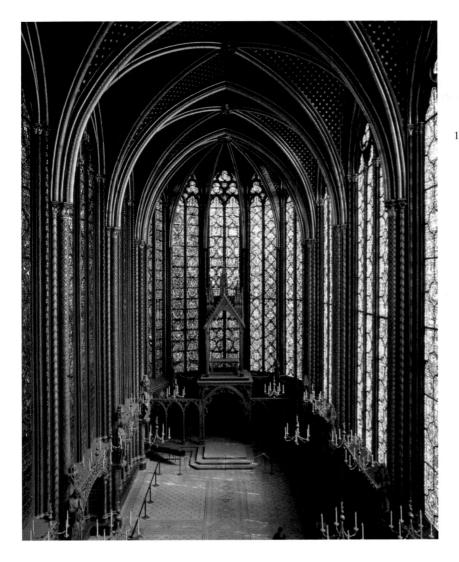

16-29. Interior, upper chapel, the Sainte-Chapelle, Paris. 1243-48 Louis IX avidly collected relics of the Passion, some of which became available in the aftermath of the Crusaders' sack of Constantinople. Those that Louis acquired were supposedly the crown of thorns that had been placed on Jesus' head before the Crucifixion, a bit of the metal lance tip that pierced his side, the vinegar-soaked sponge offered to wet his lips, a nail used in the Crucifixion, and a fragment of the True Cross. The king is depicted in the Sainte-Chapelle's stained glass walking out barefoot to meet his treasures when they arrived in Paris.

departed for Egypt on the Seventh Crusade. This exquisite structure epitomizes a new Gothic style known as Rayonnant ("radiant" or "radiating" in French) because of its radiating bar tracery, like that at Reims, or Court style because of its association with Paris and the royal court. The hallmarks of the style include daring engineering, the proliferation of bar tracery, exquisite sculptural and painted detailing, and vast expanses of stained glass.

Originally part of the king's administrative complex, the Sainte-Chapelle is located in the center of Paris. Intended to house precious relics, it resembles a giant reliquary itself, one made of stone and glass instead of gold and gems. It was built in two stories, with a ground-level chapel accessible from a courtyard and a private upper chapel entered from the royal residence. The ground-level chapel has narrow side aisles, but the upper level is a single room with a western porch and a rounded east wall. Climbing up the narrow spiral stairs from the lower to the upper level is like emerging into a kaleidoscopic jewel box (fig. 16-29). The ratio of glass to stone is higher here than in any other Gothic structure, for the walls have been reduced to clusters of slender painted colonnettes framing

tall windows filled with brilliant color. Bar tracery in the windows is echoed in the blind arcading and tracery of the dado, the decoration on the lower walls at floor level. The dado's surfaces are richly patterned in red, blue, and gilt so that stone and glass seem to merge in the multicolored light. Painted statues of the Twelve Apostles stand between window sections, linking the dado and the stained glass. The windows contain narrative and symbolic scenes. Those in the curve of the sanctuary behind the altar and relics, for example, illustrate the Nativity and Passion of Christ, the Tree of Jesse, and the life of Saint John the Baptist. The story of Louis's acquisition of his relics is told in one of the bays, and the Last Judgment appeared in the original rose window on the west.

Later Gothic Architecture. Beginning in the late thirteenth century France began to suffer from overpopulation and economic decline, followed in the fourteenth century by the devastation of the Hundred Years' War and the plague (see "The Black Death," page 607). Large-scale construction gradually ceased, ending the great age of cathedral building. The Gothic style continued to

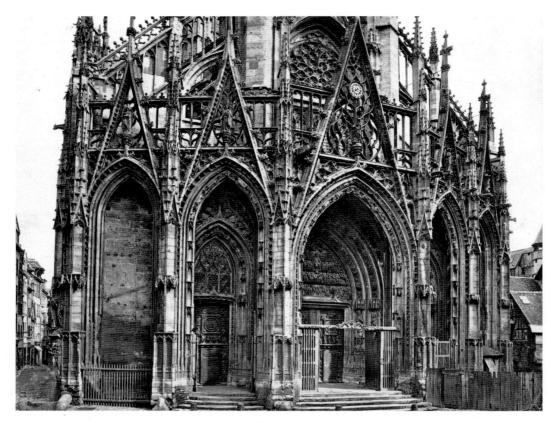

16-30. West facade, Church of Saint-Maclou, Rouen, Normandy, France. 1436–1521

develop, however, in smaller churches, municipal and commercial buildings, and private residences. Many of these later buildings were covered with elaborate decoration in the new Flamboyant ("flaming" in French) style, named for the repeated flamelike patterns of its tracery. Flamboyant may have reflected an English architectural style known as Decorated (see fig. 16-42). New window tracery was added to many earlier churches in this period, as at Amiens (see fig. 16-20), and a Flamboyant north spire, built between 1507 and 1513, was even added to the west facade of Chartres (see fig. 16-7).

In the new style, decoration sometimes seems divorced from structure. Load-bearing walls and buttresses often have stone overlays, and traceried pinnacles, gables, and **S**-curve moldings combined with a profusion of geometric and natural ornament to dizzying effect. According to one architectural historian, the style reflects "an almost pathological dread of clarity. Ambiguity is endlessly pursued, and whereas all the elements were once integrated logically and lucidly, they are now dissolved in the shimmering air" (James, page 137).

The facade of the Church of Saint-Maclou in Rouen, begun in 1436, is an outstanding example of the new style (fig. 16-30). The projecting porch bends at the sides to enfold the facade of the church, disguising it behind a screen of openwork tracery. Sunlight on the flame-shaped openings and **crockets**—the small knoblike ornaments in the form of plants that line the steep gables and slender buttresses—casts flickering, changing shadows across the busy, intentionally complex surface.

16-31. Main facade, house of Jacques Coeur, Bourges, France. 1443–51

The original owner of this house, Jacques Coeur, nicknamed the King of Bourges, was a wealthy silversmith and merchant who served as treasurer to King Charles VIII (exiled to Bourges after being driven from Paris by the English). Coeur was falsely accused of poisoning the king's mistress and jailed two years after the house was finished. Upon his release, he "took the cross" and became a Crusader. He died defending Constantinople from Turkish forces.

Secular architecture and arts flourished. The house of merchant Jacques Coeur in Bourges, in central France, built at great expense between 1443 and 1451, reflects the popularity of the Flamboyant style for secular architecture (fig. 16-31). The main facade hides a rambling structure with many rooms of varying sizes on different levels—all

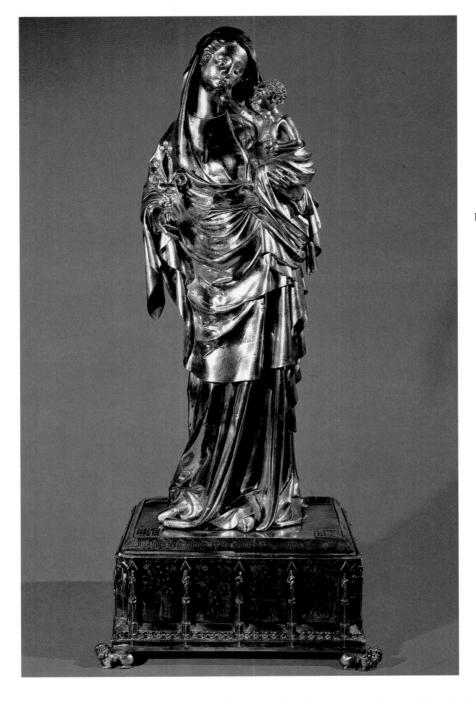

16-32. Virgin and Child, from the Abbey Church of Saint-Denis. c. 1339. Silver gilt and enamel, height 27¹/₈" (69 cm). Musée du Louvre, Paris

arranged around an open courtyard. The highest roof section covers a private chapel, and the octagonal tower, with its Flamboyant filigree crown, lights a staircase. Flamboyant detailing—the large arched window over the main entrance, the cornice balustrades and window panels, and the gable crockets—punctuates the front of the house. Among the carved decorations are puns on the patron's surname, Coeur ("heart" in French), and half-length portraits of Jacques Coeur and his wife lean from niches in the main facade to watch approaching visitors.

Independent Sculpture

Gothic sculptors found a lucrative new outlet for their work in the growing demand among wealthy patrons for small religious statues intended for homes and personal chapels or as donations to favorite churches. Busy urban workshops produced quantities of standarized statuettes and reliefs in wood, ivory, and precious metals, often decorated with enamel and gemstones. Much of this art was related to the cult of the Virgin Mary.

An excellent example of such works, among the treasures of the Abbey Church of Saint-Denis, is a silvergilt image, slightly over 2 feet tall, of a standing Virgin and Child (fig. 16-32). An inscription on the base bears the date 1339 and the name of Queen Jeanne d'Evreux, wife of Charles IV of France (ruled 1322–1328). The Virgin holds her son in her left arm, her weight on her left leg, creating the graceful S-curve pose that was a stylistic signature of the period. Fluid drapery with the consistency of heavy silk covers her body. She holds a scepter topped with a large enameled and jeweled fleur-de-lis,

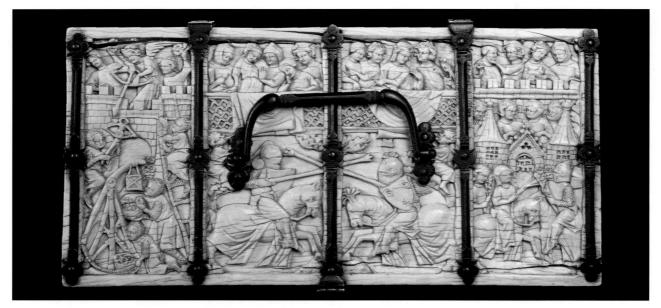

16-33. Lid of a jewelry casket, called *Attack on the Castle of Love*, from Paris. c. 1330–50. Ivory casket with iron mounts, panel $4^{1/2}$ x $9^{11/16}$ " (11.5 x 24.6 cm). Walters Art Gallery, Baltimore

the heraldic symbol of French royalty, and she originally had a crown on her head. The scepter served as a reliquary for hairs said to be from Mary's head. Despite this figure's clear association with royalty, Mary's simple clothing and sweet, youthful face anticipate a type of imagery that emerged in the later fourteenth and fifteenth centuries in northern France, Flanders, and Germany: the ideally beautiful mother. The Christ Child, clutching an apple in one hand and reaching with the other to touch his mother's lips, is more babylike in his proportions and gestures than in earlier depictions. Still, prophets and scenes of Christ's Passion in enamel cover the statue's simple rectangular base, a reminder of the suffering to come.

In addition to devotional or moralizing subjects, there was also a strong market for objects with secular subjects taken from popular literature. Themes drawn from the realm of courtly love (see "Courtly Love," page 549) decorated women's jewelry boxes, combs, and mirror cases. A casket for jewelry made in a Paris workshop around 1330–1350 provides a delightful example of such a work (fig. 16-33). Its ivory panels depict scenes of love, including vignettes from the King Arthur legend. The central sections of the lid shown here depict a tournament. Such mock battles, designed to keep knights fit for war, had become one of the chief royal and aristocratic entertainments of the day. In the scene on the lid, women of the court, accompanied by their hunting falcons, watch with great interest as two jousting knights, visors down and lances set, charge to the blare of trumpets played by young boys. In the scene on the left, ardent knights assault the Castle of Love, firing roses from crossbows and a catapult. Love, in the form of a winged boy, aids the women defenders, aiming a giant "Cupid's arrow" at the attackers. The action concludes in the scene on the right,

where the tournament's victor and his lady-love meet in a playful joust of their own.

Book Arts

France gained renown in the thirteenth and fourteenth centuries not only for its new architectural style but also for its book arts. These works ranged from practical manuals for artisans to elaborate devotional works illustrated with exquisite miniatures.

Lodge books were an important tool of the master mason and his workshop, or lodge. Compiled by heads of workshops, lodge books provided visual instruction and inspiration for apprentices and assistants. Since the drawings received hard use, few have survived. One of the most famous architect's collections is the early-thirteenth-century sketchbook of Villard de Honnecourt, a well-traveled master mason who recorded a variety of images and architectural techniques. A section labeled "help in drawing figures according to the lessons taught by the art of geometry" (fig. 16-34) illustrates the use of geometric shapes to form images and how to copy and enlarge images by superimposing geometric shapes over them as guides.

The production of high-quality manuscripts flourished in Paris during the reign of Louis IX, whose royal library was renowned. Queen Blanche of Castile, Louis's mother and granddaughter of Eleanor of Aquitaine, served as regent of France (1226–1234) until he came of age. She and the teenage king appear on the dedication page (fig. 16-35) of a Moralized Bible—one in which selected passages of the Old and New Testaments are paired to give an allegorical, or moralized, interpretation. The royal pair sit against a solid gold background under trilobed arches. Below them a scholar-monk dictates to

16-34. Villard de Honnecourt. Page from a sketchbook, with geometric figures and ornaments, from Paris. 1220–35. Ink on vellum, 9½ x 6" (23.5 x 15.2 cm). Bibliothèque Nationale, Paris

a scribe. The ornate thrones of Louis and his mother and the buildings arranged atop the arches suggest that the figures are inside a royal palace, and in fact it would not have been unusual for the queen to have housed scholar, scribe, and illuminator while they were executing her commission during her regency. Interestingly, only the slightly oversized heads of the queen and king preserve a sense of hierarchical scale. The scribe, in the lower right, is working on a page with a column of roundels for illustrations. This format of manuscript illustration—used on the pages that follow the Bible's dedication page—derives from stained-glass lancets, with their columns of images in medallions (see fig. 16-29). The illuminators also show their debt to stained glass in their use of glowing red and blue and reflective gold surfaces.

The *Psalter of Saint Louis* (the king was sainted in 1297) defines the Court style in manuscript illumination. The book, containing seventy-eight full-page illuminations, was created for Louis IX's private devotions sometime between 1253 and 1270. The illustrations fall at the

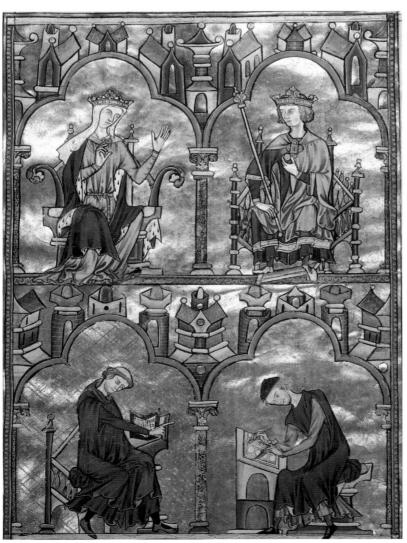

16-35. Page with Louis IX and Queen Blanche of Castile, Moralized Bible, from Paris. 1226-34. Ink, tempera, and gold leaf on vellum, 15 x 101/2" (38 x 26.6 cm). The Pierpont Morgan Library, New York M.240, f.8 Thin sheets of gold leaf were painstakingly attached to the vellum and then polished to a high sheen with a tool called a burnisher. Gold was applied to paintings before pigments.

back of the book, preceded by Psalms and other readings unrelated to them. Intricate scrolled borders and a background of Rayonnant architectural features modeled on the Sainte-Chapelle frame the narratives. Figures are rendered in an elongated, linear style. One page (fig. 16-36) illustrates two scenes from the Old Testament story of Abraham, Sarah, and the Three Strangers (Genesis 18). On the left, Abraham greets God, who has appeared to him as three strangers, and invites him to rest. On the right, he offers the men a meal that his wife, Sarah, standing in the doorway of their tent on the far right, has prepared. God says that Sarah will soon bear a child, and she laughs because she and Abraham are old. But God replies, "Is anything too marvelous for the Lord to do?" (18:14). She later gives birth to Isaac, whose name comes from the Hebrew word for "laughter." Christians in the Middle Ages viewed the three strangers in this story as symbols of the Trinity and believed that God's promise to Sarah was a precursor of the Annunciation to Mary.

The architectural background in this painting establishes a narrow stage space in which the story unfolds. Wavy clouds float within the arches under the gables. The imaginatively rendered oak tree establishes the location of the story and separates the two scenes. The gesture of the central haloed figure in the scene on the right and Sarah's presence in the doorway of the tent indicate that we are viewing the moment of divine promise. This new spatial sense, as well as the depiction of oak leaves and acorns, reflects a tentative move toward the representation of the natural world that will gain momentum in the following centuries.

Beginning in the late thirteenth century, private prayer books became popular among those who could afford them, more and more of whom were literate. Because such books contained special prayers to be recited at the eight canonical "hours" between morning and night, these books came to be called Books of Hours. The material in them was excerpted from a larger liturgical book called a breviary, which contained all the canonical offices (Psalms, readings, and prayers) used by priests in celebrating Mass. Books of Hours were most commonly devoted to the Virgin, but they could be personalized for particular patrons with prayers to other saints, a calendar of saints' feast days and other Church events, and perhaps other offices, such as that said for the dead. During the fourteenth century a richly decorated Book of Hours, like jewelry, would have been among a noble person's most important portable possessions.

A tiny, exquisite Book of Hours given by Charles IV to his queen, Jeanne d'Evreux, shortly after their marriage in 1325 is the work of an illuminator named Jean Pucelle (fig. 16-37). Instead of the intense colors used by earlier illuminators, Pucelle worked in a technique called **grisaille**—monochromatic painting in shades of gray with faint touches of color (see also "Stained-Glass Windows," page 559)—that emphasized his accomplished drawing. The book combines two narrative cycles. One, the Hours of the Virgin, juxtaposes scenes from the Infancy and Passion of Christ, a form known as the Joys and Sorrows of the Virgin. The other is a collection of scenes from the

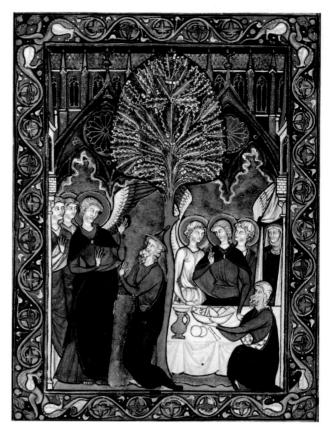

16-36. Page with *Abraham, Sarah, and the Three Strangers, Psalter of Saint Louis*, from Paris. 1253–70. Ink, tempera, and gold leaf on vellum, 5 x 3½" (13.6 x 8.7 cm).

Bibliothèque Nationale. Paris

The Court style had enormous influence throughout northern Europe, spread by illuminators who flocked to Paris from other regions. There they joined workshops affiliated with the Confrérie de Saint-Jean (Guild of Saint John), supervised by university officials who controlled the production and distribution of manuscripts.

life of Saint Louis (King Louis IX), whose new cult was understandably popular at court. In the pages shown here the "Joy" of the *Annunciation* on the right is paired with the "Sorrow" of the *Betrayal and Arrest of Christ* on the left. Queen Jeanne appears in the initial below the *Annunciation*, kneeling before a lectern and reading from her Book of Hours. This inclusion of the patron in prayer within a scene, a practice that continued in monumental painting and sculpture in the fifteenth century, conveyed the idea that the scenes were "visions" inspired by meditation rather than records of historical events. In this particular case, the young queen would presumably have identified with Mary's joy at Gabriel's message.

In the *Annunciation* Mary is shown receiving the archangel Gabriel in her Gothic style home as rejoicing angels look on from windows under the eaves. The group of romping children at the bottom of the page (known as the *bas-de-page* in French) at first glance seems to echo the joy of the angels. Scholars have determined, however, that the children are playing "froggy in the middle," a game in which one child was tagged by the others (a

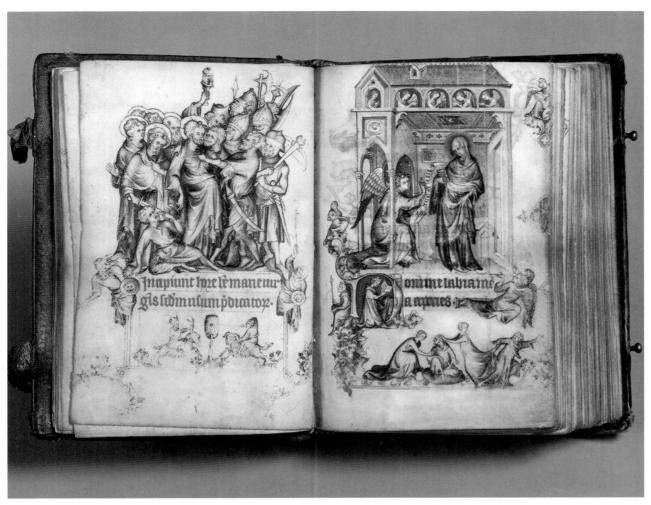

16-37. Jean Pucelle. Pages with *Betrayal and Arrest of Christ*, folio 15v. (left) and *Annunciation*, folio 16r. (right), *Petites Heures of Jeanne d'Evreux*, from Paris. c. 1325–28. Grisaille and color on vellum, each page 3½ x 2½ " (8.2 cm x 5.6 cm). The Metropolitan Museum of Art, New York

The Cloisters Collection, 1954 (54.1.2)

This book was precious to the queen, who mentioned it in her will; she named its illuminator, an unusual tribute.

symbolic reference to the Mocking of Christ). The game thus evokes a darker mood, foreshadowing Jesus' death even as his life is beginning. In the Betrayal scene on the left page, the disciple Judas Iscariot embraces Jesus, thus identifying him to the soldiers who have come to seize him and setting in motion the events that lead to the Crucifixion. Peter, on the left, realizing the danger, draws his sword to defend Jesus and slices off the ear of one of the soldiers. The *bas-de-page* on this side shows "knights" riding goats and jousting at a barrel stuck on a pole, a spoof of military training that is perhaps a comment on the valor of the soldiers assaulting Jesus.

Pucelle's work represents a sophisticated synthesis of French, English, and Italian painting traditions. From English illuminators he borrowed the merging of Christian narrative with allegory, the use of foliate borders filled with real and grotesque creatures (instead of the standard French vine scrolls), and his lively bas-de-page illustrations. His presentation of space, with figures placed within coherent architectural settings, apparently reflects his firsthand knowledge of developments in painting in Siena, Italy (for a slightly later example see

fig. 16-73). Pucelle also adapted to manuscript illumination the Parisian Court style in sculpture, with its softly modeled, voluminous draperies gathered around tall, elegantly curved figures with curly hair and broad foreheads. For instance, Jesus on the left page in figure 16-37 and Mary on the right stand in the swaying, S-curve pose typical of Court style works in other mediums, such as the Virgin and Child from Saint-Denis (see fig. 16-32). Similarly, the earnest face of the Annunciation archangel resembles that of the smiling Annunciation archangel at Reims (see fig. 16-24).

The thirteenth and fourteenth centuries saw the growing use of book margins for fresh and unusual images. Often drawn by illustrators who specialized in this kind of work, marginal imagery was a world of its own, interacting in unexpected ways with the main images and text, and often deliberately obscure or ambiguous. Visual puns on the main image or text abound. There are also humorous corrections of scribes' errors, pictures of hybrid monsters, erotic and scatological scenes, and charming depictions of ordinary activities and folklore that may or may not have functioned as

16-38. Page with Fox Seizing a Rooster, Petites Heures of Jeanne d'Evreux

"The Fox," according to a medieval bestiary, "never runs straight but goes on his way with tortuous windings. He is a fraudulent and ingenious animal. When he is hungry and nothing turns up for him to devour, he rolls himself in red mud so that he looks as if he were stained with blood. Then he throws himself on the ground and holds his breath. The birds, seeing that he is not breathing, think he is dead and come down to sit on him. As you can guess, he grabs them and gobbles them up. The Devil has this same nature" (cited in Schrader, page 24). Bestiaries, an English specialty, were popular compilations of animal lore that were sometimes, as here, made into Christian moral tales. Some of these fables or their characterizations survive in twentieth-century folklore, such as this familiar view of the fox as a cunning trickster.

ironic commentaries on what was going on elsewhere on the page. In addition to the *bas-de-page* scenes, the *Petites Heures of Jeanne d'Evreux* contains other minute but vivid marginalia, such as a fox capturing a rooster (fig. 16-38).

ENGLAND The Plantagenet dynasty, founded by Henry II and Eleanor of Aquitaine

in 1154, ruled England until 1485. Under Plantagenet rule, the thirteenth century was marked by conflicts between the Crown and England's feudal barons over their respective rights and the king's demands for funds. In 1215 King John, under compulsion from powerful barons, set his seal to the draft of the Magna Carta (Latin for "Great Charter"), which laid out feudal rights and dues and became an important document in the eventual development of the British Constitution. The thirteenth century also saw the annexation of the western territory of Wales and the settlement of long-standing border disputes with Scotland. In the mid-fourteenth century the Black Death ravaged England as it did the rest of Europe. During the Hundred Years' War (1337-1453), English kings claimed the French throne and by 1429 controlled most of France, but after a number of reversals they were driven from all their holdings in France except Calais.

Late medieval England was characterized by rural villages feeding into bustling market towns, all dominated by the great city of London. England's two universities,

Oxford and Cambridge, were both founded by the thirteenth century. The Gothic period was marked by a reassertion of English cultural identity following the imposition of Norman French culture in 1066. A rich store of Middle English literature survives, including the brilliant social commentary of the *Canterbury Tales*, by Geoffrey Chaucer (c. 1342–1400). Many of the Plantagenet kings, especially Henry III, were great patrons of the arts.

Church Architecture

Gothic architecture in England was strongly influenced by Cistercian architecture and Norman building traditions as well as by French master builders like William of Sens, who directed the rebuilding of Canterbury Cathedral between 1174 and 1178 (see "Master Builders," page 563). English cathedral builders were less concerned with height than their French counterparts, and they constructed long, broad naves, Romanesque-type galleries, and clerestory-level passageways. They focused their efforts at decoration on the cathedral walls, which retained a Romanesque solidity.

Salisbury Cathedral, because it was built in a relatively short period of time, has a consistency of style that makes it an ideal representative of English Gothic architecture (fig. 16-39). The cathedral was begun in 1220 and nearly finished by 1258, an unusually short period for such an undertaking. The west facade was completed by 1265. The huge crossing tower and its 400-foot spire are later additions, as are the flying buttresses that were added to stabilize the tower. Typically English is the parklike setting (the cathedral close) and attached cloister and chapter house for the cathedral clergy. The thirteenth-century structure hugged the earth, more akin to Cluny III, built more than a century earlier (see fig. 15-5), than to the contemporary Amiens Cathedral in France.

The small flanking towers of the west front project beyond the side walls and buttresses, giving the facade an increased width that was underscored by tier upon tier of blind tracery and arcaded niches. Lancet windows grouped in twos, threes, and fives introduce an element of vertical counterpoint. In contrast to French cathedral facades, which suggest the entrance to paradise with their mighty towers flanking deep portals, English facades like the one at Salisbury suggest the jeweled wall of paradise itself.

Typical of English cathedrals, Salisbury has double projecting transepts, a square apse, and a spacious sanctuary (fig. 16-40). The interior reflects enduring Norman traditions, with its heavy walls and tall nave arcade surmounted by a short gallery and a clerestory with simple lancet windows (fig. 16-41). The emphasis on horizontal movement of the arcades, unbroken by colonnettes in the unusually restrained nave, directs worshipers' attention forward to the altar, rather than upward into the vaults. Reminiscent of Romanesque interiors is the use of color in the stonework: the shafts supporting the four-part rib vaults are made of a darker stone that contrasts with the lighter stone of the rest of the interior. The stonework was originally painted and gilded as well as carved.

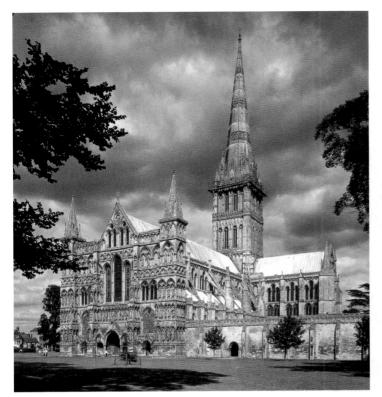

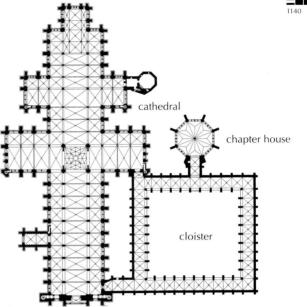

16-40. Plan of Salisbury Cathedral

16-39. West facade, Salisbury Cathedral, Salisbury, Wiltshire, England. 1220-58; west facade 1265; spire c. 1320-30 The original cathedral had been built within the hilltop castle complex of a Norman lord. In 1217 Bishop Richard Poore petitioned the pope to relocate the church, claiming the wind howled so loudly there that the clergy could not hear themselves say Mass. A more pressing concern was probably his desire to escape the lord's control; Pope Innocent III (papacy 1198-1216) had only recently lifted a six-year ban on church services throughout England and Wales after King John (ruled 1199-1216) agreed to acknowledge the Church's sovereignty. The town of Salisbury (from the Saxon Searisbyrig, meaning "Caesar's burg," or town) was laid out, by the bishop himself, after the cathedral was under way. Material carted down from the old church was used in the cathedral, along with a marblelike stone from quarries in southern England and stone from Caen. The building was abandoned and vandalized during the Protestant Reformation in England initiated by King Henry VIII (ruled 1509-1547). In the eighteenth century the English architect James Wyatt, called the Destroyer, subjected it to radical renovations, during which the remaining stained glass and figure sculpture were removed or rearranged. Similar campaigns to refurbish medieval churches were common at the time. The motives of the restorers were complex and their results far from our late-twentieth-century notions of historical authenticity. The French architect Eugène-Emmanuel Viollet-le-Duc, the best known of these restorers, redefined the appearance of many of France's greatest twelfth- and thirteenth-century churches in the nineteenth century.

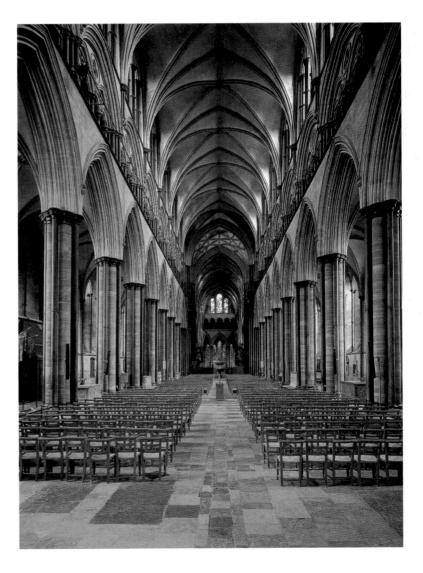

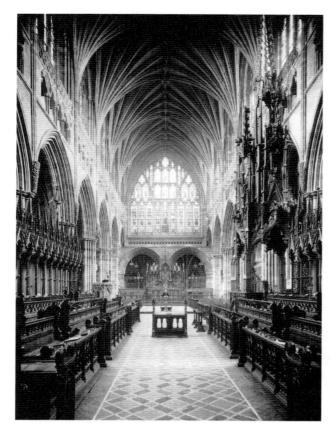

16-42. Sanctuary, Exeter Cathedral, Exeter, Devon, England. c. 1270–1366

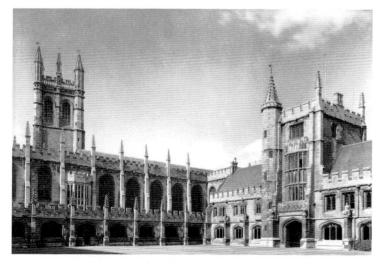

16-43. William Orchard. First Quadrangle, Magdalen College, Oxford, Oxfordshire, England. c. 1475–1500

Surviving account books reveal how much Orchard was paid for his work. For each of twenty-two cloister windows and buttresses, for example, he received 48 shillings 4 pence. In an early indication of intercollegiate rivalry, the windows were praised for being "as good as those of All Souls or better." As a final reward, the officials of Magdalen gave Orchard a lifetime lease on some college-owned land for an annual rent of one red rose, to be paid on the Feast of Saint John the Baptist.

Just as the Rayonnant style was emerging in France at mid-century, English designers were developing a new Gothic style of their own that has come to be known as the Decorated style (a nineteenth-century term). This change in taste has been credited to King Henry III's ambition to surpass his brother-in-law, Louis IX of France, as a royal patron of the arts. In 1245, two years after Louis began work on the Sainte-Chapelle, Henry started rebuilding Westminster Abbey in London, the coronation and burial church of the sainted eleventhcentury king, Edward the Confessor. Financial records indicate that Henry nearly depleted his treasury on this grandiose scheme. The new church, with its huge windows, elaborate tracery, and rich surface overlays of sculpted and painted decoration, introduced the Decorated style.

A splendid example of this new style outside London is Exeter Cathedral, in southwest England. After the Norman Conquest in 1066, a Norman church replaced an earlier structure, and it, in turn, was rebuilt beginning about 1270. When the cathedral was redesigned and vaulted in the first half of the fourteenth century, its interior was turned into a dazzling stone forest of arch moldings and vault ribs (fig. 16-42). From diamond-shaped piers (partly hidden by choir stalls in the illustration), covered with colonnettes, rise massed moldings that make the arcade seem to ripple. Bundled colonnettes spring from ornate corbels between the arches to support conical clusters of thirteen ribs that meet at the summit of the vault, a modest 69 feet above the floor. The basic structure here is the four-part vault with intersecting crossribs, but the designer added purely decorative ribs, called tiercerons, between the supporting ribs to create a richer linear pattern. Elaborately carved knobs known as bosses punctuate the intersections where ribs meet. Large clerestory lancets with bar-tracery mullions illuminate the 300-foot-long nave. Unpolished gray marble shafts, yellow sandstone arches, and a white French stone used in the upper walls add color to the manyrayed space.

Secular Architecture

Although Gothic architectural style is most studied in cathedrals and other church buildings, it also is seen in such secular structures as castles, which during the turbulent Middle Ages were necessary fortress-residences. Castles evolved during the Romanesque and Gothic periods from enclosed and fortified strongholds to elaborate defended residential complexes from which aristocrats ruled their domains. Usually sited on a promontory or similar defensive height, British castles had many elements in common with continental ones (see "Elements of Architecture," opposite).

The final period of English Gothic architecture produced the Perpendicular style, another nineteenth-century term, derived from its characteristic tall, rectilinear decorative elements. The style originated in court-sponsored projects in London at the end of the thirteenth century and was close to the earlier French Rayonnant

ELEMENTS OF ARCHITECTURE

The Gothic Castle

A typical Gothic castle was a defensible, enclosed combination of fortifications and living quarters for the lord and his family and those defend-

ing them. It was built on raised ground and sometimes included a **moat** (ditch), filled with water and crossed by a bridge; **ramparts** (heavy walls), which were freestanding or built against earth embankments; **parapets**, into which towers were set; a **keep**, or **donjon**, a tower that was the most secure place within the compound; and a great hall that was where the rulers and their closest associates lived. The **bailey**, a large open courtyard in the center, contained wooden structures such as living quarters and

stables, as well as a stone chapel. The castle complex was defended by a wooden **stockade**, or fence, outside the moat; inside the stockade lay **lists**, areas where knightly combats were staged. The main entrance was approached by a wide **bridge**, which passed through moat gateways called **barbicans**, ending in a **drawbridge** and then an iron **portcullis**, a grating set into the doorway. Elsewhere, small doors called **posterns** provided secret access for the castle's inhabitants. Ramparts and walls were topped by stone **battlements** designed to screen defenders standing on **parapet walks** while allowing them to repel attacks through notched **crenellations**. There were covered parapet walks, as well as miniature towers called **turrets**, along the more secure perimeter walls of the castle.

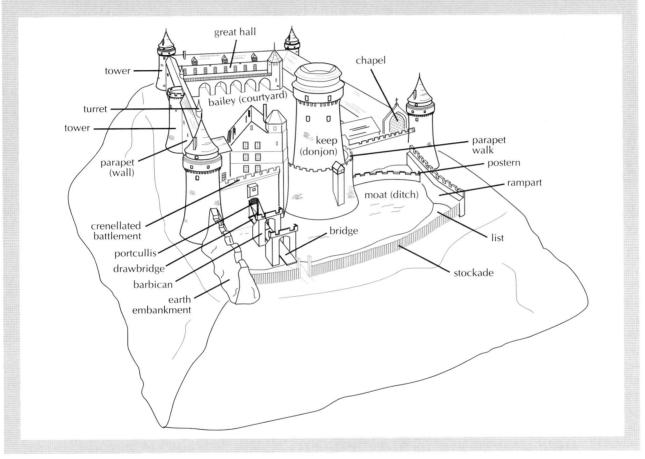

style in its emphasis on verticality and large areas of glass. As London-trained architects took commissions for work elsewhere, the style spread. Easily adapted by provincial stonemasons, the Perpendicular style appeared across England in parish churches, houses, civic buildings, and the halls, libraries, and residential colleges being added to English universities.

Magdalen College at Oxford (pronounced "maudlin" from the Middle English spelling, *Maudeleyne*) is the late-fifteenth-century work (c. 1475–1500) of a local mason, William Orchard. Laid out in an orderly way around a quadrangular courtyard similar to a monastic cloister, it has been called the ideal college, a sober and dignified setting for a life of the mind (fig. 16-43). The facades of the structures on the quadrangle exhibit a Perpendicular grid design, with the vertical lines of the arcade piers and

the pinnacles rising from them intersecting the horizontal lines of the projecting stringcourses on the wall buttresses. The crenellated roofline—a purely decorative reference to castle battlements-completes the "perpendicular" theme. Window and arcade openings are either rectangular or nearly so. Orchard's college is a grander version of a fortified aristocratic manor house, with a monumental gatehouse at the right and a great hall and chapel combined in the wing at the left. The turreted, crenellated tower and gatehouse serve no protective purpose but act instead as symbols of collegiate authority. The living quarters for students were built behind and above the covered walkways. A typical college apartment, or "set," accommodated four students in small individual bedrooms arranged around a common living and study room.

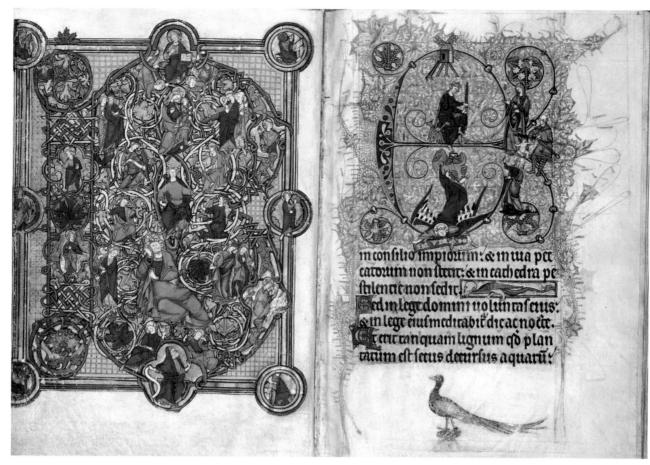

16-44. Page with *Psalm 1 (Beatus Vir), Windmill Psalter,* from London. c. 1270–80. Ink pigments and gold on vellum, each page 12³/₄ x 8³/₄" (32.3 x 22.2 cm). The Pierpont Morgan Library, New York M.102, f. lv-2

Book Arts

In France book production had become centralized in the professional scriptoria of Paris, and its main patrons were the universities and the court. In thirteenth-century England, by contrast, the traditional centers of production—far-flung rural monasteries that had produced such twelfth-century work as the beautiful Winchester Psalter (see fig. 15-29)—continued to dominate the book arts. Toward the close of the thirteenth century, however, secular workshops became increasingly active, reflecting a demand for books from newly literate landowners. townspeople, and students. These people read books, both in English and Latin, for entertainment and general knowledge as well as for prayer. The fourteenth century was a golden age of manuscript production in England, as the thirteenth century had been in France. Among the delights of English Gothic manuscripts are their imaginative marginalia (pictures in margins of pages).

The dazzling artistry and delight in ambiguities that had marked earlier Anglo-Saxon manuscript illumination reappeared in the *Windmill Psalter* (c. 1270–1290), so-called because of a windmill in the initials beginning Psalm 1 (fig. 16-44). The Psalm begins with the words "Beatus vir qui non abiit" ("Happy those who do not follow the counsel [of the wicked]," Psalm 1:1). A B, the first letter of the Psalm, fills the left page, and an E, the sec-

ond letter, occupies the top of the right page. The rest of the opening words appear on a banner carried by an angel at the bottom of the *E*. The *B* outlines a densely interlaced Tree of Jesse. The *E* is formed from large tendrils that escape from delicate background vegetation to support characters in the story of the Judgment of Solomon. The story, seen as a prefiguration of the Last Judgment, relates how two women (at the right) claiming the same baby came before King Solomon (on the crossbar) to settle their dispute. He ordered a guard to slice the baby in half with his sword and give each woman her share. This trick exposed the real mother, who hastened to give up her claim in order to save the baby's life.

Charming images appear among the pages' foliage, many of them visual puns on the text. For example, a large windmill at the top of the initial E illustrates the statement in the Psalm that the wicked would not survive the Judgment but would be "like chaff driven by the wind" (Psalm 1:4). Imagery such as this would have stimulated contemplation of the inner meanings of the text's familiar messages.

Opus Anglicanum

At least since the time of the Norman invasion and the *Bayeux Tapestry* (see fig. 15-30), the English were famous for their embroidery. From the thirteenth through the six-

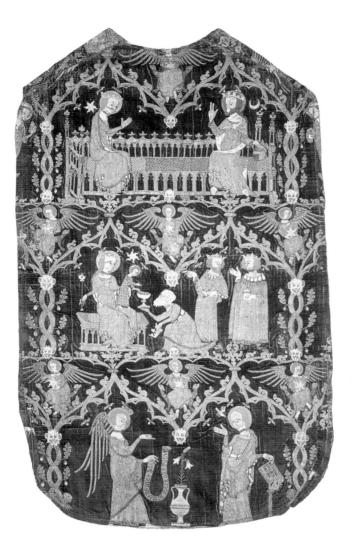

16-45. Life of the Virgin (Chichester-Constable chasuble back, from a set of vestments embroidered in opus anglicanum), from southern England. 1330-50. Red velvet with silk and metallic thread; length 5'6" (164 cm), width 30" (76 cm). The Metropolitan Museum of Art, New York Fletcher Fund, 1927 (2.7 162.1)

teenth centuries the pictorial needlework in colored silk and gold thread of English embroiderers, both men and women, gained such renown that it came to be referred to by the Latin term *opus anglicanum* (English work). The pope in Rome, for instance, had more than 100 pieces of this luxurious textile art. The names of several prominent embroiderers are known, such as Mabel of Bury Saint Edmunds, who worked for Henry III, but few can be connected to specific works.

Opus anglicanum was employed for banners, court dress, and other secular uses, as well as for the liturgical vestments worn by the clergy during Mass. A mid-fourteenth-century vestment known as the Chichester-Constable chasuble (fig. 16-45) is embroidered with scenes from the Life of the Virgin—the Annunciation, the Adoration of the Magi, and the Coronation of the Virginarranged in three registers on its back. Cusped, crocketed S-shape arches, twisting branches sprouting oak leaves, seed-pearl acorns, and animal faces define each register. The star and crescent moon in the Coronation of the Virgin scene, heraldic emblems of the royal family, suggest that the chasuble may have been made under the patronage of Edward III. The embroidery was done in split stitch with fine gradations of colored silk forming the images as subtly as painting (fig. 16-46). Where

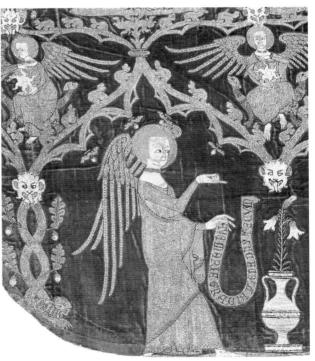

16-46. Detail, *Angel of the Annunciation*, Chichester-Constable chasuble

gold threads were laid and couched, the effect is like the burnished gold-leaf backgrounds of manuscript illuminations. During the celebration of the Mass, garments of opus anglicanum would have glinted in the candlelight amid the other treasures of the altar. So heavy did such gold and bejeweled garments become, however, that their wearers often needed help to move.

SPAIN

The Christian reconquest of Muslim Spain gained momentum in the thirteenth century under Alfonso X "the Wise" (ruled 1252–1284), king of the newly unified northern realm of León and Castile. In the east, the union of Aragón with Catalonia created a prosperous realm that benefited from expanding Mediterranean trade. Christian rulers were initially tolerant of the Muslim and Jewish populations that came under their control, but in the late fifteenth century, this tolerance gave way to a drive toward religious conformity. When Spain was united under Christian rule in 1492, Jews were expelled and soon afterward Muslims were forced to convert. Like other areas of Europe, Spain was ravaged by rebellion, war, and plague in the fourteenth century.

From the twelfth century on, the art of Christian Spain reflects the growing influence of foreign styles, particularly those of France and Italy. Patrons often brought in master masons, sculptors, and painters from these regions to direct or execute important projects. The new influences, adapted by local artisans, combined with local traditions to create a recognizably Spanish Gothic style.

Architecture

The cathedral of Barcelona in Catalonia, begun at the end of the thirteenth century, is the first monumental Spanish Gothic structure that was not built in a style directly imported from France. It has a very tall nave arcade with side aisles of nearly the same height, a continuous series of side-aisle chapels between the buttresses, a short clerestory tucked under the vaulting, and a nonprojecting transept. Many of these characteristics can be seen also in the cathedral of Palma, the capital of the island of Mallorca, which was inspired by the Barcelona Cathedral.

Mallorca, a major center of Mediterranean trade, had been captured from the Muslims in 1229 by James I of Aragón (ruled 1213–1276), who converted Palma's mosque into a church. His son initiated the construction of the new cathedral in 1306. The structure has an imposing, fortresslike exterior dominated by closely packed, stockadelike buttresses (fig. 16-47). The nave vaults rise to 143 feet and the side-aisle vaults to more than 94 feet, making the cathedral the third tallest building in Europe at the time. The interior is stunning, with slender polygonal arcade piers, high side aisles, large windows in the outer walls above low side chapels, and a truncated transept (fig. 16-48).

Book Arts

King Alfonso X of Castile was known as a patron of the arts who maintained a brilliant court of poets, scholars,

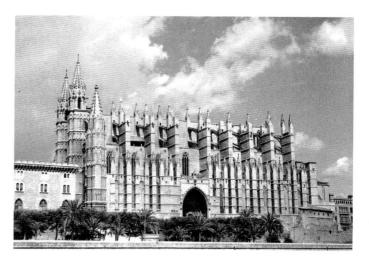

16-47. Cathedral of Palma, Mallorca, Balearic Islands, Spain. Begun 1306. View from the south

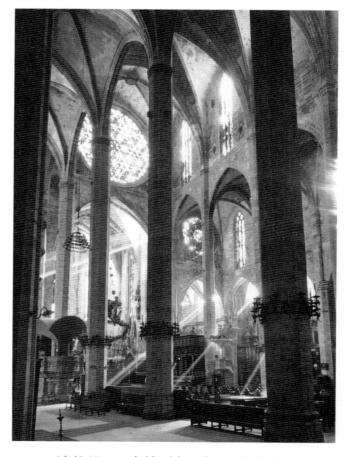

16-48. Nave and side aisle, Palma Cathedral

artists, and musicians during the mid-thirteenth century. He promoted the use of local vernacular languages instead of Latin in his realm for everything from religious literature and history to legal codes and translations of important Arabic scientific texts. He was a poet and musician himself, compiling and setting to music a collection of poems, some of them his own, devoted to the Virgin Mary. An illustration from this manuscript, the *Cantigas de Santa María* (Songs of Saint Mary), shows

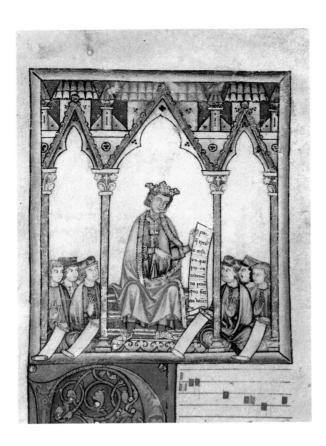

16-49. Page with Alfonso the Wise, Cantigas de Santa María, from Castile, Spain. Mid- to late-13th century. Ink, pigments, and gold on vellum. El Escorial, Real Biblioteca de San Lorenzo, Madrid

Alfonso as poet-musician above one of his own songs (fig. 16-49). Like Queen Blanche and King Louis in the French Court style Moralized Bible seen earlier (see fig. 16-35). Alfonso is shown seated in a Gothic building. He holds a copy of his poetry, which he presents to admiring courtiers.

Painted Altarpieces

The large-scale paintings on or just behind church altars, called altarpieces, began to appear in the twelfth century and proliferated throughout Europe in the thirteenth. Altarpieces, murals, and smaller paintings on wood panels were the most important forms of medieval painting; manuscript illumination and stained glass were of secondary importance (see "Altars and Altarpieces," below). Professional painters worked for both individual and institutional patrons. Many were members of painting dynasties that lasted for generations, and some had wideranging responsibilities at court.

AND ALTAR-**PIECES**

ALTARS The altar in a Christian church symbolizes both the table of the Last Supper and the tombs of Christ and the saints. Tra-

ditionally the altar is covered with a cloth, and it is usually set with candles and a cross. The reliquary of a patron saint, such as Saint Foy (see fig. 15-1), might be placed on the altar, but it might also be under or even inside the altar. Altarpieces placed behind or at the back of the altar table, the mensa, as well as altar frontals (antependia) in front of the altar tables, provide the celebrants and worshipers with images of the saints and scenes from their lives and martyrdoms. These painted, carved, or embroidered images were created to help focus meditations and prayers, but unlike Byzantine icons (see fig. 7-61) they were not intended to be conduits for prayers to saints.

The earliest altarpieces were low, fixed panels, but by the Gothic period they became increasingly large and elaborate architectonic structures filled with images and protected by movable wings that functioned like shutters. Eventually, in Spain, they grew to the full height of the building. Many altarpieces had a firm base,

called a predella, which was also covered with images. The most common type of arrangement was the triptych, a central panel flanked by side panels, or wings. Polyptychs such as Duccio's Maestà (see fig. 16-71) consisted of many panels in a stationary frame. Wings of altarpieces were painted on both front and back because the altarpieces were kept closed most of the time and were opened on holy days to reveal special imagery.

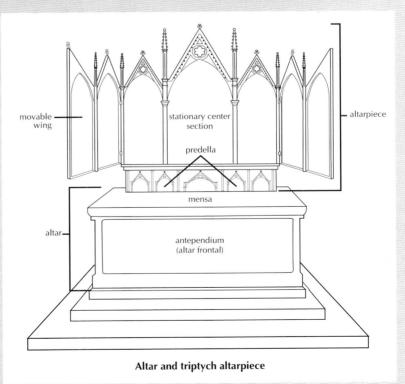

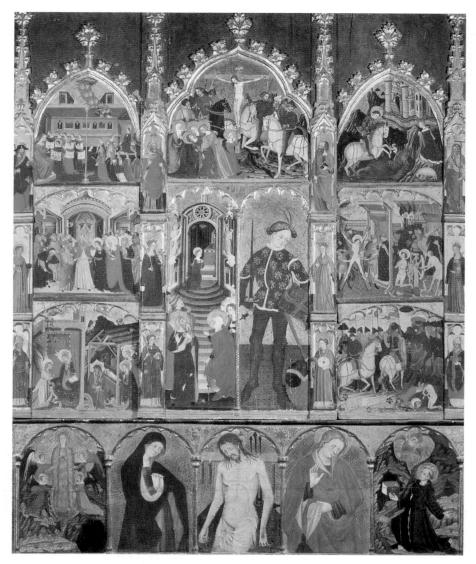

16-50. Luis Borrassá. Virgin and Saint George, altarpiece in Church of San Francisco, Villafranca del Panadés, Barcelona. c. 1399. Tempera on wood

The contract for another of Borrassá's altarpieces, dated 1402, specifies its subject matter in detail as well as its dimensions and shape. The contract requires the use of high-quality materials and calls for delivery in six months, with payment at specified stages upon inspection of work in progress. It holds the painter responsible for all stages of production "according to what is customary in other beautiful [altarpieces]" (cited in Binski, page 52).

One of the major figures in late medieval Spanish painting was Luis Borrassá (1360–1426). From a Catalán family of painters, he worked for the court of Aragón early in his career, probably in the style favored by the French-born queen. Sometime during the 1380s he set up a workshop in the Catalán capital of Barcelona. Among the altarpieces attributed to him is the *Virgin and Saint George* made for the Church of San Francisco at Villafranca del Panadés (fig. 16-50). This work is a distinctively Spanish-type altarpiece called a **retablo**, which consists of an enormous wooden framework—taking up the whole wall behind an altar—that is filled with either painted or sculpted narrative scenes. The depiction of space and the lively narrative scenes in the panels of the *Virgin and Saint George* reflect the influence of the paint-

ing style that had developed in Tuscany, in northern Italy, but the realistic details, elegant drawing, and rich colors are characteristically Catalán. Borrassá's synthesis of foreign artistic influences reflects the development of the courtly International Gothic style that emerged in much of Europe about the beginning of the fourteenth century.

The panel depicting the *Education of the Virgin* (fig. 16-51) shows Mary among a group of fourteenth-century Spanish girls presenting their embroidery for a teacher's approval. All except Mary have produced the assigned floral design. Mary instead has stitched an enclosed garden, symbolic of her purity and virginity. From the Fountain of Life at its center springs a glorious flower heralded by four golden-winged angels, a reference to the future birth of Jesus.

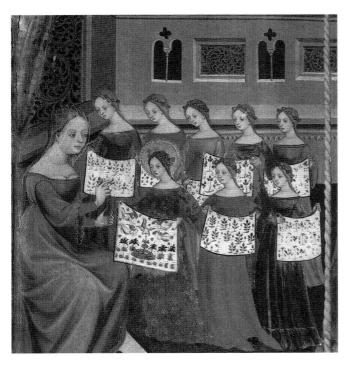

16-51. Luis Borrassá. Education of the Virgin, detail from Virgin and Saint George altarpiece

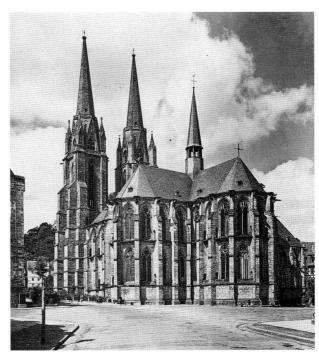

16-52. Church of Saint Elizabeth, Marburg, Germany. 1233-83

GERMANY In contrast to England and France, which were becoming strong national states, Germany had developed THE HOLY into a decentralized conglomeration **ROMAN** of independent principalities, bish-**EMPIRE** oprics, and "free" commercial cities by the middle of the thirteenth cen-

tury. The Holy Roman Empire, weakened by prolonged struggle with the papacy and with German princes, had ceased to be a significant power. Holy Roman emperors were now elected by German princes and had only nominal authority over them. Each emperor ruled from his chosen capital. Charles IV (ruled 1355–1378), for example, who was also king of Bohemia, ruled from the Bohemian city of Prague, which he helped develop into a great city. As patrons, the emperors stimulated the arts, promoting local traditions as well as the spread of the French Court style and the International Gothic style that followed it.

Architecture

A new type of church, the hall church, developed in thirteenth-century Germany in response to the increasing importance of sermons within church services. The hall church featured a nave and side aisles with vaults of the same height, creating a spacious and open interior that could accommodate the large crowds drawn by charismatic preachers. The flexible design of these "great halls" was also widely adopted for civic and residential buildings.

The Church of Saint Elizabeth at Marburg in eastern Germany, built between 1233 and 1283, was popular as a pilgrimage site and as a funerary chapel for the local nobility (fig. 16-52). The earliest example of a hall church

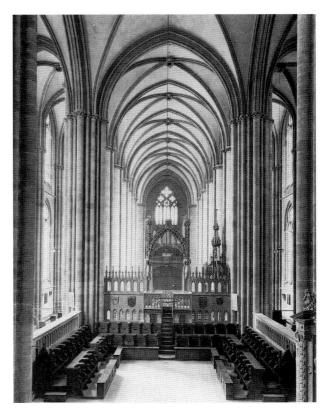

16-53. Nave, Church of Saint Elizabeth

combined with a French-style plan and structure, Saint Elizabeth has a beautiful simplicity and purity of line. Light from two stories of tall windows fills the interior, unimpeded by nave arcades, galleries, or triforia (fig. 16-53). The exterior has a similar verticality and geometric clarity.

The Gothic style was also adopted for Jewish religious structures. The oldest functioning synagogue in Europe, Prague's Altneuschul (Old-New Synagogue), was probably built in the late thirteenth or fourteenth century (fig. 16-54). One of two principal synagogues serving the Jews of Prague, it reflects the geometric clarity and regularity of Gothic architecture and demonstrates the adaptability of the Gothic hall-church design for non-Christian use (fig. 16-55). Like a hall church, the vaults of the synagogue are all the same height. Unlike a church, with its nave and side aisles, the Altneuschul has two central aisles with six bays. The bays have four-part vaulting with a decorative fifth rib.

Because of sporadic repression, Jewish communities in the cities of northern Europe tended to be small throughout the Middle Ages. Towns often imposed restrictions on the building of synagogues, requiring, for example, that they be lower than churches. Since local guilds controlled the building trades in most towns, Christian workers usually worked on Jewish construction projects.

The medieval synagogue was both a place of prayer and a communal center of learning and inspiration where men gathered to read and discuss the Torah. The synagogue had two focal points, the aron, or shrine for the Torah scrolls, and a raised reading platform called the bimah. Worshipers faced the aron, which was located on the east wall, in the direction of Jerusalem. The bimah stood in the center of the hall. The Gothic-arched aron of the Altneuschul can be seen in figure 16-54, partially obscured by an openwork partition around the bimah, which straddled the two center bays. The synagogue's single entrance was placed off-center in a corner bay at the west end. Candles along the walls and in overhead chandeliers supplemented natural light from twelve large windows. The interior was also originally adorned with murals (the large, richly decorated Torah case shown on the bimah table was made later). Men worshiped and studied in the principal space; women were sequestered in annexes.

Sculpture

Nicholas of Verdun, a pivotal figure in the development of early Gothic sculpture, influenced both French and German art through his work well into the thirteenth century. Born along the Meuse River between Flanders and Germany, he was heir to the great Mosan metalworking tradition (see fig. 15-35). Nicholas worked for a number of important German patrons, including the archbishop of Cologne, for whom he created a magnificent reliquary (c. 1190-c.1205-1210) to hold what were believed to be relics of the Three Magi (fig. 16-56). Called the Shrine of the Three Kings, the reliquary resembles a basilica, a traditional reliquary form that evolved to reflect changes in church architecture. It is made of gilded bronze and silver with gemstones and dark blue enamel that accentuate its architectonic details. Mosan classicism reached new heights in this work. Figures are fully and naturalistically modeled in gold repoussé. The Magi and Virgin are on the front, and figures of prophets and the apostles

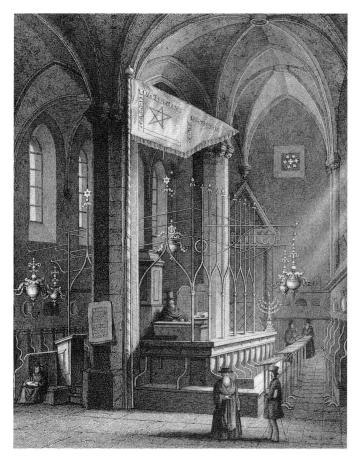

16-54. Interior, Altneuschul, Prague, Bohemia (Czech Republic). c. late 13th century; later additions and alterations. Engraving from *Das Historisches Prag in 25 Stahlstichen*, 1864

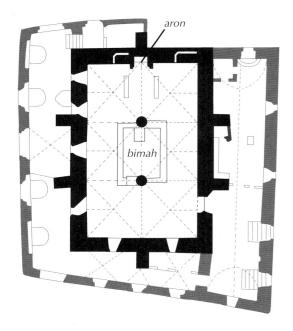

16-55. Plan of Altneuschul

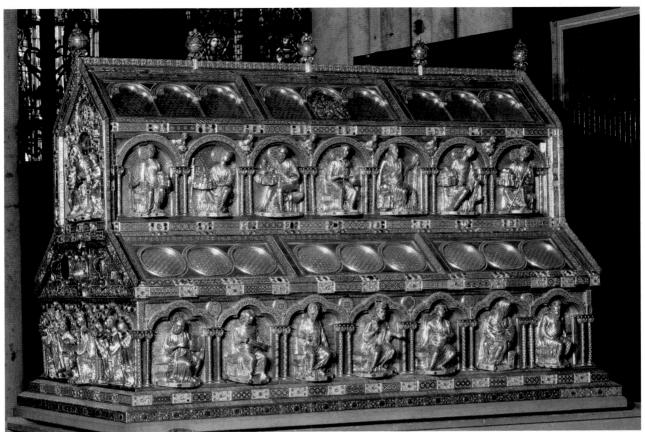

16-56. Nicholas of Verdun and workshop. *Shrine of the Three Kings*. c. 1190–c. 1205–10. Silver and bronze with enamel and gemstones, 5'8" x 6' x 3'8" (1.73 x 1.83 x 1.12 m). Cathedral Treasury, Cologne, Germany

fill the niches in the two levels of round-arched arcading on the sides. The work combines robust, expressively mobile sculptural forms with a jeweler's exquisite ornamental detailing to create an opulent, monumental setting for its precious contents.

The sculpture in the facade of Strasbourg Cathedral has a homogeneous classicizing style that reflects the influence of Nicholas of Verdun and shares features with the work produced by the "Classical Shop" at Reims (see fig. 16-24). The works on the Strasbourg facade have an emotional expressiveness, however, that is characteristic of much German medieval sculpture. A relief depicting the death and assumption of Mary, a subject known as the Dormition (Sleep) of the Virgin, fills the tympanum of the south transept portal (fig. 16-57). Mary lies on her deathbed, but Christ has received her soul, the doll-like figure in his arms, and will carry it directly to heaven, where she will be enthroned next to him. The scene is filled with dynamically expressive figures with large heads and short bodies clothed in fluid drapery that envelops their rounded limbs. Deeply undercut, the large figures stand out dramatically in the crowded scene, their grief vividly rendered.

There was a powerful naturalistic current in German Gothic sculpture, and some works—among them a famous statue from Magdeburg Cathedral of Saint Maurice, produced about 1240–1250—may have been based

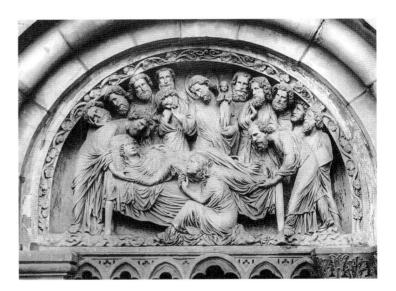

16-57. *Dormition of the Virgin*, south transept portal tympanum, Strasbourg Cathedral, Strasbourg, France. c. 1230

This sculpture is among the works traditionally attributed to a woman named Sabina, long believed to have been the daughter of the facade's designer. She is now known to have been a patron, not a sculptor. There is no evidence of women masons in medieval Europe, although a number of prominent patrons were women.

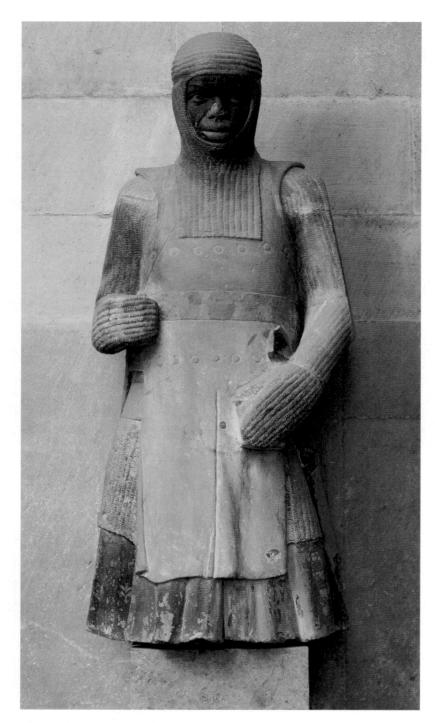

16-58. Saint Maurice, Magdeburg Cathedral, Magdeburg, Germany. c. 1240–50. Dark sandstone with traces of polychromy

on living models instead of idealized types (fig. 16-58). Magdeburg Cathedral, in north-central Germany, had been built on the site of an earlier church dedicated to Saint Maurice, and his relics were preserved there. Maurice, the leader of a group of Egyptian Christians in the Roman army in Gaul, was martyred together with his troops in 286 for refusing to fight against Christian peasants. The crusading knights of the Middle Ages viewed him and other warrior-saints, such as Saint Theodore (see fig. 16-10), as models of the crusading spirit. And like Saint George, he was a favorite saint of

military aristocrats. Because he came from Egypt, Maurice was commonly portrayed with black African features. Dressed in a full suit of chain mail covered by a sleeveless coat of decorated leather, the figure looks out from this statue with a fierce expression.

An exceptional sculptor worked for the bishop of Wettin, Dietrich II, on the decoration of a new chapel-sanctuary built at the west end of the Naumburg Cathedral about 1245–1260. Dietrich, a member of the ruling family of Naumburg, had lifesize statues of twelve ancestors who were patrons of the church placed on pedestals

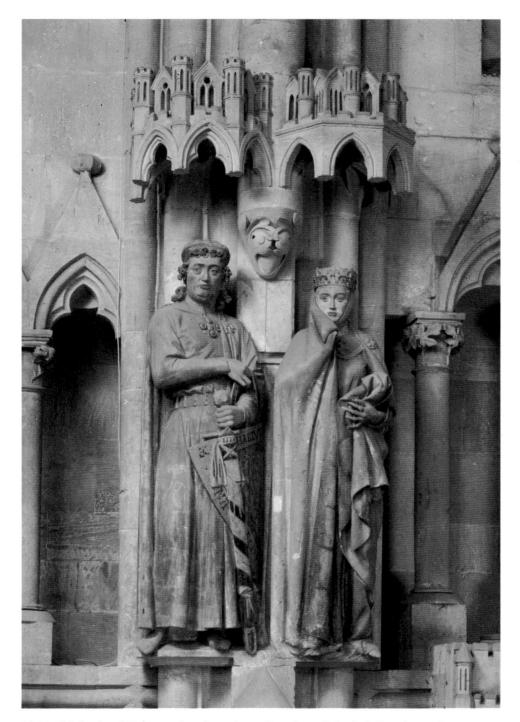

16-59. Ekkehard and Uta, west chapel sanctuary, Naumburg Cathedral, Naumburg, Germany. c. 1245–60. Stone, originally polychromed, approx. 6'2" (1.88 m)

around the chapel in perpetual attendance at Mass. Among them are representations of Ekkehard of Meissen and his Polish-born wife, Uta (fig. 16-59). Although long dead when these statues were carved, they seem extraordinarily lifelike and individualized. Ekkehard appears as a proud warrior and no-nonsense administrator, while Uta, coolly elegant, artfully draws her cloak to her cheek. Traces of pigment indicate that the figures were originally painted.

The ordeals of the fourteenth century—famines, wars, and plagues—helped inspire a mystical religiosity

that emphasized both ecstatic joy and extreme suffering. This trend is reflected in emotionally charged art in which anguish and physical torment are rendered in excruciatingly graphic terms. Small devotional statues called *Andachtsbilder* (contemplation images) were much in demand in Germany and elsewhere. They were intended to bring worshipers closer to the object of worship through empathetic, shared pain and to provide emotional release during private meditation and prayers. Gory renderings of the Crucifixion and the Virgin mourning the dead Jesus on her lap were popular. The scenes

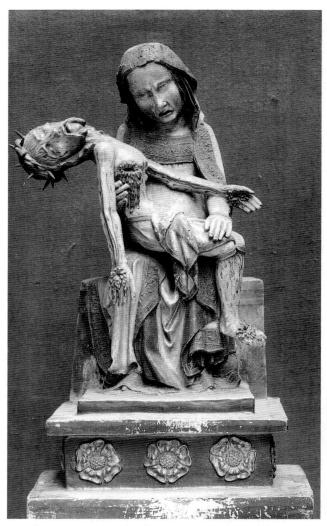

16-60. Vesperbild, from Middle Rhine region, Germany. c. 1330. Wood, height 34½" (88.4 cm). Landes-museum, Bonn

of the Virgin holding the dead Christ were sometimes called *Vesperbilder* because they were commonly used for evening prayers (vespers). In the famous example shown here (fig. 16-60), blood gushes from the wounds of an emaciated Christ in hideous rosettes. The Virgin's face conveys the intensity of her ordeal, mingling horror, shock, pity, and grief. Such images had a profound impact on later art, both within Germany and beyond.

ITALY

The thirteenth century was a period of political division and economic expansion for the Italian peninsula and its neighboring islands. With the death of Holy Roman Emperor Frederick II (ruled 1220–1250), Germany and the empire ceased to be an important factor in Italian politics and culture, and France and Spain began to vie for control of Sicily and southern Italy. The prolonged conflict between the papacy and the empire had created two factions in Italian politics: the pro-papacy Guelphs and the pro-imperial Ghibellines. Northern Italy was dominated by several independent and wealthy city-states controlled by a few powerful fam-

ilies. These cities were subject to chronic internal factional strife and conflict with one another.

In the wake of its conflict with the Holy Roman Empire, the papacy had emerged as a significant international force. But its temporal success weakened its spiritual authority and brought it into conflict with the growing power of the kings of France and England. In 1309, after the election of a French pope, the papal court moved from Rome to Avignon in southern France. During the Great Schism of 1378 to 1417, there were two rival lines of popes, one in Rome and one in Avignon.

Great wealth and a growing individualism promoted arts patronage in northern Italy. It is here that artisans begin to emerge as artists in the modern sense, both in their own eyes and the eyes of patrons. Although their methods and working conditions remained largely unchanged from before, artisans in Italy belonged to powerful urban guilds and contracted freely with wealthy townspeople and nobles and with civic and religious bodies. Their ambitious, self-aware art reflects their economic and social freedom.

Architecture

Italian Gothic architecture developed from earlier Italian Romanesque architecture in a way that only marginally reflects the influence of the French Gothic style. In the late thirteenth century, however, a new facade was erected to the Cathedral of Our Lady in Siena, Tuscany, that incorporated elements of the French style (fig. 16-61). This facade, constructed between 1284 and 1299, was the work of Giovanni Pisano (active c. 1265-1314), who may have trained or worked in France. (Giovanni Pisano was the son of the sculptor Nicola Pisano, who is discussed later in the chapter.) The new facade transformed the appearance of the cathedral. Although, in the French manner, it includes three portals and a rose window, it lacks the complex narrative sculptural programs typical of French Gothic facades. Giovanni limited his sculpture to simple decorations like those in the portal tympana and to the huge, freestanding statues that are atop crocketed gables in niches on stair towers flanking the doorways. Such freestanding statues were to become a standard feature of the Italian Gothic. As in other Italian churches, the decorative focus is on the doors themselves and, inside, on furnishings such as pulpits, tomb monuments, and baptismal fonts. The cathedral's two-tone marble banding, a hallmark of Italian Romanesque churches, was also characteristic of Italian Gothic churches.

Siena's northern neighbor and rival, Florence, erected a colossal cathedral in the fourteenth century that dwarfs Siena's (fig. 16-62). The building has a long and complex history. The original plan, by Arnolfo di Cambio, was approved in 1294, but political unrest brought construction to a halt until 1357. Several modifications of the design were made, and Florence Cathedral assumed much of its present appearance between 1357 and 1378. The west facade was rebuilt again in the sixteenth century. Its veneer of white and green marble coordinates with that of the nearby Baptistry of San Giovanni.

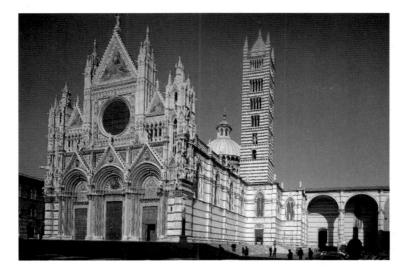

16-61. Giovanni Pisano.
West facade,
Cathedral of
Our Lady, Siena.
1284–99; facade
above gable
peaks 1369–77;
original sculpture
removed for
preservation

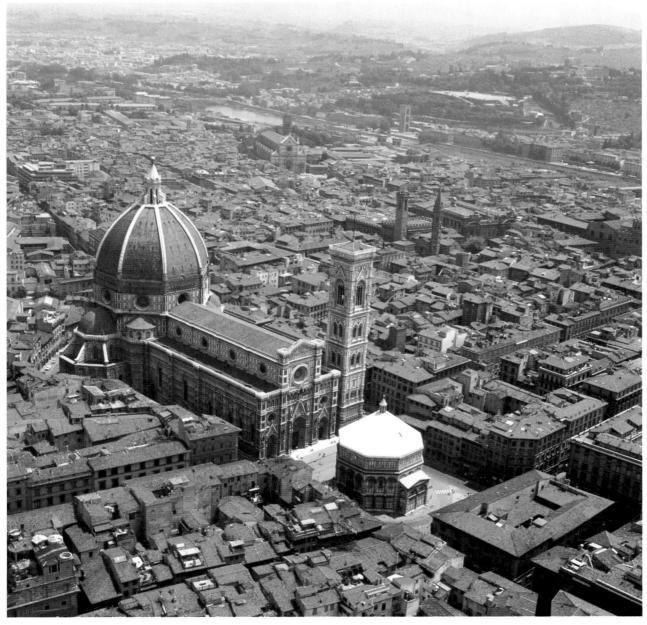

16-62. Arnolfo di Cambio, Francesco Talenti, Andrea Orcagna, and others. Florence Cathedral, Florence. Begun 1296; redesigned 1357 and 1366; drum and dome 1420–36; campanile by Giotto, Andrea Pisano, and Francesco Talenti, c.1334–50

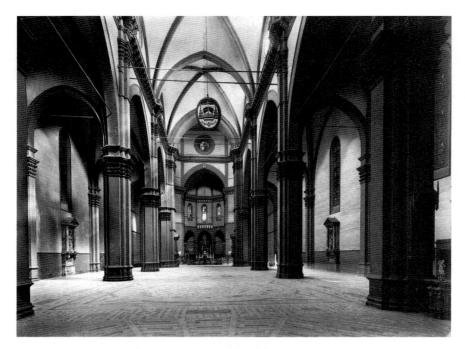

16-63. Arnolfo di Cambio, Francesco Talenti, Andrea Orcagna, and others. Nave, Florence Cathedral. 1357–78

16-64. Arnolfo di Cambio, Francesco Talenti, Andrea Orcagna, and others. Plan of Florence Cathedral. 1357–78

The spacious, square-bayed nave on the interior of the cathedral (fig. 16-63) is approximately as tall as the nave at Amiens (see fig. 16-19) but is three times as wide, giving it a radically different appearance. Here well-proportioned form is more important than light. The tall nave arcade, harkening back to single-storied imperial Christian designs, has a short clerestory with a single oculus in each bay and no triforium. The regular procession of four-part ribbed vaults springing from composite piers, however, clearly reflects northern Gothic influence. When the vaults began to crack under their own weight in 1366, unsightly iron tie bars had to be installed to hold them together. Builders in northern Europe solved this problem with exterior buttressing.

Sculptors and painters rather than trained masons were often responsible for designing Italian architecture, and as the plan of Florence Cathedral reflects, they tended to be more concerned with pure design than engineering (fig. 16-64). The long nave ends in an octagonal domed crossing, as wide as the nave and side aisles, from which the apse and transept arms extend. In basic architectural terms, this is a central-plan church grafted onto a basilica-plan church. It symbolically conjoins and separates the Dome of Heaven over the crossing, where the main altar is located, and the worldly realm of the congregation in the nave. The great ribbed dome, so fundamental to this abstract conception, was structurally unrealizable when it was planned in 1365. Not until 1420 did Filippo Brunelleschi solve the engineering problems involved in constructing it.

Sculpture

In the first half of the thirteenth century, Holy Roman Emperor Frederick II fostered a classical revival at his court in southern Italy that is often compared to Charlemagne's renaissance in the early ninth century. The revival created a trend toward greater naturalism in Italian Gothic sculpture that parallels a similar trend in the north. A leading early exemplar of the trend was Nicola Pisano (active c. 1258-1278), father of Giovanni, who came from the southern town of Apulia, where imperial patronage was strong. An inscription on a freestanding marble pulpit (fig. 16-65) in the Pisa Baptistry (see fig. 15-38) identifies it as Nicola's earliest work in northern Italy. The inscription reads: "In the year 1260 Nicola Pisano carved this noble work. May so gifted a hand be praised as it deserves." The six-sided structure is open on one side for a stairway. It is supported by columns topped with leafy Corinthian capitals and standing figures flanking Gothic trefoil arches. One of the figures is an extraordinary heroic male nude in the late Roman manner. A center column stands on a high base carved with crouching figures and domestic animals. Every second outer column rests on the back of a shaggy-maned lion guarding its prey. The format, style, and technique of Roman sarcophagus reliefs—readily accessible in the burial ground near the cathedral—may have inspired the carving on the pulpit's upper panels. The panels illustrate New Testament subjects, each treated as an independent composition unrelated to the others.

The Nativity cycle panel (fig. 16-66) illustrates three scenes—the Annunciation, the Nativity, and the Adoration—within a shallow space. The reclining Virgin dominates the middle of the composition. In the foreground, midwives wash the infant Jesus as Joseph looks on. In the upper left is the Annunciation, with the archangel Gabriel and the Virgin. The scene in the upper right combines the Adoration with the Annunciation to the Shepherds. The composition leads the eye from group to group back to the focal point in the center, the reclining and regally detached Mother of God. The sculptural treatment of the

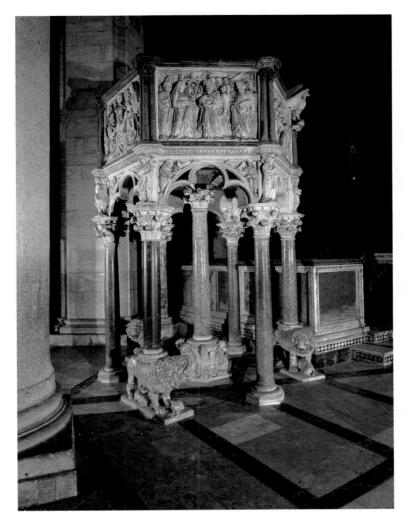

16-65. Nicola Pisano. Pulpit, Baptistry, Pisa. 1260. Marble

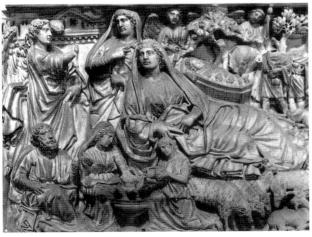

16-66. Nicola Pisano. *Nativity*, detail of pulpit, Baptistry, Pisa. $33^{1/2} \times 44^{1/2}$ " (85 x 113 cm)

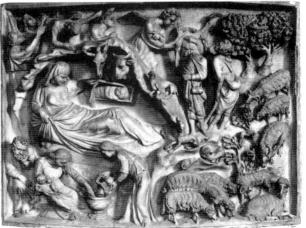

16-67. Giovanni Pisano. *Nativity*, detail of pulpit, Pisa Cathedral, Pisa. 1302–10. Marble, 34³/₈ x 43" (87.2 x 109.2 cm)

deeply cut, full-bodied forms is quite classical, as are their heavy, placid faces; the congested layout and the use of hierarchical scale are not.

Nicola's son Giovanni, the designer of the facade of the Siena Cathedral (see fig. 16-61), assisted his father in his later projects and emerged as a versatile artist in his own right near the end of the thirteenth century. Between 1302 and 1310, Giovanni created a pulpit for Pisa Cathedral that is similar to his father's in conception and general approach but is significantly different in style and execution. Giovanni's graceful, animated Nativity figures inhabit an uptilted, deeply carved space (fig. 16-67). In place of Nicola's impassive Roman matron, Giovanni depicts a slender young Virgin, sheltered by a shell-like niche, gazing delightedly at her baby. Below her, a midwife cradling the newborn tests the temperature of

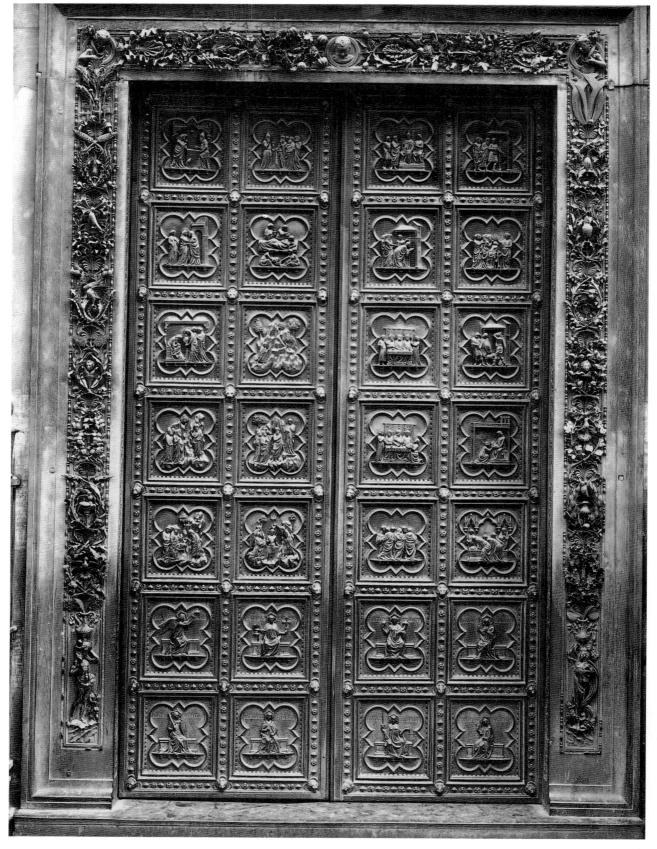

16-68. Andrea Pisano. Life of John the Baptist, south doors, Baptistry of San Giovanni, Florence. 1330–36. Gilded bronze

his bathwater. Angelic onlookers in the upper left have replaced the Annunciation. Sheep, shepherds, and announcing angels spiral up from the right, actively communicating and engaging in their surroundings. Dynamic where Nicola's was static, the scene pulses with energy.
Another Italian sculptor named Pisano (unrelated to Giovanni and Nicola), Andrea Pisano (active c. 1320s–1348), in 1330 was awarded the prestigious commission

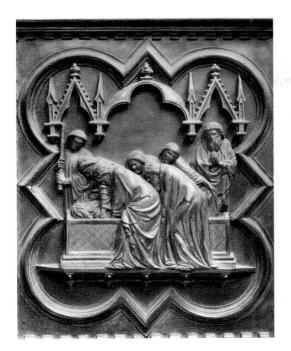

16-69. Andrea Pisano. Burial of John the Baptist, detail of south doors, Baptistry of San Giovanni, Florence. 93/4 x 17" (24.7 x 43 cm) The death of Saint John the Baptist, described in the Gospel of Mark, has been a popular subject in art since the late Middle Ages. According to Mark's account, the ruler of Judaea, Herod Antipas, at his wife's urging, reluctantly had the preacher-saint arrested after John criticized their marriage. At a banquet, Herod's stepdaughter Salome danced so seductively that he offered to grant her any request. Prompted by her mother, she asked for the saint's head on a platter, and Herod complied. Following John's death, his disciples "came and took his body and laid it in a tomb" (Mark 6:29).

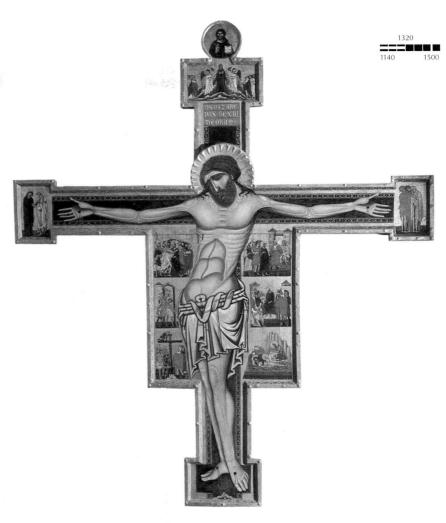

16-70. Coppo di Marcovaldo. *Crucifix*, from Tuscany, Italy. c. 1250–1300. Tempera and gold on wood, 9'7³/s" x 8'1¹/₄" (2.93 x 2.47 m). Pinacoteca, San Gimignano, Italy

Painting

Wall painting, common elsewhere in Europe in small churches and wealthy homes, became a preeminent art form in Italy, and Italian churches remained suitable for full-scale murals. Painting on wood panels also surged in popularity (see "Cennini on Panel Painting," page 596). Altarpieces—some enormous and elaborate—were commissioned not just for the main altars of cathedrals but for secondary altars, parish churches, and private chapels as well. This growing demand reflected the new sources of patronage created by Italy's burgeoning urban society. Art proclaimed a patron's status as much as it did his or her piety.

The capture of Constantinople by Crusaders in 1204 brought an influx of Byzantine art and artists to Italy, influencing Italian painters of the thirteenth and fourteenth centuries to varying degrees. This influence appears strongly in the emotionalism of a large wooden crucifix attributed to the Florentine painter Coppo di Marcovaldo and dated about 1250–1300 (fig. 16-70).

TECHNIQUE

Cennino Cennini's Il Libro dell' Arte (The Handbook of the Crafts), a compendium of early-fifteenth-century Florentine artistic techniques.

includes step-by-step instructions for making panel paintings. The wood for these paintings, he specified, should be fine-grained, free of blemishes, and thoroughly seasoned by slow drying. The first step in preparing a panel for painting was to cover its surface with clean white linen strips soaked in a gesso made from gypsum, a task best done on a dry, windy day. Gesso provides a ground, or surface, on which to paint. Cennini specified that at least nine layers should be applied, with a minimum of two-and-a-half days' drying time between layers, depending on the weather. The gessoed surface should then be burnished until it resembled ivory. The artist could now sketch the composition of the work with charcoal made from burned willow twigs. At this point, advised the author, "When you have finished drawing your figure, especially if it is in a very valuable [altarpiece], so that you are counting on profit and reputation from it, leave it alone for a few days, going back to it now and then to look it over and improve it wherever it still needs something . . . (and bear in mind that you may copy and examine things done by other good masters; that it is no shame to you)" (cited in Thompson, page 75). The final version of the design should be inked in with a fine squirrel-hair brush, and the charcoal brushed off with a feather. Gold leaf was to be affixed on a humid

PANEL PAINTING

CENNINI ON day over a reddish clay ground called bole, the tissue-thin sheets carefully glued down with a mixture of fine powdered clay and egg white. and burnished with a gemstone or the tooth of

a carnivorous animal. Punched and incised patterning was to be added later.

Italian painters at this time worked in a type of paint known as tempera, powdered pigments mixed most often with egg yolk, a little water, and an occasional touch of glue. Apprentices were kept busy grinding and mixing paints according to their masters' recipes, setting them out for more senior painters in wooden bowls or shell dishes.

Cennini specified a detailed and highly formulaic painting process. Faces, for example, were always to be done last, with flesh tones applied over two coats of a light greenish pigment and highlighted with touches of red and white. The finished painting was to be given a layer of varnish to protect it and enhance its colors. Reflecting the increasing specialization that developed in the thirteenth century, Cennini assumed that an elaborate frame would have been produced by someone else according to the painter's specifications and brought fully assembled to the studio.

Cennini claimed that panel painting was a gentleman's job, but given its laborious complexity, that was wishful thinking. The claim does, however, reflect the rising social status of painters.

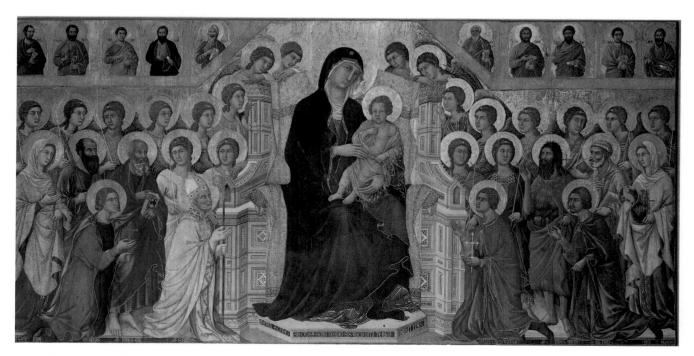

16-71. Duccio di Buoninsegna. Virgin and Child in Majesty (Maestà), main panel of Maestà Altarpiece, from Siena Cathedral. 1308-11. Tempera and gold on wood, 7' x 13'61/4" (2.13 x 4.12 m). Museo dell'Opera del Duomo, Siena

"On the day that it was carried to the [cathedral] the shops were shut, and the bishop conducted a great and devout company of priests and friars in solemn procession, accompanied by . . . all the officers of the commune, and all the people, and one after another the worthiest with lighted candles in their hands took places near the picture, and behind came the women and children with great devotion. And they accompanied the said picture up to the [cathedral], making the procession around the Campo [square], as is the custom, all the bells ringing joyously, out of reverence for so noble a picture as is this" (Holt, page 69).

1320 1140 1500

Instead of the *Christus triumphans* type common in earlier Italo-Byzantine painting, Coppo has represented the *Christus patiens*, or suffering Christ, with closed eyes and bleeding, slumped body (see fig. 14-30). The six scenes at the sides of Christ's body tell the Passion story. Such historiated crucifixes served as altarpieces in small chapels or were mounted as icons on the **rood screens** (partitions) that hid sanctuary rituals from worshipers (see fig. 16-79). Some were painted on the back, too, suggesting that they were carried in religious processions.

The two most important schools of Italian Gothic painting emerged in Siena and Florence, rivals in this as in everything else. Siena's foremost painter was Duccio di Buoninsegna (active 1278–1318), whose synthesis of Byzantine and northern Gothic influences transformed the tradition in which he worked. Duccio and his studio painted the grand *Maestà* (Majesty) *Altarpiece* for the main altar of the Siena Cathedral—dedicated, like the town itself, to the Virgin—between 1308 and 1311. Creating this altarpiece was an arduous undertaking. The work was large—the central panel alone was 7 by 13 feet—and it had to be painted on both sides because the main altar stood in the center of the sanctuary (fig. 16-71).

Because the *Maestà* was broken up in the eighteenth century, the power and beauty of Duccio's original work must be imagined today from its scattered parts (fig. 16-72). The main scene, depicting the *Virgin and Child in Majesty*, was once accompanied above and below by narrative scenes from the Life of the Virgin and the Infancy of Christ. On the back were scenes from the Life and Passion of Christ. The brilliant palette and ornate **punchwork**-tooled designs in gold leaf are characteristically Sienese. Duccio has combined a softened Italo-Byzantine figure style with the linear grace and the easy relationship between figures and their settings characteristic of the north-

16-72. Diagram, front side of *Maestà Altarpiece*. Panels seen in figure 16-71 are shaded.

Duccio's *Maestà Altarpiece* was removed from the cathedral's main altar in 1505. In 1771 the altarpiece was cut up to make it salable. Over the years, sections were dispersed, appearing later at auctions or in museums and private collections. The value of the panels remaining in Siena was finally recognized, and they were placed in the cathedral museum there in 1878.

ern High Gothic style. This subtle blending of northern and southern elements can be seen in the haloed ranks around Mary's architectonic throne (which represents both the Church and its specific embodiment, the Siena Cathedral). The central, most holy figures retain an iconic Byzantine solemnity and immobility, but those adoring them reflect a more naturalistic, courtly style which became the hallmark of the Sienese school for years to come.

Simone Martini, a practitioner (active 1315-1344) of the style pioneered by Duccio, may have been among Duccio's assistants on the Maestà. One of Martini's outstanding works, an altarpiece depicting the Annunciation (fig. 16-73), was painted in 1333 for the Siena Cathedral. This exquisite work, with its lavish punchwork, reflects a love of ornamental detail. The elegant figures, robed in fluttering draperies and silhouetted against a flat gold ground, seem weightless. Reflecting the Marian literature of his day, the painter has focused on the psychological impact of the Annunciation on a young and very human Mary. Gabriel has just appeared, his plaid-lined cloak swirling about him as he kneels in front of the Virgin. The words of his salutation—"Hail, favored one! The Lord is with you"-run from his mouth to her ear. Interrupted while reading the Bible in her room, Mary recoils in shock

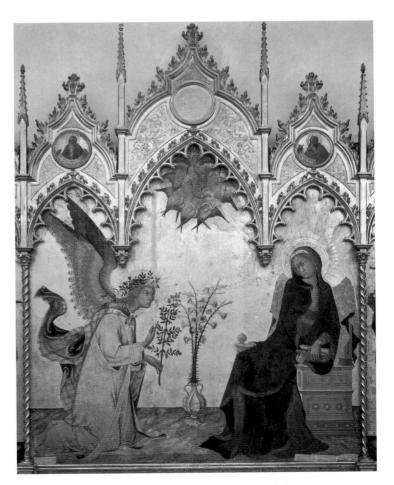

16-73. Simone Martini. Annunciation, center panel of altarpiece from Siena Cathedral. 1333. Tempera and gold on wood; 19th-century frame, 10' x 8' 9" (3.05 x 2.67 m). Galleria degli Uffizi, Florence. Side panels with standing prophets by Lippo Memmi not shown

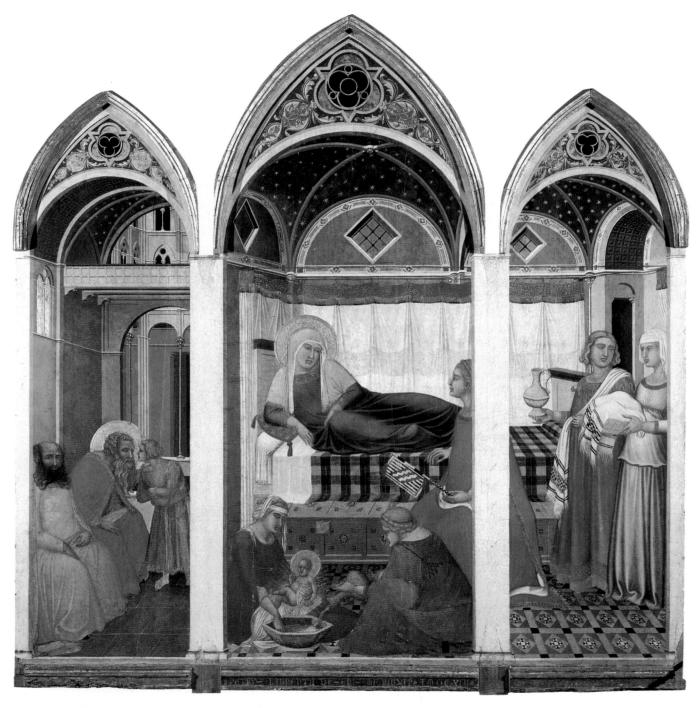

16-74. Pietro Lorenzetti. Birth of the Virgin, from Siena Cathedral. 1342. Tempera and gold on wood; frame partially replaced, $6'1^{1}/2"$ x $5'11^{1}/2"$ (1.88 x 1.82 m). Museo dell'Opera del Duomo, Siena

TECHNIQUE

BUON FRESCO could be painted quite rapidly. A wall to be

frescoed was first prepared with a rough,

thick undercoat of plaster. When this was dry, assistants copied the artist's composition onto it with sticks of charcoal, and he made any necessary adjustments. These drawings, known as sinopia, were often beautifully executed. Painting proceeded in irregularly shaped sections conforming to the contours of major figures and objects, with painters working from the top down so that drips fell on unfinished portions. Assistants covered one section at a time with a fresh, thin coat of very fine plaster over the sinopia, and when this was "set" but not dry, pigments mixed with water were painted on. Blue areas, as well as details, were usually painted afterward in tempera using the fresco secco method.

used together in Italy. The advantage of buon fresco was its durability. A chemical reaction occurred as the painted plaster dried that bonded the pigments into the wall surface. Fresco secco, in contrast, tended to flake off over time. The chief disadvantage of buon fresco was that it had to be done quickly and in sections. The painter plastered and painted only as much as could be completed in a day. Each section was thus known as a giornata, or day's work. The size of a giornata varied according to the complexity of the painting within it. The Virgin's face, for instance, could occupy an entire day, whereas large areas of sky

from Byzantine techniques and distinguished from fresco secco ("dry" fresco). The two methods were commonly

Buon ("true") fresco ("fresh") wall painting on

wet plaster was an Italian specialty, derived

and fear from this gorgeous apparition. Only essential elements occupy the emotionally charged space. In addition to the two figures, these include Gabriel's olivebranch crown and scepter (emblems of triumph and peace), Mary's thronelike seat (an allusion to her future status as Queen of Heaven), the vase of white lilies (a symbol of her purity), and the angel-winged sun disk containing the dove of the Holy Spirit that will impregnate her. The interaction of the shimmering gold ground and the Flamboyant style canopied architectural framework creates a tension between two-dimensional and threedimensional space and, hence, between iconic stillness and narrative action. Mary's face harks back to Byzantine conventions, but the stylized elegance of her body, seen in the deft curve of her recoiling form, the folds of her rich robe, and her upraised right hand, are characteristic of the Italian Gothic court style. Soon after finishing the Annunciation, Simone Martini was summoned to southern France to head a workshop at the papal court in Avignon (he had worked earlier for the French king of Sicily and Naples). His Sienese reformulation of the French Gothic style contributed to the development of the International Gothic style at the turn of the century.

The Lorenzetti brothers, Pietro (active c. 1306-1345) and Ambrogio (active c. 1319-1347), worked in a more robust style that dominated Sienese painting during the second quarter of the fourteenth century. One of Pietro's outstanding works was a triptych, the Birth of the Virgin (fig. 16-74), painted in 1342 for one of the cathedral's secondary altars. In striking contrast to the Annunciation, Pietro's ample figures people a well-furnished scene. The only supernatural elements here are the gold halos identifying the baby Mary and her parents, Anna and Joachim. The painter has attempted to create the illusion of an interior space seen through the "windows" of a triple-arched frame. The center and right windows open into a single room, and the left window opens into an antechamber. Although the figures and the architecture are on different scales, Pietro has conveyed a convincing sense of space through an intuitive system of perspective. The lines of floor tiles, the chest, and the plaid bedcover, for example, appear to converge as they recede. Thematically, the Virgin's birth is depicted as a forerunner of Jesus, with elements that echo those of Nativity scenes: the mother reclines on a bed, midwives bathe the newborn, the elderly father sits off to one side, and three people bearing gifts appear at the right. The gift bearers are local women with simple offerings of bread and wine (an allusion to the Eucharist) instead of kings bearing treasures. Mary wears the royal color purple, and gold-starred vaulting forms a heavenly canopy.

A few years earlier, in 1338, the Siena city council commissioned Pietro's brother Ambrogio to paint in fresco (see "Buon Fresco," above) a room called the Sala della Pace (Chamber of Peace) in the Palazzo Pubblico (city hall). The allegorical theme chosen for the walls was the contrast between the effects of good and bad government on people's lives (fig. 16-75; see also fig. 16-2, a detail of the same work). For the Allegory of Good Government in the City, and in tribute to his patrons, Ambrogio created an idealized but recognizable portrait of Siena and its immediate environs. The cathedral dome and the distinctive striped campanile are visible in the upper left-hand corner (compare fig. 16-61). The statue of the wolf suckling Romulus and Remus, the legendary founders of Rome, perched above the portal of the gateway identifies it as Siena's Porta Romana. An allegory of Security as a woman clad only in a wisp of transparent drapery hovers outside the gate, a scroll in one hand and a miniature gallows complete with a hanged man in the other. The scroll bids those entering the city to come in peace, and the gallows is a reminder of the consequences of not doing so.

Ambrogio's achievement in this fresco was twofold. First, he maintained an overall visual coherence despite the shifts in vantage point and scale that help keep all parts of the flowing composition intelligible. Second, he created

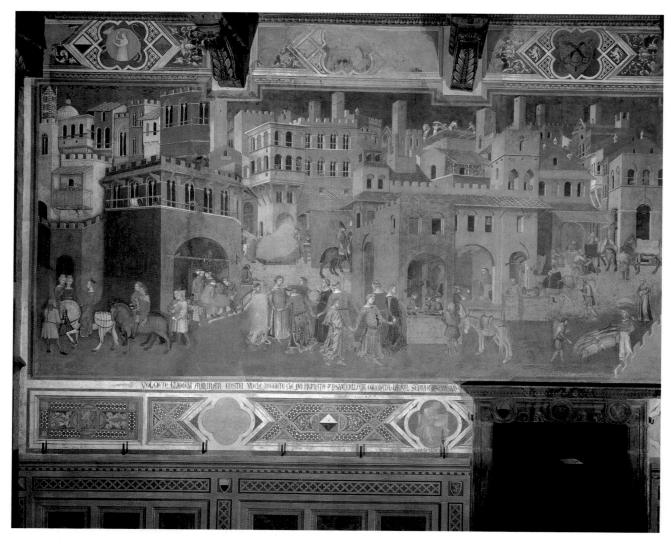

16-75. Ambrogio Lorenzetti. Allegory of Good Government in the City and Allegory of Good Government in the Country, frescoes in the Sala della Pace, Palazzo Pubblico, Siena. 1338–39

a feeling of natural scale in the relationship between figures and environment. From the women dancing to a tambourine outside a shoemaker's shop (see fig. 16-2) to the contented peasants tending fertile fields and lush vineyards (fig. 16-76), the work conveys a powerful vision of an orderly society, of peace and plenty at this particular time and place. Sadly, famine, poverty, and disease overcame Siena just a few years after this work was completed.

In Florence, the transformation of the Italo-Byzantine style began somewhat earlier than in Siena. Duccio's Florentine counterpart was an older painter named Cenni di Pepi (active c. 1272–1302), better known by his nickname, Cimabue. He is believed to have painted the *Virgin and*

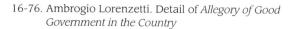

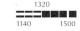

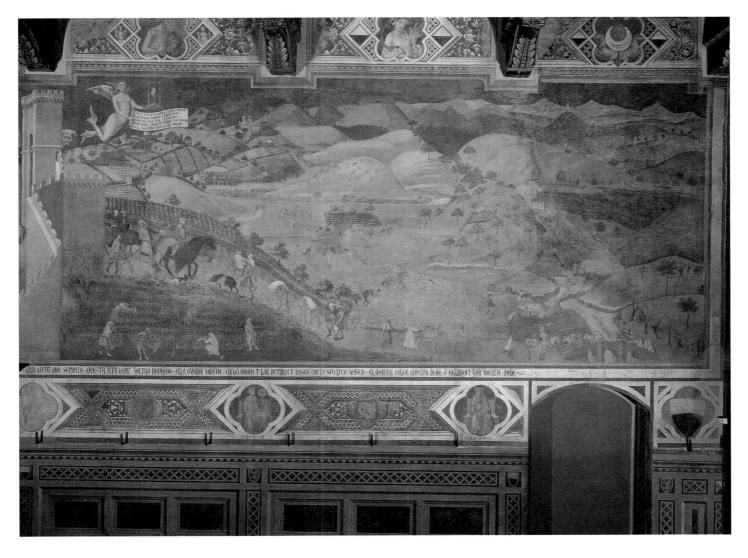

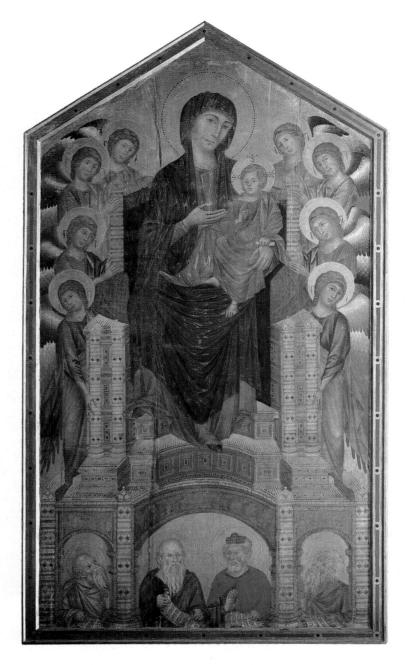

16-77. Cimabue. *Virgin and Child Enthroned*, from the Church of Santa Trinità, Florence. c. 1280. Tempera and gold on wood, 12'7¹/₂" x 7'4" (3.9 x 2.2 m). Galleria degli Uffizi, Florence

Child Enthroned (fig. 16-77) in about 1280 for the main altar of the Church of Santa Trinità (Holy Trinity) in Florence. At more than 11½ feet high, this enormous panel painting seems to have set a precedent for monumental altarpieces. In it, Cimabue combines two iconographic types: the Virgin as the Throne of Wisdom (see fig. 15-15) and the Virgin Pointing the Way. The Virgin sits surrounded by saints, angels, and Old Testament prophets. She holds the infant Jesus in her lap and points to him as the path to salvation.

Cimabue employed Byzantine formulas in determining the proportions of his figures, the placement of their

features, and even the tilts of their haloed heads. Mary's huge throne, painted to resemble gilded bronze with inset enamels and gems, provides an architectural framework for the figures. To render her drapery and that of the infant Jesus, Cimabue used the Italo-Byzantine technique of highlighting a background color with thin lines of gold where the folds break. The vantage point suspends the viewer in space in front of the image, simultaneously looking down on the projecting elements of the throne and Mary's lap while looking straight on at the prophets at the base of the throne and the splendid winged seraphim stacked on either side. These interest-

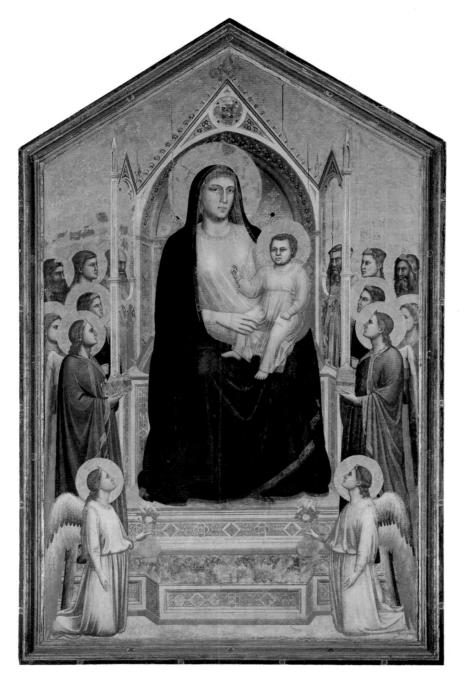

16-78. Giotto di Bondone. *Virgin and Child Enthroned*, from the Church of the Ognissanti, Florence. c. 1310. Tempera and gold on wood, 10'8" x 6'8¹/₄" (3.53 x 2.05 m). Galleria degli Uffizi, Florence

ing spatial ambiguities, as well as subtle asymmetries throughout the composition, the Virgin's thoughtful, engaging gaze, and the well-observed faces of the old men are all departures from tradition that enliven the picture. Cimabue's concern for spatial volumes, solid forms, and warmly naturalistic human figures contributed to the course of later Italian painting.

According to the sixteenth-century Renaissance chronicler Vasari, Cimabue discovered a talented shepherd boy, Giotto di Bondone, and taught him how to paint. Then, "Giotto obscured the fame of Cimabue, as a great light outshines a lesser." Vasari also credited Giot-

to (active c. 1300–1337) with "setting art upon the path that may be called the true one[, for he] learned to draw accurately from life and thus put an end to the crude Greek [i.e., Italo-Byzantine] manner" (cited in Barroughs, page 97). The painter and commentator Cennino Cennini (c. 1370–1440), writing in the late fourteenth century, was struck by the accessibility and modernity of Giotto's art, which, though it retained traces of the "Greek manner," was moving toward the depiction of a humanized world anchored in three-dimensional form.

Compared to Cimabue's *Virgin and Child Enthroned*, Giotto's 1310 painting of the same subject (fig. 16-78) for

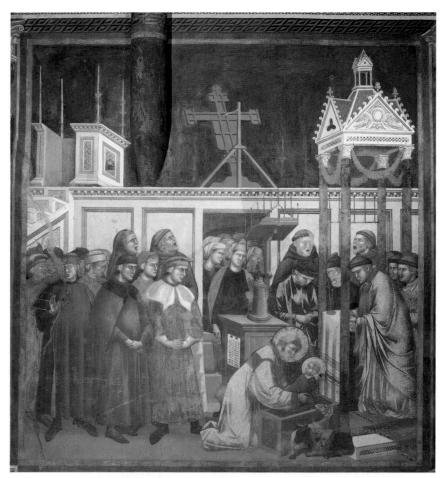

16-79. Saint Francis Master. Miracle of the Crib of Greccio, fresco in Upper Church of San Francesco, Assisi, Umbria, Italy. c. 1295–1301/30

Saint Francis, born Giovanni Bernadone (c. 1181-1226), was the educated son of a rich cloth merchant. After an early career as a soldier, he dedicated himself to God. Embracing poverty, he lived as a wandering preacher. The Franciscan order began after he and his followers gained the recognition of the pope. Contemporaries described him as an innocent eccentric. For example, encountering a poor man shivering with cold, Francis reputedly gave him the clothes off his back. Two years before his death he experienced the stigmata, wounds in his hands and feet like those of the crucified Christ.

the Church of the Ognissanti (All Saints) in Florence, while retaining certain of Cimabue's conventions, exhibits a groundbreaking spatial consistency and sculptural solidity. The central and largely symmetrical composition, the rendering of the angels' wings, and Mary's Byzantine facial type all reflect Cimabue's influence. Gone, however, are her modestly inclined head and delicate gold-lined drapery. This colossal and mountainlike Mary seems to burst forth from her slender Gothic baldachin. Giotto has imbued the picture with an unprecedented physical immediacy, despite his retention of hierarchical scale, the formal, enthroned image type, and a flat-gold ground. By rendering the play of light and shadow across their substantial forms, he has created the sense that his figures are fully three-dimensional beings inhabiting real space.

Giotto may have collaborated on murals at the prestigious Church of San Francesco in Assisi, the home of Saint Francis, the founder of the new Franciscan order, which was gaining followers throughout western Europe. Saint Francis's message of simple, humble devotion, direct experience of God, and love for all his creatures had a powerful impact on thirteenth-century Italian literature and art. The Church of San Francesco, the Franciscans' mother church, was consecrated by the pope in 1253, and the Franciscans commissioned many works to adorn it. Among those who worked there were Simone Martini, Pietro Lorenzetti, and Cimabue.

The *Life of Saint Francis*, in the upper church at San Francesco, was apparently among the last of the fresco

cycles to be completed there. Scholars differ on whether they were painted by the young Giotto as early as 1295–1301 or by his followers as late as 1330; many have adopted the neutral designation of the artist as the Saint Francis Master. One scene, the Miracle of the Crib at Greccio (fig. 16-79), shows Saint Francis making the first crèche, a Christmas tableau representing the birth of Jesus, according to legend, in the church at Greccio. The artist of this scene has made great strides in depicting a convincing space with freely moving solid figures. The fresco documents the way the sanctuary of an early Franciscan church looked and the observances that took place within it. A large wooden historiated crucifix similar to the one by Coppo di Marcovaldo (see fig. 16-70) has been suspended from a stand on top of the rood screen. It has been reinforced by cross-bracing on the back and tilted forward to hover over worshipers in the nave. A high pulpit with candlesticks at its corners rises over the screen at the left. Other small but telling touches include a seasonal liturgical calendar posted on the lectern, foliage swags decorating a Gothic baldachin, and the singing monks. Saint Francis, in the foreground, reverently places a statue of the Holy Infant in a plain, boxlike crib next to representations of various animals that might have been present at his birth. Richly dressed people—presumably patrons of the church—stand at the left, while Franciscan nuns, apparently excluded from the sanctuary, look on through an opening in the screen.

Giotto's masterpiece is the frescoed interior of another church, the Arena Chapel in Padua (fig. 16-80), painted

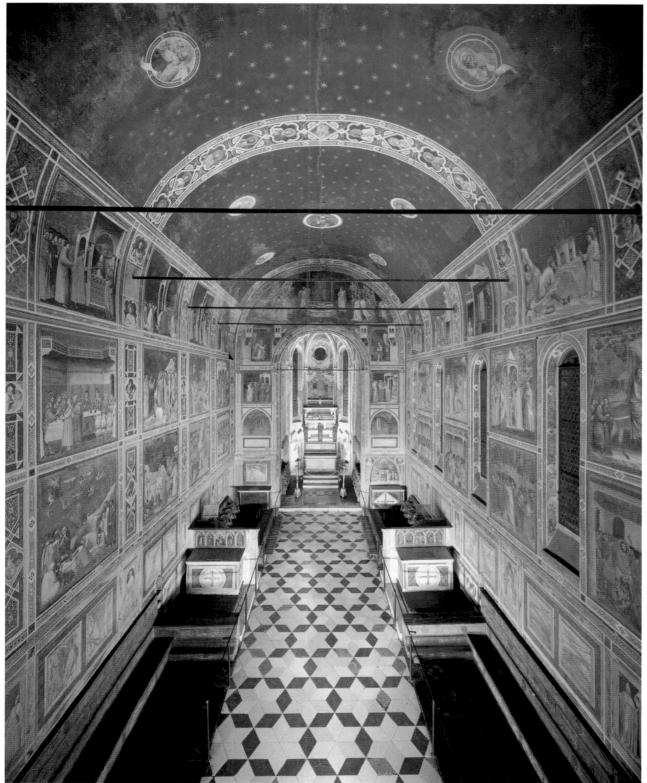

16-80. Giotto di Bondone. Fresco cycle in the Arena Chapel, Padua. c. 1305–6

Sculptors and painters influenced one another in thirteenth- and fourteenth-century Italy. Giotto, for example, is thought to have been influenced by the work of Nicola and Giovanni Pisano, and he, in turn, influenced Giovanni Pisano.

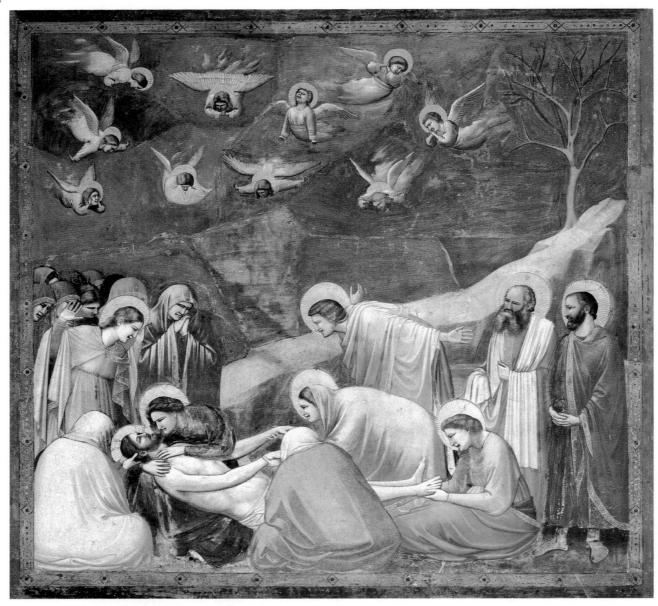

16-81. Giotto di Bondone. The Lamentation. 1305-6. Fresco in the Arena Chapel

1380

THE BLACK In the early 1340s

DEATH rumors began to circulate in Europe of a

deadly plague spreading by land and sea from Asia. By 1348 the plague had reached Constantinople, Italy, and France; by the next winter it had struck the British Isles; and by 1350 it had swept across Germany, Poland, and Scandinavia. Successive waves struck again in 1362, 1374, 1383, 1389, and 1400, and new outbreaks continued sporadically for the next 300 years, culminating in England's Great Plague of 1665. As much as half the urban population of Florence and Siena died in the summer of 1348, including many promising artists. England was similarly hard hit.

The plague, known as the Black Death, took two forms, both of which killed rapidly. The bubonic form was spread by fleas from rats, the pneumonic form through the air from the lungs of infected victims. To people of the time, ignorant of its causes and powerless to prevent it, the Black Death was a catastrophe. The fourteenth-century Italian writer Gio-

vanni Boccaccio described how "the calamity had instilled such terror in the hearts of men and women that

. . . fathers and mothers shunned their children, neither visiting them nor helping them" (cited in Herlihy,

page 355). In their panic, some people turned to escapist pleasure seeking, others to religious fanaticism. Many, seeking a scapegoat, turned against Jews, who were massacred in several cities.

Francesco Traini. *Triumph of Death*, detail of a fresco in the Campo Santo, Pisa. 1325-50

about 1305. While working at the Church of Saint Anthony in Padua, Giotto was approached by a local merchant to decorate a new family chapel. The chapel, named for a nearby ancient Roman arena, is a simple, barrel-vaulted room. Giotto covered the entrance wall with a scene of the Last Judgment. He subdivided the side walls with a dado of allegorical grisaille paintings of the Virtues and Vices, from which rise vertical bands containing quatrefoil portrait medallions. The medallions are set within a framework painted to resemble marble inlay and carved relief. The central band of medallions spans the vault, crossing a brilliant lapis-blue, star-spangled sky in which large portrait disks float like glowing moons. Set into this framework are rectangular narrative scenes juxtaposing the life of the Virgin with that of Jesus. Both the individual scenes and the overall program display Giotto's genius for distilling a complex narrative into a coherent visual experience. Among Giotto's achievements was his ability to model form with color. He rendered his bulky figures as pure color masses, painting the deepest shadows with the most intense hues and highlighting shapes with lighter shades mixed with white. These sculpturally modeled figures enabled Giotto to convey a sense of depth in landscape settings without relying on the traditional convention of an architectural framework, although he did make use of that convention.

In the moving Lamentation (fig. 16-81), in the lowest register of the Arena Chapel, Giotto focused the composition for maximum emotional effect off-center on the faces of Mary and the dead Jesus. A great downwardswooping ridge—its barrenness emphasized by a single dry tree, a medieval symbol of death—carries the psychological weight of the scene to its expressive core. Mourning angels hovering overhead mirror the anguish of Jesus' followers. The stricken Virgin communes with her dead son with mute intensity, while John the Baptist flings his arms back in convulsive despair and other figures hunch over the corpse. Instead of symbolic sorrow, Giotto conveys real human suffering, drawing the viewer into the circle of personal grief. The direct, emotional appeal of his art, as well as its deliberate plainness, embodies Franciscan values.

While Sienese painting was a key contributor to the development of the International Gothic style, Florentine painting in the style originated by Giotto and kept alive by his pupils and their followers was fundamental to the development of Italian Renaissance art over the next two centuries. Before these movements, however, came the disastrous last sixty years of the fourteenth century, in which the world of the Italian city-states—which had seemed so full of promise in Ambrogio Lorenzetti's *Good Government* frescoes—was transformed into a world of

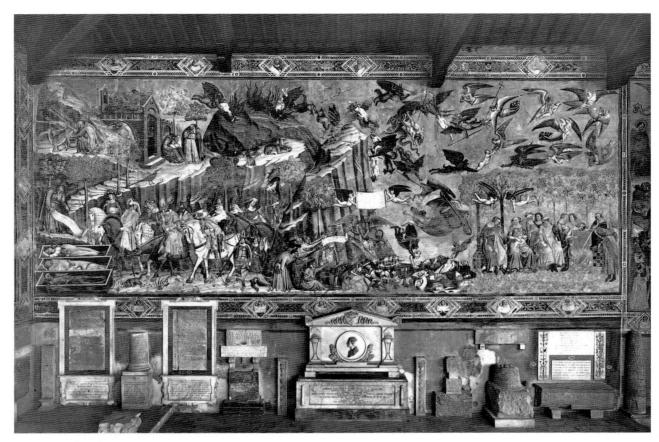

16-82. Francesco Traini. *Triumph of Death*, fresco in Campo Santo, Pisa. Mid-14th century

The fresco was damaged by American shells during World War II and has been detached from the wall to preserve it.

uncertainty, and desolation by epidemics of the plague.

The horror and the terror of impending death are vividly depicted in the *Triumph of Death* (fig. 16-82). This much-copied fresco was painted by a Pisan named Francesco Traini (active c. 1321–1363) in the Campo Santo, the funerary structure on the grounds of Pisa Cathedral. It shows the encounter between the Three Living (aristocrats leading a hunt) and the Three Dead (corpses in varying stages of decomposition), a grim theme popular in plague-wracked Europe in the mid-fourteenth century. A crowned woman in the center of the leading group of riders recoils at the sight of her dead counterpart, the

crowned man in the middle coffin. One of her courtiers covers his nose, gagging at the smell, while his wild-eyed horse cranes its neck forward. The animal's neck and the diagonal, Giottoesque cliff above lead the eye inexorably to the bloated, worm-riddled body in the top coffin. A stern old man unrolls a scroll, symbolically delivering the message of the scene: neither youth nor beauty, wealth nor power, but only piety like that of the hermits on the cliff above provides protection from the wrath of God. It was as if the self-confident hunting party in *Lorenzetti's Allegory of Good Government in the Country* fresco had set forth in sunshine only to return in shadow.

A BRIEF REVIEW OF THE EUROPEAN MIDDLE AGES

The Middle Ages, or medieval period, spans approximately 1,000 years in Europe, from the fifth to the fifteenth century. Medieval society arose after the collapse of the Western Roman Empire in 476, and the empire's vast road and water-supply networks, grandiose buildings, and places of learning quickly declined. This period of rapid change was marked by the spread of Christianity under the authority of the pope, the bishop of Rome. Christian clergy were almost the only people during this time who maintained the skills of reading and writing and undertook scholarly endeavors. The Church, as a result, had much influence on the arts.

As the migrating peoples of Euope settled down, they established kingdoms. For a time in the eighth and ninth centuries, Charlemagne, an astute and powerful ruler, united much of what are now France, Germany. Belgium, the Netherlands, and northern Italy into the Carolingian Empire, but his heirs soon divided the empire into separate kingdoms. From about 800 to 1000, Viking invaders from Scandinavia raided parts of Europe. Out of a conglomeration of mainly Germanic and northern Italian states and principalities arose a weak and often divided Holy Roman Empire in the late 900s, ruled by a series of emperors crowned by the pope.

In response to almost constant local warfare, people turned to local political, economic, and social structures for security. A new medieval way of life—combining vestiges of the old Roman Empire with Germanic traditions—expanded throughout Europe, especially after the tenth century. Powerful rulers, in order to obtain a trained local fighting force, promised tracts of land, called fiefs, to

vassals, who in turn promised loyalty and military assistance to their lords. In time, wealthy vassals controlled enough land to offer some of it to their own vassals. Vassals and subvassals often attempted to make their fiefs hereditary, which gave rise to a complex legal and economic system of rights, obligations, and dependency known as feudalism.

Most people in agricultural medieval society lived a bleak life as serfs bound to the land, laboring in return for promises of protection, a share of the crops, and economic support from their lord. Manors, or huge estates, were almost self-sufficient units, since people could no longer depend upon the long-distance trade opportunities or large cities of an empire to provide them with goods, services, or courts of law. Life for most people was short, with the events of birth, marriage, and death marked by Christian religious ceremonies conducted by the local clergy.

Beginning in the early 600s, the new religion of Islam spread from Arabia westward across North Africa and then northward into Europe. From about 800 until final victory in 1492, Christian kings fought wars to reconquer the Iberian peninsula (modern Spain and Portugal) from the Muslims. Beginning in 1096, Christian kings also led or sent military expeditions known as the Crusades from Europe into the Middle East to reclaim the Holy Land from Muslim Arabs.

On medieval Europe's southeastern borders, the Byzantine Empire (the eastern part of the former Roman Empire) flourished with a complex blend of ancient Greek, Roman, Christian, and Middle Eastern traditions. The empire lasted until 1453 when its capital, Constantinople, fell to the Muslim Ottoman Turks. In 1054 the Christian Church had split into two parts, the Roman Catholic Church in western Europe, and the Eastern Orthodox Church in the Byzantine Empire, but the Cru-

sades again brought the West into contact with the East and stimulated the flow of new ideas and new wealth from trade.

During the 1100s and 1200s this new wealth was channeled by taxes into huge building programs, making possible the soaring Gothic cathedrals with their brilliant stained-glass windows. These structures in growing towns gave work to architects, artists, stonemasons, sculptors, carpenters, craftworkers, and merchants. Within new town-centered universities students prepared for service in the Church or the government.

During the last few hundred years of the Middle Ages, the feudal system declined. In 1348 a bubonic plague, called the Black Death, struck Europe, killing more than 40 percent of the people. Growing royal power in England, France, and Spain meant a decline in the power of local nobles, who were further weakened by the Hundred Years' War (1337-1453) between England and France. Monarchs used their increased tax revenues to pay for standing armies rather than depend upon the doubtful loyalty of knights and the lessened security of castles. Medieval society was also weakened by disputes within the Church; at times in the 1300s there were two rival popes.

With the revival of urban life, merchants and craftsworkers demanded a greater say in political decisions. In the Italian city-states, in particular, wealthy merchants and rulers supported the renewed interest in ancient Greek and Roman texts, which inspired people to study language, poetry, history, and moral philosophy emphasizing harmony and balance in nature and the importance of individual achievementideas soon reflected in works of art and scholarship. After the mid-fifteenth century, printing with movable type made the spread of new knowledge faster and easier. By then the Middle Ages had given way to the Renaissance.

Limbourg Brothers Detail of seated woman, February. 1413–16

Brunelleschi
Dome of Florence Cathedral
1417–36

Donatello David After 1428

Van Eyck Portrait of Giovanni Amolfini (?) and His Wife, Giovanna Cenami (?)

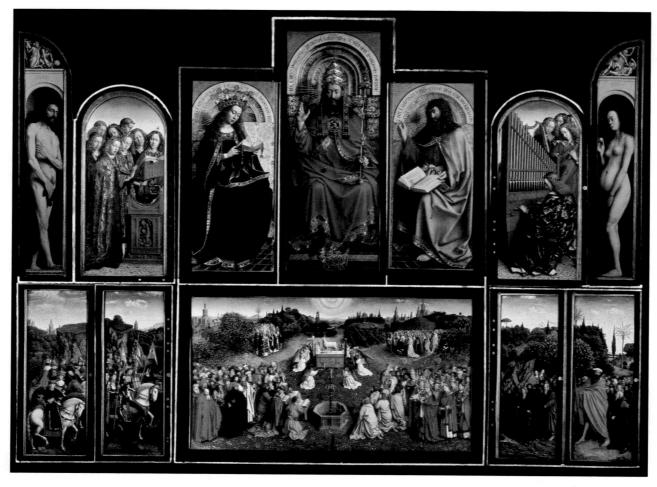

17-1. Jan and Hubert van Eyck. *Ghent Altarpiece* (open), Cathedral of Saint-Bavo, Ghent, Flanders (Belgium). 1432. Oil on panel, 11'5³/₄" x 15'1¹/₂" (3.5 x 4.6 m)

hen Philip the Good of Burgundy entered Ghent in 1458, the entire Flemish city turned out. Townspeople made elaborate decorations and presented theatrical events—much as they did for religious festivals, feast days, and visits by other important dignitaries. Local artists designed banners and made sets for the performances, most of which were about religious subjects. That day in Ghent, an especially dramatic and fascinating example of the relationship between visual art and performance took place. The powerful duke of Burgundy was greeted by small groups standing absolutely frozen, like statues: to welcome him they had become *tableaux vivants* ("living pictures") dressed in costume and posed to re-create scenes from their town's most celebrated work of art, Jan and Hubert van Eyck's *Ghent Altarpiece* (fig. 17-1).

This remarkable centerpiece of worship, completed twenty-six years earlier, shows an enthroned figure of God, seated between the Virgin Mary and John the Baptist and flanked by angel musicians. Below is a depiction of the Communion of Saints, based on the passage in the Book of Revelation that describes the Lamb of God receiving the veneration of a multitude of believers (Revelation 14:1). The church fathers, prophets, martyrs, and other saints depicted were among those staged that day to greet Philip.

The fascination with this complex and beautiful altarpiece, reflected so early in the tableaux vivants, perhaps accounts for its survival through more than five centuries. During uprisings in the sixteenth century, the panels were twice removed from their frames and hidden in a church tower. Over later centuries, panels were separated and taken to various locations to protect them. In 1894, while in the royal collection in Berlin, the six smallest panels were split through the middle so that both painted sides could be displayed at the same time. After World War I, the altarpiece was reassembled at Ghent, but a thief made off with two panels in 1934. (One, at the far left, was never recovered but was replaced by a faithful copy.) During World War II, the altarpiece panels were moved from town to town for safekeeping. Finally, in 1950–1951, the whole Ghent Altarpiece, one of the most studied and respected works of the early Renaissance in Europe, was reconstituted in Ghent.

EMERGENCE

THE In Europe many developments that had begun in the late Middle Ages reached maturity in **OF THE** the fifteenth century. Basic to **RENAISSANCE** these changes was economic growth in the late fourteenth

century that gave rise to a prosperous middle class in the Netherlands (which then included present-day Belgium), France, and Italy. Unlike the hereditary aristocracy that had dominated society during the Middle Ages, these merchants and bankers had attained their place in the world through personal achievement and were imbued with a spirit of self-confidence. In the early fifteenth century this newly rich middle class, like other people of means since the earliest civilizations, supported scholarship, literature, and the arts. Their generous patronage resulted in the explosion of learning and creation known as the Renaissance.

Renaissance is a French word for "rebirth." Although there have been other periods of economic and cultural rejuvenation in history, when people today speak of "the Renaissance," they mean this revival of certain ideals of Greek and Roman civilization, which arose and developed in the fifteenth century and spread throughout Europe in the sixteenth. This chapter considers the emergence of the Renaissance and its development during the fifteenth century. Sixteenth-century Renaissance art is covered in Chapter 18.

The intense interest in the classical past that characterized the fifteenth century did not develop suddenly in 1400. Scholars in the Middle Ages had already translated and written commentaries on the most important surviving books of antiquity. Since most of these texts were pre-Christian, the scholars who studied them became increasingly acquainted with a more secular outlook than was common among people of the Middle Ages. By the end of the fourteenth century, admiration of the ancient world had grown to such a point that humanists, as these scholars of antiquity were called, even began to use Latin texts as models for works of their own.

The Middle Ages, it is often said, was an "age of faith," a time when the goal of human existence was considered to be the salvation of the soul. Although the period produced wonderful examples of literature, poetry, history, and even science, intellectual life was largely concerned with theology and the reading of Scripture. To medieval people, despite their admiration for the accomplishments of the classical past, antiquity represented not a golden age to be revered and imitated but the unfortunate period before the coming of Christ. Thus, the humanists' admiration of the remarkable accomplishments of Greek and Roman civilization was a dramatic change. They regarded with wonder not only philosophers, poets, rhetoricians, and historians—of whom the Middle Ages also had many—but also mathematicians, astronomers, geographers, physicians, and naturalists, not to mention artists and architects. Perhaps more important, many classical writings exemplified a spirit of inquiry that tried to understand the natural world in a rational and scientific way. Renaissance scholars and artists all over Europe sought this same understanding.

In the art of northern Europe, where this survey of the Renaissance begins, interest in the natural world was manifested in detailed observation of nature. In manuscript painting, on wooden **panels**, and on canvas, artists depicted birds, plants, and animals with breathtaking accuracy. They observed that the sky is darker straight above than at the horizon, and they painted it that way. They described trees, shrubs, and even blades of grass with botanical precision. Enlarging on developments begun in the fourteenth century, artists accurately portrayed reflections in water and, in volumetric rendering, modeled the volumes of forms with light and shadow.

Along with the desire for accurate depiction came a new interest in particular personalities. Fifteenthcentury portraits have astonishingly lifelike individuality, combining careful—sometimes even unflattering—description with an uncanny sense of vitality. In a number of religious paintings, even the saints and angels seem to be portraits. Indeed, individual personalities were important

PARALLELS

<u>Europe</u>	1400-1450	1450-1500
France	Claus Sluter; Limbourg brothers; Joan of Arc burned at the stake	End of Hundred Years' War with England; René of Anjou; Mary of Burgundy Painter
Flanders	Robert Campin; Jan van Eyck; Rogier van der Weyden; Petrus Christus	Hugo van der Goes; Dirck Bouts; Geertgen tot Sint Jans; Hans Memling; Hunt of the Unicorn tapestry
Spain and Portugal	Beginning of European exploration of West Africa's coast	Nuño Gonçalvez; Isabella and Ferdinand unite Span- ish peninsula; Diego de la Cruz; beginning of Europe's Atlantic slave trade; Columbus's voyages; Vasco da Gama discovers sea route to India
Germany	Holy Roman Empire; Konrad Witz	Gutenberg's Bible; E. S.'s engravings; Martin Schongauer
Italy	Nanni di Banco; Council of Constance restores papacy to Rome; Kingdom of Naples and Sicily and Papal States begin to dominate politically; Filippo Brunelleschi; Gentile da Fabriano; Masaccio; Jacopo della Quercia; Fra Angelico; Michelozzo di Bartolommeo; Medici academy for classical learning; Andrea del Castagno; Paolo Uccello	Jacopo Bellini; Leon Battista Alberti; Fra Filippo Lippi; Piero della Francesca; Donatello; Lorenzo de' Medici rules Florence; Antonio del Pollaiuolo; Andrea Mantegna; Andrea del Verrocchio; Domenico del Ghirlandaio; Sandro Botticelli; Perugino, restoration of Sistine Chapel begins; Gentile Bellini; Savonarola preaches against worldliness; Giovanni Bellini
World	Ming dynasty (China); Muromachi period (Japan); Inka Empire established (South America); Montezuma rules Aztec Empire (South America); Ottoman Turks defeat Crusaders; <i>The Arabian Nights</i> collected	Ottoman Turks conquer Constantinople; War of the Roses (England); Mosque of Qait Bey (Egypt); first printed book in English by William Caxton (Brussels); Ivan the Great rules Russia; John Cabot (England) reaches North America; Spanish Inquisition, world

in every sphere. More names of artists were recorded during the fifteenth century, for example, than in the entire span from the beginning of the common era to the year 1400. A similar observation might be made in nearly every field.

(Egypt)

One reason for this new emphasis on individuality was that humanism implied an interest not only in antiquity but also in human beings; humanists believed that people were both worthy and capable of determining their own destinies. This perspective contrasted sharply with the medieval view that humanity was irredeemably sinful and had value only through the infinite grace of God. Nevertheless, the rise of humanism did not signify a decline in the importance of Christian belief. In fact, an intense Christian spirituality continued to inspire and pervade most European art through the fifteenth century and long after.

Despite the enormous importance of Christian faith in the fifteenth century, the established Western Church was plagued with problems. Furthermore, militant Islam was expanding toward southeastern Europe. In 1453, the Ottoman Turks actually conquered Constantinople, the capital of the Byzantine Empire and the center of Eastern Christianity. From there they pushed westward into

Greece and Serbia and ultimately lay siege to the northeastern coast of Italy. Within the Western Church, the hierarchy was being bitterly criticized for a number of its practices, including perceived indifference toward the needs of common people. Although these strains within the Western Church had little direct effect on fifteenthcentury art, they exemplified the skepticism of the Renaissance mind. In the next century, these tensions would give birth to the Protestant Reformation.

population less than 500 million

FRENCH COURT ART AT THE TURN OF THE CENTURY

In the late Middle Ages the French monarchy, from its seat in Paris, began to emerge as the powerful center of a national state after centuries of weakness following the collapse of the Carolingian Empire. In the fourteenth and fifteenth centuries royal authority was still constrained

by dukes and other nobels who controlled large territories outside the Paris region. Some of these nobles were at times powerful enough to pursue their own policies independent of the king. Many of the great dukes were members of the royal family, however, and their interests often united with those of the king. One strong centralizing

1400 1500

WOMEN ARTISTS IN THE LATE MIDDLE AGES AND THE RENAIS-SANCE Medieval and Renaissance women artists typically learned their trade from members of their families, because formal apprenticeships were not open to them. Surviving records of medieval French stone-

cutting workshops, which were operated as family businesses, show that women were active in these businesses. Similarly, Jeanne de Montbaston and her husband, Richart, worked together as book **illuminators** under the auspices of the University of Paris in the fourteenth century. After Richart's death, Jeanne continued the workshop and, following the custom of the time, was sworn in as a *libraire* (publisher) by the university in 1353.

Convents trained women artists, some of them members of the order, others unaffiliated. One of the earliest examples of a signed work by a woman painter is a tenth-century manuscript of the *Apocalypse*, illustrated by a woman named Ende, who describes herself as "painteress and helper of God." Particularly remarkable is a twelfth-century collection of sermons decorated by a nun named Guda, who not only signed her work but also included a self-portrait, one of the earliest in Western art.

In the fifteenth century women could be admitted to the guilds in some cities, including the Flemish towns of Ghent, Bruges, and Antwerp. The fifteenth-century painter Agnes van den Bossche of Ghent, for exam-

ple, learned her trade at home but went on to operate a painting workshop with her artist husband. After his death she became a free master of the painters' guild. A study of the painters' guild of Bruges has shown that by the 1480s one-quarter of its membership was female. Thus, while professional women artists were not the rule in medieval and Renaissance Europe, they were more common than is generally supposed today.

Particularly talented women were given commissions of the highest order. Bourgot, the daughter of the miniaturist Jean le Noir, illuminated books for a number of noble patrons, including Charles V of France and Jean, Duke of Berry. Christine de Pisan (1365-c. 1430), a well-known writer patronized by Philip the Bold of Burgundy and Queen Isabeau of France, described the work of an illuminator named Anastaise, "who is so learned and skillful in painting manuscript borders and miniature backgrounds that one cannot find an artisan . . . who can surpass her . . . nor whose work is more highly esteemed" (Le Livre de la Cité des Dames, 1.41.4, translated by Earl J. Richards). Besides women pursuing painting as a profession, noblewomen, who were often educated in convents, also learned to draw and paint, skills that came to be considered part of the education of a woman of rank.

Here the anonymous illuminator of a French edition of a book by the Italian author Boccaccio entitled *Concerning Famous Women*, produced for Philip the Bold in 1403, shows Tha-

myris, an artist of antiquity, at work in her studio. She is depicted in a contemporary fifteenth-century room, painting an image of the Virgin and Child. At the right, an assistant grinds and mixes the colors Thamyris will need to complete her painting. The uptilted ground plane, the minute details of the setting, and the bright colors and patterns exemplify the International Gothic style of illumination favored by the French courts at the beginning of the fifteenth century.

Page with Thamyris, from Giovanni Boccaccio's *De Claris Mulieribus (Concerning Famous Women).* 1402. Ink and tempera on vellum. Bibliothèque Nationale, Paris

factor was the threat of a common enemy, England. Claiming the French throne through inheritance, Edward III of England and his successors repeatedly invaded France between 1337 to 1453. This series of conflicts is known as the Hundred Years' War.

Just as the king held court in Paris, the most powerful of the dukes maintained courts in their own capitals. Through most of the fourteenth century, these centers had been arbiters of taste for most of Europe. From the last decades of the fourteenth century up to the 1420s, French court patronage was especially influential in northern Europe. The French king and his relatives the dukes of Anjou, Berry, Orléans, and Burgundy employed not only local artists but also gifted painters and sculptors from the Low Countries (present-day Belgium, Luxembourg, and the Netherlands). At the same time, many Dutch and Flemish artists migrated to France to work. Of major importance in the spread of new artistic ideas from the north were the construction and decoration of a

monastery at Champmol in what is now eastern France.

The French love of personal, intimate works of art set the tone for much of the art produced all over Europe in the International Gothic style, the prevailing manner of the late fourteenth century. The general characteristics of this style were charming or touching subjects, graceful poses, sweet facial expressions, and a concern for naturalistic details, including carefully rendered costumes and textile patterns, presented in a palette of bright and pastel colors with liberal touches of gold. The International Gothic style was so universally appealing that patrons throughout Europe continued to commission such works well into the fifteenth century, even as the new styles of the Renaissance took hold.

Manuscript Illumination

The French nobility were avid collectors of illustrated manuscripts, and in the late fourteenth century the

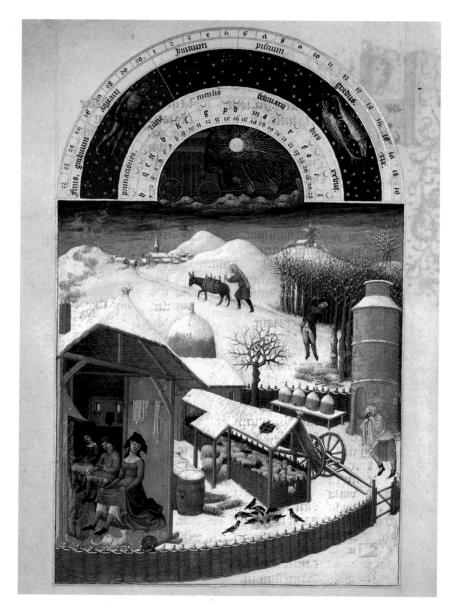

17-2. Paul, Herman, and Jean Limbourg. Page with *February, Très Riches Heures*. 1413–16. Musée Condé, Chantilly, France

The provenance, or ownership history, of this Book of Hours was unbroken up to 1530, when it passed at the death of Margaret of Austria, the regent of the Netherlandish provinces, to Jean Ruffaut, treasurer of the Holy Roman Empire. After that, it dropped out of sight until around 1850, when a French duke purchased it from an Italian collection. The duke identified its original owner as Jean, Duke of Berry, from the portrait on the *January* page of the book's calendar. Not until 1881, however, was the manuscript matched by art historian Léopold Delisle with an item in Jean's accounts, described as an incomplete but "very sumptuous hours [*très riches heures*] made by Paul and his brothers, very richly historiated and illuminated."

workshops of Paris were producing outstanding manuscripts for them. Religious texts were in great demand, as were secular writings such as herbals (encyclopedias of plants), health manuals, and works of history and literature, both ancient and contemporary.

The painters of Flanders, Holland, and other principalities of the Low Countries were increasingly influential in France at the beginning of the fifteenth century, and their fascination with creating an illusion of reality began to have an impact on French illumination, the small-scale illustration of books in color, some of which was done by women (see "Women Artists in the Late Middle Ages and the Renaissance," page 615). The most famous Netherlandish illuminators of the time were three brothers, Paul, Herman, and Jean, commonly known as the Limbourg brothers. In the fifteenth century, people generally did not have family names but were instead known by their first names, often followed by a

reference to their place of origin or parentage. The name used by the three Limbourg brothers, for example, refers to their home region. (Similarly, Jan van Eyck means "Jan from [the town of] Eyck." This chapter uses the forms of artists' names as they most commonly appear in contemporary documents.)

The Limbourg brothers are first recorded as apprentice goldsmiths in Paris about 1390. About 1404, they entered the service of the duke of Berry, for whom they produced their major work, the so-called *Très Riches Heures (Very Sumptuous Hours*), between 1413 and 1416. For the calendar section of this Book of Hours—a selection of prayers and readings keyed to Church rituals—the Limbourgs created full-page paintings to introduce each month, with subjects alternating between peasant labors and aristocratic pleasures.

Like most European artists of the time, the Limbourgs showed the laboring classes in a light acceptable to aristocrats—that is, happily working for their benefit. But the Limbourgs also showed the peasants enjoying their own pleasures. Haymakers on the *August* page shed their clothes to take a swim in a stream, and *September* grape pickers pause to savor the sweet fruit they are gathering. In the *February* page (fig. 17-2), farm people relax cozily before a blazing fire. Although many country people at this time lived in hovels, this farm looks comfortable and well maintained, with timber-framed buildings, a row of beehives, a sheepfold, and woven fences. In the distance are a small village and church.

Most remarkably, the artists convey the feeling of cold winter weather: the breath of the bundled-up worker turning to steam as he blows on his hands, the leaden sky and bare trees, the soft snow covering the landscape, and the comforting smoke curling from the farmhouse chimney. The painting clearly shows several International Gothic conventions: the high placement of the horizon line, the point at which the earth and the sky appear to meet, and the missing front wall of the house. The muted palette is sparked with touches of yellow-orange, blue, and a patch of bright red on the man's turban at the lower left. The integration of human and animal figures and architecture into the landscape has been accomplished within the prevailing Gothic style, but on a more believable scale, with a landscape receding continuously from foreground to middleground to background. The only nonrealistic element is the elaborate calendar device, with the sun god and the zodiac symbols.

Painting and Sculpture for the Chartreuse de Champmol

One of the most lavish projects of Philip the Bold, the duke of Burgundy (ruled 1363–1404) and son of the French king, was a Carthusian monastery, or *chartreuse* ("charterhouse," in English). He founded it in 1385 at Champmol, near his capital at Dijon, and its church was intended to house his family's tombs. A Carthusian monastery was particularly expensive because Carthusians, unlike most monks, did not provide for themselves by farming or other physical work but were dedicated to prayer and solitary

17-3. Claus Sluter. Well of Moses, Chartreuse de Champmol, Dijon, France. 1395–1406. Limestone, height of figures 5'8" (1.69 m)

meditation. The order is in effect a brotherhood of hermits. Although the brothers were thus free to pray at all hours for the souls of Philip and his family, it also meant that they needed continuing financial support.

Philip commissioned the Flemish sculptor Jean de Marville to direct the production of the sculptural decoration of the monastery. At Jean's death in 1389, he was succeeded by his assistant Claus Sluter (documented from 1379; d. 1405/6), from Haarlem, in Holland. Although much of this splendid complex was destroyed 400 years later during the French Revolution, the quality of Sluter's work can still be seen on the Well of Moses, a monumental fountain at the center of the main cloister, which served as the order's cemetery (fig. 17-3). Begun in 1395, the fountain was unfinished at Sluter's death. Originally the base rose from its center to support a large, freestanding Crucifixion, which included figures of the Virgin Mary, Mary Magdalen, and John the Evangelist. Surrounding the base, which still survives, are nearly 6-foot-tall stone figures of Old Testament prophets and heroes who either foretold the coming of Christ or were in some sense his precursors: Moses (the ancient Hebrew prophet and lawgiver), David (king of Israel and an ancestor of Jesus), and the prophets Jeremiah, Zechariah, Daniel, and Isaiah.

Sluter depicted the Old Testament figures as distinct individuals physically and psychologically. Moses' sad old eyes blaze out from a memorable face entirely covered with a fine web of wrinkles. Even his horns—traditionally

17-4. Melchior Broederlam. *Annunciation and Visitation* (left); *Presentation in the Temple and Flight into Egypt* (right), wings of an altarpiece for Chartreuse de Champmol. 1394–99. Oil on panel, 5'53/4" x 4'11/4" (1.67 x 1.251 m). Musée des Beaux-Arts, Dijon

given to him because of a mistranslation in the Latin Bible—are wrinkled. A mane of curling hair and a beard cascade over his heavy shoulders and chest, and an enormous cloak envelops his body. Beside him stands David, in the voluminous robes of a medieval king, the personification of nobility. The drapery, with its deep folds creating dark pockets of shadow, is an innovation of Sluter's. While its heavy sculptural masses conceal the body beneath, its strong highlights and shadows visually define the body's volumes. With these vigorous, imposing, and highly individualized figures, Sluter transcended the limits of the International Gothic style and introduced a new Renaissance manner to northern sculpture.

Between 1394 and 1399, two Flemish artists working in different towns produced a large altarpiece for the Chartreuse de Champmol. This was a triptych, a work in three panels, hinged together side by side so that the two side panels, or wings, fold over the central one. Jacques de Baerze, a wood carver, executed the central panel in carved reliefs-figures or objects carved from the surrounding plane—while Melchior Broederlam painted the exteriors of the two large wings (fig. 17-4). Broederlam's subjects illustrate the Infancy of Christ. The events take place in a continuous landscape that fills the two panels, each scene with its own architectural or natural spatial setting for the solid, three-dimensional figures. In International Gothic fashion, the front walls of the structures have been removed and the floors tilted up to give clear views of the interiors. Outdoor elements have been

arranged to lead the eye up from the foreground and into the distance along a rising ground plane. Despite the imaginative architecture, fantasy mountains, miniature trees, and solid gold sky, the artist has created a sense of light and air around his figures.

On the left wing, in the Annunciation, the archangel Gabriel greets Mary with the news of her impending motherhood. A door leads into the dark interior of the tall pink rotunda meant to represent the Temple of Jerusalem, where, according to legend, Mary was an attendant prior to her marriage to Joseph. At the left is a tiny enclosed garden, a symbol of Mary's virginity. In the Visitation, just outside the temple walls, the now-pregnant Mary greets her older cousin Elizabeth, who is also pregnant and will soon give birth to John the Baptist. On the right wing, in the Presentation in the Temple, Mary and Joseph have brought the newborn Jesus to the temple for the Jewish purification rite, where the prophet Simeon takes him in his arms to bless him (Luke 2:25-32). At the far right, the Holy Family flees into Egypt to escape King Herod's order to kill all Jewish male infants. The family travels along treacherous terrain similar to that in the Visitation scene, an element that foretells the difficulties that lie ahead for the child. As with many medieval and Renaissance scenes of the Life of Christ, much of the detail comes not from the New Testament accounts but from other legendary writings. One such detail is the statue of the pagan god breaking and tumbling from its pedestal as the Christ Child approaches, visible at the upper right.

ART

FLEMISH Netherlandish painting of this period is called Flemish because its greatest exponents lived in that province of the

Low Countries called Flanders (most of which is now part of modern Belgium, and a small part is in present-day France), although some artists' families had originally come from Brabant and Holland to the north or from nearby German states and France. Flanders, with its major seaport at Bruges, was the commercial power of northern Europe, rivaled in southern Europe only by the Italian city-states of Florence and Venice. The chief sources of Flemish wealth were the wool trade and the manufacture of fine fabrics. Powerful local guilds, or associations, oversaw nearly every aspect of their members' lives, and high-ranking guild members served on town councils and helped run city governments.

Artists who worked independently in their own studios without the sponsorship of an influential patron had to belong to a local guild. Experienced artists who moved from one city to another usually had to work as assistants in a local workshop until they met the requirements for guild membership. Different kinds of artists belonged to different guilds. Painters, for example, joined the Guild of Saint Luke, the guild of the physicians and pharmacists, because painters used the same techniques of grinding and mixing raw ingredients for their pigments and varnishes that physicians and pharmacists used to prepare salves and potions.

Civic groups, town councils, and wealthy merchants were important art patrons in the Netherlands, where the cities were self-governing, largely independent of the landed nobility. The diversity of clientele encouraged artists to experiment with new types of images, with outstanding results. Throughout most of the fifteenth century, the art and artists of the Netherlands were considered the best in Europe. The new Flemish style of painting was so admired in other countries that artists

Painting pictures on wood has an ancient

in the fifteenth century for works ranging from enormous

altarpieces to small portraits. First the wood surface was

prepared to make it smooth and nonabsorbent. After being sanded, the panel was coated—in Italy with gesso,

a fine solution of plaster, and in northern Europe with a

solution of chalk. These coatings soaked in and closed the

pores of the wood. Fine linen was often glued down over

the whole surface or over the joining lines on large panels

made of two or more pieces of wood. The cloth was then

it with either a water-soluble color, called tempera, or oil

paint. Italian artists favored tempera, using it almost

exclusively for panel painting until the end of the fifteenth

century. Northern European artists preferred the oil tech-

nique that Flemish painters so skillfully exploited at the

beginning of the century. In some cases, wood panels

Once the surface was ready, the artist could paint on

history, and wood panels were particularly

favored by European painters and their patrons

also coated with gesso or chalk.

came from abroad to see the paintings of the major Flemish artists and eventually tried to emulate them. The dukes of Burgundy expanded their empire throughout nearly the entire Netherlands, and they provided stability for the arts to flourish there, as well as spreading the influence of Flemish arts throughout Europe. Only at the end of the fifteenth century did a general preference for the Netherlandish painting style give way to a taste for the new styles of art and architecture developing in Italy.

1400

First-Generation Panel Painters

Although northern European artists painted on wood panels in the fourteenth century, too few remain to allow us to trace the emergence of the Flemish Renaissance style (see "Painting on Panel," below). Its origins are more evident in manuscript illumination of the late fourteenth century, when artists began to create full-page scenes set off with frames that functioned as windows looking into rooms or out onto landscapes with distant horizons. The panel paintings of the early fifteenth century developed logically from these works.

The most outstanding exponents of the new Flemish style were Robert Campin (documented from 1406; d. 1444), Jan van Eyck (c. 1370/90-1441), and Rogier van der Weyden (c. 1399-1464). Scholars have been able to piece together sketchy biographies for these artists from contracts, court records, account books, and mentions of their work by contemporaries. Reasonable attributions of a number of paintings have been made to each of them, but written evidence is limited, and signatures are rarely found on fifteenth-century paintings, owing in part to the custom of signing on the frames, which usually have

Only recently, for example, has Robert Campin been widely accepted as the artist formerly known as the Master of Flémalle, named for a pair of panel paintings once

TECHNIQUE

PAINTING ON were first painted with oil, then given fine PANEL detailing with tempera, a technique especially popular for small portraits.

> Tempera had to be applied in a very precise manner, because it dried almost as quickly as it was laid down. Shading had to be done with careful overlying strokes in tones ranging from white and gray to dark brown and black. Because tempera is opaque—light striking its surface does not penetrate to lower layers of color and reflect back—the resulting surface was matte, or dull, and had to be varnished to give it a sheen. Oil paint, on the other hand, took much longer to dry, and while it was still wet, errors could simply be wiped away with a cloth. Oil could also be made translucent by applying it in very thin layers, called glazes. Light striking a surface built up of glazes penetrates to the lower layers and is reflected back, creating the appearance of glowing from within. In both tempera and oil the desired result in the fifteenth century was a smooth surface that betrayed no brushstrokes and somewhat resembled enamel.

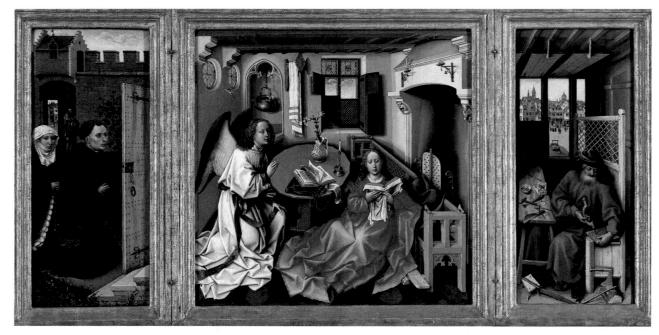

17-5. Robert Campin. *Mérode Altarpiece (Triptych of the Annunciation)* (open). c. 1425–28. Oil on panel, center 25¹/₄ x 24⁷/₈" (64.1 x 63.2 cm); each wing approx. 25³/₈ x 10⁷/₈" (64.5 x 27.6 cm). The Metropolitan Museum of Art, New York The Cloisters Collection, 1956 (56.70)

thought to have come from the Abbey of Flémalle. Despite a lack of documentary evidence, stylistic analysis has convinced most art historians that Campin and the Master of Flémalle are the same artist. His paintings reflect the Netherlandish taste for narrative emphasis and a bold volumetric treatment of the figures reminiscent of the sculptural style of Claus Sluter.

About 1425-1428 Campin painted an altarpiece now known as the *Mérode Altarpiece* from the name of modern owners. Slightly over 2 feet tall and about 4 feet wide with the wings open, it probably was made for a small private chapel or altar (fig. 17-5). Campin portrayed the Annunciation inside a Flemish home and integrated common religious symbols into this contemporary setting. The lilies on the table, for example, which symbolize Mary's virginity, were a traditional element of Annunciation imagery (see fig. 17-4). Moreover, Flemish viewers would have recognized the vase carrying them as a majolica (glazed earthenware) pitcher, commonly used then for the ritual of the Eucharist (Communion). The hanging waterpot and white towel in the niche symbolize Mary's purity and her role as the vessel for the Incarnation of Christ. These objects are often referred to as "hidden" symbols because they are treated as a normal part of the scene, but their religious meanings would have been widely understood by contemporary people. Unfortunately, the precise meanings are not always clear today.

For example, the central panel does not portray the most commonly depicted moment: Gabriel's telling Mary that she will be the Mother of Christ. Instead, according to one interpretation, it shows the moment immediately following Mary's acceptance of her destiny, and her impregnation by the Holy Spirit is signified by the rush of wind that riffles the book pages and snuffs the candle.

The Incarnation (God assuming human form) is represented by the tiny figure at the upper left descending on a ray of light, carrying a cross. Having accepted the miraculous event, Mary, sitting humbly on the footrest of the long bench as a symbol of her submission to God's will, has returned to reading her Bible.

Another interpretation of the scene is that it represents the moment just prior to the Annunciation. In this view Mary is not yet aware of Gabriel's presence, and the rushing wind is the result of the angel's rapid descent into the room, where he appears before her half kneeling and raising his hand in salutation.

The complex treatment of light in the *Mérode Altarpiece* was an innovation of the Flemish painters. The strongest illumination comes from an unseen source at the upper left from in front of the **picture plane**, apparently the sun entering through the miraculously transparent wall that allows the viewer to observe the scene. Often the light is deliberately painted to look inconsistent in order to convey symbolic meaning. Here, a few rays enter the round window at the left as the vehicle for the Christ Child's descent. More light comes from the window at the rear of the room, and areas of reflected light can also be detected.

Campin maintained the convention of boxlike space typical of the International Gothic style; the abrupt recession of the bench toward the back of the room, the sharply uptilted floor and tabletop, and the disproportionate relationship between the figures and the architectural space create an inescapable impression of instability. In an otherwise intense effort to mirror the real world, this treatment of space may be a conscious remnant of medieval style, serving the symbolic purpose of visually detaching the religious realm from the world

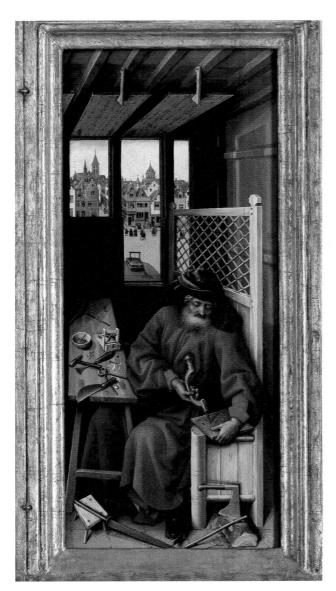

17-6. Robert Campin. Joseph in His Carpentry Shop, right wing of the Mérode Altarpiece (Triptych of the Annunciation)

The unusual attention given to Mary's husband, Joseph, is connected with the beginnings of a cult of devotion to him that resulted in his veneration by the end of the sixteenth century as an important saint in his own right. Unlike most earlier images of him as an aged, uncomprehending but kindly man, he is shown here as the well-dressed owner of a prosperous middle-class home. Moreover, his individuality and independence is stressed as a master craftsworker, creating wares in his urban shop surrounded by the tools of his trade.

of the viewers. Unlike figures by such International Gothic painters as the Limbourg brothers (see fig.17-2), the Virgin and Gabriel are massive rather than slender, and their abundant draperies increase the impression of their material weight.

Although in the biblical account Joseph and Mary were not married at the time of the Annunciation, this house clearly belongs to Joseph, shown in his carpentry shop on the right (fig. 17-6). A prosperous Flemish city can be seen through the shop window, with people going

about their business unaware of the drama taking place inside the carpenter's home. One clue indicates that this is not an everyday scene: the shop, displaying carpentry wares—mousetraps, in this case—should be on the ground floor, but its window opens from the second floor. The significance of the mousetraps would have been recognized by knowledgeable people in the fifteenth century as Saint Augustine's reference to Christ as the bait in a trap set by God to catch Satan. Joseph is drilling holes in a small board that may be a drainboard for wine making, symbolizing the central rite of the Church, the Eucharist.

Joseph's house opens onto a garden planted with a red-rose bush, which alludes to the Virgin and also to the Passion (the arrest, trial, and Crucifixion of Jesus). It has been suggested that the man standing behind the open entrance gate, clutching his hat in one hand and a document in the other, may be a self-portrait of the artist. Alternatively, the figure may represent an Old Testament prophet, since rich costumes like his often denoted highranking Jews of the Bible. Kneeling in front of the open door to the house is the donor of the altarpiece. Behind him is his wife, who was added slightly later—probably the couple married after the triptych was painted. The pair appears at first glance to be observing the Annunciation through the door, but their gazes are unfocused, and the garden where the donors kneel is unrelated spatially to the chamber where the Annunciation takes place, suggesting that the scene is a vision induced by their prayers. Such a presentation, often used by Flemish artists, allowed the donors of a religious work to appear in the same space and time, and often on the same scale, as the figures of the saints represented.

Campin's contemporary Jan van Eyck was a court painter to the duke of Burgundy. Nothing is known of Jan's youth or training, but he was born sometime between 1370 and 1390 in Maaseik, on the Maas (Meuse) River, now in Belgium on the present-day border between Belgium and the Netherlands. He was from a family of artists, including two brothers, Lambert and Hubert, and a sister, Margareta, whom sixteenth-century Flemish writers still remembered with praise. The earliest references to Jan are in 1422 in The Hague, where he was probably involved in the renovation of a castle. He was appointed painter to Philip the Good, the duke of Burgundy, in Bruges on May 19, 1425. His appointment papers stated that he had been hired because of his skillfulness in the art of painting, that the duke had heard about Jan's talent from people in his service, and that the duke himself recognized those qualities in Jan van Eyck. The special friendship that developed between the duke and his painter is a matter of record.

Although there are a number of preserved accounts of Jan's activities, the only reference to specific artworks is to two portraits of Princess Isabella of Portugal, which he painted in that country in 1429 and sent back to Philip in Flanders. Philip and Isabella were married in 1430. The duke alluded to Jan's remarkable technical skills in a letter of 1434–1435, saying that he could find no other painters equal to his taste or so excellent in art and

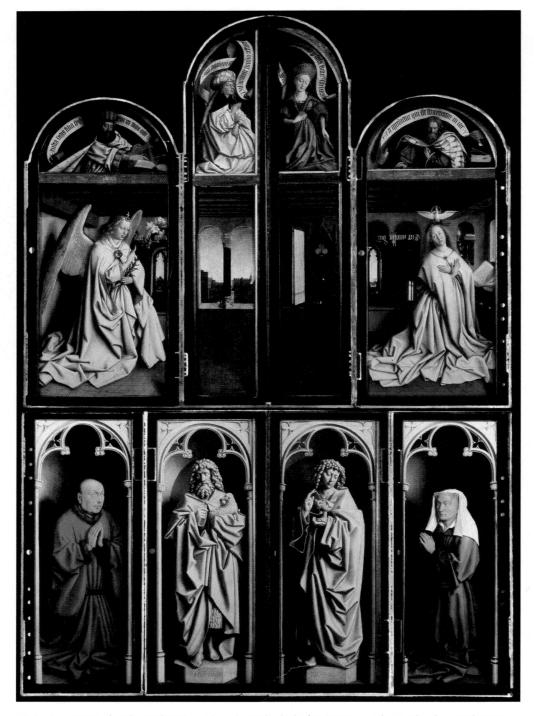

17-7. Jan van Eyck. *Ghent Altarpiece* (closed), Cathedral of Saint-Bavo, Ghent, Flanders (Belgium). 1432. Oil on panel, $11'5^3/4"$ x $7'6^3/4"$ (3.4 x 2.3 m)

science. Part of the secret of Jan's "science" was his technique of painting with oil on wood panel. So brilliant were the results of his experiments that Jan has been mistakenly credited with being the inventor of **oil painting**. Actually, the medium had been known for several centuries, and medieval painters had used oil paint to decorate stone, metal, and occasionally plaster walls.

For his paintings on wood panel, Jan built up the images in transparent oil layers, a procedure called **glazing**. His technique permitted a precise, objective description of what he saw, with tiny, carefully applied

brushstrokes so well blended that they are only visible at very close range. Other northern European artists of the period worked in the oil medium, although oil and **tempera** were still combined in some paintings, and tempera was used for painting on canvas (see "Painting on Panel," page 619).

Jan's earliest known work, the *Ghent Altarpiece*, was completed in 1432 for a wealthy official of Ghent and his wife. The complexities of this altarpiece can be challenging intellectually and emotionally. The wing exteriors (fig. 17-7) present an Annunciation scene, with Gabriel and

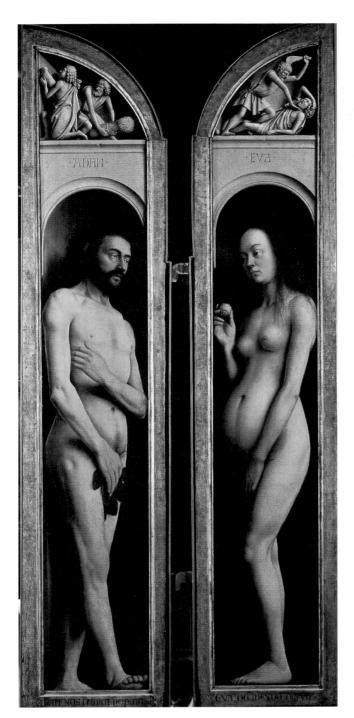

17-8. Jan van Eyck. *Adam* and *Eve,* details of the open *Ghent Altarpiece* (fig. 17-1)

the Virgin on opposite sides of a room overlooking out onto a city. In the panels above are pagan and Old Testament prophets who foretold the coming of Christ. Below, the donors are portrayed beside statues of the church's patron saints, John the Baptist and John the Evangelist.

The brilliantly painted interior of the altarpiece, which was only opened at Easter (see fig. 17-1), presents an enthroned figure of God, the Virgin Mary, John the Baptist, and angel musicians. The jewels and embroidery, meticulously re-created gem by gem and stitch by stitch, are superb examples of Jan's characteristic technique.

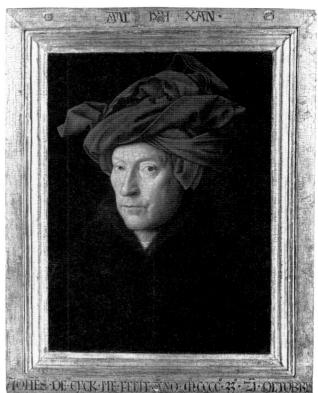

17-9. Jan van Eyck. *Man in a Red Turban*. 1433. Oil on panel, 101/4 x 71/2" (26 x 19.1 cm). The National Gallery, London

The nude figures of Adam and Eve on the outermost panels (fig. 17-8) contrast shockingly to the richly dressed figures between them. Above their heads, painted as if carved in stone, their son Cain kills his brother Abel, thus committing the first murder. This is the terrible consequence of the first couple's disobedience to God, a sin that can only be redeemed by the coming of Christ.

Below these figures is a panoramic Communion of Saints. Jan's technique is firmly grounded in the terrestrial world despite his visionary subject. The meadow and woods, painted leaf by leaf and petal by petal, and the distant city have been rendered from a careful observation of nature. Jan noted, for example, that the farther colors are from a viewer, the more muted they seem. He thus painted the more distant objects with a grayish or bluish cast and the sky paler toward the horizon, an effect called **atmospheric perspective** (see "Renaissance Perspective Systems," page 624).

The *Man in a Red Turban* of 1433 (fig. 17-9) is widely believed to be Jan's self-portrait, partly because of the strong sense of personality it projects, partly because the frame, signed and dated by him, also bears his personal motto, *Als ich chan* ("The best that I am capable of doing"). This motto, derived from classical sources, is a telling illustration of the humanist spirit of the age and the confident expression of an artist who knows his capabilities and is proud to display them.

If the *Man in a Red Turban* is, indeed, the face of Jan van Eyck, it shows us his physical appearance as if seen

1440

PERSPECTIVE **SYSTEMS**

RENAISSANCE The increasingly human-centered world of the Renaissance was re-

flected in how artists depicted space. In the fourteenth century, fresco painters such as the Lorenzetti brothers and Giotto in Italy and northern manuscript illuminators such as Jean Pucelle pioneered the rendering of figures and objects within coherent settings that created the illusion of three-dimensional space. They used intuitive perspective to approximate the appearance of things growing smaller and narrowing in the distance (see fig. 17-4).

The humanists' scientific study of the natural world and their belief that "man is the measure of all things" led to the invention of a mathematical system based on proportions of a human male body to enable artists to represent the visible world in a convincingly illusionistic way. This system-known variously as mathematical, linear, or Renaissance perspective—was first demonstrated

by the architect Filippo Brunelleschi about 1420. In 1436 Leon Battista Alberti codified mathematical perspective in his treatise Della Pittura (On Painting), making a standardized, somewhat simplified method available to a larger number of draftspeople, painters, and relief sculptors.

For Alberti, the picture's surface was a flat plane that intersected the viewer's field of vision, which he saw as cone- or pyramid-shaped, at right angles. In Alberti's highly artificial system, a one-eyed viewer was to stand at a prescribed distance from a work, dead center, and remain there. From this fixed vantage point everything appeared to recede into the distance at the same rate, shaped by imaginary lines called orthogonals that met at a single vanishing point, often on the horizon. Orthogonals distort objects by foreshortening them, replicating the optical illusion that things grow smaller and closer together as they get farther away from us. Despite its limitations, mathematical perspective has the advantage of making the viewer feel a direct, almost physical connection to the pictorial space, which seems like an extension of real space. It creates a compelling, even exaggerated sense of depth.

Early Renaissance artists following Alberti's system relied on a number of mechanical methods. Many constructed devices with peepholes through which they sighted the figure or object to be represented. They used mathematical formulas that enabled them to translate three-dimensional forms onto the picture plane, which they overlaid with a grid to provide reference points. As Italian artists became more comfortable with mathematical perspective in the course of the fifteenth century, they came to rely less on peepholes and formulas, and be less fascinated with linear forms (such as tiled floors and buildings) that had been a hallmark of early Renaissance style. Many artists adopted multiple vanishing points, which gave their work a more relaxed, less tunnel-like feeling.

Meanwhile, in the North, artists such as Jan van Eyck continued to refine intuitive perspective, coupling it with atmospheric, or aerial, perspective. This technique—applied to the landscape scenes that were a northern specialty-was based on the observation that because of haze in the atmosphere, distant elements appear less distinct and become blue-gray, and that the sky becomes paler as it nears the horizon. Among southern artists, Leonardo da Vinci made extensive use of atmospheric perspective, while in the north, the German artist Albrecht Dürer adopted the Italian system of mathematical perspective toward the end of the fifteenth century.

Paolo Uccello. The Deluge (Flood), fresco in Santa Maria Novella, Florence. c. 1450. See figure 17-52. As the overlaid orthogonals show, Uccello missed perfect convergence in his one-point perspective organization of this painting.

in an enlarging mirror—every wrinkle and scar, the stubble of a day's growth of beard on the chin and cheeks, and the tiny reflections of light from a studio window in the pupils of the eyes. The image gives not only this man's outward features but a glimpse of his soul. The outward gaze of the subject is new in portraiture, and it suggests the increased sense of pride in personal achievement of the Renaissance individual. Although eye contact between portrait subject and viewer has been interpreted as the result of the painter looking into a mirror—and thus is unique to self-portraiture—many other examples exist in fifteenth-century northern European painting that are clearly not self-portraits.

Jan's best-known painting today is an elaborate portrait of a couple, traditionally identified as Giovanni Arnolfini and his wife, Giovanna Cenami (fig. 17-10). This fascinating work has been, and continues to be, subject to a number of interpretations, most of which suggest that it represents a wedding or betrothal. One remarkable detail is the artist's inscription below the mirror on the back wall: Johannes de eyck fuit hic 1434 ("Jan van Eyck was here, 1434"). Normally, a work of art in fifteenth-century Flanders would have been signed "Jan van Eyck made this." The wording here specifically refers to a witness to a legal document, and indeed, two witnesses to the scene are reflected in the mirror, a man in

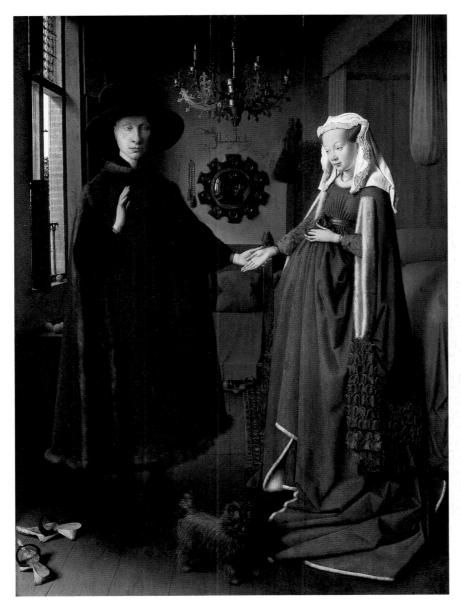

17-10. Jan van Eyck. *Portrait of Giovanni Arnolfini (?) and His Wife, Giovanna Cenami (?)*. 1434. Oil on panel, 33 x 22½" (83.8 x 57.2 cm). The National Gallery, London Odd though it may seem today, the fact that this event takes place in a bedroom is quite in keeping with the times, although somewhat unusual. A beautifully furnished room containing a large bed hung with rich draperies was a source of pride for its owners, and the bedroom was symbolic of marital happiness and pleasure. According to a later inventory description of this painting, the original frame (now lost) was inscribed with a quotation from Ovid, a Roman poet known for his celebration of romantic love.

a red turban—perhaps the artist—and one other. The man in the portrait, identified by early sources as a member of an Italian merchant family living in Flanders, the Arnolfini, holds the right hand of the woman in his left and raises his right to swear to the truth of his statements before the two onlookers. The fact that this takes place in a domestic setting, apparently the couple's bedroom, is unusual.

In the fifteenth century, a marriage was rarely celebrated with a religious ceremony. The couple signed a legal contract before two witnesses, after which the bride's dowry might be paid and gifts exchanged. If the painting indeed documents a wedding, the room where

the couple stands is their nuptial chamber, whose furnishings were often gifts from the groom to the bride. Recently, however, it has been suggested that, instead of a wedding, the painting might be a pictorial "power of attorney," by which the husband states that his wife may act on his behalf in his absence.

Whatever the painting represents, the artist has juxtaposed the secular and the religious in a work that seems to have several layers of meaning. On the man's side of the painting, the room opens to the outdoors, the external world in which men function, while the woman is silhouetted against the domestic interior, with its allusions to the roles of wife and mother. The couple is

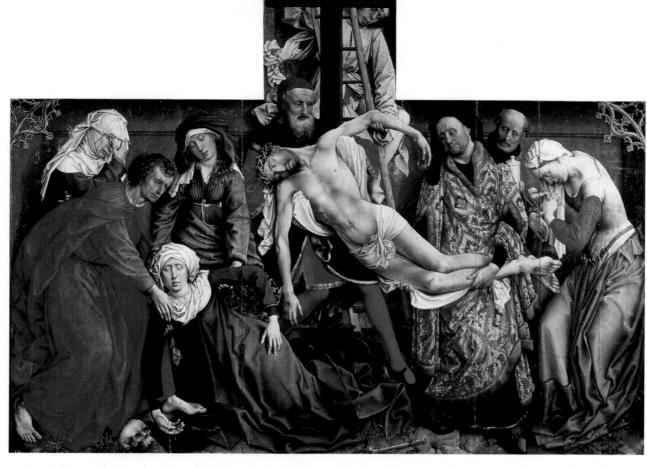

17-11. Rogier van der Weyden. *Deposition*, from an altarpiece commissioned by the Crossbowmen's Guild, Louvain, Brabant, Belgium. c. 1435. Oil on panel, 7'25/8" x 8'71/8" (2.2 x 2.62 m). Museo del Prado, Madrid

surrounded by emblems of wealth, piety, and married life. The convex mirror reflecting the entire room and its occupants is a luxury object described in many inventories of the time, but it may also symbolize the all-seeing eye of God, before whom the man swears his oath. The **roundels** decorating its frame depict the Passion of Christ, a reminder of Christian redemption.

Many other details have religious significance, suggesting the piety of the couple: the crystal prayer beads on the wall; the image of Saint Margaret, protector of women in childbirth, carved on the top of a high-backed chair next to the bed; and the single burning candle in the chandelier, which may be a symbol of Christ's presence. But the candle can also represent a nuptial taper or a sign that a legal event is being recorded. The fruits shown at the left, seemingly placed there to ripen in the sun, may allúde to fertility in a marriage and also to the Fall of Adam and Eve and the Garden of Eden. The small dog may simply be a pet, but its rare breed—affenpinscher—suggests wealth and serves also as a symbol of fidelity.

One of the most mysterious of the major early Flemish artists is Rogier van der Weyden. Although his biography has been pieced together from documentary sources, not a single existing work of art bears his name

or has an entirely undisputed connection with him. He was thought at one time to be identical with the Master of Flémalle, but evidence now suggests that he studied under Robert Campin, which would explain the similarities in their painting styles. Even his relationship with Campin is not altogether certain, however. At the peak of his career, Rogier maintained a large workshop in Brussels, to which apprentices and shop assistants came from as far away as Italy to learn his style of painting. He died in 1464.

The work scholars used to establish the thematic and stylistic characteristics for Rogier's art is a large panel, more than 7 by 8 feet, depicting the Deposition (fig. 17-11). This is the central panel of an altarpiece that once had wings painted with the Four Evangelists—Matthew, Mark, Luke, and John—and Christ's Resurrection. The altarpiece was commissioned by the Louvain Crossbowmen's Guild sometime before 1443, the date of the earliest known copy after it by another artist.

The Deposition was a popular theme in the fifteenth century because of its dramatic, personally engaging character. The viewer could identify with the grief of Jesus' friends, who tenderly and sorrowfully remove his body from the Cross for final burial. Here Jesus' suffering

17-12. Rogier van der Weyden. *Last Judgment Altarpiece* (open). After 1443. Oil on panel, open 7'45/8" x 17'11" (2.25 x 5.46 m). Musée de l'Hôtel-Dieu, Beaune, France

and death are made palpably real by the display of the lifesize corpse at the center of the composition. Rogier has arranged this figure in a graceful curve, echoed by the form of the fainting Virgin, thereby increasing the viewer's emotional identification with both the Son and the Mother. The artist's compassionate sensibility is especially evident in the facial expressions and hand gestures of the young John the Evangelist, who supports the Virgin at the left, and Jesus' friend Mary Magdalen, who wrings her hands in anguish at the right.

The removal of Jesus' body from the Cross is enacted on a shallow stage closed off by a wood backdrop that has been **gilded**, or covered with a thin overlay of gold. The solid, three-dimensional figures press forward toward the viewer's space, allowing no escape from their expressions of intense grief. Many scholars see Rogier's emotionality as a tie with the Gothic past, but it can also be interpreted as an example of fifteenth-century humanistic sensibility in its concern for individual expressions of emotion. Although united by their sorrow, the mourning figures react in personal ways.

Rogier's choice of color and pattern balances and enhances his composition. For example, the complexity of the gold brocade worn by Joseph of Arimathea, a secret disciple of Jesus whose new tomb was used for his burial, increases the visual impact of the right side of the panel, countering the larger number of figures at the left. The palette of subtle, slightly muted colors is sparked with red and white accents to focus the viewer's attention on the main subject. The whites of the winding cloth and the tunic of the youth on the ladder set off Jesus' pale body, as the white headdress and neck shawl emphasize the ashen face of Mary.

Most scholars believe that Rogier van der Weyden painted his largest and most elaborate work, the altarpiece of the *Last Judgment*, during the middle to final

years of his career (fig. 17-12). Some date the altarpiece just prior to a trip he is believed to have made to Rome in 1450, perhaps inspired by the Last Judgments so common in medieval churches. Others, who see Italianate elements in it, believe that he designed it after his return. The tall, straight figure of the archangel Michael, dressed in a white robe and priest's cope, or cloak, dominates the center of the wide **polyptych** (multiple-panel work), weighing souls under the direct order of Christ, who sits on the arc of a giant rainbow above him. Twenty saints, seated on clouds halfway between earth and heaven, include the Virgin Mary and John the Baptist at either end of the rainbow, six apostles behind them on each side, and in the outermost ranks a king, a queen, and a pope. The solid gold background serves, as it did in medieval times, to signify events in the heavenly realm or in a time remote from that of the viewer.

The Last Judgment takes place on a narrow, barren strip of earth that runs across the bottom of all but the outer panels. Resurrected men and women climb out of their tombs, turning in different directions as if confused or led by instinct. The scale of justice held by Michael tips in an unexpected direction; instead of Good weighing more than Bad, the Saved Soul has become pure spirit and rises, while the Damned one sinks, weighed down by unrepented sins. Michael's role here seems to be one of simply providing a model (with tiny token figures, perhaps) against which the resurrected dead can measure their own worth and determine in which direction to go. Those moving to the right throw themselves into the flaming pit of hell; those moving to the left—notably far less numerous—are greeted by the archangel Gabriel at the shining Gothic-style Gate of Heaven.

In his portraiture, Rogier balanced a Flemish love of detailed individuality with a flattering **idealization** of the features of men and women. A prime example is the

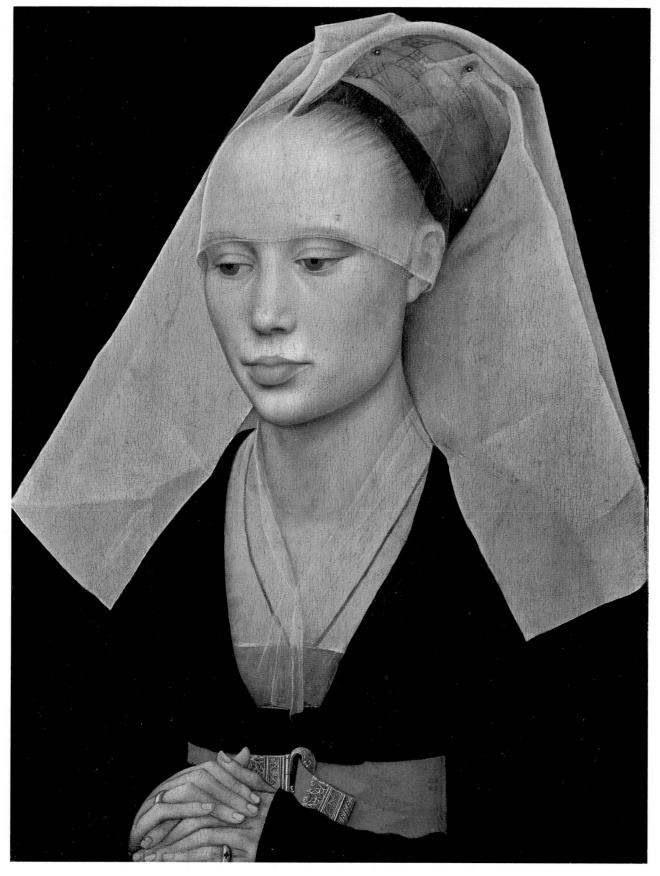

17-13. Rogier van der Weyden. Portrait of a Lady. c. 1460. Oil and tempera on panel, $14^{1/16}$ x $10^{5/8}$ " (37 x 27 cm). National Gallery of Art, Washington, D.C. Andrew W. Mellon Collection

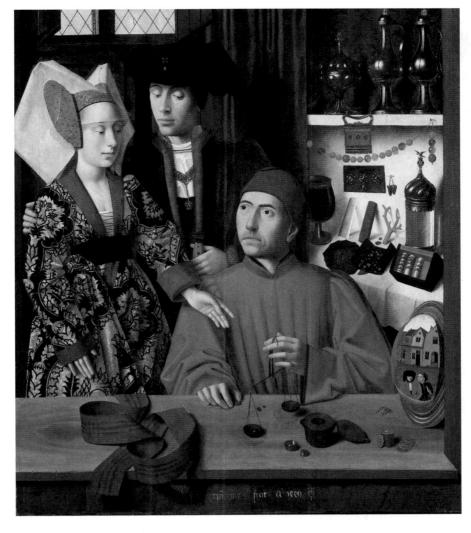

17-14. Petrus Christus. Saint Eloy (Eligius) in His Shop. 1449. Oil on oak panel, 38⁵/8 x 33¹/2" (98 x 85 cm). The Metropolitan Museum of Art, New York Robert Lehman Collection, 1975 (1975 1 110)

Portrait of a Lady, dating about 1460 and scarcely larger than a sheet of legal-size paper (fig. 17-13). The woman's broad, square-jawed face, blunt nose, and full lips have been transformed through their precise regularity and smooth, youthful skin into a vision of exquisite but remote beauty. The long, almond-shaped eyes are a characteristic of both men and women in portraits attributed to Rogier, and the half-length pose that includes the woman's high waistline and clasped hands was popularized by him. He used it as well for images of the Virgin and Child that often formed **diptychs** (two-panel works) with small portraits of this type. Since the woman's hands are folded at her waist rather than raised in prayer, this was probably a secular portrait.

Second-Generation Panel Painters

The extraordinary achievements of Robert Campin, Jan van Eyck, and Rogier van der Weyden attracted many followers. In general, the work of this second generation of Flemish painters was simpler, more direct, and easier to understand than that of their predecessors. Nevertheless, these artists produced high-quality work of great emotional power, and they were in large part responsible for the rapid spread of the Flemish style through Europe. A number of the second-generation painters received their early training in the Dutch provinces, where local schools of painting had developed strong followings.

Petrus Christus (documented from 1444; d. c.1475) probably came from the duchy of Brabant (a region partly in present-day Belgium, partly in the modern Netherlands) to Bruges, where he became a citizen in 1444, three years after the death of Jan van Eyck. Because of their stylistic affinities, it was once speculated that Christus might have worked in Jan's shop, a notion that is now generally rejected. In fact, his work seems as much influenced by Rogier van der Weyden as by Jan. He may also have spent time in Italy, where a "Piero from Bruges" was active in the ducal court of Milan in 1457.

In 1449, Christus painted one of his most admired and influential works, *Saint Eloy (Eligius) in His Shop* (fig. 17-14). Eloy, a seventh-century ecclesiastic and a gold-smith and mintmaster for the French court, according to legend used his wealth to ransom Christian captives. Here he weighs a jeweled ring to determine its price, as a handsome couple looks on. Among the objects on the shelf behind him are a number of similar rings. This may be a specific betrothal or wedding portrait, or the couple may be idealized figures personifying marital love in general. Because Saint Eloy was a special patron of illegitimate children, the moral message could be that marriage and legitimate birth were to be prized, not disregarded in the pursuit of pleasure.

As in Jan's *Portrait of Giovanni Arnolfini(?) and His Wife, Giovanna Cenami(?)* (see fig. 17-10), a convex mirror extends the viewer's field of vision, in this instance

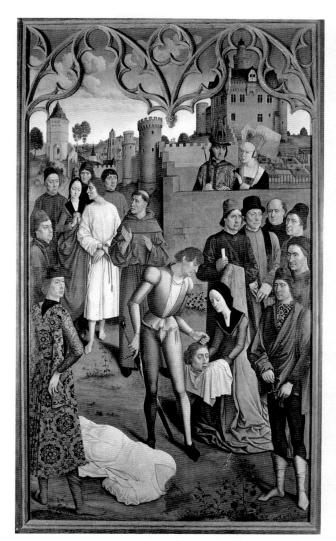

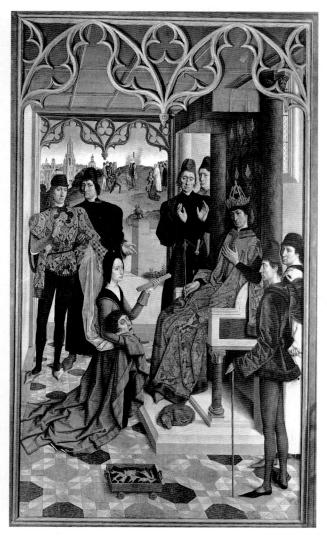

17-15. Dirck Bouts. *Wrongful Execution of the Count* (left), and companion piece, *Justice of Otto III* (right). 1470–75. Oil on panel, each 12'11" x 6'7¹/₂" (3.9 x 2 m). Musées Royaux des Beaux-Arts de Belgique, Brussels, Belgium

to the street outside, where two men, one holding a falcon, look through the window. Whether or not the reflected image has symbolic meaning, the mirror had a practical value in allowing the goldsmith to note the approach of a potential customer. All figures are dressed in the height of Flemish fashion, which spread to the rest of Europe through the export of fine local fabrics. Thus, to the modern eye, the painting might be read as an advertisement for the goldsmith. The emphasis on everyday details is so strong that the presence of the saint seems more a pretext for a secular subject than a sign of religious meaning. In fact, this painting provided the format for a long line of clearly secular pictures showing businesspeople in their shops, which persisted well into the sixteenth century.

An outstanding Haarlem painter who moved south to Flanders, Dirck Bouts (documented from 1457; d. 1475), became the official painter of Louvain in 1468. His mature style shows a strong debt to Jan van Eyck and, especially, Rogier van der Weyden, but not at the expense of his own clear-cut individuality. Bouts was an excellent storyteller, a master of direct narration rather than complex symbolism. His best-known works today are two remaining panels (fig. 17-15) from a set of four on the

subject of justice, a common theme in municipal buildings. They were commissioned by the town council of Louvain for the city hall. Unfinished at Bouts's death, the panels were completed by his workshop. The subject of the panels was a fictional twelfth-century story about a real-life Holy Roman emperor. In a continuous narrative in the left panel, Wrongful Execution of the Count, the empress falsely accuses a count of a sexual impropriety. Otto tries and convicts the count, and he is put to death by beheading. In the right panel, Justice of Otto III, the widowed countess successfully endures a trial by ordeal to prove her husband's innocence. She kneels unscathed before the repentant emperor, holding her husband's head on her right arm and a red-hot iron bar in her left hand. In the far distance, the evil empress is punished by burning at the stake.

Dirck Bouts's work is especially notable for the spatial development of its outdoor settings. Carefully adjusting the scale of his figures to the landscape and architecture, the artist created an illusion of space that recedes continuously and gradually from the picture plane back to the far horizon. For this effect, he employed devices such as walkways, walls, and winding roads along which characters in the scene are placed. Bouts's

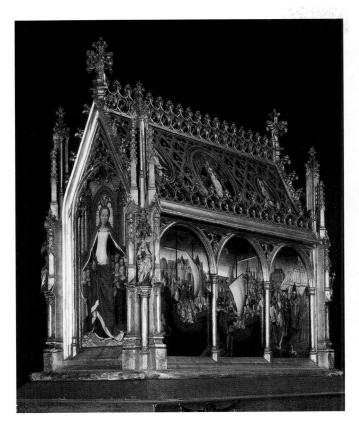

17-16. Hans Memling. Saint Ursula reliquary. 1489. Painted and gilded oak, 34 x 36 x 13" (86.4 x 91.4 x 33 cm). Memling Museum, Hospital of Saint John, Bruges, Belgium

The reliquary was commissioned presumably by the two women dressed in white habits and black hoods worn by hospital sisters and depicted on the end of the reliquary not visible here. One hypothesis is that they are Jossine van Dudzeele and Anna van den Moortele, two administrators of the hospital, where the churchshaped chest has remained continuously for more than five centuries. The story of fourth-century Saint Ursula, murdered by Huns in Cologne after she returned from a visit to Rome, is told on the six side panels. Shown from the left: the pope bidding Ursula goodbye at the port of Rome; the murder of her female companions in Cologne harbor; and Ursula's own death. On the "roof" are roundels with musician angels flanking the Coronation of the Virgin. At the corners are carved saints, and on the end is Saint Ursula in the doorway of the "church," sheltering her followers under her mantle. In early stories, Ursula was accompanied on her trip by ten maidens. By the tenth century, however, she had become the leader of 11,000 women martyrs of all ages.

figures are extraordinarily tall and slender and have little or no facial expression. Bouts is credited as the inventor of a type of official group portrait in which individuals are integrated into a narrative scene with fictional or religious characters. Thus, the Louvain justice panels, with their distinctly individualized protagonists, may have been a vehicle for a group portrait of the town council.

By far the most successful of the second-generation Flemish-school painters was Hans Memling. His work exhibits the intellectual depth and virtuosity of rendering of his predecessors, but the psychology of his figures is one of exquisite composure. Memling was born in one

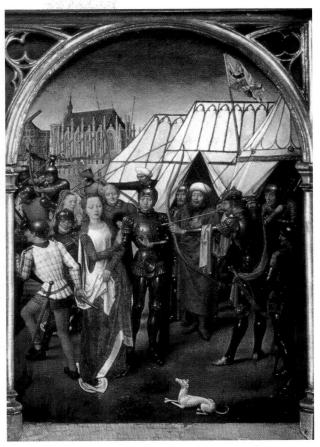

17-17. Hans Memling. *Martyrdom of Saint Ursula,* detail of the Saint Ursula reliquary. Panel 13³/₄ x 10" (35 x 25.3 cm)

of the German states about 1430–1435. Considering his mature style of painting, he was probably young when he came to Flanders, and he may have worked in Rogier van der Weyden's Brussels workshop in the 1460s. Rogier remained the dominant influence on his art, and soon after this master's death in 1464, Memling moved to Bruges, where he worked until his death in 1494. One of the most important painters in Flanders, Memling had an international clientele, and his style was widely emulated both at home and abroad.

Among the works securely assigned to Memling is a large wooden reliquary, a container for sacred relics (remains), in the form of a Gothic-style chapel, completed in 1489 (fig. 17-16). It was commissioned by two sisters for the Hospital of Saint John in Bruges, now a museum of Memling's works, to hold bone fragments believed to be those of Saint Ursula and her companions. Six side panels relate the story of Ursula's martyrdom. According to legend, Ursula, the daughter of the Christian king of Brittany, in France, was betrothed to a pagan English prince. She requested a three-year delay in the marriage to travel with 11,000 virgin attendants to Rome, during which time her husband-to-be was to convert to Christianity. On the trip home, Ursula stopped in Cologne, which had been taken over by Huns, a nomadic people from Central Asia, whose warriors on horseback inspired fear throughout Europe. They murdered her companions, and, when Ursula rejected their chief's offer of marriage, they killed her as well, with an arrow through the heart (fig. 17-17). Although the

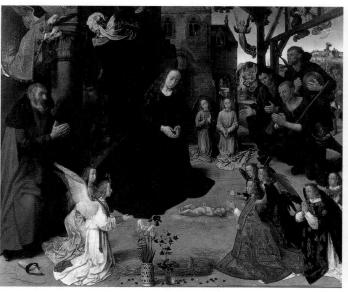

17-18. Hugo van der Goes. *Portinari Altarpiece* (open). c. 1474-76. Tempera and oil on panel, center 8'31/2" x 10' (2.53 x 3.01 m); wings each 8'31/2" x 4'71/2" (2.53 x 1.41 m). Galleria degli Uffizi, Florence

events supposedly took place in the fourth century, Memling has set them in contemporary Cologne, where its Gothic cathedral, still under construction, looms in the background of the *Martyrdom of Saint Ursula* panel. Memling created this deep space as a foil for his idealized female martyr, with her aristocratic features, swaying pose, and elaborate draperies. Rather than a means of defining the body beneath it, the drapery has been represented for its own qualities of surface pattern and intricately sculpted folds.

In the paintings of Hugo van der Goes (c. 1440–1482), the intellectualism of Jan van Eyck and the emotionalism of Rogier van Weyden were brought together in an entirely new style. Hugo's major work was an exceptionally large altarpiece, more than 8 feet tall, commissioned by an Italian living in Bruges, Tommaso Portinari, who was branch manager of the Medici bank there (fig. 17-18). Painted in Flanders, probably between 1474 and 1476, the large triptych was transported to Italy and installed in 1483 in the Portinari family chapel in the Church of Saint Egidio, Florence. Tommaso, his wife, Maria Baroncelli, and their three eldest children are portrayed on the wing interiors, kneeling in prayer. With pointing gestures, their patron saints present them. On the left wing, looming larger than life behind Tommaso and his son Antonio, are their name saints, Thomas and Anthony. The younger son, Pigello, born in 1474, was apparently added after the original composition was set and has no patron saint. On the right wing, Maria and her daughter Margherita are presented by Saints Mary Magdalen and Margaret. The theme of the altarpiece is the Nativity of Christ, with the central panel representing the Adoration of the newborn Child by Mary and Joseph, a host of angels, and a few shepherds who have rushed in from the fields. In the middle ground of the wings are scenes that precede the Adoration in the central panel. Winding their way through the winter landscape are two groups headed for Bethlehem, Jesus' birth-

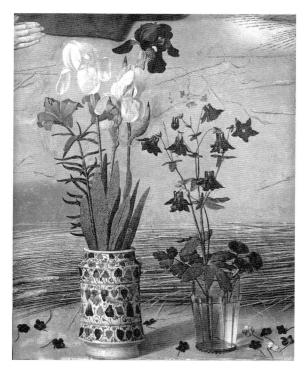

17-19. Hugo van der Goes. Detail of the foreground, central panel, *Portinari Altarpiece*

place. On the left wing Mary and Joseph travel to their native city to take part in a census ordered by the Roman ruler over the region. Near term in her pregnancy, Mary has dismounted from her donkey and staggers before it, supported by Joseph. On the right wing a servant of the Three Magi, who are coming to honor the awaited Savior, is asking directions from a poor man. The continuous landscape across the wings and central panel is the finest evocation of cold, gray, barren winter since the Limbourg brothers' *February* calendar page (see fig. 17-2).

Although the brilliant palette and meticulous accu-

1480 1400 1500

racy recall Jan van Eyck, and the intense but controlled feelings suggest the emotional content of Rogier van der Weyden's works, the composition and interpretation of the altarpiece are entirely Hugo's. The monumental figures of Joseph, Mary, and the shepherds dominating the central panel are the same size as the patron saints on the wings; the Portinari family and the angels are small in comparison. Hugo uses color as well as the gestures and gazes of the figures to focus our eye on the center panel, where the mystery of the Incarnation takes place. Instead of lying swaddled in a manger or in his mother's arms, the Child rests naked and vulnerable on the barren ground with rays of light emanating from his body. The source of this image was the visionary writing of the Swedish mystic Bridget (declared a saint in 1391), composed about 1360-1370, which specifically mentions Mary kneeling to adore the Child immediately after giving birth.

Hugo's complex symbolism recalls Jan's *Ghent Altarpiece*, which was still in its original location in the Cathedral of Saint-Bavo. The setting of the central scene refers both to Jesus' birth and to his royal ancestry. Supporting the stable, where the traditional ox and ass observe the event, is a large Roman-style column against which Mary was believed to have leaned during the birth. In the background the ancient palace of King David is identified by his symbol, the harp, over the door, which may itself be a reference to the name Portinari ("gatekeepers"). The inscription above the harp has been interpreted to mean "Here Christ was born of the Virgin Mary."

The foreground still life of vases, flowers, and a sheaf of wheat has multiple meanings (fig. 17-19). The glass vessel is a Marian symbol (related to the Virgin Mary) that alludes to the entry of the Christ Child into the Virgin's womb without destroying her virginity, the way light passes through glass without breaking it. The glass holds more Marian emblems: three red carnations, which may refer to the Trinity of Father (God), Son (Jesus), and the Holy Ghost, as well as seven blue columbines symbolizing the Virgin's future sorrows. Scattered on the ground are violets, symbolizing humility. The majolica vase holds a red lily (for the blood of Christ) and three irises white for purity and purple for Christ's royal ancestry. The iris, or "little sword," also refers to Simeon's prophetic words to Mary at the Presentation in the Temple, "And you yourself a sword will pierce so that the thoughts of many hearts may be revealed" (Luke 2:35). The vase is decorated with vines and grapes, alluding to the wine of Communion at the Eucharist, which represents the Blood of Christ. The wheat sheaf refers both to the location of the event at Bethlehem, which in Hebrew means "house of bread," and to the Host, or bread, at Communion, which represents the Body of Christ.

The central panel illustrates more than a historical Nativity scene; it is also an enactment of the Eucharist, the central rite of Christian worship. The angels wear attire appropriate to various roles at a High Mass—but the chief celebrant is missing, and it has been suggested that he is the Infant Christ himself. The exact moment in the liturgy may be indicated by the words *Sanctus, Sanctus, Sanctus, Sanctus* ("Holy, Holy, Holy") embroidered on

17-20. Geertgen tot Sint Jans. *Saint John the Baptist in the Wilderness.* c. 1490. Oil on panel, 16½ x 11" (42.3 x 27.1 cm). Staatliche Museen zu Berlin, Preussischer Kulturbesitz, Gemäldegalerie

the edge of the angel's vestment at the right, which are the first lines of a hymn that immediately precedes the Consecration of the Host. Hugo's artistic vision goes far beyond this formal religious symbolism. For example, the shepherds, who stand in unaffected awe before the miraculous event, are among the most sympathetically rendered images of common people to be found in the art of this period.

Toward the end of the fifteenth century, the Dutch-speaking northern Netherlands had grown to such political and cultural importance that its best artists no longer needed to travel south to Flanders and France to find work. Cross-influences among these regions continued, however. One of the most original Dutch painters to assimilate and transform Flemish achievements was Geertgen tot Sint Jans. His career was brief—from 1480 to about 1490—and he may have died at age twenty-eight. His name derives from his position as the "servant and painter" of a religious order in Haarlem called the Commandery of Saint John.

Geertgen's unique style, closely related to Hugo van der Goes's, is mystical, tender, and poetic, conveying an innocent, childlike charm even in such serious subjects as *Saint John the Baptist in the Wilderness* (fig. 17-20). John

1480 1400 1500 has exiled himself with his identifying emblem, the lamb, to a lush woodland setting instead of the harsh desert where he is so often portrayed. As he rests his head on his hand and rubs one big foot on the other, his expression is less that of a religious zealot contemplating the terrible moral condition of the world than of a homesick sojourner.

Manuscript Illumination

The rise in popularity of panel painting in the fifteenth century did not diminish the production of richly illustrated books for wealthy patrons. Not surprisingly, developments in manuscript illumination were similar to those in panel painting, although in miniature. Each scene was a tiny image of the world rendered in microscopic detail. Complexity of composition and ornateness of decoration were commonplace, with the framed image surrounded by a fantasy of vines, flowers, insects, animals, shellfish, or other objects painted as if seen under a magnifying glass. Ghent and Bruges were major centers of this exquisite art, and one of the finest practitioners was an anonymous artist known as the Mary of Burgundy Painter from a Book of Hours traditionally thought to have been made for Mary, the daughter and only heir of Charles the Bold, the duke of Burgundy. The manuscript dates to sometime prior to Mary's early death in 1482 (fig. 17-21).

In the Book of Hours frontispiece, the painter has attained a new complexity in treating pictorial space; we look not only through the "window" of the illustration's frame but through another window in the wall of the room depicted in the painting. The young Mary of Burgundy appears twice: once seated in the foreground, reading from her Book of Hours, and again in the background in a vision inspired by her reading, kneeling with attendants before the Virgin and Child in a church. On the window ledge is an exquisite still life—a rosary, carnations, and a glass vase holding purple irises. The artist has skillfully executed the filmy veil covering Mary's hat, the transparent glass vase, and the bull's-eye panes of the window, circular panes whose center "lump" was formed by the glassblower's pipe. The spatial recession leads the eye into the far reaches of the church interior, past the Virgin and the gilded altarpiece in the sanctuary to two people conversing in the far distance at the left. In the "painting" within an illumination in a book only 5 by 7 inches in size, reality and vision have been rendered equally tangible, as if captured by a Jan van Eyck or a Robert Campin on a large panel.

Textiles and Tapestries

The importance of textiles in the fifteenth century cannot be overemphasized. Flemish artists of the period produced outstanding designs for tapestries, embroidery, and needlepoint. These designs exhibit many of the same concerns with the bulk of figures, the illusion of three-dimensional space, and naturalistic details that are seen in Flemish paintings.

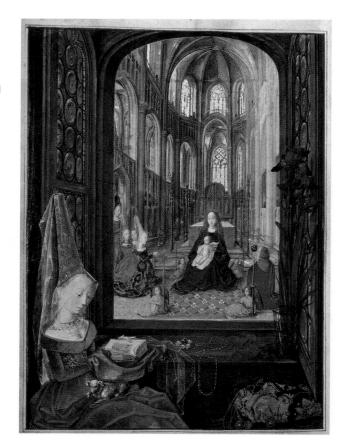

17-21. Mary of Burgundy Painter. Page with *Mary at Her Devotions*, in *Hours of Mary of Burgundy*. Before 1482. 7¹/₂ x 5¹/₄" (19.1 x 13.3 cm). Österreichische Nationalbibliothek, Vienna

A remarkable example is a sumptuous embroidered cope, or ceremonial cloak worn by high-ranking clergy on special occasions, now in the Treasury of the Golden Fleece in Vienna (fig. 17-22). Its surface is divided into compartments, with the standing figure of a saint in each one. At the top of the cloak's back, as if presiding over the standing saints, is an enthroned figure of Christ, flanked by scholar-saints in their studies. The designer of this remarkable piece of needlework was clearly familiar with contemporary Flemish painting, and the embroiderers were able to copy the preliminary drawings with great precision. The particular stitch used here consists of double gold threads tacked down with unevenly spaced colored silk threads to create an iridescent effect.

In the fifteenth and sixteenth centuries, Flemish tapestry making was considered the best in Europe. There were major weaving centers at Brussels, Tournai, and Arras, where intricately designed wall hangings were made on order for royal and aristocratic patrons, important church officials, and even town councils. Among the most common subjects were foliage and flower patterns, scenes from the lives of the saints, and themes from classical mythology and history. Tapestries provided both insulation and luxurious decoration for the stone walls of castles, churches, and municipal buildings. Often they were woven for specific places or for festive occasions such as weddings, coronations, and other public events.

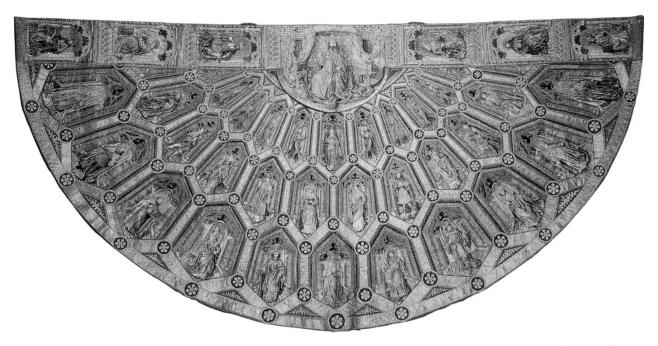

17–22. Cope, from the Treasury of the Golden Fleece. Flemish, mid-15th century. Cloth with gold and colored silk embroidery, $5'4^9/16" \times 10'9^5/16" (1.64 \times 3.3 \text{ m})$. Kunsthistorisches Museum, Vienna

The Order of the Golden Fleece was an honorary fraternity founded by Duke Philip the Good of Burgundy in 1430 with twenty-three knights chosen for their moral character and bravery. Religious services were an integral part of the meetings of the order, and opulent liturgical and clerical objects were created for the purpose. The insignia of the order was a gold ram skin, which hung as a pendant from the Collar of the Golden Fleece, given to each knight. These insignia were the property of the order and had to be returned at the death of the member. The gold ram referred to the Greek legend of Jason, who went off on his ship *Argo* to search for the Golden Fleece, the wool of a magical ram that had been sacrificed to Zeus.

Many were given as diplomatic gifts, and the wealth of individuals can often be judged from the number of tapestries listed in their household inventories.

One of the best-known tapestry suites (now in a museum in the United States) is the Hunt of the Unicorn, whose original five surviving pieces may have been made for Anne of Brittany, the young widow of the French king Charles VIII, to celebrate her marriage to King Louis XII of France on January 8, 1499. The first and seventh pieces, Start of the Hunt and Unicorn in Captivity, were added later. Unfortunately, following the French Revolution all wall hangings with royal insignia were ordered destroyed or the identifying marks cut off, as happened with this set. The unicorn, a mythological horselike animal with cloven hoofs, a goat's beard, and a single long twisted horn, appears in stories from ancient India, the Near East, and Greece. The creature was said to be supernaturally swift and, in medieval belief, could only be captured by a young virgin, to whom it came willingly. Thus, it became a symbol of the Incarnation, with Christ as the unicorn captured by the Virgin Mary, and also a metaphor for romantic love, suitable as a subject for wedding tapestries.

Each of the tapestry pieces exhibits a number of figures in a dense field with trees, flowers, and a distant view of a castle, as in the *Unicorn at the Fountain* (fig. 17-23). The letters *A* and *E*, hanging by a cord from the

fountain, may be a reference to the first and last letters of Anne's name or the first and last letters of her motto, A ma vie ("By my life," a kind of pledge). The workshop that produced the Unicorn series is not known, although Brussels is a likely possibility. The unusually fine condition of the piece allows us to appreciate its rich coloration and the subtlety in modeling the faces, creating tonal variations in the animals' fur, and depicting reflections in the water.

Because of its religious connotations, the unicorn was an important animal in the medieval bestiary, an encyclopedia of real and imaginary animals, giving information of both moral and practical value. For example, the unicorn's horn (if ever found) was thought to be an antidote to poison. Thus, the unicorn is shown dipping its horn into the fountain's waters to purify them. Other woodland creatures included here have symbolic meanings as well. For example, lions, ancient symbols of power, represent valor, faith, courage, and mercy; the stag is a symbol of Christian resurrection and a protector against poisonous serpents and evil in general; and the gentle, intelligent leopard was said to breathe perfume. Not surprisingly, the rabbits symbolize fertility and the dogs fidelity. The pair of pheasants is an emblem of human love and marriage, and the goldfinch is another symbol of fertility. Only the ducks swimming away seem to have no known message.

1400 1500

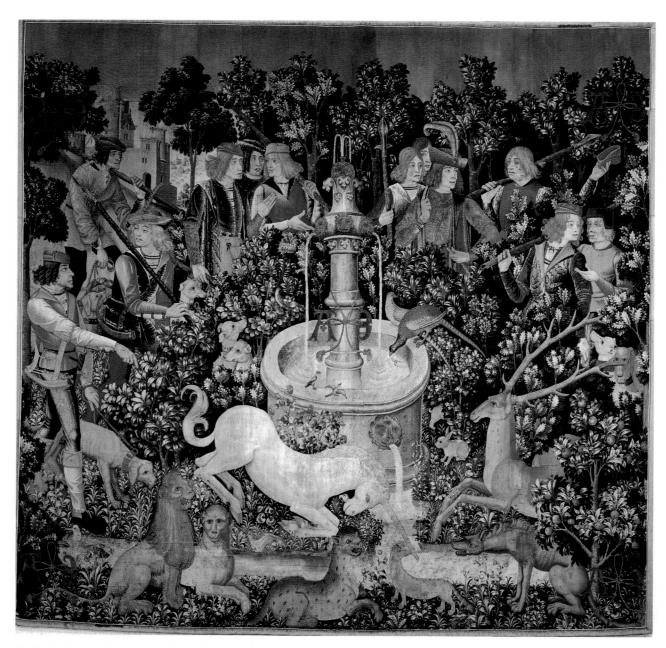

17-23. *Unicorn at the Fountain,* from the Hunt of the Unicorn tapestry series. c. 1498–1500. Wool, silk, and metal thread (13–21 warp threads per inch), 12'1" x 12'5" (3.68 x 3.78 m). The Metropolitan Museum of Art, New York The Cloisters Collection, 1937

The price of a tapestry depended on the threads used. Rarely was a fine, commissioned series woven only with wool; instead, tapestry producers enhanced it to varying degrees with silk, silver, and gold threads. The richest kind of tapestry was one made entirely of silk and gold. Because the silver and gold threads were real metal, people later damaged or even burned many tapestries in order to retrieve the precious materials. Few French royal tapestries survived the French Revolution as a result of this practice. Many existing works show obvious signs, however, that the metallic threads were painstakingly pulled out in order to preserve the tapestries.

The plants, flowers, and trees in the tapestry, identifiable from their botanically correct depictions, reinforce the theme of protective and curative powers. Each has both religious and secular meanings, but the theme of marriage, in particular, is referred to by the presence of such plants as the strawberry, a common symbol of sexual love; the periwinkle, a cure for spiteful feelings and jealousy; the pomegranate, for fertility; and the pansy, for remembrance. The trees include oak for fidelity, beech

for nobility, holly for protection against evil, hawthorn for the power of love, and orange for fertility. The parklike setting with its prominent fountain is rooted in a biblical love poem, the Song of Songs (4:12, 13, 15-16): "You are an enclosed garden, my sister, my bride, an enclosed garden, a fountain sealed. You are a park that puts forth pomegranates, with all choice fruits.... You are a garden fountain, a well of water flowing fresh from Lebanon. Let my lover come to his garden and eat its choice fruits."

HISPANO-FLEMISH ART OF SPAIN AND PORTUGAL

Spanish and Portuguese painters quickly absorbed the new Flemish style to such an extent that the term *Hispano-Flemish* is applied to their works of the second half of the fifteenth century. Not only were Flemish paintings brought to

Spain but Spanish artists went north to study the Flemish style and technique firsthand. Queen Isabella of Castile preferred Flemish painting above all other styles. Her marriage to Ferdinand of Aragon (1469) and their conquest of Granada from the Muslims (1492) effectively united the peninsula in what would later become modern Spain. By 1496, when their daughter Joanna married Philip, son and heir of Mary of Burgundy, the Flemish manner had replaced the earlier Spanish styles.

The marriage of Joanna and Philip was commemorated in an altarpiece, painted probably by Diego de la Cruz, the panels of which are now scattered, many to American collections. The strong impact of Flemish art is unmistakable in this painter's work, as in a panel depicting the Visitation (fig. 17-24).

Elizabeth and Mary embrace in front of the castlelike

home of Elizabeth and her husband, Zechariah, a Temple priest. Zechariah sits on the porch in the background, reading, his dog nearby, while two cleaning women on the upstairs gallery are hard at work with mops and ladders, getting everything tidy for the arrival of a guest. The lush garden setting is filled with accurately portrayed plants and flowers, symbolizing Mary's virginity, purity, and humility, as well as foretelling the Passion of Christ, her yet-unborn son. Included are many plants having medicinal uses, known from herbals of the time, suggesting that Elizabeth's son, John the Baptist, and Mary's son, Jesus, were born to heal the ills of humanity.

A major artist connected with the court of Portugal, Nuño Gonçalvez, also assimilated much from the style of Jan van Eyck in his intensity of detail, monumental figures, and rich color treatments. He was especially renowned for his portraiture, closer to Dirck Bouts's and Hans Memling's than to Jan's, and for his virtuoso rendering of costumes and draperies. His only extant works are six panels from a large polyptych, whose central scene may have been carved. It was made for the Convent of Saint Vincent de Fora in Lisbon between 1471 and 1481. In one of the two largest panels (fig. 17-25),

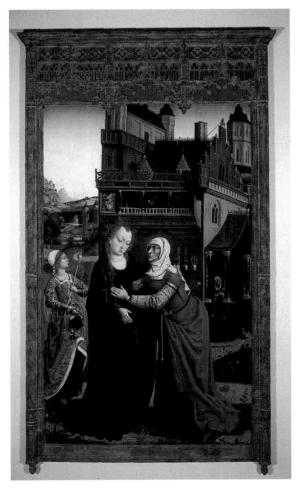

17-24. Diego de la Cruz (?). *Visitation,* panel from an altarpiece, Valladolid, Spain. 15th century. Oil on panel, 60 x 36⁷/8" (152.8 x 93.7 cm). Collection of the University of Arizona Museum of Art, Tucson Gift of Samuel H. Kress Foundation (61.13.22)

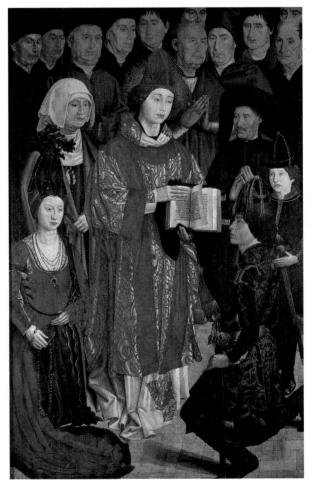

17-25. Nuño Gonçalvez. Saint Vincent with the Portuguese Royal Family, panel from the Altarpiece of Saint Vincent. c. 1471–81. Oil on panel, 6'9³/4" x 4'2⁵/8" (2.07 x 1.28 m). Museu Nacional de Arte Antiga, Lisbon

Vincent, magnificent in red and gold vestments, stands in a tightly packed group of people, with members of the royal family at the front and courtiers forming a solid block across the rear. With the exception of the idealized features of the saint, all are portraits; at the right King Alfonso V kneels before Vincent, while his young son and his deceased uncle, Henry the Navigator, look on. Alfonso and his son rest their hands on their swords; Henry's hands are tented in prayer. At the left are Alfonso's wife and mother, whose right hands are wrapped in rosary beads. The appearance of Vincent is clearly a vision, brought on by the intense prayer of the individuals around him. The altarpiece may have been created to commemorate a Portuguese crusade against the Muslims in Morocco undertaken in 1471 under Saint Vincent's standard.

FRENCH ART

During the fifteenth century, France was divided into feudal holdings that in theory were under royal rule. Many,

however, were held by dukes who were richer and more powerful than the king himself. Throughout much of the century there were repeated struggles for power. When Charles VI died in 1422, the throne was claimed for the nine-month-old Henry VI of England through his mother, the French princess. The infant king's uncle, the duke of Bedford, then assumed control of the French royal territories as regent, with the support of the duke of Burgundy. The exile of the late French king Charles VI's son, Charles VII, inspired Joan of Arc to lead a crusade to return him to the French throne. Although Joan was captured, condemned on trumped-up charges, and burned at the stake in 1431, the revitalized French forces captured Paris in 1436, and by 1453 the English had finally been driven out. In 1461, Louis XI succeeded his father, Charles VII, on the throne and began a single-minded extension of royal power. He and his successors firmly established the power and wealth of the monarchy, and under their rule the French royal court again became a major source of patronage for the arts.

An outstanding court artist of the period, Jean Fouquet (c. 1420–c. 1481), was born in Tours and may have trained in Paris as an illuminator. He appears to have traveled to Italy about 1445 and is believed to be the artist who painted a portrait of Pope Eugene IV. By about 1450, he was a master in Tours, with commissions that included portraits of the restored king, Charles VII, his family, and his courtiers, as well as illustrations for manuscripts and designs for the tomb of Charles VII's successor. Fouquet's paintings on panels and in manuscripts exhibit great familiarity with contemporary Italian architectural decoration, but he was also fully aware of and strongly influenced by Flemish painting.

Among the court officials painted by Fouquet is Étienne Chevalier (fig. 17-26), the treasurer of France under Charles VII, on the left half of a diptych that portrays the Virgin and Child on the facing panel. According to an inscription, the painting was made to fulfill a vow made by Chevalier to the king's much-loved and respected mistress, Agnès Sorel, who died in 1450. Sorel,

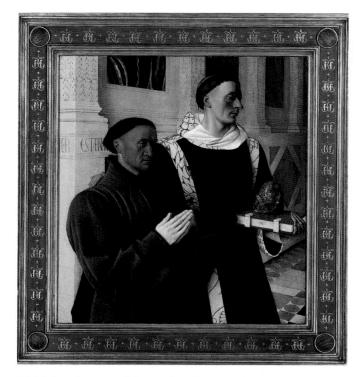

17-26. Jean Fouquet. Étienne Chevalier and Saint Stephen, left wing of the Melun Diptych. c. 1450. Oil on panel, 36½ x 33½" (92.7 x 85 cm). Staatliche Museen zu Berlin, Preussischer Kulturbesitz, Gemäldegalerie

whom contemporaries described as a highly moral, extremely pious woman, was probably the model for the Virgin, with her features taken from her death mask, which is still preserved.

Chevalier, who kneels in prayer with clasped hands and a meditative gaze, wears a houppelande, the voluminous costume of the time. Fouquet has followed the Flemish manner in depicting the courtier's ruddy features as carefully as the reflection in a mirror, and its accuracy is confirmed by other known portraits. Chevalier is presented to the Virgin by his name saint, Stephen (Étienne, in French), whose features are also distinctive enough to have been a portrait. According to legend and biblical accounts, Stephen was a deacon in the early Christian Church in Jerusalem and the first Christian martyr; he was stoned to death for preaching Christianity. The saint wears liturgical, or ritual, vestments and carries a large stone on a closed Gospel, a volume with the first four books of the New Testament. A trickle of blood can be seen on his tonsure, the shaved head adopted as a sign of humility by male members of some religious orders. The two figures are shown in a large hall decorated with marble paneling and classical pilasters, upright strips of wall masonry made to resemble columns, that have been gilded. Fouquet has arranged the figures in an unusual spatial setting, with the diagonal lines of the wall and uptilted tile floor receding toward an unseen focal point at the right. Despite his debt to Flemish realism and his nod to Italian architectural forms' linear perspective, Fouquet's somewhat austere style is uniquely his own.

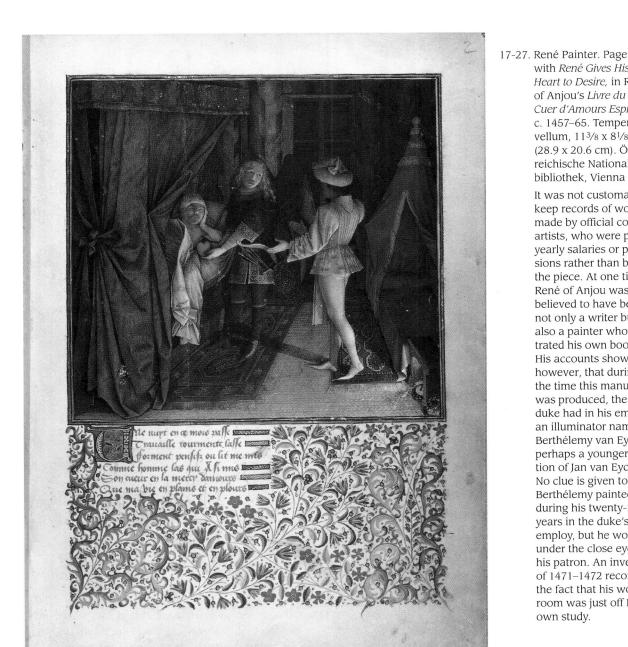

Heart to Desire, in René

with René Gives His

of Anjou's Livre du Cuer d'Amours Espris. c. 1457-65. Tempera on vellum, 113/8 x 81/8" (28.9 x 20.6 cm). Österreichische Nationalbibliothek, Vienna It was not customary to keep records of works made by official court artists, who were paid yearly salaries or pensions rather than by the piece. At one time, René of Anjou was believed to have been not only a writer but also a painter who illustrated his own books. His accounts show, however, that during the time this manuscript was produced, the duke had in his employ an illuminator named

Berthélemy van Eyck,

tion of Jan van Eyck.

perhaps a younger rela-

No clue is given to what Berthélemy painted during his twenty-five years in the duke's employ, but he worked under the close eye of his patron. An inventory of 1471-1472 records the fact that his workroom was just off René's

The brother-in-law of Charles VII, René, the duke of Anjou, was a major figure in French culture of the fifteenth century, both as a patron and as a gifted writer. Among René's noted books is a romantic allegory, Livre du Cuer d'Amours Espris (Book of the Heart Captured by Love), completed in 1457. One of the earliest illustrated copies, completed about 1465, was created by a painter of original talents, probably at René's court. The René Painter exhibits a special ability to render difficult effects of illumination, as seen in the opening illustration, René Gives His Heart to Desire (fig. 17-27). The setting is the bedroom of the king, who is unable to sleep and is tormented by desire. The allegory begins with the king's heart being taken by Amour (Love) and given to Desire, who sets off to find the perfect object for the king's affections. In spite of the dim light, every detail of the chamber is clear, from the crisp white linens and velvet

hangings on the beds to the oriental rugs and patterned

wall design to a fifteenth-century nightlight—a candle burning under a wooden stand.

GERMAN ART

In the Holy Roman Empire, a loose confederation of primarily Germanic states that lasted until the early nine-

own study.

teenth century, two major stylistic strains of art existed simultaneously during the first half of the fifteenth century. One continued the International Gothic interest in prettiness, softness, and sweetness of expression. The other was an intense investigation and detailed description of the physical world. The major exponent of the latter style was Konrad Witz (documented from 1434; d. 1446), a native of what is now southern Germany who, like many artists, was drawn to Basel (in modern Switzerland), where the numerous church officials were a rich source of patronage. His career ended with his early death, probably from the plague. Witz's last large

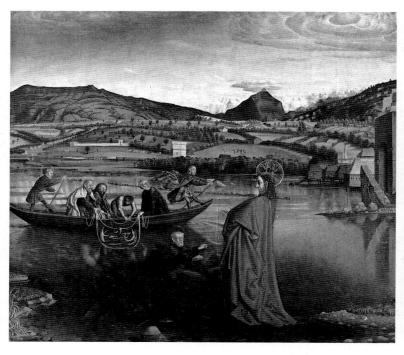

17-28. Konrad Witz. Miraculous Draft of Fish, from an altarpiece from the Cathedral of Saint Peter, Geneva, Switzerland. 1444. Oil on panel, 4'3" x 5'1" (1.29 x 1.55 m). Musée d'Art et d'Histoire, Geneva

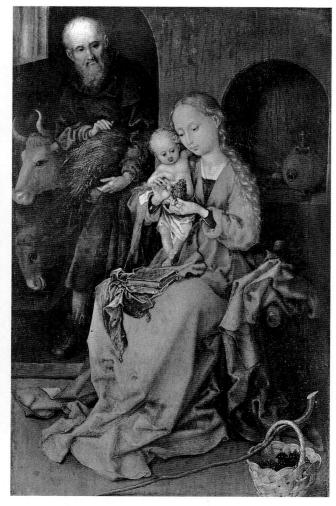

17-29. Martin Schongauer. Holy Family. 1480s. Oil on panel, 10¹/₄ x 6³/₄" (26 x 15.9 cm). Kunsthistorisches Museum, Vienna

commission was an altarpiece dedicated to Saint Peter for the Cathedral of Saint Peter in Geneva, which he signed and dated in 1444 on the wing panels, the only parts of the altarpiece preserved today. In the Miraculous Draft of Fish (fig. 17-28), a scene from the life of Saint Peter, what ultimately engages our attention is the landscape setting. The painter has created an identifiable topographical portrayal of Lake Geneva, with its dark mountain rising on the far shore behind Jesus and the surrounding Alps shining in the distance. Witz records every nuance of light and water—the rippling surface, the reflections of boats, figures, and buildings, even the lake bottom. Peter's body and legs, visible through the water, are distorted by the refraction. The floating clouds above create shifting light and dark passages over the water. Witz, perhaps for the first time in European art, recorded nature in a way that approached a modern photograph.

Martin Schongauer (c. 1450-1491), an influential artist and printmaker of the second half of the fifteenth century, thoroughly absorbed Flemish ideas while maintaining elements of the German International Gothic style, favoring charming subjects and brilliant colors. A mature work, the tiny Holy Family (fig. 17-29) from the

1480s, disarms us with what appears at first glance to be a greater interest in describing the natural world than in symbolic content. Seated in a stable, the young Mary plucks grapes from a cluster to feed the Child, who leans casually against her shoulder with one arm clutching her neck. A woven wood basket of freshly picked grapes stands in the foreground, while Joseph brings in a sheaf of grain to feed the farm animals, an ox and an ass. Except for the rich robes of the Virgin, nothing would appear out of place in a scene of everyday farm life. But, as in Hugo van der Goes's Portinari panels (see fig. 17-18), the details allude to the Eucharist, with the grapes representing the wine, or Blood of Christ, and the sheaf of wheat the Host, or Body of Christ.

THE ITALIAN In the late fourteenth century, RENAISSANCE as Italy recovered from the devastation in 1348 of the Black IN FLORENCE Death, Italian cities grew rich

from international banking and cloth manufacture. In the fifteenth century, the Kingdom of Naples and Sicily and the Papal States—states in central Italy controlled by the pope-were the largest territories, but the most impor-

1480

tant cultural centers were north of Rome at Florence, Pisa, Milan, Venice, and the smaller duchies of Mantua, Ferrara, and Urbino. Much of the power and art patronage was in the hands of wealthy families: the Medici in Florence, the Visconti and Sforza in Milan, the Gonzaga in Mantua, the Este in Ferrara, and the Montefeltro in Urbino. Cities grew in wealth and independence as people moved to them from the countryside in unprecedented numbers, and commerce became increasingly important. In some of the Italian states a noble lineage was no longer necessary for—nor did it guarantee—political and economic success. Now money conferred status, and a shrewd business or political leader could become very powerful.

Education was also an important factor. Merchants, lawyers, and courtiers needed a practical knowledge of mathematics, as well as skills in rhetoric and deportment. Schools also responded to humanist concerns by teaching Greek and Roman literature, poetry and music, history and classical philosophy, and physical education. In some ways they tried to emulate the ancient academies of Plato and Aristotle. During this period humanists put great emphasis on looking to classical antiquity for ideals of proportion as applied to architecture and the human body. They stressed the importance of the dignity of the individual.

Although most of the physical remains of classical antiquity were in Rome, Florence was the birthplace of the Italian Renaissance movement. Patronage of the arts in Florence was an important public activity with political overtones. As one Florentine merchant, Giovanni Rucellai, succinctly noted, he supported the arts "because they serve the glory of God, the honour of the city, and the commemoration of myself" (cited in Baxandall, page 2; see fig. 17-35).

The Medici of Florence were leaders in intellectual and artistic patronage, as they were in business practice. Cosimo de' Medici the Elder (1389-1464) founded his own academy devoted to the study of classical learning, especially the works of Plato and his followers, the Neoplatonists. Most basically, Neoplatonism is characterized by a sharp opposition between the spiritual (the ideal or Idea) and the carnal (Matter) that can be overcome by severe discipline and aversion to the world of the senses. The experience of transcending these opposites is a mystical, spiritual ecstasy. Writers, philosophers, and musicians dominated the Medici Neoplatonic circle. Few architects, sculptors, or painters were included, however, for although some artists had studied Latin or Greek, most had learned their craft in apprenticeships and thus were still considered little more than manual laborers. Nevertheless, interest in the ancient world rapidly spread beyond the Medici circle to artists and craftspeople, who sought to reflect the new interests of their patrons in their work. Gradually, artists began to see themselves as more than artisans, and society recognized their best works as achievements of a very high order.

Artists, like humanist scholars, looked to Classical antiquity for inspiration, studying surviving examples of ancient Roman architecture and sculpture. Because few

examples of ancient Roman painting were known in the fifteenth century, Renaissance painters looked to Roman sculpture and literature for inspiration. Despite this interest in antiquity, fifteenth-century Italian painting and sculpture continued to be predominantly religious. Secular works were rare until the second half of the century, and even these were chiefly portraits. Allegorical and mythological themes also appeared in the latter decades as patrons began to collect art for their personal enjoyment. The male nude became an acceptable subject, mainly through the study of Classical figures as models for idealized Renaissance sculpture. Other than representations of Eve or an occasional allegorical or mythological figure, female nudes were rare until the end of the century.

Like their Flemish counterparts, Italian painters and sculptors moved gradually toward a greater precision in rendering the illusion of physical reality. They did so in a more analytical way than the Flemings had, however, with the goal of achieving anatomically correct but stylistically **idealized** figures—perfected, generic types—set within a rationally, rather than intuitively, defined space. Just as Italian architects applied abstract, mathematically derived design principles to their plans and elevations, painters and relief sculptors developed a rational system of linear perspective to achieve the illusion of continuously receding space (see "Renaissance Perspective Systems," page 624).

Architecture

Travelers from across the Alps in the mid-fifteenth century found Florence very different in appearance from the northern cities. Instead of church spires piercing the sky, the Florentine skyline was dominated, as it still is today, by the enormous mass of the cathedral dome rising above low houses, smaller churches, and the block-like palaces of the wealthy, all of which had minimal exterior decoration.

The major civic project of the early years of the fifteenth century was the still-unfinished cathedral, begun in the late thirteenth century and continued intermittently during the fourteenth century. As early as 1367, its architects had envisioned a very tall dome to span the huge interior space, but they lacked the engineering know-how to construct it. When interest in completing the cathedral was revived around 1407, the technical solution was proposed by a young sculptor-turned-architect, Filippo Brunelleschi (1377-1446). Brunelleschi's intended career as a sculptor had ended with his failure to win the 1402 competition to design new bronze doors for the Baptistry, which stands next to the Florence Cathedral. Brunelleschi declined a role as assistant on that project and traveled to Rome, probably with his sculptor friend Donatello, where he studied ancient Roman sculpture and architecture.

Brunelleschi, whose father had been involved in the original plans for the dome in 1367, advised constructing first a tall **drum**, or cylindrical base. The drum was finished in 1410, and in 1417 Brunelleschi was commissioned to

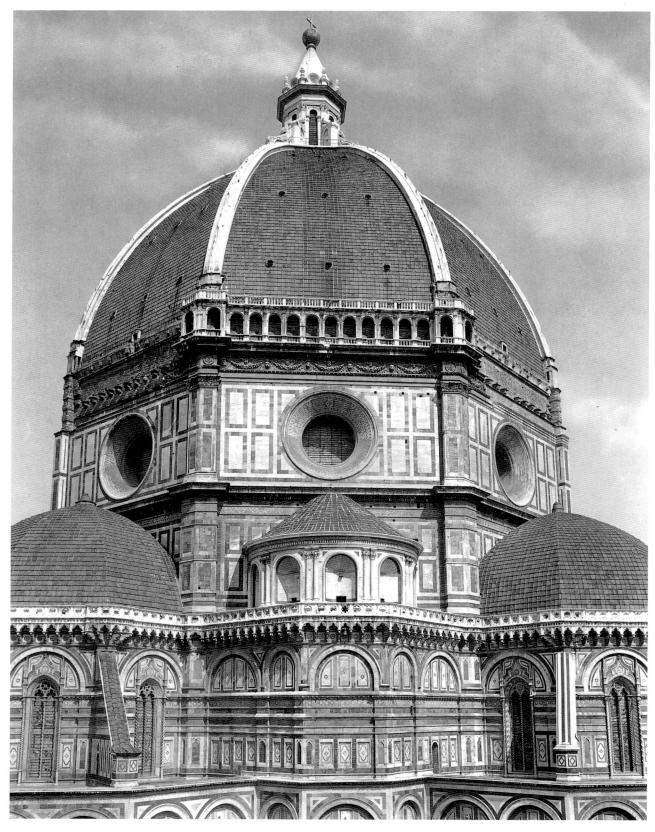

17-30. Filippo Brunelleschi. Dome of Florence Cathedral. 1417-36; lantern completed 1471

The cathedral dome was a source of immense local pride from the moment of its completion. Renaissance architect and theorist Leon Battista Alberti described it as rising "above the skies, large enough to cover all the peoples of Tuscany with its shadow" (cited in Goldwater and Treves, page 33). While Brunelleschi maintained the Gothic pointed-arch profile of the dome established in the fourteenth century, he devised an advanced construction technique that was more efficient, less costly, and safer than earlier systems. An arcaded gallery he planned to install at the top of the tall drum was never built, however. In 1507, Baccio d'Agnolo won a competition to design the gallery, using supports installed on the drum nearly a century earlier. The first of the eight sections, seen here, was completed in 1515.

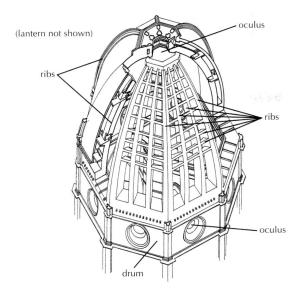

17-31. Cutaway drawing of Brunelleschi's dome, Florence Cathedral. (Drawing by P. Sanpaolesi)

design the dome itself (fig. 17-30). Work began in 1420 and was completed by 1471. A revolutionary feat of engineering, the dome is a double shell of masonry that combines Gothic and Renaissance elements. Gothic construction is based on the pointed arch, using stone shafts, or ribs, to support the vault, or ceiling. The octagonal outer shell is essentially a structure of this type, supported on ribs and in a pointed-arch profile; however, like Roman domes, it is cut at the top with an oculus (opening) and is surmounted by a lantern, a crowning structure made up of Roman architectural forms. The dome's 138-foot diameter would have made the use of centering (temporary wooden construction supports) costly and even dangerous. Therefore, Brunelleschi devised machinery to hoist building materials as needed and invented an ingenious system by which each portion of the structure reinforced the next one as the dome was built up **course**, or layer, by course. The reinforcing elements were vertical marble ribs and horizontal sandstone rings connected with iron rods, with the whole supported by oak staves and beams tying rib to rib (fig. 17-31). The inner and outer shells were also tied together internally by a system of arches. When completed, this self-buttressed unit required no external support to keep it standing.

The cathedral dome was a triumph of engineering and construction technique for Brunelleschi, who was a pioneer in Renaissance architectural design. Other commissions came quickly after the cathedral-dome project, and Brunelleschi's innovative designs were well received by Florentine patrons. From about 1421 to his death in 1446, Brunelleschi was involved in two projects for the Church of San Lorenzo. First, the architect designed a **sacristy** (a room where ritual attire and vessels are kept), completed in 1428 and called the old Sacristy, as a chapel and mausoleum for the Medici. He was then commissioned to rebuild the church itself. The precise history of this second project is obscured by intermittent construction and later alterations. Brunelleschi may have conceived the plans for the new church at the same time as he designed the sac-

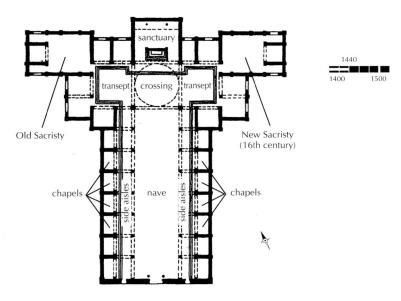

17-32. Filippo Brunelleschi. Plan of the Church of San Lorenzo, Florence. c. 1421–46; plan includes later additions and modifications

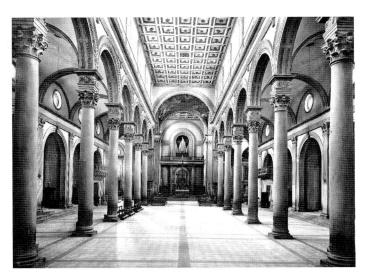

17-33. Filippo Brunelleschi. Nave, Church of San Lorenzo

risty in 1421 or perhaps as late as about 1425, after new foundations had been laid for the **transept** and **sanctuary**.

San Lorenzo is an austere **basilica-plan** church with elements of Early Christian design (fig. 17-32). The long **nave**, flanked by single side aisles opening into shallow side chapels, is intersected by a short transept with a square **crossing**. Beyond the crossing space facing the nave is a square sanctuary flanked by small chapels opening off the transept. Projecting out from the south transept is Brunelleschi's sacristy, today called the Old Sacristy to distinguish it from one built in the sixteenth century.

What is entirely new in San Lorenzo is its mathematical regularity and symmetry. To plan the church, Brunelleschi used a module—a basic unit of measure that could be multiplied or divided and applied to every element of the design. The result was a series of clear, rational interior spaces in harmony with each other and on a human scale.

Brunelleschi's modular system was also carried through in the proportions of the church's interior (fig. 17-33). Ornamental details were carved in *pietra serena*,

17-34. Michelozzo di Bartolommeo. Palazzo Medici-Riccardi, Florence. Begun 1444

Cosimo de' Medici the Elder's decision to build a new town palace was not just to provide more living space for his family. He also incorporated into the plans offices and storage rooms for conducting his business affairs. For the palace site, he chose the Via de' Gori at the corner of the Via Larga, the widest city street at that time. Despite his practical reasons for constructing a large residence and the fact that he chose simplicity and austerity over grandiosity in the exterior design, his detractors had a field day. As one exaggerated: "[Cosimo] has begun a palace which throws even the Colosseum at Rome into the shade."

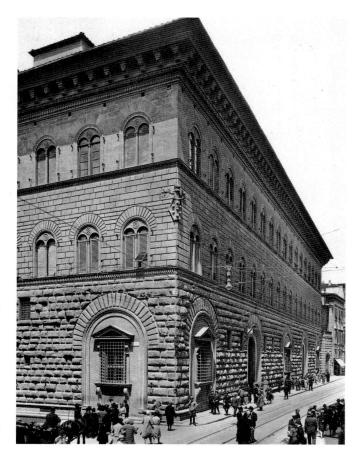

a grayish stone that became synonymous with Brunel-leschi's interiors. Below the plain **clerestory** (upper-story wall of windows) with its unobtrusive openings, the arches of the nave are carried on tall, slender **Corinthian** columns made even taller by the insertion of a favored Brunelleschian device, an **impost block** between the column capital and the springing of the round arches. The arcade is repeated in the outer walls of the side aisles in the arched openings to the chapels surmounted by arched **lunettes**. Flattened architectural forms in *pietra serena* articulate the wall surfaces, and each bay is covered by its own vaulted ceiling. The square crossing is covered by a hemispherical dome, the nave and transept by flat ceilings.

San Lorenzo was an experimental building combining old and new elements, but Brunelleschi's rational approach, unique sense of order, and innovative incorporation of Classical motifs were inspirations to later Renaissance architects, many of whom learned from his work firsthand by completing his unfinished projects.

Brunelleschi's role in the Medici palace (now known as the Palazzo Medici-Riccardi) in Florence, begun in 1444, is unclear. According to the sixteenth-century painter, architect, and biographer Giorgio Vasari, Brunelleschi's model for the palazzo, or palace, was rejected as too grand by Cosimo de' Medici the Elder, who later hired Michelozzo di Bartolommeo (1396–1474), whom most scholars have accepted as the designer of the building. In any case, the palace established a tradition for Italian town houses that, with interesting variations, remained the

norm for a century (fig. 17-34). The plain exterior was in keeping with political and religious thinking in Florence, which was strongly influenced by Christian ideals of poverty and charity. Like many other European cities, Florence had sumptuary laws, which forbid ostentatious displays of wealth—but they were often ignored. Under Florentine law, for example, private homes were limited to a dozen rooms; Cosimo, however, acquired and demolished twenty small houses to provide the site for his new residence.

Huge in scale (each story is more than 20 feet high). with fine proportions and details, the building was constructed around a central courtyard surrounded by a loggia, or covered gallery. On one side the ground floor originally opened through large, round arches onto the street. Although these arches were walled up in the sixteenth century and given windows designed by Michelangelo, they are still visible today. The facade of large, rusticated stone blocks—that is, with their outer faces left rough, typical of Florentine town house exteriorswas derived from fortifications. On the palace facade the stories are clearly set off from each other by the change in the stone surfaces from very rough at the ground level to almost smooth on the third. The Medici Palace inaugurated a new monumentality and regularity of plan in residential urban architecture.

By the middle of the fifteenth century, more artists had become students of the past, and a few humanists had ventured into the field of art theory and design. Leon Battista Alberti (1404–1472), a humanist-turned-

ARCHITECTURE

ELEMENTS OF Wealthy and noble families in Renaissance Italy built magnificent city palaces. More than just The Renaissance being large and luxurious pri-Palace Facade vate homes, these palaces were designed (often by the best archi-

tects of the time) to look imposing and even intimidating.

The facade, or front face of a building, offers broad clues to what lies behind the facade: a huge central door suggests power; rough, rusticated stonework hints of strength and the fortifications of a castle; precious marbles or carvings connote wealth; a cartouche, perhaps with a family coat-of-arms, is an emphatic identity symbol.

Most Renaissance palaces used architectural elements derived from ancient Greek and Roman buildings-columns and pilasters in the Doric, Ionic, and/or Corinthian orders, decorated entablatures, and other such pieces—in a style known as classicism. The example illustrated here, the Palazzo Farnese in Rome, was built for the Farneses, one of whom, Cardinal Alessandro Farnese, became Pope Paul III in 1534. Designed by Antonio da Sangallo the Younger, Michelangelo, and Giacomo della Porta, this immense building stands at the head of and dominates a broad open public square, or piazza. The palace's three stories are clearly defined by two horizontal bands of stonework, or stringcourses. A many-layered cornice sits on the facade like a weighty crown. The moldings, cornice, and entablatures are decorated with classical motifs and with the lilies that form the Farnese family coat-of-arms.

The massive central door is emphasized by elaborate rusticated stonework (as are the building's corners, where the shaped stones are known as quoins), and is surmounted by a balcony suitable for ceremonial appearances by the owner, over which is set the cartouche with the Farnese arms. Windows are treated differently on each story: on the ground floor, the twelve windows sit on sturdy scrolled brackets, and the window heads are topped with architraves. The story directly above is known in Italy as the piano nobile, or first floor (Americans would call it the second floor), which contains the grandest-or "noble"-rooms. Its twelve windows are decorated with alternating triangular and arched pediments, supported by pairs of engaged half columns in the Corinthian order. The second floor (or American third floor) has thirteen windows, all with triangular pediments whose supporting Ionic half columns are set on brackets echoing those under the windows on the ground floor.

Renaissance city palaces, in general, were oriented inward, away from the noisy streets. Many contained open courtyards (see fig. 17-59). Classical elements prevailed here, too. The courtyard of the Palazzo Farnese has a loggia fronted by an arcade at the ground level. Its Classical engaged columns and pilasters present all the usual parts: pedestal, base, shaft, and capital. The progression of orders from the lowest to the highest story mirrors the appearance of the orders in ancient Greece: Doric, Ionic, and Corinthian.

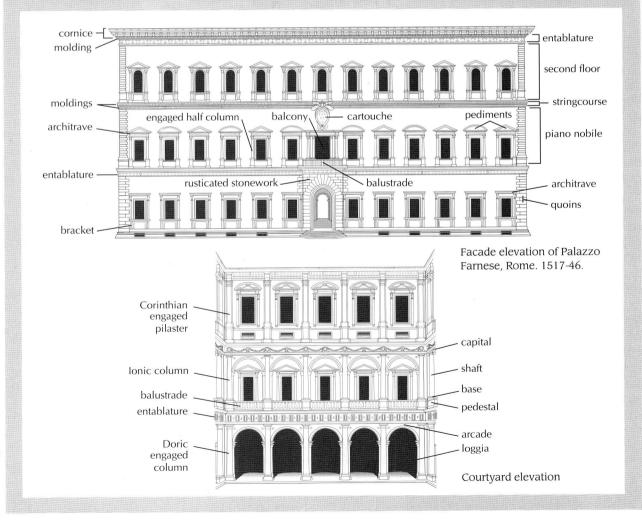

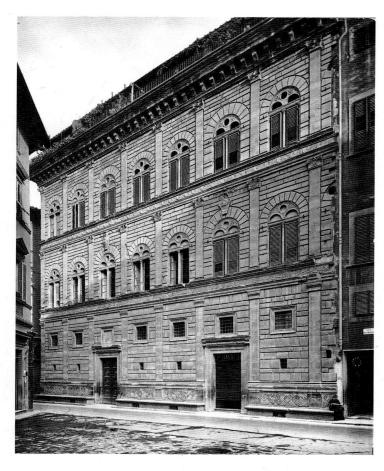

17-35. Leon Battista Alberti. Palazzo Rucellai, Florence. 1455-70

architect, wrote about his classical theories on art before he ever designed a building. Alberti studied at the universities of Padua and Bologna, then worked as a Latin scribe for Pope Eugene IV. This position, which involved diplomatic travel and thus put Alberti in contact with the best potential patrons in Italy, was critical to his later career as an architect. Alberti's various writings present the first coherent exposition of early Italian Renaissance aesthetic theory, including the Italian mathematical perspective system credited to Brunelleschi and ideal proportions of the human body derived from classical art. With Alberti began the gradual change in the status of the architect from a hands-on builder-and thus manual laborer—to an intellectual expected to know philosophy, history, and the classics as well as mathematics and engineering.

The relationship of the facade to the body of the building behind it was a continuing challenge for Italian Renaissance architects. Early in his architectural career, Alberti devised a facade—begun in 1455 but never finished—to be the unifying front for a planned merger of eight adjacent houses in Florence acquired by Giovanni Rucellai (fig. 17-35). Alberti's design, influenced in its basic approach by the Palazzo Medici, was a simple rectangular front suggesting a coherent, cubical three-story building capped with an overhanging **cornice**, a heavy, projecting horizontal molding at the top of the wall. The double windows under round arches were a feature of Michelozzo's Palazzo Medici, but other aspects of the facade were entirely new. Inspired by the ancient Colos-

seum in Rome, Alberti articulated the surface of the lightly rusticated wall with a horizontal-vertical pattern of pilasters and **architraves** that superimposed the **Classical orders**: **Doric** on the ground floor, **Ionic** on the second, and **Corinthian** on the third (see "Elements of Architecture," page 645). The Palazzo Rucellai provided a visual lesson for local architects in the use of classical elements and mathematical proportions, and Alberti's enthusiasm for classicism and his architectural projects in other cities were catalysts for the spread of the Renaissance movement.

Sculpture

In the early fifteenth century the two most important sculptural commissions in Florence were the new bronze doors for the Florence Cathedral Baptistry and the exterior decoration of the Church of Orsanmichele. Orsanmichele, once an open-arcaded market, was both the municipal granary and a shrine for the local guilds. After its ground floor was walled up near the end of the fourteenth century, each of the twelve niches on the outside of the building was assigned to a guild, which was to commission a large figure of its patron saint or saints for the niche.

Nanni di Banco (c. 1385–1421), son of a sculptor in the Florence Cathedral workshop, produced statues for three of Orsanmichele's niches in his short but brilliant career. The *Four Crowned Martyrs* was commissioned about 1410–1413 by the stone carvers and woodworkers'

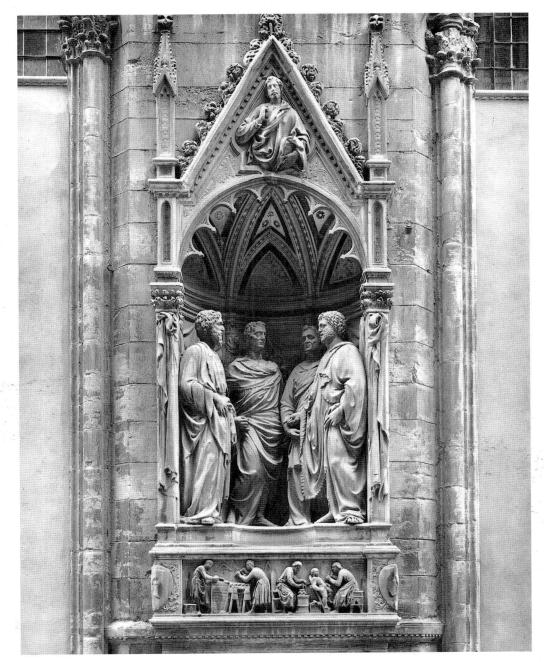

17-36. Nanni di Banco. *Four Crowned Martyrs.* c. 1410–13. Marble, height of figures 6' (1.83 m). Orsanmichele, Florence

guild, to which Nanni himself belonged (fig. 17-36). These martyrs, according to legend, were third-century Christian sculptors executed for refusing to make an image of a Roman god. Although the setting resembles a small-scale Gothic chapel, Nanni's figures—with their solid bodies, heavy, form-revealing togas, and stylized hair and beards—have the appearance of ancient Roman sculpture. Standing in a semicircle with two feet and some drapery protruding beyond the floor of the niche, the saints convey a sense of realism by their individualized features and the appearance that they are in conversation. In the relief panels below, showing wood-carvers and sculptors at work, the forms have a similar

solid vigor. Both figures and objects have been deeply undercut around their contours to cast shadows and enhance the illusion of three-dimensionality.

In 1402 a competition was held to determine who would provide bronze relief panels for a new set of doors for the north side of the Florence Baptistry of San Giovanni. The commission was awarded to Lorenzo Ghiberti (1381?–1455), a young artist trained as a painter, at the very beginning of his career. His panels were such a success that he was awarded the commission for a final set of doors for the east side of the Baptistry in 1425. Those doors, installed in 1452, were reportedly said by Michelangelo to be worthy of being the Gates of Paradise

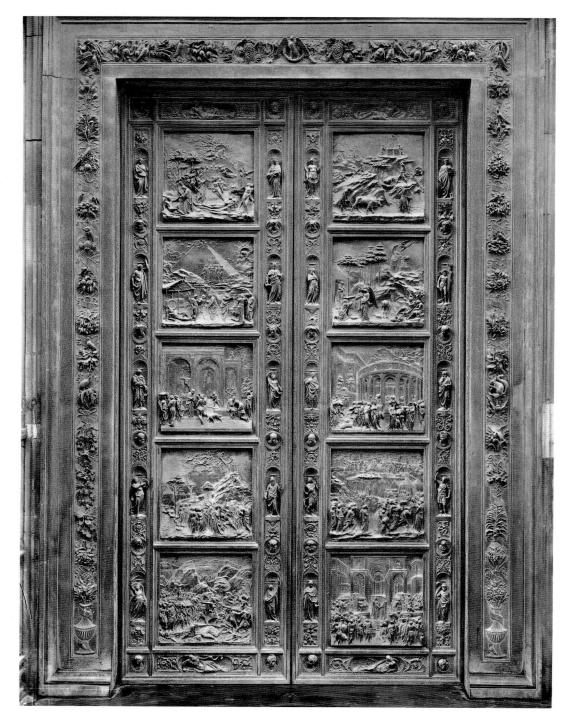

17-37. Lorenzo Ghiberti. Gates of Paradise (East Doors), Baptistry of San Giovanni, Florence. 1425–52. Gilt bronze, height 15' (4.57 m). Museo dell'Opera del Duomo, Florence The door panels contain ten Old Testament scenes from the Creation to the reign of Solomon. The upper left panel depicts the Creation, Temptation, and Expulsion of Adam and Eve from Paradise. The murder of Abel by his brother Cain follows in the upper right panel, succeeded in the same order by the great Flood and the drunkenness of Noah, Abraham sacrificing Isaac, the story of Jacob and Esau (see fig. 17-38), Joseph sold into slavery by his brothers, Moses receiving the Tablets of the Law, Joshua and the fall of Jericho, David and Goliath, and finally Solomon and the Queen of Sheba. Ghiberti, whose bust portrait appears at the lower right corner of *Jacob and Esau*, wrote in his *Commentaries* (c. 1450–55): "I strove to imitate nature as clearly as I could, and with all the perspective I could produce, to have excellent compositions with many figures."

(fig. 17-37). The ten large, square reliefs were unified by being completely gilded. Several panels were organized by a system of linear perspective approximating the one described by Alberti in his 1435 treatise on painting.

One panel (fig. 17-38) illustrates the Old Testament story of the twin brothers Jacob and Esau, whose mother tricked their father, Isaac, into giving his special blessing to Jacob, the younger son, instead of to the rightful first-

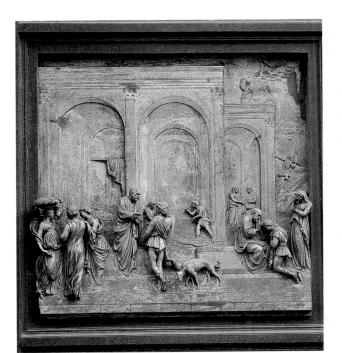

17-38. Lorenzo Ghiberti. *Jacob and Esau*, panel of the East Doors, Baptistry of San Giovanni. 1425–52. Gilt bronze, 31¹/₄ x 31¹/₄" (79.4 x 79.4 cm). Museo dell'Opera del Duomo, Florence

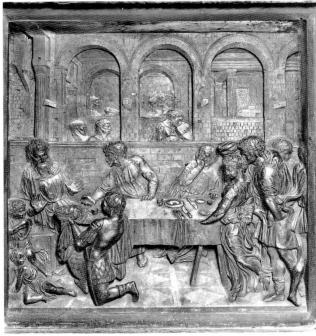

17-39. Donatello. Feast of Herod, panel of baptismal font, Siena Cathedral Baptistry. c. 1425. Gilt bronze, $23^{1/2} \times 23^{1/2}$ " (59.7 x 59.7 cm)

born Esau (Genesis 27). The incidents in the story, including the birth of the twins, take place in different parts of the same overall setting, as if they were one coherent event rather than a sequence of events. Space is organized by a series of arches leading the eye into the distance. Foreground figures, including the scene of blessing at the right, are grouped in the lower third of the panel in an uncrowded relationship with the sculpted architecture, while the other figures decrease gradually in size toward the background. In the panel, the depicted architecture, which, like Alberti's Rucellai facade (see fig. 17-35), suggests a Roman palace, illustrates the emerging antiquarian tone in Florentine art that would come to full flower in the second half of the fifteenth century. Such details as the conversational groupings of people, dogs sniffing the ground, and Esau climbing the hill with his bow provide immediacy.

The great genius of early Italian Renaissance sculpture was Donatello (Donato di Niccolò Bardi, c. 1386–1466), one of the most influential figures of the century in Italy. During his long and vigorous career, he pursued the goals of the emerging Renaissance movement in Florence but did not adhere rigidly to preconceived notions. Because he executed each commission as if it were a new experiment in expression, his sculpture is like an encyclopedia of types of work, with nearly every piece breaking new ground.

One of Donatello's innovations was a remarkably pictorial approach to relief sculpture. His reliefs have a low projection height, their space is organized by the use of linear perspective, and the forms on their background planes are delineated in shallowly cut lines, in effect drawn rather than sculpted. A fine example of Donatello's work in this

style is the Feast of Herod (fig. 17-39), a gilded-bronze panel made for the baptismal font in the Siena Cathedral Baptistry about 1425. As in the relief sculpted below Nanni's Four Crowned Martyrs (see fig. 17-36), the contours of the foreground figures have been undercut to emphasize their mass, while figures beyond the foreground are in progressively lower relief. The lines of the brickwork and many other architectural features are incised rather than carved in depth. Anticipating Ghiberti's Jacob and Esau relief (see fig. 17-38), Donatello organized the scene with Classical architecture, but he did so systematically, around a focal point at the center of the panel. Nevertheless, he avoided the artificiality of precise geometric perspective by handling some peripheral areas more intuitively. The result is a spatial setting in relief sculpture as believable as that in an illusionistic painting.

In illustrating the biblical story of Salome's dance before her stepfather, Herod Antipas, and her morbid request to be rewarded with the head of John the Baptist on a platter (Mark 6:21-28), Donatello showed Herod's palace as a series of three receding chambers separated from each other by low walls and high, round arches. Although he established a vanishing point, the central point where the lines of the architecture converge, he placed the focus of action and emotion—the severed head of John the Baptist on a platter—in the left foreground, leaving the central axis of the composition empty. As a result, the eye is led past the foreground into the rooms beyond, where the beheading had previously taken place. Donatello demonstrates his mastery of inner emotion as well as physical presence by having each person react in a personal way to the presentation of the head.

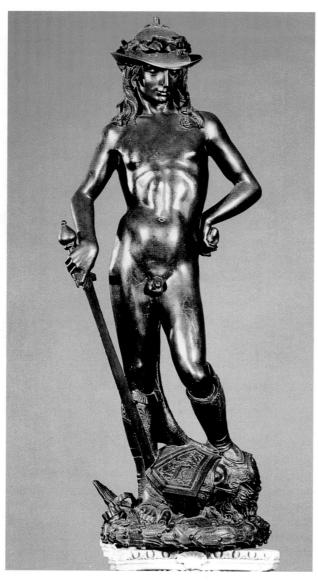

17-40. Donatello. *David*. After 1428. Bronze, height 5'21/4" (1.58 m). Museo Nazionale del Bargello, Florence

Donatello's *David* (fig. 17-40) is the earliest known lifesize freestanding bronze nude in European art since antiquity. It is first recorded in 1469 in the courtyard of the Medici Palace, where it stood on a base engraved with an inscription extolling Florentine heroism and virtue. This inscription supports the suggestion that it celebrated the triumph of the Florentines over the Milanese in 1428. Although the statue clearly draws on the Classical tradition of heroic nudity, this sensuous, adolescent boy in jaunty hat and boots has long piqued interest in the meaning of its conception. In one interpretation, the boy's angular pose, his underdeveloped torso, and the sensation of his wavering between childish interests and adult responsibility heighten his heroism in taking on the giant and outwitting him. With Goliath's severed head now under his feet, David seems to have lost interest in warfare and to be retreating into his dreams.

As Donatello's career drew to a close, his style underwent a profound change, becoming more emotionally expressive. His *Mary Magdalen* of about 1455 (fig. 17-41) shows the saint known for her physical beauty as an

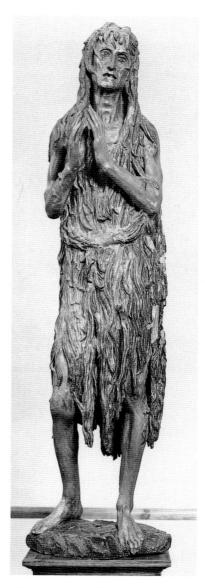

17-41. Donatello. *Mary Magdalen.* c. 1455. Polychromy and gilt on wood, height 6'2" (1.88 m). Museo dell'Opera del Duomo, Florence

emaciated, vacant-eyed hermit in a ragged animal skin. Few can look at this figure without a wrenching reaction to the physical deterioration of aging and years of self-denial. Nothing is left for her but an ecstatic vision of the hereafter. Despite Donatello's total rejection of Classical form in this figure, the powerfully felt force of the Magdalen's personality makes this a masterpiece of Renaissance imagery.

In dramatic contrast to this pious rejection of worldly life are the self-laudatory portrait tombs by such artists as Desiderio da Settignano (c. 1430–1464), who executed the funerary monument for Carlo Marsuppini (fig. 17-42). A noted humanist and chancellor of Florence, Marsuppini wanted his tomb to match in format and decoration that of humanist Leonardo Bruni, also in the Church of Santa Croce. The **triumphal arch**, Corinthian pilasters, classical moldings, marble panels, and carved foliate designs recall the Bruni tomb and, along with the graceful hanging garlands, echo antique motifs. Desiderio's work is distinguished by its tall, elegant proportions and soft modeling. Marsuppini reclines as if napping on a

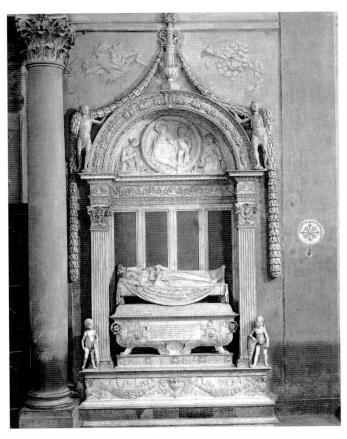

17-42. Desiderio da Settignano. Tomb of Carlo Marsuppini, Church of Santa Croce, Florence. c. 1454–64. White and colored marble, 20' x 11'9" (6.1 x 3.6 m)

couch atop an elegant sarcophagus with curved sides and spiraling foliate relief decoration. Desiderio's special talent for portraying children can be seen in the charming awkwardness of the young boys standing in front of the flanking pilasters.

Luca della Robbia (1399/1400–1482), although an accomplished sculptor in marble, specialized in glazed ceramic reliefs for architectural decoration. His workshop made molds so that a particularly popular work could be replicated many times. Luca favored a limited palette of clear blues, greens, and pale yellows with a great deal of white, as seen in his *Madonna and Child with Lilies* of 1455–1460, at Orsanmichele (fig. 17-43). The elegant and lyrical della Robbia style was continued by Luca's nephew Andrea and his children long after Luca's death.

Antonio del Pollaiuolo (c. 1432-1498), multitalented

17-44. Antonio del Pollaiuolo. *Hercules and Antaeus.* c. 1475. Bronze, height with base 18" (45.7 cm). Museo Nazionale del Bargello, Florence

Among the many courageous acts by which Hercules gained immortality was the killing of the evil Antaeus in a wrestling match by lifting him off the earth, which was the source of the giant's great physical power. Hercules had been attacked by Antaeus, the son of the earth goddess Ge (or Gaia), on his search for a garden that produced pure gold apples. Stealing the apples was one of the Twelve Labors assigned to Hercules by King Eurystheus, who promised to let the hero marry his daughter when all were completed. When the king went back on his word, Hercules killed him too.

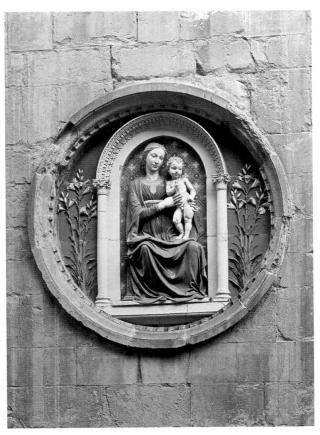

17-43. Luca della Robbia. *Madonna and Child with Lilies*, Orsanmichele, Florence. c. 1455–60. Enameled terra-cotta, tondo diameter approx. 6' (1.83 m)

and ambitious, was trained as a goldsmith and embroiderer but came to the Medici court about 1460 as a painter. His sculpture were mostly small bronzes, such as his *Hercules and Antaeus* 60 about 1475 (fig. 17-44). This

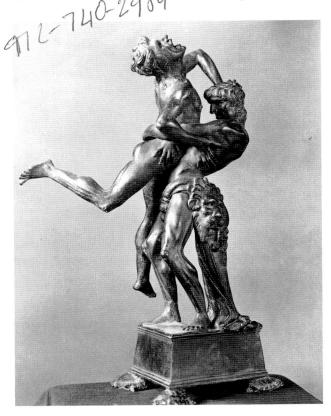

17-45. Gentile da Fabriano.

Adoration of the Magi,
altarpiece from
the Sacristy of the
Church of Santa
Trinità, Florence.
1423. Oil on
panel, 9'10" x 9'3"
(3 x 2.85 m).
Galleria degli Uffizi,
Florence

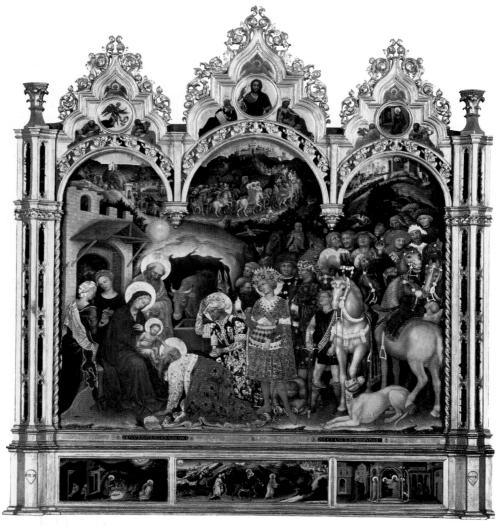

study of complex interlocking figures has an explosive energy that can best be appreciated by viewing the sculpture from every angle. Statuettes of religious subjects were still popular, but humanist art patrons began to collect bronzes of Greek and Roman subjects like this one, reflecting their changing tastes.

Painting

Italian patrons generally commissioned murals and large altarpieces for their local churches and smaller panel paintings for their private chapels. Home decoration with panel paintings was uncommon until the latter part of the fifteenth century. Artists experienced in **fresco**, mural painting on wet plaster, were in great demand and traveled widely to execute wall and ceiling decorations. Italian panel painters showed little interest in oil painting, continuing to use tempera even for their largest works until the last decades of the century, when Venetians began to use the oil medium for major panel paintings.

The new Renaissance style in painting, with its solid, volumetric forms, perspectivally defined space, and references to classical antiquity, did not immediately displace the International Gothic. One of the important painters who retained International Gothic elements in

their styles was Gentile da Fabriano (c. 1385–1427), who in 1423 completed the *Adoration of the Magi* (fig. 17-45), a large altarpiece for the Sacristy of the Church of Santa Trinità in Florence. Among the International Gothic elements are the steeply rising ground plane, graceful figural poses, brightly colored costumes and textile patterns, glinting gold accents, and naturalistic rendering of the details of the setting. But Gentile's landscape, with its endless procession of people winding from the far distance toward Bethlehem to worship the Christ Child, is broadly related to the near-contemporary *Ghent Altarpiece* (see fig. 17-1).

Gentile's skill in blending naturalistic and supernatural lighting effects is especially notable in his depiction of the nocturnal Nativity in the left panel of the **predella**, the section of the altarpiece below the main panel. As in Hugo van der Goes's *Portinari Altarpiece* (see fig. 17-18), Saint Bridget's written account of her visions was the source of the image of the Christ Child lying on the ground emitting rays of light while his mother adores him.

The most innovative of the early Italian Renaissance painters was Maso di Ser Giovanni di Mone Cassai (1401–1429?), nicknamed Masaccio ("big ugly Tom"). The exact chronology of his works is uncertain, and his fresco of the Trinity in the Church of Santa Maria Novella in

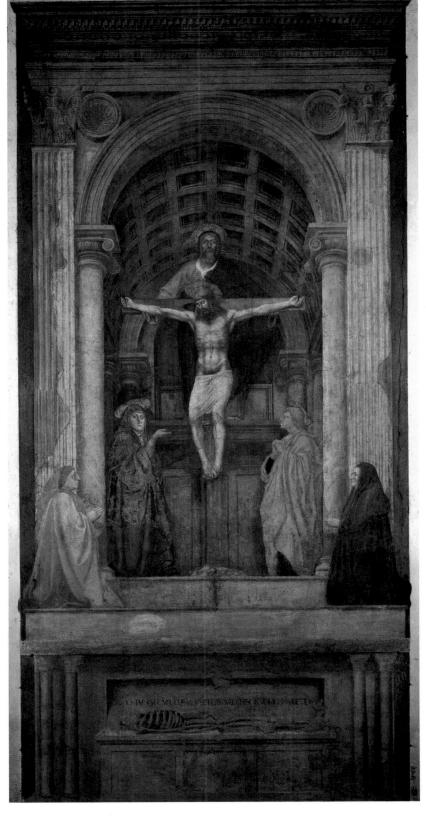

17-46. Masaccio.

Trinity with the
Virgin, Saint John
the Evangelist,
and Donors, fresco
in the Church of
Santa Maria
Novella, Florence.
c. 1425 (?).
21' x 10'5"
(6.5 x 3.2 m)

Florence has been dated as early as 1425 and as late as 1428 (fig. 17-46). The Trinity fresco was meant to give the illusion of a stone funerary monument and altar table set below a deep **aedicula** (framed niche) in the wall. The praying donors in front of the pilasters are less than lifesize, and the niche group is even smaller. The red robes of the male donor at the left signify that he was a member of the governing council of Florence.

Masaccio created the unusual **trompe l'oeil** ("foolthe-eye") effect of looking up into a barrel-vaulted niche through precisely rendered linear perspective. The eye level of an adult viewer determined the horizon line on which the vanishing point was centered, just above the base of the cross. The painting demonstrates Masaccio's intimate knowledge of both Brunelleschi's perspective experiments and his architectural style (see fig. 17-33,

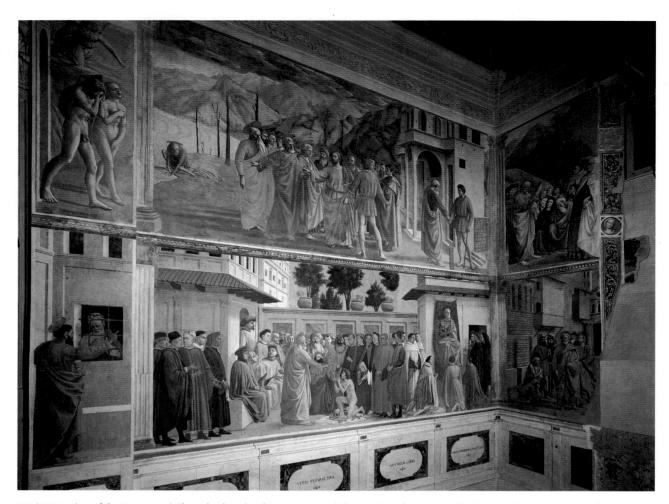

17-47. Interior of the Brancacci Chapel, Church of Santa Maria del Carmine, Florence, with frescoes by Masaccio and Masolino (c. 1423–28) and Filippino Lippi (c. 1482–84)

side aisle). The painted architecture is an unusual combination of Classical orders; on the wall surface Corinthian pilasters support a plain architrave below a cornice, while inside the niche Ionic columns support arches on all four sides (see "Elements of Architecture," page 645). The Trinity is represented by Jesus on the Cross, with the dove of the Holy Spirit poised in downward flight between his tilted halo and the head of God the Father, who stands behind the Cross on a high platform apparently supported on the rear columns. The "source" of the consistent illumination modeling the figures with light and shadow lies in front of the picture. casting reflections on the coffers, or sunken panels, of the ceiling. As in many scenes of the Crucifixion, Jesus is flanked by the Virgin Mary and John the Evangelist, but here they show no emotional reaction to the scene. Mary gazes calmly out at us, her raised hand presenting the Trinity. Below, on the sarcophagus, is a skeleton, a grim reminder that death awaits us all and that our only hope is redemption and life in the hereafter through Christian belief. The inscription above the skeleton reads: "I was once that which you are, and what I am you also will be."

Masaccio's brief six- or seven-year career reached its height in his collaboration with a painter known as

Masolino (c. 1400-1440/47) on the fresco decoration of the Brancacci Chapel in the Church of Santa Maria del Carmine in Florence (fig. 17-47). The chapel was originally dedicated to Saint Peter, and most frescoes illustrate events in his life. Masaccio's most innovative painting is the Tribute Money (fig. 17-48), completed about 1427, rendered in a continuous narrative of three scenes within one setting. The painting illustrates an incident in which a collector of the Jewish temple taxes (tribute money) demands payment from Peter, shown in the central group with Jesus and the other disciples (Matthew 17:24-27). Although Jesus opposes the tax, he instructs Peter to "go to the sea, drop in a hook, and take the first fish that comes up," which Peter does at the far left. In the fish's mouth is a coin worth twice the tax demanded, which Peter gives to the tax collector at the far right. The tribute story was particularly significant for Florentines because in 1427, to raise money for defense against military aggression, the city enacted a graduated tax, based on the ability to pay.

The *Tribute Money* is particularly remarkable for its integration of figures, architecture, and landscape into a consistent whole. The group of Jesus and his disciples forms a clear central focus, from which the landscape

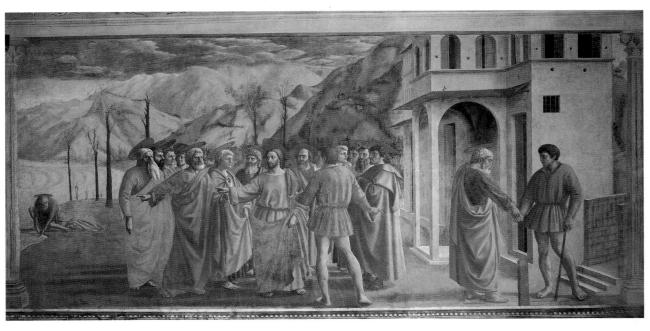

17-48. Masaccio. Tribute Money, fresco in the Brancacci Chapel. c. 1427. 8'1" x 19'7" (2.3 x 6 m)

Much valuable new information about the Brancacci Chapel frescoes was discovered during the course of a cleaning and restoration carried out between 1981 and 1991. Art historians now have a more accurate picture of how the frescoes were done and in what sequence, as well as which artist did what. One interesting discovery was that all of the figures in the *Tribute Money,* except those of the temple tax collector, originally had gold-leaf halos, several of which had flaked off. Rather than silhouette the heads against flat gold circles in the medieval manner, Masaccio conceived of the halo as a gold disk hovering in space above each head and subjected it to perspective foreshortening depending on the position of the figure.

seems to recede naturally into the far distance. To create this illusion Masaccio used linear perspective in the depiction of the house. The lines of the house converge on the head of Jesus, which Masaccio reinforced by diminishing the sizes of the barren trees and reducing Peter's size at the left. There is a second vanishing point for the steps and stone rail at the right. A recent cleaning of the fresco revealed that Masaccio also used atmospheric perspective in his intuitive rendering of the distant landscape, where mountains fade from grayish green to grayish white and the houses and trees on their slopes are loosely sketched.

Masaccio modeled the foreground figures with strong highlights and cast their long shadows on the ground toward the left, implying a light source at the far right, as if the scene were lit by the actual window in the rear wall of the Brancacci Chapel. Not only does the lighting give the forms sculptural definition, but the colors vary in tone according to the strength of the illumination. Masaccio used a wide range of hues—pale pink, mauve, gold, seafoam, apple green, peach—and a sophisticated color technique in which Andrew's green robe is shaded with red instead of darker green. Another discovery after the cleaning was that—allowing for the difference in mediums between rapidly applied water-based colors in fresco versus slow-drying oil—the wealth of linear detail is much closer to that of Masaccio's northern European contemporaries than previously thought. In contrast to Jan van Eyck's figure style, however, Masaccio's exhibits

an intimate knowledge of Roman sculpture.

Stylistic innovations take time to be fully accepted, and Masaccio's genius for depicting weight and volume, consistent lighting, and spatial integration was best appreciated by a later generation. Many important sixteenth-century Italian artists, including Michelangelo, studied and sketched from Masaccio's Brancacci Chapel frescoes. In the meantime, painting in Florence after Masaccio's death developed along lines somewhat different from that of the *Tribute Money*, as other artists experimented in their own ways with the illusion of a believably receding space.

Fra Angelico ("Brother Angel"), born Guido di Pietro (c. 1400–c. 1455), was known to his peers as Fra Giovanni da Fiesole and earned his nickname through his unusually pious nature. He is documented as a painter in Florence during the period 1417–1418 and took his vows as a Dominican monk in nearby Fiesole sometime between 1418 and about 1421. Considering the number of documented commissions he received, he must have had light religious responsibilities. One of his most extensive projects was the decoration of the Dominican Monastery of San Marco in Florence between 1435 and 1445. Fra Angelico went to work at the Vatican in Rome in 1445, and the frescoes at San Marco were completed by his assistants several years later.

Among the frescoes attributed entirely to Angelico by most scholars is the *Annunciation* in a monk's cell off the east corridor of the upper floor of the monastery

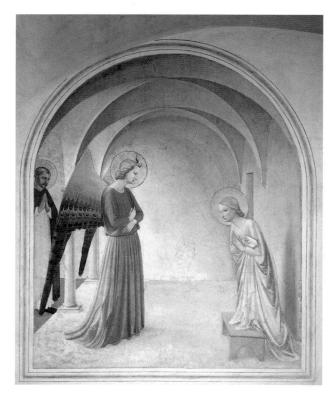

(fig. 17-49). Nearly everything about the painting is in keeping with its location. The arched frame echoes the curvature of the cell wall, and the plain white interior of the illusionistic space appears almost to be a nichelike extension of the cell's space. Although the bottom edge of the painting is above normal eye level, the effect is that of looking through a window onto a scene taking place in a cloister portico. In the painting the ceiling is sup-

17-49. Fra Angelico. *Annunciation*, fresco in Cell No. 3, Monastery of San Marco, Florence. c. 1441–45. Image 6'1¹/₂" x 5'2" (1.87 x 1.57 m)

If an early legend is true, then Fra Angelico's humility lost him the opportunity to become a saint. He had left the completion of the San Marco frescoes to his assistants in 1445 to answer Pope Eugene IV's summons to Rome. The pope was looking for a new archbishop of Florence at the time, and the current vicar of San Marco, Antonino Pierozzi, was finally appointed to the post in January 1446. When Pierozzi was proposed for canonization in the early sixteenth century, several individuals testified that Pope Eugene's first choice for archbishop had been Fra Angelico, who declined it and suggested his Dominican brother Antonino.

ported by the wall on one side and by slender Ionic columns on the other. The artist used minimal perspective indications: the edge of the porch, the base of the first column, the lines of the bench, and the angles where the ceiling planes come together. Gabriel and Mary are simplified figures enhanced with plain but glowing draperies whose folds are noticeably affected by gravity. The natural light falls from the left to model the forms, but a supernatural radiance lights Gabriel's hands and face, which ought to be in shadow, and creates a spotlight effect on the back wall. The scene is a vision within a vision; Saint Dominic appears at the left in prayer, giving rise to the vision of the Annunciation, while the whole may be seen as a vision of the resident monk.

Another painter who was a monk early in his career, Fra Filippo Lippi (c. 1406–1469), became an artist some years after joining the Carmelite order. According to his

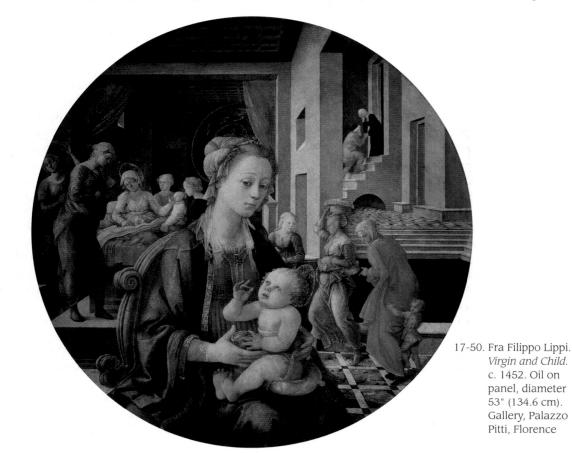

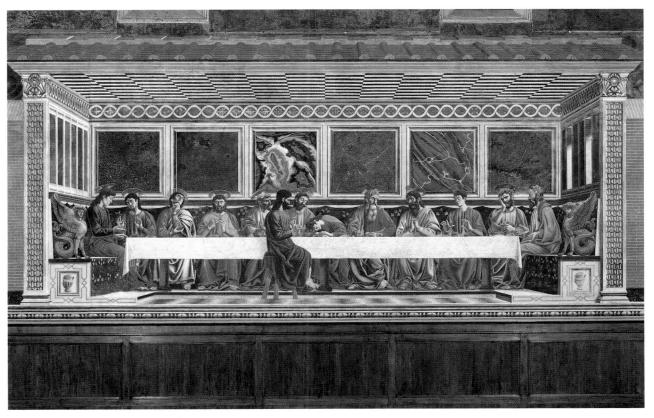

17-51. Andrea del Castagno. *Last Supper*, fresco in the Refectory, Monastery of Sant'Apollonia, Florence. 1447. Approx. 15' x 32' (4.6 x 9 m)

biographer, Vasari, Filippo began to paint after watching Masaccio at work in the Brancacci Chapel. Later, Filippo obtained permission to leave religious life and married. His son Filippino Lippi became a painter and eventually completed the Brancacci Chapel frescoes in 1481–1482.

Filippo mastered scientific perspective and the volumetric rendering of figures and objects while retaining a taste for International Gothic grace and charm. His halflength portrayals of the Madonna and Child were in great demand. Lippi's style is characterized by careful drawing, clean contours, and intense color, especially his greens, reds, and dark mauves. He tended to place the main subject of his paintings in the foreground before a deeply receding background of architecture or landscape with figures, thus creating a second level of visual interest. In a panel of about 1452 (fig. 17-50), the legend of Mary's birth is told in the background scenes. At the right in the distance, Mary's mother, Anna, greets her husband, Joachim, at the city gate with the news that they are to have a child; the birth takes place in the middle ground at the left.

Andrea del Castagno (c. 1417/19–1457) worked for a time in Venice before returning to Florence to execute his best-known work, *Last Supper*, painted in 1447 at the Monastery of Sant'Apollonia (fig. 17-51). Extending 32 feet across the end wall of the dining room and rising 15 feet high, the fresco gives the illusion of a raised alcove where Jesus and his disciples are eating their meal along with the monks. Rather than the humble "upper room" where the biblical event took place, the setting resembles

a royal audience hall with its sumptuous marble panels and inlays. The trompe l'oeil effect is aided by the creation of a focal point on the head and shoulders of the sleeping young disciple John. Some of the lines of the architecture converge here, while others merely come close; a few converge elsewhere. Thus, Andrea appears to have adjusted many of the perspectival elements intuitively to create a more believable spatial representation. The focus on the figure of John, traditionally the "disciple whom Jesus loved" (John 20:2), rather than on Jesus himself, may have been intended to enable the monks in this austere order, whose members rarely had contact with the outside world, to identify themselves with the saint.

In contrast to Andrea's approach to spatial illusion, Paolo Uccello (1397–1475) is noted today, as he was in his own time, for his absolute obsession with linear perspective. The story was told that he talked about it in his sleep to such an extent that his wife accused him of having a mistress named Perspective. Perhaps trained in Ghiberti's workshop and a member of the Florence painters' guild since 1414, Uccello worked also in Venice, Urbino, and Padua, where he may have studied Donatello's relief designs for Padua's Church of Sant'Antonio. These designs apparently influenced his frescoes on the Life of Noah, painted for the Florentine Church of Santa Maria Novella soon after his return from Padua in about 1447–1448.

Uccello used only two basic colors for his frescoes, ocher and *terra verde*, a green pigment that gave the cloister where the works are located its name, Chiostro

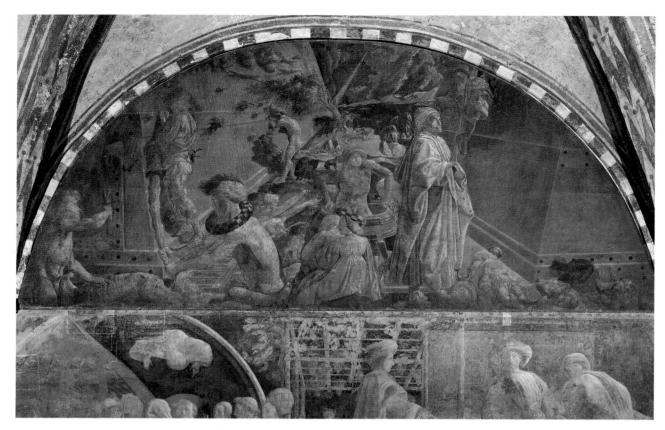

17-52. Paolo Uccello. *The Deluge (Flood)*, fresco in the Chiostro Verde, Church of Santa Maria Novella, Florence. c. 1450. 7' x 16'9" (2.13 x 5.11 m)

Verde (Green Cloister). The Deluge (Flood) of about 1450 (fig. 17-52) is a composite of two scenes organized and separated by a deep central plunge into space. At the left, Noah has closed up his oddly shaped vessel, already filled with male and female pairs of all the earth's creatures and his own family members. The people left behind react in panic as the waters rise. At the left, two men beat at the Ark with clubs, while other people cling to its sides, hoping to ride out the storm that whips clumps of foliage about them and threatens to break their grips. At the right, the ordeal is nearly over as Noah leans out of the Ark to see the dove he dispatched returning with a leafy sprig in its beak, a sign that it has found dry land. The waters between the two depictions of the Ark are filled with the dead and those too weak to struggle, but the figure appearing to stand on the water at the right has never been satisfactorily identified. Every geometric element in the composition has been subjected to perspectival rendering, from the two imposing views of the boat to the smallest details. Refer to page 624.

The most important Florentine painting workshop of the later fifteenth century was that of the painter known as Domenico del Ghirlandaio ("garland maker"), a nickname adopted by his father, a goldsmith noted for his floral designs. A specialist in narrative cycles, Ghirlandaio (1449–1494) incorporated the innovations of his predecessors into a visual language of great descriptive immediacy. He was familiar with examples of Flemish painting, seen in Florence after about 1450, which had considerable impact on his style, especially in portrai-

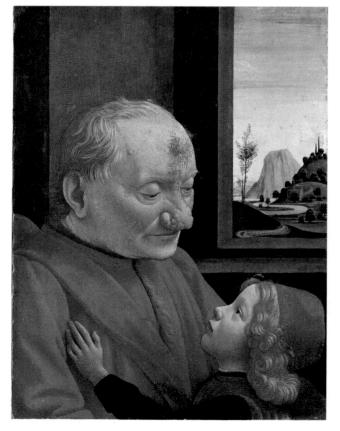

17-53. Domenico del Ghirlandaio. *A Man with His Grandchild.* c. 1480-90. Panel, 24³/₈ x 18¹/₈" (62 x 46.1 cm). Musée du Louvre, Paris

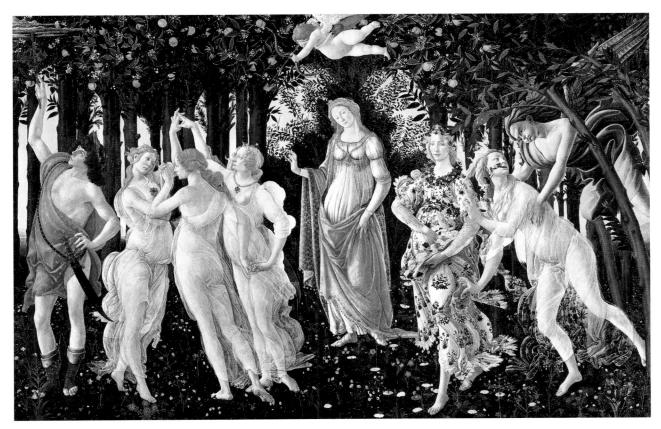

17-54. Sandro Botticelli. Primavera. c. 1482. Panel, 6'8" x 10'4" (2.03 x 3.15 m). Galleria degli Uffizi, Florence

ture. Instead of the more typical Italian full-profile format (see fig. 17-68), he adopted the three-quarter view and more relaxed pose of early-fifteenth-century Flemish painters, as in his portrait of a man and his grandchild of about 1480–1490 (fig. 17-53). Ghirlandaio painted this unknown man, whose nose is malformed as a result of a condition called rhinophyma, posthumously, using a deathbed sketch. Such an objective portrayal, recalling northern European portraiture, was a special talent of Ghirlandaio's.

Sandro Botticelli (1445–1510), one of the most poetic Renaissance painters, was a pupil of Filippo Lippi and also trained in the workshops of the sculptors and painters Pollaiuolo and Verrocchio. In his first mature phase he produced multifigured scenes with sculptural figures modeled by light from a consistent source, placed in deep landscape settings rendered with strict linear perspective. He was an outstanding portraitist who in his religious paintings often mingled recognizable contemporary figures with the saints and angels.

In 1481, after returning from Rome, where he had worked on frescoes for the Sistine Chapel, Botticelli entered a new phase of his career. He produced a series of secular paintings of mythological subjects inspired by contemporary Neoplatonic thought, including *Primavera*, or *Spring* (fig. 17-54), which may depict an ancient Roman spring festival, the Floralia. This work was commissioned about 1482 for the private collection of Lorenzo de' Medici, who had become ruler of Florence in 1469. Silhouetted and framed by an arching view through the

trees at the center of the canvas is Venus, the goddess of love. She is flanked on the right by Flora, a Roman goddess of flowers and fertility, and on the left by the Three Graces. Her son, Cupid, hovers above, playfully aiming an arrow at the Graces. At the far right is the wind god, Zephyr, in pursuit of the nymph Chloris, his breath causing her to sprout flowers from her mouth. At the far left, the messenger god, Mercury, uses his characteristic snake-wrapped wand, the caduceus, to dispel a patch of gray clouds drifting in Venus's direction. While breaking new ground in subject matter, Botticelli returned to his master Filippo Lippi for his charming ambience, graceful poses, and linear contours. The overall appearance of Primavera recalls Flemish tapestries, which were the height of fashion in Italy at the time. The decorative quality of the painting is deceptive, however, for it is a highly complex allegory, interweaving Neoplatonic ideas with esoteric references to classical sources.

Neoplatonic philosophers and poets conceived of Venus as having two natures, one terrestrial and the other celestial. The first ruled over earthly, human love and the second over universal love, making her a classical equivalent of the Virgin Mary. *Primavera* is recorded as having hung outside Lorenzo's bedroom around the time of his marriage, so it may have been intended as a painting on the nuptial theme of love and fertility in marriage. Venus, clothed in contemporary costume and wearing a marriage wreath on her head, here represents her terrestrial nature governing marital love. She stands in a grove of orange trees weighted down with lush fruit,

suggesting human fertility. Cupid embodies romantic desire, and as practiced in central Italy in ancient times, Flora's festival had definite sexual overtones.

Botticelli's later career was affected by a profound spiritual crisis. While he was composing his mythologies, a Dominican monk, Fra Girolamo Savonarola, had begun to preach impassioned sermons denouncing the worldliness of Florence. Many Florentines reacted with orgies of self-recrimination, and processions of weeping penitents wound through the streets. In the 1490s, Botticelli, too, fell into a state of religious fervor. In a dramatic gesture of repentance, he burned many of his earlier paintings and began to produce highly emotional, religious pictures. Finally, at the end of his life, he gave up painting altogether.

THE ITALIAN In the second half of the fif-RENAISSANCE teenth century, the Renaissance began to expand from OUTSIDE Florence to the rest of Italy, FLORENCE giving birth to a number of local styles. Renaissance ideas

were often spread by artists who had trained or worked in Florence, and who then traveled to other cities to work, either temporarily or permanently-including Donatello (Padua, Siena), Alberti (Mantua, Rimini, and Rome), Piero della Francesca (Urbino, Ferrara, Rome), Uccello (Venice, Urbino, Padua), Giuliano da Sangallo (Rome), and Botticelli (Rome). Northern Italy embraced the new Renaissance styles swiftly, with the ducal courts at Mantua and Urbino taking the lead. The Republic of Venice and the city of Padua, which Venice had controlled since 1404, also emerged as innovative art centers in the last quarter of the century.

Architecture

The spread of Renaissance architecture outside Florence was due in significant part to Leon Battista Alberti, who traveled widely and expounded his views to potential patrons. As a result he undertook an unusual project in Rimini, fitting for an artist steeped in classical knowledge: to transform an existing medieval church, the Church of San Francesco, into a Renaissance "temple" honoring the local ruler, Sigismondo Malatesta, and his mistress Isotta degli Atti. Although the project, designed in 1450, was never completed, the partly altered exterior shell nevertheless provides an encyclopedia of Albertian architectural ideas (fig. 17-55). The facade, set in front of the original church wall, combines forms derived from a Classical temple front and a Roman triumphal arch such as the nearby Arch of Augustus. The high podium with the Corinthian order of attached columns and the entablature supporting a triangular pediment constitute the temple front. The triple arches, attached columns, roundels, and heavy projecting cornice carry the triumphal-arch motif. This layering and combining of motifs and references is typical of humanistic thinking and similar in concept to Botticelli's treatment of mythologies.

Another patron, the ruler of Mantua, in 1470 commissioned Alberti to enlarge the small Church of Sant' Andrea,

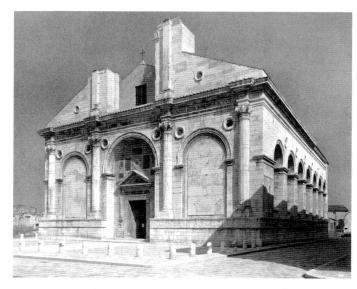

17-55. Leon Battista Alberti. Tempio Malatesta, Church of San Francesco, Rimini. Designed c. 1450

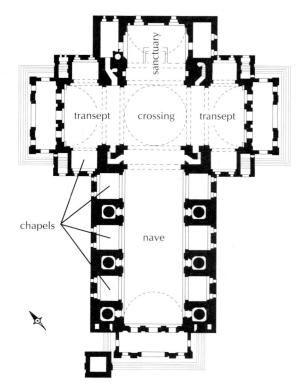

17-56. Leon Battista Alberti. Plan of the Church of Sant' Andrea, Mantua. Designed 1470

which housed a sacred relic believed to be the actual blood of Jesus. To satisfy his patron's desire for a sizable building to handle crowds coming to see the relic, Alberti proposed to build an "Etruscan temple." Work began on the new church in 1472, but Alberti died that summer. Construction went forward slowly, at first according to his original plan, but it was finally completed only at the end of the eighteenth century. Thus, it is not always clear which elements belong to Alberti's original design.

The Latin-cross plan (fig. 17-56)—a nave more than 55 feet wide intersected by a transept of equal width; a square, domed crossing; and a rectangular sanctuary on

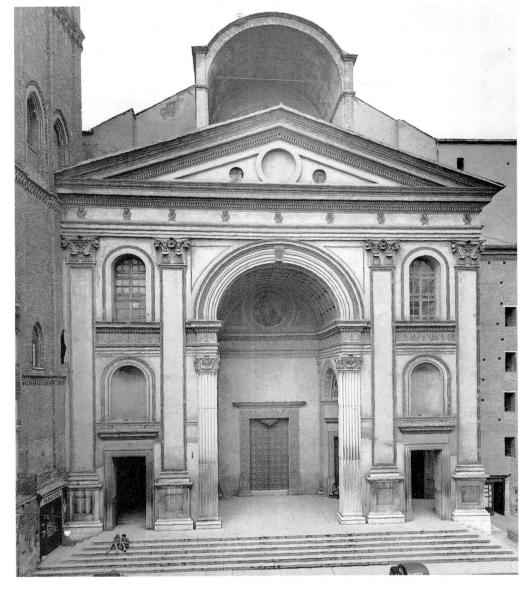

17-57. Leon Battista Alberti. Facade, Church of Sant'Andrea

axis with the nave—is certainly in keeping with Alberti's ideas. Alberti was responsible, too, for the barrel-vaulted chapels the same height as the nave and the low chapel niches carved out of the huge piers supporting the barrel vault of the nave. His dome, however, would not have been perforated and would not have been raised on a drum, as this one finally was.

Alberti's design for the facade of Sant'Andrea (fig. 17-57) echoes that of the Tempio Malatesta in Rimini in its fusion of temple front and triumphal arch, but the facade now has a clear volume of its own, which sets it off visually from the building behind. Two sets of colossal Corinthian pilasters articulate the porch face. Those flanking the barrel-vaulted triumphal-arch entrance are two stories high, whereas the others, raised on pedestals, run through three stories to support the entablature and pediment of the temple form. The arch itself has lateral barrel-vaulted spaces opening through two-story arches on the left and right.

Neither the simplicity of the plan nor the complexity of the facade hints at the grandeur of Sant'Andrea's interior (fig. 17-58). Its immense barrel-vaulted nave

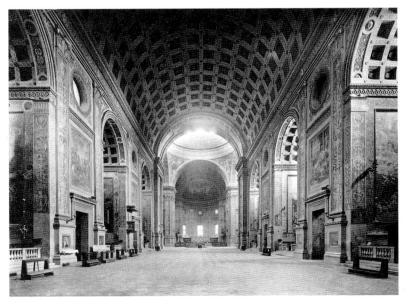

17-58. Leon Battista Alberti. Nave, Church of Sant'Andrea

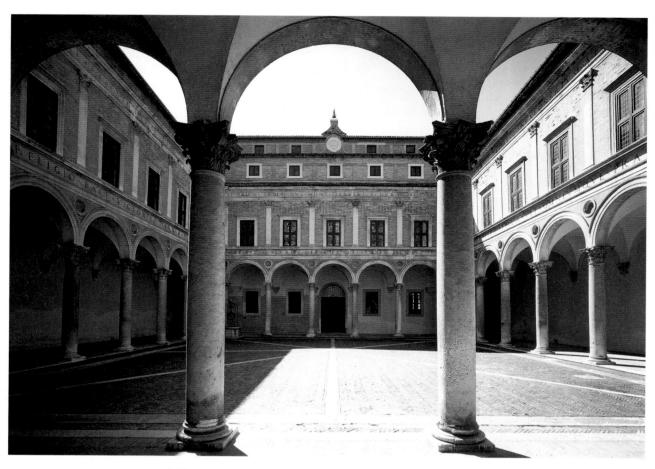

17-59. Luciano Laurana. Courtyard, Ducal Palace, Urbino. 1465-79

extended on each side by tall chapels was inspired by the monumental interiors of such ancient ruins as the Basilica of Constantine and Maxentius in the Roman Forum. In this clear reference to Roman imperial art Alberti created a building of such colossal scale and spatial unity that it affected architectural design for centuries.

The court of Urbino was an outstanding artistic center under the patronage of Federico da Montefeltro, who actively sought out the finest artists of the day to come to Urbino. In 1468, after failing to find a Tuscan to take over the construction of a new ducal palace (palazzo ducale) begun about 1450, Federico hired one of the assistants already involved in the project, Luciano Laurana, to direct the work. Among Laurana's major contributions were his closing the courtyard with a fourth wing and redesigning the courtyard facades (fig. 17-59). The result is a superbly rational solution to the problems of courtyard elevation design. The ground-level portico on each side has arches supported by columns; the corner angles are bridged with piers having engaged columns on the arcade sides and pilasters facing the courtyard. This arrangement avoided the awkward visual effect of two arches springing from a single column and gave the corner a greater sense of stability. The Composite capital (Corinthian with added Ionic volutes) was used, perhaps for the first time, on the ground level. Corinthian pilasters flank the windows in the story above, forming divisions that repeat the bays of the portico. (The two short upper

stories were added later.) The plain architrave faces were engraved with inscriptions identifying Federico and lauding his many humanistic virtues. Not visible in the illustration is an innovative feature that became standard in palace courtyard design: the monumental staircase from the courtyard to the main floor.

A fifteenth-century Florentine architect whose work was most important for developments in the sixteenth century was Giuliano da Sangallo (c. 1443-1516). From 1464 to 1472, he worked in Rome, where he produced a number of meticulous drawings after the city's ancient monuments, many of which are now lost and known today only from his work. Back in Florence, he became a favorite of Lorenzo the Magnificent, a great humanist and patron of the arts. Soon after completing a country villa for Lorenzo in the early 1480s, Giuliano submitted a model for a new church in Prato, near Florence, on which he began work in 1485. In 1484, a child had claimed that a painting of the Virgin on the wall of the town prison had come to life, and plans were soon made to remove the image and preserve it in a votive church (a church built as a special offering to a saint), to be named Santa Maria delle Carceri (Saint Mary of the Prisons).

Although the need to accommodate processions and the gathering of congregations made the long nave of a basilica almost a necessity for local churches, the votive church became a natural subject for Renaissance experimentation with the central plan. The existing tradition

17-60. Giuliano da Sangallo. Plan of the Church of Santa Maria delle Carceri, Prato. Before 1485

17-61. Giuliano da Sangallo. Interior view of dome, Church of Santa Maria delle Carceri. 1485-92

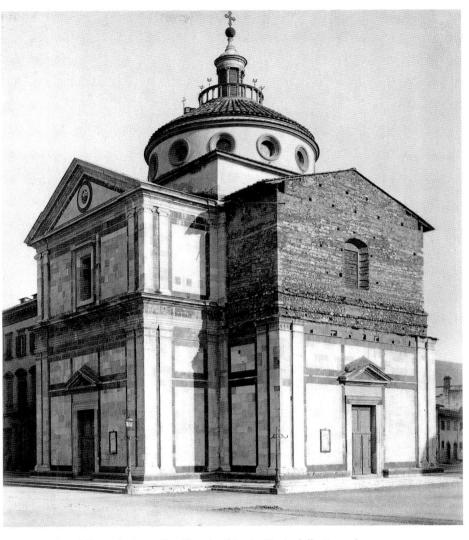

17-62. Giuliano da Sangallo. Church of Santa Maria delle Carceri

of central-plan churches extended back to the Early Christian martyrium (a round shrine to a martyred saint) and perhaps ultimately to the Classical tholos, or round temple. Alberti in his treatise on architecture had spoken of the central plan as an ideal, derived from the humanist belief that the circle was a symbol of divine perfection and that both the circle inscribed in a square and the cross inscribed in a circle were symbols of the cosmos. Thus, Giuliano's Church of Santa Maria delle Carceri, built on a Greek-cross plan, is one of the finest early Renaissance examples of humanist symbolism in architectural design (fig. 17-60). It is also the first Renaissance church with a true central plan; Brunelleschi's earlier experiment in the Old Sacristy of San Lorenzo, for example, was for an attached structure, and Alberti's Greekcross plan was never actually built. Drawing on his knowledge of Brunelleschi's works, Giuliano created a square, dome-covered central space extended in each direction by arms whose length was one-half the width of the central space. The arms are covered by barrel vaults extended from the round arches supporting the dome. Giuliano raised his dome on a short, round drum that increased the amount of natural light entering the church. He also articulated the interior walls and the twelve-ribbed dome and drum with *pietra serena* (fig. 17-61). The exterior of the dome is capped with a conical roof and a tall lantern in Brunelleschian fashion.

The exterior of the church (fig. 17-62) is a marvel of Renaissance clarity and order. The ground-floor system of slim Doric pilasters clustered at the corners is repeated in the Ionic order on the shorter upper level, as if the entablature of a small temple had been surmounted with a second smaller one. The church was entirely finished in 1494 except for installation of the fine green-and white-marble veneer above the first story. In the 1880s, one section of the upper level was veneered; however, the philosophy of twentieth-century conservation requires that the rest of the building be left in rough stone, as it is today.

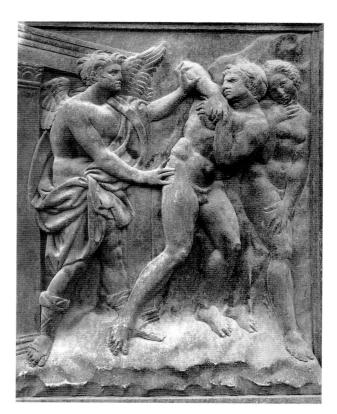

17-63. Jacopo della Quercia. *Expulsion of Adam and Eve*, panel in main portal, Church of San Petronio, Bologna. c. 1430. Stone, 34 x 27" (86.4 x 68.6 cm)

Sculpture

While Ghiberti and Donatello were forging the early Renaissance style in Florence, a sculptor in another part of Tuscany, Jacopo della Quercia of Siena (c. 1374-1438), was moving on a parallel path. Little is known of his early years, except for his participation in the 1402 competition for the Florence Baptistry doors. He seems to have worked principally in relief, and focusing on the human figure, he developed an active, monumental, idealized nude unlike any seen in Western art since classical antiquity. Between 1425 and 1438, Jacopo executed ten relief panels depicting the Genesis story of Adam and Eve in this new figural style for the Church of San Petronio in Bologna. In the Expulsion of Adam and Eve (fig. 17-63), of about 1430, the sculptor demonstrated no interest in adapting figures to settings in natural proportional relationships, as did his Florentine counterparts. Instead, the physical presence of the muscular figures dominates the relief, with just enough landscape detail to provide a sense of place. The drama is revealed through exaggerated poses, gestures, and gazes. These massive figures in emphatically active poses had little immediate influence on Italian sculpture, but in the sixteenth century, sculptors recognized and responded to their power.

Some of the best Renaissance sculpture in northern Italy was produced by artists trained in Florence. In 1443,

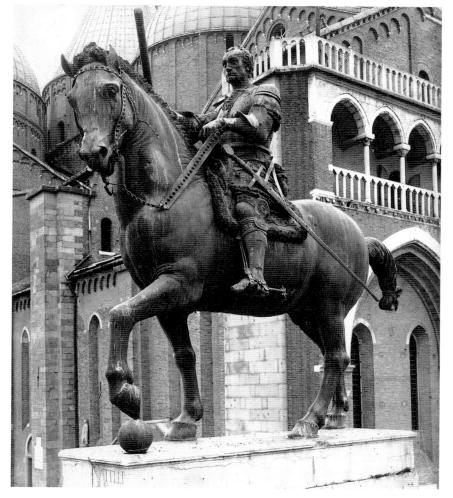

for example, Donatello was called to Padua to execute an equestrian statue commemorating the Venetian general Erasmo da Narni, nicknamed Gattamelata ("Calico Cat") (fig. 17-64). Donatello's sources for this statue were two surviving Roman bronze equestrian portraits, one (now lost) in the north Italian city of Pavia, the other of the emperor Marcus Aurelius, which the sculptor certainly saw and probably sketched during his youthful stay in Rome. Donatello's monument, installed on a high base in front of the Church of Sant'Antonio, was the first large-scale bronze equestrian portrait since antiquity. Viewed from a distance, this man-animal juggernaut seems capable of thrusting forward at the first threat. Seen from up close, however, the man's sunken cheeks, sagging jaw,

During the decade that he remained in Padua, Donatello executed other commissions for the Church of Sant'Antonio, including a bronze crucifix and reliefs for the high altar. His presence in the city introduced Renaissance ideas to northeastern Italy and gave rise to a new Paduan school of painting and sculpture.

ropey neck, and stern but sad expression suggest a war machine now grown old and tired from the constant need for military vigilance and rapid response. Such expressionism was a recurring theme in Donatello's portrayals.

In the early 1480s the Florentine painter and sculptor Andrea del Verrocchio (1435–1488) was commissioned to produce an equestrian memorial to another Venetian general, Bartolommeo Colleoni (d. 1475), this time in Venice itself. In contrast to the tragic overtones communicated by Donatello's *Gattamelata*, the impression conveyed by the tense forms of Verrocchio's equestrian monument (fig. 17-65) is one of vitality and brutal energy. The general's determination is clearly expressed

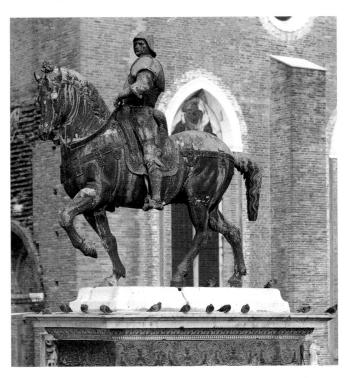

17-65. Andrea del Verrocchio. Equestrian monument of Bartolommeo Colleoni, Campo Santi Giovanni e Paolo, Venice. c. 1481-96. Bronze, height approx. 13' (4 m)

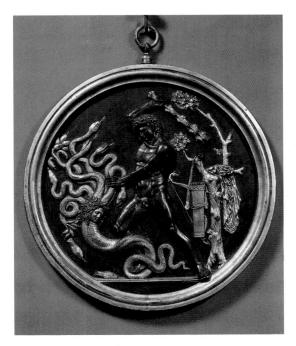

17-66. Antico (Pier Jacopo Alari Bonacolsi). *Hercules and the Hydra*. 1495–98. Gilt bronze, diameter 12¹/4" (29 cm). Museo Nationale del Bargello, Florence

in his clenched jaw and staring eyes. The taut muscles of the horse, fiercely erect posture of the rider, and complex interaction of the two make this image of will and domination one of the most compelling monuments of latefifteenth-century sculpture.

The enthusiasm of European collectors in the latter part of the fifteenth century for small bronzes contributed to the spread of classical taste. Many sculptors, especially those trained as goldsmiths, began to cast small copies after well-known Classical sculpture. Some artists executed their own designs *all'antica* ("in the antique style") as well. Although there were outright forgeries of antiquities at this time, works in the antique manner made by such sculptors as Pier Jacopo Alari Bonacolsi (c. 1460–1528) were intended simply to appeal to a cultivated humanist taste. Bonacolsi, who worked in Mantua, was so admired for such sculpture that he was nicknamed "Antico."

On a large bronze relief medallion more than a foot in diameter produced about 1495–1498, Antico represented *Hercules and the Hydra* (fig. 17-66), which shows the hero killing a multiheaded water serpent. Using the skills he had learned as a goldsmith, Antico often enriched his bronzes by gilding or inlaying details in gold and silver. A typical piece, like the one shown here, exhibits satinsmooth, glowing flesh contrasting with fine, realistic details and areas of glittering texture. This mythological scene is enlivened with naturalistic touches, such as the gnarled tree trunk, the carefully observed quiver and bow, and the exquisitely rendered scales of the hydra.

Painting

Piero della Francesca (c. 1406/12–1492) had worked in Florence in the 1430s before settling down in his native

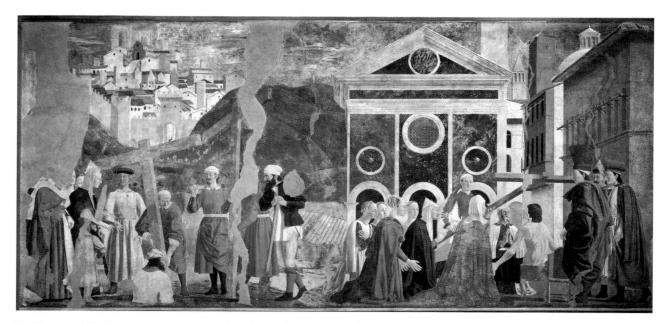

17-67. Piero della Francesca. *Discovery and Testing of the True Cross*, fresco in the Church of San Francesco, Arezzo. 1454–58. 11'8³/₈" x 6'4" (3.56 x 1.93 m)

According to legend, Helena was aided by a young Jerusalem Jew named Judas in finding Christ's Cross, whose location had been handed down in his family over the 270 years since the Crucifixion. After being thrown into a well and starved, he led Helena and her companions to the hill of Golgotha (Calvary), where they tore down a temple to Venus and excavated the crosses of Jesus and the two thieves executed with him (at the left). Judas also helped test the crosses. The "true" one was identified when its touch brought back to life a recently deceased man being carried to his tomb (at the right).

Borgo San Sepolcro, a Tuscan hill town under papal control. Piero was well acquainted with current thinking in art and art theory: Brunelleschi's system of spatial illusion and linear perspective, Masaccio's powerful modeling of forms and atmospheric perspective, and especially Alberti's theoretical treatises. Piero was one of the few practicing artists who wrote about his own theories. Not surprisingly, in his treatise on perspective he emphasized geometry and the volumetric construction of forms and spaces in his work to an unprecedented degree.

Piero continued to receive important commissions requiring him to stay in other cities for long periods of time. From about 1454 to 1458 he was in Arezzo, where he decorated the sanctuary of the Church of San Francesco with a cycle of frescoes illustrating the Legend of the True Cross. (Helena, mother of the first Christian Roman emperor, Constantine, went to Jerusalem in the early fourth century and supposedly discovered the "True Cross" of Jesus' Crucifixion.) The finding and testing of the Cross are illustrated in a single scene (fig. 17-67).

Piero reduced his figures to cylindrical and ovoid shapes and painted the clothing and other details of the setting with muted colors. His analytical modeling and perspectival projection resulted in a highly believable illusion of space around his monumental figures. The foreshortening of figures and objects—shortening the lines of forms seen head-on in order to align them with the overall perspectival system—such as the cross at the right, and the anatomical accuracy of the revived youth's nude figure are particularly remarkable. Unlike many of his contemporaries, Piero gave his figures no expression of human emotion. Of special note in Piero's composition are the inclusions of Classical architecture, which convert ancient Jerusalem into a Renaissance city. Behind the crowd at the right stands an elegant building whose facade reflects Alberti's principles and recommendations for ideal architecture: an even number of vertical elements, an odd number of openings, and decoration with panels of veined marble framed in plain marble or stone.

Piero's commissions took him later to the court of Federico da Montefeltro at Urbino, for whom he painted a pair of pendant, or companion, portraits in 1472–1473 of Federico and his recently deceased wife; Battista Sforza (fig. 17-68). In the traditional Italian fashion, the figures are portrayed in strict profile, as remote from the viewer as icons. The profile format also allowed for an accurate recording of Federico's likeness without emphasizing two disfiguring scars—the loss of his right eye and the bridge of his nose—from a sword blow. His good left eye is shown, and the angular profile of his nose seems like a distinctive familial trait. Typically, Piero

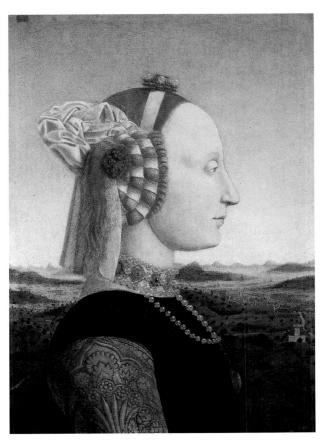

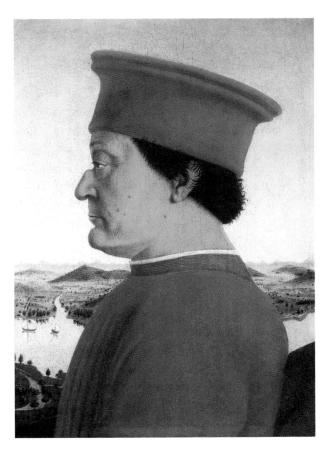

Montefeltro (right). 1472-73. Oil on panel, each 181/2 x 13"

emphasized the underlying geometry of the forms, rendering the figures with an absolute stillness. Dressed in the most elegant fashion, Battista and Federico are silhouetted against a distant view of the Tuscan hills. The portraits may have been hinged as a diptych, since the landscape appears continuous across the two panels. The influence of Flemish art is strong in careful observation of Battista's jewels and in the intuitive, well-observed use of atmospheric perspective, with the landscape features becoming lighter and paler as they recede. Piero has also used another northern European device in the harbor view near the center of Federico's panel: the water narrows into a river and leads the eye into the distant landscape.

Andrea Mantegna (1431–1506) of Padua was one of the most influential of the fifteenth-century Renaissance painters who were born and worked outside Florence. An artistic prodigy, Mantegna entered the painters' guild at the age of fifteen. The greatest influence on the young artist was the sculptor Donatello, who arrived in Padua in 1443 for a decade of work there. In his early twenties when Donatello left, Mantegna had fully absorbed the sculptor's Florentine linear-perspective system, which he pushed to its limits with experiments in radical perspective views and the foreshortening of figures. In 1459 Mantegna went to work for Ludovico Gonzaga, the ruler of

Mantua, and he continued to work for the Gonzaga family for the rest of his life, except for trips to Florence and Pisa in the 1460s and to Rome in 1488–1490. In Mantua, the artist became a member of the humanist circle, whose interests in classical literature and archeology he shared. He often signed his name using Greek letters.

Mantegna's mature style is characterized by the virtuosity of his use of perspective, his skillful integration of figures into their settings, and his love of individualization and naturalistic details. This style is exemplified in the frescoes of the Camera Picta ("Painted Room") of Gonzaga's ducal palace, a tower chamber with a lake view, which Mantegna decorated between 1465 and 1474. On the domed ceiling, the artist painted a tour-de-force of radical perspective called di sotto in sù ("seen from directly below"), which began a long-lasting tradition of illusionistic ceiling painting (fig. 17-69). The room appears to be open to a cloud-filled sky through a large oculus in a simulated marble- and mosaic-covered vault. On each side of a precariously balanced planter, three young women and an exotically turbaned African man peer over a marble balustrade into the room below. A fourth young woman in a veil looks dreamily upward. Joined by a large peacock, several putti play around the balustrade.

On two adjacent walls Mantegna created a continuous narrative illustrating aristocratic family life as well

17-69. Andrea Mantegna. Fresco on the ceiling of the Camera Picta, Ducal Palace, Mantua. 1474

as a fascinating moment in Church history (fig. 17-70). Above the fireplace, which is incorporated into the painted scene, he produced a group portrait of Ludovico, his wife, Barbara von Hohenzollern, some of their children, and a few courtiers. Ludovico, seated at the far left, has just read a letter announcing the imminent arrival from Rome of their son Francesco, who had gone there to be made

a cardinal at the age of thirteen; the young cardinal's arrival is shown on the adjoining wall. Mantegna painted recognizable portraits of the Gonzaga family and rendered the costumes and architectural setting with customary realism, but the landscape views are of imaginary hill towns rather than the flat plain around Mantua.

The establishment of Rome as a Renaissance center

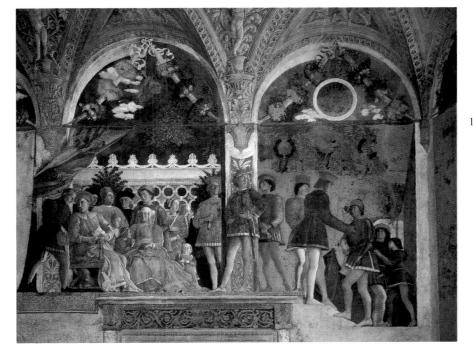

17-70. Andrea Mantegna. *Gonzaga Family*, wall of the Camera Picta

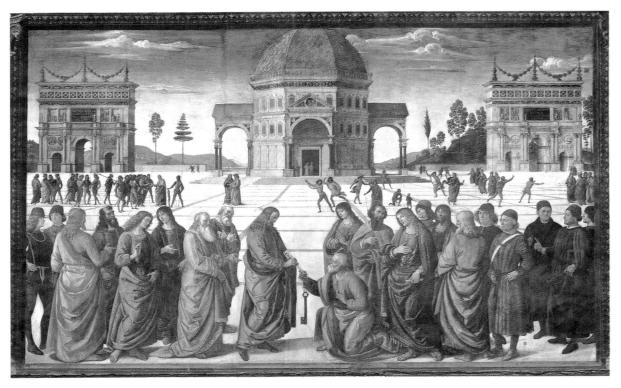

of the arts was greatly aided by Pope Sixtus IV's decision to call to the city the best artists he could find to decorate the walls of his newly built Sistine Chapel. In the early fifteenth century, a schism in the Western Church ended, and the papacy was firmly reestablished in Rome. This event had precipitated the need to restore not only the Vatican but the whole city as a center worthy of the papal court. Among those who went to Rome was Pietro Vannucci, called Perugino (c. 1445–1523), from near the town of Perugia in Umbria. Perugino had been working in Florence since 1472 and left there in 1481 to travel to Rome to work on the Sistine wall frescoes. His contribution, *Delivery of the Keys to Saint Peter* (fig. 17-71),

17-71. Pietro Perugino. *Delivery of the Keys to Saint Peter,* fresco in the Sistine Chapel, Vatican, Rome. 1482. 11'5'/2" x 18'8'/2" (3.48 x 5.70 m)

Modern eyes accustomed to gigantic parking lots would not find a large open space in the middle of a city extraordinary, but in the fifteenth century this great piazza was purely the product of artistic imagination. A real piazza this size would have been very impractical. In summer sun or winter wind and rain, such spaces would have been extremely unpleasant for a pedestrian population, but, more important, no city could afford such extravagant use of valuable land within its walls.

17-72. Jacopo Bellini. Flagellation.
c. 1450. Leadpoint drawing on parchment, 16³/₄ x 11¹/₄" (42.6 x 28.6 cm).
Musée du Louvre, Cabinet des Dessins, Paris

portrayed the event that provided biblical support for the supremacy of papal authority, Christ's giving the keys to the kingdom of heaven (Matthew 16:19) to the apostle Peter, the first bishop of Rome.

Delivery of the Keys is a remarkable work in carefully studied linear perspective that reveals much about Renaissance ideas and ideals. In a light-filled piazza whose banded paving stones provide a geometric grid for perspectival recession, the figures stand like chess pieces on the squares, scaled to size according to their distance from the picture plane and modeled by a consistent light source from the upper left. Horizontally, the composition is divided between the lower frieze of massive figures and the band of widely spaced buildings above. Vertically, it is divided by the open space at the center between Christ and Peter and by the symmetrical architectural forms on each side of this central axis. The carefully calibrated scene is softened by the subdued colors, the distant idealized landscape and cloudy skies, and the variety of the figures' positions.

Perugino's painting is, among other things, a representation of Alberti's ideal city, described in his treatise on architecture as having a "temple" (that is, a church) at the very center of a great open space raised on a dais and separate from any other buildings that might obstruct its view. His ideal church had a central plan, illustrated here as a domed octagon.

In the last quarter of the fifteenth century, Venice emerged as a major artistic center of Renaissance painting. From the late 1470s on, Venetian painters embraced the oil medium for both panel and canvas painting. The most important Venetian artists of this period were two brothers, Gentile (c. 1429-1507) and Giovanni (c. 1430-1516) Bellini. Beginning with their father, Jacopo (active c. 1423-1470), the Bellinis were central figures in Venetian art. Andrea Mantegna was also part of this circle, for he had married Jacopo's daughter in 1453. Jacopo, who had worked for a short time in Florence, was also a theorist who produced books of drawings in which he experimented with linear perspective. An experimental perspective study with a very low vanishing point and steeply plunging orthogonals—lines receding from the picture plane to converge on a vanishing point survives in a Flagellation of about 1450 from Jacopo's sketchbook (fig. 17-72). His reputation as a painter is overshadowed in modern thinking by the achievements of his sons.

Gentile Bellini, a diplomat as well as a painter, received a number of important commissions, including fresco cycles for the ducal palace and various other public and private buildings in Venice. Many of his paintings celebrate the daily life of the city in large, multifigured narrative scenes, such as the *Procession of the Relic of the True Cross before the Church of San Marco* of 1496

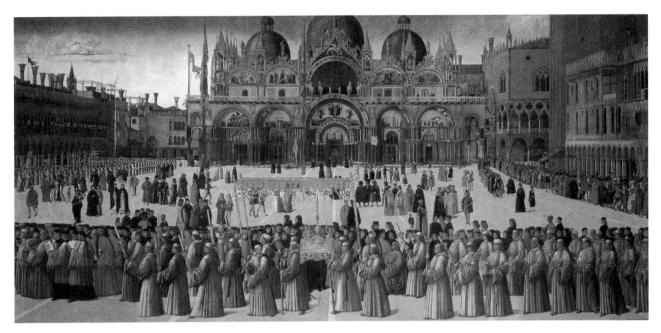

17-73. Gentile Bellini, *Procession of the Relic of the True Cross before the Church of San Marco*. 1496. Oil on canvas, 10'7" x 14' (3.23 x 4.27 m). Galleria dell'Accademia, Venice

(fig. 17-73). This work on canvas depicts a contemporary historical event: in 1444, during a procession in which a relic of the True Cross was carried through Venice's Piazza San Marco, a miraculous healing occurred, which was attributed to the relic. This accurately detailed cityscape is an early example of the topographical views that would one day be bought by wealthy tourists as souvenirs of their travels.

For almost sixty years, Giovanni Bellini's virtuosity as an artist amazed and attracted patrons. *Virgin and Child Enthroned with Saints Francis, John the Baptist, Job, Dominic, Sebastian, and Louis of Toulouse* (fig. 17-74), painted about 1478–1479 for the Ospedale of San Giobbe (Saint Job), exhibits a dramatic perspectival view up into a vaulted apse. Certainly Giovanni knew his father's perspective drawings well, and he may also have been influenced by his brother-in-law Mantegna's early experiments in radical foreshortening and the use of a low vanishing point. In Giovanni's painting, the vanishing point for the rapidly converging lines of the architecture lies at the center, on the feet of the lute-playing angel. Also, the

17-74. Giovanni Bellini. *Virgin and Child Enthroned with Saints Francis, John the Baptist, Job, Dominic, Sebastian, and Louis of Toulouse,* from the chapel for the Ospedale of San Giobbe, Venice. c. 1478–79. Panel, 15'4" x 8'4" (4.67 x 2.54 m). Galleria dell'Accademia, Venice Art historians have given a special name, *sacra conversazione* ("holy conversation"), to this type of composition showing saints, angels, and sometimes even the painting's donors in the same pictorial space with the enthroned Virgin and Child. Despite the name, no conversation or other interaction between the figures takes place in a literal sense. Instead, the individuals portrayed are joined in a mystical communion occurring outside of time, in which the viewer is invited to share.

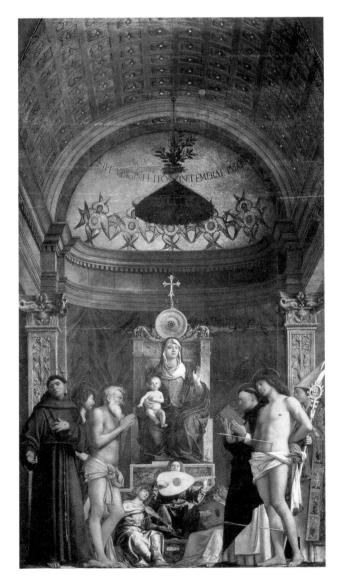

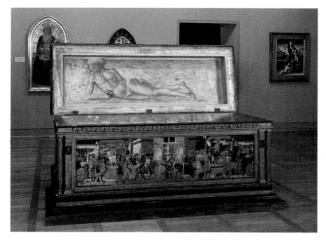

17-75. Florentine School. *Cassone.* c. 1460. Length 6'87/10" (2.05 m). Royal Museum of Fine Arts, Copenhagen

pose of Saint Sebastian, his body pierced by arrows, at the right recalls a famous *Saint Sebastian* by Mantegna. Giovanni has placed his figures in a Classical architectural interior with a coffered barrel vault, reminiscent of Masaccio's *Trinity* (see fig. 17-46). The gold mosaic with its identifying inscription and stylized angels, reminiscent of the art of the Byzantine Empire in the eastern Mediterranean, recalls the long tradition of Byzantine-inspired painting and mosaics produced in Venice.

Although Giovanni's career covered nearly all of the second half of the fifteenth century, many of his greatest paintings were produced in the first decades of the sixteenth. While his work is often discussed with that of Leonardo da Vinci in the sixteenth century, it seems fit-

ting to end our consideration of the first phase of Renaissance painting in Italy with Giovanni Bellini as an important and influential bridge to the future.

INTERIOR ARTS, PRINTS, AND BOOKS

The Italian craft artists, too, were inspired by new Renaissance ideas. As the creators of luxury goods for an educated clientele, they came into direct contact with humanistic ideas and increased interest in classical antiquity. Particularly in the

domain of home furnishings and interior decorations, the field was open for ambitious experiments in new subjects, treatments, and techniques.

Perfect objects for painted decoration were cassoni (singular, cassone, "chest") used for storing linens, fabrics, and clothing, which were often presented to couples at the time of their marriage. Few such chests survive intact today, often because the painted sections were cut out and sold as individual pictures by art dealers. Although religious subjects are found, especially on chests to store church linens and vestments, the cassone painters preferred mythological and historical subjects, allegorical or symbolic inventions, and occasionally, scenes of everyday life. An extremely elegant cassone by an unknown artist, possibly made as a bride's chest about 1460 in Florence, is painted on both the front panel and the inner side of the lid (fig. 17-75). The reclining male nude on the lid, which may have some symbolic meaning, perhaps as a fertility image, has an immediacy and sensuality suggesting a study from a live model. The front panel, framed by carved

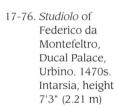

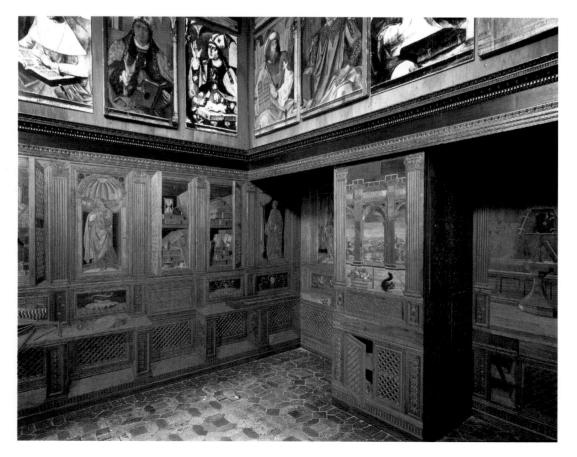

Corinthian pilasters and columns, is a panoramic view of a city filled with figures. Although the subject comes from the legendary history of Rome, the setting and costumes are of the fifteenth century.

The development of linear perspective was a strong inducement for the creation of trompe l'oeil effects in painting, but the designers of intarsia (wood inlay) carried it to its ultimate expression. During the reconstruction of the palace at Urbino, Federico da Montefeltro commissioned the intarsia decoration of the walls of his studiolo, a room for his private collection of fine books and art

objects (fig. 17-76). The trompe l'oeil design gave the small room illusionistic pilasters, carved cupboards with latticed doors, niches with statues, paintings, and built-in tables. A large window looks out onto an elegant marble loggia with a distant view of the countryside through its arches, and the shelves, cupboards, and tables are filled with all manner of fascinating things-scientific instruments, books, even the duke's armor hanging like a suit in a closet. All of this scene was inlaid in wood on flat surfaces with scrupulously applied linear perspective and foreshortening that would have been the envy of Paolo Uccello.

TECHNIQUE

AND ENGRAVINGS ON METAL

WOODCUTS in a busy workshop. One artist would make the drawing. Sometimes it was made directly on the block or plate with ink, in reverse of its printed direction, sometimes on paper to be

> transferred in reverse onto the plate or block by another person, who then cut the lines. Others would ink and print the images. Prints often were inscribed with the names and occupations (usually given in Latin, and frequently abbreviated) of those who carried out these various tasks. The following are some of the most common inscriptions (Hind, volume 2, page 26):

Sculpsit (sculp., sc.), sculptor: engraved or cut, engraver or cutter Incidit (incid., inc.), incisor: engraved or cut, engraver or cutter Fecit (fec., f.): literally "made"; engraved or cut, engraver or cutter Excudit (excud., exc.): printed, or published Impressit (imp.): printed Pinxit (pinx.), pictor: painted, painter Delineavit (delin.), delineator: drew, draftsperson Invenit (inv.), inventor: designed, designer

In the illustration of books, the plates or blocks would be reused to print later editions and even adapted for use in other books. A set of blocks or plates for illustrations was a valuable commodity often sold by one workshop to another. Early in publishing, there were no copyright laws, and many entrepreneurs simply had their workers copy book illustrations onto woodblocks and cut them for their own publications.

has a fine grain, such as fruit wood, then cutting away all the areas around the lines with a sharp tool called a gouge, leaving the lines in high relief. When the block's surface is inked and a piece of paper pressed down hard on it, the ink on the relief areas is transferred to the paper to create a reverse

Woodcuts are made by drawing on the smooth surface of a block of wood that

image. The linear effects can be varied by using thicker and thinner lines, and shading can be achieved by making the lines closer or farther apart. Other techniquessuch as punching, cross-hatching, and flicking out short strokes with the gouge—also create pictorial interest. In the fifteenth century the images were generally left in black and white or painted by hand, although a few artists experimented with adding colors during the inking of the block and using more than one block with one or two colors printed over the black-and-white image.

Engraving on metal requires a technique called intaglio, in which the lines are cut into the plate with tools called gravers or burins, while the surface remains flat. The engraver carefully scrapes any metal piled up beside the line, then burnishes any scratches left on the plate to give a clean, sharp image. Ink is applied over the whole plate and forced down into the lines, after which the surface of the plate is carefully wiped clean. The ink in the lines prints onto a sheet of paper pressed hard against the metal plate.

Both woodblocks and metal plates could be used repeatedly to make nearly identical images. If the lines of the block or plate wore down, the artists could repair them. Printing large numbers of identical prints of a single version, called an edition, was usually a team effort

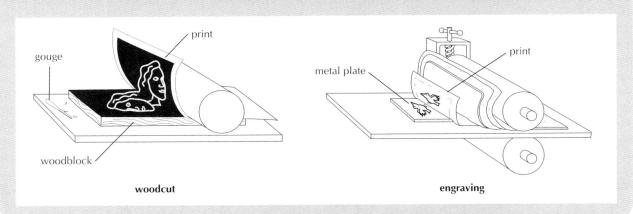

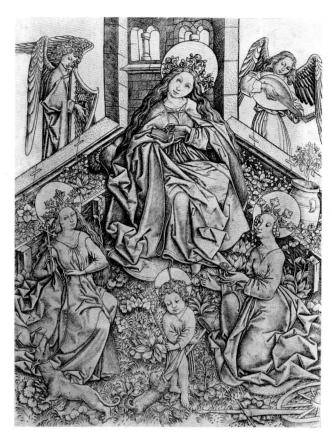

17-77. E. S. Engraver. *Virgin and Child in a Garden with Saints Margaret and Catherine* (or *Large Enclosed Garden*). c. 1461. Engraving, plate 8⁵/8 x 6³/8" (21.9 x 16.2 cm). Bibliothèque Nationale, Paris

European Printmaking and Book Printing

Printmaking emerged in Europe with the availability of locally manufactured paper at the end of the fourteenth century. Paper had been made in China as early as the second century ce, and small amounts were imported into Europe from the eighth century on. The first European paper was made in the twelfth century, but until the fourteenth century paper was rare and expensive. By the turn of the fifteenth century, however, commercial paper mills in nearly every European country were turning out large supplies that made it fairly inexpensive to use paper in a variety of ways, including for printing. Designs carved in relief on woodblocks had long been used to print on cloth, but the printing of images and texts on paper and the production of books in multiple copies of a single edition, or version, rather than copying each book by hand, emerged in the fifteenth century. Soon both handwritten and printed books were illustrated with printed images.

The Single-Sheet Print. Single-sheet woodcuts and engravings were made in large quantities in the early decades of the fifteenth century (see "Woodcuts and Engravings on Metal," page 673). In the beginning, woodcuts were often made by woodworkers with no training in drawing, but very quickly artists began to draw images for them to cut from the block. Engravings, on the other

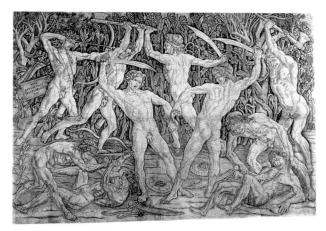

17-78. Antonio del Pollaiuolo. *Battle of the Ten Naked Men.* c. 1465–70. Engraving, 15½ x 23½ (38.3 x 59 cm). Cincinnati Art Museum, Ohio

Bequest of Herbert Green French

hand, seem to have developed from the metalworking techniques of goldsmiths and armorers. When paper became relatively plentiful around 1400, these artisans began to take impressions of the designs they were engraving on metal by rubbing the lines with lampblack and pressing paper over them.

Simply executed woodcut devotional images became popular early in the century, and they were sold as souvenirs to pilgrims at holy sites. Images for private devotion were also engraved, and in the hands of an experienced goldsmith the resulting images were often highly detailed, such as the Virgin and Child in a Garden with Saints Margaret and Catherine of about 1461 (fig. 17-77), by "E. S.," an artist known only from the engravings that carry this signature. More than 300 engravings by E. S. still exist, ranging in subject from grotesque alphabets to elaborate, symbolic representations of the Virgin. The artist worked in southern Germany, Switzerland, and eastern France from about 1450 to the late 1460s, producing extremely complex works in a style recalling that of Robert Campin, using a delicate line and fine cross-hatched shading. This charming scene in an enclosed garden, symbolic of virginity, could almost be that of a queen and her ladiesin-waiting watching over a playing child while listening to lute and harp music. But the figures are the Virgin Mary, the Christ Child, and Saints Margaret with her leashed dragon and Catherine with her wheel.

Not all prints were made for religious purposes, or even for sale. Some artists seem to have made them as personal studies, in the manner of drawings, or for use in their shops as models. The Florentine goldsmith and sculptor Antonio del Pollaiuolo may have intended his only known—but highly influential—print, *Battle of the Ten Naked Men*, an engraving done about 1465 to 1470, as a study in composition involving the human figure in action (fig. 17-78). The naked men fighting each other ferociously against a tapestrylike background of foliage seem to have been drawn from a single model in a variety of poses, many of which were taken from classical

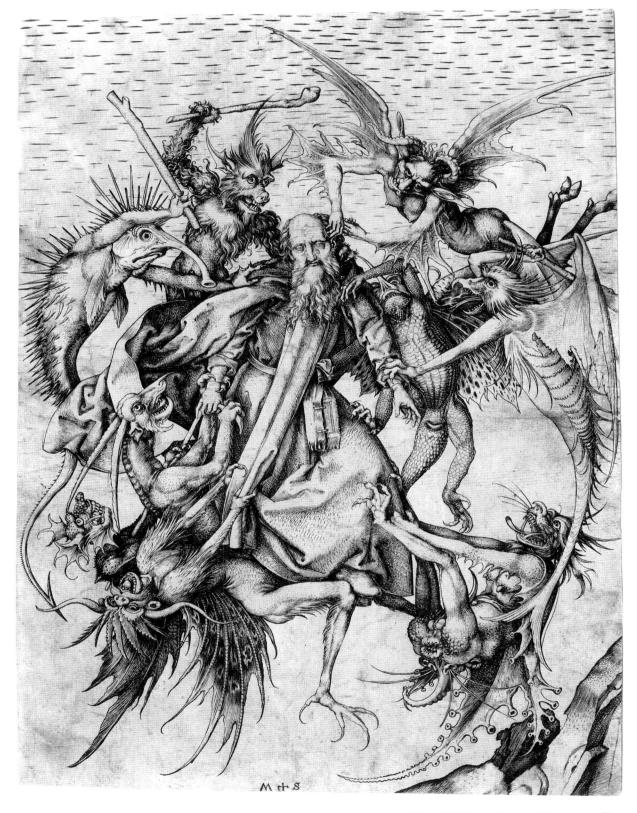

17-79. Martin Schongauer. *Temptation of Saint Anthony.* c. 1480–90. Engraving, 12¹/₄ x 9" (31.1 x 22.9 cm). The Metropolitan Museum of Art, New York Rogers Fund, 1920 (20.5.2)

sources. Like the artist's *Hercules and Antaeus* (see fig. 17-44), much of the engraving's fascination lies in how it depicts muscles of the male body reacting under tension.

The German painter Martin Schongauer, who learned engraving from his goldsmith father, was an immensely

skillful printmaker who excelled in drawing and the difficult technique of shading from deep blacks to faintest grays. One of his best-known prints today is the *Temptation of Saint Anthony*, engraved about 1480 to 1490 (fig. 17-79). Schongauer illustrated the original biblical

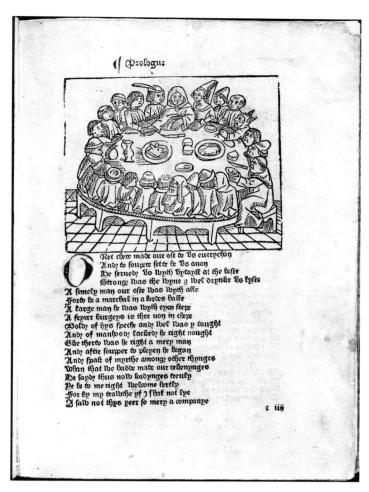

17-80. Page with *Pilgrims at Table,* Prologue to *Canterbury Tales,* by Geoffrey Chaucer, published by William Caxton, London, 1484 (second edition; first with illustrations). Woodcut, 4½16 x 4½8" (10.2 x 12 cm). The Pierpont Morgan Library, New York PMI, 693

Chaucer (c. 1342–1400) included in his *Tales* two extremely complex and engaging women, Dorigen and Alice, the Wife of Bath. Dorigen appeared in the Franklin's Tale as a good woman who refused to accept society's advice that she kill herself if her virtue were threatened. Alice, on the other hand, was one of the thirty people who joined her host in making a pilgrimage to the shrine of Saint Thomas à Becket, each one telling a story to entertain the others along the way. Some critics see the Wife of Bath as an example for good women to avoid, but Chaucer put words in the lively Alice's mouth that are well understood by many women today.

meaning of temptation, expressed in the Latin word *tentatio*, as a physical assault rather than a subtle inducement. Wildly acrobatic, slithery, spiky demons lift Anthony up off the ground to torment and terrify him in midair. The engraver intensified the horror of the moment by condensing the action into a swirling vortex of figures beating, scratching, poking, tugging, and no doubt shrieking at the stoical saint, who remains impervious to all by reason of his faith.

The Illustrated Book. The explosion of learning in Europe in the fifteenth century precipitated experiments in faster and cheaper ways of producing books than by hand-copying them. The earliest printed books were

block books, for which each page of text, with or without illustrations, was cut in relief on a single block of wood. Movable-type printing, in which individual letters could be locked together, inked, and printed onto paper by a mechanical press, was first achieved in the workshop of Johann Gutenberg in Mainz, Germany. More than forty copies of Gutenberg's Bible, printed in 1456, still exist. With the invention of this fast way to make a number of identical books, the intellectual and spiritual life of Europe—and with it the arts—changed forever. As early as 1465, two German printers were working in Italy, and by the 1470s there were presses in France, Flanders, Holland, and Spain.

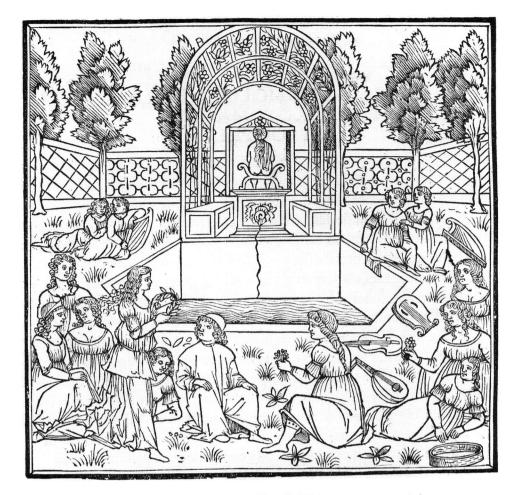

17-81. Page with *Garden of Love, Hypnerotomachia Poliphili*, by Fra Francesco Colonna, published by Aldo Manuzio (Aldus Manutius), Venice, 1499. Woodcut, image 5½ x 5½ " (13.5 x 13.5 cm). The Pierpont Morgan Library, New York PML 373

England got its first printing press in 1481 as the result of a second career launched by a former English cloth merchant, William Caxton (active 1441-1491?). Caxton lived for thirty years in Bruges, where he came in contact with the humanist community, as well as local book-printing ventures. In his spare time, he translated into English Raoul le Fevre's Histories of Troy, which became the first book printed in that language. In 1476 Caxton moved back to London, where he established the first English publishing house. He printed eighty books in the next fourteen years, including works by the fourteenth-century English author Geoffrey Chaucer. In the second edition of Chaucer's Canterbury Tales, published in 1484, Caxton added woodblock illustrations by an unknown artist (fig. 17-80). The assembled pilgrims, whose individual stories make up the Tales, appear in the Prologue seated around a table, ready to dine. Although technically simple, this woodcut and its companions are effective, original compositions.

Another famous early book was *Hypnerotomachia Poliphili* (*The Love-Dream Struggle of Poliphilo*). This charming romantic allegory tells of the wanderings of

Poliphilo through exotic places in search of his lost love, Polia—much in the manner of René of Anjou's *Livre du Cuer d'Amours Espris* (see fig. 17-27). The book, written in the 1460s or 1470s by Fra Francesco Colonna, was published in 1499 by the noted Venetian printer Aldo Manuzio (Aldus Manutius). Many historians of book printing consider Aldo's *Hypnerotomachia* to be the most beautiful book ever produced, from the standpoint of type and page design. The woodcut illustrations in the *Hypnerotomachia*, such as the *Garden of Love* (fig. 17-81), incorporate linear perspective and pseudoclassical structures that would influence future architects.

Although woodcuts, constantly refined and increasingly complex, would remain a popular medium of book illustration for centuries to come, methods for illustrating books with engravings soon emerged. The potential of these new techniques for printing illustrated books in Europe at the end of the 1400s held great promise for the spread of knowledge and ideas in the following century. The new empirical frame of mind that characterized the fifteenth century gave rise in the sixteenth century to an explosion of inquiry and new ways of looking at the world.

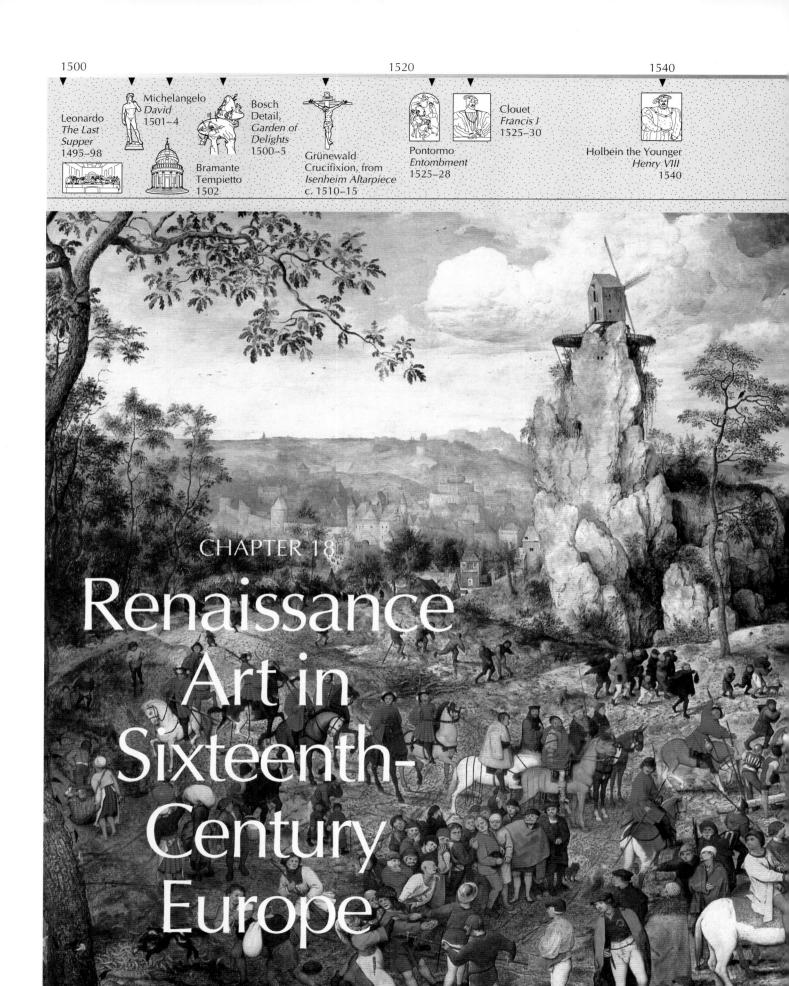

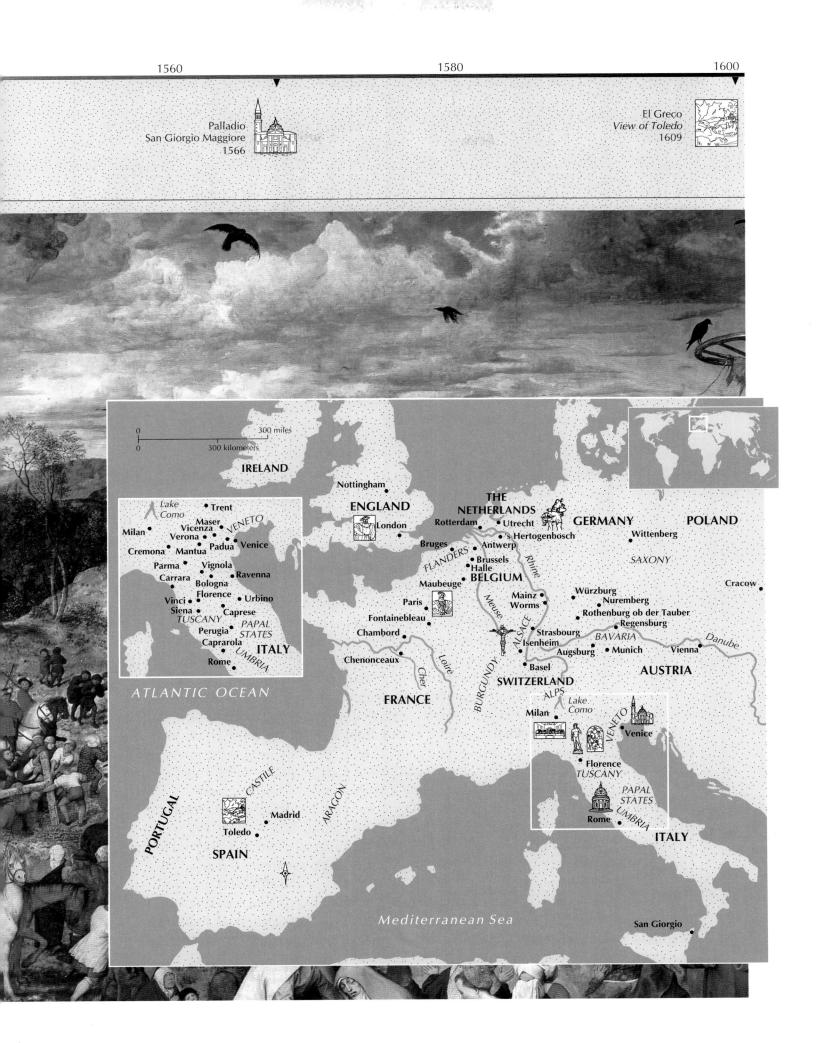

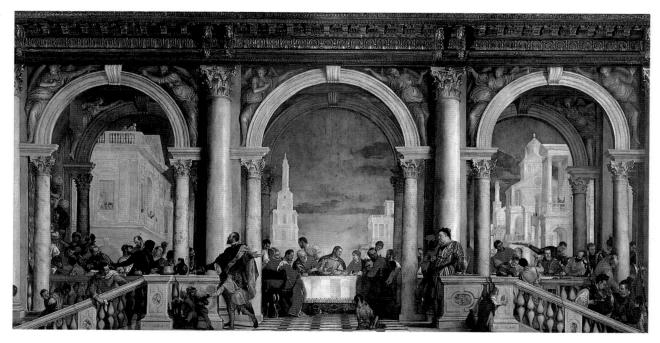

18-1. Veronese. *Feast in the House of Levi*, from the Monastery of Santi Giovanni e Paolo, Venice. 1573. Oil on canvas, 18'3" x 42' (5.56 x 12.8 m). Galleria dell'Accademia, Venice

esus among his disciples at the Last Supper was a popular image during the sixteenth century. But when the highly esteemed painter Veronese in 1573 revealed an enormous canvas that seemed at first glance to depict this scene, the people of Venice were shocked (fig. 18-1). Jesus, indeed, is in the center of the painting, with his followers, but some viewers were offended by Veronese's grandiose portraval of the subject, filled with splendor and pageantry; others, by the impiety of placing near Jesus a host of extremely unsavory characters. They were so offended, in fact, that Veronese was called before the Inquisition to explain his reasons for including such extraneous details as a man picking his teeth, scruffy dogs, a parrot, and foreign soldiers. The subject, indeed, originally may have been intended to be the Last Supper—the Inquisitors certainly thought so, although Veronese claimed it depicted the Feast in the House of Simon, a small dinner shortly before Jesus' final entry into Jerusalem. From the record of the inquiry, Veronese boldly justified his actions by saying: "We painters take the same license the poets and the jesters take. . . . I paint pictures as I see fit and as well as my talent permits" (cited in Holt, volume 2, pages 68, 69). This statement was a quite-unheard-of stance at that time, and his defense fell on unsympathetic ears. He was told to change the painting.

Accordingly, Veronese changed the picture's title so that it referred to another banquet, given by the tax collector Levi, whom Jesus had called to follow him. Thus, the "buffoons, drunkards . . . and similar vulgarities" (cited in Holt, volume 2, page 68) remained, and Veronese noted his new source—Luke, Chapter 5—on the balustrade. In that Gospel one reads that "Levi gave a great banquet for him [Jesus] in his house, and a large crowd of tax collectors and others were at table with them" (Luke 5:29). In changing the declared subject of the painting, Veronese also had modest revenge on the Inquisitors: when Jesus was criticized for associating

with such people, he replied, "I have not come to call the righteous to repentance but sinners" (Luke 5:32).

The Inquisitors who under the direction of the Church were scrutinizing works of art for heretical or profane suggestions, the painter who brashly defended his art, the very size and medium and style of the painting itself—all were products of the extraordinarily rich, inspiring, and unpredictable sixteenth century.

EUROPE The sixteenth century in Europe was IN THE an age of ferment—social, intellectual, religious, and geographic-SIXTEENTH that transformed European culture. **CENTURY** The humanism of the fourteenth and fifteenth centuries, with its

medieval roots and its often uncritical acceptance of the authority of classical texts, slowly gave way to a new spirit of discovery that led scholars to investigate the natural world around them, to conduct scientific and mechanical experiments, and to explore lands in Africa, Asia, and the Americas previously unknown to Europeans. Travel became more common than before, both within Europe and beyond it, and new ideas spread through the publication in translation of ancient and contemporary texts. An explosion of information, aided by the rapid growth of book printing, not only broadened the horizons of educated Europeans but also enabled more people to learn to read. Much more than in earlier centuries, artists and their work became mobile, traveling from city to city and from one country to another, and artistic styles became less regional and more international.

At the start of the sixteenth century, England, France, and Portugal were national states under strong monarchs. With the succession to the throne of the Habsburg Philip II in 1556, a united Spain soon became the strongest power in Europe, with vast territories in Asia, the Americas, Italy, and Flanders. Germany was divided into dozens of free cities and hundreds of territories ruled by nobles and princes. These territories ranged in size from a few square miles to large and powerful states like Saxony and Bavaria. But all the German states acknowledged the overlordship of the Habsburg Holy Roman emperors. Italy, also divided into many small states, was a diplomatic and military battlefield, where Spain, France, Venice, and the papacy warred against each other in shifting alliances for much of the century. The popes themselves behaved like secular princes. They used diplomacy and military force to regain their control over the Papal States in central Italy and in some cases to establish their families as hereditary rulers at the expense of local authorities. This behavior was expensive, and the popes' incessant demands for money aggravated the religious dissent that had long been developing, especially north of the Alps, and contributed greatly to the rise of Protestantism.

The political maneuvering of Pope Clement VII (papacy 1523-1534) led to a clash with the Holy Roman Emperor Charles V, based in Germany. As a result, in May 1527 the imperial army attacked Rome, beginning a sixmonth orgy of killing, looting, and burning. The Sack of Rome, as it is called, damaged irreparably the humanistic confidence of the Renaissance. On a more practical level, many artists simply left Rome for good.

The Effects of the Reformation on Art

The Church had witnessed many dissident movements in its history. Some of these movements had led to great controversy and outright war. But in the end, the unity of the Church and its authority had always prevailed. In the sixteenth century this unity broke down. The sixteenthcentury reformers (hence this movement is called the Reformation) not only challenged Church teaching over specific beliefs and religious practices but denied the very basis of the pope's—and thus the Church's—authority. These reformers, called Protestants because they "protested" against the practices and beliefs of the Catholic Church, succeeded in permanently breaking away from Rome for a variety of reasons. One cause of their success was the support they enjoyed from powerful rulers in Germany and Scandinavia who saw the Protestant movement as a way of enhancing their own wealth and power. Another factor was the easier availability of the printed word, which allowed scholars throughout Europe to debate religious matters among themselves and to influence many people who were already dissatisfied with the Church. Two important reformers in the early sixteenth century were themselves Catholic priests and trained theologians, Desiderius Erasmus of Rotterdam (1466?-1536) and Martin Luther (1483-1546). The wide circulation of Luther's writings especially his German translation of the Bible and his works maintaining that salvation came through faith alone—led eventually to the establishment of a Protestant church in Germany and Scandinavia.

By the end of the sixteenth century, some form of Protestantism prevailed in much of Europe. By the 1560s only Italy, Spain, Ireland, Poland, and Portugal were still entirely Catholic, although France reaffirmed its allegiance to the Roman Catholic Church in the late 1570s after decades of religious civil war. Southern Germany, the Rhineland, Austria, and Hungary also remained predominantly Catholic.

One tragic consequence of the Reformation was the destruction of religious art. In some areas, Protestant zealots smashed sculpture and stained-glass windows

1500 1600

PARALLELS

TARAELES		
<u>Europe</u>	<u>1500–1550</u>	<u>1550–1600</u>
Italy	Michelangelo's <i>David</i> ; Bramante's Tempietto; Pope Julius II; Leonardo's <i>Mona Lisa</i> ; rebuilding of Saint Peter's; Giorgione's <i>Tempest</i> ; Michelangelo's Sistine frescoes; Raphael's <i>School of Athens</i> ; Pope Leo X; Mannerism emerges; Pope Clement VII; Sack of Rome; Machiavelli's <i>The Prince</i> ; Michelangelo's <i>Last Judgment</i> ; Pope Paul III; Titian's <i>Isabella d'Este</i> ; Bronzino's <i>Ugolino Martelli</i> ; Roman Inquisition introduced; Council of Trent begins; Michelangelo takes over rebuilding of Saint Peter's	Vasari's <i>Lives</i> of artists; Palladio's San Giorgio and Villa Rotonda; Pope Pius IV; Pope Gregory XIII; Veronese's <i>Feast in the House of Levi</i> ; Pope Sixtus V; first completely sung opera
France	King Francis I; Château of Chenonceaux; Clouet's <i>Francis I</i> ; Fontainebleau begun; Reformation in France; Lescot's Cour Carré	Montaigne's <i>Essays</i> ; reaffirms allegiance to Catholic Church
Netherlands	Bosch's Garden of Delights	Brueghel the Elder's <i>Return of the Hunters</i> ; Dutch war of independence and establishment of Dutch Republic
Germany	University of Wittenberg founded; Dürer's Adam and Eve; Grünewald's Isenheim Altarpiece; Luther's "95 Theses" launches Reformation in Germany; landscape painting develops; Holy Roman Emperor Charles V; Dürer's Four Apostles	University of Würzberg founded; Holy Roman Emperor Ferdinand I
England	King Henry VIII; More's <i>Utopia</i> ; England breaks with Rome; Holbein the Younger's <i>Henry VIII</i> ; King Edward VI	Queen Mary restores Catholicism briefly; Queen Elizabeth I; Drake circumnavigates world; Smythson's Wollaton Hall; Raleigh explores present-day North Carolina and Virginia; Marlowe's <i>Tamburlaine the Great</i> ; England destroys the Spanish Armada; Shakespeare's early plays; Spenser's <i>Faerie Queene</i> ; Bacon's <i>Essays</i>
Spain	Spanish Inquisition continues to burn heretics at the stake; Columbus's final voyages to Americas; Ponce de León claims Florida; Cortés conquers Mexico; Magellan circumnavigates world; Pizarro conquers Inkas; Ignatius Loyola founds Jesuit Order	King Philip II of Spain and ruler of Netherlands, Americas, Milan, Burgundy, and Naples and Sicily; Herrera's El Escorial; El Greco's <i>Burial of Count Orgaz</i>
World	Ming dynasty (China); first African slaves in the West Indies; Montezuma II rules Aztec empire (Mexico); Copernicus (Poland) states that Earth revolves around the Sun; Ottomans take Cairo; Europeans expelled from China; Mughal dynasty founded in India; Portuguese reach Japan; Tsar Ivan the Terrible (Russia)	Sultan Suleyman I (Turkey); Akbar the Great (India); Oda Nobunaga rules Japan from Kyoto; first kabuki company, established by a woman (Japan); Hideyoshi unifies Japan; Tsar Boris Godunov (Russia)

and whitewashed religious paintings to rid the churches of what they considered to be idolatrous images. With the sudden loss of the market for religious images in the newly Protestant countries, many artists turned to portraiture and other secular subjects, including moralizing depictions of human folly and weaknesses, much as reformers such as Erasmus had done in writing. The popularity of these themes stimulated a free market for which artists created works of their own invention and sold them through dealers or by word of mouth.

During the Council of Trent (1545–1563), the Roman Catholic hierarchy formulated a program to counter the Protestant Reformation. Part of their program included a set of guidelines for religious art. Traditional images of Christ and the saints would continue to be venerated in churches, but they were to be scrutinized carefully for heresy, profanity, or any other quality that might justify Protestant criticism. Moreover, bishops and priests were to educate laypeople not to view images as having any intrinsic power. Although these rules limited what could be expressed in Christian art and led to the destruction of some works, over time they encouraged artistic creation.

The Changing Status of Artists

Sixteenth-century artists have left a considerable record of their activities, including diaries, notebooks, and letters. In addition, contemporary writers reported on everything from artists' physical appearances to their personal reputations. Giorgio Vasari's famous Lives of the Most Excellent Italian Architects, Painters, and Sculptors first appeared in 1550. Clearly, sixteenth-century society valued artists highly and rewarded them well, not only with choice commissions and generous gifts but even by elevating some of them to noble rank. Painters and sculptors hired dealers to sell their art, invested in moneymaking schemes, and ran other businesses on the side, especially in the Protestant countries. The sale of prints by or based on the works of popular artists was a means by which reputations and styles became widely known, and artists of stature were sought-after international celebrities. With their new fame and independence, the most successful artists could decide which commissions to accept, reject, or leave unfinished—even if the patron was a pope or an emperor.

During this period, theorists increasingly came to regard the conception of a painting, sculpture, or work of architecture as a liberal rather than a manual art. The artist, it was recognized, could express as much through painted, sculptural, and architectural forms as the poet or writer could with words or the musician through melody. The belief that artists were individual creative geniuses became a widespread myth—one that is still with us today. Some historians have suggested that the new status of artists in the sixteenth century worked against the participation of women in the visual arts, for, it was believed, genius was reserved to men. Yet there were women artists active in Europe despite numerous obstacles to their entering any profession. A few had achieved international renown, traveling widely to fulfill commis-

sions and accepting appointments that required relocating themselves and their families permanently.

f the sixteenth century the

ITALIAN ART

By the turn of the sixteenth century, the Renaissance movement was the dominant artistic force in Italy, and its ideas

were spreading rapidly to the rest of Europe, especially through the patronage of foreign courts. The early phase of sixteenth-century Italian art—with its self-confident humanism, its admiration of classical forms, and its dominating sense of stability and order—was once called the High Renaissance, usually roughly dated from 1500 to 1520. In time, many outstanding younger artists trained in Florence and northern Italy worked not only in other Italian cities but also in Spain, France, Germany, and the Netherlands. They interpreted Renaissance forms in their own ways, developing a number of local and personal styles that characterize the Late Renaissance, generally referring to the period after 1520.

As the fortunes of the ruling families of Florence and Milan fluctuated sharply because of political struggles, Rome became the most active artistic and intellectual center in Italy, with the popes and the noble Roman families as the most-generous patrons. The election of Pope Julius II in 1503 began a resurgence of the power of the papacy and a beautification of the city of Rome. During the ten years of his reign, he fought wars and formed alliances to consolidate his power. Julius's vision included rebuilding Rome and the Vatican, the pope's residence there, for which he enlisted the artists Bramante, Raphael, and Michelangelo. Thus Rome became the center of a program of revitalization and the development of a new Christian art based on classical forms and principles.

Painting in Florence and Northern Italy

Florence, considered the cradle of the Italian Renaissance since Vasari called it so, had developed its own style of classicism, which affected painters beyond its borders. The fifteenth-century frescoes in the Brancacci Chapel (Chapter 17), for example, inspired young sixteenth-century artists, who came to study Masaccio's solid, monumental figures and eloquent facial features, poses, and gestures (see fig. 17-47). Michelangelo's youthful sketches of the chapel frescoes clearly show the importance of Masaccio's influence on his mature style in both sculpture and painting.

At the turn of the sixteenth century, two major changes took place in Italian painting: The use of **tempera** gave way to the more flexible oil technique, and commissions from private sources increased. Many wealthy patrons in Italy and other European countries became avid collectors of paintings, as well as small bronzes, antiquities, and even minerals and fossils.

Leonardo da Vinci. A fiercely debated topic in Renaissance Italy was the question of which art was superior to others. Leonardo da Vinci (1452–1519) insisted on the supremacy of painting as the best and most complete means of creating an illusion of the natural world. Born in

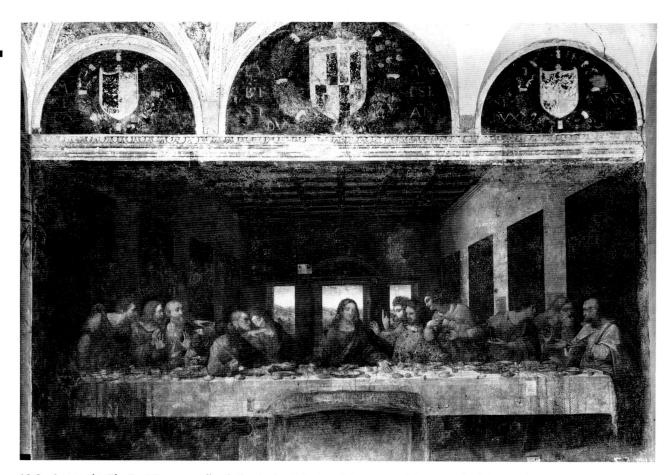

 Leonardo. The Last Supper, wall painting in the Refectory, Monastery of Santa Maria delle Grazie, Milan, Italy. 1495–98. Tempera and oil on plaster, 15'2" x 28'10" (4.6 x 8.8 m)

Instead of painting in fresco, Leonardo devised an experimental technique for this mural. Hoping to achieve the freedom and flexibility of painting on panel, he worked directly on dry intonaco—a thin layer of smooth plaster—with an oil tempera paint, whose formula is unknown. The result was disastrous. Within a short time, the painting began to deteriorate, and by the middle of the sixteenth century its figures could be seen only with difficulty. In the seventeenth century, the monks saw no harm in cutting a doorway through the lower center of the composition. Since then the work has barely survived, despite many attempts to halt its deterioration and restore its original appearance. The painting narrowly escaped complete destruction in World War II, when the refectory was bombed to rubble around its heavily sandbagged wall. The most recent restoration began in 1979.

the Tuscan village of Vinci, Leonardo was twelve or thirteen when his family moved to Florence. He was apprenticed in the shop of the painter and sculptor Verrocchio, where he was employed until about 1476. After a few years on his own, Leonardo traveled to Milan in 1482 or 1483 to work for the Sforza court. In fact, Leonardo spent much of his time in Milan on military and civil engineering projects, including an urban renewal plan for the city.

At Duke Lodovico Sforza's request, Leonardo painted one of the defining monuments of Renaissance art, *The Last Supper*, in the dining hall of the Monastery of Santa Maria delle Grazie in Milan between 1495 and 1498 (fig. 18-2). Leonardo's vision of the event takes place in a large chamber whose **one-point perspective** is defined by a **coffered** ceiling and four pairs of tapestries hanging on its walls. Its stagelike space recedes from a long table, placed parallel to the **picture plane**, to three windows on the back wall. Seated behind and at the two ends of this table are Jesus and his disciples. Jesus' outstretched arms form a pyramid at the center, and the disciples are

grouped in threes on each side. On one level, the scene is a narrative, showing the moment when Jesus tells his companions that one of them will betray him. They react with shock, disbelief, and horror. Judas, clutching his money bag in the shadows to the left of Jesus, has recoiled so suddenly that he has upset the salt dish, a bad omen. On the narrative level, the picture offers a study of human emotions, with the disciples modeled on real people Leonardo knew. He is said to have found his Judas, for example, in the thieves' quarter of Milan.

On another level, the Last Supper is presented as a symbolic evocation of transcendental truth. Breaking with traditional representations of the subject, such as the one by Andrea del Castagno (see fig. 17-51), Leonardo placed Judas in the first triad to the left of Jesus, along with the young John the Evangelist and the elderly Peter, rather than isolating him on the opposite side of the table. Judas, Peter, and John were each to play essential roles in Jesus' mission: Judas, to set in motion the events leading to Jesus' sacrifice; Peter, to lead the

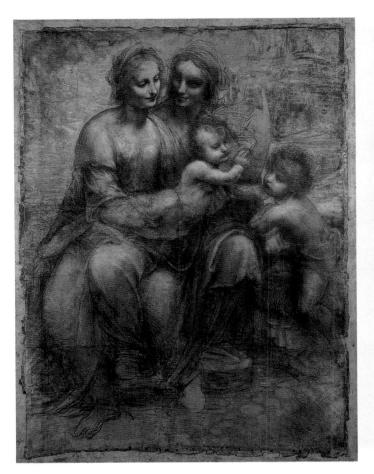

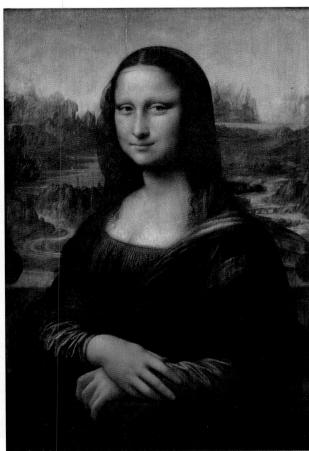

18-4. Leonardo. *Mona Lisa*. c. 1503–6. Oil on panel, 30¹/₄ x 21" (76.8 x 53.3 cm). Musée du Louvre, Paris

Church after Jesus' death; and John, the visionary, to fore-tell the Second Coming and the Last Judgment in the Apocalypse. By arranging the disciples and architectural elements into four groups of three, Leonardo incorporated a medieval tradition of numerical symbolism related to the Trinity, the Virtues (in medieval philosophy, there were three Theological and four Cardinal Virtues), the four elements (earth, air, fire, and water), and the four seasons. Thus the painting's meaning, beyond the immediate narrative subject, is symbolic and is not restricted to a particular time.

This sense of timelessness is reinforced by the painting's careful geometry, the convergence of its perspective lines, and the stability of its pyramidal forms. The calm of Jesus' demeanor in the midst of the general commotion also contributes to this effect. These qualities of stability, calm, and a sense of timeless order, coupled with the already established Renaissance forms modeled on those of classical sculpture, characterize the art of the Renaissance at the beginning of the sixteenth century.

Leonardo left Milan in 1498 and resettled in Florence. In about 1500, he produced a drawing for a painting of the *Virgin and Saint Anne with the Christ Child and the Young John the Baptist* (fig. 18-3). Drawn in black char-

coal with white highlights on brown paper, this large sheet (roughly 4'7" high) is clearly the full-scale model, called a cartoon, for a major painting, but no known finished work can be associated with it. Mary sits on the knee of her mother, Anne, and turns to the right to hold the Christ Child, who strains away from her to reach toward his cousin, the young John the Baptist. Leonardo created the illusion of high relief by modeling the figures with strongly contrasted light and shadow, called chiaroscuro (Italian for "light-dark"). Carefully placed highlights create a circular movement rather than a central focus, which retains the individual importance of each figure while also making each of them an integral part of the whole. This effect is emphasized by the complex interaction of the exquisitely tender facial expressions, particularly those of Saint Anne and the Virgin.

Between 1503 and 1506, Leonardo painted his renowned *Mona Lisa* (fig. 18-4), which he kept with him for the rest of his life. The subject was twenty-four-year-old Lisa Gherardini del Giocondo, the wife of a prominent merchant in Florence. The solid pyramidal form of her half-length figure is silhouetted against distant mountains, whose desolate grandeur reinforces the mysterious atmosphere of the painting. Mona Lisa's facial expression

18-5. Raphael. *The Small Cowper Madonna*.
c. 1505. Oil on panel, 23³/8 x 17³/8" (59.5 x 44.1 cm).
National Gallery of Art, Washington, D.C.
Widener Collection

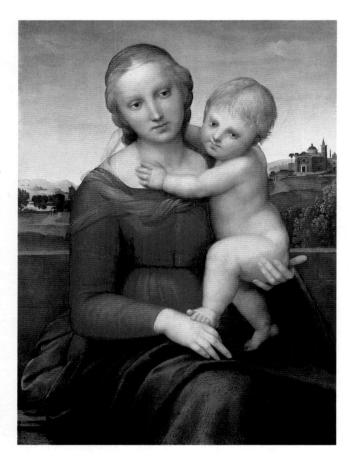

has been called enigmatic because her gentle smile is not accompanied by the warmth one would expect to see in her eyes. The contemporary fashion for plucked eyebrows and a shaved hairline to increase the height of the forehead adds to her arresting appearance. Perhaps most unsettling is the bold and slightly flirtatious way in which her gaze has shifted sideways toward the right to look straight out at the viewer. The implied challenge of her direct stare, combined with her apparent serenity and inner strength, has made the *Mona Lisa* one of the best-known works in the history of art.

For Leonardo color was secondary to the depiction of sculptural volume, which he achieved through his virtuosity in highlighting and shading. He also unified his compositions by covering them with a thin, lightly tinted varnish, which resulted in a smoky overall haze called **sfumato**. Because early evening light is likely to produce a similar effect naturally, he considered dusk the finest time of day and recommended that painters set up their studios in a courtyard with black walls and a linen sheet stretched overhead to reproduce the twilight of dusk.

Leonardo's fame as an artist is based on only a few known works. Unlike his humanist contemporaries, he was not particularly interested in classical literature or archeology. Instead, his great passions were mathematics and the natural world, and he compiled volumes of detailed drawings and notes on anatomy, botany, geology, meteorology, architectural design, and mechanics. Although he lived for a time in the Vatican at the invitation of Pope Leo X, there is no evidence that he produced any art during his stay. In 1517 he accepted Francis I's

invitation to resettle in France as an adviser on architecture. He lived there until his death in 1519.

Raphael. In 1504 Raphael Sanzio (1483-1520) arrived in Florence from his native Urbino. Raphael had studied in Perugia with the leading artist of that city, Perugino (see fig. 17-71). Raphael was quickly successful in Florence, especially for his paintings of the Virgin and Child, such as The Small Cowper Madonna (named for a modern owner) of about 1505 (fig. 18-5). Raphael was already a superb painter, but he must have studied the work of Leonardo and Michelangelo to achieve the simple grandeur of these monumental figures' shapes, uncomplicated naturalistic draperies, and rich, concentrated colors. The forms of The Small Cowper Madonna are modeled solidly but softly by clear, even lighting that pervades the outdoor setting. Raphael painted at least seventeen Madonnas, several portraits, and a number of other works in the three or four years he spent in Florence, but his greatest achievements were to come in the dozen years he spent in Rome, discussed later.

Correggio. In his brief but prolific career, Correggio (Antonio Allegri, c. 1489/99–1534), produced most of his work for patrons in Parma and Mantua in north-central Italy. Correggio's great work, *Assumption of the Virgin* (fig. 18-6), a fresco painted about 1520–1524 in the dome of the Cathedral of Parma, distantly recalls the ceiling by Andrea Mantegna in the Gonzaga ducal palace (see fig. 17-69). Leonardo clearly influenced Correggio's use of softly modeled forms, spotlighting effects of illumination,

18-6. Correggio.

Assumption

of the Virgin,
fresco in
main dome
interior, Parma
Cathedral,
Parma, Italy.
c. 1520–24.
Diameter of
base of dome
35'10" x 37'11"
(10.93 x 11.56 m)

and a slightly hazy overall appearance. Correggio also assimilated elements from Raphael's work in developing his highly personal style, which inspired artists for the next three centuries. In the *Assumption*, the architecture of the dome seems to dissolve, and the viewer is drawn up into the swirling vortex of heavenly beings accompanying the Virgin. The sensuous flesh and clinging draperies of individual figures are drawn with great attention. This, combined with their warm colors, tends to obscure the subject, which is the miraculous transporting of the Virgin directly to heaven at the moment of her death. The viewer's strongest impression is of a powerful, spiraling upward motion, as if the artist hoped to convey the spiritual essence of the Assumption. Illusionistic painting directly

derived from this work would become a hallmark of ceiling decoration in the following century.

Sculpture in Florence and Northern Italy

Florence nurtured many of the major talents of the sixteenth century. Michelangelo, the greatest of these, specialized in marble work. Leonardo da Vinci is also documented as an accomplished sculptor, and he received several important commissions early in his career, although only a few sketches and contemporary descriptions of them survive today. In the second half of the century, the Leoni family, based in Milan, became favorites of the Austrian Habsburgs, whose commissions

18-7. Michelangelo. Pietà, from Old Saint Peter's. c. 1500. Marble, height 5'81/2" (1.74 m). Saint Peter's, Vatican, Rome

for numerous statues in bronze and marble kept their studios constantly occupied. Religious sculpture was in greatest demand, but portraits were very popular, and statues and reliefs decorated homes, gardens, and court-yard fountains. Although freestanding statues in public places were still rare in most of Italy, sculpted public fountains would have a long history.

Michelangelo. Michelangelo Buonarroti (1475–1564) was born in the Tuscan town of Caprese and grew up in Florence. At the age of thirteen he was apprenticed to the painter Domenico del Ghirlandaio, in whose workshop he learned the rudiments of fresco painting and studied drawings of classical monuments. After approximately a year, Michelangelo joined the household of Lorenzo the Magnificent, where he came into contact with the Neoplatonic philosophers in Lorenzo de' Medici's circle and was given the opportunity to study sculpture with Bertoldo di Giovanni, a pupil of Donatello. Bertoldo's sculptures were primarily in bronze, and Michelangelo later

claimed that he had taught himself to carve marble by studying the Medici collection of classical statues.

After Lorenzo died in 1492, Michelangelo traveled to Venice and Bologna, then returned to Florence, where he fell under the spell of the charismatic preacher Fra Girolamo Savonarola. The preacher's execution for heresy in 1498 had a traumatic effect on Michelangelo, who said in his old age that he could still hear the sound of Savonarola's voice.

By nature, Michelangelo was an intense man who alternated between periods of depression and frenzied activity. He was difficult and often arrogant, yet he was devoted to his friends and helpful to young artists. He believed that his art was divinely inspired; later in life, he became deeply absorbed in religion and dedicated himself chiefly to religious works.

Michelangelo's major early work was a *Pietà* of about 1500, commissioned by a French cardinal and installed as a tomb monument in Old Saint Peter's in the Vatican (fig. 18-7). **Pietàs**—works in which the subject is the Vir-

18-8. Michelangelo. David. 1501-4. Marble, height 13'5" (4.09 m). Galleria dell'Accademia, Florence Michelangelo's most famous sculpture was cut from an 18-foot-tall marble block already partially carved by another sculptor during the 1460s. After studying the block carefully and deciding that it could be salvaged, Michelangelo made a small model in wax, then sketched the contours of the figure as they would appear from the front on one face of the marble. Then, according to his friend and biographer Vasari, he chiseled in from the drawn-on surface, as if making a figure in very high relief. The completed statue took four days to move on tree-trunk rollers down the narrow streets of Florence from Michelangelo's workshop to its location outside the Palazzo Vecchio. In 1837, the statue was replaced by a copy to scale and moved into the museum of the Florence Academy.

gin supporting and mourning the body of the dead Jesus—had long been popular in northern Europe but were rare in Italian art at the time. Michelangelo traveled to the marble quarries at Carrara in central Italy to select the block from which to make this large work, a practice he was to follow for nearly all of his sculpture. The choice of the stone was important because he envisioned the statue as already existing within the marble and needing

only to be "set free" from it. He later wrote in his Sonnet 15 (1536–1547): "The greatest artist has no conception which a single block of marble does not potentially contain within its mass, but only a hand obedient to the mind can penetrate to this image."

Michelangelo's *Pietà* is a very young Virgin of heroic

Michelangelo's *Pietà* is a very young Virgin of heroic stature holding the lifeless, smaller body of her grown son. The seeming inconsistencies of age and size are countered, however, by the sweetness of expression, the finely finished surfaces, and the softly modeled forms. Michelangelo's compelling vision of beauty is meant to be seen up close from directly in front of the statue and on the statue's own level, so that the viewer can look into Jesus' face. The sculpture is signed prominently on the diagonal strap across the Virgin's breast. The twenty-five-year-old artist is said to have done this after the statue was finished, stealing into the church at night to provide the answer to the many questions about its creator.

In 1501 Michelangelo accepted a commission for a statue of the biblical David (fig. 18-8) for an exterior buttress of the Florence Cathedral. When it was finished in 1504, the David was so admired that the Florentine city council placed it in the square next to the seat of Florence's government. Although Michelangelo's David embodies the athletic ideal of antiquity in its muscularity, the emotional power of its facial expression and concentrated gaze are entirely new. Unlike Donatello's bronze David (see fig. 17-40), this is not a triumphant hero with the head of the giant Goliath under his feet. Instead, slingshot over his shoulder and a rock in his right hand, Michelangelo's David frowns and stares into space, seemingly preparing himself psychologically for the danger ahead. Here the male nude implies, as it had in classical antiquity, heroic or even divine qualities. No match for his opponent in experience, weaponry, or physical strength, David represents the power of right over might. He was a perfect emblematic figure for the Florentines, who twice drove out the powerful Medici and reinstituted short-lived republics in the early years of the sixteenth century.

Upon the election of Giovanni de' Medici as Pope Leo X, the pope and his cousin commissioned a facade for the Medici family Church of San Lorenzo in Florence. Michelangelo was made chief architect for the project, but in 1519, after about three years of preliminary construction, Leo asked Michelangelo to work instead on a new funerary chapel inside the church for the duke of Urbino, who had just died, as well as for three other dukes. The Medici Chapel, called the New Sacristy, was an innovative variation on the Old Sacristy by Filippo Brunelleschi at the other end of the transept of the Church of San Lorenzo (see fig. 17-32). Construction went forward slowly and intermittently because of Leo's death in 1521 and ongoing political struggles in Florence. In 1534, detested by the new duke of Florence and fearing for his life, Michelangelo returned to Rome, where he lived for the rest of his life. Others completed the sacristy by 1559, using marble Michelangelo had selected, but they left the Medici wall tombs as they were at his departure.

18-9. Michelangelo.
Tomb of Giuliano
de' Medici.
1519–34. Marble,
height 22'9" x 15'3"
(6.94 x 4.65 m).
Medici Chapel
(New Sacristy),
Church of San
Lorenzo, Florence

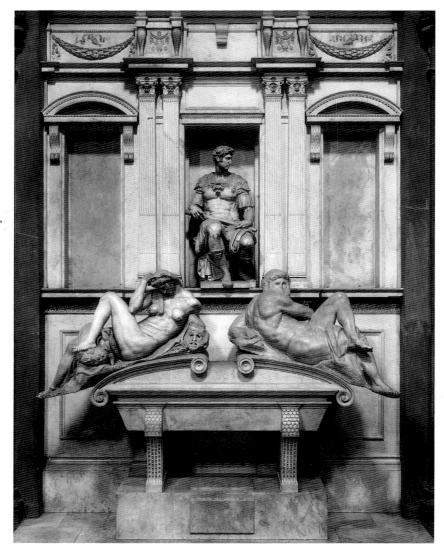

Each monument consists of an idealized portrait of the deceased seated in a niche above a pseudoclassical sarcophagus (fig. 18-9). Balanced precariously on the sarcophagus tops are male and female figures representing the Times of Day. Their positions would not seem so unsettling had reclining figures of river gods been installed below them, as originally planned, to complete the encircling effect. The Medici are shown in armor, which may designate them as "Christian soldiers." Here, Giuliano, Duke of Nemours, represents the Active Life. His sarcophagus figures are allegories of Night and Day, according to Michelangelo's notes: "Day and Night speak, and say: We with our swift course have brought the Duke Giuliano to death." Night is accompanied by her symbols: a star and crescent moon on her tiara; poppies, which induce sleep; and an owl under the arch of her leg. The huge mask at her back may allude to Death, since Sleep and Death were said to be the children of Night. According to Vasari, Michelangelo left a small piece of marble for the figure of a mouse, which, like Time, nibbles away at earthly things, but it was never carved. The portraits of the deceased, facing each other on opposite walls, are flanked by paired pilasters and empty niches meant to have been filled with allegorical figures. Finally, the walls of the sacristy are articulated with Brunelleschian pietra serena pilasters and architraves in the Corinthian order. The figures of the

dukes are finely finished, but the Times of Day are notable for their contrasting patches of rough and polished marble, a characteristic of the artist's mature work that some Michelangelo specialists call his *nonfinito* ("unfinished") quality, suggesting that he had begun to view his artistic creations as symbols of human imperfection (see fig. 18-19). Indeed, Michelangelo's poetry often expressed his belief that humans could achieve perfection only in death.

Jacopo Sansovino. Michelangelo's closest competitor in Florence was the sculptor Jacopo Tatti (1486-1570), who took the last name of his teacher Andrea Sansovino. Renaissance sculptors experimented increasingly with three-dimensional works that could be viewed satisfactorily from any angle. One strategy to achieve this effect was to incorporate a second figure facing in a different direction from the main one to give visual interest from the sides and back, as in Jacopo's Bacchus (fig. 18-10). Jacopo based his work on a statue of Bacchus, the god of wine, by Michelangelo, which he had seen on a visit to Rome in 1505. The wine god stands in contrapposto his weight supported by one leg while the other remains relaxed—holding up a drinking cup in one hand while a boy-satyr crouches behind him. The youthful, innocent Bacchus is so full of buoyant spirits that he hoists his cup high above his head.

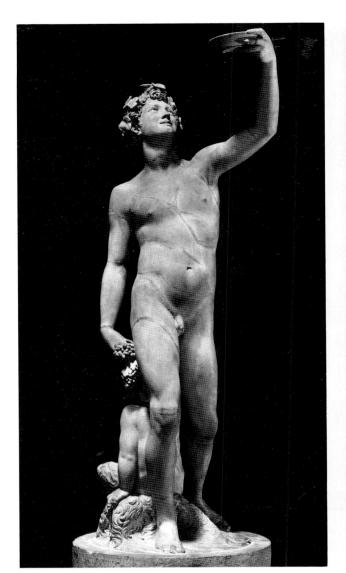

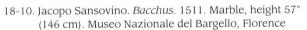

About this time, around 1511, Jacopo competed unsuccessfully for the commission to design the new San Lorenzo facade; later his bid for a role in the creation of its sculpture was rejected by Michelangelo. He returned to Rome but fled the 1527 sack of the city. He resettled in Venice, where he was appointed city architect and remained until his death.

Leone Leoni. Born near Lake Como in northern Italy, Leone Leoni (1509–1590) traveled widely, working on commissions in Venice, Padua, Brussels, and Madrid, where his son Pompeo, also a sculptor, was born. By 1542, Leone had settled in Milan, where he produced major works in bronze, many for patrons in other cities or abroad. He worked in Milan for a brother of Pope Pius IV and later became a favorite of Emperor Charles V and his son Philip II of Spain. Elevated to the nobility, the artist became rich from his sculpture, architectural designs, and goldsmith work.

One of Leone's most dramatic works is the lifesize bronze *Charles V Triumphing over Fury* (fig. 18-11), cast for the emperor between 1549 and 1555. Here Leone cre-

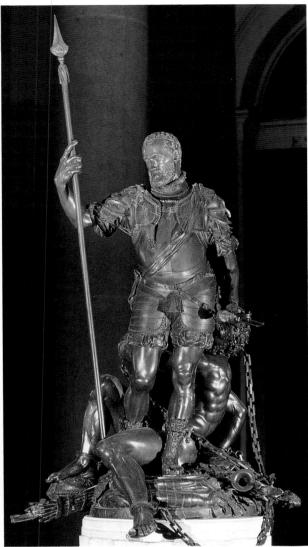

18-11. Leone Leoni. Charles V Triumphing over Fury. 1549–55. Bronze, height to top of head 5'8" (1.74 m). Museo del Prado, Madrid

ated a Herculean image wearing armor that was cast separately and can be removed to reveal a heroic nude. Although the face is recognizably a portrait of the emperor, the features have been idealized to convey an impression of regal strength, experience, and wisdom.

Commissions from the Habsburgs were so numerous that Leone and his son Pompeo could do little more than design and supervise their execution. Pompeo also acted as his father's agent at various courts and ultimately moved permanently to Spain.

Painting in Rome

In the late fifteenth century the popes had begun to repair the physical decay of Rome and the Vatican. One project was the building and decoration of the Sistine Chapel, the pope's private chapel, for which a number of notable painters from Umbria and Tuscany had come to the city (see fig. 17-71). Although Rome produced few native artists in either the fifteenth or the sixteenth century, the many patrons, painters, and sculptors from other cities living there attracted artists from across Europe.

1500 1600

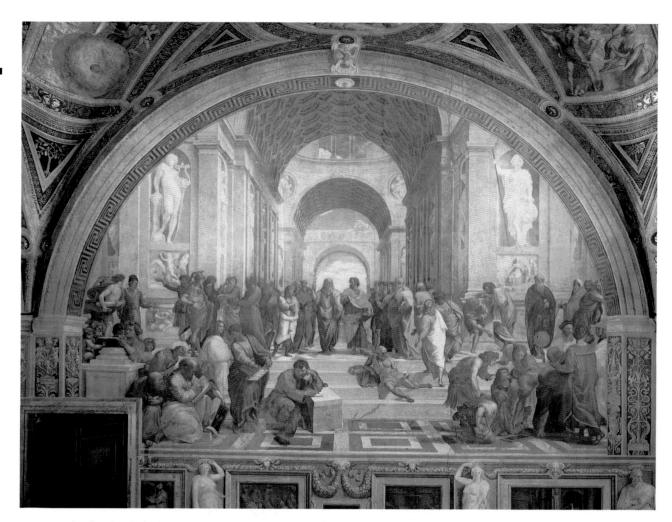

18-12. Raphael. *School of Athens*, fresco in the Stanza della Segnatura, Vatican, Rome. 1510–11. 19 x 27' (5.79 x 8.24 m)

Raphael gave many of the figures in his imaginary gathering of philosophers the features of his friends and colleagues. Plato, standing immediately to the left of the central axis and pointing to the sky, was said to have been modeled after Leonardo da Vinci, and Euclid, shown inscribing a slate with a compass at the lower right, was a portrait of Raphael's friend the architect Donato Bramante. Michelangelo, who was at work on the Sistine ceiling only steps away from the *stanza* where Raphael was painting his fresco, is shown as the solitary figure at the lower left, leaning on a block of marble and sketching, in a pose reminiscent of the figures of sibyls and prophets on his great ceiling. Raphael's own features are represented on the second figure from the far right, as the face of a young man listening to a discourse by the astronomer Ptolemy.

Raphael. Raphael left Florence in about 1508 for Rome, where Pope Julius II put him to work almost immediately decorating the papal apartments. Raphael's most outstanding achievement in these rooms (*stanze*, singular *stanza*) was the *School of Athens* (fig. 18-12), painted about 1510–1511 for the pope's library. The painting seems to summarize the ideals of the Renaissance papacy in its grand conception of harmoniously arranged forms and rational space, as well as the calm dignity of its figures. Indeed, the warrior and pragmatist Julius II was a very learned man who may not have actually devised the subjects painted but certainly approved them.

In the School of Athens, viewed through a trompe l'oeil arch decorated with a **Greek-key pattern** (an ornamental pattern in which small, straight lines intersect at right angles), Plato and Aristotle command center stage. At the left Plato gestures upward to the heavens as the ultimate source of his philosophy, while Aristotle, with his outstretched hand, palm down, seems to emphasize the importance of gathering empirical knowledge from

observing the material world. Looking down from niches in the walls are Apollo, the Greek and Roman god of sunlight, rationality, poetry, and music, carrying a lyre, and Minerva, the Roman goddess of wisdom. Around Plato and Aristotle are mathematicians, naturalists, astronomers, geographers, and other philosophers. Some debate while others demonstrate their theories to onlookers. The scene, flooded with a clear, even light from a single source, takes place in an immense barrel-vaulted interior possibly inspired by the new design for Saint Peter's, which was being rebuilt on a plan by the architect Donato Bramante. The grandeur of the building is matched by the monumental dignity of the philosophers themselves, each of whom is a distinct physical and intellectual presence. These striking individuals are organized into a dynamic unity by the sweeping arcs of the composition and the variety and energy of the poses and gestures.

Raphael's talents were also put to use by Julius II's successor, Leo X (papacy 1513–1521), whom Raphael

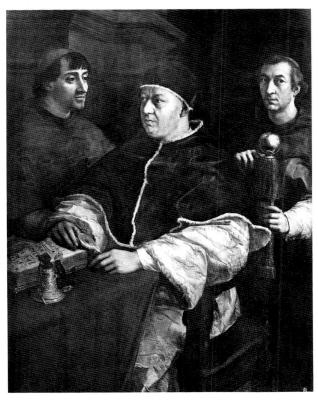

18-13. Raphael. *Leo X with Cardinals Giulio de' Medici and Luigi de' Rossi.* c. 1518. Oil on panel, 5'5/8" x 3'10⁷/8" (1.54 x 1.19 m). Galleria degli Uffizi, Florence

served as the director of all archeological and architectural projects in Rome. Raphael's portrait of Leo X of about 1518 (fig. 18-13) depicts the pope as a great collector of books, and indeed, Leo was probably already planning a new Medici library in Florence (see fig. 18-46). Leo's driving ambition was the advancement of the Medici family, and Raphael's painting is, in effect, a dynastic group portrait. Facing the pope at the left is his cousin Giulio, Cardinal de' Medici; behind him stands Luigi de' Rossi, another relative he had made cardinal. Dressed in splendid brocades and enthroned in a velvet chair, the pope looks up from a richly illuminated fourteenth-century manuscript he has been examining with a magnifying glass. Raphael lovingly depicted the contrasting textures and surfaces in the picture, including the visual distortion caused by the magnifying glass on the book page. In this telling detail, as in the reflection of the window and in Raphael's self-portrait, which are in the polished brass knob on the pope's chair, Raphael acknowledges his debt—despite great stylistic differences—to the fifteenthcentury Flemish artist Jan van Eyck and his followers (Chapter 17).

At about the same time, Raphael was working for Leo on designs for ten tapestries on themes from the Acts of the Apostles to cover the **dado** (lower wall) below the fifteenth-century wall paintings, or **murals**, in the Sistine Chapel. The first tapestry in the series was the *Miraculous Draft of Fishes*, combined with Christ's calling of his apostles (fig. 18-14). Tapestries, which were produced for

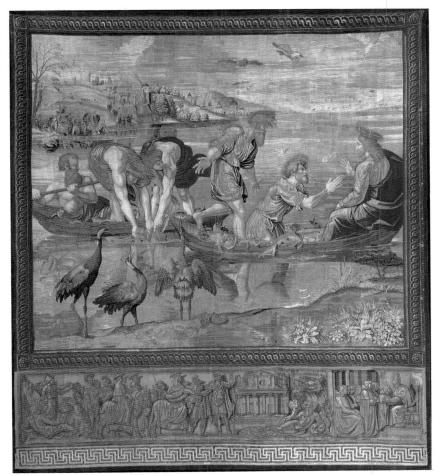

18-14. Shop of Pieter van Aelst, Brussels, after Raphael's cartoon. *Miraculous Draft of Fishes*, from the Acts of the Apostles series; lower border, two incidents from the life of Giovanni de' Medici, later Pope Leo X. Woven 1517, installed 1519 in the Sistine Chapel. Wool and silk with silver-gilt threads, 15'11⁵/6" x 14'5⁵/6" (4.90 x 4.41 m). Musei Vaticani, Pinacoteca,

Raphael's Acts of the Apostles cartoons were used as the models for several sets of tapestries woven in the van Aelst shop, including one for Francis I of France. In 1630 the Flemish painter Peter Paul Rubens discovered seven of the ten original cartoons in the home of a van Aelst heir and convinced his patron, Charles I of England, to buy them. Still part of the royal collection today, they are exhibited at the Victoria and Albert Museum in London. After being dispersed after the Sack of Rome in 1527, later returned, and dispersed again during the Napoleonic wars, the original Sistine tapestries were purchased by a private collector in 1808 and returned to the Vatican as a gift that year. They are now displayed in the Raphael room of the Vatican Painting Gallery.

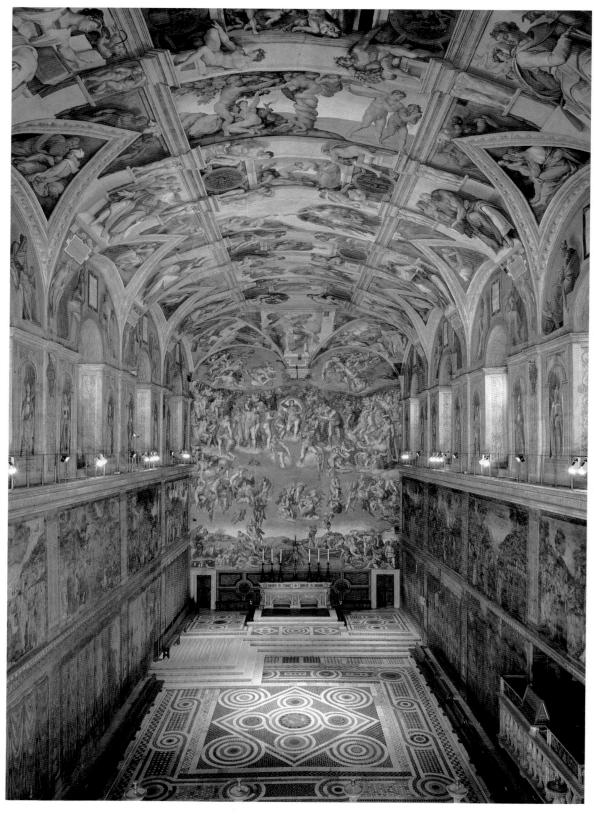

18-15. Interior, Sistine Chapel, Vatican, Rome. Built 1475-81

Named after its builder, Pope Sixtus (Sisto) IV, the chapel is slightly over 130 feet long and about 43½ feet wide, approximately the same measurements recorded in the Old Testament for the Temple of Solomon. The floor mosaic was recut from the colored stones used in the floor of an earlier papal chapel. The plain walls were painted in fresco between 1481 and 1483 with scenes from the life of Moses and the life of Christ by Perugino, Botticelli, Ghirlandaio, and others. Below these are trompe l'oeil painted draperies, where Raphael's tapestries illustrating the Acts of the Apostles once hung (see fig. 18-14). Michelangelo's famous ceiling frescoes begin with the lunette scenes above the windows (see fig. 18-16). On the wall above the altar is his *Last Judgment* (see fig. 18-17).

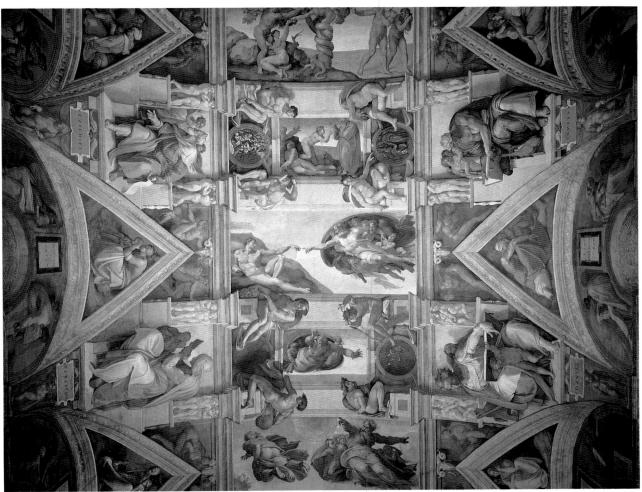

18-16. Michelangelo. Sistine Ceiling. Top to bottom: Expulsion (center); Creation of Eve with Ezekiel (left) and Cumaean Sibyl (right); Creation of Adam; God Gathering the Waters with Persian Sibyl (left) and Daniel (right); and God Creating the Sun, Moon, and Planets. Frescoes on the ceiling, Sistine Chapel. 1508–12

Italian patrons in the workshops of France and Flanders, were extremely expensive at this time. Raphael and his assistants made full-size, detailed charcoal cartoons, then painted over the 11-by-15-foot sketch with gluebased watercolors in hues the weavers had to match. The cartoons were then sent to Brussels, where they were used to make the actual tapestries. Today, the Sistine Chapel dado is painted with trompe l'oeil draperies (see fig. 18-15), and the tapestries in the papal collection are used only occasionally.

Raphael died after a brief illness in 1520, at the age of thirty-seven. In view of his study of Rome's ancient past, his burial in the ancient Pantheon, which had long been converted into a Christian church, has great poignancy.

Michelangelo. Julius II saw Michelangelo as his equal in personal strength and dedication and thus as an ideal collaborator in the artistic aggrandizement of the papacy. Despite Michelangelo's contractual commitment to the Florence Cathedral for statues of the apostles, in 1505 Julius arranged for him to come to Rome. The sculptor's first undertaking was the pope's tomb, but this commission was set aside in 1506 when Julius ordered Michelangelo to redecorate the ceiling of the Sistine Chapel (fig. 18-15).

Julius's initial directions for the ceiling were fairly simple. He wanted a decoration of trompe l'oeil "stucco" coffers to replace the original blue, star-spangled ceiling. Later he wanted the Twelve Apostles seated on thrones to be painted in the triangular **spandrels**, the areas of the walls between the **lunettes** framing the chapel windows. When Michelangelo objected to the limitations of Julius's plan, the pope told him to paint whatever he liked on the ceiling. This he presumably did, although it is unlikely that a commission of this importance would have had no supervision from the pope, and it probably also involved an adviser in theology. Whatever their source, the frescoes are a pictorial declaration of papal authority, derived from the Bible.

First, the artist painted an illusionistic, marblelike architectural framework on the vault of the chapel (fig. 18-16). Running completely around the ceiling is a painted **cornice**, with prominent projections supported by short pilasters sculpted with the figures of nude baby boys, called **putti**. Set among these projections are figures of various Old Testament prophets and Classical sibyls (female prophets) who were believed to have foretold Jesus Christ's birth. Seated on the cornice projections are heroic figures of nude young men, called *ignudi*

THE SISTINE The cleaning of CEILING the frescoes on RESTORATION the walls of the Sistine Chapel, done in the 1960s and 1970s, was so successful that in 1980 a single lunette from Michelangelo's ceiling decoration was cleaned as a test. Underneath layers of soot and dust was found color so brilliant and so different from the long-accepted dusky appearance of the ceiling that conservators summoned their courage and proposed a major restoration. In early 1981 a plan was set to begin cleaning the entire ceiling. The work was completed in the winter of 1989, and the Last Judgment over the altar was completed in the spring of 1994.

Although the restorers proceeded with great caution and frequently consulted with other experts in the field, the cleaning created a serious controversy. The greatest fear was that the work was moving ahead too rapidly for absolute safety. There was also great concern that the ceiling's final appearance might not resemble its original state. Some scholars, convinced that Michelangelo had reworked the surface of the fresco after it had dried to soften and tone

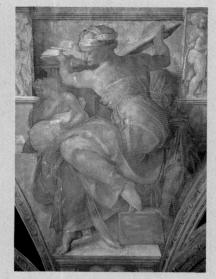

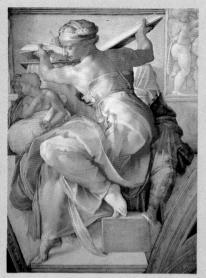

Michelangelo. *Libyan Sibyl*, Sistine Chapel, Vatican, Rome. 1511–12. On the left, the fresco before cleaning; on the right, as it appears today

down the colors, feared that cleaning would remove these finishing touches. Nevertheless, the breathtaking colors of the Sistine Ceiling fresco that the cleaning revealed forced scholars to almost completely revise their understanding of the art of Michelan-

gelo and the development of sixteenth-century Italian painting. We will never know for certain if some subtleties were lost in the cleaning, and only time will tell if this restoration has prolonged the life of Michelangelo's great work.

(singular, *ignudo*), assuming a variety of poses and holding sashes attached to large gold medallions. Rising behind the *ignudi*, shallow bands of stone span the center of the ceiling and divide it into compartments. The scenes in these compartments depict the Creation, the Fall, and the Flood, as told in Genesis. The narrative sequence begins over the altar and ends near the chapel entrance. God's earliest acts of creation are therefore closest to the altar, while the Creation of Eve at the center of the ceiling introduces the imperfect actions of humanity: the Temptation, the Fall, the Expulsion from Paradise, and God's eventual destruction of all people except Noah and his family by the Flood.

The steep sides of the triangular spandrels, which contain paintings of the ancestors of Jesus, support mirrorimage nudes in reclining and seated poses. At the apex of each spandrel-triangle is a *bucranium*, or ox skull, a **motif** (a repeated figure in a design) that appears in ancient Roman paintings and reliefs.

According to discoveries during the most recent restoration (see "The Sistine Ceiling Restoration," above), Michelangelo worked on the ceiling in two main stages, beginning in the late summer or fall of 1508 and moving from the chapel's entrance toward the altar, in reverse of the narrative sequence. The first half of the ceiling up to the Creation of Eve was unveiled in August 1511, and the second half in October 1512. Perhaps the most familiar scene is the Creation of Adam. Here Michelangelo

depicts the moment when God charges the languorous Adam with the spark of life. As if to echo the biblical text, Adam's heroic body and pose mirror those of God, in whose image he has been created. Directly below Adam is an *ignudo* grasping a bundle of oak leaves and giant acorns, which refer to Julius's family name (della Rovere, or "of the oak"), and possibly also to a passage in the Old Testament prophecy of Isaiah (61:3), "They will be called oaks of justice, planted by the Lord to show his glory."

A quarter of a century later, Michelangelo again went to work in the Sistine Chapel, this time on the *Last Judgment*, painted between 1536 and 1541 on the 48-by-44-foot end wall where the chapel altar was located (fig. 18-17). Michelangelo, now entering his sixties, had complained of feeling old for years, yet he accepted this important and demanding task, which took him two years to complete.

Abandoning the clearly organized medieval conceptions of the Last Judgment, in which the Saved are neatly separated from the Lost, Michelangelo painted a writhing swarm of resurrected humanity. At the left the dead are dragged from their graves and pushed up into a vortex of figures around Christ, who wields his arm like a sword of justice. Despite the efforts of several saints to save them at the last minute, the rejected souls are plunged toward hell on the right, leaving the Elect and still-unjudged in a dazed, almost uncomprehending state. To the right of Christ's feet is Saint Bartholomew,

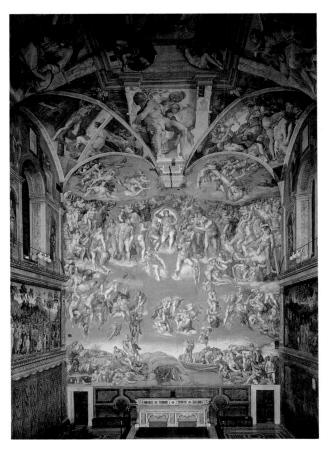

18-17. Michelangelo. *Last Judgment*, fresco in the Sistine Chapel. 1536–41

who in legend was martyred by being skinned alive, holding his flayed skin, the face of which is painted with Michelangelo's own distorted features. On the lowest level of the mural, directly above the altar, is the gaping, fiery Hellmouth, toward which Charon propels his craft on the River Styx, which encircles the underworld. The painting remains today, in the spirit of its original conception, a grim and constant reminder to the celebrants of the Mass—the pope and his cardinals—that ultimately they will be judged for their deeds.

Sculpture in Rome

Rome's sixteenth-century sculptors were perhaps too overwhelmed by the many ancient monuments surrounding them to synthesize their own classical styles. Florence still dominated sculpture, lending its geniuses on a regular basis to Roman patrons and projects and to the next generation of artists as mentors. Most papal sculpture commissions were given to Michelangelo, despite his reputation for being difficult and frequently failing to complete what he had started.

Michelangelo. Michelangelo's first papal sculpture commission, the tomb of Julius II, was to plague him and his patrons for forty years. In 1505 he presented his first designs to the pope for a large freestanding rectangular structure. With levels on three steps set back from each

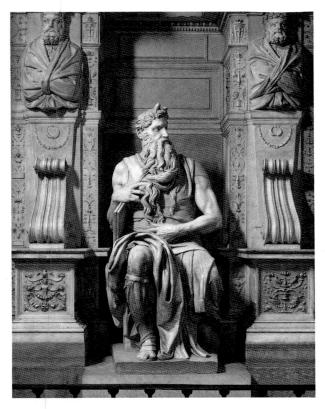

18-18. Michelangelo. *Moses*, Tomb of Julius II. c. 1513–15. Marble, height 7'8¹/₂" (2.35 m). Church of San Pietro in Vincoli, Rome

Princes of the Church, like their secular counterparts, often arranged for their burial and funerary monuments themselves, knowing that their heirs might have other priorities. Although Pope Julius II's immediate survivors ordered an even larger and more costly tomb than Julius himself had commissioned from Michelangelo, during the three decades following his death the projected size and opulence of the monument steadily diminished. In the end the pope was buried not in Saint Peter's in the Vatican, as he had wished, but elsewhere, and a few salvaged statues and reliefs were mounted with some new pieces by Michelangelo's assistants in a commemorative monument against a wall of the della Rovere family church. In this final setting the pope's small reclining image was greatly overshadowed by the only statue there made for the original tomb, Michelangelo's superb figure of Moses.

other, culminating in the pope's sarcophagus and having more than forty statues and reliefs in marble and bronze, it was to be installed in the new Saint Peter's that Julius was planning to build. After a year of preliminary work on the tomb, Michelangelo left Rome for Florence in a fit of anger on the day before the laying of the cornerstone for the new Saint Peter's. He later explained that Julius himself had decided to halt the tomb project and divert the money to building the church. After Julius died in 1513, his heirs offered the sculptor a new contract for a more elaborate tomb and a larger payment. At this time, between 1513 and 1515, Michelangelo created *Moses* (fig. 18-18), the only sculpture from the original design to be incorporated into the final, much-reduced monument

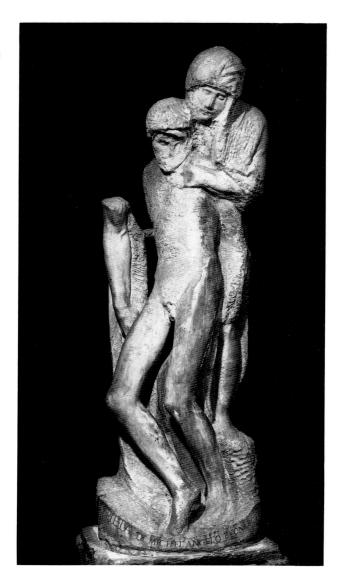

18-19. Michelangelo. *Pietà* (known as the *Rondanini Pietà*). 1555–64. Marble, height 5'3³/8" (1.61 m). Castello Sforzesco, Milan

Shortly before his death in 1564, Michelangelo resumed work on this sculpture group, which he had begun some years earlier. He cut down the massive figure of Jesus, merging the figure's now elongated form with that of the Virgin, who seems to carry her dead son upward toward heaven.

to Julius II. No longer an actual tomb—Julius was buried elsewhere—the pope's monument was installed in 1545, after decades of wrangling, in the Church of San Pietro in Vincoli, Rome.

In the original design, the *Moses* would have been one of four equally large seated figures at the corners of the second level. These were to be prominent but subordinate to the group above, depicting the pope supported by angels atop a sarcophagus. Above them were to be a large standing Madonna and Child flanked by saints. In the final configuration, however, the eloquent figure of Moses becomes the focus of the monument and an allegorical representative of the long-dead pope.

Michelangelo was seventy when the monument of Pope Julius was finally installed. His last days up to his death in 1564 were occupied by an unfinished composition now known, from the name of a modern owner, as the *Rondanini Pietà* (fig. 18-19). Dismissed by some as an oddity with no more than biographical relevance, the *Rondanini Pietà* is the final artistic expression of a lonely, disillusioned, and physically debilitated man who struggled to end his life as he had lived it—working with his mind and his hands. In his youth, the stone had released the *Pietà* in Saint Peter's as a perfect, exquisitely finished

VITRUVIUS The Roman architect and engineer Marcus Vitruvius Pollio lived and wrote in the first century BCE, during the reign of Augustus Caesar, to whom he dedicated his ten-volume De Architectura (On Architecture). Beginning in the fifteenth century this treatise was a fundamental resource for Italian humanistic investigations into the principles of ancient Roman architecture. In the sixteenth century it was widely published in translation and reached a large audience across Europe. The ten books covered not only the architecture of Vitruvius's time but also such diverse subjects as the education of an architect, materials and mechanical aids for construction, astrology and astronomy, and ways to find water. Vitruvius's chapter "On Symmetry" (Book III) in-

spired Leonardo da Vinci to create his well-known diagram for drawing the ideal male figure, called the Vitruvian Man. As Vitruvius wrote: "For if a man be placed flat on his back, with his hands and feet extended, and a pair of compasses centered at his navel, the fingers and toes of his two hands and feet will touch the circumference of a circle described therefrom. And just as the human body yields a circular outline, so too a square figure may be found from it. For if we measure the distance from the soles of the feet to the top of the head, and then apply that measure to the outstretched arms, the breadth will be found to be the same as the height" (Book III, Chapter 1, Section 2). Leonardo has added his own observations in the reversed writing he always used for his notebooks.

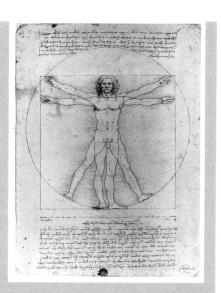

Leonardo da Vinci. *Vitruvian Man*. c. 1490. Ink, approx. 13¹/₂ x 9⁵/₈" (34.3 x 24.5 cm). Galleria dell'Accademia, Venice

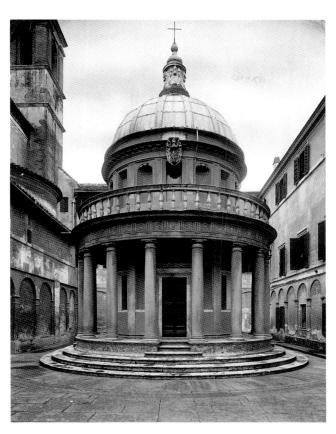

18-20. Donato Bramante. Tempietto, Church of San Pietro in Montorio, Rome. 1502

work (see fig. 18-7), but this block resisted his best efforts to shape it. The ongoing struggle between artist and medium is nowhere more apparent than in this moving example of Michelangelo's *nonfinito* creations.

Architecture in Rome and Its Environs

Benefiting from the achievements of fifteenth-century pioneers and inspired by studying the monuments of antiquity, the Renaissance architects who worked in Rome developed ideals comparable to those of contemporary painters and sculptors. The first-century Roman architect and engineer Vitruvius's ten-volume work on classical architecture (see "Vitruvius," page 698) continued to be an important source for sixteenth-century Italian architects. It inspired several encyclopedias of Renaissance architecture and practical manuals on classical style, as did Giacomo da Vignola, discussed below. Whereas religious architecture was a major source of commissions, some of the best opportunities for innovation were urban palaces and large country villas.

Donato Bramante. Born near Urbino and trained as a painter, Donato Bramante (1444–1514) turned to architectural design early in his career. Little is known of his activities until about 1481, when he became attached to the Sforza court in Milan, where he would have known Leonardo da Vinci. In 1499 Bramante settled in Rome, but work came slowly. The architect was nearing sixty when he was commissioned in 1502 to design a small

shrine over the spot where the apostle Peter was believed to have been crucified (fig. 18-20). The Tempietto ("little temple") has been admired since it was built as a nearly perfect Renaissance interpretation of the principles of Vitruvius. Without copying any specific ancient monument but perhaps inspired by the remains of a small round temple in Rome, Bramante designed the shrine, only 15 feet in diameter, with a stepped base and a Doric **peristyle** (continuous row of columns). Vitruvius had advised that the Doric order be used for temples to gods of particularly forceful character. The first story of the shrine is topped by a tall drum, or circular wall, supporting a hemispheric dome (no longer original) recalling ancient Roman round tombs. Especially notable is the sculptural effect of the building's exterior, with its deep wall niches creating contrasts of light and shadow, its Doric frieze of carved papal emblems, and its elegant balustrade (carved railing).

Shortly after Julius II's election as pope in 1503, he commissioned Bramante to renovate the Vatican Palace, and in 1506 Julius appointed him chief architect of a project to replace Saint Peter's Basilica in the Vatican, the site of Peter's tomb. Construction had barely begun when Julius died in 1513; Bramante himself died in 1514 without leaving a comprehensive plan or model that a successor could complete. After a series of popes and architects and various revisions, the new Saint Peter's was still nowhere near completion when Michelangelo took over the project in 1546 (see "Saint Peter's Basilica," page 701).

Michelangelo. After Michelangelo settled in Rome in 1534, a rich and worldly Roman noble was elected as Pope Paul III (papacy 1534–1549). He surprised his electors by his vigorous pursuit of reform within the Church, including in 1545 the Council of Trent, which brought together conservative and reform factions. He also began renovation of several important sites in Rome and the upgrading of papal properties. Among the projects in which he involved Michelangelo was remodeling the Campidoglio (Capitol), a public square atop the Capitoline Hill, once the citadel of Republican Rome. The buildings covering the irregular site had fallen into disrepair, and the pope saw its renovation as a symbol of both his spiritual and his secular power.

Scholars still debate Michelangelo's role in the Capitoline project, although some have connected the granting of Roman citizenship to him in 1537 with his taking charge of the work. Preserved accounts mention the artist by name on only two occasions, however. In 1539 his advice was taken on reshaping the base for the ancient Roman statue of Marcus Aurelius. In 1563 payment was made "to execute the orders of master Michelangelo Buonarroti in the building of the Campidoglio." Michelangelo's comprehensive plan for what is surely among the most beautiful urbanrenewal projects of all time is documented in prints identified as having been done from Michelangelo's plan and model for the new Campidoglio (fig. 18-21). The Piazza del Campidoglio today closely resembles the conception recorded in these prints only a few years after Michelangelo's death, although the square and buildings were not finished

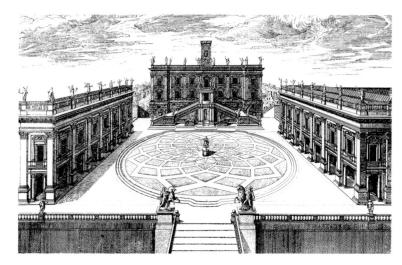

18-21. Étienne Dupérac. *Piazza del Campidoglio, Rome*, engraving after design of Michelangelo. 1569. Gabinetto Nazionale delle Stampe, Rome

Flanking the entrance to the piazza are the so-called Dioscuri, two ancient Roman statues moved to the Capitol by Paul III, along with the bronze Marcus Aurelius, an imperial Roman equestrian statue, which was installed at the center of the slightly sunken ovoid fronting the buildings. At the back of the square is the Palazzo Senatorio, whose double-ramp grand staircase is thought to have been designed by Michelangelo. At the right is the Palazzo dei Conservatori, with a new facade designed by the sculptor, and facing it, the Palazzo Nuovo, which was built in the seventeenth century to match the Conservatori. Today, air pollution so threatens the monuments that some have been brought indoors.

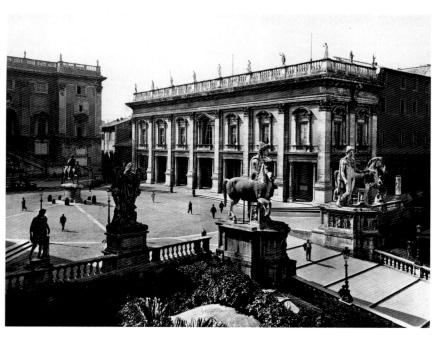

18-22. Michelangelo.
Facade of the
Palazzo dei
Conservatori,
Piazza del
Campidoglio,
Rome. c. 1563

until the seventeenth century, and Michelangelo's exquisite star design in the pavement was not installed until the twentieth century.

In 1537 the city council (the Conservatori) allotted funds to renovate the Palazzo dei Conservatori (fig. 18-22), which contained its offices and meeting rooms. Although only three bays of the new facade were finished by the time of Michelangelo's death in 1564, his repeating vertical elements were continued on the Conservatori facade and on the so-called Palazzo Nuovo facing it across the piazza (see fig. 18-21). The framework of the facade is formed by colossal Composite order pilasters raised on tall pedestals and supporting a wide architrave below the heavy cornice. Each ground-level bay opens into the deep portico through Ionic columns supporting their own architraves. On the main level above, although a wide central window was added later, the original

design called for identical bays, each with a narrow central window and a balcony flanked by **engaged columns** supporting **segmental pediments**. The horizontal orientation of the building is emphasized by the plain architrave below the balustrade of the roof and is then picked up below in the broken architrave above the portico.

Ever since the laying of the cornerstone for the new Saint Peter's by Julius II in 1506, Michelangelo had been well aware of the efforts of its architects, from Bramante to Raphael to Antonio da Sangallo. When Paul III offered the post to Michelangelo in 1546, he gladly accepted. By this time, the seventy-one-year-old sculptor was not just confident of his architectural expertise; he demanded the right to deal directly with the pope rather than through the committee of construction deputies. Michelangelo further shocked the deputies—but not the pope—by tearing down or canceling those parts of Sangallo's design

BASILICA

SAINT PETER'S The history of Saint Peter's in Rome is an in-

teresting case of the effects of individual and institutional conceits on the practical congregational needs of a major religious monument. The original church was built in the fourth century ce by Constantine, the first Christian Roman emperor, to mark the grave of the apostle Peter, the first bishop of Rome and therefore the first pope. Because this site was considered one of the holiest in the world. Constantine's architect had to build a monumental structure both to house Saint Peter's tomb and to accommodate the large crowds of pilgrims who came to visit it. To provide a platform for the church, a huge terrace was cut into the side of the Vatican Hill, in the midst of a cemetery across the Tiber River from the city. Here Constantine's architect erected a basilica, a type of Roman building used for law courts, markets, and other public gatherings. Like most basilicas, Saint Peter's had a long central chamber, or nave, with flanking side aisles set off by colonnades, and an apse, or large nichelike recess, set into the wall opposite the main door. To allow large numbers of visitors to approach the shrine a new feature was added: a transept, or long rectangular area at right angles to the nave. The rest of the church was, in effect, a covered cemetery, carpeted with the tombs of believers who wanted to be buried near the grave of the apostle. In front of the church was a walled forecourt, or atrium. When it was built, Constantine's basilica, as befitted an imperial commission, was one of the largest buildings in the world (interior length 368 feet; width 190 feet), and for more than a thousand years it was the most important pilgrim shrine in Europe.

In 1506 Pope Julius II (papacy 1503-1513) made the astonishing decision to demolish the Constantinian basilica, which had fallen into disrepair, and to replace it with a new building. That anyone, even a pope, had the nerve to pull down such a venerated building is an indication of the extraordinary sense of assurance of the age—and of Julius himself. To design and build the new church, the pope appointed Donato Bramante, who had only a few years earlier designed the Tempietto, a small, round, domed shrine at the site of Saint Peter's martyrdom (see fig. 18-20). Bramante envisioned the new Saint Peter's as a grander version of the Tempietto: a central-plan building, in this case a Greek cross (one with four arms of equal length) crowned by an enormous dome. This design was intended to continue the ancient Roman tradition of domed temples and round martyria, which had been revived by Filippo Brunelleschi in Florence Cathedral (fig. 17-30). In Renaissance thinking, the central plan and dome also symbolized the perfection of God.

The deaths of both pope and architect in 1513-1514 put a temporary halt to the project. Successive plans by the painter Raphael, the architect Antonio da Sangallo, and others changed the Greek cross to a

Latin cross (one with three shorter arms and one long one) in order to provide the church with a full-length nave. However, when Michelangelo was appointed architect in 1546, he returned to the Greek-cross plan. Michelangelo simplified Bramante's design to create a single, unified space covered with a hemispherical dome. The dome was finally completed some years after Michelangelo's death by the Baroque architect Giacomo della Porta, who retained Michelangelo's basic design but gave the dome a taller and slimmer profile.

By the early seventeenth century the needs of the basilica had changed. During the Counter-Reformation the Church emphasized congregational worship, so more space was needed for people and processions. Moreover, it was felt that the new church should more closely resemble Old Saint Peter's and should extend over roughly the same area, including the ground covered by the atrium. In 1606, therefore, more than a hundred years after Julius II had initiated the project, Pope Paul V commissioned the architect Carlo Maderno to change Michelangelo's Greek-cross plan to a Latin-cross plan. Maderno extended the nave to its final length of slightly over 636 feet and added a Baroque facade (see fig. 19-3), thus completing Saint Peter's as it is today. Later in the seventeenth century the sculptor and architect Gianlorenzo Bernini monumentalized the square in front of the basilica by surrounding it with a great colonnade (see fig. 19-5).

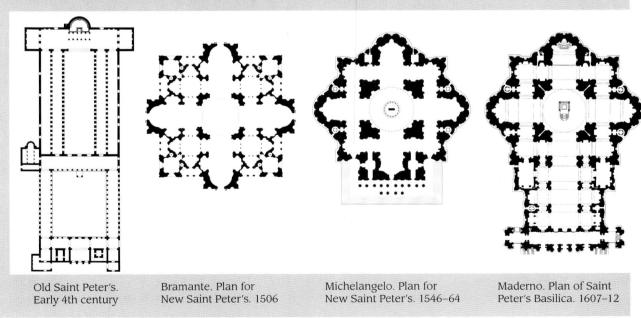

18-23. Michelangelo. Plan for New Saint Peter's, Vatican, Rome. c. 1546-64

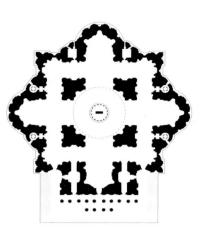

that he found without merit. Ultimately, Michelangelo transformed the central-plan church (fig. 18-23) into a vast organic structure, in which the architectural elements work cohesively together like the muscles of a torso. Seventeenth-century additions and renovations dramatically changed the original plan of the church and the appearance of its interior, but Michelangelo's Saint Peter's can still be seen in the contrasting forms of the flat

18-24. Michelangelo. Saint Peter's Basilica, Vatican. c. 1546–64 (dome completed 1590 by Giacomo della Porta). View from the southwest

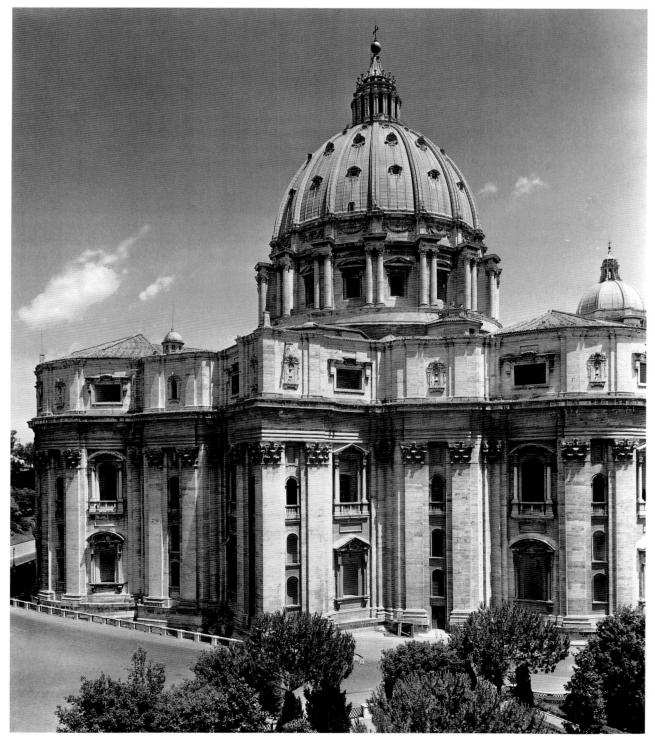

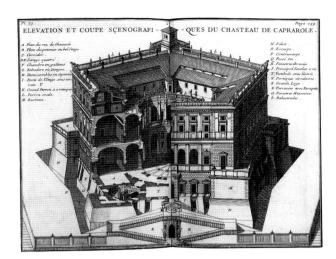

18-25. G.D. Falda. Cutaway view of the Villa Farnese, engraving from the Cours d'Architecture by A. C. Vaviler, published by Nicolas Langois, Paris, 1691. Bibliothèque Nationale, Paris

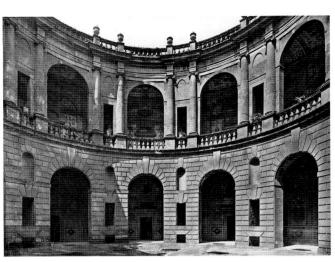

18-26. Vignola. Villa Farnese. 1559-73. Courtyard view

and angled walls and the three hemicycles (semicircular structures), whose colossal pilasters, blind windows (having no openings), and niches form the sanctuary of the church (fig. 18-24). The level above the heavy entablature was later given windows of a different shape. How Michelangelo would have built the great dome is not known; most scholars believe that he would have made it hemispherical. The dome that was actually erected, by Giacomo della Porta in 1588-1590, retains Michelangelo's basic design: a segmented dome with regularly spaced openings, resting on a high drum with pedimented windows between paired columns, and surmounted by a tall lantern reminiscent of Bramante's Tempietto. Della Porta's major changes were raising the dome height, narrowing its segmental bands, and changing the shape of its openings.

Vignola. Michelangelo designed the most prestigious buildings of sixteenth-century Rome, but there were far too much money, ambition, and demand for architectural skill for him to monopolize the field. One young artist who helped meet that demand was Giacomo Barozzi (1507-1573), called Vignola after his native town. He worked in Rome in the late 1530s surveying ancient Roman monuments and providing illustrations for an edition of Vitruvius, then worked from 1541 to 1543 in France with Francesco Primaticcio at the Château of Fontainebleau. After Vignola returned, he secured the patronage of the Farnese family, for whom he designed and supervised the building of the Villa Farnese at Caprarola from 1558 until his death.

At Caprarola, Vignola used the fortress built there by Antonio da Sangallo the Younger as a foundation (podium) for his five-sided building. Unlike medieval castle builders, who had taken advantage of the natural contours of the land in their defenses, Renaissance architects imposed geometric forms on the land. Recently developed artillery made the high walls of medieval castles easy targets, so Renaissance engineers built horizontal rather than vertical structures against long-distance firepower. Wide bastions at the outer points of such fortresses provided firing platforms for the defenders' cannons.

Vignola's building rises in three stories around a circular courtyard (fig. 18-25). He decorated the external faces with an arrangement of circles, ovals, and rectangles, just as he had advised in his book *The Rule of the Five* Orders of Architecture, published in 1562. The building was vaulted throughout, and the interior was lighted with evenly spaced windows. The courtyard appears to have only two stories, but a third story of small service rooms is screened by an open, balustraded terrace (fig. 18-26).

THE ITALIAN **SECRET GARDEN**

A special feature RENAISSANCE of Italian Renaissance palaces and villas was the secret garden, a hid-

den retreat created expressly for the enjoyment of its owners. Secret gardens became very popular in the hot Italian climate as places for intimate conversation and private contemplation, enhanced by the sound of water, the aromas and visual beauty of flowers and boxwood, and often amusing sculpture. Amid clipped

hedges and fountains, the nobility could enjoy moments of privacy away from the prying eyes and idle gossip of their courtiers.

Italian architects were great designers of gardens. Alberti, for example, wrote that gardens should have walls as "Defense against Malice," but that they should also be on hillsides to catch the breezes and provide views of the countryside. With classical Renaissance taste, he recommended that plantings be in circles and squares and trees be planted in straight lines. Vignola, one of the greatest of all garden designers, combined formal gardens having fountains and geometric planting with mazes, cascades of water, woods, grottoes, and secret gardens. The grottoes were artificial caves complete with pools, cascades of water, slimy artificial moss, and statues. One of Vignola's most ingenious ideas was a fountain constructed as a stone banquet table, with water running through a trough in the center to cool bottles of wine.

The first and second stories are ringed with galleries, and like the Palazzo Medici-Riccardi in Florence (see fig. 17-34) the ground level is **rusticated**. On the second level, Ionic half columns form a triumphal-arch motif, and rectangular niches topped with blind arches echo the arched niches of the first-floor arcade. Behind the palace, formal gardens extended beyond the moat (see "The Italian Renaissance Secret Garden," page 703).

Painting in Venice

In the sixteenth century, although Venice remained an important economic and political center, its wealth declined relative to the great monarchies of France and Spain. Venice's chiefs of state, the doges, and the republic's prosperous merchants nevertheless patronized local artists enthusiastically. Venetian painters, beginning with the Bellini family in the late fifteenth century (see figs. 17-73, 17-74), developed a distinctive style and technique. They used the oil medium for painting on both canvas and wood panel (see "Painting on Canvas," below). Oil paint was particularly suited to the brilliant color and lighting effects of Venice's four major sixteenth-century painters: Giorgione, Titian, Tintoretto, and Veronese.

Giorgione and Titian. The careers of Giorgione (Giorgio da Castelfranco, c. 1477-1510), and Titian (Tiziano Vecelli, c. 1478?-1576), were closely bound together. Giorgione's period of activity was brief, and most scholars accept only four or five paintings as entirely by his hand. Nevertheless, his importance to Venetian painting is critical. His early life and training are undocumented, but his work suggests that he studied with Giovanni Bellini. There is also a hint of inspiration from Leonardo da Vinci's subtle lighting system and mysterious, intensely observed landscapes.

Although few good examples survive, canvas paintings—chiefly in tempera on linen—were

common in the late fifteenth century. From

contracts and payment accounts, most of these paintings

appear to have been decorations for private homes.

Many may have served as inexpensive substitutes for

tapestries, but records show that small, framed pictures

of various subjects were also common. There are also

instances of copies made on canvas of religious works

for the patrons who had commissioned the originals for

a church. Canvas paintings were clearly considered less

important and less expensive than frescoes until the

Venetians began to exploit the technique of painting with

oils on canvas in the late fifteenth century.

Giorgione's most famous work, called today The Tempest (fig. 18-27), was painted shortly before his death from the plague in 1510. The figures and setting are so unusual that our interest is piqued simply to try to understand what is happening in the picture. At the right a woman is seated on the ground, nude except for the end of a long piece of white material thrown over her shoulders. Her nudity seems maternal rather than erotic as she turns to nurse the baby sitting at her side on the clothcovered ground. Across the dark, rock-edged spring stands a man wearing the costume of a German mercenary soldier. His head is turned toward the woman, but he appears to have paused for a moment before continuing to turn toward the viewer. Between them, a spring feeds a lake surrounded by a village of substantial houses, and in the far distance a bolt of lightning splits the darkening sky.

X rays of the painting show that the woman on the right was originally balanced on the left by another woman shown stepping into the spring and thus that Giorgione decided to alter his composition while he was still at work on it. This change seems to rule out any specific story as its subject matter. Some scholars have theorized that Giorgione approached his work as many modern-day artists do, by developing subjects in response to personal, private impulses, which he then expressed through his paintings.

Although *The Tempest* may have been painted purely for personal reasons, most of Giorgione's known works were of traditional subjects, produced on commission for clients: portraits, altarpieces, and frescoes to decorate the exterior walls of Venetian buildings. When given the commission in 1507 to paint the exterior of the Fondaco dei Tedeschi, the warehouse and offices of German merchants in Venice, Giorgione hired Titian as an assistant. Everything about Titian's life and career up to that time is

TECHNIQUE

ON CANVAS

PAINTING pores and smooth the surface of the rather coarse Venetian canvas. The artist then built up the forms with fine glazes of color laid on with

brushes, sometimes in as many as ten to fifteen layers. Because patrons customarily paid for paintings according to the painting's size and how richly the paint was applied, thinly painted works may reflect the patron's finances rather than the artist's choice of technique.

The use of large canvas paintings instead of frescoes for wall decoration developed in Venice, then spread elsewhere. Painting on canvas allowed greater flexibility to artists, who could complete the work in their studios and then carry the rolls of canvas to the location where they were to be installed. Because oils dried slowly, errors could be corrected and changes made easily during the work. Thus, the flexibility of the canvas support, coupled with the radiance and depth of oilsuspended color pigments, eventually made oil painting on canvas the almost universally preferred medium.

A recent scientific study of Titian's paintings reveals that he ground his pigments much finer than earlier panel painters had. The complicated process by which he produced many of his works began with a charcoal drawing on the prime coat of lead white that was used to seal the

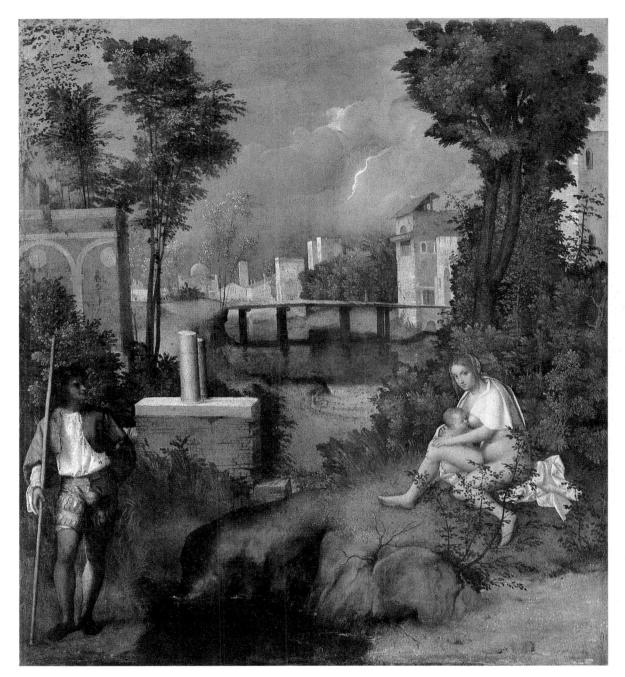

18-27. Giorgione. *The Tempest*. c. 1510. Oil on canvas, 31 x 28³/4" (79.4 x 73 cm). Galleria dell'Accademia, Venice Recent literature offers many attempts to explain this enigmatic picture, a number of which are so well reasoned that any of them might be a solution to the mystery. However, the subject of the painting, which has so preoccupied twentieth-century art historians, seems not to have particularly intrigued sixteenth-century observers, one of whom described the painting matter-of-factly in 1530 as a small landscape in a storm with a gypsy woman and a soldier.

obscure, including his age, which was given at his death in 1576 as 103 (now considered erroneous). He supposedly began an apprenticeship as a mosaicist, then studied painting under Gentile and Giovanni Bellini. His first documented work, the Fondaco frescoes, completed in 1508, has been destroyed except for a fragment of a Giorgionesque female nude preserved in the Accademia museum of Venice. Whatever Titian's work was like before that time, he had completely absorbed Giorgione's style by the time the artist died two years later and Titian completed

Giorgione's work. Having built on the success of the Fondaco frescoes, Titian was made official painter to the Republic of Venice when Giovanni Bellini died in 1516.

In 1529, Titian, who was well known outside the republic, began a long professional relationship with Emperor Charles V, who vowed to let no one else paint his portrait. Shortly after being elevated by Charles to noble rank in 1533, Titian was commissioned to paint the portrait of Isabella d'Este (see "Women Patrons of the Arts," see page 706). Isabella was past sixty when

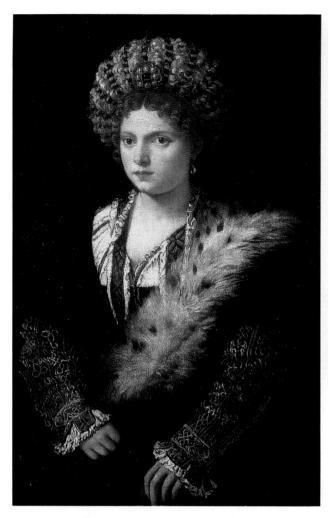

18-28. Titian. Isabella d'Este. 1534-36. Oil on canvas, 401/8 x 253/16" (102 x 64.1 cm). Kunsthistorisches Museum, Vienna

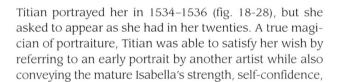

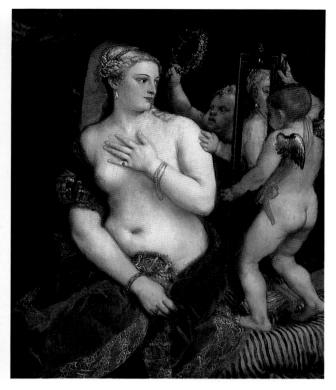

18-29. Titian. Venus with a Mirror, c. 1555. Oil on canvas. 49 x 41¹/₂" (124.5 x 105.5 cm). National Gallery of Art, Washington, D.C.

Andrew W. Mellon Collection

X rays of this painting reveal that Titian reused a horizontal canvas on which he had first painted a double portrait of a man and woman. Turning the canvas from horizontal to vertical, he then covered the portraits with a Venus clothed in a white filmy garment. Finally he painted the painting we see today. Evidently he was particularly pleased with the way he had painted the red velvet and fur garment drawn across Venus's lap, for that element survived from the earliest of the three paintings on the canvas, in which it was the man's coat.

and energy. No photograph can convey the vibrancy of Titian's paint surfaces, which he built up in layers of individual brushstrokes in pure colors, chiefly red, white, yellow, and black. According to a contemporary, Titian could make "an excellent figure appear in four brush-

OF THE ARTS

WOMEN In the sixteenth century PATRONS many wealthy women, from both the aristocracy and the merchant class, were enthusias-

tic patrons of the arts. Two English queens, the Tudor half sisters Mary I and Elizabeth I, glorified their combined reigns of half a century with the aid of court artists, as did most sovereigns of the period. The Habsburg princesses Margaret of Austria and Mary of Hungary presided over brilliant humanist courts when they were regents of the Netherlands. But perhaps the Renaissance's greatest woman patron of the arts was the marchesa of Mantua, Isabella d'Este (1474-1539), who gathered painters, musicians, composers, writers, and literary scholars around her. Married to Francesco II Gonzaga at age fifteen, she had great beauty, great wealth, and a brilliant mind that made her a successful diplomat and administrator. A true Renaissance woman, her motto was the epitome of rational thinking—"Neither Hope nor Fear." An avid reader and collector of manuscripts and books, while still in her twenties she sponsored an edition of Virgil. She also collected ancient art and objects, as well as works by contemporary Italian artists such as Botticelli, Mantegna, Perugino, Correggio, and Titian. Her grotto, or cave, as she called her study in the Mantuan palace, was a veritable museum for her collections. The walls above the storage and display cabinets were painted in fresco by Mantegna, and the carved wood ceiling was covered with mottos and visual references to Isabella's impressive literary interests.

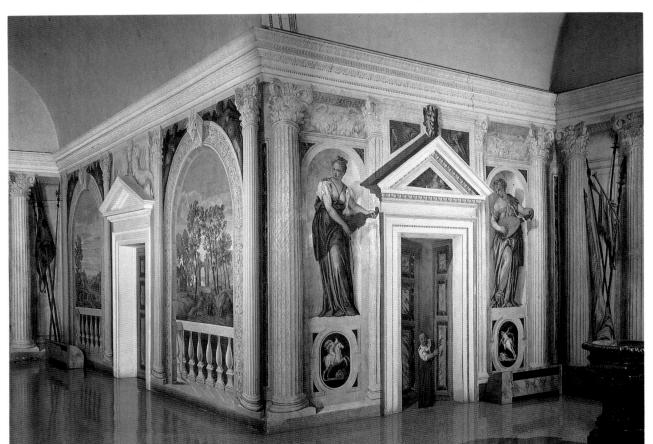

1560

18-30. Veronese. Trompe l'oeil fresco, main reception hall, Villa Barbaro, Maser, Venetia, Italy. c. 1561

strokes." His technique was admirably suited to the creation of female nudes, whose flesh seems to glow with an incandescent light. Charles V's son Philip II of Spain was so fond of Titian's nudes that he had a special room built to enjoy them in private. Typical of such paintings is *Venus with a Mirror* (fig. 18-29), of about 1555. The sensuous quality of these works suggests that Titian was as inspired by flesh-and-blood beauty as by any source from mythology or the history of art.

As in his portraits, Titian has played the textures—velvet, fur, flesh, hair, gold, silver, and pearls—against each other with such virtuosity that they dominate the image. The goddess of love at first appears to be admiring herself in a mirror held by one cupid while another holds a wreath over her head. But, as the viewer's gaze follows hers to the mirror image, it becomes apparent that Venus is not looking at herself; instead, she appears to scrutinize a viewer who is gazing at her voluptuous form. Titian evidently painted this canvas for himself, for he kept it in his home until his death.

Veronese. The paintings of Veronese (Paolo Caliari, 1528–1588), called Veronese after his home town of Verona, are nearly synonymous today with the popular image of Venice as a splendid city of pleasure and pageantry sustained by a nominally republican government and great mercantile wealth. His elaborate architectural settings and costumes, still lifes, anecdotal vignettes, and other everyday details unconnected with the main subject proved immensely appealing to Venetian patrons.

Much of Veronese's work was wall and ceiling paintings, often for monasteries and convents. Between 1559 and 1561, however, he decorated the interior of a villa built in nearby Maser by the architect Palladio. Among these works are the fanciful, trompe l'oeil murals in the main reception hall (fig. 18-30). The only real architectural forms here, other than the plain wall surfaces, are the doorframes and the heavy classical cornice below the point where the cove ceiling (a ceiling that is concave) meets the wall. Below this, a trompe l'oeil cornice is supported by Composite order columns. At the left, the wall appears to be a loggia, or gallery, opening onto distant landscape views through carved arches whose projecting keystones (central stones) are decorated with ram's heads. At the right, painted "statues" of female musicians stand in niches above an inlaid marble dado. A charming surprise is a little girl peeking out from behind double doors.

Veronese's most famous work is the religious painting of 1573 now called *Feast in the House of Levi* (see fig. 18-1), painted for the Dominican Monastery of Santi Giovanni e Paolo, Venice. At first glance the true subject of this painting seems to be architecture, with the users of the space secondary to it. The house is represented by an enormous loggia entered through colossal triumphal arches. Beyond the loggia an imaginary city of white marble gleams in the distance. The size of the canvas allowed Veronese to make his figures realistically proportional to the architectural setting without losing their substance. He also maintained visual balance by giving the figures exaggerated, theatrical gestures and poses.

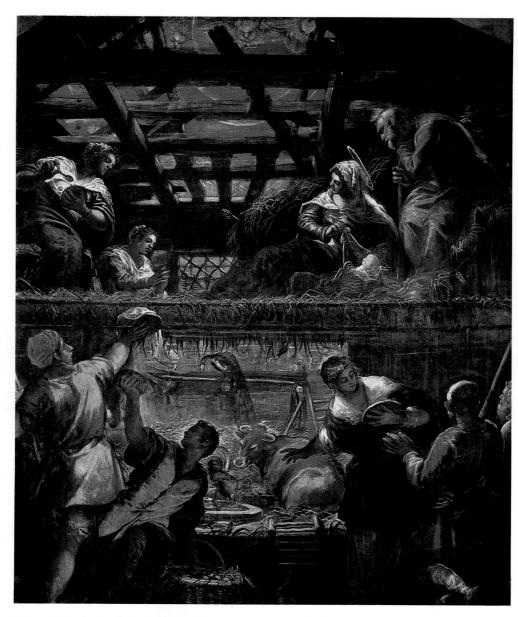

18-31. Tintoretto. *Nativity*. 1577–81. Oil on canvas, 17'9" x 14'4" (5.41 x 4.37 m). Sala Grande, Scuola Grande di San Rocco, Venice

Tintoretto, who ran a large workshop, often developed a composition by creating a small-scale model like a miniature stage set, which he populated with wax figures. He then adjusted the positions of the figures and the lighting until he was satisfied with the entire scene. Using a grid of horizontal and vertical threads placed in front of this model, he could easily sketch the composition onto squared paper for his assistants to recopy onto a large canvas. His assistants also primed the canvas, blocking in the areas of dark and light, before the artist himself, now free to concentrate on the most difficult passages, finished the painting. This efficient working method allowed Tintoretto's shop to produce a large number of paintings in all sizes.

Tintoretto. The fourth great painter of the Venetian Renaissance, Jacopo Robusti (1518–1594), called Tintoretto, worked in a style that developed from, and exaggerated, the techniques of Titian. Tintoretto ("little dyer"), nicknamed for his father's trade, was reportedly apprenticed in Titian's shop. His goal, declared on a sign in his studio, was to combine his master's color with the drawing ability of Michelangelo. The speed with which Tintoretto drew and painted was the subject of comment in his own time and of legends thereafter, and indeed, his

brilliance and immediacy were often derided in the past as carelessness. Certainly his rapid brushwork contrasted dramatically with Titian's meticulous strokes. Nevertheless, Tintoretto's visibly dynamic technique, strong colors, and bright highlights created a pictorial mood of intense spirituality that appealed to many Venetian patrons.

Like Veronese, Tintoretto often received commissions to decorate huge interior spaces. A particularly fine canvas is his *Nativity* (fig. 18-31), painted for the main hall of the Scuola Grande di San Rocco in 1577–1581. The

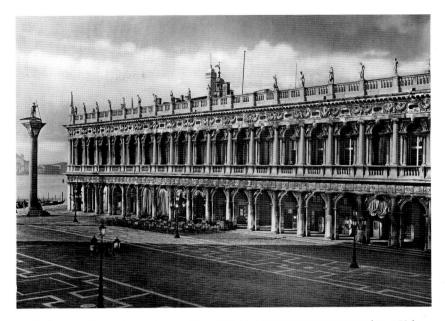

18-32. Jacopo Sansovino. Library of San Marco, Piazza San Marco, Venice. 1536

dramatic lighting of the figures in their darkened setting is reminiscent of Leonardo's *Virgin and Saint Anne* (see fig. 18-3). Like Leonardo, Tintoretto moves the viewer's eye in a circular orbit around his composition, which he staged elaborately in a two-story stable. On the lower level are farm animals and kneeling peasants, who might be looking up at a lifesize Christmas scene. On the second level, the Holy Family is adored by two women bearing gifts, probably the midwives traditionally thought to have assisted at Jesus' birth. The rafters open to a redorange sky swimming with cherubs, who gaze down at the scene. Like Veronese, Tintoretto has given his figures broad theatrical poses that enhance the emotional impact of the scene.

Tintoretto may have seemed to paint so rapidly because he organized a large workshop, which included other members of his family. Of his eight children, four became artists. His oldest child, Marietta Robusti, worked with him as a portrait painter, and two or perhaps three of his sons also joined the shop. Another daughter, famous for her needlework, became a nun. Marietta, in spite of her fame and many commissions, stayed in her father's shop until she died, at the age of thirty. So skillfully did she capture her father's style and technique that today art historians cannot be certain which paintings are hers.

Architecture in Venice and the Veneto

The Sack of Rome in 1527 benefited other Italian cities when artists fled for their livelihoods, if not for their lives. Venice had long been a vital Renaissance architectural center with its own traditions, but the field was empty when the Florentine sculptor Jacopo Sansovino arrived there from Rome. As a result, Sansovino became the most important architect of the mid-sixteenth century in Venice. The second half of the century was dominated by Andrea Palladio, a brilliant artist from the Veneto,

the mainland region ruled by Venice. Palladio brought Venetian Renaissance architecture to its grand conclusion with his villas, palaces, and churches.

Jacopo Sansovino. Soon after settling in Venice, Sansovino was appointed to renovate the Piazza San Marco, the great square in front of the Church of San Marco. In 1536 he created a model for a new library on the south side of the piazza, or open square (fig. 18-32), inspired by such classical structures as the Colosseum in Rome, which featured regular bays of superimposed orders. The flexibility of this design, with identical modules that can be repeated indefinitely, is reflected in the history of the Library of San Marco. It was opened after the first seven bays were completed at the end of 1546. Then, between 1551 and 1554, seven more bays were added, and in 1589, nearly two decades after the architect's death, more bays were added to provide office space.

Drawing upon his earlier experience as a sculptor, Sansovino enriched the facade with elaborate spandrel figures and a frieze of putti and garlands. The roofline balustrade surmounted at regular intervals by statues elegantly emphasizes the horizontal orientation of the building. Although Michelangelo never saw the library, he reinterpreted the same classical elements in his own powerful manner on the new facade of the Palazzo dei Conservatori in Rome (see fig. 18-22). The library also had a great impact on a young architect from Vicenza, Andrea Palladio, who proclaimed it "the richest and most ornate" building since antiquity.

Palladio. Probably born in Padua, Palladio (Andrea di Pietro, 1508–1580) began his career as a stonecutter. After moving to Vicenza, he was hired by the noble humanist scholar and amateur architect Giangiorgio Trissino. Trissino made him a protégé and nicknamed him Palladio, a name derived from Pallas, the Greek goddess of wisdom, and the fourth-century Roman writer

18-33. Palladio. Church of San Giorgio Maggiore, Venice. Begun 1566

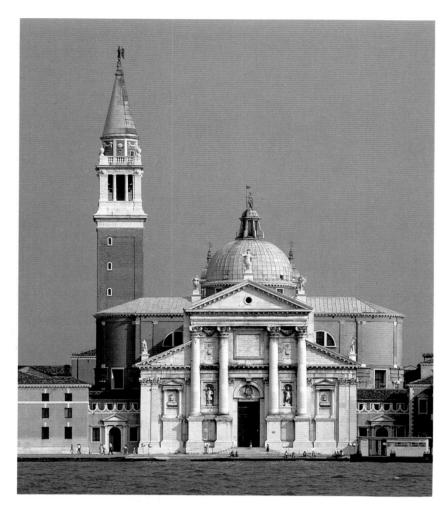

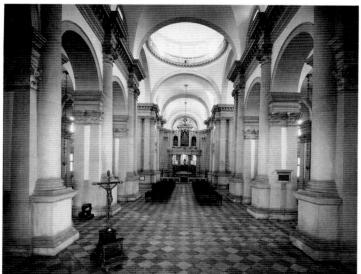

18-34. Palladio. Nave, Church of San Giorgio Maggiore

Palladius. Palladio learned Latin at Trissino's small academy and accompanied his benefactor on three trips to Rome, where Palladio made drawings of Roman monuments. Over the years he became involved in several publishing ventures, including a guide to Roman antiquities, an illustrated edition of Vitruvius, and books on architecture that for centuries were valuable resources for architectural design.

By 1559, when he settled in Venice, Palladio was one of the foremost architects of Italy. About 1566 he undertook a major architectural commission: the monastery Church of San Giorgio Maggiore on the Venetian islet of San Giorgio (fig. 18-33). His design for the Renaissance facade to the traditional basilica-plan elevation-a wide lower level fronting the nave and side aisles, surmounted by a narrower front for the nave clerestory—is the height of ingenuity. Inspired by Leon Battista Alberti's solution for Sant'Andrea in Mantua (see fig. 17-57), Palladio created the illusion of two temple fronts of different heights and widths, one set inside the other. At the center, colossal columns on high pedestals, or bases, support an entablature and pediment that front the narrower clerestory level of the church. The lower "temple front," which covers the triple-aisle width and slanted side-aisle roofs, consists of pilasters supporting an entablature and pediment running behind the columns of the taller clerestory front. Palladio retained Alberti's motif of the triumphal-arch entrance. Although the facade was not built until after the architect's death, his original design was followed.

The interior of San Giorgio (fig. 18-34) is a fine example of Palladio's harmoniously balanced geometry, expressed here in strong verticals and powerful arcs. The tall engaged columns and shorter pairs of pilasters of the

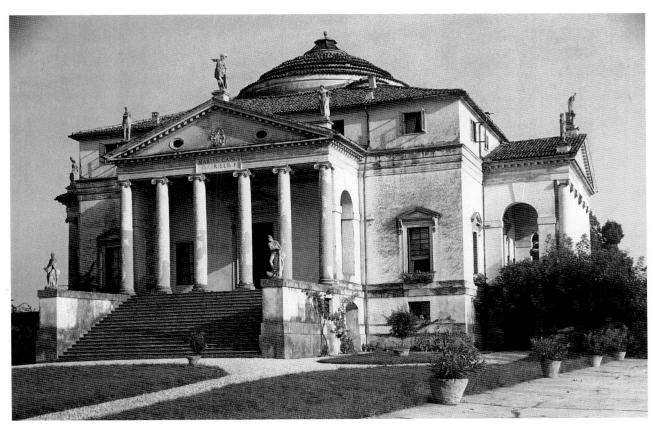

18-35. Palladio. Villa Rotonda (Villa Capra), Vicenza, Venetia, Italy. 1566-69

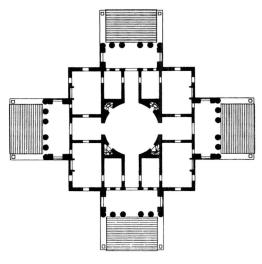

18-36. Palladio. Plan of the Villa Rotonda. c. 1550?

Palladio was a scholar and an architectural theorist as well as a designer of buildings. His books on architecture provided ideal plans for country estates, using proportions derived from ancient Roman structures. Despite their theoretical bent, his writings were often more practical than earlier treatises. Perhaps his early experience as a stonemason provided him with the knowledge and self-confidence to approach technical problems and discuss them as clearly as he did theories of ideal proportion and uses of the Classical orders. By the eighteenth century Palladio's Four Books of Architecture had become part of the library of most educated people. Thomas Jefferson had one of the first copies in America.

nave arcade echo the two levels of orders on the facade, thus unifying the exterior and interior of the building.

Palladio's diversity can best be seen in numerous villas built early in his career. In 1550 he started his most famous villa, just outside Vicenza (fig. 18-35). Although most rural villas were working farms, Palladio designed this one as a retreat for relaxation. To afford views of the countryside, he placed an Ionic order porch on each face of the building, with a wide staircase leading up to it. The main living quarters are on the second level, and the lower level is reserved for the kitchen and other utility rooms. Upon its completion in 1569, the villa was dubbed the Villa Rotonda because it had been inspired by another rotonda (round hall), the Roman Pantheon. After its purchase in 1591 by the Capra family, it became known as the Villa Capra. The villa plan (fig. 18-36) shows the geometrical clarity of Palladio's conception: a circle inscribed in a small square inside a larger square, with symmetrical rectangular compartments and identical rectangular projections from each of its faces. The use of a central dome on a domestic building was a daring innovation that effectively secularized the dome. The Villa Rotonda was the first of what was to become a long tradition of domed country houses, particularly in England and the United States.

18-37. Rosso Fiorentino. Dead Christ with Angels. 1524-27. Oil on panel, 521/2 x 41 (133.5 x 104.1 cm). Museum of Fine Arts, Boston Charles Potter King Fund

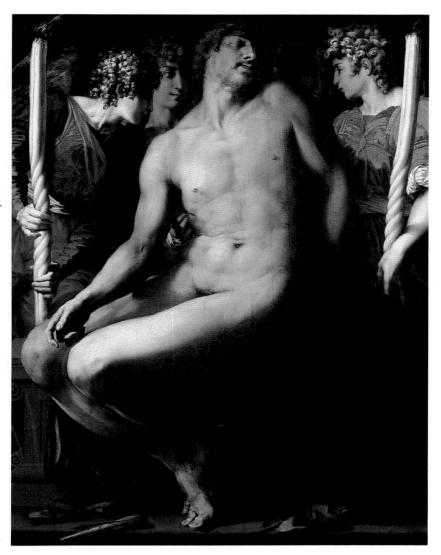

MANNERISM

ITALIAN The term *Mannerism* comes from the Italian maniera, a term used in the sixteenth century to

mean charm, grace, or even playfulness and suggesting art concerned with formal beauty for its own sake rather than idealized nature according to Renaissance conventions. In the seventeenth century and later, many critics used the word disparagingly for work they considered superficial, overly ornate, frivolous, or lacking in serious intent. Later, nineteenth-century scholars adopted Mannerism as a convenient category for any sixteenthcentury art that did not fit stylistically into the classical Renaissance style.

For this discussion, Mannerism is considered the stylistic movement that emerged at about the same time as the classical Renaissance but had its own aims, rhythms, and sources of influence, which often allowed artistic scope for considerable experimentation and individual expression. Mannerism, which was stimulated and supported by court patronage, arose in Florence and Rome before 1520 first in painting, then in other mediums, and was spread to other locations when the artists traveled. The major Mannerist artists—Rosso Fiorentino,

Pontormo, Parmigianino, Bronzino, Giulio Romano, and Primaticcio—were admirers of and were inspired by the great leaders of the earlier generation, Leonardo da Vinci, Raphael, and Michelangelo.

Any attempt to define Mannerism as a single style is futile, but certain characteristics were common: extraordinary virtuosity; sophisticated, elegant compositions; and fearless manipulations or distortions of accepted conventions of form. Paintings often exhibited irrational spatial development and figures with elongated proportions, exaggerated poses, and enigmatic gestures and facial expressions. Some artists favored obscure, unsettling, and oftentimes erotic imagery; unusual color use and juxtapositions; and unfathomable main subjects or secondary scenes. Mannerist sculpture generally exhibited the same characteristics as figural painting, especially in distorted, exaggerated body forms and poses. The sculptors also tended to prefer small size, the use of precious metals, and exquisite technical execution. Mannerist architecture involved defiance of the conventional applications of the Classical orders and reversals of the expected uniformity and rationality of elevation design, rather than structural innovations.

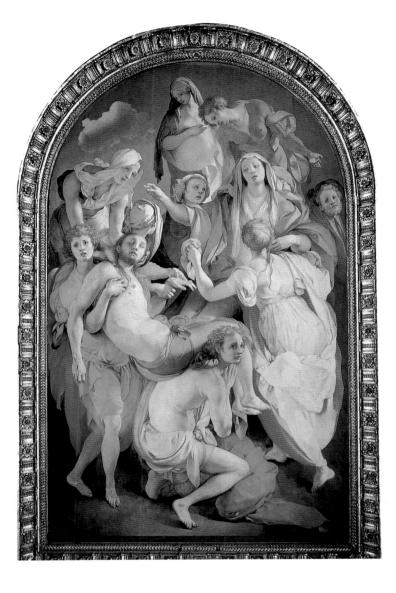

18-38. Pontormo. Entombment. 1525–28. Oil on panel, 10'3" x 6'4" (3.12 x 1.93 m). Capponi Chapel, Church of Santa Felicità, Florence

Painting

Mannerism as a style that is clearly differentiated from the classical Renaissance approach began in painting in the second decade of the sixteenth century. In Rome Raphael had already moved in a distinctly Mannerist direction in the last of his decorations in the Vatican before his death in 1520, and in Florence the first wave of Mannerist painters was already emerging. Some scholars have connected their ambiguous, unsettling new tendencies with the famine, plague, and constant war that then troubled Italy. Others have seen, instead, a formal relationship between the new painting styles and the aesthetic theories that began to appear at this time.

An early leader of the Mannerist movement was the Florentine painter known as Rosso Fiorentino (1495–1540), who later carried his style to the renovation of the Château of Fontainebleau. Rosso's *Dead Christ with Angels*, of about 1524–1527, painted while he was working in Rome, exhibits many general Mannerist characteristics (fig. 18-37). The figure of Jesus fills the picture plane and seems to press forward into the viewer's space, its exaggerated **Z** shape providing an odd combination of

contortion and almost erotic grace. All traces of the final tortured moments of the Crucifixion have been eliminated. The beautiful candle-bearing angels with curly golden hair and exquisitely colored costumes are a vivid and disturbing contrast to the enormous corpse, which they effortlessly support on a colorful shroud. Although the scene has been traditionally identified as a Deposition, it has also been interpreted as the first moment of Resurrection in the tomb, with Christ's eyes just beginning to flicker open. Supporting this hypothesis are the claustrophobic spacelessness of the painting that seems to deny the material world, the unmarked flesh of the Savior, whose wounds seem to have disappeared, and a mood that has no trace of mourning or despair.

Rosso's contemporary, with whom he may have worked in Florence in 1512, Jacopo da Pontormo (1494–1557), was a highly regarded religious painter and a favorite of the Medici ruling family. Pontormo's *Entombment* (fig. 18-38) was painted about 1525–1528 for the Church of Santa Felicità in Florence. Like Rosso's painting, its subject is ambiguous. The rocky ground and cloudy sky give only the faintest sense of location in space, which is immediately confused by the arrangement of the

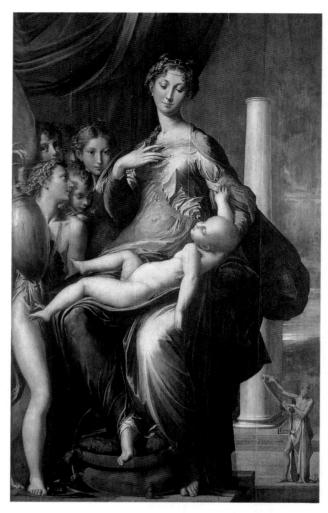

18-39. Parmigianino. *Madonna with the Long Neck.* c. 1535. Oil on panel, 7'1" x 4'4" (2.16 x 1.32 m). Galleria degli Uffizi. Florence

figures, who are either levitating or standing on a ring of boulders in the rocky terrain. Pontormo seems to have chosen a moment just after Jesus' removal from the Cross, when the youths who have lowered him have paused to regain their composure. The large green bundle of cloth below Jesus apparently represents the shroud brought for his entombment. The emotional atmosphere of the scene is expressed in a range of facial expressions, odd poses, drastic shifts in scale, and unusual costumes, but perhaps most poignantly in the dramatic use of color. The palette is predominantly blue and pink with accents of olive green, gray, scarlet, and creamy white. The overall tone of the picture is set by the color treatment of the crouching youth, whose bright pink torso is shaded in iridescent, pale gray-green.

When Parmigianino (Francesco Mazzola, 1503–1540) arrived in Rome from his native Parma in 1524, the strongest influence on his work had been Correggio, who had completed major works in Parma before the younger artist's departure. While in Rome, Parmigianino met Mannerists Rosso Fiorentino and Giulio Romano, and he also

studied Raphael and Michelangelo. His genius was to assimilate what he saw into his own distinctive style of Mannerism with none of the nervous, sharply unsettling qualities of Rosso's or Pontormo's works. Three years later, he was captured and imprisoned briefly during the 1527 Sack of Rome, after which he went first to Bologna. then to Parma, where he lived until his death. Dating from 1535 is an unfinished painting known as the Madonna with the Long Neck (fig. 18-39). The elongated figure of the Madonna, whose massive legs and lower torso contrast with her narrow shoulders and long neck, was clearly conceived to resemble the large metal vase inexplicably being carried by the youth at the left. The Madonna's neck also seems to echo the very tall white columns placed, equally mysteriously, in the middle distance. The painting has been interpreted as an abstract conception of beauty in which the female body is compared to the forms of Classical columns and vases, an aesthetic ideal illustrated by Raphael in his later stanze paintings. Like Rosso and Pontormo, Parmigianino presents a common religious image in a manner calculated to unsettle viewers. Are the young people at the left grown-up cherubs or wingless angels? Is the man with the scroll at the right an architect or an Old Testament prophet, perhaps Isaiah, who foretold the birth of Christ? There may be some truth in the explanation given by the theorist Celio Calcagnini (d. 1541): Mannerist taste is admiration for things "that are beautiful just because they are deformed, and thus please by giving displeasure" (cited in Shearman, page 156).

Bronzino (Agnolo Tori, 1503-1572), who got the nickname "Copper-Colored" because of his dark complection, was born near Florence. He became Pontormo's assistant about 1522. He established his own workshop in 1530 but continued to work with Pontormo occasionally on large projects until the older artist's death. In 1540 Bronzino became court painter to the Medici. Although he was a versatile artist who produced altarpieces. fresco decorations, and tapestry designs over his long career, he is best known today for his portraits in the courtly Mannerist style. Ugolino Martelli, of about 1535 (fig. 18-40), demonstrates Bronzino's characteristic portrayal of his subjects as intelligent, aloof, elegant, and self-assured. Bronzino's virtuosity in rendering costumes and settings sometimes dominates his compositions, creating a rather cold and formal effect. On the other hand, the calm, self-contained demeanor of his subjects admirably conveys a sense of the force of their personalities, and the wealth and elegance suggested in these portraits were highly prized by his patrons.

Northern Italy, more than any other part of the peninsula, produced a number of gifted woman artists. Sofonisba Anguissola (1528–1625), born into a noble family in Cremona, was unusual in that she was not the daughter of an artist. Her father gave his six daughters the same humanistic education as his one son, and he encouraged them all to pursue careers in literature, music, and especially painting. Anguissola's proud father consulted Michelangelo about her artistic talents in 1557, asking for a drawing that she might copy and return to be

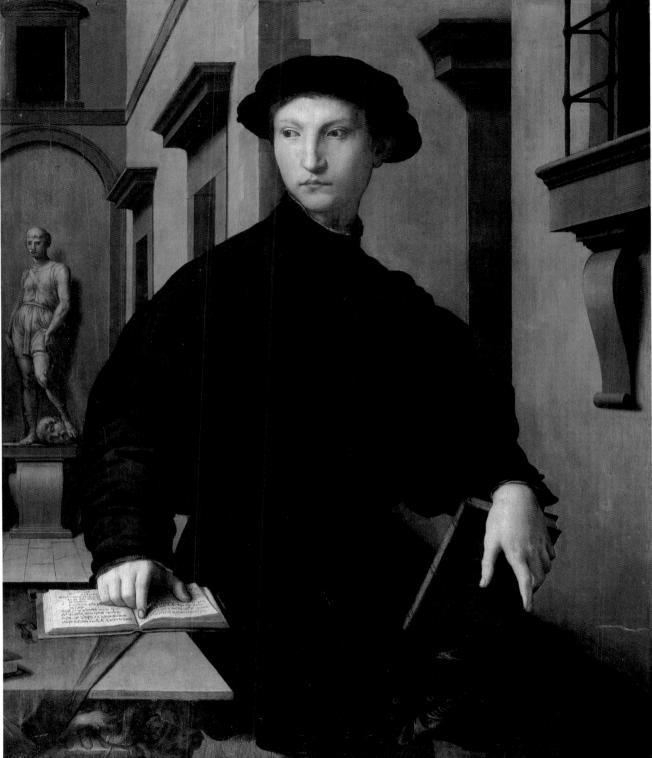

18-40. Bronzino. *Ugolino Martelli*. c. 1535. Oil on panel, 441/8 x 331/2" (102 x 85 cm). Staatliche Museen zu Berlin, Preussischer Kulturbesitz, Gemäldegalerie

critiqued. Michelangelo not only obliged but also set another task for young Anguissola; she was to send him a drawing of a crying boy. Her sketch of a girl comforting a small boy, wailing because a crayfish is biting his finger, so impressed Michelangelo that he gave it as a gift to his closest friend, who later presented it, along with a drawing by Michelangelo, to Cosimo I de' Medici.

Giorgio Vasari wrote admiringly of the Anguissola sisters' painting, especially a work by Sofonisba that portrayed two of her sisters playing chess while a younger

18-41. Sofonisba Anguissola. The Sisters of the Artist and Their Governess. 1555. Oil on canvas, 27⁹/16 x 37" (70 x 94 cm). Narodowe Museum, Poznan, Poland

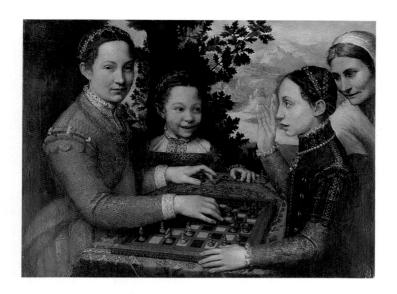

18-42. Lavinia
Fontana. Noli
Me Tangere.
1581. Oil on
canvas,
47³/₈ x 36⁵/₈"
(120.3 x 93
cm). Galleria
degli Uffizi,
Florence

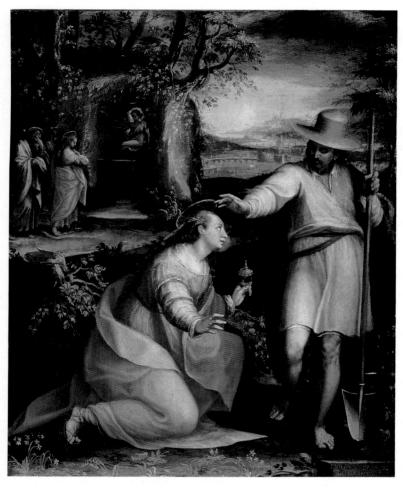

child and a governess watch (fig. 18-41). Painted in 1555, this canvas anticipates later highly popular group portraits of people engaged in everyday activities. There is a faint echo of Leonardo da Vinci's style in the facial expressions, the softly modeled forms, and the smoky unifying tone of the painting.

In 1560, Sofonisba accepted the invitation of the queen of Spain to become an official court painter, a post she held for twenty years. In a 1582 Spanish inventory, Sofonisba is described as "an excellent painter of portraits above all the painters of this time," extraordinary

praise in a court that patronized Titian and Antonis Mor, discussed later. Unfortunately, most of Sofonisba's Spanish works were lost in a seventeenth-century palace fire.

Another northern Italian, Lavinia Fontana (1552–1614), learned to paint from her father, a Bolognese follower of Raphael. By the 1570s, she was a highly respected painter of narrative as well as of portraits, the more usual field for women artists of the time. Her success was so well rewarded, in fact, that her husband, the painter Gian Paolo Zappi, eventually gave up his own artistic career to care for their large family and help

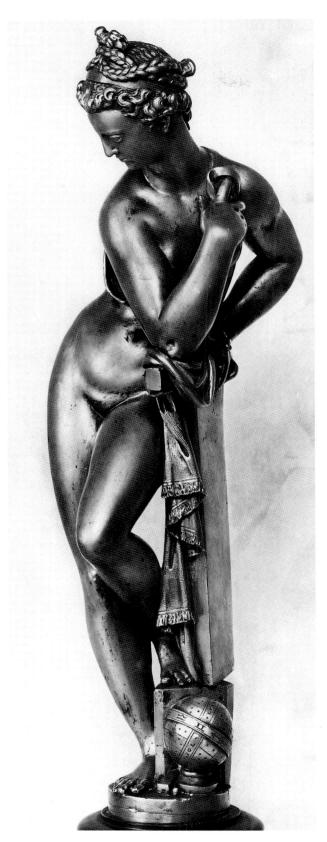

18-43. Giovanni da Bologna. Astronomy, or Venus Urania. c. 1573. Bronze gilt, height 15¹/₄" (38.8 cm). Kunsthistorisches Museum, Kunstkammer, Vienna

Lavinia with such technical aspects of her work as framing. This situation would not have been very unusual in Bologna, which boasted some two dozen women painters as well as a number of women scholars who lectured at the university in a variety of subjects, including law. While still in her twenties, Lavinia painted the *Noli Me Tangere* of 1581 (fig. 18-42), illustrating the biblical story of Christ revealing himself for the first time following his Resurrection to Mary Magdalen (Mark 16:9, John 20:17). The Latin title of the painting means "Don't touch me," Christ's words when she moved to embrace him, explaining that he now existed in a new form somewhere between physical and spiritual. Christ's costume refers to the passage in the Gospel of John, which says that the Magdalen at first mistook Christ for a gardener.

In 1603, Lavinia moved to Rome as an official painter to the papal court. She also soon came to the attention of the Habsburgs, who paid large sums for her work. In 1611, she was honored with a commemorative medal portraying her in a bust as a dignified, elegantly coiffed woman on one side and as an intensely preoccupied artist with rolled-up sleeves and wild, uncombed hair on the other.

Sculpture

Probably the most influential sculptor in Italy in the second half of the sixteenth century was the Flemish artist Jean de Boulogne, better known by his Italian name, Giovanni da Bologna (1529–1608). Born in Flanders, he settled by 1557 in Florence, where both the Medici family and the sizable Netherlandish community there were his patrons. Not only did he influence a later generation of Italian sculptors, but he also spread the Mannerist style to the north through artists who came to study his work.

Although greatly influenced by Michelangelo, Giovanni's distinctive style was generally more concerned with graceful forms and poses, as in his gilded bronze Astronomy, or Venus Urania, of about 1573 (fig. 18-43). Beginning with a Classical prototype of Venus, Giovanni designed the statuette to be seen from any viewpoint rather than from the front only, a much more difficult task for a single figure than for a group, such as Sansovino's Bacchus (see fig. 18-10). Straining the limits of the human body, the sculptor twisted Venus's upper torso and arms to the far right and extended her neck in the opposite direction, so that her chin was over her right shoulder. The elaborate coiffure of tight ringlets and the detailed textural engraving of the drapery contrast strikingly with the smooth, gleaming flesh of Venus's body. The figure's identity is suggested by the astronomical device on the base of the plinth. Following common practice for castmetal sculpture, this statuette was replicated in Giovanni's shop several times for various patrons.

Architecture

Mannerist architecture referred to Classical conventions only to reject them. An important early exponent of architectural Mannerism was Raphael's student Giulio Romano. While Giulio remained attached to the Classical

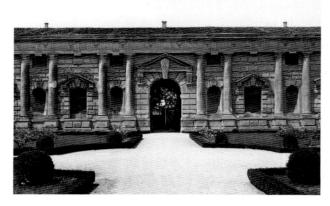

18-44. Giulio Romano. Palazzo del Tè, Mantua. 1525-32. Courtyard facade

modes, he brought a studied playfulness to his building designs and interior decoration. Giulio's inventive use of traditional forms would inspire later architects.

Giulio Romano. After Raphael's death in 1520, Giulio Romano (1492–1546) completed his unfinished painted works and began the fresco decoration of the last Vatican *stanza*. In 1524, however, he accepted an offer from

the ruling Gonzaga family to become their court artist in Mantua, where he spent the rest of his life. He carried out a number of architectural commissions there, but the only well-preserved example is the Palazzo del Tè (fig. 18-44), built on a small nearby island between 1525 and 1532. A country villa rather than a palace, it was used for entertaining, which allowed an opportunity for fanciful architectural treatment.

The basic plan is a conventional Renaissance conception: a one-story square building with four wings enclosing a central court. However, the inside face of the east wing, illustrated here, looks more like a fortress than a porticoed Renaissance-style courtyard (see fig. 18-26). Giulio has used the Doric order, but with typically Mannerist variations. The columns, resting on bases, form with the entablature a projecting screen in front of the rusticated stucco wall. Rather than being evenly spaced, the columns flank a large arched entrance and wall niches of two different sizes. The building's windows are small rectangles that seem to float just under the architrave. The oddest features are the dropped triglyphs (three-grooved blocks) on the architrave at the center of each expanse of space between the columns. The sophisticated Mannerist wit of these irregularities would have been apparent only to viewers familiar with Classical architectural theory.

In the interior, Giulio created illusions that everyone could quickly appreciate. In the Sala dei Giganti ("Room

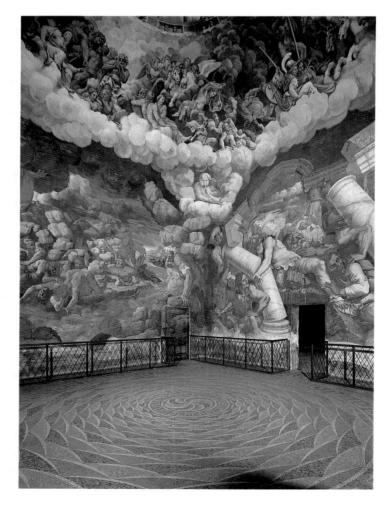

18-45. Giulio Romano.

Fall of the Giants,
fresco in the
Sala dei Giganti,
Palazzo del Tè.
1530-32

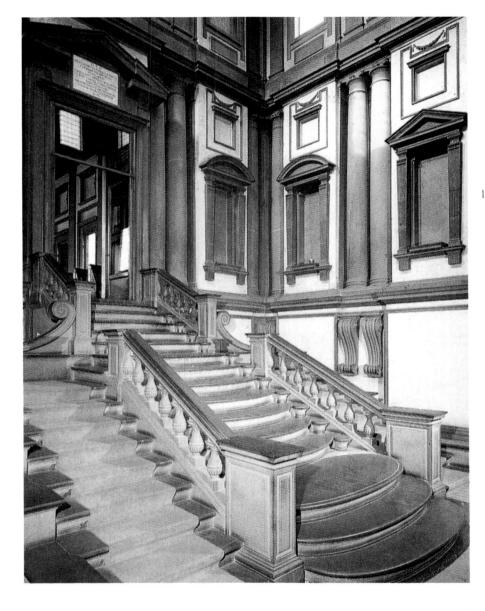

18-46. Michelangelo. Vestibule of the Laurentian Library, Monastery of San Lorenzo, Florence. 1524-33; staircase completed 1559

of the Giants"), he used the entire space—walls, ceiling, and floor—to create the effect that the viewer was in the midst of the mythological battle of the gods and Giants (fig. 18-45). The ceiling depicts the palace of Jupiter floating on a ring of billowing clouds. From its safety, the king of the gods hurls down thunderbolts on the Giants, who are crushed by falling buildings and rocks crashing down from the mountains. In its original form, the room had a fireplace made to look as though its stones were also crumbling and a floor paved with stones cut to mask the division between it and the illusionistic wall paintings.

Michelangelo. Another important work of Mannerist architecture is Michelangelo's entry hall for the Laurentian Library in Florence. Built above the monastery's dormitories, the large, rectangular reading room is reached by a grand staircase in a vestibule off the main cloister (fig. 18-46). In its final realization, Michelangelo's staircase, completed in 1559, was a remarkable Mannerist conception. The spatial proportions are somewhat unsettling: a tall room with the floor space taken up almost entirely by a staircase cascading like a waterfall, with a

central flight of large oval steps flanked by narrower flights of rectangular ones. According to Michelangelo's instructions, seats were placed at intervals along the outer edges of the stair, and the side ramps end and join the main flight just short of the door. Paired columns are embedded in the walls on the second-floor level instead of supporting an entablature; enormous volute brackets, capable of bearing great weight, are simply attached to the wall, supporting nothing. Michelangelo at one point described this project as "a certain stair that comes back to my mind as in a dream," and the strange and powerful effects do indeed suggest a dreamlike imagining brought to physical reality.

FRENCH COURT

THE Italy had experienced the military power of French kings since the end of the fifteenth century, and the French kings had experienced the aesthetic power of Ital-

ian Renaissance art. The greatest French patron of Italian artists was Francis I (b. 1494; ruled 1515-1547), despite his constant wars against Holy Roman Emperor Charles V to expand French territory.

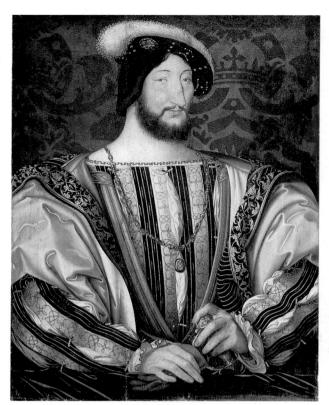

18-47. Jean Clouet. *Francis I*. 1525–30. Oil and tempera on panel, 37³/₄ x 29¹/₈" (95.9 x 74 cm). Musée du Louvre, Paris

Painting

Before the arrival of Italian painters at Francis I's court. the Flemish-born artist Jean Clouet (d. 1540) had found great favor as the king's portraitist. Clouet's origins are obscure, but he was in France as early as 1509, and in 1530 he moved to Paris as principal court painter. Clouet probably painted Francis's official portrait soon after the king's release from imprisonment in Spain by Charles V (fig. 18-47). His distinctive features have been softened but not completely idealized, for his thick neck seems at odds with his delicately worked costume of silks, satin, velvet, jewels, and gold embroidery. In its format and grandeur of presentation, Clouet's portrayal has its roots in the portrait tradition established at the French court by Jean Fouquet (see fig. 17-26). Some scholars have questioned the attribution of this particular painting to Clouet because of its stiffness, but this may simply be a court convention for official portraits. Artists generally made rapid sketches then painted a prototype for the

18-48. Primaticcio. Stucco and wall painting, Chamber of the duchess of Étampes, Château of Fontainebleau.

Primaticcio worked on the decoration of Fontainebleau from 1532 until his death in 1570. During that time, he also commissioned and imported a large number of copies and casts made from original Roman sculpture, including the Apollo Belvedere in the Vatican gardens, the newly discovered Laocoön, and even the relief decoration on the Column of Trajan. These works provided an invaluable visual source for the northern artists employed on the project.

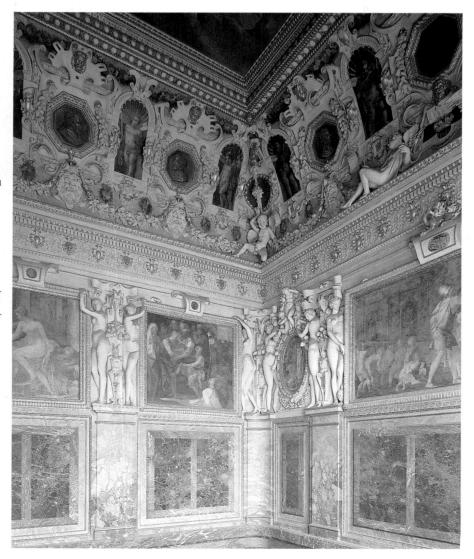

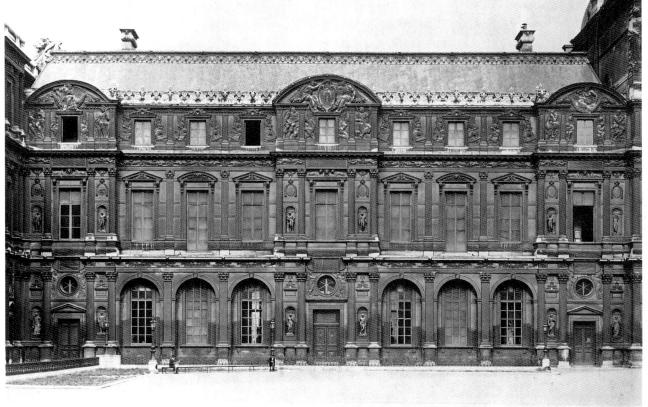

18-49. Pierre Lescot. West wing of the Cour Carré, Palais du Louvre, Paris. Begun 1546

official portrait, which, upon approval, was the model for numerous replicas for diplomatic and family purposes.

Architecture and Its Decoration

At the beginning of the sixteenth century, with the enthusiasm of French royalty for things Italian and the widening distribution of Italian books on architecture, the Italian Renaissance style began to appear in French construction. Builders of elegant rural palaces, called **châteaux**, were quick to introduce Italianate decoration on otherwise Gothic buildings, but French architects soon adapted Classical principles of building design as well.

Immediately upon his ascent to the throne in 1515, Francis I showed his desire to "modernize" the French court by acquiring the versatile talents of Leonardo da Vinci, who moved to France in 1516 and was actively involved in the design of the Château of Chambord in the Loire Valley in western France up to his death in 1519. But it was not until 1526, after Francis's military defeat by Charles V and a long imprisonment in Madrid, that the king began a major renovation of royal properties.

Having chosen as his primary residence the medieval hunting lodge at Fontainebleau, Francis began transforming it in 1526 into a grand palace. Most of the exterior structure was altered or destroyed by later renovations, but parts of the interior decoration, mainly the work of artists and artisans from Italy, have been preserved and restored. The first artistic director at Fon-

tainebleau, the Mannerist painter Rosso Fiorentino (see fig. 18-37), arrived in 1530. In 1540 he was succeeded by his colleague Francesco Primaticcio, from Mantua, where the latter had worked with Giulio Romano.

Following ancient tradition, the king maintained an official mistress-Anne, the duchess of Étampes, who was in residence at Fontainebleau. Among Primaticcio's first projects was the redecoration, in the 1540s, of Anne's bedroom (fig. 18-48), which has survived nearly intact. The artist combined the arts of woodworking, stucco relief, and fresco painting in his complex but lighthearted and graceful interior design. The lithe figures of his stucco nymphs with their long necks and small heads recall Parmigianino's painting style (see fig. 18-39), and their spiraling postures and bits of clinging drapery are playfully sexual. The wall surface is almost overwhelmed with garlands, mythological figures, and Roman architectural ornament, yet the visual effect is extraordinarily confident and joyous. The first School of Fontainebleau, as this Italian phase of the palace decoration is called, established a tradition of Mannerism in painting and interior design that spread to other centers in France and the Netherlands.

In 1546 Francis I began to renovate the royal palace in Paris, the Louvre, by replacing its central block with a courtyard. He appointed the architect Pierre Lescot (c. 1510–1578) to build a new wing along the west side of this square court, or Cour Carré, as it came to be called (fig. 18-49). Lescot's appointment was an innovation,

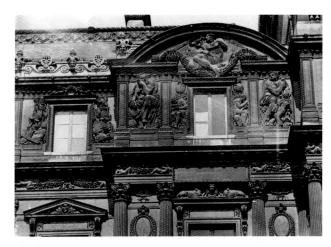

18-50. Jean Goujon. Archimedes and Euclid, with Allegorical Figures, detail of the sculptural decoration of the west wing of the Cour Carré. 1548–49

because he was a well-educated man who came not from the building trades but from the study of painting and mathematics. He was thus a French counterpart to such Italian architects as Bramante, Raphael, and Leonardo. The exterior elevation of the wing today does not reflect Lescot's original plan, but rather significant alterations he made during the course of the work. In 1549, to accommodate a grand ballroom, Lescot moved the staircase from a single projecting bay, or frontispiece, at the center of the wing to the north end. He built another frontispiece for it there and balanced this with a third projection at the south end, thus creating the triple vertical divisions of the courtyard face. The frontispiece, which had its own roof, was derived from earlier sixteenthcentury château designs. A second major change occurred during construction of the king's apartment on the south end of the building. A fourth story with large Gothic windows overlooking the Seine River was added there and disguised by an added level on the courtyard face. Lescot created this by adding about 3 feet to the height of the frontispieces and continuing this across the whole wing. Lescot designed an identical south face for the Cour Carré.

Apparently, Lescot had not visited Italy before 1556, so his Louvre design drew on native French traditions and classical elements learned from books. The result has been acknowledged as the first original French Renaissance design. Although Lescot's Cour Carré embodies classical ideals of balance and regularity and incorporates antique architectural detailing, it would never be mistaken for an Italian Renaissance building. The integration of sculptural reliefs into the facade design was original and entirely French in conception although not in sculptural style (fig. 18-50). The reliefs were the work of Jean Goujon (c.1510-1568?), whose elongated figures and elegant poses, as shown in Archimedes and Euclid, with Allegorical Figures, were clearly influenced by Italian Mannerism, but they are integrated into the architecture in the French Gothic tradition.

One of the finest examples of Italian Renaissance influence on French architectural design is the Château

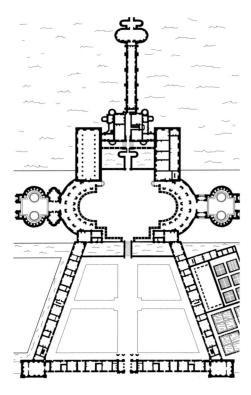

18-51. Plan of the Château of Chenonceaux, with projected additions and formal gardens, Loire Valley

of Chenonceaux, developed in three phases during the sixteenth century (fig. 18-51). The original residential block (fig. 18-52 at the left) was built between about 1515 and 1522, using the foundations of a mill built out over the Cher River to create one of the earliest château designs reflecting classical principles of geometric regularity and symmetry. Rooms are arranged on each side of a wide central hall that originally ended in a large window overlooking the river. The château also introduced to French architecture a form of the Italian straight-ramp staircase.

Later, the foremost French Renaissance architect, the Roman-trained Philibert de l'Orme (d. 1570), designed a gallery and bridge extending the rest of the way across the river (fig. 18-52). The extension was completed about 1581 on a new three-story design, probably devised by the Italian-trained architect Jean Bullant (c. 1510–c. 1578). The extension incorporated contemporary Italianate window treatments, wall moldings, and cornices that harmonized almost perfectly with the forms of the original turreted building. Chenonceaux remains today one of the most important—and beautiful—examples of classical influence on French Renaissance architecture.

Craft Arts

Italian craftspeople began to move north after the end of the fifteenth century, and the Fontainebleau treasury includes some of the finest work of the Florentine goldsmith and sculptor Benvenuto Cellini (1500–1571). Cellini worked from just before 1540 to 1545 at Fontainebleau, where he made the famous Saltcellar of Francis I (fig.

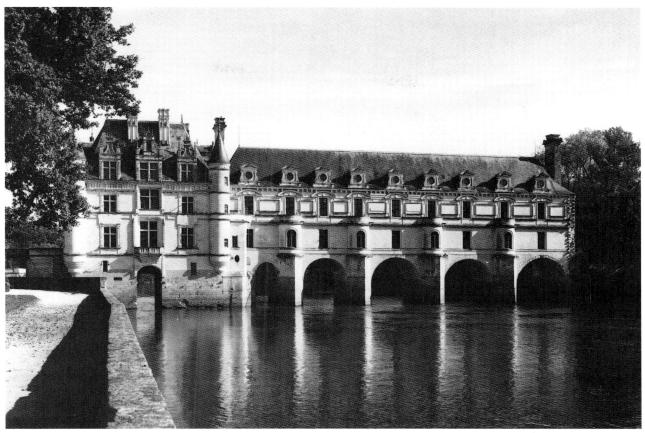

18-52. Château of Chenonceaux. 1515-22, 1556-59, and 1576-81

This château, first acquired by Francis I, was a favorite of his grandson Henry III (ruled 1574–1589). Henry III and his mother, Catherine de' Medici, who had inherited the property, delighted in throwing lavish parties here with costumed young men and women emerging from the woods to greet guests, while singers and musicians entertained from boats on the river.

18-53). This utilitarian table piece, dated about 1539–1543, was transformed into an elegant sculptural ornament through the artist's fanciful imagery and superb execution in gold and enamel. The Roman sea god, Neptune, representing the source of salt, sits next to a tiny boat-shaped container that carries the seasoning, while a personification of the Earth guards the plant-derived pepper. The Seasons and the Times of Day on the base refer to both daily meal schedules and festive seasonal celebrations. The two main figures, their poses mirroring each other with one bent and one straight leg, lean away from each other at impossible angles yet are connected and visually balanced by glances and gestures. Their supple, elongated bodies and small heads reflect the Mannerist conventions of Parmigianino and Primaticcio.

Although Italians were prominent at the French court, native French craft artists also attracted royal patronage. Among these was the ceramicist Bernard Palissy (c. 1510–c. 1590), called the "Huguenot potter" because of his Protestant faith. In 1563 Palissy was appointed "inventor of rustic figurines" and created in the garden of the Tuileries in Paris a make-believe earthenware grotto, decorated entirely with ceramic rocks, shells, crumbling statues, water creatures, a cat stalking birds, ferns, and garlands of fruits and vegetation. In creating his ceramic forms, he reportedly made casts from

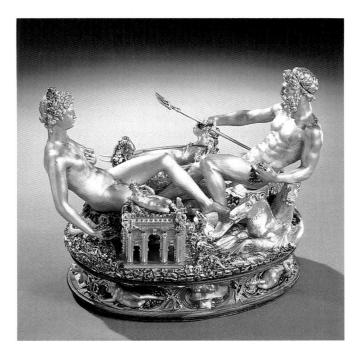

18-53. Benvenuto Cellini. *Saltcellar of Francis I*. 1539–43. Gold with enamel, 10¹/₄ x 13¹/₈" (26 x 33.3 cm). Kunsthistorisches Museum, Vienna

18-54. Attributed to Bernard Palissy. Oval plate in "style rustique." 1570-80/90? Polychromed tin and glazed earthenware. length 201/2" (52 cm). Musée du Louvre, Paris

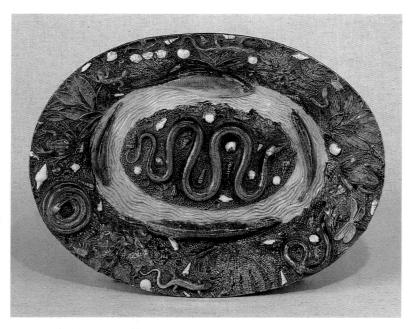

actual creatures and natural elements. From 1570 until 1576, during a period of persecution of Protestants in Paris, Palissy was exiled. He was permitted to return to Paris to teach but was arrested again in 1588 and died in prison around 1590, about the time that his Tuileries grotto was destroyed. He is known today for his distinctive ceramic platters decorated in high relief with plants, flowers, reptiles, water creatures, and insects (fig. 18-54). Existing examples are best called Palissy-style works, however, because their originality is nearly impossible to prove. His designs were copied into the seventeenth century, and pieces in his style are still made today.

ART

NETHER- Sixteenth-century art in the Nether-LANDISH lands followed several different directions. While some artists capitalized on styles of the late fifteenth century,

others looked back for models to earlier Flemish painters. A few artists, perhaps the best known today, were such individualists that they must be considered unique. Virtually all Netherlandish artists must have been well aware of developments in Italian art, and many responded without losing their northern identity. The term Romanist generally indicates that the Netherlandish painters had contact either personally or through a teacher with prevailing Italian art styles of the sixteenth century. Here we include under Romanist both those influenced by Italian Renaissance styles and those who were drawn to Italian Mannerism. The term *Mannerist* also is applied to certain types of native Netherlandish art that do not fit easily into Renaissance categories.

Painting

Although the Roman Catholic Church continued to commission works of art, unpredictable religious controversies in the Netherlands led artists to seek private patrons. An enormous market flourished for small paintings of secular subjects that were both decorative and interesting conversation pieces for homes. Certain subjects were so popular later in the century that some artists became specialists, producing variations on a particular theme rapidly, with the help of assistants.

Hieronymous Bosch. With the work of Hieronymous Bosch (c. 1450-1516), we enter a world of fantastic imagination associated with medieval art. Bosch's career was spent in the town whose name he adopted, 's Hertogenbosch, near the Maas (Meuse) River on the German border. Bosch's religious devotion is certain. His range of painting subjects, rendered with great technical virtuosity, shows that he was well educated and well read; he was also a hydraulic engineer who designed fountains and civic waterworks.

Paintings such as his triptych Garden of Delights (fig. 18-55) are challenging and unsettling. Modern critics have called the painter everything from madman to scholar, from mystic to social critic. There are many interpretations of the Garden, but a few broad conclusions can be drawn with certainty. The subject of the overall work is Sin—that is, the Christian belief in human beings' natural state of sinfulness and their inability to save themselves from its consequences. The triptych tells the story of the religious past and future of humanity, from the Creation of the World on the wing exteriors (not shown in fig. 18-55) and the Creation of Adam and Eve on the left wing to the Last Judgment on the right. The fact that only the Damned in Hell are shown in the Judgment scene supports a conclusion that the work cautions that Damnation is the natural outcome of a life lived in ignorance and folly. In the center panel (fig. 18-56), which illustrates those activities that condemn humanity, it seems that greed, jealousy, and murder are less threatening to human salvation than seemingly harmless diversions such as games, romance, music, and even art.

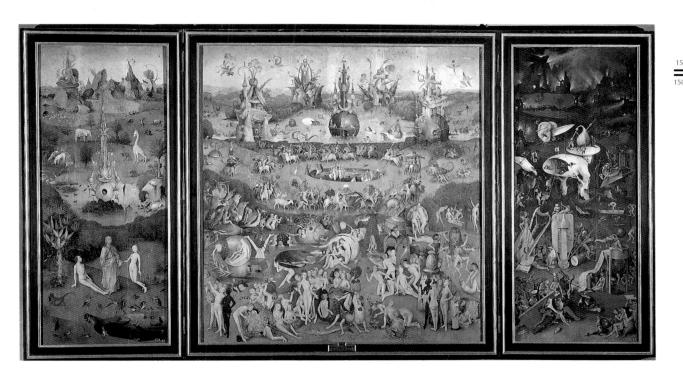

18-55. Hieronymus Bosch. *Garden of Delights*. c. 1505–15. Oil on panel, center panel 7'2\sqrt{2\"} x 6'4\sqrt{3\/4\"} (2.2 x 1.95 m); each wing 7'2\sqrt{2\"} x 3'2\" (2.19 x 0.96 m). Museo del Prado, Madrid

"The world upside down," a common folk expression in the sixteenth-century Netherlands, may represent part of the meaning of this enigmatic painting. Even the triptych format that the artist chose may be an understated irony. Before the Reformation, the altarpiece had been synonymous with religious imagery in northern Europe, but this work was commissioned by an aristocrat for his Brussels town house. As a secular work, the *Garden of Delights* may well have inspired lively discussion and even ribald comment, much as it does today in its museum setting. Despite—or perhaps because of—its bizarre subject matter, the triptych was copied in 1566 to make tapestry versions, one for a cardinal (now in El Escorial) and another for Francis I. At least one painted copy was made as well. Bosch's original triptych was acquired during the revolt of the Netherlands and sent in 1568 to Spain, where it entered the collection of Philip II.

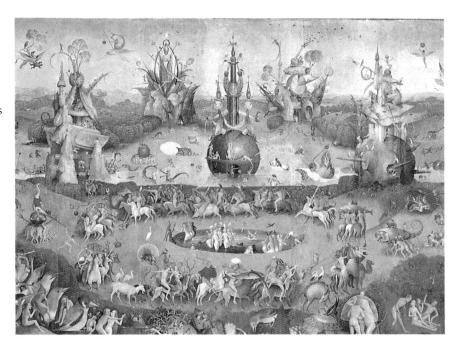

18-56. Hieronymus Bosch. Detail of the center panel, Garden of Delights

One interesting interpretation of the central panel proposes that it is a parable on human salvation in which the process sought to turn common metals into gold parallels Christ's power to convert human dross into spiritual gold. The alchemical process merged, or "married," two opposite elements (possibly symbolized here by male

and female) through distillation to form an entirely new element. The bizarre fountain at the center of the lake in the middle distance (fig. 18-56) can be seen as an alchemical "marrying chamber" complete with alembics, the glass vessels for collecting the vapors of distillation. The figure standing on its head may allude to "turning upside

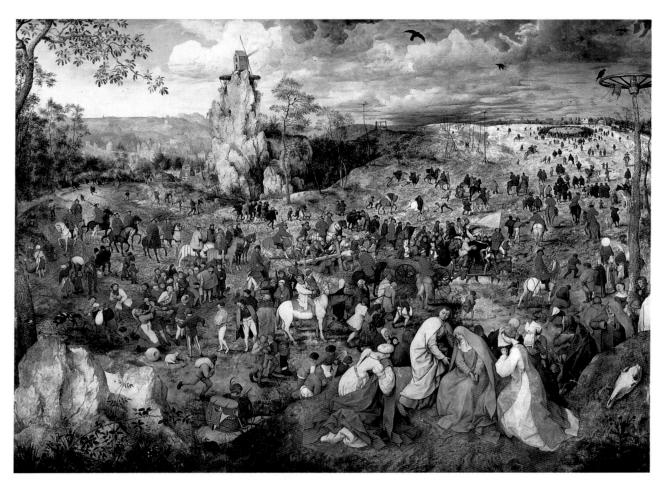

18-57. Pieter Brueghel the Elder. *Carrying of the Cross.* 1564. Oil on panel, 4'3/4" x 5'7" (1.23 x 1.70 m). Kunsthistorisches Museum. Vienna

down," the alchemical expression for distillation, also referred to as "play," which may explain the playful attitudes of even the most grotesque creatures in the picture.

Whatever Bosch's intentions were—and they must have been far more complex than an alchemical allegory—they were unknown to one art critic, who wrote in about 1600 that the triptych was called "The Strawberry Plant" because it resembled the "vanity and glory and the passing taste of strawberries or the strawberry plant and its pleasant odor that is hardly remembered once it has passed." Luscious fruits—strawberries, cherries, grapes, and pomegranates—appear everywhere in the *Garden*, serving as food, as shelter, and even as a boat. Therefore, the subject of Sin is reinforced by the suggestion that life is as fleeting and insubstantial as the taste of a strawberry.

Pieter Brueghel the Elder. So popular did the works of Hieronymous Bosch remain after his death that, nearly half a century later, the young painter Pieter Brueghel (c. 1525–1569) was able to earn a great deal of money by imitating his work. Fortunately, Brueghel's talents went far beyond those of an ordinary copyist. Nothing is known of his early training, but shortly after entering the Antwerp Guild in 1551, he spent time in Bologna and Rome, where he studied Michelangelo's Sistine ceiling and other works in the Vatican.

Brueghel maintained a shop in Antwerp from 1554 until 1563, when he moved to Brussels. His style and choices of subjects found great favor with local scholars, merchants, and bankers, who appreciated his beautifully painted, artfully composed works, which reflected contemporary social, political, and religious conditions. Brueghel's inspiration came from visiting country fairs, where he sketched the farmers and townspeople who became the focus of his paintings, whether religious or secular. No artist had ever depicted Flemish farmers so vividly and sympathetically while also exposing their faults and foolishness, an ability that earned the solidly middle-class artist the nickname of "Peasant" Brueghel. Nevertheless, Brueghel's characters were not unique individuals but well-observed types whose universality makes them familiar even today.

Although Brueghel is not strictly speaking a Mannerist, he specialized in an unsettling Manneristic approach to composition. The main subject of the picture is often deliberately hidden or disguised by being placed in the distance or amid a teeming crowd of figures, as in the *Carrying of the Cross* (fig. 18-57), painted in Brussels in 1564. At first glance, the group of large figures near the picture plane at the lower right seems to be the true subject, but they are in fact secondary to the main event: Jesus carrying his Cross to Golgotha. To find him, the viewer must visually enter the painting and search for the

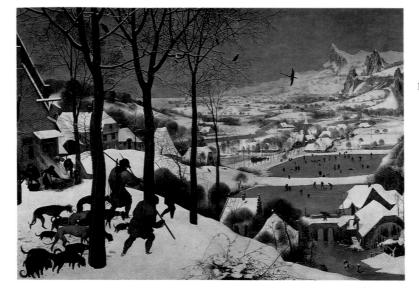

18-58. Pieter Brueghel the Elder. Return of the Hunters. 1565. Oil on panel, 3'10¹/2" x 5'3³/4" (1.18 x 1.61 m). Kunsthistorisches Museum, Vienna

main action, while being constantly distracted by smaller dramas going on among others who mill about the large open field, surging with the crowd this way and that, part of the public circus going on around the dire events central to the painting.

Brueghel's panoramic scene is carefully composed to attract our eye and guide it in swirling, circular orbits that expand, contract, and intersect. Part of this movement is accomplished by the careful spotting of the bright red coats of the guards trying to control the crowd. The figure of Jesus is finally discovered at the center of the painting where the vertical and horizontal axes intersect. The land-scape recedes skillfully and apparently naturally toward the distant horizon, except for the tall rock outcropping near the center with a wooden windmill on top. The exaggerated shape of the rock is a convention of sixteenth-century northern European landscapes, but the enigmatic windmill suggests the ambiguities of Italian Mannerism.

Cycles, or series, of paintings on a single allegorical subject—such as the Five Senses, the Times of Day, and the Seasons—were frequently commissioned as decorations for elegant Netherlandish homes. Brueghel's Return of the Hunters (fig. 18-58) of 1565 is one of a cycle of six panels, each representing two months of the year. In this November-December scene, Brueghel has captured the atmosphere of the damp, cold winter with its early nightfall in the same way that his compatriots the Limbourgs did 150 years earlier in the February calendar illustration for the duke of Berry (see fig. 17-2). In contrast to much Renaissance and Mannerist art, the Hunters appears neutral and realistic. The viewer seems to hover with the hawks slightly above the ground, looking down first on the busy foreground scene, then across the valley to the snow-covered village and frozen ponds. The main subjects of the painting, the hunters, have their backs turned and do not reveal their feelings as they slog stoically through the snow, trailed by their dogs. They pass an inn at the left, where a worker moves a table by the door to receive the pig others are singeing in a fire before butchering it. But this is clearly not an accidental image,

a slice of everyday life faithfully reproduced, for the forms of the composition are carefully calculated. The sharp diagonals, both on the picture plane and as lines receding into space, are countered by the pointed gables and roofs at the lower right as well as by the jagged mountain peaks linking the valley and the skyline along the right edge. Their rhythms are deliberately slowed and stabilized by a balance of vertical tree trunks and horizontal rectangles of water frozen-over in the distance.

As a depiction of Flemish life, this scene represents a relative calm before the storm. Two years after it was painted, the anguished struggle of the northern provinces for independence from Spain began. Pieter the Elder died young in 1569, leaving two children, Pieter the Younger and Jan, both of whom became successful painters in the next century.

Romanists and Specialists. A major change in the sixteenth-century Netherlands was the development of stronger, more-affluent art centers, such as Utrecht, in the north. Despite the long struggle for independence from Spain, which led seven northern Protestant provinces to found the United Provinces in 1579 and eventually divided the Netherlands along religious lines, people nevertheless found the resources to patronize artists.

The first Netherlandish Romanist was the Flemish painter Jan Gossaert (c. 1478–c. 1533), who later called himself Mabuse after his native city, Maubeuge. In about 1507 he entered the service of Philip, an illegitimate son of the duke of Burgundy. Gossaert's only visit to Italy was a trip with his patron a year later, during which he made drawings of antique sculpture and architecture. Philip, an avid arts patron, brought the Venetian painter and engraver Jacopo de' Barbari to his court in 1509, and Gossaert collaborated with him in late 1515 on a series of mythological paintings. From 1517 to 1524, Gossaert worked for Philip and other Burgundian patrons in Utrecht, then opened his own shop.

Gossaert's painting style went through several phases, and he seems to have responded in different ways

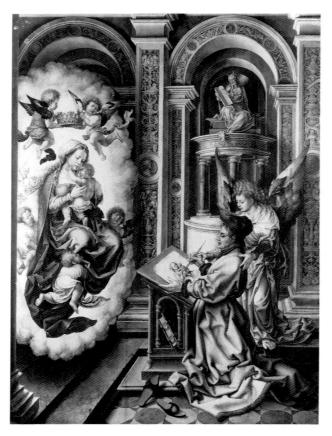

18-59. Jan Gossaert. Saint Luke Painting the Virgin. 1520. Oil on panel, 43³/₈ x 32¹/₄" (110.2 x 81.9 cm). Kunsthistorisches Museum. Vienna

according to the patron or the subject of his works. Only briefly did he work in the strongly Mannerist style of his Saint Luke Painting the Virgin (fig. 18-59) of about 1520. The subject, taken from legend, shows Luke painting a portrait of the Virgin and Child as they appeared to him in a vision. The Evangelist kneels in an imaginary church before a lectern that acts as his easel. In the niche beyond is a statue of the horned Moses seated and holding the Tablets of the Law atop a high round pedestal. The angel looking over Luke's shoulder holds his right hand as if guiding his work. Although the imaginary classical architecture was derived from Italian sources, the decorative folds of Luke's robe are typical of late Gothic drapery, echoing those of Veit Stoss's Saint Roche (see fig. 18-75). Luke's vision of the Virgin as the Queen of Heaven surrounded by an aura also has much in common with Grünewald's visionary scene on the Isenheim Altarpiece (see fig. 18-63).

An outstanding "specialist" painter, Marinus van Reymerswaele (c. 1493–after 1567), was apprenticed in Antwerp in 1509 to a glass painter. Later, he organized and ran a well-regarded shop that mainly produced secular panel paintings featuring a class of universally despised members of society—money lenders, tax collectors, and greedy, cold-hearted landlords. The *Banker and His Wife* (fig. 18-60), painted in 1538, is known in at least four copies, and no fewer than twenty-five variants presenting the subject as a tax collector have been preserved. Reymerswaele was not the inventor of either

his specialty or his pictorial format, which recalls the depiction of the goldsmith-saint Eloy in 1449 by Petrus Christus (see fig. 17-14). Such paintings were popular conversation pieces; even the satirized subjects themselves apparently bought and displayed them.

Caterina van Hemessen (1528-1587) of Antwerp developed an illustrious international reputation. She had learned to paint from her father, the Flemish Mannerist Jan Sanders van Hemessen, with whom she collaborated on large commissions, but her quiet realism and skilled rendering had roots in Renaissance Romanism. Her portraits typically depict the subject in threequarter view, carefully including background elements that could be shown perspectivally, such as the easel in her Self-Portrait (fig. 18-61). To maintain the focus on the foreground subject, Caterina painted the portrait backgrounds in an even dark color, on which she identified her subject and the subject's age, and signed and dated the work. Here, the inscription reads: "I Caterina van Hemessen painted myself in 1548. Her age 20." In delineating her own features, Caterina presented a serious young person without personal vanity yet seemingly already self-assured about her artistic abilities. During her early career, spent in Antwerp, she became a favored court artist to Mary of Hungary, regent of the Netherlands and sister of Emperor Charles V, for whom she painted not only portraits but also religious works. In 1554 Caterina married the organist of Antwerp Cathedral, and they accompanied Mary to Spain after she ceased to be regent in 1556. Unfortunately, Caterina's Spanish works have not survived or have been attributed to others.

GERMANY AND THE HOLY ROMAN EMPIRE

Through carefully calculated dynastic marriages and some good luck, the Habsburg Holy Roman Emperor Charles V (ruled 1519–1556), also known as Charles I of Spain, ruled over lands from the North Sea to the Mediterranean. Charles was a

Roman Catholic throughout his life, but he also was forced to accommodate the German Protestant Reformation. Tired of the strain of government and prematurely aged, he abdicated in 1556 and retired to a monastery, where he died two years later. After his death, Habsburg domains were divided. His son Philip II became the king of Spain, the Netherlands, and the Americas, as well as ruler of Milan, Burgundy, and the Kingdom of Naples and Sicily. Charles's brother Ferdinand I succeeded him as Holy Roman Emperor. The Habsburg dynasty lasted into the twentieth century.

From the last decades of the fifteenth century up to the 1520s, the arts flourished in Austria, Germany, and the German-speaking regions of Switzerland and Alsace. After that, religious upheavals and **iconoclastic** (imagesmashing) purges of religious images began to take a toll. Religious strife was intimately bound up with social and political problems, and some artists found their careers at an end because of their sympathies for rebels and reformers. Others left their homes to seek patronage abroad because of their support for the Roman Catholic Church.

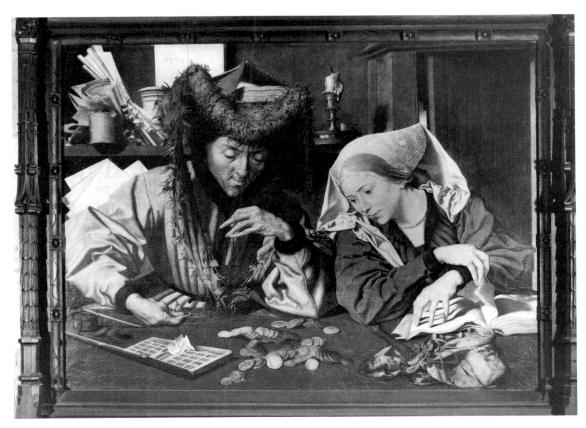

18-60. Marinus van Reymerswaele. *Banker and His Wife*. 1538. Oil on panel, 33³/₄ x 45⁷/₈" (85.7 x 116.5 cm). Museo Nazionale del Bargello, Florence

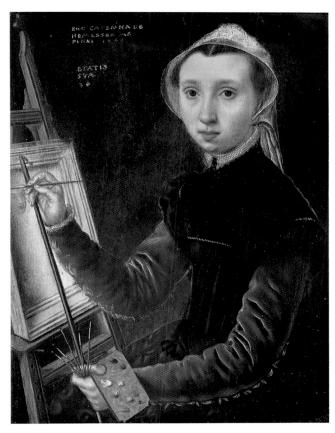

18-61. Caterina van Hemessen. *Self-Portrait*. 1548. Oil on panel, 12¹/₄ x 9¹/₄" (31.1 x 23.5 cm). Öffentliche Kunstsammlung, Basel, Switzerland

Painting and Printmaking

The first decades of the sixteenth century were dominated in German art by two very different artists, Matthias Gothardt, known as Matthias Grünewald (c. 1480–1528), and Albrecht Dürer (1471–1528). Grünewald's unique style expressed the continuing currents of medieval German mysticism and emotionalism, while Dürer's intense observation of the natural world represented the scientific Renaissance interest in empirical observation, perspective, and a reasoned canon of human proportions. Both artists sympathized with religious reforms, which affected their later lives, and their deaths in 1528 occurred just as the Protestant Reformation gained political power in Germany. Their successors were forced to make drastic efforts to survive in the radically different German market.

Matthias Grünewald. As an artist in the court of the archbishop of Mainz, Grünewald worked as an architect and hydraulic engineer as well as a painter, a common combination at the time. The work for which Grünewald is best known today, the *Isenheim Altarpiece* (figs. 18-62, 18-63), created between 1510 and 1515, illustrates the same intensity of religious feeling that motivated reformers like Martin Luther. It was created for the Abbey of Saint Anthony in Isenheim, whose hospital specialized in the care of patients with skin diseases, including the plague and leprosy. Not only did the altarpiece commemorate a major saint, the fourth-century Egyptian Anthony the Hermit, but it was thought to be able to heal

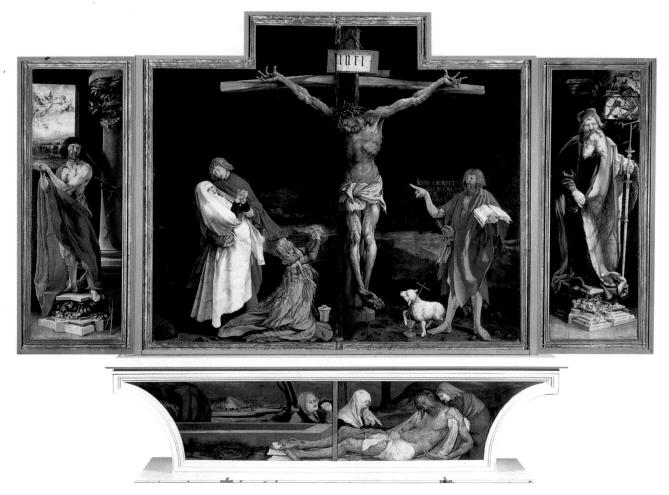

18-62. Matthias Grünewald. *Isenheim Altarpiece*, closed, from the Abbey of Saint Anthony, Isenheim, Germany. Main body: *Crucifixion*; predella: *Lamentation*; side panels: Saints Sebastian and Anthony Abbot. c. 1510–15. Oil on panel, main body 9'9½" x 10'9" (2.97 x 3.28 m), predella 2'5½" x 11'2" (0.75 x 3.4 m). Musée Unterlinden, Colmar, France

those who looked upon it. In fact, viewing the altarpiece was part of the medical care given to the sick who entered the hospital. The altarpiece is no longer mounted in its original frame, but it is, nevertheless, monumentally impressive in size and complexity. The main inner section and supporting platform, or **predella**, are of sculpted wood figures. Grünewald painted one set of fixed wings and two sets of movable ones, plus one set of small wings for the predella, so that the altarpiece could be exhibited in different configurations depending upon the Church calendar.

On normal weekdays, when the altarpiece was closed, viewers saw a shocking image of the Crucifixion in a darkened landscape, a Lamentation below it on the predella, and lifesize figures of Saints Sebastian and Anthony Abbot standing like statues on trompe l'oeil pedestals on the fixed wings (see fig. 18-62). Grünewald represented in the most horrific detail the tortured body of Jesus covered with gashes from being beaten and pierced by the thorns used mockingly to form a crown for his head. Not only do his ashen color, open mouth, and blue lips indicate that he is dead, but he also appears

already to be decaying, an effect enhanced by the palette of putrescent greens, yellows, and purplish red. A ghostlike Virgin Mary has collapsed in the arms of an emaciated John the Evangelist, and Mary Magdalen has fallen in anguish to her knees; her clasped hands with outstretched fingers seem to echo Jesus' straining, cramping fingers in rigor mortis. At the right, John the Baptist points at Jesus and repeats his prophecy, "He shall increase." The Baptist and the lamb holding a cross and bleeding from its breast into a golden chalice allude to the Christian rites of Baptism and the Eucharist. In the predella below, Jesus' bereaved mother and friends prepare his body for burial, a scene that must have been familiar indeed in the hospital. On the fixed wings, the martyred Saint Sebastian and the hermit Saint Anthony serve as models for a life of Christian devotion and as intercessors for the sick and the dying.

In contrast, the altarpiece when first opened displays Christian events of great joy—the Annunciation, the Nativity, and the Resurrection—expressed in vivid red and gold accented with high-keyed pink, lemon, and white (see fig. 18-63). Unlike the murky darkness of the

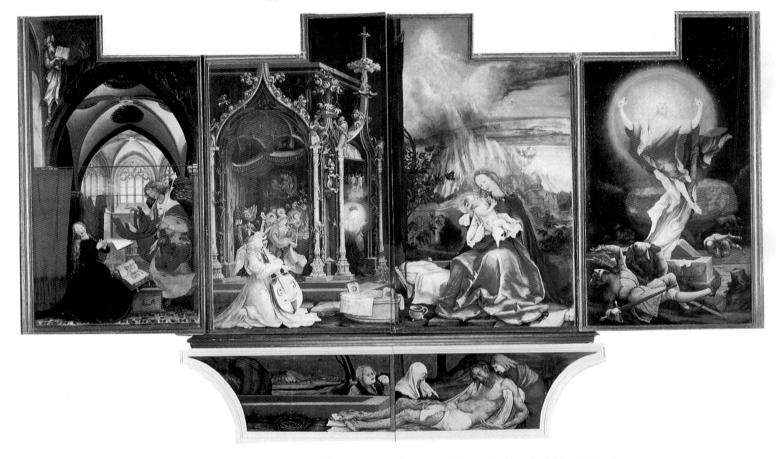

18-63. Matthias Grünewald. *Isenheim Altarpiece*, first opening. Left to right: *Annunciation*, *Virgin and Child with Angels*, *Resurrection*. c. 1510–15. Oil on panel, center panel 9'9'/2" x 10'9" (2.97 x 3.28 m), each wing 8'2'/2" x 3'1/2" (2.49 x 0.92 m)

Crucifixion, the inner scenes are illuminated with clear natural daylight, phosphorescent auras and halos, and the glitter of stars in a night sky. Fully aware of contemporary Renaissance formal achievements, Grünewald created the illusion of three-dimensional space and volumetric figures, and he abstracted, simplified, and idealized the forms. Unlike Italian Renaissance painters, his aim was to strike the heart rather than the intellect and to evoke sympathy rather than to create visual grandeur. Underlying this deliberate attempt to arouse an emotional response in the viewer is a complex, religious symbolism, undoubtedly the result of close collaboration with his monastic patrons.

The Annunciation on the left wing illustrates a special liturgy called the Golden Mass, which celebrated the divine motherhood of the Virgin and included a staged reenactment of the angel's visit to her. There were also readings from the story of the Annunciation (Luke 1:26–38) and the Old Testament prophecy of the Savior's birth (Isaiah 7:14–15), which is inscribed in Latin on the pages of the Virgin's open book. The event takes place as reenacted in the Mass.

The central panels show the heavenly and earthly realms joined in one space. In a variation on the northern visionary tradition, the new Mother adores her miraculous Child while envisioning her own future as the Queen of Heaven amid angels and cherubs. Grünewald illustrated a range of ethnic types in the heavenly realm, as well as three distinct types of angels seen in the foreground young, mature, and a feathered hybrid with a birdlike crest on its human head. Perhaps this was intended to emphasize the global dominion of the Church, whose missionary efforts were expanding as a result of the European exploration and discovery of new territories. The panel is also filled with symbolic and narrative imagery related to the Annunciation. For example, the Virgin and Child are surrounded by Marian symbols: the enclosed garden, the white towel on the tub, and the clear glass cruet behind it, which signify Mary's virginity; the waterpot next to the tub, which alludes both to purity and to childbirth; and the fig tree at the left, suggesting the Virgin Birth, since figs were thought to bear fruit without pollination. The bush of red roses at the right alludes not only to Mary but also to the Passion of Christ, thus recalling the Crucifixion on the

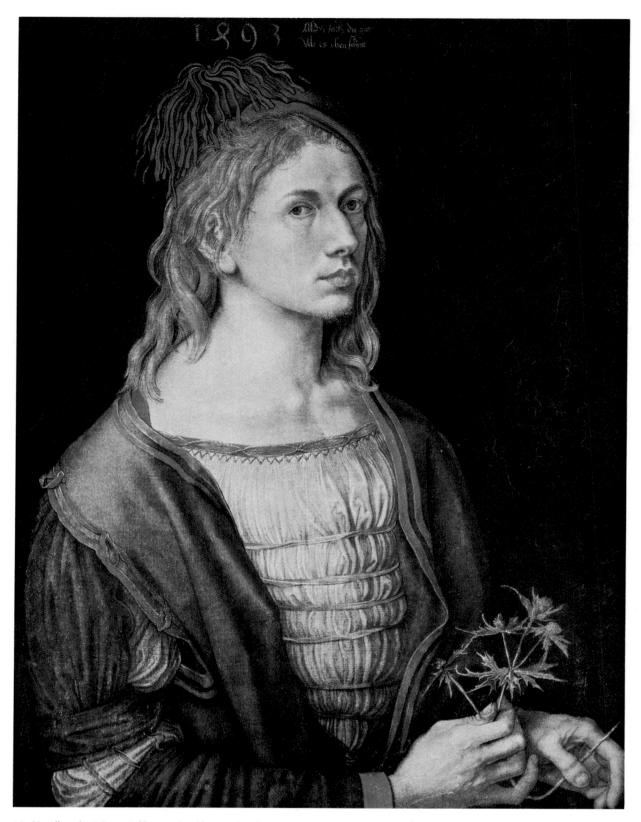

18-64. Albrecht Dürer. *Self-Portrait with a Sprig of Eryngium*. 1493. Parchment on linen, 22½ x 17½ (54 x 44.5 cm). Musée du Louvre, Paris

outer wings and providing a transition to the Resurrection on the right wing. There, the shock of Christ's explosive emergence from his stone sarcophagus tumbles the guards about, and his new state of being—no longer material but not yet entirely spiritual—is vibrantly evident in his dissolving, translucent figure.

Grünewald's personal identification with the struggles of the peasants in the social and religious turmoil of the 1520s damaged his artistic career. After actively supporting the peasants, who, because of economic and religious oppression, rose up against their feudal overlords in the Peasants' War in 1525, he left Mainz and spent his

last years in Halle, whose ruler was the chief protector of Martin Luther and a longtime patron of Grünewald's contemporary Albrecht Dürer.

Albrecht Dürer. Much is known about the life, personality, and thinking of Albrecht Dürer. Studious, analytical, observant, and meticulous but as self-absorbed and difficult as Michelangelo, Dürer was one of eighteen children of a Nuremberg goldsmith. Nuremberg at that time was a free imperial city with strong business, trade, and publishing interests. The city had an active group of humanists and internationally renowned artists and artisans who exported many works, especially large altarpieces. After an apprenticeship in painting, stained-glass design, and especially the making of woodcuts, in the spring of 1490 Dürer traveled to extend his education and gain experience as an artist. Dürer worked until early 1494 in Basel, Switzerland, providing drawings for woodcut illustrations for books published there. While in Basel, Dürer painted a self-portrait, probably for his upcoming marriage. Originally painted with oil on vellum but transferred later to linen canvas, the Self-Portrait with a Sprig of Eryngium (fig. 18-64) is inscribed: "1493. My affairs will go as it is written in the stars." The sprig the young artist holds was believed to have aphrodisiac properties and thus symbolized romantic love and betrothal. Although the pleated silks and satins are worn casually and contrast with his unkempt hair and large, capable hands, Dürer's lifelong interest in stylish clothing is already apparent here. Already, too, the artist was devoted to meticulously documenting his subjects' features in a manner that also revealed their personalities.

Not long after his marriage in 1494, Dürer traveled to Italy seeking patrons among the large, rich community of German merchants then living in Venice. Dürer's travels are documented by a series of fresh, freely executed watercolors of the Alpine landscape, such as the *Wehlsch Pirg (Italian Mountain)*, probably painted in 1495 (fig. 18-65). The artist's interest in **atmospheric perspective** is clear from the tonal variations of the blues and greens in the distant, moisture-laden air.

Back in Nuremberg, the young artist continued to experience a slow market for his work. To bolster his income, Dürer began to publish his own prints, and ultimately it was these prints, not his paintings, that made his fortune. His first major publication was the Book of Revelation, or Apocalypse, which appeared simultaneously in German and Latin editions in 1497–1498 and consisted of a woodcut title page and fourteen full-page illustrations with the text printed on the back of each. The best-known of the woodcuts is the *Four Horsemen of the Apocalypse* (fig. 18-66) based on figures in Revelation 6:1–8: a crowned rider armed with a bow, on a white horse (Conquest); a rider with a sword, on a red horse (War); a rider with a set of scales, on a black horse (Plague and Famine); and a rider on a sickly pale horse (Death).

The artist probably did not cut his own woodblocks but rather employed a skilled carver who followed his drawings faithfully. Dürer's dynamic whirlpool of figures shows affinities with *Temptation of Saint Anthony* (see fig.

18-65. Albrecht Dürer. Wehlsch Pirg (Italian Mountain). c. 1495. Watercolor and gouache, 8½ x 12½" (21 x 31.1 cm). Ashmolean Museum, Oxford

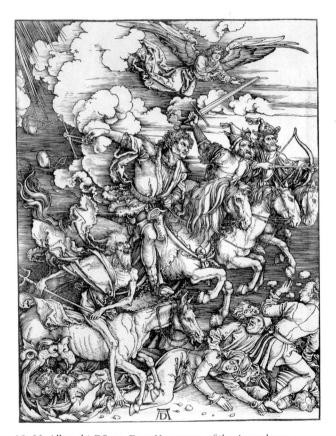

18-66. Albrecht Dürer. *Four Horsemen of the Apocalypse*, from *The Apocalypse*. 1497–98. Woodcut, 15½ x 11½" (39.4 x 28.3 cm). The Metropolitan Museum of Art, New York

Gift of Junius S. Morgan, 1919 (19.73.209)

17-79), by Martin Schongauer, whom he admired, and he adapted for woodcut Schongauer's technique for shading on the engraved plate, using a complex pattern of lines that model the forms with highlights against the tonal ground. His fifteenth-century training is evident in his meticulous attention to detail, decorative cloud and drapery patterns, and the foreground filled with large, active figures.

Perhaps as early as the summer of 1494, Dürer had begun to experiment with engravings, cutting the plates himself with artistry equal to Schongauer's. His growing

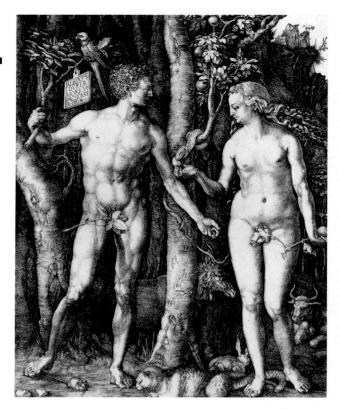

18-67. Albrecht Dürer. Adam and Eve. 1504. Engraving, $9^{7/8} \times 7^{5/8}$ " (25.1 x 19.4 cm). Philadelphia Museum of Art

interest in Italian art and theoretical investigations is reflected in his 1504 engraving Adam and Eve (fig. 18-67), which represents his first documented use of a canon of ideal human proportions. His nudes were based on Roman copies of Greek gods, probably seen as prints or small sculpture in the antique manner that had become so popular among European collectors by 1500. As idealized as the human figures may be, the flora and fauna are recorded with typically northern European microscopic detail. Dürer embedded the landscape with symbolic content related to the medieval theory that after Adam and Eve disobeyed God, they and their descendants became vulnerable to imbalances in body fluids that altered human temperament: An excess of black bile from the liver produced melancholy, despair, and greed; yellow bile caused anger, pride, and impatience; phlegm in the lungs resulted in a lack of emotion, lethargy, and disinterest; and an excess of blood made a person unusually optimistic but also compulsively interested in pleasures of the flesh.

These four human temperaments, or personalities, are symbolized here by the melancholy elk, the choleric cat, the phlegmatic ox, and the sensual rabbit. The mouse is a symbol of Satan, whose earthly power, already manifest in the Garden of Eden, was capable of bringing perfect human beings to a life of woe through their own bad choices. The parrot may symbolize false wisdom, since it can only repeat mindlessly what is said to it. Dürer's pride in his engraving can be seen in the prominence of his signature—a placard bearing his full name and date hung on a branch of the Tree of Life.

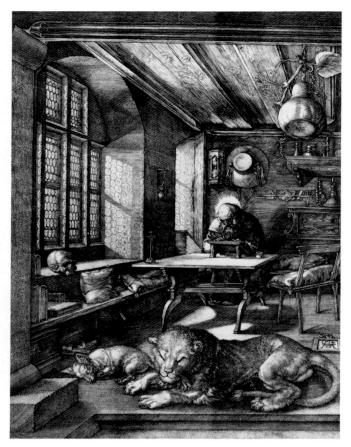

18-68. Albrecht Dürer. *Saint Jerome in His Study*. 1514. Engraving, 9⁵/₈ x 7³/₈" (24.5 x 18.7 cm). The British Museum, London

The books and pillows on the windowsill and the carefully positioned slippers below them create a marvelous study in receding forms in this engraving. The print also offers a study of light streaming in through the bull's-eye glass panes, projecting its harmonious pattern of circular and rectangular forms. In many ways this is an engraver's showpiece, demonstrating the artist's skill at implying a sense of color and texture by black line alone.

Dürer's familiarity with Italian art was greatly enhanced by a second, more leisurely trip over the Alps in 1505-1506. Thereafter, he seems to have resolved to reform the art of his own country by publishing theoretical writings and manuals that discussed Renaissance problems of perspective, ideal human proportions, and the techniques of painting. In his engraving Saint Jerome in His Study of 1514 (fig. 18-68), despite the limitations of his monochromatic medium, he integrated the rigid Italian one-point perspective system with the sensitive, naturalistic lighting effects of fifteenth-century northern European painting. Dürer displayed his technical ability in the carefully arranged furnishings and objects forming individual still-life groups. Yet the overwhelming message conveyed is not one of technical achievement but of a deeply felt joy in intellectual activity.

The contribution of Saint Jerome, a late-fourth/early-fifth-century scholar noted for his Latin translation of the Bible, was the subject of some controversy. Moreradical reformers venerated him for his rejection of

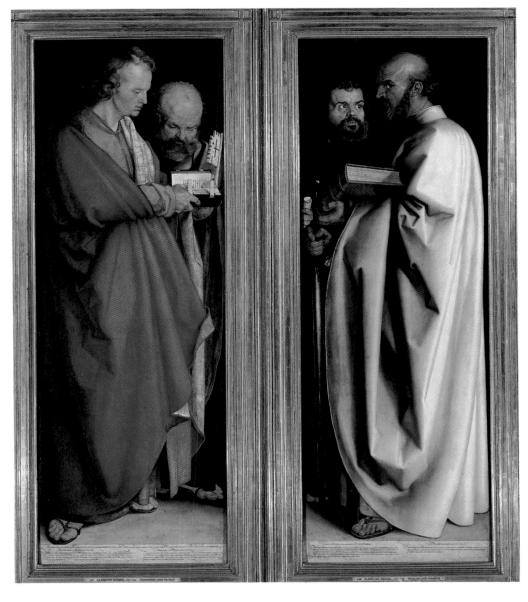

18-69. Albrecht Dürer.
Four Apostles,
1526. Oil
on panel, each
panel 7'1/2" x 2'6"
(2.14 x 0.76 m).
Alte Pinakothek,
Munich

worldly pleasures. Others, especially humanists, admired above all his scholarship. Dürer's image is clearly the humanist's. Jerome is surrounded by a reading stand, lamps, pens, and other writing equipment. The cardinal's hat on the wall reminds us that he had put aside worldly ecclesiastical power to bring the Scriptures to ordinary people. His emblem, the lion, asleep next to a little dog in the foreground, recalls Jerome's charity to animals and the story of his removing a thorn from a lion's paw, thus gaining the lifelong devotion of the beast. The hanging hourglass and the skull on the windowsill are *vanitas* symbols, reminders of the futility and brevity of human life. The large gourd, which in the biblical story of Jonah grew one night and died the next (Jonah 4:6–7), is another symbol of the fleeting nature of human life.

Dürer admired the writings of Martin Luther and had hoped to engrave a portrait of him, as he had other important Reformation thinkers. In 1526 the artist openly professed his belief in Lutheranism in a pair of inscribed panels commonly referred to as the *Four Apostles* (fig. 18-69). The paintings depict John, Peter, Paul, and Mark the Evangelist in an arrangement possibly intended to create an acceptable Protestant imagery. On the left

panel, the elderly Peter, the first pope, seems to shrink behind the young John, Luther's favorite evangelist. On the right panel, Mark is nearly hidden behind Paul, whose teachings and epistles were greatly admired by the Protestants. Dürer presented the panels to the city of Nuremberg, which had already adopted Lutheranism as its official religion. Long inscriptions below the figures (not legible here) warn the viewer not to be led astray by "false prophets" but to heed the words of the New Testament. Excerpts from the letters of Peter, John, and Paul, and the Gospel of Mark, are from Luther's German translation of the New Testament.

Luther, an avowed pacifist, never supported the destruction of religious art, and Dürer's gift to Lutheran Nuremberg was surely meant to demonstrate that a Protestant art was possible. Earlier, the artist had written: "For a Christian would no more be led to superstition by a picture or effigy than an honest man to commit murder because he carries a weapon by his side. He must indeed be an unthinking man who would worship picture, wood, or stone. A picture therefore brings more good than harm, when it is honourably, artistically, and well made" (cited in Snyder, page 347).

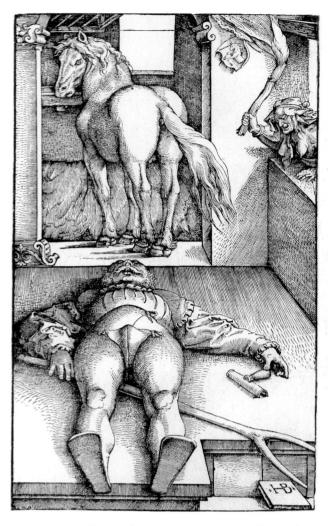

18-70. Hans Baldung Grien. Stupefied Groom. 1544. Woodcut, image 13¹⁵/16 x 7⁷/8" (33.8 x 19.8 cm). Staatliche Museen zu Berlin, Preussischer Kulturbesitz, Kupferstichkabinett

Hans Baldung Grien, Lucas Cranach the Elder, and Albrecht Altdorfer. Dürer's most successful pupil and lifelong friend, Hans Baldung (c. 1484-1545), received the nickname Grien, possibly from his habit of wearing green clothing while an apprentice from about 1503 to 1509. Baldung Grien, from a highly educated German family, spent most of his adult life in Strasbourg. Having specialized at first in religious altarpieces and stained glass, the artist adapted to the advent of Protestantism in Strasbourg in the late 1520s by painting portraits, classical subjects, and small Madonnas for private clients. He also benefited from the sale of his woodcuts, including the enigmatic Stupefied Groom (fig. 18-70), made in 1544, the year before his death. The scene shows a sturdy cavalry horse looking back at a groom, who is lying unconscious (or dead) on a barn floor as an old woman with a firebrand looks on from the window. The woman seems to have frightened the horse, which reacted by kicking the groom who was currying him. Baldung Grien's earlier prints included images of witches, as well as of wild horses symbolizing the baser human instincts, so this picture could have been intended as a moral lesson on the power of evil. The preliminary study for the print shows an even more radically foreshortened

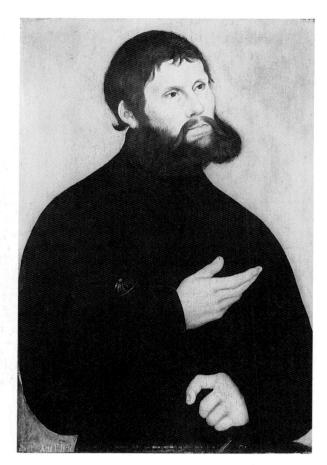

18-71. Lucas Cranach the Elder. *Martin Luther as Junker Jörg*. c. 1521. Oil on panel, 20½ x 13⁵/8" (52.1 x 34.6 cm). Kunstmuseum, Weimar, Germany

male figure and no grooming equipment, so the perspective study may have been the focus around which the artist then built his picture.

Another of Dürer's friends, Lucas Cranach the Elder (1472-1553), had moved his workshop to Wittenberg in 1504, after a number of years in Vienna. In addition to the humanist milieu of its university, Wittenberg also offered the patronage of the Saxon court. Appointed court painter in 1505, Cranach created all manner of works, including woodcuts, altarpieces, and many portraits. Cranach was Martin Luther's favorite painter, and one of the most interesting among Cranach's roughly fifty portraits of Luther is Luther as Junker Jörg (fig. 18-71). It was painted after the reformer's excommunication by Pope Leo X in early 1521—and after a meeting of princes and rulers of the German states of the Holy Roman Empire, held in the city of Worms in the spring of 1521, had declared Luther's ideas heresy and Luther himself an outlaw to be captured and handed over to Emperor Charles V. Smuggled out of Worms by Saxon agents, Luther returned to Wittenberg wearing a black beard and moustache, disguised as a knight named Jörg, or George. As his religious commissions dwindled, Cranach's later work tended to be portraits, hunting scenes, and mythological subjects.

Landscape, with or without figures, was an important new category of imagery after the Reformation. Among the most accomplished German landscape painters of the period was Albrecht Altdorfer (c. 1480–1538), who spe-

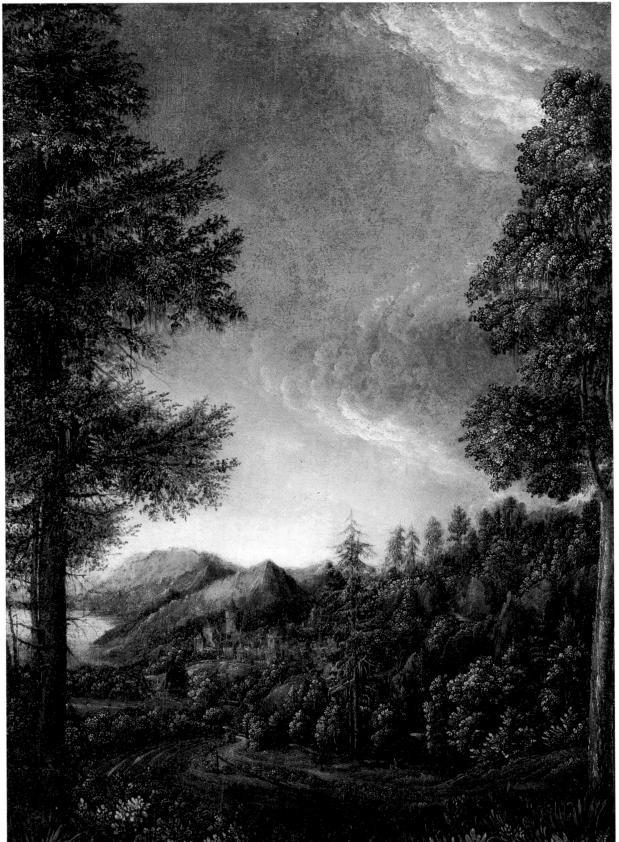

18-72. Albrecht
Altdorfer.
Danube
Landscape.
c. 1525.
Oil on
panel,
12 x 8³/₄"
(30.5 x
22.2 cm).
Alte Pinakothek,
Munich

cialized in portraying the Danube River Valley. He probably received his early training in Bavaria from his painter father, then became a citizen in 1505 of the city of Regensburg, located in the Danube River Valley, where he remained for the rest of his life. In addition to civic con-

struction projects, Altdorfer executed many paintings, often combining religious and historical subjects in magnificent wooded Danube landscapes. The artist's varied talents are barely hinted at by the single work illustrated here, his *Danube Landscape* of about 1525 (fig. 18-72), a

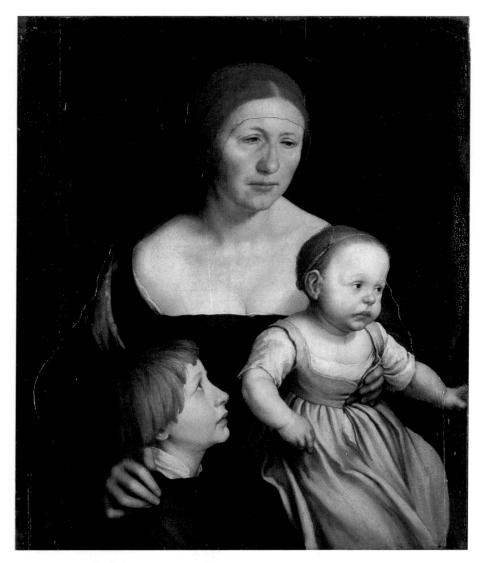

18-73. Hans Holbein the Younger. *Artist's Wife and Children*. 1528/29. Tempera on paper on limewood, 301/8 x 251/4" (79.5 x 65.5 cm). Öffentliche Kunstsammlung, Basel, Switzerland

fine example of pure landscape painting without a narrative subject or human figures, unusual for the time. A small work on vellum laid down on a wood panel, the Landscape seems to be a minutely detailed view of the natural terrain, but a close inspection reveals an inescapable picturesqueness—far more poetic and mysterious than Dürer's scientifically observed views of nature—in the low mountains, gigantic lacy pines, neatly contoured shrubberies, and fairyland castle with redroofed towers at the end of a winding path. The eerily glowing yellow-white horizon below roiling gray and blue clouds in a sky that takes up more than half the composition suggests otherworldly scenes.

Hans Holbein the Younger. A talent for portrait painting was important for nearly all German artists from the 1520s, but Hans Holbein the Younger eventually owed his entire livelihood to it. Born in Augsburg in 1497 (d. 1543), the son of a painter of altarpieces, Holbein worked for a time in Basel, Switzerland, traveled to Italy in 1518–1519, then returned to Switzerland. He received

portrait and religious commissions but also capitalized on the growing popularity of fresco decorations for house facades. After the humanist scholar Erasmus of Rotterdam settled in Basel in 1521, Holbein became his portraitist and close friend. The Protestant religion spread to Basel in 1522, and by 1526 religious problems there had greatly escalated. Holbein left with letters of introduction from Erasmus to humanist friends in Antwerp and London, where he received lucrative portrait commissions before returning home in 1528.

Although Holbein had officially become a Protestant by 1532, harassment from the reformers sent him once again, with letters from Erasmus, to England. Before leaving Basel, however, he painted a portrait of his wife and two children (fig. 18-73), perhaps meant to be paired with a self-portrait placed on the right. The pyramidal composition and monumental figures of *Artist's Wife and Children* immediately recall a Raphael *Madonna and Child* (see fig. 18-5), but the power of Holbein's work lies in the unidealized, beloved features of his subjects. His wife is already suffering from the eye disease that would eventually blind

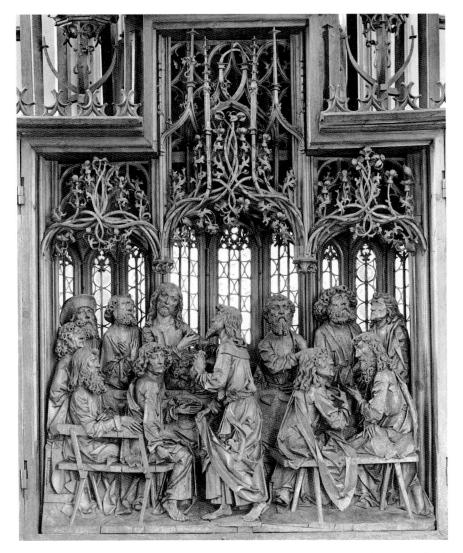

18-74. Tilman Riemenschneider. Last Supper, center of the Altarpiece of the Holy Blood, Sankt Jakobskirche, Rothenburg ob der Tauber, Germany. c. 1499–1505. Limewood, height of tallest figure 39" (99.1 cm); height of altar 29'6" (9 m)

her, and the children seem on the verge of tears as they look out to the far right, perhaps at a painting of their father. Distilled in this work is the sense of hopelessness that prompted the artist to leave his family again. He had every intention of returning to Basel from England, as he had earlier, but Holbein, while serving Henry VIII as court painter, died of the plague in London in 1543.

Sculpture

Fifteenth-century German sculpture was closely related to that of France and Flanders, but in the sixteenth century it began slowly but persistently to show the influence of the Italian Renaissance and Mannerist styles. Although German sculptors worked in every medium, they produced some of their finest and most original work in this period in limewood, from the linden or limetree, which grew abundantly in central and southern Germany. Generally wood images had been gilded and painted until Tilman Riemenschneider (active 1483–1531) introduced a natural wood finish.

Riemenschneider, from about 1500 on, ran the largest workshop in Würzburg, which included specialists in every medium of sculpture; he also was politically active in the city's government. Riemenschneider's work attracted patrons from other cities, and in 1501 he signed a contract for one of his major creations, the *Altarpiece of the Holy Blood*, for the Sankt Jakobskirche (Church of Saint James) in Rothenburg ob der Tauber, where a relic said to be a drop of Jesus' blood was preserved. The construction was to be nearly 30 feet high and made entirely of limewood. A specialist in wood shrines began work on the frame in 1499, and Riemenschneider later provided the figures. The relative value of their contributions can be judged from the fact that the frame carver received fifty florins and Riemenschneider sixty.

The main scene of the altarpiece is the *Last Supper* (fig. 18-74). Like his Italian contemporary Leonardo da Vinci (see fig. 18-2), Riemenschneider depicted the moment of Jesus' revelation that one of his followers would betray him. Unlike Leonardo, Riemenschneider composed his group with Jesus off-center at the left and the

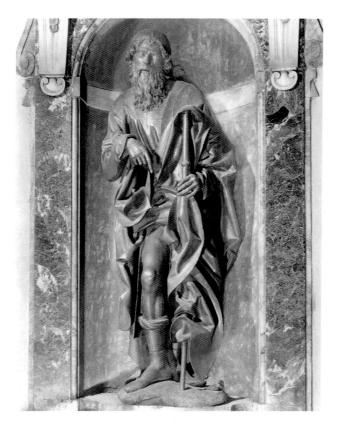

18-75. Veit Stoss. Saint Roche, Church of Santissima Annunziata, Florence. c. 1510–20. Limewood, height 5'7" (1.7 m)

Riemenschneider's style is characterized by large heads, prominent features, and elaborate hair treatments with thick wavy locks and deeply drilled curls. The muscles, tendons, and raised veins of the hands and feet are especially lifelike, as are the sharp cheekbones, sagging jowls, baggy eyes, and slim figures of Jesus and his followers. Riemenschneider's studio workers copied either from drawings or from other carved examples, including different modes of drapery rendering. Rather than creating individual portrayals, Riemenschneider simply repeated this limited number of types. Here, the deeply hollowed folds and active patterning of the drapery create strong highlights and dark shadows that unify the figural composition and the intricate carving of the framework. The scene is set in a three-dimensional space with actual benches for the figures to rest on and windows at

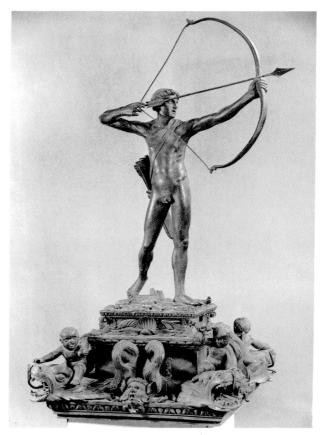

18-76. Peter Flötner. Apollo Fountain. 1532. Bronze, height without base 30" (76.2 cm). Germanisches Nationalmuseum, Nuremberg

the rear glazed with real bull's-eye glass. Natural light from the church's windows illuminates the scene with constantly changing effects, according to the time of day and weather. Despite his enormous production of religious images for churches, Riemenschneider's career ended when his support of the 1525 Peasants' War led to a fine and imprisonment just six years before his death.

Veit Stoss (c. 1438–1533), of Nuremberg, spent his career from 1477 to 1496 mainly in Cracow, Poland, where he became wealthy from his sculpture, architectural commissions, and financial investments. Upon returning to Nuremberg, he began to specialize in limewood sculpture, probably because commissions in other mediums were already dominated by established artists. Unlike Riemenschneider, he ran a small operation whose output was characterized by an easily recognizable, personal style expressing an obvious taste for German realism. Stoss's unpainted limewood works show a special appreciation for the wood itself, which he exploited for its inherent colorations, grain patterns, and range of surface finishes.

One statue in this vein is his lifesize *Saint Roche* of about 1510–1520 (fig. 18-75), first documented in 1523 in the Church of Santissima Annunziata in Florence, where it remains today. Stoss's style is often described as calligraphic because it suggests decorative lettering in the flowing linear **S** curves, swirls, and flourishes so evident in the drapery patterning. Like Riemenschneider, Stoss favored elaborate locks of hair and deeply cut drapery folds, which often contributed to dramatic effects of

lighting. His approach to physical features varied according to the subject, from minutely detailed realism to smooth, idealized countenances for women saints and the young. Images such as the Saint Roche, the patron saint for protection against the plague, soon afterward became prime objects of disdain and destruction in the north, but Stoss managed to ride out the rising tide of religious iconoclasm.

Among the earliest German sculptors to respond with enthusiasm to the Italian Renaissance movement was Peter Flötner (1486/95-1546). A Swiss native, Flötner became a Nuremberg citizen in 1523, on the eve of the disruptions that made his career a concentrated struggle for survival. Stylistic changes in his work suggest that he may have traveled to Italy about 1530, just before the creation of the cast-bronze Apollo Fountain (fig. 18-76). Many northern artists had access to Italian prints, however, and Flötner may have studied Italian engravings. His use of mythological subjects, such as this idealized sun god-archer, was a perfect means of making the transition from religious patronage, the main source of earlier sculpture commissions, to secular and civic markets. He created several classical fountains and filled gaps between large commissions by producing small sculptural works for home decoration, designs for goldsmiths, and popular prints.

ENGLAND England, in contrast to continental AND THE Europe, was economically and politically stable enough to sustain boun-ENGLISH tiful arts during the Tudor dynasty in COURT the sixteenth century. Henry VIII (ruled 1509-1547) was known for his

love of music, but he also competed with the elegant courts of Francis I and Charles V in the visual arts. Although direct contacts with Italy became difficult after Henry's break with the Roman Catholic Church in 1534, the Tudors so favored Netherlandish, German, and French artists that a vigorous native school of painters did not emerge until the eighteenth century. English architects fared better, developing their own style, which incorporated classical features but was generally independent of direct Italian influence. Nevertheless, the first architectural manual in English, published in 1563, was written by John Shute, who had spent time in Italy. Also available were stylebooks and treatises by Flemish, French, and German architects, as well as a number of books on architectural design by the Italian architect Sebastiano Serlio.

Court Painters

A remarkable record of the appearance of the Tudor monarchs survives in portraiture. Hans Holbein the Younger, who had worked for the humanist circle around Sir Thomas More during his first visit to London from 1526 to 1528, was appointed court painter to Henry VIII about four years after he returned to England in 1532. One of Holbein's official portraits of Henry at age thirtynine (fig. 18-77), according to the inscription on the dark

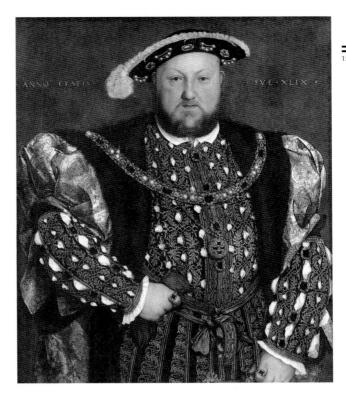

18-77. Hans Holbein the Younger. Henry VIII. c. 1540. Oil on panel, 32½ x 29½" (82.6 x 75 cm). Galleria Nazionale d'Arte Antica, Rome

Holbein used the English king's great size to advantage for this official portrait, enhancing Henry's majestic figure with embroidered cloth, fur, and jewelry to create one of the most imposing images of power in the history of art. Although in the sixteenth century gluttony was considered "the English vice," the laying of a stupendous feast at every court meal was an expression of English royal superiority. Even Henry's illegitimate son, the six-year-old duke of Richmond, is recorded as having had set before him as an evening meal soup, boiled meat, mutton, roasted rabbits, roasted birds of different types, various vegetables and fruits, breads, and alcoholic beverages. The young duke's caretakers were then charged with distributing what must have been the considerable leftovers to the beggars at the gate.

background, was painted about 1540, although the dress and appearance of the king had already been established in an earlier prototype based on sketches of the king's features. Henry's huge frame—he was well over 6 feet tall and had a 54-inch waist in his maturity—is covered by the latest style of dress, a short puffed-sleeved cloak of heavy brocade trimmed in dark fur, a narrow, stiff white collar fastened at the front, and a doublet slit to expose his silk shirt and encrusted with gemstones and gold braid. Henry was quite vain and was so fascinated with Francis I that he attempted to emulate and surpass the French king's appearance (see fig. 18-47). After Francis had set a new style by growing a beard, Henry also grew one after about 1517, as shown in this portrait.

Holbein was not the highest-paid painter in Henry VIII's court. That status belonged to a Flemish woman named Levina Bening Teerling, who worked in England

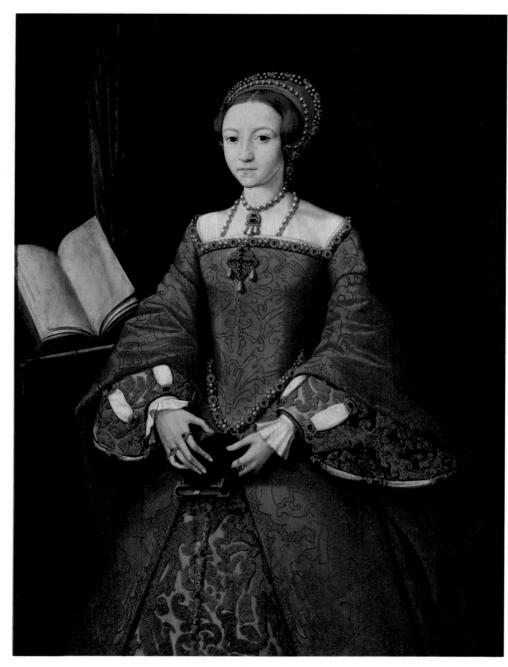

18-78. Attributed to Levina Bening Teerling. *Elizabeth I as a Princess*. c. 1559. Oil on oak panel, $42^{3}/4 \times 32^{1}/4$ " (108.5 x 81.8 cm). The Royal Collection, Windsor Castle, Windsor, England

for thirty years. The disappearance of her work is an arthistorical mystery. At Henry's invitation to become "King's Paintrix," she arrived in London in 1545 from Bruges, accompanied by her husband. She maintained her court appointment until her death around 1576 in the reign of Elizabeth I. Because Levina was the grand-daughter and daughter of Flemish manuscript illuminators, she is assumed to have painted mainly miniature portraits or scenes on vellum and ivory. One lifesize portrait frequently attributed to her, but by no means securely, is that of Elizabeth Tudor as a young princess (fig. 18-78), painted around 1559. Elizabeth wears an adaptation of the so-called French hood popularized by her mother, Anne Boleyn. The pearled headcap is set

back to expose the hair around her face, while the rest of the hood falls on her shoulders at the back. Her brocaded outer dress, worn over a rigid hoop, is split to expose an underskirt of cut velvet. Although her features are softened by youth and no doubt idealized as well, the princess's long, high-bridged nose and the unusual fullness below her small lower lip give her a distinctive appearance. The prominently displayed books were no doubt included to signify Elizabeth's well-known love of learning.

About the time Elizabeth sat for this portrait in 1559, her twelve-year-old half brother, the Protestant Edward VI, was king, and her half sister, Mary Tudor, was next in line for the throne. But Mary was a Catholic and Edward

18-79. Anthonis Mor. *Mary Tudor*. 1554. Panel, 42⁷/₈ x 33" (108.9 x 83.8 cm). Museo del Prado, Madrid

After Mary Tudor's accession to the English throne, the Scottish Protestant Reformation leader John Knox, royal chaplain under her brother Edward VI, fled into exile in Switzerland. In 1558 he published The First Blast of the Trumpet against the Monstrous Regiment of Women, expressing his view that it was against God's law for a woman to hold supreme political power. The English, however, had little problem with female rule, and public objections to it were rare, perhaps because of a strongly held belief in hereditary descent. Queen Mary I came to be known in history, however, as "Bloody Mary" for her zealous attempt to reestablish the Roman Catholic Church in England. During her reign of less than five years, 280 heretics were burned at the stake, compared with 81 during the long reign of her father, Henry VIII, and only 4 in the more than forty-four years that her half sister Elizabeth I was on the throne.

and his advisers were Protestants. Therefore, at Edward's death in 1553, the regent tried to proclaim Edward's cousin, Lady Jane Grey, successor to the throne. The thirty-seven-year-old Mary, every bit as iron-willed and ferocious as her father, Henry VIII, called for the people's support and rallied over 40,000 armed volunteers, who put her on the throne within two weeks. Queen Mary quickly reinstated Catholic practice, and in July 1554 she married the future King Philip II of Spain.

In her marriage portrait by the internationally renowned painter Anthonis Mor (1512/25–1575), brought to London by Philip, Mary I is shown with strong, unrefined features and a bold, self-assertive look (fig. 18-79). She holds a pink Tudor rose, which symbolizes that the

18-80. Nicholas Hilliard. *George Clifford, 3rd Earl of Cumberland (1558–1605)*. c. 1585–89. Watercolor on vellum on card, oval 2³/₄ x 2³/₁₆" (7.1 x 5.8 cm). The Nelson-Atkins Museum of Art, Kansas City, Missouri Gift of Mr. and Mrs. John W. Starr through the Starr Foundation. F58-60/188

Tudors were the heirs of two earlier English dynasties—the houses of York, whose symbol was the white rose, and of Lancaster, whose symbol was the red rose. Mor's skill at portraying the textures of elegant materials is balanced by his ability to use a dynamic pose and engaging expression to portray a real, even if somewhat idealized, human being.

In 1570, while Levina Teerling was still active at Elizabeth's court (ruled 1558–1603), Nicholas Hilliard (1547–1619) arrived in London from southwest England to pursue a career as a jeweler, goldsmith, and painter of miniatures. Hilliard never received a court appointment but worked instead on commission, creating miniature portraits of the queen and court notables, including George Clifford, third earl of Cumberland (fig. 18–80). This former admiral was a regular participant in the tilts (jousts) and festivals celebrating the anniversary of Elizabeth I's ascent to the throne. In Hilliard's miniature, Cumberland wears a richly engraved and gold-inlaid suit of armor, forged for his first appearance in 1583 at the

18-81. Robert Smythson. Wollaton Hall, Nottinghamshire, England. 1580-88

WHAT THE QUEEN'S CHAMPION WORE AT THE TILTS

The medieval tradition of tilting competitions at English festivals and public celebrations continued during Renais-

sance times. Perhaps the most famous of these, the Accession Day Tilts, were held annually to celebrate the anniversary of Elizabeth I's coronation. The gentlemen of the court, dressed in armor made especially for the occasion, rode their horses from opposite directions, trying to strike each other with long lances. Each pair of competitors galloped past each other six times, and the judges rated their performances the way boxers are given points today. Breaking of a competitor's lance was comparable to a knockout.

The elegant armor worn by George Clifford, third earl of Cumberland, at the Accession Day Tilts has been preserved in a nearly complete state in the collection of the Metropolitan Museum of Art in New York.

In honor of the queen, the armor's surface was decorated with engraved Tudor roses and capital *Es* back to back. As the Queen's Champion from 1590 on, Clifford also wore her jeweled glove attached to his helmet as he met all comers in the courtyard of Whitehall Palace in London.

Made by Jacob Halder in the royal armories at Greenwich, the 60-pound suit of armor is recorded in the sixteenth-century *Almain Armourers Album* along with its "exchange pieces." These allowed the owner to vary his appearance by changing mitts, side pieces, or leg protectors, and also provided backup pieces if one piece were damaged.

Armor of George Clifford, 3rd Earl of Cumberland, made in the royal workshop at Greenwich, England. c. 1580-85. Steel and gold, height 5'91/2" (1.77 m). The Metropolitan Museum of Art, New York

Munsey Fund, 1932 (32.130.6)

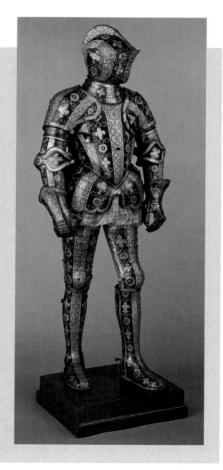

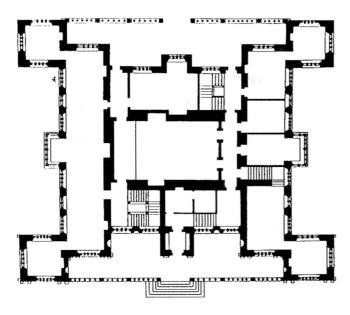

18-82. Plan of Wollaton Hall (drawn by Giroux, after John Thorpe)

tilts (see "What the Queen's Champion Wore at the Tilts," opposite). Hilliard had a special talent for giving his male subjects an appropriate air of courtly jauntiness and depicting them in extravagant costumes and hairstyles without making them appear foolish. Cumberland, a man of about thirty with a stylish beard, moustache, and curled hair, is humanized by his direct gaze and unconcealed receding hairline. Cumberland's motto, "I bear lightning and water," is inscribed on a stormy sky, with a lightning bolt in the form of a caduceus (the symbolic staff with two entwined snakes), one of his emblems.

Architecture

In the years after his 1534 break with the Roman Catholic Church, Henry VIII, as the newly declared head of the Church of England, dissolved the monastic communities in England, seized their land, and sold or gave it to favored courtiers. Many properties were bought by speculators who divided and resold them. To increase support for the Tudor dynasty, Henry and his successors created a new nobility by granting titles to rich landowners and officials. To display their wealth and status, many of these newly created aristocrats embarked on extensive building projects after about 1550. They built lavish country residences, which sometimes surpassed the French châteaux in size and grandeur.

The first English architect of the Renaissance period known at present by name was Robert Smythson (c. 1535–1614), who was commissioned in 1580 to build Wollaton Hall near Nottingham. The classical principles that Smythson applied to his basic design, as well as the superimposed orders on the pilasters flanking the windows and capping the corners (fig. 18-81), undoubtedly

drew on the books of Sebastiano Serlio, perhaps the greatest source of Italian architectural ideas outside Italy. The solid square plan of Wollaton Hall (fig. 18-82) is both geometric and symmetrical: a two-story central block with identical three-story pavilions at each corner. Smythson's confident design is visible in his bold and effective integration of nonclassical elements into the elevation. Although conforming to a classical symmetry of design on all four exterior faces, the building also brings together huge, rectangular glazed windows, Flemish gables disguising the pavilion roofs, and a castlelike keep rising from the central block, complete with arched double windows and corner turrets.

SPAIN AND THE SPANISH COURT

Philip II, the only son of Charles V and Isabella of Portugal, preferred Spain as his permanent residence and Madrid as his capital. His long reign as king, from 1556 to 1598, saw the zenith of Spanish power. Under

Philip's direction, Spain halted the advance of Islam in the Mediterranean and secured control of most of the Americas. Despite enormous effort and wealth, however, Philip could not suppress the revolt of the northern Netherlands, and his navy, the famous Spanish Armada, was destroyed by the English in 1588. From an early age, Philip was a serious art collector: for more than half a century he patronized and supported artists in Spain and abroad.

Architecture

Philip built El Escorial, the great monastery-palace complex outside Madrid, seen here in a detail from a painting (fig. 18-83), partly to comply with his father's direction to construct a "pantheon" in which all Spanish kings might be buried and partly to house his court and government. The basic plan was a collaboration between Philip and Juan

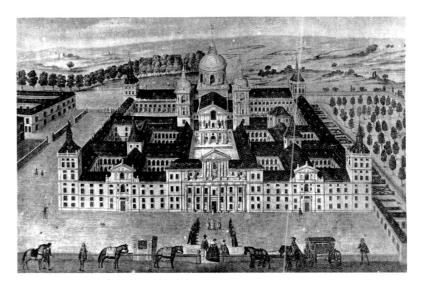

18-83. Juan Bautista de Toledo and Juan de Herrera. El Escorial, Madrid. 1563–84. 625 x 520' (205 x 160 m). Detail from an anonymous 18th-century painting

1580

Bautista de Toledo, Michelangelo's supervisor at Saint Peter's from 1546 to 1548. Summoned from Italy by the king in 1559, Juan Bautista provided a design that reflected his indoctrination with Bramantean classical principles in Rome. The king himself dictated the severity of the design, and El Escorial's grandeur comes from its great size, excellent masonry, and fine proportions. The complex comprises not only the royal residence but the Royal Monastery of San Lorenzo and a church whose crypt served as the royal burial chamber; many people's visions were involved in its creation. From Juan Bautista's death in 1567 until 1569, an Italian architect directed the project. In 1572 Juan Bautista's original assistant, Juan de Herrera, was appointed architect and immediately changed the design, adding second stories on all wings and breaking the horizontality of the main facade with a central frontispiece that resembled superimposed temple fronts. Before beginning the church, Philip solicited the advice of Italian architects, including Vignola and Palladio, and the final design was a composite of ideas that Philip approved and Herrera carried out. Although not a replica of any Italian design, the church embodies Italian classicism in its geometric clarity and symmetry and the use of superimposed orders on the temple-front facade.

Sculpture

Philip's conservative tastes in architecture were countered by his commissions and purchase of lavish paintings and sculpture to glorify his reign and adorn the interior of El Escorial. He provided so much work for the Leoni, the Milanese family of sculptors discussed earlier, that Pompeo Leoni (c. 1533-1608) finally moved to Madrid. Among his works are lifesize bronze portrait statues of Philip II and his family, placed inside the church as funerary and dynastic monuments (fig. 18-84). The group kneels in prayer facing the main altar in the Doric order gallery overlooking the sanctuary, just above a private oratory, or chapel, where the family actually worshiped. Directly opposite is a similar family group around Charles V. Shown with Philip are his wives Maria of Portugal, Elizabeth of Valois, and Anna of Austria, and his son by Maria, Don Carlos. Mary Tudor is conspicuously not among them, possibly because Philip's Armada had been destroyed by her sister and successor, Elizabeth I.

Painting

The most famous painter in Spain in the last quarter of the sixteenth century was the Greek painter Kyriakos (Domenikos) Theotokopoulos (1541–1614), who arrived in 1577 after working for ten years in Italy. El Greco (the Greek), as he is called, was trained as an icon painter in the Byzantine manner in his native Crete, then under Venetian rule. In about 1566 he went to Venice and entered Titian's shop, but he must also have closely studied the paintings of Tintoretto and Veronese. From about 1570 to 1577, he worked in Rome, apparently without finding sufficient patronage. Probably encouraged by Spanish church officials he met in Rome, El Greco immigrated to Spain and settled in Toledo, where he soon was given major commissions. He appar-

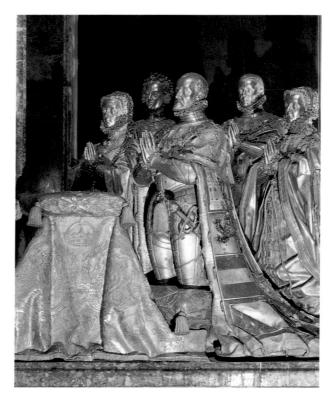

18-84. Pompeo Leoni. *Philip II and His Family*, private chapel of the royal family, El Escorial, Madrid. 1591–98. Bronze, lifesize

ently hoped for a court appointment, but Philip II disliked the one large painting he had commissioned from the artist for El Escorial and never gave him work again.

Toledo was an important cultural center, and El Greco soon joined the circle of humanist scholars who dominated its intellectual life. An intense religious revival was also under way in Spain, expressed not only in the poetry of the Spanish mystics but in the impassioned preaching of Ignatius Loyola (c. 1491–1556), the founder of a new religious order called the Society of Jesus, or Jesuits. El Greco's style, rooted in Byzantine religious art but strongly reflecting Tintoretto's Venetian love of rich color and loose brushwork, was the ideal vehicle to express in paint the intense spirituality of the two great Spanish mystics, Teresa of Ávila (1515–1582) and her follower John of the Cross (1542–1591), both later canonized.

In 1586, the artist was commissioned by the Orgaz family to paint a large canvas illustrating a legend from the fourteenth century, the *Burial of Count Orgaz* (fig. 18-85). The count had been a great benefactor of the Church, and at his funeral Saints Augustine and Stephen were said to have appeared and lowered his body into his tomb as his soul simultaneously was seen ascending to heaven. In El Greco's painting the miraculous burial takes place slightly off-center in the foreground, while Orgaz's tiny ghostly soul is lifted by an angel along the central axis through the heavenly hosts toward the enthroned Christ at the apex of the canvas. Depicting the legend also allowed El Greco to paint a group portrait of the local aristocracy and religious notables, who fill up the space around the burial scene. El Greco placed his eight-year-old

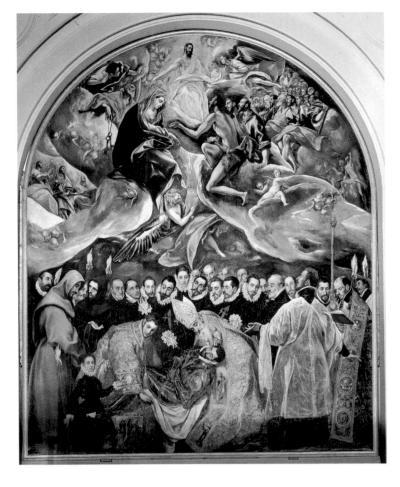

18-85. El Greco. *Burial*of Count Orgaz,
Church of Santo
Tomé, Toledo,
Spain. 1586.
Oil on canvas,
16' x 11'10"
(4.88 x 3.61 m)

son at the lower left next to Saint Stephen and signed the painting on the boy's white kerchief. El Greco may have put his own features on the man just above the saint's head, the only one who looks straight out at the viewer.

In composing the painting, El Greco used a Mannerist device reminiscent of Rosso and Pontormo, filling up the pictorial field with figures and eliminating specific reference to the spatial setting (see figs. 18-37, 18-38). He has distinguished between earth and heaven by creating a separate light source above in the figure of Christ, who sheds an otherworldly luminescence quite unlike the natural light below. The two realms are connected, however, by the descent of the light from heaven to strike the priestly figure in the alb, a long-sleeve white vestment, at the lower right.

Late in his life, El Greco commemorated Toledo in *View of Toledo*, a topographical cityscape transformed by a stormy sky and a narrowly restricted palette of greens and grays into a mystical illusion (fig. 18-86). This conception is very different from Altdorfer's peaceful, idealized *Danube Landscape* of nearly a century earlier (see fig. 18-72). If any precedent comes to mind, it is the lightningrent sky and pre-storm atmosphere in Giorgione's *Tempest* (see fig. 18-27). In El Greco's painting the geography and architecture of Toledo seem to have been overridden by the artist's mental state and desire to convey his emotions.

The emotionalism and dramatic light effects of El Greco's work would be echoed by painters in early-seventeenth-century, or early Baroque, styles in Europe. The drive to discover all that could be learned about nature and the world continued and intensified, but the way this fascination was expressed transformed the arts.

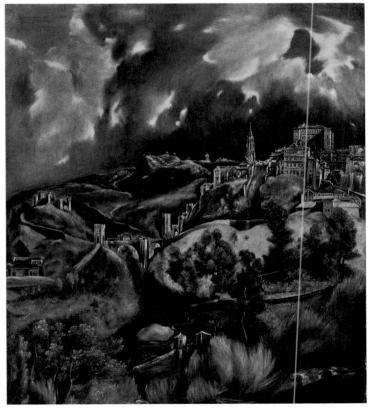

18-86. El Greco. *View of Toledo*. 1612. Oil on canvas, 47³/₄ x 42³/₄" (121 x 109 cm). The Metropolitan Museum of Art, New York

The H. O. Havemeyer Collection. Bequest of Mrs. H. O. Havemeyer, 1929 (29.100.6)

Velázquez Water Carrier of Seville c. 1619

Banqueting House 1619-22

Van Dyck

Leyster Self-Portrait 1635

Saint Peter's Square 1656-57

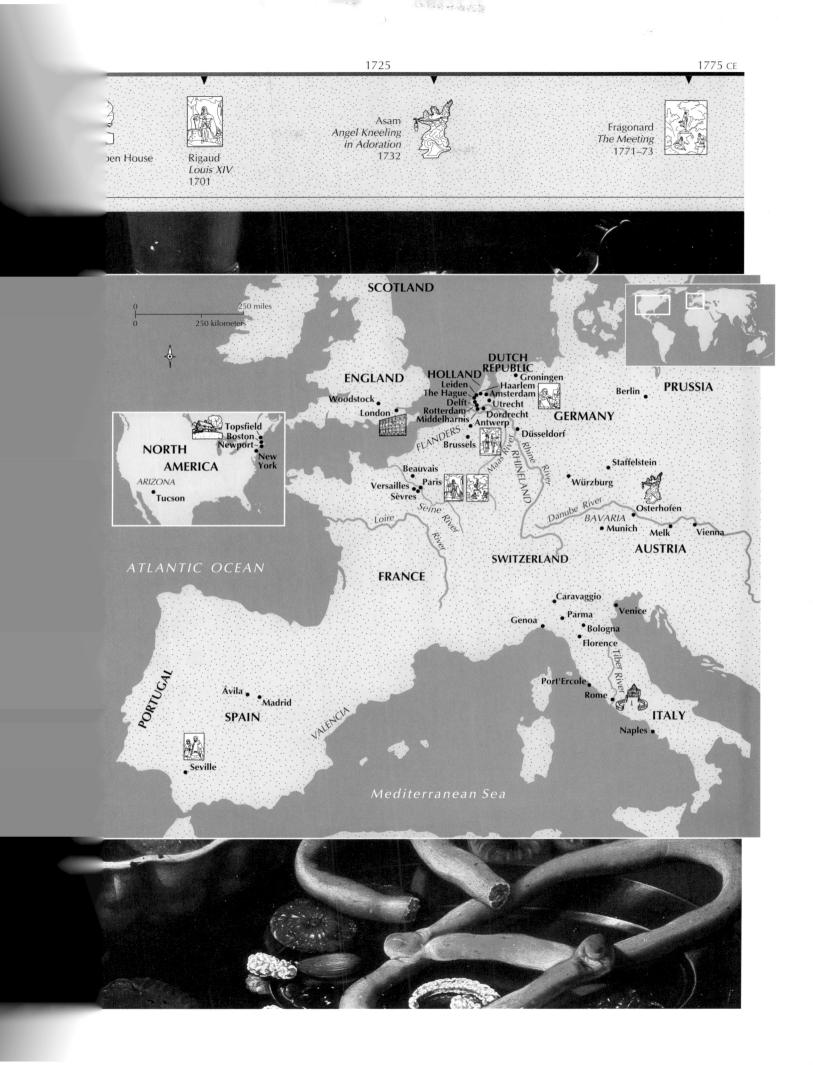

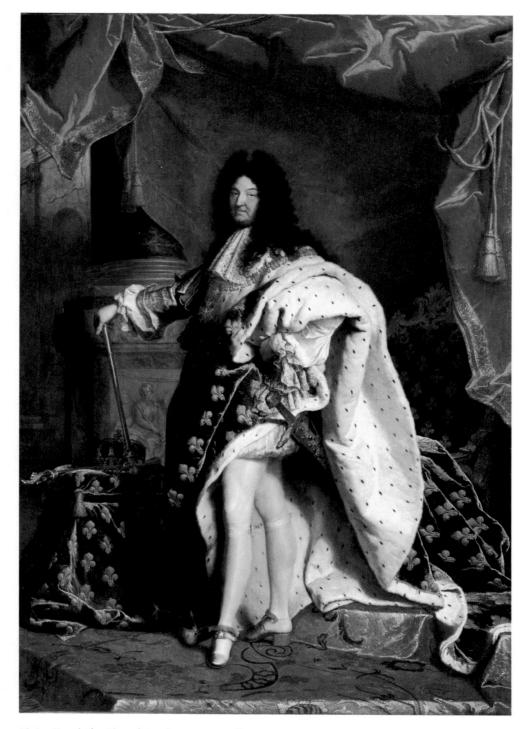

19-1. Hyacinthe Rigaud. *Louis XIV.* 1701. Oil on canvas, 9'2" x 7'10³/₄" (2.79 x 2.4 m). Musée du Louvre, Paris

n Hyacinthe Rigaud's 1701 portrait of Louis XIV, the richly costumed monarch known as le Roi Soleil ("the Sun King") is presented to us by an unseen hand that pulls aside a huge billowing curtain (fig. 19-1). Showing off his elegant legs, of which he was quite proud, the sixty-three-year-old French monarch poses in an elaborate robe of state, decorated with gold fleurs-de-lis and white ermine, and he wears the red-heeled

1575 1775

built-up shoes he had invented to compensate for his shortness. At first glance, the face under the huge wig seems almost incidental to the overall grandeur. Yet the directness of Louis XIV's gaze makes him movingly human, despite the pompous pose and the distracting magnificence that surrounds him. Rigaud's genius in portraiture was always to capture a good likeness while idealizing his subjects' less attractive features and giving minute attention to the virtuoso rendering of textures and materials of the costume and setting.

Rigaud had a workshop that produced between thirty and forty such portraits a year. From his meticulous business records, we know the cost of his materials, the salaries of his employees, and the prices he charged. His portraits, for example, varied in price according to whether the entire figure was painted from life or Rigaud merely added a portrait head to a stock figure placed in a composition he had designed but his workshop had executed.

Rigaud's long career spanned a time of great change in Western art. Not only did new manners of representation emerge, but where art had once been under the patronage of the Church and the aristocracy, a kind of broad-based commercialism arose that was reflected not only by Rigaud's "mass-produced" portraits but also by the thousands of still-life painters producing works for the many households that could now afford them. These artistic changes of the seventeenth and eighteenth centuries, the Baroque period, took place in a cultural context in which individuals and organizations were grappling with the effects of religious upheaval, economic growth, political turbulence, and a dramatic explosion of scientific knowledge.

THE Baroque Period

THE DUE astantism was already established firmly and irrevocably in much of northern Europe. The permanent division within Europe between Ro-

man Catholicism and Protestantism had a critical effect on European art. In response to the Protestant Reformation of the early sixteenth century, the Roman Catholic Church had embarked in the 1550s on a program of renewal known as the Counter-Reformation. As part of the program, the Church used art to encourage piety among the faithful and to persuade those it regarded as heretics to return to the fold. Counter-Reformation art was intended to be both doctrinally correct and visually and emotionally appealing so that it could influence the largest possible audience. Both the Catholic Church and the Catholic nobility supported ambitious building and decoration projects to achieve these ends.

There was also a variety of civic projects—buildings, sculpture, and paintings—undertaken to support numerous political positions throughout Europe, and private

patrons continued to commission works of art. Economic growth in most European countries helped create a large, affluent middle class eager to build and furnish fine houses and even palaces. By the late seventeenth century, Colonial America, both North and South, was also prospering and had eager buyers for art of every type and quality. The art produced in the American colonies was closely related to, although generally distinct from, that of Europe. In both Europe and America, building projects ranged from enormous churches and palaces to stage sets for plays and ballets, while painting and sculpture varied from large religious works and history paintings to portraits, still lifes, and genre, or scenes of everyday life. At the same time, scientific advances forced Europeans to question how they viewed the world. Of great importance was the growing understanding that the Earth was not the center of the universe but was a planet revolving around the Sun. In the eighteenth century, scientific literature became so abundant that the period has been called the Age of Enlightenment.

Within this cultural climate Baroque and Rococo art

PARALLELS

Europe and North America	<u>1575–1675</u>	<u>1675–1775</u>
Italy	Il Gesù; Pope Sixtus V; Farnese Ceiling; Gianlorenzo Bernini; first completely sung opera; Francesco Borromini; Caravaggio's <i>Entombment</i> ; Maderno's facade of Saint Peter's; Galileo constructs and improves telescope; Reni's <i>Aurora</i> ; Pope Urban VIII	Vivaldi's <i>Four Seasons</i> ; Pope Clement XIV bans Jesuits
France	King Henri IV; Nicolas Poussin; Claude Lorrain; King Louis XIII (Marie de' Medici as regent); French Royal Academy founded; Descartes's <i>Principles of Philosophy</i> ; wars with Spain end; King Louis XIV; Molière's <i>Le Misanthrope</i> ; Louvre facade begun; enlargement of Versailles begun	Jean-Antoine Watteau; Jean-Siméon Chardin; François Boucher; Honoré Frago- nard; chinoiserie design; Voltaire's Candide; Clodion's Rococo sculpture
Spain	Spain annexes Portugal; Jusepe de Ribera; Francisco de Zurbarán; Diego Velázquez; King Philip IV; expulsion of majority of Muslims	King Philip V; War of Spanish Succession; Churrigueresque style emerges
Flanders	Habsburg rule; Spanish Habsburg rule; Jan Brueghel; Peter Paul Rubens	
Netherlands	Frans Hals; Dutch Republic proclaims independence; Rembrandt van Rijn; Judith Leyster; landscape painting emerges; Jan Vermeer; Spain recognizes independence of Dutch Republic; genre painting emerges; Leeuwenhoek uses microscope	
England	Drake circumnavigates globe; Mary, Queen of Scots, executed; defeat of the Spanish Armada; Marlowe's <i>Dr. Faustus</i> ; Spenser's <i>Faerie Queene</i> ; Bacon's <i>Essays</i> ; Shakespeare's <i>Macbeth</i> ; King James Bible; Donne's <i>Holy Sonnets</i> ; Jones introduces Palladianism; First English Civil War; Parliament restores monarchy; plague kills 75,000 people in London; Great Fire in London; Milton's <i>Paradise Lost</i>	Wren rebuilds Saint Paul's Cathedral; Newton's <i>Principia</i> ; Locke's <i>Essay Concerning Human Understanding</i> ; union of England and Scotland as Great Britain; Swift's <i>Gulliver's Travels</i> ; Handel's <i>Messiah</i> ; British Museum founded; Watts develops steam engine; Cook's Pacific voyages
Germany/Austria	University of Würzburg founded; Thirty Years' War begins and spreads throughout Europe; Andreas Schlüter	Bach's <i>Brandenburg</i> Concerti; Asam's Rococo sculpture; Cuvilliés's Rococo architecture; Tiepolo's Residenz frescoes; Mozart's first symphony
North America	Spain founds St. Augustine, Fla.; Raleigh colonizes Roanoke Island, N.C.; first French settlement in Nova Scotia; English settlement of Jamestown, Va.; timber architecture in Northeast and Spanish-style mission design in Southwest; first enslaved Africans arrive in Virginia; Pilgrims at Plymouth Rock; Harvard University founded; European settlers wage wars with Native Americans	Pueblo peoples rise up against Spanish; French Huguenots arrive in North America; witchcraft trials in Salem, Mass.; John Sin- gleton Copley; Boston Tea Party; Palladian- style architecture; Seven Years' War; First Continental Congress issues Declaration of Rights and Grievances; Second Continental Congress names George Washington commander-in-chief
World	Hideyoshi unites Japan; first printing in Peru; Christians banned in Japan; Portugal explores East Africa; Tsar Boris Godunov (Russia); Japanese cap- ital moved to Edo (Tokyo); Taj Mahal (India); Qing dynasty (China)	Peter the Great (Russia); Moscow University founded; Afghanistan conquers Persia; coffee first planted in Brazil; Hermitage Museum founded (Russia); Catherine the Great (Russia)

1575 1775

arose and thrived. The term baroque is derived from the Portuguese word barroco, literally "large, irregularly shaped pearl." For a while, the word came to suggest something that was heavily ornate, complex, strange, or even in bad taste. In the late nineteenth century, critics first applied the word to the art of Europe and some European colonies in the Americas from the late 1500s to the late 1700s—that is, from the end of the Renaissance to the emergence of Neoclassicism and Romanticism (Chapter 26), now broadly known as the Baroque period. The term rococo was coined by critics who combined barroco and the French word rocaille ("stone debris"), a rock-and-shell ornament used extensively in decoration, to describe the ornate, fanciful, and often playful artwork and architectural decoration that became fashionable in France in the 1720s and spread throughout Europe. Rococo was a light, refined style that emerged late in the Baroque period. Although both baroque and rococo were originally derogatory terms, the high quality of Baroque and Rococo art is accepted today without question. Whereas Rococo has been described as a style, when theorists have tried to define the characteristics of a single Baroque style the task has proved virtually impossible, given the roughly two centuries and immense geographical expanse over which Baroque art flourished. Nevertheless, there are four stylistic features that are evident in much of Baroque art: emotionalism, naturalism, classicism, and tenebrism. Emotionalism here refers to the powerful and immediate emotional response that many seventeenth- and eighteenth-century works were deliberately meant to evoke in the viewer: astonishment, horror, sorrow, piety, and intense empathy. Naturalism, the use of elements from everyday life in seemingly unposed or informal arrangements, both as contexts for religious or historical subjects and as principal subjects in themselves, was also widespread in Baroque art. Classicism, meaning here the adherence to Renaissance ideals and principles of composition, was especially favored in Rome, in the central Italian city of Bologna, and in France. Emotionalism, naturalism, and classicism often coexisted in the same work, and many of the best examples of Baroque art combine all three elements. Finally, tenebrism, which is the use of chiaroscuro, or strong lightand-shadow effects, was a pictorial device found in all the arts across Europe. Above all, in the seventeenth and eighteenth centuries the quality most admired in a work of art was great technical skill. Artists achieved spectacular technical virtuosity. The leading artists were in complete control of their craft, and their delight in pure skill permeated their studios and workshops.

Finally, the role of the viewer changed, and the expectation of active involvement in the artwork increased. The work of art reached out in every direction physically and emotionally to draw the viewers into its orbit. Whereas Renaissance painters and patrons had been fascinated with the visual possibilities of perspective and of the fact that the beholder could look *into* a spatial illusion, seventeenth- and eighteenth-century artists regarded viewers as *participants* in the work of art and architecture. Compositions include the world beyond the frame or the piece

of sculpture, the space where the viewer stands. For example, Gianlorenzo Bernini's *David* of 1623 (see fig. 19-10) hurls a rock at the unseen giant Goliath, who seems positioned behind the viewer. Similarly, late Baroque churches and palaces break the bounds of orderly spatial units and offer instead a theater of surprise.

Not only was physical connection between the artwork and the viewer desirable but so was emotional and intellectual involvement. Horrifying scenes of martyrdoms and moments of a mystic's ecstatic religious union with God were turned by artists into opportunities for the beholder's vicarious participation in emotional, often religious, drama. In all these areas of virtuosity, artists and architects of the European Baroque were performing theatrically, so to speak, for a broad range of ecclesiastical and secular clients.

ROMAN BAROQUE

The patronage of the papal court and the Roman nobility dominated much of Italian art from the late

sixteenth to the late seventeenth century. Major architectural projects were undertaken in Rome during this period, both to glorify the Church and to improve the city. Pope Sixtus V (papacy 1585–1590) had begun the renewal by cutting long, straight avenues between important churches and public squares, replacing some of Rome's crooked medieval streets. Sixtus also began to renovate the Vatican and its library, completed the dome of Saint Peter's Basilica (Chapter 18), built splendid palaces, and reopened one of the ancient aqueducts to stabilize the city's water supply. Several of Sixtus V's successors, especially Urban VIII (papacy 1623–1644), were also vigorous patrons of art and architecture.

Architecture and Its Decoration

A major program of the Counter-Reformation was to embellish the Church with splendid architecture, some of which was so extravagant that the Vatican treasury was nearly bankrupted. In contrast to the Renaissance ideal of the **central-plan church**, Counter-Reformation thinking called for churches with long, wide **naves** to accommodate large congregations and the processional entry of the clergy at the Mass. Although in the sixteenth century the decoration of new churches was generally modest, even austere, seventeenth- and eighteenth-century taste favored opulent and spectacular visual effects to heighten the spiritual involvement of worshipers.

The Church of Il Gesù. The Society of Jesus, or Jesuit order—organized in 1539 by the Spanish noble Ignatius of Loyola—commissioned the Italian architect Giacomo Barozzi, known as Giacomo da Vignola (1507–1573; see figs. 18-25 and 18-26), to design its headquarters church in Rome. The simplicity and functionality of the Church of Il Gesù (Jesus), completed after Vignola's death by Giacomo della Porta in 1584, influenced church design for more than a century. Vignola's plan included a large nave, but the church's short **transepts** and the great

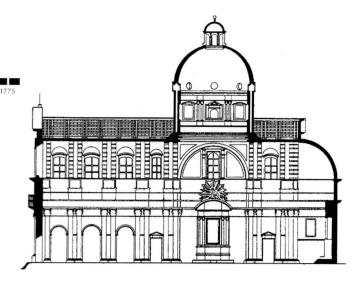

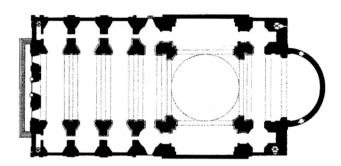

19-2. Plan and section of the Church of Il Gesù, Rome. Begun on Vignola's design in 1568; facade completed by della Porta c. 1575–84

height of its vault created a visual effect close to that of a domed, central-plan church of the Renaissance (fig. 19-2).

Especially influential was the facade (fig. 19-3), also by Vignola but altered by della Porta during construction. The general design had been established by Renaissance architects: paired colossal orders (columns or pilasters extending through two or more stories) visually tying together the first and second stories; a second order superimposed on the third story; and large volutes (scroll forms) to ease the transition between the wide lower levels and the narrow third level by masking the sloping roofs of the side aisles. Two important aspects of the facade design were new: centrality and verticality. Centrality was achieved by emphasizing the central axis of the building's main entrance. This was done by gradually moving the orders on the lower level forward, from the relatively flat pilasters at the corners to the engaged half columns at the center; by crowning the central door with a double pediment—a triangle or similar form used to surmount an entrance—and by enlarging the central window on the level above. Verticality was stressed by the intrusion of the double pediment into the level above it. An emphasis on centrality and verticality was to become a hallmark of Baroque church-facade design (see "Elements of Architecture," page 755).

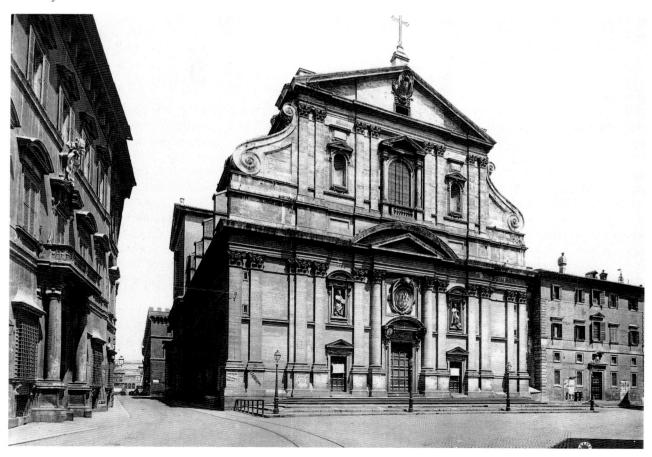

19-3. Giacomo da Vignola and Giacomo della Porta. Facade of the Church of Il Gesù

ELEMENTS OF The two facades featured here ARCHITECTURE demonstrate the shift of taste in architecture-from classicistic Baroque and to expressionistic—between the Rococo Church beginning of the Baroque and Facades the end of the Rococo. At one end of the spectrum is Giacomo da Vignola's and Giacomo della

Porta's Roman Baroque facade for Il Gesù of about 1575-1584, which, like Renaissance and Mannerist buildings, is still firmly grounded in the clean articulation and vocabulary of classical architecture. At the other end is Pedro de Ribera's portal for the Hospicio de San Fernando (now a municipal museum) in Madrid, which was designed about 150 years later, in 1722. Ribera's portal is Rococo taken to extremes, in which there is nearly a meltdown of heavily encrusted, highly elaborated ornament in the Churrigueresque style.

Il Gesù's facade employs the colossal order and at

the same time uses huge volutes to soften and aid the transition from the wide lower stories to the narrower upper level. Verticality is also stressed by the large double pediment that rises from the wide entablature and pushes into the transition zone between stories; by the repetition of triangular pedimental forms (above the aedicula window and in the crowning gable); by the push-up effect of the volutes; and most obviously by the massing of upward-moving forms at the center of the facade. Cartouches, cornices, and niches provide concave and convex rhythms across the middle zone.

The sandstone portal ensemble of the Hospicio is as much like a painting as architecture gets, and although the architect used classical elements (among them cornices, brackets, pedestals, volutes, finials, swags, and niches) and organized them symmetrically, the parts run together in a wild profusion of theatrical hollows and projections, large forms (such as the broken pediment at the roofline), and small details.

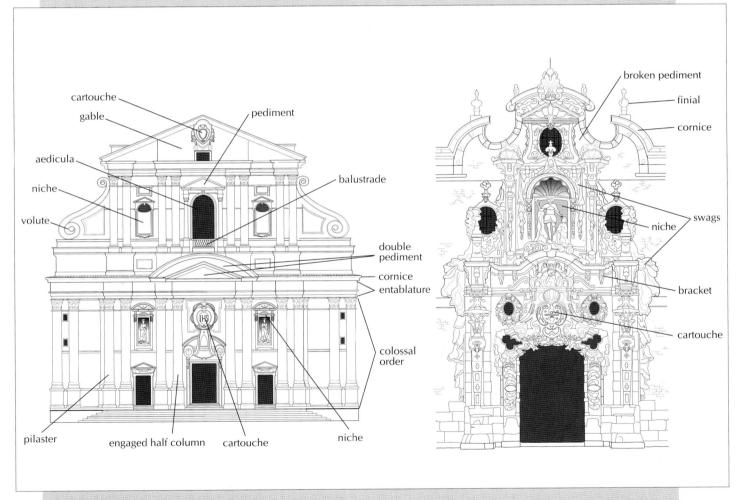

Giacomo da Vignola and Giacomo della Porta. Facade elevation of the Church of Il Gesù, Rome. c. 1575-84

Pedro de Ribera. Portal of the Hospicio de San Fernando, Madrid. 1722

19-4. Carlo Maderno. Facade of Saint Peter's Basilica, Vatican, Rome. 1607–15

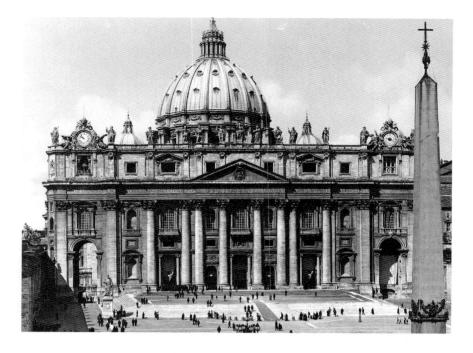

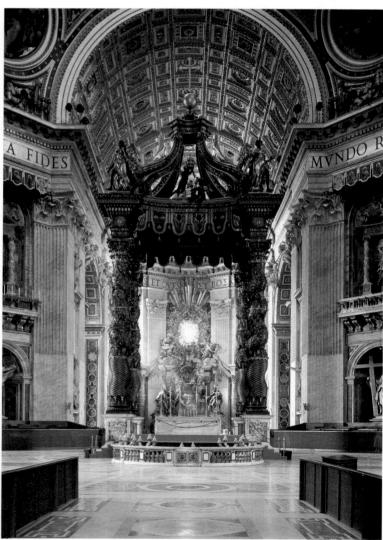

19-5. Gianlorenzo Bernini. *Baldacchino*. 1624–33. Gilt bronze, height approx. 100' (30.48 m). Chair of Peter. 1657–66. Gilt bronze, marble, stucco, and glass. Pier decorations. 1627–41. Gilt bronze and marble. Crossing, Saint Peter's Basilica, Vatican, Rome

Saint Peter's Basilica in the Vatican. Half a century after Michelangelo had returned Saint Peter's Basilica to Bramante's original vision of a central-plan building (see fig. 18-23), Pope Paul V (papacy 1605-1621) commissioned Carlo Maderno (1556-1629) to provide the church with a longer nave and a new facade (fig. 19-4). The construction was begun in 1607, and everything but the facade bell towers was completed by 1615. In essence, Maderno took the concept of the Gesù facade and enhanced its scale befitting the most important church of the Catholic world. Like that of Il Gesù, Saint Peter's facade is "stepped out" in three planes: from the corners to the doorways flanking the central entrance area, then the entrance area, then the central doorway itself (see "Saint Peter's Basilica," page 701). Similarly, the colossal orders connecting the first and second stories take the form of flat pilasters at the corners but are fully round columns flanking the doorways. These columns support a continuous entablature that also steps out—following the columns—as it moves toward the central door, which is surmounted by a triangular pediment. Similar to the Gesù facade, the pediment provides a vertical thrust, as does the superimposition of pilasters on the relatively narrow attic story above the entablature.

When Maderno died in 1629, he was replaced as Vatican architect by his collaborator of five years, Gianlorenzo Bernini (1598–1680). Bernini was born in Naples, but his family had moved to Rome about 1605. Taught by his father, Gianlorenzo was already a proficient marble sculptor by the age of eight. Part of his training involved sketching the Vatican collection of ancient sculpture, such as *Laocoön and His Sons* (see fig. 9), as well as the many examples of Renaissance painting in the papal palace. Throughout his life, Bernini admired antique art and considered himself a classicist. His fusion of classicism and emotionalism came to epitomize the Baroque style.

When Urban VIII was elected pope in 1623, he unhesitatingly gave the young Bernini the demanding task of designing an enormous cast-bronze **baldachin**, or canopy, for the main altar of Saint Peter's. The resulting

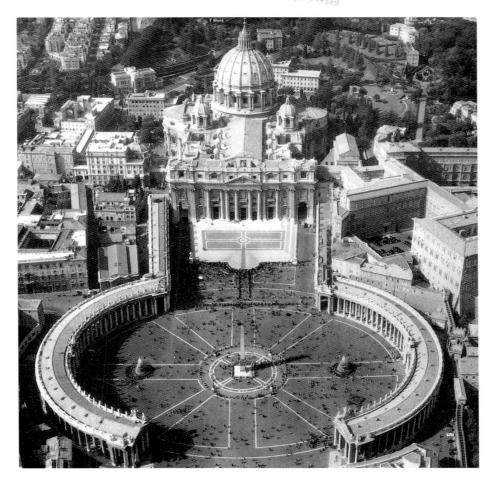

19-6. Gianlorenzo Bernini. Saint Peter's Square, Vatican, Rome. Designed c. 1656–57

Perhaps only a Baroque artist of Bernini's talents could have unified the many artistic periods and styles that come together in Saint Peter's Basilica. The visitor today sees not a piecing together of parts made by different builders at different times, starting with Bramante's original design for the building in the sixteenth century, but rather encounters a triumphal unity of all the parts in one coherent whole.

Baldacchino (fig. 19-5), which stands about 100 feet high, exemplifies the Baroque tendency to combine architecture and sculpture, and sometimes painting as well, so that a work cannot be precisely categorized as being in one medium or another. Begun in 1624, the Baldacchino was completed in 1633. The twisted columns decorated with spiraling parallel grooves and winding bronze vines were derived from Early Christian remains of the fourth-century church known as Old Saint Peter's. The fanciful Composite capitals, combining elements of both the Ionic and the Corinthian orders, support an entablature with a crowning element topped with an orb (a sphere representing the universe) and a cross, symbolizing the reign of Christ. Figures of angels and putti decorate the entablature, which is hung with tasseled panels in imitation of a cloth canopy. These symbolic elements—both architectural and sculptural—not only mark the site of the tomb of Saint Peter but also serve as a monument to Urban VIII and his family, the Barberini, whose emblems—including honeybees and suns on the tasseled panels, and laurel leaves on the climbing vines—are prominently displayed.

Between 1627 and 1641 Bernini and several other sculptors, again combining architecture and sculpture, rebuilt Bramante's crossing piers as giant **reliquaries**. Statues of Saints Helena, Veronica, Andrew (visible at

left in fig. 19-5), and Longinus (by Bernini himself, 1629-1638) stand in niches below alcoves containing their relics. Visible through the Baldacchino's columns on the back wall of the church is another reliquary, the gilded stone, bronze, and stucco encasement made by Bernini between 1657 and 1666 for the ancient wooden throne thought to have been used by Saint Peter as the first bishop of Rome. The Chair of Peter symbolized the direct descent of Christian authority from Peter to the current pope, a belief rejected by Protestants and therefore deliberately emphasized in Counter-Reformation Catholicism. The chair is carried by four theologians and lifted further by a surge of gilded clouds moving upward toward an explosion of angels, putti, and gilt-bronze rays of light bursting forth from a stained-glass panel depicting a dove (representing the Holy Spirit), lit from a window. The light penetrating the church from this window, reflected back by the gilding, is in effect part of the sculpture. Similarly, the flickering of candles during evening services, reflected and multiplied by the bronze, is incorporated into this masterpiece.

At approximately the same time that he was at work on the Chair of Peter, Bernini designed and supervised the building of a **colonnade** to enclose Saint Peter's Square (fig. 19-6). The space of the open square that he

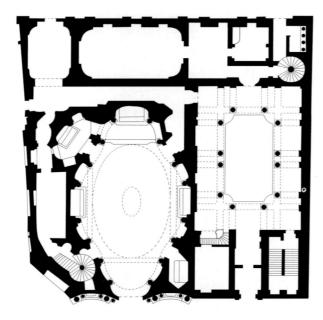

19-7. Francesco Borromini. Plan of the Church of San Carlo alle Quattro Fontane, Rome. Begun 1638

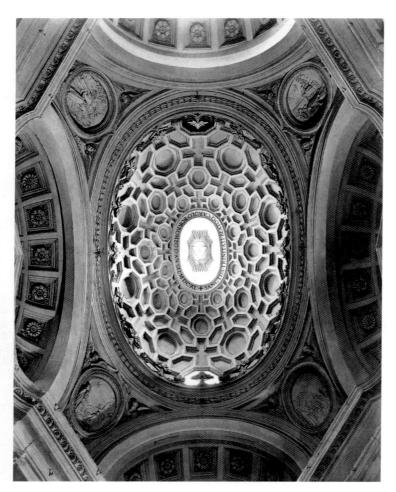

19-8. Francesco Borromini. Dome interior, Church of San Carlo alle Quattro Fontane. 1638–45

had to work with was irregular, and an Egyptian obelisk—a four-sided, tapered shaft ending in a pyramid and two fountains already in it had to be incorporated into the overall plan. Bernini's remarkable design frames the square with two enormous curved porticoes, or covered walkways, supported by Doric columns. These are connected to two straight porticoes that lead up a slight incline to the two ends of the church facade. Bernini spoke of his conception as representing the "motherly arms of the church," reaching out to the world. He intended to build a third section of the colonnade closing the side of the square facing the church so that pilgrims, after crossing the Tiber River bridge and passing through narrow streets, would suddenly emerge into the enormous open space before the church. Encountered this way, the great church, colonnade, and square with its towering obelisk and monumental fountains would have been an awe-inspiring vision.

The Church of San Carlo alle Quattro Fontane.

When young Francesco Borromini (1599–1667), a nephew of the architect Carlo Maderno, arrived in Rome in 1619 from northern Italy, he entered his uncle's workshop. Later, he worked under Bernini's supervision on the decoration of Saint Peter's, and some details of the *Baldacchino* are now attributed to him.

In 1634 Borromini received his first independent commission, to design the Church of San Carlo alle Quattro Fontane (Saint Charles at the Four Fountains). From 1638 to 1641 he planned and constructed the body of this small church, although he was not given the commission for its facade until 1665. Unfinished at Borromini's death in 1667, the church was, nevertheless, completed according to his design.

San Carlo stands on a narrow lot with one corner cut off to make room for one of the four fountains that give the church its name. To fit this site, Borromini created an elongated interior space with undulating walls, set into the irregular shell of the building (fig. 19-7). The powerful sweep of the curves of these walls creates an unexpected feeling of movement, as if the walls were actually heaving in and out. Robust pairs of columns support a massive entablature, over which an oval dome seems to float (fig. 19-8), as light as air. The coffers (inset panels in geometric shapes) filling the interior of the dome form an eccentric honeycomb of crosses, elongated hexagons, and octagons. These coffers decrease sharply in size as they approach the apex, or highest point, so that the dome appears to be inflating. Such devices make a visitor to the church feel as if it were a living, breathing organism.

It is difficult today to appreciate how audacious Borromini's design for this small church was. In it he abandoned the modular system of planning taken for granted by every architect since Brunelleschi (see figs. 17-32, 17-33) and worked instead from an overriding geometrical scheme. Moreover, his treatment of the architectural elements as if they were malleable was unprecedented. Borromini's contemporaries understood immediately what an extraordinary innovation the church represented;

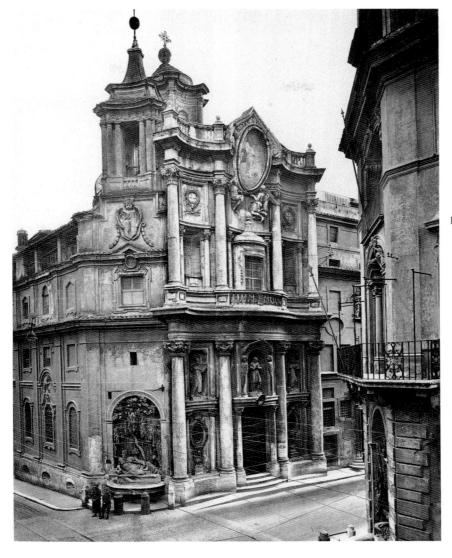

19-9. Francesco
Borromini.
Facade,
Church of
San Carlo
alle Quattro
Fontane.
1665–67

the monks who had commissioned it received requests for plans from visitors from all over Europe. Although Borromini's invention had little influence on the architecture of classically minded Rome, it was widely imitated in northern Italy and beyond the Alps.

Two decades later, Borromini's design for the facade of the same church (fig. 19-9) was as innovative as his plan for its interior had been. He turned the building's front into an undulating, sculpture-filled screen punctuated with large columns and deep niches, which create effects of light and shadow somewhat like those of a painting in chiaroscuro. Borromini also gave his facade a strong vertical thrust in the center by placing over the tall doorway a statue-filled niche, then an empty niche covered with a pointed canopy, then a giant cartouche (an oval or circular decorative element) held up by angels undercut so deeply that they appear to hover in front of the wall. The entire facade is crowned with a balustrade, or railing held up by decorative posts, that peaks sharply at the center. Like the interior of the church, Borromini's facade had little effect on the work of Roman architects, but it, too, was enthusiastically imitated in northern Italy and especially in northern and eastern Europe.

Bernini's Sculpture

Bernini became famous first as a sculptor and continued to work in that medium throughout his career, for both the papacy and private clients. His David (fig. 19-10), made for the nephew of Pope Paul V in 1623, introduced a new type of three-dimensional composition that intrudes forcefully on the viewer's space. Inspired by Annibale Carracci's athletic figures on the Farnese Ceiling, such as a Giant preparing to heave a boulder (see fig. 19-15, far end), Bernini's David bends at the waist and twists far to one side, ready to launch the fatal rock. Unlike Michelangelo's composed youth (see fig. 18-8), this more mature David, with his lean, sinewy body, is all tension and determination, a frame of mind emphasized by his ferocious expression, tightly clenched mouth, and straining muscles. Bernini's energetic, centrifugal figure activates its surrounding space by implying the presence of an unseen adversary somewhere behind the viewer, who is compelled to witness the action that is about to occur.

Among Bernini's many innovations was his approach to portrait sculpture. According to one of his biographers, it was Bernini's custom to follow his subjects' daily

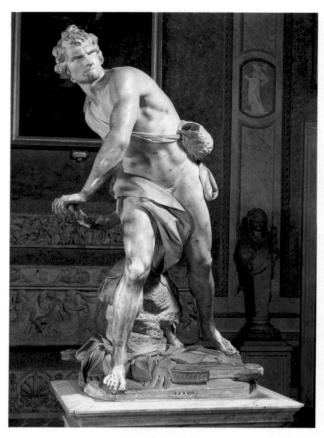

19-10. Gianlorenzo Bernini. *David*. 1623. Marble, height 5'7" (1.7 m). Galleria Borghese, Rome

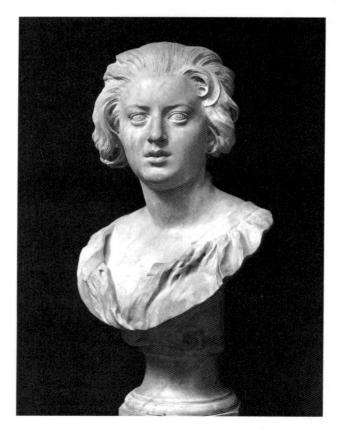

19-11. Gianlorenzo Bernini. Costanza Bonarelli. c. 1635. Marble, height 283/8" (72 cm). Museo Nazionale del Bargello, Florence

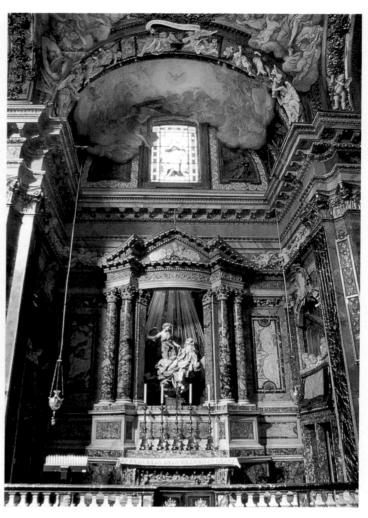

19-12. Gianlorenzo Bernini. Cornaro Chapel, Church of Santa Maria della Vittoria, Rome. 1642-52

rounds, sketching them in various activities, trying to capture a "speaking likeness." His remarkable marble portraits do, indeed, seem to transcend their medium, not only in representing flesh, hair, and clothing in a lifelike way, but also in seeming to represent a given moment in time, communicating more immediacy and naturalness than anything done in the Renaissance or in ancient times. One of Bernini's most striking portraits of this type was a bust of Costanza Bonarelli, the wife of one of his shop assistants, who was both his model and his lover. Produced about 1635, it is a superb example of Baroque naturalism (fig. 19-11). Costanza appears unaware of being portrayed. Her open collar, slightly turned head, disheveled hair, and parted lips all contribute to this effect and to the sense that we are seeing not just her outward appearance but her vivid character as well.

Even after Bernini's appointment as Vatican architect in 1629, his large workshop enabled him to accept outside commissions. One was the decoration of the funerary chapel of Cardinal Federigo Cornaro in the Church of Santa Maria della Vittoria (fig. 19-12), which Bernini carried out from 1642 to 1652. Bernini covered the walls of the tall, shallow chapel with colored marble panels, crowned with a projecting **cornice** supported

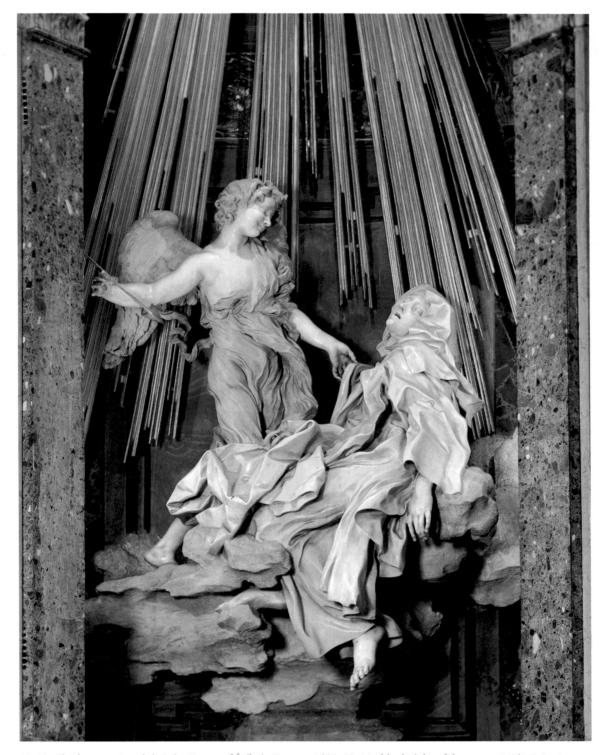

19-13. Gianlorenzo Bernini. *Saint Teresa of Ávila in Ecstasy.* 1645–52. Marble, height of the group 11'6" (3.5 m). Cornaro Chapel, Church of Santa Maria della Vittoria

with marble pilasters. Above the cornice on the back wall, the curved ceiling surrounding the window appears to dissolve into a painted vision of clouds and angels. Kneeling on what appear to be balconies are portrait statues of Federigo, his deceased father, and six cardinals of the Cornaro family. Unlike the bronze portrait statues of the Spanish royal family in Philip II's funerary church at El Escorial (see fig. 18-84), Bernini's figures are

active, informally posed "speaking likenesses." Two are reading from their prayer books; others converse; and one leans out from his seat, apparently to look at someone entering the chapel.

The chapel is dedicated to Saint Teresa of Ávila, Spain. Framed by columns in a huge oval niche above the altar, Bernini's marble group *Saint Teresa of Ávila in Ecstasy* (fig. 19-13), created between 1645 and 1652, represents a

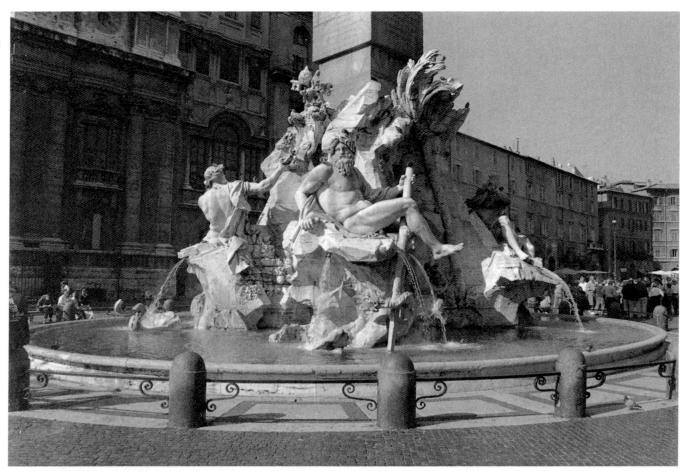

19-14. Gianlorenzo Bernini. Four Rivers Fountain. 1648-51. Travertine and marble. Piazza Navona, Rome

vision described by the saint, in which an angel pierced Teresa's body repeatedly with an arrow, transporting her to a state of religious ecstasy, a sense of oneness with God. The saint and the angel, who seem to float upward on moisture-laden clouds, are cut from a heavy mass of solid marble held in place by metal bars sunk deep into the chapel wall. Bernini's skill at capturing the movements and emotions of these figures is matched by his virtuosity in simulating different textures and colors in the pure white medium of marble; the angel's gauzy, clinging draperies seem silken in contrast with Teresa's heavy woolen robe. Yet Bernini effectively used the configuration of the garment's folds to convey the swooning, sensuous body beneath, even though only Teresa's face, hands, and bare feet are actually visible. The descending rays of light are of gilt bronze, but actual light also illuminates the scene from the window above. Bernini's complex, theatrical interplay of the various levels of illusion in the chapel, which invites the beholder to identify with Teresa's emotion, was imitated by sculptors throughout Europe.

Bernini is at his most exciting in his fountain designs, such as that of the Four Rivers Fountain for Rome's Piazza Navona (fig. 19-14), a **piazza**, or open square, that was a popular site for festivals and celebrations. The history of the project gives an idea of the effects of politics

on art in the seventeenth century. The fountain was commissioned by Pope Innocent X (papacy 1644–1655), whose family had built a palace on the piazza. Bernini, who had been publicly disgraced in 1646 when a bell tower he had begun for Saint Peter's threatened to collapse, was not invited to compete for the fountain's design. The contest was won by Francesco Borromini, who originated the Four Rivers theme and brought in the water supply for the fountain in 1647. With the collusion of a papal relative, however, the pope saw Bernini's design. Pope Innocent X was so impressed that Bernini took over work on the fountain the next year. Executed in marble and travertine, a porous stone that is less costly and more easily worked than marble, the fountain was completed in 1651. In the center is a rocky hill covered with animals and vegetation, from which flow the four great rivers of the world, each representing a continent: the Ganges (Asia, facing out); the Nile (Africa, right); the Danube (Europe, left); and the Rio de la Plata (the Americas, not visible in the figure). The central rock formation supports an Egyptian obelisk topped by a dove, the emblem of the pope's family. The installation of the obelisk—which weighs many tons—over the hidden collecting pool that feeds the rivers was a technical marvel that did much to reverse Bernini's disgrace over the bell-tower incident.

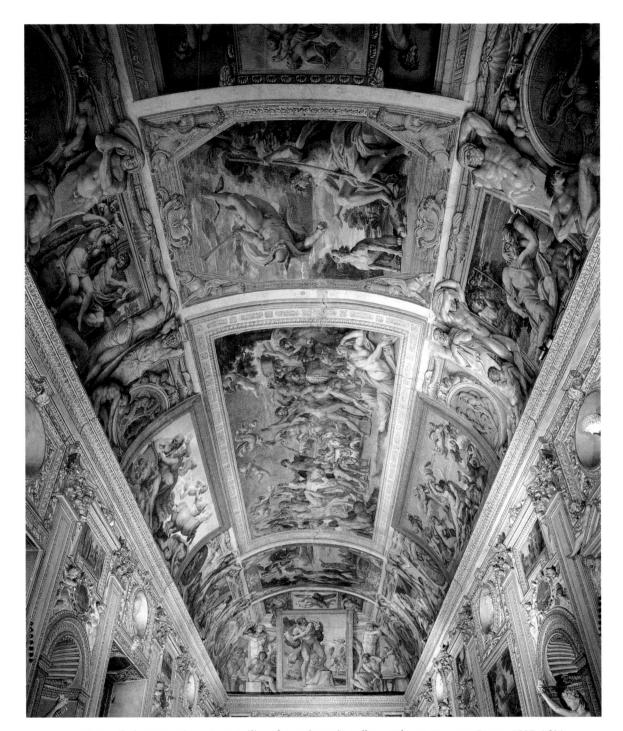

19-15. Annibale Carracci. Farnese Ceiling, fresco in main gallery, Palazzo Farnese, Rome. 1597-1601

Illusionistic Ceiling Painting

Baroque ceiling decoration went far beyond Andrea Mantegna's early Renaissance prototype in the Gonzaga ducal palace at Mantua (see fig. 17-69) or even Michelangelo's Sistine Ceiling (see fig. 18-16). Many Baroque ceiling projects were done entirely in **trompe l'oeil** painting, but some were complex constructions combining architecture, painting, and stucco sculpture. These grand illusionistic projects were carried out on the domes and vaults of churches, civic buildings, palaces, and villas.

The major monument of early Baroque classicism was a ceiling painted for the Farnese family in the last years of the sixteenth century. In 1597, to celebrate the wedding of Duke Ranuccio Farnese of Parma, the family decided to redecorate the **galleria** (great hall) of their immense Roman palace. The commission was given to Annibale Carracci (1560–1609), a noted painter and the cofounder of an art academy in Bologna. Annibale was assisted by his brother Agostino (1557–1602), who also worked briefly in Rome. The Farnese Ceiling (fig. 19-15) is an exuberant tribute to earthly love, expressed in

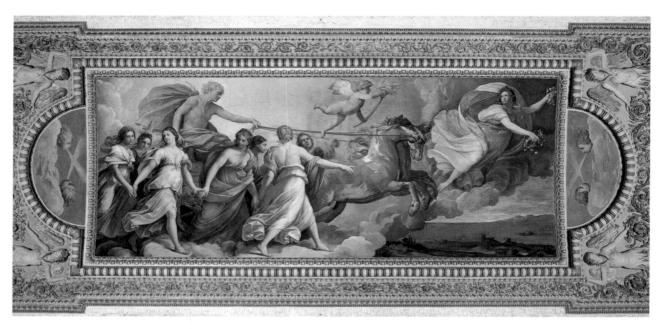

19-16. Guido Reni. Aurora, ceiling fresco in Casino Rospigliosi, Rome. 1613-14

mythological scenes. Its primary image, set in the center of the vault, is The Triumph of Bacchus and Ariadne, a joyous procession celebrating the wine god Bacchus's love for Ariadne, a woman whom he rescued after her lover abandoned her on an island. Carracci's illusionistic ceiling is a trompe l'oeil assemblage of framed paintings, stone sculpture, bronze medallions, and ignudi (nude youths) in an architectural framework, all clearly inspired by Michelangelo's Sistine Ceiling. The figure types, true to their source, are heroic and muscular and are drawn with precise anatomical accuracy. But instead of Michelangelo's cool illumination and intellectual detachment, the Farnese Ceiling glows with a warm light that recalls the work of the Venetian painters Titian and Veronese and seems buoyant with optimism. The ceiling was highly admired and became famous almost immediately. The Farnese family, proud of the gallery, were generous in allowing young artists to sketch the figures there, so that Carracci's masterpiece influenced Italian classicism well into the following century.

The most important Italian Baroque classicist after Annibale Carracci was the Bolognese artist Guido Reni (1575–1642), who briefly studied at the Carracci academy in 1595. Shortly after 1600 he made his first trip to Rome, where he worked intermittently before returning to Bologna in 1614. In 1613–1614 Reni decorated the ceiling of a garden house at a palace in Rome with his most famous work, *Aurora* (fig. 19-16). The fresco emulates

the illusionistic framed mythological scenes on the Farnese Ceiling, although Reni made no effort to relate its space to that of the room. Indeed, *Aurora* appears to be a framed oil painting incongruously attached to the ceiling. The composition itself, however, is Baroque classicism at its most lyrical. Apollo is shown driving the sun chariot, escorted by Cupid and the Seasons and led by the flying figure of Aurora, goddess of the dawn. The measured, processional staging and idealized forms seem to have been derived from an antique relief, and the precise drawing owes much to Annibale Carracci. But the graceful figures, the harmonious rhythms of gesture and drapery, and the intense color are all Reni's own.

Pietro Berrettini (1596–1669), called Pietro da Cortona after his hometown, carried the development of the Baroque ceiling in another direction altogether. Trained in Florence, the young artist was commissioned in the early 1630s by the Barberini family of Pope Urban VIII to decorate the ceiling of the audience hall of their Roman palace. Pietro's great fresco there, *Triumph of the Barberini* (fig. 19-17), became a model for a succession of Baroque illusionistic ceilings throughout Europe. Its subject is an elaborate **allegory**, or symbolic representation, of the virtues of the papal family. Just below the center of the vault, seated at the top of a pyramid of clouds and figures personifying Time and the Fates, Divine Providence gestures toward three giant bees surrounded by a huge laurel wreath (both Barberini emblems) carried by Faith,

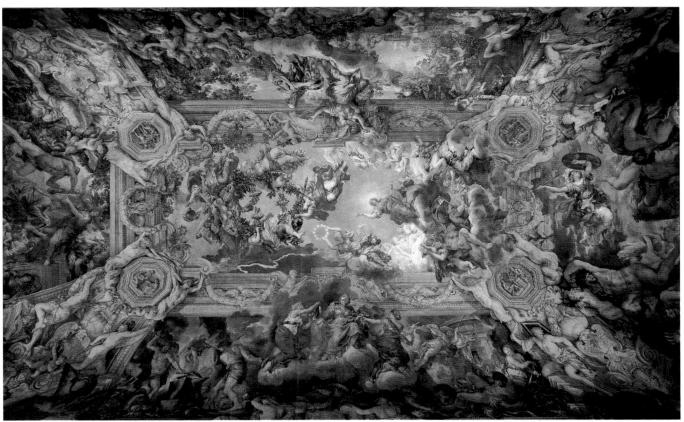

19-17. Pietro da Cortona. Triumph of the Barberini, ceiling fresco in the Gran Salone, Palazzo Barberini, Rome. 1633-39

Hope, and Charity. Immortality offers a crown of stars, while other symbolic figures present the crossed keys and the triple-tiered crown of the papacy. Around these figures are scenes of Roman gods and goddesses, who demonstrate the pope's virtues by triumphing over the vices.

Pietro, like Annibale Carracci, framed his mythological scenes with painted architecture, but in contrast to Annibale's neat separations and careful framing, Pietro partly concealed his setting with an overlay of shells, masks, garlands, and figures, which unifies the vast illusionistic space. Instead of Annibale's warm, nearly even light, Pietro's sporadic illumination, with its bursts of brilliance alternating with deep shadows, fuses the ceiling into a dense but unified whole.

Perhaps the ultimate illusionistic Baroque ceiling is *Triumph of the Name of Jesus* (fig. 19-18), which fills the vault of Il Gesù (see fig. 19-3). Originally, in the 1560s, Giacomo da Vignola had designed an austere interior for Il Gesù, but when the church was renovated a century later the Jesuits commissioned a religious allegory to cover the plain ceiling of the nave. The **fresco** was painted between 1676 and 1679 by Giovanni Battista Gaulli (1639–1709), also called Baciccia. Gaulli, who came to Rome from Genoa in 1657, had worked in his youth for Bernini, from whom he absorbed a Baroque taste for drama and for combining mediums. The elderly Bernini, who worshiped daily at Il Gesù, may well have offered his personal advice

to his former assistant, and Gaulli was certainly familiar with other illusionistic paintings in Rome as well, including Pietro da Cortona's Barberini ceiling.

Gaulli's astonishing creation went beyond anything that had preceded it in unifying architecture, sculpture, and painting. Every element is dedicated to the illusion that clouds and angels have floated down through an opening in the church's vault into the upper reaches of the nave. The figures are projected as if seen from below, and the whole composition is focused off-center on the golden aura around the letters *IHS*, a Greek abbreviation for "Jesus." The subject is, in fact, a Last Judgment, with the Elect rising joyfully toward the name of God and the Damned plummeting through the ceiling toward the nave floor. The sweeping inclusion in the work of the space of the nave, the powerful and exciting appeal to the viewer's emotions, and the nearly total unity of visual effect have never been surpassed.

Painting on Canvas

In painting, the Baroque classicism exemplified by Carracci's Farnese Ceiling and Guido Reni's *Aurora* was the logical development of mature Renaissance styles with roots in classical antiquity. A more naturalistic tendency was introduced by Carracci's younger contemporary Michelangelo Merisi (1573–1610), known as Caravaggio after his birthplace in northern Italy, who arrived in Rome in 1593.

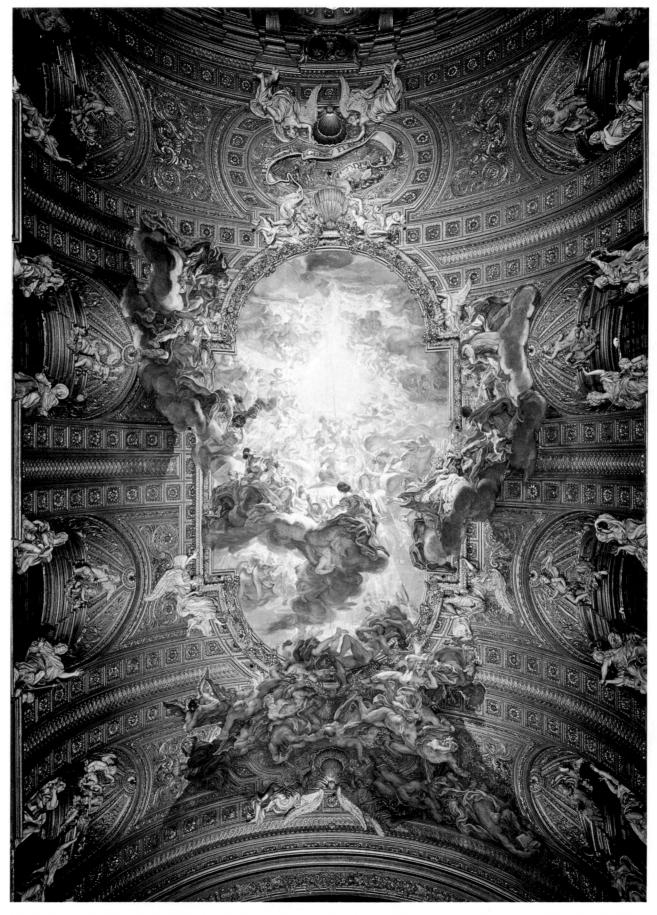

19-18. Giovanni Battista Gaulli. *Triumph of the Name of Jesus*, ceiling fresco with stucco figures in the vault of the Church of Il Gesù, Rome. 1676–79

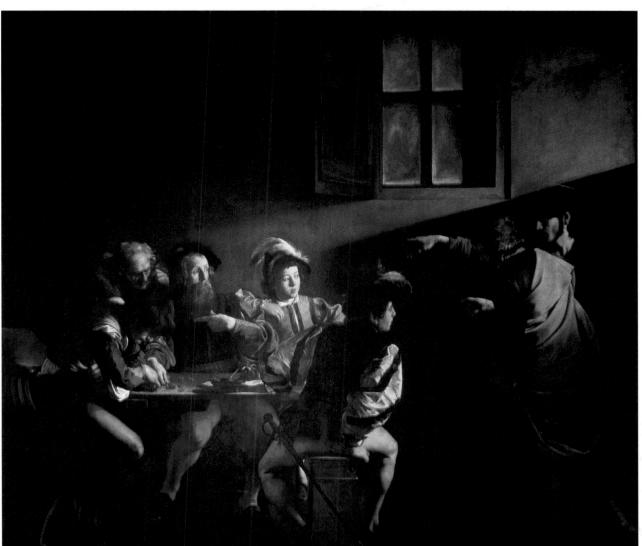

470 7777 1539

19-19. Caravaggio. *Calling of Matthew*, in the Contarelli Chapel, Church of San Luigi dei Francesci, Rome. c. 1599–1602. Oil on canvas, 11'1" x 11'5" (3.4 x 3.5 m)

At first Caravaggio painted for a small circle of sophisticated Roman patrons. His subjects from this period include still lifes and low-life scenes featuring fortune-tellers, cardsharps, and street urchins dressed as musicians or mythological figures. The figures in these pictures tend to be large, brightly lit, and set close to the picture plane. Most of his commissions after 1600 were religious, and reactions to them were mixed. On occasion his powerful, sometimes brutal, naturalism was rejected by patrons as unsuitable to the subject's dignity.

Caravaggio's approach has been likened to the preaching of Filippo Neri, later canonized as Saint Philip Neri (1515–1595), a priest and noted mystic of the Counter-Reformation who founded a Roman religious group called the Congregation of the Oratory. Philip Neri, called the Apostle of Rome, focused his missionary efforts on the people there, for whom he strove to make Christian history and doctrine understandable and

meaningful. Caravaggio, too, interpreted his religious subjects directly and dramatically, combining intensely observed forms, poses, and expressions with strong effects of light and color. The forms tend to emerge from dark backgrounds into a strong light, often falling from a single source outside the painting.

One of Caravaggio's earliest religious commissions, the *Calling of Matthew* (fig. 19-19), was painted around 1599–1602 for the private chapel of the Cointrel family (Contarelli in Italian) in the French community's church in Rome. The painting depicts the biblical story of Jesus' calling the Roman tax collector Matthew to join his apostles (Matthew 9:9–13). Matthew sits at a table, counting out gold coins for a boy at the left, surrounded by over-dressed young men in plumed hats, velvet doublets, and satin shirts. Nearly hidden behind another figure at the right, the gaunt-faced Jesus points dramatically at Matthew, a gesture that is repeated by the tax collector's

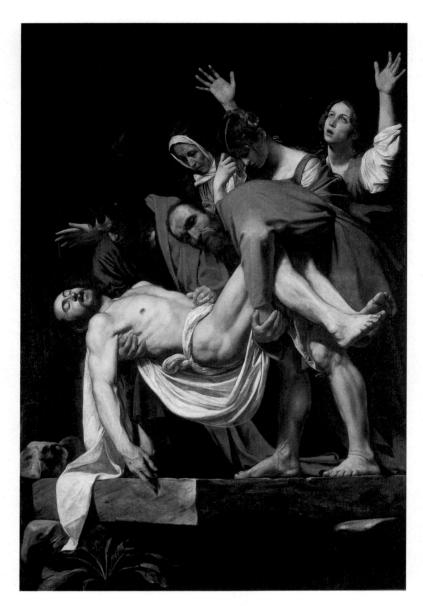

19-20. Caravaggio. *Entomb-ment*, painted for the Vittrice Chapel, Church of Santa Maria in Vallicella, Rome. c. 1603. Oil on canvas, 9'10¹/₈" x 6'7¹⁵/₁6" (3 x 2.03 m). Musei Vaticani, Pinacoteca, Rome

The Entombment was one of many paintings confiscated from Rome's churches and taken to Paris during the French occupation by Napoleon's troops in 1798 and 1808-1814. It was one of the few to be returned after 1815 through the negotiations of Pius VII and his agents, who were assisted greatly by the Neoclassical sculptor Antonio Canova, a favorite of Napoleon. The decision was made not to return the works to their original churches and chapels but rather to assemble them in a gallery where the general public could enjoy them. Today Caravaggio's painting is one of the most important in the collections of the Vatican Museums

surprised response of pointing to himself and again by the descent of the raking light that enters the painting from a high, unseen source at the right. For all of his naturalism, Caravaggio also used antique and Renaissance sources. Jesus' outstretched arm, for example, recalls God's gesture giving life to Adam in Michelangelo's *Creation of Adam* on the Sistine Ceiling (see fig. 18-16), now restated as Jesus' command to Matthew to enter a new life as his disciple.

The emotional power of Baroque naturalism combined with a solemn, classical monumentality is embodied in Caravaggio's *Entombment* (fig. 19-20), painted in about 1603 for a chapel in Santa Maria in Vallicella, the church of Saint Philip Neri's Congregation of the Oratory. With almost physical force, the size and immediacy of this painting strike the viewer, whose perspective is from within the burial pit into which Jesus' lifeless body is to be lowered. The figures form a large off-center triangle, within which angular elements are repeated: the projecting edge of the stone slab; Jesus' bent legs; the akimbo

arm, bunched coat, and knock-kneed stance of the man on the right; and even the spaces between the spread fingers of the raised hands. The Virgin and Mary Magdalen barely intrude on the scene, which, through the careful placing of the light, focuses on the dead Jesus, the sturdy-legged laborer supporting his body at the right, and the young Saint John at the triangle's apex.

Despite the great esteem in which Caravaggio was held as an artist, his violent temper repeatedly got him into trouble. During the last decade of his life he was frequently arrested, generally for minor offenses: throwing a plate of artichokes at a waiter, carrying arms illegally, or street brawling. In 1606, however, he killed a man in a fight over a tennis match and had to flee Rome. He went first to Naples, then to Malta, finding work in both places. The Knights of Malta awarded him the cross of their religious and military order in July 1608, but in October he was imprisoned for insulting one of their number, and he had to flee again. The aggrieved knight's agents tracked him to Naples in the spring of 1610 and severely

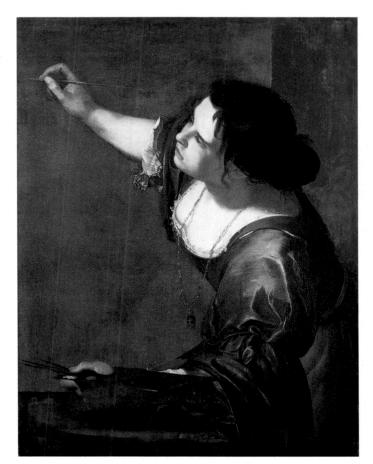

19-21. Artemisia
Gentileschi. *La Pittura*,
a self-portrait.
1630. Oil on
canvas, 38 x 29"
(96.5 x 73.7 cm).
The Royal Collection, Windsor
Castle, Windsor,
England

wounded him; the artist recovered and fled north to Port'Ercole, where he died of a fever on July 18, 1610, at age thirty-six. Despite his tragic and violent personal history, Caravaggio's naturalism and lighting influenced nearly every important European artist of the seventeenth century.

One of Caravaggio's most successful Italian followers was Artemisia Gentileschi (1593–c.1653), whose international reputation helped spread the style of Caravaggio outside Rome. Born in Rome, Artemisia first studied and worked under her father, himself a follower of Caravaggio. In 1616 she moved to Florence, where she worked for the grand duke of Tuscany and was elected, at the age of twenty-three, to the Florentine Academy of Design. In 1638 Artemisia went to England to assist her ill father, who was working for King Charles I. She eventually settled in Naples.

In 1630 she painted *La Pittura*, an allegorical self-portrait (fig. 19-21). The image of a woman with palette and brushes, richly dressed, and wearing a gold necklace with a mask pendant comes from a popular sourcebook for such images, the *Iconologia* by Cesare Ripa, which maintains that the mask imitates the human face, as painting imitates nature. The gold chain symbolizes "the continuity and interlocking nature of painting, each man learning from his master and continuing his master's achievements in the next generation" (cited in Tufts, page 61). Thus, Artemisia's self-portrait not only commemorates her profession but also pays tribute to her father.

FRENCH BAROQUE

The early seventeenth century was a difficult period in France, marked by almost continuous foreign and

civil wars. The assassination of King Henri IV in 1610 left France in the hands of the queen, Marie de' Medici, as regent for her nine-year-old son, Louis XIII (ruled 1610–1643). When Louis came of age, the brilliant and unscrupulous Cardinal de Richelieu became chief minister and set about increasing the power of the Crown at the expense of the French nobility. The death of Louis XIII again left France with a child king, the five-year-old Louis XIV (ruled 1643–1715). His mother, Anne of Austria, became regent, with the assistance of another powerful minister, Cardinal Mazarin. At Mazarin's death in 1661, Louis XIV (see fig. 19-1) began his long personal reign, assisted by an able and ingenious minister, Jean-Baptiste Colbert.

An absolute monarch whose reign was the longest in European history, Louis XIV expanded royal art patronage, making the French court the envy of every ruler in Europe. In 1635 Cardinal Richelieu founded the French Royal Academy to compile a definitive dictionary and grammar of the French language. In 1648 the Royal Academy of Painting and Sculpture was founded, which, as reorganized by Colbert in 1663, maintained strict control over the arts (see "Quarrel of the Ancients and the Moderns," page 785). Although it was not the first European arts academy, none before it had exerted such dictatorial authority—an authority that lasted in France until the late nineteenth century. Membership in the Academy assured

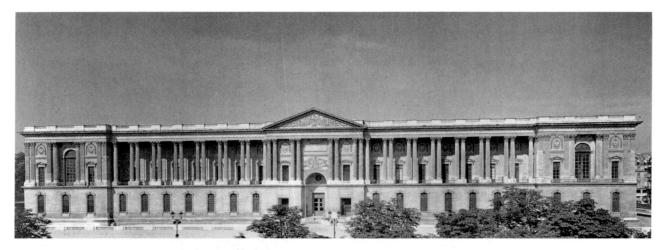

19-22. Louis Le Vau, Claude Perrault, and Charles Le Brun, East front, Palais du Louvre, Paris, 1667-70

an artist of royal and civic commissions and financial success, but many talented artists did well outside it.

Palace Architecture and Its Decoration

French architecture developed along classical lines in the second half of the seventeenth century under the influence of François Mansart (1598–1666) and Louis Le Vau (1612–1670). When the Royal Academy of Architecture was founded in 1671, its members developed guidelines for architectural design based on the belief that mathematics was the true basis of beauty. Their chief sources for ideal models were the books of Vitruvius (see "Vitruvius", page 698), Vignola (see figs. 18-26, 19-3), and Palladio (see fig. 18-35).

In early 1664 Colbert invited Bernini to submit designs for the new east facade of the Palais du Louvre being built to house royal apartments. In June 1665, Bernini came to Paris to discuss a design he had sent from Rome but was instead put to work sculpting a marble bust of the king. Bernini's third Louvre design, completed while he was in Paris, was accepted, and when he left for Rome in October the facade foundations were under way. When Bernini's assistant returned to Paris in 1666 to supervise the work, however, a group of French architects, outraged that such an important commission should go to a foreigner, succeeded in halting it.

Colbert appointed a design council that included the architect Louis Le Vau, the painter Charles Le Brun (1619–1690), and Claude Perrault (1613–1688), a physician and mathematician turned architect, who later published an edition of Vitruvius. The final model for the facade, which was constructed between 1667 and 1670, was divided into five units, with projecting blocks in the center and at each end. On the central block was a triangular pediment, suggesting a classical temple front, with long Corinthian colonnades on each side. The resulting facade was both grand and dignified, its somewhat austere forms softened by the rippling waves of light and shade cast by the rows of paired columns (fig.

19-22). The king was so pleased with this design that, despite the added expense, he had it repeated on the other palace faces. This elegant variation on the Roman temple front was the first great monument of French Baroque classicism in architectural design.

Once the design for the Louvre east front had been settled, the king turned his attention in 1668 to enlarging the small château built by Louis XIII at nearby Versailles, to which Louis XIV eventually moved his entire court. The designers of the palace and garden complex at Versailles-Le Vau, Le Brun, and André Le Nôtre (1613-1700), who planned the gardens—had already worked together on a magnificent château and gardens at Vaux-le-Vicomte for Nicolas Fouquet, the king's finance minister. The king was said to be so jealous of that beautiful country house that he not only had Fouquet imprisoned for life (the real reason was Fouquet's massive stealing from the royal treasury) but also deliberately set out to surpass the Vaux château in the design of Versailles (fig. 19-23). For both political and sentimental reasons, the old Versailles château was left standing, and the new building went up around it. This project consisted of two phases: the first additions by Le Vau, begun in 1668; and an enlargement completed after Le Vau's death by his successor, Jules Hardouin-Mansart, from 1670 to 1685.

In the hands of Le Nôtre, the terrain around the palace became an extraordinary work of art and a visual delight for its inhabitants. The garden designer's neatly contained stretches of lawn and broad, straight vistas seemed to stretch to the horizon, while the formal gardens at the rear of the palace (see the lower part of fig. 19-23) became an exercise in precise geometry. Broad intersecting paths separate reflecting pools and planting beds, called embroidered parterres for their colorful flower patterns. The entire layout, which includes mock grottoes (caves) and theaters, is accented by fountains, stone sculpture, and trimmed shrubs and small trees. From these gardens, a series of terraces descends to controlled, shaped, wooded areas and the mile-long Grand Canal. Classically harmonious and restful in their symmetrical, geometric

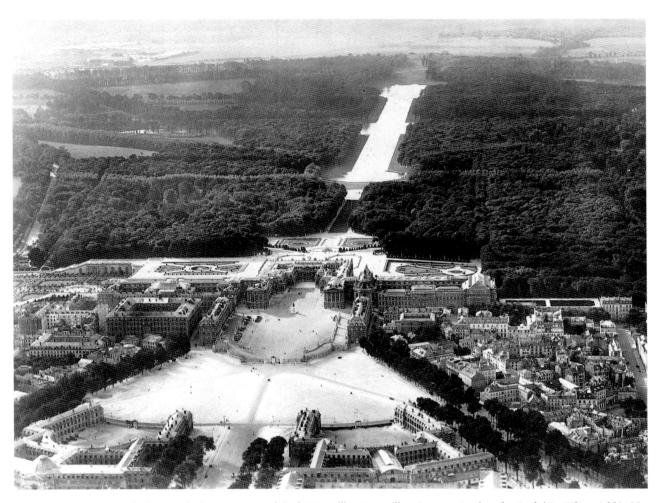

19-23. Louis Le Vau and Jules Hardouin-Mansart. Palais de Versailles, Versailles, France. Gardens by André Le Nôtre. 1668-85

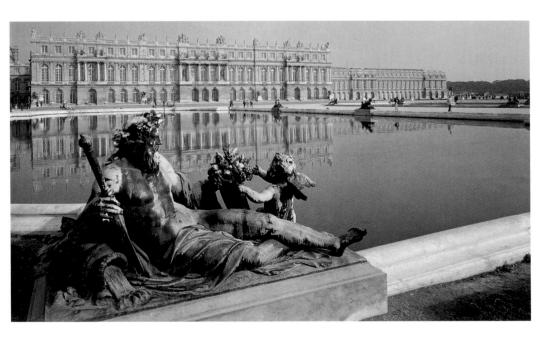

19-24. Louis Le Vau and Jules Hardouin-Mansart. Central block of the garden face, Palais de Versailles

design, the Versailles gardens are Baroque in their vast size and extension into the surrounding countryside.

Le Vau's successor, Hardouin-Mansart, was responsible for the addition of the long lateral wings and the renovation of Le Vau's central block on the garden side to match these wings (fig. 19-24). The three-story elevation

has a lightly **rusticated** ground floor, a main floor lined with enormous arched windows separated by Ionic pilasters, an attic level whose rectangular windows are also flanked by pilasters, and a flat, terraced roof. The overall design is a sensitive balance of horizontals and verticals relieved by a restrained overlay of regularly

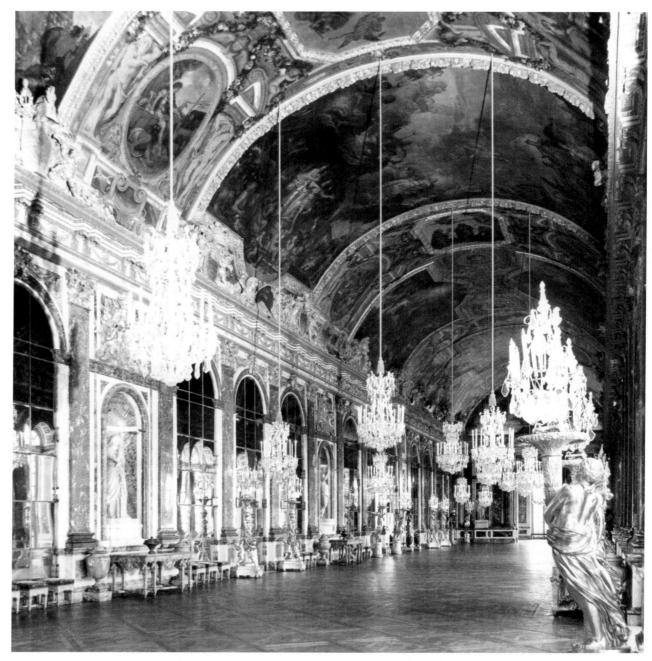

19-25. Jules Hardouin-Mansart and Charles Le Brun. Hall of Mirrors, Palais de Versailles. Begun 1678

In the seventeenth century, mirrors and clear window glass were enormously expensive. To furnish the Hall of Mirrors, hundreds of glass panels of manageable size had to be assembled into the proper shape and attached with "glazing bars," which became part of the decorative pattern of the vast room.

spaced projecting blocks with open, colonnaded porches.

In his renovation of Le Vau's original garden face in the center block, Hardouin-Mansart enclosed the previously open gallery on the main level, which is about 240 feet long. Architectural symmetry was achieved by lining the interior wall opposite the windows with Venetian glass mirrors—extremely expensive in the seventeenth century—the same size and shape as the arched windows, thus creating the famed Hall of Mirrors (fig. 19-25). The mirrors reflect the natural light from the windows and give the impression of an even larger space. In a tribute to Carracci's Farnese Ceiling (see fig. 19-15), Le

Brun decorated the vaulted ceiling with paintings glorifying the reign of Louis XIV. Le Brun had studied in Italy in 1642, where he came under the influence of the classical style of his compatriot Nicolas Poussin, discussed later in this chapter. Stylistically, Le Brun tempered the more exuberant Baroque ceiling decorations he had seen in Rome with Poussin's classicism to create spectacular decorations. The underlying theme for the design and decoration of the palace was the glorification of the king as Apollo the Sun God, with whom Louis was identified as the Sun King. Louis XIV thought of the duties of kingship, including its pageantry, as a solemn performance, so it

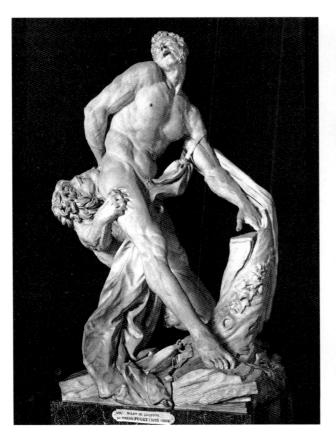

19-26. Pierre Puget. *Milo of Crotona*. 1671–82. Marble, height $8'10^{1}/2"$ (2.71 m). Musée du Louvre, Paris

was most appropriate that Rigaud's portrait of him shows him presented on a raised, stagelike platform, with a theatrical curtain (see fig. 19-1). Versailles was the splendid stage on which this grandiose drama was played.

Sculpture

In the seventeenth century, French taste in sculpture tended to favor classicizing works, whose inspiration was drawn from antiquity and from the Italian Renaissance. One exception to this was the sculpture of Pierre Puget (1620–1694), who had worked as a painter from 1640 to 1643 with Pietro da Cortona on several projects, including the Barberini Palace in Rome. After his return to France, Puget began to produce sculpture. In 1671 Louis XIV's minister Colbert commissioned him to provide three pieces for Versailles, one of which was his famous *Milo of Crotona* (fig. 19-26), completed in 1682 for the gardens.

Milo was a renowned wrestler of ancient Greece who won the Olympic Games six times. His legendary reputation for great strength was similar to that of the mythical hero Hercules. But instead of showing the athlete at a moment of triumph, Puget chose to illustrate the hero's agony before his tragic death. Having caught his hand in a tree stump that he was trying to uproot, Milo was attacked and killed by wild animals. Recalling Bernini's *David* (see fig. 19-10), every muscle of the figure's idealized physique strains against the entrapping stump, while his anguished facial expression communicates something of the passion

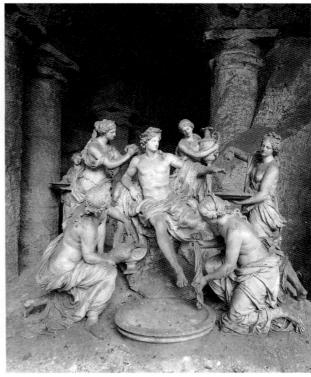

19-27. François Girardon. *Apollo Attended by the Nymphs of Thetis*, from the Grotto of Thetis, Palais de Versailles, Versailles, France. c. 1666–72. Marble, lifesize. Original setting destroyed in 1684; reinstalled in a different configuration in 1778

of Bernini's Saint Teresa of Ávila in Ectasy (see fig. 19-13).

A highly favored sculptor much more in tune with classical taste, François Girardon (1628-1715) had studied the monuments of classical antiquity in Rome in the 1640s. After working with Le Vau and Le Brun at Vaux-le-Vicomte and the Louvre, he made a considerable contribution to the decoration of Versailles. In keeping with the palace's repeated identification of Louis XIV with Apollo, he created the group Apollo Attended by the Nymphs of Thetis (fig. 19-27), executed in about 1666-1672, to be displayed in a classical arched niche in the Grotto of Thetis, a sea nymph beloved by Apollo. The original grotto was destroyed in 1684 and was replaced by the present cavelike setting in 1778. The visitor looks into Thetis's undersea grotto at the Sun God, who rests from his day's journey across the heavens while nymphs wash his tired body. All these idealized figures are based on Classical prototypes; the hair and features in particular reflect Roman sculpture.

Painting

French seventeenth-century painting was much affected by what was happening in Italian art. The lingering Mannerism of the sixteenth century gave way as early as the 1620s to Baroque classicism and **Caravaggism**—the use of strong **chiaroscuro** and raking light, and the placement of large-scale figures in the foreground. These Italianate styles found royal favor, and native French artists also established successful personal idioms. The painters

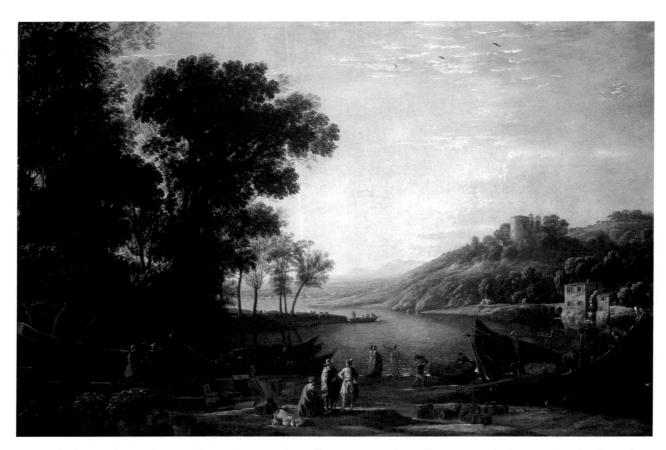

19-28. Claude Lorrain. *Landscape with Merchants*. c. 1630. Oil on canvas, 38½ x 56½ (97.2 x 143.6 cm). National Gallery of Art, Washington, D.C.

Samuel H. Kress Collection

Claude Gellée, called Claude Lorrain, or simply Claude (1600–1682), and Nicolas Poussin (1594–1665) worked for French patrons and significantly influenced other French artists, although they both pursued their careers in Italy. Claude and Poussin were classicists in that neither left nature as he found it but instead organized natural elements and figures into idealized compositions. Both were influenced by Annibale Carracci and somewhat by Venetian painting, yet each evolved an unmistakable personal style that conveyed an entirely different mood from that of their sources and from each other.

Claude went to Rome in 1613 and studied with a specialist in harbor paintings, which inspired his later enthusiasm for that subject. He dedicated himself to painting landscapes and harbor views with small figures that activated the space and provided a narrative subject. He was fascinated with light, and his works are often studies of the effect of the rising or the setting sun on colors and the atmosphere. His working method included making many sketches from nature, which he then referred to while composing in his studio. A favorite and much imitated device was to place one or two large objects in the foreground—a tree, building, or hill—past which the viewer's eye enters the scene and proceeds, often by zigzag paths, into the distance.

In his *Landscape with Merchants* (fig. 19-28) of about 1630, Claude presents an idyllic scene in which elegant

gentlemen proffer handsome goods to passersby as the sun rises on a serene world. Past the framing device of huge trees in the left foreground, the eye moves unimpeded into the open middle ground over gleaming water to arrive at a mill and waterwheel, then on to a hilltop tower illuminated by the rising sun. Along the shore is a walled city, luminous in the early morning haze. Pale blue mountains provide a final closure in the far distance.

Poussin, like Claude an important history painter, also created landscapes with small figures, but his effect is different. His Landscape with Saint John on Patmos, from 1640 (fig. 19-29), appears orderly and admirably arranged; Poussin has also created a consistent perspective progression from the picture plane back into the distance through a clearly defined foreground, middle ground, and background. These zones are marked by alternating sunlight and shade, as well as by their architectural elements, which imitate ancient Roman ruins or medieval or Renaissance buildings. Unlike some of Poussin's landscapes of identifiable sites, this is a Greek island with both real and imaginary architecture. In the middle distance are a ruined temple and an obelisk, while the round building in the distant city is Hadrian's Tomb from Rome. Precisely placed trees, hills, mountains, water, and even clouds take on a solidity of form that seems almost as structural as architecture. The reclining saint and his eagle, the symbol of Saint John, seem almost

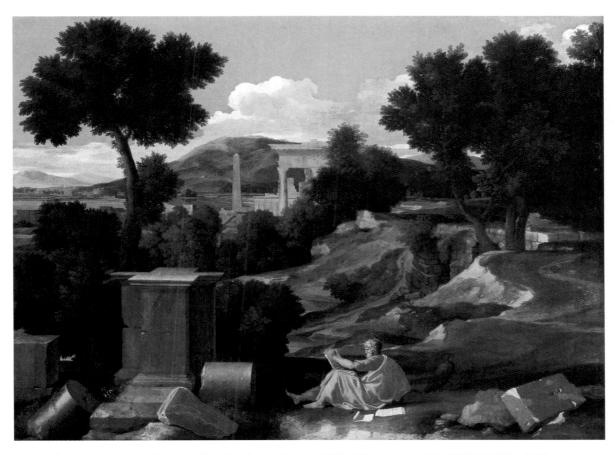

19-29. Nicolas Poussin. *Landscape with Saint John on Patmos*. 1640. Oil on canvas, 40 x 53¹/₂" (101.8 x 136.3 cm). The Art Institute of Chicago

A. A. Munger Collection, 1930.500

incidental to this perfect landscape. The subject of Poussin's painting is in effect the balance and order of nature rather than the story of Saint John the Evangelist.

One of Caravaggio's most important followers in France, Georges de La Tour (1593-1652), received major royal and ducal commissions and became court painter to King Louis XIII in 1639. La Tour may have traveled to Italy in 1614-1616, and in the 1620s he almost certainly visited the Netherlands, where Caravaggio's style was being enthusiastically emulated. Like Caravaggio, Georges de La Tour filled the foreground of his canvases with monumental figures, but in his work, Caravaggio's detailed naturalism has given way to a simplified setting and a light source within the picture so intense that it often seems to be the real subject of the painting. In his **nocturne** (night scene) *The* Repentant Magdalen (fig. 19-30), the light emanates from a candle. The hand acts as a device to establish a foreground plane, and the compression of the figure within the pictorial space leads to a sense of intimacy. The light is the unifying element of the painting and the essential conveyor of its mood. Many details of the painting have been hidden by darkness, but the essence of the forms remains, presenting a timeless image of spirituality and mystery.

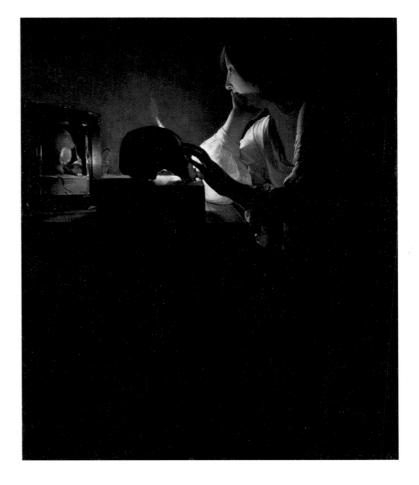

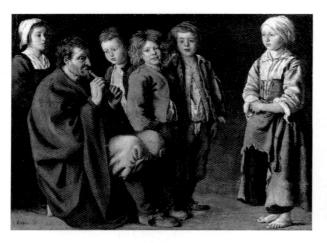

19-31. Antoine Le Nain. The Village Piper. 1642. Oil on copper, 83/8 x 111/2" (21.3 x 29.2 cm). Detroit Institute of City of Detroit Purchase

Something of this same feeling of timelessness pervades the paintings of the Le Nain brothers, Antoine (c. 1588-1648), Louis (c. 1593-1648), and Mathieu (1607-1677). Although the brothers were working in Paris by about 1630, little else is known about their lives and careers. Because they collaborated closely with each other, art historians have only recently begun to distinguish their individual styles. They did produce some history paintings, but their specialty was genre imbued with a strange sense of foreboding and enigmatic meaning. The Village Piper (fig. 19-31) of 1642, by Antoine Le Nain, is typical of the brothers' work. Peasant children gather around the figure of a flute player. The simple homespun garments and undefined setting turn the painting into a study in neutral colors and rough textures, with soft young faces that contrast with the old man, who seems lost in his simple music.

Hyacinthe Rigaud (1659–1743), trained by his painterfather, won the Royal Academy's prestigious Prix de Rome in 1682, which would have paid his expenses for study at the Academy's villa in Rome. Rigaud, however, rejected the prize and opened his own Paris studio. After painting a portrait of Louis XIV's brother in 1688, he became a favorite of the king himself. One of his best-known portraits—one representing the height of royal propaganda—is the one of the Sun King painted in 1701 with which we opened the chapter (see fig. 19-1). Rigaud, whose magnificent portraits so influenced later French portraitists, was far removed from both the classicizing and the Caravaggesque influences at work on the other French artists discussed above.

BAROQUE

SPANISH Spain's Habsburg kings in the seventeenth century—Philip III, Philip IV, and Charles II—presided over the

decline of the Spanish empire. Agriculture, industry, and trade all suffered, and there were repeated local rebellions, culminating in 1640, when Portugal reestablished its independence. The Dutch Republic was an increas-

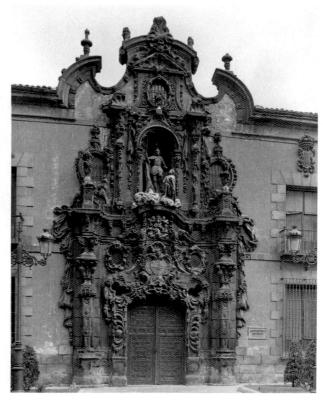

19-32. Pedro de Ribera. Portal of the Hospicio de San Fernando, Madrid. 1722

ingly serious threat to Spanish trade and colonial possessions, and what had seemed an endless flow of gold and silver from the Americas diminished, as preciousmetal production in Bolivia and Mexico declined. Nevertheless, seventeenth-century writers and artists produced much of what is considered the greatest Spanish literature and art, and the century is often called the Spanish Golden Age.

Architecture

After the severity of the sixteenth-century El Escorial (see fig. 18-83), Spanish architects returned to the lavish decoration that had characterized their art since the fourteenth century. The profusion of ornament typical of later Moorish and Gothic architecture in Spain swept back into fashion in the work of a family of architects and sculptors named Churriguera. The style, known as Churrigueresque, found its most exuberant expression in the work of eighteenth-century architects such as Pedro de Ribera (c. 1638–1742) and in the architecture of colonial Mexico and Peru. Ribera's 1722 facade for the Hospicio de San Fernando is typical (see "Elements of Architecture," page 755). The street facade is a severe brick structure with an extraordinarily exuberant architectural scheme for the portal, where the sculptural decoration is concentrated (fig. 19-32). Like a huge altarpiece, the portal soars upward, breaking through the roofline into segmental (semicircular) and triangular pediments and a dramatic broken pediment. The structural forms of classical architecture are transformed into projecting and receding layers overlaid with foliage. Carved curtains loop back as if to

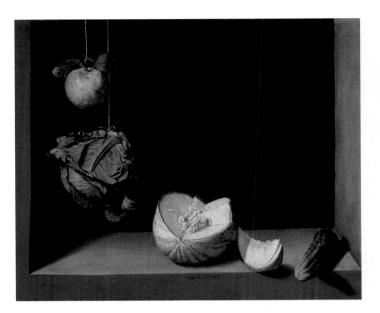

19-33. Juan Sánchez Cotán. *Still Life with Quince, Cabbage, Melon, and Cucumber.* c. 1602. Oil on canvas, 27¹/₈ x 33¹/₄" (68.8 x 84.4 cm). San Diego Museum of Art

Gift of Anne R. and Amy Putnam

reveal the doorway and the central niche, which holds the figure of the hospital's patron saint. The sophistication of the composition and carving becomes apparent when the portal is compared to its North and South American counterparts (see fig. 19-91).

Painting

The primary influence on Spanish painting in the fifteenth and sixteenth centuries had been the art of Flanders. Late in the sixteenth century, Spanish artists developed a significant interest in still lifes—paintings of artfully arranged objects-rendered with intense attention to detail. Juan Sánchez Cotán (1561-1627) was one of the earliest painters of pure still life in Spain. His Still Life with Quince, Cabbage, Melon, and Cucumber (fig. 19-33) of about 1602 is a prime example of the characteristic Spanish trompe l'oeil rendering of an artificially composed still life. Cotán's composition plays off the irregular, curved shapes of the fruits and vegetables against the angular geometry of the setting. His precisely ordered subjects, suspended from strings in a long arc from the upper left to the lower right, are set in a strong light against an impenetrable dark background. This highly artificial arrangement exemplifies a Spanish fascination with spatial ambiguity; it is not clear whether the seemingly airless space is a wall niche or a window ledge, or why these objects have been arranged in this way.

Caravaggio's most important early follower in Spanish-ruled Naples was Jusepe (José) de Ribera (1591–1652), called Lo Spagnoletto ("the Little Spaniard"). Over time, however, his Caravaggesque tenebrism gave way to more traditional illumination. After studying in Valencia and then Rome, he settled in Naples before 1620. Many of his paintings went to patrons in Spain, where they reinforced and spread the taste for Caravaggism.

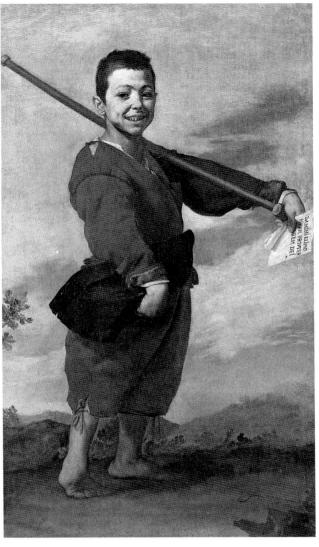

19-34. Jusepe de Ribera. *Boy with a Clubfoot*. 1642/52 (?). Oil on canvas, 5'4¹/₂" x 3'¹/₄" (1.64 x 0.92 m). Musée du Louvre. Paris

The street urchin in Ribera's *Boy with a Clubfoot* (fig. 19-34), of 1642 or 1652 (?), shows courageous optimism despite physical deformity. The boy stands silhouetted against the sky, jauntily balancing his crutch on his shoulder like a military standard. The low horizon line, sweeping vista, and rolling clouds of the setting, as well as the boy's cocky pose and direct gaze, are familiar conventions of heroic portraiture. They emphasize his spirited independence, natural vitality, and love of life. But for all its immediacy, the painting clearly embodies a moralizing theme and may even have been intended as an allegory of Charity. The paper that the boy holds bears an inscription in Spanish, which in translation is "Give me alms, for the love of God."

Diego Rodríguez de Silva y Velázquez (1599–1660), the greatest painter to emerge from the Caravaggesque school of Seville, entered its painters' guild in 1617. Like Ribera, he, too, was influenced at the beginning of his career by Caravaggesque tenebrism and naturalism.

19-35. Diego Velázquez. Water Carrier of Seville. c. 1619. Oil on canvas. 41¹/₂ x 31¹/₂" (105.3 x 80 cm). Wellington Museum, London In the oppressively hot climate of Seville, Spain, where this painting was made, water vendors walked the streets selling their cool liquid from large clay jars like the one in the foreground. In this scene the clarity and purity of the water is proudly attested to by its seller, who offers the customer a sample poured into a glass goblet. The jug contents were usually sweetened by the addition of a piece of fresh fruit or a sprinkle of aromatic herbs.

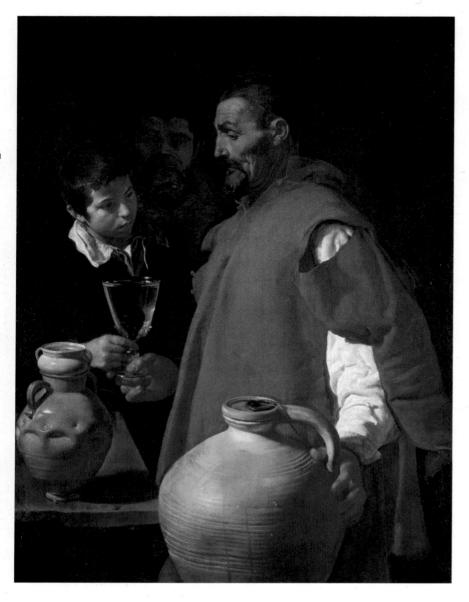

During his early years, he painted figural works set in taverns, markets, or kitchens, showing still lifes of various foods and kitchen utensils. Velázquez was devoted to studying and sketching from life, and the model for the superb Water Carrier of Seville (fig. 19-35), of about 1619, was a well-known Sevillian water seller. Like Sánchez Cotán, Velázquez arranged the elements of his paintings with almost mathematical rigor. The objects and figures allow the artist to exhibit his virtuosity in rendering sculptural volumes and contrasting textures illuminated by dramatic natural light, which reacts to the surfaces: reflecting off the glazed waterpot at the left and the matte-, or dull-, finished jug in the foreground; being absorbed by the rough wool and dense velvet of the costumes; and reflecting, being refracted, and passing through the clear glass and the waterdrops on the jug's skin.

In 1623 Velázquez moved to Madrid, where he became court painter to young King Philip IV (ruled 1621–1665), a comfortable position that he maintained until his death in 1660. The artist's style evolved subtly but significantly over his long career. The Flemish painter Peter Paul Rubens, during a 1628–1629 diplomatic visit to

the Spanish court, convinced the king that Velázquez should visit Italy, which Velázquez did in 1629–1631 and again in 1649–1651, thus being exposed to Italian painting of that time.

Although complex compositions were characteristic of many Velázquez paintings, perhaps his most striking and enigmatic work is the enormous multiple portrait, nearly 10½ feet tall and 9 feet wide, known as *Las Meninas*, or *The Maids of Honor* (fig. 19-36). Painted in 1656, near the end of the artist's life, this painting continues to reveal its creator's complex conception. Like Caravaggio's *Entombment* (see fig. 19-20), it draws the viewer directly into its action, for the viewer is standing, apparently, in the space occupied by King Philip and his queen, whose reflections can be seen in the large mirror on the back wall. The central focus, however, is on the couple's five-year-old daughter, the Infanta (Princess) Margarita, surrounded by her attendants, most of whom are identifiable portraits.

A cleaning of *Las Meninas* in 1984 revealed much about Velázquez's methods. He used a minimum of underdrawing, building up his forms with layers of loosely

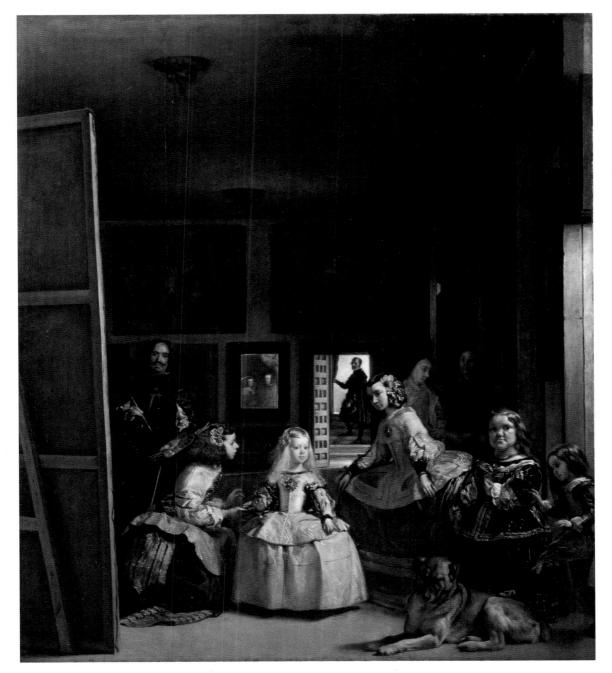

19-36. Diego Velázquez. *Las Meninas (The Maids of Honor)*. 1656. Oil on canvas, 10'5" x 9'1/2" (3.18 x 2.76 m). Museo del Prado, Madrid

applied paint and finishing off the surfaces with dashing highlights in white, lemon yellow, and pale orange. Velázquez tried to depict the optical properties of light rather than using it to model volumes in the classical manner. While his technique captures the appearance of light on surfaces, at close inspection his forms dissolve into a maze of individual strokes of paint (fig. 19-37).

In a sense, it does not matter whether the painting is meant to depict the king and queen while the others look on or to capture the royal pair stepping into the artist's studio just as he is taking a break from painting the Infanta. Throughout his life Velázquez had sought acclaim for himself and for his art. No matter what its real subject is, *Las Meninas* shows him at the peak of his good fortune, as an

19-37. Diego Velázquez. Detail of *Las Meninas (The Maids of Honor)*

19-38. Francisco de Zurbarán.
Saint Serapion.
1628. Oil on canvas, 47½ x 40¾ (120.7 x 103.5 cm).
Wadsworth
Atheneum, Hartford, Connecticut
Ella Gallup Sumner and Mary Catlin
Sumner Collection

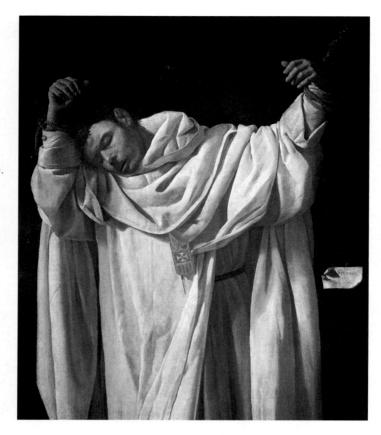

intimate of the royal family itself. Later, when he was rewarded for his long service by being made a member of the Order of the Knights of Santiago (Saint James), he added the red cross of the order to his black courtier's costume.

Francisco de Zurbarán (1598-1664) is closely associated with the monastic orders for whom he executed his major commissions. Little is known of his early years before 1625, but he was greatly influenced by the Caravaggesque taste prevalent in Seville. From it he evolved his own distinctive style incorporating a Spanish taste for abstract design, as in his 1628 Saint Serapion (fig. 19-38). Serapion was a member of the thirteenth-century Mercedarians, a Spanish order founded to rescue the Christian prisoners of the Spanish Moors. The work portrays his martyrdom after he had allowed himself to be exchanged for Christian captives. The dead man's pallor, his rough hands, and the coarse ropes contrast sharply with the off-white of his creased Mercedarian habit, its folds carefully arranged in a pattern of highlights and varying depths of shadow. The only colors are the red and gold of the insignia on a straight pin, carefully placed to hold back the outer mantle and reveal the simple tunic underneath. The effect of this composition, almost timeless in its stillness, is that of a tragic still life.

FLEMISH BAROQUE

After a period of relative autonomy from 1598 to 1621 under a Habsburg regent, Flanders returned to

direct Spanish rule and remained predominantly Catholic. Antwerp, the capital city and major arts center, gradually recovered from the turmoil of the sixteenth century, and artists of great talent flourished there, establishing

international reputations that brought them important commissions from foreign patrons.

Painting

Peter Paul Rubens (1577–1640), whose painting has become synonymous with Flemish Baroque, was born in Germany, where his father, a Protestant, had fled from his native Antwerp to escape religious persecution. In 1587, after her husband's death, Rubens's mother and her children returned to Antwerp and to Catholicism. After a youth spent in poverty, Rubens decided in his late teens to become an artist. He was accepted into the Antwerp painters' guild at age twenty-one, a testament to his energy, intelligence, and determination.

Because he lacked money to set up his own studio, Rubens worked for two years in the shop of his teacher, Otto van Veen. In 1600 he left for Italy, taking with him a pupil, whose father may have paid for the trip. While he was in Venice his work came to the attention of an agent for the duke of Mantua, and Rubens was offered a court post. His activities on behalf of the duke over the next eight years did much to prepare him for the rest of his long and stupendously successful career. Other than designs for court entertainments and occasional portraits, the duke never acquired a single original work of art by Rubens. Instead, he had him copy famous paintings in collections all over Italy to add to the ducal collection. Rubens was free, however, to accept other commissions if they did not interfere with the duke's commands.

Rubens visited every major Italian city, went to Madrid as the duke's emissary, and spent two extended periods in

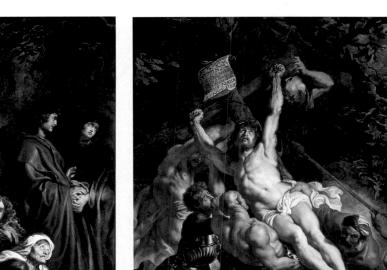

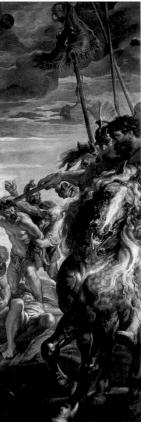

19-39. Peter Paul Rubens. The Raising of the Cross, painted for the Church of Saint Walpurga, Antwerp, Belgium. 1609-10. Oil on canvas, center panel 15'17/8" x 11'11/2" (4.62 x 3.39 m); each wing 15'17/8" x 4'11" (4.62 x 1.52 m). Cathedral of Our Lady, Antwerp

Rome, where he studied the great works of Roman antiquity and the Italian Renaissance. From 1605 to 1607, he shared quarters in Rome with his older brother Philip, providing illustrations from Classical sculpture for a book Philip was writing on Roman society. While in Italy, Rubens showed great interest in the work of two contemporaries, Caravaggio and Annibale Carracci. In 1606 he accepted a commission from the Oratorians to paint an altarpiece for the main altar of Santa Maria in Vallicella, where he certainly would have seen Caravaggio's Entombment (see fig. 19-20). Hearing of Caravaggio's death in 1610, Rubens encouraged the duke to buy the artist's painting Death of the Virgin, which had been rejected by the patron because of the shocking realism of its portrayal of the Virgin's dead body. Later, he arranged the purchase of a Caravaggio painting by an Antwerp church.

Rubens returned to Antwerp in 1608, fully expecting to go back to Italy. Once home, however, he decided to remain, and he accepted employment from the Habsburg governors of Flanders, and shortly afterward, he married. Rubens's first major commission in Antwerp was a large canvas triptych for the main altar of the Church of Saint Walpurga, The Raising of the Cross (fig. 19-39), painted in 1609-1610. Unlike earlier triptychs, where the side panels contained related but independent images, the wings here extend the action of the central scene and surrounding landscape across the vertical framing. At the center, Herculean figures strain to haul upright the

wooden cross with Jesus already stretched upon it. At the left, the followers of Jesus join in mourning, and at the right, indifferent soldiers supervise the execution. Culminating in this work are all the drama and intense emotion of a Caravaggio and the virtuoso technique of Annibale Carracci, transformed and reinterpreted according to Rubens's own unique ideal of thematic and formal unity. The heroic nude figures, dramatic lighting effects, dynamic diagonal composition, and intense emotions show his debt to Italian art, but the rich colors and surface realism, with minute attention given to varied textures and forms, belong to his native Flemish tradition.

Rubens had created a powerful, expressive visual language that was as appropriate for the secular rulers who engaged him as it was for the Catholic Church. Moreover, his intelligence, courtly manners, and personal charm made him a valuable and trusted courtier to his royal patrons, who included Philip IV of Spain, Queen-Regent Marie de' Medici of France, and Charles I of England. In 1630, while Rubens was in England on a peace mission, Charles I knighted him and commissioned him to decorate the ceiling of the new royal Banqueting House at Whitehall Palace, London (see fig. 19-63).

In 1621 Marie de' Medici, regent for her young son, Louis XIII, asked Rubens to paint the story of her life, to glorify her role in ruling France and also to commemorate the founding of the new Bourbon royal dynasty. In twenty-one paintings Rubens portrayed Marie's life and

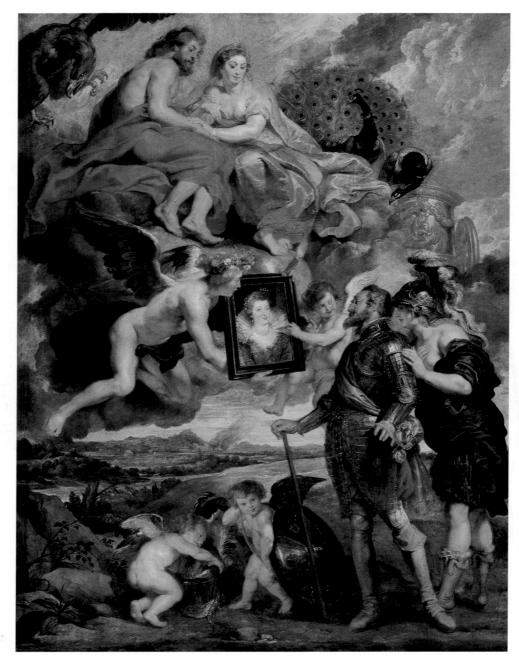

19-40. Peter Paul Rubens. *Henri IV Receiving the Portrait of Marie de' Medici*. 1621–25. Oil on canvas, 12'11¹/8" x 9'8¹/8" (3.94 x 2.95 m). Musée du Louvre, Paris

political career as one continuous triumph overseen by the gods. In fact, Marie and her husband, Henri, appear as Roman gods themselves.

In the painting depicting the royal engagement (fig. 19-40), Henri IV falls in love at once with Marie's portrait, shown to him by Cupid and Hymen, the god of marriage, as the supreme Roman god, Jupiter, and his wife, Juno, look down from the clouds. Henri, wearing his steel breastplate and silhouetted against a landscape in which the smoke of the battle lingers in the distance, is encouraged by a personification of France to abandon war for love, as putti play with the rest of his armor. The sustained visual excitement of these enormous canvases makes them not only important works of art but political propaganda of the highest order.

For all the grandeur of his commissioned paintings, Rubens was a sensitive, innovative painter, as the works he created for his own pleasure clearly demonstrate. One of his greatest joys was his country home, the Château of Steen, a working farm with gardens, fields, woods, and streams. Steen furnished subjects for several pastoral paintings, such as *Landscape with Rainbow* (fig. 19-41), of about 1635. The atmosphere after a storm is nearly palpable, with the sun breaking through clouds and the air still moisture laden, as farmworkers resume their labors. These magnificent landscapes had a significant impact on later painting.

Steen was in no sense a retirement home, and Rubens continued to produce large commissions for clients all over Europe. He employed dozens of assistants, many

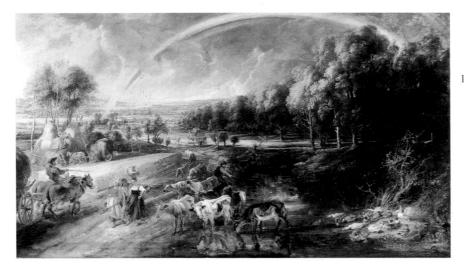

19-41. Peter Paul Rubens. *Land-scape with Rainbow.* c. 1635. Oil on panel, 4'5³/₄" x 7'9¹/₈" (1.36 x 2.36 m). Wallace Collection, London

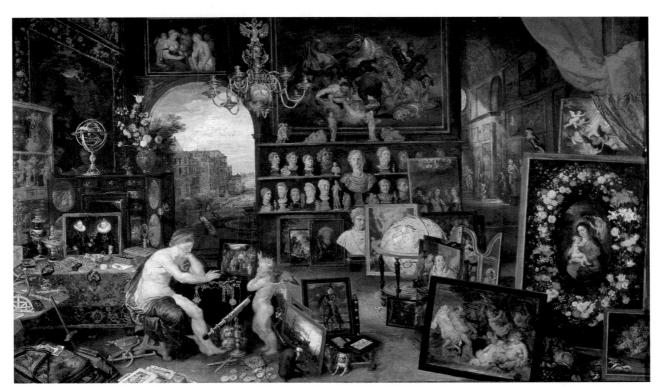

19-42. Jan Brueghel. *Sight*, from Allegories of the Five Senses. c. 1617–18. Oil on panel, 5'9½4" x 8'7½16" (1.76 x 2.64 m). Museo del Prado, Madrid

of whom were, or became, important painters in their own right. Using workshop assistants was standard practice for a major artist, but Rubens was particularly methodical, training or hiring specialists in costumes, still lifes, land-scapes, portraiture, and animal painting who together could complete a work from Rubens's detailed sketches.

One of his collaborators was Jan Brueghel (1568–1625), son of Pieter Brueghel the Elder and a highly regarded landscape and flower painter. Jan was called Velvet Brueghel, perhaps because of his love of elegant dress. Rubens and Jan may have met at the Antwerp Guild of Saint Luke, which the Brussels-born Jan entered in 1597 after working for a time in Italy. Among Jan's famous works are Allegories of the Five Senses, one of which, *Sight* (fig. 19-42), was painted about 1617–1618. Jan's arched setting

is filled with an encyclopedic display of beautiful things that appeal to the eye, including every sort of artwork, from Classical sculpture and rich decorative objects to paintings. Through the open arch is a peacock, its tail full of eyes, a fitting emblem for this particular sense.

The paintings in *Sight* are replicas of actual works, many of which are identifiable, but the large religious painting reproduced at the right is of special significance. The original *Virgin and Child in a Garland of Flowers* was a joint production, with the flowery wreath painted by Jan and the figures by Rubens. Already an extremely popular genre among Netherlandish artists at the end of the sixteenth century, still-life paintings of cut-flower arrangements were produced by the hundreds throughout the Baroque period.

19-43. Anthony Van Dyck. Charles I at the Hunt. 1635. Oil on canvas, 8'11" x 6'11" (2.75 x 2.14 m). Musée du Louvre, Paris

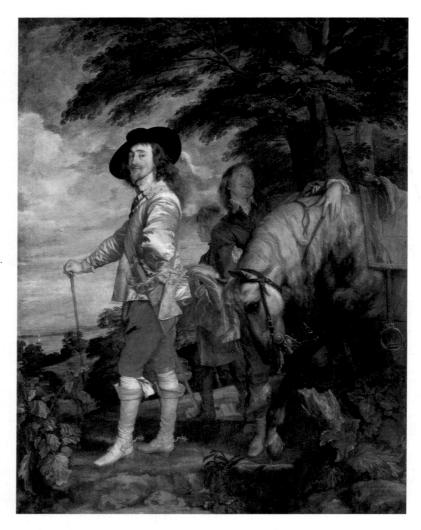

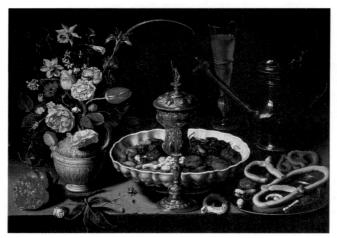

19-44. Clara Peeters. Still Life with Flowers, Goblet, Dried Fruit, and Pretzels. 1611. Oil on panel, 193/4 x 251/4" (50.2 x 64.1 cm). Museo del Prado, Madrid Typical of Dutch breakfast pieces, this painting features a pile of pretzels among the elegant tablewares. The word pretzel, which comes from the Latin pretiola, meaning "small reward," was given to this salty, twisted bread because it was invented by southern

German monks to reward children who had learned their prayers. The twisted shape represented the crossed arms of a child praying. Following a longestablished Netherlandish tradition, the artist included a portrait of herself in a reflection on the covered goblet at the center and again in the multiple reflections on the pewter pitcher in the right back-

Another of Rubens's collaborators, Anthony Van Dyck (1599–1641), had an illustrious though short career, mainly as a portraitist. Son of an Antwerp silk merchant, he was listed as a pupil of the dean of Antwerp's Guild of Saint Luke at age ten. He had his own studio and roster of pupils at age sixteen but was not made a member of the guild until 1618, the year after he began his association with Rubens as a painter of heads. The necessity for blending his work seamlessly with that of Rubens affected Van Dyck's technique, but his artistic character was expressed in the elegance and aristocratic refinement of his own work. After a trip to the

English court of James I (ruled Great Britain 1603–1625) in 1620, Van Dyck traveled to Italy and worked as a portrait painter to the nobility for seven years before returning to Antwerp. In 1632, he returned to England as the court painter to Charles I, by whom he was knighted and given a studio, a summer home, and a large salary.

Van Dyck's many portraits of the royal family provide a sympathetic record of their features, especially those of King Charles. In Charles I at the Hunt (fig. 19-43) of 1635, Van Dyck was able, by clever manipulation of the setting, to portray the king truthfully and yet as a quietly imposQUARREL OF THE **ANCIENTS** AND THE

When the French Royal Academy of Painting and Sculpture was established MODERNS in 1648, its academicians considered an-

cient art the absolute standard by which to judge contemporary work. After the reorganization of the Academy in 1663 under Jean-Baptiste Colbert, students at the Academy school were instructed chiefly by drawing casts of Roman sculpture. They attended compulsory lectures on classical art theory.

In the 1680s, however, younger members of the Academy began to rebel against this rigid program. Charles Perrault, brother of architect Claude Perrault, who helped design the east facade of the Louvre (see fig. 19-22), published two tracts in which he argued that artists of his own century had made great advances on the ancients, even surpassing them in some respects. Modern artists could draw on new styles and utilize linear perspective, which was unknown to the Greeks and Romans. The result was a series of papers and debates, which came to be known as the Quarrel of the Ancients and the Moderns.

Parallel to the guarrel ran another, which debated the value of color versus drawing in painting. The Academy's position was that in painting, drawing was superior to color because drawing appealed to the mind, while color appealed to the senses. Many younger members of the Academy, however, had come to admire the vivid colors of Titian, Veronese, and Rubens. Their position was that the principal aim of painting is to deceive the eye and that color achieves this deception more convincingly than drawing.

The defenders of the Academy position were called poussinistes in honor of the artist Nicolas Poussin (who by this time had been dead for six years), because his work was thought to embody perfectly the classical principles of subject and design. The partisans of color were called rubénistes, because of their admiration for the color of Rubens. Since these disputes attacked the most cherished academic orthodoxies, the fact that they happened at all caused the Academy's authority to be eroded, and by the end of the century the views of the rubénistes came to be generally accepted.

The portraitist and critic Roger de Piles (1635-1709), though not a member of the Academy, took a lively interest in the debate, publishing his views in a series of pamphlets, in which he defended the primacy of color and particularly praised the work of Rubens. In The Principles of Painting, de Piles evaluated the most important painters on a scale of 0 to 20 in what he considered the Four Principal Parts of Painting: composition, drawing, color, and expression. He gave no score higher than 18, for no mortal artist could achieve "sovereign perfection," that is, 20 (cited in Holt, volume 2, pages 183-87). Few people today would rank Michelangelo below Primaticcio or give Rembrandt and Caravaggio a 6 in drawing!

The Best-Known Painters	Composition	Drawing	Color	Expression
Albrecht Dürer	8	10	10	8
Giovanni Bellini	4	6	14	O
Annibale Carracci	15	17	13	13
Leonardo	15	16	4	14
Michelangelo	8	17	4	8
Caravaggio	6	6	16	O
Parmigianino	10	15	6	6
Veronese	15	10	16	3
Poussin	15	17	6	15
Primaticcio	15	14	7	10
Raphael	17	18	12	18
Rembrandt	15	6	17	12
Rubens	18	13	17	17
Titian	12	15	18	6
Van Dyck	15	10	17	13

ing figure. Dressed casually for the hunt and standing on a bluff overlooking a distant view, Charles is shown as being taller than his pages and even than his horse, since its head is down and its heavy body is partly off the canvas. The viewer's gaze is diverted from the king's delicate and rather short frame to his pleasant features, framed by his jauntily cocked cavalier's hat. As if in decorous homage, the tree branches bow gracefully toward him, echoing the circular lines of the hat.

A contemporary of Van Dyck in Antwerp who did not work for Rubens, Clara Peeters (1594-after 1657), an early still-life specialist, was a prodigy whose career seems to have begun before she was fourteen. She married in Antwerp and was a guild member there, but she may have previously spent time in Holland. Of some fifty paintings now attributed to her, many are of the type called breakfast pieces, showing a table set for a meal of bread and fruit. As in her Still Life with Flowers, Goblet, Dried Fruit, and Pretzels (fig. 19-44) of 1611, Peeters arranged rich tableware and food against neutral, almost black backgrounds, the better to emphasize the fall of light over the contrasting surface textures. The pretzels, piled high on the pewter tray, are a particularly interesting Baroque element, with their complex multiple curves. The luxurious goblet and bowl contrast with the simple pewterware, as do the flowers with the pretzels.

SCIENCE THE SEVEN-TEENTH CENTURY

Francis Bacon (1561-AND ART IN 1626) in England and René Descartes (1596-1650) in France established a new scientific method of

studying the world by insisting on scrupulous objectivity and logical reasoning. Bacon proposed that facts be established by observation and tested by controlled experiments. Descartes argued for the deductive method of reasoning, in which a conclusion was arrived at logically from basic premises, the most fundamental of which was "I think, therefore I am." Descartes even used logic to prove the existence of God. Seventeenth-century scientists continued to believe that God had created matter, the basis of all things, and that their discoveries simply amplified human understanding of Creation, and this added to God's glory. Church authorities, however, often disagreed.

In 1543 the Polish scholar Nicolaus Copernicus (1473-1543) published On the Revolutions of the Heavenly Spheres, which contradicted the long-held view that the Earth is the center of the universe (the

Ptolemaic theory) by arguing instead that the Earth and other planets revolve around the Sun. The Church viewed the Copernican theory as a challenge to its doctrines and put On the Revolutions of the Heavenly Spheres on its Index of Prohibited Books in 1616. At the beginning of the seventeenth century Johannes Kepler (1571-1630), the court mathematician and astronomer to Holy Roman Emperor Rudolf II, demonstrated that the planets revolve around the Sun in elliptical orbits. Kepler noted a number of interrelated dynamic geometric patterns in the universe, the overall design of which he believed was an expression of Divine order.

Galileo Galilei (1564-1642), an astronomer, mathematician, and physicist, was the first to develop a new invention, the telescope, as a tool for observing the heavens. His findings provided further confirmation of the Copernican theory, and after the teaching of that theory was prohibited by the Church, Galileo was tried for heresy by the Inquisition. Under duress, he publicly rejected his views, although at the end of his trial, according to legend, he muttered, "Nevertheless it [the Earth] does move." As the first person to see the craters of the moon through a telescope, Galileo began the exploration of space that would culminate in the first human steps on the moon in 1969.

The new seventeenth-century science turned to the study of the very small as well as to the vast reaches of space. Here the new technology included the microscope, developed by the Dutch lens maker and amateur scientist Anton van Leeuwenhoek (1632-1723). Although embroiderers, textile inspectors, manuscript illuminators, and painters already used magnifying glasses in their work, Leeuwenhoek perfected grinding techniques and increased the power of his lenses far beyond what was required for these uses. Ultimately, he was able to study the inner workings of plants and animals and even see microorganisms. Early scientists learned to draw or depended on artists to draw the images revealed by the microscope for further study and publication. Not until the discovery of photography in the nineteenth century could scientists communicate their discoveries without an artist's help.

DUTCH **BAROQUE**

The Dutch struggle for independence continued until Spain recognized Dutch sovereignty in 1648.

During this period the Dutch Republic, as the northern Netherlands was officially known, managed not only to maintain its hard-won independence but also to prosper.

The Hague was the capital city and the preferred residence of the ruling princes of the House of Orange, but Amsterdam was the true center of power, owing to its sea trade and the enterprise of its merchants, who made the city an international commercial center. Historically, the princes of Orange had not been enthusiastic patrons of the arts, although the situation distinctly improved under Prince Frederick Henry (ruled 1625-1647). Nevertheless, Dutch artists found many eager patrons among the prosperous middle class in Amsterdam, Leiden, Haarlem, Delft, and Utrecht.

Painting and Prints

The art popular in the seventeenth-century Netherlands shows that the Dutch delighted in depictions of themselves and their country's landscape, cities, and domestic life, not to mention beautiful and interesting objects. In addition, the Dutch, a well-educated people, were fascinated by history, mythology, the Bible, new scientific discoveries, commercial expansion abroad, and colonial exploration (see "Science and Art in the Seventeenth Century," above). Many paintings show a continuation of the

tradition of Netherlandish art, established in the time of Robert Campin and Jan van Eyck (Chapter 17), in which common objects carried underlying symbolic or moralizing meanings.

Portraits. Dutch Baroque portraiture took many forms, ranging from single portraits in sparsely furnished settings to allegorical depictions of people in elaborate costumes with appropriate symbols. Although the accurate portrayal of settings, costumes, and facial features was the most important gauge of a portrait's success, Dutch painters consistently went beyond pure description to idealize their subjects and to convey a sense of their personalities. Group portraiture that documented the membership of corporate organizations was a Dutch specialty. These large canvases filled with numerous individuals, who shared the cost of the commission, challenged painters to present a coherent, interesting composition that, nevertheless, gave equal attention to each individual portrait.

Frans Hals (c. 1581/85–1666), the leading painter of Haarlem, studied with the Flemish Mannerist Karel van Mander, but little is certain about Hals's work before 1616. He had by then developed a style grounded in the Netherlandish love of realism and inspired by the Caravaggesque style, yet it was far from slavish to either one. Like Velázquez, he tried to re-create the optical effects of light on the shapes and textures of objects. He painted boldly, with slashing strokes and angular patches

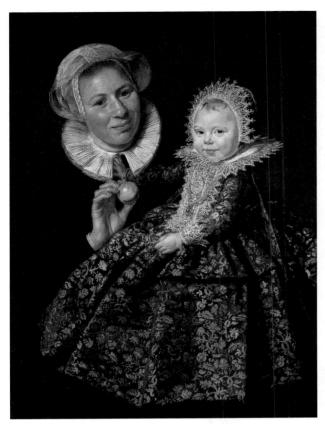

19-45. Frans Hals. *Catharina Hooft and Her Nurse.* c. 1620. Oil on canvas, 33³/₄ x 25¹/₂" (85.7 x 64.8 cm). Staatliche Museen zu Berlin, Preussischer Kulturbesitz, Gëmaldegalerie

of paint that coalesce, when seen at a distance, into solid forms over which a flickering light seems to move. In Hals's hands this seemingly effortless technique suggests a boundless joy of life.

In his unusual painting *Catharina Hooft and Her Nurse* (fig. 19-45) of about 1620, he captured the vitality of an instantaneous gesture and a fleeting moment in time. While the portrait records for posterity the great pride of the parents in their child and their wealth, it is much more than a study of rich fabrics, laces, and expensive toys. Hals depicts the heartwarming delight of the child, who seems to be acknowledging the viewer as a loving family member while her doting nurse tries to distract her with an apple.

In contrast to this intimate individual portrait are Hals's official group portraits, such as his *Officers of the Haarlem Militia Company of Saint Adrian* (fig. 19-46), of

19-46. Frans Hals. *Officers of the Haarlem Militia Company of Saint Adrian.* c. 1627. Oil on canvas, 6' x 8'8" (1.83 x 2.67 m). Frans Halsmuseum, Haarlem

Hals painted at least six group portraits of civic-guard organizations, including two for the Company of Saint Adrian. The company, made up of several guard units, was charged with the military protection of Haarlem whenever it was needed. Officers came from the upper middle class and held their commissions for three years, whereas the ordinary guards were tradespeople and craftworkers. Each company was organized like a guild under the patronage of a saint. When the men were not on war alert, the company functioned as a fraternal order, holding archery competitions, taking part in city processions, and maintaining an altar in the local church. (See also fig. 19-48.)

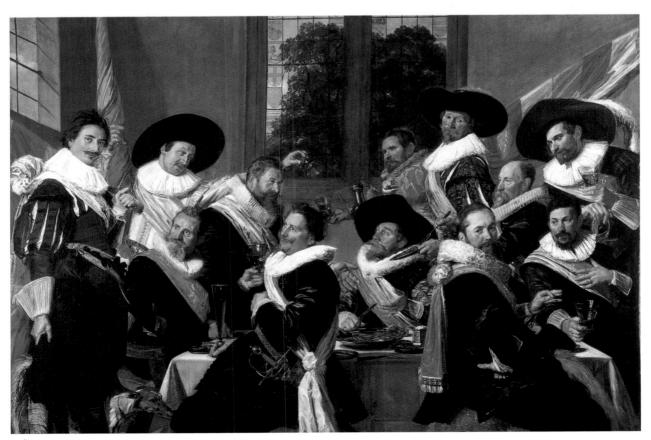

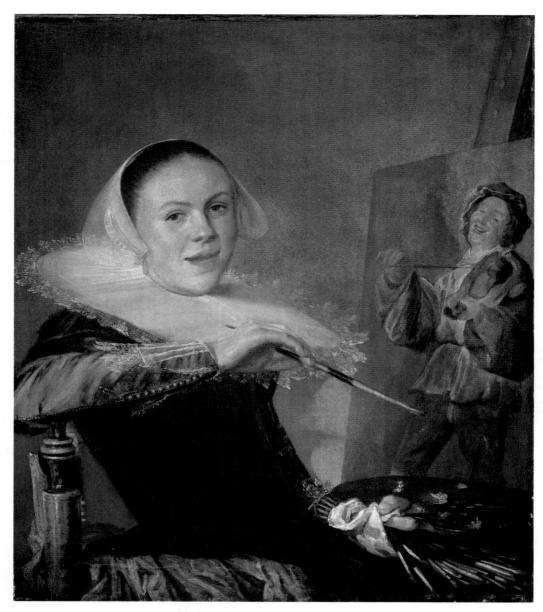

19-47. Judith Leyster. *Self-Portrait.* 1635. Oil on canvas, 29½ x 25¾ (74.9 x 65.4 cm). National Gallery of Art, Washington, D.C. Widener Collection

about 1627. Less imaginative artists had arranged their sitters in neat rows to depict every face clearly. Hals's dynamic composition turned the group portrait into a lively social event, even while maintaining a strong underlying geometry of diagonal lines—gestures, banners, and sashes—balanced by the stabilizing perpendiculars of table, window, tall wineglass, and striped banner. The black suits and hats make the white ruffs and sashes of pink, orange, blue, and green even more brilliant.

The most successful of Hals's contemporaries to adopt his almost boisterous early manner was Judith Leyster (c. 1609–1660). In fact, one painting long praised as one of Hals's finest works was recently discovered to be by Leyster when a cleaning revealed her distinctive signature, the monogram *JL* with a star, in reference to her surname, Leysterre ("Pole Star"), which her family took from the name of their Haarlem brewery.

Although almost nothing is known of her early years, in 1628-1629 she was with her family in Utrecht, where she very likely encountered artists who had traveled to Italy and fallen under the spell of Caravaggio. Leyster's work shows clear echoes of her exposure to these Utrecht Caravaggisti, who had enthusiastically adopted the Italian master's naturalism, the dramatic tenebrist lighting effects, the large figures pressed into the foreground plane, and, especially, the theatrically presented everyday or low-life themes. In 1631 Leyster signed as a witness at the baptism in Haarlem of one of Frans Hals's children, which has led to the probably incorrect conclusion that she was Hals's pupil. Leyster may have worked in his shop, however, since she entered Haarlem's Guild of Saint Luke only in 1633. Membership allowed her to take pupils into her studio, and her competitive relationship with Frans Hals around that time is made clear by Etching with acid on metal was used to decorate armor and other metal wares before it became a printmaking medium. The earliest

etchings were made in Germany in the early 1500s, and even Albrecht Dürer experimented with the technique briefly by etching a few plates. These early etchings were made on iron, which tended to produce a ragged, fuzzy line. When printmakers began to work on copper with slow-acting acids, they produced a cleaner, more reliable image. Rembrandt was the first artist to popularize etching as a major form of artistic expression.

In the etching process, a plate, or metal sheet, is coated on both sides with an acid-resistant varnish that dries hard without being brittle. Then, instead of laboriously cutting the lines of the desired image directly into the plate, the artist draws through the varnish with a sharp needle to expose the metal. The plate is then covered with acid, which eats into the metal exposed by the drawn lines. By controlling the time the acid stays on different parts of the plate, the artist can make fine, shallow lines or heavy, deep ones. The varnish covering the plate is removed before an impression is taken. If a change needs to be made, the lines can be "erased" with a sharp metal scraper. Finally, accidental scratches are eliminated by burnishing (polishing). Not surprisingly, a complex image with a wide range of tones requires many steps.

Another technique for registering images on a metal plate is called drypoint. A sharp needle is used to

ETCHING AND scratch lines in the metal, but there are two major differences in technique between the process of engraving and that of drypoint

(see "Woodcuts and Engravings on Metal," page 673). The engraving tool, or burin, is held straight and throws up equal amounts of metal, called burr, on both sides of the line, but the drypoint needle is held at a slight slant and throws up most of the burr on one side. Also, in engraving the metal burr is scraped off and the plate polished to yield a clean, sharp groove to hold the ink for printing. In drypoint the burr is left in place, and it, rather than the groove, holds the ink. Thus, under magnification, drypoint lines are white, with ink on both sides, but their rich black appearance when printed is impossible to achieve with engraving or etching. Unfortunately, drypoint burr is fragile, and only a few prints—a dozen or fewer-can be made before it flattens and loses its character. Rembrandt's earliest prints were pure etchings, but later he enriched his prints with drypoint to achieve greater tonal richness.

Like engraving, etching and drypoint use a printing technique called intaglio. After the desired image has been etched or scratched into the metal printing surface, printing ink is applied over the whole plate and forced down into the lines; then the surface of the plate is carefully wiped clean. Just as in the engraving process, the ink in the lines prints onto a sheet of paper pressed firmly against the metal plate.

the complaint she lodged against him in 1635 for luring away one of her apprentices.

Leyster is known primarily for her informal scenes of daily life, which often carry an underlying moralistic theme. In her lively Self-Portrait (fig. 19-47) of 1635, the artist has paused momentarily in her work to look back, as if the viewer has just entered the room. Her elegant dress and the fine chair in which she sits are symbols of her success as an artist whose popularity was based on

the very type of painting under way on her easel. Her subject, a man playing a violin, may be a visual pun on the painter with palette and brush. So that the viewer would immediately see the difference between her painted portrait and the painted painting, she varied her technique, executing the image on her easel more loosely. The narrow range of colors sensitively dispersed in the composition and the warm spotlighting are typical of Leyster's mature style.

19-48. Rembrandt van Rijn. *Captain Frans Banning Cocq Mustering His Company (The Night Watch).* 1642. Oil on canvas (cut down from the original size), 11'11" x 14'4" (3.63 x 4.37 m). Rijksmuseum, Amsterdam

The most important painter working in Amsterdam in the seventeenth century was Rembrandt van Rijn (1606–1669), now revered as one of the great artists of all time. Rembrandt was one of nine children born in Leiden to a miller and his wife. Rembrandt was sent to the University of Leiden in 1620 at age fourteen, but within a few months he dropped out to study painting. From 1621 to about 1624 he was apprenticed to a Leiden artist, then worked briefly in the Amsterdam studio of the history painter Pieter Lastman. Back in Leiden by 1625, Rembrandt soon developed a large following as a painter of religious pictures. In 1631 or 1632 he returned to Amsterdam to work in the studio of the art dealer Hendrick Van Uylenburgh. Although the dealer may have sold Rembrandt's original paintings, copies were also made from them for sale by a stable of artists whom Van Uylenburgh employed for this purpose.

In Amsterdam, Rembrandt broadened his repertoire to include mythological paintings, landscapes, and figure studies, but his primary source of income was portraiture. His work quickly attracted the interest of the secretary to Prince Frederick Henry, whose favorite artist was Peter Paul Rubens. Knowing this, Rembrandt studied Rubens's work and incorporated some of his compositional ideas in a series of paintings for the prince on the subject of the Passion of Christ (c. 1632–c. 1640).

Prolific and popular with Amsterdam clientele, Rembrandt ran a busy studio producing works that sold for high prices. His large workshop and the many pupils who imitated his manner have made it difficult for scholars to define his body of work, and many paintings formerly attributed to him have recently been assigned to other artists. Rembrandt's mature work reflected his new environment, his study of science and nature, and the broad-

1675 1575 1775

ening of his artistic vocabulary by the study of Italian Renaissance art, chiefly from engraved copies. In 1639 he purchased a large house, which he filled with art and an enormous supply of studio props, such as costumes, weapons, and stuffed animals.

In 1642 Rembrandt was one of several artists commissioned by a wealthy civic-guard company to create large group portraits of its members for its new meeting hall. The result, Captain Frans Banning Cocq Mustering His Company (fig. 19-48), is considered one of Rembrandt's finest works. Because of the dense layer of grime and darkened varnish on it and its dark background architecture, this painting was once thought to be a night scene and was therefore called *The Night Watch*. After recent cleaning and restoration it now exhibits a natural golden light that sets afire the palette of rich colors-browns, blues, olive green, orange, and redaround a central core of lemon yellow in the costume of a lieutenant. To the dramatic group composition, showing a company forming for a parade in an Amsterdam street, Rembrandt added several colorful but seemingly unnecessary figures. While the officers stride purposefully forward, the rest of the men and several mischievous children mill about. The young girl at the left, carrying a chicken and wearing a money pouch, and the boy firing a blank rifle at the lieutenant's fancy plumed hat are so unusual that attempts have been made to find symbolic or ironic meaning in them. From the earliest days of his career, however, Rembrandt was devoted to sketching people he encountered in the streets. These figures may simply add lively touches of interesting local color to heighten the excitement of the scene.

Rembrandt was second only to Albrecht Dürer (Chapter 18) in his enthusiasm for printmaking as an important art form with its own aesthetic qualities and expressiveness. His interest focused on etching, a relatively minor medium at the time, in which the picture is created with acid on metal plates. His earliest line etchings date from 1627. About a decade later he began to experiment with additions in the drypoint technique, in which the artist uses a sharp needle to scratch shallow lines in a plate (see "Etching and Drypoint," page 789). Because etching and drypoint allow the artist to work directly on the plate, the style of the finished print has the relatively free and spontaneous character of a drawing. Rembrandt's commitment to the full exploitation of the medium is indicated by the fact that he alone carried the creative process through from the preparation of the plate to its inking and printing, and he constantly experimented with the technique, with methods of inking, and with papers for printing.

Although he is best known for his narrative prints on religious, mythological, and historical subjects, Rembrandt found that patrons enjoyed having their portraits etched. Other than his family, his subjects were exclusively well-to-do middle-class men, several of whom posed in Rembrandt's studio in the same high-back chair with lion's-head finials that appears in his portrait *Jan Lutma, Goldsmith* (fig. 19-49) of 1656. The print was created by etching a dense, intricate web of **cross-hatched** lines, then enriching small areas by hand with

19-49. Rembrandt van Rijn. *Jan Lutma, Goldsmith.* 1656. Etching and drypoint, 7³/₄ x 6" (19.6 x 16 cm). Museum of Fine Arts, St. Petersburg, Florida
Gift of Margaret Acheson Stuart

the drypoint needle, whose soft burr created a velvety black when inked and printed. Lutma's profession is indicated by the goldsmith's mallet, a jar of punches, a basin on the table, and a statuette held in his right hand. The translation of the inscription in Latin above the table is "Jan Lutma Goldsmith, born in Groningen."

Rembrandt painted many self-portraits, in which one can trace the evolution of his style. By 1659 his past tribulations, including the death in childbirth of his wife, seem to have deepened his sensitivity to the human condition, for these images of himself became more searching and, like many of his paintings of other subjects, expressed a personal, internalized spirituality new in the history of art (fig. 19-50). Here, the half-length figure and the setting merge in a rich, luminous chiaroscuro, with the face and clasped hands emerging out of the darkness. A few wellplaced brushstrokes suggest the physical tension in the fingers and the weariness of soul in the deep-set eyes. Mercilessly analytical, the portrait depicts the furrowed brow, sagging flesh, and prematurely aged face (he was only fifty-three) of one who has suffered deeply but retained his dignity.

Although continually plagued by financial problems, Rembrandt remained a popular artist and teacher, painting ever more brilliantly in a unique manner that distilled a lifetime of study and contemplation of life and human personalities. Among his late achievements is *The Jewish*

19-50. Rembrandt van Rijn. *Self-Portrait.* 1659. Oil on canvas, 33¹/₄ x 26" (84 x 66 cm). National Gallery of Art, Washington, D.C. Andrew W. Mellon Collection

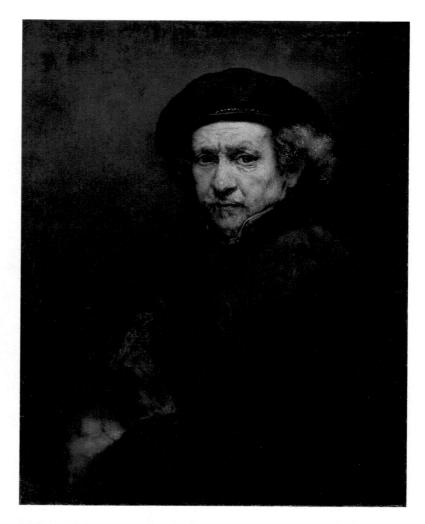

19-51. Rembrandt van Rijn. *The Jewish Bride.* c. 1665. Oil on canvas, 3'11³/₄" x 5'5¹/₂" (1.21 x 1.65 m). Rijksmuseum, Amsterdam

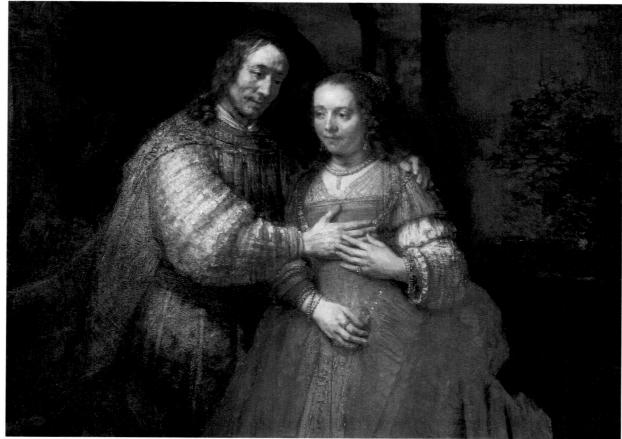

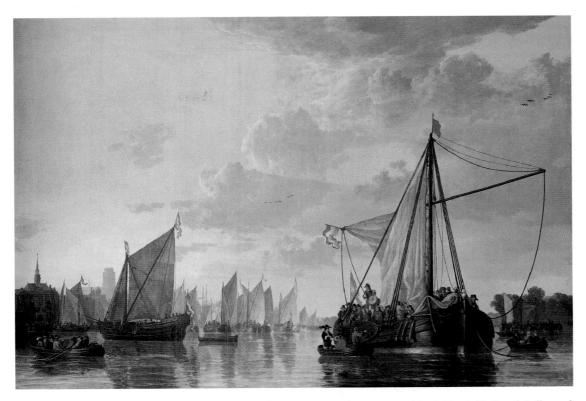

19-52. Aelbert Cuyp. *Maas at Dordrecht. c.* 1660. Oil on canvas, 3'9¹/₄" x 5'7" (1.15 x 1.70 m). National Gallery of Art, Washington, D.C.

Andrew W. Mellon Collection

Bride (fig. 19-51) of about 1665. This wedding portrait of the Jewish poet Don Miguel de Barrios and his wife, Abigael de Pina, was probably meant to refer to the marriage of Isaac and Rebecca or some other loving biblical couple. The groom's tender gesture of touching his bride's breast is an ancient symbol of fertility. Over the twenty years since the execution of Captain Frans Banning Cocq Mustering His Company, the artist's facility with brush and paint had not weakened. The monumental figures emerge from the same type of dark architectural background, perhaps a garden wall and portico, with the warm light suffusing the scene and setting the reds and golds of their costumes aglow. In comparison with Jan van Eyck's emotionally neutral Portrait of Giovanni Arnolfini (?) and His Wife, Giovanna Cenami (?) of the early fifteenth century (see fig. 17-10), where the meaning of the picture relied heavily on its symbolic setting, the significance of The Jewish Bride is emotional, conveyed by loving expressions and gestures.

Landscapes and Seascapes. The Dutch loved the landscapes and vast skies of their own country, but those who painted them were not slaves to nature as they found it. The artists were never afraid to remake a scene by rearranging, adding, or subtracting to give their compositions formal organization or a desired mood. Starting in the 1620s, view painters generally adhered to a convention in which little color was used beyond browns, grays, and beiges. After 1650, they tended to be more individualistic in their styles, but nearly all brought a broader

range of colors into play. One continuing **motif** was the emphasis on cloud-filled expanses of sky dominating a relatively narrow horizontal band of earth below.

From a family of artists, Aelbert Cuyp (1620-1691) of Dordrecht specialized early in his career in view painting. Cuyp first worked in the older, nearly monochromatic convention for recording the Dutch countryside and waterways. About 1645, his style evolved to include a wider range of colors, while also moving toward more idealized scenes drenched with a warm golden light, such as his Maas at Dordrecht (fig. 19-52), painted about 1660. This dramatic change has been attributed to Cuyp's contact with Utrecht painters who were influenced by contemporary landscape painting in Italy, especially the works of the French expatriate Claude Lorrain (see fig. 19-28). Unlike the Italian and French preference for religious, historical, or other narrative themes expressed through the figures inhabiting the landscape, Cuyp and other Dutch painters tended to represent nature for its own sake, even as they idealized it. The wide, deep harbor of the Maas River at Dordrecht was always filled with cargo ships and military vessels. A contemporary record mentions a fleet of ships with some 30,000 men in the harbor in 1646. If there is any symbolic meaning here, it might express Cuyp's pride in Dordrecht's contribution to the Dutch Republic's prosperity, independence, and peaceful life.

The Haarlem landscape specialist Jacob van Ruisdael (1628/29–1682) was especially adept at both the invention of dramatic compositions and the projection of moods in

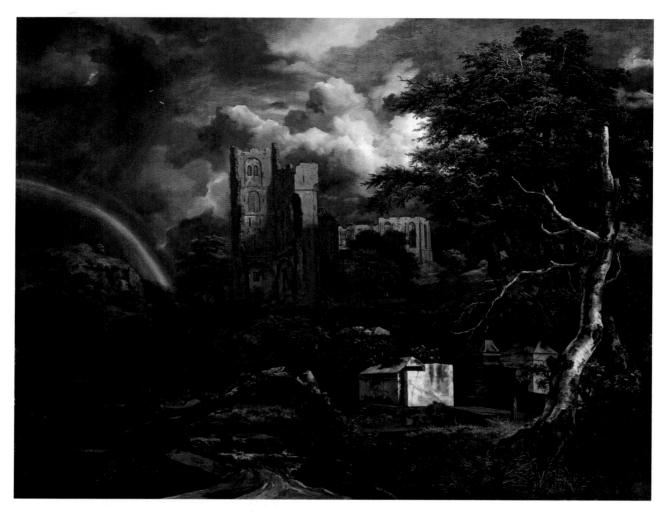

19-53. Jacob van Ruisdael. *The Jewish Cemetery*. 1655–60. Oil on canvas, $4'6" \times 6'2^{1/2}" (1.42 \times 1.89 \text{ m})$. Detroit Institute of Arts Gift of Julius H. Haass in memory of his brother Dr. Ernest W. Haass

19-54. Meindert Hobbema. Avenue at Middelharnis. 1689. Oil on canvas, $40^3/4 \times 55^1/2$ " (104 x 141 cm). The National Gallery, London

his canvases. His *The Jewish Cemetery* (fig. 19-53) of 1655–1660 is a thought-provoking view of silent tombs, crumbling ruins, and stormy landscape, with a rainbow set against dark, scudding clouds. Ruisdael was greatly concerned with spiritual meanings, which he expressed

in his choice of such environmental factors as the time of day, the weather, the appearance of the sky, or the abstract patterning of sun and shade. Here the tombs, ruins, and fallen and blasted trees suggest an allegory of transience. The somewhat melancholy mood is mitigated by the rainbow, a traditional symbol of renewal.

Ruisdael's popularity drew many pupils to his workshop, the most successful of whom was Meindert Hobbema (1638–1709), who studied with him from 1657 to 1660. Although there are many similarities with Ruisdael's style in Hobbema's earlier paintings, his mature work moved away from the melancholy and dramatic moods of his master. Hobbema's love of the peaceful, orderly beauty of the civilized Dutch countryside is exemplified by one of his best-known paintings, *Avenue at Middelharnis* (fig. 19-54). In contrast with the broad horizontal orientation of many Dutch landscapes, Hobbema's composition draws the viewer into the picture and down the rutted, sandy road toward the distant village of Middelharnis as convincingly and compellingly as if the artist were a student of Italian Renaissance perspective.

Genre Painting. Dutch genre paintings of contemporary life were categorized in their own time by such descriptive titles as the "merry company," "garden party,"

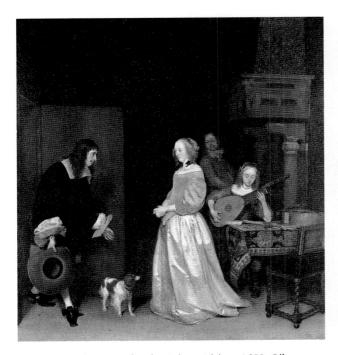

19-55. Gerard Ter Borch. *The Suitor's Visit.* c. 1658. Oil on canvas, 32½ x 29⁵/8" (80 x 75 cm). National Gallery of Art, Washington, D.C.

Andrew W. Mellon Collection

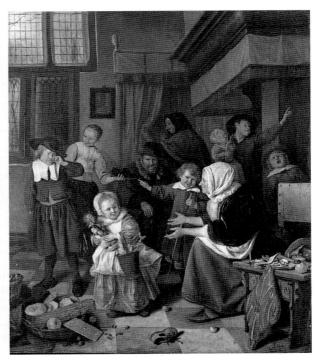

19–56. Jan Steen. The Feast of Saint Nicholas. c. 1660–65. Oil on canvas, $32^{1/4}$ x $27^{3/4}$ " (82 x 70.5 cm). Rijksmuseum, Amsterdam

and "picture with little figures." Scholars of this period have noted that many of these works contain symbolic objects that suggest underlying meanings. Many of these messages seem to be admonitory, warning against alcoholism, gambling, or sexual promiscuity. The artists probably meant for their works to be understood on more than one level, a long tradition in Netherlandish painting. Where religious symbolism had dominated earlier works, Baroque artists painted chiefly for private patrons, who seem to have wanted paintings to be instructive as well as beautiful. Recent scholarship has found clues to the meaning of Dutch genre paintings in the emblem books that were popular at the time. These books were illustrated catalogs of allegorical or symbolic images, each one generally accompanied by a moralizing verse. Although these books tell a great deal about the meanings of Dutch genre painting, they can be confusing. In an emblem book published in 1618, one of the best-known compilers of emblems gave different common meanings for each image, depending upon whether the approach was moralizing, religious, or "romantic."

Before he began to specialize in genre pictures about 1650, Gerard Ter Borch (1617–1681) was highly regarded for his battle scenes and portraits. He was renowned for his exquisite rendition of lace, velvet, and, especially, satin, a skill well demonstrated in a work traditionally known as *The Suitor's Visit* (fig. 19-55), painted about 1658. It shows a well-dressed man bowing gracefully to an elegant woman in a sumptuously furnished room in which another woman plays the lute. The painting appears to represent a prosperous gentleman paying a call on a lady of equal social status, possibly to propose marriage. The dog in the painting and the musician seem

to be simply part of the scene. We are already familiar with the dog as a symbol of fidelity, and stringed instruments were said to symbolize, through their tuning, the harmony of souls and thus, possibly, a loving relationship. However, Ter Borch's scene has also been interpreted as showing a guest arriving at a luxurious house of prostitution. Supporting this view is the woman's low-cut neckline, which would have been considered improperly revealing for most social occasions in the seventeenth-century Netherlands. Moreover, the dog symbolizes sexual appetite as well as fidelity, and lute playing in the Netherlands was almost always associated with erotic activity.

The genre paintings of Jan Steen (1626–1679), whose larger brushstrokes contrast with the meticulous treatment of Ter Borch, used scenes of everyday life to portray moral tales, illustrate proverbs and folk sayings, or make puns to amuse the spectator. Steen was influenced early in his career by Frans Hals. His work in turn influenced a **school**, or circle of artists working in a related style, of Dutch artists who emulated his style and subjects. To support his family, Steen worked in a brewery for several years, and from 1670 until his death he kept a tavern in Leiden.

Jan Steen's paintings of children are especially remarkable, for he captured not only their childish physiques but also their fleeting moods and expressions, as in *The Feast of Saint Nicholas* (fig. 19-56) of about 1660–1665. Paintings like this suggest why today the Dutch phrase "Jan Steen's household" is used to describe a disorganized or untidy home. Here members of a family with seven children have gathered to celebrate the feast with a pile of sweets and toys for the children. Most

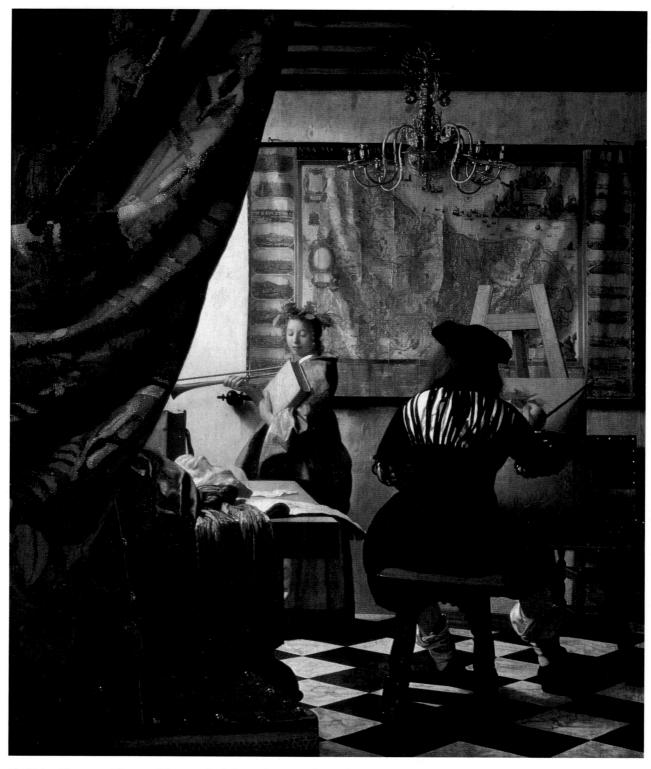

19-57. Jan Vermeer. *Allegory of the Art of Painting*. 1670–75. Oil on canvas, 52 x 44" (132 x 112 cm). Kunsthistorisches Museum, Vienna

of the children have found gifts in their shoes, except the unhappy boy at the left, who found his shoe filled with switches. To make matters worse, his younger sister and brother are having a good laugh at his expense. Meanwhile, the acquisitive little girl at the center has gathered up all the toys, including a Saint Nicholas doll, and is resisting her mother's coaxing gesture to share them with the others. A helpful oldest son distracts an infant and another child by pointing at something above their

heads, while the father of the noisy brood looks on. In the shadows at the rear corner of the room, the children's grandmother or nurse smiles broadly and beckons with her finger, perhaps to soothe the crying boy with something she has been saving for him behind the draperies. In the work of many Netherlandish artists, children's activities were used to caricature adult foolishness. Thus, Steen's painting may be an admonishment for people to rise above childish greed and jealousy. Whatever the

case, *The Feast of Saint Nicholas* presents a fascinating view of Dutch life.

Perhaps the greatest of the Dutch genre painters was Jan (Johannes) Vermeer (1632–1675) of Delft. An innkeeper and art dealer who painted only for local patrons, Vermeer entered the Delft artists' guild in 1653. Meticulous in his technique, with a unique compositional approach and painting style, Vermeer produced few works. Of the fewer than forty canvases securely attributed to him, most are of a similar type—quiet, low-key in color, and asymmetrical but strongly geometric in organization. They are frequently enigmatic scenes of women in their homes, alone or with a servant, who are occupied with some cultivated activity, such as writing, reading letters, or playing a musical instrument. Vermeer also produced history paintings, views of Delft, and pictures of men and women together in the manner of Gerard Ter Borch, whom he knew.

Vermeer also painted at least two allegorical works, one of which is the Art of Painting (fig. 19-57), the title by which it was listed in documents after his death. The exact date of the painting is unknown; it may be as early as 1662-1665 or as late as 1670-1675. In 1662 Vermeer was elected an officer of the Guild of Saint Luke in Delft and probably was involved in the decoration of its guildhall with allegories of Painting, Sculpture, and Architecture. Also, scholars have noted connections with allegorical descriptions found in Cesare Ripa's emblem book Iconologia, which had been translated into Dutch by 1644. On the table at the left in Vermeer's painting is a large stone mask, which refers to painting's imitation of life. The model's laurel-leaf crown, book, and trumpet identify her as Clio, the Muse of History. The Muses, nine goddesses associated with Apollo, were thought by the ancient Greeks to inspire the arts, including the writing of history. The old-fashioned costume worn by the painter and the map on the wall, which shows the Netherlands as it had been in the previous century, may express nostalgia for the past. The Dutch were accomplished cartographers, and Dutch genre artists frequently used maps symbolically in their paintings. In the lower border of the map is the artist's signature, "I Ver-Meer." By setting his subject far from the picture plane and framing it in a doorway, Vermeer has removed his figures psychologically from the viewer. He thus endows them with a timeless stability that is reinforced by the geometry of the painting, in which every object seems carefully placed to achieve an overall balance, by the quiet atmosphere, and by the clear, even light.

A type of genre picture that achieved great popularity in the Baroque period was the **architectural interior**. These interior views seem to have been painted for their own special beauty, just as exterior views of the land, cities, and harbors were. The Rotterdam portrait and history painter Emanuel de Witte (c. 1617–1692) specialized in this type of work after moving to Delft in 1640 and after settling permanently in Amsterdam in 1652. Although many of his interiors were composites of features from several locations combined in one idealized architectural view, de Witte also painted faithful portraits of actual buildings. One of these is his *Portuguese Synagogue, Am*-

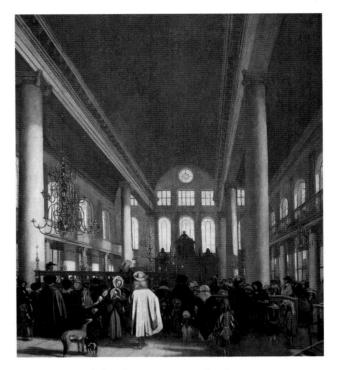

19-58. Emanuel de Witte. *Portuguese Synagogue, Amsterdam.* 1680. Oil on canvas, 43½ x 39"
(110.5 x 99.1 cm). Rijksmuseum, Amsterdam

sterdam (fig. 19-58) of 1680. The synagogue is shown here as a rectangular hall divided into one wide central aisle with narrow side aisles, each covered with a wooden barrel vault resting on lintels supported by columns. De Witte's shift of the viewpoint slightly to one side has created an interesting spatial composition, and strong contrasts of light and shade add dramatic movement to the simple interior. The caped figure in the foreground and the dogs provide a sense of scale for the architecture and add human interest.

Today, the painting is interesting both as a record of seventeenth-century synagogue architecture and as evidence of Dutch religious tolerance in an age when Jews were often persecuted. Ousted from Spain and Portugal in the late fifteenth and early sixteenth centuries, many Jews had settled first in Flanders and then in the Netherlands. The Sephardic (Spanish) and Portuguese Jews in Amsterdam enjoyed religious and personal freedom, and their synagogue was considered one of the outstanding sights of the city.

Still Lifes and Flower Pieces. The term *still life* for paintings of artfully arranged objects on a table comes from the Dutch *stilleven*, a word coined about 1650. The Dutch were so proud of their artists' still-life paintings that they presented one to the French queen Marie de' Medici when she made a state visit to Amsterdam. As with genre pictures, still-life paintings often carried allegorical or moralizing connotations. A common type was the *vanitas*, whose elements reminded viewers of the transience of life, material possessions, and even art.

Still-life paintings consisting predominantly of cutflower arrangements are often referred to as **flower pieces**. Significant advances were made in botany during

THE DUTCH ART MARKET

Visitors to the Netherlands in

the seventeenth century noted the great popularity of art, not just among aristocrats but also among merchants and working people. Peter Mundy, an English traveler, wrote in 1640: "As For the art off Painting and the affection off the people to Pictures, I thincke none other goe beeyond them, there having bin in this Country Many excellent Men in thatt Facullty, some att presentt, as Rimbrantt, etts. [etc.] All in generall striving to adorne their houses, especially the outer or street roome, with costly peeces, Butchers and bakers not much inferiour in their shoppes, which are Fairely sett Forth, yea many tymes blacksmithes, Coblers, etts., will have some picture or other by their Forge and in their stalle. Such is the generall Notion, enclination and delight that these Countrie Native[s] have to Paintings"

(cited in Temple, page 70).

This taste for art stimulated a free market for paintings that functioned like other commodity markets. Without Church patronage and with limited civic and private commissions, artists had to compete to capture the interest of their public by painting on speculation. Naturally, specialists in particularly popular types of images were likely to be financially successful, and what most Dutch patrons wanted were paintings of themselves, their country, their homes, and scenes of the life around them. It was hard to make a living as an artist, and many artists had other jobs, such as tavern keeping and art dealing, to make ends meet. In some cases, the artist was more entrepreneur than art maker, running a "stable" of painters who made copy after copy of original works to sell. Forgery was not unknown, either. The painter Jan Vermeer, a connoisseur of Italian art, was called to court at The Hague in 1672 to examine a group of paintings sold by a Dutch dealer to the Elector of Brandenburg as works by Titian, Raphael, and Michelangelo. Vermeer's judgment was that they were not Italian, "but, on the contrary, great pieces of rubbish and bad paintings" (cited in Blankert, page 17).

The market for engravings and etchings, both for original compositions and for copies after paintings, was especially active in the Netherlands. One copperplate could produce hundreds of impressions, and worn-out plates could be reworked and used again. Although most prints sold for modest prices, Rembrandt's etching *Christ Healing the Sick* (1649) was already known in 1711 as the "Hundred-Guilder Print," because of the then-unheard-of price that one patron had paid for an impression of it.

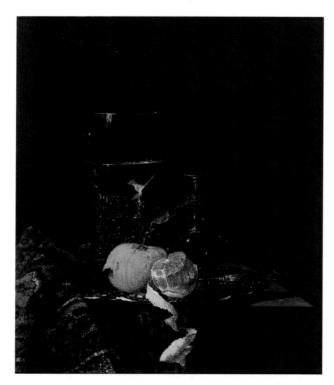

19-59. Wilhelm Kalf. *Still Life with Lemon Peel*. 1659. Oil on canvas, 20 x 17" (50.8 x 43.1 cm). Stichting Vrienden van het Mauritshuis, The Hague

the Baroque period through the application of orderly scientific methods, and objective observation was greatly improved by the invention of the microscope in 1674. The Dutch Republic was also a major importer, grower, and exporter of exotic flowers, especially tulips, which appear in nearly every flower piece in dozens of exquisite variations.

Wilhelm Kalf (1619-1693) of Rotterdam, an excellent painter of breakfast pieces, specialized in table settings of a rich and exotic character. This kind of painting was popular in the second half of the seventeenth century, and Kalf helped supply the thriving art market (see "The Dutch Art Market," above). In his Still Life with Lemon Peel (fig. 19-59) of 1659, Kalf depicts the surface textures of Chinese porcelain, gold, silver, brass, crystal, and an Oriental rug, which Dutch owners generally used to cover fine wood furniture. The half-peeled lemon—an expensive fruit in the Netherlands at the time-with its peel spiraling down implies that the unseen diner suddenly left the table. Thus, the "interrupted-meal" still life has been interpreted as a vanitas reminding the viewer that Death can come in the midst of pleasure. Citrus fruits also had sexual implications, and a half-peeled lemon often appears in depictions of houses of prostitution. One of the greatest pleasures of such paintings is the artist's virtuosity in rendering the subtle contrasts among the lemon's opaque, oily rind, its soft white pith, and the taut, transparent skin of the interior of the fruit.

Before the invention of photography, scientific investigations relied entirely on drawn and painted illustrations, and researchers hired artists to accompany them on field trips. Anna Maria Sibylla Merian (1647–1717) was unusual in making noteworthy contributions as both researcher and artist. German by birth and Dutch by training, Merian was once described by a Dutch contemporary as a painter of flowers, fruit, birds, worms, flies, mosquitoes, spiders, "and other filth." At the time, it was believed that insects emerged spontaneously from the soil, but Merian's research on the life cycles of insects proved otherwise, findings she published in 1679 and 1683 as *The Wonderful Transformation of Caterpillars and (Their) Singular Plant Nourishment.* In 1699 Amsterdam subsidized

19-60. Anna Maria Sibylla Merian. Plate from *The Metamorphosis of Insects of Surinam*. 1705. Hand-colored engraving, 18⁷/₈ x 13" (47.9 x 33 cm). National Museum of Women in the Arts, Washington, D.C.

Merian's research on plants and insects in the Dutch colony of Surinam in South America, whose results were published as *The Metamorphosis of Insects of Surinam*, illustrated with sixty large plates engraved after her watercolors. Each plate is scientifically precise, accurate, and informative, presenting insects in various stages of development along with the plants they live on (fig. 19-60).

The Dutch tradition of flower painting peaked in the long career of Rachel Ruysch (1663–1750) of Amsterdam. Her flower pieces were highly prized for their sensitive, free-form arrangements and their unusual and beautiful color harmonies. During her seventy-year career spanning the two Baroque centuries, she became one of the most sought-after and highest-paid still-life painters in Europe. In her *Flower Still Life* (fig. 19-61), painted after

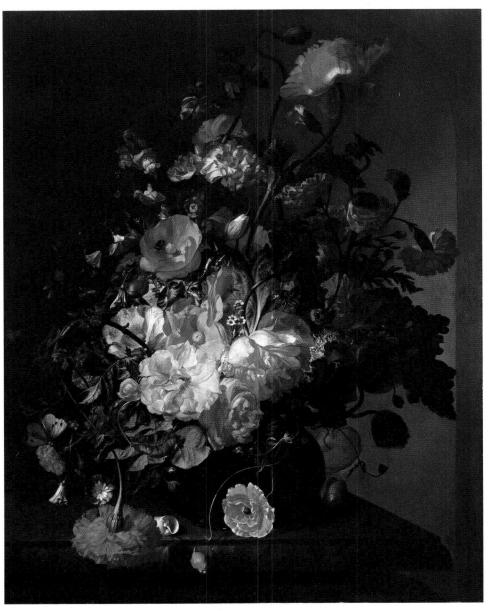

19-61. Rachel Ruysch. Flower Still Life. After 1700. Oil on canvas, 30 x 24" (76.2 x 61 cm). The Toledo Museum of Art, Toledo, Ohio Gift of Edward Drummond Libbey

Flower painting was a much-admired specialty in the seventeenth-century Netherlands. Such paintings were almost never straightforward depictions of actual fresh flowers. Instead, artists made color sketches of fresh examples of each type of flower and studied scientifically accurate color illustrations in botanical publications. Using their sketches and notebooks, in the studio they could compose bouquets of perfect specimens of a variety of flowers that could never be found blooming at the same time. In fifteenth-century painting, flowers carried religious symbolism, especially in conjunction with images of the Virgin Mary. Baroque flower paintings were less specifically symbolic, but the short life of blooming flowers was a poignant reminder of the fleeting nature of beauty and human life.

1700, Ruysch placed the container at the center of the canvas's width, then created an asymmetrical floral arrangement of pale oranges, pinks, and yellows rising from lower left to top right of the picture, offset by the strong diagonal of the tabletop. To further balance the painting, she placed highlighted blossoms and leaves against the dark left half of the canvas and silhouetted them against the light wall area on the right. Ruysch often emphasized the beauty of curving flower stems and enlivened her compositions with interesting additions, such as casually placed pieces of fruit or insects, in this case a large gray moth (lower left) and two snail shells.

BAROQUE

ENGLISH England and Scotland came under the same rule in 1603 with the ascent of James VI of Scotland to the

English throne as James I (ruled 1603-1625). James increased the royal patronage of British artists, especially in literature and architecture. William Shakespeare's Macbeth, featuring the king's legendary ancestor Banquo, was written in tribute to the new royal family and performed at court in December 1606. James's son Charles I (ruled 1625-1649) was also an important collector and patron of painting.

Unfortunately, religious and political tensions resulted in civil wars beginning in 1642 that cost Charles his throne and his life in 1649. Much of the rest of the Baroque period in England was politically uneasy, with a succession of republican and monarchical rulers, ending with the first three Hanoverian kings, George I, II, and III, who together ruled until 1802.

Architecture

In the early seventeenth century the architect Inigo Jones (1573–1652) introduced into England Renaissance classicism, an architectural design based on the style of the Renaissance architect Andrea Palladio (Chapter 18). Jones had studied Palladio's work in Venice, and Jones's copy of Palladio's Four Books of Architecture has been preserved, filled with notes in his hand. Jones was appointed surveyor-general in 1615 and was commissioned to design the Queen's House in Greenwich and the Banqueting House for the royal palace of Whitehall.

The Whitehall Banqueting House (fig. 19-62), built in 1619-1622 to replace an earlier one destroyed by fire, was used for court ceremonies and entertainments such as popular masques (see "The English Court Masque,"

THE **ENGLISH** COURT

James I and his successor, Charles I, were fond of dance-dramas MASQUE called masques, an important form of perfor-

mance in early Baroque England. Inspired by Italian theatrical entertainments, the English masque combined theater, music, and dance in a spectacle in which professional actors, courtiers, and even members of the royal family participated. The event was more than extravagant entertainment, however; the dramas also glorified the monarchy. The entertainment began with an antimasque in which actors described a world torn by dissension and vice. Then, to the accompaniment of theatrical effects designed to amaze the spectators, richly costumed lords and ladies of the court appeared in the heavens to vanquish Evil. A dance sequence followed, symbolizing the restoration of peace and prosperity.

Inigo Jones, the court architect, was frequently called on to produce awe-inspiring special effects—storms at sea, blazing hells, dazzling heavens, and other wonders. To meet these demands, Jones revolutionized English stage design. He abandoned the Shakespearean theater, where viewers sat on the stage with the actors, and devised a proscenium arch that divided the audience from

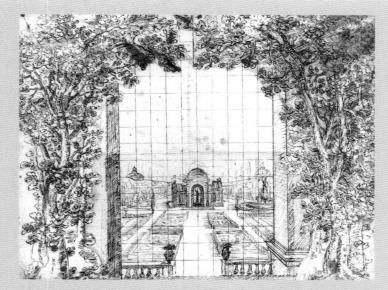

Inigo Jones. A Garden and a Princely Villa, sketch for set design for Coelum Britannicum, by Thomas Carew. Performed February 18, 1634. Pen and brown ink with green distemper wash, 165/8 x 21" (43.7 x 56.5 cm). Devonshire Collection, Chatsworth, England

the stage action. He then created a bi-level stage with an upper area, where celestial visions could take place, and a main lower area, which was equipped with sliding shutters to permit rapid set changes. Jones achieved remarkable effects of deep space using linear perspective to decorate the shutters and the back cloth. His stagecraft is known today from the many working drawings he

made, such as the design shown here, which he made for the last scene in court poet Thomas Carew's Coelum Britannicum, performed in 1634. This masque, which glorified the union of England and Scotland under James I and Charles I, ended with the appearance in clouds over the royal palace of personifications of Religion, Truth, Wisdom, Concord, Reputation, and Government.

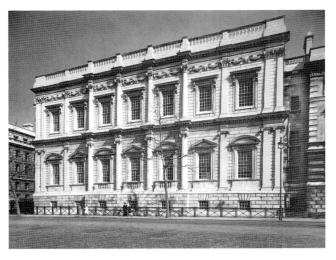

19-62. Inigo Jones. Banqueting House, Whitehall Palace, London. 1619–22

page 800). The west front shown here, consisting of two upper stories with superimposed Ionic and Composite orders raised over a plain basement level, exemplifies the understated elegance of Jones's interpretation of Palladian design. On the two upper stories, pilasters flank the end bays (vertical divisions), and engaged columns provide a subtle emphasis to the three bays at the center. These vertical elements are repeated in the balustrade along the roofline. A rhythmic effect was created in varying window treatments from triangular and segmental (semicircular) pediments on the first level to cornices with volute (scroll-form) brackets on the second. The sculpted garlands just below the roofline add an unexpected decorative touch, as does the use of a differentcolor stone—pale golden, light brown, and white—for each story.

Despite the two stories presented on the exterior, the interior of the Whitehall Banqueting House (fig. 19-63) is

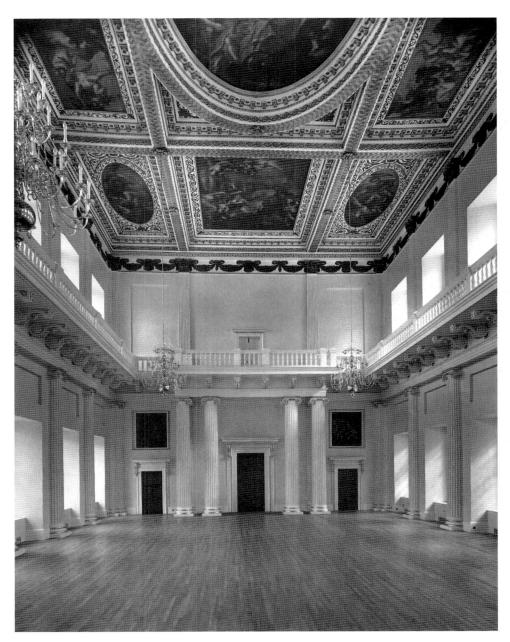

19-63. Inigo
Jones.
Interior,
Banqueting House,
Whitehall
Palace.
Ceiling
paintings
by Peter
Paul
Rubens.
1630–35

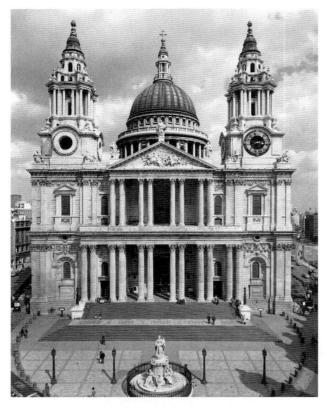

19-64. Christopher Wren. Saint Paul's Cathedral, London. 1675–1709

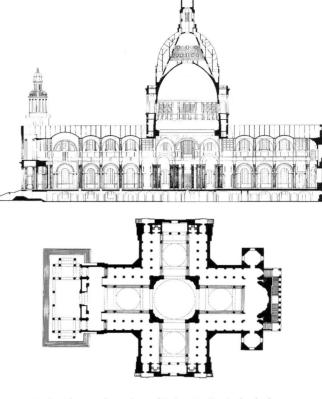

19-65. Plan and section of Saint Paul's Cathedral

actually one large hall with a balcony on the upper level and antechambers at each end. (The entrance is on the short side.) Ionic pilasters suggest a colonnade but do not impinge on the ideal, double-cube space measuring 55 by 110 feet by 55 feet high. In 1630 Charles I commissioned Peter Paul Rubens to decorate the ceiling. Jones had divided the flat ceiling into nine compartments, for which Rubens painted canvases glorifying the reign of James I. Installed in 1635, the paintings show a series of royal triumphs ending with the king carried to heaven in clouds of glory. So proud was Charles of the result that, rather than allow the smoke of candles and torches to harm the ceiling decoration, he moved the evening entertainments to an adjacent pavilion.

English architecture after 1660 was dominated by Christopher Wren (1632–1723), who built more than fifty Baroque churches. Wren began his professional career in 1659 as a professor of astronomy; architecture was a sideline until 1665, when he traveled to France to further his education. While there, he met with French architects and with Bernini, who was in Paris to consult on his designs for the Louvre. Wren returned to England with architectural books, engravings, and a greatly increased admiration for French classical Baroque design. In 1669, he was made surveyor-general, the position once held by Inigo Jones, and in 1673 he was knighted.

After the Great Fire of 1666 demolished central London, Wren was continuously involved in its rebuilding for the rest of the century and beyond. His major project was the rebuilding of Saint Paul's Cathedral (fig. 19-64), carried out from 1675 to 1709, after attempts to salvage the

burned-out medieval church failed. Like Saint Peter's Basilica in the Vatican, Saint Paul's has a long nave, short transepts with semicircular ends, and a domed crossing. Like Brunelleschi's dome for the Florence Cathedral, Wren's dome for Saint Paul's has an interior masonry vault with an oculus and an exterior sheathing of lead-covered wood (fig. 19-65). As in the two Italian churches, the dome of Saint Paul's is crowned by a tall lantern, to which a brick cone rises from the inner oculus to admit light to the interior. The dome itself is plainly derived from Bramante's Tempietto, Church of San Pietro in Montorio, Rome (see fig. 18-20). On the main west front of Saint Paul's, two stages of paired Corinthian columns—a tribute to the east front of the Louvre—support a sculpted pediment. The deep-set porches and the columned pavilions atop the towers create dramatic areas of light and shadow, recalling the facade of Borromini's Church of San Carlo alle Quattro Fontane (see fig. 19-9). The huge size of the cathedral and its triumphant verticality, complexity of form, and chiaroscuro effects make it a major monument of the English Baroque.

John Vanbrugh (1664–1726), like Wren, came late to architecture. His heavy, angular style was utterly unlike Wren's, but it was well suited to buildings intended to express power and domination, in which Vanbrugh specialized. Perhaps his most important achievement was Blenheim Palace (fig. 19-66), built from 1705 to 1721. Blenheim's enormous size and symmetrical plan, with double wings reaching out to encompass the surrounding terrain (fig. 19-67), was strongly influenced by Versailles (see fig. 19-23). Instead of the refinement of detail to be found there, however, Blenheim's classical forms, including the

19-66. John Vanbrugh. Blenheim Palace, Woodstock, Oxfordshire, England. 1705–21

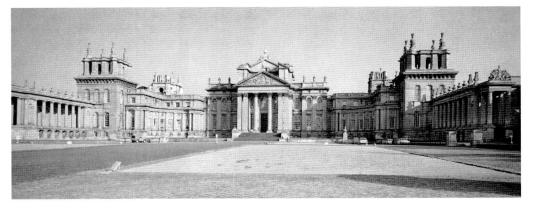

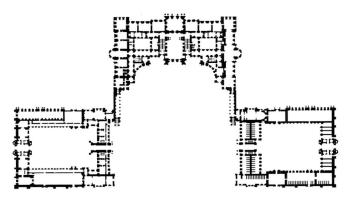

19-67. John Vanbrugh. Plan of Blenheim Palace

temple-front exterior entrance, are large and rugged. They are also combined with the expansive **glazed** windows characteristic of English palace design since the sixteenth century (see fig. 18-81). The angular exterior, with its towering statues and pinnacles, casts shadows across the central block, creating a dramatic chiaroscuro effect.

GERMAN AND AUSTRIAN BAROQUE

In the seventeenth and eighteenth centuries the Habsburg emperors ruled their vast territories from Vienna, but the rest of Germanspeaking Europe remained divided by politics and religion into small

principalities. Individual rulers decided on the religion of their territory, with Catholicism prevailing in southern and western Germany, including Bavaria and the Rhineland, and in Austria, while the north was Lutheran. Because of the devastating effects of the seventeenth-century religious wars, the Baroque style did not flourish in Germany and Austria until the eighteenth century, and then primarily under the patronage of Catholic prince-bishops.

Architecture

Eighteenth-century church architecture in Catholic Germany looked to Italian Baroque developments, which were then added to German medieval forms, such as the **westwork**, a tall west front, and bell towers. With these

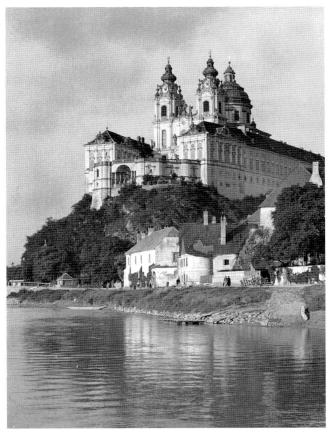

19-68. Jakob Prandtauer. Benedictine Monastery Church, Melk, Austria. 1701–38

elements German Baroque architects gave their churches an especially strong vertical emphasis. Important secular projects were also undertaken, as princes throughout Germany began building smaller versions of Louis XIV's palace and garden complex at Versailles.

One of the most imposing Baroque buildings is the Benedictine Monastery Church at Melk, built high on a promontory above the Danube River in Austria (fig. 19-68). The architect, Jakob Prandtauer (1660–1726), oversaw its construction from 1701 to 1738 on a site where there had been a Benedictine monastery since the eleventh century. Seen from the river, the monastery appears to be a huge twin-towered church. But the complex also includes two long (1,050 feet) parallel wings flanking the church, one of which contains the

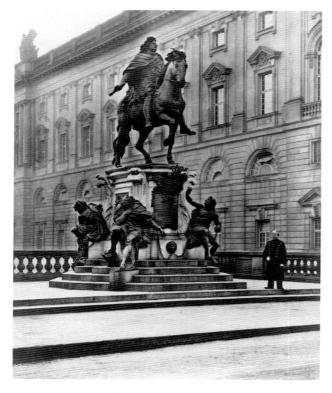

19-69. Andreas Schlüter. Frederick William, the Great Elector (of Brandenburg). 1697–1703. Bronze equestrian group, over-lifesize. Schloss Charlottenburg, Berlin

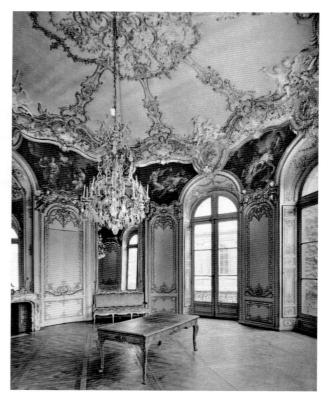

19-70. Germain Boffrand. Salon de la Princesse, Hôtel de Soubise, Paris. 1732

monastery's library. The wings are joined at the basement level by a section with a curving facade that descends from the cliff, forming a terrace overlooking the river in front of the church. Large windows and open galleries take advantage of the river view, while colossal pilasters and high bulbous-domed towers stress the verticality of the building by extending the vertical elements to a considerable height. The Melk monastery, as an ancient foundation enjoying imperial patronage, was expected to provide lodging for traveling princes and other dignitaries. Its grand and palacelike appearance was appropriate to this function.

Sculpture in Germany

Many Baroque German rulers wanted equestrian monuments of themselves. A representative example is a work by Andreas Schlüter (1664–1714), *Frederick William, the Great Elector (of Brandenburg)*, created in 1697–1703 in Berlin, the capital of Prussia (fig. 19-69). The statue commemorates the Great Elector (ruled 1640–1688) for restoring the Prussian military and improving his dominions' finances. The work is an over-lifesize bronze, set on a high podium, with its base surrounded by chained captives. Frederick's head is flung back, his hair cascading behind him like a lion's mane, as he calmly holds in check his powerful mount, with its thick neck, bulging eyes, and flaring nostrils. In contrast to the ferocity of the horse, the prince's calm demeanor suggests the cool rationality of enlightened rule. The dramatic pose of horse and rider

gives Frederick William a heroic presence, while the utter subjection of the chained captives, to whom the Great Elector seems to be oblivious, makes this an icon of absolute, unapologetic secular power. A representation of this kind greatly contrasts with the Rococo representation that developed shortly afterward in France and quickly spread to Germany and the rest of Europe.

THE ROCOCO STYLE

The Rococo style is characterized by pastel colors, delicately curving forms, dainty figures, and a light-hearted mood. It represents a lighter, more specialized phase of

Baroque. The Rococo manner may be seen partly as a reaction at all levels of society, even among kings and bishops, against the "grand manner" of art identified with the formality and rigidity of seventeenth-century court life. The movement toward a lighter, more charming manner began in French architectural decoration at the end of Louis XIV's reign (d. 1715) and quickly spread across Europe. The duke of Orléans, regent for the boyking Louis XV (ruled 1715-1774), made his home in Paris, and the rest of the court—delighted to escape Versailles—also moved there and built elegant town houses (in French, hôtels). The layout, furniture, and decor were designed for these smaller rooms, which became the settings for intimate and fashionable intellectual gatherings and entertainments, called salons, that were hosted by accomplished, educated women of the upper class whose names are still known today-Mesdames de

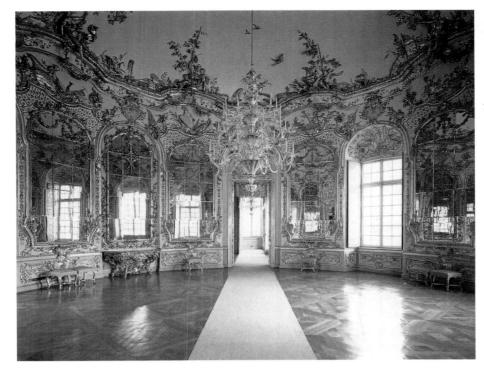

19-71. François
de Cuvilliés
the Elder.
Mirror Room,
Amalienburg,
Nymphenburg Park,
outside
Munich,
Germany.
1734–39

Staël, de La Fayette, de Sévigné, and du Châtelet, among others. The Salon de la Princesse in the Hôtel de Soubise in Paris, designed by Germain Boffrand beginning in 1732, is typical of the delicacy and lightness seen in French Rococo *hôtel* design of the 1730s (fig. 19-70). Interior designs for palaces and churches built on traditional Baroque plans were also animated by the Rococo spirit, especially in Germany and Austria. In occasional small-scale buildings the Rococo style was also successfully applied to architectural planning.

Architecture and Its Decoration in Germany and Austria

Typical Rococo elements in architectural decoration were arabesques, **S** shapes, **C** shapes, reverse **C** shapes, volutes, and naturalistic plant forms. The glitter of silver or gold against expanses of white or pastel color, the visual confusion of mirror reflections, delicate ornament in sculpted stucco, carved wood panels called *boiseries*, and inlaid wood designs on furniture and floors were all part of the new look. In residential settings, pictorial themes were often taken from classical love stories, and sculpted ornaments were rarely devoid of putti, cupids, and clouds.

The spread of the Parisian taste for Rococo architectural decoration to Germany is traditionally ascribed to the Flemish-born architect François de Cuvilliés the Elder (1695–1768), who spent almost all of his life in the service of the rulers of Bavaria. Cuvilliés studied in Paris from 1720 to 1724 and fully absorbed the new Rococo style, then returned to Munich. One of the finest examples of his style is the Amalienburg (fig. 19-71), a pavilion for royal relaxation at Nymphenburg Park outside Munich, built in 1734–1739. The main salon, or Mirror

Room, is a fantasy of sculpted silver-leafed stucco on a blue background, naturalistically depicting vines, trees, flowers, fruits, urns, baskets, and musical instruments intermingled with peacocks, putti, and reclining classical figures. The doors, window alcoves, and **dadoes** are covered with *boiseries*, and the plants that appear above the undulating cornice suggest that the domed ceiling, paler blue than the walls, is actually the sky, where birds and butterflies soar.

A major late Baroque architectural project influenced by the new Rococo style was the Residenz, a splendid palace created for the prince-bishop of Würzburg from 1719 to 1744 by Johann Balthasar Neumann (1687–1753). One of Neumann's great triumphs of planning and decoration is the oval Kaisersaal, or Imperial Hall (fig. 19-72). Although the clarity of the plan, the size and proportions of the marble columns, and the large windows recall the Hall of Mirrors at Versailles, the decoration of the Kaisersaal, with its white-and-gold color scheme and its profusion of delicately curved forms, embodies the Rococo spirit. Here one can see the earliest development of Neumann's aesthetic of interior design that culminated in his final project, the Church of the Vierzehnheiligen (see fig. 19-74).

Neumann's collaborator on the Residenz was a brilliant Venetian painter, Giovanni Battista Tiepolo (1696–1770), who began to work there in 1750. Venice in the early eighteenth century had surpassed Rome as an artistic center, and Tiepolo was acclaimed internationally for his confident and optimistic expression of the illusionistic fresco painting pioneered by such sixteenth-century Venetians as Veronese (see fig. 18-30).

Tiepolo's work in the Kaisersaal—three scenes glorifying the twelfth-century crusader-emperor Frederick Barbarossa, who had been a patron of the bishop of

1575 1775

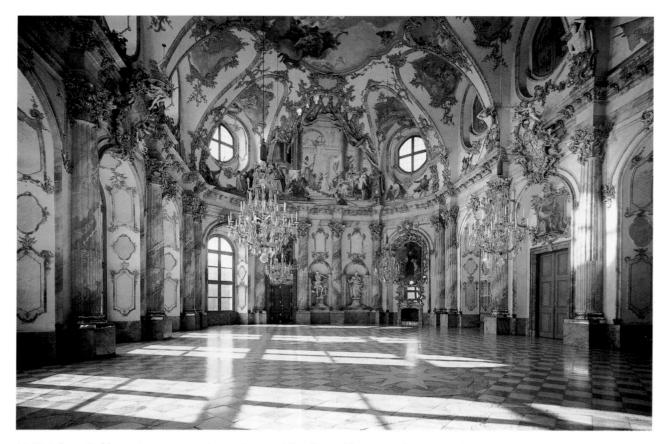

19-72. Johann Balthasar Neumann. Kaisersaal (Imperial Hall), Residenz, Würzburg, Bavaria, Germany. 1719–44. Fresco by Giovanni Battista Tiepolo. 1751–52

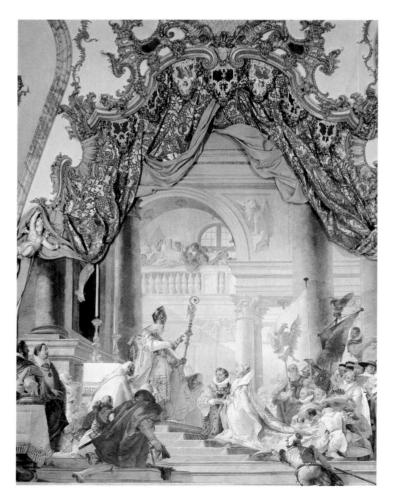

Würzburg—is a superb example of his architectural painting. The Marriage of the Emperor Frederick and Beatrice of Burgundy (fig. 19-73) is presented as if it were theater, with painted and gilded stucco curtains drawn back to reveal the sumptuous costumes and splendid setting of an imperial wedding. Like Veronese's grand conceptions (see fig. 18-1), Tiepolo's spectacle is populated with an assortment of character types, presented in dazzling light and sun-drenched colors with the assured hand of a virtuoso. Against the opulence of their surroundings, these heroic figures behave with the utmost decorum and, the artist suggests, nobility of purpose.

Rococo decoration in Germany was as often religious as secular. One of the many opulent Rococo church interiors still to be seen in Germany and Austria is that of the Church of the Vierzehnheiligen (Fourteen Auxiliary Saints) near Staffelstein (fig. 19-74), which was begun by Neumann in 1743 but was not completed until 1772, long after his death. The grand Baroque facade gives little hint of the overall plan, which is based on six interpenetrating oval spaces of varying sizes around a dominant domed ovoid center (fig. 19-75). The plan, in fact, recalls Borromini's double-shell design of the Church of San Carlo alle Quattro Fontane (see fig. 19-7). On the interior of the nave (fig. 19-76), the Rococo love of undulating surfaces and overlays of decoration creates a visionary

19-73. Giovanni Battista Tiepolo. *The Marriage of the Emperor Frederick and Beatrice of Burgundy,* fresco in the Kaisersaal (Imperial Hall), Residenz. 1751–52

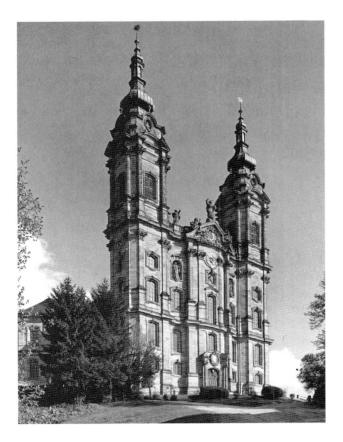

19-74. Johann Balthasar Neumann. Church of the Vierzehnheiligen, near Staffelstein, Germany. 1743–72
In the center of the nave of the Church of Vierzehnheiligen (Fourteen Auxiliary Saints) an elaborate shrine was built over the spot where, in the fifteenth century, a shepherd had visions of the Christ Child surrounded by saints. The saints came to be known as the Holy Helpers because they assisted people in need.

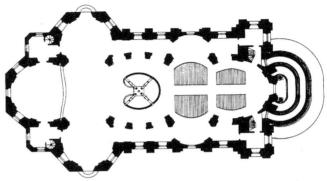

19-75. Johann Balthasar Neumann. Plan of the Church of the Vierzehnheiligen. c. 1743

world where flat wall surfaces scarcely exist. Instead, the viewer is surrounded by clusters of pilasters and engaged columns interspersed with two levels of arched openings to the side aisles and large clerestory windows illuminating the gold and white of the interior. The foliage of the fanciful capitals is repeated here and there in arabesques, wreaths, and the ornamented frames of the irregular panels that line the vault. What Neumann had begun in the Kaisersaal at Würzburg was brought to full fruition here in the ebullient sense of spiritual uplift carried by the complete integration of architecture and decoration.

Sculpture in Germany and France

Rococo sculpture style was introduced in small tabletop works on themes of fantasy and erotic love, consisting often of single figures or groups of satyrs, nymphs, cupids, Venuses, and Bacchantes (female attendants of Bacchus, the Roman wine god). Although marble and bronze were used, the less formal mediums of gilded wood, painted porcelain, and plain terra-cotta were especially popular. Over time, larger statues were also done in the Rococo manner.

From a Bavarian family of artists, Egid Quirin Asam (1692–1750) went to Rome in 1712 with his father, a

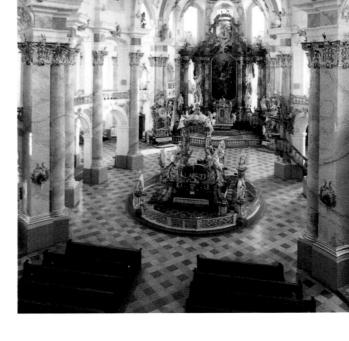

19-76. John Balthasar Neumann. Interior, Church of the Vierzehnheiligen. 1743–72

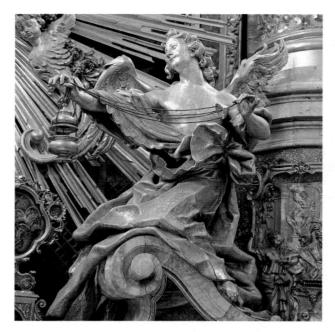

19-77. Egid Quirin Asam. *Angel Kneeling in Adoration*, part of a tabernacle on the main altar, Convent Church, near Osterhofen, Germany. c. 1732. Limewood with gilding and silver leaf, height 6'4" (2 m)

fresco painter, and his brother, Cosmas Damian (1686-1739). There, they studied Bernini's works and the illusionistic ceilings of Annibale Carracci and others. Back in Bavaria, Egid completed an apprenticeship with a Bavarian sculptor in 1716. The brothers both undertook architectural commissions, and they often collaborated on interior decoration in the Italian Baroque manner, to which they soon added lighter, more fantastic elements in the French Rococo style. Cosmas specialized in fresco painting and Egid in stone, wood, and stucco sculpture. The Rococo spirit is clearly evident in Egid's Angel Kneeling in Adoration (fig. 19-77), a detail of a tabernacle made about 1732 for the main altar of a church for which Cosmas provided the altarpiece. Sculpted of limewood and covered with silver leaf and gilding, the over-lifesize figure swings a censer and appears to have landed in a halfkneeling position on a large bracket. Bernini's angel in the Cornaro Chapel (see fig. 19-12) was the inspiration for Asam's figure, but the Bavarian artist has taken the liveliness of pose to an extreme, and the drapery, instead of revealing the underlying forms, swirls about in an independent decorative pattern.

In the last quarter of the eighteenth century, French art generally moved away from Rococo style and toward the classicizing styles that would end in Neoclassicism, but one sculptor who clung to Rococo up to the threshold of the French Revolution in 1789 was Claude Michel, known as Clodion (1738–1814). His major output consisted of playful, erotic tabletop sculpture, mainly in uncolored terra-cotta. Typical of Clodion's Rococo designs is the terra-cotta model he submitted to win a 1784 royal commission for a large monument to the invention of the hot-air balloon (fig. 19-78). Although Clodion's enchanting piece may today seem out of keeping with a

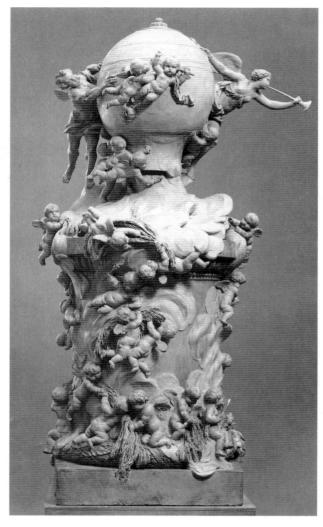

19-78. Clodion. *The Invention of the Balloon*. 1784. Terra-cotta model for a monument, height 43¹/2" (110.5 cm). The Metropolitan Museum of Art, New York Rogers Fund and Frederick R. Harris Gift, 1944 (44.21ab)

Up to the French Revolution, Clodion had a long career as a sculptor in the exuberant, precious Rococo manner seen in this work commemorating the 1783 invention of the hot-air balloon. During the austere revolutionary period of the First Republic (1792–1795), however, he became one of the few Rococo artists to adopt successfully the more acceptable Neoclassical manner (Chapter 26). In 1806 he was commissioned by Napoleon to provide the relief sculpture for two Paris monuments, the Vendôme Column and the Carrousel Arch near the Louvre.

technological achievement, hot-air balloons then were elaborately decorated with painted Rococo scenes, gold braid, and tassels. Clodion's balloon, decorated with bands of classical ornament, rises from a columnar launching pad in billowing clouds of smoke, assisted at the left by a puffing wind god with butterfly wings and heralded at the right by a trumpeting Victory. A few putti are stoking the fire basket that provided the hot air on which the balloon ascended as a host of others gathers reeds for fuel and flies up toward them.

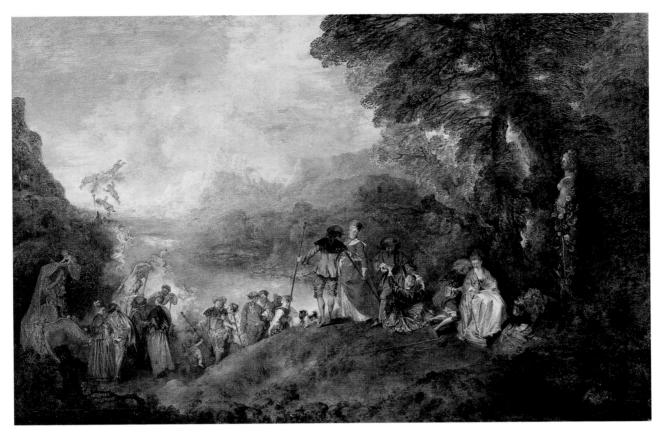

19-79. Jean-Antoine Watteau. The Pilgrimage to Cythera. 1717. Oil on canvas, 4'3" x 6'41/2" (1.3 x 1.9 m). Musée du Louvre, Paris

Painting in France

The emergence of the Rococo style in painting is marked by the career of the French artist Jean-Antoine Watteau (1684-1721), considered one of the greatest artists of the eighteenth century. For a time, he worked for a decorator of interiors, where he learned to paint charming shepherds and shepherdesses framed in arabesques, garlands, and vines. In 1717 he was elevated to full membership in the Royal Academy of Painting and Sculpture on the basis of a painting for which there was no established category. The academicians created a new category for it, called the fête galante, or elegant outdoor entertainment. The work he submitted, The Pilgrimage to Cythera (fig. 19-79), depicted a dreamworld event in which an assortment of beautifully dressed adults and children are setting out for, or perhaps taking their leave from, the mythological island of love. The flourishing landscape, which has all the reality of a painted theater backdrop, would never soil the characters' exquisite satins and velvets, nor would a summer shower ever threaten them. This idyllic vision, with its overtones of wistful melancholy, had a powerful attraction in early-eighteenth-century Paris and soon charmed the rest of Europe.

Tragically, Watteau died from tuberculosis when still in his thirties. During his final illness, while living with the art dealer Edme-François Gersaint, he painted a signboard for Gersaint's shop (fig. 19-80). The dealer later wrote, implausibly, that Watteau had completed the

painting in about a week, working only in the mornings because of his failing health. When the sign was installed, it was greeted with almost universal admiration, and Gersaint sold it shortly thereafter.

The painting shows an art gallery—not, in fact, Gersaint's-filled with paintings from the Venetian and Netherlandish schools that Watteau admired. Indeed, the glowing satins and silks of the women's gowns are an homage to artists like Gerard Ter Borch (see fig. 19-55). In certain respects the composition restages an established Dutch Baroque image, the cabinet piece, a portrait of a connoisseur's private collection. The visitors to the gallery are elegant ladies and gentlemen, at ease in these surroundings and apparently knowledgeable about paintings. Thus, they create an atmosphere of aristocratic sophistication. At the left a woman in shimmering pink satin steps across the threshold. Ignoring her companion's outstretched hand, she is distracted by the two porters packing an order for delivery. While one holds a mirror, the other carefully lowers into the wooden case a portrait of Louis XIV, which may be a reference to the name of Gersaint's shop, Au Grand Monarque ("At the Sign of the Great King"). It also suggests the passage of time, for Louis had died in 1715. A number of other elements in the work also gently suggest transience. On the right the clock positioned directly over the king's portrait, surmounted by an allegorical figure of Fame and sheltering a pair of lovers, is a traditional memento mori, a reminder of mortality. The figures on it suggest that both love and fame are subject to the depredations of time.

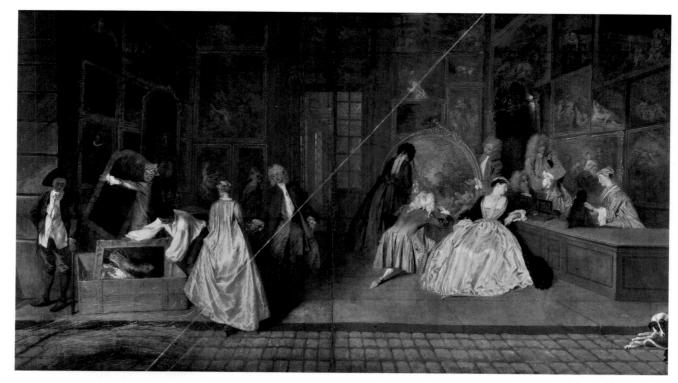

19-80. Jean-Antoine Watteau. *The Signboard of Gersaint*. c. 1721. Oil on canvas, 5'4" x 10'1" (1.62 x 3.06 m). Staatliche Museen zu Berlin, Preussischer Kulturbesitz, Verwaltung der Staatl, Schlösser und Gärden Kunstsammlungen

One of the most beautiful signboards ever created, Watteau's painting was designed to be placed under the canopy of Au Grand Monarque ("At the Sign of the Great King"), an art gallery in Paris belonging to the artist's friend and dealer, Edme-François Gersaint. Gersaint, one of the most successful dealers in eighteenth-century France, introduced the English idea of selling paintings by catalog. These systematic listings of works for sale gave the name of the artist and the title, medium, and dimensions of each work of art. The shop depicted on the signboard is not Gersaint's, the layout of which is known from contemporary documents, but an ideal gallery visited by elegant and cultivated patrons. The sign was so admired that Gersaint sold it only fifteen days after it was installed. Later it was cut in half down the middle and each piece framed separately, which resulted in the loss of some canvas along the sides of each section.

Well-established *vanitas* emblems are the straw, so easily destroyed, and the young woman gazing into the mirror (set next to a vanity case on the counter), for mirrors and images of young women looking at their reflections in them were time-honored symbols of the fugitive nature of human life. Watteau, dying, certainly knew how ephemeral life is, and no artist ever expressed the fragility of human happiness with greater delicacy.

Pastel, a new medium for finished works of art, soon became popular among Rococo artists and their patrons. Working with pastel chalks—made of chalk as a base, pulverized pigment, and weak gum water as a binder allowed for a rapid, sketchlike technique in color, to capture fleeting impressions and moods. One of the most admired practitioners was the Venetian artist Rosalba Carriera (1675-1757), a former miniaturist and patternmaker for lace, whose pastels earned her an honorary membership in Rome's Academy of Saint Luke in 1705. Watteau already knew and admired her work, for he had written to her in 1719 asking for a sample of it. In return she had sent a letter whose envelope she decorated with a sketch of the goddess Juno with a peacock. When Carriera arrived in Paris in 1720, Watteau was in London, but the two met after his return, and in the final months before his death in 1721, she did his portrait in pastel (fig. 19-81). Having been made a member of the Royal Acad-

19-81. Rosalba Carriera. *Jean-Antoine Watteau*. 1721. Pastel on paper, 14⁷/₁₆ x 9¹/₁₆" (36.6 x 23 cm). Städelsches Kunstinstitut, Graphische Sammlung, Frankfurt

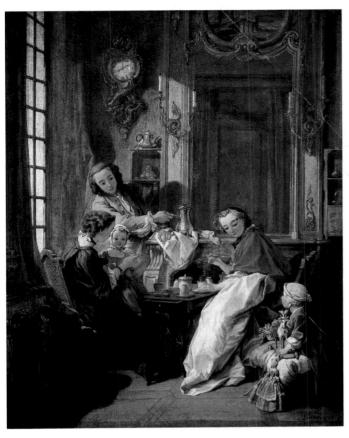

19-82. François Boucher. *Le Déjeuner (Luncheon)*. 1739. Oil on canvas, 32¹/₈ x 25³/₄" (81.5 x 65.5 cm). Musée du Louvre, Paris

emy of Painting and Sculpture in 1720, Carriera is credited with introducing French artists to the pastel medium for portraiture, so admirably suited to Rococo style and taste. She returned to Italy in 1721 and enjoyed an illustrious career until failing eyesight made it impossible for her to work.

The artist most closely associated today with the height of the Rococo phase in Paris was François Boucher (1703–1770), who was a student of Watteau despite never having met him. In 1721 Boucher, the son of a minor painter, entered the workshop of an engraver to support himself as he attempted to win favor at the Academy. The young man's facility with the engraving needle drew the attention of a devotee of Watteau, who hired him to reproduce Watteau's paintings in his collection, an event that firmly established the direction of Boucher's career.

Having won the Prix de Rome in 1724, Boucher used the money to study at the French Academy in Rome from 1727 to 1731. Although Boucher later dismissed much of Italian Renaissance and Baroque art, his work reveals that he learned a great deal from earlier artists, even as he moved in an entirely different stylistic direction.

Back in Paris, Boucher became an academician, and soon his life and career were intimately bound up with two women. The first was his artistically talented wife, Marie-Jeanne Buseau, who was a frequent model as well

as a studio assistant to her husband. The other was Louis XV's mistress, Madame de Pompadour, who became his major patron and supporter. Pompadour was an amateur artist herself and took lessons from Boucher in printmaking. After Boucher received his first royal commission in 1735, he worked almost continuously to decorate the royal residences at Versailles and Fontainebleau. In 1755 he was made chief inspector at the Gobelins Tapestry Manufactory, and he provided designs to it and to the Sèvres porcelain and Beauvais tapestry manufactories, all of which produced furnishings for the king. Boucher apparently did not meet Louis XV in person until he was made First Painter to the King in 1765. Only five years later, Boucher was found dead in his studio, having died suddenly while working at his easel.

Boucher produced extravagant compositions featuring beautiful nudes and chubby-cheeked boys and girls. But this artist of solid technique and great imagination also created magnificent portraits, breathtaking land-scapes, tapestry designs, and scenes of daily life, such as his 1739 *Le Déjeuner (Luncheon)*. This painting looks almost like a family portrait, showing a mother with her two young children, the children's nurse, and an attentive butler serving coffee (fig. 19-82). A distant echo of Dutch family-life pictures (see fig. 19-56), *Le Déjeuner* is a catalog of contemporary French middle-class life in its depiction of the costumes, the Rococo *boiseries*, candle sconces, console, and parquet floor. Even the doll and pull toy the little girl has brought to the room provide interesting details for the modern viewer.

The work of Boucher's contemporary and friend in Paris, Jean-Siméon Chardin (1699–1779), could hardly have been more different from Boucher's courtly Rococo style. A painter whose output was limited essentially to still lifes and quiet domestic scenes in the Dutch manner, Chardin tended to work on a small scale, meticulously and slowly. His still lifes consisted of a few simple objects that were to be enjoyed for their subtle differences of shape and texture, not for any virtuoso performance, complexity of composition, or moralizing content.

In the 1730s Chardin began to focus on simple, mildly touching scenes of everyday middle-class life. He was one of the first European artists to treat the lives of women and children with sympathy and to honor the dignity of women's work in his portrayals of young mothers, governesses, and kitchen maids. Ironically, these simple domestic scenes appealed to aristocrats and even to royalty, who bought so many of them that Chardin was kept busy simply making copies of his popular compositions.

One of his most popular subjects was a half-length portrayal of a young boy blowing soap bubbles (fig. 19-83), which he painted many times for different patrons. In this version, the boy leaning out the window is entirely self-absorbed in blowing a larger and larger bubble, as a smaller boy watches in anticipation. Even such a simple concept as soap-bubble blowing may have a hidden meaning. The boy enjoys a pleasurable pursuit as time wastes away, and the soap bubble itself is a traditional symbol of the fragile, fleeting nature of human life; therefore, the painting has been interpreted as a type of *vanitas*.

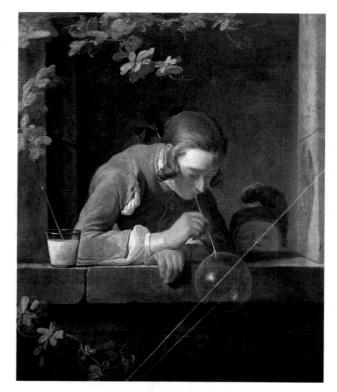

19-83. Jean-Siméon Chardin. *Soap Bubbles.* c. 1745. Oil on canvas, 36⁵/8 x 29³/8" (93 x 74.6 cm). National Gallery of Art, Washington, D.C.
Gift of Mrs. John W. Simpson

When the mother of young Honoré Fragonard (1732–1806) brought her son to Boucher's studio around 1747–1748, the busy court artist recommended that the boy first study the basics of painting with Chardin. Within a few months, Fragonard returned with some small paintings done on his own, and Boucher gladly welcomed him as an apprentice-assistant at no charge to his family. Boucher encouraged the boy to enter the competition for the Prix de Rome, which Fragonard won in 1752.

Upon his return to Paris in 1761 Fragonard was still uncertain about his professional direction and spent another four years experimenting, mainly with land-scape painting. In 1765 he was finally accepted into the Royal Academy. His reception piece drew high critical praise and was sent to be copied in a tapestry. On the brink of a potentially illustrious career as a court painter, Fragonard suddenly turned his back on the path to official success and began catering to the tastes of an aristocratic clientele. He also filled the vacuum left by Boucher's death in 1770 as a decorator of interiors.

Fragonard's great work is a group of fourteen canvases commissioned around 1771 by Madame du Barry, Louis XV's last mistress, to decorate her château. These marvelously free and seemingly spontaneous visions of lovers seem to explode in color and luxuriant vegetation. *The Meeting* (fig. 19-84) shows a secret encounter between a young man and his sweetheart, who looks back anxiously over her shoulder to be sure she has not been followed and clutches the letter arranging the tryst. The

19-84. (opposite) Honoré Fragonard. *The Meeting*, from The Loves of the Shepherds. 1771–73. Oil on canvas, 10'5'/4" x 7'5/8" (3.18 x 2.15 m). The Frick Collection, New York

rapid brushwork and creamy application that distinguish Fragonard's technique are at their freest and most lavish here. However, Madame du Barry rejected the paintings and commissioned another set in the fashionable Neoclassic style. Her view of Fragonard's manner as passé showed that the Rococo world was, indeed, ending. Fragonard's ravishing visions became outmoded, and his last years were spent living on a small pension and the generosity of his highly successful pupil Marguerite Gérard (1761–1837), who was his wife's younger sister.

Even while Fragonard was still painting erotic Rococo fantasies, a strong new reaction had begun among critics, who urged a return to seriousness and moral content in art. Jean-Baptiste Greuze (1725-1805) was a specialist in genre pictures on the subject of sin and redemption. Greuze entered the Royal Academy as a genre painter in 1775 with a painting titled A Father Explaining the Bible to His Children. Although his paintings are, indeed, outwardly moralizing, they often express a Rococo eroticism, as in his Broken Eggs (fig. 19-85) of 1756. Here, a shamefaced young woman is scolded by her mother for having broken some of the eggs she has brought into the house in a basket. An equally uncomfortable young man stands awkwardly in the background. Like the Dutch paintings that influenced Greuze profoundly, this work carries a second implied meaning: The broken eggs symbolize the loss of the young woman's sexual innocence, a meaning reinforced by her languorous pose and exposed bosom.

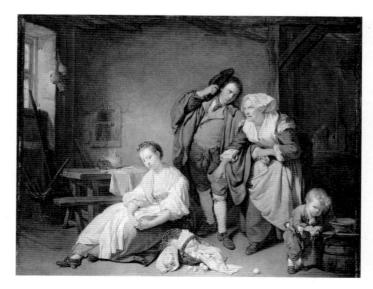

19-85. Jean-Baptiste Greuze. *Broken Eggs.* 1756. Oil on canvas, 28³/₄ x 37" (73 x 94 cm). The Metropolitan Museum of Art, New York

Bequest of William K. Vanderbilt, 1920 (20.55.8)

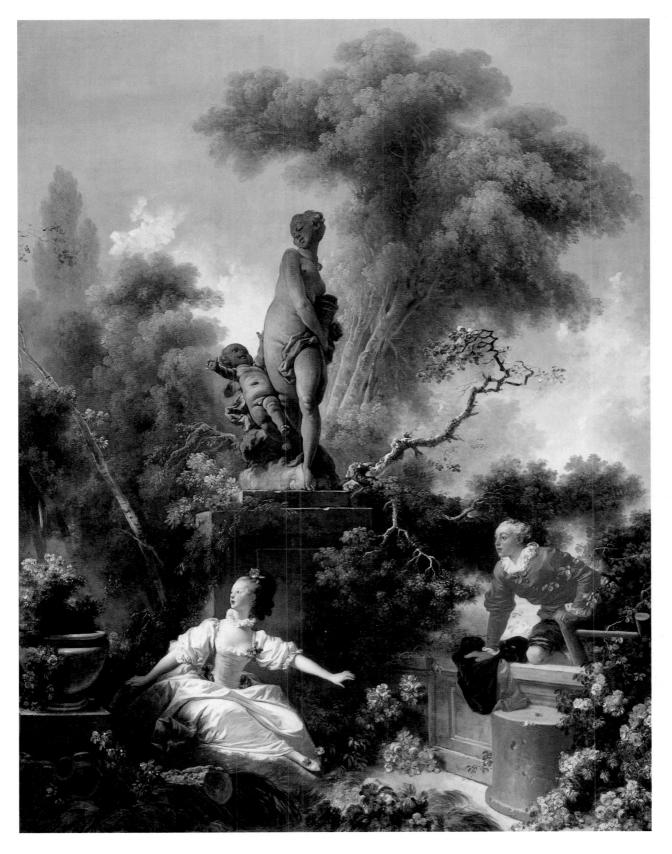

Craft Arts in France and England

A study of French Rococo art would be incomplete without the exquisite design of household furnishings. Various royal manufactories led the way in promoting the lively Rococo style in everything from chairs, consoles,

and wall hangings to **porcelain** and silverware. Inspired by Chinese art and decoration, but fully Rococo in style, was the type of craft design referred to as **chinoiserie**. An excellent example of this decorative fantasy is a tapestry from a six-piece suite done from designs by Boucher, *La Foire Chinoise (The Chinese Fair*). Ten sets of the suite

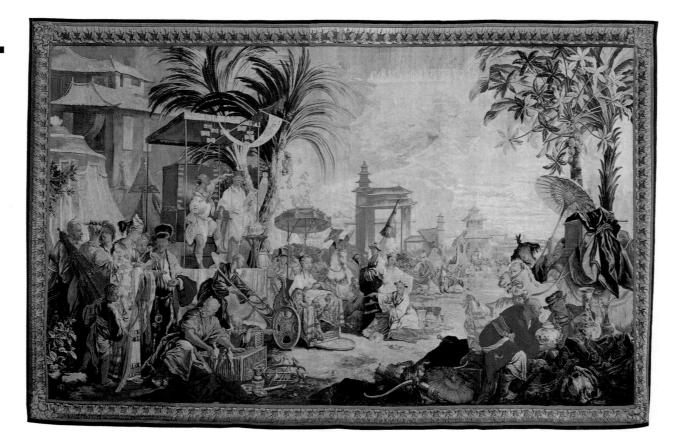

19-86. After a cartoon by François Boucher. *La Foire Chinoise (The Chinese Fair)*. Designed 1743; woven 1743–75 at Beauvais, France. Tapestry of wool and silk, approx. 11'11" x 18'2" (3.63 x 5.54 m). The Minneapolis Institute of Arts The William Hood Dunwoody Fund

were woven between 1743 and 1775, most of them for the king (fig. 19-86). The artist used his imagination freely to invent a scene in a country he had never visited and probably knew little about beyond the decorations of imported Chinese porcelains. Boucher's goal was to create a mood of liveliness and exotic charm rather than an authentic depiction of China.

French chinoiserie design directly influenced the work of a major goldsmith, Elizabeth Godfrey (c. 1700c. 1758), one of several outstanding women craft artists working in London at the time. The daughter of an immigrant French Protestant silversmith, Elizabeth married twice, both times to goldsmiths. Elizabeth first registered her personal mark, used to identify works from her shop, at the death of her first husband in 1731. During her subsequent marriage to Benjamin Godfrey, she apparently worked under his mark, but at his death in 1741 she again registered her own. At about this time Elizabeth responded to the new wave of French taste in England in creating Rococo designs, such as her tea caddies of 1755 (fig. 19-87). Made to hold a choice of black or green tea, the shapes of the caddies have been totally disguised with C shapes, spiral scrolls, swags, volutes, and convex side panels containing enchanting little chinoiseries that depict the planting and gathering of tea. Even the jar openings and lids are arched vertically with concave sides, and the lid knobs are sculpted tangles of exotic birds.

Europeans, especially Germans, had created their own version of hard-paste, or true, porcelain, of the type imported from China (see "The Secret of Porcelain," page 843). But many wares continued to be made in imitation of Chinese porcelain using soft paste, a cheaper clay mix containing ground glass, which can be fired at lower temperatures. A major production center of soft paste in France was the Royal Porcelain Factory at Sèvres, whose name today is synonymous with fine porcelain. Typical of its elegant creations for the court and other patrons able to afford such luxury items is a soft-paste potpourri jar in the shape of a boat (fig. 19-88), dated 1758, which is displayed on a base created for it. This rare technical masterpiece of sculpting and enamel painting is also a prime illustration of the Rococo taste for curved lines. In a typical blend of realistic detail and utter fantasy, the boat has gilded rope rigging and a rope ladder leading to the crow's nest at the top of the mast, which is wrapped in a fine silken length of cloth embroidered with the royal fleurs-de-lis. The portholes are actually open to the interior to allow the odor of the potpourri (aromatic herbs, rose petals, cinnamon bark, and the like) to escape. In emulation of Chinese vase decoration, the side of the boat is painted with birds and blossoms.

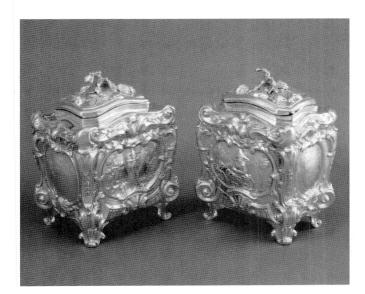

19-87. Elizabeth Godfrey. Tea caddies, from London. 1755. Silver, height approx. 5½" (14 cm). National Museum of Women in the Arts, Washington, D.C. Silver Collection assembled by Nancy Valentine, purchased with funds donated by Mr. and Mrs. Oliver Grace and family

Godfrey created her intricate Rococo designs by the repoussé technique, a manner of embossing metal by delicately beating it over forms with small mallets from inside the container. Although made in London, the style of these pieces was derived from French Rococo designs of the type called chinoiserie. This term refers to fanciful Chinese-style figures and settings used as decorations on porcelains, furniture, silver vessels, and even large tapestries.

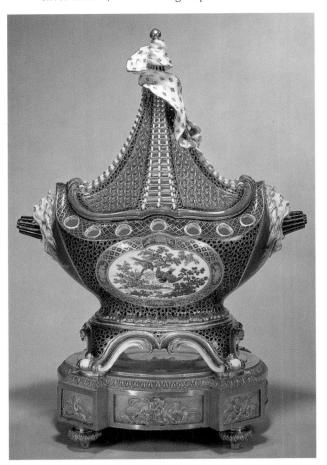

COLONIAL AMERICA BEFORE 1776

In the seventeenth and eighteenth centuries the art of Colonial America reflected the tastes of the European countries that ruled the colonies,

mainly England and Spain. Not surprisingly, much of the colonial art was done by immigrant artists, and styles often lagged behind the European mainstream. Colonial life was still hard in the 1600s, and few could afford to think of fine houses and art collections. Puritans, for example, needed only the simplest functional buildings for their religious activities. By contrast, in the pre-Revolutionary decades of the eighteenth century the American colonies had become more affluent, and Americans had a greater sense of permanence and pride of place. Easier and more frequent travel between the continents contributed to the spread of European styles, although not necessarily the most current, because of the generally conservative, austere tastes of the settlers. Architecture responded more quickly than sculpture, painting, and craft arts in the development of native styles. Unfortunately but understandably, native artists of outstanding talent often found it advantageous to resettle in Europe.

Architecture

Architecture in the eastern British North American colonies can be divided generally into two types: derivations of European provincial timber construction with medieval roots, and the Palladian classical style that arrived from England about the middle of the eighteenth century. In the Southwest, Spanish styles dominated the building of mission-church complexes.

Wood, so easily obtained in the Northeast, was used to create the same kinds of houses and churches then being built in rural England, Holland, or France, depending on the colonists' home provinces. In seventeenthcentury New England, for example, many buildings reflected the contemporary English style so appropriate to the severe North American winters—half-timber construction with steep roofs, massive central fireplaces and chimneys, overhanging upper stories, and small windows with tiny panes of glass. Building techniques were in a time-honored tradition; space between the boards of a wooden frame were filled with wattle-anddaub (woven branches packed with clay) or brick in more expensive homes. Instead of leaving this halftimber construction exposed as was common in Europe, colonists usually weatherproofed it with horizontal plank siding, called clapboard. One of the few well-preserved examples is the Parson Capen House in Topsfield,

19-88. Potpourri jar, from Sèvres Royal Porcelain Factory, France. 1758. Soft-paste porcelain with polychrome and gold decoration, vase without base $14^3/4~x$ $13^3/4~x~6^7/8$ " (37.5 x 34.6 x 17.5 cm). The Frick Collection, New York

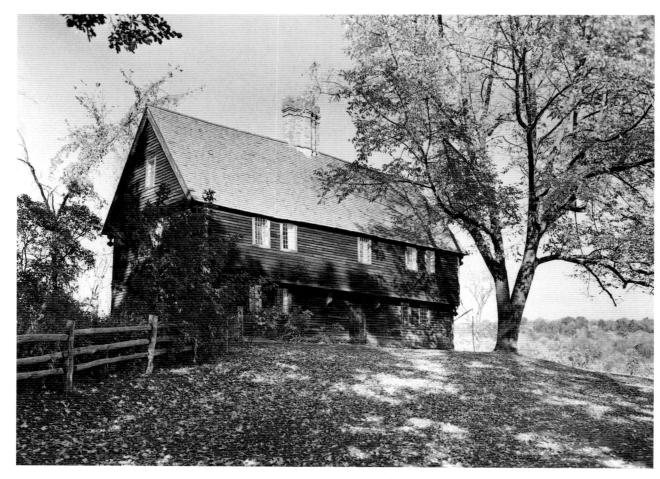

19-89. Parson Capen House, Topsfield, Massachusetts. 1683

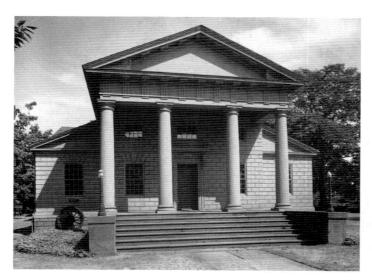

19-90. Peter Harrison. Redwood Library, Newport, Rhode Island. 1749

Massachusetts (fig. 19-89), built in 1683. The earliest homes generally consisted of a single "great room" and fireplace, but the Capen House has two stories, each with two rooms flanking the central fireplace and chimney, affording more privacy to its occupants. The main fireplace hearth was the center of domestic life, where all the cooking was done and the firelight provided illumination for reading, sewing, or game playing.

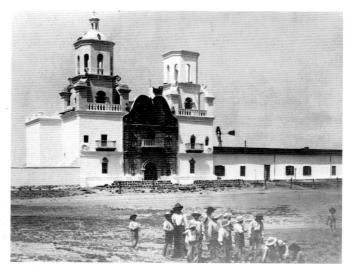

19-91. Mission San Xavier del Bac, near Tucson, Arizona. 1784–97. Arizona Historial Society, Tucson (Ash #41446)

The Palladian style, introduced into England by Inigo Jones in the seventeenth century (see fig. 19-62), continued to be popular in England and came to the British North American colonies in the mid-eighteenth century. One of the earliest examples, the work of English-born architect Peter Harrison, is the Redwood Library (fig. 19-90), built in Newport, Rhode Island, in 1749. The fusion of the temple front with a colossal Doric order and

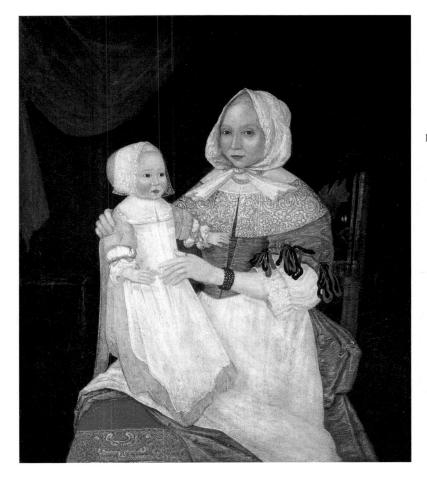

19-92. Mrs. Freake
and Baby Mary.
c. 1674. Oil on
canvas,
42½ x 36½"
(108 x 92.1 cm).
Worcester
Museum of Art,
Worcester,
Massachusetts
Gift of Mr. and Mrs.
Albert W. Rice

a lower facade with a triangular pediment is not only typically Palladian (see fig. 18-33); it is, in fact, a faithful replica of a design by Palladio in his *Fourth Book of Architecture*. The elegant simplicity of this particular design made it a favorite of English architects for small pleasure buildings on the grounds of estates.

In the Spanish colonial Southwest, the builders of one of the finest examples of mission architecture, San Xavier del Bac near Tucson, Arizona (fig. 19-91), looked to Spain for its inspiration. The foundations were begun by the Jesuit priest Eusebio Kino in 1700, using stone quarried locally by Native Americans of the Pima nation. The desert site had already been laid out with irrigation ditches, and Father Kino wrote in his reports that there would be running water in every room and workshop of the new mission, but the building never proceeded. Instead, Kino's vision was realized by the Spanish Franciscan missionary and master builder Juan Bautista Velderrain (d. 1790), who came to the mission in 1776. Velderrain in his letters spoke of his labors for God and the king of Spain-at that time Charles III, who established royal control over Spanish churches and ousted the Jesuit order from Spain. Thus, Father Kino's Jesuit mission site had been turned over to the Franciscans in 1768.

The huge church, 99 feet long with a domed crossing and flanking bell towers, was unusual for the area in being built of brick and mortar rather than **adobe**, made of earth and straw. The basic structure was finished by the time of Velderrain's death in 1790, and the exterior

decoration was completed by 1797 under the supervision of his successor. It is generally accepted that the Spanish artists executing the elaborate exterior, as well as the fine interior paintings and sculpture, were from central Mexico. Nearly thirty artists were living there in 1795. Although the San Xavier facade is far from a copy, the focus on the central entrance area, created by a combination of Spanish Churrigueresque decoration and sinuous Rococo lines and spirals, is clearly in the tradition of the earlier eighteenth-century work of Pedro de Ribera in Madrid (see fig. 19-32). The mission was dedicated to Saint Francis Xavier, whose statue once stood at the apex of the portal decoration. In the niches are statues of four female saints tentatively identified as Lucy, Cecilia, Barbara, and Catherine of Siena. Hidden in the sculpted mass is one humorous element: a cat confronting a mouse, which inspired a local Pima saying: "When the cat catches the mouse, the end of the world will come" (cited in Chinn and McCarty, page 12).

Painting

Painting and sculpture had to wait for more settled and affluent times in the colonies. For a long time carved or engraved tombstones were the only sculpture. Portraits done by itinerant "face painters," also called **limners**, have a charm and sincerity that appeal to the modern eye. The anonymous painter of *Mrs. Freake and Baby Mary* (fig. 19-92), dated about 1674, seems to have

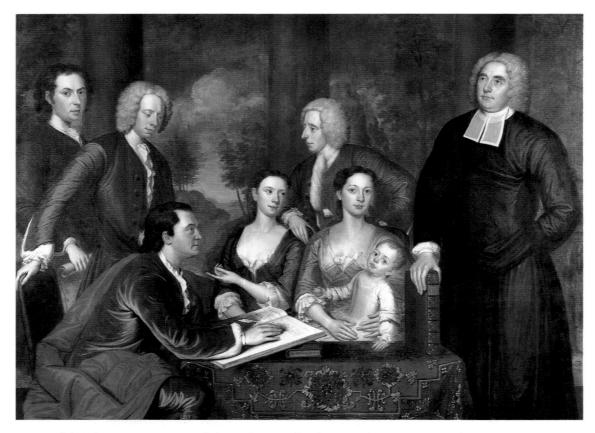

19-93. John Smibert. *Dean George Berkeley and His Family (The Bermuda Group)*. 1729. Oil on canvas, 5'9¹/2" x 7'9" (1.77 x 2.4 m). Yale University Art Gallery, New Haven, Connecticut Gift of Isaac Lathrop of Plymouth, Massachusetts

known Dutch portraiture, probably through engraved copies that were imported and sold in the colonies. Even though its painter was clearly self-taught and lacked skills in illusionistic, three-dimensional composition, the spirit of the Freake portrait has much in common with Frans Hals's *Catharina Hooft and Her Nurse* (see fig. 19-45), especially in the care given to minute details of costuming and the focus on large figures in the foreground space. Maternal pride in an infant and hope for her future are universals that seem to apply to little Mary as well as to Catharina, even though their worlds were far apart.

As patronage for portrait paintings grew with the wealth of the colonies, a few traditionally trained European artists immigrated to satisfy the market. Probably the first such artist of stature to arrive was John Smibert (1688-1751), a Scot who had studied in London and spent considerable time in Italy. He came to the colonies in 1728 with one of his patrons, George Berkeley, to be the art professor at the college Berkeley was planning to found in Bermuda. In 1729, while Berkeley and his entourage were in Newport, Rhode Island, to complete their arrangements for the project, Smibert took the opportunity to paint a group portrait, Dean George Berkeley and His Family, commonly called The Bermuda Group (fig. 19-93). Berkeley at the right dictates to a richly dressed man at the table, while Berkeley's wife and child and another couple listen, and Smibert himself appears at the far left.

Smibert's debt to Flemish painting, which was still favored in the English court at the time, is obvious in the balanced but asymmetrical arrangement of figures and the great attention paid to representing textures of the costumes and the pattern of the Oriental rug on the table. The men's features are individualized likenesses, but the women's are idealized according to a convention of female beauty current in English portraiture—ovoid heads with large, plain features, columnlike necks, and tastefully exposed bosoms. The Bermuda project never went forward, and Smibert settled in Boston, working as a portrait painter, art-supply dealer, and printseller. The native Boston artists imitated his rich foreground settings against distant landscape views, his asymmetrical composition, and, especially, his conventions for female beauty.

Among Smibert's friends was Peter Pelham, an English immigrant painter-engraver, who married a Boston widow with a tobacco shop in 1748. Pelham's stepson John Singleton Copley (1738–1815) grew up to be America's first native artist of genius. Copley's sources of inspiration were meager—Smibert's followers and his stepfather's engravings—but his work was already drawing attention when he was fifteen. Young Copley's canny instincts for survival in the colonial art world included an intuitive understanding of the psychology of his middleclass Puritanical clientele. They valued not only his excellent technique, which equaled that of European artists, but also his ability to dignify them while recording their features with unflinching realism.

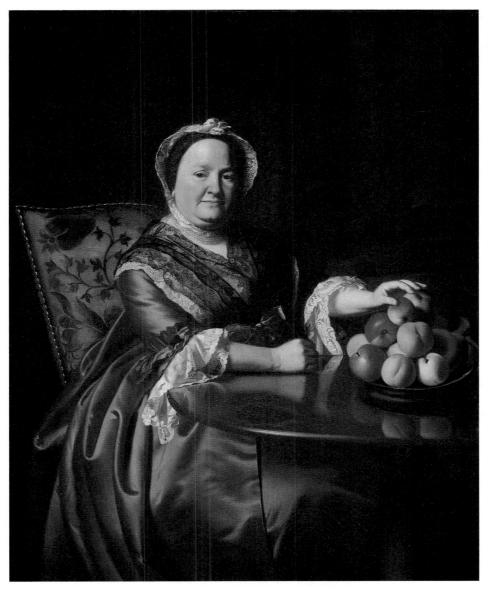

19-94. John Singleton Copley. *Mrs. Ezekiel Goldthwait (Elizabeth Lewis).* 1771. Canvas, 50³/₈ x 40¹/₄" (128 x 102.2 cm). Museum of Fine Arts, Boston Bequest of John T. Bowen in memory of Eliza M. Bowen, 1941

An example of his mature Boston style is *Mrs. Ezekiel Goldthwait* (*Elizabeth Lewis*) (fig. 19-94), painted in 1771. Elizabeth Goldthwait was well known for her fine home and gracious dinner parties, but she was also a successful agriculturist whose orchards must have supplied the lush fruits she caresses, as if offering one to the viewer. She is shown in a lace-trimmed silk dress, surrounded by such luxuries as a damask-covered chair and mirrorpolished mahogany table. Despite her obvious prosperity, Mrs. Goldthwait's open, amiable features, strong thick wrists, and large capable hands show a lack of vanity and a commitment to hard work that seem to personify the spirit of Puritan New England.

Copley's talents so outdistanced those of his colonial contemporaries that the artist aspired to a larger reputation. In 1766 he had sent a portrait of his half brother, *Boy with a Squirrel*, to an exhibition in London. The critical response was rewarding, and a colonial expatriate from

Philadelphia encouraged Copley to study in Europe. At that time, he was kept from following the advice by family ties. But in 1773, revolutionary struggles hit close to home. Colonists dressed as Native Americans boarded a ship carrying tea and threw the cargo into Boston Harbor to protest the British East India Company's monopolistic selling of tea to a select few wholesalers one of whom was Copley's father-in-law. Copley's failed attempts at negotiation between the Boston tea merchants and the company had ended with the Boston Tea Party. In June 1774 Copley sailed for Europe, where he visited London and Paris, then Italy. While there, he received word of the increasingly dangerous atmosphere in the colonies and urged his family to flee to England. Except for his widowed mother, all were reunited in London in 1775, the eve of the American Revolution. Copley spent the rest of his life in London and appears again in Chapter 26.

The Bodhisattva Avalokiteshvara 12th century

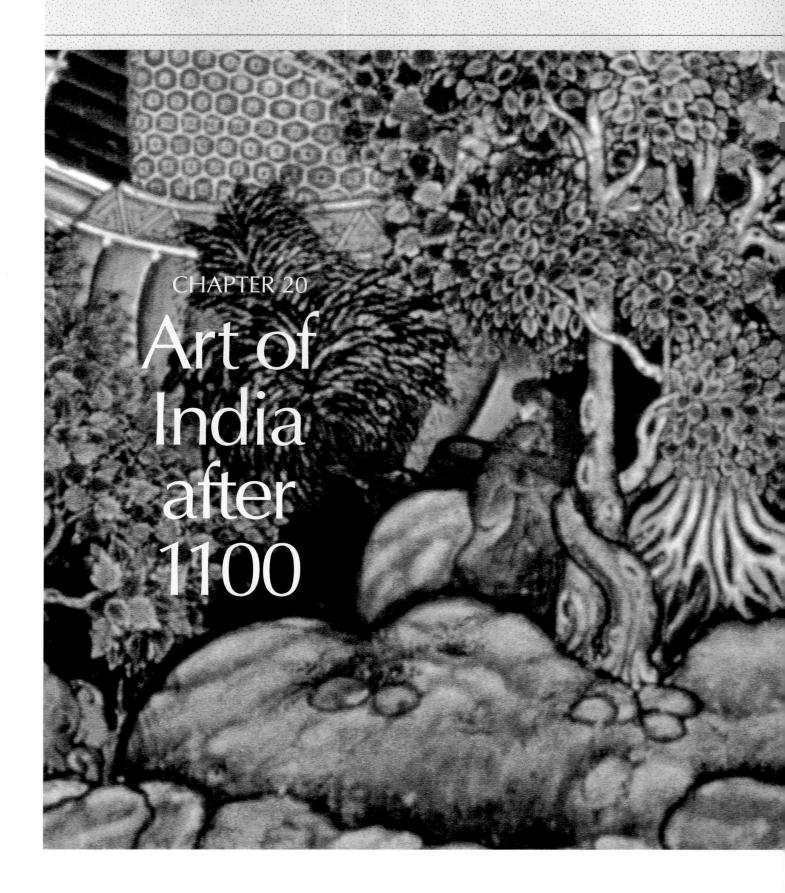

1550 1700 1850 2000 CE

Taj Mahal c. 1632–48

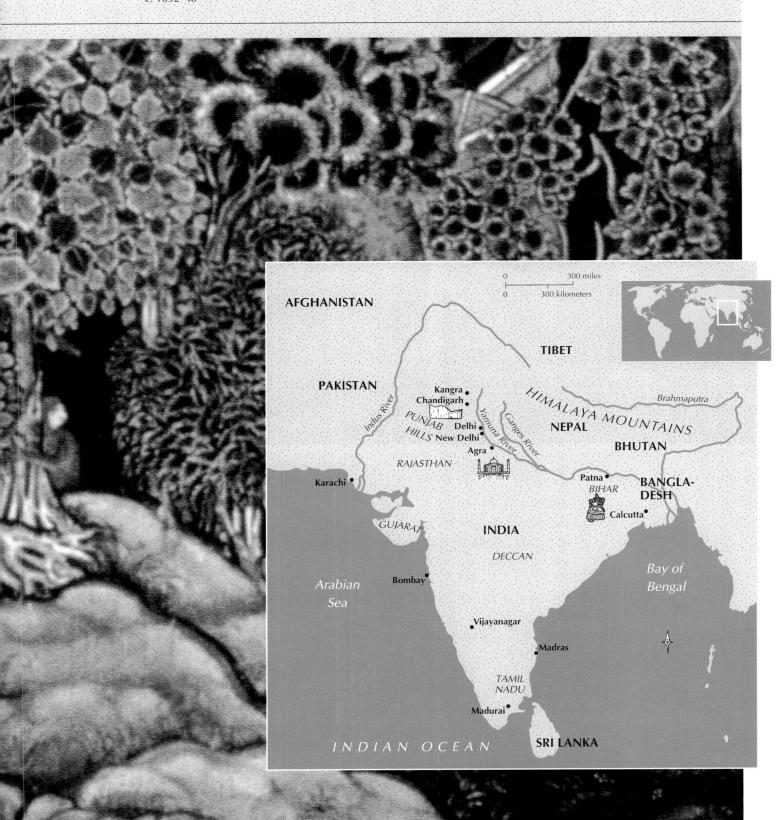

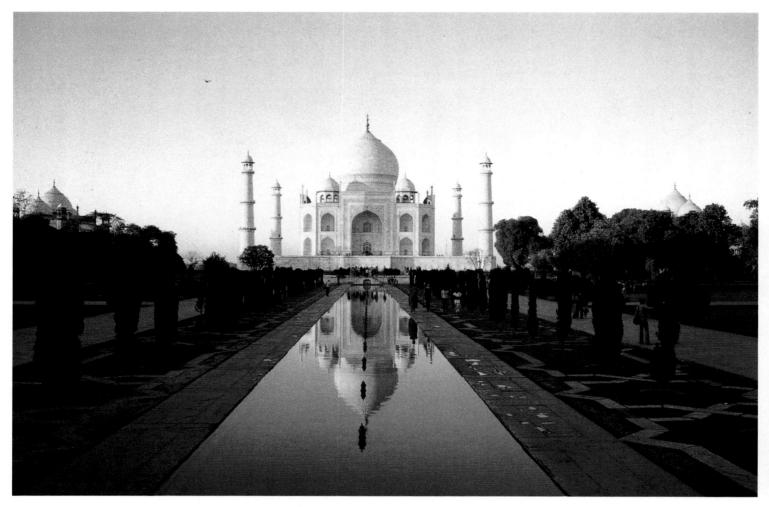

20-1. Taj Mahal, Agra, India. Mughal period, Mughal, reign of Shah Jahan, c. 1632-48

isitors catch their breath. Ethereal, weightless, the building barely seems to touch the ground. Its reflection shimmers in the pools of the garden meant to evoke a vision of paradise as described in the Koran, the holy book of Islam. Its facades are delicately inlaid with inscriptions and arabesques in semiprecious stones—carnelian, agate, coral, turquoise, garnet, lapis, and jasper. Above, its luminous, whitemarble dome reflects each shift in light, flushing rose at dawn, dissolving in its own brilliance in the noonday sun.

One of the most celebrated buildings in the world, the Taj Mahal (fig. 20-1) was built in the seventeenth century by the Mughal ruler Shah Jahan as a mausoleum for his favorite wife, Mumtaz-i-Mahal, who died in childbirth. A dynasty of Central Asian origin, the Mughals were the most successful of the many Islamic groups that established themselves in India beginning in the tenth century. Under their patronage, Persian and Central Asian influences mingled with older traditions of the South Asian subcontinent, adding yet another dimension to the already ancient and complex artistic heritage of India.

LATE MEDIEVAL PERIOD

EVAL By 1100 India was already among the world's oldest civilizations (see "Foundations of Indian Culture," below). The art that survives from its

earlier periods is almost exclusively sacred, most of it inspired by the three principal religions: Hinduism, Buddhism, and Jainism. At the start of the Late Medieval period, which extends roughly from 1100 to 1526, these three religions continued as the principal focus for Indian art, even as invaders from the northwest began to establish the new religious culture of Islam.

Buddhist Art

After many centuries of prominence, Buddhism had been in decline as a cultural force in India since the seventh century. By the Late Medieval period, the principal Buddhist centers were concentrated in the northeast, in the kingdom ruled by the Pala dynasty. There, in great monastic universities that attracted monks from as far away as China, Korea, and Japan, was cultivated a form of Buddhism known as tantric (Vajrayana) Mahayana. The

practices of tantric Buddhism, which included techniques for visualizing deities, encouraged the development of **iconographic** images such as the gilt bronze sculpture of the **bodhisattva** Avalokiteshvara in figure 20-2. Bodhisattvas are beings who are well advanced on the path to buddhahood (enlightenment), the goal of Mahayana Buddhists, and who have vowed out of compassion to help others achieve enlightenment. Avalokiteshvara, the bodhisattva of greatest compassion, whose vow is to forgo buddhahood until all others become buddhas, became the most popular of these saintly beings in India and in East Asia.

Characteristic of bodhisattvas, he is distinguished in art by his princely garments, unlike a buddha, who wears a monk's robes. Avalokiteshvara is specifically recognized by the lotus flower he holds and by the presence in his crown of his "parent" buddha, in this case Amitabha, buddha of the Western Pure Land. Other marks of Avalokiteshvara's extraordinary status are the third eye (symbolizing the ability to see in miraculous ways) and the wheel on his palm (signifying the ability to teach the Buddhist truth).

FOUNDA-TIONS OF INDIAN CULTURE

The earliest civilization on the Indian subcontinent flourished toward the end of the third millen-

nium BCE along the Indus River in present-day Pakistan. Remains of its expertly engineered brick cities have been uncovered, together with works of art that intriguingly suggest spiritual practices and reveal artistic traits known in later Indian culture.

The abrupt demise of the Indus Valley civilization during the midsecond millennium BCE coincides with (and may be related to) the arrival from the northwest of a seminomadic warrior people known as the Indo-European Aryans. Over the next millennium they were influential in formulating the new civilization that gradually emerged. The most important Aryan contributions to this new civilization included the Sanskrit language and the sacred texts called the Vedas. The evolution of Vedic thought under the influence of indigenous Indian beliefs culminated in the Upanishads, whose mystical, philosophical texts took shape sometime after 800 BCE.

The Upanishads teach that the material world is illusory; only Brahman, the universal soul, is real and eternal. We—that is, our individual souls—are trapped in this illusion in a relentless cycle of birth, death, and

rebirth. The ultimate goal of religious life is to liberate ourselves from this cycle and to unite our individual soul with Brahman.

Buddhism and Jainism are two of the many religious communities that developed in the climate of Upanishadic thought. Buddhism is based on the teachings of Shakyamuni Buddha, who lived in central India about 500 BCE; Jainism was shaped about the same time around the followers of the spiritual leader Mahavira. Both religions acknowledged the cyclical nature of existence and taught a means of liberation from it, but they rejected the authoritv. rituals, and social strictures of Vedic religion. Whereas the Vedic religion was in the hands of a hereditary priestly class, Buddhist and Jain communities welcomed all members of society, a fact that gave them great appeal. The Vedic tradition eventually evolved into the many sects collectively known as Hinduism.

Politically, India has generally been a mosaic of regional dynastic kingdoms, but from time to time, empires emerged that unified large parts of the subcontinent. The first was the Maurya dynasty (c. 322–185 BCE), whose great king Ashoka patronized Buddhism. From this time Buddhist doctrines spread widely and its artistic traditions were established.

In the first century ce the Kushans, a Central Asian people, created an empire extending from present-day Afghanistan down into central India. Buddhism prospered under Kanishka, the most powerful Kushan king, and spread into Central Asia and to East Asia. At this time, under the evolving thought of Mahayana Buddhism, traditions first evolved for depicting the image of the Buddha in art

Later, under the Gupta dynasty (c. 320–500 cE) in central India, Buddhist art and culture reached their high point. However, Gupta monarchs also patronized the Hindu religion, which from this time grew to become the dominant Indian religious tradition, with its emphasis on the great gods Vishnu (the Creator), Shiva (the Destroyer), and the Goddess—all with multiple forms.

During the long Medieval period, which lasted from about 650 to 1526 ce, numerous regional dynasties prevailed, some quite powerful and long-lasting. During the early part of this period, to roughly 1100, Buddhism continued to decline as a cultural force, while artistic achievement under Hinduism soared. Hindu temples, in particular, developed monumental and complex forms that were rich in symbolism and ritual function, with each region of India producing its own variation.

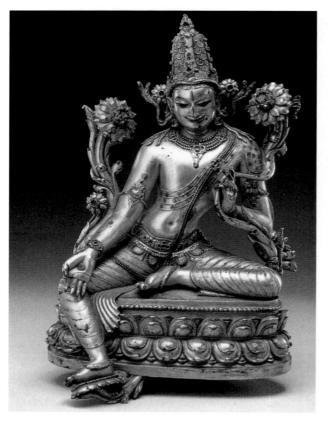

20-2. The Bodhisattva Avalokiteshvara, from Kurkihar, Bihar, Central India. Pala dynasty. Late Medieval period, 12th century. Gilt-bronze, height 10" (25.5 cm). Patna Museum, Patna

Avalokiteshvara is shown here in the posture of relaxed ease known as the royal pose. One leg angles down; the other is drawn up onto the lotus seat, itself considered an emblem of spiritual purity. His body bends gracefully, if a bit stiffly, to one side. The chest scarf and lower garment cling to his body, fully revealing its shape. Delicate floral patterns enliven the textiles, and closely set parallel folds provide a wiry, linear tension that contrasts with the hard but silken surfaces of the body. Linear energy continues in the sweep of the tightly pleated hem emerging from under the right thigh, the sinuous lotus stalks on each side, and the fluttering ribbons of the elaborate crown. A profusion of details and varied textures creates an ornate effect—the lavish jewelry, the looped hair piled high and cascading over the shoulders, the ripe blossoms, the rich layers of the lotus seat. Though still friendly and human, the image has become rather formalized. The features of the face, where we instinctively look for a human echo, are treated quite abstractly, and despite its reassuring smile, the statue's expression remains somewhat remote. Through richness of ornament and tension of line, this style expresses the heightened power of a perfected being.

With the fall of the Pala dynasty to Turkic invaders in 1199, the last centers of Buddhism in northern India collapsed, and the monks dispersed, mainly into Nepal and Tibet. From that time, Tibet has remained the principal stronghold of Tantric Buddhist practice and its arts.

20-3. Detail of a leaf with *The Birth of Mahavira*, from the *Kalpa Sutra*. Late Medieval period, western Indian school (probably Gujarat), c. 1375–1400. Gouache on paper, 3³/₈ x 3" (8.5 x 7.6 cm). Prince of Wales Museum, Bombay

The artistic style perfected under the Palas, however, became an influential international style throughout East and Southeast Asia.

Jain Art

The Jain religion traces its roots to a spiritual leader called Mahavira (d. 526 BCE), whom it regards as the final in a series of twenty-four saviors known as pathfinders, or *tirthankaras*. Devotees seek through purification to become worthy of rebirth in the heaven of the pathfinders, a zone of pure existence at the zenith of the universe. Jain monks live a life of austerity, and even laypersons avoid killing any living creature.

As Islamic, or Muslim, territorial control over northern India expanded, non-Islamic religions resorted to more private forms of artistic expression, such as illustrating their sacred texts, rather than public activities, such as building temples. In these circumstances, the Jains of western India, primarily in the region of Gujarat, created many stunningly illustrated manuscripts, such as this *Kalpa Sutra*, which explicates the lives of the pathfinders (fig. 20-3). Produced during the late fourteenth century, it is one of the first Jain manuscripts on paper rather than palm leaf, which had previously been used.

With great economy, the illustration, inserted between blocks of Sanskrit text, depicts the birth of Mahavira. He is shown cradled in his mother's arms as she reclines in her

PARALLELS

THU TELLES			
<u>Years</u>	Period	<u>India</u>	World
c. 1100–1526	Late Medieval period	Hinduism, Buddhism, Jainism coexist; Pala dynasty in northeast; Buddhist monastic universities in northeast; Turkic invaders defeat Pala dynasty; Buddhism in India declines; Vijayanagar Hindu kingdom in South India resists Islamic forces; Nayaks' Hindu temple complexes	c. 1100–1600 Mound-building cultures (North America); Oxford and Cambridge (England) and the University of Paris (France) founded; Kamakura period (Japan); Magna Carta (England); Hundred Years' War between England and France; Black Death in Europe; Ming dynasty (China); Great Schism in Roman Catholic Church (Italy, France); Columbus's voyages (Spain); Protestant Reformation
c. 1526–18th century	Mughal period	Babur first Mughal emperor; Rajput kingdoms and schools; <i>Gita Govinda</i> ; Emperor Akbar; imperial Mughal school workshops; <i>Hamza-nama</i> ; Emperor Jahangir; Emperor Shah Jahan; Taj Mahal; Mughal Empire unified; British East India Company; Kangra school	c. 1600–1800 First permanent English colony in North America; Thirty Years' War in Europe; union of England and Scotland as Great Britain; James Watt develops steam engine (Scotland); Declaration of Independence (United States); French Revolution; Napoleon's conquests (France)
c. 18th century– present	Modern period	British Empire includes India; New Delhi made capital city; India achieves independence	c. 1800–c. 1950 Simón Bolívar founds independent Venezuela (South America); Monroe Doctrine (United States); Mexico becomes a republic; Canada united; Italy united; Civil War (United States); Sino-Japanese War; Spanish-American War; Wright brothers make first flight (United States); Einstein's theory of relativity (Germany); World War I; Russian Revolution; League of Nations; Spain becomes a republic; World War II; United Nations established; People's Republic of China founded

bed under a canopy connoting royalty, attended by three ladies-in-waiting. Decorative pavilions and a shrine with peacocks on the roof suggest a luxurious palace setting. Everything appears two-dimensional against the brilliant red or blue ground. Vibrant colors and crisp outlines impart an energy to the painting that suggests the arrival of the divine in the mundane world. Transparent garments with variegated designs reveal the swelling curves of the figures, whose alert postures and gestures convey a sense of the importance and excitement of the event. Strangely exaggerated features, such as the protruding eyes, contribute to the air of the extraordinary. With its angles and tense curves, the drawing is closely linked to the aesthetics of Sanskrit calligraphy, and the effect is as if the words themselves had suddenly flared into color and image.

Hindu Art

During the Early Medieval period Hinduism had become the dominant religious tradition of India. With the increasing popularity of Hindu sects came the rapid development of Hindu temples. Spurred by the ambitious building programs of wealthy rulers, well-formulated regional styles had evolved by about 1000 ce. The most spectacular structures of the era were monumental, with a complexity and grandeur of proportion unequaled even in later Indian art.

During the Late Medieval period this emphasis on monumental individual temples gave way to the building of vast **temple complexes** and more moderately scaled yet more richly ornamented individual temples. These

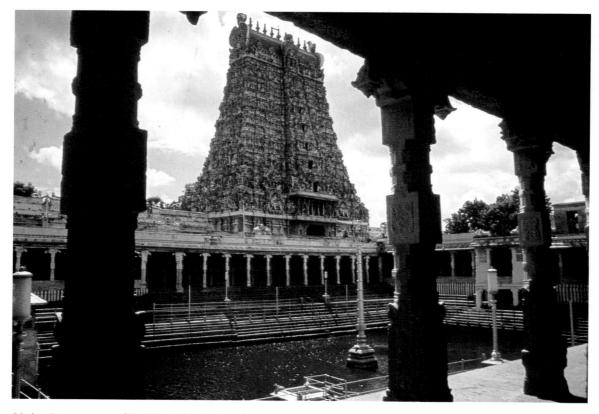

20-4. Outer *gopura* of the Minakshi-Sundareshvara Temple, Madurai, Tamil Nadu, South India. Nayak dynasty. Late Medieval period, mostly 13th to mid-17th centuries

developments took place largely in the south of India, for temple building in the north virtually ceased with the consolidation of Islamic rule there from the beginning of the thirteenth century. The mightiest of the southern Hindu kingdoms was Vijayanagar (c. 1350–1565), whose rulers successfully countered the southward progress of Islamic forces for more than 200 years. Viewing themselves as defenders and preservers of Hindu faith and culture, Vijayanagar kings lavished donations on sacred shrines. Under the patronage of the Vijayanagar and their successors, the Nayaks, the principal monuments of later Hindu architecture were created.

The enormous temple complex at Madurai, one of the capitals of the Nayaks, is an example of this late, fervent expression of Hindu faith. Founded around the thirteenth century, it is dedicated to the goddess Minakshi (the local name for Parvati, the consort of the god Shiva) and to Sundareshvara (the local name for Shiva himself). The temple complex stands in the center of the city and is the focus of Madurai life. At its heart are the two oldest shrines, one to Minakshi and the other to Sundareshvara. Successive additions over the centuries gradually expanded the complex around these small shrines and came to dominate the visual landscape of the city. The most dramatic features of this and similar "temple cities" of the south were the thousand-pillar halls, large ritualbathing pools, and especially entrance gateways, called gopuras, which tower above the temple site and the surrounding city like modern skyscrapers (fig. 20-4).

Gopuras proliferated as a temple city grew, necessitating new and bigger enclosing walls, and thus new

gateways. Successive rulers, often seeking to outdo their predecessors, donated taller and taller *gopuras*. As a result, temple cities often have their tallest structures at the periphery rather than for the central temples, which are sometimes totally overwhelmed. The temple complex at Madurai has eleven *gopuras*, the largest well over 100 feet tall.

Formally, the *gopura* has its roots in the **vimana**, the pyramidal tower characteristic of the seventh-century southern temple style. As the *gopura* evolved, it took on the graceful concave silhouette shown here. The exterior is embellished with thousands of sculpted figures, evoking a teeming world of gods and goddesses. Inside, stairs lead to the top for an extraordinary view.

MUGHAL PERIOD

Islam first touched the South Asian subcontinent in the eighth century, when Arab armies captured a small

territory near the Indus River. Later, beginning around 1000, Turkic factions from Central Asia, relatively recent converts to Islam, began military campaigns into North India, at first purely for plunder, then seeking territorial control. From 1206, various Turkic dynasties ruled portions of the subcontinent from the northern city of Delhi. These sultanates, as they are known, constructed forts, mausoleums, monuments, and **mosques**. Although these early dynasties left their mark, it was the Mughal dynasty that made the most inspired and lasting contribution to the art of India.

The Mughals, too, came from Central Asia. Babur (ruled 1494–1530), the first Mughal emperor, empha-

TECHNIQUE

Before the fourteenth century most painting in India had been made on walls or palm leaves. With the introduction of pa-

per, techniques were adapted from Persia, and over the ensuing centuries Indian artists produced jewel-toned paintings of surpassing beauty on paper.

Painters usually began their training early. As young apprentices, they learned to make brushes and grind pigments. Brushes were made from the curved hairs of a squirrel's tail, arranged to taper from a thick base to a single hair at the tip. Paint came from mineral and vegetable pigments, ground to a paste with water, then bound with a solution of gum from the acacia plant. Blue was made from lapis lazuli, pale green from malachite. Paper, too, was made by hand. Fibers of cotton and jute were crushed to a pulp, poured onto a woven mat, dried, and then burnished with a smooth piece of agate, often to a glossy finish.

Artists frequently worked from a collection of sketches belonging to a master painter's **atelier**. Sometimes sketches were pricked with small, closely spaced holes and wet color daubed over the holes to transfer the drawing to a blank sheet beneath. The dots were con-

INDIAN PAINTING onected into outlines, and the painting began.

ON PAPER

First, the painter applied a thin wash of a chalk-based white, which sealed the surface

of the paper while allowing the underlying sketch to show through. Next, outlines were filled with thick washes of brilliant, opaque, unmodulated color. When the colors were dry, the painting was laid face down on a smooth marble surface and burnished with a rounded agate stone, rubbing first up and down, then side to side. The indirect pressure against the marble polished the pigments to a high luster. Then outlines, details, and modeling—depending on the style—were added with a fine brush.

Sometimes certain details were purposely left for last, such as the eyes, which were said to bring the painting to life. Along more practical lines, gold and raised details were applied when the painting was nearly finished. Gold paint, made from pulverized, 24-karat gold leaf bound with acacia gum, was applied with a brush and burnished to a high shine. Raised details such as the pearls of a necklace were made with thick, white chalkbased paint, with each pearl a single droplet hardened into a tiny raised mound.

sized his Turkic heritage, though he had equally impressive Mongol ancestry. After some initial conquests in Central Asia, he amassed an empire stretching from Afghanistan to Delhi, which he conquered in 1526. Akbar (ruled 1556–1605), the third ruler, extended Mughal control over most of North India, and under Akbar and his two successors, Jahangir and Shah Jahan, northern India was generally unified as the Mughal Empire by 1658.

Mughal Painting

Probably no one had more control over the solidification of the Mughal Empire and the creation of Mughal art than the emperor Akbar. A dynamic, humane, and just leader, Akbar was an avid enthusiast of religious discourse and the arts, especially painting. He created an imperial **atelier** (workshop) of painters, which he placed under the direction of two artists from the Persian court. Learning from these two masters, the Indian painters of the atelier soon transformed Persian styles into the more vigorous, naturalistic styles that mark the Mughal school (see "Indian Painting on Paper," above).

One of the most famous and extraordinary works produced in Akbar's atelier is an illustrated manuscript of the *Hamza-nama*, a Persian classic about the adventures of Hamza, uncle of the Prophet Muhammad. Painted on cotton cloth, each illustration is more than $2^{1/2}$ feet high. The entire project gathered 1,400 illustrations into twelve volumes and took fifteen years to complete.

One illustration shows Hamza's spies scaling a fortress wall and surprising some men as they sleep (fig. 20-5). One man climbs a rope; another has already beheaded a figure in yellow and lifts his head aloft—realistic details are never avoided in paintings from the Mughal atelier. The receding lines of the architecture,

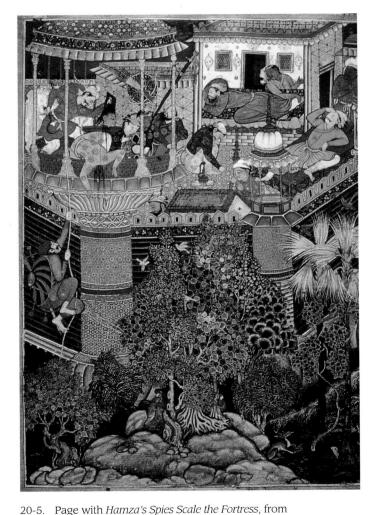

the *Hamza-nama*, North India. Mughal period, Mughal, reign of Akbar, c. 1567–82. Gouache on cotton, 30 x 24" (76 x 61 cm). Museum of Applied Arts, Vienna

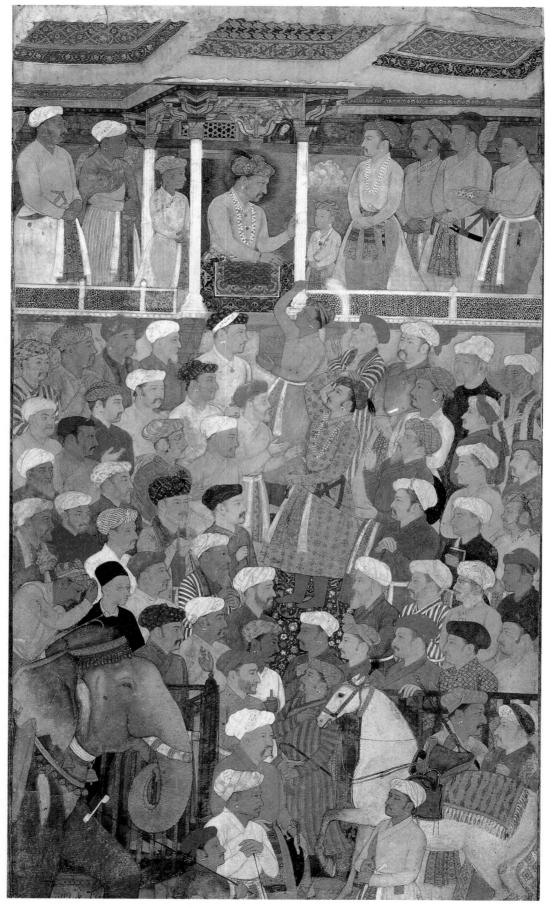

20-6. Abul Hasan and Manohar. Page with *Jahangir in Darbar*, from the *Jahangir-nama*, North India. Mughal period, Mughal, reign of Jahangir, c. 1620. Gouache on paper, 13⁵/₈ x 7⁵/₈" (34.5 x 19.5 cm). Museum of Fine Arts, Boston Frances Bartlett Donation of 1912 and Picture Fund

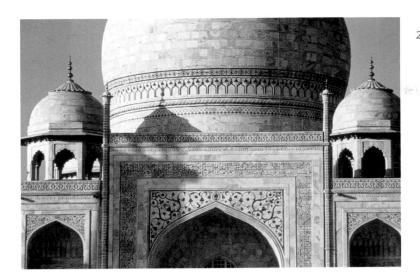

20-7. Taj Mahal, Agra, India. Mughal period. Mughal, reign of Shah Jahan, c. 1632-48 Inside, the Taj Mahal evokes the hasht behisht, or "eight paradises," a plan named for the eight small chambers that ring the interior—one at each corner and one behind each iwan. In two stories (for a total of sixteen chambers), the rooms ring the octagonal central area, which rises the full two stories to a domed ceiling that is lower than the outer dome. In this central chamber, surrounded by a finely carved octagonal openwork marble screen, are the exquisite inlaid cenotaphs of Shah Jahan and his wife, whose actual tombs lie in the crypt below.

viewed from a slightly elevated vantage point, provide a reasonably three-dimensional setting. Yet the sense of depth is boldly undercut by the richly variegated geometric patterns of the tilework, which are painted as though they had been set flat on the page. Contrasting with the flat geometric patterns are the large human figures, whose rounded forms and softened contours create a convincing sense of volume. The energy exuded by the figures is also characteristic of painting under Akbar—even the sleepers seem active. This robust, naturalistic figure style is quite different from the linear style seen earlier in Jain manuscripts (see fig. 20-3) and even from the Persian styles that inspired Mughal paintings.

Nearly as prominent as the architectural setting with its vivid human adventure is the sensuous landscape in the foreground, where monkeys, foxes, and birds inhabit a grove of trees that shimmer and glow against the darkened background like precious gems. The treatment of the gold-edged leaves at first calls to mind the patterned geometry of tilework, yet a closer look reveals a skillful naturalism born of careful observation. Each tree species is carefully distinguished—by the way its trunk grows, the way its branches twist, the shape and veining of its leaves, the silhouette of its overall form. Pink and blue rocks with lumpy, softly outlined forms add still further interest to this painting, whose every inch is full of intriguing elements.

Painting from the reign of Jahangir (ruled 1605–1627) presents a different tone. Like his father, Jahangir admired painting and, if anything, paid even more attention to his atelier. Indeed, he boasted that he could recognize the hand of each of his artists even in collaborative paintings, which were common. Unlike Akbar, however, Jahangir preferred the courtly life to the adventurous one, and paintings produced for him reflect his subdued and refined tastes and his admiration for realistic detail.

One such painting is *Jahangir in Darbar* (fig. 20-6). The work, probably part of a series on Jahangir's reign, shows the emperor holding an audience, or *darbar*, at court. Jahangir himself is depicted at top center, seated on a balcony under a bright red canopy. Members of his court, including his son, the future emperor Shah Jahan,

stand somewhat stiffly to each side. The audience, too, is divided along the central axis, with figures lined up in profile or three-quarter view. In the foreground, an elephant and a horse complete the symmetrical format.

Jahangir insisted on fidelity in portraiture, including his own in old age. The figures in the audience are a medley of portraits, possibly taken from albums meticulously kept by the court artists. Some represent people known to have died before Jahangir's reign, so the painting may represent a symbolic gathering rather than an actual event. Standing out amid the bright array of garments is the black robe of a Jesuit priest from Europe. Both Akbar and Jahangir were known for their interest in things foreign, and many foreigners flocked to the courts of these open-minded rulers. The scene is formal, the composition static, and the treatment generally twodimensional. Nevertheless, the sensitively rendered portraits and the fresh colors, with their varied range of pastel tones, provide the aura of a keenly observed, exquisite ideal reality that marks the finest paintings of Jahangir's time.

Mughal Architecture

Mughal architects were heir to a 300-year-old tradition of Islamic building in India. The Delhi sultans who preceded them had great forts housing government and court buildings. They also introduced two fundamental Islamic structures, the mosque and the tomb, along with construction based on the arch and the dome. (Indian architecture had been based primarily on post-and-lintel construction.) In turn, they drew freely on Indian architecture, borrowing both decorative and structural elements to create a variety of hybrid styles. They especially benefited from the centuries-old Indian virtuosity in stone carving and masonry. The Mughals followed in this tradition, synthesizing Indian, Persian, and Central Asian elements for their forts, palaces, mosques, tombs, and cenotaphs (tombs or monuments to someone whose remains are actually somewhere else). Mughal architectural style culminated in the most famous of all Indian Islamic structures, the Taj Mahal (figs. 20-1 and 20-7).

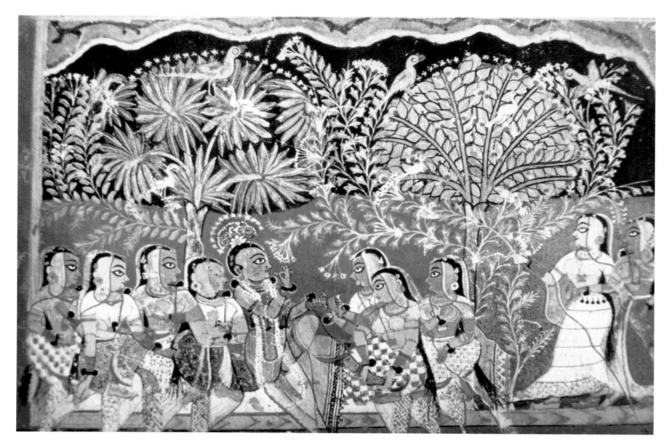

20-8. Page with *Krishna and the Gopis*, from the *Gita Govinda*, Rajasthan, India. Mughal period, Rajput, c. 1525–50. Gouache on paper, 47/8 x 71/2" (12.3 x 19 cm). Prince of Wales Museum, Bombay

The lyrical poem *Gita Govinda*, by the poet-saint Jayadeva, was probably written in eastern India during the latter half of the twelfth century. The episode illustrated here occurs early in the relation of Radha and Krishna, which in the poem is a metaphor for the connection between humans and god. The poem traces the progress of their love through separation, reconciliation, and fulfillment. Intensely sensuous imagery characterizes the entire poem, as in the final song, when Krishna welcomes Radha to his bed (Narayana is the name of Vishnu in his role as cosmic creator):

Leave lotus footprints on my bed of tender shoots, loving Radha! Let my place be ravaged by your tender feet! Narayana is faithful now. Love me Radhika!

I stroke your feet with my lotus hand—you have come far. Set your golden anklet on my bed like the sun.

Narayana is faithful now. Love me Radhika!

Consent to my love. Let elixir pour from your face!

To end our separation I bare my chest of the silk that bars your breast.

Narayana is faithful now. Love me Radhika!

(Translated by Barbara Stoller Miller)

The Taj Mahal is sited on the bank of the Yamuna River at Agra, in northern India. Built between 1632 and 1648, it was commissioned as a **mausoleum** for his wife by the emperor Shah Jahan (ruled 1628–1658), who is believed to have taken a major part in overseeing its design and construction.

Visually, the Taj Mahal never fails to impress (see fig. 20-1). As visitors enter through a monumental, hall-like

gate, the tomb looms before them across a spacious garden set with long reflecting pools. Measuring some 1,000 by 1,900 feet, the garden is unobtrusively divided into quadrants planted with trees and flowers and framed by broad walkways and stone inlaid in geometric patterns. In Shah Jahan's time, fruit trees and cypresses—symbolic of life and death, respectively—lined the walkways, and fountains played in the shallow pools. One can imagine

the melodies of court musicians that wafted through the garden. Truly, the senses were beguiled in this earthly evocation of paradise.

Set toward the rear of the garden, the tomb is flanked by two smaller structures not visible here, one a mosque and the other, its mirror image, a resting hall. They share a broad base with the tomb and serve visually as stabilizing elements. Like the entrance hall, they are made mostly of red sandstone, rendering even more startling the full glory of the tomb's white marble. The tomb is raised higher than these structures on its own marble platform. At each corner of the platform, a minaret, or slender tower, defines the surrounding space. The minarets' three levels correspond to those of the tomb, creating a bond between them. Crowning each minaret is a chattri, or pavilion. Traditional embellishments of Indian palaces, chattris quickly passed into the vocabulary of Indian Islamic architecture, where they appear prominently. Minarets occur in architecture throughout the Islamic world; from their heights, the faithful are called to prayer.

A lucid geometric symmetry pervades the tomb. It is basically square, but its chamfered, or sliced-off, corners create a subtle octagon. Measured to the base of the finial (the spire at the top), the tomb is almost exactly as tall as it is wide. Each facade is identical, with a central iwan flanked by two stories of smaller iwans. (A typical feature of eastern Islamic architecture, an iwan is a vaulted opening with an arched portal.) By creating voids in the facades, these iwans contribute markedly to the building's sense of weightlessness. On the roof, four octagonal chattris, one at each corner, create a visual transition to the lofty, bulbous dome, the crowning element that lends special power to this structure. Framed but not obscured by the chattris, the dome rises more gracefully and is lifted higher by its drum than in earlier Mughal tombs, allowing the swelling curves and lyrical lines of its beautifully proportioned, surprisingly large form to emerge with perfect clarity.

The pristine surfaces of the Taj Mahal are embellished with utmost subtlety. The sides of the platform are carved in relief with a **blind arcade** motif, and carved relief panels of flowers adorn the base of the building. The portals are framed with verses from the Koran inlaid in black marble, while the **spandrels** are decorated with floral arabesques inlaid in colored semiprecious stones, a technique known by its Italian name, *pietra dura*. Not strong enough to detract from the overall purity of the white marble, the embellishments enliven the surfaces of this impressive yet delicate masterpiece.

Rajput Painting

Outside of the Mughal strongholds at Delhi and Agra, much of northern India was governed regionally by local Hindu princes, descendants of the so-called Rajput warrior clans, whom the Mughals allowed to keep their lands in return for allegiance. Like the Mughals, Rajput princes frequently supported painters at their courts, and in these

settings, free from Mughal influence, a variety of strong, indigenous Indian painting styles were perpetuated.

The Hindu devotional movement known as bhakti, which had done much to spread the faith in the south from around the seventh century, experienced a revival in the north beginning in the Late Medieval period. As it had earlier in the south, bhakti inspired an outpouring of poetic literature, this time devoted especially to Krishna, the popular human incarnation of the god Vishnu. Most renowned is the *Gita Govinda*, a cycle of rhapsodic poems about the love between God and humans expressed metaphorically through the love between the young Krishna and the cowherd Radha.

The illustration here is from a manuscript of the Gita Govinda produced in the region of Rajasthan about 1525-1550 (fig. 20-8). The blue god Krishna sits in dalliance with a group of cowherd women. Standing with her maid and consumed with love for Krishna, Radha peers through the trees, overcome by jealousy. Her feelings are indicated by the cool blue color behind her, while the crimson red behind the Krishna grouping suggests passion. The curving stalks and bold patterns of the flowering vines and trees express not only the exuberance of springtime, when the story unfolds, but also the heightened emotional tensions of the scene. Birds, trees, and flowers are brilliant as fireworks against the black, hilly landscape edged in an undulating white line. As in the Jain manuscript earlier (see fig. 20-3), all the figures are of a single type, with plump faces in profile and oversized eyes. Yet the resilient line of the drawing gives them life, and the variety of textile patterns provides some individuality. The intensity and resolute flatness of the scene seem to thrust all of its energy outward, irrevocably engaging the viewer in the drama.

Quite a different mood pervades Hour of Cowdust, a work from the Kangra school in the Punjab Hills, foothills of the Himalaya north of Delhi (fig. 20-9). Painted around 1790, some 250 years later than the previous work, it shows the influence of Mughal naturalism on the later schools of Indian painting. The theme is again Krishna. Wearing his peacock crown, garland of flowers, and yellow garment—all traditional iconography of Krishna-Vishnu-he returns to the village with his fellow cowherds and their cattle. All eyes are upon him as he plays his flute, said to enchant all who heard it. Women with water jugs on their heads turn to look; others lean from windows to watch and call out to him. We are drawn into this charming village scene by the diagonal movements of the cows as they surge through the gate and into the courtyard beyond. Pastel houses and walls create a sense of space, and in the distance we glimpse other villagers going about their work or peacefully sitting in their houses. A rim of dark trees softens the horizon, and an atmospheric sky completes the aura of enchanted naturalism. Again, all the figures are similar in type, this time with a perfection of proportion and a gentle, lyrical movement that complements the idealism of the setting. The scene embodies the sublime purity and grace of the divine, which as in so much Indian art is evoked into our human world to coexist with us as one.

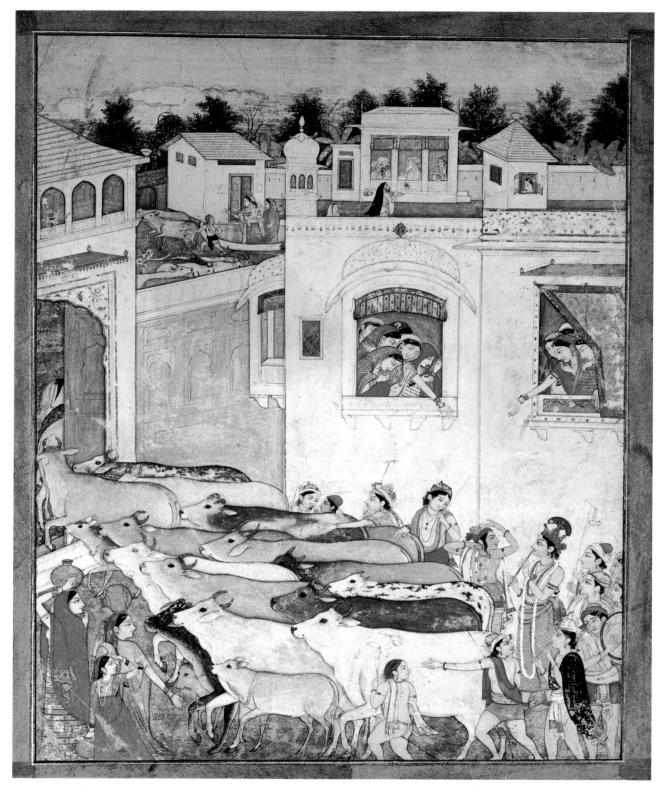

20-9. *Hour of Cowdust*, from Punjab Hills, India. Mughal period, Rajput, Kangra school, c. 1790. Gouache on paper, $10^3/4 \times 8^1/2$ " (27.2 x 21.5 cm). Museum of Fine Arts, Boston Denman W. Ross Collection

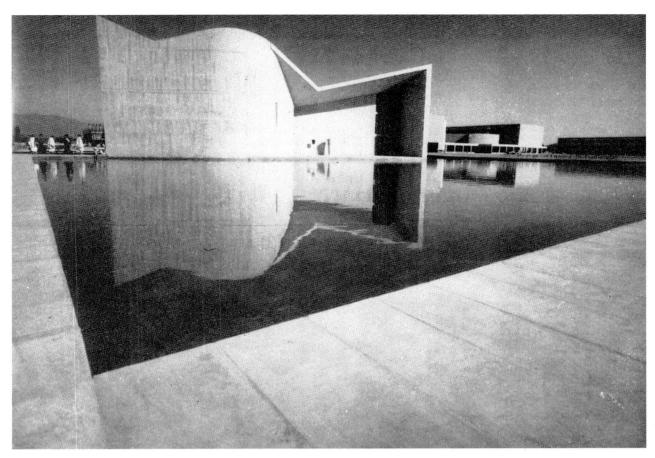

20-10. B. P. Mathur and Pierre Jeanneret. Gandhi Bhavan, Punjab University, Chandigarh, North India. Modern period, 1959-61

MODERN PERIOD

By the time *Hour of Cowdust* was painted, India's regional princes had reasserted themselves, and the vast

Mughal Empire had shrunk to a small area around Delhi. At the same time, a new power, Britain, was making itself felt, inaugurating a markedly different period in Indian history. First under the mercantile interests of the British East India Company in the seventeenth century, and then under the direct control of the British government as a part of the British Empire in the eighteenth, India was brought forcefully into contact with the West and its culture.

The political concerns of the British Empire extended even to the arts, especially architecture. Over the course of the nineteenth century, the great cities of India, such as Calcutta, Madras, and Bombay, took on a European aspect as British architects built in the revivalist styles favored in England (Chapter 26). During the late nineteenth and early twentieth centuries, architects made an effort to incorporate Indian, usually Mughal, elements into their work. But the results were superficial or overly fantastic and consisted largely of adding ornamental forms such as *chattris* to fundamentally European buildings. The most telling imperial gesture came in the 1920s with the construction of a new, Western-style capital city at New Delhi.

At the same time that the British were experimenting with Indian aesthetics, Indian artists were infusing

into their own work Western styles and techniques. One example of this new synthesis is the Gandhi Bhavan at Punjab University in Chandigarh, in North India (fig. 20-10). Used for both lectures and prayer, the hall was designed in the late 1950s by Indian architect B. P. Mathur in collaboration with Pierre Jeanneret, cousin of the French modernist architect Le Corbusier (Chapter 29), whose version of the International Style had been influential in India. The Gandhi Bhavan's three-part, pinwheel plan, abstract sculptural qualities, and fluid use of planes reflect the modern vision of the International Style. Yet other factors speak directly to India's heritage. The merging of sharp, brusque angles with lyrical curves recalls the linear tensions of the ancient Sanskrit alphabet. The pools surrounding the building evoke Mughal tombs, some of which were similarly laid out on terraces surrounded by water, as well as the ritual-bathing pools of Hindu temples. Yet the abstract style is free of specific religious associations.

The irregular stone structure, its smooth surfaces punctuated by only a few apertures, shimmers in the bright Indian sunlight like an apparition of pure form in our ordinary world. Caught between sky, earth, and water, it fittingly evokes the pulsating qualities of a world seen as imbued with divine essence, the world that has always been at the heart of Indian art.

Ming porcelain flask c. 1425–35

▲ YUAN DYNASTY 1280-1368

▲ MING DYNASTY 1368–1644

LAOS

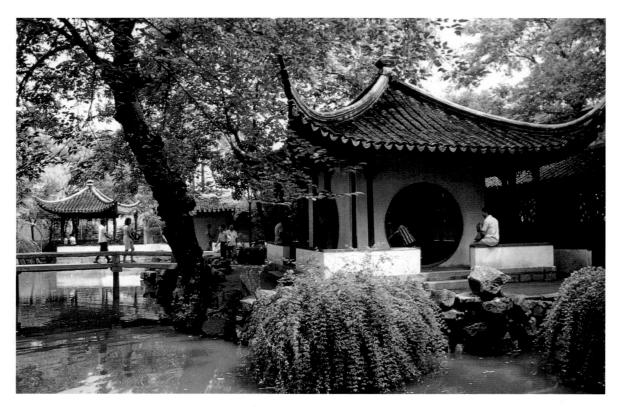

21-1. Garden of the Cessation of Official Life, Suzhou, Jiangsu. Ming dynasty, early 16th century

arly in the sixteenth century, an official in Beijing, frustrated after serving in the capital for many years without promotion, returned to his home near Shanghai. Taking an ancient poem, "The Song of Leisurely Living," for his model, he began to build a garden. He called his retreat the Garden of the Cessation of Official Life (fig. 21-1) to indicate that he had exchanged his career as a bureaucrat for a life of leisure. By leisure, he meant that he could now dedicate himself to calligraphy, poetry, and painting, the three arts dear to scholars in China.

The scholar class of imperial China was a phenomenon unique in the world, the product of an examination system designed to recruit the finest minds in the country for government service. First instituted during the Tang dynasty (618–907), the civil service examinations were excruciatingly difficult, but for the tiny percentage that passed at the highest level, the rewards were prestige, position, power, and wealth. During the Song dynasty (960–1279) the examinations were expanded and regularized, and more than half of all government positions came to be filled by scholars.

Steeped in the classic texts of philosophy, literature, and history, China's scholars—known as literati—shared a common bond in education and outlook. Their lives typically moved between the philosophical poles of Confucianism and Daoism (see "Foundations of Chinese Culture," opposite). Following the former, they became officials to fulfill their obligation to the world; pulled by the latter, they retreated from society in order to come to terms with nature and the universe: to create a garden, to write poetry, to paint.

Under a series of remarkably cultivated emperors, the literati reached the height of their influence during the Song dynasty. Their world was about to change dramatically, however, with lasting results for Chinese art.

CHINESE **CULTURE**

FOUNDA- Chinese culture is dis-TIONS OF tinguished by its long and continuous development. Between 7000 and 2000 BCE a

variety of Neolithic cultures flourished across China. Through long interaction these cultures became increasingly similar, and they eventually gave rise to the three Bronze Age dynastic states with which Chinese history traditionally begins: the legendary Xia, the Shang (c. 1700-1100 BCE), and the Zhou (1100-221 BCE).

The Shang developed a culture of splendor and violence. Society was stratified, and the ruling group maintained its authority in part by claiming power as shamans, intermediaries between the human and spirit worlds. Shamanistic practices are responsible for the earliest known examples of Chinese writing—bones inscribed with questions to and answers from the spirit world. Under the Zhou a feudal society developed, with nobles related to the king ruling over numerous small states. During the latter part of the Zhou dynasty, states began to vie for supremacy through intrigue and increasingly ruthless warfare. The collapse of social order inspired China's first philosophers, who largely concerned themselves with the pragmatic question of how to bring about a stable society.

In 221 BCE rulers of the state of Qin triumphed over the remaining states, unifying China as an empire for the first time. The Qin created the mechanisms of China's centralized bureaucracy, but their rule was harsh and the dynasty was quickly overthrown. During the ensuing Han dynasty (206 BCE-220 CE), China at last knew peace and prosperity. Confucianism was made the official state ideology, in the process assuming the form and force of a religion. Developed from the thought of Confucius (551-479 BCE), one of the many philosophers of the Zhou, Confucianism is an ethical system for the management of society based on establishing correct relationships among people. Providing a counterweight was Daoism, which also came into its own during the Han dynasty. Based on the thought of Laozi, a possibly legendary contemporary of Confucius, and the philosopher Zhuangzi (369-286 BCE), Daoism is a kind of nature mysticism that seeks to harmonize the individual with the Dao, or Way, of the Universe. Confucianism and Daoism have remained central to

individualism and creativity. Following the collapse of the Han dynasty, China experienced a long period of disunity (220-589 CE). Invaders from the north and west established numerous kingdoms and dynasties, while a series of six precarious Chinese dynasties held sway

Chinese thought—the one address-

ing the public realm of duty and con-

formity, the other the private world of

in the south. Buddhism, which had begun to filter over trade routes from India during the Han dynasty, now spread widely. The period also witnessed the economic and cultural development of the south (all previous dynasties had ruled from the north).

China was reunited under the Sui dynasty (589-618 cE), which quickly overreached itself and fell to the Tang (618-907 cE), one of the most successful dynasties in Chinese history. Strong and confident, Tang China fascinated and, in turn, was fascinated by the cultures around it. Caravans streamed across Central Asia to the capital, Chang'an, then the largest city in the world. Japan and Korea sent thousands of students to study Chinese culture, and Buddhism reached the height of its influence before a period of persecution signaled the start of its decline.

The mood of the Song dynasty (960-1279 CE) was quite different. The martial vigor of the Tang gave way to a culture of increasing refinement and sophistication, and Tang openness to foreign influences was replaced by a conscious cultivation of China's own traditions. In art, landscape painting emerged as the most esteemed genre, capable of expressing both philosophical and personal concerns. With the fall of the north to invaders in 1126, the Song court set up a new capital in the south, which became the cultural and economic center of the country.

THE MONGOL INVASIONS

At the beginning of the thirteenth century the Mongols, a nomadic people from the steppelands north of China, began to amass an empire. Led at first by Jenghiz Khan

(c. 1162-1227), then by his sons and grandsons, they swept westward into central Europe and overran Islamic lands from Central Asia through present-day Iraq. To the east, they quickly captured northern China, and in 1279, led by Kublai Khan, they conquered southern China as well. Grandson of the mighty Jenghiz, Kublai proclaimed himself emperor of China and founder of the Yuan dynasty (1280-1368).

The Mongol invasions were traumatic, and their effect on China was long lasting. During the Song dynasty, China had grown increasingly reflective. Rejecting foreign ideas and influences, intellectuals focused on defining the qualities that constituted true "Chineseness." They drew a clear distinction between their own people, whom they characterized as gentle, erudite, and sophisticated, and the "barbarians" outside China's borders, whom they believed to be crude, wild, and uncultured. Now, faced with the reality of barbarian occupation, China's inward gaze intensified in spiritual resistance. For centuries to come, long after the Mongols had gone, leading scholars continued to seek intellectually more challenging, philosophically more profound, and artistically more subtle expressions of all that could be identified as authentically Chinese.

YUAN DYNASTY

The Mongols established their capital in the northern city now known as Beijing. The cultural centers of

China, however, remained the great cities of the south, where the Song court had been located for the previous 150 years. Combined with the tensions of Yuan rule, this separation of China's political and cultural centers created a new situation in the arts.

PARALLELS

17 tit/ teles			
<u>Years</u>	Period	<u>China</u>	World
1280-1368	Yuan dynasty	Kublai Khan, emperor of China, founds Yuan dynasty; Marco Polo in China; Zhao Mengfu's Autumn Colors on the Qiao and Hua Mountains	1280–1400 Book arts flourish in France and England; Gothic style emerges (France); Aztec Empire (Mexico); Hundred Years' War between England and France; Black Death in Europe; Great Schism in Christian Church; Golden Pavilion (Japan)
1368–1644	Ming dynasty	Ni Zan's <i>The Rongxi Studio;</i> Black Death kills 30 percent of Chinese population; Forbidden City rebuilt; Garden of the Cessation of Official Life; Shen Zhou's <i>Poet on a Mountain Top;</i> Dong Qichang's <i>The Qingbian Mountains</i>	Chaucer's Canterbury Tales (England); Van Eyck's Ghent Altarpiece (Flanders); Inka Empire (South America); Ghiberti's Gates of Paradise (Italy); Gutenberg's Bible (Germany); Columbus's voyages (Spain); Michelangelo's David; Leonardo's Mona Lisa; Michelangelo's Sistine Ceiling (Italy); Protestant Reformation in Europe; Mughal period (India); Baroque style in Europe; Peter Paul Rubens (Flanders); Hideyoshi unites Japan; Rembrandt van Rijn (Netherlands); English colonize North America; Age of Enlightenment begins in Europe
1644–1911	Qing dynasty	Individualist painters; Wang Hui's <i>A Thousand Peaks and Myr-</i> <i>iad Ravines</i> ; Shitao's <i>Landscape</i> ; Sino-Japanese War	Union of England and Scotland as Great Britain; John Singleton Copley (North America); Declaration of Independence (North America); French Revolution; Romanticism and Neoclassicism arise; Mexico becomes a republic; Realism arises in Europe; Marx and Engels's Communist Manifesto; Darwin's Origin of Species; Italy united; Civil War (United States); Dominion of Canada formed; Impressionism and Post-Impressionism arise
1911–present	Modern period	First republic established by Sun Yat-Sen (Sun Yixian); People's Republic of China (Communist) established; Wu Guanzhong's Pine Spirit	1900–1950 Fauve painters emerge (France); German Expressionist movement arises; Cubism (France); World War I; Civil War (Russia); League of Nations founded; World War II; United Nations established

Throughout most of Chinese history, the imperial court had set the tone for artistic taste; artisans attached to the court produced architecture, paintings, gardens, and objects of jade, lacquer, ceramic, and silk especially for imperial use. Over the centuries, painters and calligraphers gradually moved higher up the social scale, for these "arts of the brush" were often practiced as well by scholars and even emperors, whose high status reflected positively on whatever interested them. With the establishment of an imperial painting academy during the Song dynasty, painters finally achieved a status equal to that of court officials. For the literati, painting came to be grouped with calligraphy and poetry as the trio of accomplishments suited to members of the cultural elite.

21-2. Zhao Mengfu.
Section of Autumn
Colors on the Qiao
and Hua Mountains.
Yuan dynasty, 1296.
Handscroll, ink and
color on paper,
11¹/₄ x 36³/₄"
(28.6 x 93.3 cm).
National Palace
Museum, Taipei,
Taiwan

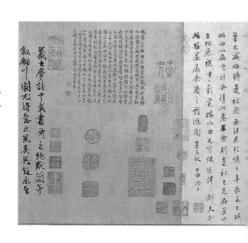

MARCO China under Kublai Khan
POLO was one of four Mongol
khanates that together

khanates that together extended west into present-day Iraq and through Russia to the borders of Poland and Hungary. For roughly a century travelers moved freely across this vast expanse, making the era one of unprecedented cross-cultural exchange. Diplomats, missionaries, merchants, and adventurers flocked to the Yuan court, and Chinese envoys were dispatched to the West. The most celebrated European traveler of the time was a Venetian named Marco Polo (c. 1254–1324), whose

descriptions of his travels were for several centuries the only firsthand account of China available in Europe.

Marco Polo was still in his teens when he set out for China in 1271. He traveled with his uncle and father, both merchants, bearing letters for Kublai Khan from Pope Gregory X. After a four-year journey the Polos arrived at last in Beijing. Marco became a favorite of the emperor and spent the next seventeen years in his service, during which time he traveled extensively throughout China. He eventually returned home in 1295.

Imprisoned later during a war

between Venice and Genoa, a rival Italian city-state, Marco Polo passed the time by dictating an account of his experiences to a fellow prisoner. The resulting book, A Description of the World, has fascinated generations of readers with its descriptions of wealthy and sophisticated lands in the East. Translated into almost every European language, it was an important influence in stimulating further exploration. When Columbus set sail across the Atlantic in 1492, one of the places he hoped to find was a country Marco Polo called Zipangu-Japan.

But while the literati elevated the status of painting by virtue of practicing it, they also began to develop their own ideas of what painting should be. Not having to earn an income from their art, they cultivated an amateur ideal in which personal expression counted for more than "mere" professional skill. They created for themselves a status as artists totally separate from and superior to professional painters, whose art they felt was inherently compromised, since it was done to please others, and impure, since it was tainted by money.

The conditions of Yuan rule now encouraged a clear distinction between court taste, ministered to by professional artists and artisans, and literati taste. The Yuan continued the imperial role as patron of the arts, commissioning buildings, murals, gardens, paintings, and decorative arts. Western visitors such as the Italian Marco Polo were impressed by the magnificence of the Yuan court (see "Marco Polo," above). But scholars, profoundly alienated from the new government, took no notice of these accomplishments, and thus nothing was written about them. Nor did Yuan rulers have much use for scholars, especially those from the south. The civil service examinations were abolished, and the highest government positions were bestowed, instead, on Mongols and their foreign allies. Scholars now tended to turn inward, to search for solutions of their own and to try to express themselves in personal and symbolic terms.

Typical of this trend is Zhao Mengfu (1254–1322), a descendant of the imperial line of Song. Unlike many scholars of his time, he eventually chose to serve the Yuan government and was made a high official. A painter, calligrapher, and poet, all of the first rank, Zhao was especially known for his carefully rendered paintings of horses. But he also cultivated another manner, most famous in his landmark painting, *Autumn Colors on the Qiao and Hua Mountains* (fig. 21-2).

Zhao painted this work for a friend whose ancestors came from Jinan, the present-day capital of Shandong province, and the painting supposedly depicts the land-scape there. Yet the mountains and trees are not painted in the accomplished naturalism of Zhao's own time but rather in the archaic yet oddly elegant manner of the earlier Tang dynasty. The Tang dynasty was a great era in Chinese history, when the country was both militarily strong and culturally vibrant. Through his painting Zhao evoked a feeling of nostalgia, not only for his friend's distant homeland but also for China's past.

This educated taste for the "spirit of the antiquity" became an important aspect of **literati painting** in later periods. Also typical of literati taste are the unassuming brushwork, the subtle colors sparingly used (many literati paintings forgo color altogether), the use of landscape to convey personal meaning, and even the intended audience—a close friend. The literati did not paint for

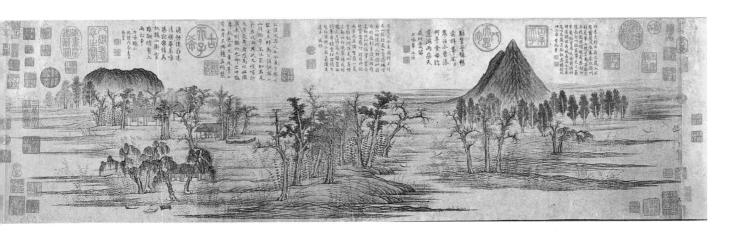

1280 1280 1980

TECHNIQUE

Aside from the large wall paintings that typically decorated palaces, temples, and tombs, most Chinese paintings were done in ink and water-based colors on silk or paper. Finished

works were generally mounted on silk as a handscroll, a hanging scroll, or an album.

An album comprises a set of paintings of identical size mounted in an accordion-fold book. (A single painting from an album is called an **album leaf**.) The paintings in an album are usually related in subject, such as various views of a famous site or a series of scenes glimpsed on one trip.

Album-size paintings might also be mounted as a handscroll, a horizontal format generally about 12 inches high and anywhere from a few feet to dozens of feet long. More typically, however, a handscroll would be a single continuous painting. Handscrolls were not meant to be displayed all at once, the way they are commonly presented today in museums. Rather, they were unrolled only occasionally, to be savored in much the same spirit as we might put a favorite film in the VCR. Placing the scroll on a flat surface such as a table, a viewer would unroll it a foot or two at a time, moving gradually through the entire scroll from right to left, lingering over favorite details. The scroll was then rolled up and returned to its box until the next viewing.

FORMATS OF CHINESE PAINTING

Like handscrolls, hanging scrolls were not displayed permanently but were taken out for a limited time—a day, a week, a season. Unlike a handscroll, however, the painting on a hang-

ing scroll was viewed as a whole, unrolled and put up on a wall, with the roller at the lower end acting as a weight to help the scroll hang flat. Although some hanging scrolls are quite large, they are still fundamentally intimate works, not intended for display in a public place.

Creating a scroll was a time-consuming and exacting process. The painting was first backed with paper to strengthen it. Next, strips of paper-backed silk were pasted to the top, bottom, and sides, framing the painting on all four sides. Additional silk pieces were added to extend the scroll horizontally or vertically, depending on the format. The assembled scroll was then backed again with paper and fitted with a half-round dowel, or wooden rod, at the top (of a hanging scroll) or right end (of a handscroll), with ribbons for hanging and tying, and with a wooden roller at the other end. Hanging scrolls were often fashioned from several patterns of silk, and a variety of piecing formats were developed and codified. On a handscroll, a painting was generally preceded by a panel giving the work's title and often followed by a long panel bearing colophons—inscriptions such as poems in praise of the work or comments by its owners over the centuries.

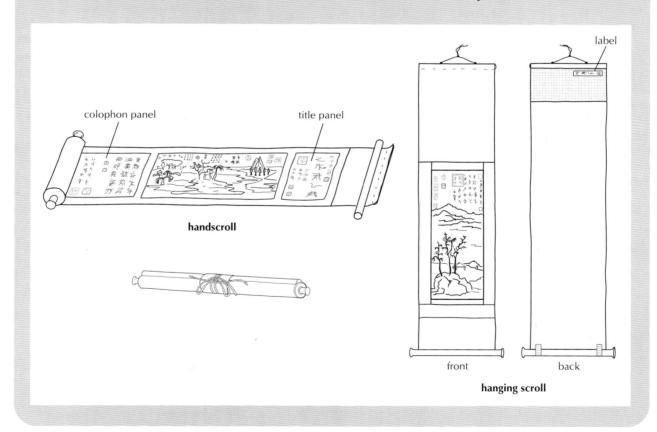

public display but for each other. They favored small formats such as **handscrolls**, **hanging scrolls**, or **album leaves** (book pages), which could easily be taken to show to friends or to share at small gatherings (see "Formats of Chinese Painting," above).

Of the considerable number of Yuan painters who took up Zhao's ideas, several became models for later generations. One such was Ni Zan (1308–1374), whose most famous surviving painting is *The Rongxi Studio* (fig. 21-3). Done entirely in ink, the painting depicts the lake

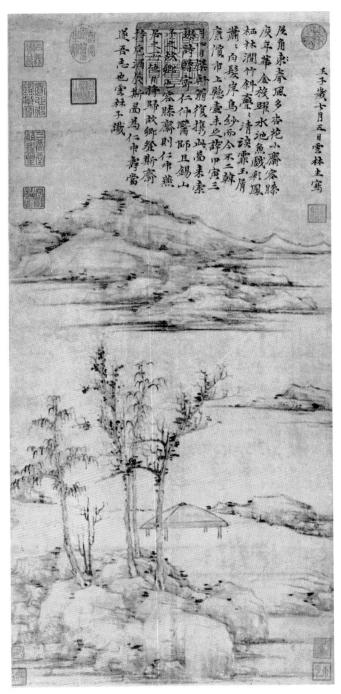

21-3. Ni Zan. *The Rongxi Studio*. Yuan dynasty, 1372. Hanging scroll, ink on paper, height 29³/8" (74.6 cm). National Palace Museum, Taipei, Taiwan

The idea that a painting is not done to capture a likeness or to satisfy others but is executed freely and carelessly for the artist's own amusement is at the heart of the literati aesthetic. Ni Zan once wrote this comment on a painting: "What I call painting does not exceed the joy of careless sketching with a brush. I do not seek formal likeness but do it simply for my own amusement. Recently I was rambling about and came to a town. The people asked for my pictures, but wanted them exactly according to their own desires and to represent a specific occasion. [When I could not satisfy them,] they went away insulting, scolding, and cursing in every possible way. What a shame! But how can one scold a eunuch for not growing a beard?" (cited in Bush and Shih, page 266).

region in Ni's home district. Mountains, rocks, trees, and a pavilion are sketched with a minimum of detail using a dry brush technique—a technique in which the brush is not fully loaded with ink but rather about to run out, so that white paper "breathes" through the ragged strokes. The result is a painting with a light touch and a sense of simplicity and purity. Literati styles were believed to reflect the painter's personality. Ni's spare, dry style became associated with a noble spirit, and many later painters adopted it or paid homage to it.

Ni Zan was one of those eccentrics whose behavior has become legendary in the history of Chinese art. In his early years he was one of the richest men in the region, the owner of a large estate. His pride and his aloofness from daily affairs often got him into trouble with the authorities. His cleanliness was notorious. In addition to washing himself several times daily, he also ordered his servants to wash the trees in his garden and to clean the furniture after his guests had left. He was said to be so unworldly that late in life he gave away most of his possessions and lived as a hermit in a boat, wandering on rivers and lakes.

Whether these stories are true or not, they were important elements of Ni's legacy to later painters, for Ni's life as well as his art served as a model. The painting of the literati was bound up with certain views about what constituted an appropriate life. The ideal, as embodied by Ni Zan and others, was of a brilliantly gifted scholar whose spirit was too fine-tuned for the "dusty world" of government service and who thus preferred to live as a recluse, or as one who had retired after having become frustrated by a brief stint as an official.

MING DYNASTY

The founder of the next dynasty, the Ming (1368–1644), came from a family of poor uneducated peasants. As

he rose through the ranks in the army, he enlisted the help of scholars to gain power and solidify his following. Once he had driven the Mongols from Beijing and firmly established himself as emperor, however, he grew to distrust intellectuals. His rule was despotic, even ruthless. Throughout the nearly 300 years of Ming rule, most emperors shared his attitude, so although the civil service examinations were reinstated, scholars remained alienated from the government they were trained to serve.

Court and Professional Painting

The contrast between the luxurious world of the court and the austere ideals of the literati continued through the Ming dynasty. A typical example of Ming court taste is *Hundreds of Birds Admiring the Peacocks*, a large painting on silk by Yin Hong, an artist active during the late fifteenth and early sixteenth centuries (fig. 21-4). A pupil of some well-known courtiers, Yin most probably served in the court at Beijing. The painting is an example of the birds-and-flowers **genre**, which had been popular with artists of the Song academy. Here the subject takes on symbolic meaning, with the homage of the birds to the peacocks representing the homage of court officials to

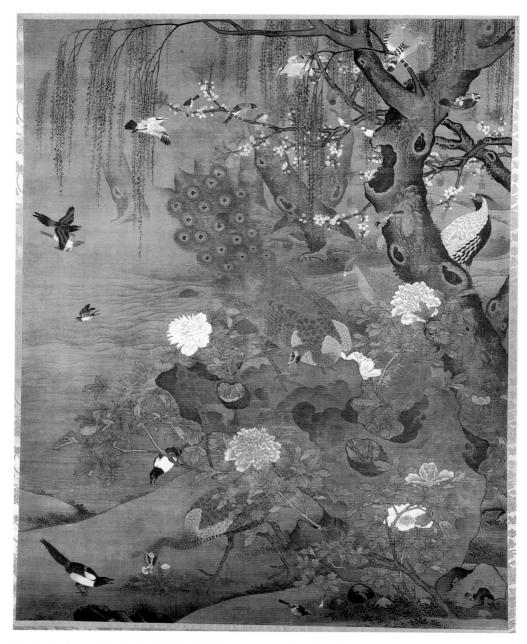

21-4. Yin Hong. Hundreds of Birds Admiring the Peacocks. Ming dynasty, c. late 15th–early 16th centuries. Hanging scroll, ink and color on silk, $7'10^{1}/2" \times 6'5"$ (2.4 x 1.96 m). The Cleveland Museum of Art

Purchase from the J. H. Wade Fund, 74.31

the emperor. The decorative style goes back to Song academy models as well, although the large format and multiplication of details are traits of the Ming.

The preeminent professional painter in the Ming period was Qiu Ying (1494–1552), who lived in Suzhou, a prosperous southern city. He inspired generations of imitators with exceptional works, such as a long handscroll known as *Spring Dawn in the Han Palace* (fig. 21-5). The painting is based on Tang dynasty depictions of women in the court of the Han dynasty (206 BCE–220 CE). While in the service of a well-known collector, Qiu Ying had the opportunity to study many Tang paintings, whose artists usually concentrated on the figures, leaving out the background entirely. Qiu's graceful and elegant figures—

although modeled after those in Tang works—are portrayed in a setting of palace buildings, engaging in such pastimes as chess, music, calligraphy, and painting. With its antique subject matter, refined technique, and flawless taste in color and composition, *Spring Dawn in the Han Palace* brought professional painting to a new high point.

Gardens and Decorative Arts

Qiu Ying painted to satisfy his patrons in Suzhou. The cities of the south were becoming wealthy, and newly rich merchants collected paintings, antiques, and art objects. The court, too, was prosperous and patronized the arts on a lavish scale. In such a setting, the decorative arts thrived.

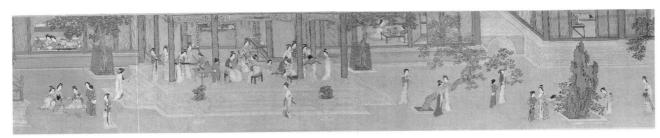

21-5. Qiu Ying. Section of *Spring Dawn in the Han Palace*. Ming dynasty, first half of the 16th century. Handscroll, ink and color on silk, 1' x 18¹³/₁₆" (0.30 x 5.7 m). National Palace Museum, Taipei, Taiwan

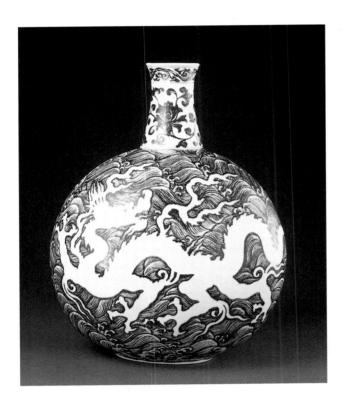

21-6. Porcelain flask with decoration in blue underglaze. Ming dynasty, c. 1425-35. Palace Museum, Beijing Dragons have featured prominently in Chinese folklore from earliest times—Neolithic examples have been found painted on pottery and carved in jade. In Bronze Age China, dragons came to be associated with powerful and sudden manifestations of nature, such as wind, thunder, and lightning. Bronze Age shamans appealed to dragons to learn the weather. At the same time, dragons also became associated with superior beings such as virtuous rulers and sages. With the emergence of China's first firmly established empire during the Han dynasty, the dragon was appropriated as an imperial symbol, and it remained so throughout Chinese history. Dragon sightings were duly recorded and considered auspicious. Yet even the Son of Heaven could not monopolize the dragon. During the Tang and Song dynasties the practice arose of painting pictures of dragons to pray for rain, and for Chan (Zen) Buddhists, the dragon was a symbol of sudden enlightenment.

Like the Song dynasty before it, the Ming has become famous the world over for its exquisite ceramics, especially **porcelain** (see "The Secret of Porcelain," below). The imperial **kilns** in Jingdezhen, in Jiangxi province, became the most renowned center for porcelain not only in all of China but eventually in all the world. Particularly noteworthy are the blue-and-white wares produced there dur-

ing the ten-year reign of the ruler known as the Xuande emperor (ruled 1425–1435), such as the flask in figure 21-6. The subtle shape, the refined yet vigorous decoration of dragons writhing in the sea, and the flawless **glazing** embody the high achievement of Ming artisans.

Chinese furniture, made mainly for domestic use, reached the height of its development in the sixteenth

THE SECRET Marco Polo, it is OF PORCELAIN said, was the one who named a new type of ceramic he found in China. Its translucent purity reminded him of the smooth whiteness of the cowry shell, porcellana in Italian. Porcelain is made from kaolin, an extremely refined white clay, and petuntse, a variety of the rockmineral feldspar. When properly combined and fired at a sufficiently high temperature, the two materials fuse into a glasslike, translucent ceramic

that is far stronger than it looks.

Porcelaneous stoneware, fired at lower temperatures, was known in China by the seventh century, but true porcelain emerged during the Song dynasty. To create blue-and-white porcelain such as the flask in figure 21-6, blue pigment was made from cobalt oxide, finely ground and mixed with water. The decoration was painted directly onto the unfired porcelain vessel, then a layer of white glaze was applied over it. (In this technique,

known as **underglaze**, the decoration is painted beneath the glaze.) After firing, the piece emerged from the kiln with a clear blue design set sharply against a snowy white background.

Entranced with the exquisite properties of porcelain, European potters tried for centuries to duplicate it. The technique was finally discovered in 1708 by Johann Friedrich Böttger in Dresden, Germany, who tried—but failed—to keep it a secret.

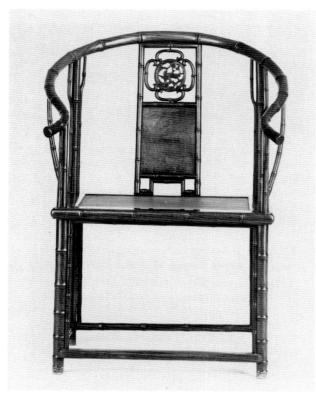

21-7. Armchair. Ming dynasty, l6th–17th century. Huanghuali wood (rosewood), 39³/₈ x 27¹/₄ x 20" (100 x 69.2 x 50.8 cm). The Nelson-Atkins Museum of Art, Kansas City, Missouri Purchase, Nelson Trust (46-78/1)

and seventeenth centuries. Characteristic of Chinese furniture, the chair in figure 21-7 is constructed without the use of glue or nails. Instead, pieces fit together based on the principle of the **mortise-and-tenon joint**, in which a projecting element (tenon) on one piece fits snugly into a cavity (mortise) on another. Each piece of the chair is carved, as opposed to being bent or twisted, and the joints are crafted with great precision. The patterns of the wood grain provide subtle interest unmarred by any painting or other embellishment. The style, like that of Chinese architecture, is one of simplicity, clarity, symmetry, and balance. The effect is formal and dignified but natural and simple—virtues central to the Chinese view of proper human conduct as well.

The art of landscape gardening also reached a high point during the Ming dynasty, as many literati surrounded their homes with gardens. The most famous gardens were created in the southern cities of the Yangzi River (Chang Jiang) delta, especially Suzhou. The largest surviving garden of the era is the Garden of the Cessation of Official Life, with which this chapter opened (see fig. 21-1). Although modified and reconstructed many times through the centuries, it still reflects many of the basic ideas of the original Ming owner. About a third of the 3-acre garden is devoted to water through artificially created brooks and ponds. The landscape is dotted with pavilions, kiosks, libraries, studios, and corridors. Many of the buildings have poetic names, such as Rain Listening Pavilion and Covered Bridge of Small Flying Rainbow.

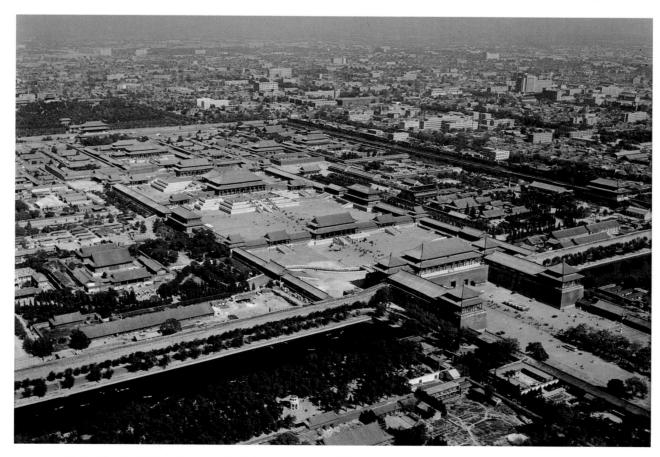

21-8. The Forbidden City, now the Palace Museum, Beijing. Mostly Ming dynasty. View from the southwest

GEOMANCY, COSMOLOGY, AND CHINESE

Geomancy is a form of divination that looks **ARCHITECTURE** for signs in the topography of

the earth. In China it has been known from ancient times as feng shui, or "wind and water." Still practiced today, feng shui assesses qi, the primal energy that is believed to flow through creation, to determine whether a site is suitably auspicious for building. Feng shui also advises on improving a site's qi through landscaping, planting, creating waterways, and building temples and pagodas.

One important task of feng shui in the past was selecting auspicious sites for imperial tombs. These were traditionally set in a landscape of hills and winding paths, protected from harmful spiritual forces by a hill to the rear and a winding waterway crossed by arched bridges in front. Feng shui was also called on to find and enhance sites for homes, towns, and, especially, imperial cities. The Forbidden City, for example, is "protected" by a hill outside the north wall and a bow-shaped watercourse just inside the entrance.

The layout of imperial buildings was as important as their site and reflected ancient principles of cosmology-ideas about the structure and workings of the universe. Since the Zhou dynasty (1100-221 BCE) the emperor had ruled as the Son of Heaven. If he was worthy and right-acting, it was believed, then all would go well in nature and the cosmos. But if he was not, cosmic signs, natural disasters, and human rebellions would make it clear that Heaven had withdrawn his

dynasty's mandate to rule—traditional histories explained the downfall of a dynasty in just these terms.

Architecture played a major role in expressing this link between imperial and cosmic order. As early as Zhou times, cities were oriented on a north-south axis and built as a collection of enclosures surrounded by a defensive wall. The first imperial city of which we have any substantial knowledge, however, is Chang'an, the capital of the Tang (Tang dynasty, 618-907 cE). Chang'an was a walled city laid out on a rectangular grid measuring 5 miles by 6 miles. At the north end was an imperial enclosure. The palace within faced south, symbolic of the emperor looking out over his city and, by extension, his realm. This orientation was already traditional by Tang times. Chinese rulersand Chinese buildings—had always turned their backs to the north, from whence came evil spirits. Confucius even framed his admiration for one early Zhou ruler by saying that all he needed to do to govern was to assume a respectful position and face south, so attuned was he to Heaven's way.

A complex of government buildings stood in front of the imperial compound, and from them a 500foot-wide avenue led to the city's principal southern gate. The city streets ran north-south and east-west. Each of the resulting 108 blocks was like a miniature city, with its own interior streets, surrounding walls, and gates that were locked at night. Two large markets to the east and west were open at specified hours. Such was the prestige of China during the Tang dynasty that the Japanese modeled their imperial capitals at Nara (built in 710 cE) and Heian (Kyoto, built in 794 ce) on Chang'an, though without the surrounding walls.

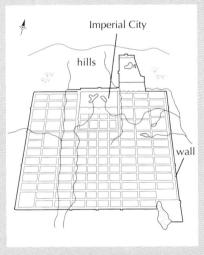

Heian (Kyoto), Japan

Architecture and City Planning

Centuries of warfare and destruction have left very few Chinese architectural monuments intact. The most important remaining example of traditional Chinese architecture is the Forbidden City, the imperial palace compound in Beijing, whose principal buildings were constructed during the Ming dynasty (fig. 21-8).

The basic plan of Beijing was the work of the Mongols, who laid out their capital city according to traditional Chinese principles. City planning began in China in the early seventh century with Chang'an (present-day Xi'an), the capital of the Sui and Tang emperors (see "Geomancy, Cosmology, and Chinese Architecture," above). The walled city of Chang'an was laid out on a rectangular grid, with evenly spaced streets that ran north-south and east-west. At the northern end stood a walled imperial complex.

Beijing, too, was developed as a walled, rectangular city with streets laid out in a grid. The palace enclosure occupied the center of the northern part of the city, which was reserved for the Mongols. Chinese lived in the southern third of the city. Later Ming and Qing emperors preserved this division, with officials living in the northern or Inner City, and commoners living in the southern or Outer City. Under the third Ming emperor, Yongle (ruled 1402-1424), the Forbidden City was rebuilt as we see it today.

The approach to the Forbidden City was impressive, and it was meant to be. Visitors entered through the Meridian Gate, a monumental U-shaped gate (at the right in fig. 21-8). Inside the Meridian Gate a broad courtyard is crossed

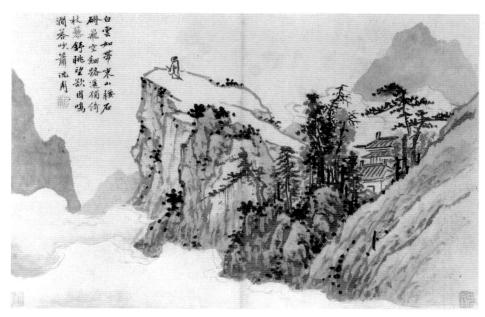

21-9. Shen Zhou. Poet on a Mountain Top, leaf from an album of landscapes; painting mounted as part of a handscroll, Ming dynasty, c. 1500. Ink and color on paper, 151/4 x 23³/4" (38.1 x 60.2 cm). The Nelson-Atkins Museum of Art, Kansas City, Missouri

Purchase, Nelson Trust (46-51/2)

The poem at the upper left reads:

White clouds like a belt encircle the mountain's waist A stone ledge flying in space and the far thin road. I lean alone on my bramble staff and gazing contented into space Wish the sounding torrent would answer to your flute.

(Translated by Richard Edwards, cited in *Eight Dynasties of Chinese Paintings*, page 185)

The style of the calligraphy, like the style of the painting, is informal, relaxed, and straightforward—qualities that were believed to reflect the artist's character and personality.

by a bow-shaped waterway that is spanned by five arched marble bridges. At the opposite end of the courtyard is the Gate of Supreme Harmony, opening onto an even larger courtyard that houses three ceremonial halls raised on a broad platform. First is the Hall of Supreme Harmony, where, on the most important state occasions, the emperor was seated on his throne, facing south. Beyond is the smaller Hall of Central Harmony, then the Hall of Protecting Harmony. Behind these vast ceremonial spaces, still on the central axis, is the inner court, again with a progression of three buildings, this time more intimate in scale. In its balance and symmetry the plan of the Forbidden City reflects ancient Chinese beliefs about the harmony of the universe, and it emphasizes the emperor's role as the Son of Heaven, whose duty was to maintain the cosmic order from his throne in the middle of the world.

Literati Painting

In the south, especially in the district of Suzhou, literati painting remained the dominant trend. One of the major literati figures from the Ming period is Shen Zhou (1427–

1509), who had no desire to enter government service but spent most of his life in Suzhou. He studied the Yuan painters avidly and tried to recapture their spirit in such works as *Poet on a Mountain Top* (fig. 21-9). Although the style of the painting recalls the freedom and simplicity of Ni Zan (see fig. 21-3), the motif of a poet surveying the landscape from a mountain plateau is Shen's creation.

In earlier landscape paintings, human figures were typically shown dwarfed by the grandeur of nature. Travelers might be seen scuttling along a narrow path by a stream, while overhead towered mountains whose peaks conversed with the clouds and whose heights were inaccessible. Here, the poet has climbed the mountain and dominates the landscape. Even the clouds are beneath him. Before his gaze, a poem hangs in the air, as though he were projecting his thoughts. The painting reflects Ming philosophy, which held that the mind, not the physical world, was the basis for reality. With its perfect synthesis of poetry, calligraphy, and painting, and its harmony of mind and landscape, *Poet on a Mountain Top* represents the very essence of literati painting.

The ideas underlying literati painting found their

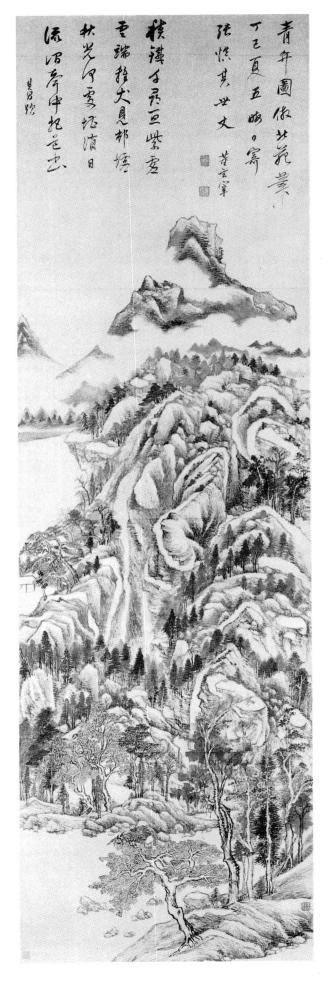

most influential expression in the writings of Dong Qichang (1555-1636). A high official in the late Ming dynasty, Dong Qichang embodied the literati tradition as poet, calligrapher, and painter. He developed a view of Chinese art history that divided painters into two opposing schools, northern and southern. The names have nothing to do with geography—a painter from the south might well be classed as northern—but reflect a parallel Dong drew to the northern and southern schools of Chan (Zen) Buddhism in China. The southern school of Chan, founded by the eccentric monk Huineng (638-713), was unorthodox, radical, and innovative; the northern school was traditional and conservative. Similarly, Dong's two schools of painters represented progressive and conservative traditions. In Dong's view the conservative northern school was dominated by professional painters whose academic, often decorative style emphasized technical skill. In contrast, the progressive southern school preferred ink to color and free brushwork to meticulous detail. Its painters aimed for poetry and personal expression. In promoting this theory, Dong gave his unlimited sanction to literati painting, which he positioned as the culmination of the southern school, and he fundamentally influenced the way the Chinese viewed their own tradition.

Dong Qichang summarized his views on the proper training for literati painters in the famous statement "Read ten thousand books and walk ten thousand miles." By this he meant that one must first study the works of the great masters, then follow "heaven and earth," the world of nature. These studies prepared the way for a transformation to self-expression through brush and ink, the goal of literati painting. Dong's views rested on an awareness that a painting of scenery and the actual scenery are two very different things. The excellence of a painting does not lie in its degree of resemblance to reality—that gap can never be bridged—but in its expressive power. The expressive language of painting is inherently abstract and lies in its nature as a construction of brushstrokes. For example, in a painting of a rock, the rock itself is not expressive; rather, the brushstrokes that add up to "rock" are expressive.

With such thinking Dong brought painting close to the realm of calligraphy, which had long been considered the highest form of artistic expression in China. More than a thousand years before Dong's time, a body of critical terms and theories had evolved to discuss calligraphy in light of the formal and expressive properties of brushwork and composition. Dong introduced some of these terms—ideas such as opening and closing, rising and falling, and void and solid—to the criticism of painting.

Dong's theories are fully embodied in his painting *The Qingbian Mountains* (fig. 21-10). According to Dong's

21-10. Dong Qichang. *The Qingbian Mountains*. Ming dynasty, 1617. Hanging scroll, ink on paper, 21'8" x 7'4³/8" (6.72 x 2.25 m). The Cleveland Museum of Art Leonard C. Hanna, Jr., Bequest, 80.10

own inscription, the painting was based on a work by the tenth-century artist Dong Yuan. Dong Qichang's style, however, is quite different from the masters he admired. Although there is some indication of foreground, middle ground, and distant mountains, the space is ambiguous, as if all the elements were compressed to the surface of the picture. With this flattening of space, the trees, rocks, and mountains become more readily legible in a second way, as semiabstract forms made of brushstrokes.

Six trees diagonally arranged on a boulder define the extreme foreground and announce themes that the rest of the painting repeats, varies, and develops. The tree on the left, with its outstretched branches and full foliage, is echoed first in the shape of another tree just across the river and again in a tree farther up and toward the left. The tallest tree of the foreground grouping anticipates the high peak that towers in the distance almost directly above it. The forms of the smaller foreground trees, especially the one with dark leaves, are repeated in numerous variations across the painting. At the same time, the simple and ordinary-looking boulder in the foreground is transformed in the conglomeration of rocks, ridges, hills, and mountains above. This double reading, both abstract and representational, parallels the work's double nature as a painting of a landscape and an interpretation of a traditional landscape painting.

The influence of Dong Qichang on the development of Chinese painting of later periods cannot be overstated. Indeed, nearly all Chinese painters since the early seventeenth century have reflected his ideas in one way or another.

QING DYNASTY

In 1644, when the armies of the Manchu people to the northeast of China marched into Beijing, many

Chinese reacted as though the world had come to an end. However, the situation turned out to be quite different from the Mongol invasions three centuries earlier. The Manchu had already adopted many Chinese customs and institutions before their conquest. After gaining control of all of China, they showed great respect for Chinese tradition. In art, all the major trends of the late Ming dynasty continued almost without interruption into the Manchu, or Qing, dynasty (1644–1911).

Orthodox Painting

Literati painting was by now established as the dominant tradition; it had become orthodox. Scholars followed Dong Qichang's recommendation and based their approach on the study of past masters, and they painted large numbers of works in the manner of Song and Yuan artists as a way of expressing their learning, technique, and taste.

The grand, symphonic composition *A Thousand Peaks and Myriad Ravines* (fig. 21-11), painted by Wang Hui (1632–1717) in 1693, exemplifies all the basic elements of Chinese landscape painting: mountains, rivers,

waterfalls, trees, rocks, temples, pavilions, houses, bridges, boats, wandering scholars, fishers—the familiar and much loved cast of actors from a tradition now many centuries old. At the upper right corner, the artist has written:

Moss and weeds cover the rocks and mist hovers over the water.

The sound of dripping water is heard in front of the temple gate.

Through a thousand peaks and myriad ravines the spring flows,

And brings the flying flowers into the sacred caves.

In the fourth month of the year 1693, in a hotel in the capital, I painted this based on a Tang dynasty poem in the manner of [the painters] Dong [Yuan] and Ju [ran].

(Translated by Chu-tsing Li)

This inscription shares Wang Hui's complex thoughts as he painted this work. In his mind were both the lines of the Tang dynasty poet Li Cheng, which offered the subject, and the paintings of the tenth-century masters Dong Yuan and Juran, which inspired his style. The temple the poem asks us to imagine is nestled on the right bank in the middle distance, but the painting shows us the scene from afar, as when a film camera pulls slowly away from some small human drama until its actors can barely be distinguished from the great flow of nature. Giving viewers the experience of dissolving their individual identity in the cosmic flow had been a goal of Chinese landscape painting since its first era of greatness during the Song dynasty.

All the Qing emperors of the late seventeenth and eighteenth centuries were painters themselves. They collected literati painting, and their conservative taste was shaped mainly by artists such as Wang Hui. Thus literati painting became an academic style and ended up within the court after all.

Individualists

In the long run, the Manchu conquest was not a great shock for China as a whole. But its first few decades were both traumatic and dangerous for those who were loyal—or worse, related—to the Ming. Some committed suicide, while others sought refuge in monasteries or wandered the countryside. Among them were several painters who expressed their anger, defiance, frustration, and melancholy in their art. They took Dong Qichang's idea of painting as an expression of the artist's personal feelings very seriously and cultivated highly original styles. These painters have become known as the individualists.

One of the individualists was Shitao (1642–1707), a descendant of the first Ming emperor who took refuge in Buddhist temples when the dynasty fell. In his later life he brought his painting to the brink of abstraction in such

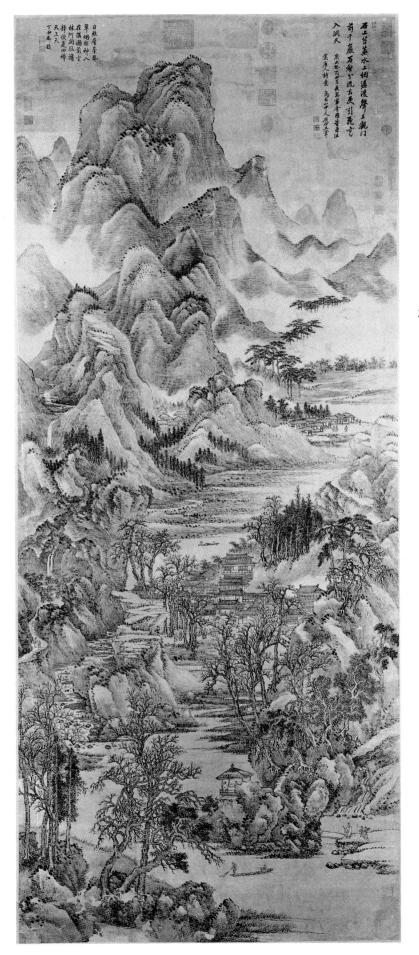

21-11. Wang Hui. *A*Thousand Peaks
and Myriad
Ravines. Qing
dynasty, 1693.
Hanging scroll,
ink on paper,
8'21/2" x 3'41/2"
(2.54 x 1.03 m).
National Palace National Palace Museum, Taipei, Taiwan

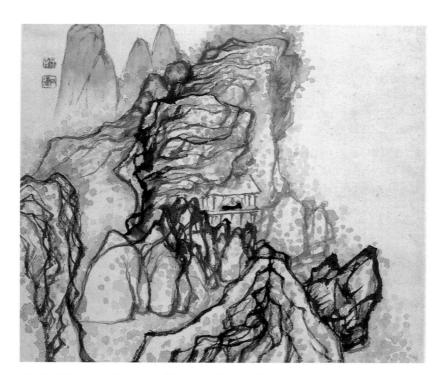

21-12. Shitao. *Landscape*, leaf from an album of landscapes. Qing dynasty, c. 1700. Ink and color on paper, $9^{1}/2 \times 11^{\circ}$ (24.1 x 28 cm) Collection C. C. Wang family

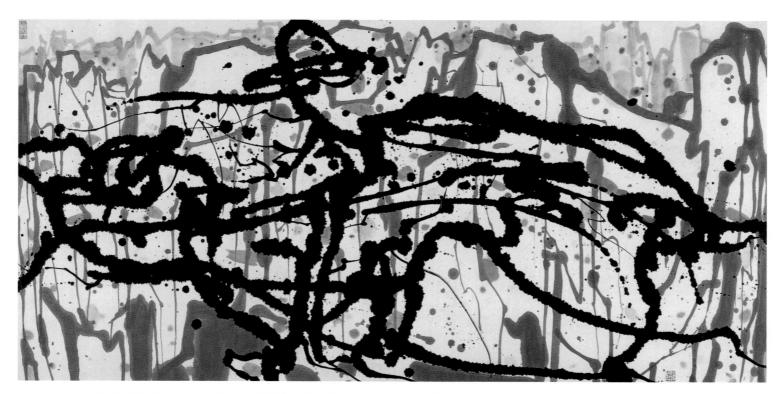

21-13. Wu Guanzhong. *Pine Spirit.* 1984. Ink and color on paper, 2'35/8" x 5'31/2" (0.70 x 1.40 m). Spencer Museum of Art, University of Kansas, Lawrence

Gift of the E. Rhodes and Leonard B. Carpenter Foundation

works as Landscape (fig. 21-12). A monk sits in a small hut, looking out onto mountains that seem to be in turmoil. Dots, used for centuries to indicate vegetation on rocks, here seem to have taken on a life of their own. The rocks also seem alive-about to swallow up the monk and his hut. Throughout his life Shitao continued to identify himself with the fallen Ming, and he felt that his secure world had turned to chaos with the Manchu conquest.

THE In the mid- and late nineteenth cen-MODERN tury China was shaken from centuries of complacency by a series of crushing PERIOD military defeats by Western powers

and Japan. Only then did the government finally realize that these new rivals were not like the Mongols of the thirteenth century. China was no longer at the center of the world, a civilized country surrounded by "barbarians." Spiritual resistance was no longer enough to solve the problems brought on by change. New ideas from Japan and the West began to filter in, and the demand arose for political and cultural reforms. In 1911 the Qing dynasty was overthrown, ending 2,000 years of imperial rule, and China was reconceived as a republic.

During the first decades of the twentieth century Chinese artists traveled to Japan and Europe to study Western art. Returning to China, many sought to introduce the ideas and techniques they had learned and explored ways to synthesize the Chinese and the Western traditions. After the establishment of the present-day Communist government in 1949, individual artistic freedom was curtailed as the arts were pressed into the service of the state and its vision of a new social order. After 1979, however, cultural attitudes began to relax, and Chinese painters again pursued their own paths.

One artist who emerged during the 1980s as a leader in Chinese painting is Wu Guanzhong (b. 1919). Combining his French artistic training and Chinese background, Wu Guanzhong has developed a semiabstract style to depict scenes from the Chinese landscape. His usual method is to make preliminary sketches on site, then, back in his studio, to develop them into free interpretations based on his feeling and vision. An example of his work, Pine Spirit, depicts a scene in the Huang (Yellow) Mountains (fig. 21-13). The technique, with its sweeping gestures of paint, is clearly linked to Abstract Expressionism, an influential Western movement of the post-World War II years (Chapter 29); yet the painting also claims a place in the long tradition of Chinese landscape as exemplified by such masters as Shitao.

Like all aspects of Chinese society, Chinese art has felt the strong impact of Western influence, and the question remains whether Chinese artists will absorb Western ideas without losing their traditional identity. Interestingly, landscape remains the most popular subject, as it has been for more than a thousand years. Using the techniques and methods of the West, China's painters still seek spiritual communion with nature through their art as a means to come to terms with human life and the world.

▲ MUROMACHI PERIOD 1392-1568

MOMOYAMA PERIOD

▲ 1568-1603

▲ EDO PERIOD 1603-1853

Kyushu

PACIFIC OCEAN

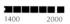

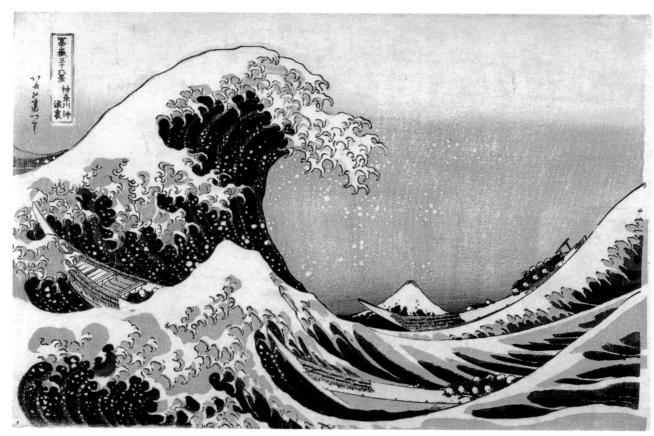

22-1. Katsushika Hokusai. *The Great Wave.* Edo period, c. 1831. Polychrome woodblock print on paper, 97/8 x 145/8" (25 x 37.1 cm). Honolulu Academy of Arts, Honolulu, Hawaii James A. Michener Collection (HAA 13, 695)

he great wave rears up like a dragon with claws of foam, ready to crash down on the figures huddled in the boat below. Exactly at the point of imminent disaster, but far in the distance, rises Japan's most sacred peak, Mount Fuji, whose slopes, we suddenly realize, swing up like waves and whose snowy crown is like foam—comparisons the artist makes clear in the wave nearest us, caught just at the moment of greatest resemblance.

If one were forced to choose a single work of art to represent Japan, at least in the world's eye, it would have to be this woodblock print, popularly known as *The Great Wave*, by Katsushika Hokusai (fig. 22-1). Taken from his series called *Thirty-Six Views of Fuji*, it has inspired countless imitations and witty parodies, yet its forceful composition remains ever fresh.

Today, Japanese prints are collected avidly around the world, but in their own day they were barely considered art. Produced by the hundreds for ordinary people to buy, they were the fleeting souvenirs of their era, one of the most fascinating in Japanese history. Not until the twentieth century would the West experience anything like the pluralistic cultural atmosphere, where so many diverse groups participate in and contribute to a common culture, as the one that produced *The Great Wave*.

MUROMACHI **PERIOD**

By the year 1392 Japanese art had already developed a long and rich history (see

"Foundations of Japanese Culture," below). Beginning with prehistoric pottery and tomb art, then expanding through cultural influences from China and Korea, Japanese visual expression reached high levels of sophistication in both religious and secular arts. Very early in the tradition, elements of a particularly Japanese aesthetic made themselves felt. These characteristics include a love of natural materials, a taste for asymmetry, a sense of humor, and a tolerance for qualities that may seem paradoxical or contradictory-characteristics that continued to distinguish Japanese art, appearing and reappearing in ever changing guises.

Toward the end of the twelfth century the political

and cultural dominance of the emperor and his court gave way to rule by warriors, or samurai, under the leadership of the shogun, the emperor's general-in-chief. In 1392 the Ashikaga family gained control of the shogunate and moved their headquarters to the Muromachi district in Kyoto. They reunited northern and southern Japan and retained their grasp on the office for more than 150 years. The Muromachi period after the reunion (1392-1568) is also known as the Ashikaga era.

The Muromachi period is especially marked by the ascendance of Zen Buddhism, whose austere ideals particularly appealed to the highly disciplined samurai. While Pure Land Buddhism, which had spread widely during the latter part of the Heian period (794-1185), remained popular, Zen, patronized by the samurai, became the dominant cultural force in Japan.

FOUNDATIONS With the end of OF JAPANESE **CULTURE**

the last Ice Age roughly 15,000 years ago, ris-

ing sea levels submerged the lowlands connecting Japan to the Asian landmass, creating the chain of islands we know today as Japan. Not long afterward, early Paleolithic cultures gave way to a Neolithic culture known as Jomon (12,000-300 BCE), after its characteristic cord-marked pottery. During the Jomon period, a notably sophisticated hunter-gatherer culture developed. Agriculture supplemented hunting and gathering by around 5000 BCE, and rice cultivation began some 4,000 years later.

A fully settled agricultural society emerged during the Yayoi period (300 BCE-300 CE), accompanied by hierarchical social organization and more-centralized forms of government. As people learned to manufacture bronze and iron, use of those metals became widespread. Yayoi architecture, with its unpainted wood and thatched roofs, already reveals the Japanese affinity for natural materials and clean lines, and the style of Yayoi granaries in particular persisted in the design of shrines in later centuries. The trend toward centralization continued during the Kofun period (300-552 cE), an era characterized by the construction of large royal tombs following Korean practice. Veneration of leaders grew into the beginnings of the imperial system that has lasted to the present day.

The Asuka era (552-646 ce) began with a century of profound change as elements of Chinese civilization flooded into Japan, initially through the intermediary of Korea. The three most significant Chinese contributions to the developing Japanese culture were Buddhism (with its attendant art and architecture), a system of writing, and the structures of a centralized bureaucracy. The earliest extant Buddhist temple compound in Japan—the oldest currently existing wooden building in the world-dates from this period.

The arrival of Buddhism also prompted some formalization of Shinto, the loose collection of indigenous Japanese beliefs and practices. Shinto is a shamanistic religion that emphasizes ceremonial purification. Its rituals include the invocation and appeasement of spirits, including those of the recent dead. Many Shinto deities are thought to inhabit various aspects of nature, such as particularly magnificent trees, rocks, and waterfalls, and living creatures such as deer. Shinto and Buddhism have in common an intense awareness of transience, and as their goals are complementary—purification in the case of Shinto, enlightment in the case of Buddhism-they have generally existed comfortably alongside each other to the present day.

The Nara period (646-794 ce) takes its name from Japan's first permanently established imperial capital. During this time the founding works of Japanese literature were

compiled, among them an important collection of poetry called the Manvoshu. Buddhism advanced to become the most important force in Japanese culture. Its influence at court grew so great as to become worrisome, and in 794 the emperor moved the capital from Nara to Heian-kyo (present-day Kyoto), far from powerful monasteries.

During the Heian period (794-1185), an extremely refined court culture thrived, embodied today in an exquisite legacy of poetry, calligraphy, and painting. An efficient method for writing the Japanese language was developed, and with it a woman at the court wrote the world's first novel, The Tale of Genji. Esoteric Buddhism, as hierarchical and intricate as the aristocratic world of the court, became popular.

The end of the Heian period was marked by civil warfare as regional warrior (samurai) clans were drawn into the factional conflicts at court. Pure Land Buddhism, with its simple message of salvation, offered consolation to many in these troubled times. In 1185 the Minamoto clan defeated their arch rivals, the Taira, and their leader, Minamoto Yoritomo, assumed the position of shogun (general-inchief). While paying respects to the emperor, Minamoto Yoritomo kept actual military and political power to himself, setting up his own capital in Kamakura. The Kamakura era (1185-1392) began a tradition of rule by shogun that lasted in various forms until 1868.

PARALLELS

<u>Years</u>	Period	<u>Japan</u>	World	
1392–1568	Muromachi	Ashikaga shogunate; capital in Muromachi district, Kyoto; ascen- dance of Zen Buddhism; Ikkyu's calligraphy; ink painting flourishes under Shubun, Bunsei, and Sesshu; Ryoan-ji garden; Kano school founded	Black Death kills 30 percent of Chinese population; Chaucer's Canterbury Tales (England); Forbidden City rebuilt (China); Jan van Eyck's Ghent Altarpiece (Flanders); Inka Empire (South America); Ghiberti's Gates of Paradise (Italy); Gutenberg's Bible (Germany); Columbus's voyages (Spain); Spanish Inquisition; Michelangelo's David, Sistine Ceiling (Italy); Leonardo's Mona Lisa (Italy); Protestant Reformation in Europe; Spanish conquest of Aztec Empire (Mexico)	
1568–1603	Momoyama	Oda Nobunaga shogunate; Westerners arrive; tea ceremony conceived by Sen no Rikyu; Kano school thrives; Toyotomi Hideyoshi shogunate; Himeji Castle	1550–1600 Mughal period (India); William Shake- speare born (England); Baroque style emerges in Europe; Peter Paul Rubens (Flanders)	
1603–1868	Edo	Tokugawa Ieyasu shogunate; period of isolation from foreigners; samurai officials; neo-Confucianism arises; Tawaraya Sotatsu and Rimpa school; Zen Buddhism revival; Maruyama-Shijo school; ukiyo-e; Nanga, or Southern, school; kabuki prints; Hokusai's Thirty-Six Views of Fuji; Hiroshige's Fifty-Three Stations of the Tokaido isolationism ends; capital at Edo (Tokyo)	Rembrandt van Rijn (Netherlands); English colonize North America; Qing dynasty (China); Age of Enlightenment in Europe; Union of England and Scotland as Great Britain; James Watt develops steam engine; Declaration of Independence (United States); French Revolution; Romanticism and Neoclassicism arise in Europe; Mexico becomes a republic; Realism arises	
1868–present	Meiji and Modern	Meiji Restoration of emperor; blending of foreign and native styles and traditions in art	1850-present Italy united; Civil War (United States); Dominion of Canada formed; Impressionism and Post-Impressionism arise; Sino-Japanese War; Chinese republic established by Sun Yat-Sen; World War I; Civil War (Russia); League of Nations; World War II; United Nations established; People's Republic of China; breakup of Soviet Union	

Ink Painting

Several forms of visual art flourished during the Muromachi period, but **ink painting**—monochrome painting in black ink and its diluted grays—reigned supreme. Muromachi ink painting was heavily influenced by the aesthetics of Zen, yet it also marked a shift away from the earlier Zen painting tradition. As Zen moved from an oppositional "outsider" sect to the chosen sect of the ruling group, the fierce intensity of earlier masters gave way to a more subtle and refined approach. And whereas earlier Zen

artists had concentrated on rough-hewn depictions of Zen figures such as monks and teachers, now Chinese-style landscapes became the most important theme.

The monk-artist Shubun (active 1414–1463) is regarded as the first great master of the ink landscape. Unfortunately, no works survive that can be proven to be his. Two landscapes by Shubun's pupil Bunsei (active c. 1450–1460) have survived, however. In the one shown here (fig. 22-2), the foreground reveals a spit of rocky land with an overlapping series of motifs—a spiky pine tree, a craggy rock, a poet seated in a hermitage, and a

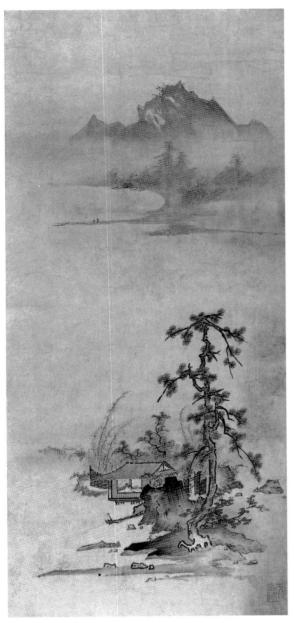

22-2. Bunsei. *Landscape*. Muromachi period, mid-15th century. Hanging scroll, ink and light colors on paper, 28³/₄ x 13" (73.2 x 33 cm). Museum of Fine Arts, Boston

Special Chinese and Japanese Fund

brushwood fence holding back a small garden of trees and bamboo. In the middleground is space—emptiness, the void.

We are expected to "read" the empty paper as representing water, for subtle tones of gray ink suggest the presence of a few people fishing from their boats near the distant shore. The two parts of the painting seem to echo each other across a vast expanse, just as nature echoes the human spirit in Japanese art. The painting illustrates well the pure, lonely, and ultimately serene spirit of the Zen-influenced poetic landscape tradition.

Ink painting took on a different spirit at the turn of the sixteenth century. By then, temples were asked for so many paintings that they formed **ateliers** staffed by monks who specialized in art rather than religious ritual

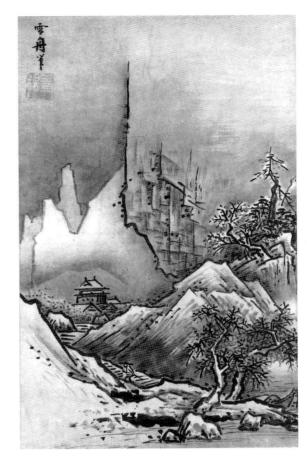

22-3. Sesshu. *Winter Landscape*. Muromachi period, c. 1470s. Ink on paper, 18¹/₄ x 11¹/₂" (46.3 x 29.3 cm). Tokyo National Museum, Tokyo

or teaching. Some painters even found they could survive on their own as professional artists. Nevertheless, many of the leading masters remained monks, at least in name, including the most famous of them all, Sesshu (1420-1506). Although he lived his entire life as a monk, Sesshu devoted himself primarily to painting. Like Bunsei, he learned from the tradition of Shubun, but he also had the opportunity to visit China in 1467. Sesshu traveled extensively there, viewing the scenery, stopping at Zen monasteries, and seeing whatever Chinese paintings he could. He does not seem to have had access to works by contemporary literati masters such as Shen Zhou (see fig. 21-9) but saw instead the works of professional painters. Sesshu later claimed that he learned nothing from Chinese artists, but only from the mountains and rivers he had seen. When Sesshu returned from China, he found his homeland rent by the Onin Wars, which devastated the capital of Kyoto. Japan was to be torn apart by further civil warfare for the next hundred years. The refined art patronized by a secure society in peacetime was no longer possible. Instead, the violent new spirit of the times sounded its disturbing note, even in the peaceful world of landscape painting.

This new spirit is evident in Sesshu's *Winter Land-scape*, which makes full use of the forceful style that he developed (fig. 22-3). A cliff descending from the mist seems to cut the composition in half. Sharp, jagged brushstrokes delineate a series of rocky hills, where a

22-4. Ikkyu. *Calligraphy Pair,* from Daitoku-ji, Kyoto. Muromachi period, c. mid-15th century. Ink on paper, each 10'2⁷/₈" x 1'4¹/₂" (3.12 x 0.42 m)

lone figure makes his way to a Zen monastery. Instead of a gradual recession into space, flat overlapping planes seem to slice the composition into crystalline facets. The white of the paper is left to indicate snow, while the sky is suggested by tones of gray. The few trees cling desperately to the rocky land, and the harsh chill of winter is boldly expressed.

A third important artist of the Muromachi period was a monk named Ikkyu (1394–1481). A genuine eccentric and one of the most famous Zen masters in Japanese history, Ikkyu derided the Zen of his day, writing, "The temples are rich but Zen is declining, there are only false teachers, no true teachers." Ikkyu recognized that success was distorting the spirit of Zen. Originally, Zen had been a form of counterculture for those who were not

22-5. Stone and gravel garden, Ryoan-ji, Kyoto. Muromachi period, c. 1480

The American composer John Cage once exclaimed that every stone at Ryoan-ji was in just the right place. He then said, "[A]nd every other place would also be just right." His remark is thoroughly Zen in spirit. There are many ways to experience Ryoan-ji. For example, we can imagine the rocks as having different visual "pulls" that relate them to one another. Yet there is also enough space between them to give each one a sense of self-sufficiency and permanence.

satisfied with prevailing ways. Now, however, Zen monks acted as government advisers, teachers, and even leaders of merchant missions to China. Although true Zen masters were able to withstand all outside pressures, many monks became involved with political matters, with factional disputes among the temples, or with their reputations as poets or artists. Ikkyu did not hesitate to mock what he regarded as "false Zen." He even paraded through the streets with a wooden sword, claiming that his sword would be as much use to a samurai as false Zen to a monk.

Ikkyu was very involved in the arts, although he treated them with extreme freedom. His calligraphy, which is especially admired, has a spirit of spontaneity. To write out the classic Buddhist couplet "Abjure evil, practice only the good," he created this pair of single-line scrolls (fig. 22-4). At the top of each scroll, Ikkyu began with standard script, in which each stroke of a character is separate and distinct. As he moved down the columns he grew more excited and wrote in increasingly cursive script, until finally his frenzied brush did not leave the paper at all. This calligraphy displays the intensity that is the hallmark of Zen.

Ryoan-ji

One of the most renowned Zen creations in Japan is the "dry garden" at the temple of Ryoan-ji in Kyoto (fig. 22-5). There is a record of a famous cherry tree at this spot, so the completely severe nature of the garden may have come about some time after its original founding in the late fifteenth century. Nevertheless, today the garden is celebrated for its serene sense of space and emptiness. Fifteen rocks are set in a long rectangle of raked white gravel. Temple verandas border the garden on the north and east sides, while clay-and-tile walls define the south and west. Only a part of the larger grounds of Ryoan-ji, the garden has provoked so much interest and curiosity that there have been numerous attempts to "explain" it. Some people see the rocks as land and the gravel as sea. Others imagine animal forms in certain of the rock groupings. However, perhaps it is best to see the rocks and gravel as . . . rocks and gravel. The asymmetrical balance in the placement of the rocks and the austere beauty of the raked gravel have led many people to meditation.

The Muromachi period is the only time when an entire culture was strongly influenced by Zen, and the results were mixed. On one hand, works such as Ryoanji were created that continue to inspire people to the present day. On the other, the very success of Zen led to a certain secularization and professionalization that artists such as Ikkyu found intolerable.

PERIOD

MOMOYAMA The civil wars sweeping Japan laid bare the basic flaw in the Ashikaga system, which was

that samurai were primarily loyal to their own feudal lord, or daimyo, rather than to the central government. Battles between feudal clans grew more frequent, and it became clear that only a daimyo powerful and bold

enough to unite the entire country could control Japan. As the Muromachi period drew to a close, three leaders emerged who would change the course of Japanese history.

The first of these leaders was Oda Nobunaga (1534-1582), who marched his army into Kyoto in 1568, signaling the end of the Ashikaga family as a major force in Japanese politics. A ruthless warrior, Nobunaga went so far as to destroy a Buddhist monastery because the monks refused to join his forces. Yet he was also a patron of the most rarefied and refined arts. Assassinated in the midst of one of his military campaigns, Nobunaga was succeeded by the military commander Toyotomi Hidevoshi (1536/37–1598), who soon gained complete power in Japan. He, too, patronized the arts when not leading his army, and he considered culture a vital adjunct to his rule. Hideyoshi, however, was overly ambitious. He believed that he could conquer both Korea and China, and he wasted much of his resources on two ill-fated invasions. A stable government finally emerged in 1600 with the triumph of a third leader, Tokugawa Ieyasu (1543-1616), who established his shogunate in 1603. But despite its turbulence, the era of Nobunaga and Hideyoshi, known as the Momoyama period (1568-1603), was one of the most creative eras in Japanese history.

Architecture

Today the very word Momoyama conjures up images of bold warriors, luxurious palaces, screens shimmering with gold leaf, and magnificent ceramics. The Momoyama period was also the era when Europeans first made an impact in Japan. A few Portuguese explorers had arrived at the end of the Muromachi era in 1543, and traders and missionaries were quick to follow. It was only with the rise of Nobunaga, however, that Westerners were able to extend their activities beyond the ports of Kyushu, Japan's southernmost island. Nobunaga welcomed foreign traders, who brought him various products, the most important of which were firearms.

European muskets and cannons soon changed the nature of Japanese warfare and even influenced Japanese art. In response to the new weapons, monumental fortified castles were built in the late sixteenth century. Some were eventually lost to warfare or torn down by victorious enemies, and others have been extensively altered over the years. One of the most beautiful of the surviving castles is Himeji, not far from the city of Osaka (fig. 22-6). Rising high on a hill above the plains, Himeji has been given the name White Heron. To reach the upper fortress, visitors must follow angular paths beneath steep walls, climbing from one area to the next past stone ramparts and through narrow fortified gates, all the while feeling as though lost in a maze, with no sense of direction or progress. At the main building, a further climb up a series of narrow ladders leads to the uppermost chamber. There, the foot-sore visitor is rewarded with a stunning 360-degree view of the surrounding countryside. The sense of power is overwhelming.

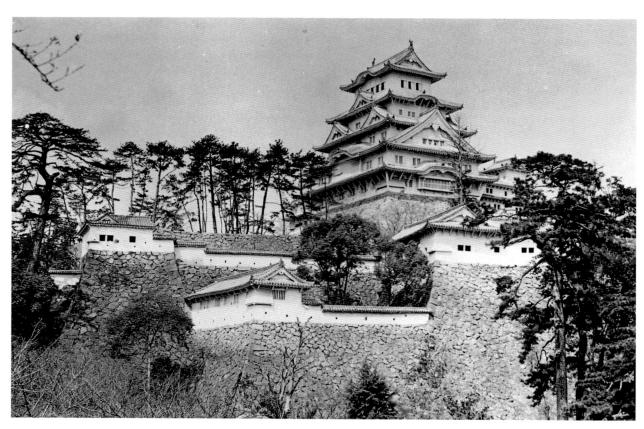

22-6. Himeji Castle, Hyogo, near Osaka. Muromachi period, 1601-9

Decorative Painting

Castles such as Himeji were sumptuously decorated, offering artists unprecedented opportunities to work on a grand scale. Large murals on **fusuma**—paper-covered sliding doors—were particular features of Momoyama design, as were folding screens with gold-leaf backgrounds, whose glistening surfaces not only conveyed light within the castle rooms but also vividly demonstrated the wealth of the warrior leaders. Temples, too, commissioned large-scale decorative paintings for their rebuilding projects after the devastation of the civil wars.

The Momoyama period produced a number of artists who were equally adept at decorative golden screens and broadly brushed fusuma paintings. Daitoku-ji, a celebrated Zen monastery in Kyoto, has a number of subtemples that are virtual treasure troves of Japanese art. One, the Juko-in, possesses fusuma by Kano Eitoku (1543–1590), one of the most brilliant painters from the Kano school, a professional school of artists that was patronized by government leaders for several centuries. Founded in the Muromachi period, the Kano school combined training in the ink-painting tradition with new skills in decorative subjects and styles. The illustration here shows two of the three walls of fusuma panels painted when the artist was in his mid-twenties (fig. 22-7). To the left, the subject is the familiar Kano school theme of cranes and pines, both symbols of long life; to

the right is a great gnarled plum tree, symbol of spring. The trees are so massive they seem to extend far beyond the panels. An island rounding both walls of the far corner provides a focus for the outreaching trees. Ingeniously, it belongs to both compositions at the same time, thus uniting them into a single organic whole. Eitoku's vigorous use of brush and ink, his powerfully jagged outlines, and his dramatic compositions all hark back to the style of Sesshu, but the bold new sense of scale in his works is a leading characteristic of the Momoyama period.

Tea

Japanese art is never one-sided. Along with castles, golden screens, and massive fusuma paintings there was an equal interest during the Momoyama period in the quiet, the restrained, and the natural. This was expressed primarily through the tea ceremony.

"Tea ceremony" is an unsatisfactory way to express *cha no yu*, the Japanese ritual drinking of tea, but there is no counterpart in Western culture, so this phrase has come into common use. Tea itself had been introduced to Japan from the Asian continent hundreds of years earlier. At first tea was molded into cakes and boiled. However, the advent of Zen in the late Kamakura period (1185–1392) brought to Japan a different way of preparing tea, with the leaves crushed into powder and then whisked in bowls with hot water. Tea was used by Zen

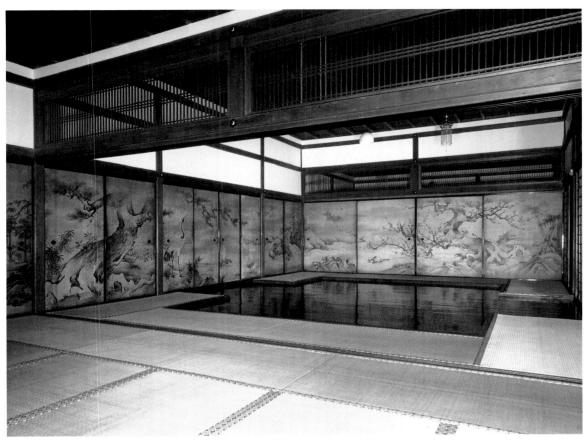

22-7. Kano Eitoku. Fusuma depicting pine and cranes (left) and plum tree (right), from the central room of the Juko-in, Daitoku-ji, Kyoto. Momoyama period, c. 1563–73. Ink and gold on paper, height 5'91/8" (1.76 m)

monks as a slight stimulant to aid meditation, and it also was considered a form of medicine.

The most famous tea master in Japanese history was Sen no Rikyu (1521-1591). Sen no Rikyu conceived of the tea ceremony as an intimate gathering in which a very few people would enter a small rustic room, drink tea carefully prepared in front of them by their host, and quietly discuss the tea utensils or a Zen scroll hanging on the wall. He did a great deal to establish the aesthetic of modesty, refinement, and rusticity that permitted the tearoom to serve as a respite from the busy and sometimes violent world outside. A traditional tearoom is quite small and simple. It is made of natural materials such as bamboo and wood, with mud walls, paper windows, and a floor covered with **tatami** mats—mats of woven straw. One tearoom that preserves Rikyu's design is named Tai-an (fig. 22-8). Originally built in 1582, it is distinguished by its tiny door (guests must crawl to enter) and its alcove, or tokonoma, where a Zen scroll or a simple flower arrangement may be displayed. At first glance, the room seems symmetrical. But the disposition of the tatami mats does not match the spacing of the tokonoma, providing a subtle undercurrent of irregularity. A longer look reveals a blend of simple elegance and rusticity. The walls seem scratched and worn with age, but the tatami are replaced frequently to keep them clean and fresh. The mood is quiet; the light is muted and diffused through three small paper windows. Above all, there is a

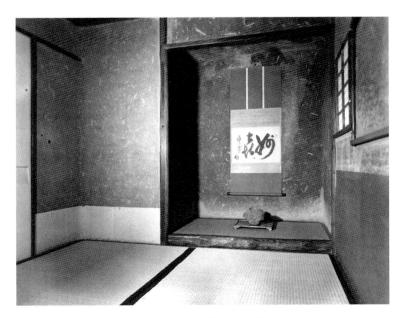

22-8. Sen no Rikyu. Tai-an tearoom, Myoki-an Temple, Kyoto. Momoyama period, 1582

sense of spatial clarity. All nonessentials have been eliminated, so there is nothing to distract from focused attention. The tearoom aesthetic became an important element in Japanese culture, influencing secular architecture through its simple and evocative form (see "Elements of Architecture," page 862).

ELEMENTS OF Of the many expressions of ARCHITECTURE Japanese taste that reached great refinement in the Momo-Shoin Design yama period, shoin architecture has had perhaps the most

enduring influence. Shoin are upper-class residences that combine a number of traditional features in more-or-less standard ways, always asymmetically. These features are wide verandas; wood posts as framing and defining decorative elements; woven straw tatami mats as floor and ceiling covering; several shallow alcoves for prescribed purposes; fusuma (sliding doors) as fields for painting or textured surfaces; and shoji screens-translucent, ricepaper-covered wood frames. The shoin illustrated here was built in 1601 as a guest hall, called Kojo-in, at the great Onjo-ji monastery. Tatami, shoji, alcoves, and asymmetry are still seen in Japanese interiors today.

In the original shoin, one of the alcoves would contain

a hanging scroll, an arrangement of flowers, or a large painted screen. Seated in front of that alcove, called tokonoma, the owner of the house would receive guests, who could contemplate the object above the head of their host. Another alcove contained staggered shelves, often for writing instruments. A writing space fitted with a low writing desk was on the veranda side of a room, with shoji that could open to the outside.

The architectural harmony of shoin, like virtually all Japanese buildings, was based on the mathematics of proportions and on the proportionate disposition of basic units, or modules. The modules were the bay, reckoned as the distance from the center of one post to the center of another, and the tatami. Room area in Japan is still expressed in terms of the number of tatami mats, so that, for example, a room is described as a seven-mat room. Although varying slightly from region to region, the size of a single tatami is about 3 feet by 6 feet.

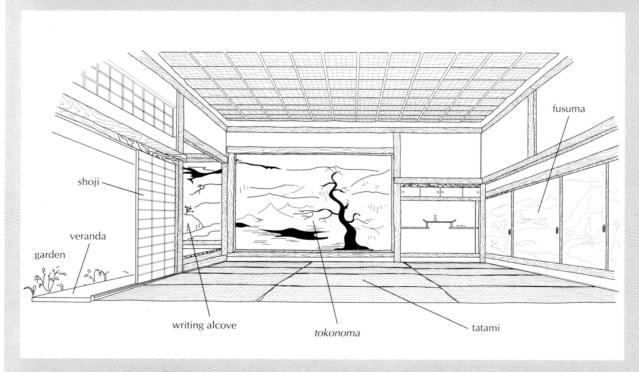

Guest Hall, Kojo-in, Onjo-ji monastery, Shiga prefecture. Momoyama period, 1601

EDO Three years after Tokugawa Ieyasu gained control of Japan, he proclaimed himself shogun. His family's control of the shogunate was to last for over 250 years, a span of time known as the Edo period (1603–1868) or the Tokugawa era.

Under the rule of the Tokugawa family, peace and prosperity came to Japan at the price of an increasingly rigid and often repressive form of government. The problem of potentially rebellious daimyo was solved by ordering all feudal lords to spend either half of each year or every other year in the new capital of Edo (present-day Tokyo), where their wives and children were sometimes required to live permanently. Zen Buddhism was supplanted as the prevailing intellectual force by a form of neo-Confucianism, a philosophy formulated in Song dynasty China that emphasized loyalty to the state. More drastically, Japan was soon closed off from the rest of the world by its suspicious government. Japanese were forbidden to travel abroad, and with the exception of small Chinese and Dutch trading communities on an island off the southern port of Nagasaki, foreigners were not permitted in Japan.

Edo society was officially divided into four classes. Samurai officials constituted the highest class, followed by farmers, artisans, and finally merchants. As time went on, however, merchants began to control the money sup-

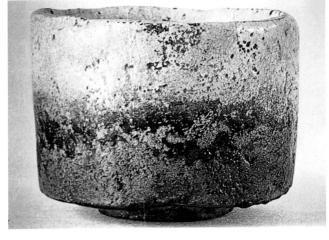

22-9. Hon'ami Koetsu. Teabowl, called Mount Fuji. Edo period, early 17th century. Raku ware, height 3³/8" (8.5 cm). Sakai Collection, Tokyo

A specialized vocabulary grew up to allow connoisseurs to discuss the subtle aesthetics of tea. A favorite term was *sabi*, which summoned up the particular beauty to be found in stillness or even deprivation. *Sabi* was borrowed from the critical vocabulary of poetry, where it was first established as a positive ideal by the early-thirteenth-century poet Fujiwara Shunzei. Other virtues were *wabi*, conveying a sense of great loneliness or a humble (and admirable) shabbiness, and *shibui*, meaning plain and astringent.

ply, and in Japan's increasingly mercantile economy they soon reached a high, if unofficial, position. Reading and writing became widespread at all levels of society. Many segments of the population—samurai, merchants, intellectuals, and even townspeople—were now able to patronize artists, and a pluralistic cultural atmosphere developed unlike anything Japan had experienced before.

Tea

The rebuilding of temples continued during the first decades of the Edo period, and for this purpose government officials, monks, and wealthy merchants needed to cooperate. The tea ceremony was one way that people of different classes could come together for intimate conversations. Every utensil connected with tea, including the waterpot, the kettle, the bamboo spoon, the whisk, the tea caddy, and, above all, the teabowl came to be appreciated for their aesthetic qualities, and many works of art were created for use in *cha no yu*.

The age-old Japanese admiration for the natural and the asymmetrical found full expression in tea ceramics. Korean bowls made by humble farmers for their rice were suddenly considered the epitome of refined taste. Tea masters even went so far as to advise rural potters in Japan to create imperfect shapes. But not every misshapen bowl would be admired. An extremely subtle sense of beauty developed that took into consideration such factors as how well a teabowl fit into the hands, how subtly the shape and texture of the bowl appealed

One of the finest teabowls extant is named *Mount Fuji* after Japan's most sacred peak (fig. 22-9). (Mount Fuji itself is depicted in figure 22-1.) An example of **raku** ware—a hand-built, low-fired ceramic developed especially for use in the tea ceremony—the bowl was crafted by Hon'ami Koetsu (1558–1637), a leading cultural figure of the early Edo period. Koetsu was most famous as a calligrapher, but he was also a painter, **lacquer** designer, poet, landscape gardener, connoisseur of swords, and potter. With its small foot, straight sides, slightly irregular shape, and crackled texture, this bowl exemplifies tea taste. In its rough exterior we seem to sense directly the two elements of earth and fire that create pottery. Merely looking at it suggests the feeling one would get from holding it, warm with tea, cupped in one's hands.

Rimpa School

One of Koetsu's friends was the painter Tawaraya Sotatsu (active c. 1600–1640), with whom he collaborated on several magnificent handscrolls. Sotatsu is considered the first great painter of the Rimpa school, a grouping of artists with similar tastes rather than a formal school such as the Kano school. Rimpa masters excelled in decorative designs of strong expressive force, and they frequently worked in several mediums.

Sotatsu painted some of the finest golden screens that have survived. The splendid pair here depict the celebrated islands of Matsushima near the northern city of Sendai (fig. 22-10). Working in a boldly decorative style, the artist has created asymmetrical and almost abstract patterns of waves, pines, and island forms. On the screen to the right, mountainous islands echo the swing and sweep of the waves, with stylized gold clouds in the upper left. The screen on the left continues the gold clouds until they become a sand spit from which twisted pines grow. Their branches seem to lean toward a strange island in the lower left, composed of an organic, amoebalike form in gold surrounded by mottled ink. This mottled effect was a specialty of Rimpa school painters.

As one of the "three famous beautiful views of Japan," Matsushima was often depicted in art. Most painters, however, emphasized the large number of pine-covered islands that make the area famous. Sotatsu's genius was to simplify and dramatize the scene, as though the viewer were passing the islands in a boat on the roiling waters. Strong, basic mineral colors dominate, and the sparkling two-dimensional richness of the gold leaf contrasts dramatically with the three-dimensional movement of the waves.

The second great master of the Rimpa school was Ogata Korin (1658–1716). Korin copied many designs after Sotatsu in homage to the master, but he also originated many remarkable works of his own, including colorful golden screens, monochrome scrolls, and paintings

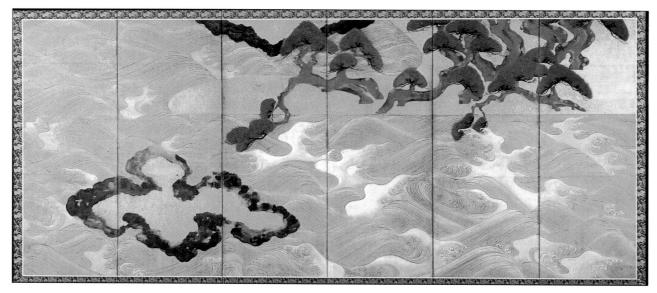

22-10. Tawaraya Sotatsu. Pair of six-panel screens, known as the Matsushima screens. Edo period, 17th century. Ink, mineral colors, and gold leaf on paper; each screen $4'97/8" \times 11'8^1/2" (1.52 \times 3.56 \text{ m})$. Freer Gallery of Art, Smithsonian Institution, Washington, D.C. (06.231; 06.232)

The six-panel screen format was a triumph of scale and practicality. Each panel consisted of a light wood frame surrounding a latticework interior covered with several layers of paper. Over this foundation was pasted a high-quality paper, silk, or gold-leaf ground, ready to be painted by the finest artists. Held together with ingenious paper hinges, a screen could be folded for preservation or transportation, resulting in a mural-size painting light enough to be carried by a single person, ready to be displayed as needed.

in glaze on his brother Kenzan's pottery. He also designed some highly prized works in lacquer (see "Lacquer," below). One famous example (fig. 22-11) is a writing box, a lidded container designed to hold tools and materials for calligraphy (see "Inside a Writing Box," opposite). Korin's design for this black lacquer box sets a

motif of irises and a plank bridge in a dramatic combination of mother-of-pearl, silver, lead, and gold lacquer. For Japanese viewers the decoration immediately recalls a famous passage from the tenth-century *Tales of Ise,* a classic of Japanese literature. A nobleman poet, having left his wife in the capital, pauses at a place called Eight

TECHNIQUE

Lacquer is derived form the sap of the lacquer tree, *Rhus verniciflua*. The tree is indigenous to China, where examples of lacquerware have been found dating back to the Neolithic period. Knowledge of lacquer spread early to Korea and Japan, and the tree came to be grown commercially throughout East Asia.

Gathered by tapping into a tree and letting the sap flow into a container, in much the same way as maple syrup, lacquer is then strained to remove impurities and heated to evaporate excess moisture. The thickened sap can be colored with vegetable or mineral dyes and lasts for several years if carefully stored. Applied in thin coats to a surface such as wood or leather, lacquer hardens into a smooth, glasslike, protective coating that is waterproof, heat and acid resistant, and airtight. Lacquer's practical qualities made it ideal for storage containers and vessels for food and drink. In Japan the leather scales of samurai armor were coated in lacquer, as were leather saddles. In China, Korea, and Japan the decorative potential of lacquer was brought to exquisite perfection in the manufacture of expensive luxury items.

The creation of a piece of lacquer is a painstaking process that can take a sequence of specialized craftsworkers several years. First, the item is fashioned

LACQUER of wood and sanded to a flawlessly smooth

finish. Next, a layer of lacquer is built up. In order to dry properly, lacquer must be applied in extremely thin coats. (If the lacquer is applied too thickly, the lacquer's exterior surface dries first, forming an airtight seal that prevents the lacquer below from ever drying.) Optimal temperature and humidity are also essential to drying, and craftsworkers quickly learned to control them artificially. Up to 30 coats of lacquer, each dried and polished before the next is brushed on, are required to build up a substantial layer.

Many techniques were developed for decorating lacquer. Particularly in China, lacquer was often applied to a thickness of up to 300 coats, then elaborately carved in low relief—dishes, containers, and even pieces of furniture were executed in carved lacquer. In Japan and Korea, **inlay** with mother-of-pearl and precious metals was brought to a high point of refinement. Japanese artisans also perfected a variety of methods known collectively as *maki-e* ("sprinkled design") that embedded flaked or powdered gold or silver in a still-damp coat of lacquer—somewhat like a very sophisticated version of the technique of decorating with glitter on glue.

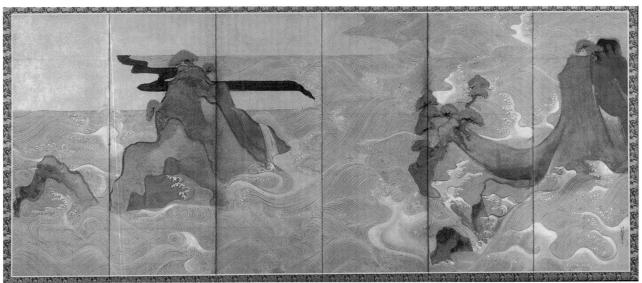

Bridges, where a river branches into eight streams, each covered with a plank bridge. Irises are in full bloom, and his traveling companions urge the poet to write a *tanka*—a five-line, thirty-one-syllable poem—beginning each line with a syllable from the word *ka.ki.tsu.ba.ta* ("iris"). The poet responds (substituting *ha* for *ba*):

Karagoromo kitsutsu narenishi tsuma shi areba harubaru kinuru tabi o shi zo omou.

When I remember my wife, fond and familiar as my courtly robe, I feel how far and distant my travels have taken me.

(Translated by Stephen Addiss)

22-11. Ogata Korin. Lacquer box for writing implements. Edo period, late 17th–early 18th century. Lacquer, lead, silver, and mother-of-pearl, 5⁵/₈ x 10³/₄ x 7³/₄" (14.2 x 27.4 x 19.7 cm). Tokyo National Museum

INSIDE A WRITING writing box shown in figure 22-11 is fitted with compartments for holding an ink stick, an ink stone, brushes, an eyedropper, and paper—tools and materials not only for writing but also for ink painting.

Ink sticks are made by burning wood or oil inside a container. Soot deposited by the smoke is collected, bound into a paste with resin, heated for several hours, kneaded and pounded, then pressed into small stick-shaped or cake-shaped molds to harden. Molds are often carved to produce an ink stick (or ink cake) decorated in low relief. The tools of writing and painting are also beautiful objects in their own right.

Fresh ink is made for each writing or painting session by grinding

the hard, dry ink stick in water against a fine-grained stone. A typical ink stone has a shallow well at one end sloping up to a grinding surface at the other. The artist fills the well with water, transferring it from a waterpot. The ink stick, held vertically, is dipped into the well to pick up a small amount of water, then is rubbed in a circular motion firmly on the grinding surface. The process is repeated until enough ink has been prepared. Grinding ink is viewed as a meditative task, time for collecting one's thoughts and concentrating on the painting or calligraphy ahead.

Brushes are made from animal hairs set in a simple bamboo or hollow-reed handle. Brushes taper to a fine point that responds with great sensitivity to any shift in pressure. Although great painters and calligra-

phers eventually develop their own style of holding and using the brush, all begin by learning the basic position for writing. The brush is held vertically, grasped firmly between the thumb and first two fingers, with the fourth and fifth fingers often resting against the handle for more subtle control.

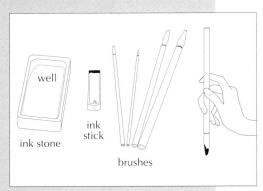

The poem brought tears to all their eyes, and the scene became so famous that any painting of a group of irises, with or without a plank bridge, immediately calls it to mind.

Nanga School

Rimpa artists such as Sotatsu and Korin are considered quintessentially Japanese in spirit, both in the expressive power of their art and in their use of poetic themes from Japan's past. Other painters, however, responded to the new Confucian atmosphere by taking up some of the ideas of the literati painters of China. These painters are grouped together as the Nanga, or Southern, school. Nanga was not a school in the sense of a professional workshop or a family tradition. Rather, it took its name from the Southern school of amateur artists described by the Chinese literati theorist Dong Qichang (Chapter 21). Educated in the Confucian mold, Nanga masters were individuals and often individualists, creating their own variations of literati painting from unique blendings of Chinese models, Japanese aesthetics, and personal brushwork. They were often experts at calligraphy and poetry as well as painting, but one, Uragami Gyokudo (1745-1820), was even more famous as a musician, an expert on a seven-string Chinese zither called the gin. Most instruments are played for entertainment or ceremonial purposes, but the qin has so deep and soft a sound that it is played only for oneself or a close friend. Its music becomes a kind of meditation, and for Gyokudo it opened a way to commune with nature and his own inner spirit.

Gyokudo was a hereditary samurai official, but midway through his life he resigned from his position and spent seventeen years wandering through Japan, absorbing the beauty of its scenery, writing poems, playing music, and beginning to paint. During his later years Gyokudo produced many of the strongest and most individualistic paintings in Japanese history, although they were not appreciated by people during his lifetime. Geese Aslant in the High Wind is a leaf from an album Gyokudo painted in 1817, three years before his death (fig. 22-12). The creative power in this painting is remarkable. The wind seems to have the force of a hurricane, sweeping the tree branches and the geese into swirls of action. The greatest force comes from within the land itself, which mushrooms out and bursts forth in peaks and plateaus as though an inner volcano were erupting.

The style of the painting derives from the Chinese literati tradition, with layers of calligraphic brushwork building up the forms of mountains, trees, and the solitary human habitation. But the inner vision is unique to Gyokudo. In his artistic world, humans do not control nature but can exult in its power and grandeur. Gyokudo's art may have been too strong for most people in his own day, but in our violent century he has come to be appreciated as a great artist.

Zen

Deprived of the support of the government and samurai officials, Zen initially went into something of a decline

22-12. Uragami Gyokudo. *Geese Aslant in the High Wind*. Edo period, 1817. Ink and light colors on paper, 12³/₁₆ x 9⁷/₈" (31 x 25 cm). Takemoto Collection, Aichi

during the Edo period. In the early eighteenth century, however, it was revived by a monk named Hakuin Ekaku (1685–1769), born in a small village not far from Mount Fuji, who resolved to become a monk after hearing a fireand-brimstone sermon in his youth. For years he traveled around Japan seeking out the strictest Zen teachers. After a series of enlightenment experiences, he eventually became an important teacher himself.

In his later years Hakuin turned more and more to painting and calligraphy as forms of Zen expression and teaching. Since the government no longer sponsored Zen, Hakuin reached out to ordinary people, and many of his paintings portray everyday subjects that would be easily understood by farmers and merchants. The paintings from his sixties have great charm and humor, and by his eighties he was creating works of astonishing force. Hakuin's favorite subject was Bodhidharma, the semilegendary Indian monk who had begun the Zen tradition in China (fig. 22-13). Here he has portrayed the wide-eyed Bodhidharma during his nine years of meditation in front of a temple wall in China. Intensity, concentration, and spiritual depth are conveyed by broad and forceful brushstrokes. The inscription is the ultimate Zen message, attributed to Bodhidharma himself: "Pointing directly to the human heart, see your own nature and become Buddha."

Hakuin's pupils followed his lead in communicating their vision through brushwork. The Zen figure once again became the primary subject of Zen painting, and the painters were again Zen masters rather than primarily artists.

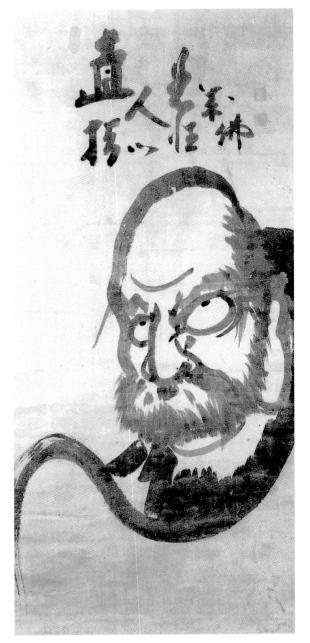

22-13. Hakuin Ekaku. *Bodhidharma Meditating*. Edo period, 18th century. Ink on paper, 49½ x 21¾ (125.7 x 55.3 cm). On extended loan to the Spencer Museum of Art, University of Kansas, Lawrence

Hakuin had his first enlightenment experience while meditating upon the koan (mysterious Zen riddle) about mu. One day a monk asked a Chinese Zen master, "Does a dog have the buddha nature?" Although Buddhist doctrine teaches that all living beings have buddha nature, the master answered, "Mu," meaning "has not" or "nothingness." The riddle of this answer became a problem that Zen masters gave their students as a focus for meditation. With no logical answer possible, monks were forced to go beyond the rational mind and penetrate more deeply into their own being. Hakuin, after months of meditation, reached a point where he felt "as though frozen in a sheet of ice." He then happened to hear the sound of the temple bell, and "it was as though the sheet of ice had been smashed." Later, as a teacher, Hakuin invented a koan of his own that has since become famous: "What is the sound of one hand clapping?"

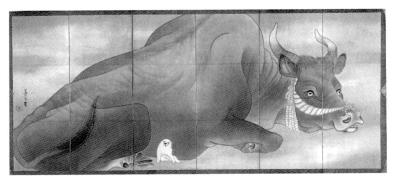

22-14. Nagasawa Rosetsu. *Bull and Puppy.* Edo period, 18th century. One of a pair of six-panel screens, ink and gold wash on paper, 5'7¹/₄" x 12'3" (1.70 x 3.75 m). Los Angeles County Museum of Art Joe and Etsuko Price Collection

Maruyama-Shijo School

Zen paintings were given away to all those who wished them, including poor farmers as well as artisans, merchants, and samurai. Many merchants, however, were more concerned with displaying their increasing wealth than with spiritual matters, and their aspirations fueled a steady demand for golden screens and other decorative works of art. One school that arose to satisfy this demand was the Maruyama-Shijo school, formed in Kyoto by Maruyama Okyo (1733-1795). Okyo had studied Western-style "perspective pictures" in his youth, and he was able in his mature works to incorporate shading and perspective into a decorative style, creating a sense of volume that was new to East Asian painting. Okyo's new style proved very popular in Kyoto, and it soon spread to Osaka and Edo (present-day Tokyo) as well. The subjects of Maruyama-Shijo painting were seldom difficult to understand. Instead of legendary Chinese themes, Maruyama-Shijo painters portrayed the birds, animals, hills, trees, farmers, and townsfolk of Japan. Although highly educated people might make a point of preferring Nanga painting, Maruyama-Shijo works were perfectly suited to the taste of the emerging upper middle class.

The leading pupil of Okyo was Nagasawa Rosetsu (1754–1799), a painter of great natural talent who added his own boldness and humor to the Maruyama-Shijo tradition. Rosetsu delighted in surprising his viewers with odd juxtapositions and unusual compositions. One of his finest works is a pair of screens, the left depicting a bull and a puppy (fig. 22-14). The bull is so immense that it fills almost the entire six panels of the screen and still cannot be contained at the top, left, and bottom. The puppy, white against the dark gray of the bull, helps to emphasize the huge size of the bull by its own smallness. The puppy's relaxed and informal pose, looking happily right out at the viewer, gives this powerful painting a humorous touch that increases its charm.

TECHNIQUE

PRINTS

JAPANESE transparent, allowing the drawing to stand out WOODBLOCK with maximum clarity. The carver then cut around the lines of the drawing with a sharp knife, always working in the same direction as

who commissioned the project and distributed the prints to stores or itinerant peddlers, who would sell them. The artist supplied the master drawing for the print, executing its outlines with brush and ink on tissue-thin paper. Colors might be indicated, but more often they were understood or decided on later. The drawing was passed on to the carver, who pasted it facedown on a hardwood block, preferably cherry wood, so that the out-

the original brushstrokes. The rest of the block was chiseled away, leaving the outlines standing in relief. This block, which reproduced the master drawing, was called the key block. If the print was to be polychrome, having multiple colors, prints made from the key block were in turn pasted facedown on blocks that would be used as guides for the carver of the color blocks. Each color generally required a separate block, although both sides of a block might be used for economy.

Once the blocks were completed, the printer took over. Paper for printing was covered lightly with animal glue (gelatin). A few hours before printing, the paper was lightly moistened so that it would take ink and color well. Water-based ink or color was brushed over the block. and the paper placed on top and rubbed with a smooth, padded device called a baren, until the design was completely transferred. The key block was printed first, then the colors one by one. To ensure that the colors printed exactly within the outlines, each block was carved with two small marks called registration marks, in exactly the same place in the margins, outside of the image area—an L in one corner, and a straight line in another. By aligning the paper with these marks before letting it fall over the block, the printer ensured that the colors would be placed correctly. One of the most characteristic effects of later Japanese prints is a grading of color from dark to pale. This was achieved by wiping some of the color from the block before printing, or by moistening the block and then applying the color gradually with an unevenly loaded brush—a brush loaded on one side with full-strength color and on the other with diluted color.

Ukiyo-e ("pictures of the floating world" as

these woodblock prints are called in Japan-

ese) represent the combined expertise of three

people: the artist, the carver, and the printer.

Coordinating and funding the endeavor was a publisher,

lines showed through the paper in reverse. A light coat-

ing of oil might be brushed on to make the paper more

An early 20th-century woodblock showing two women cutting and inking blocks

In earlier centuries, when works of art were created largely under aristocratic or religious patronage, Rosetsu's painting might have seemed too down-to-earth. In the Edo period, however, the taste for art had spread so widely through the populace that no single group of patrons could control the cultural climate. Everyday subjects like farm animals were painted as often as Zen subjects or symbolic themes from China. In the hands of a master such as Rosetsu, plebeian subject matter could become simultaneously delightful and monumental, equally pleasing to viewers with or without much education or artistic background.

Ukiyo-e: Pictures of the Floating World

Not only did newly wealthy merchants patronize painters in the middle and later Edo period, but even artisans and tradespeople could purchase works of art. Especially in the new capital of Edo, bustling with commerce and cultural activities, people savored the delights of their peaceful society. Buddhism had long preached that pleasures were fleeting; the cherry tree, which blossoms so briefly, became the symbol for the transience of earthly

beauty and joy. Commoners in the Edo period did not dispute this transience, but they took a new attitude: Let's enjoy it to the full as long as it lasts. Thus the Buddhist phrase ukiyo ("floating world") became positive rather than negative.

There was no world more transient than that of the pleasure quarters, set up in specified areas of every major city. Here were found restaurants, bathhouses, and brothels. The heroes of the day were no longer famous samurai or aristocratic poets. Instead, the admired were swashbuckling actors and beautiful courtesans. These paragons of pleasure soon became immortalized in paintings, and because paintings were often too expensive for common people, in woodblock prints known as ukiyo-e, "pictures of the floating world" (see "Japanese Woodblock Prints," above).

At first prints were made in black and white, then colored by hand when the public so desired. The first artist to design prints to be printed in many colors was Suzuki Harunobu (1724–1770). His exquisite portrayals of feminine beauty quickly became so popular that soon every artist was designing multicolored nishiki-e ("brocade pictures").

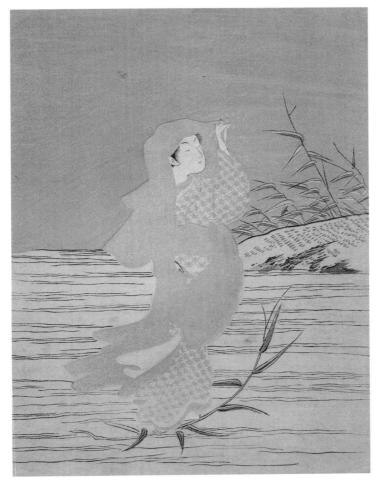

22-15. Suzuki Harunobu. Geisha as Daruma Crossing the Sea. Edo period, mid-18th century. Color woodcut, 10⁷/8 x 8¹/4" (27.6 x 21 cm). Philadelphia Museum of Art Gift of Mrs. Emile Geyelin, in memory of Anne Hampton Barnes

One print that displays Harunobu's charm and wit is Geisha as Daruma Crossing the Sea (fig. 22-15). Harunobu has portrayed a young woman in a red cloak crossing the water on a reed, a clear reference to one of the legends about Bodhidharma, known in Japan as Daruma. To see a young woman peering ahead to the other shore, rather than a grizzled Zen master staring off into space, must have greatly amused the Japanese populace. There was also another layer of meaning in this image because geishas, or courtesans, were sometimes compared to Buddhist teachers or deities in their ability to bring ecstasy, akin to enlightenment, to humans. Harunobu's print suggests these meanings, but it also succeeds simply as a portrait of a beautiful woman, with the gently curving lines of drapery suggesting the delicate feminine form beneath.

The second great subject of ukiyo-e were the actors of the new form of popular theater known as kabuki. Because women had been banned from the stage after a series of scandalous incidents, male actors took both male and female roles. Much as people today buy posters of their favorite sports or music stars, so, too, in the Edo period people clamored for images of their feminine and masculine ideals.

During the nineteenth century, landscape joined courtesans and actors as a major theme—not the idealized landscape of China, but the actual sights of Japan. The two great masters of landscape prints were Utagawa Hiroshige (1797–1858) and Katsushika Hokusai

(1760–1849). Hiroshige's Fifty-Three Stations of the Tokaido and Hokusai's Thirty-Six Views of Fuji became the most successful sets of graphic art the world has yet known. The blocks were printed and printed again until they were worn out. They were then recarved, and still more copies were printed. This process continued for decades, and thousands of prints from the two series are still extant.

The Great Wave (see fig. 22-1) is the most famous of the scenes from *Thirty-Six Views of Fuji*. Hokusai was already in his seventies, with a fifty-year career behind him, when he designed this image. Such was his modesty that he felt that his Fuji series was only the beginning of his creativity, and he wrote that if he could live until he was 100, he would finally learn how to become an artist.

When seen in Europe and America, these and other Japanese prints were immediately acclaimed, and they strongly influenced late-nineteenth- and early-twentieth-century Western art (Chapter 28). *Japonisme*, or "japonism," became the vogue, and Hokusai and Hiroshige became as famous in the West as in Japan. Indeed, their art was taken more seriously in the West; the first book on Hokusai was published in France, and it has been estimated that by the early twentieth century more than 90 percent of Japanese prints had been sold to Western collectors. Only within the past fifty years have Japanese museums and connoisseurs fully realized the stature of this "plebeian" form of art.

THE MEIJI AND MODERN PERIODS

Pressure from the West for entry into Japan mounted dramatically in the mid-nineteenth century, and in 1853 the policy of national seclusion was ended. Resulting tensions precipitated the downfall of the Tokugawa

shogunate, however, and in 1868 the emperor was formally restored to power, an event known as the Meiji Restoration. The court moved from Kyoto to Edo, which was renamed Tokyo, meaning "Eastern Capital."

The Meiji period marked a major change for Japan. After its long isolation Japan was deluged by the influx of the West. Western education, governmental systems, clothing, medicine, industrialization, and technology were all adopted rapidly into Japanese culture. Teachers of sculpture and oil painting were imported from Italy, while adventurous Japanese artists traveled to Europe and America to study.

Japan has always been a country where people have been eager to be up-to-date while at the same time preserving the heritage of the past. Even in the hasty scrambling to become a modern industrialized country, Japan did not lose its sense of tradition, and traditional arts continued to be created even in the days of the strongest Western influence. In modern Japan, artists must choose whether to work in an East Asian style, a Western style, or some combination of the two. Just as Japanese art in earlier periods had both Chinese style and native traditions, so Japanese art of the twentieth century has both Western and native aspects.

Perhaps the most lively contemporary art is ceramics. Japan remains a country where there is widespread appreciation for pottery. Many people still practice the traditional arts of the tea ceremony and flower arranging, both of which require ceramic vessels, and most people would like to own at least one fine ceramic piece. In this atmosphere potters can earn a comfortable living by making art ceramics, an opportunity that does not occur in other countries. Some ceramists continue to create raku teabowls and other traditional wares, while others experiment with new styles and new techniques. Figure 22-16 shows the work of four contemporary potters, from left to right, Miyashita Zenji (b. 1939), Morino Hiroaki (b. 1934), Tsujimura Shiro (b. 1947), and Ito Sekisui (b. 1941).

Miyashita Zenji, who lives in Kyoto, spends a great deal of time on each piece. He creates the initial form by constructing an undulating shape out of pieces of cardboard, then builds up the surface with clay of many different colors, using torn paper to create irregular shapes. When fired, the varied colors of the clay seem to form a landscape, with layers of mountains leading up to the sky. Miyashita's work is modern in shape, yet also traditional in its evocation of nature.

Morino Hiroaki's works are often abstract and sculptural, without any functional use. He has also made vases, however, and they showcase his ability to create designs in glaze that are wonderfully quirky and playful. His favorite colors of red and black bring out the asymmetrical strength of his compositions, the products of a lively individual artistic personality.

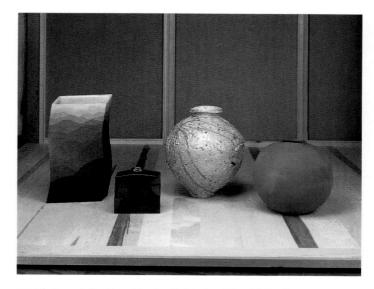

22-16. From left: Miyashita Zenji, Morino Hiroaki, Tsujimura Shiro, Ito Sekisui. Four ceramic vessels. Modern period, after 1970. Spencer Museum of Art, University of Kansas, Lawrence

Gift of the Friends of the Art Museum/Helen Foresman Spencer Art Acquisition Fund

Tsujimura Shiro lives in the mountains outside Nara and makes pottery in personal variations on traditional shapes. He values the rough texture of country clay and the natural ash glaze that occurs with wood firing, and he creates jars, vases, bowls, and cups with rough exteriors covered by rivulets of flowing green glaze that are often truly spectacular. Tsujimura's pieces are always functional, and part of their beauty comes from their suitability for holding food, flowers, or tea.

Ito Sekisui represents the fifth generation of a family of potters. Sekisui demonstrates the Japanese love of natural materials by presenting the essential nature of fired clay in his works. The shapes of his bowls and pots are beautifully balanced with simple clean lines; no ornament detracts from their fluent geometric purity. The warm tan, orange, and reddish colors of the clay reveal themselves in irregularly flowing and changing tones created by allowing different levels of oxygen into the kiln when firing.

These four artists represent the high level of contemporary ceramics in Japan, which is supported by a broad spectrum of educated and enthusiastic collectors and admirers. There is also strong public interest in contemporary painting, prints, calligraphy, textiles, lacquer, architecture, and sculpture.

One of the most adventurous and original sculptors currently working is Chuichi Fujii. Born into a family of sculptors in wood, Fujii found himself as a young artist more interested in the new materials of plastic, steel, and glass. However, in his mid-thirties he took stock of his progress and decided to begin again, this time with wood. At first he carved and cut into the wood, but he soon realized that he wanted to allow the material to express its own natural spirit, so he devised an ingenious new technique that preserved the individuality of each

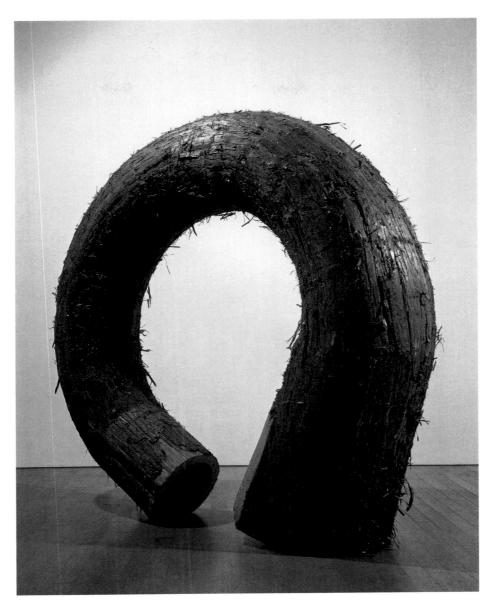

22-17. Chuichi Fujii. *Untitled '90*. Modern period, 1990. Cedar wood, height 7'5½" (2.3 m). Hara Museum of Contemporary Art, Tokyo

log while making of it something new. As Fujii explains it, he first studies the log in order to come to terms with its basic shape and decide how far he can "push to the limit the log's balancing point with the floor" (Howard N. Fox, *A Primal Spirit: Ten Contemporary Japanese Sculptors.* Exh. cat., Los Angeles County Museum of Art, 1990, page 63). Next, he inserts hooks into the log and runs wires between them. Every day he tightens the wires, very gradually, over a period of months, pulling the log into a new shape. When he has bent the log tree trunk to the shape he envisioned, Fujii makes a final cut and sees whether his sculpture will stand. If he has miscalculated, he discards the work and begins again.

Here, Fujii has created a circle, one of the most basic forms in nature but never before seen in such a thick tree trunk (fig. 22-17). The work strongly suggests the *enso*, the circle that Zen monks painted to express the universe, the all, the void, the moon—and even a tea cake. Yet Fujii

does not try to proclaim his links with Japanese culture. He says that while his works may seem to have some connections with traditional Japanese arts, he is not conscious of them. He acknowledges, however, that people carry their own cultures inside them, and he claims that all Japanese have had "the experience of sensing with their skin the fragrance of a tree. Without saying it, the Japanese understand that a tree has warmth; I believe it breathes air, it cries" (Fox, page 63).

Fujii's sculpture testifies to the depth of an artistic tradition that has continued to produce visually exciting works for 14,000 years. He has achieved something entirely new, yet his work also embodies the love of asymmetry, respect for natural materials, and dramatic simplicity encountered throughout the history of Japanese art. Whatever the future of art in Japan, these principles will undoubtedly continue to lead to new combinations of tradition and creativity.

Silver llama statue Inka 15th century

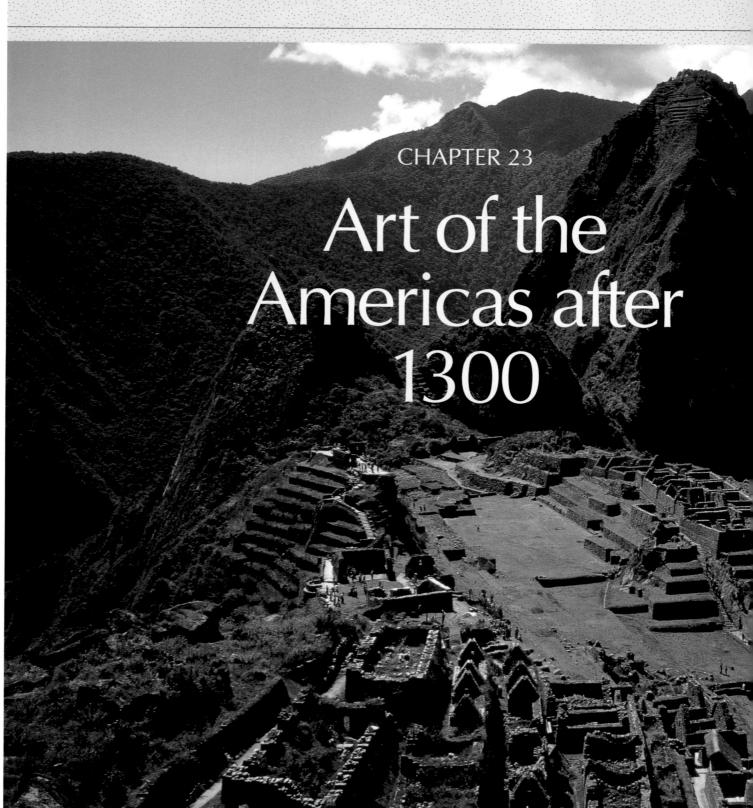

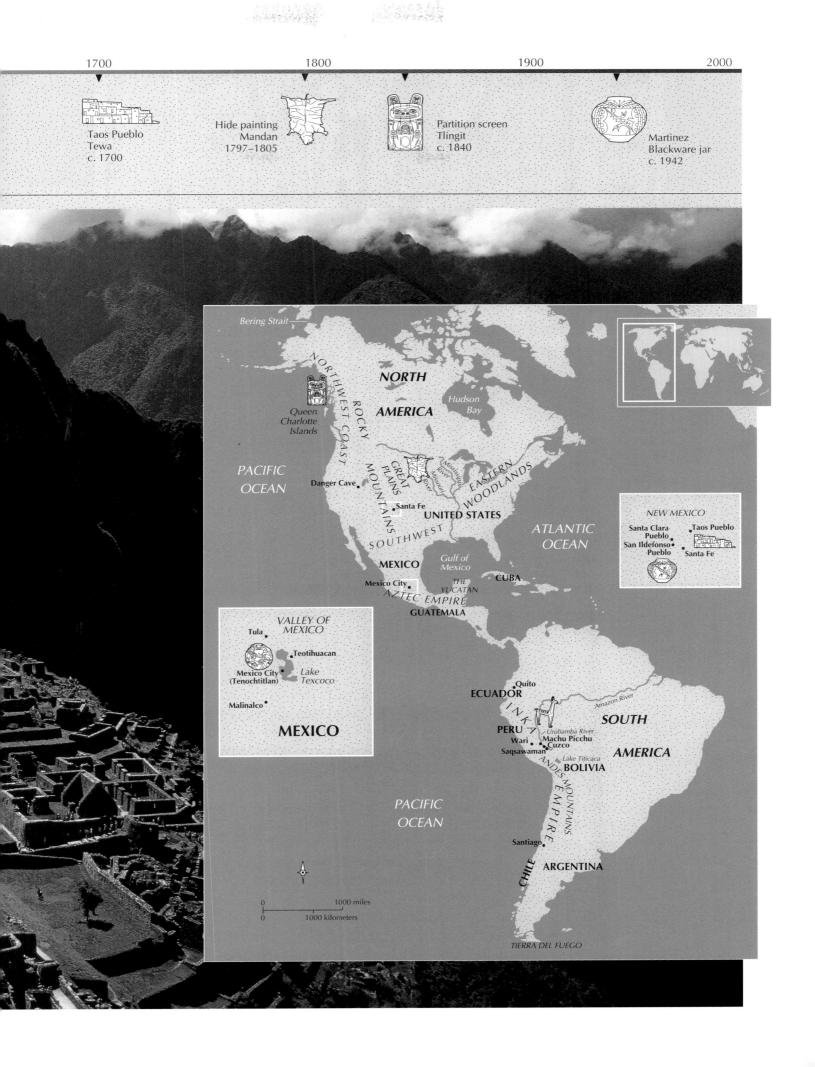

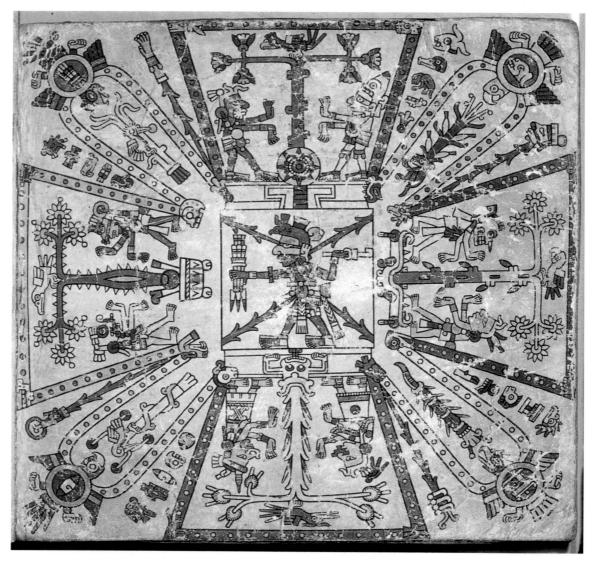

23-1. A view of the world, detail from *Codex Fejervary-Mayer*. Aztec or Mixtec, c. 1400–1521. Paint on animal hide, each page 67/8 x 67/8" (17.5 x 17.5 cm), total length 13'3" (4.04 m). The National Museums and Galleries on Merseyside, Liverpool, England

arly in November 1519, the army of the Spanish conquistador Hernán Cortés beheld for the first time the great Aztec capital of Tenochtitlan. The shimmering city, which seemed to be floating on the water, was built on islands in the middle of Lake Texcoco in the Valley of Mexico, linked by broad causeways to the mainland. One of Cortés's companions later recalled the wonder the Spanish felt at that moment: "When we saw so many cities and villages built on the water and other great towns and that straight and level causeway going towards [Tenochtitlan], we were amazed . . . on account of the great towers and [temples] and buildings rising from the water, and all built of masonry. And some of our soldiers even asked whether the things that we saw were not a dream" (cited in Berdan, page 1).

The startling mirage that Cortés's soldiers saw was indeed real, a city of stone built on islands—a city that held many treasures and many mysteries. Much of the period before the conquistadores' arrival still remains enigmatic, but a rare manuscript that survived the Spanish Conquest depicts the preconquest worldview of peoples of Mexico at that

time, though it is uncertain whether the manuscript originated with the Aztec or their rivals the Mixtec. At the center of the image here is the ancient fire god Xiuhtecutli (fig. 23-1). Radiating from him are the four directions—each associated with a specific color—as well as a deity and a tree with a bird in its branches. In each corner, to the right of a U-shaped band, is an attribute of the god Tezcatlipoca, an omnipotent, primal deity, the "smoking mirror" who could see everything—in the upper right a head, in the upper left an arm, in the lower left a foot, and in the lower right bones. Streams of blood flow from these attributes to the fire god in the center. Such images are filled with important, symbolically coded information—even the dots refer to the number of days in one aspect of the Mesoamerican calendar—and they were integral parts of the culture of the Americas.

INDIGENOUS When the first European

AMERICAN ART explorers and conquerors arrived, the Western Hemi-

sphere was already inhabited from the Arctic Circle to Tierra del Fuego by peoples with long and complex histories and rich and varied cultural traditions (see "Foundations of Civilization in the Americas," below). This chapter focuses on the arts of the indigenous peoples of Mesoamerica, Andean South America, and North America just prior to and in the wake of their encounter with an expansionist Europe.

Although art was central to their lives, the peoples of the Americas set aside no special objects as "works of art." For them, everything had a function. Some objects were essentially utilitarian and others had ritual uses and symbolic associations, but people drew no distinctions between art and other aspects of material culture or between the fine arts and the decorative arts. Understanding Native American art thus requires an understanding of the cultural context in which it was made, a context that in many cases has been lost to time or to the disruptions of the European conquest. Fortunately, art history and archeology have recently contributed to the recovery of at least some of that lost context.

MEXICO Two great empires—the Aztec AND SOUTH in Mexico and the Inka in South America—rose to prominence **AMERICA** in the fifteenth century at about

the same time that European adventurers began to explore the oceans in search of new trade routes to Asia. In the encounter that followed, the Aztec and Inka Empires were destroyed.

FOUNDATIONS OF CIVILIZATION first entered IN THE AMERICAS the Western

Humans Hemisphere

sometime between 12,000 and 30,000 years ago by way of a land bridge in the Bering region that connected Asia and North America during the last Ice Age. By 11,000 years ago they had spread over both North and South America. In many regions they developed a settled, agricultural way of life. In Mesoamerica, in the Andean region of South America, and for a time in what is now the southeastern United States, they developed hierarchical, urban societies with monumental architecture and elaborate artistic traditions.

Mesoamerica extends from north of the Valley of Mexico into Central America. The civilizations that arose there shared a number of features,

including writing, a complex calendrical system, a ritual ball game, and several deities and religious beliefs. Their religious practices included blood and human sacrifice. The earliest Mesoamerican civilization, that of the Olmec, flourished between 1200 and 400 BCE. Maya civilization arose around the beginning of the Common Era in southern Mesoamerica and endured until the Spanish Conquest. Its initial focus, during the Classic period (250-900 cE), was in the southern Yucatan but then shifted to the northern Yucatan. The Classic period Maya developed Mesoamerica's most sophisticated writing and calendrical systems. The Valley of Mexico was dominated during the Classic period by the city of Teotihuacan, which exerted widespread influence throughout Mesoamerica. The Toltec established a state north of the Valley of Mexico that endured from about 1000 to 1200. The Aztec Empire emerged in the Valley of Mexico beginning in the thirteenth and fourteenth centuries. By the end of the fifteenth century the Inka Empire controlled the entire Andean region from north of Quito in modern Ecuador to Santiago in modern Chile.

In North America the people of what is now the southeastern United States adopted a settled way of life by around the end of the second millennium BCE and began building monumental earthworks as early as 1300 BCE. The people of the American Southwest developed a settled, agricultural way of life during the first millennium ce. By around 750 ce the Anasazi-the forebears of the modern Pueblo peoples-began building multistoried, apartmentlike structures with many specialized rooms.

PARALLELS

<u>Years</u>	Americas Cultural Centers	Americas	<u>World</u>
c. 1300–1525	Aztec Empire	Capital of Tenochtitlan founded; empire expands through alliances, marriages, conquest; conquered by the Spanish under Cortés	1300–1500 Hundred Years' War between England and France; Black Death in Europe; Ming dynasty (China); Great Schism in Christian Church; Gutenberg's Bible; Columbus's voyages (Spain); Spanish Inquisition
c. 1300–1537 c. 1300–	Inka Empire Eastern Woodlands	Capital of Cuzco flourishes; strong government and religious hierarchy; empire expands to length of 2,600 miles; government control of agriculture; public-works, military, and agricultural production mandatory; extensive roads and storehouses; assassination of Atahualpa and conquest by the Spanish under Pizarro Hunting and agricultural communities; birch-bark canoes; pottery; Iroquois confederation; quillwork; beadwork; English settle Jamestown, Va.; French	Michelangelo's David (Italy); Leonardo's Mona Lisa (Italy); Michelangelo's Sistine Ceiling (Italy); Protestant Reformation in Europe; Mughal period (India); William Shakespeare born (England); Baroque style emerges in Europe; Peter Paul Rubens (Flanders); Hideyoshi unites Japan; Rembrandt van Rijn (Netherlands); Qing dynasty (China) 1700–1800 Union of England and Scotland as Great Britain; British Museum
		settle Quebec, Canada; trading; European encroachment on Native American lands; Indian Removal Act; Trail of Tears	founded; James Watt develops steam engine (Scotland); French Revolution; Age of Enlightenment in Europe
c. 1300–	Great Plains	Groups in permanent villages pursue agriculture while nomadic groups hunt buffalo; tepees; hunting groups increase after Spanish introduce horses; Spanish introduce firearms; Prairie style incorporates ele- ments from Eastern Woodlands	
с. 1300-	Northwest Coast	Extended family groups living in communal timber dwellings; fishing; dugout canoes; wood carving, weaving, and basketry; arrival of European fur traders	
с. 1300-	Southwest	Pueblo dwellers cultivate crops; Navajos establish semisedentary agricultural and herding groups; weaving, painting, sand painting; Spanish settle Sante Fe; Pueblo peoples rise up against Spanish	To do maistre che che che che che che che che che ch

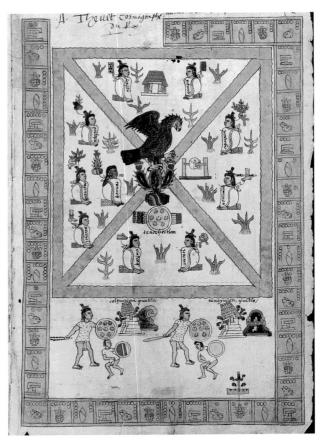

23-2. The Founding of Tenochtitlan, page from Codex Mendoza. Aztec, 16th century. Ink and color on paper, 87/16 x 126/16" (21.5 x 31.5 cm). The Bodleian Library, Oxford MS. Arch Selden. A.1.fol. 2r

The Aztec Empire

The people who lived in the remarkable city that Cortés found were then rulers of much of Mexico. Their rise to such power had been recent and swift. Only 400 years earlier, according to their own legends, they had been a nomadic people living on the shores of the mythological Lake Aztlan somewhere to the northwest of the Valley of Mexico, where present-day Mexico City is located. They called themselves the Mexica, hence the name *Mexico*. The term *Aztec* derives from Aztlan.

At the urging of their patron god, Huitzilopochtli, the Aztec began a long migration away from Lake Aztlan, arriving in the Valley of Mexico in the thirteenth century. Driven from place to place, they eventually ended up in the marshes on the edge of Lake Texcoco. There they settled on an island where they had seen an eagle perching on a prickly pear cactus (tenochtli), a sign that Huitzilopochtli told them would mark the end of their wandering. They called the place Tenochtitlan. The city, like Venice, grew on a collection of islands linked by canals.

Through a series of alliances and royal marriages, the Aztec gradually rose to prominence, emerging less than a century before the arrival of Cortés as the head of a powerful alliance and the dominant power in the valley. Only then did they begin the aggressive expansion

that so impressed the invading Spanish.

Aztec society was divided into roughly three classes: an elite of rulers and nobles, a middle class of professional merchants and luxury artisans, and a lower class of farmers and laborers. The luxury artisans were known as *Toltecca*, reflecting Aztec admiration for the earlier Toltec civilization, which had fallen in the thirteenth century. Commoners and elite alike received rigorous military training.

that brought them tribute from all over Central Mexico and transformed Tenochtitlan into the glittering capital

Aztec religion was based on a complex pantheon that combined the Aztec deities with more ancient ones that had long been worshiped in Central Mexico. According to Aztec belief, the gods had created the current universe at the ancient city of Teotihuacan. Its continued existence depended on human actions, including rituals of bloodletting and human sacrifice. The end of each round of fifty-two years in the Mesoamerican calendar was a particularly dangerous time, requiring a special fire-lighting ritual. Sacrificial victims sustained the sun god in his daily course through the sky. Huitzilopochtli, son of the earth mother Coatlicue and the Aztec patron deity associated with the sun and warfare, also required sacrificial victims so that he could, in a regular repetition of the events surrounding his birth, drive the stars and the moon from the sky at the beginning of each day. The stars were his half brothers, and the moon, Coyolxauhqui, was his half sister. When Coatlicue conceived Huitzilopochtli by inserting a ball of feathers into her chest as she was sweeping, his jealous siblings conspired to kill her. When they attacked, Huitzilopochtli emerged from her body fully grown and armed, drove off his brothers, and destroyed his half sister, Coyolxauhqui.

Most Aztec books were destroyed in the wake of the Spanish Conquest, but the work of Aztec scribes appears in several documents created for Spanish administrators after the conquest. The first page of the *Codex Mendoza*, prepared for the Spanish viceroy in the sixteenth century, can be interpreted as an idealized representation of both the city of Tenochtitlan and its sacred ceremonial precinct (fig. 23-2). An eagle perched on a prickly pear cactus—the symbol of the city—fills the center of the page. Waterways divide the city into four quarters, which are further subdivided into wards, as represented by the seated figures. The victorious warriors at the bottom of the page represent Aztec conquests.

The focal point of the sacred precinct—probably symbolized in figure 23-2 by the temple or house at the top of the page—was the Great Pyramid, a 130-foot-high stepped double pyramid with dual temples on top, one of which was dedicated to Huitzilopochtli and the other to Tlaloc, the god of rain and fertility. Two steep staircases led up the west face of this structure from the plaza in front of it. Sacrificial victims climbed these stairs to the Temple of Huitzilopochtli at the summit, where several priests threw them over a stone and another quickly cut open their chests and pulled out their still-throbbing hearts. Their bodies were then rolled down the stairs and dismembered. Thousands of severed heads were said to have been kept

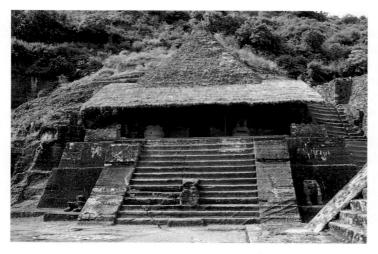

23-3. Rock-cut sanctuary, Malinalco, Mexico. Aztec, 15th century; modern thatched roof

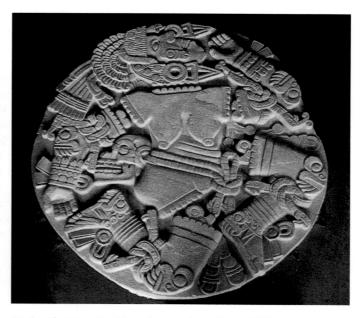

23-4. *The Moon Goddess, Coyolxauhqui*. Aztec, 15th century. Stone, diameter 11'6" (3.5 m)

This disk was discovered accidentally in 1978 by workers from a utility company who were excavating at a street corner in central Mexico City.

on a skull rack in the plaza, represented in figure 23-2 by the rack with a single skull to the right of the eagle. During the winter rainy season the sun rose behind the Temple of Tlaloc, and during the dry season it rose behind the Temple of Huitzilopochtli. The double temple thus united two natural forces, sun and rain, or fire and water. During the spring and autumn equinoxes, the sun rose between the two temples, illuminating the Temple of Quetzalcoatl, the feathered serpent, an ancient creator god associated with the calendar, civilization, and the arts.

Like other Mesoamerican peoples, the Aztec intended their temples to resemble mountains. They also carved shrines and temples directly into the mountains surrounding the Valley of Mexico. A steep flight of stairs leads up to one such temple carved into the side of a mountain at Malinalco (fig. 23-3). The formidable entrance, which resembles the open mouth of the earth monster, leads into a circular room (the thatched roof is modern). If the temple itself is a mountain, surely this space is a symbolic cave, the womb of the earth. A pit for blood sacrifices opens into the heart of the mountain. Stylized eagle and jaguar skins carved into a semicircular bench around the interior are symbols of two Aztec military orders, suggesting that members of those orders performed rites here.

Sculpture of serpents and serpent heads on the Great Pyramid in Tenochtitlan associated it with the "Hill of the Serpent," where Huitzilopochtli slew the moon goddess Coyolxauhqui. A huge circular relief of the dismembered goddess once lay at the foot of the temple stairs, as if the enraged and triumphant Huitzilopochtli had cast her there like a sacrificial victim (fig. 23-4). Her torso is in the center, surrounded by her head and limbs. A rope around her waist is attached to a skull. She has bells on her cheeks

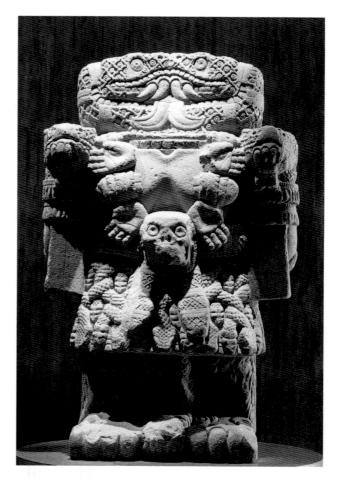

23-5. The Mother Goddess, Coatlicue. Aztec, 15th century. Stone, height 8'6" (2.65 m). Museo Nacional de Antropología, Mexico City

and balls of down in her hair. She wears a magnificent headdress and has distinctive ear ornaments composed of disks, rectangles, and triangles. The sculpture is two-dimensional in concept with a deeply cut background.

The Spanish built their own capital, Mexico City, over the ruins of Tenochtitlan and built a cathedral on the site of Tenochtitlan's sacred precinct. An imposing statue of Coatlicue, mother of Huitzilopochtli, was found near the cathedral during excavations there in the late eighteenth century (fig. 23-5). One of the conquistadores described seeing such a statue covered with blood inside the Temple of Huitzilopochtli, where it would have stood high above the vanquished Coyolxauhqui. Coatlicue means "she of the serpent skirt," and this broad-shouldered figure with clawed hands and feet has a skirt of twisted snakes. A pair of serpents, symbols of gushing blood, rise from her neck to form her head. Their eyes are her eyes; their fangs, her tusks. The writhing serpents of her skirt also form her body. Around her stump of a neck hangs a necklace of sacrificial offerings-hands, hearts, and a dangling skull. Despite the surface intricacy, the sculpture's simple, bold, and blocky forms create a single visual whole. The colors with which it was originally painted would have heightened its dramatic impact.

The Inka Empire

At the beginning of the sixteenth century the Inka Empire was one of the largest states in the world, rivaling China in size. It extended more than 2,600 miles along western South America, encompassing most of modern Peru, Ecuador, Bolivia, and northern Chile and reaching into modern Argentina. Like the Aztec Empire, its rise had been recent and swift.

The Inka called their empire the Land of the Four Ouarters. At its center was their capital, Cuzco, "the navel of the world," located high in the Andes Mountains. The initial history of the Inka people is obscure. The Cuzco region had been under the control of the earlier Wari Empire, and the Inka state was probably one of many small competing kingdoms that emerged in the highlands in the wake of the Wari collapse. In the fifteenth century the Inkas began suddenly and rapidly to expand, and they subdued most of their vast domain—through conquest, alliance, and intimidation—by 1500. To hold their linguistically and ethnically diverse empire together, the Inka relied on an overarching state religion, a hierarchical bureaucracy, and various forms of labor taxation, in which the payment was a set amount of time spent performing tasks for the state. Agricultural lands were divided into three categories: those for the gods, which supported priests and religious authorities; those for the ruler and the state; and those for the local population itself. As part of their labor tax, people were required to work the lands of the gods and the state for part of each year. In return the state provided them with gifts through their local leaders and sponsored lavish ritual entertainments. Men served periodically on public-works projects-building roads and terracing hillsides, for example-and in the army. The Inka also moved about

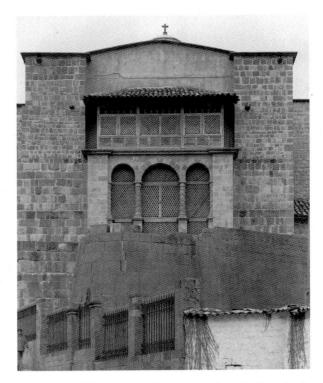

23-6. Walls of the Temple of the Sun, below the Church of Santo Domingo, Cuzco, Peru. Inka, 15th century The curving lower wall formed part of the Inka Temple of the Sun, also known as the Golden Enclosure or Court of Gold.

whole subject communities to best exploit the resources of their empire. Ranks of storehouses at Inka administrative centers assured the state's ability to feed its armies and supply the people working for it. No Andean civilization ever developed writing, but the Inka kept detailed accounts on knotted and colored cords.

To move their armies around and speed transport and communication within their empire, the Inka built nearly 15,000 miles of roads. These varied from 50-footwide thoroughfares to 3-foot-wide paths. In common with other Native American civilizations, the Inka had no wheeled vehicles. Travelers went on foot, and llamas were used as pack animals. Stairways helped travelers negotiate steep mountain slopes, and rope suspension bridges allowed them to cross river gorges. The main road on the Pacific coast, a desert region, had walls to protect it from blowing sand. All along the roads, the Inkas built administrative centers, storehouses, and roadside lodgings. These lodgings-more than a thousand have been found—were spaced a day's journey apart. A relay system of waiting runners could carry messages between Cuzco and the farthest reaches of the empire in about a week.

Cuzco, a capital of great splendor and magnificence, was home to the Inka, as the ruler of the Inka Empire was called, and the extended ruling group. The city, which may have been laid out to resemble a giant puma, was a showcase of the finest Inka masonry, some of which can still be seen in the modern city. The walls of its most magnificent structure, the Temple of the Sun, served as the foundation for the Spanish colonial Church of Santo Domingo (fig. 23-6). Within the Temple of the Sun was a room adorned

ELEMENTS OF Working with the simplest of ARCHITECTURE tools—mainly heavy stone hammers-and using no mor-Inka Masonry tar, Inka builders created stonework of great refinement and

durability: roads and bridges that linked the entire empire, built-up terraces for growing crops, and structures both simple and elaborate. At Machu Picchu (fig.

23-7), all buildings and terraces within its 3-square-mile extent were made of granite, the hard stone occurring at the site. Commoners' houses and some walls were constructed of irregular stones that were carefully fitted together. Some walls and certain domestic and religious structures were erected using squared-off, smoothsurfaced stones laid in even rows. At a few Inka sites, the stones were boulder-size: up to 27 feet tall.

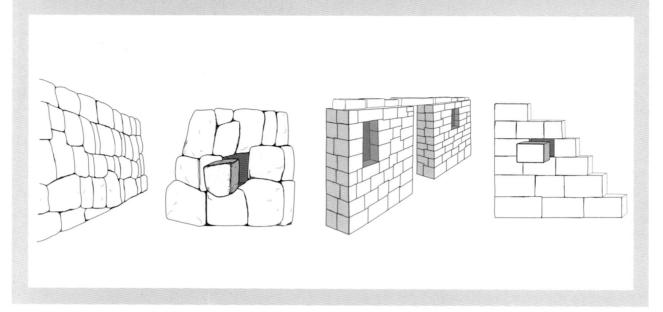

with gold dedicated to the sun and another adorned with silver dedicated to the moon.

Inka masonry has survived earthquakes that have destroyed or seriously damaged later structures. Fine Inka masonry consisted of either rectangular blocks, as in figure 23-6, or irregular polygonal blocks. Both were ground so that adjoining blocks fit tightly together without mortar (see "Elements of Architecture," above). The blocks might be slightly beveled so that the stones had a pillowed form and each block retained its identity, or they might, as in figure 23-6, be smoothed into a continuous flowing surface in which the individual blocks form part of a seamless whole. Inka structures had gabled, thatched roofs. Doors, windows, and niches were trapezoid shaped, narrower at the top than the bottom. The effort expended on building by the Inka was prodigious. The temple fortress of Saqsawaman in Cuzco, for example, was reputed to have occupied 30,000 workers for many decades.

Machu Picchu, one of the most spectacular archeological sites in the world, provides an excellent example of Inka architectural planning (fig. 23-7). At 9,000 feet above sea level, it straddles a ridge between two high peaks in the eastern slopes of the Andes and looks down on the Urubamba River. Stone buildings occupy terraces around central plazas, and narrow agricultural terraces descend into the valley. The site lies near the eastern limits of the empire, suggesting that it may have been a frontier outpost. Its temples and carved sacred stones suggest that it also had an important religious function.

The production of fine textiles is of ancient origin in the Andes, and textiles were one of the primary forms of wealth for the Inka. One kind of labor taxation was to require the manufacture of fibers and cloth, and textiles as well as agricultural products filled Inka storehouses. Cloth was a fitting offering for the gods, so fine garments were draped around golden statues, and entire images were constructed of cloth. Garments also carried important symbolic messages. Their patterns and designs were not simply decorative but indicated, among other things, a person's ethnic identity and social rank. Each square in the tunic shown in figure 23-8 represents a miniature tunic, but the meaning of the individual patterns is not yet completely understood. The four-part motifs may refer to the Land of the Four Quarters. The checkerboard pattern designated military officers and royal escorts. The meaning of the diagonal key motif is not known, but it is often found on tunics with horizontal border stripes.

The Spanish who conquered the Inka Empire were far more interested in the Inka's vast quantities of gold and silver objects than in cloth. Whatever they could find, they melted down to enrich themselves and the royal coffers of Spain. The Inka, in contrast, valued gold and silver not as precious metals in themselves but because they saw in them symbols of the sun and the moon. They are said to have called gold the "sweat of the sun" and silver the "tears of the moon." Some small figures, buried as offerings, escaped the conquerors' treasure hunt. The small llama shown in figure 23-9 was found near Lake Titicaca.

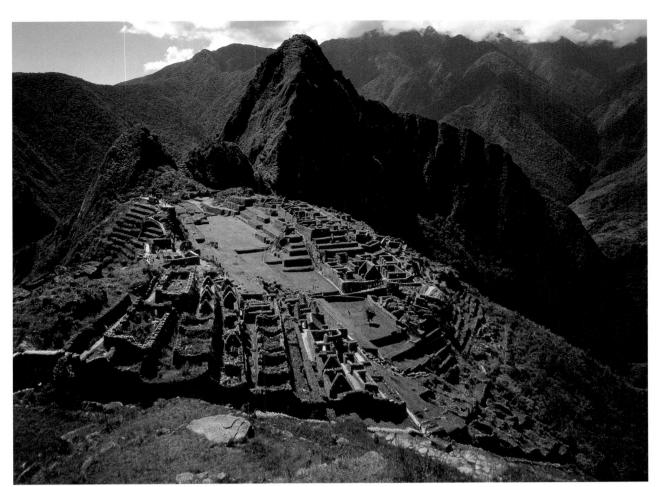

1500

23-7. Machu Picchu, Peru. Inka, 15th-16th centuries

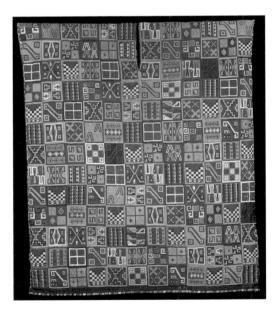

- 23-8. Tunic, from Peru. Inka, c. 1500. Wool and cotton, 357/8 x 30" (91 x 76.5 cm). Dumbarton Oaks Research Library and Collections, Washington, D.C.

 Textile patterns and colors were standardized, like European heraldry or the uniforms of today's sports teams, to convey information at a glance.
- 23-9. Llama, from Bolivia or Peru, found near Lake Titicaca, Bolivia. Inka, 15th century. Cast silver with gold and cinnabar, $9 \times 8^{1/2} \times 1^{3/4}$ " (22.9 x 21.6 x 4.4 cm). American Museum of Natural History, New York Trans. #5003

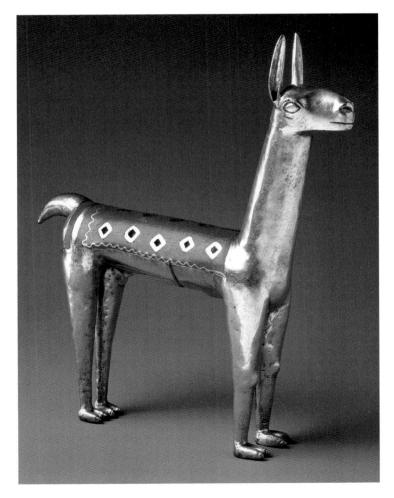

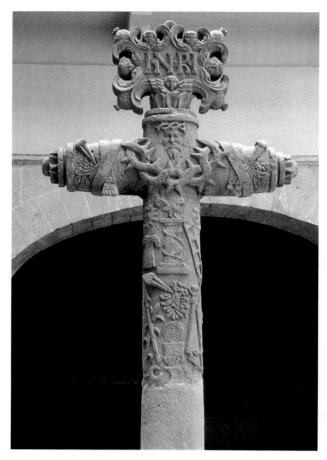

23-10. Atrial cross, from Mexico. Before 1556. Stone, height 11'3" (3.45 m). Chapel of the Indians, Basilica of Guadalupe, Mexico City

The llama had a special connection with the sun, with rain, and with fertility. In Cuzco a llama was sacrificed to the sun every morning and evening. A white llama was kept in the capital as the symbol of the Inka. Dressed in a red tunic and wearing gold jewelry, this llama passed through the streets during April celebrations. According to Spanish commentators, these processions included lifesize gold and silver images of llamas, people, and gods.

The Aftermath of the Spanish Conquest

Hernán Cortés arrived off the coast of Mexico from the Spanish colony in Cuba in 1519. Within two years, after forging alliances with the Aztec's enemies, he had succeeded in taking Tenochtitlan. Over the next several years Spanish forces subdued much of the rest of Mexico and established it as a colony of Spain. In 1532 Francisco Pizarro, following Cortés's example, led an expedition to the land of the Inka. Hearing that the Inka ruler Atahualpa, freshly victorious in the war of succession that followed the death of his father, was progressing south from the city of Quito to Cuzco, Pizarro pressed inland to intercept him. He and his men seized Atahualpa, held him for a huge ransom in gold, then treacherously strangled him. They marched on Cuzco and seized it in 1533. The conquest was followed by a period of disorder,

with Inka rebellions and struggles among the conquistadores themselves, that did not end until about 1550. In both Mexico and Peru the Native American populations declined sharply after the conquest because of the exploitative policies of the conquerors and the ravages of diseases they imported, like smallpox, against which the indigenous people had no immunity.

In the wake of the conquest, Roman Catholicism spread throughout Spanish America, and local beliefs and practices were suppressed. Native American temples were torn down, and churches erected in their place. The work of conversion in the sixteenth century fell to the Franciscan, Dominican, and Augustinian religious orders. Several missionaries were so appalled by the conquerors' treatment of the people they called Indians that they petitioned the Spanish king to improve their condition.

In the course of Native Americans' conversion to Roman Catholicism, their symbolism was to some extent absorbed into Christian symbolism. This process can be seen in the huge early colonial atrial crosses, so called because they were located in church atriums, where large numbers of converts gathered for education in their new faith. Early chroniclers wrote that the crosses were decorated with flowers and that children gathered around them for instruction. Missionaries recruited Native American sculptors to carve these crosses. One sixteenthcentury atrial cross, now in the Basilica of Guadalupe in Mexico City, suggests pre-Hispanic sculpture in its stark form and rich surface symbols, even though the individual images were probably copied from illustrated books brought by the missionaries (fig. 23-10). The work is made from two large blocks of stone that are entirely covered with low-relief images known as the Arms of Christ, the "weapons" Christ used to defeat the devil. Jesus' Crown of Thorns hangs like a necklace around the cross bar, and with the Holy Shroud, which also wraps the arms, it frames the image of the Holy Face (the cloth with which Veronica wiped Jesus' face). Blood gushes forth where huge nails pierce the ends of the cross. Symbols of regeneration, such as winged cherub heads and pomegranates, surround the inscription at the top of the cross.

The cross itself suggests an ancient Mesoamerican symbol, the World Tree or Tree of Life, and the image of blood sacrifice resonates with indigenous beliefs. Like the statue of Coatlicue (see fig. 23-5), the cross is composed of many individual elements that seem compressed to form a shape other than their own. The dense low relief combines into a single massive form. Traditional Christian imagery in a simplified form is clearly visible in the work, although it may not yet have had much meaning or emotional resonance for the artists who put it there.

In 1531 Native American converts gained their own patron saint when the Virgin Mary appeared as a Native American to a Native American named Juan Diego. She is said to have asked that a church be built on a hill where the Aztec mother goddess had once been worshiped. As evidence of this vision, Juan Diego brought flowers that the Virgin had caused to bloom, wrapped in a cloak, to the archbishop. When he opened his bundle, the cloak

bore the image of a dark-skinned Virgin Mary, standing on the moon and clothed with the sun, an image known as the Woman of Revelations. The site of the vision was renamed Guadalupe, after Our Lady of Guadalupe in Spain, and became a venerated pilgrimage center. In 1754 the pope declared the Virgin of Guadalupe to be the patron of the Americas.

AMERICA

NORTH The Europeans who settled America north of Mexico were drawn not by gold and silver but by land. As colonists set-

tled what was to become the United States and Canada, claiming land for their towns, farms, and plantations, they dispossessed the people already living there. European explorers and settlers had little interest in Native American arts. Much of it was small, portable, fragile, and impermanent; its symbolic language was misunderstood; and until recently its aesthetic quality was unappreciated.

Eastern Woodlands and the Great Plains

When European settlement began, forests covered eastern North America from Hudson Bay to the Gulf of Mexico and from the Atlantic coast to the Mississippi River and Missouri River watersheds. Between this Eastern Woodlands region and the Rocky Mountains to the west lay an area of prairie grasslands now known as the Great Plains.

The Native American peoples of the Eastern Woodlands supported themselves by a combination of hunting and agriculture. They lived in villages and cultivated corn, squash, and beans. They used flexible and waterproof birch bark to construct their homes and to make the extremely functional river and lake craft known as the canoe. After the arrival of the Europeans, they exchanged furs for such useful items as metal kettles and needles, cloth, and beads. In the sixteenth century one Eastern Woodlands group, the Iroquois, formed a sophisticated and powerful confederation of Native American nations in the Northeast that played a prominent military and political role until after the American Revolution.

Before the coming of the Europeans, two differing ways of life developed on the Great Plains, one nomadic dependent for food, clothing, and shelter on the region's great migrating herds of buffalo—and the other sedentary and agricultural. The introduction of the horse to the prairies by Spanish explorers in the late seventeenth century transformed Plains life. Horses—and, later, firearms made buffalo hunting vastly more efficient than before and attracted more people to the nomadic way of life.

As European settlers on the eastern seaboard began to turn forests into farms, they put increasing pressure on the Eastern Woodlands peoples, depriving them of their lands and forcing them westward. This steady encroachment reached a climax when the U.S. Congress passed the Indian Removal Act of 1830, which forced many eastern groups to resettle west of the Mississippi River. Just one of the consequences of this law was the infamous 1838-1839 "Trail of Tears," the forced march of the Cherokee to Oklahoma from their towns and farms in

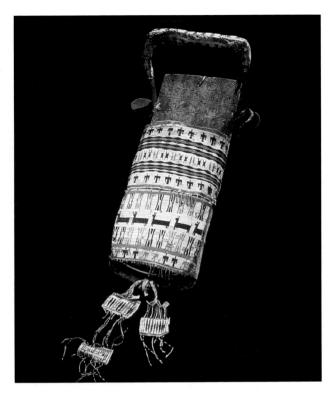

23-11. Baby carrier, from the Upper Missouri River area. Eastern Sioux, 19th century. Board, buckskin, porcupine quill, length 31" (78.8 cm). Smithsonian Institution Libraries, Washington, D.C.

Georgia. The resulting interaction of Eastern Woodlands artists with one another and with Plains artists led to the emergence of the Prairie style among numerous groups.

One distinctively Eastern Woodlands medium that found its way into the Plains was quillwork embroidery. Quillwork involved soaking porcupine and bird quills to soften them, dyeing them, and then working them into rectilinear, ornamental surface patterns on deerskin clothing and on birch-bark artifacts like baskets and boxes. A Sioux legend recounts how a mythical ancestor, Doublewoman ("double" because she was both beautiful and ugly, benign and dangerous), appeared to a woman in a dream and taught her the art of quillwork. As this legend suggests, quillwork was a woman's art form. The Sioux baby carrier shown in figure 23-11 is richly decorated with symbols of protection and well-being, including bands of antelopes in profile and thunderbirds with their heads turned and tails outspread. The thunderbird was an especially beneficent symbol, thought to be capable of protecting against both human and supernatural adversaries.

Another medium associated with the Eastern Woodlands groups that was adopted by the Plains peoples was beadwork. Eastern Woodlands peoples had long made wampum, belts of cylindrical purple and white beads made from clam shells or the center spirals of conch shells. The Iroquois and Delaware used wampum to keep records and exchanged it to conclude treaties. Decorative beadwork, on the other hand, did not become commonplace until after the European contact. It initially

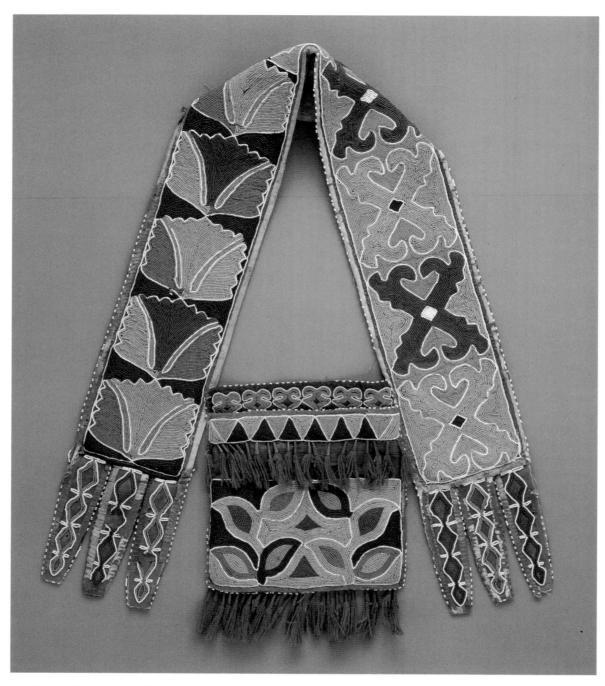

23-12. Shoulder bag, from Kansas. Delaware, c. 1860. Wool fabric, cotton fabric and thread, silk ribbon, and glass beads, 23 x 7³/₄" (58.5 x 19.8 cm). Detroit Institute of Arts Founders Society Purchase (81.216)

mimicked the patterns and colors of quillwork and in the nineteenth century began to replace quillwork in some places. In the late eighteenth century Native American artists began to acquire European colored glass beads, and in the nineteenth century they favored tiny seed beads from Venice and Bohemia. In a process known as reintegration, they began to adapt European needlework techniques and patterns and the design of European garments into their own work. Some of the functional aspects of those garments were transformed into purely decorative motifs; a pocket, for example, would be replaced by an area of beadwork in the *form* of a pocket.

An example of beadwork is the shoulder bag from Kansas, made around 1860 by a Delaware woman, shown in figure 23-12. In contrast to the rectilinear patterns of quillwork, the bag is covered with curvilinear plant motifs. White lines outline brilliant pink and blue leaf-shaped forms, heightening the intensity of the colors, and colors alternate within repeated patterns that have no consistent foreground or background.

The nomadic Plains peoples developed a light, portable dwelling known as a **tepee** (fig. 23-13), which was well designed to withstand the wind, dust, and rain of the prairies. The framework of a tepee consisted of a

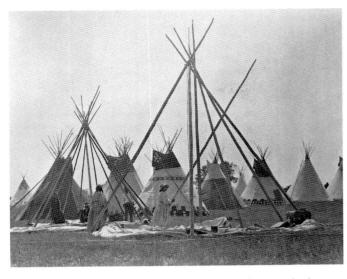

23-13. Blackfoot women raising a tepee. Photographed c. 1900. Montana Historical Society, Helena

stable frame of three or four long poles, filled out with about twenty additional poles, in a roughly egg-shaped plan. The framework was covered with hides (or, later, with canvas) to form an almost conical structure that leaned slightly in the direction of the prevailing west wind. The hides were specially prepared to make them flexible and waterproof. A typical tepee required about eighteen hides, the largest about thirty-eight hides. The opening at the top served as a smoke hole for the central hearth. The flap-covered door and smoke hole usually faced east, away from the wind. An inner lining covered the lower part of the walls and the perimeter of the floor

to protect the occupants from drafts. When packed to be dragged by a horse, the tepee served as a platform for transporting other possessions as well. When the Blackfeet gathered in the summer for their ceremonial Sun Dance, they formed their hundreds of tepees into a circle a mile in circumference. The Sioux encamped in two half circles—one for the sky people and one for the earth people—divided along an east-west axis.

Tepees were the property and responsibility of women, who raised them at new encampments and lowered them when the group moved on. Blackfeet women could set up their huge tepees in less than an hour. Women painted, embroidered, quilled, and beaded tepee linings, backrests, clothing, and equipment. The patterns with which tepees were decorated, as well as their proportions and colors, varied from Native American nation to nation. In general, the bottom was covered with a group's traditional motifs and the center section with personal images.

Plains men recorded their exploits in symbolic and narrative form in paintings on tepee linings and covers and on buffalo-hide robes. The earliest known painted buffalo-hide robe illustrates a battle fought in 1797 between the Mandan of North Dakota and their allies against the Sioux (fig. 23-14). The painter, trying to capture the full extent of a conflict in which five nations took part, shows a party of warriors in twenty-two separate episodes. Their leader appears with a pipe and wears an elaborate eagle-feather headdress. The party is armed with bows and arrows, lances, clubs, and flintlock rifles. The lively stick figures of the warriors have rectangular torsos and tiny round heads. Details of equipment and emblems of rank—headdresses, sashes, shields, feathered

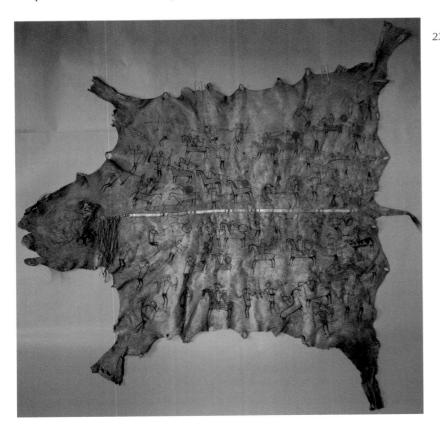

23-14. Battle-scene hide painting, from North Dakota. Mandan, 1797-1805. Tanned buffalo hide, dyed porcupine quills, and black, red, green, yellow, and brown pigment, 7'10" x 8'6" (2.44 x 2.65 m). Peabody Museum of Archaeology, Harvard University, Cambridge, Massachusetts (99-12-10/53121) This robe, collected by Meriwether Lewis and William Clark on their 1803-1806 expedition into western lands acquired by the United States in the Louisiana Purchase, is the earliest documented example of Plains painting. The robe was one of a number of Native American artworks that Lewis and Clark sent to President Thomas Jefferson. Jefferson displayed the robe in the entrance hall of his home at Monticello, Virginia.

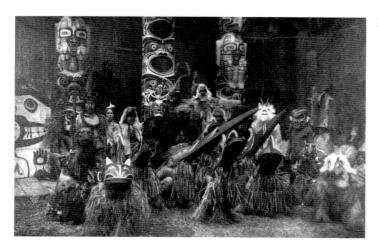

23-15. Edward S. Curtis. Hamatsa dancers, Kwakiutl, Canada. Photographed 1914

The photographer Edward S. Curtis (1868–1952) devoted thirty years to documenting the lives of Native Americans. This photograph shows participants in a film he made about the Kwakiutl. For the film, his Native American informant and assistant, Richard Hunt, borrowed family heirlooms and commissioned many new pieces from the finest Kwakiutl artists. Most of the pieces are now in museum collections. The photograph shows carved and painted posts, masked dancers (including those representing cannibal birds), a chief at the left (holding a speaker's staff and wearing a cedar neck ring), and spectators at the right.

lances, powder horns for the rifles—are accurately depicted. Horses are shown in profile with stick legs and **C**-shaped hooves. Some have clipped manes, others have flowing manes. The figures stand out against the light-colored, almost white background of the buffalo hide. Lines were pressed into the hide, and black, red, green, yellow, and brown pigments added. A strip of colored porcupine quills runs down the spine. The robe would have been worn draped over the shoulders of the powerful warrior whose deeds it commemorates. As he moved, the painted horses and warriors would have come alive, transforming him into a living representation of his exploits.

The Northwest Coast

From southern Alaska to northern California, the Pacific coast of North America is a region of unusually abundant resources. Its many rivers fill each year with salmon returning to spawn. Harvested and dried, the fish could sustain large populations throughout the year. The peoples of the Northwest Coast—among them the Tlingit, the Haida, and the Kwakiutl—exploited this abundance to develop a complex and distinctive way of life in which the arts played a central role.

Northwest Coast peoples lived in extended family groups in large, elaborately decorated communal houses made of massive timbers and thick planks. Family groups claimed descent from a mythic animal or animal-human ancestor. Social rank within and between related families was based on genealogical closeness to the mythic ancestor. Chiefs, who were in the most direct line of descent from the ancestor, administered a family's spiritual and material resources. Chiefs validated their status and garnered prestige for themselves and their families by holding ritual feasts in which they gave valuable gifts to the invited guests. Shamans, who were sometimes also chiefs, mediated between the human and spirit worlds. A family derived its name and the right to use certain animals and spirits as totemic emblems, or crests, from its mythic ancestor. These emblems appeared prominently in Northwest Coast art, notably in carved house crests and the tall, freestanding poles erected to memorialize dead chiefs.

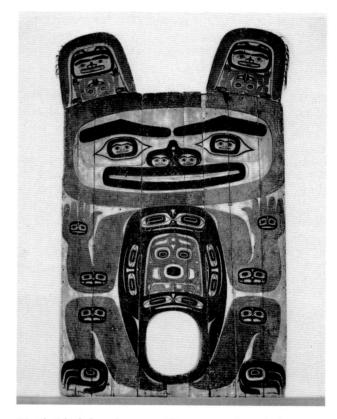

23-16. Grizzly bear house-partition screen, from the house of Chief Shakes of Wrangell, Canada. Tlingit, c. 1840. Cedar, native paint, and human hair, 15 x 8' (4.57 x 2.74 m). Denver Art Museum

The participants who danced in Northwest Coast ceremonies wore elaborate costumes and striking carved wooden masks. Among the most elaborate masks were those used by the Kwakiutl in their Winter Dance for initiating new members into the shamanistic Hamatsa society (fig. 23-15). The dance reenacted the taming of Hamatsa, a people-eating spirit, and his three attendant bird spirits. Magnificent carved and painted masks transformed the dancers into Hamatsa and the bird attendants, who searched for victims to eat. Strings allowed the dancers to manipulate the masks so that the beaks opened and snapped shut with spectacular effect.

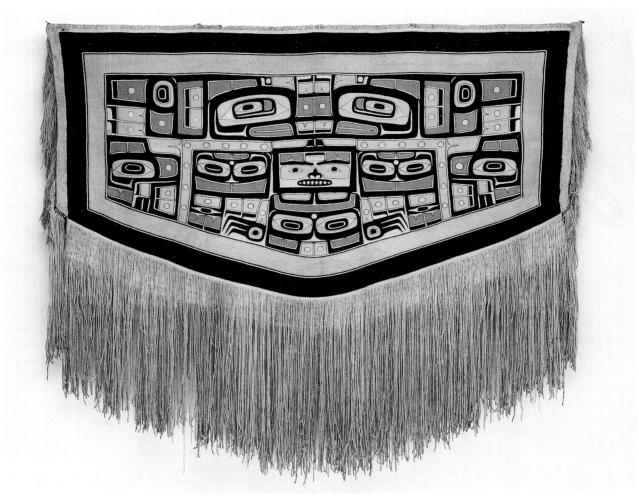

23-17. Chilkat blanket. Tlingit, before 1928. Mountain-goat wool and shredded cedar bark, 4'7¹/₈" x 5'3³/₄"(1.40 x 1.62 m). American Museum of Natural History, New York

Trans. #3804

Carved and painted house-partition screens separated a chief's quarters from the rest of a communal house. The screen shown in figure 23-16 came from the house of Chief Shakes of Wrangell (d. 1916), whose family crest was the bear. The image of a rearing grizzly painted on the screen is itself made up of smaller bears and bear heads that appear in its ears, eyes, nostrils, joints, paws, and body. The images within the image enrich the monumental symmetrical design. The oval door opening is a symbolic vagina; passing through it reenacts the birth of the family from its ancestral spirit.

Blankets and other textiles produced by the Chilkat Tlingit had great prestige throughout the Northwest Coast (fig. 23-17). Chilkat men created the patterns, which they drew on boards, and women did the weaving. The blankets are made from shredded cedar bark wrapped with mountain-goat wool. The weavers did not use looms; instead, they hung warp threads from a rod and twisted colored threads back and forth through them to make the pattern. The ends of the warp formed the fringe at the bottom of the blanket.

The small face in the center of the blanket shown here represents the body of a stylized creature, perhaps

a sea bear or a standing eagle. On top of the body are the creature's large eyes; below it and to the sides are its legs and claws. Characteristic of Northwest painting and weaving, the images are composed of two basic elements: the **ovoid**, a slightly bent rectangle with rounded corners, and the **formline**, a continuous, shape-defining line. Here, subtly swelling black formlines define structures with gentle curves, ovoids, and rectangular **C** shapes. When the blanket was worn, its two-dimensional forms would have become three-dimensional, with the dramatic central figure curving over the wearer's back and the more intricate side panels crossing over his shoulders and chest.

The contemporary Canadian Haida artist Bill Reid (b. 1920) has sought to sustain and revitalize the traditions of Northwest Coast art in his work. Trained as a wood carver, painter, and jeweler, Reid revived the art of carving dugout canoes and totem poles in the Haida homeland of Haida Gwaii—"Islands of the People"—known on maps today as the Queen Charlotte Islands. Late in life he began to create large-scale sculpture in bronze. With their black patina, these works recall traditional Haida carvings in argillite, a shiny black stone. One of them,

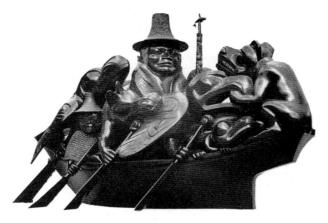

23-18. Bill Reid. *The Spirit of Haida Gwaii*. Haida, 1991. Bronze, approx. 13 x 20' (4 x 6 m). Canadian Embassy, Washington, D.C.

The Spirit of Haida Gwaii, now stands outside the Canadian Embassy in Washington, D.C. (fig. 23-18). This sculpture, which Reid views as a metaphor for modern Canada's multicultural society, depicts a collection of figures from the natural and mythic worlds struggling to paddle forward in a canoe. The dominant figure in the center is a shaman in a spruce-root basket hat and Chilkat blanket holding a speaker's pole, a staff that gives him the right to speak with authority. In the prow, the place reserved for the chief in a war canoe, is the Bear. The Bear faces backward rather than forward, however, and is bitten by the Eagle, with formline-patterned wings. The Eagle, in turn, is bitten by the Seawolf. The Eagle and

the Seawolf, together with the man behind them, nevertheless continue paddling. In the stern, steering the canoe, is the Raven, the trickster in Haida mythology. The Raven is assisted by Mousewoman, the traditional guide and escort of humans in the spirit realms. On the other side, not visible here, are the Bear mother and her twins, the Beaver, and the Dogfish Woman. According to Reid, the work represents a "mythological and environmental lifeboat," where "the entire family of living things . . . whatever their differences, . . . are paddling together in one boat, headed in one direction."

The Southwest

The Native American peoples of the southwestern United States include, among others, the Pueblo (villagedwelling) groups and the Navajo. The Pueblo groups are heirs to the ancient Anasazi and Hohokam cultures, which developed a settled, agricultural way of life around the beginning of the Common Era. The Anasazi built the many large, multistoried, apartmentlike villages and cliff dwellings whose ruins are found throughout northern Arizona and New Mexico. The Navajo, who moved into the region more recently—in about the eleventh century or later—developed a semisedentary way of life based on agriculture and, after the introduction of sheep by the Spanish, sheepherding. Both groups have succeeded in maintaining many of their traditions despite first Spanish and then Anglo-American encroachments. Their arts reflect the adaptation of traditional forms to new technologies, new mediums, and the influences of the dominant American culture that surrounds them. Such adaptations are seen among various groups and in all mediums (see "Basketry," below).

TECHNIQUE

Basketry involves weaving reeds, grasses, and other materials to form containers. In North America the earliest evidence of basketwork, found in Danger Cave, Utah, dates to as early as 8400 BCE. Over the subsequent centuries Native American women, notably in California and the Southwest, developed basketry into an art form that combined utility with great beauty.

There are three principal basket-making techniques: coiling, twining, and plaiting. Coiling involves sewing together a spiraling foundation of rods with some other material. Twining involves sewing together a vertical warp of rods. Plaiting involves weaving strips over and under each other.

The coiled basket shown here was made by the Pomo of California. According to Pomo legend, the earth was dark until their ancestral hero stole the sun and brought it to earth in a basket. He hung the basket first just over the horizon, but, dissatisfied with the light it gave, he kept suspending it in different places across the dome of the sky. He repeats this process every day, which is why the sun moves across the sky from east to west. In the Pomo basket the structure of coiled willow and bracken fern root produces a spiral surface into which the artist worked sparkling pieces of clamshell, trade

BASKETRY beads, and the soft tufts of woodpecker and quail feathers. The underlying basket, the glittering shells, and the soft, moving feathers make this an exquisite container. Such baskets were treasured possessions, cremated with their owners at death.

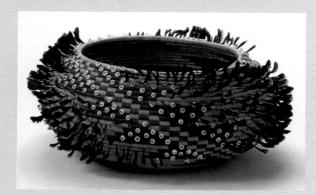

Wedding basket. Pomo, c. 1877. Willow, bracken fern root, clamshell, trade beads, woodpecker and quail feathers, height $5^{1/2}$ " (14 cm), diameter 12" (36.5 cm). Philbrook Museum of Art, Tulsa, Oklahoma Clark Field Collection

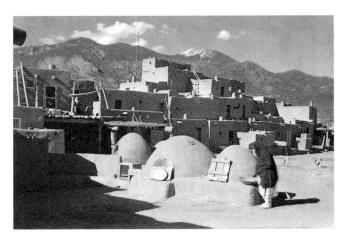

23-19. Laura Gilpin. Taos Pueblo, Tewa, Taos, New Mexico.
Photographed 1947. Amon Carter Museum, Forth
Worth, Texas
Laura Gilpin Collection (neg. # 2528.1)

The Pueblos. Some Pueblo villages today, like those of their Anasazi forebears, consist of multistoried, apartmentlike dwellings of considerable architectural interest. One of these, Taos Pueblo, shown here in a mid-twentieth-century photograph, is located in north-central New Mexico (fig. 23-19). The northernmost of the surviving Pueblo communities, Taos once served as a trading center between Plains and Pueblo peoples. It burned in 1690 but was rebuilt about 1700 and has often been modified since. Its great "houses," multifamily dwellings, stand on either side of Taos Creek, rising in a stepped fashion to form a series of roof terraces. The houses border a plaza that opens toward the neighboring mountains. The plaza and roof terraces are centers of communal life and ceremony. Pottery traditionally was a woman's art among Pueblo

peoples, whose wares were made by coiling and other handbuilding techniques, then fired at low temperature in wood bonfires. One of the best-known twentiethcentury Pueblo potters is Maria Montoya Martinez (1887-1980) of San Ildefonso Pueblo. Inspired by prehistoric blackware pottery that was unearthed at nearby archeological excavations, she and her husband, Julian Martinez (1885-1943), developed a distinctive new ware decorated with matte (nongloss) black forms on a lustrous black background (fig. 23-20). The Martinezes achieved the ware's black color through creating an oxygen-poor atmosphere by smothering vessels with horse manure and wood ash near the end of a firing. They achieved the lustrous surface areas by polishing the matte areas with a fine shale paste that they discovered in 1918. Their decorative patterns were inspired by both traditional Pueblo imagery and the then-fashionable Euro-American Art Deco style.

In the 1930s Anglo-American art teachers and dealers worked with Native Americans of the Southwest to create a distinctive "Indian" style in several mediums—including jewelry, pottery, weaving, and painting—that would appeal to tourists and collectors. A leader in this effort was Dorothy Dunn, who taught painting in the Santa Fe Indian School, a government high school, from 1932 to 1937. Dunn inspired her students to create a painting style that combined the outline drawing and flat colors of folk art, the decorative qualities of Art Deco, and "Indian" subject matter. The success of the style made painting a viable occupation for young Native American artists.

Pablita Velarde (b. 1918), a 1936 graduate of Dorothy Dunn's school, was only a teenager when one of her paintings was selected for exhibition at the Chicago

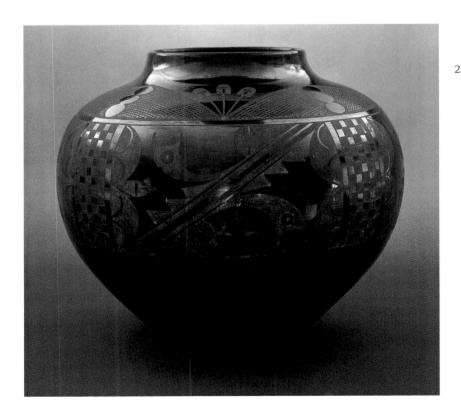

23-20. Maria Montoya Martinez and Julian Martinez. Blackware storage jar, from San Ildefonso Pueblo, New Mexico. Hopi, c. 1942. Ceramic, height 183/4" (47.6 cm). diameter 221/2" (57.1 cm). Museum of Indian Arts and Culture/ Laboratory of Anthropology, Museum of New Mexico, Santa Fe

NIGHT CHANT

NAVAIO This chant accompanies the creation of a sand painting during a Navajo curing ceremony. It is

sung toward the end of the ceremony and indicates the restoration of inner harmony and balance.

In beauty (happily) I walk. With beauty before me I walk. With beauty behind me I walk. With beauty below me I walk. With beauty above me I walk. With beauty all around me I walk.

It is finished (again) in beauty. It is finished in beauty.

> (cited in Washington Mathews, American Museum of Natural History Memoir, no. 6, New York, 1902, page 145)

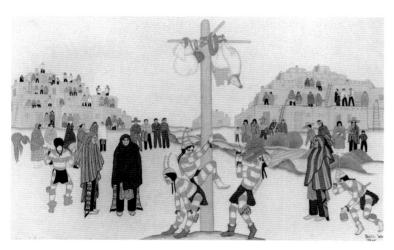

23-21. Pablita Velarde. Koshares of Taos, from Santa Clara Pueblo, New Mexico. 1946-47. Watercolor, 137/8 x 223/8" (35.3 x 56.9 cm). Philbrook Museum of Art, Tulsa. Oklahoma

World's Fair in 1933. Velarde, from the Santa Clara Pueblo in New Mexico, began to document Pueblo ways of life as her work matured. Koshares of Taos (fig. 23-21) illustrates a moment during a ceremony celebrating the winter solstice when koshares, or clowns, have taken over the plaza from the kachinas—the supernatural counterparts of animals, natural phenomena like clouds, and geological features like mountains—who are central to traditional Pueblo religion. Kachinas become manifest in the human dancers who impersonate them during the winter solstice ceremony, as well as in the small figures known as kachina dolls that are given to children. Velarde's painting combines bold, flat colors and a simplified decorative line with European perspective to produce a kind of Art Deco abstraction.

The Navajos. Navajo women are renowned for their skill as weavers. According to Navajo mythology, the universe itself is a kind of weaving, spun by Spider Woman out of sacred cosmic materials. Spider Woman taught the art of weaving to Changing Woman (a mother earth figure who constantly changes through the seasons), who in turn taught it to Navajo women. The earliest Navajo blan-

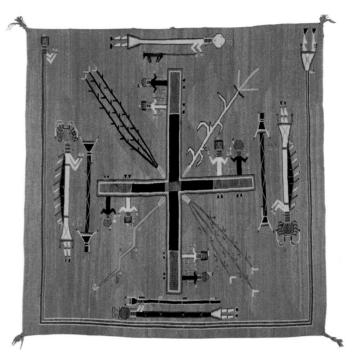

23-22. Hosteen Klah. Whirling Log Ceremony, sand-painting tapestry by Mrs. Sam Manuelito. Navajo, c. 1925. Wool, 5'5" x 5'10" (1.69 x 1.82 m). Heard Museum, Phoenix, Arizona

kets have simple horizontal stripes, like those of their Pueblo neighbors, and are limited to the white, black, and brown colors of natural sheep's wool. Over time, the weavers developed finer techniques and introduced more intricate patterns. In the mid-nineteenth century they began unraveling the fibers from commercially manufactured and dyed blankets and reusing them in their own work. By 1870–1890 they were weaving spectacular blankets that were valued as prestige items among the Plains peoples as well as Euro-American collectors.

Another traditional Navajo art, sand painting, is the exclusive province of men. Sand paintings are made to the accompaniment of chants by shaman-singers in the course of healing and blessing ceremonies and have great sacred significance (see "Navajo Night Chant," above). The paintings depict mythic heroes and events; as ritual art they follow prescribed rules and patterns that ensure their power. To make them, the singer dribbles pulverized colored stones, pollen, flowers, and other natural colors over a hide or sand ground. The rituals are intended to restore harmony to the world. The paintings are not meant for public display and are destroyed by nightfall of the day on which they are made.

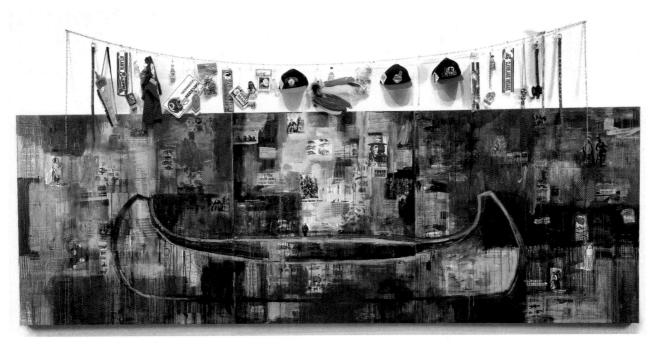

23-23. Jaune Quick-to-See Smith. *Trade (Gifts for Trading Land with White People)*. Salish-Cree-Shoshone, 1992. Oil and collage on canvas, 5' x 14'2" (1.56 x 4.42 m). Chrysler Museum, Norfolk, Virginia Courtesy Steinbaum Krauss Collection, New York City

In 1919 a respected shaman-singer named Hosteen Klah began to incorporate sand-painting images into weavings, breaking with the traditional prohibition against making them permanent. Many Navajos took offense at Klah both for recording the sacred images and for doing so in a woman's art form, but the works were ultimately accepted because of his great skill and prestige. Klah's Whirling Log Ceremony sand-painting, shown here in a tapestry (fig. 23-22), depicts a part of the Navajo creation myth in which the Holy People divide the world into four parts, create the Earth Surface People (humans), and bring forth corn, beans, squash, and tobacco, the four sacred plants. The Holy People surround the image, and a male-female pair of humans stands in each of the four quarters defined by the central cross. The guardian figure of Rainbow Maiden encloses the scene on three sides. The open side represents the east. Like all Navajo artists, Hosteen Klah hoped that the excellence of the work would make it pleasing to the spirits. Recently, singers have started making permanent sand paintings on boards for sale, but they always introduce slight errors in them to render them ceremonially harmless.

CONTEMPORARY NATIVE AMERICAN ART

Many Native American artists today are seeking to move beyond the occasionally self-conscious revival of tradi-

tional forms to a broader art that acknowledges and mediates among the complex cultural forces shaping their lives. One exemplar of this trend is Jaune Quick-to-See Smith (b. 1940), who was raised on Flatrock Reservation in Montana and traces her descent to the Salish of the Northwest Coast, the Shoshone of southern California,

and the Cree, a northern woodlands and plateau people. Quick-to-See Smith described the multiple influences on her work this way: "Inhabited landscape is the continuous theme in my work. Pictogram forms from Europe, the Amur, the Americas; color from beadwork, parfleches, the landscape; paint application from Cobra art, New York expressionism, primitive art; composition from Kandinsky, Klee, or Byzantine art provide some of the sources for my work. Study of the wild horse ranges, western plants and animals, and ancient sites feed my imagination and dreams. This is how I reach out and strike new horizons while I reach back and forge my past" (Women of Sweetgrass, page 97).

During the United States' quincentennial celebration of Columbus's arrival in the Americas—in her words, the beginning of "the age of tourism"—Quick-to-See Smith created paintings and collages of great formal beauty that also confronted viewers with their own, perhaps unwitting, stereotypes (fig. 23-23). In Trade (Gifts for Trading Land with White People), a stately canoe floats over a richly colored and textured field, which on closer inspection proves to be a dense collage of newspaper clippings from local Native American newspapers. Wide swatches and rivulets of red, yellow, green, and white cascade over the newspaper collage. On a chain above the painting is a collection of both Native American cultural artifacts tomahawks, beaded belts, feather headdresses-and American sports memorabilia for teams with names like the Atlanta Braves, the Washington Redskins, and the Cleveland Indians that many Native Americans find offensive. Surely, the painting suggests, Native Americans could trade these goods to retrieve their lost lands, just as European settlers traded trinkets with Native Americans to acquire the lands in the first place.

Mimis and Kangaroo Aborigine 16,000–7000 BCE

Pottery fragment Lapita 1200–1100 BCE

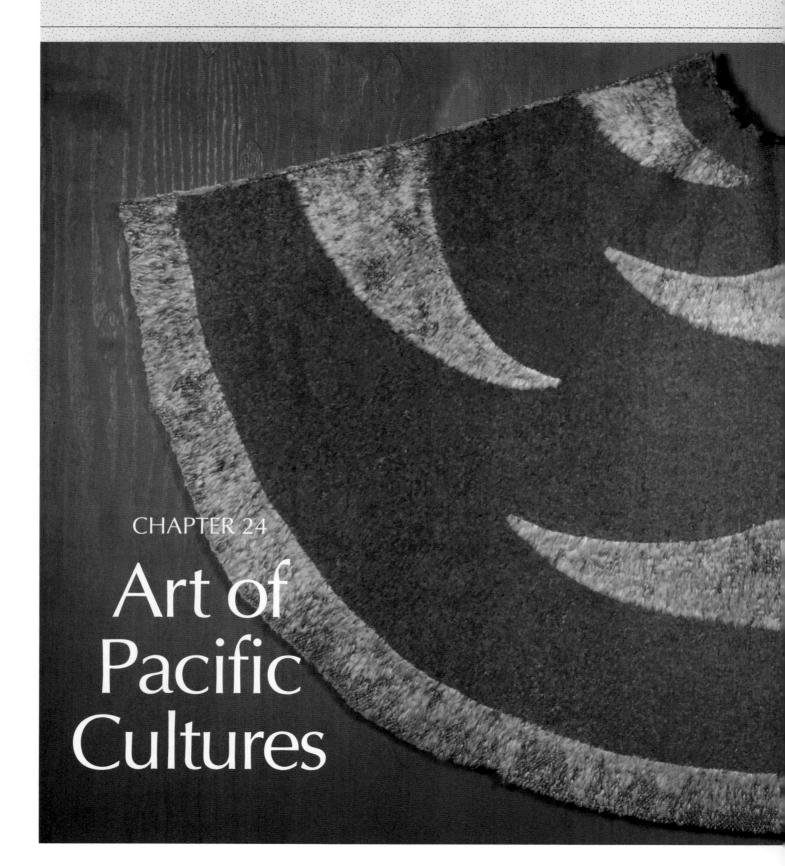

1500 BCE 2000 CE

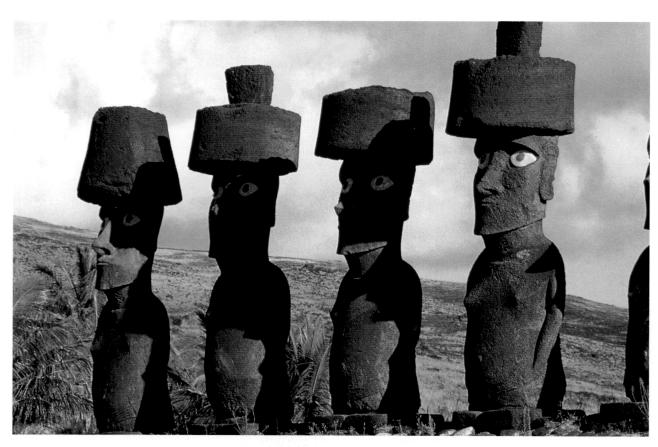

24-1. Ancestor figures (moai)? Ahu Nau Nau, Easter Island, Polynesia. c. 1000–1500, restored 1978. Volcanic stone (tufa), average height approx. 36' (11 m)

In an effort to preserve the culture and landscape of Easter Island, the Chilean government has made its archeological sites into a national park. Some of the huge stone figures have been re-erected and restored with their coral and stone eyes and their red tufa topknots in place. Some of the topknots are as tall as 9 feet.

n the middle of the Great Ocean, in a region where no one ever passes, there is a mysterious and isolated island; there is no land in the vicinity and, for more than eight hundred leagues in all directions, empty and moving vastness surrounds it. It is planted with tall, monstrous statues, the work of some now-vanished race, and its past remains an enigma" (Pierre Loti, *L'Île de Pâques*, 1872).

The early travelers who successfully reached the islands that lie in the Pacific Ocean found far more than the mysterious, "monstrous" statues of Easter Island (fig. 24-1). Those islands that came to be described as simple paradises by romantic European and American visitors, in fact, support widely differing ecosystems, peoples, and cultures. There, over many thousands of years, people have developed complex belief systems that have encouraged a rich, visionary life. And they have expressed their beliefs in concrete form—in ritual objects, masks, and the enrichment of their material environment.

Nineteenth-century explorers who sought that vastness using the earliest maps of the region, about a hundred years old, found only an uncertain location for the unknown "continent" that mapmakers believed extended to the South Pole. For them, as for us, maps helped to create a view of the world and establish their place in it. European medieval maps, for example, placed Jerusalem in the center, while later cartographers

1500 pcs 2000 cs

focused on Rome. Westerners are so accustomed to thinking of a world grid originating at an observatory in Greenwich, England, or to imagining a map with the United States as the center of the world that other images are almost inconceivable. From a Northern Hemisphere point of view the great landmasses of Australia, New Guinea, and New Zealand become lands "down under," sliding off under the globe, remote from "our" world. But a simple shift of viewpoint—or a map in which the vast Pacific Ocean forms the center of a composition—suddenly marginalizes the Americas, and Europe disappears altogether.

THE PEOPLING OF THE PACIFIC

On a map with the Pacific Ocean as its center, only the peripheries of the great landmasses of Asia and the Americas appear. This immense, watery region consists of four cultural-geographic areas: Australia,

Melanesia, Micronesia, and Polynesia. Australia includes the island continent as well as the island of Tasmania to the southeast. Melanesia (a term meaning "black islands," a reference to the dark skin color of its inhabitants) includes New Guinea and the string of islands that extends eastward from it as far as Fiji and New Caledonia. Micronesia ("small islands"), to the north of Melanesia, is a region of small islands, including the Marianas. Polynesia ("many islands") is scattered over a huge, triangular region defined by New Zealand in the south, Easter Island in the east, and the Hawaiian Islands to the north. The last region on earth to be inhabited by humans, Polynesia covers some 7.7 million square miles, of which fewer than 130,000 square miles are dry land—and most of that is New Zealand. Melanesia and Micronesia are also known as Near Oceania, and Polynesia as Far Oceania.

Australia, Tasmania, and New Guinea formed a single continent during the last Ice Age, which began some 2.5 million years ago. Some 50,000 years ago, when the sea level was about 330 feet lower than it is today, people had moved into this continent from Southeast Asia, making at least part of the journey over open water. Some 27,000 years ago they were settled on the large islands north and east of New Guinea as far as San Cristóbal, but they ventured no farther for another 25,000 years. By about 4000 BCE—possibly as early as 7000 BCE the people of Melanesia were raising pigs and cultivating taro, a plant with edible rootstocks. As the glaciers melted, the sea level rose, flooding low-lying coastal land. By around 4000 BCE a 70-mile-wide waterway, now called the Torres Strait, separated New Guinea from Australia, whose people retained a hunting and gathering way of life into the twentieth century.

The settling of the rest of the islands of Melanesia and the westernmost islands of Polynesia—Samoa and Tonga—coincided with the spread of the seafaring Lapita culture, named for a site in New Caledonia, after about 1500 BCE. The Lapita people were farmers and fisherfolk who lived in often large coastal villages, probably cultivated taro and yams, and produced a distinctive style of pottery. They were skilled shipbuilders and navigators

and engaged in interisland trade. Over time the Lapita culture lost its widespread cohesion and evolved into various local forms. Polynesian culture apparently emerged in the eastern Lapita region on the islands of Tonga and Samoa. Around the beginning of the first millennium CE, daring Polynesian seafarers, probably in double-hulled sailing canoes, began settling the scattered islands of Far Oceania and eastern Micronesia. Voyaging over open water, sometimes for thousands of miles, they reached Hawaii and Easter Island after about 500 CE and settled New Zealand by about 800/900–1200 CE.

In this vast and diverse region the arts of the Pacific display enormous variety and are generally closely linked to a community's ritual and religious life. In this context the visual arts were often just one strand in a rich weave that also included music, dance, and oral literature.

AUSTRALIA The aboriginal inhabitants of Australia, or Aborigines, were nomadic hunter-gatherers closely attuned to the varied environments in which they lived until European settlers disrupted their way of life. The Aborigines had a complex social organization and a rich mythology that was vividly represented in the arts. As early as 18,000 years ago they were painting images on rocks and caves in western Arnhem Land, which is on the northern coast of Australia. One such painting contains a later image superimposed on an earlier one (fig. 24-2). The earlier painting is of skinny,

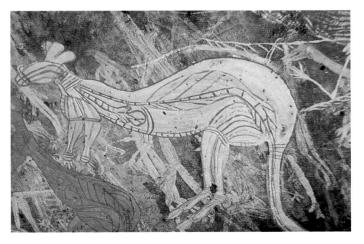

24-2. Mimis and Kangaroo, prehistoric rock art, Oenpelli, Arnhem Land, Australia. Older painting 16,000–7000 BCE. Red and yellow ocher and white pipe clay

PARALLELS

Years	Pacific Cultures	World
с. 50,000-20,000 все	People from Southeast Asia migrate to Australia, New Guinea, and nearby islands	Paleolithic hunter-gatherers migrate to New World; Woman from Willendorf (Austria)
с. 16,000-1500 все	Mimis cave paintings in Australia; x-ray style painting in Australia; plants and pigs domesticated	Lascaux cave paintings (France); first pottery vessels (Japan); plants and animals domesticated (Near East, Southeast Asia, Americas); metallurgy (Near East); first writing (Sumer, China, India); Great Pyramids at Giza (Egypt); Stonehenge (England)
с. 1500 все-с. 500 се	Lapita culture spreads through Melanesia	Olmec civilization (Mexico); Rome's legendary founding (Italy); birth of Siddhartha Gautama, founder of Buddhism (Nepal); crucifixion of Jesus (Jerusalem); Maya civilization (Central America)
с. 500–1500 се	Hawaii and Easter Island settled; Easter Island <i>moai</i> figures; Polynesian seafarers settle Far Oceania; monumental structures at Nan Madol in Micronesia	Birth of Muhammad, founder of Islam (Arabia); first Viking colony in Greenland; Marco Polo in China; Ottoman Empire (Asia Minor); Aztec Empire (Mexico); Black Death in Europe; Ming dynasty (China); Great Schism in Christian Church; Inka Empire (South America); Renaissance begins in Europe; Gutenberg's Bible (Germany); Columbus's voyages (Spain)
с. 1500–1900 се	Captain James Cook explores New Zealand, Australia, and Easter Island; first British settlement in Australia; quilting introduced in Hawaii; Australia becomes British dependency; Peruvian slave hunters decimate Easter Island population	Protestant Reformation in Europe; Mughal period (India); Hideyoshi unites Japan; English colonize North America; Qing dynasty (China); union of England and Scotland as Great Britain; Declaration of Independence (United States); French Revolution; Mexico becomes a republic; Italy is united; Darwin's Origin of Species; Civil War (United States); Dominion of Canada is formed
c. 1900 CE-present	Abelam <i>tamberan</i> houses in Papua New Guinea; Asmat <i>mbis</i> sculpture in Irian Jaya; <i>malanggan</i> cere- monies in New Ireland; Confedera- tion of Australia	World War I; World War II; United Nations established; People's Republic of China founded; breakup of the Soviet Union

sticklike humans that the Aborigines call *mimis* (ancestral spirits). Superimposed over the *mimis* is a kangaroo rendered in the distinctive **x-ray style**, in which the artist drew important bones and internal organs—including the spinal column, other bones, the heart, and the stomach—over the silhouetted form of the animal. In the picture shown here, all four of the kangaroo's legs have been drawn, and the ears have been placed symmetrically on top of its head. In some images both eyes appear in the head, which is shown in profile. The x-ray style was still prevalent in western Arnhem Land when European settlers arrived in the nineteenth century.

Bark paintings from northeastern Arnhem Land are entirely filled with elaborate narrative compositions in delicate striping and **cross-hatching**. The Aborigines do not reveal the full meaning of these works to outsiders, but in general they depict origin myths from the Dream Time, when, according to their beliefs, the world and its inhabitants were created. The paintings and the rituals associated with them provide a way to restore contact with the Dream Time. The myths and rituals also explain the origin of important features of the landscape, of climatic phenomena like the monsoon season, and of aboriginal social groupings: In the beginning, the world was

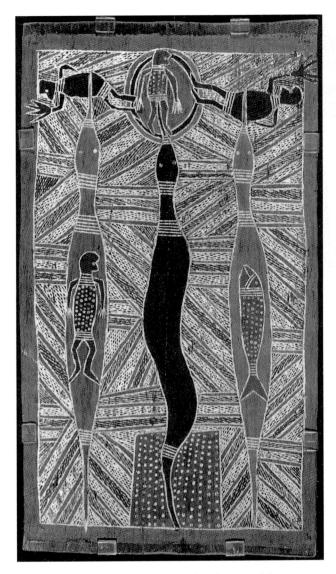

24-3. Mawalan Marika. *The Wawalag Sisters and the Rainbow Serpent*. 1959. Ochers on eucalyptus bark, 18³/₄ x 10¹/₈" (48 x 26 cm). Collection, Art Gallery of Western Australia, Perth

The sisters dance outside their home in an attempt to escape the Rainbow Serpent's wrath. The serpent slithers out of his hole at the bottom of the bark. It has already devoured a human and a fish.

flat, but animals and the ancestral beings shaped it into mountains, sand hills, creeks, and water holes. Animals became the totemic ancestors of human groups, and the places associated with them became sacred sites. In one origin myth depicted in a bark painting by Mawalan Marika (1908–1967), the first humans, the Wawalag Sisters (seen at the top of figure 24-3), walked about with their digging sticks, singing, dancing, naming things, and populating the land with their children. But they offended the Rainbow Serpent, a symbol of the monsoon rains that bring both fertility and destruction. The serpent swallowed the sisters and designated the place where their descendants were to perform the Wawalag rituals.

Aboriginal artists have continued to work in timehonored and ritually sanctioned ways, and their explana-

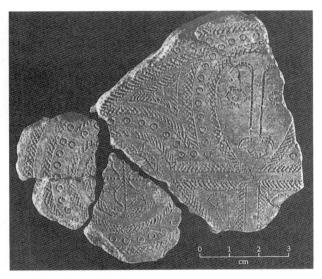

24-4. Fragments of a large Lapita jar, from Venumbo, Reef Santa Cruz Island, Solomon Islands, Melanesia.
 c. 1200–1100 BCE. Clay, height of human face approx.
 11/2" (4 cm)

tions of their work provide insight into the meaning of prehistoric images. Paintings in ocher and clay on eucalyptus bark, created in a ritual context, were used to help maintain and transmit cultural traditions from generation to generation. These paintings reduced complex stories and ideas to essentials and served as memory aids that elders could elaborate upon. Aboriginal artists today may paint with **acrylic** paint on canvas instead of with ocher, clay, and charcoal on rock and eucalyptus bark, but their imagery has remained relatively constant.

MELANESIA Exceptional seafarers spread the Lapita culture throughout the

islands of Melanesia beginning around 1500 BCE. They brought with them the plants and animals that colonizers needed for food, thus spreading agricultural practices through the islands. They also carried with them the distinctive ceramics whose remnants today enable us to trace the extent of their travels. Lapita potters, probably women, produced dishes, platters, bowls, and jars. Sometimes they covered their wares with a red slip, and they often decorated them with bands of incised and stamped geometric patterns-dots, lines, and hatching-heightened with white lime. Most of the decoration was entirely geometric, but some was figurative. The human face that appears on one example (fig. 24-4) is among the earliest representations of a human being in Oceanic art. Over time Lapita pottery evolved into a variety of regional styles in Melanesia, but in western Polynesia, the heartland of Polynesian culture and the easternmost part of the Lapita range, the making of pottery ceased altogether by between 100 and 300 ce.

In Melanesia, as in Australia, the arts were intimately involved with belief and provided a means for communicating with supernatural forces. Rituals and ritual arts were primarily the province of men, who devoted a great

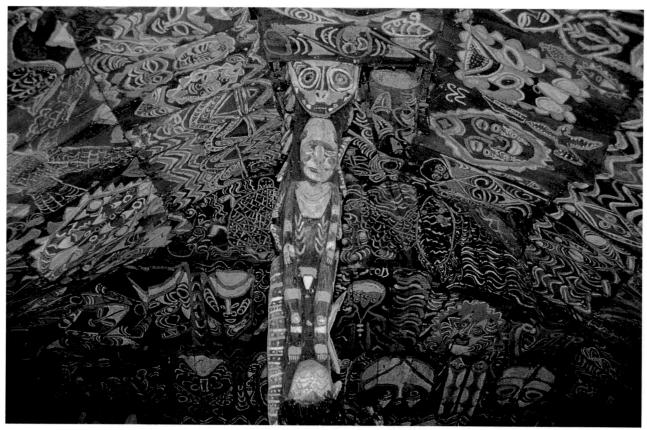

24-5. Detail of *tamberan* house, Sepik River, Papua New Guinea, New Guinea. Abelam, 20th century. Carved and painted wood, with ocher pigments on clay ground

deal of time to both. In some societies most of the adult male population were able to make ritual objects. Although barred from ritual arts, women gained prestige for themselves and their families through their skill in the production of other kinds of goods. To be effective, ritual objects had to be well made, but they were often allowed to deteriorate after they had served their ceremonial function.

Papua New Guinea

New Guinea, the largest island in Melanesia (and at 1,500 miles long and 1,000 miles wide, the second largest island in the world), is today divided between two countries. The eastern half of the island is part of the present-day nation of Papua New Guinea; the western half is Irian Jaya, a province of present-day Indonesia. Located near the equator and with mountains that rise to 16,000 feet, the island's diverse environments range from tropical rain forest to grasslands to snow-covered peaks.

The Abelam, who live in the foothills of the mountains on the north side of Papua New Guinea, raise pigs and cultivate yams, taro, bananas, and sago palms. In traditional Abelam society, people live in extended families or clans in hamlets. A hamlet includes sleeping houses, cooking houses, storehouses for yams, a central space for rituals, and a special men's ceremonial struc-

ture called a *tamberan* house. Wealth among the Abelam is measured in pigs, but men gain status from participation in a yam cult that has a central place in Abelam society and in the **iconography** of its art and architecture. The yams that are the focus of this cult—some of which reach an extraordinary 12 feet in length—are associated with clan ancestors and the potency of their growers. Village leaders renew their relationship with the forces of nature that yams represent during the Long Yam Festival, which is held at harvest time and involves processions, masked figures, singing, and the ritual exchange of the finest yams.

Tamberan houses, which play a central role in these rituals, shelter tamberans, images and objects associated with the yam cult and with clan identity, keeping them hidden from women and uninitiated boys. Men gather in these structures to organize rituals, to conduct community business, and, in the past, to plan raids. The prestige of a hamlet is linked to the quality of its tamberan house and the size of its yams. Constructed on a frame of poles and rafters and roofed with split cane and thatch, tamberan houses have been as much as 280 feet long and more than 40 feet wide. The ridgepole is set at an angle, making one end higher than the other, and the roof extends forward in an overhanging peak that is braced by a carved pole (fig. 24-5). The entrance facade is thus a large, in-folded triangular form, elaborately painted and

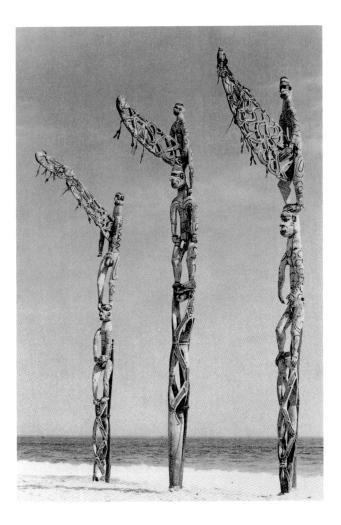

carved. A lintel with carved heads representing ancestors divides the triangular facade into two parts. The lower section is covered by woven rattan panels. The upper section, fully two-thirds of the facade's height, is covered with detachable panels that are painted in red, ocher, white, and black with the faces of a clan's ancestral spirits. The Abelam believe the paint itself has magical qualities. The effectiveness of the images depends in part on accurate reproduction, and master painters direct the work of younger initiates. Regular, ritual repainting revitalizes the images and ensures their continued potency. Every stage in the construction of a tamberan house is accompanied by ceremonies, which are held in the early morning while women and uninitiated boys are still asleep. The completion of a house is celebrated with elaborate fertility rituals and an all-night dance. Women participate in these inaugural ceremonies and are allowed to enter the new house, which is afterward ritually cleansed and closed to them.

Irian Jaya

The Asmat, who live in the grasslands on the southwest coast of Irian Jaya, were known in the past as warriors and headhunters. They believe that a mythic hero carved their ancestors from trees, and to honor the dead they erect memorial poles covered with elaborate sculpture

(fig. 24-6). The poles are known as *mbis*, and the rituals surrounding them, intended to reestablish the balance between life and death, are known as *mbis* ceremonies. After *mbis* ceremonies, the poles are abandoned and allowed to deteriorate.

24-6. Asmat ancestral spirit poles (*mbis*), Faretsj River, Irian Jaya, Indonesia, New Guinea. c. 1960. Wood, paint, palm leaves, and fiber, height approx. 18' (5.48 m).

The Metropolitan Museum of Art, New York

The Michael C. Rockefeller Memorial Collection, Gift of Nelson A. Rockefeller and Mrs. Mary C. Rockefeller, 1965 (1978.412.

Mbis house the souls of the recent dead and stand in front of the village men's house, where the souls can observe the rituals. In the past, once the poles had been carved, villagers would organize a headhunting expedition so that they could place an enemy head in a cavity at the base of each pole. The abstract shapes of the spaces for enemy heads represent the roots of the banyan tree. Above the base are figures representing tribal ancestors supporting figures of the recent dead. The bent pose of the figures associates them with the praying mantis, one symbol of headhunting; another symbol of headhunting is birds breaking open nuts. The large, lacy phalluses emerging from the figures at the top of the poles symbolize male fertility, and the surface decoration suggests tattoos and scarification (patterned scars), common body ornamentation in Melanesia.

New Ireland

The people of the central part of the island of New Ireland, which is one of the large easternmost islands of the nation of Papua New Guinea, are known for their malanggan ceremonies, elaborate funerary rituals for which they make striking painted carvings and masks. Malanggans involve an entire community as well as its neighbors and serve to validate social relations and property claims.

Because preparations are costly and time consuming, malanggans are often delayed for several months or even years after a death and might commemorate more than one person. Although preparations are hidden from women and children, everyone participates in the actual ceremonies. Arrangements begin with the selection of trees to be used for the malanggan carvings. In a ceremony marked by a feast of taro and pork, the logs are cut, transported, and ritually pierced. Once the carvings are finished, they are dried in the communal men's house, polished, and then displayed in a malanggan house in the village malanggan enclosure. Here the figures are painted and eyes made of sea snail shell are inserted. The works displayed in a malanggan house include figures on poles and freestanding sculpture representing ancestors and the honored dead, as well as masks and ritual dance equipment. They are accorded great respect for the duration of the ceremony, then allowed to decay.

Another ritual, the *tatanua* dance, assures male power, and men avoid contact with women for six weeks beforehand. *Tatanua* masks, worn for the dance, represent

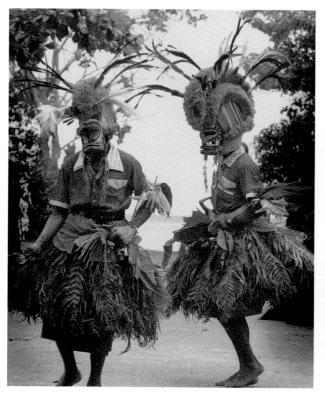

24-7. Dancers wearing *tatanua* masks, Pinikindu Village, central New Ireland, Papua New Guinea, New Guinea. 1979. Masks: wood, vegetable fibers, trade cloth, and pigments, approx. 17 x 13" (43 x 33 cm)

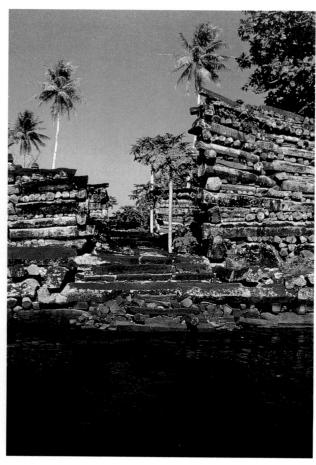

24-8. Royal mortuary compound, Nan Madol, Pohnpei, Federated States of Micronesia. c.1200/1300-c.1500/1600. Basalt blocks, wall height up to 25' (7.62 m)

the spirits of the dead (fig. 24-7). The helmetlike masks are carved and painted with simple, repetitive motifs such as ladders, zigzags, and stylized feathers. The paint is applied in a ritually specified order: first lime white for magic spells; then red ocher to recall the spirits of those who died violently; then black from charcoal or burned nuts, a symbol of warfare; and finally yellow and blue from vegetable materials. The magnificent crest of plant fiber is a different color on the right and the left sides, perhaps a reflection of a lost hairstyle in which the hair was cut short and left naturally black on one side and dyed yellow and allowed to grow long on the other. The contrasting sides of the masks allow dancers to present a different appearance by turning from side to side. A good performance of the tatanua dance is considered a demonstration of strength, while a mistake can bring laughter and humiliation.

MICRONESIA Over the centuries the people of Oceania erected monumental stone architecture and carvings in a number of places. In some cases, in Polynesia for example, widely scattered structures share enough characteristics to suggest that they spring from a common origin. Others

appear to be unique. The site of Nan Madol, on the southeast coast of Pohnpei in Micronesia, is the largest and one of the most remarkable stone complexes in Oceania. Together with a similar, smaller complex on another island nearby, it is also apparently without precedent.

Pohnpei, where today the Federated States of Micronesia's capital city of Palikir is located, is a mountainous tropical island with cliffs of prismatic basalt. By the thirteenth century ce the island's inhabitants were evidently living in a hierarchical society ruled by a powerful chief with the resources to harness sufficient labor for a monumental undertaking. Nan Madol, which covers some 170 acres, consists of 92 small artificial islands set within a network of canals. Most of the islands are oriented northeast-southwest, receiving the benefit of the cooling prevailing winds. Seawalls and breakwaters 15 feet high and 35 feet thick protect Nan Madol from the ocean. Openings in the breakwaters allowed canoes access to the ocean and allowed seawater to flow in and out with the tides and regularly to flush clean the canals. The islands and structures of Nan Madol are built of prismatic basalt "logs" stacked in alternating courses (rows or lavers). Through ingenious technology the logs were split from their source by alternately heating the base of a

PAUL ON OCEANIC ART

At the end of the nine-GAUGUIN teenth century the French Post-Impressionist painter Paul Gauguin (1848-1903) moved to Polynesia,

settling first in Tahiti and later in the Marquesas Islands. Seeking inspiration for his own work, he was deeply appreciative of Oceanic culture and art. He was also, as this passage from his diary reveals, concerned about the destructive impact on that art of European collectors' and colonial administrators' commercial influence:

"In the Marquesan especially there is an unparalleled sense of decoration. Give him a subject even of the most ungainly geometrical forms and he will succeed in keeping the whole harmonious and in leaving no displeasing or incongruous empty spaces. The basis is the human body or the face, especially the face. One is astonished to find a face where one thought there was nothing but a strange geometric figure. Always the same thing, and yet never the same thing.

Today, even for gold, you can no longer find any of those beautiful objects in bone, rock, ironwood which they used to make. The police have stolen it all and sold it to amateur collectors; yet the Administration has never for an instant dreamed of establishing a museum in Tahiti, as it could so easily do, for all this Oceanic art."

(Translated by Van Wyck Brooks)

basalt cliff with fire and dousing it with water. Nan Madol at one time was home to as many as 1,000 people, but it was deserted by the time Europeans discovered it in the nineteenth century.

The royal mortuary compound, which once dominated the southeast side of Nan Madol (fig. 24-8), has walls rising in subtle upward and outward curves to a height of 25 feet. To achieve the sweeping, rising lines, the builders increased the number of stones in the header courses (the courses with the ends of the stones laid toward the face of the wall) relative to the stretcher courses (the courses with the lengths of the stones laid parallel to the face of the wall) as they came to the corners and entryways. The plan of the structure consists simply of rectangles within rectangles: outer walls, interior walls, and a tomb in the center. Visitors arriving at the entrance on the west side and disembarking on the landing there would have stepped up from level to level as they passed through two sets of enclosing walls to an inner courtyard and a small, cubical tomb.

POLYNESIA The settlers of the far-flung islands of Polynesia quickly developed distinctive cultural traditions but also retained linguistic and cultural affinities that reflect their common origin. Traditional Polynesian society was generally far more stratified than Melanesian society, and Polynesian art objects served as important indicators of rank and status. Reflecting this function, they tended to be more permanent than art objects in Melanesia, and they often were handed down as heirlooms from generation to generation. European colonization had a profoundly disruptive effect on society and art in Polynesia, as elsewhere in Oceania. Ironically, a major factor contributing to that impact was the very high regard these outsiders felt for the art they found. The result was that European artists and collectors admired Polynesian art and purchased it avidly, but in so doing they totally altered the context in which much of it was produced (see "Paul Gauguin on Oceanic Art," above).

Easter Island

Easter Island, the most remote and isolated island in Polynesia, is also the site of Polynesia's most impressive sculpture. Stone temples, or marae, with stone altar platforms, or ahu, are common and are found throughout Polynesia. Most of the ahu are built near the coast, parallel to the shore. About 900 ce, Easter Islanders began to erect huge stone figures on ahu, perhaps as memorials to dead chiefs. Nearly 1,000 of the figures, called moai, have been found, including some unfinished in the quarries where they were being made. Carved from tufa, a vellowish brown volcanic stone, most are about 36 feet tall, but one unfinished figure measures almost 70 feet. In 1978 several figures were restored to their original condition, with red tufa topknots on their heads and white coral eyes with stone pupils (see fig. 24-1). The heads have deep-set eyes under a prominent browridge; a long, concave, pointed nose; a small mouth with pursed lips; and an angular chin. The extremely elongated earlobes have parallel engraved lines that suggest ear ornaments. The figures have schematically indicated breastbones and pectorals, small arms with hands pressed close to the sides, but no legs.

Easter Islanders stopped erecting moai around 1500 and apparently entered a period of warfare among themselves, possibly because overpopulation was straining the island's available resources. Most of the moai were knocked down and destroyed during this period. The island's indigenous population, which may at one time have consisted of as many as 10,000 people, was nearly eradicated in the nineteenth century by Peruvian slave traders, who lured inhabitants to the beaches with trading goods, then captured and exported about 1,000 of them. Missionaries secured the freedom of the approximately 100 who survived diseases in Peru, but only 15 lived through the trip home. The smallpox and tuberculosis they brought with them precipitated an epidemic that left only about 600 inhabitants alive on Easter Island.

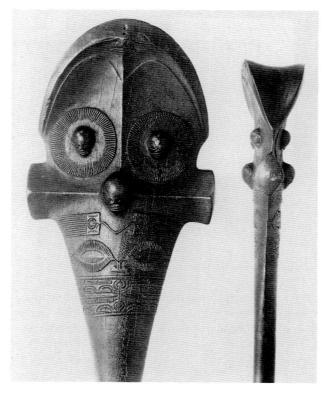

24-9. War club, from Marquesas Islands, Polynesia. Early 19th century. Ironwood, length approx. 5' (1.52 m). Peabody Essex Museum, Salem, Massachusetts

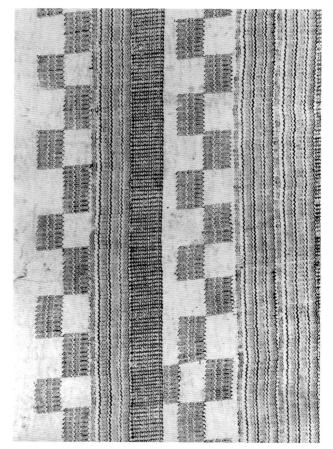

24-10. Skirt originally belonging to Queen Kamamalu, Hawaii. 1823–24. Paper mulberry (wauke) bark, stamped patterns, 12'3" x 5'6" (3.77 x 1.7 m). Bishop Museum, Honolulu Gift of Evangeline Priscilla Starbuck, 1927 (C.209)

Marquesas Islands

Warfare was common in Polynesia and involved hand-to-hand combat. Warriors dressed to intimidate and to convey their rank and status, so weapons, shields, and regalia tended to be especially splendid creations. A 5-foot-long ironwood war club from the Marquesas Islands (fig. 24-9) is lavishly decorated, with a Janus-like double face at the end. More faces appear within these faces. The high arching eyebrows frame sunburst eyes whose pupils are tiny faces. Other patterns seem inspired by human eyes and noses. The overlay of low relief and engraved patterns suggests tattooing, a highly developed art in Polynesia (see fig. 24-12).

Hawaiian Islands

Until about 1200 ce the Hawaiian Islands remained in contact with other parts of Polynesia, but thereafter they were isolated until the English explorer Captain James Cook landed there in 1778. Hawaiian society, divided into several independent chiefdoms, was rigidly stratified. By 1810 one ruler, Kamehameha I (c. 1758–1819), had consolidated the islands into a unified kingdom. The influence of United States missionaries and economic

interests increased during the nineteenth century, and Hawaii's traditional religion and culture declined. The United States annexed Hawaii in 1898, and the territory became a state in 1959.

Decorated bark cloth and featherwork, found elsewhere in Polynesia, were highly developed in Hawaii. Bark cloth, commonly known as tapa (kapa in Hawaii), is made by pounding together moist strips of the inner bark of certain trees, particularly the mulberry tree. The clothmakers, usually women, used mallets with incised patterns that left impressions in the cloth. Like a watermark in paper, these impressions can be seen when the cloth is held up to the light. Fine bark cloth was dyed and decorated in red or black with repeated geometric patterns laboriously made with tiny bamboo stamps. One favorite design consists of parallel rows of chevrons printed close together in sets or spaced in rows. The cloth could also be worked into a kind of appliqué, in which a layer of cutout patterns, usually in red, was beaten onto a light-colored backing sheet. The traditional Hawaiian women's dress consisted of a sheet of bark cloth worn wrapped around the body either below or above the breasts. The example shown here (fig. 24-10) belonged to Queen Kamamalu. Such garments were highly prized and were considered to be an appropriate diplomatic gift. The queen took bark-cloth garments with

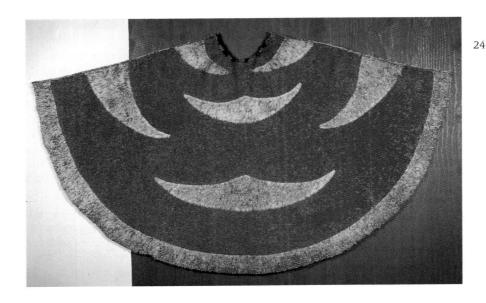

24-11. Feather cloak, known as the Kearny Cloak, Hawaii. c. 1843. Red, yellow, and black feathers, olona cordage, and netting, length 553/4" (143 cm). Bishop Museum, Honolulu Hawaiian chiefs wore feather cloaks into battle, making them prized war trophies as well as highly regarded diplomatic gifts. King Kamehameha III (ruled 1824–1854) presented this cloak to Commodore Lawrence Kearny, commander of the U.S. frigate Constellation.

her when she and King Kamehameha II made a state visit to London in 1823.

The Hawaiians prized featherwork even more highly than fine bark cloth. Feather cloaks, helmets, capes, blankets, and garlands (leis) conveyed special status and prestige, and only wealthy chiefs could command the resources to make them. Tall feather pompons (kahili) mounted on long slender sticks symbolized royalty. And the images of the gods that Hawaiian warriors carried into battle were made of light, basketlike structures covered with feathers. Feather garments, made following strict ritual guidelines, consisted of bundles of feathers tied in overlapping rows to a foundation of plant-fiber netting. Yellow feathers, which came from the Hawaiian honey eater bird, were extremely valuable because one bird produced only seven or eight suitable feathers. Some 80,000 to 90,000 honey eaters were used to make King Kamehameha I's full-length royal cloak. Lesser men had to be satisfied with short capes. Cloaks and capes hung funnel-like from the wearer's shoulders, creating a

sensuously textured and colored abstract design. The typical cloak was red (the color of the gods) with a yellow border and sometimes a narrow decorative neckband. The symmetrically arranged geometric decoration in the example shown here (fig. 24-11) falls on the wearer's front and back; the paired crescents on the edge join when the garment is closed to match the forms on the back. Captain Cook, impressed by the "beauty and magnificence" of Hawaiian featherwork, compared it to "the thickest and richest velvet" (Voyage, 1784, volume 2, page 206; volume 3, page 136).

New Zealand

New Zealand was the last part of Polynesia to be settled. The first inhabitants had arrived by about the tenth century, and their descendants, the Maori, numbered in the hundreds of thousands by the time of European contact in the seventeenth and eighteenth centuries. Captain Cook, before he landed in Hawaii, led a British scientific

ART AND SCIENCE: THE FIRST **CAPTAIN** COOK

The ship Endeavour, under the command of Captain James VOYAGE OF Cook, a skilled geographer and navigator, sailed from Ply-

mouth, England, in August 1768 on a scientific expedition to the Pacific Ocean. On board-in addition to a research team of astronomers, botanists, and other scientists-were two artists, Sydney Parkinson (1745?-1771), a young Scottish botanical drafter, and Alexander Buchan, a painter of landscape and portraits. At that time drawings and paintings served science the way photographs and documentary films and videotapes do today, recording, as Cook wrote, "a better idea . . . than can be expressed by word . . ." (Journal, 1773).

The Endeavour sailed west to Brazil, then south around South America's Cape Horn, and westward across the Pacific Ocean to Tahiti, where Buchan died. The ship went on to explore New Zealand, Tasmania, Australia, and the Great Barrier Reef before returning to England in July 1771, by sailing westward and around Africa's southern tip, the Cape of Good Hope.

Parkinson, frequently working with decaying specimens in cramped quarters on rough seas or plagued by insects, completed more than 1,300 drawings and paintings. His watercolors of plants are especially outstanding. Although he could not replace Buchan as a portrait painter, he did make a few sketches and wash drawings of people, among them drawings of the Maori that provide valuable evidence of their traditional way of life (see fig. 24-12). He died on the return journey, on January 21, 1771. In addition to fulfilling his duties as expedition artist, Parkinson, like the other expedition members, had kept a journal, which was later published.

2000 CE 1500 BCE 2000 CE

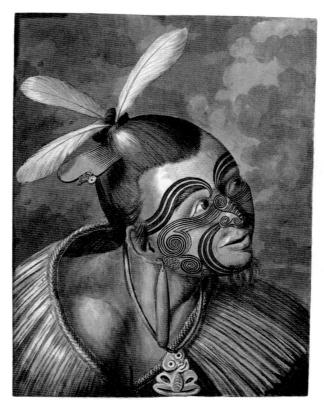

24-12. Sydney Parkinson. Portrait of a Maori. 1769. Wash drawing, 15½ x 115/8" (39.37 x 29.46 cm), later engraved and published as plate XVI in Parkinson's *Journal*, 1773. The British Library, London Add MS 23920 f.55

expedition to the Pacific that explored the coast of New Zealand in 1769. Sydney Parkinson (1745?–1771), an artist on the expedition, documented aspects of Maori life and art at the time (see "Art and Science: The First Voyage of Captain Cook," page 903). An unsigned drawing by Parkinson (fig. 24-12) shows a Maori with facial tattoos (*moko*) wearing a headdress with feathers, a comb, and a hei-tiki (a carved pendant of a human figure).

Combs similar to the one in the drawing can still be found in New Zealand. The long ear pendant is probably made of greenstone, a form of jade found on New Zealand's South Island that varies in color from off-white to very dark green. The Maori considered greenstone to have supernatural powers. The hei-tiki hanging on a cord around the man's neck would have been among his most precious possessions. Such tiki figures, which represented legendary heroes or ancestor figures, gained power from their association with powerful people. The tiki in this illustration has an almost embryonic appearance, with its large tilted head, huge eyes, and seated posture. Some tiki had large eyes of inlaid shell.

The art of tattoo was widespread and ancient in Oceania; bone tattoo chisels have even been found in Lapita sites. Maori men generally had tattoos on the face and on the lower body between the waist and the knees. Women were tattooed around the mouth and on the chin. The typical design of facial tattoos, like the striking one shown here, consisted of broad, curving parallel

lines from nose to chin and over the eyebrows to the ears. Small spiral patterns adorned the cheeks and nose. Additional spirals or other patterns were added on the forehead and chin and in front of the ears. A formal, bilateral symmetry controlled the design. Maori men considered their *moko* designs to be so personal that they sometimes signed documents with them. Ancestor carvings in Maori meetinghouses also have distinctive *moko*. According to Maori mythology, tattooing, as well as weaving and carving, was brought to them from the underworld, the realm of the Goddess of Childbirth. *Moko* might thus have a birth-death symbolism that links the living with their ancestors.

The Maori are especially known for their wood carving, which is characterized by a combination of massive underlying forms with delicate surface ornament. This art form found expression in small works like the hei-tiki in Parkinson's drawing as well as in the sculpture that adorned storehouses and meetinghouses in Maori hilltop villages. The meetinghouse in particular became a focal point of local tradition under the influence of one built in 1842-1843 by Raharuhi Rukupo as a memorial to his brother (fig. 24-13). Rukupo, who was an artist, diplomat, warrior, priest, and early convert to Christianity, built the house with a team of eighteen wood carvers. Although they used European metal tools, they worked in the technique and style of traditional carving with stone tools. They finished the carved wood by rubbing it with a combination of red clay and shark-liver oil to produce a rich, brownish red color.

The whole structure symbolizes the sky father. The ridgepole is his backbone, the rafters are his ribs, and the slanting **bargeboards**—the boards attached to the projecting end of the **gable**—are his outstretched enfolding arms. His head and face are carved at the peak of the roof. The curvilinear patterns on the rafters were made with a silhouetting technique. Artists first painted the rafters white, then outlined the patterns, and finally painted the background red or black, leaving the patterns in white. Characteristically Maori is the *koru* pattern, a curling stalk with a bulb at the end that is said to resemble the young tree fern.

Relief figures of ancestors—Raharuhi Rukupo included a portrait of himself among them—cover the support poles, wall planks, and the lower ends of the rafters. The ancestors, in effect, support the house. They were thought to take an active interest in community affairs and to participate in the discussions held in the meeting-house. Like the hei-tiki in figure 24-12, the figures have large heads. Flattened to fit within the building planks and covered all over with spirals, parallel and hatched lines, and tattoo patterns, they face the viewer head on with glittering eyes of blue-green inlaid shell. Their tongues stick out in defiance from their grimacing mouths, and they squat in the posture of the war dance.

Lattice panels made by women fill the spaces between the wall planks. Because ritual prohibitions, or taboos, prevented women from entering the meeting-house, they worked from the outside and wove the panels from the back. They created the black, white, and

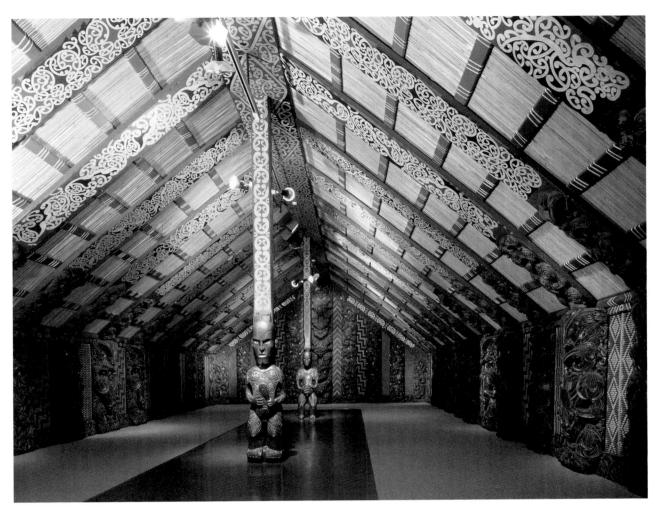

24-13. Raharuhi Rukupo, master carver. Te-Hau-ki-Turanga (Maori meetinghouse), from Manutuke Poverty Bay, New Zealand. 1842–43, restored in 1935. Wood, shell, grass, flax, and pigments. The Museum of New Zealand Te Papa Tongarewa, Wellington, New Zealand. Neg. B18358

orange patterns from grass, flax, and flat slats. Each pattern has a symbolic meaning: Chevrons represent the teeth of the monster Tamsha, steps represent the stairs of Heaven climbed by the hero-god Tashaki, and diamonds represent the flounder.

Considered a national treasure by the Maori, this meetinghouse was restored in 1935 by Maori artists from remote areas still working in traditional methods, and moved to the Museum of New Zealand.

RECENT ART IN OCEANIA

Many contemporary artists in Oceania, in a process anthropologists call **reintegration**, have responded to the impact of European culture by adapt-

ing traditional themes and subjects to new mediums and techniques. The work of a Hawaiian quilt maker and an Australian aboriginal painter provide two examples of the striking and challenging results of this process.

Missionaries introduced fabric patchwork and quilting to the Hawaiian Islands in 1820, and Hawaiian women were soon making distinctive, multilayered stitched quilts. Over time, as cloth became increasingly available, the new arts replaced bark cloth in prestige,

and today they are held in high esteem. Quilts are brought out for display and given as gifts to mark holidays and rites of passage such as weddings, anniversaries, and funerals. They are also important gifts for establishing bonds between individuals and communities.

Royal Symbols, by Deborah (Kepola) U. Kakalia, is a luxurious quilt with a two-color pattern reminiscent of bark-cloth design (fig. 24-14). It combines heraldic imagery from both Polynesian and European sources to communicate the artist's proud sense of cultural identity. The crowns, the rectangular feather standards (kahili) in the corners, and the boldly contrasting red and yellow colors—derived from traditional featherwork—are symbols of the Hawaiian monarchy, even though the crowns have been adapted from those worn by European royalty. The kahili are ancient Hawaiian symbols of authority and rule, and the eight arches arranged in a cross in the center symbolize the uniting of Hawaii's eight inhabited islands into a single Christian kingdom. The quilt's design, construction, and strong color contrasts are typically Hawaiian. The artist created the design the way children create paper snowflakes, by folding a piece of red fabric into eight triangular layers, cutting out the pattern,

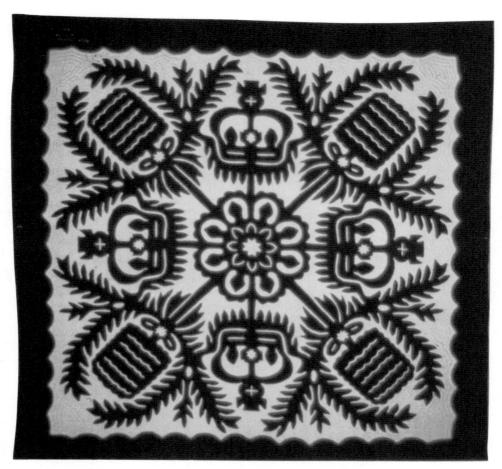

24-l4. Deborah (Kepola) U. Kakalia. *Royal Symbols*. 1978. Quilt (*tifaifai*) of cotton fabric and batting, appliqué, and contour quilting, 6'6¹/₄" x 6'4¹/₂" (1.98 x 1.96 m). Joyce D. Hammond Collection

and then unfolding it. The red fabric was then sewn onto a yellow background with a technique known as contour stitching, in which the quilter follows the outlines of the design layer with parallel rows of tiny stitches. This technique, while effectively securing the layers of fabric and batting together, also creates a pattern that quilters liken to breaking waves.

In Australia, Aborigine artists have adopted canvas and acrylic paint for rendering imagery traditionally associated with more ephemeral mediums like bark, sand, and body painting. Under the influence of an art teacher named Geoff Bardon, who introduced them to the new mediums, a group of Aborigines expert in sand painting—an ancient ritual art form that involves creating large colored designs on the ground—formed an art cooperative in 1971 in Papunya, in central Australia. Their success in transforming their transient, ritual form into a salable commodity encouraged community elders to allow others, including women, to try their hand at painting, which soon became an economic mainstay for many aboriginal groups in the region.

Sand paintings consist of red and yellow ochers, seeds, and feathers arranged on the earth in dots and other symbolic patterns that convey tribal lore to young initiates. Clifford Possum Tjapaltjarri, a founder of the Papunya cooperative who gained an international reputa-

tion after an exhibition of his paintings in 1988, works with his canvases on the floor, using traditional patterns and colors, as well as touches of blue. The superimposed layers of concentric circles and undulating lines and dots in a painting like Man's Love Story (fig. 24-15) create an effect of shifting colors and lights. The painting seems entirely abstract, but it actually conveys a complex narrative involving two mythical ancestors. One of these men came to Papunya in search of honey ants; the white ${\bf U}$ shape on the left represents him seated in front of a water hole with an ants' nest, represented by the concentric circles. His digging stick lies to his right, and white sugary leaves lie to his left. The straight white "journey line" represents his trek from the west. The second man, represented by the brown-and-white U-shape form, came from the east, leaving footprints, and sat down by another water hole nearby. He began to spin a hair string (a string made from human hair) on a spindle (the form leaning toward the upper right of the painting) but was distracted by thoughts of the woman he loved, who belonged to a kinship group into which he could not marry. When she approached, he let his hair string blow away (represented by the brown flecks below him) and lost all his work. Four women (the dotted U shapes) from the group into which he could marry came with their digging sticks and sat around the two men. Rich symbolism fills other areas of

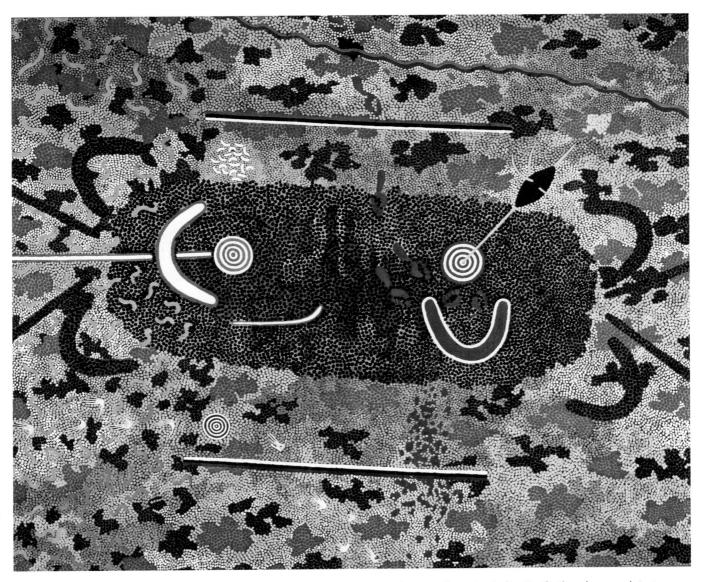

24-15. Clifford Possum Tjapaltjarri. *Man's Love Story*. 1978. Papunya, Northern Territory, Australia. Synthetic polymer paint on canvas, 6'11³/₄" x 8'4¹/₄" (2.15 x 2.57 m). Art Gallery of South Australia, Adelaide

Visual Arts Board of the Australia Council Contemporary Art Purchase Grant, 1980

the painting: The white footprints are those of another ancestral figure following a woman, and the wavy line at the top is the path of yet another ancestor. The black, dotted oval area indicates the site where young men were taught this story. The long horizontal bars are mirages. The wiggly shapes represent caterpillars, and the dots represent seeds, both forms of food.

The point of view of this work may be that of someone looking up from beneath the surface of the earth rather than down from above. Possum first painted the landscape features and the impressions left on the earth by the figures—their tracks, direction lines, and the **U**-shaped marks they left when sitting. Then, working carefully, dot by dot, he captured the vast expanse and

shimmering light of the arid landscape. The painting's resemblance to modern Western painting styles like Abstract Expressionism, **gestural** painting, or Color Field painting (Chapter 29) is accidental. Possum's work remains deeply embedded in the mythic, narrative traditions of his people. Although few artifacts remain from prehistoric times on the Pacific islands, throughout recorded history artists such as Possum have worked with remarkable robustness, freshness, and continuity. They have consistently created arts that express the deepest meanings of their culture despite the incursions of peoples from the Americas and from Europe, who were, at about the same time, "discovering" the classic arts of another continent, Africa.

1900 1925

Bwami mask Lega early 20th century

Spirit spouse Baule early 20th century

Kanaga mask Dogon early 20th century

Ekpo mask Anang Ibibio late 1930s

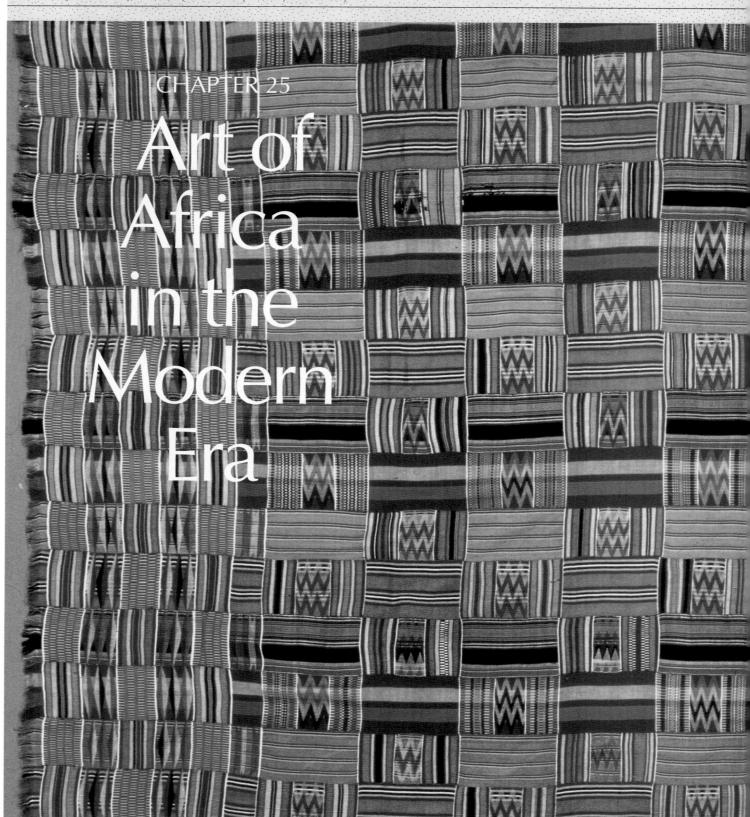

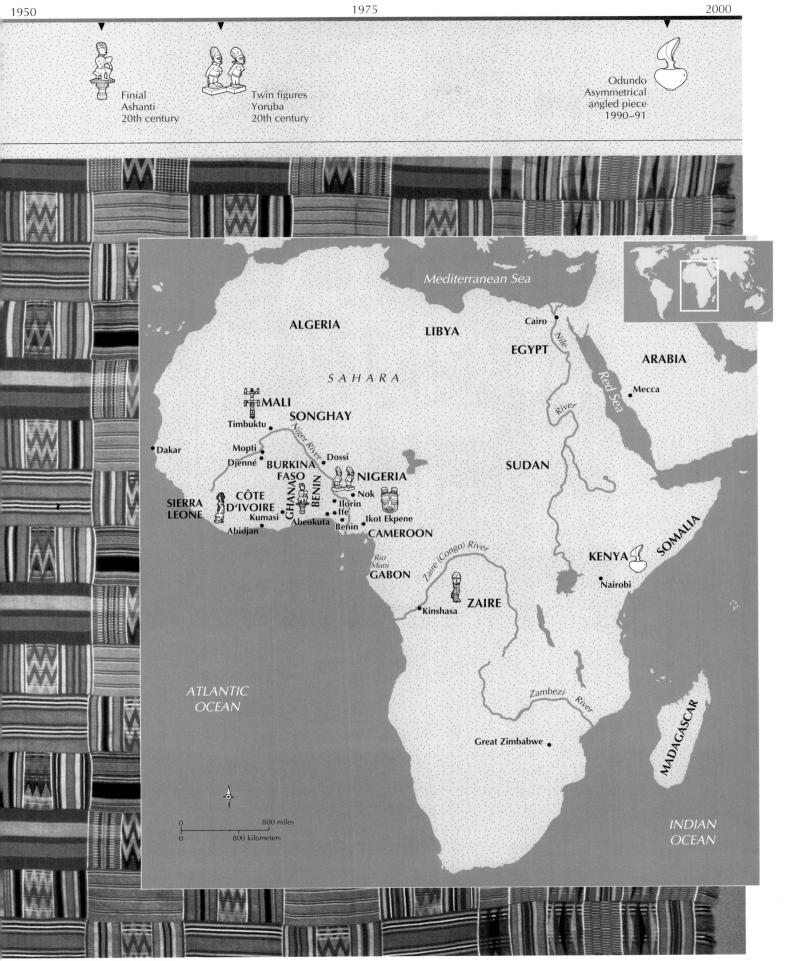

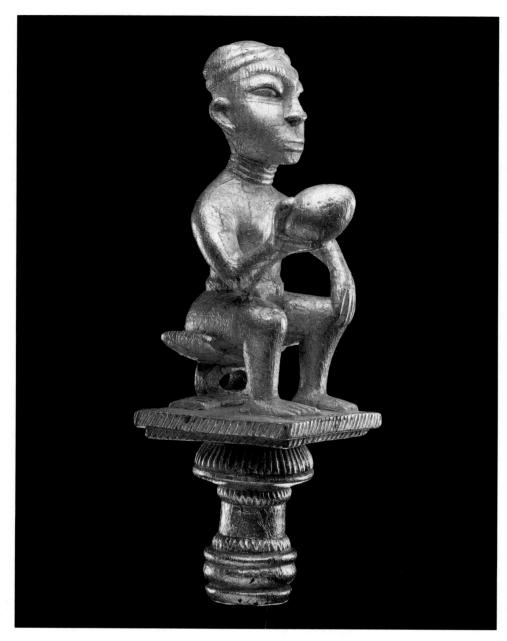

25-1. Finial of a spokesperson's staff (*okyeame poma*), from Ghana. Ashanti culture, 20th century. Wood and gold, height 11¹/₄" (28.57 cm). Musée Barbier-Mueller, Geneva

olitical power is like an egg, says an Ashanti proverb. Grasp it too tightly and it will shatter in your hand; hold it too loosely and it will slip from your fingers. Whenever the *okyeame*, or spokesperson, for one twentieth-century Ashanti ruler was conferring with that ruler or communicating the ruler's words to others, he held before their eyes a staff with this symbolic caution on the use and abuse of power prominently displayed on the gold-leaf-covered **finial** (fig. 25-1).

If we are to attempt to understand African art such as this staff on its own terms, we must first restore it to life. As with the art of so many periods and societies, we must take it out of the glass cases of the museums where we usually encounter it and imagine the artwork playing its vital role in a human community.

TRADITIONAL The second largest conti-AND nent in the world, Africa is a land of enormous diversity. Geographically,

AFRICA it ranges from enormous deserts to tropical rain

forest, from flat grasslands to spectacular mountains and dramatic rift valleys. Human diversity in Africa is equally impressive. More than 1,000 languages have been identified, grouped by scholars into five major linguistic families. Various languages represent unique cultures, with their own history, customs, and art forms.

Before the nineteenth century, the most important outside influence in Africa had been the religious culture of Islam, which spread gradually and largely peacefully through much of West Africa and along the East African coast (see "Foundations of African Cultures," below). The modern era, in contrast, begins with the European exploration and subsequent colonization of the African conti-

nent, developments that brought traditional African societies into sudden and traumatic contact with the "modern" world that Europe had largely created.

European ships first visited sub-Saharan Africa in the fifteenth century. For the next several hundred years, however, European contact with Africa was almost entirely limited to coastal areas, where trade, including the tragic slave trade, was carried out. During the nineteenth century, as the slave trade was gradually eliminated, European explorers began to investigate the unmapped African interior. They were soon followed by Christian missionaries, whose reports greatly fueled popular interest in the continent. Drawn by the potential wealth of Africa's natural resources, European governments began to seek territorial concessions from African rulers. Diplomacy soon gave way to force, and toward the end of the century, competition among rival powers fueled the so-called scramble for Africa, when European governments raced to lay claim to whatever portion of the continent they were powerful

FOUNDATIONS Africa was the OF AFRICAN **CULTURES**

site of one of the great civilizations of the

ancient world, that of Egypt, which arose along the fertile banks of the Nile River over the course of the fourth millennium BCE and lasted for some 3,000 years. Egypt's rise coincided with the emergence of the Sahara, the largest desert in the world, from the formerly lush grasslands of northern Africa. Some of the oldest known African art, images inscribed and painted in the mountains of the central Sahara beginning around 8000 BCE, bears witness to this gradual transformation as well as to the lives of the pastoral peoples who once lived in the region.

As the grassland dried, its populations most likely migrated in search of pasture and arable land. Many probably made their way to the Sudan, the broad band of savanna south of the Sahara. During the sixth century BCE, knowledge of iron smelting spread across the Sudan, enabling larger and more complex societies to emerge. One such society was the iron-working Nok culture, which arose in present-day Nigeria around 500 BCE and lasted until about 200 ce. Terra-cotta figures created by Nok artists are the earliest known sculpture from sub-Saharan Africa.

Farther south in present-day Nigeria, a remarkable culture developed in the city of Ife, which rose to prominence around 800 ce. There, from roughly 1000 to 1400, a tradition of naturalistic sculpture in bronze and terra-cotta flourished, focused on exquisitely modeled memorial heads-possibly actual portraits-of rulers. Ife was, and remains, the sacred city of the Yoruba people, two of whose modern-era sculpture are included in this chapter (figs. 25-3 and 25-10). According to legend, Ife artists brought the techniques of bronze casting to the kingdom of Benin to the southeast. From 1400 through the nineteenth century Benin artists in the service of the court created numerous works in bronze, at first in the naturalistic style of Ife, then becoming increasingly stylized and elaborate.

With the Arab conquest of North Africa during the seventh and eighth centuries, Islamic travelers and merchants became regular visitors to the Sudan. Largely through their writings, we know of the powerful West African empires of Ghana, Mali, and Songhay, which flourished successively from the fourth through the sixteenth centuries along the great bend in the Niger River. All three empires grew wealthy by controlling the flow of African gold and forest products into the lucrative trans-Sahara trade. During their time, such fabled West African cities as Mopti, Djenné, and Timbuktu arose, serving not only as commercial hubs but also as prominent centers of Islam, which became an important cultural force in Africa.

Peoples along the coast of East Africa, meanwhile, had participated since before the Common Era in a maritime trade network that ringed the Indian Ocean and extended east to the islands of Indonesia. Over the course of time, trading settlements arose along the coastline, peopled by Arab, Persian, and Indian merchants as well as Africans. By the thirteenth century these settlements had become important cities, and a new language, Swahili, had developed from the longtime mingling of Arabic with local African languages. Peoples of the interior organized extensive trade networks to funnel goods to these ports, and large-scale political formations grew up around the control of the interior trade. From 1000 to 1500 many of these interior routes were controlled by the Shona people from a site called Great Zimbabwe. The extensive stone ruins of the palace compound there once stood in the center of this city of some 10,000 at its height. With the decline of Great Zimbabwe, control of the southeastern trade network passed to the Mwene Mutapa and Kami empires a short distance to the north.

Numerous cities and kingdoms, often of great wealth and opulence, greeted the astonished eyes of the first European visitors to Africa at the end of the fifteenth century.

PARALLELS

<u>Years</u>	Africa	World
1880-1912	European colonization of all of continent except Ethiopia creates boundaries unre- lated to cultural and language groups	Sino-Japanese War; Alfred Nobel's prizes for peace, science, and literature established (Sweden); Spanish-American War; Russo-Japanese War; Albert Einstein's special theory of relativity
1950–1975	European powers begin granting inde- pendence to territories in Africa; Egypt becomes republic; Organization of African Unity founded; first successful human heart transplant; severe drought spreads south of the Sahara	Korean War begins; French defeated at Dien Bien Phu (Vietnam); Federal Republic of West Germany established; European Common Market established; first human orbits the earth (Soviet Union); first astronauts land on the moon (United States)
1975–present	Political and social upheaval spreads throughout continent; Namibia gains independence; apartheid in South Africa legally dismantled; AIDS and famine resulting from droughts take heavy tolls	Nuclear nonproliferation treaty signed by fifteen nations; Muslim leaders take control of Iran; Soviet Union invades Afghanistan; Indira Gandhi assassinated (India); discovery of AIDS virus reported (United States, France); first Islamic woman prime minister elected (Pakistan); breakup of Soviet Union

enough to take. By 1914 virtually all of Africa had fallen under colonial rule.

In the years following World War I, nationalistic movements arose across Africa. Their leaders generally did not advocate a return to earlier forms of political organization but rather demanded the transformation of colonial divisions into Western-style nation-states governed by Africans. From 1945 through the mid-1970s one colony after another gained its independence, and the present-day map of modern African nations took shape.

Change has been brought about by contact between one people and another since the beginning of time. And art in Africa has both affected and been affected by such contacts. During the early twentieth century the art of traditional African societies played a pivotal role in revitalizing the Western tradition. The formal inventiveness and expressive power of African sculpture were sources of inspiration for European artists trying to rethink strategies of representation. Many contemporary African artists, especially those from major urban centers, have come of age in the postcolonial culture that mingles European and African elements. Drawing easily on the influences from many cultures, both African and non-African, today's artists have established a firm place in the lively international art scene along with their European, American, and Asian counterparts, and their work is shown as readily in Paris, Tokyo, and Los Angeles as it is in the African cities of Abidjan, Kinshasa, and Dakar.

Many traditional societies persist, both within and across contemporary political borders. From the time of the first European explorations and continuing through the colonial era, quantities of art from traditional African societies were shipped back to Western museums. At

first these were not art museums but museums of natural history or ethnography, where the works were exhibited as curious artifacts of "primitive" cultures. Toward the end of the nineteenth century, however, profound changes in Western thinking about art gradually led more and more people to appreciate the inherent aesthetic qualities of traditional African "artifacts" and finally to embrace them fully as art. Art museums began to collect African art more seriously and methodically, both in Africa and in the West. Together with the living arts of traditional peoples today, these collections afford us a rich sampling of African art in the modern era.

Traditional African art plays a vital role in the spiritual and social life of the community. It is used to express Africans' ideas about their relation to their world and as a tool to help them survive in a difficult and unpredictable environment. This chapter explores African art in light of how it addresses some of the fundamental concerns of human existence. Because African art must be considered within its cultural and social contexts, in this chapter we look at works of art within various broad contexts rather than by geographical region or time frame.

CHILDREN AND THE CONTINUITY OF LIFE

Among the most fundamental of human concerns is the continuation of life from one generation to the next. In traditional societies children are especially important, for not

only do they represent the future of the family and the community, but they are also a form of "social security," guaranteeing that parents will have someone to care for them when they are old.

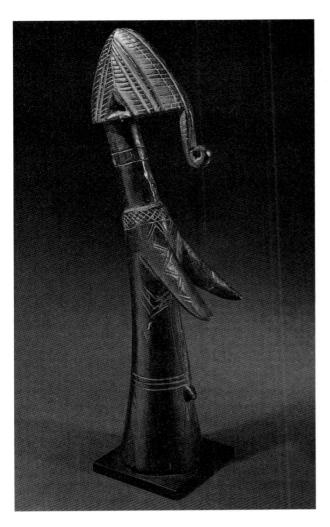

25-2. Doll (*biiga*), from Burkina Faso. Mossi culture, mid-20th century. Wood, height 11¹/4" (28.57 cm). Collection Thomas G. B. Wheelock

In the often harsh and unpredictable climates of Africa, human life can be fragile. In some areas half of all infants die before the age of five, and the average life expectancy may be as low as forty years. In these areas women may bear many children in hopes that a few will survive into adulthood, and failure to have children is a disaster for a wife, her husband, and her husband's lineage. It is very unusual for a man to be blamed as the cause of infertility, so women who have had difficulty bearing children appeal with special offerings or prayers, often involving the use of art.

The Mossi people of Burkina Faso, in West Africa, carve a small wooden figure called *biiga*, or "child," as a plaything for little girls (fig. 25-2). The girls feed and

25-3. Twin figures (*ere ibeji*), from Nigeria. Yoruba culture, 20th century. Wood, height 77/8" (20 cm). The University of Iowa Museum of Art, Iowa City

The Stanley Collection

As with other African sculpture, patterns of use result in particular signs of wear. The facial features of *ere ibeji* are often worn down or even obliterated by repeated feedings and washings. Camwood powder applied as a cosmetic builds to a thick crust in areas that are rarely handled. Even the blue indigo dye regularly applied to the hair eventually builds to a thin layer.

bathe the figures and change their clothes, just as they see their mothers caring for younger siblings. At this level the figures are no more than simple dolls. Like many children's dolls around the world, they show ideals of mature beauty, including elaborate hairstyles, lovely clothing, and developed breasts. The *biiga* shown here wears its hair just as little Mossi girls do, with a long lock projecting over the face. (A married woman, in contrast, wears her lock in back.)

Other aspects of the doll, however, reveal a more complex meaning. The elongated breasts recall the practice of stretching by massaging to encourage lactation, and they mark the doll as the mother of many children. The scars that radiate from the navel mimic those applied to Mossi women following the birth of their first child. Thus, although the doll is called a child, it actually represents the ideal Mossi woman, one who has achieved the goal of providing children to continue her husband's lineage.

Mossi girls do not outgrow their dolls as one would a childhood plaything. When a young woman marries, she brings the doll with her to her husband's home to serve as an aid to fertility. If she has difficulty in bearing her first child, she carries the doll on her back just as she would a baby. When she gives birth, the doll is placed on a new, clean mat just before the infant is placed there, and when she nurses, she places the doll against her breast for a moment before the newborn receives nourishment.

In all societies everywhere, the death of a child is a traumatic event. Many African peoples believe that a dead child continues its life in a spirit world. The parents' care and affection may reach it there, often through the medium of art. The Yoruba people of Nigeria have one of the highest rates of twin births in the world. The birth of twins is a joyful occasion, yet it is troubling as well, for twins are more delicate than single babies, and one or both may well die. When a Yoruba twin dies, the parents consult a diviner, a specialist in ritual and spiritual practices, who may tell them that an image of a twin, or *ere ibeji*, must be carved (fig. 25-3).

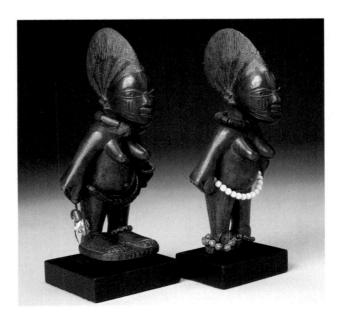

The mother cares for the "birth" of this image by sending the artist food while the figure is being carved. When the image is finished, she brings the artist gifts. Then, carrying the figure as she would a living child, she dances home accompanied by the singing of neighborhood women. She places the figure in a shrine in her bedroom and lavishes care upon it, feeding it, dressing it with beautiful textiles and jewelry, anointing it with cosmetic oils. The Yoruba believe that the spirit of a dead twin thus honored may bring its parents wealth and good luck.

The figures here represent female twins. They may be the work of the Yoruba artist Akiode, who died in 1936. Akiode belonged to the school of Esubiyi, an artist who worked in the Itoko quarter of the city of Abeokuta in southwestern Nigeria. Like most objects that Africans produce to encourage the birth and growth of children, the figures emphasize health and well-being. They have beautiful, glossy surfaces, rings of fat as evidence that they are well fed, and the marks of mature adulthood that will one day be achieved. They represent hope for the future, for survival, and for prosperity.

INITIATION Eventually, an adolescent must leave behind the world of children and take his or her place in the adult world. In contemporary Western societies, initiation into the adult

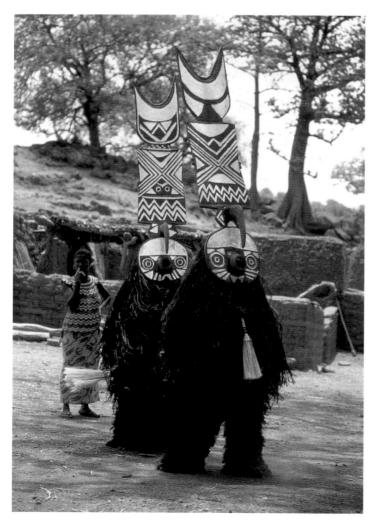

world is extended over several years and punctuated by numerous rites, such as graduating from high school, being confirmed in a religion, earning a driver's license, and reaching the age of majority. All of these steps involve acquiring the spiritual and worldly knowledge Western society deems necessary and accepting the corresponding responsibilities. In other societies, initiation is more concentrated, and the acquisition of knowledge may be supplemented by physical tests and trials of endurance to prove that the candidate is equal to the hardships of adult life.

The Bwa people of central Burkina Faso initiate young men and women into adulthood following the onset of puberty. The initiates are first separated from younger playmates by being "kidnapped" by older relatives, though their disappearance is explained in the community by saying that they have been devoured by wild beasts. The initiates are stripped of their clothing and made to sleep on the ground without blankets. Isolated from the community, they are taught about the world of nature spirits and about the wooden masks that represent them.

The initiates have watched these masks in performance every month for their entire lives. Now, for the first time, they learn that the masks are made of wood and are worn by their older brothers and cousins. They learn of the spirit each mask represents, and they memorize the story of each spirit's encounter with the founding ancestors of the clan. They learn how to construct costumes from hemp to be worn with the masks, and they learn the songs and instruments that accompany the masks in performance. Only the boys wear each mask in turn and learn the dance steps that express the character and personality it represents. Returning to the community, the initiates display their new knowledge in a public ceremony. Each boy performs with one of the masks, while the girls sing the accompanying songs. At the end of the mask ceremony the young men and young women rejoin their families as adults, ready to marry, to start farms, and to begin families of their own.

25-4. Two masks in performance, from Dossi, Burkina Faso. Bwa culture, 1984. Wood, mineral pigments, and fiber, height approx. 7' (2.13 m)

The Bwa have been making and using such masks since well before Burkina Faso achieved its independence in 1960. We might assume their use is centuries old, but in this case, the masks are a comparatively recent innovation. The elders of the Bwa family who own these masks state that they, like all Bwa, once followed the cult of the spirit of Do, who is represented by masks made of leaves. In the last quarter of the nineteenth century the Bwa were the targets of slave raiders from the north and east. Their response to this new danger was to acquire wooden masks from their neighbors, for such masks seemed a more effective and powerful way of communicating with spirits who could help them. Thus, faced with a new form of adversity, the Bwa sought a new tradition to cope with it.

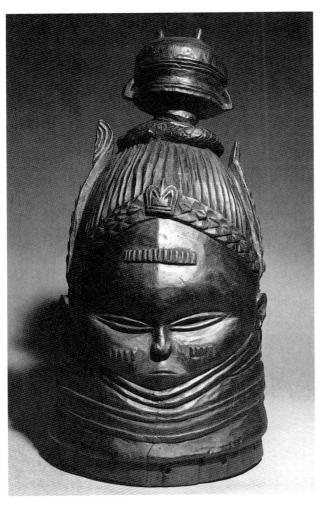

25-5. *Nowo* mask, from Sierra Leone. Mende culture, 20th century. Wood, height 187/8" (48 cm). The Baltimore Museum of Art

Most Bwa masks depict spirits that have taken an animal form, such as crocodile, hyena, hawk, or serpent. Others represent spirits in human form. Among the most spectacular masks, however, are those crowned with a tall, narrow plank (fig. 25-4), which are entirely abstract and represent spirits that have taken neither human nor animal form. The graphic patterns that cover these masks are easily recognized by the initiated. The white crescent at the top represents the quarter moon, under which the initiation is held. The white triangles below represent bull roarers-sacred sound makers that are swung around the head on a long cord to re-create spirit voices. The large central X represents the scar that every initiated Bwa wears as a mark of devotion. The horizontal zigzags at the bottom represent the path of ancestors and symbolize adherence to ancestral ways. That the path is difficult to follow is clearly conveyed. The curving red hook that projects in front of the face is said to represent the beak of the hornbill, a bird associated with the supernatural world and believed to be an intermediary between the living and the dead. Through abstract patterns, the mask conveys a message about the proper moral conduct of life with all the symbolic clarity and immediacy of a traffic signal.

Among the Mende people of Sierra Leone, in West Africa, the initiation of young girls into adulthood is organized by a society of older women called Sande. The initiation culminates with a ritual bath in a river, after which the girls return to the village to meet their future husbands. At the ceremony the Sande women wear black gloves and stockings, black costumes of shredded raffia fibers that cover the entire body, and black masks called nowo (fig. 25-5).

With its high and glossy forehead, plaited hairstyle decorated with combs, and creases of abundance around the neck, the mask represents the Mende ideal of female beauty. The meanings of the mask are complex. One scholar has shown that the entire mask can be compared to the chrysalis of a certain African butterfly, with the creases in particular representing the segments of the chrysalis. Thus, the young woman entering adulthood is like a beautiful butterfly emerging from its ugly chrysalis. The comparison extends even further, for just as the butterfly feeds on the toxic sap of the milkweed to make itself poisonous to predatory birds, so the medicine of Sande is believed to protect the young women from danger. The creases may also refer to concentric waves radiating outward as the mask emerges from calm waters to appear among humankind, just as the initiates rise from the river to take their place as members of the adult community.

A ceremony of initiation may accompany the achievement of other types of membership as well. Among the Lega people, who live in the dense forests between the headwaters of the Zaire River and the great lakes of East Africa, the political system is based on a voluntary association called *bwami*, which comprises six levels or grades. Some 80 percent of all male Lega belong to *bwami*, and all aspire to the highest grade. Women can belong to *bwami* as well, although not at a higher grade than their husbands.

Promotion from one grade of bwami to the next takes many years. It is based not only on a candidate's character but also on his or her ability to pay the initiation fees, which increase dramatically with each grade. No candidate for any level of bwami can pay the fees alone, but all must depend on the help of relatives to provide the necessary cowrie shells, goats, wild game, palm oil, clothing, and trade goods. Candidates who are in conflict with their relatives will never be successful in securing such guarantees and thus will never achieve their highest goals. The ambitions of the Lega to move from one level of bwami to the next encourage a harmonious and well-ordered community, for all must stay on good terms if they are to advance. The association promotes a lifelong growth in moral character and an ever-deepening understanding of the relationship of the individual to the community.

Bwami initiations are held in the plaza at the center of the community in the presence of all members. Dances and songs are performed, and the values and ideals of the appropriate grade are explained through proverbs and sayings. These standards are illustrated by natural or crafted objects, which are presented to the initiate as signs of membership. At the highest two levels of *bwami*, such objects include masks and sculpted figures.

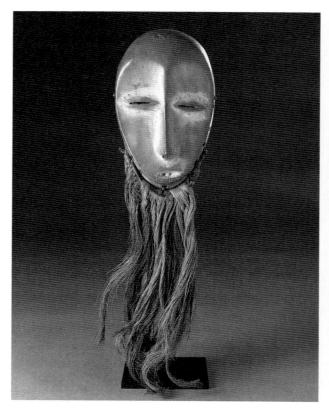

25-6. Bwami mask, from Zaire. Lega culture, early 20th century. Wood and kaolin, height 75/8" (19.3 cm). The University of Iowa Museum of Art, Iowa City The Stanley Collection

The mask in figure 25-6 is associated with yananio, the second highest grade of bwami. Typical of Lega masks, the head is fashioned as an oval into which is carved a concave, heart-shaped face with narrow, raised features. The masks are often colored white with clay and fitted with a beard made of hemp fibers. Too small to cover the face, they are displayed in other ways—held in the palm of a hand, for example, or attached to a thigh. Each means of display recalls a different value or saying, so that one mask may convey a variety of meanings. For example, held by the beard and slung over the shoulder. this mask represents "courage," for it reminds the Lega of a disastrous retreat from an enemy village during which many Lega men were slain from behind.

WORLD

THE SPIRIT Why does one child fall ill and die while its twin remains healthy? Why does one year bring rain and a

bountiful crop, while the next brings drought and famine? All people everywhere confront such fundamental and troubling questions. For traditional African societies the answers are often felt to lie in the workings of spirits. Spirits are believed to inhabit the fields that produce crops, the river that provides fish, the forest that is home to game, the land that must be cleared in order to build a new village. A family, too, includes spirits—those of its ancestors as well as those of children yet unborn. In the blessing or curse of these myriad surrounding spirits lies the difference between success and failure in life.

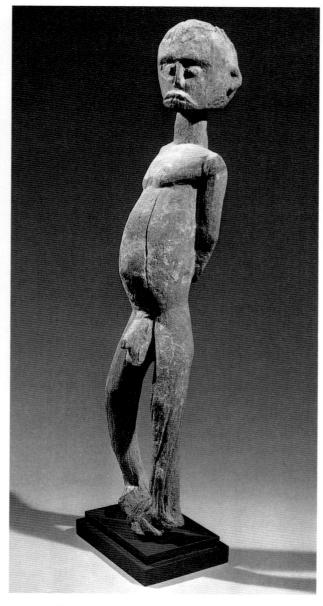

Spirit figure (boteba), from Burkina Faso. Lobi culture, 19th century. Wood, height 3011/16" (78 cm). Collection Kerchache, Paris

To communicate with these all-important spirits, African societies usually rely on a specialist in ritual—the person known elsewhere in the world as priest, minister, rabbi, pastor, imam, or shaman. Whatever his or her title, the ritual specialist serves as an essential link between the supernatural and human worlds, opening the lines of communication through such techniques as prayer, sacrifice, offerings, magic, and divination. Each African people has its own name for this specialist, but for simplicity we can refer to them all as diviners. Art often plays an important role in dealings with the spirit world, for art can make the invisible visible, giving identity and personality to what is abstract and intangible.

To the Lobi people of Burkina Faso, the spirits of nature are known as thila (singular, thil), and they are believed to control every aspect of life. Indeed, their power is so pervasive that they may be considered the true rulers of the community. Lobi houses may be widely scattered

over miles of dry West African savanna. These houses are considered a community when they acknowledge the same *thil* and agree to regulate their society by its rules, called *zoser*. Such rules bear comparison to those binding many religious communities around the world and may include a prohibition against killing or eating the meat of a certain animal, sleeping on a certain type of mat, or wearing a certain pattern or cloth. Totally averse to any form of kingship or centralized authority, the Lobi have no other system of rule but *zoser*.

Thila are normally believed to be invisible. When adversity strikes, however, the Lobi may consult a diviner, who may prescribe the carving of a wooden figure called a *boteba* (fig. 25-7). A *boteba* gives a *thil* physical form. More than simply a carving, a *boteba* is thought of as a living being who can see, move, and communicate with other *boteba* and with its owner. The owner of a *boteba* can thus address the spirit it gives form to directly, seeking its protection or aid.

Each *thil* has a particular skill that its representative *boteba* conveys through pose or expression. A *boteba* carved with an expression of terrible anger, for example, represents a *thil* whose skill is to frighten off evil forces. The *boteba* in figure 25-7 is carved in the characteristic Lobi pose of mourning, with its hands clasped tightly behind its back and its head turned to one side. This *boteba* mourns so that its owner may not be saddened by misfortune. Like a spiritual decoy, it takes on the burden of grief that might otherwise have come to the owner. Shrines may hold dozens of *boteba* figures, each one contributing its own unique skill to the family or community.

Among the most potent images of power in African art are the *nkisi*, or spirit, figures made by the Kongo and Songye peoples of Zaire. The best known of these are the large wooden *nkonde*, which bristle with nails, pins, blades, and other sharp objects (fig. 25-8). A *nkisi nkonde* begins its life as a simple, unadorned wooden figure that may be purchased from a carver at a market or commissioned by a diviner on behalf of a client who has encountered some adversity or who faces some important turning point in his or her life. Drawing on vast knowledge, the diviner prescribes certain magical/medicinal ingredients, called *bilongo*, that will help the client's problem. These *bilongo* are added to the figure, either mixed with white clay and plastered directly onto the body or suspended in a packet from the neck or waist.

The *bilongo* transform the *nkonde* into a living being with frightful powers, ready to attack the forces of evil on behalf of a human client. *Bilongo* ingredients are drawn from plants, animals, and minerals, and may include human hair, nail clippings, and other materials. Each ingredient has a specific role. Some bring the figure to life by embodying the spirit of an ancestor or a soul trapped by a malevolent power. Others endow the figure with specific powers or focus the powers in a particular direction, often through metaphor. For example, the Kongo admire the quickness and agility of a particular species of mouse. Tufts of this mouse's hair included in the *bilongo* act as a metaphor for quickness, ensuring that the *nkisi nkonde* will act rapidly when its powers are activated.

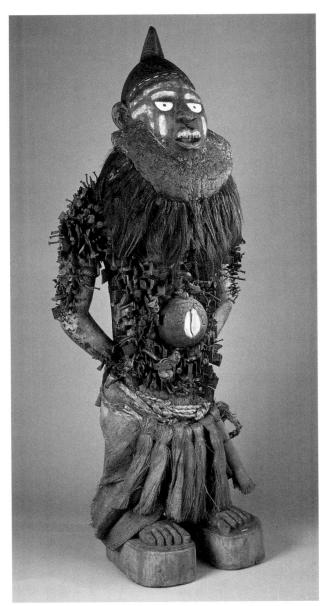

25-8. Power figure (*nkisi nkonde*), from Zaire. Kongo culture, 19th century. Wood, nails, pins, blades, and other materials, height 44" (111.7 cm). The Field Museum, Chicago

Acquisition A109979 c

Nkisi nkonde provide a dramatic example of the ways in which African sculpture are transformed by use. When first carved, the figure is "neutral," with no particular significance or use. Magical materials applied by a diviner transform the figure into a powerful being, at the same time modifying its form. Each client who activates that power further modifies the statue. While the object is empowered, nails may also be removed as part of a healing or oath-taking process. And when the figure's particular powers are no longer needed, the additions may all be stripped away to be replaced with different magical materials that give the same figure a new function. The result is that many hands play a role in creating the work of art we see in a museum. The person we are likely to label as the "artist" is only the initial creator. Many others modify the work, and in their hands the figure becomes a visual document of the history of the conflicts and afflictions that have threatened the community.

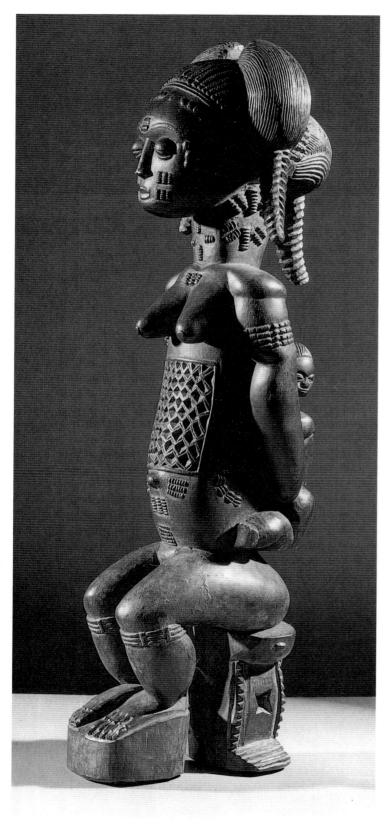

25-9. Spirit spouse (*blolo bla*), from Côte d'Ivoire. Baule culture, early 20th century. Wood, height 17¹/8" (43.5 cm). University Museum, University of Pennsylvania, Philadelphia

To activate the powers, clients drive in a nail or other pointed object to get the nkonde's attention and prick it into action. A nkisi nkonde may serve many private and public functions. Two warring villages might agree to end their conflict by swearing an oath of peace in the presence of the *nkonde* and then driving a nail into it to seal the agreement. Two merchants might agree to a partnership by driving two small nails into the figure side by side and then make their pact binding by wrapping the nails together with a stout cord. Someone accused of a crime might swear his innocence and drive in a nail, asking the nkonde to destroy him if he lied. A mother might invoke the power of the *nkonde* to heal her sick children. The objects driven into the nkonde may also operate metaphorically. For example, the Kongo use a broad blade called a *baaku* to cut into palm trees, releasing sap that will eventually be fermented into palm wine. The word baaku derives from the word baaka, which means both "extract" and "destroy." Thus tiny replicas of baaku driven into the nkonde are believed to destroy those who use evil power.

The word *nkonde* shares a stem with *konda*, meaning "to hunt," for the figure is quick to hunt down a client's enemies and destroy them. The *nkonde* here stands in a pose called *pakalala*, a stance of alertness like that of a wrestler challenging an opponent in the ring. Other *nkonde* figures hold a knife or spear in an upraised hand, ready to strike or attack.

Some African peoples conceive of the spirit world as a parallel realm in which spirits may have families, attend markets, live in villages, and possess personalities complete with faults and virtues. The Baule people in Côte d'Ivoire believe that each of us lived in the spirit world before we were born. While there, we had a spirit spouse, whom we left behind when we entered this life. A person who has difficulty assuming his or her gender-specific role as an adult Baule—a man who has not married or achieved his expected status in life, for example, or a woman who has not borne children—may dream of his or her spirit spouse.

For such a person, the diviner may prescribe the carving of an image of the spirit spouse (fig. 25-9). A man has a female figure (blolo bla) carved; a woman has a male figure (blolo bian) carved. The figures display the most admired and desirable marks of beauty so that the spirit spouses may be encouraged to enter and inhabit them. Spirit spouse figures are broadly naturalistic, with swelling, fully rounded musculature and careful attention to details of hairstyle, jewelry, and scarification patterns. They may be carved standing in a quiet, dignified pose or seated on a traditional throne. The throne contributes to the status of the figure and thus acts as an added incentive for the spirit to take up residence there. The owner keeps the figure in his or her room, dressing it in beautiful textiles and jewelry, washing it, anointing it with oil, feeding it, and caressing it. The Baule hope that by caring for and pleasing their spirit spouse a balance may be restored that will free their human life to unfold smoothly.

While nature spirits are often portrayed in African art, major deities are generally considered to be far

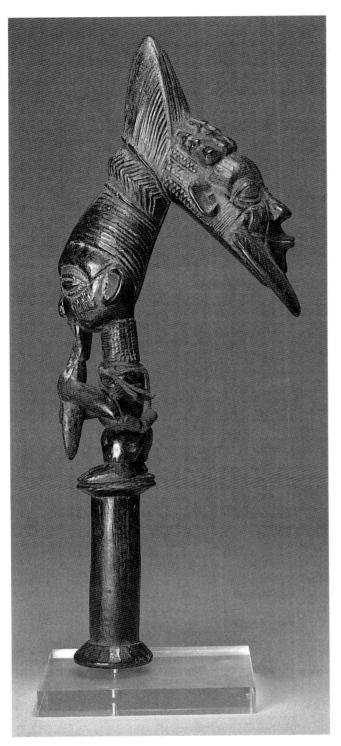

25-10. Dance staff depicting Eshu, from Nigeria. Yoruba culture, 20th century. Wood, height 17" (43.2 cm). The University of Iowa Museum of Art, Iowa City The Stanley Collection

removed from the everyday lives of humans and are thus rarely depicted. Such is the case with Olodumare, also known as Olorun, the creator god of the Yoruba people of southwestern Nigeria. According to Yoruba myth, Olodumare withdrew from the earth when he was insulted by one of his eight children. When the children later

sought him out to ask him to restore order on earth, they found him sitting beneath a palm tree. Olodumare refused to return, although he did consent to give humanity some tools of divination so that they could learn his will indirectly.

The Yoruba have a sizable pantheon of lesser gods, or *orisha*, who serve as intermediaries between Olodumare and his creation. One that is commonly represented in art is Eshu, also called Elegba, the messenger of the gods. Eshu is a trickster, a capricious and mischievous god who loves nothing better than to throw a wrench into the works just when everything is going well. The Yoruba acknowledge that all humans may slip up disastrously (and hilariously) just when it is most important not to, and thus all must recognize and pay tribute to Eshu.

Eshu is associated with two eternal sources of human conflict, sex and money, and is usually portrayed with along hairstyle, because the Yoruba consider long hair to represent excess libidinous energy and unrestrained sexuality. Figures of Eshu are usually adorned with long strands of cowrie shells, a traditional African currency. Shrines to Eshu are erected wherever there is the potential for encounters that lead to conflict, especially at crossroads, in markets, or in front of banks. Eshu's followers hope that their offerings will persuade the god to spare them the pitfalls he places in front of others.

Eshu is intriguingly ambivalent and may be represented as male or female, as a young prankster or a wise old man. The dance staff here beautifully embodies the dual nature of Eshu (fig. 25-10). To the left he is depicted as a boy blowing loud noises on a whistle just to annoy his elders—a gleefully antisocial act of defiance. To the right he is shown as a wise old man, with wrinkles and a beard. The two faces are joined at the hair, which is drawn up into a long phallic knot. The heads crown a dance wand meant to be carried in performance by priests and followers of Eshu, whose bodies the god is believed to enter during worship.

LEADERSHIP As in societies throughout the world, art in Africa is also used to identify those who hold power, to validate their right to kingship or their authority as representatives of the family or community and to communicate the rules for moral behavior that must be obeyed by all members of the society.

The gold-and-wood spokesperson's staff with which this chapter opened is an example of the art of leadership (see fig. 25-1). It belongs to the culture of the Ashanti peoples of Ghana, in West Africa, and was probably carved in the 1960s or 1970s by Kojo Bonsu. The son of Osei Bonsu, a famous carver who died in 1977, Kojo Bonsu lives in the Ashanti city of Kumasi and continues to carve prolifically. Gold was a major source of power for the Ashanti, who traded it first via intermediaries across the Sahara to the Mediterranean world, then later directly to Europeans on the West African coast. Along with other peoples of the region, the Ashanti have used gold for jewelry as well as for objects reserved for the use of rulers, such as the staff.

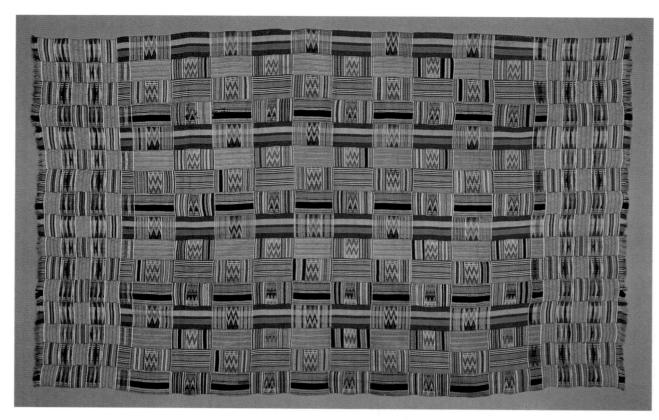

25-11. *Kente* cloth, from Ghana. Ashanti culture, 20th century. Silk, 6'109/16" x 4'39/16" (2.09 x 1.30 m). National Museum of African Art and National Museum of Natural History, Washington, D.C.
Purchased with funds provided by the Smithsonian Collections Acquisition Program, 1983–85, EJ 10583

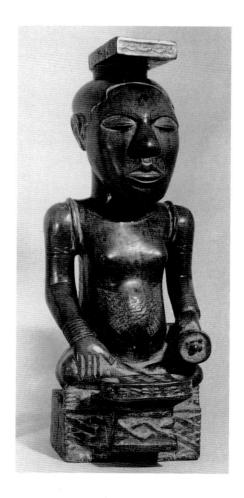

The Ashanti are also renowned for the beauty of their woven textiles, called *kente* (fig. 25-11). Ashanti weavers work on small, light, horizontal looms that produce long, narrow strips of cloth. They begin by laying out the long warp threads in a brightly colored pattern. Today the threads are likely to be rayon. Formerly, however, they were silk, which the Ashanti produced by unraveling Chinese cloth obtained through European trade. Weft threads are woven through the warp to produce complex patterns, including double weaves in which the front and back of the cloth display different patterns. The long strips produced by the loom are then cut to size and sewn together to form large rectangles of finished *kente* cloth.

The *kente* cloth here began with a warp pattern that alternates red, green, and yellow. The pattern is known as *oyokoman ogya da mu*, meaning "there is a fire between two factions of the Oyoko clan," and refers to the civil war that followed the death of the Ashanti king Osai Tutu in about 1730. Traditionally, only the king of the Ashanti was allowed to wear this pattern. Other complex patterns were reserved for the royal family or members of the court. Commoners who dared to wear a restricted pattern were severely punished. In present-day Ghana the wearing of *kente* and other traditional textiles has

25-12. Portrait figure (*ndop*) of Shyaam a-Mbul a-Ngwoong, from Zaire. Kuba culture, mid-17th century. Wood, height 21³/8" (54.5 cm). Museum of Mankind, London

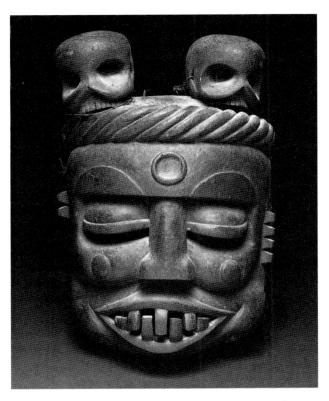

25-13. Ekpo mask, from Nigeria. Anang Ibibio culture, late 1930s. Wood, height 23⁵/8" (60 cm). Musée Barbier-Mueller, Geneva

This mask embodies many characteristics the Ibibio find repulsive or frightening, such as swollen features, matte black skin, and large, uneven teeth. The pair of skulls atop the head are potent death imagery. The circular scar on the forehead and the ropelike headband indicate membership in the diviner's cult, *idiong*, whose members were particularly feared for their supernatural power. The mask is in the style of the Otoro clan from the Ikot Abia Osom area near the city of Ikot Ekpene.

been encouraged, and patterns are no longer restricted to a particular person or group.

The Kuba people of central Zaire have produced elaborate and sophisticated political art since at least the seventeenth century. Kuba kings were memorialized by portrait sculpture called *ndop* (fig. 25-12). While the king was alive, his *ndop* was believed to house his double, a counterpart of his soul. After his death the portrait was believed to embody his spirit, which was felt to have power over the fertility both of the land and of his subjects. Together, the twenty-two known *ndop* span almost 400 years of Kuba history.

Kuba sculptors did not try to capture a physical likeness of each king. Indeed, several of the portraits seem interchangeable. Rather, each king is identified by an icon, called *ibol*, carved as part of the dais on which he is seated. The *ibol* refers to a skill for which the king was noted or an important event that took place during his lifetime. The *ndop* in figure 25-12 portrays the seventeenth-century king Shyaam a-Mbul a-Ngwoong, founder of the Kuba kingdom. Carved on the front of his dais is a board for play-

ing mancala, a game he is said to have introduced to the Kuba. Icons of other kings include an anvil for a king who was a skilled blacksmith, a slave girl for a king who married beneath his rank, and a rooster for a twentieth-century king who was exceptionally vigilant.

Kuba ndop figures also feature carved representations of royal regalia, including a wide belt of cowrie shells crossing the torso. Below the cowries is a braided belt that can never be untied, symbolizing the ability of the wearer to keep the secrets of the kingdom. Cowrieshell bands worn on the biceps are called mabiim. Commoners are allowed to wear two bands; the royal family wear nine. The brass rings depicted on the forearms may be worn only by the king and his mother. The ornaments over each shoulder are made of cloth-covered cane. They represent hippopotamus teeth, and they reflect the prestige that accrues to a hunter of that large animal. Finally, all of the Kuba king figures wear a distinctive cap with a projecting bill. The bill reminds the Kuba of the story of a dispute that arose between the sons of their creator god in which members of one faction identified themselves by wearing the blade of a hoe balanced on

Not all African peoples centralized power in a single ruler. Most of the peoples of southeastern Nigeria, for example, depended on a council of male elders or on a men's voluntary association to provide order in the life of the community. The Anang Ibibio people of Nigeria were formerly ruled by a men's society called Ekpo. Ekpo expressed its power in part through art, especially large, dark, purposely frightening masks (fig. 25-13). In most rituals involving masks, it is "the mask," not the person wearing it, who takes the action. Such masks were worn by the younger members of the society when they were sent out to punish transgressors. Accompanied by assistants bearing torches, the mask would emerge from the Ekpo meetinghouse at night and proceed directly to the guilty person's house, where a punishment of beating or even execution might be meted out. The identity of the executioner was concealed by the mask, which identified him as an impersonal representative of Ekpo in much the same way that a uniform makes it clear that a police officer represents the authority of the state.

DEATH AND ANCESTORS

In the traditional African view, death is not an end but a transition—the leaving behind of one phase of life and the beginning of another. Just as ceremonies

marked the initiation of young men and women into the community of adults, so they mark the initiation of the newly dead into the community of spirits. Like the rites of initiation into adulthood, death begins with a separation from the community, in this case the community of the living. A period of isolation and trial follows, during which the newly dead spirit may, for example, journey to the land of ancestors. Finally, the deceased is reintegrated into a community, this time the community of ancestral spirits. The memory of the deceased may be preserved among the living, and his or her spirit may be

1900 2000

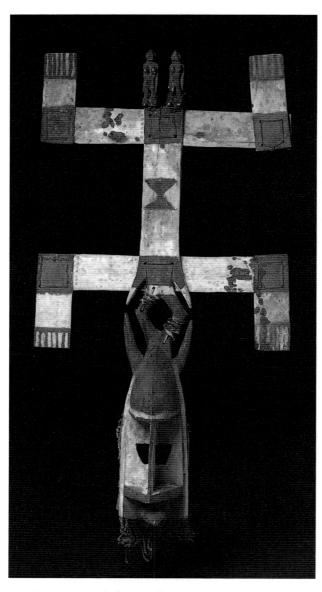

25-14. *Kanaga* mask, from Mali. Dogon culture, early 20th century. Wood, height 45¹/4" (115 cm). Musée Barbier-Mueller, Geneva

appealed to for intercession on their behalf with nature spirits or to prevent the spirits of the dead from using their powers to harm.

Among the Dogon people of Mali, in West Africa, the period of mourning following the death of an elder is brought to an end by a ceremony called *dama*, meaning "forbidden" or "dangerous." During *dama*, masks perform in the public square to the sound of gunfire to drive the soul of the deceased from the village. Among the most common masks is the *kanaga*, whose rectangular face supports a superstructure of planks that depict a crocodile or lizard with splayed legs (fig. 25-14).

If the deceased was a man, men from the community later engage in a mock battle on the roof of his home and participate in ritual hunts; if the deceased was a woman, the women of the community smash her cooking vessels on the threshold of her home. These portions of *dama* are reminders of human activities the deceased will no longer engage in. An elaborate *dama* commissioned by a wealthy

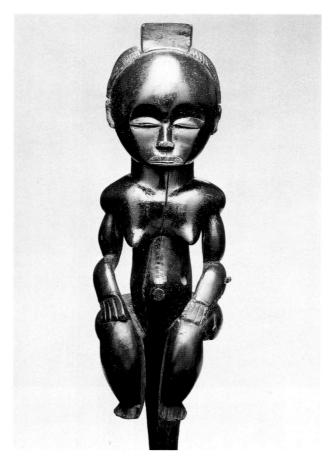

25-15. Reliquary guardian (*nlo byeri*), from Gabon. Fang culture, 19th century. Wood, height 16⁷/8" (43 cm). Musée Dapper, Paris

family may last as long as six days and include the performance of as many as 100 masks. Because a *dama* is so costly, it may be performed for several deceased elders, both male and female, at the same time.

The Fang people, who live near the Atlantic coast from southern Cameroon through Rio Muni and into northern Gabon, follow an ancestral religion in which the long bones and skulls of ancestors who have performed great deeds are collected after burial and placed together in a cylindrical bark container called nsekh o byeri. Deeds thus honored include killing an elephant, being the first to trade with Europeans, bearing an especially large number of children, or founding a particular lineage or community. On top of the container the Fang place a wooden figure called nlo byeri, which represents the ancestors and guards their relics from malevolent spirit forces (fig. 25-15). Nlo byeri are carved in a naturalistic style, with carefully arranged hairstyles, fully rounded torsos, and heavily muscled legs and arms. Frequent applications of cleansing and purifying palm oil produce a rich, glossy black surface.

The strong symmetry of the statue is especially notable. The layout of Fang villages is also symmetrical, with pairs of houses facing each other across a single long street. At each end of the street is a large public meetinghouse. The Fang immigrated into the area they now occupy during the early nineteenth century. The

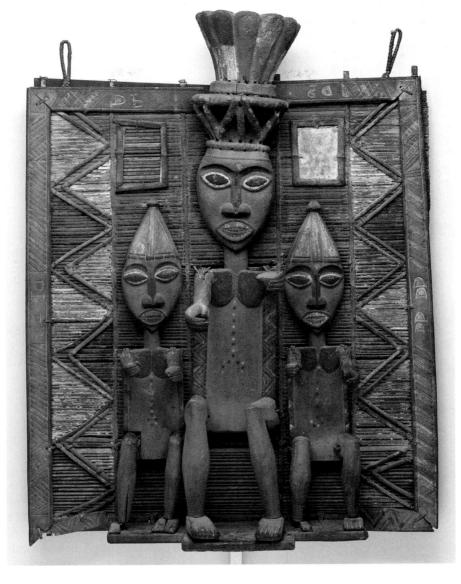

the contract which is

25-16. Ancestor screen (duen fobara), from Abonnema village, Nigeria. Kalabari group, Ijo culture, 19th century. The Minneapolis Institute of Arts

experience was disruptive and disorienting, and Fang culture thus emphasizes the necessity of imposing order on a disorderly world. Many civilizations have recognized the power of symmetry to express permanence and stability (see, for example, the Forbidden City in Beijing, China, fig. 21-8).

Internally, the Fang strive to achieve a balance between the opposing forces of chaos and order, male and female, pure and impure, powerful and weak. They value an attitude of quiet composure, of reflection and tranquillity. These qualities are embodied in the powerful symmetry of the *nlo byeri* here, which communicates the calm and wisdom of the ancestor while also instilling awe and fear in those not initiated into the Fang religion.

Among the most complex funerary art in Africa are the memorial ancestral screens made during the nineteenth century by the Ijo people of southeast Nigeria (fig. 25-16). The Ijo live on the Atlantic coast, and with their great canoes formerly mediated the trade between European ships anchored offshore and communities in the interior of Nigeria. During that time groups of Ijo men organized themselves into economic associations called

canoe houses, and the heads of canoe houses had much power and status in the community. When the head of a canoe house died, a screen such as the one in figure 25-16 was made in his memory. The Ijo call these screens *duen fobara*, meaning "foreheads of the dead." (The forehead were believed to be the seat of power and the source of success.) The screens are made of wood and cane that were joined, nailed, bound, and pegged together. The assembly technique is unusual, because most African sculpture is carved from a single piece of wood.

Although each screen commemorates a specific individual, the central figure was not intended as a physical likeness. Instead, as is common in Africa, identity was communicated through attributes of status, such as masks, weapons, or headdresses that the deceased had the right to wear or display. The central figure of the example here wears a hat that distinguishes him as a member of an important men's society called *peri*. He is flanked by assistants, followers, or supporters of the canoe house, who are portrayed on a smaller scale. All three figures originally held weapons or other symbols of aggressiveness and status. Other extant screens include

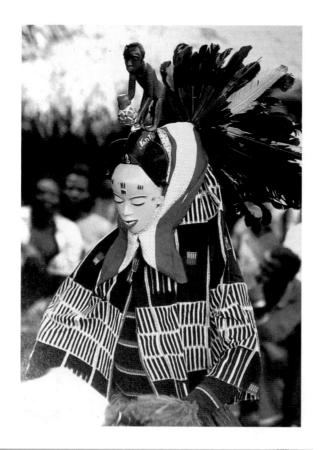

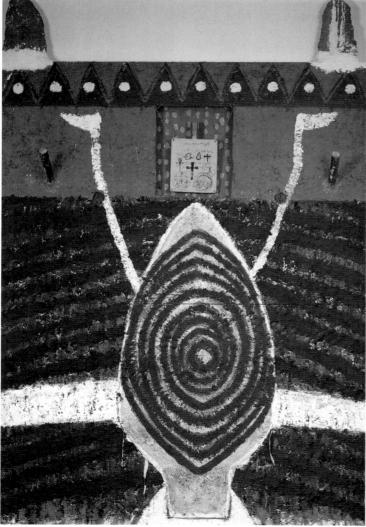

25-17. Spirit mask in performance, from Côte d'Ivoire. Guro culture, early 1980s. Polychrome wood, height approx. 18" (45.72 cm)

smaller heads attached to the top of the frame, perhaps wearing masks that the deceased had commissioned. and representations of the severed heads of defeated enemies at the feet of the figures.

Memorial screens were placed in the ancestral altars of the canoe house, where they provided a dwelling for the spirit of the dead, who was believed to continue to participate in the affairs of the house after his death, ensuring its success in trade and war.

CONTEMPORARY The photograph in this

ART chapter of the Bwa masks in performance (see fig.

25-4) was taken in 1984. Even as you read this chapter, new costumes are being made for this year's performance, in which the same two masks will participate. Many traditional communities continue their art in contemporary Africa. But these communities do not live as if in a museum, re-creating the forms of the past as though nothing had changed. As new experiences pose new challenges or offer new opportunities, art changes with them.

Perhaps the most obvious change in traditional African art has been in the adaptation of modern materials to traditional forms. The Guro people of Côte d'Ivoire, for example, continue to commission delicate masks dressed with costly textiles and other materials. But now they paint them with oil-based enamel paints, endowing the traditional form with a new range and brilliance of color (fig. 25-17). The Guro have also added inscriptions in French and depictions of contemporary figures to sculptural forms that have persisted since before the colonial period. Other peoples have similarly made use of European textiles, plastics, metal, and even Christmas tree ornaments to enhance the visual impact of their art. Some Yoruba have used photographs and even brightly colored imported plastic children's dolls in place of the traditional ere ibeji, the images of twins shown in figure 25-3.

Throughout the colonial period and especially during the years following World War II, Europeans established schools in Africa to train talented artists in the mediums and techniques of European art. In the postcolonial era numerous African artists have studied in Europe and the United States, and many have become known internationally through exhibits in galleries and museums.

One such artist is Ouattara (b. 1957), represented here by Nok Culture (fig. 25-18). Ouattara's background exemplifies the fertile cross-cultural influences that shape the outlook of contemporary urban Africans. Born in Côte d'Ivoire, he received both formal French schooling and traditional African spiritual schooling. His father practiced both Western-style surgery and traditional African heal-

25-18. Ouattara. Nok Culture. 1993. Acrylic and mixed mediiums on wood, 9'81/2" x 6'73/4" (2.96 x 2.03 m). Collection of the artist

ing. At nineteen Ouattara moved to Paris to absorb at first-hand the modern art of Europe. He currently lives and works in New York, Paris, and Abidjan. In paintings such as *Nok Culture*, Ouattara draws on his entire experience, synthesizing Western and African influences.

Nok Culture is dense with allusions to Africa's artistic and spiritual heritage. Its name refers to a culture that thrived in Nigeria from about 500 BCE to 200 CE and whose naturalistic terra-cotta sculpture are the earliest known figurative art from sub-Saharan Africa. Here, thickly applied paint has built up a surface reminiscent of the painted adobe walls of rural architecture. Tonalities of earth browns, black, and white appear frequently in traditional African art, especially in textiles. The conical horns at the upper corners evoke the ancestral shrines common in rural communities as well as the buttresses of West African adobe mosques. The motif of concentric circles at the center of the composition looks much like the traditional bull-roarer sound maker used to summon spirits. Suspended in a window that opens into the painting is a lesson board of the type used by Muslim students in Koranic schools. On the board appear Arabic writing, graphic patterns from African initiation rituals, and symbols from the Christian, ancient Egyptian, and mystical Hebrew traditions—a vivid if cryptic evocation of the many spiritual currents that run together in Africa.

Another art that has brought contemporary African artists to international attention is ceramics. Traditionally, most African pottery has been made by women. In some West African societies, potters were married to blacksmiths, both husband and wife making products that take raw ingredients from the earth and transform them by fire. These couples lived apart from the community both physically and socially, respected for their skills yet feared for the intimate contact they had with the powers of earth and fire.

Today, making pottery has enabled many women from traditional communities to attain a measure of economic independence. In Nigeria it is not uncommon to see large trucks stopped at a potters' village, loading up pots to be transported to distant markets. The women do not usually share their pottery income with the male head of the family but keep it to buy food for themselves and their children. In one large pottery community in Ilorin, a northern city of the Yoruba people in Nigeria, women have subcontracted the dreary and physically demanding tasks of gathering raw clay and fuel to local men so that they can concentrate on forming their wares, for which there is a great demand. In this way they control much of the local economy.

Nourished by this long tradition, some women have achieved broader recognition as artists. One is Magdalene Odundo (b. 1950), whose work displays the flawless surfaces of traditional Kenyan pottery (fig. 25-19). Indeed, she forms her pots using the same coiling technique that her Kenyan relatives use. Like Ouattara,

25-19. Magdalene Odundo. *Asymmetrical Angled Piece*. 1991. Reduced red clay, height 17" (43.18 cm). Collection of Werner Muensterberger

Odundo draws her inspiration from a tremendous variety of sources, both African and non-African. In the workshops she presents at colleges and art schools she shows hundreds of slides of pottery. She begins with images of Kenyan potters and pottery, then quickly moves on to pottery from the Middle East, China and Japan, and ancient North and South America. Odundo works in England, teaches in Europe and the United States, and shows her art through a well-known international dealer. Yet the power of traditional African forms is abundantly evident in the elegant pot illustrated here.

The painter Ouattara probably speaks for most contemporary artists around the world when he says, "[M]y vision is not based only on a country or a continent, it's beyond geography or what you see on a map, it's much more than that. Even though I localize it to make it understood better, it's wider than that. It refers to the cosmos" (cited in McEvilley, page 81). In his emphasis on the inherent spirituality of art, Ouattara voices what is most enduring about the African tradition.

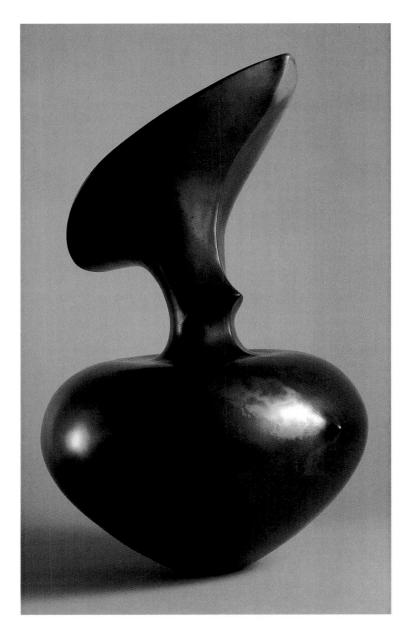

Boyle Chiswick House

Patterson and Washington Mount Vernon

The Nightmare David
Oath of
the Horatii
1784–85

Langhans Brandenburg Gate 1788–91

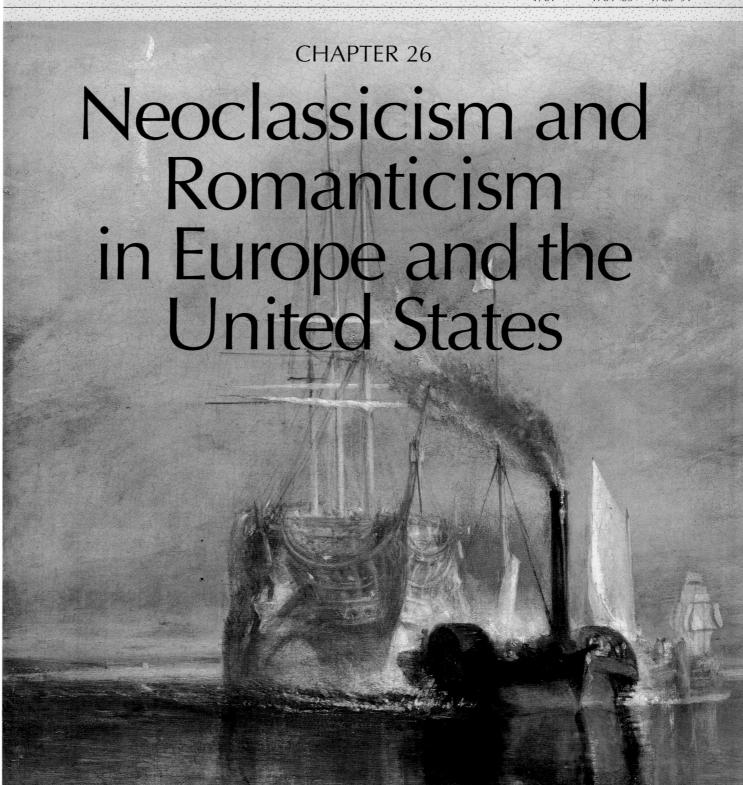

as Venus Victrix

Canova Maria Paulina Borghese

Goya Third of May, 1808 1814–15

Barye Lion Crushing a Serpent 1833

Bingham Fur Traders Descending the Missouri

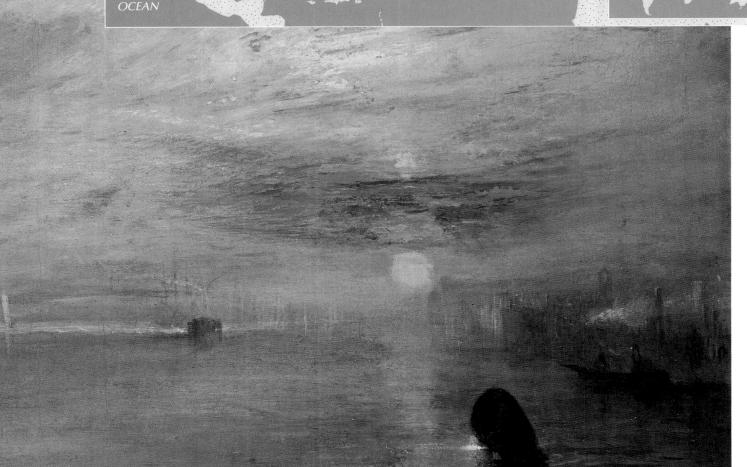

26-1. William Hackwood, for Josiah Wedgwood. "Am I Not a Man and a Brother?" 1787. Black-and-white jasperware, 13/8 x 13/8" (3.5 x 3.5 cm). Trustees of the Wedgwood Museum, Barlaston, Staffordshire, England

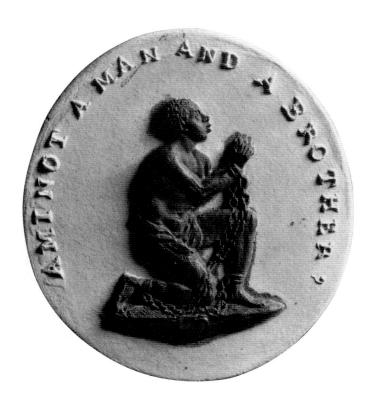

or two centuries the name *Wedgwood* has been synonymous with exquisitely made English ceramics. The man who first gave his name to these fine ceramics, Josiah Wedgwood, had begun to work in his family's pottery business at age nine, and through sheer inventiveness and superlative taste he transformed ceramics in England from an industry to a popular art. Wedgwood became the maker of a creamcolored earthenware that quickly gained wide popularity and was known as Queen's ware, in honor of England's Queen Charlotte, and he created a dinner service for Catherine the Great of Russia.

But there was another side to Wedgwood. He established a village named Etruria for his employees and cared deeply about their living conditions. Wedgwood was also active in the international effort to halt the African slave trade and abolish slavery. To publicize the abolitionist cause, he asked the sculptor William Hackwood to design an emblem for the British Committee to Abolish the Slave Trade, formed in 1787. The compelling image created by Hackwood, a small white-and-black medallion, was carved in relief in the likeness of a black African man kneeling in chains, with the legend "Am I Not a Man and a Brother?" (fig. 26-1). Wedgwood sent copies of the medallion to Benjamin Franklin, the president of the Philadelphia Abolition Society, and to others in the abolitionist movement. In the nineteenth century the women's suffrage movement in the United States adapted the image by representing a woman in chains with the motto "Am I Not a Woman and a Sister?"

A work of art as explicitly political as this was highly unusual in the eighteenth century, although not unique. There were artists in both Europe and America who responded to the tumultuous social and political changes with powerful and courageous works of art.

ENLIGHTENMENT

REVOLUTION In the eighteenth cen-AND tury, growing dissatisfaction with the political system in Great Britain, France, and Colonial

America led to sweeping changes. In Britain the king's prerogatives gradually came to be exercised by a cabinet responsible to Parliament, while in North America thirteen of Britain's colonies successfully revolted against George III. The monarchy in France was also overthrown in armed revolution. As political power was shifting from the Crown and the nobility, the Industrial Revolution was bringing a new prosperity to the middle classes.

Despite the republican fervor of the French Revolution, which began in 1789, the revolutionary government did not endure. After a series of political upheavals, General Napoleon Bonaparte established himself first as dictator (First Consul) in 1799, then in 1804 as Emperor Napoleon I. Napoleon's subsequent military conquests redrew the map of Europe and radically altered its political life.

These enormous changes reflected an attitude, which developed during the eighteenth century, that valued scientific inquiry both into the natural world and into human life and society. Reason became the touchstone for evaluating nearly every civilized endeavor, including philosophy, art, and politics. By extension, nature, which was thought to embody reason, was also evoked to corroborate the correctness—and goodness—of everything from political systems to architectural designs. It was generally believed that people are inherently reasonable and that if given an opportunity and if their ignorance were dispelled they would choose what is reasonable and good. These beliefs led cultural historians to call the eighteenth century the Age of Enlightenment, or the Age of Reason.

Two of the most influential theorists of the Enlightenment were the French philosopher and critic Denis Diderot (1713-1784) and the Swiss philosopher Jean-Jacques Rousseau (1712-1778). Diderot published criticism of the Royal Academy's biennial Salon exhibitions

ACADEMY EXHIBITIONS

During the seventeenth century

the French government founded a number of royal academies for the support and instruction of students in literature, painting and sculpture, music, dance, and architecture. In 1667 the Royal Academy of Painting and Sculpture began to mount occasional exhibitions of the members' recent work. These exhibitions came to be known as Paris Salons because they were held in the Salon d'Apollon ("Salon of Apollo") in the Palais du Louvre. After a reorganization of the Royal Academy in 1737 the Salons were held every other year, with a jury of members selecting the works that would be shown. As the only public art exhibitions of any importance in Paris, the Salons were enormously influential in establishing officially approved styles and in molding public taste, and they helped consolidate the Royal Academy's dictatorial control over the production of fine art.

In England the Royal Academy of Arts was quite different. Although chartered by King George III in 1768, it was a private institution independent of any interference from the Crown. It had only two functions, to operate an art school and to hold two annual exhibitions, one of art of the past and another of contemporary art, which was open to any exhibitor on the basis of merit alone. The Royal Academy continues to function in this way to the present day.

In France the Revolution of 1789 brought a number of changes to the Royal Academy. In 1791 the jury system was abolished as a relic of the monarchy, and the Salon was democratically opened to all artists. In 1793 all of the royal academies were disbanded and in 1795 reconstituted as the newly founded Institut de France, which was to administer the art school-the École des Beaux-Artsand sponsor the Salon exhibitions. The number of would-be exhibitors was soon so large that it became necessary to reintroduce some screening procedure, and so the jury system was revived.

In 1816, with the return of the monarchy after the defeat of Napoleon I at Waterloo, the division of the

Institut dedicated to painting and sculpture was renamed the Académie des Beaux-Arts, and thus the old Academy was in effect restored. During the following years this new Academy exerted enormous influence over artistic matters, just as the old one had in the past. As time went on, increasing numbers of artists began to protest its control of the Salons. In response to the growing dissatisfaction, Emperor Napoleon III established the Salon des Refusés ("Salon of the Rejected Ones") in 1863 to exhibit work that had not been accepted by the Academy's jury. The opening of an officially sanctioned alternate exhibition greatly changed the artistic climate of Paris, encouraging increasing numbers of independent exhibitions and, ultimately, breaking the absolute dominance of the Academy.

Johann Zoffany. Academicians of the Royal Academy. 1771-72. Oil on canvas, 471/2 x 591/2" (120.6 x 151.2 cm). The Royal Collection. Windsor Castle, Windsor, England

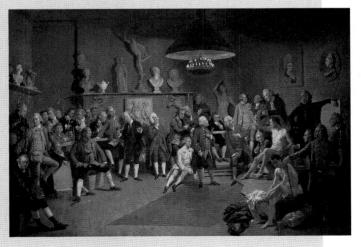

1725	1875

PARALLELS		
Culture Center	<u>1725–1800</u>	<u>1800–1875</u>
Italy	Excavations of Pompeii and Hercula- neum; Winckelmann distinguishes Greek and Roman styles in painting and sculpture; Antonio Canova; Neoclassi- cism emerges	
Britain	Lord Burlington promotes Neoclassical architecture; Hogarth's Marriage à la Mode; British landscape and genre paintings increase; British Empire in India; history paintings gain popularity; James Watt develops steam engine; Joshua Reynolds's Grand Manner portraits; romance of science paintings; Copley exhibits at London Society of Artists; George III charters Royal Academy of Art; Angelica Kauffmann and Mary Moser named to Royal Academy; Josiah Wedgwood perfects jasperware; Britain recognizes American independence; Gainsborough's portraits; Romantic literary movement	United Kingdom of Great Britain and Ireland established; Constable's White Horse; Houses of Parliament redesigned; Turner's Fighting "Téméraire"
France	Grand Manner emerges; Jean-Jacques Rousseau's Émile and Le Contrat Social; David's Oath of the Horatii; Vigée- Lebrun's portraits of Marie Antoinette; French Revolution; David's Death of Marat; Napoleon First Consul; Neoclas- sicism in France at its peak	Napoleon I of First Empire; Ingres's Large Odalisque; Romanticism emerges; royal restoration of Louis XVIII; Géricault's Raft of the "Medusa"; Charles X; Delacroix's The Twenty-eighth of July: Liberty Leading the People; Revolution of 1830; Louis Philippe; Rude's La Marseillaise; Napoleon III of Second Empire
Germany	King Frederick William II of Prussia; Langhans's Brandenburg Gate; Mozart's <i>Don Giovanni</i>	Beethoven's Ninth Symphony; Marx and Engels's Communist Manifesto
Spain	King Charles III; King Charles IV	Goya's <i>Third of May, 1808</i> ; King Joseph Bonaparte; King Ferdinand VII installed by British
United States	Georgian style; Boston Tea Party; Declaration of Independence; Federal style; George Washington president	Thomas Jefferson president; Latrobe initiates Greek Revival style; Louisiana Purchase from France doubles U.S. territory; Audubon's <i>The Birds of America</i> ; Cole's <i>The Oxbow</i> ; Texas annexed; Oregon acquired; California gold rush; Stowe's <i>Uncle Tom's Cabin</i> ; South Carolina secedes; Civil War begins; slavery abolished; Abraham Lincoln assassinated; first transcontinental railroad
World	Qing dynasty continues (China); Catherine the Great (Russia); Hermitage Museum founded (Russia)	Mexico becomes a republic; South African Republic established; Crimean War between Turkey and Russia; Italy is united; Dominion of Canada is formed

(see "Academy Exhibitions," page 929) in the popular press, decrying what he considered the empty pomposity of the Baroque period and the frivolity of the Rococo style, calling instead for an edifying art that would glorify virtue. To forge this new artistic expression, artists sought models in classical antiquity, the Renaissance, and even the Baroque period. Raphael and Poussin were held in high esteem, but by far the most influential artist was Michelangelo. Michelangelo's art was heroic, serious, and certainly edifying, and it reflected unparalleled virtuosity. Many late-eighteenth-century artists felt the need to come to terms with his example, often by deliberate imitation.

Another manifestation of the eighteenth-century spirit of inquiry that profoundly affected both art and literature was the development of historicism, or the consciousness of history. Literate people increasingly valued accurate descriptions of historical events, which resulted in greater accuracy in the depiction of not only classical subjects but also Gothic, Romanesque, and various Asian styles.

Around 1750 Rococo tendencies in art and architecture, responding to the general longing for a noble and serious mode of expression, gave way to a restrained and formal style of representation referred to as the Grand Manner. This term encompassed not only the new style but also the more restrained modes of seventeenthcentury classicism, the monumental stillness of Greek sculpture, and the dignified gravity of Roman painting. Thus, the Grand Manner was not a radical change but essentially a shift toward greater reserve and formality. It was an important change, however, for it signaled a movement toward true Neoclassicism.

The theoretical basis for the specifically classical style called Neoclassicism emerged in Rome in the 1760s. It was stimulated in part by new discoveries in excavations of Pompeii and Herculaneum, Roman cities buried by the first-century eruption of Mount Vesuvius. The leaders of the Neoclassic movement were German and British expatriates, primarily the German archeologist and art critic Johann Winckelmann (1717–1768), the German painter Anton Raphael Mengs (1728-1779), and the Scottish artist and archeologist Gavin Hamilton (1723-1798). Winckelmann was the movement's main propagandist, and although he never visited Greece himself, his ideas influenced nearly every artist who worked in Rome during the 1750s and 1760s, whether Italian or foreign. Winckelmann was the first antiquarian, or scholar of antiquities, to distinguish between Greek and Roman styles of architecture and sculpture, and he considered the Greek superior. As a result, artists in Rome began to emulate Classical models more closely, particularly those thought to be Greek. The Neoclassicism that developed in Rome was characterized by Classical subject matter, formal dependence on antique sources, heroic nudity in sculpture, and the use of pure line in painting and drawing. These qualities were generally accompanied by an underlying moralism that exalted the virtues associated by the moderns with Republican Rome: moral incorruptibility, patriotism, and courage.

In the late eighteenth century the French artist

Jacques-Louis David developed a distinctively Neoclassical painting style by bringing together his study of Classical sculpture in Rome and of academic realism at the Royal Academy, one of a number of academies—official societies of learned persons founded to advance the arts—established in Europe during this period. The first public showing of this work, in 1781, was enthusiastically received, and Diderot declared the young man a genius.

Despite the dominance of classicism in the second half of the eighteenth and early nineteenth centuries, much art of that period was imaginative and "irrational"-a strain of expression called Romanticism because many of its themes were taken from medieval "romances"-novellas, stories, and poems in Romance (Latin-derived) languages. Thus, the term Romantic suggests something fantastic or novelistic, perhaps set in a remote time or place, and a spirit of poetic fancy or even melancholy. Many paintings and sculpture combined elements of Neoclassicism and Romanticism. Indeed, because Neoclassical and Romantic art are both characterized by "remoteness in time or place," it can even be argued that the overriding impulse in European and American art from roughly 1725 to 1875 was Romanticism and that Neoclassicism was simply one of its subcategories. In fact, Neoclassicism itself embodies many contradictions, and some Neoclassic art exhibits such clearly "Romantic" qualities as eroticism, violence, and expressive formal distortions. Many artists also moved from one style to another, perhaps painting in a very Baroque vein for one work, then in a Neoclassic manner for another.

GRAND

THE From the late 1600s until well into the nineteenth century, one feature of the education of young gentlemen (and, TOUR occasionally, gentlewomen) of northern

Europe and the American colonies that had great influence on European art was the grand tour. Generally accompanied by a tutor and an entourage of servants, wealthy travelers visited the cultural sights of primarily France and Italy for several years as a way of enhancing a classical education. Typically, the tour began with visits to the Louvre and the Royal Academy in Paris, then proceeded to southern France to see a number of wellpreserved Roman monuments, followed by a passage to Italy through the Alps, considered the ultimate in sublime scenery. In Italy the principal points of interest were Venice, Florence, Rome, and Naples, whose picturesque settings, magnificent art, and exciting social life led many tourists to stay for months. All these cities had large expatriate communities, where a traveler from the north could feel at home.

The grand tour was influential for several reasons. As art collecting and connoisseurship (the study of styles and quality in art) came to be considered proper aristocratic pastimes, many important Italian paintings and antique statues were acquired for private collections in northern Europe. The sights of the grand tour also had a profound effect on those artists who traveled. Not surprisingly, Italian artists responded to this rich and

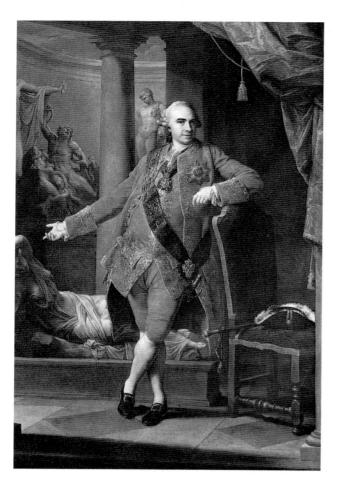

26-2. Pompeo Batoni. *Portrait of Count Razoumowsky.* 1766. Oil on canvas, 9'9¹/2" x 6'5" (2.99 x 2.07 m). Collection Count Razoumowsky, Vienna

cultivated foreign clientele. In Rome the portraits of Pompeo Batoni (1708–1787) were considered the pinnacle of urbanity and refinement, and visiting foreigners besieged him with commissions. A full-length painting of the Russian Count Razoumowsky (fig. 26-2), president of the St. Petersburg Academy of Science, is typical of Batoni's Grand Manner portraits. The count, in an embroidered velvet coat sparkling with imperial decorations, is portrayed as a cultivated visitor to the papal collection of antique sculpture, his somewhat studied gestures and relaxed but dignified demeanor marking him as a model of cosmopolitan nobility.

Travelers on the grand tour also enthusiastically bought *vedute* (Italian for "views"; singular, *veduta*), paintings of the cities they visited. The Venetian artist Giovanni Antonio Canal, called Canaletto (1697–1768), became so popular among British clients that his dealer arranged for him to work from 1746 to 1755 in England, where he painted views of London and the surrounding countryside, giving impetus to a school of English land-scape painting.

In 1762 George III purchased Canaletto's *Santi Giovanni e Paolo and the Monument to Bartolommeo Colleoni* (fig. 26-3), painted probably in 1735–1738. The Venetian square is shown as if the viewer were in a gondola on a

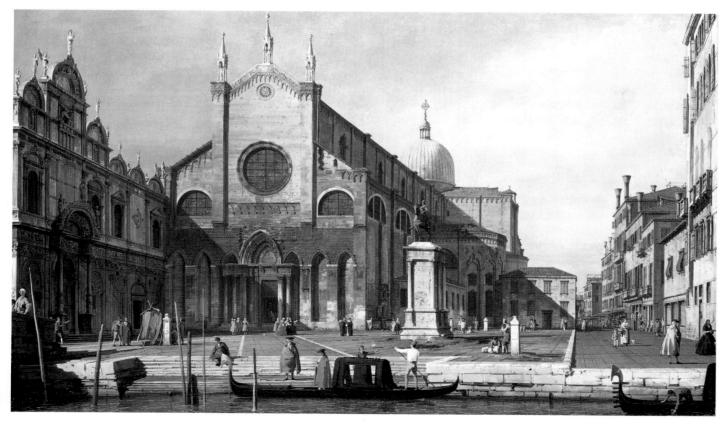

26-3. Canaletto. Santi Giovanni e Paolo and the Monument to Bartolommeo Colleoni. c. 1735–38. Oil on canvas, 183/8 x 307/8" (46 x 78.4 cm). The Royal Collection, Windsor Castle, Windsor, England

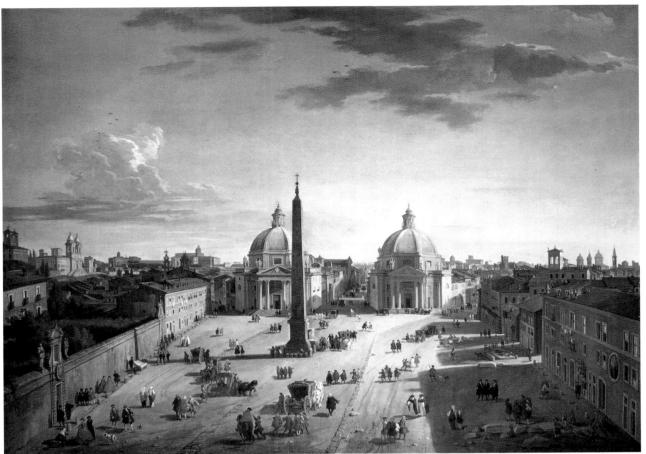

26-4. Giovanni Paolo Panini. *View of the Piazza del Popolo, Rome*. 1741. Oil on canvas, 38 x 52³/₄" (96.6 x 134 cm). The Nelson-Atkins Museum of Art, Kansas City, Missouri

Purchase: Acquired through the Generosity of an Anonymous Donor (F79-3)

nearby canal. Immediately to the right is a perspectival plunge down the street into the distance. Many of Canaletto's views, like this one, are topographically correct; in others he rearranged the buildings to tighten the **composition** (the way the parts of the painting were put together), even occasionally adding features to produce a **capriccio** ("caprice"), or mixture of pleasing motifs.

In Rome the view painter Giovanni Paolo Panini (c. 1692–1765), like Canaletto, specialized in painting his city's sights and was especially favored by French patrons. His views, too, are sometimes topographically correct and sometimes imaginary, with actual ruins placed in fantasy settings. His *View of the Piazza del Popolo, Rome* (fig. 26-4) of 1741 is a faithful view of a Roman square from above, which a visitor today might see from a tall building.

Giovanni Battista Piranesi (1720–1778), another artist catering to Rome's foreign clientele, became one of the most successful publishers of prints in the eighteenth century. Trained in Venice as an architect, Piranesi went to Rome in 1740. After studying etching, he began in 1743 to produce portfolios of prints, and in 1761 he established his own publishing house. Piranesi is best known for his views of ancient Roman ruins, such as *The Arch of Drusus* (fig. 26-5), published in a portfolio of etchings called *Le Antichità Romane* (*Roman Antiquities*) in

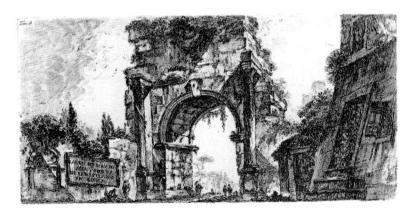

26-5. Giovanni Battista Piranesi. *The Arch of Drusus*. 1748. Etching, 14⁷/₁₆ x 28³/₄" (37 x 73 cm). Published in *Le Antichità Romane* (later retitled *Arco Trionfali*), Rome, 1748. The Pierpont Morgan Library, New York PML 12601

Piranesi's children carried on his publishing business after his death. Encouraged by Napoleon's officials, his sons Francesco and Piero moved the operation in 1799 to Paris, where between 1800 and 1807 they made and sold restrikes (posthumous impressions) of all of their father's etchings. Later Piranesi's plates were purchased by the Royal Printing House in Rome and reprinted again.

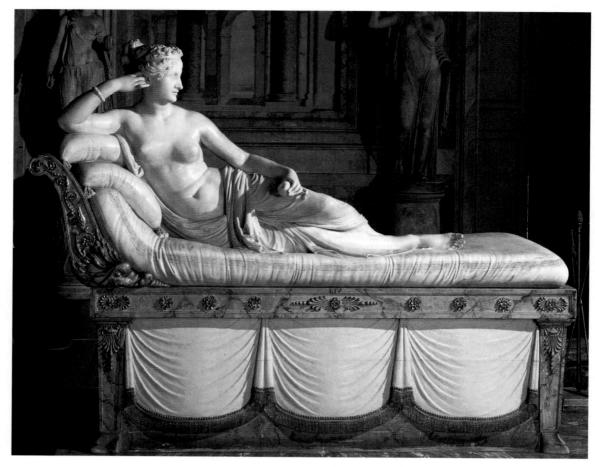

26-6. Antonio Canova. *Maria Paulina Borghese as Venus Victrix*. 1808. Marble, 5'27/8" x 6'6³/₄" (1.6 x 2 m). Galleria Borghese, Rome

Paulina Borghese was a younger sister of Napoleon Bonaparte. The widow of a French general, in 1803 she married Prince Camillo Borghese, a member of the old nobility of Rome. Prince Borghese remained a firm supporter of his brother-in-law, serving as his governor of Piedmont in 1807.

1748. Although Piranesi was deeply in sympathy with the antiquarianism of Winckelmann and the Neoclassicists, the poetry of his vision, with its dramatic shadows, wild growths of trees and vines, picturesque figures, colossal sense of scale, and his monuments' aura of crumbling majesty, reveals an early Romantic sensibility. Piranesi's imaginative evocation of antiquity is one of many intersections of the Neoclassic and Romantic impulses.

ITALY Although Rome was the cradle of the Neoclassic movement, few Italian artists were stylistic innovators. In the second half of the eighteenth century, however, sculptors in Rome began to assimilate the new classicism, which in turn influenced many foreign artists who had come to the city to study and work.

Antonio Canova

In the late eighteenth century the foremost Neoclassical artist in Italy—and, indeed, in Europe—was the sculptor Antonio Canova (1757–1822). Born into a family of stonemasons near Venice, Canova settled in Rome in 1781 after traveling to Naples to see the Greek temples at Paestum and the excavations at Pompeii and Hercula-

neum in 1779–1780. Canova rapidly achieved such renown that critics compared him with Michelangelo. Every serious collector hoped to own one of his pieces, including Catherine the Great of Russia, whose invitation to her court the sculptor politely declined.

Napoleon, too, became a patron. One of Canova's most admired works is a portrait of the emperor's sister, Maria Paulina Borghese as Venus Victrix (fig. 26-6), completed in 1808. The princess is shown as an idealized, partially nude goddess reclining on an elaborately carved Neoclassical couch, her calm facial expression suggesting divine detachment. In one hand she holds an apple, an allusion to the golden apple awarded by the Trojan prince Paris to Aphrodite (the Greek name of Venus) for her beauty. Canova's sculpture is a study in delicately calibrated contrasts. The rounded forms of the goddess's body are set off by crisp folds of drapery, the softness of her skin by the rough texture of her hair, and the lustrous off-white finish that Canova gave his marbles by the veined gray-lavender stone and gilded details of the couch. Canova is said to have finished his surfaces by candlelight so that no subtlety would be lost, which enabled him to produce the almost miraculously delicate shading evident in this work. Although carved fully in the

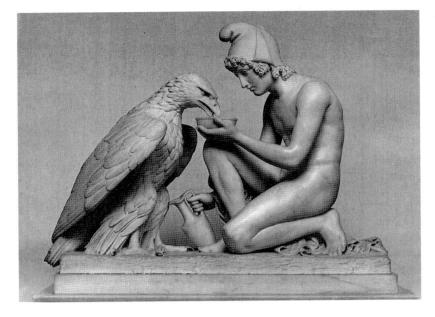

26-7. Bertel Thorvaldsen. *Ganymedes* with Jupiter's Eagle. 1817. Marble, lifesize. Thorvaldsens Museum, Copenhagen

round, the figure is meant to be seen from one side, as if it were a relief sculpture. Canova's interest in line here is characteristic of his style and of the Neoclassic style in general after 1800.

Bertel Thorvaldsen

After studying for five years at the Royal Academy of Sculpture in Copenhagen, the Danish sculptor Bertel Thorvaldsen (1768/1770-1844) arrived in Rome on March 3, 1797, a day he thereafter considered his birthday. By the early nineteenth century his reputation was second only to Canova's in Neoclassic sculpture. The work of the two sculptors is quite different. Thorvaldsen left his marbles stark white, whereas Canova preferred an off-white finish; Thorvaldsen's proportions were heavier, his cutting sharper, and his surfaces harder. He maintained a large workshop—with about forty assistants by 1820—that inculcated his severe Neoclassic style in the young sculptors who came to Rome to study, including many Americans. A particularly fine example of Thorvaldsen's work is a statue of Ganymedes with Jupiter's Eagle (fig. 26-7), of 1817. Like most Neoclassic sculpture after 1800, this piece presents the carefully articulated profile of a line drawing, and many of its effects—such as the precise cutting of feathers and hair and the dry, spare treatment of muscle and drapery—tend to be linear.

BRITAIN In the early eighteenth century the British theorists Colin Campbell (d. 1729) and Jonathan Richardson the Elder (1665–1745), like Diderot later in France, called for a reform in art because of the moral decay and disillusionment they found in government, in Britain's case those of George I (ruled 1714–1727) and George II (ruled 1727–1760). Like Diderot, Campbell and Richardson believed that art should promote and support "civic humanism," or public virtue and integrity, and for this they favored a restrained classical style.

Later in the century there were nonclassical developments in Britain, as well. The term *Romantic*, originally invented to denote a literary preoccupation with nature that lasted from around 1790 to 1830, was extended to cover painting in the same vein. The subject of most Romantic painting in Britain, like British Romantic poetry, was the country's landscape and everyday life. Like the poetry, these paintings often suggested melancholy, loss, and disillusionment. Indeed, in contrast to the Enlightenment point of view, the Romantic sensibility both in Britain and on the Continent considered nature not "reasonable" or idyllic but poetically lonely, eerie, thrilling, or even terrifying.

Two terms common in Romantic art criticism were picturesque and sublime. In 1757, for example, the British philosopher and diplomat Edmund Burke distinguished the familiar, comprehensible, and reassuring as the beautiful (or the picturesque), while subjects that evoked a strong emotional reaction were sublime. Thus, pleasant country views or rural genre scenes (episodes of everyday life) were called picturesque, and more aweinspiring subjects were considered sublime. The art of Michelangelo was quintessentially sublime. Dramatic landscape features, such as towering mountains, thundering waterfalls, rocky crags, dismal forests, crumbling ruins, or erupting volcanoes, were inherently sublime, especially if portrayed to emphasize their extremes. Paintings of historical and literary subjects might also be sublime if they were presented dramatically.

Architecture and Decoration

In Britain Vitruvius (first century BCE) and Palladio (sixteenth century CE) were major inspirations for architecture during most of the eighteenth century, although British architects, like their seventeenth-century predecessor Inigo Jones (see fig. 19-62), often integrated Baroque, Rococo, or more modern elements into their Palladian buildings. Early in the century Richard Boyle,

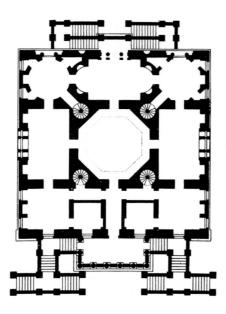

 Richard Boyle, Lord Burlington. Plan of Chiswick House, West London. 1724

third earl of Burlington (1695-1753), promoted classicism in English architecture. He made two trips to Italy, including one dedicated to the study of Palladio's architecture. The best-preserved of Burlington's works is his residence at Chiswick, West London, designed in 1724. The building's plan (fig. 26-8) shares the mathematical rationale and symmetry of Palladio's Villa Rotonda (see fig. 18-36), although its central core is octagonal rather than round and there are only two entrances on opposite sides, one with a porch designed to look like a Classical temple. Chiswick's elevation is characteristically Palladian, with a main floor resting on a basement, and tall rectangular windows with triangular pediments, but Burlington introduced a staircase on each side of the porch rather than a single steep flight at the center (fig. 26-9). The result is a lucid evocation of Palladio's design, whose few but crisp details seem perfectly suited to the refined proportions of the whole. It is hard to believe that only twenty years separate this exquisite building from the rugged angularity of Blenheim Palace (see fig. 19-66).

In Rome Burlington had persuaded an English expatriate, William Kent (1685–1748), to return to London as his collaborator. Kent designed first Chiswick's interior, then the grounds, in a style that became known throughout Europe as the "English landscape garden." Kent's garden, in contrast to the regularity and rigid formality

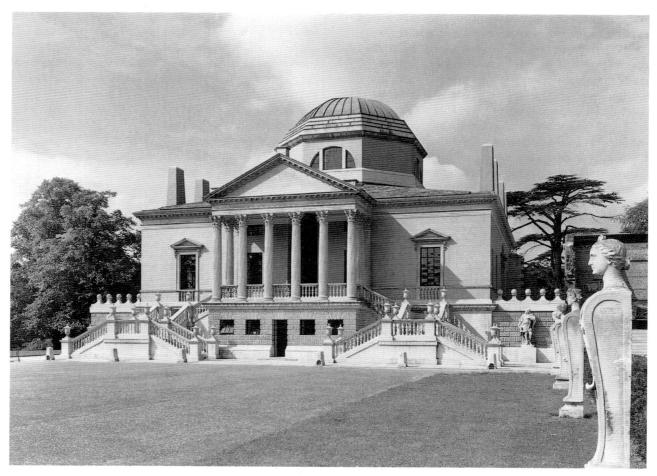

26-9. Richard Boyle, Lord Burlington. Chiswick House. 1724–29. Interior decoration (1726–29) and new gardens (1730–40) by William Kent

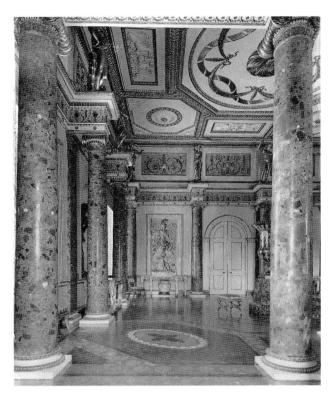

26-10. Robert Adam. Anteroom, Syon House, Middlesex, England. 1760–69

of Baroque gardens (see fig. 19-23), featured winding paths, a lake with a cascade, irregular plantings of shrubs, and other effects imitating the appearance of the natural rural landscape. To Kent and Burlington, such a garden, far from seeming at odds with the pristine classicism of the house, was "natural" and "reasonable," and thus in perfect accord with it.

Kent's interior designs and furniture remained highly ornate. For the finest Neoclassical interior design the wealthy turned to the Scots Robert Adam (1728–1792) and his brothers. On tour in Rome, Robert Adam became enthralled with the remains of classical antiquity and even hired other artists to sketch and paint Roman architectural monuments for him. His fascination with Roman architecture and its decoration profoundly affected his style after he returned to London in 1758. In about 1760 Hugh Percy, first duke of Northumberland, commissioned Adam to renovate the interior of his country estate, Syon House, near London. The anteroom, a square chamber between the entrance hall and the dining room, remains today a prime example of Adam's brilliance in interior design (fig. 26-10). The opulent colored marbles, gilded relief panels and statues, spirals, garlands, rosettes, and heavily carved, gilded moldings are profuse yet are restrained by the strong geometric order imposed on them and by the visual relief of plain wall and ceiling surfaces. Adam's great gift was the seeming effortlessness with which he combined a variety of classical motifs into elegant designs perfectly scaled for a British interior.

Another medium influenced by classicism was ceramics, especially the wares of Josiah Wedgwood (1730–1795), who invented several new wares early in

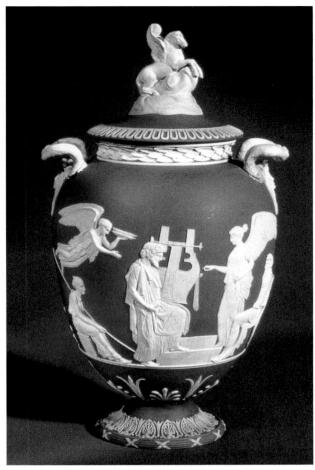

26-11. Josiah Wedgwood. Vase, made at the Wedgwood Etruria factory, Staffordshire, England. 1786. White jasper body with a mid-blue dip and white relief, height 18" (45.7 cm). Relief of *The Apotheosis of Homer* by John Flaxman, Jr., after a Greek vase in the British Museum. 1778. Trustees of the Wedgwood Museum, Barlaston, Staffordshire

his career. In 1768 he started a pottery factory that he named Etruria after the red-and-black "Etruscan" (actually Greek) vases being excavated in Italy. This production-line shop had several divisions, each with its own **kilns** (firing ovens) and workers trained in individual specialties.

In 1774-1775 Wedgwood perfected a fine-grained, unglazed, colored pottery, which he named jasperware. At first he made the new ware only in white, blue, and blue green; later he invented a method to add other colors by dipping. Jasperware was used for ornamental works that imitated Greek vases and Roman cameo-glass vessels and medallions (see fig. 26-1). An important example is a dark blue urn decorated in white relief with a scene of The Apotheosis of Homer (fig. 26-11), designed by the sculptor John Flaxman, Jr. (1755-1826). Flaxman, who was only fifteen when his work was first exhibited at the Royal Academy, worked for Wedgwood as a designer from 1775 to 1787. Later he studied in Italy, where he became a leading Neoclassic sculptor. He also became famous for illustrating classical literary works with line drawings, which were engraved and widely published. These drawings, like

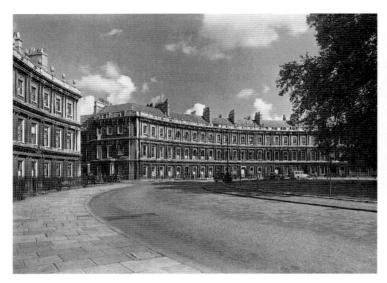

26-12. John Wood the Elder and John Wood the Younger. The Circus, Bath, England. 1754–58

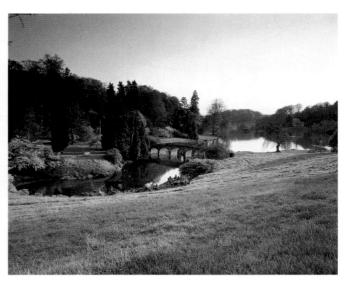

26-13. Henry Flitcroft and Henry Hoare. The Park at Stourhead, Wiltshire, England. Laid out 1743; executed 1744-65, with continuing additions

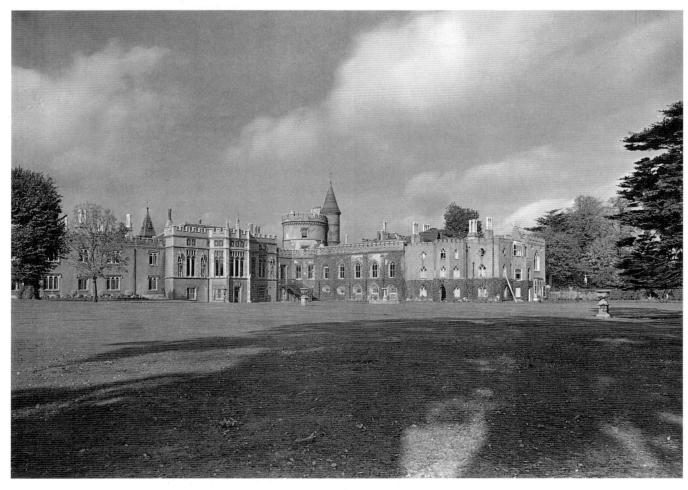

 $26\text{-}14.\ Horace\ Walpole\ and\ others.\ Strawberry\ Hill,\ Twickenham,\ England.\ 1749-77$

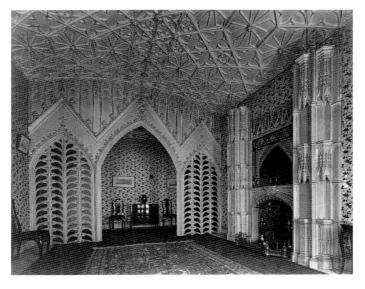

26-15. Richard Bentley. Holbein Chamber, Strawberry Hill. After 1754

his designs for Wedgwood, exemplify the late-eighteenthcentury Neoclassic tendency toward linear images set against empty backgrounds.

A remarkable phenomenon of eighteenth-century British art and letters was the Provincial Enlightenment, so called because the ideas of innovative artists from outside London, like Josiah Wedgwood, influenced developments in the capital, rather than the other way around. One of these innovators was John Wood the Elder (c. 1704–1754), who dreamed of turning into a new Rome his native Bath—a spa town in the west near Wales originally built by the Romans in the first century, where well-to-do people came to "take the waters." On a large property near the town center, Wood began in 1727 to lay out a public meeting place, sports arena, and gymnasium. Much of his plan was never carried out, but in 1754 he began building the Circus (fig. 26-12), an elegant housing project that was completed in 1758 by his son, John Wood the Younger (d. 1782). The Circus was a circle of thirtythree town houses, all sharing a single three-story facade modeled on the exterior of the Roman Colosseum, with an attic to house the servants' quarters, and steeply pitched roofs and large chimneys as a concession to English winters. In 1764 Wood the Younger began another housing project in Bath, a semicircle of houses called the Royal Crescent, also following a Roman theme. Like the Circus, the Royal Crescent has a single classical exterior elevation, in this case a row of colossal Ionic columns, surmounted with a roofline balustrade. The Woods' elegant Circus and Royal Crescent, with their handsome yet modestly scaled classical fronts, were imitated enthusiastically in London and other British and American cities well into the nineteenth century.

The British were fascinated with sculpting artificial vistas. Following William Kent's lead, landscape architecture flourished in the hands of such designers as Lancelot ("Capability") Brown and Henry Flitcroft. In 1743 the banker Henry Hoare redid the grounds of his estate at Stourhead in Wiltshire (fig. 26-13) with the assistance of Flitcroft, a protégé of Burlington. The resulting gardens at Stourhead carried William Kent's

ideas much further. Stourhead is, in effect, an exposition of the picturesque, with orchestrated views dotted with Greek and Roman temples, grottoes, copies of antique statues, and such added delights as a rural cottage, a Chinese bridge, a Gothic cross, and a Turkish tent. In the view illustrated here a replica of the Pantheon in Rome is visible across a carefully placed lake, whose undulating shoreline resembles an irregular Rococo ornament. The repeated evocation at Stourhead of the past and the exotic, suggesting poetic contemplation of the passage of time and the decay of civilizations, is quintessentially Romantic.

A Romantic spirit informed the work of Horace Walpole, an aristocratic man of letters, in remodeling his Strawberry Hill house in Twickenham (fig. 26-14), near London. Working with friends and professional architects, including Robert Adam, he devoted nearly thirty years (1749-1777) to converting the house into a neo-Gothic mansion, one of the early monuments of the Gothic Revival style. The house's sprawling asymmetry and its many medievalizing touches, such as fireplaces and wall ornaments copied from Gothic tombs and choir screens, epitomize the Romantic sensibility. Among the fanciful rooms was the architect Richard Bentley's Holbein Chamber (fig. 26-15), a Gothic Revival fantasy as elegant as any classical Adam interior. Although the Gothic style was admired for its romantic ruins and haunted castles and the like, Walpole aptly described the interior of Strawberry Hill as "pretty and gay." Indeed, the house's playful charm has much in common with such joyful Rococo pleasure pavilions as the Amalienburg (see fig. 19-71), which antedates it by only a few years.

The medieval revival in architecture was not a passing fancy. After Parliament's Westminster Palace burned in 1834, entries in the competition to design the new Houses of Parliament were required to be in English Gothic or Elizabethan style, evoking England's history. The commission was granted to Charles Barry (1795–1860) and Augustus Welby Northmore Pugin (1812–1852), who began construction in 1836. Barry was responsible for the basic plan of the buildings, while Pugin designed the

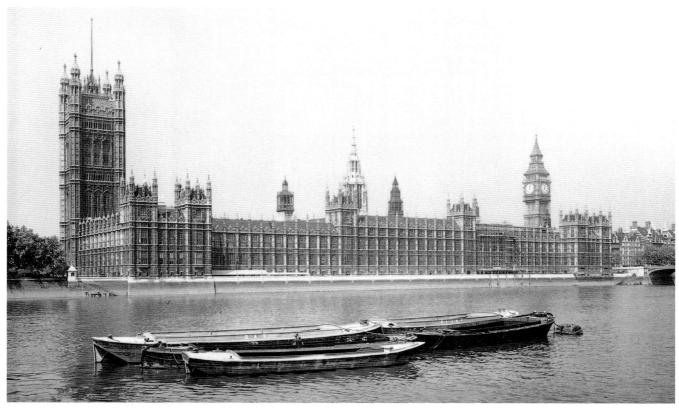

26-16. Charles Barry and Augustus Welby Northmore Pugin. Houses of Parliament, London. 1836–60. Royal Commission on the Historical Monuments of England, London

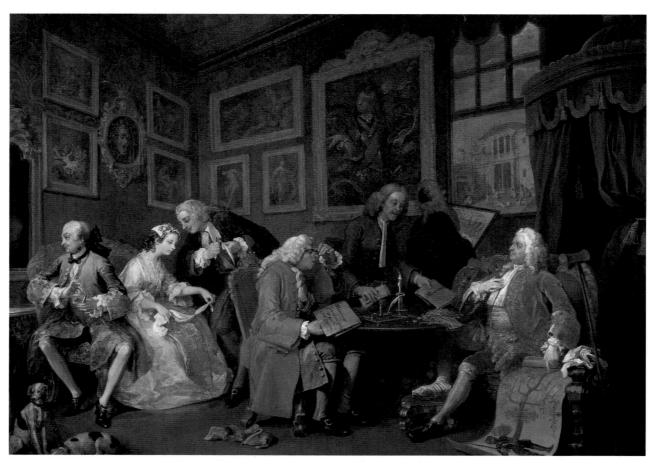

26-17. William Hogarth. *The Marriage Contract,* from Marriage à la Mode. 1743–45. Oil on canvas, 28×36 " (71.7 x 92.3 cm). The National Gallery, London

Gothic decoration (fig. 26-16). Pugin had had many earlier commissions for churches, for which the Gothic style was especially popular. The plan of the Houses of Parliament building is actually classical, with two vast halls for the House of Commons and the House of Lords symmetrically flanking the main entrance. Offices, committee rooms, and libraries surround these two chambers. The exterior is elaborated with a splendid array of Gothic spires, **turrets**, and towers, including that of the House of Lords at the left and the clock tower known as Big Ben at the right.

Painting

When the newly prosperous middle classes began to buy art, they wanted portraits of themselves. But taste was also developing for other subjects, such as moralizing satire and caricature, ancient and modern history, the British land-scape and people, and scenes from English literature.

The Satiric Spirit. Satiric essays, songs, and cartoons provided social commentary on and criticism of eighteenth-century Britain. Perhaps the most important satirist of the century was the engraver William Hogarth (1697-1764). In 1721 Hogarth began to produce original prints lampooning current events. Shrewd and somewhat puritanical, he was particularly drawn to English social conventions. About 1731, Hogarth began illustrating moralizing tales of his own invention in sequences of four to six paintings that he then reproduced in prints. Sold in sets, the prints were like acts in a play telling a story of sin and its consequences. The Harlot's Progress, the tale of a country girl lured into prostitution in London, was quickly followed by The Rake's Progress, a story of male debauchery and decline. Financially successful from engraving, Hogarth also hoped to be a painter, but despite his considerable gifts, he was not a success and gave up painting after 1745.

Between 1743 and 1745, Hogarth painted a series for engraving called Marriage à la Mode. The opening scene (fig. 26-17) shows a marriage contract being drawn up between the daughter of a rich merchant and the son of the bankrupt earl of Squanderfield. The middle-class bride will become a viscountess by the stroke of her father's pen, and the penniless young lord will enjoy his wife's generous dowry and future inheritance, but a bad end to this loveless marriage is already predicted. While the bride listens intently to the blandishments of the lawyer, Silvertongue, the groom admires himself in the mirror and takes a pinch of snuff. The dogs at his feet, suggesting his lazy and decadent character, are chained together in an allusion to the upcoming marriage. The old earl rests one gouty foot on a velvet cushion and displays the family tree springing from the side of his first noble forebear, while on the table is a large pile of gold coins and bank notes furnished by the bride's father, whose dedication to making money has enabled him to buy his daughter a title.

Hogarth's contempt is not directed only at the actors in this drama. The earl's house is hung floor to ceiling with paintings in the Grand Manner, which the artist personally abhorred, and through the window the viscount's new Palladian mansion can be seen under construction.

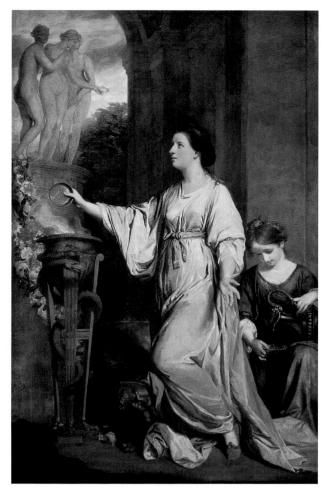

26-18. Joshua Reynolds. *Lady Sarah Bunbury Sacrificing to the Graces*. 1765. Oil on canvas, 7'10" x 5' (2.42 x 1.53 m). The Art Institute of Chicago

Mr. and Mrs. W. W. Kimball Collection, 1922. 4468

The architect at the window checking his plan against the progress of the building is an unflattering reference to Lord Burlington and his architecture (see fig. 26-9).

In his book *Analysis of Beauty* (1753), Hogarth praised social satire as equal to the highest artistic effort, because it was both difficult to do and useful to society. He also wrote that art should be accessible to ordinary people in public exhibitions and should be understandable in subject matter and treatment—a point of view that some of his contemporaries strongly criticized.

Portraits in the Grand Manner. The outstanding British Grand Manner portrait artist was Sir Joshua Reynolds (1723–1792). Although he came from a clerical family, he was the antithesis of the moralistic Hogarth. After studying Renaissance painting in Italy, he settled in London in 1753 and worked vigorously to educate artists and patrons to appreciate classical history painting. He was never a popular history painter, but his portraits, which resonate with high-minded seriousness, were immensely successful. Often presented in historical settings and costumes, his subjects personify the quiet authority of the traditional Grand Manner.

Lady Sarah Bunbury Sacrificing to the Graces (fig. 26-18), of 1765, portrays a Roman priestess sacrificing to the

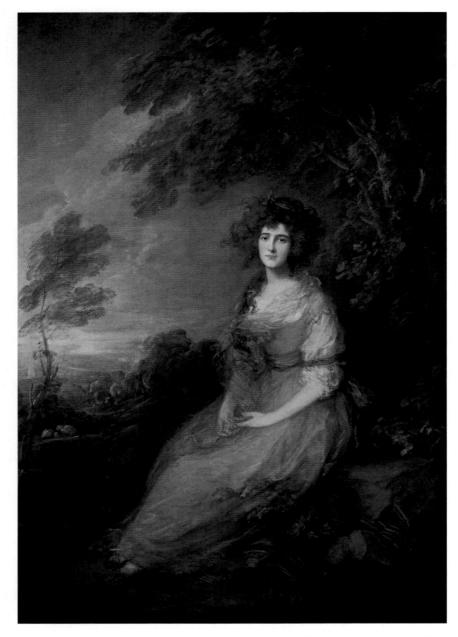

26-19. Thomas Gainsborough. *Portrait of Mrs. Richard Brinsley Sheridan.* 1785–87. Oil on canvas, 7'2'/2" x 5''/2" (2.2 x 1.54 m). National Gallery of Art, Washington, D.C. Andrew W. Mellon Collection

Three Graces, who appear as marble statues atop a high plinth. As if echoing the Graces, the canvas is divided into three sections with arched openings on each side of a wide pier, and the foreground elements are grouped in a large triangle. Reynolds monumentalized his subject by dropping the viewer's eye-level and placing Lady Sarah above the kneeling servant and the tripod of burning incense. There is even a suggestion of classical sculpture in her emphatic **contrapposto**, a stance Reynolds also adopted for heroic male portraits.

Reynolds was determined to cultivate a class of patron who not only bought art on the grand tour but also collected work at home. He helped convince George III to charter the Royal Academy of Arts in 1768, and he was its first president, until 1790. Knighted in 1769, Reynolds

was appointed painter to the king in 1784. Not only was he the most important portraitist in Britain, he also profoundly influenced British art through his lectures at the Academy (subsequently published), in which he argued that art could be mastered by following prescribed rules derived from exemplary models of the past, especially Michelangelo.

Reynolds's younger contemporary Thomas Gainsborough (1727–1788) established his reputation as a portraitist early. In 1759 he and his wife moved to Bath, which was attracting the rich and noble in large numbers. For this clientele the artist developed an elegant and relaxed portrait style. In 1768 he was elected a founding member of the Royal Academy and in 1774 moved permanently to London. In 1785–1787 Gainsborough,

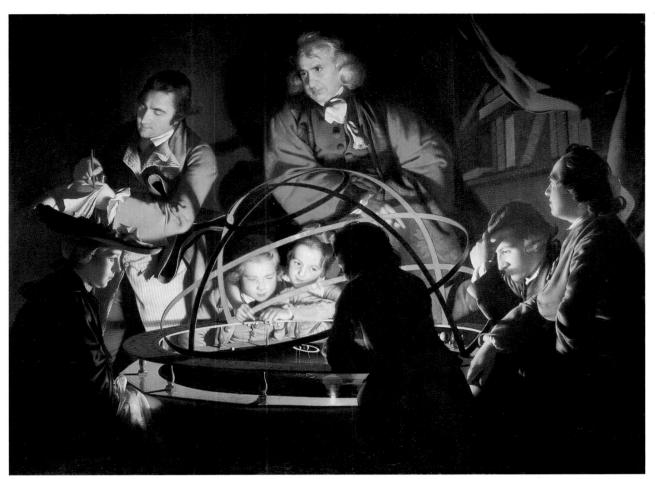

26-20. Joseph Wright. A Philosopher Giving a Lecture on the Orrery. 1766. Oil on canvas, 4'10" x 6'8" (1.47 x 2.03 m). Derby Museum and Art Gallery, Derby, England

using light, rapid brushstrokes in a delicate palette (selection of colors), painted a portrait of Mrs. Richard Brinsley Sheridan (fig. 26-19), a professional singer who had married a celebrated wit and playwright. He also created superb landscape paintings, evident in the feathery, windblown trees in the background. Although Gainsborough's portraits incorporated many Grand Manner elements popularized by Reynolds, they are painted with the freshness and immediacy of sketches, and their light palette and elegant figures in graceful, informal poses have a decidedly Rococo flavor.

The Romance of Science. Joseph Wright of Derby (1734-1797) from about 1765 had experimented with such nocturnal light effects as moonlight and candlelight, and he painted several carefully observed views of Mount Vesuvius erupting at night. One of his best candlelight scenes is A Philosopher Giving a Lecture on the Orrery (fig. 26-20), which shows a group of enthralled observers of a mechanical model of the solar system, with a lamp to represent the sun. Wright was Romantically fascinated with science and industry, and he depicted scientific experiments and factory scenes with

IRON AS A Technology, the prop-BUILDING erties of a material, MATERIAL and engineering skills in large part determine

form and often produce an unintended and revolutionary new aesthetic. In 1779 Abraham Darby III completed a bridge over the Severn River at Coalbrookdale in England. The bridge was a functional structure in the new industrial environment where factories and workers' hous-

ing filled the valley. The bridge's importance lies in the fact that it is the first use of structural metal on a large scale. Iron replaced the heavy, hand-cut, stone voussoirs used to construct earlier bridges. Five pairs of cast-iron, semicircular arches form a strong, economical, 100-foot span. The light, space, movement, and skeletal structure desired by builders since the twelfth century at last were possible.

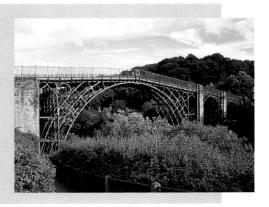

a brilliant **tenebrism** (use of shadow) reminiscent of the work of Georges de La Tour (see fig. 19-30). Wright's paintings are a remarkable combination of Baroque style and contemporary subject matter.

Innovations in construction technology and materials (see "Iron as a Building Material," page 943) enabled architects and engineers to build new kinds of structures whose designs both contributed to and reflected the Romantic fascination with science during this period.

History Painting. European academies had long considered history painting, with subjects drawn from classical literature, the Bible, and mythology, as the highest form of artistic endeavor, but British patrons were reluctant to purchase such works from native artists. Instead, they favored Italian paintings bought on the grand tour or acquired through agents in Italy. Thus, the arrival in London in 1766 of the Italian-trained Swiss history painter Angelica Kauffmann (1741–1807) was a great impetus to those artists in London aspiring to success as history painters. She was welcomed immediately into Joshua Reynolds's inner circle. In 1768 Kauffmann was one of two women artists named among the founding members of the Royal Academy (see "Women and the Academies in the Eighteenth Century," below); the other, Mary Moser (1744-1819), was also of Swiss heritage.

Kauffmann had assisted her father on church murals and was already accepting portrait commissions at age fifteen. Then, in a highly unusual move, she embarked on an independent career as a history painter. She first encountered the new classicism in Rome, in the circle of Johann Winckelmann, whose portrait she painted in 1763, and where she was elected to the Academy of Saint Luke. Kauffmann's style of painting figures was not derived from Renaissance models but was based loosely on the figure types found in Roman wall paintings in the excavations of Pompeii and Herculaneum. Her lyrical classicism is typified by Zeuxis Selecting Models for His Picture of Helen of Troy (fig. 26-21) of about 1765, which

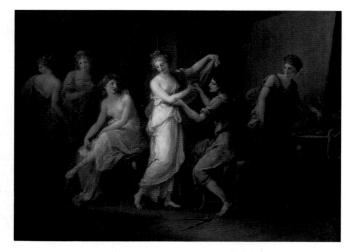

26-21. Angelica Kauffmann. Zeuxis Selecting Models for His Picture of Helen of Troy. c. 1765. Oil on canvas, 321/8 x 441/8" (81.6 x 112.1 cm). The Annmary Brown Memorial, Brown University, Providence, Rhode Island

illustrates a paradigm of classical idealization: the Greek painter Zeuxis seeks the most beautiful features of many women in order to paint a perfect image of Helen of Troy. The woman picking up a brush at the right is thought to be Kauffmann's self-portrait. In England Kauffmann married the painter Antonio Zucchi, who was working for Robert Adam, and she, too, provided paintings for Adam's projects and decorated ceramics and furniture in the Neoclassical style.

Kauffmann's devotion to history painting was shared by her American friend Benjamin West (1738-1820). who, after studying art in Philadelphia, traveled to Italy in 1759 and became a pupil of Anton Raphael Mengs and met Winckelmann, then settled permanently in London in 1763. West acted with generosity and encouragement toward fellow Colonial artists, and his studio became a veritable "American academy" abroad. A founder of the Royal Academy, West exhibited at its 1770 Salon his

WOMEN AND THE **ACADEMIES** IN THE CENTURY

Although several women were made members of the European acade-EIGHTEENTH mies of art before the eighteenth century, their inclu-

sion amounted to little more than honorary recognition of their achievements. In France, Louis XIV had proclaimed in the founding address of the Royal Academy that its intention was to reward all worthy artists, "without regard to the difference of sex," but this resolve was not put into practice. Only seven women were awarded the title of academician

between 1648 and 1706, the year the Royal Academy declared itself closed to women. Nevertheless, four women had been admitted to the Academy by 1770, when the men became worried that women members would become "too numerous" and declared four women members to be the limit for any one time, noting, however, that the Academy was not obliged to maintain that number. Young women were not admitted to the Academy school or allowed to compete for Academy prizes, both of which were nearly indispensable for professional success.

Women fared even worse at

London's Royal Academy. After the Swiss painters Mary Moser and Angelica Kauffmann were named as founding members in 1768, no other women were elected until 1922, and then only as associates. Johann Zoffany's 1771-1772 portrait of the London academicians shows the men grouped around a nude male model, along with the Academy's study collection of Classical statues and plaster copies (see page 929). Propriety prohibited the presence of women in this setting, so Zoffany painted their portraits on the wall. In more formal portraits of the Academy, however, the two women were included.

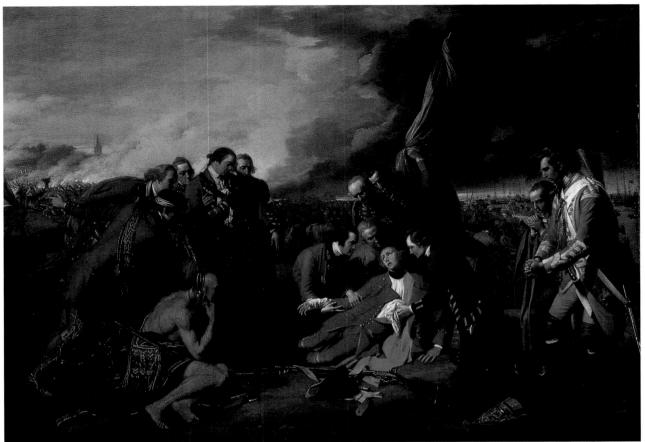

26-22. Benjamin West. *Death of General Wolfe.* 1770. Oil on canvas, 4'11½" x 7' (1.51 x 2.14 m). The National Gallery of Canada, Ottawa

Gift of the Duke of Westminster, 1918

While West was still working on this canvas, George III made it clear that he would not buy such a painting showing British heroes in modern dress. Joshua Reynolds, president of the Royal Academy, called on West at his studio and begged him not to continue this aberration of "taste." When the painting was exhibited at the Academy in 1770, Reynolds apologized for his error in judgment, and George III commissioned a replica from West after he learned that the original had been purchased by Lord Grovesnor. West painted four more replicas but made the largest amount of money by far in royalties from an engraving after the painting.

remarkable history painting Death of General Wolfe (fig. 26-22). West's re-creation of a recent historical event as though it were happening before the viewer's eyes shocked contemporaries but was well received. General Wolfe had been killed in 1759 in a battle with the French for control of Quebec during the Seven Years' War. West depicted Wolfe in his red uniform dying in the arms of his comrades, although contemporary accounts record that Wolfe died in a field tent with only two or three men around him. Thus, even though West's painting is powerfully naturalistic, it is not "factual," nor was it meant to be. The Grand Manner intended to convey not an anecdotal report of the battle but a larger truth about the valor of the fallen hero, the loyalty of the British soldiers, and the justice of their cause. West included a figure of a Native American to locate the action in North America and to provide an "objective" observer of Wolfe's death. The dramatic illumination increases the emotional intensity of the scene, as do the poses of Wolfe's attendants, arranged to suggest a Lamentation over the dead Christ. The rhetorical power of the work so strongly impressed the great Shakespearean actor David Garrick that he is said to have enacted an impromptu interpretation of the dying Wolfe in front of the painting at the Academy's exhibition hall. West also painted scenes of antiquity in a strong Neoclassic style, typifying an eighteenth-century tendency for artists to work in more than one manner.

At the 1766 exhibition of the London Society of Artists, the organization that preceded the Royal Academy, West had seen and admired a painting by a young American, who was in fact the most important portrait painter in the British colonies at the time, John Singleton Copley (1738–1815). After corresponding with Copley and arranging his membership in the Society of Artists, West encouraged him to travel to Italy and invited him to visit London as well. Copley arrived in England in 1774, then journeyed on to Italy. With the coming of the American Revolution, Copley's family fled to London, where the artist joined them and remained for the rest of his life.

After coming to England, Copley abandoned his colonial portrait style (see fig. 19-94) for a career as a history painter. One of his most celebrated paintings was

1725 1875

26-23. John Singleton
Copley. *Watson and the Shark*.1778. Oil on
canvas, 6'1/2" x 7'61/4"
(1.84 x 2.29 m).
National Gallery of Art,
Washington, D.C.
Ferdinand Lammot Belin

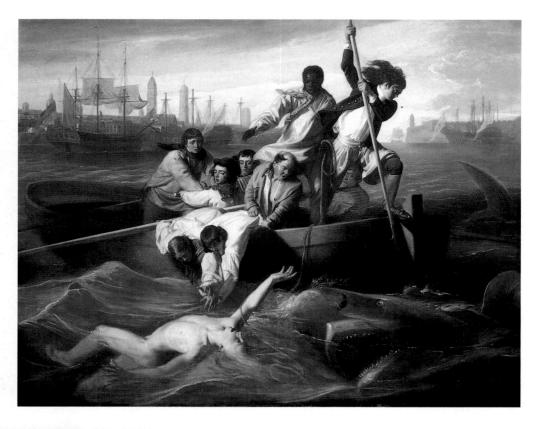

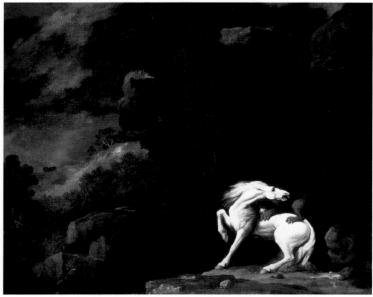

26-24. George Stubbs. Lion Attacking a Horse. 1770. Oil on canvas, $40^{1/8}$ x $50^{1/4}$ " (102 x 128 cm). Yale University Art Gallery, New Haven, Connecticut Gift of the Yale University Art Gallery Associates

Watson and the Shark (fig. 26-23), painted in 1778 to commemorate Brook Watson's escape from a shark attack in the harbor of Havana, Cuba. Following the example of West, Copley staged the event with intense drama, depicting the terrifying moment when the shark was closing in for the kill. The background for the classical pyramid of figures is a distant view of Havana, with Morro Castle at the right. In what looks like an eighteenth-century version of the biblical story of Jonah and

the Whale, the ferocious creature rushes on Watson, shown as an idealized nude with his hair trailing in the water. The harpooner has raised his spear, and the sailor at the center risks being thrown into the shark-infested waters in his effort to balance the weight of his mates leaning forward to rescue Watson, but their outstretched hands have not yet reached the youth. Each figure in the boat is a careful study of emotion and action.

West and Copley belonged to a generation of Americans who sought their fortunes in Europe, where they believed they could find a more cultivated patronage than in America. The next generation of American artists who traveled abroad, however, were able to earn their livings in the United States or to work in Europe for American patrons, as improving economic conditions and political stability after the American Revolution made the arts an important part of life in the United States.

The Sublime. The notion of the sublime can be applied to a type of painting that can be called **literary illustration**, although the artists' own imaginations significantly affected the form and style of their works, even to the point of devising original subjects of a literary character. Many who practiced in this style were British.

George Stubbs (1724–1806) combined a meticulous study of comparative anatomy with a considerable imaginative gift. Stubbs, who first specialized in portraiture, began to study equine (horse) anatomy and dissected a number of horse cadavers to prepare drawings for his *Anatomy of a Horse*, which he published in 1766. In the meantime, he painted individual and group portraits of clients on their country estates with their horses, though he was more adept at depicting animals than people.

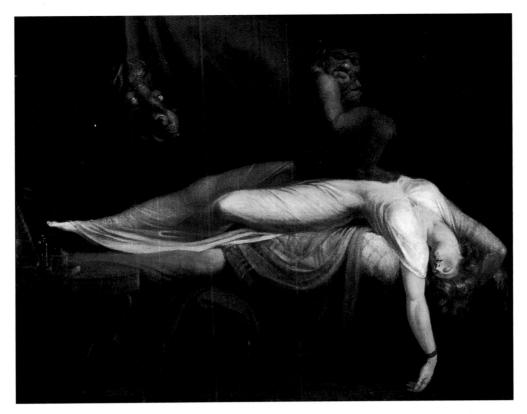

26-25. John Henry Fuseli. *The Nightmare*. 1781. Oil on canvas, 40 x 50" (111 x 127 cm). Detroit Institute of Arts Founders Society purchase with funds from Mr. and Mrs. Bert L. Smokler and Mr. and Mrs. Lawrence A. Fleischman Fuseli was not popular with the English critics. One writer said Fuseli's 1780 entry in the London Royal Academy exhibition "ought to be destroyed," and Horace Walpole called another painting in 1785 "shockingly mad, mad, mad, madder than ever." Even after achieving the highest official acknowledgment of his talents, Fuseli was called the Wild Swiss and Painter to the Devil. But the public appreciated his work, and *The Nightmare*, exhibited at the Academy in 1782, was repeated in at least six versions, all of which were sold to commercial engravers for reproduction in prints. One of these prints would one day hang in the office of the Austrian psychoanalyst Sigmund Freud, who believed that dreams were manifestations of the dreamer's repressed desires.

A subject that Stubbs first depicted about 1762, then repeated in paintings and original prints, was a horse being frightened or attacked by a lion (fig. 26-24). This violent motif is so uncharacteristic of his work as a whole that it has been suggested that the artist actually witnessed such an attack on a trip to North Africa or perhaps saw a sculpture of a lion killing a horse among the antiquities in Rome. However, Stubbs probably made drawings of a lion kept as a curiosity by his patron, Lord Shelburne. In *Lion Attacking a Horse*, the sublime theme of nature's cruelty is underscored by the dark, craggy landscape setting for the terrible moment when the horse tries in vain to dislodge its attacker. Stubbs's work of this type anticipated the fascination of the French Romanticists with animal subjects half a century later.

A contemporary of Stubbs, John Henry Fuseli (1741–1825), a highly educated Swiss minister, arrived in London in 1764 and quickly became a member of the city's intellectual elite. After two visits to Italy he returned to England to pursue a career as a painter. Although Fuseli was knowledgeable about classical principles and was particularly influenced by Michelangelo, his unusual style seems to have originated in his own psyche. His usual approach was to illustrate scenes from literary

works—including Norse myths, Dante, Shakespeare, Milton, contemporary writers, and even his own poetry—but one of his best-known works, *The Nightmare* (fig. 26-25), painted in 1781, was instead a personal expression of the experience of awaking from a terrible dream with the sensation that something heavy has been pressing on one's chest. In this dark fantasy of night terrors, Fuseli combined the irrational and the erotic, two persistent subthemes in most of his works. The creature sitting on the woman's abdomen is an incubus, a demon from folklore who was believed to steal upon sleeping women and have sexual intercourse with them, a subject Fuseli also painted. Adding to the interest of this canvas today is a portrait on the reverse. She is Anna Landolt, with whom Fuseli fell passionately in love on a visit to Zurich in 1779.

Fuseli's friend William Blake (1757–1827) also drew subjects for his paintings from literary sources, mainly the Bible, Milton, Shakespeare, and his own poetry and prose. His imagery and figural style were greatly influenced by his love of Michelangelo, whom he knew from reproductions and whose images he transformed with his idiosyncratic mysticism. Throughout his life Blake experienced hallucinatory states of mind. Even as a young child, he told his family that he saw angels walking in the fields and a tree

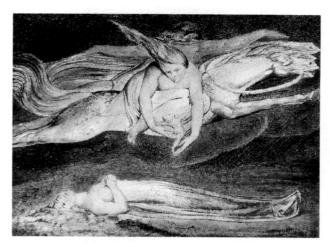

26-26. William Blake. *Pity.* 1795. Color monotype in tempera touched with pen, black ink, and watercolor, 15³/₄ x 20⁷/₈" (40 x 53 cm). The Metropolitan Museum of Art, New York

Gift of Mrs. Robert W. Goelet, 1958 (58.603)

glittering with angels' wings. Blake was apprenticed to an engraver at the age of seven, then later briefly attended the Royal Academy school, where he developed a strong dislike of Reynolds and his **formalist** ideas. One of his most compelling creations was the spirit Urizen ("your Reason"), representing rationalist thought, which Blake believed encumbered creative vision. Although he painted in **tempera**, an egg-based paint, on wood panel, Blake's reputation is based mainly on his **monoprints** (single-

impression prints), hand-colored and drawn over with ink. The sale of these and his self-illustrated books of poems and the fees for engravings done of other artists' works provided his modest living.

In 1795 Blake created the large painted print Pity (fig. 26-26), inspired by a passage from Shakespeare's Macbeth. Regarding his plan to assassinate the Scottish king Duncan, Macbeth says: "And Pity, like a naked new-born babe, / Striding the blast, or heaven's cherubin, hors'd / Upon the sightless couriers of the air, / Shall blow the horrid deed in every eye, / That tears shall drown the wind" (act 1, scene 7, lines 21–25). The passage was only a touchstone for Blake, who added the horizontal floating form of a woman with bared breasts. A planet's orbit has been interposed between her and the enormous, windblown cherub above, who gently retrieves the naked baby. This type of eroticized imagery seems to have been taken up by Blake in response to Fuseli's works. The two men met about 1779, and Fuseli hired Blake not long after to make prints of his paintings. They remained friends until Blake became a complete recluse in the last decade of his life.

Sublime and Romantic effects soon made their appearance in landscape painting as well. The two great masters of English Romantic landscape were John Constable (1776–1837) and Joseph Mallord William Turner (1775–1851), who, championed by Fuseli and others, profoundly influenced later landscape painting, especially in France.

The son of a well-to-do miller, Constable later claimed that the landscape of his youth had made him a

26-27. John Constable. The White Horse. 1819. Oil on canvas, 4'33/4" x 6'21/8" (1.31 x 1.88 m). The Frick Collection, New York

26-28. Joseph Mallord William Turner. *The Fighting "Téméraire," Tugged to Her Last Berth to Be Broken Up.* 1838. Oil on canvas, 351/4 x 48" (89.5 x 121.9 cm). The National Gallery, London

painter before he ever picked up a brush. He continuously found inspiration in rural southern England, and he credited such seventeenth-century Netherlandish artists as Ruisdael, Rembrandt, and especially Rubens with teaching him about landscape painting. In a lecture, he said of Rubens's Landscape with Rainbow (see fig. 19-41): "More than the rainbow itself, I mean dewy light and freshness, the departing shower, with the exhilaration of the returning sun, effects which Rubens, more than any other painter, has perfected on canvas" (cited in Emmons, page 161). Constable went to work in 1795 for a London engraver, who discouraged his aspirations and sent him home. In 1800 he returned to London and entered the Royal Academy school, but he received little official recognition and was not made an academician, or member of the Royal Academy, until 1829, five years after he had been discovered by French connoisseurs and patrons (see "Academy Exhibitions," page 929).

Constable's *The White Horse* of 1819 (fig. 26-27) draws on the artist's intense observation of every facet of the natural landscape, recorded in sketches he made on walking tours. He detested what he called "cold, trumpery stuff" and "bravura" in other landscape painters' work, by which he meant Romantic effects of drama and grandeur. He preferred to portray the landscape and the mundane activities taking place in it without suggestions of underlying cosmic or philosophical meaning.

Turner was an exceptional creator of moods, light, and drama. After only two years of study in the Royal Academy school, one of his watercolors—the only medium he worked in until 1796—was accepted at the Royal Academy's annual exhibition of 1790. At the age of twenty-seven he was elected a full academician, and he later became a professor in the Royal Academy school. First turning to Claude and Poussin for inspiration—both in composition and in the handling of color and atmosphere—Turner imbued his early works with a pleasant, picturesque quality not far removed from Constable's. But as his personal style matured, the phenomena of colored light and atmospheric movement became the true subjects of his paintings. To the academicians his works increasingly looked like sketches or the preliminary underpainting of unfinished canvases, but to his admirer Constable they were "golden visions, glorious and beautiful," painted with "tinted steam." Between 1819 and 1840 Turner made four trips to Italy, where he was most affected by the technique and coloration of Venetian Renaissance paintings and by Venice's own watery brilliance and glowing atmosphere.

Turner's *The Fighting "Téméraire," Tugged to Her Last Berth to Be Broken Up* (fig. 26-28) of 1838 is both a history painting and a study in the optical effects of the setting sun over water. The *Téméraire* had been the secondranking British ship in the Battle of Trafalgar in 1805, a

great British naval victory over the combined fleets of Spain and Napoleon's France. Some thirty-three years later, however, the ship was ready for the scrap heap, and Turner watched from a ferry as it was towed away to be destroyed. Some have interpreted the scene as a symbol of the passing of the old order. But the narrative content is entirely overwhelmed by light and color; the glowing red sun reflecting off the water creates, instead, a sense of apotheosis for the dying ship. Turner's painting style continued to develop toward his ultimate near-abstract style, which some critics consider the finest phase of his work.

FRANCE Neoclassicism and Romanticism in France are closely tied to its turbulent history. The Revolution of 1789, the reign of Emperor Napoleon I (ruled 1804–1814, 1815), and, later, that of Emperor Napoleon III (ruled 1852–1870) all espoused Neoclassicism. Similarly, much of the art of the Romantic artists of the nineteenth century also had political associations.

Changes in artistic taste were evident as early as 1749, when Louis XV's mistress, Madame de Pompadour, sent her brother to Italy to report firsthand on the archeological finds at Pompeii and Herculaneum and on the new ideas current in Roman art circles. When the young man was later made marquis de Marigny and subsequently appointed director of royal buildings, he encouraged French architects to embrace the Neoclassic principles that were to dominate French art through the next century. Young painters and sculptors studying at the French Academy in Rome also responded to the new classicizing movement there and brought its ideas back to Paris. But, as in England, stylistic change was more gradual in painting and sculpture than in architecture. The peak of French Neoclassicism came under Napoleon I, who hoped to make his empire a modern version of imperial Rome.

During the thirty-three-year restoration of the monarchy (1815–1848), Romanticism emerged as a strong parallel strain in French painting and sculpture. Unlike Neoclassicism, the Romantic style was not embraced by the restored kings but instead became identified with a type of social commentary in which the dramatic presentation was intended to stir public emotions, especially in the work of its chief exponents, Théodore Géricault and Eugène Delacroix.

Neoclassical Architecture

Classicism in architectural design was revived in a new, modern spirit in the second half of the eighteenth century under the dictates of the marquis de Marigny. He challenged the profession to avoid what he did *not* want—neither "modern chicory" (fussy detail) nor an "austere antique." Aiming for something in between, French architects worked with cubical masses and purity of geometric form both in the refined classicism they adopted for private buildings and in more severe large-scale Neoclassical religious and civic architecture.

26-29. Jacques-Germain Soufflot. Panthéon (Church of Sainte-Geneviève), Paris. 1755–92

This building, popularly known as the Paris Panthéon, has a strange history. Before it was completed, the revolutionary government in control of Paris confiscated all religious properties to raise desperately needed public funds. Instead of selling Sainte-Geneviève, however, they voted in 1791 to make it the Temple of Fame for the burial of heroes of Liberty. Under Napoleon I the building was resanctified as a Catholic church and was again used as such under King Louis Philippe (ruled 1830-1848) and Napoleon III (ruled 1852-1870). Then it was permanently designated a nondenominational lay temple. In 1851 the building was used as a physics laboratory. Here the French physicist Jean-Bernard Foucault suspended his famous pendulum on the interior of the high crossing dome and by measuring the path of the pendulum's swing proved his theory that Earth rotates on its axis in a clockwise motion. In 1995 the ashes of Marie Curie, who with her husband won the Nobel Prize for chemistry in 1911, were moved into this "memorial to the great men of France," making her the first woman to be enshrined here for her accomplishments.

Jacques-Germain Soufflot (1713–1780), who accompanied Marigny on his Italian tour in 1749, was an early convert to Neoclassicism in architecture. His major work, controversial with critics at the time, was the Church of Sainte-Geneviève (figs. 26-29, 26-30), which was begun in 1755 but not completed until 1792. After the Revolution it was renamed the Temple of Fame, dedicated to French heroes, but it became known as the Paris Panthéon. The building is a **central-plan** Greek cross, with a tall dome and a deep Corinthian order porch with a triangular pediment at the main entrance. The dome, raised on a high **drum**, recalls Wren's dome of Saint Paul's in London (see fig. 19-64), but the building's

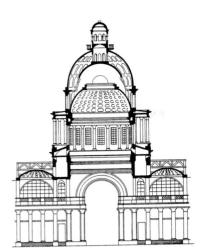

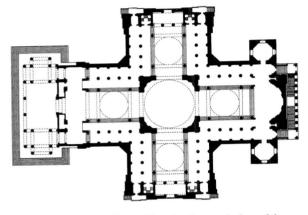

26-30. Jacques-Germain Soufflot. Section and plan of the Panthéon

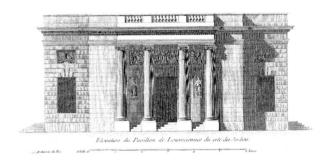

26-31. Claude-Nicolas Ledoux. Pavillon du Madame du Barry, Château de Louveciennes. c. 1771. Engraving of the facade. British Architectural Library, RIBA, London

Étienne-Louis Boullée (1728-1799), like Ledoux, designed private residences in the Neoclassic style. He is chiefly remembered today, however, for drawings for visionary projects that were considerably beyond eighteenth-century technology. In these designs, made between 1780 and 1790 and rediscovered in the twentieth century, Boullée worked in an abstract style derived from classical models that seems ultramodern, even utopian. His Cenotaph for Isaac Newton (fig. 26-32), designed in 1784, is based on round Roman monumental tombs, which were stepped and planted with trees. What would have been a hemispherical dome in a Roman tomb has been projected into a gigantic sphere. The interior was to have been empty, except for Newton's sarcophagus, with illumination provided by hundreds of small holes piercing the sphere's fabric to represent the starry heavens.

Neoclassical Sculpture

Early in the eighteenth century, French sculpture continued in the Grand Manner. Jean-Baptiste Pigalle (1714–1785), whose restrained, yet forceful, style represents this tradition at its best, continued to work within it almost to the end of the century. After studying in Rome, Pigalle became a favorite sculptor of Madame de Pompadour. His grandest and most ambitious work was the *Monument to the Maréchal de Saxe* that he designed in 1753 for

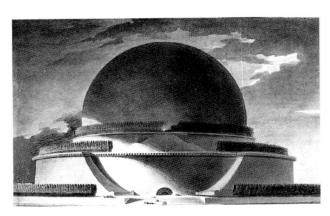

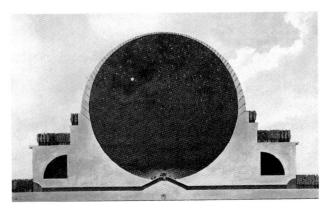

26-32. Étienne-Louis Boullée. Exterior and cross section of the Cenotaph for Isaac Newton (never built). 1784. Ink and wash drawings, 15½ x 25½ (39.4 x 64.8 cm). Bibliothèque Nationale, Paris

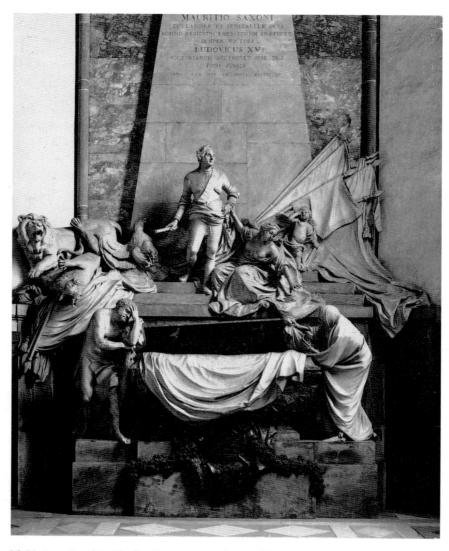

26-33. Jean-Baptiste Pigalle. *Monument to the Maréchal de Saxe*. Designed 1753. Marble, lifesize figures. Church of Saint Thomas, Strasbourg, France

the Church of Saint Thomas in Strasbourg (fig. 26-33). Maurice de Saxe was a military hero and a much-loved royal cousin, but because he was a Protestant, he could not be buried with the royal family after his death in 1750. To honor him suitably, Pigalle rebuilt the choir of the church so that the enormous tomb could fill it and broke new windows through the walls for spotlighting effects. The result is one of the great monuments of French sculpture.

The marshal general of France is shown in full uniform, descending the steps of his pyramidal tomb toward a coffin held open by a stooped figure of Death. On the steps are heraldic animals representing the defeated enemies of France, whose personification tearfully tries to intervene on the general's behalf, while Hercules, representing the armies of France, weeps. Despite the forceful drama of this scene and the almost symphonic interplay of forms and motifs, perhaps what is most moving about this work is its intense naturalism. De Saxe stands in proud isolation, staring scornfully into the face of Death, whose horror and mystery are represented with un-

flinching directness. It would be difficult to conceive of a more poignant tribute to courage and nobility.

Pigalle's portraits embraced the informality of the Rococo spirit, always maintaining a profoundly sympathetic naturalism. A fine example is his *Portrait of Diderot* (fig. 26-34) of 1777. Here is the intellectual vigor, the energetic spirit of inquiry, the impassioned curiosity that made Diderot such a quintessential champion of the Enlightenment. Nevertheless, the subject's unsmiling dignity shows Pigalle to be still a Baroque artist, perhaps its last.

Jean-Antoine Houdon (1741–1828) developed Pigalle's naturalistic tendencies into an art of a more relaxed, more spontaneous sensibility. He lived in Italy from 1764 to 1769 after winning the **Prix de Rome**, a competitive prize that enabled young French artists to study in Rome for five years. There he absorbed Winckelmann's theories and established his reputation as a sculptor before returning to Paris. After executing a **bust**, or statue of the head and upper torso, of Benjamin Franklin in 1778, Houdon was commissioned in 1784 by the Virginia legislature to portray its native son, George Washington

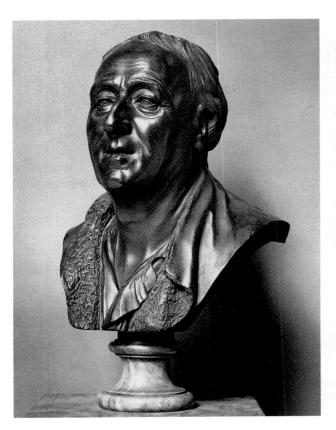

26-34. Jean-Baptiste Pigalle. Portrait of Diderot. 1777. Bronze, height $16^{1}\!/2^{\circ}$ (42 cm). Musée du Louvre, Paris

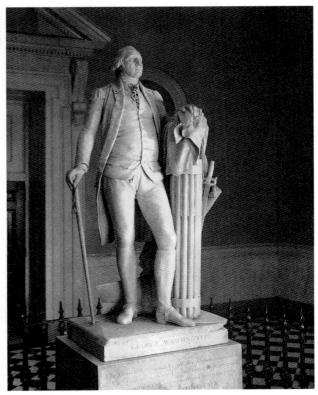

26-35. Jean-Antoine Houdon. *George Washington*. 1788–92. Marble, height 6'2" (1.9 m). State Capitol, Richmond, Virginia

(fig. 26-35). Houdon traveled to the United States in 1785 to make a cast of Washington's features and a bust in plaster, then executed the lifesize marble figure in Paris for the State Capitol in Richmond. Although in contemporary dress, Washington is portrayed in an imposing stance typical of painted portraits in the Grand Manner, with his left hand resting on a fasces, an ancient Roman symbol of authority consisting of wooden rods and an axe tied together, attached to which are a sword of War and a plowshare of Peace. But despite the dignity of the presentation, Washington is shown as a man very much at ease, a person of considered action and good sense, and above all, of gentlemanly approachability.

Painting

In the mid-eighteenth century many French artists began to work in a classicizing mode, which was first revealed in a new feeling of sobriety in subject matter and treatment, then later evolved into a clearly defined Neoclassical style. But not all artists were interested in classicism. Portraiture, particularly at court, was often relaxed, elegant, and urbane rather than severe or academic. In the late eighteenth century, however, the history painter Jacques-Louis David, inspired by Roman and Greek sculpture, developed a true Neoclassical painting style, in which his numerous pupils and followers continued to work well into the nineteenth century. Around the turn of the nineteenth century, Romantic elements began to appear in

French art, and even David's pupils were known to temper their Neoclassical style with Romantic subjects or treatments. The acknowledged leaders of the new movement were Théodore Géricault and Eugène Delacroix, whose works exemplify not only Romantic subjects and meanings but an **anticlassical** painting style as well.

Women Painters at Court. Two important women portraitists, Adélaïde Labille-Guiard (1749-1803) and Marie-Louise-Élisabeth Vigée-Lebrun (1755-1842), found favor early in their careers at the court of Louis XVI. Members of the Paris Academy of Saint Luke before its disbanding in 1777 by royal decree, both women were elected in 1783 to the Royal Academy, where they joined Marie Thérèse Reboul (1729-1805) and Anne Vallayer-Coster (1744-1818) as the four women academicians allowed at the time. Critics viewing the portraits by Vigée-Lebrun and Labille-Guiard at their debut in the 1783 biennial Paris Salon praised both artists highly, and in the years just before the French Revolution both women had similar careers and patronage—mainly royal and aristocratic but also including middle-class intellectuals, artists, writers, and actors. Both survived the political turmoil of 1789-1794 and continued their careers under the new regimes or outside France.

Labille-Guiard showed great drawing talent early in life and was apprenticed at fourteen to a painter of miniatures. She studied and specialized in pastels until 1780, when she began painting oil portraits as well. In

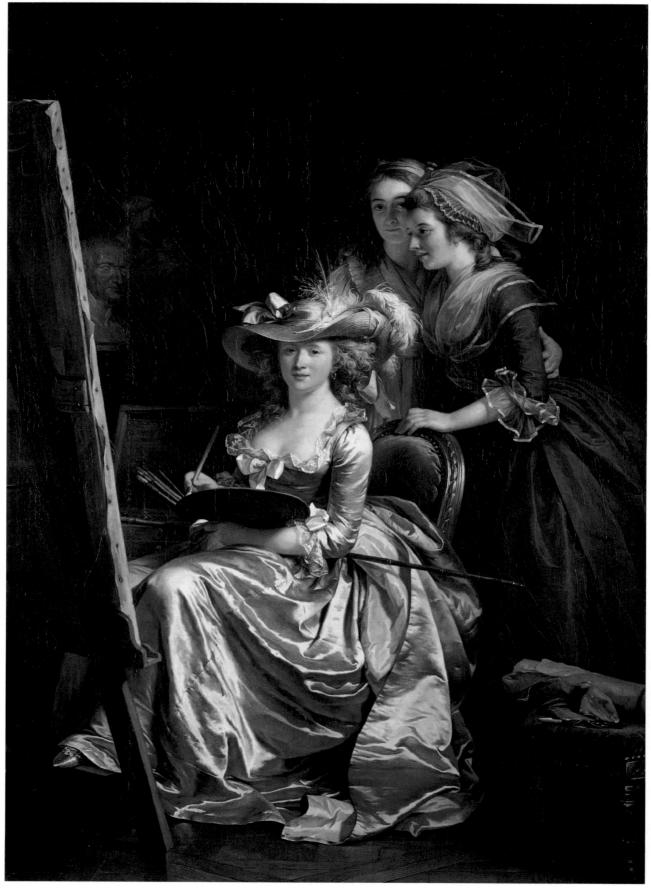

26-36. Adélaïde Labille-Guiard. *Self-Portrait with Two Pupils, Mademoiselle Marie Gabrielle Capet (1761–1818) and Mademoiselle Carreux de Rosemond (died 1788).* 1785. Oil on canvas, 6'11" x 4'111/2" (2.11 x 1.51 m). The Metropolitan Museum of Art, New York

Gift of Julia A. Berwind, 1953 (53.225.5)

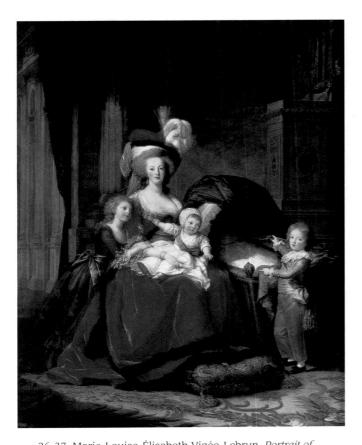

Det Screen

上方方面的特殊的 品味品源

26-37. Marie-Louise-Élisabeth Vigée-Lebrun. *Portrait of Marie Antoinette with Her Children*. 1787. Oil on canvas, 9'1/4" x 7'5/8" (2.75 x 2.15 m). Musée National du Château de Versailles, Versailles, France

As the favorite painter to the queen, Vigée-Lebrun escaped from Paris with her daughter on the eve of the Revolution of 1789 and fled to Rome. After a very successful self-exile working in Italy, Austria, Russia,

the Revolution of 1789 and fled to Rome. After a very successful self-exile working in Italy, Austria, Russia, and England, the artist finally resettled in Paris in 1804 at the invitation of Napoleon I and again became popular with French art patrons. Over her long career, she painted about 800 portraits in a vibrant style that changed little over the decades.

Labille-Guiard's *Self-Portrait with Two Pupils* (fig. 26-36) of 1785, the three women pose in front of an easel in an allusion to the Three Graces. The portrait bust is of the artist's father, sculpted by a family friend. Labille-Guiard was committed to the education of women artists and petitioned successfully in 1790 to end the restriction on the number of women admitted to the Royal Academy.

Vigée-Lebrun's reputation paralleled Labille-Guiard's. The daughter of a professor at the Academy of Saint Luke, she entered its school at age fourteen. She exhibited in the Saint Luke's 1774 Salon, along with Labille-Guiard, and received her first court patronage in 1776. In 1779 she became painter to Queen Marie Antoinette. Initially refused membership in the Royal Academy because her husband, Lebrun, was an art dealer, she later had to combat gossip that she had been admitted only because of pressure from the court.

Vigée-Lebrun painted more than twenty portraits of Marie Antoinette, including one in 1787 of the queen with her children (fig. 26-37), made in the hope that the queen's depiction as a devoted mother would counter her public image as immoral, extravagant, and conniving. In a poignant touch, the little dauphin—the eldest son and heir to a throne he would never ascend—points to the empty cradle of a recently deceased infant. The princess leans affectionately against her mother, who holds the infant Louis Charles on her lap. Even though the French upper classes routinely used wet nurses and governesses, the image of a loving mother surrounded by numerous children represented an ideal in the work of many Neoclassic artists. The portrait thus identified the gueen as a sister to women everywhere, united with them in sacred motherhood (see "Jean-Jacques Rousseau on Educating Children," below). The image here also alluded to the well-known allegory of Abundance, suggesting the peace and prosperity of society under the king's rule.

But the king's rule was rapidly coming to an end. One summer afternoon in 1789, a Parisian mob stormed the Bastille, a notorious prison; early that autumn a Parisian

JEANJACQUES ROUSSEAU ON EDUCATING CHILDREN

Although he never married and he placed his own children in orphanages, the French-Swiss philosopher

Jean-Jacques Rousseau (1712–1778) formulated a behavioral program of childhood education that affected all French schools after the Revolution of 1789. His essay on education, Émile, ou de l'Éducation (Emile, or Regarding Education), was written at the same time as his well-known political tract Le Contrat Social (The Social Contract), in which he argued that all people were equal and inherently good and

that rulers held their positions only by the consent of the people they governed. Émile, which contained a preliminary outline restating the theory of the social contract, was published in Paris in May 1762. Believing that children were inherently good until society corrupted them and broke their naturally independent, inquisitive spirits, Rousseau advised mothers to breast-feed their babies themselves, dress them in loose clothing with no bonnet, wash them in unheated water, give them freedom to crawl about, and never to rock them, which Rousseau considered harmful. As boys grew, they were to be taught to value nature, human liberty, and personal valor and virtue. This environment would inevitably produce a citizen committed to political freedom and civic duty. Girls were to be educated only as needed for their futures as wives and mothers. Once married, women were to stay at home, out of the public eye, caring for their households and children, which Rousseau saw as "the manner of living that nature and reason prescribe for the sex" (Richard and Richard, pages 457-458). The Contrat Social became the basis for the French Constitution, and Émile a manual for the country's public education programs.

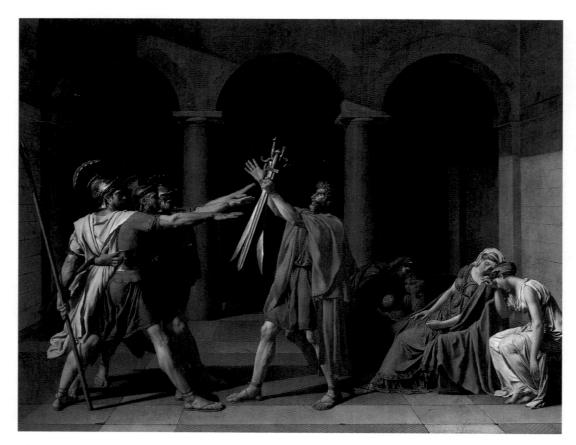

26-38. Jacques-Louis David. Oath of the Horatii. 1784–85. Oil on canvas, $10'8^{1}/4" \times 14' (3.26 \times 4.27 \text{ m})$. Musée du Louvre, Paris

crowd marched to Versailles and forced the royal family to move to Paris. The monarchy was doomed; the king and queen were beheaded in 1793, and their one surviving son, Louis Charles, died two years later in prison.

Jacques-Louis David. More than any other artist, Jacques-Louis David (1748–1825) is identified today with the French Revolution, even though his first patronage and early successes came from the court of Louis XVI. David had prepared for a career as an architect, but when he insisted on becoming a painter, he was **apprenticed** to Joseph-Marie Vien—that is, contracted to work for Vien while he learned his art. David also worked briefly for Fragonard on interior decoration (now lost) for one of Ledoux's Paris town houses, but after winning the Prix de Rome in 1774, David accompanied Vien to Italy.

Back in Paris, David exhibited at the 1781 Salon, where his work elicited Diderot's highest praise. Louis XVI, as part of a program to decorate his palaces with history paintings, in 1783 commissioned from David *Oath of the Horatii* (fig. 26-38). This work, which David painted in Rome so that he might be in close communion with the Classical past, would be the first major expression of his mature Neoclassic style.

As early as 1781 the artist had considered painting this duel to the death, fought by three Roman brothers (the Horatii) and three brothers from nearby Alba (the Curatii) to settle a dispute between their native cities. David's sources for the story may have included a play he

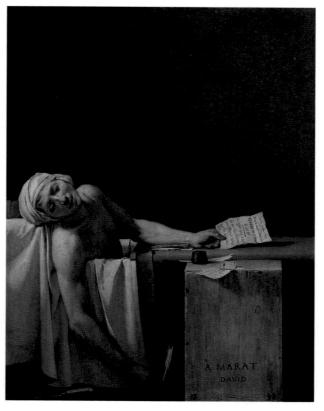

26-39. Jacques-Louis David. *Death of Marat.* 1793. Oil on canvas, 5'5" x 4'2¹/₂" (1.65 x 1.28 m). Musées Royaux des Beaux-Arts de Belgique, Brussels

saw in late 1782. Somewhat surprisingly, he depicted an incident that is not actually part of the story in any known source: the three Horatii taking an oath to fight to the death for Rome. The meaning of the finished painting the value of putting patriotic duty above personal interests and even family obligations—is expressed with such clarity and power that it created a sensation when David exhibited it in Rome and Paris in early 1785. The three brightly dressed Horatii and their father are spotlighted in a shallow, stagelike space in front of a darkened portico, whose three arches organize the composition. Standing at the center, the father, Horatius, administers the oath to his sons. Fired with patriotism, the energetic young men with their glittering swords are a powerful contrast to the swooning women already mourning the tragedy to come. Ignored by her husband and sons, the wife of Horatius embraces her grandchildren, while her daughter Camilla, who is betrothed to one of the Curatii, and her daughter-in-law Sabina, a Curatii herself, weep together, knowing that whatever the outcome of the battle, they will inevitably lose someone dear to them.

Painted for a royal commission, David's *Oath of the Horatii* was fully within the tradition of chivalric self-sacrifice. Heroic subjects from Roman history were later extolled by leaders of the French Revolution as examples of republican virtue, so it is tempting to read revolutionary warnings into David's work of the 1780s. But the artist's political radicalism did not emerge until some years after the picture was painted, and it seems unlikely that he intended any overt antimonarchist statement at this point. It should be said, however, that David almost certainly shared in the general desire for moral renewal, and his impassioned paintings of Roman virtue helped to feed revolutionary fervor.

In 1793 the radical Jacobin party came to power. The Jacobins drafted a new constitution, abolished the monarchy—and also slavery in the French colonies—and proclaimed the year 1793 Year I. As an elected deputy to the National Convention, David became propaganda minister and director of public festivals. Possibly at his instigation, the Royal Academies were abolished as the last refuge of the aristocracy; they were reconstituted two years later, however, as the Institut de France.

In 1793 the Jacobins commissioned from David a tribute to one of their leaders, Jean-Paul Marat, who had been assassinated that year. Marat, a radical pamphleteer and revolutionary firebrand, had been responsible in part for the 1792 riots in which Jacobins had killed hundreds of helpless prisoners. A young woman named Charlotte Corday d'Armont heard accounts of these atrocities and decided that Marat was a monster who should be destroyed. Marat, who took long daily medicinal baths for a skin ailment, wrote and received visitors while sitting in his bathtub. It was there that Charlotte

26-40. Jacques-Louis David. *Napoleon Crossing the Saint-Bernard.* 1800–01. Oil on canvas, 8'11" x 7'7" (2.7 x 2.3 m). Musée National du Château de la Malmaison, Rueil-Malmaison, France

Corday, pretending to be an informant about enemies of the Revolution, stabbed him to death.

In his *Death of Marat* (fig. 26-39), David combined naturalistic immediacy with a strong Neoclassical clarity in a manner that also recalls Caravaggio in its spare setting, dramatic lighting, and forceful intrusion into the viewer's space. The slumped figure of the dead revolutionary deliberately evokes images of the dead Jesus, a suggestion reinforced by the single wound under Marat's collarbone. Thus, like West's *Death of General Wolfe* (see fig. 26-22), David's painting reenacts a contemporary event using the visual language of Christian imagery and Baroque realism.

The fall from power of the Jacobin party eventually brought Napoleon Bonaparte to power. Made commander of French forces in Italy in 1796, Napoleon rose through his spectacular military successes there and in Austria and returned to Paris in 1797 to wide public acclaim. Napoleon agreed to sit for a portrait for David, but after three hours of posing, the general became impatient, and the portrait was never completed. Nevertheless, David kept the sketch in his studio and proclaimed to everyone that "Bonaparte is my hero." In November 1799 Napoleon was declared First Consul—in effect, dictator—and the government was reorganized.

In May 1800 Napoleon and his army returned to northern Italy, an event that David commemorated in his *Napoleon Crossing the Saint-Bernard* (fig. 26-40). As with the *Death of Marat*, the painting treats contemporary history in an idealized Grand Manner, portraying what was

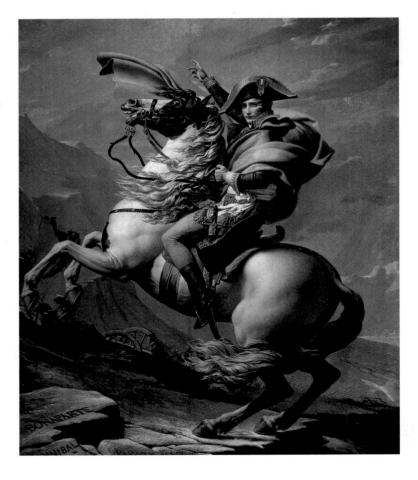

actually an uneventful trip as a thrilling drama. Napoleon charges up the mountain slope past rocks incised with his name and those of the heroes who had preceded him, Hannibal and Charlemagne, while a strong wind whips his cloak and the horse's mane and tail into a passionate frenzy. Here, Napoleon—actually quite a small man—seems to tower over the figures of his soldiers, who are hauling a cannon up the steep trail.

Napoleon appointed David his chief painter in 1803 and, after assuming the title of emperor in 1804, promoted him to chief imperial painter and made him a baron. When Napoleon fell from power, David moved to Brussels, where he was quickly surrounded by admirers and patrons. He died there in 1825 without ever returning to Paris.

David's Pupils. Among David's first pupils was Anne-Louis Girodet-Trioson (1767–1824), whose mature style, which anticipated Romanticism, David considered a betrayal of his teachings. Winner of the Prix de Rome in 1789, Girodet remained in Italy from 1790 to about 1796. Upon his return he held his own in competition with David and his fellow students and later gained favor with Napoleon.

Girodet favored mythological and literary subjects, but he also painted portraits in a proto-Romantic style. In his 1797 *Portrait of Jean-Baptiste Belley* (fig. 26-41), a

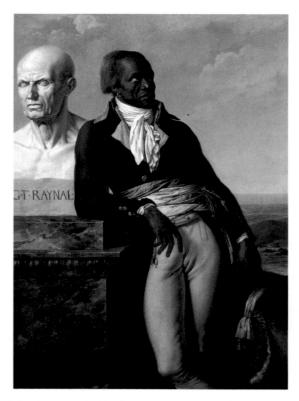

26-41. Anne-Louis Girodet-Trioson. *Portrait of Jean-Baptiste Belley.* 1797. Oil on canvas, 5'2¹/₂" x 3'8¹/₂" (1.59 x 1.13 m). Musée National du Château de Versailles, Versailles, France

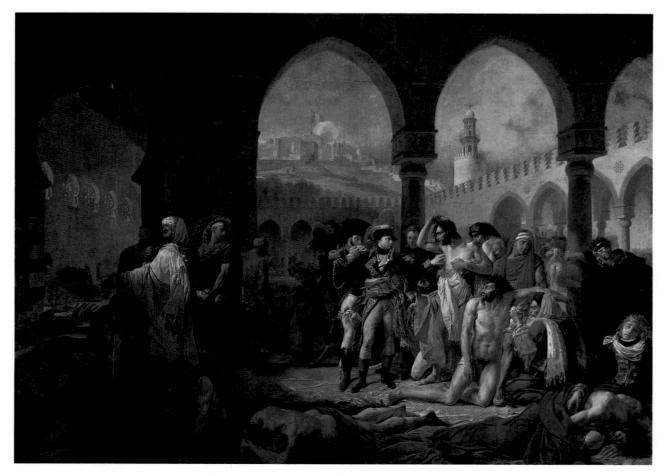

26-42. Antoine-Jean Gros. *Napoleon in the Plague House at Jaffa*. 1804. Oil on canvas, 17'5" x 23'7" (5.32 x 7.2 m). Musée du Louvre, Paris

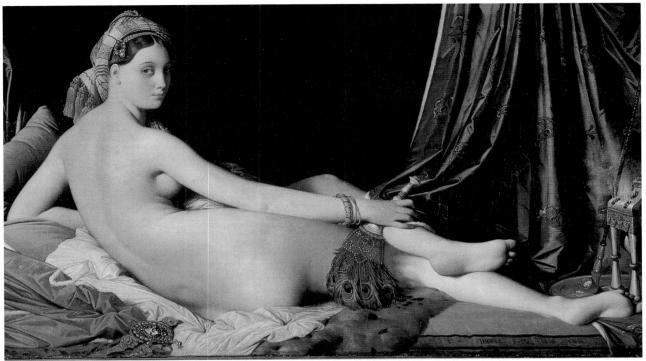

26-43. Jean-Auguste-Dominique Ingres. *Large Odalisque*. 1814. Oil on canvas, approx. 2'10" x 5'4" (0.88 x 1.62 m). Musée du Louvre, Paris

respected diplomat from the French-ruled colony of Saint-Domingue (now Haiti), he combined a casual but elegant pose inspired by classical sculpture and realistic features with an allusion to events related to his subject's past. Belley, a tall man with a distinctive African appearance, leans on a pedestal holding a bust of the abbot Guillaume Raynal, the French philosopher-historian who wrote a book attacking European policies toward the peoples of the Caribbean. Raynal, who had had to flee France as a result, was later extolled as a champion of human rights. The inclusion of his bust in Belley's portrait set the historical tone of the picture and also commemorated Raynal's death the year before. Unfortunately, Napoleon reestablished slavery in the islands.

Antoine-Jean Gros (1771-1835), who began to work in David's studio in 1783 at age twelve, eventually vied with his master for commissions from Napoleon. He also went further than Girodet in his embrace of Romanticism. Gros traveled with Napoleon in Italy in 1796-1797 as an appraiser of artworks to be confiscated and sent back to Paris, a practice David deplored. Later Gros became an official chronicler of Napoleon's military campaigns. His Napoleon in the Plague House at Jaffa (fig. 26-42) of 1804 portrayed the emperor as a near-divine ruler courageously touching one of his soldiers who was ill from an infectious disease. The gesture recalls the medieval belief that monarchs could, by their touch, cure scrofula, a form of tuberculosis of the lymph glands or bones. Gros's heroic fiction hides a terrible truth: Napoleon subsequently ordered the sick soldiers to be poisoned because they were an impediment to his campaign. There are a number of Romantic elements in the painting: the exotic location, the smoky red sky seen through the dark Moorish arches, and the moving image of the dead and dying.

Jean-Auguste-Dominique Ingres (1780–1867) thoroughly absorbed his teacher David's Neoclassical vision but reinterpreted it in a new manner. Inspired by Raphael rather than by antique art, Ingres emulated the Renaissance artist's precise drawing, formal **idealization**, classical composition, and graceful lyricism. Ingres won the Prix de Rome in 1801 and lived in Italy from 1806 to 1824; he returned to Italy to serve as director of the French Academy in Rome from 1835 to 1841. As a teacher and theorist, Ingres became the most influential artist of his time, helping to formulate the taste of his own generation and using his academic position to suppress other artistic styles.

Painted in Rome in 1814, Ingres's Large Odalisque (fig. 26-43), despite its cool and precise treatment, is in many respects anticlassical. The exotic subject—an odalisque, who is any woman living in the women's quarter of a Turkish house (oda)—allowed the artist to paint a full nude, but the odd distortions of her body seem akin to Mannerist art of the late sixteenth century. To make this figure conform to his idiosyncratic aesthetic, Ingres has given her several extra vertebrae and tiny, boneless feet scarcely capable of supporting her weight. Surrounded by exotic paraphernalia, Ingres's cool, languorous woman personifies an elegant eroticism reminiscent of Canova's Maria Paulina Borghese as Venus Victrix (see fig. 26-6). She remains forever aloof as part of a remote and imaginary world.

A superb portraitist, Ingres could capture a true likeness while creating a Grand Manner impression. His

26-44. Jean-Auguste-Dominique Ingres. *Madame de Moitessier.* 1851. Oil on canvas, 57 ³/₄ x 39 ¹/₂" (146.7 x 100.3 cm). National Gallery of Art, Washington, D.C. Samuel H. Kress Collection

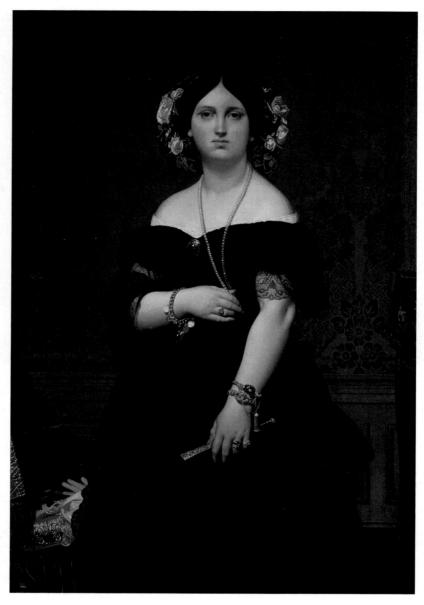

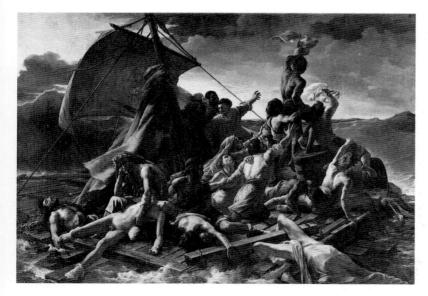

26-45. Théodore Géricault. *Raft of the "Medusa."* 1818–19. Oil on canvas, 16'1" x 23'6" (4.9 x 7.16 m). Musée du Louvre, Paris

Madame de Moitessier (fig. 26-44), painted in 1851, conveys a monumental presence through the subject's confident pose, authoritative eye contact with the viewer, and rich costume. Here, as in the *Large Odalisque*, the emphasis on clearly defined contours and carefully drawn details exemplifies Ingres's belief in the superiority of drafting over color.

The Romanticism of Géricault and Delacroix.

Romanticism, already anticipated in French painting in Napoleon's reign, flowered during the royal restoration that lasted from 1815 to 1848. French artists not only drew upon literary sources but also added the distinctive new dimension of social criticism. Romantic painting was characterized by loose, fluid brushwork, strong colors, complex compositions, dramatic contrasts of light and dark, and expressive poses and gestures. These qualities represent a return to the Baroque, but Romanticism is very much a modern art movement in that artists were free to choose from a variety of subjects, styles, and techniques as their inspiration dictated.

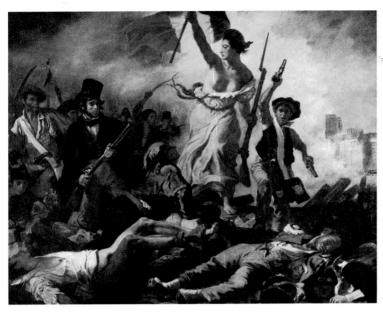

26-46. Eugène Delacroix. *The Twenty-eighth of July: Liberty Leading the People.* 1830. Oil on canvas, 8'6" x 10'7" (2.59 x 3.25 m). Musée du Louvre. Paris

Delacroix painted this patriotic allegory after watching the three-day Revolution of 1830 fought in the streets near his studio. Critics did not appreciate the picture when it was exhibited at the 1831 Salon, but the new royal government of "Citizen King" Louis Philippe bought it for a high price. Hung in the painting gallery of the Palais du Luxembourg, it began to annoy the king, however, and was returned after a few months to Delacroix, who gave it to his Aunt Félicité. When the Revolution of 1848 ended the monarchy and established the Second Republic, the painting was returned to the State and exhibited at the 1848 Salon.

Théodore Géricault (1791–1824) began his career painting works inspired by Napoleon's military campaigns. In 1818–1819 Géricault found the subject for his major work, *Raft of the "Medusa"* (fig. 26-45). When the French ship *Méduse* foundered off the African coast in July 1816, during a shipboard celebration marking the crossing of the equator, the commander ordered 149 passengers and crew onto a small raft attached by a rope to a lifeboat holding the ship's officers. The towline either broke or was deliberately cut to save the lifeboat, and the raft tossed about on stormy seas for nearly two weeks before it was found, with only fifteen survivors. The wreck of the *Méduse* became a scandal involving the elderly, incompetent aristocratic commander appointed by the government.

Géricault researched the subject thoroughly, starting with the study of a widely circulated pamphlet in which two survivors gave a horrifying account of insanity and cannibalism. He visited hospitals and morgues to sketch the dying and dead, and he launched a raft in the ocean to observe how it rode the waves. In his studio he used live models, one of whom was the painter Delacroix, who appears as the corpse lying facedown at the center of the canvas. The Romantic subject of human tragedy and injustice is illustrated with indignant compassion, but Géricault's academic training underlies the painting's organization as a series of interlocking triangles. The outstretched arms of the victims lead the viewer's eye up to the climactic figure of an African held aloft to wave a red-and-white cloth to attract the attention of a ship that is only a speck on the horizon. Like so many Neoclassic and Romantic artists, Géricault was powerfully influenced by Michelangelo; the writhing movements of the monumental, idealized male bodies in his painting reflect Michelangelo's Last Judgment (see fig. 18-17). To disguise the implied criticism of the government, Géricault had to change the painting's title to an anonymous "ship" wreck" for the 1819 Salon. Failing to find a buyer, he followed a trend of the time and began exhibiting the enormous canvas to the public for a fee. In 1820 he took the painting to England, where it created a sensation. Despite its controversial subject and realistic detail, *Raft of the "Medusa"* was a sufficiently heroic and universal image for the painting to be purchased by the French government shortly after Géricault's death at thirty-two.

Eugène Delacroix (1798-1863) followed his friend as the inspirational leader of the Romantic movement. His social conscience was expressed mainly in works that conveyed a dramatic concern for personal and political liberty. But he had an equally consuming interest in literary drama, such as Shakespeare's plays, and in all manner of exotic subjects remote in time or place. Delacroix's political sympathies were republican throughout the royal restoration. In commemorating the Revolution of 1830 with his painting The Twenty-eighth of July: Liberty Leading the People (fig. 26-46), he created an image that became a widely recognized symbol of liberation. In that fierce but brief uprising, Parisians had forced the abdication of Charles X. Delacroix showed the contemporary event as an allegory in which the rebels are urged on by a monumental figure of Liberty with "powerful breasts and robust charm," as she was described in a popular French song. The motley group of fighters, seemingly oblivious to the dead and dying over whose bodies they charge, includes a twelve-year-old boy who killed a royal soldier before being badly wounded himself. Delacroix seems to have taken the visual drama of Géricault's Raft of the "Medusa" and combined it with the fervent patriotic spirit of David's Oath of the Horatii (see fig. 26-38).

A trip to North Africa in 1832 made a deep impression on Delacroix and provided him with enough sketches of exotic subjects to feed his pictorial imagination for the rest of his life. A particularly fruitful resource for his work back in Paris was a series of quick watercolor sketches that he had made during a secret visit to an Algerian harem. One result of this adventure was his *Women of Algiers* of 1834 (fig. 26-47). Drawing with brilliant color and laying down his intense tones with loaded brushes in short strokes, the artist re-created on canvas a vision of his afternoon with the odalisques, whom he described

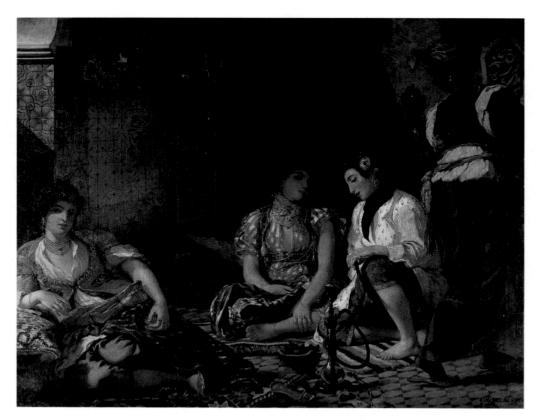

26-47. Eugène Delacroix. *Women of Algiers*. 1834. Oil on canvas, 5'10⁷/8" x 7'6¹/8" (1.8 x 2.29 m). Musée du Louvre, Paris

as "tame gazelles." Delacroix was particularly impressed not only by the exoticism but also by the dignity of the North Africans, who seemed to him to have a nobility like that of the ancient Greeks and Romans.

Romantic Sculpture

Neoclassicism prevailed throughout the Napoleonic period, but by the fall of Napoleon in 1815, a new approach to sculpture emerged that paralleled Romanticism in painting. A renowned sculptor in this mode, François Rude (1784-1855), arrived in Paris at the height of Napoleon's reign. A fervent supporter of the emperor, he fled to Brussels when his hero first fell from power in 1814. When Rude returned to Paris in 1827, his early Neoclassical style gave way to a taste for high drama and violently active poses, as seen in his major work, Departure of the Volunteers of 1792 (fig. 26-48), popularly called The Marseillaise in reference to France's revolutionary anthem. Executed between 1833 and 1836, this relief decorates the base of one of the most prominent public monuments of Paris, the Neoclassical Arc de Triomphe at the Place de l'Étoile, commissioned by Napoleon. The sculpture commemorates the volunteer army that halted a Prussian invasion in 1792–1793 which aimed to restore the rule of Louis XVI. The soldiers, dressed in Roman battle gear or heroically nude, are urged forward by the lunging figure of the Goddess of Liberty, brandishing a sword. The compression of the gesticulating figures and the forward surge of activity convey an unprecedented

feeling of passion and excitement in a sculptural group.

Antoine-Louis Barye (1796-1875), like Rude, was trained as a Neoclassical sculptor. Influenced by Géricault and Delacroix, he was praised by critics for his entry in the 1831 Salon of a bronze figure of a tiger devouring a hare. Barye closely studied the wild animals in Paris's zoo, where his friend Delacroix occasionally joined him on sketching trips. Barye's Lion Crushing a Serpent (fig. 26-49) of 1833 is one of his many compositions involving a powerful animal and its weaker prey. Characteristic of his Romantic approach is the theme of Nature's cruelty expressed through a dynamic composition and an intense naturalism in the anatomically correct rendering of the animals. His work exploits the expressive possibilities and dark tonalities of bronze particularly well. In demand internationally, Barye was a favorite sculptor of Napoleon III during the Second Empire (1852-1870).

GERMANY King Frederick William II of Prussia (ruled 1786–1797), like Napoleon, found in Neoclassicism the perfect style for his regime. Frederick William thought of himself as a philosopherking, personifying not only power and severity but also intelligence and discipline, and Neoclassicism seemed to embody precisely those attributes. At his direction the royal architect Karl Gotthard Langhans (1732–1808) built the Brandenburg Gate (fig. 26-50) as a monumental entrance to one of the main boulevards of Berlin, the Prussian capital. Almost certainly familiar with the Vitruvian

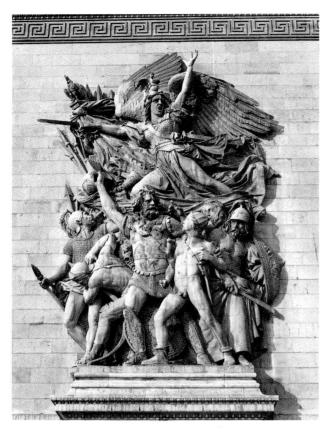

26-48. François Rude. *Departure of the Volunteers of 1792* (*The Marseillaise*). 1833–36. Limestone, height approx. 42' (12.8 m). Arc de Triomphe, Place de l'Étoile, Paris

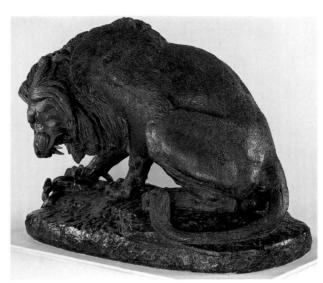

26-49. Antoine-Louis Barye. *Lion Crushing a Serpent*. 1833. Bronze, height 5'10" (1.8 m). Musée du Louvre, Paris Barye's dramatic animal sculpture in the Romantic vein attracted many American patrons. After his death they joined together to raise money through exhibits of his works in New York and Paris to commission a public memorial to the sculptor. The result was Square Barye, a park in the heart of Paris on the southeast tip of an island in the Seine River behind Nôtre-Dame Cathedral. To mark the site, a large marble monument was created by reproducing several of Barye's best-known works, including this one.

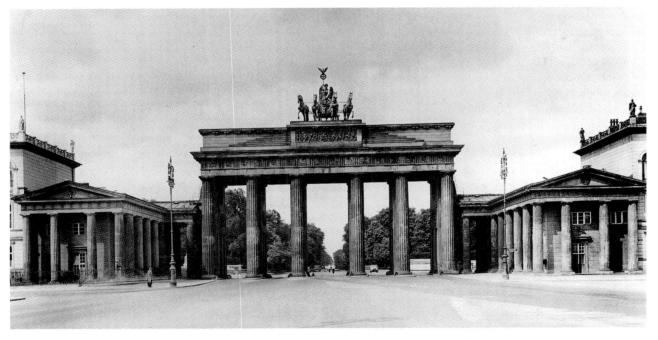

26-50. Karl Gotthard Langhans. Brandenburg Gate, Berlin. 1788-91

conception of the austere and heavily proportioned Doric as being the most masculine order, Langhans took as his model for the project the Propylaia, the Doric gateway to the Acropolis in Athens built in the fifth century BCE. Thus, the Brandenburg Gate was the first classical monument in Germany to be modeled on a Greek rather than a

Roman example. Langhans's severe Doric style was continued well into the nineteenth century in Germany by his pupils.

Other artists turned to aspects of the Middle Ages as inspiration for a national German art. Neo-Gothic castles and churches asserted traditional German values as

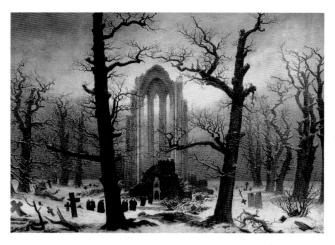

26-51. Caspar David Friedrich. *Cloister Graveyard in the Snow.* c. 1817–19. Oil on canvas, 47⁵/₈ x 66⁷/₈" (121 x 169.9 cm). Former collection of Staatliche Museen zu Berlin, Preussischer Kulturbesitz, Nationalgalerie. Destroyed in World War II

Neoclassicism gave way to Romanticism. The work of the painter Caspar David Friedrich (1774-1840) represents the brooding melancholy that characterizes German Romanticism. Friedrich, like the sculptor Thorvaldsen (see fig. 26-7), attended the Royal Academy in Copenhagen, then he settled permanently in Dresden in 1798. His early work was almost exclusively monochromatic: pen-and-ink sketches, sepia (dark brown ink) drawings, and etchings. Friedrich began to paint in oils in 1807, but even then confined himself to a restrained palette. His precise execution often depends on light, fog, snow, or some other blanketing element to unify his haunting compositions, which frequently seem to express loneliness and dejection. Friedrich's mature work uses a poetic and symbolic vocabulary, fusing images of religion, nature, and death to express his intense obsession with the impermanence of human life.

Cloister Graveyard in the Snow (fig. 26-51) of about 1817–1819 shows a snow-covered forest landscape. where bare-headed monks move in procession past crumbling gravestones in the foreground, through the portal of a ruined church, and toward an altar. In the background is the hulking remnant of the church's choir, which seems to hover over the scene like a presiding spirit. The lonely grandeur of the snow-covered landscape and the rugged building, as well as the sheer indecipherability of the event taking place contribute to the eerie fascination this painting often evokes. With characteristic precision, Friedrich based the architecture on sketches he had made of a ruined Cistercian monastery near the Baltic Sea. He is known to have considered bare-limbed oak trees as emblems of the pre-Christian world, which suggests that this desolate forest with its ruined Gothic choir and liturgical procession may be intended as an elegy on loss and the transience of human life and society.

SPAIN In eighteenth-century Spain, patrons looked to foreign artists, such as Giovanni Battista Tiepolo (see fig. 19-73), who spent his last nine years in

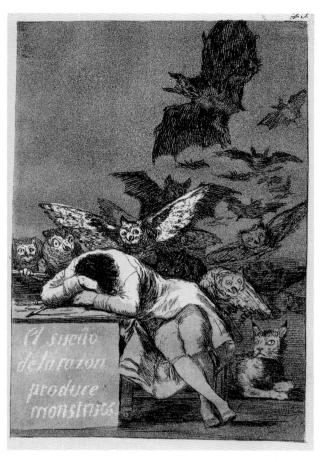

26-52. Francisco Goya. *The Sleep of Reason Produces Monsters*, No. 43 from *Los Caprichos* (The Caprices). 1796–98, published 1799. Etching and aquatint, 8½ x 6" (21.6 x 15.2 cm). The Hispanic Society of America, New York

After printing about 300 sets of this series of 80 prints, Goya advertised them for sale in February 1799 in two Madrid newspapers. When only 27 sets had been sold after four years, in 1803 Goya made a gift of the plates and the remaining sets to the Royal Printing Office, in return for which his nineteen-year-old son, Francisco Xavier, was granted a yearly stipend to further his education.

Madrid, to fill major commissions. Not until late in the century did a native painter emerge whose achievements were comparable to those of Velázguez. Francisco Goya v Lucientes (1746-1828), in fact, learned as much from Velázquez as from his own teachers by making etchings after Velázquez's paintings. He also studied the paintings and etchings of Rembrandt, whom he considered his other great inspiration. During the first half of his long career, however, Goya chiefly produced formal portraits and Rococo genre pictures, including sixty-three full-scale tapestry designs for the Royal Manufactory in Madrid, painted in a light palette that clearly shows the influence of Tiepolo. Around 1800, however, Goya's study of Velázquez and Rembrandt began to be expressed in his work in a darker tonality, freer brushwork, and dramatic presentation. His style continued to develop in this direction for the rest of his career.

In 1799 Goya published his first suite of etchings, *Los Caprichos* (The Caprices), which exhibit a new bitterness

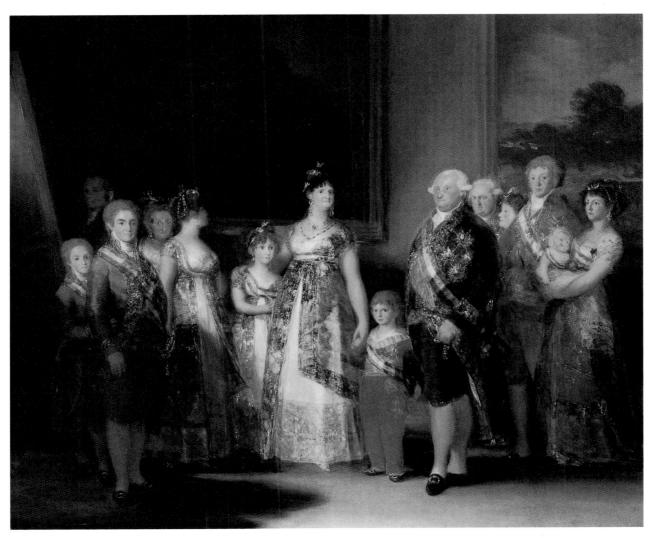

26-53. Francisco Goya. Family of Charles IV. 1800. Oil on canvas, 9'2" x 11' (2.79 x 3.36 m). Museo del Prado, Madrid

in his outlook. Setting the tone for eighty etchings is the print originally intended as its frontispiece, The Sleep of Reason Produces Monsters (fig. 26-52). Although the text published with the print sounds a hopeful note ("Imagination abandoned by reason produces impossible monsters; united with her, she is the mother of the arts and the source of their wonders"), the images are an angry attack on contemporary Spanish manners and morals that makes Hogarth's satire (see fig. 26-17) seem tame by comparison. Goya did not share the Enlightenment faith in the ultimate rationality and goodness of humanity. On the contrary, he believed that the violence, greed, and foolishness of his society had to be examined mercilessly if it were to be changed in any way. Each Capricho depicts a dramatic moment, emphasized by strongly contrasting areas of light and shadow, provided by the stark, unprinted paper and shading in gray and black.

Goya's paintings and prints were admired for their dazzling technical execution, even by critics who might otherwise have been offended by the searching realism and astute psychological penetration of his best work. Appointed court painter to Charles III in 1786, Goya was elevated to principal painter under Charles IV (ruled

1788-1808). The one portrait that he made of Charles IV and his extended family in 1800 (fig. 26-53) is an enigmatic homage to Velázquez's Las Meninas (see fig. 19-36). In a clear allusion to that portrait, Goya placed himself at work at his easel in a room of the palace, with the royal family gathered about him. But instead of the grave dignity of Velázquez's king and queen and the playful charm of their daughter, a chill foreboding seems to grip Goya's royal family. Charles IV appears almost catatonic, and the rest of the group is strangely quiet and apprehensive before the artist's—and the viewer's pitiless scrutiny. Even the future Ferdinand VII, presumably at the height of his youth and vigor, shares in the general paralysis, and his fiancée at his side is shown, curiously, with her face averted. Despite the clear allusion to Las Meninas, Goya's glittering encrustation of paint recalls the surface of Rembrandt's Jewish Bride (see fig. 19-51) rather than the flickering brushwork of Velázquez. What the artist thought about painting this disturbing image can only be surmised, but it, too, seems touched by the bitterness shown in Goya's earlier Caprichos.

Spain, with its extensive American territories and strategic location at the entrance to the Mediterranean

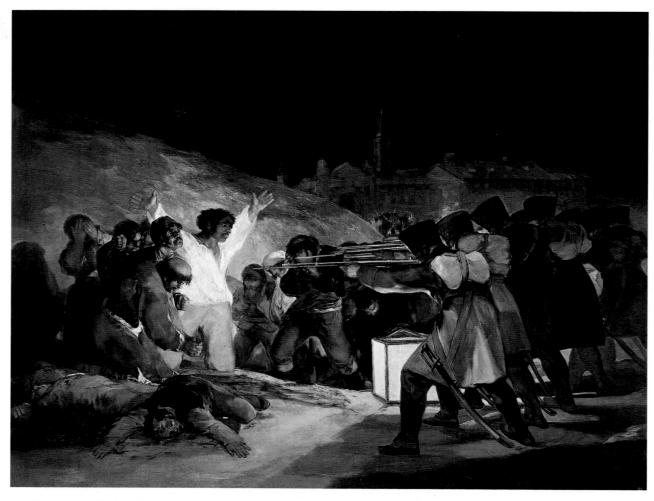

26-54. Francisco Goya. Third of May, 1808. 1814-15. Oil on canvas, 8'9" x 13'4" (2.67 x 4.06 m). Museo del Prado, Madrid

Sea, soon attracted Napoleon's interest. In 1808 he occupied the country, forced Charles IV to abdicate, and installed his brother, Joseph Bonaparte, as king. At first many Spaniards welcomed the new regime, hoping for much-needed political reform. However, many of the hoped-for reforms outraged conservatives and Spanish nationalists, and there were continuous bloody revolts, which the French ruthlessly put down.

Charles IV's son Ferdinand VII, imprisoned in France by Napoleon, was returned to power in 1814. Goya quickly made overtures to him, painting two works commemorating the first popular uprising in Madrid in support of the royal family. In Third of May, 1808 (fig. 26-54), Goya depicted the summary execution of a group of rebels. Although he had probably not seen any of the rebellion at firsthand, he sketched the site of the execution and would have heard many descriptions of it. The violent gestures of the terrified rebels and the almost mechanized efficiency of the firing squad seem to be scenes from a nightmare. The man in the white shirt, confronting his faceless killer with outstretched arms suggesting the crucified Jesus, is an image of particular horror and pathos.

Ferdinand VII's reactionary reign was disastrous for Spain. The king abolished the constitution and reinstated the Inquisition. Goya joined a community of Spanish exiles in France, where he died four years later.

UNITED **STATES**

THE The United States emerged from the War of Independence from Britain with sufficient resources, technology, and entrepreneurism to move into the forefront of the industrialized world. The country's

territory was doubled by the purchase from France in 1803 of Louisiana, a vast expanse that reached from the Gulf of Mexico northward to what is now Canada and from the Mississippi River northwestward to present-day Oregon. As explorers spoke glowingly of opportunities in the West, Americans began migrating to California and the Pacific Northwest. When gold was discovered in California in 1848, the migration became a flood. The transcontinental railroad completed in 1869 made the journey considerably easier, and by the 1890s the frontier had disappeared.

Architecture

At the end of the eighteenth century, classicism was still the prevailing style for architecture in the United States, especially for major public buildings. Only in the midnineteenth century did Romanticism, in the form of Romanesque and Gothic revivalism, begin to appear in American architecture as the new rich built replicas of medieval castles and European mansions.

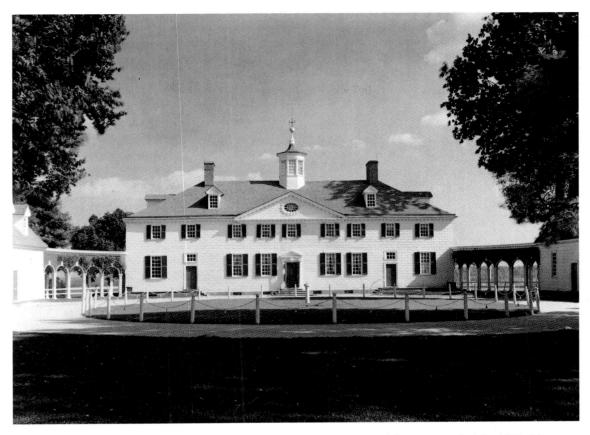

26-55. James Patterson and George Washington. Mount Vernon, Fairfax County, Virginia. 1758-86

Perhaps the most famous old house in North America is Mount Vernon. George Washington, with a 1754 lease, acquired Mount Vernon, his family's estate in Fairfax County, Virginia, and in 1758 began enlarging the small farmhouse on the property. Work on the mansion was interrupted during the War of Independence, and the house was finally completed in 1786. Mount Vernon (fig. 26-55) is a Georgian building, the style named for the kings of England and inspired by English country houses and the Renaissance villas of Palladio (see fig. 18-35). Although Mount Vernon is constructed of wood, the siding on the outside is designed to look like stone. The elevation is simple and symmetrical, with a triangular pediment suggesting a Roman temple front. Curving arcades link this central block with the outbuildings, including the kitchen.

The large dining room at Mount Vernon (fig. 26-56), called simply the "new room" by the Washingtons, was decorated by John Rawlins and Richard Thorpe in 1786–1787. Its decoration belongs to the Federal phase of American architecture, which spanned the period from the end of the American Revolution in 1783 to the 1820s. In the Federal period there was a move toward archeologically correct decorative details prompted by the excavations going on in Italy. In some buildings the motifs came directly from Roman sources, but in others, such as the dining room, they were derived from the work of Robert Adam (see fig. 26-10). Rawlins and Thorpe created a graceful and intimate effect using recognizable classical elements such as the triumphal-arch, or Pal-

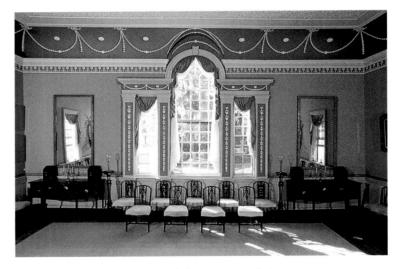

26-56. John Rawlins and Richard Thorpe. Large dining room, Mount Vernon. 1786–87

ladian, window, with its high arch supported on **pilasters**. The pilasters are decorated with a design of modified Roman lamp forms, and the walls are articulated with simple moldings and delicate beaded garlands. The ceiling, which has been enriched with **stucco** (plaster) moldings, strongly recalls Adams' designs.

Thomas Jefferson, political leader and principal author of the Declaration of Independence, believed fervently in architecture as a means of expressing the ideals of the newly independent United States and in Neoclassic

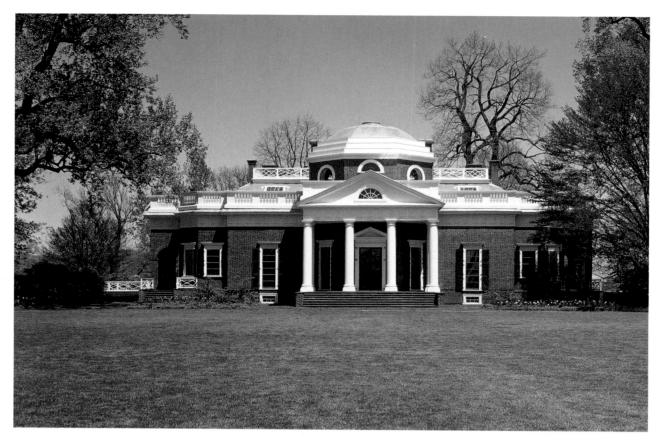

26-57. Thomas Jefferson. Monticello, Charlottesville, Virginia. 1770-84, 1796-1806

as the style appropriate for the new national capital, Washington, D.C. The product of a classical education, Jefferson was also an amateur architect of great knowledge and imagination. Not surprisingly, his designs for Virginia's State Capitol at Richmond and the library and academic buildings of the University of Virginia at Charlottesville (1817–1826) copied Roman temples. In true Enlightenment spirit, Jefferson intended these buildings to be not only handsome but also instructive, helping to encourage in students a spirit of inquiry and, more practically, to provide examples for the study of classical architecture.

Jefferson's first attempts at architectural design were at his home, Monticello, near Charlottesville, Virginia (fig. 26-57). In his enthusiasm he continually altered its design. He began in 1770 with a Palladian structure with superimposed Doric and Ionic orders on the two stories, but by the time the building was completed in 1806, he had transformed it into a Neoclassical design of his own creation—part Roman temple, part Palladian villa, reminiscent of Chiswick House (see fig. 26-9). On the exterior he simplified and unified the facade by using a single story of the Doric order, with its frieze continued from the porch around the walls of the building. A balustrade acts as a screen to disguise the upper level. The materials are red brick with wooden trim painted white and columns formed of bricks covered with stucco and painted white. The central block of the house contains a reception hall on the main level and a ballroom above, whose walls form the octagonal drum supporting the dome.

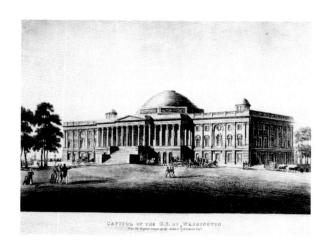

26-58. William Thornton and Benjamin Henry Latrobe.
 U.S. Capitol, Washington, D.C. c. 1808. Engraving by
 T. Sutherland, 1825. New York Public Library
 I. N. Phelps Stokes Collection

While Jefferson was president (1801–1809), he was advised on renovations of the unfinished President's Palace (the original White House) in Washington, D.C., by Benjamin Henry Latrobe (1764–1820), who had immigrated from England in 1796. Jefferson appointed Latrobe surveyor of public buildings in 1803, which gave Latrobe the major responsibility for completing the U.S. Capitol. The basic Capitol plan and exterior design (fig. 26-58) were the work of William Thornton (1759–1828), a physician and amateur architect from the British West Indies, who had won an open competition for it in 1792.

26-59. Benjamin Henry Latrobe. U.S. Capitol. Corncob capital sculpted by Giuseppe Franzoni, 1809

Praised by George Washington for its "grandeur, simplicity, and convenience," the plan resembled a domed Roman temple inserted between two wings of equal size containing on one side the House of Representatives and on the other the smaller Senate chamber and committee rooms. Thornton's elevation, which Latrobe retained, featured a **rusticated** (rough-stone) basement, a temple-front entrance reached by a straight flight of steps, and over the central section, a round dome on an octagonal drum. The Capitol was partially burned during the British attack on Washington in 1814 and had to be rebuilt.

A committed classicist, Latrobe believed that Greek principles and sources, not Roman ones, were more appropriate for a democracy. Although Latrobe worked in the Federal period, he is credited with initiating the

26-60. James Renwick, Jr. Smithsonian Institution, Washington, D.C. 1848–55. Smithsonian Institution Archives, Washington, D.C.

Greek Revival, which became the principal public building style in the United States for the next century. Today Latrobe's ingenuity can be seen in the decoration of the Capitol interior. Determined to find new symbolic forms within the classical mode, he created a variation on the Corinthian order in which ears of corn (fig. 26-59) and tobacco plants were substituted for the acanthus leaves on Greek capitals. Latrobe resigned in 1817, and the Capitol was completed under Charles Bulfinch (1763–1844), the first American-born architect to work on the building. By 1850 the U.S. Congress had grown to 62 senators and 232 representatives, and a major renovation of the Capitol was undertaken that brought the building closer to its present appearance.

The Greek Revival style became a dominant force in nineteenth-century American architecture, but many architects and patrons preferred the parallel revival of Romanesque and Gothic styles. A well-known example, the Smithsonian Institution (fig. 26-60), was built between 1848 and 1855 by James Renwick, Jr. (1818-1895), to house the new scientific and cultural organization established in Washington, D.C., by the English scientist and philanthropist James Smithson. Renwick was the century's foremost designer of neomedieval churches, such as Grace Church (1845) and Saint Patrick's Cathedral (1858–1888), both in New York City. At the Smithsonian he combined elements from Romanesque and Gothic styles into an imaginative gathering of red-brick towers, crenellations, and chimneys. Like the Houses of Parliament in London (see fig. 26-16), the building has an irregular skyline that disguises a symmetrical plan for its exhibition galleries, laboratories, library, auditorium, and offices.

26-61. Frederick Law Olmsted and Calvert Vaux. Greensward Presentation Sketch No. 5, for Central Park, New York City, before and after. 1858. Oil painting and photograph mounted on board, 28½ x 21" (72.4 x 53.3 cm). The Municipal Archives, New York

26-62. Thomas Crawford. Charles Sumner. 1839. Marble, height 27" (69 cm). Museum of Fine Arts, Boston Bequest of Charles Sumner

Originally, an inventive landscape setting was planned for the Smithsonian, and although it was never completed, interest in landscape architecture and in practical gardening was growing in America. The most successful landscape architect of nineteenth-century America was Frederick Law Olmsted (1822-1903). In 1857 he was appointed superintendent of New York's Central Park, which was already under construction through the efforts of the New York writer and publisher William Cullen Bryant. A practical man and a believer in the unaltered beauties of nature, Bryant had envisioned the project as a few winding paths cut through the woods with some water from the aqueduct to the main Manhattan reservoir spilling over the rocks here and there. Olmsted, however, was a great admirer of the eighteenth-century landscape gardens of England, and he accepted an offer of collaboration from the English landscape architect Calvert Vaux (1824-1895) to prepare a new design for the park for an announced competition. Their detailed presentation, called Greensward (fig. 26-61), easily won the competition. Each page of the presentation contained at the top the overall plan of the long rectangular parkland, at the center a black-and-white photograph of the specific area outlined on the plan, and at the bottom a detailed sketch of its proposed "after" appearance. The park as it exists today still essentially reflects the Olmsted-Vaux project.

American Sculptors in Italy

After the American Revolution the demand for monumental sculpture in marble and bronze grew significantly in the United States. At first patrons looked to European Neoclassical sculptors like Houdon and Canova, but soon American sculptors were given opportunities to study and work abroad for their American patrons. As it was for painting, Italy was the wellspring of Neoclassical inspiration in sculpture, and it was also the source of the materials and skilled workers needed to assist in the execution of large commissions. The first sculptors from the United States began arriving in Italy around 1825, and by the 1840s they were flocking to the American artists' colonies in Rome and Florence. (After visiting the large American colony in Rome, Nathaniel Hawthorne was inspired to make these expatriate sculptors the protagonists of his novel The Marble Faun, published in 1860.)

Thomas Crawford (1813–1857) settled in Rome at age twenty-two. There he studied with the Danish Neoclassical sculptor Bertel Thorvaldsen (see fig. 26-7) and quickly developed a solid reputation with both European and American patrons. One of Crawford's early patrons was the Bostonian Charles Sumner (fig. 26-62), who sat for his portrait bust in Rome in 1839. Crawford modeled his subject in the classical manner as an idealized nude with smooth skin and a conventional hair treatment, yet

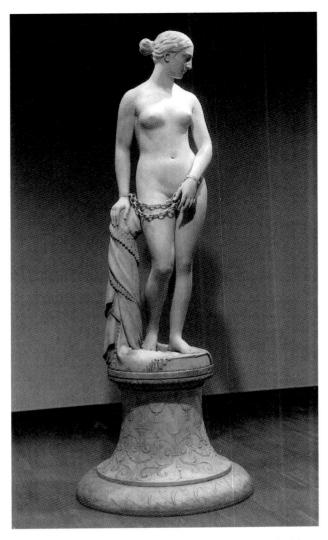

26-63. Hiram Powers. *The Greek Slave*. 1843. Marble, height 5'5¹/2" (1.68 m). Yale University Art Gallery, New Haven, Connecticut

Olive Louise Dann Fund

In time-honored tradition, the creation of a large marble statue was rarely carried through from beginning to end by the artist who conceived it. By delegating the more time-consuming processes of execution to specialists, artists were able to accept and carry out more commissions, including replicas of popular works. *The Greek Slave* exists in seven authentic versions produced in Powers's Florence workshop. This statue put Powers in such demand that he was able to charge the then-unheard-of price of \$4,000 for each of its six replicas. Unlike many artists, Powers earned a reputation as a hard-headed businessperson; when his patrons did not pay for their portrait busts, he would display them on a shelf in his shop under a large sign with the word *Delinquent*.

the modish sideburns and distinctive realism of the facial features identify it as a fully modern work. At the time Sumner was only twenty-eight and on the grand tour, but he later served in the U.S. Senate, where he was a fiery opponent of slavery. Among Crawford's later commissions were bronze doors for the U.S. Capitol and the *Armed Liberty* statue adorning its dome.

The "Yankee stonecutter," as Hiram Powers (1805–1873) liked to call himself, was raised in Cincinnati, Ohio,

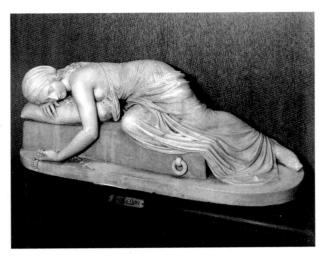

26-64. Harriet Hosmer. *Beatrice Cenci*. 1856. Marble, 2'4 x 5'2" (0.71 x 1.57 m). The St. Louis Mercantile Library Association, St. Louis, Missouri

where as a young man he repaired lifesize wax figures used in historical displays at the Western Museum in Cincinnati. The director of the museum, following the advice of the English writer Frances Trollope, put Powers to work on a series of displays illustrating Dante's Inferno. Encouraged by Trollope, who remained a lifelong friend, Powers undertook with a local sculptor his only formal training. A Cincinnati art patron paid Powers's way to Europe for study, and he settled permanently in 1837 in Florence. There he created his most famous work, The Greek Slave (fig. 26-63), exhibited first in London in 1845 and then in New York in 1846, where long lines of people paid 25 cents each to view the work. The subject of this first fully nude female figure by an American sculptor had great appeal in Europe at the time, for it represented Greece held captive by Turkey before the Greeks had gained their independence in 1832. Powers was later to say that the image came to him in a dream, but the figure actually emulates a common type of antique Venus that he could easily have seen in Italian collections. The statue became internationally famous when it was exhibited in the American section of the first World Exposition, held in London's Crystal Palace in 1851. After it was bought by an English duke, orders for replicas poured in, the celebrated poet Elizabeth Barrett Browning wrote a sonnet about it, and Powers's reputation was made.

Another American sculptor who worked in Italy was Harriet Hosmer (1830–1908), who first came to Rome in 1852. Hosmer had studied with a Boston sculptor and had taken anatomy classes in a St. Louis medical school before leaving for Europe. In Rome she became the pupil of the English Neoclassical sculptor John Gibson. When her father's financial problems ended his ability to support her, she made a small marble of Shakespeare's character Puck sitting on a toadstool, the sales of which brought her about \$50,000, a tremendous sum at a time when skilled American artisans earned about \$400 to \$500 a year. Soon she was receiving commissions from both European royalty and American clients. Among her many idealized works is her *Beatrice Cenci* (fig. 26-64) of 1856. Beatrice, the daughter of a Roman nobleman, conspired

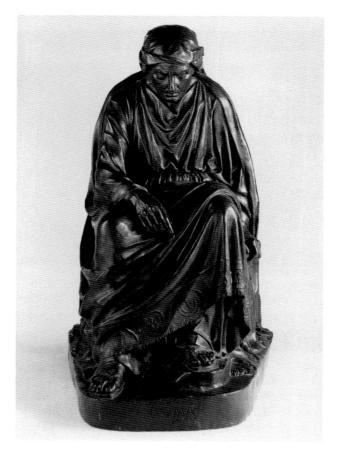

26-65. Anne Whitney. *Roma*. 1869. Bronze, height 265/8" (67.6 cm). Davis Museum and Cultural Center, Wellesley College, Wellesley, Massachusetts
Gift to the College by the Class of 1886 (1891.1)

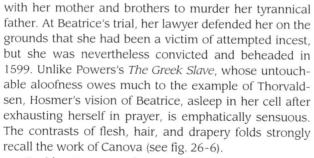

Besides Hosmer, other American women sculptors forged careers in Italy. Anne Whitney (1821–1915) worked intensely for the two causes that dominated her life, feminism and the fight against slavery, and she used her art to express her views on social problems. Little is known about her early career as a sculptor, but she was already an accomplished artist when she arrived in Rome in 1867. Her allegorical bronze statue Roma (fig. 26-65) so irritated the modern Romans that the statue was moved to Florence. Instead of the traditional triumphant goddess, Whitney's Roma (Rome) is represented as a weary, depressed, aging woman, with the decline of the empire told in a series of images along the hem of her classical costume. After completing this figure, Whitney returned to the United States, where she taught sculpture at Wellesley College, in Massachusetts, and received commissions for important public monuments.

Edmonia Lewis (1845–1890), who arrived in Rome the same year as Whitney, was the daughter of a Chippewa

26-66. Edmonia Lewis. *Hagar.* 1875. Marble, $52\frac{5}{8} \times 15\frac{1}{4} \times 17$ " (136.2 x 39.1 x 43.59 cm). National Museum of African Art, Smithsonian Institution, Washington, D.C.

moccasin maker and an African American. She attended Oberlin College in Ohio on scholarship from 1856 to 1859, but in her senior year two of her white friends were poisoned, and Lewis was charged with their murder. Defended by John Mercer Langston (who was later a professor of law, a diplomat, and a member of Congress), Lewis was acquitted. She went to Boston with an introduction to the abolitionist William Lloyd Garrison, who arranged for her to study with a Neoclassical sculptor. In 1862 she sculpted a bust of the white colonel Robert Gould Shaw after seeing him and his famed African American Fifty-fourth Massachusetts Regiment on their way to fight in the Civil War. The sale of plaster replicas of the Shaw portrait earned her enough money to travel to Europe in 1867. Settling in Rome, Lewis quickly drew important patrons for her portrait busts and idealized works on African and Native American themes. In 1873 she reportedly received two \$50,000 commissions. That same year she visited San Francisco, where five of her statues were on exhibit, and did not return to Rome until 1885. One of her important works on a biblical subject, Hagar (fig. 26-66), was made on this American sojourn, in 1875.

Hagar was the Egyptian concubine of the biblical patriarch Abraham, given to him by his childless wife, Sarah, so that he might have a son. When Hagar's son Ishmael was in his teens, Sarah gave birth to Isaac. Jealous of her husband's other family, Sarah demanded that Abraham drive them into the desert to survive as best they could. When Hagar and her son were dying from

26-67. John James Audubon. *Common Grackle,* for *The Birds of America*. 1825. Watercolor, graphite, and selective glazing, 23⁷/8 x 18¹/₂" (61.22 x 47.44 cm). New-York Historical Society

To create Audubon's *The Birds of America* (1827–38), his watercolors, like this one of grackles, were copied by the London printmaker Robert Havell using the aquatint process. Broad areas of neutral color were inked on the plates and the rest added by hand on the prints themselves. This bird encyclopedia was Audubon's first successful business venture. The cost to him of the first issue was \$100,000, and 2,000 sets were eventually sold at \$1,000 each. Between 1840 and 1844, before his health and eyesight began to fail, he supervised the production of *Birds* with reduced-size illustrations.

thirst, an angel led her to a well and foretold that her son Ishmael's descendants would be a great nation (Genesis 16:1–16; 18:1–21). In Lewis's conception Hagar is shown standing with her hands clasped in gratitude for her rescue, an overturned water pitcher at her foot. Her hair is swept back, and her tunic is pressed against her as if from a rush of wind from the angel's wings, while her eyes seem to gaze into the distance, as if she were seeing a vision. The bravery suggested by her erect stance and the touching simplicity of her gesture make this one of the most moving works of American Neoclassicism.

Painting the American Scene

Although many American painters, like the architects and sculptors, looked to Europe for their inspiration in the early nineteenth century, others found everything they needed in their native landscape and took pride in the American scene. These artists tended to paint their subjects with a detailed realism combined with an idyllic aura that suggested peace and limitless abundance.

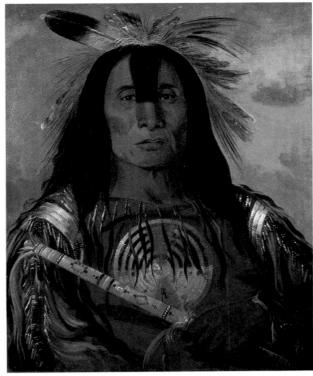

26-68. George Catlin. *Buffalo Bull's Back Fat, Head Chief, Blood Tribe.* 1832. Oil on canvas, 29 x 24" (73.7 x 60.9 cm). National Museum of American Art, Smithsonian Institution, Washington, D.C.

Before the advent of photography, artists played an important role in the development of knowledge about the natural world. John James Audubon (1785-1851) set out to make accurate drawings of the birds of America, reproduce them in prints, and publish hand-colored impressions of them in portfolios. Audubon had come from his native Saint-Domingue (Haiti) at age seventeen to oversee family property near Philadelphia, but he was a poor manager and decided about 1822 to work on a bird encyclopedia, for which he solicited subscriptions from patrons in advance. Traveling and sketching from Florida to Labrador and southwest to Texas, he completed 435 bird studies in detailed watercolors. Audubon combined close observation with an artist's eye for design to convey, often whimsically and a bit dramatically, the birds' natural habitats. In his Common Grackle (fig. 26-67), these beautiful and fearless birds are shown assaulting ears of corn.

George Catlin (1796–1872) was one of the first artists to travel west of the Mississippi in search of Native American subjects for his paintings. A lawyer and self-taught artist, Catlin was working as a portrait painter in Philadelphia when a delegation of Western Native American chiefs visited the city. Inspired by their visit, Catlin in 1832 traveled to the West and lived with forty-eight different Native American groups. In 1839 he brought East an "Indian Gallery," consisting of 200 scenes of Native American village life and hunting forays, 310 portraits of chiefs, and a collection of Native American art and artifacts.

Among the striking portraits was that of *Buffalo Bull's Back Fat, Head Chief, Blood Tribe* (fig. 26-68). The title is Catlin's translation of this Blackfoot chief's name, which

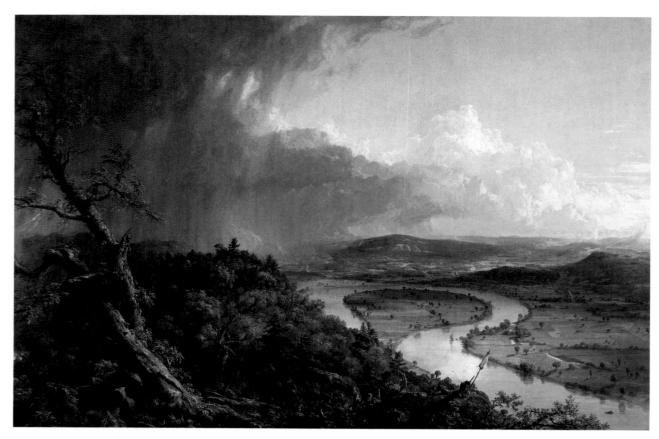

26-69. Thomas Cole. *The Oxbow*. 1836. Oil on canvas, $4'3^{1}/2"$ x 6'4" (1.31 x 1.94 m). The Metropolitan Museum of Art, New York Gift of Mrs. Russell Sage, 1908 (08.228)

refers to the hump of fat on a male buffalo's back. Catlin described in his notes how the man's deerskin costume was made and decorated. The seams on the sleeves were covered from shoulder to wrist with decorations in porcupine quills and a fringe of black human hair taken from the heads of Back Fat's opponents in battle. The pipe, made by the chief himself, had a carved red-stone bowl and a long stem wrapped with braided porcupine quills. Through lectures, articles, and the exhibition of the Indian Gallery, Catlin attempted to educate the public about the dignity, beauty, and independence of the Native American peoples. When the U.S. government refused to set up a museum for his collections, Catlin took them on tour to England and France.

The French poet Charles Baudelaire admired Catlin's Native American portraits, and the French painter Rosa Bonheur made a pencil-and-watercolor copy after *Back Fat.* In 1841 Catlin's *Letters and Notes on the Manners, Customs, and Conditions of the North American Indians,* with 300 illustrations, was published in London, and in 1845, the artist issued a suite of twenty-five hand-colored **lithographs** (prints made from impressions produced by a flat stone) with accompanying texts, called Catlin's North American Indian Portfolio. Other artists painted Romantic scenes of exotic and entirely imaginary Native American subjects, but Catlin's work was distinguished by its great realism and authenticity and is

still an invaluable anthropological source.

Thomas Cole (1801–1848), called in his own time the father of American landscape painting, emigrated from England at age seventeen. He began in 1820 to work as an itinerant limner, or portrait painter, walking through the countryside with his paints and brushes on his back. finding commissions where he could. His real interest, however, was sketching and painting the landscape. He arrived in New York City in 1825 and placed three of his landscapes of the Catskill Mountains in the window of a framer's shop. The paintings soon drew the attention of several influential New Yorkers, who purchased Cole's paintings. With his career under way, Cole found a patron to finance a trip to Europe from 1829 to 1831. In England Cole was impressed by Turner's early landscapes but not by his later, more abstract ones. In Italy he admired the work of Raphael and other Renaissance painters, and he was also profoundly affected by the ruins of classical antiquity, which he viewed as a vast and tragic symbol of the transience of human life and achievements. Such sights later inspired his series The Course of the Empire (1833-1837?), in which he traced the same landscape view from its primeval state to its architectural peak under the Roman Empire to its final state of desolation. Cole took occasional breaks from his work on the Course to go on sketching trips, one of which resulted in a painting now called The Oxbow (fig. 26-69). When it was first

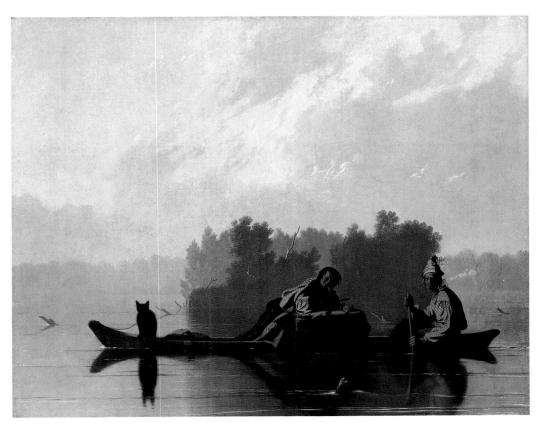

26-70. George Caleb Bingham. *Fur Traders Descending the Missouri.* c. 1845. Oil on canvas, 29 x 36" (73.7 x 91.4 cm). The Metropolitan Museum of Art, New York Morris K. Jesup Fund, 1933 (33.61)

exhibited, in 1836, it was identified as a spectacular bend in the Connecticut River. To Cole ancient geological formations such as this constituted America's "antiquities," which he already recognized as being threatened with destruction by urbanization and industrial development. But even Cole, who still roamed on foot in search of picturesque landscape views, found the train the most convenient way to get from New York to his favorite haunts in the Catskills. His stirring landscapes of the immense Hudson River Valley were the first of a tradition of painting that came to be known as the Hudson River School. Just as Catlin recorded the daily lives of the vanishing Native Americans, in such paintings as *The Oxbow* Cole commemorated the moment when the wilderness was giving way to cultivated fields and cattle.

George Caleb Bingham (1811–1879), the first major painter to live and work west of the Mississippi River, like Cole began his career as an itinerant portrait painter. He also sketched and painted scenes of everyday life along the river and eventually abandoned portrait painting. In 1838 he went to New York, where he exhibited his work at the new National Academy of Design.

With his Fur Traders Descending the Missouri (fig. 26-70), painted in about 1845, Bingham began an association with the newly formed American Art-Union in New York. As a way to promote American painters, the union purchased works for a flat fee, then reproduced prints to be

sold by subscription. A lottery was held for the paintings themselves, which allowed people of modest means to own original works of art. Fur Traders Descending the Missouri, which Bingham sold to the union for \$25, is an idyllic scene of a French trapper and his son with their pet bear cub and cat in a dugout canoe, gliding through the early morning stillness with only faint ripples on the water marking their passage. The still-hidden sun tinges the clouds with rosy gold, and morning mists shroud the river landscape in mystery. Despite the overt peacefulness of the scene, there is an underlying ominousness. Branches and rocks sticking up out of the water are reminders of the everyday hazards river boaters faced, and the mysterious black shape of the chained bear mirrored in the glassy water surface produces an eerie effect reminiscent of the demon in Fuseli's The Nightmare (see fig. 26-25). Later in life, Bingham became heavily involved in local politics and drew subjects for his paintings from that experience.

The same forces that brought about the Neoclassic and Romantic movements also helped bring them to an end: the spirit of inquiry that subjected so much of traditional life and culture to rational analysis; the desire to edify humanity and to improve the world; and growing out of these, a new sense of the value of the individual. These impulses, coupled with the turbulent history of revolution in America and Europe in the late eighteenth and early nineteenth centuries, gave birth to the modern age.

Paxton Crystal Palace London 1850–51

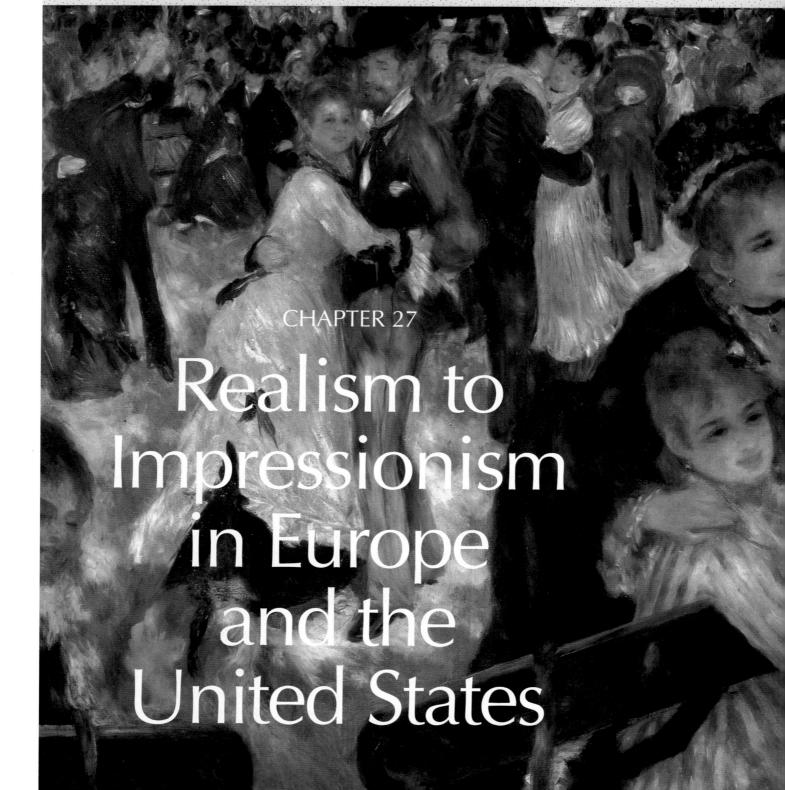

Rossetti

La Pia de' Tolomei

Church Niagara 1857

Nadar. Portrait of Charles Baudelaire 1863

Carpeaux
The Dance

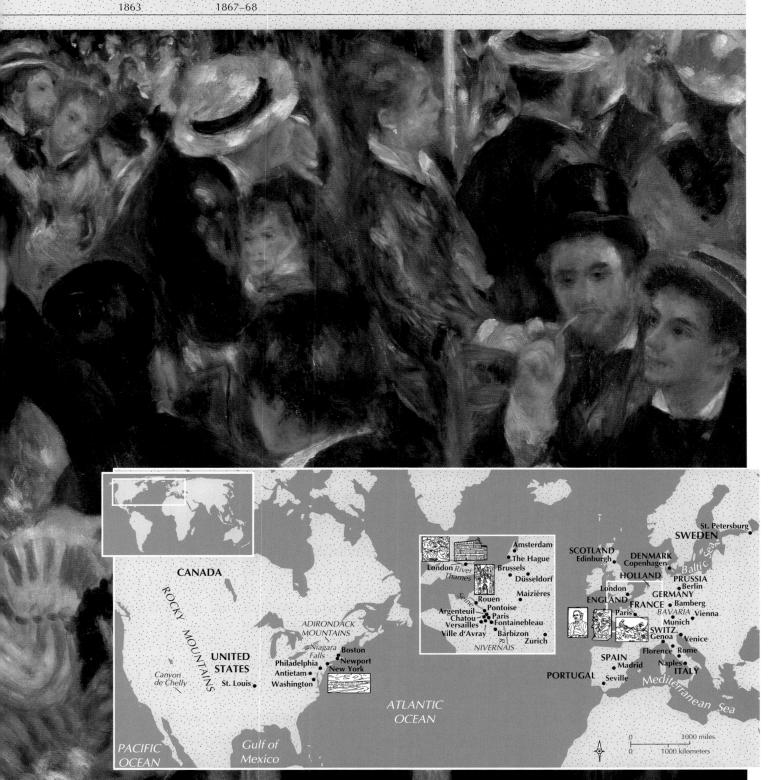

1820 1890

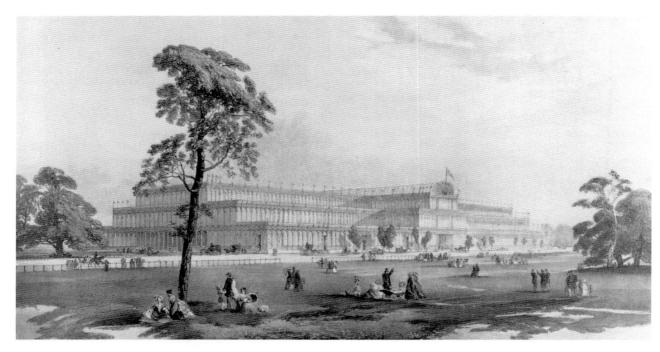

27-1. Sir Joseph Paxton. Crystal Palace, London. 1850-51. Iron and glass. Lithograph, The Mansell Collection, London

arly in 1850, a British royal commission announced a design competition for a massive temporary edifice to house the London Great Exhibition, a showcase of advances in industry and technology, which Queen Victoria and her husband, Prince Albert, wanted to open the following year in London's Hyde Park. By June it was evident that none of the 245 entries could possibly be completed in time. Ten days before the commission was to submit its own plan for a domed brick shed—which would also have required additional time—one of the commissioners met Joseph Paxton, a professional gardener who had recently designed a number of impressive greenhouses. Paxton agreed to submit a design, scale drawings, and cost sheet for an exhibition hall that was, in effect, a greatly enlarged greenhouse.

The commissioners, relieved but unenthusiastic, accepted his plan, and the structure was completed in the extraordinarily brief span of just over six months (fig. 27-1). The triple-tiered edifice, dubbed a "crystal palace" by a journalist for a humor magazine, was the largest space ever enclosed up to that time—1,848 feet long, covering more than 18 acres, and providing for almost a million square feet of exhibition space. The central vaulted transept—based on the new railway stations and, like them, meant to echo imperial Roman architecture—rose 108 feet to accommodate a row of elms dear to Prince Albert.

Although everyone agreed that the Crystal Palace was a technological marvel, most architects and critics did not consider it to be legitimate architecture. Some observers, however, were more forward-looking. One visitor called it "a revolution in architecture from which a new style will date." And indeed it was an expression of the positivism that would dominate this period.

THE POSITIVIST AGE

THE VIST The second half of the nineteenth century has been called the positive tivist age, an age of faith in the positive consequences of what can be

achieved through the close observation of the natural and human realms. The term *positivism* was used by the French philosopher Auguste Comte (1798–1857) during the 1830s to describe what he saw as the final stage in the development of philosophy, in which all knowledge would derive from science and scientific methods. One of the founders of sociology, Comte intended to bring to the study of human society the same scientific rigor that was advancing fields like physics, biology, astronomy, and chemistry. Comte's faith that science and its objective methods could solve all human problems was not novel; the idea of human progress had been gradually maturing since its first tentative expression by the Enlightenment thinkers of the late eighteenth century. Comte's achievement was to clarify this idea and give it a name. In the second half of the

century, the term *positivism* came to be applied widely to any expression of the new emphasis on objectivity.

In the visual arts the positivist spirit is most obvious, perhaps, in the widespread rejection of Romantic subjectivism and imagination in favor of the accurate and apparently objective description of the ordinary, observable world, a change especially evident in painting. Although some historians, for quite valid reasons, call this new emphasis on descriptive accuracy naturalism, we employ the term *realism* because this was the label used around 1850 by the artists and critics who pioneered the development (see "Realist Criticism," page 994).

Positivist thinking is evident not simply in the growth of realism but also in the full range of artistic developments of the period after 1850—from the highly descriptive style of academic art, with its realistic figures and elements, to the Impressionist emphasis on the phenomenon of light; and from the development of photography to the application of new technologies in architecture.

1820 1890

PARALLELS

Years

Events

lears	LVEIIS
1820–1829	Beethoven's Ninth Symphony (Germany); Niépce makes first positive-image photographs (France); Audubon's <i>The Birds of America</i> (United States)
1830–1839	Slavery abolished in British Empire; Hokusai's <i>Hundred Views of Mount Fuji</i> (Japan); Cole's <i>The Oxbow</i> (United States); Houses of Parliament redesigned (England); first daguerreotype made (France)
1840–1849	Talbot publishes first book illustrated with photographs (England); Labrouste's Bibliothèque Sainte-Geneviève (France); Marx and Engels's book <i>Communist Manifesto</i> (Germany); revolt in Paris establishes French Second Republic; Pre-Raphaelite Brotherhood established in England; Seneca Falls Women's Rights Convention (United States); Courbet's <i>The Stone Breakers</i> (France)
1850–1859	Paxton's Crystal Palace (England); Stowe's novel <i>Uncle Tom's Cabin</i> (United States); Melville's novel <i>Moby-Dick</i> (United States); Napoleon III emperor of France; South African Republic established; Thoreau's book <i>Walden</i> (United States); Whitman's poetry collection <i>Leaves of Grass</i> (United States); Millet's <i>The Gleaners</i> (France); Flaubert's novel <i>Madame Bovary</i> (France); Darwin's book <i>Origin of Species</i> (England); Dickens's novel <i>A Tale of Two Cities</i> (England); Italy is united
1860–1869	Civil War (United States); serfdom abolished in Russia; Hugo's novel <i>Les Misérables</i> (France); Manet's <i>Le Déjeuner sur l'Herbe</i> (France); Tolstoy's novel <i>War and Peace</i> (Russia); Dostoyevsky's novel <i>Crime and Punishment</i> (Russia); Brooklyn Bridge begun (United States); Dominion of Canada is formed; Meiji Restoration of emperor (Japan); revolution in Spain; first transcontinental railroad in United States
1870–1879	Franco-Prussian War; Third Republic in France; first Impressionist art exhibition (France); Tchaikovsky's Piano Concerto No. 1 (Russia); Renoir's <i>Moulin de la Galette</i> (France); Alexander Graham Bell patents telephone (United States); William Morris promotes Arts and Crafts Movement (England); Muybridge's <i>Galloping Horse</i> (United States); Edison invents phonograph and electric lightbulb (United States)
1880–1890	Major European colonization of Africa begins; Hertz discovers and produces radio waves (Germany); Eastman's box camera (United States)

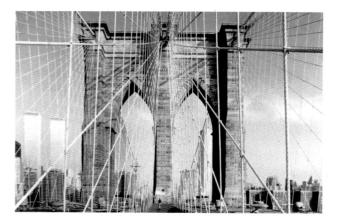

27-2. John Augustus Roebling and Washington Augustus Roebling. Brooklyn Bridge, New York. 1867-83

Henri Labrouste. Reading Room, Bibliothèque Sainte-Geneviève, Paris. 1843-50

TECHNOLOGICAL The positivist faith that **PROGRESS**

technological progress was the key to human

progress spawned a long succession of world's fairs devoted to advances in industry and technology. The first of these fairs, the London Great Exhibition of 1851, introduced new building techniques that ultimately contributed to the abandonment in the twentieth century of historicism—the use of historically based styles—in architecture. The revolutionary modular construction of the Crystal Palace (see fig. 27-1), created for the London Great Exhibition by Joseph Paxton (1801-1865), featured a structural skeleton of cast iron that held iron-framed glass panes measuring 49 by 30 inches, the largest size that could then be mass-produced. Prefabricated wooden ribs and bars supported the panes.

Engineering

Bridge designers had pioneered the use of cast iron as a building material—the first cast-iron bridge had been erected in England in 1776–1779 (see "Iron as a Building Material," page 943)—as well as the use of wrought iron and then steel, the results of new refining processes. The most famous early steel bridge, the Brooklyn Bridge (fig. 27-2), was constructed between 1869 and 1883 to link the burgeoning borough of Manhattan in New York City to the growing city of Brooklyn (which eventually became another borough of New York City). The designer, John Augustus Roebling (1806-1869), a German-born civil engineer, had written his university thesis on the suspension bridge at Bamberg, Germany, one of the first built in Europe. In 1841, ten years after emigrating to the United States, he invented twisted-wire cable, a considerable structural advance over the wrought-iron chains then being used for suspension bridges. In 1867, after designing and supervising the construction of a number of innovative suspension bridges in the eastern United States, Roebling was appointed chief engineer for the longproposed Brooklyn-Manhattan bridge, whose main span

would be the longest in the world at that time. He died in 1869 of complications from a work-related accident just as construction was to begin, and the project was completed by his engineer son, Washington Augustus Roebling (1837–1926), who had assisted his father in earlier projects.

The bridge roadbed, nearly 6,000 feet long, hangs beneath a web of stabilizing and supporting steel-wire cables (the heaviest of which is 16 inches in diameter) suspended from two massive masonry towers that rise 276 feet above the water. The roadbed and cables are purely functional, with no decorative adornment, but the granite towers feature projecting cornices over pointedarch roadbed openings. These historicist elements allude both to Gothic cathedrals and to Roman triumphal arches. Rather than military victories, however, Roebling's arches celebrate the triumphs of modern engineers while paying homage to those of their ancient Roman forebears.

Architecture

A less religious attitude toward technological progress can be seen in the first attempt to incorporate structural iron into architecture proper, the Bibliothèque Sainte-Geneviève (fig. 27-3), a library in Paris designed by Henri Labrouste (1801-1875). Conventionally trained at the École des Beaux-Arts and employed as one of its professors, Labrouste was something of a radical in his desire to reconcile the École's conservative design principles with the technological innovations being developed by industrial engineers. Apparently reluctant to promote this goal in his teaching, he clearly pursued it in his practice.

Because of the Bibliothèque Sainte-Geneviève's educational function, Labrouste wanted the building to suggest the course of both learning and technology. The window arches on the exterior have panels with the names of 810 important contributors to Western thought from its religious origins to the positivist present, arranged chronologically from Moses to the Swedish chemist Jöns Jacob Berzelius. The exterior's stripped-down Renaissance

style reflects the belief that the modern era of learning dates from that period. The move from outside to inside subtly outlines the general evolution of architectural techniques. The exterior of the library features the most ancient of permanent building materials, cut stone, which was then considered the only "noble" construction material, that is, suitable for a serious building. The columns in the entrance hall are solid masonry with cast-iron decorative elements. In the main reading room, however, cast iron plays a structural role. Slender iron columns—cast to resemble the most ornamental Roman order, the Corinthian—support two parallel barrel vaults. The columns are set on tall concrete pedestals, reminding the attentive viewer that modern construction technology rests on the accomplishments of the Romans, who developed concrete. The design of the delicate floral cast-iron ribs in the vaults is borrowed from the Renaissance architectural vocabulary.

Academic architects more typically used iron only as an internal support for conventional materials, as is the case with the Opéra, the Paris opera house (fig. 27-4), designed by Charles Garnier (1825–1898) and built as part of the transformation of Paris begun in the 1850s by Napoleon Bonaparte's nephew, Napoleon III. Elected president of the Second Republic in 1848 and declared emperor in 1852, Napoleon III ruled France until 1870. He inaugurated a controversial program to modernize Paris and promote greater prosperity for its upper and middle classes. The plan, drawn up by Georges-Eugène Haussmann (1809-1891)—who was given the title of baron in 1857 for his administrative work in transforming Paris included new sewer and water systems, improved railroad lines, parks, and a network of straight, wide boulevards to facilitate business, the flow of traffic, and military action against any threatened insurrections. The Opéra was to be a focal point, located at the intersection of several major boulevards in a chic section of downtown Paris full of banks, businesses, and the new department stores for which the city became famous.

Garnier was a graduate of the École dès Beaux-Arts and one of the architects helping Baron Haussmann realize his plans for Paris. Garnier's design for the Opéra was selected in a competition announced in 1860 for a new building to replace the city's dilapidated existing opera house. He won the competition despite the Empress Eugénie's objection that his proposal fitted no recognizable style. To her charge that it was "neither Louis XIV, nor Louis XV, nor Louis XVI," Garnier retorted, "It is Napoleon III." The massive facade, featuring a row of paired columns above an arcade, is essentially a heavily ornamented, Baroque version of the Louvre (see fig. 19-22), an association meant to suggest the continuity of French greatness and to flatter Emperor Napoleon III by comparing him favorably with King Louis XIV. The luxuriant treatment of form, in conjunction with the building's primary function as a place of entertainment, was intended to celebrate the devotion to wealth and pleasure that characterized Napoleon III's reign. The ornate architectural style is also appropriate for the most elaborate of all musical forms, the opera.

27-4. Charles Garnier. The Opéra, Paris. 1861-74

27-5. Charles Garnier. Grand staircase, the Opéra

The inside of what some critics called the "temple of pleasure" (fig. 27-5) was even more opulent, with its neo-Baroque sculptural groupings, heavy, gilded decoration, and lavish mix of expensive, **polychromed** materials. The highlight of the interior was not the spectacle on stage so much as that on the great, sweeping Baroque staircase where the various members of the Paris elite—

Jean-Baptiste Carpeaux. The Dance. 1867-68. Plaster, height c. 15' (7.1 m). Musée de l'Opéra, Paris

from old nobility to newly wealthy industrialists—could display themselves, the men in black tailcoats accompanying women in bustles and long trains. As Garnier himself said, the purpose of the Opéra was to fulfill the most basic of human desires: to hear, to see, and to be seen.

FRENCH One of the large sculptural groups on ACADEMIC the entranceway of the Opéra is The Dance (fig. 27-6) by Jean-Baptiste ART Carpeaux (1827–1875). Carpeaux,

who had studied at the École des Beaux-Arts under the Romantic sculptor François Rude (see fig. 26-48), had previously worked in both Romantic and Rococo styles. Dramatic and somber themes, however, were considered inappropriate to the new atmosphere of the capital, and in the years after about 1850 there was a marked decline in Romantic themes in French art and literature. Carpeaux's sculptural subjects, drawn from the eighteenth century, were better suited to the new taste for lighthearted pleasure. In The Dance a winged personification of Dance, a slender male carrying a tambourine, leaps up joyfully in the midst of a compact, entwined group of mostly nude female dancers, reflecting the theme of uninhibited Dionysian revelry. When the group was unveiled in 1869, it

was criticized as indecent, and it almost was removed not because of the general theme or the nudity of any of the figures or even the presence of a satyr, a mythological creature known for its lascivious appetites, which is discreetly hidden behind the women, but because the figures seemed so shockingly lifelike. To Parisians used to smooth, generalized nudes, Carpeaux's figures appeared simply naked.

Ironically, the basis of Carpeaux's treatment can be found in the time-honored practices of academic teaching. Students at the Academy began their training in figure drawing by copying two-dimensional pictures of Classical and Renaissance sculpture. Later, after drawing from plaster casts of such sculpture, they were finally allowed to study live models, both men and women posed like Classical sculpture. The emphasis in this last phase was on exact delineation; every individual nuance of knee, hand, and face was rendered with extreme care. The point was to develop technical skill and knowledge of the human form. When artists finally began making actual paintings, they were expected to recall their earlier immersion in Classical art and "correct"—generalize ordinary nature according to its higher ideal. Until the reign of Napoleon III, they had largely done so.

Carpeaux's unwillingness to idealize physical details was symptomatic of a major shift in French academic art in the second half of the nineteenth century. Although the influence of photography on the taste of the period has sometimes been cited as the probable cause of this change, both photography and the new exactitude in academic art were simply manifestations of the increasingly positivist values of the era. These values were particularly evident among the bankers and businesspeople who came to dominate French society and politics in the years after 1830. As patrons, these practical leaders of commerce were generally less interested in art that idealized than in art that brought the ideal down to earth.

The effect of this new taste on academic art is nowhere more evident than in the case of Adolphe-William Bouguereau (1825–1905), who became one of the richest and most powerful painters in France in the late nineteenth century by catering to bourgeois taste. At the beginning of his career, in the middle to late 1850s, Bouguereau specialized in Romantic themes of death and suffering. By the early 1860s, however, he realized that these themes were not compatible with period taste. He later explained: "I soon found that the horrible, the frenzied, the heroic does not pay, and as the public of today prefers Venuses and Cupids and I paint to please the public, it is to Venus and Cupid I chiefly devote myself" (cited in Zafran, page 55).

Bouguereau gave the public not only the subjects it wanted but also the factual detail it loved. In Nymphs and a Satyr (fig. 27-7), for example, four young and voluptuous wood nymphs attempt to drag a reluctant satyr into the water. The slight smile on his face and the lack of real struggle on his part suggest that this is goodnatured teasing. The painting's power depends less on the subject than on the way Bouguereau was able to make it seem palpable and "real" for the spectator through a

27-7. Adolphe-William Bouguereau. *Nymphs and a Satyr*. 1873. Oil on canvas, 9'3/8" x 5'10⁷/8" (2.6 x 1.8 m). Sterling and Francine Clark Art Institute, Williamstown, Massachusetts

1870 1820 1890

heightened depiction of texture and appearance. In order to produce a persuasive satyr Bouguereau made careful anatomical studies of horses' ears and of the hindquarters of goats. Bouguereau makes the scene not only real but accessible. The figure on the right appears to back toward the viewer, so the viewer's world and the world of the painting seem continuous. The viewer is invited to step in and join the figures in their romp.

A positivist taste for descriptive accuracy is also evident in the academic history painting of the period. In *Death of Caesar* (fig. 27-8), for example, Jean-Léon Gérôme (1824–1904) attempted an objective and archeologically correct re-creation of the event. In order to avoid Romantic emotionalism Gérôme chose to depict not the moment of the assassination but instead the sudden calm that follows as the conspirators rush out to announce their action to the city. Gérôme wanted us to observe a historical event as it might have occurred, not to identify with its protagonists. To this end he combined an impeccably descriptive style with a reporter's concern for the facts. He carefully researched the building where Caesar died, the Theater of Pompey, in order to situate it

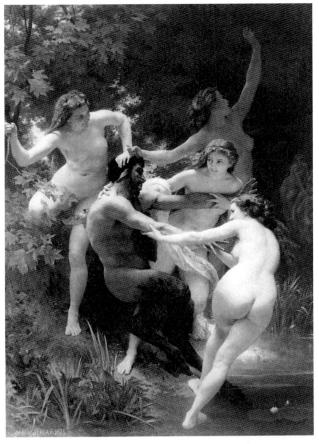

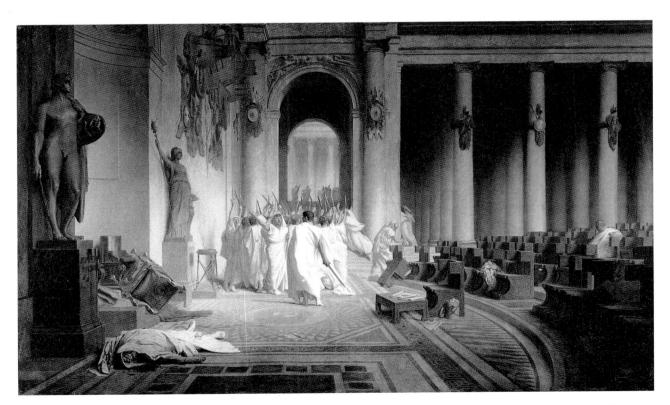

27-8. Jean-Léon Gérôme. *Death of Caesar*. 1859. Oil on canvas, 335/8 x 571/4" (86.2 x 146.8 cm). Walters Art Gallery, Baltimore Gérôme was one of the leading antagonists of innovative art forms. As a member of the Salon jury during the last four decades of the nineteenth century, he skillfully opposed the acceptance of much of the new art, especially that of the Impressionists, which he considered "the disgrace of French art." In 1884 he fought the installation of the Manet memorial exhibition at the École, and in 1895–1897 he led the fight against the acceptance by the government of an important bequest of Impressionist works.

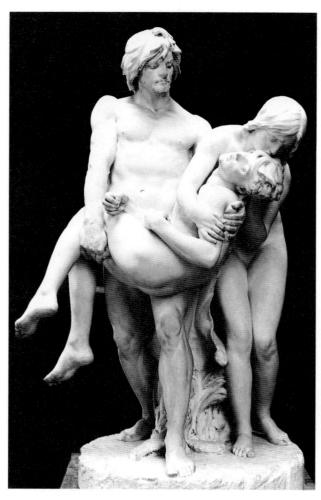

27-9. Louis-Ernest Barrias. *The First Funeral*. 1878–83. Marble, height 7'11" (2.4 m). Musée du Petit Palais, Paris

properly. From historical accounts he learned that the conspirators gave Caesar a petition scroll to distract him, that he knocked over a chair during the assassination, and that he struggled to the base of the statue of Pompey, which he grasped with his bloodied hands before succumbing. All this is reflected in Gérôme's painting. In applying the lessons of realism to history painting Gérôme was completing a shift of emphasis well under way in the work of certain academic artists of the second quarter of the century, men such as his own teacher, Paul Delaroche (1797–1856), who began to think of history more as a set of objective facts than as something from which to learn moral lessons. Jacques-Louis David, too, had sought archeological accuracy, for example in *Oath of the Horatii* (see fig. 26-38), but not as an end in itself.

Moral lessons continued to be contained in much academic art of the period, but they were more implicit than explicit, more a matter of confirming existing social attitudes than of improving them. *The First Funeral*, by Louis-Ernest Barrias (1841–1905), is indicative of this trend (fig. 27-9). A marble version of a plaster model that won Barrias a medal of honor at the **Paris Salon** of 1878, this statue shows a grieving Adam and Eve burying their son Abel after he had been killed by his jealous brother Cain. There is no mention of such a funeral in the Bible;

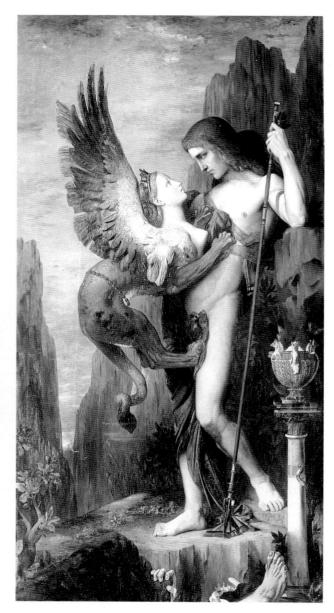

27-10. Gustave Moreau. *Oedipus and the Sphinx*. 1864. Oil on canvas, 6'9¹/4" x 3'5¹/4" (2.1 x 1.1 m). The Metropolitan Museum of Art, New York Bequest of William H. Herriman

the scene is based instead on medieval biblical commentaries that claimed Adam and Eve grieved for a hundred years. The work is typical of much academic art of the period in the way it combines sentimentality and a conservative social message. The idealized body of Eve, who is usually presented in academic sculpture of the period as a fallen seducer, here bends gently and sadly over her lifeless son, her tender feeling evoking and foreshadowing the Virgin Mary's grief over the death of Jesus. Looking down on the scene is Adam, whose muscular body is to be taken as an outward sign of his greater emotional containment. Like David in *Oath of the Horatii*, Barrias contrasts female "emotionalism" with male stoic "rationalism," thereby reinforcing gender stereotypes of the late nineteenth century.

The works of Gustave Moreau (1826-1898) also

depict men as rational and self-controlled. Nineteenthcentury academic art came to be deprecated in the twentieth century, but Moreau's reputation endured, partly because of his interest in probing the nature of the relations between men and women. Unlike Bouguereau, he did not abandon Romantic themes to appeal to popular taste. His early work was influenced by Delacroix. About 1860 he became preoccupied with a dramatic theme that would also concern many other late-nineteenth- and early-twentieth-century artists and writers: the confrontation between a male hero and an alluring femme fatale determined to destroy him.

Moreau's first statement of this theme was Oedipus and the Sphinx (fig. 27-10), which he produced for the Salon of 1864. The painting's subject, taken from ancient Greek mythology, had been popular among Romantics and other academics. It involves an episode in the tragic life of Oedipus in which he saves the city of Thebes from the tyranny of the sphinx, a winged creature that was part lion, part woman. The sphinx required a yearly human sacrifice from the city and would leave only when someone correctly answered her riddle: What walks on four legs in the morning, two at noon, and three in the evening? She killed anyone who gave a wrong answer, as was the fate of those whose grisly remains lie in the foreground of Moreau's painting. Oedipus, however, gives the correct answer, which is "man," who crawls in infancy (morning), walks on two legs as an adult (noon), and walks with a stick in old age (evening). Earlier depictions of the story generally showed Oedipus at the decisive moment, giving the answer, but Moreau presents a calm and self-possessed hero determinedly staring down a transfixing woman-animal who looks up into his eyes. Unlike the original myth, which celebrates the victory of human rationality over the irrational forces of nature, Moreau emphasizes instead what he sees as a gendered conflict: in his notes on the painting Moreau said it pitted moral idealism against sensual desire.

EARLY Another expression of the PHOTOGRAPHY new, positivist interest in descriptive accuracy—one

that had a profound impact on the arts—was the development of photography. Photography as we know it emerged around 1850, but since the late Renaissance, artists and others had been seeking a mechanical method for exactly recording or rendering a scene. One device that emerged for this purpose was the camera obscura (Latin for "dark chamber"), which consists of a darkened room or box with a lens on one side. Light passes through the lens, projecting an exact image of the outside scene on the opposite wall or side. An artist can trace the image, and in the sixteenth century several artists and theoreticians offered practical advice on how to use the camera obscura to do so. By the eighteenth century a small, portable camera obscura, or camera, had become standard equipment for many landscape painters in particular. Photography developed essentially as a way to fix, that is, to make permanent, the images produced by a camera obscura on light-sensitive material.

The first to make a permanent picture by the action of light was Joseph-Nicéphore Niépce (1765-1833), one of the many "gentlemen inventors" in the West in the eighteenth and early nineteenth centuries. In 1796 he and his brother Claude tried unsuccessfully to record camera images on chemically treated surfaces. About twenty years later Joseph resumed those experiments in an attempt to find an easier and less cumbersome substitute for another recently invented reproductive process, lithography (see "Lithography," below). His success in copying translucent engravings by attaching them to pewter plates covered with a kind of lightsensitive asphalt used by etchers led Niépce to try this substance in the camera. Using metal and glass plates covered with this substance, called bitumen, he succeeded around 1826 in making the first positive-image photographs of views from a window of his estate at

TECHNIQUE

Aloys Senefelder invented lithography in Bavaria, Germany, in 1796 and registered for an exclusive right to the process the following year. Lithography is a planographic process—that is, the printing is done from a flat surface. It was the first wholly new printing process to be introduced since the fifteenth century, when the intaglio, or incising, process was developed. Lithography, still popular today, is based on the natural antagonism between oil and water. The artist draws on a flat surface—traditionally, fine-grained stone with a greasy, crayonlike instrument. The stone's surface is wiped with water, then with an oil-based ink. The ink adheres to the greasy but not to the damp areas. A sheet of paper is laid face down on the inked stone, which is passed through a flatbed press. A scraper applies light pressure from above as the stone and paper pass under it, transferring ink from stone to paper, thus making lith-

LITHOGRAPHY ography a direct method of creating a printed image. Francisco Goya, Honoré Daumier, and Henri de Toulouse-Lautrec exploited the medium to great effect.

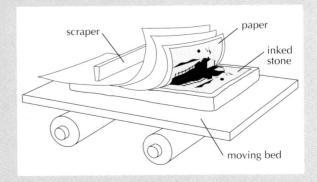

27-11. Joseph-Nicéphore Niépce. View from His Window at Le Gras. 1826. Heliograph, 6¹/₂ x 7 ⁷/₈" (17 x 20 cm). Gernsheim Collection, University of Texas, Austin

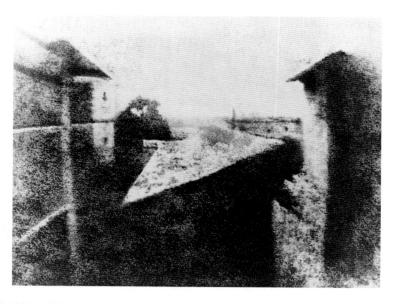

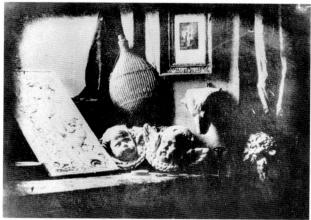

27-12. Louis-Jacques-Mandé Daguerre. *The Artist's Studio*. 1837. Daguerreotype, 6¹/₂ x 8¹/₂" (16.5 x 21.6 cm). Société Française de Photographie, Paris

27-13. William Henry Fox Talbot. *The Open Door*. 1843. Salt-paper print from a calotype negative. Science Museum, London

Fox Talbot Collection

Le Gras, France. Only one of his **heliographs** (or "sun drawings") survives (fig. 27-11). This view of the outbuildings on Niépce's estate required an exposure of about eight hours, which explains why sunlight is evident on the inside portions of the taller buildings on both left and right. The image was fixed simply by cleaning the asphalt from the plate after exposure.

While seeking financial help in the development of his discovery, Niépce met Louis-Jacques-Mandé Daguerre (1787–1851), a Parisian painter who was also experimenting in creating images for his diorama (a popular theater built for the display of huge, dramatically lit, illusionistic paintings on semitransparent fabric). Working with a lens maker, Daguerre had developed an improved camera. In 1829 Daguerre and Niépce formed a partnership. After Niépce's death in 1833, Daguerre continued their research using copper plates coated in iodized silver, long known to be light-sensitive. In 1835 he left one of the plates he had been working on in a cupboard. When he returned several days later, he was amazed to find an image on it. Through a process of elimination, he deter-

mined that the vapor of a few drops of spilled mercury from a broken thermometer had produced the effect. Thus Daguerre discovered that an exposure to light of only twenty to thirty minutes would produce a latent image on one of his silvered plates treated with iodine fumes, which could then be made visible through an after-process involving mercury vapor. By 1837 he had developed a method of fixing the image by bathing the plate in a strong solution of common salt after exposure.

The inventor's first such picture, or **daguerreotype**, was a still life of plaster casts, a wicker-covered bottle, a framed drawing, and a curtain (fig. 27-12). Through its subject the work makes the earliest claim for photography as an art form. Although many of the objects, including the bottle, seem to have been included for their textures, the drawing and sculpture identify the process with the realm of art. Specifically, Daguerre suggests that this is a naturalistic, not an expressive, art form. The work is a still life, considered by the Academy a legitimate form but a minor one because it was thought to involve the technical skills of a copyist more than the imaginative ones of a history

TECHNIQUE

A camera is essentially a lightproof box with a hole, called an aperture, which is usually adjustable in size and which regulates the amount of light that strikes the film. The aper-

ture is covered with a lens, which focuses the image on the film, and a shutter, a kind of door that opens for a controlled amount of time, to regulate the length of time that the film is exposed to light—usually a small fraction of a second. Modern cameras also have a viewer that permits the photographer to see virtually the same image that the film will "see."

Photography is based on the principle that certain substances are sensitive to light and react to light by changing value. In modern black-and-white photography, silver halide crystals (silver combined with iodine, chlorine, or other halogens) are suspended in a gelatin base to make an emulsion that coats the film (in early photography, before the invention of plastic, a glass plate was used with a variety of emulsions). The film is then exposed. Light reflected off objects enters the camera and strikes the film. Pale objects reflect more light than do dark ones. The silver in the emulsion collects most densely where it is exposed to the most light, producing a "negative" image on the film. Later, when the film is placed in a chemical bath (developed), the silver deposits turn

HOW **PHOTOGRAPHY**

black, as if tarnishing. The more light the film receives, the denser the black tone created. A positive image is created from the negative WORKS in a darkroom: the film negative is placed over

a sheet of paper that, like the film, has been treated to be light-sensitive, and light is directed through the negative onto the paper. Multiple positive prints may be made from a single negative.

Color photography works on much the same principle as black-and-white: a light-sensitive emulsion reacts to exposure by changing color. Most color film uses a complicated process based on color theory—the concept that three primary colors (red, yellow, and blue) can be combined to make up all the hues the eye sees. (Thus, the discovery of color theory that was so important to the Neo-Impressionists was of equal importance to the invention of color photography.) The resulting negative does not reverse black and white values, but "reverses" the primary colors to their complements. Originally, this meant that three separate emulsions on the film, each sensitive to a different primary color, had to be developed, using many chemicals, bleaches, and dyes in the darkroom. Other, later film processes simplified this function. Some color processes are now quite direct and mechanized; others require complex chemistry and much handwork in the darkroom.

painter. At the time, still life was most strongly identified with the work of the seventeenth-century Dutch naturalists, whom Daguerre here implies were his forebears in the search for verisimilitude. They, too, often used curtains to help display the objects they copied.

The 1839 announcement of Daguerre's invention prompted the English scientist William Henry Fox Talbot (1800-1877) to publish the results of his own work on what he called the calotype (from the Greek term for "beautiful image"). Talbot's process, even more than Daguerre's, became the basis of modern photography because, unlike Daguerre's, which produces a single, positive image, Talbot's calotype is a negative image from which an unlimited number of positives can be printed. In his book The Pencil of Nature (issued in six parts, 1844-1846), the first to be illustrated with photographs, Talbot describes the evolution of his process from the first experiments, in the mid-1830s, using paper impregnated with silver chloride. At first, engravings, pieces of lace, and leaves were copied in negative by laying them on this paper and exposing them to light. By the summer of 1835 he was using this chemically treated paper in both large and small cameras. Then, in 1840, he discovered, independently of Daguerre, that latent images resulting from exposure to the sun for short periods of time could be developed chemically. Applying the technique he had earlier used with engravings and leaves, he was able to make positive prints from the calotype negatives.

One of the calotypes hand-pasted into The Pencil of Nature was The Open Door (fig. 27-13). The subject, like many by Talbot, is rural. As with a number of his contemporaries, he seems to have been distressed by the growing industrialization of Britain. His photograph is a nostalgic evocation of an agrarian way of life that was fast disappearing. The viewer is invited into an old, time-worn cottage in whose doorway Talbot has placed a sturdy broom, the handle carefully positioned to parallel the shadows on the door. This is the kind of traditional, handcrafted broom that mass production was beginning to make obsolete, but the use of photography itself also suggests that something made by mechanical means could have a genuine value, comparable to that of the handmade. Talbot's "soliloquy of the broom," as his mother called it, gives evidence of his conviction that photography might offer a creative artistic outlet for those, like himself, without the manual talent to draw or paint.

The final step in the development of early photography was taken in 1851 by Frederick Scott Archer, a British sculptor and photographer, who was one of many in Western Europe trying to find a way to make silver nitrate adhere to glass. The result would be a glass negative, from which countless positive proofs could be made. Archer's solution was collodion, a combination of guncotton, ether, and alcohol used in medicinal bandages. He found that a mixture of collodion and silver nitrate, when wet, needed only a few seconds' exposure to light to create an image. Although the wet-collodion process was more cumbersome than earlier techniques, it quickly replaced them because of its greater speed and the sharper tonal subtleties it produced. Moreover, it was universally available because Archer, unlike Daguerre and Talbot, generously refused to patent his invention. Thus the era of modern photography was launched (see "How Photography Works," above).

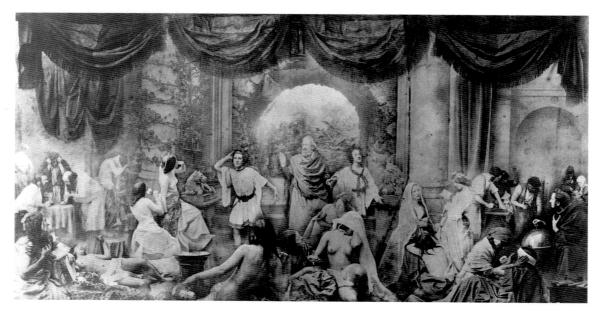

27-14. Oscar Rejlander. *The Two Paths of Life*. 1857. Combination albumen print, 16 x 31" (41 x 79.5 cm). The Royal Photographic Society, London

Once a practical photographic process had been invented, the question became how to use it. Those in the sciences agreed on its value for recording data, but artists were less certain how to take advantage of it. For some, like Delacroix, who occasionally worked from photographs instead of a live model, it was a cost-saving convenience. A number of critics argued that it could popularize fine art by making cheap reproductions of famous works available to the masses. For the academic painter Delaroche, however, photography represented a serious threat. He responded to Daguerre's invention in 1839 by declaring, "From this moment, painting is dead!" Although some artists in the ensuing years may have continued to feel uneasy about photography, it was soon clear that it threatened only one kind of painting: portraiture (see fig. 2, page 17). And even there, it was used mostly as a cheap, democratic substitute for the brand of expensive, high-society portraiture that continued undiminished into the twentieth century. The real issue was whether photography, taken on its own terms, could be a new art form.

Among the first photographers to argue for its artistic legitimacy was Oscar Rejlander (1813-1875) of Sweden, who had studied painting and sculpture at the Academy in Rome. In 1841 Rejlander settled in England. He first took up photography in the early 1850s as an aid for painting but was soon attempting to create photographic equivalents of the painted and engraved moral allegories so popular in Britain since the time of Hogarth (see fig. 26-17). In 1857 he produced his most famous work, The Two Paths of Life (fig. 27-14), by combining thirty negatives. This allegory of good and evil, work and idleness, was loosely based on Raphael's School of Athens (see fig. 18-12). At the center an old sage ushers two young men into life. The serene youth on the right turns toward personifications of Religion, Charity, Industry, and other virtues, while his counterpart eagerly responds to the enticements of pleasure. The figures on

the left Rejlander described as personifications of "Gambling, Wine, Licentiousness and other Vices, ending in Suicide, Insanity, and Death." In the lower center, with a drapery over her head, is the hopeful figure of "Repentance." Although Queen Victoria purchased a copy of *The Two Paths of Life* for her husband, it was not generally well received as art. One typical response was that "mechanical contrivances" could not produce works of "high art," a criticism that would continue to be raised against photography.

Another pioneer of photography as art was Julia Margaret Cameron (1815–1879), who received her first camera as a gift from her daughters when she was forty-eight. Cameron's work was more personal and less dependent on existing forms than Rejlander's. Although she did numerous portraits of her family and of strangers whose faces she found interesting, Cameron's principal subjects were the great men of British arts, letters, and sciences, many of whom had long been family friends.

Like all of Cameron's portraits, that of the famous British historian Thomas Carlyle is slightly out of focus (fig. 27-15). Cameron produced this blurred effect deliberately, consciously rejecting the sharp stylistic precision of popular portrait photography, which she felt accentuated the merely physical attributes and neglected a subject's inner character. By blurring the details she sought to call attention to the light that suffused her subjectsa metaphor for creative genius—and to their thoughtful, often inspired expressions. Carlyle's concentrated expression is so intense that the dramatic lighting of his hair, face, and beard almost seems to emanate from within. In her autobiography Cameron said: "When I have had such men before my camera my whole soul has endeavored to do its duty towards them in recording faithfully the greatness of the inner as well as the features of the outer man." This sense of picturing both what was seen and what was not seen accorded with her larger goals for photography.

With regard to her medium Cameron said: "My aspirations are to ennoble Photography and to secure for it the character and uses of High Art by combining the real and ideal." To this end, she showed her portraits at the major European photographic exhibitions of the period, which were many.

An even more ambitious conception of photography was pursued by the most famous French practitioner of the time, known as Nadar (1820–1910). Born Gaspard-Félix Tournachon, he began his career as a drama critic. After a variety of other jobs and enthusiasms he worked as a caricaturist. He became interested in photography in 1849 as a tool to help him with a project called the Panthéon-Nadar, a series of four lithographs that was to include the faces of all the well-known Parisians of the day. He quickly saw the documentary potential of the photograph and opened a portrait studio in 1853. His thriving studio, which at one point had twenty-six employees, became a meeting place for many of the great intellectuals and artists of the period. The first exhibition of Impressionist art was held there in 1874.

Nadar was a realist in the tradition inaugurated by Daguerre. He embraced photography because of its ability to record people and their surroundings exactly. As part of a heroic effort to produce a comprehensive and factual portrait of his era, in 1858 he took successful aerial photographs of Paris, the first of their kind, from a hotair balloon. In 1863 he built a balloon called The Giant that could carry about fifty passengers and was equipped with a darkroom. At the other extreme he made numerous photographs of the catacombs and sewers of Paris. He also produced a series on typical Parisians. Finally, Nadar attempted to photograph all the leading figures of French culture, among them the poet Charles Baudelaire (fig. 27-16). As can be seen in the portrait of Baudelaire, Nadar eschewed the use of props and avoided formal poses in favor of informal ones determined, like their facial expressions, by the sitters themselves. His goal was not so much an interpretation as a factual record of a sitter's characteristic appearance and demeanor. The drawn expression on Baudelaire's face, for example, tells much about him. The year this photograph was taken, 1863, Baudelaire published "The Painter of Modern Life," a newspaper article in which he called on artists to provide an accurate and insightful portrait of the times. The idea may have come from Nadar, who had been trying to do just that for some time.

27-16. Nadar. *Portrait of Charles Baudelaire*. 1863. Silver print. Although Baudelaire never wrote about the photographic work of his friend Nadar, he was highly critical of the vogue for photography and of its influence on the visual arts. In his Salon review of 1859 he said: "The exclusive taste for the True . . . oppresses and stifles the taste of the Beautiful. . . . In matters of painting and sculpture, the present-day *Credo* of the sophisticated is this: 'I believe in Nature . . . I believe that Art is, and cannot be other than, the exact reproduction of Nature. . . .' A vengeful God has given ear to the prayers of this multitude. Daguerre is his Messiah."

27-15. Julia Margaret Cameron. *Portrait of Thomas Carlyle*. 1863. Silver print, 10 x 8" (25.4 x 20.3 cm). The Royal Photographic Society, London

SCHOOL. **FOLLOWER** OF, AND **OTHER TERMS OF**

In art history the word school has several meanings. Artists whose work is related by peri-ATTRIBUTION od, style, and place are linked by the

term school, as in "Barbizon School." School of is sometimes used for works that are not attributable to a known

artist but that show strong stylistic similarities to him or her, for example, "school of Rubens." When a term such as Sienese school is used, it means that the work shows traits common in the art from Siena during the period being discussed. Follower of most often suggests a secondgeneration artist working in a variant style of the named artist. Workshop of

is an attribution appropriate to the centuries when the guild system was in place in Europe and implies that a work was created by an artist or artists trained in the workshop of an established artist. Attributed to, like a question mark next to an artist's name, means that there is some uncertainty as to whether the work is by that artist.

NATURALISM OUTGROWTHS

FRENCH Realistic figure painting of the late nineteenth century shared with photography AND REALISM an allegiance to factual ac-AND THEIR curacy. The descriptive approach to scenes of daily life emerged in France out

of the tradition of Romantic naturalism, which itself gained a new respectability and popularity after about 1850. The kind of work produced in the 1830s and 1840s by the Barbizon School—a group centered in the village of Barbizon on the edge of the Fontainebleau Forest, painting landscapes and rural scenes that academic jurors and conservative critics had attempted to bar from the Salons—was now embraced by the Parisian art world (see "School, Follower of, and Other Terms of Attribution." above). One reason for this critical shift was the radically changed conditions of Parisian life. Between 1831 and 1851 the city's population doubled, and thereafter Haussmann's renovations completed its transformation from a collection of small neighborhoods to a modern, crowded, noisy, and fast-paced metropolis. To those living in this new environment, the image of a peaceful and contented country life began to have increasing appeal.

Another factor in the new acceptance of rural landscapes, especially those featuring farm workers, was the widespread uneasiness over the political and social effects of the Revolution of 1848 and its aftermath. This revolution began in February of that year when Parisian workers overthrew the monarchy and established the Second Republic (1848–1851). Its founders' socialist goals, including collective ownership of means of production and distribution, were abandoned when conservative factions won elections that summer, and fear of further disruptions continued to trouble many. These people found solace in images of the seemingly unchanging and traditional life of the countryside.

One naturalist landscape painter who saw his reputation soar after 1850 was Jean-Baptiste-Camille Corot (1796-1875). Corot had been trained in the 1820s to accept the academic distinction between the heroic landscape—an idealized and carefully finished composite with a subject from the Bible or classical history—and the rural landscape, a direct record of an ordinary country scene. The heroic landscape, because it required learning and imagination as well as technical skill, was considered the higher and nobler of the two. Although Corot produced heroic landscapes for the Salons, like his younger friends the Barbizon painters he found the rural scenes more satisfying and congenial. After 1850 he began to enjoy critical and financial success with paintings of a dreamy subjectivity as well as more naturalistic works, such as Sèvres-Brimborion, View toward Paris (fig. 27-17).

Corot painted Sèvres-Brimborion in his Paris studio from studies he made in a small town southwest of Paris near Ville d'Avray, where he spent many of his summers. Throughout his career Corot liked to set viewers on such country roads, inviting them to follow in their imaginations the slow, peaceful pace of the other travelers, all of them enveloped in a haze of pleasant weather. The quiet mood is underscored by the harmony of browns, blues, and greens (achieved by mixing a little off-white with each color) and by the apparently casual application of the paint. The picture's slow tempo and emotional tranquillity offer a sharp contrast to city life, subtly suggested by the Paris skyline barely visible in the distance.

One of the most popular French painters to address the taste for rural landscapes was Rosa Bonheur (1822-1899). Her success in what was then a male domain owed much to the socialist convictions of her parents, who belonged to a radical utopian sect founded by the Comte de Saint-Simon, which believed not only in the equality of women but in a female Messiah. Of women Bonheur said in her Reminiscences (published posthumously in 1910): "I am persuaded that the future belongs to us." Her father, a drawing teacher, provided most of her artistic training.

Although she did a few Barbizon-like landscapes in the early 1840s, Bonheur was from the first dedicated to a realistic depiction of the farm animals she loved. This commitment to rural subjects was partly the result of her aversion to Paris, where she had been raised. To record farm animals accurately, she read zoology books and made detailed studies in the countryside and in slaughterhouses. Because these settings were rugged, she often wore men's clothing, for which she had to get police permission.

Although Bonheur received some critical praise for her animal portraits in the 1840s, her success dates from the Salon of 1848, where she showed eight paintings and won a first-class medal. As a result, the government commissioned a work from her, Plowing in the Nivernais: The Dressing of the Vines (fig. 27-18). This monumental painting features one of her favorite animals, the ox, engaged

27-17. Jean-Baptiste-Camille Corot. *Sèvres-Brimborion, View toward Paris*. 1864. Oil on canvas, 16¹/₄ x 24¹/₂" (41.3 x 61.6 cm). The George A. Lucas Collection of the Maryland Institute, College of Art, on extended loan to the Baltimore Museum of Art

27-18. Rosa Bonheur. *Plowing in the Nivernais: The Dressing of the Vines*. 1849. Oil on canvas, 5'9" x 8'8" (1.8 x 2.6 m). Musée d'Orsay, Paris

Bonheur was often compared with the writer George Sand, a contemporary woman who adopted a male name as well as male dress. Sand devoted several of her novels to the humble life of farmers and peasants. Critics at the time noted that *Plowing in the Nivernais* may have been inspired by a passage in Sand's *The Devil's Pond* (1846) that begins: "But what caught my attention was a truly beautiful sight, a noble subject for a painter. At the far end of the flat ploughland, a handsome young man was driving a magnificent team [of] oxen."

27-19. Jean-François Millet. *The Gleaners*. 1857. Oil on canvas, 33 x 44" (83.8 x 111.8 cm). Musée d'Orsay, Paris

27-20. Gustave Courbet. *The Stone Breakers*. 1849. Oil on canvas, 5'3" x 8'6" (1.6 x 2.6 m). Formerly Gemäldegalerie, Dresden. Present whereabouts unknown; possibly destroyed during World War II

in a time-honored rural activity. The powerful beasts, anonymous workers, and fertile soil offer a reassuring image of the continuity of agrarian life. The stately movement of people and animals reflects the kind of carefully balanced compositional schemes taught in the Academy and echoes scenes of processions found in Classical art. The painting's compositional harmony—expressed in the way the shape of the hill is answered by and continued in the general profile of the four white oxen and their handler on the right—as well as its stylistic illusionism. pleasant landscape, and conservative theme were very appealing to the taste of the times, in England and the United States as well as in France. Bonheur became so famous that in 1865 she received France's highest award, membership in the Legion of Honor, becoming the first woman to be awarded its Grand Cross.

The most renowned of the French rural realists, Jean-François Millet (1814–1875), actually grew up on a

farm. After moving to Paris to study in 1837 he went through a difficult period. His teacher, an academician, considered him nearly unteachable, and Millet intensely disliked the city. He stayed on until after the Revolution of 1848, however, becoming a painter of the female nude. The Revolution's preoccupation with ordinary people seems to have led Millet to focus on peasant life, which had been only a marginal concern in his early work, and his support of the Revolution earned him a state commission that allowed him to leave Paris and settle in the village of Barbizon. After moving to Barbizon in 1849, he devoted himself almost exclusively to the difficulties and simple pleasures of rural existence.

Perhaps the most famous of his mature works is The Gleaners (fig. 27-19), which shows three women gathering grain at harvesttime. The warm colors and slightly hazy atmosphere are soothing, but the scene is one of extreme poverty. Gleaning, or the gathering of the grains left over after the harvest, was a form of relief offered the rural poor. It required hours of backbreaking work to gather the scant reward of enough wheat to produce a single loaf of bread. When the painting was shown in 1857, a number of critics thought Millet was attempting to rekindle the sympathies and passions of 1848, especially because he was known to have supported the Revolution. Yet Millet's intentions were actually quite conservative. An avid reader of the Bible, he saw in such scenes the fate of humanity, condemned since the Expulsion of Adam and Eve from the Garden of Eden to earn its bread by the sweat of its brow. Despite his brief enthusiasm for the Revolution Millet was neither a revolutionary nor a reformer but a fatalist who found exemplary the peasant's heroic acceptance of the human condition. To suggest the timeless nature of the scene, Millet generalized, even monumentalized, his figures, making them not specific individuals but representatives of their class. To avoid the unique and the idiosyncratic, Millet rarely studied from nature.

Millet, who disliked change, was also drawn to scenes like that of *The Gleaners* because they evoked an enduring way of life. He purposefully omitted from his paintings any evidence of the technological improvements recently introduced in French agriculture. He chose instead to emphasize those tools, like the rake and the hoe, that had served humanity from time immemorial. Like Talbot, he was nostalgic for the preindustrial past.

Gustave Courbet (1819–1877) was also inspired by the events of 1848 to turn his attention to the poor and ordinary. Trained around 1840 at an independent Paris studio, Courbet had until the Revolution devoted himself primarily to narcissistic images of himself in flattering portraits and romantic roles. The street fighting of 1848, however, seems to have radicalized him, as it did some of his close friends. He told one newspaper in 1851 that he was "not only a Socialist but a democrat and a Republican: in a word, a supporter of the whole Revolution." Courbet proclaimed his new political commitment in three large paintings he submitted to the Salon of 1850–1851.

One of these, The Stone Breakers (fig. 27-20), shows

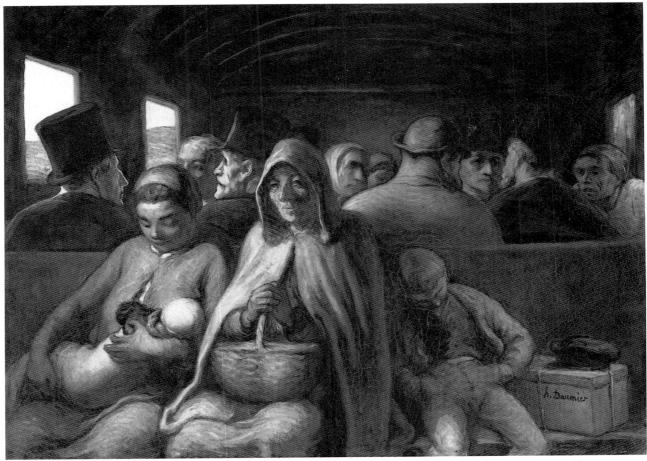

27-21. Honoré Daumier. *The Third-Class Carriage*. c. 1862. Oil on canvas, 25³/₄ x 35¹/₂" (65.4 x 90.2 cm). The National Gallery of Canada, Ottawa

two men preparing the small stones used for roadbeds. Courbet describes the painting and its origins in a letter:

[N]ear Maizières, I stopped to consider two men breaking stones on the highway. It is rare to encounter the most complete expression of poverty, so an idea for a picture came to me. . . . I made an appointment with them for the next day at my studio. On the one side is an old man, seventy. . . . On the other side is a young fellow . . . in his filthy tattered shirt. . . . Alas, in labor such as this, one's life begins that way, it ends the same way.

Despite its subject, the painting is not an obvious piece of political propaganda. By hiding the faces of his two protagonists, Courbet makes it difficult for the viewer to identify with them and their plight. He objectified the pair, treating them simply as two more facts in a painting that emphasizes the appearance, texture, and weight of things. This impersonal treatment and the reference in his letter to the sad course of a laborer's life have led many to speculate that Courbet's work is less a political statement than an expression of conservative fatalism akin to Millet's. In 1866 one of Courbet's own friends questioned his intention: "Did you mean to make a social protest out of those two men bent under the inexorable compulsion of Toil? I see in them, on the contrary, a

poem of gentle resignation, and they inspire in me a feeling of pity." Courbet responded, "But that pity springs from the injustice, and that is how I stirred up, not deliberately, but simply by painting what I saw, what they call the social question" (cited in Lindsay, page 60).

Like his other offerings to the Salon of 1850–1851, *The Stone Breakers* testifies to Courbet's respect for ordinary people. In French art before 1848 such people had been shown only in small, modestly scaled paintings. Monumental canvases had been reserved for heroic subjects and for pictures of the powerful (see "Realist Criticism," page 994). In his three large Salon paintings Courbet implicitly claimed that humble men and women were worthy of respect. *The Stone Breakers* also reveals the artist's fondness for depicting stone. Rocky landscapes, usually without human presence, would become his favorite subject. His use of impasto (thickly applied paint), which he often laid on with a palette knife, seems intended to convey the rugged materiality of nature that he so loved.

Partly for convenience, Courbet, Millet, Bonheur, and the other county-life realists who emerged in the 1850s are sometimes referred to as "the generation of 1848." Because of his sympathy with working-class people, the somewhat older Honoré Daumier (1808–1879) is also grouped with this generation. Unlike Courbet and the others, however, Daumier often depicted urban scenes, as in *The Third-Class Carriage* (fig. 27-21). The painting

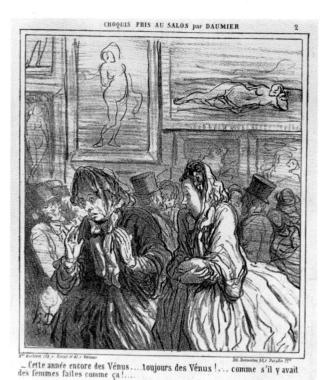

27-23. Aimé-Jules Dalou. *Breton Woman Nursing Her Child*. 1873. Terra-cotta, height 49³/₄" (126 cm). Victoria and Albert Museum, London

REALIST CRITICISM

The critical insistence that art should focus not on histori-

cal, biblical, or literary themes but on the realities of contemporary life was a major factor in the rise of artistic Realism in France after 1848. A French utopian socialist, the Comte de Saint-Simon (1760-1825), was largely responsible for this view. Saint-Simon, like both Auguste Comte and Karl Marx after him, believed that the laws of human society could be discovered by science and used to construct what he called the "golden age of humanity." Art would contribute significantly to this process, according to Saint-Simon, by preparing the public to accept the changes advocated by the new social scientists. Saint-Simon's Opinions (1825) contains a fictional dialogue between such a scientist and an artist in which the latter says: "It is we, artists, who will serve you as avantgarde [vanguard]: the power of the arts is in fact most immediate. . . .

When we wish to spread new ideas among [people], we inscribe them on marble or in canyas."

Saint-Simon's view of art's function was quickly embraced by a number of liberal critics. One of them, Gustave Planche (1808-1857), first applied the word realism to art in 1833. For Planche and for others prior to about 1860, Realism meant a combination of contemporary subjects and socialist intentions. The leading realist critic of the era was probably Théophile Thoré (1807-1869), who during the 1830s and 1840s advised artists to reject as irrelevant to the present the subjects and formulas of the past. He also insisted that art must have a moral dimension.

The ideas of Thoré, Planche, and other realist critics were much discussed by a group of younger critics, artists, poets, and writers who gathered at a Paris beer hall in the years just prior to the Revolution of 1848. Among the regulars were Courbet and the fledgling art and literary

critic known as Champfleury (1821-1889; born Jules-François-Félix Husson). Courbet's first defender, Champfleury later helped the artist write his so-called Realist Manifesto. When two of Courbet's thirteen submissions were rejected by the jury for the Universal Exposition of 1855, Courbet withdrew and organized a private exhibition for which he and Champfleury wrote a brief catalog introduction. In it Courbet said, "To know in order to be able to create, that was my idea. To be in a position to translate the customs, the ideas, the appearance of my epoch, according to my own estimation; to be not only a painter, but a man as well; in short, to create living art—this is my goal."

In this manifesto both Courbet and Champfleury were apparently renouncing the political and moral associations long carried by the term *realism* in favor of the apolitical and individualistic conception that would prevail among the critics and artists of the following generation.

1870 1820 1890

depicts the interior of one of the large, horse-drawn buses that transported Parisians along Baron Haussmann's new boulevards. Daumier places the viewer in the poor section of the bus, opposite a serene grandmother, her daughter, and her two grandchildren. Their intimacy and unity (Daumier has arranged them in a pyramid shape) are in sharp contrast to the separateness of the upper- and middle-class passengers whose heads appear behind them. The work could be seen as a commentary on urban alienation, which would become an important topic in art after 1880.

As The Third-Class Carriage suggests, Daumier had a genuine affection for working-class people. A political liberal like Courbet, he had been greatly affected by the Revolution of 1830. Then a student at the Academy, Daumier began producing antimonarchist and prorepublican caricatures in leftist journals. He was soon obliged to focus on social and cultural themes, rather than strictly political ones, however, because of stringent censorship laws. His biting satires of the bourgeoisie and of academic art helped usher in the new taste for realism. This Year, Venuses Again . . . Always Venuses! (fig. 27-22), for example, humorously contrasts academic standards of ideal female beauty with two quite ordinary women visiting the Salon. One of them turns away from a wall of academic nudes with the comment, "This year, Venuses again . . . always Venuses! As if there really were women built like that!"

One of the artists who carried the concerns of the generation of 1848 into the later part of the century was the sculptor Aimé-Jules Dalou (1838-1902). Encouraged by Carpeaux, Dalou studied sculpture at the Academy. He enjoyed considerable success in the 1860s for works essentially made for the market. His more personal work emerged in the context of the Commune of 1871, the short-lived socialist government established in Paris after the defeat of the French in the Franco-Prussian War and the abdication of Napoleon III. Like his friend Courbet, Dalou actively supported the Commune. At this time he produced the first of his realist sculpture, a lifesize figure of an embroiderer. When the leaders of the Commune were driven from power, Dalou, like Courbet, was forced into exile. Until the amnesty of 1879-1880 he lived in England, where he specialized in scenes of people engaged in everyday pursuits. Many of these works were later used for porcelain figurines issued in large editions.

One of Dalou's favorite themes can be seen in *Breton Woman Nursing Her Child* (fig. 27-23). This work delighted the British public when it was exhibited in 1873, possibly because Dalou's concern for common people and occurrences resulted in imagery that supported a conservative view then prevalent that the home is a woman's "natural" domain.

Following the French lead, artists of other Western European nations also embraced realism in the period after 1850. Among them was the German painter Wilhelm Leibl (1844–1900). Trained at the Munich Academy, Leibl was a fairly conventional academician until Courbet's visit in 1869 to the Munich International Exhibition, where some of his paintings were on display. Inspired by

27-24. Wilhelm Leibl. Three Women in a Village Church. 1878–81. Oil on wood, $44^{1/2}$ x $30^3/8$ " (113 x 77 cm). Kunsthalle, Hamburg

About this painting, Leibl wrote to his mother in 1879: "Here in the open country and among those who live close to nature, one can paint naturally. . . . It takes great staying power to bring such a difficult, detailed picture to completion in the circumstances. Most of the time I have literally taken my life in my hands in order to paint it. For up to now the church has been as cold as a grave, so that one's fingers get completely stiff. Sometimes, too, it is so dark that I have the greatest difficulty getting a clear enough view of the part on which I am working. . . . Several peasants came to look at it just lately, and they instinctively folded their hands in front of it. . . . I have always set greater store by the opinion of simple peasants than by that of so-called painters."

Courbet's work, and on his advice, Leibl went to Paris to familiarize himself with its realist currents. After Leibl's return to Germany he lived in Munich for several years before moving to rural Bavaria, in southern Germany, where he dedicated himself to peasant subjects.

Leibl's best-known painting is *Three Women in a Village Church* (fig. 27-24), which was based on countless sittings by villagers he used as models. The work features a young woman, whose fresh beauty stands in sharp contrast to the weathered faces of the women next to her. The contrast is emphasized by the different backgrounds

27-25. Ilya Repin. The Composer Moussorgsky. 1881. Oil on canvas, 271/4 x 221/2" (69.9 x 57.7cm). Tretyakov Gallery, Moscow

behind the older women and the young woman. The work is more than a reverie on youthful beauty, however. It also extols the conservative customs and values of Bavarian peasants, as embodied in the traditional dress and ardent piety of the three women. Carrying on the practices of her elders, the young woman represents the enduring strength of those customs and values. Even the elaborately carved pews, which seem to date from the Baroque period, suggest a faithfulness to the past. The scene is rendered with a minute care that owes more to the example of Hans Holbein (figs. 18-73, 18-77) and Jan Vermeer (fig. 19-57) than to that of Courbet. Leibl thereby demonstrates his own devotion to time-honored artistic standards threatened by innovation and change.

In Russia, too, realism developed in relation to a new concern for the peasantry. In 1861 the czar abolished serfdom, emancipating Russia's peasants from the virtual slavery they had endured on the large estates of the aristocracy. Two years later a group of painters inspired by the emancipation declared allegiance to both the peasant cause and freedom from the St. Petersburg Academy of Art, which had controlled Russian art since 1754. Rejecting what they considered the idealized, "art for art's sake" aesthetics of the Academy, the members of the group dedicated themselves to a socially useful realism. Committed to bringing art to the people in traveling exhibitions, they called themselves the Wanderers. By the late 1870s, members of the group, like their counterparts in music and literature, were also becoming active in a broad nationalistic movement to reassert what they con-

sidered to be an authentic Russian culture rooted in the traditions of the peasantry. This movement developed in reaction to the Western European customs that had long predominated among the Russian aristocracy. Since the late eighteenth century, for example, French had been spoken at court and among Russia's educated elite.

Ilya Repin (1844-1930), who attended the St. Petersburg Academy and won a scholarship to study in Paris, joined the Wanderers on his return to Russia in 1878. His work included genre scenes, history paintings, and portraits of other leading figures in the arts. His portrait of Modest Moussorgsky, one of a group of composers incorporating Russian folk melodies into their symphonic music, shows him with tousled hair and a rugged demeanor, a man of the people rather than a slick sophisticate in the Western mold (fig. 27-25).

UNITED

ART IN Art in the United States at mid-century, like Russian art after the emancipation of the serfs, was marked by the tension between an academic tradition imported **STATES** from Western Europe and an unbroken American tradition of realism. In the

case of the United States, however, the tension was not recent. The advocates of realism had long considered it distinctively American and democratic; others, in contrast, saw the academic ideal as a link to a higher Western European culture.

Sculpture

In the years immediately before and after the Civil War, sculpture, especially in marble, remained the essential medium for those committed to "high," or European, culture. A new generation of sculptors continued the European Neoclassical tradition established in Rome by Antonio Canova (see fig. 26-6) and brought to the United States in the second quarter of the nineteenth century by artists like Thomas Crawford and Hiram Powers (Chapter 26). Most members of this new generation studied in Rome, but a few, including Erastus Dow Palmer (1817-1904), had no formal training. A carpenter from upstate New York, Palmer had begun making small cameo portraits around 1845 and had moved to large-scale marble figures by the early 1850s. He achieved his greatest popular success in 1859, when he exhibited The White Captive (fig. 27-26). The work, which places a realistic head on a classically idealized body, was displayed alone in a room carefully illuminated by gaslight that warmed the marble to a semblance of flesh. This theatrical presentation, reminiscent more of Daguerre's diorama than of the Paris Salon, was typical of the way Americans saw art in this period.

Painting and Photography

In contrast to the late Neoclassicism prevalent in sculpture, during the years before the Civil War American landscape painters shifted from the Romantic tradition of Thomas Cole (see fig. 26-69) toward a more factual natu-

27-26. Erastus Dow Palmer. *The White Captive*. 1857–59. Marble, height 5'6" (1.68 m). The Metropolitan Museum of Art, New York
Gift of Hamilton Fish

ralism. This transition is particularly evident in the work of Frederick Edwin Church (1826-1900), Cole's only student. Like Cole, Church favored the grand spectacles of nature, such as Niagara Falls (fig. 27-27). In its epic aspirations Church's Niagara remains Romantic in conception, but its Romanticism is tempered by a scientific eye. Church's cool coloring and precise rendering reflect the influence of Alexander von Humboldt, a German naturalist who advocated a factual approach to the study of landscape as a prerequisite for grasping nature's grandeur, not an end in itself. The painting's magnificent spectacle, precarious vantage point, and huge scale were designed to generate grand emotions. Its subject also sparked considerable nationalistic pride. Niagara Falls was one of those august places that exemplified to Americans the greatness of their nation. By including a rainbow over the falls, a traditional symbol of divine approval, Church clearly meant to appeal to the public's preconceptions about their national destiny. Drawn by its combination of naturalism, lofty emotion, and nationalism, people flocked to see the painting in New York City in 1857 and, despite a twenty-five cent fee, on its national tour in 1859. More than 1,100 visitors to the 1857 exhibition ordered colored reproductions of Niagara.

One of them, John Frederick Kensett (1816–1872), was a landscape painter with an even more naturalistic approach to the Romanticism of his predecessors. Trained as an engraver, Kensett toured and studied in Europe between 1840 and 1847. After his return he traveled in the United States, making detailed records of the beautiful

27-27. Frederick Edwin Church. *Niagara*. 1857. Oil on canvas, 3'6½" x 7'6½" (1.1 x 2.3 m). The Corcoran Gallery of Art, Washington, D.C.

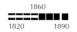

27-28. John Frederick Kensett. *Beacon Rock, Newport Harbor*. 1857. Oil on canvas, 22½ x 36" (57.2 x 91.4 cm). National Gallery of Art, Washington, D.C. Gift of Frederick Sturges, Jr.

scenery of the Northeast and West. He and a group of his contemporaries, including Fitz Hugh Lane (1804–1865), Martin Johnson Heade (1819–1904), and Worthington Whittredge (1820–1910), have together come to be known as the Luminists because of the radiant light that suffuses the atmosphere in their landscapes.

Characteristic of Kensett's work in its combination of the documentary with the metaphorical is *Beacon Rock*. Newport Harbor (fig. 27-28). The painting, which shows the entrance to the Rhode Island city's harbor, employs a three-part spatial arrangement that derives ultimately from the seventeenth-century French Baroque painter Claude Lorrain (see fig. 19-28). From a narrow foreground plane, where the viewer stands, the eye moves around a large mass that establishes the middle ground to the elements of the far distance. But whereas Claude and his later imitators composed ideal landscapes to fit this format, Kensett has accommodated the format to the topographical facts. For example, the harmony of human and nature signaled in the Claudian tradition by Arcadian herders is here indicated by the people in boats that Kensett actually observed on the site. Nevertheless, the scene's tranquil noonday light, which looks naturalistic to the twentieth-century eye, must be seen in the context of the mid-nineteenth century's insistence on metaphorical readings of the landscape. Kensett, like his predecessors, seems to have considered light to be evidence of the divine. Unlike his predecessors, however, he shunned the theatrical handling of such metaphors and a preoccupation with their narrative implications. In Beacon Rock Kensett makes no claims about the future of the United States. He simply records a single, blessed moment.

In retrospect we know that Kensett's luminous calm was about to be broken by a terrible storm. Four years after he painted *Beacon Rock*, the Civil War erupted. This conflict lasted four bloody years (1861–1865) and cost

nearly 620,000 lives, more than all other United States wars combined. It generated intense national and international interest, attracting not only journalists and artists but also practitioners of the new medium of photography. Inspired by the pioneering documentary work of a handful of British war photographers in the middle to late 1850s, more than 300 American and foreign photographers eventually entered the battle zone with passes from the U.S. government.

The first photographer at the front was Mathew B. Brady (1823–1896), who ran large portrait studios in New York City and Washington, D.C. When the war broke out, he used his friendship with the influential government officials whose portraits he had made to obtain permission to take a team of photographers and a darkroom wagon to the front, where they endured considerable hardship and danger. After Brady himself was almost killed in an early battle he left the actual photographing to his twenty assistants. Brady's Photographic Corps amassed more than 7,000 negatives documenting every aspect of the war except the actual fighting, because the cameras were still too slow for action scenes.

The most memorable images by Brady and his assistants were taken immediately after battles, before the dead could be buried. An example is *Confederate Dead Gathered for Burial, Antietam, September 1862* (fig. 27-29), by Brady's most acclaimed assistant, Alexander Gardner (1821–1882). Lying in a neat, wedge-shaped pile are the corpses of some of the more than 10,000 Confederate soldiers who had fallen in that battle. The grim evidence of carnage in such works made a powerful impression on the American public, cutting through the conventional glamour of war in a way that even Francisco Goya had been unable to do (Chapter 26).

After the war the nation tried to heal its wounds in a variety of ways. In both North and South, public sculpture

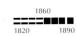

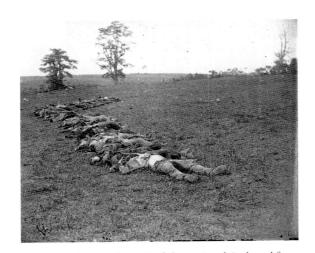

27-29. Alexander Gardner. *Confederate Dead Gathered for Burial, Antietam, September 1862*. Albumen silver print. Library of Congress, Washington, D.C.

An 1862 editorial in the *New York Times* on the Antietam photographs commented that Mathew Brady and his assistants "bring home to us the terrible reality... of the war. If [they have] not brought bodies and laid them in our door yards... [they have] done something very like it."

was commissioned not only to commemorate the dead and provide an outlet for grief but to provide satisfactory explanations for the epic sacrifice. One of the most popular subjects in the North was Abraham Lincoln, shown either alone or freeing slaves, as in Thomas Ball's bronze sculpture The Emancipation Group (fig. 27-30). Ball (1819-1911), a self-trained sculptor who moved to Italy in 1854, produced this and a number of similarly naturalistic commemorative monuments in his Florence studio. The work shows President Lincoln in contemporary dress, with his 1863 Emancipation Proclamation in one hand, blessing with the other a man who, his wrist chains of enslavement just broken, is about to rise a free person. Lincoln was the perfect subject for such explanatory sculpture because his assassination immediately following the war was seen as its final tragedy and epitomizing symbol. For Northerners, at least, his personal sacrifice in the name of a great moral cause personified that of the nation as a whole.

Among the most important factors in the nation's recovery from the war was the massive westward expansion that soon came to preoccupy its citizens. This expansion into the so-called wilderness between the eastern seaboard and California—already occupied by Native Americans—was justified as the nation's Manifest Destiny, a term coined in 1845. To help open up territory, the U.S. government sponsored a number of exploratory surveys into the West, and many Civil War photographers, toughened by combat and looking for fresh subjects, accompanied them.

One of those photographers was Timothy H. O'Sullivan (1840–1882), who had trained in Brady's portrait studios and worked for him during the war. As his most famous photograph, *Ancient Ruins in the Cañon de Chelley, Arizona*, makes clear, O'Sullivan's landscapes are more a personal expression of awe than they are documentary records (fig. 27-31). Taken on a government geological

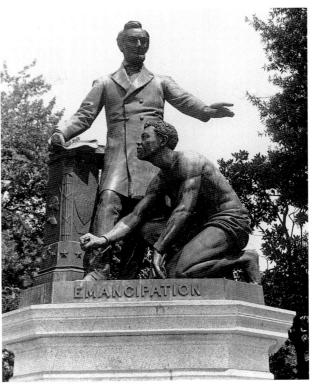

27-30. Thomas Ball. *The Emancipation Group*. 1874. Bronze, over-lifesize. Lincoln Park, Washington, D.C.

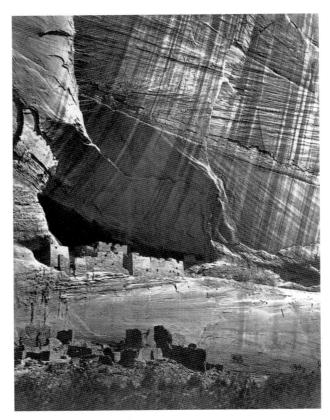

27-31. Timothy H. O'Sullivan. *Ancient Ruins in the Cañon de Chelley, Arizona*. 1873. Albumen print. National Archives, Washington, D.C.

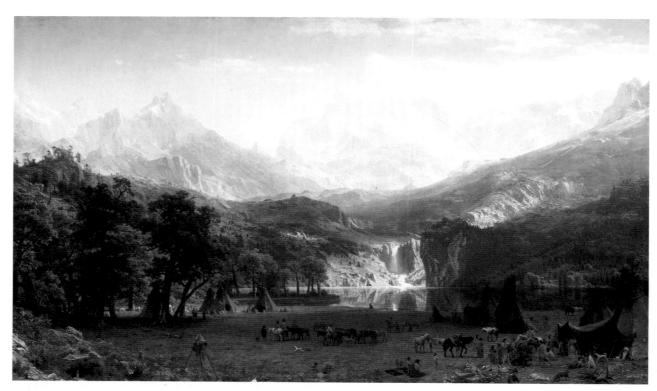

27-32. Albert Bierstadt. *The Rocky Mountains, Lander's Peak*. 1863. Oil on canvas, 6'1¹/₄" x 10'³/₄" (1.86 x 3 m). The Metropolitan Museum of Art, New York
Rogers Fund

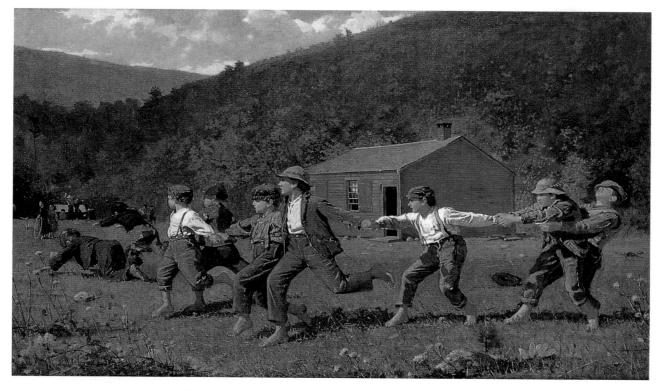

27-33. Winslow Homer. Snap the Whip. 1872. Oil on canvas, $22^{1/4}$ x $36^{1/2}$ " (55.9 x 91.4 cm). The Butler Institute of American Art, Youngstown, Ohio

survey of the Southwest, this landscape view is virtually without precedent. The canyon wall, 700 feet high, fills the image, giving the viewer no clear vantage point and scant visual relief. The bright, raking sunlight across the rock face reveals little but the cracks and striations

formed over countless eons. The image suggests not only the immensity of geological time but humanity's insignificant place within it. Like the Classical ruins that were a popular theme in European art and poetry, the eleventh-to-fourteenth century Anasazi ruins suggest

the inevitable passing of all civilizations. For O'Sullivan, whose Romantic pessimism was surely fueled by the Civil War, the four puny humans standing in this majestic yet barren place would have reinforced the message of human futility and insignificance.

The paintings of Albert Bierstadt (1830–1902) impart a more optimistic view of the Western landscape. Born in Germany and raised in the United States, Bierstadt studied at the Düsseldorf Academy in the mid-1850s. In 1858–1859, just before the Civil War, he accompanied an expedition of U.S. Army engineers, led by Colonel Frederick Lander, mapping an overland route from St. Louis to the Pacific Ocean. Working from his sketches of this pristine territory, especially the Rocky Mountains, he produced a series of paintings that made his fame. The first of these, The Rocky Mountains, Lander's Peak (fig. 27-32), sold for \$25,000, the highest price an American painting had yet brought-more than forty times what a skilled carpenter or mason then earned per year. The huge canvas, intended for Eastern audiences only slightly familiar with Native Americans and even less familiar with the Rockies, combines a documentary approach to Native American life in the tradition of George Catlin (see fig. 26-68) with an epic, composite landscape in the tradition of Frederick Edwin Church (see fig. 27-27). The painting is more than a geography lesson, however. As in the work of Church and Cole, it conveys an implicit historical narrative. From the Native American encampment in the foreground, with its apparent associations to the Garden of Eden, the eye is drawn into the middle ground by the light on the waterfall, then up to Lander's Peak. To audiences that accepted the concept of a divinely sanctioned Manifest Destiny, the work's spatial progression must have seemed to map out their nation's westward and upward course. The painting seems virtually to beckon them into this paradise to displace the Native Americans already inhabiting it.

The myth of America as the new Eden, challenged by the war, also reasserted itself in genre painting and sculpture. One of those who specialized in reassuring scenes of American innocence was the painter Winslow Homer (1836–1901). Homer began his artistic career in 1857 as a free-lance illustrator for popular periodicals such as *Harper's Weekly* and *Ballou's Pictorial. Harper's* sent him to cover the Civil War in 1862. His quiet scenes of life behind the lines could hardly be more different from the harsh photographs by Gardner and others. In 1866–1867 he spent ten months in France, where the realist art he saw may have inspired him to begin painting rural subjects when he returned.

About 1870 Homer began painting scenes based on frequent forays from his New York City home to upstate New York villages. Works like *Snap the Whip* (fig. 27-33), with its depiction of boys playing outside a one-room schoolhouse in the Adirondack Mountains on a glorious day in early fall, evoke the innocence of childhood and the imagined charms of a preindustrial America for an increasingly urbanized audience. Many of these paintings were reproduced as wood engravings for illustrated books and magazines. Homer apparently shared his

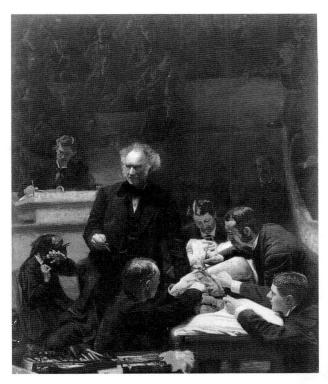

27-34. Thomas Eakins. *The Gross Clinic*. 1875. Oil on canvas, 8' x 6'5" (2.44 x 1.98 m). Jefferson Medical College of Thomas Jefferson University, Philadelphia

In 1876 Eakins joined the staff of the Pennsylvania Academy of the Fine Arts, where he taught anatomy and figure drawing. He disapproved of the academic technique of drawing from plaster casts. In an interview in 1879 he said, "At best, they are only imitations, and an imitation of an imitation cannot have so much life as an imitation of nature itself." He added that "The Greeks did not study the antique . . . the draped figures in the Parthenon pediment were modeled from life, undoubtedly." Eakins introduced the study of the nude model, which shocked many in staid Philadelphia society. In 1886 he was given the choice of changing his teaching policies or resigning. He chose the latter.

audience's nostalgia for a more carefree past, and the paintings seem to have reminded him of his own active, outdoor childhood in Cambridge, Massachusetts, then still an almost-rural suburb of Boston. In one of them a boy signs the painter's initials on a schoolhouse wall.

Another famous American realist to emerge after the Civil War, Thomas Eakins (1844–1916), completely renounced such artistic pleasantries. Trained at the Pennsylvania Academy of the Fine Arts, he, too, went to Europe in 1866, studying for three years at the French École des Beaux-Arts under Jean-Léon Gérôme. He then spent six months in Spain, encountering the works of Diego Velázquez and José Ribera, whose profound realism came as a revelation to him. After he returned to Philadelphia in 1870 he specialized in frank portraits and genre scenes whose lack of conventional charm generated little popular interest.

One work that did attract attention, *The Gross Clinic* (fig. 27-34), was severely criticized. The painting shows

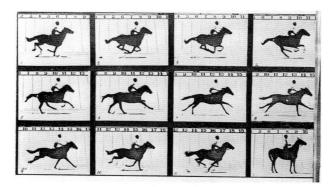

27-35. Eadweard Muybridge. *Galloping Horse*. 1878. Wetplate photography

27-36. Thomas Eakins. *The Pole Vaulter*. 1884. Multipleexposure photograph. The Metropolitan Museum of Art, New York Gift of Charles Bregler

Dr. Samuel Gross performing an operation at the Jefferson Medical College, which commissioned the work. Ranged behind him are young medical students, to whom he turns to make a point. The representatives of science—a young medical student, the doctor, and his helpers—are all highlighted. This dramatic use of light, borrowed, like the theme, from paintings of anatomy lessons by Rembrandt, is not meant to stir emotions but to make a point: From the darkness of ignorance and fear modern science is bringing forth the light of knowledge. The light in the center falls not on the doctor's face but on his forehead—on his mind.

Most observers found the work's bluntness offensive, in particular the details of the operation and the blood on the doctor's hand. Refused exhibition space in the art section of the 1876 Philadelphia Centennial, the painting was shown, instead, at the army's hospital display.

Eakins was chosen to paint *The Gross Clinic* because he often attended the doctor's lectures—he included a portrait of himself among the students in the painting—and even wrote a scientific paper on muscles. His interest in anatomy led him in turn to photography, which he used both as an aid for painting and as a tool for studying the body in motion. He made a number of studies with Eadweard Muybridge (1830–1904), a pioneer in motion photography.

The English-born Muybridge, who was born Edward James Muggeridge but changed his name to what he thought was its original Anglo-Saxon form, set up shop as a bookseller in San Francisco in 1852. He began taking landscape photographs in the 1860s and by the end of the decade was directing photographic surveys of the California coast for the U.S. government. In 1872 railroad owner and former California governor Leland Stanford bet a friend \$25,000 that a running racehorse has all four feet off the ground at some point in its stride, and he hired Muybridge to settle the issue. Muybridge's initial studies, for which he developed a fast new shutter, were promising but inconclusive, so Stanford asked him to continue working on the problem. After a number of interruptions, including his own trial for murder and his eventual acquittal, Muybridge succeeded in 1878 in proving Stanford's contention (fig. 27-35).

Galloping Horse was produced by twelve cameras, with shutter speeds, according to Muybridge, of "less than two-thousandth part of a second." The cameras, spaced 27 inches apart, were triggered by electric switches attached to fine black threads stretched across the track. In order to maximize the amount of light, the ground was covered with powdered lime and a white screen was set up along the rail, its linear divisions corresponding to the spacing of the cameras. When Eakins saw this photograph in 1879, he began a correspondence with Muybridge that eventually led to their collaboration under a contract from the University of Pennsylvania. With Muybridge's less than enthusiastic assistance Eakins devised a revolving disk for use over the camera lens that would permit a series of superimposed yet distinguishable images to be taken on one plate. The results are seen in such works as The Pole Vaulter (fig. 27-36).

ART IN ENGLAND

In 1848 seven young artists formed the Pre-Raphaelite Brotherhood to counter what they considered the

misguided practices of contemporary British art. Instead of the Raphaelesque conventions taught at the Royal Academy, the Pre-Raphaelites advocated the naturalistic approach of certain early Renaissance masters, especially those of northern Europe. They advocated as well a moral approach to art, in keeping with a long tradition in Britain established by Hogarth (see fig. 26-17).

The combination of didacticism and realism that characterized the first phase of the movement is best represented in the work of one of its leaders, William Holman Hunt (1827–1910), for whom moral truth and visual accuracy were synonymous. Typical of this academically trained artist is *The Hireling Shepherd* (fig. 27-37). The landscape portions of the composition were painted outdoors, an innovative approach at the time. Space was left for the figures, who were painted in his London studio. The work depicts a paid farmhand neglecting his duties to discuss with a woman a death'shead moth that he holds in his left hand. Meanwhile, some of his employer's sheep are wandering into an adjacent field, where they may die or become sick from eating green corn. Hunt later explained that he meant to

satirize pastors who spend time discussing theological questions he deemed to have no value rather than tending to their flock. The painting is also a moral lesson on the perils of temptation, with the woman cast as a latterday Eve. She feeds an apple—a symbolic reference to the Fall of humankind from the state of grace—to the lamb on her lap, and she distracts the shepherd from his duty.

The other major members of the group, John Everett Millais (1829–1896) and Dante Gabriel Rossetti (1828–1882), were less inclined to this sort of moralizing and by 1852 had broken with Hunt, which led to the dissolution of the group. In 1857 Rossetti, son of an exiled Italian poet, met two young Oxford students, William Morris (1834–1896) and Edward Burne-Jones (1833–1898), while working on a mural at the university. Their shared interest in the Middle Ages inaugurated the second, unofficial phase of Pre-Raphaelitism. Despite Hunt's protests, critics continued to identify Rossetti with the term, which is now more equated with his later work and that of his Oxford friends than with Hunt and the original group.

Morris's wife, Jane Burden, became Rossetti's favorite model. Her particular blend of physical beauty and sad, aloof spirituality perfectly suited Rossetti's vision of the

27-37. William Holman Hunt. *The Hireling Shepherd*. 1851. Oil on canvas, 30¹/₈ x 43¹/₈" (76.4 x 109.5 cm). Manchester City Art Gallery, England

Middle Ages and lent itself to his yearning for the spiritual beauty he found lacking in the present.

After he and Burden became lovers, sometime in the 1860s, his images of her took on an added biographical dimension. *La Pia de' Tolomei* (fig. 27-38) uses an incident from Dante's *Purgatory* to articulate the artist's own

27-38. Dante Gabriel Rossetti. *La Pia de' Tolomei*. 1868–69. Oil on canvas, 41½ x 47½ " (105.4 x 119.4 cm). Spencer Museum of Art, University of Kansas, Lawrence

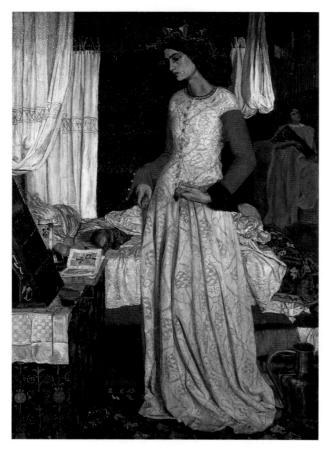

27–39. William Morris. *Queen Guinevere*. 1858. Oil on canvas, $27^{7/8}$ x $19^{3/4}$ " (71.8 x 50.2 cm). Tate Gallery, London

unhappy romantic situation. La Pia ("Pious One"), locked up by her husband in a castle, was soon to die. The rosary and devotional in front of her refer to the piety from which she takes her name. The stakes wrapped in the banner of her husband on the ramparts suggest her captivity. The sundial and ravens apparently allude to her impending death. Her continuing love for her husband, whose freshly read letters lie under the devotional, is symbolized by the evergreen ivy behind her. However, the luxuriant fig leaves that surround her, traditionally associated with the Fall, have no source in Dante's tale. Rossetti personalizes the tale in other ways, showing her fingering her wedding ring, a captive not so much of her husband as of her marriage.

Jane Burden also appears in the only painting ever produced by William Morris, *Queen Guinevere* (fig. 27-39). Ironically, given later events in Morris's and Burden's lives, Guinevere was the unhappy wife of King Arthur, in love with the king's friend and most famous knight of his Round Table, Sir Lancelot. Morris chose the subject not for the story, however, but essentially as an excuse for depicting medieval objects and dress. Morris made the work only at Rossetti's prompting, for he was less interested in painting than in the kinds of handcrafts displayed in *Queen Guinevere*. Morris's interest in handcrafts developed in the context of a widespread reaction against the gaudy design of industrially produced goods that began with the Crystal Palace exhibition of 1851.

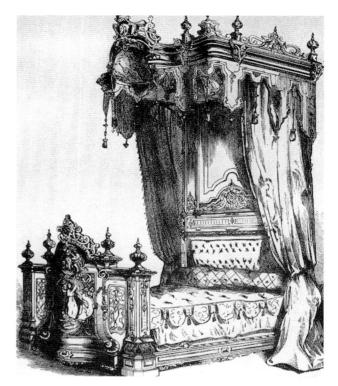

27-40. Bedstead, illustration from *The Art Journal Illustrated Catalogue of the Great Exhibition*, London, 1851

The elaboration of decorative elements at the expense of function and good taste, as was evident in the objects on display, like the bed shown here (fig. 27-40), distressed many, including the event's organizers. Prince Albert and his associates sought to improve industrial products through the teaching of better design principles, but a number of critics—led by writer, artist, and art critic John Ruskin-were convinced that industrialism itself was the problem. Morris became the leader of this faction soon after his marriage to Burden in 1859. Unable to find satisfactory furnishings for their new home, Morris, with the help of a number of friends, designed and made them himself. He then founded a decorating firm, Morris, Marshall & Faulkner (later changed to Morris & Company), to produce a full range of medieval-inspired objects. Morris designed for a variety of materials, including cloth. Bird Woolen (fig. 27-41) is typical of his fabric design in its use of flattened motifs consistent with the two-dimensional medium. The organic subjects, the decorative counterparts to those of naturalistic landscape painting, were meant to provide relief from modern urban existence.

Morris promoted and inspired what became known as the Arts and Crafts Movement. His aim was to benefit not just a wealthy few but society as a whole. As he said in the lectures he began delivering in 1877, "What business have we with art at all unless we can share it?" A socialist, Morris meant to eliminate the machine not only because he found its products ugly but also because of its deadening influence on the worker. With craftwork, he maintained, the laborer gets as much satisfaction as the consumer. Unlike his Pre-Raphaelite friends, who wished to escape into idealizations of the Middle Ages, Morris saw in that era the model for economic and social reform.

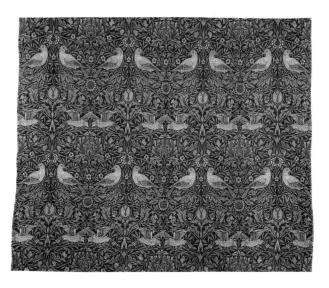

27-41. William Morris. Bird Woolen double cloth, designed for the drawing-room tapestry for Kelmscott House, Hammersmith. 1878. Victoria and Albert Museum, London

27-42. James McNeill Whistler. *Black Lion Wharf.* 1859.
Etching, 57/8 x 87/8" (15 x 22.6 cm). The Metropolitan Museum of Art, New York
Harris Brisbane Dick Fund
A copy of this work can be seen on the wall in Whistler's most famous painting, the portrait of his mother.

Not all of those who participated in the revival of the decorative arts were committed to improving the conditions of modern life, however. Many, including the American expatriate James McNeill Whistler (1834–1903), saw in the Arts and Crafts revival simply another way to satisfy an elitist taste for beauty. After failing out of West Point in

the early 1850s Whistler studied art in Paris, where he came under the influence of Courbet. His first important works were **etchings**, which he had learned to make while employed in the U.S. government's Coastal Survey Department in Washington, D.C. Typical of his early work is *Black Lion Wharf* (fig. 27-42), a realistic scene of life along the

THE PRINT REVIVAL

During the Romantic period a number of artists, including

Théodore Géricault and Eugène Delacroix, had used the new medium of lithography, invented in the mid-1790s, to produce fine art prints (see "Lithography," page 985). But as a result of the more prolific use of lithography by newspaper caricaturists such as Honoré Daumier (see fig. 27-23), the medium soon became identified with the popular arts.

Delacroix, Camille Corot, and Jean-François Millet had also produced the occasional etching, an art form at that time employed almost exclusively to produce cheap reproductions of well-known works (see "Etching and Drypoint," page 789). The Barbizon artist Charles-Émile Jacque (1813-1894), who as a student had studied and copied etchings by Rembrandt and other Dutch artists of the seventeenth century, was the first to devote himself more fully to the medium. Inspired partly by the work of Jacque and partly by the amateur example of his brother-in-law, Francis Seymour Haden, James Mc-Neill Whistler turned to etching in

1858, just before moving to England. Whistler's early work may be said to have inaugurated a great age of etching. The interest it generated convinced an amateur French etcher and printer, Alfred Cadart, to organize the Society of Etchers in 1862. Cadart, who was also a print dealer, conceived the society partly as a way to bring before the public the kind of innovative work rejected by the Salon jury and partly as a way to protest the growth and influence of photography. The Romantic poet and critic Théophile Gautier said in his preface to the first volume of etchings Cadart issued:

In these times when photography fascinates the vulgar by the mechanical fidelity of its reproductions, it is needful to assert an artistic tendency in favor of free fancy and picturesque mood. The necessity of reacting against the positivism of the mirrorlike apparatus has made many a painter take to the etcher's needle; and the gathering of these men of talent, annoyed at seeing the walls crowded with monoto-

nous and soul-less pictures, has given birth to the "Society of Etchers."

Included in the inaugural volume of etchings were works by forty-eight artists, among them Corot, Charles Daubigny, Édouard Manet, Alphonse Legros (who had introduced Manet to etching in 1861), Francis Seymour Haden, and C.R. (for Carolus Rex, the king of Sweden). The critical response to Cadart's early annuals was so positive that even the conservative organizers of the Salon decided to dedicate an entire room to the etching at the exhibition of 1866.

Philippe Burty, who later coined the term *japonisme*, commented that the show of that year should be called the Salon of the Etchers. Cadart's efforts established a solid foundation for a tradition that eventually included the work of Edgar Degas, Mary Cassatt, and a host of French artists. Cadart also contributed to the spread of etching when he helped form the French Etching Club in New York City in 1866. By the middle of the 1870s, however, general interest in etching had begun to decline.

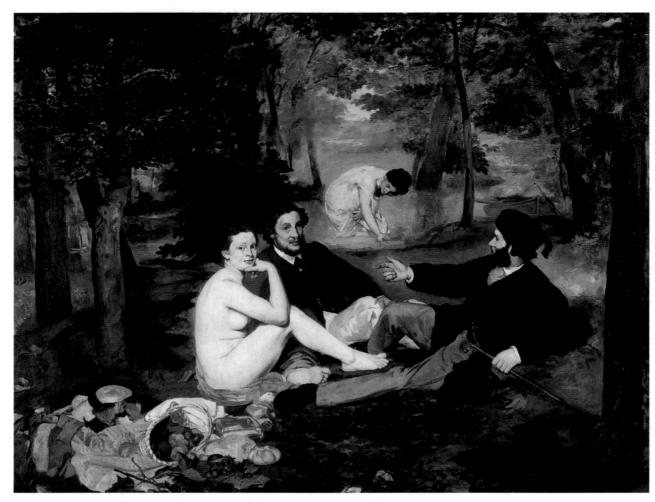

27-43. Édouard Manet. *Le Déjeuner sur l'Herbe (The Luncheon on the Grass)*. 1863. Oil on canvas, 7' x 8'10" (2.13 x 2.64 m). Musée d'Orsay, Paris

River Thames. Although inspired by Courbet, Whistler's etching shows little of that artist's interest in either the solid tangibility of things or in the social or human significance of work. Because of its horizontal emphasis and the absence of a strong focal point, the eye scans the etching's registers, making a quick survey of its picturesque details before passing on and out of the frame. This approach to composition anticipates the French Impressionists. The work is important, too, because of Whistler's crucial early place in the print revival of the later nineteenth century (see "The Print Revival," page 1005).

Black Lion Wharf was produced soon after Whistler had moved to London early in 1859, partly to separate himself from Courbet and his influence. The new vogue for the arts of Japan helped fuel in him a growing dissatisfaction with realism (see "Japonisme," page 1008). Whistler had been one of the first to collect Japanese art when it became available in curio shops in London and Paris after the 1854 reopening of that nation to the West. The simplified, elegant forms and subtle chromatic harmonies of Japanese art (Chapter 22) had a profound influence on his art in the early 1860s. In 1864 he exhibited three paintings that signaled his new direction. One of them, Rose and Silver: The Princess from the Land of Porcelain (see fig. 22, page 26, showing the Peacock Room Whistler later designed to house it), shows a woman

posed amidst a collection of Asian arts. The work is Whistler's answer to the medieval costume pieces of the Pre-Raphaelites (see fig. 27-39). What Whistler saw in Japanese objects was neither a preferable world nor a way to reform European decorative arts, but rather a model for painting. As the work's main title declares, Whistler attempted to create a formal and coloristic harmony similar to that of the objects displayed in the room. Thus, delicate organic shapes are shown against a rich orchestration of colors featuring silver and rose. By leaving his wet brushmarks visible, Whistler emphasized the paint itself over the depicted subject. In a remark that says more about his own commitments than about those of the Japanese, he later commented: "Japanese art is not merely the incomparable achievement of certain harmonies of color; it is the negation, the immolation, the annihilation of anything else."

Whistler's insistence on art as an antidote to the ugliness of modern life was shared by a number of influential British writers and critics, including Walter Pater (1839–1894) and Oscar Wilde (1854–1900). By the late 1870s this view and its manifestation in artworks like those of Whistler and Rossetti had come to be known as Aestheticism. Aestheticism became so popular in the 1880s that young men and women displayed their devotion to its tenets by carrying peacock feathers.

ARTISTIC

Manet had in his ALLUSIONS studio a copy by IN MANET'S Henri Fantin-Latour of the Pastoral Con-

cert, a work in the Louvre then attributed to Giorgione, now attributed to Titian. It is plain that in painting Le Déjeuner sur l'Herbe (see fig. 27-43) he took inspiration from the Pastoral Concert, making a modernized reply to its theme of ease in nature.

At the same time, in preparing his composition Manet directly adapted a group of river gods and nymphs from an engraving by Marcantonio Raimondi, based on Raphael's The Judgment of Paris-an image that, in turn, looked back to Classical reliefs. Manet's allusion to the engraving was apparently quite clear to some observers at the time; in reviewing the Salon at which the Déjeuner was exhibited, the critic Ernest Chesneau specifically noted this borrowing and objected to it.

In making these two references to artworks from the Renaissance, Manet's painting addresses not only the ostensible subject, figures in a landscape. Just as important, it also addresses the history of art and helps define Manet's relationship to it by encouraging the viewer to compare Manet's painting with the works that inspired it. To a viewer who has in mind the traditional perspective and the rounded modeling of forms of the two Renaissance works, the stark lighting of Manet's nude and the flat, cutout quality of his figures become all the more shocking. Thus, by openly referring to these exemplary works of the past, Manet emphasized his own radical innovations.

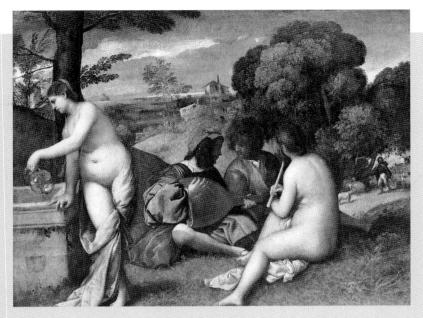

Titian. Pastoral Concert (formerly attributed to Giorgione). c. 1509-10. Oil on canvas, 431/4 x 543/8" (109.9 x 138.1 cm). Musée du Louvre, Paris

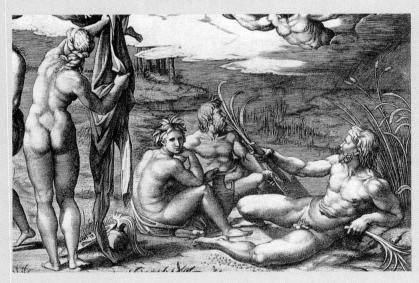

Marcantonio Raimondi. Detail of engraving after Raphael's The Judgment of Paris. c. 1520. The Metropolitan Museum of Art, New York Rogers Fund, 1919

IMPRESSIONISM

While British artists were moving away from the

naturalism advocated by the original Pre-Raphaelite Brotherhood, their French counterparts were pushing the traditions of Courbet, Corot, and the Barbizon painters into new territories. Instead of themes of the working classes and the country, the generation that matured around 1870 was generally devoted to subjects of leisure, the upper-middle class, and the city. Although many of these artists specialized in paintings of the country, the point of view they adopted was usually that of a city person there on holiday.

Édouard Manet

The leader of this loosely knit group was Édouard Manet (1832-1883). Born into an upper-middle-class Parisian

family, Manet studied in the early 1850s with the painter Thomas Couture (1815–1879), an academician with progressive leanings. Manet often quarreled with Couture and some of his models, however, because he wanted the models to adopt more naturalistic poses and because he thought that during the summer months studies might be done outdoors, under natural light. Manet's realist inclinations were at first overshadowed by his fondness for Velázquez and the current vogue for Spanish themes; his commitment to realism emerged in the early 1860s, largely as a result of his close friendship with the poet Baudelaire. In "The Painter of Modern Life," Baudelaire called for an artist who would be the painter of contemporary manners, "the painter of the passing moment and of all the suggestions of eternity that it contains." Manet seems to have responded to this call.

1860 1820 1890 JAPONISME In his Portrait of Émile Zola, painted

in gratitude for the writer's defense of his work, Édouard Manet included a Japanese screen and a portrait of a sumo wrestler by Kuniaki II, a nineteenth-century Japanese printmaker. These items probably say more about Manet's interest in Japanese art than they do about Zola's taste. In particular, the reductive design principle evident in Japanese woodblock prints and their tendency to flatten form probably inspired similar features in some of Manet's early works. On the wall next to the Kuniaki portrait is a print after one of Manet's own paintings that was severely criticized for just these qualities.

Manet's interest in Japanese prints and decorative arts was part of a widespread fascination with Japan and its art that swept across the West in the last half of the nineteenth century. The vogue began shortly after the U.S. Navy forcibly opened Japan to Western trade and diplomacy in 1854. By the late 1850s Japanese lacquers, fans, bronzes, hanging scrolls, kimonos, ceramics, illustrated books, and **ukiyo-e** prints (images of the "floating world," the realm of geishas and popular entertainment) were beginning to appear in Western Euro-

pean specialty shops, art galleries, and even some department stores. French interest in Japan and its arts reached such proportions by 1872 that the art critic Philippe Burty gave it a name: *japonisme*.

Japanese art profoundly influenced Western painting, printmaking, applied arts, and eventually architecture. Although the tendency toward simplicity, flatness, and the decorative evident in much painting and graphic art in the West between roughly 1860 and 1900 is probably the most characteristic result of that influence, its impact was extraordinarily diverse. What individual artists took from the Japanese depended on their own interests. Thus, James McNeill Whistler, for example, found encouragement for his decorative conception of art (see fig. 22, page 26) while Edgar Degas discovered both realistic subjects and interesting compositional arrangements (see fig. 27-48). Those interested in the reform of late-nineteenth-century industrial design, on the other hand, found in Japanese objects both a technical excellence and a smooth elegance lacking in the West. There were even some, like Vincent van Gogh, who saw in the spare harmony of Japanese art and wares evidence of an idyllic

society, which they considered a model for the West (Chapter 28). Perhaps the most strongly influenced were the new printmakers, like Mary Cassatt, who, lacking a strong tradition of their own, often thought of themselves more as part of the Japanese tradition than the Western.

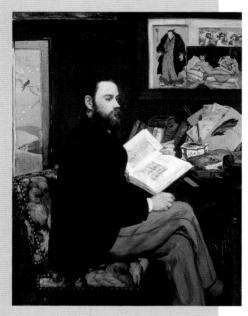

Édouard Manet. *Portrait of Émile Zola*. c. 1868. Oil on canvas, 57¹/₈ x 44⁷/₈" (145.3 x 113.8 cm). Musée d' Orsay, Paris

Le Déjeuner sur l'Herbe (The Luncheon on the Grass) (fig. 27-43), one of Manet's most famous and controversial paintings, reflects his Baudelairean program. When the jury for the official Salon of 1863 turned down nearly 3,000 works, including Manet's, a storm of protest erupted, prompting Napoleon III to order an exhibition of the refused work called the Salon des Refusés ("Salon of the Rejected Ones"). In that exhibition Le Déjeuner sur l'Herbe provoked a critical avalanche that was a mixture of shock and bewilderment.

Manet was no doubt surprised by both the moral outrage and the puzzlement, because he thought his basic intention—which, according to a close friend, was to make a modern version of a highly respectable painting in the Louvre, Giorgione's Pastoral Concert (now attributed to Titian)—would be fairly obvious (see "Artistic Allusions in Manet's Art," page 1007). Even with this information, however, what Manet intended by his radical remake of the Pastoral Concert remains unclear and a matter of considerable debate. One contested theory sees in the work a portrayal of alienation, not unlike Daumier's Third-Class Carriage (see fig. 27-22). The figures in Manet's painting are distant in both their physical and their psychological relationships. Although the man on the right seems to gesture toward his companions, the other man gazes off absently while the nude turns her attention away from them and to the viewer. Moreover, the look she gives us makes us conscious of our role as outside observer; we, too, are estranged. Manet's rejection of warm colors for a scheme of cool blues and greens plays an important role, as do his flat, sharply outlined figures, which seem starkly lit because of the near absence of modeling. The figures are not integrated with their natural surroundings, as in the Titian, but seem to stand out sharply against them, as if seated before a painted backdrop.

Manet may have intended to make a modern version of the popular Renaissance theme of sacred and profane love, a contrast between the higher spiritual love and that of the flesh. Several details in the picture suggest as much. For example, the man on the right makes a curious hand gesture, with his thumb pointing to the clothed woman in the stream and his index finger pointing to the nude. Above the woman in the water, itself a symbol of purity, is a bird, traditionally associated with the spirit. In the lower-left corner, next to the nude's discarded garments, is a frog, often an emblem of the flesh. With these hints, perhaps, Manet fulfills Baudelaire's mandate giving us not only "the passing moment" of a contemporary picnic but "all the suggestions of eternity that it contains." It is worth noting in this regard that the "duality of man," which would include the conflict between the

sacred and the profane, is one of Baudelaire's central concerns in "The Painter of Modern Life."

Claude Monet

While Manet was attempting to paint modern life without breaking entirely with the great art of the past, most of his slightly younger associates sought a completely fresh and unmediated vision. The leader in this quest was Claude Monet (1840–1926). Although Monet studied in the Paris studio of an academician, his real training came at the hands of Barbizon landscape painters such as Charles Daubigny (1817–1878) and a number of lesser-known naturalists associated with them, Eugène Boudin (1824–1898) and Johan Jongkind (1819–1891) in particular. From the latter pair he learned how to transcribe directly his visual sensations of nature. Whereas the Barbizon landscape painters had conceived nature essentially as a "site"—that is, a place—Monet learned to approach it largely as a "sight," something to stimulate the eye.

His early commitment to this conception of landscape painting is evident in *The River* (fig. 27-44). Painted directly from nature at one of the small towns along the Seine River outside Paris, *The River* shows a young woman enjoying the scenery. Monet, unconcerned with who she is and what she might be feeling, treats her simply as another of the color patches that make up the landscape. The most important of these are found in the broken reflections in the water of the town and sky. Monet, less interested in the village than he is in its reflection, chose a view that largely obscures the village behind a screen of trees.

Monet was more interested in the shifting play of light on the surface of the object and the light's effect on the eye than the actual depiction of physical objects. One of the painters he later befriended remembers him offering this advice:

"When you go out to paint, try to forget what objects you have before you—a tree, a house, a field, or whatever. Merely think, Here is a little square of blue, here an oblong of pink, here a streak of yellow, and paint it just as it looks to you, the exact color and shape, until it gives your own naive impression of the scene before you."

He [Monet] said he wished he had been born blind and then had suddenly gained his sight so that he could have begun to paint in this way without knowing what the objects were that he saw before him. He held that the first real look at the *motif* was likely to be the truest and most unprejudiced one. (cited in Janson, page 908)

Two important ideas are expressed here. One is that a quickly painted oil sketch most accurately records a land-scape's general appearance. This view had been a part of academic training since the late eighteenth century, but such sketches were considered merely one part of the preparation for a finished work. In essence, Monet attempted to raise these traditional "sketch aesthetics" to the same level as a completed painting. As a result, the major criticism directed against him was that his paintings

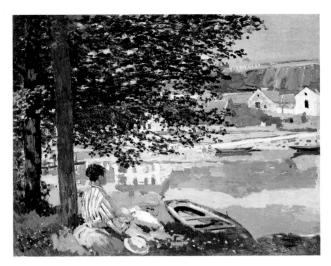

27-44. Claude Monet. *The River*. 1868. Oil on canvas, 32¹/₈ x 39⁵/₈" (81.6 x 100.6 cm). The Art Institute of Chicago

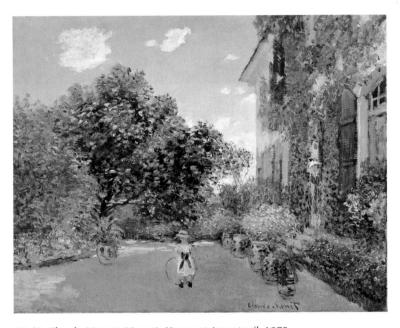

27-45. Claude Monet. *Monet's House at Argenteuil*. 1873. Oil on canvas, 23³/4 x 28⁷/8" (60.3 x 73.3 cm). The Art Institute of Chicago Mr. and Mrs. Martin A. Ryerson Collection

were not "finished." The second idea, that art benefits from a naive vision untainted by intellectual preconceptions, was a part of both the naturalist and the realist traditions, from which his work evolved. Both Corot and Courbet had expressed a similar desire to regain the unprejudiced vision of the child. Monet could never achieve such a childlike vision, however. Despite his stated objective he looked at the world largely through the eyes of an uppermiddle-class tourist, as can be seen in *The River*. One factor in Monet's enormous popularity is the way he implicitly puts the viewer in the position of someone on holiday enjoying a beautiful scene. As one critic remarked, Monet never painted weekdays. The son of a grocer, he had an ardent desire to rise in society that is often reflected in his work. *Monet's House at Argenteuil* (fig. 27-45), a somewhat

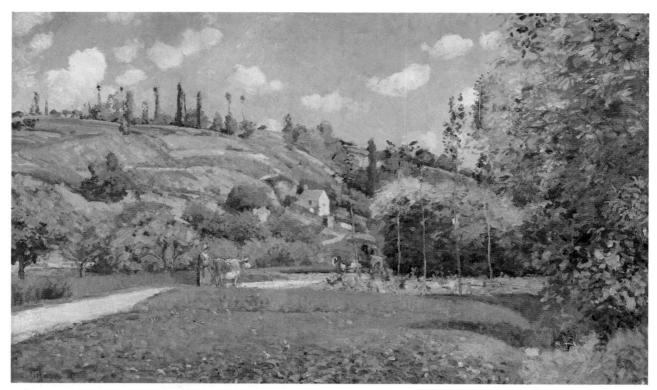

27-46. Camille Pissarro. *A Cowherd on the Route du Chou, Pontoise*. 1874. Oil on canvas, 215/8 x 361/4" (55.5 x 93 cm). The Metropolitan Museum of Art, New York

Gift of Edna H. Sachs

later work than *The River*, is an example. On one level the painting is simply a feast for the eye. In his search for ways to capture the shimmering appearance of sunlight in a world of constant flux, Monet around 1870 largely eliminated dark colors from his palette and progressively reduced his brushwork from broad planes to smaller strokes and touches. Compared with *The River*, *Monet's House at Argenteuil* is thus both a more scrupulous record of nature's appearance and a more dazzling display of its visual delights.

Monet's House at Argenteuil is hardly a "pure" vision, however, for beneath its surface is a scene eloquent with iconographic implications. It was painted in the garden of his new residence in one of Paris's burgeoning suburbs. Although he continued to borrow money from friends and patrons, his growing success allowed him to rent this fairly substantial and impressive property. His wife, in the doorway, and daughter, in the yard, are extremely well dressed, indicating not only their new station but that the day is a special one, probably a Sunday or holiday. More than an innocent vision, then, the painting records Monet's social aspirations and thereby locates the viewer, too, as the satisfied and idle proprietor of this beautiful and charming French home.

Monet's financial situation was far from secure, however. An economic boom that had buoyed art prices and sales in the early 1870s was waning, prompting Monet to revive an idea he and friends had considered in the late 1860s, the formation of an independent society to exhibit and market their art. In 1874 thirty artists exhibited 165 works in Nadar's studio. One of Monet's entries, *Boulevard des Capucines, Paris* (see fig. 25, page

28), is a view from the studio's window. Hoping to avoid being falsely identified with a single philosophy or movement, they called themselves a Corporation [Société Anonyme] of Artists, Painters, Sculptors, and Engravers. One critic, however, inspired by Monet's *Impression, Sunrise* (1872), titled his review "Exhibition of Impressionists," and the term *Impressionist* was quickly adopted as a convenient, if not entirely accurate, label for all those who participated in the 1874 show and the seven subsequent exhibitions Monet and his circle organized between 1874 and 1886.

Camille Pissarro

The oldest member of the group, Camille Pissarro (1830-1903), began his career under the influence of Corot's naturalism. In 1864 and 1865 Pissarro exhibited at the Salon as a "pupil of Corot," but the two had a falling-out shortly thereafter as a result of Pissarro's growing interest in the way Courbet opposed light and dark masses. The dark, Courbet-influenced phase of Pissarro's career gave way to an early Impressionist phase in 1870. In that year he and Monet were both living in London, having fled there to escape the Franco-Prussian War. Influenced by John Constable, J. M. W. Turner, and other British landscape painters, they worked closely together, dedicating themselves, as Pissarro later recalled, to "plein air [outdoor], light and fugitive effects." The result, for both painters, was a lightening of color and a loosening of paint handling. After the Franco-Prussian War, Monet and Pissarro returned to France, where they continued to work together on occasion for mutual inspiration.

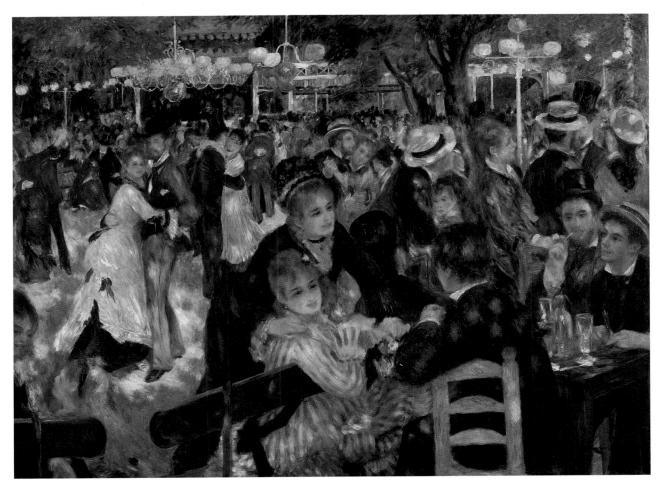

27-47. Pierre-Auguste Renoir. Moulin de la Galette. 1876. Oil on canvas, 4'31/2" x 5'9" (1.31 x 1.75 m). Musée d'Orsay, Paris

Pissarro's particular brand of Impressionism had stronger ties to the naturalism of Corot and the Barbizon painters than that of any of his younger colleagues. Reflecting these influences, after his return to France Pissarro settled in Pontoise, a small village not far from Argenteuil but decidedly more agrarian. The works he produced there in the 1870s, such as A Cowherd on the Route du Chou, Pontoise (fig. 27-46), are typically Impressionist in their high-keyed color, short brushstrokes, and direct appeal to the eye, but the narrow range of soft greens and blues is closer to Corot than to Monet. An important feature of the painting, the woman with the cow, demonstrates Pissarro's adherence to the previous generation's conception of the landscape as a place where peasants live and work, not simply a vacationer's source of visual pleasure.

Pierre-Auguste Renoir

More typical of the Impressionists in his proclivity for scenes of upper-middle-class recreation is Pierre-Auguste Renoir (1841–1919). The son of a tailor, Renoir met Monet at the École des Beaux-Arts after enrolling in 1862. Despite his early predilection for figure painting in a softened, Courbet-like mode, the affable Renoir was encouraged by his more forceful friend Monet to follow his lead in the creation of pleasant, light-filled land-

scapes painted outdoors. By the mid-1870s Renoir was combining Monet's lessons in the rendering of natural light with his own taste for the figure.

Moulin de la Galette (fig. 27-47), for example, features dancers dappled in bright afternoon sunlight. The Moulin de la Galette (the "Pancake Mill"), in the section of Paris called Montmartre, was an old-fashioned Sunday afternoon dance hall, which during good weather made use of its open courtyard. Renoir has glamorized its normally working-class clientele by replacing them with his young artist friends and their models. Typical of Renoir's work of the period, these attractive members of the middle class are shown in attitudes of relaxed congeniality, smiling, dancing, and chatting. The innocence of their flirtations is underscored by the children in the lower left. The lack of tension in their relations is emphasized by the relaxed informality of the composition itself. The painting is knit together not by figural arrangement but by the overall mood, the sunlight falling through the trees, and by the way Renoir's soft brushwork weaves his blues and purples through the crowd and across the canvas. This idyllic image of a carefree age of innocence, a kind of paradise, nicely encapsulates Renoir's essential notion of art: "For me a picture should be a pleasant thing, joyful and pretty—yes pretty! There are quite enough unpleasant things in life without the need for us to manufacture more" (cited in Hanson, page 38).

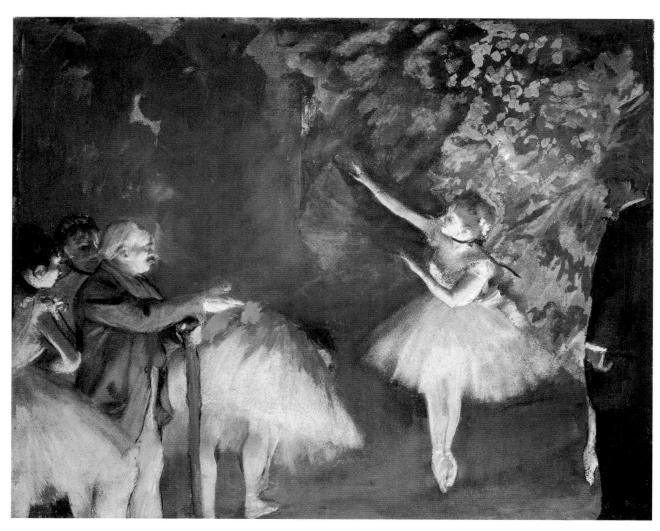

27-48. Edgar Degas. *Ballet Rehearsal*. c. 1874. Gouache and pastel over monotype, 21³/₄ x 26³/₄" (55.3 x 68 cm). The Nelson-Atkins Museum of Art, Kansas City, Missouri

Acquired through the Kenneth A. and Helen F. Spencer Foundation Acquisition Fund

Edgar Degas

The Impressionist whose work most severely tests the legitimacy of the label is Edgar Degas (1834–1917). The son of a Parisian banker, Degas was closer to Manet than to the other Impressionists in age and social background. He entered the École des Beaux-Arts in 1855 but soon became dissatisfied with its conservatism and left to study on his own. His friendship with Manet, whom he met in 1862, and with the realist critics in his circle, turned him gradually toward the depiction of contemporary life. After a period during which he specialized in psychologically probing portraits of friends and relatives, he turned his attention in the 1870s to a range of Paris amusements, including the music hall, opera, ballet, circus, and racetrack. Although a few of these works record the sadder aspects of the times, Degas began to think of art less as a mirror held up to the world than as a lofty form of entertainment that employed realistic elements. The very subjects of his work suggest something of this.

The best known of his themes is the ballet, an entertainment that played an important role in upper-middleclass social life at that time. Although he sometimes

painted performances, Degas's main interest was in scenes of the work that preceded them. From a collection of carefully observed, realistic studies of individual dancers and striking groupings, Degas arranged, in effect, his own visual choreography. Ballet Rehearsal (fig. 27-48), for example, is not a factual record of something seen but a careful contrivance, inspired partly by Japanese prints (see "Japonisme," page 1008), and was intended to delight the eye. In this respect Degas's pictorial intentions are generally consistent with those of his Impressionist colleagues. But unlike their works, which depend on colored light and the principle of regularity and agreement, his paintings rely on a combination of unusual figural groupings and sharply differing bodily attitudes. Ballet Rehearsal is built around the counterpoint between the static, aging, and earthbound ballet master and the dynamic, ethereal beauty of the student he observes. The tightly compacted and darkly silhouetted group around him, which includes a flatfooted and awkwardly bending dancer, provides additional visual foils for the open, airy, and more conventionally beautiful elements on the right. The man at the right margin, who also contrasts with the dancer, is included largely to balance the overall composition. Finally,

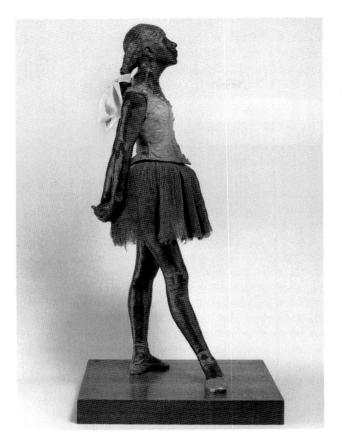

27-49. Edgar Degas. *Little Dancer Fourteen Years Old*. 1880–81. Bronze with gauze tutu and satin hair ribbon, height 39¹/₂" (100.3 cm). The Norton Simon Museum, Pasadena, California

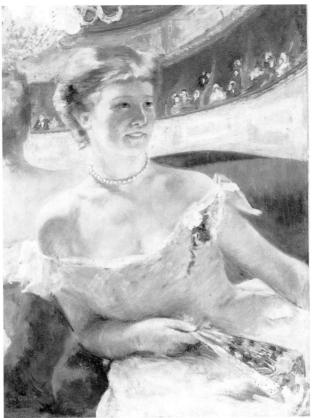

27-50. Mary Cassatt. *Lydia in a Loge, Wearing a Pearl Necklace*. 1879. Oil on canvas, 31⁵/₈ x 23" (80.3 x 58.4 cm). Philadelphia Museum of Art Bequest of Charlotte Dorrance Wright

the whole is pulled together and further embellished by the unusual stage lighting from below and by the touches of blue and red in the curtain and costumes. The colorful sashes and black throat ribbons that enliven this and so many of his rehearsal scenes were Degas's inventions.

Although Degas's works most directly address the spectator's eye, they also evoke an empathetic sense of movement. The perceived difference between the ballet master and the lead dancer in *Ballet Rehearsal* is more than purely visual. Degas makes it possible for us to intuit something of what it might feel like to be his subjects as they rest, twist, bend, stretch, or elevate on point. His acute sensitivity to bodily feeling apparently led him during the 1870s to begin experimenting in the more tactile medium of sculpture. After his death about 150 small clay figures of ballerinas, bathers, and horses were found in his studio. These had been made not for exhibition and sale but for purposes of study.

Degas exhibited only one piece of sculpture during his lifetime, a piece in wax of a young dancer, which he showed at the 1881 Impressionist exhibition. After his death this work, called *Young Dancer Fourteen Years Old* (fig. 27-49), was cast in bronze. The original was done in the hyperrealistic mode now identified with wax museums. The figure was adorned with actual slippers, a gauze skirt, and a silk bodice. The real hair on her head was tied in a cloth ribbon. In the bronze cast all that

remains of this extreme verisimilitude is the cloth skirt and hair ribbon. The young girl stands with her arms clasped behind her. She pulls back her shoulders, stretching her upper chest, while turning the foot of her extended leg. Because her head is up and her eyes closed, her mind appears fully preoccupied with the purely physical sensations her complex pose entails.

Mary Cassatt

Another artist who showed with the Impressionists was the American expatriate Mary Cassatt (1845–1926). After studying at the Pennsylvania Academy of the Fine Arts in Philadelphia between 1861 and 1865, Cassatt moved to Paris, where she lived for most of the rest of her life. The realism of the figure paintings she exhibited at the Salons of the early and middle 1870s attracted the attention of Degas, who invited her to participate in the fourth Impressionist exhibition, in 1879. Although she, like Degas, rejected the Impressionist label, her distaste for what she called the tyranny of the Salon jury system made her one of the group's staunchest supporters. Cassatt focused her work on the world to which she had access, the domestic and social life of well-off women.

One of the two paintings she exhibited in 1879 was Lydia in a Loge, Wearing a Pearl Necklace (fig. 27-50). The

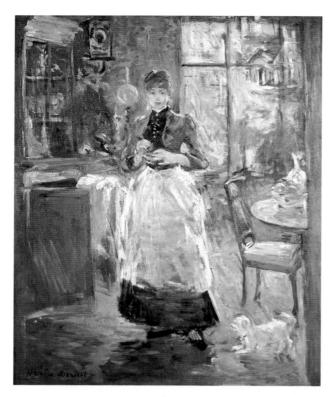

27-51. Berthe Morisot. *In the Dining Room.* 1886. Oil on canvas, 24¹/8 x 19³/4" (61.3 x 50.2 cm). National Gallery of Art, Washington, D.C.

Chester Dale Collection

model for the painting was Cassatt's sister, who had recently come to live with her. The painting's bright and luminous color, fluent brushwork, and urban subject were no doubt chosen partly to demonstrate her solidarity with her new associates. Renoir had exhibited a very similar image of a woman at the opera in 1874. *Lydia in a Loge* is an attempt to capture a glamorous aspect of Parisian social life. Reflected in the mirror behind Lydia are other women and men in their boxes, some with opera

glasses trained not on the stage but on the crowd around them, scanning it for other elegantly dressed socialites. As Garnier had noted, his new Opéra (see fig. 27-5) was designed partly as an appropriate backdrop for just the kind of display in which Lydia is here engaged.

Berthe Morisot

Berthe Morisot (1841–1895) also was a prominent French Impressionist artist. Unlike Cassatt, who seems to have decided early on to be a professional, Morisot came to this decision only after a considerable period of painting in the amateur role that was conventional for women at that time (see "The Tradition of the Amateur Artist," below). Morisot and her sister, Edma, studied with a minor drawing master in 1857. Admirers of the Barbizon painters, Berthe and Edma then studied with Corot for three years. beginning in 1860. The sisters showed in the five Salons between 1864 and 1868, the year they met Manet. In 1869 Edma married, and, following the traditional course, gave up painting to devote herself to domestic duties. Berthe, on the other hand, continued painting after her 1874 marriage to Manet's brother, Eugène. In the same year she joined the Impressionists, against the advice of Manet, who thought their independent society misguided, and she showed in all but one of their subsequent exhibitions.

Under the influence of Manet and the Impressionists Morisot adopted a looser, more **painterly** style to replace the Corot-influenced style in which she had been working. Like Cassatt, she focused on women and domestic scenes, such as that of *In the Dining Room* (fig. 27-51). Through this subject matter she sought to demonstrate that women had a unique vision, which, she said, was "more delicate than that of men." Her touch, although vigorous, is lighter than that of her male colleagues, and her colors are gentler, with a tendency to pastels. The brushwork of *In the Dining Room* calls attention to the act of painting itself. Both the subject and the style of *In the Dining Room* subtly insist that women be taken serious-

THE TRADITION OF THE AMATEUR ARTIST

Amateur describes artists, women

and men, who draw and paint for their own pleasure (and sometimes because of social expectations), not to make a living from their art. The tradition of the amateur artist is long and honorable; only in our century has the word *amateur* acquired some negative connotations.

Jean-Jacques Rousseau, writing in France at the end of the eighteenth century, was highly influential in prescribing éducational goals that fostered amateur artists, especially women (see "Jean-Jacques Rousseau on Educating Children," page 955).

For at least 200 years, as part of their preparation for married life, European women of the upper classes were usually tutored in drawing and watercolor-both mediums being portable and needing little equipment. The depiction of family, friends, vignettes of daily life, and scenes from their travels was accepted by both men and women as an effective and virtuous way for women to sharpen and cultivate sensibilities that would make them "accomplished" women (and, it was assumed, wives and mothers). While in the nineteenth century in particular women were expected to give up their art after marriage, those who continued to pursue it could do so as amateurs—that is, as artists who

painted or drew or sculpted as a pastime, not as an occupation—and still be considered "respectable" according to the strict social codes of the period.

It is against this backdrop that women such as Rosa Bonheur (see fig. 27-17), Mary Cassatt, and Berthe Morisot (and many others whose works, ignored for so long, have recently begun to be discussed) came forward as professional artists, earning their living from their work. In France and England many women artists, amateur and professional, showed their work in official exhibitions. In 1855, for example, 133 works by women were included in the Paris Salon.

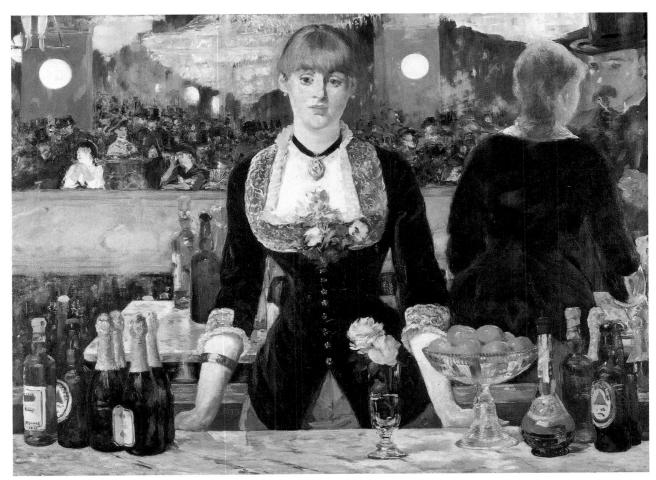

27-52. Édouard Manet. *A Bar at the Folies-Bergère*. 1881–82. Oil on canvas, 37³/₄ x 51¹/₄" (95.9 x 130 cm). Courtauld Institute Galleries, London

Home House Collection

ly for their work. Morisot sought an equality for women that she felt men refused to cede. Late in life she commented: "I don't think there has ever been a man who treated a woman as an equal, and that's all I would have asked, for I know I'm worth as much as they" (cited in Higonnet, page 19).

Later Impressionism

Many Impressionists, including Morisot, continued throughout their careers to work in the manner they developed around 1870. In the years after 1880, however, some began to reconsider their earlier approaches or make important adjustments to them.

Even before what historians now call the crisis of Impressionism, Manet was quietly objecting to its essentially cheerful terms. During the 1860s Manet had engaged in a dialogue with the art of the past, as his *Le Déjeuner sur l'Herbe* (see fig. 27-43) attests. After about 1870 he embraced his younger colleagues' brighter palette, and he seems to have adopted as well their more direct approach to modern life. But behind his apparent participation in the Impressionist movement lay a commitment, conscious or not, to use their essentially optimistic interpretation of modern life as the new foil for his more pessimistic one.

The last major painting of Manet's career, *A Bar at the Folies-Bergère* (fig. 27-52), for example, contradicts the happy aura of works such as *Monet's House at Argenteuil* (see fig. 27-45), *Moulin de la Galette* (see fig. 27-47), and *Lydia in a Loge* (see fig. 27-50). The painting features one of the barmaids at the Folies-Bergère, a large nightclub with a series of bars arranged around a theater that offered what would later in America be called vaudeville acts. Reflected in the mirror behind the barmaid is part of the elegant crowd, many identifiable as Manet's friends, watching a trapeze act. (The legs of one of the performers can be seen in the upper left.) On the bar itself Manet has placed an assortment of objects, from champagne bottles to tangerines and flowers, that characterize the pleasures for which the place was famous.

The items on the bar are associated not only with the place but with the barmaid herself, whose hips, strong neck, and closely combed golden hair are echoed in the champagne bottles. Her demeanor, however, refutes these associations. Manet puts the viewer directly in front of her, in the position of her customer. She neither smiles at this customer, as her male patrons and employers expected her to do, nor gives the slightest hint of recognition. She appears instead to be self-absorbed and downcast. Her reflection and that of her customer in the

1890 1820 1890

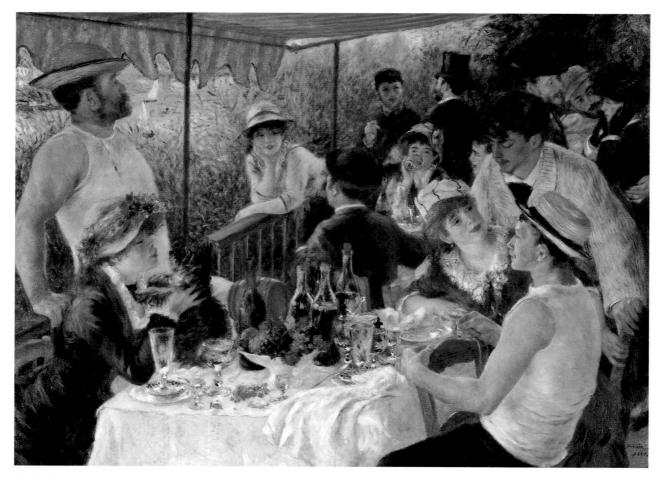

27-53. Pierre-Auguste Renoir. *Luncheon of the Boating Party.* 1881. Oil on canvas, 4'3" x 5'8" (1.3 x 1.7 m). The Phillips Collection, Washington, D.C.

mirror behind her and to the right, in contrast, tells a different story. There, she leans toward the patron, whose intent gaze she appears to meet; the physical and psychological distance between them has vanished. Exactly what Manet meant to suggest by this juxtaposition has been much debated. One possibility is that he wanted to contrast poignantly the longing for happiness and intimacy with the disappointing reality of ordinary existence.

What many of the Impressionists themselves found objectionable in their earlier art was not its truth value but its lack of permanence. One of the first to reject Impressionism for something that could compete with the classic art of the past was Renoir. The shift in his work is first signaled in Luncheon of the Boating Party (fig. 27-53), the last in a series of works he produced at Chatou on the theme of boating. The village on the Seine just outside Paris had become a favorite site for those Parisians interested in the new vogue for rowing. Here, Renoir depicts a group of rowers, in short sleeves and straw hats (known as boaters), and their friends on the terrace of the popular Restaurant Fournaise, located on the island that divided the Seine at Chatou. The company has gathered on this glorious summer day for refreshments and for the company of other beautiful young men and women. The painting, which again features an assortment of male artist friends and female models, is the suburban equivalent of Moulin de la Galette (see fig. 27-47).

Despite the fundamental similarity of conception and the persistent combination of sensual brushwork and lush color, Luncheon of the Boating Party differs from earlier works such as Moulin de la Galette in two fundamental respects. First, the elements, especially the figures, are more solidly and conventionally defined. The arm of the male seated in the foreground, for example, has a descriptive clarity and solidity not seen in Renoir's work since the late 1860s. Second, the composition, too, is more conservative. Beneath the apparent informality is a variation on the traditional pyramidal structure advocated by the academies. A small triangle whose apex is the woman leaning on the rail is set within a larger, somewhat looser one that culminates in the two men in the rear. Thus, instead of a moment quickly scanned in passing (an impression), Renoir creates a more stable and permanent scene.

The direction signaled by this work was confirmed and further encouraged by Renoir's subsequent visit to Italy in late 1881 and early 1882. In particular, the paintings by Raphael that he saw there made him reconsider his commitment to contemporary themes. Renoir became convinced that, unlike the enduring themes of Renaissance art, his records of modern life were too bound to their time to maintain the interest of future viewers. He therefore began to focus on the nude, a subject more difficult to locate in a particular time and place.

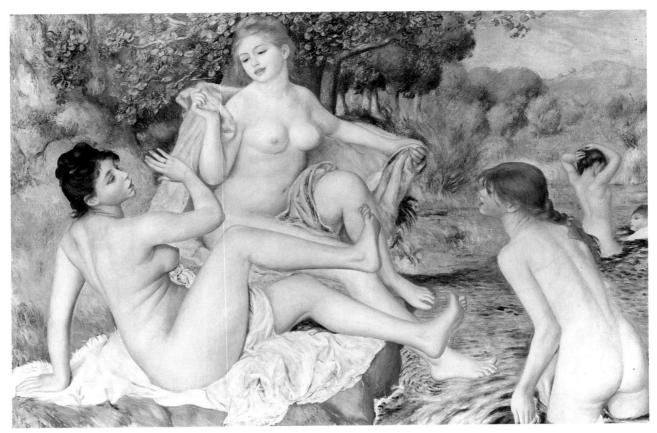

27-54. Pierre-Auguste Renoir. *Bathers*. 1887. Oil on canvas, 3'10³/8" x 5'7¹/4" (1.18 x 1.71 m). Philadelphia Museum of Art Mr. and Mrs. Carroll S. Tyson Collection

The first of these was *Bathers* (fig. 27-54). The stable, pyramidal grouping of three female bathers was based on a seventeenth-century sculpture by François Girardon at Versailles (see fig. 19-27). This source clearly indicates Renoir's new commitment to the classical tradition of the female nude that originated in the Hellenistic period and was first adopted by French artists during the reign of Louis XIV. The work is perhaps closer to Bouguereau's *Nymphs and a Satyr* (see fig. 27-7) than to *Moulin de la Galette*, although the nudes are certainly more innocent than those in Bouguereau's work.

The women are shown from three different views—front, back, and side—a convention that had been established in countless paintings of the Three Graces. Their chiseled contours also reflect a move toward academicism. Only the more loosely brushed landscape, the high-keyed colors, and the women themselves, who could be contemporary Parisians on the banks of the Seine, prevent the painting from being a wholesale rejection of Impressionism.

Cassatt, too, in the period after 1880 moved toward a firmer handling of form and more classic subjects. The shift is most apparent in her new focus on the theme of mother and child. In *Maternal Caress* (fig. 27-55), for

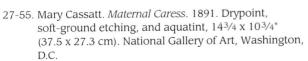

Rosenwald Collection

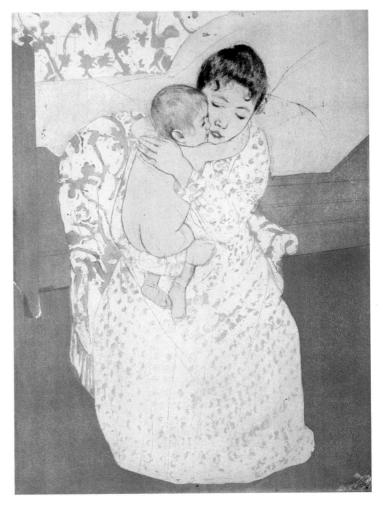

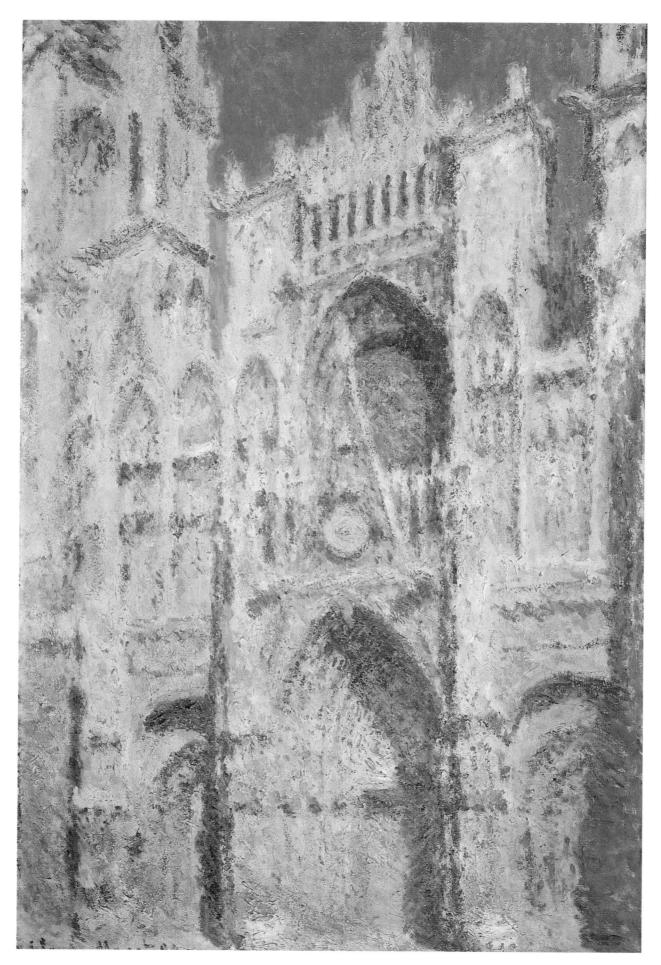

27-56. (opposite) Claude Monet. *Rouen Cathedral: The Portal* (in Sun). 1894. Oil on canvas, 39\frac{1}{4} x 26\frac{1}{2} (99.7 x 66 cm). The Metropolitan Museum of Art, New York

Theodore M. Davis Collection, bequest of Theodore M. Davis

189 1820 189

example, one of the many colored prints she produced in her later career, we see her sensitive response to the tradition of the Madonna and Child. Apparently fresh from the bath, the plump infant shares a tender moment with its adoring mother. Their intimacy is underscored by the subtle harmony of apricots and browns. Even the pairing of decorative patterns reinforces the central theme.

These patterns, like the work's simple contours and sharply sloping floor, derive from Japanese prints. Works such as *Maternal Caress* appear to be Cassatt's Western answer to the work of Japanese printmakers such as Utamaro (see fig. 7, page 19). As such, they apparently aim at not only the timeless but the universal. Like Renoir, she, too, moved far from her early commitment to depicting only contemporary moments.

Even Monet, who at first appeared immune to the growing crisis of Impressionism, eventually responded to it in the choice of some of his themes. During the 1880s he continued to record the transitory appearance of nature's more beautiful sites. In 1890 he appeared to take his brand of Impressionism even further with two series devoted to single themes, one to the haystack and the other to the poplars along a riverbank. Each painting concentrates on the light effects observable at a single instant in time. The two series thus seem to insist that

time is but a collection of unique moments with little relation to one another. Monet, however, may have been exploring not only the singular beauty of each isolated moment, but also the underlying continuities that link them. The poplar, for example, known as the Tree of Liberty during the French Revolution, had strong and enduring associations in France. The graceful **S** curves that dominate the paintings likewise have their counterparts in French Rococo art of the eighteenth century, which was then undergoing a revival.

Monet's apparent desire to place Impressionism within the great traditions of French art is most evident in a third series of paintings, this one devoted to the play of light over the variegated facade of Rouen Cathedral (fig. 27-56). The subject is unusual for Monet. Although he painted it with dazzling colors, the stony surface of the cathedral, unlike a row of poplars, actually has little color. Monet apparently chose the subject not for its coloristic appeal but for its iconographic associations. The building symbolizes the continuity of human institutions such as the Church and the enduring presence of the divine. And like the Rococo, the Gothic style of the cathedral originated in France in the Paris region. In effect, Rouen Cathedral: The Portal (in Sun) seems to argue that beneath the shimmering, insubstantial veneer of shifting appearances is a complex web of durable and expanding connections. Thus, while Renoir, Cassatt, and others were moving away from Impressionism, Monet was apparently trying to place it in a more enduring, coherent context. This pattern of rejection and reform is evident, as well, in the works of the next generation of French artists, the Post-Impressionists.

Rodin Burghers of Calais 1884–86

van Gogh The Starry Night 1889

Munch The Scream 1893

Picasso Les Demoiselles d'Avignon 1907

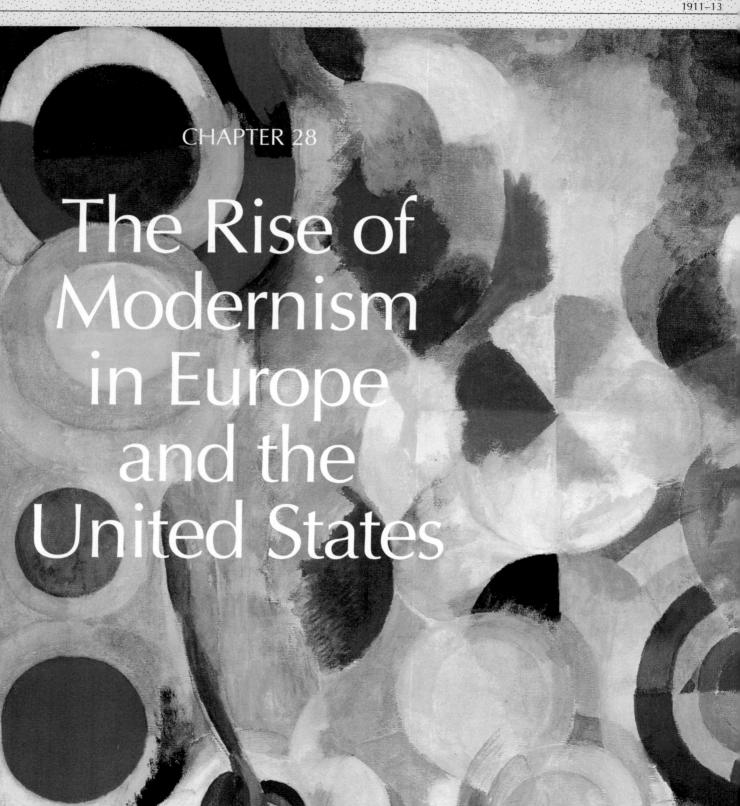

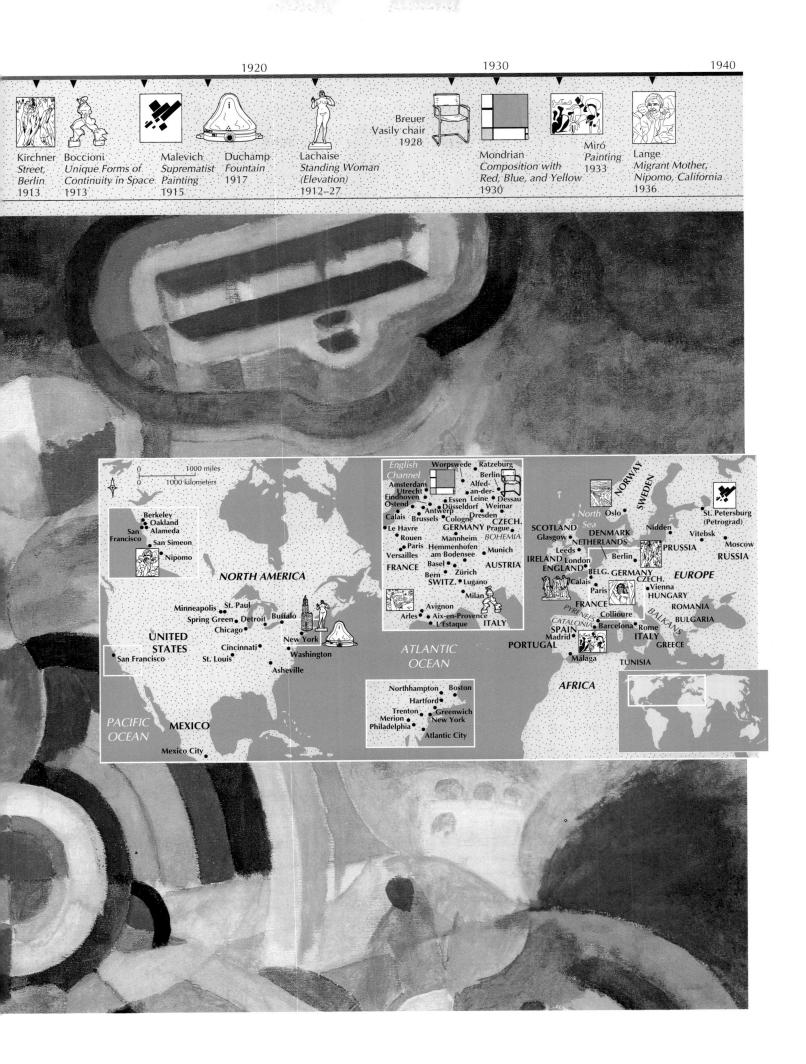

28-1. Marcel Duchamp.
Fountain. 1917.
Porcelain plumbing
fixture and enamel
paint, height 245/8"
(62.23 cm). Photograph by Alfred
Stieglitz. Philadelphia
Museum of Art
Louise and Walter
Arensberg Collection

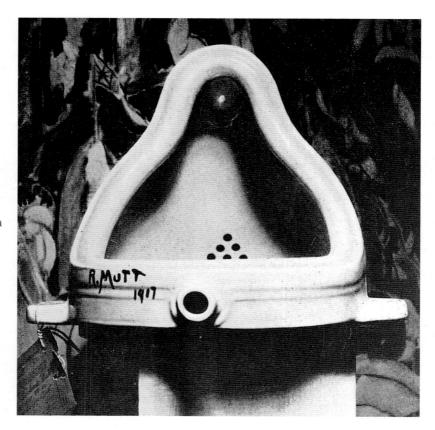

s the American Society of Independent Artists prepared for its first annual exhibition, in 1917, its members were committed to a large, unjuried show. Any artist who paid six dollars could enter a work in its exhibition. But members of the society were stunned, some even outraged, when a work titled *Fountain*, signed "R. Mutt" and accompanied by the entry fee, turned out to be a urinal mounted in such a way as to be seen from above (fig. 28-1).

In fact, *Fountain* was submitted by Marcel Duchamp, a founding member of the society and chair of the hanging committee, among other reasons, to see just how open the members really were. Duchamp, who strongly believed that art is a matter of what the head creates, not what the hand makes, bought the fixture made by the J. L. Mott Iron Works, signed it "R. Mutt," and submitted it under that name. Because some members of the society considered it gross, offensive, and even indecent, the work was refused. The decision did not surprise Duchamp.

Fountain was more than a cynical vexation, however. In a small journal he helped found, Duchamp published a letter on the Mutt case refuting the immorality charge and wryly noting: "The only works of Art America has given are her plumbing and her bridges." In a more serious vein, he added: "Whether Mr. Mutt with his own hands made the fountain or not has no importance. He CHOSE it. He took an ordinary article of life, placed it so that its useful significance disappeared under the new title and point of view—and created a new thought for that object" (cited in Harrison and Wood, page 248).

Confronted by *Fountain* and other jarringly innovative works, viewers who had previously debated standards for judging the aesthetic quality of works of art found themselves challenged even to define the term *art*.

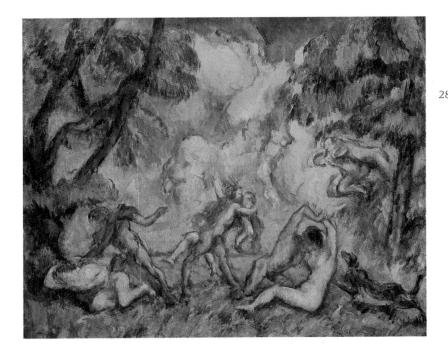

28-2. Paul Cézanne. The Battle of Love. c. 1880. Oil on canvas, 147/8 x 181/2" (37.8 x 47 cm). National Gallery of Art, Washington, D.C. Gift of Averell W. Harriman in memory of Marie N. Harriman

MODERNISM?

WHAT IS The years between 1880 and the outbreak of World War II in 1939 witnessed a dizzy-

ing proliferation of different styles and artistic movements in Western European art and architecture. These various tendencies, often consciously at odds with one another, are nevertheless traditionally grouped under a common label, modernism. Like the word Romanticism, the term modernism is a disputed one, with neither an authoritative definition nor an entirely agreed-upon time frame. The most useful way to think of modernism, perhaps, is to consider it a collection of artistic and architectural tendencies that shared two general but fundamental characteristics. Artists and architects are here considered modernists if their work exhibits at least one of these.

The first modernist characteristic was a commitment to progressive formal innovation. In general, each generation of modernists attempted to develop the most original aspects of the styles initiated by its immediate predecessors, in the belief that it was thereby advancing or culminating the mainstream, that is, the central, dominant line of artistic innovation (see "The Idea of the Mainstream," page 1110). Because there were often competing notions of what the mainstream was, the fields of art and architecture were multifaceted and constantly changing. The second modernist characteristic was the belief that art could address the problems of modern life. Modernists disagreed, however, on what those problems were and how best to respond to them. In short, modernism should perhaps be considered the sum of the various competing expressions of artists and architects who, despite their very real differences, nevertheless shared a fundamental set of beliefs about art and the world.

An analysis of the career of the French painter Paul Cézanne (1839-1906), generally considered one of the pioneers of modernism, provides a good introduction to some of the basic issues, complexities, and difficulties of the art of this era. Cézanne's early work from around 1870 dealt with a number of violently Romantic themes in a purposefully dark, rough style. Then, under the guidance of one of the Impressionists, Camille Pissarro, Cézanne in 1872 turned outward to the direct transcription of his encounter with nature.

Cézanne's move toward Impressionism, however, did not resolve the psychological conflicts that had generated his tumultuous early work, as can be seen in those rare instances after 1872 when he returned to erotic themes. The Battle of Love of about 1880 (fig. 28-2), for example, shows the naked followers of Bacchus, the Roman god of wine, engaged in a violent orgy. Throughout the picture, women are under attack, sometimes by what appear to be other women. Short, brisk brushstrokes and the quick, scalloped rhythms of the cloud and body contours convey the agitation of this unusual scene. Here, the painting style developed by the Impressionists to record optical sensations has been used, instead, to record emotion. Because its effect is nervous rather than violent, the viewer might justifiably conclude that the brushwork has less to do with the aggressive feelings of the combatants than with the artist's own edgy response to sexual issues.

The potential that the quick, loose Impressionist brushstroke had to reveal the inner state of the artist—in the same way a seismograph records earthquakes would be more fully developed by other painters, such as Vincent van Gogh. Cézanne's commitment to the continuing evolution of Impressionism took a different, although equally radical, form: a movement toward abstraction, or nonrepresentational art. Many historians have identified the "progress" of modernism in its shift away from the representation of specific things, whether imaginary or real, in favor of an emphasis on the intrinsic characteristics of an artistic medium itself. In painting, this shift meant simply an increasing concern with colored

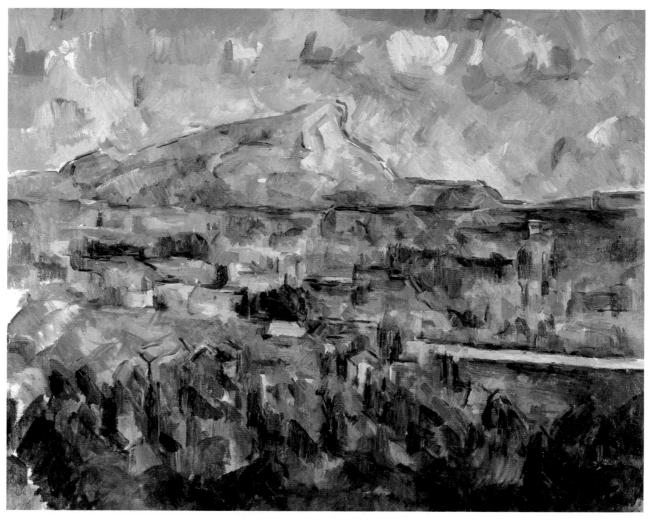

28-3. Paul Cézanne. *Mont Sainte-Victoire*. 1904–6. Oil on canvas, 25½ x 32" (65 x 81 cm). Private collection, Pennsylvania After receiving a considerable inheritance upon the death of his father in 1886, Cézanne returned to his hometown, Aix-en-Provence, in the south of France, to avoid the distractions of Paris and its cultural debates. In 1901–1902 he built a studio in the countryside with a large window facing Mont Sainte-Victoire, to facilitate painting the subject that increasingly had come to preoccupy him.

paint and its two-dimensional canvas support. The frankly acknowledged paint surfaces of Cézanne's mature works and his growing disregard for the depiction of specific landscape features, which culminates in late paintings such as *Mont Sainte-Victoire* (fig. 28-3), were major steps in the move toward the completely nonrepresentational art that emerged in the second decade of the twentieth century. Again, it was the Impressionists who had opened this door when they shifted attention away from the subject matter itself to the painted record of how it appears to the viewer.

Although it is tempting to see in *Mont Sainte-Victoire* evidence of Cézanne's ultimate rejection of Impressionist aesthetics for an interest in the paint itself, this and works like it remained firmly grounded in the understanding of the individual brush mark as a record of the artist's immediate "sensation" of nature. What Cézanne apparently objected to in Impressionism was not its theory but its application. He rejected Monet's early preoccupation with nature's sensual surface for what he

referred to in his notebooks as "the concrete study of nature," by which he seems to have meant the investigation of its deeper truths as revealed through experience. Judging from his paintings, Cézanne saw in nature not only its shifting, ever-changing surface but also the solidity and constancy that lay beneath it. This is perhaps what Cézanne meant when he said, "I want to make of Impressionism something solid and durable, like the art of the museums." Cézanne's brushwork reveals the tension between nature's stability and instability. In the middle section of Mont Sainte-Victoire, for example, the solid, rectangular strokes, generally applied according to a rigid grid of vertical and horizontal lines, nevertheless form dynamic and irregular contours. Thus, Cézanne was able to define through paint his sense of the essential, or abstract, characteristics of nature behind the changing specifics of appearance.

Cézanne's late work is characterized by a number of such opposites held in tension. He often subtly disrupted his symmetrical and pyramidal compositions by tipping

PARALLELS

1900 1880 1940

Years

Events

1880–1889

Major European colonization of Africa begins; Rodin wins competition for *Burghers of Calais* (France); steel first used in building construction (United States); Neo-Impressionists emerge (France); Seurat's *A Sunday Afternoon on the Island of La Grande Jatte* (France); Richardson's Marshall Field Warehouse (United States); Eastman's box camera (United States); Eiffel Tower (France); Art Nouveau emerges (France); van Gogh's *The Starry Night* (France)

1890-1899

Riis's How the Other Half Lives (United States); Roman School of classicists (France); James's book The Principles of Psychology (United States); Sullivan's Wainwright Building (United States); McKim, Mead, and White's Boston Public Library; Gropius's facade for Fagus Factory (Germany); Horta's Tassel House (Belgium); World's Columbian Exposition in Chicago; Sino-Japanese War; antiacademic Secession movement begins in France; Hunt's Biltmore estate (United States); Olympic Games reestablished (Greece); Spanish-American War; World of Art group forms in St. Petersburg (Russia); Freud's book The Interpretation of Dreams (Austria) and advent of psychoanalysis

1900-1909

Stieglitz organizes Photo-Secession group later known as 291 (United States); Wright brothers' first powered flight (United States); Russo-Japanese War; Fauves named (France); Die Brücke formed (Germany); Golden Fleece group forms in Moscow (Russia); Picasso's *Les Demoiselles d'Avignon* (France); Braque's *Houses at L'Estaque* inspires term *Cubism* (France); Ford's Model T automobile (United States); Ashcan School forms (United States); Braque and Picasso develop Analytic Cubism (France); Futurism emerges (Italy)

1910-1919

Union of South Africa formed; Wright's Taliesin (United States); Kandinsky organizes Der Blaue Reiter (Germany); Braque and Picasso evolve Synthetic Cubism (France); Cubo-Futurism emerges (Russia); Balkan Wars; Republic of China established by Sun Yat-Sen; Gilbert's Woolworth Building (United States); Armory Show launches modernism in the United States; World War I; Sant'Elia's *Manifesto of Futurist Architecture* (Italy); Malevich's *Suprematist Painting* (Russia); Wright's Imperial Hotel in Tokyo (Japan); Einstein's general theory of relativity (Germany); Dada movement begins in Switzerland; de Stijl emerges in the Netherlands; Russian Revolution; Purism emerges (France); worldwide influenza epidemic kills 20 million people; Gropius establishes Bauhaus (Germany)

1920-1929

Census shows more people living in urban than rural United States; League of Nations; Harlem Renaissance (United States); women citizens granted the right to vote in the United States; Constructivist movement (Russia); Leger's *Three Women* (France); Le Corbusier's design for a Contemporary City of Three Million Inhabitants (France); Eliot's poem *The Waste Land* (England); Joyce's novel *Ulysses* (Ireland); Breton's "Manifesto of Surrealism" (France); Griffith's film *America* (United States); Rietveld's Shröder House (Netherlands); Hitler publishes *Mein Kampf* (Germany); John Scopes convicted of teaching evolution in public school (United States); Morgan's San Simeon estate (United States); Hemingway's novel *The Sun Also Rises* (United States); Lindbergh makes first solo trans-Atlantic flight (United States); American Scene Painting emerges; Eisenstein's film *Ten Days That Shook the World* (Russia); Kellogg-Briand Pact, signed by 62 nations, attempts to end war; Mead's book *The Coming of Age in Samoa* (United States); Rivera's murals for the Mexico City Ministry of Education; dirigible *Graf Zeppelin* circles the globe (Germany); stock-market crash in United States signals worldwide economic depression; Woolf's essay *A Room of One's Own* (England); Museum of Modern Art founded (United States)

1930-1939

Mondrian's *Composition with Red, Blue, and Yellow* (Netherlands); Regionalist painters emerge (United States); Huxley's novel *Brave New World* (England); Social Realism in art instituted by Stalin (Russia); Hitler takes dictatorial power in Germany; Malraux's novel *Man's Fate* (France); Stein's *The Autobiography of Alice B. Toklas* (United States); Lange's *Migrant Mother, Nipomo, California,* photographed for Farm Securities Administration (United States); Roosevelt establishes Federal Arts Program (United States); Mitchell's novel *Gone with the Wind* (United States); Spanish Civil War; American Abstract Artists group forms; Renoir's film *The Grand Illusion* (France); Carlson invents xerography (United States); Nazis launch anti-Jewish campaign throughout Germany; Miller's novel *Tropic of Capricorn* (United States); Steinbeck's novel *Grapes of Wrath* (United States); Kahlo's *Two Fridas* (Mexico); Krasner's *Red, White, Blue, Yellow, Black* (United States); World War II

individual elements or placing them unexpectedly, revealing the tension between stability and instability. Heightening this tension is the juxtaposition of warm colors like red and yellow, which appear to come forward, with cool colors like blue, which appear to recede. And there is a spatial tension between two and three dimensions arising from the contradiction between the presumed depth and distance of the features depicted in a painting—the mountain in Mont Sainte-Victoire, for example—and the flat painted surface the viewer actually sees.

In the final analysis the exact source and meaning of the unresolved tensions that characterize Cézanne's entire mature output remain unknown. Yet the underlying resemblance between the nervous excitement of The Battle of Love and the more contained energy of Mont Sainte-Victoire raises an obvious question: To what extent did Cézanne's personal feelings contribute to his findings about nature? Or, phrased differently, did Cézanne merely discover in the external world confirmation of his own conflicted nature?

What makes these questions different from those asked about earlier art is the idiosyncratic nature of both Cézanne's quest and the visual vocabulary he employed to articulate it. By trying to express himself in an innovative and novel fashion, he made it more difficult for both the public and historians to interpret his work. Even Cézanne doubted whether his works could be fully understood by those accustomed to the conventional language of earlier representational art. This would become the chief difficulty, in fact, with much modernist art. In striving to frame universal truths in their own very personal ways, many modernists would, ironically, risk losing the ability to communicate their ideas clearly and well to a wide audience.

IMPRESSIONIST way his work developed out

POST- Cézanne, because of the of the Impressionist style of **ART** the 1870s, is considered a

Post-Impressionist, a term that has two distinct meanings. Narrowly defined, it refers to five painters—Cézanne, Henri de Toulouse-Lautrec (1864-1901), Georges Seurat (1859–1891), Paul Gauguin (1848–1903), and Vincent van Gogh (1853-1890)—who assimilated much from Impressionism but in the end moved beyond its collective aesthetic principles to develop five quite different styles. In this sense, Post-Impressionism, unlike Impressionism, is not a true ism at all but a catchall term for the work of these five artists. Broadly defined, Post-Impressionist refers to the period when these five artists were either active or still influential. In this sense the term encompasses the entire generation of innovators, including sculptors and photographers as well as painters, whose principal work falls between about 1880 and 1910.

Auguste Rodin

The most important sculptor of the Post-Impressionist era, as it has been broadly defined, is Auguste Rodin (1840-1917), whose career dates from the mid-1860s but whose work has little in common with that of the five painters of Post-Impressionism narrowly defined. Rodin was rejected three times by the École des Beaux-Arts, but after an 1875 trip to Italy, where he saw the dramatic art of Michelangelo, he began to produce intensely muscular figures in unconventional poses, works that were attacked by the academic critics but were increasingly admired by the general public.

Rodin's status as the leading sculptor in France was confirmed in 1884, when he won a competition for Burghers of Calais (fig. 28-4), commissioned to commemorate an event from the Hundred Years' War. In 1347 King Edward III of England had besieged Calais but offered to spare the city if six leading citizens (or burghers)dressed only in sackcloth with rope halters and carrying the keys to the city—would surrender themselves to him for execution. Rodin shows the six volunteers marching out to what they assume will be their deaths.

The Calais commissioners were not pleased with Rodin's conception of the work because they imagined calm, idealized heroes. Instead, Rodin presented ordinarylooking men in various attitudes of resignation and despair. He expressively lengthened their arms, greatly enlarged their hands and feet, and changed the light fabric he knew they wore into a much heavier one, showing not only how they may have looked but how they must have felt as they forced themselves to take one difficult step after another. Nor were the commissioners pleased with Rodin's plan to display the group at close to ground level. Rodin felt that the usual placement of such figures on a high pedestal suggested that only higher, superior humans are capable of heroic action. By placing the figures at street level, or close to it, Rodin hoped to convey to viewers that ordinary people, too, are capable of noble acts.

In its focus on great historical events that address human themes, Rodin's work looks back to a long tradition that began with the Greeks. Burghers of Calais is thus not typical of the art produced during the Post-Impressionist era or later. Although the sculptors and painters who followed him absorbed many of Rodin's specific stylistic innovations, their works increasingly responded to contemporary life rather than the past.

Documenting Modern Life

By 1880 the impact of industrialization on the West was becoming clear. Although modern technology had produced new and unheard-of levels of material well-being. it had also created a new set of human problems. Some involved the hardships of industrial working conditions, while others were connected with the growth of massive industrial cities. The separation of these new cities from nature was thought by many to have terrible psychological consequences. When people moved to the urban centers to find work, their old family and community ties were often strained or broken, and they found themselves surrounded by strangers, feeling alienated and alone.

One common response to these problems was simply to document them, an activity already begun in the preceding era by artists like Honoré Daumier. The Post-

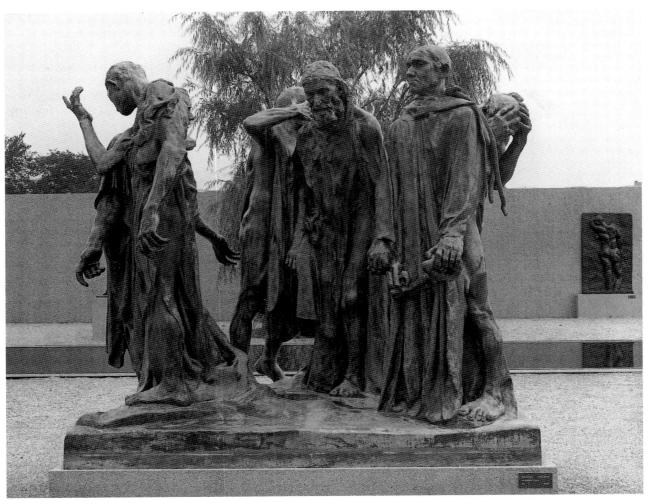

28-4. Auguste Rodin. *Burghers of Calais.* 1884–86. Bronze, 6'10¹/₂" x 7'11" x 6'6" (2.1 x 2.4 x 2 m). Hirshhorn Museum and Sculpture Garden, Smithsonian Institution, Washington, D.C.

Impressionist most identified with this current is Henri de Toulouse-Lautrec. Born a count in a small French town, Toulouse-Lautrec had a passion for drawing as a child. Medical problems drastically stunted his growth and so affected his face that he often drooled. Because of his appearance, he was not welcome in his own family.

In 1882 Toulouse-Lautrec moved permanently to Paris, where he entered the studio of an academic painter. He was soon drawn to the art of the Impressionists, especially that of Edgar Degas. He also discovered Montmartre, a part of Paris devoted to entertainment and inhabited by many who were on the fringes of society. From the late 1880s he dedicated himself to documenting this fascinating realm in individual **caricatures**—drawings that exaggerate the characteristic features of a subject for satirical effect—and in naturalistic scenes. He recorded his observations both in the posters for which he became famous (see "Posters and Prints of the 1890s," page 1028) and in paintings.

Typical of such works is *At the Moulin de la Galette* (fig. 28-5), a conscious remake of Pierre-Auguste Renoir's earlier painting of the popular dance hall (see fig. 27-47), which Toulouse-Lautrec had recently seen in an exhibition. Clearly, Toulouse-Lautrec wished to contradict the optimistic terms of the earlier work and of

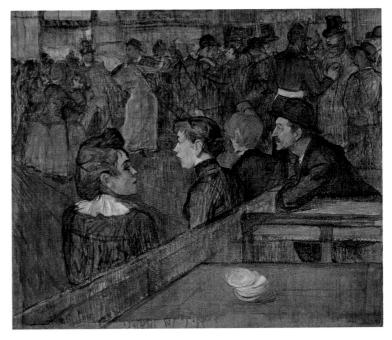

28-5. Henri de Toulouse-Lautrec. *At the Moulin de la Galette*. 1889. Oil on canvas, 35½ x 39½ " (90.2 x 99.7 cm). The Art Institute of Chicago

Mr. and Mrs. Lewis L. Coburn Memorial Collection

POSTERS AND A second phase in the late-nine-teenth-century

teenth-century print renaissance began around 1890 and lasted well into the next decade. (On the first phase, see "The Print Revival," page 1005.) Although this one, too, was centered in Paris, the medium was chromolithography. The artist largely responsible for it was a poster designer, Jules Chéret (1836-1932). After seventeen years working as a lithographic technician, in 1866 Chéret opened his own printing firm in Paris, where he produced a variety of commercial work, from menus to posters. He specialized in color lithography, a technique that he greatly helped to perfect (see "Lithography," page 985). His clever theater and café posters of the late 1860s and 1870s attracted the attention of both collectors and critics. In 1880 Joris-Karl Huysmans advised his readers to ignore the paintings and prints at the Salon and to turn, instead, to the "astonishing fantasies of Chéret" that could be found on any street.

In 1884 two histories of the French poster were published. Two years later, Henri Beraldi's Les Graveurs du XIXe siècle (The Printmakers of the Nineteenth Century) included a section devoted to Chéret's posters. In that year, too, the print dealer Edmond

Sagot began listing posters, particularly those by Chéret, among his offerings. Other print dealers soon followed his lead, and by the end of the decade the poster vogue was in full flower not only in France but throughout the West. A number of talented and ambitious young artists turned their attention to designing them, including Alexandre Steinlen, Eugène Grasset, Alphonse Mucha, Will Bradley, Maxfield Parrish, Ethel Reed, John Sloan, Maurice Prendergast, and the Beggarstaff brothers. The most famous poster artist was Henri de Toulouse-Lautrec, who produced thirty between 1891 and his death in 1901.

Japanese prints influenced not only Toulouse-Lautrec's posters but those of many others as well. Another important influence came from Art Nouveau, which helped fuel the poster craze with its commitment to beautifying the urban environment.

One result of the poster phenomenon inaugurated by Chéret was a renewed interest in artistic lithography, especially in color. As André Mellerio stated in his 1898 book on the subject, "Chéret's posters opened up a new path—a path which the print happily followed" (cited in Cate and Hitchings, page 80). The year before, Mellerio had started a journal

that implicitly made the same point, L'Estampe et l'Affiche (The Print and the Poster). Toulouse-Lautrec's first poster, for example, inspired a larger commitment to the lithographic print. A number of other famous artists also participated in this development, largely through the urgings of the art dealer Ambroise Vollard. Beginning in 1896 Vollard organized two annual editions of prints similar to those produced two decades earlier by Cadart. In 1896 he published an edition of twenty-four and the following year one containing thirty-two. Vollard's artists included Henri de Toulouse-Lautrec, Paul Cézanne, Pierre-Auguste Renoir, James McNeill Whistler, Paul Gauguin, Camille Pissarro, Pierre Bonnard, and Édouard Vuillard.

Vollard also contributed significantly to the renewed interest in book illustration, a genre neglected since the days of Édouard Manet. He asked a number of the artists just mentioned, as well as Marc Chagall and Georges Rouault later, to provide original lithographs for books. The best known of the English book illustrators was Aubrey Beardsley, whose work combined influences from Whistler, the second phase of the Pre-Raphaelite movement, and Japanese prints to form a beautifully "unnatural" style.

Impressionism in general. Whereas Renoir painted idealized, pretty young women and handsome young men, Toulouse-Lautrec depicts the sadder reality of such places. The happy couples in the back of the Toulouse-Lautrec work are only foils for the four lonely, dispirited figures in the front. The diagonal rail, similar to the one found in the Renoir painting, here creates a barrier between the sexes. Moreover, the rail and foreground table separate the viewer from the foreground figures, thus reinforcing the viewer's outside position. In these ways the painting reveals the artist's sensitivity to a new kind of loneliness: the modern feeling of alienation.

Another medium, photography, was ideally suited to recording the problems of modern life. One who contributed importantly to its rich documentary tradition was Eugène Atget (1857–1927), an actor who turned to photography in the early 1890s to earn a living. The Paris business he opened in 1892 specialized in providing artists with photographs on which they would base their

28-6. Eugène Atget. *Magasin, Avenue des Gobelins*.
1925. Albumen-silver print, 9½ x 7" (24.1 x 17.8 cm).
The Museum of Modern Art, New York
Abbott-Levy Collection. Partial gift of Shirley C. Burden

28-7. Eugène Atget. *Pontoise, Place du Grand-Martroy.* 1902. Albumen-silver print, 7 x 9³/8" (17.8 x 23.8 cm). The Museum of Modern Art, New York

Abbott-Levy Collection. Partial gift of Shirley C. Burden

Atget's interest in the France of earlier times was part of a larger current in French culture that had been made manifest by the publication of Victor Hugo's medieval tale, *The Hunchback of Nôtre-Dame* (1831). Nostalgia for the premodern era was significantly heightened by Baron Haussmann's renovations of Paris in the 1850s and 1860s (Chapter 27). In the late nineteenth century, local groups throughout the city were organized to preserve what remained of the past, and a number of publications appeared documenting those buildings and sites that dated from between the Middle Ages and the Revolution of 1789.

compositions. By the end of the 1890s, however, Atget had begun to make, purely for himself, two kinds of photographs: nostalgic images of "old France" and pictures of the new age that threatened it.

A fine example of the latter type is *Magasin, Avenue des Gobelins* (fig. 28-6), which shows the seventeenth-century Gobelins tapestry works reflected in the window of a men's clothing store. The age-old methods of making fabrics by hand are thus contrasted with the modern industrial techniques that produced the cloth in the window. Price labels on the cloth and suits remind us that in factory production, price—not quality—is what matters. The mannequins themselves may well represent Atget's view of modern industrial humanity: anonymous, interchangeable, soulless, and wearing a price tag.

Artistic Alternatives to Modern Life

Magasin, Avenue des Gobelins is less typical of Atget than are his works that fondly record premodern France. These photographs of an older world are less exercises in nostalgia than countermoves against the encroachment of the new age. In most of his work Atget sought an image of a stable, unchanging world that would provide an imaginary escape from the increasingly noisy, unstable world of modernity. Pontoise, Place du Grand-Martroy (fig. 28-7), for example, shows the kind of small-town square that had been a center for community life in Renaissance and post-Renaissance Europe. Around the

square are the various small, family-run businesses—boulangerie ("bakery"), sabotier ("wooden-shoe maker"), patisserie ("pastry shop")—that served community needs long before big department stores began to appear in the late nineteenth century.

The square is formally stabilized on two sides by balancing architectural masses and symbolically stabilized by the church at the rear. The church represents both the personal security that belief can provide and a major force for social cohesion. Between the fall of Rome and the advent of the industrial age, Christianity had largely organized the life of western Europe, but its centrality was now being threatened by science, technology, and commerce. Atget, whether intentionally or not, shows an awareness of that threat.

In this, Atget was not alone. One important aspect of modernist art and architecture was the search for visual forms that would give psychological relief from the troubling conditions of a rapidly changing and increasingly complicated world. The painter Pierre-Cécile Puvis de Chavannes (1824–1898) was an important early contributor to this tradition. Puvis began his career as a Romantic painter, but partly because his early works were refused by the **Paris Salon** jury during the 1850s, in 1859 he adopted a **classical** mode. His inspiration came from the so-called Parnassian poets, who were then attempting to escape from the modern present into an idealized antiquity. By the late 1860s municipal buildings had become a major source of commissions for Puvis's large

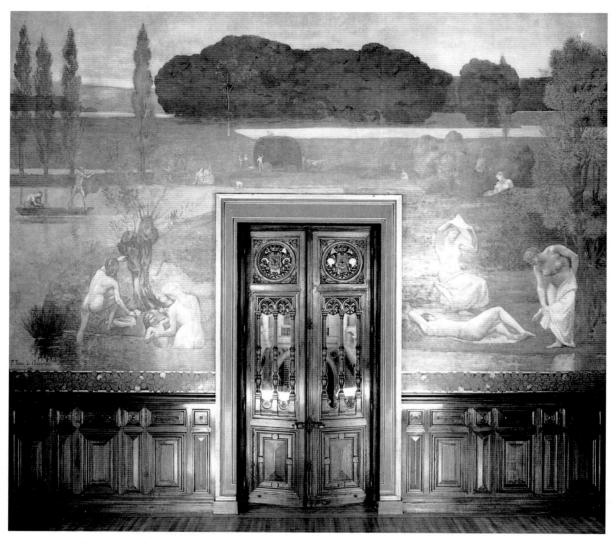

28-8. Pierre-Cécile Puvis de Chavannes. Summer. 1889-93. Oil on canvas, applied to wall. Hôtel de Ville, Paris

classical murals. Because the great popularity of such works dates from the early 1880s, Puvis, like Rodin, is usually grouped with the Post-Impressionists.

A good example of Puvis's canvas murals (he never learned the fresco technique) is *Summer* (fig. 28-8), set, like all his classical views, 2,000 years earlier in an idealized France after the arrival of Greek-Roman civilization. Against a simple agrarian background a scene of a family bathing suggests both a dignified pace of life and the notion that the larger community was composed of happy family units. To the right of the door, three indolent bathers, meant to resemble classical statuary in color and texture, anchor the scene both formally and psychologically. Puvis's lovely park is populated by sculpture; the marblelike figures create a static, timeless quality. The sense of tranquil unreality is further enhanced by the way he has simplified his forms and softly muted his colors.

Puvis's murals contributed to a new wave of classicism in French arts and letters, which included Renoir's *Bathers* (see fig. 27-54). During the 1890s the literary classicists called themselves l'École Romane ("the Roman School"). The major sculptor of this broad artis-

tic movement was Aristide Maillol (1861–1944), who during the 1880s trained as a painter at the École des Beaux-Arts. Late in the decade, he became a member of a group of young artists who greatly admired Puvis's murals. He first adapted Puvis's style to the making of tapestry, but because his eyesight became strained by such work, he turned to creating small sculpted pieces.

Maillol's reputation dates from 1905, when the exhibition of *The Mediterranean* (fig. 28-9) received widespread popular and critical acclaim. The large, relaxed female bather almost seems to have escaped from one of Puvis's murals. The smooth, simplified modeling—so different from the tense, tortured surfaces of Rodin's work—combines with the stable triangular arrangement of the figure to emphasize its psychological calm. As the title indicates, the bather personifies the ideal of the classical Mediterranean world established by Puvis and the Roman School of literature.

The year Maillol exhibited *The Mediterranean*, Constantin Brancusi (1876–1957), who had trained as a sculptor in a Romanian school for arts and crafts, enrolled in the École des Beaux-Arts. Early in 1907, Rodin hired him as an assistant, but Brancusi left after just two

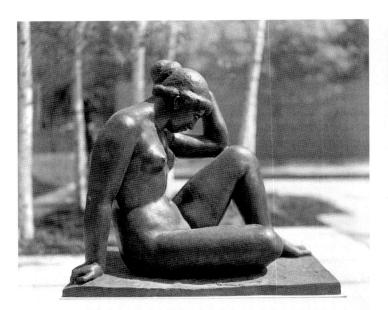

28-9. Aristide Maillol. The Mediterranean. 1902–5. Bronze, height including base 41" (104 cm). The Museum of Modern Art, New York Gift of Stephen C. Clark

months, to avoid being overshadowed by the well-known sculptor. The rough surfaces of Brancusi's first works in France reflect Rodin's influence, but by the end of the decade, he had completely rejected Rodin's style for one that emphasized formal and conceptual simplicity. Behind this change stood the ancient Greek philosophy of Plato, who had held that all creatures and things are imperfect imitations of perfect models, or Ideas.

Brancusi's quest for the timeless essence of things is most completely expressed in *Magic Bird* (fig. 28-10). The piece is formed of two separate sections. The lower, limestone section has three parts, the middle one showing two rough-hewn figures (one of which has its face buried in the other's shoulder) representing the imperfect world of ordinary human existence. The top section, carved in pure white marble, is a symbol of the higher world of Ideas: the simplified form of a bird in flight.

The bird was apparently inspired by Russian-born composer Igor Stravinsky's 1910 ballet score *The Firebird*, which premiered in Paris. The ballet features a beautiful bird with magical powers that reminded Brancusi of the many Romanian folktales of the *pasarea maiastra*, or magic bird, able to heal the sick and restore sight to the blind. Unlike the magic birds of those tales, which always have dazzling plumage, the beauty of Brancusi's bird is in its utter simplicity. Brancusi tried to eliminate all unnecessary details in his search for the Platonic ideal of "birdness" itself. The bird also represents what many people believe the modern urban mind seeks and needs: the primal simplicity underlying nature. Brancusi's *Magic Bird* may not provide a healing force, but it does offer a satisfying artistic antidote to modern complexity.

As was often the case with modern artists, Brancusi longed for the way of life of his homeland but felt a greater need for the company of sophisticated urban artists and

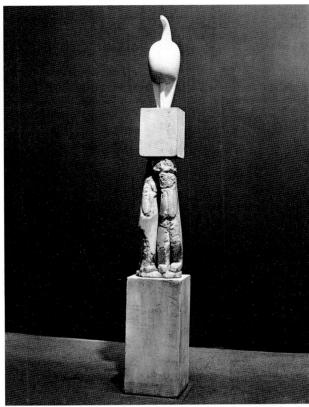

28-10. Constantin Brancusi. *Magic Bird.* 1908–12. White marble, height 22" (55.8 cm), on three-part limestone pedestal, height 5'10" (1.78 m), of which the middle part is the *Double Caryatid* (c. 1908), overall 7'8" x 12³/₄" x 10⁵/₈" (237 x 32 x 27 cm). The Museum of Modern Art, New York Katherine S. Dreier Bequest

28-11. Ernst Barlach. *Seated Woman*. 1907. Bronze, 8 x $7^{1/2}$ " (20.3 x 18 cm), diameter $4^{3/4}$ " (12 cm). Ernst und Hans Barlach Lizenzverwaltung, Ratzeburg, Germany

writers. Quite the opposite was true for the German sculptor Ernst Barlach (1870–1938), who in 1916 moved to a small town to be closer to the "backward but healthy primitivism" he admired. Barlach produced graceful decorative figures until 1906, when on a visit to Russia he was deeply moved by the humble lives of the peasants. Typical of Barlach's early mature style is *Seated Woman* (fig. 28-11), a small bronze model for a work he intended to carve in

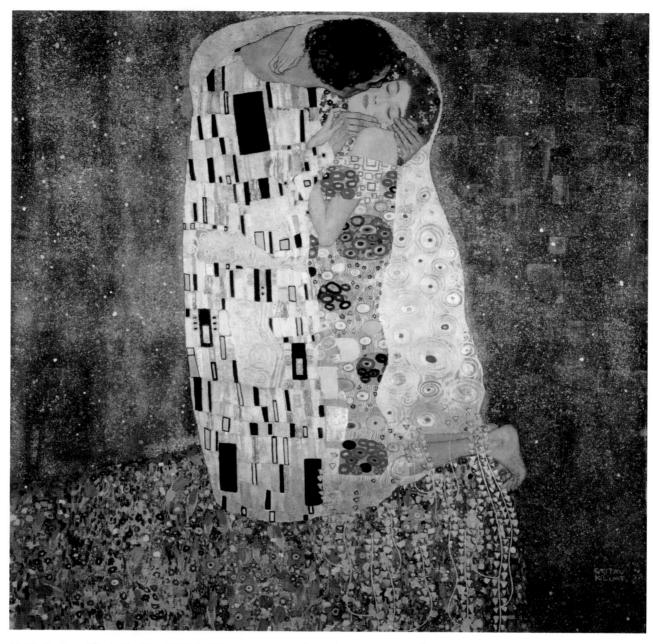

28-12. Gustave Klimt. *The Kiss.* 1907–8. Oil on canvas, 5'10³/₄" x 6' (1.8 x 1.83 m). Österreichische Galerie, Vienna The Secession was part of a reaction by younger European artists against the conservative society in which they were raised. The generational revolt was also expressed in politics, literature, and the sciences. Sigmund Freud, the founder of psychoanalysis, may be considered part of this larger cultural movement, one of whose major aims was, according to the architect Otto Wagner, "to show modern man his true face."

wood. The handling of detail is simple, in keeping with the life of its farm woman subject. The pyramidal shape of the whole and the almost symmetrical arrangement of details give her a monumental stability, which is reinforced by the columnar striations of her skirt. The small but erect head makes her appear, despite her poverty, proud and confident. Like Maillol's *The Mediterranean* (see fig. 28-9), *Seated Woman* personifies and celebrates an entire way of life.

The very sophistication and ornate beauty that Barlach rejected became for Gustave Klimt (1862–1918), the leading Austrian painter of the period, the chosen avenue of escape from modern life. Klimt, whose father was a

goldsmith, trained for a career as a historical-scene painter for public buildings. During the mid-1890s he participated in the French-inspired revolt against academic standards in art and architecture known as the Secession. Klimt was the center of one faction, dedicated to an art that would offer refuge from the ordinary through highly decorative and artificial beauty.

Between 1907 and 1908 Klimt perfected what is called his golden style, shown in *The Kiss* (fig. 28-12). A man and woman—perhaps Klimt and his mistress—embrace in an aura of golden light. The representational elements here are subservient to the decorative ones.

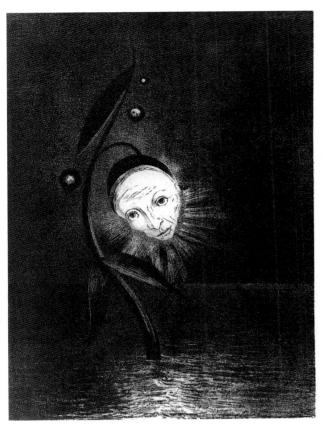

28-13. Odilon Redon. *The Marsh Flower, a Sad and Human Face* (plate 2 from *Homage to Goya*). 1885. Lithograph, 10⁷/₈ x 8" (27.5 x 20.3 cm). The Museum of Modern Art, New York

Abby Aldrich Rockefeller Purchase Fund

The complex play of the jewel-like shapes and colors and the dazzling surface can distract the viewer from the human drama of the scene. For example, the position of the man's head actually forces the woman's head uncomfortably against her shoulder. And the marked difference between them, also evident in their hands, is further played out in the forms that decorate their garments: angular shapes dominate those worn by the male, whereas only a few such shapes are found amid the rounded forms of the woman's garment. What at first appears a single unit is in fact two separate and very distinct beings in a somewhat forced embrace. That they kneel dangerously close to the edge of a precipice further unsettles the initial impression.

Odilon Redon (1840–1916), a French painter and graphic artist, developed still another response to the modern world. He considered his visionary works his "revenge on an unhappy world." Examples such as *The Marsh Flower, a Sad and Human Face* (fig. 28-13) are not purely fanciful but express certain of the larger ideas of his era. Growing in a dark, featureless marsh, a scene probably inspired by the landscape of his youth, is a plant whose flowers are sad, lonely faces. Specifically, this work expresses the pessimism that swept France in the years after the Germans had defeated them in the Franco-Prussian War of 1870–1871. Many felt that France was

aging and in decline. Redon's image suggests that nations flower and wilt like plants but also expresses hope for regeneration. That the face glows with a radiant light suggests not only the power of the imagination over the darkness of despair but Redon's larger hope that his "suggestive art," akin to music, would reverse the French decline and promote "the supreme elevation and expansion of our personal life" (cited in Chipp, page 117). Redon's art thus participates in the broad artistic endeavor actually to change the world. Many historians consider this effort, and not the stress on formal innovation, the essential core of modernism.

The Avant-Garde

During the middle to late 1880s French art witnessed the birth of the **avant-garde** tradition. The term, originally a military one meaning "vanguard," was used in 1825 by a French socialist to refer to those artists whose propagandist art would prepare people to accept the social changes he and his colleagues envisioned (see "Realist Criticism," page 994). The idea of producing a socially revolutionary art had attracted such artists as Courbet (see fig. 27-20), but the real popularity of this notion dates from the Post-Impressionist era.

One of the first in his generation apparently to think of himself in these terms was Georges Seurat (1859–1891). Seurat trained at the École des Beaux-Arts, but after his graduation he devoted his energies to "correcting" Impressionism, which he found both intellectually shallow and too improvisational. In the mid-1880s he gathered around him a circle of young artists who became known as the Neo-Impressionists. The work that made his reputation and became the centerpiece of the new movement was *A Sunday Afternoon on the Island of La Grande Jatte* (fig. 28-14).

Seurat took a typical Impressionist subject, weekend leisure activities, and gave it an entirely new handling. An avid reader of scientific color theory, he applied his paint in small dots of pure color in the belief that when they are "mixed" in the eye—as opposed to being mixed on the palette—the resulting colors would be more luminous. His scientific approach to painting does not work in practice, however, because his dots of color are large enough to remain separate to the eye. Other aspects of his rational approach to expression were also problematic. He thought, for example, that upward-moving lines (like the coastline shown here) and warm, bright colors created "happy" paintings. Many viewers, however, find the stiff formality of his figures inconsistent with such a mood, which has led to controversy about the work.

From its first appearance the painting has been subject to a number of conflicting interpretations. Contemporary accounts of the island indicate that on Sundays it was noisy, littered, and chaotic. By painting it the way he did, Seurat may have intended to show how tranquil it should be. In doing this, was Seurat merely criticizing the Parisian middle class, or was he trying to establish a social ideal—a model for a more civilized way of life in the modern city? The key to Seurat's ideal, perhaps, is shown

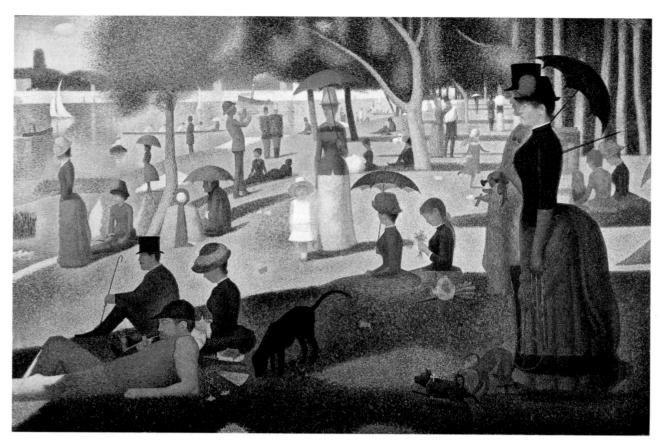

28-14. Georges Seurat. A Sunday Afternoon on the Island of La Grande Jatte. 1884–86. Oil on canvas, $6'9^{1/2}$ " x $10'1^{1/4}$ " (2.07 x 3.08 m). The Art Institute of Chicago

Helen Birch Bartlett Memorial Collection

Although the painting is highly stylized and carefully composed, it has a strong basis in factual observation. Seurat spent months visiting the island, making small studies, drawings, and oil paintings of the light and the people he found there. All of the characters in the final painting, including the woman with the monkey, were based on his observations at the site.

in the composure of the central figures in the work, the mother and child who stand as the still point around which the others move. The child, in particular, is a model of self-restraint. She may even represent Seurat's sense of the progress of human evolution, as obliquely suggested by the contrasting presence of the monkey in the right foreground.

Whereas Seurat seems to have felt that people were not civilized enough, the French painter Paul Gauguin (1848–1903) held the opposite view. Gauguin, whose mother was part French and part Peruvian Indian, had spent five years in the early 1850s with his family in Peru before they returned to France. He led an apparently conventional existence until the age of thirty-seven, when he quit his job as a Paris stockbroker and left his wife and five children to pursue a full-time painting career. Gauguin so loathed the instinctually restrained and moneyoriented modern world that in 1891 he moved to Tahiti, an island in the South Pacific Ocean, in the belief that he could return to what he called Eden.

The first picture he painted there was *Ia Orana Maria* (We Hail Thee Mary) (fig. 28-15). The new Mary, a strong Polynesian woman holding an utterly contented Christ Child, stands in sharp contrast to the crucified Christs

and mourning Marys that dominated the Catholicism Gauguin knew and had sometimes painted in the late 1880s. In Tahiti he wrote an essay arguing that what was needed was Adam and Eve's blissful ignorance before the Temptation. Among the supposedly childlike Tahitians (as he and other Europeans then imagined them— Tahiti at that time was a French-controlled colony), he thought he could reenter the Garden of Paradise. The warm, rich colors and decorative patterns underscore the message that life in this supposedly uncivilized world is sweet and harmonious. The chief argument, however, is made through the fruit on the table. Like Adam and Eve before the Fall, people here need simply to pick the fruit off the trees. The fruit is put within the viewer's easy reach, as well. As in all of Gauguin's Tahitian works, we, too, are invited to leave a sorry industrial society and enjoy the fruits of Eden.

Among the artists in Gauguin's circle before his departure for Tahiti was the Dutch painter Vincent van Gogh (1853–1890). The oldest surviving son of a Protestant minister, after failing at a number of attempts to find a life's work, in 1880 he moved to Brussels to attend the Academy. His dark Dutch period ended in 1886, when he moved to Paris. There he was influenced by the work of

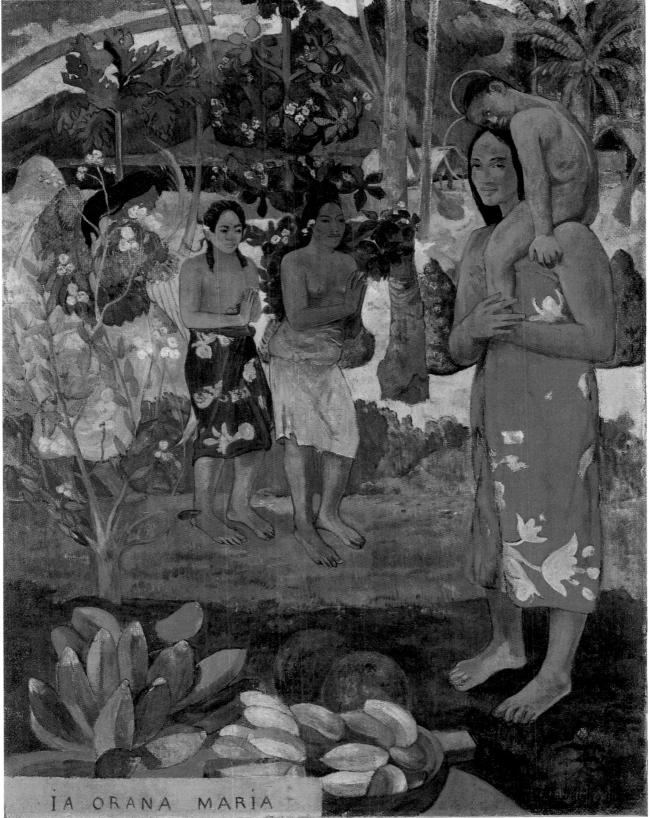

28-15. Paul Gauguin. *Ia Orana Maria (We Hail Thee Mary).* c. 1891–92. Oil on canvas, 44³/₄ x 34¹/₂" (113.7 x 87.7 cm). The Metropolitan Museum of Art, New York Bequest of Samuel A. Lewisohn, 1951

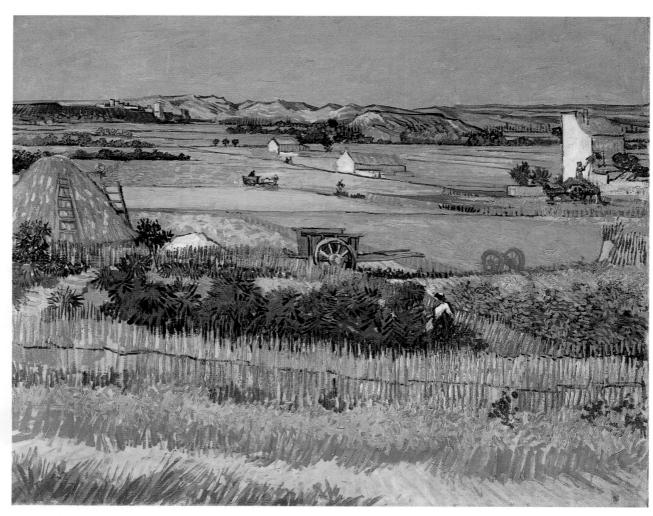

28-16. Vincent van Gogh. *Harvest at La Crau (The Blue Cart).* 1888. Oil on canvas, 28¹/₂ x 36¹/₄" (72.5 x 92 cm). Rijksmuseum, Vincent van Gogh, Amsterdam

the Impressionists and Neo-Impressionists and met Gauguin. Van Gogh shared Gauguin's preference for simple, preindustrial life, and they planned to move to the south of France and establish a commune of like-minded artists. In the spring of 1888, van Gogh moved to Arles, where Gauguin was to join him.

The works van Gogh produced in his Arles period, such as *Harvest at La Crau (The Blue Cart)* (fig. 28-16), were strongly influenced by the Neo-Impressionist interest in **complementary colors**, pairs of colors that optically balance each other, such as blue and orange. But unlike Seurat and his followers, who applied these colors in small dots, van Gogh, inspired by Japanese prints (see "Japanese Woodblock Prints," page 868), juxtaposed large color areas. Van Gogh felt that the combination of Japanese forms and Neo-Impressionist colors effectively expressed the quiet, harmonious life of this rural community. Although the lively brushwork in the foreground foliage adds vitality to the scene, the insistent repetition of horizontal forms effectively dampens that effect and contributes to the calmness of the whole.

Works such as *Harvest at La Crau (The Blue Cart)* function less to provide an escape from the industrial city than to point the way back to a simpler agrarian life.

Although van Gogh's later work is meant to do this, too, it changed in both style and function at the beginning of 1889. Late in 1888, Gauguin finally arrived in Arles, but constant quarrels led to a violent confrontation in which van Gogh threatened Gauguin with a razor. After Gauguin fled, van Gogh turned the implement on himself and cut off the lobe of his right ear. This was the first of a series of psychological crises that led to his eventual suicide in July 1890. During the last year and a half of his life van Gogh's heightened emotional state was recorded in a series of paintings that contributed significantly to the emergence of the **expressionistic** tradition, in which the intensity of an artist's feelings overrides fidelity to the actual appearance of things.

Expressionism

One of the earliest and most famous examples of Expressionism is *The Starry Night* (fig. 28-17), which van Gogh painted from the window of his cell in a mental asylum. Above the quiet town is a sky pulsating with celestial rhythms and ablaze with exploding stars—clearly not a record of something seen but of what van Gogh felt. One explanation for the intensity of van Gogh's feelings in this

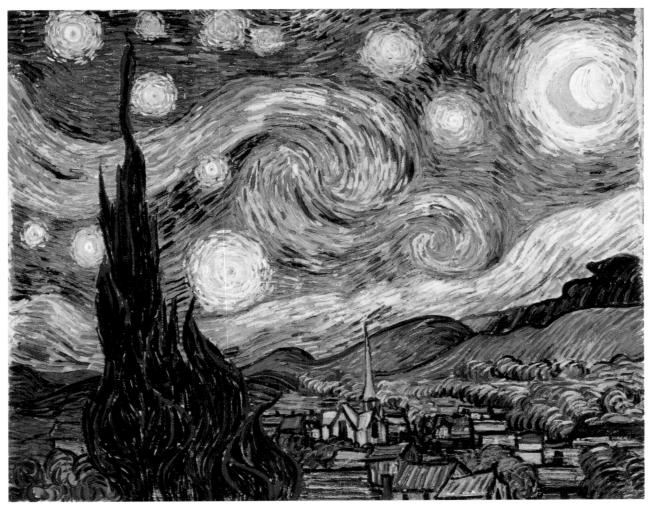

28-17. Vincent van Gogh. *The Starry Night*. 1889. Oil on canvas, 28³/₄ x 36¹/₂" (73 x 92 cm). The Museum of Modern Art, New York Acquired through the Lillie P. Bliss Bequest

case focuses on the then-popular theory that after death people journeyed to a star, where they continued their lives. Contemplating immortality in a letter, van Gogh wrote: "Just as we take the train to get to Tarascon or Rouen, we take death to reach a star." The idea is given visible form in this painting by the cypress tree, a traditional symbol of both death and eternal life, which dramatically rises to link the terrestrial with the stars. The brightest star is actually Venus, which is associated with love. Is it possible that the picture's extraordinary excitement also expresses van Gogh's euphoric hope of gaining the companionship that had eluded him on Earth?

Whether modern artists have faced greater emotional difficulties than those from earlier ages is a matter of conjecture. What cannot be denied is that a great many artists of this period assumed that the chief function of art was to express their intense feelings to the world. The Belgian painter and printmaker James Ensor (1860–1949) was such an artist. Except for his four years at the Brussels Academy, Ensor spent his entire life in the coastal resort town of Ostend. Although his sense of isolation was sharpened by the hostile reception to both his early naturalistic and his later expressionistic art, it was

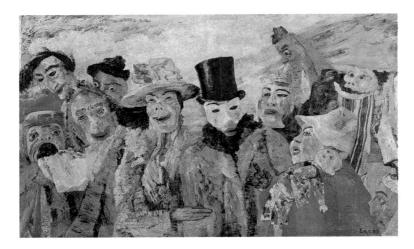

28-18. James Ensor. *The Intrigue.* 1890. Oil on canvas, 35½ x 59" (90.3 x 150 cm). Koninklijk Museum voor Schone Kunsten, Antwerp

apparently formed by his experiences with the ordinary tourists and townspeople of Ostend, as works such as *The Intrigue* (fig. 28-18) clearly attest. The painting shows a crowd of masked revelers celebrating Mardi Gras, one of the main holiday events in Ostend. Their grotesque

28-19. Edvard Munch. *The Scream.*1893. Tempera and casein on cardboard, 36 x 29"
(91.3 x 73.7 cm). Nasjonalgalleriet, Oslo

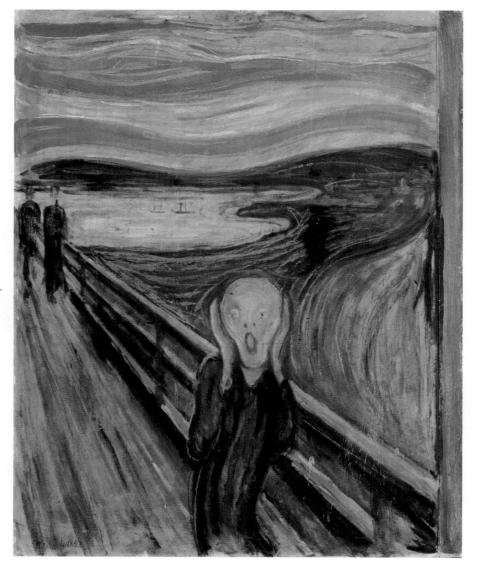

masks, rather than hiding the wearers' true identities, are here used to reveal them. Mouths hang open stupidly or smile without warmth. Eyes stare absently into space or focus menacingly on the viewer. The luminous colors oddly increase the sense of caricature, as does the crude handling of form. The rough paint is both expressive and expressionistic: its lack of subtlety well characterizes the subjects, while its almost violent application directly records Ensor's feelings toward them.

The Norwegian painter and printmaker Edvard Munch (1863–1944) dealt with problems of a different kind. When he was five, he witnessed his mother's death from tuberculosis. In 1875 he nearly died of the same disease. Three years later, his favorite sister hemorrhaged to death just as his mother had. As an artist, he was rejected for his frank treatments of death and sex not only by viewers with no particular interest in art but by progressive artists and critics as well. The members of the Berlin Secession, who invited him to show his work in 1892, were so shocked by it they closed the exhibition.

Munch's personal and professional anxiety in the aftermath of this rejection found expression in his most famous work, *The Scream* (fig. 28-19). Munch recorded

the painting's genesis in his diary: "One evening I was walking along a path; the city was on one side, and the fjord below. I was tired and ill. . . . I sensed a shriek passing through nature. . . . I painted this picture, painted the clouds as actual blood." In the painting itself, however, the figure is on a bridge and the scream emanates from him. Although he vainly attempts to shut out its sound by covering his ears, the scream fills the landscape with clouds of "actual blood." The overwhelming anxiety that sought release in this primal scream was chiefly a dread of death, as the sky and the skull-like head of the figure suggest, but the setting of the picture should also remind us that Munch suffered from a fear of open spaces.

Another painter of intense feelings was the Austrian Egon Schiele (1890–1918). Schiele's father died insane when Egon was fourteen. After a brief period of experimentation with the decorative style of Vienna's most famous artist, Gustave Klimt (see fig. 28-12), Schiele began to specialize in erotic paintings and drawings of women. In 1912 he was jailed briefly for allowing neighborhood children to see some of this work. Even before this traumatic event, Schiele revealed in an extraordinary series of self-portraits a deep ambivalence toward the

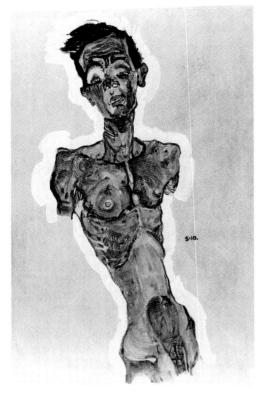

28-20. Egon Schiele. Self-Portrait Nude. 1910. Gouache, watercolor, and black crayon with white, 175/8 x 133/8" (44.7 x 34 cm). Private collection Courtesy Galerie St. Étienne, New York

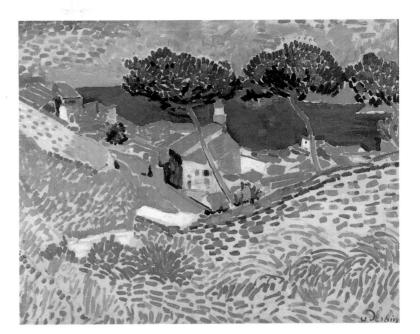

28-21. André Derain. View of Collioure. 1905. Oil on canvas, 26 x 323/8" (66 x 82.3 cm). Museum Folkwang, Essen, Germany

sexual themes of many of his works. One of these, Self-Portrait Nude (fig. 28-20), presents an image of both physical and psychological suffering. The body is emaciated, the sad record of long victimization; the skin is raw, as if flayed.

EXPRESSIONISTIC In the years just before **MOVEMENTS**

and after 1910 the expressionistic approach

pioneered by Ensor, Munch, and van Gogh, in particular, was developed in the work of three artists' groups. The first of these groups to emerge was the Fauves.

The Fauves

In the fall of 1905 a French critic, Louis Vauxcelles, referred to a loosely affiliated group of young painters as fauves ("wild beasts"), a term that caught the spirit of the work of the leading members of their circle, André Derain (1880-1954), Maurice de Vlaminck (1876-1958), and Henri Matisse (1869-1954). For some years, these artists had been trying to advance the colorist tradition in modern French painting, which they dated from the work of Eugène Delacroix (see figs. 26-46, 26-47) and which included that of the Impressionists, Neo-Impressionists, and Gauguin. Before leaving for a summer painting trip to Collioure, a seaside resort and port on the Mediterranean near the Spanish border, Derain and Matisse (along with Vlaminck) had seen a van Gogh retrospective exhibition. In works from that summer, like Derain's View of Collioure (fig. 28-21), the two artists combined the dynamic brushwork of van Gogh with the pure colors they had been experimenting with since about 1900. These bold primary colors (red, yellow, and blue), often applied directly from the tube, produced an explosive effect—"like sticks of dynamite," Derain said. Here, for the first time, the intensity of color is heightened by the exciting rhythms of the brush. As in almost all Fauve painting, Derain in View of Collioure shows little concern for the appearance of his subject. He is interested simply in recording the complete complex of sensations it produces in him.

Derain and Matisse sought to communicate a raw intensity of experience, what one of their favorite writers, the German philosopher and poet Friedrich Nietzsche, called "a new taste, a new appetite, a new gift of seeing colors, of hearing sounds, of experiencing emotions." This ideal was a response not only to the perception that modern times were dull and drab but to the pessimistic view that the French were an aging people with a declining capacity for life. The Fauves were part of an important strain in early-twentieth-century France that sought to reverse that downward direction and regenerate the nation.

For Gauguin, the ideal had been the "primitive" and the child (see fig. 28-15). For the Fauves, it was simply the child. We see this not in their subjects but in their styles, especially that of Vlaminck. Unlike Derain and Matisse,

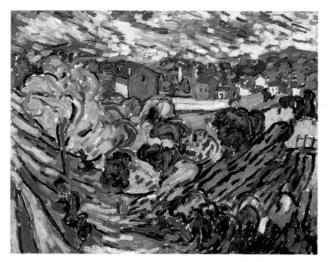

28-22. Maurice de Vlaminck. *Landscape near Chatou*. 1906. Oil on canvas, 23⁷/8 x 29"(60.6 x 73.7 cm). Stedelijk Museum, Amsterdam

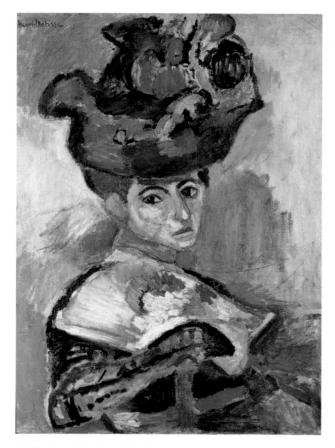

28-23. Henri Matisse. *The Woman with the Hat.* 1905. Oil on canvas, 31³/₄ x 23¹/₂" (80.6 x 59.7 cm). San Francisco Museum of Modern Art Bequest of Elise S. Haas

Vlaminck was self-taught and proud of it. In works like Landscape near Chatou (fig. 28-22), he shows even less concern than van Gogh, his major inspiration, with looking sophisticated. The strong colors have been crudely applied with a stiff, broad brush. "I try to paint with my heart and my loins, not bothering about style," he once said. Vlaminck practiced this approach because he envied and wished to regain the child's fresh vision of the world.

A similar insistence on directness was one factor in

the paintings produced in 1905 by the leading Fauve, Henri Matisse. Matisse's early work was largely inspired by Impressionism and Neo-Impressionism. The works he showed in the fall of 1905 culminated this early experimental phase. Among them was The Woman with the Hat (fig. 28-23), an image of his wife, Amélie, who until recently had supported the family with the proceeds from her millinery shop. She looks at the artist with wide, sad eyes, and her mouth is slightly turned down. This highly revealing presentation is surprising in a painting Matisse considered an exercise in immediate sensation. Although Matisse never quite succumbed to Vlaminck's example, the rapid, unrefined paint handling suggests their affinity. These were precisely the qualities that incensed the critics, who considered this work simply a bad preliminary sketch. Matisse himself soon came around to something like this view. In 1908 he published an essay, "Notes of a Painter," in which he rejected his Fauve approach for a more thoughtful and soothing one:

Often when I sit down to work I begin by noting my immediate and superficial color sensations. Some years ago this first result was often enough for me. . . . [But now] I prefer to continue working on it so that later I may recognize it as a work of my mind. There was a time when I never left my paintings hanging on the wall because they reminded me of moments of nervous excitement. . . . Nowadays, I try to put serenity into my pictures and work at them until I feel that I have succeeded.

One of the first of Matisse's post-Fauve works is The Joy of Life (fig. 28-24), which he painted in his studio during the winter of 1905-1906. Despite the spontaneous sketch he began with, the finished painting is not a quick response to something seen. Like Cézanne's The Battle of Love (see fig. 28-2), it treats the hedonistic pursuits of the followers of Bacchus. But unlike Cézanne's scene, Matisse's is completely untroubled. These uninhibited, naked revelers dance, make love, commune with nature, or simply stretch out in their idyllic glade by the Mediterranean. The banquet of luscious colors comes from the developments of the previous summer at Collioure, but all traces of nervous intensity have been removed. The brushwork is now soft and careful, subservient to the pure sensuality of the color. The only movement is in the long, flowing curves of the trees and the bodily contours. These undulating rhythms, in combination with the relaxed poses of the two reclining women at the center, establish the "serenity" that Matisse wanted to characterize his work from this point.

In "Notes of a Painter" Matisse explains the purpose of his new emphasis: "What I dream of is an art . . . devoid of troubling or depressing subject matter . . . which might be for every mental worker, be he businessman or writer, like . . . a mental comforter, something like a good armchair in which to rest." Here Matisse signals his allegiance to the side of modernist art that sought relief from the stress of modern life. According to one biographer, Matisse himself was sometimes "madly anxious" and well understood the temporary peace art could provide.

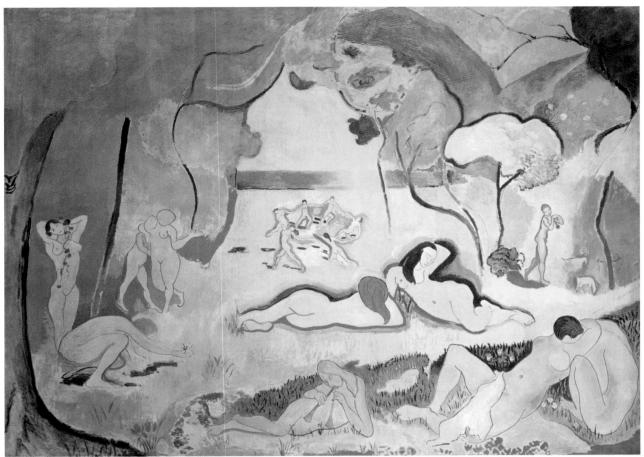

28-24. Henri Matisse. *The Joy of Life.* 1905–6. Oil on canvas. $5'8^{1/2}$ " x $7'9^{3/4}$ " (1.74 x 2.38 m). The Barnes Foundation, Merion, Pennsylvania

During an illness in his youth, Matisse was given a box of paints by his mother, a moment that he recalled as fundamental to his later concerns as a painter: "When I started to paint, I felt transported into a kind of paradise. . . . In everyday life, I was usually bored and vexed by the things that people were always telling me I must do. Starting to paint, I felt gloriously free, quiet and alone." The reference to paradise, in particular, suggests that his mature paintings, such as *The Joy of Life*, are not concerned simply with the escapist Western myth of Arcadia but with painting itself as an ideal realm.

Die Brücke

The German counterpart to Fauvism was Die Brücke ("The Bridge"), which formed in the same year the Fauves were named. In 1905 three architecture students at the Dresden Technical College—Karl Schmidt-Rottluff (1884–1976), Erich Heckel (1883–1970), and Ernst Ludwig Kirchner (1880–1938)—decided to take up painting and form a brotherhood. For the next eight years they lived and worked together. Their collective name was taken from a passage in Nietzsche's *Thus Spake Zarathustra* (1883) in which the prophet Zarathustra speaks of contemporary humanity's potential to be the evolutionary "bridge" to a more perfect specimen of the future, the *Ubermensch* ("beyond man," but usually translated as "superman").

In their art, however, the group demonstrated little interest in advancing the evolutionary process. Their paintings, sculpture, and graphics suggest, instead, a Gauguinesque yearning to return to imaginary origins. Among their favorite motifs were women living harmoniously in nature. Typical is Schmidt-Rottluff's *Three Nudes—Dune Picture from Nidden* (fig. 28-25), which shows three simplified female nudes formally integrated with their landscape. The style is purposefully simple and

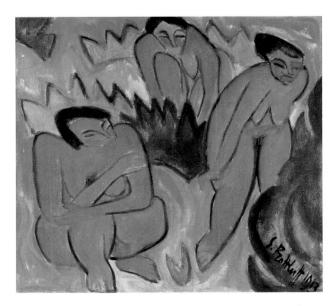

28-25. Karl Schmidt-Rottluff. *Three Nudes—Dune Picture from Nidden*. 1913. Oil on canvas, 38⁵/8 x 41³/4" (98 x 106 cm). Staatliche Museen zu Berlin, Preussischer Kulturbesitz, Nationalgalerie

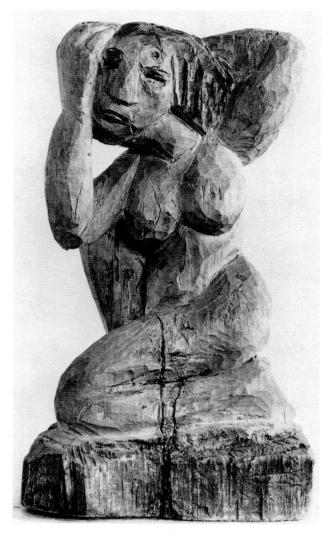

28-26. Erich Heckel. *Crouching Woman.* 1912. Painted linden wood, 11⁷/₈ x 6³/₄ x 3⁷/₈" (30 x 17 x 10 cm). Estate of Erich Heckel, Hemmenhofen am Bodensee, Germany

direct, in keeping with the painting's evocation of the prehistoric. Instead of the graceful contours of Matisse's erotic nudes in *The Joy of Life*, Schmidt-Rottluff gives his larger, lumbering subjects thick, inelegant outlines. Although both artists nostalgically look back, one looks to the golden age of Greece whereas the other seems more interested in Europe's Neolithic past.

The two artists also share a vocabulary of simple, flattened shapes of pure color mostly inspired by the same stylistic sources. Around 1905, when Derain and Vlaminck were discovering African art in Paris's shops and in its natural history museum, their German counterparts were studying African and Oceanic sculpture in their ethnographic museums. This interest led Die Brücke artists to make their own "primitive" sculpture. Heckel's *Crouching Woman* (fig. 28-26) is crudely carved in wood not only to emulate its non-European sources but to revive what the group considered the more honest methods of German Gothic artists. In turning to wood they were rejecting the classical tradition of both marble and

bronze. What they sought was not sophisticated beauty but unsophisticated strength, as the actions and features of the woman suggest. In this work the medium itself suggests the desire to return to nature that is depicted in Schmidt-Rottluff's *Three Nudes*.

During the summers Die Brücke artists actually did return to nature. They visited the remotest areas of northern Germany, such as Nidden. But in 1911 they moved to Berlin, preferring to imagine the simple life rather than live it. Ironically, the images they made of cities, especially Berlin, offer powerful arguments against living there. Kirchner's *Street, Berlin* (fig. 28-27), for example, forcefully demonstrates the isolation that can occur in cities. Although physically close, the well-dressed men and women are psychologically distant. And instead of becoming a larger formal unit, they are presented as a series of independent vertical elements, an accumulation of isolated individuals, not a tight-knit community. The angular, brittle shapes and the sharp contrast of predominantly cool colors formally underscore the message.

What made it possible for modernists like Kirchner to endure such conditions was their collective belief that they lived not in Berlin or Paris or New York but in bohemia, a cultural space uncontaminated by the ordinary conditions of those cities. The term bohemian was originally used during the 1830s in Paris to describe certain Gypsies (the Romany people, wrongly thought to have originated in Bohemia, a region of central Europe) who lived within a modern urban environment while maintaining a separate cultural identity. The term was then applied to young artists and writers who wanted the advantages of a cultural center without its crass, materialist, "bourgeois" (or middle-class) trappings. They were opposed to the new mass-produced things, like the ready-to-wear suits in Atget's Magasin, Avenue des Gobelins (see fig. 28-6), which they considered both shoddy and ugly, as well as to what they believed to be the bourgeoisie's appalling lack of interest in the life of the spirit and the mind.

By 1900 these new bohemians in various European centers were committed as well to resisting both the social fragmentation of the modern city and what they considered the puritanism of bourgeois life. Like Gauguin, many bohemians were attracted to the ideal of so-called primitive culture, imagining in it not only a less alienated society but also a more natural sexuality, free of inhibitions and learned restraints. But unlike Gauguin, who decided to return to what he thought of as a precivilized existence, the artists of Die Brücke attempted to "primitivize" bohemia. Uninhibited sexuality was often featured in one major subject of their art: the life of their studios.

In Kirchner's *Girl under a Japanese Umbrella* (fig. 28-28), for example, the viewer is put in the position of the artist as he gazes at his half-naked model. What are we to make of the bold brushstrokes, crude contours, and intense colors used to paint her? Do the partially parted lips, flared nostrils, and twisting torso suggest an independent creature whose passion challenges the artist rather than a passive sex object? The painting behind her of women in a landscape expresses her vital,

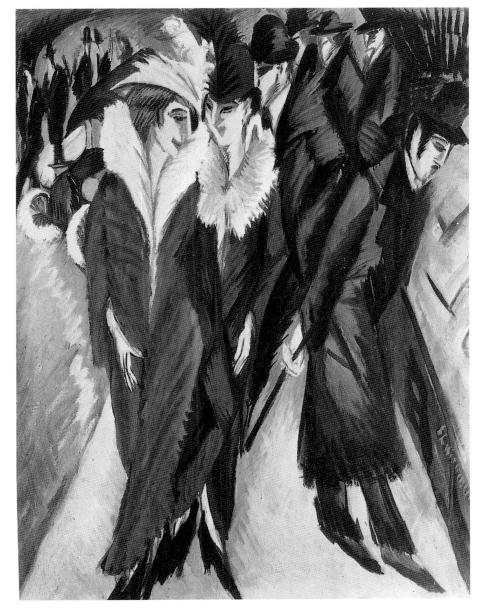

28-27. Ernst Ludwig Kirchner. Street, Berlin. 1913. Oil on canvas, 471/2 x 377/8" (120.6 x 91 cm). The Museum of Modern Art, New York Purchase

"natural" attitude. The umbrella she holds is also suggestive of the Japanese **ukiyo-e** prints then in vogue in Europe, which often featured geishas (see fig. 22-15).

Such images conceive of women in terms of male desire, and Die Brücke artists restricted women to this role. Although they often depicted themselves and their male friends reading, writing, painting, and playing chess, they almost never showed women engaged in such pursuits. The brotherhood may have been antibourgeois in most respects, but its attitudes toward women were utterly conventional.

The women who participated in the modernist enterprise, although tolerated, were rarely treated as equals.

28-28. Ernst Ludwig Kirchner. *Girl under a Japanese Umbrella*. c. 1909. Oil on canvas, 36½4 x 31½" (92 x 80 cm). Kunstsammlung Nordrhein-Westfalen, Düsseldorf Collection Dr. Frederic Bauer Davo

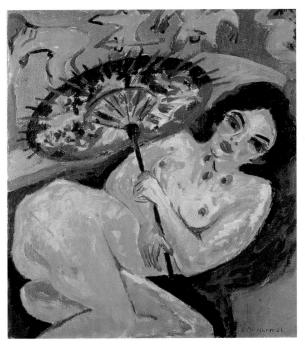

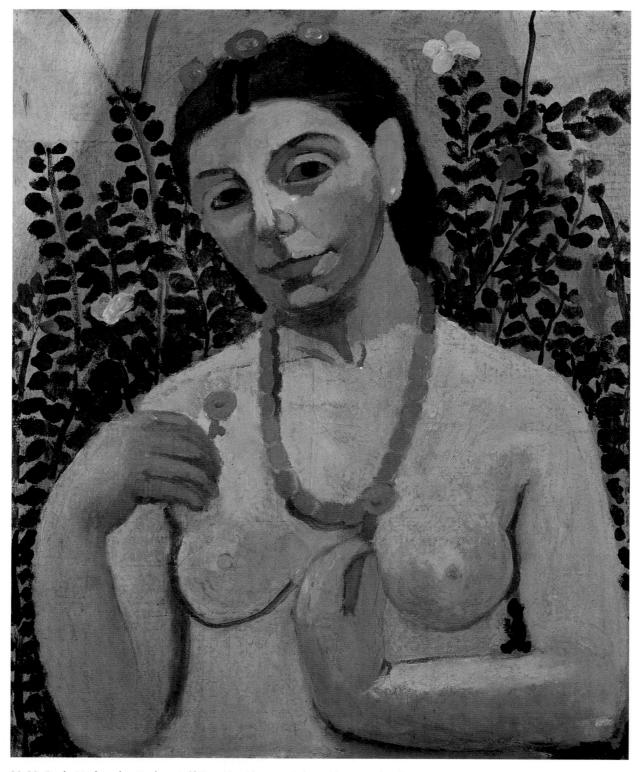

28-29. Paula Modersohn-Becker. *Self-Portrait with an Amber Necklace*. 1906. Oil on canvas, 24 x 19³/₄" (61 x 50 cm). Öffentliche Kunstsammlung, Kunstmuseum, Basel, Switzerland

One such woman was Paula Modersohn-Becker (1876–1907). In 1896 she enrolled in the Berlin School of Art for Women, where she was allowed to study the female nude and, on occasion, the partially dressed male models. In 1897 Modersohn-Becker moved to Worpswede in northern Germany, one of the many charming and rustic European villages that became famous artists' retreats, where

she married a leading painter working in the Barbizon-related style (Chapter 27) identified with the town.

She quickly became dissatisfied with the naturalistic approach to rural life, which she said was not broad enough. Between 1900 and her death in 1907 she made four trips to Paris in order to assimilate the leading developments in Post-Impressionist painting. In particular,

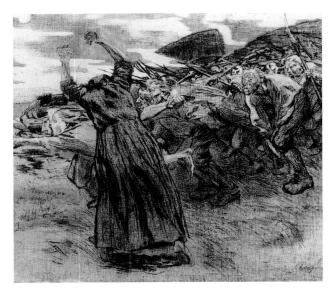

28-30. Käthe Schmidt Kollwitz.

The Outbreak, from
the Peasants' War.
1903. Etching. Staatliche
Museen zu Berlin, Preussischer Kulturbesitz,
Kupferstichkabinett

she found amenable the formal simplicity developed by Gauguin and his circle. Inspired by such examples, she evolved at the end of her life a very personal approach to painting the women of Worpswede, including herself.

Modersohn-Becker's *Self-Portrait with an Amber Necklace* (fig. 28-29), for example, features greatly simplified shapes and crude outlines similar to those used in Schmidt-Rottluff's *Three Nudes—Dune Picture from Nidden* (see fig. 28-25). Avoiding the intense color in that work, however, Modersohn-Becker employed a muted palette of browns and blues. These colors combine with the soft layering of her paint to produce a formal effect similar to the gentle expression on her face. Emphasis is given to the figure's relationship with nature. The artist presents herself against a screen of flowering plants wearing only a necklace. In her large, somewhat awkward hands she tenderly holds the kind of little flower that also decorates her hair.

Another German who was an important artist of this period is Käthe Schmidt Kollwitz (1867–1945). Raised in a socialist household, she also studied at the Berlin School of Art for Women and at a similar school in Munich. In 1891 she married a doctor who shared her leftist political views, and they settled in a working-class neighborhood of Berlin. Art for her was a political tool, and to reach as many people as possible, she preferred printmaking to other forms. Although she made a number of effective self-portraits, the main subject of her art is the poor, oppressed worker.

Using a stark graphic style, Kollwitz attempted not only to win sympathy for working-class people but to inspire them and her viewers to action on their behalf. Between 1902 and 1908 she produced the Peasants' War series, seven etchings that depict events in a rebellion of German peasants in the sixteenth century. The most important of the seven, and the first completed, was *The Outbreak* (fig. 28-30). Here Kollwitz shows the peasants' built-up fury from years of mistreatment exploding in mass action against their oppressors. No longer single individuals, the tired and worn figures join in a powerful

wedge. To the artist's contemporaries, the work is thus a lesson in the power of group action. In the front, with her back to us, is Black Anna, the leader of the revolt, who raises her hands to signal the attack. Kollwitz said that she modeled the figure of Anna after herself.

Der Blaue Reiter

The last of the important pre-World War I expressionist groups to come out of the crucible of late-nineteenthcentury painting was formed in Munich around the Russian painter Vasily Kandinsky (1866–1944), who was born and raised in Moscow. In 1895 Kandinsky saw a Monet painting whose color so moved him that he decided to give up his law professorship in Moscow and devote himself fully to art. The following year he moved to Munich to study art because of the research being done there on the effects of color and form on the human psyche. During the first decade of the new century he traveled often to Paris and other European centers to familiarize himself with the latest artistic developments. The wealth of expressionist work he encountered convinced him that a new artistic era had begun. The development of his own style in this period depended not only on the contemporary art he saw but on the folk art and children's art he collected. In 1911 he organized Der Blaue Reiter ("The Blue Rider"), a group of nine artists who shared his interest in the power of color. Der Blaue Reiter was more diverse than the Fauves or Die Brücke, and its name says more about Kandinsky's aims than those of his colleagues.

"Der Reiter" was the popular name for the image of Saint George, mounted and slaying a dragon, that appeared on the Moscow city emblem. According to a long tradition revived around 1900, Moscow would be the new capital of the world during the millennium, the thousand years of Christ's reign on earth that would follow the Apocalypse, as prophesied by Saint John the Divine. Millennial and apocalyptic imagery appears often in Kandinsky's art in the years just prior to World War I. In

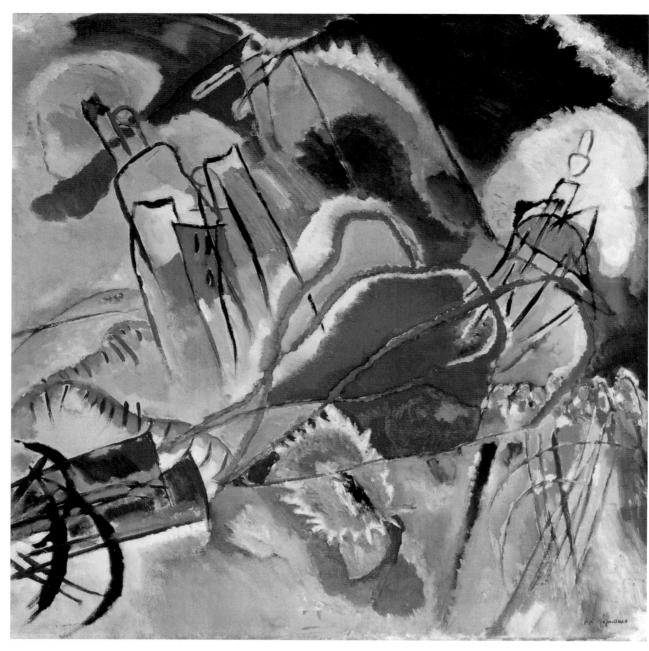

28-31. Vasily Kandinsky. *Improvisation No. 30 (Warlike Theme).* 1913. Oil on canvas, 43¹/₄ x 43¹/₄" (109.9 x 109.9 cm). The Art Institute of Chicago

Arthur Jerome Eddy Memorial Collection

The traditional Russian idea that Moscow would be the "third Rome" was central to Kandinsky's art prior to World War I. The first center of Christianity had been Rome itself. The second Rome, according to Russian Orthodox tradition, had been Constantinople, the capital of the Christian world until 1453, when the Muslim Turks conquered it. The third and final Rome would be Moscow, according to the vision of a sixteenth-century monk, whose descriptive letter to the grand prince of Moscow led the prince's successor, Ivan the Terrible, to assume the title *czar*, Russian for "Caesar."

Improvisation No. 30 (Warlike Theme) (fig. 28-31), the firing cannons in the lower right combine with the intense reds, blackened sky, and precariously leaning mountains to suggest a scene from the end of the world. Such paintings, sometimes thought to reflect fear of the coming war, are, instead, ecstatic visions of the destructive prelude to the Second Coming of Christ. The schematic churches on top of the mountains are based on the churches of the Kremlin, Moscow's central district, and thus symbolize the coming Russian millennium.

Kandinsky never expected his viewers to understand

his symbolism, nor did he think they needed to understand it. He intended, instead, to influence them directly through the sheer force of color. As he explained it: "[C]olor directly influences the soul. Color is the keyboard, the eyes are the hammers, the soul is the piano with many strings. The artist is the hand that plays, touching one key or another purposively, to cause vibrations in the soul" (cited in Chipp, pages 154–155). In essence, Kandinsky believed that his "largely unconscious" color improvisations would awaken the spiritual capacity and "urge" of one spectator after another and thus inaugurate "a great

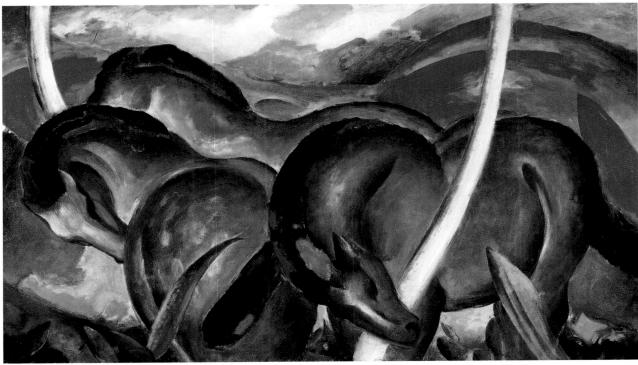

28-32. Franz Marc. *The Large Blue Horses*. 1911. Oil on canvas, 3'5³/8" x 5'11¹/4" (1.05 x 1.81 m). Walker Art Center, Minneapolis Gift of T. B. Walker Collection, Gilbert M. Walter Fund, 1942

spiritual epoch." Kandinsky, then, was "der Reiter" who would prepare the way for the Second Coming.

Der Blaue Reiter was blue because Kandinsky and the group's cofounder, Franz Marc (1880-1916), considered blue the color of the male principle of spirituality. Marc, a man of gloomy disposition, was born and trained in Munich. Over the course of his career he moved from naturalism to expressionism, a process that culminated in 1910 when he met Kandinsky and became a member of his circle. Some years earlier Marc had turned to animals as subjects for his work. In The Large Blue Horses (fig. 28-32), he shows three horses, each defined by the same colors and shapes, in a tight, homogeneous unit. The fluid neck contours of the two horses in front, echoed in the shape of the third animal, reflect the harmony of their collective existence. With their billowing curves and graceful arabesques, the horses are also shown in perfect harmony with their surroundings. The simple but strong colors reflect the uncomplicated intensity of their experience as Marc enviously imagined it.

The third major artist associated with Der Blaue Reiter was Paul Klee (1879–1940), who was born near Bern, Switzerland, to a musical family. He married a pianist and until his final illness played the violin for an hour every morning. Although he was included in the second Blaue Reiter exhibition, in 1912, his involvement with the group was never more than tangential. It was not Blaue Reiter but a 1914 trip to Tunisia that inspired his interest in the expressive potential of color. "Color and I are one," he wrote in his diary while there.

On his return Klee painted a series of watercolors based on his memories of North Africa, among them *Hammamet with Its Mosque* (fig. 28-33). The play between

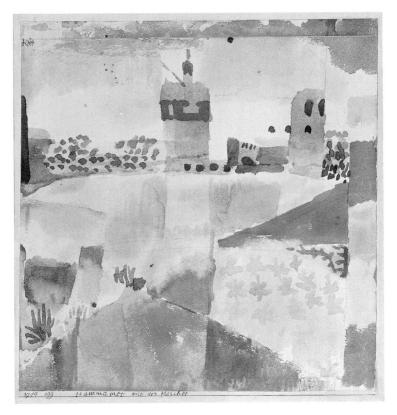

28-33. Paul Klee. *Hammamet with Its Mosque*. 1914. Water-color and pencil on two sheets of laid paper mounted on cardboard, 8½ x 7½8" (20.6 x 19.7 cm). The Metropolitan Museum of Art, New York

The Berggruen Klee Collection, 1984

geometrical composition and irregular brushstrokes in this watercolor is reminiscent of Cézanne's work, which Klee had recently seen. The luminous colors and delicate washes, or applications of dilute watercolor, result in a gently shimmering effect that is more than a record of something seen under a hot sun. The subtle modulations of red across the bottom, especially, are positively melodic. Klee seems to have wanted to use color the way a musician would use sound, not to describe appearances but to evoke subtle nuances of feeling. That this had for Klee a spiritual dimension is suggested by the mosque presiding over the picture. Klee's spirituality of pure color links his work with Kandinsky's and Marc's. What differentiates it is the absence of any trace of a preconceived intellectual program. Though Klee, too, was a prolific theorist, his art was not meant to illustrate his ideas but rather to explore complicated and difficult-to-verbalize imaginative experiences. That it usually eludes translation into clear and certain concepts is, for many, the essence of its appeal.

CUBISM Hammamet with Its Mosque reflects the influence of the most radical, innovative, and influential ism of twentieth-century art, Cubism. The complete flattening of space and the use of independent facets or blocks of color in Klee's painting derive from the Cubist paintings he had recently seen in Paris. Cubism was the joint invention of two men, Pablo Picasso (1881–1973) and Georges Braque (1882–1963). Their achievement was built upon the foundation of Picasso's early work.

Picasso's Early Art

Picasso was born in Málaga, Spain, where his father taught in the School of Fine Arts. His talent was evident at an early age, and at fifteen he entered the Barcelona Academy. A year later, he was admitted as an advanced student to the Academy in Madrid. Picasso's involvement in the avant-garde began at the end of the 1890s, when he moved back to Barcelona and joined a group of young writers and artists interested in both progressive art and politics. Beginning in 1900 he made frequent extended visits to Paris and moved there early in 1904.

During this time Picasso was drawn to the socially conscious tradition in nineteenth-century French painting that included Honoré Daumier (see fig. 27-22) and Toulouse-Lautrec (see fig. 28-5). In what is known as his Blue Period, he painted the outcasts of Paris in weary poses and a coldly expressive blue. Two factors seem to have been at work in these paintings. The first was Picasso's political sensitivity to those he considered the victims of modern society, which would eventually lead him to join the Communist Party. The second was his own unhappiness, which appears clearly in his 1901 Self-Portrait (fig. 28-34). The painter's sallow complexion and hollow cheeks reveal his familiarity with cold, hunger, and disappointment. Whether his mood at this time colored his perception of the world or merely sharpened his political sensitivity to the suffering of others is a much debated point.

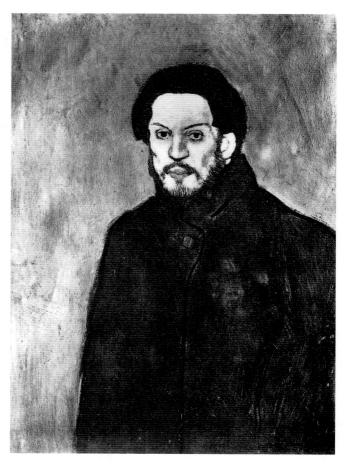

28-34. Pablo Picasso. Self-Portrait. 1901. Oil on canvas, $317/8 \times 23^{5/8}$ " (81 x 60 cm). Musée Picasso, Paris

In 1904 Picasso's personal circumstances greatly improved. By the end of the year he had a large circle of supportive friends, and his work had attracted the attention of several important collectors. His works from the end of 1904 and the beginning of 1905, known collectively as the Rose Period because of the introduction of that color into his still predominantly blue palette, show the last vestiges of his earlier despair.

Between early 1905 and the winter of 1906-1907, Picasso's art went through an extraordinary and complex transformation. Wanting to produce art of greater formal and psychological strength, he began to study classical sculpture at the Louvre. Picasso's interest in classical art coincided with a new flowering of the Roman School that followed a Puvis retrospective late in 1904, the exhibition of Maillol's The Mediterranean (see fig. 28-9) in 1905, and an Ingres retrospective the same year. Despite his initial attraction to this kind of art, Picasso soon rejected it because of its association with French nationalism. Ever since Louis XIV had resisted the influence of the Italian Baroque in the seventeenth century (Chapter 19), French critics and historians considered a taste for classical balance to be deeply rooted in the national character. The works of Puvis, Ingres, and Maillol, in line with this tradition, were seen as quintessentially French. In response, the young Picasso began to cultivate his own ethnic identity.

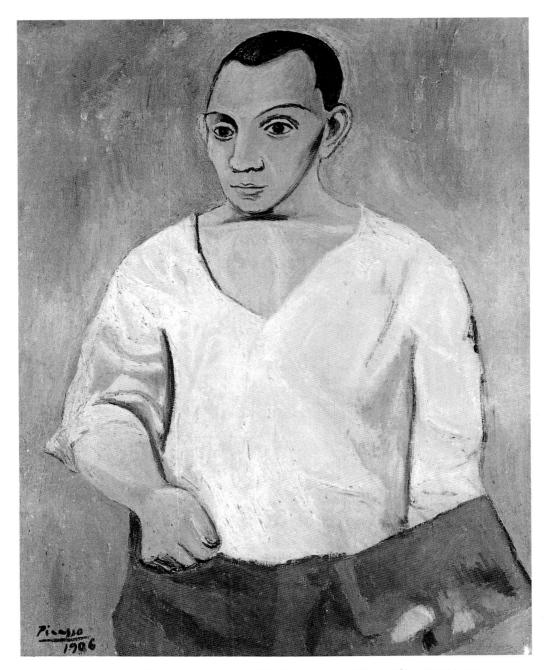

28-35. Pablo Picasso. Self-Portrait with Palette. 1906. Oil on canvas, $36^{1/4}$ x $28^{3/4}$ " (92 x 73 cm). Philadelphia Museum of Art A. E. Gallatin Collection

In 1906 the Louvre installed a newly acquired collection of sculpture from the Iberian region (the region of modern Spain and Portugal) that dated to the sixth and fifth centuries BCE. Inspired by these archaic figures, which had been excavated in the province of his birth, Picasso spent the summer of 1906 rediscovering his roots in a small village in the Spanish Pyrenees. The ancient Iberian figures, which he identified with the stoic dignity of the Pyrenean villagers, became the chief influence on his work for the next several years. Another important influence came from Gauguin's "primitive" sculpture, which Picasso also studied at this time. The Gauguin connection allowed Picasso to develop his Spanish identity while simultaneously contributing to a major current in modernist art.

The Iberian influence appears clearly in *Self-Portrait* with *Palette*, painted in 1906 (fig. 28-35). The frail, sensitive young man of the earlier self-portrait has become strong and self-contained. The simple sculptural modeling of the head lends firmness and certainty to his calm expression. Accentuated by heavy outlines, the powerful upper body and strong right arm, which ends in a fist, add a sense of newfound psychological strength. Picasso pointedly shows himself without a brush in his fist, making a statement as much about himself as a man as about himself as an artist.

Picasso's Iberian period culminated in 1907 in *Les Demoiselles d'Avignon* (fig. 28-36). The painting is Picasso's response to Matisse's *Joy of Life* (see fig. 28-24),

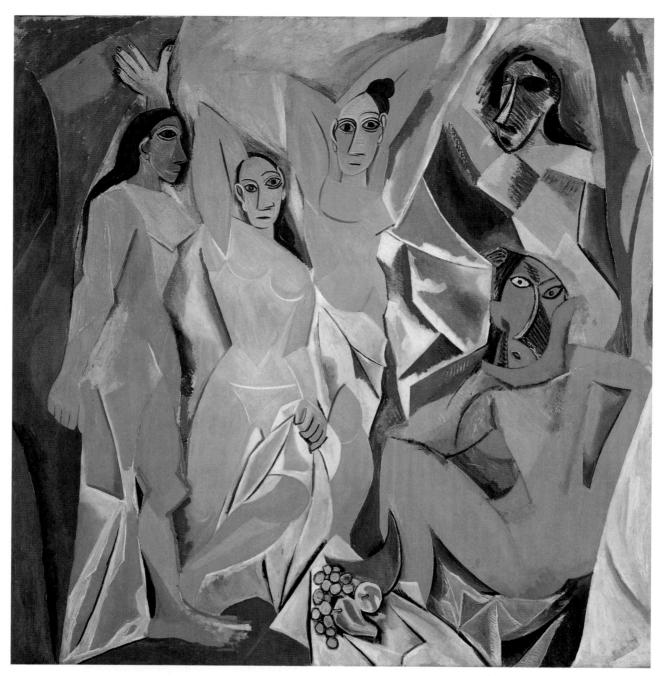

28-36. Pablo Picasso. *Les Demoiselles d'Avignon*. 1907. Oil on canvas, 8' x 7'8" (2.43 x 2.33 m). The Museum of Modern Art, New York
Acquired through the Lillie P. Bliss Bequest

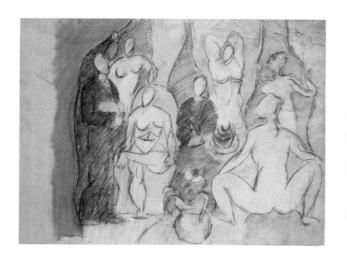

exhibited the year before, and to the French classical tradition that stood behind it, which to Picasso was embodied in Ingres's harem paintings exhibited in a 1905 retrospective. Picasso began by substituting the bordello for the harem. The term *demoiselles* is a euphemism for prostitutes, and Avignon refers not to the French town but to the red-light district of Barcelona. In a preliminary study for the painting (fig. 28-37), Picasso had included two men with the five women. The man on the left holding a book seems to be a student. Other studies suggest

28-37. Pablo Picasso. Study for *Les Demoiselles d'Avignon*. 1907. Pastel on paper, 18¹/₄ x 30" (47.6 x 63.7 cm). Kunstmuseum, Kupferstichkabinett, Basel, Switzerland

that the seated man is a sailor. Picasso may have meant to contrast the contemplative life of the student with the active life of the sailor. His decision to eliminate the men was probably based on a number of considerations. For one, the allegory they suggest detracts from the central issue of sexuality. For another, their confrontation with the women on display makes the viewer a mere onlooker. In the final painting the viewer is a participant: the women now pose for and look directly at us.

Picasso made a number of other changes. The women in the sketch are conventionally rendered in soft curves, but the only "feminine" curve in the finished painting is the line of the inner arm and breast of the central figure. Elsewhere, there are either sharp curves or angles. Picasso's central pair raise their arms in a conventional gesture of open accessibility, contradicted by their hard, piercing gazes and firm mouths. In working out his theme Picasso completely transformed the conventional masculine fantasy of easy access to willing women into a hostile confrontation. Even the fruit displayed in the foreground, a traditional symbol of female sexuality, seems hard and dangerous. Picasso flattened the figures and transformed the entire space into a turbulent series of sharp curves and angles, conveying what one art historian has called "a tidal wave of aggression."

Les Demoiselles d'Avignon was also conceived in opposition to Ingres's Large Odalisque (see fig. 26-43) and, in fact, to the entire Western tradition of erotic imagery since the Renaissance. Women, Picasso asserts, are not the gentle and passive creatures men would like them to be. In remarks to a friend about the African masks he used for the faces of the two demoiselles on the right, Picasso spoke of the work's purpose:

Men had made those masks . . . as a kind of mediation between themselves and the unknown hostile forces that surrounded them, in order to overcome their fear and horror by giving [them] a form and image. And that moment I realized that . . . painting isn't an aesthetic operation; it's a form of magic designed as a mediator between this . . . hostile world and us, a way of seizing the power by giving form to our terrors as well as our desires. (cited in Gilot and Lake, page 266)

When Picasso showed the finished work to his friends, they were horrified. Matisse, for example, accused Picasso of making a joke of modern art and threatened to break off their friendship. Only one artist, Georges Braque, eventually responded positively, and he saw in Les Demoiselles d'Avignon a potential that Picasso probably had not fully intended. Picasso had set out to produce a stunningly innovative painting that would put him in control of the Parisian avant-garde, but he used broken and flattened forms to express his view of women, not consciously to break with the Western pictorial tradition that had been in place since the early-fourteenth-century painter Giotto. It was this formal revolution that Braque responded to in the work, however, and quickly set out, with Picasso's help, to develop.

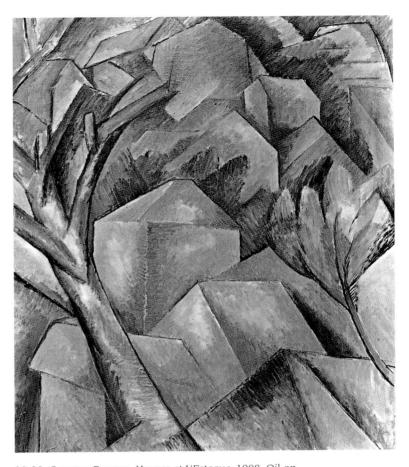

28-38. Georges Braque. *Houses at L'Estaque*. 1908. Oil on canvas, 36¹/₄ x 23⁵/₈" (92 x 60 cm). Kunstmuseum, Bern, Switzerland
Collection Hermann and Magrit Rupf-Stiftung

28-39. D. H. Kahnweiler. Photograph of houses at L'Estaque. 1909

Analytic Cubism

Georges Braque was born a year after Pablo Picasso, near Le Havre, France, where he trained to become a house decorator, like his father and grandfather. In 1900 he moved to Paris to complete his apprenticeship but by 1902 had enrolled in one of the city's private academies.

The fledgling painter was so impressed by the Fauves' exhibition of 1905 that he joined them, but he soon grew tired of expressionism. The Cézanne retrospective that he saw in the fall of 1907 established his future course. He later said that exhibition was "more than an influence, it was an initiation." His interest in altered form and compressed space, kindled by Cézanne, was sharpened by Picasso's *Demoiselles*. Picasso, Braque observed, had flattened space and taken liberties with form much as Cézanne had in his late landscapes (see fig. 28-3).

Picasso's radical painting seems to have emboldened Braque to make his own advances on what he saw as Cézanne's late direction. In Houses at L'Estaque (fig. 28-38), painted in 1908 in one of Cézanne's favorite locales, we see the emergence of early Cubism. Inspired by Cézanne's example, Braque has reduced nature's many colors to its essential browns and greens. A comparison of the painting with a photograph of the site taken the following year by Braque's dealer (fig. 28-39) shows that the artist also eliminated detail to emphasize basic geometric forms. The houses have been arranged approximately into a pyramid and reduced to a kind of Platonic "houseness." Those in the distance have been pushed closer to the foreground. so the viewer looks up the canvas more than into it. In short, Braque simplified and reorganized the scene. The painting is less a Cézannesque study of nature than an attempt to translate nature's complexity into an independent, aesthetically satisfying whole; that is, the painting seems not so much a landscape as an arrangement of form and color meant to gratify a classical taste.

Houses at L'Estaque was put on view in Picasso's studio. Matisse said the avant-garde "considered it as something quite new, about which there were many discussions." Matisse explained to the puzzled critic Vauxcelles, who had coined the term Fauvism, that Braque made the painting out of "small cubes." When the critic later described the painting in print using that term, the name Cubism was born.

Picasso found in Braque's painting the artistic direction he had seemed to lack since the disastrous private showings of *Les Demoiselles d'Avignon*. By the end of 1908 the two artists had begun an intimate working relationship that lasted until Braque went off to war in 1914. During this period Picasso and Braque visited each other's studio almost every evening to see what the other had done during the day. The two were engaged in a difficult quest for a new conception of painting as, first and foremost, an arrangement of form and color on a two-dimensional surface. This arduous journey would require both Picasso's audacity and Braque's sense of purpose.

The move toward abstraction begun in Braque's landscapes in 1908 continued in the series of moderately scaled still lifes the two artists produced over the next two and a half years. The result of this series is the gradual elimination of space and subject matter. In Braque's *Violin and Palette* (fig. 28-40), the process is well under way. The still-life items are not arranged on a table in **illusionistic** depth but parallel to the picture plane in a shallow space. Using the **passage** technique developed by Cézanne, in which shapes closed on one side are open

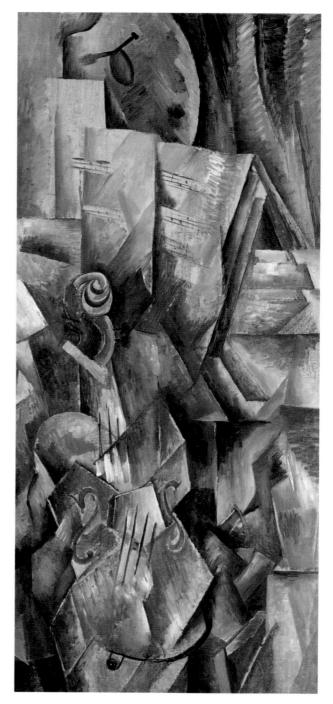

28-40. Georges Braque. *Violin and Palette*. 1909–10. Oil on canvas, 36¹/₈ x 16⁷/₈" (91.8 x 42.9 cm). Solomon R. Guggenheim Museum, New York

on another so that they can merge with adjacent shapes, Braque has attempted to knit the various elements together into a single shifting surface of forms and colors. In some areas of the painting, the right most noticeably, these formal elements have lost not only their natural spatial relations but their identities as well. Where representational motifs remain—the violin, for example—Braque has fragmented them in order to facilitate their integration into the whole.

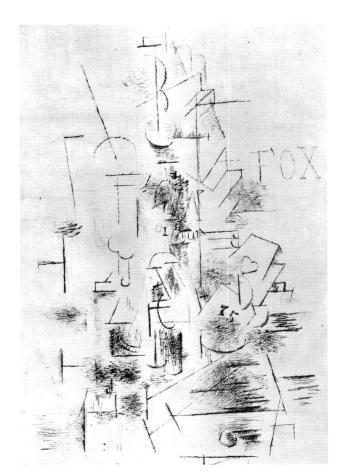

28-41. Georges Braque. *Fox.* 1912. Drypoint, printed in brown, 21½ x 15" (54.8 x 38 cm). The Museum of Modern Art, New York
Gift of Abby Aldrich Rockefeller

What Braque was aiming at in the work is indicated by the subjects that remain: the palette, sheet music, and violin. In identifying the palette with the musical elements, Braque reveals his new conception of painting. As their close friend the critic and poet Guillaume Apollinaire wrote in 1912, during these years the two were "moving toward an entirely new art which will stand, with respect to painting as envisaged heretofore, as music stands to literature. It will be pure painting, just as music is pure literature" (cited in Chipp, page 222). Just as the musician arranges sounds to make music, so Braque arranged forms and colors to make art. Braque and, to a somewhat lesser extent, Picasso felt that subject matter could sometimes be just as incidental to art as it is to symphonic music.

Braque's and Picasso's paintings of 1909 and 1910 initiated what is known as Analytic Cubism because of the way the artist took objects like the violin in *Violin and Palette* and broke them down into parts as if to analyze them. The works of 1911 and early 1912 are also grouped under the Analytic label, although in these the artists took a different approach to the breaking up of forms. Instead of simply fracturing an object, Picasso and Braque picked it apart and rearranged its elements. The process by which they worked is most clearly evident in etchings such as Braque's *Fox* (fig. 28-41). Braque began,

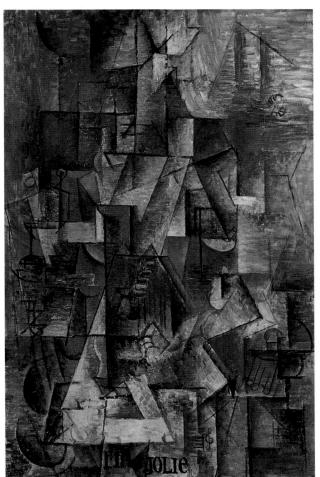

28-42. Pablo Picasso. *Ma Jolie.* 1911–12. Oil on canvas, $39^3/8$ x $25^3/4$ " (100 x 65.4 cm). The Museum of Modern Art, New York

Acquired through the Lillie P. Bliss Bequest In 1923, Picasso said, "Cubism is no different from any other school of painting. The same principles and the same elements are common to all. The fact that for a long time Cubism has not been understood . . . means nothing. I do not read English, [but] this does not mean that the English language does not exist, and why should I blame anyone . . . but myself if I cannot understand [it]?" (cited in Chipp, page 264).

as they always did, by setting up a still life on a table in the studio. This one included playing cards among the usual bottles and books. Rather than copy these motifs, Braque proceeded to take from them various shape elements (curves, angles, and lines) and areas of shadow seen from various vantage points, which he then carefully assembled on the surface of his work in a pyramidal fashion. "The goal," as Braque said, "is not the reconstitution of an anecdotal fact, but the constitution of a pictorial fact." His concern for a classical balance is also evident in the even distribution of these elements on both sides of the central axis and in the frequent use of T-square elements aligned with the paper edge. The "pictorial fact" in Fox, as in all the works from this period, is defined not by subject but by the subtle nuance of formal harmonies organized in a classical fashion.

Picasso's *Ma Jolie* (fig. 28-42) was also the product of a careful reworking of a studio motif. Remnants of the

subject from which he worked, a woman holding a zither or guitar, are evident throughout the painting, but a search for clues that might allow one to reconstruct that subject would be misguided. The subject provided little more than the raw material for a particular formal arrangement. It is not a painting of a woman, or of a place, or of an event, but a painting pure and simple—or as Apollinaire said, "pure painting." Again, Picasso has suggested a musical analogy: he has painted in a G clef, and the words at bottom, *Ma Jolie*, were the title of a popular song. These references suggest that the viewer should approach the painting the way one would a musical composition, either by simply enjoying the arrangement of its elements or by analyzing it, but not by asking what it represents.

Throughout the painting, Picasso has maintained a subtle tension between order and disorder. For example, the shifting effect of the surface, a delicately patterned texture of grays and browns, is given regularity through the use of short, horizontal brushstrokes. Similarly, with the linear elements, although many irregular curves and angles are to be found, strict horizontals and verticals dominate. The combination of horizontal brushwork and right angles firmly establishes a grid that effectively counteracts the surface flux. Moreover, the repetition of certain diagonals and the relative lack of details in the upper left and upper right create a pyramidal shape. Thus, what at first may seem a random assemblage of lines and muted colors turns out to be well organized. The aesthetic satisfaction of such a work depends on the way chaos seems to resolve itself into order.

Synthetic Cubism

In works like Ma Jolie, Picasso and Braque were on the brink of complete formalism. (This term, which carries a host of meanings, is used here to refer to a kind of abstract art that is completely preoccupied with formal elements like line, shape, and color.) Having reached this brink, they retreated, and in the spring of 1912 they began to create works with more clearly discernible subjects. Rather than rendering subjects naturalistically, however, they suggested them. This second major phase of Cubism is known as Synthetic Cubism because of the way the artists created motifs by combining simpler elements, as in a chemical synthesis. Picasso's Glass and Bottle of Suze (fig. 28-43), like most of the works he and Braque created from 1912 to 1914, is a collage, a work composed of separate elements pasted together. At the center is a combination of newsprint and construction paper cut and assembled to suggest a tray or round table upon which are a glass and a bottle of liquor with an actual label. Around this arrangement, Picasso has pasted larger pieces of newspaper and wallpaper. The elements together evoke not only a place—a bar—but an activity there: the viewer alone with a newspaper, enjoying a quiet drink. The tranquillity of the scene is suggested by the harmony of the browns, grays, and blues and by the classical pyramidal composition of the central elements.

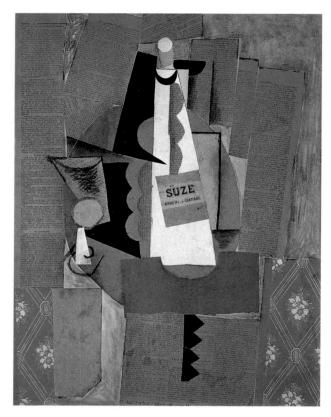

28-43. Pablo Picasso. *Glass and Bottle of Suze*. 1912. Pasted paper, gouache, and charcoal, 25³/₄ x 19³/₄" (65.4 x 50.2 cm). Washington University Gallery of Art, St. Louis, Missouri

University Purchase, Kende Sale Fund, 1946

The refuge from daily bustle that both art and quiet bars can provide was a central theme in the Synthetic Cubist works produced by Braque and Picasso. The two artists, however, used different types of newspaper clippings. Braque's clippings deal almost entirely with musical and artistic events. Picasso, signaling a renewed interest in the personal and social themes that had concerned him before his association with Braque, often included references to political events that would soon shatter the peaceful pleasures these works feature.

In *Glass and Bottle of Suze*, for example, the newspaper clippings deal with the First Balkan War of 1912–1913, which contributed to the mounting tensions that resulted in World War I. *Glass and Bottle of Suze* includes graphic descriptions of the war's victims, which are placed upside down in the collage, just possibly to suggest a world turned on its head. The clippings also include a report of a meeting in France of about 50,000 pacifists from all over Europe hoping to prevent "a general European war." Picasso's collage may record his uneasy response to the political events, or conversely, the clippings may simply document the problems from which bohemian bars and art itself provided a safe, if temporary, refuge.

In addition to collage, Picasso produced a number of Synthetic Cubist sculpture, such as *Mandolin and Clarinet* (fig. 28-44). Composed of wood scraps, the sculpture sug-

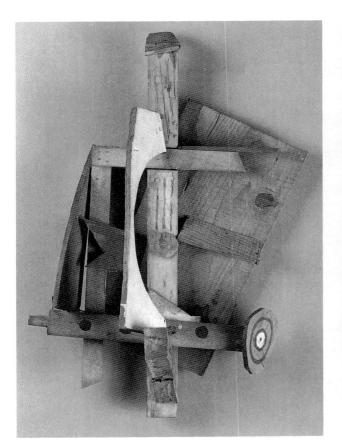

28-45. Jacques Lipchitz. *Man with a Guitar.* 1915. Limestone, 38 ¹/₄ x 10 ¹/₂ x 7 ³/₄" (97.2 x 26.7 x 19.7 cm). The Museum of Modern Art, New York Mrs. Simon Guggenheim Fund (by exchange)

gests two musical instruments at right angles to one another. The scrap wood and unfinished surfaces call attention to the everyday world of the workers and craftspeople with whom both Picasso and Braque identified themselves at the time. The result is a fascinating integration of the fabricating techniques of the ordinary workplace with the high-art aesthetics of Cubism.

Responses to Cubism

As the various phases of Cubism emerged from the studios of Braque and Picasso, it became clear to the art world that something of great significance was happening. The radical innovations of the new style confused and upset the public and most critics, but the avantgarde saw in them the future of art.

French Responses. Some artists put these innovations into the service of a less radical art, as can be seen in the Cubist-inspired sculpture of Jacques Lipchitz (1891–1964). Lipchitz, who came to Paris from Russia in 1909, met Picasso in 1913. The influence of both Analytic and Synthetic Cubism can be seen in his work of the period before and during World War I. *Man with a Guitar* (fig. 28-45), for example, is in the Synthetic Cubist mode. Like Picasso in *Mandolin and Clarinet*, Lipchitz assembled curvilinear and angular shapes, in this case to approximate a figure hold-

ing a guitar. The hole at the center of the work is wittily used to suggest both the sound hole of the guitar and the figure's navel. The piece aims simply to create a pleasant arrangement of shifting but ultimately stable forms.

At the other end of the spectrum was the radical painting of Robert Delaunay (1885–1941), who attempted to take a monochromatic, static, and antisocial Analytic Cubism into a new, wholly different direction. By 1904 Delaunay had become a landscape painter, first in the Impressionist mode, then, after 1905, in the Fauvist vein. His insistence on the spirituality of color, which recommended him to Der Blaue Reiter, was first evident in the series of paintings of a Gothic church interior he did in 1909.

Beginning in 1910 he attempted to fuse Fauvist color with Analytic Cubist form in a series of works dedicated to modern technology. One of these, *Homage to Blériot* (fig. 28-46), is a tribute to the French pilot who in 1909 was the first to fly across the English Channel. One of Louis Blériot's early airplanes, somewhat like the less-advanced one the Wright brothers used in 1903, is shown in the upper right, just above the Eiffel Tower. The airplane and the Eiffel Tower were powerful symbols of both technological and social progress in this period. The crossing of the channel was considered evidence of a new, unified world without frontiers and national antagonisms. The arrangement of brightly colored circular

28-46. Robert
Delaunay.
Homage to
Blériot. 1914.
Tempera
on canvas,
8'2¹/₂" x 8'3"
(2.5 x 2.51 m).
Kunstmuseum, Basel,
Switzerland
Emanuel
Hoffman
Foundation

THE FUTURIST On February 20, MANIFESTO 1909, the Italian poet and publisher Filippo Tommaso Marinetti, who liked to think of himself as "the caffeine of Europe," published in the French newspaper *Le Figaro* "The Foundation and Manifesto of Futurism." The manifesto opens with a long, detailed description of a late-night automobile accident caused by

two cyclists, wavering in front of me like two equally persuasive but contradictory arguments. . . . What a nuisance! Auff! . . . I stopped short and—disgusting—was hurled, wheels in the air, into a ditch. . . .

Oh! maternal ditch, almost to the top with muddy water! Fair factory drainage ditch! I avidly savored your nourishing muck. . . . When I got out from under the upturned car—torn, filthy, and stinking—I felt the red-hot iron of joy pass over my heart!

After this preamble, Marinetti declares:

1. We intend to glorify the love of danger . . . the strength of daring. . . .

- Literature having up to now glorified thoughtful immobility . . . and slumber, we wish to exalt the aggressive movement, the feverish insomnia, running, the perilous leap, the cuff, and the blow.
- 4. We declare that the splendor of the world has been enriched with a new form of beauty, the beauty of speed. A race-automobile . . . which seems to rush over exploding powder is more beautiful than the *Victory of Samothrace*. . . .
- 7. There is no more beauty except in struggle. No masterpiece without the stamp of aggressiveness. . . .
- We will glorify war—the only true hygiene of the world militarism, patriotism, the destructive gesture of [the] anarchist, the beautiful Ideas which kill, and the scorn of woman.
- We will destroy museums, libraries, and fight against moralism, feminism, and all utilitarian cowardice.

11. We will sing the great masses agitated by work, pleasure, or revolt; we will sing the multicolored and polyphonic surf of revolutions in modern capitals. . . .

It is in Italy that we hurl this overthrowing and inflammatory declaration, with which today we found Futurism, for we will free Italy from her numberless museums which cover her with countless cemeteries....

To admire an old picture is to pour our sentiment into a funeral urn instead of hurling it forth in violent gushes of action and productiveness....

Therefore welcome the kindly incendiarists with the carbon fingers! Here they are! . . . Away and set fire to the bookshelves! . . .

The oldest among us are thirty; we have thus at least ten years in which to accomplish our task. When we are forty, let others—younger and more daring men—throw us into the wastepaper basket like useless manuscripts!

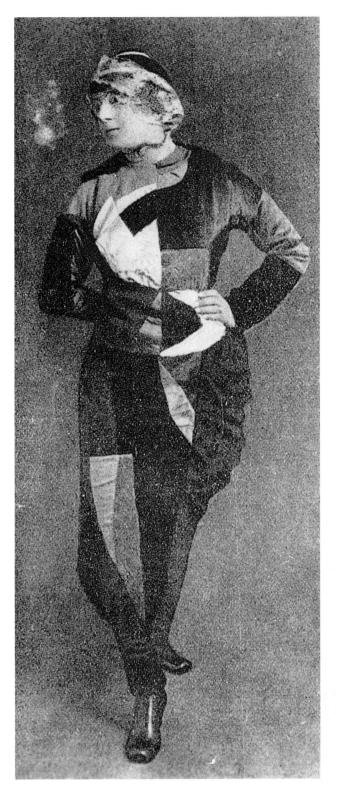

28-47. Sonia Delaunay-Terk, photographed wearing a "simultaneous dress" of her own design at the Bal Bullier. Paris. 1914

forms that fills the canvas is more than an expressionistic record of Delaunay's excitement at this prospect. The circular shapes, which suggest both the movement of the propeller on the left and the blazing sun, are meant to evoke as well the great **rose windows** of Gothic cathedrals. By combining images of progressive science with

those of divinity, Delaunay meant to suggest that progress is part of God's divine plan. The ecstatic painting is thus a synthesis not only of Fauvist color and Cubist form but of conservative religion and modern technology as well.

Critics labeled Delaunay's art Orphism to suggest its affinities with Orpheus, the legendary Greek poet whose lute playing charmed wild beasts. Delaunay preferred to think of his work in terms of simultaneity, a vague and complicated concept he developed with his wife, the Russian-born artist Sonia Delaunay-Terk (née Sonia Terk, 1885–1979), that centered on a faith in the great unity of opposites.

Terk had moved to Paris in 1905 after a short period of study in Germany. By 1907 she was producing simplified portraits and figure studies using a Fauvist palette. After her marriage to Delaunay, in 1910, she produced work very similar to his both in style and in theme. In 1913, for example, she made a painting celebrating Paris's newly installed electric streetlights. Her work has received less attention than his partly because she worked in the applied arts, with fabrics in particular. Following the birth of their son in 1911, she made him a patchwork quilt, like those produced by Russian peasant women, out of pieces of colored fabric. The quilt seems to have come as a revelation for both Delaunays. It helped Robert develop a series of nonrepresentational works in 1912, and it led Sonia to design other utilitarian objects, especially clothing. In 1914 she designed the "simultaneous dress" (fig. 28-47) to wear at the dance hall where the Delaunays and their friends met every week. The simple, formfitting dress is made of brightly colored patches arranged dynamically. A spinning solar form like those found in Homage to Blériot decorates the front. By applying motifs from their forward-looking paintings to clothing, she was attempting to bring to daily life the dynamic and progressive rhythms that she and her husband felt were invigorating the modern era.

Italian Responses. Another of the twentieth century's isms, Futurism, emerged on February 20, 1909, when a controversial Milanese literary magazine editor, Filippo Marinetti, published his "Foundation and Manifesto of Futurism" in a Paris newspaper. An outspoken attack against everything old, dull, "feminine," and safe, Marinetti's manifesto promoted the exhilarating "masculine" experiences of warfare and reckless speed (see "The Futurist Manifesto," opposite). Although the stated aim of Futurism was to free Italy from its past, the deeper purpose was to promote a new taste for heightened experience.

In 1909 a number of artists and poets gathered around Marinetti in Milan to create art forms for a modernized and revitalized Italy. Prominent among the artists was the sculptor and painter Umberto Boccioni (1882–1916), who had followed his training in Rome with extensive European travel. In 1907 he settled in Milan, the industrial center of Italy, where he applied a modified Neo-Impressionist technique to modern subjects. After joining Marinetti he helped draft two manifestos of Futurist painting in 1910 and wrote one on sculpture in 1912.

His major sculptural work was Unique Forms of

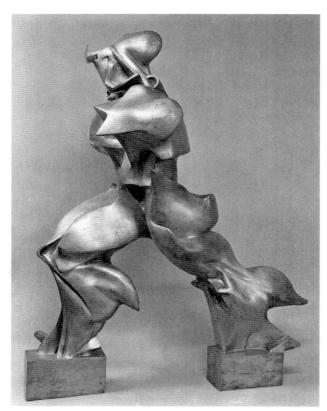

28-48. Umberto Boccioni. *Unique Forms of Continuity in Space*. 1913. Bronze, 43⁷/₈ x 34⁷/₈ x 15³/₄" (111 x 89 x 40 cm). The Museum of Moden Art, New York Acquired through the Lillie P. Bliss Bequest

Boccioni and the Futurist architect Antonio Sant'Elia (see fig. 28-74) were both killed in World War I. The Futurists had ardently promoted Italian entry into the war on the side of France and England. After the war Marinetti's movement, still committed to nationalism and militarism, supported the rise of fascism under Benito Mussolini, although a number of the original members of the group rejected their youthful values.

Continuity in Space (fig. 28-48). The bronze sculpture depicts a powerful nude figure in full stride. The formal vocabulary of exaggerated muscular curves and countercurves was inspired by early Analytic Cubist still lifes and figure studies that he had seen in Paris in 1911. But whereas the Cubists had broken forms to integrate their compositions, here Boccioni dynamically stretches and swells them to express the figure's power and speed. In contrast to the Cubist taste for order and stability, this work revels in movement and change. The figure personifies the new Italian envisioned by the group, a powerful male rushing headlong into the future.

Boccioni's paintings celebrate the modern industrial city. *States of Mind: The Farewells* (fig. 28-49), for exam-

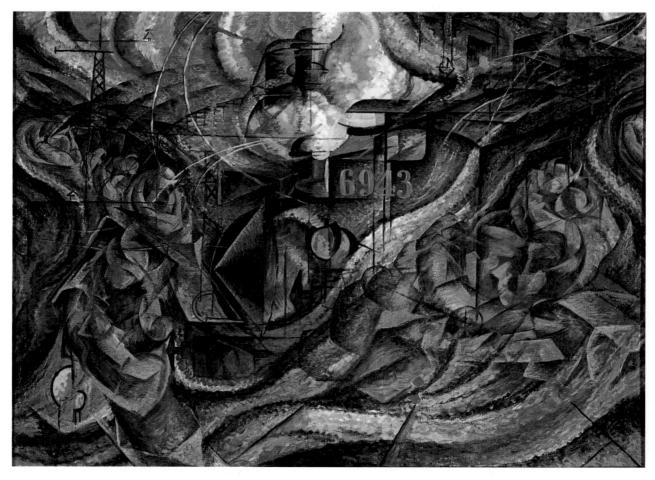

28-49. Umberto Boccioni. *States of Mind: The Farewells.* 1911. Oil on canvas, 27 7/8 x 37 7/8" (70.7 x 96 cm). The Museum of Modern Art, New York

Gift of Nelson A. Rockefeller

28-50. Giacomo Balla. *Dynamism of a Dog on a Leash (Leash in Motion)*. 1912. Oil on canvas, 35³/₄ x 43³/₈" (91 x 110 cm). Albright-Knox Art Gallery, Buffalo, New York

George F. Goodyear Bequest

28-51. Anton Giulio Bragaglia. *Greetings!* 1911. From *Fotodinamismo Futurista*, Rome, 1913

ple, immerses the viewer in the crowded, exciting chaos of a train station. At the center, with numbers emblazoned on its front, is a powerful steam locomotive. Pulsing across the top of the work is a series of bright curves meant to suggest radio waves emanating from the steel tower in the left rear. Adding to the complexity of the tightly packed surface are the longer, more fluid rhythms that seem to pull a crowd of metallic figures from beneath the tower down and across the work. The figures are actually a single couple shown moving through space and time. Although their simplified, blocky forms were borrowed from Analytic Cubism, their sequential arrangement was inspired by time-lapse photography. Boccioni wanted to convey more than a purely physical sense of such a place. He wanted, as well, to suggest the variety of sounds, smells, and emotions that filled the train station and made it the very epitome of the noisy urban existence he and his colleagues so loved.

The time-lapse photography (or chronophotography) of Eadweard Muybridge (see fig. 27-35) and Étienne-Jules Marey also provided the formal vocabulary for another of the Futurists, the Roman painter Giacomo Balla (1871-1958). Entirely self-taught, he worked first in a naturalistic manner and then in the modified Neo-Impressionist mode he introduced to his former student, Boccioni. In 1910 he signed the Futurist painting manifesto written in Milan. His paintings such as Dynamism of a Dog on Leash (Leash in Motion) (fig. 28-50) exhibit the less aggressive side of Futurism. The work, which condenses a series of time-lapse photographs into a single image, charmingly shows the excited movements of a dachshund and its owner out for a stroll. The painting expresses the group's love of movement but does so without any of the force or violence characteristic of its rhetoric.

Futurism found its own chronophotographer in Anton Giulio Bragaglia (1890–1960), who began his career in the fledgling movie industry of Rome in 1906. He

turned to photography in 1910, partly as a result of reading the various Futurist manifestos. By the following year he had evolved his own brand of Futurist photography, which he called Photodynamism. He produced photographs like *Greetings!* (fig. 28-51) by leaving the camera's shutter open while his subjects moved. The polite subject is in keeping with the less published side of Futurist production. Bragaglia also made photographs more consistent with the values outlined in Marinetti's manifesto, which ultimately helped produce Italian fascism.

Russian Responses. Since the time of Peter the Great (ruled 1682-1725), Russia's ruling classes had turned to Western Europe for cultural models. Throughout the eighteenth and nineteenth centuries, for example, French had been the official language of the Russian court and the educated elite. Until two wealthy young men, Aleksandr Benois (1870-1960) and Serge Diaghilev (1872-1929), began championing them, however, the leading-edge developments in Western European art in the late nineteenth century had been of little interest to Russian artists, writers, and critics. Benois and Diaghilev wanted not just to import Western innovations into Russia but also to make Russia for the first time a center of innovation that would contribute significantly to Western European culture. In 1899 they launched a magazine, World of Art, dedicated to international art, literature, and music. In the following year the World of Art group held the first in a series of international art exhibitions, which included works by Degas, Monet, Whistler, and Puvis de Chavannes. Following the group's desire to contribute to Western culture, Diaghilev took an exhibition of contemporary Russian art to Paris in 1906. Three years later he brought the Ballets Russes to the French capital, where it enjoyed enormous success.

The activities of the World of Art group, which was centered in Russia's capital, St. Petersburg, inspired the

28-52. Natalia Goncharova. *Haycutting*. 1910. Oil on canvas, $38^{5}/8 \times 46^{1/4}$ " (98 x 117 cm). Private collection

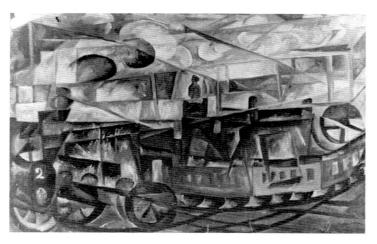

28-53. Natalia Goncharova. Aeroplane over Train. 1913. Oil on canvas, $21^5/8 \times 32^7/8$ " (55 x 83.5 cm). Kazan-skil Muzej, Russia

formation of a similar group in Moscow, the Golden Fleece. In 1906 it launched an art magazine by that name and in 1908 organized a major exhibition of Russian and French art, which included works by Rodin, Maillol, Toulouse-Lautrec, Gauguin, Cézanne, Matisse, Derain, and Braque. This exhibition had a complicated effect on the city's young artists, as is evident in the work of Natalia Goncharova (1881–1962), one of many women in Russia's avant-garde.

By the early 1900s Goncharova had come under the influence of Moscow's pro–Russian (or Slavophile) movement, which opposed the pro–Western European stance in St. Petersburg. She and her friends were convinced that in order to participate in the international avantgarde, they would, ironically, have to return to their own roots. Reflecting these beliefs, the paintings she made around 1905 are based on medieval Russian icons. The works that she contributed to the first Golden Fleece exhibition in 1908 created a sensation and launched the Russian Neo-Primitive movement. Goncharova's *Haycutting* (fig. 28-52) is typical of her Neo-Primitive paintings.

In it she expresses the Slavophile view that the simple virtues of the provincial peasant represented the best of Russia. Not an idealized depiction meant to delight city people, it is, instead, a tribute to peasant strength in the vein of Jean-François Millet (see fig. 27-19). The crude style, meant to express the quality of peasant life, is based on the cheap **woodblock** prints of religious and political scenes (*lubok*) that decorated peasant homes. Disregard for scale was characteristic of these prints.

Haycutting also seems to support a negative attitude toward the industrialization of Russia. In the face of the recent exodus of peasants to the burgeoning urban centers, this work appears to argue for a traditional way of life. Three years later, however, Goncharova produced Aeroplane over Train (fig. 28-53), which suggests a completely changed viewpoint, one now consistent with Futurist values. The work combines two of the leading symbols of technological progress in a style derived from both early Analytic Cubism and Futurism. Blocky Cubist shapes are closely packed in a dynamic Futurist rhythm across a surface also marked by a series of sharp diagonals. Because knowledge of Analytic Cubism and Futurism arrived in Moscow almost simultaneously and because they were superficially similar, artists such as Goncharova tended to link them. Thus, the style that evolved from them in the period 1912-1914 is known as Cubo-Futurism, even though it had less to do with Cubist than with Futurist values.

The brief time between *Haycutting* and *Aeroplane over Train* suggests the considerable confusion that many Russians felt over the questions of rural versus urban, agrarian versus industrial, and Russian versus French. The one issue Goncharova and the Cubo-Futurists were not in doubt about was artistic progress. They embraced Cubism and Futurism out of a commitment to "advance" art. And like Benois and Diaghilev, they were not satisfied simply with keeping up with the new advances; they wanted to contribute to them.

The first Russian to go beyond Cubo-Futurism was Kazimir Malevich (1878-1935). After Goncharova and her husband, the artist Mikhail Larionov (1881–1964), left for Paris in 1915 to work for Diaghilev's Ballets Russes, Malevich emerged as the leading figure in the Moscow avant-garde. By 1913 he was producing his own brand of Cubo-Futurism and his first truly abstract work. According to his later reminiscences, "in the year 1913, in my desperate attempt to free art from the burden of the object, I took refuge in the square form and exhibited a picture which consisted of nothing more than a black square on a white field." Because he did not exhibit such a work until 1915, there is some question about the exact date of his first completely nonrepresentational work. Whatever the case, Malevich exhibited thirty-nine works in this radically new and highly controversial vein at the "Zero Ten" exhibition in St. Petersburg in the winter of 1915-1916. One work, Suprematist Painting (Eight Red Rectangles) (fig. 28-54), consists simply of eight red rectangles arranged diagonally on a white painted ground. Here is the move to total abstraction that Picasso and Braque refused to make in 1912.

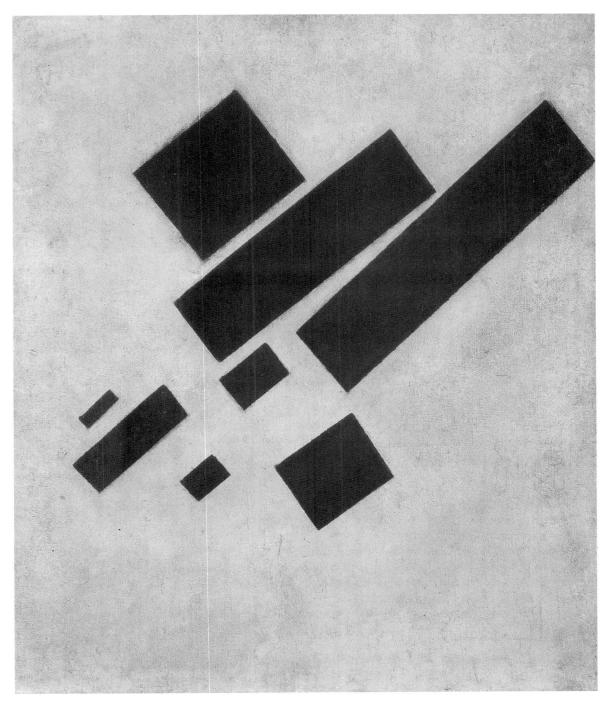

28-54. Kazimir Malevich. *Suprematist Painting (Eight Red Rectangles).* 1915. Oil on canvas, 22 ¹/₂ x 18 ⁷/₈" (57 x 48 cm). Stedelijk Museum, Amsterdam

Malevich's Suprematist works, like many abstract paintings, do not reproduce well—their aesthetically appealing subtleties of texture, line, and color are not readily apparent in photographs. Even more than other artworks, they need to be seen firsthand to be fully appreciated.

Malevich called this art Suprematism, short for "the supremacy of pure feeling in creative art." Although he sometimes spoke of this feeling in terms of technology ("the sensation of flight . . . of metallic sounds . . . of wireless telegraphy"), a later essay suggests that what motivated these works was "a pure feeling for plastic [that is, formal] values." By eliminating objects and focusing entirely on formal issues, Malevich thought that he was "liberating" the essential beauty of all great art.

While Malevich was launching an art that transcended the events and conditions of the present, his chief competitor for leadership of the Russian avantgarde, Vladimir Tatlin (1885–1953), was somewhat inadvertently opening a very different direction for Russian art, one inspired by Synthetic Cubism. In 1913 he went to Paris specifically to visit Picasso's studio. What impressed him most was the new Synthetic Cubist sculpture, such as *Mandolin and Clarinet* (see fig. 28-44).

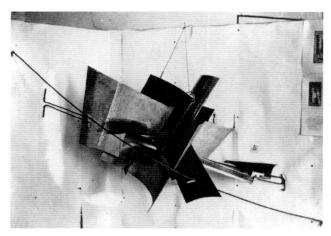

28-55. Vladimir Tatlin. *Corner Counter-Relief.* 1915.

Mixed mediums, 31¹/₂ x 59 x 29¹/₂" (80 x 150 x 75 cm).

Present whereabouts unknown

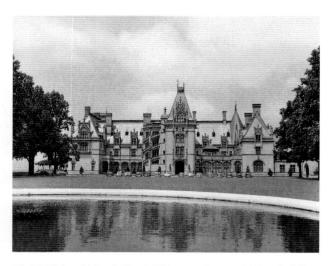

28-56. Richard Morris Hunt. Biltmore, George W. Vanderbilt estate, Asheville, North Carolina. 1888–95

After returning to Moscow Tatlin produced an innovative series of entirely nonrepresentational relief sculpture constructed of various materials, including metal, glass, stucco, asphalt, wire, and wood. These Counter-Reliefs, as he called them, were based on the concept of faktura, the conviction that each material generates its own precise repertory of forms and colors. Partly because he wanted to place "real materials in real space," and because he thought the usual placement on the wall tended to flatten his reliefs, he began at the "Zero Ten" exhibition of 1915-1916 to suspend them across the upper corners of rooms (fig. 28-55). The upper corner of a room was also the traditional location for Russian icons. In effect, these Corner Counter-Reliefs were intended to replace the old symbol of Russian faith with one dedicated to the principle of respect for materials. But because his choice of materials increasingly favored the industrial over the natural, these modern icons should also be viewed as incipient expressions of the post-World War I shift away from aestheticism and toward utilitarianism in Russia, a topic to be explored more fully later in this chapter.

ARCHITECTURE BEFORE World War I

The history of architecture between 1880 and World War I is a story of the impact of modern conditions and materials on the

still-healthy Beaux-Arts historicist tradition, a tradition based on the emulation of historical models. Unlike painting and sculpture, where anti-academic forces dominated after 1880, in architecture the search for modern styles occurred somewhat later and met with considerably more resistance. While the artistic education offered at the École des Beaux-Arts in Paris was rapidly losing importance, its architecture department was becoming the central training ground for the profession in both Europe and the United States.

American Beaux-Arts Architecture

The dean of late-nineteenth-century American architects was Richard Morris Hunt (1827–1895). In 1846 Hunt became the first American to study architecture at the École des Beaux-Arts in Paris. In 1855, determined to raise the standards of American architecture, he opened an office in New York City. Extraordinarily skilled in Beaux-Arts eclecticism, he produced work in every accepted style, including Gothic, French Classicist, and Italian Renaissance. Hunt did much of his work after the American Civil War (1861–1865) for the growing class of wealthy Eastern industrialists and financiers. One of his most impressive works is Biltmore (fig. 28-56), constructed in Asheville, North Carolina, for George W. Vanderbilt, the youngest son of one of America's richest families.

Vanderbilt conceived the 125,000-acre estate he had assembled as a model farm and forest. With the assistance of Gifford Pinchot, who later established the national park system under President Theodore Roosevelt (in office 1901-1909), he introduced at Biltmore the concept of what he called "selective cutting [of trees] for sustained yield." Surrounding the house are a series of historic gardens designed by Frederick Law Olmsted (1822-1903), the United States' first landscape architect. These include an Italian water garden, a picturesque eighteenth-century English ramble, a walled medieval garden, and, fronting the mansion, a broad esplanade in the manner of those at Versailles (see fig. 19-23). The 225-room house itself is modeled on a French Renaissance château. Its aristocratic pretensions reflect the social ambitions not only of the young Vanderbilt but of his entire class, which wanted to establish in the United States a hereditary social hierarchy like that of Europe.

While Biltmore was under construction, Hunt participated in another large project with more democratic aims as head of the board of architects for the 1893 World's Columbian Exposition in Chicago. For the exposition, organized to commemorate the 400th anniversary

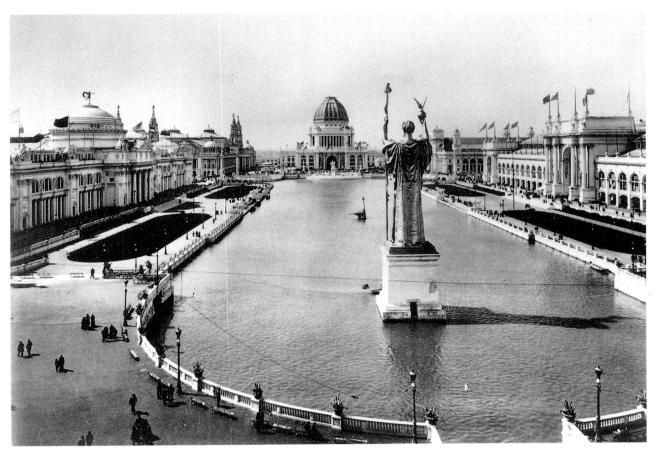

28-57. Richard Morris Hunt. Court of Honor, World's Columbian Exposition, Chicago. 1893

of Columbus's arrival in the Americas, the board abandoned the metal-and-glass architecture of earlier world's fairs in favor of the appearance of what it called "permanent buildings—a dream city." (The buildings were actually temporary ones composed of staff, a mixture of plaster and fibrous materials.) To create a sense of unity, they decided to use a single, classical, style for all the exposition's buildings. This style, with its associations both to the birth of democracy in ancient Greece and to the imperial power of ancient Rome, reflected United States pride in its democratic institutions and the country's incipient emergence as a world power. Hunt's design for the Administration Building at the end of the Court of Honor (fig. 28-57), like that for most of the buildings, was in the Renaissance classicist mode used by Jefferson and other early American architects for civic buildings (see fig. 26-58). This particular version of the classical was also meant to communicate that the United States was cultivating a new, more democratic renaissance after the Civil War.

The World's Columbian Exposition also provided a model for the new American dream city. The rapidly growing American urban centers of the late nineteenth century were, on the whole, ill-planned, sooty, and overcrowded. The exposition offered reassurance that the city of the future could be clean, timeless, carefully planned, and spacious. One of the most important features of what became known as the City Beautiful move-

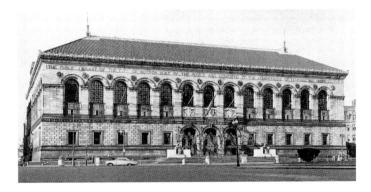

28-58. McKim, Mead, and White. Boston Public Library. 1887-92

ment signaled here was the concern for city parks. Frederick Law Olmsted, who designed the gardens at Biltmore, also contributed to the extensive landscape design of the World's Columbian Exposition. Olmsted spearheaded the city park movement in the United States and firmly believed that nature softened many of the harmful effects of modern city life. When he designed New York City's Central Park in 1858 he called it "the green lung of the city" (see fig. 26-61).

Many civic buildings of the late nineteenth century reflect a similar vision that informed the World's Columbian Exposition: that of the United States as a site of a democratic renaissance. One such building, the Boston Public Library (fig. 28-58), was designed by the New York

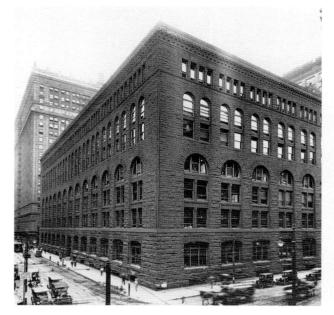

28-59. Henry Hobson Richardson. Marshall Field Warehouse, Chicago. 1885–87. Demolished c. 1935

architectural firm of Charles Follen McKim (1847–1909). who had studied for three years at the École des Beaux-Arts, William Rutherford Mead (1846-1928), and Stanford White (1853-1906). During the 1890s McKim, Mead, and White was the largest architectural firm in the world. The Boston Public Library has a Renaissance palacestyle design that reflects the trustees' request that it be a "palace of the people." The reading room inside is based on Florentine palace courtyards. On the exterior, arcaded windows (set in a row of connected arches) surmount smaller square windows on the street level. Although a group of wealthy families paid for the library, the inscription above the windows states that it was "built by the people and dedicated to the advancement of learning." The building housed the largest circulating library in the world and was intended as a testament to the power of learning. It is built of light pink granite and is raised above the ground on a platform base to suggest the uplifting effects of public education.

The second American architect to study at the École des Beaux-Arts was Henry Hobson Richardson (1838-1886). Born in Louisiana and schooled at Harvard, Richardson returned from Paris in 1865. Like Hunt, he worked in a variety of styles, but he became famous for a simplified Romanesque style known as Richardsonian Romanesque. His best-known building is probably the Marshall Field Warehouse in Chicago (fig. 28-59). Although it is reminiscent of Renaissance palaces in form and of Romanesque churches in its heavy stonework and arches. it has no precise historical antecedents. Instead, Richardson took a fresh approach to the design of the utilitarian building. Applied ornament is all but eliminated in favor of the intrinsic appeal of the rough stone and the subtle harmony between the red sandstone and the darker red granite of the base. The solid corner piers, the vertical structural supports, give way to the regular rhythm of the broad arches of the middle floors, which are doubled in the smaller arches above, then doubled again in the

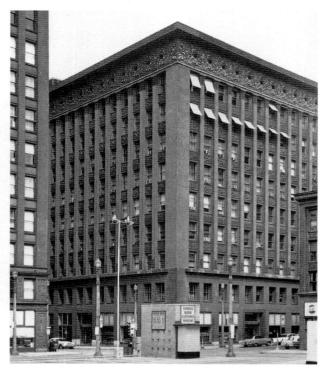

28-60. Louis Sullivan. Wainwright Building, St. Louis, Missouri. 1890–91

square windows of the attic. The integrated mass of the whole is completed in the clean, crisp line of the simple cornice at the top.

Richardson's break with the historicist tradition may partly be explained in terms of a strong anti–East Coast establishment current among Chicago's business executives and architects. Whether or not Richardson meant to appeal to Chicago's businesslike self-image, he certainly did. The plain, sturdy building was a revelation to the young architects of Chicago then engaged in rebuilding the city after the disastrous fire of 1871, which had destroyed the entire downtown. Richardson's building helped them give shape to their emerging desire to develop a distinctly American architecture.

The American Skyscraper

From a technical standpoint, Richardson's Marshall Field Warehouse represents the end of a short-lived tradition of iron-framed buildings in the United States. Many of the first iron-framed buildings of the mid-nineteenth century also had cast-iron facade elements. These structures were soon found to have a fatal susceptibility to fire; exposed to intense heat, iron will warp, buckle, collapse, or melt altogether. The solution was to encase the internal iron supports in fireproof materials and return to masonry sheathing, which suited Richardson's taste.

The perfection at this time of a technique for making inexpensive steel (a more refined, stronger iron) introduced entirely new possibilities for architecture. Steel was first used for buildings in 1884 by the young architects soon to be grouped under the label of the Chicago School. These architects saw in the stronger, lighter material the answer to both their desire for an independent

ELEMENTS OF The evolution of the skyscraper ARCHITECTURE depended on the development of these essentials: metal beams

The Skyscraper and girders for the structuralsupport skeleton; the separation

of the building-support structure from the enclosing layer (the cladding); fireproofing materials and measures; elevators; and plumbing, central heating, artificial lighting, and ventilation systems. First-generation skyscrapers, built between about 1880 and 1900, were concentrated in the Midwest, especially Chicago (see figs. 28-59 and 28-60). Second-generation skyscrapers, with more than twenty stories, date from 1895. At first the tall buildings were freestanding towers, sometimes with a base, like the Woolworth Building of 1911-1913 (see fig. 28-61). New York City's Building Zone Resolution of 1916 introduced mandatory setbacks-recessions from the ground-level building line-to ensure light and ventilation of adjacent sites. Built in 1931, the 1,250-foot, setback-form Empire State Building is thoroughly modern in having a streamlined exterior-its cladding is in Art Deco style-that conceals the great complexity of the internal structure and mechanisms that make its height possible. The Empire State Building is still the third-tallest building in the world, after the Sears Tower in Chicago (1,454 feet) and the World Trade Center Towers in New York City (each 1,350 feet).

elevator

(layer two)

stairwells

(layer one)

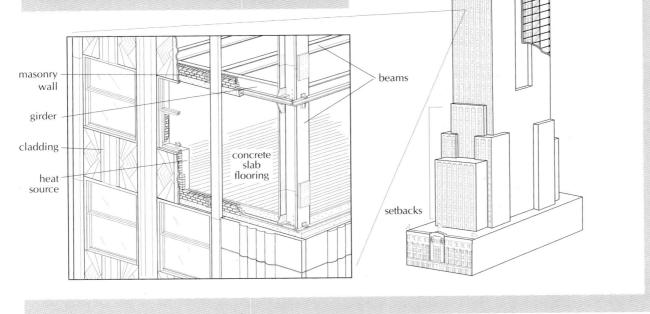

dent style and their clients' desire for taller buildings. Interest in tall buildings was essentially economic. By 1880 Chicago was the largest railroad juncture in the nation and the hub of the biggest system of inland waterways in the world. Between 1860 and 1880 its population had risen from about 100,000 to more than a million people. The rapidly rising cost of commercial property made its more efficient use a major consideration for businesspeople. Another technological development that made the tall office building feasible was the passenger elevator, the first of which was installed in 1857. The first electric elevator dates from 1889.

Equipped with steel and with the improved passenger elevators, driven by new economic considerations, and inspired by Richardson's radical departure from Beaux-Arts historicism, the Chicago School architects produced a new kind of building, the skyscraper, and a new style (see "Elements of Architecture," above). A fine early example of their work, and evidence of its rapid spread throughout the Midwest, is Louis Sullivan's Wainwright Building in St. Louis, Missouri (fig. 28-60). Sullivan (1856-1924), the creative leader of the firm of Adler and Sullivan, had studied for a year at the Massachusetts Institute of Technology (MIT), home of the United States' first architectural program, and equally briefly at the École des Beaux-Arts, where he seems to have developed his lifelong distaste for historicism. After apprenticeships in Philadelphia and in New York with Hunt, he moved to Chicago in 1875, partly because of the building boom there that followed the fire of 1871.

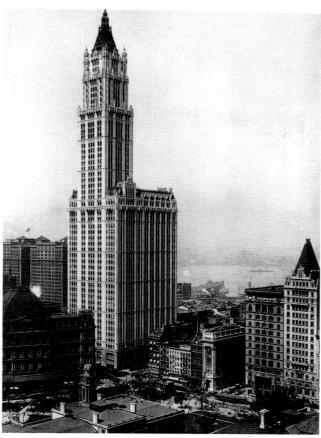

28-61. Cass Gilbert. Woolworth Building, New York. 1911-13

Sullivan may have been against historicism, but he was no revolutionary, as the Wainwright Building attests. Like Richardson's Marshall Field Warehouse, Sullivan's ten-story office building adapts the formal vocabulary of the Beaux-Arts tradition. Its organization into three parts respects the basic compositional rule taught at the French Academy. Although Sullivan claimed to have renounced the classical column, with its base, shaft, and capital, the facade of the Wainwright Building nevertheless conforms to that time-honored model. The building's ornamentation also reflects ties to the historicist tradition. Giving expression to both his own taste and the growing desire to bring nature into the city, Sullivan invented the dense tendril motif on the terra-cotta tiles in the cornice and below the windows. What is entirely new is the building's vertical emphasis. Unlike Richardson's warehouse, this structure is taller than it is wide; whereas Richardson tried to make his building look shorter by organizing multiple floors into single arcades and by organizing his dominant rhythms horizontally, Sullivan used dominant verticals to emphasize height. The strong corner piers, borrowed from Richardson, rise in clean and uninterrupted lines to the cornice. The smaller piers between the windows, intended to suggest the steel framing beneath them, echo those dominant verticals and reinforce them.

In the period after 1900 New York City assumed leadership in the development of the skyscraper, although clients there rejected the innovative Chicago style for the historicist approach still in favor in the East. The Wool-

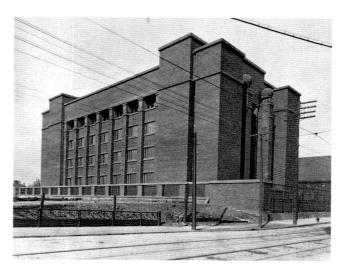

28-62. Frank Lloyd Wright. Larkin Building, Buffalo, New York. 1904. Demolished 1949

Wright later said about the Larkin Building: "Down all the avenues of time architecture was an enclosure ... and the simplest form of enclosure was the box. ... As a young architect, I began to feel annoyed, held back ... by this sense of enclosure which you went into and there you were—boxed, crated. . . . I think I first consciously began to try to beat the box in the Larkin building. . . . I found a natural opening to the liberation I sought when (after a great struggle) I finally pushed the staircase towers out from the corners of the main building [and] made them into free-standing individual features... the first real expression of the idea that the space within the building is the reality of that building" (cited in Pfeiffer and Nordland, page 9).

worth Building (fig. 28-61), designed by Cass Gilbert (1859–1934), is representative of this trend. Gilbert studied at MIT for a year before going to work for McKim, Mead, and White in 1880. Three years later, he opened his own office in St. Paul, Minnesota, where he had grown up. He won the prestigious commission to design the Woolworth Building, the headquarters of the giant department-store chain, in 1910. When completed at 792 feet and 55 floors, the gleaming white structure was the world's tallest office building. The Gothic style of the building, inspired by the great soaring towers of late medieval churches, resonated as well with the United States' increasing worship of business. Gilbert explained that he wished to make something "spiritual" of what others called his Cathedral of Commerce.

Frank Lloyd Wright

The most celebrated American architect of the Chicago School was Frank Lloyd Wright (1867–1959). His mother was so determined that he would be an architect that she hung engravings of cathedrals over his crib. Summers spent working on his uncle's farm in Wisconsin gave him a deep respect for nature, natural materials, and agrarian life. After studying engineering for two years at the University of Wisconsin, Wright apprenticed for a year with a Chicago architect, then spent the next five years with Adler and Sullivan, eventually becoming their chief drafter. Sullivan fired him in 1893 for moonlighting. Thus, in the

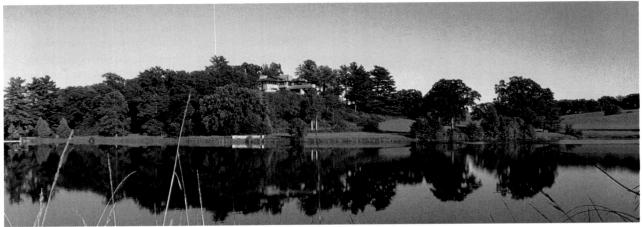

28-63. Frank Lloyd Wright. Taliesin, Spring Green, Wisconsin. Original built 1911, destroyed by fire 1914, rebuilt 1915–22, again destroyed by fire 1925, rebuilt 1927

year of the World's Columbian Exposition, Wright opened his own office, specializing in the domestic architecture he had been doing for Sullivan's firm. Seeking better ways to integrate house and site, he turned away from the traditional boxlike design and began by 1900 to create homes with a series of horizontal elements that echoed and opened into the surrounding landscape. These so-called **Prairie Style** houses also reflected the Japanese concept that the requirements of the interior spaces of a house should determine its shape.

One of the rare commercial buildings Wright produced in his early career was the Larkin Building in Buffalo, New York (fig. 28-62). The debt to Richardson's Marshall Field Warehouse (see fig. 28-59) is evident in the way Wright enclosed a series of windows between massive piers under a simple corniced roof. There the similarity ends, however, for Wright abandoned the historicist vocabulary for a completely modern one of simple geometric shapes. Only at the top of the window piers and above the entrance did he employ any decoration, and even then it was entirely of his own invention. The formal geometric vocabulary was apparently inspired by the large Froebel kindergarten blocks-named after the German educator and founder of the kindergarten system-that his mother had bought for him at the 1876 World's Fair. (Wright later mentioned the importance of these blocks to his education.) The outside piers, which echo the taller structural ones, contain stairways and the ductwork for an innovative ventilation system that alleviated the poor air quality of the building's polluted neighborhood. Partly because of its unsightly industrial surroundings, Wright turned the building in on itself. Where the Prairie house opened out onto the landscape, the Larkin Building looks inward, with every floor overlooking a central skylit atrium. By focusing the building onto a central space and using a warm-colored brick throughout, Wright also sought to foster a greater sense of community among the people working there.

In 1909 Wright experienced a personal crisis. Unhappy with his marriage and with his architecture, he abandoned (despite his oft-stated belief in the sanctity of the family) his wife, his six children, and his practice and

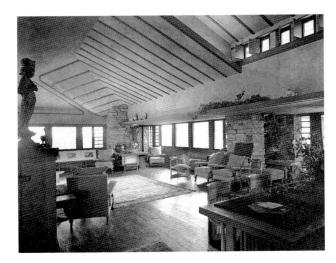

28-64. Frank Lloyd Wright. Living room, Taliesin

traveled to Europe with the wife of a neighbor. When he returned to the United States in 1911, he went back to Wisconsin, where his mother had bought him some property, a low hill on a small lake. There he built a home, Taliesin I (fig. 28-63), which he called "a natural house" and which finally fulfilled his stated desire for a completely "organic" and "American" architecture. Of his intentions for the dwelling, Wright wrote: "It was unthinkable to me, at least unbearable, that any house should be put on that beloved hill. . . . It should be of the hill. Belonging to it." Using the basic vocabulary developed in his early Prairie houses, Wright conceived Taliesin in terms of a series of horizontal elements irregularly assembled "low, wide and snug" to the hill, as if it had grown there naturally. The use of local stone and wood also wedded the building to its site. Instead of dominating the hill like certain ancient Greek temples, for example, Taliesin harmonizes with it, like earlier Cretan palaces. The building is not simply a testament to the ideal of living in harmony with nature but a declaration of warfare on the modern industrial city. When asked what could be done to improve a city, the architect responded bluntly: "Tear it down."

Wright also designed the furnishings at Taliesin himself (fig. 28-64). Unhappy that clients had violated the

28-65. Julia Morgan. *Drawing for the Oakland YWCA*. 1913. Pen and ink and watercolor, 11³/4 x 21" (30 x 53 cm). Special Collections, California Polytechnic State University, San Luis Obispo

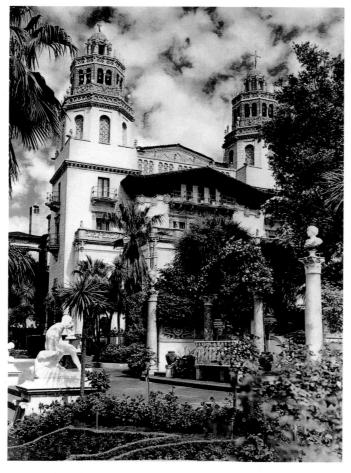

28-66. Julia Morgan. Front entrance, Casa Grande, San Simeon, California. 1922–26. Special Collections, California Polytechnic State University, San Luis Obispo

designs of his Prairie homes with eclectic furnishings of their own choosing, he had earlier embarked on a comprehensive program to design everything from lighting units to rugs and wall hangings. In 1897 he helped found the Chicago Arts and Crafts Society, an outgrowth of the movement begun in England by William Morris (Chapter 27). But whereas his English predecessors looked nostalgically back to the Middle Ages and rejected machine production, Wright did not. He detested standardization,

but he thought the machine could produce beautiful and affordable objects. Wright sought harmony among all the elements of a house, including its site, its exterior, its interior, and its furnishings. Thus, the stones and woods used on the exterior of Taliesin are repeated throughout the open, "organic" spaces of the interior.

Another architect who participated in the American Arts and Crafts movement was the Californian Julia Morgan (1872–1957). Morgan received her degree in engineering in 1894 from the University of California at Berkeley, where she was the only female student. Encouraged by a local architect, she decided to become one. Although the École des Beaux-Arts did not accept women, she moved to Paris anyway and in 1896 enrolled in a private architectural studio. Two years of persistence paid off when she was admitted to the École as its first female student. In 1904 she opened her own office in San Francisco and over the course of her career designed nearly 800 buildings. By 1927 she had a staff of fourteen architects, six of them women.

Morgan did much of her early work for friends and for women's organizations. At Mills College for women she designed several buildings in a revival of the Mission Style, first introduced by early Spanish settlers, that was then becoming popular. For the Oakland Young Women's Christian Association (YWCA), however, she used an Italian Renaissance style (fig. 28-65). The YWCA, founded in London in 1855, was one of the many women's organizations intended to address the social problems of the new industrial cities. The YWCA's particular mission was to provide temporary residences and recreational facilities for the young women flocking to cities to take lowpaying factory and office jobs. Morgan almost never discussed her work, so it is difficult to know why she and her clients chose a Renaissance palace style to house poor working women. Certainly the perfect symmetry of her conception suggests that she wanted to provide the short-term residents with an image of stability.

The distinctive feature of Morgan's architecture was the quality and care of its detailing, or finishing elements. In the Oakland YWCA, for example, the terra-cotta decor used around the windows featured California fruits and flowers. The tiles were made in nearby Alameda from Morgan's own handsome designs. The same concern for careful craft is evident in the work she did for her major patron, William Randolph Hearst, shortly after World War I. In 1919 Hearst commissioned her to design a palatial estate on a hilltop in San Simeon, about 200 miles south of San Francisco. Although Hearst mentioned a "Jappo-Swisso bungalow" in his first meeting with her, he eventually decided on the popular Mission Style for his Casa Grande. The main building (fig. 28-66), of reinforced concrete (see "Space-Spanning Construction Devices," page 32), is a free interpretation of a Spanish Mission church. Above the single doorway and below the pair of wide, sturdy columns typical of such churches, Morgan added a house front to indicate the building's function. Since the Renaissance, the Greek temple had been adapted to domestic architecture, but similar domestic adaptation of the Christian church was rare.

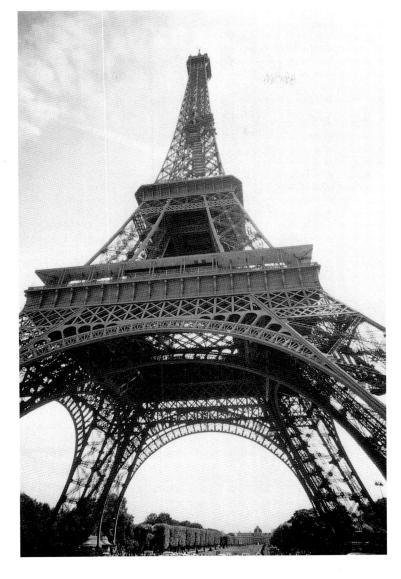

28-67. Gustave Eiffel. Eiffel Tower, Paris. 1887–89

The elaborate decoration on the facade of San Simeon reflects the detailing throughout. The decor and furnishings represent a final manifestation of the Arts and Crafts tradition. Morgan employed a host of stonecutters, experts in ornamental plasters, wood-carvers, iron casters, weavers, tapestry makers, and tile designers. All the craftwork was copied or improvised from historical models.

By the 1920s, most young designers, like their architect counterparts, had completely rejected historicism and handcrafts for a modern machine aesthetic. The story of that change begins in Europe in the late nineteenth century.

Art Nouveau

While the Chicago School was looking for an American alternative to the European Beaux-Arts tradition, its European counterparts had been calling for an end to historicism and the invention of an architectural and design style appropriate to the modern age. The search would lead eventually, in the early twentieth century, to the frank acceptance of new industrial materials and tech-

niques—like those that first appeared in buildings such as the Crystal Palace (see fig. 27-1)—as the basis of legitimate architecture. In the interim, the Art Nouveau ("New Art") phenomenon of the 1890s in Europe was a brief attempt at something less radical.

Art Nouveau was essentially a continental development with roots in the English Arts and Crafts Movement. Like that movement, it emerged initially in response to a world's fair, in this case the Paris Universal Exposition of 1889. The centerpiece of the fair was an enormous tower designed by civil engineer Gustave Eiffel (1832–1923), the winner of a competition for the design of a monument that would symbolize French industrial progress. The Eiffel Tower (fig. 28-67), composed of iron latticework, stands on four huge legs reinforced by trussed arches like those Eiffel used for his famous railway bridges. The passenger elevators, themselves an innovation, allowed fairgoers to ascend to the top of what was then, at 984 feet, the tallest structure in the world.

Although the French public loved the tower, most architects, artists, and writers found it completely lacking in beauty. Even before it was completed, several

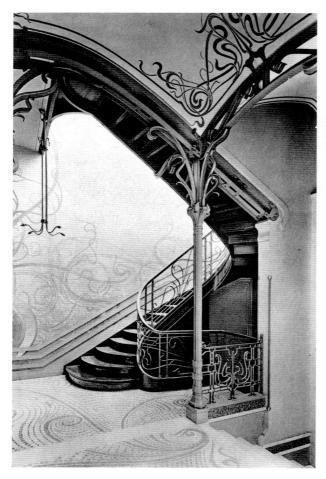

28-68. Victor Horta. Stairway, Tassel House, Brussels. 1892-93

dozen of them signed a petition protesting it to the government: "This tower dominating Paris, like a gigantic and black factory chimney, crushing with its barbarous mass Nôtre-Dame, the Sainte-Chapelle . . . all our monuments humiliated. . . . And in twenty years we shall see, stretching over the entire city . . . the odious shadow of the odious column built up of riveted iron plates" (cited in Holt, volume 1, page 70). The last part of their protest refers not to the literal shadow of the tower but to its metaphorical one, its anticipated influence on the future of architecture in Paris.

Art Nouveau, a style that attempted to be modern without the loss of a preindustrial sense of beauty, was one response to this concern, which extended beyond the French borders. Art Nouveau's commitment to the organically beautiful and its emphasis on traditional materials such as stone and wood were in many ways an attempt to forestall what might be called the industrialization of architecture and design. For the practitioners of Art Nouveau, a purely functional structure like the Crystal Palace or a railway bridge was just not beautiful. They appreciated the simplicity of such structures but found their naked engineering lacking in the linear grace long considered the very essence of beauty.

The man who launched the Art Nouveau style of the 1890s was a Belgian, Victor Horta (1861–1947). Horta trained as an architect at the Brussels Academy, then

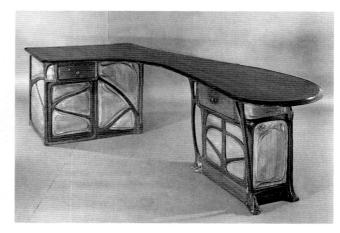

28-69. Hector Guimard. Desk. c. 1899 (remodeled after 1909).

Olive wood with ash panels, 28³/₄ x 47³/₄" (73 x 121 cm).

The Museum of Modern Art, New York

Gift of Madame Hector Guimard

worked in the office of a Neoclassical architect. In 1892 he received his first independent commission, to design a private residence in Brussels for a Professor Tassel. The result, especially the house's entry hall and staircase (fig. 28-68), was strikingly original. The ironwork, wall decoration, and floor tile were all designed in terms of an intricate series of long, graceful curves. Although Horta's sources are still a matter of debate, he apparently was much impressed with the stylized linear graphics produced by artists of the English Arts and Crafts Movement of the late 1880s, such as the architect and designer Arthur Heygate Mackmurdo (1851–1942) and the painter and illustrator Walter Crane (1845-1915). Horta's concern for integrating the various arts into a more unified whole, like his reliance on a refined decorative line, also derived largely from English reformers.

The application of graceful linear arabesques to all aspects of design, evident in the entry hall of the Tassel House, began a vogue that lasted for more than a decade. During its lifetime the movement had a number of regional names. In Italy it was called *Stile floreale* ("Floral Style") and *Stile Liberty* (after the Liberty department store in London); in Germany, *Jugendstil* ("Youth Style"); in Spain, *Modernismo* (Modernism); in Vienna, *Secessionsstil*, after the secession from the Academy led by Klimt; in Belgium it was called *Paling Style* ("Eel Style"); and in France it had a number of names, including *moderne*. The name eventually accepted in most countries derives from a shop, La Maison de l'Art Nouveau ("The House of the New Art"), which opened in Paris in 1895.

In France it was also sometimes known as *Style Guimard* after its leading French practitioner, Hector Guimard (1867–1942). Like Horta, Guimard was more a designer than an architect in the strictest sense. His major production was in the area of interior design and furnishings. Typical of his work is the desk that he made for himself out of olive wood and ash wood (fig. 28-69). Instead of a static and stable object, Guimard has hand-crafted an organic entity that seems to undulate and grow.

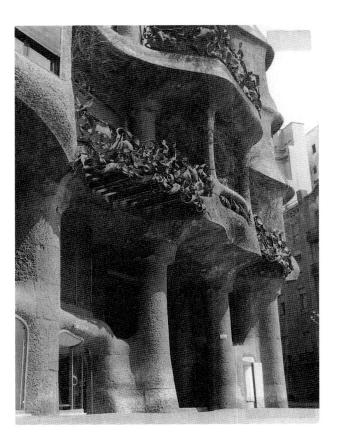

28-70. Antonio Gaudí. Casa Milá apartment building, Barcelona. 1905–7

Both the organic principle and the concern to unify all areas of life into a beautiful whole relate Art Nouveau to the nearly contemporary work of Frank Lloyd Wright. But whereas Wright wanted this integration to occur in a rural setting and to involve the way people actually lived, the Art Nouveau designers and architects were content to redecorate the modern city in a natural style. Guimard's desk, for example, is less a utilitarian object than it is an objet d'art.

The one major exception to this generalization is the Catalan architect Antonio Gaudí y Cornet (1852–1926). The son of an ironworker, Gaudí studied architecture in the 1870s at the Academy in Barcelona. Like Horta, he was familiar with the writings of Morris and the graphics of Crane, Mackmurdo, and other English Arts and Crafts practitioners. His work paralleled developments in the work of Horta and others but did not depend on them. Almost ten years before Horta's decorative ironwork at the Tassel House, Gaudí had produced similar work in Barcelona for his patron Count Güell.

Unlike his counterparts, Gaudí attempted to introduce the organic principle into the very structure of his buildings. In the Casa Milá apartment house in Barcelona (fig. 28-70), for example, the interior and exterior walls gently undulate like ocean waves. The work has no straight lines. Constructed around a steel frame, it is cov-

28-71. Charles Rennie Mackintosh. Director's Room, Glasgow School of Art. 1897–1909 ered with cut stones hammered to give the surface a look of natural erosion, like beach cliffs. The organic effect is completed by the stylized ironwork, which seems to grow like foliage or seaweed on the balconies. Like Wright's organic architecture, this is a national alternative to both historicism and the threat of industrialism.

Despite the role the English Arts and Crafts Movement played in the formation of Art Nouveau, the English did not participate in the style. During the 1890s they remained faithful to the styles and principles associated with Morris. The British architect and designer whose work most closely approximates Art Nouveau was the Scot Charles Rennie Mackintosh (1868-1928). In 1891 he and a colleague at his firm, Herbert McNair, met and eventually married two students at the Glasgow School of Art, Margaret Macdonald (1865-1933) and Frances Macdonald (1874-1921), who shared their taste and ideas. The four soon began to collaborate in a variety of decorative projects, including posters, metalwork, glass, and fabrics. Their work, shown at La Maison de l'Art Nouveau in 1896, featured an elegant, elongated line reminiscent of Horta's and Guimard's but used more sparingly and in conjunction with large empty spaces.

The style developed by "The Four," or "Mac's Group," is evident in the Director's Room at the Glasgow School of Art (1897–1909), which was designed largely by Mackintosh but with considerable help from his wife, Margaret Macdonald (fig. 28-71). The Director's Room is the first of the Mackintoshes' innovative "white rooms." The wood paneling, instead of being left naturally dark, is painted white to match the walls. In sharp reaction to both the Victorian and the Arts and Crafts preference for filling the walls with decor, here they are refreshingly clean and spare. The focus is on the wooden furniture designed in

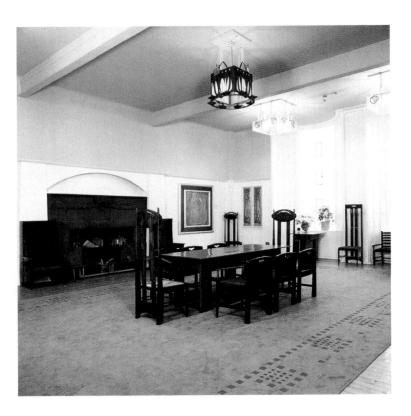

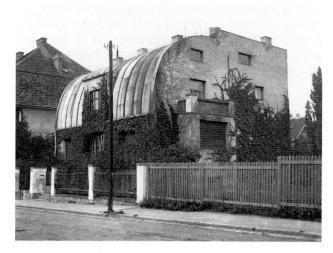

28-72. Adolf Loos. Steiner House, Vienna. 1910

a simplified medieval style and produced by local craftspeople under Mackintosh's supervision. Some of the furniture, particularly the famous high-backed Mackintosh chair with the oval rail seen here, sacrifices utilitarian comfort to beauty. The linear designs used in the metalwork on the cabinet and in the frosted-glass lighting fixtures were inspired by the **interlaces** featured in Celtic manuscripts. The Mackintoshes, like Wright and Gaudí, were interested in developing not simply a modern style but one based on their own cultures.

Early Modernism

In 1900 the Mackintoshes were invited to design a room for an exhibition in Vienna. The restrained style of the result seems to have encouraged a number of young Viennese architects, already dissatisfied with Art Nouveau, to turn vehemently against it. The most radical of this group was Adolf Loos (1870–1933). Born in Austria-Hungary, Loos studied in Dresden, Germany. He spent three years in the United States and was impressed by the industrial buildings he saw there. In Vienna he began to make a name for himself not with his architecture, of which there is little, but with his writing. In his most famous essay, "Ornament and Crime" (1908), he insisted: "The evolution of culture is synonymous with the removal of ornament from utilitarian objects." For Loos, ornament was a sign of weakness.

Two years after that essay, Loos designed the Steiner House (fig. 28-72), a rather unimpressive building whose reputation depends largely on the fact that it illustrates

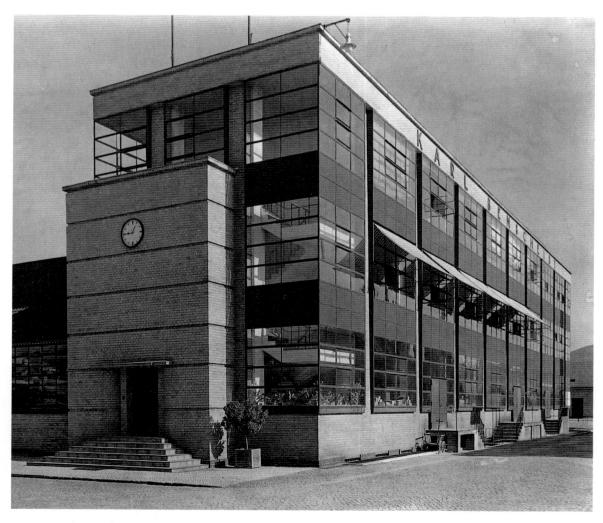

28-73. Walter Gropius and Adolph Meyer. Fagus Factory, Alfeld-an-der-Leine, Germany. 1911-16

28-74. Antonio Sant'Elia. Central Station project, Milan. 1914. After Banham

"We are no longer the men of the cathedrals, the palaces, the assembly halls," Sant'Elia wrote in the 1914 *Manifesto of Futurist Architecture,* "but of big hotels, railway stations, immense roads, colossal ports, covered markets... demolition and rebuilding schemes. We must invent and build the city of the future, dynamic in all its parts... and the house of the future must be like an enormous machine."

its architect's famous views. The simple stucco construction is devoid of embellishment. Windows are not arranged decoratively but simply where the needs of the interior call for them. For Loos, an exterior was not to delight the aesthetic sense but simply to provide protection from the elements. The curved roof allows rain and snow to run off but, unlike the traditional steeped roof, creates no wasted space.

The purely functional exteriors of Loos's buildings and his outspoken opposition to ornament would seem to qualify him as one of the founders of modernist architecture. Loos later objected to this attribution, however, because he found modernism too stark. Although his exteriors contributed to the emergence of modernism, his sumptuous interiors, which often featured colorful marble, reflect enduring ties to the nineteenth century.

A better candidate for founder of modernist architecture is Walter Gropius (1883–1969). After conventional architectural training in Munich and Berlin between 1903 and 1907, Gropius became the chief assistant to Peter Behrens, whose Berlin firm specialized in industrial architecture. In 1910 he opened his own office. His lectures on ways to increase workers' productivity by improving their workplace environment caught the attention of an industrialist, and in 1911 he was commissioned to design the facade for the Fagus Factory (fig. 28-73). This building represents the emergence of modernist architecture from the engineering advances of the

nineteenth century. Unlike the Crystal Palace or the Eiffel Tower, it was conceived not to demonstrate those advances or to solve a specific problem but as legitimate architecture. With it Gropius was the first to proclaim that modern architecture should make intelligent and sensitive use of what the engineer can provide.

Inspired partly by Wright, Gropius produced a purely functional building in the tradition of the Crystal Palace. Unlike the buildings of Wright and Behrens, however, the Fagus Factory facade has no elaboration beyond that dictated by its modern construction methods. The slender brick piers along the outer walls mark the building's steel frame, and the narrow bands of brickwork at the top and bottom, like the opaque panels between them, mark floors and ceilings. A curtain wall—an exterior wall that does not bear any weight but simply separates the inside from the outside-hangs over the frame. Large rectangular windows dominate the exterior. The corner piers standard in earlier buildings have been eliminated as unneeded gestures to tradition. The glass both reveals the building's structure and floods the workplace inside with light.

Just prior to World War I, a Futurist architect, Antonio Sant'Elia (1888-1916), conceived a more dynamic, less functional solution to the search for a modern style. Sant'Elia apparently joined the Futurists soon after taking his degree in 1912. Beginning that year, he produced a series of drawings of his vision of the city of the future (fig. 28-74), and in 1914, he published his Manifesto of Futurist Architecture, which explains those drawings. His conception of the new city is not based on new technology alone but on the way it can emphasize the energy of modern life. He wanted to use steel, glass, and reinforced concrete to create an architecture of dynamic appearance. The basic structure of the new city would be the skyscraper, serviced by dramatic exterior glass elevators and connected by open walkways. The stepped-back design of these high-rise buildings, like the soaring towers at their top, is not functional but expressive. The verticals, diagonals, and curves are meant to characterize the essential feature of the new city—rapid movement. Cutting through and beneath the city's architecture would be a network of roads and subways extending in places to seven levels below the ground. Nowhere is there a trace of nature.

Although Sant'Elia's visionary drawings had a profound effect on one strain of architecture after World War I, he did not live to see it. He was among the nearly 10 million young men who died in the war that broke out in 1914.

EUROPEAN ART AND ARCHITECTURE BETWEEN THE WARS

The Great War, as World War I was then known, had a profound effect on Europe's artists and architects. While many responded pessimistically, most sought in the war's

ashes the basis for a new, more secure civilization. For many, that basis was to be found in the seemingly timeless culture of the classical tradition.

28-75. Pablo Picasso. *Woman in White (Madame Picasso).* 1923. Oil on canvas, 39 x 31 ¹/₂" (99 x 80 cm). The Metropolitan Museum of Art, New York Rogers Fund

Postwar Classicism

Perhaps the most unexpected reaction to World War I was Picasso's. After Braque's departure for the front in 1914, Picasso stayed in Paris, where he faced a growing tide of nationalistic criticism against Cubism. Because many of the art dealers who sold Cubist works were German, their collections were confiscated, and Cubism itself was denounced as a manifestation of German "destructive" tendencies. That Spanish and French artists invented it was conveniently ignored in the heated rhetoric aimed at restoring the preeminence of what was considered a spiritually healthy French classicism.

Picasso responded to this climate by adopting a classical style. During the war and for several years after, the man who had earlier spurned a French style, then rejected conventional representation altogether, produced works like *Woman in White* (fig. 28-75). The large, calm, self-contained figure seems to derive directly from ancient Greek sculpture or from Puvis's murals. Even the chalky whites are reminiscent of classical marble and the muted tones Puvis preferred. The bohemian Picasso of the prewar years was giving way to the later Picasso who aspired to be counted among the wealthy. In 1918 he married Olga Koklova, a Russian dancer in Diaghilev's Ballets Russes.

The British sculptor Henry Moore (1898–1986) also adopted a form of classicism, but for less self-serving and

28-76. Henry Moore. Reclining Figure. 1929. Brown Hornton stone, $22^{1/2}$ x 33 x 15" (57 x 83.8 x 38 cm). Leeds City Art Gallery, England

1920 1880 1940

personal reasons. In his early work from the late 1920s he attempted to reinvigorate the classical tradition with the strength and power of the "primitive" art very much in favor in Britain after the war. His Reclining Figure (fig. 28-76) combines the pose found in certain of the Elgin Marbles (sculpture from the Parthenon, housed in the British Museum) with the blocky formal language of pre-Columbian art. As with the women in Picasso's Les Demoiselles d'Avignon (see fig. 28-36), the erotic connotations of the figure's pose are subsumed by her psychological and physical strength. The erect head, based on that of Achilles from the Parthenon frieze, suggests intelligence. With its imposing monumentality, Moore's work, almost all of which was made for public display, comforts the modern viewer anxious about the human capacity to endure.

Russian Utilitarian Art Forms

In March 1917 growing Russian dissatisfaction with the war gave revolutionary elements the opportunity to overthrow the czarist monarchy. In October the government was seized by the Bolsheviks ("radical socialists") under Vladimir Lenin, who immediately took Russia out of the war.

Most members of the Russian avant-garde enthusiastically supported the Bolsheviks, who in turn supported them. Vladimir Tatlin's case is fairly typical. In 1919 he was appointed head of the Studio for Volumes, Materials, and Construction at the Petrograd State Free Art Studios (previously the St. Petersburg Academy). Partly as a result of his work on the committee in charge of implementing Lenin's Plan for Monumental Propaganda, Tatlin devised his own inspirational work, the Monument to the Third International (fig. 28-77). The monument he envisioned was intended to demonstrate that only a revolutionary formal language could properly commemorate the new revolutionary society. It also sought to show how the formal experiments of the prerevolutionary period could serve more utilitarian ends. In Tatlin's model for a 1,300-foot building to house the new Russian congress, the steel structural support, a spiraling diagonal, is on the outside rather than inside the building. Tatlin combined the Eiffel Tower with the formal vocabulary of the Cubo-Futurists to convey the dynamism of the new Soviet state. Inside the steel frame would be four separate spaces: a large cube to house legislative meetings, a smaller pyramid for executive committees, a cylinder for propaganda offices, and a hemisphere at the top, apparently meant for radio equipment. Each of these units would rotate at a different speed, from yearly at the bottom to hourly at the top.

Neither Tatlin nor anyone else had the slightest idea how such a visionary piece of architecture could actually be built. The monument is both an affirmation of faith in what Soviet science could achieve and an object meant to inspire the genius of the Russian people in that direction. The small model was shown in propaganda parades in 1920 and 1921, and a 130-foot model of iron and glass was later built in Petrograd.

28-77. Vladimir Tatlin. Model for the Monument to the Third International. 1919–29. Wood, iron, and glass. Destroyed

Karl Marx helped organize the International Working Men's Association, or First International, an uneasy alliance of British trade-union leaders and various continental Communist groups that lasted from 1864 to 1872. By 1889 Socialist parties had gained sufficient strength in enough European nations to form a loose international association, the Second (or Socialist) International, which came to an end at the onset of World War I, when most Socialist leaders abandoned internationalism for the nationalist interests of the war. The Third (or Communist) International was formed under Vladimir Lenin in March 1919 to promote the spread of communism through what he called "permanent revolution."

Tatlin's associates in the postrevolutionary period, known as the Constructivists, were committed to the notion that the artist must quit the studio and "go into the factory, where the real body of life is made." In place of those artists now considered "outlaws"—that is, those who were dedicated to pleasing themselves—they envisioned politically committed artists devoted to creating useful objects whose forms would be perfectly suited to their functions and to the mechanical processes necessary for their production. One of the founders of the movement, launched in 1921, was Aleksandr Rodchenko (1891–1956). His work in Moscow with Tatlin in about 1917–1919 gradually convinced him that painting and sculpture did not contribute enough to practical needs. In 1921, after exhibiting a triptych of red, yellow, and blue

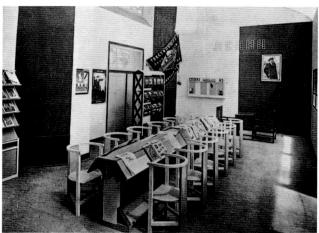

28-78. Aleksandr Rodchenko. View of the Workers' Club, exhibited at the Exposition Internationale des Arts Décoratifs et Industriels Modernes, Paris. 1925. Rodchenko-Stepanova Archive, Moscow

canvases that he considered the end of painting, he gave up traditional "high art" mediums (painting and sculpture) to make photographs and to design posters, books, textiles, and theater sets, all of which were intended to promote the ends of the new Soviet society.

In 1925 Rodchenko also designed a model workers' club for the Russian pavilion at the Paris World's Fair (fig. 28-78). Although Rodchenko said such a club "must be built for amusement and relaxation," the space was essentially a reading room dedicated to the proper training of the Soviet mind. One corner of the room was devoted to materials on the life and ideas of Lenin, who had died the year before. Even the one recreational element, the chess table in the back beneath Lenin's photograph, sharpens the intellect. The furniture was designed for simplicity of use, standardization, and the necessity of being able to expand or contract the number of its parts. Thus many of the items were collapsible, so they could be stored when not in use. The furniture is wood because Russian industry was best equipped for mass production in that medium. The design of the chairs is not strictly util-

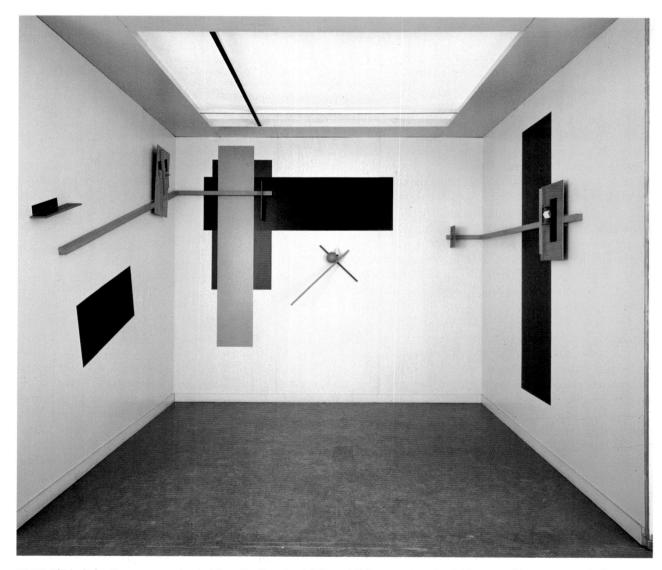

28-79. El Lissitzky. Proun space created for a Berlin art exhibition. 1923, reconstruction 1965. Van Abbemuseum, Eindhoven, the Netherlands

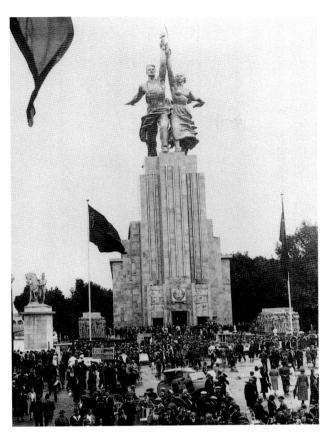

28-80. Vera Mukhina. *Worker and Collective Farm Worker,* sculpture for the Soviet Pavilion, Paris Exposition. 1937

itarian, however. The high, straight backs were meant to promote a physical and moral posture of uprightness among the workers.

A less radical devotion to socialism and utilitarianism was practiced in the early 1920s by many artists, including El Lissitzky (1890-1941). After the 1917 Russian Revolution, Lissitzky, who had trained as an engineer in Germany, was invited to teach architecture and graphic arts at the Vitebsk School of Fine Arts. There he came under the influence of Malevich, who also taught at the school. By 1919 he was using Malevich's formal vocabulary for propaganda posters and for artworks he called Prouns, an acronym for "Project for the Affirmation of the New." Most are paintings, but a few, like that made for an exhibition in Germany (fig. 28-79), were Proun spaces. Lissitzky, who rejected conventional painting instruments as too personal and imprecise, produced his Prouns with the aid of mechanical instruments. Their engineered look is meant not merely to celebrate industrial technology but to encourage precise thinking among the public, to produce, as he suggested in one of his works, a "new man."

As was typical of the general trend in Russian art of the late 1920s, Lissitzky grew disillusioned with the power of formalist art to communicate broadly. By the end of the decade, he had turned to more utilitarian projects—architecture and typography, in particular—and had begun to produce, along with Rodchenko and others,

propaganda photographs and **photomontages**, the combination of several photographs into one work. During the 1930s he worked for *USSR in Construction*, a magazine meant to give its foreign readers a positive impression of Soviet society.

The move away from abstraction was led by a group of realists, deeply antagonistic to the avant-garde, who banded together in 1922 to form the Association of Artists of Revolutionary Russia (AKhRR) and promote a clear, representational approach to revolutionary art. The AKhRR looked back to artists such as Repin (see fig. 27-25) and dedicated itself to the depiction of workers, peasants, revolutionary activists, and, in particular, to the life and history of the Red Army. After Joseph Stalin succeeded Lenin in 1924, the artists of the AKhRR were more and more often called on to produce images for the state. Their tendency to create huge, overly dramatic canvases on heroic or inspirational themes established the basis for the Socialist Realism instituted by Stalin after he took control of the arts in 1932.

One of the sculptors who worked in this official style was Vera Mukhina (1889-1963), who had studied briefly in Paris before the war. Her most famous work is Worker and Collective Farm Worker (fig. 28-80), made for the Soviet Pavilion at the Paris Exposition of 1937. The powerfully built male factory worker and female farm laborer hold aloft their respective tools, a hammer and a sickle, to mimic their appearance on the Soviet flag. The two figures are shown as equal partners striding purposefully into the future. Their determined faces look forward and upward. The dramatic, windblown drapery and the forward propulsion of their diagonal poses, not unlike the forceful spiraling angles of Tatlin's Monument (see fig. 28-77), enhance the sense of vigorous idealism. The work was not meant for domestic inspiration but to convince an increasingly skeptical international audience of the continuing vitality of the Soviet system.

Dutch Rationalism

In the Netherlands the Dutch counterpart to the inspirational formalism of Lissitzky was the group de Stijl. The Dutch term de Stijl means "the Style." The movement's leading artist was Piet Mondrian (1872-1944), whose early naturalistic landscapes gave way during the first decade of the twentieth century to a more classically composed kind of Fauvism. The turning point in his life came in 1911 when he went to Paris and encountered Analytic Cubism. Beginning with works quite similar to Picasso's Ma Jolie, he gradually moved from radical abstractions of landscape and architecture to a simple, austere form of geometric art inspired by them, one whose basic schema of horizontals and verticals symbolized a whole range of opposites, including male versus female and material versus spiritual. In the Netherlands during World War I, he met Theo van Doesburg, another painter who shared his artistic views, and in 1917 the two started a magazine, De Stijl, which became the focal point of a Dutch movement of artists, architects, and designers that lasted until van Doesburg's death in 1931.

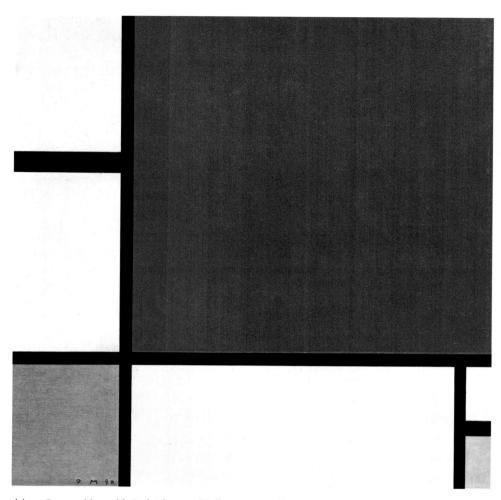

28-81. Piet Mondrian. *Composition with Red, Blue, and Yellow.* 1930. Oil on canvas, 20 x 20" (50.3 x 50.3 cm). Private collection Mondrian so disliked the sight of nature, whose irregularities he held largely accountable for humanity's problems, that when seated at a restaurant table with a view of the outdoors, he would ask to be moved.

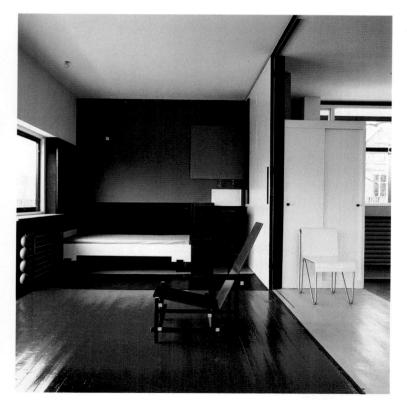

The de Stijl movement was grounded in the conviction that there are two kinds of beauty: a sensual or subjective one and a higher, rational or objective— "universal"-kind. In his mature works Mondrian sought the essence of the second kind, eliminating representational elements because of their subjective associations. In paintings such as Composition with Red, Blue, and Yellow (fig. 28-81) he "purified" his formal vocabulary, reducing it to basic elements-the horizontal and vertical, the three primary hues (red, yellow, and blue) and the two primary values (black and white)—in order to distill the essence of higher beauty. That essence, he believed, was to be found in what he called a dynamic equilibrium among basic elements, achieved in Composition with Red, Blue, and Yellow through the precise arrangement of color areas of different weight. The heavier weight of the red threatens to tip the painting to the right, but the placement of the tiny rectangle of yellow at the lower right prevents this by supporting its weight.

The tension between competing color areas in a Mondrian work is intended as a metaphor. For example, the relation between colors can symbolize the competi-

28-82. Gerrit Rietveld. Interior, Schröder House, Utrecht, the Netherlands. 1924

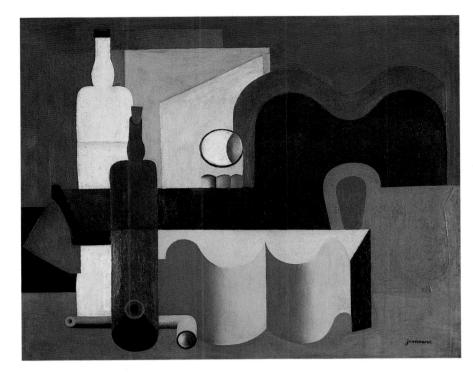

28-83. Le Corbusier.

Still Life. 1922.
Oil on canvas,
25 ³/₈ x 31 ¹/₂"
(64 x 80 cm).

Musée National
d'Art Moderne,
Centre Georges
Pompidou, Paris

tion between individuals in society, which the painting here harmonizes. More important, the ultimate purpose of such paintings is not to hang in the home of a wealthy collector but to demonstrate a universal style, based on ideas of balance, with applications beyond the realm of art. Like Art Nouveau, de Stijl wished to redecorate the world. But to Mondrian and his colleagues, nature's example only encourages what they felt were "primitive animal instincts," and they therefore rejected the organic style of Art Nouveau. If, instead of living in a state of nature, we lived in an environment designed according to the rules of "universal beauty," we too, like our art, would be balanced, our natural instincts "purified." For these reasons, Mondrian could hope to be the world's last artist. He felt that earlier art had provided humanity with something that was lacking in daily life. But if we did have beauty in every aspect of our lives, we would have no further need for art.

The major architect and designer of the de Stijl movement was Gerrit Rietveld (1888-1964), whose famous "red and blue" chair is shown here in the bedroom of his most important project, the Schröder House (fig. 28-82) in Utrecht. Inspired partly by both Wright and the Constructivists, Rietveld applied Mondrian's design principle of a dynamic symmetry of rectangular planes of color to the entire house and its built-in furnishings. Some of the compositional planes on the interior were sliding partitions designed to allow modifications in the spaces used for sleeping, working, and entertaining. These innovative wall partitions were actually the idea of the owner, Truus Schröder, who worked with Rietveld on the design of this and several later projects. A wealthy woman, Schröder wanted her austere home to suggest the rejection of luxury for simple necessities sensitively integrated into a beautiful whole.

French Rationalism

Among French artists, the dominant response to the Great War was similar to that of de Stijl. Many saw the war as the inevitable consequence of a culture in which the spirit of competition and individualism had run amok. For them the solution was what one conservative critic labeled "the return to order," the formation of a more disciplined society along lines suggested in visual terms by Seurat in A Sunday Afternoon on the Island of La Grande Jatte (see fig. 28-14). One expression of this widespread conviction was Purism, whose leading figure was the Swiss-born Charles-Édouard Jeanneret (1887–1965). A largely self-taught architect and designer, Jeanneret moved to Paris in 1917, where he met Amédée Ozenfant (1886–1966). In 1918 they published a book, After Cubism, and between 1920 and 1925 they edited a magazine, L'Esprit nouveau (The New Spirit).

Like the Constructivists and the proponents of de Stijl, the Purists firmly believed in the power of art to change the world. In 1920 Jeanneret, partly to demonstrate his faith in the ability of individuals to remake themselves, renamed himself Le Corbusier, a play on the French word for raven. Le Corbusier and Ozenfant thought of themselves as producing a new and improved Cubism that would not only provide aesthetic pleasure but also, by placing viewers in an orderly frame of mind, promote social order in the world. These ideas led to a series of paintings like Le Corbusier's Still Life (fig. 28-83), in which the subdued harmony of colors supports the strict arrangement of elements along the horizontal and vertical axes. The Purists included musical instruments, especially guitars, to suggest the harmony they sought. And they featured simple containers, such as bottles, to emphasize what they considered the basic utilitarian purposes of their paintings.

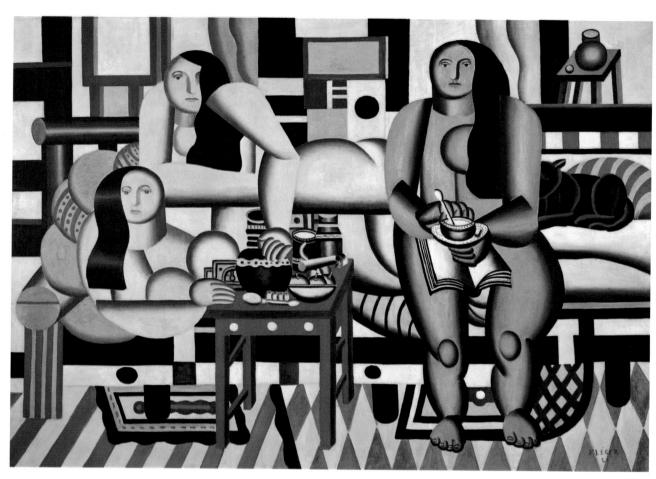

28-84. Fernand Léger. *Three Women.* 1921. Oil on canvas, 6' 1/2" x 8'3" (1.84 x 2.52 m). The Museum of Modern Art, New York Mrs. Simon Guggenheim Fund

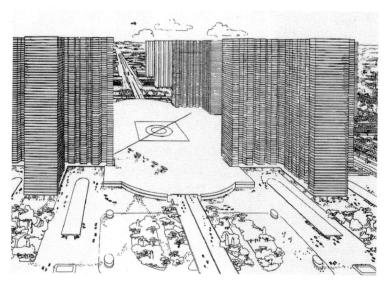

28-85. Le Corbusier. Plan for a Contemporary City of Three Million Inhabitants. 1922

In 1925 Le Corbusier devised a similar plan for Paris, convinced that the center of the city needed to be torn down and rebuilt to accommodate automobile traffic. The Parisian street was a "Pack-Donkey's Way," he said: "Imagine all this junk . . . cleared off and carried away and replaced by immense clear crystals of glass, rising to a height of over six hundred feet!"

One of the artists strongly influenced by Purism was Fernand Léger (1881-1955). By 1910 he belonged to Picasso's circle and was producing a dynamic, personal brand of Analytic Cubism in which he attempted to reconcile traditional artistic subjects with his radical taste for industrial metal and machinery. In the early 1920s he briefly experimented with Purism in a series of stilllife and figure paintings that included Three Women (fig. 28-84). His answer to the French odalisque tradition, the painting takes Delacroix's Women of Algiers (see fig. 26-47) and transforms it according to a Purist ideal of anonymity and order. The women, arranged within a geometric grid, stare out blankly at us. They have identical faces, and their bodies seem assembled from standardized, detachable metal parts. The bright, cheerful colors and patterns suggest a positive vision of an orderly industrial society.

Purism's most important contributions were not in painting or sculpture but in architecture. Although he never gave up painting, from 1922 until his death Le Corbusier concentrated on architecture and urban planning. One of his first mature projects was his conception for a Contemporary City of Three Million Inhabitants (fig. 28-85), a design he exhibited in Paris in 1922. Le Corbusier hated the crowded, noisy, chaotic, and polluted places that

cities had become in the late nineteenth century. What he envisioned for the future was a city of uniform style, laid out on a grid, and dominated, like Sant'Elia's (see fig. 28-74), by skyscrapers, with wide traffic arteries that often passed beneath ground level. Le Corbusier's city would be different from Sant'Elia's, however, in two fundamental respects. First, the buildings would be strictly functional, in the manner of Gropius's Fagus Factory (see fig. 28-73). And second, nature would not be neglected. Set between the widely spaced buildings would be large expanses of parkland. The result, Le Corbusier thought, would be a new, clean, and efficient city filled with light, air, and greenery. Le Corbusier's vision had a profound effect on later city planning, especially in the United States.

The Bauhaus

The German counterpart to the total and rational planning envisioned by de Stijl and Le Corbusier was conceived between 1919 and 1933 at the Bauhaus ("House of Building"), the brainchild of Walter Gropius. Gropius, who belonged to several utopian groups, including one in sympathy with the Russian Revolution, admired the spirit of the medieval building guilds—the Bauhütten that had built the great German cathedrals. He sought to revive that spirit and commit it to the reconciliation of modern art and industry through what he called a cultural synthesis, which would emerge from the combined efforts of architects, artists, and designers. The Bauhaus was formed in 1919, when Gropius convinced the authorities of Weimar, Germany, to allow him to combine the city's schools of art and craft. The Bauhaus moved to Dessau and then to Berlin, where it remained until 1933, when Hitler, who detested the avant-garde, closed it (see "Suppression of the Avant-Garde in Germany," below). Gropius left the school in 1928.

There was no formal architectural curriculum at the Bauhaus. Gropius felt that workshop courses in construction, metalwork, carpentry, interior design (including painting), and furniture making—all of which emphasized the understanding of materials—had to be fully mastered before architecture. For teachers, Gropius hired ordinary craftspeople as well as famous artists, among them Kandinsky and Klee. The goal was the training of a generation of architects dedicated to "a clear, organic architecture, whose inner logic will be radiant

OF THE AVANT-GARDE was strong poli-IN GERMANY

SUPPRESSION During the 1930s in Germany there tical reaction to avant-garde art.

One of the principal targets was the Bauhaus (see fig. 28-86), the art and design school founded in 1919 by Walter Gropius, where Paul Klee, Vasily Kandinsky, Josef Albers, Ludwig Mies van der Rohe, and other luminaries taught (see figs. 28-31, 28-33, 29-37). Through much of the 1920s the Bauhaus had been struggling against an increasingly hostile and reactionary political climate. As early as 1924, conservatives had accused the Bauhaus of being not only educationally unsound but also politically subversive. In order to avoid having the school shut down by this opposition, Gropius moved it to Dessau in 1926 at the invitation of the city's liberal mayor. Gropius left the Bauhaus not long after its relocation to Dessau. His successors faced increasing political pressure on the school because it was one of the prime centers of modernist practice, and they were again forced to move it in 1932, this time to Berlin.

After Adolf Hitler came to power in 1933, the Nazi party mounted an aggressive campaign against all modernist art. In his youth Hitler had been a mediocre academic painter, and he had developed an intense hatred of the avant-garde. During the first year of his regime the Bauhaus was forced to close for good. A number of the artists, designers, and architects who had been on its faculty emigrated to the United States, including Albers, Gropius, and Mies van der Rohe.

The Nazis also launched attacks against the German Expressionists, whose often intense depictions of German soldiers defeated in World War I and of the economic depression following the war the Nazis considered unpatriotic. Most of all, the treatment of the human form in these works, such as the expressionistic exaggeration of facial features, was deemed offensive. The works of these and other artists were removed from museums, while the artists themselves were subjected to public ridicule and often forbidden to buy canvas and paint.

As a final move against the avantgarde, the Nazi leadership organized in 1937 a notorious exhibition of banned works. The "Degenerate Art" exhibition was intended to erase modernism once and for all from the artistic life of the nation. Seeking to brand as sick and "degenerate" all the experimental movements of art, it presented modern artworks as if they were

specimens of pathology. As part of the exhibition, the organizers printed derisive slogans and comments to that effect on the gallery walls. The 650 paintings, sculpture, prints, and books confiscated from German public museums were viewed by 2 million people in the four months the exhibition was on view in Munich and by another million during its subsequent threeyear tour of German cities.

By the time World War II broke out, the authorities had confiscated countless works from all over the country. Most were burned, though the German government sold a number of the works at public auction in Switzerland to obtain foreign currency for its agenda.

Among the many artists crushed by the Nazi suppression was Ernst Ludwig Kirchner, whose Street, Berlin (see fig. 28-27) was included in "Degenerate Art." The state's open animosity was a factor in his suicide in 1938. Other artists, such as John Heartfield, left the country in order to continue their work and to voice their opposition to the Nazis. In his scathing caricatures of Hitler, such as Have No Fear-He's a Vegetarian (see fig. 28-91), Heartfield took some of the modernist artistic innovations that Hitler had condemned and used them to mock him.

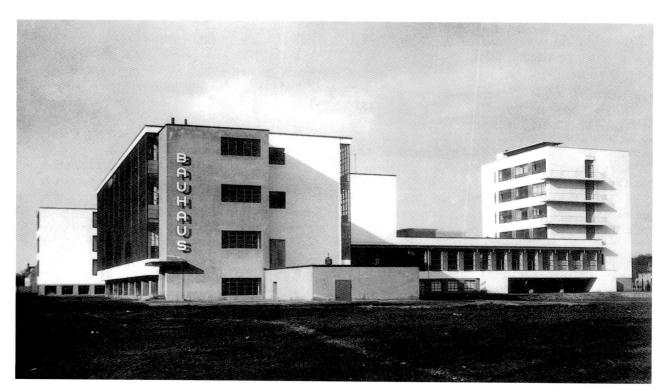

28-86. Walter Gropius. Bauhaus Building, Dessau, Germany. 1925-26

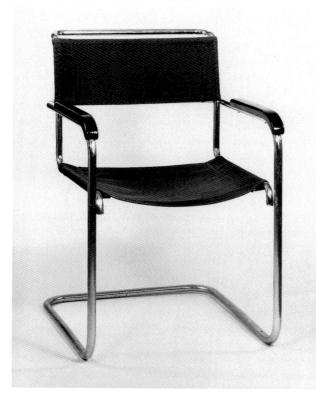

28-87. Marcel Breuer. Vasily chair. 1928. Chromium-plated tubular steel, painted wood, and canvas, 33½ x 21½ x 21½ x 24* (85.1 x 55.6 x 61 cm). Wadsworth Atheneum, Hartford, Connecticut

and naked, unencumbered by lying facades and trickeries; we want an architecture adapted to our world of machines, radios and fast motor cars, an architecture whose function is clearly recognizable in the relation of its forms" (cited in Bayer, Gropius, and Gropius, page 27).

What Gropius had in mind may be seen in his design for the new Dessau Bauhaus, built in 1925-1926 (fig. 28-86). The building frankly acknowledges the reinforced concrete, steel, and glass of which it is built; Gropius made no attempt to cover or decorate them. The building is not strictly utilitarian, however. The asymmetrical balancing of the large, cubical structural elements is meant to convey the dynamic quality of modern life. (If this design principle seems reminiscent of de Stijl, that is because van Doesburg worked briefly at the old Bauhaus in 1922 and influenced the development of Gropius's ideas.) The expressive glass-panel wall that wraps around two sides of the workshop wing of the building recalls the glass wall of the Fagus Factory (see fig. 28-73) and reflects the industrial activities of the workshop. The raised parapet below the workshop windows demonstrates the ability of modern engineering methods to create light, airy spaces unlike the heavy spaces of past styles.

The Vasily chair designed by Marcel Breuer (1902–1981), a Bauhaus instructor and former student, is characteristic of the kind of utilitarian objects Gropius hoped to see in this new architecture (fig. 28-87). Breuer, born in Hungary, was typical of the international student body attracted to the Bauhaus. From 1920 to 1924 he studied in the furniture design workshop. When the school moved to Dessau, he was promoted to "young master" in the same

1930 1880 1940

studio. Shortly before he left to join an architect's firm in Berlin, he designed the Vasily chair, named in honor of one of his teachers, Vasily Kandinsky. The cantilevered frame, eliminating the need for back legs, is of chrome-plated steel tubing. The back and seat are of inexpensive canvas. Painted wood armrests complete the design. The simple utilitarian chair was intended to be cheaply mass-produced. Its elegant lines and industrial materials suggest what can be achieved through the marriage of modern industry and a trained artistic sensibility.

Dada

The emphasis on individuality and irrational instinct evident in the work of artists like Gauguin and many of the Expressionists did not die out entirely after World War I. It endured in the Dada movement, which began with the opening of the Cabaret Voltaire in Zürich on February 5, 1916. The cabaret's founders, German actor and artist Hugo Ball (1886-1927) and his companion, Emmy Hennings, a nightclub singer, had moved to neutral Switzerland when the war broke out. Their cabaret, in the neighborhood where Lenin then lived in exile, was inspired by the bohemian artists' cafés they had known in Berlin and Munich. The advertisement for the opening of the Cabaret Voltaire invited "young artists of Zürich, whatever their orientation . . . to come along with suggestions and contributions of all kinds." The cabaret immediately attracted a circle of avant-garde writers and artists of various nationalities who shared in Ball's and Hennings's disgust with bourgeois culture, which they blamed for the war. The way Ball performed one of his sound poems, "Karawane" (fig. 28-88), reflects the spirit of the place. His legs and body encased in blue cardboard tubes, his head surmounted by a white-and-blue "witchdoctor's hat," as he called it, and his shoulders covered with a huge cardboard collar that flapped when he moved his arms, he slowly and solemnly recited the poem, which consisted entirely of nonsense sounds. As was typical of Dada, this performance involved two separate and distinct aims, one critical and one playful. The first, as Ball said, was to renounce "the language devastated and made impossible by journalism." In other words, by retreating into precivilized sounds, he avoided language, which had been spoiled by the lies and excesses of journalism and advertising. The second aim was simply to amuse by reintroducing the healthy play of children back into what he considered overly restrained adult lives.

By the end of 1916 it was clear to Ball's circle that the group needed a name. *Dada* seems to have been chosen because of its flexibility. In German the term signifies baby talk; in French it means "hobbyhorse"; in Russian, "yes, yes"; and in Romanian, "no, no." The name and therefore the movement could be defined as the individual wished. Early in 1917 one of Ball's colleagues, Tristan Tzara (1896–1963), organized the Galerie Dada. Tzara also edited a magazine, *Dada*, which soon attracted the attention of like-minded men and women in various European capitals.

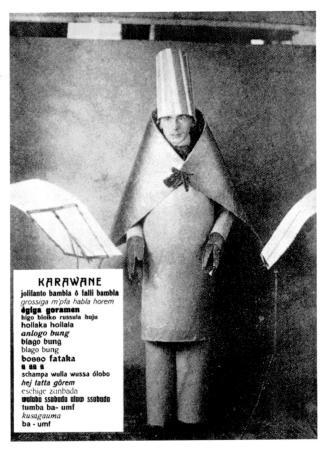

28-88. Hugo Ball reciting the sound poem "Karawane." Photographed at the Cabaret Voltaire, Zürich, 1916

The movement was spread farther when members of Ball's circle returned to their respective homelands. Even before the end of the war, writer Richard Huelsenbeck brought the Dada movement to Germany when he helped form the Berlin Dada Club. By early 1919 Huelsenbeck and his associates were organizing Dada evenings featuring nonsense poetry, poems read simultaneously by two or more poets, and other playful events, including a race between a typewriter and a sewing machine. Following the example of some of his Zürich predecessors, Johannes Baader took Dada out of the cabaret into the streets. His most famous "intervention" occurred during the 1919 inauguration of the president of the new German republic, when Baader scattered leaflets from a balcony proclaiming himself President of the World.

One of the distinctive features of Berlin Dada was its sympathies with the newly formed German Communist party. In 1919 Huelsenbeck and the Austrian painter and photographer Raoul Hausmann (1886–1971) formed a so-called Dadaist Revolutionary Central Council, which published a manifesto, "What Is Dadaism and What Does It Want in Germany?" One of their demands called for "the immediate expropriation of property (socialization) and the communal feeding of all." Such serious demands were undercut, however, by more playful requests.

The coauthor of this manifesto, Hausmann, worked in various mediums, including sculpture. *The Spirit of Our*

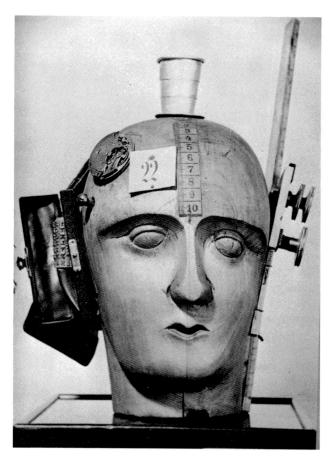

28-89. Raoul Hausmann. *The Spirit of Our Time.* 1921. Assemblage, height 12³/₄" (32 cm). Musée National d'Art Moderne, Centre Georges Pompidou, Paris

28-90. Hannah Höch. *Dada Dance*. 1922. Photomontage, 12^{5} /8 x 9^{1} /8" (32 x 23 cm). Collection Arturo Schwartz, Milan

Time (fig. 28-89) is typical of the Dada artistic approach. The assemblage of various objects is not meant to be aesthetically appealing but to satirize contemporary folly. The instruments used for the ears, the clockworks attached to the head, and the measuring tape running down the forehead all refer to the growing popularity in Western Europe of the idea that humans should model themselves on the machine. The dummy's head reminds us that such a notion is dehumanizing.

Another distinctive feature of Berlin Dada was the amount of art it produced. Dada elsewhere tended to be more literary. Berlin Dada members especially favored the photomontage. One of the leading figures in this direction was Hannah Höch (1889–1978). At twenty-two she had come to Berlin to study applied arts and painting. From 1916 to 1926 she worked for Berlin's major newspaper in a department that produced brochures on knitting, crocheting, and embroidering. She became romantically involved with Hausmann in 1915 and seems to have been the source of many of his political commitments. Höch, the only woman associated with the Berlin Dada Club, remained a marginal member, apparently because she was a woman. She was admitted to the first Dada exhibition in Berlin in 1920 only because Hausmann threatened to withdraw his works if hers were refused.

Höch's photomontages focus on women's issues. In the aftermath of the war, the status of women improved in Germany when they received the vote and new job opportunities opened to them. The subject of the "new woman" was much discussed in the German news media, but Höch's contribution to this discussion was largely critical. In works such as Dada Dance (fig. 28-90), she seems to ridicule the way changing fashions establish standards of beauty that women, regardless of their natural appearance, must observe. On the right is an odd composite figure, wearing high-fashion shoes and dress, in a ridiculously elegant pose. The taller woman, with a small, black African head, looks down on her with a pained expression. For Höch, as for many in the modernist era, Africa represented what was natural, so Höch presumably meant to contrast natural elegance with its foolish, overly cultivated counterpart. The work's message is not immediately evident, however, nor is it spelled out clearly by the text, which reads: "The excesses of Hell fell into the cash box for innocent criminal catchers." Whether this statement is meant as an indictment of the fashion business or, in larger terms, of the hellish chaos of contemporary German life is uncertain.

Because the precise meaning of such works is extremely difficult to decipher, their power as social commentary is limited. One of the first to change his approach

28-91. John Heartfield. *Have No Fear—He's a Vegetarian*.

Photomontage in *Regards* no. 121 (153) (Paris), May 7, 1936. Stiftung Archiv der Akademie der Künste, Berlin

in recognition of this limitation was John Heartfield (1891–1968). Born Helmut Herzfeld near Berlin, he trained in a crafts school in Munich and subsequently worked as a commercial artist for a book publisher in Mannheim. He was drafted in 1914 but after a feigned nervous breakdown was released from the army to work as a letter carrier. He often dumped his mail deliveries in order to encourage dissatisfaction with the war. In protest against the nationalistic war slogan "May God Punish England," Herzfeld anglicized his name to John Heartfield. After the war he joined Berlin Dada but spent most of his time doing election posters and illustrations for Communist newspapers and magazines. Recognizing the primacy of the message, he evolved a clear and simple approach to photomontage that might be called post-Dada.

Typical of his mature work is *Have No Fear—He's a Vegetarian* (fig. 28-91), a version of which appeared in a French magazine in 1936. The work shows Hitler sharpening a knife behind a rooster, the symbol of France. The warning being communicated is ironic, given that the whispering man is Pierre Laval, then the pro-German premier of France. Hitler, then in the process of rising to power in Germany on a program of nationalism, militarism, and hatred for Jews, would soon pose a threat to France, as indeed he did. When the Nazis had gained control of Germany in 1933, Hitler ordered Heartfield's

Marcel Duchamp

photomontages.

A small group of French and American artists in New York, producing work similar to that of the European Dadaists, also adopted the Dada label. The leading figure in this group was the French artist Marcel Duchamp (1887–1968). In 1906 Duchamp had moved from Rouen to Paris, where he worked as a librarian and learned to paint essentially on his own. Through his two older brothers, both artists, he became a member of the avant-garde then assimilating Cubism. In this atmosphere his early Fauve-inspired landscapes gave way to a personal brand of Analytic Cubism. In 1915 he left Paris for New York, partly out of disgust with what he called the European "art factory."

arrest. Heartfield literally jumped out his window to escape and moved to Prague, Czechoslovakia, then to England, where he produced his powerful anti-Hitler

Duchamp and his New York group maintained that art should appeal to the mind rather than the senses. A good example of this cerebral approach is Duchamp's Fountain (see fig. 28-1), with which this chapter began. Fountain is one of the first of Duchamp's readymades, ordinary objects transformed into artworks simply through the decision of the artist. The ideas expressed in Duchamp's art are complex and often cynical. Besides those ideas mentioned in the discussion of Fountain at the beginning of this chapter is a subtle reply to his modernist colleagues that art plays no important function in ordinary life. Here, as elsewhere in his art, a useful object is rendered useless by its transformation into art.

Duchamp's most intellectually challenging work is probably The Bride Stripped Bare by Her Bachelors, Even (fig. 28-92), usually called The Large Glass. He made his first sketches for the piece in 1913 but did not begin work on it until he arrived in New York. Notes he made while working on the piece confirm that it is enormously complex in conception and operates on several esoteric levels. At the most obvious level it is a pessimistic statement of insoluble frustrations of male-female relations. The tubular elements encased in glass at the top represent the bride. These release a large romantic sigh that is stimulating to the bachelors below, who are represented by nine different costumes attached to a waterwheel. The wheel resembles and is attached to a chocolate grinder, a reference to a French euphemism for masturbation. A bar separates the males from the female, preventing the fulfillment of their respective sexual desires. Male and female are not only separate but fundamentally different. The female is depicted as a gas—the three strips of gauze in her sigh punningly reveal this—while the males are represented as liquids. Duchamp not only contradicts the conventionally optimistic view of malefemale relations found in much art, he also reverses the conventional power roles of men and women. Unlike what is implied in Kirchner's Girl under a Japanese Umbrella (see fig. 28-28), for example, Duchamp places the female in the superior position. The males merely react to her.

28-92. Marcel Duchamp. *Bride Stripped Bare by Her Bachelors, Even (The Large Glass)*. 1915–23. Oil and lead wire on glass, 9'1¹/₄" x 5'¹/₈" (2.77 x 1.76 m). Philadelphia Museum of Art Bequest of Katherine S. Dreier

28-93. Salvador Dalí. *Accommodations of Desire*. 1929. Oil on panel, 8⁵/₈ x 13³/₄" (21.9 x 34.9 cm). Private collection While a student in 1922 at the Madrid Academy, Dalí became friends with the poet and dramatist Federico García Lorca (later killed by the Nationalists during the Spanish Civil War of 1936–39) and the film maker Luis Buñuel. He and Buñuel later collaborated on what is probably the most famous Surrealist film, *Un Chien Andalou* (*An Andalusian Dog*).

28-94. Joan Miró. *Painting*. 1933. Oil on canvas, 4'3¹/₄" x 5'3¹/₂" (1.30 x 1.61 m). Wadsworth Atheneum, Hartford, Connecticut

The Ella Gallup Sumner and Mary Catlin Sumner Collection

Surrealism

The second European movement that resisted the rationalist tide of postwar art and architecture, Surrealism, was the creation of a French writer, André Breton (1896-1966), one of the many writers involved in the Paris Dada movement after the war. Breton became dissatisfied with the playful nonsense activities of his colleagues and wished to turn Dada's implicit desire to free human behavior into something more programmatic. In 1924 he published his "Manifesto of Surrealism," outlining his own view of Freud's discovery that the human psyche is a battleground where the rational, civilized forces of the conscious mind struggle against the irrational, instinctual urges of the unconscious. The way to achieve happiness, Breton argued, does not lie in strengthening the repressive forces of reason, as the Purists insisted, but in freeing the individual to express personal desires, as Gauguin and Die Brücke had asserted. Breton and the group around him developed a number of techniques for liberating the individual unconscious, including dream analysis, free association, automatic writing, word games, and hypnotic trances. Their aim was to help people discover the larger reality, or "surreality," that lay beyond narrow rational notions of what was real.

Among the writers and artists around Breton was the Spanish painter and printmaker Salvador Dalí (1904–1989). In the early 1920s Dalí had trained at the Academy in Madrid, where he quickly mastered the traditional methods of representation. In 1928 he took a taxi from Spain to see Versailles and meet Picasso in Paris. While there, he also met the Surrealists and quickly converted to their cause. In 1929 he married Gala Éluard, the former wife of one of the Surrealist poets.

Dalí's desire for Éluard apparently triggered classically Freudian fears, which he recorded in works such as Accommodations of Desire (fig. 28-93). The combined figures of Éluard and Dalí's mother in the upper left—identified with a group of vases, a traditional symbol for the female as sexual "receptacle"—suggest that he associated his desire for Éluard with oedipal feelings toward his mother. The guilt and sorrow these feelings bring are reflected in the grieving figure just above center. The angry lion dominating the work represents Dalí's father, with whom he competes for the affection of his mother. Like the Prodigal Son of the Bible, son and father attempt reconciliation, in the scene at top center. The feeding ants at the lower right were one of Dalí's favorite devices for evoking anxiety and apprehension. Breton was so impressed with Dalí's ability to make Freudian concepts seem "real" that for several years he considered him the movement's official painter.

Another Spanish artist associated with the Surrealists was Joan Miró (1893–1983), who attempted in his early work to reconcile a diversity of French influences with his devotion to his native Catalan landscape. In 1922 he moved to Paris, where he began to produce a more fantastic brand of landscape painting, inspired, he later claimed, by the hallucinations brought on by hunger and produced by staring at the cracks in his ceiling. The Surrealist painter André Masson (1896–1987), who lived near Miró, brought his work to the attention of Breton, and he was asked to participate in the first Surrealist exhibition, in 1925, and in subsequent ones. Although Miró showed with the Surrealists, he never shared their theoretical interests.

Typical of his mature work is *Painting* (fig. 28-94), based partly on collages he made using illustrations of machine tools in catalogs. Miró developed these works by

28-95. Max Ernst. *The Joy of Life.* 1936. Oil on canvas, $28^{3/4}$ x $36^{1/4}$ " (73 x 92 cm). Collection Sir Roland Penrose, London

freely drawing a series of lines without considering what they might be or become, a technique called **automatism**, which he learned from Surrealists such as Masson. Next he consciously reworked the lines into the fantastic animal and vegetable forms that they suggested to his imagination. The result is a charming assortment of delicate flora and fauna that seems to float gracefully and effortlessly across a dry Catalan landscape.

As the work of Miró and Dalí suggests, the artists associated with Breton were generally more concerned with their own needs than with the liberation of others. This was particularly true of one of the most inventive artists in the group, the self-taught painter Max Ernst (1891-1976). Ernst was born near Cologne, Germany, in a family headed by a stern disciplinarian father. Horrified by World War I, Ernst helped organize a Dada movement in Cologne. In 1922 he moved to Paris and joined the Dada group there. When Paris Dada evolved into Surrealism, he participated in the search for new ways to free his imagination. One of the liberating techniques he developed was frottage, the rubbing of a pencil or crayon across a piece of paper placed on a textured surface. Ernst found that these imprints stimulated his imagination. He discovered in them a host of strange creatures and places. A good example of his frottage-inspired work is The Joy of Life (fig. 28-95), a dense jungle landscape populated by threatening creatures at first difficult to discern.

Breton's quest to free humanity from the tyranny of conscious, practical mental habits was also given a singular expression in the work of the Belgian painter René Magritte (1898–1967). Trained at the Brussels Academy in 1916–1917, he became a member of the city's vanguard literary circle, where the ideas of Dada and eventually Surrealism were discussed and applied. After the unsympathetic critical reception of his earliest Surrealist work, he moved in 1927 to Paris, where he played an active part in Breton's group of artists and writers. In 1930 he returned to Brussels, partly in order to free himself from Breton's emphasis on confessional content.

Magritte's work from before 1930 demonstrates two distinct tendencies, one toward the revelation of the psy-

28-96. René Magritte. *Time Transfixed*. 1939. Oil on canvas, 57 ¹/₂ x 38 ¹/₂" (146 x 97.8 cm). The Art Institute of Chicago
Winterbotham Collection

che and the other toward surprising alterations of ordinary situations, often featuring unusual juxtapositions or changes in scale. It was in this latter mode that Magritte specialized after 1930, largely because he felt that it had a greater potential for public good. Time Transfixed (fig. 28-96), for example, features the startling appearance of a locomotive steaming out of an empty dining-room fireplace. Some of the work's effect depends on the fact that the two objects are such obvious male and female symbols. Magritte himself, however, insisted that his work not be approached in this way, in part because he did not wish to be psychoanalyzed via his art, but mostly because he thought that it led viewers away from his conscious intention. His purpose was to discredit ordinary reality and open to view what he called the world's mystery. Psychoanalysis is simply another way to explain things, whereas he, on the contrary, wished to demonstrate the "mystery that has no meaning." Therefore, instead of focusing on the allusive symbolism, Magritte would rather we simply enjoy the marvelous absurdity of the scene, wondering at the reduction of the locomotive or the enormous enlargement of the room. A determined enemy of the tired, colorless view of the ordinary, he meant to subvert it, to defamiliarize the ordinary for us, showing that we have the capacity to view the banal objects that populate our immediate existence in fresher, more interesting ways.

28-97. Leonora Carrington. *Self-Portrait.* 1937. Oil on canvas, 25 ½ x 32" (64.7 x 81.2 cm). Private collection Courtesy Pierre Matisse Foundation, New York

However, Magritte rarely banished altogether the existential drabness he detested. The dining room in *Time Transfixed* is typically cold and barren, while the mirror suggests that the rest of the room is even emptier than the part we see. The prosaic handling of the paint itself contributes much to a residual sense of the everyday. Magritte was well aware of what he called "my defeatism." In 1943 he wrote: "I have few illusions; the cause is lost in advance. As for me, I do my part, which is to drag a fairly drab existence to its conclusion."

Surrealism, like most of the modernist movements, was essentially a male phenomenon, treating women for the most part merely as sexually desirable creatures who could liberate the male imagination. Beginning with the Surrealist exhibition of 1929, some women were allowed to participate in the movement at its margins. Most of those women who showed with the Surrealists were, like Leonora Carrington (b. 1917), also romantically involved with men in the group. As an adolescent Carrington had been outrageously rebellious. Against her wealthy parents' wishes she decided on a career in art and studied for a year in London with the Purist Amédée Ozenfant. The following year, 1937, she met the much older Ernst and went with him to Paris. There she wrote stories and made paintings loosely related to them. Her Self-Portrait (fig. 28-97), for example, includes the hyena from her short story "The Debutante." In the story the animal, masquerading as a debutante but emitting a foul odor, takes the place of a young woman who does not wish to attend the ball in her honor. The two horses featured in the painting reappear in a later play, Penelope (1946), in which the heroine falls in love with her rocking horse, Tartar (after Tartarus, the Greek underworld), and longs to escape from her authoritarian father and from men, who do not know magic and fear the night. She succeeds by becoming a white colt and flying into a world where imagination neutralizes the male enemies of magic. Beneath the rocking horse is the figure of Carrington herself, seated in a fussy Victorian chair but with her hair flying loose and wild, like her imagination.

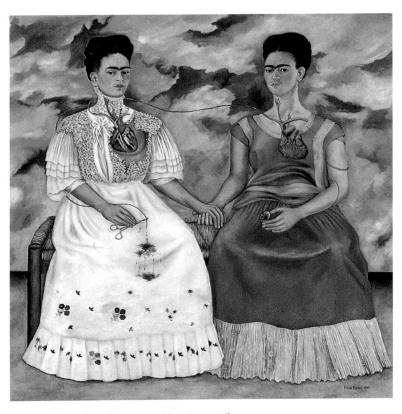

28-98. Frida Kahlo. *The Two Fridas*. 1939. Oil on canvas. 5'8¹/2" x 5'8¹/2" (1.74 x 1.74 m). Museo del Arte Moderno, Instituto National de Bellas Artes, Mexico City

The best known of the women artists associated with Surrealism is Frida Kahlo (1910-1954), born near Mexico City. Her father was a German photographer and her mother a Mexican. A nearly fatal trolley accident when she was fifteen left her crippled and in pain for the rest of her life. While convalescing from the accident, she taught herself to paint. Her work soon brought her into contact with Diego Rivera (see fig. 28-119), one of Mexico's leading artists, whom she later called her "second accident." In 1929, when she was eighteen, they married, but their relationship was always stormy. Although they later remarried, the two were divorced in 1939. While the divorce papers were being processed, she painted The Two Fridas (fig. 28-98), a large work intended for an international Surrealist exhibition in Mexico City in 1940, that deals with her personal pain. She once said of her paintings that they were "unimportant, with the same personal subjects that only appeal to myself and nobody else." Here she presents her two ethnic selves: the European one, in a Victorian dress, and the Mexican one, wearing a traditional Mexican peasant skirt and blouse. She told an art historian at the time that the European image was the Frida whom Diego loved and the Mexican one the Frida whom he did not. The two Fridas join hands, and they are intimately connected by the artery running between them. The artery begins at the miniature of Diego

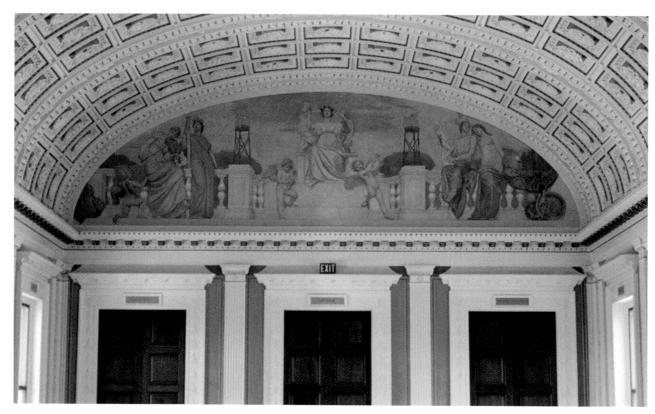

28-99. Kenyon Cox. The Arts, mural in the Library of Congress, Washington, D.C. 1890

as a boy that the Mexican Frida holds, and it ends in the lap of the other Frida, who attempts without success to stem the flow of blood from it.

In 1939 Breton came to Mexico to meet Leon Trotsky, the exiled Russian revolutionary. Rivera arranged for Breton to meet Kahlo at that time, and he was so impressed with her that he wrote the introduction to the catalog of her New York exhibition in 1939 and the following year arranged for her to show in Paris. Although Breton claimed her as a natural Surrealist, she herself said she was not: "I never painted dreams. I painted my own reality." Whether she could have painted it in the imaginative ways that she did without the example of Surrealism is an open question.

AMERICAN ART

American painters and sculptors were slow to assimilate modernism. In fact, the radical changes be-

ing made by European artists during this period were almost entirely ignored by their American counterparts until after 1910. From a Western European vantage point, American art between 1880 and the outbreak of World War I was essentially provincial. Its artists continued either to develop realist traditions or to follow premodernist European examples.

European Influences

The European academic tradition continued to be a strong influence in the United States, partly because of the growing interest of American architects in the conservative training of the École des Beaux-Arts, discussed earlier. One of the most important advocates of academic art was the painter and critic Kenyon Cox (1856–1919). Cox studied first at the Art Academy in Cincinnati, then at the Pennsylvania Academy of the Fine Arts in Philadelphia, and finally, between 1877 and 1882, in the Paris studios of several leading academicians, including Alexandre Cabanel and Jean-Léon Gérôme (see fig. 27-8). After his return to the United States, he settled in New York City and specialized in images of classical nudes resting comfortably in idyllic landscapes.

His academic style brought him a number of mural commissions for the Beaux-Arts architecture then in vogue, including in 1890 the two lunettes in a long gallery at the new Library of Congress, constructed in a French classical style related to that of the Louvre (see fig. 19-21). The style of the two allegories Cox produced—one devoted to the sciences, the other to the arts (fig. 28-99) was strongly influenced by Puvis de Chavannes, whom he considered the leading artist of the period. He thought. however, that the American public needed a more descriptive approach to the figure and a less subdued color scheme. And unlike the relaxed figures in Puvis's murals and in his own easel pictures, here the more monumental figures are symmetrically arranged, which Cox considered both more appropriate to public architecture and better suited to his conservative social message. He believed in a static society, one with as little change as possible. The female figures who personify the various art forms are generically classical and are statically posed and grouped to achieve a sense of timelessness.

28-100. Herman Atkins MacNeil. *Sun Vow.* 1898. Bronze, height 6'1" (1.85 m). The Metropolitan Museum of Art, New York

The influence of French academicism can be seen also in the sculpture of Herman Atkins MacNeil (1866–1947). After briefly teaching sculpture at Cornell University he went to Paris in 1888 to study at the Academy. Soon after his return to the United States, he went to the World's Columbian Exposition, where he was particularly impressed with the finale of Buffalo Bill's Wild West Show, one of the fair's main attractions. The end of the show featured an attack on a wagon train by "Indians," even though by 1893 no such attack had occurred for almost twenty years. After seeing Buffalo Bill's show, MacNeil spent the next ten years studying the customs of the surviving Native American nations.

In works such as *Sun Vow* (fig. 28-100), the descriptive style, the slightly exaggerated poses and expressions, and the realistic details like the moccasins and hairstyles are derived from the French academic tradition. The particular theme and message, however, are American. An old man is instructing an adolescent in the ceremony of shooting an arrow toward the sun, a rite of passage accompanied by a vow of dedication. Such images of a communal life close to nature sustained by simple religious faith were, roughly speaking, the American counterpart to the European escapist ideals first evident in the Romantic period.

Another European style that American artists adopted after 1880 was Impressionism. During the 1880s, when French artists were reacting against Impressionism, a group of Americans were still in the process of absorbing it. One of these was Childe Hassam (1859-1935), who began his career producing naturalistic paintings of Boston city life. In 1886 he moved to Paris to study at one of the leading private academies. By the time he returned in 1889, he had become an Impressionist. He settled in New York City and specialized in painting pleasant views of the places he lived and visited. While many, like Mac-Neil and Cox, avoided the city, Hassam embraced it and presented it positively, as in Union Square in Spring (fig. 28-101), an image of a large, informal park in New York City, where dozens of people are enjoying the fine spring weather. The relaxed, informal brushstrokes add much to our sense of the activities of the place, as do the cheerful, high-keyed colors.

The African American painter Henry Ossawa Tanner (1859–1937) also learned from Impressionism. Raised in Philadelphia, Tanner studied under Thomas Eakins at the Pennsylvania Academy of the Fine Arts sporadically between 1879 and 1885. In search of further training and a more hospitable environment for his naturalistic landscape painting, he moved to Paris in 1891. There he assimilated something of the Impressionists' interest in light effects as well as their looser brushwork.

When he returned to Philadelphia in 1893, to recover from typhus, Tanner briefly turned these interests to the depiction of genre subjects featuring African Americans,

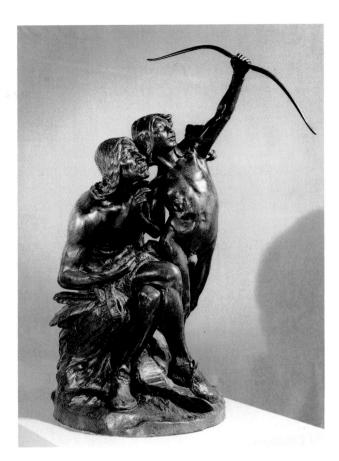

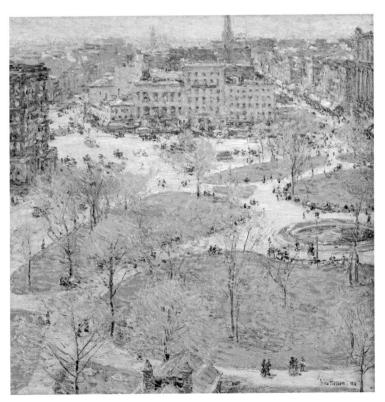

28-101. Childe Hassam. *Union Square in Spring.* 1896. Oil on canvas, 21½ x 21" (54.6 x 53.3 cm). Smith College Museum of Art, Northampton, Massachusetts

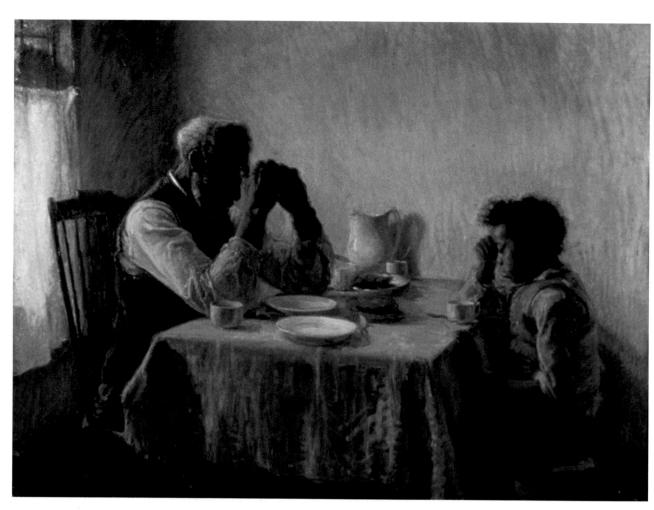

28-102. Henry Ossawa Tanner. *The Thankful Poor.* 1894. Oil on canvas, 35 x 44¹/4" (88.9 x 112.39 cm). Private collection

28-103. Albert Pinkham Ryder. *Jonah. c.* 1885. Oil on canvas, mounted on fiberboard, 27 ¹/₄ x 34³/₈" (69.2 x 87.3 cm). National Museum of American Art, Smithsonian Institution, Washington, D.C. Gift of John Gellatly

such as The Thankful Poor (fig. 28-102). The light that streams across the wall and over the figures in this painting has less to do with Impressionist concerns than with spiritual connotations of light (seen earlier in fifteenthcentury Netherlandish painting; see fig. 17-5, for example). Its soft glow, and the gentle brushwork that defines it, quietly envelops the old man and child shown offering thanks for their humble lot. The theme of the reverent poor, a popular one in European academic art of the period, was here put to a new use. As Tanner said in his writings at the time, he intended to counter the comic stereotype of African Americans then common in art and literature and to represent, instead, "the serious, and pathetic side of life among them." After his return to Paris in 1894, he gave up such subjects, partly because of a lack of European interest in them and partly as a result of his decision to pursue the goal his minister father imagined for him, to make his art serve religion.

One painter generally thought to have resisted Europe and to have evolved a purely personal style was Albert Pinkham Ryder (1847–1917). During the 1870s Ryder made several brief trips to Europe but never studied there. By the early 1880s he had evolved a distinctive approach to landscapes and seascapes, inspired in part by his love of opera, with its grand, generalized effects

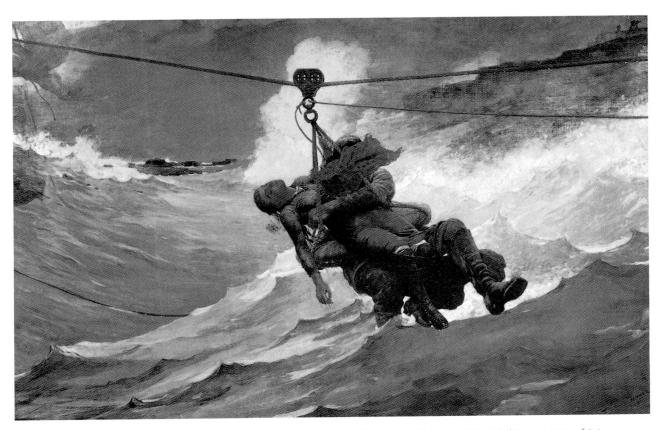

28-104. Winslow Homer. *The Life Line.* 1884. Oil on canvas, 28³/₄ x 44⁵/₈" (73 x 113.3 cm). Philadelphia Museum of Art The George W. Elkins Collection

In the early sketches for this work, the man's face was visible. The decision to cover it focuses more attention not only on the victim but on the true hero of the scene, the breeches buoy.

and its reliance on classic themes. His interest in these features was also inspired by the European Romantic painting tradition, especially as represented by Delacroix and Turner.

A fine example of Ryder's mature work is the biblical Jonah (fig. 28-103). Jonah, fleeing from God's command to tell the people of Nineveh of their wickedness, took passage on a ship. When God sent a tempest that threatened to destroy the ship, Jonah's shipmates threw him overboard and he was swallowed by a great fish. But in the end he was forgiven and saved by the loving God, shown holding the orb, symbol of divine power, who appears in a blaze of redemptive light. Both the subject, being overwhelmed by hostile nature, and its intensified treatment through dynamic curves and sharp contrasts of light and dark are characteristically Romantic. The broad, generalized handling of the violent sea is particularly reminiscent of Turner, whose work Ryder had seen several times in the 1870s. The theme and its handling were unusual for the period.

Winslow Homer (1836–1910) also turned to dramatic images of the sea, following his return from a tiny English fishing village on the rugged North Sea coast, where he lived in 1881–1882. The strength of character of the people there so impressed him that he turned from the

pleasant subjects of his earlier work (see fig. 27-33) to serious themes involving confrontations with a dangerous nature.

During his stay in England he was particularly impressed with the breeches buoy, a device developed by the British to rescue those aboard foundering ships. This line-and-tackle device is featured in *The Life Line* (fig. 28-104). Homer spent part of the summer of 1883 in Atlantic City, New Jersey, apparently because the life-saving crew there had imported one of the new breeches buoys. He had the crew demonstrate its use while he made sketches. On the basis of these, he painted *The Life Line* early the following year on the roof of his New York City tenement. The painting is not simply a testament to humanity's goodness and courage but to its ingenuity. Here someone is saved not through the grace of God but through human skill and bravery.

Realist Styles

By the early 1890s the American author Hamlin Garland was calling for an end to European domination of American art and for the development of a purely American style and subject matter. Perhaps the artist most committed to this cause was Robert Henri (1865–1929). Henri studied

28-105. Robert Henri. *Laughing Child.* 1907. Oil on canvas, 24 x 20" (61 x 50.8 cm). Whitney Museum of American Art, New York

Lawrence H. Bloedel Beguest

28-106. John Sloan. *Backyards, Greenwich Village*. 1914. Oil on canvas, 24 x 20" (61 x 50.8 cm). Whitney Museum of American Art, New York

Purchase

between 1886 and 1888 at the Pennsylvania Academy of the Fine Arts, where conventional academic training was tempered by the realist convictions of the director, Thomas Eakins. By 1892 Henri had become the leader of a group of young Philadelphia realists, four of whom were newspaper illustrators later prominent in the development of American realism: John Sloan (1871–1951), William J. Glackens (1870–1938), Everett Shinn (1876–1953), and George Luks (1867–1933). Henri spoke out against both the academic conventions and the Impressionist style then dominating American art. He advised his unofficial students: "Paint what you see. Paint what is real to you."

Henri nevertheless turned to Europe for models, living in Paris from 1895 to 1900 and studying the great European realists, especially Diego Velázquez, Frans Hals, and Édouard Manet. He particularly admired the rapid brushwork of these artists, which he felt conveyed their fresh and immediate response to their subjects. What mattered to him was not the European roots of this approach but its potential for American art. He felt, somewhat ironically, that by emulating it, American artists could free themselves from European conventions and express "themselves in their own time and in their own land."

Henri thought that only realism would appeal to the American public and contribute to "the progress of our existence." For him, America's reality was to be found in its children. After he settled in New York City in 1900, he specialized in paintings—like *Laughing Child* (fig. 28-105)—of happy, high-spirited, and wholesome youth who personified the nation and represented its essential goodness.

Henri's efforts to liberalize the teaching and exhibition standards at New York's National Academy of Design, which had been founded as an American counterpart to the French École des Beaux-Arts, put him at the center of a battle between progressives and conservatives there. When he was not reelected as a member of the Academy's exhibition jury in 1908, he responded by organizing an independent exhibition of eight artists. These artists were often thereafter referred to as The Eight, although they never all exhibited together again.

Five of The Eight were Henri and his earlier colleagues—Sloan, Glackens, Shinn, and Luks—who had moved to New York to be near him. The work of these five formed the core of what was known collectively as the Ashcan School, a name applied largely in response to the work of John Sloan. Sloan briefly attended the Pennsylvania Academy in 1892, then worked as an illustrator for the *Philadelphia Inquirer* newspaper. He moved to New York City in 1903, where he did illustrations for a number of national magazines. Beginning in 1907 he began to devote more time to painting.

Responding to Henri's advice to "paint what is real to you," Sloan painted scenes like *Backyards, Greenwich Village* (fig. 28-106), which depicts the backyard of an apartment in which he and his wife had once lived. Like the laundry in it, the work seems fresh and clean, an effect that depends on both the wet look of the paint and the refreshing blues that dominate it. Balancing those cool tonalities are the warm yellows of the building and fence,

1910 1880 1940

which give the work its emotional temperature. Like much of Henri's work, this painting features children. Beneath the laundry, which suggests the presence of caring parents, two warmly dressed children are building a snowman, while an alley cat looks on. The most important figure is the little girl in the window, a stand-in for the artist, who looks out with joy on this ordinary backyard and its simple pleasures.

While Henri and his followers were developing a confident, American brand of realism in painting, a European immigrant, Jacob Riis (1849–1914), was initiating a new and harsher type of realistic documentary photography. The view of American life that emerged from his works was quite at odds with the celebratory view of Henri and Sloan. If Riis and the photographers he inspired were aware of these differences, they never addressed them. They did not think of themselves as artists. Their goal was to galvanize public concern for the unfortunate poor. For them photography was a means of bringing about social change, not an art form.

Riis was born in Denmark and learned journalism by helping his father, a schoolteacher, prepare a weekly paper. Riis emigrated to New York City in 1870. Three years later he was hired as a police reporter for the *New York Tribune*. He quickly established himself as a maverick among his colleagues by actually investigating slum life himself rather than merely rewriting police reports. His contact with the poor convinced him that crime, poverty, and ignorance were largely environmental problems that resulted from, rather than caused, harsh slum conditions.

Riis was convinced that if Americans knew the truth about slum life, they would support reforms to provide the poor with better sanitation, housing, education, and jobs. He later recalled: "It was upon my midnight trips with the . . . police [from the Health Department] that the wish kept cropping up in me . . . [for] some way of putting before the people what I saw there. . . . A drawing might have done it, but it would not have been evidence of the kind I wanted" (cited in Hales, page 169). In 1887 he decided to try the camera. His success was made possible by several technical advances in photography. In the 1870s manufacturers developed a dry-plate process that was much faster and far less clumsy than the wet-plate process still favored by professional photographers for its higher-quality results. Because photographs could now be taken at exposures of one-thirtieth of a second or less, manufacturers began producing cameras for amateurs that could be used either on or off a tripod. To permit interior and nighttime shots, they devised a flash powder that was shot from a pistol. At first Riis employed professional photographers to accompany him into the slums at night, but because they were so often reluctant to go, he soon began taking his own photographs.

His first works, such as *Tenement Interior in Poverty Gap: An English Coal-Heaver's Home* (fig. 28-107), were published in 1890 in his groundbreaking study, *How the Other Half Lives*. All the illustrations were accompanied by texts that described their circumstances in matter-offact terms. Riis said he found this family when he visited

28-107. Jacob Riis. *Tenement Interior in Poverty Gap: An English Coal-Heaver's Home.* c. 1889. Museum of the
City of New York

The Jacob A. Riis Collection

During the late nineteenth and early twentieth centuries, American social and business life operated under the British sociologist Herbert Spencer's theory of Social Darwinism, which in essence held that only the fittest will survive. Riis saw this theory as merely an excuse for neglecting social problems.

a house where a woman had been killed by her drunken, abusive husband:

The family in the picture lived above the rooms where the dead woman lay on a bed of straw, overrun by rats. . . . A patched and shaky stairway led up to their one bare and miserable room. . . . A heap of old rags, in which the baby slept serenely, served as the common sleeping-bunk of father, mother, and children—two bright and pretty girls, singularly out of keeping in their clean, if coarse, dresses, with their surroundings. . . . The mother, a pleasant-faced women, was cheerful, even light-hearted. Her smile seemed the most sadly hopeless of all in the utter wretchedness of the place.

What comes through clearly in the picture itself is the family's attempt to maintain a clean, orderly life despite the rats and the chaotic behavior of their neighbors. The broom behind the older girl suggests as much, as does the caring way the father holds his youngest daughter. These are decent people who deserve better.

In his successful campaign on behalf of social reform Riis delivered lectures illustrated with slides made from his photographs. Some of the scenes so shocked his audiences that some people are reported to have fainted, while others leapt yelling out of their chairs. In 1893 Riis delivered one of these lectures in Chicago in conjunction with the World's Columbian Exposition. Both he and the architects of the fair were concerned with the condition of the American city, he with its human inhabitants and they with the buildings in which they lived and worked.

Stieglitz and European Modernism

1900 1880 1940

Shortly before Riis discovered the camera's documentary power, another American opponent of the Henri tradition, Alfred Stieglitz (1864–1946), was developing the camera's aesthetic potential. Stieglitz was born to a wealthy German immigrant family, who sent him to Berlin to study mechanical engineering. Through a course in photochemistry in 1883, he discovered photography and almost immediately, it seems, decided to try to make of it an art form: "I saw that what others were doing was to make hard cold copies of hard cold subjects in hard cold light. I did not see why a photograph should not be a work of art, and I studied to learn to make it one" (cited in Homer, page 13).

Typical of his early work, devoted to atmospheric studies of the city, is Spring Showers (fig. 28-108). The sanitation worker behind the tree is not the subject of the image; he is there only to balance the composition. The off-center placement of the tipping tree and the diagonal of the curb, inspired by the example of Japanese prints, would be aesthetically disturbing without the visual weight of his presence. The sanitation worker functions much as the yellow square does in Mondrian's Composition with Red, Blue, and Yellow (see fig. 28-81). The appeal of the work also depends on the contrast between the indefinite forms of the horse-drawn vehicles seen through the drizzle and the sharper forms of the tree and fence in the front. For Stieglitz the purpose of such a picture was purely aesthetic. He intended it not for public consumption but rather for the few with sufficient education and discernment to appreciate it.

Stieglitz's first vehicle for promoting his conception of photography was the Camera Club of New York. Between 1896 and 1902 he helped organize exhibitions of photographers he believed in, assembled loan shows to national and foreign institutions, and most important, edited and managed *Camera Notes*, the club's quarterly journal. A growing dissatisfaction with Stieglitz's extreme views among the club's conservative rank and file led him to organize the Photo-Secession group in 1902. The following year, he launched the magazine *Camera Works* and two years later opened the Little Galleries of the Photo-Secession on the top floor of 291 Fifth Avenue, which soon became known simply as 291.

Stieglitz's chief ally in these efforts was another American photographer, Edward Steichen (1879–1973), who then lived in Paris. They had decided from the first to exhibit modern art as well as photography at 291 in order to help break down what they considered the artificial barrier between the two. Through Steichen's contacts in Paris, the gallery arranged exhibitions unlike any seen before in the United States, including works by Matisse (1908 and 1911), Toulouse-Lautrec (1910), Rodin (1908 and 1910), Cézanne (1911), Picasso (1911), Brancusi (1914), and Braque (1915). Thus, in the years around 1910 Stieglitz's gallery became the American focal point not only for the advancement of photographic art but for the larger cause of European modernism.

The event that climaxed Stieglitz's pioneering efforts on behalf of European modernism was the International

28-108. Alfred Stieglitz. Spring Showers. 1901. The Art Institute of Chicago

Exhibition of Modern Art, held in 1913 at the 69th Regiment Armory in Manhattan. It is one of the great ironies of American art that this exhibition, known as the Armory Show, was assembled not by Stieglitz or his colleagues but by one of The Eight, Arthur B. Davies, the only member of Henri's circle to attend events at the 291 gallery. The aim of the exhibition, quite simply, was to demonstrate how outmoded were the views of the

28-109. Max Weber.

Rush Hour,

New York.

1915. Oil

on canvas,

361/4 x 301/4"

(92 x 76.9 cm).

National

Gallery of Art,

Washington, D.C.

Gift of the

Avalon

Foundation

National Academy of Design. Unhappily for the Henri group, the Armory Show also demonstrated how old-fashioned their realistic approach was.

Of the more than 1,300 works in the show, only about a quarter were by Europeans, but it was to these works that all attention was drawn. Critics claimed that Matisse, Kandinsky, Braque, Duchamp, and Brancusi were the agents of "universal anarchy." Kenyon Cox called them mere "savages." When a selection of works continued on to Chicago, civic leaders there called for a morals commission to investigate the show. Faculty and students at the School of the Art Institute were so enraged they hanged Matisse in effigy.

A great many artists, however, responded positively. Although the impact of the Armory Show is sometimes exaggerated, it marks an important turning point. Between the 1913 exhibition and the early 1920s, American art was characterized by a new desire to assimilate the most recent developments from Europe. The issue of realism versus academicism, so critical before 1913, suddenly seemed inconsequential. For the first time in their history, American artists began fighting their provincial status.

Indicative of the work produced by Americans in the

aftermath of the Armory Show is that of Max Weber (1881-1961). Weber studied at the Pratt Institute in New York City in 1898-1900 and briefly with Matisse in Paris in 1907. During his stay in Paris in 1905-1908 he also became friendly with Picasso and Delaunay. Before the Armory Show he had worked in both the Fauvist and early Analytic Cubist styles. In the new climate established by the exhibition, however, he produced an American version of Cubo-Futurism, although no one called it that. Rush Hour, New York (fig. 28-109), for example, at first seems a fairly typical example of the Futurist embrace of city life. The tightly packed surface of angular and curvilinear elements suggests the noisy, crowded rush hour, but the harmony of soft grays, blues, browns, and greens undercuts that effect considerably and produces an aesthetically pleasing formal symphony as well.

Weber was one of the American artists whom Stieglitz showed at his 291 gallery. Another artist, who became a more intimate member of the gallery's circle after the Armory Show, was Georgia O'Keeffe (1887–1986). She studied at the Art Institute of Chicago in 1904–1905 and at the Art Students League in New York in 1907–1908.

28-110. Georgia O'Keeffe. *Drawing XIII*. 1915. Charcoal on paper, 29½ x 19" (62.2 x 48.4 cm). The Metropolitan Museum of Art, New York Alfred Stieglitz Collection, 1949

In 1914 or 1915 she read Kandinsky's *Concerning the Spiritual in Art*, which equated color and sound. Shortly afterward, she passed a college classroom where students were making rapid sketches to the music from a phonograph. Fascinated, she joined in. At first she resisted the implications of this experience, but encouraged by one of her teachers and emboldened by the budding feminist movement, she soon decided to follow her own artistic instincts. Convinced that color was a distraction, she decided to work only in charcoal until she had exhausted its possibilities. "It was like learning to walk," she said.

One of the works she produced at this time, *Drawing XIII* (fig. 28-110), features a series of budding organic shapes nestled against a fluid current of lines; both elements seem to rise gently against an angular geometric ground. The arrangement of shapes is less a formalist exercise than a self-expression. "Isn't it enough," she said at this point, "just to express yourself?" What she seemed to convey here was her profound feeling for nature. Her friends recall how she liked to rub a leaf between her fingers or, in a somewhat daring action for that era, thrust her bare feet into a stream to feel the cool water currents. Here the feeling for the basic forces of nature that would characterize all her mature art, whether done in New York or in her spiritual home, the Southwest, was first given shape.

In 1916 one of O'Keeffe's New York friends showed Stieglitz some of these drawings. The friend wrote O'Keeffe that Stieglitz had exclaimed: "At last, a woman on paper!"

28-111. Gaston Lachaise. *Standing Woman (Elevation)*. 1912–27. Bronze, height 5'10" (1.79 m). Albright-Knox Art Gallery, Buffalo, New York

when he finished looking at her work. Without consulting her, Stieglitz included the work in a small group show. The next year she had a one-person exhibition at 291. One critic said that O'Keeffe had "found expression in delicately veiled symbolism for 'what every woman knows,' but what women heretofore kept to themselves." This was the beginning of a long line of written criticism that focused on the artist's gender, to which O'Keeffe violently objected. She wanted to be considered an artist, not a woman artist.

American sculptors were slower to respond to contemporary developments in Europe than were painters, and none of them produced works in this period comparable to Weber's or O'Keeffe's. The most innovative sculptural work was produced by a Parisian who had moved to the United States, Gaston Lachaise (1882–1935). Lachaise entered the French Academy in 1898. Sometime between 1900 and 1902 he met Isabel Dutaud Nagle, an older married woman from Boston, who redirected the course of his life and his art. In 1906 he moved to Boston, and in 1912 to New York City to further his career. He dealt with the separation from Isabel by beginning the first of his monumental images of her, *Standing Woman (Elevation)* (fig. 28-111). The plaster model was shown in 1918, but Lachaise could not afford to cast it in

28-112. Charles Sheeler. *American Landscape*. 1930. Oil on canvas, 24 x 31" (61 x 78.7 cm). The Museum of Modern Art, New York Gift of Abby Aldrich Rockefeller

bronze until 1927. The work is in the classical tradition of the strong female nude, and the simplified modeling of form is reminiscent of Maillol's classical nudes (see fig. 28-9). The work is not generic, however, but a specific tribute to Isabel. Nude photographs of her, now in the Lachaise Foundation, show the same arched back, slender calves and ankles, narrow waist, and proud bearing. What Lachaise exaggerated was her size, for Isabel was only about 5 feet 2 inches tall. The sculpture, 6 feet tall, makes her appear larger than life. But Lachaise also succeeded in making her seem quite light by raising her on her toes and by having her gracefully lift her arms. She closes her eyes, suggesting an inwardness that complements and intensifies our sense of her graceful elevation.

American Scene Painting and Photography

The entry of the United States into World War I in 1917 promised to further stimulate the new American fascination with contemporary European art. Instead, the country entered a period of isolationism that lasted from about 1920 to the bombing of Pearl Harbor in 1941 and had a powerful effect on its artists. A minority continued

to look to Europe for direction, but the brief ascendancy of the Stieglitz viewpoint was followed by two decades when convictions more like Henri's prevailed. In the 1920s and 1930s American artists returned to realism, which they used to chronicle American life. The various tendencies of this broad movement in painting are grouped under the term *American Scene Painting*.

The shift back to realism is evident in the work of Charles Sheeler (1883–1965), who attended the Pennsylvania Academy in 1903 after studying for two years at the School of Industrial Art, also in Philadelphia. He apparently objected to the arts-and-crafts orientation but liked industrial design. From early Fauvist still lifes he moved to landscapes inspired by Cézanne and Analytic Cubism. By the early 1920s, however, he had shifted to a highly descriptive realism. This change was partly the result of his growing interest in photography. In 1912 he had opened a photographic business to support himself, and into the 1920s he continued to take commercial assignments, some of which he translated into paintings.

In 1927, for example, he was hired by an advertising firm to take photographs of the new Ford Motor Company plant outside Detroit. In 1930 he used one of these photographs to make *American Landscape* (fig. 28-112), a

28-113. John Steuart Curry.

Baptism in Kansas. 1928.

Oil on canvas, 40 x 50"

(102.5 x 128 cm). Whitney

Museum of American

Art, New York

Gift of Gertrude Vanderbilt

Whitney

Curry painted this work in his Greenwich, Connecticut, studio. He did not revisit the Midwest until the summer of the next year. Between that date and his appointment as artist-in-residence at the College of Agriculture at the University of Wisconsin, he made annual sketching trips to the Midwest for the paintings he produced in his Eastern studio during the winter.

28-114. Reginald Marsh. *Why Not Use the "L"?* 1930. Egg tempera on canvas, 36 x 48" (91.4 x 121 cm). Whitney Museum of American Art, New York Purchase

remarkably faithful transcription of the photograph. Ford, determined to be independent of suppliers, made its own steel on the site, so the painting is, among other things, about the transformation of raw materials into industrial goods. The title suggests that Sheeler was responding to the enthusiastic discussion of modern industry that surrounded the opening of the plant. One journalist had commented that "Detroit . . . [should] be considered the mother-city of the new industrial America" (cited in Troyan and Hirschler, page 17). Another saw such factories as the new American churches, the sites of its new faith in

a better future. Sheeler's painting seems to celebrate this point of view. That he painted the work a year after the great stock-market crash of 1929, which began the Great Depression, suggests that the painting may well be a testament to his continuing faith in American industry and in its fundamental stability.

A small group of American painters that emerged about 1930, known collectively as the Regionalists, also responded to the crisis of the Great Depression but put their faith in agriculture. One of these was John Steuart Curry (1897-1946), born on a farm near Dunavant, Kansas. After ten years as a magazine illustrator he began to specialize in the late 1920s in paintings featuring Kansas farm life. The first and most famous of these is Baptism in Kansas (fig. 28-113). The painting, based on a real incident, focuses on a woman being baptized in a farm trough. Arranged in a circle around her is the church community. The solid basis of this larger group is the family, one of which is featured in the foreground. The automobile is here reduced to a peripheral place and role. The painting is characterized by a number of circles, a traditional symbol of unity. That the farm is a holy place is made clear by the churchlike arrangement of the barn and windmill, as well as the rays of sunshine and the birds, traditionally associated with the divine spirit. The painting thus honors the sanctity of the farm and its stable. conservative way of life.

The 1920 census had demonstrated that for the first time in history, more Americans were living in urban centers than in rural areas. The work of Curry and two other artists—Grant Wood (1891–1942) and Thomas Hart Benton (1889–1975)—represents one response to that change. These artists insisted that the real solution to the

28-115. Isabel Bishop.

Resting. 1943. Oil on gesso panel, 16 x 17" (40.6 x 43.1 cm).

Collection Dr. and Mrs. Howard C.

Taylor, Jr., New York

many and growing problems of urban American life, made clear by the depression, was for the United States to return to its agrarian roots.

The Regionalists' argument received unintentional support from the so-called Urban Realists, who focused their attention on the city. One, Reginald Marsh (1898–1954), was born in Paris, the son of American artists then living there. After graduating from Yale in 1920, he moved to New York City, which he sketched for the cartoons he sold to various journals. When the *New Yorker* magazine was founded in 1925, he became one of its regular cartoonists. By the late 1920s, he was also producing paintings based on these studies from life.

One of his early paintings, *Why Not Use the "L"?* (fig. 28-114), is in the documentary tradition established by Toulouse-Lautrec. A record of the alienating effects of the city, it shows two women and a sleeping man on a subway car. The two women are alone and withdrawn. The woman on the left is tightly squeezed between the edge of the painting and the steel beam that separates her from the other two figures. The sign above the seated figures ironically tries to convince riders of the "comfort" of the open-air elevated ("L") trains that characterized much of New York's subway system, but the window is closed and barred. The sleeping man may be unemployed and homeless, as was a rapidly growing percentage of New York's work force then. Marsh, merely a fascinated observer, offers no solution to the problems documented here.

Another of the unaffiliated artists grouped under the label of the Urban Realists was Isabel Bishop (1902–1988). Her mother had worked to secure the vote for women in 1920 and had urged Bishop and her sisters toward the independence she had lost once she started her family. Bishop studied illustration at the School of Applied Design for Women in New York. Deciding on a career in painting, she then enrolled at the Art Students League, where she attended lectures by Henri and a course on Cubist painting taught by Weber. Her mentor at the school was another realist, Kenneth Miller, who

criticized Picasso and Matisse for celebrating their individual artistic personalities at the expense of commentary on contemporary life. The work of Bishop's new friend, Reginald Marsh, also reinforced in her the notion that art should address social, not individual, truths.

The social realities she focused on were those of women. Although women figure prominently in the work of both Miller and Marsh, Bishop's work is unique in its sensitivity to women's strength. In *Resting* (fig. 28-115), for example, she gently undercuts traditional stereotypes by showing a woman supporting a man. The woman's head forms the apex of a stable triangle established by the man's head and the arrangement of her right arm. Her relative strength is also evident in the darker, more sculptural forms used to depict her. His body, in contrast, appears vague and almost vaporous.

An artist not usually grouped with Marsh and Bishop but who perhaps should be is Jacob Lawrence (b. 1917). In 1930 Lawrence moved to Harlem, where he attended neighborhood art classes. Between 1932 and 1934 he studied at the Harlem Art Workshop. There he met Alain Locke, Langston Hughes, and other important thinkers and writers who had contributed to what was known as the Harlem Renaissance of the 1920s. During World War I thousands of African Americans left the rural South for jobs in Northern defense plants. The Great Migration, as it is known, created racial tensions over housing and employment that in turn fostered a concern for the rights of African Americans. It produced as well a growing concern among African American writers and artists with black experience and identity.

Alain Locke, educated at Harvard and Oxford and an influential voice in the Harlem Renaissance, encouraged younger black artists and writers to seek their contemporary cultural identity in their African and African American heritage. The influence of this advice can be seen in Lawrence's earliest depictions of Harlem, although the artist claimed that his intent was simply to "record my environment." The bright colors and flat

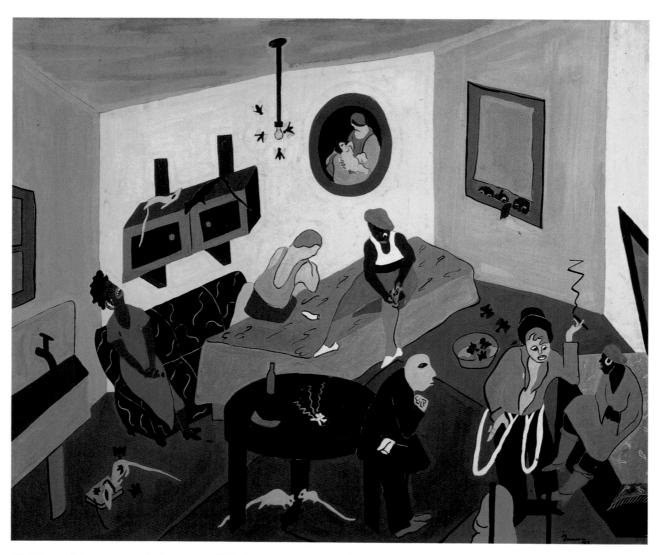

28-116. Jacob Lawrence. *Interior Scene*. 1937. Tempera on paper, 28¹/₂ x 33³/₄" (72.4 x 85.7 cm). Collection Philip J. and Suzanne Schiller

areas in *Interior Scene* (fig. 28-116) of 1937, for example, are borrowed from Southern folk art. The cheerful colors and lively patterning lend an almost playful air to what is otherwise a grim scene of a brothel infested with cockroaches and rats. Neighborhood children peek through the window at the women and their disheveled white patrons. Below a **tondo** of the Madonna and Child, a woman tucks her recently earned money into her stocking. The unstable composition and steep perspective suggest a world out of kilter. Lawrence's purposes here are unclear. Are we to be amused, appalled, or both?

In the final analysis Lawrence's work may occupy a position between the documentary concerns of the Urban Realists and the reformist aims of those artists who specifically used their art to criticize social injustices. Most of these artists, collectively known as the Social Realists, were affiliated with political organizations: with the various Communist groups that sprang up in the United States in the 1920s and 1930s, with labor organizations, and even with the U.S. government under President Franklin D. Roosevelt (in office 1933–1945).

One of the Social Realists associated with the Com-

munists was William Gropper (1897–1977), born to a poor working-class family in New York City. Gropper studied with Henri between 1912 and 1915, and he began working as a political cartoonist in 1919, when he was hired by the *New York Tribune*. During the 1920s he contributed biting political caricatures to a number of magazines, including *Vanity Fair* and *New Masses*, a Communist publication launched in 1926. By then he apparently was a convert to communism. In 1927 he visited the Soviet Union with the writers Theodore Dreiser and Sinclair Lewis, and while there he contributed work to the official Communist Party newspaper, *Pravda*. Although he also made paintings, he devoted most of his energy to his drawings and cartoons because they could reach a larger audience.

Sweatshop (fig. 28-117), of about 1938, is typical of the work he produced for the Communist press. Sweatshops—small businesses where people are employed at low wages, for long hours, and under harsh conditions—were common in American cities before the strict enforcement of labor, health, and safety laws and regulations. The destructive physical effect of such working conditions is

28-117. William Gropper. *Sweatshop.* c. 1938. Ink, 18 x 15³/₄" (45.7 x 40 cm). Collection Eugene Gropper

Despite state laws enacted in the 1880s and 1890s, called "anti-sweating" laws, it was not unusual for people to work ten to twelve hours a day, seven days a week in hot, crowded, and unsanitary workplaces. When Gropper made this drawing, effective labor laws, including minimum-wage legislation, were still years away.

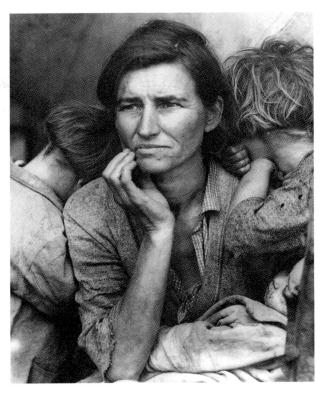

28-118. Dorothea Lange. *Migrant Mother, Nipomo, California*. February 1936. Gelatin-silver print. Library of Congress, Washington, D.C.

clearly evident in the tired and stooped bodies of the workers shown here. The style is purely descriptive. "I draw pictures of this world of ours," he said, "and they're not all pretty." Like Riis, Gropper was trying simply to enlist the viewer's sympathy, hoping to translate it into political action.

The United States government also used art to sell its political programs during the 1930s and 1940s. President Roosevelt sought to use the power and resources of the federal government to help those in need during the depression. Drawing on the tradition inaugurated by Riis, his newly established Farm Securities Administration (FSA) began in 1935 to hire photographers to document the problems of farmers. These photographs, with captions, were supplied free to newspapers and magazines.

Dorothea Lange (1895–1965) played a major role in the formation of the FSA photography program. After studying photography in 1917 at Columbia University in New York City, she opened a studio in San Francisco as a free-lance photographer and portraitist. Distressed by the depression, she began photographing the city's poor and unemployed. After seeing some of these photographs in 1934, Paul S. Taylor, an economics professor at Berkeley, asked her to collaborate on a report on migrant farm laborers in California. The report, which helped convince state officials to build migrant labor camps, was also influential in the federal government's decision to include a photographic unit in the FSA. Lange was hired as one of the first photographers in the unit in 1935.

Perhaps her most famous photograph is *Migrant Mother, Nipomo, California* (fig. 28-118). The woman in the picture is Florence Thompson, the thirty-two-year-old mother of ten children. Two of her children are shown leaning on her for support. She looks past the viewer with a preoccupied, worried look. With her knit brow and her hand on her mouth, she seems to capture the fears of an entire population of disenfranchised people.

The Roosevelt administration's decision to enlist the arts on behalf of its social programs had a precedent in Mexico, where the revolutionary government that took control in 1921 after a prolonged civil war employed artists to help forge a national cultural identity. Diego Rivera (1886–1957), one of the most prominent of these artists, helped found the modern Mexican mural movement. Rivera, who later married Frida Kahlo (see fig. 28-98), received his initial formal training at the Academy in Mexico City around 1900. At the age of twenty-one he won a scholarship to Europe, where he assimilated the work of the modernists from Cézanne to Picasso and became close friends with the latter. In 1920 he met David Siqueiros (1896-1974), another future Mexican muralist, with whom he began to discuss Mexico's need for a national and revolutionary art. Rivera went to Italy to study the great Renaissance frescoes and began studying Mexico's pre-Columbian art. When he returned to Mexico in 1921 he began a series of monumental murals, the first of which were for Mexican government buildings.

Rivera's second commission was for the courtyard of the Ministry of Education in Mexico City. Among the

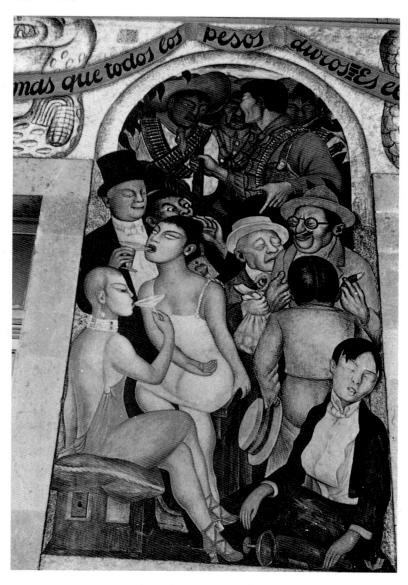

28-119. Diego Rivera. *Night of the Rich*, mural in the Ministry of Education, Mexico City. 1923–28

scenes in this mural are the *Night of the Poor* and the *Night of the Rich*. The *Night of the Poor* shows some peasants sleeping peacefully while others study by lamplight to educate themselves. The *Night of the Rich* (fig. 28-119), in contrast, shows wealthy Mexicans and foreigners, the "debauchers," as Rivera called them, hoarding money and drinking champagne. One sly-looking man is plying a woman with the drink. Another man has passed out. Revolutionary soldiers in the background look on scornfully. The two scenes offer a clear and pointed contrast between the wholesomeness of the poor peasants—the descendants of Mexico's pre-Columbian civilizations—and the Europeanized decadence of the wealthy. The simple shapes and outlines, reminiscent of the art of ancient Maya, reinforce this message.

The Resurgence of Modernism in the 1930s

Although realism dominated American art in the period between the two world wars, some artists of that period showed a renewed interest in the nonrepresentational styles of European art. One of these was Theodore Roszak (1907–1981), whose family migrated to Chicago from Poland when he was two. On a trip to Europe in 1929 he was impressed with the Bauhaus industrial aesthetic, and after his return to New York City in 1931 he produced a series of constructions in modern industrial materials. An example is Airport Structure (fig. 28-120). Made of copper, aluminum, steel, and brass, the work resembles a scientific instrument. Roszak claimed that for him "the machine was a tool, not an ideological entity." What he seems to have meant was that although he resisted the Russian Constructivist notion that the person of the future would be more machinelike, he nevertheless felt that modern technology could contribute to human progress. His celebration of the beauty and utility of the machine is the nonrepresentational counterpart to Sheeler's homage to American industry in American Landscape (see fig. 28-112).

Roszak later joined the American Abstract Artists, a group that had banded together in 1937 to promote the abstract tradition of the European avant-garde. Another of the approximately forty artists in the group around 1940 was Lee Krasner (1908-1984). An exhibition of Matisse and Picasso at the Museum of Modern Art in 1929 (the year of its founding) so impressed her and some of her classmates at New York's conservative National Academy of Design that, as she put it, they "staged a revolution" there. When she painted a sketch in brilliant Fauve colors, her instructor told her to "go home and take a mental bath." After getting a teaching certificate, she stopped painting and supported herself as a waiter. She resumed her studies in 1937 under Hans Hofmann (1880-1966), a German teacher and painter who had studied in both Paris and Munich before World War I and was considered America's living link with the modernist tradition.

Unlike Hofmann, whose own work from the period was still tied to representation, Krasner was producing fully nonrepresentational works such as *Red, White, Blue, Yellow, Black* (fig. 28-121). This painting, a complicated arrangement of different shapes and colors, is based on the Analytic Cubism of Braque and Picasso (see figs. 28-40, 28-41, 28-42). It threatens to disintegrate into chaos but is held together by the balancing of colors and the even distribution of curvilinear and rectangular shapes across the surface.

The leading critic for the American Abstract Artists, George L. K. Morris, noted that works such as *Red, White, Blue, Yellow, Black* allowed one to escape from the problems of life into a world of order, a world where tensions are resolved. For those Americans tired of the Great Depression and worried by the growing signs of the coming war in Europe, the pleasures of what they called "pure" art seemed compelling.

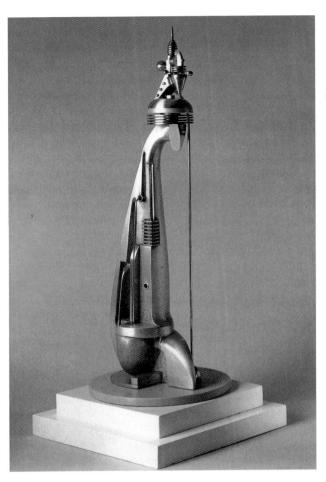

28-120. Theodore Roszak. *Airport Structure*. 1932. Copper, aluminum, steel, and brass, height 19¹/₈" (48.6 cm). Newark Museum, New Jersey
Purchase 1977, The Members Fund

The American Abstract Artists provided an important training ground for some of the critics and artists, including Krasner, who put the United States in the forefront of modernism after World War II. Another important factor in this shift was Roosevelt's Works Progress Administration (WPA), formed in 1935 to help get Americans back to work. The most important work-relief agency of the depression era, the WPA, which remained in effect until 1943, employed more than 6 million workers by that date. Among its initiatives was a group of programs to support the arts, including the Federal Theater Project, the Federal Writers' Project, and the Federal Art Project. Although they involved only about 5 percent of WPA funds and employed only about 38,000 people, these programs had a profound impact on the arts community. The Federal Arts Program (FAP) paid the then-considerable salary of \$26.86 a week (a salesclerk at Woolworth's earned only \$10.80), allowing painters and sculptors to devote themselves full-time to art and to think of themselves as professionals in a way few had been able to do before 1935. New York City's painters, in particular, began to develop a group identity, largely because they now had time to meet and discuss art in the bars and coffeehouses of Greenwich Village, the city's answer to the cafés that played such an important role in the art life of Paris. Finally, the FAP gave New York's art community a sense that high culture was important in the United States. The FAP's monetary support and its professional consequences would prove crucial to the artists later known as the Abstract Expressionists, who would shortly transform New York City into the new art capital of the world.

28-121. Lee Krasner.
Red, White,
Blue, Yellow,
Black. 1939.
Collage of
oil on paper,
25 x 19"
(63.5 x 48.5 cm).
ThyssenBornemisza
Collection,
Lugano,
Switzerland

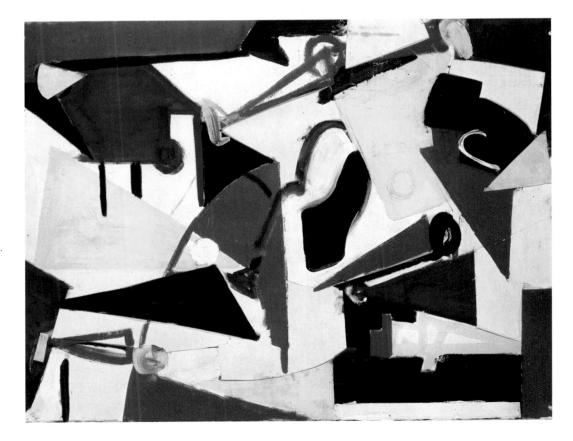

1940 1950 1960 1970

Giacometti City Square 1948

de Kooning Woman I 1950–52

Johns Target with Four Faces 1955

Smith Cubii XIX 1964

Smithson Spiral Jetty 1969–70

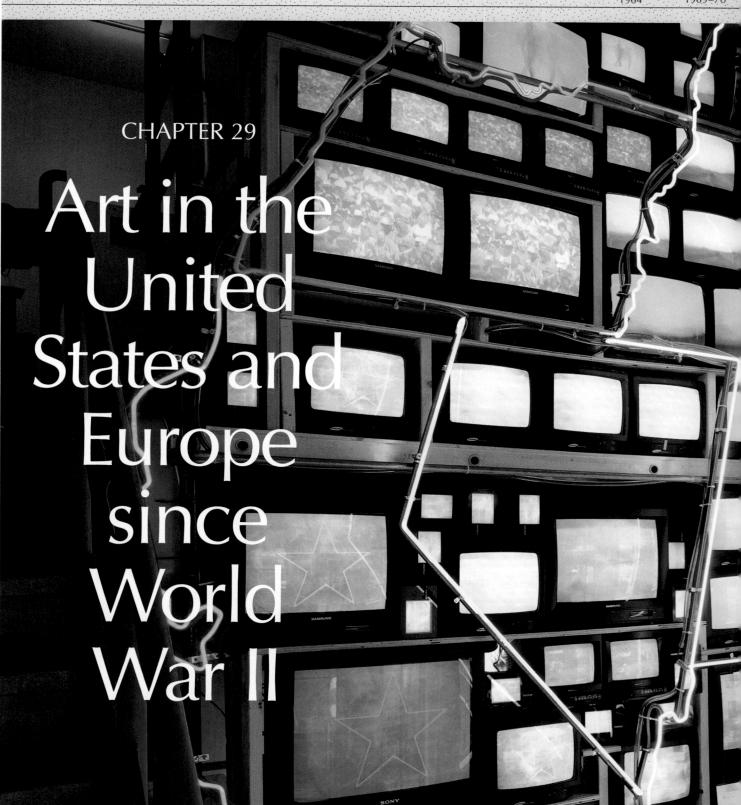

Chicago The Dinner Party 1974–79

Rothenberg Axes 1976

Serra Tilted Arc 1981

Clemente Untitled 1983

Rossi Town Hall 1986–90

Horn High Moon 1991

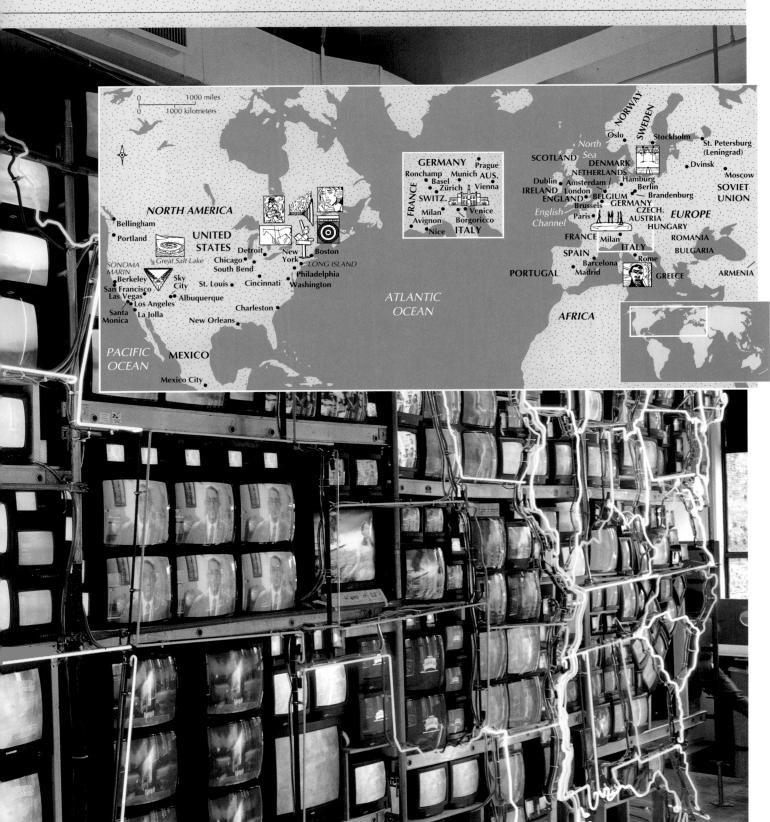

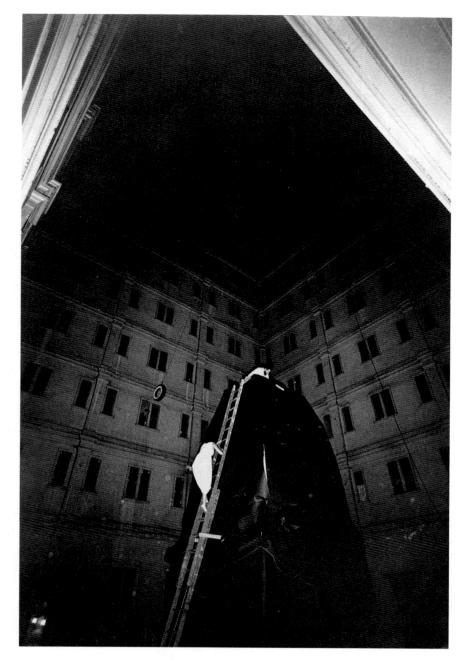

29-1. Allan Kaprow. The Courtyard. 1962. Happening at the Mills Hotel, New York

onsumers of culture in New York City have tended, over the years, to be quite blasé about innovations in artwork. There was a time in the early 1960s, however, when attendance at some rather unique art openings caused considerable excitement. At one such opening, of a 1962 work by Allan Kaprow called *The Courtyard* (fig. 29-1), the dominant feature of the work was the eruption of tar-paper balls from a volcanic mountain erected in a tenement courtyard. The viewers, who became participants after being given brooms, watched two men build an altar/bed of mattresses on top of the volcano. A young woman, wearing a nightgown and carrying a transistor radio, then climbed the mountain, where a kind of inverse mountain was lowered over her.

This new kind of art reflected a question and answer raised by musician and philosopher John Cage, who surveyed art and music in 1961 and

asked, "Where do we go from here?" His answer: "Towards theater." What emerged were happenings, theatrical events that were, in and of themselves, "objects" of art. Kaprow's works and those of his followers were badly received by the avant-garde New York art critics, because they were considered theater and because spectators enjoyed the happenings so much. One critic even asked the rhetorical question "Is artistic experience about being entertained?" Such questions about what art is and what role it plays in society have marked the richly innovative period following World War II.

"MAINSTREAM" **CROSSES** THE ATLANTIC

When the United States emerged from World War II as the most powerful nation in the world, its new stature was soon reflected in the arts. Ameri-

can artists and architects—especially those living in New York City—assumed a leadership in artistic innovation that by the late 1950s had been acknowledged across the Atlantic, even in Paris. Critics, curators, and art historians, trying to follow art's "mainstream," now focused on New York as the new center of modernism, viewing trends in Europe as secondary. This American dominance endured until around 1970, when the belief that there is such a thing as an identifiable mainstream, or single dominant line of artistic development, began to wane (see "The Idea of the Mainstream," page 1110).

EUROPEAN ART

POSTWAR Despite the shift of critical focus away from Europe, several European artists received worldwide attention following the war. One

of these artists was the Dublin-born painter Francis Bacon (1909-1992). Trained as an interior decorator, Bacon taught himself to paint about 1930 but produced few pictures until the early 1940s, when the onset of World War II crystallized his harsh view of the world. His style draws on the expressionist works of Vincent van Gogh (see figs. 28-16, 28-17) and Edvard Munch (see fig. 28-19), as well as on Picasso's figure paintings. His subject matter comes from a wide variety of sources, including post-Renaissance Western art.

Head Surrounded by Sides of Beef (fig. 29-2), for example, is part of a famous series of paintings inspired by Diego Velázquez's Pope Innocent X (see "Artistic Allusions in Contemporary Art," page 1111). Bacon has transformed the solid and imperious pope of the original into an anguished and insubstantial figure howling in a black void. The feeling is reminiscent of Munch's The Scream, but unlike Munch's figure on the bridge, Bacon's pope is enclosed in a claustrophobic box that seems to contain his frightful cries. Bacon forces the viewer into that box to share his figure's terror, which the sides of beef behind him, copied from a Rembrandt painting, seem to magnify. Bacon said that for him, slaughterhouses and meat brought to mind the Crucifixion of Jesus. The figure is

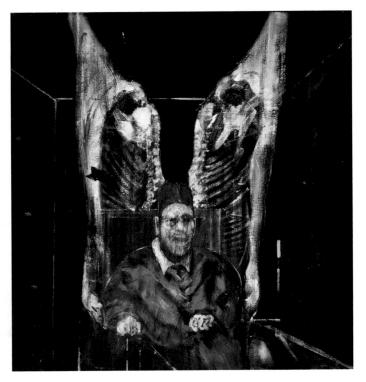

29-2. Francis Bacon. Head Surrounded by Sides of Beef. 1954. Oil on canvas, 503/4 x 48" (129 x 122 cm). The Art Institute of Chicago Harriott A. Fox Fund

responding, then, to the realization that humanity is merely mortal flesh.

The French painter Jean Dubuffet (1901–1985) developed a very different but equally distinctive form of expressionism during the war. Dubuffet's paintings were inspired by what he called art brut ("raw art")—the work of children and the insane-which he considered "uncontaminated by culture." Like artists as diverse as Paul Gauguin, Maurice de Vlaminck, and the Surrealists, he thought that civilization corrupts innate human sensibilities. Working at times with paint mixed with tar, sand, and mud applied with his fingers and ordinary kitchen utensils, he developed a deliberately crude and spontaneous style in imitation of art brut. In the early 1950s he began to mix oil paint with new, fast-drying industrial enamels, laying them over a preliminary base of still-wet oils. The result was a texture of fissures and crackles that

THE IDEA OF THE

One of the central convictions cher-MAINSTREAM ished by modernist artists, critics, and

historians was the existence of an artistic mainstream, the notion that some artworks are more important than others-not by virtue of their greater aesthetic quality but because they participate in the progressive unfolding of some larger historical purpose. According to this view. the overall evolutionary pattern was what conferred value, and any art that did not fit within it, regardless of how appealing, could be for the most part ignored.

Ultimately, such thinking depended on two long-standing Western ideas about historical change. The first was the ancient Greek belief that history records the steady advance, or progress, of human learning and accomplishment. The second was the Judeo-Christian faith that humanity is passing through successive stages that will inevitably bring it to a final state of perfection on earth, the restoration of Eden in the millennium. The specifically modern notion of the mainstream arose from the way the Enlightenment German philosopher Georg Wilhelm Friedrich Hegel (1770-1831) reformulated these old ideas about progress. In his "Lectures on the Philosophy of History" (first published in 1834, after his death), Hegel

argued that history is the gradual manifestation of divinity over time. It is, in other words, the process by which the divine reveals itself to us. As one modern writer succinctly put it, history is thus "the autobiography of God." The important men and women who seem to shape events are actually the vehicles by which the divine "Spirit" unfolds itself.

Hegel's conception of history as the record of large, impersonal forces struggling toward some transcendent end had a profound effect on the following generations of Western European philosophers, historians, and social theorists. In France his ideas were assimilated and developed by the socialists responsible for the concept of the artistic avantgarde, a notion of artistic advance central to the rise of modernism.

In the period after World War II the critical discussion of what constituted the modernist mainstream, which had remained largely unstated earlier, was encouraged and shaped by the critical writings of Clement Greenberg (1909-1994), whose thinking was grounded in a Hegelian concept of the development of art since about 1860. In essence, Greenberg argued that modern art since Édouard Manet (Chapter 27) involved the progressive disappearance of both pictorial space and figuration because art itself-whatever the artists may have thought they were

doing-was supposedly undergoing its own "process of self-purification" in reaction to a deteriorating civilization. Although Greenberg's conception of the mainstream was rejected by members of the art world during the Abstract Expressionist era, it was embraced by a powerful group of American critics and historians, the so-called Greenbergians, who began to express themselves around 1960.

In the ensuing decades, belief in the concept of the mainstream gradually eroded, partly because of the narrow way it had been conceived by Greenberg and his followers. Because it omitted so much of the history of recent art, observers quite simply began to question whether there had, in fact, ever been a single, dominant mainstream at all. The extraordinary proliferation of art styles and trends in the period after the 1960s greatly contributed to those doubts. Finally, and perhaps most important, these doubts were compounded by the general decline of faith in the very concept of historical progress. Few historians today would disagree with the assessment of the art critic Thomas McEvilley, "History no longer seems to have any shape, nor does it seem any longer to be going any place in particular." Thus, the concept of the mainstream has been relegated to the status of another of modernism's myths.

29-3. Jean Dubuffet. Cow with the Subtile Nose. 1954. Oil on enamel on canvas, 35 x 453/4" (89.7 x 117.3 cm). The Museum of Modern Art, New York

Benjamin Scharps and David Scharps Fund

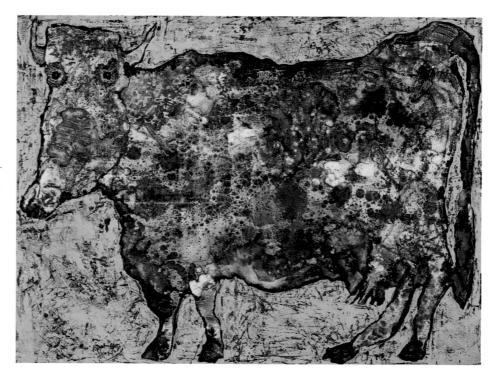

ARTISTIC **ALLUSIONS** IN CON-ART

Contemporary artists, like their earlier counterparts TEMPORARY (see "Artistic Allusions in Manet's Art," page 1007),

have continued to find inspiration, both for subject matter and for formal elements, in the art of the past. Sometimes the borrowings are obvious, as in the case of Francis Bacon's Head Surrounded by Sides of Beef (see fig. 29-2), which refers to Rembrandt's Butchered Ox and Diego Velázquez's Pope Innocent X. Of his fascination with Velázquez's portrait, Bacon said: "It just haunts me, and it opens up all sorts of feelings . . . in me." The nature of those feelings is suggested by the fact that on his studio wall next to a reproduction of that painting were photographs of Nazi leaders and various newspaper images of death and disaster. This combination of real-life and high art imagery suggests that, as it was for earlier artists such as Manet, art is simply one of the sources used by contemporary artists to stimulate and promote the creative process.

Other connections with art of the past are subtly allusive and not apparent to the casual observer, as in the case of Mark Rothko's Slow Swirl by the Edge of the Sea (see fig. 29-7), which was inspired by Sandro Botticelli's Renaissance painting The Birth of Venus.

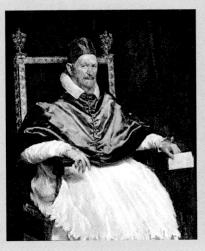

Diego Velázquez. Pope Innocent X. 1650. Oil on canvas, 55 x 45 1/4" (139.7 x 115 cm). Galleria Doria Pamphili, Rome

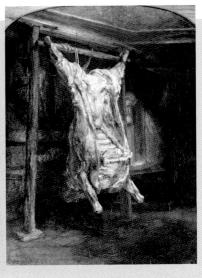

Rembrandt van Rijn. Butchered Ox. 1655. Oil on panel, 37 x 263/8" (94 x 67 cm). Musée du Louvre, Paris

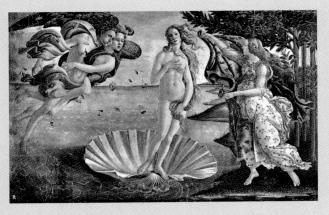

Sandro Botticelli. The Birth of Venus. c. 1480. Tempera on canvas, 5'87/8" x 9'17/8" (1.8 x 2.8 m). Galleria degli Uffizi, Florence

suggests organic surfaces, like those of Cow with the Subtile Nose (fig. 29-3). Dubuffet observed that "the sight of this animal gives me an inexhaustible sense of well-being because of the atmosphere of calm and serenity it seems to generate." What is particularly delightful about this cow is its dazed expression. The animal seems utterly content and unaware of its own gracelessness. Its entire being seems focused on its "subtile" nose, which appears to twitch just slightly, perhaps at the scent of some grassy morsel.

Another major French artist to emerge after the war was Swiss-born Alberto Giacometti (1901-1966). Between 1935 and 1945 Giacometti began modeling human figures in works that became, despite his conscious attempts to resist the tendency, progressively smaller. In the period immediately after World War II he sometimes organized these tiny figures into groups, as in City Square (fig. 29-4). The dominant feature of these lumpy, frail, and unbeautiful figures is their heavy feet. The very antithesis of the classical ideal, the figures are anonymous and alone in a desolate space. Their blank faces and mechanical body language suggest life without purpose.

The psychological isolation of Giacometti's figures reflects the influence of the existentialist philosophy of

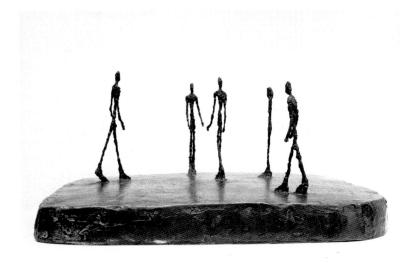

29-4. Alberto Giacometti. City Square. 1948. Bronze, 81/2 x 253/8 x 171/4" (21.6 x 64.5 x 43.8 cm). The Museum of Modern Art, New York Purchase

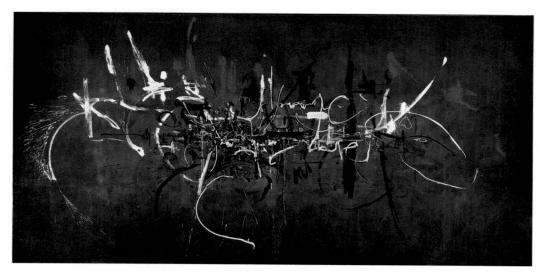

29-5. Georges Mathieu. Capetians Everywhere. 1954. Oil on canvas, 9'81/4" x 19'81/4" (2.95 x 6 m). Musée National d'Art Moderne, Centre Georges Pompidou, Paris

his friend Jean-Paul Sartre (1905–1980). According to existentialism, humans are alone in a universe without meaning. Sartre maintained that this condition leaves us absolutely free to choose how to live. Such themes pervaded European art and literature after the war. Many younger painters, seeking an appropriately avant-garde way to reveal states of inner being, adapted the Surrealist drawing technique of automatism to existential ends. The result was a gestural style—one in which the movement of the body is used to express an idea or a feelingthat swept Western Europe in the early 1950s, which some called art informel ("informal art") and others called tachisme (from the French for "patch").

One of the leading figures in this development was Georges Mathieu (b. 1921), who in 1944 began using an automatist technique to produce wholly spontaneous, nonrepresentational imagery. France was then under German control, which may explain Mathieu's attraction to such a completely "liberated" technique. More profoundly, he was convinced that only unmediated expressionism could capture the truth of existence. He first described the paintings that resulted with the term psychic nonfiguration, but by 1947 he was using the label lyrical abstraction. Many of these works, like Capetians Everywhere (fig. 29-5), are huge. Mathieu was descended from the Capetians—the kings who ruled France during much of the Middle Ages—so the work is about himself. As with all of his mature work, Mathieu painted Capetians Everywhere quickly—he called himself "the fastest painter in the world"—applying paint directly from the tube. Surrealists like Joan Miró (see fig. 28-94) had used automatism only as a first step, before consciously reworking the shapes and lines into a finished painting. By eliminating this more deliberate second step, Mathieu may have been trying to advance the Surrealist quest for total freedom.

As art informel was emerging, artists in the United States were also developing a form of expressionism that derived from Surrealism. The American version quickly overshadowed its European counterpart, partly because to many it appeared more profound.

EXPRESSIONISM

ABSTRACT The rise of fascism in Europe and the outbreak of World War II led a num-

ber of leading European artists and writers to move to the United States. By 1940, for example, André Breton, Salvador Dalí, Fernand Léger, Piet Mondrian, and Max Ernst were all living in New York. Although many of these émigrés kept to themselves, their very presence provoked fruitful discussions among American abstract artists, who were most deeply affected by the ideas of the Surrealists. The main result of this new American fascination with Surrealism was the emergence of Abstract Expressionism, a term that designates a wide variety of work-not all of it abstract or expressionistic—produced in New York between 1940 and roughly 1960. Abstract Expressionism is also known as the art of the New York School, a more neutral label many art historians prefer.

The Abstract Expressionists found inspiration in both Cubist formalism and Surrealist automatism, two very different strands of modernism. From the Cubists they learned certain pictorial devices and a standard of aesthetic quality. From the Surrealists they gained both a commitment to examining the unconscious and techniques for doing so. But whereas the European Surrealists had derived their notion of the unconscious from Sigmund Freud, many of the Americans subscribed to the thinking of Swiss psychoanalyst Carl Jung (1875–1961). His theory of the "collective unconscious" holds that beneath one's private memories is a storehouse of feelings and symbolic associations common to all humans. Dissatisfied with what they considered the provincialism of American art in the 1930s, Abstract Expressionists sought universal themes within themselves.

One of the first artists to bring these various influences together was Arshile Gorky (1904–1948). Gorky was born in Turkish Armenia. His mother died of starvation during Turkey's brutal repression and eviction of its Armenian population. He emigrated in 1920 and moved to New York in 1925. In the 1930s his work went through a succession of styles that followed the evolution of

PARALLELS

<u>Years</u> 1940–1949 **Events**

Modernist period in architecture emerges (United States); New York School arises (United States); Camus's novel *The Stranger* (France); Jews rise up against Nazis in Warsaw Ghetto (Poland); Pollock pioneers action painting (United States); United States drops first atomic bomb, on Hiroshima, Japan; World War II ends; first digital computer (United States); United Nations first meets; Orwell's novel *1984* (England); (Communist) People's Republic of China established

1950-1959

Art informel sweeps Western Europe; President Truman sends first U.S. military advisers to Vietnam; Rothko and Newman pioneer Color Field painting (United States); color television introduced in United States; Salinger's novel *The Catcher in the Rye* (United States); Frankenthaler's Mountains and Sea (United States); Independent Group produces British Pop art (England); de Kooning's Woman I (United States); Sartre's book Being and Nothingness (France); Gutai Bijutsu Kyokai formed by Jiro Yoshihara (Japan); Mies van der Rohe's Seagram Building designed (United States); U.S. Supreme Court bans racial segregation in public schools; Ray's film Pather Panchali (India); Martin Luther King, Jr., leads Montgomery, Ala., bus-desegregation strike, sparking civil rights movement in the United States; Bergman's film The Seventh Seal (Sweden); Elvis Presley's first recordings released (United States); first Earth-orbiting satellite (Soviet Union); Jewish Museum's "New York School: The Second Generation" exhibition (United States); Kerouac's novel On the Road (United States); Kaprow's first happening (United States); Minimalist art emerges (United States); Museum of Modern Art's "The New American Painting" exhibition (United States); the Beatles are formed (England); Museum of Modern Art's "New Images of Man" exhibition (United States); Resnais's film Hiroshima, Mon Amour (France); Wright's Guggenheim Museum opens (United States)

1960-1969

Berlin Wall built (Germany); Heinlein's novel *Stranger in a Strange Land* (United States); Cage's book *Silence* (United States); Lichtenstein's *Oh, Jeff...* (United States); Museum of Modern Art's "The Art of Assemblage" exhibition (United States); Peace Corps founded in United States; Carson's *Silent Spring* (United States); Maciunas launches the Fluxus movement (Germany); Solzhenitsyn's novel *One Day in the Life of Ivan Denisovich* (Soviet Union); Warhol's *Marilyn Diptych* (United States); assassination of President Kennedy (United States); escalation of Vietnam War; Civil Rights Act of 1964 (United States); Friedan's book *The Feminine Mystique* (United States); *Autobiography of Malcolm X* (United States); National Endowment for the Arts established (United States); Capote's "nonfiction novel" *In Cold Blood* (United States); Masters and Johnson's book *Human Sexual Response* (United States); National Organization for Women founded in the United States; assassination of Martin Luther King, Jr. (United States); student unrest in Europe and the United States; site-specific earthworks emerge (United States); Angelou's autobiographical novel *I Know Why the Caged Bird Sings* (United States); first astronauts on moon (United States); riot at Stonewall Inn in New York City begins gay liberation movement (United States); Woodstock popular music festival attended by 400,000 (United States)

1970-1979

Fiftieth anniversary of women's vote spurs feminist art movement (United States); postmodernist architecture and art arise (United States); Super Realism and Post-Conceptual art emerge (United States); Ginsberg's book *The Fall of America* (United States); last U.S. forces leave Vietnam; Watergate scandal forces President Nixon to resign (United States); Chicago's *The Dinner Party* (United States); first personal computer (United States); Haley's novel *Roots* (United States); New Museum's "Bad Painting" and Whitney Museum's "New Image Painting" exhibitions (United States); graffiti art movement launched by "Times Square Show" (United States)

1980-1989

Neo-Expressionism emerges in Europe and the United States; Neo-Conceptualism arises (United States); discovery of AIDS virus reported (France, United States); Morrison's novel *Beloved* (United States); Communist governments in Eastern Europe collapse; Berlin Wall dismantled (Germany)

1990-present

Unification of Germany; Cincinnati Contemporary Arts Center wins court case on Mapplethorpe exhibit (United States); breakup of Soviet Union; Persian Gulf War; apartheid in South Africa legally dismantled; war expands between Bosnians and Serbs in former Yugoslavia; civil wars continue in central Africa

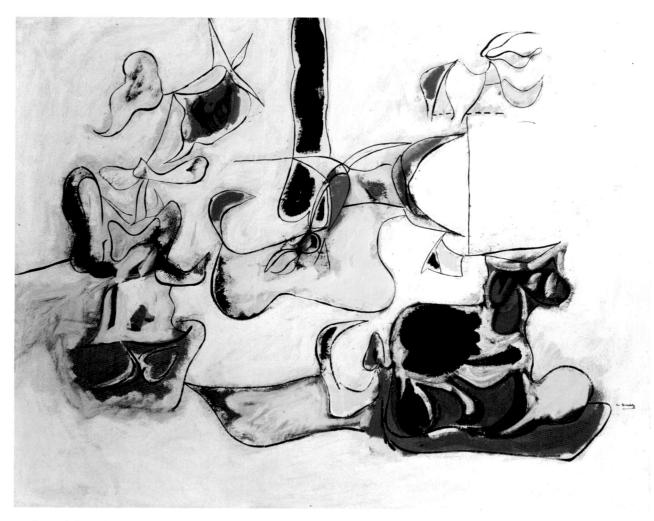

29-6. Arshile Gorky. *Garden in Sochi. c.* 1943. Oil on canvas, 31 x 39" (78.7 x 99.1 cm). The Museum of Modern Art, New York Acquired through the Lillie P. Bliss Bequest

modernism from Cézanne to Picasso to Miró. Three factors converge in his mature work of the 1940s: his intense childhood memories of Armenia, which provided his primary subject matter; his growing interest in Surrealism, first sparked by a major exhibition, "Dada, Surrealism, Fantastic Art," presented in 1936 at the Museum of Modern Art in New York; and the many discussions of Jungian ideas he had with colleagues.

These factors began to come together in 1940 with Gorky's Garden in Sochi series (fig. 29-6). The title refers to his father's garden at his family's Armenian home, but the paintings, rather than illustrating the place, are meant to evoke its larger meaning. The fluid, organic shapes and sprouting forms—derived from Miró (see fig. 28-94)—suggest the vital forces of life itself. With these seemingly unpremeditated, automatist-generated forms and colors, Gorky meant to put himself and his viewers in touch not only with his own past but also with a universal, unconscious identification with the earth that dates to humanity's prehistoric, preanalytic past. Despite their improvisational appearance, Gorky's paintings were not completely spontaneous but were the result of a process that involved preparatory drawings. He wanted

the paintings to touch his viewers deeply, but he also wanted them to be formally beautiful.

In his paintings of the 1940s Mark Rothko (1903-1970) also sought to convey Jungian themes in works of high aesthetic quality. Born in the poor Jewish ghetto of Dvinsk in Russian-controlled Latvia, Rothko emigrated with his family to Portland, Oregon, when he was ten. His work of the 1930s included quiet street scenes in a somewhat decorative Urban Realist manner. About 1940 he and his friend the artist Adolph Gottlieb (1903-1974) became interested in Surrealism and in Jung and began to produce works based on mythic imagery culled from the subconscious. On a 1943 radio program explaining these works, they said: "If our titles recall the known myths of antiquity, we have used them again because they are eternal symbols. . . . They are the symbols of . . . primitive fears and motivations, no matter in which land, at what time, changing only in detail but never in substance." In a letter to the New York Times that same year, they also insisted that subject matter is crucial in art, "and only that subject matter is valid which is tragic and timeless" (cited in Ashton, pages 128-129).

This concern with "primitive fears" and the "tragic"

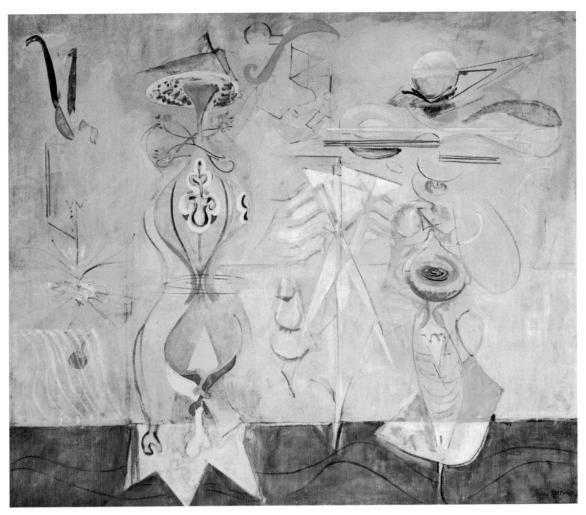

29-7. Mark Rothko. *Slow Swirl by the Edge of the Sea*. 1944. Oil on canvas, 6'3³/8" x 7'³/4" (1.91 x 2.15 m). The Museum of Modern Art, New York

Bequest of Mrs. Mark Rothko through the Mark Rothko Foundation, Inc.

quality of human experience partly reflects the widespread anxiety in the early years of World War II, but it also resonates with Rothko's character. Often depressed and deeply pessimistic, he enjoyed a rare period of optimism in 1944, when he met and fell in love with Mary Alice (Mell) Beistle, who became his second wife. During their courtship he painted Slow Swirl by the Edge of the Sea (fig. 29-7). This large canvas is the first in which he relied fully on the automatist technique and his first to depict a watery, primeval world where life is just beginning to develop. Rising from the sea floor amid a variety of indeterminate forms are two more-complicated organic shapes. Some critics have tried to identify these forms as male and female, but all that can be said of them is that they complement each other. The delicate beauty of their forms and colors seems far removed from the world of the tragic. This painting may be in part Rothko's response to a Renaissance painting by Sandro Botticelli, The Birth of Venus (see "Artistic Allusions in Contemporary Art," page 1111), which he saw in 1940 and found "the most marvelous thing" he had ever seen. This possibility is supported by the observation of a friend that "Mark thought Mell was his Venus." The painting takes the viewer back

to the very beginnings of life, while at the same time it records the beginning of Rothko's new life with Mell. Perhaps it is even a kind of Jungian wedding portrait—one intended to hold its own with the great art of Europe, modern and premodern. Although the artists of the emerging New York School were committed to innovation, most also saw themselves within the Western tradition of high art that reaches back to ancient Greece.

Jackson Pollock (1912–1956), however, the most famous of the Jung-influenced Abstract Expressionists, rejected much of the European tradition of aesthetic refinement for cruder, rougher formal values often identified with the American frontier. Pollock came to New York in the early 1930s and studied with the Regionalist painter Thomas Hart Benton (1889–1975). Pollock, self-destructive and alcoholic, was introduced to Jung's ideas in 1939, when his family sent him to a Jungian therapist. Pollock was reluctant to talk about his problems, so the therapist tried to engage him through his art, analyzing the drawings Pollock brought in each week in terms of Jungian symbolism.

Although the therapy had little apparent effect on Pollock's personal problems, it greatly affected his work, giving him a new vocabulary of signs and symbols and a

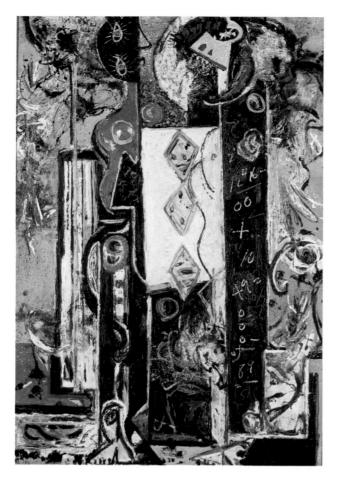

29-8. Jackson Pollock. *Male and Female*. 1942. Oil on canvas, 6'1¹/₄" x 4'1" (1.86 x 1.24 m). Philadelphia Museum of Art
Gift of Mr. and Mrs. Gates Lloyd

belief in the therapeutic role of the artist in society. Jung maintained that the artist whose images tapped into "primordial" human consciousness would have a positive psychological effect on viewers. In paintings such as Male and Female (fig. 29-8), which attempt to give new psychological and formal dimensions to a standard Picasso subject from the late 1920s and 1930s—two figures facing one another-Pollock apparently sought to put this belief into practice. The surface of the painting is covered with a variety of small signs and symbols Pollock ostensibly retrieved from his unconscious. Beneath this veneer is a firm compositional structure of strong vertical elements flanking a central rectangle. The more angular elements on the left, intended to represent the male principle, balance the more curvilinear ones on the right, intended to express the female principle. In the healthy adult psyche, as suggested here, they are balanced.

When he painted *Male and Female*, Pollock was beginning a relationship with the artist Lee Krasner (see fig. 28-121), and to some extent, like Rothko's *Slow Swirl by the Edge of the Sea*, Pollock's work is a kind of lovers' portrait. But Pollock's painting features a rougher paint surface than Rothko's, less-refined linear rhythms, and more-blatant color contrasts. Although these qualities were partly inspired by recent paintings of women by Picasso, whom Pollock and others of his generation revered as the greatest living artist, and were partly a

matter of innate inclination, they may reflect as well a conscious effort to introduce specifically American formal values. Many of the critics who reviewed Pollock's one-person exhibition in 1943, while less than enthusiastic about his work as a whole, noted approvingly that he had broken with French taste in favor of a "native sensibility." In the context of World War II, Pollock's rugged "Americanism" was much appreciated.

Action Painting

In the second phase of Abstract Expressionism, which dates from the late 1940s, two different approaches to expression emerged, one based on fields of color and the other on active paint handling. The second approach, known as action painting, or gesturalism, first inspired the label Abstract Expressionism. The term action painting was coined by art critic Harold Rosenberg (1906-1978) in his 1952 essay "The American Action Painters," in which he claimed: "At a certain moment the canvas began to appear to one American painter after another as an arena in which to act—rather than a space in which to reproduce, redesign, analyze, or 'express' an object. actual or imagined. What was to go on the canvas was not a picture but an event." Although he did not mention them by name, Rosenberg was referring primarily to Pollock and to Pollock's chief rival for leadership of the New York School, Willem de Kooning (b. 1904).

Pollock began to replace painted symbols with freely applied paint as the central element of his work during the mid-1940s. After moving in 1945 to Springs, a small, rural community on Long Island, New York, he created a number of rhythmic, dynamic paintings devoted to nature themes. The largest of these works were done on the floor of his upstairs studio because the room was too small to accommodate an easel.

Pollock found this working method congenial, and when he moved his studio into a renovated barn in the fall of 1946, he continued to place his canvases on the floor and to work on his knees over and around them. Sometime in the winter of 1946–1947, he also began to employ enamel house paints along with conventional oils, dripping them onto his canvases with sticks and brushes using a variety of fluid arm and wrist movements (fig. 29-9). As a student in 1936, he had experimented not only with this approach but also with industrial paints in the studio of the visiting Mexican muralist David Siqueiros. He had no doubt been reminded of those experiments by the 1946 exhibition of the small drip paintings of a self-taught painter, Janet Sobel (1894-1968), which he had seen in the company of his chief artistic adviser, the critic Clement Greenberg (1909–1994).

Greenberg's view that the mainstream of modern art (see "The Idea of the Mainstream," page 1110) was flowing away from representation and easel painting toward abstraction and large-scale murals may have influenced Pollock's formal evolution at this time, but his shift in working method was grounded in his own continuing interests in both automatism and nature. The result over the next four years was a series of graceful linear

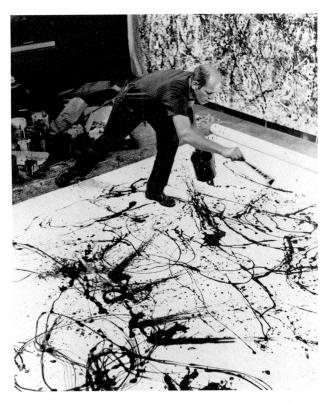

29-9. Hans Namuth. Photograph of Jackson Pollock painting, Springs, New York. 1950
In the summer and fall of 1950, Namuth made dozens of still photographs and one film of Pollock at work. Pollock apparently agreed to the sessions partly because he understood that they would help promote his growing fame.

abstractions such as *Autumn Rhythm (Number 30)* (fig. 29-10). As the titles of this and the other paintings in the series suggest, Pollock seems to have felt that in the free, unselfconscious act of painting he was giving vent to primal, natural forces.

Soon after he began the drip paintings Pollock wrote: "On the floor I am more at ease.... [T]his way I can... literally be *in* the painting.... When I am *in* the painting I am not aware of what I am doing.... [T]here is pure harmony" (cited in Chipp, page 546). His remarks suggest that one of the deepest pleasures of the new technique for Pollock was the sense it provided him of being fully absorbed in action, which eliminated the anxiety of self-consciousness—the existential sense of estrangement between one-self and the world. Even when the painting is shifted from the floor to the wall, the spectator can vicariously participate in this experience, without knowing about how Pollock painted, because of the mesmerizing way the delicate skeins of paint effortlessly loop over and under one another in a pattern without beginning or end.

In response to Pollock's claim that he found painting "pure harmony," Willem de Kooning insisted, "Art never seems to make me peaceful or pure." De Kooning emigrated to the United States from the Netherlands in 1926, and during the 1930s he shared a studio with his close friend Gorky. Although de Kooning adopted some of Gorky's formal language, he resisted the shift to Jungian Surrealism. For him it was more important to record accurately and honestly his sense of the world around him, which was never simple or certain. "I work out of doubt," he once remarked. During the course of the 1940s his nervous uncertainty was expressed in the agitated and sometimes frantic way he handled paint itself.

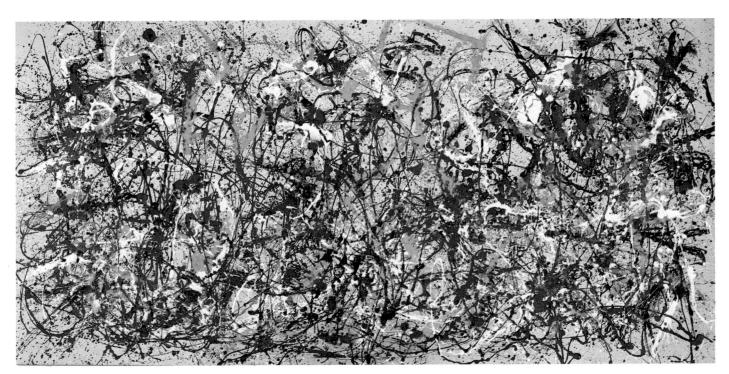

29-10. Jackson Pollock. *Autumn Rhythm (Number 30)*. 1950. Oil on canvas, 8'9" x 17'3" (2.66 x 5.25 m). The Metropolitan Museum of Art, New York

George A. Hearn Fund

29-11. Willem de Kooning. Woman I. 1950-52. Oil on canvas, 6'37/8" x 4'10" (1.93 x 1.47 m). The Museum of Modern Art, New York Purchase Dissatisfied with the results of his extended work on this painting, de Kooning left it outside his studio, where Meyer Schapiro, a Columbia University art historian and supporter of the New York School, found it when he came to visit. He admired the work and convinced de Kooning that it was worth keeping and exhibiting.

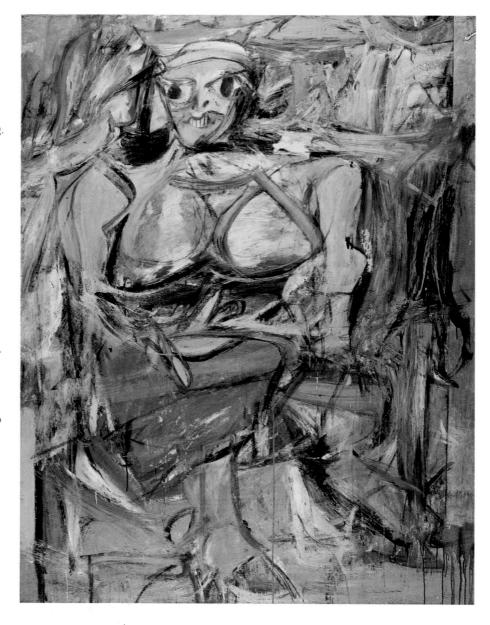

De Kooning shocked the New York art world in the early 1950s by returning to the figure with a series of paintings of women. The paintings were also shocking because of the brutal way he depicted his subjects. The first of the series, Woman I (fig. 29-11), took him almost two years (1950–1952) to paint. His wife, the artist Elaine de Kooning (1918–1989), said that he painted it, scraped it, and repainted it several dozen times at least. Part of de Kooning's dissatisfaction stemmed from the way the images in this and the other paintings in the series kept veering away from the conventionally pretty women in American advertising that inspired them. What emerges in Woman I is not the elegant companion of Madison Avenue fantasy but a powerful adversary, more dangerous than alluring. Only the soft pastel colors and luscious paint surface give any hint of de Kooning's original sources, and these qualities are nearly lost in the furious slashing of the paint. Like Les Demoiselles d'Avignon did for Picasso (see fig. 28-36), the painting reflects de Kooning's feelings toward women. "Women irritate me sometimes," he said. "I painted that irritation in the Woman series."

De Kooning, like Gorky, was committed to the highest level of **aesthetic** achievement. As one of his friends claimed, for de Kooning being a painter "meant meeting full-force the professional standard set by the great Western painters old and new." Although paintings such as *Woman I* may appear blunt, they represent a carefully orchestrated buildup of interwoven strokes and planes of color based largely on the example of Analytic Cubism (see figs. 28-40, 28-41, 28-42). "Liquefied Cubism" is the way one art historian described them. The real roots of de Kooning's work, however, lie in the Venetian tradition of artists such as Titian (see figs. 18-28, 18-29), Rubens (see figs. 19-41, 19-42), and their heirs, who superbly transformed flesh into paint.

Color Field Painting

During the 1950s de Kooning dominated the avant-garde in New York. Among the handful of modernist painters who resisted his influence were Mark Rothko and Barnett Newman. By 1950 these two had evolved individual

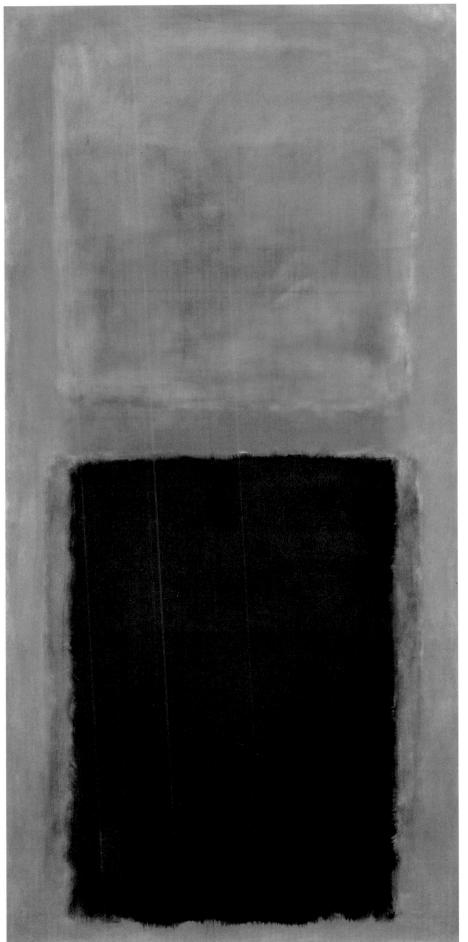

29-12. Mark Rothko. Homage to Matisse. 1953. Oil on canvas, 8'10" x 4'3" (2.69 x 1.3 m). Collection the Edward R. Broida Trust

styles that relied on large rectangles of color to evoke transcendent emotional states. Because of the formal and emotional similarities of their work, they were soon referred to collectively as Color Field painters.

In 1947 Rothko gave up his earlier pursuit of a "mythic" art for one inspired by the recent color abstractions of his painter friend Clyfford Still (1904–1980), which, he said, left him "breathless." In the summer of that year he taught with Still at the California School of Fine Arts in San Francisco. Rothko's first efforts in this new direction, freely painted and lacking any clear organizational structure, often looked like soft versions of Still's work. By 1948 he was beginning to organize his colors into rectangular units. By 1950 he had evolved his mature format, which typically involved two to four softedged rectangular blocks of color hovering one above another against a monochrome ground.

In works such as *Homage to Matisse* (fig. 29-12) Rothko consciously sought a profound harmony between the two divergent human tendencies that German philosopher Friedrich Nietzsche (1844–1900) called the Dionysian and the Apollonian. The rich color represents the emotional, instinctual, or Dionysian (after the Greek god of wine, the harvest, and inspiration) element, whereas the simple compositional structure is its rational, disciplined, or Apollonian (after the Greek god of light, music, and truth) counterpart. In his paintings Rothko sought to transform this fundamental human duality into a consonant and deeply satisfying unity. The title of *Homage to Matisse*, with its reference to the great colorist and creator of such harmonious works as *The Joy of Life* (see fig. 28-24), reflects this goal.

Unlike Matisse, however, Rothko could never fully surrender himself to the harmonic ideal. He was convinced of Nietzsche's contention, which he reread many times, that the modern individual was "tragically divided." Thus, the surfaces of Rothko's paintings are never completely unified but remain a collection of separate and distinct parts. What gives this fragmentation its particular force is that these elements offer an abstraction of the human form. In figure 29-12, as elsewhere, the three blocks approximate the human division of head, torso, and legs. The vertical paintings, usually somewhat larger than life, therefore present the viewer with a kind of mirror image of the divided self. Thus the dark tonalities that Rothko increasingly featured in his work emphasize the tragic implications of this division. The best of his mature paintings maintain a tension between the harmony they seem to seek and the fragmentation they regretfully acknowledge.

Rothko's colleague Barnett Newman (1905–1970) also devised a nonrepresentational art to address modern humanity's existential condition. Newman experimented with various styles until, on his forty-third birthday, he prepared a canvas with a single stripe running down the center of a darker monochrome field. Although he had intended to develop the work further, he found its simplicity surprisingly resonant. He looked at it for eight months before he decided that his quest for a style had ended. From this point on, Newman specialized

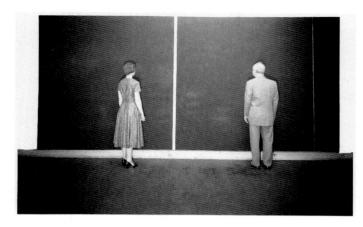

29-13. Barnett Newman. Cathedra. 1958. Installation. Photograph, National Museum of American Art, Smithsonian Institution, Washington, D.C. Peter A. Juley and Son Collection

in monochrome canvases with one or more of these linear "zips," as he called them, dividing the surface, as in Cathedra (fig. 29-13). The zips, like Rothko's rectangles, are extreme abstractions of the single human figure and are meant to provide an element with which viewers can identify. Newman sought to contrast the small, finite vertical of the self with the infinite expanse of the universe, suggested in Cathedra and other works of its type by the monochromatic field that seems to extend beyond our vision. The word cathedra (Latin for "throne") refers here to the ecstatic vision of the prophet Isaiah (6:1): "I saw the Lord seated on a high and lofty throne, with the train of his garment filling the temple." Newman seems to have wanted the painting's viewer to feel what Isaiah must have felt: not the smallness of the self but the sublime fullness of the divine presence.

Sculpture

Although the New York School was made up almost exclusively of painters, a handful of sculptors also participated at its fringes. Many are just now emerging from undeserved relative obscurity. The one sculptor who rose to fame alongside his painter colleagues was David Smith (1906–1965). Born in Indiana, Smith learned metalworking when at nineteen he worked as a riveter in the Studebaker automobile plant in South Bend. Concentrating initially on painting, he turned to sculpture in 1933 after seeing a reproduction of a welded metal sculpture by Picasso and Julio González (1876–1942). Smith's early sculpture is diverse, ranging from social commentary to a three-dimensional version of automatist drawing.

During the 1950s he produced his Tank Totem series, a group of works that seems to look back to the sculpture of Picasso and González. The title of the series combines a reference to army tanks with the concept of a totem, an animal or plant that serves as an emblem for a clan. As a totem for himself, the tank may reflect Smith's belligerent streak as well as his experience as a welder helping to produce tanks during World War II. *Tank Totem III*

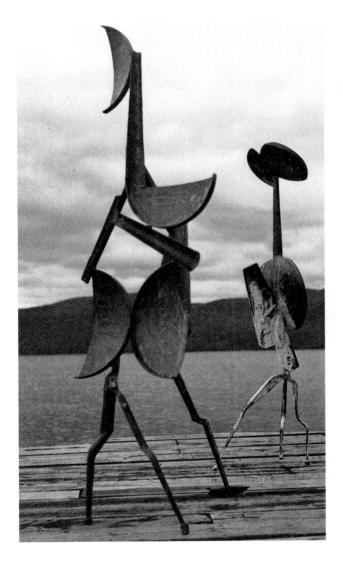

29-14. David Smith. *Tank Totem IV* (left). 1953. Steel, 7'8¹/2" x 3'7¹/2" x 2'5" (2.34 x 0.85 x 0.73 m). Albright-Knox Gallery, Buffalo, New York. *Tank Totem III* (right). 1953. Steel, 7'9" x 2'5" x 2'6¹/2" (2.36 x 0.73 x 0.77 m). Private collection

and *Tank Totem IV* (fig. 29-14), like others in the series, seem more amusing than dangerous, however. The warriors they portray, armed with shields and swords, seem to strut proudly across a landscape that they mean to conquer or defend, apparently unaware of how frail and foolish they appear.

The Second Generation of Abstract Expressionism

A second generation of Abstract Expressionists, most of whom took their lead from Pollock or de Kooning, emerged in the 1950s to produce the movement's last major phase. Among these artists were Joan Mitchell (1922-1992), Grace Hartigan (b. 1922), and Helen Frankenthaler (b. 1928). Frankenthaler, like Pollock, worked on the floor, drawn to what she described as Pollock's "dancelike use of arms and legs." She produced a huge canvas, Mountains and Sea (fig. 29-15), in this way, working from watercolor sketches she had made in Nova Scotia. Instead of using thick, full-bodied paint, as Pollock did, Frankenthaler thinned her oils and applied them in washes that soaked into the raw canvas, producing an effect that somewhat resembles watercolor. Clement Greenberg, who had introduced her to Pollock, saw in Frankenthaler's stylistic innovation a possible direction for avant-garde painting as a whole. That recognition played an important

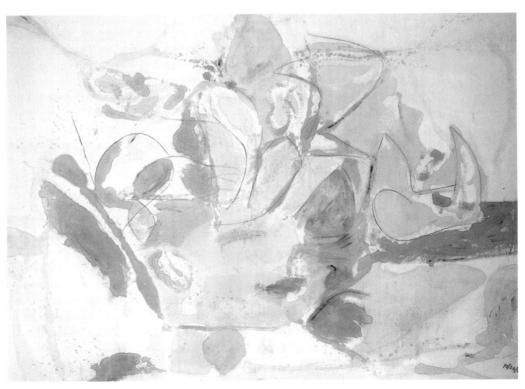

29-15. Helen
Frankenthaler.
Mountains and
Sea. 1952.
Oil on canvas,
7'2³/₄" x 9'8¹/₄"
(2.2 x 2.98 m).
Collection of
the artist on
extended loan
to the National
Gallery of Art,
Washington,
D.C.

29-16. Richard Diebenkorn. Girl on a Terrace. 1956. Oil on canvas, 6'4" x 5'6" (1.93 x 1.68 m). Neuberger Museum, State University of New York at Purchase Gift of Roy N. Neuberger

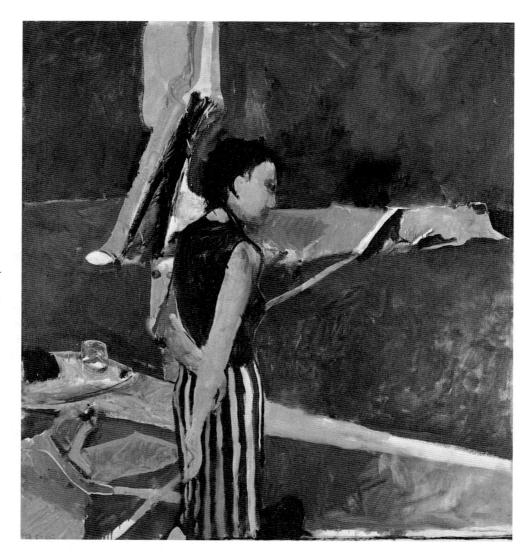

part in what happened after the so-called crisis of Abstract Expressionism at the end of the 1950s.

ALTERNATIVE In 1958–1959 the Muse-**DEVELOPMENTS** um of Modern Art orga-**EXPRESSIONISM** New American Painting,"

FOLLOWING nized an exhibition of first-generation Abstract nized an exhibition of ABSTRACT Expressionist work, "The and circulated it to eight

European capitals before its New York showing. But just at the moment when the Museum of Modern Art and many Europeans were finally acknowledging Abstract Expressionism as "the vanguard of the world," as one Spanish critic called it, there were growing suspicions in the New York art world about the group's right to such a title. The major cause of such doubt was the fact that Abstract Expressionism was no longer, in fact, new. Critic Harold Rosenberg, who disagreed with this emerging critical consensus, nevertheless summed it up succinctly in a published article: "Today it is felt that a new art mode is long overdue, if for no other reason than that the present avant-garde has been with us for fifteen years. . . . No innovating style can survive that long without losing

its radical nerve and turning into an Academy." Thus by the end of the 1950s New York critics were dismissing second-generation Abstract Expressionists as "method actors" who faked genuine subjectivity and were accusing members of the first generation, such as de Kooning, of faltering. Amid the growing critical conviction that Abstract Expressionism had lost its innovative edge, attention turned to the question of what would succeed it as the next leading avant-garde development. A number of options quickly emerged.

Return to the Figure

The alternative with the least chance of success was figuration, because the history of modernist art was to a great extent the story of a turning away from representation and the human figure and moving toward increasing abstraction. Although many American artists in the 1940s and 1950s had continued to work in a representational mode, their reputations had suffered for it, which deterred others from following their path. The crisis of Abstract Expressionism now freed many of those artists to follow their long-frustrated inclination to paint the figure.

An artist who had returned to figural subjects even before the crisis of Abstract Expressionism, and not without consequences, was Richard Diebenkorn (1922–1993). After World War II he taught at the California School of Fine Arts, where he came under the influence of his colleagues Still and Rothko, although by 1950 his style was closer to the action painting of de Kooning. About 1954 he resumed working from the model and became a central figure among a group of figurative painters in the San Francisco area that included David Park (1911–1960) and Elmer Bischoff (1916–1991), who held that abstraction lacked sufficient contact with the real world. Many of Diebenkorn's former admirers saw his "defection" not as an act of courage but as a caving in to "provincial" West Coast taste.

Diebenkorn's figure paintings, such as *Girl on a Terrace* (fig. 29-16), reflect the influence of both action painting and Color Field painting. The loose, expressionistic handling of the paint comes from de Kooning, while the large blocks of color and the emphasis on a single figure derive from the work of Rothko. Diebenkorn, however, shared none of Rothko's existential concerns. The woman in the painting may be alone, but the details of her setting and the way she holds one arm behind the other suggest that she is quite happily so. The painting's compositional and coloristic harmony conveys a sense of what the subject is seeing and feeling and, like the paintings of Matisse, elevates her air of tranquillity to a higher, aesthetic plane.

One of the painters liberated by the "crisis" of Abstract Expressionism was Philip Pearlstein (b. 1924). The turning point in his career occurred in 1959 when he joined a drawing group organized by Mercedes Matter (b. 1913), a longtime member of the Abstract Expressionist circle and the founder of the New York Studio School who was then committed to reviving figure painting. Over the next few years Pearlstein's paintings became progressively more descriptive. Pearlstein was also influenced by Matter's approach, which was to pose two models together, emphasizing the formal rather than the narrative connections between them. In Pearlstein's Two Models, One Seated (fig. 29-17), for example, as in all of his mature work, there is no psychological connection between figures. To stress this detached, matter-of-fact approach, he often omits or hides his figures' heads. Instead of individuals involved in life's dramas, they are simply studio props arranged for purely aesthetic interest. The appeal of such work depends largely on their unusual compositional grouping.

Another artist who participated in the figural revival about 1960 was the sculptor George Segal (b. 1924). As a painter in the early and mid-1950s he was included among the second generation of Abstract Expressionists. By the late 1950s, however, he had grown tired of the modernist emphasis on flatness, which led him in 1958 to begin experimenting with sculpture. He constructed figures with supports of wood scraps and chicken wire, over which he modeled human forms in plaster. He was comfortable with these cheap materials, he said, because he had used them on a chicken farm he had owned since 1949. In 1961 he discovered that by making casts of live

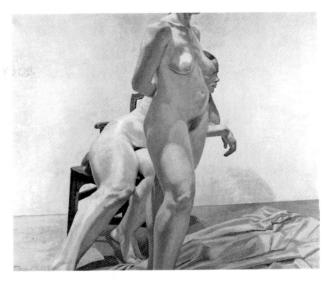

29-17. Philip Pearlstein. *Two Models, One Seated.* 1966. Oil on canvas, 5'1/2" x 6'1/2" (1.54 x 1.84 m). The Frances Lehman Loeb Art Center, Vassar College, Poughkeepsie, New York

Purchase, the Betsy Mudge Wilson class of 1956, Memorial Fund 1968

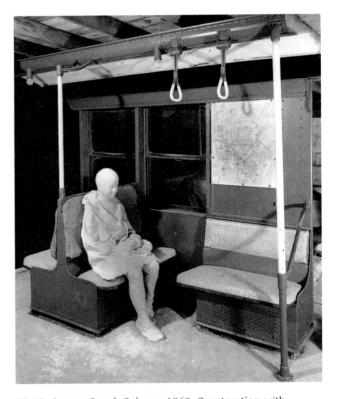

29-18. George Segal. *Subway*. 1968. Construction with plastic, metal, glass, rattan, electrical parts, and light bulbs, 7'6" x 9'6¹/₂" x 4'5" (2.29 x 2.91 x 1.37 m). Collection Mrs. Robert B. Mayer, Chicago

models with plaster-soaked bandages he could get more satisfying results.

As in *Subway* (fig. 29-18), Segal liked to place his white, bandaged figures in realistic, three-dimensional settings. For this work he cut out a section of a discarded New York City subway car. The isolated figure, drained of color, appears ordinary, her lonely train ride a metaphor for the existential isolation of modern life.

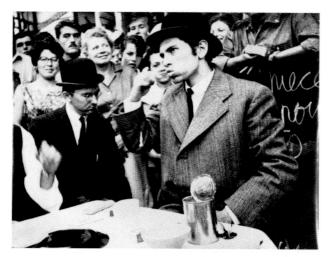

29-19. Ben Vautier brushing his teeth after eating Flux Mystery Food at the "Fluxus Festival of Total Art and Comportment," Nice, France. July 1963

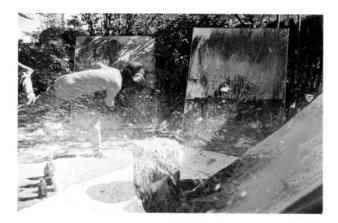

29-20. Shozo Shimamoto. Hurling Colors. 1956. Happening

Happenings

Segal's realistic environmental sculpture was largely inspired by the ideas of his friend Allan Kaprow (b. 1927), who, in turn, had been influenced by the ideas of the philosopher and musician John Cage (1912-1992). Cage later articulated in his 1961 book Silence the views he had promoted in the 1950s: that art and music should be "an affirmation of life-not an attempt to bring order out of chaos nor to suggest improvements in creation . . . a way of waking up to the very life we're living, which is so excellent once one gets one's mind and one's desires out of its way and lets it act of its own accord." Kaprow incorporated Cage's ideas, including the notion that art should move toward theater, into an influential essay he published in 1958, "The Legacy of Jackson Pollock," his response to the emerging crisis of Abstract Expressionism. In it he argued that Pollock left avant-garde artists with two options: to continue working in Pollock's style or to give up making paintings altogether and develop the ritualistic aspects of Pollock's act of painting. In a willful leap of logic he concluded that Pollock "left us at the point where we must become preoccupied with . . . the space and objects of our everyday life . . . chairs, food, electric and neon lights,

smoke, water, old socks, a dog, movies . . . or a billboard selling Draino [sic]." For modernists this was a shocking statement, for these were precisely the ordinary things they aspired to transcend.

Kaprow's happenings—the first of which was held on Segal's chicken farm in 1958—were not so much an embrace of the everyday as an attempt to reestablish meaningful communal rituals. His 1962 happening, *The Courtyard* (fig. 29-1), with which this chapter opened, was not an ordinary one but a revival of some sacrificial ritual. It was less a Cageian acceptance of ordinary life than a Gauguinesque expression of nostalgia for what modern urban dwellers have lost.

In 1960 one participant in the burgeoning happenings movement, George Maciunas (1931–1978), was led by his interest in avant-garde art and music, especially that of Cage, to open the AG Gallery, which specialized in happenings with a musical component. In 1962, temporarily living in what was then West Germany, Maciunas launched the Fluxus movement with a series of happenings, including *Après John Cage*, and the publication of an art magazine. The main thrust of the movement, he said, was to counter the traditional "separation of art and life," to "promote living art . . . to be grasped by all peoples, not only critics, dilettantes, and professionals."

Fluxus quickly attracted many young artists in Germany and France, among them Ben Vautier (b. 1935), a self-trained artist working in Nice, France. In 1963 he, Maciunas, and others organized the "Fluxus Festival of Total Art and Comportment" in Nice. One of Vautier's contributions to this festival was a work dedicated to the "de-elevation" of art. In it he ate what he called Flux Mystery Food—canned food from which the labels had been removed-and then brushed his teeth (fig. 29-19). By calling these objects and activities "art," he simultaneously raised the everyday to the level of art and lowered art to the status of an ordinary event, thereby eliminating the distinction between the two. The ultimate goal was less to criticize the transcendent purposes of modernist art than it was to enliven daily life and its stale routines. In this respect Fluxus represented a continuation of the playful side of the earlier Dada movement (Chapter 28). Maciunas, in fact, titled his inaugural lecture on Fluxus "Neo-Dada in the United States."

In the fall of 1963 Maciunas returned to New York, which became the new headquarters of his expanding Fluxus movement. Despite the lack of critical attention given Fluxus and the related happenings produced by members of Kaprow's circle, the artists themselves perceived their actions as part of a truly international movement that extended beyond the West. In 1959 Kaprow learned of a Japanese group—the Gutai Bijutsu Kyokai (Concrete Art Association)—that had been producing performance art similar to what he was advocating. Gutai had been formed in Osaka in 1954 by Jiro Yoshihara (1905– 1972), a leading prewar Japanese abstractionist, in an effort to revitalize Japanese art. Inspired by the rich heritage of the Japanese Dada movement that had helped stimulate the arts in Japan following World War I and by European Dada, Gutai organized a series of outdoor

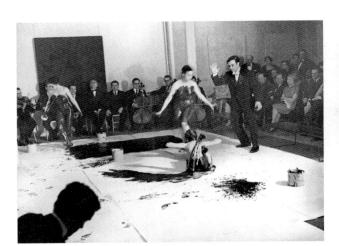

29-21. Yves Klein. *Anthropométries of the Blue Period.* 1960. Performance at the Galerie Internationale d'Art Contemporain, Paris

installations, theatrical events, and dramatic displays of art making. At the second Gutai Exhibition, in 1956, for example, Shozo Shimamoto (b. 1928), dressed in protective clothing and eyewear, produced *Hurling Colors* (fig. 29-20) by smashing bottles of paint on a canvas laid on the floor. The event was meant to be more exhilarating than violent. Thus Gutai was apparently pushing Pollock's drip technique (see fig. 29-10) into new and innovative territory some two years before Kaprow advocated doing so.

Assemblage

A third alternative development was assemblage. In 1961 the Museum of Modern Art organized "The Art of Assemblage," whose exhibition catalog argued that assemblage, the putting together of disparate elements to construct a work of art, "has indeed provided an effective outlet for artists of a generation weaned on abstract expressionism but unwilling to mannerize Pollock, de Kooning, or other masters who they admire." In other words, assemblage was the work of artists brought up on Abstract Expressionism who sought to move beyond its tired formulas into new and unexplored terrain. Avant-garde critics were not convinced, however, partly because so much of the work looked not like a new development but like a Dada revival; partly because it was mostly sculpture, at a time when painting took pride of place; and partly because almost none of it seemed to "transcend" the ordinary materials from which it was composed.

The European artists in the exhibition were all associated with the Paris-based movement called *nouveau réalisme* ("new realism"). The movement's leading figure, who, in fact, had not participated in the exhibition, was Yves Klein (1928–1962). In the mid-1950s he began making transcendent monochrome paintings of various hues, and in 1957 he turned to blue alone, which he considered the most spiritual color. The purpose of these blue paintings, he said, was to imbue the viewer with spirituality. Klein's desire to spiritualize humanity—to bring about what he called a "blue revolution"—was evident in his 1960 *Anthropométries of the Blue Period* (fig. 29-21). For this event Klein invited about a hundred members of the

29-22. Jean Tinguely. *Homage to New York*. 1960. Selfdestroying sculpture in the garden of the Museum of Modern Art, New York

Paris art world to watch him direct nude female models covered in blue paint press themselves against large sheets of paper. This attempt to spiritualize flesh was accompanied by Klein's *Symphonie monoton*—twenty minutes of a slow progression of single notes followed by twenty minutes of silence—which he considered to be the aural equivalent of the color blue. *Anthropométries of the Blue Period* was Klein's only performance piece, although he had been moving toward that form in the late 1950s in the openings to some of his shows. At one of them, for example, he had served blue cocktails.

More representative of both nouveau réalisme and assemblage were the sculpture of the Swiss-born Jean Tinguely (1925-1991). After producing abstract paintings, constructions of various materials, and a few edible sculpture made of grass, Tinguely moved to Paris in 1951 and gave up painting for kinetic sculpture, or sculpture made of moving parts. He called his awkward and purposely unreliable motor-driven sculpture métamécaniques (meaning "beyond the machine," later shortened to méta-matics). They were the very antithesis of perfectly calibrated industrial machines. Tinguely, an anarchist, wanted to free the machine, to let it play. "Art hasn't been fun for a long time," he said. Not since Dada, he might have added. Like the creations of his Dada forebears, then, Tinguely's work was implicitly critical of an overly restrained and practical bourgeois mentality.

Tinguely's most famous work is probably *Homage to New York* (fig. 29-22), which he designed for a special

29-23. Robert Rauschenberg. Canyon. 1959. Combine painting: oil, pencil, paper, metal, photograph, fabric, wood on canvas, plus buttons, mirror, stuffed eagle, pillow tied with cord, and paint tube. 6'1" x 5'6" x 2'3/4" (1.85 x 1.68 x 0.63 m). Collection Mr. and Mrs. Michael Sonnabend, on infinite loan at the Baltimore Museum of Art Avant-garde critics were not bothered by the fact that much of Rauschenberg's and the other assemblers' materials were drawn from popular culture. Many of the early-twentieth-century collagists, including Picasso and Braque, had worked with similar materials. However, critics such as Hilton Kramer (at the New York Times) and Thomas Hess (at ArtNews) pointed out that whereas earlier artists had aesthetically coordinated such elements, transforming the crude materials of life into the finer ones of art, Rauschenberg and his associates left them in their raw, "unpurified" condition. In this view, therefore, such work as this one was not art at all.

one-day exhibition in the sculpture garden of the Museum of Modern Art in New York City. The work was assembled from yards of metal tubing, several dozen bicycle and baby-carriage wheels, a washing-machine drum, an upright piano, a radio, several electric fans, a noisy old Addressograph machine, a bassinet, numerous small motors, two motor-driven devices that produced abstract paintings by the yard, several bottles of chemical stinks, and various noisemakers—all of which was painted white and topped by an inflated orange meteorological balloon. The machine was designed to destroy itself when activated. On the evening of March 17, 1960, before a distinguished group of guests, including Governor Nelson Rockefeller of New York, the work was plugged in. As smoke poured out of the machinery and covered the crowd, parts of the contraption broke free and scuttled off in various directions, sometimes threatening the onlookers. A device meant to douse the burning piano—which kept playing only three notes—failed to work, and fire fighters had to be called in. They extinguished the blaze and finished the work's destruction to boos from the crowd, which, except for the museum officials present, had been delighted by the spectacle.

Unlike his French colleagues, Robert Rauschenberg (b. 1925), one of two major American artists included in "The Art of Assemblage," rejected the antagonism to ordinary culture that had characterized the avant-garde. Rauschenberg went to Black Mountain College in North Carolina in 1948 to work with Joseph Albers (1888–1976),

a former Bauhaus instructor, but discovered there a more congenial mentor in John Cage. Under Cage's influence Rauschenberg evolved a distinctive style by chaotically mixing painted and found elements in assemblages he called combines. Canyon (fig. 29-23), for example, features an assortment of old family photographs (the boy with the upraised arm is Rauschenberg), public imagery (the Statue of Liberty, which echoes the boy's pose), fragments of political posters (in the middle), and various objects salvaged from trash (the flattened steel drum at upper right) or donated by friends (the stuffed eagle). The rich disorder challenges the viewer to make sense of it. In fact, Rauschenberg meant his work to be open to various readings, assembling material that each viewer might interpret differently. One could, for example, see the Statue of Liberty in Canyon as a symbolic invitation to interpret the work freely. Or perhaps, covered as it is with paint applied in the manner of action painting, it symbolizes that distinctively American style. Following Cage's ideas, Rauschenberg created a work of art that was to some extent beyond his control—a work of iconographic as well as formal disarray. Rauschenberg cheerfully accepted the chaos and unpredictability of modern urban experience and tried to find artistic metaphors for it. "I only consider myself successful," he said, "when I do something that resembles the lack of order I sense."

The other major American included in the assemblage exhibition was Rauschenberg's close friend Jasper Johns (b. 1930). In 1954, while working in a bookstore

29-24. Jasper Johns. *Target with Four Faces*. 1955. Assemblage: encaustic on newspaper and cloth over canvas, surmounted by four tinted plaster faces in wood box with hinged front, overall, with box open, $33^{5/8} \times 26 \times 3$ " (85.3 x 66×7.6 cm). The Museum of Modern Art, New York Gift of Mr. and Mrs. Robert C. Scull

and producing art part time, Johns had met Rauschenberg, who encouraged him to pursue art more seriously. Unlike Rauschenberg's works, Johns's are controlled, emotionally cool, and highly cerebral. Inspired by the example of Marcel Duchamp (see figs. 28-1, 28-92), Johns produced conceptually puzzling works that seemed to bear on issues raised in contemporary art. Art critics and art historians, for example, had praised the evenly dispersed, "nonhierarchical" or "all-over" quality of so much Abstract Expressionist painting, particularly Pollock's (see fig. 29-10). The target in *Target with Four Faces* (fig. 29-24), an emphatically hierarchical, orga-

nized image, can be seen as a reference to this discourse. The image also raises thorny questions about the difference between representation and abstraction. The target, although arguably a representation, is flat, whereas representational art is usually identified with three-dimensional space. The target therefore occupies a troubling middle ground between the two kinds of painting then struggling for dominance in American art.

Johns's works are more than a simple reaction to the emotional and autobiographical dimensions of Abstract Expressionism. They also had a psychological dimension for Johns, providing him with a way to avoid certain

anxieties and fears, particularly concerning death. The sense of denial is particularly evident in the faces at the top of *Target with Four Faces*, which have been cut off below eye-level and thus depersonalized. The viewer can complete the process of depersonalization by closing the lid over the faces. The casts for the faces were made from the same model but at different times, so they are not identical, a feature that objectifies them further by inviting the viewer to compare them for formal differences. All four faces are as blank and neutral as the target below. In the final analysis, then, the intellectual issues do not disguise the more troubling concern with emptiness that pervades such a work.

The work of Johns had a powerful effect on the artists who matured around 1960. His interest in Duchamp, for example, helped elevate that artist to a place of importance previously occupied by Picasso. And Johns's conceptually intriguing use of subjects from ordinary life, a feature also evident in the work of Rauschenberg, helped open the way for the most controversial development to emerge after Abstract Expressionism, Pop art.

Pop Art

In 1961–1962 several exhibitions in New York City featured art that drew on **popular culture** for style and subject matter. Because of its popular sources (comic books, advertisements, movies, television), this emerging movement came to be called Pop art. Many critics were alarmed by the movement, uncertain whether Pop art was embracing or parodying popular culture and fearful that it threatened the survival of both modernist art and high culture—meaning a civilization's best, not its most representative, products.

Such fears were not entirely unfounded. Pop artists' open acknowledgment of the powerfully compelling realm of commercial culture contributed significantly to the eclipse, about 1970, of traditional modernism and thus, some argue, the very notion of "standards" that kept high culture safely insulated from low. This is not to say that all Pop artists embraced popular culture. Even the first post–World War II artists to turn to it for their inspiration, the British Pop group, reveal a somewhat ambivalent attitude toward their sources.

British Pop was the product of the Independent Group (IG), formed in 1952 by a few members of the Institute of Contemporary Art (ICA) in London who resisted the institute's commitment to modernist art, design, and architecture. The IG's most prominent figures were the artists Richard Hamilton (b. 1922) and Eduardo Paolozzi (b. 1924), the architecture critic Reyner Banham (1922-1988), the art critic Lawrence Alloway (1926-1990), and the writer John McHale. At their first meeting Paolozzi showed slides of American ads whose utopian vision of a future of contented people with ample leisure time to enjoy cheap and plentiful material goods was very appealing to those living under the austerity of postwar Britain. Members of the group were particularly intrigued by American automobile design, with its emphasis on "planned obsolescence," the intentional production of

29-25. Cover from the London *Sunday Times*, color section. 1955. Illustration from article "How American Are We?"

goods that would soon require replacement. In a 1955 article titled "Vehicles of Desire" Banham argued against the modernist search for "classic" and "timeless" styles in industrial design like that conducted by the Bauhaus artists (see fig. 28-87), advocating instead designs that met the need for "an expendable, replaceable vehicle of popular desires." His article included a reproduction of a recent London *Sunday Times* cover with a photograph of the tail fins of an American car against the backdrop of Big Ben that illustrated a feature article titled "How American Are We?" (fig. 29-25).

One of Banham's colleagues in the IG, the artist Richard Hamilton, was perhaps the first to create work based entirely on advertising sources. His \$he (fig. 29-26), for example, includes a "cornucopia refrigerator" from an RCA Whirlpool ad, a pop-up toaster and a vacuum cleaner from General Electric appliance ads, and a stylized image of Vikky Dougan, a model who specialized in ads for backless dresses and bathing suits. Hamilton said he meant to counter the artistic image of women as timeless beings with the more down-to-earth picture of them presented in advertising. The evocative, somewhat mysterious result, however, seems closer to traditional art than it does to the clear, simple, and straightforward imagery of the advertisements on which it draws. In short, one of the primary imperatives of modern advertising-clarity of message—has here been sacrificed to those of avantgarde art: individuality and provocative invention.

American Pop artists, such as Roy Lichtenstein (b. 1923), were the first to accept the look as well as the

29-26. Richard Hamilton. \$he. 1958–61. Oil, cellulose, collage on panel, 24 x 16" (61 x 40.6 cm). Tate Gallery, London

29-27. Roy Lichtenstein. *Oh, Jeff...1 Love You, Too...*But...1964. Oil on magna on canvas, 4 x 4'

(1.22 x 1.22 m). Private collection

subjects of popular culture. Lichtenstein experimented with a number of approaches to popular imagery, even attempting, in the late 1950s, to apply a gestural style to cartoon characters, including Bugs Bunny. In 1960, however, he was producing simple stripe paintings using a stain technique inspired by the work of Helen Frankenthaler (see fig. 29-15). At Rutgers University in New Jersey, he became close friends with Kaprow, who was also teaching there.

29-28. Claes Oldenburg in "The Store" exhibition, 107 East Second Street, New York. December 1961– January 1962

Kaprow encouraged him to give up abstraction and return to comic-book imagery. In 1961 Lichtenstein began producing paintings whose style—featuring heavy outlines and the **Benday dots** used to add tone in printing—and imagery were drawn from cartoons and advertisements.

The most famous of these early works, such as Oh, Jeff...I Love You, Too...But... (fig. 29-27), were based on romance comics. When asked about his comic-book sources in 1963, Lichtenstein said that he turned to them for formal reasons. Although many assume that he merely copied from the comics, in fact he made numerous subtle yet important formal adjustments that tightened, clarified, and strengthened the final image. The cartoonist, he said, "intends to depict and I intend to unify." Nevertheless, the paintings retain a sense of the cartoon plots they draw on. Oh, Jeff, for example, compresses into a single frame the generic romance-comic story line, in which two people fall in love, face some sort of crisis, or "but," that temporarily threatens their relationship, and then live happily ever after. Lichtenstein reminds the grown-up viewer, however, that this plot is only an adolescent fiction; real-life relationships, as in the painting, often end with the "but."

Whereas Lichtenstein's impersonal style tends to subdue emotional content, the opposite is true of that of the Swedish-born Claes Oldenburg (b. 1929). In 1960 Oldenburg conducted a rigorous self-analysis to rid himself of a melancholic preoccupation with death. One of the first results of his new focus on the affirmation of life was "The Store," a collection of painted sculpture of ordinary things on sale—shoes, shirts, dresses, and food items—exhibited together in a New York shop front (fig. 29-28). The objects were not hung on the wall as art but were displayed in cases and on racks as the real objects would have been in an actual store. The implication seemed to be that art

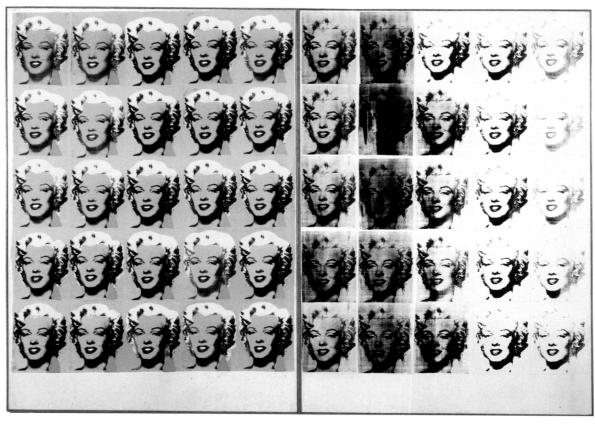

29-29. Andy Warhol. Marilyn Diptych. 1962. Oil, acrylic, and silk screen on enamel on canvas, $6'87/8" \times 4'9"$ (2.05 x 1.44 m). Tate Gallery, London

Warhol assumed that all the Pop artists shared his affirmative view of ordinary culture. In his account of the beginnings of the movement he wrote: "The Pop artists did images that anybody walking down Broadway could recognize in a split second—comics, picnic tables, men's trousers, celebrities, shower curtains, refrigerators, Coke bottles—all the great modern things that the Abstract Expressionists tried so hard not to notice at all."

was merely another commercial product. Oldenburg's intention, however, was the opposite: to render more "human" what he called the "hostile objects" of commerce. He meant to fight the clean, antiseptic dehumanization of the American marketplace with objects that seemed to fairly ooze with life's juices. In 1961 he wrote: "I am for an art that takes its lines from life itself, that twists and extends and accumulates and spits and drips, and is heavy and coarse and blunt and sweet and stupid as life itself." Like Gauguin, Kandinsky, Mondrian, and their heirs, Oldenburg was confident that, in the end, "the reality of art will replace reality."

The most famous Pop artist, Andy Warhol (1928?–1987), did not share Oldenburg's idealism. A successful commercial illustrator in New York City during the 1950s, Warhol grew envious of Rauschenberg's and Johns's emerging "star" status and decided in 1960 to pursue a career as an artist along the general lines suggested by their work. His decision to focus on popular culture was more than a careerist move, however; it also allowed him to celebrate the middle-class social and material values he had absorbed growing up amid the hardships of the Great Depression.

Warhol's lifelong interest in movie stars first surfaced in his art in 1962. Having decided to give up conventional painting for silk-screening photo-images on canvas be-

cause it was faster and thus more profitable, he had just begun working on portraits of male movie stars when Marilyn Monroe suddenly died. Thus, he said, "I got the idea to make screens of her beautiful face." One of the first of the series he did of her was the Marilyn Diptych (fig. 29-29). The strip of pictures in this work suggests the sequential images of film, the medium that made Monroe famous. The face Warhol portrays, taken from a publicity photograph, is not that of Monroe the person but of Monroe the star. Warhol was interested in her public mask, not in her personality or character. He borrowed the diptych format from the Byzantine icons of Christian saints he saw at the Greek Orthodox church services he attended every Sunday. By symbolically treating the famous actress as a saint, Warhol shed light on his own fascination with fame. Not only does fame bring wealth and transform the ordinary into the beautiful (Warhol was dissatisfied with his own looks), it also confers, like holiness for a saint, a kind of immortality.

Warhol attempted to keep his personal motives from showing through too clearly in his works, however, preferring to leave their meaning open to the interpretation of viewers. The success of the Marilyn series, in particular, has depended in great measure on viewers' ability to find in Warhol's images their own feelings and ideas about the tragedy of her life.

AND COMMERCE

PATRONAGE Art museums, both public and private, are relatively new, distinctly Western

institutions. Museums evolved in the eighteenth century out of the tradition of private collecting. They continued to flourish under the lasting influence of the Enlightenment, which placed a high value on public education. In the twentieth century, museums emerged as major buyers of art and occasional patrons of living artists, sharing with private collectors the roles once played by religious institutions and aristocratic courts.

Major patrons must have money, and patterns of patronage shift according to where money is. For about a hundred years, from the mid-nineteenth to the mid-twentieth century, families of wealth, education, and social privilege were the primary supporters of the arts. Indeed, art patronage could secure or increase social standing. Such families gave heavily to establish and fund museums. Their generosity in loaning or giving works of art are often noted on museum labels and in captions for illustrations of works of art in books, including this one. Donor information is a major aspect of a work's provenance and for that reason alone merits such notice.

The late 1940s-1950s was a transition period for art buying in the United States. The New York School was the annointed avant-garde and was promoted by several critics whose opinions carried enormous weight with some museum curators and with adventuresome collectors, who were not paying high prices for the paintings and sculpture they added to their collections. It is often argued that such critics, notably Clement Greenberg and Harold Rosenberg, in fact had a profound influence on the work of New York School artists.

Sometime in the 1960s, as the United States consolidated its position as the wealthiest country in the world, patterns and intentions of art buying and art making began to change. Museums were built where none had been before, especially in the thriving Sun Belt of the United States. People with newly made fortunes, banks, and commercial corporations began to acquire art as investments. Prices rose. Critics began to accuse some contemporary artists of pandering to this new class of patrons.

By the 1980s the art market was booming. In the five years between

1982 and 1987, prices for major Impressionist paintings rose 400 percent. The art market went global, with Japanese and Latin American investors putting in some of the highest bids ever offered for "blue chip" Impressionist paintings. A painting by Jasper Johns, a living artist, that might have fetched a quarter of a million dollars in the early 1970s commanded \$17 million in the late 1980s. Most museums just could not compete as buyers in this market. But they did benefit from loans and gifts from collectors who could reduce their taxes by such largesse. Ironically, artists now began to protest the commercialization of art.

With the advent of the sober 1990s the "commodification" of art suddenly cooled. Some works offered at auction failed to reach their minimum prices. Many corporations started divesting themselves of their art collections. The private collectors who sold their once overpriced artworks to raise cash rarely recovered what they had paid. Museums were again able to purchase works of art, at least modestly. The trend in the 1980s, then, proved to have been an exception for the art market. For those people who buy art because they love it, not because they plan to sell it for profit, that the inflated market was so short-lived was a relief.

Minimalism and Conceptualism

Three related styles that emerged in the wake of Abstract Expressionism—post-painterly abstraction, Hard Edge, or Minimalist, art, and Conceptualism-shared a commitment to reducing art to its essentials. Here we use the term Minimalism broadly to refer to the first two of these styles that developed in the period 1958–1970.

Most avant-garde critics, curators, and art historians, following the lead of Clement Greenberg, considered post-painterly abstraction to be the legitimate heir to Abstract Expressionism. Greenberg coined the term post-painterly, using it to describe the style that he believed had evolved naturally from the "painterly" or gestural abstraction of the New York School. He helped cultivate the style, promoting its practitioners and praising their efforts as the only "authentically new episode in the evolution of contemporary art."

In 1953 Greenberg introduced Morris Louis (1912-1962), a painter from Washington, D.C., then working in a late Cubist style, to the work of Helen Frankenthaler (see fig. 29-15). Impressed with Frankenthaler's stain technique and apparently convinced by Greenberg's ideas on the evolution of modernism and the historical inevitability of pure formalism (see "The Idea of the Mainstream," page 1110), Louis stepped "beyond" Abstract Expressionism by eliminating all extra-artistic meanings from his work. In

29-30. Morris Louis. Saraband. 1959. Acrylic resin on canvas, 8'51/8" x 12'5" (2.57 x 3.78 m). Solomon R. Guggenheim Museum, New York

paintings such as Saraband (fig. 29-30) he purged not only the figural and thematic references found in the work of Frankenthaler but also the subjective, emotional connotations found in that of Pollock, de Kooning, Rothko, and Newman. Here, color does not represent emotion; it is simply color. Red is red, not passion. The painting is simply a painting, not a representation of something beyond art. The luscious rainbow of colors in Saraband—which he created by tipping the canvas to allow the thinned oils to

29-31. Frank Stella. "Die Fahne Hoch." 1959. Enamel on canvas, 12'1/2" x 6'1" (3.67 x 1.85 m). Whitney Museum of American Art, New York

> Gift of Mr. and Mrs. Eugene M. Schwarz and purchase with funds

While studying painting at Princeton University in the late 1950s, Stella and an undergraduate English major, Michael Fried, often went to New York City to hear Clement Greenberg lecture on the course of modern art. Fried went on to become the leading Greenbergian critic of the 1960s. He primarily wrote for Artforum, the most influential art journal of the period. "Die Fahne Hoch" is one of the names for the Horst Wessel Lied, a German folksong that was virtually an anthem for the German army in World War II. It translates "the banner raised aloft "

flow according to their inherent properties—offers pure delight to the senses.

Another artist motivated by Greenberg to purge art of its "inessentials" was Frank Stella (b. 1936). In his early Black series stripe paintings such as "Die Fahne Hoch" (fig. 29-31), inspired in part by a series of flag paintings by Johns, he eliminated the conventional notion of individual sensibility: he featured black, for example, not because it appealed to his taste or expressed his mood but because it signifies the absence of color, its denial. The rectangular design elements derive from the shape of the canvas itself. "Depicted shape," the artist claimed, was logically determined by the "literal shape" of the canvas support. Even the 3-inch widths of the stripes were determined by the physical object: the canvas stretchers are 3 inches deep. What Stella achieved was a group of artworks whose features refer not to the artist or the outside world but to other aspects of the art object itself. The individual paintings are therefore hermetically sealed from everything beyond their edges except other paintings of the series. In that sense they are "pure."

Greenberg's influence was also felt in sculpture, as reflected in his friend David Smith's decision around 1960 to turn from his earlier figural work (see fig. 29-14) and pursue a more formalist direction. This transition was also the result of a shift in materials; Smith had begun to build his figures from unpainted but burnished stainless steel and became increasingly preoccupied with that metal's formal qualities. The most famous of the resulting works are perhaps those of the Cubi series, monumental combinations of geometric forms inspired by and offering homage to Cubism, the painting style that helped give birth to formalism. Like the works of Picasso and Braque (see figs. 28-40, 28-41, 28-42), Cubi XIX (fig. 29-32) presents a tense, finely tuned balance of elements that threaten to collapse at the slightest provocation. The viewer's aesthetic pleasure depends as well on the way light, especially sunlight, catches and dynamically plays over the burnished surfaces.

One of the younger formalist sculptors to emerge at this time was Donald Judd (1928–1994). Judd's reductive sensibility had more in common with Stella's than with

29-32. David Smith. *Cubi XIX*. 1964. Stainless steel, 9'5³/₈" x 1'9³/₄" x 1'8" (2.88 x 0.55 x 0.51 m). Tate Gallery, London

Smith's, however. Convinced along with Greenberg and others that Abstract Expressionism had deteriorated into a set of techniques for faking both the subjective and the transcendent, Judd began around 1960 to search for an art free of falsehood. By the early 1960s he had decided that sculpture offered a better medium than painting for creating literal, matter-of-fact art. Rather than *depicting* shapes, as Stella did—which Judd thought still smacked of illusionism and therefore fakery—he would create *actual* shapes. In search of a greater simplicity and clarity, he soon evolved a formal vocabulary featuring identical rectangular units arranged in rows and constructed of industrial materials, especially anodized aluminum and Plexiglas. Figure 29-33 is a typical example of his mature work.

Judd liked industrial materials because they had the crisp "certainty" he sought, were more impersonal than organic materials, and were imbued with their own color, thus minimizing his need to choose a color for them. His later boxes, like those in figure 29-33, are always open to avoid any uncertainty about what might be inside. He arranged them in rows—the simplest, most

29-33. Donald Judd. *Untitled*. 1969. Anodized aluminum and blue Plexiglas, each 3'11¹/₂" x 4'11⁷/₈" x 4'11⁷/₈" x (1.2 x 1.5 x 1.5 m); overall 3'11¹/₂" x 4'11⁷/₈" x 23'8¹/₂" (1.2 x 1.5 x 7.2 m). The St. Louis Art Museum, St. Louis, Missouri

Purchase funds given by the Shoenberg Foundation, Inc.

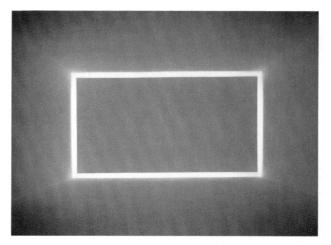

29-34. James Turrell. *Rayzor*. Conceptualized 1968; constructed 1982. Fluorescent and outside light, 12' x 22' 1 /4" x 23' 5 /8" (3.65 x 6.78 x 7.18 m) Courtesy the artist

impersonal way to integrate them—and avoided sets of two or three because of their potential to be read as representative of something other than a row of boxes. Judd provided the viewer with a set of clear, self-contained facts. The viewer's satisfaction derives from the contrast between the work's conceptual clarity and the messy complexity of the real world.

Greenberg's influence did not extend to all Minimalist art. California artist James Turrell (b. 1943), for example, produced a Minimalist art using light in empty rooms that reflects his fascination with the pure effects of illumination. Turrell was interested in the phenomenon of light itself, not in what it reveals or symbolically represents. Beginning with shaped slide projections on blank walls, he was, by the end of the 1960s, investigating the way light affects the perception of space. Rayzor (fig. 29-34), one of a group of works he called Shallow-Space Constructions, was conceived in 1968 but not realized until 1982. It consisted of powerful fluorescent lights hidden behind a partition at the end of a completely white room. The dazzling light emerging from a narrow slit all the way around the partition obscured the wall, floor, and ceiling joints. Without perspective cues, the chamber seemed to the viewer to fold into a shallow, ambiguous space. The partition wall, which appeared translucent, seemed to float at an uncertain distance. Such work not only provided viewers a serene perceptual experience but also raised interesting questions about the accuracy of ordinary vision.

Meanwhile, in New York City the sculptor Eva Hesse (1936–1970) was applying the formal vocabulary of Minimalism to self-expression. After graduating from Yale School of Art in 1959 she painted self-portraits, and in 1964 she began to produce abstract sculpture with a similar purpose. Her works, in effect, are Minimalist standins for herself. *Hang-Up* (fig. 29-35), like much of her mature work, was meant to express the frailties of her body. The painted cloth wrapped over the wood frame and steel loop suggests flesh covering bone or bandages over damaged flesh. The steel loop that protrudes irrationally from the frame seems an unnatural growth. The empty frame, too, may have had a personal significance

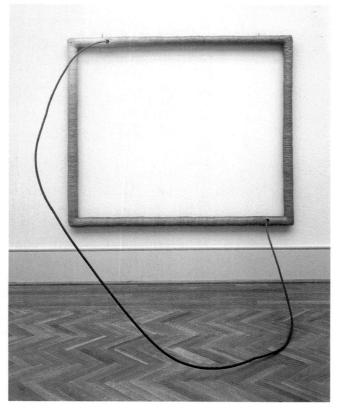

29-35. Eva Hesse. *Hang-Up*. 1965–66. Acrylic on cloth over wood and steel, 6' x 7' x 6'6" (1.8 x 2.1 x 2 m). The Art Institute of Chicago

Through prior gift of Arthur Keating and Mr. and Mrs. Edward.

Through prior gift of Arthur Keating and Mr. and Mrs. Edward Morris. 1988

for Hesse, who often lamented that she never had children. The absurdity of the empty frame and senseless cord are probably meant to echo Hesse's view of her life: "Art and life," she commented, "are very connected and my whole life has been absurd."

About this time a group of New York artists who came to be known as Conceptualists was pushing Minimalism to its logical extreme by eliminating the object itself. Although these artists always produced something physical, it was often no more than a set of directions or a documentary photograph. Part of this shift away from the aesthetic object toward the pure idea was inspired by the growing reputation of Marcel Duchamp within the Neo-Dada revivals of the early 1960s, and in particular by Duchamp's assertion that art should be a mental, not a physical, activity. Deemphasizing the art object also kept art from becoming simply another luxury product, a concern raised by the booming business for contemporary art that developed as a result of the rising prices of Abstract Expressionist works and the growing popularity of Pop art among collectors (see "Patronage and Commerce," page 1131). Without an object, there would be nothing to sell. Art would therefore remain safe from bourgeois materialism.

The Conceptual art of the 1960s, unlike the intellectually complex art of Duchamp, aimed for a simplicity and clarity similar to that found in the works of Stella and Judd. For example, Bruce Nauman's (b. 1941) *Bound to Fail* (fig. 29-36), a photograph of the artist tied with a rope, offers an obvious visual pun on the word *bound*.

29-36. Bruce Nauman. Bound to Fail from Eleven Color Photographs. 1966-67/70. One in a portfolio of eleven color photographs, published in an edition of eight by Leo Castelli Gallery, 1970, $19^{3/4} \times 23^{1/2}$ " (50.2 x 59.7 cm). The Heithoff Family Collection

Although Conceptualist works usually provide little for the mind to ponder, on a second level the work suggests that given the overly ambitious social agenda of the modernist artist, he or she was bound to fail.

FROM Nauman's Bound to Fail and the MODERNISM loss of confidence in the transformative power of art it repre-TO POST- sents is symptomatic of a larger MODERNISM phenomenon affecting Western art and architecture in the 1960s

and 1970s: the end of modernism. In retrospect, the Minimalist emphasis on reducing art to its essence should perhaps be seen as an admission of a diminished notion of its power. Minimalists continued to believe, however, that art represented a pure realm outside ordinary existence and that the history of art had a coherent, progressive shape. To most of the artists who followed them, by contrast, the concepts of artistic purity and the mainstream seemed naive. In fact, the entire generation that grew to maturity around 1970 shared little of the faith in either purity or progress that marked earlier generations. Precisely how and why this loss of faith happened are matters of debate, but among the contributing factors were a widespread sense of disillusionment that followed in the wake of the political protests and social reform movements of the 1960s and the growing awareness that the material improvements brought by industrial technology had a high environmental cost. In short, the utopian optimism that had characterized the beginning of the modernist era and had survived both world wars gave way to a growing uncertainty about the future and about art's power to influence it.

The decline of modernism in the various arts was neither uniform nor sudden. Its gradual erosion occurred over a long period and was the result of many individual transformations. The many approaches to art that have emerged from the ruins of modernism are designated by the catchall term postmodernism.

29-37. Ludwig Mies van der Rohe and Philip Johnson. Seagram Building, New York City. 1954-58

Architecture

As in painting and sculpture, modernism endured in architecture until about 1970. The stripped-down, rationalist style pioneered by Walter Gropius (see figs. 28-73, 28-86) and Le Corbusier (see fig. 28-85) dominated new urban construction in much of the world after World War II and came to be known as the International Style. Many of the most famous examples of International Style architecture were built in the United States by German architects associated with the Bauhaus, who during the Nazi era had been offered prestigious positions in American schools. Gropius, for example, was hired in 1937 by Harvard, where he eventually headed the architecture department. In the same year Ludwig Mies van der Rohe (1886-1969), who ran the Bauhaus from 1930 to its closing in 1933, was named director of the Armour Institute in Chicago, which later became the Illinois Institute of Technology. Even more than Gropius, Mies was committed to a radically simplified architecture of steel and glass.

Whether designing schools, apartments, or office buildings like the Seagram Building in New York City (fig. 29-37), Mies used the same simple, rectilinear industrial vocabulary. The differences among his buildings are to be found in their details. Because he had a large budget for the Seagram Building, for example, he used custommade bronze (instead of standardized steel) beams on the exterior. Mies would have preferred to have visible steel supports for the structure, but building codes required him to encase them in concrete. The ornamental beams on the outside thus stand in for the functional beams inside, much as the shapes in a Stella painting refer to the structural frame that holds the canvas. The tall, narrow

29-38. Le Corbusier. Nôtre-Dame-du-Haut, Ronchamp, France. 1950–55. View from the southwest

29-39. Louis Kahn. Salk Institute of Biological Studies, La Jolla, California. 1959–65

windows emphasize the verticality of the thirty-eightstory building, helping it compete for attention with surrounding skyscrapers. The building is set back from the street and rises quickly and impressively off pilotis (metal or concrete columns that raise a building above ground level) from a sunlit plaza with reflecting pools, fountains, and, originally, beech trees (the city air killed them).

The dark glass was meant to give the Seagram company a discreet and dignified image. The building's clean lines and crisp design seemed, in fact, to epitomize the efficiency, standardization, and impersonality that had become synonymous with the modern corporation itself—which, in part, is why this particular style dominated corporate architecture after World War II. Such buildings were also cheaper to build. For Mies, however, the goal was to find a suitable architectural style not only for American businesses but also for modern humanity. He believed that the industrial preoccupation with

streamlined efficiency was the dominant value of the entire age. As he intimated in his comment "Less is more," the only legitimate architecture was one that expressed this modern **zeitgeist** ("spirit of the age").

While business leaders, in particular, were embracing the International Style, a number of critics both inside and outside the architectural profession were growing increasingly hostile to it, not least because it had become so identified with the prevailing corporate zeitgeist. These critics called for an architecture that would provide the starved modern sensibility with the spiritual nourishment it so badly needed.

Among the first architects to offer a radical alternative to the International Style was one of its originators. Le Corbusier. Although he never entirely rejected his original vision of the rational, uniform city of the future (see fig. 28-85), he did come to recognize its deficiencies. In the early 1950s he shocked the architectural profession with his radically antimodernist design for Nôtre-Dame-du-Haut (fig. 29-38), a pilgrimage church on a hill above Ronchamp, France. Instead of a thin, industrial skin, the church has thick, rough, masonry walls faced with whitewashed Gunite (sprayed concrete). The darker concrete roof is finished in a contrasting striated pattern. The large overhang is partly functional, covering the entranceways and the exterior pulpit and altar used for outdoor services. More important, the upward lift of the roof recalls the spiritually symbolic vertical emphasis of conventional church architecture. It also appears to respond to the winds that sweep across the hill and the building. Finally, the shape of the roof was inspired, Le Corbusier said, by a crab shell. The building's organic. gently swelling curves are reminiscent of the work of Henry Moore (see fig. 28-76), but its identification of the natural with the spiritual harks back to the premodern ideas of the Romantics. Its dark, cavelike interior recalls the far earlier association of the natural with the divine that dates to humanity's prehistoric past.

Louis Kahn (1901–1974) developed a less radical antimodernist architecture. Trained in conventional Beaux Arts methods at the University of Pennsylvania in the early 1920s, he did not fully develop his own theories until he encountered the architecture of ancient Egypt, Greece, and Rome during a year spent at the American Academy of Rome in 1950-1951. What struck him about this architecture was the way it translated clearly conceived functions into boldly simple structures. He returned to the United States committed to finding a modern equivalent of those early Mediterranean styles. Rejecting the modernist preoccupation with a single, uniform style, he sought to tailor the form of each building to its intended use. He viewed a building as a living organism and maintained that like an organism, its form should efficiently integrate its functioning parts.

For the Salk Institute of Biological Studies on the shores of the Pacific Ocean in La Jolla, California, Kahn designed a large laboratory building and two rows of student and faculty housing on a severe courtyard open to the sea (fig. 29-39). The modular housing units, whose regularity is both punctuated and relieved by the abrupt

diagonal juts in the facades, are formed with concrete slabs, which he preferred to thinner industrial materials because of the way they more assertively defined space. The windows and balconies are simple geometric cuts in the walls. The harsh contrast of solid and void is somewhat softened by the wood around the facade openings. Kahn, who asked himself what institutional housing "wanted" to look like, seems to have decided that it wanted to look like it housed a community of equals. Although Kahn based his ideas on what he viewed as the simple functionalism of ancient architecture, his spare design for the Salk Institute's housing seems consistent with the Minimalism of contemporary painting and sculpture.

Postmodern Architecture. Although the historically informed antimodernism of Le Corbusier and Kahn contributed to the decline of modernism, it was the willingness of Robert Venturi (b. 1925) and his associates to turn to vernacular (meaning popular) sources that marks the emergence of postmodern architecture. Parodying Mies van der Rohe's famous aphorism "Less is more," Venturi claimed "Less is a bore" in his 1966 pioneering publication Complexity and Contradiction in Architecture. The problem with Mies and the other modernists, he argued, was their impractical unwillingness to accept the modern city for what it is: a complex, contradictory, and heterogeneous collection of "high" and "low" architectural forms. Taking these ideas further in 1972 in Learning from Las Vegas, he and his colleagues suggested that rather than turning their backs in disdain at ordinary commercial buildings, architects should get in "the habit of looking nonjudgmentally" at them. "Main Street is almost all right," they observed. Just as we "look backward at history and tradition to go forward; we can also look downward to go upward."

Venturi's first attempt to work within the vernacular tradition while improving it was the Guild House (fig. 29-40), a public-housing project with ninety-one apartments for seniors in a Philadelphia working-class neighborhood. Over the entrance is a large, billboard-inspired sign that proclaims the building's identity to passersby. The contrast between the pretentious name and the modest public housing it designates is the key to understanding the building's design. The sparse metal windows, although much larger than their ordinary mass-produced counterparts, and the inexpensive, dark brown brick recall earlier post-World War II urban-renewal projects. The building is designed to fit into its surroundings while subtly evoking features of the high architecture of the past. For example, the symmetrical massing of the wings around a central unit that projects out from them—a feature that helps make the arrangement of rooms more homelike and less institutional—was inspired by Baroque churches. Another historicist reference is the neo-Palladian window that fronts the common room above the entry. Above the common room is a fake TV antenna of gold anodized aluminum, which Venturi called "a symbol of the aged, who spend so much time looking at TV." Through such juxtapositions Venturi aims less to contrast the high art of the past with the inane distractions of pop-

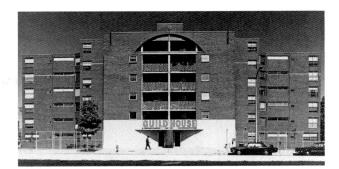

29-40. Robert Venturi and John Rauch. Guild House, Philadelphia. 1960–63

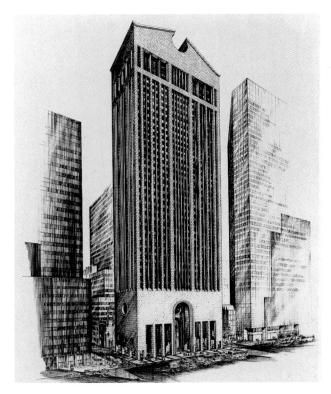

29-41. Philip Johnson and John Burgee. Pencil drawing made in 1977 for AT&T Headquarters, New York. 1978–83

After collaborating on the Seagram Building (see fig. 29-37) with Mies, who had long been his architectural idol, Johnson grew tired of the limited modernist vocabulary. During the 1960s he experimented with a number of alternatives, especially a weighty, monumental style that looked back to nineteenth-century Neoclassicism. At the end of the 1970s he became fascinated with the new possibilities opened by Venturi's postmodernism, which he found "absolutely delightful."

ular culture than to embrace the vernacular traditions of low culture and join them with high culture in an architecture of "complexity and contradiction."

Although both the accommodating message and the clever historicist references in the Guild House were lost on the general public, they provided many architects, including Philip Johnson (b. 1906), with a path out of modernism. Johnson's major contribution to postmodernism is the AT&T Headquarters in New York City (fig. 29-41), an

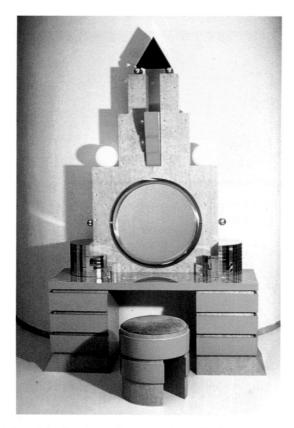

29-42. Michael Graves. Plaza Dressing Table for Memphis Furniture Company, Milan. 1981 Courtesy Michael Graves

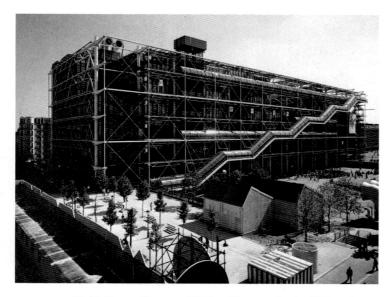

29-43. Renzo Piano and Richard Rogers. Centre National d'Art et de Culture Georges Pompidou, Paris. 1971–77

elegant, granite-clad building whose thirty-six oversized floors reach the height of an ordinary sixty-story building. Like Venturi's Guild House, the AT&T Headquarters makes gestures of accommodation to its surroundings. Its smooth, uncluttered surfaces match those of its International Style neighbors, while the classically symmetrical window groupings between vertical piers echo those in more conservative Manhattan skyscrapers of the early to middle 1900s. What critics focused on, however, was the

building's resemblance to a type of eighteenth-century furniture, the Chippendale highboy, a chest of drawers with a long-legged base. The piers at the base of the building resemble a giant highboy's spindly legs, the body of the building its cabinet drawers, and the top its scrolled "bonnet" ornament. Johnson seems to have intended a pun on the terms highboy and high-rise. In addition, the round notch at the top of the building and the arched entryway at the base recall the coin slot and coin return on old pay telephones. Many critics were not amused by Johnson's effort to add a touch of humor to high architecture. His purpose, however, was less to poke fun at his client or his profession than to create an architecture that would amuse the public and at the same time, like a fine piece of furniture, meet its deeper aesthetic needs with a formal, decorative elegance.

While Johnson and others were making architecture look like furniture, many postmodernist designers, such as the architect Michael Graves (b. 1934), were making furniture look more like architecture. In 1981 he designed the Plaza Dressing Table (fig. 29-42), whose name itself is architectural, meant to evoke the famous Plaza Hotel in New York. Like so much postmodernist architecture and design, this dressing table, inspired by an architectural mode popular in the 1920s known as Art Deco, recycles older styles into a new decorative ensemble. The blond maple-root wood, mirror-glass **tesserae**, globe lamps, geometrical drawers and stool, as well as the symmetrical massing of elements, all derive from Art Deco style.

One of the earliest manifestations of the decorative, playful use of historical forms that became identified with postmodern architecture was in the Centre National d'Art et de Culture Georges Pompidou (fig. 29-43) in Paris, designed by Renzo Piano (b. 1937) of Italy and Richard Rogers (b. 1933) of England. The building, which utilizes a modernist vocabulary, appears to have been whimsically turned inside out and then cheerfully painted. The coloring is not random, however. Red designates elevators, blue designates the air-conditioning ducts, green the water pipes, and yellow the electrical units. The external placement of these service structures increases the flexibility of the interior space. The arrangement also makes a historical reference to the origins of functional architecture in Paris, evoking both the glassand-iron sheds that once stood in the historical market area adjacent to it and the most famous of the exposedmetal structures that gave birth to modernist architecture, the Eiffel Tower (see fig. 28-67).

Unlike Piano and Rogers, whose high-tech architecture lightheartedly revisits the technological basis of modernism, the Italian Aldo Rossi (b. 1931) has attempted to salvage modernism's rationalist and reductive tendencies. His approach to architecture, known as neorationalism, is based on a return to certain premodernist building archetypes (typologies)—such as the church, the house, and the factory—stripped of all elaboration and ornamentation and reduced to their geometric essentials, much as in the designs of Neoclassicists like Claude-Nicolas Ledoux and Étienne-Louis Boullée (see figs. 26-31, 26-32). His goal was to achieve both historical

continuity and universal timelessness. To enrich the emotional impact of these rationally conceived typologies, Rossi believed that architects should use them in mysterious and evocative ways.

The Town Hall Rossi built in Borgoricco, Italy (fig. 29-44), near Venice, illustrates these concepts. Because Borgoricco is in Italy's industrial belt, he based the central forms of the building on an industrial, rather than a civic, typology. The large windows, metal roof, and smokestack are based on nineteenth- and earlytwentieth-century factory designs (see fig. 28-73), whereas the temple fronts on the flanking wings, which evoke the building's civic function, are done in a style typical of the housing in the surrounding countryside. The result is a provocative and unexpected marriage of local forms and other European architectural types. The blending succeeds because of the way Rossi plays the warm brick against the cool concrete in both the flanking and central elements and because of the way he has reduced the whole to strict geometric forms. This geometric reduction and the building's rigorous symmetry give it a stable, timeless air.

The early work of Frank Gehry (b. 1929), in contrast, took a radically destabilizing approach to postmodernist architecture. Consciously keeping his options open, Gehry avoided developing a comprehensive theory of architecture, seeking neither, like Rossi, to impose order on the environment nor, like Venturi, to join the vernacular to high culture. His approach was characterized, instead, by a willingness to accept the chaotic terms of urban life. His most famous early project is the renovation of his home in Santa Monica, California (fig. 29-45). The message he read in what he called the "body language of the neighbors' houses," with their chain-link fencing and concrete blocks, was "Stay out; leave me alone." Rather than resisting this message in his own house, he incorporated it. Several symbolic barriers separate him from his neighbors. A cinder-block wall encloses his front yard, an unlovely and unfriendly chainlink fence encloses his upstairs porch, and a corrugatedmetal wall acts as part of the new facade below the porch. The unfinished look of the front door and steps creates the impression that the house, like many in the neighborhood, was being renovated by amateurs. Other similarly haphazard-looking effects were also carefully planned. One of the most peculiar of these effects resulted from Gehry's decision to make it appear that "a different mind had designed each window." Across the front are a wooden-framed window, in keeping with the original design of the house; a cheap, metal-framed picture window; and a customized, free-form opening of glass and timber. Though the chain-link fencing echoed his neighbors' desire for privacy, Gehry wanted this last window "to demonstrate to them that one could have windows that offer views into the private realm of the house without compromising the privacy of the house." Gehry's house, then, is a series of conflicting messages and materials, a hodgepodge of elements that not only accepts the architectural and social chaos of the modern city and its suburbs but revels in it.

29-44. Aldo Rossi. Town Hall, Borgoricco, Italy. 1986–90 Courtesy Aldo Rossi

29-45. Frank O. Gehry. The architect's house, Santa Monica, California. 1978–79 Courtesy Frank O. Gehry and Associates, Inc.

Photography

Post–World War II photography before about 1970 can be divided into three categories: abstract, fantastic, and photojournalistic. All three shared both a belief in photography's access to a higher truth (whether aesthetic, personal, or social) and a commitment to a formally handsome finished product. By about 1970, however, a major change in photography, as great as that in architecture, became evident. This change was characterized by a shift—best seen in the work of photojournalists—from what might be called high art photography to deliberately bad or low art photography.

One of the leading photojournalists of the postwar period was Henri Cartier-Bresson (b. 1908) of France, who roamed the world as a free lance from the late 1940s to 1966, providing photographs for Western newspapers and magazines, including *Life*. Cartier-Bresson's goal

was to capture what he called "the decisive moment," one that revealed the essence of his subject in a formally coherent, rigorously organized image. He specialized in subjects of general human and historical interest, such as The Berlin Wall (fig. 29-46). The wall, a famous symbol of Communist oppression and the Cold War rivalry between the Soviet Union and the nations of the West, was built in 1961 by the Communist government of East Germany to prevent East Berliners from fleeing to the greater freedoms and economic opportunities of the West. Cartier-Bresson's photograph is both symbolically expressive and formally coherent. In it three men, well dressed and apparently prosperous, peer thoughtfully over the wall from the western side at the abandoned buildings on the eastern side. A gray sky lights this scene of hard, cold surfaces, evocative of the harsh political realities that created it. Two street signs on the far right, one of them marking a street interrupted by the wall, balance the figures on the left, closing the composition and directing the viewer's eye back along the row of houses.

The transition away from Cartier-Bresson's kind of aesthetic standards first appears in the work of the Swiss-born American photographer Robert Frank (b. 1924). Frustrated by the pressure and banality of the various news and fashion assignments on which he had been working, Frank packed his family into a used car in 1955 and undertook a yearlong photographic tour of the United States. From more than 28,000 images, he selected 83 for a book published first in France as *Les Américains* in 1958 and a year later in an English-language edition as *The Americans*, with an

29-46. Henri Cartier-Bresson. *The Berlin Wall*. 1963

After World War II, Germany and its capital, Berlin, were each divided into separate zones controlled by the four wartime allies. Those parts of Germany controlled by Britain, France, and the United States became West Germany while those under Soviet control became the East German Communist state. Most of

divided Berlin, though located in East Germany, be-

came part of West Germany, a kind of remote outpost.

introduction by the beat writer Jack Kerouac (1922-1969).

The book was poorly received. The photographic community was disturbed by Frank's often haphazard style, by the way some elements were purposefully out of focus, sloppily cropped, and disorganized. Frank, however, was capable of producing classically balanced and

29-47. Robert Frank. Trolley, New Orleans. 1955-56. Gelatin-silver print, 9 x 13" (23 x 33 cm). The Art Institute of Chicago

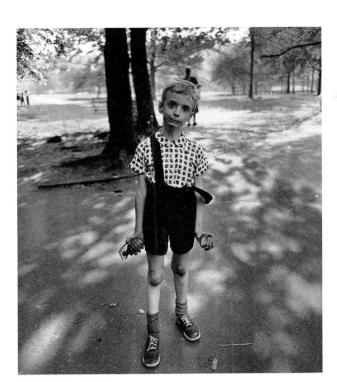

29-48. Diane Arbus. Child with Toy Hand Grenade, New York. 1962. Gelatin-silver print, 71/4 x 81/4" (18 x 21 cm). The Museum of Modern Art, New York Purchase

sharply focused images, but only when it suited his sense of the truth. The perfect symmetry of Trolley, New Orleans (fig. 29-47), for example, ironically underscores the racial prejudice of segregation that it documents. White passengers sit in the front of the trolley, African Americans in the back. At the same time, the rectangular frames of the trolley windows isolate the individuals looking through them, evoking a sense of urban alienation. Both children and adults stare at the viewer without warmth or recognition.

The harsh view of American life in works such as Trolley, New Orleans also upset many people outside the photography profession. What comes through in The Americans is a critical, disillusioned portrait of a culture with profound problems that contradicted the contented, self-satisfied view many in the United States had of their country in the 1950s. Frank's questioning perspective pales in comparison to the stark portrait of American people presented during the next decade by Diane Arbus (1923–1971). In her complete preoccupation with subject matter, Arbus, even more than Frank, rejected the concept of the elegant photograph, discarding the niceties of conventional art photography (fig. 29-48). She developed this approach partly in reaction to her experience as a fashion photographer during the 1950s, when she and her husband, Allan Arbus, had been Seventeen magazine's favorite cover photographers, but mostly because she did not want formal concerns to distract viewers from her compelling, often disturbing subjects.

Among the postmodernist heirs to the tradition of Frank and Arbus, perhaps the most radical was Duane Michals (b. 1932). An art director at Dance Magazine and

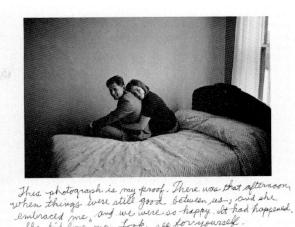

29-49. Duane Michals. This Photograph Is My Proof. Gelatinsilver print with text Courtesy the artist

She did love me. Look, see for yourself

Time, Michals became increasingly dissatisfied with photography's inability to deal with the inner life. Inspired by the Surrealist paintings of René Magritte (see fig. 28-96), whom he came to know quite well, Michals began at the end of the 1960s to fabricate photographic sequences, often accompanied by written narratives. Although those series inspired by his Zen Buddhist convictions are optimistic, most treat themes of human limitation and disappointment. In some cases Michals tells the story in a single frame, as in This Photograph Is My Proof (fig. 29-49). Meant to resemble a snapshot in a personal photo album, the work purports to record a young man's attempt to cope with unrequited love. Convinced by the conventional notion that photographs do not lie, the man in the photo tries to persuade himself, and the viewer, that the woman hugging him once really did love him. This picture—a record of a single moment in a bleak little room—is his best and only proof. Michals's deliberate use of amateurish-looking photographs with scratchy writing on them underscores his banal stories and completes the shift from high art photography to the era of so-called bad photography.

"Bad Painting" and Super Realism

Michals's rough counterpart in painting was Philip Guston (1913-1980), who had intended to be a cartoonist. Guston's paintings and drawings of the 1930s focused on themes of social injustice, particularly those involving the Ku Klux Klan. After World War II he gave up the figure and evolved a refined, somewhat hesitant gestural style that earned him recognition as a leading member of the New York School. His increasing dissatisfaction with what he came to see as the narrow limitations of Abstract Expressionism, however, reached crisis proportions in the late 1960s, and he returned to figurative work. He later said, "I got sick and tired of all that purity. I wanted to tell stories." The stories he tells in his late paintings deal with his own shortcomings.

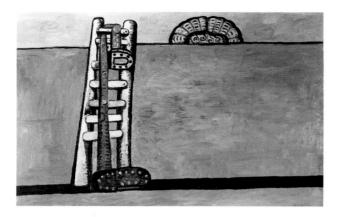

29-50. Philip Guston. *Ladder*. 1978. Oil on canvas, 5'10" x 9' (1.78 x 2.74 m). Collection the Edward R. Broida Trust

Often, as in *Ladder* (fig. 29-50), he represents himself simply by his large, clumsy feet. Here he attempts to climb a ladder to reach a goal on the horizon, a setting sun that is actually the forehead and hair of his wife, Musa. The contrast between her exalted status and his awkward attempt to reach her is more than a confession; it also seems to be a gentle exhortation to the viewer to strive for some higher goal, even if it is unattainable.

Guston's paint handling—"confessionally" crude, coarse, ungainly, and so unlike his elegantly executed work of the 1930s—had far-reaching influence. In 1978, works by artists who could be considered his heirs were shown in two New York exhibitions, "Bad Painting" at the New Museum and "New Image Painting" at the Whitney Museum of American Art. Susan Rothenberg (b. 1945), among those in the Whitney show, developed, like Guston, a self-referential imagery. One day in 1973, she doodled a horse's profile on a small piece of unstretched canvas and something clicked. The horse became her alter ego—a way, perhaps, of dealing with the self without actually painting it. This is suggested in some 1974 Polaroids she took of herself on all fours as studies for possible self-portraits.

Rothenberg's horses may at first seem somewhat ungainly. For example, because of its off-center placement in the picture frame, the horse in *Axes* (fig. 29-51) appears to be stumbling. The two straight lines, one dividing the picture frame and the other dividing the horse, are the axes of the painting's title. If these axes (and the parts of the horse they align) were reoriented to be parallel on the vertical axis, the animal would be upright, in midstride. The painting's "awkward" aspects are countered by the rich, appealing buildup of painting strokes and the low-keyed harmony of its creams and blacks—derived, like its simple forms, from the Minimalist aesthetic of the 1960s.

Another, very different kind of painting, which also had ties to Minimalism, developed around 1970 and came to public attention in 1972 in an exhibition called "Sharp Focus Realism" at the Sidney Janis Gallery in New York City. Instead of being personal, deliberately rough, and painterly, works of this kind, known by the label Super Realist, are impersonal, technically impressive, and

so carefully descriptive that they are often mistaken for color photographs.

One of the leading figures in the Super Realist movement was American painter Richard Estes (b. 1936). Inspired by the urban photographs of Eugène Atget and the paintings of Philip Pearlstein (see fig. 29-17), Estes had developed his mature style by the late 1960s. He was particularly intrigued by Atget's images of reflections in shop windows, like Magasin, Avenue des Gobelins (see fig. 28-5). During the 1970s and early 1980s he produced a series of paintings on the theme, including *Prescriptions* Filled (Municipal Building) (fig. 29-52). Seeking to objectify his scenes, Estes always eliminated people when he transcribed his source photographs to canvas. Like Pearlstein, Estes was interested in the aesthetic pleasures of refined compositional arrangements. The window reflection in Prescriptions Filled, for example, allows Estes to create a nearly perfect symmetry. The picture's formal tension comes from the subtle differences between the two halves, especially at the very center of the painting, the point between the lamppost and the edge of the glass window.

Estes, like Monet, was also drawn to reflections because they are in some ways visually more stimulating than the solid reality they mirror. The reflection in *Prescriptions Filled* is more engaging than the scene reflected, just as the painting as a whole is more rewarding to look at than the original live scene would have been. Estes thus used the language of realism against realism. He was not interested in celebrating or condemning something in the world. Instead, his cool, static, and closed paintings are the representational counterpart to Minimalism.

Much less typical of Super Realist painting in the 1970s is the work of Audrey Flack (b. 1931). In the late 1960s Flack projected a slide image directly onto a canvas in order to copy it and became fascinated with the brilliant colors she observed. Using an airbrush (a mechanical device often used in photo retouching that produces a fine spray of paint), she began to create paintings with colors of an even greater lushness that appealed to her for their emotional effect. During the 1970s she employed these methods to create a series of still lifes inspired by seventeenth-century vanitas paintings, a genre dominated by symbols of the transitory nature of life and its pleasures (Chapter 19). Many of these paintings, including Marilyn (Vanitas) (fig. 29-53), feature imagery that relates specifically to women. The many vanitas reminders of time—watch, calendar, hourglass, and candle—are contrasted with conventional and popular objects of another kind of "vanity"—mirror, jewelry, cosmetics—in what can be seen as a powerful comment on the human quest for love and beauty. The text in the book at the back of the painting, decorated by a traditional symbol of love, the rose, poignantly recounts how being made up and told she was pretty brought Marilyn Monroe her first compliments and sense of being loved. Her lips rouged, Marilyn's face beams triumphantly from the book. Among the beautiful fruits with which Marilyn is identified is an opened peach, a traditional

29-51. Susan Rothenberg. Axes. 1976.
Synthetic polymer paint and gesso on canvas, 5'4⁵/8" x 8'87/8" (1.64 x 2.66 m). The Museum of Modern Art, New York
Purchased with the aid of funds from the National Endowment for the Arts

29-52. Richard Estes. Prescriptions Filled (Municipal Building). 1983. Oil on canvas, 3 x 6' (0.91 x 1.83 m). Private collection

symbol of female sexuality. The peach pit, however, is a reminder that at her core was a hard, tough center.

Near the middle of the painting is an old photograph, probably of Flack and her brother as children. This detail is not simply another reminder of the passage of time but a signal of Flack's identification with the film star's struggle against it. The drop of bright red paint at the tip of the artists's paintbrush hovering magically above the open book is apparently meant to suggest that such paintings are invested with the artist's own life blood.

Another of the Super Realists who wished to communicate inspirational messages was the movement's major sculptor, Duane Hanson (b. 1925). His earliest works, which dealt with large social issues such as war, poverty, and racism, were highly dramatic, but about 1970 he turned to more mundane subjects. As he said of this change, "You can't always scream and holler, you have to once in a while whisper, and sometimes that whisper is more powerful than all the screaming and hollering." Since about 1970, Hanson has held an unflattering mirror up to American society, both its work and its leisure pursuits. One of his favorite themes is the American obsession with shopping. *The Shoppers*, for example

29-53. Audrey Flack. *Marilyn (Vanitas)*. 1977. Oil over acrylic on canvas, 8 x 8' (2.4 x 2.4 m). Collection of the University of Arizona Museum of Art, Tucson Purchase Edward J. Gallagher, Jr., Memorial Fund

29-54. Duane Hanson. *The Shoppers*. 1976. Cast vinyl, polychromed in oil with accessories, lifesize. Collection the Nerman Family

(fig. 29-54), shows two garishly dressed and overweight consumers carrying bags with their recent purchases. The material goods that are supposed to make them happy clearly do not. The communicative power of this work depends greatly on the fact that the figures are not only lifesize but lifelike. Every detail is convincing. For example, Hanson uses real hair and clothing (one arm is detachable to allow for the garments' removal and laundering). Gallerygoers often mistake them for real people, apologizing when they brush against them.

Post-Conceptual Art

Hanson's critique of American culture carried a strain of the modernist reform impulse into the postmodernist era. Most didactic art in the period after 1970 was less ambitious but more political. These qualities are evident in the work of German-born Hans Haacke (b. 1936), one of a number of artists working in the early 1970s who employed the Conceptual vocabulary of the preceding decade for decidedly anti-Minimalist purposes. Because their work otherwise shares little with the earlier Conceptualists, they are referred to as Post-Conceptualists.

Haacke came to the United States to teach in 1960. By the end of the decade he was producing a kind of Minimalist art that featured simple natural processes. In one piece, for example, he planted grass in a gallery. The turning point in his career came in 1968, after the assassination of Martin Luther King, Jr. "Nothing," he wrote in a letter, "but really absolutely nothing is changed by whatever type of painting or sculpture or happening you produce on the level where it counts, the political level"

28 # 5 80. or 13 5 story vall-og all due tenement

Secular Spin or 13 county from 100 F 13 81, FDC

Good by Repeal healty Inc., 500 F 13 81, FDC

Good by Repeal healty Inc., 500 F 13 81, FDC

Finishing and Company of the Spin of the S

29-55. Hans Haacke. *Shapolsky et al. Manhattan Real Estate Holdings, a Real-Time Social System, as of May 1, 1971*. Photograph by the artist

(cited in Burnham, page 130). Despite these misgivings, by 1970 Haacke was making politically conscious art, although with modest aims and expectations. Rather than change the world, he hoped merely to educate a sizable number of people about specific wrongs, many of them involving the art world itself.

One of his first socially conscious pieces was *Shapolsky et al. Manhattan Real Estate Holdings, a Real-Time Social System, as of May 1, 1971* (fig. 29-55). The work documented the buildings, some of them slum apartments, owned by a trustee of the Guggenheim Museum, where an exhibition of Haacke's work was scheduled to open. When the museum's director learned of the nature of the work, he claimed that it wasn't art and canceled the exhibition.

Another Post-Conceptualist who came out of Minimalism, William Wegman (b. 1943), responded with unexpected humor to the disillusionment many felt with American culture. In 1972, about the time he began producing the photographs of his dog Man Ray that made him famous, he did a series of short videos satirizing commercial advertisements and mocking the pretensions and shortcomings of science, including the failure of the psychiatric profession to solve psychological problems. In Rage and Depression (fig. 29-56) Wegman assumed the role of a psychotic who relates the somewhat grotesque tale of how attempts to cure his anger through shock treatments only froze a permanent smile on his face. He remains depressed and dangerous, but everybody thinks he is happy. Like much of Wegman's work from this period and after, Rage and Depression suggests that laughter is the only sane response to incurable human ills.

Earthworks

As Post-Conceptualism was emerging, a number of sculptors, responding to the New York art scene in general and to the Minimalist retreat from the world in particular sought to take art back to nature and out of the marketplace. Because they often used raw materials

29-56. William Wegman. *Rage and Depression*. 1972–73. Video image
Courtesy the artist

found at the location, their pieces are known as **earthworks**. They pioneered a new category of art making, called **site-specific sculpture**, works designed for a particular location, usually outdoors.

One of the leaders of the earthworks movement was Michael Heizer (b. 1944), the son of a specialist in Native American archeology. Disgusted by the growing emphasis on art as an investment, he spent the summer of 1968 in the Nevada desert, where, among other things, he dynamited huge boulders out of mountainsides and moved them to holes he had dug for them miles away. What Heizer liked about these works was that they could not easily be bought and sold, and they required a considerable commitment of time from viewers who wanted to see them. Recalling the ancient Native American art and architecture to which he had been exposed since childhood, they also seemed to him vaguely religious, suggesting mysterious rites and drawing attention to the sublime qualities of nature.

In 1969-1970 he returned to the Nevada desert and produced his most famous work, Double Negative (fig. 29-57). Using a simple Minimalist formal vocabulary, he made two gigantic cuts—the larger of which is longer than the Empire State Building is tall—in a canyon wall. To fully understand the work, the viewer needs to walk into the deep channels and experience their awe-inspiring scale. The work's title refers not only to the two cuts in the earth but also to the double zero on the roulette wheels of Las Vegas, 80 miles away. Heizer, who liked to gamble, meant to establish a sharp contrast between the raucous artificiality of Las Vegas and the unspoiled simplicity of nature. Heizer's implied criticism of the vulgarity of American culture and his search for a pure, transcendent artistic alternative, so reminiscent of Barnett Newman's work, are more modernist than postmodernist.

Another earthworks artist to carry similar modernist concerns into the postmodernist era is Nancy Holt (b. 1938). Since visiting the Nevada desert in 1968 with Heizer and her late husband, Robert Smithson (1938–1973), Holt has specialized in making intimate spaces for viewing the tranquil, sublime beauties of the natural world, especially the sky. In 1977–1978 she built *Stone*

29-57. Michael Heizer. *Double Negative*. 1969–70. 240,000-ton displacement, 1,500 x 50 x 30' (457.2 x 15.2 x 9.1 m). Museum of Contemporary Art, Los Angeles

Gift of Virginia Dwan. Photograph courtesy the artist

29-58. Nancy Holt. Stone Enclosure: Rock Rings. 1977–78.

Brown Mountain stone, height 10' (3 m), outer ring diameter 40' (12.2 m), inner ring 20' (6.1 m). Western Washington University, Bellingham

Funding from the Virginia Wright Fund, the National Endowment for the Arts, Washington State Arts Commission, Western Washington University Art Fund, and the artist's contributions

Enclosure: Rock Rings (fig. 29-58) on the campus of Western Washington University, in Bellingham. The work consists of two concentric 10-foot-high stone rings, the outer one about 40 feet in diameter. Four aligned doorways suggestive of processional entryways give access to the interior of the rings. Strong, secure, and snug, the interior provides a number of impressive vistas—into the woods, across the campus, or into the heavens. On a clear night the contrast between the small, confined, earthbound space and the infinitely expanding sky is particularly stirring. Sublime, too, is the play between the present and the distant histories of early humans that the work evokes. Stone Enclosure: Rock Rings is meant to remind the viewer of a variety of prehistoric and historic forms, from the Neolithic Stonehenge to the Roman Colosseum. As Holt says, "I'm interested in conjuring up a sense of time that is longer than the built-in obsolescence we have all around us."

Holt's husband, Robert Smithson, also wanted to impress the spectator with the vastness of time, but his

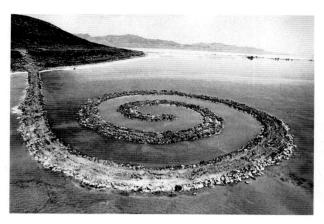

29-59. Robert Smithson. *Spiral Jetty*. 1969–70. Black rock, salt crystal, and earth spiral, length 1,500' (457.2 m). Great Salt Lake, Utah

expression of it was less reassuring than Holt's and not at all modernist. In his mature work he sought to illustrate what he called the "ongoing dialectic" in nature between constructive forces—those that build and shape form—and destructive forces—those that destroy it. Spiral Jetty (fig. 29-59), a 1,500-foot spiraling stone and earth platform extending into the Great Salt Lake in Utah, reflects these ideas. Smithson chose the lake because it brought to mind both the origins of life in the salty waters of the primordial ocean and the end of life. One of the few organisms that lives in the otherwise dead lake is a bacterium that gives it a red tinge, vaguely suggestive of blood. Smithson also liked the way the abandoned oil rigs that dot the lake's shores suggested both prehistoric dinosaurs and some vanished civilization. He used the spiral because it is a fundamental shape that appears throughout the natural world, for example, in galaxies, seashells, and most important, salt crystals. Finally, Smithson chose the spiral because, unlike modernist squares, circles, and straight lines, it is a "dialectical" shape, one that opens and closes, curls and uncurls endlessly. More than any other shape, it suggested to him the perpetual "coming and going of things."

The work of Christo (b. 1935) and Jeanne-Claude (b. 1935), who think of themselves as environmental artists, reflects, in the view of many, a postmodern sense of social mission. Born and trained in Bulgaria, Christo Javacheff (who uses only his first name) emigrated to Paris in 1958, where he met Jeanne-Claude de Guillebon, the nouveaux réalistes, and some of the Fluxus artists. His interest in wrapping things, which apparently began as a form of social criticism, soon became an obsession. Even before the pair moved to New York City in 1964, Christo was packaging progressively larger items. In 1968 Christo and Jeanne-Claude wrapped the Kunsthalle in Bern and in 1969, 1 million square feet of the Australian coastline.

Their best-known work, Running Fence (fig. 29-60), consisted of a 241/2-mile-long, 18-foot-high nylon fence that crossed two counties in northern California and extended into the Pacific Ocean. Although ranchers in South Africa and Mexico had offered them land for Running Fence, the artists chose to locate it in Sonoma and Marin Counties because of the beautiful rolling hills there and because they wanted to immerse the work in the

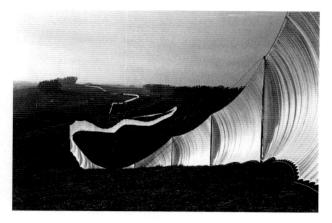

29-60. Christo and Jeanne-Claude. *Running Fence*. 1972–76. Nylon fence, height 18' (5.5 m), length 24¹/₂ miles (40 km). Sonoma and Marin Counties in northern California

society and politics of late-twentieth-century United States. Before it could be created they spent forty-two months overcoming the resistance of landowners, county commissioners, and social and environmental organizations. The artists considered all these actions to be part of a work. Their purpose for *Running Fence* was not just to produce a work of art that would celebrate the beautiful contours of the land and, as they put it, "describe the wind." The Christos also wanted to open to greater scrutiny the workings of the political system. Most important, they wanted to bring people together in the making of the project, to forge a community drawn from groups as diverse as college students, ranchers, lawyers, and artists. They wanted their fence, unlike the Berlin Wall (which was about the same length and height), to break down barriers.

Feminist Art

An even more ambitious attempt to break down old barriers was initiated by feminist artists. During the 1970s, almost entirely as a result of the feminist movement, women finally began to achieve increased recognition in the American art world. The watershed event was the march in August 1970 commemorating the fiftieth anniversary of the Nineteenth Amendment to the Constitution, by which women gained the vote. The anniversary gave women an opportunity to assess their progress in various fields since 1920, and they were disappointed by what they found. A survey of women in art, for example, revealed that although they constituted half of the nation's practicing artists, only 18 percent of commercial New York galleries carried the work of any women at all. Of the 151 artists in the 1969 Whitney Annual, one of the country's most prominent exhibitions of the work of living artists, only 8 were women. The next year, the Ad Hoc Group, a number of women critics and artists disappointed by the lukewarm response of the Whitney's director to their concerns, organized a protest at the opening of the 1970 Annual. To focus more attention on women in the arts, feminist artists began organizing women's cooperative galleries. While feminist art historians wrote about women artists and the issues raised by their work in textbooks and journals, feminist curators and critics promoted the work of both emerging women artists and long-neglected ones, like Alice Neel (1900–1984), who had her first major one-artist show at age seventy-four.

Neel received a solid academic training at the Philadelphia School of Design for Women in the 1920s. Reflecting a series of life crises, including the death in infancy of one of her children and the abduction of another by the child's father, Neel's early work featured distorted, expressionistic images of children. Her style softened after she moved to New York in 1932 and began to specialize in frank and revealing images of the people she knew. She became, as she said, "a collector of souls."

The revival of figurative art in the early 1960s first brought her to the attention of the New York art world, although her penetrating portraits were considered far too subjective for the prevailing aesthetic. Her subjects now included well-known critics, curators, and artists, such as Andy Warhol (fig. 29-61). The portrait of Warhol shows him unclothed from the waist up, revealing the scars from the 1968 attempt on his life. Exposed by Neel, he closes his eyes, as if denying his frail body, his pallid complexion, and his unbeautiful features. The indefinite handling of the upper body and the placement of the feet off the ground make the figure appear almost weightless. With his upturned head, Warhol seems to want to free himself of this body and rise above it. Neel has cut through Warhol's cool and distant public persona to reveal the fragile, wounded human being beneath it.

While events on the East Coast focused on gaining more attention for women artists, on the West Coast two feminist artists and teachers, Judy Chicago (b. 1939) and Miriam Schapiro (b. 1923), established in 1971 at the new California Institute of the Arts (CalArts) the Feminist Art Program, dedicated to training women artists.

Born Judy Cohen in the city whose name she took in 1970, Chicago was originally a Minimalist sculptor, but at

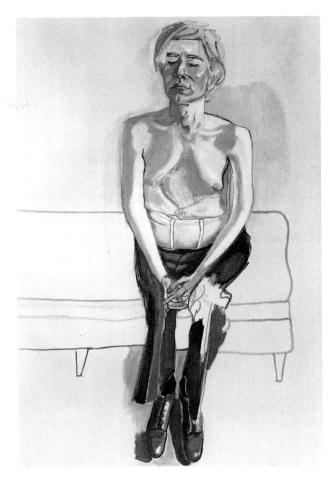

29-61. Alice Neel. *Andy Warhol*. 1970. Oil on canvas, 5' x 3'4" (1.5 x 1 m). Whitney Museum of American Art, New York Gift of Timothy Collins

the end of the 1960s she began to use female sexual imagery to expose the sexism of the male-dominated art world. Her most famous piece is *The Dinner Party* (fig. 29-62). The finished work, the combined labor of hundreds

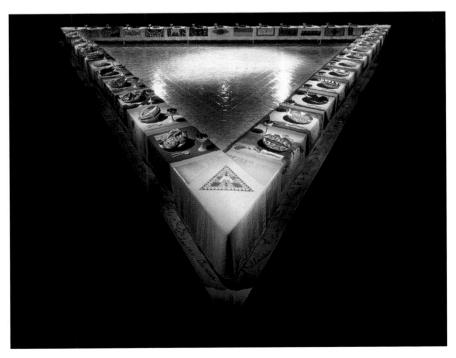

29-62. Judy Chicago.

The Dinner Party.
1974–79. White
tile floor inscribed
in gold with 999
women's names;
triangular table
with painted
porcelain, sculpted
porcelain plates,
and needlework,
each side 48'
(14.6 m)
Courtesy the artist

29-63. Miriam Schapiro. *Heartfelt*. 1979. Acrylic and fabric on canvas, 5'10" x 3'4" (1.8 x 1 m). Collection the Norton Neuman Family

Courtesy Steinbaum-Krauss Gallery, New York

of women and several men, records the names of 999 notable women and pays special homage to 39 historic and legendary women—from Egyptian Queen Hatshepsut to Georgia O'Keeffe. Each side of the triangular table has thirteen settings, because thirteen is the number of witches in a coven and the number of men at the Last Supper. The triangular shape is a symbol for woman and during the French Revolution was an emblem of equality. Each individual place setting features a runner, designed in a style historically appropriate to the woman it represents, and a large ceramic plate. The stitchery, needlepoint, and china painting are all traditional women's art forms that Chicago wished to raise to the status granted to painting and sculpture. Most of the plates feature shapes based on female genitalia because, Chicago says, "that is all [the women at the table] had in common. . . . They were from different periods, classes, ethnicities, geographies, experiences, but what kept them within the same confined historical space" was the fact that they were women (cited in Broude and Garrard, page 71).

Of the various art movements of the 1970s, feminist art most displayed the old modernist optimism about art's capacity to contribute meaningfully to a better future. The function of Chicago's tribute to women and women's traditional art forms, for example, was not sim-

29-64. Ana Mendieta. Untitled work from the Tree of Life series. 1977. Color photograph, 20 x 13¹/₄" (50.8 x 33.7 cm)

Courtesy Galerie Lelong, New York. © The Estate of Ana Mendieta

ply to improve women's place in history and their sense of themselves but, as she said, "to change the world."

Feminists were outspoken critics, however, of the increasingly restrictive modernist concept of mainstream art and its virtual exclusion of women (see "The Idea of the Mainstream," page 1110). The major champion of a specifically feminine aesthetic was Chicago's partner at CalArts, Miriam Schapiro. During the late 1950s and 1960s Schapiro had made explicitly female versions of the dominant modernist styles. At the end of the 1960s, for example, she was painting reductive, hard-edged abstractions of the female form: large **X** shapes with openings in their center.

Typical of Schapiro's mature work is *Heartfelt* (fig. 29-63), one of a type of construction she called femmage (from *female* and *collage*). Made with painted fabrics, these works celebrate traditional women's craftwork. *Heartfelt* is shaped like a house because that was where most women worked and because their domestic art forms were part of a larger concern with the care of others, which Schapiro associated with the idea of home. The patterns of *Heartfelt* suggest the curtains, shelf papers, wallpapers, quilts, rugs, and other decorative forms women make or use in their domestic spaces. The title evokes an essential feature, in Schapiro's and other

1970s feminists' view, of female sensibility. Both the formal and the emotional richness of *Heartfelt* were meant to counter the Minimalist aesthetic of the 1960s, which Schapiro and other feminists considered typically male.

Many feminists accepted and celebrated the notion that women have a deeper identification with nature than do men, a belief evident in a number of artworks from the 1970s, including those by Cuban-born Ana Mendieta (1948-1985). By 1972 Mendieta had rejected painting for performance and body art, which she documented through photography, film, and video. Inspired by the customs of Santería, an Afro-Caribbean religion emphasizing immersion in nature, she produced a series of ritualistic performances on film and about 200 earth and body works, called Silhouettes, which she recorded in color photographs. Some were done in Mexico, and others, like the Tree of Life series (fig. 29-64), were set in Iowa, where she had moved in 1961, after the Cuban Revolution. In Tree of Life Mendieta stands covered with mud, her arms upraised like a prehistoric goddess, appearing at one with nature, her "maternal source."

The feminist art movement of the 1970s was a widespread and multifaceted phenomenon fed by an assortment of common concerns with celebrating and improving the lives of women, especially artists. The category, like so many that historians employ to organize the diverse materials of history, is very flexible and at times simply a matter of emphasis. Audrey Flack, for example, belongs among the feminists if one focuses on the content of much of her work but with the Super Realists if one emphasizes her style.

POST-MODERNISM

POST- RNISMMuch of the art being made by the end of the 1970s was widely considered to be *postmodern*.

Although there has been virtually no universal agreement on just what this term means, it involves rejection of the concept of the mainstream and a recognition of artistic pluralism, the acceptance of a variety of artistic intentions and styles. A number of critics have resisted using the label *postmodern*, insisting that pluralism applies to modernism as well and has been a characteristic of art since at least the Post-Impressionist era. Others, in response, argue that the art world's attitude toward pluralism has changed. Where critics and artists previously searched for what they considered a historically inevitable mainstream in the midst of pluralistic variety, many now accept pluralism for what it probably always was, a manifestation of our culturally heterogeneous age.

Those who resist the label *postmodern* also point to the continued use of the term *avant-garde* to describe the most recent developments in art. But whereas *avant-garde* formerly indicated a significant newness, it now lacks that connotation. Indeed, many recent avant-garde styles implicitly acknowledge the exhaustion of the old modernist faith in innovation—and in what it implied about the "progressive" course of history—by reviving older styles. For this reason, the names of a number of recent styles, in both art and architecture, begin with the prefix *neo*, denoting a new and different form of something that already exists.

29-65. David Salle. *What Is the Reason for Your Visit to Germany*. 1984. Oil, acrylic, and lead on wood and canvas, 8' x 15'11¹/2" (2.44 x 4.86 m)

Courtesy Mary Boone Gallery, New York

Neo-Expressionism

A number of shows in leading New York art galleries in 1980 signaled the emergence of the first of the neos, Neo-Expressionism. The renewed interest in expressionism, long thought dead, was inspired partly by the emphasis on personal feeling in feminist art. Although six of the nineteen artists discussed in an early assessment of Neo-Expressionism in the magazine *Art in America* (December 1982–January 1983) were women, some of them, like Rothenberg, never fit comfortably under the label Neo-Expressionist. Other women were soon dropped from the category when critics decided, perhaps somewhat prematurely, that the style was a male phenomenon, reasserting masculine values and viewpoints.

David Salle (b. 1952) has been considered typical of Neo-Expressionism, even though only some aspects of his work are truly expressionistic. Salle studied at CalArts with the Conceptual photographer John Baldessari (b. 1931) and then worked at various jobs. Some of his images of women, including the bending figure in the left panel of What Is the Reason for Your Visit to Germany (fig. 29-65), derive from his experience doing layout for a pornographic magazine. Over each leg of this figure, Salle imposed a drawing of Lee Harvey Oswald (President Kennedy's presumed assassin) being shot. He splashed an acid green wash over one of these drawings and obscured the face of the other with an expressionistic \boldsymbol{V} shape. The word fromage (French for "cheese"), lettered across the panel, may be a pun on Schapiro's term femmage and on cheesecake, a slang expression for erotic images of women. Inspired by Rauschenberg's example (see fig. 29-23), Salle presents a discontinuous world of coexistent fragments that defy synthesis. Some of his early advocates argued that Salle's chaotic paintings—badly drawn and painted in unpleasant, impure, dissonant colors—are meant to intensify, and therefore to indict, the empty anarchy of what art critic Robert Hughes calls the "image haze that envelops us," but most observers now seem to agree that Salle accepts and submits to it. According to one of his titles, what we see in his work is simply the unedited contents of "his brain" offered to us as art.

Salle's roommate at CalArts, Eric Fischl (b. 1948), evolved a more critical form of Neo-Expressionism in the

29-66. Eric Fischl. *A Visit To/A Visit From/The Island*. 1983. Oil on canvas, each panel 7 x 7' (2.13 x 2.13 m), overall 7' x 14' (2.13 x 4.26 m). Whitney Museum of American Art, New York

Purchased with funds from the Louis and Bessie Adler Foundation, Inc., Seymour M. Klein, President

29-67. Francesco Clemente. *Untitled*. 1983. Oil on canvas, 6'6" x 7'9" (1.98 x 2.36 m). Collection Thomas Ammann Fine Art, Zürich

late 1970s. Impressed by the emotional and personal content of recent feminist art, in 1976 he invented the Fishers, an archetypal Canadian seafaring family, around whom he built a body of related paintings. The Fishers were an apparent surrogate for the less idyllic Fischl family in which he had grown up in suburban Long Island, New York. Although many of his paintings about American suburban life had connections with his own, what Fischl set out to create about 1980 was a portrait of a class.

Many of his early paintings involve the middle-class pursuit of pleasure. Some, like *A Visit To/A Visit From/The Island* (fig. 29-66), feature an American family on vacation in the tropics. Signaling their desire to "return to nature" à la Gauguin, a mother and her children are naked on an island beach. Although the woman relaxes on a foam mattress, the scene is crowded, nervously painted, and, judging by the motorboat, noisy. The

daughter, who stands idly by, seems bored. The unsuccessful "escape" to the tropics is contrasted with the consequences of a more literal attempt at escape shown in the right panel. Here islanders on a stormy beach react to the sight of their dead comrades (one of whose legs seems almost to extend from the sunbathing woman in the left panel), apparently drowned in a desperate bid to flee the island. Exactly what is going on is uncertain, however. Fischl's intention is not to tell a story with a clear conclusion but to force viewers to confront for themselves his ambiguous and morally troubling images.

The Resurgence of European Art

In the early 1980s the work of a number of European artists, much of it stylistically consistent with the Neo-Expressionism then coming into vogue in the United States, gained widespread critical recognition. The Italian artist Francesco Clemente (b. 1952), for example, searching for an alternative to what he considered the overintellectualization of Italian art and criticism, developed a largely anti-intellectual and amoral form of Neo-Expressionism. Sensual experience and bodily functions became central elements of Clemente's art after he spent 1977 living in Madras, India. His basic premise is stated in an untitled painting (fig. 29-67) that is a kind of selfportrait. In each opening of the subject's head is another head, suggesting that we are what we see, hear, smell, and taste. The work is crudely painted, reflecting a deliberate lack of effort—particularly intellectual effort—and testifying to Clemente's pursuit of basic sensation. The problem with ordinary thought, Clemente felt, is that it takes us beyond direct experience to meaning. "Keep on the surface," he advises, "don't look for meaning." Thus, Clemente, like Salle, does not struggle to change, transcend, or even understand the world around him. He tries simply to experience and accept it.

American interest in contemporary European artists increased in 1981, when German art was shown in galleries all over New York City. One of the most fascinating of these German artists was Anselm Kiefer (b. 1945). Born in the final weeks of World War II—in what Germans who

29-68. Anselm Kiefer. *March Heath*. 1984. Oil, acrylic, and shellac on burlap, 3'10¹/₂° x 8'4" (1.18 x 2.54 m). Van Abbemuseum, Eindhoven, the Netherlands

wished to erase it from collective memory called Year Zero—Kiefer has long sought to confront his country's Nazi past. In 1969 he produced a book of photographs showing himself offering the Nazi salute in various European sites that had been occupied by Germans during the war. Interpreted by many as a right-wing celebration of Hitler's conquests, the book raised a storm of controversy.

In the early 1970s Kiefer turned to painting but continued his efforts to get other Germans to confront their country's troubled past, "in order," he said, "to understand the madness." The burned and barren landscape in *March Heath* (fig. 29-68) evokes the ravages of war that the Brandenburg area, near Berlin, has frequently experienced, most recently in World War II. The road that lures us into the landscape, a standard device in nineteenth-century landscape paintings, here invites us into the history of this region. Like those of his American counterpart Fischl, Kiefer's works compel viewers to come to grips with troubling historical and social realities.

Kiefer's unofficial mentor, Joseph Beuys (1921-1986), helped shape Kiefer's sense of art's social mission. Beuys was one of several older German artists whose reputations in the United States rose dramatically with the resurgent interest in European art. A fighter pilot during World War II, Beuys was shot down over the Soviet Union in 1943 and was saved by nomadic Tartars. Apparently in an effort to assuage the guilt and anxiety with which his war experiences left him, Beuys elaborated his rescue by the Tartars into a personal mythology of rebirth, which became central to his art. After joining Fluxus in 1962 he began producing performance art based on an exaggerated account of this experience in which he insisted not only that the Tartars had saved him—by wrapping him in fat and animal-hair felt-but that their leader had made him an honorary member of their community.

For his 1974 *Coyote: I Like America and America Likes Me* (fig. 29-69), Beuys landed in New York, was wrapped in felt, and was taken by ambulance to a Manhattan

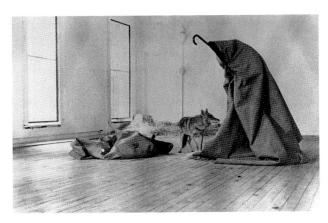

29-69. Joseph Beuys. *Coyote: I Like America and America Likes Me*. 1974. Weeklong action staged in the René Block Gallery, New York

Courtesy Ronald Feldman Fine Arts, New York

gallery, part of which was cordoned off with industrial chain-link fencing. Inside was a live coyote, a symbol of the American wilderness threatened with extinction by modern industrial society. For seven days Beuys and the coyote lived together. Beuys, wrapped in a felt tent from which a shepherd's crook protruded, silently followed the animal around, sometimes mimicking it. Beuys saw felt, in which the Tartars had supposedly wrapped him, as a regenerative natural material, one capable of healing the sick. The crook is the Tartar shaman's symbol. The artist was thus presenting himself as the shaman, come to help save the wildlife of the United States and in this way heal a sick nation. The artist's arrival in an ambulance suggested that he, too, was threatened and needed healing. In effect, the work showed two endangered species healing each other through their mutual communion. The work celebrates the power of empathy to save a world threatened, according to Beuys, by cutthroat economic and political competition.

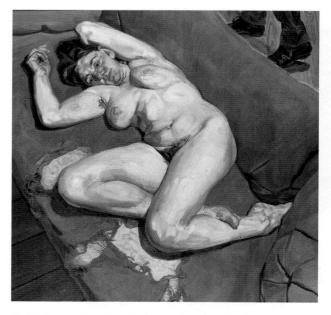

29-70. Lucian Freud. *Naked Portrait with Reflection*. 1980. Oil on canvas, 35½ x 35½" (90.3 x 90.3 cm). Private collection

Another long-neglected European whose reputation rose sharply in the 1980s was Lucian Freud (b. 1922). The grandson of Sigmund Freud, Lucian was born in Berlin and moved with his family to England in 1933. Inspired by the work of his friend Francis Bacon (see fig. 29-2), he gradually loosened his style, beginning around 1960. Although expressionistic elements appear in his late work, he remained a realist. Freud took his subjects from a group of acquaintances. In his later work he usually portrayed them nude, as in Naked Portrait with Reflection (fig. 29-70). Although the woman lies in a characteristically erotic pose, she seems more tired than relaxed and alluring, an impression reinforced by Freud's choice of colors. Her flesh is heavy and sad and echoes her weary expression. The painting conveys a sense of the irrevocable processes of age and the body's inevitable decay. Lushly painted, it seems to suggest from a distance that art can provide some consolation for the sadness of life. Up close, however, the coarsely caked paint on the woman's face is a frank reminder of human mortality.

Graffiti Art

Another formerly marginal arena that caught the attention of the New York art world about 1980 was street art, or **graffiti** art. The movement took shape following an exhibition called the "Times Square Show," held in an old massage parlor in 1980.

One of the artists to emerge from the "Times Square Show" was Keith Haring (1958–1990), who had been invited to participate on the basis of his graffiti-inspired paintings on black photographic backdrop paper. In 1981 Haring took his art into New York City subway stations. On the black panels used to block out obsolete advertising, he began to make cheerful chalk drawings, like *Art in Transit* (fig. 29-71), of a memorable cast of characters in a distinctive linear style. Haring said he was committed to an art "open to everybody" that would "break down this supposed

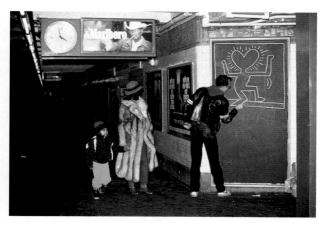

29-71. Keith Haring. *Art in Transit*. 1982 Courtesy Estate of Keith Haring

During the 1970s the East Village section of New York City was colonized by young artists and art students such as Haring, particularly those from the School of Visual Arts, in search of low-cost housing and gallery space. In addition to alternative galleries and performance-art spaces, a host of nightclubs catering to this clientele sprang up in the area. The art produced by these young artists, often inspired by street graffiti, was frequently used to decorate these nightclubs.

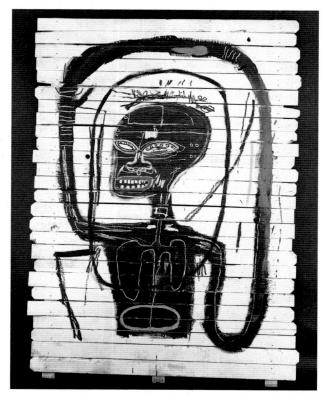

29-72. Jean-Michel Basquiat. *Flexible*. 1984. Acrylic and oilstick on wood, 7'4" x 6'3" (2.59 x 1.9 m) Courtesy Robert Miller Gallery, New York

barrier between low art and high art." His work features a personalized symbolism, however, which many found puzzling. When asked what a particular figure meant, he answered, "That's your part; I only do the drawings." The figure shown here is the harried commuter, whose head is sometimes a clock but in this example is a radiant heart, a sign of love and perhaps, as one critic observed, of "the uni-

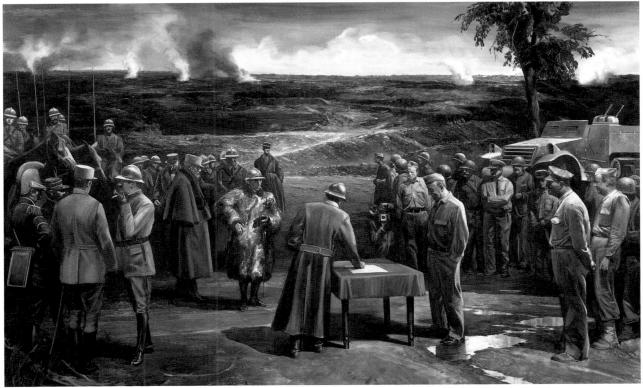

29-73. Mark Tansey. *Triumph of the New York School*. 1984. Oil on canvas, 6'2" x 10' (1.88 x 3.05 m). Whitney Museum of American Art, New York

Promised gift of Robert M. Kaye

Tansey is the son of art historians. Inspired by the deconstructive critical method of Jacques Derrida, he set out around 1980, as he said, to "problematize and destabilize" some of the leading dogmas in the discourse of contemporary art. He made his monochromatic paintings resemble photographs because of that medium's reputation for unvarnished truthfulness.

fying force that courses through all beings and things."

Jean-Michel Basquiat (1960–1988) developed a less innocent brand of graffiti art. Basquiat, originally a street artist whose graffiti featured witty philosophical texts, was invited to paint a large wall for the "Times Square Show." His success encouraged him to begin painting professionally. Although he was untrained and wanted to make "paintings that look as if they were made by a child," he was a sophisticated artist. He carefully studied the Abstract Expressionists, Picasso's late paintings, and the works of Dubuffet (see fig. 29-3), among others. To give his work a less sophisticated look and to demonstrate his allegiance with naive artists of the Caribbean, he often painted on crudely constructed canvases and surfaces made from wooden slats, as in *Flexible* (fig. 29-72).

Like much of his work, *Flexible* features an African American male, perhaps the artist, with angry eyes and mouth. On his head he wears a combination crown and crown of thorns, a symbol Basquiat used to convey a sense of both superiority and suffering. The figure's flexible arms, which give the work its title, may suggest the social flexibility required of people, like the artist, who must live within both their own minority culture and the dominant culture of the larger society. As in paintings in the so-called **x-ray style** of the Australian Aborigines (see fig. 24-2), Basquiat shows the figure's internal organs, perhaps suggesting that beneath the skin we all share a common humanity.

Neo-Conceptualism

An analytic and often cynical style emerged in the mid-1980s that seemed to be a reaction both to the emotion-alism of Neo-Expressionism and to the populism of graffiti art. Known as Neo-Conceptualism, it reflected the influence of the difficult and usually skeptical ideas on literature, philosophy, and society of a group of French intellectuals—among them Roland Barthes (1915–1980), Jacques Derrida (b. 1930), Jean Baudrillard (b. 1929), and Michel Foucault (1926–1984)—who had become popular among American intellectuals in the late 1970s.

One Neo-Conceptualist, the representational painter Mark Tansey (b. 1949), evolved a working technique by the mid-1980s that involved photocopying elements from his growing picture file and then collaging these pieces into various configurations that allowed him to explore a subject slowly and methodically. Characteristic of his work is Triumph of the New York School (fig. 29-73), a brownish monochrome painting that resembles the kind of photographic reproduction that used to appear in Sunday newspapers. The title refers to the received wisdom in art history that the New York School wrested control of art's mainstream from the Paris School after World War II. Tansey's painting, playing on the word triumph, depicts the event as a military victory formally recognized by the combatants on both sides—the French on the left in the uniforms of World War I, the Americans on the right

29-74. Louise Lawler. *Pollock and Tureen*. 1984. Cibachrome, 28 x 39" (71 x 99 cm)

Courtesy Metro Pictures, New York

The work of Louise Lawler (b. 1947) also undertakes a thought-provoking investigation into artistic issues. About 1980 she began to document how specific presentations of art objects-from public museums to private homes to exhibition catalogs—reveal the way art is actually used and, thus, how it is conceived. Her photograph Pollock and Tureen (fig. 29-74), for example, was taken in a private home. It shows a detail of one of Pollock's drip paintings hanging above a sideboard with an antique soup tureen tastefully flanked by two vintage casserole dishes. The classical format and the subtle harmonies between the linear rhythms in the Pollock and those on the tureen's surface and in its shape might suggest that Lawler meant simply to make an aesthetically pleasing photograph. Her interest, in fact, was to show how the treatment of this famous painting as a decorative object within a setting of other decorative objects alters the vital

29-75. Peter Halley. *Yellow Cell with Conduits*. 1985. Acrylic and Day-Glo on canvas, 5'4" x 5'4" (1.63 x 1.63 m). Courtesy the artist

meaning that it had for Pollock. The irony here, which Lawler fully appreciates, is that her lovely photograph contributes to this subversion of the painting's meaning. Lawler does not mean to criticize the collectors so much as simply to open to analysis—and its pleasure—the way art objects take on meaning in context.

An equally nonjudgmental social commentary can be found in the work of Peter Halley (b. 1953), which reflects the influence of the French social critics Jean Baudrillard and Michel Foucault. Baudrillard has argued that movies, television, and advertising have made ours the age of the "simulacrum," the substitution of images that simulate reality for reality. These images, moreover, often seem "hyperreal," or more real than the world they purport to reflect. The television stereotype of the average American family, for example, has replaced the social reality of family life, and advertising employs supersaturated colors to make products seem hyperreal.

Halley realized that the fluorescent **Day-Glo** colors he had been using in his work were themselves signs of this new social phenomenon. Moreover, he also began to question the Minimalist assertion that abstract forms are referentially neutral, suggesting, for example, that the stripes in a Stella painting from the mid-1960s could as easily be interpreted as a metaphor for the interstate highway system as an exercise in pure form. By the beginning of the 1980s Halley was making abstract paintings with forms intended to be read as meaningful signs of the contemporary cultural phenomena described by Baudrillard and Foucault.

In Yellow Cell with Conduits (fig. 29-75), one of his socalled Neo-Geo (or new geometry) paintings, he applied hyperreal colors to the kind of simulated stucco used in suburban housing. This false stucco surface is itself, therefore, a sign of the new domination of the simulacrum. The large central square, or cell, represents both the home and the brain (which is composed of cells). The rectangular

forms that connect with it thus refer on one level to plumbing and electrical circuitry, and on another to information reaching the brain. In this second sense the lower piping represents information reaching the brain from the subconscious and the upper piping represents information coming to it through conscious processes. Finally, the central cell has yet another meaning, that of jail, or imprisonment, a reference to Foucault's claim that modern bureaucratic political regimes imprison the individual. The central square has therefore three referents: home, brain cell, and prison cell. Halley's intent in works like Yellow Cell with Conduits is not to protest troubling social phenomena but to find an interesting way to illustrate them. The work of all the Neo-Conceptualists has been called "endgame" art, a reference to the moves in a chess game when loss is inevitable.

One of the most famous endgame moves was made by Sherrie Levine (b. 1947), who is known for work in which she "appropriates," or borrows, images from art history (see "Appropriation," below). In 1981 she began to attack the predominantly male Neo-Expressionist movement and its ideas about originality and individuality by making photographic copies of famous twentieth-century originals. As she explained, "I felt angry at being excluded. As a woman, I felt there was not room for me. The whole art system was geared to celebrating . . . male desire." Her endgame response was to copy only the work of male artists.

Untitled (After Aleksandr Rodchenko: 11) (fig. 29-76) is not an homage to the Russian Constructivist (see fig. 28-78)

29-76. Sherrie Levine. Untitled (After Aleksandr Rodchenko: 11). 1987. Black-and-white photograph, 20 x 16" (50.8 x 40.6 cm) Courtesy Marian Goodman Gallery, New York

APPROPRIATION

During the late 1970s and 1980s, appropriation, or the representation of a preexisting image as one's own, became a popular technique among postmodernists in both the United States and Western Europe. The borrowing of figures or compositions has been an essential technique throughout the history of art, but the emphasis had always been on changing or personalizing the source. A copy or reproduction was not considered a legitimate work of art until Marcel Duchamp changed the rules with his readymades (Chapter 28). His insistence that the quality of an artwork depends not on formal invention but on the ideas that stand behind it established the theoretical basis for the recent popularity of the technique. Duchamp's own type of appropriations first inspired the Pop artists Andy Warhol and Roy Lichtenstein, whose reuse of imagery from popular culture, high art, ordinary commerce, and the tabloids, in turn, helped point the way for the artists of the 1970s and 1980s.

Unfortunately, perhaps, critics

and historians now use the term appropriation to describe the activities of two distinct groups. To the first belong artists such as John Baldessari and his student David Salle (see fig. 29-65), who combine and shape their borrowings in personal ways. These, along with earlier artists such as Robert Rauschenberg (see fig. 29-23), might be called "collage appropriators." "Straight appropriators," on the other hand, include artists such as Sherrie Levine (see fig. 29-76), who simply repaint or rephotograph imagery from commerce or the history of art and present it as their own.

The work of the second group is grounded not only in the Duchampian tradition but in the recent ideas of the French literary and cultural critics known collectively as the Post-Structuralists. Of particular importance was their critique of certain basic and unexamined assumptions about art. In "Death of the Author" (1968), for example, Roland Barthes argued that the meaning of a work of art depends not on what the author meant (which Jacques Derrida and others argued was neither certain nor entirely recoverable) but on what the reader understands. Furthermore, Barthes questioned the modernist notion of originality, of the author as a creator of an entirely new meaning. The author, Barthes argued, merely recycles meanings from other sources. A text, he said "is a tissue of quotations drawn from the innumerable centers of culture" (cited in Fineberg, page 454). Levine's work seems almost to illustrate such ideas.

The straight appropriators soon ran into a legal problem. Levine's first high art reproductions were rephotographs of Edward Weston originals. When lawyers for the Weston estate threatened to sue her for infringement of copyright, she moved to the work Walker Evans produced during the 1930s for the Works Progress Administration, which has no copyright. Others faced with the possibility of legal action, especially from owners of commercial trademarks, have taken the same cautious route. What remains to be settled, then, is whether commercial copyright protections, when applied to art, constitute an infringement of freedom of speech.

1980 1940 2000 but a critique of certain ideas associated with him and with modernism. Levine's work is inspired by the deconstructionism of Jacques Derrida, in which he unravels, or "deconstructs," prevailing cultural assumptions, or "myths," by revealing them to contain self-conflicting messages. By appropriating images of men associated with originality and innovation—the viewpoint of Rodchenko's photography, for example, was considered wholly innovative—Levine intended to deconstruct those concepts and suggest that all art and thought are derivative.

Later Feminism

Because of the feminist content of much of her work, Levine may also be grouped with a second generation of feminists. These artists, who emerged in the 1980s, tended to believe in the idea that differences between the sexes are not intrinsic but fabricated, or "socially constructed," primarily by media images and other cultural forces, to suit the needs of those in power. According to this view, young people, particularly women, learn how to behave from the role models they see heralded in magazines, movies, and other sources of cultural coercion. A major task of feminism and feminist art should, therefore, be to resist the power of these forces.

Barbara Kruger (b. 1945) is an important representative of this generation. Drawing on her experience as a designer and photo editor for women's magazines, by the end of the 1970s she began creating works that combined glossy high-contrast images, usually borrowed from advertisements, and bold, easily readable, catchy texts. The purpose of such work was to undermine the media with its own devices, "to break myths," as she put it, "not to create them."

Although she has said of her work that it can be effective in questioning sexual representations, it seems at times that she expresses a sense of futility as well. In We Won't Play Nature to Your Culture (fig. 29-77), for example, the text is strong and defiant. The female voice represented by the text asserts that women will no longer accept the dichotomy—forced on them by men—between men as producers of culture and women as products of nature. In the image, however, the woman is symbolically blinded by the leaves over her eyes.

One of the most prominent of the later feminists, Cindy Sherman (b. 1954), is known for challenging and provocative photographs of herself in various assumed roles. In 1977 she began work on a series of black-and-white photographs that simulate stills from B-grade movies of the 1940s and 1950s. Each photograph from

VIDEO ART Among the many new mediums of art making created by the technology revolution in the late twentieth century, the video monitor is one of the most provocative. The video form, like film, uses a variety of approaches and styles, from raw documentary material to scripted theatrical performance, from animation to pure

Nam June Paik. *Electronic Superhighway*. 1995. Installation: multiple television monitors, laser disk images, and neon, 15 x 32' (4.57 x 9.95 m). Holly Solomon Gallery, New York Courtesy Holly Solomon Gallery, New York

abstraction. As in film, time is an element of the medium, and video art may consist of images only seconds long or be a full-length feature. A key difference is that for the video artist the monitor is itself a visible part of the artwork.

Video art may use sophisticated computer programs or a simple handheld video camera. It may include only still images or a running narrative. Originally an inexpensive alternative to film, video has its own distinctive visual qualities, often including washed-out or intense color; unlikely juxtapositions of images and scenes; jerky, staccato camera motions; rough cutting; and a sense of spontaneity and immediacy, as in home movies. The essential technical distinction between video and film is that video is based on an electronic transmission of images, while film is a sequence of translucent images, using projected light and motion.

Because video has developed in a period in which many artists are self-consciously avant-garde, video artists pay particular attention to the relationship between the imagery of popular culture (commercial television, newscasts, advertising) and the traditional arts of painting and sculpture. Video art may be distinguished from other kinds of video (a television show, for example) by its special concern with the visual values of the screen images and its critical, often ironic view of the mass-media television culture to which it refers. Video art is often political in content, and like some experimental dance and theater, it links the performing arts with the visual arts.

Video art sometimes uses monitors inserted as elements within larger sculpture or structures, such as Nam June Paik's (b. 1932) 1995 Electronic Superhighway. It may be austere and minimal, like Bruce Nauman's ethereal self-portraits, or quite ornate, as in Paik's colorful, rapidly flickering multiple patterns, which are often computer generated or manipulated. Installations may be accompanied by sound, music, or a voice-over, and some are interactive, including cameras that permit the viewer to enter the artwork by appearing on screen. Feminist artist Adrian Piper makes harsh, raw, talking heads. Some video art shows the stylized theatricality of performance art, as in the work of Matthew Barney. Alan Rath's richly humorous composite creatures have eyes and noses made from tiny, odd-shaped video screens.

29-77. Barbara Kruger. *We Won't Play Nature to Your Culture*. 1983. Photostat, red painted frame, 6'1" x 4'1" (1.85 x 1.24 m)

Courtesy Mary Boone Gallery, New York

the series, which numbered about seventy-five, shows a single female figure, always Sherman in some guise. In *Untitled Film Still* (fig. 29-78) she is dressed as a perplexed young innocent apparently recently arrived in a big city, its buildings looming threateningly behind her. The image suggests a host of films in which some such character is overwhelmed by dangerous forces, perhaps to be destroyed, or perhaps to be rescued by some hero. While Sherman's motives are complex, many observers have suggested that in these works she indicts Hollywood's stereotypical images of women and femininity by showing how one can "invent" oneself in a variety of roles.

Art and the Public

The issue of the relationship between art and the community at large, long a central concern of the modern period, took on a new prominence in the 1990s and seems destined to shape emerging styles and trends. As artists take advantage of such new mediums as video (see "Video Art," opposite), they nevertheless continue their search for a set of artistic principles to replace the old modernist ones. At the same time, their search—and their community's response to it—is resulting in many sensational controversies involving public funding, censorship, and individual rights.

29-78. Cindy Sherman. *Untitled Film Still*. 1978. Black-and-white photograph, 8 x 10" (20.3 x 25.4 cm)

Courtesy Metro Pictures, New York

In the context of feminist film criticism's emphasis on the negative impact of movie "representations," it appeared that Sherman intended to re-create such roles as part of a critical, deconstructive agenda. Sherman suggested as much when she said: "And there's always me making fun—making fun of these role models of women from my childhood. And part of it maybe is to show that . . . these actresses know what they're doing, know they are playing stereotypes—but what can they do?" (cited in Marks, page 359).

One of the least controversial public artists is Jenny Holzer (b. 1950), whose work is often grouped with that of the later feminists. In the mid-1970s Holzer took a course in the history of contemporary art at the Whitney Museum of American Art in New York City. The reading, much of it by postmodern intellectuals like those who influenced the Neo-Conceptualists, seemed to her "important and profound." She then set out to try "to translate these things into a language that was accessible. The result was the Truisms." For two years, 1977 and 1978, she rephrased the ideas from her reading as one-liners suited to the reading habits of Americans raised on advertising messages. She compiled these statements in alphabetical lists, had them printed, and plastered them all over her neighborhood. With an accumulation of remarks reflecting a variety of viewpoints and voices, such as "Any Surplus Is Immoral" and "Morality Is for Little People," she hoped to "instill some sense of tolerance in the onlookers or the reader."

Since her first posters, Holzer has moved progressively into mediums that would allow her to address an even wider audience. She turned to some of advertising's more technical tools, including electronic signage, to reach more than the proportionally small number of people who go to galleries and museums. Moreover, she preferred to use popular media devices already in place. In her

29-79. Jenny Holzer. Protect Me from What I Want, excerpt from Survival series. 1985–86. Spectacolor board, Times Square, New York Courtesy Barbara Gladstone Gallery, New York

Survival series (fig. 29-79), for example, she used the Spectacolor board in New York City's Times Square to flash a series of short, provocative messages, now in her own voice. The one illustrated here, *Protect Me from What I Want*, is a reference to the way advertising generates a desire in people for products and services they may not need.

Another, very different concept of public art emerged in the late 1980s, partly as a result of growing interest in Hispanic art, itself a response to the growing influence of multiculturalism—the recognition that American culture is a heterogeneous mix of ethnic, racial, sexual, and socioeconomic subcultures. Beginning in the 1970s, reviving a tradition started by Diego Rivera (see fig. 28–119) and other Mexican artists following the Mexican revolution in the early twentieth century, Mexican American artists, particularly in the Chicano community in East Los Angeles, began painting murals. Until the 1990s these murals were considered by art professionals a sociological, not an artistic, phenomenon.

Typical of the Chicano muralists is Wayne Alaniz Healy (b. 1949). A social activist from East Los Angeles, Healy joined Mechicano, a nonprofit art center specializing in graphics, in 1972. He had no professional training in art but had been interested in it since childhood. When members of Mechicano decided quite spontaneously to do a mural at a grocery store, Healy says he was "terminally bitten by the mural bug."

A good example of Healy's work is *Ghosts of the Barrio* (fig. 29-80), done on a housing project wall. The mural shows four *vatos locos* ("street dudes") with three ancestors: an Aztec, a Spanish conquistador, and a revolutionary soldier. According to Healy, the mural addresses the question Where do we go from here? The figures look outward for advice, thus including the viewer in the group. Healy's audience, however, is not the public at large but the local Chicano population. The work speaks to that population in its own visual language, drawn from Mexican culture. Healy is concerned not with artistic innovation but with social effectiveness.

The strategy of reaching a particular public with its own signs and symbols has also been employed by cer-

tain African American artists who, like the Chicano muralists, were until the 1980s working well outside the acknowledged art world. One African American artist, David Hammons (b. 1943), has been an outspoken critic of that art world despite its interest in him, viewing it as a system that encourages and rewards work that is "so watered down that the bourgeoisie can consume it." Art today is "like Novocain. It used to wake you up but now it puts you to sleep." Only street art, uncontaminated by commerce, he maintains, can still serve the old function.

Although Hammons sometimes addresses a broader audience, for the most part his work has been aimed at specific segments of the African American community. His best-known work is probably Higher Goals (fig. 29-81), several versions of which were made between 1982 and 1986. The one shown here, temporarily set up in a Brooklyn park, has backboards and baskets set on telephone poles—a reference to communication—that rise 40 feet into the air. The poles are decorated with bottle caps, a substitute for the cowerie shells used not only in African design but in some African cultures as money. Although the series may appear to honor the game, Hammons said it is "antibasketball sculpture." "Basketball has become a problem in the black community because kids aren't getting an education. . . . It means you should have higher goals in life than basketball."

As a result of these and many other similar examples, some of them from Europe, the international art world in the 1980s witnessed a growing commitment to the notion that art is most effective as a social tool when it avoids an institutional setting, moves to a specific community, and addresses locally important issues in straightforward language. In other words, like environmental earthworks, socially conscious art seems to function best when it is site-specific.

Following this principle, a European television company collaborated with a regional arts association to commission a series of works for economically and politically troubled places. One of Britain's leading young sculptors, Antony Gormley (b. 1950), was assigned to make a piece for a site overlooking the religiously divided

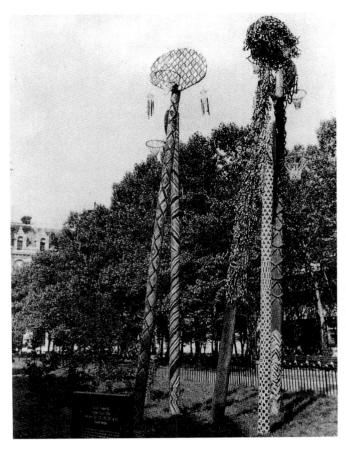

29-81. David Hammons. *Higher Goals*. 1982, shown installed in Brooklyn, New York, 1986. Poles, basketball hoops, and bottle caps, height 40' (12.19m)

Hammons likes to allow local conditions and issues to dictate the subjects and to some degree the appearance of his public sculpture. In preparation for a given piece, he goes out onto the streets to discover the local concerns. He admits that in order "to let the community speak, I have to give up my ego."

city of Derry in Northern Ireland, a region torn by civil warfare in which Protestants generally support continued union with the United Kingdom and Catholics generally oppose it. From a cast of his own body Gormley made a double image in iron of two figures with arms outstretched, facing away from each other but joined back to back (fig. 29-82). With its obvious reference to Jesus on the Cross, the work is a pointed reminder of the countless casualties on both sides—Catholic and Protestant, Irish and British—and a plea to find in shared grief a basis for reconciliation and unity. Within days the piece was vandalized with political graffiti and a burned tire was hung around its neck, a demonstration that the work had at least been understood and taken seriously.

In the late 1980s Europeans also pioneered a new kind of site-specific art exhibition, temporary pieces by several artists set up throughout a particular community, all dealing with a single relevant political or historical issue. In 1991 the directors of the Spoleto Festival U.S.A., in Charleston, South Carolina, decided to emulate this European precedent with an event called "Places with a Past." The event's curator invited eighteen artists, including Gormley and Hammons, to find sites in the city for temporary works that would provide an "intimate and meaningful exchange" with the citizens of Charleston on issues from its history.

Because Charleston had been a center for the slave trade in the South and was the place where the Civil War began, Ann Hamilton (b. 1956) originally planned to deal with the issue of slavery in her work for "Places with a Past." When she found an abandoned automobile repair shop on Pinkney Street, however, she decided to treat an aspect of American life ordinarily overlooked by most historians. The street was named for Eliza Lucas Pinkney, who in 1744 introduced the cultivation of indigo to the American colonies. Indigo produces a blue dye used for, among other things, blue-collar work clothes. Hamilton thus decided to use the garage—a blue-collar

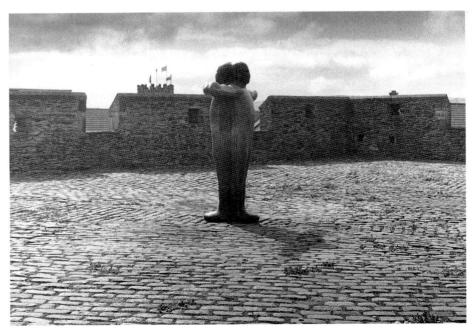

29-82. Antony Gormley.

Derry Sculpture.

1987. Cast iron,

6'5¹/₈" x 6'4" x 1'9¹/₄"

(1.96 x 1.93 x 0.54 m)

Courtesy the artist

29-83. Ann Hamilton.

Indigo Blue. 1991.

Installation for

"Places with a

Past," Spoleto

Festival U.S.A.,

Charleston,

South Carolina

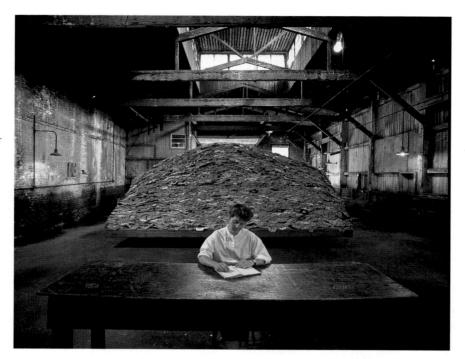

workplace—for a piece she called *Indigo Blue* (fig. 29-83). The focal point of the piece was a pile of about 48,000 neatly folded work pants and shirts. *Indigo Blue* is more a tribute to the women who washed, ironed, and folded such clothes than to the men who worked in them. The piece is meant to show respect for the labor involved in laundry. Hamilton and a few women helpers, including her mother, did all the folding and piling. In front of the great mound of shirts and pants sat a woman erasing the contents of old history books—creating page space, Hamilton claimed, for the ordinary, working-class people usually omitted from conventional histories.

The many references and meanings in Hamilton's work perhaps escaped most viewers, though its impressive visual force and moral integrity may have affected many at some level. This piece illustrates a central problem faced by artists trying to communicate to a large public: To what extent should the artist be willing to compromise artistic vision for clear communication?

"Places with a Past" was funded partly through a \$200,000 grant from the National Endowment for the Arts (NEA), an agency of the federal government established in 1965 to help support writers, dancers, artists, and the organizations that make their work available to the American public, as well as to fund community art education programs. In the spring of 1989 the NEA came under fire from members of Congress who threatened to curtail or eliminate the agency's funding because they were offended by the art of a few artists who had received direct or indirect funds from the NEA. Since then, the threat to the NEA and other arts agencies has grown, amplified by those who believe the government has no business spending tax dollars on the arts.

One of the principals who figured in this controversy was Karen Finley (b. 1956), a performance artist. Her work is raw, uninhibited, and, while it often conveys a powerful message, certainly not suited to everyone's taste. In *We Keep Our Victims Ready* (fig. 29-84), she denounces the

29-84. Karen Finley. We Keep Our Victims Ready. Performance at The Kitchen, New York, 1990

In an interview published in 1991 Finley said: "I was really upset when the NEA tried to censure my work as 'obscene,' because I think my work is extremely moral. I'm trying to speak out about sexual violence and how hateful that is, and make it *understandable*. Yet many times I'm just viewed as 'hysterical'—as a sexual deviant who's 'out of her mind.'"

29-85. Robert Mapplethorpe. *Ajitto (Back)*. 1981. Gelatinsilver print, 16 x 20" (40.6 x 50.8 cm). The Robert Mapplethorpe Foundation, New York

mistreatment of women, the homeless, and people with AIDS, alternately howling, moaning, chanting, crying, and screaming. In another performance that has particularly incensed opponents of NEA and public funding of the arts, she covers her body with chocolate syrup to make a point about the way society perceives women.

An artist whose work was at the core of the controversy over public funding was photographer Robert Mapplethorpe (1946-1989), who was openly gay. Most of the 150 photographs in his 1989–1990 touring retrospective exhibition (funded in part by an NEA grant to the show's organizing institution) consisted of classic studies of nudes and flowers. Ajitto (Back) (fig. 29-85), for example, is a fairly conventional investigation of the subtle formal nuances of the human body. Some of the photographs, however, showed homoerotic subjects and explicit sex acts. Fears of protests by some members of Congress caused the Corcoran Gallery in Washington, D.C., to cancel its plans to mount the show in 1989. The Cincinnati Contemporary Arts Center, however, presented it in 1990, putting the controversial works in their own room with a clear printed advisement. Cincinnati officials nevertheless charged the museum and its director with obscenity and put them on trial. The jury was not convinced that the photographs "lack[ed] serious literary, artistic, political, or scientific value"—one of the criteria for obscenity set by the Supreme Court in a 1973 decision-and acquitted the museum and its director. The jury had decided, as one juror commented, "we may not have liked the pictures" but they were art. "We learned," he added, "that art doesn't have to be pretty."

29-86. Richard Serra. *Tilted Arc.* 1981. Hot-rolled steel, length 120' (36.58 m). Formerly, Federal Plaza, Foley Square, New York; removed in 1989

In his 1989 article on the destruction of the work, Serra pointed out that during a three-day hearing in 1985, some 122 people spoke in favor of retaining the sculpture and only 58 spoke for removal. Moreover, the new petition for removal presented at the hearing had 3,791 signatures, which represented fewer than a quarter of the approximately 12,000 employees in the federal buildings at the site. Also, a petition with 3,763 signatures was presented against removal. He argued that the general perception that the majority of the public wanted its removal was simply untrue, a useful exaggeration for those who simply did not like the work.

Richard Serra's (b. 1939) Minimalist sculpture Tilted Arc (fig. 29-86) figured in a different controversy involving art and the public. In this case the issue was the artist's right to control what happens to a work commissioned or purchased for that public. Tilted Arc, a steel wall 12 feet high and 120 feet long that tilts 1 foot off its vertical axis, was commissioned for the plaza of a government building complex in New York City on the recommendation of an artists' panel appointed by the NEA. Typical of Serra's work, it was strong, simple, tough, and given its tilt, quite threatening. Some employees in the building found the work objectionable. Calling it an "ugly rusted steel wall" that "rendered useless" their "once beautiful plaza," they petitioned to have it removed. The government agreed to do so, but Serra went to court to preserve his work. He eventually lost his case, and the sculpture was removed in 1989.

29-87. Maya Ying Lin. Vietnam Veterans Memorial. 1982. Black granite, length 500' (152 m). The Mall, Washington, D.C.

The Vietnam Veterans Memorial (fig. 29-87), now widely admired as a fitting and moving testament to the Americans who died in that conflict, was also a subject of public controversy when it was first proposed. In its request for proposals for the design of the monument, the Vietnam Veterans Memorial Fund—composed primarily of veterans themselves—stipulated that the memorial be without political or military content, that it be reflective in character, that it harmonize with its surroundings, and that it include the names of the more than 58,000 dead and missing. In 1981 they awarded the commission to Maya Ying Lin (b. 1960), then an undergraduate in the architecture department at Yale University. Her Minimalist-inspired design called for two 200-foot-long walls (later expanded to almost 250 feet) of polished black granite, to be set into a gradual rise in Constitution Gardens on the Mall in Washington, D.C., meeting at a 136-degree angle at the point where the walls and slope would be at their full 10-foot height. The names of the dead, arranged chronologically in the order in which they died, were to be incised in the stone, with only the dates of the first and last deaths, 1959 and 1975, to be recorded.

While construction was under way, several veterans groups—who had provided much of the approximately \$8 million for the project and who originally had supported the Lin proposal—asked that a realistic 8-foot sculpture of three soldiers on patrol be added toward the **apex** of the memorial and that a 50-foot flagpole be raised some dis-

tance behind. The veterans felt that in this way the survivors, too, would be honored at the site. After much negotiation between the concerned parties, a compromise was worked out whereby the additions would be made farther from the Lin design, at one entrance to the memorial grounds.

The additions as originally proposed would have fatally compromised the simple power of Lin's design. To visitors, the memorial has turned out to be one of the most compelling monuments in the United States, largely because it creates an understated encounter between the living, reflected in the mirrorlike polished granite, and the dead, whose names are etched in its black, inorganic permanence. Quiet and solemn, the work allows visitors the opportunity for individual contemplation. Adding significantly to the memorial's intrinsic power are the many individual mementos, from flowers to items of personal clothing, that have been left below the names of loved ones by friends and relatives.

Art and Craft

Since the Renaissance, Western artists, critics, and art historians have generally maintained a distinction between the so-called high or fine arts—painting, sculpture, and architecture—and the so-called minor arts— such as printmaking, the decorative arts, pottery, and folk art. (A further distinction, although rarely stated, has been

29-88. Peter Voulkos. *29, Sculpture, 5000 Feet.* 1958. Fired clay, including base 45¹/₂ x 21¹³/₁₆" (115.57 x 55.62 cm). Los Angeles County Museum of Art Purchase award, 1958 (Annual Exhibition of Artists of Los Angeles and Vicinity)

observed during the modern period between certain kinds of painting, sculpture, and architecture considered to be the mainstream and others outside it and therefore of less significance.) In recent years, however, the notion that one medium is intrinsically superior to another, like the idea of the mainstream, has come under scrutiny.

Peter Voulkos (b. 1924) is one of many artists who have helped overcome long-standing hierarchical distinctions between art and craft. (Another is glass artist Dale Chihuly; see fig. 13, page 22.) Voulkos was trained as a potter at the California College of Arts and Crafts. His career changed direction when he came under the influence of the gestural painters he met on a visit to New York City in 1953. Inspired by their example, as well as by Picasso's ceramic works, he advocated to his students at the Otis Art Institute in Los Angeles that they freely adapt long-established ceramic traditions to self-expressive ends. By the late 1950s he had moved away from the pot form entirely and was making large sculptural works.

One such piece, *29, Sculpture, 5000 Feet* (fig. 29-88), was assembled from fired-clay pieces, covered with black iron **slip** wash, and then **glazed**. Inspired by Cubist sculpture and painting (see fig. 28-42), as well as by the improvisational jazz he loved to listen to, play, and compose, Voulkos combined the formal elements of the sculpture in a "musical" arrangement of free-form shapes.

In 1959 Voulkos left Otis to teach at the University of California at Berkeley, where Robert Arneson (1930–

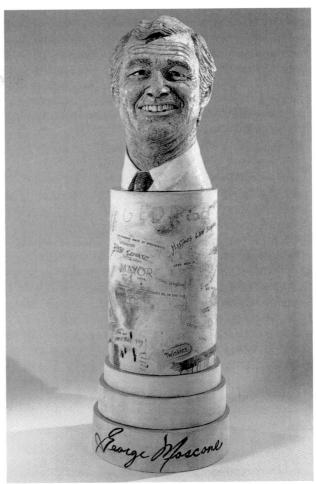

29-89. Robert Arneson. *Portrait of George*. 1981. Glazed ceramic, height 8' (2.44 m). Collection Foster Goldstrom

Courtesy Estate of Robert Arneson

1992), then a conventional potter, became his unofficial student. Under Voulkos's influence Arneson also began experimenting with a more innovative approach to his medium. In 1961, while demonstrating pottery techniques at the California State Fair, he made a sturdy bottle of about quart size, carefully sealed it with a clay bottle cap, and stamped it "No Return." This piece, which provoked the irritation of local critics, was simply the beginning of a series of increasingly uninhibited works that included his John series of toilets—reminiscent of Marcel Duchamp's *Fountain* (see fig. 28-1)—impertinent remakes of famous paintings, and portraits of political figures.

Portrait of George (fig. 29-89) depicts the former San Francisco mayor George Moscone, who with the first openly gay city supervisor, Harvey Milk, was assassinated in 1978 by Dan White, a former city supervisor. Commissioned for San Francisco's new Moscone Center, Arneson's work was considered too irreverent for public display, placed in storage, and later sold to a private collector. The column that supports Moscone's smiling face is adorned with graffiti-like writing that gives details of his education and career and the facts surrounding his assassination. The Hostess Twinkies wrapper near the

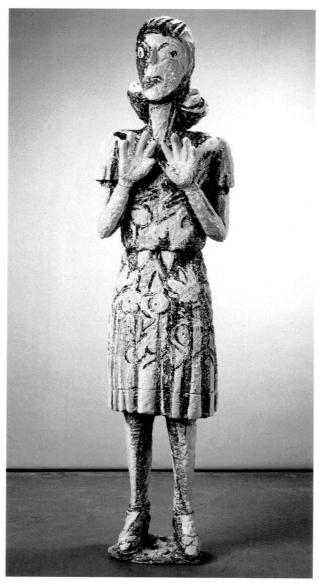

29-90. Viola Frey. Woman in Blue and Yellow II. 1983. Ceramic, 8'8" x 2'2¹/2" x 1'5" (2.64 x 0.67 x 0.43 m) Courtesy Rena Bransten Gallery, San Francisco

base refers to what has come to be known as the Twinkies defense, the claim that White killed Moscone and Milk while temporarily insane from eating too much junk food. The defense was successful enough that the jury sentenced White to only eight years in prison.

While the controversy over his portrait of Moscone was raging in San Francisco, another involving Arneson was brewing in New York City as a result of an innovative event at the Whitney Museum: an exhibit of six West Coast ceramicists, including Voulkos and Arneson. The first exhibition of its kind in a major New York museum, it appeared to signal the art world's acceptance of ceramics as a legitimate medium for high art.

The show was criticized, however, because it included no women. In response the Whitney organized an exhibition of the work of Viola Frey (b. 1933), another San Francisco Bay Area ceramicist. Inspired by Pop art and Arneson's iconoclasm, in the 1960s Frey began to make

large-scale works based on the cheap ceramic figurines found in variety stores and flea markets, which reminded her of her childhood. "I decided," she said, "to make them big—take them out of the crib and off the coffee tables, make them myths of childhood." The culmination of this process was the series of 7- to 10-foot figures of women and men that she produced in the late 1970s and 1980s.

The men in this series often appear angry and disapproving, the women either reassuring or fearful. The startled woman in *Woman in Blue and Yellow II* (fig. 29-90), for example, raises her hands protectively. The scale—which makes adults, including the artist, feel like children—and the 1940s-style clothing suggest that the artist has represented figures and events from her own childhood. By presenting these generalized but often dark events in the beguiling guise of figurines, Frey demonstrates what she sees as the function of figurines: "to make acceptable those things [we find] unacceptable."

The sculptural works of Voulkos, Arneson, and Frey helped ceramics gain acceptance as a high art medium, but they left intact the distinction between sculpture as art and pottery as craft. The hierarchy of materials had been challenged, but the hierarchy of the arts was still secure. During the 1970s and 1980s, however, a number of critics began to ask why a ceramic pot should not be considered as valuable as a ceramic sculpture. Many of these critics, such as John Perreault, came to question the dogmas of their art historical training as a result of their experience with the new importance given certain craft forms by 1970s feminists (see figs. 29-62, 29-63).

Although critics and historians such as Perreault are still in the minority, they seem to be getting a hearing, partly because of the high quality of the artwork they have attempted to bring to public notice. One of the craft artists who received considerable attention in the 1990s is Pueblo potter Lucy M. Lewis (c. 1900-1992). A member of the Acoma Pueblo people, Lewis grew up near Albuquerque, New Mexico, and learned to make pottery in the traditional manner from her great-aunt. Acoma pottery is based on that of the Anasazi people (Chapter 23), believed to be their ancestors. The Anasazi explored with great ingenuity and finesse a basic format of black paint on a white ground. The early potters who inherited this tradition quickly transformed it into a less austere and more polychromatic one, adding a greater repertoire of figures to the largely geometric patterns of the Anasazi. Although much of Lewis's work, especially when she was young, was in the traditional orange, brown, and black bird-and-flower patterns, she also revived the austere geometric style of her earlier ancestors, as in Black on White Jar with Lightning Pattern (fig. 29-91). The "fine-line decoration" here is Lewis's own invention, inspired by ancient shards but not a copy of them. Like other Native American artists, Pueblo potters such as Lewis seek personal solutions within the confines of tradition.

Continuity versus Change

The growing interest in works by artists such as Lewis has been fed by a number of extra-aesthetic factors: the

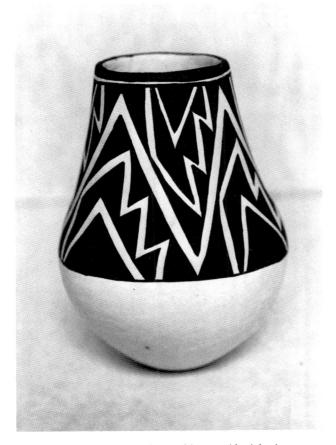

29-91. Lucy M. Lewis. *Black on White Jar with Lightning Pattern*. c. 1970–80. Earthenware, height 5" (12.7 cm), diameter 4" (10.1 cm)

Courtesy Adobe Gallery, Albuquerque, New Mexico

The Lewis heritage is being maintained, in particular, in the work of two of her sons, Ivan and Andrew, and three of her daughters, Emma, Dolores, and Belle.

fear that traditional methods are fast disappearing; the conviction that art should be an affordable part of daily life, not a luxury item set apart in a gallery or museum; and, not least of all, the psychological appeal that traditional art forms have in an era of rapid, uncertain change. Lewis's pottery, for example, presents a reassuring image of uninterrupted continuity.

A concern for continuity can also be seen in the 1980s work of a number of painters and sculptors, among them the African American sculptor Martin Puryear (b. 1941). While in the Peace Corps in Sierra Leone on the west coast of Africa, Puryear studied the traditional, preindustrial woodworking methods of local carpenters and artisans. In 1966 he moved to Stockholm, Sweden, to learn the techniques of Scandinavian cabinetmakers. Two years later he began graduate studies in sculpture at Yale, where he encountered the work of a number of visiting Minimalist sculptors, including Serra (see fig. 29-86). By the middle of the 1970s he had combined these formative influences into a distinctive personal style reminiscent, in its organic simplicity, of Constantin Brancusi (see fig. 28-10).

Typical of Puryear's mature work is *Empire's Lurch* (fig. 29-92). This simple, dark green form of carefully fit-

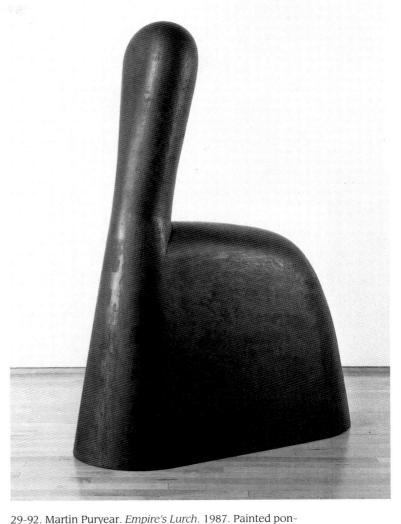

derosa pine, 6'3" x 4' x 2'11/2" (1.91 x 1.22 x 0.65 m).
Private collection, New York
Courtesy McKee Gallery, New York
In the same year that he made this work, Puryear said:
"I think all my work has an element of escape. . . . The materials tend to be natural; I don't have a lot of feeling for materials that are highly processed and industrialized. But I am a city person, and perhaps because

I am, an urge for the country comes out."

ted pieces of ponderosa pine conveys a sense of continuity with both the natural world and the art of the past. Its indefinite organic shape suggests both the body and neck of an animal and a plant bursting through the soil. Although it reflects Brancusi's influence in its organic simplicity and soothing textures and contours, unlike his work it has no clear referent. Brancusi always began with a clear theme, but Puryear discovers his final product in the process of making it. Sounding like an early-twentieth-century modernist, Puryear has said, "The task of any artist is to discover his own individuality at its deepest."

Another contemporary artist who would rather work

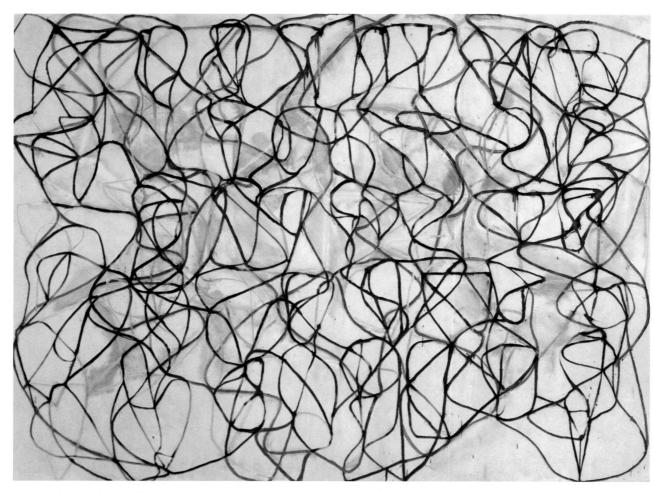

29-93. Brice Marden. *Cold Mountain 3*. 1988–91. Oil on linen, 9 x 12' (2.74 x 3.66 m). Collection John and Frances Bowes, San Francisco

Courtesy Mary Boone Gallery, New York

within and deepen the artistic traditions of the past than break with them is the painter Brice Marden (b. 1938). A 1963 graduate of the Yale School of Art, he became an important Minimalist, specializing in one-color paintings, usually gray. From these monochromes he moved on in the 1970s to paintings that featured a subtle dialogue between blocks of subdued color. Increasingly interested in Asian art and philosophy, in the mid-1980s Marden started making calligraphic drawings using twigs of ailanthus wood, known to the Chinese as the tree of heaven. From these drawings came a series of large paintings (fig. 29-93) dedicated to Cold Mountain, an eighth-century Chinese poet who quit the imperial court, retired to a mountain community of Buddhist monks, and wrote short, simple, and beautifully penned verses declaring his independence from the material "world of dust." Marden's allegiance to that philosophical stance is embodied by his painting style, which combines the delicate nuances and slower rhythms of classic Chinese calligraphy with the monumental scale and looser tracery of Pollock. Marden thus aligns himself with the modernist view of art as a transcendent and spiritually nourishing form of expression. Like Puryear's and Lewis's, his work suggests that innovation need not come at the cost of either disruption or interruption.

The continuing vitality of the contrary view—that avant-garde art should be shockingly new and different can be seen in the work of the itinerant German artist Rebecca Horn (b. 1944). Raised in post-World War II Berlin, Horn now divides her time between Hamburg and New York City. In 1968, after a near-fatal asphyxiation from polyester resin fumes, she turned from conventional sculpture to mysterious and ritualistic performances focused on the human body. These works gave way in the late 1970s to a dual focus on fictional films and kinetic installations such as High Moon (fig. 29-94), which apparently refers to the concluding shootout in the classic Western film High Noon. The machines in these installations are human substitutes, or "Melancholic actors," as Horn called them in an interview. Of High Moon, Horn said: "In it, two Winchester rifles hanging at about the height of a person's heart move in the gallery space. First, they focus on the people coming into the gallery. Then, they move until they face each other. Finally, they shoot red liquid [fed by tubes from two glass funnels]. I've always wanted to make two rival guns shoot each other with bullets that melt, like a kiss of death." The result is a bloody-looking pool that spills out onto the gallery floor, making it look like a crime scene. Even Horn isn't sure what the work means. "There is never a story per se," she admits. "I sim-

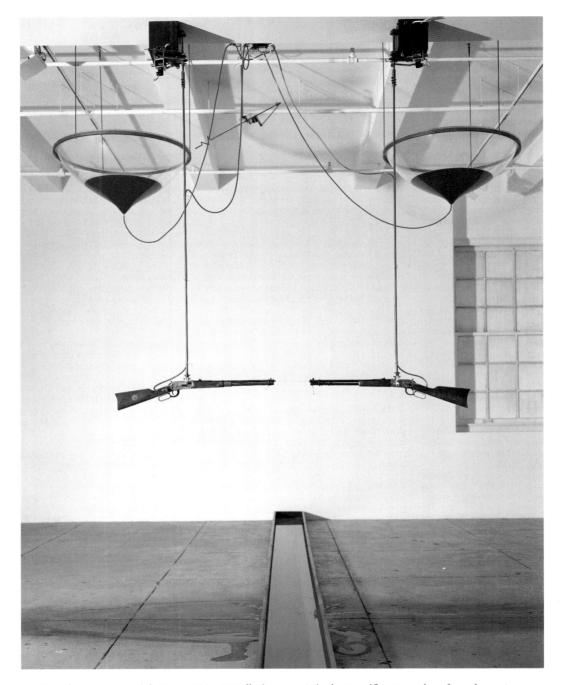

29-94. Rebecca Horn. High Moon. 1991. Installation: two Winchester rifles, two glass funnels, motor, metal, water, and dye, dimensions variable Courtesy Marian Goodman Gallery, New York

ply allow the consequences of whatever the machine is doing to meet with the particular reality or mood each person brings to it." Whatever interpretation one chooses, *High Moon*'s subtle interweaving of contrasting elements—male and female, human and machine, danger and pleasure, life and death—is unsettling.

The contrast between the soothing art of Puryear and Marden and the challenging art of Horn is hardly new. Since the Renaissance, at least, the history of art has involved just this debate over the function of art. Some artists have sought to comfort us, others to unsettle us. Both of these positions demonstrate the continuing relevance of art to our lives. The case for art and the artist

was eloquently made at a congressional subcommittee hearing by Robert Motherwell (1915–1991), a major New York School painter:

Most people ignorantly suppose that artists are the decorators of our human existence, the esthetes to whom the cultivated may turn when the real business of the day is done. But actually what an artist is, is a person skilled in expressing human feeling. . . . Far from being merely decorative, the artist's awareness . . . is one . . . of the few guardians of the inherent sanity and equilibrium of the human spirit that we have.

Glossary

abacus The flat, usually square slab placed on top of a **capital**, directly underneath the **entablature**.

absolute dating A method of assigning a precise historical date to ancient periods and objects previously dated only by **relative dating**. Based on known and recorded events in the region as well as technically extracted physical evidence (such as carbon-14 disintegration). *See also* **radiometric dating**.

abstract, abstraction Any art that does not represent observable aspects of nature or transforms visible forms into a pattern resembling something other than the original model. Also: the formal qualities of this process.

academy, academician An academy is an institutional group established for the training of artists. Most academies date from the Renaissance and after, and they were particularly powerful state-run institutions in the seventeenth and eighteenth centuries. In general, academies replaced the guilds as the venue where students learned the craft of art and were also provided with a complete education, including art theory and artistic rules. The academies helped artists be seen as trained specialists, rather than craftspeople, and promoted the change in the social status of the artist. An academician is an official academy-trained artist, whose work conforms to the accepted style of the day.

acanthus A leaflike architectural ornamentation used in the **Corinthian** and **Composite orders**, based on the forms of a Mediterranean plant.

acropolis In general, the citadel of an ancient Greek city, located at its highest point and consisting of grouped temples, a treasury, and sometimes a royal palace. Specifically, the Acropolis refers to this structure as it is found in Athens, where the ruins of the Parthenon and other famous temples can be found.

acrylic A synthetic paint popular since the 1950s, which has a very fast drying time.

adobe Sun-baked building material made of clay mixed with straw. Also: the buildings made with this material

adyton The innermost **sanctuary** of a Greek temple. If a temple with an **oracle**, the place where the oracles were delivered. More generally, a very private space or room.

aedicula (aediculae) A type of decorative architectural frame, usually found around a niche, door, or window. An aedicula is made up of a pediment and entablature supported by columns, pilasters, or piers.

aesthetics The philosophic theories relating to the concept of beauty in art and, by extension, to the history of art appreciation and taste.

agora An open space in a Greek town used as a central gathering place or market. In Roman times, called a **forum**.

album A book consisting of blank pages (leaves) on which typically an artist may sketch, draw, or paint

album leaves See album.

alignment In prehistoric architecture, an arrangement of **menhirs** in straight rows.

allegory The representation in a work of art of an

abstract concept or idea using specific objects or human figures.

altar A place, invariably raised, where religious rites are performed. In Christian churches, the altar is the site of the **Eucharist**.

altarpiece A painted or carved **panel** or winged structure placed at the back of or behind an **altar**. Contains religious imagery, often specific to the place of worship for which it was made.

amalaka In Hindu architecture, the circular or square-shaped element on top of a **shikhara**, often crowned with a **finial**, symbolizing the cosmos.

ambulatory The passage or aisle that leads around the **apse** of a Christian church. Developed for use in pilgrimage churches, an ambulatory usually allows general passage from the **nave** around the east end of a church without giving access to the restricted areas of the **choir** and **altar**.

amphiprostyle Term describing a building, usually a temple, with **porticoes** at each end but without **columns** along the other two sides.

amphora An ancient Greek jar for storing oil or wine, with an egg-shaped body and two curved handles

Andachtsbild (Andachtsbilder) Literally "devotional image," a painting or sculpture that expressionistically depicts themes of Christian grief and suffering, such as the pietà. Popular in Germanspeaking areas beginning in the late thirteenth century.

aniconic A term describing a representation without images of human figures, often found in Islamic cultures.

animal interlace Decoration made up of interwoven animal-like forms, often found in Celtic and northern European art of the medieval period.

animal style A type of artistic design popular in Europe and western Asia during the ancient and medieval periods, characterized by linear, animal-like forms arranged in intricate patterns. The style is often used on metalwork or other precious materials.

ankh A **hieroglyph** signifying life, used by ancient Egyptians.

anta (antae) A rectangular pier or pilaster found at the ends of the framing walls of a recessed portico.

antependium (antependia) The front panel of a **mensa**.

anticlassical A term designating any image, idea, or style that opposes the classical norm propounded by classicism.

apex A peak or top point.

apotheosis Religious glorification or deification of an individual. In painting, often shown as an ascent to Heaven, borne by angels or **putti**.

appliqué A piece of any material applied as a decorative **motif** onto another.

apprentice A student of art or artist in training. In a system of artistic training established under the **guilds** and still in use today, master artists took on an apprentice (who usually lived with the master's family) for several years. The apprentice

was taught every aspect of the artist's craft, and he or she participated in the workings of the master's workshop or atelier.

appropriation Term used to describe an artist's practice of borrowing from an external source for a new work of art. While in previous centuries artists often copied one another's figures, motifs, or compositions, in modern times the sources for appropriation extend from material culture to wholesale lifting of others' works of art.

apse, apsidal A large semicircular or polygonal (and usually vaulted) niche protruding from the end wall of an axial building. Also: the eastern end of a Christian church, containing the altar. Apsidal is an adjective describing the condition of having a semicircular or polygonal space within a building.

aquamanile A vessel used for washing hands, whether during the celebration of the Catholic Mass or before eating at a secular table. An aquamanile is often formed in the shape of a human figure or a grotesque animal.

aquatint A type of intaglio printmaking developed in the eighteenth century that produces an area of even tone without laborious cross-hatching. Basically similar in technique to an etching, the aquatint is made through use of a porous resin coating of a metal plate, which when immersed in acid allows an even, all-over biting of the plate. When printed, the end result has a granular, textural effect.

aqueduct A trough to carry flowing water. Under the Romans, built over long distances at a gradually decreasing incline.

arabesque A type of **linear** surface decoration based on organic forms, usually characterized by flowing lines and swirling shapes.

arcade A series of arches, carried by columns or piers and supporting a common wall. In a blind arcade, the arches and supports are engaged (attached to the background wall) and have a decorative function.

arch In architecture, a curved structural element that spans an open space. Built from wedgeshaped stone blocks called voussoirs, which, when placed together and held at the top by an oblong keystone, form an effective weightbearing unit. Requires support at either side to contain outward thrust of structure. Found in a variety of shapes and sizes, depending upon style of period. Corbel arch: an arch over an open space created by the layering of corbels and finished with a capstone. Horseshoe arch: an arch with a rounded horseshoe shape; the standard arch form in western Islamic architecture. Ogival arch: a pointed arch created by S curves; a popular arch form in Islamic architecture. Relieving arch: an arch built into a heavy wall just above a post-and-lintel structure (such as a gate, door, or window) to help support the wall above. Relieves some of the weight on the lintel by transferring the load to the side walls.

Archaic smile The fixed expression of an ancient Greek statue, usually interpreted as a half smile.

architectonic Resembling or relating to the spatial or structural aspects of architecture.

architectural interior A subject in genre painting particularly popular in Holland in the seventeenth century, depicting the interiors of churches and other important civic buildings, usually with small figures going about ordinary activities.

architrave The bottom layer of an **entablature**, beneath the **frieze** and the **cornice**. More generally, the frame surrounding a door or window.

archivolt One of several continuous decorative bands or **moldings** on the face of an **arch**, across the **voussoirs**.

ashlar See dressed stone.

assemblage An artwork created by gathering together and manipulating found objects and other three-dimensional items. The technique of assemblage was especially popular in the first half of the twentieth century.

astragal A thin convex decorative **molding**, often found on **Classical entablatures**, and usually decorated with a continuous row of beadlike circles.

atelier The studio or workshop of a master artist or craftsperson, usually consisting of junior associates and **apprentices**.

atmospheric perspective See perspective.

atrial cross The cross placed in the atrium of a church. In Colonial America, used as a marker of a gathering and teaching place. Atrial crosses were often carved by native sculptors in local styles.

atrium An interior courtyard or room built with an opening in the roof, usually over a pool or garden. Most often found in Roman domestic buildings. Also: the vestibule of an Early Christian **basilica-plan** church, usually roofed.

attached column See column.

attic The portion of a Classical temple or facade above the entablature and below the crowning element (such as a roof or pediment).

attic story The top level or division of a building. In Greek architecture, the (often highly decorated) level found above the **entablature**.

attribute The symbolic object or objects that identify a particular deity or saint in art.

automatism A technique whereby the usual intellectual control of the artist over his or her brush or pencil is foregone. The artist's aim is to allow the subconscious to create the artwork without rational interference. Also called automatic writing, automatism was developed by the Surrealists in the 1910s, and it was influential for later movements such as Abstract Expressionism

avant-garde A term derived from the French word meaning "before the group" or "vanguard." Avant-garde denotes those artists or concepts of a strikingly new, experimental, or radical nature for the time.

axial Term used to describe a **plan** or design that is based on a symmetrical, **linear** arrangement of elements.

axis mundi A Buddhist concept of an axis of the world, which denotes important sacred sites and provides a link between the human and celestial realms. In Buddhist art, the axis mundi can be marked by monumental freestanding decorated pillars.

axonometric projection A type of building diagram that represents graphically all the parts of a building. Axonometric projections use an established vertical axis, from which the vertical lines are drawn, while the horizontal lines are drawn at unequal angles to the base horizontal axis.

background Within the depicted space of an artwork, the area of the image at the greatest distance from the **picture plane**.

backstrap loom A type of loom common among the indigenous peoples of Asia and the Americas in which the warp threads are wound between two bars, one attached to an object such as a pole or tree and the other to the weaver's waist. Also called a body-tensioned loom.

bailey The outermost walled courtyard of castle fortifications. Usually the first line of defense, the bailey was bounded on the outer side by a defensive wall such as a palisade.

baldachin A canopy (whether suspended from the ceiling, projecting from a wall, or supported by **columns**) placed over an honorific or sacred space such as a throne or church **altar**.

balustrade A series of short circular posts (called balusters), with a rail on top. Sometimes balusters are replaced by decorated panels or ironwork under the rail.

baptismal font A large open vessel, usually made of stone, containing water for the Christian ritual of baptism.

baptistry A building used for the Christian ritual of baptism. It is usually separate from the main church and often octagonal or circular in shape.

barbican A defensive structure located at the gate to a city or castle. Found close to (or sometimes attached to) the exterior wall, a barbican is usually heavily fortified for the use of guards.

bargeboard A wooden board, often carved in a decorative manner, affixed to the apex of a roof gable to conceal or protect the end of a roof timber.

barrel vault See vault.

bar tracery See tracery.

base A slab of masonry supporting a statue or the **shaft** of a **column** (also called a **plinth**).

basilica A large rectangular building with an open interior space. Often built with a clerestory and side aisles separated from the center space by colonnades. Used in Roman times as centers for administration or justice and later adapted to the Christian church. A basilica-plan structure incorporates the essential elements of this plan.

basilica plan See basilica.

bas-relief See relief sculpture.

battered A building technique used in the construction of stone walls without mortar. For stability, a battered wall is built with a distinct inward slope at the top.

battlement The uppermost, fortified sections of a building or **parapet**, used for military purposes, usually including **crenellated** walls and other defensive structures.

bay One segment of a decorative system of a building. The bays divide the space of a building into regular spatial units and are usually marked by elements such as columns, piers, buttresses, windows, or vaults.

beadwork Any decorative elements created with beads. Also: a type of **molding** made from convex circles, often found on furniture.

beehive tomb A type of aboveground burial place

marked by an earthen mound with a rounded, conical shape like a beehive.

Benday dots In modern printing and typesetting, the individual dots which, together with many others, make up lettering and images. Often machine- or computer-generated, the dots are very small and closely spaced to give the effect of density and richness of tone.

bevel, beveling A cut made at any angle except a right angle. Also: the technique of cutting at a slant, which creates shadows. Used in architecture, carpentry, printmaking, metalwork, and sculpture.

bi A jade disk with a hole in the center used in China for the ritual worship of the sky. Also: a badge indicating noble rank.

black-figure A decorative style of ancient Greek pottery in which black figures are painted on a red clay background.

blackware An ancient ceramic technique that produced pottery with a primarily black surface. As rediscovered and adapted by Maria Montoya Martinez, a Native American potter in the United States, blackware exhibits alternating **matte** and glossy patterns on the black surfaces of the objects.

blind arcade See arcade.

blind window The outlining elements of a window applied to a solid wall, often to help create symmetry on a **facade**, but without the actual window opening.

block book A book printed from carved blocks. Common in medieval times, block books were superseded by the invention, about 1450, of printing from movable type. See also movable-type printing, woodblock print.

block printing A printed image, such as a **wood-cut** or wood **engraving**, made from a carved wooden block.

bobbin A cylindrical reel around which a material such as yarn or thread is wound when spinning, sewing, or weaving.

bodhisattva A deity that is far advanced in the long process of transforming itself into a buddha. While seeking enlightenment or emancipation from this world (nirvana), bodhisattvas help others attain salvation.

boiserie Wood paneling or wainscoting, usually applied to seventeenth- and eighteenth-century French interiors, where it was often decorated with painting and **relief carving**.

boss A decorative knoblike element. Bosses can be found many places, such as at the intersection of Gothic ceiling or vault ribs (and, similarly, at the end of a molding) and as buttonlike projections in medieval decorations and metalwork. Also: the projecting ornamental element at the top of a Corinthian capital, placed directly underneath the entablature.

bracket, bracketing An architectural element that projects from a wall, and that often helps support a horizontal part of a building, such as beams or the eaves of a roof.

breakfast piece A painting depicting a still life of plates and food, usually shown in a post-eating disarray. The breakfast piece was popular in Dutch seventeenth-century painting and may have had a *vanitas* significance.

broken pediment See pediment.

bronze A metal made from copper alloy, usually

mixed with tin. Also: any sculpture or object made from this substance.

bulwark A raised promontory built for the purposes of defense.

buon fresco See fresco.

burin A metal instrument used in the making of **engravings** to cut lines into the metal plate. The sharp end of the burin is trimmed to give a diamond-shaped cutting point, while the other end is finished with a wooden handle that fits into the engraver's palm.

bust A portrait sculpture depicting only the head and shoulders of the subject.

buttress, buttressing A type of architectural support. Usually consists of a masonry pillar with a wide base built against an exterior wall to brace the wall and strengthen vaults. Acts by transferring the weight of the building from a higher point to the ground. Flying buttress: An arch built on the exterior of a building that transfers the thrust of the roof vaults at important stress points through the wall to a detached buttress pier.

cabinet piece A term often applied to seventeenth-century Dutch art, meaning a small-scale painting executed with a luscious surface and finest detail. The cabinet piece carries the associations of a precious object meant for close scrutiny and leisured appreciation.

caduceus In Classical mythology, the staff carried by the god Hermes. It possessed various powers, including the guarantee of safe passage by any messenger. The caduceus is shaped like a wand with two wings at the top and snakes intertwined around the shaft.

cairn A pile of stones or earth and stones that served both as a prehistoric burial site and as a marker of underground tombs.

calligraph A form of writing with pictures, as in the Chinese language.

calligraphy The art of highly ornamental handwriting.

calotype The first photographic process utilizing negatives and paper positives. It was invented by William Henry Fox Talbot in the late 1830s.

calyx krater See krater.

came (cames) A lead strip used in the making of leaded or stained-glass windows. Cames have an indented vertical groove on the sides into which the separate pieces of glass are fitted to hold the design together.

cameo A gemstone (or, alternatively, a **medium** such as clay, glass, or a shell) carved in low **relief**.

camera obscura An early cameralike device used in the Renaissance and later for capturing images of nature. Made from a dark box (or room) with a hole in one side (sometimes fitted with a lens), the camera obscura operates when bright light shines through the hole, casting an image of an object outside onto the inside wall of the box. This image then can be traced.

campanile The campanile, from the Italian word meaning "bell tower," is usually a freestanding structure found near a church entrance.

canon of proportions A set of ideal mathematical ratios in art, especially sculpture, originally applied by the Egyptians and later the ancient Greeks to measure the various parts of the human

body in relation to each other.

capital The sculpted block which tops a classical column. According to the conventions of the orders, capitals include different decorative elements. For example, a Composite capital is one in which the elements from Ionic and Corinthian orders are mixed.

capriccio A painting or print of a fantastic, imaginary landscape, usually with architecture.

capstone The final, topmost stone in a **corbel arch** or **vault**, which joins the sides and completes the structure.

Caravaggism A style of painting based on the example of the Italian seventeenth-century painter Michelangelo da Caravaggio and popular throughout Europe around 1600–1620. Caravaggist painters are marked by, among other elements, the use of half-length figures, strong chiaroscuro, and lower-class types for subjects.

caricature An artwork that exaggerates a person's features or individual peculiarities, usually with humorous or satirical intent.

Caroline minuscule The clear and legible script developed in Carolingian times, using spaces between words and large initials at the beginning of sections of text.

cartoon A full-scale drawing used to transfer the outline of a design onto a surface to be painted (such as a wall, canvas, or **panel**).

cartouche A frame for a hieroglyphic inscription formed by a rope design surrounding an oval space. Used to signify a sacred or honored name. Also: in architecture, a decorative device or plaque, usually with plain center and rolled or sculpted edges, used for inscriptions or epitaphs.

caryatid A **column** that supports an **entablature** and that is carved into a sculpture of a draped female figure.

catacomb An underground system of tunnels used by the Romans for burial; also called a hypogeum. Urns and busts of the dead were placed in niches along the tunnels, which crisscrossed the area under an existing cemetery and often incorporated rooms (cubiculae) and several different levels.

cella The principal interior structure at the center of a Greek or Roman temple within which the cult statue was usually housed. Also called the **naos**.

cenotaph A funerary monument commemorating an individual or group buried elsewhere.

centaur In Greek mythology, a creature with the head, arms, and torso of a man and the legs and lower body of a horse.

centering The wooden scaffolding and supports erected in the construction of **vaults**, **arches**, or **domes**. The centering is a temporary structure, which supports the vault or arch until the mortar is fully dried and the arch is self-sustaining.

central-plan building Any structure designed with a primary central space surrounded by symmetrical areas on each side. Also called a **Greek-cross plan**.

Chacmool In Mayan sculpture, a half-reclining figure, often on a **monumental** scale and carved in a block style. Probably representing fallen warriors, or used for particular religious rites, such Chacmools can be found at Chichen Itza.

chaitya A type of Buddhist temple found in India.

Built in the form of a hall or **basilica**, a chaitya hall is highly decorated with sculpture, and usually carved from a cave or natural rock location. It houses the sacred shrine or **stupa** for worship.

chamfer The slanted surface produced when an angle is trimmed or **beveled**, common in building and metalwork.

château (châteaux) The country house or castle of a French aristocrat. Usually built on a grand scale, châteaux are luxurious homes intended for an elegant lifestyle (although many do incorporate defensive fortifications such as **moats** and towers).

chattri (chattra) A decorative pavilion with an umbrella-shaped **dome** common in Indian architecture.

cherub (cherubim) In painting, the head of an angelic child with wings. Also: in general, any angelic small child, usually depicted naked and with wings.

chevet The easternmost end of a church, including all sections east of the **crossing** (such as the **apse**, **ambulatory**, and any radiating apsidal chapels).

 $\begin{tabular}{ll} \begin{tabular}{ll} \beg$

chiaroscuro An Italian word designating the relative contrast of dark and light in a painting, drawing, or print. Artists use **chiaroscuro** to create spatial depth and volumetric forms through slight gradations in the intensity of light and shadow.

chinoiserie The imitation of Chinese art and style common in the eighteenth century, and related to the lighthearted art of the Rococo period.

chip carving A type of decorative incision, usually made with a knife or chisel, characterized by small geometric patterns and often found on furniture.

chiton A thin sleeveless garment, held in place at waist and shoulders, worn as a gown by men and women in ancient Greece.

choir The section of a church, usually between the **crossing** and the **apse**, where the clergy presides and singers perform.

chromolithography A type of **lithographic** process utilizing color. A new stone is made for each color, and all are printed onto the same piece of paper to create a single, colorful lithographic image.

chronophotography In the mid-nineteenth century, the development of the camera to the point where quick shutter speeds allowed the freezing of motion enabled photographers to use multiple-exposure photographs to analyze movement. Chronophotographs, such as those by Eadward Muybridge, showed the subject against a black background performing a particular action, each frame depicting a different moment in the movement.

Churrigueresque A showy, painterly style of Baroque architecture and ornament seen in Spain, Portugal, and Central America, named after the Spanish architect José Benito de Churriguera (1665–1725).

ciborium An honorific pavilion erected in Christian churches to mark places of particularly sacred significance, such as an **altar**. The ciborium usually consists of a domed roof supported by **columns**, all highly decorated. Also: the

receptacle for the Eucharist in the Catholic Mass.

circus An oval arena built around a racetrack by ancient Romans and usually enclosed by an extensive **stadium** with raised seats for spectators.

citadel An area of a fortress or defended city placed in a high, commanding spot.

clapboard Horizontal planks used as protective siding for buildings, particularly houses in North America.

Classical A term referring to the art and architecture of the ancient Greeks and Romans.

classical, classicism Any aspect of later art or architecture reminiscent of the rules, canons, and examples of the art of ancient Greece and Rome. Also: in general, any art aspiring to the qualities of restraint, balance, and rational order exemplified by the ancients.

Classical orders See order.

clerestory The topmost zone of a wall with windows (especially of a church or temple), when it extends above any abutting aisles or secondary roofs. Provides direct light into the central interior space.

cloison See cloisonné.

cloisonné A technique in enameled decoration of metal involving metal wire (filigree) that is affixed to the surface in a design. The resulting areas (cloisons) are filled with decorative enamel.

cloister A square or rectangular courtyard, sometime with gardens, surrounded on all sides by a vaulted arcade. Typically devoted to spiritual contemplation or scholarly reflection, a cloister is usually part of a monastery, a church, or occasionally, a university.

cloth of honor A piece of fabric, usually rich and highly decorated, hung behind a person of great rank on ceremonial occasions. Signifying the exalted status of the space before it, cloths of honor can be found behind thrones as well as altars, or behind representations of holy figures.

codex (codices) A group of **manuscript** pages held together by stitching or other binding on one side.

codex style A style of vase painting derived from the fluid and elegant script of **manuscripts**.

coffer A recessed decorative panel that, with many other similar ones, is used to decorate ceilings or **vaults**. The use of coffers is called coffering

coiling A technique in basketry. Coiled baskets are made from a spiraling structure of wood to which another material is sewn.

collage A technique in which cutout paper forms (often painted or printed) are pasted onto another surface in a composition. Also: an image created using this technique.

colonnade A sequence or row of **columns**, supporting a straight **lintel** (as in a **porch** or **portico**) or a series of **arches** (an **arcade**).

colonnette A small columnlike vertical element, usually found attached to a **pier** (with several others) in a Gothic church. Colonnettes are decorative features, and they can reach into the **vaulted** sections of the building, contributing to the vertical effect of a Gothic cathedral.

colophon The data placed at the end of a book, especially a late medieval **manuscript**, listing the

book's author, publisher, **illuminator**, and other information related to its production; sometimes called the imprint.

colossal order See order.

column An architectural element used for support and/or decoration. Consists of a rounded vertical pillar (shaft) placed on a raised block (base) topped by a larger, usually decorative block (capital). Usually built in accordance with the rules of one of the architectural orders. Although often freestanding, columns can be attached to a background wall, when they are called engaged.

column statue A carved image, usually of a religious person but also of **allegorical** or mythological themes, that is attached to a **column** or carved from it

complementary color A term used to describe an optical phenomenon in color theory. In the color circle, when a **primary color** is juxtaposed with a secondary color (created from a mix of the two other primary colors), the secondary color appears brighter. In this case, the primary color is called the complementary color because it strengthens the secondary color.

Composite order See order.

composition The arrangement of elements in an artwork.

compound pier Typically found in a Romanesque or Gothic church, a compound pier is a **pier** or large **column** with multiple **shafts**, **pilasters**, or **colonnettes** attached to it on one or all sides.

conch A semicircular recess, such as an apse or niche, with a half-dome vault.

concrete A building material invented by the Romans, which was easily poured or molded when wet, and hardened into a particularly strong and durable stonelike substance. Made primarily from lime, sand, cement, and rubble mixed with water.

cone mosaic A type of decoration of planar surfaces created by pressing colored bits of baked clay or stones into prepared wet plaster.

cong A square or octagonal tube made of jade with a cylindrical hole in the center. A symbol of the earth, it was used for ritual worship and astronomical observations in ancient China.

connoisseurship A term derived from the French word connaisseur, meaning "an expert," and signifying the practice of art history based primarily on formal visual and stylistic analysis. A connoisseur studies the **style** and technique of an object with an eye to deducing its relative quality and possible maker. This is done through visual association with other, similar objects and styles the connoisseur has seen in his or her study. See also contextualism, formalism.

content When discussing a work of art, the term can include all of the following: its subject matter; the ideas contained in the work; the artist's intention; and even its meaning for the beholder.

contextualism A methodological approach in art history of recent origin, which focuses on the cultural background of an art object. Unlike connoisseurship, contextualism utilizes the literature, history, economics, and social developments (among others) of a period, as well as the object itself, to inform the meaning of an artwork. See also **connoisseurship**.

contrapposto A way of representing the human

body so that its weight appears to be resting on one leg. These observations were translated into sculpture during the ancient Greek age, when sculptors adopted a great degree of **naturalism** in their works.

corbel, corbeling Early roofing technique in which each course of stone projects inward slightly over the previous layer (a corbel) until all sides meet. Results in a high, narrowly pointed arch or vault. A corbel table is a table supported underneath by corbels.

corbel arch See arch.

corbel vault See vault.

Corinthian order See order.

cornice The uppermost section of a Classical entablature. More generally, any horizontally projecting element of a building, usually found at the top of a wall or a pedestal. A raking cornice is formed by the junction of two slanted cornices, most often found in pediments.

course A horizontal layer of stone used in building.

cove A concave **molding** or area of ceiling where a wall and ceiling converge. A cove ceiling incorporates such moldings on all sides.

cove ceiling See cove.

crenellation A pattern of open notches built into the top **parapets** and **battlements** of many fortified buildings for the purposes of defense.

crocket A leaflike decorative element found in Gothic architecture, often on **pinnacles**, **gables**, and the open surfaces of roofs. A crocket is shaped like an open leaf which gently curves outward, its edges curling up.

cromlech In prehistoric architecture, a circular arrangement of **menhirs**.

cross vault See vault.

cross-hatching A technique primarily used in printmaking and drawing, in which a set of parallel lines (hatching) is drawn across a previous set, but from a differing (usually right) angle. Cross-hatching gives a great density of **tone**, and allows the artist to create the illusion of shadows efficiently.

crossing The part of a cross-shaped church where the **nave** and the **transept** meet, often marked on the exterior by a tower or **dome**.

cruciform A term describing anything that is cross-shaped, as in the cruciform **plan** of a church.

crypt The **vaulted** underground space beneath the floor of a church, usually at the east end, which contains tombs and relics.

cubiculum (cubicula) A private chamber for burial in the **catacombs**. The **sarcophagi** of the affluent were housed there in arched wall **niches**.

cuneiform writing An early form of writing with wedge-shaped marks, impressed into wet clay with a **stylus**, primarily by ancient Mesopotamians.

curtain wall A wall in a building that does not support any of the weight of the structure. Also: the freestanding outer wall of a castle, usually encircling the inner **bailey** and **keep**.

cycle A series of paintings, frescoes, or tapestries depicting a single story or theme and

intended to be displayed together.

cyclopean construction Any large-scale, monumental building project that impresses by sheer size. Based on Greek myth of giants of legendary strength. Also: a prehistoric method of building, utilizing megalithic blocks of rough-hewn stone.

cylinder seal A small cylindrical stone decorated with **incised** patterns. When rolled across soft clay or wax, a raised pattern or design (**relief**) is left, which served in Mesopotamian times as an identifying signature.

dado (dadoes) The lower part of a wall, differentiated in some way (by a molding or different color) from the upper section. Also: the part of a pedestal between the base and the cornice, usually constructed of plain stone without decoration.

daguerrotype An early photographic process invented and marketed in 1839 by Louis-Jacques Mondé Daguerre. The first practically possible photographic system, a daguerrotype was a positive print made onto a light-sensitized copperplate.

Day-Glo A trademark name for fluorescent materials.

Deesis In Byzantine art, the representation of Christ (usually enthroned or in a **hieratic** pose) flanked by the Virgin Mary and Saint John the Baptist.

demotic writing An informal script developed under the ancient Greeks in about the eighth century BCE, and used exclusively for nonsacred texts.

dentil Small, toothlike blocks arranged in a continuous band to decorate a **Classical entablature**

diorama A large painting made to create an environment giving the viewer the impression of being at the site depicted. Usually hung on several walls of a room and specially lit, the diorama was a popular attraction in the nineteenth century, and could be exhibited with sculpted figures.

dipteral A term that describes a building with a double **peristyle**, that is, surrounded by two rows of **columns**.

diptych A form created when two images (usually paintings on **panel** or **reliefs**) are hinged together.

dogu Small human figurines made in Japan during the Jomon period. Shaped from clay with exaggerated expressions and in contorted poses, dogu were probably used in religious rituals.

dolmen A prehistoric structure made up of two or more large (often upright) stones supporting a large, flat, horizontal slab or slabs (called **capstones**).

dome A round vault, usually over a circular space. Consists of the supporting vertical wall (drum), from which the vault springs, and a curved masonry vault of shapes and cross sections that can vary from hemispherical to bulbous to ovoidal. Usually crowned by an open space (oculus) and/or an exterior lantern. When a dome is built over a square space, an intermediate element is required to make the transition to a circular drum. There are two types: A dome on pendentives incorporates sloping intermediate sections of wall at the upper corners of the space (called pendentives) to spread the weight of the dome evenly. A dome on

squinches uses an **arch** built into the wall (squinch) in the upper corners of the space to carry the weight of the dome across the corners of the square space below.

donjon See keep

Doric order See order.

dormer A vertical window built into a sloping roof. A dormer window has its own roof and side panels that adjoin the body of the roof proper.

dressed stone A highly finished, precisely cut block of stone. When laid with others in even courses, dressed stone creates a uniform face with fine joints. Most often used as a facing on the visible exterior of a building, especially as a veneer for the facade. Also called ashlar.

drillwork In sculpture, the decorative effect created by the use of the drill. Also: the technique of using a drill for the creation of certain effects in sculpture.

drum The wall that supports a **dome**. Also: a segment of the circular **shaft** of a **column**.

drypoint An **intaglio** printmaking process by which a metal (usually copper) plate is directly inscribed by means of a pointed instrument (**stylus**). The resulting design of scratched lines is inked, wiped, and printed. Also: the print made by this process.

earthworks Artwork and/or sculpture, usually on a large scale, created by manipulating the natural environment.

easel painting Any painting of small to intermediate size that can be executed on an artist's easel

echinus A cushionlike circular slab found below the abacus of a Doric capital. Also: a similarly shaped molding (usually with eggand-dart motifs) underneath the volutes of an Ionic capital.

edition A single printing of a book (or print). An edition can be of differing numbers but includes only the objects printed at a particular moment (and usually pulled from the same press by the same publisher).

egg-and-dart A decorative **molding** made up of an alternating pattern of round (egg) and downward-pointing tapered (dart) elements.

elevation The arrangement, proportions, and details of any vertical side or face of a building. Also: an architectural drawing showing an exterior or interior wall of a building. A building's main elevation is usually its **facade**.

emblema (emblemata) In a mosaic, the elaborate central motif in a floor, usually a self-contained unit done in a more refined manner, with smaller tesserae of both marble and semi-precious stones. Also: an object or action represented in painting, prints, and drawings as a symbol for an idea, action, or other subject (as in an allegory). Emblemata are commonly associated with seventeenth-century Dutch art.

emblem book A collection of individual symbolic images, often concerning a single theme, and published with texts or verse. These books were sometimes used by artists as a source of inspiration. They were especially popular as literature in the Netherlands and England during the sixteenth and seventeenth centuries.

embossing See repoussé.

embroidery The technique in needlework of decorating fabric by stitching designs and figures of colored threads of fine material (such as silk) into another material (such as cotton, wool, leather, or paper). Also: the material produced by this technique.

emotionalism Any aspect of art that appeals overtly to sentimentality, melodrama, excitement, or other strong emotion.

enamel A technique in which powdered glass is applied to a metal surface in a decorative design. After firing, the glass forms an opaque or transparent substance that is fused with the metal background. Also: an object created with enamel technique.

encaustic A type of painting technique utilizing pigments mixed with a **medium** of hot wax. Encaustic paintings were typically made in ancient times, particularly in Egypt.

engaged column See column.

engraving The process of inscribing an image, design, or letters onto a metal or wood surface from which a print is made. An engraving is usually drawn with a sharp implement (**burin**) directly onto the surface of the plate. Also: the print made from this process.

entablature In the Classical orders, the horizontal elements above the columns and capitals. The entablature consists of, from top to bottom, a cornice, frieze, and architrave.

entasis A slight bulge built into the **shaft** of a Greek **column**. The optical illusion of entasis makes the column appear from afar to be consistent and straight from end to end.

etching An intaglio printmaking process, in which a metal plate is coated with acid-resistant resin and inscribed with a stylus in a design, revealing the plate below. The plate is then immersed in acid, and the design of exposed metal is eaten away by the acid. The resin is removed, leaving the design etched permanently into the metal and the plate ready to be inked, wiped, and printed

Eucharist The Christian ritual marking the Last Supper of Jesus. It is celebrated as a Mass, also known as Holy Communion, in which bread, symbolizing the body of Jesus, and wine, symbolizing his blood, are consumed.

exedra (exedrae) In architecture, a semicircular **niche**. On a small scale, often used as decoration, whereas larger exedrae can form interior spaces (such as an **apse**).

expressionism, expressionistic Terms describing a work of art in which forms are created primarily to evoke subjective emotions rather than to portray objective reality.

extrados The uppermost, curving surface of a **vault** or **arch**.

facade The face or front wall of a building, usually including the main **elevation**.

faience A glazing technique for ceramic vessels, utilizing a glass paste that, upon firing, acquires a lustrous shine and smooth texture.

faktura An idea current among Russian Constructivist artists and other Russian artists of the early twentieth century that referred to the inherent forms and colors suitable to different materials. Used primarily in their mixed-medium constructions of a nonrepresentational type,

faktura focused the artists' attention on the manner in which different materials create a variety of effects

fang ding A square or rectangular bronze vessel with four legs. The fang ding was used for ritual offerings in ancient China during the Shang dynasty.

fête galante A subject in painting depicting well-dressed people at leisure in a park or country setting. It is most often associated with eighteenth-century French Rococo painting and the work of Antoine Watteau.

filigree Thin strips of metal used in cloisonné enamel and openwork decoration.

finial A knoblike architectural decoration usually found at the top points of a spire, **pinnacle**, canopy, or **gable**. Also found on furniture.

flower piece Any painting with flowers as the primary subject. **Still lifes** of flowers became particularly popular in the seventeenth century in the Netherlands and Flanders.

fluting In architecture, a decorative pattern of evenly spaced parallel vertical grooves incised on shafts of columns or columnar elements (such as pilasters).

flying buttress See buttress.

folio In technical bookmaking terms, a large sheet of paper, which, when folded and cut, becomes four separate pages in a book. Also: a page or leaf in a large-scale **manuscript** or book; more generally, any large book.

foreground Within the depicted space of an artwork, the area that is closest to the **picture plane**.

foreshortening The illusion created on a flat painted or drawn surface in which figures and objects appear to recede or project sharply into space. Often accomplished according to the rules of **perspective**.

form In speaking of a work of art or architecture, the term refers to purely visual components: line, color, shape, texture, mass, spatial qualities, and composition—all of which are called formal elements.

formal elements See form.

formalism, formalist An approach to the understanding, appreciation, and valuation of art based almost solely on considerations of form. This approach tends to regard an artwork as independent of its time and place of making.

formline In Native American works of art, a line that defines a space.

forum The central square of a Roman town, often used as a market or gathering area for the citizens. Site of most community temples and administrative buildings.

freestanding column See column.

fresco A painting technique in which pigments are applied to a surface of wet plaster (called *buon fresco*). Fresco secco is created by painting on dried plaster. Wall murals made by both these techniques are called frescoes.

fresco secco See fresco.

frieze The flat middle layer of an **entablature**, between the **architrave** and the **cornice**. Usually decorated with sculpture, painting, or **moldings**. Also: any continuous flat band with **relief sculpture** or painted decorations.

fritware A type of pottery made from a mix of white clay, quartz, and other chemicals that, when fired, produces a very brittle substance.

frontispiece An illustration opposite or preceding the title page of a book. Also: the primary **facade** or main entrance **bay** of a building.

frottage A design produced by laying a piece of paper over a **relief** or **incised** pattern and rubbing with charcoal or other soft **medium**.

fusuma Sliding doors covered with paper, used in an East Asian house. Fusuma are often highly decorated with paintings and colored backgrounds.

gable The triangular wall space found on the end wall of a building between the two sides of a pitched roof. Also: a triangular decorative panel that has a gablelike shape.

gadrooning A form of decoration most frequently found on architecture and in metalwork, characterized by sequential convex **moldings** that curve around a circular surface.

galleria A long room, usually above the ground floor in a large residence, used for entertainment and sometimes to display paintings. In English, gallery.

gallery In church architecture, the story found above the side aisles of a church, usually open to and overlooking the nave. In a large church, such as a cathedral, the gallery may also be used as a corridor. Also: in secular architecture, a long room in a private house or a public building for exhibiting pictures or promenading.

garbhagriha From the Sanskrit word meaning "womb chamber," a small room or shrine in a Hindu temple containing a holy image.

genre A type or category of artistic form, subject, technique, **style**, or **medium**. Also: a subject in art representing scenes of daily life. *See also* **genre painting**.

genre painting A term used to loosely categorize paintings depicting scenes of everyday life, including (among others) domestic interiors, merry companies, inn scenes, and street scenes.

geoglyphs Earthen designs on a colossal scale, often created in a landscape as if to be seen from an aerial viewpoint.

geometric A term describing Greek art, especially pottery, from about 1100 to 600 BCE and characterized by patterns of rectangles, squares, and other **abstract** shapes. Also: any **style** or art using primarily these shapes.

gesso A thick **medium** usually made from glue, gypsum, and/or chalk and often forming the ground, or priming layer, of a canvas. A gesso ground gives a smooth surface for painting and seals the absorbency of the canvas.

gesturalism The motivation behind painting and drawing in which the brushwork or line visibly records the artist's physical gesture at the moment the paint was applied or the lines laid down. Associated especially with expressive styles, such as European Baroque, Zen painting, and Abstract Expressionism.

gilding The application of paper-thin **gold leaf** to an object made from another **medium** (for example, a sculpture or painting). Usually used as a decorative finishing detail.

giornata Adopted from the Italian term meaning

"a day's work," a *giornata* is the section of a **fresco** plastered and painted in a single day.

glaze See glazing.

glazing In ceramics, a method of treating earthenwares with an outermost layer of vitreous liquid (glaze) that, upon firing, renders a waterproof and decorative surface. In painting, a technique particularly used with oil mediums in which a transparent layer of paint (glaze) is laid over another, usually lighter, painted or glazed area.

gloss A type of clay **slip** used in ceramics by ancient Greeks and Romans that, when fired, imparts a colorful sheen to the surface.

golden section A linear measurement said to be of ideal proportions, supposedly discovered by the ancient Greeks. When the measurement is divided into two, the smaller part is the same proportion to the larger as the larger is to the whole.

gold leaf The paper-thin sheets of hammered gold that are used in **gilding**. In some cases (such as Byzantine **icons**), also used as a ground for paintings.

Good Shepherd The representation in art of Jesus with a sheep around his shoulders or at his side, based on the biblical parable of the Good Shepherd.

gopura The towering gateway to an Indian Hindu **temple complex**. A temple complex can have several different *gopuras*.

gouache A type of opaque **watercolor** that has a distinct, chalky effect.

graffiti Imposed on public structures by anonymous persons, graffiti usually consists of drawings and/or text of an obscene, political, or violent nature, and can be found in all periods and all **mediums**.

Grand Manner A grand and elevated style of painting popular in the Neoclassical period of the eighteenth century. An artist working in the Grand Manner looked to the ancients and to the Renaissance for inspiration; for portraits as well as **history painting**, the artist would adopt the poses, **compositions**, and attitudes of Renaissance and antique models.

granulation A technique for decorating gold in which tiny balls of the precious metal are fused to the main surface in a pattern.

graphic arts A term referring to those branches of the arts that utilize paper as primary support. The graphic arts, whether drawn, typeset, or printed, often have a heavy emphasis on **linear** means of expression.

graphic design A concern in the visual arts for geometric shape, line, and two-dimensional patterning, often especially apparent in works including typography and lettering.

Greek-cross plan See central plan.

Greek-key pattern See meander.

grid A system of regularly spaced horizontally and vertically crossed lines that gives regularity to an architectural **plan**. Also: in painting, use of a grid enables designs to be enlarged or transferred easily. See also **cartoon**.

griffin A creature with the head, wings, and claws of an eagle and the body and hind legs of a lion.

grisaille A painting executed primarily in various tones of gray.

groin vault See vault.

groundline The solid baseline that indicates the ground plane of an image, on which the figures stand. In ancient representations, such as those of the Egyptians, the figures and objects are placed on the groundline without reference to their actual spatial relationships.

grout A soft cement placed between the **tesserae** of a **mosaic** to hold the design together. Also used in tiling.

guild The association of craftspeople in a particular town, established during medieval times. The guild had great political power, as it controlled the selling and marketing of its members' products, and it provided economic protection, political solidarity, and training in the craft to its members. The artists' guild was usually dedicated to Saint Luke, the patron saint of artists.

half-barrel vault See quadrant vault.

half-timber construction A method of building utilized in the sixteenth and seventeenth centuries, particularly in northern European areas, for vernacular structures. Beginning with a timber framework built in the post-and-lintel manner, the builder constructed walls between the timbers with bricks, mud, or wattle. The exterior could then be faced with plaster or other material.

hall church A church (typified by those in the Gothic style in Germany), with a **nave** and aisles that are all the same height, giving the impression of a large, open hall.

halos An outdoor pavement used by ancient Greeks for ceremonial dancing.

handscroll A long, narrow, horizontal painting or text (or combination thereof) common in Chinese and Japanese art, and of a size intended for individual use. A handscroll is stored wrapped tightly around a wooden pin and is unrolled for viewing or reading.

hanging scroll In Chinese and Japanese art, a vertically oriented painting or text mounted within sections of silk. At the top is a semicircular rod; at the bottom is a round dowel. Hanging scrolls are kept rolled and tied except for special occasions, when they are hung for display, contemplation, or commemoration.

haniwa Pottery figures that were placed on top of Japanese tombs or burial mounds.

happening A type of art form incorporating performance, theater, and visual images, developed in the 1960s. A happening was organized without a specific narrative or intent; with audience participation, the event proceeded according to chance and individual improvisation.

header In building, a brick laid so that the end, rather than the side, forms the face of the wall.

heliograph A type of early photograph created by the exposure to sunlight of a plate coated with light-sensitive asphalt.

hemicycle A semicircular interior space or structure.

henge A circular area enclosed by stones or wood posts set up by Neolithic peoples. It is usually bounded by a ditch and raised embankment.

herm A statue that has the head and torso of a human, but the lower part of which is a plain, tapering pillar of rectangular shape. Used primarily for architectural decoration.

hieratic In painting and sculpture, when the concern for spiritual over material values results in a formalized, grand style for representing sacred or priestly figures. Can also be seen in the use of different scales for holy figures and those of the everyday world.

hieroglyphic An alphabet of phonetic signs rendered in the form of pictorial symbols, utilized primarily for sacred names and ceremonial inscriptions (**cartouches**) by the ancient Egyptians.

high relief See relief sculpture.

himation In ancient Greece, a garment wrapped around the body, with a rectangular piece of cloth thrown over the shoulder. Worn by both men and women.

historicism A nineteenth-century consciousness of and attention to the newly available and accurate knowledge of the past, made accessible by historical research, textual study, and archeology.

history painting The term used to denote those paintings that include figures in any kind of historical, mythological, or biblical narrative. Considered since the Renaissance (until the twentieth century) as the noblest form of art, history paintings generally convey a high moral or intellectual idea, and often adopted a grand pictorial style.

hollow-casting See lost-wax casting.

horizon line A horizontal "line" formed by the actual or implied meeting point of earth and sky. In scientific **perspective**, the **vanishing point** or points are located on this line.

horseshoe arch See arch.

house-church In early Christian times, any small and relatively secret church, usually located in a private home.

house-synagogue A Jewish place of worship located in a private home.

hue The shade of a color, as opposed to its brightness or saturation.

hydria A large ancient Greek and Roman jar with three handles (horizontal ones at both sides and one vertical at the back), used for storing water.

hypogeum (hypogea) See catacomb.

hypostyle hall In ancient Egyptian architecture, a large interior gathering room of a **temple complex** that precedes the **sanctuary**. Marked by numerous rows of tall, closely spaced **columns**.

icon A panel painting representing a sacred figure of the Eastern Orthodox Church according to ancient established pictorial conventions.

iconoclasm Any movement that prescribes the banning or destruction of images. Historically iconoclasm has occurred primarily as a result of different opinions about the function and purpose of imagery in religion.

iconography In the visual arts, the study of the subject matter of a representation and its meaning.

iconology The study of the significance and interpretation of the subject matter of art. Iconology often incorporates contextual evidence regarding traditions of representation of specific subjects to aid in understanding.

iconostasis The wall or screen in an Early Chris-

tian or Greek Orthodox church between the sanctuary (where the Mass was performed) and the body of the church (where the congregation assembled). The iconostasis was usually hung with icons.

idealization A process in art through which artists strive to make their forms and figures attain perfection, based on pervading cultural values or their own mental image of what the ideal is.

ideograph A motif or written character that expresses an idea or symbolizes an action in the world. It is distinct from a pictograph, which symbolizes or represents an actual object, person, or thing. Egyptian hieroglyphs and Chinese calligraphs are examples of writing which consist of both ideographs and pictographs.

ignudi A nude male figure, particularly those found on Michelangelo's Sistine Ceiling.

illumination A painting on paper or parchment used as illustration and/or decoration for manuscripts or albums. Usually done in rich colors, often supplemented by gold and other precious materials. The illustrators are referred to as illuminators. Also: the technique of decorating manuscripts with such paintings.

illusionism, illusionistic An appearance of reality in art created by the use of certain pictorial means, such as **perspective** and **foreshortening**. Also: the quality of having this type of appearance.

impost, impost block A decorative block imposed between the **capital** of a **column** and the springing of an **arch** above.

impression Any single printing of an **intaglio** print (**engraving** or **etching**). Each and every impression of a print is by nature different, given the possibilities for variation inherent in the printing process, which requires the plate to be inked and wiped between every impression.

in antis Term used to describe the position of columns set between two walls, as in a portico or a cella

incising A technique in which a design or inscription is cut into a hard surface with a sharp instrument.

ink painting A style of painting developed in China using only monochrome colors, usually black ink with gray **washes**. Ink painting was often used by artists in the **literati painting** style and is connected with Zen Buddhism.

inlay A decorative process in which pieces of one material are set into the surface of an object fashioned from a different material.

intaglio Term used for a technique in which the design is carved out of the surface of an object, such an engraved seal stone. In the graphic arts, intaglio includes engraving, etching, and drypoint, all processes in which ink transfers to paper from incised, ink-filled lines cut into a metal plate.

intarsia The decoration of wood surfaces with **inlaid** designs created of contrasting materials, such as metal, shell, and ivory.

interlace A type of **linear** decoration particularly popular in Celtic art, in which ribbonlike bands are **illusionistically** depicted as if woven under and over one another.

intrados The curving inside surface of an **arch** or **vault**.

intuitive perspective See perspective.

Ionic order See order.

isometric projection A building diagram that represents graphically the parts of a building. Isometric projections have all planes of the building parallel to two established vertical and horizontal axes. The vertical axis is true, while the horizontal is drawn at an angle to show the effect of recession. All dimensions in an isometric drawing are proportionally correct. See also plan, section.

iwan A large, **vaulted** chamber in a **mosque** with a **monumental arched** opening on one side.

jamb In architecture, the vertical element found in pairs on both sides of an opening in a wall, such as a door or window.

japonisme A style in American nineteenth-century art that was highly influenced by Japanese art, especially prints.

joined-wood sculpture A method of constructing large-scale wooden sculpture developed by Japanese craftspeople. The entire work is constructed from smaller hollow blocks, each individually carved, and assembled when complete. The joined-wood technique allowed the production of larger sculpture, as the multiple joints alleviate the problems of drying and cracking found with sculpture carved from a single block.

ka The name given by ancient Egyptians to the human life force, or spirit.

kantharos A type of Greek vase or goblet with two large handles and a wide mouth.

keep The most heavily fortified defensive structure in a castle, usually built in the form of a tower and located at the heart of the castle complex.

kente A woven cloth made by the Ashanti peoples of Africa. *Kente* cloth is woven in long, narrow pieces with a complex and colorful pattern, which are then sewn together.

key block A key block is the master block in the production of a colored **woodcut**, which requires different blocks for each color. The key block is a flat piece of wood with the entire design carved or drawn on its surface. From this, other blocks with partial drawings are made for printing the areas of different colors.

keystone The topmost **voussoir** at the center of an **arch**, usually last to be placed. The pressure of this block holds the arch together. Often of a larger size and/or highly decorated.

kiln An oven designed to produce enough heat for the baking, or firing, of clay.

kiva The room in a Native American pueblo used for community gatherings and rituals.

kondo The main hall inside a Japanese Buddhist temple where the images of Buddha are housed.

kore An archaic Greek statue of a young woman.

kouros An archaic Greek statue of a young man or boy.

krater An ancient Greek vessel for mixing wine and water, with many subtypes that each have a distinctive shape. **Calyx krater**: a bell-shaped vessel with handles near the base that resemble a flower calyx. **Volute krater**: a type of krater with handles shaped like scrolls.

kylix A shallow Greek vessel or cup, used for drinking, with a wide mouth and small handles near the rim.

lacquer A type of hard, glossy surface varnish used on objects in East Asian cultures. Lacquer can be layered and manipulated or combined with pigments and other materials for various decorative effects.

lakshana Term used to designate the thirty-two marks of the Buddha. These characteristics of the historical Buddha have come to be part of the iconography of the Buddha in general. The lakshana includes, among others, the Buddha's golden body, his long arms, the wheel impressed on his palms and the soles of his feet, and his elongated earlobes.

lancet A tall narrow window crowned by a sharply pointed **arch**, typically found in Gothic architecture.

landscape architecture Any design for an outdoor space.

landscape painting A painting in which a natural outdoor scene or vista is the primary subject.

lantern A cylindrical turretlike structure situated on top of a **dome**, with windows that allow light into the space below.

Latin-cross plan A cross-shaped building plan, incorporating one longer stem (nave) and three arms of equal length. The common form for a Christian church, popular both for practical liturgical reasons and for the symbolic resemblance of the plan to the shape of the cross on which Christ was crucified.

lectionary An ecclesiastical book. A lectionary is part of the fittings of a church and contains readings from Christian Scripture. It is the book from which the officiant reads to the congregation during holy services.

lekythos A slim Greek oil vase with one handle and a narrow mouth.

limner The name used to denote an artist, particularly a portrait painter, in England during the sixteenth and seventeenth centuries and in New England during the eighteenth and nineteenth centuries.

linear, linearity A descriptive term indicating an emphasis on line, as opposed to mass or color, in art.

linear perspective See perspective.

lingam shrine A place of worship centered on an object or representation in the form of a phallus (the lingam), which symbolizes the power of the Hindu god Shiva.

lintel A horizontal element of any material carried by two or more vertical supports to form an opening.

list An open section of the grounds of a fortified building or castle, usually in the **bailey**, that was set aside for knightly combat.

literary illustration An image or artwork with a subject or content drawn from a literary source.

literati See literati painting.

literati painting A style of painting that reflects the taste of the educated class of East Asian intellectuals and scholars. Aspects include an appreciation for the antique, smaller scale, and

an intimate connection between maker and audience.

lithograph A print made from a design drawn on a flat stone block with greasy crayon. Ink is applied to the stone, and when printed, adheres only to the open areas of the design. *See also* **chromolithography**.

loculus (loculi) A **niche** in a tomb or **catacomb** in which a **sarcophagus** was placed.

loggia Italian term for a covered open-air gallery. Often used as a corridor between buildings or around a courtyard, loggia usually have arcades or colonnades on the exterior side.

lost-wax casting A method of casting metal, such as bronze, by a process in which a wax mold is covered with clay and plaster, then fired, melting the wax and leaving a hollow form. Molten metal is then poured into the hollow space and slowly cooled. When the hardened clay and plaster exterior shell is removed, a solid metal form remains to be smoothed and polished.

low relief See relief sculpture.

lozenge A decorative **motif** in the shape of a diamond.

lunette A semicircular wall area, framed by an **arch** over a door or window. Can be either plain or decorated with **reliefs**.

lusterware A type of ceramic pottery decorated with colorful metallic **glazes**.

madrasa An Islamic institution of higher learning, where teaching is focused on theology, law, and the sciences.

maenad In ancient Greece, a female devotee of the wine god Dionysos who participated in orgiastic rituals. She is often depicted with swirling drapery and a tambourine. More generally, a mad or frenzied woman. (Also called a Bacchante, after Bacchus, the Roman name of Dionysos.)

majolica Pottery painted with a tin glaze that, when fired, gives a lustrous and colorful surface.

maki-e In Japanese art, the effect achieved by sprinkling gold or silver powder on successive layers of **lacquer** before each layer dries.

mandala An image of the cosmos represented by an arrangement of circular or concentric geometric shapes containing diagrams or images. Used for meditation and contemplation, mandalas are most often found in Buddhist temples.

mandapa In a Hindu temple, an open hall dedicated to ritual worship.

mandorla An almond- or womb-shaped area in which a sacred figure, such as Christ in Heaven, is represented.

manifesto A written declaration of an individual or group's ideas, purposes, and intentions.

manuscript A handwritten book or collection of handwritten documents.

maqsura A separate enclosure in a Muslim **mosque** near the **mihrab**, designated for dignitaries.

martyrium (martyria) A sacred place in Catholic churches where the relics of martyrs are buried, often marked by shrines for worship.

mastaba A flat-topped, one-story building with

slanted walls. Invented by the ancient Egyptians to mark underground tombs.

mathematical perspective See perspective.

matte A surface that is smooth but without shine or luster.

mausoleum A monumental building used as a tomb. Named after the tomb of Mausolos erected at Halikarnassos around 350 BCE.

meander A type of two-dimensional ornament made up of intertwined **geometric motifs** and often used as a decorative border. Also called **Greek-key pattern**.

medallion In architecture, any round ornament or decoration. Also: a large medal.

medium (mediums) In general, the material from which any given object is made. In painting, the liquid substance in which pigments are suspended to create paint.

megaron The main hall of a Mycenaean palace or grand house. Usually of a rectangular shape, and sometimes subdivided into two unequal spaces by **columns**.

memento mori From Latin terms meaning "reminder of death." An object, such as a skull or extinguished candle, typically found in a *vanitas* image, symbolizing the transience of life.

menhir A megalithic stone block, placed by prehistoric peoples in an upright position.

menorah A Jewish lamp, usually in the form of a candelabrum, divided into seven or nine branches; the nine-branched menorah is used during the celebration of Hanukkah. Representations of the seven-branched menorah, once used in the Temple of Jerusalem, became in general a symbol of Judaism.

mensa The blocklike table serving as the **altar** in a Christian church.

metope The rectangular spaces, sometimes decorated but often plain, between the **triglyphs** of a **Doric frieze**.

mezzanine Any intermediate story of a building, inserted between two stories of regular size.

middle ground Within the depicted space of an artwork, the area that takes up the middle distance of the image. See also foreground, background.

mihrab A recess or niche that distinguishes the wall oriented toward Mecca (qibla) in a mosque.

minaret A tall slender tower on the exterior of a **mosque** from which believers are called to prayer.

 $\begin{tabular}{ll} \textbf{minbar} & A \ high \ platform \ or \ pulpit \ in \ an \ Islamic \ mosque. \end{tabular}$

miniature A small-scale painting. Miniatures have a variety of uses, from illustrations within albums or manuscripts to intimate portraits.

mirador A three-sided balcony common in Spanish and Islamic palace architecture. The mirador usually has windows on the three sides, and is found overlooking gardens or courtyards.

mithuna The amorous male and female couples in Buddhist sculpture, usually found in the entrance to a sacred building. The *mithuna* symbolize the harmony and fertility of life.

moat A large ditch or canal dug around a castle or fortress for military defense. When filled with water, the moat protects the walls of the building from direct attack.

modeling In painting, the process of creating the illusion of three-dimensionality on a two-dimensional surface by use of light and shade. In sculpture, the process of molding a three-dimensional form out of a malleable substance.

module A segment or portion of a repeated design.

molding A shaped or sculpted strip with varying contours and patterns. Used as decoration on architecture, furniture, frames, and other objects.

monolith Tall monumental wall-like pillars used for commemoration and sacred ritual. Monoliths are often capped with sculpture and decorated on the sides.

Monophysitism The Christian doctrine stating that Jesus Christ has only one nature, and that it is partly divine and partly human.

monoprint A single print pulled from a hard surface (such as a blank plate or stone) that has been prepared with a painted design. Each print is an individual artwork, as the original design is a transient one, lost in the printing process.

monumental A term used to designate a project or object that, whatever its physical size, gives an impression of grandeur, excellence, and simplicity.

mortise-and-tenon joint A method of joining two elements. A projecting pin (tenon) on one element fits snugly into a hole designed for it (mortise) on the other. Such joints are very strong and flexible.

mosaic A method of creating designs with small colored stone or glass pieces (**tesserae**), which are affixed to a cement surface.

mosque An edifice dedicated to communal Muslim worship.

motif Any discrete element of a design or **composition**, often referring to those that can be easily separated from the whole for the purposes of copying or study.

movable-type printing A method of printing text in which the individual letters, cast on small pieces of metal (die), are assembled into words on a mechanical press. When each edition was complete, the type could be reused for the next project. Movable-type printing, invented around 1450, revolutionized the printing industry in Europe and allowed the large-scale dissemination of affordable books.

mudra A symbolic hand gesture in Indian art. The many different mudras each denote certain behaviors, actions, or feelings.

mullion A slender vertical element or **colonnette** that divides a window into subsidiary sections.

multiculturalism A policy of inclusion of all cultures and ethnicities in a society or civilization.

multiple-point perspective See perspective.

muqarna The geometric patterning used in Islamic architecture to smooth the transition between decorative flat and rounded surfaces; usually found on the **vault** of a **dome**.

mural Any painting done directly on a wall.

naos See cella.

narthex The rectangular vestibule at the main (usually western) entrance of a church. In Early Christian architecture, it can also be an entrance **porch** with **columns** on the outside of a church.

naturalism, naturalistic A style of depiction in which the physical appearance of the rendered image in nature is the primary inspiration. A naturalistic work appears to resemble visible nature.

nave The long central space of a Christian church, usually rectangular in shape and often separated from the side aisles by **colonnades**.

necking On a **column**, the **molding** or cluster of moldings between the column **shaft** and the **capital**.

necropolis A large cemetery or burial area.

negative space Empty or open space within or bounding a painting, sculpture, or architectural design. Negative space emphasizes the overall form of the work.

niche A hollow or recess in a wall or other solid architectural element. Niches can be of varying size and shape, and may be intended for many different uses, from display of objects to housing of a tomb.

niello An **inlay** technique in which a black sulphur alloy is rubbed into fine lines **engraved** into a metal (usually gold or silver). The alloy becomes fused with the surrounded metal when heated, and provides contrasting detail.

nishiki-e A multicolored and ornate Japanese print.

nocturne A night scene in painting, usually lit by artifical illumination.

nonfinito An Italian term designating the unfinished effect used by Michelangelo in his sculpture to enliven and give texture to marble surfaces.

nonrepresentational A term describing any artwork of an **abstract** nature. Nonrepresentational art does not attempt to reproduce the appearance of the natural world.

obelisk A tall stone **shaft** of four-sided rectangular shape, hewn from a single block, that tapers at the top and is completed by a **pyramidion**. Erected by the ancient Egyptians in ceremonial spaces (such as entrances to **temple complexes**) as commemorative monuments.

oblique perspective See perspective.

oculus (oculi) In architecture, a circular opening. Oculi are usually found either as windows or at the **apex** of a **dome**. When at the top of a dome, it is either open to the sky or covered by a decorative exterior **lantern**.

odalisque A subject in painting of a reclining female nude, usually shown with the accoutrements of an exotic, haremlike environment.

ogival arch See arch.

oil painting Any painting executed with the pigments floating in a **medium** of oil. Oil paint has particular properties that allow for greater ease of working (among others, a slow drying time, which allows for corrections, and a great range of relative opaqueness of paint layers, which permits a high degree of detail and luminescence). It

was adopted on a wide scale in Europe after about 1450.

oil sketch An oil painting, usually on a small scale, intended as a preliminary stage for the production of a larger work. Oil sketches are often very **painterly** in technique.

oinoche A Greek wine jug with a round mouth and a curved handle.

olpe Any Greek vase or jug without a spout.

one-point perspective See perspective.

openwork Decoration, such as **tracery**, with open spaces incorporated into the pattern. Also: a needlework technique in which some of the fabric support is left visible within the design.

oracle A person, usually a priest or priestess, who acts as a conduit for divine information. Also: the information itself or the place at which this information is communicated.

orant The representation, usually in ancient or Early Christian art, of a standing figure praying with outstretched arms.

order A system categorizing Classical architecture into five standardized types. Doric: the column shaft of the Doric order can be fluted or smooth-surfaced and has no base. The Doric capital consists of an undecorated echinus and abacus. The Doric entablature has a plain architrave, a frieze with metopes and triglyphs, and a simple cornice. Tuscan: a variation of Doric characterized by a smooth-surfaced column shaft with a base, a plain architrave, and an undecorated frieze. Ionic: the column of the Ionic order has a fluted shaft and a capital on top decorated with volutes. The Ionic entablature consists of an architrave decorated with moldings, a frieze usually containing sculpted relief ornament, and a cornice with dentils. Corinthian: the most ornate of the orders, the Corinthian includes a fluted column shaft with a capital elaborately decorated with acanthus leaf carvings. Its entablature consists of an architrave decorated with moldings, a frieze often containing sculpted relief ornament, and a cornice with dentils. Composite: a combination of the Ionic and the Corinthian in one. Composite columns are slender, and the capital combines acanthus leaves with spiralling volutelike scrolls at the top. A colossal order is any of the above types built on a large scale, stretching over several stories in height and often raised from the ground by a pedestal.

orthogonal Any line running back into the represented space of a picture perpendicular to the imagined picture plane. In linear perspective, all orthogonals converge at a single vanishing point in the picture and are the basis for a grid that maps out the internal space of the image. An orthogonal plan is any plan for a building or city that is based exclusively on right angles, such as the grid plan of many modern cities.

orthogonal plan See orthogonal.

ovoid An adjective describing a rounded oval object or shape. Also: a characteristic form in Native American art, consisting of a rectangle with bent sides and rounded corners.

pagoda A heavily decorated Buddhist temple in the form of a tower built with successively smaller, repeated stories. Each story is usually marked by an elaborate projecting roof.

painterly A painting, or style of painting, that emphasizes the techniques and surface effects

of brushwork.

palace complex A group of buildings used for living and governing by a particular ruler, usually located in a fortress or **citadel**.

palette An oval or otherwise rounded handheld support used by artists for the storage and mixing of paint during the process of painting. Also: the choice of a range of colors made by an artist in a particular work, or typical of his or her style.

Palladian An adjective describing a style of architecture, or an architectural detail, reminiscent of the **classicizing** work of the sixteenth-century Italian architect Andrea Palladio.

palmette A fan-shaped ornament with radiating leaves

panel painting Any painting executed on a wood support. The wood is usually planed down to a board to provide a smooth surface and easy transportation. A panel can consist of several boards joined together.

papyrus A native Egyptian plant from the stems of which ancient Egyptians produced an early form of paper. Also: a decorative form adapted from this plant used in Egyptian architecture.

parapet A low wall at the edge of a balcony, bridge, roof, or other place from which there is a steep drop, built for the safety of onlookers. A parapet walk is the passageway, usually open, immediately behind the uppermost exterior wall or battlement of a fortified building.

parapet walk See parapet.

parchment A writing surface made from treated skins of animals and used during antiquity and the Middle Ages.

Paris Salon The annual display of art by French artists in Paris during the eighteenth and nineteenth centuries. Originally established in the seventeenth century as a venue to show the work of members of the French Academy, the Salon and its judges favored primarily academic art of the accepted official style at the time.

parterre An ornamental, highly regimented flower bed. Parterre became a crucial element of the ornate gardens of seventeenth-century palaces and **châteaux**.

passage In painting, passage refers to any particular area within a work, often those where painterly brushwork or color changes exist. Also: a term used to describe the style of Paul Cézanne and his technique of blending shapes open on one side with adjacent ones.

passage grave A prehistoric tomb under a cairn, reached by a long, narrow, slab-lined access passageway or passageways.

pastel A drawing material in stick or crayon form. Composed of dry pigment, chalk, and gum, pastel imparts soft color **tones** to drawings.

pedestal A platform or base supporting a sculpture or other monument. Also: the block found below the **base** of a **Classical column** (or **colonnade**), serving to raise the entire structure off the ground.

pediment A triangular gable found over major architectural elements such as Classical Greek porticoes, windows, or doors. Formed by an entablature and the ends of a sloping roof or a raking cornice. A similar architectural element is often used decoratively above a door or window, sometimes with a curved upper molding. A bro-

ken pediment is a variation on the traditional pediment, with an open space at the center of the topmost angle and/or the horizontal cornice. Often filled with a decorative element, such as a **cartouche**.

pendentive The concave triangular section of a wall that forms the transition between a square or polygonal space and the circular base of a **dome**.

pendentive dome See dome.

peplos A loose outer garment worn by women of ancient Greece. Belted below the bust or at the hips, it was worn in billowing folds.

performance art An artwork based on a live, theatrical performance by the artist.

peripteral A term used to describe any building (or room) that is surrounded by a single row of **columns**. When such columns are engaged instead of freestanding, called **pseudo-peripteral**.

peristyle A surrounding **colonnade** in Greek architecture. A peristyle building is surrounded on the exterior by a colonnade. Also: a peristyle court is an open courtyard with the same colonnade form found on all sides.

perspective A system for reproducing threedimensional space on a flat surface. There are several different techniques. Atmospheric perspective: A method of rendering the effect of spatial distance on a two-dimensional plane by subtle variations in color and clarity of representation. One-point and multiple-point perspective (also called linear, scientific, or mathematical perspective): A method of creating the illusion of three-dimensional space on a two-dimensional surface by delineating a horizon line and multiple orthogonal lines. These recede to meet at one or more points on the horizon (called vanishing points), giving the appearance of spatial depth. Called scientific or mathematical because its use requires some knowledge of geometry and mathematics, as well as optics. Intuitive perspective: A method of representing three-dimensional space on a two-dimensional surface by the use of formal elements that act to give the impression of recession. This impression, however, is achieved by visual instinct, not by the use of an overall system or program (usually involving scientific principles or mathematics) for depicting the appearance of spatial depth. Oblique perspective: An intuitive spatial system used in painting, in which a building or room is placed with one corner in the picture plane, and the other parts of the structure all recede to an imaginary vanishing point on its other side. Oblique perspective is not a comprehensive, mathematical system. Reverse perspective: A Byzantine perspective theory in which the orthogonals or rays of sight do not converge on a vanishing point in the picture, but are thought to originate in the viewer's eye in front of the picture. Thus, in reverse perspective the image is constructed with orthogonals that diverge, giving a slightly tipped aspect to objects.

photomontage A photographic work created from many smaller photographs arranged (and often overlapping) in a **composition**.

 $\boldsymbol{piazza}\;$ The Italian word for an open city square.

pictograph A highly **stylized** depiction serving as a symbol for a person or object. Also: a type of writing utilizing such symbols.

pictured stone A stone used in medieval northern Europe as a commemorative monument, which is carved or inscribed with representations of human figures or other natural forms.

picture plane The theoretical spatial plane corresponding with the actual surface of a painting (usually vertical).

picturesque A term describing the taste for the familiar, pleasant, and pretty, popular in the eighteenth and nineteenth centuries in Europe. When contrasted with the **sublime**, the picturesque stood for all that was ordinary but pleasant.

piece-mold casting A casting technique in which the mold consists of several sections that are connected together during the pouring of molten metal, usually **bronze**. After the cast form has hardened, the pieces of the mold are then disassembled, leaving the completed object. Because it is made in pieces, the mold can be used again.

pier A large columnar support, often square or rectangular in plan, used to carry the heaviest architectural loads. Also: the masonry structure found between paired openings such as windows, doors, and arches.

pietà A devotional subject in religious painting from the life of Jesus, which occurs after the Crucifixion, when the body of the dead Jesus is laid across the lap of his grieving mother, Mary.

pietra dura (pietre dure) A type of mosaic made in relief from semiprecious stones. Popular among the Florentine nobility of the seventeenth century, pietre dure often depicted ornamental designs such as flowers or fruit. In singular, pietra dura indicates a mosaic made entirely from the same type of stones; in plural, the mosaic includes a mix of stones.

pilaster An engaged columnar element that is rectangular in format and used for decoration in architecture.

pillar In architecture, any large, freestanding vertical element. Usually functions as an important weight-bearing unit in buildings.

pinnacle In Gothic architecture (especially cathedrals), the small vertical elements placed on spires, buttresses, and facades for decoration. Often capped with a finial, pinnacles can be constructed in a variety of shapes and sizes.

plaiting In basketry, the technique of weaving strips of fabric or other flexible substances under and over each other.

plan A graphic convention for representing the arrangement of the parts of a building.

plasticity The three-dimensional quality of an object, or the degree to which any object can be **modeled**, shaped, or altered.

plinth The slablike base or pedestal of a column, statue, wall, building, or piece of furniture.

pluralism A social structure or goal that allows members of diverse ethnic, racial, or other groups to exist within the society while continuing to practice the customs of their own divergent cultures. Also: an adjective describing the state of having many valid contemporary styles available at the same time to artists.

podium A raised platform that acts as the foundation for a building. Most often used for Etruscan, Greek, and Roman temples.

polychromy The multicolored painted decoration applied to any part of a building, sculpture, or piece of furniture.

polyptych An altarpiece constructed from mul-

tiple panels, sometimes with hinges to allow for movable wings.

popular culture The accoutrements of society that are shared by the general public. Popular culture has the associations of something cheap, fleeting, and accessible to all.

porcelain A type of extremely hard and fine pottery made from a mixture of kaolin and other minerals. Porcelain is fired at a very high heat, and the final product has a translucent surface.

porch The covered entrance on the exterior of a building. With a row of **columns** or **colonnade**, also called a **portico**.

portal A grand entrance, door, or gate, usually to an important public building, and often decorated with elaborate sculpture.

portcullis A fortified gate, often made of metal bars, used for the defense of a city or castle. When lowered, the portcullis prevents access to the main doors and thus entry into the defended area.

portico In architecture, a projecting roof or **porch** supported by **columns**, often marking an entrance.

post-and-lintel construction An architectural system of construction with two or more vertical elements (posts) supporting a horizontal element (**lintel**).

postern A side entrance into a fortified city or castle, usually on a much smaller scale than the main gates.

potsherd A broken piece of ancient ceramic ware, most often found in archeological sites.

Prairie Style A style of architecture originally describing the work of Frank Lloyd Wright done during the first decade of the twentieth century. Characterized by large flat roofs with broad overhanging eaves and open-planned spatial arrangements, the style is epitomized by the houses of Wright in Illinois and Wisconsin and was popularized generally in the following decades by the houses of his followers, such as Walter Burley Griffin and the firm of Purcell & Elmslie.

predella The lower zone, or base, of an **altarpiece**, decorated with painting or sculpture related to the main **iconographic** theme of the altarpiece.

primary colors Blue, red, and yellow, the three colors from which all others are derived.

Prix de Rome A prestigious scholarship offered by the French **Academy** at the time of the establishment of its Roman branch in 1666. The scholarship allowed the winner of the prize to study in Rome for four years at the expense of the state. Originally intended only for painters, the prize was later expanded to include printmakers, architects, and musicians.

pronaos The enclosed vestibule of a Greek or Roman temple, found in front of the **cella** and marked by a row of **columns** at the entrance.

propylon (propylaia) A large, often elaborate gateway to a temple or other important building.

proscenium The stage of an ancient Greek or Roman theater. In modern theater, the area of the stage in front of the curtain. Also: the framing **arch** which separates a stage from the audience.

prostyle A term used to describe a **Classical** temple with a **colonnade** placed across the entrance.

provenance The history of ownership of a work of art from the time of its creation to the present.

pseudo-kufic Designs intended to resemble the script of the Arabic language.

pseudo-peripteral See peripteral.

punchwork Decorative designs that are stamped onto a surface, such as metal or leather, using a punch (a handheld metal implement).

putto (putti) A divine figure in the form of a plump, naked little boy, often with wings. Also called a cupid or **cherub**.

pylon A massive gateway formed by a pair of tapering walls of oblong shape. Erected by ancient Egyptians to mark the entrance to a **temple complex**.

pyramidion A pyramid-shaped block set as the finishing element atop an **obelisk**.

qibla The **mosque** wall oriented toward Mecca that includes the **mihrab**.

quadrant vault See vault.

quatrefoil A four-lobed decorative pattern common in Gothic art and architecture.

quillwork A Native American decorative craft technique. The quills of porcupines and bird feathers are dyed, woven together in patterns, and attached to fabric, birch bark, or other material.

quincunx The name for a square building **plan** that incorporates a central hall and similar units extending from each side.

quoin A stone, often decorated for emphasis, forming the corner of two walls.

radiometric dating A method of dating prehistoric works of art made from organic materials, based on the rate of degeneration of radiocarbons in these materials. See also relative dating, absolute dating.

raigo A painted image that depicts the Buddha Amida and other Buddhist deities guiding the soul of a dying worshiper to paradise.

raking cornice See cornice.

raku A type of ceramic pottery made by hand, coated with a thick dark glaze, and fired at a low heat. The resulting vessels are irregularly shaped and glazed, and are highly prized. Raku ware is the pottery used in the Japanese tea ceremony.

rampart The raised walls or embankments used as primary protection in the fortification of a city or castle. Ramparts may be of different heights or thicknesses, and are usually surmounted by a parapet.

readymade An object from popular or material culture presented as an artwork by the artist without further manipulation.

realism The representation in art of things and experiences as they appear to be in actual, visible reality.

recto The right-hand page in a book or **manuscript**. Also: the principal or front side of a leaf of paper, as in the case of a drawing.

red-figure A style of ancient Greek vase painting made in the sixth and fifth century BCE. Characterized by red clay-colored figures on a black background.

refectory The dining hall for monks or nuns in a monastery or convent.

register A device used in systems of spatial definition. In painting, a register indicates the use of differing groundlines to differentiate layers of space within an image. In sculpture, the placement of self-contained bands of reliefs in a vertical arrangement. In printmaking, the marks at the edges used to align the print correctly on the page, especially in multiple-block color printing.

reintegration The process of adaptation and transformation of European craft techniques and stylistic models by artists in colonial areas.

relative dating A method of dating ancient artifacts by their relation to other objects, not to a historical moment. *See* also **radiometric dating**, **absolute dating**.

relief sculpture A sculpted image or design whose flat background surface is carved away to a certain depth, setting off the figure. Called high or low (bas) depending upon the extent of projection of the image from the background. Called sunken relief when the image is modeled below the original surface of the background, which is not cut away.

relieving arch See arch.

reliquary A container, often made of precious materials, used as a repository for sacred relics.

replica A very close copy of a painting or sculpture, sometimes done by the same artist who created the original.

repoussé A technique by which metal **reliefs** are created. Thin sheets of metal are gently hammered from the back to create a protruding image. More elaborate reliefs are created with wooden forms against which the metal sheets are pressed.

representational Any art that attempts to depict an aspect of the external, natural world in a visually understandable way.

reredos A decorated wall behind the **altar** of a church.

retablo The screen placed behind an altar. Often built on a large scale, with multiple painted panels and successive stories, a retablo can substitute for an altarpiece. Retablos are most commonly found in Spain or in Spanish-influenced areas such as Latin America.

reverse perspective See perspective.

revetment A covering of cut stone, fine brick, or other solid facing material over a wall built of coarser materials. Also: surface covering used to reinforce a retaining wall, such as an embankment.

revivalism The practice of using older styles and modes of expression in a conscious manner. Revivalism does not usually entail the same academic and historical interest of **historicism**.

rhyton A vessel in the shape of a figure or an animal, used for drinking or pouring liquids on special occasions.

ribbon interlace A **linear** decoration made up of interwoven bands, often found in Celtic and northern European art of the medieval period.

rib vault See vault.

ridge rib See tierceron.

ring wall Any wall surrounding a building, town, or fortification, intended to separate and protect the enclosed area.

rock-cut tomb Ancient Egyptian multichambered burial site, hewn from solid rock and often thoroughly hidden. Most often found in remote cliffs and valleys of southern Egypt.

rood screen In a church, a screen that separates the public **nave** from the private and sacred area of the **choir**. The screen is usually topped by a rood (sculpted crucifix).

roof comb In a Mayan building, a masonry wall along the **apex** of a roof that is built above the level of the roof proper. Roof combs support the highly decorated false **facades** that rise above the height of the building at the front.

rosette A round or oval ornament resembling a rose.

rose window A round window, often made of stained glass, with tracery patterns in the form of wheel spokes. Large, elaborate, and finely crafted, rose windows are usually a central element of the facade of Gothic cathedrals.

rotulus (rotuli) A term usually applied to medieval **manuscripts** that are rolled or in a tubular form.

rotunda Any building (or part thereof) constructed in a circular (or sometimes polygonal) shape, usually producing a large open space crowned by a **dome**.

round arch See arch.

roundel Any element with a circular format, often placed as a decoration on the exterior of architecture.

round vault See vault.

rune stone A stone used in medieval northern Europe as a commemorative monument, which is carved or inscribed with ancient German or Scandinavian writing.

running spirals A decorative **motif** based on the shape formed by a line making a continuous spiral.

rustication In building, the rough, irregular, and unfinished effect deliberately given to the exterior facing of a stone edifice. Rusticated stones are often large and used for decorative emphasis around doors or windows, or across the entire lower floors of a building, probably deriving from fortifications.

sacristy In a Christian church, the room in which the priest's robes and the sacred vessels are housed. Sacristies are usually located close to the sanctuary and often have a place for ritual washing as well as a private door to the exterior.

sahn The central courtyard of a Muslim mosque.

sanctuary In Greek architecture, a sacred or holy enclosure used for worship consisting of one or more temples and an altar. Also: the space around the altar in a church, usually at the east end (also called the chancel or presbytery).

sand painting Ephemeral designs created with different colored sands by Native Americans of North America, Australian Aborigines, and other peoples in Japan and Tibet.

sanghati The robe worn by a Buddhist monk. Draped over the left shoulder, the robe is made

from a single piece of cloth wrapped around the body.

sarcophagus (sarcophagi) A rectangular stone coffin, used by ancient Egyptians, Greeks, and Romans, and others. Often decorated with relief sculpture in side panels.

scarification Ornamental marks, scars, or scratches made on the human body.

school of artists An art historical term describing a group of artists, usually working around the same time and sharing similar styles, influences, and ideals. The artists in a particular school may not necessarily be directly associated with one another, unlike in a workshop or atelier.

scientific perspective See perspective.

scriptorium (scriptoria) A room in a monastery for writing or copying **manuscripts**.

scroll painting A painting executed on a rolled paper support. Usually found with rigid bars at either end, scroll paintings can be stored rolled or hung as decoration.

sculpture in the round Three-dimensional sculpture that is carved free of any attaching background or block.

section A method of representing the threedimensional arrangement of a building in a graphic manner. A section is produced when an imaginary vertical plane intersects with a building, laying bare all the elements that make up the structure at that point.

segmental pediment A **pediment** formed when the upper cornice is a shallow arc.

sepia An ink **medium** often used in drawing that has an extremely rich, dark **tone** of brownish color.

seraph (seraphim) An angel of high rank in the Christian hierarchy.

serdab In Egyptian tombs, the small room in which the **ka** statue was placed.

sesto The curve of an arch.

sfumato In painting, the effect of haze in an image. Resembling the color of the atmosphere at dusk, sfumato gives a very **naturalistic**, smoky effect and was perfected by Leonardo da Vinci.

shade Any area of an artwork that is shown through various technical means to be in shadow. Also: the technique of making such an effect.

shaft The main vertical section of a **column** between the **capital** and the **base**, usually circular in cross section.

shater A type of roof or **dome** used in Russia and the Near East with a steep pitch and tentlike shape.

shikhara In the architecture of northern India, a conical (or pyramidal) spire found atop a Hindu temple and often crowned with an amalaka.

shoin The architecture of the aristocracy and upper classes in Japan, built in traditional asymmetrical fashion and incorporating the traditional elements of residences, such as the *tokonoma* and **shoji** screens.

shoji A standing Japanese screen covered in translucent rice paper and used in interiors.

sinopia The preparatory design or underdrawing of a **fresco**. Also: a reddish chalklike earth pigment.

site-specific sculpture A sculpture commissioned and designed for a particular spot. Most site-specific sculpture requires the location for which it was designed in order to be complete.

slip A mixture of clay and water applied to a ceramic object as a final decorative coat. Also: a solution that binds different parts of a vessel together, such as the handle and the main body.

spandrel The area of wall adjoining the exterior curve of an **arch** between its springing and the **keystone**, or the same between two arches, as in an **arcade**.

speech scroll A scroll painted with words indicating the speech or song of a depicted figure.

squinch A small **arch** built over the upper corners of a square space, allowing a circular or polygonal **dome** to be more securely set above the walls.

stadium In ancient Greece, a usually oval building or outdoor arena for sports, with tiers of seats for spectators.

stained glass A decorative process in glassmaking by which glass is given a color (whether intrinsic in the material or painted onto the surface). Stained glass is most often used in windows, for which small pieces of differently colored glass are precisely cut and assembled into a design, held together by cames.

stela (stelae) A stone slab placed vertically and decorated with inscriptions or **reliefs**. Used as a grave marker or memorial.

still life A type of painting that has as its subject inanimate objects (such as food, dishes, fruit, or flowers).

stoa In Greek architecture, a **portico** or promenade with long rows of **columns** attached to a building or meeting place.

stockade A defensive fencelike wood fortification built around a village, house, or other enclosed area.

stretcher The wooden framework on which an artist's canvas is attached, usually with tacks, nails, or staples. Also: a reinforcing horizontal brace between the legs of a piece of furniture, such as a chair. Also: in building, a brick laid so that the side, rather than the end, faces the wall.

stringcourse A continuous horizontal band, such as a **molding**, decorating the face of a wall.

stucco A mixture of lime, sand, and other ingredients into a material that can be easily molded or **modeled**. When dry, produces a very durable surface used for covering walls or for architectural sculpture and decoration.

stupa In Buddhist architecture, a bell-shaped or pyramidal religious monument, made of piled earth or stone, and containing sacred relics.

style A particular manner, form, or character of representation, construction, or expression typical of an individual artist or of a certain school or period.

stylization A manner of representation that conforms to an intellectual or artistic idea rather than to **naturalistic** appearances.

stylobate In **Classical** architecture, the stone foundation on which a temple **colonnade** stands.

stylus An instrument with a pointed end (used for writing and printmaking), which makes a del-

icate line or scratch. Also: a special writing tool for **cuneiform** writing with one pointed end and one triangular, wedge end.

subject matter See content.

sublime A concept, thing, or state of exceptional and awe-inspiring beauty and moral or intellectual expression. The sublime was a goal to which many nineteenth-century artists aspired in their artworks.

sunken relief See relief sculpture.

swag A decorative device in architecture or interior ornament (and in paintings), in which a loosely hanging garland is made to look as if constructed of flowers or gathered cloth.

syncretism In religion or philosophy, the union of different ideas or principles.

talud-tablero A design characteristic of Mayan architecture at Teotihuacan in which a sloping talud at the base of a building supports a wall-like tablero, where ornamental painting and sculpture are usually placed.

taotie A mask with a dragon or animal-like face common as a decorative **motif** in Chinese art.

tapa A cloth made in Polynesia by pounding the bark of a tree, such as the paper mulberry. It is also known as bark cloth.

tapestry A highly decorated piece of woven fabric meant to be hung from a wall or placed on a piece of furniture.

tatami Mats of woven straw used in Japanese houses as a floor covering.

temenos A group of buildings, including a temple as well as residences and recreational buildings, used for ritual worship.

tempera A painting medium made by blending egg yolks with water, pigments, and occasionally other materials, such as glue. The technique was often used during the fourteenth and fifteenth centuries to paint frescoes and panel paintings.

temple complex A group of buildings dedicated to a religious purpose, usually located close to one another in a **sanctuary**.

tenebrism A term signifying the prevalent use of dark areas in a painting. A tenebrist style, such as **Caravaggism**, uses strong **chiaroscuro** and artificially illuminated areas to create a dramatic contrast of light and dark.

tepee A dwelling constructed from stretched hides on a structure of poles set at the base in a circle and leaning against one another at the top. Tepees were typically found among the nomadic Native Americans of the North American plains.

terminal Any element of sculpture or architecture that functions as decorative closure. Terminals are usually placed in pairs at either end of an object (such as furniture) or **facade** (as on a building) to help frame the **composition**.

terra-cotta A **medium** made from clay fired over a low heat and usually left un**glazed**. Also: the orange-brown color typical of this medium.

tessera (**tesserae**) The small piece of stone, glass, or other object that is pieced together with many others to create a **mosaic**.

tholos A small, round, domed building. Sometimes built underground, as in a Mycenaean tomb.

tierceron In **vault** construction, a secondary rib that arcs from a springing point to the rib that runs lengthwise through the vault, called the ridge rib.

tint The dominant color in an object, image, or pigment.

tokonoma A **niche** for the display of an art object (such as a scroll or flower arrangement) in a Japanese tearoom.

tomb effigy A sculpted image on a tomb or sarcophagus that commemorates a deceased individual or group of individuals.

tondo A painting or relief of circular shape.

tone The overall degree of brightness or darkness in an artwork, often combined with a particular hue.

torana In Indian architecture, an ornamented gateway arch in a temple, usually leading to the stupa.

torii The ceremonial entrance gate to a Shinto temple.

toron In West African mosque architecture, the wooden beams that project from the walls. *Torons* are used as support for the scaffolding erected annually for the replastering of the building.

torque A type of neckpiece. Worn as jewelry in ancient times, the torque could be fashioned as a metal chain or rigid collar.

tracery The thin stone or wooden bars in a Gothic window, screen, or panel, which create an elaborate decorative matrix or pattern.

transept The entire arm of a **cruciform** church, perpendicular to the **nave**. The transept includes the **crossing** and often marks the beginning of the **apse**.

travertine A mineral building material similar to limestone, typically found in central Italy.

treasury A building, room, or box for keeping holy (and often highly valuable) offerings.

trefoil An ornamental design made up of three rounded lobes placed adjacent to one another.

triforium An arcaded element of the interior elevation of a Gothic church, usually found directly below the clerestory and consisting of a series of arched openings. The triforium can be made up of openings from a passageway or gallery, or can be a purely decorative device built into the wall.

triglyph Rectangular blocks between the **metopes** of a **Doric frieze**. Identified by the three carved vertical grooves, which approximate the appearance of the ends of wooden beams.

triptych A painting, usually an **altarpiece**, made up of three **panels**. The panels are often hinged together so the side segments (**wings**) fold over the central area.

triumph In Roman times, a celebration of a particular military victory, usually granted to the commanding general upon his return to Rome. Also: in later times, any depiction of a victory.

triumphal arch A freestanding, massive stone gateway with a large central **arch**, built as urban ornament and/or to celebrate military victories (as by the Romans).

trompe l'oeil A manner of representation in which the appearance of natural space and objects is re-created with the express intention of fooling the eye of the viewer, who may be convinced that the subject actually exists as three-dimensional reality.

trophy A grouping of captured military objects such as armor and weapons that Romans displayed in an upheld pole or tree to celebrate victory. Also: a similar grouping that recalls the Roman custom of displaying the looted armor of a defeated opponent.

trumeau A column, pier, or post found at the center of a large portal or doorway, supporting the lintel

tugra The calligraphic imperial monograms used in Ottoman courts.

tunnel vault See barrel vault.

turret A tall and slender tower.

Tuscan order See order.

twining A basketry technique in which short rods are sewn together vertically. The panels are then joined together to form a vessel.

tympanum The roughly semicircular area of stone or other material enclosed by an arch that springs from a lintel. Usually found in medieval architecture above a doorway or portal, and often highly decorated. Also: in Classical architecture, the area enclosed by a pediment.

typology The study of symbolic types of representation in art history, especially of Old Testament events of the Bible as they prefigure those of the New Testament.

ukiyo-e A Japanese term for a type of popular art that was favored from the sixteenth century, particularly in the form of color **woodblock prints**. Ukiyo-e prints often depicted the world of the common people in Japan, such as courtesans and actors, as well as landscapes and myths.

undercutting A technique in sculpture by which a form is carved to project outward, then under. Undercutting gives a highly three-dimensional effect with deep shadows behind the forms.

underglaze See glazing.

urna In Buddhist art, the curl of hair on the forehead that is a characteristic mark of a Buddha. The *urna* is a symbol of divine wisdom.

ushnisha In Eastern art, a round turban or tiara symbolizing royalty and, when worn by a Buddha, enlightenment.

value The relative relationships in a painting between darks and lights, as well as differing hues.

vanishing point In a perspective system, the point on the horizon line at which orthogonals meet. A complex system can have multiple vanishing points.

vanitas An image, especially popular in Europe during the seventeenth century, in which all the objects symbolize the transience of life. Vanitas paintings are usually of still lifes or genre subjects.

vault An arched masonry structure or roof that spans an interior space. In different shapes, called by different names. Barrel vault: a continuous semicircular vault. Corbel vault: a vault made by the technique of corbeling. Groin vault or cross vault: a vault created by the intersection of two barrel vaults of equal size. Rib vault: a rib vault is found when the joining of curved sides of a groin vault is demarcated by a raised rib. Quadrant vault: a vault with two diagonally crossed ribs, which creates four side compartments of equal size and shape.

veduta (*vedute*) A term derived from the Italian word for a vista, or view. *Veduta* paintings are often of expansive city scenes or of harbors.

vellum A type of paper made from animal skins. Vellum is a thick, expensive support.

veneer In architecture, the exterior facing of a building, often in decorative patterns of fine stone or brick. In decorative arts, a thin exterior layer for decoration laid over wooden objects or furniture. Made of fine materials such as rare wood, ivory, metal, and semiprecious stones.

verism A style in which artists concern themselves with capturing the exterior likeness of an object or person, usually by rendering its visible details in a finely executed, meticulous manner.

verso The left-hand page of a book or **manuscript**. Also: the subordinate or back side of a leaf of paper, as in the case of drawings.

vignette A small **motif** or scene that has no established border and that fades on the edges into the background. Also: the foliated decoration around a capital letter in an **illuminated manuscript**.

vihara From the Sanskrit term meaning "for wanderers." A vihara is, in general, a Buddhist monastery in India. It also signifies the monks' cells and gathering places in such a monastery.

vimana The main element of a Southern Indian Hindu temple, usually in the shape of a pyramidal or tapering tower raised on a plinth.

volumetric A term indicating the concern for rendering the impression of three-dimensional volumes in painting, usually achieved through **modeling** and the manipulation of light and shadow (**chiaroscuro**).

volute A spiral scroll, most often decoration on an Ionic capital.

volute krater See krater.

votive figure An image created as a devotional offering to a god or other deity.

voussoirs The oblong, wedge-shaped stone blocks used to build an **arch**. The topmost voussoir is called a **keystone**.

wall painting A large-scale painting intended for a particular interior space, usually as part of a scheme for interior decoration.

ware A general term designating the different techniques by which pottery is produced and decorated. Different wares utilize different procedures to achieve different decorative results. See also black-figure, red-figure, and whiteground.

warp The vertical threads in a weaver's loom. Warp threads make up a fixed framework that provides the structure for the entire piece of cloth, and are thus often thicker than weft threads.

wash A diluted watercolor. Often washes are applied to drawings or prints to add tone or touches of color.

watercolor A type of painting using watersoluble pigments that are floated in a water **medium** to make a transparent paint. The technique of watercolor is most suited to a paper support.

wattle-and-daub A wall construction method combining upright branches (wattles) plastered with clay or mud (daub).

weft The horizontal threads in a woven piece of cloth. Weft threads are woven at right angles to and through the warp threads to make up the bulk of the decorative pattern. In carpets, the weft is often completely covered by the rows of trimmed knots that form the carpet's soft surface.

westwork The monumental west-facing entrance section of a Carolingian, Ottonian, or Romanesque church. The exterior consists of multiple stories between two towers; the interior includes an entrance vestibule, a chapel, and a series of galleries overlooking the nave.

white-ground A type of ancient Greek pottery ware in which the background color of the object is painted with a type of slip that turns white in the firing process. Figures and details were added by painting on or incising into this slip. White-ground wares were popular in the High Classical period as funerary objects.

wing The side panel of a **triptych** (usually found in pairs), which was hinged to fold over the central panel. Wings often held the depiction of the donors or of subsidiary scenes relating to the central image.

woodblock print A print made from a block of wood that is carved in relief or incised.

woodcut A type of print made by carving a design into a wooden block. The ink is applied to the plate with a roller. As the ink remains only on the raised areas between the carved-away lines, these carved-away areas and lines provide the white areas of the print. Also: the process by which the woodcut is made.

x-ray style In aboriginal art, a manner of representation in which the artist depicts a figure or animal by illustrating its outline as well as essential internal organs and bones.

yaksha, yakshi The male (yaksha) and female (yakshi) nature spirits that act as agents of the Hindu gods. Their sculpted images are often found on Hindu temples and other sacred places, particularly at the entrances.

zeitgeist From the German word for "spirit of the time," the term means cultural and intellectual aspects of a time period that pervade human experience and are expressed in all creative and social endeavors.

ziggurat A tall, stepped tower of earthen materials, often housing a temple or shrine. Built by ancient Near Eastern cultures.

Bibliography

Susan Craig

This bibliography is composed of books in English that are appropriate "further reading" titles. Most items on this list are available in good libraries, whether college, university, or public institutions. There are three classifications of listings: general surveys and art history reference tools, including journals; surveys of large periods (ancient art in the Western tradition, European medieval art, European Renaissance through eighteenth-century art, modern art in the West, Asian art, and African and Oceanic art and art of the Americas); and books for individual Chapters 1 through 29. Sources of quotations cited in short form in the text will also be found in this bibliography.

General Art History Surveys and Reference Tools

- Adams, Laurie. A History of Western Art. Madison: Brown and Benchmark, 1994.
- Bazin, Germain. A Concise History of World Sculpture. London: David & Charles, 1981.
- Brownston, David M., and Ilene Franck. Timelines of the Arts and Literature. New York: HarperCollins, 1994
- Bull, Stephen. An Historical Guide to Arms and Armor. Ed. Tony North. New York: Facts on File, 1991.
- Chadwick, Whitney. Women, Art, and Society. New York: Thames and Hudson, 1990.
- Cole, Bruce, and Adelheid Gealt. Art of the Western World: From Ancient Greece to Post-Modernism. New York: Summit, 1989.
- Crofton, Ian, comp. A Dictionary of Art Quotations. New York: Schirmer, 1989.
- Crouch, Dora P. A History of Architecture: Stonehenge to Sky-scrapers. New York: McGraw-Hill, 1985.
- Encyclopedia of World Art. 16 vols. New York: McGraw-Hill, 1972-83.
- Fleming, John, Hugh Honour, and Nikolaus Pevsner. The Penguin Dictionary of Architecture. 4th ed. New York: Penguin, 1991.
- Fletcher, Banister. Sir Banister Fletcher's A History of Architecture. 19th ed. Ed. John Musgrove. London: Butterworths, 1987. Gardner, Helen. *Gardner's Art through the Ages*. 9th ed. Ed. Horst
- de la Croix, Richard G. Tansey, and Diana Kirkpatrick. San Diego: Harcourt Brace College, 1991. Hall, James. *Dictionary of Subjects and Symbols in Art*. Rev. ed.
- New York: Harper & Row, 1979.
- Hartt, Frederick. Art: A History of Painting, Sculpture, Architecture. 4th ed. New York: Abrams, 1993.
- Heller, Nancy G. Women Artists: An Illustrated History. New York. Abbeville, 1987.
- Holt, Elizabeth Gilmore, ed. A Documentary History of Art. 3 vols. New Haven: Yale Univ. Press, 1986. Honour, Hugh. *The Visual Arts: A History*. 3rd ed. New York:
- Abrams, 1991. Janson, H. W. History of Art. 5th ed. Rev. and exp. Anthony
- F. Janson. New York: Abrams, 1995. Jervis, Simon. The Penguin Dictionary of Design and Designers.
- London: Lane, 1984. Jones, Lois Swan. Art Information: Research Methods and
- Resources. 3rd ed. Dubuque: Kendall/Hunt, 1990. Kostof, Spiro. A History of Architecture: Settings and Rituals. New
- York: Oxford Univ. Press, 1985. Kurtz, Bruce D. Visual Imagination: An Introduction to Art. Englewood Cliffs, N.J.: Prentice-Hall, 1987.
- Lindemann, Gottfried. Prints and Drawings: A Pictorial History. Trans. Gerald Onn. Oxford: Phaidon, 1976.
- Mair, Roslin. Key Dates in Art History: From 600 BC to the Present. Oxford: Phaidon, 1979.
- Mayor, A. Hyatt. Prints and People: A Social History of Printed Pic tures. New York: Metropolitan Museum of Art, 1971.
- McConkey, Wilfred J. Klee as in Clay: A Pronunciation Guide. Lantham, Md.: Univ. Press of America, 1985. Myers, Bernard, ed. *McGraw-Hill Dictionary of Art.* 5 vols. New
- York: McGraw-Hill, 1969. Rothberg, Robert I., and Theodore K. Rabb, eds. Art and History.
- Images and Their Meaning. Cambridge: Cambridge Univ. Press, 1988. Stangos, Nikos. The Thames and Hudson Dictionary of Art and
- Artists. Rev ed. World of Art. New York: Thames and Hudson, 1994. Steer, John, and Antony White. Atlas of Western Art History: Artists, Sites and Movements from Ancient Greece to the
- Modern Age. New York: Facts on File, 1994. Thacker, Christopher. The History of Gardens. Berkeley: Univ. of
- California Press, 1979
- Trachtenberg, Marvin, and Isabelle Hyman. Architecture, from Prehistory to Post-Modernism: The Western Tradition. New York: Abrams, 1986.
- Tufts, Eleanor. Our Hidden Heritage: Five Centuries of Women Artists. New York: Paddington, 1974.
- Wilkins, David G., Bernard Schultz, and Katheryn M. Linduff. Art Past / Art Present. 2nd ed. New York: Abrams, 1994 The World Atlas of Architecture. Boston: Hall, 1984.

Art History Journals: A Selected List

African Arts. Quarterly. Los Angeles, Calif. American Art. Quarterly. Washington, D.C. American Journal of Archaeology. Quarterly. Boston, Mass.

Antiquity. Quarterly. Oxford Apollo. Monthly. London

Architectural History. Annually. London

Archives of American Art Journal. Quarterly. Washington, D.C. Archives of Asian Art. Annually. New York

Ars Orientalis. Ann Arbor, Mich.

Art Bulletin, Quarterly, New York Artforum. Monthly. New York

Art History. Quarterly. Oxford

Art in America. Monthly. New York

Art Journal. Quarterly. New York Art News. Monthly. New York

Arts and the Islamic World. Annually. London

Asian Art and Culture. Triannually. New York

Burlington Magazine. Monthly. London Flash Art. Bimonthly. New York

Gesta. Semiannually. New York

History of Photography. Quarterly. London Journal of Egyptian Archaeology. Quarterly. London

Journal of Hellenic Studies. Annually. London

Journal of Roman Archaeology. Annually. Ann Arbor, Mich Journal of the Society of Architectural Historians. Quarterly. Philadelphia

Journal of the Warburg and Courtauld Institutes. Annually. London Marg. Quarterly. Bombay, India

Oriental Art. Quarterly. Richmond, Surrey, England Oxford Art Journal. Semiannually. Oxford Simiolus. Quarterly. Apeldoorn, Netherlands

Textile History. Semiannually, London Woman's Art Journal. Semiannually, Laverock, Penn.

Ancient Art in the Western Tradition, General

- Adam, Robert. Classical Architecture: A Comprehensive Handbook to the Tradition of Classical Style. New York: Abrams,
- Amiet, Pierre. Art in the Ancient World: A Handbook of Styles and Forms. New York: Rizzoli. 1981.
- Becatti, Giovanni. The Art of Ancient Greece and Rome, from the Rise of Greece to the Fall of Rome. New York: Abrams, 1967. Ehrich, Robert W., ed. Chronologies in Old World Archaeology. 3rd ed. Chicago: Univ. of Chicago Press, 1992.
- Groenewegen-Frankfort, H. A., and Bernard Ashmole. Art of the Ancient World: Painting, Pottery, Sculpture, Architecture from Egypt, Mesopotamia, Crete, Greece, and Rome. Library of Art History. Englewood Cliffs, N.J.: Prentice-Hall, 1972
- Huyghe, René. *Larousse Encyclopedia of Prehistoric and Ancient Art.* Art and Mankind. New York: Prometheus, 1966.
- Laing, Lloyd Robert, and Jennifer Laing. Ancient Art: The Challenge to Modern Thought. Dublin: Irish Academic, 1993.
- Lloyd, Seton, and Hans Wolfgang Muller. Ancient Architecture. New York: Rizzoli. 1986.
- Oliphant, Margaret. The Atlas of the Ancient World: Charting the Great Civilizations of the Past. New York: Simon & Schuster, 1992.
- Powell, Ann. Origins of Western Art. London: Thames and Hudson. 1973.
- Saggs, H. W. F. Civilization before Greece and Rome. New Haven: Yale Univ. Press, 1989.
- Scranton, Robert L. Aesthetic Aspects of Ancient Art. Chicago: Univ. of Chicago Press, 1964.
- Smith, William Stevenson. Interconnections in the Ancient Near East: A Study of the Relationships between the Arts of Egypt, the Aegean, and Western Asia. New Haven: Yale Univ. Press, 1965.
- Stillwell, Richard, ed. Princeton Encyclopedia of Classsical Sites. Princeton: Princeton Univ. Press, 1976.

European Medieval Art, General

- Calkins, Robert C. Monuments of Medieval Art. New York: Dutton, 1979
- Duby, Georges. Sculpture: The Great Art of the Middle Ages from the Fifth to the Fifteenth Century. New York: Skira/Rizzoli, 1990 Hurlimann, Martin, and Jean Bony. French Cathedrals. Boston:
- Houghton Mifflin, 1951. Kenyon, John. *Medieval Fortifications*. Leicester: Leicester Univ. Press, 1990.
- Labarge, Margaret Wade. A Small Sound of the Trumpet: Women in Medieval Life. London: Hamilton. 1990.
- Larousse Encyclopedia of Byzantine and Medieval Art. London: Hamlyn, 1963.
- Mâle, Emile. Religious Art in France: The Late Middle Ages: A Study of Medieval Iconography and Its Sources. Princeton: Princeton Univ. Press, 1986.
- Murphey, Cecil B., comp. Dictionary of Biblical Literacy. Nashville: Oliver-Nelson, 1989.
- Snyder, James. Medieval Art: Painting-Sculpture-Architecture, 4th-14th Century. New York: Abrams, 1989.
- Stoddard, Whitney. Art and Architecture in Medieval France: Medieval Architecture, Sculpture, Stained Glass, Manuscripts. The Art of the Church Treasuries. New York: Harper & Row, 1972.
- Stokstad, Marilyn. Medieval Art. New York: Harper & Row, 1986.

Zarnecki, George. The Art of the Medieval World: Architecture, Sculpture, Painting, the Sacred Arts. New York: Abrams, 1975.

European Renaissance through Eighteenth-Century Art, General

- Art and Politics in Late Medieval and Early Renaissance Italy, 1250-1500. South Bend, Ind.: Univ. of Notre Dame Press, 1990.
- Black, C. F., et al. Cultural Atlas of the Renaissance. New York: Prentice Hall, 1993.
- Blunt, Anthony. Art and Architecture in France, 1500 to 1700. Pelican History of Art. Harmondsworth, Eng.: Penguin, 1957. Circa 1492: Art in the Age of Exploration. Washington, D.C. National Gallery of Art, 1991.
- Cole, Bruce. Italian Art, 1250-1550: The Relation of Renaissance
- Art to Life and Society. New York: Harper & Row, 1987.
 Cuttler, Charles D. Northern Painting from Pucelle to Bruegel: Fourteenth, Fifteenth and Sixteenth Centuries. New York: Holt, Rinehart and Winston, 1973.
- Evers, Hans Gerhard. The Modern Age: Historicism and Functionalism. Art of the World. London: Methuen, 1970.
- Hartt, Frederick. History of Italian Renaissance Art: Painting, Sculpture, Architecture. 3rd ed. New York: Abrams, 1987.
- Heydenreich, Ludwig Heinrich. Architecture in Italy, 1400 to 1600. Pelican History of Art. Harmondsworth, Eng.: Penguin, 1966.
- Huizinga, Johan. Waning of the Middle Ages: A Study of the Forms of Life, Thought, and Art in France and the Netherlands in the XIVth and XVth Centuries. Garden City, N.Y.: Doubleday, 1954
- Husband, Timothy. Wild Man: Medieval Myth and Symbolism. New York: Metropolitan Museum of Art, 1980.
- Huyghe, René. *Larousse Encyclopedia of Renaissance and Baroque Art*. Art and Mankind. New York: Prometheus, 1964.
- Kubler, George, and Martin Soria. Art and Architecture in Spain and Portugal and Their American Dominions, 1500-1800. Pelican History of Art. Harmondsworth, Eng.: Penguin, 1959
- Levey, Michael. Early Renaissance. Harmondsworth, Eng.: Penguin, 1967.
- Murray, Peter. Renaissance Architecture. History of World Architecture. Milan: Electa, 1985.
- and Linda Murray. The Art of the Renaissance. World of Art. London: Thames and Hudson, 1963.
- Stechow, Wolfgang. Northern Renaissance, 1400-1600: Sources and Documents. Englewood Cliffs, N.J.: Prentice-Hall, 1966
- Waterhouse, Ellis K. *Painting in Britain: 1530 to 1790.* 4th ed. Pelican History of Art. Harmondsworth, Eng.: Penguin, 1978
- Whinney, Margaret Dickens. Sculpture in Britain: 1530-1830. 2nd ed. Rev. by John Physick. Pelican History of Art. London: Penguin, 1988.

Modern Art in the West, General

- Arnason, H. H. History of Modern Art: Painting, Sculpture, Architecture, Photography. 3rd ed. rev. New York: Abrams, 1986. Bearden, Romare. A History of African American Artists: From 1792 to the Present. New York: Pantheon, 1993.
- Brown, Milton W. American Art: Painting, Sculpture, Architecture,
- Decorative Arts, Photography. New York: Abrams, 1979. Canaday, John. *Mainstreams of Modern Art*. 2nd ed. New York: Holt, Rinehart and Winston, 1981.
- Chipp, Herschel Browning. Theories of Modern Art: A Source Book by Artists and Critics. California Studies in the History of Art. Berkeley: Univ. of California Press, 1984.
- Craven, Wayne. American Art: History and Culture. New York: Abrams, 1994.
- Eitner, Lorenz. An Outline of Nineteenth Century European Painting: From David to Cezanne. 2 vols. New York: Harper & Row, 1987.
- Ferebee, Ann. A History of Design from the Victorian Era to the Present. New York: Van Nostrand Reinhold, 1980.
- Ferrier, Jean Louis, ed. Art of Our Century: The Chronicle of Western Art, 1900 to the Present. New York: Prentice Hall, 1989. Frampton, Kenneth. Modern Architecture: A Critical History.
- World of Art. New York: Oxford Univ. Press, 1980.
 Hamilton, George Heard. 19th and 20th Century Art: Painting. Sculpture and Architecture. Library of Art History. New
- York: Abrams, 1972. Hammacher, A. M. *Modern Sculpture: Tradition and Innovation*. Enlg. ed. New York: Abrams, 1988.
- Handlin, David P. American Architecture. World of Art. London: Thames and Hudson, 1985.
- Harris, Ann Sutherland, and Linda Nochlin. Women Artists: 1550-1950. Los Angeles: Los Angeles County Museum of Art, 1976. Harrison, Charles, and Paul Wood, eds. Art in Theory, 1900-
- 1990: An Anthology of Changing Ideas. Cambridge: Blackwell, 1992. Hitchcock, Henry Russell. Architecture: Nineteenth and Twentieth
- Centuries. 4th ed. Pelican History of Art. Harmondsworth, Eng.: Penguin, 1977.

- Hunter, Sam, and John Jacobus. American Art of the 20th Century: Painting, Sculpture, Architecture. New York: Abrams, 1973 . Modern Art: Painting, Sculpture, Architecture. 3rd ed. New
- York: Abrams, 1992. Jeffrey, Ian. Photography: A Concise History. London: Thames and Hudson, 1981
- Lynton, Norbert. The Story of Modern Art. 2nd ed. Oxford: Phaidon, 1989.
- McCoubrey, John W. American Art, 1700–1960: Sources and Doc-
- uments. Englewood Cliffs, N.J.: Prentice-Hall, 1965. Newhall, Beaumont. The History of Photography: From 1839 to the Present. Rev. ed. New York: Museum of Modern Art, 1982
- Pevsner, Nikolaus, Sir. The Sources of Modern Architecture and Design. World of Art. New York: Oxford Univ. Press, 1968. Read, Herbert. A Concise History of Modern Painting. London:
- Thames and Hudson, 1974. A Concise History of Modern Sculpture. World of Art. New
- York: Praeger, 1964. Rosenblum, Naomi. A World History of Photography. Rev. ed.
- New York: Abbeville, 1989. Rosenblum, Robert, 19th Century Art, New York: Abrams, 1984 Schapiro, Meyer. Modern Art: 19th and 20th Century Art. New York: Braziller, 1978.
- Selz, Peter. Art in Our Times: A Pictorial History 1890–1980. New York: Abrams, 1981.
- Sparke, Penny. Introduction of Design and Culture in the Twentieth Century. New York: Harper & Row, 1986.
- Stangos, Nikos, ed. Concepts of Modern Art. 3rd ed. World of Art. New York: Thames and Hudson, 1994.
- Tafuri, Manfredo. Modern Architecture. 2 vols. History of World Architecture. New York: Electa/Rizzoli, 1986.
- Tuchman, Maurice. The Spiritual in Art: Abstract Painting 1890-1985. Los Angeles: Los Angeles County Museum of Art,
- Weaver, Mike, ed. The Art of Photography, 1939-1989. London: Royal Academy of Arts, 1989.
- Wilmerding, John. American Art. Pelican History of Art. Harmondsworth, Eng.: Penguin, 1976.

Asian Art, General

- Akiyama, Terukazu. Japanese Painting. Treasures of Asia. Geneva: Skira, 1961
- Arts of China. 3 vols. Tokyo: Kodansha International, 1968–70. Blunden, Caroline, and Mark Elvin. Cultural Atlas of China. New
- York: Facts on File, 1983. Bussagli, Mario. *Oriental Architecture*. 2 vols. History of World Architecture. New York: Electa/Rizzoli, 1989.
- Chang, Leon Long-Yien, and Peter Miller. Four Thousand Years of Chinese Calligraphy. Chicago: Univ. of Chicago Press,
- Collcutt, Martin, Marius Jansen, and Isao Kumakura. Cultural Atlas of Japan. New York: Facts on File, 1988.
- Craven, Roy C. Indian Art: A Concise History. World of Art. New York: Thames and Hudson, 1985.
- Fisher, Robert E. Buddhist Art and Architecture. World of Art. New York: Thames and Hudson, 1993.
- Frankfort, Henri. Art and Architecture of the Ancient Orient. 4th ed. Pelican History of Art. Harmondsworth, Eng.: Penguin, 1970.
- Goetz, Hermann. The Art of India: Five Thousand Years of Indian Art. 2nd ed. Art of the World. New York: Crown, 1964. Harle, James C. Art and Architecture of the Indian Subcontinent
- Pelican History of Art. Harmondsworth, Eng.: Penguin, 1987.
- Lee, Sherman E. A History of Far Eastern Art. 4th ed. New York Abrams, 1982.
- Loehr, Max. The Great Painters of China. New York: Harper & Row. 1980.
- Martynov, Anatolii Ivanovich. Ancient Art of Northern Asia Urbana: Univ. of Illinois Press, 1991.
- Mason, Penelope. History of Japanese Art. New York: Abrams,
- Medley, Margaret. Chinese Potter: A Practical History of Chinese Ceramics. 3rd ed. Oxford: Phaidon, 1989.
- Michell, George. The Penguin Guide to the Monuments of India. 2 vols. New York: Viking, 1989.
- Mikami, Tsugio. Art of Japanese Ceramics. Trans. Ann Herring. Heibonsha Survey of Japanese Art, vol. 29. New York Weatherhill, 1972
- Nakata, Yujiro. Art of Japanese Calligraphy. Trans. Alan Woodhull. Heibonsha Survey of Japanese Art, vol. 27. New York: Weatherhill, 1973
- Paine, Robert Treat, and Alexander Soper. Art and Architecture of Japan. 3rd ed. Pelican History of Art. Harmondsworth, Eng.: Penguin, 1981.
- Rowland, Benjamin. Art and Architecture of India: Buddhist, Hindu, Jain. Pelican History of Art. Harmondsworth, Eng. Penguin, 1977
- Seckel, Dietrich. Art of Buddhism. Art of the World. New York: Crown, 1964.
- Sickman, Lawrence, and Alexander Soper. Art and Architecture of China. Pelican History of Art. Harmondsworth, Eng.: Penguin, 1971
- Speiser, Werner. The Art of China: Spirit and Society. Art of the World. New York: Crown, 1961.
- Stanley-Baker, Joan. Japanese Art. World of Art. New York Thames and Hudson, 1984.

- Stutley, Margaret. Harper's Dictionary of Hinduism: Its Mythology, Folklore, Philosophy, Literature and History. New York: Harper & Row, 1977
- Tregear, Mary. Chinese Art. World of Art. New York: Oxford Univ. Press, 1980.
- Vainker, S. J. Chinese Pottery and Porcelain: From Prehistory to the Present. London: British Museum, 1991 Varley, H. Paul. Japanese Culture. 3rd ed. Honolulu: Univ. of

Hawaii Press, 1984

Yoshikawa, Itsuji. Major Themes in Japanese Art. Trans. Armins Nikovskis. Heibonsha Survey of Japanese Art, vol. 1. New York: Weatherhill, 1976.

African and Oceanic Art and Art of the Americas, General

- Anderson, Richard L. Art in Small-Scale Societies. 2nd ed. Englewood Cliffs, N.J.: Prentice Hall, 1989.
- Berlo, Janet Catherine, and Lee Ann Wilson. Arts of Africa, Oceania, and the Americas: Selected Readings. Englewood Cliffs, N.J.: Prentice Hall, 1993.
- Blocker, H. Gene. The Aesthetics of Primitive Art. Lantham, Md.: Univ. Press of America, 1994.
- Coote, Jeremy, and Anthony Shelton, eds. Anthropology, Art, and Aesthetics. New York: Oxford Univ. Press, 1992
- D'Azevedao, Warren L. The Traditional Artist in African Societies. Bloomington: Indiana Univ. Press, 1989.
- Drewal, Henry, and John Pemberton III. Yoruba: Nine Centuries of African Art and Thought. New York: Center for African Art. 1989.
- Guidoni, Enrico. Primitive Architecture. Trans. Robert Eric Wolf. History of World Architecture. New York: Rizzoli, 1987
- Leiris, Michel, and Jacqueline Delange. African Art. Arts of Mankind, London: Thames and Hudson, 1968. Leuzinger, Elsy. Africa: The Art of the Negro Peoples. 2nd ed. Art
- of the World. New York: Crown, 1967. Mbiti, John S. African Religions and Philosophy. 2nd ed. Oxford:
- Heinemann, 1990.
- Mexico: Splendors of Thirty Centuries. New York: Metropolitan Museum of Art. 1990.
- Murray, Jocelyn, ed. Cultural Atlas of Africa. New York: Facts on File, 1981.
- Price, Sally. Primitive Art in Civilized Places. Chicago: Univ. of Chicago Press, 1989.
- Willett, Frank. African Art: An Introduction. Rev ed. World of Art. New York: Thames and Hudson, 1993.

Chapter 1 Prehistory and Prehistoric Art in Europe

- Anati, Emmanuel. Camonica Valley: A Depiction of Village Life in the Alps from Neolithic Times to the Birth of Christ, as Revealed by Thousands of Newly Found Rock Carvings.
- Trans. Linda Asher. New York: Knopf, 1961. Bandi, Hans-Georg, et al. Art of the Stone Age: Forty Thousand Years of Rock Art. 2nd ed. Trans. Ann E. Keep. Art of the World, London: Methuen, 1970.
- Beltrán Martínez, Antonio. Rock Art of the Spanish Levant Trans. Margaret Brown. Cambridge: Cambridge Univ. Press, 1982.
- Castleden, Rodney. The Making of Stonehenge. London: Rout ledge, 1993
- Chippindale, Christopher. Stonehenge Complete. New York: Thames and Hudson, 1994.
- Freeman, Leslie G. Altamira Revisited and Other Essays on Early Art. Chicago: Institute for Prehistoric Investigation, 1987. Gowlett, John A. J. Ascent to Civilization: The Archaeology of Early
- Humans. 2nd ed. New York: McGraw-Hill, 1993 Graziosi, Paolo. Paleolithic Art. New York: McGraw-Hill, 1960. Leroi-Gourhan, André. The Dawn of European Art: An Introduc-
- tion to Paleolithic Cave Painting. Trans. Sara Champion. Cambridge: Cambridge Univ. Press, 1982. Treasures of Prehistoric Art. New York: Abrams, 1967
- Roger. The Origins of Modern Humans. New York: Scientific American Library, 1993.
- Lhote, Henri. The Search for the Tassili Frescoes: The Story of the Prehistoric Rock-Paintings of the Sahara. 2nd ed. Trans. Alan Houghton Brodrick. London: Hutchinson, 1973.
- Marshack, Alexander. The Roots of Civilization: The Cognitive Beginnings of Man's First Art, Symbol, and Notation. New York: McGraw-Hill, 1971.
- Moscati, Sabatino, ed. The Phoenicians. New York: Abbeville,
- O'Kelly, Michael J. Newgrange: Archaeology, Art, and Legend. New Aspects of Antiquity. London: Thames and Hudson,
- Powell, T. G. E. Prehistoric Art. World of Art. New York: Oxford Univ. Press, 1966
- Price, T. Douglas, and Gray M. Feinman. Images of the Past. Mountain View, Calif.: Mayfield, 1993. Renfrew, Colin, ed. The Megalithic Monuments of Western
- Europe. London: Thames and Hudson, 1983. Ruspoli, Mario. The Cave of Lascaux: The Final Photographs.
- New York: Abrams, 1987.
- Sandars, N. K. *Prehistoric Art in Europe.* 2nd ed. Pelican History of Art. Harmondsworth, Eng.: Penguin, 1985. Sieveking, Ann. *The Cave Artists*. Ancient People and Places,
- vol. 93. London: Thames and Hudson, 1979. Soffer, Olga. The Upper Paleolithic of the Central Russian Plain. Studies in Archaeology. Orlando, Fla.: Academic, 1985.

- Torbrugge, Walter. Prehistoric European Art. Trans. Norbert Guterman. Panorama of World Art. New York: Abrams,
- Ucko, Peter J., and Andree Rosenfeld. Paleolithic Cave Art. New York: McGraw-Hill, 1967.

Chapter 2 Art of the Ancient Near East

- Akurgal, Ekrem. The Art of the Hittites. Trans. Constance McNab. New York: Abrams, 1962.
- Amiet, Pierre. Art of the Ancient Near East. Trans. John Shepley and Claude Choquet. New York: Abrams, 1980.
 Baring, Anne, and Jules Cashford. The Myth of the Goddess: Evo-
- lution of an Image. London: Viking Arkana, 1991
- Bottero, Jean. Mesopotamia: Writing, Reasoning, and the Gods. Trans. Zainab Bahrani and Marc Van De Mieroop. Chicago: Univ. of Chicago Press, 1992.
- Collon, Dominque. First Impressions: Cylinder Seals in the Ancient Near East. Chicago: Univ. of Chicago Press, 1987. Ferrier, R. W., ed. Arts of Persia. New Haven: Yale Univ. Press,
- 1989 Ghirshman, Roman. The Arts of Ancient Iran from Its Origins to the Time of Alexander the Great. Trans. Stuart Gilbert and James Emmons. Arts of Mankind. New York: Golden,
- 1964. Giedion, Sigfried. The Eternal Present: A Contribution on Constancy and Change. 2 vols. New York: Pantheon, 1962–64.
- Harper, Prudence, Joan Arz, and Françoise Tallon, eds. The Royal City of Susa: Ancient Near Eastern Treasures in the Louvre. New York: Metropolitan Museum of Art, 1992.
- Kramer, Samual Noah. History Begins at Sumer: Thirty-Nine Firsts in Man's Recorded History. 3rd rev. ed. Philadelphia: Univ. of Pennsylvania Press, 1981.
- -. The Sumerians, Their History, Culture, and Character.
 Chicago: Univ. of Chicago Press, 1963.
- Lloyd, Seton. Ancient Turkey: A Traveller's History of Anatolia. Berkeley: Univ. of California Press, 1989.
- Mellaart, James. The Earliest Civilization of the Near East. London: Thames and Hudson, 1965.
- Oppenheim, A. Leo. Ancient Mesopotamia: Portrait of a Dead Civilization. Rev. ed. completed by Erica Reiner. Chicago: Univ. of Chicago Press, 1977.
- Parrot, André. The Arts of Assyria. Trans. Stuart Gilbert and James Emmons. Arts of Mankind. New York: Golden,
- Sumer: The Dawn of Art. Trans. Stuart Gilbert and James Emmons. Arts of Mankind. New York: Golden, 1961
- Porada, Edith. The Art of Ancient Iran: Pre-Islamic Cultures. Art of the World. New York: Crown, 1965.
- Roaf, Michael. Cultural Atlas of Mesopotamia and the Ancient Near East. New York: Facts on File, 1990.
- Roux, Georges. Ancient Iraq. 3rd ed. London: Penguin, 1992. Russell, John Malcolm. Sennacherib's Palace without Rival at Nineveh. Chicago: Univ. of Chicago Press, 1991
- Saggs, H. W. F. Everyday Life in Babylonia and Assyria. New York: Dorset, 1987 Civilization before Greece and Rome. New Haven: Yale
- Univ. Press. 1989. Wolkstein, Dianne, and Samuel Noah Kramer. Inanna: Queen
- of Heaven and Earth. New York: Harper & Row, 1983. Woolley, Leonard. The Art of the Middle East including Persia, Mesopotamia and Palestine. Trans. Ann E. Keep. Art of the World, New York: Crown, 1961.

Chapter 3 Art of Ancient Egypt

- Aldred, Cyril. Akenaten and Nefertiti. New York: Brooklyn Museum, 1973.
- Egyptian Art in the Days of the Pharaohs, 3100–320 B.C. World of Art. London: Thames and Hudson, 1980.
- Andrews, Carol. Ancient Egyptian Jewelry. New York: Abrams, 1991
- Baines, John, and Jaromír Málek. Atlas of Ancient Egypt. New York: Facts on File, 1980.
- Bierbrier, Morris. Tomb-Builders of the Pharaohs. London: British Museum, 1982.
- Breasted, James Henry. A History of Egypt from the Earliest Times to the Persian Conquest. New York: Scribner's, 1909. Brier, Bob. Egyptian Mummies. New York: Morrow, 1994
- David, A. Rosalie. The Pyramid Builders of Ancient Egypt: A Modern Investigation of Pharaoh's Workforce. London: Routledge, 1986.
- Edwards, I. E. S. The Pyramids of Egypt. Rev. ed. Harmonds-
- worth, Eng.: Penguin, 1985. The Egyptian Book of the Dead: The Book of Going Forth by Day: Being the Papyrus of Ani (Royal Scribe of the Divine Offerings). Trans. Raymond O. Faulkner. San Francisco: Chron-
- Grimal, Nicolas. A History of Ancient Egypt. Trans. Ian Hall. Oxford: Blackwell, 1992.
- James, T. G. H. Egyptian Painting. London: British Museum, 1985
- –, and W. V. Davies. *Egyptian Sculpture*. Cambridge: Harvard Univ. Press, 1983. Kozloff, Arielle P., and Betsy M. Bryan. Egypt's Dazzling Sun: Amenhotep III and His World. Cleveland: Cleveland Muse-
- um of Art, 1992. Manniche, Lise. City of the Dead: Thebes in Egypt. Chicago: Univ. of Chicago Press, 1987

Martin, Geoffrey Thorndike. The Hidden Tombs of Memphis. New Discoveries from the Time of Tutankhamun and Ramesses the Great. London: Thames and Hudson, 1991.

Montet, Pierre. Everyday Life in Egypt in the Days of Ramesses the Great. Trans. A. R. Maxwell-Hysop and Margaret S. Drower. Philadelphia: Univ. of Pennsylvania Press, 1981. Pemberton, Delia. Ancient Egypt. Architectural Guides for Trav-

elers. San Francisco: Chronicle, 1992.

Reeves, C. N. The Complete Tutankhamun: The King, the Tomb, the Royal Treasure. London: Thames and Hudson, 1990. Russmann, Edna R. Egyptian Sculpture: Cairo and Luxor. Austin:

Univ. of Texas Press, 1989. Smith, W. Stevenson. The Art and Architecture of Ancient Egypt.

Rev. ed. Pelican History of Art. Harmondsworth, Eng.: Penguin, 1981.

Strouhal, Eugen. Life of the Ancient Egyptians. Norman: Univ. of Oklahoma Press, 1992.

Treasures of Tutankhamun, New York: Ballantine, 1976.

Wilkinson, Charles K. Egyptian Wall Paintings: The Metropolitan Museum of Art's Collection of Facsimiles. New York: Metropolitan Museum of Art, 1983.

Winstone, H. V. F. Howard Carter and the Discovery of the Tomb of Tutankhamun. London: Constable, 1991

Woldering, Irmgard. The Art of Egypt: The Time of the Pharaohs.

Trans. Ann E. Keep. Art of the World. New York: Crown,

Chapter 4 Aegean Art

Barber, R. L. N. The Cyclades in the Bronze Age. Iowa City: Univ. of Iowa Press, 1987.

Castleden, Rodney. The Knossos Labyrinth: A New View of the "Palace of Minos" at Knossos. London: Routledge, 1990.

Demargne, Pierre. The Birth of Greek Art. Trans. Stuart Gilbert and James Emmons. Arts of Mankind. New York: Golden,

Doumas, Christos. *The Wall-Paintings of Thera*. Trans. Alex Doumas. Athens: Thera Foundation, 1992.

Fitton, J. Lesley. Cycladic Art. Cambridge: Harvard Univ. Press, 1990

Higgins, Reynold. Minoan and Mycenean Art. Rev. ed. World of Art. New York: Oxford Univ. Press, 1981.

Immerwahr, Sara Anderson. Aegean Painting in the Bronze Age
University Park: Pennsylvania State Univ. Press, 1990.

Marinatos, Nanno. Art and Religion in Thera: Reconstructing a Bronze Age Society. Athens: Mathioulakis, 1984.

Marinatos, Spyridon, and Max Hirmer. Crete and Mycenae. New York: Abrams, 1960.

Matz, Friedrich. The Art of Crete and Early Greece: Prelude to Greek Art. Trans. Ann E. Keep. Art of the World. New York: Crown, 1962.

Morgan, Lyvia. The Miniature Wall Paintings of Thera: A Study in Aegean Culture and Iconography. Cambridge: Cambridge Univ. Press 1988

Pellegrino, Charles R. Unearthing Atlantis: An Archaeological Survey. New York: Random House, 1991

Chapter 5 Art of Ancient Greece

Akurgal, Ekrem. The Art of Greece: Its Origins in the Mediterranean and Near East. Trans. Wayne Dynes. Art of the World. New York: Crown, 1968.

Andrewes, Antony. The Greeks: History of Human Society. New York: Knopf, 1967.

Arafat, K. W. Classical Zeus: A Study in Art and Literature. Oxford: Clarendon, 1990.

Arias, Paolo. A History of 1000 Years of Greek Vase Painting. New York: Abrams, 1962.

Ashmole, Bernard. Architect and Sculptor in Classical Greece. Wrightsman Lectures. New York: New York Univ. Press, 1972.

Avery, Catherine, ed. The New Century Handbook of Greek Mythology and Legend. New York: Appleton-Century Crofts, 1972.

Berve, Helmut, and Gottfried Gruben. Greek Temples, Theatres, and Shrines. New York: Abrams, 1963.

Biers, William. The Archaeology of Greece: An Introduction. Rev. ed. Ithaca: Cornell Univ. Press, 1987.

Blumel, Carl. Greek Sculptors at Work. 2nd ed. Trans. Lydia Holland. London: Phaidon, 1969. Boardman, John. Greek Art. Rev. ed. World of Art. New York:

Oxford Univ. Press, 1973. . Greek Sculpture: The Archaic Period: A Handbook. World

of Art. New York: Oxford Univ. Press, 1978.

Greek Sculpture: The Classical Period: A Handbook. London: Thames and Hudson, 1985.

Oxford History of the Classical World. Oxford: Oxford Univ. Press, 1986

. The Parthenon and Its Sculptures. Austin: Univ. of Texas

Branigan, Keith, and Michael Vickers. Hellas: The Civilizations of

Ancient Greece. New York: McGraw-Hill, 1980. Camp, John M. The Athenian Agora: Excavations in the Heart of Classical Athens. New York: Thames and Hudson, 1986.

Carpenter, Thomas H. Art and Myth in Ancient Greece: A Hand-book. World of Art. London: Thames and Hudson, 1991.

Charbonneaux, Jean, Robert Martin, and François Villard. Archaic Greek Art (620-480 B.C.). Trans. James Emmons and Robert Allen. Arts of Mankind. New York: Braziller, 1971.

Classical Greek Art (480-330 B.C.). Trans. James Emmons. Arts of Mankind. New York: Braziller, 1972.

–. Hellenistic Art (330–50 B.C.). Trans. Peter Green. Arts of

Mankind. New York: Braziller, 1973.

Chitham, Robert. The Classical Orders of Architecture. New York:

Finley, Moses. The Ancient Greeks: An Introduction to Their Life and Thought. New York: Viking, 1963. Francis, E. D. Image and Idea in Fifth-Century Greece: Art and Literature after the Persian Wars. London: Routledge, 1990.

Havelock, Christine Mitchell. Hellenistic Art: The Art of the Classical World from the Death of Alexander the Great to the Battle of Actium. 2nd ed. New York: Norton, 1981.

Homann-Wedeking, Ernst. *The Art of Archaic Greece*. Trans. J. R. Foster. Art of the World. New York: Crown, 1968. Hood, Sinclair. Arts in Prehistoric Greece. Pelican History of Art.

Harmondsworth, Eng.: Penguin, 1978. Hopper, Robert John. *The Acropolis*. London: Weidenfeld and

Nicolson, 1971. Hurwit, Jeffrey M. The Art and Culture of Early Greece 1100–480

B.C. Ithaca: Cornell Univ. Press, 1985 Jenkins, Ian. The Parthenon Frieze. Austin: Univ. of Texas Press,

Kagan, Donald. The Outbreak of the Peloponnesian War.

Ithaca: Cornell Univ. Press. 1969. Lawrence, A. W. Greek Architecture. 4th ed. Pelican History of Art. Harmondsworth, Eng.: Penguin, 1983.

Lullies, Reinhart, and Max Hirmer. Greek Sculpture. Rev. ed. Trans. Michael Bullock. New York: Abrams, 1957.

Martin, Roland. Greek Architecture: Architecture of Crete, Greece, and the Greek World. History of World Architecture. New York: Electa/Rizzoli, 1988.

Morg, Catherine. Athletes and Oracles: The Transformation of Olympia and Delphi in the Eighth Century B.C. Cambridge: Cambridge Univ. Press, 1990

Onians, John. Art and Thought in the Hellenistic Age: The Greek World View 350–50 B.C. London: Thames and Hudson, 1979. Papaioannou, Kostas. The Art of Greece. Trans. I. Mark Paris. New York: Abrams, 1989.

Pedley, John Griffiths. Greek Art and Archaeology. New York: Abrams, 1993.

Pollitt, J. J. Art in the Hellenistic Age. Cambridge: Cambridge Univ. Press, 1986.

. The Art of Ancient Greece: Sources and Documents. Cambridge: Cambridge Univ. Press, 1990. Ridgway, Brunilde Sismondo. Fifth Century Styles in Greek

Sculpture. Princeton: Princeton Univ. Press, 1981.

- Hellenistic Sculpture I: The Styles of ca. 331–200 B.C. Wisconsin Studies in Classics. Madison: Univ. of Wisconsin Press. 1990.

Robertson, Martin. Greek Painting: The Great Centuries of Painting. Geneva: Skira, 1959.

Roes, Anna. Greek Geometric Art: Its Symbolism and Its Origin. London: Oxford Univ. Press, 1933.

Schefold, Karl. Classical Greece. Trans. J. R. Foster. Art of the World, London: Methuen, 1967. Schmidt, Evamaria. The Great Altar of Pergamon. Trans. Lena

Jack. Leipzig: VEB Edition Leipzig, 1962. Scully, Vincent. The Earth, the Temple, and the Gods: Greek

Sacred Architecture. Rev. ed. New Haven: Yale Univ. Press, 1979. Smith, R. R. R. Hellenistic Sculpture: A Handbook, World of Art.

New York: Thames and Hudson, 1991.

Stewart, Andrew F. *Greek Sculpture: An Exploration*. 2 vols. New Haven: Yale Univ. Press, 1990.

. Skopas of Paros. Park Ridge: Noyes, 1977

Webster, T. B. L. The Art of Greece: The Age of Hellenism. Art of the World. New York: Crown, 1966.

Whitley, A. James M. Style and Society in Dark Age Greece: The Changing Face of a Pre-literate Society, 1100-700 B.C. New Studies in Archaeology. Cambridge: Cambridge Univ. Press. 1991

Chapter 6 Etruscan Art and Roman Art

Andreae, Bernard. The Art of Rome. Trans. Robert Erich Wolf. New York: Abrams, 1977.

Aries, Philippe, and Georges Duby, eds. A History of Private Life Vol. 1: From Pagan Rome to Byzantium. Trans. Arthur Goldhammer. Cambridge, Mass.: Belknap, 1987.

Balsdon, J. P. V. D. Roman Women: Their History and Habits. London: Bodlev Head, 1962.

Bianchi Bandinelli, Ranuccio. Rome: The Centre of Power: Roman Art to A.D. 200. Trans. Peter Green. Arts of Mankind. London: Thames and Hudson, 1970.

Rome: The Late Empire: Roman Art A.D. 200-400. Trans. Peter Green. Arts of Mankind. New York: Braziller, 1971. Bloch, Raymond. Etruscan Art. Greenwich, Conn.: New York

Graphic Society, 1965. Boardman, John. Oxford History of the Classical World. Oxford:

Oxford Univ. Press, 1986.

Boethius, Axel, and J. B. Ward-Perkins. Etruscan and Early Roman Architecture. 2nd ed. Pelican History of Art. Harmondsworth, Eng.: Penguin, 1978.

Breeze, David John. *Hadrian's Wall*. London: Allen Lane, 1976.

Brendel, Otto J. Etruscan Art. Pelican History of Art. Harmondsworth, Eng.: Penguin, 1978.

Brilliant, Richard. Roman Art from the Republic to Constantine. London: Phaidon, 1974

Brown, Peter. The World of Late Antiquity: A.D. 150-750. New York: Norton, 1989.

Buranelli, Francesco. The Etruscans: Legacy of a Lost Civilization from the Vatican Museums. Memphis: Lithograph,

Christ, Karl. The Romans: An Introduction to Their History and Civilisation. Berkeley: Univ. of California Press, 1984.

Cornell, Tim, and John Matthews. Atlas of the Roman World. New York: Facts on File, 1982.

Guilland, Jacqueline, and Maurice Guilland. Frescoes in the Time of Pompeii. New York: Potter, 1990.

Heintze, Helga von. Roman Art. New York: Universe, 1990. Henig, Martin, ed. A Handbook of Roman Art: A Comprehensive Survey of All the Arts of the Roman World. Ithaca: Cornell Univ. Press 1983

Kahler, Heinz. The Art of Rome and Her Empire. Trans. J. R. Foster. Art of the World. New York: Crown, 1963.

Ling, Roger. Roman Painting. Cambridge: Cambridge Univ. Press. 1991

L'Orange, Hans Peter. The Roman Empire: Art Forms and Civic Life. New York: Rizzoli, 1985.

MacDonald, William L. The Architecture of the Roman Empire: An Introductory Study. Rev. ed. 2 vols. Yale Publications in the History of Art. New Haven: Yale Univ. Press 1982

The Pantheon: Design, Meaning, and Progeny. Cambridge: Harvard Univ. Press, 1976.

Maiuri, Amedeo. Roman Painting: The Great Centuries of Painting. Trans. Stuart Gilbert. Geneva: Skira, 1953.

Mansuelli, G. A. *The Art of Etruria and Early Rome*. Art of the World. New York: Crown, 1965. Pollitt, J. J. The Art of Rome, c. 753 B.C.-337 A.D.: Sources and Doc-

uments. Englewood Cliffs, N.J.: Prentice-Hall, 1966. Quennell, Peter. *The Colosseum*. New York: Newsweek, 1971. Ramage, Nancy H., and Andrew Ramage. Roman Art: Romulus

to Constantine. New York: Abrams, 1991.
Rediscovering Pompeii. Rome: L'Erma di Bretschneider, 1990. Sprenger, Maja, and Bartolini, Gilda. The Etruscans: Their His-

tory, Art, and Architecture. New York: Abrams, 1983. Strong, Donald. Roman Art. 2nd ed. Pelican History of Art. Har-

mondsworth, Eng.: Penguin, 1988. Ward-Perkins, J. B. Roman Architecture. History of World Archi-

tecture. New York: Electa/Rizzoli, 1988. Wheeler, Robert Eric Mortimer, Sir. Roman Art and Architecture.

World of Art. New York: Oxford Univ. Press, 1964. Wilkinson, L. P. The Roman Experience. New York: Knopf, 1974.

Chapter 7 Early Christian, Jewish, and Byzantine

Age of Spirituality: Late Antique and Early Christian Art, Third to Seventh Century. New York: Metropolitan Museum of Art,

Beckwith, John. The Art of Constantinople: An Introduction to Byzantine Art 330-1453. 2nd ed. London: Phaidon, 1968. -. Early Christian and Byzantine Art. 2nd ed. Pelican Histo-

ry of Art. Harmondsworth, Eng.: Penguin, 1979. Boyd, Susan A. Byzantine Art. Chicago: Univ. of Chicago Press, 1979.

Buckton, David, ed. The Treasury of San Marco, Venice. Milan: Olivetti, 1985.

Carr, Annemarie Weyl. Byzantine Illumination, 1150-1250: The Study of a Provincial Tradition. Chicago: Univ. of Chicago Press. 1987.

Christe, Yves. Art of the Christian World, A.D. 200-1500: A Handbook of Styles and Forms. New York: Rizzoli, 1982.

Cutler, Anthony. The Hand of the Master: Craftsmanship, Ivory, and Society in Byzantium (9th–11th Centuries). Princeton: Princeton Univ. Press, 1994.

Demus, Otto. Byzantine Art and the West. Wrightsman Lectures. New York: New York Univ. Press, 1970.

. Byzantine Mosaic Decoration: Aspects of Monumental Art in Byzantium. New Rochelle: Caratzas, 1976.

The Church of San Marco in Venice: History, Architecture, Sculpture. Washington, D.C.: Dumbarton Oaks, 1960 Ferguson, George Wells. Signs and Symbols in Christian Art.

New York: Oxford Univ. Press, 1967. Gough, Michael. Origins of Christian Art. World of Art. London: Thames and Hudson, 1973.

Grabar, André. The Art of the Byzantine Empire: Byzantine Art in the Middle Ages. Trans. Betty Forster. Art of the World. New York: Crown, 1966.

Early Christian Art: From the Rise of Christianity to the Death of Theodosius. Trans. Stuart Gilbert and James Emmons. Arts of Mankind. New York: Odyssey, 1969.

The Golden Age of Justinian from the Death of Theodosius to the Rise of Islam. Trans. Stuart Gilbert and James Emmons. Arts of Mankind. New York: Odyssey, 1967. Hubert, Jean, Jean Porcher, and W. F. Volbach. Europe of the

Invasions. Trans. Stuart Gilbert and James Emmons. Arts of Mankind. New York: Braziller, 1969. Krautheimer, Richard. Early Christian and Byzantine Architec-

ture. 4th ed. Pelican History of Art. Harmondsworth, Eng: Penguin, 1986. Kitzinger, Ernst. Byzantine Art in the Making: Main Lines of Styl-

istic Development in Mediterranean Art, 3rd-7th Century. Cambridge: Harvard Univ. Press, 1977. Lane Fox, Robin. Pagans and Christians. Harmondsworth, Eng.: Viking, 1986.

Mainstone, R. J. Hagia Sophia: Architecture, Structure and

- Liturgy of Justinian's Great Church. London: Thames and Hudson, 1988
- Mango, Cyril. Art of the Byzantine Empire, 312–1453: Sources and Documents. Englewood Cliffs, N.J.: Prentice-Hall, 1972

. Byzantine Architecture. History of World Architecture. New York: Rizzoli, 1985. Manicelli, Fabrizio. *Catacombs and Basilicas: The Early Chris*

- tians in Rome. Florence: Scala, 1981.
- Mathew, Gervase. Byzantine Aesthetics. London: J. Murray, 1963.
- Milburn, R. L. P. Early Christian Art and Architecture. Berkeley: Univ. of California Press, 1988.
- Oakshott, Walter Fraser. The Mosaics of Rome: From the Third to the Fourteenth Centuries. London: Thames and Hudson, 1967
- Rice, David Talbot. Art of the Byzantine Era. New York: Praeger, 1963.
- . Byzantine Art. Harmondsworth, Eng.: Penguin, 1968. Schapiro, Meyer. Late Antique, Early Christian, and Mediaeval
- Art. New York: Braziller, 1979.
- Simson, Otto Georg von. Sacred Fortress: Byzantine Art and Statecraft in Ravenna. Chicago: Univ. of Chicago Press, 1948.
- Snyder, James. Medieval Art: Painting, Sculpture, Architecture, 4th-14th Century. Englewood Cliffs, N.J.: Prentice-Hall, 1989.
- Stevenson, James. The Catacombs: Rediscovered Monuments of Early Christianity. Ancient Peoples and Places. London: Thames and Hudson, 1978.
- Weitzmann, Kurt. Late Antique and Early Christian Book Illumination. New York: Braziller, 1977.

 —, Place of Book Illumination in Byzantine Art. Princeton: Art
- Museum, Princeton Univ., 1975.
- Wharton, Annabel Jane. Art of Empire: Painting and Architecture of the Byzantine Periphery: A Comparative Study of Four Provinces. University Park: Pennsylvania State Univ. Press, 1988.

Chapter 8 Islamic Art

- Akurgal, Ekrem, ed. The Art and Architecture of Turkey. New York: Rizzoli, 1980.
- Al-Faruqi, Ismail R, and Lois Lamya'al Faruqi. Cultural Atlas of Islam. New York: Macmillan, 1986.
- Aslanapa, Oktay. Turkish Art and Architecture. London: Faber,
- Atasov, Nurhan. Splendors of the Ottoman Sultans. Ed. and
- Trans. Tulay Artan. Memphis, Tenn.: Lithograph, 1992. Atil, Esin. *The Age of Sultan Suleyman the Magnificent.* Washington, D.C.: National Gallery of Art, 1987.
- Art of the Arab World. Washington, D.C.: Smithsonian Institution, 1975.
- Islamic Art and Patronage: Treasures from Kuwait. New York: Rizzoli, 1990.
- Renaissance of Islam: Art of the Mamluks. Washington, D.C.: Smithsonian Institution, 1981.
- Blair, Sheila S., and Jonathan M. Brown. The Art and Architecture of Islam 1250-1800. New Haven: Yale Univ. Press,
- Brend, Barbara. Islamic Art. Cambridge: Harvard Univ. Press, 1991.
- Dodds, Jerrilynn D., ed. Al-Andalus: The Art of Islamic Spain. New York: Metropolitan Museum of Art, 1992.
- Ettinghausen, Richard, and Oleg Grabar. The Art and Architecture of Islam: 650-1250. Pelican History of Art. Harmondsworth, Eng.: Penguin, 1987.
- Falk, Toby, ed. Treasures of Islam. London: Sotheby's, 1985. Ferrier, R. W., ed. Arts of Persia. New Haven: Yale Univ. Press,
- 1989 Frishman, Martin, and Hasan-Uddin Khan. The Mosque.
- History, Architectural Development and Regional Diversity London: Thames and Hudson, 1994.
- Glasse, Cyril. The Concise Encyclopedia of Islam. San Francisco: Harper & Row, 1989. Grabar, Oleg. The Alhambra. Cambridge: Harvard Univ. Press,
- The Formation of Islamic Art. Rev. ed. New Haven: Yale
- Univ. Press, 1987. The Great Mosque of Isfahan. New York: New York Univ.
- Press. 1990. The Mediation of Ornament. A. W. Mellon Lectures in the
- Fine Arts. Princeton: Princeton Univ. Press, 1992.
 Grube, Ernest J. Architecture of the Islamic World: Its History and
- Social Meaning. Ed. George Mitchell. New York: Morrow,
- Hoag, John D. Islamic Architecture. History of World Architecture. New York: Abrams, 1977.
- Jones, Dalu, and George Mitchell, eds. The Arts of Islam. London: Arts Council of Great Britain, 1976.
- Khatibi, Abdelkebir, and Mohammed Sijelmassi. The Splendour of Islamic Calligraphy. New York: Rizzoli, 1977
- The Koran. Rev. ed. Trans. N. J. Dawood. London: Penguin, 1993.
- Lentz, Thomas W., and Glenn D. Lowry. Timur and the Princely Vision: Persian Art and Culture in the Fifteenth Century. Los Angeles: Los Angeles County Museum of Art, 1989
- Papadopoulo, Alexandre. Islam and Muslim Art. Trans. Robert Erich Wolf. New York: Abrams, 1979.
- Petsopoulos, Yanni, ed. Tulips, Arabesques and Turbans: Decorative Arts from the Ottoman Empire. New York: Abbeville, 1982.

- Raby, Julian, ed. The Art of Syria and the Jazira, 1100-1250. Oxford Studies in Islamic Art. Oxford: Oxford Univ. Press, 1985.
- Rice, David Talbot. Islamic Art. World of Art. New York: Thames and Hudson, 1965.
- Schimmel, Annemarie. Calligraphy and Islamic Culture. New York: New York Univ. Press, 1983.
- Sharma, Arvind, ed. Our Religions. San Francisco: HarperSan-Francisco, 1993. Ward, R. M. Islamic Metalwork. New York: Thames and Hudson,
- 1993 Welch, Anthony. Calligraphy in the Arts of the Muslim World. Austin: Univ. of Texas Press, 1979.

Chapter 9 Art of India before 1100

- Berkson, Carmel. Elephanta: The Cave of Shiva. Princeton: Princeton Univ. Press, 1983.
- Chandra, Pramod. The Sculpture of India, 3000 B.C.-1300 A.D. Washington, D.C.: National Gallery of Art, 1985
- Coomaraswamy, Ananda K. Yaksas: Essays in the Water Cosmology. Rev. ed. Ed. Paul Schroeder. New York: Oxford Univ. Press, 1993.
- Czuma, Stansilaw J. Kushan Sculpture: Images from Early India. Cleveland: Cleveland Museum of Art, 1985.
- De Bary, William, ed. Sources of Indian Tradition. New York: Columbia Univ. Press, 1958.
- Dehejia, Vidya. Art of the Imperial Cholas. New York: Columbia Univ. Press. 1990.
- Early Buddhist Rock Temples. Ithaca: Cornell Univ. Press, 1972
- Dessai, Vishakha N., and Darielle Mason. Gods, Guardians, and Lovers: Temple Sculptures from North India, A.D. 700–1200. New York: Asia Society Galleries, 1993.
- Dimmitt, Cornelia. Classical Hindu Mythology. Philadelphia Temple Univ. Press, 1978.
- Eck, Diana L. Darsan. Seeing the Divine Image in India. 2nd rev. ed. Chambersburg, Penn.: Anima, 1985
- Errington, Elizabeth, and Joe Cribb, eds. The Crossroads of Asia: Transformation in Image and Symbol in the Art of Ancient Afghanistan and Pakistan. Cambridge, Eng.: Ancient India and Iran Trust, 1992.
- Goswamy, B. N. An Early Document of Indian Art: The Citralak-sa-na of Nagnajit. New Delhi: Manohar Book Service,
- Harle, James C. Art and Architecture of the Indian Subcontinent. Pelican History of Art. Harmondsworth, Eng.: Penguin,
- . Gupta Sculpture. Oxford: Clarendon, 1974
- Huntington, Susan L. Art of Ancient India. New York: Weatherhill 1985.
- . Leaves from the Bodhi Tree: The Art of Pala India (8th–12th Centuries) and Its International Legacy. Dayton: Dayton Art Institute 1990
- Hutt, Michael. Nepal: A Guide to the Art and Architecture of the Kathmandu Valley. Boston: Shambala, 1995. Johnston, E. H. Buddhacharita, or Acts of the Buddha. 2nd ed.
- New Delhi: Oriental Books Reprint, 1972.
- Knox, Robert. Amaravati: Buddhist Sculpture from the Great Stupa. London: British Museum, 1992
- Kramrisch, Stella. The Art of Nepal. New York: Abrams, 1964. The Hindu Temple. 2 vols. Calcutta: Univ. of Calcutta, 1946.
- Presence of Siva. Princeton: Princeton Univ. Press, 1981. Vichnudharmottara, Part III: A Treatise on Indian Painting and Image-Making. 2nd rev. ed. Calcutta: Calcutta Univ
- Press, 1928 Meister, Michael, ed. Discourses on Siva: On the Nature of Religious Imagery. Philadelphia: Univ. of Pennsylvania Press,
- O'Flaherty, Wendy. Hindu Myths. Harmondsworth, Eng.: Pen-
- guin, 1975. Pal, Pratapaditya, ed. Aspects of Indian Art. Leiden: Brill, 1972.
- The Ideal Image: The Gupta Sculptural Tradition and Its Influence. New York: Asia Society, 1978.
- Peterson, Indira Vishnvanathan. Poems to Shiva: The Hymns of the Tamil Saints. Princeton: Princeton Univ. Press, 1989
- Possehl, Gregory, ed. Ancient Cities of the Indus. Durham: Carolina Academic, 1979. . Harappan Civilization: A Recent Perspective. 2nd ed. New
- Delhi: American Institute of Indian Studies, 1993. Poster, Amy G. From Indian Earth: 4,000 Years of Terracotta Art.
- Brooklyn: Brooklyn Museum, 1986. Rosenfeld, John M. The Dynastic Arts of the Kushans. California Studies in the History of Art. Berkeley: Univ. of California
- Press, 1967. Shearer, Alistair. Upanishads. New York: Harper & Row, 1978 Singh, Madanjeet. The Cave Paintings of Ajanta. London:
- Thames and Hudson, 1965. Skelton, Robert, and Mark Francis. Arts of Bengal: The Heritage of Bangladesh and Eastern India. London: Whitechapel Gallery, 1979.
- Smith, Bardwell L., ed. Essays in Gupta Culture. Delhi: Motilal Banarsidass, 1983.
- Thapar, Romila. Asoka and the Decline of the Mauryas. 2nd ed. Delhi: Oxford, 1973.
- History of India. Harmondsworth, Eng.: Penguin, 1972. Weiner, Sheila L. Ajanta: Its Place in Buddhist Art. Berkeley: Univ. of California Press, 1977.

- Williams, Joanna G. Art of Gupta India, Empire and Province.
- Princeton: Princeton Univ. Press, 1982. Zimmer, Heinrich Robert. Myths and Symbols in Indian Art and Civilization. ed. Joseph Campbell. Bollingen Series. New York: Pantheon, 1946.

Chapter 10 Chinese Art before 1280

- Ackerman, Phyllis. Ritual Bronzes of Ancient China. New York: Dryden, 1945.
- The Art Treasures of Dunhuang. Hong Kong: Joint, 1981. Arts of China. 3 vols. Tokyo: Kodansha International, 1968–70.
- Barnhart, Richard. Along the Border of Heaven: Sung and Yuan Painting from the C. C. Wang Family Collection. New York: Metropolitan Museum of Art, 1983.
- Billeter, Jean François. The Chinese Art of Writing. New York: Skira/Rizzoli, 1990.
- Blunden, Caroline, and Mark Elvin. Cultural Atlas of China. New York: Facts on File, 1983.
- Cahill, James. Art of Southern Sung China. New York: Asia Society, 1962.
- Chinese Painting. Treasures of Asia. Geneva: Skira, 1960.
- Index of Early Chinese Painters and Paintings: T'ang,
- Sung, and Yuan. Berkeley: Univ. of California Press, 1980. Cleary, Thomas, trans. The Essential Tao: An Initiation into the Heart of Taoism through the Authentic Tao Te Ching and the Inner Teachings of Chuang Tzu. San Francisco: Harper-SanFrancisco, 1991.
- De Silva, Anil. The Art of Chinese Landscape Painting: In the Caves of Tun-huang. Art of the World. New York: Crown, 1967
- Fong, Wen, ed. Beyond Representation: Chinese Painting and Calligraphy, 8th-14th Century. Princeton Monographs in Art and Archaeology. New York: Metropolitan Museum of Art, 1992
- The Great Bronze Age of China: An Exhibition from the People's Republic of China. New York: Metropolitan Museum of Art, 1980.
- Fong, Wen, and Marilyn Fu. Sung and Yuan Paintings. New York:
- New York Graphic Society, 1973. Gridley, Marilyn Leidig. Chinese Buddhist Sculpture under the Liao: Free Standing Works in Situ and Selected Examples from Public Collections. New Delhi: International Academy of Indian Culture, 1993.
- Ho, Wai-kam, et al. Eight Dynasties of Chinese Painting: The Collections of the Nelson Gallery-Atkins Museum, Kansas City and the Cleveland Museum of Art. Cleveland: Cleveland
- Museum of Art, 1980. Juliano, Annette L. Art of the Six Dynasties: Centuries of Change
- and Innovation. New York: China House Gallery, 1975.
 Lawton, Thomas. Chinese Art of the Warring States Period:
 Change and Continuity, 480–222 B.C. Washington, D.C.: Freer Gallery of Art, Smithsonian Institution, 1982
- . Chinese Figure Painting. Washington, D.C.: Smithsonian Institution, 1973.
- Lim, Lucy. Stories from China's Past: Han Dynasty Pictorial Tomb Reliefs and Archaeological Objects from Sichuan Province, People's Republic of China. San Francisco: Chinese Culture Foundation, 1987.
- Medley, Margaret. Chinese Potter: A Practical History of Chinese Ceramics. 3rd ed. Oxford: Phaidon, 1989.
- Munakata, Kiyohiko. Sacred Mountains in Chinese Art. Champaign: Krannert Art Museum, Univ. of Illinois, 1991
- Paludan, Ann. Chinese Spirit Road: The Classical Tradition of Stone Tomb Sculpture. New Haven: Yale Univ. Press, 1991
- Chinese Tomb Figurines. Hong Kong: Oxford Univ. Press, 1994
- Powers, Martin J. Art and Political Expression in Early China. New Haven: Yale Univ. Press, 1991
- Rawson, Jessica. Ancient China: Art and Archaeology. London: British Museum, 1980.
- Sickman, Lawrence, and Alexander Soper. Art and Architecture of China. Pelican History of Art. Harmondsworth, Eng. Penguin, 1971
- Speiser, Werner. The Art of China: Spirit and Society. Art of the World. New York: Crown, 1961.
- Tregear, Mary. Chinese Art. World of Art. New York: Oxford Univ. Press, 1980. Vainker, S. J. Chinese Pottery and Porcelain: From Prehistory to
- the Present. London: British Museum, 1991 Watson, William. Art of Dynastic China. New York: Abrams,
- Weidner, Marsha, ed. Latter Days of the Law: Images of Chinese Buddhism, 850-1850. Lawrence: Spencer Museum of Art,
- Univ. of Kansas, 1994. Whitfield, Roderick, and Anne Farrer. Caves of the Thousand Buddhas: Chinese Art from the Silk Route. London: British Museum, 1990.

Chapter 11 Japanese Art before 1392

- Bethe, Monica. Bugaku Masks. Japanese Arts Library, vol. 5. New York: Kodansha International, 1978.
- Egami, Namio. *The Beginnings of Japanese Art.* Trans. John Bester. Heibonsha Survey of Japanese Art, vol. 2. New York: Weatherhill, 1973.
- Elisseeff, Danielle, and Vadime Elisseeff. Art of Japan. Trans.

- I. Mark Paris. New York: Abrams, 1985.
- Fujioka, Ryoichi. Shino and Oribe Ceramics. Trans. Samuel Crowell Morse. Japanese Arts Library, vol. 1. New York: Kodansha International, 1977.
- Fukuyama, Toshio. Heian Temples: Byudo-in and Chuson-ji. Trans. Ronald K. Jones. Heibonsha Survey of Japanese Art, vol. 9. New York: Weatherhill, 1976.
- Hashimoto, Fumio, ed. Architecture in the Shoin Style: Japanese Feudal Residences, Trans, and adapted by H. Mack Horton. Japanese Arts Library, vol. 10. New York: Kodansha International, 1981.
- Hayashi, Ryoichi. Silk Road and the Shoso-in. Trans. Robert Ricketts. Heibonsha Survey of Japanese Art, vol. 6. New York: Weatherhill, 1975.
- Ienaga, Saburo. Japanese Art: A Cultural Appreciation. Trans. Richard L. Gage. Heibonsha Survey of Japanese Art, vol. 30. New York: Weatherhill, 1979.
- Painting in the Yamato Style. Trans. John M. Shields. Heibonsha Survey of Japanese Art, vol. 10. New York: Weatherhill 1973
- Ishida, Hisatoyo. Esoteric Buddhist Painting. Trans. and adapted by E. Dale Saunders. Japanese Arts Library, vol. 15. New York: Kodansha International, 1987.
- Itoh, Teiji. Traditional Domestic Architecture of Japan. Trans. Richard L. Gage. Heibonsha Survey of Japanese Art, vol. 21. New York: Weatherhill. 1972.
- Kidder, J. Edward. Early Buddhist Japan. Ancient People and Places. New York: Praeger, 1972.
- Early Japanese Art: The Great Tombs and Treasures.
 Princeton: Van Nostrand, 1964.
- Japanese Temples: Sculpture, Paintings, Gardens, and Architecture. London: Thames and Hudson, 1964.
- Prehistoric Japanese Arts: Jomon Pottery, Tokyo: Kodansha International, 1968.
- Kobayashi, Takeshi. *Nara Buddhist Art: Todai-ji.* Trans. and adapted by Richard L. Gage. Heibonsha Survey of Japanese Art, vol. 5. New York: Weatherhill, 1975.
- Kurata, Bunsaku. Horyu-ji, Temple of the Exalted Law: Early Bud-dhist Art from Japan. New York: Japan Society, 1981.
- Miki, Fumio. Haniwa. Trans. and adapted by Gino Lee Barnes. Arts of Japan, 8, New York: Weatherhill, 1974.
- Miner, Earl, Hiroko Odagiri, and Robert E. Morrell. The Princeton Companion to Classical Japanese Literature. Princeton: Princeton Univ. Press. 1985.
- Mino, Yutaka. The Great Eastern Temple: Treasures of Japanese Buddhist Art from Todai-ji. Chicago: Art Institute of Chicago, 1986.
- Mizuno, Seiichi. Asuka Buddhist Art: Horyuji. Trans. Richard L. Gage. Heibonsha Survey of Japanese Art, vol. 4. New York: Weatherhill, 1974.
- Mori, Hisashi. Japanese Portrait Sculpture. Trans. Widayati Roesijadi. Japanese Arts Library, vol. 2. New York: Kodansha International, 1977.
- Sculpture of the Kamakura Period. Trans. Katherine Eickman. Heibonsha Survey of Japanese Art, vol. 11. New York: Weatherhill, 1974.
- Murase, Miyeko. *Iconography of the Tale of Genji: Genji Mono-gatari Ekotoba*. New York: Weatherhill, 1983.
- Nakagawa, Sensaku. Kutani Ware. Trans. and adapted by John Bester. Japanese Arts Library, vol. 7. New York: Kodansha International, 1979.
- Nishiwara, Kyotaro, and Emily J. Sano. The Great Age of Japanese Buddhist Sculpture, A.D. 60-1300. Fort Worth, Tex.: Kimbell Art Museum, 1982.
- Okazaki, Joji. Pure Land Buddhist Painting. Trans. Elizabeth ten Grutenhuis. Japanese Arts Library, vol. 4. New York: Kodansha International, 1977.
- Okudaira, Hideo. Narrative Picture Scrolls. Trans. Elizabeth ten Grutenhuis. Arts of Japan, 5. New York: Weatherhill, 1973. Ooka, Minoru. *Temples of Nara and Their Art*. Trans. Dennis
- Lishka. Heibonsha Survey of Japanese Art, vol. 7. New York: Weatherhill, 1973.
- Pearson, Richard J. Ancient Japan. Washington, D.C.: Sackler Gallery, 1992
- Rosenfield, John M., Fumiko E. Cranston, and Edwin A. Cranston. The Courtly Tradition in Japanese Art and Literature: Selections from the Hofer and Hyde Collections. Cambridge: Fogg Art Museum, Harvard Univ., 1973. — Japanese Arts of the Heian Period: 794–1185. New York:
- Asia Society, 1967.
- Sato, Kanzan. Japanese Sword. Trans. and adapted by Joe Earle. Japanese Arts Library, vol. 12. New York: Kodansha International, 1983
- Sawa, Takaaki. Art in Japanese Esoteric Buddhism. Trans Richard L. Gage. Heibonsha Survey of Japanese Art, vol. 8. New York: Weatherhill, 1972.
- Soper, Alexander Coburn. Evolution of Buddhist Architecture in Japan. Princeton Monographs in Art and Archaeology, no. 22. New York: Hacker Art, 1978.
- Sugiyama, Jiro. Classic Buddhist Sculpture: The Tempyo Period. Trans. and adapted by Samuel Crowell Morse. Japanese Arts Library, vol. 11. New York: Kodansha International, 1982
- Suzuki, Kakichi. Early Buddhist Architecture in Japan. Trans. and adapted by Mary Neighbor Parent and Nancy Shatzman Steinhardt. Japanese Arts Library, vol. 9. New York: Kodansha International, 1980.
- Swann, Peter. The Art of Japan: From the Jomon to the Tokugawa Period. Art of the World. New York: Crown, 1966

- Tanaka, Ichimatsu. Japanese Ink Painting: Shubun to Sesshu. Trans. Bruce Darling. Heibonsha Survey of Japanese Art, vol. 12. New York: Weatherhill, 1972.
- Varley, H. Paul. Japanese Culture. 3rd ed. Honolulu: Univ. of Hawaii Press, 1984.
- Watanabe, Yasutada, Shinto Art: Ise and Izumo Shrines, Trans Robert Ricketts. Heibonsha Survey of Japanese Art, vol. 3. New York: Weatherhill, 1974.
- Yamane, Yuzo. Momoyama Genre Painting. Trans. John M. Shields. Heibonsha Survey of Japanese Art, vol. 17. New York: Weatherhill, 1973.
- Yonezawa, Yoshiho, and Chu Yoshizawa, Japanese Painting in the Literati Style. Trans. and adapted by Betty Iverson Monroe. Heibonsha Survey of Japanese Art, vol. 23. New York: Weatherhill, 1974

Chapter 12 Art of the Americas before 1300

- Abel-Vidor, Suzanne. Between Continents/Between Seas: Pre
- columbian Art of Costa Rica. New York: Abrams, 1981. Abrams, Elliot Marc. How the Maya Built Their World: Energet ics and Ancient Architecture. Austin: Univ. of Texas Press, 1994
- Alcina Franch, José, Pre-Columbian Art, Trans, I. Mark Paris New York: Abrams, 1983.
- Anton, Ferdinand. Art of the Maya. Trans. Mary Whitall. London: Thames and Hudson, 1970
- Berlo, Janet Catherine, ed. Art, Ideology, and the City of Teotihuacan: A Symposium at Dumbarton Oaks. Washington, D.C.: Dumbarton Oaks, 1992.
- Berrin, Kathleen, ed. Feathered Serpents and Flowering Trees: Reconstructing the Murals of Teotihuacan. San Francisco: Fine Arts Museums of San Francisco, 1988.
- and Esther Pasztory. Teotihuacan: Art from the City of the Gods. New York: Thames and Hudson, 1993
- Brody, J. J. The Anasazi: Ancient Indian People of the American Southwest. New York: Rizzoli, 1990.
- . Anasazi and Pueblo Painting. Albuquerque: Univ. of New Mexico Press, 1991.
- Clewlow, C. William. Colossal Heads of the Olmec Culture. Contributions of the Univ. of California Archaeological Research Facility. Berkeley: Archaeological Research Facility, Univ. of California, 1967.
- Coe, Michael D. The Jacquar's Children: Pre-Classical Central Mexico. New York: Museum of Primitive Art, 1965.
- Coe, Ralph T. Sacred Circles: Two Thousand Years of North Amer ican Indian Art. London: Arts Council of Great Britain, 1976
- Donnan, Christopher B. Ceramics of Ancient Peru. Los Angeles: Fowler Museum of Cultural History, Univ. of California, 1992.
- Moche Art of Peru: Pre-Columbian Symbolic Communi cation. Rev. ed. Los Angeles: Museum of Cultural History, Univ. of California, 1978.
- Fash, William Leonard. Scribes, Warriors, and Kings: The City of Copan and the Ancient Maya. London: Thames and Hudson, 1991.
- Fewkes, Iesse Walter. The Mimbres: Art and Archaeology. Albuquerque: Avanyu, 1989.
- Fitzhugh, William, and Aron Crowell, eds. Crossroads of Conti nents: Cultures of Siberia and Alaska. Washington, D.C.: Smithsonian Institution, 1988
- Frazier, Kendrick. People of Chaco: A Canyon and Its Culture. New York: Norton, 1986.
- Herreman, Frank. Power of the Sun: The Gold of Colombia. Antwerp: City of Antwerp, 1993. Heyden, Doris, and Paul Gendrop. *Pre-Columbian Architecture*
- of Mesoamerica. Trans. Judith Stanton. History of World Architecture. New York: Electa/Rizzoli, 1988.
- Korp, Maureen. The Sacred Geography of the American Mound Native American Studies. Lewiston, N.Y.: Mellen, 1990.
- Kubler, George, The Art and Architecture of Ancient America: The Mexican, Maya, and Andean Peoples. 2nd ed. Pelican History of Art. Harmondsworth, Eng.: Penguin, 1975.
- Esthetic Recognition of Ancient Amerindian Art. Yale Publications in the History of Art. New Haven: Yale Univ. Press. 1991
- Miller, Arthur G. The Mural Painting of Teotihuacan. Washington, D.C.: Dumbarton Oaks, 1973.
- Miller, Mary Ellen. The Art of Mesoamerica: From Olmec to Aztec World of Art. New York: Thames and Hudson, 1986
- and Karl Taube. The Gods and Symbols of Ancient Mexico and the Maya: An Illustrated Dictionary of Mesoamerican Religion. New York: Thames and Hudson,
- Moseley, Michael. The Incas and Their Ancestors: The Archaeology of Peru. London: Thames and Hudson, 1992
- Pang, Hildegard Delgado. Pre-Columbian Art: Investigations and Insights. Norman: Univ. of Oklahoma Press, 1992. Paul, Anne. Paracas Art and Architecture: Object and Context in
- South Coastal Peru. Iowa City: Univ. of Iowa Press, 1991 Schele, Linda, and David Freidel. A Forest of Kings: The Untold
- Story of the Ancient Maya. New York: Morrow. 1990. Schele, Linda, and Mary Ellen Miller. The Blood of Kings: Dynasty and Ritual in Maya Art. New York: Braziller, 1986. Stone-Miller, Rebecca. To Weave for the Sun: Andean Textiles in
- the Museum of Fine Arts, Boston: Museum of Fine Arts, 1992.

- Townsend, Richard, ed. The Ancient Americas: Art from Sacred Landscapes. Chicago: Art Institute of Chicago, 1992.
- The Aztecs. Ancient Peoples and Places. London: Thames and Hudson, 1992.
- Wuthenau, Alexander von. The Art of Terracotta Pottery in Pre-Columbian Central and South America. Art of the World. New York: Crown, 1970.

Chapter 13 Art of Ancient Africa

- Bassani, Ezio, and William Fagg. Africa and the Renaissance: Art in Ivory, New York: Center for African Art, 1988
- Ben-Amos, Paula. The Art of Benin. London: Thames and Hudson, 1980.
- and Arnold Rubin. The Art of Power, the Power of Art: Studies in Benin Iconography. Monograph Series, no. 19. Los Angeles: Museum of Cultural History, Univ. of California 1983
- Cole, Herbert M. Igbo Arts: Community and Cosmos. Los Angeles: Museum of Cultural History, Univ. of California, 1984
- Connah, Graham. African Civilizations: Precolonial Cities and States in Africa: An Archaeological Perspective. Cambridge: Cambridge Univ. Press, 1987.
 Eyo, Ekpo, and Frank Willett. *Treasures of Ancient Nigeria*. Ed.
- Rollyn O. Kirchbaum. New York: Knopf, 1980.
- Ezra, Kate. Royal Art of Benin: The Perls Collection in the Metropolitan Museum of Art. New York: Metropolitan Museum of Art. 1992
- Fagg, Bernard. Nok Terracottas. Lagos: Ethnographica, 1977. Garlake, Peter S. Great Zimbabwe. London: Thames and Hudson, 1973.
- The Painted Caves: An Introduction to the Prehistoric Art of Zimbabwe, Harare: Modus, 1987
- Huffman, Thomas N. Symbols in Stone: Unravelling the Mystery of Great Zimbabwe. Johannesburg: Witwatersrand Univ. Press. 1987.
- Lhote, Henri. The Search for the Tassili Frescoes: The Story of the Prehistoric Rock-Paintings of the Sahara. 2nd ed. Trans. Alan Houghton Brodrick. London: Hutchinson, 1973.
- Shaw, Thurstan. Unearthing Igbo-Ukwu: Archaeological Discoveries in Eastern Nigeria. New York: Oxford Univ. Press, 1977
- Willcox, A. R. The Rock Art of Africa. London: Croon Helm, 1984. Willett, Frank. Ife in the History of West African Sculpture. New York: McGraw-Hill, 1967

Chapter 14 Early Medieval Art in Europe

- Alexander, J. J. G. Medieval Illuminators and Their Methods of Work. New Haven: Yale Univ. Press, 1992.
- Backes, Magnus, and Regine Dolling. Art of the Dark Ages. Trans. Francisca Garvie. Panorama of World Art. New York: Abrams, 1971.
- Backhouse, Janet, D. H. Turner, and Leslie Webster, The Golden Age of Anglo-Saxon Art, 966-1066. Bloomington: Indiana Univ. Press, 1984.
- Beckwith, John, Early Medieval Art: Carolingian, Ottonian, Romanesque. World of Art. New York: Oxford Univ. Press, 1974.
- Calkins, Robert G. Illuminated Books of the Medieval Ages. Ithaca: Cornell Univ. Press, 1983.
- Cirrker, Blanche, ed. The Book of Kells: Selected Plates in Full Color. New York: Dover, 1982.
- Conant, Kenneth John. Carolingian and Romanesque Architecture, 800–1200. 3rd ed. Pelican History of Art. Harmondsworth, Eng.: Penguin, 1973.
- Davis-Wever, Caecilia, Early Medieval Art, 300-1150: Sources and Documents. Englewood Cliffs, N.J.: Prentice-Hall, 1971.
- Dodds, Jerrilynn D. Architecture and Ideology in Early Medieval Spain. University Park: Pennsylvania State Univ. Press
- Dodwell, C. R. The Pictorial Arts of the West, 800-1200. Pelican History of Art. New Haven: Yale Univ. Press. 1993.
- Evans, Angela Care. The Sutton Hoo Ship Burial. London: British Museum, 1986
- Fernie, E. C. The Architecture of the Anglo-Saxons. London: Batsford, 1983. Henderson, George. Early Medieval. Style and Civilization. Har-
- mondsworth, Eng.: Penguin, 1972.

 —. From Durrow to Kells: The Insular Gospel-Books, 650-800. London: Thames and Hudson, 1987.
- Horn, Walter W., and Ernest Born. Plan of Saint Gall: A Study of the Architecture and Economy of and Life in a Paradigmatic Carolingian Monastery. 3 vols. California Studies in the History of Art. Berkeley: Univ. of California Press, 1979.
- Hubert, Jean, Jean Porcher, and W. F. Volbach. Carolingian Renaissance. Arts of Mankind. New York: Braziller, 1970. Laing, Lloyd. Art of the Celts. World of Art. New York: Thames
- and Hudson, 1992. Lasko, Peter. Ars Sacra, 800-1200. Pelican History of Art. Harmondsworth, Eng.: Penguin, 1972.
- Mayr-Harting, Henry. Ottonian Book Illumination: An Historical Study. 2 vols. New York: Oxford Univ. Press, 1991.
- Megaw, Ruth, and Vincent Megaw. Celtic Art: From Its Beginnings to the Book of Kells. New York: Thames and Hudson, 1989
- New American Bible, New York: Catholic 1992
- Nordenfalk, Carl Adam Johan. Early Medieval Book Illumination. New York: Rizzoli, 1988.

- Palol, Pedro de, and Max Hirmer. Early Medieval Art in Spain. Trans. Alisa Jaffa. London: Thames and Hudson, 1967
- Richardson, Hilary, and John Scarry. An Introduction to Irish
- High Crosses. Dublin: Mercier, 1990. Treasures of Irish Art, 1500 B.C. to 1500 A.D.: From the Collections of the National Museum of Ireland, Royal Irish Academy, Trinity College, Dublin. New York: Metropolitan Museum of Art 1977
- Verzone, Paola. The Art of Europe: The Dark Ages from Theodo-ric to Charlemagne. Art of the World. New York: Crown, 1968.
- Williams, John. Early Spanish Manuscript Illumination. New York: Braziller, 1977
- Wilson, David M. Anglo-Saxon Art: From the Seventh Century to the Norman Conquest. London: Thames and Hudson, 1984. , and Ole Klindt-Jensen. Viking Art. 2nd ed. Minneapolis: Univ. of Minnesota Press, 1980

Chapter 15 Romanesque Art

- Armi, C. Edson. *Masons and Sculptors in Romanesque Burgundy: The New Aesthetics of Cluny III*. 2 vols. University Park: Pennsylvania State Univ. Press, 1983.
- Busch, Harald, and Bernd Lohse. Romanesque Sculpture. London: Batsford, 1962
- Cahn, Walter. Romanesque Bible Illumination. Ithaca: Cornell Univ. Press, 1982.
- Evans, Joan, Cluniac Art of the Romanesque Period. Cambridge: Cambridge Univ. Press, 1950.
- Focillon, Henri. *The Art of the West in the Middle Ages*. 2 vols. Ed. Jean Bony. Trans. Donald King. London: Phaidon, 1963.
- Forsyth, Ilene H. The Throne of Wisdom: Wood Sculptures of the Madonna in Romanesque France. Princeton: Princeton Univ. Press, 1972.
- Gantner, Joseph, and Marvel Pobe. Romanesque Art in France.
- London: Thames and Hudson, 1956. Grape, Wolfgang. The Bayeux Tapestry: Monument to a Norman Triumph. New York: Prestel, 1994.
- Hearn, M. F. Romanesque Sculpture: The Revival of Monumental Stone Sculptures in the Eleventh and Twelfth Centuries. Ithaca: Cornell Univ. Press, 1981.

 Holt, Elizabeth Gilmore. A Documentary History of Art. 3 vols.
- Princeton: Princeton Univ. Press, 1982.
- Jacobs, Michael. Northern Spain: The Road to Santiago de Compostela. Architectural Guides for Travelers. San Francisco: Chronicle, 1991.
- Kennedy, Hugh. Crusader Castles. Cambridge: Cambridge Univ. Press. 1994.
- Kubach, Hans Erich. Romanesque Architecture. History of World Architecture. New York: Electa/Rizzoli, 1988. Kuhnel, Biana. *Crusader Art of the Twelfth Century: A Geograph*
- ical, and Historical, or an Art Historical Notion? Berlin: Gebr. Mann 1994.
- Kunstler, Gustav. Romanesque Art in Europe. Greenwich, Conn.: New York Graphic Society, 1969.
- Little, Bryan D. G. Architecture in Norman Britain. London: Bats-
- Mâle, Emile. Religious Art in France, the Twelfth Century: A Study of the Origins of Medieval Iconography. Bollingen Series. Princeton: Princeton Univ. Press, 1978.
- Nebosine, George A. Journey into Romanesque: A Traveller's Guide to Romanesque Monuments in Europe. Ed. Robyn Cooper. London: Weidenfeld and Nicolson, 1969.
- Norton, Christopher, and David Park. Cistercian Art and Architecture in the British Isles. Cambridge: Cambridge Univ. Press, 1986.
- Radding, Charles M., and William W. Clark. Medieval Architec ture, Medieval Learning: Builders and Masters in the Age of Romanesque and Gothic. New Haven: Yale Univ. Press,
- Rollason, David, Margaret Harvey, and Michael Prestwich, eds. Anglo-Norman Durham: 1093-1193. Rochester, N.Y.: Boydell 1994
- Schapiro, Meyer. Romanesque Art. New York: Braziller, 1977 The Romanesque Sculpture of Moissac. New York: Braziller 1985
- Swarzenski, Hanns. Monuments of Romanesque Art: The Art of Church Treasures of North-Western Europe. 2nd ed. Chicago: Univ. of Chicago Press, 1967.
- Tate, Robert Brian, and Marcus Tate. The Pilgrim Route to Santiago. Oxford: Phaidon, 1987.
 Theophilus. On Divers Arts: The Treatise of Theophilus. Trans
- John G. Hawthorne and Cyril Stanley Smith. Chicago. Univ. of Chicago Press, 1963. Wilson, David M. The Bayeux Tapestry: The Complete Tapestry in
- Color. New York: Random House, 1985.
- The Year 1200. 2 vols. New York: Metropolitan Museum of Art, 1970.
- Zarnecki, George. Romanesque Art. New York: Universe, 1971. –, Janet Holt, and Tristam Holland. English Romanesque Art, 1066–1200. London: Weidenfeld and Nicolson, 1984.

Chapter 16 Gothic Art

- Alexander, Jonathan, and Paul Binski, eds. Age of Chivalry: Art in Plantagenet England, 1200–1400. London: Royal Academy of Arts, 1987.
- Andrews, Francis B. The Mediaeval Builder and His Methods. New York: Barnes & Noble, 1993

- Armi, C. Edson. The "Headmaster" of Chartres and the Origins of "Gothic" Sculpture. University Park: Pennsylvania State Univ. Press, 1994.
- Aubert, Marcel. The Art of the High Gothic Era. Rev. ed. Art of the World. New York: Greystone, 1966.
- Binski, Paul. Medieval Craftsmen: Painters. London: British Museum, 1991.
- Bogin, Magda. Gothic Cathedrals of France and Their Treasures. London: Kaye, 1959.
- The Women Troubadours. New York: Norton, 1980
- Bony, Jean. French Gothic Architecture of the 12th and 13th Cen-turies. California Studies in the History of Art. Berkeley: Univ. of California Press, 1983
- Borsook, Eve, and Fiorella Superbi Gioffredi. *Italian Altarpieces*, 1250–1550: Function and Design. Oxford: Clarendon, 1994. Bottineau, Yves. Notre-Dame de Paris and the Sainte Chapelle.
- Trans. Lovett F. Edwards. London: Allen, 1967. Branner, Robert. Manuscript Painting in Paris during the Reign of
- Saint Louis: A Study of Styles. California Studies in the History of Art. Berkeley: Univ. of California Press, 1977
- Chiellini, Monica. Cimabue. Trans. Lisa Pelletti. Florence: Scala
- Coe, Brian. Stained Glass in England, 1150-1550. London: Allen, 1981.
- Cole, Bruce. Giotto and Florentine Painting, 1280-1375. New
- York: Harper & Row, 1975. Crosby, Sumner McKnight. *The Royal Abbey of Saint-Denis from* Its Beginnings to the Death of Suger, 475-1151. Yale Publications in the History of Art. New Haven: Yale Univ. Press, 1987.
- Erlande-Brandenburg, Alain. Gothic Art. Trans. I. Mark Paris New York: Abrams, 1989.
- Favier, Jean. The World of Chartres. Trans. Francisca Garvie New York: Abrams, 1990.
- Franklin I W Cathedrals of Italy London: Batsford, 1958
- Frisch, Teresa G. Gothic Art, 1140-c. 1450: Sources and Docu-
- ments. Englewood Cliffs, N.J.: Prentice-Hall, 1971. Grodecki, Louis. *Gothic Architecture*. Trans. I. Mark Paris. History of World Architecture. New York: Electa/Rizzoli, 1985
- --, and Catherine Brisac. Gothic Stained Glass, 1200-1300. Ithaca: Cornell Univ. Press, 1985.
- Herlihy, David. Medieval Households. Cambridge: Harvard Univ. Press 1985
- Jantzen, Hans. High Gothic: The Classic Cathedrals of Chartres, Reims, Amiens. Trans. James Palmes. New York: Pantheon 1962
- Katzenellenbogen, Adolf. The Sculptural Programs of Chartres Cathedral: Christ, Mary, Ecclesia. New York: Norton, 1964.
- Mâle, Emile. Chartres. Trans. Sarah Wilson. New York: Harper & Row, 1983
- Religious Art in France, the Thirteenth Century: A Study of Medieval Iconography and Its Sources. Princeton: Princeton Univ. Press, 1984
- Martindale, Andrew. *Gothic Art*. World of Art. London: Thames and Hudson, 1967.
- McIntyre, Anthony. Medieval Tuscany and Umbria. Architectural Guides for Travellers, San Francisco: Chronicle, 1992
- Moskowitz, Anita Fiderer. The Sculpture of Andrea and Nino Pisano. Cambridge: Cambridge Univ. Press, 1986.
 Panofsky, Erwin. Abbot Suger on the Abbey Church of St.-Denis
- and Its Art Treasures. 2nd ed. Ed. Gerda Panofsky-Soergel. Princeton: Princeton Univ. Press, 1979.
- Gothic Architecture and Scholasticism. Latrobe, Penn.: Archabbey, 1951
- Pevsner, Nikolas, and Priscilla Metcalf. *The Cathedrals of England*. 2 yols. Harmondsworth, Eng.: Viking, 1985.
- Pope-Hennessy, John. Italian Gothic Sculpture. 3rd ed. Oxford: Phaidon, 1986.
- Sauerlander, Willibald, Gothic Sculpture in France, 1140-1270. Trans. Janet Sandheimer. London: Thames and Hudson,
- Simson, Otto Georg von. The Gothic Cathedral: Origins of Gothic Architecture and the Medieval Concept of Order. 3rd ed. Bollingen Series. Princeton: Princeton Univ. Press, 1988. Smart, Alastair. The Dawn of Italian Painting, 1250–1400.
- Ithaca: Cornell Univ. Press, 1978.
- White, John. Art and Architecture in Italy, 1250 to 1400. 3rd ed. Pelican History of Art. Harmondsworth, Eng.: Penguin,
- Duccio: Tuscan Art and the Medieval Workshop. New York: Thames and Hudson, 1979.
- Wieck, Roger S. Time Sanctified: The Book of Hours in Medieval Art and Life. New York: Braziller, 1988
- Wilson, Christopher. The Gothic Cathedral: The Architecture of the Great Church, 1130-1530. New York: Thames and Hudson, 1990.

Chapter 17 Early Renaissance Art in Europe

- Ainsworth, Maryan Wynn. Petrus Christus: Renaissance Master of Bruges. New York: Metropolitan Museum of Art, 1994.
- Baxandall, Michael. Painting and Experience in Fifteenth-Century Italy: A Primer in the Social History of Pictorial Style Oxford: Clarendon, 1972.
- Blum, Shirley. Early Netherlandish Triptychs: A Study in Patronage. California Studies in the History of Art. Berkeley: Univ. of California Press, 1969.
- Borsi, Franco. Leon Battista Alberti: The Complete Works. New York: Electa/Rizzoli, 1989

- and Stefano Borsi. Paolo Uccello. Trans. Elfreda Powell.
- New York: Abrams, 1994. Campbell, Lorne. Renaissance Portraits: European Portrait-Painting in the 14th, 15th, and 16th Centuries. New Haven: Vale Univ Press 1990
- Chastel, André. The Flowering of the Italian Renaissance. Trans. Jonathan Griffin. Arts of Mankind. New York: Odyssey, 1965
- Studios and Styles of the Italian Renaissance. Trans. Jonathan Griffin. Arts of Mankind. New York: Odyssey, 1966
- Christianity and the Renaissance: Image and Religious Imagination in the Quattrocento. Syracuse. N.Y.: Syracuse Univ. Press. 1990.
- Christiansen, Keith. Andrea Mantegna: Padua and Mantua. New York: Braziller, 1994.
- , Laurence B. Kanter, and Carl Brandon Strehlke. Painting in Renaissance Siena, 1420-1500. New York: Metropolitan Museum of Art. 1988.
- Cole, Bruce. Masaccio and the Art of Early Renaissance Florence. Bloomington: Indiana Univ. Press, 1980.
- Davies, Martin. Rogier van der Weyden: An Essay, with a Critical Catalogue of Paintings Assigned to Him and to Robert Campin. London: Phaidon, 1972.
- de Pisan, Christine, Le Livre de la Cité des Dames (The Book of the City of Ladies). Trans. Earl J. Richards. New York: Persea, 1982.
- Dhanens, Elisabeth. Van Eyck: The Ghent Altarpiece. New York: Viking, 1973.
- Flanders in the Fifteenth Century: Art and Civilization. Detroit: Detroit Institute of Arts, 1960.
- Freeman, Margaret B. The Unicorn Tapestries. New York: Met-
- ropolitan Museum of Art, 1976. Gilbert, Creighton, ed. Italian Art, 1400–1500: Sources and Doc uments. Evanston: Northwestern Univ. Press, 1992
- Goffen, Rona. Giovanni Bellini. New Haven: Yale Univ. Press, 1989.
- Goldwater, Robert, and Marco Treves. Artists on Art: From the
- XIV to the XX Century. New York: Random House, 1945. Hind, Arthur M. An Introduction to a History of Woodcut. New York: Dover, 1963.
- Joannides, Paul. Masaccio and Masolino: A Complete Catalogue. London: Phaidon, 1993.
- Krautheimer, Richard. Ghiberti's Bronze Doors. Princeton: Princeton Univ. Press. 1971.
- Lane, Barbara G. The Altar and the Altarpiece: Sacramental Themes in Early Netherlandish Painting. New York: Harper & Row 1984
- Lightbown, Ronald. Piero della Francesca. New York: Abbeville, 1992
- Sandro Botticelli: Life and Work. New ed. New York: Abbeville, 1989
- Lloyd, Christopher. Fra Angelica. Rev. ed. London: Phaidon, 1992
- Meiss, Millard. French Painting in the Time of Jean de Berry: The Limbourgs and Their Contemporaries. New York: Braziller, 1974.
- Muller, Theodor. Sculpture in the Netherlands, Germany, France, and Spain: 1400–1500. Trans. Elaine and William Robson Scott. Pelican History of Art. Harmondsworth, Eng.: Penguin, 1966.
- Pacht, Otto. Van Eyck and the Founders of Early Netherlandish Painting. Ed. Maria Schmidt-Dengler. Trans. David Britt. London: Miller, 1994.
- Panofsky, Erwin. Early Netherlandish Painting: Its Origins and Character. 2 vols. Cambridge: Harvard Univ. Press, 1966.
- Plummer, John. The Last Flowering: French Painting in Manu-scripts, 1420–1530, from American Collections. New York: Pierpont Morgan Library, 1982.
- Pope-Hennessy, Sir John. Donatello: Sculptor. New York: Abbeville, 1993.
- Saalman, Howard. Filippo Brunelleschi: The Buildings. Univer-
- sity Park: Pennsylvania State Univ. Press, 1993. Seymour, Charles. *Sculpture in Italy, 1400–1500*. Pelican History of Art. Harmondsworth, Eng.: Penguin, 1966.
- Snyder, James. Northern Renaissance Art: Painting, Sculpture, the Graphic Arts from 1350 to 1575. New York: Abrams, 1985. Vos, Dirk de. Hans Memling: The Complete Works. Ghent:
- Ludion, 1994.

Chapter 18 Renaissance Art in Sixteenth-Century Europe Ackerman, James S. The Architecture of Michelangelo. Rev ed.

- Studies in Architecture. London: Zwemmer, 1966 Baldini, Umberto. The Sculpture of Michelangelo. Trans. Clare
- Coope. New York: Rizzoli, 1982. Baxandall, Michael. The Limewood Sculptors of Renaissance Germany. New Haven: Yale Univ. Press, 1980
- Beck, James H. *Raphael*. New York: Abrams, 1994. Bier, Justus. *Tilman Riemenschneider, His Life and Work*. Lexington: Univ. of Kentucky Press, 1989.
- Blankert, A. Vermeer of Delft. Oxford: Phaidon, 1978. Blunt, Anthony. Art and Architecture in France: 1500–1700. 4th ed. Pelican History of Art. Harmondsworth, Eng.: Penguin, 1981.
- Bosquet, Jacques. Mannerism: The Painting and Style of the Late Renaissance. Trans. Simon Watson Taylor. New York: Braziller, 1964.

- Boucher, Brude. Andrea Palladio: The Architect in His Time. New York: Abbeville, 1994.
 Bronstein, Leo. El Greco (Domenicos Theotocopoulos). New
- York: Abrams, 1990.
- Brown, Jonathan. *The Golden Age of Painting in Spain*. New Haven: Yale Univ. Press, 1991.
- Bruschi, Arnaldo. Bramante. London: Thames and Hudson, 1977. Chastel, André. *The Age of Humanism: Europe, 1480–1530.*Trans. Katherine M. Delavenay and E. M. Gwyer. London: Thames and Hudson, 1963
- Ettlinger, Leopold D., and Helen S. Ettlinger. Raphael. Oxford: Phaidon, 1987.
- Farmer, John David. The Virtuoso Craftsman: Northern European Design in the Sixteenth Century. Worcester, Mass.: Worcester Art Museum, 1969.
- Foote, Timothy. The World of Bruegel, c. 1525-1569. New York: Time-Life, 1968.
- Freedberg, S. J. Painting in Italy, 1500 to 1600. 3rd ed. Pelican History of Art. New Haven: Yale Univ. Press, 1993
- Gibson, Walter. Hieronymus Bosch. World of Art. New York: Oxford Univ. Press, 1973.
- Goldschneider, Ludwig. Leonardo da Vinci: Life and Work, Paintings and Drawings. 7th ed. London: Phaidon, 1964.
- Hartt, Frederick. Michelangelo. New York: Abrams, 1984.
- Hayum, André. The Isenheim Altarpiece: God's Medicine and the Painter's Vision. Princeton Essays on the Arts. Princeton: Princeton Univ. Press, 1989.
- Heydenreich, Ludwig H. Leonardo-'The Last Supper." Art in Context. London: Allen Lane, 1974.
- Hollingsworth, Mary. Patronage in Renaissance Italy: From 1400
- to the Early Sixteenth Century. London: Murray, 1994. Howard, Deborah. Jacopo Sansovino: Architecture and Patronage in Renaissance Venice. New Haven: Yale Univ. Press, 1975.
- Huse, Norbert, and Wolfgang Wolters. Art of Renaissance Venice: Architecture, Sculpture and Painting, 1460–1590. Trans. Edmund Jephcott. Chicago: Univ. of Chicago Press. 1990.
- Jones, Roger, and Nicholas Penny. Raphael. New Haven: Yale Univ. Press, 1983.
- Klein, Robert, and Henri Zerner. Italian Art. 1500-1600: Sources and Documents. Englewood Cliffs, N.J.: Prentice-Hall, 1966. Kubler, George. *Building the Escorial*. Princeton: Princeton Univ. Press, 1982.
- Landau, David, and Peter Parshall. The Renaissance Print:
- 1470–1550. New Haven: Yale Univ. Press, 1994. Langdon, Helen. *Holbein*. 2nd ed. London: Phaidon, 1993.
- Lazzaro, Claudia. The Italian Renaissance Garden: From the Con ventions of Planting, Design, and Ornament to the Grand Gardens of Sixteenth-Century Central Italy. New Haven: Yale Univ. Press, 1990.
- Lieberman. Ralph. Renaissance Architecture in Venice, 1450-1540. New York: Abbeville, 1982.
- Linfert, Carl. Hieronymus Bosch. Masters of Art. New York: Abrams, 1989.
- Martineau, Jane, and Charles Hope. The Genius of Venice, 1500-1600. New York: Abrams, 1984.
- McCorquodale, Charles. Bronzino. New York: Harper & Row,
- McMullen, Roy. Mona Lisa: The Picture and the Myth. Boston: Houghton Mifflin, 1975. Murray, Linda. The High Renaissance. World of Art. New York:
- Praeger, 1967 Late Renaissance and Mannerism. World of Art. London:
- Thames and Hudson, 1967 Michelangelo. World of Art. New York: Oxford Univ
- Press, 1980 Olson, Roberta J. M. Italian Renaissance Sculpture. World of Art.
- New York: Thames and Hudson, 1992. Osten, Gert von der, and Horst Vey. Painting and Sculpture in
- Germany and the Netherlands, 1500–1600. Pelican History of Art. Harmondsworth, Eng.: Penguin, 1969. Perlingieri, Ilya Sandra. Sofonisba Anguissola: The First Great
- Woman Artist of the Renaissance. New York: Rizzoli, 1992. Pietrangeli, Carlo, et al. The Sistine Chapel: The Art, the History, and the Restoration. New York: Harmony, 1986.
- Pignatti, Terisio. *Giorgione*. New York: Phaidon, 1971. Pope-Hennessy, Sir John. *Cellini*. New York: Abbeville, 1985.
- Italian High Renaissance and Baroque Sculpture. 3rd ed. Oxford: Phaidon, 1986.
- Italian Renaissance Sculpture. 3rd ed. Oxford: Phaidon. 1986 Rearick, William R. The Art of Paolo Veronese, 1528-1588, Wash-
- ington, D.C.: National Gallery of Art, 1988. Rosand, David. Painting in Cinquecento Venice: Titian, Veronese,
- Tintoretto. New Haven: Yale Univ. Press, 1982. Russell, Francis. The World of Dürer, 1471–1528. New York: Time-Life, 1967.
- Settis, Salvatore. Giorgione's Tempest: Interpreting the Hidden Subject. Trans. Ellen Bianchini. Chicago: Univ. of Chicago Press. 1990
- Shearman, John. Mannerism. Harmondsworth, Eng.: Penguin,
- Smith, Jeffrey Chipps. Nuremberg, a Renaissance City, 1500-1618. Austin: Huntington Art Gallery, Univ. of Texas, 1983. Stechow, Wolfgang. *Pieter Bruegel the Elder*. Masters of Art.
- New York: Abrams, 1990. Strong, Roy C. Artists of the Tudor Court: The Portrait Miniature Rediscovered, 1520-1620. London: Victoria and Albert Museum, 1983

- Summerson, John, Architecture in Britain: 1530 to 1830. 7th ed. Pelican History of Art. Harmondsworth, Eng.: Penguin, 1983
- Tavernor, Robert. Palladio and Palladianism. World of Art. New York: Thames and Hudson, 1991.
- Valcanover. Francesco. Tintoretto. Trans. Robert Erich Wolf Library of Great Painters. New York: Abrams, 1985.
- Vasari, Giorgio. The Lives of the Artists. Trans. Julia Conaway Bondanella and Peter Bondanella. New York: Oxford Univ. Press, 1991.
- Verheyen, Egon. The Paintings in the Studiolo of Isabella d'Este at Mantua. Monographs on Archaeology and Fine Arts. New York: New York Univ. Press, 1971.
- Vitruvius Pollio. Vitruvius: The Ten Books on Architecture. Trans.
- Morris Hicky Morgan. New York: Dover, 1960. Whiting, Roger. Leonardo: A Portrait of the Renaissance Man. London: Barrie and Jenkins, 1992.

Chapter 19 Baroque, Rococo, and Early American

- Ackley, Clifford S. Printmaking in the Age of Rembrandt. Boston: Museum of Fine Arts, 1981 The Age of Caravaggio, New York: Metropolitan Museum of Art
- Bazin, Germain. Baroque and Rococo. Trans. Jonathan Griffin. World of Art. New York: Praeger, 1964.
- Berger, Robert W. The Palace of the Sun: The Louvre of Louis XIV. University Park: Pennsylvania State Univ. Press, 1993.

 —. Versailles: The Chateau of Louis XIV. Monographs on the
- Fine Arts. University Park: Pennsylvania State Univ. Press, 1985
- Blunt, Anthony, et al. Baroque and Rococo Architecture and Decoration. New York: Harper & Row, 1982
- Boucher, François. *François Boucher*, 1703–1770. New York: Metropolitan Museum of Art, 1986.
- Brown, Christopher. Scenes of Everyday Life: Dutch Genre Painting of the Seventeenth Century. London: Faber & Faber,
- Brown, Dale. The World of Velázquez, 1599-1660. New York: Time-Life, 1969.
- Brown, Jonathan. The Golden Age of Painting in Spain. New Haven: Yale Univ. Press, 1991
- . Velázquez, Painter and Courtier. New Haven: Yale Univ. Press, 1986.
- Domingues Ortiz, Antonio, Alfonso E. Perez Sanchez, and Julian Gallego. Velázquez. New York: Metropolitan Museum of Art, 1989.
- Enggass, Robert, and Jonathan Brown. Italy and Spain 1600-1750: Sources and Documents. Englewood Cliffs, N.J.: Prentice-Hall, 1970.
- Frankenstein, Alfred Victor. The World of Copley, 1738–1815. New York: Time-Life, 1970.
- Fuchs, R. H. Dutch Painting. World of Art. New York: Oxford Univ. Press, 1978.
- Gerson, Horst, and E. H. ter Kuile. Art and Architecture in Belgium, 1600-1800. Pelican History of Art. Baltimore: Penguin, 1960.
- Rembrandt Paintings. Trans. Heinz Norden. Ed. Gary Schwartz. New York: Reynal, 1968. Grasselli, Margaret Morgan, and Pierre Rosenberg. Watteau,
- 1684-1721. Washington, D.C.: National Gallery of Art, 1984.
- Grimm, Claus. Frans Hals-The Complete Work. Trans. Jurgen Riehle. New York: Abrams, 1990. Haak, Bob. *The Golden Age: Dutch Painters of the Seventeenth*
- Century. Trans. and ed. Elizabeth Willems-Treeman. New York: Abrams 1984
- Held, Julius Samuel, and Donald Posner. 17th and 18th Century Art: Baroque Painting, Sculpture, Architecture. Library of Art History, New York: Abrams, 1971.
- Hempel, Eberhard. Baroque Art and Architecture in Central Europe: Germany, Austria, Switzerland, Hungary, Czechoslovakia, Poland. Painting and Sculpture: 17th and 18th Centuries. Architecture: 16th to 18th Centuries, Trans. Elisabeth Hempel and Marguerite Kay. Pelican History of Art. Harmondsworth, Eng.: Penguin, 1965.
- Jacobson, Dawn, Chinoiserie, London: Phaidon, 1993
- Kalnein, Wend, and Michael Levey. Art and Architecture of the Eighteenth Century in France. Pelican History of Art. Harmondsworth, Eng.: Penguin, 1972.
- Köning, Hans. The World of Vermeer, 1632–1675. New York: Time-Life, 1967.
- Lagerlof, Margaretha Rossholm. Ideal Landscape: Annibale Caracci, Nicolas Poussin, and Claude Lorrain. New Haven: Yale Univ. Press, 1990. Martin, John Rupert. "The Baroque from the Viewpoint of the
- Art Historian." Journal of Aesthestics and Art Criticism 15(2): 164 - 70.
- Moir, Alfred. Anthony Van Dyck. New York: Abrams, 1994. Caravaggio. Library of Great Painters. New York
- Abrams 1982 Montagu, Jennifer. Roman Baroque Sculpture: The Industry of
- Art. New Haven: Yale Univ. Press, 1989. Norberg-Schulz, Christian. Baroque Architecture. New York Rizzoli, 1986.
- . Late Baroque and Rococo Architecture. History of World Architecture. New York: Rizzoli. 1985
- Rosenberg, Jakob, Seymour Slive, and E. H. ter Kuile. Dutch Art

- and Architecture, 1600 to 1800. 3rd ed. Pelican History of
- Art. Harmondsworth, Eng.: Penguin, 1977. Rosenberg, Pierre. *Chardin, 1699–1779.* Trans. Emilie P. Kadish and Ursula Korneitchouk. Ed. Sally W. Goodfellow. Cleveland: Cleveland Museum of Art, 1979.
- Fragonard. New York: Metropolitan Museum of Art, 1988. Russell, H. Diane. Claude Lorrain, 1600–1682. Washington, D.C.: National Gallery of Art, 1982.
- Schwartz, Gary. Rembrandt, His Life, His Paintings. New York: Penguin, 1991. Scribner, Charles, III. *Gianlorenzo Bernini*. Masters of Art. New
- York: Abrams, 1991. Peter Paul Rubens. Masters of Art. New York: Abrams.
- Slive, Seymour, et al. Frans Hals. London: Royal Academy of Arts. 1989
- Stechow, Wolfgang. Dutch Landscape Painting of the Seventeenth Century. 3rd ed. Oxford: Phaidon, 1981
- Summerson, John. Architecture of the Eighteenth Century. World of Art. New York: Thames and Hudson, 1986.
- Inigo Jones. Harmondsworth, Eng.: Penguin, 1966 Sutton, Peter. The Age of Rubens. Boston: Museum of Fine Arts,
- Wallace, Robert. The World of Bernini, 1598-1680. New York: Time-Life, 1970.
- Temple, R. C., ed. The Travels of Peter Mundy in Europe and Asia, 1608–1667. London: n.p., 1925. Wedgwood, C. V. *The World of Rubens*. 1577–1640. New York:
- Time-Life, 1967.
- Welu, James A., and Pieter Biesboer, eds. Judith Leyster: A Dutch Master and Her World. New York: Yale Univ. Press, 1993. Wheelock, Arthur K., Jr. Jan Vermeer. New York: Abrams, 1988
- Susan J. Barnes, and Julius S. Held. Anthony Van Dyck Washington, D.C.: National Gallery of Art, 1990.
- White, Christopher. Peter Paul Rubens: Man & Artist. New Haven: Yale Univ Press 1987 Rembrandt. World of Art. London: Thames and Hudson,
- Wittkower, Rudolf. Art and Architecture in Italy, 1600 to 1750. 3rd ed. Pelican History of Art. Harmondsworth, Eng.: Pen-

Chapter 20 Art of India after 1100

guin, 1982.

- Asher, Catherine B. Architecture of Mughal India. New York: Cambridge Univ. Press, 1992.
- Beach, Milo Cleveland. Grand Mogul: Imperial Painting in India, 1600-1660. Williamstown: Sterling and Francine Clark Art Institute, 1978.
- . Imperial Image, Paintings for the Mughal Court. Washington, D.C.: Freer Gallery of Art, Smithsonian Institution,
- -. Mughal and Rajput Painting. New York: Cambridge Univ. Press, 1992.
- Blurton, T. Richard. Hindu Art. Cambridge: Harvard Univ. Press, 1993.
- Davies, Philip. Splendours of the Raj: British Architecture in India, 1660 to 1947. London: Murray, 1985 Desai, Vishakha N. Life at Court: Art for India's Rulers, 16th-19th
- Centuries. Boston: Museum of Fine Arts, 1985. Losty, Jeremiah P. The Art of the Book in India. London: British
- Library, 1982. Miller, Barbara Stoller. Love Song of the Dark Lord: Jayadeva's Gitagovinda, New York: Columbia Univ. Press. 1977
- Mitchell, George. The Royal Palaces of India. London: Thames and Hudson, 1994. Nou, Jean-Louis. *Taj Mahal*. Text by Amina Okada and M. C
- Joshi. New York: Abbeville, 1993
- Pal, Pratapaditya. Court Paintings of India, 16th-19th Centuries New York: Navin Kumar, 1983. et al. Romance of the Taj Mahal. Los Angeles: Los Ange-
- les County Museum of Art, 1989.
 Tillotson, G. H. R. *Mughal India*. Architectural Guides for Trav-
- elers. San Francisco: Chronicle, 1990. . The Tradition of Indian Architecture: Continuity, Controversy and Change since 1850. New Haven: Yale Univ.
- Welch, Stuart Cary. The Emperors' Album: Images of Mughal
- India. New York: Metropolitan Museum of Art, 1987 India: Art and Culture 1300-1900. New York: Metropolitan Museum of Art, 1985.

Chapter 21 Chinese Art after 1280

- Andrews, Julia Frances. Painters and Politics in the People's Republic of China, 1949–1979. Berkeley: Univ. of California Press 1994
- Barnhart, Richard M. Painters of the Great Ming: The Imperial Court and the Zhe School. Dallas: Dallas Museum of Art, 1993.
- Peach Blossom Spring: Gardens and Flowers in Chinese Painting. New York: Metropolitan Museum of Art, 1983.
- -, et al. The Jade Studio: Masterpieces of Ming and Qing Painting and Calligraphy from the Wong Nan-p'ing Collection. New Haven: Yale Univ. Art Gallery, 1994
- Beurdeley, Michael. Chinese Furniture. Trans. Katherine Watson. Tokyo: Kodansha International, 1979.
- Billeter, Jean François. The Chinese Art of Writing. New York: Skira/Rizzoli 1990

- Bush, Susan, and Hsui-yen Shih, eds. Early Chinese Texts on Painting. Cambridge: Harvard Univ. Press, 1985.
- Cahill, James. The Compelling Image: Nature and Style in Seven-teenth-Century Chinese Painting. Charles Norton Lectures 1978-79. Cambridge: Harvard Univ. Press, 1982.
- The Distant Mountains: Chinese Painting in the Late Ming Dynasty, 1580–1644. New York: Weatherhill, 1982.
- Hills beyond a River: Chinese Painting of the Y'uan Dynasty, 1279–1368. New York: Weatherhill, 1976.
- Parting at the Shore: Chinese Painting of the Early and Middle Ming Dynasty, 1368-1580. New York: Weatherhill, 1978
- Chan, Charis. Imperial China. Architectural Guides for Travelers. San Francisco: Chronicle, 1992.
- Fontein, Jan, and Money Hickman. Zen Painting and Calligraphy: An Exhibition of Works of Art Lent by Temples, Private Collectors, and Public and Private Museums in Japan. Boston: Museum of Fine Arts, 1971
- Ho, Wai-Kam, ed. *The Century of Tung Ch'i-Chiang.* 2 vols. Kansas City: Nelson-Atkins Museum of Art, 1992.
- In Pursuit of the Dragon: Traditions and Transitions in Ming Ceramics: An Exhibition from the Idemitsu Museum of Arts. Seattle: Seattle Art Museum, 1988.
- Jenyns, Soame. Later Chinese Porcelain: The Ch'ing Dynasty, 1644-1912. 4th ed. London: Faber & Faber, 1971
- Keswick, Maggie. The Chinese Garden: History, Art and Architec ture. New York: Rizzoli, 1978
- Knapp, Ronald G. China's Vernacular Architecture: House Form and Culture. Honolulu: Univ. of Hawaii Press, 1989.
- Lee, Sherman, and Wai-Kam Ho. Chinese Art under the Mongols: The Y'uan Dynasty, 1279–1368. Cleveland: Cleveland Museum of Art, 1968.
- Li, Chu-tsing. The Autumn Colors on the Ch'iao and Hua Mountains: A Landscape by Chao Meng-fu. Artibus Asiae, supplementum 21. Ascona: Artibus Asiae, 1965.
- Lim, Lucy. Contemporary Chinese Painting: An Exhibition from the People's Republic of China. San Francisco: Chinese Culture Foundation of San Francisco, 1983.
- –, ed. Wu Guanzhong: A Contemporary Chinese Artist. San Francisco: Chinese Culture Foundation, 1989.
- Liu, Laurence G. Chinese Architecture. New York: Rizzoli, 1989 Ng, So Kam. Brushstrokes: Styles and Techniques of Chinese Painting. San Francisco: Asian Art Museum of San Francisco, 1993.
- Polo, Marco. The Travels of Marco Polo. Trans. Teresa Waugh and Maria Bellonci. New York: Facts on File, 1984.
- Shih-t'ao. Returning Home: Tao-chi's Album of Landscapes and Flowers. Commentary by Wen Fong. New York: Braziller,
- Sullivan, Michael. Symbols of Eternity: The Art of Landscape Painting in China. Stanford: Stanford Univ. Press, 1979
- Tregear, Mary. Chinese Art. World of Art. New York: Oxford Univ. Press, 1980. Tsu, Frances Ya-sing. Landscape Design in Chinese Gardens.
- New York: McGraw-Hill, 1988.
- Vainker, S. J. Chinese Pottery and Porcelain: From Prehistory to the Present. London: British Museum, 1991.
- Walters, Derek. Feng Shui: The Chinese Art of Designing a Harmonious Environment. New York: Simon & Schuster,
- Yu Zhuoyun, comp. Palaces of the Forbidden City. Trans. Ng Mau-Sang, Chan Sinwai, and Puwen Lee. New York: Viking, 1984.

Chapter 22 Japanese Art after 1392

- Addiss, Stephen. The Art of Zen: Painting and Calligraphy by Japanese Monks, 1600–1925. New York: Abrams, 1989.
- -. Zenga and Nanga: Paintings by Japanese Monks and Scholars, Selections from the Kurt and Millie Gitter Collection. New Orleans: New Orleans Museum of Art, 1976.
- Baekeland, Frederick, and Robert Moes. Modern Japanese Ceramics in American Collections. New York: Japan Societv. 1993
- Doi, Tsugiyoshi. Momoyama Decorative Painting. Trans. Edna B. Crawford. Heibonsha Survey of Japanese Art, vol. 14. New York: Weatherhill, 1977
- Forrer, Matthi. *Hokusai*. New York: Rizzoli, 1988. Hayakawa, Masao. *The Garden Art of Japan*. Trans. Richard L. Gage. Heibonsha Survey of Japanese Art, vol. 28. New York: Weatherhill, 1973.
- Hayashiya, Tatsusaburo, Masao Nakamura, and Seizo Hayashiya. Japanese Arts and the Tea Ceremony. Trans. and adapted by Joseph P. Macadam. Heibonsha Survey of Japanese Art, vol. 15. New York: Weatherhill, 1974.
- Hinago, Motoo. Japanese Castles. Trans. and adapted by William H. Coaldrake. Japanese Arts Library, vol. 14. New York: Kodansha International, 1986.
- Hirai, Kiyoshi. Feudal Architecture of Japan. Trans. Hiroaki Sato and Jeannine Ciliotta. Heibonsha Survey of Japanese Art, vol. 13. New York: Weatherhill, 1973.
- Hosono, Masanobu. *Nagasaki Prints and Early Copperplates*. Trans. and adapted by Lloyd R. Craighill. Japanese Arts Library, vol. 6. New York: Kodansha International, 1978.
- Leach, Bernard. Kenzan and His Tradition: The Lives and Times of Koetsu, Sotatsu, Korin and Kenzan. London: Faber, 1966.
- Kanazawa, Hiroshi. Japanese Ink Painting: Early Zen Master ieces. Trans. and adapted by Barbara Ford. Japanese Arts Library, vol. 8. New York: Kodansha International, 1979

- Kawahara, Masahiko, The Ceramic Art of Ogata Kenzan, Trans. and adapted by Richard L. Wilson. Japanese Arts Library, vol. 13. New York: Kodansha International, 1985.
- Kawakita, Michiaki. Modern Currents in Japanese Art. Trans. and adapted by Charles S. Terry. Heibonsha Survey of Japanese Art, vol. 24. New York: Weatherhill, 1974
- Meech-Pekarik Julia The World of the Meiji Print: Impressions of a New Civilization. New York: Weatherhill, 1986.
- Merritt, Helen. Modern Japanese Woodblock Prints: The Early Years. Honolulu: Univ. of Hawaii Press, 1990.
- Michener, James A. The Floating World. New York: Random
- Mizuo Hiroshi Edo Painting: Sotatsu and Korin Trans. John M. Shields. Heibonsha Survey of Japanese Art, vol. 18. New York: Weatherhill, 1972.
- Muraoka, Kageo, and Kichiemon Okamura. Folk Arts and Crafts of Japan. Trans. Daphne D. Stegmaier. Heibonsha Survey of Japanese Art, vol. 26. New York: Weatherhill, 1973.
- Murase, Miyeko, Emaki, Narrative Scrolls from Japan. New York: Asia Society, 1983.
- Masterpieces of Japanese Screen Painting: The American Collections. New York: Braziller, 1990. Tales of Japan: Scrolls and Prints from the New York Pub-
- lic Library. Oxford: Oxford Univ. Press, 1986.
 Noma. Seiroku. Japanese Costume and Textiles Arts. Trans.
- Armins Nikoskis. Heibonsha Survey of Japanese Art, vol. 16 New York: Weatherhill, 1974.
- Oka, Isaburo. Hiroshige: Japan's Great Landscape Artist. Trans. Stanleigh H. Jones. Tokyo: Kodansha International, 1992
- Okakura, Kakuzo. The Book of Tea. Ed. Everett F. Bleiler. New York: Dover, 1964.
- Okamoto, Yoshitomo. The Namban Art of Japan. Trans. Ronald K. Jones, Heibonsha Survey of Japanese Art. vol. 19, New York: Weatherhill/Heibonsha, 1972.
- Okawa, Naomi. Edo Architecture: Katsura and Nikko. Trans Alan Woodhull and Akito Miyamoto. Heibonsha Survey of Japanese Art, vol. 20. New York: Weatherhill, 1975.
- Okyo and the Maruyama-Shijo School of Japanese Painting Trans, Miyeko Murase and Sarah Thompson, St. Louis: St Louis Art Museum, 1980.
- Takahashi, Seiichiro. *Traditional Woodblock Prints of Japan*.

 Trans. Richard Stanley-Baker. Heibonsha Survey of Japanese Art, vol. 22. New York: Weatherhill, 1972.
- Takeda, Tsuneo, Kano Eitoku, Trans, Catherine Kaputa, Japanese Arts Library, vol. 3. New York: Kodansha Interna-
- Takeuchi, Melinda, Taiga's True Views: The Language of Land scape Painting in Eighteenth-Century Japan. Stanford:
- Stanford Univ. Press, 1992. Terada, Toru. *Japanese Art in World Perspective*. Trans. Thomas Guerin. Heibonsha Survey of Japanese Art, vol. 25. New York: Weatherhill, 1976.
- Thompson, Sarah E., and H. D. Harpptunian. Undercurrents in the Floating World: Censorship and Japanese Prints. New York: Asia Society Gallery, 1992.
- Wilson, Richard L. The Art of Ogata Kenzan: Persona and Produc
- tion in Japanese Ceramics. New York: Weatherhill, 1991. Yamane, Yuzo. Momoyama Genre Painting. Trans. John M Shields. Heibonsha Survey of Japanese Art, vol. 17. New York: Heibonsha, 1973

Chapter 23 Art of the Americas after 1300

- Archuleta, Margaret, and Rennard Strickland. Shared Visions: Native American Painters and Sculptors in the Twentieth Century. Phoenix: Heard Museum, 1991.
- Baquedano, Elizabeth. Aztec Sculpture. London: British Museum. 1984.
- Berdan Frances F. The Aztecs of Central Mexico: An Imperial Society. New York: Holt, 1982.
- Bringhurst, Robert. The Black Canoe: Bill Reid and the Spirit of Haida Gwaii. Seattle: Univ. of Washington Press, 1991.
- Broder, Patricia Janis. American Indian Painting and Sculpture. New York: Abbeville, 1981.
- Coe, Ralph. Lost and Found Traditions: Native American Art 1965-1985. Ed. Irene Gordon. Seattle: Univ. of Washington Press, 1986.
- Conn, Richard. Circles of the World: Traditional Art of the Plains Indians. Denver: Denver Art Museum, 1982.
- Dockstader, Frederick J. The Way of the Loom: New Traditions in Navajo Weaving. New York: Hudson Hills, 1987
- Feest, Christian F. *Native Arts of North America*. Updated ed. World of Art. New York: Thames and Hudson, 1992.
- Haberland, Wolfgang. Art of North America. Rev. ed. Art of the World. New York: Greystone, 1968. Hawthorn, Audrey. Art of the Kwakiutl Indians and Other North
- west Coast Tribes. Vancouver: Univ. of British Columbia Press, 1967
- Hemming, John. Monuments of the Incas. Boston: Little, Brown,
- Highwater, Jamake. The Sweet Grass Lives On: Fifty Contemporary North American Indian Artists. New York: Lippincott and Crowell, 1980.
- Jonaitis, Aldona. Art of the Northern Tlingit. Seattle: Univ. of Washington Press, 1986.
 - ed. Chiefly Feasts: The Enduring Kwakiutl Potlatch. Seattle: Univ. of Washington Press, 1991.
- Kahlenberg, Mary Hunt, and Anthony Berlant. The Navajo Blan ket. New York: Praeger, 1972.

- Levi-Strauss, Claude. Way of the Masks. Trans. Sylvia Modelski. Seattle: Univ. of Washington Press, 1982.
- MacDonald, George F. Haida Monumental Art: Villages of the Queen Charlotte Islands. Vancouver: Univ. of British Columbia Press, 1983.
- Maurer, Evan M. Visions of the People: A Pictorial History of Plains Indian Life. Minneapolis: Minneapolis Institute of Arts,
- McNair, Peter L., Alan L. Hoover, and Kevin Neary. Legacy: Tradition and Innovation in Northwest Coast Indian Art. Vancouver: Douglas and McIntyre, 1984.
- Nicholson, H. B., and Eloise Quinones Keber. Art of Aztec Mexico: Treasures of Tenochtitlan. Washington, D.C.: National Gallery of Art, 1983.
- Parezo, Nancy I. Navajo Sandpainting: From Religious Act to Commercial Art. Tucson: Univ. of Arizona Press, 1983
- Pasztory, Esther. Aztec Art. New York: Abrams, 1983. Penney, David. Art of the American Indian Frontier: The Chandler-Pohrt Collection. Detroit: Detroit Institute of Arts, 1992
- Peterson, Susan. The Living Tradition of Maria Martinéz. Tokyo: Kodansha International, 1977.
- Smith, Jaune Quick-to-See, and Harmony Hammond. Women of Sweetgrass: Cedar and Sage. New York: American Indian Center, 1984.
- Stewart, Hilary. Totem Poles. Seattle: Univ. of Washington Press, 1990.
- Stierlin, Henri. Art of the Aztecs and Its Origins. New York: Rizzoli. 1982
- -. Art of the Incas and Its Origins. New York: Rizzoli, 1984. Trimble, Stephen. Talking with the Clay: The Art of Pueblo Pottery. Santa Fe: School of American Research Press, 1987
- Wade, Edwin, and Carol Haralson, eds. The Arts of the North American Indian: Native Traditions in Evolution. New York Hudson Hills 1986.
- Walters, Anna Lee. Spirit of Native America: Beauty and Mysticism in American Indian Art. San Francisco: Chronicle, 1989
- Wood, Nancy C. Taos Pueblo. New York: Knopf, 1989.

Chapter 24 Art of Pacific Cultures

- Allen, Louis A. Time before Morning: Art and Myth of the Australian Aborigines. New York: Crowell, 1975.
- Barrow, Terrence. The Art of Tahiti and the Neighbouring Society, Austral and Cook Islands. New York: Thames and Hudson, 1979
- An Illustrated Guide to Maori Art. Honolulu: Univ. of Hawaii Press 1984
- Buhler, Alfred, Terry Barrow, and Charles P. Montford, The Art of the South Sea Islands, including Australia and New Zealand. Art of the World. New York: Crown, 1962.
- Caruana, Wally. Aboriginal Art. World of Art. New York: Thames and Hudson, 1993.
- Craig, Robert D. Dictionary of Polynesian Mythology. New York: Greenwood, 1989.
- Gauguin, Paul. Intimate Journals. Trans. Van Wyck Brooks. Bloomington: Indiana Univ. Press, 1958.
- Gell, Alfred. Wrapping in Images: Tattooing in Polynesia. Oxford Studies in Social and Cultural Anthropology. New York: Oxford Univ. Press, 1993.

 Greub, Suzanne, ed. Art of Northwest New Guinea: From
- Geelvink Bay, Humboldt Bay, and Lake Sentani. New York: Rizzoli, 1992.
- Guiart, Jean. The Arts of the South Pacific. Trans. Anthony Christie. Arts of Mankind. New York: Golden, 1963.
- Hammond, Joyce D. Tifaifai and Quilts of Polynesia. Honolulu: Univ. of Hawaii Press, 1986. Hanson, Allan, and Louise Hanson. Art and Identity in Oceania
- Honolulu: Univ. of Hawaii Press, 1990. Heyerdahl, Thor. *The Art of Easter Island*. Garden City, N.Y.:
- Doubleday, 1975 Jone, Stella M. Hawaiian Quilts. Rev. 2nd ed. Honolulu: Daughters of Hawaii, 1973.
- Layton, Robert. Australian Rock Art: A New Synthesis. New York: Cambridge Univ. Press, 1992. Leonard, Anne, and John Terrell. *Patterns of Paradise: The Style*
- and Significance of Bark Cloth around the World. Chicago: Field Museum of Natural History, 1980.
- Mead, Sydney Moko, ed. Te Maori: Maori Art from New Zealand Collections. New York: Abrams, 1984. Morphy, Howard, Ancestral Connections: Art and an Aboriginal
- System of Knowledge. Chicago: Univ. of Chicago Press, 1991
- People of the River, People of the Trees: Change and Continuity in Sepik and Asmat Art. St. Paul: Minnesota Museum of Art, 1989. Rabineau, Phyllis. Feather Arts: Beauty, Wealth, and Spirit
- from Five Continents. Chicago: Field Museum of Natural History, 1979. Scutt, R. W. B., and Christopher Gotch. Art, Sex, and Symbol: The
- Mystery of Tattooing. 2nd ed. New York: Cornell Univ. Press. 1986.
- Serra, Eudaldo, and Alberto Folch. The Art of Papua and New Guinea. New York: Rizzoli, 1977 Sutton, Peter, ed. Dreamings, the Art of Aboriginal Australia. New
- York: Braziller, 1988 Wardwell, Allen. Island Ancestors: Oceania Art from the Masco

Chapter 25 Art of Africa in the Modern Era

- Abiodun, Rowland, Henry J. Drewal, and John Pemberton III, eds. The Yoruba Artist: New Theoretical Perspectives on African Arts. Washington, D.C.: Smithsonian Institution, 1994
- Adler, Peter, and Nicholas Barnard, African Maiesty: The Textile Art of the Ashanti and Ewe. New York: Thames and Hudson, 1992.
- Astonishment and Power. Washington, D.C.: National Museum of African Art, Smithsonian Institution, 1993
- Barley, Nigel. Foreheads of the Dead: An Anthropological View of Kalabari Ancestral Screens. Washington, D.C.: National Museum of African Art, Smithsonian Institution, 1988
- —. Smashing Pots: Feats of Clay from Africa. London: British Museum, 1994.
- Biebuyck, Daniel P. Lega Culture: Art, Initiation, and Moral Philosophy among a Central African People. Berkeley: Univ. of California Press, 1973.
- Brincard, Marie-Therese, ed. *The Art of Metal in Africa*. Trans. Evelyn Fischel. New York: African-American Institute, 1984.
- Cole, Herbert M., ed. I Am Not Myself: The Art of African Mas querade. Los Angeles: Museum of Cultural History, Univ. of California, 1985
- Icons: Ideals and Power in the Art of Africa. Washington D.C.: National Museum of African Art. Smithsonian Institution, 1989
- Mbari, Art and Life among the Owerri Igbo. Bloomington: Indiana Univ. Press. 1982
- Drewal, Henry John. African Artistry: Technique and Aesthetics in Yoruba Sculpture. Atlanta: High Museum of Art, 1980.
- –, and Margaret Thompson Drewal. Gelede: Art and Female Power among the Yoruba. Bloomington: Indiana Univ. Press. 1983.
- Fagg, William Buller, and John Pemberton III. Yoruba Sculpture of West Africa. Ed. Bryce Holcombe. New York: Knopf, 1982.
- Gilfoy, Peggy S. Patterns of Life: West African Strip-Weaving Traditions. Washington, D.C.: National Museum of African Art. Smithsonian Institution, 1992.
- Glaze. Anita. Art and Death in a Senufo Village. Bloomington: Indiana Univ. Press, 1981
- Heathcote, David. The Arts of the Hausa. Chicago: Univ. of Chicago Press, 1976.
- Kennedy, Jean. New Currents, Ancient Rivers: Contemporary Artists in a Generation of Change. Washington, D.C.: Smithsonian Institution, 1992.
- Laude, Jean. African Art of the Dogon: The Myths of the Cliff Dwellers. Trans. Joachim Neugroschell. New York: Brooklyn Museum, 1973.
- Martin, Phyllis, and Patrick O'Meara, eds. Africa. 2nd ed. Bloomington: Indiana Univ. Press. 1986.
- McEvilley, Thomas. Fusion: West African Artists at the Venice
- Biennale. New York: Museum for African Art, 1993.

 McNaughton, Patrick R, The Mande Blacksmiths: Knowledge, Power and Art in West Africa. Bloomington: Indiana Univ. Press 1988
- Neyt, François. Luba: To the Sources of the Zaire. Trans. Murray Wyllie. Paris: Editions Dapper, 1994. Perrois, Louis, and Marta Sierra Delage. *The Art of Equatorial*
- Guinea: The Fang Tribes. New York: Rizzoli, 1990
- Picon, John, and John Mack. African Textiles. New York: Harper & Row, 1989.
- Roy, Christopher D. Art of the Upper Volta Rivers. Meudon, France: Chaffin, 1987
- Schildkrout, Enid, and Curtis A. Keim. African Reflections: Art from Northeastern Zaire. Seattle: Univ. of Washington Press, 1990.
- Sieber, Roy. African Furniture and Household Objects. Bloomington: Indiana Univ. Press, 1980.
 - African Textiles and Decorative Arts. New York: Museum of Modern Art, 1972.
- –, and Roslyn Adele Walker. African Art in the Cycle of Life. Washington, D.C.: National Museum of African Art, Smithsonian Institution, 1987.
- Thompson, Robert Farris, and Joseph Cornet. The Four Moments of the Sun: Kongo Art in Two Worlds. Washington, D.C.: National Gallery of Art, 1981.
- Vogel, Susan. Africa Explores: 20th Century African Art. New York: Center for African Art, 1991.

Chapter 26 Neoclassicism and Romanticism in Europe and the United States

- Abrams, Ann Uhry. The Valiant Hero: Benjamin West and Grand-Style History Painting. Washington, D.C.: Smithsonian Institution, 1985.
- Age of Neoclassicism. London: Arts Council of Great Britain,
- Bindman. David. William Blake: His Art and Time. New Haven: Yale Center for British Art, 1982.
- Boime, Albert. Art in an Age of Bonapartism, 1800-1815. Chicago: Univ. of Chicago Press, 1990. —. Art in an Age of Revolution, 1750–1800. Chicago: Univ. of
- Chicago Press, 1987.
- Braham, Allan. The Architecture of the French Enlightenment. Berkeley: Univ. of California Press, 1980.
- Brion, Marcel. Art of the Romantic Era: Romanticism, Classicism, Realism. World of Art. New York: Praeger, 1966.

- Byson, Norman, Tradition and Desire: From David to Delacroix. New York: Cambridge Univ. Press, 1984.
- Clark, Kenneth. The Romantic Rebellion: Romantic versus Classic Art. New York: Harper & Row, 1973.
- Cooper, Wendy A. Classical Taste in America 1800-1840. Baltimore: Baltimore Museum of Art, 1993.
- Eitner, Lorenz. Neoclassicism and Romanticism, 1750-1850: An Anthology of Sources and Documents. New York: Harper & Row, 1989.
- French Painting 1774–1830: The Age of Revolution. Detroit:
- Wayne State Univ. Press, 1975. Harris, Enriqueta. *Goya*. Rev. ed. London: Phaidon, 1994 Honour, Hugh. Neo-Classicism. Harmondsworth, Eng.: Penguin, 1968.
- Romanticism. London: Allen Lane, 1979
- Kroeber, Karl. British Romantic Art. Berkeley: Univ. of California Press. 1986. Lindsay, Jack. Death of the Hero: French Painting from David to
- Delacroix. London: Studio, 1960. Manners and Morals: Hogarth and British Painting 1700-1760.
- London: Tate Gallery, 1987
- Mayoux, Jean-Jacques. English Painting. Trans. James Emmons. New York: Grove, 1975. Middleton, Robin, and David Watkin. Neoclassical and 19th
- Century Architecture. 2 vols. History of World Architecture. New York: Electa/Rizzoli, 1987. Novotny, Fritz. Painting and Sculpture in Europe, 1780-1880.
- Pelican History of Art. Harmondsworth, Eng.: Penguin, 1980
- Paulson, Ronald. The Art of Hogarth. London: Phaidon, 1975. Perez Sanchez, Alfonso E., and Eleanor A. Sayre. Goya and the Spirit of Enlightenment. Boston: Museum of Fine Arts,
- 1989 Powell, Earl A. Thomas Cole, New York: Abrams, 1990.
- Prideaux, Tom. World of Delacroix, 1798-1863. New York: Time-Life. 1966
- Roberts, Warren E. Jacques-Louis David, Revolutionary Artist: Art. Politics, and the French Revolution. Chapel Hill: Univ. of North Carolina Press, 1989.
- Rosenblum, Robert. Jean-Auguste-Dominique Ingres. Masters of Art. New York: Abrams, 1990.
- Rousseau, Jean-Jacques. Emile. Ed. F. and P. Richard. New York: French & European, 1962.
- Roworth, Wendy Wassyng. Angelica Kauffman: A Continental
- Artist in Georgian England. London: Reaktion, 1992. Rykwert, Joseph, and Anne Rykwert. Robert and James Adam: The Men and the Style. New York: Rizzoli, 1985.
- Shapiro, Michael Edward. George Caleb Bingham. New York: Abrams, 1993.
- Turner, Roger. Capability Brown and the Eighteenth Century English Landscape. London: Weidenfeld and Nicolson, 1985
- Vaughan, William. German Romantic Painting. New Haven: Yale Univ. Press, 1980.
- -. Romanticism and Art. World of Art. New York: Thames and Hudson, 1994.
- Walker, John. John Constable. New York: Abrams. 1991. Wilton, Andrew. *Turner in His Time*. New York: Abrams, 1987.
- Wolf, Bryan Jay. Romantic-Revision: Culture and Consciousness in Nineteenth-Century American Painting and Literature. Chicago: Univ. of Chicago Press, 1986

Chapter 27 Realism to Impressionism in Europe and the United States

- Adams, Steven. The Barbizon School and the Origins of Impres sionism. London: Phaidon, 1994. Art of the July Monarchy: France, 1830 to 1848. Columbia: Univ.
- of Missouri Press, 1989.
- Ashton, Dore. Rosa Bonheur: A Life and a Legend. New York: Viking, 1981.
- Barger, M. Susan, and William B. White. The Daguerreotype. Nineteenth-Century Technology and Modern Science. Washington, D.C.: Smithsonian Institution, 1991.
- Baudelaire, Charles. The Painter of Modern Life, and Other Essays. Trans. and ed. Jonathan Mayne. London: Phaidon, 1964. Boime, Albert. *The Academy and French Painting in the Nine*
- teenth Century. London: Phaidon, 1971.
- Cachin, Françoise, Charles S. Moffett, and Michel Melot, eds Manet, 1832-1883. New York: Metropolitan Museum of Art, 1983.
- Clark, T. I. The Absolute Bourgeois: Artists and Politics in France. 1848–1851. London: Thames and Hudson, 1973
- . Image of the People: Gustave Courbet and the 1848 Rev olution. London: Thames and Hudson, 1973.
- Clarke, Michael. Corot and the Art of Landscape. London: British Museum, 1991.
- Cumming, Elizabeth, and Wendy Caplan. Arts and Crafts Movement. World of Art. New York: Thames and Hudson, 1991
- Denvir Bernard The Thames and Hudson Encyclopedia of Impressionism. World of Art. New York: Thames and Hudson, 1990
- Faxon, Alicia Craig. Dante Gabriel Rossetti. Oxford: Phaidon, 1989 Fried, Michael. Courbet's Realism. Chicago: Univ. of Chicago
- Press 1982 Gordon, Robert, and Andrew Forge. Degas. Trans. Richard
- Howard. New York: Abrams, 1988. Hanson, Lawrence. Renoir: The Man, the Painter, and His
- World. London: Thames and Hundson, 1972.

- Harding, James. Artistes Pompiers: French Academic Art in the 19th Century. New York: Rizzoli, 1979.
- Hargrove, June, ed. The French Academy: Classicism and Its Antagonists. Newark: Univ. of Delaware Press, 1990.
- Hendricks, Gordon, Albert Bierstadt: Painter of the American West. New York: Abrams, 1974.
- Higonnet, Anne. Berthe Morisot's Images of Women. Cambridge: Harvard Univ. Press. 1992.
- Hilton, Timothy. Pre-Raphaelites. World of Art. London: Thames and Hudson, 1970. Homer, William Innes. Thomas Eakins: His Life and Art. New
- York: Abbeville, 1992. Lindsay, Jack. Gustave Courbet: His Life and Art. New York:
- State Mutual Reprints, 1981. Mathews, Nancy Mowll. Mary Cassatt. Library of American Art.
- New York: Abrams, 1987. McKean, John, Crystal Palace: Joseph Paxton and Charles Fox
- Architecture in Detail. London: Phaidon, 1994. Mead, Christopher Curtis. Charles Garnier's Paris Opera: Architectural Empathy and the Renaissance of French Classicism Cambridge: MIT Press, 1991
- Murphy, Alexandra R. Jean-François Millet. Boston: Museum of Fine Arts, 1984
- Needham, Gerald. 19th-Century Realist Art. New York: Harper & Row 1988
- Nochlin, Linda. Impressionism and Post-Impressionism, 1874-1904: Sources and Documents. Englewood Cliffs, N.J.: Prentice-Hall 1966
- Realism and Tradition in Art, 1848–1900: Sources and Documents. Englewood Cliffs, N.J.: Prentice-Hall, 1966
- Pissarro, Joachim. Camille Pissarro. New York: Abrams, 1993. Pool, Phoebe. Impressionism. World of Art. New York: Praeger,
- The Pre-Raphaelites. London: Tate Gallery, 1984
- Prideaux, Tom. The World of Whistler, 1834–1903. New York: Time-Life, 1970.
- Rewald, John, The History of Impressionism, 4th rev. ed. New York: Museum of Modern Art, 1973.
- Rouart, Denis. Renoir. New York: Skira/Rizzoli, 1985. Schaaf, Larry J. Out of the Shadows: Herschel, Talbot and the Invention of Photography. New Haven: Yale Univ. Press, 1992
- Schneider, Pierre. The World of Manet, 1832-1883. New York: Time-Life, 1968.
- Spate, Virginia. Claude Monet: Life and Work. New York: Rizzoli, 1992
- Stansky, Peter. Redesigning the World: William Morris, the 1880s, and the Arts and Crafts. Princeton: Princeton Univ. Press, 1985.
- Touissaint, Hélène. Gustave Courbet, 1819-1877. London: Arts Council of Great Britain, 1978.
- Triumph of Realism. Brooklyn: Brooklyn Museum, 1967
- Valkenier, Elizabeth Kridl. *Ilya Repin and the World of Russian* Art. New York: Columbia Univ. Press, 1990.
- Wagner, Anne Middleton. Jean-Baptiste Carpeaux: Sculptor of the Second Empire. New Haven: Yale Univ. Press, 1986
- Walker, John. James McNeill Whistler. Library of American Art. New York: Abrams, 1987 Weisberg, Gabriel P. The European Realist Tradition. Blooming-
- ton: Indiana Univ. Press, 1982.
- Wilmerding, John, et al. American Light: The Luminist Move-ment, 1850–1875: Paintings, Drawings, Photographs. Washington, D.C.: National Gallery of Art, 1980. Zafran, Eric M. French Salon Paintings from Southern Collections. Altanta: High Museum of Art, 1983.

Chapter 28 The Rise of Modernism in Europe and America

- Ades, Dawn. Photomontage. Rev ed. World of Art. New York: Thames and Hudson, 1986.
- Alexandrian, Sarane. Surrealist Art. World of Art. London: Thames and Hudson, 1970.
- Art into Life: Russian Constructivism, 1914-32. New York: Rizzoli. 1990. Baigell, Matthew. The American Scene: American Painting of the
- 1930's. New York: Praeger, 1974.
- Banham, Reyner. Theory and Design in the First Machine Age. 2nd ed. Cambridge: MIT Press, 1980. Barr, Alfred H., Jr. Cubism and Abstract Art: Painting, Sculpture, Constructions, Photography, Architecture, Industrial Arts, Theatre, Films, Posters, Typography. Cambridge, Mass.: Belknap, 1986.
- Barron, Stephanie, ed. Degenerate Art: The Fate of the Avant-Garde in Nazi Germany. Los Angeles: Los Angeles County Museum of Art, 1991.
- Bayer, Herbert, Walter Gropius, and Ise Gropius. Bauhaus, 1919–1928. New York: Museum of Modern Art, 1975.
- Brown, Milton. Story of the Armory Show: The 1913 Exhibition That Changed American Art. 2nd ed. New York: Abbeville,
- Cate, Phillip Dennis, and Sinclair Hamilton Hitchings. The Color Revolution: Color Lithography in France, 1890-1900. Santa Barbara: Smith, 1978.
- Champigneulle, Bernard. Rodin. World of Art. New York: Oxford Univ Press 1980
- Chipp, Herschel B., ed. Theories of Modern Art. Berkeley: Univ. of California Press, 1969.
- Cowling, Elizabeth. Picasso: Sculptor/Painter. London: Tate Gallery, 1994

- Curtis James Mind's Eve. Mind's Truth: FSA Photography Reconsidered. Philadelphia: Temple Univ. Press, 1989
- Curtis, William J. R. Le Corbusier: Idea and Forms. New York: Rizzoli 1986
- Dachy, Marc. The Dada Movement, 1915-1923. New York Skira/Rizzoli, 1990.
- Davidson, Abraham A. Early American Modernist Painting, 1910-1935. New York: Harper & Row, 1981
- Denvir, Bernard. Post-Impressionism. World of Art. New York: Thames and Hudson, 1992.
- Toulouse-Lautrec. World of Art. New York: Thames and Hudson, 1991.
- Doherty, Robert J., ed. The Complete Photographic Work of Jacob Riis. New York: Macmillan, 1981
- Dube Wolf-Dieter Expressionism. Trans. Mary Whittall, World of Art. New York: Praeger, 1973.
- Duncan, Alastair. Art Nouveau. World of Art. New York: Thames and Hudson 1994
- Eldredge, Charles C. Georgia O'Keeffe. Library of American Art.
- New York: Abrams, 1991. Freeman, Judi. *The Fauve Landscape*. Los Angeles: Los Angeles
- County Museum of Art, 1990.
- Fry, Edward. Cubism. New York: McGraw-Hill, 1966. Gay, Peter. Art and Act: On Causes in History—Manet, Gropius, Mondrian. New York: Harper & Row, 1976.
- Gerdts, William H. American Impressionism. New York: Abbeville. 1984.
- Gilot, Françoise, and Carlton Lake. Life with Picasso. New York: McGraw-Hill, 1964.
- Glackens, Ira. William Glackens and the Ashcan Group: The Emergence of Realism in American Art. New York: Crown, 1957
- Golding, John. Cubism: A History and an Analysis, 1907–1914. Cambridge, Mass.: Belknap, 1988.
- Gordon, Donald E. Expressionism: Art and Idea. New Haven: Yale Univ. Press. 1987. Gowing, Lawrence. Matisse. World of Art. New York: Oxford
- Univ. Press, 1979.
- Gray, Camilla. Russian Experiment in Art, 1863-1922. New York: Abrams, 1970.
- Hahl-Koch, Jelena. *Kandinsky*. New York: Rizzoli, 1993. Haiko, Peter, ed. *Architecture of the Early XX Century*. Trans. Gor-
- don Clough. New York: Rizzoli, 1989.
- Hales, Peter B. Silver Cities: The Photography of American Urbanization, 1839–1950. Philadelphia: Temple Univ.
- Hamilton, George Heard. *Painting and Sculpture in Europe,* 1880–1940. 2nd ed. Pelican History of Art. Harmondsworth, Eng.: Penguin, 1981.
- Harrison, Charles, Francis Frascina, and Gill Perry. *Primitivism*, Cubism, Abstraction: The Early Twentieth Century. New
- Haven: Yale Univ. Press, 1993. Harrison, Charles, and Paul Wood, eds. Art in Theory, 1900 to
- 1990. Cambridge, Mass.: Blackwell, 1993. Herbert, James D. Fauve Painting: The Making of Cultural Politics. New Haven: Yale Univ. Press, 1992.
- Herrera, Hayden. Frida Kahlo: The Paintings. New York: Harper-Collins, 1991.
- Hilton, Timothy. Picasso. World of Art. New York: Praeger, 1975 Holt, Elizabeth Gilmore, ed. *The Expanding World of Art,* 1874–1902. New Haven: Yale Univ. Press, 1988.
- Homer, William Innes. Alfred Stieglitz and the American Avant-Garde. Boston: New York Graphics Society, 1977
- Hulsker, Jan. The Complete Van Gogh: Paintings, Drawings, Sketches. New York: Abrams, 1980.
- Hulten, Pontus. Futurism and Futurisms. New York: Abbeville,
- Jaffe, Hans L. C. *De Stijl, 1917–1931: The Dutch Contribution to Modern Art*. Cambridge, Mass.: Belknap, 1986. Kuenzli, Rudolf, and Francis M. Naumann. *Marcel Duchamp:*
- Artist of the Century. Cambridge: MIT Press, 1989. Lane, John R., and Susan C. Larsen. Abstract Painting and Sculp-
- ture in America 1927-1944. Pittsburgh: Museum of Art, Carnegie Institute, 1984.
- Larkin, David, and Bruce Brooks Pfeiffer. Frank Lloyd Wright: The Masterworks. New York: Rizzoli, 1993.
- Lloyd, Jill. German Expressionism: Primitivism and Modernity. New Haven: Yale Univ. Press, 1991.
- McQuillan, Melissa. Van Gogh. World of Art. New York: Thames and Hudson, 1989.
- Milner, John. Vladimir Tatlin and the Russian Avant-Garde. New Haven: Yale Univ. Press, 1983.
- Norman, Dorothy. Alfred Stieglitz, an American Seer. New York: Aperture, 1990.
- O'Gorman, James F. Three American Architects: Richardson, Sullivan, and Wright, 1865-1915. Chicago: Univ. of Chicago Press 1991
- Overy, Paul. De Stijl. World of Art. New York: Thames and Hudson 1991
- Pfeiffer, Bruce Brooks, and Gerald Nordland, eds. Frank Lloyd Wright in the Realm of Ideas. Carbondale, Ill.: Southern Illinois Univ. Press, 1988.
- Picon, Gaetan. Surrealists and Surrealism, 1919-1939. Trans. James Emmons. New York: Rizzoli, 1977.
 Post-Impressionism: Cross-Currents in European and American
- Painting, 1880–1906. Washington, D.C.: National Gallery of Art. 1980.
- Rewald, John. Post-Impressionism: From Van Gogh to Gauguin 3rd ed. New York: Museum of Modern Art, 1978

- Rosenblum, Robert. Cubism and Twentieth-Century Art. Rev. ed. New York: Abrams, 1984. Rubin, William, ed. *Pablo Picasso, a Retrospective*. New York:
- Museum of Modern Art, 1980.
- –, comp. *Picasso and Braque: Pioneering Cubism.* New York: Museum of Modern Art, 1989. Russell, John. Seurat. World of Art. London: Thames and Hud-
- son, 1965. . The World of Matisse, 1869–1954. New York: Time-Life,
- Spate, Virginia. Orphism: The Evolution of Non-Figurative Paint-ing in Paris, 1910–1914. Oxford Studies in the History of Art and Architecture. Oxford: Clarendon, 1979
- Stich, Sidra, Anxious Visions: Surrealist Art, New York: Abbeville 1990
- Sutter, Jean, ed. The Neo-Impressionists. Greenwich, Conn.: New York Graphic Society, 1970.
- Thomson, Belinda. Gauguin. World of Art. New York: Thames and Hudson, 1987.
- Tisdall, Caroline, and Angelo Bozzolla. Futurism. World of Art. New York: Oxford Univ. Press, 1978.
- Troyan, Carol, and Erica E. Hirschler. Charles Sheeler: Paintings and Drawings. Boston: New York Graphic
- Verdi, Richard, Cezanne, World of Art, New York: Thames and Hudson, 1992.
- Weiss, Jeffrey S. The Popular Culture of Modern Art: Picasso, Duchamp, and Avant-Gardism. New Haven: Yale Univ. Press, 1994.
- Whitford, Frank. Bauhaus. World of Art. London: Thames and Hudson, 1984. Wilkin, Karen. *Georges Braque*. New York: Abbeville, 1991
- Zhadova, Larissa A. *Malevich: Suprematism and Revolution in Russian Art*. Trans. Alexander Lieven. London: Thames and Hudson, 1982.

Chapter 29 Art in the United States and Europe since World War II

- Alloway, Lawrence. Roy Lichtenstein. New York: Abbeville, 1983. Andersen, Wayne. American Sculpture in Process, 1930-1970. Boston: New York Graphic Society, 1975. Anfam, David. Abstract Expressionism. World of Art. New York:
- Thames and Hudson, 1990. Ashton, Dore. American Art since 1945. New York: Oxford Univ
- Press, 1982. The New York School: A Cultural Reckoning. Harmonds-
- worth, Eng.: Penguin, 1979. Atkins, Robert. *Artspeak: A Guide to Contemporary Ideas, Move*
- ments, and Buzzwords. New York: Abbeville, 1990 Baker, Kenneth. Minimalism: Art of Circumstance. New York
- Abbeville, 1988. Battcock, Gregory. Idea Art: A Critical Anthology. New York: Dut-
- ton, 1973 Minimal Art: A Critical Anthology. New York: Dutton, 1968.
- and Robert Nickas. The Art of Performance: A Critical Anthology. New York: Dutton, 1984.
- Beardsley, John. Earthworks and Beyond: Contemporary Art in the Landscape. New York: Abbeville, 1984.

 Berger, Maurice. Labyrinths: Robert Morris, Minimalism, and the
- 1960s. New York: Harper & Row, 1989.
- Blake, Peter. No Place Like Utopia: Modern Architecture and the Company We Kept. New York: Knopf, 1993. Bolton, Richard, ed. Culture Wars: Documents from the Recent
- Controversies in the Arts. New York: New, 1992. Bourdon, David. Warhol. New York: Abrams, 1989.
- Broude, Norma, and Mary D. Garrard. The Power of Feminist Art: The American Movement of the 1970s, History and Impact. New York: Abrams, 1994.
- Burnham, Jack. Hans Haacke: Framing and Being Framed.
- Halifax: Nova Scotia College of Art and Design, 1975. Castleman, Riva, ed. *Art of the Forties*. New York: Museum of Modern Art, 1991.
- Cernuschi, Claude, *Jackson Pollock: Meaning and Significance*. New York: Icon Editions, 1992.
- Chase, Linda. Hyperrealism. New York: Rizzoli, 1975
- Collins, Michael, and Andreas Papadakis. Post-Modern Design. New York: Rizzoli, 1989.
- Deutsche, Rosalyn, et al. Hans Haacke, Unfinished Business. Ed. Brian Wallis, Cambridge: MIT Press, 1986.

 Dormer, Peter. Design since 1945. World of Art. New York:
- Thames and Hudson, 1993. Endgame: Reference and Simulation in Recent Painting and
- Sculpture. Boston: Institute of Contemporary Art, 1986. Ferguson, Russell, ed. Discourses: Conversations in Postmodern Art and Culture. Documentary Sources in Contemporary Art. Cambridge: MIT Press, 1990.
- Fineberg, Jonathan. Art since 1940: Strategies of Being. New York: Abrams, 1994. Goldberg, Rose Lee. Performance Art: From Futurism to the Pre-
- sent. Rev. ed. New York: Abrams, 1988. Green, Jonathan. American Photography: A Critical History since 1945 to the Present. New York: Abrams, 1984.
- Greenough, Sarah, and Philip Brookman. Robert Frank. Washington, D.C.: National Gallery of Art, 1994.
- Grundberg, Andy. Photography and Art: Interactions since 1945. New York: Abbeville, 1987

- Hays, K. Michael, and Carol Burns, eds. Thinking the Present: Recent American Architecture, New York: Princeton Architectural, 1990.
- Henri, Adrian. Total Art: Environments, Happenings, and Performance. World of Art. New York: Oxford Univ. Press, 1974.
- Hertz, Richard. Theories of Contemporary Art. 2nd ed. Englewood Cliffs, N.J.: Prentice Hall, 1993. Hobbs, Robert Carleton, and Gail Levin. Abstract Expressionism.
- The Formative Years. Ithaca: Cornell Univ. Press, 1981
- Hoffman, Katherine. *Explorations: The Visual Arts since 1945*. New York: HarperCollins, 1991. Jencks, Charles. Architecture Today. 2nd ed. London: Academy,
- 1993 The New Moderns from Late to Neo-Modernism. New
- York: Rizzoli, 1990. Post-Modernism: The New Classicism in Art and Architec
- ture. New York: Rizzoli, 1987 What Is Post-Modernism? 3rd rev. ed. London: Academy
- Editions, 1989. Joachimedes, Christos M., Norman Rosenthal, and Nicholas Serota, eds. New Spirit in Painting. London: Royal Acade-
- my of Arts, 1981. Johnson, Ellen H., ed. American Artists on Art from 1940 to 1980.
- New York: Harper & Row, 1982. Kaprow, Allan, Assemblage, Environments & Happenings. New York: Abrams, 1965.
- Kingsley, April. The Turning Point: The Abstract Expressionists and the Transformation of American Art. New York: Simon & Schuster, 1992.
- Kramer, Hilton. *The Age of the Avant-Garde: An Art Chronicle of* 1956–1972. New York: Farrar, Straus & Giroux, 1973.
- Kuspit, Donald B. Clement Greenberg, Art Critic. Madison: Univ. of Wisconsin Press 1979
- Levick, Melba. The Big Picture: Murals of Los Angeles. Boston: Little, Brown, 1988.
- Lewis, Samella S. African American Art and Artists. Rev. ed. Berkeley: Univ. of California Press, 1994 Lippard, Lucy. Pop Art. World of Art. New York: Praeger, 1966.
- Livingstone, Marco. Pop Art: A Continuing History. New York: Abrams, 1990.
- Lucie-Smith, Edward. Art in the Eighties. Oxford: Phaidon, 1990. Art in the Seventies. Ithaca: Cornell Univ. Press, 1980
- Art Today: From Abstract Expressionism to Superrealism
- 3rd ed. Oxford: Phaidon, 1989. —. *Movements in Art since 1945*. Rev. ed. World of Art. Lon-
- don: Thames and Hudson, 1984. Super Realism Oxford: Phaidon 1979
- Manhart, Marcia, and Tom Manhart, eds. The Eloquent Object: The Evolution of American Art in Craft Media since 1945. Tulsa: Philbrook Museum of Art, 1987.
- Marks, Claude, ed. World Artists: 1980-1990. New York:
- Wilson 1991. Meisel, Louis K. Photo-Realism. New York: Abrams, 1989
- Morgan, Robert C. Conceptual Art: An American Perspective. Jef-ferson, N.C.: McFarland, 1994.
- Nash, Steven A. Arneson and Politics: A Commemorative Exhibition. San Francisco: Fine Arts Museums of San Francisco,
- Risatti, Howard, ed. *Postmodern Perspectives: Issues in Contemporary Art.* Englewood Cliffs, N.J.: Prentice Hall, 1990.
- Rosen, Randy, and Catherine C. Brawer, comps. Making Their Mark: Women Artists Move into the Mainstream, 1970-85. New York: Abbeville, 1989.
- Russell, John. Pop Art Redefined. New York: Praeger, 1969. Sandler, Irving. American Art of the 1960's. New York: Harper & Row, 1988.
- The New York School: The Painters and Sculptors of the Fifties. New York: Harper & Row, 1978.

 —. The Triumph of American Painting: A History of Abstract
- Expressionism. New York: Harper & Row, 1976
- Sayre, Henry M. The Object of Performance: The American Avant-Garde since 1970. Chicago: Univ. of Chicago Press, 1989. Shapiro, David, and Cecile Shapiro. Abstract Expressionism: A
- Critical Record. New York: Cambridge Univ. Press, 1990. Slivka, Rose. Peter Voulkos: A Dialogue with Clay. Boston: New
- York Graphic Society, 1978. Smith Paul I, and Edward Lucie-Smith. Craft Today: Poetry of the Physical. New York: American Craft Museum, 1986
- Spaeth, David A. Mies Van Der Rohe. New York: Rizzoli, 1985. Stich, Sidra. Made in USA: An Americanization in Modern Art, the
- '50s & '60s. Berkeley: Univ. of California Press, 1987 Taylor, Paul, ed. *Post-Pop Art*. Cambridge: MIT Press, 1989. Vaizev, Marina. *Christo*. New York: Rizzoli, 1990.
- Waldman, Diane. Collage, Assemblage, and the Found Object. New York: Abrams, 1992.
- Jenny Holzer. New York: Abrams, 1989.
- Transformations in Sculpture: Four Decades of American and European Art. New York: Solomon R. Guggenheim Foundation, 1985.
- Willem de Kooning. Library of American Art. New York: Abrams, 1988.
- Wallis, Brian, ed. Art after Modernism: Rethinking Representation. Documentary Sources in Contemporary Art. New York: New Museum of Contemporary Art, 1984. Wheeler, Daniel. Art since Mid-Century: 1945 to the Present.
- Englewood Cliffs, N.J.: Prentice Hall, 1991.
- Word as Image: American Art. 1960–1990, Milwaukee: Milwaukee Art Museum, 1990.

Index

Illustration references are in italic type. Definitions of Aeroplane over Train, Natalia Goncharova, 1060, 1060 al-Mulk al-Muzaffar, Majd, 355; pen box of, Shazi, glossary references are in boldface type Aeschylus, 209 355-56. 355 Aesop, 162 al-Mustasim, Yaqut, 348 Aestheticism, 1006, 1062 al-Mutasim, Caliph, 347 Aachen (Aix-la-Chapelle), Germany, Palace Chapel of al-Mutawakkil, Caliph, 347 aesthetics, 32, 646, 912 Charlemagne, 492-93, 493 aesthetic sense, 37, 46 alpha symbol, 525 abacus, 163, 165, 165, 374 Afghanistan, 366 Altamira, Spain, cave paintings, 42-43, 46, 135; Bison, Abbasid dynasty, 340-41, 344, 347 Africa, ancient, 464-77; trade, 466, 472, 474 43, 43; dating of, 49 abbey church, 510 African American art, 1091–92, 1101–2, 1158 altar frontals, 521 Abd ar-Rahman I, 344 African art, 910-25; ancient, 468-74; contemporary, Altar of Zeus, Pergamon, Turkey, 212-13, 213, 237; frieze Abd ar-Rahman III, 345 924-27; influence on modernism, 1042, 1051, 1084; sculpture, detail Athena Attacking the Giants, 212, 213, Abduction of Persephone (wall painting), 205-6, 205 motifs, 925; social function of, 912-16 246 Abelam people, 898 Agbonbiofe (African artist), 470 Altarpiece of Saint Vincent, panel Saint Vincent with the Portuguese Royal Family, Nuño Gonçalvez, 637–38, 637 Altarpiece of the Holy Blood, centerpiece Last Supper, abolitionist movement, 928 AG Gallery, 1124 Aborigines (Australian), 895–97, 906–7 Agony in the Garden (in Christian art), 306 Abraham, Sarah, and the Three Strangers, from Psalter of agora, 185, 238 Tilman Riemenschneider, 739-40, 739 Saint Louis, 567, 574, 574 Agora, Athens, Greece, 185-86, 185, 199 altarpieces, 618, 619; Christian, 583, 583; Gothic, absolute dating, 49, 129, 143 Agra, India. See Taj Mahal 583-84. 595-97 Abstract Expressionism, 851, 1105, 1110, 1112-22, agriculture: Americas, 447; Egypt, 93, 108; Near East, 62; altars, Christian, 583, 583 1141, 1153; second generation, 1121; successors to, Neolithic, 48 Altar to Amitabha Buddha (Sui dynasty, China), 410, 410, 1122-25, 1133 Agrippa, 264 abstraction in art, 19, 21, 30, 40; African art, 915; Agrippina, 259 Altdorfer, Albrecht, 736-38; Danube Landscape, 737-38, Byzantine, 312–13, 318; early Christian, 305; Egyptian, Ahenny, Tipperary, Ireland, South Cross, 488, 488 737, 747 94; Greek, 160; Indian, 380; Indus Valley art, 369; Altneuschul, Prague, Bohemia, 586, 586 ahu. 901 Islamic, 339; modernist, 1023-24, 1054, 1060, 1062, Ain Ghazal, Jordan, 63-64, 63; figure from, 64, 65, 69 amalaka, 375, 383, 390 1112, 1127; Ottoman, 363; Roman, 277, 279; Scandi-Airport Structure, Theodore Roszak, 1104, 1105 Amalienburg, Mirror Room, Nymphenburg Park, near navian, 481-82 Aisha, 340 Munich, Germany, François de Cuvilliés the Elder, Abu Bakr, 339, 341 Ajanta caves, Bodhisattva (wall painting), 382, 383, 392 805, 805, 939 Abul Hasan and Manohar, Jahangir-nama (illustrated Ajax, 156 Amaravati School, 378, 380-81 manuscript), 828, 829 Ajitto (Back), Robert Mapplethorpe, 1161, 1161 Amarna period (Egypt), 119-22 Abu Simbel, Nubia, temples of Ramesses II and Akbar, Indian ruler, 827-29 Amasis Painter, 174-75; Dionysos with Maenads (vase Nefertari, 118-19, 118 Akhenaten (Amenhotep IV), 119-22 painting), 174-75, 174 Acacus mountains, Libya, 466 Akhenaten and His Family (Egyptian), 119-20, 119 Ambrose, 540 ambulatory, 300-2, 492, 511, 512, 558 Academicians of the Royal Academy, Johann Zoffany, 929 Akhetaten, Egypt (modern Tell el-Amarna), 119-22 academic style, 982-85; of architecture, 981; influence Akiode (Yoruba artist), 914 Amenemhet I, 112 on American art, 1090–91, 1094, 1097; influence on Akkad, 73-74; Stela of Naramsin, 74, 74, 76-77, 84, 96 Amenhotep III, 114, 120 Impressionists, 1016-19 Akkadians, 62-63 Amenhotep IV (Akhenaten), 119-22 Académie des Beaux-Arts, 929 Akrotiri, Thera, Greek island, 128, 141; Landscape (wall Amenhotep Huy, tomb of, 122-23 academies, 929, 931; appointment of academicians, painting), 141, 142; Priestess (?), 141, 141 American Abstract Artists, 1104-5 949 Albers, Josef, 1081, 1126 American art. See United States art Academy of Saint Luke: Paris, 953, 955; Rome, 944 Albert, prince, of England, 1004 American Art-Union (New York), 975 acanthus leaves motif, 165, 165, 247 Alberti, Leon Battista, 642, 644-46, 660-62, 663, 666, American Colonial art, 751, 815-19 Accommodations of Desire, Salvador Dalí, 1087, 1087 703, 710; Church of San Francesco, Tempio American Landscape, Charles Sheeler, 1099-1100, 1099, Achaemenid Persians, 63, 85, 359 Malatesta, Rimini, Italy, 660, 660, 661; Church of Achilles, 156 Sant' Andrea, Mantua, Italy, 660-62, 660, 661, 710; American peoples (Native Americans), 84, 442-63, Achilles Painter, style of, Woman and Maid (vase Della Pittura (On Painting) (book), 624; ideal city of, 670; 874-91, 1091; art before 1300 A.D., 442-63; contempainting), 197, 197 Palazzo Rucellai, Florence, Italy, 641, 646, 646, 649 porary artists, 891, 1164; Eastern Woodlands, 883; Acoma Pueblo, 1164 album, 840 Great Plains, 883; Mexico, 875-79, 882-83; Neolithic, Acropolis, Athens, Greece, 171, 171, 172, 185, 186–93, album leaf, 840, 840 48; Northwest Coast, 886-88; Paleolithic, 445; South Alcuin of York, 494 America, 879-82; Southwest, 888-91 acroterion, 165 Alexander III, Pope, 564 American Pop, 1129-31 acrylic, 897, 906 Alexander the Great, 88, 198 American Revolution, 819, 945 action painting, 1116–18, 1123 Acts of the Apostles, 290 Alexander the Great, Lysippos (copy after), 203–5, 205 Alexander the Great (coin from Thrace), 205, 205 American Scene Painting, 1099-1104 American Society of Independent Artists, exhibition of Adam, creation of, 341 Alexander the Great Confronts Darius III at the Battle of Issos 1917, 1022 Adam. See Eyck, Jan van, Ghent Altarpiece (Roman copy of Greek painting, possibly by Philoxenos American Southwest, 462-63 Adam, Robert, 937, 939, 944, 967; Syon House, of Eretria or Helen of Greece), 88, 206-7, 206 Amida Buddha, 432 Middlesex, England, 937, 937, 967 Alexandria, Egypt, 209; Lighthouse at, 102, 209 Amida Buddha, Jocho, 432-33, 433 Adam and Eve, Albrecht Dürer, 734, 734 Alfonso the Wise, from Cantigas de Santa Maria (manu-Amida Buddha (fresco), Horyu-ji, Nara, Japan, 430, 430 Adena culture (North America), 460-61 script), 582-83, 583 Amiens, Île-de-France, France, Nôtre-Dame Cathedral, Adler and Sullivan, 1065, 1066 Alfonso VI of León and Castile, King, 514 560, 561-64, 561, 562, 568, 570, 592; Beau Dieu (relief), Admonitions of the Imperial Instructress to Court Ladies Alfonso X, the Wise, 582 562, 563; Virtues and Vices (relief), 562, 563 (scroll) 407-8 408 al-Hakam II, 345 "Am I Not a Man and a Brother?," William Hackwood, adobe brick: Africa, 474; Americas, 459, 817 Alhambra, Granada, Spain, 350-52; Palace of the Lions, 928, 928, 937 Adoration of the Magi (in Christian art), 306 347, 350, 351-52, 351, 360 Amitabha Buddha, 410 Adoration of the Magi (altarpiece), Gentile da Fabriano, Ali, Caliph, 339, 341 Amorites, 76 652, 652 alignments (menhirs), 53 amphiprostyle, 164, 192 Adoration of the Shepherds (in Christian art), 306 all'antica, 665 Amphitrite, 156 "A.D." Painter, Women at a Fountain House (vase Allegorical Harbor Scene (Roman), 269, 270 amphora, 174 painting), 176, 176 Allegories of the Five Senses (cycle), detail Sight, Jan Amsterdam, the Netherlands, 786 adyton, 164 Brueghel, 783, 783, 1118 Amun, 95, 96, 114, 119, 122 aedicula, **653**, **755**, 755 allegory, 23, 334, 490, 764 Amun-Ra, 95 Aegean culture, 126-49; archeological discoveries, 143; Allegory, Rome, Italy, Ara Pacis, 246, 247 Analects, 405 collapse of, 153; dating of, 128; see also Cycladic Allegory of Good Government in the City, Ambrogio Anang Ibibio people (Nigeria), 921 culture; Minoan culture; Mycenaean culture Lorenzetti, Palazzo Pubblico, Siena, frescoes, 548, Anasazi culture, 462-63, 875, 888, 1164 Aegeus, 132 549, 599-600, 600-1 Anastaise (French artist), 25, 615 Aegina, Greece, Temple of Aphaia: Dying Warrior, Allegory of Good Government in the Country, Ambrogio Anastasis (in Christian art), 307 168-69, 168, 212; pediment, 168-69, 168, 188, 212 Lorenzetti, Palazzo Pubblico, Siena, frescoes, 599-600, Anastasis, Istanbul, Turkey, Church of the Monastery of Aelst, Pieter van, shop of, Miraculous Draft of Fishes Christ in Chora (now Kariye Muzesi), 330, 330 (after Raphael's Sistine tapestries), 693-95, 693 Allegory of the Art of Painting, Jan Vermeer, 796, 797, 996 Anatolia (modern Turkey), 62, 63, 83-84, 349

Alloway, Lawrence, 1128

allusion, artistic, 1007, 1111

alloys, Peruvian, 459

Ancestor figures, Easter Island, Polynesia, 894, 894, 901

Ancestor screen (duen fobara) (Ijo culture), Abonnema

village, Nigeria, 923, 923

Aeneas, 156, 233

Aeneid, 233

Aeolians, 153

apse, 261, 298, 378, 512, 558, 558, 701 Ariadne, 132 ancestor worship: China, 399; Near East (Neolithic), 64; apsidal chapel, 558, 558 Arian Christianity, 304, 488 Roman, 243 Ancient Ruins in the Cañon de Chelley, Arizona, Timothy H. aguamanile, 538 Aristarete, 207 Aquamanile, griffin-shaped (Romanesque), 538, 538, 586 Aristotle, 198, 549-50 O'Sullivan, 999-1001, 999 aquatint process, 973 Arius, 304 ancient world. See Classical (Greco-Roman) art Andachtsbilder (devotional statues), 589-90 aqueducts, Roman, 235, 240, 241, 243 Ark of the Covenant, 289, 292 Aguinas, Thomas, 550 Armchair (China, Ming dynasty), 844, 844 Andean culture, 456-60 arabesques, in Islamic art, 339 Armed Liberty (on U.S. Capitol dome), Thomas Crawford, Andhras dynasty, 374-81 Andy Warhol, Alice Neel, 1147, 1147 Arabic language, 113, 338, 348 Ara Pacis, Rome, Italy, 245-46, 245, 503; Allegory, 246, Armenia, 323-24 angel (Christian symbol), 294 247; Imperial Procession, 246, 246, 254, 284 Armenian Orthodox Church, 323-24 Angelico, Fra (Guido di Pietro), 655-56; Annunciation, Florence, Italy, Monastery of San Marco, 655–56, armor, Japan, 438 Arbus, Allan, 1141 Armor of George Clifford (English), 744 Arbus, Diane, 1141, 1156; Child with Toy Hand Grenade, 656 New York, 1141, 1141, 1156 Armory Show (New York, 1913), 1096-97 Angel Kneeling in Adoration (detail of tabernacle), Egid arcade, 226, 243, 558, 558, 645, 645, 967, 981 Arneson, Robert, 1163-64; Portrait of George, 1163-64, Quirin Asam, 808, 808 Angel of the Annunciation, "Life of the Virgin" (vestments, arcaded windows, 1064 Arnhem Land, Australia, 895-97 Arcadius, 302 English), 581-82, 581 aron, 586 Arc de Triomphe, Paris, France, 962 Angles, 485 arch, 32, 226, 236, 345, 347, 354, 488, 829 Arras, Flanders, 634 Anglo-Saxon culture, 485-86, 530, 532, 534 Anguissola, Sofonisba, 714-16; The Sisters of the Artist Archaic smile, 170, 229 art: beginning of, 37; display of, 26-27; high vs. low, Archangel Michael (Byzantine icon, 10th c.), 331–33, 332 1139; how to look at, 16-21; major vs. minor (fine vs. and Their Governess, 716, 716 Archangel Michael (Byzantine panel, 6th c.), 318–19, 318, craft), 1162-64; naming of works of, 41; opinions Anicia Juliana, 319 about, 27-28; ownership rights to, 84; and the public, 331 aniconic. 339 1157-62; social function of, 24-25, 919, 994, 1079, archbishops, 291 animal-combat motif, 71-73, 208, 488 1157-62, 1165; sources of, 23-24 archeology: methods, 57, 65, 71, 89, 140, 205; women animal husbandry, Neolithic, 48 animal interlace, 483 Artaxerxes I. 87 in. 143 Archer Frederick Scott, 987 art brut, 1109 animal portraiture, 136 Archimedes and Euclid, with Allegorical Figures (sculptural art critics, 28, 1131 animal style, 519; Scandinavian, 482 Art Deco style, 888, 889, 1138 decoration), Jean Goujon, 722, 722 animated scripts, 356 Artemis, 155, 156; Temple of, at Ephesos, 102 architectonic decoration, 540-41 Anjou, France, 615 Artemis Slaying Actaeon (vase painting), Pan Painter, 184, architects: status of, 646; training of, 741 ankh (Egyptian symbol), 94, 114 Architect's house, Santa Monica, California, Frank O. Anne of Austria, 769 Artforum (journal), 1132 Gehry, 1139-40, 1139 Anne of Brittany, 635 architectural decoration: Gothic, 554-56; low relief, 488; art history, 32; methodology of, 16-19; and under-Annunciation (in Christian art), 306 Roman, 247; Romanesque, 521 standing art, 23-24, 28 Annunciation, Broederlam. See Broederlam, Melchior, Art in America (journal), 1149 architectural interior paintings, 797 altarpiece architectural sculpture: Gothic, 554, 563, 565-68; Greek, art informel ("informal art"), 1112 Annunciation, Fra Angelico, 655-56, 656 Art in Transit, Keith Haring, 1152-53, 1152 166-69, 178-79; Romanesque, 516-21, 543 Annunciation, Grünewald. See Grünewald, Matthias, architecture, 31; academic style, 981; African, 474; artisans, 22 Isenheim Altarpiece American, 966-70, 1062-66; American Colonial, Annunciation, Jean Pucelle, Petites Heures of Jeanne 815-17: antimodernist, 1136-37; Austrian, 803-4, amateur tradition, 1014 d'Evreux (manuscript), pages from, 574-75, 575 805-7; Baroque, 753-59, 770-73, 776-77, 800-4, 981, individual expression of, 24 Annunciation (panel), Siena, Italy, Cathedral, altarpiece, nature of, 21-24 1137; Beaux-Arts, 1062-64; beginnings of, 38; Simone Martini, 575, 597-99, 597 Annunciation (relief), Reims, Île-de-France, France, Nôtre-Dame Cathedral, 566–67, 566, 575, 587 Buddhist, 374-77, 409, 412-13; Byzantine, 323-30; and patrons, 25-26 (see also patronage) Carolingian, 491-94; Chinese, 406-7, 409, 412-13, role of, in society, 1116, 1167 status of, 22, 641, 683; in African societies, 470; in 845-46; Christian, early, 297-305, 541; Cistercian, Annunciation, The, Jan van Eyck, 18, 18, 19 Egypt, 111; Italian Renaissance, 22; in Rome, 235; 515-16; classicist, 660, 662, 666, 966, 1063; Egyptian, Annunciation to the Shepherds (in Christian art), 306 99–104, 108–9, 226, 237; elements of, 101, 103, 226, women, 22, 207, 539 antae, 166 227, 236; English, 530-32, 576-79, 745, 800-3, Artist's Studio, The, Louis-Jacques-Mandé Daguerre, antependia, 583 Anthemius of Tralles, 309, 310 935-41; Etruscan, 225-29; French, 550-71, 721-22, 986-87, 986 Anthropométries of the Blue Period (performance), Yves 770-73, 950-51; German, 535-37, 585-86, 803-4, Artist's Wife and Children, Hans Holbein, the Younger, 805-7; Gothic, 550-71, 576-79, 582, 585-86, 590-92, 738-39, 738, 996 Klein, 1125, 1125 art market: contemporary, 1131; Dutch, 798; French, 810 609; Greek, 162-65, 185-86, 198-201; Hellenistic, anticlassical style, 953 Art Nouveau, 1028, 1069-72, 1079 Antico (Pier Jacopo Alari Bonacolsi), 665; Hercules and 209-11, 237, 253; historicist, 1062, 1065-66; India, "Art of Assemblage, The" exhibition (New York, 1961), the Hydra (medallion), 665, 665 829-31, 833; Inkan, 879-80; Islamic, 340, 341-48, 350-55; Italian, 539-43, 590-92, 641-46, 660-63, 1125 Antigonus, 209 699-704, 709-11, 717-19, 753-59; Japanese, 425, 859, Arts, The (mural), Kenyon Cox, 1090, 1090 antimodernism, 1136-37 862; mannerist, 717-19; Mayan, 452-54; medieval, Arts and Crafts Movement, 1004-5; American, 1068; Antiochus IV, 211 early, 488; Mesoamerican, 449; Mesopotamian, English, 1069, 1070, 1071 Antoninus Pius, 259 Asam, Cosmas Damian, 808 65-66, 226; Minoan, 131-33; modern, 1072-73, Antwerp, Belgium, 780 1135-37; monastic, 493-94; Mycenaean, 143-47; Asam, Egid Quirin, 807-8; Angel Kneeling in Adoration Anubis, 96, 124 (detail of tabernacle), 808, 808 Anu Ziggurat, Uruk (modern Warka, Iraq), 66, 67, 73 Neoclassical, 935-41, 950-51, 967-68; Neo-Gothic, 939, 963; Neolithic, 48, 50-55; Ottoman, 345; Otto-Ascension, Rabbula Gospels (manuscript), 320-22, 321, 333 Apadana of Darius and Xerxes, Persepolis, Iran, Ascension, the (in Christian art), 289, 307 nian period, 498-99, 536; Peruvian, 457; positivist ceremonial complex, 86-87, 86 designs, 980-82; postmodern, 1137-40; pre-World Ashanti people (Ghana), 919-21 apex, 758 Ashcan School, 1094 War I, 1062-73; Purism in, 1080; Renaissance, 641-Aphrodite, 155, 156, 202 Ashikaga family, 855 46, 660-63, 699-704, 981; Rococo, 805-7; Roman, Aphrodite of Knidos, Praxiteles, 202, 202, 219 Aphrodite of Melos (Venus de Milo) (Hellenistic statue), ancient, 235-43, 252-55, 260-68, 274-76, 281-83; ashlar, 145 Ashoka, Indian ruler, 366, 372-73, 374, 375, 823 Romanesque, 511-16, 530-32, 535-37, 539-43, 576, 218, 219 590; Romantic, 935-41, 966-70, 1136; Spanish, 488, Ashokan pillars, 366 Apollinaire, Guillaume, 1053 Ashvagosha, Buddhacharita, 381 582, 745-46, 776-77; Sumerian, 65-66; see also Apollinaris, Saint, 313 funerary architecture; temple architecture Asia Minor: art, influence on Greek, 161; Greeks in, 153, Apollo, 155, 156 architrave, 163, 165, 165, 645, 645, 646 177; Seleucid, 209 Apollo (statue), Veii, Italy, Temple of Apollo, 228, 229 archivolt, 517, 517, 519, 558, 558 Asklepios, 156 Apollo Attended by the Nymphs of Thetis, François Arch of Constantine, Rome, Italy, 271, 282, 283; Con-Asmat ancestral spirit poles (mbis), Faretsj River, Irian Girardon, 773, 773, 1017 stantine Speaking to the People (relief), 282, 283, 313 Jaya, Indonesia, 899, 899 Apollo Belvedere (Roman statue), 720 Arch of Drusus, The, Giovanni Battista Piranesi, 933, 933 Asmat people, 899 Apollodorus of Damascus, 260-61 assemblage, 30, 1125-28 Arch of Septimius Severus, Rome, Italy, 283 Apollo Fountain, Peter Flötner, 740, 741 Assisi, Umbria, Italy, Upper Church, Miracle of the Crib of Arch of Tiberius, Rome, Italy, 283 Apostles (relief), Reims, Île-de-France, France, Nôtre-Arch of Titus, Rome, Italy, 253-55, 254, 283; Spoils from Greccio, Saint Francis Master, 597, 604, 604 Dame Cathedral, 567-68, 567 Association of Artists of Revolutionary Russia (AKhRR), the Temple of Solomon, Jerusalem (relief), 254, 254, 292 apotheosis, 73; of Lord Pacal (Mayan), 454; of Roman Arena Chapel, Padua, Italy, frescoes, Giotto, 604-7, 605; 1077 emperors, 234, 235, 248, 249 Assumption of the Virgin (fresco), Correggio, 686-87, 687 The Lamentation, 606, 607 Appar, 393 Assurbanipal, Assyrian king, 67, 80 Ares, 155, 156 appliqué, 902 Arezzo, Italy. See San Francesco, Church of Assurbanipal and His Queen in the Garden, Nineveh apprenticeship, 22-23, 956 (modern Kuyunjik, Iraq), 80, 80 Argos, Greece: model of a temple, 160, 161; Sanctuary of appropriation, 1155 Assurnasirpal II, 79 Après John Cage (happening), Maciunas, George, 1124 Hera. 160

Assurnasirpal II Killing Lions, Kalhu (modern Nimrud, 102; Hanging Gardens, 81, 83, 102; Ishtar Gate, 81, basilica-plan churches, 297-300, 313, 488, 492, 494, 82, 83, 84; Marduk Ziggurat, 81, 83 Iraq), Palace of Assurnasirpal II, 78, 79 499, 592, 643 Assyrians, 63, 78-80 Babylonians, 63, 289 Basilica Ulpia, Rome, Italy, 261, 261, 281, 298 Astarte (Ishtar), 202 Bacchus, Jacopo Sansovino, 690, 691, 717 basilisk 563 astragal, 210 Baccio d'Agnolo, 642 Basil the Great of Cappadocia, Saint, 322 astronomical siting of buildings, 54-55, 104, 448 background, 29 basketry, Native American, 445, 888, 888 Astronomy, or Venus Urania, Giovanni da Bologna, 717, Basquiat, Jean-Michel, 1153; *Flexible*, 1152, 1153 backstrap loom, Andean culture, 457 Backyards, Greenwich Village, John Sloan, 1094-95, Bath, England. See Circus housing project; Royal Asuka period (Japan), 426-29, 855 1094 Crescent Asymmetrical Angled Piece, Magdalene Odundo, 925, 925 Bacon, Francis, 786, 1109, 1152: Head Surrounded by Bathers, Pierre-Auguste Renoir, 1017, 1017, 1030 asymmetry, 422; in Japanese art, 855, 862, 863, 871 Sides of Beef, 1109, 1109, 1111, 1152 bathhouses: Islamic (hammam), 362; Roman, 224-25, atelier 827, 857 Bactria 379 Atget, Eugène, 1028–29, 1142; Magasin, Avenue des "bad painting," 1141-42 Baths of Caracalla, Rome, Italy, 274-75, 274 Gobelins, 1028, 1029, 1042; Pontoise, Place du Grand-"Bad Painting" exhibition (New York, 1978), 1142 Batlló Crucifix (Romanesque, from Spain), 523, 523 Martrov, 1029, 1029 Batoni, Pompeo, 932; Portrait of Count Razoumowsky, Baerze, Jacques de, 618 Athanadoros, 215 Athena, 155, 156, 185, 186, 199 Athena, Herakles, and Atlas, Olympia, Greece, Temple of bailey, 531, 579, 579 932 932 Balbilla Julia 259 battered wall, 475 balcony, 645 Baldacchino, Gianlorenzo Bernini, 701, 756, 757, 758 Battista Sforza, Piero della Francesca, 659, 666-67, 667 Zeus, pediment sculpture, 178, 179, 196, 202 Battle between the Romans and the Barbarians (relief), Athens, Greece, 153, 155, 173, 177, 184-93, 197-98 from Ludovisi Battle Sarcophagus, 278, 278 baldachin, 543, 595, 756-57 Acropolis. 171, 172, 185, 186-93, 187 battlement, **579**, *579* Baldessari, John, 1149, 1155 Battle of Centaurs and Wild Beasts (floor mosaic), Tivoli, Baldung Grien, Hans, 736; Stupefied Groom, 736, 736 Ball, Hugo, 1083; reciting "Karawane" (photograph), Agora, 185-86, 185, 199 Dipylon Cemetery, 159; vase from, 159, 159, 173 Italy, Hadrian's Villa, 265, 272-73, 272 Panathenaic Way, 185 1083. 1083 Battle of Love, The, Paul Cézanne, 1023, 1023, 1040 See also Erechtheion; Parthenon; Propylaia; Temple Ball, Thomas, The Emancipation Group, 999, 999 Battle of the Bird and the Serpent (manuscript page), 490, of Athena Nike; Temple of the Olympian Zeus Balla, Giacomo, 1059; Dynamism of a Dog on a Leash 491,539 athletes, depiction of, 135–36, 203 (Leash in Motion), 1059, 1059 Battle of the Ten Naked Men, Antonio del Pollaiuolo, atmospheric perspective, 30, 258, 334 Ballet Rehearsal, Edgar Degas, 1008, 1012-13, 1012 674-75, 674 atrial cross, 882 balloon frame 32 Battle-scene hide painting (Native American, Mandan), Atrial cross (Mexico City, Mexico), Basilica of Guadalupe, balustrade, 645, 667, 699, 755, 759, 951 885-86, 885 Chapel of the Indians, 882, 882 Bangladesh, 366 Baudelaire, Charles, 974, 989; "The Painter of Modern atrium, 225, 298, 701 Banham, Reyner, 1128; "Vehicles of Desire," 1128 Life," 1007-9 attached columns 101 Banker and His Wife, Marinus van Reymerswaele, 728, Baudrillard, Jean, 1153, 1154 Attalos I. 211 Bauhaus Building, Dessau, Germany, Walter Gropius, AT&T Headquarters, New York City, Philip Johnson (with Banner, painted (Han dynasty, China), 402-4, 403, 406 1081, 1082, 1082, 1135 John Burgee), 1137–38, 1137 At the Moulin de la Galette, Henri de Toulouse-Lautrec, Banner of Las Navas de Tolosa (Islamic, from Spain), Bauhaus movement, 1081-83, 1104, 1128, 1135 357, 358 Baule people (Côte d'Ivoire), 918 1027, 1027, 1048, 1142 Banqueting House. See Whitehall Palace Bavaria, 681 attic story, 253 Banquet Scene, Rome, Italy, Catacomb of Priscilla, 291, bay. 226, 413, 801, 862 attribute (identifying symbol of a god), 171, 294; of 292, 293 Bayeux Tapestry (Norman-Anglo-Saxon), 534-35; Bishop Buddha, 427 baptism, 540 Odo Blessing the Feast (detail), 534-35, 535, 580 attributed to, meaning of term, 990 Baptism in Kansas, John Steuart Curry, 1100, 1100 bavts. 344 Au Cacau, tomb of, Tikal, 452 Baptism of Christ (in Christian art), 306 Beacon Rock, Newport Harbor, John Frederick Kensett, baptistries, 296-97, 298, 540 audience. 29 998, 998 Audubon, John James, 973; Birds of America (book), print Baptistry of San Giovanni, Florence, Italy, doors, Life of beadwork: Egyptian, 357; Native American, 883-84 Common Grackle, 973, 973 John the Baptist from, Andrea Pisano, 594, 595, 595; Beardsley, Aubrey, 1028 Augustine, archbishop of Canterbury, 486 detail, Burial of John the Baptist, 595, 595 Bearing of the Cross (in Christian art), 307 Augustine, Saint, 291 Baptistry of the Arians, Ravenna, Italy, 304 Baptistry of the Orthodox, Ravenna, Italy, 304–5, 304 Beatrice Cenci, Harriet Hosmer, 971-72, 971 Augustus Caesar, 234-35, 245, 249, 260, 264, 276, 291 Beatus of Liébana, Commentary on the Apocalypse, 490, Augustus of Primaporta (Roman), 247-48, 247, 255 Bar at the Folies-Bergère, A, Édouard Manet, 1015-16, 527-28 Auk, Cosquer cave, Cap Morgiou, France, cave painting, 1015 Beau Dieu (relief), Amiens, Île-de-France, France, Nôtre-Barbari, Jacopo de', 727 36, 36, 41 Dame Cathedral, 562, 563 Barbaro, Villa, Venetia, Italy, Maser, 707, 707, 805 Aulos, son of Alexas, 20; gem with Apollo and beauty, as expressed in art, 19-21 Cassandra, 20 Barberini family, 757, 764 Beauvais, Vincent de, Speculum Maius, 550 Aulus Metellus ("The Orator") (Roman statue), 244, 245, Barberini Palace, Rome, Italy, 764–65, 765, 773 Beauvais tapestry manufactory, 811 barbican, 579, 579 Beaux-Arts architecture, 1062-64 Aurora (ceiling fresco), Guido Reni, 764, 764 Barbizon painters, 990, 1007, 1009, 1011, 1014 Bedstead, Victorian, 1004, 1004 Australian Aborigines, 895-97, 906-7 Barcelona, Catalonia, Spain: Cathedral, 582; see also beehive tomb, Mycenaean, 144, 145, 148, 199 Austria, 687-88 Beggarstaff brothers, 1028 Casa Milá apartment building Austrian art: Baroque, 803-4; Rococo, 805-7 Bardon, Geoff, 906 Behrens, Peter, 1073 automatism, 1088, 1112 Beijing, China, 837; Forbidden City, 844, 845–46, 923 baren, 868 Autumn Colors on the Qiao and Hua Mountains bargeboard, 904 Belisarius, 308, 309 (handscroll), Zhao Mengfu, 838-39, 839 bark cloth, 902-3 Bellini, Gentile, 670-71, 705; Procession of the Relic of the Autumn Rhythm (Number 30), Jackson Pollock, 1117, Barlach, Ernst, 1031-32; Seated Woman, 1031-32, 1031 True Cross before the Church of San Marco, 670-71, 1117, 1125, 1127 Barna, 330 671,704 Autun, Burgundy, France, Saint-Lazare Cathedral Barney, Matthew, 1156 Bellini, Giovanni, 670, 671-72, 704, 705, 785; Virgin and carved portals of, 517, 520-21 Baroque art, 750-817; architecture, 753-59, 770-73. Child Enthroned with Saints Francis, John the Baptist, Last Judgment (relief), 520, 521, 525, 533, 555, 568; 776-77, 800-4, 981, 1137; Austrian, 803-4; Dutch, Job, Dominic, Sebastian, and Louis of Toulouse, Venice, Weighing of Souls from, 520, 521 786-800; English, 800-3; Flemish, 780-85; French, Italy, Ospedale of San Giobbe, 671-72, 671, 704 The Magi Asleep (relief), 512-13, 521, 521 769-76, 802; German, 803-4; influence on Romantic, Bellini, Jacopo, 670; Flagellation, 670, 670 Bellini family, 704 960; Italian, 753–69, 808; painting, 624, 763–65, Avalokiteshvara, 823-24 avant-garde, 1033-36, 1081, 1110, 1112, 1149 773-800; sculpture, 773, 804; Spanish, 776-80 Bells, set of (Zhou dynasty, China), 402, 402 barrel vault, 225, 226, 226, 235, 378, 981 Avenue at Middelharnis, Meindert Hobbema, 794, 794 Benday dots. 1129 Avenue of the Dead, Teotihuacan, Mexico, 449 barrel-vaulted passage, 300-2 Benedictine Monastery Church, Melk, Austria, Jakob Barrias, Louis-Ernest, 984; The First Funeral, 984, 984 Axe, double-bladed (from Zakro, Crete), 133, 138, 138, Prandtauer, 803-4, 803 Barry, Charles, 939–41; Houses of Parliament (with Benedictine order of monks, 493-94 Axes, Susan Rothenberg, 1142, 1142 A. W. N. Pugin), London, England, 940, 941, 969 Benedict of Nursia, Rule for Monasteries, 493 axial plan, 117, 237 Barthes, Roland, 1153; "Death of the Author," 1155 Beni Hasan, Egypt, 110-11; rock-cut tombs, 110, 110, axis mundi, 373, 374, 375, 383, 414, 427 bar tracery, 568, 569 111; tomb of Khnumhotep, Harvest Scene, 111, 111 Aztec culture, 449, 875, 877-79 Barye, Antoine-Louis, 962; Lion Crushing a Serpent, 962, Benin, 471-74, 911 963 Benois, Aleksandr, 1059 В bas-de-page scenes, 575–76 base, **87**, **101**, **165**, *165*, **645**, *645* Bentley, Richard, Strawberry Hill, Twickenham, England, Baader, Johannes, 1083 Holbein Chamber, 939, 939 baaku (Kongo), 918 basilica, 235, 261, 297, 341, 701 Benton, Thomas Hart, 1100-1, 1115 Babur, Indian ruler, 826-27 Basilica Julia, Rome, Italy, 283 Beowulf 485 Baby carrier (Native American, Sioux), 883, 883 Basilica of Maxentius and Constantine (Basilica Nova), Beraldi, Henri, The Printmakers of the Nineteenth Century, Babylon, Mesopotamia (modern Iraq), 76-78, 81-83, 81, Rome, Italy, 280, 281, 281, 662 1028

Bradley, Will, 1028 Berlin, Germany. See Brandenburg Gate in Space, 1058, 1058 Berlin Dada Club, 1083-84, 1085 Bodh Gaya, 371 Brady, Mathew B., 998 Bragaglia, Anton Giulio, 1059; Greetings!, 1059, 1059 Bodhidharma, 866 Berlin Secession, 1038 Bodhidharma Meditating, Hakuin Ekaku, 866, 867 Bramante, Donato, 683, 699, 700, 701; Church of San Berlin Wall, The (photograph), Henri Cartier-Bresson, bodhisattva, 371, 383, 410, 426, 823-24 Pietro in Montorio, Tempietto, Rome, Italy, 699, 699, 1140.1140 Bodhisattva (wall painting), Ajanta caves, 382, 383, 392 701, 703, 802; Saint Peter's (plan), Rome, Italy, 701 Bernard de Soissons 565 Bernard of Clairvaux, Abbot, 514, 519, 539, 551 Bernini, Gianlorenzo, 701, 756–58, 765, 770, 802, 808; Bodhisattva Avalokiteshvara, The (India, Late Medieval), Brancacci Chapel. See Santa Maria del Carmine Brancusi, Constantin, 1030-31, 1096, 1097, 1165; Magic 823-24, 824 Baldacchino, Rome, Italy, Saint Peter's Basilica, 701, 756, 757, 758; Church of Santa Maria della Vittoria, Boffrand, Germain, Hôtel de Soubise, Salon de la Bird, 1031, 1031, 1165 Brandenburg Gate, Berlin, Germany, Karl Gotthard Princesse, Paris, France, 804, 805 Cornaro Chapel, Rome, Italy, 760–61, 760, 808; Langhans, 962-63, 963 bohemianism, 1042 Costanza Bonarelli, 760, 760; David, 753, 759, 760, boiserie, 805 Braque, Georges, 1048, 1051-53, 1054-55, 1060, 1096, bole (reddish clay ground), 596 1097, 1126; Fox, 1053, 1053, 1118, 1132; Houses at 773; Four Rivers Fountain, Piazza Navona, Rome, L'Estaque, 1051, 1052; Violin and Palette, 1052, 1052, Italy, 762, 762; Saint Peter's Square, 757-58, 757; Saint Bologna, Giovanni da (Jean de Boulogne), 717; Astronomy, or Venus Urania, 717, 717 Teresa of Ávila in Ecstasy, 761-62, 761, 773; sculpture Bologna, Italy, 717; see also San Petronio, Church of Brassempouy, France, Woman (figurine), 39-40, 40 of 759-62 breakfast pieces, 785 Bolsheviks, 1075 Bernward of Hildesheim, Bishop, 501 Berrettini, Pietro. See Cortona, Pietro da Bonanno Pisano, 540 Breton, André, 1090, 1112, 1154; "Manifesto of Berry, Jean, duke of, 615, 616, 617 Bonaparte, Joseph, 966 Surrealism." 1087 Bertoldo di Giovanni, 688 Bonaparte, Napoleon. See Napoleon I, emperor of Breton Woman Nursing Her Child, Aimé-Jules Dalou, 994, 995. 1005 France bestiaries, 576 Breuer, Marcel, 1082-83; Vasily chair, 1082, 1082, 1128 Betrayal, the (in Christian art), 307 Bonheur, Rosa, 974, 990-92, 1014; Plowing in the Betrayal and Arrest of Christ, Jean Pucelle, Petites Heures of Nivernais: The Dressing of the Vines, 990–92, 991; Breuil, Abbé Henri, 46 Reminiscences (book), 990 breviaries, 574 Jeanne d'Evreux (manuscript), page from, 574-75, 575 Bride Stripped Bare by Her Bachelors, Even (The Large Beuys, Joseph, 1151; Coyote: I Like America and America Bonnard, Pierre, 1028 Bonsu, Kojo, 919 Glass), Marcel Duchamp, 1085, 1086, 1127 Likes Me. 1151, 1151 Bonsu, Osei, 919 bridge, 579, 579 beveling, 40, 880 Book of Kells (Hiberno-Saxon manuscript), Chi Rho Iota Bridget, Saint, 633 Bhagavad Gita, 372, 391 page from, 486, 487-88, 487 Britain, 268; Middle Ages, 485-88; Norman conquest, bhakti devotion, 391-93, 831 509, 530, 534–35; Romanesque period, 530–35; see Book of the Dead, Egyptian, 124–25; Judgment before bi (jade piece), 404 Osiris (illustration), 96, 121, 124–25, 125, 521 books: Britain, 486–88, 532–33; Carolingian period, also England Bible, 289, 297, 494 British East India Company, 833 Bierstadt, Albert, 1001; The Rocky Mountains, Lander's 494–98; early forms of, 319; England, 580–82; France, British Pop, 1128-29 Peak, 1000, 1001 572–76; Germany, 538–39; Gothic, 572–76, 580–83; Broederlam, Melchior, altarpiece, wings Annunciation, Bihzad, Kamal al-Din, 361-62; The Caliph al-Rashid Visits illustration, 676-77, 1028; Ireland, 486-88; later Visitation, Presentation in the Temple, and Flight into the Turkish Bath (miniature), 362-63, 362 Islamic, 361-63; Middle Ages, 486-88, 490; Egypt, Dijon, France, Chartreuse de Champmol, 618, biiga (Mossi), 913 Normandy, 532-33; Ottonian period, 503-5; printing, 618, 620, 624 bilongo (Kongo/Songye), 917 674–77; Romanesque, 527–30, 532–33, 538–39; Spain, Broken Eggs, Jean-Baptiste Greuze, 812, 812 Biltmore, George W. Vanderbilt Estate, Asheville, North 582–83; see also illumination; manuscripts broken pediment, 268, 755, 755, 776 Carolina, Richard Morris Hunt, 1062, 1062 Books of the Hours (prayer books), 574 bronze: Aegean, 128; African, 911; Chinese, 843; bimah, 586 Bingham, George Caleb, 975; Fur Traders Descending the Borgoricco, Italy, Town Hall, Aldo Rossi, 1139, 1139 Etruscan, 231-33; Japanese, 425; Ottonian, 501; technology, 177, 181, 400; Yoruba, 470; see also Missouri, 975, 975 Borrassá, Luis, 584 Bird (detail of monolith), Great Zimbabwe, Zimbabwe, Virgin and Saint George (altarpiece), 584, 584; Education of the Virgin from, 584, 585 Bronze Age: Aegean, 128, 129; China, 399-402, 843; 476-77 477 Borromini, Francesco, 758-59, 762; Church of San Carlo Cycladic, 129-31; Europe, 58-59; Greece, 142-49; Bird-Headed Man with Bison and Rhinoceros, Lascaux, alle Quattro Fontane, Rome, Italy, 758, 758, 759, 759, France, cave painting, 44, 45 birds-and-flowers genre, China, 841–42 Bronze Foundry, A (vase painting), Foundry Painter, 177, Bosch, Hieronymus, 724-26; Garden of Delights, 724-26, Birds of America (book), print Common Grackle, John James Audubon, 973, 973 Bronzino (Agnolo Tori), 712, 714; Ugolino Martelli, 714, 715 Boscoreale (near Pompeii), Italy, House of Publius Brooklyn Bridge, New York City, John Augustus Roebling Bird Woolen (textile), William Morris, 1004, 1005 Fannius Synistor: bedroom (reconstruction), 250, 251; (with W. A. Roebling), 980, 980 Birth of the Virgin, Pietro Lorenzetti, 598, 599 Birth of Venus, The, Sandro Botticelli, 1111, 1111, 1115 Cityscape (wall painting), 222, 223, 251, 251 Brown, Lancelot, 939 boss, 165, 165, 210, 488, 578 Bruce, Thomas, 189 Bischoff, Elmer, 1123 Bossche, Agnes van den, 615 Brücke, Die, 1041-45, 1087 Bishop, Isabel, 1101; Resting, 1101, 1101 Bishop Odo Blessing the Feast (detail), Bayeux Tapestry Boston Public Library, Boston, Mass., McKim, Mead, and Brueghel, Jan, 783; Allegories of the Five Senses (cycle), White, 1063-64, 1063 783; detail Sight, 783, 783, 1118 (Norman-Anglo-Saxon), 534-35, 535, 580 boteba (Lobi), 917 Brueghel, Pieter, the Elder, 726-27; Carrying of the Cross, bishops, 291 Böttger, Johann Friedrich, 843 726–27, 726; Return of the Hunters, 727, 727 Bison, Altamira, Spain, cave painting, 43, 43 Botticelli, Sandro, 659-60, 694; The Birth of Venus, 1111, Bruges, Flanders, 619, 629, 634, 677 Bison, Le Tuc d'Audoubert, France, relief, 45-46, 45 1111, 1115; Primavera, 659-60, 659 Brunelleschi, Filippo, 592, 624, 641-44, 646, 653, 663, Black Death, 550, 569, 576, 607, 608, 609 black-figure vase painting, 161, 162, 173, 176, 197 Bottle, enameled and gilded (Syrian), 348, 356-57, 356 666, 701; Cathedral, Florence, Italy, 641-43, 642, 643, Boucher, François, 811-12; Le Déjeuner (Luncheon), 811, 701; San Lorenzo, Florence, Italy, 643-44, 643, 653, Blackfoot Indians, 885 Black Lion Wharf, James McNeill Whistler, 1005-6, 1005 811; La Foire Chinoise (The Chinese Fair) (tapestry copy after), 813-14, 814 Brushing his teeth after eating Flux Mystery Food Black on White Jar with Lightning Pattern, Lucy M. Lewis, (photograph of event), Ben Vautier, 1124, 1124 Boudin, Eugène, 1009 1164, 1165 Brussels, Belgium, 634; see also Tassel House Bouguereau, Adolphe-William, 982-83; Nymphs and a blackware, 889 Blake, William, 947–48; Pity, 948, 948 Blanche of Castile, Queen, 572–73 Brutus, Lucius Junius, 232 Satyr, 982-83, 983, 1017 Bryant, William Cullen, 970 bouleuterion, 186 Blanket (Chilkat Tlingit), 887, 887 Blaue Reiter, Der, 1045–48, 1055 Boulevard des Capucines, Claude Monet, 27, 28, 1010 Buchan, Alexander, 903 Buddha, 371; marks of, 427; representations of, 378-81, Boullée, Étienne-Louis, 951, 1138; Cenotaph for Isaac Newton (plan), 951, 951, 1138 Blegen, Carl, 216 Buddha and Attendants (Kushan period, India), 379-80, Bound to Fail. See Nauman, Bruce, Eleven Color Blenheim Palace, Woodstock, Oxfordshire, England, John Vanbrugh, 802–3, 803, 936 blind arcade, **302**, **499**, **831** Photographs Buddhism, 366, 370, 371-73, 381, 389, 415, 431, 823, Bourges, France, house of Jacques Coeur, 570-71, 570 837; architecture of, 374-77, 409, 412-13; in China, Bourgot (medieval artist), 615 blind porch, 192 Bourke-White, Margaret, 17-18; Fort Peck Dam, 407, 409, 412-13; iconography of, 371, 378, 426, 427, blind window, 703 823; in India, 378, 823-24; in Japan, 426, 428-29, 430, Montana, 17-18, 17 block book 676 855; painting of, 430, 440; sculpture of, 381-83, 409, Bouts, Dirck, 630-31, 637; Justice of Otto III, 630-31, 630; block-printing, Japanese, 434 Wrongful Execution of the Count, 630-31, 630 410, 412, 440 blolo bla and bian (Baule), 918 Bowl, painted (Chinese Neolithic), 398-99, 399 Buffalo, New York. See Larkin Building Blue Bird, Mari (modern Tell Hariri, Iraq), wall painting Buffalo Bull's Back Fat, Head Chief, Blood Tribe, George Bowl with kufic border (Uzbekistan), 348, 348 from, 77-78, 77 Catlin, 973–74, 973, 1001 Boyd, Harriet, 143 boats, Egyptian, 123 Boyle, Richard, Lord Burlington, 935–37; Chiswick House, London, England, 936, 936, 941, 968 building construction: modern, 32, 980, 1064-65; bobbin, 457 Roman, 236, 263 Boccaccio, Giovanni, 607; De Claris Mulieribus, page with Bulfinch, Charles, 969 Boy with a Clubfoot, Jusepe de Ribera, 777, 777 Thamyris from, 615 Bull and Puppy, detail. See Rosetsu, Nagasawa, Screen Boy with a Squirrel, John Singleton Copley, 819 Boccioni, Umberto, 1057-59; States of Mind: The

Farewells, 1058-59, 1058; Unique Forms of Continuity

Berkeley, George, 818

bracket, 406, 645, 645, 755, 755

Bullant, Jean, 722 Camera Club of New York, 1096 Loge, Wearing a Pearl Necklace, 1013-14, 1013, 1015; Bull Jumper (statuette), Knossos, Crete, 135-36, 135, 137 Camera Notes (journal), 1096 Maternal Caress, 1017–19, 1017 Bull Jumping (wall painting), Knossos, Crete, palace camera obscura, 985 cassone, 672–73 complex 140-41 140 Camera Picta. See Mantua, Italy Cassone (chest), Florentine School, 672-73, 672 Bunsei, 856-57; Landscape (hanging scroll), 856-57, 857 Camera Works (journal), 1096 Castagno, Andrea del, 657; Last Supper (fresco), Buñuel, Luis, 1087 Cameron, Julia Margaret, 988-89; Portrait of Thomas Florence, Italy, Sant'Apollonia, 657, 657, 684 Carlyle, 988, 989 buon fresco, 599 Castillo pyramid, Chichen Itza, Yucatan, Mexico, 455–56, Burden, Jane, 1003-4 cames, 559 Burgee, John, AT&T Building. See under Johnson, Philip campanile, 539, 599 cast iron, 980, 981, 1064 Burghers of Calais, Auguste Rodin, 1026, 1027 Campbell, Colin, 935 castles, Gothic, 561-65, 578-79, 579 Burgundy, 615, 621, 631, 634, 638 Campidoglio, Piazza del, Palazzo dei Conservatori, Catacomb of Priscilla, Rome, Italy: Banquet Scene, 291, burial customs: Chinese, 399, 401, 402; Cycladic, 131; Michelangelo (and others), 700, 700, 709 292, 293; Teacher and Pupils, Orant, and Woman and Egyptian, 99, 121, 124-25; Etruscan, 229; Greek, Campin, Robert, 619-20, 626, 674, 786 Child, 293-94, 293 159-60; Helladic, 144; Japanese, 425; Mesopotamian, Mérode Altarpiece, 620–21, 620, 1092; wing Joseph in Catacomb of Saints Peter and Marcellinus, Rome, Italy, 71; Mycenaean, 144, 148; Near East (Neolithic), 64; His Carpentry Shop, 621, 621 Good Shepherd, Orants, and Story of Jonah, 294–95, Roman, 243, 278; Viking, 480, 483; see also "funerary," Campo Santo, Pisa, Italy, fresco, Francesco Traini, 607, 295. 303 terms beginning with 608, 608 Catacomb of the Jordani, Rome, Italy, 292, 292 Burial of Count Orgaz, El Greco, 746-47, 747 Canaletto (Giovanni Antonio Canal), 932-33; Santi catacombs, 243, 291-92, 294, 295 Burial of John the Baptist, Florence Baptistry of San Giovanni e Paolo and the Monument to Bartolommeo Catalonian Pyrenees (Spain), Romanesque wall Giovanni, doors, Life of John the Baptist, Andrea Colleoni, 932-33, 932 paintings from, 525 Pisano, 595, 595 canon of proportions: Egyptian, 98-99, 98, 99, 110; of Catharina Hooft and Her Nurse, Frans Hals, 787, 787, 818 burial ship (Viking), Oseberg, Norway, 480, 480, 483; Polykleitos, 193-95, 201, 248; Renaissance, 729, 734 Cathedra, Barnett Newman, 1120, 1120 post with animal figures, 483, 484, 519 Canopus area, Tivoli, Italy, Hadrian's Villa, 265-66, 266, Cathedral of Our Lady, Siena, Italy, 590, 591, 593, 599 burin, 673, 789 cathedrals, 291; Gothic, 548-49, 561-65, 609 Burke, Edmund, 935 Canova, Antonio, 768, 934-35, 970, 996; Maria Paulina Catholic Church (Western). See Roman Catholic Church Burne-Jones, Edward, 1003 Borghese as Venus Victrix, 934-35, 934, 959, 972, 996 Catlin, George, 973-74, 1001; Buffalo Bull's Back Fat, burr, 789 Canterbury, England, Cathedral, rebuilding of, 576 Head Chief, Blood Tribe, 973-74, 973, 1001; Letters and Burty, Philippe, 1005, 1008 Canterbury Tales by Geoffrey Chaucer, 576; printed by Notes on the Manners, Customs, and Conditions of the Buseau, Marie-Jeanne, 811 William Caxton, page Pilgrims at Table, 676, 677 North American Indians (book), 974; North American Busketos, 539 Cantigas de Santa Maria (manuscript), page with Alfonso Indian portfolio, 974 bust, 952 the Wise, 582-83, 583 Cattle Gathered next to a Group of Huts, from Herders' Bust of a Man (Mohenjo-Daro, Indus Valley), 369, 369, 430 cantilever, 32 Village, The (rock-wall painting, Algeria), 466-68, 467 bust portraits, Amarna period (Egypt), 120 canvas, painting on, 704, 765-69, 906 cave art, 41-46, 135; dating of, 46, 49 Butchered Ox, Rembrandt van Rijn, 1111, 1111 Canyon (combine), Robert Rauschenberg, 1126, 1126, Cave-Temple of Shiva, Elephanta, Maharashtra, India. buttress, 226, 281, 310, 391, 558; masonry, 511 1149, 1155 386-87, 386; Eternal Shiva (relief), 387, 387, 393 buttress pier, 558, 558 Capetian dynasty, 510 cave temples, India, 377-78, 386-87 bwami grade associations (Lega), 915-16 Capetians Everywhere, Georges Mathieu, 1112, 1112 Caxton, William, 677 Bwa people, 914-15 capital, 87, 101, 165, 165, 373, 645, 645 ceiling painting, 667, 686-87; illusionistic, 763-65 Byodo-in temple, Uji (near Kyoto), Japan, 432–33, 432 Capitoline Wolf (Etruscan), 231-32, 232 cella, **161**, **164**, *164*, **238**, 309 Byzantine art, 296; early (first Golden Age), 288, 308-22; capriccio, 933 Cellini, Benvenuto, 722-23; Saltcellar of Francis I, 722-23, influence on Islamic, 339; influence on Italian Gothic, Caprichos, Los (The Caprices), page The Sleep of Reason 595-97; influence on Renaissance, 672; influence on Produces Monsters, Francisco Goya y Lucientes, 964, Celtic languages, 485 Romanesque, 524, 525-27, 529; late (second Golden cemetery complexes, Greek, 205-6 Cennini, Cennino, 603; Il Libro dell'Arte, 596 Age), 323-35; textiles, 519; wall painting, 328-30, 524 capstone, 51, 53, 53, 145, 375, 389, 391 Byzantine Empire, 290, 308, 313, 350, 510, 609; and Captain Frans Banning Cocq Mustering His Company (The cenotaph, 829 Christianity, 290 Night Watch), Rembrandt van Rijn, 787, 790, 791, 793 Cenotaph for Isaac Newton (never built), Étienne-Louis Byzantium, 280, 290 Caracalla, 273, 274, 276, 278-79 Boullée, 951, 951, 1138 Caracalla (Roman bust), 276, 276 Centaur, Lefkandi, Euboea, Greece, 158, 159 C Caravaggio (Michelangelo Merisi), 765-69, 781, 785; centaurs, 159 Cabanel, Alexandre, 1090 Calling of Matthew, 767-68, 767; Death of the Virgin, centering, 226, 643 Cabaret Voltaire (Zürich), 1083 781; Entombment, 768, 768, 778, 781 Central America, 456 Cabinet d'Amateur with a Painter, Giles van Tilborch, 26, 26 Caravaggism, 773-76, 777, 780, 786, 788 Central Park, New York City, Frederick Law Olmsted cabinet piece, 809 carbon-14 (radiocarbon) dating, 49 (with Calvert Vaux), 970, 970, 1063 Cadart, Alfred, 1005, 1028 cardo, 266, 267 central-plan churches, 298, 298, 300-5, 313, 323-24, Caen, Normandy, France, Saint-Étienne church, 531-32, Carew, Thomas, Coelum Britannicum, 800 492, 592, 663, 753, 950 531, 551 caricature, 1027 central-plan mosques, 345, 345, 354 caesaropapism, 308 Carnarvon, Lord, 122 Central Station project, Milan, Italy, Antonio Sant'Elia, Caesars, 234 Caroline minuscule (script), 494 1058, 1073, 1073, 1081 Cage, John, 858, 1108-9, 1126; Silence (book), 1124 Carolingian art, 491–98; influence on Ottonian, 499–501; Centre National d'Art et de Culture Georges Pompidou, Cahokia, Illinois, mounds, 461-62, 461 influence on Romanesque, 527, 535; stained-glass Paris, France, Renzo Piano and Richard Rogers, 1138, cairns, 51, 53, 53 windows of, 559 1138 Cairo, Egypt, Sultan Hasan mosque complex, 353-54, 353 Carolingian Empire, 609, 614 Centula, France, Monastery of, Abbey Church of Saint Carpeaux, Jean-Baptiste, 982, 995; The Dance, Paris, Calcagnini, Celio, 714 Riquier, 492, 492, 499 Calchas (Greek priest), 232-33 France, Opéra, 982, 982 ceramics: African, 925; Chinese, 57, 363; contemporary, calendrical systems, Mesoamerican, 445, 448, 451-52 carpets, Islamic, 359, 360 1163-64; decoration of, 159-60, 353; English, 937; Calf Bearer (Moschophoros), Athens, Greece, Acropolis, Carracci, Agostino, 763 Greek, 162; Indus Valley, 370; Islamic, 348, 353, 357; sculpture from, 172, 172 Carracci, Annibale, 763-64, 774, 781, 785, 808; Farnese Japanese, 423-26, 863, 870; Lapita culture, 897; California Institute of the Arts (CalArts), Feminist Art ceiling, Rome, Italy, Palazzo Farnese, 759, 763-64, Minoan, 139; Mycenaean, 149; Neolithic, 56-58; Program, 1147 technique, 57-58, 162 763, 772 Caliph al-Rashid Visits the Turkish Bath (miniature), Carriera, Rosalba, 810–11; Jean-Antoine Watteau, 810, 810 Ceramic vessel, Ito Sekisui, 870, 870 Bihzad, Kamal al-Din, 362-63, 362 Carrington, Leonora, 1089; Self-Portrait, 1089, 1089 Ceramic vessel, Miyashita Zenji, 870, 870 Caliphate period, 340-49 Carrousel Arch, Paris, France, 808 Ceramic vessel, Morino Hiroaki, 870, 870 calligraphs, 400, 408 Carrying of the Cross, Pieter Brueghel, the Elder, 726–27, Ceramic vessel, Tsujimura Shiro, 870, 870 calligraphy: Chinese, 408-9, 838, 847, 1166; Islamic, 726 ceremonial complexes: Persian, 86-87; Peruvian, 457 339, 348, 354–56, 361–63; Japanese, 433–35 Carter, Howard, 122 ceremonial structures, Neolithic, 51-55 Calligraphy Pair, Ikkyu, 858, 859 Carthage, North Africa, 234 Cernavoda, Romania, ceramic figures of man and Calling of Matthew, Caravaggio, 767-68, 767 Cartier-Bresson, Henri, 1139-40; The Berlin Wall woman, 56-57, 56 Calling of Matthew (in Christian art), 306 (photograph), 1140, 1140 Cerveteri, Italy, La Banditaccia, Etruscan cemetery, 229, calotype, 987 cartoon, 685 229; sarcophagus from, 230, 230; Tomb of the Reliefs, Calvert, Frank, 216 cartouche, 114, 253, 645, 645, 755, 755, 759 Cézanne, Paul, 1023, 1028, 1048, 1052, 1060, 1096, 1099; The Battle of Love, 1023, 1023, 1040; Mont calyx krater, 176 carved portal. See portal Cambio, Arnolfo di, 590 caryatid, 166, 266 Cambridge University, 576 Casa Grande, San Simeon, California, Julia Morgan, Sainte-Victoire, 1024, 1024, 1052 Cambyses II, 85 1068-69, 1068 Chacmools, 456 Camel Carrying a Group of Musicians (earthenware, Casa Milá apartment building, Barcelona, Spain, Chaco Canyon, New Mexico, Pueblo Bonito (Anasazi China), 411, 411 culture), 462-63, 462 Antonio Gaudí y Cornet, 1071, 1071 cameo, 249

Cassatt, Mary, 1005, 1008, 1013-14, 1017-19; Lydia in a

Chagall, Marc, 1028

chinoiserie, 813-14, 815 city-states: Greece (polis), 153-55; Italian Renaissance, Chair of Peter (in Saint Peter's Basilica), 757 Chios (?), Greek island, kore from, 171, 172 chaitva, 377 Ciudadela, Teotihuacan plaza, 449 chakra (Buddhist symbol), 427, 427 chip carving, 482 Chalcedon, Council of, 304 chi rho abbreviation, 280, 288, 294, 487-88 Civil War (United States), 998-99 chalice, 288 Chi Rho Iota page, Book of Kells (Hiberno-Saxon clapboard, 815 Chalkotheke, 187 manuscript), 486, 487-88, 487 Claricia, 539 Chiswick House, London, England, Richard Boyle, 936, Clark, William, 885 Chambord, Château of, 721 chamfering, 831 936, 941, 968 classical, use of term, 20 Champfleury (Jules-François-Félix Husson), 994 Champmol, France. See Chartreuse de Champmol chiton, 171 Classical (Greco-Roman) art: architecture, 666; copies after, 660, 662, 666, 966, 1063; eighteenth-century choir, 488, 512, 558, 558 Champollion, Jean-François, 113 Chola dynasty, 391 interest in, 931; idealism in, 19-20; motifs, 644, 645, Chrétien de Troyes, 549 696; Renaissance interest in, 609, 613, 641; sculpture, Chan Buddhism, 419, 440–41, 843, 847; see also Zen Christ (relief), Reims, Île-de-France, France, Nôtre-Dame copies after, 665; see also Greek art; Hellenistic art; Buddhism Cathedral, 567-68, 567 Roman art Chandella dynasty, 389-90 Chandigarh, India. See Punjab University Christ Healing the Sick, Rembrandt van Rijn, 798 classical orders, 163, 165, 165, 227, 645, 646, 654 classical style, 753, 931, 935; in American architecture, Christian art: architecture, 297-305, 541; early, 286-335, Chang'an (Tang capital), 845 966, 1063; in English architecture, 936; in French 495, 541; early transitional, 559; iconography of, 18, Chanhu-Daro, Indus Valley, 367 painting, 1029-30, 1048; post-World War I, 1074-75; cha no yu (tea ceremony), 860-61, 863 294, 306-7, 620-21; influence of Islamic art, 489; Chanson de Roland, La (The Song of Roland), 509, 559 Protestant destruction of, 681-83; in Renaissance, in Renaissance architecture, 645, 666 609, 614, 641, 683, 688, 695–96 classicizing style (early Christian art), 300-2 Claude Lorrain (Claude Gellée), 774, 793, 949, 998; Chapel of the Indians. See Guadalupe, Basilica of Christianity: in Britain, 486; description of, 291, 583; Landscape with Merchants, 774, 774, 793, 998 Middle Ages, 481, 609; origins of, 289-91; in Renais-Chardin, Jean-Siméon, 811-12; Soap Bubbles, 811, 812 Cleansing of the Temple (in Christian art), 306 sance, 614; in Roman Empire, 235, 284, 289–91, 297–308; in Scandinavia, 481; schisms and heresies, 304 Charioteer, Delphi, Greece, Sanctuary of Apollo, 157, Clemente Francesco, Untitled, 1150, 1150 181. 181 Charlemagne, 491, 492, 609 Christians: persecution of, by Romans, 274, 280, 291; Clement VII, Pope, 681 Charlemagne Window (stained glass), Chartres, Île-detreatment of, by Muslims, 339 Cleopatra, 116, 209 clerestory, 116, 261, 298, 492, 558, 558, 644 France, France, Cathedral, 559, 559 Christine de Pisan, 25, 615 Clifford, George, 743–45 Clodion (Claude Michel), 808; *The Invention of the* Charles I at the Hunt, Anthony Van Dyck, 784-85, 784 Christine Presenting Her Book to the Queen of France Charles I, of England, 781, 784-85, 800, 802 (French), 25, 25 Christ in Majesty (relief), Moissac, Toulouse, France, Balloon (model for monument), 808, 808 Charles II, of Spain, 776 Charles IV, of France, 574, 585 Saint-Pierre priory church, south portal, 518, 519, 525 cloison, 487 Charles IV, of Spain, 965 Christ in Majesty (wall painting), Tahull, Lérida, Spain, cloisonné, 324, 331, 333, 485, 488 Charles V, Emperor (Charles I of Spain), 681, 691, 705, San Clemente church, 525, 526, 529 cloister, 492 Christo (Javacheff), 1146; Running Fence (with Jeanne-Cloister Graveyard in the Snow, Caspar David Friedrich, 728 Claude), 1146, 1146 964, 964 Charles V, of France, 615 Christos (chi rho) monogram, 280, 288, 294 cloths of honor, 523 Charles V Triumphing over Fury, Leone Leoni, 691, 691 Christ Pantokrator (mosaic), Daphni, Greece, Church of Clottes, Jean, 16, 42, 49 Charles VI. of France, 638 the Dormition, 326, 326, 335, 519 Clouet, Jean, 720-21; Francis I, 720, 720, 741 Charles VII, of France, 638 Charles Sumner, Thomas Crawford, 970-71, 970 Christus, Petrus, 629-30; Saint Eloy (Eligius) in His Shop, Cluny, Burgundy, France, abbey church, 510, 514, 514, 576; carved portals, 517 629-30, 629, 728 Charles the Bald, 497-98 Cluny Lectionary (Romanesque manuscript), Pentecost Christ Washing the Feet of His Disciples page, Gospels of Chartres, Île-de-France, France, Cathedral, 546, 547, 553–61, 553, 555, 556, 557, 570; Charlemagne Window (stained glass), 559, 559; Furrier's Shop (stained page from, 528, 529 Otto III (Ottonian manuscript), 503-4, 504 chromolithography, 1028 cobra (Egyptian symbol), 94, 95, 104, 114 glass), 559–61, 559; Prophets and Ancestors of Christ chronophotography, 1059 (relief), 554, 554; Royal Portal, 554–55, 554; Saint Stephen and Saint Theodore (reliefs), 555, 555, 588; Codex Fejervary-Mayer (Aztec or Mixtec), 874, 875 Chrysaor, 166 Codex Mendoza (Aztec), page The Founding of Chryssolakkos (near Mallia), Crete, pendant in the form Tree of Jesse (stained glass), 557-59, 557 of two bees, 136-38, 137 Tenochtitlan, 877-78, 877 Church, Frederick Edwin, 997, 1001; Niagara, 997, 997, 1001 codex style, 455 Chartreuse de Champmol, Dijon, France, 617-18, 617, churches: basilica-plan, 297-300, 313, 488, 492, 494, Coeur, Jacques, house of, Bourges, France, 570-71, 570 618, 620, 624 499, 592, 643; central-plan, 298, 298, 300-5, 313, coffer, 264, 654, 684, 758 Chatal Huyuk, Anatolia, 64-65; shrine room at, 65, 65 château. 721, 1062 323-24, 492, 592, 663, 753, 950; cruciform-plan, coffered ceiling, 299 302, 558; early medieval, 488; facades, 755, 755 Cogul, Catalonia, Women and Animals (rock-shelter chattri, 831, 833 Gothic, 558, 558; Greek-cross plan, 663, 701, 950; of painting), 48, 49 Chaucer, Geoffrey, 576 Chavin de Huantar (Early Horizon period), 457 Late Roman Empire, 281, 283; Latin-cross plan, 660, coiling: basketry, 888; pottery, 889 Chenonceaux, Château of, Loire Valley, France, 722, 722, 660, 701; pilgrimage, 512-14; plan of, 298; Romancoinage: Greek, 205; Persian, 88; techniques, 89, 89 esque, 510-30; Scandinavian, 483-84 Colbert, Jean-Baptiste, 769, 770, 785 723 Chéret, Jules, 1028 cherub, **289**, **882**, **948** Church of the Dormition, Daphni, Greece: Christ Cold Mountain 3, Brice Marden, 1166, 1166 Pantokrator (mosaic), 326, 326, 335, 519; Crucifixion Cole, Thomas, 974-75, 996; The Course of the Empire series, 974; The Oxbow, 974-75, 974, 996 (mosaic), 326-27, 327, 335 Chesneau, Ernest, 1007 Church of the Holy Cross, Lake Van, Armenia, 324, 324 collage, 30, 1054, 1126, 1155; Japanese, 434 chevron, 145, 531, 902 chiaroscuro, 685, 753, 773, 791 Church of the Monastery of Christ in Chora (now Kariye collectors, 25, 931, 1131 Chicago, Illinois. See Marshall Field Warehouse; Sears Muzesi), Istanbul, Turkey, 329, 329; Anastasis, 330, Colleoni, Bartolommeo, 665 Tower: World's Columbian Exposition 330; First Steps of Mary, 330, 330 collodion, 987 Chicago, Judy (Judy Cohen), 1147–48; *The Dinner Party*, 1147–48, *1147*, 1164 Churriguera family, 776 Cologne, Germany, 586; Cathedral, Gero Crucifix, 501-3, Churrigueresque style, 755, 776, 817 502, 523, 597 ciborium, 298 colonialism, 681-83, 776, 817, 911-12 Chicago Arts and Crafts Society, 1068 Ci'en Temple, Xi'an, Shanxi, China, Great Wild Goose Colonna, Francesco, 677 Chicago School (architecture), 1064-65 colonnade, 101, 101, 117, 158, 165, 701, 757 Chicano artists, 1158 Pagoda, 413, 413 Cimabue (Cenni di Pepi), 600-4; Virgin and Child colonnette, 558, 561 Chichen Itza, Yucatan, Mexico, 455-56; ball court, 445; Enthroned, 602, 602 Castillo pyramid, 455-56, 455, 456 colophon, 486, 490, 840 color, 29, 785, 987, 1046-47, 1055, 1078 Chien Andalou, Un (film), Lorca and Buñuel, 1087 Cincinnati Contemporary Arts Center, 1161 cinerary urns: Etruscan, 230; Roman, 243 Color Field painting, 1118–20, 1123 Chihuly, Dale, 22; Violet Persian Set with Red Lip Wraps, colorist tradition, French, 1039 circuses, 235 22 22 Circus housing project, Bath, England, John Wood the colossal order, 754, 755, 755 children: in art, 246; as influence in African art, 912-14; Colosseum, Rome, Italy, 252-53, 252, 253, 1145 Elder and John Wood the Younger, 938, 939 Rousseau's theories of education, 955 Child with Toy Hand Grenade, New York, Diane Arbus, Cistercians, 514-16; architecture of, 515-16, 576; book Colossus of Rhodes, 102 1141, 1141, 1156 production of, 529; window adornments, 559 column, 101, 165, 165, 226, 645; Egyptian, 101, 101; citadel, 79, 143, 198 Minoan, wood, 134; Persian, 87, 101 Chilkat Tlingit people, 887 Column of Trajan, Rome, Italy, 261-62, 261, 720; Romans China, 837, 843; archeology, 397; Bronze Age, 399-402, cities and city planning: China, 845-46; Egypt, 108-9, 843; Neolithic period, 57, 397-99 198; Etruscan, 223-25; Greek, 198-99; Near East Crossing the Danube and Building a Fort (relief), 262, Chinese art, 394-419, 836-51; architecture, 406-7, 409, (Neolithic), 63-65; orthogonal plan, 198-99; Paris, 412-13, 845-46; ceramic technology, 57, 363; ico-1080-81; Rome, 235, 238-41, 266-68 column statues, 554-55 City Beautiful movement, 1063 Comb, carved (French or Swiss), 549 nography of, 404, 406; influence on Islamic, 363; influence on Japanese, 429, 430; official academy Cityscape (wall painting), Boscoreale (near Pompeii), combine, 1126 comic books, as sources for art, 1129 style, 838-39, 841-42; painting, 407-8, 414, 838-42, Italy, House of Publius Fannius Synistor, 222, 223, Commentaries by Beatus and Jerome: Battle of the Bird 846-51; sculpture, 406, 409, 410, 412; silk

City Square, Alberto Giacometti, 1111, 1111

technology, 349, 407; six principles of, 407

and the Serpent page from, Emeterius and Senior

Emeterius and Senior, 486, 490, 490, 527 Correggio (Antonio Allegri), 686-87, 714; Assumption of Cubism, 1048-62, 1112, 1163; Analytic, 1051-54, 1058-Commentary on Isaiah by Jerome (Romanesque manuthe Virgin (fresco), Parma, Italy, Cathedral, 686-87, 687 59, 1060, 1077, 1080, 1085, 1097, 1099, 1104, 1118; script), Tree of Jesse page from, 529, 529, 557 Cortés, Hernán, 882 rejection of, 1074; responses to, 1055-62; Synthetic, Commentary on the Apocalypse by Beatus of Liébana Cortona, Pietro Berrettini da. 764-65, 773: Triumph of the 1054-55, 1061 (Romanesque manuscript), 490; Flood page from, Cubi XIX, David Smith, 1132, 1133 Barberini (ceiling fresco), Palazzo Barberini, Rome, Stephanus Garsia, 527-28, 527 Italy, 764-65, 765 Cubo-Futurism, 1060, 1075, 1097 Commodus, 271-72, 273 Cosmati work 543 cuneiform writing, 65, 66 Commodus as Hercules (Roman), 271-72, 271 cosmology, Chinese, 845 curators, 26 Common Grackle. See Audubon, John James, Birds of Curry, John Steuart, 1100; Baptism in Kansas, 1100, 1100 Cosquer, Henri, 36 Cosquer Cave, Cap Morgiou, France, 49 America curtain wall, 1073 Curtis, Edward S., 886; Hamatsa dancers, Kwakiutl, Commune of 1871 (France), 995 cave painting, 46; Auk, 36, 36, 41 Communism, 851, 1048, 1075, 1083, 1102 Cossutius, 211 Canada, 886, 886 complementary colors, 987, 1036 Costanza Bonarelli, Gianlorenzo Bernini, 760, 760 cutaway drawings, 31 Composer Moussorgsky, The, Ilya Repin, 996, 996, 1077 Cotán, Juan Sánchez, 777; Still Life with Quince, Cabbage, Cuthbert, Saint, 530 Composite order, 227, 227, 254, 268, 662, 757 Melon, and Cucumber, 777, 777 Cuvilliés, François de, the Elder, 805; Amalienburg, composition, 29, 933 Coubertin, Pierre de, 179 Mirror Room, Nymphenburg Park, near Munich, Composition with Red, Blue, and Yellow, Piet Mondrian, Council of Trent, 683, 699 Germany, 805, 805, 939 1078, 1078, 1096 Counter-Reformation, 751, 753, 757 Cuyp, Aelbert, 793; Maas at Dordrecht, 793, 793 compound pier, 513, 558 Counter-Reliefs, 1062 Cuzco, Peru, 879; Santo Domingo, Church of, 879-80; Comte, Auguste, 979, 994 country houses, 711, 967 see also Temple of the Sun Conceptualism, 1131, 1134-35 Courbet, Gustave, 992-93, 994, 1005-6, 1007, 1009, 1010, Cyclades, Greek islands, 128; "frying pan" terra-cotta conch, 309, 492 1033; The Stone Breakers, 992-93, 992, 999, 999, 1033 vessel, 129-30, 129, 145; Harp Player, 131, 131, 209; concrete, Roman invention of, 235-37 Cour Carré. See Louvre, Palais du women figurines, 130-31, 130 cone mosaics, 66; technique, 68 course, 50, 145, 225, 643, 900 Cycladic culture: Bronze Age, 129-31; Neolithic period, Confederate Dead Gathered for Burial, Antietam, Course of the Empire, The (series), Cole, Thomas, 974 129; wall painting, 141 September 1862, Alexander Gardner, 998, 999 courtly love, 548, 549, 550, 572 cycle, 727 Confrérie de Saint-Jean, 574 Court of Honor. See World's Columbian Exposition cyclopean construction, 144-45 Confucianism, 404-6, 407, 412, 836, 837 Court painters: English, 741–45; French, 719–24 cylinder seals, Sumerian, 71-73, 73-74 Confucius, 405 Court style (French Gothic), 569, 575, 585; manuscript Cyrus the Great, 85, 88, 89, 177 cong jade piece (Chinese Neolithic), 399, 399 illumination, 573-74 Congregation of the Oratory, 767 D Courtyard, The, Allan Kaprow, 1108, 1108, 1124 connoisseurship, 25, 32, 931 courtyards, 644, 645, 662 D', de: names with, are often listed under next element Conques, France, Sainte-Foy abbey church, 512, 512, Couture, Thomas, 1007 of name (e.g., La Tour, Georges de) 513, 556; carved portals of, 517; Saint Foy (reliquary cove ceiling, 707 Dacians, 261, 282 statue), 508, 509, 512, 513, 583 Cowherd on the Route du Chou, Pontoise, A, Camille "Dada, Surrealism, Fantastic Art" exhibition (New York, conservation and restoration, 124, 202; of churches, 577, Pissarro, 1010, 1011 1936), 1114 Cow with the Subtile Nose, Jean Dubuffet, 1110, 1111, 1153 Cox, Kenyon, 1090, 1097; The Arts (mural), Washington, 663; Riace Warriors, 182; Sistine Chapel frescoes, 696 Dada (magazine), 1083 Conservatori, Palazzo dei. See Campidoglio, Piazza del Dada Dance, Hannah Höch, 1084, 1084 Constable, John, 948-49, 1010; The White Horse, 948, D.C., Library of Congress, 1090, 1090 Dada movement, 1083-85, 1088, 1124, 1125; Berlin, Coyote: I Like America and America Likes Me, Joseph 1083-84, 1085; Japan, 1124; New York, 1085; Paris, Constantina, mausoleum of, 300 Beuys, 1151, 1151 Constantine I, the Great, 701 C. R. (Carolus Rex), 1005 dado, 227, 227, 250, 329, 342, 569, 693, 805 Constantine I the Great, 271, 280-84, 290. 297 crackle glaze technique, 419 craft arts: English, 814, 937; French, 813–14; French Daguerre, Louis-Jacques-Mandé, 986-87; The Artist's Constantine Speaking to the People (relief), Rome, Italy, Arch of Constantine, 282, 283, 313 Studio, 986-87, 986 Court, 722-24; handmade vs. industrial, 1004-5; daguerreotype, 986 Constantine the Great (Roman statue), 283-84, 283 Italian Renaissance, 672-77; low prestige of, 1162-64; Daitoku-ji, Kyoto, Japan, 860; Juko-in, 860, 861 Constantinople, 280, 290, 308, 309–13, 323, 350, 609, see also individual arts, e.g., pottery Dalí, Salvador, 1087, 1112; Accommodations of Desire, 614; seizure of, by Fourth Crusade, 549, 595 Cranach, Lucas, the Elder, 736; Martin Luther as Junker 1087, 1087 Constantius II, 284, 309 Jörg, 736, 736 Dalou, Aimé-Jules, 995; Breton Woman Nursing Her Constructivism, 1075, 1079, 1104 Crane, Walter, 1070, 1071 Child, 994, 995, 1005 content. 29 Crawford, Thomas, 970–71, 996; Armed Liberty (U.S. Capitol dome), 971; Charles Sumner, 970–71, 970 damnatio memoriae, 279 contextualism, 32 Dance, The (sculptural group), Jean-Baptiste Carpeaux, contrapposto, 690, 942 Creation and Fall (relief), Modena, Emilia, Italy, Cathe-982. 982 dral, Wiligelmus, 543, 543 convents, 615 Dance staff depicting Eshu (Yoruba culture), Nigeria, creation myths: Egypt, 96; Greek, 157 crenellation, **83**, **579**, *579*, **969** Cook, James, 902, 903-4 911, 919, 919 Cope, from the Treasury of the Golden Fleece (Flemish), Dante Alighieri, 549 Crete, 128, 131-42; see also Minoan culture 634, 635 Danube Landscape, Albrecht Altdorfer, 737-38, 737, 747 Copernicus, Nicolaus, 786 Crispus, 297 dao. 404 criticism, realist, 994 crocket, 558, **570** Copley, John Singleton, 818-19, 945-46; Boy with a Daodejing, 404 Squirrel, 819; Mrs. Ezekiel Goldthwait (Elizabeth Lewis), Daoism, 404, 407, 415, 836, 837 819, 819, 945; Watson and the Shark, 946, 946 Croesus, king of Lydia, 88, 89, 157 cromlechs (menhirs), **53** Daphni, Greece, Church of the Dormition: Christ Coppo di Marcovaldo, Crucifix, 595–97, 595, 604 Pantokrator mosaic, 326, 326, 335, 519; Crucifixion corbel, 253, 310, 347, 578 cross (Christian symbol), 294 mosaic, 326-27, 327, 335 cross-hatching, 673, 674, 791, 896 corbeled arch, 143, 225 Darby, Abraham, III, 943; bridge over Severn River, crossing, 492, 558, 643 crossing tower, 558 corbeled vault, 50, 145, 452 Coalbrookdale, England, 943 corbeling, 32, 50 daric (Persian coin), 88 corbel tables, 541 cross vault 226 Darius and Xerxes Receiving Tribute, Persepolis, Iran, Corcoran Gallery (Washington, D.C.), 1161 Crouching Woman, Erich Heckel, 1042, 1042 ceremonial complex, 87-88, 87 Córdoba, Spain, Great Mosque, 310, 344-47, 346, 354, Crucifix, Coppo di Marcovaldo, 595–97, 595, 604 Darius I, 85-86, 89 crucifixes, 521; wooden, Romanesque, 523 488 Darius III 88 core glass, 112, 120-21 Crucifixion (in Christian art), 289, 307 dating of art, 143; Aegean art, 128, 129, 143; archeological methods, 57, 71, 89, 205; prehistoric art, 49 Corinth, Greece, 155, 235; pitcher (olpe) from, 161, 161, Crucifixion. See Grünewald, Matthias, Isenheim Altarpiece Crucifixion, The, Hildesheim, Germany, Saint Michael abbey church, Doors of Bishop Bernward, 501, 501 Daubigny, Charles, 1005, 1009 174, 197; vase painting, 161, 173 Corinthian order, 163, 165, 165, 200, 210-11, 227, 247, Daumier, Honoré, 985, 993–95, 1005, 1026, 1048; The Third-Class Carriage, 993–95, 993; This Year, Venuses Again . . . Always Venuses!, 994, 995, 1008, 1048 253, 268, **644**, 645, 645, **981**; Romanesque, **521**; Crucifixion (mosaic), Daphni, Greece, Church of the Roman modification of, 227 Dormition, 326–27, 327, 335 David, Jacques-Louis, 931, 953, 956-58, 984; Death of Cornaro Chapel. See Santa Maria della Vittoria Crucifixion, from Rabbula Gospels (manuscript), 320, 321, corncob capitals, Benjamin Latrobe, 969, 969 326, 333 Marat, 956, 957; Napoleon Crossing the Saint-Bernard, Corner Counter-Relief, Vladimir Tatlin, 1062, 1062 Crucifixion with Angels and Mourning Figures (book 957-58, 957; Oath of the Horatii, 956-57, 956, 961, 984 cover), Lindau Gospels (Carolingian manuscript), cornice, 163, 165, 165, 227, 227, 302, 389, 645, 645, David, King, 291, 333 646, 695, 755, 755, 760 497-98, 497, 502 David, Donatello, 650, 650, 689 Corot, Jean-Baptiste-Camille, 990, 1005, 1007, 1009, 1010, cruciform plan, 302, 512, 539 David, Gianlorenzo Bernini, 753, 759, 760, 773 Crusades, 323, 328, 510, 549, 552, 569, 609 1011, 1014; Sèvres-Brimborion, View toward Paris, 990, David, Michelangelo, 689, 689, 759 crypt, 298, 499, 525 David the Psalmist, from Paris Psalter (manuscript), Corporation of Artists, Painters, Sculptors, and Crystal Palace, London, England, Joseph Paxton, 978, 333-34. 333 Engravers (French Impressionists), 1010 978, 980, 1069 Davies Arthur B 1096

corporations, as art sponsors, 1131, 1136

cubicula. 243. 292

(with Ende), 490, 491, 539; colophon page from,

Double Negative, Michael Heizer, 1145, 1145 Dead Christ with Angels, Rosso Fiorentino, 712, 713, 721, 650-51, 651 double-winged motif (Persian), 342 Desk, Hector Guimard, 1070, 1070 747 Dessau, Germany. See Bauhaus Building Doubting Thomas (relief), Santo Domingo de Silos, Dead Sea Scrolls, 291 Dean George Berkeley and His Family (The Bermuda de Stijl movement, 1077-79 Castile, Spain, abbey church, 516-17, 516 Group), John Smibert, 818, 818 Devi, 372, 387 dove (Christian symbol), 294 devotional images, 674; Romanesque, 521-23 dragons (Chinese motif), 843 death masks, Roman, 243 drawbridge, 579, 579 Death of Caesar, Jean-Léon Gérôme, 983-84, 983, 1090 devotional statues, German Gothic, 589-90 Death of General Wolfe, Benjamin West, 945, 945, 957 Dharmaraja Ratha, Mamallapuram, Tamil Nadu, India, drawing, 30 Drawing Lesson, The, Jan Steen, 23, 23 Death of Marat, Jacques-Louis David, 956, 957 388, 389, 391 Diadem (Greek), 208, 208 Drawing XIII, Georgia O'Keeffe, 1098, 1098 Death of Sarpedon (vase painting), Euphronios, 176-77, 177, 216 Diaghilev, Serge, 1059 Dream of Henry I, John of Worcester, Worcester Chronicle Death of the Virgin, Caravaggio, 781 diagonal perspective, 30 (English manuscript), 532, 532 Diary, Roger Shimomura, 25, 25 Dreiser, Theodore, 1102 De Claris Mulieribus (Concerning Famous Women) (illuminated book), page with Thamyris, 615 Diderot, Denis, 929-31 dressed stone, 132, 375, 475 deconstruction, 1153, 1156 Didyma, modern Turkey, Temple of Apollo, 164 drillwork, 255, 308 Diebenkorn, Richard, 1123; Girl on a Terrace, 1122, 1123 drum, 165, 165, 226, 264, 342, 641, 699, 831, 950 Decorated style (English Gothic), 570, 578 "Die Fahne Hoch," Frank Stella, 1132, 1132 dry-plate process (photography), 1095 decorative arts: Chinese, 842-44; Persian, 88; Roman, 255; Victorian, 1004–5 decumanus, 266, 267 Diego de la Cruz, 637; Visitation (attributed to) (panel drypoint, 789, 791 from altarpiece), 637, 637 du Barry, Madame, 812, 951; Pavillon du (see Dietrich II, bishop of Wettin, 588-89 Louveciennes, Château de) Deer Park (Sarnath), 371 Dijon, France. See Chartreuse de Champmol Dubuffet, Jean, 1109-11, 1153; Cow with the Subtile Nose, Deesis group, 331 Degas, Edgar, 1005, 1008, 1012–13, 1027, 1059; Ballet 1110, 1111, 1153 diminution, 30 Duccio di Buoninsegna, 597; Maestà Altarpiece, Siena Dinner Party, The, Judy Chicago, 1147-48, 1147, 1164 Rehearsal, 1008, 1012–13, 1012; Little Dancer Fourteen Dinsmoor, Samuel Perry, 24; Goddess of Liberty and the Cathedral, 597, 597; detail, Virgin and Child in Majesty, Years Old. 1013, 1013 Destruction of the Trusts by the Ballot, 24–25, 25 "Degenerate Art" exhibition (Germany, 1937), 1081 583, 596, 597 Diocletian, 274, 280, 290 Duchamp, Marcel, 1022, 1085, 1097, 1127, 1128, 1134, deification of rulers. See apotheosis 1155; Bride Stripped Bare by Her Bachelors, Even (The Dionysius, 547 Deir el-Bahri, Egypt: Large Glass), 1085, 1086, 1127; Fountain, 1022, 1022, Dionysos, 156, 209 funerary temple of Hatshepsut, 116-17, 117, 158, 237 1085, 1127, 1163 Dionysos with Maenads (vase painting), Amasis Painter, Hatshepsut as Sphinx (sculpture), 116, 117 tomb of Nefertari, 123-24; Queen Nefertari Making du Châtelet, Madame, 805 174-75, 174 duen fobara (Ijo), 923-24 diorama, 986 an Offering to Isis (wall painting), 93, 96, 123, 123, Dioscorides, Pedanius, De Materia Medica (manuscript), Dunhuang, Gansu, China, The Western Paradise of Wild Blackberry from, 318, 319-20 Amitabha Buddha (wall painting), 412, 412, 414 Déjeuner (Luncheon), Le, François Boucher, 811, 811 Dioscuri (ancient statue), 700 Dunn, Dorothy, 889 Déjeuner sur l'Herbe (The Luncheon on the Grass), Le, Édouard Manet, 1006, 1007, 1008–9, 1015 dipteral temple, 163, 164, 164 Dupérac, Étienne, Piazza del Campidoglio, Rome (print), diptych, 284, 305, 486, 629, 1130; Carolingian and 699-700, 700 de Kooning, Elaine, 1118 Ottonian, 499-501 Dura-Europos, Syria, 295-97 de Kooning, Willem, 1116, 1117-18, 1121, 1122, 1123, Dipylon Cemetery, Athens, Greece, vase from, 159, 159, Christian house-church at, 297, 297 1131; Woman I, 1118, 1118 synagogue at, 296, 296; Finding of the Baby Moses, Delacroix, Eugène, 950, 953, 961-62, 985, 988, 1005, 173 Diquis culture, 456 1039, 1093; The Twenty-eighth of July: Liberty Leading Director's Room. See Glasgow School of Art Dürer, Albrecht, 624, 729, 733-35, 738, 785, 789; Adam and the People, 961, 961, 1039; Women of Algiers, 961-62, Eve, 734, 734; Four Apostles, 735, 735; Four Horsemen Discovery and Testing of the True Cross. See Piero della 962, 1039, 1080 of the Apocalypse, 733, 733; Saint Jerome in His Study, Delaroche, Paul, 984, 988 Francesca 734–35, 734; Self-Portrait with a Sprig of Eryngium, Delaunay, Robert, 1055-57, 1097; Homage to Blériot, Discus Thrower (Diskobolos), Myron, 152, 153, 183, 189 732, 733; Wehlsch Pirg (Italian Mountain), 733, 733 Dish, silver (British-Roman), 285, 285 1055-57, 1056 Disk of Enheduanna, Ur (modern Muqaiyir, Iraq), 73-74, Delaunay-Terk, Sonia, 1057; Wearing a Simultaneous Durga, 387-88, 389 Durga as Slayer of the Buffalo Demon (relief), 7.3 Dress at the Bal Bullier (photograph), 1057, 1057 di sotto in sù, 667 Mamallapuram, Tamil Nadu, India, 388, 388 Delisle, Léopold, 616 Delivery of the Keys to Peter (in Christian art), 306 divergent perspective, **30** divination, 225, 233 Durham, Northumberland, England, 530-31; castle-Delivery of the Keys to Saint Peter (wall fresco), Pietro Perugino, 669–70, 669, 686, 691 monastery-cathedral complex, 530, 530, 531; Divine Comedy, 549 Cathedral, 530, 531, 531, 551, 557 Delphi, Greece, 157–58, 166–68; see also Sanctuary of Apollo; Sanctuary of Athena; Siphnian Treasury; diviners, 916-19 Dur Sharrukin (modern Khorsabad, Iraq), 79 Djenné, Mali, 474, 911; Great Friday Mosque, 474, 475 citadel and palace complex of Sargon II: guardian figure from, 79, 79; reconstruction drawing, 78 Djoser, Egyptian king, 99 Temple of Apollo Djoser, pyramid of, Saqqara, Egypt, 99–102, 100 Ziggurat, 79 Deluge (Flood), The (fresco), Florence, Italy, Santa Maria Djoser's funerary complex, Saqqara, Egypt, 99–102, 100; Dutch art: Baroque, 786-800; iconography, 793, 795, Novella, Paolo Uccello, 624, 624, 658, 658 North Palace, walls with engaged columns, 100, 101 797; Rationalism, 1077-79 De Materia Medica (manuscript), Wild Blackberry from, Doesburg, Theo van, 1077, 1082 Dutch Republic, 776, 786; see also Netherlands, the Pedanius Dioscorides, 318, 319-20 Dogon people (Mali), 922 Dyck, Anthony Van, 784–85; Charles I at the Hunt, Demeter, 156 dogu earthenware figure (Jomon period, Japan), 424, 784-85, 784 Demeter, Persephone, and Triptolemos (stela), Eleusis, dyeing technology, Andean, 458 Greece, 195-96, 196 424-25, 425 Doll (*biiga*) (Mossi culture), Burkina Faso, 913, 913 dolls, fertility, 913 Dying Gallic Trumpeter, Epigonos (attributed to), 211-12, democracy, Greek, 155 212 Demoiselles d'Avignon, Les, Pablo Picasso, 1049-51, Dying Warrior, Aegina, Greece, Temple of Aphaia, 1050, 1052, 1075, 1118 dolmen, 51, 53, 53 dome, **226**, **298**, 302, 310, **375**, 829 Dome of the Rock, Jerusalem, 341–42, *343* 168-69, 168, 212 demotic writing, 113 Dynamism of a Dog on a Leash (Leash in Motion), Giacomo Balla, 1059, 1059 Denial of Peter (in Christian art), 307 Dominicans, 549 Denis, Saint, 551 Denmark, ceramic vessels (Neolithic), 57-58, 57 Domitian, 252 E Donatello (Donato di Niccolò Bardi), 649-50, 660, 665, 667; David, 650, 650, 689; Feast of Herod (panel of eagle (Christian symbol), 294 Deogarh, Uttar Pradesh, India, Vishnu Temple, 383-86, Eakins, Thomas, 1001–2, 1091, 1094; The Gross Clinic, baptismal font), Siena, Italy, Cathedral Baptistry, 649, 384, 390; Vishnu Narayana on the Cosmic Waters 1001-2, 1001; The Pole Vaulter, 1002, 1002 649; Gattamelata (Equestrian Monument of Erasmo (relief), 384-86, 385, 387 Earrings (Greek), 209, 209 Departure of the Volunteers of 1792 (The Marseillaise), da Narni), Padua, Italy, 664, 665; Mary Magdalen, 650, Earspool (Moche culture, Peru), 460, 460 François Rude, 962, 963, 982 earthenware, 57 Dong Qichang, 847-48, 866; The Qingbian Mountains Deposition (detail of altarpiece), Rogier van der Weyden, earthworks, 1144-46 626-27, 626 (hanging scroll), 847-48, 847 Easter Island, 895, 901-2 Dong Yuan, 848 Derain, André, 1039-40, 1042, 1060; View of Collioure, Eastern Orthodox Church. See Orthodox Church donjon (keep), 531, 579, 579 1039, 1039 East Village, New York City, 1152 Derrida, Jacques, 1153, 1155, 1156 Doors of Bishop Bernward, Hildesheim, Germany, Saint Ebbo, archbishop of Reims, 495 Derry Sculpture, Antony Gormley, 1159, 1159 Michael abbey church, 500, 501, 595; The Temptation and The Crucifixion from, 501, 501 Ebbo Gospels (Carolingian manuscript), Matthew the Descartes, René, 786 Evangelist page from, 495, 496 Descent from the Cross (Deposition) (in Christian art), 307 Dorians, 153 Doric order, 163, 165, 165, 210, 227, 645, 645; Etruscan Ecclesius (Arian bishop of Ravenna), 313 Descent into Limbo (in Christian art), 307 modification of, 227 echinus, 163, 165, 165 Descent of the Amida Trinity (triptych, Kamakura period, École des Beaux-Arts, 929, 1062, 1090 Dormition of the Virgin (relief), Strasbourg, France, Japan), 440, 440

Cathedral, 587, 587

Desiderio da Settignano, 650-51; Tomb of Carlo

Marsuppini, Florence, Italy, Church of Santa Croce,

Day-Glo colors, 1154

double-ax motif (Minoan), 133, 138

École Romane, l' (French), 1030, 1048

Education of the Virgin, Villafranca del Panadé, entablature, 163, 165, 165, 225, 227, 449, 645, 645, Ghent Altarpiece (with Hubert van Eyck), Ghent, Barcelona, Spain, San Francisco church, from Virgin 660, 755, 755, 756 Flanders, Cathedral of Saint-Bavo, 612-13, 612, and Saint George (altarpiece), Luis Borrassá, 584, 585 622-23, 622, 633, 652; details Adam and Eve, entasis, 164 Edward III, of England, 615 Entombment, Caravaggio, 768, 768, 778, 781 Edward VI, of England, 742–43 Entombment, Jacopo da Pontormo, 713-14, 713, 747 Man in a Red Turban, 623–24, 623 egg-and-dart moldings, 255 Entombment, the (in Christian art), 307 Portrait of Giovanni Arnolfini(?) and His Wife, Egypt: Amarna period, 119–22; ancient, 90–125; dynastic Entry into Jerusalem (in Christian art), 306 Giovanna Cenami(?), 624-26, 625, 629, 793 chronology, 94; Early Dynastic period, 94–99; Middle Eos, 156 Eyck, Lambert van, 621 Kingdom, 108–14; Neolithic and predynastic period, ephemeral arts, 30 Eyck, Margareta van, 621 93–94; New Kingdom, 114–25; Old Kingdom, 99–108; Ephesos, Asia Minor, Temple of Artemis, 102 Ptolemaic, 209; gueens of, 116-17; Upper and Lower, Ephesus, Council of, 299 94; writing, 97, 107, 113, 319 Epic of Gilgamesh, 67 facade, 145, 160; Baroque and Rococo, 755, 755; Egyptian art: architecture, 99–104, 108–9, 226, 237; Epidauros, Greece, theater at, 209–10, 210 Renaissance palace, 645, 645, 646 artists' status, 111; beads, 357; ceramic technology, Epigonos (attributed to), Dying Gallic Trumpeter, 211-12, Fagus Factory, Alfeld-an-der-Leine, Germany, Walter Gropius (with Adolph Meyer), 1072, 1073, 1081, 1082, Neolithic period, 57; compared to Greek, 158, 160, 212 169–70; compared to Minoan, 136; domestic, 120–22; Epistles, 290 1135, 1139 funerary art, 122-24, 160; influence on Aegean, 128; Eguestrian Monument of Bartolommeo Colleoni, Andrea faience: Egyptian, 112; Minoan, 134 influence on Greek, 158, 161, 162; influence on del Verrocchio, 665, 665 Faiyum style (Egypt), 278 Minoan, 131-32, 137; influence on Mycenaean, 149; equestrian monuments, 23-24, 271, 665 faktura, 1062 Erasmus of Rotterdam, 681, 738 portraits, 111-12, 232; symbols of, 94, 95-97, 104, falcon (Egyptian symbol), 94 114, 121; temple construction, 51 Erechtheion, Athens, Greece, Acropolis, 186, 187, Fall of the Giants (fresco), Giulio Romano, 718, 719 191–92, *192*; Porch of the Maidens, 192, *192*, 266 Family of Charles IV, Francisco Goya y Lucientes, 965, Eiffel, Gustave, 1069 Eiffel Tower, Paris, France, Gustave Eiffel, 1069-70, ere ibeji (Yoruba), 913-14, 924 965 1069, 1075, 1138 Ergotimos 173 Family of Vunnerius Keramus (Roman portrait), 279-80, Eight, The, 1094, 1096-97 Ergotimos and Kleitias, François Vase, Greek, 173-74, 173 279 Ernst, Max, 1088, 1089, 1112; The Joy of Life, 1088, 1088 eightfold path (Buddhism), 371 fang ding, 401 fang ding bronze (Shang dynasty, China), 401, 401 Eirene, 207 Eros. 156 Eitoku, Kano, 860; Fusuma, Kyoto, Japan, Daitoku-ji, Escorial, El, Madrid, Spain, Juan Bautista de Toledo (with Fang people (West Africa), 922-23 Juko-in, 860, 861 Juan de Herrera), 745-46, 745, 776 Fan Kuan, 416: Travelers among Mountains and Streams. E. S. Engraver, Virgin and Child in a Garden with Saints Ekkehard and Uta (statues), Naumburg, Germany, 416-17, 416 Margaret and Catherine (or Large Enclosed Garden), Cathedral, 589, 589 Farm Securities Administration, photography program, Elam. 63, 84-85 674 674 1103 Eshnunna (modern Tell Asmar, Iraq), votive statues Eleanor of Aquitaine, 550, 551, 552, 576 Farnese, Palazzo, Rome, Italy, 645, 645, 759, 763-64, electron spin resonance dating, 49 from, 69-70, 70 763, 772; ceiling, Annibale Carracci, 759, 763-64, 763, Elephanta, Maharashtra, India, Cave-Temple of Shiva, Esoteric Buddhism, 431-32; art of, 440 Esprit nouveau, L' (magazine), 1079 Este, Isabella d', 705–6 386-87, 386; Eternal Shiva (relief), 387, 387, 393 Farnese, Villa, Caprarola, Italy, Giacomo da Vignola, 703–4, 703, 718, 753, 770 Eleusis, Greece: Demeter, Persephone, and Triptolemos (stela), 195-96, 196; Sanctuary of Demeter and Este family, 641 Farnese family, 645, 703 Estes, Richard, 1142; Prescriptions Filled (Municipal Persephone, 195, 196 fascism, 1058, 1059, 1112 elevation, 31, 163, 936 Father Explaining the Bible to His Children, A, Jean-Building), 1142, 1143 elevators, 1065 Esubiyi (Nigerian artist), 914 Baptiste Greuze, 812 Eleven Color Photographs, plate Bound to Fail, Bruce Étampes, Anne, duchess of, 721; Chamber of (see Fauvism, 1039-40, 1052, 1055, 1057, 1077, 1085, 1097, Fontainebleau, Château of) etching, **789**, **791**, 798, **964**, **1005** Nauman, 1134, 1135 1099 Elgin, Lord, 84 Feast in the House of Levi, Veronese, 680-81, 680, 707, Eternal Shiva (relief), Elephanta, Maharashtra, India, Elgin Marbles, 84, 188–89, 189 Cave-Temple of Shiva, 387, 387, 393 Ethelbert of Kent, King, 486 Elizabethan style, 939 Feast of Herod (panel of baptismal font), Donatello, 649, Elizabeth I, of England, 706, 742 Elizabeth I as a Princess, Levina Bening Teerling, Étienne Chevalier and Saint Stephen. See Fouquet, Jean, Feast of Saint Nicholas, The, Jan Steen, 795-97, 795, 811 attributed to, 742, 742 Melun Diptych Feather cloak (the Kearny Cloak) (Hawaiian), 903, 903 Emancipation Group, The, Thomas Ball, 999, 999 Etruria pottery factory (Wedgwood's), 937 featherwork, 903 February, page. See Limbourg, Paul, Herman, and Jean, Très Riches Heures (illuminated manuscript) Federal Art Project, 1105 embankment, 579 Etruscans, 173, 223–33; architecture, 225–29; artists and emblemata, 272, 486 artisans, 232; influence on Romans, 223, 235-37 emblem books, 795 Eucharist (Christian rite), 292-93, 620 embodiments (Christian symbols as), 294 Eugene IV, Pope, 638, 646 Federal style, 967 Federal Theater Project, 1105 embroidery, 458, 534; Anglo-Saxon style, 534, 534; Eumenes II, 212 English Gothic, 580-82; Peruvian, 457-58 Federal Writers' Project, 1105 Euphronios, 176-77; Death of Sarpedon (vase painting), Emeterius and Senior, Commentaries by Beatus and 176-77, 177, 216 Federico da Montefeltro, Piero della Francesca, 659, Jerome: (with Ende) Battle of the Bird and the Serpent Euripides, 209 666-67, 667 page from, 490, 491, 539; colophon page from, 486, Europe: Bronze Age, 58-59; Medieval, 480-505; Neofeminist art, 1146-49, 1156-57 lithic, 47-58; Paleolithic, 37-47 Feminist Art Program, California Institute of the Arts (CalArts), 1147 490, 490, 527 emotionalism in art, 747, 753 European art: influences on American art, 1090-93, Emperor Justinian and His Attendants, Ravenna, Italy, San 1150-52; post-World War I, 1073-90; post-World War feng shui, 845 Ferdinand I, of Aragon, 637, 728 Vitale, 288-89, 288, 314 II, 1109-12; resurgence of, in 1980s, 1150-52 Empire's Lurch, Martin Puryear, 1165, 1165 Ferdinand VII, of Spain, 966 Eusebius, 280, 297 Empire State Building, New York City, 1065 Evans, Sir Arthur, 129, 143 Ferrara, Italy, 641 Empress Theodora and Her Attendants, Ravenna, Italy, Evans, Walker, 1155 Fertile Crescent, 62–63 fertility symbols, 40, 41, 65, 912–14 San Vitale, 288, 314, 316 Eve. See Eyck, Jan van, Ghent Altarpiece enamel, 319, 324, 331, 333 exedrae, 237, 309 fête galante, 809 encaustic, 171 Exekias, 175-76; The Suicide of Ajax (vase painting), 166, feudalism, 481, 510, 609 Ende (Spanish scribe painter), 490, 615 175-76, 175, 216 Fifty-Three Stations of the Tokaido, Utagawa Hiroshige, 869 engaged colonnette, 558 Exeter, Devon, England, Cathedral, 570, 578, 578 Fighting "Téméraire," Tugged to Her Last Berth to Be engaged column, 101, 238, 253, 391, 558, 558, 645, existentialism, 1111-12 Broken Up, The, Joseph Mallord William Turner, Exposition Internationale des Arts Décoratifs et 645.700 949-50.949 engaged half column, 645, 645, 754 Industriels Modernes (Paris, 1925), Workers' Club, figurative painting, revival of, 1122-23 England, 609, 615, 681, 741, 745; influence in India, 833; Aleksandr Rodchenko, 1076-77, 1076, 1155-56 figurines: African, 468; Chinese, 397, 402; clay, 402, 424; Expressionism, 1036-48, 1081, 1083 see also Britain Cycladic, 130-31; Egypt, predynastic, 93-94; Greek, English art: architecture, 530-32, 576-79, 745, 800-3, expressionistic style, 30, 665, 1109, 1112; Byzantine, 160, 177; Japanese, Jomon clay, 424; Mesopotamian, 935-41; Arts and Crafts Movement, 1069, 1070, 1071; 328; Hellenistic, 211, 219 69-70; Minoan, 134-36; Paleolithic, 38-40, 41; terra-Baroque, 800-3; of the Court, 741-45; craft arts, 814, Expulsion of Adam and Eve (portal sculpture), Jacopo cotta, 397, 468 937; Gothic period, 576-82; naturalism in, 1002; della Quercia, 664, 664 Fiji, 895 nineteenth-century, 1002-6; painting, 941-50; extrados, 226 filette, 165 Rococo, 814; Romantic, 935-50 Eyck, Berthélemy van, 639 filigree, 137, 256; technique, 88 engraving, 521, 538, 673, 674-76, 677, 798, 985; Eyck, Hubert van, 621; Ghent Altarpiece (see under Eyck, Finding of the Baby Moses, Dura-Europos, Syria, technique, 789 Jan van) synagogue at, 296, 296

Enheduanna, 73-74

Enlightenment, 751, 929, 979, 1131

Ensor, James, 1037-39; The Intrigue, 1037-39, 1037

Eyck, Jan van, 18-19, 617, 619, 621-26, 629, 630,

632-33, 637, 693, 786

The Annunciation, 18, 18, 19

Edict of Milan, 280, 297

Edo period (Japan), 862-69

edition: of books, 674; of prints, 673

fountains, 688, 762 Fusuma, Kano Eitoku, 860, 861 finial, 196, 383, 558, 558, 755, 755, 831, 910 Finial of a spokesperson's staff (okyeame poma) (Ashanti Fouquet, Jean, 638, 720; Melun Diptych, wing Étienne Futurism, 1057, 1060; Manifesto of, 1056 Chevalier and Saint Stephen, 638, 638, 720 culture), Ghana, 910, 910, 919 Fouquet, Nicolas, 770 Finley, Karen, 1160-61; We Keep Our Victims Ready (performance), 1160-61, 1160 Four Apostles, Albrecht Dürer, 735, 735 gable, 160, 165, 558, 745, 755, 755, 904 firman (Islamic imperial edict), 363 Four Crowned Martyrs, Nanni di Banco, 646-47, 647, 649 gabled porch, 558 First Funeral, The, Louis-Ernest Barrias, 984, 984 four evangelists (Christian symbol), 294 gadrooning, 488 First Steps of Mary, Istanbul, Turkey, Church of the Monastery of Christ in Chora, 330, 330 Four Horsemen of the Apocalypse, Albrecht Dürer, 733, 733 Gagik of Vaspurakan, King, 324 four-iwan mosque, 345, 345, 352-53 Gainsborough, Thomas, 942–43; Portrait of Mrs. Richard Fischl, Eric, 1149–50, 1151; A Visit To/A Visit From/The Four Noble Truths (Buddhism), 371 Brinsley Sheridan, 942, 943 Four Rivers Fountain, Piazza Navona, Gianlorenzo Galerie Dada, 1083 Island, 1150, 1150 fish (Christian symbol), 294 Galgenburg, Austria, figurine from, 19, 19 Bernini, 762, 762 Fox, Georges Braque, 1053, 1053, 1118, 1132 Galilei, Galileo, 786 Fishing in a Mountain Stream, Xu Daoning, 417, 417 Fox Seizing a Rooster, Jean Pucelle, Petites Heures of galleria, 763 fish-shaped vase (Egyptian), 112, 120, 121 Five Pillars (Islamic duties), 339 Jeanne d'Evreux (manuscript), page from, 576, 576 gallery, 309, 492, 513 Gallic Chieftain Killing His Wife and Himself (Hellenistic Five Rathas (Hindu temples), 389 Flack, Audrey, 1142-43, 1149; Marilyn (Vanitas), 1143, Fragonard, Honoré, 812, 956; The Meeting, 812, 813, 951 sculpture), 211-12, 211 France, 609, 615, 681, 990 Galloping Horse, Eadweard Muybridge, 1002, 1002, 1059 1143 Flagellation, Jacopo Bellini, 670, 670 Francis, Saint, 604 Gandharan period (India), 430 Flagellation, the (in Christian art), 307 Flamboyant style (French Gothic), 570–71, 599 Gandhara School, 378, 379, 381 Franciscans, 549 Francis I, of France, 686, 719-22, 741 Gandhi Bhavan. See Punjab University Francis I, Jean Clouet, 720, 720, 741 Ganymedes with Jupiter's Eagle, Bertel Thorvaldsen, 935, Flanders, 619 935, 964, 970 François Vase, Greek, Ergotimos and Kleitias, 173-74, 173 flat weaves (carpet), 359 Garamante peoples (Africa), 468 Frank, Robert, 1140; Les Américains (The Americans), Flavian dynasty, 252–59 Flavianus, Virius Nicomachus, 284 1140; Trolley, New Orleans, 1140, 1141 garbhagriha, 375, 383, 385, 389, 390, 391 Frankenthaler, Helen, 1121, 1129, 1131; Mountains and Garden, stone and gravel. See Ryoan-ji Flaxman, John, Jr., 937-39 Garden and a Princely Villa, A (set design), Inigo Jones, 800 Sea, 1121, 1121, 1129, 1131 Flémalle, Abbey of, 620 Flemish art: Baroque, 780-85; illumination, 619, 624, Franklin, Benjamin, 928; Houdon's bust of, 952 Garden carpet (Persian), 359, 360, 360 Frederick Henry, prince, Dutch, 786, 790 Garden in Sochi, Arshile Gorky, 1114, 1114 634; influence of, 667; painting, 658-59, 818; Frederick II, Emperor, 590, 592
Frederick William, the Great Elector (of Brandenburg), Garden of Delights, Hieronymus Bosch, 724–26, 725 Renaissance, 619-36 Garden of the Cessation of Official Life, Suzhou, Jiangsu, Flexible, Jean-Michel Basquiat, 1152, 1153 Andreas Schlüter, 804, 804 Frederick William II, of Prussia, 962 China, 836, 836, 844 Flight into Egypt. See Broederlam, Melchior, altarpiece gardens: Chinese, 844; English landscape, 936–37; Flight into Egypt (in Christian art), 306 Japanese, 659; secret, 703, 704; urban, Roman, 240 Freeman, Leslie G., 46 Flitcroft, Henry, 939; The Park (with Henry Hoare), Garden Scene (wall painting, detail), Primaporta, Italy, Freer, Henry, 26 Stourhead, Wiltshire, England, 938, 939 freestanding columns, 101 Villa of Livia, 240, 251-52, 251, 292 Flood, from Commentary on the Apocalypse by Beatus of freestanding sculpture, **31**, 169–72, 179–83, 650, 688 Gardner, Alexander, 998; Confederate Dead Gathered for Liébana (Romanesque manuscript), Stephanus French art: architecture, 550–71, 721–22, 770–73, 950– Burial, Antietam, September 1862, 998, 999 Garsia, 527-28, 527 51; Baroque, 769–76, 802; classical style, **1029–3**0, Garland, Hamlin, 1093 Florence, Italy 1048; Court, 719–24; craft arts, 722–24, 813–14; Cubist, 1055–57; Gothic, 550–76, 580, 590, 599, 722; Garnier, Charles, 981; Opéra, Paris, France, 981-82, 981, Cathedral (Duomo), Filippo Brunelleschi, 590-92, 1014 591, 592, 592, 641-43, 642, 643, 701; dome of, Impressionist, 1006, 1007–19; influence on English, Garsia, Stephanus, 528; Commentary on the Apocalypse 641-43 802; naturalism, 952, 990–93, 1007, 1011; Neoclasby Beatus of Liébana (Romanesque manuscript), Early Renaissance, 640-60 sicist, 950–62; painting, 617–18, 720–21, 773–76, 809–12, 953–62, 990–93, 1009; Rationalism, 1079–81; Flood page from, 527–28, 527 High Renaissance, 683-91 Gates of Paradise (East Doors), Florence, Italy, Baptistry See also Medici-Riccardi, Palazzo; Orsanmichele; realism, 990-96; Renaissance, 722; Renaissance, of San Giovanni, Lorenzo Ghiberti, 647-49, 648; panel Rucellai, Palazzo; San Giovanni, Baptistry of; San early, 614-18, 638-39; Rococo, 813-14; Romanesque, Jacob and Esau, 648–49, 649 Lorenzo, Church of; San Lorenzo, Monastery of; Gattamelata (Equestrian Monument of Erasmo da Narni), 510-30; Romantic, 950, 958-62; sculpture, 617-18, San Marco, Monastery of; Santa Croce; Santa Donatello, 664, 665 773, 807–8, 951–53, 962 Maria del Carmine; Santa Maria Novella; French Etching Club (New York City), 1005 Gaucher de Reims, 565 Sant' Apollonia; Santa Trinità Gaudí y Cornet, Antonio, 1071; Casa Milá apartment French Gothic style: influence on Italian Gothic, 590; Florentine School, Cassone (chest), 672-73, 672 Martini's Sienese reformulation of, 599 building, Barcelona, Spain, 1071, 1071 Florentine School, Italian Gothic painting, 596, 597, 600-8 French Revolution, 929, 950, 955–56 Gauguin, Paul, 901, 1026, 1028, 1034, 1036, 1039, 1045, Flötner, Peter, 741; Apollo Fountain, 740, 741 1049, 1060, 1083, 1087, 1109, 1130; Ia Orana Maria flower pieces, Dutch, 797-800 French Royal Academy, 769 (We Hail Thee Mary), 1034, 1035, 1039 fresco, 231, 383, 525, 624, 652, 765; Byzantine, 329; Flower Still Life, Rachel Ruysch, 799-800, 799 Hindu, 391-92; Teotihuacan, 450; see also wall painting Gaul (modern France), Roman conquest of, 234 fluting, 87, 165, 165, 387 Gaulli, Giovanni Battista (Baciccia), 765; Triumph of the fresco secco, 599 "Fluxus Festival of Total Art and Comportment" (Nice, Freud, Lucian, 1152; Naked Portrait with Reflection, 1152, Name of Jesus (ceiling fresco), Rome, Italy, Church of Il 1963), 1124 Gesù, 765, 766 Fluxus movement, 1124, 1146, 1151 1152 Gauls, 211-12 Freud, Sigmund, 1032, 1087, 1112 flying buttress, 555, 558, 558, 564 Gautier, Théophile, 1005 Frey, Viola, 1164; Woman in Blue and Yellow II, 1164, Foire Chinoise (The Chinese Fair), La (tapestry), François Ge, 156 Boucher, copy after, 813-14, 814 1164 Geb 96 Fried, Michael, 1132 folding screens, Japanese, 860 Geertgen tot Sint Jans, 633-34; Saint John the Baptist in Friedrich, Caspar David, 964; Cloister Graveyard in the follower of, meaning of term, 990 the Wilderness, 633-34, 633 Fontainebleau, Château of, 703, 713, 721, 811; stucco Snow, 964, 964 frieze, 163, 165, 165, 225, 250, 344, 1075 Geese Aslant in the High Wind, Uragami Gyokudo, 866, 866 and wall painting, Chamber of the duchess of Gehry, Frank O., 1139; The Architect's House, Santa Étampes, Francesco Primaticcio, 720, 721 fritware, 357 Monica, California, 1139–40, 1139 Frolicking Animals, detail, Toba Sojo, 436-37, 437 Fontainebleau, School of, 721 frontispiece, 722, 965 Geisha as Daruma Crossing the Sea, Suzuki Harunobu, Fontana, Lavinia, 716-17; Noli Me Tangere, 716, 717 frottage, 1088 869, 869, 1043 Fontenay, Burgundy, France, abbey church, 515-16, 515 Gemma Augustea (Roman cameo), 249, 249, 503 "frying pan" terra-cotta vessel, Cyclades, Greek islands, foot-washing ritual, 504 Gem with Apollo and Cassandra, by Aulos, son of Forbidden City (now Palace Museum), Beijing, China, 129-30, 129, 145 Alexas, 20, 20 Fujii, Chuichi, 870-71; Untitled '90, 871, 871 844, 845-46, 923 General and Officers (brass, from Benin), 473, 473 foreground, 29 Fujiwara, Shunzei, 863 "generation of 1848," 993 foreshortening, 30, 177, 273, 624, 666, 667, 671 Fujiwara family, 432 Genesis (manuscript), Rebecca at the Well from, 320, 320 funerary architecture, Egyptian, 99-104, 116-18 form, 29 genre painting, 23, **751**, **935**; Chinese, **841**; Dutch, 794–97 Gentile da Fabriano, 652; *Adoration of the Magi* funerary art, Africa, 921-24 formal elements, 29 formalism (formal analysis), 32, 948, 1054 funerary sculpture, Roman, 255, 278 (altarpiece), Florence, Italy, Santa Trinità, 652, 652 Gentileschi, Artemisia, 769; *La Pittura*, 769, 769, 1090 funerary urns: Etruscan, 225; Greek, 159-60, 197 formline elements, 887 Fort Peck Dam, Montana, Margaret Bourke-White, 17-18, 17 furniture: Chinese, 843-44; Neolithic, 50-51; postgeoglyphs, Peruvian, 458-59 modern, 1138 Fortuna, 156 forum, 238 Furrier's Shop (stained glass), Chartres, Île-de-France, geomancy, 431, 845 geometric design: Byzantine, 313; Greek, 158-61; Foucault, Michel, 1153, 1154 France, Cathedral, 559-61, 559 Islamic, 361; Roman, 277-78 Founding of Tenochtitlan, The. See Codex Mendoza Fur Traders Descending the Missouri, George Caleb George Clifford, 3rd Earl of Cumberland, Nicholas Hilliard, Foundry Painter, 177; A Bronze Foundry (vase painting), Bingham, 975, 975 Fuseli, John Henry, 947, 948; The Nightmare, 947, 947, 975 743-45. 743 George I, of England, 800 Fountain, Marcel Duchamp, 1022, 1022, 1085, 1127, 1163 fusuma, 860, 862

George Washington, Jean-Antoine Houdon, 952–53, 953 Goddess of Liberty and the Destruction of the Trusts by the Great Mosque of al-Mutawakkil, Samarra, Iraq, 347, 347 Gerald of Wales 487 Ballot, Samuel Perry Dinsmoor, 24-25, 25 Great Panathenaia, festival of the (Athens), 190 Gérard, Marguerite, 812 Godescalc (Frankish scribe), 494 Great Pyramid and ball court, La Venta, Mexico, 447-48, Géricault, Théodore, 950, 953, 961, 962, 1005; Raft of the Godescalc Evangelistary (Carolingian manuscript), Mark 447 Great Schism, 550, 590 "Medusa" 960, 961 the Evangelist page from, 494-95, 495 German art: architecture, 803–4, 805–7; Baroque, 803–4; Godfrey, Elizabeth, 814; Tea caddies, 814, 815 Great Serpent Mound, Adams County, Ohio (Adena Expressionist, 1081; Gothic, 585–90; Neoclassicism and gods: African, 918-19; Egyptian, 95-96; Greek, 155, 156, culture), 444, 444, 460 Romanticism, 962-64; painting, 729-39; printmaking, 225, 234, 235; Hindu, 372, 386-88; Roman, 156, 228, Great Sphinx, Giza, Egypt, 104, 105 733-36; realist, 995-96; Renaissance, early, 639-40; 234, 235 Great Stupa, Sanchi, Madhya Pradesh, India, 374-76, Romanesque, 535-39; sculpture, 739-41, 804, 807-8 Goes, Hugo van der, 632-33; Portinari Altarpiece, 632-33, 374, 427; gateway (torana) of, 376, 376; yakshi figure, Germans, 481 632, 640, 652 376-77, 377 Germany, 681, 728-41, 1083, 1151; influence in Britain, Gogh, Vincent van, 1008, 1023, 1026, 1034-37, 1039, Great Temple of Amun, Karnak, Egypt, 114, 115-16, 115, 485 1109; Harvest at La Crau (The Blue Cart), 1036, 1036, Gernrode, Germany, Saint Cyriakus church, 498, 499, 1109; The Starry Night, 1036-37, 1037, 1109; Great Wall of China, 402 499, 532, 536 Sunflowers, 28, 28 Great Wave, The. See Hokusai, Katsushika, Thirty-Six Gero, archbishop of Cologne, 499, 502 Golden Age of Justinian, 288, 308-22 Great Wild Goose Pagoda, Xi'an, Shanxi, China, Ci'en Gero Crucifix, Cologne, Germany, Cathedral, 501-3, 502, Golden Fleece (Russia), 1060 523. 597 golden screens, 860, 863 Temple, 413, 413 Gérôme, Jean-Léon, 983-84, 1001, 1090; Death of gold inlay, 404 Great Zimbabwe, Zimbabwe, 474-77, 911; Bird (detail of Caesar, 983-84, 983, 1090 gold leaf, 88, 136, 137, 280, 440, 827, 859; in book monolith), 476-77, 477; conical tower at, 476, 476 Gersaint, Edme-François, 809, 810 decoration, 486 Greco, El (Domenikos Theotokopoulos), 746–47; Burial gesso, 596, 619 gold work: Greek, 208-9; Inka, 880; Mesoamerica, 456 of Count Orgaz, 746-47, 747; View of Toledo, 747, 747 gesturalism, 1116, 1163 Gonçalvez, Nuño, 637; Altarpiece of Saint Vincent, panel Greece, Greeks, ancient, 150-219; Antigonid, 209; Gesù, Church of Il, Rome, Italy, Giacomo da Vignola Saint Vincent with the Portuguese Royal Family, 637-38, Bronze Age, 142-49; colonies, 155; Neolithic, 142; (with Giacomo della Porta), 701, 753-54, 754, 755, origins of, 153; Persian invasion of, 177-78; Roman 755, 756, 765, 766, 770 Goncharova, Natalia, 1060; Aeroplane over Train, 1060, conquest of, 234; trade, 155, 223, 466; see also Geta, 273, 278-79 1060; Haycutting, 1060, 1060 Mycenaean culture Ghana, empire of, 911 Gonzaga, Ludovico, 667, 668 Greek art: Archaic, 158, 162-77, 179-81; Classical, 162: Ghent, Flanders, 634 Gonzaga family, 641, 667-68, 718 Early Classical (transitional), 177-84; eclecticism in, Ghent Altarpiece, Jan and Hubert van Eyck, 612-13, 612, Gonzaga Family. See Mantegna, Andrea, frescoes 219; Fourth Century period, 158, 197-209, 219; 622-23, 622, 623, 633, 652 González, Julio, 1120 Geometric period, 158-61; Hellenistic, 158, 209-19; Ghibellines, 590 Good Shepherd, Ravenna, Italy, Mausoleum of Galla High Classical, 158, 184-97, 212-13, 219; influence Ghiberti, Lorenzo, 647-49, 657 Placidia, 303, 303, 318 on Roman, 219, 247, 271; Proto-Geometric, 158–59; Gates of Paradise (East Doors), Florence, Italy, Good Shepherd, Orants, and the Story of Jonah, Rome, Roman copies of, 206; temple construction, 51 Baptistry of San Giovanni, 647-49, 648; panel Italy, Catacomb of Saints Peter and Marcellinus, Greek civilization: emergence of, 153-58; influence on Etruscans, 223, 225; influence on Neoclassicism, 931; influence on Renaissance, 609, 613, 641; influence on Jacob and Esau, 648–49, 649 294-95, 295, 303 Ghirlandaio, Domenico del, 658-59, 688, 694; A Man Good Shepherd motif, 291, 294-95, 297, 308 with His Grandchild, 658, 659 Good Shepherd Sarcophagus (Christian), 308, 308 Romans, 235 Ghosts of the Barrio (mural), Wayne Alaniz Healy, 1158, Greek-cross plan churches, 298, 663, 701, 950 gopura, 826 Gordian III, 277 Greek-key pattern, **692** Greek Revival, 969 Giacometti, Alberto, 1111; City Square, 1111, 1111 Gorky, Arshile, 1112-14, 1117; Garden in Sochi, 1114, 1114 Gormley, Antony, 1158–59; *Derry Sculpture*, 1159, *1159* Greek Slave, The, Hiram Powers, 971, 971, 972 Gibson, John, 971 Gilbert, Cass, 1066; Woolworth Building, New York City, Gospel Book of Durrow (Hiberno-Saxon manuscript), Greenberg, Clement, 1110, 1116, 1121, 1131-34, 1154 1065, 1066, 1066 Lion page from, 486-87, 487 Greetings!, Anton Giulio Bragaglia, 1059, 1059 Gregorian chant (plainchant), 514 gilding, 137, 627 Gospels, the, 290 Gilpin, Laura, Taos Pueblo (photograph), 889, 889 Gospels of Otto III (Ottonian manuscript), Christ Washing Gregory I the Great, Pope, 486 Gregory of Nazianus, Saint, 284, 291 Giorgione (Giorgio da Castelfranco), 704-7; The Tempest, the Feet of His Disciples page from, 503-4, 504 704, 705, 747 Gossaert, Jan (Mabuse), 727–28; Saint Luke Painting the Gregory VII, Pope, 535, 542 giornata, 599 Greuze, Jean-Baptiste, 812; Broken Eggs, 812, 812; A Virgin, 728, 728 Giotto di Bondone, 603-7, 624 Gothic, French art, 722 Father Explaining the Bible to His Children, 812 Arena Chapel, Padua, frescoes, 604-7, 605; The Gothic art, 481, 544-608, 722; architecture, 548-71, grid. 86 Lamentation, 606, 607 576-79, 582, 585-86, 590-92, 609; cathedrals, 548-49, griffin, liturgical symbolism of, 538 Virgin and Child Enthroned, 603-4, 603 561-65, 609; England, 576-82; France, 550-76, 580, Griffin (Islamic), 355, 355, 538, 539 Girardon, François, 773, 1017; Apollo Attended by the 590, 599; Germany, 585-90; Italy, 590-608; religious, Grimal, Nicolas, 94 Nymphs of Thetis, 773, 773, 1017 576-78; sculpture, 571-72, 586-90, 592-95; secular, "gripping beasts" ornament (Viking), 483 Girl on a Terrace, Richard Diebenkorn, 1122, 1123 578-79; Spain, 582-84; symbols of, 557 grisaille painting, **574**, 607 Girl under a Japanese Umbrella, Ernst Ludwig Kirchner, Gothic Revival, 939, 966, 969 grisaille windows, 559 1042-43, 1043, 1085 Gottlieb, Adolph, 1114 Grizzly bear house-partition screen (Native American, Girodet-Trioson, Anne-Louis, 958-59; Portrait of Jean-Goujon, Jean, 722; Archimedes and Euclid, with Allegorical Tlingit), Wrangell, Canada, House of Chief Shakes, Baptiste Belley, 958-59, 958 Figures (sculptural decoration), Palais du Louvre, Cour 886, 887 Gislebertus, 521, 543 Carré. 722. 722 groin vault, 226, 226, 252, 511, 552, 552 Last Judgment (relief), 520, 521, 525, 533, 555, 568; Gournia, Crete, 143 Gropius, Walter, 1073, 1081-82, 1135; Bauhaus Building, Weighing of Souls from, 520, 521 Dessau, Germany, 1081, 1082, 1082, 1135; Fagus Goya y Lucientes, Francisco, 964, 985; Los Caprichos Gita Govinda (illustrated manuscript), 830, 831; page (The Caprices), page The Sleep of Reason Produces Factory (with Adolph Meyer), Alfeld-an-der-Leine, Krishna and the Gopis, 830, 831 Monsters, 964, 965; Family of Charles IV, 965, 965; Germany, 1072, 1073, 1081, 1082, 1135, 1139 Gropper, William, 1102–3; Sweatshop, 1102–3, 1103 Giulio Romano, 712, 714, 717-19 Third of May, 1808, 966, 966 Palazzo del Tè, Mantua, Italy, 718-19, 718; Sala dei Gozbert of Abbey of Saint Gall, 493 Gros, Antoine-Jean, 959; Napoleon in the Plague House at Giganti, Fall of the Giants (fresco), 718, 719 Grace Church, New York City, 969 Jaffa, 958, 959 Giza, Egypt: funerary complex, 99, 103-4, 103; Great graffiti art, 1152-53 Gross Clinic, The, Thomas Eakins, 1001–2, 1001 Sphinx, 104, 105; Khafre (statue), 104, 105, 108, 111, Granada, Spain, 350; Alhambra, Palace of the Lions. groundline, 69, 97, 168, 246 131; pyramids at, 102-4, 102; temple of Khafre, 104, 347, 350, 351–52, 351, 360 ground plane, 29 Grand Manner, 931, 932, 941-43, 945 grout, 272 Glackens, William J., 1094 Grand Tour, The, 931-34 Grünewald, Matthias (Matthias Gothardt), 729-33; Glasgow School of Art, Director's Room, Glasgow, granulation, 137 Isenheim Altarpiece, details Annunciation, Virgin and Scotland, Charles Rennie Mackintosh, 1071-72, 1071 Grapes, Vines, and Birds (relief), Quintanilla de las Viñas, Child with Angels, Resurrection, Crucifixion, Glass and Bottle of Suze, Pablo Picasso, 1054, 1054 Burgos, Spain, Santa Maria, 488, 489 Lamentation, 728, 729-32, 730 glassmaking: Egyptian, 112, 120-21; Islamic, 356-57 graphic arts, 30, 1033 Guadalupe, Basilica of, Chapel of the Indians, Mexico glaze (ceramic), 778, 843, 1163; technique, 411-12 graphic design, 18 City, 882, 882 glazed bricks, 83 Grasset, Eugène, 1028 Guan Ware, 419 glazed windows, 803 Graves, Michael, 1138; Plaza Dressing Table, 1138, Guan Ware vase (Song dynasty, China), 419, 419 glazing (painting), 525, 619, 622 11.38 Guanyin, 410 Gleaners, The, Jean-François Millet, 992, 992, 1060 Great Bath, Mohenjo-Daro, India, 367 guardian figures: Assyrian, 79; Hittite, 83-84; gloss, 161, 162 Great Depression, 1100 Mycenaean, 143-44 Glykera, 207 Great Friday Mosque, Djenné, Mali, 474, 475 Guda (medieval artist), 615 Gnosis, 208; Stag Hunt (mosaic), 206, 207-8 great hall, 579 Gudea, king of Lagash, 76

Gobelins Tapestry Manufactory, 811

Go-Daigo, 441

Great Mosque, Córdoba, Spain, 310, 344-47, 346, 354,

George II. of England, 800

George III, of England, 800, 945

Guelphs, 590 Haraldsson, Magnus, 481 Henry IV, Emperor, 535, 537, 542 Guercino (Giovanni Francesco Barbieri), 22; Saint Luke Haraldsson, Olaf, 481 Henry I, of England, 532 Displaying a Painting of the Virgin, 22, 23, 23 Harappa, Indus Valley, 367, 369 Henry II, of England, 550, 576 Guggenheim Museum, 1144 Harbaville Triptych (Christian devotional piece), 331, 331 Henry III, of England, 576, 578, 581 Guild House, Philadelphia, Pennsylvania, Robert Venturi Hard Edge art, 1131 Henry III, of France, 723 (with John Rauch), 1137, 1137 Hardouin-Mansart, Jules, 770, 771-72; Palais de Henry IV, of France, 769 guilds, 548, 590, 615, 619, 1081 Versailles, Hall of Mirrors (with Charles Le Brun), Henry VI, of England, 638 Guimard, Hector, 1070; Desk, 1070, 1070 Versailles, France, 772-73, 772 Henry VIII, of England, 577, 741, 745 Gu Kaizhi, 407-8; Admonitions of the Imperial Instructress Hardraade, Harald, 481 Henry VIII, Hans Holbein, the Younger, 741, 741, 996 Hephaistos, 156 to Court Ladies (scroll), 407-8, 408 Haring, Keith, 1152-53; Art in Transit, 1152-53, 1152 Gummersmark brooch (from Denmark), 482, 482 Harlem Renaissance, 1101 Hera, 155, 156 Gupta period (India), 381-83, 823 Harlot's Progress, The, Hogarth, William, 941 Heracleitus, 273; The Unswept Floor (Roman mosaic Guro people (Côte d'Ivoire), 924 Harmony in Blue and Gold (The Peacock Room), James copy), 273, 273 Guston, Philip, 1141-42; Ladder, 1142, 1142 McNeill Whistler, 26, 26, 1006 Herakles, 156, 179; Twelve Labors of, 178 Gutai Bijutsu Kyokai, 1124–25 Harp Player, Cyclades, Greek islands, 131, 131, 209 Herat Academy (Khurasan), 361-63 Herculaneum, Italy, 931, 944, 950 Harrison, Peter, 816; Redwood Library, Newport, Rhode Gutenberg, Johann, 676 Hercules and Antaeus, Antonio del Pollaiuolo, 651-52, Island, 816-17, 816 Guti. 74-76 Gyokudo, Uragami, 866; Geese Aslant in the High Wind, Hartigan, Grace, 1121 651.675 866, 866 Harunobu, Suzuki, 868-69; Geisha as Daruma Crossing Hercules and the Hydra (medallion), Antico, 665, 665 Herders' Village, The (rock-wall painting, Algeria), detail, the Sea, 869, 869, 1043 Harvest at La Crau (The Blue Cart), Vincent van Gogh, Cattle Gathered next to a Group of Huts, 466-68, 467 Haacke, Hans, 1144; Shapolsky et al. Manhattan Real Hermes, 156 1036, 1036, 1109 Harvester Vase, Hagia Triada, Crete, 136, 136, 137 Hermes and the Infant Dionysos, Praxiteles, 201-2, 201 Estate Holdings, a Real-Time Social System, as of May 1, Harvesting of Grapes, Rome, Italy, Santa Costanza, 302, herm statue, 258 1971. 1144. 1144 Habsburg dynasty, 728, 803; Austria, 687–88; Spain, 776 Herod the Great, 289, 291 302.308 Hackwood, William, 928; "Am I Not a Man and a Brother?" (ceramic medallion), 928, 928, 937 Harvest Scene, Beni Hasan, Egypt, tomb of Khnumhotep, heroic subjects, 650, 689, 990 Herrera, Juan de, 746; Escorial (see under Toledo, Juan 111.111 Hasan (Mamluk sultan), 353 Bautista de) Haden, Francis Seymour, 1005 Hess, Thomas, 1126 Hassam, Childe, 1091; Union Square in Spring, 1091, 1091 Hades, 156 Hesse, Eva, 1134; Hang-Up, 1134, 1134 Hatshepsut, 116-17, 466; funerary complex and temple Hadith, 340 of, Deir el-Bahri, Egypt, 116-18, 117, 158 Hadrian, 259, 260, 261, 263-66, 271, 283 Hestia, 156 Hiberno-Saxon style, 486 Hadrian Hunting Boar and Sacrificing to Apollo (Roman Hatshepsut as Sphinx (sculpture), Deir el-Bahri, Egypt, Hideyoshi, Toyotomi, 859 Hierakonpolis, Egypt, 94; jar from, 94, 94, 130; Palette of Narmer, 96–97, 97, 98; wall painting, 94 reliefs, now on Arch of Constantine), 270, 271, 282 116.117 Hattushash (Hittite), in modern Turkey, 83; Lion Gate, Hadrian's Villa, Tivoli, Italy, 265-66, 266, 275; Battle of Centaurs and Wild Beasts from (floor mosaic), 265, 83-84, 83, 143 hieratic style, 313 Hausmann, Raoul, 1083-84; The Spirit of Our Time, 1084, 272-73, 272; Canopus area, 265-66, 266, 276 hieratic writing, 113 Hadrian's Wall (Britain), 268, 269 1084 hieroglyph, 113, 113, 114 Hagar, Edmonia Lewis, 972-73, 972 Haussmann, Baron Georges-Eugène, 981, 1029 hieroglyphic writing: Egyptian, 97, 107, 113, 319; Mayan, Hagesandros, Polydoros, and Athanadoros of Rhodes, Havell, Robert, 973 Laocoön and His Sons, 20, 21, 215-16, 215, 720, 756 Have No Fear-He's a Vegetarian, John Heartfield, 1081, 451-52; Minoan, 131 Hagia Sophia, Istanbul, Turkey, 309-12, 309, 311, 325, 1085. 1085 high crosses (monumental stone crosses), 488 Higher Goals, David Hammons, 1158, 1159 345, 354, 355 Hawaiian Islands, 895, 902-3, 905-6 Hagia Triada, Crete, Harvester Vase, 136, 136, 137 Haycutting, Natalia Goncharova, 1060, 1060 High Moon, Rebecca Horn, 1166-67, 1167 high relief, 31, 46, 74, 166, 380, 673 Haida people, 886, 887-88 Head (Nok culture, Nigeria), 469, 469 Heade, Martin Johnson, 998 Haito of Reichenau, Abbot, 493 hiira, 339 Hakuin Ekaku, 866; Bodhidharma Meditating, 866, 867 header course, 901 Hilda Gospels (Ottonian manuscript), presentation page Head from Temple of Athena Alea, Tegea, Greece, Skopas, 203, 203 Halder, Jacob, 744 from, 504-5, 505 half-timber construction, 815 Hildegard of Bingen, 538-39, 552 Halikarnassos (modern Bodrum, Turkey), Mausoleum, Head of a king (from Benin), 472, 472 Hildegard's Vision, page from Liber Scivias (Romanesque Head of a king (Ife culture, Nigeria), 470, 471 manuscript), 538-39, 538 102, 200-1, 200, 202; Mausolos (?) (statue), 200, 201 Head of a Man (perhaps Lucius Junius Brutus) (Etruscan Hildesheim, Germany, Saint Michael abbey church, Hall, Edith, 143 Doors of Bishop Bernward, 500, 501, 595; The hall churches, 585 or Roman), 232, 233 Head of Lajuwa (?) (Ife culture, Nigeria), 470, 471 Temptation and The Crucifixion from, 501, 501 Halley, Peter, 1154-55; Yellow Cell with Conduits, Hilliard, Nicholas, 743-45; George Clifford, 3rd Earl of Head Surrounded by Sides of Beef, Francis Bacon, 1109, 1154-55, 1154 Cumberland, 743-45, 743 Hall of Bulls, Lascaux, France, cave paintings, 43, 44 1109, 1111, 1152 Hall of Mirrors. See Versailles, Palais de Healy, Wayne Alaniz, 1158; Ghosts of the Barrio (mural), himation, 171 Himeji Castle, Hyogo, near Osaka, Japan, 859, 860 Hall of One Hundred Columns, Persepolis, 87 1158, 1158 Hearst, William Randolph, 1068 Hinavana Buddhism, 371 halo, 303, 655 Heartfelt, Miriam Schapiro, 1148-49, 1148, 1164 Hindu art: late medieval period, 825-26; symbols of, 385; halos, 158 Hals, Frans, 786-88, 795, 1094; Catharina Hooft and Her Heartfield, John (Helmut Herzfelde), 1081, 1085; Have No temples, 375, 383-86, 389-91 Hinduism, 370, 371, 372, 381, 383, 389, 823; Bhakti, 391– 93, 831; influence on Buddhism, 431; tantric, 391 Nurse, 787, 787, 818; Officers of the Haarlem Militia Fear—He's a Vegetarian, 1081, 1085, 1085 Company of Saint Adrian, 787-88, 787 Hebrew Scriptures (Old Testament), 289, 291 Hamatsa dancers, Edward S. Curtis, 886, 886 Heckel, Erich, 1041, 1042; Crouching Woman, 1042, 1042 Hippodamian plan, 198-99 Hippodamos of Miletos, 198-99 Hamilton, Ann, 1159-60; Indigo Blue (installation), 1160, Hector, 156 Hegel, Georg Wilhelm Friedrich, 1110 Hippopotamus (statue), Meir, Egypt, tomb of Senbi, 112, Hamilton, Gavin, 931 Heian-kyo (Kyoto), Japan, 845, 855 112 hiragana, 434, 434 Hamilton, Richard, 1128-29; \$he, 1128, 1129 Heian period (Japan), 430-37, 855 Hireling Shepherd, The, William Holman Hunt, 1002-3, Heizer, Michael, 1145; Double Negative, 1145, 1145 Hammamet with Its Mosque, Paul Klee, 1047-48, 1047, 1081 Hammons, David, 1158, 1159; Higher Goals, 1158, 1159 Helen, Mother of Constantine (Roman), 284, 284 1003 Helen of Egypt, 206, 207 Hiroaki, Morino, 870; Ceramic vessel, 870, 870 Hammurabi, 76-77 Hiroshige, Utagawa, 869; Fifty-Three Stations of the Tokaido, 869 Hampton, James, Throne of the Third Heaven of the heliograph, 986 Nations' Millennium General Assembly, 20-21, 21 Helladic period (Bronze Age Greece), 142-49; dating of, Hispanic American art, 24 Hamza-nama (illustrated manuscript), page Hamza's Hellenistic art, 158, 209-19; influence on Indian, 379; Hispano-Flemish art, 637-38 Spies Scale the Fortress, 827-29, 827 influence on Roman, 237, 253 Hissarlik Mound (Turkey), 143, 216 handcrafts aesthetic, 1004-5, 1069; see also craft arts historicism: in architecture, 1062, 1065-66; in design, Hellenistic Ruler (Hellenistic statue), 219, 219 Hand mirror (Egyptian), 121-22, 121 1069; rejection of, 980 handprints, Pech-Merle cave, 41-42 Hellmouth, page from Winchester Psalter (English history: consciousness of, 931; theories of progress in, handscrolls, 408, 414, 840, 840; perspective in, 417 manuscript), 532-33, 533, 580 Hemessen, Caterina van, 728; Self-Portrait, 728, 729 Han dynasty (China), 402-7, 837, 843 1110 history painting, 941, 944-46, 983-84 Hanging Gardens of Babylon, 81, 83, 102 Hemessen, Jan Sanders van, 728 hemicycle, 703 Hitler, Adolf, 1081, 1085 hanging scrolls, 840, 840 Hitomaro, 430 Hang-Up, Eva Hesse, 1134, 1134 henge, 53, 462 Hittites 63 83-84 118 Hennings, Emmy, 1083 haniwa, 425-26 Henri, Robert, 1093–94, 1101, 1102; Laughing Child, Hoare, Henry, 939; The Park, Stourhead (see under haniwa earthenware figure (Kofun period, Japan), Flitcroft, Henry) 425-26, 426 1094.1094 Hobbema, Meindert, 794; Avenue at Middelharnis, 794, 794 Henri IV Receiving the Portrait of Marie de' Medici, Peter Hanson, Duane, 1143-44; The Shoppers, 1143-44, 1144

Paul Rubens, 782, 782

happenings, 1109, 1124-25

Höch, Hannah, 1084; Dada Dance, 1084, 1084

Hogarth, William, 941, 1002; Analysis of Beauty (book), Hughes, Robert, 20, 1149 Imperial Forums, Rome, Italy, 260-61, 260, 298 941; The Harlot's Progress, 941; Marriage à la Mode Hugo, Victor, The Hunchback of Nôtre-Dame, 1029 Imperial Procession, from Ara Pacis, Rome, Italy, 246, series, The Marriage Contract, 940, 941, 965, 988, Huguenots, 723-24 246, 254, 284 1002; The Rake's Progress, 941 Huineng, 847 impost, 226, 304 Hohlenstein-Stadel, Germany, Lion-Human (figurine), Huizong, Emperor, Ladies Preparing Newly Woven Silk, impost block, 488, 644 38-39, 38, 45 detail of (copy of painting by Zhang Xuan), 414, 415, Impression, Sunrise, Claude Monet, 1010 Hohokam culture, 462, 888 impression (printing), 948 Hokusai, Katsushika, 869 human figure Impressionism, 27-28, 1007-19, 1023-24; American, Thirty Six Views of Fuji, 869; print The Great Wave, ideal proportions of: Egyptian art, 97-99; Greek art, 1091, 1094; auction prices of works, 1131; influence of, 854, 854, 863, 869 193-95, 201, 203, 248, 646, 698; Renaissance, 624, 1036, 1039, 1040, 1055; later, 1015-19; opponents of, Holbein, Hans, the Younger, 738-39, 741; Artist's Wife and 698, 729, 734 983; origins of, 1006, 1010; reaction to, 1015-19, 1033 Children, 738-39, 738, 996; Henry VIII, 741, 741, 996 naturalistic depiction of, 369 Improvisation No. 30 (Warlike Theme), Vasily Kandinsky, Holbein Chamber. See Strawberry Hill humanism, 613-14, 641, 663, 667, 681, 683 1046, 1046, 1081 hollow-casting, 177, 181 Inanna (Sumerian goddess), 69; hymn to, 67 Humboldt, Alexander von, 997 Holt, Nancy, 1145-46; Stone Enclosure: Rock Rings, 1145, humor in art, 423, 437 Inanna Receiving an Offering, Uruk (modern Warka, Iraq), Hundreds of Birds Admiring the Peacocks (hanging scroll), carved vase from, 69, 69 Holy Family, Martin Schongauer, 640, 640 Yin Hong, 841-42, 842 in antis, 164, 164, 166 Hundred Years' War, 550, 569, 576, 609, 615 Incarnation Cycle (in Christian art), 306 Holy Land, 609 Holy Roman Empire, 498, 585, 590, 609, 728-41 Hungry Tigress Jataka (panel), Horyu-ji, Nara, Japan, Incense burner (Han dynasty, China), 404, 405 Holzer, Jenny, 1157-58; Survival series, excerpt Protect temple at, Tamamushi Shrine, 428-29, 428 incised designs, 71, 129 Me from What I Want, 1158, 1158; Truisms, 1157 Hunt, Richard, 886 incised line, 380 Homage to Blériot, Robert Delaunay, 1055-57, 1056 Hunt, Richard Morris, 1062-63; Biltmore, George W. incising, 42, 897, 985; in pottery, 424 Incredulity of Thomas (in Christian art), 307 Homage to Matisse, Mark Rothko, 1119, 1120 Vanderbilt Estate, Asheville, North Carolina, 1062. Independent Group (IG), 1128 India: medieval period, 389–93; religion, 370–72; see also 1062; World's Columbian Exposition, Court of Honor, Homage to New York (assemblage), Jean Tinguely, 1125-26, 1125 Chicago, Illinois, 1063, 1063 Indus Valley civilization
Indian art, 20, 364–93, 822–35; influence on Chinese, home furnishings, Italian Renaissance, 672-73 Hunt, William Holman, 1002-3; The Hireling Shepherd, Homer, 143, 176 1002-3 1003 Homer, Winslow, 1001, 1093; The Life Line, 1093, 1093; hunting, depictions of, 107-8 409; late medieval period, 823-26; modern period, Snap the Whip, 1000, 1001, 1093 Hunt of the Unicorn (tapestry series), 635-36; detail 833: symbols of, 366 Unicorn at the Fountain, 635-36, 636 Homo sapiens sapiens, 37 Indigo Blue (installation), Ann Hamilton, 1160, 1160 Hurling Colors (happening), Shozo Shimamoto, 1124, 1125 Honorius, 302, 313 Indo-Europeans, 823 Hopewell culture (North America), 461 Hurrem, Sultana, 363 Indra, 370 Hopi, 462 Huysmans, Joris-Karl, 1028 industrial design, 1008, 1083 Hora, Victor, 1070 hydria, 176 industrialization, 929, 1004, 1026-29, 1060, 1099-1100 Horemheb, tomb of (Valley of the Kings), 110 Hyksos people, 114 industrial materials, 1133 Indus Valley (Harappan) civilization, 366-70, 823 horizon line: 30, 617 Hypnerotomachia Poliphili by Fra Francesco Colonna Horn, Rebecca, 1166-67; High Moon, 1166-67, 1167 (printed by Aldus Manutius), page Garden of Love, Ingres, Jean-Auguste-Dominique, 959, 1048, 1050; Large Horse and Sun Chariot (bronze sculpture), Trundholm, Zealand, Denmark, 58, 59, 59, 481 677, 677 Odalisque, 959, 959, 1051; Madame de Moitessier, 960, hypogeum, 243 960 Horsemen, detail of Procession, Athens, Greece, hypostyle hall, 114, 261, 345 initiation rites, 46, 914-16 Initiation Rites of the Cult of Bacchus (?) (wall painting, Acropolis, Parthenon, friezes, 190, 190 hypostyle mosque, 345 horseshoe arch, 345, 347, 347, 488 detail), Pompeii, Italy, Villa of the Mysteries, 250-51, Horta, Victor, Tassel House, Brussels, Belgium, 1070, 1070 250, 292 Horus, 95, 96, 97, 104 Iaia, 207 Inka Empire, 875, 879-82 Horus falcons, 114 Ia Orana Maria (We Hail Thee Mary), Paul Gauguin, 1034, ink painting, 856, 865; Japanese, 856-59 Horyu-ji, Nara, Japan, temple at, 409, 426–28, 428; Amida 1035, 1039 inlay, 68, 88, 112, 137, 369, 404, 864 Buddha (fresco), 430, 430; Shaka Triad, by Tori Busshi, Iberian peninsula, 510-11, 609 Innocent III, Pope, 577 429, 429; Tamamushi Shrine, Hungry Tigress Jataka ibn Muqla, 348 Innocent X, Pope, 762 (panel), 428-29, 428 ibn Naghralla, Samuel, 350 inscriptions, commonly used in prints, 673 Hosmer, Harriet, 971-72; Beatrice Cenci, 971-72, 971 Ice Age, 37, 47-48, 423; in Americas, 445 Institut de France, 929, 957 Houdon, Jean-Antoine, 952-53, 970; George Washington, iconoclasm, 322, 323, 728, 735, 741 Institute of Contemporary Art (ICA), 1128 952-53, 953 Iconodules, 322 intaglio, 673, 789, 985 Hour of Cowdust (India, Mughal period), 831, 832 iconography, 18, 29; Buddhist, 371, 378, 426, 427, 823; intarsia, 673 Hours of Mary of Burgundy, page Mary at Her Devotions, Christian, 18, 294, 306-7, 620-21; Dutch, 795, 797 intensity, 29 Mary of Burgundy Painter, 634, 634 Monet's, 1010; Pacific cultures, 898; sourcebooks for, interior design: Neoclassical, 937; Renaissance, 672-73 Interior Scene, Jacob Lawrence, 1102, 1102 house-church (Christian), 295-97 769, 797 House of Chief Shakes, Wrangell, Canada, 886, 887 iconology, 29 Interior with Portraits, Thomas LeClear, 16, 17, 19, 23 House of G. Polybius, Pompeii, Italy, 240 iconostasis, 310 interlace, 519, 529 icons, 23, 310, 322, 322; painted, Byzantine, 335 House of Julia Felix, Still Life (wall painting, detail), International Exhibition of Modern Art (Armory Show) Pompeii, Italy, 256-58, 257, 258-59 idealism (idealization), 19-20, 21, 30, 217, 219, 471, (New York, 1913), 1096-97 House of M. Lucretius Fronto, wall painting, Pompeii, 627-29, 641, 959, 982 International Gothic style, 547, 584, 585, 599, 607, 615, Italy, 256, 257 ideas, contained in a work of art, 29 617, 618, 620, 639-40, 652, 657 House of Pansa, Pompeii, Italy, 239, 239 ideograph, 400 International Style (modern architecture), 833, 1135-36 House of Publius Fannius Synistor, Boscoreale (near Idia (Benin iyoba), 474 In the Dining Room, Berthe Morisot, 1014-15, 1014 Pompeii), Italy: bedroom (reconstruction), 250, 251; idolatry, 322 intonaco, 684 Cityscape (wall painting), 222, 223, 251, 251 Ieyasu, Tokugawa, 859 intrados, 226 House of the Silver Wedding, Pompeii, Italy, 239-41, 239 Ife culture (Nigeria), 469-71, 911 Intrigue, The, James Ensor, 1037-39, 1037 House of the Vestal Virgins, Rome, Italy, 273 ignudi, 695-96, 764 intuitive perspective, 30, 251, 599 House of the Vettii, Pompeii, Italy, peristyle garden, 240, Iguegha, 472 Invention of the Balloon, The (model for monument), 241.241 Ijo people (Nigeria), 923-24 Clodion, 808, 808 houses: Etruscan, 225; Roman, 238-41 Ikkyu, 858-59; Calligraphy Pair, 858, 859 Investiture Controversy, 510, 535, 537, 542 Houses at L'Estaque, Georges Braque, 1051, 1052 Iktinos, 187 Inyotef VII, King, poem in tomb of, 125 Houses at L'Estaque (photograph), D. H. Kahnweiler, Île-de-France, France, 510; origins of Gothic style in, 547 Iona, 481 Ionia, 177 1051, 1052 Iliad, 143, 149, 176, 216 Houses of Parliament, London, England, Charles Barry illumination, 319, 488; Anglo-Saxon tradition of, 532; Ionians, 153 (with A. W. N. Pugin), 940, 941, 969 English, 575, 580; Flemish, 619, 624, 634; French, Ionic order, 163, 165, 165, 210, 227, 253, 645, 645; house-synagogue (Jewish), 259, 295-96 573-74; Gothic, 573-74, 580; Islamic, 361-63; Italian, Roman modification of, 227 housing projects, 939 575; Renaissance, early, 615-17; Romanesque, 532 Iran. See Persia "How American Are We?" (Sunday magazine cover), illuminators, 615, 616; Islamic, 361 Ireland, Middle Ages, 485-88 Times (London), 1128, 1128 illusionism, 300, 494; Baroque painting, 624, 763-65; Irene, Empress, 322 How the Other Half Lives (illustrated book), Jacob Riis, Greek, 207 Irian Jaya, 899 illusionistic depth, 1052 1095 Iron Age, Greece, 153 Hudson River School, 975 illustration: book, 676-77, 1028; scientific, 798-99, 903 iron-framed buildings, 943, 1064 hue. 29, 987, 1078 Ilorin, Nigeria, 925 ironwork: Africa, 468; African, 911; Hittite, 83 Huelsenbeck, Richard, 1083 Imba Huru (Big House) (Great Zimbabwe), 475, 477 Iroquois Nation, 883 Hugh de Semur, 514 Imhotep, 99-102 Isabella, of Castile, 637

Hughes, Langston, 1101

impasto, 993

Hofmann, Hans, 1104

Isabella, princess, of Portugal, 621 Jenghiz Khan, 349, 837 Isabella d'Este, Titian, 706, 1118 Ise, Japan, shrine at, 422, 422, 425, 426 Jericho, Palestine, 63 Jerome, Saint, 297 ka (spirit), 99, 121; statue, 104 Isenheim Altarpiece, Matthias Grünewald, details: Annun-Kaaba, 340 Jerusalem Dome of the Rock, 341-42, 343 kabuki theater, 869 ciation. Virgin and Child with Angels, Resurrection, 728, fall of, 254 kachina dolls, 890 729-32, 730; Crucifixion, Lamentation, 729-32, 730 kahili, 905 First Temple, 292; destruction by Babylonians, 289 Isfahan, Persia (Iran), Masjid-i Jami (Great Mosque), 345, Kahlo, Frida, 1089-90, 1103; The Two Fridas, 1089-90, Second Temple, destruction by Romans, 289 347, 348, 352, 353 Ishiyama-gire, 434-35; album leaf from, 434, 435 Jesuits, 746, 753 1089, 1103 Jesus, 289–91; iconography of, 306–7 Kahn, Louis, 1136-37; Salk Institute of Biological Ishtar Gate, Babylon (modern Iraq), 81, 82, 83, 84 Jesus among the Doctors (in Christian art), 306 Studies, La Jolla, Calif., 1136-37, 1136 Isidorus of Miletus, 309, 310 Kahnweiler, D. H., Houses at L'Estaque (photograph), Jesus before Pilate (in Christian art), 307 Isis, 95, 96, 125, 235 Jesus Crowned with Thorns (in Christian art), 307 1051, 1052 Islam, 289, 609, 614, 824, 826, 911; history and tenets of, Jesus Walking on the Water (in Christian art), 306 Kahun (near modern el-Lahun), Egypt, 108-9; town 339–40; in India, 393; origins of, 338 Islamic art, 338–63, 519, 538, 829; early, 340–49; plan, 108-9, 109, 198 Jesus Washing the Disciples' Feet (in Christian art), 306 jewel (Shinto symbol), 426 Kaisersall (Imperial Hall). See Residenz influence on Christian, 489; influence on jewelry: Assyrian, 80; Greek, 208-9; Minoan, 136-38; Kakalia, Deborah (Kepola) U., Royal Symbols (quilt), Romanesque, 520, 527; later, 349-63 Near Eastern, 136-38; prehistoric, 40; see also Islamic world: Christian crusades against, 510; Kalf, Wilhelm, 798; Still Life with Lemon Peel, 798, 798 metalwork competition with Romanesque Italy, 539; in Iberian Kalhu (modern Nimrud, Iraq), 79; Palace of Jewelry casket lid, called Attack on the Castle of Love peninsula, 488-89, 510-11; trade with Africa, 466, (French Gothic), 572, 572 Jewish Bride, The, Rembrandt van Rijn, 791–93, 792, 965 Jewish Cemetery, The, Jacob van Ruisdael, 794, 794 Assurnasirpal II, Assurnasirpal II Killing Lions, 78, 79; tomb of Queen Yabay, jewelry from, 80, 80 Istanbul, Turkey, 280 Church of the Monastery of Christ in Chora (now Kallikrates, 187, 192 Jews, treatment of, by Muslims, 339 Kalpa Sutra (illustrated manuscript), leaf The Birth of Kariye Muzesi), 329, 329; Anastasis, 330, 330; First Mahavira, 824-25, 824, 829, 831 Jiangzhai, China, 397 Steps of Mary, 330, 330 Jiaxiang, Shandong, China, Wu family shrine, rubbing from relief, 406, 406 Kalypso, 207 Hagia Sophia, 309-12, 309, 311, 325, 345, 354, 355 Kamakura period (Japan), 437-41, 855 Italian art: architecture, 539-43, 590-92, 641-46, 660-63, Jimenez, Luis, Vaquero, 23-24, 23 Kamares Ware, 139 699-704, 709-11, 717-19, 753-59; Baroque, 808; craft Kamares Ware jug, Phaistos, Crete, 139, 139 arts, 672-77; Cubism and, 1057-59; Gothic, 590-608; Jingdezhen kilns (China), 843 Kamehameha I, Hawaiian king, 902 influence on English, 741; influence on French, 721; Joan of Arc, 638 Jocho, 432; *Amida Buddha*, 432–33, *433* kami, 426 Mannerism, 712-19, 722, 723, 724, 727; Neoclassicism Kami empire (Africa), 477, 911 John, king of England, 550, 576, 577 and Romanticism, 934-35; painting, 652-60, 665-72, kana, 434 683-87, 691-97, 704-9; Renaissance, 640-72, 683-711, John, Saint, 294 Kandariya Mahadeva temple, Khajuraho, Madhya John of Damascus, Saint, 322 724, 739; Romanesque, 539-43; sculpture, 646-52, Pradesh, India, 389-91, 389 655, 664-65, 687-91, 697-99, 717, 934-35 John of the Cross, 746 Kandinsky, Vasily, 1045-47, 1048, 1081, 1083, 1097, 1130; John of Worcester, Worcester Chronicle (English Italic peoples, 223 Concerning the Spiritual in Art (book), 1098; Impromanuscript), Dream of Henry I from, 532, 532 Italo-Byzantine style: influence on Italian Gothic, 600-4; visation No. 30 (Warlike Theme), 1046, 1046, 1081 Johns, Jasper, 1126–28, 1130, 1131; Target with Four influence on Romanesque, 527 Kanishka, Indian ruler, 378, 823 Italy, 609, 681 Faces, 1127, 1127 kanji, 434, 434 Johnson, Philip, 1137–38; AT&T Headquarters (with John Itza (Mayan), Post-Classic period, 455-56 Kano school of painting (Japan), 860 Burgee), New York City, 1137-38, 1137; Seagram Ivan IV, the Terrible, 330 kantharos, 174 ivories: Benin, 473-74; Byzantine, 318-22, 330-33; Building (see under Mies van der Rohe, Ludwig) Kao, attributed to, Monk Sewing, 441, 441 Carolingian, 499; carved panels, 499-501; Ottonian, John the Baptist, Saint, 294, 304, 595 Kaprow, Allan, 1124, 1129; The Courtyard, 1108, 1108, joined-wood, Japan, 433 499; Roman, 284 Jomon period (Japan), 423–25, 855 Jonah, Albert Pinkham Ryder, 1092, 1093 1124; "The Legacy of Jackson Pollock," 1124 iwan, 352-53, 831 Karla, Maharashtra, India, chaitya hall, 377-78, 377 Karnak, Egypt: Great Temple of Amun, 114, 115-16, 115, Ionah and the Whale, 295 261; temples at, 96, 114-16 Jacob and Esau. See Ghiberti, Lorenzo, Gates of Paradise Jonah Swallowed and Jonah Cast Up (Christian Kassotis Spring, 157 Jacque, Charles-Émile, 1005 statuettes), 295, 295 Jones, Inigo, 800–2, 816, 935; A Garden and a Princely katakana, 434, 434 jade, 399 Villa (set design), 800; Whitehall Palace, Banqueting House, 781, 800–2, 801, 816, 935 Katholikon, Stiris, Greece, Monastery of Hosios Loukas, jaguar (Olmec symbol), 448 324-25, 325 Jahangir, Indian ruler, 827, 829 Kauffmann, Angelica, 944; Zeuxis Selecting Models for His Jongkind, Johan, 1009 Jahangir-nama (illustrated manuscript), Abul Hasan and Joseph in His Carpentry Shop, wing. See Campin, Robert, Picture of Helen of Troy, 944, 944 Manohar, 828, 829 keep (donjon), 531, 579, 579 Mérode Altarpiece Jainism, 370, 371, 823; art of, 824-25 Kensett, John Frederick, 997-98; Beacon Rock, Newport Josephus, 254, 289 jamb, 225, 226, 384, 517, 517, 520, 558, 558 Joshua Leading the Israelites, from Joshua Roll (Christian Harbor, 998, 998 James I, of Aragon, 582 Kent, William, 936-37 James I, of England (James VI of Scotland), 784, 800, manuscript), 334-35, 334 kente cloth, 920-21 Joshua Roll (Christian manuscript), Joshua Leading the Kente cloth (Ashanti culture), Ghana, 920, 920 Israelites from, 334-35, 334 Jan Lutma, Goldsmith, Rembrandt van Rijn, 791, 791 Joy of Life, The, Max Ernst, 1088, 1088 Kepler, Johannes, 786 Janus, 156 Joy of Life, The, Henri Matisse, 1040, 1041, 1042, 1049-Keratea (near Athens), Greece, kore from, 170, 171 Japan: Asuka period, 426-29; Heian period, 430-37; Kerouac, Jack, 1140 Kamakura period, 437-41; Kofun period, 425-26; 50, 1120 key block, 868 Nara period, 429-30; prehistoric, 423-29; Yayoi Judaea, 291 keystone, 225, 226, 707 Judaism: early art of, 291-97; Gothic-style religious period, 425-26 Khafre, 102, 103; funerary complex of, 104 architecture, 586; origins of, 289; in Roman Empire, Japanese art, 420-41, 854-71; influence on Western, Khafre (statue), Giza, Egypt, 104, 105, 108, 111, 131 1006, 1008, 1019, 1028, 1036 (see also japonisme); 235, 289-91 Khajuraho, Madhya Pradesh, India, Kandariya "men's hand" and "women's hand" styles, 436; Judd, Donald, 1133-34; Untitled, 1133-34, 1133 Mahadeva temple, 389-91, 389 modern, 1124-25; prints, 854, 868-69, 1008, 1028, Judgment before Osiris, from Book of the Dead, 96, 121, Khamerernebty, Queen, 104–6 Khepri (scarab beetle), statue of, 114 1036, 1043 124-25, 125, 521 Judgment of Paris, The (engraving after Raphael), japonisme, 869, 1005, 1006, 1012 Khonsu, 96, 114 Marcantonio Raimondi, 1007, 1007 Jar, blackware storage, Maria Montoya Martinez and Khufu, 102, 103 Jugendstil, 1070 Julian Martinez, 889, 889 Khurasan, 348 Jar, fragments (Melanesian, Lapita culture), 897, 897 Juko-in. See Daitoku-ji Kiefer, Anselm, 1150–51; March Heath, 1151, 1151 Jar, painted, with birds (Chanhu-Daro, Indus Valley), 370, Julia Domna, 273, 278-79 kilim, Turkish, 359, 359 kiln, **57**, **162**, **843**, **93**7 Julian, Emperor, 284 370Jashemski, Wilhelmina, 240 Julian the Apostate (Roman coin), 284, 284 jasperware, 937 Kimon of Athens, 187 Julio-Claudian dynasty, 252-59 jataka tales, 428-29 King Henry III Supervising the Work (from English Julius Caesar, 234 Jean-Antoine Watteau, Rosalba Carriera, 810, 810 Julius II, Pope, 683, 692, 701 manuscript), 531 Jean d'Orbais, 565 Kino, Eusebio, 817 Jean le Loup, 565 Jeanne-Claude (de Guillebon), 1146 Jung, Carl, 1112, 1114-16 Ki no Tsurayuki, 434 junzi, 405 Kirchner, Ernst Ludwig, 1041, 1042–43, 1081; Girl under a Japanese Umbrella, 1042–43, 1043, 1085; Street, Justice of Otto III, Dirck Bouts, 630-31, 630 Jeanne d'Evreux, 574 Jeanneret, Charles-Édouard. See Le Corbusier Justinian Code, 308 Justinian I the Great, Emperor, 288, 308, 309, 313, 314, Berlin, 1042, 1043, 1081 Jeanneret, Pierre, Punjab University. See under Mathur, B. P. Kiss, The, Gustave Klimt, 1032-33, 1032, 1038 Jefferson, Thomas, 243, 444, 711, 967-68; Monticello, 316, 323 Jutes, 485 kiva, 463 Charlottesville, Virginia, 968, 968

Lagash (modern Telloh, Iraq), 74-76; votive statue of Klah, Hosteen, 891; Whirling Log Ceremony (woven by Laurentian Library. See San Lorenzo, Monastery of Mrs. Sam Manuelito) (sand-painting tapestry), 890, 891 Gudea from, 75, 76, 77 La Venta, Mexico, 447-48; colossal head, 448, 448; Klee, Paul, 1047-48, 1081; Hammamet with Its Mosque, La Jolla, California. See Salk Institute of Biological Studies pyramid and ball court, 447-48, 447 1047-48, 1047, 1081 Lake Van, Armenia, Church of the Holy Cross, 324, 324 Lawler, Louise, 1154; Pollock and Tureen, 1154, 1154 Klein, Yves, 1125; Anthropométries of the Blue Period lakshanas 378 427 Lawrence, Jacob, 1101-2; Interior Scene, 1102, 1102 (performance), 1125, 1125 Lakshmi, 387 Lawrence, Saint, 303 Kleisthenes, 155 lamb (Christian symbol), 294 Le Brun, Charles, 770, 772, 773; Palais de Versailles, Hall Kleitias, 173 Lamentation. See Grünewald, Matthias, Isenheim Altarpiece of Mirrors (see under Hardouin-Mansart, Jules) Klimt, Gustave, 1032-33, 1038; The Kiss, 1032-33, 1032, Lamentation, Nerezi (near Skopje), Macedonia, Saint LeClear, Thomas, 16–17; Interior with Portraits, 16, 19, 23 1038 Panteleimon, 328, 328 Le Corbusier (Charles-Édouard Jeanneret), 1079, 1080, Knossos, Crete, 141-42 Lamentation, Padua, Italy, Arena Chapel, Giotto, 606, 607 1135, 1136; After Cubism (book) (with Amédée Bull Jumper, 135-36, 135, 137 Lamentation (in Christian art), 307 Ozenfant), 1079; Nôtre-Dame-du-Haut, Ronchamp, bull's head rhyton from, 136, 136, 137 Laming-Emperaire, Annette, 46 France, 1136, 1136; Plan for a Contemporary City of Minos' palace at, 131 La Mouthe cave, Dordogne, France, lamp with ibex Three Million Inhabitants, 1080-81, 1080, 1135, 1136; palace complex, 132, 133-34, 133, 134, 143, 275; design (Paleolithic), 41, 47, 47 Still Life, 1079, 1079 Bull Jumping (wall painting), 140-41, 140; Throne lamps, prehistoric, 41, 47 lectionaries, 529 Room, 140; wall paintings, 139-41 lancet, 556, 558, 558 Ledoux, Claude-Nicolas, 951, 956, 1138; Château de Woman or Goddess with Snakes, 134-35, 134 Lander, Frederick, 1001 Louveciennes, Pavillon du Madame du Barry, 951. knots, 359 landscape, heroic vs. rural, 990 951, 1138 knotted carpets, 359 Landscape (album), Shitao, 850, 851 Leeuwenhoek, Anton van, 786 Knox, John, The First Blast of the Trumpet against the Le Fevre, Raoul, *Histories of Troy* (printed by Caxton), 677 Lefkandi, Euboea, Greece, *Centaur*, 158, 159 landscape architecture, 939, 970 Monstrous Regiment of Women, 743 Landscape (hanging scroll), Bunsei, 856–57, 857 Landscape near Chatou, Maurice de Vlaminck, 1040, 1040 legalism, 402 Koetsu, Hon'ami, 863; Mount Fuji (teabowl), 863, 863 landscape painting, 736-38, 932; American, 974-75, Lega people (East Africa), 915-16 Léger, Fernand, 1079–80, 1112; Three Women, 1080, Kofun period (Japan), 425-26, 855 996-98; Chinese, 407, 416-18, 837, 846, 848-51; Dutch, Koi Konboro, king, 474 793-94; French, 990-93, 1009; Japanese, 856-58, 869; Kojo-in, Guest Hall. See Onjo-ji monastery naturalist, 990-93; Roman, 258; Romantic, 948-50 Legros, Alphonse, 1005 Leibl, Wilhelm, 995–96; Three Women in a Village Church, Kollwitz, Käthe Schmidt, 1045; The Outbreak, 1045, 1045 Landscape (wall painting), Akrotiri, Thera, Greek island, kondo, 426, 428 995-96, 995 Kongo people (Zaire), 917-18 Landscape with Merchants, Claude Lorrain, 774, 774, 793, lekythos, 197 Le Mas d'Azil, Ariège, Dordogne, France, spear thrower, ibex-headed (Paleolithic), 47, 47 Koran, 289, 338, 339, 340, 348, 822 manuscript pages: Egyptian, 361, 361; Syrian, 338, Landscape with Rainbow, Peter Paul Rubens, 782, 783, Le Nain, Antoine, *The Village Piper*, 776, 776 339, 348 949, 1118 kore, 169-72 Landscape with Saint John on Patmos, Nicolas Poussin, Le Nain brothers, 776 Korea, United Silla period, 430 774-75, 775 Lenin, Vladimir, 1075 Korean art, influence on Japanese, 425, 430 Lane, Fitz Hugh, 998 Le Nôtre, André, 770 Lange, Dorothea, 1103; Migrant Mother, Nipomo, Korin, Kenzan, 864 Leo III, Emperor, 322 Korin, Ogata, 863-66; Lacquer box for writing California, 1103, 1103 Leo III, Pope, 491 implements, 864-66, 865 Langhans, Karl Gotthard, 962–63; Brandenburg Gate. Leonardo da Vinci, 624, 683–86, 687, 704, 712, 721, 785; Korkyra (Corfu), Greece, Temple of Artemis, 166, 166; Berlin, Germany, 962-63, 963 The Last Supper (wall painting), Milan, Italy, Santa sculpture from pediment of, 166, 166 lantern, 643, 802 Maria delle Grazie, 684-85, 684, 739; Mona Lisa, Koshares of Taos, Pablita Velarde, 890, 890 lantern tower, 513 685-86, 685; Virgin and Saint Anne with the Christ Kosho, 439; Kuya Preaching, 439, 439 Laocoön and His Sons, Hagesandros, Polydoros, and Child and the Young John the Baptist, 685, 685, 709; kouros, 169-72, 179-80, 229 Athanadoros of Rhodes, 20, 21, 215–16, 215, 720, 756 Vitruvian Man. 698, 698 Kouros (Greek statue), 169-70, 169 Laozi, 404, 837 Leoni, Leone, 691; Charles V Triumphing over Fury, 691, Kramer, Hilton, 1126 La Pia de' Tolomei, Dante Gabriel Rossetti, 1003-4, 1003 691 Krasner, Lee, 1104-5, 1116; Red, White, Blue, Yellow, Lapita culture, 895, 897 Leoni, Pompeo, 691, 746; Philip II and His Family, 746, 761 Lapith Fighting a Centaur, Athens, Greece, Acropolis, Parthenon, metopes sculpture, 189, 189, 190
Larbro Saint Hammers, Gotland, Sweden, pictured Black, 1104, 1105, 1116 Leoni family, 687-88, 746 Leo X, Pope, 686, 689, 692–93 Leo X with Cardinals Giulio de' Medici and Luigi de' Rossi, Kritias, 197 Kritios Boy, 180-81, 180, 195 Raphael, 693, 693 Kroisos (?) (Greek statue), 170, 170, 171, 181, 229 Large Blue Horses, The, Franz Marc, 1047, 1047 Leroi-Gourhan, André, 46 Kruger, Barbara, 1156; We Won't Play Nature to Your Large Odalisque, Jean-Auguste-Dominique Ingres, 959, Leroy, Louis, 28 Culture, 1156, 1157 959, 1051 Les Américains (The Americans), Robert Frank, 1140 Kuba people (Zaire), 921 Larionov, Mikhail, 1060 Lescot, Pierre, 721–22; Palais du Louvre, Cour Carré, Kublai Khan, 419, 837, 839 Larkin Building, Buffalo, New York, Frank Lloyd Wright, 721-22, 721 kufic script, 348, 349, 352, 355, 355 Le Tuc d'Audoubert, France, Bison (relief sculpture), 1066, 1067 Kushan period (India), 378-81 Lascaux, France, cave paintings, 43-45, 135; Bird-45-46, 45 Kuva, 438-39 Headed Man with Bison and Rhinoceros, 44, 45; Hall of Levant, the, Neolithic, 48 Kuya Preaching, Kosho, 439, 439 Bulls, 43, 44; plan, 43, 44 Le Vau, Louis, 770, 773; Palais de Versailles (with Jules Hardouin-Mansart), Versailles, France, 770–73, 771, Kwakiutl people, 886 Last Judgment (frescoes), Michelangelo, 694, 696-97, kylix, 177 802, 811, 937, 1062; Palais du Louvre, East front (with Kyoto, Japan. See Daitoku-ji; Myoki-an Temple; Ryoan-ji Last Judgment (relief), Autun, Burgundy, France, Saint-Claude Perrault and Charles Le Brun), Paris, France, Lazare Cathedral, Gislebertus, 520, 521, 525, 533, 770, 770, 785, 981 L Levine, Sherrie, 1155–56; Untitled (After Aleksandr La Banditaccia, Etruscan cemetery, Cerveteri, Italy, 229, Last Judgment (relief), Reims, Île-de-France, France, Rodchenko: 11), 1155-56, 1155 229; sarcophagus from, 230, 230; Tomb of the Reliefs, Nôtre-Dame Cathedral, 567-68, 567 Lewis, Edmonia, 972-73; Hagar, 972-73, 972; Robert 229, 229 Last Judgment Altarpiece, Rogier van der Weyden, 627, 627 Gould Shaw, 972 Labille-Guiard, Adélaïde, 953-55; Self-Portrait with Two Lastman, Pieter, 790 Lewis, Lucy M., 1164-65, 1166; Black on White Jar with Lightning Pattern, 1164, 1165 Pupils, Mademoiselle Marie Gabrielle Capet and Made-Last Supper (in Christian art), 306 Last Supper (centerpiece). See Riemenschneider, Tilman, moiselle Carreux de Rosemond, 954, 955 Lewis, Meriwether, 885 Labrouste, Henri, 980-81; Bibliothèque Sainte-Altarpiece of the Holy Blood Lewis, Sinclair, 1102 Last Supper (fresco), Andrea del Castagno, 657, 657, 684 Last Supper, The (wall painting), Leonardo da Vinci, 684– Geneviève, Reading Room, Paris, France, 980-81, 980 Leyland, Frederick, 26 Labyrinth, Cretan, 132, 133 Leyster, Judith, 788-89; Self-Portrait, 788, 789 labyrinth, in Gothic cathedrals, 561, 565 85, 684, 739 li, 405, 415, 416 Lachaise, Gaston, 1098-99; Standing Woman (Elevation), Latin-cross plan churches, 298, 558, 660, 660, 701 Liang Wudi, 409 1098-99, 1098 Latin language, 233 Liangzhu culture, 399 lacquer, 863, 864 Latium, 233 Libergier, Hughes, 563 Lacquer box for writing implements, Ogata Korin, La Tour, Georges de, 775; The Repentant Magdalen, 775, Liber Scivias (Romanesque manuscript), Hildegard's 864-66, 865 775 944 Vision page from, 538-39, 538 Lactantius, 297 Latrobe, Benjamin Henry, 968-69; corncob capitals, 969, Library of Congress, Washington, D.C., 1090, 1090 Ladder, Philip Guston, 1142, 1142 969; U.S. Capitol (see under Thornton, William) Libyan Sibyl (fresco), Rome, Italy, Vatican Palace, Sistine Ladies Preparing Newly Woven Silk (detail) (copy of paint-Laugerie-Basse, France, Pregnant Woman and Deer, Chapel, Michelangelo, 696 ing by Zhang Xuan), Emperor Huizong, 414, 415, 417 engraved antler, 40, 40 Lichtenstein, Roy, 1128-29, 1155; Oh, Jeff. . . I Love You, Lady Sarah Bunbury Sacrificing to the Graces, Joshua Laughing Child, Robert Henri, 1094, 1094 Too . . . But . . ., 1129, 1129 Reynolds, 941-42, 941 Laurana, Luciano, 662; Ducal Palace, Urbino, Italy, 645, Licinius, 280 La Fayette, Madame de, 805 662, 662 Life (magazine), 17-18, 1140; first cover, 17

Life Line, The, Winslow Homer, 1093, 1093 Lorenzetti brothers, 624 Magasin, Avenue des Gobelins, Eugène Atget, 1028, 1029, "Life of the Virgin" (vestments, English), 581-82, 581; Lorenzo the Magnificent, 662, 688 detail, Angel of the Annunciation, 581-82, 581 lost-wax casting process, 31, 88, 137, 209, 400, 402, 456 Magdalen College, Oxford, Oxfordshire, England, light. Impressionism and, 1009 lotus flower (Buddhist symbol), 104, 427, 427 Orchard, William, 578, 579 Lighthouse of Alexandria, 102, 209 lotus throne (Buddhist symbol), 427, 427 Magdeburg, Germany, 499; Cathedral, Saint Maurice lilies (Minoan symbol), 140, 141 Louis, Morris, 1131-32; Saraband, 1131-32, 1131 (sculpture), 499, 587-88, 588 Limbourg, Paul, Herman, and Jean, Très Riches Heures Magdeburg Ivories (German), Otto I Presenting Louis VI, of France, 550, 551 (illuminated manuscript), page February, 616-17, 616, Louis VII, of France, 550, 551, 552 Magdeburg Cathedral to Christ (plaque), 499-501, 499 Louis IX, of France, 568-69, 572-73, 578 Magi Asleep, The (relief), Autun, Burgundy, France, Saint-621, 632, 727 Louis IX and Queen Blanche of Castile, page from Mora-Lazare Cathedral, 512-13, 521, 521 limner, 817, 974 Lin, Maya Ying, 1162; Vietnam Veterans Memorial, 1162. lized bible (French Gothic), 572-73, 573, 583 Magic Bird, Constantin Brancusi, 1031, 1031, 1165 Louis XI, of France, 638 Magna Carta, 576 1162 Magritte, René, 1088-89, 1141; Time Transfixed, 1088-89, Lindau Gospels (Carolingian manuscript), 498; Crucifixion Louis XII, of France, 635 with Angels and Mourning Figures (book cover), Louis XIII, of France, 769 1088, 1141 Louis XIV, of France, 750–51, 769, 772–73, 776, 804, 811 Maguey Bloodletting Ritual (fresco), Teotihuacan, Mexico, 497-98 497 502 Louis XIV, Hyacinthe Rigaud, 750–51, 750, 769, 773, 776 450, 451 Lindisfarne, 481 line, 29 Louis XV, of France, 804, 811, 950, 951 Mahabharata, 371, 372 Louis XVI, of France, 955-56 Mahavira, 371, 823, 824 Linear A, 131 Louis Philippe, king of the French, 961 Mahayana Buddhism, 371, 378, 410, 823 Linear B, 131, 147 Maillol, Aristide, 1030, 1048, 1060, 1099; The Louis the Pious, Emperor, 495, 498 linear perspective, 30 Mediterranean, 1030, 1031, 1032, 1048, 1099 Louvain, Flanders, 626, 630 linear style, 29 mainstream art, 1023, 1110, 1149 Louveciennes, Château de, Pavillon du Madame du lines of force, 29 Barry, Claude-Nicolas Ledoux, 951, 951, 1138 Maison Carrée, Nîmes, France, 242, 243 lingam shrine, 387 Maison de l'Art Nouveau, La, 1071 Louvre, Palais du, Paris, France, 721-22, 773; Cour lintel 283, 384 Carré, Pierre Lescot, 721–22, 721, 722; East front Maitreya, 371 Lintong, Shaanxi, China, mausoleum of Qin emperor, (Louis Le Vau, Claude Perrault, and Charles Le Brun), majolica, 620 earthenware soldiers from, 396, 397, 402 Ma Jolie, Pablo Picasso, 1053-54, 1053, 1077, 1118, Lion, page from Gospel Book of Durrow (Hiberno-Saxon 770, 770, 785, 981 low relief, 31, 40, 69, 229, 374, 399, 488 1132, 1163 manuscript), 486-87, 487 maki-e, **864** lion (Christian symbol), 294 Loyola, Ignatius, 746, 753 Maku (African artist), 470 lozenge, 361 Lion Attacking a Horse, George Stubbs, 946, 947 malanggan ceremonial art, 899 Lion capital (India, Maurya period), 366, 373-74, 373 Luanda, Africa, 474 Ludovisi Battle Sarcophagus, Battle between the Romans Malatesta, Sigismondo, 660 Lion Crushing a Serpent, Antoine-Louis Barye, 962, 963 Malatesta, Tempio. See San Francesco, Church of and the Barbarians from (relief), 278, 278 Lioness Gate, Mycenae, Greece, 143, 144 Male and Female, Jackson Pollock, 1116, 1116 Luke, Saint, 22, 294, 335 Lion Gate, Hattushash (Hittite), in modern Turkey, 83-84 Luks, George, 1094 Luminists, 998 Malevich, Kazimir, 1060-61, 1077; Suprematist Painting 83, 143 (Eight Red Rectangles), 1060-61, 1061 Lion-Human (figurine), Hohlenstein-Stadel, Germany, Mali, empire of, 911 Luncheon of the Boating Party, Pierre-Auguste Renoir, 38-39, 38, 45 Malinalco, Mexico. See Rock-cut sanctuary (Aztec) Lions and Prophet Jeremiah (?) (relief), Moissac, Toulouse, 1016, 1016 lunette, 291, 514, 519, 644, 695, 1090 Mallorca, 582 France, Saint-Pierre priory church, south portal, 519-Mamallapuram, Tamil Nadu, India: Dharmaraja Ratha, lusterware, 357 388, 389, 391; Durga as Slayer of the Buffalo Demon Lipchitz, Jacques, 1055; Man with a Guitar, 1055, 1055 lustrum, 245 (relief), 388, 388; rock-cut temples, 389 Luther, Martin, 681, 735, 736 Lippi, Filippino, 657 Luxor, Egypt: Temple of Amun, Mut, and Khonsu, 116, 116; temples at, 96, 114–16 Lippi, Filippo, 656-57, 659; Virgin and Child, 656, 657 Mamluk dynasty, 349, 361 Man and Centaur (statuette), Olympia, Greece, 160, 160 Lissitzky, El, 1077; Proun space, 1076, 1077 Lydia in a Loge, Wearing a Pearl Necklace, Mary Cassatt, 1013–14, 1013, 1015 Manchu peoples, 848 list, 579, 579 mandala, 375-76, 385, 427, 427, 431-32 literary illustration, 946-48 mandapa, 375, 390 literati, Chinese, 836, 838-41, 857 Lydians, 88, 89 lyre, bull, Ur (modern Muqaiyir, Iraq), 70–71, 72, 486 Mander, Karel van, 786 literati painting (China), 839-41, 846-48, 866 Mandolin and Clarinet, Pablo Picasso, 1054-55, 1055, 1061 lyrical abstraction, 1112 literature, Sumerian, 67 lithography, 974, 985, 1005, 1028 Lysimachos, king of Thrace, 205 mandorla, 312, 503, 519 Manet, Édouard, 983, 1005, 1007-9, 1012, 1014, Little Dancer Fourteen Years Old, Edgar Degas, 1013, 1013 Lysippos, 201, 203-5, 219, 271; (copy after) Alexander the Little Galleries of the Photo-Secession (291 Gallery), 1096 Great, 203, 205; The Scraper (Apoxyomenos), 203, 204, 1015-16, 1094, 1110; A Bar at the Folies-Bergère, Little Girl with a Bird (stela), Paros, Greek island, 196–97, 1015-16, 1015; Le Déjeuner sur l'Herbe (The Luncheon on the Grass), 1006, 1007, 1008-9, 1015; Portrait of Émile Zola, 1008, 1008 Liuthar (Aachen) Gospels (Ottonian manuscript), Otto III Maas at Dordrecht, Aelbert Cuyp, 793, 793 Manetho (Egyptian priest/historian), 94, 106 Enthroned page from, 503, 503 Man in a Red Turban, Jan van Eyck, 623-24, 623 Maat. 124 Liuthar School, 503-4 Mannerism, 712-19, 722-24, 726-27, 739, 747, 773 Mabel of Bury Saint Edmunds, 581 Livia (Roman), 248, 249 Macdonald, Frances, 1071 Mansart, François, 770 Livia, wife of Augustus, 234, 249 Man's Love Story, Clifford Possum Tjapaltjarri, 906-7, 907 Macdonald, Margaret, 1071 Livre du Cuer d'Amours Espris by René of Anjou Macedonia, 234; Antigonid, 209 Mantegna, Andrea, 667-68, 670, 671, 706 (illuminated book), page René Gives His Heart to frescoes, Mantua, Italy, Ducal Palace, Camera Picta, Macedonian dynasty (Byzantine), 323 Desire, René Painter, 639, 639, 677 667-68, 668, 686, 763; detail Gonzaga Family, 668, machine aesthetic, 1069 Llama (statuette) (Inka), 880, 881 669 Machu Picchu, Peru, 880, 881 Loango, Africa, 474 Saint Sebastian, 672 Maciunas, George, 1124; Après John Cage (happening), Lobi people (Burkina Faso), 916-17 1124; "Neo-Dada in the United States" (lecture), 1124 Mantle with bird impersonators (Paracas culture, Peru), Locke, Alain, 1101 Mackintosh, Charles Rennie, 1071–72; Glasgow School of Art, Director's Room, Glasgow, Scotland, 1071–72, 457-58, 457 loculi, 292 mantra, 431, 432 lodge books, 572 Mantua, Italy, 641, 660, 780-81; Ducal Palace, Camera loggia, 644, 645, 645, 707 1071 Picta, 667-68, 668, 669, 686, 763; see also Sant'Andrea; Mackmurdo, Arthur Heygate, 1070, 1071 Lombard style, influence on Romanesque, 527, 535, Tè. Palazzo del MacLaren, Charles, 216 Manuelito, Mrs. Sam, Whirling Log Ceremony. See under MacNeil, Herman Atkins, 1091; Sun Vow, 1091, 1091 London, England: Great Fire (1666), 802; see also Madame de Moitessier, Jean-Auguste-Dominique Ingres, Klah. Hosteen Chiswick House; Crystal Palace; Houses of 960, 960 manuscript illumination. See illumination Parliament; Saint Paul's Cathedral manuscripts, 319; Byzantine, 318-22, 333-35; Carolin-Maderno, Carlo, 701, 756; Saint Peter's Basilica (plan), London Great Exhibition (1851), 978, 980, 1004 gian, 494-98; Gothic, 573-74; Islamic, 361-63; see London Society of Artists, 945 Rome, Italy, 701, 756, 756 also book production Madonna and Child with Lilies, Luca della Robbia, 651, 651 Loos, Adolf, 1072-73; "Ornament and Crime," 1072; Manutuke Poverty Bay, New Zealand. See Te-Hau-ki-Steiner House, Vienna, Austria, 1072-73, 1072 Madonna with the Long Neck, Parmigianino, 714, 714, Turanga (Maori meetinghouse) Lorblanchet, Michel, 42 Manuzio, Aldo (Aldus Manutius), 677 Lorca, Federico García, 1087 madrasas, 345, 352-53 Man with a Guitar, Jacques Lipchitz, 1055, 1055 Man with His Grandchild, A, Domenico del Ghirlandaio, Madrid, Spain. See Escorial, El; San Fernando, Hospicio de Lorenzetti, Ambrogio, 599-600 Palazzo Pubblico, Siena, frescoes: Allegory of Good Madurai, Tamil Nadu, India. See Minakshi-Sundareshvara 658, 659 Government in the City, 548, 549, 599-600, 600-1; Manyoshu (Japanese poetry anthology), 430, 855 maenad, 174 Allegory of Good Government in the Country, Maori people, 903-5 Maestà Altarpiece, Siena Cathedral, Duccio di 599-600, 600-1 Mapplethorpe, Robert, 1161; Ajitto (Back), 1161, 1161 Lorenzetti, Pietro, 599-600, 604; Birth of the Virgin, 598, Buoninsegna, 597, 597; detail, Virgin and Child in maasura, 344 Majesty, 583, 596, 597

Marburg, Germany, Saint Elizabeth church, 585, 585 Mask, kanaga (Dogon culture), Mali, 922, 922 Meir, Egypt, tomb of Senbi, Hippopotamus (statue), 112, Mask, nowo (Mende culture), Sierra Leone, 915, 915 Marc, Franz, 1047, 1048; The Large Blue Horses, 1047, Melanesia, 895, 897-900 1047 "Mask of Agamemnon" (funerary mask), Mycenae, Marcellinus, 294 Greece, 137, 148, 148 Melk, Austria. See Benedictine Monastery Church March Heath, Anselm Kiefer, 1151, 1151 Mask of an iyoba (from Benin), 473-74, 473 Mellerio, André, 1028 Marcus Aurelius, 259, 260, 283, 284 Masks (Bwa culture), Dossi, Burkina Faso, 914, 915, 924 Melun Diptych, wing Étienne Chevalier and Saint Stephen, Marcus Aurelius (Roman equestrian statue), 270, 271, Masolino, 654 Jean Fouquet, 638, 638, 720 278, 700 masonry, Inka, 879-80 memento mori, 809 Memling, Hans, 631-32, 637; Saint Ursula reliquary, 631, Marden, Brice, 1166; Cold Mountain 3, 1166, 1166 masons: Gothic cathedral construction, 563; lodge Marduk ziggurat, 81, 83 books of, 572 631; detail Martyrdom of Saint Ursula, 631-32, 631 Marey, Étienne-Jules, 1059 masques, English Court, 800 Memorial head (from Benin), 472, 472 Margaret of Austria, 616, 706 mass (in art), 29 memorial stones, Viking, 482-83 marginalia, 575-76; English Gothic, 580 Massacre of the Innocents (in Christian art), 306 memory images, 40 Mari (modern Tell Hariri, Iraq), 77 Masson, André, 1087 Memphis, Egypt, 122 palace of Zimrilim, 131 mastaba, 99, 103, 103 Mende people (Sierra Leone), 915 wall painting from, 77-78, 77, 83, 131-32; detail, Master of Buli, 470 Mendieta, Ana: Silhouettes (performances), 1149; Tree Blue Bird, 77-78, 77 Master of Flémalle, 619-20, 626, 674, 786 of Life series (photographs of), 1148, 1149 Master of the Smiling Angels (Saint Joseph Master), 567 Ménec, Carnac, France, menhir alignments, 52, 53 Mariana Islands, 895 Maria Paulina Borghese as Venus Victrix, Antonio Canova, materials: African use of, 924; industrial, 1133; Japanese Mengs, Anton Raphael, 931, 944 934-35, 934, 959, 972, 996 use of, 422, 425, 855, 863, 870-71; modern, 924, 1069, menhir, 53 Marie Antoinette, queen of France, 955-56 1104; natural, 422, 425, 855, 863, 870-71, 1070 menhir statue, 55-56, 56 Maternal Caress, Mary Cassatt, 1017-19, 1017 Meninas (The Maids of Honor), Las, Diego Velázquez, Mariette, Auguste, 108 Marigny, marquis de, 950 mathematical perspective. See perspective 778-80, 779, 965 Marika, Mawalan, The Wawalag Sisters and the Rainbow Mathieu, Georges, 1112; Capetians Everywhere, 1112, 1112 Menkaure, 102, 103, 104-6 Mathur, B. P., Punjab University (with Pierre Jeanneret), Menkaure and His Wife, Queen Khamerernebty (Egyptian), Serpent, 897, 897 Marilyn Diptych, Andy Warhol, 1130, 1130 Gandhi Bhavan, Chandigarh, India, 833, 833 94, 98, 104-6, 106, 125, 169 Marilyn (Vanitas), Audrey Flack, 1143, 1143 Mathura School, 378, 379-80, 381 menorah, 254, 289, 292 Marine Style (Minoan), 139 Matisse, Henri, 1039-40, 1051, 1052, 1060, 1096, 1097, Menorahs and Ark of the Covenant, Rome, Italy, Villa Marinetti, Filippo Tommaso, "The Foundation and 1104, 1123; The Joy of Life, 1040, 1041, 1042, 1049-50, Torlonia, 291-92, 292 Manifesto of Futurism," 1056, 1057 1120; "Notes of a Painter," 1040; The Woman with the mensa, 583 Mark, Saint, 294 Hat, 1040, 1040 Mentuhotep II, 108 Market Gate, Miletos, Asia Minor (modern Turkey), 268, matriarchy, in prehistoric societies, 40 Merian, Anna Maria Sibvlla, 798–99; The Metamorphosis 268 Matsushima screens, Tawaraya Sotatsu, 863, 864-65 of Insects of Surinam (illustrated book), 799, 799 Markets of Trajan, Rome, Italy, 262-63, 262, 263 matte, 619, 889 Mérode Altarpiece, Robert Campin, 620-21, 620, 1092; Market Woman (Hellenistic statue), 217-19, 217 Matter, Mercedes, 1123 wing Joseph in His Carpentry Shop, 621, 621 Mark the Evangelist, page from Godescalc Evangelistary Matthew, Saint, 294 Meryeankhnes, Queen, 106 Mesoamerica, 445–56, 875; ritual ball game, 445–47 (Carolingian manuscript), 494–95, 495 Matthew the Evangelist, page from Ebbo Gospels (Carolingian manuscript), 495, 496 Maurice, Saint, 499, 501, 587–88 Marquesas Islands, 902 Mesolithic period, 37 Marriage à la Mode series, The Marriage Contract, Mesopotamia (modern Iraq), 62-63, 69-70, 76-77, 349; William Hogarth, 940, 941, 965, 988, 1002 Maurya period (India), 372-74, 823 Seleucid, 209 mausoleum, 200, 830; of Charlemagne, 492; Chinese, Marriage of the Emperor Frederick and Beatrice of Mesopotamian art: architecture, 65-66, 226; influence Burgundy, The (fresco), Giovanni Battista Tiepolo, 402; of Constantina, 300 on Etruscan, 225; influence on Indus Valley art, 369 806, 806, 964 Mausoleum of Galla Placidia, Ravenna, Italy, 302, 302; metalwork: Aegean, 128; Africa, 468; Americas, 445; Bronze Age, 58–59; Byzantine, 330–33; German, 537–38; Greek, 160; Hittite, 83; Inka, 880; Islamic, 355–56; Good Shepherd, 303, 303, 318; Martyrdom of Saint Marsh, Reginald, 1101; Why Not Use the "L"?, 1100, Lawrence, 302-3, 303, 319 1101 Marshall Field Warehouse, Chicago, Illinois, Henry Hobson Richardson, 1064, 1064, 1065, 1067 Mausoleum of Halikarnassos (modern Bodrum, Turkey), 102, 200–1, 200, 202; Mausolos (?) (statue), 200, 201 Japanese, 425; Mesoamerican, 456; Meuse Valley (Mosan), 537, 538, 586; Minoan, 136–38; Mycenaean, Marshals and Young Women, from Procession, Athens, Mausoleum of Qin emperor, Lintong, Shaanxi, China, 148-49; Near Eastern, 137; Persian, 88; Peruvian, 459; Greece, Acropolis, Parthenon, friezes, 190, 191, 246 earthenware soldiers from, 396, 397, 402 Romanesque, 537-38; Scythian, 208; techniques, 88; Marsh Flower, a Sad and Human Face, The, Odilon Mausoleum under Construction (relief), Rome, Italy, tomb Visigoth, 488; see also bronze; gold work; jewelry Redon, 1033, 1033 Metamorphosis of Insects of Surinam, The (illustrated of Haterius family, 255, 255 Martinez, Maria Montoya and Julian, 889; Jar, blackware Mausolos, prince of Karia, 200 book), Anna Maria Sibylla Merian, 799, 799 storage, 889, 889 Mausolos (?) (statue), Halikarnassos (modern Bodrum, Metochites, Theodore, 329 metope, 164, 165, 225 Martini, Simone, 597-99, 604; Siena Cathedral altar-Turkey), Mausoleum, 200, 201 piece, Annunciation panel from, 575, 597-99, 597 Maxentius, 280, 281, 283 Meuse Valley/Mosan, metalwork, 537, 538, 586 Martin Luther as Junker Jörg, Lucas Cranach, the Elder, Maximian, 280 Mexico, 776, 817, 882-83; indigenous peoples, 875-79, 882-83; mural movement, 1103 736, 736 Maximianus, Archbishop, 314, 316 Martyrdom of Saint Lawrence, Ravenna, Italy, Mausoleum Mayan culture, 447, 451-56, 875 Mexico City, Mexico, 879; Ministry of Education, murals, of Galla Placidia, 302-3, 303, 319 1089, 1104, 1104, 1158 Mayapan, 456 Martyrdom of Saint Ursula, detail. See Memling, Hans, Mazarin, Cardinal, 769 Meyer, Adolph, Fagus Factory. See under Gropius, Walter Saint Ursula reliquary Michals, Duane, 1141; This Photograph Is My Proof, mbis (New Guinea spirit poles), 899 martyrium, 298, 325, 341, 492, 663 McEvilley, Thomas, 1110 1141-42.1141 Maruyama-Shijo school (Japan), 867-68 McHale, John, 1128 Michelangelo Buonarroti, 644, 645, 655, 683, 687, 688-90, Marville, Jean de, 617 McKim, Charles Follen, 1064 712, 714-15, 719, 764, 785, 931, 935, 942, 947, 961 Marx, Karl, 994, 1075 McKim, Mead, and White, 1064; Boston Public Library, architecture, 699-703 Boston, Mass., 1063-64, 1063 Marxist art theory, 24 David, 689, 689, 759 Mary, Mother of Jesus, 289, 299 McNair, Herbert, 1071 Monastery of San Lorenzo, Laurentian Library, Mary at Her Devotions, page. See Mary of Burgundy Painter, Hours of Mary of Burgundy Florence, Italy, 693, 719, 719

Moses, Rome, Italy, San Pietro in Vincoli, Tomb of Mead, William Rutherford, 1064 meander, 247 Mary I (Tudor), of England, 706, 742-43 Mechicano, 1158 Julius II, 697-98, 697 Mary Magdalen, Donatello, 650, 650 Medes 81 painting, 695-97 Mary of Burgundy Painter, 634; Hours of Mary of Burgundy, page Mary at Her Devotions, 634, 634 Medici, Catherine de', 723 Medici, Cosimo de', the Elder, 641, 644 Piazza del Campidoglio: Palazzo dei Conservatori, 700, 700, 709; Palazzo Nuovo, 700; Palazzo Mary of Hungary, 706, 728 Marys at the Tomb (in Christian art), 307 Medici, Lorenzo de', 659 Medici, Marie de', 769, 781–82 Senatorio, 700 Pietà (Rondanini), 688-89, 688, 690, 698-99, 698 Mary's silk, 553 Medici Chapel (New Sacristy). See San Lorenzo, Church of Saint Peter's Basilica, Rome, Italy, 700-3, 701, Mary Tudor, Anthonis Mor, 743, 743 Medici family, 641, 689, 693 702-3, 702, 756 Masaccio (Maso di Ser Giovanni di Mone Cassai), 652–55, 657, 666, 683; *Tribute Money* (fresco), Florence, Italy, Santa Maria del Carmine, Brancacci Chapel, 654–55, 655, 657; *Trinity with the Virgin, Saint John the* Medici-Riccardi, Palazzo, Florence, Italy, Michelozzo di sculpture, 697-99 Bartolommeo, 644, 644, 646, 704 Tomb of Giuliano de' Medici, Florence, Italy, Church Mediterranean, The, Aristide Maillol, 1030, 1031, 1032, of San Lorenzo, Medici Chapel (New Sacristy), 1048, 1099 689-90, 690 Evangelist, and Donors (fresco), Florence, Italy, Santa medium, 29, 30, 31; and prestige of an artwork, 1162-64 Vatican Palace, Sistine Chapel, Rome, Italy Maria Novella, 653-54, 653, 672 Medusa, 166 ceiling frescoes, 694, 695-96, 695, 763, 764, 768; Masjid-i Jami (Great Mosque), Isfahan, Persia (Iran), 345, Meeting, The, Honoré Fragonard, 812, 813, 951 Libyan Sibyl, 696 347, 348, 352, 353 megalithic architecture, Neolithic, 51-55 wall fresco, Last Judgment, 694, 696–97, 697, 961

Mask, bwami (Lega culture), Zaire, 916, 916

Mask, ekpo (Anang Ibibio culture), Nigeria, 921, 921

megaron, 147, 160-61

Meiji period (Japan), 870-71

marae, 901

Marat, Jean-Paul, 957

624, 638, 641, 646, 648, 653, 655, 657, 666, 667, 670, Piles, Roger de, The Principles of Painting, 785 polyptych, 583, 627 673, 684, 729, 734, 785; reverse, 316; two-point, 30; pilgrimage churches, 24 Pomona, 156 vertical, 30 pilgrimage routes, 508-9, 512-14, 513 Pompadour, Madame de, 811, 950 Peru, 457-60, 776, 882 Pilgrimage to Cythera, The, Jean-Antoine Watteau, 809, 809 Pompeii, Italy, 222-23, 238-39, 931, 944, 950; city plan, Perugia, Italy, Porta Augusta, 225, 225, 253 pillar, 101, 164; Buddhist, 373 238, 239; House of G. Polybius, 240; House of Julia Perugino (Pietro Vannucci), 669-70, 694; Delivery of the Pinchot, Gifford, 1062 Felix, Still Life (wall painting, detail), 256-58, 257, Pine Spirit, Wu Guanzhong, 850, 851 Keys to Saint Peter (wall fresco), Rome, Italy, Vatican 258-59; House of M. Lucretius Fronto, wall painting, Palace, Sistine Chapel, 669-70, 669, 686, 691 pinnacle, 558, 558 256, 257; House of Pansa, 239, 239; House of the Silver Peter, Saint, 294, 297 Piper, Adrian, 1156 Wedding, 239-41, 239; House of the Vettii, peristyle Petites Heures of Jeanne d'Evreux (manuscript), Jean Pipe with beaver effigy (Hopewell culture, Illinois), 460. garden, 240, 241, 241; Sacred Landscape (wall Pucelle, pages from: Annunciation, 574-75, 575; painting), 258, 258, 334; Villa of the Mysteries, Initiation Betrayal and Arrest of Christ, 574-75, 575; Fox Seizing Piranesi, Giovanni Battista, 933-34; Le Antichità Romane Rites of the Cult of Bacchus (?) (wall painting, detail), a Rooster, 576, 576 (Roman Antiquities), 933–34; The Arch of Drusus, 933, 250-51, 250, 292; wall paintings, styles of, 249-51; Phaistos, Crete: Kamares Ware jug, 139, 139; palace Young Woman Writing (wall painting), 258, 279 complex, 133 Pisa, Italy, 539 Pompeijan red. 250 pharaoh (title), 114 Baptistry, 540; pulpit, Nicola Pisano, 592–93, 593 Pont du Gard, Nîmes, France, 241-43, 241 Pheidias, 186, 187–88, 190, 201; Zeus, statue of, at Campo Santo, fresco, Francesco Traini, 607, 608, 608 Pontius Pilate, 291 Cathedral, 540, 540; pulpit, Giovanni Pisano, Olympia, 102 Pontoise, Place du Grand-Martroy, Eugène Atget, 1029, Philadelphia, Pennsylvania. See Guild House 593-94 593 cathedral complex, 539–40, *540*, 592 Pisano, Andrea, 594–95 Philip II, of Macedon, 158, 198, 205 Pontormo, Jacopo da, 712, 713-14; Entombment, 713-14, Philip II, of Spain, 681, 691, 707, 728, 743, 745-46 713, 747 Philip II and His Family, Pompeo Leoni, 746, 761 Baptistry of San Giovanni, Florence, Italy, doors, *Life of John the Baptist* from, *594*, 595; detail, *Burial of* Poore, Richard, bishop, 577 Philip III, of Spain, 776 Pop Art: American, 25, 1155, 1164; British, 1128-30 Philip IV, of Spain, 776, 778, 781 John the Baptist, 595, 595 Pope, Catholic, 291 Philip the Arab (Roman bust), 276–77, 277 Pisano, Giovanni, 590, 593; Pisa Cathedral pulpit, detail, Pope Innocent X, Diego Velázquez, 1109, 1111, 1111 Philip the Bold of Burgundy, 615, 617 Nativity, 593-94, 593; Siena, Cathedral of Our Lady, Popol Vuh, Book of (Mayan), 455 Philip the Good of Burgundy, 612, 621, 635 590 591 593 599 popular culture, 1128 Philosopher Giving a Lecture on the Orrery, A, Joseph Wright, 943, 943 Pisano, Nicola, 592 Populonia, Italy, 223 Pisa Baptistry pulpit, 592, 593; detail, Nativity, porcelain, 57, 813, 814, 843, 995 "philosopher" portraits (Roman), 271 Philostratus, 279 592-93 593 Porcelain flask (Chinese, Ming dynasty), 843, 843 Pissarro, Camille, 1010–11, 1023, 1028; A Cowherd on the porch, 160 Philoxenos of Eretria, 206 Route du Chou, Pontoise, 1010, 1011 Porch of the Maidens, Athens, Greece, Acropolis, Phoenicians, 155, 223, 234, 466 Pitcher, fritware (Persian), 357, 357 Erechtheion, 192, 192, 266 Photodynamism, 1059 Pittura, La, Artemisia Gentileschi, 769, 769, 1090 porphyry, 277–78 Photograph of Jackson Pollock painting, Hans Namuth, Pity, William Blake, 948, 948 Porta, Giacomo della, 645, 701, 703, 753; Church of Il 1116 1117 Pius VII, Pope, 768 Gesù (see under Vignola, Giacomo da) photography: American, 998–1002, 1103; as art, 988–89, 1096; documentary, 1095, 1099, 1103; early, 985–89; effect on art, 982, 1028–29; portrait, 988–89; post– Pizarro, Francisco, 882 Porta Augusta, Perugia, Italy, 225, 225, 253 "Places with a Past," Spoleto Festival U.S.A. (Charleston, portable arts: late Islamic, 355–61; prehistoric, 47 S.C., 1991), 1159-60 portal, 298, 512, 558, 558; carved, Romanesque, 514, World War II, 1139-42; and realism, 16-18; rebellion plainchant (Gregorian chant), 514 517-21, 517, 543 against, 1005; scientific, 1002; technique, 18, 987 plaiting (basketry), 888 portcullis, 579, 579 photojournalism, 1139–40 photomontage, **1077**, 1084 plan (architecture), 31 portico, 109, 164, 758 Planche, Gustave, 994 Pórtico de la Gloria, Joan Myers, 24, 24 Photo-Secession group, 1096 Piano, Renzo, 1138; Centre National d'Art et de Culture Plan for a Contemporary City of Three Million Portinari Altarpiece, Hugo van der Goes, 632-33, 632, Inhabitants, Le Corbusier, 1080-81, 1080, 1135, 1136 Georges Pompidou (with Richard Rogers), Paris, Plantagenet, Henry, 550, 576 Portrait figure (ndop) of King Shyaam a-Mbul France, 1138, 1138 plaques, brass, Benin, 472-73 a-Ngwoong (Kuba culture), Zaire, 920, 921 piano nobile, 645, 645 piazza, 645, 709, 762 Plataea, 177 Portrait of a Day, First Day, Georgia O'Keeffe, 22, 22 Plate, "style rustique," Bernard Palissy, attributed to, 724, Portrait of a Lady, Rogier van der Weyden, 628, 629 Piazza del Campidoglio, Rome (print), Étienne Dupérac, 724 Portrait of a Maori, Sydney Parkinson, 902, 903, 904 699-700, 700 Plato, 193, 198, 641, 1031 Portrait of Charles Baudelaire, Nadar, 989, 989 Picasso, Pablo, 132, 1052, 1053-55, 1126, 1154; Blue Plaza Dressing Table, Michael Graves, 1138, 1138 Portrait of Count Razoumowsky, Pompeo Batoni, 932, 932 Period, 1048; Les Demoiselles d'Avignon, 1049-51, plein air painting, 1010 Portrait of Diderot, Jean-Baptiste Pigalle, 952, 953 1050, 1052, 1075, 1118; Les Demoiselles d'Avignon, study for, 1050–51, 1050; early art, 1048–51; exhibitions, 1096, 1097, 1104; Glass and Bottle of Suze, 1054, 1054; Iberian Period, 1049–51; influence of, plinth, 227, 227, 375, 717, 942 Portrait of Émile Zola, Édouard Manet, 1008, 1008 Pliny the Elder, 169, 207, 222, 243, 245, 258 Portrait of George, Robert Arneson, 1163-64, 1163 Pliny the Younger, 222 Portrait of Giovanni Arnolfini(?) and His Wife, Giovanna Plowing in the Nivernais: The Dressing of the Vines, Rosa Cenami(?), Jan van Eyck, 624-26, 625, 629, 793 1109, 1116, 1120, 1128, 1153, 1163; Ma Jolie, 1053–54, 1053, 1077, 1118, 1132, 1163; Mandolin and Clarinet, Bonheur, 990-92, 991 Portrait of Jean-Baptiste Belley, Anne-Louis Girodetpluralism, 1149 Trioson, 958-59, 958 1054–55, 1055, 1061; reaction to World War I, 1074; Rose Period, 1048; Self-Portrait, 1048, 1048; Self-Plutarch, 203, 235 Portrait of Marie Antoinette with Her Children, Mariepodium, 186, 225 Louise-Élisabeth Vigée-Lebrun, 955, 955 Portrait with Palette, 1049, 1049; Woman in White (Madame Picasso), 1074, 1074 Poet on a Mountain Top (handscroll), Shen Zhou, 846, Portrait of Mrs. Richard Brinsley Sheridan, Thomas 846, 857 Gainsborough, 942, 943 Picaud, Aymery, 513 pictographs, 66, 96, 97, 113; Chinese, 400 poetry: Arabic, 340; Japanese, 430, 433-35; by women, Portrait of Thomas Carlyle, Julia Margaret Cameron, 988, 162 pictorial depth, 29 Pohnpei, Micronesia, 900 portrait sculpture: African, 470-72, 921; Renaissance, pictorial space, 29, 40, 246, 251–52, 254; Byzantine, 316; pointed arch, 515, 516, 558 759-60; Roman, 255, 271-72, 275-78, 283-84 Roman, 258 Poitiers, Aquitaine, France, 550 portrait tombs, 650-51 Picts, 268 pole-and-thatch construction, Mayan, 452-53 portraiture: Dutch, 786–93; Egyptian, 111–12, 232; Etruspictured stones, 482-83 Pole Vaulter, The, Thomas Eakins, 1002, 1002 can, 232; French Court, 720; Grand Manner, 932, picture plane, 29, 620, 624, 670, 684 political art, 928, 950, 957, 961, 993, 1033, 1045, 1048, 941-43; group, 786; Hellenistic, 217; Japanese, 439; picturesque subject, 931, 935 1077, 1084-85, 1095, 1102-4, 1144, 1146-49 photography and, 988–89; Renaissance, 613–14; piece-mold casting, 400 Pollaiuolo, Antonio del, 651-52, 659, 674; Battle of the Renaissance, early, 658-59; Roman, 258-59, 278-80; pier, 226, 1064 Ten Naked Men, 674-75, 674; Hercules and Antaeus, self-, 623-24 Piero della Francesca, 660, 665–67; Battista Sforza and 651-52, 651, 675 Portugal, 681, 776; Hispano-Flemish art, 637–38; trade Federico da Montefeltro (pendant portraits), 659, 666–67, 667; Discovery and Testing of the True Cross (fresco), Pollock, Jackson, 1115-17, 1121, 1124, 1131, 1154, 1166; with Benin, 472 Autumn Rhythm (Number 30), 1117, 1117, 1125, 1127; Portuguese Synagogue, Amsterdam, Emanuel de Witte, Arezzo, Italy, Church of San Francesco, 666, 666 Male and Female, 1116, 1116 797, 797 pietà (in Christian art), 307, 688–89 Pollock and Tureen, Louise Lawler, 1154, 1154 Poseidon, 155, 156 Pietà (Rondanini), Michelangelo, 688–89, 688, 690, Polo, Marco, 839, 843 positive space, 29 698-99, 698 polychrome, 868, 981 positivism, 979, 980-82 pietra dura, 831 Polydoros, 215 Possum Tjapaltjarri, Clifford, Man's Love Story, 906-7, pietra serena, 643-44, 663 Polygnotos Thasos, 186 Pigalle, Jean-Baptiste, 951–52; Monument to the Maréchal Polykleitos of Argos, 193–95, 198, 201, 203; canon of proportions, 193–95, 201, 248; *Spear Bearer* post-and-lintel construction, 32, 51, 53, 53, 143, 163, de Saxe, 951–52, 952; Portrait of Diderot, 952, 953 225, 253, 390, 829 pigment, 38, 39, 42, 171; prehistoric, 49 (Doryphoros), 193-95, 195, 201, 203, 248 Post-Conceptual art, 1144 pilaster, 225, 638, 645, 755, 967

Polynesia, 895, 901-5

postern, 579, 579

Palace of Assurnasirpal II, Kalhu (modern Nimrud, Iraq), metopes sculpture, Lapith Fighting a Centaur, 189, Orchard, William, 578, 579; Magdalen College, Oxford, 189, 190 Assurnasirpal II Killing Lions, 78, 79 578, 579 pediment sculpture, 84, 188-89, 189; Three Seated Palace of Diocletian, Split, Dalmatia, 275-76, 275 Order of the Golden Fleece, 635 Goddesses, 188-89, 189 Palace of the Lions, Granada, Spain, Alhambra, 347, 350, orders of architecture. See classical orders Parthians, 248 351-52, 351, 360 Orientalizing period, Greek, 158, 161-62, 174 Parting of Lot and Abraham, Rome, Italy, Santa Maria Palace of Zimrilim, Mari (modern Tell Hariri, Iraq), 131 Orléans, France, 615 Pala dynasty (India), 823, 824 Maggiore, 300, 300, 495 Orme, Philibert de l', 722 Palaikastro, Crete, Octopus Flask, 139, 139
Palatine Chapel, Palermo, Sicily, Italy, Nativity, 328, 328 passage graves, 51, 52, 53, 53, 144 Orphism, 1057 passage technique, 1052 Orsanmichele, Church of, Florence, Italy, 651, 651; Passion Cycle (in Christian art), 306 Palenque, Mexico, 453-54 sculpture for, 646-47 Passover seder, 289 palace, 453, 453 Orthodox Church (Eastern), 290, 291, 323-24, 609 pastel. 810-11 orthogonal plan, 198-99 Temple of the Inscriptions, 453, 453; portrait of Lord Pastoral Concert, Titian, 1007, 1007, 1008 Pacal, 454, 454; sarcophagus lid from tomb of orthogonals, 30, 198, 624, 670 Pater, Walter, 1006 Lord Pacal, 454, 454 Oseberg, Norway, burial ship (Viking), 480, 480, 483; Paleolithic period: Americas, 445; Europe, 37-47 patriarch, 291 post with animal figures, 483, 484, 519 Palermo, Sicily, Italy, Palatine Chapel, 328; Nativity, 328, 328 Patroclus, 156 Osiris, 95, 96, 124, 125, 235 patronage of art, 25-26; Africa, 470; contemporary, 1131; Palestine, 289, 291, 339 Osman, 350 Palestrina, Italy, Sanctuary of Fortuna, 236, 237, 237 Europe, 481, 548, 590, 595; merchant princes, 613, Ostia, Italy, Trajan's Harbor, 268-70 641; middle-class, 613, 786, 798; religious, 548, 609; palette (painter's choice of colors), 943 Ostrava Petrkovice, Czech Republic, Woman (figurine), Renaissance, 683; royal, 769, 800; by women, 706 palette (utensil for mixing colors), 96 39, 39 Patterson, James, Mount Vernon (with George Palette of Narmer, Hierakonpolis, Egypt, 96-97, 97, 98 Ostrogoths, 302, 313 Washington), Fairfax County, Virginia, 967, 967 O'Sullivan, Timothy H., 999-1001; Ancient Ruins in the Paling Style, 1070 Palissy, Bernard, 723-24; Plate, "style rustique," Paul (Saul), Saint, 290, 291 Cañon de Chelley, Arizona, 999-1001, 999 Paul III, Pope, 699 Otto I, Emperor, 498, 499 attributed to, 724, 724 Paul V, Pope, 701, 756 Palladian architecture, 935-36, 1137 Otto I Presenting Magdeburg Cathedral to Christ (plaque), Pausanias, 201 Palladio, Andrea, 707, 709-11, 746, 770, 935, 967; from Magdeburg Ivories (German), 499-501, 499 Pausias, 207, 273 Church of San Giorgio Maggiore, Venice, Italy, Otto II. Emperor, 498 Pax Romana, 235, 245 710-11, 710, 817; Four Books of Architecture, 711, 800, Otto III. Emperor, 498, 501, 503 Otto III Enthroned, page from Liuthar (Aachen) Gospels Paxton, Joseph, 978, 980; Crystal Palace, London, 817; Villa Rotonda (Villa Capra), Vicenza, Venetia, England, 978, 978, 980, 1069 (Ottonian manuscript), 503, 503 Italy, 711, 711, 770, 936, 967 Pearlstein, Philip, 1123, 1142; Two Models, One Seated, Pallavas dynasty, 388 Ottoman Empire, 350, 354 Ottoman Turks, 290, 323, 350, 363, 609, 614; art, 345, 363 Palma, Mallorca, Spain, Cathedral, 582, 582 1123. 1123. 1142. 1143 Pech-Merle Cave, France, Spotted Horses and Human Ottonian art, 498-505; influence on Romanesque, 535; Palmer, Erastus Dow, 996; The White Captive, 996, 997 Hands (cave painting), 41-42, 41, 42 palmette, 176 stained-glass windows, 559 Pedanius Dioscorides, 319 Ouattara, 924-25; Nok culture, 924-25, 924 Pan, 156 pedestal, 166, 227, 227, 517, 517, 645, 645, 755 Outbreak, The, Käthe Schmidt Kollwitz, 1045, 1045 Panathenaic Way, Athens, Greece, 185 pediment, 163, 165, 243, 645, 645, 660, 754, 755, 755, overlapping, 30 Ovid, 259 panel painting, 613, 619, 652; Byzantine, 318-22; Italian 936 Gothic, 595-97 Peeters, Clara, 785; Still Life with Flowers, Goblet, Dried Panini, Giovanni Paolo, 933; View of the Piazza del ovoid elements, 887 Fruit, and Pretzels, 784, 785 ox (Christian symbol), 294 Popolo, Rome, 933, 933 Peisistratos, 155 Oxbow, The, Thomas Cole, 974-75, 974, 996 Pan Painter, 183-84; Artemis Slaying Actaeon (vase Oxford, Oxfordshire, England: Magdalen College, 578, Pelham, Peter, 818 painting), 184, 184 Peloponnesian Wars, 184-85 Pantheon, Rome, Italy, 145, 226, 263-64, 264, 265, 298, 579; Oxford University, 576 Pencil of Nature, The (book), Talbot, William Henry Fox, Ozenfant, Amédée, 1079, 1089 987; The Open Door, 986, 987 Panthéon (Church of Sainte-Geneviève), Paris, France, pendentive, 309, 310, 324; dome on, 302, 310 Jacques-Germain Soufflot, 950-51, 950, 951 Pennsylvania Academy of the Fine Arts, 1001, 1094 Panthéon-Nadar (photograph series), 989 Pacal, Lord, 453-54 Pentecost, page from Cluny Lectionary (Romanesque Pacific peoples, 894-907; art of (see Oceanic art) Pantokrator, Romanesque interpretation of, 525, 529 Padua, Italy, 660, 665; Arena Chapel, frescoes, Giotto, Paolozzi, Eduardo, 1128 manuscript), 528, 529 paper, 674; painting on, 827 peplos, 171 604-7, 605, 606, 607 Peplos Kore, Athens, Greece, Acropolis, sculpture, 171, Paestum, Italy, 163; Temple of Hera I, 163-64, 163, 164 Papua New Guinea, 898-99 papyrus, 96, 101-2, 104, 319 171 paganism, late Roman Empire, 284 pagoda, 413, 414, 414; Japan, 426; stone, 414; wooden, Pepy II, 106 Paracas culture (Peru), 457-58 Pepy II and His Mother, Queen Merye-ankhnes (Egyptian), parapet, 579, 579 parchment, 319, 486, 490 106.106 Paik, Nam June, Electronic Superhighway, 1156, 1156 Percy, Hugh, duke of Northumberland, 937 Paris, France, 953, 955, 981, 990, 1029, 1080-81, 1088; Île-Painted Pottery cultures (Neolithic China), 398-99 de-la-Cité, 564; Nôtre-Dame Cathedral, 564, 564; Pergamene Style, 211-16 Painted Stoa, 186 Pergamon, Asia Minor (in modern Turkey), 211 University of, 615; see also Arc de Triomphe; Carrousel Painter in Her Studio (tomb relief, Rome), 259 Altar of Zeus, 212-13, 213, 237; frieze sculpture, painterly style, 29, 1014 Arch; Centre National d'Art et de Culture Georges Athena Attacking the Giants, 212, 213, 246 painting, **30**; American, 973–75, 996–98; American Pompidou; Eiffel Tower; Louvre, Palais du; Opéra; Colonial, 817–19; Australian Aborigine, 895–97; Baroque, 773–76, 777–85, 786–800; Buddhist, 430, sculptural style of, 219 Panthéon (Church of Sainte-Geneviève); Saint-Denis Perikles, 185-86, 187, 191 abbey church; Sainte-Chapelle; Sainte-Geneviève, 440; on canvas, 704, 765–69, 906; Chinese, 407–8, 414, 838–42, 846–51; Dutch, 786–800; early Christian, Bibliothèque; Soubise, Hôtel de; Vendôme Column period, 29, 31 peripteral temple, **163**, **164**, *164*, 187, **238** peristyle, **163**, **164**, **699** Paris (hero), 156 291-95; Egyptian, 110; English, 941-50; figure, 414; Paris Psalter (manuscript), David the Psalmist from, peristyle court, 116, 241, 275-76 finished vs. sketches, 1009; Flemish, 780–85; French, 617–18, 720–21, 773–76, 809–12, 953–62; German, peristyle garden, 240 Paris Salon, 929, 953, 984, 1008, 1013, 1014, 1029 Perpendicular style (English Gothic), 578–79 Perrault, Charles, 785 Paris Universal Exposition (1889), 1069 729-39; Greek, 205-6; Indian, 383, 827-29, 831-32; Indus Valley, 370; Italian, 652-60, 665-72, 683-87, Park, David, 1123 Perrault, Claude, 770 691–97, 704–9; Italian Gothic, 595–608; Japanese, Park, The, Stourhead, Wiltshire, England, Henry Flitcroft Perreault, John, 1164 428-29, 430, 435-37, 441, 860; Judaic, 291-95; Mayan, (with Henry Hoare), 938, 939 455, 456; Native American, 885; Neoclassical, 941-50, Parkinson, Sydney, 903, 904; Portrait of a Maori Persephone, 156, 171 Persepolis, Persia (modern Iran), 86–88 (drawing), 902, 903, 904 953-60; Netherlandish, 724-28; oil, 619, 622, 652, ceremonial complex: Apadana of Darius and 683, 704; panel, 613, 619, 652; on paper, 827; Peru-Parma, Italy, Cathedral, 686-87, 687 Xerxes, 86–87, 86; column from, 87, 87; detail of Parmigianino (Francesco Mazzola), 712, 714, 723, 785; vian, 459; prehistoric, 41-46; Renaissance, 617-18, relief, Darius and Xerxes Receiving Tribute, 87-88, 665–72, 683–87, 691–97, 704–9; Renaissance, early, Madonna with the Long Neck, 714, 714, 721 87; Hall of 100 Columns, 87; plan, 86, 86 Parnassian poets, 1029 652-60: Rococo, 809-12; Roman (ancient), 278-80, Perseus, 156, 166 944; Romantic, 941-50, 953, 958-62; Spanish, 746-47, parodos, 210 Persia (modern Iran), 62, 63, 85-89, 101, 177-78, 349; Paros, Greek island, 130, 169; Little Girl with a Bird Daric (coin) from, 88, 89; influence on Indian art, 827, 829; Seleucid, 209 777-80 Painting, Joan Miró, 1087-88, 1087, 1112, 1114 (stela), 196-97, 196 Parrish, Maxfield, 1028 pakalala (Kongo), 918 Parson Capen House, Topsfield, Mass., 816, 816 Persian knot, 359 Pakistan, 366 Persian War, 88, 177-78, 184 parterre, 770 palace architecture, 662, 770-73 perspective: atmospheric (aerial), 30, 258, 334, 623, Parthenon, Athens, Greece, Acropolis, 164, 186, 187–90, 188 Palace Chapel of Charlemagne, Aachen (Aix-la-**624**, 655, 666, **733**; Chinese landscape, **417**; diago-Chapelle), Germany, 492-93, 493 friezes, 190, 190; Horsemen, detail of Procession, nal, 30; divergent, 30; intuitive, 30, 251, 599, 624, palace complexes: Aegean, 128; Assyrian, 79; 190, 190; Marshals and Young Women, detail of 657: linear (scientific, mathematical, one-point), 30, Procession, 190, 191, 246 Mesopotamian, 77; Minoan, 131-34

Nanni di Banco, 646-47; Four Crowned Martyrs, 646-47, Neoplatonism, 641, 659, 688 Northern Song dynasty, 415, 416 647, 649 Neo-Primitive movement, 1060 Northern Wei dynasty, 409 naos, 161, 164, 164, 238, 309 neorationalism, 1138-39 Nôtre-Dame Cathedral. See Amiens; Paris; Reims Napoleon I, emperor of France, 92, 768, 808, 929, 934, Nepal, 366 Nôtre-Dame-du-Haut, Le Corbusier, 1136, 1136 950, 957–58, 959, 962, 966 Nephthys, 96, 125 nouveau réalisme, 1125, 1146 Napoleon III, emperor of France, 929, 950, 962, 981, Nerezi (near Skopje), Macedonia, Saint Panteleimon nsekh o byeri (Fang), 922 church, 328; Lamentation, 328, 328 nudes: female, 641, 707; in Greek sculpture, 169-70, Napoleon Crossing the Saint-Bernard, Jacques-Louis Neri, Filippo, 767 201-2; heroic, 650, 689; idealistic vs. realistic, 982; David. 957-58, 957 Nero. 252 models, 1001; in religious art, 695-96; Renaissance, Napoleon in the Plague House at Jaffa, Antoine-Jean Gros, Nerva, 259 641, 650, 664; as traditional subject, 1016-17 Netherlandish art, 786; Renaissance, 724–28; see also numerical symbolism, Gothic, 557 Nara, Japan, 845; Tamamushi Shrine, 428; Todai-ji Dutch art; Flemish art Nuremberg, Germany, 733 temple, 430 Netherlands, the, 633, 727, 745, 776 Neumann, Johann Balthasar, 805-7; Church of the Naramsin, 74 Nymphenburg Park, Germany. See Amalienburg Nara period (Japan), 429-30, 855 Vierzehnheiligen, near Staffelstein, Germany, 805, Nymphs and a Satyr, Adolphe-William Bouguereau, Narmer, 96-97 806-7, 807; Residenz, Kaisersall (Imperial Hall), 982-83, 983, 1017 narrative art: Assyrian, 79; Greek, 206; Hindu, 386–88, 389; Judaic, 296; Roman, 261–62; Sumerian, 69 Würzburg, Bavaria, Germany, 805, 806 "New American Painting, The" exhibition (New York, narthex, 298, 558; multistory, 492 1958-1959), 1122 Oakland YWCA, Oakland, California, Julia Morgan, 1068, nashki script, 348, 355, 355 New Caledonia, 895 Nasrid dynasty, 350 New Delhi, India, 833 Oath of the Horatii, Jacques-Louis David, 956-57, 956, National Academy of Design (New York), 1094, 1097, Newgrange, Ireland: passage grave, 144; tomb interior, 961, 984 1104 52, 53 oba (Benin royalty), 471-74 National Endowment for the Arts (NEA), 1160-61 New Guinea, 895, 898-99 obelisk, 116, 758 Native Americans. See American peoples "New Image Painting" (New York, 1978), 1142 Obembe Alaye (African artist), 470 Nativity, Palermo, Sicily, Italy, Palatine Chapel, 328, 328 "New Images of Man" exhibition (New York, 1959), 1122 Oceanic art: iconography of, 898; influence on mod-Nativity, Pisa Baptistery pulpit, Nicola Pisano, 592-93, 593 New Ireland, 899-900 ernism, 1042; recent, 905-7 Nativity, Pisa Cathedral pulpit, Giovanni Pisano, 593-94, Newman, Barnett, 1118-20, 1131; Cathedra, 1120, 1120 ocher, 38, 39 New Museum, "Bad Painting" exhibition (New York, Octavian. See Augustus Caesar Nativity, the (in Christian art), 306 1978), 1142 Octopus Flask, Palaikastro, Crete, 139, 139 Nativity, Tintoretto, 708-9, 708 Newport, Rhode Island. See Redwood Library oculus, 226, 264, 310, 556, 643, 802 naturalism, 29, 178, 369; Baroque, 753, 765-69, 777, New York City: as center of modernism, 1085, 1109; see odalisque, 959 788; Chinese, 411; English, 1002; French, 952, 990-96, also AT&T Headquarters; Brooklyn Bridge; Central Odo, bishop of Bayeux in Normandy, 534 1007, 1011; Gothic, 550, 587, 592; Greek, 178, 313; Park; Empire State Building; Grace Church; Saint Odundo, Magdalene, 925; Asymmetrical Angled Piece, Impressionist, 1009; Indian, 380, 383; Indus Valley, Patrick's Cathedral; Seagram Building; Woolworth 369; Islamic, 362; Japanese, 439; landscape painting, Building; World Trade Center Towers Odysseus, 156 990-93; Mughal, 831; nineteenth-century, 979; New York School, 1112, 1131; see also Abstract Expres-Odyssey, 143, 216 Ottoman, 363; Renaissance, 613, 640, 729; Roman, sionism Oedipus and the Sphinx, Gustave Moreau, 984, 985 305; Yoruba, 469, 471 New Zealand, 895, 903-5 Officers of the Haarlem Militia Company of Saint Adrian, natural materials, 855, 863, 870-71, 1070; Japanese use Ngongo ya Chintu, 470 Frans Hals, 787-88, 787 of, 422, 425 Niagara, Frederick Edwin Church, 997, 997, 1001 ogival arch, 347, 347, 354 Nauman, Bruce, Eleven Color Photographs, plate Bound Nicaea: First Council of, 290, 304; Second Council of, 322 Oh, Jeff . . . I Love You, Too . . . But . . . , Roy Lichtenstein, to Fail, 1134, 1135 niche, 755, 755, 757; muqarnas-filled, 347 1129, 1129 Naumburg, Germany, Cathedral, Ekkehard and Uta Nicholas of Verdun, 586, 587; Shrine of the Three Kings oil painting, 619, 622, 652, 704; technique, 683 (statues), 589, 589 (reliquary), 566, 586-87, 587 oinochoe (wine pitcher), 161 Navajo people, 888, 890-91 niello, 58, 137, 149, 537 O'Keeffe, Georgia, 22, 1097-98; Drawing XIII, 1098, 1098; nave, 281, 298, 558, 558, 643, 701, 753 Niépce, Joseph-Nicéphore, 985-86; View from His Portrait of a Day, First Day, 22, 22 Naxos, Greek island, 130, 169 Window at Le Gras, 986, 986 Okyo, Maruyama, 867 Olbrechts, Frans, 470 Nayak kingdom (India), 826 Nietzsche, Friedrich, 1039, 1041, 1120 Nazca culture (Peru), 457, 458-59 Night Attack on the Sanjo Palace (scroll, Kamakura Oldenburg, Claes, 1129-30; "The Store" exhibition, Nazca lines, 459, 459 period, Japan), 437-38, 437 1129-30, 1129 Naziism, 1081, 1151 Nightmare, The, John Henry Fuseli, 947, 947, 975 Old Saint Peter's, Rome, Italy, 297-99, 297, 492, 701, 757 ndop (Kuba), 921 Night of the Rich and the Poor. See Rivera, Diego, murals Old Testament Trinity, The (Three Angels Visiting Abraham) Near East: ancient, 60-89; Neolithic period, 63-85 Nike, 156 (icon), Rubiyov, Andrey, 335, 335, 583 Near Eastern art, ancient: ceramic technology, 57; com-Nike (Victory), Samothrace, Macedonia, 214, 215 Olmec culture, 447-48, 875; influence on Mayan, 451 pared to Minoan, 135, 136; compared to Mycenaean, Nike (Victory) Adjusting Her Sandal (relief sculpture), Olmsted, Frederick Law, 970, 1062, 1063; Central Park 143; influence on Aegean, 128; influence on Greek, Athens, Temple of Athena Nike, 193, 194, 202, 219, 247 (with Calvert Vaux), New York City, 970, 970, 1063 161, 202; influence on Judaic, 291; influence on Nile River, 93 olpe (wide-mouthed pitcher), 161 Minoan, 131-32, 137; jewelry, 136-38 Nîmes, France, 243; Maison Carrée, 242, 243; Pont du Olympia, Greece Near Oceania. See Melanesia; Micronesia Gard, 241-43, 241 Man and Centaur (statuette), 160, 160 Nebuchadnezzar II, 81, 102 Nineveh (modern Kuyunjik, Iraq), 80; Assurbanipal and Sanctuary of Hera and Zeus, 153, 155-57, 178 necking, 165, 165 His Queen in the Garden, 80, 80; sculpted head of a Temple of Hera, 201 necropolis, 99 man, 74, 74 Temple of Zeus, pediment sculpture, 178-79, 178, Neel, Alice, 1147; Andy Warhol, 1147, 1147 Nishapur, Iran, 348 179, 189, 202; Athena, Herakles, and Atlas, 178. Nefertiti, 119-22, 140 179, 196, 202 nishiki-e, 868 Nefertiti (Egyptian), 120, 120 Nizami, Khamsa (Five Poems), 362 Olympian/ic Games, 153, 157, 179 negative space, 29, 160 Ni Zan, 840-41; The Rongxi Studio (hanging scroll), Olympias (artist), 207 Olympos, Mount, 155, 156 Nekhbet, 106 840-41, 841, 846 Neo-Babylonia, 63, 81-83 nkisi (Kongo/Songye), 917-18 omega symbol, 525 one-point perspective. See perspective oni (Yoruba royalty), 469–71
Onjo-ji monastery, Shiga prefecture, Japan, Kojo-in, Guest Hall, 862, 862 Neoclassicism, 808, 931-75, 1137; American, 966-75, nkonde (Kongo/Songye), 917-18 996; architecture, 935-41, 950-51, 967-68; French, nlo byeri (Fang), 922-23 950-62; German, 962-64; interior design, 937; Italian, Nobunaga, Oda, 859 934–35; painting, 941–50, 953–60; sculpture, 934–35, nocturne, 775 951-53, 970-73 Nok culture (mixed media), Ouattara, 924-25, 924 Open Door, The. See Talbot, William Henry Fox, The Pencil of Nature (book) Opéra, Paris, France, 982, 982; sculpture, Charles Garnier, 981–82, 981, 1014 Neo-Conceptualism, 1153-56 Nok culture (Nigeria), 468-69, 911 Noli Me Tangere (in Christian art), 307 Neo-Confucianism, 415-16, 862; "School of the Mind," Noli Me Tangere, Lavinia Fontana, 716, 717 Neo-Dada revivals, 1134 nonfinito, 690, 699 opet festival (Egypt), 96 Neo-Expressionism, 1149-50, 1153, 1155 nonrepresentational (nonobjective) style, 29, 1023–24 opus anglicanum, 580-82 Neo-Geo, 1154 Normandy, France, 481; Romanesque period, 530-35 opus incertum, 236, 236 Neo-Gothic style, 939, 963 opus reticulatum, 236, 236 Normans, 327 Neo-Impressionism, 1033; influence of, 1036, 1039, architecture of, influence on English, 576 opus testaceum, 236, 236 1040, 1057, 1059 conquest of Britain, 509, 530; tapestry depiction of, oracle bones, 400 Neolithic period, 37; Aegean, 128-29; China, 57, 397-99; 534-35 oracles, 157 Egypt, 93–94; Europe, 47–58; Near East, 63–85 Norse peoples, 481, 483 North Acropolis, Tikal, 452

North America, 460-63

Orange, France, Roman theater at, 242, 243

Orange, House of, 786

orant figures, 291, 293, 295

neo movements, 1149

Neon, Bishop, 304

Mount Fuji (teabowl), Hon'ami Koetsu, 863, 863 (relief), 518, 519, 525; Lions and Prophet Jeremiah (?) Michelozzo di Bartolommeo, 644; Palazzo Medici-Mount Sinai, Egypt, Monastery of Saint Catherine: (relief), 519-20, 519, 525 Riccardi, Florence, Italy, 644, 644, 646, 704 Transfiguration of Christ, 312, 312; Virgin and Child moko. 904 Micronesia, 895, 900-1 with Saints and Angels (Christian icon), 322, 323, 521 Middle-Aged Flavian Woman (Roman bust), 255, 256, moksha, 372 molding, 163, 165, 247, 390, 645, 645 Mount Vernon, Fairfax County, Virginia, James Patterson (with George Washington), 967, 967; dining room Momoyama period (Japan), 859-61 Middle Ages, 481-88, 510, 587, 609, 613, 615 Mona Lisa, Leonardo da Vinci, 685–86, 685 (John Rawlins and Richard Thorpe), 967, 967 middle ground, 29 Monastery of Hosios Loukas, Stiris, Greece: churches at, movable-type printing, 609, 676 Middle Kingdom, China, 397 324-25, 324: Katholikon, 324-25, 325 Mozarabic art, 489; influence on Romanesque, 527 Mies van der Rohe, Ludwig, 1081, 1135-36, 1137; Mozarabs, 488-89 Monastery of Saint Catherine, Mount Sinai, Egypt: Seagram Building (with Philip Johnson), New York Mrs. Ezekiel Goldthwait (Elizabeth Lewis), John Singleton Transfiguration of Christ, 312, 312; Virgin and Child City, 1081, 1135-36, 1135, 1137 with Saints and Angels (Christian icon), 322, 323, 521 Copley, 819, 819, 945 Migrant Mother, Nipomo, California, Dorothea Lange, Mrs. Freake and Baby Mary (American Colonial), 817-18, monastic communities, 493-94, 510 1103, 1103 Mondrian, Piet, 1077–79, 1112, 1130; Composition with Red, Blue, and Yellow, 1078, 1078, 1096 mihrab, 344 Mshatta, Jordan, palace at, 342-44, 344, 354; facade of, Milan, Italy, 302, 641, 684; see also Central Station Monet, Claude, 1009-10, 1019, 1045, 1059; Boulevard des 344.344 project; Santa Maria delle Grazie; Sant'Ambrogio Muawiya, Caliph, 339 Capucines, 27, 28, 1010; Impression, Sunrise, 1010; Monet's House at Argenteuil, 1009–10, 1009, 1015; The Mucha, Alphonse, 1028 Miletos, Asia Minor (modern Turkey), 198; Market Gate, River, 1009, 1009; Rouen Cathedral: The Portal (in Sun), mud bricks, 63, 227 268, 268; Trajan's market at, 267-68 1018, 1019 mudfish (Benin symbol), 474 Millais, John Everett, 1003 Monet's House at Argenteuil, Claude Monet, 1009-10, mudras, 380, 392, 430; types of, 380 Miller, Kenneth, 1101 Mughal dynasty (India), 826–32; architecture, 833 1009, 1015 Millet, Jean-François, 992, 1005, 1060; The Gleaners, 992, Mongols, 349, 419, 827; invasion of China, 837 Muhammad, the Prophet, 339; life of, 340-41 992, 1060 Monk Sewing, Kao (attributed), 441, 441 Muhammad II (Ottoman Sultan), 335 Milo of Crotona, Pierre Puget, 773, 773 Muhammad V, of Spain, 351 Mimis and Kangaroo (rock art), Oenpelli, Arnhem Land, monks' tower, 540 muhaqqaq scripts, 348, 352 monograms (Christian symbols), 294 Australia, 895-96, 895, 1153 Mukhina, Vera, 1077; Worker and Collective Farm Worker, monoliths, Great Zimbabwe, 476 Minakshi-Sundareshvara Temple, gopura of, Madurai, 1077, 1077 Tamil Nadu, India, 826, 826 Monophysitism, 304 mullion, 568 monoprint, 948 Minamoto clan (Japan), 437, 855 Montagnac, France, menhir statue of a woman, 55-56, multiculturalism, 1158 Minamoto Yoritomo, 855 mummies, 121 minaret, 344, 347, 354, 831 56 Munch, Edvard, 1038, 1109; The Scream, 1038, 1038, 1109 minbar, 340 Montbaston, Jeanne de, 615 Mundy, Peter, 798 Montbaston, Richart, 615 Ming dynasty (China), 841-48 Montefeltro, Federico da, 662, 666-67, 673 mugarnas, 347, 347, 351-52 miniatures, 319, 361-63 murals: American, urban, 1158; French, 1030; Mexican Minimalism, 1131-35, 1142, 1144, 1165, 1166 Montefeltro family, 641 movement, 1103; Renaissance, 652, 693; see also Monticello, Charlottesville, Virginia, Thomas Jefferson, Minoan art, 131-32, 135-37; dating of, 129, 143; influence wall paintings on Mycenaean, 148; symbols of, 140; see also Aegean 968, 968 Murasaki, Lady, Tale of Genji, 431, 435-36; paintings of, Mont Sainte-Victoire, Paul Cézanne, 1024, 1024, 1052 monumental statues, 76; Easter Island, 901 436 Minoan culture, 129, 131-42; archeological sites of, 143; Muromachi period (Japan), 855-59 monumental tombs, Greek, 198, 200-1 see also Crete Museum of Modern Art, New York City, 1104 monuments, Neolithic, 48, 51 Minos, king of Crete, 131, 132, 135 exhibitions: "The Art of Assemblage" (1961), 1125; Monument to the Maréchal de Saxe, Jean-Baptiste Pigalle, Minotaur, legend of, 132, 135, 138 "Dada, Surrealism, Fantastic Art" (1936), 1114; Miracle of the Crib of Greccio, Assisi, Umbria, Italy, Upper 951-52, 952 'The New American Painting" (1958-1959), 1122; Moon Goddess, Coyolxauhqui, The (Aztec), 878–79, 878 Church, Saint Francis Master, 597, 604, 604 "New Images of Man" (1959), 1122 Miraculous Draft of Fish (detail of altarpiece), Konrad Moore, Henry, 1074-75, 1136; Reclining Figure, 1074, museums, 20, 26-27, 32, 1131 Witz, 640, 640 1075, 1136 music, Chinese, 402 Miraculous Draft of Fishes (after Raphael's Sistine Mopti, Africa, 911 Musicians and Dancers (detail of wall painting) Mor, Anthonis, 743; Mary Tudor, 743, 743 tapestries) (cartoon), Pieter van Aelst, shop of, 693, Tarquinia, Italy, Tomb of the Lionesses, 230-31, 231 Mora, Paolo and Laura, 124 Moralized bible (French Gothic), Louis IX and Queen Blanche of Castile page from, 572–73, 573, 583 Moreau, Gustave, 984–85; Oedipus and the Sphinx, 984, Muslims. See Islam mirador, 351 Mussolini, Benito, 1058 Miró, Joan, 1087-88, 1112; Painting, 1087-88, 1087, Mut, 96, 114 1112, 1114 Muybridge, Eadweard, 1002, 1059; Galloping Horse, Mirror (Egyptian), 121-22, 121 985 Morgan, Julia, 1068–69; Casa Grande, San Simeon, California, 1068–69, *1068*; Oakland YWCA, Oakland, 1002, 1002, 1059 Mirror (Etruscan), 232-33, 233 Mwene Mutapa empire, 477, 911 Mirror Room. See Amalienburg Mycenae, Greece, 142; citadel, 143-45, 144; dagger mirror (Shinto symbol), 426 California, 1068, 1068 Morisot, Berthe, 1014-15; In the Dining Room, 1014-15, blades, 137, 148-49, 149; Lioness Gate, 143, 144; Mission Style, 1068 "Mask of Agamemnon" (funerary mask), 137, 148, 1014 Mississippian culture (North America), 461 148; Treasury of Atreus, 144-45, 145, 199; Two Morris, George L. K., 1104 Mitchell, Joan, 1121 Women with a Child (figurine), 148, 148; wall painting, Morris, William, 1003, 1004, 1068, 1071; Bird Woolen Mithras cult, 284, 295; spread of, in Rome, 235 141; Warrior Vase, 149, 149 (textile), 1004, 1005; Queen Guinevere, 1004, 1004, mithuna couples, 378, 380, 384 Mycenaean culture, 142-49, 199; collapse of, 153; dating mixed medium arts, 30 of, 129, 143; see also Aegean culture; Greece, Greeks Morris & Company, 1004 Mnesikles, 191; Propylaia, Athens, Greece, 191, 191 Myers, Joan, Pórtico de la Gloria, 24, 24 mortise-and-tenon joinery, 844 moai, 901 mosaics: Byzantine, 312, 326-28, 330; early Christian, Myoki-an Temple, Tai-an tearoom, Kyoto, Japan, Sen no moat, 425, 531, 579, 579 495; Greek, 205–8; Islamic, 342, 353; replaced by wall painting, 524; Roman, 240, 241, 272–73, **272**; Rikyu, 861, 861 Moche culture (Peru), 457, 459-60 Myron, 183; Discus Thrower (Diskobolos), 152, 153, 183, Moche Lord with a Feline (ceramic, Peru), 459-60, 459 189 Model for the Monument to the Third International, Romanesque, 543; technique, 68 Mysteries of Eleusis, 196 Vladimir Tatlin, 1075, 1075, 1077 Moscow, Russia, Saint Basil the Blessed, 330, 331 mystery plays (liturgical dramas), 533 mystery religions: Greek, 196; Roman, 235, 250 modeling, 110; in cave art, 45-46 Moser, Mary, 944 Model of a house (Han dynasty, China), 406-7, 407, 413 Moses, 289 Model of a house and garden (Egyptian), 109, 109 Moses, Michelangelo, 697-98, 697 mysticism, 729 mythocentric view, China, 402-4, 416 mosque, 340, 826, 829 models (life), 1001 myths: Greek, 156; Norse, 483 Modena, Italy, Cathedral, Creation and Fall (relief), 543, 543 architecture, 345, 345; Umayyad dynasty, 344; West modern architecture, 1072-73, 1135-37 Africa, 474, 474 Mosque of the Prophet, Medina, Arabia, 340 moderne style, 1070 Nadar (Gaspard-Félix Tournachon), 989, 1010; Portrait of modernism, 1023-26, 1109-10; American, 1096-1105; Mossi people (Burkina Faso), 913 Charles Baudelaire, 989, 989 end of, 1135; primitive art and, 1042, 1051, 1075, 1084; Mother Goddess, Coatlicue, The (Aztec), 878, 879, 882 Naked Portrait with Reflection, Lucian Freud, 1152, 1152 Motherwell, Robert, 1167 reforming spirit of, 1023, 1033 Namu Amida Butsu, 432, 438, 439 motifs: African, 925; classical, 644, 645, 696; Dutch Modernismo, 1070 Namuth, Hans, photograph of Jackson Pollock painting, Modersohn-Becker, Paula, 1044-45; Self-Portrait with an landscape, 793; see also subject matter of art Amber Necklace, 1044, 1045 Moulin de la Galette, Pierre-Auguste Renoir, 1011, 1011, 1116, 1117 Nanchan Temple, Wutaishan, Shanxi, China, 412-13, 413 1015, 1016, 1027-28 Mogollon culture (American Southwest), 462

mound builders, North America, 460-62

Mountains and Sea, Helen Frankenthaler, 1121, 1121,

mounds, Mesopotamian, 65

1129, 1131

Mohenjo-Daro, Indus Valley, 367-69; citadel area, 367;

Moissac, Toulouse, France, Saint-Pierre priory church,

south portal, 517-20, 518, 519, 555; Christ in Majesty

Great Bath, 367

Nanga (Southern) school (Japan), 866

compound, 900, 901

Nan Madol, Pohnpei, Micronesia, 900-1; Royal mortuary

Nanna Ziggurat, Ur (modern Muqaiyir, Iraq), 66-68, 67, 73

Raft of the "Medusa," Théodore Géricault, 960, 961 prostyle temple, 164, 164, 225, 238 posters, 1028 Rage and Depression (video image), William Wegman, Protect Me from What I Want. See Holzer, Jenny, Survival Post-Impressionism, 1026–39 1144, 1145 postmodernism, 1135, 1137-40, 1149-67 raigo paintings, Japanese, 439-40 Protestantism, 614, 681-83, 723-24, 735, 751 Postnik, 330 Raimondi, Marcantonio, engraving after Raphael's The post-painterly abstraction, 1131 Proun space, El Lissitzky, 1076, 1077 Judgment of Paris, 1007, 1007 provenance, 19, 1131 Post-Structuralism, 1155 Raising of Lazarus (in Christian art), 305, 306 Provincial Enlightenment, 939 potassium-argon dating, 49 Psalm 1 (Beatus Vir), from Windmill Psalter, 580, 580 Raising of the Cross, The, Peter Paul Rubens, 781, 781 Potpourri jar, Sèvres Royal Porcelain Factory (France), Rajaraja, 391 Psalms, Book of, 333 814, 815 Rajarajeshvara Temple to Shiva, Thanjavur, Tamil Nadu, psalter, 333, 532 potsherds, 57, 71, 205 Psalter from Augsburg, page with initial Q, 539, 539 India, 390, 391; Rajaraja I and His Teacher (wall potter's wheel, 57, 139 Psalter of Saint Louis (manuscript), 573–74; page with painting), 391, 392 pottery: Anasazi culture, 463; Chinese, 398–99, 419; Abraham, Sarah, and the Three Strangers, 567, 574, 574 Rake's Progress, The, Hogarth, William, 941 Cycladic, 129-30; dating of, 71; Egypt, predynastic, pseudo-kufic script, 523 raking cornice, 163, 165 93-94; Elamite, 84; Greek, 158; Japanese, 423; Korean gray-green, 425; Neolithic, 70, 398–99; Peruvian, 458, raku, 863 pseudoperipteral temple, 238 Ramayana, 371 psychic nonfiguration, 1112 459-60; technology, 57-58, 424; workshops, 207; see Ramesses II, 114, 115, 116, 118 also ceramics; vase painting
Poussin, Nicolas, 772, 774–75, 785, 931, 949; Landscape Ptolemy, 209 rampart, 579, 579 Puabi, Oueen of Ur, Tomb of, 70-71 Public Ministry Cycle (in Christian art), 306 Raphael (Raffaello Sanzio), 683, 686, 692-95, 700, 701, with Saint John on Patmos, 774-75, 775 712, 713, 714, 716, 717, 785, 931, 974, 1016; Judgment Pucelle, Jean, 574, 575, 624 poussinistes, 785 of Paris, 1007, 1007; Leo X with Cardinals Giulio de' Petites Heures of Jeanne d'Evreux (manuscript), pages Poverty Point, Louisiana, earthworks site, 460 Medici and Luigi de' Rossi, 693, 693; School of Athens from: Annunciation, 574-75, 575; Betrayal and Power figure (nkisi nkonde) (Kongo culture), Zaire, (fresco), Rome, Italy, Vatican Palace, Stanza della Arrest of Christ, 574-75, 575; Fox Seizing a Rooster, Segnatura, 692, 692, 988; Sistine tapestries (cartoon Powers, Hiram, 971, 996; The Greek Slave, 971, 971, 972 576 576 for), 693-95, 693; The Small Cowper Madonna, 686, Pueblo Bonito (Anasazi culture), Chaco Canyon, New Prague, Bohemia (Czech Republic), Altneuschul, 586, 586 686, 738 Mexico, 462-63, 462 Prairie Style (architecture), 1067 Rath, Alan, 1156 Pueblo Indians, 888-90, 1164 Prairie style (Native American), 883 Rationalism: Dutch, 1077-79; French, 1079-81 Puget, Pierre, 773; Milo of Crotona, 773, 773 Prandtauer, Jakob, 803-4; Benedictine Monastery Pugin, Augustus Welby Northmore, 939–41; Houses of Rauch, John, Guild House. See under Venturi, Robert Church, Melk, Austria, 803-4, 803 Rauschenberg, Robert, 1126, 1130, 1149, 1155; Canyon Parliament (see under Barry, Charles) Prato, near Florence, Italy. See Santa Maria delle Carceri (combine), 1126, 1126, 1149, 1155 punchwork-tooled designs, 597 Praxiteles, 201-2, 203, 219, 271; Aphrodite of Knidos, 202, Ravenna, Italy, 302, 303-4, 308, 313-18 Punic Wars, 234 202, 219; Hermes and the Infant Dionysos, 201-2, 201 Punitavati (Karaikkalammaiiyar) (Indian statue), 20, 21 Baptistry of the Arians, 304 prayer books, 574 Baptistry of the Orthodox, 304-5, 304 Punjab University, Gandhi Bhavan, Chandigarh, India, Prayer carpet (Turkish), 359, 360, 361 Mausoleum of Galla Placidia, 302, 302; Good B. P. Mathur (with Pierre Jeanneret), 833, 833 prayer rugs, 360 Shepherd, 303, 303, 318; Martyrdom of Saint Pure Land Buddhism, 431, 432-33, 441, 855; art of, 438predella, 583, 652, 730 Lawrence, 302-3, 303, 319 40: see also Western Pure Land Pregnant Woman and Deer, engraved antler, Laugerie-Sant'Apollinare in Classe, 316, 316; Saint Apollinaris, Purism. 1079-81 Basse, France, 40, 40 First Bishop of Ravenna, 316-18, 317 Puryear, Martin, 1165; Empire's Lurch, 1165, 1165 prehistoric art: Europe, 34-59; meaning and function of, putti, 302, 667, 695, 757 San Vitale, 298, 313-14, 313, 314, 315, 342, 492; 46; technique, 42 Puvis de Chavannes, Pierre-Cécile, 1029–30, 1048, 1059, 1074, 1090; *Summer* (canvas mural), 1030, *1030* Emperor Justinian and His Attendants, 288-89, 288, Prendergast, Maurice, 1028 314; Empress Theodora and Her Attendants, 288, Pre-Raphaelite movement, 1002–4, 1007, 1028 314, 316 pylons, 114 Prescriptions Filled (Municipal Building), Richard Estes, Rawlins, John, 967; Mount Vernon, Fairfax County, Pylos, Greece, 142 1142, 1143 Virginia, dining room (with Richard Thorpe), 967, 967 palace, 147; megaron of, 147, 147 Presentation in the Temple. See Broederlam, Melchior, Rayonnant style (French Gothic), 569, 574 pyramid, Egyptian, 102-4, 103; building of, 104; parts of, altarpiece Rayzor, James Turrell, 1134, 1134 Presentation in the Temple (in Christian art), 306 pyramidion, 116 readymades, 1085, 1155 Priam, 156 realistic style, 16-19, 21, 29, 178; vs. academic art, Pyramid of the Moon, Teotihuacan, Mexico, 449 Priapus, 156 1097; American, 996-1002, 1093-95, 1099; Greek, Pyramid of the Sun, Teotihuacan, Mexico, 449 Priene, Asia Minor (modern Turkey), city plan, 198-99, 178; Hellenistic, 217, 219, 273; Japanese, 439; nine-Pyramids of the Sun and Moon, Peru, 459 teenth-century (French Realism), 979, 990-96, 1009; Pythia, 157 Priestess (?), Akrotiri, Thera, Greek island, 141, 141 Pythian Games, 157 Roman, 246 Priestess of Bacchus (?) (Roman panel), 284, 285, 305, 318 Realist Manifesto, 994 Python, 157 priests, Christian, 291 Rebecca at the Well, from Genesis (manuscript), 320, 320 Primaporta, Italy, Villa of Livia, Garden Scene (wall Q Reboul, Marie Thérèse, 953 painting, detail), 240, 251-52, 251, 292 Reciting "Karawane" (photograph), Hugo Ball, 1083, 1083 ai. 407, 415 primary colors, 29, 987, 1039 Reclining Figure, Henry Moore, 1074, 1075, 1136 Primaticcio, Francesco, 703, 712, 721, 723, 785; Château gibla. 344 Red, White, Blue, Yellow, Black, Lee Krasner, 1104, 1105, Qin dynasty (China), 397, 402, 837 of Fontainebleau (stucco and wall painting), Chamber Qingbian Mountains, The (hanging scroll), Dong of the duchess of Étampes, 720, 721 "red and blue" chair, Rietveld, Gerrit, 1078, 1079 Qichang, 847-48, 847 Primavera, Sandro Botticelli, 659-60, 659 Qing dynasty (China), 848-51 red-figure vase painting, 162, 176, 183, 197, 207 primitive art: influence on Cubism, 1049; influence on Qiu Ying, 842; *Spring Dawn in the Han Palace* (handscroll), 842, 843 Redon, Odilon, 1033; The Marsh Flower, a Sad and modernism, 1042, 1075; use of term, 468 Human Face, 1033, 1033 Princess from the Land of Porcelain, The, James McNeill Redwood Library, Newport, Rhode Island, Peter quadrant vaulting, 513 Whistler, 26 Harrison, 816-17, 816 Quarrel of the Ancients and the Moderns, 785 Print and the Poster, The (journal), 1028 quatrefoils, 562, 563 Reed, Ethel, 1028 printing: of books, 674-77; editions, 673; inscriptions refectory, 494 Oueen Guinevere, William Morris, 1004, 1004, 1006 commonly found in, 673; single-sheet, 674-76, 948 Queen Nefertari Making an Offering to Isis (wall painting), Deir el-Bahri, Egypt, tomb of Nefertari, 93, 96, 123, Reformation, the, 681-83 printmaking: Dutch, 786, 791; German, 733-36; Regionalists, 1100-1 Japanese, 854, 868-69, 1008, 1028, 1036, 1043; registers, 69, 96, 110, 159, 386 nineteenth-century, 1005, 1006, 1028; Renaissance, 123. 124 registration mark, 868 674-76; technique, 789; see also woodblock printing Queen Tiy (Egyptian), 120, 120 Quercia, Jacopo della, 664; Expulsion of Adam and Eve Reid, Bill, 887-88; The Spirit of Haida Gwaii, 888, 888 Prix de Rome, 952 Reims, Île-de-France, France, Nôtre-Dame Cathedral, (portal sculpture), Bologna, Italy, Church of San Processional Way, Babylon, 81-83, 81 564-68, 565, 568; Annunciation (relief), 566-67, 566, Procession of the Relic of the True Cross before the Church Petronio, 664, 664 575, 587; Apostles (relief), 567-68, 567; Christ (relief), of San Marco, Gentile Bellini, 670-71, 671, 704 quillwork, 883 567-68, 567; Last Judgment (relief), 567-68, 567; Saint quincunx, 330 Procopius of Caesarea, 309 Joseph (relief), 566, 567; Visitation (relief), 566-67, pronaos, 161 Quintanilla de las Viñas, Burgos, Spain, Santa Maria, 566, 575, 587 propaganda, 1077 488, 489; Grapes, Vines, and Birds (relief), 488, 489 Reinach, Salomon, 46 Prophet Muhammad and His Companions Traveling to the quoin, 645, 645 reintegration, 884, 905 Fair, from Siyar-i Nabi, 341 R Rejlander, Oscar, 988; The Two Paths of Life, 988, 988 Prophets and Ancestors of Christ (relief), Chartres, Île-derelative dating, 49, 71, 129 France, France, Cathedral, 554, 554 Ra, 95, 96, 114 relics 509 553 Propylaia, Athens, Greece, Acropolis, 186, 191, 191 Rabbula, 320 relief sculpture, 31; Chinese, 406; Egyptian, 93-94, 110, propylon, 186 Rabbula Gospels (manuscript): Ascension from, 320-22, 116; Greek, 166, 167, 179; Hindu, 386-89; Mesoproscenium, 210 321, 333; Crucifixion from, 320, 321, 326, 333 american, 445, 450; Persian, 87-88; prehistoric, 40, radiocarbon (carbon-14) dating, 49, 129 proscenium arch, 800

45-46; Renaissance, early, 649; Roman, 245, 249, 255. 261-62, 268-71, 278; Romanesque, 543; see also high relief low relief

relieving arch, 143

religion: Aegean, 128; Christian (see Christianity); Egyptian, 95-97, 99, 114-15; Etruscan, 225, 229; Greek, 155–58; Indian, 370–72; Mesopotamian, 68– 70; Near Eastern, 62; Neolithic, 51-55; prehistoric, 40, 41, 44-45, 46; Roman, 234, 235, 250

religious art, Indian, 823; see also Christian art religious complexes: Egyptian, 158; Greek, 158; see also ceremonial complexes; temple complexes

reliquaries, 374-75, 502, 509, 521, 631, 757; Christian, 481

reliquary crosses, 488

Reliquary guardian (nlo byeri) (Fang culture), Gabon, 922-23 922

Rembrandt van Rijn, 785, 789, 790-93, 949, 964; Butchered Ox, 1111, 1111; Captain Frans Banning Cocq Mustering His Company (The Night Watch), 787, 790, 791, 793; Christ Healing the Sick, 798; Jan Lutma, Goldsmith, 791, 791; The Jewish Bride, 791-93, 792, 965; Self-Portrait, 791, 792

ren. 405

Renaissance: beginning of, 335, 613-14, 672; early, 614-18, 639-40, 652-60; High, 683-91; Late, 683 "Renaissance" (12th c.), 510

Renaissance art: architecture, 641-46, 660-63, 699-704, 981; Flemish, 619-36; French, 722; interior design, 672-73; Italian, 640-72, 683-711, 724, 739; Netherlandish, 724-28; painting, 617-18, 665-72, 683-87, 691-97, 704-9; printmaking, 674-76; sculpture, 617-18, 664-65, 687-91, 697-99; sources of, 609, 613, 641

Renaud de Cormont, 561

René, duke of Aniou 639

René Painter, 639; Livre du Cuer d'Amours Espris by René of Anjou (illuminated book), page René Gives His Heart to Desire, 639, 639, 677

Reni, Guido, 764; Aurora (ceiling fresco), Rome, Italy, Casino Rospigliosi, 764, 764

Renoir, Pierre-Auguste, 1011, 1016-17, 1027, 1028; Bathers, 1017, 1017, 1030; Luncheon of the Boating Party, 1016, 1016; Moulin de la Galette, 1011, 1011, 1015, 1016, 1027-28

Renwick, James, Jr., 969-70; Smithsonian Institution Washington, D.C., 969-70, 969

Repentant Magdalen, The, Georges de La Tour, 775, 775,

Repin, Ilya, 996; The Composer Moussorgsky, 996, 996, 1077

replica, 193

repoussé, 137, 138, 333, 498, 586, 815

representational style, 29, 1122-23, 1127; in Christian art, 322; Islamic beliefs against, 339

Republican Forum, Rome, Italy, 260, 273

Residenz, Kaisersall (Imperial Hall), Würzburg, Bavaria, Germany, 806, 806, 964; Johann Balthasar Neumann,

Resting, Isabel Bishop, 1101, 1101

restoration. See conservation and restoration Resurrection. See Grünewald, Matthias, Isenheim Altarpiece Resurrection, the (in Christian art), 289, 307

Resurrection and Angel with Holy Women at the Tomb (Christian panel), 305, 305

retablo, 584

Return of the Hunters, Pieter Brueghel, the Elder, 727, 727 Revelation (the Apocalypse), 290-91

revivalism, 966

Revolution of 1830 (France), 961 Revolution of 1848 (France), 990, 992

Reymerswaele, Marinus van, 728; Banker and His Wife, 728. 729

Reynolds, Joshua, 941, 945, 948; Lady Sarah Bunbury Sacrificing to the Graces, 941-42, 941 Rhine Valley, metalwork, 537

Rhodes, Asia Minor: Colossus of, 102; sculptural style of, 219; vase painting, 161-62; wine pitcher (oinochoe) from, 161-62, 162, 174

rhyton, 136

Rhyton, bull's head, Knossos, Crete, 136, 136, 137 Riace Warriors, 181-83, 182, 183, 195

ribbon interlace, 483

Ribera, Jusepe (José) de (Lo Spagnoletto), 777, 1001; Boy with a Clubfoot, 777, 777

Ribera, Pedro de, 776-77; Hospicio de San Fernando, Madrid, Spain, 755, 755; Portal, 776-77, 776, 817

ribs, 643, 981

rib vaulting, 552, 552, 558, 558

Richardson, Henry Hobson, 1064; Marshall Field Warehouse, Chicago, Illinois, 1064, 1064, 1065, 1067

Richardson, Jonathan, the Elder, 935

Richardsonian Romanesque, 1064 Richard the Lion-Hearted, 550

Richelieu, Cardinal de, 769

Riemenschneider, Tilman, 739-40; Altarpiece of the Holy Blood, centerpiece Last Supper, 739-40, 739

Rietveld, Gerrit: "red and blue" chair, 1078, 1079; Schröder House, Utrecht, the Netherlands, 1078, 1079

Rigaud, Hyacinthe, 750-51, 776; Louis XIV, 750-51, 750, 769, 773, 776

Riis, Jacob, 1095; How the Other Half Lives (illustrated book), 1095; Tenement Interior in Poverty Gap: An English Coal-Heaver's Home, 1095, 1095

Rimini, Italy. See San Francesco, Church of

Rimpa school, 863-65

ring wall, 143, 185

Ripa, Cesare, Iconologia, 769, 797

ritual arts: African, 912-19; Pacific cultures, 897-98

ritual ball game, Americas, 445-47, 462

ritual bronzes, China, 401

ritual centers, Neolithic, 53-55

River, The, Claude Monet, 1009, 1009

Rivera, Diego, 1089, 1103-4, 1158; murals, Mexico City. Mexico, Ministry of Education: Night of the Poor, 1104; Night of the Rich, 1089, 1104, 1104, 1158

Robbia, Luca della, 651; Madonna and Child with Lilies. Florence, Italy, Orsanmichele, 651, 651

Robert de Luzarches, 561, 562

Robert Gould Shaw, Lewis, Edmonia, 972

Robusti, Marietta, 709

rock art, Saharan, 466-68

rock-cut caves, China, 409

rock-cut halls: India, 377-78, 389; paintings on, 383 Rock-cut sanctuary (Aztec), Malinalco, Mexico, 878, 878 rock-cut tombs, 110-11

Rockefeller, Nelson, 1126

rock-shelter art, Neolithic, 48

Rocky Mountains, Lander's Peak, The, Albert Bierstadt, 1000, 1001

Rococo style, 751-53, 804-14, 817

Rodchenko, Aleksandr, 1075-77; Exposition Internationale des Arts Décoratifs et Industriels Modernes (Paris, 1925), Workers' Club, 1076-77. 1076, 1155-56

Rodin, Auguste, 1026, 1030-31, 1060, 1096; Burghers of Calais, 1026, 1027

Roebling, John Augustus, 980; Brooklyn Bridge (with W. A. Roebling), New York City, 980, 980 Roebling, Washington Augustus, 980

Roger ("Theophilus"), 543; On Diverse Arts, 537-38 Roger II of Sicily, 327-28

Roger of Helmarshausen, portable altar of Saints Killian and Liborius, 537-38, 537, 543

Rogers, Richard, Centre Pompidou. See under Piano, Renzo

Rollo, 530

Roma, Anne Whitney, 972, 972

Roman art (ancient), 220-85; architecture, 226, 235-43, 252-55, 260-68, 274-76, 281-83; artists' status, 235; Christian art of, 297-305; emulation of Greek art, 219; fusion with Germanic, 481; influence on Indian, 379; influence on Islamic, 339; influence on Judaic, 291; influence on Romanesque, 527; painting, 278-80. 944; sculpture, 243–49, 255, 261–62, 268–72, 275–78.

Roman Catholic Church, 290, 291, 308, 609, 614, 751, 882 Roman civilization: influence of, 609, 613, 641, 931, 944; origins of, 233-35; see also Roman Empire; Romans: Rome. Italy

Roman Empire: Augustan age, 245-49; early empire, 252–73; emperors (chart), 234; late empire, 273–85; Western, 290, 609

Romanesque art, 481, 506-43; architectural sculpture, 516-21, 543; architecture, 511-16, 530-32, 535-37, 539-43, 576, 590; Britain and Normandy, 530-35; influence on Italian Gothic, 590; stained-glass windows of 559

Romanesque revival, 966, 969

Roman fort (Housesteads, England), 268, 269

Romanists (Netherlandish), 724, 727–28

Romans, 156; in Britain, 485; Etruscans and, 232; trade with Africa, 466

Roman School (French), 1030, 1048

Romanticism, 931-75, 997, 1093, 1136; naturalist tradition in, 990; proto-Romanticism, 958–59; rejection of 979

Rome, Italy, 668-69, 683, 944

Ara Pacis, 245–46, 245, 503; Allegory from, 246, 247; Imperial Procession from, 246, 246, 254, 284

Baroque period, 753-69

beginnings of city, 232, 233-34

decline of, as center of empire, 280, 290

Renaissance in, 691-704

Republican period, 234, 235-52

sack of (1527), 681

See also Arch of Constantine; Arch of Titus; Barberini Palace; Basilica of Maxentius and Constantine; Basilica Ulpia; Baths of Caracalla; Catacomb of Priscilla; Catacomb of Saints Peter and Marcellinus; Catacomb of the Jordani; Colosseum; Column of Trajan; Farnese, Palazzo; Gesù, Church of Il; House of the Vestal Virgins; Imperial Forums; Markets of Trajan; Old Saint Peter's: Pantheon: Republican Forum; Rospigliosi, Casino; Saint Paul's Outside the Walls; Saint Peter's Basilica; Saint Peter's Square; San Carlo alle Quattro Fontane; San Clemente church; San Pietro in Montorio; San Pietro in Vincoli; Santa Costanza; Santa Maria della Vittoria; Santa Maria Maggiore; Santa Sabina church; Temple of the Divine Trajan; Tombof Haterius family; Vatican Palace; Villa Torlonia

Romulus and Remus legend, 232, 233

Rongxi Studio, The (hanging scroll), Ni Zan, 840-41, 841, 846

rood screen. 597

roof comb 453

roof framing, 558

Roosevelt, Franklin Delano, 1102, 1103, 1105

Rosenberg, Harold, 1116, 1122, 1131

Rosetsu, Nagasawa, 867-68; Screen, detail Bull and Puppy, 867, 867

Rosetta Stone, 84, 113, 113

rosette, 161, 165, 165, 264, 344, 519

rose window, 553, 558, 558, 1057

Rospigliosi, Casino, Rome, Italy, 764, 764 Rossetti, Dante Gabriel, 1003-4; La Pia de' Tolomei,

1003-4, 1003 Rossi, Aldo, 1138-39; Town Hall, Borgoricco, Italy, 1139, 1130

Rosso Fiorentino, 712, 713, 714, 721; Dead Christ with

Angels, 712, 713, 721, 747 Roszak, Theodore, 1104; Airport Structure, 1104, 1105

Rothenberg, Susan, 1142, 1149; Axes, 1142, 1142 Rothko, Mark, 1114-16, 1118-20, 1123, 1131; Homage to Matisse, 1119, 1120; Slow Swirl by the Edge of the Sea, 1111, 1115, 1115, 1116

Rotonda, Villa (Villa Capra), Vicenza, Venetia, Italy, Andrea Palladio, 711, 711, 770, 936, 967

rotulus 319

rotunda, 263, 492, 711

Roualt, Georges, 1028

Rouen, Normandy, France, Saint-Maclou church, 570, 570

Rouen Cathedral: The Portal (in Sun), Claude Monet, 1018, 1019

round arch, 225, 226, 226, 235

roundel, 84, 225, 331, 626; Roman, 271

Rousseau, Jean-Jacques, 929, 955, 1014

Royal Academy of Architecture (France), 770 Royal Academy of Arts (England), 929, 942, 944, 949 Royal Academy of Painting and Sculpture (France),

769-70, 785, 929, 931, 944, 957 Royal Crescent, Bath, England, John Wood the Younger,

Royal mortuary compound, Nan Madol, Pohnpei,

Micronesia, 900, 901

Royal Porcelain Factory (Sèvres), 814 Royal Portal, Chartres, Île-de-France, France, Cathedral, 554-55. 554

Royal Symbols (quilt), Deborah (Kepola) U. Kakalia, 905-6, 906

rubénistes, 785

Rubens, Peter Paul, 693, 778, 780-83, 785, 790, 802, 1118; collaborations, 783-85; Henri IV Receiving the Portrait of Marie de' Medici, 782, 782; Landscape with Rainbow, 782, 783, 949, 1118; The Raising of the Cross, 781, 781; Whitehall Palace ceiling fresco, 781, 801-2, 801

Rublyov, Andrey, 335; The Old Testament Trinity (Three Angels Visiting Abraham) (icon), 335, 335, 583

Rucellai Giovanni 641 646 Rucellai, Palazzo, Florence, Italy, Leon Battista Alberti, 641, 646, 646, 649 Rude, François, 962, 982; Departure of the Volunteers of 1792 (The Marseillaise), 962, 963, 982 Rudolf of Swabia, tomb effigy of, 536, 537 Ruffaut, Jean, 616 Ruisdael, Jacob van, 793–94, 949; The Jewish Cemetery, 794, 794 Rukupo, Raharuhi, Te-Hau-ki-Turanga (Maori meetinghouse), Manutuke Poverty Bay, New Zealand, 904-5, runes, 482 rune stones, 482 Running Fence, Christo (with Jeanne-Claude), 1146, 1146 running spiral motif (Aegean), 145 Rush Hour, New York, Max Weber, 1097, 1097 Ruskin, John, 1004 Russia, 1075; Upper Paleolithic mammoth-bone dwellings, 38 Russian art: Byzantine churches, 330; Cubism and, 1059-62; realist, 996; Soviet era, 1075-77 Russian Orthodox Church, churches of, 330 Russian Revolution, 1075 rustication, 644, 645, 645, 704, 771, 969 Ruysch, Rachel, 799-800; Flower Still Life, 799-800, 799 Ryder, Albert Pinkham, 1092–93; Jonah, 1092, 1093 Ryoan-ji, 859; Garden, stone and gravel, Kyoto, Japan, 858, 859 Sabina, 587 sacra conversazione, 671 Sacred Landscape (wall painting), Pompeii, Italy, 258, Salians, 535 sacred places, Greek, 155-58 sacrifice, 138, 245; Mexico, 877-78; Peru, 460; Viking, 480 sacristy, 643 Safavids, 350 Sagot, Edmond, 1028 Saharan culture, rock art, 466-68 sahn, 344, 345 Saint(s). See name of saint(s) Saint Apollinaris, First Bishop of Ravenna, Ravenna, Italy, Sant'Apollinare in Classe, 316-18, 317 Saint Basil the Blessed, Moscow, Russia, 330, 331 Saint-Bavo, Cathedral of, Ghent, Flanders, 612-13, 612,

622-23, 622, 623, 633, 652 Saint Cyriakus church, Gernrode, Germany, 498, 499, 499, 532, 536

Saint-Denis, near Paris, Île-de-France, France, abbey church, 546-47, 551-53, 551, 552; Virgin and Child (sculpture), 571-72, 571, 575

Sainte-Chapelle, Paris, France, 568-69, 569, 573 Sainte-Foy abbey church, Conques, France, 512, 512, 513, 517, 556; Saint Foy (reliquary statue), 508, 509, 512, 513, 583

Sainte-Geneviève, Bibliothèque, Reading Room, Paris, France, Henri Labrouste, 980-81, 980

Saint Elizabeth church, Marburg, Germany, 585, 585 Saint Eloy (Eligius) in His Shop, Petrus Christus, 629-30, 629.728

Sainte-Madeleine church, Vézelay, Burgundy, carved portals of, 517, 520

Saint-Étienne church, Caen, Normandy, France, 531-32,

Saint Foy (reliquary statue), Conques, France, Sainte-Foy abbey church, 508, 509, 512, 513, 583

Saint Francis Master, 604

Saint Gall, Switzerland, Abbey of, 493-94, 494 Saint Jerome in His Study, Albrecht Dürer, 734-35, 734 Saint John the Baptist in the Wilderness, Geertgen tot Sint Jans, 633-34, 633

Saint Joseph (relief), Reims, Île-de-France, France, Nôtre-Dame Cathedral, 566, 567

Saint Joseph Master (Master of the Smiling Angels), 567 Saint-Lazare Cathedral, Autun, Burgundy, France, 517, 520-21; Last Judgment (relief), 520, 521, 525, 533, 555, 568; The Magi Asleep, 512-13, 521, 521; Weighing of Souls, 520, 521

St. Louis, Missouri. See Wainwright Building Saint Luke Displaying a Painting of the Virgin, Guercino, 22. 23. 23

Saint Luke Painting the Virgin, Jan Gossaert, 728, 728 Saint-Maclou church, Rouen, Normandy, France, 570, 570 Saint Maurice (sculpture), Magdeburg, Germany, Cathedral, 499, 587-88, 588

Saint Michael abbey church, Doors of Bishop Bernward, Hildesheim, Germany, 500, 501, 595; The Temptation and The Crucifixion from, 501, 501

Saint Panteleimon, Lamentation, Nerezi (near Skopje), Macedonia, 328, 328

Saint Patrick's Cathedral, New York City, 969 Saint Paul's Cathedral, London, England, Christopher Wren, 802, 802, 950

Saint Paul's Outside the Walls, Rome, Italy, 299, 299, 499 Saint Peter's Basilica, Rome, Italy, 701, 756-58, 756 plans: Bramante, 701; Maderno, 701, 756, 756; Michelangelo, 700-3, 701, 702, 756

St. Petersburg, Russia: Academy of Art, 996; Petrograd State Free Art Studios, 1075

Saint Peter's Square, Rome, Italy, Gianlorenzo Bernini, 757-58, 757

Saint-Pierre priory church, south portal, Moissac, Toulouse, France, 517-20, 518, 519, 555; Christ in Majesty (relief), 518, 519, 525; Lions and Prophet Jeremiah (?) (relief), 519-20, 519, 525

Saint Roche, Veit Stoss, 728, 740-41, 740 Saint-Savin-sur-Gartempe, Poitou, France, abbey church, 524-25, 524; Tower of Babel (wall painting), 525, 525 Saint Sebastian, Andrea Mantegna, 672

Saint Serapion, Francisco de Zurbarán, 780, 780 Saint-Simon, Comte de, 990, 994

Saint Stephen and Saint Theodore (relief), Chartres, Îlede-France, France, Cathedral, 555, 555, 588

Saint Teresa of Ávila in Ecstasy, Gianlorenzo Bernini, 761-62, 761, 773

Saint Ursula reliquary, Hans Memling, 631, 631; detail Martyrdom of Saint Ursula, 631-32, 631

Saint Vincent with the Portuguese Royal Family. See Gonçalvez, Nuño, Altarpiece of Saint Vincent Sala dei Giganti. See Tè, Palazzo del

Salisbury, Wiltshire, England, Cathedral, 576, 577 Salk Institute of Biological Studies, La Jolla, California, Louis Kahn, 1136-37, 1136

Salle, David, 1149, 1155; What Is the Reason for Your Visit to Germany, 1149, 1149, 1155

Salon de la Princesse. See Soubise, Hôtel de Salon des Refusés, 929, 1008

Salons (Paris). See Paris Salon

Saltcellar of Francis I, Benvenuto Cellini, 722-23, 723

Samaritan Women at the Well (in Christian art), 306 Samarkand, 348; ware, 348

Samarra, Iraq, Great Mosque of al-Mutawakkil, 347, 347 Samoa, 895

Samothrace, Macedonia, Nike (Victory), 214, 215 samsara, 370-71, 372

San Carlo alle Quattro Fontane, Church of, Rome, Italy, Francesco Borromini, 758-59, 758, 759, 802, 806 Sánchez Cotán. See Cotán

Sanchi, Madhya Pradesh, India, Great Stupa, 374-76, 374, 427; gateway (torana) of, 376, 376; yakshi figure, 376-77, 377

San Clemente church, Rome, Italy, 542-43, 542 San Clemente church, Tahull, Lérida, Spain, Christ in Majesty wall painting from, 525, 526, 529

San Clemente Master, 525-27

sanctuary, 155, 512, 558, 643

Sanctuary of Apollo, Delphi, Greece, 157–58, 157 Charioteer, 157, 181, 181

Siphnian Treasury, 158, 164, 166-68, 167; sculpture from frieze, 167-68, 167

Sanctuary of Athena, Delphi, Greece, tholos at, 199-200, 199 210

Sanctuary of Demeter and Persephone, Eleusis, Greece, 195, 196

Sanctuary of Fortuna, Palestrina, Italy, 236, 237, 237 Sanctuary of Hera, Argos, Greece, 160

Sanctuary of Hera and Zeus, Olympia, Greece, 153, 155-57, 178

Sand, George, 991

sand painting, **906**; Navajo, 890–91

San Fernando, Hospicio de, Madrid, Spain, Pedro de Ribera, 755, 755, 776-77, 776, 817

San Francesco, Church of, Arezzo, Italy, 666, 666 San Francesco, Church of, Tempio Malatesta, Rimini, Italy, Leon Battista Alberti, 660, 660, 661

San Francisco church, Barcelona, Spain, Villafranca del Panadé, Virgin and Saint George (altarpiece), 584, 584; Education of the Virgin from, 584, 585

Sangallo, Antonio da, the Younger, 645, 700-2 Sangallo, Giuliano da, 660, 662-63; Santa Maria delle Carceri, Prato, near Florence, Italy, 662-63, 663

sanghati, 378, 379, 380, 383, 409

San Giobbe, Ospedale of, Venice, Italy, 671-72, 671, 704 San Giorgio Maggiore, Church of, Venice, Italy, Andrea Palladio, 710-11, 710, 817

San Giovanni, Baptistry of, Florence, Italy, 647–49, 648, 649, 664; doors, Life of John the Baptist from, Andrea Pisano, 594, 595, 595

San Lorenzo, Church of, Florence, Italy, Filippo Brunelleschi, 643-44, 643, 653, 689, 758; Medici Chapel (New Sacristy), 689-90, 690; Old Sacristy, 663 San Lorenzo, Mexico, Olmec center, 448

San Lorenzo, Monastery of, Laurentian Library, Florence, Italy, Michelangelo, 693, 719, 719

San Marco, Cathedral of, Venice, Italy, 325, 325 San Marco, Library of, Venice, Italy, Jacopo Sansovino,

709, 709 San Marco, Monastery of, Florence, Italy, 655–56, 656 San Petronio, Church of, Bologna, Italy, 664, 664 San Pietro in Montorio, Church of, Tempietto, Rome,

Italy, Donato Bramante, 699, 699, 701, 703, 802 San Pietro in Vincoli, Tomb of Julius II, Rome, Italy, 697-98.697

San Simeon, California. See Casa Grande Sanskrit, 370, 823

Sansovino, Andrea, 690

Sansovino, Jacopo (Jacopo Tatti), 690-92, 709; Bacchus, 690, 691, 717; Library of San Marco, Venice, Italy, 709,

Santa Costanza, Rome, Italy, 300-2, 300, 301, 313; Harvesting of Grapes, 302, 302, 308

Santa Croce, Florence, Italy, 650-51, 651

Santa Maria, Quintanilla de las Viñas, Burgos, Spain, 488, 489; Grapes, Vines, and Birds (relief), 488, 489 Santa Maria del Carmine, Brancacci Chapel, Florence,

Italy, 654-55, 655; frescoes by Masaccio, Masolino, and F. Lippi, 654, 654, 683

Santa Maria della Vittoria, Cornaro Chapel, Rome, Italy, Gianlorenzo Bernini, 760-61, 760, 808

Santa Maria delle Carceri, Prato, near Florence, Italy, Giuliano da Sangallo, 662-63, 663

Santa Maria delle Grazie, Milan, Italy, 684–85, 684, 739 Santa Maria Maggiore, Rome, Italy, 299–300, 299; Parting of Lot and Abraham, 300, 300, 495

Santa Maria Novella, Florence, Italy, 624, 624, 653-54, 653, 658, 658, 672

Sant'Ambrogio, Milan, Lombardy, Italy, 531, 540–41, 541 Sant'Andrea, Mantua, Italy, Leon Battista Alberti, 660-62, 660, 661, 710

Sant'Antonio, Padua, Italy, Donatello's statue for, 665 Sant'Apollinare in Classe, Ravenna, Italy, 316, 316; Saint Apollinaris, First Bishop of Ravenna, 316–18, 317

Sant'Apollonia, Florence, Italy, 657, 657, 684

Santa Sabina church, Rome, Italy, 501 Santa Trinità, Florence, Italy, 652, 652

Sant'Elia, Antonio, 1058; Central Station project, Milan, Italy, 1058, 1073, 1073, 1081; Manifesto of Futurist Architecture, 1073

Santiago de Compostela, Spain, Cathedral, 24, 513 Santi Giovanni e Paolo and the Monument to Bartolommeo Colleoni, Canaletto, 932-33, 932

Santo Domingo, Church of, Cuzco, Peru, 879-80 Santo Domingo de Silos, Castile, Spain, abbey church, Doubting Thomas (relief), 516-17, 516

San Vitale, Ravenna, Italy, 298, 313-14, 313, 314, 315, 342, 492; Emperor Justinian and His Attendants, 288-89, 288, 314; Empress Theodora and Her Attendants, 288, 314, 316

San Xavier del Bac Mission, near Tucson, Arizona, 777, 816.817

Sappho, 162

Saqqara, Egypt

Djoser's funerary complex, 99, 100; North Palace, walls with engaged columns, 100, 101 pyramid of Djoser, 99-102, 100 Sculptors at Work (relief), 98, 98 tomb complex at, 99-102 Tomb of Ti, Ti Watching a Hippopotamus Hunt, 107-8, 108, 111, 112

Sagsawaman (Inka temple fortress), 880 Saraband, Morris Louis, 1131-32, 1131

sarcophagi, 99, 292; Byzantine, 329; Etruscan, 230-31; Roman, 278, 592

Sarcophagus of Junius Bassus (Christian), 305-8, 305 Sargon I, 73 Sargon II, 79

palace of, Dur Sharrukin (modern Khorsabad, Iraq), 78; guardian figure from, 79, 79

Sarnath Gupta style, 381 Seated Scribe (Egyptian statue), 106, 107 shape. 29 Sarpedon, 156 Seated Woman, Ernst Barlach, 1031-32, 1031 Shapolsky et al. Manhattan Real Estate Holdings, a Real-Sartre, Jean-Paul, 1112 Seattle Art Museum, Stair Hall, Robert Venturi and Time Social System, as of May 1, 1971, Hans Haacke. Sassanian Persian Empire, 339, 349; double-winged Denise Scott-Brown, 27, 27 motif, 342 Secession, 1032; Berlin, 1038 "Sharp Focus Realism" exhibition (New York, 1972), 1142 satire in art, 941, 1027 Secessionsstil, 1070 shater, 330 saturation, 29 secondary colors, 29 Shazi, pen box of al-Mulk, 355-56, 355 Saturn, 156 sections, 31 \$he, Richard Hamilton, 1128, 1129 Saul (Saint Paul), 290, 291 sed rituals (Egypt), 93, 99-101 Sheeler, Charles, 1099–1100, 1104; American Landscape, Savonarola, Girolamo, 660, 688 see (seat of bishopric), 291 1099-1100, 1099, 1104 Saxons, 485 Seed jar (Anasazi culture, North America), 463, 463 Shen Zhou, 846; Poet on a Mountain Top (handscroll). Saxony, 681; metalwork, 537 Segal, George, 1123, 1124; Subway, 1123, 1123 846, 846, 857 scaffold, 558 segmental pediment, 700, 776 Sherman, Cindy, 1156-57; Untitled Film Still, 1157, 1157 Scandinavia, 681; Middle Ages, 481–84 Sekisui, Ito, 870; Ceramic vessel, 870, 870 She-Wolf (Etruscan), 231–32, 232 scarab (Egyptian symbol), 94, 95, 114 Sekou Amadou, king, 474 Shihuangdi, Emperor of China, 397, 402 scarification patterns, **470**, 474 Seleucus, 209 Shiite sect (Muslim), 339, 341, 350 Scarlet Ware, 70, 71 Self-Portrait, Leonora Carrington, 1089, 1089 shikara, 375 Schapiro, Mever, 1118 Self-Portrait, Caterina van Hemessen, 728, 729 Shimamoto, Shozo, 1125; Hurling Colors (happening), Schapiro, Miriam, 1147, 1148–49; *Heartfelt*, 1148–49, Self-Portrait, Judith Leyster, 788, 789 1124, 1125 1148, 1164 Self-Portrait, Pablo Picasso, 1048, 1048 Shimomura, Roger, Diary, 25, 25 Schiele, Egon, 1038-39; Self-Portrait Nude, 1039, 1039 Self-Portrait, Rembrandt van Rijn, 791, 792 Shingon Buddhism, 431 Schliemann, Heinrich, 143, 148, 216 Schliemann, Sophia, 143 Self-Portrait Nude, Egon Schiele, 1039, 1039 Shinn, Everett, 1094 Self-Portrait with an Amber Necklace, Paula Modersohn-Shinto, 426, 430, 855; symbols of, 426 Schlüter, Andreas, Frederick William, the Great Elector (of Becker, 1044, 1045 shipwrecks, and archeological finds, 140 Brandenburg), 804, 804 Self-Portrait with a Sprig of Eryngium, Albrecht Dürer, Shiro, Tsujimura, 870; Ceramic vessel, 870, 870 Schmidt-Rottluff, Karl, 1041–42; Three Nudes—Dune Shitao, 848–51; *Landscape* (album), *850*, 851 732, 733 Picture from Nidden, 1041–42, 1041, 1045 Self-Portrait with Palette, Pablo Picasso, 1049, 1049 Shiva, 372, 386, 389 Scholastic philosophy, 550, 557 Schongauer, Martin, 640, 675–76, 733; Holy Family, 640, Self-Portrait with Two Pupils, Mademoiselle Marie Gabrielle Shiva Nataraja (Dancing Shiva) (sculpture, Chola dynasty, Capet and Mademoiselle Carreux de Rosemond, India), 392, 393 640; Temptation of Saint Anthony, 675–76, 675, 733 Adélaïde Labille-Guiard, 954, 955 shoin architecture, 862 school (artistic), 795 Selim II. 355 shoji screens, 862 School of, meaning of term, 990 School of, Meaning of term, 990 School of Athens (fresco), Raphael, 692, 692, 988 Schröder House, Utrecht, the Netherlands, Gerrit Selimiye Cami (Mosque of Selim), Edirne, Turkey, Sinan, Shona people (Great Zimbabwe), 475, 911 345, 354, 355, 360-61 Shoppers, The, Duane Hanson, 1143–44, 1144 Selinus, Sicily, Temple B, 164 Shotoku, Prince, 426 Rietveld, 1078, 1079 Seljuk Turks, 349-50, 352, 353-54, 357 Shoulder bag (Native American, Delaware), 884, 884 science, seventeenth century, 786 Shrine of the Three Kings (reliquary), Nicholas of Verdun, Senefelder, Aloys, 985 scientific illustration, 798–99, 903 Senenmut, 116 566, 586-87, 587 scientific photography, 1002 Senior (Spanish scribe painter), 490 shrines: central-plan, 492; Hindu, 389; Shinto, 430 Scots, 268 Sen no Rikyu, 861; Myoki-an Temple, Tai-an tearoom, Shroud of Turin, 322 Scott-Brown, Denise, Seattle Art Museum (with Robert Venturi), Stair Hall, 27, 27 Kyoto, Japan, 861, 861 Shu, 96 Senwosret II, 108-9, 198; funerary complex of, 114; Shubun, 856 Scraper, The (Apoxyomenos), Lysippos, 203, 204, 219 pectoral of, 112-14, 112 Shuhda, 348 Scream, The, Edvard Munch, 1038, 1038, 1109 Senwosret III, statue of, 111-12, 111, 232 Shungas dynasty, 374–78 Shute, John, 741 Screen, detail Bull and Puppy, Nagasawa Rosetsu, 867, sepia, 964 867 Sepik River, Papua New Guinea. See tamberan house Sicily, 327-28 scribes: Byzantine, 319; Egyptian, 107, 319; Islamic, 348, (Abelam culture) Siddhartha Gautama, 371 361 Septimius Severus, 273, 274, 278 Siddhartha in the Palace (relief, Andhra period, India), scriptoria, 334, 486, 490, 527; Carolingian, 494; French Septimius Severus, Julia Damna, and Their Children, 380, 381 Gothic, 580 Caracalla and Geta (Roman painting), 278-79, 279 side aisle, **558**, *558* Sculptors at Work (relief), Saqqara, Egypt, 98, 98 serdab, 99, 103 Sidney Janis Gallery, "Sharp Focus Realism" exhibition sculpture, 30–31; abstract, 1062; Abstract Expressionist, 1120–21; African, 468–69, 477, 912–19; American, 970–73, 996, 998–99; American Colonial, 817; Serlio, Sebastiano, 741, 745 (New York, 1972), 1142 Serra, Richard, 1161-62, 1165; Tilted Arc, 1161-62, 1161. Siena, Italy 1165 Cathedral Baptistry, 649, 649 Baroque, 773, 804; Buddhist, 381-83, 409, 410, 412, Cathedral of Our Lady, 590, 591, 593, 599 altarpiece, Simone Martini, Annunciation panel Sesshu, 857-58, 860; Winter Landscape, 857-58, 857 440; Chinese, 409, 410, 412; Cubist, 1054-55, 1061; setback, 1065 Cycladic, 130-31; early Christian, 291-95, 305-8; Seth, 96, 108 from, 575, 597–99, 597 Egyptian, 104-6, 111-12, 120, 169-70; freestanding, setting marks (masons' marks), 566 Maestà Altarpiece, Duccio, 597, 597; panel, Virgin 31, 169-72, 179-83, 650, 688; French, 571-72, Sety, Temple of the Spirit of, 115 and Child in Majesty, 583, 596, 597 617-18, 773, 807-8, 951-53, 962; German, 586-90, Setv I. 115 Palazzo Pubblico, Allegory of Good Government 739-41, 804, 807-8; Gothic, 571-72, 586-90, 592-95; Seurat, Georges, 1026, 1033-34; A Sunday Afternoon on frescoes by Ambrogio Lorenzetti, 548, 549, Greek, 87, 160, 169–72, 179–83, 193–95, 201–5, 229; the Island of La Grande Jatte, 1033-34, 1034, 1079 599-600, 600-1 Hellenistic, 211–19; Indian, 381–83, 390–91, 392–93; Italian, 646–52, 655, 664–65, 687–91, 697–99, 717, Sienese School, Italian Gothic painting, 597–600, 607–8 Seven Wonders of the World, 102, 200, 209 Severn River, bridge over, Coalbrookdale, England, Sight, detail. See Brueghel, Jan, Allegories of the Five 934–35; Japanese, 425–26, 433, 439, 870–71; joined-Abraham Darby III, 943 Senses wood (Japan), 433; mannerist, 717; Mauryan, 372-73; Severus Alexander, 273 Signboard of Gersaint, The, Jean-Antoine Watteau, Mayan, 454, 456; minimalist, 1132–34; Minoan, 134– Sévigné, Madame de, 805 809-10, 810 36; Mycenaean, 148; neo-Baroque, 981; Neoclassical, Sèvres-Brimborion, View toward Paris, Jean-Baptistesikhara, 383, 390 934-35, 951-53, 970-73; Neolithic, 55-58; Olmec, Camille Corot, 990, 991, 1014 Silhouettes (performances), Mendieta, Ana, 1149 448; Ottonian, 499-503; Paleolithic, 38-40; religious, silk: Chinese, 349, 407; Islamic woven, 357–60 Silk Road, 348, 402, 403, 411 Sèvres Royal Porcelain Factory (France), 811; Potpourri 688; Renaissance, 617-18, 664-65, 687-91, 697-99; jar, 814, 815 Renaissance, early, 646-52; Rococo, 807-8; Roman, Sforza, Battista, 666-67 Silpa Shastra, 385 ancient, 243-49; Romanesque, 514, 521-23; Roman-Sforza, Lodovico, 684 silver work, Inka, 880 tic, 962; Spanish, 746; Sumerian, 68-69; wood, 477, Sforza family, 641, 699 Sinan, 354–55; Selimiye Cami (Mosque of Selim) (Turkey), 345, 354, 355, 360–61 523, 739-40; Yoruba peoples, 469-71; see also archisfumato, 686 tectural sculpture; relief sculpture; stela sculpture shaft, 87, 101, 165, 165, 373, 645, 645 sinopia, 599 sculpture in the round, 131, 188; Etruscan, 231-32; Olmec shaft grave, Mycenaean, 148 Sipan, Peru, sacrificial tomb site, 460 monumental basaltic heads, 448; prehistoric, 40 Shah Jahan, Indian ruler, 827, 830 Siphnian Treasury, Delphi, Greece, Sanctuary of Apollo, Scythian art, 81; metalwork, 208; pectoral, 208, 208 Shaka Triad, Tori Busshi, 429, 429 158, 164, 166-68, 167; sculpture from frieze, 167-68, Seagram Building, New York City, Ludwig Mies van der Shakespeare, William, Macbeth, 800 Rohe (with Philip Johnson), 1081, 1135-36, 1135, 1137 shakti, 387 Sippar, Akkad, 74 seals, 89; Chinese, 408; Indian, 366-69; Indus Valley, Shakyamuni Buddha, 371, 823 Siqueiros, David, 1103, 1116 Shallow-Space Constructions, Turrell, James, 1134 shamanism, 44–45, 399, 400–1; in Shang China, 837 366, 367, 369; Sumerian, 71 Sisters of the Artist and Their Governess, The, Sofonisba seal script (China), 408 Anguissola, 716, 716 Sears Tower, Chicago, Illinois, 1065 Shaman with Drum and Snake (pendant, Costa Rica), Sistine Chapel. See Vatican Palace seascapes, Dutch, 793-94 456, 456 Sistine tapestries, Raphael, 693-95, 693 Seated Buddha (rock sculpture), Yungang, Shanxi, China, Shangdi (Chinese deity), 400 site-specific sculpture, 1145 409, 409, 429 Shang dynasty (China), 400-1, 837 Sithathoryunet, tomb of, 114

Spear Bearer (Doryphoros), Polykleitos, 193-95, 195, 201, stoa. 158, 186 Six Dynasties (China), 407-9 stockade, 461-62, 579, 579 Sixtus III, Pope, 300 stone, transporting of, in Middle Ages, 550-51 spear thrower, ibex-headed (Paleolithic), Le Mas d'Azil, Sixtus IV, Pope, 669 Stone Age, 37-58 Ariège, Dordogne, France, 47, 47 Sixtus V, Pope, 753 Stone Breakers, The, Gustave Courbet, 992-93, 992, 999, Siyar-i Nabi, The Prophet Muhammad and His Companions Traveling to the Fair from, 341 speech scroll, 450 Spencer, Herbert, 1095 999, 1033 Skara Brae, Orkney Islands, Scotland, 50; house interior, Speyer, Germany, Imperial Cathedral, 535–37, 536, 557 stone building construction, 550-51, 981 Spiral Jetty, Robert Smithson, 1146, 1146 stone crosses, Ireland, 488 50-51, 51; village plan, 50-51, 50 Stone Enclosure: Rock Rings, Nancy Holt, 1145, 1145 spire, 558 skene, 210 Stonehenge, Salisbury Plain, England, 51, 53-55, 54, 55, Spirit figure (boteba) (Lobi culture), Burkina Faso, 916, 917 sketch aesthetics, 1009 Spirit mask (Guro culture), Côte d'Ivoire, 924, 924 1145 Skirt of Queen Kamamalu (Hawaiian), 902, 902 stone masonry, in Romanesque churches, 511 Skopas, 201, 202-3; Head from Temple of Athena Alea, Spirit of Haida Gwaii, The, Bill Reid, 888, 888 Spirit of Our Time, The, Raoul Hausmann, 1084, 1084 stoneware, 57 Tegea, Greece, 203, 203 Spirit spouse (blolo bla) (Baule culture), Côte d'Ivoire, "Store, The" exhibition, Claes Oldenburg, 1129-30, 1129 skyscrapers, American, 1064-66 Stoss, Veit, 740-41; Saint Roche, 728, 740-41, 740 slavery, 928, 959 Stourhead, Wiltshire, England. See Park, The spirit world, in African art, 916-19 Slavophile movement, 1060 Split, Dalmatia, Palace of Diocletian, 275–76, 275 Strabo, 162 Sleep of Reason Produces Monsters. See Goya y Lucientes, Strasbourg, France, Cathedral, Dormition of the Virgin Spoils from the Temple of Solomon, Jerusalem (relief), Francisco, Los Caprichos Rome, Italy, Arch of Titus, 254, 254, 292 (relief), 587, 587 slip (pottery), 159, 162, 370, 897, 1163 Spoleto Festival U.S.A. (Charleston, S.C., 1991), "Places Stravinsky, Igor, The Firebird, 1031 Sloan, John, 1028, 1094-95; Backyards, Greenwich Strawberry Hill, Twickenham, England, Horace Walpole with a Past," 1159-60 Village, 1094-95, 1094 Spotted Horses and Human Hands (cave painting), Pech-(and others), 938, 939; Holbein Chamber, Richard Slow Swirl by the Edge of the Sea, Mark Rothko, 1111, Bentley, 939, 939 Merle Cave, France, 41-42, 41 1115, 1115, 1116 Spring and Autumn period (China), 401 Street, Berlin, Ernst Ludwig Kirchner, 1042, 1043, 1081 Sluter, Claus, 617-18, 620; Well of Moses, Dijon, France, Spring Dawn in the Han Palace (handscroll), Qiu Ying, stretcher course, 901 Chartreuse de Champmol, 617-18, 617 stringcourse, 532, 558, 558, 645, 645 Small Cowper Madonna, The, Raphael, 686, 686, 738 842. 843 Spring Festival on the River, detail, Zhang Zeduan, Stubbs, George, 946-47; Anatomy of a Horse (book), 946; Smibert, John, 818; Dean George Berkeley and His Family Lion Attacking a Horse, 946, 947 417-18, 418 (The Bermuda Group), 818, 818 stucco, 186, 229, 449, 757, 967, 1062 springing, 226 Smith, David, 1120-21, 1132 Spring Showers, Alfred Stieglitz, 1096, 1096 Studiolo of Federico da Montefeltro. See Urbino, Italy Cubi series, 1132; Cubi XIX, 1132, 1133 squinch, 310, 324–25, 347, 351, 513; dome on, 310 stupa, 374-78, 375, 375, 413, 414, 414, 427 Tank Totem series, 1120-21; Tank Totem III and IV, Stupefied Groom, Hans Baldung Grien, 736, 736 Sri Lanka, 366 1120-21, 1121, 1132 stadium, 155, 235 Sturluson, Snorri, Prose Edda, 483 Smith, Jaune Quick-to-See, 891; Trade (Gifts for Trading Staël, Madame de, 804-5 style, 19, 29; meaning of term, 990 Land with White People), 891, 891 Staffelstein, Germany. See Vierzehnheiligen, Church of the stage design, Baroque, 800 Style Guimard, 1070 Smithson, Robert, 1145-46; Spiral Jetty, 1146, 1146 stylization, 77; Cycladic, 129; in Islamic art, 339; in Smithsonian Institution, Washington, D.C., James Stag Hunt (mosaic), Gnosis, 206, 207–8 stained-glass windows, 559; Gothic, 557–61, 568, 569; influence on book illumination, 573; technique, 559 Mesopotamian art, 77 Renwick, Jr., 969-70, 969 stylobate, 163, 165, 165 Smythson, Robert, 745; Wollaton Hall, Nottinghamshire, stylus, 65, 66, 162 England, 744, 745, 745, 803 subject matter of art, 29; religious, 641, 683; secular, staircases, 722; monumental, 662 Snap the Whip, Winslow Homer, 1000, 1001, 1093 578-79, 641, 683, 724; traditional, 1016-17 Stalin, Joseph, 1077 Soap Bubbles, Jean-Siméon Chardin, 811, 812 Stamatakis, Christos, 145 sublime subject, 931, 935, 946-50 Sobekneferu, 116 Subway, George Segal, 1123, 1123 stamps, Sumerian, 71 Sobel, Janet, 1116 Standing Buddha (from Gandhara), 378, 379 Sufism, 352 Social Darwinism, 1095 Standing Buddha (Gupta period, India), 381–83, 381, 393 Suger, Abbot of Saint-Denis, 546-47, 551-53 Socialism, 1075 Standing Woman (Elevation), Gaston Lachaise, 1098–99. Suicide of Ajax, The (vase painting), Exekias, 166, 175-76, Socialist Realism (U.S.S.R.), 1077 Social Realists (American), 1102-3 Sui dynasty (China), 410, 837 Stanford, Leland, 1002 Society of Etchers, 1005 Stanza della Segnatura. See Vatican Palace Suitor's Visit, The, Gerard Ter Borch, 795, 795, 809 Socrates, 193, 198 Starry Night, The, Vincent van Gogh, 1036–37, 1037, 1109 Sukkoth, 292 Solomon, King, 289 State Ship (Egyptian wall painting, detail), 122, 123 Suleyman, Sultan, 354-55, 363 Solon, 155 States of Mind: The Farewells, Umberto Boccioni, Sullivan, Louis, 1065-66; Wainwright Building, St. Louis, Song dynasty (China), 415–19, 836, 837, 838–39, 841–42, Missouri, 1064, 1065 1058-59, 1058 statues, 169-72, 179-83, 650, 688; bronze, 177, 181; free-Sulpicia, 259 Songhay, empire of, 911 Sultan Hasan mosque complex, Cairo, Egypt, 353–54, 353 standing, 169–72, 179–83, 650, 688; nude, 169–70, 201–2 Song of Roland, The (La Chanson de Roland), 509, 559 steal building construction, **32**, 980, 1064–65 steel building construction, **32**, 980, 1064–65 Steen, Jan, 22–23, 795–97; *The Drawing Lesson*, 23, 23; *The Feast of Saint Nicholas*, 795–97, 795, 811 Sumer, 65-73; cylinder seal from, 71-73, 73, 366 Songye people (Zaire), 917-18 Sumerian art, 62-63, 66-74 Sophocles, 209 Summer (canvas mural), Pierre-Cécile Puvis de Sorel, Agnès, 638 Chavannes, 1030, 1030 Steichen, Edward, 1096 Sosos, 273 Sumner, Charles, 970-71 Steiner House, Vienna, Austria, Adolf Loos, 1072-73, 1072 Sotatsu, Tawaraya, 863; Matsushima screens, 863, sumptuary laws, 644 Steinlen, Alexandre, 1028 Sunday Afternoon on the Island of La Grande Jatte, A, stela, 74, 195, 379 Soubise, Hôtel de, Salon de la Princesse, Paris, France, Georges Seurat, 1033-34, 1034, 1079 Stela of Hammurabi, Susa (modern Shush, Iran), 76-77, Germain Boffrand, 804, 805 Sunflowers, Vincent van Gogh, 28, 28 Soufflot, Jacques-Germain, 950-51; Panthéon (Church of 76,84 sunken relief, 31, 119-20, 119 Sainte-Geneviève), Paris, France, 950–51, 950 Stela of Naramsin, Akkad, 74, 74, 76-77, 84, 96 Sunni sect (Muslim), 339 stela sculpture: Greek, 195-97; Mayan, 451 South America, 456-60; indigenous peoples, 879-82 Sun Vow, Herman Atkins MacNeil, 1091, 1091 South Cross, Ahenny, Tipperary, Ireland, 488, 488 Stella, Frank, 1132; "Die Fahne Hoch," 1132, 1132 Super Realism, 1142-44, 1149 stepped pyramid, 103, 103 Southeast Asia, Neolithic, 48 Supper at Emmaus (in Christian art), 307 stereobate, 165, 165 Southern Song dynasty (China), 415; landscape painting, Suprematism, 1061 Stieglitz, Alfred, 1096, 1097; Spring Showers, 1096, 1096 418-19 Suprematist Painting (Eight Red Rectangles), Kazimir Stijl, de, 1082 Southwest, American, 462-63 Stile floreale, 1070 Malevich, 1060-61, 1061 Soviet-era art, 1075-77 Surrealism, 1087–90, 1109, 1112, 1114, 1141
Survival series, excerpt *Protect Me from What I Want,* Stile Liberty, 1070 space, 29; see also pictorial space Spain, 681, 727, 745-47, 776, 965-66; American Still, Clyfford, 1120, 1123 colonies, 776, 817; Christian, 488-90; conquest of still life, 23, 777, 986-87; Dutch, 797-800; Roman, Jenny Holzer, 1158, 1158 Susa (modern Shush, Iran), 84-85, 86; beaker from, Americas, 882-83; early medieval, 488; Golden Age, 256-58, 273 84-85, 84; Stela of Hammurabi, 76-77, 76, 84; torque Still Life. Le Corbusier, 1079, 1079 776; Gothic, 582-84; Islamic, 345, 350-52 Still Life (wall painting, detail), Pompeii, Italy, House of from, 88, 88; Woman Spinning from, 85, 85 spandrel, 226, 299, 517, 517, 695, 831 Julia Felix, 256–58, 257, 258–59 suspension, 32 Spanish Armada, 745 sutras, copying of, in Japan, 430 Still Life with Flowers, Goblet, Dried Fruit, and Pretzels, Spanish art: architecture, 488, 582, 745–46, 776–77; Sutton Hoo, England, burial ship, purse cover from, Clara Peeters, 784, 785 Baroque, 776-80; eighteenth-century, 964-66; Still Life with Lemon Peel, Wilhelm Kalf, 798, 798 485-86, 485, 488 Hispano-Flemish, 637-38; Islamic style, 345; painting, Still Life with Quince, Cabbage, Melon, and Cucumber, Suzhou, Jiangsu, China. See Garden of the Cessation of 746-47, 777-80; Romanesque, 510-30; sculpture, 746 Official Life Juan Sánchez Cotán, 777, 777 Sparta, Greece, 153, 184-85, 197-98; Vapheio Cup, 137, swag, 246, 755, 755 138, 138 still photography, 30 Stiris, Greece, Monastery of Hosios Loukas: churches at, Swahili language, 466, 911 spatial qualities, 29 Sweatshop, William Gropper, 1102-3, 1103 324-25, 324; Katholikon, 324-25, 325

spatial recession. See pictorial depth

sword (Shinto symbol), 426 Temple of Aphaia, Aegina, Greece: Dying Warrior, 168-This Photograph Is My Proof, Duane Michals, 1141–42, 1141 symbols. See iconography 69, 168, 212; pediment, 168–69, 168, 188, 212 Temple of Apollo, Delphi, Greece, 158 This Year, Venuses Again . . . Always Venuses! , Honoré Daumier, 994, 995, 1008, 1048 Symmachus, Quintus Aurelius, 284 symmetry, in African art, 922-23 Temple of Apollo, Didyma, modern Turkey, 164 tholos, **186**, 198, 199–200, **237**, **300**, **663** sympathetic magic, 425; and cave painting, 46 Temple of Apollo, Veii, Italy, Apollo (statue), 228, 229 Thomas de Cormont, 561 synagogues, 289; Gothic, 586 Temple of Artemis, Ephesos, Asia Minor, 102 Thoré, Théophile, 994 syncretism, 291 Temple of Artemis, Korkyra (Corfu), Greece, 166, 166; Thornton, William, 968–69; United States Capitol (with Syon House, Middlesex, England, Robert Adam. 937. sculpture from pediment of, 166, 166 Benjamin Henry Latrobe), Washington, D.C., 968-69, 937, 967 Temple of Athena Nike, Athens, Greece, 164, 192-93, Syracuse, Sicily, 155 193; Nike (Victory) Adjusting Her Sandal (relief Thorpe, Richard, 967; Mount Vernon (see under Rawlins, Syria, 339 sculpture), 193, 194, 202, 219, 247 John) Temple of Hera, Olympia, Greece, 201 Thorvaldsen, Bertel, 935, 964, 970; Ganymedes with Temple of Hera I, Paestum, Italy, 163-64, 163 Jupiter's Eagle, 935, 935, 964, 970 Thousand Peaks and Myriad Ravines, A (hanging scroll), tableaux vivants, 612-13 Temple of Khafre, Giza, Egypt, 104, 104 tablinum, 243 Temple of Solomon, 341 Wang Hui, 848, 849 tachisme, 1112 Temple of the Divine Trajan, Rome, Italy, 261 three-dimensional arts, 30 Tahull, Lérida, Spain, San Clemente church, Christ in Temple of the Feathered Serpent, Teotihuacan, Mexico, Three Nudes—Dune Picture from Nidden, Karl Schmidt-Rottluff, 1041–42, 1041, 1045 Majesty from, 525, 526, 529 449, 450, 450 Tai-an tearoom. See Myoki-an Temple Temple of the Giant Jaguar, Tikal, 452 Three Seated Goddesses, Athens, Greece, Acropolis, Parthenon, pediment sculpture, 188–89, 189 Taira clan (Japan), 437, 855
Taj Mahal, Agra, India, 822, 822, 829–31, 829 Temple of the Inscriptions, Palenque, Mexico, 453-54, 453 tomb of Lord Pacal: portrait of Lord Pacal, 454, 454; Three Women, Fernand Léger, 1080, 1080 Taking of the Roman Census (temple frieze), 244, 245, 255
Talbot, William Henry Fox, 987; The Pencil of Nature sarcophagus lid from, 454, 454 Three Women in a Village Church, Wilhelm Leibl, 995-96, Temple of the Olympian Zeus, Athens, Greece, 211, 211 (book), The Open Door, 986, 987
Tale of Genji (Murasaki), 431, 435–36, 855; paintings of, 436; scene from scroll of, 436, 436 Temple of the Sun, Cuzco, Peru, 879-80, 879 Throne of the Third Heaven of the Nations' Millennium Temple of Zeus, Olympia, Greece, pediment sculpture, General Assembly, James Hampton, 20–21, 21 178-79, 178, 179, 189, 202; Athena, Herakles, and Throne of Wisdom (devotional image), 521-23, 602 Tales of Ise, 864–66 Atlas, 178, 179, 196, 202 thuluth script, 348, 357 Taliesin, Spring Green, Wisconsin, Frank Lloyd Wright, Temple perhaps of Portunus, Rome, Italy, 238, 238 Ti, mastaba of, 107-8 1067-68, 1067 Temples I and II, Tikal, 452 Tian (Heaven), 401 talud-tablero construction, 449 Temples of Ramesses II and Nefertari, Abu Simbel. Tiberius, 249, 252, 291 Tamamushi Shrine, Horyu-ji, Nara, Japan, temple at, Hungry Tigress Jataka (panel), 428–29, 428 Nubia, 118–19, 118 Tibet, 824 Temptation, The, Hildesheim, Germany, Saint Michael Tiepolo, Giovanni Battista, 805-6, 964; The Marriage of tamberan house (Abelam culture), Sepik River, Papua abbey church, Doors of Bishop Bernward, 501, 501 the Emperor Frederick and Beatrice of Burgundy New Guinea, 898-99, 898 Temptation of Saint Anthony, Martin Schongauer, 675–76, (fresco), Würzburg, Bavaria, Germany, Residenz, Tang dynasty (China), 410-14, 430, 836, 837, 839, 843, 675, 733 Kaisersall (Imperial Hall), 806, 806, 964 Ten Commandments, 289 tiercerons, 578 Tank Totem series, Tank Totem III and IV from, David Tendai Buddhism, 431 Tikal, Guatemala, 452-53; temples at, 452, 452 Smith, 1120–21, 1121, 1132 tenebrism, 753, 777, 788, 944 Tilborch, Giles van, Cabinet d'Amateur with a Painter, 26, 26 Tanner, Henry Ossawa, 1091–92; The Thankful Poor, Tenement Interior in Poverty Gap: An English Coaltilework, Islamic, 353 1092. 1092 Heaver's Home, Jacob Riis, 1095, 1095 Tilted Arc, Richard Serra, 1161-62, 1161, 1165 Tansey, Mark, 1153–54; Triumph of the New York School, Tenochtitlan (Aztec capital), 874-75, 877 tilting competitions, 744 1153–54, *1153* tantric Buddhism, 823 Teotihuacan, Mexico, 445, 448–50, 875; ceremonial Timarete, 207 center at, 449, 449; Maguey Bloodletting Ritual (fresco), 450, 451; Temple of the Feathered Serpent, Timbuktu, Africa, 911 tantric Hinduism, 391 Times (London), "How American Are We?" (Sunday Taos Pueblo (photograph), Laura Gilpin, 889, 889 450, 450 magazine cover), 1128, 1128 taotie motif, 399, 401 tepee, 884-85 Times Square Show" (New York, 1980), 1152, 1153 tapa, 902-3 Tepees (photograph) (Native American, Blackfoot), Time Transfixed, René Magritte, 1088-89, 1088, 1141 tapestry, 359, 634–36, 693–95 tapestry-weave, **458**, 458; Andean, 458 884-85, 885 Timgad, Algeria, Roman town at, 266–67, 267 Ter Borch, Gerard, 795, 809; The Suitor's Visit, 795, 795, Timurid dynasty, 361 Target with Four Faces, Jasper Johns, 1127, 1127 809 Tinguely, Jean, 1125-26; Homage to New York Tarquinia, Italy, Tomb of the Lionesses, Musicians and Teresa of Ávila, Saint, 746 (assemblage), 1125–26, 1125 Dancers (detail of wall painting), 230-31, 231 terminal, 88 Tintoretto (Jacopo Robusti), 708–9, 746; Nativity, 708–9, Tarquinius Superbus, 234 Terminus, 156 Tarquins, 234 terra-cotta: Aegean, 129; African, 911, 925; Etruscan, Tiryns, Greece, 142; citadel at, 146-47, 146, 160 Tasmania, 895 229; figurines, 397, **468**; Greek, 217; Indus Valley, Titans, 155, 156 Tassel House, Brussels, Belgium, Victor Horta, 1070, 1070 369; Yoruba, 470 Titian (Tiziano Vecelli), 704-7, 746, 764, 785, 1118: Tassili-n-Ajjer range, Algeria, 466 tesserae, 272, 300, 1138 Isabella d'Este, 706, 1118; Pastoral Concert, 1007, 1007, tatami mats, 861, 862 Tetrarchs, The (Roman statue group), 277–78, 277, 283, 1008; Venus with a Mirror, 706, 707, 1118 tatanua mask dance, New Ireland, Papua New Guinea, Titus, 254 899-900.900 textiles: African, 920-21; Byzantine, 519; Flemish, Tivoli, Italy, Hadrian's Villa, 265-66, 266; Battle of 634–36; Islamic, 348, 357–61; Native American, 887, Tatlin, Vladimir, 1061-62, 1075; Corner Counter-Relief, Centaurs and Wild Beasts from (floor mosaic), 265, 1062, 1062; Model for the Monument to the Third 890-91; Peruvian, 457-58, 880 272-73, 272; Canopus area, 265-66, 266, 276 International, 1075, 1075, 1077 Textile with elephants and camels (Persian), 349, 349, 357 Ti Watching a Hippopotamus Hunt, Saqqara, Egypt, Tomb tattooing, 902, 904 texture, 29 of Ti, 107-8, 108, 111, 112 Tè, Palazzo del, Mantua, Italy, Giulio Romano, 718-19, Thamyris (ancient woman artist), 615 Tiy, Queen of Egypt, 120 718; Sala dei Giganti, 718, 719 Thangmar, 501 Tjapaltjarri, Clifford Possum, 906–7 Thanjavur, Tamil Nadu, India, Rajarajeshvara Temple to Tea caddies, Elizabeth Godfrey, 814, 815 Tlingit people, 886 tea ceremony (cha no yu), 860-61, 863 Shiva, 390, 391; Rajaraja I and His Teacher (wall Toba Sojo, 436; Frolicking Animals, detail, 436–37, 437 Teacher and Pupils, Orant, and Woman and Child, Rome, painting), 391, 392 Todai-ji temple, Nara, Japan, 430 Italy, Catacomb of Priscilla, 293-94, 293 Thankful Poor, The, Henry Ossawa Tanner, 1092, 1092 tokonoma, 861, 862 technology, 980-82 theaters: Hellenistic, 209-10; Roman, 243 Tokugawa, Ieyasu, 862 Toledo, Juan Bautista de, 745–46; El Escorial (with Juan de Herrera), Madrid, Spain, 745–46, 745, 776 Teerling, Levina Bening, 741-42; (attributed to) Elizabeth theatrical sets, 251 I as a Princess, 742, 742 Thebes, Egypt, 114, 119; map of district, 114, 114, 117 Toledo, Spain, 510–11, 746 Toltec civilization, 875 Theodora, Empress, 308, 309, 314, 316, 322 Te-Hau-ki-Turanga (Maori meetinghouse), Manutuke Theodorus, 199 Poverty Bay, New Zealand, Raharuhi Rukupo, 904-5, Theodosius I, Emperor, 153, 179, 302 tomb decoration: Egyptian, 106–8, 109–11, 122–24; Thera (Santorini), Greek island: eruption of, 128, 129, Etruscan wall paintings, 230–31 temenos (Greek temple complex), 155 141; see also Akrotiri tomb effigies, Romanesque, 537 tempera, 162, 197, 596, 619, 622, 652, 683, 704, 948 Tempest, The, Giorgione, 704, 705, 747 Theravada Buddhism, 371 Tomb figures (Ming dynasty, China), 27 thermoluminescence dating, 49 Tomb of Carlo Marsuppini, Desiderio da Settignano, Tempietto. See San Pietro in Montorio Theseus, 132, 156 650-51, 651 temple architecture: Egyptian, 51, 96; Etruscan, 225–29, 225, 227; Greek, 51, 160–61, 162–65, 164; Indian, 375, 375, 383–86, 389–91; Roman, 237–38 thila (Lobi), 916-17 Tomb of Giuliano de' Medici, Michelangelo, 689–90, 690 Third-Class Carriage, The, Honoré Daumier, 993-95, 993 Tomb of Haterius family, Rome, Italy, Mausoleum under Third of May, 1808, Francisco Goya y Lucientes, 966, 966

Thirty-Six Immortal Poets, 434–35

Hokusai, 854, 854, 863, 869

Thirty-Six Views of Fuji, The Great Wave, Katsushika

Construction (relief), 255, 255

Tomb of Julius II. See San Pietro in Vincoli

Tomb of Khnumhotep, Beni Hasan, Egypt, Harvest Scene,

temple complexes: Egyptian, **101**, 114–19; India, **825–26**; Near East, Neolithic, **62**; Sumerian, 66

Temple of Amun, Mut, and Khonsu, Luxor, Egypt, 116, 116

1103; Pop Art, 25, 1155, 1164; realist, 996-1002, Triumph of the New York School, Mark Tansey, 1153-54, Tomb of Lord Pacal, Palenque, Mexico, Temple of the 1093-95, 1099; Romantic, 966-75, 997, 1093; Inscriptions: portrait of Lord Pacal, 454, 454; sculpture, 970-73, 996, 998-99 Trojan War, 216, 232-33 sarcophagus lid from, 454, 454 United States Capitol, Washington, D.C., William Trolley, New Orleans, Robert Frank, 1140, 1141 Tomb of Nefertari, Deir el-Bahri, Egypt, Queen Nefertari Thornton (with Benjamin Henry Latrobe), 968–69, trompe l'oeil, 273, 304-5, 653, 657, 673, 692, 707, 763, Making an Offering to Isis (wall painting), 93, 96, 123, 968, 969, 971, 1063 777; Byzantine, 329 123 124 universities, growth of, in Europe, 547-48 trophy, 249 Tomb of Queen Yabay, Kalhu (modern Nimrud, Iraq), Unkei, 439 iewelry from, 80, 80 Trotsky, Leon, 1090 Unswept Floor, The (Roman mosaic copy), Heracleitus, troubadours, 549 Tomb of Senbi, Meir, Egypt, Hippopotamus (statue), 112, 273. 273 Troy, 108, 216 Untitled, Francesco Clemente, 1150, 1150 Tomb of the Lionesses, Tarquinia, Italy, Musicians and Truisms series, Jenny Holzer, 1157 Untitled, Donald Judd, 1133–34, 1133 Dancers (detail of wall painting), 230–31, 231 trumeau, 520, 563 Untitled (After Aleksandr Rodchenko: 11), Sherrie Levine, Trundholm, Zealand, Denmark, Horse and Sun Chariot Tomb of the Reliefs, Cerveteri, Italy, La Banditaccia, 1155-56, 1155 Etruscan cemetery, 229, 229 (bronze sculpture), 58, 59, 59, 481 Tomb of Ti, Saqqara, Egypt, *Ti Watching a Hippopotamus Hunt*, 107–8, *108*, 111, 112 Untitled Film Still, Cindy Sherman, 1157, 1157 truss. 32 Untitled '90, Chuichi Fujii, 871, 871 Tryggvason, Olaf, 481 tombs: Assyrian royal, 80; Egyptian, 92–93, 109–11; Etruscan, 225, 229–31; Islamic, 829; Japanese, 425; Upanishads, 370, 823 Tudor dynasty, 741 Upper Paleolithic period, 37; figurines, 38–40; shelters, 38 tufa, 227 tugra (imperial emblem), 363; of Sultan Suleyman Ur (modern Mugaiyir, Iraq), 66; bull lyre from, 70-71, 72, Neolithic, 51-55; see also tomb decoration 486; Disk of Enheduanna, 73–74, 73; Nanna Ziggurat tondo, 258, 305, 1102 (Turkish), 363, 363 at, 66-68, 67, 73 Tuileries, Paris, France, 723-24 Tonga, 895 uraeus (cobra symbol), 104 Tunic (Inka), 880, 881 Torah scrolls, 289: niche for, 296 Urban II, Pope, 510 Turkic peoples, 824, 826-27 torana, 375, 376, 377 Urban VIII, Pope, 753, 756, 757, 764 Tori Busshi, 429; Shaka Triad, 429, 429 Turkish knot, 359 Turner, Joseph Mallord William, 948, 949–50, 974, 1010, Urban Realism, 1101-2, 1114 torii. 426 Urbino, Italy, 641, 660, 662 1093; The Fighting "Téméraire," Tugged to Her Last torons, 474 Ducal Palace, Luciano Laurana, 645, 662, 662; Berth to Be Broken Up, 949-50, 949 torque, 88, 208 Studiolo of Federico da Montefeltro, 672, 673 Torso (Harappa, Indus Valley), 369, 369 Turrell, James, 1134; Rayzor, 1134, 1134; Shallow-Space urna, 379, 380, 427, 427 Constructions, 1134 totems, Native American, 886 Toulouse-Lautrec, Henri de, 985, 1026, 1027–28, 1048, 1060, Urnes, Norway, church at, doorway panels from, 483, 484 turret, 579, 579, 941 Urnes carvings, 483–84 Tuscan order, 227, 227, 253 1096: At the Moulin de la Galette, 1027, 1027, 1048, 1142 Ursula, Saint, 631-32 Tournai, Flanders, 634 Tuscany, 223; painting style of, 584 Uruk (modern Warka, Iraq) Tutankhamun (Tutankhaten): coffin of, 92, 122, 122; tower, 558, 579; in Romanesque churches, 511 Anu Ziggurat, 66, 67, 73 funerary mask of, 92, 92, 122; sarcophagus of, 122; Tower of Babel (wall painting), Saint-Savin-sur-Gartempe, carved vase from, 69, 69; detail, Inanna Receiving an Poitou, France, abbey church, 525, 525 town-houses, Renaissance, 644–46 tomb of, 92-93 Offering, 69, 69 Tuthmose I, 116, 117 sculpted face of woman from, 68, 68, 69 Tuthmose II, 114, 116 tracery, 558 White Temple, 66, 67 trade: Aegean, 140; Africa, 466, 472, 474; China, 411; Tuthmose III, 114, 116 ushnisha, 379, 380, 409, 427, 427 Tutub (modern Tell Khafajeh, Iraq), vase from, 70, 71 Etruscan, 223; European, Romanesque period, 510; Great Zimbabwe, 477; Greek, 155, 233, 466; India, USSR in Construction (magazine), 1077 Twelve Views from a Thatched Hut, detail, Xia Gui, Gical Zilliaawe, 477; Greek, 155, 233, 466; India, 366; Italy, 539; Near East (Neolithic), 63; Olmec, 447; Silk Road, 348, 402, 403, 411

Trade (Gifts for Trading Land with White People), Jaune Quick-to-See Smith, 891, 891 Utamaro, Kitigawa, 22; Woman at the Height of Her 418-19, 418-19 Beauty, 19, 19, 25, 1019 Twenty-eighth of July: Liberty Leading the People, The, Uthman, 339 Eugène Delacroix, 961, 961, 1039 29, Sculpture, 5000 Feet, Peter Voulkos, 1163, 1163 Utilitarianism, Russian, 1062, 1075-77 Traini, Francesco, *Triumph of Death*, 607, 608, 608 Trajan, 259–62, 266–68, 283 Utrecht, the Netherlands, 727, 793; see also Schröder Twin figures (ere ibeji) (Yoruba culture), Nigeria, 911, 913-14, 913, 924 Utrecht Psalter (Carolingian manuscript), page from, twining (basketry), 888 Trajan's Harbor, Ostia, Italy, 268–70 Trajan's market, Miletos, Asia Minor (modern Turkey), two-dimensional arts, 30 Two Fridas, The, Frida Kahlo, 1089–90, 1089, 1103 Uylenburgh, Hendrick Van, 790 267-68 Two Models, One Seated, Philip Pearlstein, 1123, 1123, transept, 298, 492, 558, 558, 643, 701, 753 Transfiguration, the (in Christian art), 306 1142, 1143 291 Gallery, 1096, 1097, 1098 Two Paths of Life, The, Oscar Rejlander, 988, 988 Vallayer-Coster, Anne, 953 Transfiguration of Christ, Mount Sinai, Egypt, Monastery Vallon-Pont-d'Arc, Ardèche gorge, France, cave of Saint Catherine, 312, 312 painting, 16, 16, 41 Traoré, Ismaila, 474 Twosret, 116 value (optical), 29, 987, 1078 two-tone marble banding, 590 Travelers among Mountains and Streams, Fan Kuan, Van, von: names with, are often listed under next Two Women with a Child (figurine), Mycenae, Greece, 416-17, 416 element of name (e.g., Gogh, Vincent van) travertine, 762 148, 148 Vanbrugh, John, 802–3; Blenheim Palace, Woodstock, tympanum, 514, 517, 517, 519, 558 treasuries, Greek, 155 Oxfordshire, England, 802-3, 803, 936 Treasury of Atreus, Mycenae, Greece, 144–45, 145, 199 typology, 1138 vanishing point, 30, 624, 649, 670, 671 Tree of Jesse (in Christian art), 529 tyrants, 155 vanitas painting, 735, 797, 798, 810, 811, 1143 Tree of Jesse, from Commentary on Isaiah by Jerome Tzara, Tristan, 1083 Vapheio, Sparta, Greece, tomb at, 138 (manuscript), 529, 529, 557 Vapheio Cup, Sparta, Greece, 137, 138, 138 Tree of Jesse (stained glass), Chartres, Île-de-France, France, Cathedral, 557–59, 557 Vaquero, Luis Jimenez, 23-24, 23 Uccello, Paolo, 657-58, 660; The Deluge (Flood) (fresco), Vasari, Giorgio, 547, 644, 715; Lives of the Most Excellent Florence, Italy, Santa Maria Novella, 624, 624, 658, 658 Tree of Life motif, 292, 344 Italian Architects, Painters, and Sculptors, 683 Tree of Life series (photographs of), Ana Mendieta, 1148, Ugolino Martelli, Bronzino, 714, 715 Vase (with Apotheosis of Homer by John Flaxman, Jr.), Uji (near Kyoto), Japan, Byodo-in temple, 432-33, 432 1149 Josiah Wedgwood, 937, 937 ukiyo-e prints, 868-69, 1008, 1043 trefoil, 369, 558, 562 Vase Painter and Assistants Crowned by Athena and Ukraine, mammoth-bone dwellings, 38, 38 Très Riches Heures (illuminated manuscript), page Victories, A (vase painting), 207 Ulu Burun, off Turkey, shipwreck discovery at, 140 February, Paul, Herman, and Jean Limbourg, 616, 617, vase painting Umar, 339 621, 632, 727 Greek, 161–62, 172–77, 183–84, 197; Geometric, Umayyad dynasty, 339, 340, 344, 345, 347; architecture, Tribute Money (fresco), Masaccio, 654-55, 655 158–59; Orientalizing, 161–62 342, 354 Trier, Germany, basilica at, 281, 281 Mayan, 455 undercutting, 255, 285, 308, 521, 647, 649 triforium, 555-56, 558, 558 technique, 162, 173 underglaze, 843 triglyph, 164, 165, 225, 718 Union Square in Spring, Childe Hassam, 1091, 1091 vases Trinity, the (Christian), 289, 304; artistic representation Greek: funerary, 159-60, 197; standard shapes, 173, Unique Forms of Continuity in Space, Umberto Boccioni, 1058, 1058 Trinity with the Virgin, Saint John the Evangelist, and Mesopotamian, 68-69 United Provinces, revolt of, 727 Donors (fresco), Masaccio, 653-54, 653, 672 Vasily chair, Marcel Breuer, 1082, 1082, 1128 United States, westward expansion, 999-1001 triptych, 583, 599, 618, 781 Vastupurusha mandala, 385 United States art: Academic influences, 1090-91, 1094, Trissino, Giangiorgio, 709 Vatican Palace, Rome, Italy 1097; architecture, 966-70, 1062-66; Arts and Crafts triumphal arch, 499, 650, 660; Roman, 253-55 Sistine Chapel, 669–70, 669, 686, 691, 693–97, 693, Movement, 1068; Colonial, 751, 815-19; European Triumph of Death, Francesco Traini, 607, 608, 608 694, 696, 697, 961; ceiling frescoes (Michelangle), 694, 695–96, 695, 763, 764, 768
Stanza della Segnatura, 692, 692, 988 influences on, 1090-93, 1150-52; Impressionist, 1091, Triumph of the Barberini (ceiling fresco), Pietro da 1094; indigenous, 875, 883-91; and modernism, Cortona, 764-65, 765 1096-1105; Neoclassical, 966-75, 996; painting, Triumph of the Name of Jesus (ceiling fresco), Giovanni vaulting, 32, 226, 236, 531, 643 973-75, 996-98, 1001-2; photography, 998-1002, Battista Gaulli, 765, 766

Vautier, Ben, 1124; Brushing his teeth after eating Flux Mystery Food (photograph of event), 1124, 1124 Vaux, Calvert, 970; Central Park (see under Olmsted, Frederick Law) Vauxcelles, Louis, 1039, 1052 Vaux-le-Vicomte, France, Château at, 770, 773 Vedas, 370, 371, 372, 823 Vedic period (India), 370–72 vedute, 932 Veen, Otto van, 780 Veii, Italy, Temple of Apollo, Apollo (statue), 228, 229 Veiled and Masked Dancer (Hellenistic statue), 216–17, 217 Velarde, Pablita, 889–90; Koshares of Taos, 890, 890 Velázquez, Diego, 777–80, 964, 1001, 1094; Las Meninas (The Maids of Honor), 778–80, 779, 965; Pope Innocent *X*, 1109, 1111, *1111*; *Water Carrier of Seville*, 778, 778 Velderrain, Juan Bautista, 817 vellum, 319, 320, 348, 486, 490, 733 Vendôme Column, Paris, France, 808 veneer, 99, 236 Venice, Italy, 325, 619, 660, 670, 805; architecture. 709–11; painting, 704–9, 774; *see also* San Giobbe, Ospedale of; San Giorgio Maggiore, Church of; San Marco, Cathedral of: San Marco, Library of Venturi, Robert, 1137; Complexity and Contradiction in Architecture (book), 1137; Guild House (with John Rauch), Philadelphia, Pennsylvania, 1137, 1137; Learning from Las Vegas (book), 1137; Seattle Art Museum (with Denise Scott-Brown), Stair Hall, 27, 27 Venus de Milo (Hellenistic statue), 218, 219 "Venus figures," 41 Venus with a Mirror, Titian, 706, 707, 1118 Vergil, 216, 223 Vergina, Macedonia (ancient Aigai): Abduction of Persephone (wall painting), 205–6, 205; Great Tumulus at, 205-6 verism 243-45: Roman 255 Vermeer, Jan, 797, 798; Allegory of the Art of Painting, 796, 797, 996 Veronese (Paolo Caliari), 707, 764, 785; Feast in the House of Levi, 680–81, 680, 707, 806; Maser, Venetia, Italy, Villa Barbaro, fresco, 707, 707, 805 Verrocchio, Andrea del, 659, 665, 684; Equestrian Monument of Bartolommeo Colleoni, Venice, Italy, 665, 665 Versailles, Palais de, Versailles, France, Louis Le Vau (with Jules Hardouin-Mansart), 770-73, 771, 802, 811, 937. 1062; Grotto of Thetis, 773; Hall of Mirrors, Jules Hardouin-Mansart (with Charles Le Brun), 772-73, 772 Vespasian, 252 Vesperbild (Christian art form), 307, 590 Vesperbild (in Bonn museum), 590, 590 Vessel, painted (Mayan), 455, 455 Vessel (Jomon period, Japan), 423-24, 423 Vézelay, Burgundy, Sainte-Madeleine church, carved portals of, 517, 520 Vicenza, Venetia, Italy. See Rotonda, Villa Victorian style, 1004-5 video art, 1156 Vien, Joseph-Marie, 951, 956

Vienna, Austria. See Steiner House Vierzehnheiligen, Church of the, near Staffelstein, Germany, Johann Balthasar Neumann, 805, 806-7, 807 Vietnam Veterans Memorial, Maya Ying Lin, 1162, 1162

View from His Window at Le Gras, Joseph-Nicéphore Niépce, 986, 986 View of Collioure, André Derain, 1039, 1039

View of the Piazza del Popolo, Rome, Giovanni Paolo Panini 933 933

View of Toledo, El Greco, 747, 747

viewer, spirit of, in art, 753

Vigée-Lebrun, Marie-Louise-Élisabeth, 953, 955; Portrait of Marie Antoinette with Her Children, 955, 955 vignette 320

Vignola, Giacomo da (Giacomo Barozzi), 699, 703-4, 746, 753, 765, 770; Church of Il Gesù (with Giacomo della Porta), 701, 753-54, 754, 755, 765, 770; The Rule of the Five Orders of Architecture, 703; Villa Farnese, 703-4, 703, 718, 753, 770

vihara, 375, 377

Vijayanagar, Indian kingdom, 826

Vikings, 480, 481, 609; memorial stones of, 482-83; symbols of, 483

Villafranca del Panadé, Barcelona, Spain, San Francisco church, Virgin and Saint George (altarpiece), 584, 584; Education of the Virgin from, 584, 585

Village Piper, The, Antoine Le Nain, 776, 776 villages, Neolithic, 48, 51 Villanovans, 223

Villa of Livia, Primaporta, Italy, Garden Scene (wall painting, detail), 240, 251–52, 251, 292

Villa of the Mysteries, Pompeii, Italy, Initiation Rites of the Cult of Bacchus (?) (wall painting, detail), 250-51, 250, 292

Villard de Honnecourt, sketchbook, page from, 572, 573 Villa Torlonia, Rome, Italy, Menorahs and Ark of the Covenant 291-92 292

vimana, 375, 389, 826 Vindhya Hills, 366

Violet Persian Set with Red Lip Wraps, Dale Chihuly, 22, 22 Violin and Palette, Georges Braque, 1052, 1052, 1118, 1132 Viollet-le-Duc, Eugène-Emmanuel, 564, 577 Virgin and Child, Filippo Lippi, 656, 657

Virgin and Child (French Romanesque sculpture), 522, 523 602

Virgin and Child (sculpture), Saint-Denis, Île-de-France, France, abbey church, 571-72, 571, 575

Virgin and Child Enthroned: Cimabue (Cenni di Pepi), 602, 602; Giotto di Bondone, 603-4, 603 Virgin and Child Enthroned with Saints Francis, John the

Baptist, Job, Dominic, Sebastian, and Louis of Toulouse, Giovanni Bellini, 671-72, 671, 704

Virgin and Child in a Garden with Saints Margaret and Catherine (or Large Enclosed Garden), E. S. Engraver, 674, 674

Virgin and Child in Majesty, Siena Cathedral, Maestà Altarpiece, Duccio di Buoninsegna, 583, 596, 597 Virgin and Child with Angels. See Grünewald, Matthias,

Isenheim Altarpiece
Virgin and Child with Saints and Angels (Christian icon), Mount Sinai, Egypt, Monastery of Saint Catherine, 322, 323, 521

Virgin and Saint Anne with the Christ Child and the Young John the Baptist, Leonardo da Vinci, 685, 685, 709

Virgin and Saint George (altarpiece), Villafranca del Panadé, Barcelona, Spain, San Francisco church, Luis Borrassá, 584, 584; Education of the Virgin from, 584, 585 Virgin Mary, 289, 299

Virgin of Compassion, 335

Virgin of Vladimir (Christian icon), 334, 335, 529 Virtues and Vices (relief), Amiens, Île-de-France, France, Nôtre-Dame Cathedral, 562, 563

Visconti family, 641 Vishnu, 372, 384–86, 389

Vishnu Narayana on the Cosmic Waters (relief), Deogarh, Uttar Pradesh, India, Vishnu Temple, 384–86, 385, 387 Vishnu Temple, Deogarh, Uttar Pradesh, India, 383-86,

384, 390; Vishnu Narayana on the Cosmic Waters (relief), 384-86, 385, 387

Visigoths, 345, 488; influence on Romanesque art, 527 Visitation, the (in Christian art), 306
Visitation. See Broederlam, Melchior, altarpiece

Visitation (panel from altarpiece), Diego de la Cruz (?), 637.637

Visitation (relief), Reims, Île-de-France, France, Nôtre-Dame Cathedral, 566-67, 566, 575, 587

Visit To/A Visit From/The Island, A, Eric Fischl, 1150, 1150 Vitalis, Saint, 313

Vitruvian Man, Leonardo da Vinci, 698, 698

Vitruvius, 225, 227, 703, 770, 935; De Architectura, 698, 699 Vlaminck, Maurice de, 1039–40, 1042, 1109; *Landscape near Chatou*, 1040, *1040*

Vollard, Ambroise, 1028

Volto Santo sculpture, 523

volume, 29

volumetric rendering, 613

volute, 165, 165, 173, 254, 662, 754, 755, 755 volute capital, 167

volute krater, 173

votive church, 662-63

votive figures, 225; Cycladic, 131; Mesoamerica, 445; Mesopotamian, 69-70, 76

Voulkos, Peter, 1163, 1164; 29, Sculpture, 5000 Feet, 1163, 1163

voussoir, 225, 226, 345, 517, 517, 519, 557, 943 Vuillard, Édouard, 1028

Vulca, 229

Vulgate Bible, 297, 494

Wagner, Otto, 1032

Wainwright Building, St. Louis, Missouri, Louis Sullivan,

wall niche, Pompeii, 240

wall painting: Byzantine, 328-30, 524; Chinese Buddhist, 412; Egyptian, 93-94, 111; Etruscan, 230-31; Greek, 205-8; Islamic, 361-62; Italian Gothic, 595-97; Minoan, 139-42; Roman, 249-52, 256-59;

Romanesque, 524-27; see also fresco; murals

wall reliefs, Egyptian, 114 Walpole, Horace, 939, 947; Strawberry Hill (and others),

Twickenham, England, 938, 939 Wanderers, the, 996

Wang Hui, 848; A Thousand Peaks and Myriad Ravines (hanging scroll), 848, 849

Wang Xizhi, 409; calligraphy sample, 408, 409 War club, Marquesas Islands, Polynesia, 902, 902

ware, 57, 84, 129 Warhol, Andy, 1130, 1155; Marilyn Diptych, 1130, 1130 Wari Empire, 879

warp: basketry, 888; weaving, 359, 457, 458, 887, 920 Warring States period (China), 401

Warrior Vase, Mycenae, Greece, 149, 149

wash, 827, 1048, 1121

Washington, D.C. See Library of Congress; Smithsonian Institution; United States Capitol

Washington, George, 967; Houdon's bust of, 952-53, 953; Mount Vernon (see under Patterson, James) watchtower, 414; China, 414

Water and Moon Kuan-yin Bodhisattva, The (Chinese painted panels), 27, 27

Water Carrier of Seville, Diego Velázquez, 778, 778 watercolor, 949, 1048

Watson and the Shark, John Singleton Copley, 946, 946 Watteau, Jean-Antoine, 809-10, 811; The Pilgrimage to Cythera, 809, 809; The Signboard of Gersaint, 809-10,

wattle-and-daub, 815

Wawalag Sisters and the Rainbow Serpent, The, Mawalan Marika, 897, 897

Wearing a Simultaneous Dress at the Bal Bullier (photograph), Sonia Delaunay-Terk, 1057, 1057

weaving: Americas, 445; Navajo, 890-91; Peruvian, 457-58; see also textiles Weber, Max, 1097, 1101; Rush Hour, New York, 1097, 1097

Wedding basket (Native American, Pomo), 888 Wedgwood, Josiah, 928, 937, 939; Vase (with Apotheosis

of Homer by John Flaxman, Jr.), 937, 937 Wedgwood ceramics, 928

wedjat (Egyptian symbol), 94

weft, 359, 457, 458, 920

Wegman, William, 1144; Rage and Depression (video image), 1144, 1145

Wehlsch Pirg (Italian Mountain), Albrecht Dürer, 733, 733 Weickman, Christopher, 477

Weighing of Souls, Autun, Burgundy, France, Saint-Lazare Cathedral, Last Judgment (relief), Gislebertus, 520, 521

We Keep Our Victims Ready (performance), Karen Finley,

1160-61, 1160 Well of Moses, Claus Sluter, 617-18, 617

West, Benjamin, 944-45, 946; Death of General Wolfe, 945 945 957

West Africa, 474

Western Church. See Roman Catholic Church Western Paradise of Amitabha Buddha (wall painting), Dunhuang, Gansu, China, 412, 412, 414

Western Pure Land, 371, 410, 412

Western Roman Empire, 290, 609

Westminster Abbey, London, England, 578

Weston, Edward, 1155

west portal, 558

westwork, 492, 803

wet-collodion process, 987

We Won't Play Nature to Your Culture, Barbara Kruger, 1156, 1157

Weyden, Rogier van der, 619, 626-29, 630, 631, 632-33; Deposition (detail of Louvain altarpiece), 626-27, 626; Last Judgment Altarpiece, 627, 627; Portrait of a Lady, 628, 629

What Is the Reason for Your Visit to Germany, David Salle, 1149, 1149, 1155

Whirling Log Ceremony (woven by Mrs. Sam Manuelito) (sand-painting tapestry), Hosteen Klah, 890, 891

Whistler, James McNeill, 26, 1005-6, 1008, 1028, 1059: Black Lion Wharf, 1005-6, 1005; Harmony in Blue and Gold (The Peacock Room), 26, 26, 1006; The Princess from the Land of Porcelain, 26

White, Stanford, 1064

White Captive, The, Erastus Dow Palmer, 996, 997

587; in modern times, 1084, 1101; Rome, 243, Xia Gui, 418-19; Twelve Views from a Thatched Hut, white-ground vase painting, 162, 197 Whitehall Palace, London, England, Banqueting House, 258-59 detail, 418-19, 418-19 Inigo Jones, 800–1, 801, 816, 935; ceiling painting by as patrons of the arts, 706 Xi'an, Shanxi, China, Ci'en Temple, Great Wild Goose Rubens, 781, 801–2, 801 writers, 66, 162 Pagoda, 413, 413 White Horse, The, John Constable, 948, 949 Women and Animals (rock-shelter painting), Cogul, Xie He, 407 Xi River, 397 White Temple, Uruk (modern Warka, Iraq), 66, 67 Catalonia, 48, 49 Women at a Fountain House (vase painting), "A.D." Whitney, Anne, 972; Roma, 972, 972 Whitney Museum of American Art, New York City, 1142, Painter 176, 176 Women of Algiers, Eugène Delacroix, 961-62, 962, 1039, 1146; "New Image Painting" (1978), 1142 Whittredge, Worthington, 998 1080 Why Not Use the "L"?, Reginald Marsh, 1100, 1101 women's suffrage movement, 928 417, 417 Wild Blackberry, from Dioscorides, Pedanius, De Materia wood, joined, as sculpture material (Japan), 433 Y Wood, Grant, 1100-1 Medica (manuscript), 318, 319-20 Wood, John, the Elder, 939; Circus housing project, Bath, Wilde Oscar 1006 England, 938, 939 "Wild Goat Style" (vase painting), 161–62 Wiligelmus, 543; Creation and Fall (relief), 543, 543 Wood, John, the Younger, 939; Circus housing project, 938, 939; Royal Crescent, Bath, England, 939 Willendorf, Austria, Woman (figurine), 39, 39, 40, 41 William II of Normandy, Duke (William the Conqueror), woodblock printing, 19, 673; for books, 674-76; Japanese, 854, 868-69, 1008, 1028, 1036, 1043 530, 531 William of Saint Thierry, 519 wood carving: Maori, 904; Scandinavian, 483 William of Sens, 576 woodcuts (popular), 677, 733 wooden panels, **619**; see also panel painting wood sculpture, 477, 501–2, 523; German, 739–40 Winchester Psalter (English manuscript), Hellmouth page from, 532-33, 533, 580 Winckelmann, Johann, 931, 944 Woolworth Building, New York City, Cass Gilbert, 1065, Windmill Psalter, page with Psalm 1 (Beatus Vir), 580, 580 1066, 1066 Worcester Chronicle (English manuscript), Dream of Henry I from, John of Worcester, 532, 532 Winter Landscape, Sesshu, 857-58, 857 Worker and Collective Farm Worker, Vera Mukhina, 1077, Witte, Emanuel de, 797; Portuguese Synagogue, 1077 Amsterdam, 797, 797 Witz, Konrad, 639–40; Miraculous Draft of Fish (detail of altarpiece), 640, 640 Workers' Club. See Exposition Internationale des Arts 258, 279 Décoratifs et Industriels Modernes (Paris, 1925) Wolf of Rome (Etruscan), 231-32, 232 workshop of, meaning of term, 990 Wollaton Hall, Nottinghamshire, England, Robert workshops, artists', 22, 708, 782-83 Smythson, 744, 745, 745, 803 Works Progress Administration (WPA), 1105 World of Art group, 1059-60 Woman (figurines): Brassempouy, France, 39-40, 40; Z Ostrava Petrkovice, Czech Republic, 39, 39; World's Columbian Exposition (Chicago, 1893), 1062-63, Willendorf, Austria, 39, 39, 40, 41 1091, 1095; Court of Honor, Richard Morris Hunt, Woman I, Willem de Kooning, 1118, 1118 1063 1063 Woman and Maid (vase painting), Achilles Painter, style World Trade Center Towers, New York City, 1065 Wrangell, Canada. See House of Chief Shakes of. 197, 197 Wren, Christopher, 802; Saint Paul's Cathedral, London, Woman at the Height of Her Beauty, Utamaro, Kitigawa, England, 802, 802, 950 19, 19, 25, 1019 Wright, Frank Lloyd, 1066–68, 1071, 1073, 1079; Larkin Woman in Blue and Yellow II, Viola Frey, 1164, 1164 Building, Buffalo, New York, 1066, 1067; Taliesin, Woman in White (Madame Picasso), Pablo Picasso, 1074, Spring Green, Wisconsin, 1067–68, 1067 1074 Wright, Joseph (of Derby), 943-44; A Philosopher Giving a Woman or Goddess with Snakes, Knossos, Crete, 134-35, Lecture on the Orrery, 943, 943 Zeuxis, 272 writing: Chinese, 400, 400, 434; Egyptian, 97, 113; Greek, Woman Spinning, Susa (modern Shush, Iran), 85, 85 Woman with the Hat, The, Henri Matisse, 1040, 1040 155; Japanese, 426, 434, 434; Mesoamerican, 445, Womb World mandala (Buddhist concept), 427, 431 448; Minoan, 131; runic, 482 Womb World mandala (Heian period, Japan), 427, writing boxes, Japanese, 865 Wrongful Execution of the Count, Dirck Bouts, 630–31, 630 431-32, 431 wrought iron, 980 Wu (Han emperor), 406 archeologists, 143 artists: African, 925; amateur, tradition of, 1014; Wu family shrine, Jiaxiang, Shandong, China, rubbing from relief, 406, 406 Greece, 207; Middle Ages, 615; in modernist Wu Guanzhong, 851; Pine Spirit, 850, 851 movements, 1043-44, 1089, 1098; Neoclassical, Würzburg, Bavaria, Germany. See Residenz 953-55; Renaissance, 22, 615-16, 683, 714-17; Wutaishan, Shanxi, China, Nanchan Temple, 412–13, Romanesque, book production, 539; Rome,

ancient, 259

depiction of: in contemporary art, 1051, 1118; Cycladic sculpture, 130–31; Etruscan, 231; Greek

statues, 201, 202; Minoan sculpture, 134–36; as

nudes, 641, 707; prehistoric, 40 life of: Etruscan culture, 223; Greece, 176; Islamic

world, 340; Japan, 435; medieval Europe, 510,

413

wu wei, 404 Wyatt, James, 577

Xerxes I. 87 Xia dynasty (China), 400, 837 x-ray style, 896, 1153 Xuande, Chinese emperor, 843 Xuanzang, 413 Xu Daoning, 417; Fishing in a Mountain Stream, detail, Yakshi Holding a Fly Whisk (India, Maurya period), 372, yakshis and yakshas, 372, 376-77, 379 Yangshao culture, 398 Yangzi River, 397 Yayoi period (Japan), 425-26, 855 Yellow Cell with Conduits, Peter Halley, 1154-55, 1154 Yellow River, 397, 399 Yi, marquis of Zeng, 402 Yin Hong, 841; Hundreds of Birds Admiring the Peacocks (hanging scroll), 841–42, 842 Yongle, Chinese emperor, 845 Yoruba people, 469–71, 911, 913, 919, 925 Yoshihara, Jiro, 1124 Young, Thomas, 113 Young Flavian Woman (Roman bust), 255, 256, 567 Young Woman Writing (wall painting), Pompeii, Italy, Yuan dynasty (China), 419, 837-41 Yungang, Shanxi, China, Seated Buddha (rock sculpture), 409, 409, 429 Zakro, Crete, palace complex, 138 zeitgeist, 1136 Zen Buddhism, 419, 440–41, 855, 856–57, 858–59, 862, 866–67, 871; and tea ceremony, 860–61; see also Chan Buddhism Zenji, Miyashita, 870; Ceramic vessel, 870, 870 "Zero Ten" exhibition (St. Petersburg) (1915-1916), 1060, Zeus, 155, 156; Lysippos's sculpture of, 203-5; Pheidias's statue of, at Olympia, 102 Zeuxis Selecting Models for His Picture of Helen of Troy, Angelica Kauffmann, 944, 944 Zhang Xuan, 414 Zhang Zeduan, 417-18; Spring Festival on the River, detail, 417-18, 418 Zhao Mengfu, 839; Autumn Colors on the Qiao and Hua Mountains (handscroll), 838-39, 839 Zhou dynasty (China), 401-2, 837, 845; Eastern, 401, Zhuangzi, 404, 837 ziggurat, 65-68, 99, 347 Zimrilim, 77 Zoffany, Johann, 944; Academicians of the Royal Academy, Zoroaster, 295 zoser (Lobi), 917 Zucchi, Antonio, 944 Zuni. 462

Zurbarán, Francisco de, 780; Saint Serapion, 780, 780

Credits

Credits and Copyrights

The author and publisher wish to thank the galleries, libraries, museums, and private collectors named in the picture captions for permitting the reproduction of works of art in their collections and for supplying the necessary photographs. Photographs from other sources are gratefully acknowledged below.

Jon and Anne Abbott, New York: 29-94; Stephen Addiss: 22-4, 22-9; Adros Studio, Rome: 7-16; 7-17, 15-17, 15-18, 16-41, 19-12; Aerofilms, Borehamwood, Herts, England: pages 34–35, 1-21, 8-8; Mark Horton, Aga Kahn Program Visual Archives, Massachusetts Institute of Technology, Cambridge, MA, 1981: 13-9; Courtesy Albright-Knox Art Gallery: 28-47; Alexandria Press, London: 8-25; Archivi Alinari, Florence 5-54, 5-70, 5-79, 5-87, 6-2, 6-20, 6-40, 6-41, 6-42, 6-43, 6-44, 6-46, 6-51, 6-52, 6-66, 6-67, 6-71, 6-73, 6-76, 6-77, 6-78, 6-84 6-85, 6-87, 15-40, 16-63, 16-67, 16-68, 16-69, 16-80, 16-82 17-19, 17-30, 17-33, 17-34, 17-35, 17-36, 17-37, 17-39, 17-42 17-44, 17-56, 17-61, 17-62, 17-63, 17-64, 17-69, 17-70, 18-8, 18-9, 18-13, 18-18, 18-19, 18-22, 18-26, 18-44, 18-75, 18-77 19-3, 19-4, 19-8, 19-9, 19-11, 19-26, page 1111 top left, page 1111 middle; Alt-Lee, Inc., Columbia, SC: 28-117; American Institute of Indian Studies, Ram Nagar, India: 9-5, 9-18, 9-25; Alison Frantz Collection, American School of Classical Studies, Athens: 4-9, 4-20, 5-50, 5-52, 7-42; Gil Amiaga, New York: 29-41; Pierre Amiet, The Art of the Ancient Near East, New York, Harry N. Abrams, Inc./Paris, Citadelles & Mazenod, 1980, fig. 680: 2-33; Amigos de Gaudi, Barcelona: 28-70; © 1981, Laura Gilpin Collection, Amon Carter Museum, Fort Worth, TX: 23-19; Ronald Sheridan's Ancient Art & Architecture Collection, Harrow-on-Hill, London: 7-50, 8-15, 19-25; Francis B. Andrews, *The Mediaeval Builder and* His Methods, New York, Barnes & Noble Books, 1993, fig. 1: page 564; Sören Hallgren, 1965 © Antikvarisk-Topografiska Arkivet (ATA), Stokholm: 14-3; Clay Perry, ARCAID, Kingstonupon-Thames, London: 26-13; Archeological Survey of India, Government of India, Calcutta: 9-19; Archiv für Kunst und Geschichte, Berlin: 7-46, 7-54, 15-32; David Smith Papers, Archives of American Art, Smithsonian Institution, Washington, D.C.: 29-14; Philippe Ariès and Georges Duby, A History of Private Life, Vol. I. From Pagan Rome to Byzantium, Cambridge MA and London, The Belknap Press of Harvard University Press, © 1987, page 41: page 259; Jean Arlaud, Geneva: 17-28; © 1995 The Art Institute of Chicago, All Rights Reserved: 11-17, 12-17, 19-29, 26-18, 27-44, 27-45, 28-5, 28-14, 28-31, 28-96, 28-108, 29-2, 29-35, 29-47; Art of Ancient India (exhibition catalog), plate 155, courtesy Marylin Rhie: 9-15; Art Resource, New York: 2, 11, 16, 19-71, 26-66, 26-68, 27-39, 29-26, 29-29; Cameraphoto-Arte, Venezia/Art Resource, New York: 17-73; Bildarchiv Foto Marburg/Art Resource, New York: 14-24, 14-26, 14-29, 16-8, 16-31, 16-42, 16-52, 16-53, 16-57, 27-3; Erich Lessing/Art Resource, New York: pages 464-65, 13-1, 15-43; Scala/Art Resource, New York: 5-38, 7-1, 7-30, 7-32, 7-34, 7-60, 16-2, 16-75, 16-76, 16-79, pages 610-11, 17-11, 17-25, 17-40, 17-43, 17-50, 17-52, 17-54, 17-59, 17-66, 17-67, 17-74, 17-76, 18-6, 18-7, 18-12, 18-27, 18-30, 18-31, 18-33, 18-45, 19-5, 19-18; Gian Berto Vanni/Art Resource, New York: 19-10; Werner Forman Archive, London/Art Resource, New York: page 110 below; Artothek, Munich: 18-69, 18-72; Asian Art Archives, University of Michigan, photo by Dr. Michael Meister University of Pennsylvania: 9-24; Asian Art Archives, University of Michigan: pages 364-65, 9-9, 9-11, 9-20, 9-22, 9-23, pages 820-21, 20-3, 20-4, 20-5, 20-8; Photo Atelier 35 Philipe François, courtesy of the Gilbert and Lila Silverman Fluxus Collection, Detroit: 29-19; James Austin, Cambridge, England: 15-2, 15-27, 16-23; Avery Architectural and Fine Arts Library, Columbia University in the City of New York 16-54; © Dirk Bakker, 1985, Detroit, MI: 20-2; © Dirk Bakker courtesy Detroit Institute of Arts: 13-2, 13-3, 13-4, 13-7; James Balog, Boulder, CO: 24-1; © The Barnes Foundation, Merion, PA: 28-24; Foto Gaetano Barone, Florence: 18-60; Bernard Beaujard, Martignargues, France: 6-24, 16-6; Raffaello Bencini, Florence: 8-6, 8-7; Jacques Bendien, Naples: 6-47; Benrido, Tokyo: 11-6, 11-8, 11-9; Jean Bernard, Aix-en-Provence, France: 16-1, 16-14, 16-29; The Bettmann Archive, New York: 28-57; Dawoud Bey: 29-81; Constantin Beyer, Weimar, Germany: 15-33, 16-58, 16-59, 18-71; Bibliothèque Nationale, Paris: 14-21; Bildarchiv Preussischer Kulturbesitz, Berlin: 2-27, 3-36, 3-37, 3-38, 5-22, 5-32, 5-80, 5-81, 6-62, 6-69, 6-79, 8-5, 17-20, 17-26, 18-40, 18-70, 19-45, 19-69, 19-80, 26-51, 28-25, 28-30; Montserrat Blanch, Arte Gortico en Espagñe, Barcelona, Ediciones Poligrafa, 1972: 16-51; Blaser,

Hannaford & Stucky, Drawings of Great Buildings, Basel, Birkhäuser Verlag AG, © 1993: 15-41 (p. 60 Joseph Weber), 16-13 (p. 80 Alex Sims), 16-18 (p. 82 James McCahon), 16-27 (p. 81 Charles Young), 16-40 (p. 93 Peter Blinn), 16-64 (p. 108 Raymond Krebs), 17-32 (p. 110 Terry Hildebrand), page 701 far left (p. 41 Michael Messerle), page 701 far right (p. 114 George Trandel), 18-36 (p. 119 Christopher Lue), 19-2 (p. 122 Thomas Peterson), 19-65 (pp. 146–47 Robert Musgrove & Andrew Morrall), 19-75 (p. 150 Frank LaMantia), 26-30 (p. 149 John Balas); Jon Blumb, Lawrence, KS: 18; Axel Boëthius and J. B. Ward-Perkins, Etruscan and Roman Architecture, Penguin Books, © 1970, fig. 96: 6-53; Erwin Böhm, Mainz, Germany: 2-5; Boltin Picture Library, Croton-on-Hudson, NY: 5-72; Courtesy The Trustees of The Boston Public Library: 28 58; E. Brandl, Courtesy AIATSIS Pictorial Collection: 24-2; Bridgeman Art Library, London: 29-70; The British Museum London: 5-61; Percy Brown, Indian Architecture, Vol. I, Bombay Taraporevale Sons & Co., 1965 (reprint), plate XIX 9-10; Buffalo and Erie County Historical Society, New York State: 28-62; Martin Bühler, Basel, Switzerland: 18-61, 18-73; Diana Buitron-Oliver, The Greek Miracle, Classical Sculpture from the Dawn of Democracy, the Fifth Century B.C. Washington, National Gallery of Art, © 1992 Board of Trustees, pages 154–55 below: 5-18; Photographie Bulloz, Paris: 15-12, 15-13, 18-52, 26-29, 26-33, 27-9; Barbara Burg/Olivier Schuh: 29-44; Hillel Burger, © President and Fellows of Harvard College: 23-14; © Dr. Brian Byrd, University of California, San Diego and Dr. E. B. Banning University of Toronto, drawn by Jonathan Mabry: 2-1; Caisse Nationale des Monuments Historiques et des Sites, Paris © Arch.Phot.Paris/SPADEM: 1-12, 15-4, 15-7, 15-11, 16-7, 16-10, 16-21, 16-26, 18-50, 19-27, 26-34, 27-6, 27-16 Fotoarchiv Helga Schmidt-Glassner, © Callwey Verlag. Munich: 6-23, 19-68; Calveras/Sagristà, Barcelona: 15-19; Calzolari, Mantua: 17-58; Cambridge University Collection of Air Photographs, copyright reserved, Cambridge, England 15-23; © Cameraphoto-Arte, Venice: 18-1; Canali Photobank Capriolo, Italy: 5-1, 5-13, 5-27, 6-5, 6-16, 6-25, 6-36, 6-38, 6-58, 7-12, 7-13, 7-14, 7-19, 7-20, 7-21, page 319, 15-39, 15-42, 16-65, 16-70, 16-71, 16-73, 16-74, page 607, 17-18, 17-45, 17-49, 17-51, 17-71, 18-38, 18-42, 18-46, 19-13, 19-14, 19-15, 19-16, 19-17, 19-19, 19-20, 26-6, Piero Codato courtesy Canali Photobank, Capriolo, Italy: 16-81, 17-65; Luciano Pedicini courtesy Canali Photobank, Capriolo, Italy: 6-55; © Paul Caponigro: 1-23; Mario Carrieri, Milan: 7-57, 8-18; Casement Collection Photo Library, London: 13-10; Dott. Eugenio Cassin, Florence: 18-10, 18-32; Centre d'Études et Documentation sur l'Art Chrétien Oriental, Estampes, France 7-41; Centro Studi Bragaglia, Rome: 28-51; Samuel Chamberlain, Marblehead, MA: 16-9; Chicago Architectural Photographing Company: 28-59; China Pictorial Publications, Beijing: 10-1; © Jeanne-Claude: 29-60; University of Cincinnati Department of Classics, reproduced by permission of Princeton University Press: 4-25; Éditions Citadelles & Mazenod, Paris: 6-15 Jean Mazenod, Éditions Citadelles & Mazenod, Paris: 2-10; Brenda J. Clay, Lexington, KY: 24-7; Peter Clayton: 3-33; © 1995 The Cleveland Museum of Art: 11-18, page 458 left, 12-7, 21-4, 21-10; Commissariat General au Tourisme, Paris: 26-48; Georg Gerster, Comstock, Inc., New York: 12-3, 12-16; drawing by Stephen Conlin, from Margaret Oliphant, The Atlas of the Ancient World, New York, Simon & Schuster, © 1992, p. 95, courtesy Marshall Editions, London: 4-4; A. C. Cooper, Ltd: 26-31; © Country Life, London: 18-81, 26-10, 26-15; Courtauld Institute of Art, London: page 800; The Conway Library, Courtauld Institute of Art, London: 4-22; Crown copyright reserved: 19-35; Cultural Relics Publishing House, Beijing: 10-3, 10-6, 10-7, 10-8, 10-14, 10-15, 10-16, 10-17; Henry Curtis, Newport, RI: 19-90; Nina M. Davis, Ancient Egyptian Paintings, Volume I, University of Chicago/Oxford University Press, 1936, Plate VII: 3-23; Dawn Gallery, New York: 29-59; © Denver Art Museum, 1994: 23-16; Courtesy Department of the Environment, London: 26-9; © 1995 Detroit Institute of Arts: 19-31, 19-53, 23-12, 26-25; Deutscher Kunstverlag, Munich: 26-50; Deutsches Archäeologisches Institut, Rome: 5-78, 6-12, 6-31, 6-57, 6-86; Deutsches Archäologisches Institut, Athens: 5-14, 5-15, 5-65, 5-77; Laboratoires Photographiques Devos, Boulogne-sur-Mer, France: 5-29; Frank Tomio, Dom- und Diözesanmuseum Hildesheim, Germany: 14-28; © Domkapitel Aachen (Foto Münchow), Aachen, Germany: 14-31; Christos Doumas, *The Wall-Paintings of Thera*, Athens, The Thera Foundation, 1992, page 56: 4-17; Hughes Dubois, Archives Musée Dapper, Paris: 25-15; Hugues Dubois, Brussels/Paris: 13-6; Dumbarton Oaks, Washington, D.C., © Byzantine Visual Resources: 7-47, 7-48, 7-53; Ursula Edelmann, Frankfurt, Germany: 19-81; Nikos Kontos, courtesy Ekdotike Athenon, Athens: 7-28, 7-40;

Peter Aaron, © ESTO, Mamaroneck, NY: 27-2, 29-87; Wavne Andrews, © ESTO, Mamaroneck, NY: 19-89, 28-56, 29-39; Ezra Stoller, © ESTO, Mamaroneck, NY: 28-64; M. Lee Fatherree: 29-89, 29-90; Pierre-Alain Ferrazzini: 25-1, 25-13 25-14; Michael Flinn, courtesy Marylin Rhie: 20-7; Istituto di Storio dell'Arte, Fondazione Giorgio Cini, Venice: 18-34; Fotocielo, Rome: 6-37, 7-33, 19-6; Fototeca Unione, American Academy, Rome: 6-14, 6-28, 6-29, 6-39, 6-49, 6-54, 6-60, 6-65, 6-81; Fotowerkstatte, Cologne, Germany: 14-19; Susan Einstein, Fowler Museum of Cultural History, University of California, Los Angeles: 12-18; French Embassy Press and Information Division, New York: 19-23; Gabinetto Fotografico Nazionale, Florence: page 624, 6-11, 18-20, 18-21, 26-2; Gabinetto Fotografico, Pisa: 16-66; David Gahr, New York: 29-22; Gayle Garrett, Washington, D.C.: page 359; GEKS, New York: 7-25; courtesy George Eastman House, Rochester, NY 27-35; Getty Conservation Institute, Marina del Rey, CA: 3-43, page 124; Photographie Giraudon, Paris: 15-10, 16-30, 19-34 27-4, 27-5; Glasgow School of Art: 28-71; Erwin R. Goodenough, Jewish Symbols in the Greco-Roman Period, Bollingen Series 37, Vol. II: Symbolism in the Dura Synagogue, © 1964, Princeton University Press (photographs by Fred Andregg), reprinted by permission of Princeton University Press: 7-8; Oleg Grabar, The Formation of Islamic Art, New Haven and London, © Yale University Press, 1973, fig. 66: 8-4; The Green Studio Limited, Dublin: 14-8, 14-9; Griffith Institute, Ashmolean Museum, Oxford: 3-1: Gulf International (U.K.) Ltd, London: 8-21; Dr. Reha Günay, Istanbul: 7-51; Bret Gustafson: 29-54; Sonia Halliday Photographs, Weston Turville, Bucks, England: 8-16; Courtesy of Joyce D. Hammond: 24-14; Photo Hassia: 4-7; © 1994 Thomas A. Heinz: 8-63; Michael Heizer: 29-57; Françoise Henry, Irish Art in the Early Christian Period, Ithaca, Cornell University, 1965: 14-10; © 1994 Her Royal Majesty Queen Elizabeth II: 18-78, 19-21, page 929, 26-3; Brian Brake, John Hillelson Agency, London: 6-63; Colorphoto Hinz, Allschwil-Basel, Switzerland: 28-29, 28-46; Hirmer Fotoarchiv, Munich: 9, 2-8, 3-12, 3-13, 3-18, 4-5, 4-6, 4-14, 4-27, 4-28, 5-2, 5-8, 5-11, 5-17, 5-25, 5-34, 5-35, 5-36, 5-44, 5-45, 5-46, 5-49, 5-51, 5-55, 5-63, 5-67, 5-68, 5-82, 6-7, 6-8, 6-9, 7-18, 7-22, 7-23, 7-24, 7-31, pages 544-45, page 554, 16-22, 16-56, 19-70; Ove Holst, Oslo: 14-4; Lorenz Homberber, 1983: 25-17; The Human Figure in Early Greek Art, 1988, Greek Ministry of Culture/National Gallery of Art, Washington, page 58: 5-4; Martin Hürlimann, India: The Landscape, the Monuments and the People, New York, B. Westermann, 1928, fig. 131: 9-21; The Hutchison Library, London: 6-61; The Image Bank, New York: pages 90-91, 3-8 3-10, 3-14, 3-35; (former) Imperial Embassy of Iran, Washington, DC: 8-13; Benoy K. Behl, Bombay, courtesy Indira Gandhi National Centre for the Arts, New Delhi: 9-16, 9-26; IRPA-KIK, Brussels: 17-1, 17-7, 17-8, 17-15, 19-39; Japan National Tourist Organization, NY: 11-10, 22-6; A. J. Wyatt, © Jefferson Medical College, Philadelphia: 27-34; Jesse D. Jennings, *The Prehistory of Polynesia*, Cambridge, Harvard University Press, © 1979, p. 28: 24-4; Bertrand Jestaz, *L'Art de* la Renaissance, Paris, Édition Citadelles & Mazenod, © 1984, p. 474/fig. 608: 18-82; © Wolfgang Kaehler, Bellevue, WA: 10-12, 21-1, 24-5; © Justin Kerr, New York: pages 442-43, 12-8, 12-12, 23-8; A. F. Kersting, London: 8-2, 8-17, 15-26, 19-62, 19-63, 19-64, 19-66, 26-12, 26-14; Frank Khoury: pages 908-09, 25-11; © Kodansha Ltd, Tokyo: 3-2; Herlinde Koelbl, Munich: 19-77; © Studio Kontos, Athens: 4-1, 4-3, 4-8, 4-11, 4-13, 4-15, 4-16, 4-19, 4-26, 4-29, 5-21, 5-23, 5-24, 5-37, 5-42 5-69; © Estate of Tseng Kwon Chi: 29-71; Laboratoire Photographique Blow Up, Dijon, France: 15-22; Kurt Lange, Oberstdorf/Allgäu, Germany: 3-4; Michael Larvey, Austin, TX: 6-21, 6-27, 6-33, 6-45, 6-68; Lautman Photography, Washington, D.C.: 26-57; Fanny Broadcast, Liason International, New York: 1-1; Library of Congress, Washington, D.C.: 26-59; © Tony Linck, Fort Lee, NJ: 12-1; James Linders, Rotterdam: 28-82; © 1993 Museum Associates, Los Angeles County Museum of Art. All Rights Reserved: 22-14; H. Maartens, Bruges: 17-16, 17-17; Magnum Photo, New York: 29-46; Marg, Vol. XVII, No. 1, Dec. 1963, plate 1, p. 58: 20-10; Gene Markowski: 9-8; Arxiu MAS, Barcelona: 1-16, 8-11, 8-22, 16-47, 16-48, 16-49, 18-85; Arxiu MAS, Barcelona, © Museo del Prado: 18-55, 18-56; Arxiu MAS, Barcelona, © Patrimonio Nacional, Madrid: 16-49, 18-83, 18-84; Mauritshuis, The Hague: 19-59; Junkichi Mayuyama, Tokyo: 11-5; Dona Ann McAdams, New York: 29-84; Robert R. McElroy: 29-28; © Rollie McKenna, Stonington, CT: 17-57, 18-35; All rights reserved, The Metropolitan Museum of Art: 2-13, 3-32, 5-6, 5-20, 5-56, 5-84, 5-85, 6-35, 6-75, 16-38, 17-79, 18-66, 19-78, 19-85, 24-6, 27-10, 27-26, 27-36, 27-42, page 1008, 28-100, 28-110; Copyright © By The Metropolitan Museum of Art: 3-20 (1993), 3-25 (1983), 3-26 (1983), 3-42

(1978), 5-5 (1978), 5-7 (1985), 5-31 (1986), 5-73 (1990), 5-74 (1993), 6-1 (1986), 6-34 (1986), 8-1 (1994), 8-14 (1982), 8-27 (1986), 12-2 (1990), 12-9 (1990), 14-13 (1994), 14-27 (1986), 15-15 (1982), 16-37 (1985), 16-45 (1981), 16-46 (1981), 17-5 (1981), 17-6 (1981), 17-14 (1993), 17-23 (1988), page 744 below (1991), 18-86 (1980), 26-26 (1979), 26-36 (1980), 26-69 (1986), 26-70 (1992), 27-32 (1985), 27-46 (1984), 27-56 (1980), 28-15 (1978), 28-33 (1986), 29-10 (1978); Schecter Lee, copyright © 1986 By The Metropolitan Museum of Art: 13-8: Stephen S. Meyers: 23-17: Kazimierz Michalowski, Art of Ancient Egypt, Paris, Éditions d'Art Lucien Mazenod/New York, Harry N. Abrams, Inc., fig. 476: 3-41; Jacques Michot, Lusigny-sur-Oche, France: 17-12; Ministry of Culture/ Archaeological Receipts Fund (TAP Service), Athens: pages 126-27, 4-10, 4-18, 5-53; Ministry of Public Buildings and Works, Edinburgh. Crown Copyright Reserved: 1-18; Monumenti Musei e Gallerie Pontificie, Vatican City (Rome): 5-64, 5-66, 5-83, pages 220-21, 6-13, 6-30, 6-70, 18-14; William N. Morgan, Prehistoric Architecture in Micronesia, Austin, University of Texas Press, © 1988, p. 61: 24-8; Roger Moss, Cornwall, England: 16-12, 18-48; The Mount Vernon Ladies' Association: 26-55, 26-56; Erich Müller, Kassel, Germany: 19-74; Foto Ann Münchow, Aachen, Germany: 14-17; Peter Murray, Architecture of the Renaissance, Milan, Electa Editrice, © 1971/New York, Harry N. Abrams, Inc., p. 26: 17-31; Photothèque des Musées de la ville de Paris: 28-8; Courtesy The Museum of Modern Art. New York: 28-68, 28-86; Joan Myers, Tesugue, NM: 17; © 1995 Board of Trustees, National Gallery of Art, Washington: 5, 17-13, 18-5, 18-29, 19-28, 19-30, 19-47 19-50, 19-52, 19-83, 26-19, 26-44; Sisse Brimberg, National Geographic Society Image Collection, Washington, D.C.: 1-6, 1-9, 1-11; National Monuments Record Center, Swindon, England: 16-43, 26-16: National Museum, Copenhagen: 1-28: National Park Service, U.S. Department of the Interior, Washington, D.C.: 12-22, 27-30; © The Nelson Gallery Foundation. All Reproduction Rights Reserved: 18-80, 26-4; Jim Frank, © Neuberger Museum, State University of New York at Purchase: 29-16: Sarah Wells, © 1989 The Newark Museum: 28-120: The New-York Historical Society: 28-61; Edward Nausner, The New York Times Pictures: 29-86; Maggie Nimkin, New York, Courtesy of Anthony Slayter-Ralph/US Representative: 25-19; Nippon Television Network Corporation, Tokyo: 18-15, 18-16, 18-17, page 696 left, page 696 right: Kevin Noble, New York: 28-115; Archive Jean-Louis Nou, Paris: 9-2, 9-3, 9-6, 9-17; OBB Verlag Bornschlegel, Saffelstein, Germany: 19-76; Office of Public Works, Dublin: 1-19; Takashi Okamura, Rome: 17-38; Courtesy The Oriental Institute, The University of Chicago: 2-9, 2-22, 2-32, 2-34, Oroñoz, Madrid: 14-14, 16-50, 19-42, 19-44, 26-53, 26-54; Oroñoz, Madrid, © Museo del Prado: 18-11, 18-79, pages 748-49; Palace Museum, Beijing/Wan-go Weng Inc. Archive: 21-8; K. Papaioannou, The Art of Greece, New York, Harry N. Abrams, Inc., 1989/Éditions Mazenod, Paris, 1972, pages 400-01 above: 5-43; Douglas M. Parker Studio, Los Angeles: 29-12, 29-93: André Parrot, Sumer, The Dawn of Art, New York, Golden Press, 1961, fig. 346: 2-19, 2-20; Ben Patnoi: 24-10; Copyright Patrimonio Nacional, Madrid: 18-84 Phillips/Schwab Studio, New York: 29-72; The Pierpont Morgan Library, New York: 15-36; Pinacoteca di Brera, Milan: 18-2; Donato Pineider, Florence: 7-38; 7-39; Nicholas Platon, Zakros: The Discovery of a Lost Palace of Ancient Crete, New York, Charles Scribner's Sons, 1971, page 46 below: 4-12; Eric Pollitzer: 29-18; Pontificia Commissione di Archeologia Sacra, Rome: 7-2, 7-3, 7-4, 7-5, 7-6; Antonio Quattrone, Florence, Courtesy of Olivetti: 17-47, 17-48; Studio Mario Quattrone, Florence: 16-77, 16-78, 17-41, 17-46, 17-68, 18-39; Archivio e Studio Folco Quilici, Rome: 6-6, 15-38, 16-62; Stephen Quirke and Carol Andrews, The Rosetta Stone, Facsimile Drawing with an Introduction and Translation, New York, Harry N. Abrams, Inc., 1989, © 1988 The Trustees of the British Museum: page 113 above; Fotostudio Rapuzzi, Brescia, Italy: 6-80; Gerhard Reinhold, Leipzig, Germany: 27-20; Studio R. Remy, Dijon, France: 17-4; A. Renger-Patzsch: 28-73; © Réunion des Musées Nationaux, Paris: 1-7, 1-15, 2-16, 2-17, 2-18, 2-29, 2-30, 2-35, 3-17, pages 150-51, 5-48, 5-86, 6-26, 7-56, 8-9, 8-10, 16-32, 17-53, 17-72, 18-4, 18-47, 18-54, 18-64, 19-1, 19-40, 19-43, 19-79, 19-82, 26-37, 26-38, 26-40, 26-41, 26-42, 26-43, 26-45, 26-46, 26-47, 26-49, pages 976-77, 27-18, 27-19, page 1006, 27-43, page 1008 top, 27-47, 28-34, 28-44, page 1111 top right; Rheinisches Bildarchiv, Cologne, Germany: 14-30, 16-60; Rheinisches Landesmuseum Trier, Germany: 6-83; Merle Greene Robertson © 1976: 12-10; Roger-Viollet, Paris: 28-80; photo by Peter Dorrell and Stuart Laidlaw, courtesy University of London, Institute of Archaeology, © Dr. Gary Rollefson, 'Ain Ghazal Research Institute, Ober-Ramstadt, Germany: 2-2; Jean Roubier, Paris

15-14, 16-19; © Christopher Roy, Iowa City, IA: 25-4; Royal Smeets Offset, Amsterdam: 9-1; S.A.D.E. (Surrealism and Dada, Even) Archives, Milan: 28-90; Sakamoto Manschichi Photo Research Library, Tokyo: 11-11, 11-14, 22-7, 22-8, 22-12; Peter Sanders Photography, Chesham, Bucks, England: pages 336-37, 8-12; reconstruction drawing by J.v. Schaubild, Der heilige Bezirk von Delphi, published 1913: 5-3; Dr. Schliemann's Houses and Magazine/Plan of Troy and Hellspont, Plate X, page 287: page 143; Toni Schneiders, Lindau, Germany: 18-74; Joseph Seagram Company: 29-37; Susan Dirk, © Seattle Art Museum: 24; Courtesy Shozo Shimamoto: 29-20; © Harry Shunk, New York: 29-21; Lawrence Shustack: 29-1; Smithsonian Institution Libraries, Washington, D.C.: 23-15: Ann Pearce, Heroic Bronzes of Fifth Century B.C. Regain Old Splendor, Smithsonian Magazine, Volume 12, No. 8, November 1981, page 130 top left: page 182; David Heald, © Solomon R. Guggenheim Museum: 28-40, 29-30; Soprintendenza ai Beni Artistici e Storici di Venezia, Venice: page 698; Soprintendenza Archeologica all'Etruria Meridionale, Tarquinia, Italy: 6-10; Sovfoto/Eastfoto. New York: 7-61; Spectrum Colour Library, London: 4-24, page 943 below; Ulli Steltzer, Vancouver, Canada: 23-18; George Stewart, National Geographic Society: 23-3; Dr. Franz Stoedtner, Dusseldorf, Germany: 5-16; Tim Street-Porter: 29-45: William Struhs: 29-83: Wim Swaan, New York: 2-28, 3-9, 3-31, pages 286-87, 7-27, 7-52, 12-6, 12-13, 15-9, 16-11, 16-16, 16-24, 16-25, 16-28, 16-39, 17-3, 19-24, 19-32, 20-1, pages 872-73; 23-6, 23-7; © Jean Clottes, SYGMA, New York: Joseph Szasfazi: 19-93; John Bigelow Taylor, New York: 12-14, 23-9; Thames & Hudson Ltd, London: 28-88; A. Hamilton Thompson, Military Architecture in England During the Middle Ages, Oxford University Press, 1912, page 199: 15-24; Barry Iverson, Time Magazine, (Time Picture Syndication, New York): pages 60-61, 2-25; Time Picture Syndication, New York: 3; © 1974 Caroline Tisdall, courtesy Ronald Feldman Fine Arts, New York: 29-69; Richard Todd Los Angeles: 9-7, 9-12, 9-14, 9-27; Enrique Franco Torriios. La Herradura, Mexico: 12-4, 23-4, 23-5, 23-10; Marvin Trachtenberg, New York: 5-75, 7-44, 16-4, 16-5, 28-67, 29-38; Paulus Leeser, © Vassar College: 29-17; Jean Vertut Archive, Issy-les-Moulineaux, France: 3-21, 3-30; Gemeinnützige Stiftung Leonard von Matt, Buochs, Switzerland: 6-48, 15-1. 15-8. 18-24: Joseph Szaszfai, @ Wadsworth Atheneum: 28-87; courtesy Walker Art Center, Minneapolis: 29-36; Jonathan Wallen: 28-99; Clarence Ward, Oberlin, OH: 16-17, 16-20; Yoshio Watanabe, Tokyo: 11-1; John Webb: 28-95; Fred Scruton, courtesy John Weber Gallery, New York: 29-77; Archille Weider, Zurich: 1-8; Etienne Weill, Paris: 29-43; Kit Weiss, Copenhagen: 14-2; Whitaker Studio, Richmond, VA: 26-35; Geoffrey Clements, © Whitney Museum of American Art: 28-113, 28-114, 29-61, 29-73; Sheldon C. Collins, © Whitney Museum of American Art: 28-106: Tadasu Yamamoto, Tokyo: 22-17; Michael Yamashite, Mendham, New Jersey: 22-5: Photo YAN (Jean Dieuzaide), Toulouse, France: 1-13; (former) Yugoslav State Tourist Office, New York: 6-74; Zefa Pictures, London: 5-59; O. Zimmerman, Colmar, Germany: 18-63; Zodiaque, La Pierre-Qui-Vire, France: 14-6, 14-11, 14-12; Foto Zwicker-Berberich, Gerchsheim/Würzburg, Germany: 19-72, 19-73.

Illustration Copyrights

Copyright © Blaser, Hannaford & Stucky, Drawings of Great Buildings, Basel, Birkhäuser Verlag AG © 1983: 15-41, 16-13, 16-18, 16-27, 16-40, 16-64, 17-32, 18-36, page 701 far left, page 701 third from left, 19-2, 19-65, 19-75, 26-30; reconstruction by Geoffrey Waywell and Brian Cooke copyright © The British Museum, London, drawn by Susan Bird: 5-61; copyright © Dr. Brian Byrd, University of California, San Diego, and Dr. E. B. Banning, University of Toronto, drawn by Jonathan Mabry: 2-1; Betrand Jestaz, L'Art de la Renaissance, Édition Citadelles & Mazenod, © Édition, Paris 1984: 18-82; Peter Murray, Architecture of the Renaissance, Milan, Electa Editrice, © 1971/New York, Harry N. Abrams, Inc.: 17-31; Blegen and Rawson, The Palace of Nestor at Pylos, Vol. I, copyright © 1966 Princeton University Press. Reprinted/ reproduced by permission of Princeton University Press: 4-25; © 1976 Staatliche Antikensammlungen und Glyptothek, Munich: 5-18; calligraphy by Paulo Suzuki: page 434: Oleg Grabar, The Formation of Islamic Art, New Haven and London, © Yale University Press, 1973, fig. 66: 8-4.

Artist Copyrights

Copyright © 1972 Estate of Diane Arbus: 29-48; © 1995 Estate of Robert Arneson: 29-89; © 1995 ARS, New York: 28-97;

© 1995 ARS New York/ADAGP Paris: pages 1020-21 28-1 28-10, 28-21, 28-22, 28-31, 28-38, 28-40, 28-41, 28-46, 28-52, 28-53, 28-92, 28-94, 28-96, 29-3, 29-4; © 1995 ARS, New York/Demart Pro Arte, Geneva: 28-93; © 1995 ARS, New York/SPADEM, Paris: 25, 27-44, 27-45, 28-9, 28-34, 28-35, 28-36, 28-37, 28-42, 28-43, 28-44, 28-75, 28-83, 28-84, 28-95; © 1995 ARS, New York/V.G. Bild-Kunst, Bonn: 28-25, 28-30, 28-33, 28-89, 28-91, 29-55; © Estate of Jean-Michel Basquiat: 29-72; © Paul Caponigro: 1-23; © Cartier-Bresson/Magnum, New York: 29-46; © 1995 Estate of Mary Cassatt/ARS, New York/ADGAP, Paris: 27-55; © Judy Chicago: 29-62; © 1976 Christo: 29-60; © 1995 The Conservators of Willem de Kooning/ARS, New York: 29-11: @ 1995 Estate of James Ensor/VAGA, New York/SABAM, Brussels: 28-18; © 1995 Richard Estes/VAGA, New York: 29-52; © Helen Frankenthaler: 29-15; © 1995 Estate of Arshile Gorky/ARS, New York: 29-6; © Peter Halley: 29-75; © 1995 Richard Hamilton/VAGA, New York: 29-26: @ Estate of Erich Heckel: 28-26: @ Michael Heizer: 29-57: @ 1995 Estate of Eva Hesse: 29-35: @ 1980 Luis Jimenez: 16; © 1995 Jasper Johns/VAGA, New York: 29-24; © Estate of Donald Judd: 29-33; © 1995 Jacob Lawrence/VAGA, New York: 28-116; © Roy Lichtenstein: 29-27; © The Robert Mapplethorpe Foundation: 29-85; © 1995 Estate of Georges Mathieu: 29-5; @ 1995 Succession H. Matisse, Paris/ARS New York: 28-23, 28-24: © Estate of Ana Mendieta: 29-64; © Joan Myers: 17; © Estate of Hans Namuth, New York: 29-9; © 1995 Bruce Nauman/ARS, New York: 29-36; © Estate of Alice Neel: 29-61; © Annalee Newmann: 29-13; © 1995 The Georgia O'Keeffe Foundation/ARS, New York: 28-11: @ 1995 The Georgia O'Keeffe Foundation/ Spencer Museum of Art/ARS, New York: 12; © Claes Oldenburg: 29-28; © 1995 Pollock-Krasner Foundation/ARS, New York: 28-121, 29-8, 29-10; © 1995 Robert Rauschenberg/VAGA, New York: 29-23; © 1995 Kate Rothko-Prizel & Christopher Rothko/ARS, New York: 29-7, 29-12; © 1995 David Salle/VAGA, New York: 29-65; © Miriam Schapiro: 29-63; © 1995 George Segal/VAGA, New York: 29-18; © 1995 Estate of David Smith/VAGA, New York: 29-14; © Estate of David Smith/VAGA, New York: 29-32; © 1995 Frank Stella/ARS, New York: 29-31; Margaret Bourke-White, LIFE Magazine © Time, Inc.: 3, 4; © James Turrell: 29-34; © 1995 VAGA, New York/Beeldrecht, Amsterdam: 28-81; © 1995 The Estate & Foundation of Andy Warhol: 29-29; © William Wegman: 29-56.

Text Credits

Reprinted from Magda Bogin, The Women Troubadours, New York, W.W. Norton & Company, Inc., 1980. Copyright © Magda Bogin: page 549; Selected excerpt from The Essential Tao: An Initiation into the Heart of Taoism through the Authentic Tao Te Ching and the Inner Teachings of Chuang Tzu, translated by Thomas Cleary. Copyright © 1991 by Thomas Cleary. Reprinted by permission of HarperCollins Publishers, Inc.: page 404; Reprinted from Eight Dynasties of Chinese Painting: The Collections of the Nelson Gallery-Atkins Museum, Kansas City and Cleveland Museum of Art: Cleveland Museum of Art & Indiana University Press. 1980: page 846: From Love Song of the Dark Lord by Barbara Stoller Miller. Copyright © 1977 by Columbia University Press. Reprinted by permission of the publisher: page 830; Scripture selections are taken from the New American Bible © 1991, 1986, 1970 Confraternity of Christian Doctrine, Washington, D.C. Used with permission: pages 322, 327, 487, 496-497, 525, 580, 595, 633, 636, 657, 680, 681, 696; Reproduced by permission of The Georgia O'Keeffe Foundation/ARS, New York: page 22; Buddhacharita, or Acts of the Buddha, translated by E. H. Johnston, published by permission of Munshiram Manoharlal Publishers Pvt. Ltd., New Delhi: page 381; From Life of the Ancient Egyptians, by Eugen Strouhal. Copyright © 1992 by Opus Publishing Limited. Text @ 1989, 1992 by Eugen Strouhal Reprinted with permission of Opus Publishing Limited and University of Oklahoma Press: page 107; Earl Miner, Hiroko Odagiri, and Robert E. Morrell, The Princeton Companion to Classical Japanese Literature. Copyright © 1989 by Princeton University Press. Reprinted by permission of Princeton University Press: page 434; Indira Vishvanathan Peterson, translator, Poems to Shiva: The Hymns of the Tamil Saints, copyright © 1989 by Princeton University Press. Reprinted by permission of Princeton University Press: page 393; Miriam Lichtheim, Ancient Egyptian Literature, Vol. I, copyright © 1973 The Regents of the University of California by arrangement with the University of California Press, Berkeley: page 125; Diane Wolkstein and S. N. Kramer, Inanna Queen of Heaven and Earth/Her Stories and Hymns from Sumer, New York, HarperCollins, 1983, p. 14: page 67.